D1254535

The Dictionary of Art · volume twelve

The Dictionary of Art

12

Gairard
TO
Goodhue

GROVE

The Dictionary of Art

edited by JANE TURNER, in thirty-four volumes, 1996

Reprinted with minor corrections, 1998, 2002

This edition is distributed within the United Kingdom and Europe
by Macmillan Publishers Limited, London, and within the United States and Canada by
Grove's Dictionaries Inc., New York.

Text keyboarded by Wearset Limited, Sunderland, England
Database management by Pindar plc, York, England
Imagesetting by William Clowes Limited, Suffolk, England
Printed and bound by China Translation and Printing Services Ltd, Hong Kong

British Library Cataloguing in Publication Data

The dictionary of art
 1. Art - Dictionaries 2. Art - History -
 Dictionaries
I. Turner, Jane
703

ISBN 1-884446-00-0

Library of Congress Cataloging in Publication Data

The dictionary of art / editor, Jane Turner.
 p. cm.
 Includes bibliographical references and index.
 Contents: 1. A to Anckerman
 ISBN 1-884446-00-0 (alk. paper)
 1. Art—Encyclopedias.
 I. Turner, Jane, 1956–
N31.D5 1996 96–13628
 703—dc20 CIP

Contents

List of Colour Illustrations

General Abbreviations

The abbreviations employed throughout this dictionary, most of which are listed below, do not vary, except for capitalization, regardless of the context in which they are used, including bibliographical citations and for locations of works of art. The principle used to arrive at these abbreviations is that their full form should be easily deducible, and for this reason acronyms have generally been avoided (e.g. Los Angeles Co. Mus. A. instead of LACMA). The same abbreviation is adopted for cognate forms in foreign languages and in most cases for plural and adjectival forms (e.g. A.= Art, Arts, Arte, Arti etc). Not all related forms are listed below. Occasionally, if a name, for instance of an artists' group or exhibiting society, is repeated within the text of one article, it is cited in an abbreviated form after its first mention in full (e.g. The Pre-Raphaelite Brotherhood (PRB) was founded...); the same is true of archaeological periods and eras, which are abbreviated to initial letters in small capitals (e.g. In the Early Minoan (EM) period...). Such abbreviations do not appear in this list. For the reader's convenience, separate full lists of abbreviations for locations, periodical titles and standard reference books and series are included as Appendices A–C in vol. 33.

A.	Art, Arts	Anthropol.	Anthropology	Azerbaij.	Azerbaijani
A.C.	Arts Council	Antiqua.	Antiquarian, Antiquaries	B.	Bartsch [catalogue of Old Master prints]
Acad.	Academy	app.	appendix		
AD	Anno Domini	approx.	approximately	*b*	born
Add.	Additional, Addendum	AR	Arkansas (USA)	BA	Bachelor of Arts
addn	addition	ARA	Associate of the Royal Academy	Balt.	Baltic
Admin.	Administration			*bapt*	baptized
Adv.	Advances, Advanced	Arab.	Arabic	BArch	Bachelor of Architecture
Aesth.	Aesthetic(s)	Archaeol.	Archaeology	Bart	Baronet
Afr.	African	Archit.	Architecture, Architectural	Bask.	Basketry
Afrik.	Afrikaans, Afrikaner	Archv, Archvs	Archive(s)	BBC	British Broadcasting Corporation
A.G.	Art Gallery	Arg.	Argentine	BC	Before Christ
Agrar.	Agrarian	ARHA	Associate of the Royal Hibernian Academy	BC	British Columbia (Canada)
Agric.	Agriculture			BE	Buddhist era
Agron.	Agronomy	ARIBA	Associate of the Royal Institute of British Architects	Beds	Bedfordshire (GB)
Agy	Agency			Behav.	Behavioural
AH	Anno Hegirae	Armen.	Armenian	Belarus.	Belarusian
A. Inst.	Art Institute	ARSA	Associate of the Royal Scottish Academy	Belg.	Belgian
AK	Alaska (USA)			Berks	Berkshire (GB)
AL	Alabama (USA)	Asiat.	Asiatic	Berwicks	Berwickshire (GB; old)
Alb.	Albanian	Assist.	Assistance	BFA	Bachelor of Fine Arts
Alg.	Algerian	Assoc.	Association	Bibl.	Bible, Biblical
Alta	Alberta (Canada)	Astron.	Astronomy	Bibliog.	Bibliography, Bibliographical
Altern.	Alternative	AT&T	American Telephone & Telegraph Company	Biblioph.	Bibliophile
a.m.	ante meridiem [before noon]			Biog.	Biography, Biographical
Amat.	Amateur	attrib.	attribution, attributed to	Biol.	Biology, Biological
Amer.	American	Aug	August	bk, bks	book(s)
An.	Annals	Aust.	Austrian	Bkbinder	Bookbinder
Anatol.	Anatolian	Austral.	Australian	Bklore	Booklore
Anc.	Ancient	Auth.	Author(s)	Bkshop	Bookshop
Annu.	Annual	Auton.	Autonomous	BL	British Library
Anon.	Anonymous(ly)	Aux.	Auxiliary	Bld	Build
Ant.	Antique	Ave.	Avenue	Bldg	Building
Anthol.	Anthology	AZ	Arizona (USA)		

Bldr	Builder	Chin.	Chinese	Cur.	Curator, Curatorial, Curatorship
BLitt	Bachelor of Letters/Literature	Christ.	Christian, Christianity	Curr.	Current(s)
BM	British Museum	Chron.	Chronicle	CVO	Commander of the [Royal] Victorian Order
Boh.	Bohemian	Cie	Compagnie [French]		
Boliv.	Bolivian	Cinema.	Cinematography	Cyclad.	Cycladic
Botan.	Botany, Botanical	Circ.	Circle	Cyp.	Cypriot
BP	Before present (1950)	Civ.	Civil, Civic	Czech.	Czechoslovak
Braz.	Brazilian	Civiliz.	Civilization(s)	$	dollars
BRD	Bundesrepublik Deutschland [Federal Republic of Germany (West Germany)]	Class.	Classic, Classical	*d*	died
		Clin.	Clinical	d.	denarius, denarii [penny, pence]
		CO	Colorado (USA)		
Brecons	Breconshire (GB; old)	Co.	Company; County	Dalmat.	Dalmatian
Brez.	Brezonek [lang. of Brittany]	Cod.	Codex, Codices	Dan.	Danish
Brit.	British	Col., Cols	Collection(s); Column(s)	DBE	Dame Commander of the Order of the British Empire
Bros	Brothers	Coll.	College		
BSc	Bachelor of Science	collab.	in collaboration with, collaborated, collaborative	DC	District of Columbia (USA)
Bucks	Buckinghamshire (GB)			DDR	Deutsche Demokratische Republik [German Democratic Republic (East Germany)]
Bulg.	Bulgarian	Collct.	Collecting		
Bull.	Bulletin	Colloq.	Colloquies		
bur	buried	Colomb.	Colombian	DE	Delaware (USA)
Burm.	Burmese	Colon.	Colonies, Colonial	Dec	December
Byz.	Byzantine	Colr	Collector	Dec.	Decorative
C	Celsius	Comm.	Commission; Community	ded.	dedication, dedicated to
C.	Century	Commerc.	Commercial	Democ.	Democracy, Democratic
c.	*circa* [about]	Communic.	Communications	Demog.	Demography, Demographic
CA	California	Comp.	Comparative; compiled by, compiler	Denbs	Denbighshire (GB; old)
Cab.	Cabinet			dep.	deposited at
Caerns	Caernarvonshire (GB; old)	Concent.	Concentration	Dept	Department
C.A.G.	City Art Gallery	Concr.	Concrete	Dept.	Departmental, Departments
Cal.	Calendar	Confed.	Confederation	Derbys	Derbyshire (GB)
Callig.	Calligraphy	Confer.	Conference	Des.	Design
Cam.	Camera	Congol.	Congolese	destr.	destroyed
Cambs	Cambridgeshire (GB)	Congr.	Congress	Dev.	Development
can	canonized	Conserv.	Conservation; Conservatory	Devon	Devonshire (GB)
Can.	Canadian	Constr.	Construction(al)	Dial.	Dialogue
Cant.	Canton(s), Cantonal	cont.	continued	diam.	diameter
Capt.	Captain	Contemp.	Contemporary	Diff.	Diffusion
Cards	Cardiganshire (GB; old)	Contrib.	Contributions, Contributor(s)	Dig.	Digest
Carib.	Caribbean	Convalesc.	Convalescence	Dip. Eng.	Diploma in Engineering
Carms	Carmarthenshire (GB; old)	Convent.	Convention	Dir.	Direction, Directed
Cartog.	Cartography	Coop.	Cooperation	Directrt	Directorate
Cat.	Catalan	Coord.	Coordination	Disc.	Discussion
cat.	catalogue	Copt.	Coptic	diss.	dissertation
Cath.	Catholic	Corp.	Corporation, Corpus	Distr.	District
CBE	Commander of the Order of the British Empire	Corr.	Correspondence	Div.	Division
		Cors.	Corsican	DLitt	Doctor of Letters/Literature
Celeb.	Celebration	Cost.	Costume	DM	Deutsche Mark
Celt.	Celtic	Cret.	Cretan	Doc.	Document(s)
Cent.	Centre, Central	Crim.	Criminal	Doss.	Dossier
Centen.	Centennial	Crit.	Critical, Criticism	DPhil	Doctor of Philosophy
Cer.	Ceramic	Croat.	Croatian	Dr	Doctor
cf.	confer [compare]	CT	Connecticut (USA)	Drg, Drgs	Drawing(s)
Chap., Chaps	Chapter(s)	Cttee	Committee	DSc	Doctor of Science/Historical Sciences
Chem.	Chemistry	Cub.	Cuban		
Ches	Cheshire (GB)	Cult.	Cultural, Culture	Dut.	Dutch
Chil.	Chilean	Cumb.	Cumberland (GB; old)	Dwell.	Dwelling
				E.	East(ern)

| | | | | | | |
|---|---|---|---|---|---|
| EC | European (Economic) Community | figs | figures | Heb. | Hebrew |
| Eccles. | Ecclesiastical | Filip. | Filipina(s), Filipino(s) | Hell. | Hellenic |
| Econ. | Economic, Economies | Fin. | Finnish | Her. | Heritage |
| Ecuad. | Ecuadorean | FL | Florida (USA) | Herald. | Heraldry, Heraldic |
| ed. | editor, edited (by) | *fl* | *floruit* [he/she flourished] | Hereford & Worcs | Hereford & Worcester (GB) |
| edn | edition | Flem. | Flemish | Herts | Hertfordshire (GB) |
| eds | editors | Flints | Flintshire (GB; old) | HI | Hawaii (USA) |
| Educ. | Education | Flk | Folk | Hib. | Hibernia |
| e.g. | *exempli gratia* [for example] | Flklore | Folklore | Hisp. | Hispanic |
| Egyp. | Egyptian | fol., fols | folio(s) | Hist. | History, Historical |
| Elem. | Element(s), Elementary | Found. | Foundation | HMS | His/Her Majesty's Ship |
| Emp. | Empirical | Fr. | French | Hon. | Honorary, Honourable |
| Emul. | Emulation | frag. | fragment | Horiz. | Horizon |
| Enc. | Encyclopedia | Fri. | Friday | Hort. | Horticulture |
| Encour. | Encouragement | FRIBA | Fellow of the Royal Institute of British Architects | Hosp. | Hospital(s) |
| Eng. | English | FRS | Fellow of the Royal Society, London | HRH | His/Her Royal Highness |
| Engin. | Engineer, Engineering | | | Human. | Humanities, Humanism |
| Engr., Engrs | Engraving(s) | ft | foot, feet | Hung. | Hungarian |
| | | Furn. | Furniture | Hunts | Huntingdonshire (GB; old) |
| Envmt | Environment | Futur. | Futurist, Futurism | IA | Iowa |
| Epig. | Epigraphy | g | gram(s) | ibid. | *ibidem* [in the same place] |
| Episc. | Episcopal | GA | Georgia (USA) | ICA | Institute of Contemporary Arts |
| Esp. | Especially | Gael. | Gaelic | | |
| Ess. | Essays | Gal., Gals | Gallery, Galleries | Ice. | Icelandic |
| est. | established | Gaz. | Gazette | Iconog. | Iconography |
| etc | *etcetera* [and so on] | GB | Great Britain | Iconol. | Iconology |
| Ethnog. | Ethnography | Gdn, Gdns | Garden(s) | ID | Idaho (USA) |
| Ethnol. | Ethnology | Gdnr(s) | Gardener(s) | i.e. | *id est* [that is] |
| Etrus. | Etruscan | Gen. | General | IL | Illinois (USA) |
| Eur. | European | Geneal. | Genealogy, Genealogist | Illum. | Illumination |
| Evangel. | Evangelical | Gent. | Gentleman, Gentlemen | illus. | illustrated, illustration |
| Exam. | Examination | Geog. | Geography | Imp. | Imperial |
| Excav. | Excavation, Excavated | Geol. | Geology | IN | Indiana (USA) |
| Exch. | Exchange | Geom. | Geometry | in., ins | inch(es) |
| Excurs. | Excursion | Georg. | Georgian | Inc. | Incorporated |
| exh. | exhibition | Geosci. | Geoscience | inc. | incomplete |
| Exp. | Exposition | Ger. | German, Germanic | incl. | includes, including, inclusive |
| Expermntl | Experimental | G.I. | Government/General Issue (USA) | Incorp. | Incorporation |
| Explor. | Exploration | | | Ind. | Indian |
| Expn | Expansion | Glams | Glamorganshire (GB; old) | Indep. | Independent |
| Ext. | External | Glos | Gloucestershire (GB) | Indig. | Indigenous |
| Extn | Extension | Govt | Government | Indol. | Indology |
| f, ff | following page, following pages | Gr. | Greek | Indon. | Indonesian |
| | | Grad. | Graduate | Indust. | Industrial |
| F.A. | Fine Art(s) | Graph. | Graphic | Inf. | Information |
| Fac. | Faculty | Green. | Greenlandic | Inq. | Inquiry |
| facs. | facsimile | Gr.-Roman | Greco-Roman | Inscr. | Inscribed, Inscription |
| Fam. | Family | Gt | Great | Inst. | Institute(s) |
| fasc. | fascicle | Gtr | Greater | Inst. A. | Institute of Art |
| *fd* | feastday (of a saint) | Guat. | Guatemalan | Instr. | Instrument, Instrumental |
| Feb | February | Gym. | Gymnasium | Int. | International |
| Fed. | Federation, Federal | h. | height | Intell. | Intelligence |
| Fem. | Feminist | ha | hectare | Inter. | Interior(s), Internal |
| Fest. | Festival | Hait. | Haitian | Interdiscip. | Interdisciplinary |
| fig. | figure (illustration) | Hants | Hampshire (GB) | intro. | introduced by, introduction |
| Fig. | Figurative | Hb. | Handbook | inv. | inventory |

Inven.	Invention	m	metre(s)	Moldov.	Moldovan
Invest.	Investigation(s)	m.	married	MOMA	Museum of Modern Art
Iran.	Iranian	M.	Monsieur	Mon.	Monday
irreg.	irregular(ly)	MA	Master of Arts; Massachusetts (USA)	Mongol.	Mongolian
Islam.	Islamic			Mons	Monmouthshire (GB; old)
Isr.	Israeli	Mag.	Magazine	Montgoms	Montgomeryshire (GB; old)
It.	Italian	Maint.	Maintenance	Mor.	Moral
J.	Journal	Malay.	Malaysian	Morav.	Moravian
Jam.	Jamaican	Man.	Manitoba (Canada); Manual	Moroc.	Moroccan
Jan	January	Manuf.	Manufactures	Movt	Movement
Jap.	Japanese	Mar.	Marine, Maritime	MP	Member of Parliament
Jav.	Javanese	Mason.	Masonic	MPhil	Master of Philosophy
Jew.	Jewish	Mat.	Material(s)	MS	Mississippi (USA)
Jewel.	Jewellery	Math.	Mathematic	MS., MSS	manuscript(s)
Jord.	Jordanian	MBE	Member of the Order of the British Empire	MSc	Master of Science
jr	junior			MT	Montana (USA)
Juris.	Jurisdiction	MD	Doctor of Medicine; Maryland (USA)	Mt	Mount
KBE	Knight Commander of the Order of the British Empire			Mthly	Monthly
		ME	Maine (USA)	Mun.	Municipal
KCVO	Knight Commander of the Royal Victorian Order	Mech.	Mechanical	Mus.	Museum(s)
		Med.	Medieval; Medium, Media	Mus. A.	Museum of Art
kg	kilogram(s)	Medic.	Medical, Medicine	Mus. F.A.	Museum of Fine Art(s)
kHz	kilohertz	Medit.	Mediterranean	Music.	Musicology
km	kilometre(s)	Mem.	Memorial(s); Memoir(s)	N.	North(ern); National
Knowl.	Knowledge	Merions	Merionethshire (GB; old)	n	refractive index of a medium
Kor.	Korean	Meso-Amer.	Meso-American	n.	note
KS	Kansas (USA)			N.A.G.	National Art Gallery
KY	Kentucky (USA)	Mesop.	Mesopotamian	Nat.	Natural, Nature
Kyrgyz.	Kyrgyzstani	Met.	Metropolitan	Naut.	Nautical
£	libra, librae [pound, pounds sterling]	Metal.	Metallurgy	NB	New Brunswick (Canada)
		Mex.	Mexican	NC	North Carolina (USA)
l.	length	MFA	Master of Fine Arts	ND	North Dakota (USA)
LA	Louisiana (USA)	mg	milligram(s)	n.d.	no date
Lab.	Laboratory	Mgmt	Management	NE	Nebraska; Northeast(ern)
Lancs	Lancashire (GB)	Mgr	Monsignor	Neth.	Netherlandish
Lang.	Language(s)	MI	Michigan	Newslett.	Newsletter
Lat.	Latin	Micrones.	Micronesian	Nfld	Newfoundland (Canada)
Latv.	Latvian	Mid. Amer.	Middle American	N.G.	National Gallery
lb, lbs	pound(s) weight	Middx	Middlesex (GB; old)	N.G.A.	National Gallery of Art
Leb.	Lebanese	Mid. E.	Middle Eastern	NH	New Hampshire (USA)
Lect.	Lecture	Mid. Eng.	Middle English	Niger.	Nigerian
Legis.	Legislative	Mid Glam.	Mid Glamorgan (GB)	NJ	New Jersey (USA)
Leics	Leicestershire (GB)	Mil.	Military	NM	New Mexico (USA)
Lex.	Lexicon	Mill.	Millennium	nm	nanometre (10^{-9} metre)
Lg.	Large	Min.	Ministry; Minutes	nn.	notes
Lib., Libs	Library, Libraries	Misc.	Miscellaneous	no., nos	number(s)
Liber.	Liberian	Miss.	Mission(s)	Nord.	Nordic
Libsp	Librarianship	Mlle	Mademoiselle	Norm.	Normal
Lincs	Lincolnshire (GB)	mm	millimetre(s)	Northants	Northamptonshire (GB)
Lit.	Literature	Mme	Madame	Northumb.	Northumberland (GB)
Lith.	Lithuanian	MN	Minnesota	Norw.	Norwegian
Liturg.	Liturgical	Mnmt, Mnmts	Monument(s)	Notts	Nottinghamshire (GB)
LLB	Bachelor of Laws			Nov	November
LLD	Doctor of Laws	Mnmtl	Monumental	n.p.	no place (of publication)
Lt	Lieutenant	MO	Missouri (USA)	N.P.G.	National Portrait Gallery
Lt-Col.	Lieutenant-Colonel	Mod.	Modern, Modernist	nr	near
Ltd	Limited	Moldav.	Moldavian		

Nr E.	Near Eastern
NS	New Style; Nova Scotia (Canada)
n. s.	new series
NSW	New South Wales (Australia)
NT	National Trust
Ntbk	Notebook
Numi.	Numismatic(s)
NV	Nevada (USA)
NW	Northwest(ern)
NWT	Northwest Territories (Canada)
NY	New York (USA)
NZ	New Zealand
OBE	Officer of the Order of the British Empire
Obj.	Object(s), Objective
Occas.	Occasional
Occident.	Occidental
Ocean.	Oceania
Oct	October
8vo	octavo
OFM	Order of Friars Minor
OH	Ohio (USA)
OK	Oklahoma (USA)
Olymp.	Olympic
OM	Order of Merit
Ont.	Ontario (Canada)
op.	opus
opp.	opposite; opera [pl. of opus]
OR	Oregon (USA)
Org.	Organization
Orient.	Oriental
Orthdx	Orthodox
OSB	Order of St Benedict
Ott.	Ottoman
Oxon	Oxfordshire (GB)
oz.	ounce(s)
p	pence
p., pp.	page(s)
PA	Pennsylvania (USA)
p.a.	per annum
Pak.	Pakistani
Palaeontol.	Palaeontology, Palaeontological
Palest.	Palestinian
Pap.	Paper(s)
para.	paragraph
Parag.	Paraguayan
Parl.	Parliament
Paroch.	Parochial
Patriarch.	Patriarchate
Patriot.	Patriotic
Patrm.	Patrimony
Pav.	Pavilion
PEI	Prince Edward Island (Canada)
Pembs	Pembrokeshire (GB; old)

Per.	Period
Percep.	Perceptions
Perf.	Performance, Performing, Performed
Period.	Periodical(s)
Pers.	Persian
Persp.	Perspectives
Peru.	Peruvian
PhD	Doctor of Philosophy
Philol.	Philology
Philos.	Philosophy
Phoen.	Phoenician
Phot.	Photograph, Photography, Photographic
Phys.	Physician(s), Physics, Physique, Physical
Physiog.	Physiognomy
Physiol.	Physiology
Pict.	Picture(s), Pictorial
pl.	plate; plural
Plan.	Planning
Planet.	Planetarium
Plast.	Plastic
pls	plates
p.m.	post meridiem [after noon]
Polit.	Political
Poly.	Polytechnic
Polynes.	Polynesian
Pop.	Popular
Port.	Portuguese
Port.	Portfolio
Posth.	Posthumous(ly)
Pott.	Pottery
POW	prisoner of war
PRA	President of the Royal Academy
Pract.	Practical
Prefect.	Prefecture, Prefectural
Preserv.	Preservation
prev.	previous(ly)
priv.	private
PRO	Public Record Office
Prob.	Problem(s)
Proc.	Proceedings
Prod.	Production
Prog.	Progress
Proj.	Project(s)
Promot.	Promotion
Prop.	Property, Properties
Prov.	Province(s), Provincial
Proven.	Provenance
Prt, Prts	Print(s)
Prtg	Printing
pseud.	pseudonym
Psych.	Psychiatry, Psychiatric
Psychol.	Psychology, Psychological
pt	part

Ptg(s)	Painting(s)
Pub.	Public
pubd	published
Publ.	Publicity
pubn(s)	publication(s)
PVA	polyvinyl acetate
PVC	polyvinyl chloride
Q.	quarterly
4to	quarto
Qué.	Québec (Canada)
R	reprint
r	*recto*
RA	Royal Academician
Radnors	Radnorshire (GB; old)
RAF	Royal Air Force
Rec.	Record(s)
red.	reduction, reduced for
Ref.	Reference
Refurb.	Refurbishment
reg	*regit* [ruled]
Reg.	Regional
Relig.	Religion, Religious
remod.	remodelled
Ren.	Renaissance
Rep.	Report(s)
repr.	reprint(ed); reproduced, reproduction
Represent.	Representation, Representative
Res.	Research
rest.	restored, restoration
Retro.	Retrospective
rev.	revision, revised (by/for)
Rev.	Reverend; Review
RHA	Royal Hibernian Academician
RI	Rhode Island (USA)
RIBA	Royal Institute of British Architects
RJ	Rio de Janeiro State
Rlwy	Railway
RSA	Royal Scottish Academy
RSFSR	Russian Soviet Federated Socialist Republic
Rt Hon.	Right Honourable
Rur.	Rural
Rus.	Russian
S	San, Santa, Santo, Sant', São [Saint]
S.	South(ern)
s.	solidus, solidi [shilling(s)]
Sask.	Saskatchewan (Canada)
Sat.	Saturday
SC	South Carolina (USA)
Scand.	Scandinavian
Sch.	School
Sci.	Science(s), Scientific
Scot.	Scottish
Sculp.	Sculpture

SD	South Dakota (USA)	suppl., suppls	supplement(s), supplementary	Urb.	Urban
SE	Southeast(ern)	Surv.	Survey	Urug.	Uruguayan
Sect.	Section	SW	Southwest(ern)	US	United States
Sel.	Selected	Swed.	Swedish	USA	United States of America
Semin.	Seminar(s), Seminary	Swi.	Swiss	USSR	Union of Soviet Socialist Republics
Semiot.	Semiotic	Symp.	Symposium		
Semit.	Semitic	Syr.	Syrian	UT	Utah
Sept	September	Tap.	Tapestry	*v*	*verso*
Ser.	Series	Tas.	Tasmanian	VA	Virginia (USA)
Serb.	Serbian	Tech.	Technical, Technique	V&A	Victoria and Albert Museum
Serv.	Service(s)	Technol.	Technology	Var.	Various
Sess.	Session, Sessional	Territ.	Territory	Venez.	Venezuelan
Settmt(s)	Settlement(s)	Theat.	Theatre	Vern.	Vernacular
S. Glam.	South Glamorgan (GB)	Theol.	Theology, Theological	Vict.	Victorian
Siber.	Siberian	Theor.	Theory, Theoretical	Vid.	Video
Sig.	Signature	Thurs.	Thursday	Viet.	Vietnamese
Sil.	Silesian	Tib.	Tibetan	viz.	*videlicet* [namely]
Sin.	Singhala	TN	Tennessee (USA)	vol., vols	volume(s)
sing.	singular	Top.	Topography	vs.	versus
SJ	Societas Jesu [Society of Jesus]	Trad.	Tradition(s), Traditional	VT	Vermont (USA)
Skt	Sanskrit	trans.	translation, translated by; transactions	Vulg.	Vulgarisation
Slav.	Slavic, Slavonic			W.	West(ern)
Slov.	Slovene, Slovenian	Transafr.	Transafrican	w.	width
Soc.	Society	Transatlant.	Transatlantic	WA	Washington (USA)
Social.	Socialism, Socialist	Transcarpath.	Transcarpathian	Warwicks	Warwickshire (GB)
Sociol.	Sociology	transcr.	transcribed by/for	Wed.	Wednesday
Sov.	Soviet	Triq.	Triquarterly	W. Glam.	West Glamorgan (GB)
SP	São Paulo State	Tropic.	Tropical	WI	Wisconsin (USA)
Sp.	Spanish	Tues.	Tuesday	Wilts	Wiltshire (GB)
sq.	square	Turk.	Turkish	Wkly	Weekly
sr	senior	Turkmen.	Turkmenistani	W. Midlands	West Midlands (GB)
Sri L.	Sri Lankan	TV	Television		
SS	Saints, Santi, Santissima, Santissimo, Santissimi; Steam ship	TX	Texas (USA)	Worcs	Worcestershire (GB; old)
		U.	University	Wtrcol.	Watercolour
SSR	Soviet Socialist Republic	UK	United Kingdom of Great Britain and Northern Ireland	WV	West Virginia (USA)
St	Saint, Sankt, Sint, Szent			WY	Wyoming (USA)
Staffs	Staffordshire (GB)	Ukrain.	Ukrainian	Yb., Y.-b.	Yearbook, Year-book
Ste	Sainte	Un.	Union	Yem.	Yemeni
Stud.	Study, Studies	Underwtr	Underwater	Yorks	Yorkshire (GB; old)
Subalp.	Subalpine	UNESCO	United Nations Educational, Scientific and Cultural Organization	Yug.	Yugoslavian
Sum.	Sumerian			Zamb.	Zambian
Sun.	Sunday	Univl	Universal	Zimb.	Zimbabwean
Sup.	Superior	unpubd	unpublished		

A Note on the Use of the Dictionary

This note is intended as a short guide to the basic editorial conventions adopted in this dictionary. For a fuller explanation, please refer to the Introduction, vol. 1, pp. xiii–xx.

Abbreviations in general use in the dictionary are listed on pp. vii–xii; those used in bibliographies and for locations of works of art or exhibition venues are listed in the Appendices in vol. 33.

Alphabetization of headings, which are distinguished in bold typeface, is letter by letter up to the first comma (ignoring spaces, hyphens, accents and any parenthesized or bracketed matter); the same principle applies thereafter. Abbreviations of 'Saint' and its foreign equivalents are alphabetized as if spelt out, and headings with the prefix 'Mc' appear under 'Mac'.

Authors' signatures appear at the end of the article or sequence of articles that the authors have contributed; in multipartite articles, any section that is unsigned is by the author of the next signed section. Where the article was compiled by the editors or in the few cases where an author has wished to remain anonymous, this is indicated by a square box (□) instead of a signature.

Bibliographies are arranged chronologically (within section, where divided) by order of year of first publication and, within years, alphabetically by authors' names. Abbreviations have been used for some standard reference books; these are cited in full in Appendix C in vol. 33, as are abbreviations of periodical titles (Appendix B). Abbreviated references to alphabetically arranged dictionaries and encyclopedias appear at the beginning of the bibliography (or section).

Biographical dates when cited in parentheses in running text at the first mention of a personal name indicate that the individual does not have an entry in the dictionary. The presence of parenthesized regnal dates for rulers and popes, however, does not necessarily indicate the lack of a biography of that person. Where no dates are provided for an artist or patron, the reader may assume that there is a biography of that individual in the dictionary (or, more rarely, that the person is so obscure that dates are not readily available).

Cross-references are distinguished by the use of small capital letters, with a large capital to indicate the initial letter of the entry to which the reader is directed; for example, 'He commissioned LEONARDO DA VINCI . . .' means that the entry is alphabetized under 'L'.

G

[continued]

Gairard, Raymond [Raimon Gairart; Raimundus Gayrardus] (*d* 3 July 1118; *can* 1652). French saint and patron. He is chiefly associated with the building of the church of St Sernin, Toulouse. Apparently well-born in Toulouse, he became an oblate there and later a canon following his wife's death. Soon after the reform of the chapter in the 1070s, he was placed in charge of a hospice for the poor founded by Comte Guilhem and Comtesse Matilda. His name appears in the cartulary with the title *ecolanus* ('schoolmaster') late in the 11th century. He is also credited with building two bridges over the River Hers, east of Toulouse.

Raymond's involvement in building the pilgrimage church of St Sernin is mentioned in two biographical accounts published in *Acta sanctorum* (Julii, I. 680–82; II. 683–6). The earlier 15th-century account states that he built the *corpus* ('body') of the church 'from the foundations to the level of the windows before his death'; the language has an archaeological precision that indicates it was based on a nearly contemporaneous source. Raymond was certainly present when building began following the reform, and the hospice, which later became the College Saint-Raymond, may have served to recruit workers for the new basilica. Two carved representations of clerics in the building, as well as an inscription, may also attest his collaboration.

BIBLIOGRAPHY
C. Douais: 'La Vie de Saint Raymond, chanoine, et la construction de l'église Saint-Sernin', *Mélanges sur Saint-Sernin de Toulouse* (Toulouse, 1894), fasc. 1, pp. 7–22; repr. in *Bull. Soc. Archéol. Midi France* (1893–4), pp. 150–63
T. W. Lyman: 'Raymond Gairard and Romanesque Building Campaigns at Saint-Sernin in Toulouse', *J. Soc. Archit. Hist.*, xxxvii (1978), pp. 71–91
P. Gérard: 'Un Précurseur de l'aide sociale: Raimon Gairart, fondateur de l'hospice Saint-Raimond de Toulouse', *Mem. Acad. Sci., Inscr. & B.-Lett. Toulouse*, 16th ser., X/cli (1989), pp. 253–62

THOMAS W. LYMAN

Gaitonde, Vasudev S. (*b* Nagpur, Maharashtra, 2 Nov 1924). Indian painter. He distinguished himself by developing a stylistic vocabulary of semi-abstract expression that reflects his distinctive ideation. Deeply interested in metaphysics, philosophy and classical music, he evolved a highly personalized idiom in his work that captures the vibrancy of the indigenous environment and its complex thought processes. A pragmatic distillation of these ele-

ments and ideas are seen in the visual paradigms and textural codes that Gaitonde created to portray the inner dimensions of colour, space and form. His multi-layered works subtly open luminous colour fields that seem to float and hover over one another in absolute harmony. His meticulous technical virtuosity and prodigious creativity put him in the vanguard of Indian modernism.

Gaitonde received a diploma from the Sir Jamshetjee Jeejebhoy School of Art, Bombay, in 1948. In the early 1950s he struggled to rid himself of the shackles of academicism through experimentation. He worked at the Bhulabhai Memorial Institute, Bombay, which offered artists studio facilities and housed multi-disciplinary facilities, including the theatre unit of Ebrahim Alkazi and Ravi Shankar's Kirana School of Music, offering an ideal environment for introspection, interaction and creative growth. During the 1950s Gaitonde shifted from figuration to the linear geometrics of a semi-abstract style. Disciplined draughtsmanship and compositional strength characterized his work. Using the palette knife he manipulated oil pigments on large canvases in a dense, opaque configuration of intensely rhythmic structures. Diffused figuration was focally placed within immense undulating matrices of powerfully textured space. A low-key, nearly monochromatic palette integrated such subtly related tones as pale greys, subdued blues and white. He worked the palette knife in broad and narrow strokes.

Gaitonde was profoundly influenced by the senior artist Palsikar and the works of Paul Klee. From the late 1960s the metaphysical concepts of Zen, Indian philosophy and music, as well as Chinese calligraphy, led him to use a roller to achieve a unique technique, applying pigment in thin, translucent layers heightened by the presence of stained, feathery, textured forms. Light suffused these often brilliantly toned works, which evoke the timeless, inner dimensions of space and colour. Cut-outs placed on the pigment and then removed created a mysterious hieroglyphic imagery that reflected the organic flux that lies beyond concrete form. These imprints were repeated in Gaitonde's ink drawings. The fluency and contemplative intensity of his style influenced several younger painters.

He participated in several important group shows in Europe, the USA and Japan, and held one-man shows in India and abroad. In 1957 he received the Young Artists

Award, Tokyo, and in 1964 the J. D. Rockefeller III Fund Travelling Fellowship. In 1971 he was awarded the Padma Shri in recognition of his contribution to contemporary Indian art. From the early 1990s Gaitonde stopped painting and lived in seclusion in New Delhi.

WRITINGS

Gaitonde (New Delhi, 1983)

BIBLIOGRAPHY

A. F. Couto: 'Some Contemporary Painters of Goa', *Marg*, viii, no. 1 (1954), pp. 34–5
F. Nissen: 'Contemporary Indian Artists: V. S. Gaitonde', *Design*, ii, no. 2 (1958), pp. 16–27
G. Kapur: *Contemporary Indian Artists* (New Delhi, 1978), pp. 10, 92, 190
D. C. Ghose: *Bibliography of Modern Indian Art* (New Delhi, 1980), p. 109

SUMITRA KUMAR SRINIVASAN

Gajipur. *See under* RAWALPINDI.

Gakojō. *See* MATSUMOTO CASTLE.

Gakyōjin. *See* KATSUSHIKA HOKUSAI.

Galaktionov, Stepan (Filippovich) (*b* St Petersburg, 1778; *d* St Petersburg, 1854). Russian draughtsman and printmaker. He studied from 1785 to 1800 at the Academy of Arts in St Petersburg under the painter Mikhail Ivanov (1748–1823) and the engravers Anton Radig (*c.* 1719–1809) and Ignaty Klauber (1754–1817). From 1799 Galaktionov assisted Klauber in the engraving class, and from 1817 until his death he himself taught at the academy. Although working in a variety of techniques and genres, he is chiefly known for his landscape prints and for his book illustrations.

Galaktionov's first work of note was his contribution to a series of engravings (*c.* 1800) of the surroundings of St Petersburg after drawings by Semyon Shchedrin (1745–1804). These are models of classical engraving, distinguished by rigorous composition, by their picturesque and decorative but also documentary quality. Subsequently, Galaktionov engraved paintings from Count Aleksandr Stroganov's collection (1807), maps to record the extensive travels in 1809–13 of Ivan Kruzenshtern, and illustrations for editions of Pavel Svin'in's *Dostopamyatnosti Sankt-Peterburga* ('Curiosities of St Petersburg') and *Otechestvennyye zapiski* ('Notes about the fatherland'; 1816–30).

From the early 1820s Galaktionov ranked among the foremost Russian artists. He took up the new technique of lithography and executed a number of excellent prints (examples in St Petersburg, Rus. Mus.; Moscow, Pushkin Mus. F.A.; and elsewhere) after his own drawings, including some from the series *Views of St Petersburg and Its Surroundings*. These are distinguished by delicate and expressive drawing, refined tonality, softness of line and a certain poetic quality. Galakionov's 'mood-landscapes' brought him a reputation as the 'poet of St Petersburg'.

Galaktionov was also one of the most popular illustrators of books in Russia, notably of texts by some of the great writers of his time, such as Aleksandr Pushkin. Of great interest for their iconography as well as their style are his vignettes for the collection *Novosel'ye* ('New home'; 1833–4). Galaktionov's few paintings are notably much inferior to his prints.

BIBLIOGRAPHY

M. Babenchikov: *Stepan Filippovich Galaktionov* (Moscow, 1951)
Stepan Filippovich Galaktionov (exh. cat., Leningrad, Rus. Mus., 1984)

G. KOMELOVA

Galanis, Demetrios (*b* Athens, 23 May 1882; *d* Athens, 20 March 1966). French illustrator, printmaker and designer of Greek birth. At a very early age he showed a talent for drawing and soon took to drawing cartoons. He studied mathematics for two years at the National Technical University in Athens, but he finally enrolled at the Higher School of Fine Arts in Athens, where he studied under Nikiforos Lytras. In 1899, when he was still a student, he won first prize in a competition for cartoons run by the Paris newspaper *Le Journal*. Upon graduation he went to Paris on a scholarship and studied for some time at the Ecole des Beaux-Arts under Fernand Cormon. He continued to draw cartoons for the Greek magazines *Pinakothiki* and *Panathinea*; he also worked for the German periodicals *Simplicissimus* and *Lustige Blätter*, and on the strength of this was invited to go to Germany, where he stayed from 1907 to 1909.

In 1914 Galanis joined the Foreign Legion, took out French nationality and was transferred to an infantry regiment. In the course of his postings during World War I he was sent to Corfu in 1916; here he executed a number of woodcuts, which were published in the *Corfu Anthology*. On his return to Paris in 1918 Galanis reoccupied his studio in the Rue Corot; this was frequented by Picasso, Matisse, Braque and Derain, and here Galanis installed a 17th-century press bequeathed to him by Degas. In 1919 he exhibited at the Salon d'Automne. In 1922 he had a one-man show at the Galerie Licorne en Mongolfière in Paris, and in 1923 he was commissioned to design theatre sets. He had further one-man shows in Athens (1928), at the Marie Harriman Gallery in New York (1934), and two in Egypt in 1935. He designed postage stamps in 1934 and 1936 for the issue commemorating the Exposition Internationale des Arts et Techniques dans la Vie Moderne in Paris (1937) and also designed two commemorative stamps for the Greek post office in 1948 and 1952. He executed a number of designs for the Sèvres porcelain factory. Having taught for some years at the Académie André Lhote, he ran his own school of engraving after 1930. In 1945 he was appointed a professor at the Ecole des Beaux-Arts and in the same year he was elected to the Académie Française. In 1950 he was awarded the Légion d'honneur. His work, even in the years of contact with Cubism (e.g. *Still-life, July 1915*; priv. col., see exh. cat.), was characterized by a strong linear quality associated with his graphic techniques.

BIBLIOGRAPHY

Hommage à Demetrios Galanis (exh. cat., Paris, Cent. Cult. Hell.; Mus. Vieux-Montmartre; 1976)

FANI-MARIA TSIGAKOU

Gal'berg, Samuil (Ivanovich) (*b* Kattentak estate, Esthland [now Estonia], 2 Dec 1787; *d* St Petersburg, 10 May 1839). Estonian sculptor, active in Russia. He studied from 1795 to 1808 under the sculptor Ivan Martos at the Academy of Arts in St Petersburg, and from 1818 to 1828 he was in Italy. His first works produced in Italy were in a classical style (e.g. *Boy Blowing Bubbles*, bronze, 1826, and

Faun Listening to a Reed Flute, marble, 1824–30; both St Petersburg, Rus. Mus.). He also produced several portrait busts in Italy: *V. A. Glinka* (plaster, 1819) and *A. Ya. Italinsky* (marble, 1823; both St Petersburg, Rus. Mus.).

After his return to Russia, Gal'berg was made an academician in 1830 and a professor at the Academy of Arts in 1836. His later works include a plaster statue of *Euripides* for the façade of the public library (now the Russian National Library) in St Petersburg (1830–31; *in situ*) and the monumental bronze statue to *Aleksandr I* in the village of Gruzino, province of Novgorod (1828–30). Gal'berg also worked on monuments to the poet *Gavriil Derzhavin* in Kazan' (bronze, 1833–5) and to the writer *Nikolay Karamzin* in Simbirsk [now Ul'yanovsk] (bronze, 1833–40); both of these were completed by Gal'berg's pupils after his death. These works are somewhat affected in their conception and they lack genuine monumentality.

Gal'berg's portraits are among his best works: while using the form of the antique herm in line with the tenets of strict classicism, he nonetheless produced convincing likenesses. Those portrayed include: *Aleksey Perovsky* (marble, 1829), *Aleksey Olenin* (marble, 1831; both St Petersburg, Rus. Mus.), *Ivan Martos* (plaster, 1837; Moscow, Tret'yakov Gal.) and *Aleksandr Pushkin* (plaster, 1837; Pushkin, A. S. Pushkin Mus.). Although a competent representative of European Neo-classicism in Russia, Gal'berg lacked the *élan* and genuine creative spirit of artists such as Mikhail Kozlovsky and Ivan Martos.

BIBLIOGRAPHY

Ye. Mroz: *Samuil Ivanovich Gal'berg* (Moscow, 1948)

SERGEY ANDROSSOV

Galdiano, José Lázaro. *See* LÁZARO GALDIANO, JOSÉ.

Galeazo, José Vallejo y. *See* VALLEJO Y GALEAZO, JOSÉ.

Galeotti. Italian family of painters. (1) Sebastiano Galeotti was one of the foremost fresco artists in northern Italy in the early 18th century. He had two sons, (2) Giuseppe Galeotti and Giovanni Battista Galeotti, the latter a painter of views, none of whose works are known.

(1) Sebastiano Galeotti (*b* Florence, 1676; *d* Mondovì, 16 Oct 1741 or 1746). He was trained in Florence under Alessandro Gherardini and later in Bologna under Giovanni Gioseffo dal Sole. In the first decade of the 18th century he painted five lunettes with *Stories of St Dominic* in the second cloister of S Marco, Florence (*in situ*). These are clearly influenced by the work of Pietro da Cortona and Luca Giordano. Around 1710 he was in Pisa, where he frescoed the ceiling of the salon of the Palazzo Quarantotti (*in situ*). In 1715 he went to Parma to paint frescoes in S Teresa (mainly destr.; fragments, Parma, G.N.). He produced numerous works in that city, for example decorating the dome of the oratory of the Madonna delle Grazie, and painting frescoes in the Palazzo Pallavicino, the castle of Sala Baganza and in the chapel of the Blessed Virgin of the Angels in the cathedral (1716). While based in Parma he accepted work elsewhere: in 1722 in Rivoli, where he frescoed the atrium of the royal apartment. In 1725 he was in Vicenza, painting the ceilings in the Palazzo Porto-Breganze. From 1729 he was based in Genoa, producing some of his best work, and was influenced by the style of Gregorio de' Ferrari. Surviving examples from this period include the fresco decoration of the church of the Maddalena, the frescoes of the Palazzo Spinola depicting the *Marriage of Cupid and Psyche*, and the *Triumph of Virtue* in the Palazzo Ravashieri–Negroni. His frescoes in the Palazzo dell' Università are also important. In addition Galeotti worked in places far outside Genoa, for example in Savona, where he executed the fresco of the *Assumption* in the church of the Annunziata (now the oratory of the Cristo Risorto), and in Pontremoli, where he decorated the oratory of Nostra Donna. From 1738 he lived in northern Italy, first in Pinerolo, where he painted frescoes in the church of the Visitazione, and later in Cremona, where he decorated the Cavalcabò Chapel in S Agostino. In 1740 he was in Lodi to work in S Francesco and in the Palazzo Modigliani e Barni. He died in Mondovì, where he had gone to decorate the sanctuary.

BIBLIOGRAPHY

N. Carboneri: *Sebastiano Galeotti* (Venice, 1955)

P. Torriti: *Attività di Sebastiano Galeotti in Liguria* (Genoa, 1956)

E. Gavazza: 'Il momento della grande decorazione', *Dal seicento al primo novecento*, ii of *La pittura a Genova e in Liguria*, ed. G. Bruno, G. V. Castelnovi, P. Costa Calcagno, F. Franchini Guelfi and others (Genoa, 1971), pp. 193–299

L'arte a Parma dai Farnese ai Borbone (exh. cat., ed. E. Riccomini; Parma, Pal. Pilotta, 1979), pp. 41–6

G. P. Bernini: *Splendore e decadenza: Le decorazioni pittoriche della Rocca di Sala* (Parma, 1981), pp. 206–9

(2) Giuseppe Galeotti (*b* Florence, 1708; *d* Genoa, 1778). Son of (1) Sebastiano Galeotti. He learnt Baroque fresco painting in his father's workshop. Following the lead of Marcantonio Franceschini and Giacomo Antonio Boni, he later became interested in Emilian classicist art. In 1751 he was listed among the founders of the Accademia Ligustica of Genoa, where from 1765 he was Director of the school of drawing. He worked mainly in Genoa, but also in other Ligurian centres. In Genoa his frescoes remain in the presbytery and choir of S Francesco d'Albaro (which also contains a canvas of *St Anthony of Padua*), in the Scuole Pie (1750), in the church of the Gesù (dome of the first chapel in the right aisle), and in the Palazzo Campanella (formerly Salvago). In S Pietro in Vincoli, Sestri Levante, there are a *St Peter in Glory* and a canvas of *St Peter Released from Prison* (both 1751); in the presbytery and choir of the nearby parish church are some frescoes executed in 1770. His works on canvas include the *Fight between Cupid and Pan* (Genoa, Mus. Accad. Ligustica B.A.) and the *Monk of the Caracciolini Order* (Genoa, S Fede).

BIBLIOGRAPHY

D. Castagna: *Nuova guida storico-artistica di Genova* (Genoa, 1970)

F. R. Pesenti: 'L'illuminismo e l'età neoclassica', *Dal seicento al primo novecento*, ii of *La pittura a Genova e in Liguria*, ed. G. Bruno, G. V. Castelnovi, P. Costa Calcagno, F. Franchini Guelfi and others (Genoa, 1971), pp. 389–416

MARIO DI GIAMPAOLO

Galeotti, Pietro Paolo [Romano] (*b* Monte Rotondo, nr Rome, 1520; *d* Florence, 19 Sept 1584). Italian medallist, goldsmith and sculptor. The son of Pietro di Francesco, he was brought to Florence at a young age by Benvenuto Cellini, who described in his *Vita* how he found Galeotti in Rome in 1528. Galeotti accompanied Cellini to Ferrara

and Paris in 1540 and worked in his Paris workshop with Ascanio de' Mari (*d* 1566) in the Château du Petit-Nesle in 1548–9. He settled in Florence around 1552 and entered into the service of the Mint. He became a Florentine citizen in 1560. A payment to him from Cellini is recorded in January 1552, for chasing done on Cellini's *Perseus*. A sonnet of 1555 by the historian and critic Benedetto Varchi (*I Sonetti*, Venice, 1555, i, 252) describes Galeotti as an equal rival of Domenico Poggini, another medallist also employed by the Mint. Briefly in 1575, Galeotti appears to have been an assistant engraver at the Papal Mint in Rome, taking the place of Lodovico Leoni (1542–1612).

Galeotti's extant oeuvre comprises around 80 medals, many bearing his signature PPR, or PETRVS PAVLVS ROM, or a derivative. Eight are dated, between 1552 and 1570, the earliest depicting *Cardinal Madruzzo* (1512–87). In addition to Florence, his sitters came from Genoa, Milan, Turin and north of the Alps, but his best-known work was a series of medals depicting Cosimo I de' Medici (*see* MEDICI, DE', (14)) and his accomplishments (such as the building of the Florentine aqueducts, or the Uffizi), both before and after 1569, when Cosimo became 1st Grand Duke of Tuscany. The same bust is featured on both early and late medals and derives from Poggini's medals of 1561, but the inscription, COS.MED.MAGNVS.DVX. ETRVRIAE (Cosimo de' Medici, Grand Duke of Tuscany), on the later examples identifies Cosimo's heightened importance. Vasari praised the series, describing the medals, particularly in regard to the portrait, as graceful and beautiful. As with Galeotti's works in general, they are classicizing in style and probably reflect the Roman coins in Cosimo's extensive collection.

Only one monumental work by Galeotti is known, a bronze bust, *all'antica*, of *Ottavio Farnese*, 2nd Duke of Parma and Piacenza, signed P PAV.ROM.F (London, Cyril Humphris Gal., summer 1990, no. 17). The work, which recalls Cellini's bronze bust of *Cosimo I* (Florence, Bargello), was one of two instances when Galeotti portrayed Farnese, the other being a medal, which also depicted the Duke's wife, Margaret of Austria (1522–86).

BIBLIOGRAPHY

Thieme–Becker
G. Vasari: *Vite* (1550, rev. 2/1568); ed. G. Milanesi (1878–85), v, p. 390; vi, p. 251; vii, p. 542–3
B. Cellini: *Vita di Benvenuto Cellini . . .* (Cologne, 1728; Eng. trans., Oxford, 1949), pp. 150, 152, 165
L. Forrer: *Biographical Dictionary of Medallists* (London, 1904–16), ii, pp. 190–94
C. Johnson: 'Cosimo I de' Medici e la sua "Storia metallica" nelle medaglie di Pietro Paolo Galeotti', *Medaglia*, xii (1976), pp. 14–46
D. Myers: 'Pietro Paolo Galeotti, Called Romano', *The Currency of Fame: Portrait Medals of the Renaissance* (exh. cat., ed. S. K. Scher; New York, 1994), pp. 164–5

DONALD MYERS

Galeotti Torres, Rodolfo (*b* Quetzaltenango, 4 March 1912; *d* Guatemala City, 22 May 1988). Guatemalan sculptor. He began his career as an apprentice to his father, Antonio Galeotti, a sculptor and marble-worker from Tuscany. When he finished his secondary education in Quetzaltenango he went to Italy, where from 1930 to 1933 he studied drawing, modelling and sculpture in marble at the Accademia di Belle Arti e Liceo Artistico in Carrara. On his return to Guatemala he made an *Obelisk to Victory* (h. 19 m, 1934–5; Quetzaltenango) and worked on the

sculptural decoration in hammered cement of the Palacio de la Unión (known as the 'Maya Palace', 1940) in San Marcos and on the Palacio Nacional (1940–43) in Guatemala City.

Galeotti Torres twice won first prize in the Concurso Nacional de Escultura Rafael Yela Günther, and in 1945 he was commissioned to produce a monument to the *Revolution of 1944* (hammered cement, h. 2 m; Guatemala City, Escuela Federación Pamplona). This was followed in 1946 by a one-man show that was a resounding success. During these years he developed his particular style of vigorous figures under the influence of contemporary Mexican sculptors. Among his outstanding works are *Three Moments in Engineering* (relief, 1959), for the School of Engineering at the Ciudad Universitaria in Guatemala City; *Tecún Umán* (1968; Quetzaltenango); and busts of diverse distinguished personages from Guatemalan history, such as Bernal Díaz del Castillo, Rafael Landívar, the doctors Rodolfo Robles and Juan J. Ortega, the musician Rafael Alvarez (composer of the national anthem), Marshal J. V. Zavala and the writer Carlos Wyld Ospina. In the last years of his life he made two large pieces of sculpture sited in Guatemala City: *Ball Player* (1984; Banco Indust. Col.) and *Pope John Paul II* (1986; Guatemala City, Avenida Las Americas).

BIBLIOGRAPHY
J. A. de Rodríguez: *Arte contemporáneo occidente–Guatemala* (Guatemala City, 1966), pp. 53–5
C. C. Haeussler: *Diccionario general de Guatemala* (Guatemala City, 1983), pp. 668–9

JORGE LUJÁN-MUÑOZ

Galestruzzi, Giovan Battista (*b* Florence, 1618; *d* after 1661). Italian painter and engraver. He was a pupil of Francesco Furini (Bartsch). His most important work is a series of engravings for Leonardo Agostini's book *Le gemme antiche figurate* (Rome, 1657–9). He also produced several collections of engravings of low reliefs and friezes by Polidoro da Caravaggio, published by Vincenzo Belly in *Opere di Polidoro da Caravaggio* (Rome, 1658). His engraving after Giovanni Francesco Grimaldi's *Triumph of Piety* dates from the same year. He was an accomplished draughtsman and his attractive, light and sketchy engraving style is close to that of Stefano della Bella. He completed and signed the *Sixth Death* (see Vesme and Massar, no. 92), one of the latter's uncompleted plates for the series the *Dance of Death*. There is only one known painting by Galestruzzi, a *Magdalene* owned by the Accademia di S Luca in Rome; the artist was a member of the Accademia from 1652.

BIBLIOGRAPHY
Bolaffi, v, p. 10
A. de Vesme and P. D. Massar: *Stefano della Bella: Catalogue raisonné*, 2 vols (New York, 1971)
P. Bellini: *Italian Masters of the 17th Century* (1982), 46 [XXI/i] of *The Illustrated Bartsch*, ed. W. L. Strauss (New York, 1978–), pp. 75–256, nos 1–333
A. Caputi and M. Penta: *Incisioni italiane del '600 nella raccolta dell'Istituto Suor Orsola Benincasa* (Naples, 1988), p. 199

ANNAMARIA NEGRO SPINA

Galfetti, Aurelio (*b* Lugano, 13 June 1936). Swiss architect. As a student he designed the Casa Rotalinti (1960), Bellinzona, a work of brilliant simplicity inspired by Le Corbusier. After producing kindergartens and schools on

similar principles in Biasca and Riva San Vitale, he designed the neuro-psychological clinic (1969–75), Mendrisio, a glass and steel structure recalling the technical positivism of Fritz Haller. Galfetti established his reputation with his open-air swimming pool (1970; with Flora Ruchat and Ivo Trümpy), Bellinzona, undertaken as an urban renovation project influenced by the theories of Aldo Rossi. Galfetti's aim of modernizing the historic urban fabric of Bellinzona was further demonstrated by the tennis court complex and several residential blocks in the form of towers, which are related by the use of traditional and modern elements to the historic palaces and walls of the city. In contrast is his severe, unsentimental restoration of the Castelgrande, the castle overlooking Bellinzona, an example of his stated aims of 'conserving by transformation' and of 'making the past topical'. Here the lift entrance hewn from the supporting rock is designed in the manner of an expressively grandiose Wagnerian cave. Although a leading member of the Ticino school, it was only after the completion of the large Main Post Office (1985), Bellinzona, that he established an international reputation.

BIBLIOGRAPHY
X. Güell and others: *Aurelio Galfetti* (Barcelona and Berlin, 1989)

ROMAN HOLLENSTEIN

Galgario, Fra **Vittore**. *See* GHISLANDI, GIUSEPPE.

Galiano, Giovanni Pieroni da. *See* PIERONI DA GALIANO, GIOVANNI.

Galich. *See* HALICH.

Galilee. Church porch at the western entrance of the nave. The term is probably derived from the siting of the last station of the Sunday procession, especially on Easter Sunday, which commemorates Christ going into Galilee after his Resurrection (Mark 16:7 and Matthew 28:10). The 16th-century *Rites of Durham* describes this part of the processional route thus: 'we also name the place Galilee, from where we finish the procession at the last station'. The procession halted outside the closed west doors before being permitted to re-enter the church. The doors were also closed in the face of the Palm Sunday procession while the *Gloria Laus* was sung. Both liturgical events may well have benefited from some permanent cover in northern climates.

Matthew 4:15 refers to 'Galilee of the Gentiles', and the galilee porch may also represent a vestige of the Early Christian narthex or atrium reserved for the unbaptized catechumens. The Italian *Farfa Customary* (1043) describes the layout of a Cluniac abbey, presumably that of Farfa's mother house at Cluny. It calls the western narthex the galilee, and excavation has revealed that by *c.* 1000 the second church at Cluny ('Cluny II') possessed a large, three-bay basilican narthex (*c.* 14×18 m). The narthex at St Philibert, Tournus (Saone-et-Loire, France; after 1000), may represent a two-storey version of Cluny. The name 'galilee' was not applied to the narthex of Cluny III, built from 1088, and the term was uncommon in France: the west entry of the Carolingian abbey church of Saint-Riquier was called 'paradise'.

The medieval use of the term 'galilee' appears more frequently in England; for example Bishop Eustace of Ely

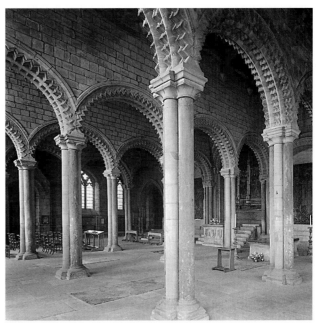

Galilee at Durham Cathedral, interior looking north-east, late 12th century

(*reg* 1197–1215) built the 'new Galilee against the west end of the church at Ely at his own expense'. This is a rectangular, two-storey porch projecting some 14 m from the nave door. The outer entry is entirely open (bird nets were purchased in 1368). The upper chamber was open to the interior of the church and was probably used for singing: several English churches had permanent or temporary galleries associated with the principal entry for antiphonal singing during the Palm Sunday liturgy, including the cathedrals of Exeter and Winchester, and York Minster.

Durham Cathedral (see fig.), Glastonbury Abbey (Somerset) and Byland Abbey (N. Yorks) all had west porches contemporarily called galilees. Those at both Durham and Glastonbury contained late medieval Lady altars, although the original 13th-century purpose at Glastonbury was as a porch, doubling as a link between the western Lady chapel, the *vetusta ecclesia*, and the church proper. The late 12th-century galilee at Durham is a unique ecclesiastical structure. Owing to the precipitous sloping site, it is wider north–south than east–west and consists of five aisles divided by slender compound piers and heavily decorated arches. The effect is more like a mosque than a church. Since at least the 15th century the west door has been blocked by a Lady altar, indicating that the galilee no longer functioned as a principal processional entry. Traditionally, although with little historical authority, the Durham galilee was reserved for women; in fact it served as the monks' parlour.

The galilee at Byland Abbey appears to have been a standard open-arcaded narthex in the Cistercian manner. It is not clear why this particular example, and not all the other English and continental Cistercian west porches, should have been called a galilee in the medieval period. Unusually for a 12th-century English Cistercian church,

Byland has three western doors within the galilee, so that the procession could leave by a side door and re-enter through the central portal as at Durham. French, German, Italian and Spanish usages all have variants of the term galilee, but none appears to apply it to their own west porches.

Several British porches have been called galilees at later, post-Reformation dates, with little or no medieval authority. These include the cathedrals of Lincoln, Chichester and Peterborough, and the abbeys of Westminster (London), Fountains (N. Yorks) and Melrose and Kelso (Borders). How many of these may truly have been galilees is doubtful. Peterborough, which was formerly Benedictine, has a 14th-century two-storey west porch, open below and enclosed above, similar to that at Ely. Given the geographic proximity of the two, Peterborough might also have been built as a galilee. As the only known medieval use of the word is found in monastic houses, secular cathedrals such as Chichester and Lincoln might possibly be ignored: the two-storey porch at Lincoln (*c.* 1220) stands at the south-west angle of the transept, an unlikely place for the galilee station.

The galilee has no precise architectural form, the design and very presence of the various examples probably depending upon local conditions and liturgy. 'Galilee' was also the name of a chamber in the Old Palace of Westminster, which linked the Great and Little Halls. It appears to have had no liturgical significance.

BIBLIOGRAPHY

D. J. Stewart: *Ely Cathedral* (London, 1868)
Farfa Customary (MS.; 1043); ed. B. Albers, *Consuetudines Farvensis* (1900), i of *Consuetudines monasticae* (Stuttgart, 1900–12), pp. 137–9
The Rites of Durham (MS.; 1593); ed. J. T. Fowler, *Surtees Soc.*, cvii (1903), pp. 42–51
H. E. Bishop and E. Prideaux: *The Building of Exeter Cathedral* (Exeter, 1922)
F. H. Crossley: *The English Abbey* (London, 1935)
K. J. Conant: *Carolingian and Romanesque Architecture, 800–1200*, Pelican Hist. A. (Harmondsworth, 1959, rev. 2/1978)
D. Parsons: 'The Pre-Romanesque Church of St-Riquier: The Documentary Evidence', *J. Brit. Archaeol. Assoc.*, cxxx (1977), pp. 21–51

FRANCIS WOODMAN

Galilei, Alessandro (Maria Gaetano) (*b* Florence, 25 Aug 1691; *d* Rome, 21 Dec 1737). Italian architect. He was one of the most important Italian architects of the early 18th century, along with Ferdinando Fuga, Nicola Salvi and Luigi Vanvitelli, his work having a far-reaching influence on the formation of Neo-classicism in Europe.

1. Early life and career in England, before 1720. 2. Florence, 1720–31. 3. Rome, from 1731.

1. EARLY LIFE AND CAREER IN ENGLAND, BEFORE 1720. Galilei was descended from an old Florentine family and took a lifelong pride in his distant relationship with Galileo Galilei. He seems to have inherited his artistic talent from his mother, Margherita Merlini, whose father, Marc Antonio Merlini (*fl* 1655; *d* 1688), was a medallist and in charge of the grand-ducal mint in Florence; one of his uncles, Lorenzo Merlini, worked as a sculptor, medallist and architect in Florence and Rome. Galilei attended the Florence Academy, where he studied mathematics and physics, as well as architecture, probably under Antonio Maria Ferri (*d* 1716) and Giovanni Battista Foggini. His training was primarily based on studying the buildings and decorative forms of 16th-century Florence.

In January 1714 Galilei visited Rome with John Molesworth (later 2nd Viscount Molesworth; 1679–1726), the British ambassador to Florence; in July 1714 he left Florence to spend a year in London at Molesworth's invitation, in order to further his technical and architectural knowledge. Unable to afford to return to Florence, however, from 1715 Galilei tried, with the support of his hosts, to establish himself as an architect in London, although he was unsuccessful in obtaining either private or public commissions. Designs for seven London churches nevertheless date from this period (1715–16), as do two proposals for a royal palace (1716–18), one for St James's Park, the other for Hyde Park, London. Surviving sketches for the churches (Florence, Archv Stato) show that Galilei tried to harmonize the demands of Anglican ritual with the form of building he preferred—a centrally planned type with a dome—by incorporating galleries into it. The designs, the theoretical basis of which lay in the writings of Alberti and Serlio, show an eclectic selection of motifs from the Renaissance and a restrained Baroque ornamentation. The most interesting is the design for a church in the form of a Doric temple with columns around three sides, looking almost like an archaeological reconstruction of Vitruvius' basilica. In spite of details in the design indicating a delight in ornament, which can be traced back to 16th-century Florentine models, there is a clear tendency to formal restraint. Galilei's palace designs, rather than indicating any familiarity with the projects of Christopher Wren or John Vanbrugh, give the impression of referring back to the Palazzo Pitti in Florence.

It was not until 1718 that Galilei, in association with Nicholas Dubois (*c.* 1665–1735), the translator of the first English edition of Palladio's *I quattro libri dell'architettura*, published by James Leoni (London, 1715), was able to establish himself as an architect, with a five-year contract to complete the Burlington estate in the West End of London. The first three houses (destr.), in Brewer Street and Cork Street, were typical examples of London terraced housing. That same year he was commissioned by Charles Montagu, 1st Duke of Manchester, to build the east façade of Kimbolton Castle, Cambs (see fig. 1). The elegance of the portico of slender Doric columns that Galilei constructed in front of the façade is in sharp contrast with the castellated appearance of the other elevations designed by John Vanbrugh a decade earlier.

During a two-month visit to Ireland in the summer of 1718, Galilei designed a garden temple for Marmaduke Coghill (*d* 1739) at Drumcondra House, near Dublin, as well as plans for the impressive Castletown House, Co. Kildare, for William Conolly, Speaker of the Irish House of Commons. The construction of this building, the first all-stone mansion in Ireland, which had a great influence on Irish architecture, did not begin until *c.* 1722, supervised by Edward Lovett Pearce; the overall Palladian plan, including the elegant colonnades and the design of the façades, is probably the work of Galilei, who in 1723, when he was in Florence, provided Pearce with further drawings for the façades. In 1718 Galilei was also employed by James Brydges, 1st Duke of Chandos, at Canons, Middx, being built by James Gibbs, where he possibly

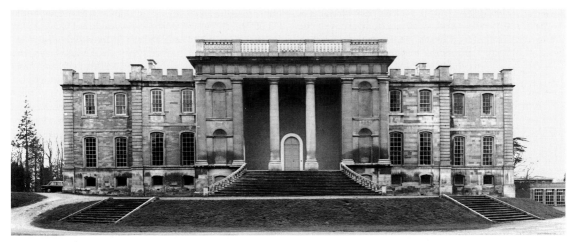

1. Alessandro Galilei: Kimbolton Castle, Cambridgeshire, east façade, begun 1718

designed an orangery similar to the one, after a design by Galilei, that appeared in the standard botanical work *The Gentleman and Gardeners Calendar* (1718) by Robert Bradley of Oxford. At the end of 1719, however, despite his newly acquired independence as an architect, Galilei returned to Florence to serve as a court architect at the behest of the Tuscan ambassador to London and Paris, Neri Corsini.

During the five years Galilei spent in England, what seems to have been more important to him than familiarity with the contemporary work of such architects as Wren, Vanbrugh and Hawksmoor was the influence of the artistic philosophy of Molesworth's friend Anthony Ashley Cooper, 3rd Earl of Shaftesbury, with its insistence on a return to the clarity and formal simplicity of Greek art. A reform movement in London, the 'New Junta for Architecture', with which Galilei was in contact but of which nothing more specific is known, had also set itself a programme of artistic renewal with unambiguously anti-Baroque tendencies. Galilei may also have been in touch with the group centred on Richard Boyle, 3rd Earl of Burlington, but the latter's interest in Palladianism did not develop until after Galilei had returned to Florence. In his designs for English country houses Galilei adopted the Palladian layout of a main block linked to side wings by colonnades, but he remained committed to Florentine models, particularly the works of Antonio Maria Ferri, in his designs for façades. While he articulated the otherwise flat façades with a grid of vertical and horizontal elements—pilaster-strips and string courses—he created a sense of three-dimensional movement by means of grand staircases in front of the façade, although they were never actually incorporated into the main body of the building. Even in his early designs, Galilei had a sense of monumentality to which he gave expression through the harmonious overall disposition of the built mass with a clearly defined contour.

2. FLORENCE, 1720–31. During the period Galilei spent in Florence as court architect (1720–31), a time of economic depression, he received few commissions either from the court or from private patrons. He worked mainly for the Corsini family, carrying out minor projects on their estates, and in 1730–31 he designed a simple high altar for the abbey church of S Gaggio, Florence. An extension to the Palazzo Corsini in Florence, designed in 1724, was not executed. In 1722–4 Galilei renovated the *galleria* of Agostino Cerretani's palazzo in Florence. The relief-style wall decoration, designed with strict symmetry, is in stark contrast to the luxuriant Florentine Baroque decoration of the period. In 1724 Galilei began to design the oratory of the Madonna del Vivaio (largely destr.; rest.) in Scarperia, Tuscany, an almost unadorned, coolly elegant domed building on a circular plan that was never completed. When renovating the choir of Cortona Cathedral in 1729–30, Galilei inserted a triumphal arch with the sparsest decoration, deliberately subordinating it to the 16th-century building. Such restriction of ornament in favour of Renaissance motifs can also be observed in his alterations to the Villa Venuti (1725–30; partially executed) at Catrosse, near Cortona, and in his design for a tomb (1726; destr. 1854), commissioned in Florence by Sir Edward Gascoigne, for All Saints, Barwick-on-Elmet, W. Yorks; the latter was conceived by Galilei as a simple aedicula, with the large coat of arms as the only decoration.

Although Galilei received few commissions, this period was crucial for his development. The impetus towards a return to antiquity that he had absorbed in England found theoretical support from his circle of acquaintances in Florence, including such philologists, historians and theologians as Antonio Maria Salvini, Antonio Francesco Gori and Giovanni Gaetano Bottari, who belonged to Lodovico Antonio Muratori's 'Republic of Scholars'. In 1727 the Venuti brothers founded the Accademia Etrusca in Cortona, with Galilei as one of its first members. The renewed appreciation of Giotto, Dante and Brunelleschi, regarded as the founders of the Renaissance in Florence, can be traced back to this patriotic circle of Florentine scholars. In these years, under the influence of Muratori, a new epistemological view of history and art developed in Florence, also encompassing the Middle Ages, which were positively reassessed. This attitude can be traced, in the case of Galilei, in several expert reports, including a building survey (1724) on the condition of the Cistercian abbey of S Galgano, near Siena, in which he demanded

the preservation of the Gothic building, and in his plea (1722) for the preservation of medieval frescoes in the church of S Francesco, Terranuova, Tuscany. In 1723 he spoke out sharply against the installation of a Baroque high altar, based on a design by Giovanni Battista Foggini, in the Baptistery in Florence, both to preserve the visual unity of the interior and out of respect for the artistic achievements of the past. Galilei took this opportunity to launch a major attack on Baroque art. He emphasized the principles of rectilinearity and the unconditional subordination of ornament: architecture should depend only on symmetry, proportion and fitness for purpose.

3. ROME, FROM 1731. In July 1730 Cardinal Lorenzo Corsini was elected Pope Clement XII, and Galilei was given an opportunity to put his ideas into practice. His patron, the Pope's nephew Neri Corsini, became a Cardinal and, being closely associated with Muratori's 'Republic', immediately began a dedicated policy of economic and artistic reform for the Vatican State, with a particular commitment to the promotion of architecture. All the large papal building projects other than the Trevi Fountain were awarded to Galilei, an almost unknown figure in Rome, and to Ferdinando Fuga, also a Florentine.

Galilei's first commission in Rome (1731) was to build the Corsini family burial chapel in S Giovanni in Laterano. The Cappella Corsini (1732–5) became the major work to exemplify both Galilei's style and the intentions of Neri Corsini. A domed building on a Greek-cross plan, it followed Flaminio Ponzio's Cappella Paolina (1611) in S

Maria Maggiore in form, at the express wish of the Pope. Unlike the chapel on which it was modelled, however, in Cappella Corsini there is a sharp differentiation between the dome, the drum and the arms of the cross, and the internal construction of the space is clearly expressed. The tombs do not dominate the space but are in harmony with the overall architectural concept, as are the statues and reliefs, the sculptors having been contractually committed to such an approach. The Baroque harmony of architecture, sculpture and painting was abandoned in favour of the pre-eminence of architecture, with the use of different types of subtly coloured marble providing a painterly effect. The Cappella Corsini constitutes an example of structural clarity and elegance of formal vocabulary unparalleled in Rome at that time.

In July 1732 Galilei won the competition to build the façade of S Giovanni in Laterano (see fig. 2; *see also* ROME, §V, 15(ii)), in spite of the embittered opposition of the Accademia di San Luca, whose members supported Luigi Vanvitelli's proposal. Galilei's design, a two-storey façade with loggias on both floors articulated only by colossal pilasters, with a slightly projecting central bay and raised pediment, adopts motifs from Carlo Maderno's façade (1607) for St Peter's but uses them two-dimensionally, referring back to Michelangelo's Palazzo dei Conservatori (after 1561) on the Capitoline Hill. When built, the design was modified to make it 'more Roman', to placate the Academy: the central projection was emphasized by columns, and the top balustrade was made higher, which

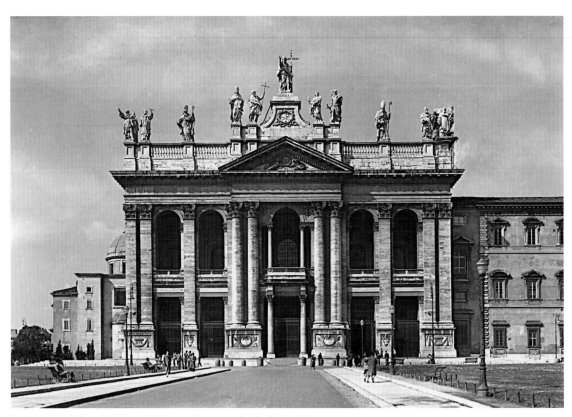

2. Alessandro Galilei: S Giovanni in Laterano, Rome, east façade, begun 1732

had a detrimental effect on the overall composition. All the decorative forms conform to the standard formulae. The frames of the doorways and niches are based on the entablature features of the Corinthian order, and all the ornament can be traced back to antique models. The lower vestibule is inlaid with different types of subtly coloured marble. The completed building shocked the Roman art world profoundly, owing to its uncompromising expression of functionalism and architectural rationality. Galilei's façade exactly marks the boundary between two stylistic movements, being too severe for the Baroque but insufficiently doctrinaire for the Neo-classical taste that followed, not having a free-standing columned portico in front of it. A scheme (1735–6) to create a square in front of the façade, with an encircling colonnade, was not executed due to lack of money.

In 1733–5 Galilei was commissioned by Pope Clement XII to build the façade of S Giovanni dei Fiorentini. Deliberately drawing on 16th-century models, it is widely regarded as Galilei's weakest work in Rome. The design was produced in great haste, although apparent inconsistencies, such as the superimposition of two Corinthian orders and the articulation of the lower storey, are based on ideas adopted from Michelangelo's wooden model for the façade of S Lorenzo in Florence.

Galilei's smaller projects included designs (1731) for Neri Corsini's villa (largely destr.) in Anzio, which was built by Niccolò Michetti in 1732–5 with some modifications. The distinguishing feature of this simple building was a large staircase located in front of it. Around 1736 Galilei built a villa (destr. 1849) on the Janiculum for Monsignore Giuseppe Feroni, which was articulated apparently by pilasters and had an oval stair-well, recalling his English designs.

Galilei's buildings met with widespread disapproval in his own day, although they had some influence on the artistic development of Nicola Salvi and Luigi Vanvitelli and on the young architects of the Académie de France in Rome, Jacques-Germain Soufflot, Jean-Laurent Legeay and Louis-Joseph Le Lorrain. His work, particularly the façade of S Giovanni in Laterano, provoked a fundamental discussion about the principles of architecture in Rome in the 1730s, contributing to a rapid process of disaffection with the Baroque. For Galilei, the reform of architecture meant a return to the Renaissance and to a literary familiarity with antiquity. In this sense it was possible for him to relate equally to antiquity and to Michelangelo. Galilei's preoccupation with pure, functional building was the direct starting-point for the classicism created in Rome in the 1740s by members of the Académie de France.

BIBLIOGRAPHY

F. Milizia: *Memorie degli architetti antichi e moderni*, ii (Bassano, 1785), pp. 249–50
I. Toesca: 'Alessandro Galilei in Inghilterra', *Eng. Misc.*, iii (1952), pp. 189–220
P. Sanpaolesi: 'L'oratorio del Vivaio a Scarperia, architettura di Alessandro Galilei', *Atti del VIII convegno nazionale di storia dell'architettura: Caserta, 1953*, pp. 193–8
A. Schiavo: *La fontana di Trevi e le altre opere di Nicola Salvi* (Rome, 1956)
V. Golzio: 'La facciata di S Giovanni in Laterano e l'architettura del settecento', *Misc. Bib. Hertz.*, Röm. Forsch. Bib. Hertziana, xvi (1961), pp. 450–63
J. Cornforth and others: 'Castletown, Co. Kildare', *Country Life*, cxlv (27 March 1969), pp. 722–6; cxlvi (3 April 1969), pp. 798–802; cxlvii (10 April 1969), pp. 882–5
E. Kieven: 'The Gascoigne Monument by Alessandro Galilei', *Leeds A. Cal.*, lxxvii (1975), pp. 13–23
L. Zangheri: 'Apparati di Alessandro Galilei alla corte medicea', *Ant. Viva*, xiv/1 (1975), pp. 32–6
E. Kieven: *Alessandro Galilei: Architekt in England, Florenz und Rom* (diss., U. Bonn, 1977)
R. Poso: 'Qualche osservazione su Alessandro Galilei, restauratore del granducato mediceo', i, *Itinerari* (1979), pp. 187–207
E. Kieven: 'Rome in 1732: Alessandro Galilei, Nicola Salvi and Ferdinando Fuga', *Light on the Eternal City: Recent Observations and Discoveries in Roman Art and Architecture*, Pap. A. Hist. PA State U., ii (1987), pp. 255–75
——: 'Überlegungen zu Architektur und Ausstattung der Cappella Corsini', 'L'architettura da Clemente XI a Benedetto XIV: Pluralità di tendenze', *Stud. Settecento Romano*, v (1989), pp. 69–91

ELISABETH KIEVEN

Galilei, Galileo (*b* Pisa, 15 Feb 1564; *d* Arcetri, nr Florence, 18 Jan 1641). Italian scientist, astronomer, mathematician and writer. He studied medicine at Pisa University from 1581, eventually becoming a lecturer there (1589–91), due to the influence of Cosimo II de' Medici, Grand Duke of Tuscany (*see* MEDICI, DE', (19)). He subsequently held the chair of mathematics (1592–1610) at Padua University, where in 1609 he constructed a telescope. He used it to calculate the movements of Jupiter and its satellites, and to observe the true physical nature of the moon, even going so far as to observe the sun as well. In 1610 he settled in Florence, where he was a member of the Accademia della Crusca and the Accademia del Disegno. Galileo was also appointed philosopher and mathematician extraordinary to Cosimo II, who set up a telescope for him at Arcetri. He formulated the law on the acceleration of masses and studied ballistics, optics, hydrostatics and acoustics. In 1632 he wrote a defence of the Copernican system, which led to his arrest and trial for heresy, following which Galileo's work was proscribed. In 1633 he was banished to Arcetri.

In addition to his scientific achievements, Galileo was an expert draughtsman, a master of perspective and an art critic. He was a friend of the painter LODOVICO CIGOLI, whose fresco of the *Assumption of the Virgin* (1610–12; *in situ*) on the soffit of the dome of the Cappella Paolina in S Maria Maggiore, Rome, shows a lunar landscape with mountains and craters, as illustrated in Galileo's *Sidereus nuncius* (vol. 4 of *Opere*, 1610). In a letter to Cigoli (26 June 1612) Galileo compared sculpture and painting. The latter was considered the more admirable because it could show the effects of light and shade by colour, and those of depth by perspective, using 'deception' rather than three-dimensional relief. Galileo's concentration on the specific and demonstrable divergencies between the two media in relation to the scientific problems of vision represents an original contribution that anticipates the modern critical distinction between tactile and optical values. Attention has also been drawn (Feigenbaum Chamberlain) to the influence of Galileo, through his studies of gravity and matter, on the two statues by Gianlorenzo Bernini of *St Mary Magdalene* and *St Jerome* (1661–3), which are situated in two niches beside the entrance to the Chigi Chapel in Siena Cathedral.

WRITINGS

A. Favaro, A. Garbasso and G. Abetti, eds: *Le opere di Galileo Galilei*, 20 vols (Florence, 1890–1909)

BIBLIOGRAPHY

E. Panofsky: *Galileo as a Critic of the Arts* (The Hague, 1954), p. 8
H. Feigenbaum Chamberlain: 'The Influence of Galileo on Bernini's Saint Mary Magdalene and Saint Jerome', *A. Bull.*, lix (1977), pp. 71–84
W. R. Shea: 'Panofsky Revisited: Galileo as a Critic of the Arts', *Studies in Honour of Craig Hugh Smyth*, i (Florence, 1985), pp. 481–92

PETER BOUTOURLINE YOUNG

Galimard, (Nicolas-)Auguste (*b* Paris, 25 March 1813; *d* Montigny-lès-Corneilles, nr Paris, 16 Jan 1880). French painter, writer and lithographer. He was given his first art lesson by his uncle, Nicolas-Auguste Hesse, in Paris, then moved to the studio of Jean-Auguste-Dominique Ingres. According to Auvray in the *Dictionnaire général*, he also studied with the sculptor Denys Foyatier. Like a number of Ingres's pupils, Galimard was involved in decorating the newly built or newly restored churches of the July Monarchy and the Second Empire. At his first Salon in 1835 he exhibited *Three Marys at the Tomb*, a *Châtelaine of the 15th Century* and a portrait of his cousin, *Mme Lefèvre* (all untraced). The following year he exhibited one of his first attempts at glass painting, *The Queen of the Angels* (broken by a gust of wind during the exhibition), and a painting, *Liberty Leaning on Christ Flanked by the Apostles James and John* (untraced), a subject indicating sympathy with the social ideology of Charles Fourier or Saint-Simon. In 1848 and 1849 he exhibited a series of cartoons for his first major project, the decoration of the medieval church of St Laurent in Paris, then undergoing restoration by Victor Baltard. When the church was remodelled and extended in 1866–7, Galimard again supplied designs for decorating the choir. None of this remains, but his windows in the south aisle of St Clothilde, Paris, Théodore Ballu's Gothic Revival masterpiece, finished in 1859, provide a good indication of his talent for organizing areas of strong colour in large, simple shapes. According to Auvray's account, Galimard also supplied windows for St Phillipe-du-Roule, Paris, for the church at Celle-Saint-Cloud and elsewhere.

As a painter Galimard is difficult to assess: surviving paintings by him are rare. His *Supper at Emmaus* in St Germain-l'Auxerrois, Paris, is too black to see. His *Ode* of 1846 (Paris, Louvre), however, survives in good condition. This half-length figure of a muse, inspired, it seems, by Nicolas Boileau's *Art poétique* (Paris, 1674), has the soulfulness, the exaggerated purity of form, the strong local colour and enamelled finish common in the work of Ingres's followers. His *Juno* (exh. Salon 1849; Narbonne, Mus. A. & Hist.) is a more eccentric figure, sharply outlined in profile like a character on a Greek vase, with little sense of academic modelling. *Leda and the Swan* (untraced), commissioned by Napoleon III as a present for William I, King of Württemberg, and submitted by the artist to the Exposition Universelle of 1855, was refused by the jury on the grounds of its indecency. Galimard retaliated by holding a private exhibition. It reappeared at the Salon of 1857, and in 1863 Galimard exhibited a drawing of the picture.

Galimard was the author of articles and reviews in *L'Artiste*, *La Patrie* and *La Revue des deux mondes*, published under the names of 'Judex' and 'Dicastes'. He also published lithographs after his own designs for stained glass (1854; Paris, Bib. N., Cab. Est.), a life of the lithographer Hyacinthe Aubry-Lecomte and a review of the Salon of 1849. He based his criticism on the absolute superiority of religious art (pagan and Christian), and, although not unsympathetic to Théodore Rousseau or Eugène Delacroix, he took Ingres as his ideal. His nickname, 'Pou mystique' ('mystic louse'), reflects the amused contempt felt by some of his contemporaries towards the religious and artistic idealism of Ingres's pupils.

WRITINGS

Chapelle Saint-Paul: Peintures, murales, exécutées à la cire dans l'Eglise Saint-Sulpice, par Martin Drölling (Paris, n.d.)
Les Grands Artistes contemporains: Aubry-Lecomte (Paris, 1860)
Les Peintures murales de Saint Germain-des-Prés (Paris, 1864)

BIBLIOGRAPHY

Bellier de La Chavignerie–L. Auvray, p. 601
B. Foucart: *Le Renouveau de la peinture religieuse en France (1800–60)* (Paris, 1987)

JON WHITELEY

Galimberti. Hungarian painters.

(1) Valéria Galimberti [née Dénes] (*b* Budapest, 2 Nov 1877; *d* Pécs, 18 July 1915). She began her artistic training at Ferenc Szablya-Frischauf's private school in Budapest, and she frequented the Nagybánya colony. In 1906 she went to live in Paris and for two years was a pupil of Matisse, showing her pictures at the Salons. Her street scenes and still-lifes were influenced by the Fauves: using the natural world as her starting-point she painted with thick contours and powerful colours. In 1911 she married the painter (2) Sándor Galimberti, and their work became increasingly similar. Her paintings of Provence and Saint-Raphaël use dynamic geometric forms for houses and rooftops. She developed a new type of composition for her paintings, using monumental foreground emphasis and short, sweeping motifs for the upper section; she also employed various viewpoints, and sometimes used oval formats. The influence of Analytical Cubism was prominent in her work, although she used softer forms and paler colours, as in *Gypsy Girl* (1914; Pécs, Pannonius Mus.).

Valéria Galimberti held her first exhibition at the National Salon in Budapest in 1914 with her husband, but during World War I they lived for a short time in Holland. Her pictures, like his, influenced the Hungarian avant-garde grouped around Lajos Kassák who in 1918 organised *MA*'s 6th exhibition at the *MA* premises in Budapest, dedicated to the work of Galimberti and her husband.

(2) Sándor Galimberti (*b* Kaposvár, 31 May 1883; *d* Budapest, 20 July 1915). Husband of (1) Valéria Galimberti. He began his studies in 1903 at the *plein-air* painting school at the Nagybánya colony, painting in a Neo-Impressionist style. He attended the Akademie der Bildenden Künste in Munich for a short time and went to Simon Hollósy's summer painting school in Técső. In 1907 he entered the Académie Julian in Paris, and in 1908 his work was shown at the Salon d'Automne and the Salon des Indépendants. He attempted in his painting to combine realistic depiction with decorative pictorial elements (e.g. *Rooftops*, 1908; Kaposvár, Rippl-Rónai Mus.), and he was

influenced by József Rippl-Rónai, who had discovered his talent. Galimberti used a Fauvist style in his work, enclosing forms with dark contours and using vivid colours. His depictions of houses in Saint-Raphaël are geometric in form; their dynamism points to an interest in Cubism, but, like his wife Valéria, he never ceased to use the natural world as his pictorial starting point (e.g. *Nagybánya*, *c.* 1910; Budapest, N.G.).

After the outbreak of World War I, when the Galimbertis worked in Holland, Sándor Galimberti produced his last great work, the modern cityscape *Amsterdam* (1914–15; Pécs, Pannonius Mus.), using typical Dutch motifs and a kaleidoscope of forms. In this new type of pictorial unity, the influence of Cubism is less obvious, and it marks a new direction away from his use of powerful colours. With his wife he became an important representative of Analytical Cubism in Hungarian art, and they held their first exhibition in Budapest in 1914.

BIBLIOGRAPHY
B. Uitz: 'Galimbertiék' [The Galimbertis], *MA*, 12 (1918), p. 144
O. Mezei: 'Les Galimberti, couple d'artistes hongrois des années 1910', *Acta Hist. A. Acad. Sci. Hung.* (1977), pp. 329–55
Z. Dénes: *Galimbertiék* [The Galimbertis] (Budapest, 1979)
The Hungarian Avant-garde: The Eight and the Activists (exh. cat. by J. Szabó and others, London, Hayward Gal., 1980), pp. 28–30, 62
Standing in the Tempest: Painters of the Hungarian Avant-garde, 1908–1930 (exh. cat. by S. Mansbach, Santa Barbara, Mus. A., 1991), pp. 117–18, 231

ÉVA BAJKAY

Galizia, Fede (*b* Milan, 1578; *d* Milan, 1630). Italian painter. She was the daughter and pupil of Nunzio Galizia (*fl* 1573–95), who moved to Milan from Trento. Her precocious achievements were first noted when she was 12 (Lomazzo); by 1596 she was known as a painter of portraits and religious compositions. The style of her portraits derived from the naturalistic traditions of the Renaissance in Italy, demonstrated in the work of such artists as Moretto da Brescia, Giovanni Battista Moroni and Lorenzo Lotto. The sharply realistic portrait of *Paolo Morigia* (1596; Milan, Bib. Ambrosiana; see fig.), an early patron who extolled her work in *La nobiltà di Milano* (Milan, 1595), shows this scholar and historian (1525–1604) in the act of completing laudatory verses in her honour. She received several public commissions for altarpieces in Milanese churches, among them that for the *Noli me tangere* (1616; Milan, S Stefano) for the high altar of S Maria Maddalena.

No 17th-century source mentions Galizia's still-life paintings, although they constitute her principal surviving oeuvre. A signed *Still-life* (1602; ex-Anholt priv. col., Amsterdam, see Bottari, 1965, fig. 6) is the first dated still-life by an Italian artist and documents her early involvement in this relatively new genre. Her still-lifes are normally frontal and symmetrical compositions, featuring a basket, bowl or fruit-stand containing a single kind of fruit (e.g. the *Bowl of Peaches*; Cremona, Mus. Civ.) with a few cut flowers or, as in the *Still-life with Peaches and a Porcelain Bowl* (Campione d'Italia, Silvano Lodi priv. col., see 1983 exh. cat., no. 5), other fruits set on the counter to provide contrast, scale and, in some cases, to suggest the *vanitas* theme. Such works show the influence of Caravaggio's *Basket of Fruit* (before 1600; Milan, Bib. Ambrosiana), which at that time was in the collection of Cardinal

Fede Galizia: *Paolo Morigia*, oil on canvas, 880×790 mm, 1596 (Milan, Biblioteca Ambrosiana)

Federico Borromeo. Galizia did not explore the more elaborate compositions and forms taken up by many of her contemporaries working in this genre, preferring instead an austere simplicity reminiscent of Francisco de Zurbarán.

BIBLIOGRAPHY
G. P. Lomazzo: *Idea del tempio della pittura* (Milan, 1950), p. 163
S. Bottari: 'Fede Galizia', *A. Ant. & Mod.*, xxiv (1963), pp. 309–60
——: *Fede Galizia pittrice (1578–1630)* (Trento, 1965) [cat. with illus.]
Women Artists, 1550–1950 (exh. cat. by A. S. Harris and L. Nochlin, Los Angeles, CA, County Mus. A.; Austin, U. TX, A. Mus.; Pittsburgh, PA, Carnegie Inst.; New York, Brooklyn Mus.; 1976–7), pp. 115–17
Italian Still-life Painting, 1600–1800 (exh. cat. by J. Spike, New York, N. Acad. Des.; Tulsa, OK, Philbrook A. Cent.; Dayton, OH, A. Inst.; 1983), pp. 30–32

ANN SUTHERLAND HARRIS

Gałkowski. Polish tapestry-weavers. Stefan Gałkowski (*b* Warsaw, 1912; *d* Kraków, 1984) and his wife Helena Gałkowski (*b* Morawica, nr Kraków, 1911; *d* nr Kraków, 1992) are credited with the revival of the art of tapestry-weaving in Poland. Both studied at the Academy of Fine Arts in Warsaw, and Stefan continued his studies in Italy and France (1937). The Gałkowskis started making tapestries in secret in the village of Morawica during the Nazi occupation of World War II, when private weaving was strictly prohibited because wool was required for the German army. They made small tapestries with figurative subjects based mainly on Polish legends and landscapes. Instead of the fine, chemically dyed wool used in French tapestry, they followed the local country tradition of using thick, hand-spun yarn coloured with vegetable dyes. This gives their tapestries the rough, variegated surface that is

a distinctive feature of their work. Stefan's work is often touched by satire, while Helena's is more lyrical.

Immediately after World War II, in 1946, the Gałkowskis helped to establish an artists' cooperative, Wanda, in Kraków. Here they could realize larger projects from painted cartoons. Allegorical, mythological and biblical subjects (e.g. *Niobe*, the *Invasion of Centaurs*, the *Rape of Europa*, *The Flood*, the *Judgement of Solomon*, the *Massacre of the Innocents* and *Paradise*) were depicted in tapestries of monumental scale that were suitable for the decoration of public buildings. Their work was soon in demand internationally as well as in Poland. It was exhibited in many countries, winning several awards, and is in various collections (e.g. Łódź, Cent. Mus. Textiles; Warsaw, N. Mus.; New York, United Nations Bldg). From 1956 Stefan was associated with the Academy of Fine Arts in Kraków, where from 1965 he held the Chair of Tapestry.

BIBLIOGRAPHY

T. Dobrowolski: 'Gobeliny Heleny i Stefana Gałkowskich' [Tapestries by Helena and Stefan Gałkowski], *Twórczość*, i (1945)

Wystawa tkanin Heleny i Stefana Gałkowskich [Textiles by Helena and Stefan Gałkowski] (exh. cat. by I. Huml, Warsaw, Zachęta Gal., 1961)

J. Grabowski: 'Tkaniny ich są obrazami' [Their textiles are pictures], *Pregląd A.*, i (1962)

H. Blum: 'O tkaninach Gałkowskich' [Textiles by the Gałowskis], *Znak*, xii (1964)

Wystawa gobelinów i projektów Heleny i Stefana Gałkowskich [Tapestries and projects by Helena and Stefan Gałkowski] (exh. cat. by H. Blum, Kraków, 1966)

Wystawa gobelinów Heleny i Stefana Gałkowskich w Muzeum Narodowym w Poznaniu [Tapestries by Helena and Stefan Gałkowski in the National Museum, Poznań] (exh. cat. by L. Wilkowa, Poznań, N. Mus., 1968)

Helena i Stefan Gałkowscy: Gobeliny [Helena and Stefan Gałkowski: Tapestries] (exh. cat. by K. Kondratink, Łódź, 1975)

ZDZISŁAW ŻYGULSKI JR

Gallaccini, Teofilo (*b* Siena, 22 Sept 1564; *d* 28 April 1641). Italian antiquary and theorist. As a boy he took drawing lessons from Francesco Vanni. He studied as a physician at Siena University, gaining his doctorate in 1597, and later occupied the chair of mathematics in the faculty of medicine. He was a member of the Accademia dei Filomati, Siena, and from at least 1593 produced papers on scientific and artistic subjects, including *Dell'arte in comparation a la natura* and *Della nobilità dell'architectura*. Among his pupils was Fabio Chigi, who later, as Pope Alexander VII, collected a portion of Gallaccini's antiquarian writings, *L'Antichità risorta*, and had them prepared for publication. Gallaccini was not an innovative thinker, although his writings show evidence of extensive reading of Classical and contemporary literature. He laid particular emphasis on primary evidence, such as inscriptions, medals and archival documents, to support his theories. His best-known treatise is his *Trattato sopra gli errori degli architetti* (1625). Although paradoxically he was somewhat old-fashioned in his adherence to established values and methods of architecture, his strictures against ornament and views on restraint in art and architecture were in keeping with the neo-Palladian sympathies of the 18th century and drew his work to the attention of such later figures as Joseph Smith and Antonio Visentini.

UNPUBLISHED SOURCES

Rome, Vatican, Bib. Apostolica

Siena, Bib. Com. Intronati [MSS include a travel notebook (1610; MS. K.VIII.4), *De capitelli delle colonne* (1631; MS S.IV.3) and *Teoriche e pratiche di prospettiva scenografia* (1641; MS L.IV.4)]

WRITINGS

Della nobilità dell'architettura (after 1600; Siena, Bib. Com. Intronati, MS. L.IV.I) (Siena, 1869)

Sopra gli errori degli architetti (1625; London, BL, MS. King's 281); ed. G. A. Pecci (Venice, 1767/*R* Farnborough, 1970) [unreliable prefatory biog.]

BIBLIOGRAPHY

G. M. della Fina: 'Un taccuino di viaggio di Teofilo Gallaccini (1610)', *Prospettiva* [Florence], 24 (Jan 1981), pp. 41–51

P. Collins: 'A Manuscript of an Architectural Work: *Il Tempio* by Teofilo Gallaccini', *Florence and Italy: Renaissance Studies in Honour of Nicolai Rubinstein*, ed. P. Denley and C. Elam (London, 1988), pp. 493–501

G. Simoncini, ed.: *Sopra i porti di mare, I*, iii of L'Ambiente storico (Florence, 1993)

PATRICIA COLLINS

Gallait, Louis(-Joseph) (*b* Tournai, 10 May 1810; *d* Brussels, 20 Nov 1887). Belgian painter and draughtsman. Although he came from an impoverished background, he entered the Académie of Tournai in 1823, where he worked first under Cornelis Cels and then under Philippe Auguste Hennequin, a pupil of Jacques-Louis David. Hennequin instilled in him the principles of Neo-classical drawing and had a profound influence on his choice of subject-matter. Gallait's first Classical subject, the *Death of Epaminondas* (Tournai, Mus. B.-A.), and his many early drawings show this influence clearly. Gallait's first success was with *Caesar's Tribute* (Ghent, Mus. S. Kst.) exhibited in 1832 at the Salon of Ghent. On the advice of Hennequin, Gallait went to Antwerp to continue his training under Mathieu Van Brée. Here he discovered the Baroque colour of Peter Paul Rubens and the nascent Romanticism of Gustaf Wappers. During this period he produced a *Christ Healing the Blind Man*, which was bought by the cathedral of Tournai (*in situ*). Gallait used the proceeds of this sale to go to Paris to continue his studies. He familiarized himself with the Old Master works in the Louvre and sought to achieve a calm and restrained Romanticism in such works as the *Oath of Vargas* (London, Wallace). He received commissions for the Musée Historique at Versailles, including a portrait of *Charles de Gontant, Duc de Biron* (Versailles, Château), which, with the *Oath of Vargas* and *Job* (Lille, Mus. B.-A.), was exhibited at the Salon of 1836 in Paris.

Gallait met with international acclaim when he showed the *Abdication of Charles V* (Tournai, Mus. B.-A.) at the Salon of 1841 in Paris. In this immense composition (*c.* 5×7 m) Gallait marshalled more than 100 figures around a central diagonal, emphasizing the main characters in the drama by careful use of light. The figure style owed much to Ary Scheffer and Paul Delaroche, under whom he studied in Paris. Among those depicted are the Dukes of Egmont and of Hoorn, who became the objects of the painter's veneration. In 1851 he again achieved international success with the macabre *Severed Heads, or the Last Honours of the Dukes of Egmont and Hoorn* (Tournai, Mus. B.-A.). Gallait settled in Brussels, where he was flooded with commissions. His paintings made him the leader of the moderate school of Romantic history painting in Belgium, in contrast to the unrestrained Rubenists of Antwerp.

As well as his great historical frescoes, whose subjects were taken from a national medieval and Renaissance past (e.g. the *Plague in Tournai in 1092*, 1843; Tournai, Mus. B.-A.), Gallait also resorted to a sweet and somewhat

vapid Romanticism, tinged with melancholy, controlled in mood and careful in technique. He frequently used the theme of the mother and child as pretext for the evocation of charm and tenderness: for example, the *Fall of the Leaves* (Brussels, Musées Royaux B.-A.). He also treated the life of the poor in such genre paintings as *Art and Freedom* and *Forgetting one's Sorrows* (study; both Brussels, Musées Royaux B.-A.).

Gallait was a prolific and important portrait painter. Among the most beautiful of his portraits is *Mme Gallait and her Daughter* (1848; Brussels, Mus. A. Anc.), which is marked by an elegant and graceful realism. He also produced drawings (*c.* 400 at Tournai, Mus. B.-A.) and some landscapes and views of monuments: views of Tournai and paintings made from his travels in Germany and Italy in 1839 and in France in 1844. On the Isle of Wight in 1862 and 1866 he made watercolours, heightened with white gouache, that are remarkably free in technique. Gallait taught at the Académie Royale de Belgique from 1845 and was its director between 1871 and 1880.

BIBLIOGRAPHY

S. Le Bailly de Tilleghem: *Louis Gallait, 1810–1887: Répertoire des oeuvres* (diss., Brussels, U. Libre, 1973)

——: 'La Formation néo-classique d'un maître romantique: Louis Gallait à l'Académie de Tournai, analyse de dessins inédits', *Rev. Archéologues & Historiens A. Louvain*, ix (1976), pp. 170–203

1770–1830: Autour du néo-classicisme en Belgique (exh. cat., Brussels, Mus. Ixelles, 1985–6), pp. 260–64

Louis Gallait, 1810–1887: La Gloire d'un romantique (exh. cat. by S. Le Bailly de Tilleghem, Tournai, Mus. B.-A., 1987–8)

DOMINIQUE VAUTIER

Galland, P(ierre) V(ictor) (*b* Geneva, 15 July 1822; *d* Paris, 30 Nov 1892). French painter. He studied metalwork with his father Jacques Galland, an accomplished goldsmith, until age 16. He then entered the studio of Henri Labrouste to study architecture. After two years of training, Labrouste encouraged him to pursue his interest in decorative painting under the direction of Michel-Martin Drolling. In 1843 the decorative painter Pierre-Luc-Charles Ciceri (1782–1868) hired Galland to assist with the painting of figures, flowers, garlands and fruit. He worked again with Labrouste, in 1848, on the decoration of the national festival, the Fête de la Concorde.

Galland received his first independent commission in 1851 from a rich Armenian to decorate the interior of his palace in Constantinople (destr.) built by a student of Labrouste, J. Mélick. After 18 months, he returned to France through Italy, stopping in Rome, Florence and Venice; sketches made during these travels record his serious study of Raphael and Veronese. In 1853 Galland decorated the tympana of nine small chapels at St Eustache in Paris, and in 1854 he submitted his first tapestry designs to the Gobelins factory. He became inspector of artistic interpretation at Gobelins in April 1877. The two major projects Galland completed in Paris in 1855, at the Ministry of Finance and the palace at Saint-Cloud, were destroyed by the Commune in 1871. From 1856 to 1872 Galland decorated ceilings and panels in private houses in France and abroad; among these were allegories of the Arts and Sciences (Stuttgart, Kön. Schloss), Apollo and the Muses (London, Baron Guy de Rothschild priv. col.), the Four Seasons (Paris, Hôtel Garfunkel) and the Five Senses

(Paris, Hôtel Mme de Cassin). Despite his growing international reputation, he habitually refused to exhibit at the annual Paris Salon.

In May 1873 Galland accepted a special chair at the Ecole des Beaux-Arts to teach a course on the decorative arts. The two-year course encouraged collaboration between the arts, but despite support from the school's director, Eugène Guillaume, and pressure from the French government to strengthen the alliance between fine arts training and industrial production, the course was ill-attended and openly discouraged by resentful colleagues. In support of Galland, the Director of Fine Arts, Charles-Philippe de Chennevières, commissioned a monumental history painting, the *Sermon of St Denis*, for the right entrance wall of the Panthéon (1874–88). In 1876 Galland's studies for the stairway decorations in the Palace of Prince Narishkine in St Petersburg were permanently installed at the Union Centrale des Arts Décoratifs, Paris, as exemplary of the true principles of decorative painting: subordination of painting to the architectural ensemble by the radical suppression of details, elimination of illusionism, simplification of colour and composition and uniformity of surface; a method of painting described by Galland as 'interpretation guided by logic and love of nature'. Galland's work links the mural paintings of Pierre Puvis de Chavannes and the craft of ornamental decorative painting. His range and innovation can be seen in the unique vocabulary of ornament he developed based on 40 years of painstaking study of the indigenous flora of France.

Galland's most important decorative scheme, the *Glorification of Work* (1888–91), spans the 13 vaults of the lateral Galerie des Métiers of the Hôtel de Ville, Paris, and celebrates, in scenes of craftsmen at work, his lifelong commitment to the collaboration of artists and artisans. In 1890 Galland and Albert Besnard decorated the Salle des Conversations for the first Salon of the Société Nationale des Beaux-Arts. The retrospective exhibition of Galland's work that opened at the Palais de l'Industrie on 26 March 1894 revealed that he was also a prolific and varied painter of genre still-lifes, interiors and history painting. The French State purchased numerous works from the sale that followed for the Ecoles des Arts Décoratifs in Paris, Limoges, Nancy and Roubaix. Galland was awarded the Légion d'honneur in 1878.

BIBLIOGRAPHY

DBF

Le Flore et l'ornement: Dessins de P. V. Galland, 1822–1892 (exh. cat. by M.-N. de Gary, Paris, Mus. A. Déc., n.d.)

G. Duplessis: 'La Peinture décorative de P. V. Galland', *Rev. A. Déc.*, i (1880–81), pp. 65–76

H. Havard: *L'Oeuvre de P. V. Galland, 1822–1892* (Paris, 1895)

Le Triomphe des mairies (exh. cat., Paris, Petit Pal., 1986), pp. 325–33

MARIE JEANNINE AQUILINO

Galla Placidia (*b* Constantinople, *c.* AD 388 or 393; *d* Rome, 450). Late Roman empress and patron. She was the daughter of Theodosius I the Great and half-sister to the Emperor Honorius (*reg* 395–425). She was brought up in Constantinople and Rome, from where she was taken hostage by the Visigoths during the sack of 410, and was married to their leader Athaulf in 414. On his death the following year, she was returned to her own people and in

417 reluctantly married her brother's Master of Armies, who was to become Constantius III (*reg* 421). After quarrelling with Honorius, she fled to Constantinople, but on his death her son Valentinian III (*reg* 425–55) was installed as Emperor in the West by the eastern armies. At first her influence was dominant, but she was unable to stop the increasing power of Aetius (*c.* 391–454), and by 438 she had been forced into virtual retirement.

Placidia's building works reflect the piety she apparently gained while in exile in Constantinople. In Rome she commissioned the mosaics in S Paolo Fuori le Mura, of which only one piece survives, though much restored, above the triumphal arch. Her preference, however, was for the new court city at Ravenna, which she adorned with several ecclesiastical buildings. One building to have survived intact is the so-called Mausoleum of Galla Placidia (*see* RAVENNA, §2(ii)), which was erected *c.* 425–6 as an ante-chapel of Santa Croce and dedicated to St Lawrence. This small, cruciform structure was almost certainly not used as her tomb. Her work at the Basilica Ursiana (now the Cathedral) has disappeared, while the baptistery and the cruciform basilica of Santa Croce are known only from excavation. Fragments, however, remain of the basilica of S Giovanni Evangelista (424–34), which was built in fulfilment of a vow made to the saint when Placidia and her children were nearly shipwrecked on the Adriatic. Their experiences were depicted on the pavement and walls in mosaic (destr.), with representations of her imperial lineage. In addition to the portraits of her in S Giovanni Evangelista, others are known from coins and a medallion (*c.* 420; diam. *c.* 60 mm; Paris, Bib. N., Cab. Médailles).

BIBLIOGRAPHY

G. Bovini: *Il cosidetto mausoleo di Galla Placidia in Ravenna* (Vatican City, 1950)
——: *Ravenna Mosaics* (New York, 1956)
F. Gerke: *Das Christusmosaik in der Laurentius-kapelle der Galla Placidia in Ravenna* (Stuttgart, 1965)
S. I. Oost: *Galla Placidia Augusta* (Chicago and London, 1968)

L. JAMES

Gallardo, Mateo (*b c.* 1600; *d* Madrid, 11 Sept 1667). Spanish painter. He is documented from 1628, always in Madrid, but nothing is known of his training and little of his work has been preserved. In 1656–9 Lázaro Díaz del Valle mentioned him among the painters of Madrid as 'a famous painter, and with good reason' (Sánchez Canton, ed., p. 371) and there are occasional references to his activity in and out of the court. Gallardo's work is basically conservative in spirit, and he continued until well into the second half of the 17th century to use compositional schemes and models from the first third of the century, recalling those of Vicente Carducho. Nevertheless, he developed a personal style incorporating luminous, soft colours and a human type characterized by refined, delicate features. Significant examples of his works are *Tobias and the Angel* (Madrid, Prado, on dep. Brussels, Sp. Embassy), the *Circumcision* of the principal retable of the Cathedral of Plasencia (Cáceres), documented in 1653, the *Martyrdom of St Catherine* (1653; Oviedo, Mus. B.A.) and a series of *Angels with Instruments of the Passion* (Barcelona, priv. col.).

BIBLIOGRAPHY

L. Díaz del Valle: *Epílogo y nomenclatura de algunos artífices* (MS.; 1656–9); ed. F. J. Sánchez Cantón in *Fuentes literarias para la historia del arte español* (Madrid, 1934), pp. 323–93
D. Angulo Iñiguez and A. E. Pérez Sánchez: *Pintura madrileña del segundo tercio del siglo XVII* (Madrid, 1983)

JESUS URREA

Gallarus Oratory. Chapel on the Dingle Peninsula, Co. Kerry, Ireland. Gallarus Oratory is the most perfect of the Irish 'boat-shaped' oratories, so named because the form resembles that of an inverted boat. Approximately 30 other examples, almost all in ruins, are concentrated along the Atlantic coasts of Kerry, Clare and Mayo. The chapel at Gallarus stands in a stone-walled enclosure, which also contains a rough slab inscribed with a cross. The building is an outstanding example of a corbelled structure, in which horizontally bedded stones overhang in succession to form a graceful roof of stone. All four walls curve gently inwards to meet a horizontal ridge. Constructed of roughly coursed masonry, the individual pieces were carefully selected and fitted together with great intricacy. The experience of the masons is indicated by the slight outward angle at which the stones are bedded to ensure that water drains away from the interior. Although frequently described as a 'dry stone' building, there is evidence that lime mortar was employed. The slight sag in the roof, visible on both the north and south sides, is the consequence of an inherent defect in rectangular corbelled structures, which are less stable than circular ones. A series of triangular stones defines the exterior ridge; at least one end terminated in a stone finial. The interior, 4.65×3.15 m, is surprisingly spacious, reaching at the apex a height of 4.3 m. The west door has inclined jambs in the Irish fashion and it is surmounted by a single stone lintel. On the interior two stones project above the lintel, each pierced to facilitate some form of door mechanism. The east window, the only one in the building, has a wide interior splay and its rounded head is cut out of two to three stones. The smoothly dressed masonry visible here is also evident in the doorway and on the under surfaces of the vault.

No historical information survives concerning either Gallarus or the nature of the Christian settlement there. The ancient technique of corbelling has encouraged antiquaries to think of Gallarus as one of the first stone churches in Ireland and a landmark in the evolution of European architecture. Although it was once ascribed to the 6th to 8th centuries, the fine quality of the masonry, the use of an arch system in the window and the hints of dressed masonry give the building a Romanesque veneer. It is now regarded not as a harbinger of Irish Christian architecture but as a late though highly accomplished version of a local building style. Even deprived of its historical status, it is still, with its pleasing geometry and superb masonry, a structure of uncomplicated beauty.

BIBLIOGRAPHY

H. G. Leask: *Irish Churches and Monastic Buildings*, i (Dundalk, 1955), pp. 21–5
P. Harbison: 'How Old is Gallarus Oratory? A Reappraisal of the Role of Gallarus Oratory in Early Irish Architecture', *Med. Archaeol.*, xiv (1970), pp. 34–59

Archaeological Survey of the Dingle Peninsula (Ballyferriter, 1986), pp. 286–9

ROGER STALLEY

Gallatin, A(lbert) E(ugene) (*b* Villanova, PA, 23 July 1881; *d* New York, 15 June 1952). American collector, painter and critic. He was a great-grandson of Albert Gallatin, Secretary of the Treasury under President Jefferson and President Madison and one of the founders of New York University. Around 1900 he began establishing his reputation as a leading connoisseur of Aubrey Beardsley and James McNeill Whistler through his extensive writing and collecting of their work. Frequent visits to Paris and Europe from 1921 to 1938 resulted in Gallatin's conversion to acquiring modernist art through his contacts with artists, dealers and collectors. In 1927 he opened his collection to the public as the Gallery of Living Art, in the South Study Hall of New York University's Main Building. It was the first museum in the USA devoted exclusively to modern art. As its director Gallatin developed the collection into a significant survey focusing on Cubism, De Stijl, Neo-plasticism and Constructivism. Works by Picasso, Braque, Gris, Léger, Mondrian, Jean Hélion, El Lissitzky and many others reflected Gallatin's formalist emphasis on abstract pictorial structure. Other works by Miró, Arp and André Masson provided an abstract Surrealist component. Among the most important paintings in the collection were Picasso's *Three Musicians* (1921), Léger's *The City* (1919), Miró's *Dog Barking at the Moon* (1926) and Mondrian's *Composition with Blue and Yellow* (1932; all Philadelphia, PA, Mus. A.).

In 1936 Gallatin renamed his institution the Museum of Living Art and resumed painting after a brief, undocumented period of experimentation in the mid-1920s. His collection played a formative role in the evolution of his Synthetic Cubist style primarily based upon the work of Gris, Picasso and Léger. It was also an influential resource for many others, particularly his fellow members of the American Abstract Artists, whose work he purchased and exhibited. The Museum of Living Art was forced to close in 1943, when New York University asked Gallatin to remove his works as a wartime measure. He placed most of the works on loan with the Philadelphia Museum of Art, adding further works by Ad Reinhardt, Fritz Glarner and others and bequeathing the collection to the museum. During his last years Gallatin continued to write and to exhibit his own paintings.

WRITINGS

Whistler's Art Dicta and Other Essays (Boston, 1904)
Portraits of Whistler: A Critical Study and an Iconography (London and New York, 1918)
Charles Demuth (New York, 1927)
Gallatin Iconography (Boston, 1934)
Georges Braque: Essay and Bibliography (New York, 1943)
Of Art: Plato to Picasso (New York, 1944)

BIBLIOGRAPHY

A. D. Wainwright: 'A Checklist of the Writings of Albert Eugene Gallatin', *Princeton U. Lib. Chron.*, xiv/3 (Spring 1953), pp. 141–51
Albert Eugene Gallatin and his Circle (exh. cat., essays D. B. Balken and S. C. Larsen; Pittsfield, MA, Berkshire Mus.; New York U., Grey A.G.; Coral Gables, FL, U. Miami, Lowe A. Mus.; and elsewhere; 1986–7)
G. Stavitsky: 'A. E. Gallatin's Gallery and Museum of Living Art (1927–1943)', *Amer. A.*, vii (Spring 1993), pp. 47–64
——: 'A Landmark Exhibition: Five Contemporary American Concretionists', *Archvs Amer. A. J.*, xxxiii/2 (1993), pp. 2–10

——: 'The A. E. Gallatin Collection: An Early Adventure in Modern Art', *Bull. Philadelphia Mus. A.*, lxxxix (1994), pp. 3–47

GAIL STAVITSKY

Galle. Flemish family of artists and publishers of Dutch origin. The print workshop and publishing house founded by (1) Philip Galle was one of the most important centres for engraving in Antwerp from the late 16th century to the early 17th. The business was continued by his sons (2) Theodor Galle and (3) Cornelis Galle (i), who are chiefly known as reproductive engravers after compositions by Rubens and who, with their colleagues in the workshop, were among the first generation of engravers whose reputations were made by this work. Many of the titlepages and book illustrations produced in the Galle workshop were reprinted by the Plantin and Moretus presses. Philip's grandsons (4) Cornelis Galle (ii) and (5) Joannes Galle continued the family business.

(1) Philip [Philipp; Philips] **Galle** (*b* Haarlem, 1537; *d* Antwerp, 12 or 29 March 1612). Draughtsman, engraver, publisher, print dealer, writer and historian. It is possible that he was a pupil in Haarlem of Dirk Volkertsz. Coornhert, but more than likely he was trained in the Antwerp workshop of Hieronymous Cock, who published Galle's first prints in 1557 and for whom he worked for many years. Shortly after 1557 Philip Galle started his own publishing and print business, for which he travelled extensively: in 1560–61 he visited the southern Netherlands, France, Germany and Italy. After 1564 he settled in Antwerp, where he acquired citizenship in 1571, the same year in which he became a master in the city's Guild of St Luke. He served as dean of the guild from 1585 to 1587. His documented pupils were H. van Doort in 1580, Karel van Mallery (1571–1635) in 1586, Jean-Baptiste Barbé (1578–1649) in 1594 and Peter Backereel (*d* 1637) in 1605. Others working at the workshop and publishing house included Philip's sons Theodor and Cornelis (i), his son-in-law Adriaen Collaert, pupils van Mallery and Barbé, the Wierix brothers, Hendrick Goltzius, Crispijn de Passe I and other members of the Collaert family.

Philip Galle's engraved oeuvre is extensive and includes work after his own compositions as well as after many other artists, including Maarten van Heemskerck (e.g. the series of the *Triumphs of Petrarch*, 1565; Hollstein, nos 389–94; *see* ICONOGRAPHY AND ICONOLOGY, fig. 3), Frans Floris (e.g. *Lot and his Daughters*, Hollstein, no. 3), Pieter Bruegel the elder (e.g. the *Death of the Virgin*, 1574; see fig.), Marten de Vos (e.g. the *Annunciation*, Hollstein, no. 98) and a number of Italian artists. Philip also engraved portraits of learned men, among them many contemporaries, and these prints appeared in the *Images virorum doctorum et disciplinis bene merentium effigies XLIV* (1587; Hollstein, nos 785–834), the *Illustrium Galliae Belgicae scriptorum icones et elogia* (1558; Hollstein, nos 835–86) and elsewhere. The rather dry style that he employed even in his early engravings is generally typical of his oeuvre; he was not receptive to the influence of the engraving technique then being adopted by Hendrick Goltzius, which later became so widespread. Only after 1586 is there a somewhat freer style in Galle's engravings, achieved through his greater use of chiaroscuro. A few engravings

Philip Galle (after Pieter Bruegel the elder): *Death of the Virgin*, engraving, 310×420 mm, 1574 (London, British Museum)

(e.g. by Adriaen Collaert and Crispijn de Passe) name Philip Galle as the designer. Philip also wrote and published two books, one on techniques for artists.

WRITINGS

Corte verhael van de ghedinckweerdigste zaken die in de provincien van de Nederlanden . . . geschied zyn [Short history of memorable events in the provinces of the Netherlands] (Antwerp, 1566–79)
Instructions et fondements de bien pourtraire, pour les peintres (Antwerp, 1589)

(2) Theodor [Dirck] **Galle** (*b* Antwerp, *bapt* 16 July 1571; *d* Antwerp, *bur* 18 Dec 1633). Engraver, publisher and print dealer, son of (1) Philip Galle. He was a pupil of his father. In 1596 he was admitted to the Antwerp Guild of St Luke and about the same time established a print-selling business. He travelled to Italy with his brother Cornelis (i) in the same year. Theodor married the daughter of the Antwerp publisher Jan Moretus the elder and after his father's death in 1612 took over the direction of the Galle workshop and publishing house. Theodor Galle was chiefly active as a publisher and print dealer. However, while in Rome, he engraved, after his own designs, the *Imagines ex antiquis marmoribus, numismatibus et gemmis expressae* (Hollstein, nos 226–376). He also reproduced compositions by others including Hans Bol (e.g. the *Story of Abraham*, Hollstein, nos 1–4), Joannes Stradanus (e.g. the *History of the Romans*, Hollstein, nos 390–95) and Peter Paul Rubens (e.g. the title-pages for the *Breviarum Romanum*, 1628; Hollstein, no. 435; Augustini Mascardi's *Silvarum libri IV*, 1622; Hollstein, no 436; and *Obras en verso de Don Francesco de Borja*, 1633; Hollstein, no. 437).

(3) Cornelis Galle (i) (*b* Antwerp, 1576; *d* Antwerp, 29 March 1650). Engraver and publisher, son of (1) Philip Galle. He was also a pupil of his father. In 1596 he visited Rome with his brother Theodor and remained there perhaps until 1610, when he was in Antwerp and became a member of the city's Guild of St Luke. Shortly thereafter he founded a school of engraving in the city where many notable artists trained. The oeuvre of Cornelis Galle (i) includes engravings after his own drawings as well as after compositions by other artists. During his stay in Rome, he made drawn copies of works by such artists as Raphael, Titian, Annibale Carracci, Giudo Reni and Jacopo Bassano, which he later used as preparatory designs for reproductive engravings after these Italian masters. Cornelis's work for Rubens includes *Judith Beheading Holofernes*, known as the '*Great Judith*' (Hollstein, no. 31; see fig.), the *Raising of the Cross* (Hollstein, no. 58), the *Passion* (Hollstein, nos 85–105) and the illustrations for the *Vita beati P. Ignatii Loyolae* (Hollstein, nos 162–249). Cornelis Galle often engraved after the work of Anthony van Dyck (e.g. the *Crucifixion*, Hollstein, no. 56, and the portrait of *Artus Wolfart*, Hollstein, no. 283). He also engraved works by numerous other Netherlandish artists including Marten de Vos, Hendrick Goltzius and Jacques Francuart; his engravings after the latter include the series of illustrations for the *Pompa funebris optimi potentissimique Principis Alberti Pii* (1623; Hollstein, nos 292–345) by Erycius Puteanus (1574–1646). Cornelis Galle (i) employed a traditional, dry engraving technique and style, typical of his father's workshop. In the long term he could not

BIBLIOGRAPHY

BNB; Hollstein; *Dut. & Flem.*; Thieme–Becker; Wurzbach

C. Le Blanc: *Manuel de l'amateur d'estampes*, ii (Paris, 1856–8), pp. 262–3, 265

G. K. Nagler: *Monogrammisten* (1858–1920), ii, p. 57; iii, pp. 236, 2408; iv, pp. 2968, 2975–6, 3033

J. J. P. Van den Bemden: *Die familie Galle: Plaetsnyders van het laetst der XVe en de eerste helf der XVIIe eeuw* [The Galle family: plate-cutters from the end of the fifteenth century to the first half of the seventeenth] (Antwerp, 1865)

H. Hymans: *Histoire de la gravure dans l'école de P. P. Rubens* (Brussels, 1879), pp. 15–18

G. K. Nagler: *Neues allgemeines Künstler-Lexikon*, iv (Frankfurt am Main, 1920), pp. 564–6

B. A. Vermaseren: 'De Antwerpse graveur Philips Galle en zijn kroniekje over de opstand (1579)' [The Antwerp engraver Philip Galle and his short chronicle of the revolt (1597)], *Gulden Passer*, xxxv (1957), pp. 139–47

S. Gieben: 'Philip Galle's Original Engravings of the *Life of St Francis* and the Corrected Edition of 1587', *Collct. Franciscana*, xlvi (1976), pp. 241–307

——: *Philip Galle's Engravings Illustrating the 'Life of Francis of Assisi'* (Rome, 1977)

Philips Galle, 56 of *The Illustrated Bartsch*, ed. W. Strauss (New York, 1978–)

E. A. Saunders: 'A Commentary on Iconoclasm in Several Print Series by Maarten van Heemskerck', *Simiolus*, x (1978–9), pp. 59–83

W. Couvreur: 'Galle en Hoefnagels stadsplattegronden en de Antwerpse verdedigingswerken van september 1577 tot februari 1581' [Galle and Hoefnagel's town plans and the Antwerp defence works of September 1577 to February 1581], *Gulden Passer*, lxi–lxiii (1983–5), pp. 519–45 [issues dedicated to Léon Voet]

B. Haeger: 'Philips Galle's Engravings after Maarten vam Heemskerk's *Parable of the Prodigal Son*', *Oud-Holland*, cii (1988), pp. 127–140

I. M. Veldman: 'Philips Galle: Een inventieve prentontwerpers' [Philip Galle: an inventive print designer]', *Oud-Holland*, cv (1991), pp. 262–90

CHRISTINE VAN MULDERS

Cornelis Galle (i) (after Peter Paul Rubens): *Judith Beheading Holofernes*, engraving, 545×378 mm, *c*. 1600 (London, British Museum)

produce work that satisfied Rubens's requirements for reproductions of his paintings, and after 1610 the latter employed almost exclusively members of the Haarlem school for such work. However, Cornelis Galle (i) retained Rubens's patronage as an engraver of title-pages and book illustrations for Christoph Plantin.

(4) **Cornelis Galle (ii)** (*b* Antwerp, *bapt* 23 Feb 1615; *d* Antwerp, 18 Oct 1678). Engraver and publisher, son of (3) Cornelis Galle (i). He was a pupil of his father and became a master in the Antwerp Guild of St Luke in 1638–9. The engraved oeuvre of Cornelis Galle (ii) is extensive and consists chiefly of prints after such artists as Rubens (e.g. *Crucifixion*, Hollstein, no. 9, and the portrait of *Justus Lipsius*, Hollstein, no. 177) and Anthony van Dyck (e.g. the portrait of *Jan Meyssens*, Hollstein, no. 181). It is often difficult to separate his prints from those of his father, and it is very rare to find the epithet 'junior' next to the signature. However, the son's engravings are distinguished by their freer technique and style.

(5) **Joannes** [Jan] **Galle** (*b* Antwerp, *bapt* 27 Sept 1600; *d* Antwerp, 20 Dec 1676). Engraver, publisher and print dealer, son of (2) Theodor Galle. He became a master in the Antwerp Guild of St Luke in 1627–8 and its dean in 1638–9. Although various engravings have been attributed to him, he was probably only their publisher. However, engravings after Rubens's *Crucifixion* (Hollstein, no. 2) and *All Saint's Day* (Hollstein, no. 5) are definitely by him.

Galle, André (*b* St Etienne, Loire, 15 May 1761; *d* Paris, 21 Dec 1844). French medallist. He first worked in Lyon as an engraver of dies in a button factory, becoming its owner in 1786. In 1790 enthusiasm for the French Revolution inspired him to produce a medal for the Fédération. He followed this with a trial piece for the proposed bell-metal coinage, bearing a portrait of the *Marquis de Mirabeau* as the French Demosthenes, and in the following year another piece, representing *French Liberty* (in imitation of Augustin Dupré's *American Liberty*). Galle was sent to Paris to take part in the deliberations on the new coinage; there he worked for Dupré at the Mint, while studying sculpture under Antoine-Denis Chaudet. His opportunity came when Dominique-Vivant Denon began to produce his medallic history of Napoleon's reign. Galle's numerous contributions included the *Conquest of Upper Egypt*, the *Arrival of General Bonaparte at Fréjus*, the *Battle of Friedland* and the *Battle of Jena*, while his coronation portrait of *Napoleon* (1806) was much admired. After the Bourbon Restoration Galle was soon reconciled with the new regime and received a number of important commissions, including a medal for the *Entry of Louis XVIII into Paris in 1814* (ordered in 1816 and completed in 1822); at the same period he executed portraits of contemporaries such as *Jacques-Louis David*, *Henry Grattan* and *Matthew Boulton*. Galle was elected to the Institut de France in 1819 and was made a Chevalier of the Légion d'honneur in 1825. In 1828 he invented an articulated chain of the kind later used in bicycles and devoted much of the rest of his life to its manufacture.

Forrer
BIBLIOGRAPHY
Biographie des hommes vivants, iii (Paris, 1817), pp. 202–3
C. Gabet: *Dictionnaire des artistes de l'école française au XIXe siècle* (Paris, 1834), pp. 184–5
J. M. Darnis: 'André Galle', *Bull. Club Fr. Médaille*, li/lii (1976), pp. 160–72
MARK JONES

Gallé, Emile (Charles Martin) (*b* Nancy, 4 May 1846; *d* Nancy, 23 Sept 1904). French glassmaker, potter and cabinetmaker. He was the son of Charles Gallé-Reinemer, a manufacturer of ceramics and glass in Nancy, and as early as 1865 he started working for his father, designing floral decoration. From 1862 to 1866 he studied philosophy, botany and mineralogy in Weimar, and from 1866–7 he was employed by the Burgun, Schwerer & Cie glassworks in Meisenthal. On his return to Nancy he worked in his father's workshops at Saint-Clément designing faience tableware. In 1871 he travelled to London to represent the family firm at the International Exhibition. During his stay he visited the decorative arts collections at the South Kensington Museum (later the Victoria and Albert Museum), familiarizing himself with Chinese, Japanese and Islamic styles. He was particularly impressed with the Islamic enamelled ware, which influenced his early work. In 1874, after his father's retirement, he established his own small glass workshop in Nancy and assumed the management of the family business.

Gallé's work reflects the contemporary interest in botany and entomology, and he turned his knowledge and studies to revitalizing the decorative arts. At the Exposition Universelle of 1878 in Paris, Gallé exhibited pieces made in the 'clair-de-lune' technique: glass was coloured with traces of cobalt oxide, which produced a sapphire hue. From *c*. 1884 Gallé produced his first *verreries parlantes*, which were inscribed with quotations from poems and prose by such writers as François Villon (e.g. 'La Ballade des dames du temps jadis', 1884; Nancy, Mus. Ecole Nancy). Gallé first exhibited this glass in 1884 at the Union Centrale des Arts Décoratifs in Paris, where he showed over 300 pieces of glass and ceramics, for which he was awarded a gold medal. Perhaps Gallé's greatest innovation was his development of cameo glass: the inspiration for this type of glass came from the Chinese cased glass of the Qian long period (1736–96). Two or more fused layers of coloured glass were painted with an acid-resistant material and then immersed in an acid bath. The decoration was revealed in low relief and then carved to highlight the motifs (e.g. 'Jardinière', 1884; Paris, Mus. A. Déc.). Gallé experimented with a variety of techniques and also with metal foils and coloured oxides for their decorative effects and exploited such imperfections as crazing and air bubbles in order to create novel and often surreal effects.

In the late 1880s Gallé opened a studio for the production of furniture and first exhibited examples at the Exposition Universelle of 1889 in Paris. Gallé's furniture was generally traditional in form but enhanced with complex marquetry decoration using a variety of indigenous and exotic woods and inlaid with mother-of-pearl and hardstones (e.g. buffet, 1904; Paris, Mus. d'Orsay). His decoration included such popular Art Nouveau motifs as dragonflies and water-lilies. Victor Prouvé (*see* PROUVÉ) and Louis Hestaux assisted with the design for much of the sculpture, marquetry and inlay of the furniture. From *c*. 1897 Gallé developed his technique of *marqueterie de verre*, which was inspired by his involvement in wood marquetry. Motifs of hot glass were impressed on to the body of coloured glass, and once the body had cooled the inlaid pieces were lightly carved into relief.

Gallé manufactured three types of products: his so-called 'industrial' production began *c*. 1890, and signed vases in simplified shapes and colours were produced in large quantities; and his more complex and sophisticated limited editions (called 'semi-rich') and his *pièces uniques* were executed by himself (as seen in the portrait of Gallé by Prouvé, 1892; Nancy, Mus. Ecole Nancy; see fig.) or by highly skilled craftsmen. By 1894 Gallé was managing a burgeoning business with over 300 employees. Gallé triumphed at the Exposition Universelle of 1900 in Paris, presenting a retrospective of his career and a working furnace at which the art of glassmaking was demonstrated. Gallé's talent was now widely recognized, and he was elected to the Légion d'honneur. In 1901 Gallé was responsible for the creation of the Alliance Provinciale des Industries d'Art (later called the Ecole de Nancy) to which

Emile Gallé by Victor Prouvé, oil on canvas, 1.58×0.96 m, 1892 (Nancy, Musée de l'Ecole de Nancy)

Auguste Daum, Louis Majorelle and Prouvé also belonged. After 1901 Gallé was ill with leukaemia, but he nevertheless remained productive and innovative both from a technical and decorative point of view; for example, he adapted his production for electric lighting (e.g. 'Les Coprins', 1904; Nancy, Mus. Ecole Nancy). After Gallé's death in 1904, the business was continued under the artistic direction of Prouvé until 1913. Production finally ceased in 1931, and the shop closed in 1935.

For an illustration of a vase by Gallé *see* ART NOUVEAU, fig. 1.

WRITINGS
Ecrits pour l'art (Paris, 1908)

BIBLIOGRAPHY
R. Marx: 'Emile Gallé: Psychologie de l'artiste et synthèse de l'oeuvre', *A. & Déc.* (1911)
P. Garner: *Emile Gallé* (Paris, 1977)
B. Hakenjos: 'Emile Gallé', *Keramik, Glas und Möbel des Art Nouveau* (Cologne, 1982)
Emile Gallé: Dreams into Glass (exh. cat. by W. Warmus, Corning, NY, Mus. Glass, 1984)

ELISABETH LEBOVICI

Gallego, Fernando (*b* Salamanca, *fl* 1468–1507). Spanish painter. He was active in Salamanca, at that time an important city due to its double status as episcopal see and university city, but he also worked in the regions of León and Extremadura, in such cities as Toro, Zamora, Ciudad Rodrigo and Plasencia. Nothing definite is known about his training, but his plastic concept of form and his interest in spatial definition link him to 15th-century Flemish painting, in particular to the style of Rogier van der Weyden and Dieric Bouts the elder. The similarities between his art and that of the latter, who was contemporary with him, point to a possible stay in the Low Countries, although he may also have trained in the circle of Jorge Inglés. Nevertheless, he was an artist of considerable individuality, defined by an excellent mastery of technique and an inventive originality, by his interest in realism and by the characterization of his figures, as well as by an expressiveness similar to that found in the work of Konrad Witz. At times he achieved in his work a dramatic intensity unrivalled in Spanish painting of the period.

The first documented date relating to Gallego's work is 1468, when he was working in Palencia Cathedral. During this period Cardinal Juan de Mella (1397–1467) commissioned him to paint an altarpiece dedicated to S Ildefonso for one of the chapels in Zamora Cathedral (*in situ*), and this shows a great attention to detail. Around 1470 he painted a triptych of the *Virgin of the Rose* flanked by *St Andrew* and *St Christopher* (Salamanca, Mus. Catedralicio) for the cloisters of the Old Cathedral in Salamanca. It is one of his few signed works and shows a lengthening of the figures and an accentuation of the folds of the heavy garments, qualities that are similar to those found in the work of Bouts. On 23 February 1473 Gallego signed a contract to execute six panels (untraced) for Coria Cathedral (Cáceres). Towards the end of the 1470s he reached his artistic maturity, and a period of success and intense productivity began. Between *c.* 1478 and *c.* 1495 he created large altarpieces with considerable workshop involvement, such as that (*c.* 1480) for the principal altar of S María at Trujillo (Cáceres; *in situ*), the principal altarpiece (*c.* 1480–

88; Tucson, AZ, Mus. A.) for Ciudad Rodrigo Cathedral (Salamanca), the altarpiece (before 1490) of S Lorenzo at Toro in Zamora (*in situ* except for the central panel dedicated to *Christ Blessing*, Madrid, Prado), and the main altarpiece (*c.* 1494) of Zamora Cathedral. This last work originally comprised 35 panels, of which 15 exist, following their transfer in the 18th century to the parish church of Arcenillas (Zamora).

Significant among Gallego's work is his decoration (*c.* 1479–83) of the vault of the library at the Universidad de Salamanca, a third of which is preserved. Using a secular theme with great imagination, this depicts the constellations and signs of the zodiac in what was a unique ensemble in contemporary Spanish painting and was admired by the humanist Lucio Marineo Sículo in his book *De laudibus hispaniae* (Burgos, 1493), as well as by the German Hieronymus Münzer in his *Viaje por España*, which describes a journey undertaken between 1494 and 1495. Gallego was one of the most significant figures in Hispano-Flemish painting in Castile, and after his death he left an important school represented notably by Pedro Bello and Francisco Gallego, who may have been his brother.

BIBLIOGRAPHY
Ceán Bermúdez
M. Gómez Moreno and F. Sánchez Cantón: 'Sobre Fernando Gallego', *Archv Esp. A. & Arqueol.*, iii (1927), pp. 349–57
C. Post: *A History of Spanish Painting* (Cambridge, MA, 1933), pp. 87–150
J. Gudiol Ricart: *Pintura gótica*, A. Hisp., ix (Madrid, 1955), pp. 320–34
J. A. Gaya Nuño: *Fernando Gallego* (Madrid, 1958)
R. M. Quinn: *Fernando Gallego and the retablo of Ciudad Rodrigo* (Tucson, 1961)
J. L. Garcia Sebastian: *Fernando Gallego y su taller en Salamanca* (Salamanca, 1979)

TRINIDAD DE ANTONIO SAÉNZ

Gallen-Kallela, Akseli (Valdemar) [Gallén, Axel until 1904] (*b* Pori [Swed. Björneborg], Finland, 26 April 1865; *d* Stockholm, 7 March 1931). Finnish painter, graphic artist and designer. He learnt the elements of drawing and painting in Helsinki at the School of the Finnish Arts Society and the studio of the painter Adolf von Becker (1831–1909).

His first significant painting, *The Boy and the Crow* (1884; Helsinki, Athenaeum A. Mus.), shows his ambition to keep abreast of developments in Naturalism, a style introduced to him through the works of young Finnish and Scandinavian painters in Paris. In the autumn of 1884 he arrived in Paris, where he attended the Académie Julian and the studio of Fernand Cormon. In 1885 he completed his oil painting *Old Woman with a Cat* (Turku, A. Mus.), a veristic study of poverty and deprivation. Gallén's single-figure compositions of this period followed a formula exploited by Jean-François Millet, Jules Breton and Jules Bastien-Lepage. In these seemingly static images, the life story of the protagonist was suggested through significant attributes, physiognomic elaboration and background details.

While in Paris, Gallén became interested in the problem of visualizing Finnish mythology, a challenge faced by Finnish artists since the 1850s. In 1889 he painted the first version of his Aino triptych (Helsinki, Bank of Finland). It depicts three scenes from the Aino legend as recounted

Akseli Gallen-Kallela: *Lemminkäinen's Mother*, tempera on canvas, 0.85×1.18 m, 1897 (Helsinki, Athenaeum Art Museum)

in the Finnish national epic, the *Kalevala*. When completing the definitive version of the Aino (1891; Helsinki, Athenaeum A. Mus.) Gallén still adhered to a realistic mode in the paintings themselves, although the carved ornamentation of the frame already reflected his search for a primitive idiom appropriate for the rendering of Finnish myth.

In 1890 and 1892 Gallén travelled in eastern Finland and Karelia, documenting folk art, vernacular architecture and physiognomic types for future use. Inspired by Karelian buildings he designed a studio for himself in central Finland (Ruovesi, 1894–5); this is a key work in the architectural development of the Finnish National Romanticism movement. In his Ruovesi studio Gallén produced pioneering woodcuts, stained glass and other examples of the applied arts.

During trips to the Continent in 1892–4 and 1895 Gallén became acquainted with Symbolism, Synthetism and *Jugendstil*. *Symposium*, originally entitled *The Problem* (1894; sketch, Mänttä, Serlachius A. Mus.; definitive version Helsinki, priv. col., see 1986 exh. cat., no. 22), represents the climax in Gallén's assimilation of Symbolism. In this group portrait of the artist and his friends (including the composer Jean Sibelius) Gallén successfully combined two formulae then current in literature and art:

the *roman-à-clef* and the Symbolist pictorial manifesto. The picture is also a stylistic fusion of realist foreground still-life and Symbolist background. It provoked outrage when exhibited in Helsinki in 1894.

Gallén's contact with Synthetist linearism and surface patterning provided him with the key to the problem of 'national' style, that is, an adequate visual expression of Finnish myth. The linear simplification of his woodcut the *Defence of the Sampo* (1895) recurred in the final tempera painting of this subject (1896; Turku, A. Mus.). A dramatic scene of violent fighting was frozen into an almost ornamental surface pattern inspired by medieval and, perhaps, Pre-Raphaelite tapestries. Gallén created a series of stylized renderings of the *Kalevala* and Finnish folk poetry. *Joukahainen's Revenge* (1897; Turku, A. Mus.), *Fratricide* (1897) and *Kullervo's Curse* (1897–9; both Helsinki, Athenaeum A. Mus.) deal with themes of desperation and violence; despite their simplified surface style (emphasized by the use of tempera), all three contain profound psychological characterizations of their protagonists. The culmination of this series of easel paintings was *Lemminkäinen's Mother* (1897; Helsinki, Athenaeum A. Mus.; see fig.), a *pietà* with Finnish components.

Gallén's ultimate goal was to inaugurate an era of monumental art based on the *Kalevala*. A commission to

paint a wall in the Students' Corporation Building in Helsinki (*Kullervo Taking the Field*, 1901) encouraged Gallén to visit Italy in 1898, where he studied fresco technique. For the Finnish pavilion at the Paris Exposition Universelle in 1900, he executed vault frescoes with *Kalevala* motifs, some (e.g. *Defence of Sampo*) based on earlier compositions, others (e.g. *Ilmarinen Ploughing the Snake Field*) designed specifically for the occasion. For the Iris Room in the Finnish Paris pavilion Gallén contributed furniture and textile designs, which had been manufactured at the Iris works in Porvoo (Swed. Borgå). This factory had been set up by Gallén and the Swedish artist Louis Sparre (*b* 1863), who had settled in Finland at Gallén's suggestion and who led this short-lived but artistically important venture (closed 1902). Gallén's design work represented the consummation of a long-felt wish to bring about a national renaissance based on traditional Finnish forms, including natural emblems (e.g. spruce twigs and fir cones) and highly abstracted organic patterns.

Between 1901 and 1903 Gallén was busy with his most extensive commission yet, the decoration of a family chapel for the Juselius family in Pori. The mausoleum had been built to commemorate the death of the patron's young daughter, and to Gallén, who had himself recently lost his daughter, the commission offered the opportunity to deliver a personal statement. The main frescoes visualized concepts of life and death and the place of man in the world through symbolic themes (*Cosmos, Paradise, Spring, Autumn, Winter, Building, Destruction, Journey to Tuonela*). As a result of the faulty construction of the sandstone wall of the mausoleum, Gallén's frescoes were soon completely ruined and were later replaced with replicas painted by his son, Jorma Gallen-Kallela (1898–1939).

For Gallén the set-back with the Juselius frescoes was aggravated by the swift changes in the art scene in the early 20th century brought about by international modernism. Although sceptical about the dictates of fashion, Gallén had succeeded in assimilating trends from Naturalism to Synthetism to his own purposes, but superficial acquaintance with Cubism and direct contacts with Die Brücke group elicited merely half-hearted experiments with a more contemporary idiom. In 1909–10 Gallen-Kallela went on a trip to East Africa. During this safari he painted fresh and vigorous pictures of members of his family and the indigenous inhabitants, animals and landscapes. A group of sun-drenched, simplified landscapes, such as *Kilimanjaro* (1909–10; priv. col.), in a high colour key parallel contemporary developments in late Symbolism (e.g. Mondrian).

In 1911–13 Gallen-Kallela built a new studio at Tarvaspää, near Helsinki (now the Gallen-Kallela Museum). In the 1920s he worked on two major projects, the vault frescoes of the National Museum in Helsinki (1927–8) and the illustrations for a de luxe edition of the *Kalevala* (*Suur-Kalevala*). The latter project was never completed, but a simpler version with black-and-white vignettes (*Koru-Kalevala*) was published in Porvoo in 1922.

WRITINGS

Kallela-kirja (Porvoo, 1924; Swed. trans., Stockholm, 1932)
Afrikka-kirja (Porvoo, 1931, rev. 2/1964)

BIBLIOGRAPHY

Kalevalan riemuvuoden näyttely: Akseli Gallen-Kallelan muistonäyttely [The *Kalevala* anniversary exhibition: the Akseli Gallen-Kallelan memorial exhibition] (exh. cat., Helsinki, Messuhalli, 1935)
O. Okkonen: *A. Gallen-Kallela: Elämä ja taide* [A. Gallen-Kallela: life and work] (Porvoo, 1949, rev. 2/1961)
K. Gallen-Kallela: *Isäni Akseli Gallen-Kallela* [My father Akseli Gallen-Kallela], 2 vols (Porvoo, 1964–5)
A. Lindström: 'Kalevalaromantiken i Akseli Gallen-Kallelas konst', *Åb. Stat. Kstmus.*, xviii (1971), pp. 80–97
R. Tuomi: 'Axel Gallenin varhaisia luonnoksia maaseutuateljeeta varten' [Axel Gallen's early sketches for his rural atelier], *Taidehist. Tutkimuksia/Ksthist. Stud.* (1978), pp. 265–76
T. Martin and D. Sivén: *Akseli Gallen-Kallela, 1865–1931* (Sulkava, 1984; Swed. trans. with suppl. documentation, 1985; Eng. trans., Helsinki, 1985)
Dreams of a Summer Night (exh. cat., ACGB, 1986), pp. 104–15

SIXTEN RINGBOM

Gallery (i). Upper storey open on one side to the main interior space of a building. The term is applied variously, for example in church architecture to the area over a side aisle (also called a TRIBUNE) and in secular architecture to the elevated seating in a theatre.

Gallery (ii). Long, covered or partially covered service passageway, acting as a corridor inside or outside or in between buildings (*see* ARCADE).

Gallery (iii). Long narrow room in a grand private house, used for recreation or entertainment.

Gallery (iv). Place where works of art are displayed (*see* DISPLAY OF ART; *see also* MUSEUM, §I).

☐

Galli, Giovanni Antonio. *See* SPADARINO, LO.

Galli, Jacopo (*d* Rome, 1505). Italian banker and patron. He was from a noble family in Rome, prominent in banking and as civic officials, and received a humanist education. He formed a collection of antiquities, which was arranged in the garden of the Casa Galli (destr.), near the Palazzo della Cancelleria, Rome. In 1496, probably through his friend Cardinal Raffaele Riario, he met Michelangelo, who was on his first visit to Rome. Michelangelo came to live in Galli's house, and Galli bought his first large-scale sculpture, the marble *Bacchus* (1496; Florence, Bargello). The *Bacchus* was displayed in the garden of the Casa Galli, where it was recorded in a drawing of 1536 by Maarten van Heemskerck (1532–5; Berlin, Gemäldegal.) and in a description *c.* 1550 by Ulisse Aldrovandi, until its purchase in 1571–2 by Francesco I de' Medici, Grand Duke of Tuscany. Galli is documented as owning a standing marble *Cupid*, or *Apollo* (untraced), by Michelangelo. He also supervised the contract of 27 August 1498 between Michelangelo and Jean Bilhères de Lagraulas (or Villiers di Fezensac; *d* 1499), Cardinal of S Sabina, Rome, for the *Pietà* (Rome, Vatican, St Peter's). As the sculptor's guarantor, Galli stated in the contract that the work would be the most beautiful marble statue in Rome.

BIBLIOGRAPHY

U. Aldrovandi: Le statue antiche di Roma (MS.; *c.* 1550); as an app. to L. Mauro: *Le antichità della città di Roma* (Venice, 1556)

G. Vasari: *Vite* (1550, rev. 2/1568); ed. G. Milanesi (1878–85), vii, pp. 149–50

K. Frey: *Michelangelo Buonarroti* (Berlin, 1907), pp. 285–330, passim

A. Condivi: *Vita di Michelangiolo*, ed. A. Maraini (Florence, 1926), pp. 28–9

C. de Tolnay: *The Youth of Michelangelo* (Princeton, 1943), pp. 142–50

JANET SOUTHORN

Galliari. Italian family of painters and stage designers. They came from Andorno, near Vercelli, Piedmont, and were active in the 18th century and the first half of the 19th. Their works are mainly in Piedmont and Lombardy, although they also worked for leading European courts, such as those at Vienna, Paris and Berlin. Giovanni Galliari the elder (*c.* 1680–1720), from Andorno, was a minor provincial painter who worked in Milan and Crema in 1707 and 1709 with members of the Piedmontese branch of the Cignaroli. He may have painted several decorations for religious processions for the Sanctuary of the Madonna of Oropa, an ancient and celebrated place of pilgrimage. His three sons were (1) Bernardino Galliari, (2) Fabrizio Galliari and Giovanni Antonio Galliari (1718–83). The artistic tradition of the family was continued by the children of Fabrizio: Giovanni Galliari the younger (1746–1818), who went to Berlin, Giuseppe Galliari (1748–1817), who was an architect and figure painter, and Luigi Galliari (1761–1818), who was a musician, and by the sons of Giovanni Antonio, a painter: Fabrizio Galliari the younger and Gasparo Galliari (*d* 1823), who were both painters. On many occasions the family worked as a team, which makes attributions difficult.

(1) Bernardino Galliari (*b* Andorno, 3 Nov 1707; *d* Andorno, 1794). He moved to Milan *c.* 1720, where according to tradition he worked as a craftsman modelling

Bernardino Galliari: *Apollo in his Chariot*, design for the curtain of the Teatro di Casale Monferrato, Alessandria, oil on canvas, 892×913 mm, 1787 (Turin, Galleria Sabauda)

small nativity crib figures, until his talent was discovered by a member of the Clerici family. Little is known about his early development, although it seems likely that he was influenced by Giambattista Tiepolo, who was in Milan in 1730–31, and by Giovanni Battista Crosato. In 1735 Bernardino and (2) Fabrizio decorated the castle of the Visconti family at Brignano Gera d'Adda with *trompe l'oeil* architecture and landscape. Bernardino painted the figures, his brother the architecture. The figures are executed with long, even brushstrokes and have a clean, almost geometrical appearance. At Brignano he painted the *Fall of the Giants*, which is almost a replica of the fresco by Giulio Romano in the Palazzo del Te, Mantua. The style is strongly Baroque, typical of Bernardino's earlier work. Bernardino also carried out commissions for stage designs. In 1742 he won a competition for new stage designs at the ducal theatre in Milan, in which the Galli-Bibienas had also competed. The same year he was made stage designer of the Teatro Regio in Turin. Many commissions for sets followed, such as *Apollo in his Chariot* (1787; Turin, Gal. Sabauda; see fig.), and he worked in Paris, Chambéry (Savoy) and Vienna.

Bernardino's later decorations are more Rococo in manner and include those at the Villa Bettoni at Bogliaco, on the western shore of Lake Garda, and at the Castello della Croce at Pieta d'Asti, Asti, Piedmont (both early 1760s). The ceiling (1750–60) of the Villa Crivelli at Castellazzo di Bollate, Milan, representing the *Chariot of the Sun*, is perhaps his most representative fresco from this period. It reveals French influence, probably absorbed in Turin through the court painter Claudio Francesco Beaumont. At the end of his career Bernardino adopted a more classical style, derived from Filippo Juvarra, as in his decorations (*c.* 1785–90) at the castle of Les Marches, near Chambéry.

In 1772 Frederick II, King of Prussia, summoned Bernardino to Berlin, where he decorated the Catholic church of St Hedwig and designed stage sets for the royal theatre (drawings, Milan, Mus. Teat. alla Scala; Turin, Bib. Reale; Bologna, Pin. N.). His theatre designs, like those of the rest of the family, were richly ornamented, with coffered ceilings, false domes and broken pediments hung with rich swags of fruit and flowers and were painted in light greys, mauves and pinks. While in Prussia he painted a portrait of *King Frederick* (Andorno, priv. col., see Bossaglio), one of his few known portraits and one that reveals his lack of talent in this area. In 1778 he was made Professor at the Accademia di Pittura e Scultura in Turin.

(2) Fabrizio Galliari (*b* Andorno, 28 Sept 1709; *d* Treviglio, Bergamo, 1790). Brother of (1) Bernardino Galliari. He followed Bernardino to Milan, where he studied stage design. His career often coincided with that of his brother and it is often difficult to distinguish between their work, although Fabrizio concentrated on architecture. He worked for various local ecclesiastical and aristocratic patrons, besides designing theatrical sets. In 1738 he painted a triumphal arch to celebrate the arrival in Venice of Maria Amalia Walpurga of Poland, on her way to be married to Prince Charles of Sicily (the future Charles III of Spain). The decorations at the castle of Les Marches in Savoy are mostly his work, as was the *trompe l'oeil* dome

of Vercelli Cathedral (*c.* 1750; destr.). Three stage designs painted by Fabrizio (Vercelli, Mus. Civ. Borgogna) unusually show their subject in side view rather than the frontal view more typical of Neo-classical taste.

BIBLIOGRAPHY

G. de Gregory: *Istoria vercellese della letteratura e delle arti* (Vercelli, 1824)

G. Avogadro di Valdengo: *Sulla vita e sulle opere di Bernardino Galliari* (Turin, 1847)

R. Bossaglio: *I fratelli Galliari* (Turin, 1964)

M. Viale-Ferrero: *La scenografia del settecento ed i fratelli Galliari* (in preparation)

MARC'ALVISE DE VIERNO

Galli-Bibiena [Bibiena; Galli da Bibiena]. Italian family of painters, architects and designers. For three generations they were prominent in many Italian cities and throughout the Habsburg empire. The founder of the dynasty was Giovanni Maria Galli-Bibiena (i) (*b* Bibiena, nr Bologna, 1625; *d* Bologna, 21 June 1665), who was a pupil and much-prized assistant of Francesco Albani (being, apparently, particularly adept at the depiction of water). He produced faithful copies of his master's paintings. His surviving independent works include a fine *Ascension* (1651; Bologna, Certosa) and, in the church of Buon Gesù, Bologna, a frescoed *St Bernardino* and two sibyls. His daughter Maria Oriana Galli-Bibiena (*b* Bologna, 1656; *d* Bologna, 1749) studied with Carlo Cignani and Marcantonio Franceschini and specialized in portraits and history pictures. She married the landscape painter Gioacchino Pizzoli (1661–1773), and their son Domenico Pizzoli (1687–1720) was also a painter. Giovanni Maria had two

Ferdinando Galli-Bibiena: mathematical requirements for angular perspective, demonstrated in a set for a courtyard; engraving (by an unknown artist) from *L'architettura civile* (Parma, 1711) (Cologne, Theatermuseum)

sons, (1) Ferdinando Galli-Bibiena and (2) Francesco Galli-Bibiena, who trained as painters but became best known for architectural design and the creation of festival decorations. Ferdinando in his turn had several children who were artists: Alessandro Galli-Bibiena (*b* Parma, 1687; *d* before 1769), Giovanni Maria Galli-Bibiena (ii) (*fl* Prague, 1739–69), (3) Giuseppe Galli-Bibiena and (4) Antonio Galli-Bibiena. Alessandro became architect and painter to the Elector Palatine Charles Philip (*reg* 1716–42) and in 1719 supervised the building of the right wing of the Schloss at Mannheim (destr.). Between 1733 and 1756, under Charles Theodore Wittelsbach, Elector of Bavaria, he designed the Jesuit church in Mannheim. Giovanni Maria (ii) worked as a painter and architect until his marriage to a wealthy woman obviated the necessity. Giuseppe was his father's pupil and assistant at the Habsburg court in Vienna before embarking on an influential career that took him to the main cities of the Habsburg empire. Antonio also worked with his father, in Bologna, and with his uncle Francesco in Rome and his brother Giuseppe in Vienna, before pursuing an independent career as architect, designer and painter. Giovanni Carlo Galli-Bibiena (*d* Lisbon, 20 Nov 1760), the son of Francesco, was a member of the Accademia Clementina, Bologna. In Bologna he decorated the staircase of Palazzo Savini and the Cappella di S Antonio in S Bartolommeo di Porta Ravegnana. He also produced a scheme for the decoration of the high altar of S Petronio, Bologna, for the Bolognese Pope Benedict XIV. He was then (1752) summoned by Joseph, the King of Portugal, to Lisbon, where he designed an opera house next to and communicating with the royal palace. It was completely destroyed only seven months after completion in the notorious earthquake of 1755. Finally, (5) Carlo Galli-Bibiena, son of Giuseppe, found work throughout Europe as a designer of court and festive decoration and, most notably, as a theatre architect.

BIBLIOGRAPHY

Thieme–Becker

C. Ricci: *I Bibiena* (Milan, 1915)

A. H. Mayor: *The Bibiena Family* (New York, 1945)

F. Hadamowsky: *Die Familie Galli-Bibiena in Wien* (Vienna, 1962)

Disegni teatrali dei Bibiena (exh. cat., ed. M. T. Muraro and E. Povoledo; Venice, Fond. Cini, 1970)

Juvarra, Vanvitelli, the Bibiena Family and Other Italian Draughtsmen (exh. cat. by M. L. Myers, New York, Met., 1970)

J. A. Hatfield: *The Relationship between Late Baroque Architecture and Scenography, 1703–1778* (diss., Ann Arbor, U. MI, 1984)

(1) Ferdinando Galli-Bibiena (*b* Bologna, 18 Aug 1657; *d* Bologna, 3 Jan 1743). Soon after the death of his father, Giovanni Maria Galli-Bibiena, he was apprenticed to Carlo Cignani, who quickly recognized his talent for architectural design and placed him with a series of specialized teachers. Ferdinando soon showed his precocious genius for stage design and became much in demand for theatrical work in Bologna. Cignani brought him to the attention of Ranuccio II Farnese, 6th Duke of Parma and Piacenza, who in the early 1680s made Ferdinando his chief painter and architect. Ferdinando stayed at the ducal courts of Parma and Piacenza for nearly 30 years, providing the scene decorations for numerous theatrical entertainments, particularly for such celebrations as those for the marriage of Odoardo Farnese in 1690. But he also created more lasting works, such as the Duke's ravishing

villa and garden at Colorno. In Parma he decorated the loggia of the Teatro Farnese, a gallery in the Palazzo del Giardino and a chapel in the Palazzo Ducale (all destr.). An anonymous 18th-century painting of a *Performance in the Teatro Farnese* (London, N.G.), in which the lavishly decorated proscenium arch frames a tall perspective scene of fantastically elaborate Late Baroque architecture, with further vistas beyond, indicates the character of the style that Ferdinando and his sons were to take to many of the greatest courts in Europe.

In 1708 Ferdinando was summoned to Barcelona to contribute to the festive decorations for the marriage of the Archduke Charles of Austria (later Emperor Charles VI); he was also made official artist to the Archduke in the latter's capacity of claimant to the Spanish throne. That was how Ferdinando chose to describe himself in his book *L'architettura civile* (1711; see fig.). This influential publication described the exciting Bolognese innovation of *scene vedute in angolo*, theatrical settings showing diagonal perspectives (*see* THEATRE, fig. 12). Shortly afterwards (Archduke Charles's ambitions having shifted to becoming emperor rather than king) in 1712 Ferdinando was summoned to Vienna. There he supervised various sumptuous ceremonial decorations, both celebratory and funerary. However, his architectural project for the new Karlskirche was rejected in favour of one by Johann Bernhard Fischer von Erlach. In 1716 an eye infection caused him to return precipitately to Bologna, and even after a successful operation he could not be persuaded to return to Vienna. He became a distinguished figure in Bolognese artistic circles. He also designed the Teatro Reale in Mantua (completed 1731) and may have contributed to the lavish decoration of the cupola of S Andrea, Mantua (begun 1732).

WRITINGS

Ferdinando Galli-Bibiena: *L'architettura civile preparata su la geometria, e ridotta alle prospettive* (Parma, 1711)

——: *Direzione a' giovani studenti nel disegno dell'architettura civile...* (Parma, 1731–2)

(2) Francesco Galli-Bibiena (*b* Bologna, 12 Dec 1659; *d* Bologna, 20 Jan 1739). Brother of (1) Ferdinando Galli-Bibiena. Like Ferdinando, he was sent to study under Carlo Cignani, who encouraged his interest in architecture. In 1682 he contributed painted decorations to the Palazzo Ducale in Piacenza. Later he went to Rome, where he painted theatre sets. He was then appointed court architect in Mantua and completed Giulio Romano's elaborate courtyard of the Cavallerizza in the Palazzo Ducale. There followed sojourns in Genoa, again as a theatre designer, and in Naples, as theatre designer and as a creator of festive decorations. He then left Italy for Vienna, where he built a magnificent new Opera House (much altered) for the Holy Roman Emperor Leopold I. After the latter's death (1705) he returned briefly to Italy and also visited London; he then went to Nancy, for consultations about the new theatre there. He was summoned back to Vienna by the Emperor Joseph I (*reg* 1709–11) in 1710 to continue the construction of the Opera and to design further entertainments. In 1712, however, the new Emperor, Charles VI, brought (1) Ferdinando Galli-Bibiena to Vienna as his architectural adviser. Francesco left for Italy,

finding commissions for theatre-building in Verona (Teatro Filarmonico) and in Rome (Teatro Aliberti, 1720). He returned to Bologna in 1726, subsequently executing various small religious commissions and becoming director of the Accademia Clementina.

(3) Giuseppe Galli-Bibiena (*b* Parma, 5 Jan 1696; *d* Berlin, 1756). Son of (1) Ferdinando Galli-Bibiena. He was his father's pupil and assisted him on various projects at the Habsburg court in Vienna. In 1716 he produced his first independent designs, as part of the festive decoration for the birth of the Archduke Leopold of Austria. For a similar occasion the following year he erected a magnificent triumphal decoration of his own (his father had by then left the imperial service). In 1718 he was given a position at court and was subsequently involved in all the major Habsburg celebratory decorations, including those for the marriage of Emperor Joseph's daughter in Munich (1722). His lavish designs for open-air operatic performances were much admired. In 1727 he officially became chief theatrical designer to the imperial court. His subsequent employment on less secular schemes, such as his superb triumphal arch for the celebration in Prague of the canonization of St John Nepomuk (1729), may have contributed to the theatrical aspect of much German architecture of the period. During the next decade he was again mainly occupied with decorative settings for operas, funerals and celebrations, the most important of which were those for the marriage of Emperor Charles VI's daughter Maria Theresa to Francis I, Duke of Lorraine (1736). In 1740 he produced his most lasting work, *Architetture e prospettive*, a book dedicated (like his father's) to Charles VI. It consists of engravings of fantastic architectural scenes, which, while showing more Neo-classical rigour in architectural detail than Ferdinando's, far surpass them in variety of combined perspectives, expertly controlled groupings of space and structure and dazzlingly free evocations of endless vistas. Many of them accurately record the extraordinary temporary decorations he provided for religious festivals in the imperial chapel in the Hofburg, Vienna. His stage setting design of a *Monumental Hall Supported by Spiral and Square Pilasters* (Cleveland, OH, Mus. A.; see fig.) exemplifies the style.

In the early 1740s Giuseppe supervised the decoration (mainly destr.) of the Opera House built in Vienna by his uncle, (2) Francesco Galli-Bibiena. Meanwhile the political manoeuvrings that resulted in the imperial crown being transferred (albeit briefly) to a new dynasty may have made Vienna an uncomfortable, or at least artistically arid, place. In 1747 Giuseppe went to Dresden to take charge of the decorations and entertainments accompanying a double wedding between the Saxon and Bavarian royal (and imperial) houses. The following year he was appointed 'Erster Theatralischer Architekt' to Frederick Augustus II of Saxony, but he also found time to visit Bayreuth, where with the assistance of his son (5) Carlo Galli-Bibiena he initiated the exuberant decoration of the new theatre (altered). In 1750 he rebuilt and decorated, in lavish Baroque style, the theatre in the Zwinger (destr.) in Dresden. During this period, too, he provided settings of unparalleled magnificence for the operas of Johann Adolf Hasse. From 1751 he was also frequently summoned to

Giuseppe Galli-Bibiena: *Monumental Hall Supported by Spiral and Square Pilasters*, stage setting design, pen and brown ink and grey wash, 316×451 mm (Cleveland, OH, Cleveland Museum of Art)

Berlin by Frederick II, King of Prussia, to provide opera designs. In 1754 he settled there but died within two years, perhaps partly from the overwork engendered by Frederick's passion for entertainment.

<center>PRINTS</center>

Giuseppe Galli-Bibiena: *Architetture e prospettive* (Augsburg, 1740)

(4) Antonio Galli-Bibiena (*b* Parma, 16 Jan 1700; *d* ?Mantua, 1774). Son of (1) Ferdinando Galli-Bibiena. He was a pupil of Giuseppe dal Sole and later of Marcantonio Franceschini. In 1718 he began to assist his father on theatre decoration and scene-painting in Bologna and in nearby Cento and Fano. He also spent some time with his uncle, (2) Francesco Galli-Bibiena, in Rome, on similar projects. After returning briefly to Bologna, he went in 1721 to join his elder brother (3) Giuseppe Galli-Bibiena in Vienna. There he contributed regularly to the elaborate theatrical entertainments, and in 1727 was officially appointed as his brother's deputy in the post of 'Theatralingenieur'.

Typically, in the climate of German Baroque, Antonio then achieved his first important religious commissions. In 1730–32 he completed the presbytery of St Peter, Vienna, designed the elaborate high altar and frescoed the vault of the choir. He was then summoned by the Prince-Archbishop Esterházy to Hungary, where he painted the dome of the Trinitarian church in Pressburg (now Bratislava, Slovakia). On the death of Emperor Charles VI

(1740) he contributed funerary decorations both there and in Vienna, but soon the political upheavals in Austria caused him to return to Italy.

At first he found theatrical work in Milan. Then in 1751 he was commissioned to rebuild the theatre in the Palazzo Pubblico, Siena (completed 1753; destr.). At probably the same time he was employed on the decoration of S Agostino, Siena. Subsequently he provided decorations for theatres in Florence and Pistoia. In 1756 the elegant Teatro Comunale in Bologna was begun to his design and was sufficiently advanced by 1763 for the first operatic performance to be staged there. During this period in Bologna (and perhaps also on later visits there) he received various decorative commissions, both religious—the dome of S Maria della Vita, the Cappella Monterengoli in S Giacomo Maggiore and numerous temporary works—and secular—the Sala Maggiore of the Palazzo Comunale, the gallery of Palazzo Banchi and various ephemeral stage designs. Similarly in the mid-1760s he combined theatrical and ecclesiastical activities in Livorno and in Parma, where he continued his father's decoration of the Teatro Farnese and initiated that of the chapel of the Jesuit college of S Rocco (both destr.). He then moved to Mantua, designing the Teatro Scientifico (completed 1769; destr.) in the Accademia and the delightful façade of S Barnaba. In nearby Sabbioneta he provided the Cappella del SS Sacramento in S Maria Assunta with an unusual double dome,

the inner pierced to resemble a fretwork pergola, the outer painted like sky; this effect was copied in a garden grotto and, solely in illusionistic paint, in the Sala dei Fiumi of the Palazzo Ducale, Mantua.

(5) Carlo Galli-Bibiena (*b* Vienna, 1728; *d* after 1778). Son of (3) Giuseppe Galli-Bibiena. As early as 1746 he was contributing to the decorations for the marriage of the daughter of the Margrave of Bayreuth. Two years later he was appointed supervisor of court decorations in Bayreuth. However, in the same year (1748) he acted as his father's assistant on the decoration of the new theatre there (much still *in situ*). In 1753 he undertook independently the decoration of a theatre in Munich (destr.) for Maximilian III Joseph, Elector of Bavaria. He returned to Bayreuth, but soon an arrangement was made whereby he was to spend half the year there and half as architect and theatre designer to the Margrave's brother-in-law, Charles I, Duke of Brunswick-Wolfenbüttel. Such comfortable proposals were interrupted by the outbreak of the Seven Years War (1756) and Carlo retreated to Italy, finding work in Rome and Bologna. In 1758 the death of the Princess Wilhelmina, Margravine of Bayreuth, took him briefly back to Bayreuth to design the funerary monuments and decorations. However, he was soon on the move again, travelling to France, the Netherlands and eventually London, where he stayed (engaged on theatrical work) until 1763. The resumption of peace (1763) beckoned him to the court of the victor, Frederick II, in Berlin, where he succeeded his late father as opera designer, though he does not seem to have been entirely successful there. His later life is uncertain. He is recorded in Naples (1772), designing festive decoration, and may have designed the Teatro Grande in Pavia (1773). A supposed subsequent trip to Russia ended in 1778.

Gallier. American family of architects of Irish origin. (1) James Gallier (i) was one of the best-known and most successful 19th-century architects working in New Orleans, where he was an exponent particularly of the Gothic and Greek Revival styles. His son (2) James Gallier (ii), less prominent than his father, also worked mainly in New Orleans.

(1) James Gallier (i) (*b* Ravensdale, Ireland, 24 July 1798; *d* at sea, 3 Oct 1866). After a limited basic education he was apprenticed to his father, Thaddeus Gallier, to learn the building trade. As there was little work, however, he attended the School of Fine Arts, Dublin, and learnt the art of architectural drawing. In 1816 he worked on the building of a cotton mill in Manchester and then worked briefly in Liverpool. He subsequently returned home, but in 1822 he moved to London, where he and his brother John Gallier worked for a building firm and where James spent his spare time studying engineering, architecture and the fine arts. He married in 1823. In 1826 he was engaged as Clerk of Works by William Wilkins for the Huntingdon County Gaol. On its completion (1828) he returned to London and worked for a time for John Peter Gandy (later Deering; 1787–1850), but deciding that he might find greater success in the USA, Gallier left England (1832) for New York. His first employment there was

with the architect James H. Dakin. Gallier soon formed a partnership (1832–4) with Minard Lafever and together they produced numerous drawings for local builders. During this period he published the *American Builder's General Price Book and Estimator* (1833). His association with Wilkins, Dakin and Lafever gave him valuable experience in the Gothic Revival and Greek Revival styles, which he used in most of his subsequent works.

Seeking new opportunities in the South, Gallier and Charles Bingley Dakin (1811–39), James Dakin's brother, left for New Orleans, where they established an architectural office under the name Gallier & Dakin in 1834. They were immediately successful and in their first year designed such distinguished classical buildings as the St Charles Hotel, the Merchants' Exchange, the Arcade Baths, Christ Church and several residences (all 1835–6; destr.). The firm exerted great influence on the architecture of New Orleans, and as the best-known 19th-century architect there, Gallier was, until recently, credited with the design of almost every classical columned building in the city.

In 1835 James Dakin arrived in New Orleans to form a new partnership with his brother, and Gallier withdrew shortly afterwards to practise alone. In 1837 Dakin & Dakin began the construction of the great Gothic Revival church of St Patrick, which was completed by Gallier in 1839. The entire interior, including the high altar, is his work, probably his first and finest work in the Gothic Revival style. His most notable surviving building is the former New Orleans City Hall (1845–50; now Gallier Hall), with a white marble Ionic portico and a grey granite lower storey. Due to failing eyesight, Gallier retired from active practice in 1850 to travel in America and abroad. He and his second wife were lost at sea in a shipwreck off Cape Hatteras.

WRITINGS
Autobiography of James Gallier (Paris, 1864/*R* New York, 1973)

(2) James Gallier (ii) (*b* Huntingdon, England, 25 Sept 1827; *d* New Orleans, LA, 18 May 1868). Son of (1) James Gallier (i). He was educated at the University of North Carolina and, after his father retired, was in partnership first with John Turpin and later with Richard Esterbrook. His works include numerous residences and commercial buildings in New Orleans, mostly in the Italianate style, of which many survive. His own house (1857) on Royal Street was restored and opened in 1971 as a historic house museum. His most notable work was the French Opera House (1859; destr. 1919), built by Gallier & Esterbrook. Other surviving works include the Luling Mansion (1865; later the Louisiana Jockey Club) and the Bank of America (1866), a notable commercial building with a cast-iron façade. He is buried in the splendid marble cenotaph in St Louis Cemetery No. 3, which he originally built in memory of his father and stepmother.

BIBLIOGRAPHY
Macmillan Enc. Architects
T. Hamlin: *Greek Revival Architecture in America* (New York, 1944/*R* 1964)
L. V. Huber: *New Orleans: A Pictorial History* (New York, 1971)
New Orleans Architecture, i–iii, v–vi (Gretna, LA, 1971–80)
J. M. Farnsworth and A. M. Masson, eds: *The Architecture of Colonial Louisiana: Collected Essays* (Lafayette, LA, 1987)

SAMUEL WILSON JR

Gallinazo. Pre-Columbian culture and art style that flourished in northern coastal Peru during the Early Intermediate period, between *c*. 300 BC and *c*. AD 200. It was named after the site of Gallinazo (Sp. 'turkey buzzard') in the Virú valley, which was excavated by the American archaeologist Wendell Bennett in 1936. The Gallinazo culture has been shown to have succeeded that of SALINAR in the Virú, Moche and Chicama valleys. Gallinazo architecture in the Virú valley was characterized by a honeycomb dwelling pattern. Some of the walls of the buildings were decorated with cut-out designs in *tapia* (puddled clay) and adobe mosaics, such as the frieze at El Carmelo. The Gallinazo culture as represented in the Virú valley was subdivided by Bennett into three phases, on the basis of changes in building methods and pottery styles. Gallinazo I is characterized by incised and punch-decorated pottery with some use of negative-painted decoration, which involved covering the design areas in a heat-resistant substance and then firing it. The substance was removed after firing, leaving the negative design. In Gallinazo II most pottery was decorated using negative painting. Small lugs, mainly in bird and animal form, were often added. A basic change took place during Gallinazo III, due to outside influences from the MOCHE and RECUAY cultures. Moche forms, such as the stirrup-spout bottle, the dipper and the face-neck jar (in which the neck of the jar contains the shape of a face), were introduced, and greater emphasis was placed on modelling. Although negative-painted decoration continued in use, some white-on-red and white-on-brown positive painting was introduced, probably from the Moche area. Recuay influence was represented by small figures on pottery and by more elaborate negative designs, which included the feline figure. Later Gallinazo-style pottery in the Moche valley consisted of oxidized ware, similar in style to Salinar pottery but unslipped. Some use was made of the techniques of incision and white slip decoration, but negative painting predominated. Although Gallinazo pottery shapes were similar to those of Salinar, the modelling was more naturalistic. Shapes included bottles with bridge handles attached to spouts modelled in the form of figures, spout- and handle-bottles, jars and large urns. Most metal artefacts were made of copper. The Museo Nacional de Antropología y Arqueología in Lima has a large holding of Gallinazo pottery.

For general discussion of Pre-Columbian Central Andean pottery *see* SOUTH AMERICA, PRE-COLUMBIAN, §III, 5.

BIBLIOGRAPHY
R. Larco Hoyle: *La cultura Virú* (Buenos Aires, 1948)
W. C. Bennett: *The Gallinazo Group, Virú Valley* (New Haven, 1950)
C. B. Donnan and C. J. Mackey: *Ancient Burial Patterns in the Moche Valley, Peru* (Austin, 1978), pp. 45–54

GEORGE BANKES

Galloche, Louis (*b* Paris, 24 Aug 1670; *d* Paris, 21 July 1761). French painter. He was a pupil of Louis Boullogne (ii). In 1695 he won the Prix de Rome and subsequently lived in Rome for two years. Because of a lull in royal patronage, Galloche was obliged, on his return to Paris, to accept commissions from churches and monasteries. Between 1706 and 1713 he painted, in collaboration with Louis de Silvestre, *St Scholastica Praying for a Storm* (Brussels, Mus. A. Anc.) and scenes from the life of *St*

Benedict for the refectory of St Martin-des-Champs, Paris. In 1711 he was received (*reçu*) as a member of the Académie Royale, Paris, on presentation of *Hercules Restoring Alcestis to her Husband* (Paris, Ecole N. Sup. B.-A.). He became professor at the Académie in 1720, rector in 1746 and chancellor in 1754. Between 1737 and 1751 he exhibited regularly at the Salons.

For the church of St Lazare (now Ste Marguerite), Paris, Galloche painted *St Vincent de Paul Preaching* (*in situ*). In 1720 he was among a group of artists who painted the ceiling of the Salle des Machines in the Palais des Tuileries, and in 1724 he was one of 12 painters commissioned to provide decorative panels in an elegant Rococo style for the Hôtel du Grand Maître at Versailles: he contributed the panel *Venus and Adonis* (now Versailles, Hôtel de Ville). Portraits by Galloche are rare, but those that survive, such as that of *Bernard Le Bovier de Fontenelle* (1723; Versailles, Château), are forceful and expressive. His landscapes were inspired by 17th-century Italian landscapes and the tradition of Nicolas Poussin, and they particularly display his abilities as a colourist (e.g. *Two Landscapes*, 1737, Fontainebleau, Château; *Summer*, Montargis, Mus. B.-A.). Despite his stay in Rome, Galloche remained most influenced by the Flemish-inspired colourists of his youth.

BIBLIOGRAPHY
L. Dimier: *Les Peintres français du XVIIIe siècle: Histoire des vies et catalogue des oeuvres*, i (Paris, 1930), pp. 217–26
P. Rosenberg: 'Le Concours de peinture de 1727', *Rev. A.* [Paris], xxxvii (1977), pp. 29–42
J.-L. Bordeaux: 'La Commande royale de 1724 pour l'hôtel du Grand Maître à Versailles', *Gaz. B.-A.*, n. s. 5, civ (1984), pp. 113–26

Gallucci, Nicola [Nicola da Guardiagrele] (*b c.* 1395; *d* before 1462). Italian goldsmith and sculptor. He was active in Guardiagrele in the Abruzzi region, which was an area celebrated since ancient times for the work of its goldsmiths. It is probable that he was trained in the workshop of his father, Andrea Gallucci, who was also a goldsmith and sculptor. The earliest of Nicola's many documented and securely attributed works is a monstrance (1413; Francavilla al Mare, S Maria Maggiore), which, like all his early works, is in the Late Gothic style. Some of his works reflect Tuscan influence, in particular that of Lorenzo Ghiberti. This is already apparent in a cross (1431; Guardiagrele, S Maria Maggiore), but is particularly marked in his altar frontal (1448; Teramo Cathedral) with scenes from the *Life of Christ*, some of which are based directly on those of Ghiberti's doors of 1401–24 (Florence, Baptistery). The *Annunciation* (Florence, Bargello) attributed to Nicola and his bust of *St Giustino* (Chieti Cathedral) are examples of Nicola's activity as a goldsmith-sculptor, but it was his crosses that earned him renown. According to Chini, Nicola made the one destined for S Maria, Paganica, in his workshop in Guardiagrele, but he then had to take it to L'Aquila at his own expense in order to have it assayed and marked. Nicola's processional crosses are of the standard 15th-century type, common also in southern Italy. They are made of silver sheets that are chased, embossed and attached to a wooden support; they are often decorated along the edges with small copper balls. The figures were made to commission and are

sometimes quite complex iconographically, and characterized by a great variety of pose and a refinement of execution: for example the *Christ* on the fine cross (L'Aquila, Mus. N. Abruzzo) and the finely carved figures of the gilded silver cross (Rome, S Giovanni in Laterano). They were normally cast separately and then fixed to the terminals of the cross and to the *suppedaneum* on the reverse, or placed at the base of the crucifix, often specifically requested by the patron. The crosses would be fixed on to a processional staff by means of a spherical fitting that could be altered to make the crosses free-standing.

BIBLIOGRAPHY

Enc. It.; Thieme–Becker

M. Chini: 'Documenti relativi all'arte nobile dell'argento in Aquila', *Rivista abruzzese* (1913)

E. Matiocco: 'L'oreficeria medioevale abruzzese', *Abruzzo*, vi/2 (1968), pp. 361–403

ANGELA CATELLO

Galván Candela, José María (*b* Valencia, 1837; *d* Madrid, 1899). Spanish printmaker and painter. He was a pupil of Luis Fernández Noseret and studied at the Escuela Superior de Bellas Artes in Madrid. At the Exposición Nacional in Madrid in 1864 Galván Candela showed both etchings and steel-engravings. From 1866 he was engraver at the Dirección de Hidrografía in Madrid. Although he was one of the best 19th-century Spanish etchers, he devoted himself mainly to engraving and religious painting. He executed reproductive prints of paintings by Velázquez, Murillo, Zurbarán and Rosales Martínez but is best known for those he made of Goya's works. For example, he produced an album of prints (1888) after Goya's frescoes (1798) in the Hermitage church of S Antonio de la Florida, Madrid. Galván Candela's print, *Ash Wednesday*, after Goya's painting in the Prado in Madrid, was awarded a medal at the Exposición Nacional in Madrid in 1897.

BIBLIOGRAPHY

A. Mendez Casal: *La vida y las obras de José María Galván* (Burgos, 1929)

E. Lafuente Ferrari: 'Una antología del grabado español, II', *Clavileño*, xx (1953), pp. 135–50

E. Páez Ríos: *Repertorio* (1981–3), i, pp. 385–8

J. Vega: *El aguafuerte en el siglo XIX* (Madrid, 1985)

BLANCA GARCÍA VEGA

Galvanoplasty. *See* ELECTROTYPE.

Gálvez. Guatemalan family of sculptors. Antonio Joseph de Gálvez was a master carpenter and mason. Few of his works are known. In 1720 he contracted with S Francisco, Santiago de Guatemala (now Antigua), to make the *monumento* (altar) used on Maundy Thursdays. He was in charge of the rebuilding of the monastic hospital of S Pedro in Santiago de Guatemala. His son Francisco Javier de Gálvez was also a master carver, whose surviving works show high ability. In 1747 he contracted to make the retable of the *Crucifixion* (untraced) in the Capilla de Los Reyes in Santiago de Guatemala Cathedral. In 1758 he was commissioned by the church of La Merced in Santiago de Guatemala to make two retables (*in situ*), one of *Jesus of Nazareth* and the other of *Our Lady of Slavery*. He also worked in the Real Palacio in the 1760s under the direction of Luis Díez Navarro. His brother, Vicente de Gálvez (*d* 1780), was also a master carver. He directed the erection of the temporary catafalques for the funeral ceremonies of Ferdinand VI (1760) and Isabella Farnese (1767) and probably also made others. He moved to Tegucigalpa, Honduras, where he had made the high altar of the parish church, and at his death he was working on the statues of *El Señor Crucificado de las Animas* and *St Joseph* and the gilding of the pulpit. Both Francisco Javier and Vicente can be considered among the principal exponents of Spanish American Baroque in Guatemala. They developed new forms of columns and pilasters and at the same time extended the decorative repertory of altarpieces and occasional architecture.

BIBLIOGRAPHY

H. Berlin: *Historia de la imaginería colonial en Guatemala* (Guatemala City, 1952)

H. Berlin and J. Luján-Muñoz: *Los túmulos funerarios en Guatemala* (Guatemala City, 1983)

Gálvez Suárez, Alfredo (*b* Cobán Alta Verapaz, 28 July 1899; *d* Guatemala City, 14 Dec 1946). Guatemalan painter. He was a pupil of Justo de Gandarias (1848–1933), a Spanish artist residing in Guatemala, and of Agustín Iriarte (1876–1962); in spite of this training he is often considered self-taught because he did not attend the Escuela Nacional de Bellas Artes. When his reputation was already established, he was awarded a grant by the Mexican government in 1923, which made it possible for him to study recent artistic developments there at close hand and thus to complete his training.

Gálvez Suárez divided his time between his own art and his work (between 1928 and 1939) as a draughtsman in a print shop and lithographer's workshop. He was especially effective in tempera and watercolour, as attested by such works as *Women Weavers of Atitlán* (tempera, *c.* 1936) and *Decorator of Masks, Chichicastenango* (watercolour, 1938; both Guatemala City, Mus. N.A. Mod.). His most important works, however, were paintings on a mural-like scale executed in tempera on fibreglass and cardboard panels for the main staircases in the north façade of the Palacio Nacional in Guatemala City (1940–43). These include *The Conflict* (4.56×19.56 m), a major scene representing the struggle between the Indians and the Spaniards following the Conquest; two minor scenes, *Don Quixote* (4.52×3.26 m) and *The Message* (4.52×3.38 m, a reference to *Popol Vuh*), symbolizing the Spanish and Mayan–Quiche languages respectively by way of literature; and three panels showing the evolution of a national identity, including *Blood, Technique and Spirit* (4.27×17.26 m), which moves from the pre-Hispanic period to the 20th century. Gálvez Suárez also executed other large-scale paintings that were later destroyed, for example in the Guatemala pavilion at the Golden Gate International Exhibition (San Francisco, CA, 1933) and *The Four Continents* (*c.* 1944; Guatemala City, San Carlos Gran Hotel). He taught at the Academia Nacional de Bellas Artes in Guatemala City from 1940, and in 1945 he was visiting professor of drawing and painting at the University of New Mexico in Albuquerque.

BIBLIOGRAPHY

M. Alvarado and R. Galeotti: *Indice de pintura y escultura* (Guatemala City, 1946)

I. L. de Luján and L. Luján Muñoz: *Alfredo Gálvez Suárez (1899–1946)* (Guatemala City, 1989)

<div align="right">JORGE LUJÁN-MUÑOZ</div>

Galzetta Bianca, Matteo. *See* WITHOOS, MATTHIAS.

Gamarra, José (*b* Tacuarembó, 12 Feb 1934). Uruguayan painter and printmaker. He studied from 1952 to 1959 at the Escuela Nacional de Bellas Artes in Montevideo under the painter Vicente Martín (*b* 1911), supplementing his education with training as a printmaker in Rio de Janeiro in 1959 under Johnny Friedlaender and Iberé Camargo. He exhibited widely after settling in France in 1963, winning a major prize at the Paris Biennale in 1963 and taking part in the Venice Biennale in 1964. In his early works Gamarra often favoured archaic 'magical' signs, as in *Painting* (see Argul, pl. 63), in which spiky linear forms are displayed in relief on a textured surface; other works, such as *Painting* (1962; see Argul, pl. 65), are indicative of the more openly mythical side of his early painting. His later paintings, some of which are dependent on photography (see exh. cat., pls 167, 168), often treat specifically Latin American subjects, in the context of their historical origins, seen with a critical eye.

BIBLIOGRAPHY
J. P. Argul: *Las artes plásticas del Uruguay* (Montevideo, 1966); rev. as *Proceso de las artes plásticas del Uruguay* (Montevideo, 1975)
Art of the Fantastic: Latin America, 1920–1987 (exh. cat., ed. H. T. Day and H. Sturges; Indianapolis, Mus. A., 1987), pp. 166–9, 246–7
José Gamarra (exh. cat., Paris, Gal. Albert Loeb, 1992)

<div align="right">ANGEL KALENBERG</div>

Gamba. Italian family of artists. Francesco Gamba (*b* Turin, 1818; *d* Turin, 10 May 1887) was a painter and museum director. He trained at the Accademia Albertina di Belle Arti in Turin. From 1845 to 1855 he travelled, principally in northern Europe. In Düsseldorf he became friends with the painter Andreas Achenbach (1815–1910) and perfected his landscape technique. Gamba painted seascapes such as *After the Storm* (1862; Turin, Gal. Civ. A. Mod.). In 1869 he became Director of the Regia Pinacoteca (now Galleria Sabauda) of Turin, and from this time he also began to study and research 15th- and 16th-century painters of Piedmont. Francesco's brother Enrico Gamba (*b* Turin, 3 Jan 1831; *d* Turin, 19 Oct 1883) was a painter, engraver and stage designer. He studied first at the Accademia Albertina di Belle Arti in Turin, and, from 1850, at the Stadelsche Kunstinstitut in Frankfurt am Main under Friedrich Overbeck. He travelled in Holland, Belgium and Switzerland. Later he lived in Venice and Rome, and in 1856 he became professor of drawing and life drawing at the Accademia Albertina in Turin. He was one of the principal exponents, in Piedmont, of a genre of painting that was still academic in its form and at the same time romantic and literary in its social and patriotic content. He was principally a history and genre painter. Occasionally he also painted portraits. His *Funeral of Titian* (1855; Turin, Gal. Civ. A. Mod.) was greatly admired in 1855, and it was acquired in the following year by Victor-Emanuel II, King of Sardinia-Savoy, for the Palazzo Reale in Turin. Gamba also worked in fresco, made engravings and painted designs for backdrops.

BIBLIOGRAPHY
Bolaffi
F. Sapori: *Enrico Gamba* (Turin, 1920)
A. M. Comanducci: *Dizionario illustrato dei pittori, scultori, desegnatori e incisori italiani moderni e contemporanei*, 5 vols (Milan, 1934, rev. 3/1962)

<div align="right">SILVIA LUCCHESI</div>

Gambara, Lattanzio (*b* Brescia, 1530; *d* Brescia, 18 March 1574). Italian painter. It is generally agreed that he received his early training with Giulio Campi in Cremona, where he developed his style, derived from Lombard and Emilian Mannerism. In 1549 Gambara returned to Brescia, where he became an assistant to Gerolamo Romanino and married the latter's daughter in 1556. During the 1550s he collaborated with Romanino on the fresco cycles in the Averoldi and Bargnani palaces in Brescia, where he made some accommodation in his style to Romanino's, though demonstrating his innate eclecticism. His first important independent commissions were the façade frescoes (*c.* 1557) on the Case del Gambero (Brescia). Here, Gambara fused the decorative elegance of Parmigianino and Camillo Boccaccino with the Michelangelesque qualities of Giulio Romano and Pordenone. He was a prolific fresco painter and draughtsman, and after Romanino's death in 1560 he became the leading artist in Brescia. In 1561 he frescoed four scenes from the *Apocalypse* in the Broletto Palace in Brescia (destr.), which reflected strongly the influence of Giulio Romano. This is true also of his *Nativity* (*c.* 1561–8; Brescia, SS Faustino e Giovità), where an academic dryness begins to appear. From 1567 to 1573 Gambara was engaged in frescoing the nave arcade and internal façade of Parma Cathedral together with the Cremonese painter Bernardino Gatti. These frescoes, as well as the contemporary frescoes in Cremona Cathedral, are in a turgid Mannerist style, filled with large figures and complicated foreshortening. He died while executing the vault frescoes in S Lorenzo, Brescia.

BIBLIOGRAPHY
Thieme–Becker
G. Vasari: *Vite* (1550, rev. 2/1568), ed. G. Milanesi (1878–85), vi, pp. 491, 498, 506
F. Nicoli Cristiani: *Della vita e delle pitture di Lattanzio Gambara* (Brescia, 1807)
S. Fenaroli: *Dizionario degli artisti bresciani* (Brescia, 1877)
A. Venturi: *Storia* (1901–40), ix, pp. 323–34
M. L. Ferrari: *Il Romanino* (Milan, 1961)
L. Crosato: *Gli affreschi nelle ville venete del cinquecento* (Treviso, 1962)
G. Treccani degli Alfieri, ed.: *La Storia di Brescia*, iii (Brescia, 1963–4)
Mostra di Girolamo Romanino (exh. cat., ed. G. Panazza; Brescia, Duomo Vecchio, 1965)
G. Godi: 'Anselmi, Sojaro, Gambara, Bedoli: Nuovi disegni per una corretta attribuzione degli affreschi in Steccata', *Parma A.*, viii (1976), pp. 55–79
G. Vezzoli and P. V. Begni-Redona: *Lattanzio Gambara, pittore* (Brescia, 1978)
M. Di Giampaolo: 'Lattanzio Gambara, pittore', *Prospettiva*, xviii (1979), pp. 57–9
C. S. Cook: 'The Lost Last Works by Romanino and Gambara', *A. Lombarda*, 70–71 (1984), pp. 159–67
——: 'The Collaboration of Romanino and Gambara through Documents and Drawings', *A. Ven.*, xxxviii (1984), pp. 186–92
Pittura del cinquecento a Brescia (Milan, 1986)

<div align="right">CATHY S. COOK</div>

Gambarini, Giuseppe (*b* Bologna, 1680; *d* Bologna, 11 Sept 1725). Italian painter. Knowledge of this charter-member of the Accademia Clementina comes almost wholly from Giovan Pietro Zanotti, who knew Gambarini

personally, and had used him as a model when the artist was in his early adolescence. Gambarini's was a fairly short career; at the time of his unexpected death he was gaining prominence in Bologna as a specialist in scenes of working-class domestic life.

Gambarini came from a family of humble origins; he began his study of painting with a minor pupil, a certain Boccia (Zanotti), of the distinguished Bolognese master Lorenzo Pasinelli. Diligent study and some association with the master himself soon advanced him to the status of 'molto buon pittore' (Zanotti). He next worked in the studio of Benedetto II Gennari, recently returned to Bologna from a long period of residence at the courts of the English monarchs Charles II and James II, and assimilated something of Gennari's manner. According to Zanotti, his first independent work was a mural commission (1698; destr.) in the Casa Tassoni at Ferrara, in which as figure painter he collaborated with a *quadratura* specialist, producing a work that was 'much esteemed'. Then, again as *figurista*, he teamed up with the celebrated *quadraturista* Marcantonio Chiarini (1652–1730) to decorate a ceiling in the Casa Supini at Bergamo. Chiarini was so impressed with Gambarini's ability that he invited him to collaborate on an important large-scale palace decoration in Vienna. Unfortunately his work with Chiarini encountered malicious comment and the hypersensitive Gambarini returned to Bologna, leaving his colleague to find another painter.

In 1712–13 Gambarini worked in Rome, with the *quadraturista* Pompeo Aldrovandi (1677–1735), on a decorative commission in SS Giovanni e Petronio dei Bolognesi. He then returned permanently to Bologna, where he occasionally received commissions for altarpieces but more frequently private commissions for narrative pictures. Examples are *Hagar and Ishmael in the Desert* (Prague, N. Mus.) or the two quite beautiful pastoral mythologies, the *Birth of Adonis* and its companion, the *Nurture of Jupiter* (Bologna, Maccafferi priv. col., see Miller), painted for Conte Raimondo Buonaccorsi of Macerata.

Gambarini took great pleasure in making studies of the incidents of life about him in Bologna and especially the daily scene in his own family. Through these exercises he discovered his true métier as a painter of genre subjects. His, generally cabinet-sized, pictures of 'soggetti umili e bassi' (Zanotti), observed with an amused but compassionate eye and demonstrating a sure touch and sharp characterization, soon became popular with local patrician collectors, rivalling pictures of this type by the better-known Giuseppe Maria Crespi, and of much higher quality than those of Gambarini's imitator Stefano Gherardini (1696–1756). Towards the end of his career, however, he received a commission for two large history paintings from Count Vincenzo Ranuzzi, who wanted two multi-figured scenes celebrating Charles V's visit to Bologna to hang in his senatorial palace.

BIBLIOGRAPHY

G. P. Zanotti: *Storia dell'Accademia Clementina*, 2 vols (Bologna, 1739/*R* 1977), i, pp. 387–92
L. Crespi: *Felsina pittrice: Vite de' pittori bolognesi* (Rome, 1769), p. 140
H. Voss: 'Giuseppe Gambarini', *Pantheon*, ii (1928), pp. 512–15
G. Fiocco: *Pittura del settecento italiano nel Portogallo* (Rome, 1940)
D. Miller: 'Per Giuseppe Gambarini', *A. Ant. & Mod.*, 4 (1958), pp. 390–93
G. Heintz: 'Die italienischen Maler im Dienste des Prinzen Eugen', *Mitt. Österreich. Gal.* (1963), p. 117
R. Roli: *Pittura bolognese, 1650–1800: Dal Cignani ai Gandolfi* (Bologna, 1977), pp. 57, 95, 173–4, 186–8, 261–2
L'arte del settecento emiliano: La pittura: L'Accademia Clementina (exh. cat. by A. Emiliani and others, Bologna, Pal. Podestà and Pal. Re Enzo, 1979), pp. 32–5
G. Briganti, ed.: *La pittura in Italia: Il settecento* (Milan, 1989, rev. 1990), p. 727 [with bibliog.]

DWIGHT C. MILLER

Gambart, (Jean Joseph) Ernest (Théodore) (*b* Courtrai, 12 Oct 1814; *d* Nice, 12 April 1902). British publisher and dealer. He began his career in his father's printing, binding and bookselling business, with a reading-room, at Courtrai, Belgium. From *c*. 1833 he was established in Paris, with his own print and paper-making business. In April 1840 Gambart arrived in England, representing Goupil's print publishing business. By autumn 1842 he had formed a partnership known as Gambart & Junin, which specialized in the import of prints from the Continent. After a brief period at 12 Denmark Street, London, the expanding business was set up at 25 Berners Street, in March 1844, as publishers, importers and exporters of prints. It was from this address that Gambart launched his career as one of the leading print publishers of the mid-Victorian period, with engravings after all the most celebrated British and continental artists of the time, including Edwin Landseer, John Everett Millais, Rosa Bonheur, Lawrence Alma-Tadema and William Holman Hunt. Probably his most famous publication (1858) was the engraving by William Henry Simmons of Hunt's *The Light of the World*.

On 8 July 1846 Gambart became a British subject. Within three years he gave his first exhibition (of bronze sculptures of animals by Pierre-Jules Mène); other exhibitions followed, after a while on an annual basis, first at 120–21 Pall Mall, which became known as the French Gallery, and from 1868 at 1A King Street, St James's. At these galleries exhibitions of works by British artists alternated with those of works by their leading contemporaries in France and the Netherlands. These commercial exhibitions formed the model for most subsequent ventures of a similar kind at other dealers' establishments. Friendship with leading artists, with the new middle-class patrons (Joseph Gillott being the most celebrated) and with critics, notably Ruskin and F. G. Stephens, helped to establish in Britain the system of dealers, critics and patrons on which the modern art trade is based.

Gambart's business dealings with living artists were considered to be scrupulously fair, although artists under contract often complained of his stringent observation of the terms of agreements. Artists with whom Gambart made business arrangements include John Linnell (ii), Turner, David Roberts, Landseer, Frederick Goodall, Millais, Dante Gabriel Rossetti, Holman Hunt, Ford Madox Brown and William Powell Frith (the engraving of whose *Derby Day* he published). His long friendships with Bonheur (whom he brought to England in 1855) and Alma-Tadema, whom he introduced to England, did much to advance their reputations. Gambart was a popular and influential figure with the artistic establishment: his only

true rivals were, at first, Louis Victor Flatow and, later, William Agnew. His affairs were conducted with integrity and flair.

Gambart was married three times but had no children. On his retirement in 1870, the business passed to his nephew Léon Lefèvre and became known as Pilgeram & Lefèvre; it survives as the Lefevre Gallery, 30 Bruton Street. Gambart's remaining years were spent as Spanish Consul-General in Nice, at Les Palmiers, a sumptuous marble palace built to his specifications. He also had a summer château at Spa, Belgium. He was made a Member of the Royal Victorian Order in 1898 and received many other honours.

BIBLIOGRAPHY
J. Maas: *Gambart: Prince of the Victorian Art World* (London, 1975)

JEREMY MAAS

Gambello. Italian family of artists.

(1) Antonio (di Marco) Gambello (*fl* 1458; *d* Venice, 1481). Architect and sculptor. His documented work is limited to one important building, the wealthy monastic church of S Zaccaria, Venice, to which he was appointed proto (chief architect) in 1458, and with which he was closely associated until his death (*see* ITALY, fig. 9). S Zaccaria holds a pivotal position between Gothic and Renaissance architecture in Venice, although the church was unfinished on Gambello's death and was completed by Mauro Codussi between 1483 and *c.* 1490. Gambello's progress was delayed by frequent journeys abroad at the behest of the Venetian government, to design and inspect fortifications. He was firstly responsible for extensive alterations to the earlier, Gothic church of S Zaccaria, parts of which were incorporated into the new structure. These alterations are all in a late, purely Gothic style. Gambello's new church has a spacious three-bay nave terminating at the east end in an ambulatory with radiating chapels, the only example in the city before Baldassare Longhena's nave (begun 1631) at S Maria della Salute. The apse contains an unusual but harmonious mixture of Gothic and Renaissance motifs, some partly the work of assistants after his death. Gambello was also responsible for the stylobate of the façade, again continued by assistants before Codussi was appointed to complete the building. Often claimed as the work of Gambello, although undocumented, is the land-gate (completed 1460) to the Venetian Arsenal, a complex early Renaissance work, loosely based on the Roman Arch of the Sergii at Pula (Croatia), then a Venetian colony. In detail immature, the land-gate is notable for its classical, rather than Lombard Renaissance, origins. Gambello is also associated with S Giobbe, Venice, although the chancel, choir and chapels are attributable to Pietro Lombardo.

BIBLIOGRAPHY
P. Paoletti: *L'architettura e la scultura del rinascimento in Venezia*, 2 vols (Venice, 1897)
A. Angelini: *Le opere in Venezia di Mauro Codussi* (Milan, 1945)
E. Arslan: *Venezia gotica* (Milan, 1970)
L. O. Puppi and L. Puppi: *Mauro Codussi: L'opera completa* (Milan, 1977)
J. McAndrew: *Venetian Architecture of the Early Renaissance* (Cambridge, MA, and London, 1980)

(2) Vittore [Vittorio] **Gambello** [Camelio; Camelius; Camelus] (*b* Venice, 1455 or 1460; *d* Venice, 1537). Medallist and sculptor, son of (1) Antonio Gambello. He studied drawing under Giovanni Bellini. The earliest references to him document his employment as *maestro della stampe* at the Venetian Mint in 1484. He perfected a method for stamping medals in high relief rather than casting them in sand or by the lost-wax process; this allowed the easier production of medals in larger editions. While certain scholars (Armand and Fabriczy) include 13 medals—8 cast and 5 stamped—in their accounts of Gambello's production, others list 11 or 12. The hypothesis that medals signed *Moderni* or *Moderno* might be attributed to Gambello has been abandoned for stylistic reasons. His style has been criticized (Fabriczy and Hill) for its lifeless academicism. It has also been argued (Fabriczy) that his designs display an incomplete knowledge of Greek reliefs and Classical principles, and that although he initially practised a vigorous naturalism, his later work involved less distinctive modelling and weaker compositions. However, Foville claimed that Gambello successfully modernized antique forms for 16th-century taste.

Gambello's earliest medal (1482 or 1484) has a portrait of Pope Sixtus IV wearing the traditional papal tiara and cape, while the reverse depicts the enthroned Pope surrounded by a cardinal and other persons. Around 1490 he produced portrait medals of *Gentile Bellini* and *Giovanni Bellini*. His most successful medal has been considered to be that of Pope Julius II, which has a bust in profile of the Pope, while the reverse depicts Christ enthroned, delivering the papal keys to the kneeling St Peter. The justification of papal authority is a common theme of Gambello's portrait medals, most of which have a relevant allegorical or classical scene on the reverse. He also executed a medal with a *Self-portrait* (1508), inscribed *Camelio*. From 1515 to 1517 Gambello worked as a die-engraver at the Papal Mint, as a result of his expertise in the process of stamping medals. Moreover, he still held his position at the Venetian Mint at the time of his last appearance in official records in 1523. Gambello's work also included large-scale sculptures: among those that have been attributed to him are the marble statues of Apostles and other saints in the old choir of S Stefano, Venice, later moved to the presbytery.

BIBLIOGRAPHY
Thieme–Becker
V. Lazari: *Notizia delle opere d'arte e d'antichità della raccolta Correr di Venezia* (Venice, 1859), pp. 181–3
A. Armand: *Les Médailleurs italiens* (Paris, 1883–7), i, pp. 114–17
C. von Fabriczy: *Medaillen der italienischen renaissance* (Leipzig, 1903); Eng. trans. as *Italian Medals* (London, 1904), pp. 56, 78–9, 186
J. de Foville: 'Médailleurs de la Renaissance: Camelio', *Rev. A. Anc. & Mod.*, xxxii (Oct 1912), pp. 274–88
G. F. Hill: *Portrait Medals of Italian Artists of the Renaissance* (London, 1912), pp. 13, 14, 38–9, 43–4

WILLIAM L. ANTHES JR

Gamberelli. *See* ROSSELLINO.

Gambia, the [Republic of]. Country in West Africa. Except for its western Atlantic coast, the Gambia is completely surrounded by Senegal. Of its total area of 11,295 sq. km, one fifth comprises the River Gambia and the rest river flats. The capital is Banjul (formerly Bathurst).

The Gambia gained its independence from Britain in 1965. Each of the five major ethnic groups found in the Gambia also inhabits Senegal. The largest group, the Mandingo, comprises almost half the population. Traditionally agriculturalists, they live in the central part of the country. The Wolof are the largest group in Banjul and along the Atlantic coast. They are primarily merchants and traders. Fula herdsmen dominate the eastern section of the country. Jolas live to the south, and Serahuli traders are found throughout the country. Over 90% of the population is Muslim, although many also follow traditional African religions. The British settlement in the Gambia consisted of a small mercantile community around Banjul. Despite the colonial presence, most of the Gambia remained relatively unchanged into the 20th century. The bonds of village life were maintained by a highly structured society, stratified by castes and age-groups. This entry covers the art produced in the area since colonial times. For the art of the region in earlier periods, see AFRICA, §VII, 3.

Colonial architecture in the Gambia is found in Banjul and trading stations along the banks of the River Gambia. In the early 1900s Banjul was a small, picturesque town catering for a bustling import and export trade. MacCarthy Square, in the middle of town, separated the commercial district in Wellington Street from the government offices along Marina Parade. Both areas include fine examples of colonial architecture. Wellington Street, with its imposing two-storey whitewashed warehouses with arched, covered colonnades, was one of the most remarkable thoroughfares in West Africa. Marina Parade was a palm-lined avenue along which are situated the State House and most of the government buildings. With the possible exception of the modern five-storey Central Bank, these colonial structures are still the most interesting architecturally.

Carved wooden masks are rare among the people of the Gambia. Nonetheless, a masking tradition is central to everyday life, especially in the rural areas. Costumes are made of bark, leaves and branches, and cover the entire body. The masked, dancing figures impersonate spirits, which then intervene, sometimes forcefully, in the affairs of the community. They possess the power to redirect social action, punish wrongdoers and educate the young. They also provide entertainment. The Gambia's traditional artistic strength, however, lies in the praise-songs of the griots, or praise-singers. Accompanied by music, griots recount the histories of the Gambian people and their former kings. One of the largest collections of these recorded oral histories in West Africa is housed in the National Museum on Independence Drive, Banjul, a fine example of colonial architecture (formerly the Bathurst Club for British expatriates). It also houses a wide selection of musical instruments, prehistoric artefacts, basketry, beads and other decorative ornaments from the Gambia and neighbouring countries.

A form of visual art that is immediately striking to visitors is textile production, embellishment and use. Local tie-and-dye and batik techniques are applied to imported cottons and damasks and then crafted into stylish gowns, often heavily embroidered. Gambian society also places great value on garments made from narrow pieces of strip-cloth, hand-woven by male artisans throughout much of West Africa.

Art education in the Gambia is rudimentary. By the early 1990s there was still no formal training available for aspiring artists. Creative young people tended to leave the country for Dakar in Senegal, the closest urban centre at which formal courses were available. Most Gambian-born contemporary artists who have made a name for themselves, such as Momodou Ceesay (b 1944), live abroad. The largest market for art and craft is the tourist trade. The government-supported Gambian Craft Cooperative (GAMCO), in the suburb of Bakau, and a non-profit, artist-managed art gallery provide the only other outlets for contemporary art. Nor does modern Gambian society foster artistic patronage. The former caste-based patronage system, in which chiefs supported griots, has almost disappeared. The few griots who still earn a living from their skills are supported by politicians and wealthy bureaucrats.

In 1990 the Government began to develop a cultural policy based on a detailed evaluation of cultural life throughout the country. This led to the establishment of a National Cultural Council to provide funding to promote and support traditional art forms and contemporary art and artists.

BIBLIOGRAPHY
H. A. Gailey jr: *A History of The Gambia* (London, 1964/R New York, 1982)
D. Gardella: 'Momodou Ceesay of The Gambia', *Afr. A.*, vii/4 (1974), pp. 40–41
U. Wagner: *Catching the Tourist: Women Handicraft Traders in The Gambia*, Stockholm Studies in Social Anthropology, x (Stockholm, 1982)
N. Lemann: 'Fake Masks', *The Atlantic*, cclx/5 (1987), pp. 24–39
'Art and Development: Gambian Artist Njogu Touray Took Alison Perry round his Current Exhibition at the Commonwealth Institute in London', *W. Africa*, 3645 (1987), pp. 1204–5
D. P. Gamble: *The Gambia*, World Bibliographical Series, xci (Oxford, 1988)
D. A. Hoover: 'Developing a Cultural Policy in The Gambia: Problems and Progress', *J. A. Mgmt & Law*, xviii/3 (1988), pp. 31–9
N. Guez: *L'Art africain contemporain/Contemporary African Art: Guide Edition 92–94* (Paris, 1992) [bilingual text]
J. Kennedy: *New Currents, Ancient Rivers: Contemporary African Artists in a Generation of Change* (Washington, DC, and London, 1992), p. 94
DEBORAH A. HOOVER

Gambier-Parry, Thomas [Parry, Thomas Gambier] (b 22 Feb 1816; d Highnam, Glos, 28 Sept 1888). English collector and painter. He formed one of the most distinguished collections of early Italian art in the British Isles during the second half of the 19th century; as a painter, he experimented with the techniques of mural painting and devised a process that was suitable for use in a northern climate. He was educated at Eton and Trinity College, Cambridge, and in 1838 acquired the estate of Highnam, near Gloucester. His interest in art began early, when he was at Cambridge, and his taste was at first traditional, but by the 1850s it had begun to narrow in favour of 14th- and 15th-century Italian painting, especially works of the Tuscan school, of which the *Annunciation* diptych by Pesellino (U. London, Courtauld Inst. Gals) is an outstanding example. Most of his purchases were made abroad through such dealers as W. B. Spence, but he did buy some major pictures at the 1863 sale of the Rev. Walter Davenport Bromley's collection (e.g. the *Crucifixion and Saints* polyptych by Bernardo Daddi, the *St Peter* from the Sienese school c. 1340, the *Coronation of the*

Virgin by Lorenzo Monaco and the predella panel from the circle of Fra Angelico; all U. London, Courtauld Inst. Gals).

At the same time Gambier-Parry was collecting medieval and Renaissance works of art, including not only Italian sculpture and maiolica, but also ivories, glass, enamels and Islamic metalwork. The collection was housed at Highnam Court and was notable for its consistently high quality. Apart from some isolated purchases made during the 1870s, the bulk of the collection had been acquired by 1860. Inventories date from 1860 and 1863 (for the paintings) and 1875 (for the other works). A manuscript catalogue of the whole collection, based on Gambier-Parry's notes and prepared in 1897 by his son, Ernest, is still in the family's possession, together with further documentation and correspondence. Some items were sold (London, Christie's, 17 June 1864, lots 89–101) or given away during Gambier-Parry's lifetime, and a few others were sold in 1920–21 by a descendant, but the collection remains basically intact and was bequeathed in 1966 by his grandson, Mark Gambier-Parry, to the Courtauld Institute at the University of London.

As an artist Gambier-Parry played a major role in the British revival of fresco painting, along with Charles Lock Eastlake and Mary Merrifield. Gambier-Parry's process, which apparently influenced Ford Madox Brown and Frederic Leighton, was called 'spirit fresco', and he used it extensively for his own work at Ely Cathedral (1862–5; 1874–5), Gloucester Cathedral (St Andrew's chapel, 1866–8), Tewkesbury Abbey (1875–80) and Highnam parish church (dedicated to the Holy Innocents; 1859–c. 1880). In 1880 he published a short account of the technique; it involved heating a concoction of elemi resin, wax, oil of spike-lavender and copal (with the appropriate pigments) and applying this to plaster that had been previously coated with whiting and lead white mixed with turpentine. It is also possible that with his knowledge of early methods he restored some of the paintings in his own collection.

Gambier-Parry epitomizes the Victorian gentleman as portrayed in the novels of Anthony Trollope. It is said, for example, that he preferred to vault over gates rather than to open them. His interests were varied, incorporating languages, travel, archaeology, music and horticulture. In addition, he was a notable philanthropist. Some of his personal attitudes are expressed in his *Essays*. There is a portrait drawing of him by Margaret Sarah Carpenter in the British Museum, London.

WRITINGS

Spirit Fresco Painting (London, 1880)
The Ministry of Fine Art to the Happiness of Life: Essays on Various Arts (London and Edinburgh, 1886)

DNB
 BIBLIOGRAPHY
F. Boase: *Modern English Biography*, ii (London, 1897/R 1965)
A. Blunt: 'Thomas Gambier-Parry: A Great Art Collector', *Apollo*, lxxxi (1965), pp. 288–95
'The Gambier-Parry Bequest to the University of London', *Burl. Mag.*, cix (March 1967) [special issue devoted to the col.]
The Gambier-Parry Collection: Provisional Catalogue: Courtauld Institute of Art, University of London, intro. A. Blunt (London, 1967)
D. Verey: 'The Building of Highnam Parish Church', *Country Life*, cxlix (13 May 1971), pp. 1160–02
Thomas Gambier-Parry (1816–1888) as Artist and Collector (exh. cat., ed. D. Farr; U. London, Courtauld Inst. Gals, 1993)

CHRISTOPHER LLOYD

Gamborino, Miguel (*b* Valencia, 1760; *d* Madrid, 1828). Spanish printmaker. He studied in Valencia at the Real Academia de S Carlos. In 1788 he executed a plate for the *Descripción histórica del Obispado de Osma* (Madrid, 1788) by Juan Loperráez Corvalán. His published portraits include those for *Icones et descriptiones plantarum* (Madrid, 1791–1801) by Antonii Joséphi Cavanilles. The most important of his numerous religious prints are *Vía Crucis* (e.g. Madrid, Bib. N.), after a drawing by Vicente López y Portaña, and *St Lawrence* (1812). His series of 18 plates for *Los 'gritos' de Madrid* (Madrid, 1817) was the most important of the many illustrations of contemporary habits and customs (*costumbrismo*) produced during the 19th century. His last known work is the lithograph (1827) he made after one of Murillo's versions of *St Joseph Leads the Light of the World by the Hand*.

 BIBLIOGRAPHY
M. Ossorio y Bernard: *Galería biográfica de artistas españoles del siglo XIX* (Madrid, 1868, 2/1883–4/R Barcelona, 1975)
A. Gallego: *Historia del grabado en España* (Madrid, 1979)
E. Páez Ríos: *Repertorio* (1981–3), i, pp. 391–4
El Escorial en la Biblioteca Nacional (exh. cat., ed. E. Santiago; Madrid, Bib. N., 1985–6), pp. 448–59
J. Carrete, F. Checa and V. Bozal: *El grabado en España, siglos XV al XVIII*, Summa A., xxxi (Madrid, 1987), p. 458

BLANCA GARCÍA VEGA

Gamelin, Jacques (*b* Carcassonne, 3 Oct 1738; *d* Carcassonne, 12 Oct 1803). French painter, draughtsman and engraver. He was employed as a book-keeper in Toulouse by Nicolas-Joseph Marcassus, Baron de Puymaurin, who (on the strength of marginal drawings in the ledgers) sent him to study with Pierre Rivalz and then to Paris to the studio of the history painter Jean-Baptiste Deshays. He failed to win the Prix de Rome in 1763 and 1764, but Puymaurin's generosity enabled him to go to Rome. There he completed his training within the circle of such independent French artists as Laurent Pécheux, who was influenced by the Neo-classicism of Anton Raphael Mengs, and of Italian painters such as Marco Benefial, Domenico Corvi and, later, Giuseppe Cades. In 1770 he travelled to Naples and the following year he was elected to the Accademia di S Luca, Rome, as a battle painter. The most important work of these years is in the gallery of the Palazzo Rondanini, Rome, where in 1772 he decorated the vault with the *Fall of Phaëthon*, a painting in oil on canvas. Its effects of sublimity and terror are akin to contemporary work by Henry Fuseli.

In 1774 Gamelin returned to France, where despite recurrent financial troubles and the disruptive effects of the French Revolution he was a sought-after and prolific painter in his native Languedoc. He was at first based in Toulouse, where he became a member of the Académie in 1776. He painted a number of large compositions for the churches of Montréal and Narbonne (both in the département of Aude) as well as five works (1783; Carcassonne Cathedral; Narbonne, Hôtel-Dieu) for the Abbey of Fontfroide, near Narbonne. He also engraved the *Nouveau recueil d'ostéologie et de myologie* (1779), an anatomical work in which he combined realist observation and macabre imagination in a style reminiscent of Francisco de Goya. It was, however, a financial failure and in 1780 he was obliged to accept the directorship of the

Académie of Montpellier. Further financial difficulties led him to renounce this post to settle in Narbonne, where he remained from 1782 to 1796. He worked for the cathedral, for the Pénitents Blancs and the Pénitents Bleus, painting for the latter order four scenes from the *Life of St Louis* (1783–5; Narbonne, Hôtel-Dieu), as well as for churches in the area, including those at Gruissan, Sallèles and Perpignan. Besides religious canvases he painted portraits, such as those of the *Children of Baron de Puymaurin* (1775; Carcassonne, Mus. B.-A., Toulouse, Mus. Augustins) and of *Frion* (1796; Perpignan, Mus. Rigaud); lively genre scenes in the Flemish style, including the *Toper and his Family* (1789; Carcassonne, Mus. B.-A.); and scenes evoking the ancient Roman world, for instance the *Vestal Virgins* (Carcassonne, Mus. B.-A.). He continued to paint battle scenes throughout his career: during the French Revolution he followed the Republican armies in the Roussillon campaign, depicting the *Battles of the Pyrenees* (1793; Narbonne, Mus. A. & Hist.; Béziers, Mus. B.-A.), and was also an organizer of Revolutionary celebrations. He was involved in the foundation of the museum in Carcassonne, saving the treasures of local monasteries and churches and in particular his own canvases. In 1796 he returned to settle in Carcassonne, where he became a professor at the Ecole Centrale. In addition to the *Nouveau recueil d'ostéologie* Gamelin produced more than 100 other prints (e.g. Toulouse, Mus. Dupuy) and was a prolific draughtsman (e.g. *Fire in the Temple of Vesta*, 1787; Toulouse, Mus. Dupuy; *Cavalry Skirmish*, Paris, Louvre). His son Jacques-François Gamelin (1774–1871) was a painter of minor talent.

BIBLIOGRAPHY

Note sur les honneurs funèbres rendus à Jacques Gamelin, et éloge funèbre de Jacques Gamelin peintre d'histoire (Carcassonne, 1803)

R. Portalis and H. Béraldi: *Les Graveurs du dix-huitième siècle*, ii (Paris, 1881), pp. 231–2

Jacques Gamelin, 1738–1803 (exh. cat. by J. Hahn, O. Michel and G. Sarraute, Paris, Gal. Joseph Hahn, 1979) [with bibliography]

O. Michel: 'Huit tableaux du peintre languedocien Jacques Gamelin, 1738–1803', *Rev. Louvre*, xxxiv (1984), pp. 359–66

Le portrait toulousain de 1550 à 1800 (exh. cat. by J. Penent, Ch. Peligny and J.-P. Suzzoni, Toulouse, Musèe des Augustins, 1987), pp. 147–162, no. 97–103

Toulouse et le Néo-Classicisme: Les artistes toulousains de 1775 à 1830 (exh. cat. by J. Penent and J.-P. Suzzoni, Toulouse, Musée des Augustins, 1989), pp. 9–23, 59–63, 82, no. 1–19, 72–80, 102

O. Michel and J.-F. Mozziconacci: *Jacques Gamelin, 1738–1803*, ii of *Les collections du Musée des Beaux-Arts de Carcassonne* (Carcassonne, 1990) [with bibliog.]

OLIVIER MICHEL

Gameren, Tylman van (*bapt* Utrecht, 5 July 1632; *d* Warsaw, 1706). Dutch architect and painter, active in Poland. He studied in Holland and worked as a painter in Venice between 1650 and 1660. Although none of his paintings has been found, hundreds of designs and sketches, mostly of an architectural character, have survived (U. Warsaw, Lib.). In 1660 he was summoned to Poland by the powerful Lubomirski family, with whom he remained in contact for the rest of his life. His other clients were the Polish kings Michael Wiśniowiecki (*reg* 1669–73), who appointed him Royal Civil and Military Architect (1672), and John Sobieski (*reg* 1674–96), who knighted him (1685), as well as Queen Mary Casimira and a large number of Polish magnates and rich gentry.

In his church buildings Tylman preferred centralized domed structures. Some were traditional in shape, for example the Kotowski Chapel, S Jacek, Warsaw (1690–3), while others display marked originality, for example the Bonifrater Brothers Church, Warsaw (*c.* 1670, unfinished), which is in the form of a stepped pyramid on a rusticated base. Notable, too, are his designs for a monumental centralized church crowned by an obelisk, intended for the Place Marieville, Warsaw (1695), and his church of S Casimir, Warsaw (1688–92), where a Greek-cross plan features a central octagon roofed by a dome with eight ribs rising to a lantern. Longitudinal churches, influenced by Il Gesù, Rome (*see* ROME, §V, 16(i)), include one built for the Benedictine Sisters in Radom (after 1678) and the University Church of St Anne, Kraków (1689–1703): its four-bay nave and pair of towers have a façade where the rhythm and thrust of the articulation build up towards the centre in one of the first Baroque elevations to be found in Polish architecture. Tylman also designed churches where the plan is a compromise between the centralized and the longitudinal. The best example of this genre is his church of S Antonius in the Czerniaków suburb of Warsaw (1687–92), which features a Greek-cross nave with a central dome, abutting an octagonal mausoleum, evoking the perspective effects of Baldassare Longhena's S Maria della Salute, Venice (begun 1631; *see* VENICE, §IV, 5). Tylman also designed the décor and fittings of his churches, always subordinating them to the architectural structure. His work, which includes altar retables, mortuary plaques and sepulchres, introduced elements of Roman and Venetian Baroque into Polish architecture. In addition, he occasionally made use of the designs of Jean Le Pautre.

The greater part of Tylman's oeuvre consists of secular buildings—in particular a large group of palaces and mansions (*see* POLAND, fig. 4). Built of brick or timber in one or two storeys, their design derives from the North Italian suburban or rural villa, even when erected in towns. The plan of the Lubomirski mansion at Czerniaków (before 1687) recalls Giuliano da Sangallo's Villa Medici at Poggio a Caiano (early 1480s), and there are further instances of motifs derived from Vincenzo Scamozzi and other Italian sources (Gniński and Kotowski palaces, Warsaw, early 1680s). Intersecting pediments in the manner of Andrea Palladio's Venetian church façades are used on the raised central hall of the Lubomirski Palace at Puławy (from 1671), while a Greek-cross plan is used for the hall of the Lubomirski Palace at Przeworsk (designed before 1666). Tylman's supreme achievement in the field of secular architecture is the palace in Warsaw (1689–95; see fig.), built for the voivode Jan Dobrogost Krasiński, which now houses the National Library. The exterior, in 19 bays, articulated by Ionic pilasters on a banded plinth, is inflected at the ends and in the centre, where it is crowned with a colossal pediment filled with figures carved by Andreas Schlüter (*see* WARSAW, fig. 6). The influence has been suggested here of Jacob van Campen's Amsterdam Stadhuis (begun 1648; now the Royal Palace; *see* AMSTERDAM, §V, 2). Other major schemes by Tylman have undergone extensive reconstruction, including the Bath House (Łazienka) built for Stanisław Herakliusz Lubomirski in his park at Ujazdów, which formed the core of the miniature palace of King Stanislav II Poniatowski

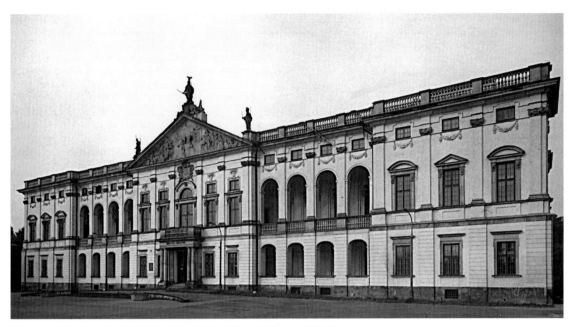

Tylman van Gameren: Krasiński Palace (now National Library), Warsaw, 1689–95

(*reg* 1764–95; *see* MERLINI, DOMENICO), and later Brühl Palace in Warsaw (after 1681).

Tylman sometimes designed garden layouts and landscaping, where he followed Italian and French models. He carried out urban-planning schemes in Warsaw, the most interesting of which was the development of the five-sided Place Marieville (1692–5), a multi-purpose area that combined an elegant shopping centre with a square designed for court activities. Tylman represented the modern concept of an architect who designs schemes to be executed by others. His surviving drawings reveal the gradual evolution of his designs from a preliminary concept. His 'Baroque style with classicist elements' (Hempel) exerted an influence on the later development of architecture in central Poland and in the Berlin works of such a prominent artist as Andreas Schlüter. It is also evident in the court architectural projects of the Saxon dynasty during the reign of Augustus II, King of Saxony and Poland.

BIBLIOGRAPHY
Thieme–Becker
M. Boschini: *La carta del navegar pitoresco* (Venice, 1660), pp. 542–3, 606–9
T. Makowiecki: *Archiwum planów Tylmana z Gameren architekta epoki Sobieskiego* [Archive of plans by Tylman van Gameren, an architect of the Sobieski period] (Warsaw, 1938)
E. Hempel: *Baroque Art and Architecture in Central Europe*, Pelican Hist. A. (Harmondsworth, 1965)
A. Miłobędzki: *Architektura polska XVII wieku* (Warsaw, 1980), pp. 349–95
S. Mossakowski: *Tilman van Gameren: Leben und Werk* (Munich, 1994)
STANISŁAW MOSSAKOWSKI

Games. *See under* TOYS AND GAMES.

GAN. *See* ADRIAN-NILSSON, GÖSTA.

Gan, Aleksey (Mikhaylovich) (*b* ?1889/93/95; *d* ?1940/42). Russian theorist and designer. In 1918–20 he was head of the section of mass performances and spectacles of the theatrical department of Narkompros, and he made a radical proposal for the entire population of Moscow to enact the May Day spectacle 'The Communist City of the Future' (1920). This 'mass action' activity presaged the anti-aesthetic stance that was to characterize Gan's approach. Through his co-founding with Varvara Stepanova and Aleksandr Rodchenko of the First Working Group of Constructivists (1921–4), and his publication of Constructivist principles in his book *Konstruktivizm* (1922), Gan played a leading role in the development of the Constructivist aesthetic. In his interpretation of Constructivism, which he saw as the creative counterpart to the socio-political tasks of the Revolution, Gan called for creative activity to be politicized to the maximum and for its artistic component to be minimized (*see* CONSTRUCTIVISM, §1). His slogans included 'we declare uncompromising war on art' and 'death to art', which he attempted to encapsulate in his designs for portable book kiosks, folding street stalls, exhibition posters and clothing, where the objects were reduced to the most simple and functional forms. It was this extreme approach that led to a split with fellow Constructivists Rodchenko and Stepanova in 1923 and his setting up of what he considered the true group of Constructivists, comprised of students at Vkhutemas. This group consisted of several production cells: the equipment for everyday life, children's books, specialized work clothes and typography, as well as cells concerned with material structures, mass action, and cinema and photography (Kino-Fot). The group exhibited their work at the First Discussional Exhibition of the Union of Active Revolutionary Art (Moscow, May 1924). Gan also published and edited the journal *Kino-Fot* (1922–3), in which he advanced his idea of the replacement of painting by photography and promoted the cinema as a medium unconnected with

tradition and capable of the objective recording of successful changes in Soviet life. He developed these theories in *Da zdravstvuyet demonstratsiya byta* (1923) and in his articles for *Sovremennaya arkhitektura* (1926–30), the journal of OSA, for which he was artistic editor. He was also a founding member of 'October' (1928–32), a union of artists, designers and architects, which primarily advocated Constructivist ideals as the most suitable for the advancement of the material culture of Soviet society.

WRITINGS
Konstruktivizm (Tver', 1922); Eng. trans., extracts, in *Russian Art of the Avant-garde: Theory and Criticism, 1902–1934*, ed. J. Bowlt (London, 1988), pp. 214–25
Da zdravstvuyet demonstratsiya byta [Long live the demonstration of life] (Moscow, 1923)

BIBLIOGRAPHY
C. Lodder: *Russian Constructivism* (London and New Haven, 1983)

JEREMY HOWARD

Ganagobie Monastery. Former Cluniac priory dedicated to Notre-Dame in Provence, France. Ganagobie is a Carolingian monastic foundation, although none of the surviving buildings is earlier than the 12th century. The church consists of a single nave with a pointed barrel vault, transepts of a single bay, and an east end comprising a central main apse flanked by apsidal chapels. The cloisters and associated monastic buildings are to the south of the church. Set high on a hilltop above the valley of the Durance, north-east of Forcalquier, Ganagobie was remote from the main centres of Romanesque sculpture. Its Cluniac affiliation, however, may explain its rich decoration, which includes an extensive mosaic floor. The main sculptural decoration is on the west door, where the jambs and arches are enriched with multiple lobes. Although this curious form does have parallels in Aquitaine, Languedoc and Spain, the particular example here is thought not to be original but to date from a later medieval reconstruction of the portal. The tympanum shows *Christ in Majesty* flanked by the symbols of the Evangelists, with the Apostles on the lintel below. The style is somewhat crude but reflects the distant influence of the west front of St Trophime at Arles. A similar inspiration may be detected in the cloister, although the capitals are, with a single exception, entirely foliate. At the south-west angle there is a simple column figure, perhaps representing one of the priors. Both the cloister and the west front (in its original form) may be dated to the last quarter of the 12th century. The decoration is typical of the sort of work produced in Haute-Provence, where there are few other lavishly decorated buildings, the main exception being the church at Saint-Christol. It is clear that outside the main centres there was a secondary level of artistic activity that distantly reflected metropolitan achievement.

BIBLIOGRAPHY
G. Arnaud d'Agnel: 'Notice archéologique sur le prieuré de Ganagobie', *Bull. Archéol. Com. Travo Hist. & Sci.* (1910), pp. 314–27
G. Barruol: *Provence romane: La Haute-Provence*, Nuit Temps (La Pierre-qui-vire, 1977)

ALAN BORG

Gand, Olivier de. *See* OLIVIER OF GHENT.

Gandara, Antonio de La (*b* Paris, 16 Dec 1862; *d* Paris, 30 June 1917). French painter, pastellist and draughtsman. He studied with Jean-Léon Gérôme at the Ecole des Beaux-Arts, Paris, from 1876 to 1881 and made his début at the Salon of the Société des Artistes Français in 1882 with a portrait of *Mlle Dufresne*. He soon became successful as a portrait painter of the aristocracy and the French élite (e.g. *Paul Escudier*; Paris, Petit Pal.). He was concerned only with the depiction of physical likeness and the rendering of elegant dress and showed little interest in the sitter's psychology or character (e.g. *Woman in Pink*, Nancy, Mus. B.-A.). He was an acute observer of the fashionable Parisian woman and often included her, along with children, in his many paintings of Paris, especially of the Jardins du Luxembourg (e.g. *Le Luxembourg*). In addition to painting in oil and pastel, he executed drawings in charcoal and pencil.

BIBLIOGRAPHY
Bénézit; Edouard-Joseph

ATHENA S. E. LEOUSSI

Gandellini, Giovanni Gori. *See* GORI GANDELLINI, GIOVANNI.

Gandelsonas, Mario. *See under* AGREST, DIANA.

Ganden [dga 'ldan]. Site near Dagzê, *c.* 40 km east of Lhasa, Tibet. It was the principal monastery founded by Tsong Khapa (1357–1419) in the early decades of the 15th century, and it thereafter became a major sanctuary of the Gelugpa school of Buddhism that he established. Formerly an impressive monastery town with several hundred shrines and chapels and a population of over 5000 lamas, Ganden was utterly destroyed during the Chinese Cultural Revolution (1966–76). The monastery is still largely ruined, though some reconstruction has begun. The buildings that stand today all date from after 1980.

Ganden was built on the slopes of a hill with the buildings constructed in descending layers in a crescent shape. The heart of Ganden and its most important structure is Tsong Khapa's Golden Tomb, the Ser Dung. This consists of several interconnecting buildings with high, tower-like superstructures and a courtyard; the inward-sloping walls are painted brown-red. This sanctuary contains several chapels with golden images of Buddhas and guardian deities. In the central chapel in the upper storey is Tsong Khapa's tomb, a replica of the large stupa made of silver and gold in which the master was originally enclosed. Other main buildings include the Tri Dok Khang, where the abbot of Ganden lived. In a chapel on the second floor is kept a set of the *Kanjur*, the first part of the Tibetan Buddhist canon. On the ground floor are four lesser shrines, of which that devoted to Samvara the Protector is especially noteworthy on account of its paintings of wrathful deities. Located next to this building is the Ser Tri Khang, or Golden Throne Room, containing a single chapel housing Tsong Khapa's throne, which is placed behind statues of the master and his two main disciples. The largest reconstructed building in the monastery is the Ngari Khangtsen, which houses a large shrine-room with bronze statues of the monk Atisha (982–1054) and other masters of the Kadampa order, which was founded by Atisha. Jangtse and Shartse, the two major

colleges in Ganden founded by Tsong Khapa's two main disciples, are in ruins.

BIBLIOGRAPHY

S. C. Das: *Journey to Lhasa and Central Tibet* (London, 1902/*R* New Delhi, 1970)
M. Henss: *Tibet: Die Kulturdenkmäler* (Zurich, 1981), pp. 171–6, pls 64, 66
D. L. Snellgrove and H. E. Richardson: *A Cultural History of Tibet* (Boston, 1986)
S. Batchelor: *The Tibet Guide* (London, 1987), pp. 177–89
K. Dowman: *The Power-places of Central Tibet: A Pilgrim's Guide* (London and New York, 1988), pp. 99–104
Liu Lizhong: *Buddhist Art of the Tibetan Plateau* (Hong Kong, 1988)

HENRIK H. SORENSEN

Gandhara. Ancient region of the north-west Indian subcontinent centred between the Indus and Kabul rivers north-east of Peshawar, Pakistan. It is first recorded in the late 6th century BC as an Achaemenid province in a rock inscription at Bisitun in Iran. The term is also applied to the Buddhist art and architecture of *c.* 1st–5th century AD from the north-west region and eastern Afghanistan. Gandharan art shows a combination of Indian, Hellenistic and Iranian influences and comprises reliefs, primarily of schist, illustrating stories on the life or previous incarnations (*jātaka*s) of the Buddha, and schist, stucco or clay images of the Buddha, *bodhisattva*s and subsidiary deities (*see* INDIAN SUBCONTINENT, §V, 5(ii)). Sites include BUTKARA, JAMALGARHI, LORIYAN TANGAI, PANR, RANIGAT, SAHRI BAHLOL, SAIDU SHARIF, SHAH-JI-KI-DHERI, TAKHT-I-BAHI and TAXILA in Pakistan; and BAMIYAN, FONDUKISTAN, GULDARA, HADDA, SARDAR TEPE and SHOTORAK in eastern Afghanistan. Close links are also evident in Central Asia.

See also AFGHANISTAN, §II, 3(iii), 4(ii) and 5(ii), and CENTRAL ASIA, §I, 2(i)(b), 3(ii)(a) and (iii)(a) and 4(iv). □

Gandja [Ganja; formerly Elizavetpol and Kirovabad]. Town in Azerbaijan. Located on the Gyandza-chay, a tributary of the Kura River in the Transcaucasus, it is recorded by medieval geographers as an important strategic and trading centre from the 9th century AD onwards. The town flourished under the local Shaddadid dynasty (*reg c.* 951–1174), and, following an Alan invasion, the city walls were strengthened by Abu'l-Asvar Shavur I (*reg* 1049–67). Copper door-knockers from a city gate erected by him in 1063 were taken to GELATI MONASTERY near Kutais after Demetrius, King of Georgia, sacked Gandja in 1138–9. Archaeological investigation has revealed that in the 12th century the town had three bands of fortifications with towers and bridges and a square fortress. The town flourished in the 12th and 13th centuries and was considered one of the most beautiful in western Asia. It was the home of the great Azerbaijan poet Nizami (1141–1209), author of the *Khamsa* ('Five poems'), one of the most popular books for illustration (*see* ISLAMIC ART, §III, 4(ii)(b)). Gandja was burnt by the Mongols in 1235 and declined in importance thereafter.

The complex of Gey-imam or Imamzade (14th–17th century; rest. 1878–9) in the north-east of the town comprises a central mausoleum abutted by various mosques, convents for dervishes and service buildings.

The tall drum and blue-glazed cupola of the mausoleum were severely distorted during restoration, and the mausoleum of Dzhomard-Qassab (17th century), a domed octagonal building with entrances on the main axes and engaged columns at the corners, gives a better idea of religious architecture in the town. The Djuma (Friday) Mosque, built in 1606 by the architect Baha' al-Din, is a square hall with a dome supported on squinches and a deep entrance iwan. It is set in a walled courtyard with the main entrance beneath paired minarets.

Two types of houses have survived from the 17th and 18th centuries. One type is rectangular; the subterranean lower floor is roofed with a cupola, and the main floor is covered by a hemispherical dome. The second type has a flat roof; its façade has an open gallery with an iwan. These houses were set in gardens, with the main façade facing the garden. The houses in residential quarters were linked by a system of irrigation canals and gardens, creating the microclimate of a large estate. The main material of construction was mud-brick or pisé and occasionally stone. The exterior stucco was sometimes replaced by a facing of small stones. Interior walls were plastered and floors covered in baked brick.

During the Soviet period several large public buildings were erected: the Pedagogical Institute (1940) by M. Useynov and S. Dadashev (*see* USEYNOV & DADASHEV) and the administrative building on Central Square (1961; formerly Lenin Square) by E. Ismailov, which has a façade in the form of arched openings resting on square columns. A memorial was erected for the poet Nizami in 1946 by the sculptor F. Abdurakhmanov and the architects Useynov and Dadashev. Its form, a tall tower with engaged columns, recalls earlier tomb towers in the region, such as the 14th-century examples at BARDA and Karabaghlar 40 km north-west of Nakhichevan.

Gandja was a centre for various forms of applied art, particularly glazed ceramics, gold-embroidered fabrics and carpets (*see* ISLAMIC ART, §VI, 4(iv)(c)). The town has a local history museum, the Nizami Picture Gallery of contemporary art, and a museum of medieval Azerbaijani book illustrations.

BIBLIOGRAPHY

Enc. Islam/2: 'Gandja'
N. G. Mel': 'Ob arkhitekture goroda Gyandzhi XII veka' [On the architecture of the town of Gandja in the 12th century], *Izvestiya Azerbay. Filiala Akad. Nauk SSSR* (1941), no. 5, pp. 21–5
I. Dzhafarzade: *Istoriko-arkheologicheskiy ocherk staroy Gyandzhi* [A historical and archaeological outline of old Gandja] (Baku, 1949)
L. Bretanitsky and A. Salamzade: *Kirovabad* (Moscow, 1960)
S. S. Blair: *The Monumental Inscriptions of Early Islamic Iran and Transoxiana* (Leiden, 1992), no. 49

E. R. SALMANOV

Gandolfi. Italian family of artists. The work of the brothers (1) Ubaldo Gandolfi and (2) Gaetano Gandolfi and of the latter's son, (3) Mauro Gandolfi, reflects the transition from late Bolognese Baroque through Neo-classicism and into early Italian Romanticism. During their period of collective productivity, from *c.* 1760 to *c.* 1820, the Gandolfi produced paintings, frescoes, drawings, sculptures and prints. Their drawings (examples by all three artists, Venice, Fond. Cini) made an outstanding contribution to the great figurative tradition of Bolognese draughtsmanship that had begun with the Carracci. Their prolific output

and their activity as teachers gave them considerable influence throughout northern Italy, except in Venice. One of Ubaldo's five children, Giovanni Battista Gandolfi (*b* 1762), trained at the Accademia Clementina, Bologna, but apart from a vault fresco signed and dated 1798 in the church of S Francesco in Bagnacavallo nothing is known of his adult career. A drawing (Paris, Fond. Custodia, Inst. Néer.) is signed Ubaldo Lorenzo Gandolfi, who may have been another son. Mauro's daughter, Clementina Gandolfi (*b* 1795), was an artist and amateur musician, and his son by a second marriage, Democrito Gandolfi (*b* 1796), studied with Antonio Canova but was an unsuccessful sculptor. He delivered a eulogy at Mauro's funeral and sculpted the portrait bust that stands on the tomb of Gaetano and Mauro in the Certosa di Bologna.

(1) Ubaldo Gandolfi (*b* San Matteo della Decima, nr Bologna, 28 April 1728; *d* Ravenna, 27 July 1781). Painter, draughtsman and sculptor. He painted frescoes, altarpieces and mythological scenes. His vast output of drawings, of which there is a representative collection in the Fondazione Cini, Venice, includes compositional drawings of both religious and mythological subjects and studies from the nude model. He is documented as a sculptor, and a few works executed in terracotta are known. He was enrolled by the age of 17 at the Accademia Clementina in Bologna, where he was taught by Ercole Graziani II, Felice Torelli and Ercole Lelli. Lelli is mainly known for the eerily lifelike wax models of dissected cadavers that he made for the Istituto d'Anatomia; the precise knowledge of human anatomy that is so evident in both Ubaldo's and Gaetano's paintings could well be due to his teaching. Between 1745 and 1749 Ubaldo won three medals for figure drawing. In 1749 his name then disappears from the records of the academy until 1759, when he again received a medal for drawing. The lapsed ten years constitute a lacuna in his career, though a few paintings from this period have recently been identified (see Biagi-Maino, nos 1, 4). Possibly he spent some of the time travelling, for Oretti states that he 'vidde Firenze, Venezia, ed altre famose scuole'.

Ubaldo made his official debut as a professional artist in 1759 with a large altarpiece for the parish church of S Maria Maggiore in the small town of Castel San Pietro, near Bologna: the *Assumption of the Virgin with SS Peter, Nicholas of Bari, Louis Gonzaga and Mary Magdalene of Pazzi*. This is a polished and competent work in the grand tradition of the late Bolognese Baroque, with a palette of bland and pallid colours and a highly finished paint surface. In 1760 he was elected to the Accademia Clementina and appointed Director of Drawing, a teaching position he continued to hold intermittently for the rest of his career. In the same year he married Rosa Spisani, by whom he had five children. His works from the first half of the 1760s were almost exclusively religious paintings, mainly single-figure saints. They are distinguished by impeccable drawing and an intense, portrait-like verisimilitude (e.g. *St Francis of Sales*; Bologna, priv. col., see 1993 exh. cat., no. 2). In the latter half of the decade his painting assumed a fresh vitality. There was a steady progression towards a greater realism, and in his religious paintings the earlier stiff grouping of isolated figures was replaced by dynamic

compositions of devout participants who acted out their narratives of martyrdom or revelation in a setting skilfully illuminated by a single hidden light source to heighten the drama. Examples include *St Vincent Ferrer* (1765; Budrio, S Domenico), *Christ in Glory with SS Lawrence, Anthony of Padua, Eligius and Ignatius Loyola* (1766; Medicina, S Mamante) and, most strikingly, the *Virgin of the Rosary with SS Dominic and Vincent Ferrer* (*c*. 1770; Bologna, Mus. S Domenico), conspicuous for the intense psychological interaction of all the protagonists.

The Marchese Gregorio Casali (1721–1802), himself an amateur painter and a member of the Accademia Clementina, was an enthusiastic patron. Between 1768 and 1776 he commissioned a series of small paintings of saints (*in situ*) as a gift from himself to the Conservatory of S Maria del Barraccano, a girls' orphanage in Bologna that he helped administrate. In the later 1770s Ubaldo also produced for the Marchese a number of engaging little portraits, usually of women or children (e.g. *Boy with a Medal* and the so-called *Pastorello*, both 1777; Bologna, Pin. N.), which demonstrate his ability as a sympathetic portraitist. Casali also commissioned three full-figure paintings of saints: *St Dominic, St Francis of Sales* (both 1768; Bologna, priv. col.) and *St Martin of Tours* (S Martino in Casola, parish church). The saints were no longer portrayed as generalized types but rather as living portraits of the nameless sitters, and their intensely expressive and closely observed facial expressions and gestures projected an eloquent and personal religious conviction rare in the 18th century.

Ubaldo's art reached maturity *c*. 1770, relatively late in his career. In this period he produced *Perseus and Andromeda* (see fig.) and *Selene and Endymion* (both *c*. 1770; Bologna, Pal. Com.) with their *bozzetti* (Bologna, priv. col., see 1993 exh. cat., no. 9). These paintings were commissioned by Casali for the apartments of the Senatori Gonfalonieri in the Palazzo Pubblico, Bologna. Six large paintings on the theme of Argus, Mercury and Io (two, Raleigh, NC Mus. A.; others, France, priv. col.) were painted at the same date for the Marescalchi family. These are primarily beautiful and unidealized depictions of naked people, and this straightforward realism remained a distinctive feature of Ubaldo's art. A red chalk study (Venice, Fond. Cini) of the *Andromeda* is a rare example of an academic study of a female nude. His earlier restrained use of pallid colours yielded to a broader palette with freer brushwork. The mythological pictures of *c*. 1770 exemplify this use of a range of blues and greens against warm golds and orange ochres, with the occasional brilliant accent of red.

Major commissions were neither frequent nor regular, yet in this period Ubaldo painted important frescoes and altarpieces. Of his seven documented palace decorations, only three remain, all in Bologna: the *Jupiter* ceiling in the Palazzo Malvezzi (*c*. 1758), the *Mercury* and other frescoes in the Palazzo Bovi–Silvestri (*c*. 1775) and the two *Hercules* ceilings in the Palazzo Malvasia (*c*. 1775–80), today part of the University of Bologna. He painted some of his most important altarpieces for Bologna and for the towns of Emilia Romagna. These include such impressive works as *SS Mark, Anthony Abbot and Sebastian Adoring the Virgin* (1773; Vigorso di Budrio, S Marco Evangelista), the

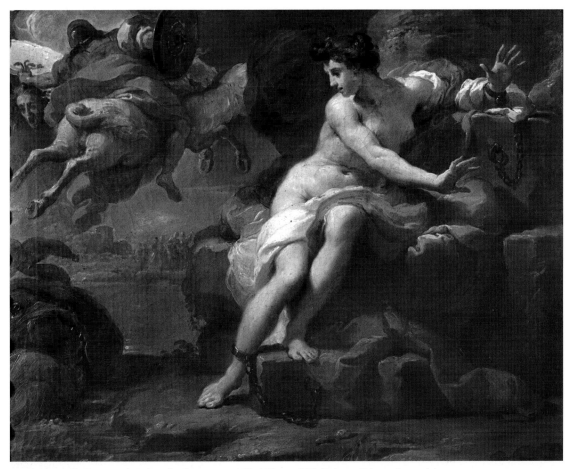

Ubaldo Gandolfi: *Perseus and Andromeda*, oil on canvas, 1.39×1.82 m, *c.* 1770 (Bologna, Palazzo Comunale)

Annunciation (1772; Bologna, S Maria della Misericordia) and *St Anne with the Virgin and St Joachim* (*c.* 1778; S Giovanni in Persiceto, parish church). A compositional study (New York, Met.) for the last-mentioned is an excellent example of Ubaldo's pen-and-wash drawings, in which wash is used to define the forms. He also produced smaller religious works of great beauty and sincerity for the little churches dotted about the Po valley, such as *St Jerome Listening to the Angels' Trumpets* (*c.* 1776–8; Budrio, Pin. Civ. Inzaghi) and *St Lucy* (1781; Villa Fontana, parish church).

In the last few years of his life Ubaldo also produced some of his finest devotional paintings, among them the four oval half-figures of saints: *Francis, Dominic, Lucy* and *Mary Magdalene* (all *c.* 1777; Bologna, Pal. Com.). The two female figures are intimate portraits of relaxed and thoughtful women, and it is the perfect melding of the portrait and the devotional genres that gave these paintings their strength. The deep spirituality of Ubaldo's religious pictures also characterizes his late works of sculpture, such as the two monumental stucco figures of *Jeremiah* and *Isaiah* (1780), part of a Neo-classical church decoration, and the monogrammed terracotta group, *St Joseph with the Christ Child* (all Bologna, S Giuliano). His last project was a fresco, the *Apotheosis of St Vitale*, for the saint's great

Byzantine church in Ravenna (*in situ*). It was left unfinished when Ubaldo was struck down by a sudden and fatal illness.

(2) Gaetano Gandolfi (*b* S Matteo della Decima, nr Bologna, 31 Aug 1734; *d* Bologna, 20 June 1802). Painter, draughtsman, sculptor and etcher, brother of (1) Ubaldo Gandolfi. He was a successful artist, whose oeuvre includes about 220 paintings, terracotta sculptures, etchings and a huge number of drawings. He was enrolled at the Accademia Clementina in Bologna by the age of 17 and claimed Felice Torelli and Ercole Lelli as his teachers. He had a distinguished academic career and between 1751 and 1756 won two medals for sculpture and four for drawing. His first documented commission was for drawings: between 1756 and 1760 he produced for private patrons a series of large finished red chalk copies (Bologna, Bib. Cassa di Risparmio; Windsor Castle, Berks, Royal Col.) of the classics of 17th-century painting. These and other early works are documented and dated in his manuscript autobiography, which, however, does not extend past *c.* 1769. His earliest known painting is the *Calling of St James the Greater* (1753; Piumazzo, nr Modena, parish church). The painting is close in style to the early work of his brother Ubaldo: highly finished, smooth and static,

with low-key, muted colours. The figure types are the stereotyped ones of the Bolognese tradition. A surge of self-confidence is evident in the next datable paintings, the large *St Jerome* (1756) and *St Mary Magdalene* (1757; both Bazzano, oratory of the Suffraggio).

A major turning point in Gaetano's career came in 1760 when, with the financial support of the Bolognese merchant Antonio Buratti (1736–1806), he studied in Venice for a year. The contact with Venetian 18th-century painting was immediately evident in his work, and faint echoes of Venice continued to reverberate until the 1780s. In 1763 he married Giovanna Spisani and celebrated the occasion with his *Self-portrait* and *Portrait of Giovanna Spisani* (both Bologna, priv. col., see Biagi-Maino, figs 83 and 82), rare examples of his accomplished work as a portrait painter. The virtuoso brushwork, indistinct contours and rainbow palette of such works as *Circe and Ulysses* (1766; Piacenza, Mus. Civ.) and *St Peter in Prison* (*c*. 1766; Stuttgart, Staatsgal.) reveal the influence of Venetian art, although he still used the face and figure types pioneered by his brother Ubaldo. It was during these years that their styles reached the closest point of convergence.

In the 1770s Gaetano received a series of important commissions, both religious and secular. From this decade, too, come the *Old Beggar Man* and *Old Woman* (both 1771; Bologna, Cassa di Risparmio), genre subjects that remain isolated. His major canvas of the decade is the *Marriage at Cana* (1776; Bologna, Pin. N.), painted for the refectory of the wealthy Lateran convent of S Salvatore, Bologna.

Gaetano's major decorative projects were executed during these successful middle years of his career. Of the ten documented projects, only six still exist (all in Bologna) and some of these only fragmentarily. These are *The Four Elements* (late 1760s) for the Palazzo Odorici (now Zani–Odorici), *Aurora* (1770) for the Palazzo Guidotti (now Guidotti–Senni), *Venus* and *Bacchus and Ariadne* (1772) for the Palazzo Gini (now Gini–Veronese), *Faith* and *Abundance* (1774) for the Palazzo Bianconcini, the *Sacrifice of Iphigeneia* (1780) and various grisaille figures (1780) for the Palazzo Scagliarini and the splendid *Rape of Deianeira* (1782) for the Palazzo Monari (now Calzoni). There were also some minor decorative projects for religious institutions, such as the grisaille wall fresco *St Proculus and Time* (1770), with *quadratura* by Flaminio Minozzi (1735–1817), for the Dormitorio of the Benedettini of S Procolo, of which only the figure of *Time* remains.

In 1779 Gaetano completed the major religious commission of his career, the cupola fresco of the *Assumption of the Virgin with Old Testament Figures* (1776–9), in S Maria della Vita in Bologna, for which two *bozzetti* exist (Notre Dame, IN, Snite Mus. A.; Kansas City, MO,

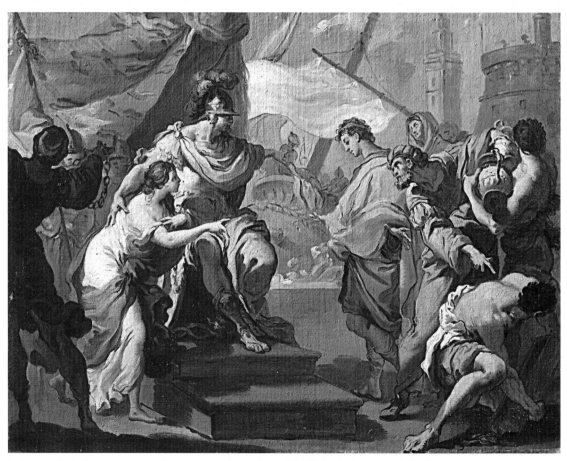

1. Gaetano Gandolfi: *Continence of Scipio*, oil on canvas, 357×458 mm, 1784 (Bologna, Pinacoteca Nazionale)

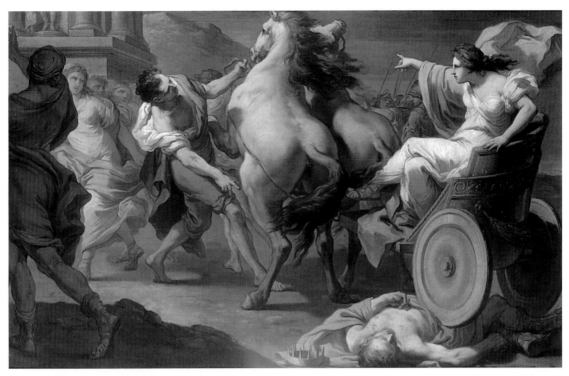

2. Gaetano Gandolfi: *Tullia Driving over the Body of her Father, Servius Tullius*, oil on canvas, 0.96×1.53 m, 1797–9 (London, private collection)

Nelson–Atkins Mus. A.). Three preparatory compositional drawings and a number of black chalk single-figure studies (e.g. *Noah*, New York, Pierpont Morgan Lib.) for the latter *bozzetto* survive (see 1993 exh. cat., nos 77–87).

In the 1780s the patronage for major projects fell off sharply, yet Gaetano's style continued to develop. The large *Death of Socrates* (1782; Bologna, priv. col.) heralds his explorations in the freer use of bright primary colours and Neo-classical subject-matter, innovations that were carried further with energy and vitality in the large *Continence of Scipio* (see fig. 1) and *Coriolanus and his Mother* (both 1784; Bologna, Pin. N.). The composition of the *Scipio* is based on the painting by Gavin Hamilton, the *Anger of Achilles at the Departure of Briseis*, which Gaetano probably knew from the engraving by Domenico Cunego, and indicates the artist's new interest in English Neo-classical prototypes. His remarkable *Self-portrait* (*c.* 1785; Bologna, Pin. N.), in a more realistic and robustly informal style, shows the artist at work, dressed in a rather shabby hunting-coat, with his pipe stuck in his tricorne and some freshly killed birds hanging from the easel. Many informal chalk drawings of children also date from the 1780s. Among the most enchanting and picturesque, reminiscent of Piazzetta, is the *Portrait of a Boy and a Girl* (Bologna, Pin. N.).

In 1787 Gaetano was invited by Richard Dalton, librarian to George III of England, for a visit of six months to London, passing through Paris *en route*. No work was produced on this trip, but the exposure to the broader European scene had a distinct effect on his subsequent style. Immediately on his return he executed the enormous painting for Pisa Cathedral, the *Inauguration of the Foundling Hospital by the Beato Bernagalli* (*in situ*), and for the first time fully integrated the simplified forms and static compositions of Neo-classicism into his robust figurative style. Other stylistic characteristics of the Pisa painting, which remained for the rest of his career, were a narrowing of his palette to a set of subtle neutral tonalities, with the dramatic emphasis gained by sharp contrasts in light and dark rather than through colour, and a studied stylization of face and gesture.

In the last years of his life Gaetano continued to execute paintings of religious and mythological subjects. *Christ the Judge with the Virgin and Saints* (1791; Ferrara, S Dominic), *Communion of the Apostles* and the *Martyrdom of St Lawrence* (both 1795–6; Budrio, S Lorenzo) are successful examples of his attempts to graft Neo-classical compositions and colour schemes on to traditional religious compositions. Four paintings evidently conceived as a group, which demonstrate his fully mature Neo-classicism as well as his personal late style, are *Alexander Presenting Campaspe to Apelles*, the *Rape of the Sabine Women* (both Liechtenstein, priv. col.), *Tullia Driving over the Body of her Father, Servius Tullius* (see fig. 2) and *Mourning the Body of Hector* (both London, priv. col.). The paintings are datable to 1797–9 by inscriptions on four preparatory compositional drawings. The compositions are rigorously Neo-classical, with the subjects that signify obedience to decorum on a vertical-horizontal grid, those dealing with violation on a diagonal grid (a convention that Gaetano also applied to his late religious paintings). His late palette is limited to a range of neutrals enlivened by brilliant primary colours sparsely applied.

Gaetano died suddenly in the summer of 1802 while playing *bocce* in the field of the church of S Emidio, just outside the gate of S Donato near his house. The funeral oration by Vincenzo Martinelli clearly describes a death from cardiac arrest, not, as some of the literature whimsically has it, from being hit on the head by a *bocce* ball.

(3) Mauro Gandolfi (*b* Bologna, 18 Sept 1764; *d* Bologna, 4 Jan 1834). Painter and printmaker, son of (2) Gaetano Gandolfi. He was the eldest of seven children. By his own rather boastful account he ran away from home at the age of 16, joined the French army and returned home to Bologna only in 1786. By 1791 he was enrolled in the school of the Accademia Clementina, as two superb figure drawings dated 1791 and 1792 are among those preserved in the archives of the present Accademia di Belle Arti. His chief mentor was his own father. In 1792 he married Laura Zanetti, and in 1794 he was made a professor of the Accademia Clementina. The fine *Self-portrait with a Lute* (*c*. 1794; Bologna, Pin. N.) may have been painted to commemorate this latter occasion. The decade of the 1790s was the most professionally productive time of Mauro's long life. In his manuscript autobiography written in 1833 (Milan, Brera), he listed his oeuvre, all of which he claimed to have done between 1786 and 1796: 1 painted carriage, 6 ceilings, about 28 'quadretti', 20 large drawings, 40 'capricci disegnati all' inchiostro con diversi colori all' acquarello di for a adattabile a tabacchiere', 8 to 10 miniatures, over 100 'nudi' (drawings?) and the pen drawing of his father (Bologna, Pin. N.).

Curiously Mauro did not mention his inaugural public commission, *St Dominic Burning the Heretical Books* (see fig.) and *St Dominic Reviving Napoleone Orsini* (both 1791), a large pair of altarpieces for the church of S Domenico in Ferrara that, with Gaetano's altarpiece, formed a triad of paintings for a private chapel in the church. Judging by the attitudes expressed in Mauro's copious writings, these subjects could not have been in line with his own beliefs, which probably explains their exclusion from the inventory. Small enigmatic *quadretti* in grisaille are known, such as the *Old Man and Young Girl* (Bologna, Pin. N.), with a *trompe l'oeil* broken picture-glass painted over its surface. Highly finished watercolours, often on vellum, include the unabashedly erotic *Artist's Dream* (1811; sold London, Sotheby's, 1 Dec 1983, lot 201), which he considered important enough to include in his *Testamento*.

Mauro's capacity for facile elegance is best shown by the painted exterior panels on three carriages (berlins) that he produced for Bolognese patrons, now in the Musée National de la Voiture et du Tourisme in Compiègne. Equally graceful but more serious in subject are the enigmatic paintings of a *Cavalier Spearing a Classical Statue* and a *Cavalier Firing at a Classical Statue*, allegories of an attack on the *ancien régime* (both ex-art market, early 1980s; see Roli, 1977, fig. 278b). These paintings are sophisticated and brilliant in technique and point to Mauro's potential. His major weaknesses were his casual and irrational compositions, where the brilliant colour distracts from, rather than enhances, the integrity of the image.

Events of 1796 interrupted Mauro's career. In June of that year Napoleon Bonaparte entered Bologna at the

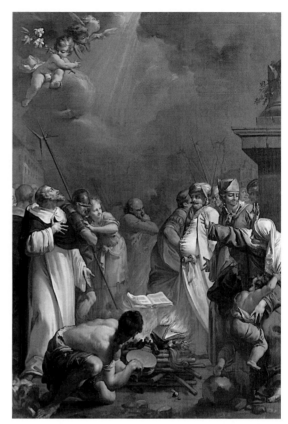

Mauro Gandolfi: *St Dominic Burning the Heretical Books*, oil on canvas, 3.00×2.05 m, 1791 (Ferrara, S Domenico)

head of his conquering army. He was welcomed by a committee of citizens led by Mauro, who was an ardent partisan of the revolution and of France. In this same year Mauro served as a member of the first Cispadane congress in Modena and was commissioned to design the flag for their military unit, the tricolor (green, white and red) with a Tree of Liberty, the antecedent of the modern Italian flag. Commissions to engrave vignettes for *cartes-de-visite* and ephemera for the provisional government in Bologna set him on the path of printmaking, and in 1801 he moved to Paris in order to learn the art of engraving, a move doubtless prompted by the fact, recounted in his autobiography, that he had ceased to receive painting commissions.

Disillusioned by the coronation of Napoleon, Mauro returned to Italy in 1806. He apparently did well as a reproductive engraver since he was able, in the decade after his return, to maintain a house in Pistoia, one in Bologna and a country house in Pieve del Pino. His numerous small pen drawings of 'teste di carattere', of old men, orientals and carnival figures (e.g. Venice, Fond. Cini), reveal the hand of a practised engraver.

In 1816 Mauro embarked on an ambitious trip to the USA with his mistress Teresa Diana, which included a sojourn of several months in New York and Philadelphia. He recorded his trip in a manuscript of 1822, with acute and amusing observations on the life and times of the new

republic that he so admired. He claims to have lived on the proceeds of trading the watercolours he had brought with him (no traces of which have been found in the USA) and gems. He returned to Italy at the end of 1817, moving in 1818 to Milan, where he remained until about 1823, continuing fitfully to make engravings and to trade in gems. Many drawings (Venice, Fond. Cini) can be identified as by Mauro, frequently copies of originals by either Gaetano or Ubaldo. He died in Bologna, apparently of typhoid, and was buried with modest rites next to his father.

UNPUBLISHED SOURCES

Bologna, Bib. Accad. B.A., MS. Archv. Accad. Clementina, *Atti & Mem. Accad. Clementina*, i (1710–63), ii (1764–82) [contains a life of Ubaldo by L. Landi]; iii (1783–1804) [contains a life of Gaetano by V. Martinelli]

Bologna, Bib. Cassa di Risparmio, MS. (1816) [MS. of Mauro's *Viaggio in America* (1822)]

Bologna, Bib. Com. Archiginnasio, MS. B 95 [M. Oretti's *Vite di pittori scritte da loro medesimi*]

Bologna, Bib. Com. Archiginnasio, MS. B 134, pp. 177–83 [M. Oretti's *Notizie de' professori del disegno cioè pittori, scultori ed architetti bolognesi*]

Bologna, Bib. Com. Archiginnasio, Col. Autog. Palliotti, MS. XIV. 839, XXXI [letters from Mauro to Luigi Sedazzi]

Vienna, Inst. Kstgesch. U. Wien, MS. Inv. ll. 334, Sign.: Quellen, Viten, Ital. 54 [contains J. A. Calvi's *Succincte notizie dei due celebri professori di pittura Ubaldo e Gaetano Gandolfi* (1802)]

WRITINGS

'Memorie della vita di Mauro Gandolfi bolognese scritte da se stesso', in *Piacevole raccolta di opuscoli sopra argomenti d'arti belle*, ed. N. Laurenti and F. Gasparoni (Rome, 1844), v, pp. 2–42

BIBLIOGRAPHY

L. Landi: *Storia pittorica dell'Italia del risorgimento delle belle arti fin presso la fine del XVIII secolo* (Bassano, 1789, 4/Florence, 1822), v, pp. 181–2

Chiese parrocchiali della diocesi di Bologna: Ritratte e descritte, 4 vols (Bologna, 1844–51)

'Brevi cenni della vita di Mauro Gandolfi bolognese', *Com. Bologna*, xi (1925), 2, pp. 73–81; 3, pp. 145–53; 6, pp. 388–93 [with preface, notes and vignettes by A. Zanotti]

A. Zanotti: 'Un documento inedito del pittore bolognese Gaetano Gandolfi', *Com. Bologna*, xx/9 (1934), pp. 67–9

L. Bianchi: *I Gandolfi* (Rome, 1936)

G. Zucchini: 'Quadri e disegni inediti di Gaetano Gandolfi', *Atti & Mem. Accad. Clementina*, v (1953), pp. 49–60

O. Kurz: *Bolognese Drawings of the 17th and 18th Centuries in the Collection of H.M. the Queen at Windsor Castle* (London, 1955)

S. Zamboni: *Dal Bernini al Pinelli* (Bologna, 1968), pp. 31–2

M. Cazort Taylor: 'The Pen-and-wash Drawings of the Brothers Gandolfi', *Master Drgs*, xiv/2 (1976), pp. 159–65

R. Roli: 'Aggiunte e precisazione sui Gandolfi plasticatori', *Il Carrobbio*, ii (1976), pp. 317–23

E. Riccomini: *Vaghezze e furore: La scultura del settecento in Emilia* (Bologna, 1977)

R. Roli: *Pittura bolognese, 1650–1800: Dal Cignani ai Gandolfi* (Bologna, 1977)

P. Rosenberg and O. Sebastiani: 'Trois berlines peintes par Mauro Gandolfi', *Antol. B.A.*, i/3 (1977), pp. 225–45

L'arte del settecento emiliano: La pittura, l'Accademia Clementina (exh. cat., Bologna, Pal. Podestà, 1979) [incl. M. Cazort Taylor: 'I Gandolfi: I disegni']

D. Biagi-Maino: 'Ritratti dei Gandolfi', *Paragone*, xxxvii/431–2 (1986), pp. 114–20

I Gandolfi: Disegni e dipinti (exh. cat., ed. A. Bettagno; Venice, Fond. Cini; Bologna, Pal. Pepoli Campogrande; 1987)

D. Garstang: 'A Deposition Figure by Ubaldo Gandolfi', *Apollo*, cxxxi (1989), pp. 87–9

Bella pittura: The Art of the Gandolfi (exh. cat., ed. M. Cazort; Ottawa, N.G.; Little Rock, AR A. Cent.; 1993)

MIMI CAZORT

Gandolfi, José Maria (*b* São Paulo, 1933). Brazilian architect. He graduated from the Faculty of Architecture of Mackenzie University, São Paulo (1958), and established an office in Curitiba in 1961, when he was appointed Professor of Architectural Composition at the Federal University of Paraná. Working in association with others, he won a series of important public competitions including a club (1962; with Luiz Forte Netto) at Campo Santa Monica, near Curitiba; the Municipal Theatre (1966; with Roberto Luiz Gandolfi and L. F. Dunin) at Campinas, São Paulo; and the Petrobrás Headquarters (1968; with Roberto Luiz Gandolfi, Luiz Forte Netto, J. Sanchotene, A. Assad and V. de Castro) in Rio de Janeiro, which concealed its gigantic size in a composition of mass and space created by hanging gardens. He and his brother, Roberto Luiz Gandolfi (*b* 1936), then won competitions for the offices of the Banco do Brasil (1970) in Caxias do Sul and the Instituto Brasileiro do Café headquarters (1976) in Paranaguá. They went into practice together and the reputation gained from the competition entries led to an impressive number of contracts for both public and private works; the partnership became one of the best known in Brazil. Gandolfi helped form the Directorate of Urban Development in Curitiba in 1971, becoming Director of Parks and Open Spaces; in four years he expanded the city's green areas from 0.5 sq. m to 12.5 sq. m per head, giving Curitiba an unequalled quality of environment. Later concern for the integration of buildings and landscape was revealed in designs for two branches of Citicorp Bank, one in Porto Alegre (1980) and the other at Curitiba (1984) in which internal gardens and a series of terraces continue the open space in front of the building towards the central atrium.

BIBLIOGRAPHY

'Master Plan: State of Paraná Coast', *Acrópole*, 341 (1967), pp. 22–5

'Petrobrás Headquarters', *Constr. São Paulo*, 1250 (1972), pp. 6–12

'Citibank Headquarters in Curitiba and Porto Alegre', *Projeto*, 82 (1985), pp. 80–89

PAULO J. V. BRUNA

Gandon, James (*b* London, 20 Feb 1741; *d* Dublin, 24 Dec 1823). English architect, active in Ireland. Gandon was the most distinguished architect resident in Ireland at the end of the 18th century. He was trained in the office of William Chambers in London for seven years from *c.* 1757 and always remained loyal to Chambers's principles of academic, even conservative, classicism. Like Chambers he was a francophile, but he never travelled outside Britain and Ireland and derived his familiarity with Classical architecture from English building of the 17th and 18th centuries. His knowledge of antiquity was second-hand, from publications and from Chambers's own experiences of Rome. In the late 1770s he formed a loose partnership with James 'Athenian' Stuart, but this soon languished, either because of Stuart's fecklessness, or perhaps because of Gandon's lack of sympathy for Greek Revival forms. He received few commissions before 1781, when he moved to Dublin; his only important building in England is the County Hall, Nottingham (now Shire Hall, designed 1768; extended 1876–80). In these London years, however, he published some slight decorative designs and a two-volume continuation of Colen Campbell's *Vitruvius Britannicus*. Gandon's study of English classicism is reflected

James Gandon: central block of the Four Courts, Dublin, 1786–1802

in his buildings, which show his sympathy for currently unfashionable styles of British architecture: he learnt much from Wren and justified his design (1768; unexecuted) for the Royal Exchange in Dublin by citing precedents in the work of Hawksmoor and James Gibbs.

Gandon was by nature gregarious, and it was through the convivial gatherings in the London house of his friend Paul Sandby that he first attracted the notice of Irish connoisseurs. One of these, John Dawson, 2nd Viscount Carlow, later 1st Earl of Portarlington, invited him to Ireland (where, said Carlow, there was not 'any architect of the least merit') to be supported for two years by a subscription raised among Carlow's friends. The subscription became unnecessary because soon afterwards Carlow introduced Gandon to John Beresford, who ordered from him designs for the new Dublin Custom House. Consequently Gandon decided to refuse an invitation from the Princess Dashkova to visit St Petersburg and to work for Catherine the Great. Instead, in 1781 he travelled to Dublin to conduct the building of the Custom House. Although he considered the move a temporary one, he lived in Ireland for the rest of his life.

Gandon was nearly 40 when he designed the Custom House (1781–91; gutted 1921; restored) and he responded magnificently to the challenge. Aesthetically and practically it is notably more mature than any of his earlier designs. The building was rectangular in plan with two internal courtyards and a main façade to the river, *c.* 113 m in length. It took ten years to build and cost £200,000. Gandon drew inspiration from Chambers, in particular Chambers's Casino at Marino House near Dublin (1758–76), built for the 1st Earl of Charlemont, and from Wren, whose domes at the Royal Hospital, Greenwich (1696 onwards), he adapted for the central crowning feature of the river front. As always his eclecticism, like his sense of detail and scale, was subject to rigorous intellectual control.

The Four Courts, Dublin (1786–1802; gutted 1922; restored; see fig.), another riverside building, is a less perfect but more exciting composition than the Custom House. The dependence on Chambers is less marked and the influence of Wren more evident. The building as it now stands had been begun by Thomas Cooley as a repository for public records in 1776, and two ranges had been built by the time of his death in 1784. On Gandon's appointment to the work the decision was finally taken to incorporate a building for the courts in the scheme. Gandon brilliantly surmounted the problems involved in

extending another man's work. His central block, with its startling geometry of drum and dome and the flanking arcades, adds drama and movement to the riverside composition. As with the Custom House, the wide-ranging eclecticism of the Four Courts is controlled by powers of synthesis that Gandon cultivated in the belief, derived from Reynolds's *Discourses*, that 'genius. . .is the child of imitation', imitation being understood not as copying but as the profound and analytical study of earlier works.

The Custom House and the Four Courts are Gandon's greatest buildings and reveal him as an architect of European distinction. Splendid though these two buildings are as individual works of art, however, they should not be seen in isolation but as part of the development of Dublin at the end of the 18th century, in which Gandon played a major role (*see* DUBLIN, §I, 2). He attracted some of the commissions for new streets and public buildings there, in particular for the new Carlisle (now O'Connell) Bridge (begun 1791, opened 1795) and extensions to the House of Lords (now Bank of Ireland; 1782–*c*. 1789).

Gandon designed one important country house in Ireland, Emo Court, Co. Laois, for his friend Lord Carlow (probably *c*. 1780), and some elegant villas of Adam-style plan, of which Emsworth, Co. Dublin (1794), built for James Woodmason, is a good though altered example. He also designed one large provincial public building, the Court House in Waterford (1784–7; destr. 1837–49). Otherwise he concentrated on his monopoly of public work in Dublin. On his retirement *c*. 1808 from supervision of his designs for the King's Inns in Dublin, Gandon was the doyen of the architectural profession. He had fought to establish its status and he exercised a formative influence on younger Irish architects such as Henry Aaron Baker, Francis Johnston and Richard Morrison.

WRITINGS
with J. Woolfe: *Vitruvius Britannicus*, iv, v (London, 1767, 1771)
Six Designs of Frizes (London, 1767)
A Collection of Antique and Modern Ornaments (London, 1778)
A Collection of Frizes, Capitals and Grotesque Ornaments (London, 1778)
BIBLIOGRAPHY
Colvin
J. Gandon jr and T. Mulvany: *The Life of James Gandon, Esq.* (Dublin, 1846/*R* London, 1969)
M. Craig: *Dublin, 1660–1860* (London, 1952/*R* Dublin, 1980)
E. McParland: *James Gandon, Vitruvius Hibernicus* (London, 1985)
EDWARD McPARLAND

Gandy, Joseph Michael (*b* London, 1771; *d* London, Dec 1843). English architect, writer and illustrator. A brilliant draughtsman, speculative archaeologist and an avid reader of ancient myth, he was one of England's most remarkable visionary architects. His career began in 1787, when he was apprenticed to James Wyatt. Two years later he entered the Royal Academy Schools, London, and won the Silver Medal in his first year and the Gold in the next. He then left for Italy, where he visited all the important Classical sites as well as less well-known sites in the Roman Campagna. He usually travelled with painters and architects, most often with C. H. Tatham and G. A. Wallis (1770–1847). Gandy won a special medal in an Accademia di S Luca competition in 1795 but was forced to return to London in 1797 because of the advance of Napoleon's army into Italy and the bankruptcy of his financial supporter John Martindale.

Gandy was unable to set up an architectural practice when he returned to England owing to financial difficulties and worked for John Soane as a draughtsman. Soane helped him throughout his career and benefited from Gandy's drawing skills and powers of imagination. In middle age Gandy tried to run an architectural practice in London and Liverpool (1809) but was forced to maintain himself and his large family by executing drawings for Soane, for example *Architectural Visions of Early Fancy and Dreams* (1820; London, Soane Mus.), from a series of panoramas. He also instructed Soane's son in architecture and produced illustrations for books such as John Britton's *Architectural Antiquities of Great Britain* and William Gell's *Pompeiana*. His financial difficulties forced him into debtors' prison on two occasions.

Gandy's notable built works include the Phoenix Fire and Pelican Life Insurance Offices (1804–5; destr. *c*. 1920), London, and Doric House (*c*. 1818), Sion Hill, Bath; in these works his inventive but unadorned and refined Neo-classical forms are evident. Soane's influence is also apparent in these buildings. Gandy's plain style is especially obvious in his two books on cottage architecture published in 1805. These designs also illustrate how Gandy wished to improve the dwelling conditions of the labouring class. In 1821 he published two articles in the *Magazine of Fine*

Joseph Michael Gandy: *Comparative Architecture*, watercolour, 1.04×0.68 m, exhibited Royal Academy, London, 1836 (London, Sir John Soane's Museum)

Arts on 'The Philosophy of Architecture'. The subjects treated briefly there were to be examined more fully in an eight-volume work entitled *Art, Philosophy and Science of Architecture*. Three volumes of an unfinished, unpublished manuscript survive.

Gandy exhibited his visionary drawings and paintings at the Royal Academy and the British Institution, London, throughout his career. The compositional techniques and subject-matter of these pictures derive from the works of Piranesi and anticipate those of Thomas Cole and John Martin. Gandy often used the techniques of Baroque illusionism and stage set design: the two-point perspective (It. *veduta per angolo*); darkening the foreground and illuminating the centre of the composition; and aerial perspective. The subjects of these pictures are most often speculative reconstructions of ancient architectural types: the mythical primitive dwelling; the tombs of heroes such as Agamemnon and Merlin; temples of Diana and Nitocris; and imperial fora.

In 1836 Gandy announced his intention to produce 1000 illustrations for a history of world architecture, of which only five were actually completed (London, Soane Mus.; see fig.). His paintings comparing architectural styles and motifs exemplify this interest. Gandy also illustrated many literary subjects, including Pandemonium, Dante's *Inferno*, the deeds of Ossian, and Milton's *Paradise*. He also produced many grandiose designs for imperial palaces. Gandy's drawings demonstrate his fertile and visionary imagination, arcane scholarship, attention to minute detail, eclectic historicism and alienation from the cultural and political realities of his time.

UNPUBLISHED SOURCES

Art, Philosophy and Science of Architecture, i, v and vi (*c.* 1825) [in possession of Gandy's descendants]

WRITINGS

Designs for Cottages, Cottage Farms, and Other Rural Buildings (London, 1805/*R* Amersham, Bucks, 1971)
The Rural Architect (London, 1805/*R* Amersham, Bucks, 1971)
'The Philosophy of Architecture', *Mag. F.A.*, i (1821), pp. 289–93, 370–79

BIBLIOGRAPHY

J. Summerson: 'The Strange Case of J. M. Gandy', *Architect & Bldg News*, cxlv (1936), pp. 38–44
D. Tselos: 'Joseph Gandy: Prophet of Modern Architecture', *Mag. A.*, xxxiv (1941), pp. 251–3
J. Summerson: 'J. M. Gandy: Architectural Draughtsman', *Image*, i (1949), pp. 40–50
——: 'The Vision of J. M. Gandy', *Heavenly Mansions and Other Essays on Architecture* (London, 1949)
Joseph Michael Gandy (1771–1843) (exh. cat., ed. B. Lukacher; London, Archit. Assoc., 1982)
B. Lukacher: *Joseph Michael Gandy: The Poetical Representation and Mythology of Architecture* (diss., Newark, U. Delaware, 1987; microfilm, Ann Arbor, 1987)

DAVID LEATHERBARROW

Gangaikondacholapuram [Gaṅgaikoṇḍacolapuram]. Town and temple site in Tamil Nadu, India. It was founded by Rajendra Chola I (*reg* AD 1012–44) to commemorate his conquests up to the River Ganga in northern India. Displacing the earlier centre at THANJAVUR, Gangaikondacholapuram remained the capital of the CHOLA dynasty until the 13th century.

Excavations have revealed that the royal enclave at Gangaikondacholapuram was laid out according to canonical prescription. The palace was in the centre and shrines to various gods were placed in the appropriate quarters (Shiva to the north-east, Vishnu to the west, etc). Two broad brick walls, with the intervening space filled with sand, formed the base for the fort walls and a multi-storey palace. Only the base and parts of the lime-plaster flooring have been exposed. Inscriptions in contemporary temples refer to outer and inner fortifications, named the Rajendra Chola *madil* (Tamil: 'enclosure of Rajendra Chola') and *utpaḍaivīttu madil* ('inner garrisoned enclosure'). Also mentioned are such multi-storey palace structures as the Gangaikondacholan Maligai and such features as the *ādibhūmi* (Skt: 'ground floor') and the *kīlaisopāna* (Tamil: 'eastern portico'). After *c.* 1100 the fortifications were strengthened and new palace residences built. None of these buildings survived the wars that brought down the Chola empire. To the west of the old capital is the Chola Gangai tank excavated by Rajendra but no longer containing water.

Rajendra Chola also erected a Shiva temple at the site, naming it *Gaṅgaikoṇḍacolīśvara*, or its inscribed name Rajendra Cholishvara (Skt: 'Lord of Gangaikondachola'). The temple, located 1.5 km south-east of the palace, consists of a square *vimāna* (Skt: 'sanctum-tower') and a pillared *maṇḍapa* (hall), rebuilt in the 18th century. Standing in a dilapidated enclosure with a towered gateway, the temple, known as the Brihadishvara Temple (*see* TEMPLE, fig. 5), rises to about 50 m and is second only in size to the Brihadishvara Temple at Thanjavur. The superstructure has a concave profile; the bottom is square, the middle octagonal and the top circular. Fine sculptures are set in the niches of the two-tiered temple wall and outstanding bronzes of Rajendra's time have been preserved in the temple complex; that of Subrahmanya is an exceptional work of art. Two shrines flanking the main temple were originally dedicated to Shiva; one now enshrines the goddess Parvati. Other structures in the enclosure contain trophies that the Cholas brought from conquered lands. An image of Durga and a Surya *pīṭha* (Skt: 'solar altar') are Chalukya sculptures (*see* CHALUKYA, §2), while the Nandi is a NOLAMBA example.

See also INDIAN SUBCONTINENT, §§III, 5(i)(i) and IV, 7(vi)(a).

BIBLIOGRAPHY

Enc. Ind. Temple Archit.: 'Gangaikondacolapuram'
R. Nagaswamy: *Gangaikondacholapuram* (Madras, 1970)
K. R. Srinivasan: *Temples of South India* (New Delhi, 1971)
S. R. Balasubrahmanyam: *Middle Chola Temples* (Madras, 1975)
K. R. Srinivasan: 'Gangaikondacholapuram', *South India, Lower Drāviḍadēśa, 200 BC–AD 1324*, i, pt1 of *Encyclopaedia of Indian Temple Architecture*, ed. M. Meister (New Delhi and Philadelphia, 1983), pp. 241–9

R. NAGASWAMY

Ganganelli, Lorenzo. *See* CLEMENT XIV.

Ganghofer, Jörg. *See* JÖRG VON HALSBACH.

Ganja. *See* GANDJA.

Ganj Dareh. Early Neolithic mound in the Zagros Mountains of western Iran, occupied from *c.* 7500 to *c.* 6600 BC. Finds from Philip Smith's excavations (1967–74), now in the Archaeological Museum, Tehran, and in Montreal, illustrate the material culture of a society in a transitional phase between hunting and gathering, and true

food production based on a sedentary life (*see* IRAN, ANCIENT, §I, 2(i)(b)). At this site the only controlled sources of food were barley and goats, and subsistence was still largely based on wild resources.

The earliest level had no permanent architecture and was probably a seasonal encampment. The later levels contain buildings of mud-brick and other materials; some are two-storey and are intricately subdivided into cubicles. Skulls of wild sheep were attached to the walls of some buildings, possibly for ritual purposes. A characteristic of this site is the varied and sophisticated use of clay. Soft-baked pottery occurs in small quantities, sometimes used for storage vessels. There are many baked clay animal figurines (probably representing goats, sheep and pigs in most cases) and schematic female figurines. Many hundreds of small geometric clay items also occur: cones, tetrahedrons, balls and discs. There are impressions and incisions on pottery, clay discs and bone artefacts. Personal ornaments are common, consisting of stone and bone beads, perforated shells (some from the Persian Gulf) and pendants.

BIBLIOGRAPHY
P. E. L. Smith: 'An Interim Report on Ganj Dareh Tepe, Iran', *Amer. J. Archaeol.*, lxxxii/4 (1978), pp. 538–40

PHILIP E. L. SMITH

Gano di Fazio [Gano da Siena] (*fl* 1302; *d* before 1318). Italian sculptor. He was one of the founders of the Sienese school of sculpture in the 14th century. The first documentary reference to him is on 23 May 1302, when he purchased land in Siena; in the same year, on 18 June, he paid tax on this purchase. His only certain work is the signed tomb monument (Casole d'Elsa, Collegiate Church) of *Tommaso d'Andrea*, Bishop of Pistoia (*d* 30 July 1303), which is inscribed on the border of the sarcophagus: CELAVIT GANVS OPVS HOC INSIGNE SENENSIS—LAVDIBVS IMMENSIS EST SVA DIGNA MANVS. It was probably executed in 1303–4 and is the earliest existing example of a complete Sienese funerary monument. Facing it, and possibly executed by Gano not long after, is the wall-tomb of Porrina, Lord of Casole and Radi di Montagna (*d* 1313). The portrait of *Porrina* is remarkable for its realism, and the tomb is unique among Tuscan sculpture of this period in that it presents a full-length standing figure beneath a Gothic canopy. Several documents dated between 1311 and 1313 record Gano as a tax-payer in Siena, and in 1316 he was mentioned in a document as an owner of land valued at 283 Sienese lire. Although no further works are documented, a number of attributions have been made on stylistic grounds. These include the tomb of *St Margaret of Cortona* (Cortona, S Margherita), together with two further works in Cortona: a marble statue of the *Virgin and Child* (Cortona, Mus. Dioc.), from the façade of S Margherita, and a series of small marble relief busts of *Saints* and *Christ Blessing* (Cortona, S Margherita), discovered in an 18th-century pedestal of a statue of *St Margaret*. A marble slab carved with narrative reliefs of three scenes from the *Life of Beato Giloacchino Piccolomini* (*c.* 1308–11; ex-S Maria dei Servi, Siena; Siena, Pin. N.) has been attributed to Gano, as have some of the busts at the tops of columns and pilasters in the windows of Siena Cathedral. Also attributed to him are the full-length standing statues of the *Virgin and Child with SS Imerio and Omobono* (Cremona Cathedral). Eleven statuettes of *Prophets* and *Saints* (Massa Marittima Cathedral) have been added to Gano's oeuvre (Bellosi) and placed in the last years of his activity. The sculptor died before 1318, as in that year his children Agnese and Ganuccia are described as 'heredes Gani magistri lapidum'.

BIBLIOGRAPHY
P. Bacci: 'Notizie originali inedite e appunti critici su Gano di Fazio scultore (metà XIII sec.–1317)', *Fonti e commenti per la storia dell'arte senese* (Siena, 1944), pp. 50–109
E. Carli: *Gli scultori senesi* (Milan, 1980), pp. 12–13, pls 21–4
G. Bardotti-Biasion: 'Gano di Fazio e la tomba-altare di Santa Margherita da Cortona', *Prospettiva*, xxxvii (April 1984), pp. 2–19
L. Bellosi: 'Gano a Massa Marittima', *Prospettiva*, xxxvii (April 1984), pp. 19–22 □

Gansevoort Limner. *See under* MASTERS, ANONYMOUS, AND MONOGRAMMISTS, §I: GANSEVOORT LIMNER.

Ganssog [Gansauge; Ganstaug; Gantzow], **Johannes** (*b* Breslau, *c.* 1555; *d* after 1592). German sculptor, active in Sweden. The son of a painter, in 1569 he graduated from the University of Frankfurt an der Oder. In 1588 a 'Hans Gantzow' is mentioned in the group of German sculptors working on decorative sculpture under Hans van Steenwinkel the elder at Kronborg Castle in Helsingør. In 1592 a contract for the new pulpit for Lund Cathedral was drawn up between Ganssog and the cathedral chapter, and Ganssog completed the commission in October of that year. The signed and dated black limestone hexagonal pulpit, supported on a carved basket and surmounted by a baldacchino, is decorated with alabaster figurines and reliefs of scenes from the *Passion* (originally highlighted with colour and gilding). Here north German Renaissance ornament is combined with motifs ultimately derived from the ornamental designs of Cornelis Floris and Hans Vredeman de Vries, but invested with a more Baroque spirit. The similarity of some of the pulpit's figural and decorative elements to Hans van Steenwinkel the elder's monument to *Anders Bing* at Smedstorp (*c.* 1590–95) and portals at Kronborg has led scholars to suggest that the prestigious commission was originally offered to Steenwinkel, who in turn recommended his talented assistant, supplying the original design which Ganssog then modified.

BIBLIOGRAPHY
Thieme–Becker
L. Weibull: 'Bildhuggare och träsnidare i Malmö och Lund under renaissancen' [Sculptors and carvers in Malmö and Lund during the Renaissance], *Hist. Tidskr. Skåneland*, i (1903), pp. 1–48
G. Paulsson: *Skånes dekorativa konst* [Skåne's decorative art] (Stockholm, 1915), pp. 107–36
T. Allgulin: 'Hans van Steenwinkel den Äldre', *Uppsala U. Årsskr.* (1932), pp. 76, 96, 98, 100, 102–3

ANTONIA BOSTRÖM

Gantner, Joseph (*b* Baden, Switzerland, 11 Sept 1896; *d* Basle, 7 April 1988). Swiss art historian, teacher and editor. In 1920 he received his doctorate under Heinrich Wölfflin in Munich, and in 1921–2 he travelled with Wölfflin in Italy. Gantner was editor of the periodical *Werk* (1923–7), and he lectured at the university of Zurich (1926–8). He also edited *Neue Frankfurt* (1927–32) and lectured at

the Staatliche Hochschule für Bildende Künste, Frankfurt am Main. Until 1932 he was engaged in writing about modern architecture, architectural theory and urban development, having established his hallmark of systematic analysis of art historical material and an emphasis on philosophical considerations. He again lectured at the university of Zurich (1933–8) and began to concentrate his research on medieval art history. From 1938 to 1967 he was Chairman of the Department of Art History at the university of Basel and, from 1954, its Director. After 1950 the question of artistic fantasy and its means of expression became his major concern: his theory of the *non finito*, appreciation of the artistic merit of unfinished sculpture, and prefiguration, which focused on the conception of pictorial ideas before their realization in a work of art, resulted from his study of the art of Leonardo, Michelangelo, Rembrandt, Goya and Rodin. The principal influences on his work were the writings of Wölfflin, Jacob Burckhardt, Henri Focillon and the philosopher Benedetto Croce. His work was especially well-received in Japan, where he promoted the translation of Wölfflin's major writings and many of his own writings, all of which were published in translation by Japanese art historians.

WRITINGS

with A. Reinle: *Kunstgeschichte der Schweiz*, 4 vols (Leipzig and Frauenfeld, 1936–62)
Schönheit und Grenzen der klassischen Form: Burckhardt-Croce-Wölfflin (Vienna, 1949)
'*Das Bild des Herzens*': *Ueber Vollendung und Un-Vollendung in der Kunst* (Berlin, 1979) [with bibliog. of scholarly writings, 1918–78]

BIBLIOGRAPHY

G. Boehm: 'Kunstgeschichte nach dem Ende der Aesthetik: Zum Werk Joseph Gantners', *Neue Zürch. Ztg.* (29 June 1969)
M. Sitt, ed.: *Kunsthistoriker in eigener Sache: Zehn autobiographische Skizzen* (Berlin, 1990)

<div align="right">HANSPETER LANDOLT</div>

Ganymede Painter. *See* VASE PAINTERS, §II.

Gaochang. *See* KHOCHO.

Gao Fenghan [Kao Feng-han; *hao* Nanfu Shanren] (*b* Jiaozhou (modern Jiao xian), Shandong Province, 1683; *d* ?Shandong Province, 1748–9). Chinese painter, calligrapher, seal-carver, collector and poet. The son of a minor official in charge of local education, Gao developed an interest in poetry, painting and seal-carving in his early youth, when he also began to collect old seals and inkstones. The great poet Wang Shizhen took a liking to him and left instructions before his death that Gao be admitted into the ranks of his disciples. A relative of the poet, Wang Qilei, also provided Gao with some formal instruction in the art of painting, beyond what he could learn from his father, an amateur painter of orchids and bamboo. Gao's official career did not begin until 1729, when he took up an appointment as assistant magistrate of She xian, Anhui Province. In 1734 a new assignment took him to Taizhou, east of Yangzhou, Jiangsu Province. In 1736, having become entangled in a legal dispute involving a chief commissioner of the salt gabelle, he was briefly imprisoned; this and his deteriorating health, which resulted in the paralysis of his right hand, inevitably led to his resignation from officialdom.

His physical disability compelled him to paint with his left hand and this produced a dramatic change in his style. The former ease, assurance and strength, as displayed in such paintings from the 1720s to the mid-1730s as *Peony by the Grotto* (see fig.) were never repeated. His calligraphy, however, which had previously betrayed his penchant for the mannered repetition of specific sets of movement, rhythm and cadence, evolved and matured. The earlier tremulous, childlike strokes gave way to increasingly steady pacing and controlled rhythm.

Although the uniqueness of Gao's style set him apart from the contemporary art scene, it also gave him a degree of notoriety, even fame. Cast as an eccentric, he was strongly associated with the Eight Eccentrics of Yangzhou (and sometimes counted as a ninth; *see* YANGZHOU SCHOOL), although his sojourns in that city rarely lasted long. He is more accurately described as a Shandong artist who, for most of his life, fashioned his vision in response to artistic currents in that province. A series of paintings in album format (1723; Hong Kong, Bei Shan Tang Col.) shows not only that he was keenly aware of the local artistic heritage as exemplified by such minor artists as Yang Han and Wang Yushi (both active a generation or two earlier than Gao, and whose paintings he collected), but also that he occasionally affected their styles. In the darkened tonality and repeated forms of his later works, there is a faint echo of such Shandong precursors as FA RUOZHEN, whose individualistic landscapes featured ambiguous renderings of form and bold contrasts of light and shade. In addition to paintings by Gao on the themes of landscape, ancient trees and crows, and flowers and plants, eight portraits of the artist are extant, painted by followers, with the background sketched in by Gao himself. Some bear laudatory comments from friends and acquaintances and reflect the image-consciousness to which several of his contemporaries were also prone. Gao's literary works include *Nanfu Shanren quanji* ('Complete works of Nanfu Shanren [Gao]'; known to have survived in manuscript form), *Nanfu Shanren shiji leigao* ('Selection of poems by Nanfu Shanren'; Shanghai, 1919) and *Nanfu Shanren xiaowen cungao* ('Surviving essays by Nanfu Shanren'; Shanghai, 1983). *Yanshi* ('History of Inkstones'; 4 *juan*) was published only in 1849 as a result of the funding and collaboration of later admirers, Wang Xiang (1789–1852), Wang Yuesheng (*c.* 1788–1841) and Wu Xizhai (1799–1870).

BIBLIOGRAPHY

Li Dou: *Yangzhou huafeng lu* [Picture-boats of Yangzhou] (preface 1741/*R* Taipei, 1969)
Lu Jianzeng, ed.: *Guochao Shanzuo shichao* [A record of contemporary poems from Shandong] (1758/*R* 1795)
Feng Jinbo: *Moxingju huashi* [Feng Jinbo's knowledge of painting] (*c.* 1790)
Jiang Baolin: *Molin jinhua* [Comments on contemporary painters] (Shanghai, 1852/*R* Taipei, 1975)
Zang Huayun: 'Mantan Gao Fenghan *Yanshi*' [A note on Gao Fenghan's *History of Inkstones*], *Wenwu* (1962), no. 10, pp. 48–53
Li Jitao: *Gao Fenghan* (Shanghai, 1963)
Qiu Liangren: 'Lu Jianzeng jiqi *Chusai tu*' [Lu Jianzeng and the painting *Exile to the Frontier*], *Gugong Bowuyuan Yuankan* [Palace Museum Journal], ii (1983), pp. 43–8, 96
Paintings by Yangzhou Artists of the Qing Dynasty from the Palace Museum (exh. cat., Hong Kong, Chin. U., A. G., 1984–5), pp. 147–59

Gao Fenghan: *Peony by the Grotto*, leaf from an album of finger paintings, ink and colour on paper, 285×427 mm, 1734 (Osaka, Municipal Museum)

Ju-hsi Chou and C. Brown: *The Elegant Brush: Chinese Painting under the Qianlong Emperor, 1735–1795* (Phoenix, 1985)

JU-HSI CHOU

Gao Jianfu [Kao Chien-fu] (*b* Panyu County, Guangdong Province, 12 Oct 1879; *d* Macao, 22 May 1951). Chinese painter. He was one of the principal founders of the LINGNAN SCHOOL of painting in southern China in the 1920s and 1930s. He sought to modernize the Chinese art world by introducing new painting techniques and through such innovations as public art exhibitions and art classes in public institutions.

The three founders of the Lingnan school—Gao Jianfu, his younger brother Gao Qifeng (1889–1935), and Chen Shuren (1883–1949)—all served their apprenticeships in traditional Chinese painting at the studio of Ju Lian (1828–1904) in Lishan in Panyu County. Between 1892 and 1898 Gao studied and executed paintings of birds, flowers and insects in Ju Lian's style and, under the patronage of a wealthy collector, Wu Deyi (*d c.* 1920), made numerous copies of paintings of the Song (960–1279) and Yuan (1279–1368) periods in Wu's collection. In 1903 Gao enrolled at the Guangzhou (Canton) Christian College, where he studied Western painting under Mai La (a Frenchman). Two years later he became a teacher at an elementary school. These were formative years, not only artistically but also in Gao's exposure to the turbulent political and intellectual currents of the time, which made him increasingly open to revolutionary ideology. To continue his artistic studies, Gao travelled to Tokyo in 1905, followed by Gao Qifeng and Chen Shuren, and soon became a member of the Alliance Society (Tongmeng hui), a precursor of the Chinese Nationalist Party (Guomindang or KMT). In his bid to forge a new visual language, Gao turned to subjects found in Japanese painting, particularly lions, tigers, hawks and eagles set in picturesque landscapes, which were fused with a naturalism and vigour quite new to contemporary Chinese painting. He also introduced a romantic element by his frequent use of mists and snow and by underscoring allegorical messages.

When Gao returned to Guangzhou in 1908 he helped establish a branch of the Alliance Society under cover of a painting shop. He worked for the Alliance until the end of the 1911 uprising that marked the end of the Qing dynasty (1644–1911), and the establishment of the Republic (1912–49). In 1912 he withdrew from politics and moved to Shanghai with his brother. There he opened his own publishing house, the most significant product of which was *The True Record* (Zhenxiang huabao), a magazine containing photographs as well as drawings and text closely linked to politics. He also pioneered the public art exhibition, showing (and selling) his work in Shanghai, Nanjing, Hangzhou, Guangzhou and Hong Kong.

In 1916 the Gao brothers moved back to Guangzhou and Jianfu became a member of the Guangdong Industrial Art Commission, head of the Provincial Industrial School

and founder of the Spring Slumber Studio (Chunshui huayuan), where his students and associate artists became known as the Lingnan Painters. Characteristic of the New Chinese-style Painting (*Xin guohua*) they created was the fusion of Japanese and Western artistic values, such as perspective, atmosphere and chiaroscuro, with traditional Chinese brushwork. *Steed Hualiu in Wind and Rain* (1925), the *Five-storey Pavilion* (1926) and *Evening Bell at the Misty Temple* (undated) are typical paintings of the new movement.

In 1931 Gao travelled to Burma, India, Ceylon, Persia and Egypt. On his return to China, he wrote several books on his experiences and took up a post at the National Sun Yat-sen university, Guangzhou. In 1935 he became visiting professor at the Central University in Nanjing, which became an important platform for his views. In one lecture he delivered there, published in 1955 as 'My Views on Modern Chinese Painting', he stressed the need to combine Western artistic ideas with Chinese traditions and to include modern subject-matter in Chinese painting. During the 1920s and 1930s Gao painted landscapes in which aeroplanes, automobiles, railways and the ravages of war were clearly depicted. With the outbreak of war against Japan in 1937 the Lingnan school quickly fell from favour, and although exhibitions continued to be held in Macao, where Gao fled after the Communist takeover of China in 1949, it lost its momentum.

BIBLIOGRAPHY

H. L. Boorman and R. C. Howard: *Biographical Dictionary of Republican China* (New York, 1968), ii
R. Croizier: *Art and Revolution in Modern China: The Lingnan (Cantonese) School of Painting* (Berkeley, CA, 1988)

DEBORAH NASH

Gao Kegong [Kao K'o-kung; *zi* Yanjing; *hao* Fangshan] (*b* Fangshan, Beijing, 1248; *d* 1310). Chinese painter, poet and government official. Of Muslim Uygur descent, he was the eldest of five sons from a family that combined Muslim and Han cultures and enjoyed favourable social status when the Mongols ruled China as the Yuan dynasty (1279–1368). From an early age he was taught by his father, a highly respected Confucian scholar who instructed Gao in the Chinese classics, preparing him well for government service. Gao began his service in the Yuan government at the age of 27, eventually achieving the high rank of governor and a minister of justice. In addition to serving at the court in Dadu (Khanbalik, now Beijing), he held various positions in many parts of China, including Shandong, Henan, Jiangsu and Zhejiang provinces.

While serving in the River Yangzi delta area, Gao became acquainted with many of the painters and poets of that southern region; these included other northern literati who also served in the south, such as Li Kan, Xianyu Shu (1257–1302) and Li Zhongfang (*fl c.* 1245–1320). One of his close friends was the leading painter and calligrapher Zhao Mengfu, a southerner who served the Mongols both in the south and at the court in Beijing. As a northerner, Gao developed his art mainly from the literati tradition of the Northern Song period (960–1127), especially from the landscape painting of Mi Fu and the bamboo painting of Su Shi. As a result he held a special position in the art of the Yuan period, transmitting the landscape painting tradition begun by Mi Fu to the Yuan and later periods and encouraging its introduction into the southern areas of China.

Gao's two best-known works are *Clearing after a Spring Rain in the Mountains* (hanging scroll, ink on silk; Taipei, N. Pal. Mus.), which has an inscription by Li Kan dated 1299, and *Clouds Encircling Luxuriant Peaks* (hanging scroll, ink on silk; Taipei, N. Pal. Mus.), also with an inscription by Li Kan but dated 1309. While the former reflects Gao's earlier manner, when he was still attempting to solve the problems of the Mi Fu tradition, the latter represents his maturity. It demonstrates the transformation of the monumental landscape typical of the Northern Song period into a style that is both more characteristic of Yuan period painting and representative of Gao's individual contribution to it. His bamboo painting style is exemplified by *Bamboo and Rock* (hanging scroll, ink on silk; Beijing, Pal. Mus.), which is inscribed with a poem by Zhao Mengfu and includes rocks executed in the long 'hemp-fibre' brushstrokes (*pima cun*), derived from Dong Yuan, that were commonly used by literati painters of the Yuan period.

BIBLIOGRAPHY

O. Sirén: *Chinese Painting: Leading Masters and Principles*, vi (New York and London, 1958), pp. 54–9
J. Cahill: *Hills Beyond a River: Chinese Painting of the Yuan Dynasty, 1279–1368* (New York and Tokyo, 1976), pp. 47–50
C. Brizendine: *Cloudy Mountains: Kao K'o-kung (1248–1310) and the Mi Tradition* (diss., Lawrence, U. KS, 1980)
Chen Gaohua: *Yuan dai huajia shiliao* [Literary sources of Yuan period painters] (Shanghai, 1980), pp. 1–29

CHU-TSING LI

Gao Qipei [Kao Ch'i-p'ei; *zi* Weizhi; *hao* Qieyuan] (*b* Mukden [now Shenyang], Liaoning Province, 1672; *d* 1732). Chinese painter of Manchu birth. Gao Qipei was born far north of the major centres of artistic activity in Zhejiang and Jiangsu provinces. Consequently, he did not associate with the most important painters of the time, nor did he serve in the imperial painting academy. Nevertheless, he had a successful official career at the courts of the Qing-dynasty emperors Kangxi (1662–1722) and Yongzheng (1723–35), and his duties afforded him time to paint. Gao began to paint at a time when the two main schools of Chinese painting—the styles of the followers of Dong Qichang and the Individualists, such as Hongren—were suffering from a lack of originality. From the age of 20 Gao was anxious about establishing a distinctive style; he was constantly depressed, and reportedly took to bed with exhaustion. Gao's solution, which allegedly came to him in a dream, was to paint with his fingers rather than with a brush. He used the balls of his fingers or his whole hand to apply washes and broad strokes; for lines he used a long fingernail which was split like a pen, but he also painted large landscapes with a brush. Although both the smaller-scale finger paintings and the more conventional brush landscapes were very popular at the court, it was generally accepted that his finger paintings had brought him renown—though, due to the supreme position of the brush and its techniques in Chinese painting, critics were at pains to champion his brush works. Since his finger-paintings met with so much success, and since he found it easier, with increasing years, to work with his fingers, he

Gao Qipei: *Landscape*, leaf J from an album of twelve, finger painting, ink and light colours on paper, 270×330 mm, *c.* 1700 (Amsterdam, Rijksmuseum)

abandoned the brush completely, and consequently brush works by him are rare. Those that do survive, such as *Landscape*, a hanging scroll (undated; Taipei, N. Pal. Mus.), do little to support the critics' enthusiastic assessment. They often demonstrate a high degree of technical prowess in the variety of brushstrokes, the calculated arrangement of dark and light areas of foliage, and the rhythmic patterns of mountain masses, resulting in a somewhat glibly academic painting devoid of spirit. Gao Qipei's merits are more easily seen in handscroll paintings and album leaves executed wholly or in part with his fingers. Although these too, often rely on calculated pictorial devices, as in a leaf entitled *Water buffalo* from an album, *Eight Scenes in Water* (undated; Nanjing, Jiangsu Prov. Mus.), where the artist has suggested the visible forms of a swimming water-buffalo with two simple areas of ink wash, the effects are more appealing and appropriate to the subject.

One of Gao's most highly regarded albums consists of a series of landscape views. The untitled twelve-leaf series (Amsterdam, Rijksmus.) includes such subjects as water-fowl descending to a reedy bank, spire-like peaks joined by bridges, boats riding in a ghostly mist, and wind-sculpted pines on rocky crags. The tenth leaf (see fig.) is characteristic of Gao Qipei's approach. He first established the broad shapes of the hills with pale ink washes and then, using his fingernails, applied dots and scratchy lines in black to suggest foreground trees, a path and a temple roof rising above the mist. The spontaneity of his method created evocative landscapes of the mind with the most economical means.

BIBLIOGRAPHY
O. Sirén: *Chinese Painting: Leading Masters and Principles*, (New York and London, 1956–8), v, pp. 222–4
J. Cahill: *Fantastics and Eccentrics in Chinese Painting* (New York, 1967), p. 90
E. Capon and M. A. Pang: *Chinese Paintings of the Ming and Qing Dynasties: XIV–XXth Centuries* (Melbourne, 1981), pp. 146–9
 VYVYAN BRUNST, with JAMES CAHILL

Gao Shiqi [Kao Shih-ch'i] (*b* Pinghu County, Zhejiang Province, 1645; *d* Hangzhou, Zhejiang Province, 1703). Chinese collector, connoisseur, painter and government official. He grew up in Hangzhou and in 1665 moved to Beijing, where he studied at the imperial academy. In 1687 he attained the highest of his civil-service posts, that of Supervisor of Interpretation in the Hanlin Academy. He was also court painter to the Kangxi emperor (*reg* 1662–

1722). Despite his relatively low rank he was a favourite of the emperor, a position he perhaps exploited to build a finer collection of paintings than would have been possible on his official salary alone. Implicated in a bribery case in 1688, he was dismissed from his official position and retreated to Hangzhou, where he lived in semi-retirement for the rest of his life. Nevertheless, he retained the affection of the emperor, with whom he continued to travel until his own death.

Many of Gao's published works are accounts of these tours with the emperor. He wrote or edited over 50 works, including *Tianlu zhiyu* (1690), a work of poetry and prose, and *Jin'ao tuishi biji* (1684), a description of places of historical interest in the Forbidden City, Beijing. Subsequently he became best known for his catalogue of paintings, the *Jiangcun xiaoxia lu* (1693). This catalogue was the first of its type in detail and range and served as the prototype for catalogues compiled by later Chinese collectors. It contains descriptions of paintings from both his own collection and works he had studied elsewhere. One of the treasures of his own collection was a pair of handscrolls entitled *Panorama of the Yangzi River*, attributed to the 11th-century master Li Gonglin (Tokyo, N. Mus.; Washington, DC, Freer).

Gao died in Hangzhou soon after returning from an extended tour with the emperor. Many of his paintings were then acquired by An Qi, a younger contemporary and equally well-known art collector, and then passed into the collection of the Qianlong emperor (*reg* 1736–96) before finding their way, in the 20th century, into Western collections.

BIBLIOGRAPHY

Hummel: 'Kao Shih-ch'i'
A. Waley: *An Introduction to the Study of Chinese Painting* (London, 1923), p. 149
R. H. van Gulik: *Chinese Pictorial Art as Viewed by the Connoisseur*, Serie Orientale Roma, xix (Rome, 1958), p. 494, app. I, no. 44
J. Cahill: 'Collecting Paintings in China', *A. Mag.* (April 1963), pp. 66–72
Eight Dynasties of Chinese Paintings: The Collections of the Nelson–Atkins Museum, Kansas City, and the Cleveland Museum of Art (exh. cat. by Wai-kam Ho and others; Kansas City, MO, Nelson–Atkins Mus. A., Cleveland, OH, Mus. A. and Tokyo, N. Mus.; 1980–81), p. 350
Yu Jianhua, ed.: *Zhongguo meishujia renming cidian* [Dictionary of Chinese artists] (Shanghai, 1981), p. 776

LAURA RIVKIN

Gaozong [Kao-tsung], Emperor of the Song dynasty (*b* Bianliang [modern Kaifeng], Henan Province, 1107; *reg* 1127–62; *d* Lin'an, now Hangzhou, Zhejiang Province, 1187). Chinese calligrapher, art patron and founding emperor of the Southern Song dynasty (1127–1279). He was the ninth son of the Song artist–emperor Huizong and inherited his father's artistic talent. He played an important role in encouraging the arts, reviving imperial patronage and setting a standard for his royal successors. Gaozong received a thorough classical education, and his artistic interests were not discouraged, for he was not expected ever to rule. When his oldest brother, the Emperor Qinzong (*reg* 1126–7), was captured by the Jürchen nomads, founders of the Jin dynasty (1115–1234) in the north, Gaozong took the throne in order to perpetuate the Song dynasty in the south. He rallied support among the literati and the military by bestowing his calligraphic transcriptions of carefully selected texts on

specific individuals. His calligraphy enjoyed widespread familiarity and influence after he started distributing rubbings of his works to successful *jinshi* (civil service examination graduates) in 1135; in the 1140s he had his transcriptions of the Confucian classics engraved on stone tablets.

Gaozong particularly excelled in the slightly informal Song *kai* (Song regular script, also called *xing kaishu*) and the somewhat archaic *zhang caoshu* (draft cursive) script. His development as a calligrapher is attested by a series of dated works, as well as by the comments of late 12th-century writers. As a youth he was strongly influenced by the distinctively individual style of HUANG TINGJIAN, whose diagonal and horizontal strokes were written with a tremulous brush and strokes of exaggerated length. The influence of Huang's style is seen in Gaozong's earliest extant writing, *Foding Guangming ta bei* ('Stele for the Guangming pagoda', rubbing, 1133; Tokyo, Imp. Household col.). In the late 1130s, Gaozong changed to the more classically elegant style of Mi Fu (*see* MI, (1)), as is seen in his *Ci Yue Fei shouchi* ('Handwritten order to general Yue Fei', *c.* 1138; Taipei, N. Pal. Mus.). In the early 1140s, he turned directly to Mi Fu's own models, the Two Wangs (Wang Xizhi and Wang Xianzhi; *see* WANG (i), (1) and (2)), and followed their styles for the rest of his life. Most of his extant calligraphy is in this mode, the best-known example being his *Huizong wenji xu* ('Preface to the collected writings of Huizong', 1154; Kyoto, Mrs Ogawa priv. col.). Late in life he favoured *zhang caoshu* script, seen in his transcription of *Luoshen fu* ('Nymph of the Luo River', after 1162; Shenyang, Liaoning Prov. Mus.).

See also CHINA §IV, 2(iv)(b).

WRITINGS

Han mozhi [Gaozong's writings on callig.]

BIBLIOGRAPHY

Franke: 'Kao-tsung'
Tuotuo and others: *Song shi* [History of the Song] (compiled 1345, rev. Beijing, 1977), *Juan*, xxiv–xxxii, pp. 439–613
K. Shimonaka, ed.: *Shodō zenshū* [Complete collection of calligraphy] (Tokyo, 2/1955), xvi, pp. 1–3, 137–44, 168–9, pls 1–25
Y. Nakata: *Chūgoku shoron shū* (Tokyo, 1967), pp. 271–6
Song Huizong, Gaozong moji, xiii of *Gugong fashu* [Calligraphy in the National Palace Museum] (Taipei, 1970)
S. Nishibayashi, ed.: *Sō Kōsō shinso senjibon* [Song Gaozong's 1000-character essay] (1974), clxxxviii of *Shoseki meihin sōkan* [Calligraphic masterpieces of China and Japan] (Tokyo, 1958–81)
J. K. Murray: 'The Role of Art in the Southern Song Dynastic Revival', *Bull. Sung-Yuan Stud.*, xviii (1986), pp. 41–59
——: *Ma Hezhi and the Illustration of the Book of Odes* (Cambridge and New York, 1993)

JULIA K. MURRAY

Gaozong, Emperor of the Qing dynasty. *See* QIANLONG.

Garage. *See* SERVICE STATION.

Garanin, Anatoly (Sergeyevich) (*b* ?Moscow, 1912). Russian photographer. In the 1930s he was interested in Pictorial photography, but he made his name as a war photographer in World War II, gaining a reputation for photographing 'decisive moments' and producing a number of dramatic images, for example *Death of a Soldier* (early 1940s; see Morozov, p. 235), a picture of a soldier at the point of being fatally wounded, which later became

famous. As a professional photojournalist working for *Sovetskiy Soyuz* from the 1950s, he made a major contribution towards the development of the thoughtful photoessay, particularly regarding the extended portrait or essay concerning an individual, for example the series *Eight Questions to Gennady Vinogradov* (published *Sovetskiy Soyuz*, 1972), which was constructed like an interview, the photographs representing visual translations of the answers given by the subject.

Besides his work as a photojournalist, Garanin concentrated on photographing musical and theatrical subjects, and rehearsals and performances. He brought to this material his ability to treat a subject in depth and to choose moments particularly expressive of personality, as in his portrait of *Professor Nadezhda Artobarevskaya of the Moscow Conservatory* (see Mrázková and Remeš, no. 126), and his ability to capture the idiosyncracies of a particular performance, as in his multiple-exposure portrait *Pierrot* (see Morozov, p. 265). By using in his reportage effects normally associated with Pictorial photography, such as soft focus, blur, lens obstructions, multiple exposures and other technical interventions, Garanin did much to erode the traditional borders between photographic genres.

WRITINGS
'Mysli vslukh' [Thoughts aloud], *Kul't. & Zhizn'*, 11 (1978), p. 47

BIBLIOGRAPHY
S. Morozov: *Tvorcheskaya fotografiya* [Creative photography] (Moscow, 1986)
D. Mrázková and V. Remeš: *Another Russia: Through the Eyes of the New Soviet Photographers* (London, 1986)

KEVIN HALLIWELL

Garavito, Humberto (*b* Quezaltenango, 26 Jan 1897; *d* Guatemala City, 1 June 1970). Guatemalan painter, collector and writer. He began his artistic studies in Quezaltenango, where he was fortunate to come into contact with the Spanish painter Jaime Sabartés (1881–1968) and Carlos Mérida, with whom he became friends. He continued his studies in Guatemala City and then in Mexico City at the Academia de San Carlos, where his fellow students included Rufino Tamayo, Roberto Montenegro and Miguel Covarrubias. He returned briefly to Guatemala only to leave for Europe. He studied in Madrid at the Academia de Bellas Artes de San Fernando and from 1924 to 1925 lived in Paris. He returned to Guatemala City in 1927 and in 1928 became director of the Academia de Bellas Artes. By then he had developed a style derived from French Impressionism, although he gradually moved towards a more naturalistic style, perhaps in response to the taste of his clients.

Garavito generally painted in oils on a medium or small scale, concentrating on the beautiful Guatemalan landscape, of which he can in a sense be considered the 'discoverer'. His preferred subjects were the mountains, volcanoes and lakes of the Guatemalan high plateau, and he was the first to incorporate in his works the Indians in their brightly coloured clothes. He was the central figure and teacher of a group of figurative painters and painters working in a naturalistic style, such as Antonio Tejeda Fonseca (1908–66), Valentín Abascal (1909–81), Hilary Arathoon (1909–81), Miguel Angel Ríos (*b* 1914) and José Luis Alvarez (*b* 1917), and his influence on young painters

continued even after his death. As a collector and art historian he was responsible for the revaluation of Francisco Cabrera.

WRITINGS
Francisco Cabrera: Miniaturista guatemalteco (Guatemala City, 1945)

BIBLIOGRAPHY
Humberto Garavito, pintor de Guatemala (exh. cat. by I. L. de Luján and L. Luján Muñoz, Guatemala City, Gal. Dzunún, 1981)

JORGE LUJÁN-MUÑOZ

Garav-kala. *See* YAVAN.

Garay (Caicedo), Epifanio (*b* Bogotá, 1849; *d* Bogotá, 1903). Colombian painter and singer. He studied at the Académie Julian in Paris, where he began his career as a painter of religious subjects and scenes of local customs and manners. Later he devoted himself to portraiture, earning a reputation as its greatest exponent in Colombia and establishing a workshop. His work in this genre was not only constant and prolific but also represented a considerable achievement through his ability both to capture the sitter's likeness and to convey a sense of his or her personality.

Garay's parallel career as an opera singer, which enabled him to travel extensively, helped him acquire the sophistication and worldly air visible in his work. He also exhibited his paintings in Paris with some success. His association with opera led him to use props, accessories and costumes in his paintings, as if he were choosing these elements to enhance the beauty, courage, spiritual qualities or dignity of the sitter. Garay's realistic and detailed rendering of women's accessories and clothing, and of objects such as books, pens and walking sticks in his portraits of men, contributes to the solemn attraction of his work.

BIBLIOGRAPHY
Epifanio Garay: Iniciación de una guía de arte colombiano (exh. cat. by F. A. Cano, Bogotá, Acad. N. B.A., 1934)
Garay (exh. cat. by N. Haime, Bogotá, Mus. N., 1979)

EDUARDO SERRANO

Garbieri, Lorenzo (*b* Bologna, 1580; *d* Bologna, 1654). Italian painter. He was a follower of Ludovico Carracci, creating a more rigid yet at times powerfully expressionist style in response to the master's emotionalism. His closeness to his teacher can be seen in the early fresco, *Lamentation* (1600–02; Bologna, oratory of S Colombano), and in the *Flagellation* that forms part of the *Mysteries of the Rosary* (Bologna, S Domenico) traditionally attributed to Ludovico himself. Later Garbieri painted the *Stoning of St Stephen* (Bologna, Pin. N.), the scenes from the *Life of Jacob* (1606–14; Bologna, S Maria della Pietà) and the scenes from the *Life of St Carlo Borromeo* (1611; Bologna, S Paolo Maggiore), in which Ludovico's classicism is transformed into a stiffer academicism. The harsh, austere style of these works, which include striking nocturnal scenes, movingly evokes the world of the poor; they were perhaps indebted to the painter's contacts with Caravaggio, both through his awareness of Lionello Spada and through direct knowledge of Caravaggio's *Incredulity of St Thomas* (untraced), which was then in the Lambertini house in Bologna and which Garbieri copied. With his nocturnal scenes of the *Deposition* and the *Entombment* (Milan, S

Antonio Abate), painted after a visit to Loreto in 1609, he created deeply moving works of true expressive power, which are among the finest Emilian paintings of that period. His style softened in his later years, as in the *Healing of the Blind Man* (Rome, Gal. Pallavicini). His bright clear light is reminiscent of Giovanni Lanfranco and Sisto Badalocchio's reinterpretation of Correggio's style, as, for example, in the *Adoration of the Shepherds* (Imola, S Stefano), and in the scenes from the *Life of the Virgin* (1613–14; Modena, S Bartolomeo). But later, in the scenes from the *Life of St Felicity* (1613–26; Mantua, S Maurizio) and in the *Circe* (Bologna, Pin. N.), his tense, rhetorical style brings new dramatic power to the stylistic inheritance of Ludovico Carracci.

BIBLIOGRAPHY

C. C. Malvasia: *Felsina pittrice* (1678); ed. G. Zanotti (1841), ii, pp. 211–18

F. Arcangeli: 'Una "gloriosa gara"', *A. Ant. & Mod.*, 3 (1958), pp. 236–54

Maestri della pittura del seicento emiliano (exh. cat., ed. F. Arcangeli, M. Calvesi, G. C. Cavalli and A. Emiliani; Bologna, Pal. Archiginnasio, 1959), pp. 102–5

San Maurizio a Mantova: Due secoli di vita religiosa e di cultura artistica (exh. cat., ed. R. Navarrini and G. Pastore; Mantua, S Maurizio, 1982), pp. 105–9

L'arte degli Estensi: La pittura del seicento e del settecento a Modena e a Reggio (exh. cat., ed. A. Emiliani; Modena, Pal. Com.; Gal. & Mus. Estense, 1986)

A. Brogi: 'Lorenzo Garbieri: Un incamminato fra romanzo sacro e romanzo nero', *Paragone*, xl/471 (1989), pp. 3–25

UGO RUGGERI

Garbisch. American collectors. Edgar William Garbisch (*b* La Porte, IN, 7 April 1899; *d* Cambridge, MD, 13 Dec 1979), president of Grocery Store Products, and his wife, Bernice Chrysler Garbisch (*b* Oelwein, IO, 1908; *d* Cambridge, MD, 14 Dec 1979), daughter of the motor-car magnate Walter P. Chrysler, amassed one of the largest and most comprehensive collections of 18th- and 19th-century American naive painting to decorate their country home, 'Pokety', on Maryland's eastern shore. Because the Garbisches were among the first to show interest in such art, they were able to assemble rapidly a collection of over 1000 naive paintings of extraordinary quality, including the *Cornell Farm* (1848) by Edward Hicks, the colonial portraits of *Capt Samuel Chandler* and *Mrs Samuel Chandler* (*c.* 1780; all Washington, DC, N.G.A.) by Winthrop Chandler and several portraits and Egyptian scenes by Erastus Salisbury Field. Other important artists represented in the collection were Ammi Phillips, William Matthew Prior, Joshua Johnson and Thomas Chambers (1808–after 1866). They also collected outstanding American watercolours, pastels, theorem paintings, examples of *Fraktur*, needlework and furniture, Impressionist, Post-Impressionist and modern paintings, French furniture and European porcelain.

Wishing to foster appreciation of naive art, the Garbisches frequently exhibited their collection. In addition, between their first gifts to the National Gallery, Washington, DC, in 1953, and their bequest in 1979, they donated numerous paintings to museums throughout America. While the National Gallery was the largest recipient of works from the bequest, 31 other museums benefited from their generosity, notably the Chrysler Museum,

Norfolk, VA, the Metropolitan Museum of Art, New York, the Museum of Fine Arts, Boston, and the Philadelphia Museum of Art. The remainder of their collection was auctioned in 1980.

BIBLIOGRAPHY

M. Black: 'Collectors: Edgar and Bernice Chrysler Garbisch', *A. America*, lvii/3 (1969), pp. 48–59

J. E. Patterson: 'The Garbisch Collection: A Major Saleroom Event', *Connoisseur*, cciv/819 (1980), pp. 46–51

American Naive Paintings from the National Gallery of Art (exh. cat., intro. M. Black; Washington, DC, N.G.A., 1985)

LAURIE WEITZENKORN

Garbo. Family of builders and masons of Italian origin, active in Portugal. Giovanni Battista Garbo (*b* ?Milan, *fl* 1670; *d* ?Lisbon) went to work in Lisbon *c.* 1670 for the Jesuits at São Antão (now the chapel of the hospital of São José) and perhaps also for the church of Nossa Senhora de Loreto. His son Carlos Baptista Garbo (*d* Mafra, 1725) was trained in the same skills of masonry at São Antão, and he also became a designer of altarpieces. The high altar with marble mosaic for the old Jesuit church, now the seminary, Santarém, was designed by Carlos Baptista along 17th-century lines and made in 1713 in the workshops of São Antão. It was here that his son António Baptista Garbo (*b* Lisbon, 1692; *d* ?Lisbon) was trained and also worked in the service of the Jesuits.

The ability of the Garbo family is most visible at Mafra, where Carlos Baptista superintended the construction of the vast palace, church and convent, following the plans of João Frederico Ludovice, from 1718 until his own death in 1725; by that time the foundations had been laid and the church had reached the height of the nave. His work was continued until 1750 by António Baptista, who directed the vast army of 30,000 craftsmen and trained the teams of masons and stone-cutters, and whose experience was to be of considerable value during the rebuilding of Lisbon after the earthquake of 1755.

BIBLIOGRAPHY

R. C. Smith: *The Art of Portugal, 1500–1800* (London, 1968), pp. 101, 164

A. de Carvalho: 'D. João V e a arte do seu tempo: Documentário artístico do primeiro quartel de setecentos', *Bracara Augusta* [Braga], xxxvii (1973)

ANTÓNIO FILIPE PIMENTEL

Garbo, Raffaellino del. *See* RAFFAELLINO DEL GARBO.

García. Spanish sculptors. Jerónimo Francisco García and Miguel Jerónimo García (both *b* ?Granada, *c.* 1580; *fl* to 1640) were twin brothers who worked in wood, wax and especially in terracotta and painted their own work. They are thought to have made a series of images of Christ at different moments of the Passion. The finest of these are the various versions of *Ecce homo*, mainly in polychromed terracotta. These are full-length figures with the bust section elongated, either in the round or in relief. An example is in the Cartuja at Granada, and replicas of this version are in the convent of the Angel and the church of SS Justo y Pastor, both also in Granada. Another example is the *Ecce homo* in polychromed wood, noted for the skilled carving, in S Jorge, Hospital de la Caridad, in Seville. The dates of all of these works are unknown.

BIBLIOGRAPHY
E. Orozco Díaz: 'Los hermanos García', *Martínez Montañés (1568–1649) y la escultura andaluza de su tiempo* (exh. cat., Madrid, Dir. Gen. B.A., 1972)
J. D. Sánchez-Mesa Martín: *El Arte del Barroco*, vii of *Historia del arte en Andalucía* (Seville, 1991)

MARÍA TERESA DABRIO GONZALES

García, Alfonso Sánchez. *See under* ALFONSO.

García, Antonio López. *See* LÓPEZ GARCÍA, ANTONIO.

García, Domingo (*b* Coamo, 1932). Puerto Rican painter and printmaker. He studied painting at the School of the Art Institute of Chicago, the National Academy of Design in New York and with William Locke in London. In 1959 he founded the Campeche Workshop and Gallery in San Juan, where for nine years he taught painting, drawing and screenprinting. In the 1950s, when Puerto Rican painting was dominated by social realism, he was rare in developing an expressionist style with the aim of expressing a subjective reality. In both paintings and screenprints he used figurative subject-matter as a point of departure for the exploration and communication of his psychological and emotional state, with portraits and especially self-portraits playing a constant and significant role.

Primarily a portraitist, García also painted urban landscapes and abstract themes. Although he consistently used intense colour and gestural brushwork, his production can be divided into several stylistic phases: gestural expressionist depictions of landscape and figures (1957–68); portraits and cityscapes in a style related to hard-edge and colour field painting (1965–75); and from 1976 a return to imaginative, expressionistic modes of painting, this time characterized by a more sombre palette dominated by blacks. In some works, particularly in his poster designs, he manifested a concern with the social and political reality of Puerto Rico, and in 1986 he embarked on an ambitious project aimed at representing the conflict of Puerto Rican history through monumental iconic portraits of key figures of the island's past.

BIBLIOGRAPHY
Personajes del recuerdo: Recent Works by Domingo García (exh. cat. by L. S. Sims, New York, Mus. Barrio, 1979)
Domingo García: Cuatro décadas de pintura (exh. cat. by L. Homar, J. A. Pérez Ruiz and L. S. Sims, San Juan, Inst. Cult. Puertorriqueña, 1987)
Domingo García: Recent Work (exh. cat. by E. García Gutiérrez and M. C. Ramírez, San Juan, Park Gal., 1988)

MARI CARMEN RAMÍREZ

García, Gay (Enrique) (*b* Santiago de Cuba, 15 Jan 1928). Cuban sculptor, painter and printmaker. He graduated from the Academia de S Alejandro in Havana in 1955 and went to Mexico, where he studied with David Alfaro Siqueiros in Mexico City. In 1962 he travelled to Italy on a Unesco scholarship. As a political exile from Cuba he lived for several years in Europe and other parts of the USA and Puerto Rico before settling in Miami in 1978. He worked in bronze and steel, realized murals, drawings, lithographs and tapestries. His tapestries echo the concern with gestural brushwork and grainy texture evident in his drawings and lithographs. His painting and sculpture were initially influenced by Abstract Expressionism, but as a sculptor working in bronze and steel, his

affinities were with Arnaldo Pomodoro. García's originality lay in the tensions he created between smooth and coarse textures, and between geometric and asymmetrical forms as a means of suggesting metaphors within an essentially abstract formal language. For example, in *Icarus* (1984; Coral Gables, FL, priv. col., see 1987 exh. cat., p. 143) he transposed the frailty attributed to Icarus's wings on to the torso and his strength on to the wings.

BIBLIOGRAPHY
M. V. Adell, ed.: *Pintores cubanos* (Havana, 1962)
R. Pau-Llosa: 'Gay García: La escultura de la acción', *Vanidades*, xxv/2 (1985), pp. 12–13
Outside Cuba/Fuera de Cuba (exh. cat., New Brunswick, NJ, Rutgers U., Zimmerli A. Mus., 1987)

RICARDO PAU-LLOSA

Garcia, (Frederico) Ressano (*b* Lisbon, 12 Nov 1847; *d* Lisbon, 27 Aug 1911). Portuguese engineer, urban planner and politician. He studied engineering at the Escola Politécnica, Lisbon, and at the Ecole des Ponts et Chaussées, Paris, where he obtained his diploma in 1869. On his return to Lisbon he divided his time between teaching engineering at the Instituto Industrial e Comercial and, after 1880, at the Escola do Exército, and his work as engineer to the Lisbon Municipality, a post gained in competition in 1874. In this position he was responsible for the lines along which the modern city developed. He first reorganized the technical section of the Municipality, giving it some autonomy from political direction. He then evolved a systematic plan of programmed growth for Lisbon (*see* LISBON, §I), which gave form to the extension northwards away from the Tagus river that was envisaged in projects of a century before in the time of the Marquês de Pombal. He planned the Avenida da Liberdade (inaugurated in 1879) and, where it ended, the Praça Marquês de Pombal, the Parque Eduardo VII and the broad, interconnecting Avenidas Novas (1890–1910), which for the next 50 years defined the principal middle-class residential areas of the city. The technical and aesthetic model for his plan was partly provided by the avenues built in Paris in the 1850s and 1860s by Baron Georges-Eugène Haussmann, which Garcia would have known from his studies there. As with the Parisian example, the rectangular network of avenues was intended to modernize the city, carrying drains, gas and electricity supplies, and facilitating the installation of tram-lines and telephone wires. In the broad central and lateral bands of the avenues, trees were planted in accordance with the principles of garden cities, and on the sites that lined them the newly-rich classes built town houses and residential blocks for renting. Other contributions to the modernization of Lisbon by Garcia included the routing of the ring railway, the renovation of the sewage system, the planning of the new port and the investigation of the city's water supply. He also had a distinguished political career as deputy and minister of state; he eventually became a peer of the realm.

BIBLIOGRAPHY
E. Pereira and G. Rodrigues: 'Ressano Garcia', *Portugal: Dicionário histórico* (Lisbon, 1908)
J.-A. França: *A arte em Portugal no século XIX*, ii (Lisbon, 1967)
R. Henriques da Silva: *As Avenidas Novas de Lisboa* (diss., Lisbon, U. Nova, 1986)

RAQUEL HENRIQUES DA SILVA

García, Romualdo (*b* Guanajuato, 1852; *d* Guanajuato, 1930). Mexican photographer. In 1887 he opened a photographic studio, at a time when Guanajuato, a mining town, was experiencing an unprecedented economic boom that made it one of Mexico's most important commercial centres. He became the most popular society photographer, recording the aristocracy in their fashionable European clothes, as well as the priesthood, the agricultural labourers and the miners.

Stylistically and technically traditional, García took all his photographs in the studio, always in front of the same props and in the same lighting conditions. He did not present detail, or suggest internal emotion. His subjects either stood or sat, and always appeared full-figure; they knew that they were appearing in a photograph, and looked appropriately static.

BIBLIOGRAPHY
C. Canales: *Romualdo García: Un fotógrafo, una ciudad, una época* (Guanajuato, 1980)
E. Billeter: *Fotografie Lateinamerika* (Zurich and Berne, 1981)
Images of Mexico: The Contribution of Mexico to 20th Century Art (exh. cat., ed. E. Billeter; Frankfurt am Main, Schirn Ksthalle; Dallas, TX, Mus. A.; 1987–8), pp. 377–9

ERIKA BILLETER

García, Víctor Manuel. *See* VÍCTOR MANUEL.

García Crespo, Manuel (*b* Tordesillas, *c.* 1698; *d* Salamanca, 1766). Spanish goldsmith. He worked in Salamanca from 1713, where he produced mostly ecclesiastical pieces, although some secular works are also extant. About 50 pieces of various types by him survive. In 1728 he made the *andas* (processional litter) for Salamanca Cathedral after a design by Alberto Churriguera and in 1734 a Maundy Thursday coffer and a set of altar-cards for the Carmelite Convent of Peñaranda de Bracamonte, near Avila. He was commissioned by Bishop Osorio to make a collection of pieces (1738–48) for Nuestra Señora de la Encina, Ponferrada, León. His processional crosses were original on account of their high-relief supports to the arms (examples at Madrigal de las Altas Torres, 1745; Tordesillas, 1747–8; Becerril de Campos). His monstrances, on which seraphim support the sun above the world, followed 17th-century French models already known in Salamanca but which he refined and standardized (examples at Astorga Cathedral, 1757; La Seca, 1766; Carmelite Convent at Peñaranda). An outstanding secular work is the ewer set (1752–9) in Avila Cathedral (*see* SPAIN, fig. 041567–029). In Crespo's work, which is characterized by ornate Baroque flowers and figures in high relief, Rococo elements do not seem to have appeared. Many Spanish craftsmen, especially his son Luis García Crespo, were influenced by his style.

For bibliography *see* SPAIN, §IX, 1.

JOSÉ MANUEL CRUZ VALDOVINOS

García de Miranda, Juan (*b* Madrid, 1677; *d* Madrid, 1749). Spanish painter. He was the principal representative of an extensive family of artists active in Madrid in the 18th century. He studied in the studio of Juan Delgado, and in 1724 he was appointed valuer of paintings and court painter. He was a skilled restorer and after the fire at the Alcázar in Madrid in 1734 was involved in the extensive restoration work needed on the paintings that survived. In 1735 he was appointed Pintor de Cámara. He was also a capable portrait painter, whose sitters included *Philip V* and his first wife, *María Luisa Gabriela of Savoy* (both Madrid, Prado), as well as the future *Charles III* (Murcia, Soc. Econ.). In his portraits he kept to early 18th-century compositions, although they also contain some archaic features.

García de Miranda worked in the Aranjuez Palace and in other royal palaces, for which he painted genre paintings as well as historical and religious subjects. He painted 17 canvases in 1733 for the Iglesia Nueva de Guadalupe and others for the hermitage of S Isidro, the Capuchin Convento del Prado and the church of S Gil, all in Madrid. His most important religious work is the series of scenes from the *Life of St James*, painted for the convent of the same name, Alcalá de Henares (now Madrid, Prado). Also of interest are the four paintings with scenes from the *Life of the Virgin* (parish church of S Lorenzo, Valladolid; *in situ*) and the series depicting scenes from the *Life of St Teresa of Jesús* from an unknown Carmelite community (three paintings preserved; Madrid, Prado). In his religious paintings he continued in the traditions of the Spanish school of the second half of the 17th century, displaying a surprising sobriety that is often reminiscent of Diego de Velázquez, although without the latter's technical quality or masterly compositions. He also worked for private collectors and had connections in the world of politics and court administration.

BIBLIOGRAPHY
T. Jimenez Priego: 'Juan García de Miranda, Pintor de Cámara de Felipe V, en Guadalupe', *Estud. Extremenos* (1975), pp. 575–93
——: 'Los Miranda, pintores madrileños del siglo XVIII', *An. Inst. Estud. Madril.*, xv (1978), pp. 255–78
C. Trujillo García: 'Juan García de Miranda', *Bol. Mus. Prado*, iv (1981), pp. 11–26

JUAN J. LUNA

García de Quiñones, Andrés (*b* Santiago de Compostela, 9 Aug 1709; *d* Salamanca, 15 Nov 1784). Spanish architect. He was probably trained by Domingo A. de Andrade. In 1729 he moved to Salamanca, competing for work against the successful Churriguera family. He produced an excellent drawing of the north side of the incomplete Plaza Mayor, in an unsuccessful bid to be appointed overseer. In 1749, however, he achieved his aim and was made Master of Works for the town hall. With its low relief architectural articulation, it dominated the north side of the square, which, like the south side, was completed by 1755 under García's supervision.

Between 1730 and 1745 García was appointed to build a wing for the Colegio Real de la Compañía de Jesús. He designed the exterior to blend in with the main building using the classical style of J. Gómez. The courtyard is considered a masterpiece in the Spanish Baroque style. He also designed the staircase, library and a hall with stuccoed vaults, in a style similar to that produced by French decorators such as Jean Bérain I. He also worked on the church façade, adding two slender towers with varied silhouettes, their belfries and cupolas stacked in decreasing size and decorated with stone reliefs in the Rococo style. While working at the Colegio Real de la Compañía de Jesús, García designed two altarpieces for the church and

one for the sacristy. These, with their weighty volumes and undulating surfaces, are much more dynamic than those by the Churriguera family, who were known for their extravagant style. García's more progressive, Rococo style was subsequently taken up by his son Jerónimo García de Quiñones and other imitators.

BIBLIOGRAPHY

A. R. Ceballos: 'Noticias sobre el arquitecto Andrés García de Quiñones', *Archv Esp. A.*, clxi (1968), pp. 35–43

——: 'La arquitectura de Andrés García de Quiñones', *Archv Esp. A.*, clxii–clxiii (1968), pp. 105–30

ALFONSO RODRÍGUEZ CEBALLOS

García Guerrero, Luis (*b* Guanajuato, 18 Nov 1921). Mexican painter. He practised as a lawyer in Mexico City before enrolling in 1949 at the Escuela Nacional de Artes Plásticas, Mexico City, and the Escuela de Pintura Escultura y Grabado 'La Esmeralda', also in Mexico City. His landscapes, usually in small format, were strongly influenced by Cézanne and depicted in detail the countryside around Guanajuato and Mexico City (*The Three Kingdoms of Nature*, oil on wood, 1982; Mexico City, Gal. A. Mex.). He also produced still-lifes, which were realistic and characterized by a uniform, warm light; they reveal great simplicity, precision and delicacy. In his portraits Guerrero often painted workmen and farm labourers, and he emphasized the expression of the eyes. He exhibited throughout Mexico, and frequently at the Galería de Arte Mexicano, Mexico City.

BIBLIOGRAPHY

M. Traba: *La zona del silencio: Ricardo Martínez, Gunther Gerzso, Luis García Guerrero* (Mexico City, c. 1975)

L. Cardoza y Aragón: *Luis García Guerrero* (Mexico City, 1982)

ELISA GARCÍA BARRAGÁN

Garci-Aguirre, Pedro (*b* Cádiz, ?1750; *d* Guatemala City, 15 Sept 1809). Spanish engraver and architect, active in Guatemala. He studied in Cádiz around 1760, and in 1773 he moved to Madrid, where he was probably taught by the noted engraver Tomás Francisco Prieto (1726–82). In 1778 he was appointed assistant engraver of the Real Casa de la Moneda in Guatemala, where he arrived the next year. Following the death of the principal engraver, he was confirmed in this post in 1783 and held it until his death. Besides his work as engraver of coin dies and medal stamps, Garci-Aguirre made numerous fine copperplate engravings for books (e.g. P. Ximena: *Reales Exequias por el Señor Don Carlos III*, Guatemala City, 1790) and other publications. In Guatemala he revived the art of engraving, working in the Neo-classical style, which he was one of the first to introduce to the country. He soon became involved with architectural works in connection with the building of the new capital of Guatemala City, first in the Real Casa de la Moneda and then on other royal projects. From 1783, together with Santiago Marqui, he was responsible for the construction of the cathedral in Guatemala City. He was mainly associated with the Dominican Order, for which he worked at their sugar plantation in San Jerónimo (Verapaz) and built their large vaulted church and monastery in Guatemala City (both completed 1809). Though building had already begun, his design for the church of the convent of S Clara in Guatemala City was not approved by the Real Academia de S Fernando in Madrid since it was considered to be in bad taste. He took part in the initial stages of the construction of the great churches of S Francisco and La Recolección (1780–1808), both in Guatemala City. In 1795 his design for an Academia de Bellas Artes was not accepted by the Crown. As a member of the Sociedad de Amigos del País of Guatemala, he was responsible for establishing the first Escuela de Dibujo in Guatemala and was the first director from March 1797. When the Sociedad de Amigos was closed by royal decree in 1800, the school continued under his direction until his death. In this school leading Guatemalan artists such as José Casildo España (1798–1848) and the miniaturist Francisco Cabrera were trained.

BIBLIOGRAPHY

R. Toledo Palomo: *Las artes y las ideas de arte durante la independencia, 1794–1821* (Guatemala City, 1977)

J. Luján-Muñoz: 'Pedro Garci-Aguirre, arquitecto neo-clásico de Guatemala', *Bol. Cent. Invest. Hist. & Estét. U. Caracas*, xxiii (1978), pp. 74–109

JORGE LUJÁN-MUÑOZ

García Hidalgo, José (*b* Villena, Alicante, *c.* 1645; *d* Madrid, 28 June 1717). Spanish painter, engraver and writer. He began his training in Murcia with Nicolás de Villacis (*c.* 1618–94) and Mateo Gilarte (*c.* 1620–after 1680), who both worked in a naturalist and tenebrist style. He travelled to Rome in the 1660s and came into contact with the Italian Baroque, especially the work of Pietro da Cortona and Carlo Maratti. On his return he was first in Valencia, where the work of Jerónimo Jacinto Espinosa became a strong influence. Towards 1674 he established himself in Madrid, where he entered the circle of Juan Carreño de Miranda.

García Hidalgo's numerous paintings were frequently signed, and he painted a good many for the Augustinian Order in Madrid, Madrigal de las Altas Torres, Santiago de Compostela and Sigüenza (e.g the *Vision of St Augustine*, 1680; Sigüenza Cathedral), and for the Carmelite Order in Alba de Tormes, Peñaranda de Bracamonte and Segovia (e.g. the *Carmelite Allegory*, Segovia, Convento de Carmelitas Descalzos). The *Virgen del Carmen* (1674) for the oratory of the Rey led to his nomination by Charles II as Pintor del Rey that year, though in 1703 in his request for nomination as Pintor de Cámara to Philip V—who gave it to him *ad honorem*—he declared to have spent 27 years in the service of the Crown. He also held the title of Censor del Santo Oficio for the Inquisition and in 1677 he belonged to the Congregación de Pintores, based in the Hermanidad de los Siete Dolores. From *c.* 1674 to 1711 he painted 24 canvases of the *Lives of St Augustine and St Philip* for S Felipe el Real in Madrid, some of which are preserved in the Prado. There are numerous works from the 1680s, including two canvases from the dismantled altarpiece dedicated to St Augustine (*c.* 1680; Sigüenza Cathedral), *St Paschal Baylon* (1681; Saragossa, Mus. Zaragoza), *St Francis of Assisi* (1684; Barcelona, Mus. A. Catalunya; see fig.) and the *Death of St Joseph* (1688; Hartford, CT, Wadsworth Atheneum).

About 1680 García Hidalgo began to etch the 151 prints that make up his theoretical work, the *Principios para estudiar el nobilissimo y real arte de la pintura* (Madrid, *c.* 1693; *see* SPAIN, fig. 28, and MADRID, fig. 5), with models intended for the teaching of beginners. He also published

José García Hidalgo: *St Francis of Assisi*, oil on canvas, 1.32×0.87 m, 1684 (Barcelona, Museu d'Art de Catalunya)

the *Geometría práctica*, with 29 prints (Madrid, *c.* 1693). In 1697 he returned to Valencia, buying a house there in 1700, and he was again in the city in 1706. A work that may date from these years is the *Foundation of the Convento de S Ursula by the Blessed Juan de Ribera* (Valencia, Convento de S Ursula). Late works painted in Madrid include the portraits of *Mariana of Austria* (1709; Madrigal de las Altas Torres, Agustinas), *Luis I* (1710; Salamanca, Pal. Monterrey) and *Don Manuel de Coloma, Marqués de Canales* (*c.* 1713; Salamanca, Mus. Salamanca). His last known painting is the *Mystical Marriage of St Catherine* (1714; Salamanca, Residencia Sotomayor).

In spite of his extensive work, García Hidalgo was a secondary painter in the school of Madrid. His style is consistent and is characterized by complex compositions, with great scenes of architectural perspectives that open on to connecting spaces. These are populated by strongly built figures, whose faces often have little expression, and angels seen in extreme foreshortening. All this is unified by an earthy colouring, resulting from his earlier training and removed from the brilliant tones of other contemporary painters in Madrid.

WRITINGS

Geometría práctica (Madrid, *c.* 1693)
Principios para estudiar el nobilissimo y real arte de la pintura (Madrid, *c.* 1693/*R* 1965) [facs. edn incl. biog. study by A. Rodríguez Moñino]

BIBLIOGRAPHY

J. Urrea Fernández: 'El pintor José García Hidalgo', *Archv. Esp. A.*, xlviii (1975), pp. 97–117
A. Piedra: 'Fecha y lugar de nacimiento de José García Hidalgo', *Archv Esp. A.*, lxiii (1990), pp. 325–6

ISMAEL GUTIÉRREZ PASTOR

García Joya, Mario. *See* MAYITO.

García Mercadal, Fernando (*b* Saragossa, 5 April 1896; *d* Madrid, Jan 1984). Spanish architect. In 1919 he went to Paris and studied at the Institut d'Urbanisme, where his teachers included Jacques Gréber. In 1921 he graduated from the Escuela de Arquitectura, Madrid, with the highest marks in his year, and from 1923 he spent four years based at the Academia de España, Rome, as a result of winning the Premio de Roma. A travelling scholarship allowed him also to visit France, Germany and Austria. In Berlin (1925–6) he studied urban planning with Hans Poelzig and Hermann Jansen at the Technische Hochschule. During these years of international study he met several of the leading contemporary architects: Le Corbusier in Paris (1925); Peter Behrens (1920), Josef Hoffmann (1924) and Adolf Loos (1927) in Vienna. As a practising architect García Mercadal moved in two complementary directions: he took an interest in popular, mainly Mediterranean, architecture, which had been a focus of his studies in Rome and is reflected in his books (e.g. *La casa popular in España*), but he was also interested in rationalist architecture, an influence that is apparent in his Rincón de Goya (1927–8; remodelled) in Saragossa. This small pavilion, designed as an alternative to the traditional sculptural monument, is one of the first examples of Modernist architecture in Spain. Another example of his rationalist-inspired architecture is the series of houses he built in 1930 for the Colonia Residencia de Madrid, in the Calle Carbonero y Sol.

From 1927 to 1932 García Mercadal was the most distinguished architect in the campaign to link Spanish architecture with developments in Europe; he was a founder member of CIRPAC and organized a number of conferences inviting some of the most notable contemporary architects as speakers: Peter Breuer, Erich Mendelsohn, Theo van Doesburg, Walter Gropius and Le Corbusier. In 1928 he took part in the meeting that founded CIAM (*see* CIAM, fig. 1), and he later represented Spain at CIAM congresses in Frankfurt (1929) and Brussels (1930). He also helped set up GATEPAC and contributed to its publication, *Documents de actividad contemporanea*, and to some of its urban development projects. He took part in various competitions for urban planning (for Bilbao, Burgos, Ceuta, Seville, Badajoz and Logroño) and in the work for the Projectos de Ordenación de Madrid (1930), which was directed by Secundino Zuazo and Hermann Jansen. From 1932 his importance to Spanish architectural debate lessened. Between 1932 and 1940 he was in charge of parks and gardens for Madrid, and from 1946 he was architect to the Instituto Nacional de Previsión, a body responsible for social and sanitary assistance.

WRITINGS

La casa popular in España (Madrid, 1930)
Arquitectura regionales (1984)
La casa mediterranea (1984)

BIBLIOGRAPHY
'1927: Primera arquitectura moderna en España', *Hogar & Archit.*, lxx (1967)
A. Campo Baeza: *La arquitectura racionalista en Madrid* (Madrid, 1982)
J. D. Fullaondo: *Fernando García Mercadal* (Madrid, 1984)

P. BENITO

García Mesa, José (*b* Cochabamba, 1846; *d* La Paz, 1911). Bolivian painter. In 1864 he went to Europe to study painting. He remained there for some years, visiting Rome and working in Paris, where he had a studio. On his return to Bolivia, he worked for a time and then returned to Europe. In 1880 he offered his services as portrait painter to the newspaper *El Comercio* in La Paz, stating that he had founded an academy of drawing and painting in the Instituto Nacional de Ciencias y Letras. At this time he painted murals with religious themes for Cochabamba Cathedral. In 1882 the Musée du Louvre in Paris bought one of his paintings. In 1889 he took part in the Exposition Universelle in Paris and in the Salon d'Artistes Libres, where he obtained an honourable mention for his painting *Lake Titicaca*. His style was academic, with rigid figures in grandiose poses, painted in a limited range of cool colours. He frequently made use of photography to treat urban topics. While in Paris he painted large views of the principal cities of Bolivia, based on photographs, for example *The City of Sucre* (1889; Sucre, City Hall) and *Cochabamba Main Square* (1889; Cochabamba, City Hall). His later paintings include *The Execution of Murillo* (1905; La Paz, Mus. Casa Murillo). Several of his landscapes and seascapes, painted in France, are in the Real Museo Charcas, Universidad Mayor, Sucre.

BIBLIOGRAPHY
M. Chacón Torres: *Pintores del siglo XIX* (La Paz, 1963)
P. Querejazu: *La pintura boliviana del siglo XX* (Milan, 1989)

PEDRO QUEREJAZU

García Ponce, Fernando (*b* Mérida, Yucatán, 1933; *d* Mexico City, 11 July 1987). Mexican painter and draughtsman. He studied architecture at the Universidad Nacional Autónoma de México in Mexico City, at the same time taking private painting lessons from the Spanish painter Enrique Climent (1897–1980). Like the majority of artists of his generation, he made various study trips to Europe and shared the general desire to practise a cosmopolitan art without nationalistic traits. His early works showed the impact of his architectural training and of the Cubism of Braque and Gris, but he later abandoned all traces of figuration in favour of an abstract style that focused attention on the process by which the painting was constructed. His prolific production, which consisted not only of paintings but also of collages and prints, showed a variety of influences during and after the 1960s, including Art Informel, matter painting (especially from Catalonia), the austerity of Minimalism but above all the assemblages of Kurt Schwitters, within compositions clearly structured by orthogonals criss-crossed by diagonal elements and aggressive fissures. His brother Juan García Ponce (*b* 1932) was a noted writer and the leading critic of the so-called 'generation of rupture' artists in Mexico.

BIBLIOGRAPHY
Fernando García Ponce (exh. cat., intro. M. L. Borrás; Mexico City, Mus. A. Mod., 1978)
El mundo plástico de Fernando García Ponce (exh. cat., essay R. Eder; Monterrey, Mus. Reg. Nue. León, 1982)

TERESA DEL CONDE

García Reinoso, Antonio (*b* Cabra, Córdoba, *c.* 1610–20; *d* Córdoba, 12 Aug 1677). Spanish painter, designer and gilder. He trained in Jaén with Sebastián Martínez and started his career working in such small towns as Andújar, near Jaén, where he painted the large altarpiece of the *Trinity with Saints* for the high altar in the Capuchin church. At Martos, also near Jaén, he decorated the chapel of Jesús Nazareno and the church of Nuestra Señora del Rosario. In his middle age he established himself in Córdoba and painted religious works for churches and convents, such as that of the Capuchins and the Calced Carmelites (untraced). Ceán Bermúdez states that he was also known there as a painter of landscape works, but none have been traced. He was an able gilder and worker in *estofado* (relief on gilt ground), producing religious images. He also made designs for furniture, retables and silverware, for which several drawings are preserved (Córdoba, Mus. Prov. B.A.).

BIBLIOGRAPHY
Ceán Bermúdez; Thieme–Becker
D. Angulo Iñiguez: *Pintura del siglo XVII*, A. Hisp., xv (Madrid, 1958), p. 265
A. E. Pérez Sánchez: *Pintura barroca española* (Madrid, 1992), p. 275

ENRIQUE VALDIVIESO

Gardella, Ignazio (*b* Milan, 30 March 1905). Italian architect, engineer and designer. He graduated in civil engineering from the Polytechnic of Milan (1931) and immediately gave his support to the group of Rationalists who were connected with the review *Casabella*. In 1935 he worked on the restoration of the Villa Borletti in Milan, where one of the traits that distinguished his later work emerged: a balance between apparently irreconcilable elements of styles. In the Dispensario Antitubercolare (1936) at Alessandria, an important Rationalist building, Gardella proved that the language of modern architecture could be highly sensitive to its setting and capable of assimilating the features of the site. It is enhanced by sympathetic use of local materials. This characteristic is present in later works, such as the Casa alle Zattere (1954–8), Venice, in which he made open historicist references to the building's sensitive context. In 1949 Gardella studied for a degree in architecture at the Istituto Universario di Architettura di Venezia, also teaching there from 1952 to 1975. He was a member of all the main architectural bodies, including the Movimento Studi per l'Architettura (MSA) and the Istituto Nazionale di Urbanistica (INU), and played an active part in CIAM. With Vico Magistretti, De Carlo and Ernesto Nathan Rogers, he represented Italy at its last meeting at Otterlo in 1959. In 1955 Gardella won the Olivetti Prize for architecture. Echoes of a Rationalism of the 1930s are less detectable in later commissions such as the projected reconstruction of Carlo Francesco Barabino's Teatro Carlo Felice (1982; with Aldo Rossi and Fabio Reinhart), Genoa. He wrote little about his work, preferring to express his divergence from the canonic tendencies of the Modern Movement through his buildings.

For an illustration of Gardella's scheme for the Teatro Verdi (1969–80) in Vicenza *see* THEATRE, fig. 21.

BIBLIOGRAPHY
G. C. Argan: *Ignazio Gardella* (Milan, 1959)
A. Samonà: *Ignazio Gardella e il professionalismo italiano* (Rome, 1981)
M. Porta, ed.: *L'architettura di Ignazio Gardella* (Rome, 1985)

ANNALISA AVON

Gardelle, Robert, *le jeune* (*b* Geneva, 6 April 1682; *d* Geneva, 7 March 1766). Swiss painter and engraver. He was a member of a family of artists and jewellers in Geneva. At an early age he showed a pronounced talent for art, but as there was no school of drawing in Geneva, he moved to Germany. At Kassel, Baron von Mardefeld became his patron, sent him to Berlin and recommended him to important people at court. Gardelle is said to have painted the royal family; however, this was most probably simply a question of copying existing portraits. In 1711, on his return to Kassel, he painted from life a portrait of *Frederick II, Landgrave of Hesse-Kassel*. In 1712 he travelled to Paris, where he spent a year perfecting his art in the studio of Nicolas de Largillierre. It was there that he acquired the fluid and elegant style of the French Rococo. He returned to Switzerland for good in 1713 and became a portrait painter, painting both the great and the humble, not only in Geneva but also in Berne, Neuchâtel and the Vaud. He was a very prolific artist and often executed replicas of his paintings for himself. These paintings, often in a small format (usually 240×180 mm), are particularly remarkable for their brightness of colour and their close attention to likenesses (e.g. *Luc Morin-Marchinville*, 1720; Geneva, Mus. A. & Hist.). Gardelle's work also includes views of Geneva, Berne and Switzerland in general, as well as etched and mezzotinted prints after his own work.

SKL

BIBLIOGRAPHY
D. Baud-Bovy: *Peintres genevois, 1702–1817*, i (Geneva, 1904), pp. 9, 164
F. Aubert: 'Notes sur l'iconographie calvinienne et Robert Gardelle', *Geneva*, xvii (1939), pp. 87–95
'Les Plaisirs et les arts', *Encyclopédie de Genève*, x (Fribourg, 1994), pp. 23, 27

ANNE PASTORI ZUMBACH

Garde Meuble de la Couronne. *See* MAISON DU ROI, §IV.

Garden. Relatively small space of ground, usually out of doors, distinguished from the surrounding terrain by some boundary or by its internal organization or by both. A combination of architectural (or hard) and natural (or soft) materials is deployed in gardens for a variety of reasons—practical, social, spiritual, aesthetic—all of which are explicit or implicit expressions of the culture that

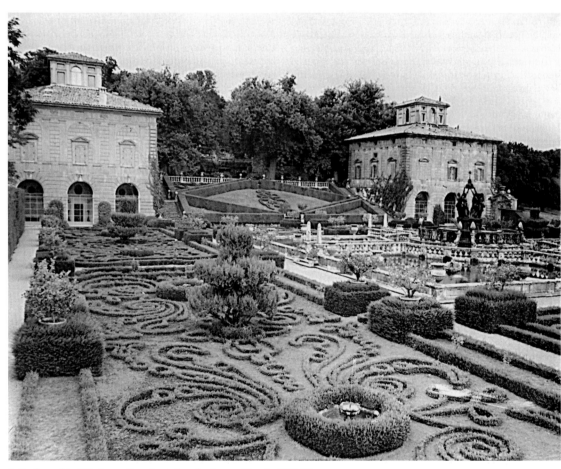

1. Gardens of the Villa Lante, Bagnaia, attributed to Jacopo Vignola, 1568–78

created them. A garden is the most sophisticated expression of a society's relationship with space and nature. This necessarily imprecise definition is meant to accommodate a profusion of examples: the pleasure garden, winter garden, flower garden, vegetable garden, BOTANIC GARDEN, landscape garden, public garden, SCULPTURE GARDEN, community garden, allotment garden, victory garden, peace garden, cloister garden, edible garden, rock garden, water garden, dry garden, nursery garden, remembrance garden, zoological garden etc. Between these examples exists a complicated network of similarities, criss-crossing and overlapping, that inhibit any more concrete definition.

See also CONSERVATORY; GREENHOUSE; ORANGERY; FOLLY; GROTTO; HERMITAGE.

I. Introduction. II. Ancient world. III. Byzantine lands. IV. Indian subcontinent. V. Islamic lands. VI. East Asia. VII. South-east Asia. VIII. Western.

I. Introduction.

1. General. 2. Iconography and phenomenology. 3. 'Three natures': gardens, cultural landscapes and wilderness. 4. Garden designers and landscape architects. 5. Treatises and theoretical writings. 6. Historiography.

1. GENERAL. Local cultural circumstances determine many aspects of the garden's form and meaning, including the proportion of hard to soft elements, the relationship of gardens to adjacent buildings or the larger landscape and the specific or unconscious motives for its creation. To the extent that a garden depends on natural materials, it is at best ever-changing (even with human care and attention) or at worst destined from its inception for delapidation and ruin. Given this fundamental contribution of time to the garden, it exists in and takes its special character from four dimensions, unlike most art forms. Almost all the great civilizations of the world have prized gardens and practised what has come to be termed landscape architecture, often deeming those who worked in this medium as much artists as designers, technicians or gardeners.

The full scope and history of Western gardens as art, design and technology were sketched out in the late 17th century by JOHN EVELYN as a contents list for his unfinished magnum opus, the *Elysium Britannicum* (MS. Oxford, Christ Church College, Lib.). Evelyn began by considering the four elements and especially the constitution of the earth; his treatise continues by reviewing in detail all the horticultural skills and tools required by the gardener to manage the natural elements, the structures by which garden space is created and subdivided (terraces, allees, groves etc) and the devices with which it is diversified and decorated (waterworks, grottoes, pavilions, arbours, topiary work, knots, parterres etc). He proposed also to treat of 'Hortulan Entertainments, Divine, Moral, and Natural, to shew the riches, beauty, wonder, plenty, delight and universal use of a Garden', these being what might be called the metaphysical as opposed to the physical aspects of a garden. Evelyn's agenda for the study of princely or royal gardens has been followed piecemeal ever since. This emphasis on élite examples is perhaps inevitable, since they have always displayed the most complex and sophisticated garden art; it is this type,

moreover, that generally survives. The impulse to create gardens, however, has never been exclusively patrician. Popular or vernacular gardens have always existed, though their transience and the fact that they have usually elicited little contemporary commentary mean that the materials for their study are sparse. Vernacular gardens have acquired a fresh esteem in modern society, in the allotment or victory garden and in the vogue for community garden projects. Their study and that of middle-class gardening extend significantly an understanding of the impulses, forms and significances of high garden art.

2. ICONOGRAPHY AND PHENOMENOLOGY. One of the most frequent, largely art-historical approaches to gardens has been to consider the iconography of aristocratic examples and the patronage system that brought them into being. Some Renaissance and Renaissance-influenced gardens had elaborate programmes or at least clusters of imagery; the most elaborated of these are at the Villa d'Este at Tivoli (*see* TIVOLI, fig. 5), the VILLA LANTE, BAGNAIA (see fig. 1), VERSAILLES (see fig. 2), HET LOO (see fig. 53 below), Stowe and Stourhead (for illustrations *see* STOWE and STOURHEAD). The most frequent impulse of such programmes is ideological, usually a display of the owner's power whereby the skills of technology and art are united with the resources of nature to create a quasi-mythical place. Such achievements may be signalled (as at the Villa d'Este and the Villa Lante) by statues of Pegasus, whose hoof, striking Mt Parnassus,

2. Plan of the gardens at Versailles by André Le Nôtre, 1662–77; from an engraving by Abbé Delagrive, 1746 (Paris, Bibliothèque Nationale)

released the Helicon spring, or Hercules, one of whose labours was to steal golden apples from the legendary Garden of the Hesperides, the relocation of which is implied by Hercules' presence in a real one. Gardens may also announce themes without formulating them as programmes, and the articulation of these in garden terms probably outnumbers occasions on which iconographic programmes occur.

The identification of sacred mystery in specific places intersects with garden art in many cultures and at many periods. The Shinto traditions in Japan, for example, identified deities with specific places, as did Classical traditions of *genius loci*, revived during and sustained long after the Renaissance; Daoist belief locates immortal sages on enchanted islands. The sense of gardens as being special places to be revered may survive even in cultures that have lost other explicit contacts with the sacred. As indicated by literary and poetic testimony, gardens have accommodated a variety of meanings, and their creators, visitors or users have been able to discover in them their own ideas and values.

3. 'THREE NATURES': GARDENS, CULTURAL LANDSCAPES AND WILDERNESS. Italian Renaissance humanists called gardens a 'third nature' incorporating both nature and art. This referred to Cicero's definition of a second nature as one altered by man for utilitarian purposes—the fields, villages, roads, harbours, bridges etc, of what has become known as the cultural landscape. By implication, Cicero also defined a first nature: a primal, unmediated wilderness. Gardens take their place and are best studied in this hierarchy of three natures. The scale of human intervention in the first nature increases in the transition from second to third natures; there is more elaboration, more planning, more art, design and technology within gardens than, for example, within fields or orchards. Furthermore, the garden itself tends to allude to the other natures. By direct imitation, idealization, recreation or even simply by contrast, gardens define themselves and establish their own meaning by comparison with the other two natures.

Sometimes gardens are created directly out of the first nature or wilderness, such as the great Persian hunting parks or *paradeisos*, the technologically sophisticated oases of Mughal gardens in their desert settings, some of the early American colonial gardens in Virginia (e.g. Bacon's Castle and Middleton Place; see fig. 57 below) or those tiny green enclaves visible in paintings of hermit saints in the wilderness. Sometimes, rather than stark juxtapositions to a surrounding wilderness, gardens are an elaboration of a cultural landscape of terraced agrarian land, fields and orchards. This may best be seen in the series of lunettes by Giusto Utens (*d* before 19 April 1609) depicting Medici villas in and around Florence at the end of the 16th century (1599–1602; Florence, Mus. Firenze com'era; see fig. 3; Florence, Sopr. B. A. & Storici Col.). Besides spaces for hunting, farming, growing fruit and vines, there are more sophisticated enclosures and geometrical elaborations of orchards and flower beds; with the introduction of pergolas, waterworks, statuary, grottoes and pavilions in some properties, a triumphant vision of garden art was created. Gardens distinguish themselves from both wilderness and cultural landscapes either by their boundaries or by their more elaborate decoration and concentration of effects or by both.

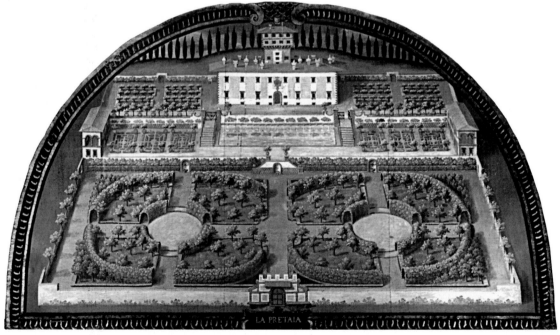

3. Gardens of the Villa Petraia, near Florence, after 1576; from a painting by Giusto Utens, 1599–1602 (Florence, Museo Storico Topografico Firenze com'era)

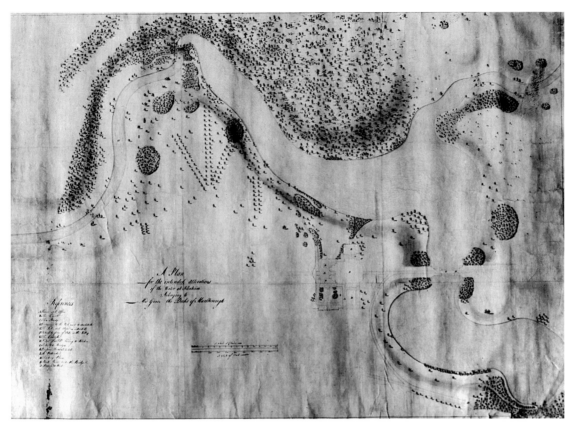

4. Plan of the gardens and park (1764–74) at Blenheim Palace, Oxfordshire, by 'Capability' Brown (Blenheim Palace, Oxfordshire)

The etymology of words for garden confirms their essential characteristic of enclosure. The enclosed area is visibly different from the surrounding land by virtue of the extent, scope and variety of its elaboration and decoration. These effects may be vegetal or architectural, including sculptural and hydraulic. They may be concentrated and massed, as if to represent the fullness of the world outside (e.g. lush herbaceous borders or the profusion of architectural and sculptural elements at Stowe and the Villa Orsini, Bomarzo (for illustration *see* BOMARZO, SACRO BOSCO), or the fountains at the Villa d'Este). The effect may also be minimal or reduced, as if a garden's art consisted in stripping nature of accidents and mere contingency (e.g. the landscapes of 'CAPABILITY' BROWN (see fig. 4) or the sand and stone garden of Ryōanji (*see* KYOTO, fig. 8)).

4. GARDEN DESIGNERS AND LANDSCAPE ARCHITECTS. Since the 19th century in Europe and North America, apart from amateur enthusiasts, landscape architects have created gardens and other landscapes and nursery gardeners have undertaken similar tasks as they had done before the development of landscape architecture as a profession. However, as early as the Ming period (1368–1644), a much respected group of itinerant professionals, trained in painting, applied their artistry to the creation of rock formations in gardens. The training of these Chinese gardenists as painters, however, emphasizes the fact that before trained or professional specialists were available, the art and skills necessary to create gardens were derived from other fields of activity. People from a wide variety of backgrounds, including architects who extended their organization of space to the exterior of dwellings, priests, poets, humanists or similar virtuosi, were called on at various times to design gardens. It is partly the intellectual vision that such amateurs brought to and realized in tangible forms in gardens that authorized the high esteem in which garden art was held in many cultures.

Since the profession of garden designer or landscape architect has become established, there has been an increased tendency to think of their work not as art but as design. However, whenever cultural transfer took place from other arts into gardens, as during the Ming period, their creation was ranked among the highest of artistic achievements. During the high-point of English garden design in the 18th century, for example, both theorists and practitioners argued strenuously for a niche among the fine arts for gardens. They tended to borrow arguments from other visual or literary arts, especially art's claim either to imitate or to perfect nature, in order to boost their prestige. But others, including Antoine Quatremère de Quincy in France and Joshua Reynolds in England, were sceptical of these claims. Reynolds, for example, in his 13th *Discourse* (1786), argued that 'as far as Gardening is an Art, or entitled to that appellation, [it] is a deviation

from nature'; but 'if the true taste consists, as many hold, in banishing every appearance of Art, or any traces of the footsteps of man, it would be then no longer a Garden'. The sheer imagination, invention and ingenuity that have gone into the creation of gardens in many civilizations argue for garden design to be placed among the pantheon of fine arts. In Latin the term *ars toparia* refers not to the craft of shaping vegetation, as does the English word 'topiary', but to the composition of landscapes in which plants are part of both imagery and palette. Gardens are indeed artificial arrangements of space, where manmade and natural elements are arranged deliberately into forms and patterns chosen by man. The search for aesthetic quality and the expression of such abstract concepts as the creation of an 'ideal nature' also argue for the affinity and identification of garden design with other arts. With its fusion of art, culture and nature, the garden has been the form *par excellence* through which human beings have expressed some of their deepest and strongest ideas and emotions.

5. TREATISES AND THEORETICAL WRITINGS. Many early garden features may survive to be studied *in situ*, even though modified in form; changes in gardens wrought by time or human alterations are a fundamental aspect of their existence. Records of garden art, design and technology survive as well in treatises and theoretical handbooks, which are invaluable to the historian as records of a given culture's garden theories and practices. Such treatises have almost invariably and not surprisingly been produced at moments when gardens became prominent in a given culture, when the establishment of gardens was pervasive enough to be celebrated and recorded, or codified so that others could imitate their designs. Both motives, celebration and codification, can be found in texts as various as the Classical writings by Varro and Columella, the 11th-century Japanese *Sakuteiki* ('Records of making gardens'), the 14th-century Andalusian poem by Ibn Luyun on agriculture that deals with horticultural and design elements or the mid-17th-century Chinese text *Yuanye* ('The fusing of gardens') by Ji Cheng. After the Renaissance the development of printing and a growing readership enabled a greater diffusion of such works as the voluminous 19th-century garden writings of JOHN CLAUDIUS LOUDON and Jane Loudon. These manuals were usually composed for and used by a specific readership of garden enthusiasts. In contrast, such literary texts as the *Hypnerotomachia Poliphili* of 1499, though in fact a narrative composition, exercised a wide influence over European garden design during the Renaissance, largely through the illustrations, which were made available in its different language editions, of garden knots (see fig. 5), labyrinths, trelliswork, arbours, fountains and even ruins in the landscape.

During periods when garden design was not only highly regarded but also in the process of evolution, each phase elicited its own theoretical and practical exposition. In France, for example, the focus of the *Praedium rusticum* (1554) by Charles Estienne (1504–64) is as much on agrarian issues as on the third nature of gardens. This emphasis changes with *Le Jardin de plaisir* (Stockholm, 1651) by André Mollet and *Le Théâtre des plans et jardinages*

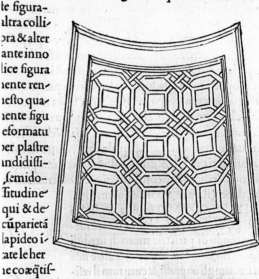

rhombea connodato, cum gli fui anguli ancora, & effi, c perpendiculariamente coniugati, & per tale mutuo có iente quefti uno altro octogonio, nel primo intrufo bel nauano, confotialmente gli noue quadri inclauftrádo.

5. Knot garden; woodcut from *Hypnerotomachia Poliphili* (Venice, 1499)

(Paris, 1652–63) by his father Claude Mollet where the concentration is wholly on the design and elaboration of the pleasure garden. These concerns were in their turn replaced 50 years later in *La Théorie et la pratique du jardinage* (Paris, 1709) by Antoine-Joseph Dezallier D'Argenville (*see* DEZALLIER D'ARGENVILLE, (1)), a formulation of the subsequent development of French garden art under ANDRÉ LE NÔTRE. Again in the later 18th century a new taste in picturesque landscaping was publicized and promoted, and eventually a new eclecticism became codified in the *Plans raisonnés de toutes les espèces de jardins* (Paris, 1819–20) by Gabriel Thouin (1747–1829). Similarly, English designs underwent considerable changes between the late 17th ecntury and the mid-19th; these were accompanied by a succession of treatises that sought to pioneer or to chronicle changing taste in both design and horticultural fashions as well as the availability of materials. Modern handbooks and coffee-table books that purvey glamorous garden imagery for practical or merely wistful emulation extend a tradition well established in Europe by the early 18th century. Furthermore, magazines and other periodical literature on gardens have become, since the 19th century, a staple element in forming garden taste and practice. The coverage and themes of these treatises, manuals and periodicals usefully chart differences in plant availability, garden use, garden vocabulary and syntax, garden techniques and tools and landscape aesthetics.

6. HISTORIOGRAPHY. Many 18th-century treatises undertook a historical overview of garden arts, usually to provide a context for new prescriptions perceived as the culminating point of development. Horace Walpole's *The History of the Modern Taste in Gardening*, published as a separate volume in 1785, is a prime example of this strategy in England, as he set out to prove that the work of William Kent and 'Capability' Brown was the climax of many centuries and many cultures of garden tradition. By the end of the 19th century, there was a fresh impulse to narrate garden history, spurred perhaps by new thinking about the purpose, scope and use of history in general. The most accomplished of such work and the first serious attempt to write a comprehensive survey of the art form was Marie-Louise Gothein's *Geschichte der Gartenkunst* (1914). Histories of garden art continue to be produced and Christopher Thacker's *The History of Gardens* (1979) has had a wide readership in many languages. Garden history lags far behind the visual arts and architecture, however, in achieving a recognizable and reputable method and purpose. While academic training is available in other historical disciplines, the formal study of garden history is nowhere available. Its practitioners therefore necessarily come from other areas and bring to the study of gardens procedures developed in other disciplines. In this respect, the study of garden history is like such other new branches of learning as the histories of urbanism, furniture or material culture. Garden history demands a wide range of expertise, including economic and social history, the history of ideas, patronage, religion, science, technology and engineering, material culture, architectural and botanical history, aesthetics, anthropology and archaeology. The early histories of the museum, theatre and zoo also touch substantially on the role of gardens in given societies. The very complexity of the task has led to less progress than might be hoped. The central challenge for any history is to offer perspectives that other histories do not. If it is allowed that garden art is, above all, the expression of a society's relationship with both space and nature, this holds out the promise that its history can make just such a unique and dynamic contribution.

BIBLIOGRAPHY

EWA: 'Landscape architecture'
G. Sitwell: *An Essay on the Making of Gardens* (London, 1909)
M. L. Gothein: *A History of Garden Art*, 2 vols (Jena, 1914; Eng. trans., London, 1928/*R* New York, 1979)
D. Coffin: *The Villa d'Este at Tivoli* (Princeton, 1960)
A. Marie: *Naissance de Versailles: Le Château, les jardins* (1968), i of *Versailles au temps de Louis XIV* (Paris, 1968–76)
K. Woodbridge: *Landscape and Antiquity: Aspects of English Culture at Stourhead, 1718–1838* (Oxford, 1970)
N. T. Newton: *Design on the Land: The Development of Landscape Architecture* (Cambridge, MA, 1971)
G. Clarke: 'Grecian Taste and Gothic Virtue: Lord Cobham's Gardening Programme and its Iconography', *Apollo*, xcvii (1973), pp. 566–71
Yi-Fu Tuan: *Topophilia: A Study of Environmental Perception, Attitudes and Values* (Engelwood Cliffs, 1974)
B. Henrey: *British Botanical and Horticultural Literature before 1800*, 3 vols (Oxford, 1975)
J. Dixon Hunt and P. Willis, eds: *The Genius of the Place: English Landscape Garden, 1620–1820* (Cambridge, MA, 1975, rev. 1988)
C. Thacker: *The History of Gardens* (London, 1979)
F. H. Hazelhurst: *Gardens of Illusion: The Genius of André Le Nostre* (Nashville, 1980)
J. B. Jackson: 'Gardens to Decipher and Gardens to Admire', *The Necessity for Ruins and other Topics* (Amherst, MA, 1980)
D. Mignani: *Le ville medicee di Giusto Utens* (Florence, 1980)
'Current Bibliography of Garden History', *J. Gdn Hist.*, iii–iv (1983), pp. 347–81
A. Marie and J. Marie: *Versailles au temps de Louis XIV, 1715–1745* (Paris, 1984)
A. van Erp-Houtepen: 'The Etymological Origins of the Garden', *J. Gdn Hist.*, vi (1986), pp. 227–31
G. Jellicoe and S. Jellicoe, eds: *The Oxford Companion to Gardens* (Oxford and New York, 1986)
E. de Jong: 'Het Loo', *The Anglo-Dutch Garden in the Age of William and Mary* (exh. cat., ed. J. Dixon Hunt and E. de Jong; Apeldoorn, Pal. Het Loo; London, Christie's; 1988) [special issue of *J. Gdn Hist.*, viii/2–3, 1988], pp. 144–59
C. W. Moore, W. J. Mitchell and W. Turnbull jr: *The Poetics of Gardens* (Cambridge, MA, 1989)
M. Francis and R. T. Hester jr, eds: *The Meaning of Gardens* (Cambridge, MA, 1990)
E. Harris with N. Savage: *British Architectural Books and Writers, 1556–1785* (Cambridge, 1990)
C. Lazzaro: *The Italian Renaissance Garden: From the Conventions of Planting, Design and Ornament to the Grand Gardens of Sixteenth-century Italy* (New Haven and London, 1990)
J. Dixon Hunt: *Gardens: Theory, Practice, History* (London, 1992)
J. Dixon Hunt, ed.: *The Oxford Book of Garden Verse* (Oxford, 1992)
Garden History: Issues, Approaches, Methods: Dumbarton Oaks Colloquium on the History of Landscape Architecture, xiii: Washington, DC, 1992
J. Goody: *The Culture of Flowers* (Cambridge, 1993)
The Vernacular Garden: Dumbarton Oaks Colloquium on the History of Landscape Architecture, XIV: Washington, DC, 1986

JOHN DIXON HUNT

II. Ancient world.

There is sufficient evidence to confirm that the garden formed a constituent of all the ancient civilizations around the eastern half of the Mediterranean. These civilizations, supported by great rivers and seas—the Tigris, Euphrates and the Nile, and the Mediterranean, Adriatic and Aegean—grew up in a climate ranging from hot and arid to warm and dry. The climatic variation corresponds to geographical differences, from the alluvial plains of Egypt and Mesopotamia to the higher plains and hills of Syria–Palestine, to the more mountainous and variegated landscape of the peninsulas and islands of Greece and Italy.

Over this geographical range there is a remarkable degree of similarity in the general form of the ancient garden. There is the small enclosed or courtyard garden of the Assyrians and Egyptians, the *kepos* of the Greeks and the *hortus* of the Romans. Often directly associated with a dwelling, palace or temple, the fundamental elements of these small gardens were an enclosure wall and rows of trees or other planting surrounding a central pool or water feature. Hanging gardens existed both in Babylon and in the Pre-Columbian city of Tenochtitlán. Another common form of garden was the park or *paradeisos*, the province of kings and great men. These were large areas enclosed by walls and extensively planted with fruit trees and ornamental plants. They also often contained game for hunting and pavilions in which to find relief from the heat and sun. In the *paradeisos* water was an essential element, serving the necessary utilitarian function of irrigation but also providing added relief from heat as well as aesthetic pleasure. Written sources suggest that water also had considerable symbolic import as the source of life. Equally, the tree was a potent symbol and both the river and tree or orchard appear in the myths and legends of ancient civilizations, particularly as elements in creation and the afterlife.

The differences between gardens from different areas and periods of antiquity, either as depicted or known from archaeological evidence, are as remarkable as the similarities. The elaboration of forms in the Roman gardens is startling in comparison with the depictions of the relatively simple Assyrian or Egyptian gardens. Yet still there is the enclosure, the rows of plants and water. With so little evidence, however, even such general statements must remain guarded. Equally, the question of origins must be approached with caution. Whether the similarity of form is due to dispersion from a single source or to separate development is not a question that can be answered with certainty.

K. S. KROPF

1. Ancient Near East. 2. Egypt. 3. Greece. 4. Rome. 5. Pre-Columbian Americas.

1. ANCIENT NEAR EAST. Few actual gardens have survived, but their appearance may in some measure be reconstructed from wall paintings and reliefs, and from lists of plants and descriptions in the texts. The biblical Garden of Eden, traditionally set at the confluence of the Tigris and Euphrates rivers in southern Iraq, reflects a blooming of the desert made possible by the invention of irrigation agriculture *c.* 5000 BC. Throughout the Ancient Near East the larger houses and palaces probably had courtyard gardens, much as today. They would have produced herbs used in cooking as well as flowers; shrubs and small trees would have served to give shade, retain moisture and keep the surrounding rooms cool. The archives from the 18th-century BC palace at Mari refer to a palm court, and a Mari wall painting (Paris, Louvre) shows a doorway framed by palm trees from which dates are being harvested (*see* SYRIA-PALESTINE, fig. 10).

From at least the 3rd millennium BC agrarian festivals were held in the countryside, by a waterway. A building set up especially for the celebration of the Mesopotamian New Year festival, the *bit akitu*, was excavated outside ASSUR in Iraq. At the time of the Assyrian king Sennacherib (*reg* 704–681 BC), it stood at the end of a garden on either side of which were arcades. There was an axial processional way lined four rows deep with flowering shrubs or small trees, probably pomegranates. There were also gardens outside the *bit akitu*; altogether there were holes for some 16,000 plants linked by irrigation channels. Texts state that Sennacherib moved the Assyrian capital to Nineveh and surrounded it with hunting parks, gardens and orchards in which he placed exotic plants brought from various parts of his empire. They would have been placed in rows to facilitate irrigation. Reliefs (London, BM) show columned pavilions standing by streams, and lilies and vines growing among palm trees. A later king, Assurbanipal (*reg* 668–627 BC), is shown relaxing under a vine-covered trellis in the harem while the head of one of his enemies hangs in a nearby tree (London, BM; for illustration *see* ASSYRIAN). In order to provide Nineveh with an adequate water-supply, Sennacherib constructed dams in the mountains to the north-east and diverted rivers into aqueducts, one of which has been found at Jerwan. On the cliffs at Hinis, the site of one of the dams, Sennacherib carved rock reliefs which were incorporated into landscaped gardens linked by an arch cut out of the rock. The 6th-century BC

Hanging Gardens of BABYLON were one of the Seven Wonders of the ancient world. A series of vaulted chambers in the palace may have supported its terraces; alternatively, terraced gardens could have overlooked the Euphrates, or the various levels of the ziggurat (temple tower) may have been landscaped. In a lecture in 1992, Stephanie Dalley suggested convincingly that Sennacherib's gardens at Nineveh were the origin of the Hanging Gardens (see Dalley, 1993).

Excavations at Pasargadae in Iran show that the Achaemenid king Cyrus the Great (*reg* 559–530 BC) endowed his new capital with well-irrigated gardens, bridges and pavilions. The evidence suggests that this was the prototype not only for the Persian *paradeisoi* (from which the word paradise derives) but also for some Islamic gardens (*see* §V below).

RLA

BIBLIOGRAPHY

W. Bachmann: *Felsreliefs in Assyrien*, Wiss. Veröff. D. Orient-Ges., 52 (Leipzig, 1927/*R* Osnabrück, 1969)
W. Andrae: *Das wiedererstandene Assur* (Leipzig, 1938, rev. Munich, 1977)
W. al-Khalesi: *The Court of the Palm: A Functional Interpretation of the Mari Palace* (Malibu, 1978)
J. Reade: 'Studies in Assyrian Geography: Sennacherib and the Waters of Nineveh', *Rev. Assyriol.*, lxxii (1978), pp. 47–72, 157–80
E. Bleibtreu: *Die Flora der neuassyrischen Reliefs* (Vienna, 1980)
J. Margueron: 'Du nouveau sur la Cour du Palmier', *Mari Annales de Recherches Interdisciplinaires*, v (Paris, 1987), pp. 463–82
D. Stronach: 'The Royal Garden at Pasargadae: Evolution and Legacy', *Archaeologica Iranica et Orientalis: Miscellanea in honorem Louis Vanden Berghe* (Leuven, 1989)
——: 'The Garden as a Political Statement: Some Case Studies from the Near East in the First Millennium BC', *Bull. Asia Inst.*, n.s. 4 (1990), pp. 171–80
S. Dalley: 'Ancient Mesopotamian Gardens and the Identification of the Hanging Gardens of Babylon Resolved', *Gdn Hist.*, xxi (1993), pp. 1–13

DOMINIQUE COLLON

2. EGYPT. The typical form of the ancient Egyptian garden was already established in the Old Kingdom (*c.* 2575–*c.* 2150 BC), when, for example, tomb inscriptions of high-ranking officials sometimes included descriptions of the digging of a pool and the planting of trees as an integral part of founding a household. The essential elements of a modest garden include a central rectangular pool (deep enough to be filled by ground-water), surrounded by plants growing on its banks, one or more rows of trees and a rectangular enclosure wall with a single entrance, which, ideally, led directly from the house. A pool of sufficient size might allow lotuses to grow and might provide a home for fish or even water-fowl (*see* EGYPT, ANCIENT, fig. 7). More expansive gardens were made either by simply creating a larger pool and additional rows of trees or by the roughly symmetrical duplication of self-contained gardens. Garden pavilions occasionally featured in larger gardens, and, on the grandest scale, a boating-trip occurred in the garden of the royal palace, as is known from an ancient literary source.

The basic idea of the Egyptian garden underwent little change, though some developments can be detected, especially during the Amarna period (*c.* 1353–*c.* 1332 BC) and during the Greco-Roman Period (332 BC–AD 395), when foreign ideas and plants were introduced. Many features were determined by the climate. Primarily designed as a pleasant setting for private and domestic relaxation, the garden had to provide shade from the sun

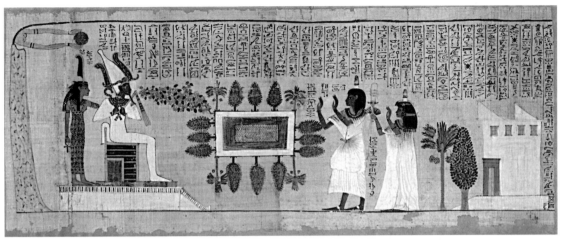

6. Egyptian garden of the royal scribe Nakhte, consisting of a pool and fruit trees in front of his house; illustration from the Book of the Dead papyrus, 350×880 mm, 18th Dynasty, *c.* 1400 BC (London, British Museum)

while catching the cooling northern breeze that blows for most of the year. Constant irrigation was needed from the pool (although larger, well-established trees might directly tap the ground-water), for gardens, like the houses they usually adjoined, were not allowed to occupy good, irrigated agricultural land; nor were they placed in a position that risked obliteration by each year's inundation of the Nile. Surrounding walls not only gave privacy and kept out animals, they also protected against the occasional desert winds and the encroaching sand.

The sources for the Egyptian garden are not plentiful, and they are weighted in favour of the upper strata of society. Literary references are revealing but few, and documentary evidence is very scarce. What little can be learnt from excavation tends to concern atypical, chiefly desert, sites (e.g. the fortress of Mirgissa in Nubia). The most abundant sources of information are the gardens shown in wall paintings in private tombs of the New Kingdom (*c.* 1540–*c.* 1075 BC; *see* WALL PAINTING, colour pl. I, fig. 1) and on funerary papyri (see fig. 6). The funerary nature of this evidence poses a problem: it is not just that funerary ceremonies are sometimes shown taking place in gardens; almost every aspect of these scenes is capable of a symbolic interpretation. The pool with its ground-water was Nūn, the primeval water from which creation began. All the contents of the garden may be seen to have a symbolic connection with creation, regeneration or rebirth, from the most obvious instance, that of the lotus, to the largest trees at the edge of the garden. The range of plants and trees represented, although considerable (among the commonest plants were the poppy, cornflower and mandrake, and, for trees, the sycamore fig, a variety of palms, the vine, persea and pomegranate), is perhaps confined to those with some symbolic or magical role. It is also true that the same contents are virtually all useful: the trees all bear fruit, the fish and birds are edible, and the plants were in regular use for garlands and floral displays. However, the regular vegetable crops, which clearly formed an important part of the economy, were not shown. It is reasonable to suppose that, much as in modern Egypt,

vegetable cultivation usually took place among other crops on prime cultivated land.

While the typical enclosed Egyptian garden formed an important part of the Egyptian house, trees, set in pits or containers (and thus requiring constant watering), were also used in more public places, particularly the forecourts of palaces and temples. The most famous example is the planting of regular rows of tamarisks and sycamores, each accompanied by a statue of the king, in front of the mortuary temple of Mentuhotpe III (*reg c.* 1957–*c.* 1945 BC) at Deir el-Bahri in western Thebes. Such arrangements of trees were especially appropriate on higher ground where the ground-water was not accessible by a pool. Excavations at el-Amarna have revealed combinations of typical pool gardens and plantings of trees. Grander schemes, such as the canals and lakes that accompanied palaces and temples, fall more within the scope of architecture than of gardens.

See also EGYPT, ANCIENT, §XVII, 7.

BIBLIOGRAPHY
LÄ: 'Garten', 'Gartenanlage, -bau', 'Gartenzimmer'
L. Keimer: *Die Gartenpflanzen im alten Ägypten*, i (Hamburg, 1924); ii (Mainz, 1984)
A. Badawy: *Le Dessin architectural chez les anciens Egyptiens* (Cairo, 1948)
M. Hammad and H. F. Werkmeister: 'Haus und Garten im alten Ägypten', *Z. Ägyp. Spr. & Altertknd.*, lxxx (1955), pp. 104–8
D. Hennebo: 'Betrachtungen zur altägyptischen Gartenkunst', *Archv Gtnbau*, iii (1955), pp. 175–218
M.-F. Moens: 'The Ancient Egyptian Garden in the New Kingdom: A Study of Representations', *Orient. Lovan. Period.*, xv (1984), pp. 11–53
J. [R.] B[aines] and H. W[hitehouse]: 'Egypt, Ancient', *The Oxford Companion to Gardens*, ed. G. Jellicoe and others (Oxford, 1986), pp. 155–8
L. Manniche: *An Ancient Egyptian Herbal* (London, 1989)

W. J. TAIT

3. GREECE. Little is known about Bronze Age Greek gardens, but the love of plants can be seen in the skilfully depicted flowers and trees in frescoes (e.g. at Knossos and Akrotiri) and on both utilitarian and ornamental pottery. The farm gardens described in Homeric epic reflect the simplicity of Bronze Age life. King Laertes toiled in his garden (*Odyssey* XXIV.205–7, 244–7) and taught the young Odysseus to garden by giving him a row of fruit trees and

vines (*Odyssey* XXIV.336–44). Similarly, the palace garden of Alkinoos was really a smallholding with an orchard, a vineyard and vegetable beds watered by a nearby spring. Sacred groves are also frequently mentioned, and the description of the Sanctuary of the Nymphs at Ithaka (*Odyssey* XIII.102–12) prefigures the nymphaea that were popular in later Greek and Roman gardens.

It is not until Classical and Hellenistic times that gardens can be considered on the basis of fuller information, and their importance is clear, both from literary allusions and from the many references to *kepoi* in property inscriptions and Egyptian papyri. The term *kepos* usually designated a food-producing garden, applying not only to vegetable gardens, but also to orchards and vineyards, though it was sometimes used of planted groves and parks, and even funeral gardens. Temples frequently owned food-producing *kepoi*, which they rented out for revenue. Inscriptions document the production from *kepoi* owned by the cult of Apollo on Delos, Mykonos and Rheneia. *Kepoi* were never connected to dwellings in the cities, and most gardens were located in suburban or rural areas. There was little space in the crowded Greek towns for either private or public gardens; the small central courtyard of a Greek house was usually paved or of beaten earth, not planted. The city-dweller did not have far to go, however, to his suburban or country farm garden, many of which were located near a stream or river outside the city. Within the city, shade and greenery were confined to public places, such as the agora or an occasional sanctuary near a source of water. Kimon planted plane trees along the walks in the Athenian Agora after its destruction by the Persians (480/479 BC). Outside the city walls the famous Athenian gymnasia and 4th-century BC philosophy schools were located in well-watered suburban parks. However, parks were concentrated in specific areas within the city in the more spacious Hellenistic cities outside Greece itself, such as Alexandria and Daphne, near Antioch.

Archaeological evidence for Greek gardens is extremely sparse. In the Athenian Agora planting holes for trees or shrubs were found around the Altar of the Twelve Gods (521 BC; rebuilt late 5th century BC), and along the south side of the Hephaisteion two rows of cuttings in the rock containing planting pots preserve traces of a temple garden of Hellenistic and early Roman date (*see* GREECE, ANCIENT, fig. 36).

4. ROME. The evidence for Roman gardens is much more plentiful. Their importance is clear from numerous references by ancient authors, including several detailed descriptions of ornamental gardens, such as those in Pliny the younger's Laurentine and Tuscan villas, as well as agricultural manuals by Cato, Varro and Columella with specific instructions for planting and caring for vegetable and flower gardens, orchards and vineyards. It is, however, the abundance of archaeological evidence that has made close study of Roman gardens possible. Pompeii, Herculaneum and the neighbouring Campanian villas, preserved by volcanic deposits from the eruption of Vesuvius in AD 79, provide the most extensive remains. Examination of these sites has shown that the garden was intimately related to many aspects of Roman life, influencing such diverse areas as architecture, painting, sculpture, urban

planning, economics, religion, work and recreation. Gardens were associated with both public and private buildings: almost every house had one, and the more elegant houses might have three or four.

The earliest Roman gardens were normally to the rear of the house and, though they were simple plots, formed a significant part of any family's inheritable wealth. In the 2nd century BC, when the Hellenistic peristyle was added to the rear of the Italic atrium house, it did not retain its Greek form as a paved court, but was transformed into a garden. The houses at Pompeii and Herculaneum belong to two categories. The most important were of atrium-peristyle form, with one or more peristyles, which might have a portico on from one to all four sides; sometimes there was an additional garden plot at the rear. Some houses, such as the recently excavated mansion of Fabius Rufus built over the western city wall during the Imperial period, even had impressive roof gardens overlooking the Bay of Naples. Seneca the younger spoke sarcastically of such gardens, planted with trees with their roots where the roofs ought to be. There were also many smaller houses of irregular plan. Some too small to incorporate gardens had only a tiny light well that contained plants. In some Roman gardens, a few vegetables and herbs were cultivated with ornamental shrubs and flowers.

There has been much speculation as to the actual schemes of planting. The careful removal of volcanic

7. Roman peristyle garden with fountain statuettes, House of the Vettii, Pompeii

debris from the cavities formed as roots decayed, which can then be filled with cement to reveal the shape of the roots, and the excavation of ancient soil contours have provided vital evidence of planting patterns. Ancient pollen, carbonized stems and roots, seeds and fruit can also indicate which plants were grown. Carbonized bacteria and insects give further information.

In early Pompeian houses the only water source for all domestic purposes was a rainwater cistern. Consequently, their peristyles were generally planted with trees, which required little watering. The peristyle garden in the House of Polybius contained five large trees, a row of smaller trees (which appear to have been espaliered) along the west wall, as well as several smaller trees and numerous shrubs. When the Augustan aqueduct which supplied this area was built, the sudden abundance of water greatly altered the appearance of gardens. Low ornamental plantings requiring regular watering became popular, and pools, fountains and nymphaea, such as those in the House of the Little Bull, the House of the Anchor and the so-called House of Loreius Tiburtinus or Octavius Quartio became an important part of the garden. The pool became a natural focal-point for garden design. Pools were painted blue inside and sometimes decorated with representations of water plants and fish; in the centre there was often a fountain jet. Small garden sculptures, mostly of marble but sometimes of bronze, also became prominent garden ornaments. Wealthy Romans eagerly sought Archaic or Classical Greek statuettes, though since originals were difficult to obtain, copies and adaptations were mass-produced. In the House of the Vettii (see fig. 7) water from twelve fountain statuettes jetted into marble basins standing in the water channel around the edge of the garden, and two simple fountains stood within the garden itself. The finest display of garden sculpture was found in the Villa of the Papyri at Herculaneum (mid-1st century BC); the luxurious villa at Oplontis near Pompeii had a huge swimming pool around which were numerous statuettes and two herms of *Hercules*. Richly decorated garden furniture was also found in many gardens. Peristyle gardens were occasionally enclosed by a low masonry wall, but more often by a fence of wood or reeds.

Information from ancient authors, together with archaeological evidence of planting patterns, reveals that even when more plentiful water supplies made formal herbaceous plantings possible, trees were still valued for their shade. Pliny the younger's Tuscan villa had a courtyard garden crowded with four trees in the old-fashioned manner, but it also included a portico looking out on a formally planted garden with bordered walks, beds of various shapes edged with box, hedges and a wide variety of topiary work (Pliny: *Letters* V.vi). The plants most often cited in connection with formal gardens, usually belonging to villas, are ivy, clipped box, laurel, myrtle, acanthus and rosemary. The emphasis was on greenery, and the main plants were evergreen, though their blooms were also valued. Amid the greenery, in season, there would be the profusion of white flowers of the myrtle, the greenish-yellow blossoms of the ivy, the white clusters of the viburnum, the stately Madonna lily and accents of colour when the rose and the violet were in flower. Roses

8. Flowering oleander and myrtle depicted in a Roman garden painting, House of Venus Marina, Pompeii, AD 62–79

and violets are the garden flowers most frequently mentioned by ancient authors. Oleander was rarely cited, but archaeological evidence shows that it was used in the sculpture garden along the pool at Oplontis. The plants depicted in the paintings of gardens that decorated many a garden wall to make a small garden appear larger are a unique source of information about ancient plants and birds (e.g. in the House of Venus Marina, Pompeii; see fig. 8; *see also* ROME, ANCIENT, fig. 85, and WALL PAINTING, colour pl. I, fig. 2). Oleander, the most frequently depicted plant, is often shown behind the garden fence, amid luxurious and unconstrained vegetation, but it is also shown as a specimen plant. Some garden walls had huge paintings of wild animals, presumably as references to the wild beast parks incorporated into the estates of many wealthy Romans, both in Italy and in the provinces, by the 1st century AD. Fish-ponds occur in some garden paintings and were no doubt considered desirable features. Roman householders bred fish both as pets and for the table: one Roman matron even bought earrings for her pet eel.

The multiple role of the garden in daily life, as suggested by the evidence preserved around Vesuvius, was as a place to work, to play, to keep domestic pets, to dine, as a family or with guests, and to worship the gods. There were gardens connected to public spaces such as fora and in

temples, palaestras and baths, as well as shops, inns and schools. There were also many large cultivated areas inside Pompeii itself, including vineyards, orchards, market gardens and a large commercial flower garden, and the tombs along the roads leading into the city had many gardens.

Elsewhere in Italy and throughout the Roman provinces the evidence for gardens is much more limited, but the same types occur. Excavations at the Roman colony of Cosa (founded 273 BC) revealed that the colonists planted eight trees at the south-east end of the forum to provide shade for the citizen assembly. The original house plots at Cosa were narrow strips divided about equally between the dwelling and the garden at its rear, but by the 1st century BC one prosperous inhabitant had acquired five house plots and built a beautiful ornamental garden complete with a pool.

Rome was famous for its gardens, both public and private. The names of 70 luxurious private *horti*, belonging to emperors and rich men, are known from literature and inscriptions, and, from the Renaissance until the present day, their remains have yielded many works of art. Excavations at Hadrian's Villa at Tivoli have uncovered terraced gardens in the Canopus area, which had a lavish nyphaeum at one end, with prize shrubs or trees planted in broken amphorae, as well as rock-cut planting pits around the edge of the Piazza d'Oro that had been cut into the tufa to accommodate shrubs or trees. Similar rows of rock-cut planting pits were found in the garden of the 3rd-century BC temple at nearby Gabii. On each side of the Euripus in the Piazza d'Oro at Tivoli which also had a nymphaeum at the rear, excavation has revealed a complex underground irrigation system. Numerous rural villas have recently been excavated throughout Italy, for example that at Boscoreale, near Pompeii, in the locality of Villa Regina, where a vineyard and a small vegetable garden were found. At Settefenestre, near Cosa, a large, late Republican villa and farm had a peristyle garden and terraced gardens.

Excavations show that Romans who settled in the provinces tried, if the climate permitted, to reproduce as nearly as possible traditional Italian gardens, and that these were imitated by the native aristocracy. Few provincial Roman gardens have been carefully explored, but many are recognizable simply from their architectural context. In Britain, at the luxurious Flavian villa at Fishbourne, four different types of gardens were found, and subsoil excavation of the large formal garden in the central court uncovered bedding trenches cut in the hard clay and gravel and filled with top soil, revealing the ancient planting pattern. At Mountmaurin (mid-1st century AD onwards), one of the largest villas in Gaul, beds of dark compost marked the plantings in the gardens of the semicircular entrance courtyard and the central courtyard. The Portico of Pompey, a public garden presented by a wealthy citizen to the town of Vasio Vocontiorum (now Vaison-la-Romaine) in southern Gaul, was a public promenade and pleasure park surrounded by a wall with niches containing many fine statues (see fig. 9). At Lugdunum (now Lyon) and at nearby Vienna (now Vienne) the U-shaped pools found from the end of the 1st century AD or beginning of the 2nd to *c.* middle of the 2nd century in the peristyle gardens appear to be a local innovation never adopted

9. Niche in garden wall with a statue of the *Diadoumenos* type in the Roman public garden known as the Portico of Pompey, Vasio Vocontiorum (now Vaison-la-Romaine, France)

elsewhere. Water was a prominent feature of private gardens at Conimbriga in Portugal. The House of the Jets of Water takes its name from the 400 jets in the magnificent peristyle garden with elaborately curved planting beds. The town also contains a stadium-like garden (AD 98–117), connected with the Trajanic Baths, of a type well known in Italy (e.g. Domitian's garden on the south-east side of the Palatine Hill at Rome, AD 81–96; and the Stadium Garden in Hadrian's Villa at Tivoli). In the eastern Empire, careful excavations in the gardens of Herod the Great's winter palace at Jericho (late 1st century BC) have yielded significant information about their planting patterns. North African provinces offer one of the most promising fields for investigation, since larger residential areas have been excavated there than anywhere else in the Roman Empire outside Italy. Preliminary excavations at Thuburbo Maius in Tunisia uncovered well-preserved evidence of beautiful domestic gardens as well as a temple garden. Semicircular pools, often decorated with fish mosaics, occur frequently in Tunisian gardens. In the northernmost regions of the Empire, where it was too cold for peristyle or courtyard gardens, few gardens have been excavated. At the military stronghold of Carnuntum, near Vienna, however, a row of houses (mainly 3rd century AD) with gardens at the rear has been explored.

BIBLIOGRAPHY

D. B. Thompson: 'The Garden of Hephaistos', *Hesperia*, vi (1937), pp. 396–425
P. Grimal: *Les Jardins romains* (Paris, 1943, rev. 3/1984)
D. B. Thompson: *Garden Lore of Ancient Athens* (Princeton, 1963)
N. Neuerburg: 'L'architettura delle fontane e dei ninfei nell'Italia antica', *Mem. Accad. Archeol., Lett. & B.A. Napoli*, n.s. v (1965)

W. F. Jashemski: *The Gardens of Pompeii, Herculaneum and the Villas Destroyed by Vesuvius*, i and ii (New Rochelle, NY, 1979) [good illus.]

A. Hoffman: *Das Gartenstadion in der Villa Hadriana* (Mainz, 1980)

Ancient Roman Gardens: Dumbarton Oaks Colloquium on the History of Landscape Architecture, VII: Washington, DC, 1981

Ancient Roman Villa Gardens: Dumbarton Oaks Colloquium on the History of Landscape Architecture, X: Washington, DC, 1987

K. Gleason: 'Garden Excavations at the Herodian Winter Palace in Jericho, 1985–7', *Bull. Anglo-Israel Archaeol. Soc.*, vii (1987–8), pp. 21–39

M. Carroll-Spillecke: *KIPOS: Der antike griechische Garten* (Munich, 1989)

——: 'The Contribution of Archaeology to the Study of Ancient Roman Gardens', *Garden History: Issues, Approaches, Methods: Dumbarton Oaks Colloquium on the History of Landscape Architecture, XIII: Washington, DC, 1992*

W. F. Jashemski and E. Salza Prina Ricotti: 'Preliminary Excavations in the Gardens of Hadrian's Villa: The Canopus Area and the Piazza d'Oro', *Amer. J. Archaeol.*, xcvi (1992), pp. 579–97

W. F. Jashemski: 'Roman Gardens in Tunisia: Preliminary Excavations in the House of Bacchus and Ariadne and in the East Temple of Thurburbo MAIVS', *Amer. J. Archaeol.*, xcix (1995)

WILHELMINA F. JASHEMSKI

5. PRE-COLUMBIAN AMERICAS. Both Aztecs and Incas made formal gardens with collections of plants and animals from local and distant parts of their empires. These were landscaped and provided with walkways, terracing, irrigation systems, fountains and artificial ponds for birdlife as well as planting. Commoners used their courtyards, roofs and pots to grow flowers, fruits and vegetables, and plants and herbs used in ritual and healing.

Descriptions of gardens in and around Tenochtitlán and Cuzco are contained in codices and chronicles written before or at the time of the Spanish Conquest. It is known, for example, that the *chinampas* (manmade island plots in lakes) of Tenochtitlán supplied flowers and fresh vegetables; and that the suburb of Xochimilco was literally 'the place of the field of flowers'. Before planting, seedlings were carefully nurtured in nursery beds. Cortés described gardens along the streets of Tenochtitlán and the 'hanging' roof gardens of palaces. Motecuhzuma II's gardens at Iztapalapa were both botanical and zoological, with systematically grouped species. Similarly, the native Ixtlilxochitl described the Texcoco gardens of Nezaualcoyotl. Both kings also had country palaces with gardens, such as Motecuhzuma's at Huaxtepec, with tropical species and 40 Native American families from the plants' homelands as caretakers. According to the chronicler Garcilasso, the gardens of the Inca kings at Yucay, near Cuzco, were irrigated, landscaped and planted with an abundance of trees and flowers from throughout the empire.

From these few literary sources, it can be surmised that contemporary peoples elsewhere in Mesoamerica and the Andes also had gardens. How far back into pre-Aztec and pre-Inca times such assumptions can be projected is uncertain. For example, trees whose bark or resin was used in ceremonies were grown around élite residences in Maya cities; and Maya households maintained kitchen gardens for vegetables, fruit, spices and medicinal plants. The regular plans of Chan Chan and Purgatorio in Peru may also have provided garden plots within the cities.

BIBLIOGRAPHY

W. H. Prescott: *The Conquest of Mexico* (New York and London, 1843/*R* London, 1909)

——: *The Conquest of Peru* (New York and London, 1847/*R* London, 1908)

J. Soustelle: *La Vie quotidienne des Aztèques à la veille de la conquête espagnole* (Paris, 1955; Eng. trans., London, 1961)

W. Bray: *Everyday Life of the Aztecs* (London, 1968)

M. P. Weaver: *The Aztecs, Maya and their Predecessors: Archaeology of Mesoamerica* (New York, 1972, rev. 2/1981)

H. Silvester and J. Soustelle: *Land of the Incas* (London, 1986)

DAVID M. JONES

III. Byzantine lands.

The importance of gardens during the Byzantine period can be inferred from texts, inscriptions, images and, to a lesser extent, excavations. While descriptions tend to follow formulaic patterns set by Libanios in the 4th century AD, garden imagery is more various and includes agricultural scenes, portraits of individual plants and garden landscapes. Byzantine authors extolled the idyllic delights of gardens, which seem to have been a commonplace of the urban landscape. The *Geoponika*, a 10th-century manual on farming and horticulture, prescribes gardens around houses, and that spaces between trees be filled with roses, lilies, violets and crocuses. Images as diverse as the apse mosaic at Herakleia Lynkestis (now Bitolj; *c.* 500) and a 12th-century miniature (Mt Athos, St Panteleimon, Cod. 6, fol. 37*v*) accompanying the sermons of St Gregory of Nazianzus (329–89) suggest that this latter prescription accorded with actual practice, while a mosaic (*c.* 400) from Tabarka (Tunisia) depicts a villa amid trees and trained grapevines. Palaces and villas contained numerous images of gardens. A description by Theophanes Continuatus, for example, mentions how a 10th-century emperor turned a room in the Great Palace at Constantinople 'into a blooming and sweet smelling rose garden by means of minute, variegated mosaic cubes imitating the colours of freshly opened flowers'. Garden vistas in mosaic preserved from the early 8th century in the Great Mosque at Damascus, and from the 12th at the Palazzo dei Normanni in Palermo, both indebted to Byzantine examples, corroborate and illustrate the descriptions.

Garden imagery in religious settings ranged from the superficially secular to visions of paradise. The 6th-century decoration of Hagia Sophia in Constantinople and of St Stephen at Gaza included landscape motifs divorced from any overt religious meaning and, apparently, it was only motifs such as these that the iconoclasts allowed to remain in churches under their control during the iconoclastic controversy (*c.* 730–843). As Maguire (1987) demonstrated, however, seemingly innocuous garden images, such as those at Herakleia Lynkestis and, slightly later, the basilica of Doumetios at Nikopolis, often represent the terrestrial world created by God. The Byzantines also represented paradise as a garden. Examples are found in the 6th-century Genesis manuscripts such as the Vienna Genesis (Vienna, Österreich. Nbib., Cod. theol. gr. 31), mosaics in S Apollinare in Classe at Ravenna, the Middle Byzantine *Homilies* of the monk James of Kokkinobaphos (e.g. Paris, Bib. N., MS. gr. 1208) and the 14th-century wall paintings at Dečani Monastery. Gardens also appear in biblical narrative scenes, especially in images of the Annunciation, for Christ's incarnation heralded a spring-like renewal and the date established for the event, 25 March, neatly coincided with the first day of Byzantine spring. Plants sprout from the headpieces and borders of

manuscripts in such profusion that 'flower-petal ornament' has become a standard descriptive term in Byzantine manuscript studies. Botanically accurate images of plants also appear in herbals, of which the most popular was Dioskurides' *De materia medica* (Vienna, Österreich. Nbib., Cod. med. gr. 1).

BIBLIOGRAPHY

C. Singer: 'The Herbal in Antiquity and its Transmission to the Later Middle Ages', *J. Hell. Stud.*, xlvii (1927), pp. 1–52
K. Weitzmann: *Die byzantinische Buchmalerei des 9. und 10. Jahrhunderts* (Berlin, 1935)
G. Galavaris: *The Illustrations of the Liturgical Homilies of Gregory of Nazianzenus* (Princeton, 1969)
S. Pelekanides and others: *The Treasures of Mount Athos: Illuminated Manuscripts*, 2 vols (Athens, 1973–5)
H. Maguire: *Art and Eloquence in Byzantium* (Princeton, 1981)
——: *Earth and Ocean: The Terrestrial World in Early Byzantine Art* (University Park, 1987)
C. Barber: 'Reading the Garden in Byzantium: Nature and Sexuality', *Byz. & Mod. Gr. Stud.*, xvi (1992), pp. 1–19
L. Brubaker and A. Littlewood: 'Byzantinische Gärten', *Der Garten von der Antike bis zum Mittelalter*, ed. M. Carroll-Spillecke (Mainz, 1992), pp. 213-48

LESLIE BRUBAKER

IV. Indian subcontinent.

Climate, religion and politics have all influenced the style and development of the gardens of the Indian subcontinent. The region as a whole enjoys a monsoon climate, but there are wide variations in rainfall (from less than 10 cm to more than 320 cm annually) and in the possibilities for irrigation. The north, with the Indus, Ganga and Brahmaputra rivers and their tributaries, receives water from the melting snow of the Himalayas and the monsoons. Peninsular India, however, derives its water almost entirely from the monsoon rains and during the hot season even its largest rivers are almost dry. Such seasonal fluctuations in water-supply as well as the subcontinent's varied topography determine the type of garden that can be created. Religion and politics (for a brief overview *see* INDIAN SUBCONTINENT, §I, 2 and 7) are often inseparable and both are reflected in the division of gardens into four main categories: early Hindu/Buddhist, Islamic, British–Indian and modern.

Little survives of early gardens, but texts indicate that the gardens of Hindu and Buddhist kings and nobles reflected a similar culture and exhibited few, if any, differences. By *c.* 1200 parts of north India were ruled by Muslims, who brought with them a strong garden tradition. By the end of the 17th century even Hindu rulers were laying out 'Islamic-style' gardens. The coming of Europeans, and most importantly the British, also influenced Indian garden design. The British–Indian garden style was utilized mainly within the confines of the British community, and its influence was not felt within the Indian community until the early 1900s when young Indians educated in Britain and familiar with British gardens turned to this style on their return to the subcontinent. The Islamic garden remained essentially a single style with variations resulting from geography and climate, while British gardens reflected trends 'at home'. In the 20th century a mixture of Islamic, British, Buddhist and Japanese garden styles, either separately or combined, have flourished in the subcontinent. While the popular view of Indian gardens sees only the Mughal gardens of Kashmir and the Taj Mahal, these are only part of a much larger and more complex garden history that has its roots in the early centuries of the subcontinent's cultural history.

1. Early Hindu/Buddhist, before *c.* 1200. 2. Islamic, *c.* 1200–*c.* 1800. 3. British–Indian and modern, *c.* 1800 and after.

1. EARLY HINDU/BUDDHIST, BEFORE *c.* 1200. Like later Islamic gardens (*see* §2 below), early Indian gardens often reflect a religious vision of paradise, in this case the paradises of Hindu mythology with their centre at Mt Meru in the Himalayas. Svar-loka or 'bright-realm', where the deities live and are joined by their devoted followers until it is time for their next reincarnation, is a place of jewelled palaces with golden pathways, acres of green grass and bowers of sweet-scented flowers. Svar-loka is composed of a number of different paradises, each associated with a particular god. Indra-loka or Svarga, the heaven of Indra, is on the north side of Mt Meru and is inhabited by *asparāsa*s and *gandharva*s (celestial musicians). It contains Indra's palace, surrounded by a garden named Nandana. Krishna's paradise, Golaka, is filled with groves and bowers. Alaka, the paradise of Kubera, god of wealth, contains his garden called the Chaitra-ratha while Mt Suparsva has a celestial grove called Vaibhraja.

The dominant theme in all these celestial gardens is their trees, many of which are sacred. In Indra's garden grow the kapittha tree whose fruit gives victory, virility and courage as well as the *pañca vṛkṣa* ('five trees') which have magical qualities. Under the shade of the mandara tree all cares are forgotten and one is undisturbed by lust. The parijata tree is famous for its perfume, as is the chandana tree whose perfume scents all of Svarga. The samtanaka tree has magical leaves, which if chewed will ensure progeny and immortality, while the *kalpa-vṛkṣa* ('wishing-tree') will grant every wish.

How was this view of paradise as a place of sumptuous buildings, groves of trees and sweet-scented flowers translated into reality? As almost nothing survives, and visual representations are limited to a few indeterminate garden-like scenes among the carving on the gateways of the Great Stupa at Sanchi (*c.* 1st century BC) or the paintings of Ajanta (*c.* 5th century AD), information on these early gardens is predominantly literary. It is contained in religious works, secular texts such as the *Kāmasūtra* ('On the pleasures of life') and in drama, poetry, historical commentaries and occasionally inscriptions.

Early Indian kings set aside land for pleasure gardens, groves and public parks, and gardens were attached to the palaces and mansions of kings and nobles. The *Kāmasūtra* recommends that a man of wealth and learning should surround his house with a garden. Private gardens were under the care of the mistress of the house, who was expected to be knowledgeable about gardening. According to the *Kāmasūtra*, the wife dictated the layout of the garden and its planting, while the physical labour was left to professional gardeners. The *Kāmasūtra* is also specific about what should be planted in gardens. The practical garden must include beds of green vegetables, sugar cane, fig trees, mustard, parsley and fennel. The pleasure garden should include jasmine, yellow amarantha, the China rose and many other decorative flowers, which should be planted amid fragrant grass.

Sanskrit drama was expected to contain a garden scene, the trees and flowers often determined by symbolism. Literary gardens in *c.* 4th–5th-century AD works by Shudraka, Bhasa and Kalidasa are generally walled with fancy gateways and filled with trees and flowers. There are creeper-covered arbours, water ponds, stone or jewelled seats and a swing. Typical of literary gardens is that described by Dandin, a Sanskrit writer who flourished perhaps in the later half of the 7th century, in his prose narration *Daśa-kumāra carita* ('Adventures of the ten princes'). Prince Upaharavarman scales a garden wall and once inside finds himself facing a row of mulsari trees while a path along the wall is lined with trumpet-flowers. Past the mulsari trees is an alley of sandal trees, which is followed by a sanded path with a double row of ashoka and fig trees. This leads to a mango tree alley, which culminates in a jasmine bower sheltering a jewelled bench.

Trees, the most important element of the garden both as giver of shade and fruit, were planted either in groves or in rows. Among the trees frequently mentioned are the ashoka, which bears scarlet and orange blossoms, champaka, a tree of the magnolia family, with fragrant yellow flowers, the mango, sandal, citron and tilaka. Groves of trees were important in Buddhism. According to the Buddhist Pali text, the *Majjhima nikāya*, groves were specially cultivated for groups of monks. Buddhist hermits also took up residence in royal gardens and it was expected that the king would provide them with shelter and food.

That the garden as described in literary sources, though prone towards exaggeration, reflected the basic framework of garden style is supported by the *Kāmasūtra*. These early pleasure gardens are fairly elaborate horticultural displays designed to enhance the owner's amorous pleasures or sensual enjoyment. They were filled with flowering trees and flowers to appeal to the sense of sight and smell. The heat was combated by shade trees and the coolness from the water pond, which the *Kāmasūtra* considered an essential element to be placed in the middle of the garden. Strolling through the garden was impractical and instead one rested in the cooling comfort of covered arbours, on seats, swings and hammocks. The early Indian pleasure garden lived up to the idea of a place of pleasure and reflected people's ideas of a heavenly paradise.

For discussion of the oldest surviving gardens in the Indian subcontinent *see* SIGIRIYA.

2. ISLAMIC, *c.* 1200–*c.* 1800. Islamic gardens (*see also* §V below) took as their inspiration the Koran and the royal pleasure gardens and hunting parks of the Persian Sasanian empire, conquered by the Arabs in AD 636. The two major periods in Indian Muslim history are the Delhi Sultanate (1206–1526) and the MUGHAL dynasty (1526–1858). While the gardens of the Mughals are well documented in literature and art and many survive and have been restored (*see also* INDIAN SUBCONTINENT, §III, 7(i)), gardens dating from the 300 years of Islamic rule prior to the arrival of the Mughals rarely survive and are little studied. One of the earliest references is to a park established by the sultan Mu'iz al-din Kayqubadh (*reg* 1287–90) near his palace at Kilokari in Delhi (*see* DELHI, §I). It was laid out along the Yamuna River and was probably a traditional hunting park filled with trees,

grass, scattered flowers and a pond or stream. The reign of Firuz Shah Tughluq (*reg* 1351–88) was apparently a high-point in garden design. Firuz Shah is reputed to have laid out 1200 gardens. These produced fruit and flowers and while some were planted as pleasure gardens, the sheer numbers would suggest that their primary purpose was agricultural revenue. However, the layout of fruit trees and flowerbeds in a revenue garden would not necessarily prevent it from also being used as a pleasure garden. Firuz Shah laid out pleasure gardens for himself at his capital of Firuzabad at Delhi. Writing in the early 17th century, the historian Muhammad Abu al-Qasim Firishta said that Firuz Shah, on the death of his favourite son, built a park outside Delhi surrounded by a wall 9–14 km in circumference, inside which were shade trees and animals for hunting.

The only detailed description of a Sultanate-period garden comes in reference to a madrasa (college) built by Firuz Shah in 1351 in the vicinity of Delhi: the madrasa was placed in the centre of a garden, which was described by the poet Mutahhar of Kara as a place of verdure where hyacinths, basils, roses and tulips were beautifully arranged, and where pomegranates, oranges, guavas, quinces, apples and grapes were also prominent. K. A. Nizami in his translation of the poem says that there were alleys and avenues within the garden. This combination of a centrally placed building within a garden of rows of trees and arranged flowerbeds would make it a typical formal Islamic garden.

Gardens were also laid out by the Muslim sultans of the Deccan at Bijapur and other centres and possibly by the sultans of Gujarat and Bengal. It appears that following the devastating invasion of Delhi by Timur in 1398, economic and political problems meant that few new gardens were established in the region and old ones were neglected. When Babar (*reg* 1526–30), the founder of the Mughal dynasty, gained power he was not impressed with what he saw and in his diary, the *Bābarnāma*, recorded that the gardens of Agra were so disorderly that they filled him with repulsion. Within his first year in India he laid out a garden in Agra (probably the Ram Bagh) with running water, tamarind trees and symmetrical flowerbeds of roses and narcissus; all perfectly arranged and orderly. He also established gardens at Dholpur and Sikri (later Fatehpur Sikri).

The Mughal garden followed the *chār-bāgh* (from Pers. *chahārbāgh*: 'four [plot] garden'). In Mughal gardens two intersecting water-channels or walkways divided the garden into quarters, the four water-channels serving as reminders of the four rivers of paradise. The layout was symmetrical with a tomb, pavilion or water tank placed in the centre. (The one major exception is the Taj Mahal, where the garden is placed in front of the tomb; *see* AGRA, §II, 1.) Water was the most important feature of the garden. Its channels divided up the garden space and provided the framework for its design. Symmetrical flower beds and trees were arranged within the divisions. More complex variations of the *chār-bāgh* design were developed; for example at Humayun's tomb in Delhi (*see* DELHI, §III, 4), the water-channels divide the garden space into 32 symmetrical plots. Water jets or simple fountains that sprayed water into the air were placed along

the length of the water-channels or massed in tanks. Flowing water was used for its visual effect. Ripple patterns were created by carved water-chutes, which directed the water downwards between levels. These features were employed, for example, in the gardens of the Lal Qil'a (Red Fort) in Delhi (*see* DELHI, §III, 5) and Nishat Bagh, Kashmir. In both the Nishat and Achibal gardens in Kashmir huge cascades of water were used for their visual beauty and sound.

Trees were important for their shade and the beauty and scent of their blossoms. Fruit trees and cypresses were a popular combination, seen sometimes as a symbolic allusion to life and death. Plane trees were the most common shade tree, often planted in rows along water-channels. Flowers were chosen for their beauty and scent and were often used to give the garden a theme. In the Lal Qil'a in Delhi the Hayat Baksh Bagh (Life-Giving Garden) was planted with flowers chosen for their scent, while the Mahtab Bagh (Moonlight Garden) contained only white or pale-coloured flowers.

Though basic elements of design remained the same, some variations occurred in Mughal gardens due to differing climate and terrain. The two major areas for Mughal gardens were the Gangetic Plain (which contained the capital cities of Agra and Delhi) and Kashmir (which the Mughals loved for its climate). On the Gangetic Plain garden planners had to contend with a flat landscape and a monsoon climate, which limited the species of flowers and trees and the quantity of available water. Kashmir, with its temperate climate and mountainous terrain, allowed for a greater variety of flowers and a more intricate use of water based on the terracing of the land.

The Muslim practice of segregating women and men meant that certain gardens or parts of gardens were reserved for women only. The highest terrace in the multi-terraced gardens of Kashmir was reserved for women, as were enclosed courtyard gardens in the royal palaces, such as the Anguri Bagh in Agra Fort (*see* AGRA, §II, 3). Gardens were the setting for many activities of everyday court life, as paintings of the Mughal period testify. The painting *Prince in a Garden* (*c.* 1640–50; see fig. 10), for example, shows a prince, sages and musicians seated on a garden terrace for an evening's discussion and entertainments. In the distance a bed is being laid out in a garden pavilion, presumably for the prince.

The reigns of the third and fourth Mughal emperors, Jahangir and Shah Jahan (*reg* 1627–58), were particularly important for the development of major gardens. During Jahangir's reign gardens were laid out in 1604–13 incorporating the tomb of Akbar (*reg* 1556–1605; *see* SIKANDRA) and in 1622–8 of I'timal al-Daula (*see* AGRA, §II, 2). Shalimar Bagh (see fig. 11) on the bank of Lake Dal at Srinagar, Kashmir, was begun *c.* 1620. The garden has three terraces and is dominated by a central water-channel. Jahangir also was responsible for Achibal, a small water garden, outside Srinagar.

Nishat Bagh (Pers. *Bāgh-i Nishāt*: 'Garden of joy'), a non-imperial garden whose ownership is debated, was laid out next to Shalimar Bagh *c.* 1625. (It has been attributed to Asaf Khan, Jahangir's brother-in-law.) The garden is enormous with 12 terraces representing the Signs of the

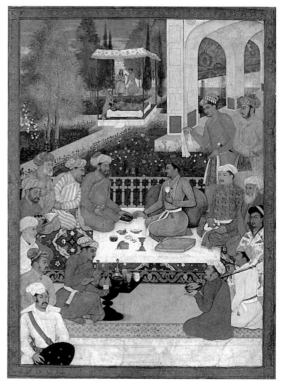

10. Bichitr: *Prince in a Garden*, opaque colour on paper, 280×202 mm, *c.* 1640–50 (Dublin, Chester Beatty Library and Gallery of Oriental Art, MS. 7:7)

Zodiac and is designed around a central water-channel leading down to the lake.

Shah Jahan's gardens are, with few exceptions, associated with his grand building schemes. He made major additions to the main palace-forts at Lahore and Agra and built the Lal Qil'a for his new city of Shahjahanabad at Delhi. All were filled with gardens. In 1642 he laid out in LAHORE the Shalimar Bagh, which, like its Kashmiri counterpart, has three terraces. Again water in the form of channels, pools and jets is the main feature. The gardens of the Taj Mahal, the tomb built for Shah Jahan's wife Mumtaz Mahal, were laid out from 1632 to 1654. These have a large central pool with four water-channels dividing the garden into quarters. Along the main water-channel leading to the front of the tomb are water jets, while the sides are lined with cypress trees placed within a geometrically patterned ground surface.

The gardens of Shah Jahan are the culmination of the Mughal garden style. They make extensive use of water wherever possible and even on the plains the water-channels are noticeably wider than in earlier Mughal gardens. Pavilions are situated in the centre of water pools filled with fountains and the sides of the large pools contain carved niches which were filled with vases of flowers during the day and lighted lamps in the evening. The placement of water jets along the major water-channels is also typical of a Shah Jahan-period garden

The Mughal garden style was adopted by the Hindu rulers of the north, most of whom had political and often

marital alliances with the Mughal emperor. For example the palace built by the Rajput rulers of Amber in the 16th and 17th centuries has two fine gardens. Inside Amber palace is a star-shaped, sunken courtyard garden divided into quarters by a central fountain and four walkways. The quarters are planted with flowers and shrubs. More spectacular is the three-tiered Maunbari garden built on an artificial island in the middle of the lake below the palace. The Maunbari garden was used by the women of the palace at late evening or night. In the centre of the upper tier is a fountain with two intersecting water-channels; the main axial channel carryies the water down the tiers to the lake. Since the garden was intended for use at night, there was no need for trees. Instead the emphasis was on highly scented, night-blooming flowers which were arranged in geometrical parterres formed by plastered brick, similar to the Anguri Bagh in the Agra Fort. Another outstanding Mughal-style garden was laid out at Dig in Bharatpur District, Rajasthan, in the 18th century by local Jat rulers. The garden is of *chār-bāgh* design with the usual water-channels, tanks, carved water chutes, flower beds and trees.

The Mughal garden style persisted as the dominant style in northern India until the end of the 19th century, despite the introduction of new styles by the British. Its endurance is due to its comfort in a hot climate. It provided shade, cooling water and beautiful and pleasant scented flowers and trees in a pleasing arrangement to be enjoyed by people who wished to sit and appreciate the beauties of their garden.

3. BRITISH-INDIAN AND MODERN, *c.* 1800 AND AFTER. The British introduced to India a fundamentally different concept of the garden. Whereas Indians viewed gardens as places of rest and relaxation, the British designed their gardens for walking and exploring the garde1 space. An early example of the British determination to reproduce the gardens of 'home' was the introduction of the landscape style of 'Capability' Brown. Lord Edward Clive, as Governor of Madras, laid out a large landscape park at Government House in 1801, helping to further the British enthusiasm for a style that was already out of date in Britain. Though it remained popular in Madras and in the fashionable area of Garden Reach, outside Calcutta, the style was not generally successful. To achieve a reasonable landscape park, plenty of water and a smooth-textured lawn were required, two commodities scarce in India. Large areas tended to degenerate to dry cracked dust for most of the months, although the style was more successful in Bengal which had a more constant water supply.

Barrackpur, up river from Calcutta, was the country estate of the Governor-General and it too was laid out as a landscape park, but with some variation and with greater success. Richard Wellesley, who was responsible for its early development (1798–1805), had hills created from the soil excavated in the creation of lakes. The hills were a novelty in a very flat area, but the park, which was popular for outdoor dining, also contained other interesting features such as a Classical temple, a Gothic ruin, a menagerie and a banyan tree.

11. Shalimar Bagh, or Gardens, Srinagar, Kashmir, begun *c.* 1620; from a photograph of 1871

The major gardens of British India, laid out at the Viceregal residences during the time of the Raj, were designed to reflect the power and prestige of the British. The garden at Government House (1876–80), Calcutta, was largely the work of Lord Lytton. It was designed in the grand Victorian manner with lakes, rustic bridges and an Italianate flower parterre. Simla, the capital of British India during the hot weather, acquired a new Viceregal Lodge in 1888 and Lord Lansdowne was responsible for its garden (1888–94). Due to the mountainous nature of the Simla area, the garden was terraced, Lord Lansdowne using as his inspiration his own terraced gardens at Bowood House in Wiltshire.

The greatest of all Viceregal gardens was that laid out by EDWIN LUTYENS for the Viceroy's House (now Rashtrapati Bhavan) at New Delhi. Started in 1918, it was completed in 1925. The Viceregal garden contained two separate units. The state garden, known as the 'Mughal Garden' (see fig. 12), was inspired by Mughal design and made extensive use of water and fountains, although the central feature was an enormous expanse of lawn in the centre that was used for state functions. This garden was connected by a pergola to the private garden, which was on a much smaller scale and consisted of three tiers of flowers around a circular pool.

Though the British in India laid out their gardens in the familiar styles of home, India kept intruding. British–Indian gardens were much more exotic than contemporary gardens in Britain, and many Britons, while pining for familiar flowers, nonetheless relished the exotic Indian flora at their disposal. Native Indian flowers, creepers and trees were all planted for their colourful effect. The British in India also developed their own distinctive garden features, for example trees with creepers climbing up their trunks and beds of flowers planted at the base. Initially European flowers, which were difficult to grow in India, were kept in pots so that when the household moved it was easy to take the plants along. Later, potted plants were

12. 'Mughal Garden' by Edwin Lutyens and W. R. Mustoe, Rashtrapati Bhavan (formerly Viceroy's House), New Delhi, 1911–31

used as a decoration on the verandah and stairs, even by those who had a fixed residence. Both remain popular features in the subcontinent.

In the post-Independence period the gardening legacy left by the British has been cared for and developed. Botanical gardens have been maintained or established in many towns and cities, including Calcutta, Bangalore, Ootacamund and Darjeeling. In the early 1960s Japanese gardens such as the one in the Lalbagh Botanical Gardens in Bangalore became popular. Nehru had Buddha Jayanti Park laid out in Delhi to commemorate the 2500th anniversary of the birth of the Buddha in a design to inspire peace and calmness of spirit. At Chandigarh in the Punjab a spectacular rose garden, which is world famous, was designed to display its numerous species of roses in a formal and informal manner.

BIBLIOGRAPHY

Kāmasūtra [Text on pleasure], attributed to the sage Vatsyayana (*c.* 1st–5th century AD), annotated Eng. trans. S. C. Upadhyaya (Bombay, 1961); Eng. trans. R. Burton and F. F. Arbuthnot (Frogmore, 1963)

Zahir al-Din Muhammad Babar: *Bābarnāma* (*c.* 1530); Eng. trans. and ed. A. S. Beveridge, 2 vols (London, 1922/*R* Delhi, 1970)

Muhammad Abu al-Qasim Firishta: *Gulshan-i Ibrāhīmī* [Rose garden of Ibrahim], also known as *Tārīkh-i Firishta* [History of Firishta] (1607); Eng. trans. J. Briggs as *History of the Rise of Mahomedan Power in India, til the year 1612* (London, 1909)

Nur al-Din Muhammad Jahangir: *Tūzuk-i Jahāngīrī* [Memoirs of Jahangir] (*c.* 1624); Eng. trans. A. Rogers, ed. H. Beveridge (London, 1909–14/*R* Delhi, 1968)

Khaliq Ahmad Nizami: *Studies in Medieval Indian History* (Aligarh, 1956)

G. S. Randhawa, K. L. Chadha and D. Singh: *The Famous Gardens of India* (New Delhi, 1969)

S. Crowe, S. Haywood and S. Jellicoe: *The Gardens of Mughul India* (London, 1972)

E. Moynihan: *Paradise as a Garden in Persia and Mughal India* (London, 1979)

J. Lehrman: *Earthly Paradise: Garden and Courtyard in Islam* (Los Angeles, 1980)

J. Brookes: *Gardens of Paradise* (London, 1987)

W. H. Siddiqi: 'Découvertes des vestiges d'un jardin en terrasses tughluq à New Delhi', *A. Asiatiques*, xliv (1989), pp. 21–4

VIVIAN A. RICH

V. Islamic lands.

1. Introduction. 2. Central Islamic lands and North Africa. 3. Spain. 4. Iran and western Central Asia. 5. Anatolia and the Balkans.

1. INTRODUCTION. As the traditional Islamic lands stretch from the Atlantic to the Indian oceans and from the steppes of western Central Asia to the deserts of Arabia and Africa, a variety of climates—ranging from the Mediterranean and desert kinds prevalent in the central and western regions to the humid tropical and subtropical climates of the east—dictate the types of plants that can be cultivated, leading to distinct regional traditions of garden design. Gardens have always been an essential feature of settlement throughout the region. The Mediterranean lands inherited the Classical tradition of the *hortus* (*see* §II, 4 above), whereas the eastern Islamic lands were heir to the ancient Iranian tradition of the *firdaws* (Gr. *paradeisos*), a walled garden quartered by irrigation channels. The Koran (xxv.15) describes paradise as the garden of eternity (Arab. *jannat al-khuld*) with four rivers of water, milk, wine and honey (xlvii.15) and a fountain named Salsabil (lxxvi.18). The garden became the dominant image of paradise in Islamic thought and art, and later philosophers and poets elaborated and specified this metaphor. The memory of other gardens, such as the Garden of Eden and the Hanging Gardens of Babylon, was also revived at specific times or places.

The amount of effort necessary to make plants flourish in the Islamic lands has led gardeners to delimit carefully the area under cultivation. Most gardens in this region, whether in the palaces of the rich or the modest houses of villagers, were one of two types: a courtyard garden in which buildings completely enclosed the garden, or an exterior garden in which buildings were set in a walled space. As the arid climate in much of the region meant that little would grow without irrigation, water has always played a major part in garden design, whether as still pools or flowing channels, and water was a major element used to link interior and exterior garden spaces, whether at the Ziza Palace (*c.* 1164–6) in Palermo, the Court of the Lions in the Alhambra of Granada or the Hasht Bihisht in Isfahan (*see* §§2, 3 and 4 below). The culmination of garden design in the Islamic lands was reached in their furthest extremities: in Spain and in India (*see* §IV, 2 above).

There has traditionally been little distinction drawn between the economic and aesthetic benefits of gardens. Cherry and orange trees, for example, were appreciated as much for the beauty and fragrance of their blossoms as for their fruit. Trees, shrubs, flowers and even vegetables were cultivated together and the resultant produce, even from the sultan's garden, was used to feed the palace or was sold on the open market. Gardeners in the Islamic lands were responsible for the introduction of many fruits—such as Seville oranges, lemons, peaches and apricots—to Europe, primarily through Sicily and Spain. Sometimes the relationship was more complicated. The tulip, the name of which derives from the Turkish *tülband* and Persian *dül band* ('turban'), grows wild in eastern Anatolia and the Iranian Plateau. It was introduced to Europe by Ogier Ghislain de Busbecq (1522–92), ambassador of the Habsburg Ferdinand I (*reg* 1522–64) to the

court of the Ottoman sultan Süleyman, who brought bulbs to Austria. Its cultivation in Europe was developed through the efforts of Charles de l'Ecluse, chair of botany at the University of Leiden, and the predeliction for tulips spread rapidly, culminating in the great tulip mania of 1636–7 in Holland. In the Islamic lands the taste for this plant reached its most extravagant height during the Tulip Period (Turk. *lâle devri*) under the Ottoman sultan Ahmed III (*reg* 1703–30), when the cultivation of and decoration with the tulip affected many of the arts. The introduction of many new plant species, particularly from the Americas in the 16th century, transformed the traditional flora of the Islamic garden, and the development of the Renaissance garden changed traditional garden design, particularly in Spain.

The evanescent nature of the garden, where a season can effect major changes and the need for human intervention is constant, means that no gardens have remained from the earlier periods, although garden structures and layout are known from archaeological remains and descriptions—often hyperbolic—preserved in texts and poetry. In addition, the metaphoric importance of gardens meant that they and their constituent parts—flowers, trees, birds etc—were represented in the other arts of Islam, such as book illustrations, tile revetments and textiles. Perhaps the most explicit depictions of gardens in Islamic art are to be found in the Garden carpets of 17th-century Iran and later, where the rectangular field depicts a walled garden divided by water-channels into parterres with pavilions, flowers and trees (see fig. 13; *see also* CARPET, colour pl. IV, and ISLAMIC ART, §VI, 4(iii)(c)). This idea was already known in pre-Islamic times, for the audience hall

of the Sasanian palace at Ctesiphon had, when conquered by the Arabs in AD 637, a magnificent carpet (destr.) known as the Spring of Khusraw; it depicted paths and streams between garden plots that were planted with trees and flowers and was enriched with gold, silver, silk and gemstones.

BIBLIOGRAPHY

Enc. Islam/2: 'Būstān' [Garden]; 'Filāḥa' [Agriculture]

E. B. MacDougall and R. Ettinghausen, eds: *The Islamic Garden* (Washington, DC, 1976)

J. Lehrman: *Earthly Paradise: Garden and Courtyard in Islam* (Berkeley and Los Angeles, 1980)

J. Brooks: *Gardens of Paradise: The History and Design of the Great Islamic Gardens* (London, 1987)

Images of Paradise in Islamic Art (exh. cat., ed. S. S. Blair and J. M. Bloom; Hannover, NH, Dartmouth Coll., Hood Mus. A; New York, Asia Soc. Gals; Brunswick, ME, Bowdoin Coll. Mus. A.; and elsewhere; 1991–2)

□

2. CENTRAL ISLAMIC LANDS AND NORTH AFRICA. Two kinds of gardens were used in the region from Iraq to Syria, Egypt and North Africa: an extra-urban park or zoological garden used for sport and agriculture (Arab. *ḥāʾir*, *ḥayr*) and the courtyard garden (*rawḍa*, pl. *riyāḍ*). The first type, always large and monumental in scale with free-standing structures within its precincts, was the prerogative of kings and princes, whereas the second type, entirely enclosed by a single building or wall, was constructed and enjoyed by men of all means. Both styles had been known to the ancient Persians (*see* §II, 1 above).

The *ḥayr* is first encountered in Islamic times in a series of palaces constructed by the Umayyad caliphs (*reg* 661–750) in the Syrian desert (*see* ISLAMIC ART, §II, 3(iii)). Many of these comprised walled enclosures containing vast areas of arable land irrigated by aqueducts and drained by means of sluice-gates. One of the most elaborate of these palaces, the site of KHIRBAT AL-MAFJAR near Jericho, contained various practical installations within the 60 ha enclosure. A domed pavilion with an ornamental fountain in the forecourt was perhaps surrounded by a small garden.

The Umayyad desert palaces and their enclosures are totally dwarfed by the splendour of the many palaces and gardens at SAMARRA', the 9th-century AD capital of the Abbasid caliphs in Iraq. The gardens are known through hyperbolic descriptions in contemporary court poetry, and excavations by Viollet, Herzfeld and Susa. These sources make it possible to draw an impressionistic picture of the gardens of Samarra', which fall into the two categories. The largest of the *ḥayr*-type gardens was the game reserve, (*ḥayr al-wuḥūsh*) built by al-Mutawakkil (*reg* 847–61) south of Samarra'. This was a vast rectangular enclosure (about 30 km in diameter) traversed from north to south by a large canal, a branch of which fed the legendary Birkat al-Mutawakkil, a square pool about 200 m to a side which once had animal- and bird-shaped fountains made of precious materials. A substantial palace with an arcaded terrace overlooked the pool and the park from a southern, shaded vantage point. South of the palace itself extended a smaller garden which contained an artificial mound in the middle.

The palaces of Samarra', such as the Dar al-Khilafa (Jawsaq al-Khaqani) and the Balkuwara, also enclosed vast courtyards divided into quadrangular parterres by

13. Wagner Garden Carpet (detail), wool knotted pile, 4.32×5.31 m, from Iran, 18th century (Glasgow, Burrell Collection)

14. *Shādirwān* fountain, Ziza Palace, Palermo, Sicily, *c.* 1164–6

axial water-channels crossed at regular intervals by subsidiary channels and flanked by paths. These are the earliest Islamic examples of the Persian type of four-fold garden (Pers. *chahārbāgh*). The parterres were probably depressed below the level of the channels and paths, a Persian custom continued later, particularly in North Africa and Spain (*see* §3 below).

The palaces and gardens of Samarra' provided a model for those built by many medieval Islamic dynasties, particularly in Egypt, North Africa and also Spain. Few of these dynasties possessed the Abbasids' wealth, which perhaps explains the smaller size of their gardens and the simplified plan. In some courtyards only a single watercourse was used, but it was often elaborated with a new type of fountain (Arab. *salsabīl*, *shādirwān*) that became popular from the 11th century throughout the region. The fountain, set into a wall, consists of an animal-shaped spout under a *muqarnas* niche; water flows from the spout down an inclined carved marble slab, collects in a little pool, and runs in a narrow channel which in turn empties into a pool in the centre of the courtyard. This device introduced a dynamic element to courtyard and garden design, a quality that was henceforth incorporated into many gardens in the Islamic lands. Although used primarily in palaces, such as those in the citadels of Diyarbekır and Aleppo, the type was also used in madrasas and other pious institutions, such as Firdaws Madrasa in Aleppo (1235–7), the hospital of Nur al-Din in Damascus (1154–5) and the hospital of Qala'un in Cairo (1284–5), as well as in private houses.

Another variation of the four-fold garden was used in the courtyard houses and palaces of Morocco from as early as the first half of the 12th century. Combining the Roman peristyle courtyard with an Oriental garden type, the *riyāḍ* evolve into variations, often consisting of an orthogonally divided rectangular garden with a central pool, flanked at its narrow sides by two-storey pavilions with arcaded porches. More elaborate gardens may contain a central fountain flanked by two or even four subsidiary fountains axially connected by a narrow channel.

The *ḥayr*-type garden also provided a model for later gardens in North Africa, although these too were reduced in size and elaborated. The palaces of the Hammadid rulers (*reg* 1015–1152), such as those at QAL'AT BANI HAMMAD (the Qasr al-Bahr) and Bijaya (now Annaba, Algeria), had squarish pavilions overlooking large pools. A similar arrangement in the Ziza Palace (*c.* 1164–6) outside Palermo was probably inspired by the North African examples (see fig. 14). Here, however, water flows from a *shādirwān* fountain through the palace and empties into the facing cistern, itself containing an island supporting a little pavilion.

Medieval literary references and extant gardens and courtyards can provide a general idea of the horticulture of these gardens. Some trees—elm, plane, maple, spruce and pine—were grown to provide shade; others, such as fig, pomegranate, apricot, peach, cherry and the citrus family, were grown for their flowers and fruits. Shrubs such as box, hawthorn, myrtle and lavender were used mostly for edging, reinforcing the geometric character of the garden, and vines, including bougainvillaea, grapes and especially jasmine, were either trained on a trellis or allowed to cascade freely over a wall. Flowering plants such as rose, daffodil, carnation and lily were never massed together in a herbaceous border but planted independently and randomly in island beds in the grass. Shade- and moisture-loving plants such as hostas and ferns were planted in pots and clustered informally in corners and around the pool, while calla lilies and waterlilies grew out of the pool itself.

BIBLIOGRAPHY

Enc. Islam/2: 'Bidjaya' [Annaba]; 'Būstān' [Garden]; 'Ḥa'ir' [Park]
H. Viollet: 'Description du palais de al-Moutasim fils d'Haroun al-Raschid à Samarra et de quelques monuments peu connus à la Mesopotamie', *Mém. Acad. Inscr. & B.-Lett.*, xii (1909), pp. 567–94
L. Gallotti: *Le Jardin et la maison arabes au Maroc*, 2 vols (Paris, 1926)
E. Herzfeld: *Geschichte der Stadt Samarra* (Hamburg, 1948), vi of *Die Ausgrabungen von Samarra* (1923–48)
A. Sūsa: *Anẓima al-riyy fī samarrā' hawla hukm al-'abbāsiyyīn* [The irrigation system of Samarra' during the Abbasid caliphate], 2 vols (Baghdad, 1948–9)
R. W. Hamilton: *Khirbat al-Mafjar: An Arabian Mansion in the Jordan Valley* (Oxford, 1959)
Y. Tabbaa: 'Toward an Interpretation of the Use of Water in Islamic Courtyards and Courtyard Gardens', *J. Gdn Hist.*, vii (1987), pp. 197–220
——: 'The Medieval Islamic Garden: Typology and Hydraulics', *Garden History: Issues, Approaches, Methods: 13th Dumbarton Oaks Colloquium on the History of Landscape Architecture: Washington, DC, 1992*, pp. 303–29

YASSER TABBAA

3. SPAIN.

(i) Introduction. (ii) Before *c.* 1031. (iii) *c.* 1031–1492.

(i) Introduction. The Hispano-Islamic garden, unlike its counterparts in Iran and India, has to be reconstructed

not from pictorial documentation but from surviving and excavated examples, supplemented by contemporary descriptions. The destruction of Arabic manuscripts following the Christian reconquest of Spain ensured that surviving literary sources would be scanty, and the Garden carpets of 18th-century Iran (*see* ISLAMIC ART, §VI, 4(iii)(c)) have no equivalent in Christian Spain. Writers on gardens rely too heavily on the present appearance of their subject, thereby ignoring the garden's inherent mutability. In Spain the issue is further complicated by the coincidental discovery of America in the late 15th century, which altered the cultivated flora of Europe as New World plants were introduced into gardens. No less serious was the italianization of Spanish palaces and gardens following Renaissance tenets in the 16th century, a process that erased the indigenous Islamic tradition in less than a century. Of the classical parterres in the Alcázar of Seville, the Romantic garden hanging on the Generalife terraces and the trimmed box-edging at the Alhambra and Generalife, not one represents or even approximates what was there before *c.* 1500.

The courtyard house, which compressed and formalized the idea of a garden, had been the standard post-Roman Iberian type which the Arabs found congenial when they conquered the peninsula in the 8th century AD. Roman tradition included both the *domus urbana* and the *villa rustica*, an informally planned house set amid gardens and orchards. Formal gardens functioned within palaces not only as courtyard space but also as connectors between palatial elements, which were conceived as units within an overall horticultural scheme. Such palaces existed inside and outside city walls; suburban palaces, when small, approximated villas and, when large, palatine cities (e.g. Hadrian's Villa at Tivoli in Italy). The continuation of these traditions can be seen, for example, in the 14th-century palace surrounding the Court of the Lions at the Alhambra (*see* GRANADA, §III, 1), which exemplifies the small urban villa; the 10th-century site of MADINAT AL-ZAHRA', which exemplifies the palatine city; and the Generalife (*see* GRANADA, §III, 2) of the Nasrid dynasty (*reg* 1230–1492), which is a *villa rustica*. Generally the Muslim ruler dwelt in a fortress (Sp. *alcázar*; Arab. *al-qaṣr*), with a system of interlocking courtyards supplemented by garden space for relaxation.

The public park was another Roman feature inherited by the Muslims of Spain. The private domain of a landholder was sometimes bequeathed in trust (*waqf*) for public use in accordance with Islamic law (*see* ISLAM, §III). Such parks were often found in the suburbs to avoid the congestion of the walled city. Cemeteries, similarly following Roman precedent, were suburban. Public cemeteries, although not formally landscaped, were certainly planted, and private cemeteries and dynastic mausolea were attached to palaces. The royal necropolis, figuratively known as *rawḍa* ('garden'), was so in actuality because ancillary garden space accommodated the less important burials.

A special terminology developed in Spain for gardens. In Almería the term for villa was *burj* ('tower'); in Córdoba it was *munya* ('object of desire'). In Granada the standard term was *manjara* ('orchard'), although royal properties tended to boast poetic or hyperbolic appellations, such as the name of a constellation. The term *carmen* (from *karma*,

'vine') is still used there as well, the vine being the only productive plant the culture of which was economically feasible under such restricted climatic conditions.

Basic components of the Hispano-Islamic garden are a raised grid, irrigation under gravitational pressure, central collecting pool or distribution point, and formal walkways incorporating channels by which the irrigation is accomplished. The walks define the zone formally, leaving room for a less formal approach within the areas so defined. A quadripartite arrangement was standard, but not *de rigeur*. Quite apart from any Jungian or eschatological significance it might have, the four-fold plan is the easiest way to irrigate a rectangular area.

(ii) Before c. 1031. Evidence for gardens constructed by the Umayyad dynasty (*reg* AD 756–1031) after they assumed the caliphate in 936 comes from the excavated examples at Madinat al-Zahra' and a contemporary account of a pleasure garden at Córdoba. The gardens at the three-terraced site of Madinat al-Zahra' included a zoological park, a cultivated zone around the palace (*ḥayr*) and an aqueduct (for plan, see Ruggles). The canals at al-Zahra' were described as serpentine watercourses, and, according to the poet Ibn Zaydun (1003–70), the pools there had shaded margins and were so deep as to appear blue. Pools corresponding to this description were excavated at the site: a large pool between the Salón Rico (situated on the lowest of the three terraces, and the focus of the site's reception complex) and the pavilion opposite would have reflected both buildings. The pavilion stands at the intersection of the axes of a huge quadripartite garden; the outlines of its beds are clearly visible, as are the remains of smaller pools on the three other sides of the pavilion. These pools supplied narrow channels which flanked the garden beds. Apertures closed by means of wooden bungs allowed the beds to be flooded periodically.

The anthologist al-Fath ibn Khāqān (*d* 1134) described a Córdoban garden of the early 11th century known as the Hayr al-Zajjali, after its owner, the vizier Abu Marwan al-Zajjali. It had files of trees arranged symmetrically, a courtyard, a serpentine watercourse, a central basin into which all the waters flowed and a pavilion exquisitely decorated in gold and azure. The garden was so dense that the sun's rays could not penetrate, and any breeze was instantly impregnated with perfume. Although the poet Ibn Shuhayd was buried there in 1035, the garden was not of the *rawḍa* type but a Roman *hortus*, a combination of flower garden and orchard.

(iii) c. 1031–1492. The collapse of the Umayyad caliphate in 1031 led to a diffusion of talent and the emergence of multiple cultural centres in the Iberian peninsula. For example, an arrangement of basins linked by serpentine channels similar to that known from the Hayr al-Zajjali was found at the Sumadihiyya, the palace of al-Mu'tasim (*reg* 1052–91) at Almería, and the Alcazaba at Málaga preserves a waterspout with a serpentine channel fashioned out of a Visigothic monolith. At the Aljaferia at Saragossa, seat of the Banu Hud (*reg* 1039–1146), a courtyard and garden have come to light. Pools at oppposite ends of the court, obviously intended to reflect the delicate tracery of the porticoed sides, are linked by a straight watercourse; there is no transverse axis.

The heir to Córdoba as cultural capital was Seville, where the remains of the famed al-Mubarak Palace of the poet–king al-Mu'tamid (*reg* 1069–91) have been discovered in the Alcázar. Several deeply sunken flowerbeds, the sides painted in imitation of arches, have been discovered in a courtyard garden; this may be identified as the garden designed for al-Mu'tamid *c.* 1080 by the Toledan agronomist Ibn Bassal. The arrangement of three beds on either side of a presumed central tank resembles that at Saragossa. An impressive new palace and garden, built by the Almoravids (*reg* 1056–1147) in the 12th century, all but obliterated the earlier one. The sides of the very deep beds are decorated with blind brick arches, and crossed axes incorporate channels lined with tiles radiating from a central pool (see fig. 15). Dwarf orange trees once grew in each corner, four to a bed. Another Almoravid garden partially excavated in the Alcázares had even deeper beds for orange trees. Seen by the local 17th-century historian Rodrigo Caro before its destruction in the Lisbon earthquake of 1755, it had crossed axes formed by aqueducts supported on high arches from which water descended through clay pipes embedded in the brickwork to the level of the beds. To pass from one side of the garden to the other, one walked beneath the arches. A third garden of the Almoravid period, discovered in 1924 in the Castillejo fortress of Monteagudo near Murcia, is attributed to a local chieftain Ibn Mardanish (*d* 1172). The palace, precariously perched atop a pinnacle of rock rising dramatically out of the level valley, must have presented the builders with enormous hydraulic problems. The rectangular court was bisected by longitudinal and transverse axes, the long axis emphasized by square pools at either end in front of a triple arcade and a reception-room.

The gardens of the Nasrid period in Granada are the most famous and extensive to survive. Numerous royal demesnes in and around the capital were all of the *hortus* type, as were the country houses that noblemen had on their estates outside the city. The largest of all was the royal estate of the Generalife (Arab. *jinān al-'arīf*: 'gardens of the overseer'), some ten to twelve times the size of the Alhambra; its extensive lands afforded pasturage for the royal herds, ovine and bovine. Often misleadingly referred to as a summer palace, the relationship between the Alhambra and the Generalife is properly understood as that between manor and home farm.

The Alhambra Palace comprised a palatine city built in successive phases as the state prospered or languished. The urban setting accounts for the presence of the Comares Palace in the shape of a *domus urbana*. The palace is an independent entity, and as the seat of government has an audience hall located in the tower that gives the palace its name. A large pool on the axes, flanked by shrubbery, not only reflects the two porticoed sides but cools the surrounding apartments during the summer.

The palace incorporating the Court of the Lions represents a *villa urbana*. The tanks at Monteagudo have contracted into fountains sheltered by pavilions, and the courtyard has been transformed from an atrium into a peristyle structure. The fountain at the convergence of the axes in the centre of the court is innovative, replacing the depressed basin found at Seville. The fountain's lion supports are reused from the 11th-century palace of the Jewish Banu Nagrallah, which explains their archaic style. Orange trees in the corners are recorded by the historian Ibn al-Khatīb (1313–75).

The Generalife, on the opposite side of the gorge, was one of the three fortified villas (*munya*) that protected the Alhambra from the rear, the other two being the Alixares (destr. 19th century) and the House of the Bride (*Dār al'-arūsa*) on the Cerro del Perdiz. Under its 19th-century

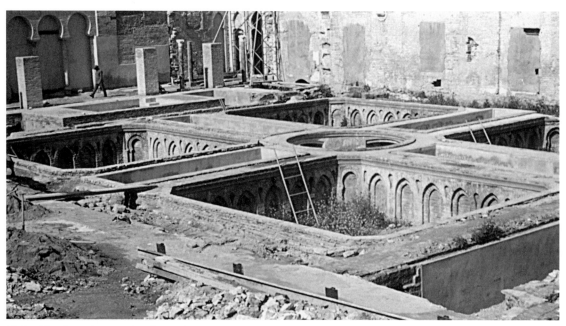

15. Quadripartite garden, Qasr al-Mubarak, Alcázar, Seville, 12th century

Romantic disguise, it is difficult to visualize the Generalife as the fortress it once was, fortified from before and behind, yet the fortifications are still there. All three palaces are examples of the *villa rustica*, *manjara* (orchard) and *hortus* type, and stood embowered amidst orchards, as did the Generalife until the 19th century. The location of the House of the Bride is a tribute to the formidable hydraulic skills of the engineers; to raise water to such a height it was necessary to tap the Darro and then hollow out the centre of the hill so that water could be raised by a system of interlocking paternosters. Endless chains of working buckets, or perhaps skins, brought the water halfway up, where it was decanted into a cistern whence it was raised to the summit by a second chain of buckets. The Alcázar Genil, built over in the 20th century, was another *hortus*, with a huge pool (121×28 m) for the irrigation of a very large area as well as the performance of aquatic spectacles. This palace lay on the opposite side of the Genil River and bore no relation to the Alhambra.

Ibn Luyūn (1282–1349) gave rules for the design and management of such estates in his poem on agriculture, a metric treatise dealing with such practical matters as the natural situation of the villa, its soil and climate, tools, fertilizers, different operations, the crops that form the object of such operations and the seasons at which these operations are to be performed. Of the 157 sections into which the poem is divided, no fewer than 70 deal with horticulture. Various former and extant features of the Generalife, such as the cistern and the water staircase, can be identified from Ibn Luyūn. This productive garden was far removed in appearance from the Romantic garden that occupies the site. The courtyard of the Generalife, the Patio de la Acequia (see fig. 16) is organized along the same quadripartite lines as the Court of the Lions, which it antedates by almost a century, but emphasizes perspective. According to Ibn Luyūn, the length should exceed the breadth so that the gaze may roam freely in its contemplation. The sequence of courtyards in the Generalife, arranged on different axes to produce an L-shaped figure, is precisely that of the Palace of Comares in the Alhambra.

BIBLIOGRAPHY

Ibn Bassal (*c.* 1080): *Kitāb al'qaṣd wa'l-bayān* [The book of thrift and clarity], ed. and Sp. trans. by J. M. Millás-Vallicrosa and M. Aziman as *Libro de agricultura* (Tetouan, 1955)
al-Fatḥ ibn Khāqān al-Ishbīlī (*d* 1134): *Qalā'id al-'iqyān fī maḥāsin al-a'yān* [Anthology], ed. M. al-'Innābī (Tunis, 1966)
Ibn Luyūn (1282–1349): *Treatise on Agriculture*, ed. and Sp. trans. by J. Eguarras Ibáñez as *Ibn Luyūn: Tratado de agricultura* (Granada, 1975)
Ibn al-Khaṭīb (1313–75): *Al-lamḥa al-badriyya fī'l-dawlat al-naṣriyya* [History of the Nasrids] (Cairo, 1927)
E. García Gómez: 'Sobre agricultura arábigo-andaluza', *Al-Andalus*, x (1945), pp. 127–46
L. Torrés Balbás: 'Dār al-'Arusa y las ruinas de palacios y albercas granadinos situados por encima del Generalife', *Al-Andalus*, xiii (1949), pp. 185–97
——: 'Patios de Crucero', *Al-Andalus*, xxiii (1958), pp. 171–92
J. Dickie: 'Notas sobre la jardinería árabe en la España musulmana', *Misc. Estud. Árab. & Heb.*, xiv–xv (1965–6), pp. 75–87; Eng. trans. as 'The Hispano-Arab Garden: Its Philosophy and Function', *Bull. SOAS*, xxxi (1968), pp. 237–48
J. Harvey: 'Gardening and Plant Lists of Moorish Spain', *Gdn Hist.*, iii (1975), pp. 10–22
J. Dickie: 'The Islamic Garden in Spain', *The Islamic Garden*, ed. R. Ettinghausen and E. MacDougall (Washington, DC, 1976), pp. 87–105
P. Cressier: 'Un Jardin d'agrément "chrétien" dans une campagne de tradition moresque: Le *cortijo* to Guarros (Almería, Espagne)', *Flaran*, ix (1987), pp. 231–7
J. Dickie: 'The Hispano-Arab Garden: Notes Toward a Typology', *The Legacy of Muslim Spain*, ed. S. K. Jayyusi (Leiden, 1992), pp. 1016–35
D. F. Ruggles: 'The Gardens of the Alhambra and the Concept of the Garden in Islamic Spain', *Al-Andalus: The Art of Islamic Spain* (exh. cat., ed. J. D. Dodds; Granada, Alhambra; New York, Met; 1992), pp. 163–71

JAMES DICKIE

4. IRAN AND WESTERN CENTRAL ASIA. The idea of a garden (Pers. *bāgh*, *būstān*, *gulistān*) and its association with paradise have deep antecedents in pre-Islamic Iran (*see* §II, 1 above). The four-fold garden (*chahārbāgh*), an enclosed space with intersecting watercourses forming four plots, was used throughout the Islamic period, and the method of planting one is described by Fazil Haravi in his treatise *Irshād al-zarā'a* ('Instructions for agriculture'; 1515). The garden was to be surrounded with walls along which a row of poplars, together with two water-channels bordered with flowers and walks, constituted the element of enclosure. In the middle, a straight grand canal, flanked by paved walks and flowers, brought water to a tank in front of a pavilion. On either side of this axis quinces, peaches, pomegranates and pears were planted in regular rows within four plots of clover. Beyond these, nine flowerbeds planted with various species were the culmination of the vista from the pavilion. This type of layout is represented in other media, most notably in Garden carpets (*see* ISLAMIC ART, §VI, 4(iii)(c); CARPET, colour pl. IV; and fig. 13 above), but no early gardens survive and the history of the Iranian garden in the Islamic period must be reconstructed from literary sources. For example, al-Mafārrukhi's contemporary account of the gardens that were laid out for the Saljuq sultan Malikshah

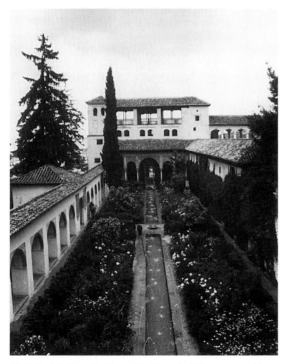

16. Patio de la Acequia, Generalife, Granada, 13th century and later

(*reg* 1072–92) in Isfahan mentions pavilions, fruit and shade trees, scented flowers and pools.

Most of the evidence for Iranian gardens dates from the period after *c.* 1400, when the literary accounts—both local and foreign—are supplemented by manuscript illustrations. According to Ruy Gonzáles de Clavijo (*d* 1412), ambassador of Henry III of Castile and León to the court of Timur in 1404, gardens were used as royal encampments. Numerous gardens were laid out beyond the walls of Samarkand along the Zerafshan River and its tributary. They had probably been made by Shihab al-Din Ahmad Zardakashi, listed in Timur's entourage as a planter of trees. The Bagh-i Dilgusha ('Exhilarating garden'), ordered by Timur in 1396, had a high gateway and was planted with fruit and shade trees. Avenues and raised paths, bordered by palings, led to a central palace with a cross-axial plan. Clavijo related that throughout the garden many tents had been pitched with pavilions of coloured tapestries, structures typical of Timurid gardens. In addition to the Bagh-i Chinar ('Plane-tree garden'), there was the Bagh-i Naw ('New garden'), where a large tank had been dug before a central palace. In the nearby village of Misr, where the embassy was encamped, the Bagh-i Khalvat ('Garden of solitude') had six water tanks connected by a large stream passing from end to end. In the centre stood an artificial mound on which the palace stood, like a fortress apart. Clavijo mentioned that streets with open squares passed between the orchards and the vineyards surrounding Samarkand, but the formal relation between these gardens and the city is not clear, except for the stately avenue planted with poplars that linked the Bagh-i Dilgusha to the Firuz Gate of the city.

The type of garden described by Clavijo is illustrated in the double-page frontispiece to a manuscript (Baltimore, MD, Johns Hopkins U., Garrett Lib.) of Sharaf al-Din 'Ali Yazdi's *Zafarnāma* ('Book of victory') copied in 1467–8 for the Timurid ruler Husayn Bayqara, which shows Timur receiving courtiers in front of a tent set up in a royal garden. Indeed many of these same types of gardens were laid out in the suburbs of HERAT, particularly when it became his capital. This development was stimulated by the new canal that had been dug to the north of the city, and the sultan's own residence was a huge estate known as the Bagh-i Jahanara ('Garden of the world-adorning') on the slopes near Gazurgah. The tradition of royal gardens outside the city was adopted by the Safavids (*reg* 1501–1732) in their capitals in north-west Iran, to judge from representations of Safavid court life in contemporary illustrated manuscripts, but the relationship between the city and the system of royal gardens is particularly clear in Isfahan, the city in central Iran that the Safavid ruler 'Abbas I designated capital in 1598 (*see* ISFAHAN, §1).

The new development of Isfahan was conceived as a great garden on an urban scale. According to the contemporary historian Iskandar Munshi, the architects Ustad 'Ali Akbar and Muhammad Riza Isfahani based the town design on a promenade that crossed the Zaindeh River and quartered the city: to the north-east was the old centre with the bazaars and the royal maidan; to the north-west was 'Abbasabad, the new quarter inhabited by people from Tabriz; to the south-east was Sa'adatabad, the quarter of the Zoroastrian community; and to the south-west was

New Julfa, the settlement inhabited by Armenians. The Italian traveller Pietro della Valle described the promenade, known as Chahar Bagh, as a beautiful allée lined with cypress and plane trees. Water ran in stone channels down the middle through varied basins with water jets and cascades. Two paved paths bordered by flowerbeds ran the length of the promenade. Starting at the Dawlat Gate, from which there was a fine vista, the promenade crossed the river by the bridge with 33 arches erected by Allahvardi Khan (*d* 1662) and ended in a vast public garden known as Hazar Jarib ('Thousand acres'). Straight walls of the same height separated the promenade from the gardens on either side, which belonged to the king and his courtiers and had belvederes (*bālā-khāna*) at the entrances. Many of the 30 gardens were described in detail by Engelbert Kaempfer, who gave information on the layout, pavilions, plants, flowers and hydraulics (*see* ISLAMIC ART, fig. 86). He also mentioned topiary work, which may have been introduced as a result of the Shah's close relations with Europe.

A noteworthy system of gardens was also created by 'Abbas at his winter residences at Farahabad and Ashraf (now Behshahr) on the Caspian coast. Although the woody slopes provided a completely different setting from the arid plains of Isfahan, the gardens followed similar organization. At Farahabad there was a vast walled enclosure divided into two sections for official receptions and private residence. The constructions at Ashraf were even more extensive, with at least eight walled gardens containing pavilions, pools and watercourses. The development at SHIRAZ by Karim Khan (*reg* 1750–79), Zand regent for the nominal Safavid rulers, followed the model of the Chahar Bagh in Isfahan. An avenue lined with cypresses and set with a watercourse led from the Koran Gate through a dense system of orchards across the Kushk River to the city centre. The gardens included the Bagh-i Naw, depicted in the 19th century by Eugène Flandin (1809–76), and the Bagh-i Jahan-nama ('Garden of the world-revealing'), comprising a palace and a garden arranged with four allées of cypress trees separating beds planted with orange trees and a magnificent pavilion with a tank in the centre. The palace, the entrance portal of which had a beautiful belvedere, had tanks on its four sides.

The same tradition of Iranian gardens continued into the period of Qajar rule (*reg* 1779–1924). The summer residence that Agha Muhammad (*reg* 1779–97) erected to the north of his capital, Tehran, was built on a sloping site, which was improved through a series of terraces. From afar the successive elevation of the terraces appeared as a grandiose palace with many storeys. The survey and description of this garden by PASCAL-XAVIER COSTE reveal the close connection between the palace and the lower orchard through an elaborate system of open and semi-closed spaces: from the courtyard of the palace through a vaulted entrance to four descending terraces through a belvedere to an orchard with lake and pavilion. This was one of the last royal gardens in traditional style, for by the mid-19th century the English style of picturesque garden had been introduced, to judge from two parks belonging to the courtiers Zil al-Sultan and Amin al-Dawla represented on an 1891 plan of Tehran.

The persistence of the geometric layout and of the central role of water and pavilions for shade shows the close relationship between garden design and the natural setting of Iran. On the arid Iranian Plateau the very existence of settlement depends on the presence of water and the creation of an oasis rich with trees and plantings. Natural oases at the foot of the Zagros and Elburz mountains were irrigated by rivers or perennial springs; subterranean aqueducts (*qanāt*) were also dug into the water-table to bring the water to the surface, where it was distributed in open channels throughout the oasis and stored in cisterns and tanks. Orchards and gardens surround villages and towns, and most buildings—including houses, mosques, madrasas, palaces and caravanserais—are arranged around one or more internal courtyards with a tank and plants.

The presence of a natural spring was occasion for the creation of the gardens, such as the Bagh-i Takht at Shiraz, the Shah Goli at Tabriz and the Chashma 'Ali near Damghan. Spring-water was collected in a small lake, which was the most striking feature of these gardens. Sometimes a *qanāt* was dug expressly to water a particular garden. For example, the Safavid ruler Isma'il I ordered one in 1504 to supply the Bagh-i Fin near KASHAN—the finest surviving example of a formal Iranian garden (see fig. 17)—and the Qajar Nasir al-Din (*reg* 1848–96) ordered one to supply his hunting grounds, the Bagh-i Dilgusha at Dushan Tepe near Tehran. Garden design was deeply dependent on water: irrigation canals run along the slope and define the layout, often articulating the main axis with stone channels, small cascades and geometric basins. In Iran the mere presence of water causes pleasure. Dozens of different flowers, including narcissi, tulips, lilies, saffron crocuses, irises, violets, primroses, hollyhocks, poppies, pinks and evening primroses, were planted along with such trees and shrubs as lilacs, oranges and jasmines in a seemingly natural arrangement, for the artifice in the Iranian garden lies in creating an environment where plants will grow in the midst of arid nature.

BIBLIOGRAPHY

al-Mafārrukhi: *Risāla maḥāsin Isfahān* [Epistles on the beauties of Isfahan] (*c.* 1072–92), ed. J. Tihrani (Tehran, 1933); Pers. trans. as *Tarjuma-yi maḥāsin-i Isfahān*, ed. 'A. Iqbal (Tehran, 1949); Eng. trans., abridged, by E. G. Browne as 'Account of a Rare Manuscript History of Isfahan', *J. Royal Asiat. Soc. GB & Ireland*, liii (1902), pp. 411–46, 661–704

R. González de Clavijo (*d* 1412): *Vida y hazañas del gran Tamorlan con la descripción de las tierras de su imperia y señoría* (St Petersburg, 1881/*R* 1971); Eng. trans. by G. Le Strange as *Embassy to Tamerlane (1403–1406)* (London, 1928)

Fāzil Haravī: *Irshād al-zarā'a* [Instructions for agriculture] (1515), ed. I. Afshār (Tehran, 1966)

Iskandar Munshī: *Tārīkh-i 'alamārā-yi 'Abbāsī* [History of the world-conquering 'Abbas] (1629); Eng. trans. by R. Savory as *History of Shah 'Abbas the Great* (Boulder, 1978)

Pietro della Valle: *Viaggi di Pietro della Valle il Pellegrino . . . divisi in tre parti cioe' la Turchia, la Persia e l'India* (Rome, 1650/*R* 1972)

E. Kaempfer: *Amoenitatum exoticarum politico-physico-medicarum*, fasc. v (Lemgo, 1712)

E. Flandin and P. Coste: *Voyage en Perse*, 8 vols (Paris, 1843–54)

P. Coste: *Monuments modernes de la Perse* (Paris, 1867)

D. N. Wilber: 'Bāgh-e Fīn near Kashan', *A. Orient.*, ii (1957), pp. 506–8

M. R. Pechère: 'Etude sur les jardins iraniens', *Proceedings of the 2nd International Symposium on Protection and Restoration of Historical Gardens: Granada, 1973*

R. Pinder-Wilson: 'The Persian Garden', *The Islamic Garden*, ed. E. B. MacDougall and R. Ettinghausen (Washington, DC, 1976), pp. 89–105

E. B. Moynihan: *Paradise as a Garden in Persia and Mughal India* (London, 1979)

N. M. Titley: *Plants and Gardens in Persian, Mughal and Turkish Art* (London, 1979)

D. N. Wilber: *Persian Gardens and Garden Pavilions* (Washington, DC, 1979)

——: 'The Timurid Court: Life in Gardens and Tents', *Iran*, xvii (1979), pp. 127–33

T. Allen: *Timurid Herat* (Wiesbaden, 1983)

MAHVASH ALEMI

5. ANATOLIA AND THE BALKANS. Gardens under the Ottoman dynasty (*reg* 1281–1924) developed following both Byzantine and Islamic precedents (*see* §§III and V, 2 above). The climate of Anatolia being more continental than that of other Islamic lands, the courtyard and hence the courtyard garden played a smaller role than elsewhere. The polarity between the courtyard garden within a structure and the wooded park already existed under the early Ottomans and Beyliks. For example, the Moroccan traveller Ibn Battuta (1304–*c.* 1370) was received by the shaykh of the madrasa at Birgi in a garden court with a marble pool into which water spouted from the mouths of four large lion-shaped fountains. By contrast, the traveller was received by the ruler seated in front of his tent in a walnut grove beside a stream. Palaces and houses were often set in walled gardens, and towns were surrounded by garden suburbs, which often contained large park-like cemeteries. Often set on hillsides to take advantage of the view, cemeteries were planted with cypresses

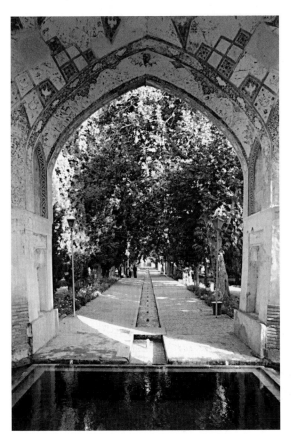
17. Bagh-i Fin, near Kashan, Iran, 16th century and later

and had graves with little plots for flowerbeds. Walled gardens were planted with rows of fruit trees, which were enjoyed as much for their blossom and scent as for their produce. Gardens were designed for both economic considerations and pleasure, and there was no strict division between kitchen and flower gardens. According to Lady Mary Wortley Montagu (1689–1762), who visited Turkey in 1717, the gardens and vineyards alongside the rivers of Edirne supplied the city with fruit and vegetables, and orderly orchards were laid out for miles around the city. The city residents would go out to the gardens where they would spread their carpets and drink coffee; the gardeners and their families had little houses there. In central Anatolia the townsfolk cultivated gardens outside the city walls wherever there was water and would spend the summer months at their cool retreats.

The history of gardens under the Ottomans can be reconstructed from a variety of sources, including horticultural treatises, travellers' accounts and contemporary representations in manuscripts, poetry and tiles, in addition to surviving examples. The *Rawnaq-i būstān* ('Splendour of the garden') by al-Hajj Ibrahim ibn Mehmed is a horticultural treatise concerned with the growing of fruit trees and contains chapters on soils, planting, pruning, grafting and diseases of trees, as well as a final section on the gathering and keeping of fruit. Contemporary manuscript representations include the depiction of the gardens of Topkapı Palace in the *Bayān-i manāzil-i safari-i 'Irāqayn-i Sulṭān Sulaymān Khān* ('Description of the stages of Sultan Süleyman's campaign to the two Iraqs'; 1537–8; Istanbul, U. Lib., 5964) by NASUH MATRAKÇI. The garden was idealized in Ottoman poetry as a sanctuary removed from wordly troubles and a setting for the leisurely life of pleasure and contemplation. The interior walls of mosques and palaces were revetted with underglaze-painted tiles that depict garden-like settings, and model gardens of spun sugar were carried on parade during festivals (see fig. 18).

Topkapı Palace, the sprawling residence of the Ottoman sultans in Istanbul until the 19th century, had several types of gardens within its walls. The outer courts were walled and terraced and planted like miniature parks with cypress and other trees, which were protected by walls against the gazelles and other animals that roamed at liberty there. Formal gardens were restricted to the Fourth Court, where the terrace was paved and set with formal beds; these were destroyed in the 17th century when the Revan and Baghdad kiosks and the reflecting pool were constructed. Murad III (*reg* 1574–95) constructed a pool and terrace garden (destr.) beneath his apartments in the Harem.

Although none of these gardens was large, the palace ordered prodigious quantities of bulbs and trees. For example, in May 1759 Murad III ordered 50,000 tulips (or possibly hyacinths) from the province of Aleppo and in May 1593 he ordered 50,000 white and 50,000 blue hyacinth bulbs from Maraş. The following September 40 tons of rose trees were ordered for the gardens of the summer palace at Edirne. It is likely that the great quantities were used to turn indoors into out with banks of flowers in the inner courtyards, corridors and chambers of the palace. The practice seems to have set the precedent for the festivals of flowers that took place in the Tulip Period

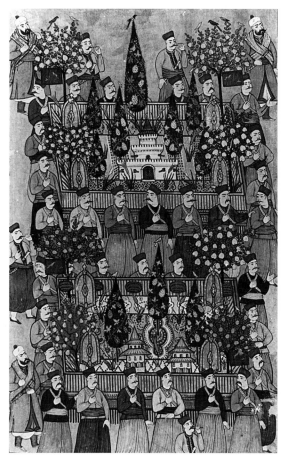

18. Spun sugar gardens carried on parade, from a manuscript of Vehbi's *Sūrnāma* ('Book of festivals'), 1720–32 (Istanbul, Topkapı Palace Library)

under Ahmed III (*reg* 1703–30). The parks were constantly and carefully replanted: in the 17th century 4000 young trees were ordered for Topkapı Palace and 5000 for the palace in Edirne. The size of the orders implies that the trees were supplied from nurseries, and the importance of flowers and trees is underscored by clauses in treaties that required their dispatch for indemnities. The palace gardens were under the control of the Lord of the Garden, who was effectively the Lord Chamberlain. The gardens supplied not only the palace kitchens but also the market, for fruit, vegetables and flowers were sold to the public, the profits going to the sultan's private purse.

Nobles imitated the gardens of the sultans. The garden in the palace of the grand vizier Ibrahim Pasha overlooking the Atmeydan in Istanbul (now the Museum of Turkish and Islamic Art) was described by the French officer Jérome Maurand in 1544. The court was planted with double violets, the scent of which must have been overpowering, particularly when it wafted into the great hall on the sheltered side. A row of cypresses led from the gate to the suburban hunting lodge of Siyavuş Pasha, which was built over a pool; below its terraces and belvedere the banks slope down to parkland. The much

grander kiosk of Davud Pasha stood in a rectangular walled park on the road to Edirne. In one corner was a smaller enclosure with a pool, kiosk and flowerbeds.

The embassy of Mehmed Yirmisekiz Çelebi (d 1732) to the court of Louis XV in 1720 was ordered to bring back plans of French palaces and gardens. Consequently, an elaborate imitation of the basin and pavilions of the château of MARLY was built at the Sweet Waters of Europe outside Istanbul, and cascades and orange trees in tubs were introduced. From this beginning there developed elaborately terraced and parterred gardens, especially along the shores of the Bosporus in the 19th century. These gardens were surrounded with high walls; bridges across lanes carried women unseen from the waterside gardens to the wooded hillsides. The gardens also had grottoes and fountains, comprising taps set in marble. The Ottoman delight in water was expressed in Baroque decoration and large fountains. The traditional *salsabīl* fountain type was also elaborated, with water sliding or dripping from cup to cup and sometimes designed to play a tune. Some of these miniature cascades descended from considerable, often pyramidal, height. Exterior and interior garden spaces were integrated by pavement carpets of different shades of pebbles and interior grottoes. The lofty salon of the Şakir Pasha mansion (Turk. *konak*) on the island of Büyükada, for example, had a grotto full of plants and ferns covering one wall. Although fake marble caves provided refreshment in summer, they did not provide the views that the Ottomans relished in their gardens.

Flowering trees and shrubs, the leaves and flowers of which provided contrast throughout the seasons, were valued along with evergreens, particularly cypress. Chestnut, plane, hornbeam and lime were mingled in the gardens of the palaces in Istanbul and Edirne, which were filled with beautiful shrubs and trees. Almond and cherry trees held highest place, and their flowering branches are often depicted on fine Iznik tiles. Flowers were grown in inner courts. The most favoured included carnations, roses, tulips, hyacinths, daffodils, jonquils, cyclamens and narcissi, but other plants were grown as herbs or to repel insects. Lilies, ranunculi, irises, love-in-a-mist, acanthus, primroses, anemone, bellflowers, campion and violets were also cultivated. The tulip, which the Flemish traveller Ogier Ghislain de Busbecq (1522–92) brought to Europe from Turkey sparking the craze for this plant, derived from a speckled variety with spiked petals cultivated in eastern Anatolia, Persia and Afghanistan. Wild flowers were also admired and depicted in book illustrations of hunting and country scenes.

BIBLIOGRAPHY

Ibn Baṭṭūṭa: *Riḥla* [Travels] (*c.* 1354), ed. and Eng. trans. by H. A. R. Gibb as *The Travels of Ibn Baṭṭūṭa*, 3 vols (Cambridge, 1971)

J. Maurand: *Itinéraire d'Antibes à Constantinople* (1544), ed. and trans. by L. Dorez (Paris, 1901)

al-Ḥajj Ibrahim ibn Meḥmed: *Rawnaq-i būstān* [Splendour of the garden], Turk. ed. by H. Tunçer as *Revnak-i Bostan* (Ankara, 1961)

M. Wortley Montagu: *The Complete Letters of Lady Mary Wortley Montagu*, ed. R. Halsband (Oxford, 1965)

J. H. Harvey: 'Turkey as a Source of Garden Plants', *Gdn Hist.*, iv (1976), pp. 21–42

G. Goodwin: 'Landscape in Ottoman Art', *Landscape Style in Asia*, ed. W. Watson, Percival David Colloquies on Art and Archaeology in Asia, ix (London, 1980), pp. 138–49

——: 'Gardens of the Dead in Ottoman Times', *Muqarnas*, v (1988), pp. 61–9

G. Necipoğlu: *Architecture, Ceremonial and Power: The Topkapı Palace in the Fifteenth and Sixteenth Centuries* (Cambridge, MA, and London, 1992)

GODFREY GOODWIN

VI. East Asia.

The prototype of the garden in East Asia can be traced back to the Zhou period (*c.* 1050–256 BC) in China. According to inscriptions on bones and carapaces, kings had already begun hunting in enclosed parks, where rare animals and birds were kept. Such enclosed areas were the origin of the tradition of the royal or imperial park (*see* §1(ii) below). In the Han period (206 BC–AD 220), another type of garden was developed: the private gardens owned by the aristocracy and the wealthy. During the reign of Emperor Wudi (*reg* 141–87 BC) of the Han dynasty, a garden layout was created with a pond in the centre containing artificial mountains symbolizing the islands of Penglai, Fangzhang and Yingzhou—supposedly the abode of the Daoist Immortals. This garden design also influenced gardens in Korea and Japan (*see* §§2 and 3 below). In comparison to the changing styles evident in Chinese gardens, gardens in Korea and Japan preserved rather a conservative style in that their main principle remained to express natural scenery with simple mountains and water. However, in the 15th and 16th centuries, in Japanese Zen Buddhist temples, dry landscape gardens (Jap. *kare sansui*; 'dried-up mountain and water') were created. In these gardens the sea and rivers were represented solely by sand and small stones, without the use of water. During the Ming (1368–1644) and Qing (1644–1912) periods in China, gardening methods became much more elaborate, as did all the elements of a garden. As a result, the gardens of China generally appear to be more 'artificial' than those of Japan and Korea, which give the impression of preserving natural scenery.

TAN TANAKA

1. China. 2. Korea. 3. Japan.

1. CHINA. Chinese gardens are generally composed of artificial mounds and rockeries; water in the form of streams, ponds or lakes; buildings, usually one or two storeys high; paths and covered ways; and plants. Each garden as a whole as well as its scenic areas and buildings are given names, often rich in literary allusion, which intimate their significance and special qualities. Historically they fall into two categories: the large royal hunting and pleasure parks up to the Han period (206 BC–AD 220), and the smaller estates and much more intimate gardens of the literati and gentry of later periods.

(i) Introduction. (ii) Up to Six Dynasties period (AD 222–589). (iii) Tang (AD 618–907) and Song (AD 960–1279) periods. (iv) Ming period (1368–1644). (v) Qing period (1644–1911). (vi) After 1911.

(i) *Introduction.* Chinese gardens are intrinsically ephemeral. Because their appearance varies with the season and time of day, they were not intended to be fixed in design or form. The subsequent addition of inscriptions, buildings, plants and animals, changes of names and alterations to various architectural elements were carried out as a matter of course and were not necessarily considered injurious to the original designs. The constant care of

plants and periodic renovation of buildings, mostly constructed of timber, were essential; in turn, such maintenance depended on the continued prosperity of the owners and the well-being of the state. The vicissitudes of familial and dynastic fortunes ensured that few gardens avoided drastic modification.

Consequently, modern scholarship relies to a large extent on primary texts as repositories of Chinese memories of gardens. The rhetorical relation of word and image and the specific form of memory practised by the Chinese are therefore important. The Chinese memory of gardens was fragmentary and selective. It did not involve the reconstruction of a concrete reality; neither was aesthetic excellence the sole criterion. The personal moral or literary standing of the owner and famous events associated with a garden were often more important. Gardens have been the topic of discussion from the earliest Chinese writings onwards. However, it was only in the Song period (AD 960–1279) that gardens emerged generally in Chinese discourse as spatial objects, and accounts of the spatial composition of famous gardens became common. The views and descriptions of owners and visitors dominated discourse on gardens until the 20th century. The distinction between the owner or the visitor and the designer did not emerge until the Ming period (1368–1644).

(ii) To Six Dynasties period (AD 222–589). The imagery of the earliest Chinese gardens can be related to the idea of a paradise of earthly pleasures similar to a *locus amoenus* in Western traditions. For example, the Xuanpu ('Hanging garden'), is described in the *Huainanzi* ('Book of the Prince of Huainan') of the 2nd century BC as a place with warm, windless climate, clear streams and numerous animals. According to tradition, it was located on the legendary Mt Kunlun, the central mountain of the universe in Chinese cosmography. Such sacred precincts as Xuanpu and Lingyu (Numinous Park) later became prototypes for the royal hunting parks and animal preserves of the Zhou period (*c.* 1050–256 BC). Some of these hunting parks were enclosed by walls, and some included architectural elements. According to the *Zhou li* ('Rites of Zhou'), probably compiled in the 1st or 2nd century BC, the royal parks, administered by special officials from the late Zhou period onwards, supplied animals for sacrifices and often served as venues of important religious ceremonies. The parks of feudal lords appear to have been less involved in ritual, some serving recreational purposes. Initially the common people were allowed entry to the hunting parks to hunt and gather fuel, but by the Warring States period (403–221 BC) the parks had become exclusively the domain of rulers.

Detailed accounts of hunting parks became available in the Han period. Although the general purposes of contemporary parks were similar to those of their predecessors, a new emphasis on rare plants and animals emerged at this time and certain meanings of the parks were articulated in discourse. The largest of the Han-period parks, Shanglin yuan (Supreme Forest Garden), was enclosed by a wall *c.* 200 km long. The park, developed by Emperor Wudi in 138 BC, was said to contain 36 detached palaces and separate hostels, with 'divine ponds and numinous pools', 3000 species of plants, precious stones and rare creatures ranging from cormorants to yaks. Plants and animals were placed in different areas according to their place of origin. Some parts of the park were named after distant places. Kunming Lake, for instance, was named after a kingdom far to the south-west that the Emperor had planned to conquer. In this way, the park became a microcosm of the Chinese world.

Not far away from the splendours of the Shanglin yuan, in the Jianzhang Palace just outside the Han-dynasty capital Chang'an (near modern Xi'an, Shaanxi Province), Emperor Wudi created a smaller, but equally significant garden in 104 BC. It contained a platform called Jian tai (h. *c.* 27 m), which was designed as a place for him to meet immortals. On the Taiye chi (Lake of Supernal Essences), the three islands of Penglai, Fangzhang and Yingzhou were created in imitation of and named after the famous mythical island-mountains of the immortals in the Eastern Sea that were described in the Daoist text *Liezi*, probably written in the 3rd century AD, and other geographical accounts of paradises. Similar representations of these islands were built in later imperial gardens.

The royal hunting park and garden was the major form of garden design in China up to the Han period, but in the subsequent Six Dynasties period gardens belonging to the aristocracy, literati and temples became prominent. Han landscape design activity had been focused around the imperial capitals of Chang'an and Luoyang (Henan Province). With the partition of the Han empire into various independent states, the construction of gardens spread to the new capitals of these states, southwards to Jiangnan (the area south of the River Yangzi) and to the Buddhist and Daoist temples in mountainous regions. Private gardens were often donated to temples, and temple gardens in cities were not substantially different from private gardens.

At this time, private gardens were distinct areas separated from the residences to which they belonged. They can be divided into two types. Gardens of the first type, mainly located in northern centres such as Luoyang and Yecheng (now Linzhang County, Hebei Province), had an opulent image fostered by a spirit of competition among members of the aristocracy and the urban literati. Shi Chong's Jingu yuan (Garden of the Golden Valley), the best known, had an artificial lake, winding streams and waterways for boating and fishing, as well as rockeries, pavilions and other buildings. Apart from being a recreational site, it was also used for agriculture and had an economic function. The finest gardens of this type were said to rival the splendour of the contemporary imperial gardens. Gardens of the second type, mainly located in the Jiangnan area, were relatively small, simple, rustic creations made famous by their talented literati owners, and were often the site of much poetic activity. The garden (destr.) of Tao Yuanming, the famous poet of the 4th to 5th century AD who renounced an official career in favour of eremitism, became the most famous among such gardens. Tao's *Taohua yuan* ('Peach blossom spring'), telling the story of a fisherman's discovery of a utopia separated from the world of men by mountain ranges and accessible only through a cave passage, came to represent an archetypal image of a paradise. Later, the story became a favourite subject in Chinese painting, and gardens were

given names that allude to the story, thereby affirming their paradisial nature.

(iii) Tang (AD 618–907) and Song (AD 960–1279) periods. The private gardens of the literati continued to flourish in the Tang and Song periods and gained even greater prominence in Chinese culture. The main forms of garden design are best represented by four famous gardens. The Wangchuan bieye (Wang River Estate) of Wang Wei and Li Deyu's Pingchuan shanzhuang (Ping River Mountain Estate; destr.) were country estates similar in nature to the Jingu yuan built by Shi Chong (*see* §(ii) above). Bai Juyi's Cao tang (Thatched Hall) was a rustic abode on Mt Lu (Jiangxi Province), Sima Guang's Dule yuan (Garden of Solitary Happiness) was a relatively small urban garden. All four owners were famous: Wang Wei and Bai Juyi were two of China's best-known poets; Li Deyu was a major statesman and Sima Guang one of the most important Chinese historians. The personal eminence of these literati had a considerable bearing on the fame of their gardens; celebrated in contemporary poetry, the gardens came to represent the ideals and concerns of later garden designers and builders. The country estates of Wang and Li, as well as Bai's Cao tang, consisted of manmade structures arranged in natural landscapes. The Cao tang, constructed of plain unpainted timber and completed in AD 817, was sited on Mt Lu and orientated to obtain shade and capture special views in each season. Apart from a small waterfall, there was also a terrace and a pond, all common features of gardens of later periods. Wang's estate, constructed *c.* 742, had 20 architectural elements such as terraces, pavilions, bridges and walled or fenced compounds in addition to special areas for agricultural purposes, all arranged in the Wang River valley outside Chang'an (now Xi'an, Shaanxi Province), the capital of the Tang dynasty. Li's estate outside Luoyang, Henan Province, completed *c.* 825, was similar in nature but larger and more lavish. It had rare plants, rocks and animals, and over 100 pavilions, terraces and other buildings.

Bai's Cao tang and the estates of Wang and Li demonstrate the fluid and ambiguous distinction between landscape and garden. They were clearly different in nature to later gardens but remained prominent in the discourse on gardens in subsequent periods: this is because a garden was not primarily defined as a type of spatial object but as a kind of experience, a conjunction of feelings or sentiments (*qing*) and scenery (*jing*). Perfect accord between the two elements, in which the person and nature became one, was the ideal aspired to in the appreciation of both gardens and natural landscapes. Wang Wei's 20 poems about his estate, on which its reputation is based, were considered in Chinese literary criticism exemplary of just this ideal. The appreciation of gardens and natural landscapes shared a similar basis and were given expression together in literary collections. Hence no separate discussion of gardens took place.

Sima Guang's Dule yuan (destr.), constructed in Luoyang in 1073, had seven major parts: a library; a fisherman's hut made of a ring of bamboos with their tips tied together; a herb garden; a terrace; and three other pavilions. These were sited among an intricate layout of streams and waterways. Each major part of the garden honoured a worthy from the past. The Jianshan tai (Terrace for Viewing the Mountain), for instance, honoured Tao Yuanming. The name of the terrace alludes to Tao's famous lines 'Plucking chrysanthemums beneath the eastern fence, / I distantly see the southern mountains'. In later periods, garden enthusiasts exhorted each other to imitate Sima Guang's garden. Just as he imitated the ancient worthies by striving to live as they did, later literati sought to follow his example. There was, however, no question of copying the details of Sima Guang's original garden. Known only from literary sources in later periods, the composition of the garden could not be established in any definitive manner; in garden design, as in Chinese painting and calligraphy, innovations were frequently promoted under the banner of 'imitating the ancients'.

The most important imperial garden of the Tang and Song periods was Emperor Huizong's Genyue yuan, constructed in the Song capital Bianliang (modern Kaifeng) between 1117 and 1122 on the advice of a geomancer. Huizong was a renowned petrophile and amassed the largest collection of fine rocks in his park. The love of rocks was widespread among the cultural élite for centuries. Li Deyu was a noted connoisseur, and Mi Fu, the famous painter and calligrapher, was said to have bowed down in front of a rock and addressed it as his elder brother. This became a popular theme in Chinese painting. Rocks were not considered inanimate objects but manifestations of dynamic natural processes charged with *qi*

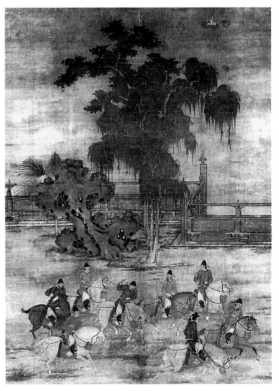

19. Chinese royal park depicted in Zhao Yan: *Eight Gentlemen on a Spring Outing* (detail), hanging scroll, 10th century (Taipei, National Palace Museum)

('pneuma' or 'energy'). Traditionally, four criteria were applied in the appreciation of rocks: *shou* ('leanness'), referring to a tight relationship between internal *qi* patterns and exterior configuration; *zhou* ('surface texture'), requiring the articulation of surface details to respond to macrostructural configurations, such as the shapes of real mountains; *tou* and *lou*, which denote foraminous structure and refer to types of horizontal and vertical small holes and perforations respectively. Rocks from Lake Tai, Jiangsu Province, formed when limestone deposits of the Permian era were corroded by the action of water, were the most sought after. *Eight Gentlemen on a Spring Outing* (Taipei, N. Pal. Mus.) by Zhao Yan (*d* AD 923) is one of the earliest depictions of such rocks, shown set into the ground in a palatial park (see fig. 19). Smaller rocks were often set on pedestals in gardens or piled up to form artificial mountains (*jiashan*). Such artificial mountains were constructed of earth, rocks or a combination of the two. Apart from rocks from Lake Tai, many other varieties were used. Over a hundred varieties are discussed in Du Wan's *Yunlin shipu* ('Stone catalogue of cloudy forest'; *c.* 1126), the most famous catalogue of its kind. Smithsonite and realgar were said to be common ingredients of artificial mountains in the Song period. In the Genyue yuan, smithsonite was reportedly used to produce mist in damp weather, while realgar was used to ward off insects and snakes, a particularly important consideration in the construction of artificial grottoes and caves.

(iv) Ming period (1368–1644). Up to the Song period, Chinese garden design had been the product of the silent tradition of craftsmen and the discursive practices of the literati. In the Ming period, however, the views and concerns of a professional class of designers emerged in Chinese discourse on gardens. Highly respected by the cultural élite in the 16th and 17th centuries, these designers were itinerant professionals engaged principally in the design of artificial mountains. Famous designers during this period usually came from Jiangnan (the area south of the River Yangzi), a cultural centre and the heartland of garden design in the Ming and Qing (1644–1911) periods. They were trained in painting and conceived of their work in pictorial terms. According to contemporary sources, Zhang Lian (1587–?1671), his son Zhang Ran (*fl* 17th century) and Ji Cheng (1582–after 1634) all created rockeries according to *cunfa*, the elaborately formularized methods of using textured brushstrokes to describe landscape in traditional monochrome ink paintings; rockery design and painting were considered analogous. Ji Cheng regarded the whitewashed walls of buildings or courtyards as paper, and the plants and rocks as ink. Just as 'the idea should precede the brushwork', according to Wang Wei's famous essay on landscape painting, so similarly the careful conception of a rockery's overall composition should precede its construction.

The views of designers appear mostly in fragments in the writings of the literati, but in a unique treatise entitled *Yuan ye* ('The fusing of gardens') of *c.* 1635, Ji Cheng expounded the ideals of his art at length. Individual concerns such as the selection of sites are discussed in detail, but there is a telling silence on the synthesis of actual designs. In long paratactic passages, evocative scenic images, many drawn from famous literary works on historic places and gardens, are grouped together in syntactically parallel sentences in such a way that the distinctions between suggestion, description and prescription are sometimes blurred. In this manner, Ji upheld the principle that the design of each garden should respond to its site and that a designer should avoid putting forward model designs that could be used mindlessly anywhere, while still disseminating aspects of historic gardens recorded in famous writings as ideals.

Because the majority of Ming gardens were privately owned, and since private resources could not approach those available to former rulers, the expression of traditional themes such as the garden as a paradise and a microcosm (*see* §(ii) above) became more abstract and, at times, largely rhetorical. At the same time, the traditional imagery associated with these themes became more diversified and compounded. For instance, in Gong Fu's 16th-century garden Yuyang dongtian (Cave-heaven of the Jade Sun), Yuxu tang (Jade Empyrean Hall) was encircled by eight chambers organized according to the traditional configuration of eight trigrams of the *Yijing* ('Book of changes'). The garden therefore symbolically contained all the possibilities of cosmic transformation. Here, the microcosmic significance of the garden was compounded with a paradisial reference. *Dongtian* ('cave-heaven') was the most common expression for paradise in Daoism. In other cases, gardens acquire a paradisial significance by virtue of names relating to gourds and vases. The Pao lu (Gourd Hut) and Hu yuan (Vase Garden) in respectively Yangzhou and Suzhou, both in Jiangsu Province, provide good examples. The names of these gardens refer to a

20. Yu yuan (Yu Garden), Shanghai, 1557–9; view of passageway through vase-shaped doorway

legend about gourds containing paradisial realms, which immortals could enter by magical means. Numerous wall openings in Chinese gardens in the shape of gourds or vases, such as those in the Yu yuan (Yu Garden; see fig. 20), Shanghai, built between 1557 and 1559, are also related to this legend.

By means of allusive names, space in Ming gardens, as in the gardens of Song and later Qing times, was bound up with religious thought and charged with memories in which history and moral value were one. Space in these gardens was not considered isotropic, infinite and empty, but qualified, relational and dynamic. Each site chosen for a garden was seen to possess peculiar qualities, sometimes conceived in terms of GEOMANCY. A designer had to act in accordance with existing conditions to establish a new set of harmonious relations in the garden. The primary focus of attention was directed to relationships, not spatial volumes. Relationships—between the various elements of the design, between the terrain and these elements, between the garden and the surrounding landscape and between the visitor and all of these—constitute the garden. These relationships, moreover, were conceived not statically, but dynamically with regard to temporal processes such as diurnal and seasonal changes, and also the succession of views apprehended by the visitor in walking through the garden.

(v) Qing period (1644–1911). Jiangnan continued as the focus of garden building in the Qing period. Even parts of the imperial gardens in the north imitated famous gardens owned by the literati in this area. The imperial Xiequ yuan (Garden of Harmonious Charms) at the Yihe yuan (Summer Palace) in Beijing, for instance, was said to be modelled on the Jichang yuan in WUXI, Jiangsu (see fig. 21). Modern studies of Qing gardens have concentrated on extant gardens, which owe their present condition largely to changes made during the late Qing and early Republican period (1912–49). They are generally divided into three types: northern gardens, concentrated around Beijing and Chengde (Hebei Province); Jiangnan gardens, concentrated around Nanjing (Zhejiang), Yangzhou, Suzhou (both in Jiangsu) and Shanghai; and Lingnan (a former name for Guangdong) gardens.

The most famous of the extant gardens in the north are the imperial gardens in the northern part of the Forbidden City and the Yihe yuan (Summer Palace), both in Beijing, and the Bishu shanzhuang, the imperial summer resort at CHENGDE. The last two gardens are the largest of their kind. Working plans with full measurements to the scales of 1:100, 1:200 and 1:300 as well as timber models were made by a section of the Board of Works before construction of the gardens; a number of these items survive. Buildings in these gardens are mainly laid out in strong axial compositions in an enclosed, artificially modified, but informal landscape. They often have red columns and yellow tiles characteristic of imperial structures, but certain structures such as those at the Bishu shanzhuang were designed in imitation of the plainer buildings in Jiangnan gardens and have unpainted columns and grey tiles. Buildings such as those on Mt Wanshou in the Yihe yuan are often orientated to distant views (see fig. 22) and thereby 'borrow the landscape' (*jie jing*) beyond as part of their own composition. Buddhist motifs are commonly found on these buildings, and are related to the fact that the Qianlong emperor was considered the reincarnation of Manjushri, the *bodhisattva* of wisdom. The references to Buddhist thought in imperial gardens is also revealed in the hilltop area of Mt Wanshou, which is devoted to Buddhist structures and was once known as Xumi lingjing

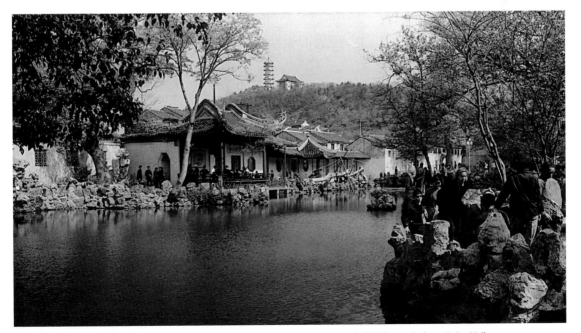

21. Jichang yuan (Jichang Garden), Wuxi, Jiangsu Province; view looking south towards Mt Xi pagoda from Jiashu Hall

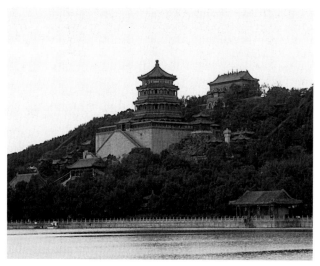

22. Yihe yuan, Summer Palace, Beijing, 1880; view over Kunming Lake towards Mt Wanshou

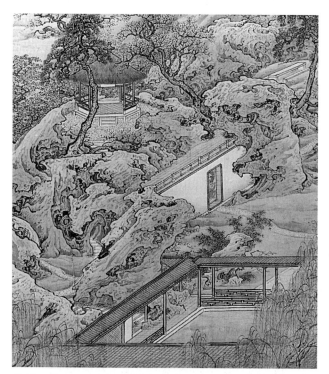

23. Yuan Jiang: *Gazing Garden* (detail), handscroll, ink and colour on silk, 552×2946 mm, late 17th century–early 18th (New York, Metropolitan Museum of Art)

('Spiritual realm of Mt Sumeru', the latter being the central mountain of the Buddhist cosmos).

The characteristics of private gardens in Beijing are very distinct from those in Jiangnan. On the one hand, Beijing gardens such as the Ge yuan are commonly axial and rectilinear in overall organization and were designed to fit into an urban setting dominated by the traditional court-yard pattern of spatial division employed in domestic architecture. Jiangnan gardens such as the Liu yuan (Garden for Lingering) in Suzhou, on the other hand, usually occupy irregular plots of land, and axial arrangements rarely play a significant part in their design. Jiangnan gardens are renowned for the tight spaces and extensive subdivisions formed by architectural elements and rockeries. There is less subdivision of spaces in Beijing gardens, and individual spaces are generally larger than those in Jiangnan gardens. Owing to a shortage of sources of running water within the walls of Beijing, architectural elements are generally given dominant roles and artificial ponds and artificial mountains are often used as minor elements. Jiangnan is an area abundant in water, and whenever rivers or streams were not available to supply water, it was usually possible to excavate to the water-table. In the larger Jiangnan gardens, such as the Zhuo-zheng yuan (Garden of the Humble Administrator) in Suzhou, the water body is usually divided into a series of ponds of different sizes; in smaller gardens such as the Wangshi yuan (Garden of the Master of the Nets), also in Suzhou, water is mainly concentrated in one pond. In response to the harsh winter weather in Beijing, architectural structures have heavier, more solid building envelopes and lower eaves than their Jiangnan counterparts. Consequently, the separation of the interior and exterior in garden structures of northern gardens is also more pronounced. Where local rocks are used in Beijing, they are generally yellow with a hint of reddish-orange and are less foraminous in structure than the Lake Tai rocks of the south, which are grey. In the north, rocks are commonly set on stone bases and placed axially in relation to surrounding buildings. In Jiangnan gardens, rockeries often play a major role in the articulation of spaces. The large artificial mountains often incorporate internal stair-ways and paths, and in certain cases these paths are connected to the upper storey of adjacent buildings so that visitors can step directly on to the mountain as though it were an ordinary staircase. Special individual specimens of fine rocks are commonly placed in stone flowerbeds in front of the buildings. Northern gardens have few of the broad-leaved subtropical evergreens usually found in Jiangnan gardens; hardy pines, cypresses and gingkos are commonly planted to withstand the harsher climate. Generally, again owing to the climate, northern gardens have a smaller variety of plants than those in Jiangnan.

Existing gardens in the southern province of Guang-dong are extremely small in number, and few might be categorized as traditional gardens of Lingnan. A typical Lingnan garden had a pond, tall trees and orchids and was surrounded by two-storey buildings on all sides. The trees provided complete shade in summer, thereby diffusing the strong sunlight and cooling the air.

The typological analysis of extant gardens, suggestive as it is of various regional differences in Chinese garden design, does not reveal much about the spatial complexity of individual gardens. This spatial complexity, particularly evident in the gardens of Jiangnan, is constituted by an intricate order of interdependent elements and processes. Of fundamental significance is the relation between land and water. Moulding the land and defining the body of water are interrelated processes, the result of which is expressed by the edge of the water. How the water body

is defined is partly determined by the land levels established around the water, and how these are established is partly determined by the desired relationship between the land and water body. The banks of ponds often consist of irregularly placed rocks that overhang the water-line so that the water appears to flow underground; the rocks around the pond in the Wangshi yuan, Suzhou, are a case in point. In other gardens, if a building is placed on or close to the edge of a pond, a bank may be constructed of vertical masonry.

Moulding the land and defining the body of water also determines the general form of the views within a garden, which take form as the buildings, plants and rockeries are positioned on the site. At the same time, routes connecting the various internal and external spaces of the garden are established. The composition of views is interdependent with the organization of routes through a garden that often link up rockeries, grottoes and buildings by means of paths. The *Gazing Garden* by Yuan Jiang (New York, Met.; see fig. 23) shows the close juxtaposition of these elements. Buildings and paths are placed according to the scenery, and views are obtained according to the paths and buildings, which often help orientate the visitor to special views and at the same time serve as scenic elements from other viewpoints. An example of the dual aspect of architectural elements is the building in the form of a

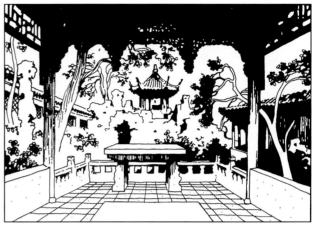

24. Yi yuan (Garden of Ease), Suzhou, Jiangsu Province; impression of view looking east towards the Luoji Pavilion from inside barge-shaped building

barge in the Yi yuan (Garden of Ease; see fig. 24) in Suzhou. From inside the barge, distant views are framed by the structure of the building, while the barge itself forms part of many different scenes from other viewpoints. Bridges that zigzag across ponds, found in gardens such as the Zhuozheng yuan (see fig. 25), Suzhou, also help

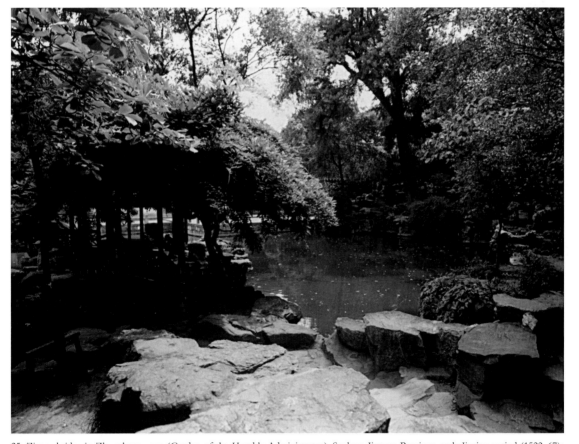

25. Zigzag bridge in Zhuozheng yuan (Garden of the Humble Administrator), Suzhou, Jiangsu Province, early Jiaqing period (1522–67); rebuilt 1960s

26. Chinese garden wall openings: (a) Jixiao shanzhuang (Mountain Estate for Whistling), Yangzhou, Jiangsu Province; view through a four-lobed window; (b) Shilin xiaoyuan (Little Court of the Stone Forest) in the Liu yuan (Garden for Lingering), Suzhou, Jiangsu Province, 1876

orientate the visitor. As a route twists and turns, it places into order a sequence of contrasting spaces and views. In the Liu yuan, for instance, the sequence of spaces at the entrance incorporates alternations in light and darkness, constriction and expansion in architectural elements, as well as changes in direction, to enliven an otherwise uneventful passage to the major parts of the garden.

At every point in a garden, selected scenic elements are presented to the visitor, while others are half revealed or completely hidden, only to be presented at another point. Apart from scenic elements within the garden, fine features outside the garden are also brought into view by careful planning. The distant pagoda on the hill beyond the Jichang yuan (see fig. 21 above) is an example of this. At the same time, undesirable sights outside the garden are carefully blocked from view. Within the garden, the isolation of scenic elements is interdependent with the process of guiding the visitor to various views by means of the careful organization of routes. The screening of certain areas by bamboo, rocks or buildings, for example, orders individual scenic elements into limited groups, while the organization of routes orders the dynamic viewpoint of the visitor walking along the paths. Neither of these processes, however, is absolute. The composition of views and the seclusion of elements are complementary; they have a common aim in that they half reveal scenic elements. These elements help create a sense of mystery and curiosity. The organization of routes presents a series of spatial cues to guide the visitor, but the unpredictable appearance of such cues helps create a sense of surprise. Visitors are often led into an apparent cul-de-sac, which opens up unexpectedly to another section of a garden.

Walls are commonly used to organize routes and separate scenic elements; they also play a major role in the partition of spaces. When wall openings are made to connect adjacent spaces, as in the Liu yuan (see fig. 26b), they often offer glimpses of receding layers of connected spaces and opportunities to frame special views. One important requirement for framing such views is the coordination of architecture and vegetation. Plants are organized according to the pattern of shade established by the placement of buildings; and buildings, in their turn, often rely on vegetation to provide shade. Windows are commonly used to frame scenic compositions formed by plants, rocks and buildings, the resulting patterns of fenestration often forming part of a scenic composition framed by windows elsewhere. In the Jixiao shanzhuang (Mountain Estate for Whistling), Yangzhou, a small wall opening near the entrance frames a view of the western part of the garden (see fig. 26a). Another aspect of the coordination of architecture and planting in Chinese gardens can be experienced in the Yuanxiang tang (Hall of Distant Fragrances) in the Zhuozheng yuan, Suzhou, as it is positioned next to a lotus pond to receive the scent of the blossoms.

There are many considerations in the basic organization of a Chinese garden site and the placement of the many elements in the garden, as well as their relations with the outside. These appear in their most complex form in Jiangnan gardens, but, with minor adjustments in emphases, they are also relevant to other types of Chinese gardens. However, the coherence revealed in the spatial analysis of extant gardens does not imply that each must be appreciated in its entirety; individual parts are designed to be savoured separately at any time. For example, pathways often establish a series of circuitous routes; however, these do not form a closed circuit of the garden and the visitor is often presented with choice. Also, since a garden is commonly divided into separate areas, a visitor may leave a garden without even suspecting the existence of unseen areas; and among the views presented to the visitor, there are often half-revealed areas that might be seen only from a distance. Some views depend on seasonal changes and can be appreciated only at the appropriate time. Equally, the visitor's attention to any view is necessarily selective. Successive visits to the same garden will thus inevitably offer a variety of experiences.

In addition, it is important to recognize the constitutive role of the visitor in appreciating gardens. Traditionally, a visitor would alternately walk through the garden, sit and then continue devoting himself to a wide range of activities. A maxim recorded in a 17th-century anthology of quotations entitled *Zuigu tang jiansao* ('The sweep of a sword from the hall for the inebriation of antiquity') provides a glimpse of the sophisticated level of appreciation in gardens of late imperial China: 'With flowers, one should look at their reflections in water; with bamboos, one should look at their shadows in the moonlight; with beautiful ladies, one should look at their shadows on bamboo blinds'. Another passage from the same anthology provides an example of the contribution of sound to gardens and also an idea of the common activities of visitors: 'The sounds of pine trees, of brooks, of mountain beasts, of nocturnal insects, of cranes, of lutes, of chess pieces falling, of rain dripping on steps, of snow splashing on windows and of tea boiling are all sounds of the utmost purity. But the sound of someone reading is supreme.' The traditional reader brings with him the literary knowledge without which the numerous plaques bearing the names of buildings inscribed in fine calligraphy could not be deciphered and a crucial dimension of the sights would remain out of reach.

(vi) After 1911. With the momentous changes in Chinese society in the 20th century, the traditional patterns of life

in which Chinese gardens played some part have been supplanted by the realities of public ownership. The art of traditional Chinese garden design developed almost entirely independently of foreign influences. It played an important role in the history of Korean and Japanese gardens (*see* §§2 and 3 below), and in 18th-century Europe a selective and somewhat distorted image of it helped to promote the development of landscape and picturesque gardens. In the 20th century, however, there has been a two-way exchange of ideas. With the advent of Western forms of landscape design in China, botanical gardens and public parks were constructed in many Chinese cities, such as on Mt Lu (Jiangxi) and in Shanghai. Since the 1970s, a number of Chinese gardens have been built in the West. Among the more notable examples is the Astor Court (1981; New York, Met.), which is modelled on a part of the Wangshi yuan (Garden of the Master of the Nets) in SUZHOU. Because the modern scholar replaced the traditional Chinese literatus in discussions of the subject, European concepts of historical thought displaced the traditional memory and concept of gardens. The internal turmoil caused by long periods of war and the Cultural Revolution (1966–76) contributed to the number of traditional gardens that have fallen into ruin. Of the gardens that remain from the Ming and Qing periods (*see* §§(iv) and (v) above), many of the most significant were renovated and are protected by law as cultural relics.

BIBLIOGRAPHY

O. Sirén: *Gardens of China* (New York, 1949)
Y. Murakami: 'Tōdai kizoku no teien' [Garden of the Tang aristocracy], *Tōhōgaku*, xi (1955), pp. 71–80
Chen Congzhou: *Suzhou yuanlin* [Gardens of Suzhou] (Shanghai, 1956)
E. H. Schafer: *Tu Wan's 'Stone Catalogue of Cloudy Forest': A Commentary and Synopsis* (Berkeley, 1961)
Xie Guozhen: *Ming Oing biji tancong* [Collected chats on Ming and Qing historical notebooks] (Shanghai, 1962), pp. 297–309 [study on Zhang Lian and Zhang Ran]
Tong Jun: *Jiangnan yuanlin zhi* [Record of Jiangnan gardens] (Beijing, 1963, rev. 1984)
E. H. Schafer: 'Hunting Parks and Animal Enclosures in Ancient China', *J. Econ. & Soc. Hist. Orient*, xi (1968), pp. 318–43
Y. Murakami: *Rikuchō shisō shi kenkyū* [Studies in Six Dynasties thought] (Kyoto, 1974), pp. 360–94
M. Keswick: *The Chinese Garden: History, Art and Architecture* (London and New York, 1978, rev. 1986)
Liu Dunzhen: *Suzhou gudian yuanlin* [Classical gardens of Suzhou] (Beijing, 1979)
Chen Congzhou: *Yuanlin tancong* [Collected essays on gardens] (Shanghai, 1980)
A. Murck and W. Fong: *A Chinese Garden Court: The Astor Court at the Metropolitan Museum of Art* (New York, 1980)
Ji Cheng: *Yuan ye zhushi* [Annotated 'Fusing of gardens'], ed. Chen Zhi, Yang Chaobo and Chen Congzhou (Beijing, 1981)
Cao Xun: 'Ji Cheng yanjiu' [Study on Ji Cheng], *Jianzhu Shi*, xiii (1982), pp. 1–16
Liu Dunzhen: 'The Traditional Gardens of Suzhou', *Gdn Hist.*, x (1982), pp. 108–41 [Eng. trans. by F. Wood]
Liu Xujie: 'Yuanlin qiaoyi' [The ingenious and the extraordinary in gardens], *Jianzhu Lishi Yu Lilun*, iii and iv (1982–3), pp. 153–63
R. M. Barnhart: *Peach Blossom Spring: Gardens and Flowers in Chinese Paintings* (New York, 1983)
Chen Congzhou: *Yangzhou yuanlin* [Gardens of Yangzhou] (Shanghai, 1983)
Chen Zhi, Zhang Gongchi and Chen Congzhou, eds: *Zhongguo lidai mingyuan ji xuanzhu* [Selected and annotated Chinese records of celebrated gardens of various periods] (Hefei, 1983)
L. Ledderose: 'The Earthly Paradise: Religious Elements in Landscape Art', *Theories of the Arts in China*, ed. S. Bush and C. Murck (Princeton, 1983), pp. 165–83
Chen Congzhou: *On Chinese Gardens/Shuo yuan*, Eng. trans. by Mao Xinyi and others (Shanghai, 1984)
Zhu Jiang: *Yangzhou yuanlin pinshang lu* [Appraisals of Yangzhou gardens] (Shanghai, 1984)
J. Hay: *Kernels of Energy, Bones of Earth: The Rock in Chinese Art* (New York, 1985)
Meng Zhaozhen: *Bishu shanzhuang yuanlin yishu* [Art of garden design at the Summer Palace, Chengde] (Beijing, 1985)
J. Needham: *Biology and Biological Technology: Botany* (1986), vi, pt 1 of *Science and Civilisation in China*, 7 vols (Cambridge, 1956–)
Peng Yigang: *Zhongguo gudian yuanlin fenxi* [Analysis of classical Chinese gardens] (Beijing, 1986)
J. Hay: 'Structure and Aesthetic Criteria in Chinese Rocks and Art', *Res*, xiii (1987), pp. 5–22
R. A. Stein: *Le Monde en petit: Jardins en miniature et habitations dans la pensée religieuse d'Extrême-Orient* (Paris, 1987)
Zhou Weiquan: 'Chengde de Puning si yu Beijing Yiheyuan de Xumi Lingjing' [Chengde's Puning Temple and the Spiritual Realm of Sumeru in the Summer Palace, Beijing], *Jianzhu Shi Lunwen Ji*, viii (1987), pp. 57–81
Yang Hongxun: *Jiangnan yuanlin lun* [A theory of Jiangnan gardens] (Beijing, in preparation)

STANISLAUS FUNG

2. KOREA. In Korean landscaped gardens, mountains were regarded as the holy trunk of nature, rocks as bones, rivers as veins, and flowers, plants and trees as hairs on the holy trunk. The intention was for human beings to live in harmony with nature. Royal palaces, private residences and villas, Buddhist temples, and Confucian academies and shrines (Kor. *hyanggyo* or *sŏwŏn*; *see also* KOREA, §I, 3(i)(b)) were built with the least possible disturbance of the natural environment. Koreans viewed a house with a hill behind and a stream in front as ideally situated according to the principles of GEOMANCY.

Trees were not planted in a row or in a geometric formation, they were not pruned and no attempt was made to shape them artificially. Koreans loved trees with branches growing sideways. According to the *Cho'onch'on yanghwasorok* ('Book on plants and flowers') by the 15th-century literati painter Kang Hŭi-an, Koreans regarded the pine, bamboo, plum and orchid as noble (*see also* KOREA, §II, 3(iv)(b)). In gardens of private houses persimmon, date, pear, apricot, cherry or pomegranate trees were planted, while in royal palaces and public places zelkova, locust, willow, maple, pine and oak trees were common. Gingko trees were planted in Confucian academies and shrines. Paths were opened up across the natural terrain in gardens.

Korean garden designers made good use of the natural flow of water, creating brooks, ponds and waterfalls. Believing that it is against nature for water to spurt up, they did not make fountains. Korean ponds had natural borders or straight edges. Artificial hills, such as that at Anap-chi Pond (AD 674; rest.) in the crown prince's palace Kyŏngju, were built by ponds or brooks. Water mills, stone troughs and low stone tables were placed at strategic points and stone, wooden or bamboo bridges spanned ponds or brooks (*see also* KOREA, §II, 3(iv)(b)). Lotus ponds, emulating the lotus pond of the Pure Land of Amitabha Buddha, were made in Buddhist temples. Tea gardens, generally built around a pavilion for tea-drinking, were created in temples associated with Sŏn Buddhism (the Korean variant of Chinese Chan Buddhism). In the

27. Puyong-ji, the lotus pond in the secret garden at the Ch'angdŏk Palace, Seoul, with Chuhapnu Pavilion (18th century) and Yŏnghwadang Pavilion (1692)

technique known as *susŏk* ('rock arrangement'), rocks were placed either in groups or individually. From the 6th to the 15th century AD they were planted in earth to represent mountains and sea cliffs. After the 15th century, however, rocks were placed in pots; examples survive in royal palaces and private houses. They were also set in ponds.

Bowers and pavilions are closely associated with Korean landscaping. Built by a pond or stream, they serve as an important element of the landscape while also providing places from which to appreciate the landscape. Korean landscaping is often referred to as static, as opposed to dynamic, because it is best appreciated by those seated in a bower or pavilion. Red, blue, yellow, white and black, and the range of colours produced by mixing these, were used to paint colourful decorations on wooden structures. Bowers and pavilions have overhanging eaves and wooden sculptural ornamentation.

Fences and walls were used to divide gardens. There were fences of live flowers and plants and fences of bamboo, straw or sorghum stalks. Walls could be of earth, stone, stone and earth, brick or dressed stone, and they were decorated with crane, dragon, cloud, sea, sun, moon, rock and plant motifs, Chinese characters etc. Fences and walls constituted landscaping structures in Korean courtyards where few trees or flowers were planted in order to let in the maximum sunlight.

Since it was prohibited by law, beginning in the Unified Shilla period (AD 668–935), to use dressed stones to build private houses, bases and walls were built of natural stone (*see also* KOREA, §II, 2). Private houses were not allowed to be decorated with bright colours or to have large pavilions. This prohibition continued to the end of the Chosŏn period (1392–1910). Private gardens tended to have small ponds and bowers, trees and flowers, an example being that of Hwasŏldang (1630) at Samari, South Chŏlla Province. More elaborate private gardens include the series of three gardens built in 1637 at Puyongdong, Pogil Island, South Chŏlla Province, with a number of ponds and pavilions.

Examples of palace gardens include those of the Anhak Palace, built in P'yŏngyang in the 6th century AD, the 7th-century Anap-chi Pond at Wŏlsŏng, Kyŏngju, and such Chosŏn-period palaces as Kyŏngbok (1394; rebuilt 1865), Ch'angdŏk (1405; rest.) and Ch'anggyŏng palaces in Seoul. The so-called secret garden (rest.) at the rear of the Ch'angdŏk Palace (*see also* KOREA, §II, 3(iii)(a)) is a world-renowned example of the Korean garden, covering an area of 20 ha. Its lotus pond, Puyong-ji, is surrounded by graceful pavilions (see fig. 27).

Confucian sites include Sosoewon in Tamyang, Pogil Island, and Ch'ongam-jong in Ponghwa. Buddhist examples include the following temples: Mirŭk in North Chŏlla Province, Pulguk (AD 751) in Kyŏngju, Songgwang in Sŭngju, South Chŏlla Province, Sŏnam also at Sŭngju, and the 19th-century tea garden at the Ilchi-am Hermitage of Taehŭng, Haenam, South Chŏlla Province. Famous pavilions in gardens include the Kwanghan-run Temple in

Namwon, Ch'oksŏng-ru in Chinju, Yŏngnam-ru in Miryang, Chuksŏ-ru (1274) in Samch'ŏk and Pubyŏng-ru in P'yŏngyang.

BIBLIOGRAPHY

Lee Kyu: 'Aspects of Korean Architecture', *Apollo*, 88 (1968), pp. 94–103

Joo Nam Chull: 'A Study on the Stone Work of Korean Traditional Gardens', *Architecture* [New York], xxii/93 (1980), pp. 34–43 [in Kor.]

——: 'A Study on the Method for Restoration of Korea Traditional Gardens', *Architecture*, xxvi/107 (1982), pp. 43–55

Min Kyung-hyun: 'Traditional Korean Landscape Garden with Special Attention to Traditional Susŏk', *XXIII World Congress of the International Federation of Landscape Architects Tokyo, 1985*

——: 'Traditional Korean Rock Garden', *Kor. Cult.*, viii/1 (Los Angeles, 1987)

——: 'L'Environnement géographique et la tradition spirituelle du jardin coréen', *Rev. Corée*, xix/1 (1987)

——: *Han'guk chŏngwŏn munhwa* [Korean garden landscaping culture], 2 vols (Seoul, 1991)

——: *Korean Gardens* (Seoul, 1992)

JAE HOON CHUNG

3. JAPAN. Most Japanese gardens are composed of rocks, water and plantings, carefully combined to give the impression of a natural setting. Even when such manmade features as buildings and bridges are added, they are integrated into the design in a harmonious way. This representation of natural scenery may be in miniature or full-scale, but the overriding principle is the sensitive imitation and idealization of nature.

The islands of Japan are essentially volcanic mountain peaks and level land is scarce. In most areas, except in the extreme north, the soil is rich, the water abundant and the climate temperate. Although historically the centres of Japanese culture have developed on the main island of Honshu, and specifically in the plains now occupied by the cities of Osaka, Nara and Kyoto, gardens have been built throughout the country at religious sites, such as the Buddhist temple of Mōtsuji in Hiraizumi (*see* HIRAIZUMI, §2(ii)), and at castles, such as Kenrokuen in Kanazawa (*see* §(iii) below). Many of the famous gardens are located in and around Kyoto, the imperial capital from AD 794 until 1868, and the history of Japanese gardens can be traced by studying extant examples in that region.

(i) Early (3rd–12th centuries). (ii) Medieval (12th century–1600). (iii) Edo period (1600–1868). (iv) Modern (1868 and after).

(i) Early (3rd–12th centuries). The religions of Japan have greatly affected the design and meaning of gardens. According to Shinto traditions, the world is filled with deities (*kami*), some of which are associated with specific places, such as a mountain or a valley, or with extraordinary features in the landscape, such as an enormous boulder, a particularly tall tree or a beautiful waterfall. The Shinto idea that the *kami* dwell in the landscape, rather than in another realm, has given special meaning to the natural environment, and the Japanese have traditionally tried to live in harmony with their surroundings rather than to restructure it. Some of the earliest gardens in Japan are the sacred groves and special rock outcroppings of Shinto shrines where the *kami* are worshipped. In Shinto practice such sites or objects are usually marked off by a wooden fence or by a rope made of rice straw. The site may then be purified by having white sand or gravel spread around the precinct, as at ISE SHRINE in Wakayama Prefecture.

By the end of the 6th century, Daoist and Buddhist ideas had been introduced from China and Korea to Japan. These religions gave new meaning to gardens, and continental garden designs began to influence the Japanese. According to some Daoist beliefs, the immortal sages lived on enchanted isles, and the building of islands in a pond garden might induce the immortals to visit this world and teach the secrets of immortality. Three specific islands were identified, called in Japanese Hōrai (Chin. Penglai), Hōjō (Chin. Fangzhang) and Eishū (Chin. Yingzhou); these could be recreated either by rock arrangements or by earthen mounds. Stone groupings could also represent the cranes on which the Daoist immortals flew, the tortoises that carried the islands through the seas or the dragons that could bring the rains.

Following Chinese customs, other garden rock formations were given Buddhist interpretations. A single-peaked boulder could represent Mt Sumeru (Jap. Shumisen), the centre of the Buddhist cosmos. A large stone flanked by two smaller rocks might represent the triad of Buddha and attendant *bodhisattva*s. The nine mountains and eight seas described in Buddhist *sūtra*s could be recreated in a pond garden setting.

During the same period, Chinese rules of GEOMANCY were also introduced, although not always followed. According to these rules, the negative and positive forces of nature (*yin* and *yang*) could be determined by divination and garden features and buildings sited with careful regard to them. For example, hills and watercourses must be planned with concern for the proper blockage or flow of good and evil forces, and entrances beneficially positioned. Such principles are still applied to city planning, building construction and garden design in Japan.

The earliest Japanese gardens modelled on continental prototypes no longer exist, but brief references can be found in the mid-8th-century poetry anthology *Man'yōshū* ('Collection of ten thousand leaves') and in the official history, *Nihon shoki* ('Chronicle of Japan'; AD 720). Descriptions of ponds for pleasure boating suggest that several estates were quite sizeable; the pond garden of the government minister Soga no Umako (*d* 626) was elaborate enough to earn him the nickname 'Minister of Islands'. In the 20th century, excavations in Nara, the imperial capital from 710 to 794 (then called Heijōkyō), uncovered the stonework for several small pond gardens, probably built for aristocratic residences. One meandering waterway was about 55 m long and varied in width between 1.5 and 5 m, with an average depth of 300 mm. The edges of the shore and islands were lined with boulders of various shapes and sizes, to give the impression of a natural stream-bed. According to the *Man'yōshū*, such gardens had willows, plums, cherries and various flowering plants. Even given this limited evidence, it seems that the development of pond gardens was well advanced by the end of the 8th century.

When the imperial capital was moved to Heiankyō (now Kyoto) in 794, careful attention was paid to both the layout of the city and the disposition of imperial and private gardens. Using the Chinese city of Chang'an (now Xi'an, Shaanxi Province) as a model, the new Japanese capital (as indeed its predecessor too) was laid out on a grid, with streets orientated to the cardinal points (*see*

28. *Shinden*-style residence in Heiankyō (now Kyoto); reconstruction of the 12th-century imperial residence of the retired emperor GoShirakawa (*reg* 1155–8)

JAPAN, §IV, 2 and KYOTO, §I). Low mountains edged the city on the northern, eastern and western sides, and two shallow rivers flowed from north to south, providing fresh water for the residences and gardens. The imperial palace complex (Daidairi) was located at the centre of the northernmost edge of the city, and the Suzaku Ōji, a broad avenue lined with willows, extended southwards to the city's main gate, dividing the capital into two equal parts.

Within the palace compound, symmetrically dispersed rectangular halls were joined together by covered corridors to form large and small courtyards. The throne hall, located at the head of the central axis, faced south over a vast, enclosed gravel court where ceremonies could be staged. The only plantings here were two trees flanking the steps to the throne hall, a mandarin orange symbolic of China and a cherry representing Japan. The white gravel of the court was similar to the purified spaces of Shinto shrines, which accorded with the conviction that the emperor was descended from the Shinto sun goddess, Amaterasu no Ōmikami, and served to recall his role as intermediary between the Japanese people and the *kami*.

The buildings and gardens were much smaller and arranged more informally in the residential areas of the imperial palace than in the public spaces and administrative offices, which were impressive symbols of authority. The emperor's personal quarters, the Seiryōden, faced east on to a gravelled enclosure planted with two clumps of bamboo. Behind it was a smaller walled garden filled with bush clover. While the open area of the front court was used for ceremonial gatherings, the rear yard was designed to be viewed from inside the hall and was not meant to be entered. Such small courtyards adjoining residential quarters (*tsubo*) were often planted with flowers or blossoming trees and provided the palace with many delightful vistas. In the 11th-century novel *Genji monogatari* ('Tale of

Genji'), the author, Lady Murasaki Shikibu, described a mansion in which each lady of the household was given a garden designed to match her personality and planted with specific seasonal flowers so that the ladies could visit each other to see their respective gardens in full bloom.

The *Tale of Genji* describes other gardens typical of Kyoto estates in the 10th to 13th centuries. Most aristocratic mansions were designed in the *shinden zukuri* ('sleeping hall construction' technique; *see* JAPAN, §III, 3(iii)), with a group of pavilions linked by covered corridors and arranged around a pond garden. The main reception hall usually faced south on to the pond, which contained an island. Flanking pavilions were generally positioned to the east and west of the pond, and some structures might even extend over the water's edge. The irregularly shaped shoreline was lined with rocks and plantings. The pond was fed by a stream that meandered through the estate or by a spring channelled into an artificial cascade. Rocks and plants were placed and waterways dug to create an idealized vision of the landscape. The buildings of the *Shinden*-style residence of the retired emperor GoShirakawa (*reg* 1155–8), for example, overlooked the pond to the south and were connected by corridors to fishing pavilions at its edge (see fig. 28).

Important information about the design and meaning of such aristocratic pond gardens can be found in the 11th-century treatise on garden construction called the *Sakuteiki* ('Records of making gardens'), thought to have been compiled by Tachibana no Toshitsuna (*d* 1094), a courtier whose own estate was noted for its tranquil beauty. Toshitsuna provided a theoretical basis for garden design as well as recording practical information about setting stones and choosing plants. He insisted that each site be carefully analysed for its inherent features and that gardens recall the scenic beauty of famous places. He also

discussed geomancy and the symbolic meaning of certain rock arrangements and special plantings. References are made to both Japanese and continental traditions. The *Sakuteiki*, the oldest extant document on Japanese gardens, is invaluable in understanding the history and development of landscape design not only in Japan but also in China, Korea and to some extent in India (*see* §§1 and 2 and §IV, 1 above).

During the same period, pond gardens were made for Buddhist temples as well as private residences, but their meaning was somewhat different. The worship of Amida Buddha (Skt Amitabha), who presides over the Pure Land of the Western Paradise and is particularly benevolent to those who believe in him, gained popularity among the Japanese aristocracy in the 11th century. In temple gardens the pond was often cut in the shape of the letter 'A' in the Sanskrit script (*devanāgarī*), for Amida, and filled with lotus plants, a flower that symbolized rebirth in the Pure Land. A chapel to Amida was constructed in the garden, usually on the western edge of the pond, so that, when viewed from across the water, the brilliantly decorated hall and its reflection would seem like an image of the Western Paradise. According to the 11th-century history *Eiga monogatari* ('Tale of flowering fortunes'), the regent Fujiwara no Michinaga (AD 966–1027) built a spectacular Amida Hall (Amidadō) at his retirement estate outside Kyoto and, to ensure that the setting was always beautiful, he had jewelled nets hung from the trees and artificial flowers strewn around the garden. The Buddhist connotations of pond gardens also influenced residential garden design. The Phoenix Hall (Hōōdō) of the BYŌDŌIN, built near Kyoto in 1052, and the 12th-century temple of JŌRURIJI outside Nara provide rare examples of such Amida halls and pond gardens.

(ii) Medieval (12th century–1600). In contrast to the visions of heaven on earth associated with Pure Land Buddhism, new ideas about garden design were brought to Japan from China with the introduction of Zen Buddhism in the late 12th century. Zen practice emphasizes simplicity and self-discipline and includes many hours daily of seated meditation and manual labour. Gardens became an important part of Japanese Zen temple grounds because they provided an isolated setting for devotional practice, where the daily routine of picking weeds and raking gravel was viewed as one path to self-understanding. According to Zen tradition, many monks had attained enlightenment while working in their gardens. The design of Zen temple gardens has changed over time, but essentially all serve as quiet retreats from secular distractions.

The overall setting of Zen temples, their public courtyards and the private gardens adjoining the residential quarters (*hōjō*) of abbots and monks vary greatly in form and function. In the 12th to 15th centuries Zen monasteries were usually located in or near forested mountains. The wooded slopes and other natural features of the site served as backdrops for the architectural compounds and were incorporated into the total site plans, and the landscaped gardens within the grounds tended to duplicate nature in scale, texture and arrangement of materials. Some modifications might be necessary to fit buildings on the sites, but generally the conditions of nature were

accepted. In the 15th century, this concept of man's integration with nature began to change. Many new Zen temples were built in or near urban centres and there was little concern to merge them with their surroundings. During the 16th century, the influence of Chinese ink landscape painting made itself felt in attitudes towards the environment, and in many Zen gardens efforts were focused increasingly on small plots of land in which mountains and rivers were suggested in miniature. Rocks were valued for their sculptural qualities, and plants were clipped into stylized rock forms. By the mid-17th century aesthetic concerns predominated in most designs for Zen gardens, and many of the major monasteries were situated quite far from mountain settings. Gardens became highly intellectualized representations of the idea of nature; the *hōjō* garden at Ryōanji in Kyoto (*see* KYOTO, §IV, 7) is the best-known of these later Zen gardens (see fig. 29). Thus, the contact with the natural environment that inspired earlier gardens gradually lost its immediacy, becoming more distant and abstracted.

The first Zen monasteries in Japan were established in Hakata (a port city in northern Kyushu), Kamakura (the shogunal capital from 1185 to 1333, near modern Tokyo) and Kyoto. Little is known about the appearance of the Hakata temples, but some of those in Kamakura preserve their original layouts and reflect continental prototypes. The monasteries of Engakuji and Kenchōji (*see* KAMAKURA, §2(i) and (ii)), founded in the late 13th century, are situated at the openings to narrow mountain ravines. Following Chinese models, the building sites are terraced, with major halls positioned on the valley floor and

29. Japanese pond garden south of the *hōjō*, Ryōanji, Kyoto, *c.* 1473

secondary structures located in the hills to each side. The main halls originally opened on to cloistered courtyards, which were gravelled areas for outdoor assemblies; if trees were planted, they were symmetrically dispersed along walkways or in front of buildings. The formal layout of the monastic core was balanced by the forested setting and the informal gardens found to the rear of some residential halls. The abbot's quarters at Kenchōji still has a naturalistic pond garden which merges into the wooded slopes. The Zen master MUSŌ SŌSEKI is credited with creating several important gardens, such as Saihōji near Kyoto (see KYOTO, §IV, 2) and Eihōji near Nagoya, in which the temple buildings are intimately tied to their natural settings.

During the 15th and 16th centuries an important new garden type developed in many Zen temples: the dry-landscape garden (*kare sansui*, literally: 'dried-up mountain and water') designed for the residential quarters of subtemple abbots (see KYOTO, fig. 8). The *hōjō* was typically a one-storey rectangular wooden structure with deep eaves and verandahs on all four sides. Usually the building faced south on to a walled space of nearly equal size, and the rooms that opened to this garden were more public in nature, being reception rooms for the abbot and a chapel dedicated to the subtemple's founder and patron families. Smaller gardens might be created for the side and rear parts of the compound, but these adjoined the study and sleeping rooms of the abbot and his disciples and were more private. The entire compound, including *hōjō*, south garden, secondary gardens and auxiliary buildings, usually covered less than 1 ha. A single monastery often had more than a dozen such subtemples, each with a distinctive set of private walled gardens. Although dry-landscape gardens do not actually include water, their design suggests ponds or streams through the use of rock or gravel materials. *Hōjō* gardens were intended to be seen from the verandah or from inside the rooms and often served as aids to meditation.

Zen temple *hōjō* gardens are small in size but suggest vast landscapes. Elements are selected for their pictorial qualities: striated rocks suggest cascading waters, mosses can appear to be tiny forests, shrubs can be trimmed into mountainous shapes. Such miniature landscape designs are often likened to painting in the techniques of arrangement, the choice of colours and textures and the control of viewpoints. The harmonic balance of elements must be convincing without being obviously artificial.

Among the most famous examples of the dry landscape are *hōjō* gardens in the Zen temples of Daitokuji (see KYOTO, §IV, 5) and Myoshinji in Kyoto. Significantly, both monasteries are located on level ground some distance from actual mountains and forests, so that the miniaturized landscapes seem all the more powerful. Within the small walled confines of the Taizōin, a subtemple of Myōshinji, a vast panorama is suggested. The garden design is attributed to the noted landscape painter Kanō Motonobu (see KANŌ, (2)). Craggy rocks form peaks and valleys, white gravel areas flow like a river, and camellias, azaleas and ferns give the whole scene a lush, secluded quality. Altogether, the composition imparts a sense of calm.

Such dry-landscape gardens became increasingly popular in the late 16th century when many Zen temples were being rebuilt following decades of civil war in Japan. The designers were often Zen monks, tea masters or professional artists working for the temple. Gradually, their designs became more abstract, with fewer elements and more dramatic compositions. A single stone or rock grouping might be set in a raked gravel bed against a bare wall to highlight the unique character and beauty of the objects and to suggest that the grand scale of nature has been reduced to its essence.

In parallel with the dry-landscape style, a new type of landscaped environment emerged to accommodate the rituals of the tea ceremony. The drinking of tea had been introduced to Japan from China as early as the 8th century AD, but it was not until the 15th century that special rules for serving and receiving bowls of tea were devised and the tea ceremony came into being. In the early days, tea was served to guests by *dōbōshū* ('lay companions', attendants trained in the arts) and the host would sit with his guests in a room which perhaps had a view into the garden. The pavilions at the Ginkakuji in Kyoto (see KYOTO, §IV, 8) were used in this way by the shogun Ashikaga Yoshimasa (1435–90). By the mid-16th century traditions had changed: tea was made and served by the host, the room was small and lacked any views to the outside, and the guests would arrive at the tea-room via a garden that was specifically designed to prepare them mentally for the ceremony.

The path leading to the tea-room is designed as a visual and psychological buffer against activities of the everyday world. Like the *hōjō* garden, it should be conducive to calm and introspection. Quite often the tea-room is at the back of a temple compound, in the rear of a residential lot or in a quiet part of a larger garden. To slow the guest's approach to the tea-room, the pathway is usually made of irregular stepping stones. The designer's intention was to control the changing vistas and focus attention on the garden's subtle features as the guest made his way through space and time.

Since many tea ceremonies in the late 16th century were held in the early morning or late evening, the path was lit by stone lanterns. To be properly prepared for the ceremony, a guest should ritually cleanse his hands and mouth to wash off the dirt and concerns of everyday life, for which purpose stone water basins and bamboo dippers were provided. Many of these aspects of tea garden design were devised by SEN NO RIKYŪ, FURUTA ORIBE and other tea masters who developed the complex aesthetic of *wabi*, in which qualities of understated beauty and rustic simplicity were admired.

The changes in Zen and tea gardens inevitably influenced developments in residential gardens, because many of the temple patrons and tea enthusiasts were newly empowered military officials in charge of building castles and palaces. The demand for distinctively shaped rocks created a thriving market, and notable garden objects were taken as booty during the wars of the late 16th century. The military dictator Toyotomi Hideyoshi was notorious for removing stones, as symbols of his power, from the estates he captured; he had many of these added to the gardens of the Sanbōin (see KYOTO, §IV, 3(ii)), a temple

he patronized. Gradually in the 16th century the dry-landscape garden format was adapted to suit larger secular sites, and the components of the tea garden were freely incorporated to form a richer design style.

(iii) Edo period (1600–1868). The 17th century was an extraordinary period for Japanese garden construction. Palatial estates were built or rebuilt in the Kyoto area, large residential and castle complexes with elaborate grounds were erected throughout the country and major temple compounds were renovated or built anew for nearly all the Buddhist sects. After a century of civil war, the country was reunified under the Tokugawa shogunate. The new rulers spent lavishly on their own quarters and generously funded the rebuilding of imperial family palaces as a way of winning favour. KOBORI ENSHŪ, a distinguished samurai, was placed in charge of many of these projects, such as Nijō Castle (*see* KYOTO, §IV, 9) and the imperial palaces in Kyoto.

Japanese palace gardens created in the 17th century have an exuberant quality. Many are composed of rolling hills and languid ponds, dense plantings and bold rockwork, with paths and pavilions set around the estate to encourage strolling and sitting within the landscaped environment. All artificially created, these stroll gardens (*kaiyū*: 'many-pleasures garden') combined the old traditions of simulating nature with a new emphasis on sequential vistas. Imperial estates such as Katsura Detached Palace (see fig. 30) and Shūgakuin Detached Palace (*see* KYOTO, §IV, 10 and 11) are complex environments with constantly changing moods and multiple literary allusions. Enshū brought a strong sense of design to his gardens, giving the impression that every element has been placed to optimum effect, achieving a rich yet quiet elegance. Only a few of his gardens have survived, the Konchiin at Nanzenji in Kyoto (*see* KYOTO, §IV, 4) being the best example, but his taste so permeated the period that extant gardens by other designers are often said to be in the Enshū style. Other examples that illustrate the predominance of aesthetic concerns and the increasing abstraction of the contact with the natural environment are Nishi Honganji and Daitokuji Daihōjō.

Another design technique employed throughout much of Japanese garden history and refined in the 17th century by Enshū and others grew out of the idea of *shakkei* ('borrowed scenery'), in which elements outside the garden are incorporated into the garden design. The rules of geomancy had long been one way of orientating gardens within their sites. Subsequently, elements in the garden were placed so as to highlight features such as distant mountain peaks or nearby groves of trees and bring them into the garden composition. Two 17th-century temples outside Kyoto, Shōdenji and Entsūji, are renowned for their gardens, which frame views of Mt Hiei; and the imperial gardens at Shūgakuin in the foothills of Mt Hiei include in their design views of other more distant mountain ranges. *Shakkei* literally expanded the parameters of the garden and became a favourite technique in later centuries.

In the early 17th century, the first Tokugawa shogun, Ieyasu (1543–1616), moved the military government from Kyoto to Edo (now Tokyo). Tokugawa policy required

30. *Kaiyū* ('many pleasures') garden, consisting of tea gardens around a central pond, Katsura Detached Palace, Kyoto, 17th century

provincial governors to maintain residences in both their home districts and Edo, where they were obliged to live in alternate years. This led to a spate of garden-building activities throughout the country as the officials vied for the most impressive estates in Edo and brought the latest gardening designs to the distant provinces. Only a few of the large residential compounds built in Edo survive, but two, Kōrakuen (*see* TOKYO, §III, 2) and Rikugien, are now public parks. The Kōrakuen is less than a third of its original size, but some of its best-known features have been preserved, including recreations of famous sites in China and Japan. The Rikugien, built by the powerful military leader Yanagisawa Yoshiyasu (1658–1714), is a stroll garden that has maintained its extensive grounds and its 88 famous views, which are designed to recall poems from the *Man'yōshū* and other literary anthologies. Tea houses were positioned at several points around a large pond and artificial hills were raised to give vistas of Mt Fuji over 100 km away.

Similarly, great estate gardens were constructed at the provincial homes of the military governors. Some of these were adjacent to castles, such as the Kenrokuen in Kanazawa (*see* KANAZAWA, §2(ii) and fig. 31) and the Genkyūen in Hikone (on Lake Biwa, Shiga Prefecture), and others were separate, such as the Kōrakuen in Okayama (*see* OKAYAMA, §2). Whatever the site, the grounds were laid out for walking, with paths winding around ponds and through cool groves. Some owners

31. Plan of castle and garden at Kenrokuen, Kanazawa, 17th century: (a) Misty pond (Kasumi gaike); (b) turtle-shaped island; (c) Seven Gods of Good Fortune; (d) statue of Prince Yamato Takeru; (e) pavilion on Yamazaki Hill; (f) Seisonkaku residence, 1863; (g) Kanazawa Shrine; (h) gourd-shaped pond; (i) waterfall; (j) Yugaotei Tea House; (k) seashell-shaped hill with spiral path

went to great expense bringing rocks and trees from the Kyoto area to simulate the imperial gardens, while others adapted the Enshū style to local conditions. The practice of replicating famous places on a reduced scale was popular in the provinces too: the powerful Hosokawa family made a miniature version of Mt Fuji in their garden at Kumamoto in Kyushu.

Tsuki Katsura in Hōfu, Yamaguchi Prefecture, is a famous residential dry-landscape garden designed in 1712 by the tea master Katsura Tadaharu. Within a walled, L-shaped site are 19 stones, all set into a gravel bed except for a crescent-shaped monolith, which is raised off the ground (for illustration see TSUKI KATSURA). The garden is unusual among residential gardens for the multiplicity of religious and mythical allusions that have been incorporated into the placement of the stones, including references to the moon (*tsuki*), animals and plants (*katsura* is Japanese for 'cinnamon' and is also the family name of the garden's owners).

Garden patrons in the 18th century were assisted by a number of publications that set down the techniques of garden design and maintenance. Among the most famous was the *Tsukiyama teizoden* ('Records of building gardens and artificial mountains') written by Kitamura Enkin and first published in 1735. The woodblock-printed text was illustrated by Fujii Shigeyoshi with bird's-eye views of famous Kyoto gardens. The author described in very practical terms how to create a garden: how to choose and set stones, dig ponds and raise carp, clip shrubs and groom moss. Enkin's work continued the tradition of the *Sakuteiki*, which also revealed the very important techniques used to make a garden look natural.

(iv) Modern (1868 and after). With the rapid introduction of Western culture to Japan in the late 19th century, the traditional ideals of Japanese garden design were seriously challenged. Many of the old estates in Edo were neglected or destroyed as the city of Tokyo expanded, and new parks were laid out in European styles, with straight walks and symmetrical plantings. Ueno Park in Tokyo, a 17th-century complex of Buddhist temples and Shinto shrines, was overlaid with formal promenades, and public buildings in the French mode were added to it. Hibiya Park, adjacent to the Tokyo Imperial Palace, was opened in 1903 as Japan's first completely Western-style public park.

In Tokyo the inner and outer gardens of the Meiji Shrine, completed during the early 1920s, are an interesting attempt to combine the traditional qualities of asymmetry, naturalness and sequential vistas with imported ideas of garden design (see fig. 32). Broad lawns and tree-lined promenades in one area are skilfully linked with naturalistic woodlands and pond gardens in another. Yoshichika Kodaira, the principal designer of these gardens, was reportedly working from ideas suggested by Emperor Meiji (*reg* 1867–1912) himself, to whom the grounds were later dedicated as a Shinto shrine. Thickly wooded areas of the Meiji Shrine recall the sacred groves of ancient times and various rock arrangements follow traditional configurations, but the introduction of some non-Japanese plant material gives the garden an international character. Perhaps the most famous feature is the iris beds, in which more than 100 varieties fill a long, winding valley. A nearby tea house overlooks the South Pond with its multitude of waterlilies. Kodaira was also involved in the redesign of Shinjuku Imperial Garden in Tokyo, which contains gardens in both English and French styles and some botanical collections.

While Tokyo residents were emulating Western garden designs, Kyoto patrons continued to build with traditional methods and materials while exploring variations on past designs. One of the most influential garden designers of the late 19th century was Jihei Ogawa (1860–1933), a seventh-generation gardener whose family had worked in the Kyoto area for over 300 years. In 1896 he designed the Murin'an, one of several small estates in the foothills east of Kyoto, and used 17th-century ideas of borrowed scenery and sequential vistas, together with the attention to detail found in tea gardens, to create a new style with archaistic overtones. For the difficult triangular plot of the Murin'an, Ogawa sited the residence at the broad downhill end, with a view up to the apex where careful plantings framed the nearby mountains. A shallow cascade and winding stream animate the space, and a lawn area adjacent to the house provides a smooth transition from interior to exterior space. Ogawa was also the principal designer for the gardens of the Heian Shrine (1894) in Kyoto, an influential work which proved that the age-old garden traditions were still vital to Japan.

The garden historian Mirei Shigemori (1896–1975) was also instrumental in reviving Japanese traditions, painstakingly excavating and rebuilding lost gardens and publishing important documentary evidence crucial to the research of garden history. However, Shigemori did not just look to the past. He was also active as a landscape architect, creating new gardens using modern materials such as concrete and finding inspiration in the abstract arts of Europe and America. During the 1930s he was closely involved in the rebuilding of the Zen temple Tōfukuji

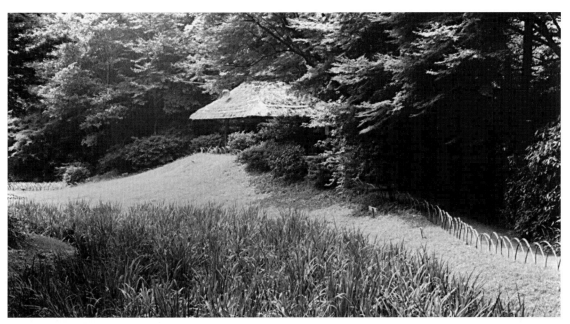

32. Garden (completed early 1920s) of the Meiji Shrine, Tokyo, commemorating Emperor Meiji (*reg* 1867–1912), showing the Asumaya rest-house and the iris field

(damaged 1995 by earthquake) in Kyoto and, while he helped restore old ruined gardens, he also made several startlingly modern additions. At the *hōjō*, for example, Shigemori made random chequer-board patterns of moss, gravel, cut stones and clipped azaleas that seem to express the spiritual and psychological tensions found in a 20th-century Zen monastery. For the *hōjō* at Reiun'in, a subtemple of Tōfukuji, he set pink concrete pads and scolloped white cloud forms into a raked-gravel bed, juxtaposing modern and traditional shapes in a truly bold manner. He also created many private residential gardens in the Kyoto–Osaka area using modern interpretations of 17th-century styles. Similarly, the garden historian Osamu Mori (*b* 1912) has both restored older gardens and created new ones.

Many modern Japanese landscape architects continue to blend the rich traditions of Japanese garden design with ideas and technology from the West to create exciting innovations. Koki Fukaya (*b* 1926) has devised impressive water gardens for Tokyo hotels and office buildings using chiselled and crushed stone, two elements not previously favoured in Japan. In 1962 Masayuki Nagare (*b* 1923) designed an extraordinary rock-and-gravel garden on the roof of the Tokyo Tenrikyōkan (headquarters of the Tenrikyō religion), which at once recalls the compositions of Zen temple gardens yet is strikingly modern. The American-born ISAMU NOGUCHI has applied the principles of traditional Japanese rock arrangement with new insight to the SCULPTURE GARDEN, of which he has created examples throughout the world. Some garden designers, such as Sentaro Iwaki (*b* 1898), whose work includes the Hotel Okura in Tokyo (1962) and Hourin Country Club in Chiba Prefecture (1989), and Ken Nakajima (*b* 1914), who designed the gardens for the Hotel Koyokan in Iwate Prefecture, have preferred to work more strictly within the older styles. Bringing a fresh vision to the many private residential gardens he has designed, Nakajima has combined the exquisite detail of tea gardens with the spaces of modern architecture. Kinsaku Nakane (*b* 1917) has not only revived old gardens in the Kyoto area but has created new works in traditional styles at the Adachi Museum of Art in Shimane Prefecture (1972), the Boston Museum of Fine Arts (1986) and the Jimmy Carter Presidential Library (1986). A common theme running through much of 20th-century Japanese landscape architecture is a great sensitivity to the integrity of materials and a strong feeling for the harmonious balance that can be achieved between the manmade and the natural elements of a garden.

BIBLIOGRAPHY

L. Kuck: *The World of the Japanese Garden: From Chinese Origins to Modern Landscape Art* (New York, 1968, rev. 1980)

K. Fukuda: *Japanese Stone Gardens: How to Make and Enjoy them* (Rutland and Tokyo, 1970)

M. Hayakawa: *Niwa* [Gardens], suppl. ii of *Nihon no bijutsu* [Arts of Japan] (Tokyo, 1965); Eng. trans. by R. L. Gage as *The Garden Art of Japan*, Heibonsha Surv. Jap. A., xxviii (Tokyo, 1973)

K. Shigemori and S. Shigemori: *Nihon teienshi taikei* [Compendium of Japanese garden history], 35 vols (Tokyo, 1973–6)

T. Soga, gen. ed.: *Tanbō Nihon no niwa* [Investigation of Japanese gardens], 12 vols (Tokyo, 1978–9); i: *Kyūshū, Shikoku* (1979); ii: *San'in* (1979); iii: *San'yō* (1979); iv: *Kinki* (1979); v: *Kyōtō I: Rakutō, Rakun'an* [Kyoto I: eastern and southern Kyoto] (1978); vi: *Kyōtō II: Rakuchū, Rakuhoku* [Kyoto II: central and northern Kyoto] (1979); vii: *Kyōtō III: Rakusei* [Kyoto III: western Kyoto] (1978); viii: *Ōmi* (1979); ix: *Tōkai, Hokuriku* (1979); x: *Kantō, Tōhoku* (1979); suppl. 1: *Chatei to tsubo niwa* [Tea and small courtyard gardens] (1979); 2: *Gendai no meitai* [Famous gardens of the modern era] (1979)

I. Schaarschmidt-Richter: *Japanese Gardens* (New York, 1979)

T. Itoh: *The Gardens of Japan* (Tokyo, 1984)

G. Nitschke: *The Architecture of the Japanese Garden: Right Angle and Natural Form* (Hohenzollernring, 1991)

BRUCE A. COATS

VII. South-east Asia.

1. Cambodia, Thailand and Indonesia. 2. Vietnam.

1. CAMBODIA, THAILAND AND INDONESIA. Before the arrival of the Europeans, ornamental gardening in South-east Asia was almost entirely limited to religious complexes and royal palaces, hardly any of which display their original landscapes today. Around most dwelling-houses a few trees and shrubs—*Jasminium*, for instance, or members of the *Michelia* family—might be selected for their fragrance; but the great majority of garden plants served practical culinary or medicinal needs, and little thought was given to arranging them in ways purely pleasing to the eye.

Symbolism played a great role both in the choice of plants and in the landscape design of religious gardens throughout South-east Asia, particularly those based on Indian and Chinese models (*see* §§IV and VI, 1 above and §2 below). *Ficus religiosa*—the so-called *bodhi* tree, under which the Buddha attained enlightenment and regarded as sacred in Hinduism and other religions—was a prominent feature of most, usually being given a special enclosure to itself and surrounded by food and floral offerings. In Buddhist countries, such trees were sometimes brought as seedlings from India in the belief that they were the offspring of the original *bodhi* tree, and were accordingly regarded with even greater respect. The lotus was another plant noted for its symbolic qualities, grown in pools or in ceramic containers. Water, which was used both for ritual purposes and probably also because of its cooling effect in the tropics, was an important feature, as can be seen in the great Hindu and Buddhist temple complexes of Cambodia, Thailand and Bali, where pools, fountains and moats often take up a large part of the garden area.

Although the general outlines of these gardens often remain, it is difficult to say what their original appearance was, since many of their present plants are of more recent origin. One prominent example is *Plumeria*, probably introduced by either the Portuguese or the Spanish and now commonly found in religious compounds throughout the region, as its flowers are widely used in offerings. In Thailand, the religious associations—together with the fact that its Thai name resembles the word for 'sadness'—has resulted in a reluctance to use the tree in private gardens.

Royal palaces also often had extensive pleasure gardens, although it would be risky to attempt an accurate description of their original appearance, owing to a lack of reliable written records in most places, together with the frequent alterations that came with new cultural influences and the introduction of new plants. Most likely, however, the palace gardens of Java, Bali and Malaysia resembled royal Indian models, employing such flowering trees as *Saraca indica* and *Butea frondosa*, both of which are frequently mentioned in Indian poetry, and assorted fragrant shrubs and creepers. *Ficus religiosa*, however, because of its sacred associations, was reserved for use in religious compounds. In Thailand and Indochina, Chinese influences were more prominent, resulting in formal gardens with trees and shrubs that were often twisted or clipped into unnatural shapes, and in the extensive use of plants in ceramic pots.

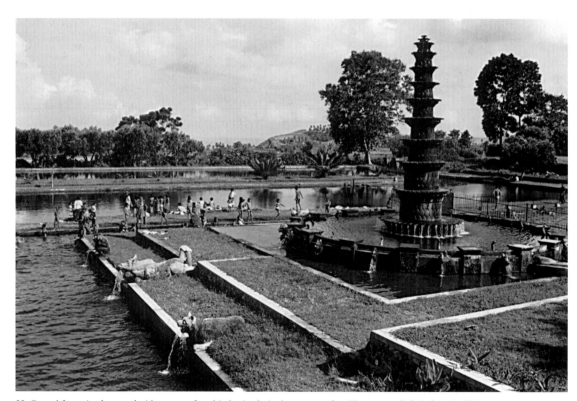

33. Central fountain, decorated with statues of mythical animals, in the water garden, Tirtagangga, Bali, Indonesia, 18th century

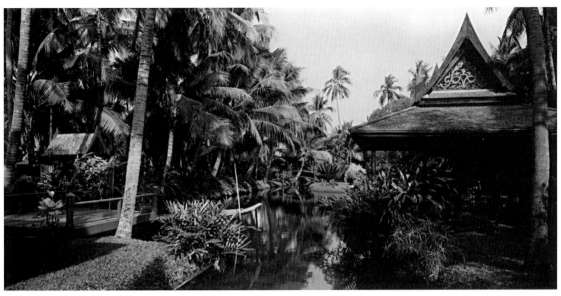

34. Ornamental garden and guest pavilion, house of M. Achille Clarac, Bangkok, Thailand

The outer courtyard of Bangkok's Grand Palace survives more or less in its original form, to judge from old photographs, while the inner garden, once reserved exclusively for the king and his royal wives, has been almost entirely westernized, most recently in 1982 as part of the city's bicentennial celebration.

Throughout the region, water features were used extensively, and these are perhaps the most unchanged element today, since they were often integral parts of the architecture. Notable Indonesian examples include the Taman Sari (also known as the 'Water Castle'), the pleasure garden of the sultans of YOGYAKARTA in Java, the network of ponds and fountains at Tirtagangga (literally, 'Ganges Water') in Bali (see fig. 33) and the royal water gardens of Suranadi, 7 km from Narmada in west Lombok.

European colonization, to which every country in South-east Asia except Thailand was subjected, had a profound effect on garden designs. This began with city planning and the consequent introduction of Spanish concepts in the Philippines, Dutch in Indonesia, British in Malaysia and French in Cambodia, Laos and Vietnam. The effect was to create 'a landscape neither natural nor indigenous, but fashioned according to the dictates of Western culture, technology, and aesthetic taste ... not only beautiful to Western travellers [but] also emblems of security and comfort, and signs of dignified culture and civilization' (see Savage). The influence was even more widespread in those countries where important botanic gardens were established. The fundamental purpose of nearly all gardens during the colonial period was economic; that is, they were places where potential cash crops could be tested and acclimatized for later commercial growing. At Bogor in Java, where the botanic gardens founded by Sir Thomas Stamford Raffles during the British occupation (1812–16) were developed by the Dutch into one of the world's greatest tropical botanic gardens, important experiments were made with tea, cassava, tobacco, African

oil palm and Cinchona, all of which contributed to the wealth of the Netherlands East Indies; and it was at Singapore's Botanic Garden that Henry Nicholas Ridley discovered innovative ways of tapping and cultivating *Hevea brasiliensis* and so gave birth to the Malayan rubber industry.

However, the gardens did not have a solely scientific function. They also played a major role in the introduction of new ornamental plants and the creation of imaginative landscape designs. The Bogor gardens, for example, now known as the Kebun Raya, served as a recreational park for the Dutch governor-general, whose permanent residence was near by, while the Singapore Botanic Garden was founded as a pleasure garden by an association of local residents and only after some years became a serious centre for research under government supervision.

The landscape principles followed by these gardens were essentially European: well-trimmed lawns setting off beds of carefully mixed shrubs (both requiring considerable maintenance in the tropics), flowering trees, clipped hedges and various water features. These often reflected similar features found in the great Western glass houses of the 19th century, notably those built by JOSEPH PAXTON in England at Chatsworth and Kew to accommodate the numerous exotics brought back from the tropics. There was also traffic in the other direction. In most colonial countries efforts were also made to bring ornamental plants from home to enhance the sense of familiarity, and some of these specimens became acclimatized, especially in higher altitude gardens such as those at Cibodas in Java and Baguio in the Philippines.

Increasingly, though, the new components of these gardens were tropical plants introduced, as methods of transportation improved, from gardens throughout the world. One of the richest sources was South America, from where, over a relatively short period, came a vast number of such popular ornamentals as bougainvillaea,

allamanda, heliconia, alpinia, philodendron, bromeliad, poinsettia, plumeria, dieffenbachia and canna. These spread so rapidly that they soon began growing wild and were mistakenly thought by many people to be native.

The non-economic designs of botanic gardens were emulated, on a smaller scale, in plantings around private homes, at first those of colonial officials and later of more westernized members of the local aristocracy. Thus what may be called 'modern' tropical gardens gradually evolved, replacing older landscapes and becoming increasingly uniform, despite the differing cultures in which they were created. As a result, except where there are traditional architectural features, it is difficult to distinguish between a garden in Bangkok and one in Bali solely on the basis of its plant material. An example of this process can be seen at the Bali Hyatt Hotel, built in 1973 on Sanur Beach, Bali, where the extensive, multi-layered garden was conceived as a major element of the overall effect. A series of designers, both Balinese and European, worked on the garden, and plants then new to Bali were brought from Singapore and Hawaii, among them Red Ginger (*Alpinia*), heliconias and assorted plumerias. Most of these can now be found in gardens all over the island, sometimes in hybrid forms developed from the originals.

In recent years the introduction of new ornamental plants has accelerated greatly, sometimes through the work of older institutions such as the Singapore Botanic Gardens but more often through professional growers in response to increasing demands from private gardeners. Thailand, for example—a relatively late starter owing to the lack of an influential government-sponsored botanic garden—has become an important regional centre, not only for imported plants but also for locally developed hybrids, particularly dieffenbachias, aglaonema and other specimens grown for their decorative foliage (see fig. 34). These ornamentals, given elaborate Thai names, are frequently regarded as being lucky and bringing good fortune to their owners and command correspondingly high prices.

In the late 20th century, interest in ornamental gardening has been more widespread than ever before throughout South-east Asia, and what has been lost in cultural distinctions is compensated for by the much wider choice of plant material and greater enthusiasm on the part of ordinary homeowners as well as designers of public buildings and urban planners.

BIBLIOGRAPHY

R. E. Holtum: *Gardening in the Lowlands of Malaya* (Singapore, 1955)
E. A. Menninger: *Flowering Trees of the World* (New York, 1955)
A. L. Bruggeman: *Tropical Plants and their Cultivation* (London, 1957)
M. L. Steiner: *Philippine Ornamental Plants* (Manila, 1960)
E. Hyams and W. MacQuitty: *Great Botanical Gardens of the World* (London, 1969)
Pimsai Amranand: *Gardening in Bangkok* (Bangkok, 1976)
A. B. Graf: *Tropica: Color Cyclopedia of Exotic Plants and Trees* (New Jersey, 1978)
J. N. Hepper, ed.: *Kew: Gardens for Science and Pleasure* (London, 1982)
R. V. Savage: *Western Impressions of Nature and Landscape in South-east Asia* (Singapore, 1984)
E. R. Scidmore: *Java: The Garden of the East* (Singapore, 1984)
G. Jellicoe and S. Jellicoe, eds: *The Oxford Companion to Gardens* (Oxford, 1986)
I. Polunin: *Plants and Flowers of Singapore* (Singapore, 1987)
F. Eiseman and M. Eiseman: *Flowers of Bali* (Berkeley, 1988)
B. Tinsley: *Visions of Delight: The Singapore Botanic Gardens through the Ages* (Singapore, 1989)
D. Pickell, ed.: *Bali: Island of the Gods* (Berkeley, 1990)

WILLIAM WARREN

2. VIETNAM. In Vietnam the art of the miniature garden contained in a pot has reached a high level of refinement, and such gardens are to be found in imperial palace compounds, temple courtyards, the inner patios of private residences and official buildings and on virtually every urban balcony. Although designed to be aesthetically pleasing, with such carefully selected natural elements as flowers, shrubs, dried wood, stones and water pools, they also serve certain magical purposes. Founded on principles of alchemy and Daoism mixed with popular religion, they represent the harmonious balance between opposing forces of nature, so that each of their elements must be carefully chosen in order not to disrupt this harmony. For instance wood is balanced with stone, stone with water and water with fire. Some elements, such as rare woods, precious stones, dwarf trees and exotic plants, are of special value and bring certain qualities to the microcosm that is created in the garden. Old trees represent the wisdom of age, twisted trees and rare rock formations fuse qualities of beauty and longevity. The gardens are usually set in a round, glazed ceramic pot, which can vary in size from 300 mm to several metres in diameter. They may contain live flowers and shrubs, or dead wood, stones and moss, or both. The plants fulfil a role similar to that of medicinal herbs or architectural sculpture, symbolizing longevity, prosperity and happiness. Certain plants, stones and types of wood are considered more valuable and therefore possessed of more power to act in this way. They may be chosen because they are found in distant locations or in places that have a special significance, such as legendary or historical sites.

BIBLIOGRAPHY

R. A. Stein: *World in Miniature* (Berkeley, 1990)

NORA TAYLOR

VIII. Western.

1. Introduction. 2. Medieval. 3. Early Renaissance. 4. *c.* 1550–*c.* 1800. 5. After *c.* 1800.

1. INTRODUCTION. Just as Europe is not a homogeneous cultural, political or geographical land mass, so its gardens have displayed both design debts to other cultures and civilizations, notably the Islamic and the Mughal empire, and horticultural obligations to the whole world. The European garden is, as the national and historical entries below make clear, a complex, multi-cultural phenomenon that varies according to topography, climate, and social and political needs. The broad historical pattern of its development, however, is distinct enough to allow some introductory points to be made.

A conventional garden history tends to focus on the respective elements of art/nature, formal/informal, regular or even symmetrical/irregular or picturesque. It explains how the first medieval and Renaissance gardens were highly controlled, even overdetermined manipulations of the physical world and how these ideas were disseminated north to such countries as France, the Netherlands and England. It then addresses the issue of 'natural' design, which eventually banished architectural

and other artificial elements from the garden, which tended to become a park and merge with the unmediated territory beyond.

Although this is not a false narrative in itself, it fails to address garden history of the last 200 or so years when no such obvious 'progressive' pattern is traceable through a somewhat sterile battle of styles, which in Britain reached its climax in the confrontation between William Robinson (1838–1935) and REGINALD BLOMFIELD, and finally into a period when the landscape architect failed to find a substantial modernist role.

The eclecticism of European landscape architecture since 1800 not only calls into question the teleological progression from the Italian Renaissance towards the climax of the 'English' landscape or PICTURESQUE garden, but more constructively, it also proposes a different approach to the European garden as a whole. Instead of adjudicating the respective contributions of art and nature to any historical garden, a more useful approach—since all gardens are 'unnatural'—is to consider how each society, even different groups within one society, has determined what sort of nature can be reified within the garden and by what artificial means this could be accomplished. Thus the idea of wilderness, generally excluded from the medieval garden, was admitted into the Renaissance garden in the form of labyrinths; in the 17th century it became a more loosely structured bosquet (ornamental grove), perhaps crossed with paths, or in the 18th century a wild grove or woodland. This came to seem irrelevant in the 19th-century Romantic garden when the real wastelands of the Alps and Highlands attracted tourists, but it reappeared in the guise of rock gardens, even miniature reconstructions of the Savoy Alps, Chamonix or the Matterhorn (see SUBLIME, THE). In the 20th century this concept materialized, for example, as the science-fiction elements of the Garden of the Anterior (1975) by Bernard Lassus for the new French town of L'Isle d'Abeau.

It becomes, then, a more useful approach to enquire how the natures outside the confines of European gardens—what Italian humanists called the 'third nature' (see §I, 3 above)—are revised and represented within the garden and for what aesthetic, practical, social, cultural or other reasons. Other manifestations of human attitudes towards nature—whether the cabinet of curiosities or Darwinian science—could cast further light on contemporary representations or imitations of nature within gardens. If gardens may be seen as the qualitative and aesthetic maximum to be achieved in the practice of agriculture, they constitute the most sophisticated human idea of possession of natural space.

One fundamental reason to refashion a natural or cultural environment (the 'first' and 'second' natures) into a supreme art of milieu is to display power—first of man over the natural world and then by such reorganization over larger social and political concerns. Early 18th-century engravings of Karlsruhe, for example, show the Grand Duke's castle and gardens at the centre of radiating avenues and roads, not only dominating the town but through these axes determining the shape of the town itself.

Gardens enable their owners to present an ostentatiously constructed image of themselves. Sometimes this is done with conscious intent—the Renaissance princes used gardens as part of a whole panoply of self-promoting devices, while Versailles (see VERSAILLES, §2) constituted part of the huge propaganda machine of Louis XIV, as did HET LOO for William III (see ORANGE NASSAU, (5)). This kind of public display can be found also in the private world of Sir Richard Temple, 1st Viscount Cobham (1675–1749) at STOWE, Bucks, or Hermann, Fürst von Pückler-Muskau (1785–1871) at Muskau, Germany. At other times a garden may be a wholly unselfconscious manifestation of its creator(s); many gardens will present a mixture of those conscious and unconscious impulses.

Garden art in the West (as elsewhere) may therefore be studied as a repertory of signs, which declare their owners' attitudes, ideas and opinions on a wide range of affairs, including architectural and horticultural matters. The tendency for scholars to focus on exceptional examples of garden art has elevated the garden to the realm of patrician culture; but the incidence of bourgeois and vernacular gardens, although less documented, underlines the expressive function of all sorts of gardens.

If the Renaissance princes used garden art to express their position in and to the world, they were in effect rediscovering the theatrical potential of gardens. Gardens were used as sites for specific theatrical performances from the Renaissance and by the 17th century gardens often came to include an outdoor theatre (e.g. HELLBRUNN) or were entirely designed in a theatrical format. It therefore seems useful to consider European garden designs as scenery for a theatre of life played out in gardens. This perspective allows fresh considerations both of the architectural, sculptural and other artificial elements of European gardens, especially those items that came to be called *fabriques* (ornamental buildings), and of the relationship of private to public in gardens.

The Renaissance garden, as the influential *Hypnerotomachia Poliphili* (Venice, 1499) illustrates (see fig. 5 above), made much of the garden's reliance on fountains, inscriptions, statues and pavilions; variations on these features were the staple of all gardens except those of resolutely naturalistic design. What had practical or decorative purposes also lent to the garden world the character of scenery (a word that long retained its theatrical associations). Such features established a garden's allusive and associative character and were endlessly exploited for that purpose. Of these devices, it was above all *fabriques* that came to dominate garden design by the early 19th century; an early French example, however, would be the profusion of structures devised by Louis Carrogis, known as Carmontelle, for the Jardin Monceau (from 1773), in Paris, where 'all times and all places' were united in one spot.

The ingenuity and invention invested in these garden buildings are clear from the pattern books in which enterprising European publishers offered amateur gardeners a range of scenery to erect—a Dutch example is the *Magazijn van tuinen-sieraaden* (1802) by Gijsbert van Laar (see fig. 35). This universal taste for constructions that are 'halfway between idea and reality' (Mosser and Teyssot, p. 263) and erected in all styles (Chinese, Turkish, Moorish, Rustic, Gothick etc) suggests how important to the development of the European garden was the individual's need to stimulate his or her imagination by surrounding him or herself with spiritual playgrounds; the seriousness

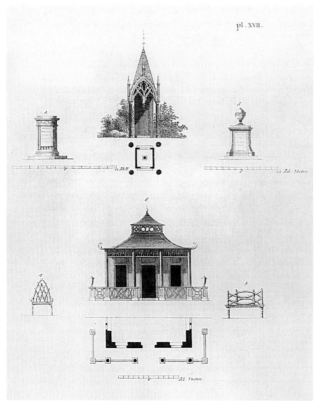

pl . XVII.

35. Two garden pavilions; from G. van Laar: *Magazijn van tuinen-sieraaden* (1802), pl. xvii

of the experiences that such garden scenery initiated tends to be neglected.

As gardens began as essentially private zones or as expressions of individuality, so the concept of the 'public' garden is something of a contradiction in terms. Just as private gardens had their public areas and aspects, which the secret garden or *hortus conclusus* within a larger complex implied, so public gardens provided secluded areas as well as social arenas, especially for sports and communal festivities. The development of Western garden art yields valuable evidence on the intricate, sometimes even ambiguous, connections between private and public existence.

Some private, patrician gardens—for example the Tuileries in Paris or St James's Park in London—had been opened to decently behaved members of the public from the early 17th century. By the 18th century the demand by the public for their own green areas ensured that some private gardens became wholly public—Vauxhall Gardens (*see* LONDON, §V, 6), for example, developed into one of the most famous European garden-theatres—and that such parks as the Englischer Gärten in Munich were specially designed and created for public enjoyment and use. By the 19th century, when urban conditions began to deteriorate, the public parks movement came into its own.

Gardens were originally created through the combination of artistic and design skills. Before the 19th century there were no landscape architects or garden designers as such, and the task of designing and laying out grounds

was entrusted to architects, military or hydraulic engineers, surveyors, poets, painters (including stage designers), dramatists, stewards, gardeners and indeed any amateur or virtuoso who would or could turn their hand to the job. As a result, gardens tended to accommodate and display debts to many artistic and technical skills, of which those to painting have been much emphasized by art historians.

By the 19th century both the claim of the Enlightenment that a garden could be an art form in its own right, and the public's demand for gardens brought into existence the professional garden designer. These professionals were always in competition with 'do-it-yourself' amateurs who devised their gardens by referring to an ever-increasing body of publications, which were often produced by professionals who chose to exert their influence indirectly. Yet this concentration of garden design in the hands of a single group did not in theory diminish, although in practice it frequently limited the range of materials and skills that continued to be required for fine gardens and landscape architecture throughout the Western world.

BIBLIOGRAPHY

M. L. Gothein: *A History of Garden Art*, 2 vols (Jena, 1914/*R* 1925; Eng. trans., London 1928/*R* New York, 1979)
S. Bann: 'The Landscape Approach of Bernard Lassus', *J. Gdn. Hist.*, iii (1983), pp. 79–107
V. Vercelloni: *European Gardens: An Historical Atlas* (New York, 1990)
J. Dixon Hunt: 'The Garden as Cultural Object', *Denatured Visions: Landscape and Culture in the Twentieth Century*, ed. S. Wrede and W. Howards Adams (New York, 1991), pp. 19–32
M. Mosser and G. Teyssot, eds: *The History of Garden Design: The Western Tradition from the Renaissance to the Present Day* (London, 1991)

JOHN DIXON HUNT

2. MEDIEVAL. Knowledge of medieval gardens is limited by the fact that although many cloisters or stretches of wall beside medieval buildings survive, not one garden with its original layout and planting is extant. What is known has been pieced together from written and visual sources, which are limited, as few practical writings directly concerned with gardens were produced before the 13th century, and there are virtually no detailed illustrations before the later 14th century. Care is therefore needed when assembling texts and illustrations produced at different times for different purposes. Illustrations of medieval gardens present a particular difficulty: while illustrations of actual gardens are rare, there are innumerable religious paintings the subject of which is set in an idealized garden—particularly that representing the Garden of Eden or the *hortus conclusus* ('enclosed' or 'secret garden') described in Solomon's Song of Songs (4:12), which in Christian thought is likened to the purity of the Virgin Mary. In these paintings the garden provides only a background for the figures. In the 15th century, when the garden details in these paintings were more precise, artists depicted exceptional rather than everyday gardens.

(i) Sources. (ii) General characteristics. (iii) Function and symbolism. (iv) Features.

(i) Sources.

(a) Texts. Between *c.* 795 and *c.* 1450 seven main documents were written that relate to practical gardening. To these practical texts passages on gardens in imaginative literature may be added, particularly the *Roman de la rose*

(c. 1220). The first 1700 lines of this poem, by Guillaume de Lorris, concerned the garden and were translated into English c. 1400 by Geoffrey Chaucer. Several of Chaucer's own works also contain references to gardens, including the 'Knight's Tale' (lines 1051–69) and the last quarter of the 'Merchant's Tale' from the *Canterbury Tales* (1387), and the 'Parlement of Foules' (lines 172–211).

Capitulare de villis vel curtis imperii (c. 795 or later). This treatise concerns the administration of towns in Charlemagne's empire; section 70 lists 73 plants and fruit trees to be grown in the gardens.

The St Gall plan (c. 820; *see* ST GALL ABBEY, §2). This shows the plan for an ideal monastery, in which cloisters and three further gardens are detailed.

Liber de cultura hortorum or *Hortulus* ('little garden'; before 849). This poem of 444 lines was written by Walafrid Strabo (c. 809–49) and describes the making of his small monastic garden and the 30 or so plants that he cultivated.

De vegetabilibus liber (c. 1260) by Albertus Magnus [Albert, Count of Bollstädt]. The chapter entitled 'De plantatione viridarium' (vii:xiv) describes making a garden, composed of a lawn surrounded by borders, a turf seat and trees.

Liber ruralium commodorum (c. 1305) by Pietro Crescenzi. The author borrowed extensively from such earlier writers as Albertus Magnus. Crescenzi proposed gardens of various sizes, according to the wealth of the owner.

Ménagier de Paris (c. 1394). This was supposedly written by a husband for his young wife; the second chapter deals with the practical aspects of gardening.

The Feate of Gardeninge (c. 1450) by Jon Gardener. This poem of 196 lines lists nearly 100 plants, with advice for their seasonal cultivation.

(b) Illustrations. Although these are also rare and lacking in detail during the early Middle Ages, they became more numerous and detailed from the 1450s; the St Gall plan, for example, shows only the basic outline of each feature. The *Liber ruralium commodorum* and the *Ménagier de Paris* were both illustrated in the 15th century, while the *Roman de la rose* exists in many illustrated versions of the manuscript from c. 1300 until the 1490s; the early printed editions of the poem were illustrated with woodcuts. In addition to these illustrations, there are innumerable pictorial representations of biblical garden scenes and backgrounds to episodes from the lives of saints and martyrs. Further illustrations are included in imaginative, historical, medical and encyclopedic secular works.

(ii) General characteristics. Throughout the Middle Ages European gardens were enclosed. This is apparent in the three 8th-century documents mentioned above. The St Gall plan depicts square or rectangular garden areas: the cloister beside the church, the *hortus* or vegetable garden, the *herbularius* or physic garden and the cemetery, which had 13 fruit or nut trees placed symmetrically beside the graves. Enclosures were generally formed by a wall for a royal or patrician garden, with a paling or wattle fence or a quickset hedge for a farmer's garden. Illustrations of the enclosure of the Garden of Eden vary from low, wattle

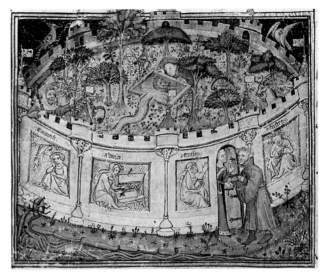

36. Medieval enclosed garden showing Narcissus looking at his reflection in the pool; at the gate the Lover is about to enter; miniature from the *Roman de la rose*, c. 1400 (London, British Library, Egerton MS. 1069, fol. 1v)

fencing in a perfect circle (the 'Earthly Paradise', in Jean Corbechon's *Des Proprietez des choses*, c. 1415) to a complex, many-sided structure, part stone, part wattle, in the version of the *Creation and the Fall* depicted in the Bedford Hours (c. 1423; London, BL, Add. MS. 18850) by the BEDFORD MASTER (*see* MASTERS, ANONYMOUS, AND MONOGRAMMISTS, §I). The visionary garden in the *Roman de la rose* is walled (see fig. 36), while Crescenzi advised walls or hedges, according to one's means.

Inside the enclosure, the garden was divided by regular, geometrically laid out cross-paths. In the St Gall plan both the *hortus* and the *herbularius* are divided by paths into neat, parallel rows of beds—18 in the vegetable garden, 16 in the physic garden; this was a common arrangement in medieval gardens. Individual beds, held firm along the outer edges by wooden planks, were often raised above the level of the paths. This method of drainage, first described in *De cultura hortorum*, was often illustrated and was recommended by garden writers for many centuries.

(iii) Function and symbolism. The plants and trees named in the *Capitulare*, the *Liber de cultura hortorum* and the St Gall plan were grown, virtually without exception, for culinary purposes or for medicines. The beds in the vegetable and physic gardens in the St Gall plan are each inscribed with the name of a different plant. In the vegetable garden, there are mainly salads and vegetables, including onions, leeks, garlic, celery, parsley, lettuce, radishes, parsnips and beetroot. In the physic garden, there are such medicinal plants as fennel, borage, tansy, sage, rue, mint and rosemary. Although Walafrid grew roses, flag irises, lilies and poppies, which may be regarded as 'ornamental', all these had a utilitarian purpose: the poppy (*papaver somniferum*) yielded opium (essential in medieval medicine); the lily cured snake bites; the iris quelled bladder pains and helped starch linen; while oil of roses, according to Walafrid, had innumerable uses.

Throughout the Middle Ages the variety of garden plants gradually increased (for detailed comment and comparative lists see Harvey); even from the late 14th century to the mid-15th, as the texts of the *Ménagier* and the *Feate of Gardeninge* suggest, their purpose was still culinary and medicinal. During this period knowledge of plants was extensive, as shown in the many extant illustrated herbals (*see* HERBAL). These were based on works by Theophrastus (4th century BC) and the *De materia medica* by Dioskurides (1st century AD), which were gradually enlarged and refined. While the illustrations of flowers and plants in herbals are of both botanical and art-historical interest, they should not be considered as guides indicating the range of plants in gardens, as many of those described may have been gathered in the wild, rather than from a cultivated garden.

Plants and flowers were also symbolically important in literature and painting (although not necessarily in real gardens). Such white flowers as the lily and the white rose symbolized purity; the former in particular signified the purity of the Virgin Mary. The red rose was a symbol of blood and so of passion; in Christian terms, the red rose could therefore represent the Passion of Christ and the blood of the martyrs. In secular literature and related imagery, the rose was the flower of love, and in the *Roman de la rose* it is the mystical goal of Amant, the Lover. It was therefore not illogical for Walafrid, having stressed the uses of oil of roses, to continue with an ecstatic passage on the beauty and virtues of Christ. In the St Gall plan the trees in the cemetery were useful, but they also numbered 13—the number of Christ and his disciples. Such lesser flowers as the columbine, heart's-ease, red and white carnations and even dandelions formed part of this symbolic *lexis* and featured in many medieval paintings. The area of the cloister garden was even more symbolic: its use for seated or ambulatory contemplation is well known, but no texts or illustrations as to their planting have survived. However, the paths that quartered the cloister were symbolically complex, representing both the Cross and the four rivers of the Garden of Eden, flowing from the centre. If a well-head was constructed, it could symbolize the 'spring shut up, a fountain sealed' of the Virgin Mary, herself the *hortus conclusus*, which the cloister might be seen to represent.

(iv) Features. Both monastic and secular gardens had lesser features relating to the garden as a place for contemplation or pleasure, rather than as a source of vegetables. The

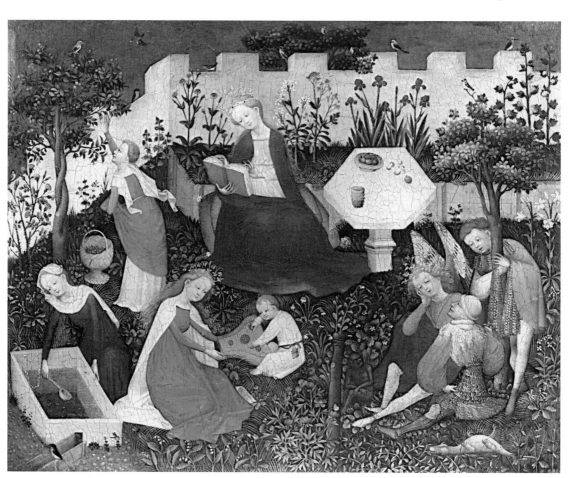

37. *Garden of Paradise*, oil and tempera on panel, 2.63×3.34 m, by an Upper Rhenish master, *c.* 1410–20 (Frankfurt am Main, Historisches Museum: on deposit at Städelsches Kunstinstitut und Städtische Galerie)

nature of these enclosed gardens favoured tranquil enjoyment, and both open and canopied seats appear in early accounts. In *De vegetabilibus liber* Albertus's description of a private pleasure garden stresses the need for turf seats, which were raised, edged with planks, bricks or woven wattle and covered with a layer of turf; these appear in numerous illustrations. In Sir Thomas More's *Utopia* (1516) the narrator sits on a turf seat and listens to the account of the island of Utopia.

Behind these seats and along the garden walls, there was often a trellis-work support, usually for roses but also for jessamine or vines. Such lower-growing plants as white or red carnations, lilies, irises, roses, daisies, peonies, violets, columbines or pot marigolds might be planted against the walls or beside the turf seats (see fig. 37). Carnations were often grown in round pots surrounded by light wickerwork frames. Trellis-work fences behind seats or along the walls were diamond-patterned or more often composed of vertical rectangles (see fig. 38). In grander gardens (as recommended by Crescenzi) trellises might be formed into extensive arbours and tunnels enclosing private sections of the garden. As several paintings show, raised seats were sometimes built around a tree trunk with the front or vertical edge executed in woven wattle. Ornamental trees were rarely mentioned, except in fictional works, unless they were also fruit- or nut-bearing. Individual trees were, however, sometimes trained into decorative shapes, the most common of which was the 'estrade', where the branches were trained outwards from the central stem in a succession of flat, clipped platforms, the larger ones being enclosed by a wickerwork rim. More elaborate topiary did not appear until the late 15th century, when the practice was developed in Italy in imitation of trees from ancient Roman gardens.

Water features were simple and included streams, wells, useful fish-ponds and pools—possibly with a stone border (as seen in numerous illustrations to the *Roman de la rose* when Narcissus looks into the magical pool; see fig. 36 above). Complex water effects, including water jets, were virtually unknown before the rediscovery of hydraulics during the Renaissance. In the introduction to the Sixth Day in Boccaccio's *Decameron* (*c.* 1353), such a jet is described, but no successful fountains appear to have been made before the late 15th century or early 16th.

In *De vegetabilibus liber* Albertus described a lawn in front of the turf seat and provided the instructions for making it: clearing the roots, pouring boiling water over the soil to kill any remaining scraps, covering the ground with turfs cut from meadow land and beating them level with mallets. This process was followed by garden writers until the late 16th century. In such lawns the grass was unavoidably scattered with numerous small plants, the varied leaves and flowers of which enliven the grass in almost every garden illustration featuring a lawn. The medieval lawn, with its integrated, yet random pattern of small flowers, was closely related to the unenclosed and irregular medieval garden known as the *locus amoenus*, 'flowery mead' or 'pleasant place' of both Latin and medieval literature. Such an area constituted the central open space of an ideal garden, in both religious and secular writing. In the *Mystère d'Adam* (*c.* 1150), the Latin stage directions refer to Paradise as 'a most pleasant place'

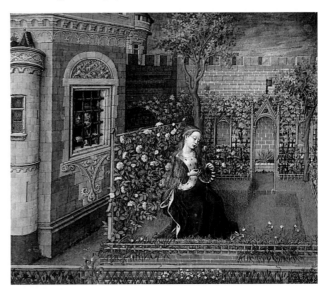

38. Medieval enclosed garden with turf seats, trellis arbour, vines and roses; miniature from the *Livre du cuer d'Amours espris*, *c.* 1470 (Vienna, Österreichische Nationalbibliothek, Cod. 2617, fol. 53)

(*amenissimus locus*), while the frescoes (*c.* 1365) by Bartolo di Fredi Cini of the Garden of Eden in the cathedral at San Gimignano depict a Paradise of unordered luxuriance—a grassy clearing among vines and palm, fig, pomegranate and rose trees. In medieval romances (*see* ROMANCE MANUSCRIPT, §2(i)), such as *Cligès* (*c.* 1170) and *Erec et Enide* (*c.* 1165–70) by Chrétien de Troyes, similar magical spaces are briefly described; in the *Roman de la rose* and the *Decameron* the descriptions confirm the untended, ungardened quality of the space, 'one continuous lawn of tiny blades of grass interspersed with flowers, many of them purple in colour' (the *Decameron*, Conclusion to the Sixth Day).

BIBLIOGRAPHY

EARLY SOURCES

Capitulare de villis vel curtis imperii (*c.* AD 795); ed. B. E. C. Guérard as *Explication du capitulaire de villis* (Paris, 1969)

W. Strabo: *Liber de cultura hortorum* (*c.* 825); Eng. trans. by R. Payne as *The Hortulus of Walahfrid Strabo*, commentary W. Blunt (Pittsburgh, 1966)

G. de Lorris: *Le Roman de la rose* (*c.* 1220); Eng. trans. and ed. by R. Sutherland (Oxford, 1967)

A. Magnus: *De vegetabilibus liber* (*c.* 1260); ed. E. Meyer and C. Jessen (Berlin, 1867)

P. Crescenzi: *Liber ruralium commodorum* (*c.* 1305); Fr. trans. by J. Roubinet as *Les Profits champêtres* (Paris, 1965)

G. Boccaccio: *Decameron* (MS; 1350–*c.* 1353); Eng. trans. by G. H. McWilliam (Harmondsworth, 1972)

Le Ménagier de Paris (*c.* 1394); Eng. trans. and intro. by E. Power as *The Goodman of Paris* (London, 1928); Fr. edn by G. E. Brereton and J. M. Ferrier (Oxford, 1961)

J. Gardener: *The Feate of Gardeninge* (*c.* 1450); ed. M. M. Strachan (Oxford, 1980)

GENERAL

A. Arber: *Herbals* (Cambridge, 1912/*R* 1986)

F. Crisp: *Mediaeval Gardens*, 2 vols (London, 1924)

D. Hennebo: *Gärten des Mittelalters* (Hamburg, 1962)

W. Blunt and S. Raphael: *The Illustrated Herbal* (London, 1979)

W. Horn and E. Born: *The Plan of St Gall*, 3 vols (Berkeley, 1979)

C. Thacker: *The History of Gardens* (London, 1979, rev. 1985)

J. Harvey: *Mediaeval Gardens* (London, 1981)

J. Prest: *The Garden of Eden* (London, 1981)

Gardens of the Middle Ages (exh. cat. by M. Stokstad and J. Stannard, Lawrence, U. KS, Spencer Mus. A., 1983)

F. A. Roach: *Cultivated Fruits of Britain* (Oxford, 1985, rev. 1986)

CHRISTOPHER THACKER

3. EARLY RENAISSANCE.

(i) Italy. (ii) France. (iii) Elsewhere.

(i) Italy. Despite some continuities with the medieval garden, Italian attitudes to the making of gardens show substantial changes from the mid-15th century onwards. These changes are closely associated with HUMANISM, the primarily literary movement, originating in Tuscany, which sought to recover the admired qualities of ancient Greece and Rome. For many of humanism's dominant figures garden-making and the great project of a Renaissance were profoundly connected; its ideas came to influence other Italian provincial cultures (as well as those of northern European countries).

(a) Classical and humanist background. Some Classical elements of garden design, such as the Roman peristyle garden (*see* §II, 4 above), which influenced the monastery cloister, had survived the Middle Ages. This continuity extended into the Renaissance with monasteries serving as the nuclei of such estates as the Villa d'Este at Tivoli. The connection between monasteries and ancient villas was recognized in the Middle Ages and contributed to an understanding of Classical gardening that was not confined to monasteries; the Emperor Frederick II excavated Roman villas and created sophisticated gardens in imitation. This response to Classically inspired gardens culminated in the first half of the 15th century in the creation of the gardens of Poggio Reale, Naples. The splendour of Neapolitan gardens, with their sculpture, water features, architectural organization and horticultural riches led Charles VIII of France to take the Neapolitan gardener Pacello da Mercogliano (*d* 1534) back with him to France (1495), where he probably worked at Amboise, Gaillon and Blois (*see* §(ii) below).

The most important sources for early Renaissance gardens were, however, descriptions of life in Roman villas, Roman horticultural manuals and accounts of the Greek sense of the sacredness of groves and woods, as expressed in Classical texts recently discovered or made available through humanist scholarship. These stimulated a new idea of the garden as composing, with the house and the landscape, a unified ensemble. The power of the descriptions of Classical villas lay in the vision they presented of the life of cultured men in ancient times. The villa expressed an ideal, summed up in the word *villeggiatura*, of healthy mental and physical life, in contact with the natural world while retaining proper commitment to city and society.

The works of Virgil, Pliny the younger and Vitruvius were particularly influential in forming this ideal, along with the frequently reprinted *Res rustica scriptores*, collections of Classical writings on rural subjects, first printed in Venice in 1470. Included were works by Columella, Varro, Cato and Palladius, some of them authors central to Classical literature. Their prominence, and the place of garden-related material in their works, reinforced the association between the love of antiquity and the love of gardens. Ancient descriptions of villas and gardens were conveniently suggestive and non-prescriptive. Even with the additional evidence of the remains of Roman villas, some above ground and others being excavated, the information available was insufficiently clear to force sterile repetition; it rather offered a repertory of elements for designed landscapes, fostering creative imitation.

The writings of Leon Battista Alberti both stimulated the desire to imitate the Roman ideal and provided a summary of villa features. He based his instructions on studies of the surviving evidence of Classical architecture, both texts and buildings, and on archaeological exploration. His principal contribution was *De re aedificatoria libri X* (printed in 1485, but circulating from 1452). Although such writers as Antonio Filarete (*Trattato d'architettura*, 1461–4) and Francesco di Giorgio Martini (*Trattato di architettura civile e militare*, 1486–92) extended and altered the thrust of Alberti's treatise and provided more detailed guidance, he remained supremely important as interpreter of the architecture and gardening of the ancient world. Alberti stressed the mixed character of the ideal dwelling, citing Cicero, Terence and Martial in support of his vision of *utilità* and *comodità*. He also emphasized the advantages of a hillside site, enabling owner and guests to enjoy views and fresh air, and he suggested features to provide shade in summer and shelter in winter, and to blur the distinction between house, garden and wider landscape.

(b) Villas and their gardens. Early Renaissance villas show an immediate response to Alberti's theories. The Villa Medici at Fiesole (1458–61; see fig. 39) and other houses placed on natural or artificial elevations used their situations to offer views that extended the garden into the landscape; the terraced gardens that descended from them increasingly seized opportunities to incorporate variety through changes of level. Within the house, representations of gardens and landscapes connected interior and exterior, as did vistas. Loggias, garden rooms, pergolas and the medieval *hortus conclusus* ('enclosed' or 'secret garden'), now integrated into the overall design, exhibited the interpenetration of house and garden, also incorporating orchards and vineyards. Classically inspired restraint ensured that the design of each terrace remained simple: commonly a quartered rectangular pattern of beds with a water feature, usually a fountain, at the centre, and perhaps incorporating statues, grottoes and watercourses. The gardener's resources included evergreens for topiary in the Roman manner and exotic plants. Axial organization increasingly dominated the overall design, following Alberti's recommendation and its implementation at the Villa Quaracchi in Florence (before 1459), designed perhaps by him or his colleague Bernardo Rossellino; there the arrangement continued beyond the road dividing the estate to lead the eye from the slightly elevated house, through the garden with its *hortus conclusus*, and through the landscape to the banks of the Arno.

Within this new garden setting, the owner and his guests engaged in the cultivation of the human mind, most famously in Cosimo de' Medici's Villa Medici at Careggi, where the remodelling of house and garden was again inspired by Alberti's works, being intended as the setting for study and conversation. Although little survives of the

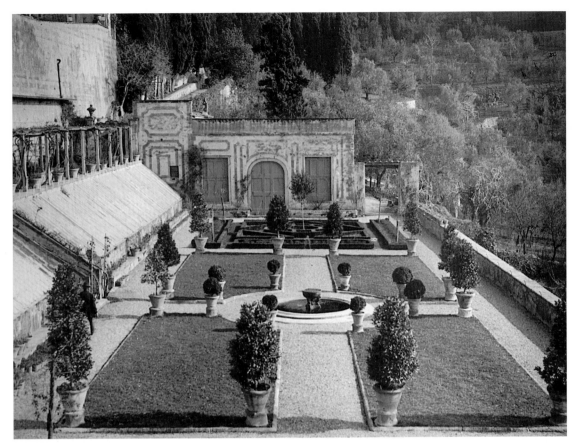

39. Garden of the Villa Medici, Fiesole, 1458–61

garden at Careggi, it is clear that Cosimo asked Michelozzo di Bartolomeo to reconstruct both house and garden in imitation of a Roman villa. In style and spirit, the garden shows a remarkable advance on Michelozzo's work at the Medici villa of Il Trebbio, near Cafaggiolo (1451), which, with its detached walled garden, remained essentially medieval in concept. The garden at Careggi was dominated by evergreens—bay, box, cypress and myrtle—permitting the imitation of Roman topiary. Following the advice of Pliny the younger and others, the west side of the villa was adorned with a double loggia, for summer shade and winter warmth. The garden was regarded as the philosopher's Helicon (a phrase used by Petrarch), philosophical debate being associated with gardens, in emulation of Plato's Academy.

Following ancient Roman practice, gardens also contained statues, since the creation and contemplation of visual art was important to villa life. The collection of Lorenzo the Magnificent fostered the formation of the 'garden school' in Florence, where Michelangelo gained his first knowledge of antique statuary. With their combination of natural and artificial elements, and their owners' heightened awareness of both nature and art, gardens frequently formed a meditation on the relationships between human and universal creativity, and embodied increasingly a witty competition between the two.

(c) The villa and the town. Although many of the early Renaissance gardens were associated with rural life, they were nevertheless dominated by awareness of the town. Thus the Medici villas around Florence were recreative departures from the city, not permanent alternatives. Alberti taught that the supreme commodiousness of the villa depended on its simultaneous relationships with town and country. Other, more troublesome ambiguities stemmed from the fact that the early Renaissance villas were constructed mainly for rulers and princes. The tensions are recognizable in the palace and garden created by Aeneas Silvius Piccolomini in Corsignano, his birthplace, which he renamed Pienza, immediately after his election to the papacy as Pius II in 1458. Piccolomini was a distinguished humanist, and the garden of the Palazzo Piccolomini (see fig. 40), which was the work of, among others, Alberti and Rossellino, was, at first sight, that of a scholar–statesman, rather than that of a Renaissance pope. Facing away from the city and launched out on a manmade terrace, it appeared to be the garden of a rural villa, encouraging the eye to range over the peaceful agricultural landscape far below. The garden and the landscape beyond were overlooked by a supremely elegant triple loggia, full of light and air, and without any thought of defence. But the Palazzo Piccolomini's other façades, which faced the town, were closed and dominating, their towering walls

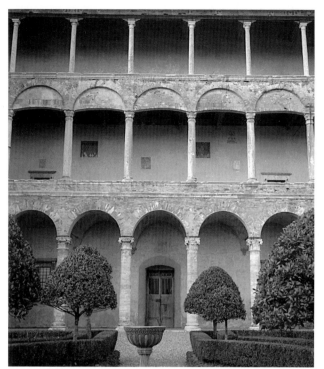

40. Loggia and garden of the Palazzo Piccolomini, Pienza, 1460–62

permitting only the occasional glimpse of the palace's courtyard and, distantly, the garden beyond. The garden had additional ranges of meaning in relation to the town: the Palazzo Piccolomini's dominance of Pienza was the expression of the prince's dominance, and the *hortus conclusus* a political statement, by virtue of its possession of a privacy the palace simultaneously denied to others. The garden, surrounded by pergolas, was the prince's privileged viewing place, from which he watched, concealed, the labours of his subjects. Thus the garden expressed both recreation and involvement. The hanging gardens at Pienza were not the enclosed, inward-looking courtyards of the cloister or peristyle garden, but the eye's avenues into the world beyond. However, the Palazzo Piccolomini displayed the instability of the humanist garden, resulting from incompatibility between the republican ideal that inspired it and the reality in the service of which the Albertian villas were created. Both Alberti and Rossellino had also been on the architectural staff of Nicholas V, the last great builder pope; both had used their understanding of Classical culture in the service of autocracy.

BIBLIOGRAPHY

A. Filarete: *Trattato d'architettura* (Florence, 1461–4)
Columella, Varro, Cato, Palladius and others: *Res rustica scriptores* (Venice, 1470)
L. B. Alberti: *De re aedificatoria libri X* (Florence, 1485); Eng. trans. as *On the Art of Building in Ten Books* (Boston and London, 1988)
F. di Giorgio Martini: *Trattato di architettura civile e militare* (Florence, 1486–92)
B. Taegio: *La villa* (Milan, 1559)
A. F. Doni: *Le ville* (Bologna, 1566)
D. Coffin: *The Villa D'Este at Tivoli* (Princeton, 1960)
A. Perosa, ed.: *Giovanni Rucellai ed il suo Zibaldone*, Stud. Warb. Inst., 2 vols (London, 1960)
G. Masson: *Italian Gardens* (London, 1961/R 1966)
D. Coffin, ed.: *The Italian Garden* (Washington, DC, 1972)
H. Acton: *The Villas of Tuscany* (London, 1973, rev. 1984)
T. Comito: *The Idea of the Garden in the Renaissance* (New Brunswick, 1977)
J. Dixon Hunt: *Garden and Grove: The Italian Renaissance Garden in the English Imagination, 1600–1750* (London, 1986)
J. S. Ackerman: *The Villa: Form and Ideology in Country Houses* (Princeton, 1990)
C. Lazzaro: *The Italian Renaissance Garden: From the Conventions of Planting, Design and Ornament to the Grand Gardens of Sixteenth-century Italy* (New Haven and London, 1990)
M. Mosser and G. Teyssot, eds: *The History of Garden Design: The Western Tradition from the Renaissance to the Present Day* (London, 1991)

MICHAEL LESLIE

(ii) France. At the beginning of the 16th century, most French gardens were small and simple, composed of rectangular compartments divided by paths in which utility and recreation were combined. Typically the garden was divided into four equal compartments by two paths intersecting at right angles, with each quarter containing vegetables, herbs, flowers and fruit trees. While gardens were often symmetrically arranged, they did not, for the most part, form part of a larger composition with the house or château with which they were associated. Nevertheless, the rectangular compartment remained the basic element of French gardens as they developed during the early Renaissance period.

In 1494 Charles VIII (*reg* 1483–98) campaigned through Italy as far as Naples, during which he and his followers observed the design and management carried out on Italian estates. Impressed by what they saw, they started improving their own houses and gardens, on returning to France, with the assistance of Italian artists and craftsmen, among whom was the garden designer Pacello da Mercogliano (*c.* 1455–1534). They also took up the ideas that had been emerging in Italy during the 15th century and set out in such treatises as Alberti's *De re aedificatoria libri X* (Florence, 1485), published in Paris in 1512. Alberti, following Vitruvius, stressed the importance of symmetry and balance, proportion and harmony to form an integrated design conceived as a whole (*see* §(i) above). Another source of ideas for gardens coming from Italy was the *Hypnerotomachia Poliphili* (Venice, 1499), the French version of which included over 200 woodcuts illustrating Love's esoteric quest among architectural and garden scenes. These included labyrinths, obelisks, pyramids, fountains, arbours and trellised enclosures. Using some of these ideas, Cardinal Georges I d'Amboise had the old castle at Gaillon (Eure; *see* GAILLON and fig.) transformed into a magnificent palace in 1502, with loggias and open arcades overlooking the valley of the River Seine. Pacello da Mercogliano planted the upper walled garden, the square trellised compartments of which included fruit trees, flowers, topiary, herbs and various symbolic and decorative motifs.

Similar improvements were undertaken in the region of the Loire Valley at Amboise (Indre-et-Loire). The King's seat there was adorned with a garden of ten compartments laid out on a terrace within the château's precincts. Similarly, at the château of BLOIS (Loir-et-Cher), Pacello planted a large ten-compartment garden (*c.* 1505) with

Italianate arbour walks surrounding it, adjoining an earlier one of six compartments. One of the developments of this period was the placement of a fountain in the middle of the garden at the crossing of two main paths. An example is found in early drawings of Blois and of Gaillon with the addition of a domed pavilion over the fountain. While the gardens at Gaillon, Blois and Amboise were additions to existing châteaux, the château of BURY (destr.; see fig. 41) was the first example of a house and garden designed together as a whole (c. 1513). One central axis ran through the whole composition including the house, passing down a double flight of steps to the walled garden and a chapel that provided a visual climax at the end of the main walk. Next to the main garden was a more simple one, the surrounding walls of which were lined with Italianate vine arbours.

In 1527, Francis I (reg 1515–47), whose interests included both hunting and the arts, decided to leave the Loire Valley and establish his headquarters in Paris. As a result of this, royal residences, such as the château of Saint-Germain-en-Laye (rest. c. 1539; destr. 1789–92; Yvelines) or Fontainebleau (begun 1528; Seine-et-Marne), soon became magnificent centres for the arts. Under the patronage of Francis, Italian architects and artists, among them Sebastiano Serlio and the painter and decorator

Francesco Primaticcio, embellished the château and gardens of Fontainebleau (for further discussion see FONTAINEBLEAU, §§1 and 2). Their most important contribution to garden design, however, took place around 1546 at Ancy-le-Franc (Yonne). There, the rectangular moated château, raised on a platform, displayed four façades. It stood detached from, though linked to, a rectangular garden of 12 compartments. As at Bury, the central axis was the integrating device, around which both the château and garden were symmetrically arranged. A symmetrical Italianate design was also seen at Vallery (c. 1550; Yonne), where the gardens were divided lengthwise by a decorative canal.

BIBLIOGRAPHY

C. Estienne and J. Liébault: *L'Agriculture et maison rustique* (Paris, 1564, rev. 1582); Eng. trans. by R. Surfet as *Maison Rustique, or the Countrie Farme* (London, 1600)

J. A. Du Cerceau: *Les Plus Excellents Bastiments de France*, 2 vols (Paris, 1576–9/*R* 1988)

O. de Serres: *Le Théâtre d'agriculture et mesnage des champs* (Paris, 1600, rev. 2/1603)

J. Boyceau de la Barauderie: *Traité du jardinage selon les raisons de la nature et de l'art* (Paris, 1638)

E. de Ganay: *Les Jardins de France et leur décor* (Paris, 1949)

A. Marie: *Jardins français créés à la Renaissance* (Paris, 1955)

T. Comito: *The Idea of the Garden in the Renaissance* (New Brunswick, 1977)

W. H. Adams: *The French Garden, 1500–1800* (New York, 1979)

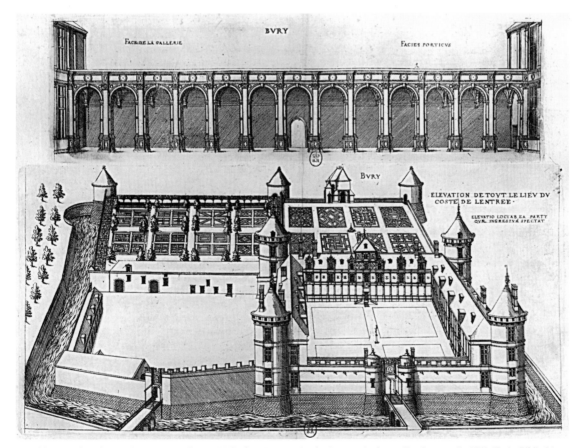

41. Château and gardens at Bury, Loir-et-Cher, c. 1513 (destr.); engraving by Jacques Androuet Du Cerceau (i), 1579 (Paris, Bibliothèque Nationale)

G. Jellicoe and S. Jellicoe, eds: *The Oxford Companion to Gardens* (Oxford and New York, 1986)

K. Woodbridge: *Princely Gardens: The Origins and Development of the French Formal Style* (London, 1986)

G. Bazin: *Paradeisos: The Art of the Garden* (London, 1990)

M. Mosser and G. Teyssot, eds: *The History of Garden Design: The Western Tradition from the Renaissance to the Present Day* (London, 1991)

DENIS A. LAMBIN

(iii) Elsewhere. At this time the ideals of the Renaissance garden began to spread from Italy to the rest of Europe. Countries in central Europe were foremost to benefit, due to a series of dynastic marriages with ruling Italian families. In 1475 Matthias Corvinus of Hungary (*reg* 1458–90) married Beatrice of Aragon from Naples and they had terraced gardens designed in the Renaissance style at Buda Castle (in Budapest) and at their summer palace in nearby VISEGRÁD. Of these, only some impressive, Classically inspired fountains from Visegrád remain. In 1518 Sigismund I of Poland (*reg* 1506–48) married Bona Sforza of Milan. From this time Italian architects in Poland began to design new houses with formal, axial gardens, of which Baranów Castle, designed by Santi Gucci, north-east of Rzeszów, is among the best preserved. In Croatia Dubrovnik came under the political influence of the city-state of Venice and a series of villas with gardens, among them Trsteno, near Dubrovnik (1502), were built along the coast of Dalmatia.

The Habsburg emperor Charles V (*reg* 1519–58) was, as ruler not only of the Holy Roman Empire, Spain and the Netherlands but also Milan, Naples and Sicily, able to introduce Italian Renaissance principles of design into gardens throughout his empire. In 1520, for example, he created a new formal garden for the grounds of the Court of Brussels and in 1543 commissioned a new garden pavilion in Classical style at the Alcázar in Seville. His brother Ferdinand I, first Habsburg king of Bohemia (*reg* 1526–62), not only used Italian designers to lay out the gardens (*c.* 1540) at Hradčany Castle in Prague but had the Italian botanist Pietro Andrea Mattioli (1501–77) in his employ for 20 years.

The diffusion of Renaissance garden design also came about as a result of extended visits paid to Italy by many noblemen from other parts of Europe. One of the most complete surviving gardens of the period is at the Quinta da Bacalhoa at Azeitão, near Lisbon, completed between 1528 and 1553 by BRÁS DE ALBUQUERQUE, who in 1521 had accompanied the Infanta Dona Beatriz, daughter of Manuel I (*reg* 1495–1521), to Italy. The Casa de Pilatos in Seville was inherited in 1509 by the 1st Marqués de Tarifa after he had paid an extended visit to Italy. While there, he commissioned from the sculptor Antonio Aprile (*fl* 1519–36) of Genoa two fountains, which arrived in Seville in 1529 (*see also* SEVILLE, §IV, 3).

In northern Europe the influence of Italian Renaissance design was often felt indirectly through an intermediate country. England's first Renaissance gardens—at Hampton Court Palace (1531–4), Nonsuch Palace (1538–47; *see* NONSUCH PALACE, §2) and Whitehall Palace (completed 1545)—were created by Henry VIII (*reg* 1509–47) as a result of his rivalry with the French king Francis I (*reg* 1515–47). The Royal Garden (Kungsträdgården) in Stockholm, commissioned *c.* 1545 by Gustav I (*reg* 1523–

60), was designed by Hans Friese (*fl c.* 1545–79), a German gardener. The first Renaissance garden in Norway was created in the mid-16th century for the Lutheran bishop of Bergen, who imported a Flemish gardener for this purpose. In Russia a large imperial garden of formal design was by 1495 already in place between the buildings of the Kremlin and the Moscow River.

Advances in garden design suffered a setback as a result of religious and political disturbances of the last third of the 16th century. Many early Renaissance gardens were also unfortunately later altered, and few survive in any more than fragmentary form. However, through many contemporary visual and literary descriptions, for example Jan Vredeman de Vries's *Hortorum viridariorumque* (Antwerp, 1583), it is possible to gain an understanding of their layout.

BIBLIOGRAPHY

Marquesa de Casa Valdés: *Jardines de España* (Madrid, 1977; Eng. trans., Woodbridge, 1987)

R. Strong: *The Renaissance Garden in England* (London, 1979)

G. Jellicoe, S. Jellicoe, P. Goode and M. Lancaster, eds: *The Oxford Companion to Gardens* (Oxford, 1986)

P. Bowe: *Gardens of Portugal* (New York, Lisbon and London, 1989)

——: *Gardens in Central Europe* (New York and Woodbridge, 1991)

PATRICK BOWE

4. *c.* 1550–*c.* 1800.

(i) Italy. (ii) France. (iii) Spain and Portugal. (iv) British Isles. (v) The Netherlands. (vi) Germany, Central and Eastern Europe. (vii) Russia. (viii) Scandinavia. (ix) North America.

(i) Italy. The gardens in Italy from the 16th century to the end of the 18th century for which the greatest traces survive are the aristocratic gardens in which the land was significantly altered, architectural structures were built and water was brought in by aqueduct and prominently displayed in sculpted fountains. Although in virtually all extant gardens the planting has been altered, considerable evidence from contemporary views, descriptions and documents allows the reconstruction of their former appearance.

(a) General characteristics. (b) Historical development.

(a) General characteristics.

Design. The modern term 'formal' has come to denote a characteristic aspect of Italian gardens, as distinct from the landscape and Picturesque English gardens of the 18th century. Notwithstanding the modern distinction, Italian gardens were described by their contemporaries as an interaction of art and nature in which nature was ordered by art: geometry was the basis of their designs. Bilateral symmetry governed the relationship of the geometric units, while both terrain and plant materials were regularized and ordered. Trees were planted in rows, compartments defined by hedges, avenues covered with pergolas and large areas separated by walls. Trees and shrubs were clipped and shaped into topiary, labyrinths and theatres of greenery. However, the Italian garden of the period was not characterized solely by its so-called formal aspect or ordered nature. The geometric garden included a planted *bosco*; this had a counterpart in the park, which contained areas of unaltered terrain and freely growing trees. The wild aspect of nature was also given expression within the garden through rustic ornaments, such as fountains and

grottoes, which imitated nature's own by the use of such natural materials in rough form as pebbles or shells.

Origins. Underlying these aspects of Italian gardens was a conscious and persistent relationship to Classical antiquity, which provided the model for the ordering of plant materials, the vocabulary of architectural and decorative forms and the terracing of the land with massive retaining walls, architectural frontispieces, staircases and ramps. Antiquity provided the subjects and styles of garden sculpture, and the myths about nature that they expressed. The aqueducts and hydraulics that brought water to fountains, as well as the automata and water tricks, were all inspired by the desire to outdo the ancients. Classical antiquity, in particular the heritage of ancient Rome known through literature, letters and surviving ruins, informed every aspect of the Italian garden. Ancient Rome was in a sense a living presence, stimulating invention, not, as in later gardens, a distant culture that was simply one among many represented in garden ornaments for their associative value.

Use for display. Like palaces and villas, grand gardens expressed their owners' magnificence, conveying status, power and wealth. This was achieved through terracing, architecture, sculpture and fountains, as well as exotic and expensive planting and labour-intensive garden ornaments, such as pergolas and topiary. Water was a most important expression of magnificence, since it was often acquired at great expense. Gardens formed a significant aspect of the building campaigns of rulers: in the 15th century the Este in Ferrara and the Aragonese dukes in Naples, in the 16th century the Medici in Tuscany, in the 17th and 18th centuries the House of Savoy around Turin, the Farnese dukes of Parma at Colorno and Charles III, King of Spain (Charles VII of Naples) at Caserta. In Rome and the Papal States gardens were created by popes and cardinals. The Borromeo family, which transformed a rocky island into the flourishing garden of Isola Bella, had long been feudal lords in that region. Where no single family or ruler had authority over the land, the wealthy and politically powerful built gardens, an example in Genoa being Andrea Doria, founder of the Genoese Republic. In the Veneto, at Valsanzibio, the most splendid surviving 17th-century garden was created by Antonio Barbarigo (*d* 1702). In the 18th century one of the most magnificent gardens, that at Stra, belonged to the Pisani brothers, one of whom, Alvise Pisani (1664–1741), was procurator and later doge. All manner of distinguished guests, including kings and emperors, were entertained in these gardens. At the Boboli in Florence, the U-shaped garden behind the Pitti Palace, begun by Duke Cosimo de' Medici in 1550, was transformed into an amphitheatre built of stone in 1637 and became the site of extravagant court entertainment. The semicircular theatre form, whether made of stone or greenery, became a popular garden feature; some were actually used as theatres.

Views and detailed descriptions of grand gardens served to make their magnificence known far and wide. A description, written *c.* 1571, of the garden created by Cardinal Ippolito d'Este II, governor of Tivoli, was sent to Emperor Maximilian II; another (1611) of the villa at Frascati belonging to Pietro Aldobrandini, nephew of Pope Clement VIII, was addressed to Charles-Emanuel I of Savoy. Many views of gardens were produced, among the most famous being the 14 lunettes of Medici villas (Florence, Mus. Firenze com'era; see fig. 3 above) painted in 1599–1602 by Giusto Utens (*d* before 19 April 1609) and originally hung in the palace at Artimino. Most of the grand gardens were recorded in prints; in the 16th century these were single engravings, such as that by Etienne Dupérac of the *Villa d'Este at Tivoli* (1573). Over the next two centuries many prints appeared in series, such as Giovanni Battista Falda's *I giardini di Roma* (Rome, 1670) and the *Ville di delizia osiano palagi camperecci nello stato di Milano* (1726 and 1743) by Marc'Antonio dal Re (1697–1766).

Planting. Despite regional and chronological differences, the plant materials in Italian gardens throughout this period consisted, in varying proportions, of herbs and flowers, fruit trees and larger trees, many of them evergreen. At the Villa d'Este, as in many other gardens, the three conventional plant materials ascended the hillside: herbs and flowers, together with a few fruit trees, were on the lowest terrace, with grapevines and smaller trees on the intermediate slope, and a dense *bosco* above. Important criteria in garden planting were the variety of plants within the three categories, and the inclusion of rare and exotic specimens. From the early 16th century to the end of the 18th new plants were being imported from the Middle East, America, Africa and Asia. This influx prompted the creation of the first botanic garden in Europe, the Orto Botanico in Padua (1545), for the scientific study of plants. In the 17th century valuable bulbs and hybrids were collected and the first horticultural manuals appeared, a leading example being Giovanni Battista Ferrari's *De florum cultura* (Rome, 1633). By 1625 the exotic plants in the Orti Farnesiani in Rome included some just arrived from the New World, among them acacia, agave, passion flower and yucca. A late 17th-century inventory of the Villa Barbarigo at Valsanzibio reveals that the basic categories of plants remained, but their number and variety had much expanded. Among the 226 flowers, the hyacinth, rose, violet, ranunculus, tulip and carnation had been favourites since the 16th century. The 233 fruit trees included the traditional citrus, peach, pear, plum, cherry, nut and fig trees in numerous varieties.

(b) Historical development.

16th century. Gardens were composed of regular units or compartments, which represent the ordered cosmos in microcosm. Circles and squares, being considered the most perfect geometric figures, dominated the design of gardens, as in Raphael's design for the garden of the Villa Madama in Rome (*c.* 1518), the Orto Botanico in Padua and the Medici estate at Petraia (1590s; see fig. 3 above). Views of 16th-century gardens emphasized the order, as in Dupérac's engraving of the Villa d'Este (*see* TIVOLI, fig. 5), which was designed by Pirro Ligorio from *c.* 1560; in it the steeply sloping site and architectural elements were subordinated to the regular units. The Giardino Giusti in Verona, created in the 1560s or 1570s, retains most of the original nine square compartments, which end at the base of a sheer cliff, with a balcony at the summit

overlooking the garden. Like other Renaissance gardens, the Giusti garden is finite and measurable.

Since much of the topography of Italy is hilly, gardens were frequently laid out on hillside sites. They were regularized by terracing, with supporting walls and connecting staircases, inspired by descriptions of ancient villas and visible archaeological remains. These architectural gardens were furnished with a variety of inventions suggested by Classical gardens, but over time the relationship between natural and architectural elements changed significantly. At the Este garden at Tivoli and the VILLA LANTE, BAGNAIA (1568–78), attributed to Vignola (see fig. 1 above), as well as at the Genoese gardens of the Palazzo Doria (now Doria-Pamphili, 1540s) by Giovanni Angelo Montorsoli and Galeazzo Alessi's Villa Imperiale-Scassi (1560s), each terrace forms a large garden, in some cases square, balanced but not dominated by the succession of architectural features that mark the central axis. Also new in these 16th-century terraced gardens were architectural fountains and water chains. The great fountains at Tivoli—the Fountain of the Dragon, the Oval Fountain and the Water Organ—were the backdrop for dramatic water displays in which the water was manipulated in a number of ways: formed into cascades, shot up in high jets and arcs and used to power booming and singing hydraulic devices. Another part of the Classical

tradition in Italian gardens were the omnipresent water tricks.

The sculpture and sculpted fountains prominent in 16th-century gardens were also derived from Classical precedents and provided the repertory of garden ornament for the next two centuries. Much of the imagery refers to the natural world through mythological figures, such as Neptune, Venus, Ceres and satyrs, or through personified rivers and mountains. Pastoral literature inspired the representation of shepherds and shepherdesses with their sheep and goats, and of peasants with hoes and wine barrels. Sculpted animals appropriately populated the *boschi* or grottoes, as at the Villa Medici at Castello, where the interior of the grotto, covered in natural stalactites, has three niches filled with animal figures of every sort. The rustic was given metaphoric expression in the large grotesque heads that also appeared in gardens at this period, most dramatically at the Giardino Giusti in Verona and the Sacro Bosco or Villa Orsini, Bomarzo (*see* BOMARZO, SACRO BOSCO). By contrast with such artifice, some 16th-century estates were designed as parks. Like the park of the Villa Lante at Bagnaia adjacent to the geometric garden, these were planted principally with trees and did not have either compartments or terracing. The *barco* (park) of Francesco I de' Medici at Pratolino, which is

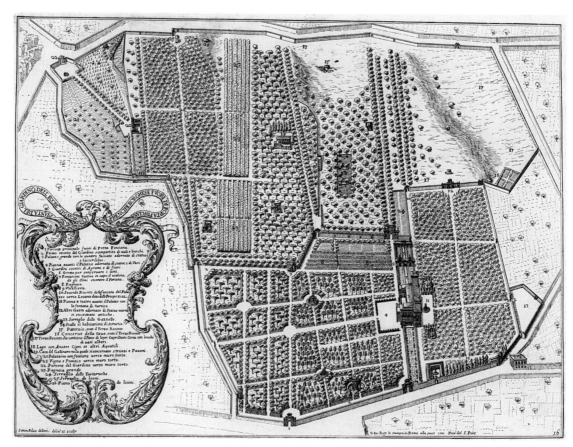

42. Giovanni Battista Falda: plan of the garden of the Villa Borghese, Rome; engraving from *I giardini di Roma* (Rome, 1670), pl. 16 (London, British Library)

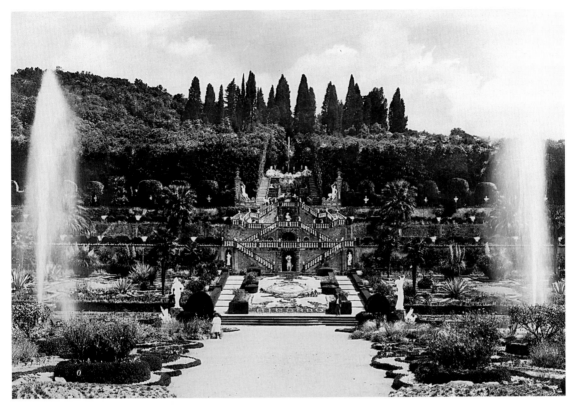

43. Garden of the Villa Garzoni, Collodi, Lucca, mid-17th century

known in its original state only from a painting by Utens (Florence, Mus. Firenze com'era), was densely planted with trees, predominantly fir, and ornamented with water channels, grottoes, statues, automata and Giambologna's colossal figure of *Appennino*.

17th and 18th centuries. Parks continued to be developed: among the estates that were expanded in the 17th century with the design and planting of parks were the Boboli Gardens in Florence (1630s; *see* FLORENCE, §V, 9(iii)) and the Villa Mattei and the Villa Montalto in Rome. The new villa-parks in Rome, which included the Borghese, Doria-Pamphili and Ludovisi villas, covered much greater expanses than their predecessors; in keeping with the site they were ornamented with large-scale rustic fountains. The early appearance of the Villa Borghese, begun about 1605 by Cardinal Scipione Borghese, nephew of Pope Paul V, is documented in views published in 1683 by Falda in *I giardini di Roma* (see fig. 42). Designed by the architect Flaminio Ponzio, the gardener Domenico Savino da Montepulciano and later the architect Girolamo Rainaldi, the estate was composed of three principal parts, divided by high walls, within which were enclosures for the popular sports of hunting animals and birds. Falda's plan emphasizes the regularity and geometry of the design of much of the estate. The park was principally planted with trees— more than 1000 fir trees, pine, ilex, oak, plane and many others—some in compartments, but most in rows.

Unlike the villa-parks, gardens of the 17th century were still designed in a grid plan, but shared with the parks a new spatial dynamism and often a newly expanded size. On a gently sloping site, the garden of the Villa Barbarigo at Valsanzibio, which dates from 1665, preserves much of its original plan with regular compartments. It is similar to the (albeit smaller) 16th-century Giardino Giusti at Verona, but differs from it fundamentally in that the compartments are dominated by two perpendicular axes: one is the wide avenue lined by high hedges leading to the palace and the other is an elaborate waterway, beginning with what was once the main gate on to the canal from Venice. The vista along the principal avenue extends beyond the palace and up a hillside, where it is continued in a double row of cypress trees. Valsanzibio is less apparently measurable than earlier gardens and the boundaries are indeterminate.

In the hillside gardens of the 17th and 18th centuries there is a similar extension of axes and a greater separation of art and nature, through massive architecture and land alteration on the one hand, and more naturalistic cascades and rustic fountains on the other. The garden of the Villa Aldobrandini at Frascati (begun *c.* 1603; *see* FRASCATI, fig. 1) is centred on a water theatre, a great semicircular structure that frames a large open piazza and buttresses the hillside above. Compartmented gardens originally occupied the terraces at either side. The massive theatre sharply juxtaposes ordered nature and wild nature. In the *bosco* above, a great stream of water, brought from a distance by aqueduct, cascades over rustic fountains in imitation of a natural waterfall, then rushes over monu-

mental water stairs, its swirling shaped and regulated. At Isola Bella, begun before 1630 by Angelo Crivelli (*d c.* 1730) and completed 40 years later, the garden is dominated by art, which is complemented by its stunning natural setting in Lago Maggiore. The existing island, to which quantities of earth were brought, was made into an absolutely regular structure with ten terraces, for the most part narrow and step-like. Contemporaries, such as Bishop Gilbert Burnet in 1684 and Charles de Brosses in 1719, interpreted the garden structure as an artificial mountain, since it is both a manmade mountain and a form of nature entirely ordered by art.

Other terraced gardens of the 17th and 18th centuries are dominated by monumental architecture and staircases. In the grand Savoy gardens in Piedmont, known chiefly through the prints of the *Theatrum Sabaudiae* (1700; see Chatfield, p. 23), curving staircases were particularly favoured, but more common elsewhere were the double stairs inspired by 16th-century gardens and ultimately derived from the remains of ancient terraced structures at Praeneste and the gardens of Lucullus in Rome. Typical is the Villa Garzoni (see fig. 43) at Collodi in the territory of Lucca, begun shortly before the mid-17th century on land owned by the Garzoni family for three centuries. A level

terrace ornamented with *parterres de broderie* abuts the steep hillside, buttressed with a massive wall and superimposed double and curving staircases. Down the centre of the upper slopes of the *bosco* falls a channel of water, ornamented with monumental river gods, on the scale of that at the Villa Aldobrandini. The staircases dominate the garden, as they do not at Tivoli or Bagnaia, because they are grander and the supporting structure is larger in scale, but also because the hillside is steeper and the terraces narrower. Similar designs continued into the 18th century, as at the Villa Carlotta on Lake Como (completed before 1743), where superimposed double staircases along the central axis likewise link narrow terraces.

The influence of French gardens was first felt in the 17th century, especially in the second half; it was imported to Italy by André Le Nôtre, in designs for the Parco di Racconigi (1670) in Piedmont and for the Giardino Reale (1697) in Turin. It became much greater in the 18th century, due both to the increasing French presence on the Italian peninsula and to the practical manual of Antoine-Joseph Dezallier d'Argenville, *La Théorie et la pratique du jardinage*, published in four editions between 1709 and 1747. This provided models for the designs of *parterres de broderie*, which supplemented (if they did not

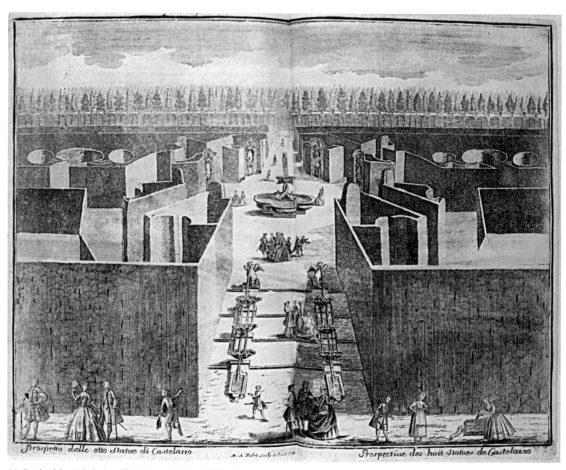

44. Garden labyrinth designed by Giovanni Gianda, Villa Arconati, Castelazzo, before 1743; from Marc'Antonio dal Re: *Ville di delizia osiano palagi camperecci nello stato di Milano* (Milan, 1743) (London, Victoria and Albert Museum)

entirely replace) the traditional geometric compartments planted with flowers. The manual also influenced the architectural treatment of vegetation, advocating very high hedges, some clipped into curvilinear shapes, galleries of hornbeam trees and enclosed garden rooms, where densely planted trees were precisely trimmed into geometric patterns or labyrinths. The views of Milanese gardens of 1726 and 1743 by Marc'Antonio dal Re record both the *parterres de broderie* and the prevalence of tall, sheer walls of greenery; those of the labyrinths of the Villa of Castelazzo (see fig. 44), designed by Giovanni Gianda before 1743, still survive. The popular theatres of greenery resemble each other in the subjection of plant materials to architectural forms: in the theatre at Villa Reale at Marlia near Lucca, created in 1652, the stage has tall backdrops of yew and seating on grassy tiers. The last of the surviving theatres, dated 1796, is at the Villa Rizzardi at Negrar.

The French garden style shared with earlier Italian gardens the basic vegetation, the ordering of nature and the importance of water and elaborate fountains, but differed in the contrast of vast open spaces, framed by wall-like hedges, with enclosed garden rooms. In the Villa Pisani at Stra, the original design and planting (from 1719) of Girolamo Frigimelica (1653–1732) have been altered and the estate much reduced, but there remains the general relationship of broad central space and the surrounding wood with its labyrinth and scattered structures. Under the French influence, the traditional *bosco* with regular compartments was transformed into a bosquet with diagonal avenues and a *rond-point*, a central point with radiating avenues cutting through straight rows of trees, which gave a sense of infinite expansion in all directions. At Stra, vistas down the long avenues of the park lead to the openwork gates in the enclosing wall, although the avenues are no longer delineated by tall hedges, nor the bosquet planted in rigorous order. The design of the great circular wood of the hunting park of the Dukes of Savoy at Stupinigi, by the architect Filippo Juvarra and the French gardener J. F. Benard (from 1740), is one huge *rond-point*, bisected by the avenue that extends to Filippo Juvarra's palace in one direction and far into the distance in the other.

The climax of the 18th-century estates is the royal park of Charles III of Spain at Caserta, designed by Luigi Vanvitelli in 1751 and expanded and altered by his son Carlo Vanvitelli (1739–1821). In the 18th-century plan, the general scheme of which remains, the great open area behind the palace with a central avenue was filled with *parterres de broderie*; beyond them were green rooms of carved trees like those at Castelazzo, and alongside was a great wood for hunting crossed by a network of long avenues. Later, the central avenue was continued in an axis of water and extended to the hillside in the far distance, beginning with a great cascade, which roared past dramatic sculpted fountains of familiar mythological figures, fell in sheets over broad steps and finally emerged in the long canal. This great waterway, unprecedented in scale and in the vast supply of water, was nevertheless the culmination of the development of Italian gardens from the 16th century.

In the late 18th century the influence of the English garden style was widely felt, even at Caserta, where one of the new gardens was added to the park from 1786. In subsequent years many existing gardens were likewise transformed into the English style, while others were profoundly altered by the new plants that entered Italy in the late 18th century and the 19th, among them magnolia, bougainvillea and rhododendron.

BIBLIOGRAPHY

C. A. Platt: *Italian Gardens* (1884/*R* London, 1993)
D. Coffin: *The Villa d'Este at Tivoli* (Princeton, 1960)
G. Masson: *Italian Gardens* (London, 1961/*R* 1966)
C. D'Onofrio: *La Villa Aldobrandini di Frascati* (Rome, 1963)
I. Belli Barsali: *Ville di Roma* (Milan, 1970, rev. 1983)
E. B. MacDougall: *The Villa Mattei and the Development of the Roman Garden Style* (diss., Cambridge, MA, Harvard U., 1970)
D. Coffin, ed.: *The Italian Garden* (Washington, DC, 1972)
S. Langé: *Ville della provincia di Milano* (Milan, 1972)
E. B. MacDougall, ed.: *Fons Sapientiae: Renaissance Garden Fountains* (Washington, DC, 1978)
I. Belli Barsali: *Ville e committenti dello stato di Lucca* (Lucca, 1979)
D. Coffin: *The Villa in the Life of Renaissance Rome* (Princeton, 1979)
M. Fagiolo: *Natura e artificio: L'ordine rustico, le fontane, gli automi nella cultura del Manierismo europeo* (Rome, 1979)
M. Pellegri: *Colorno: Villa Ducale* (Parma, 1981)
G. Ragionieri, ed.: *Il giardino storico italiano: Problemi di indagine, fonti letterarie e storiche* (Florence, 1981)
F. Mazzocca: *Villa Carlotta* (Milan, 1983)
G. L. Hersey: *Architecture, Poetry and Number in the Royal Palace at Caserta* (Cambridge, MA, 1983)
L. Puppi: 'Il Giardino Barbarigo at Valsanzibio', *J. Gdn Hist.*, iii (1983), pp. 281–300
F. Borsi and G. Pampaloni: *Ville e giardini* (Novara, 1984)
S. Langé and F. Vitali: *Ville nella provincia di Varese* (Milan, 1984)
M. Azzi Visentini: *L'Orto botanico di Padova e il giardino del rinascimento* (Milan, 1984)
G. Chigiotti: 'The Design and Realization of the Park of the Royal Palace at Caserta by Luigi and Carlo Vanvitelli', *J. Gdn Hist.*, v (1985), pp. 184–206
B. Di Gaddo: *Villa Borghese: Il giardino e le architetture* (Rome, 1985)
G. L. Gorse: 'The Villa of Andrea Doria in Genoa: Architecture, Gardens and Suburban Setting', *J. Soc. Archit. Historians*, xliv (1985), pp. 18–36
E. B. MacDougall: 'Imitation and Invention: Language and Decoration in Roman Renaissance Gardens', *J. Gdn Hist.*, v (1985), pp. 119–34
L. Magnani: ' "L'uso d'ornare i fonti": Galeazzo Alessi and the Construction of Grottoes in Genoese Gardens', *J. Gdn Hist.*, v (1985), pp. 135–53
J. Dixon Hunt: *Garden and Grove: The Italian Renaissance Garden in the English Imagination, 1600–1750* (London, 1986)
V. Vercelloni, ed.: *Il giardino a Milano, per pochi e per tutti, 1288–1945* (Milan, 1986)
L. Magnani: *Il tempio di Venere: Giardino e villa nella cultura genovese* (Genoa, 1987)
J. Chatfield: *A Tour of Italian Gardens* (London and New York, 1988)
G. Gritella: *Stupinigi: Dal progetto di Juvarra alle premesse neoclassiche* (Modena, [1988])
A. Tagliolini: *Storia del giardino italiano: Gli artisti, l'invenzione, le forme dall'antichità al XIX secolo* (Florence, 1988)
M. Azzi Visentini, ed.: *Il giardino veneto: Dal tardo medioevo al novecento* (Milan, 1988)
C. Lazzaro: *The Italian Renaissance Garden: From the Conventions of Planting, Design and Ornament to the Grand Gardens of Sixteenth-century Central Italy* (New Haven and London, 1990)
H. Mosser and G. Teyssot: *L'architettura dei giardini d'Occidente: Dal rinascimento al novecento* (Milan, 1990); Eng. trans. as *The Architecture of Western Gardens: A Design History from the Renaissance to the Present Day* (Cambridge, MA, 1991)

CLAUDIA LAZZARO

(ii) France. In the second half of the 16th century French gardens continued to develop the symmetric regularity that was a common feature of the first half of the century (*see* §3(ii) above), although there was a more elaborate development of a grid-like plan and of such features as parterres and bosquets, and a greater attention was paid

to terraces, avenues and vistas in relationship to the house or château itself. The vast and panoramic scale of symmetrically laid-out gardens reached its culmination *c*. 1660–90 in the work of ANDRÉ LE NÔTRE, who executed impressive designs at VAUX-LE-VICOMTE and VERSAILLES. During the 18th century the influence of English garden design was seen in a greater emphasis on a more irregular plan and a more picturesque setting. This made the French garden appear more 'natural', as if there had been no intervening hand of a garden designer.

(a) The development of the French Renaissance garden, *c*. 1550–1655. (b) André Le Nôtre and late 17th-century garden design, 1656–*c*. 1700. (c) Landscape gardens in the 18th century.

(a) The development of the French Renaissance garden, c. *1550–1655.* From 1547 PHILIBERT DE L'ORME rebuilt Anet, Eure-et-Loir (*see* ANET and fig.), incorporating part of the old building into a new symmetrical château. Its central axis ran from a stately gateway, on through the house and down to a terrace commanding a large compartmented flower garden framed by elegant arcades. Etienne Dupérac had the garden redesigned (*c*. 1582) as one *parterre de broderie*, with dwarf box used to outline the design's flowery volutes. Other châteaux, such as Charleval (*c*. 1560–74; Eure) and Verneuil (*c*. 1558–75; Oise; *see* DU CERCEAU, (1), fig. 2), were also provided with such parterres, the embroidered motifs of which were designed either by Jacques Androuet Du Cerceau (i) or his sons Baptiste Androuet Du Cerceau and Jacques Androuet Du Cerceau (ii) (*see* DU CERCEAU). In 1615 the grandson of Jacques Androuet Du Cerceau (i), SALOMON DE BROSSE, built the Palais du Luxembourg in Paris, creating a parterre surrounded by terraces as a complete composition, reminiscent of the Boboli Gardens (from *c*. 1550) in Florence. In the Jardins du Luxembourg JACQUES BOYCEAU and Claude Mollet (i) (*see* MOLLET) designed highly florid parterres that harmonized with the architecture.

A central axis became the rule in garden design, and the idea of extending it beyond the confines of the single enclosed garden was carried out *c*. 1555 at Chenonceaux, Indre-et-Loire, where one ran through the park, old gardens, courts, château and bridge-gallery, and then over the river to new gardens beyond. With the extension of the axis, a taste for the vista also developed. At Chambord (from 1519; Loir-et-Cher; for illustration *see* CHAMBORD), the roof terraces allowed commanding views of the surrounding landscape. About 1547, a superb residence was built on a hill at Montceaux (Seine-et-Marne), with gardens and balustraded terraces overlooking the valley of the River Marne. Around 1563, the Palais des Tuileries (destr.) in Paris was designed to face parterres between lateral terraces; its central vista was to determine the future axis of the city. During the same period there was a growing taste for open-air entertainments that included ephemeral garden decorations, recalling those in the *Hypnerotomachia Poliphili* (Venice, 1499). Less transient features were also erected, for example piles of rockwork symbolizing Mt Parnassus or grottoes such as the ceramic one (*c*. 1567; destr.) devised by BERNARD PALISSY for the Jardin des Tuileries (*see* GROTTO).

During the 16th century water began to play an increasingly important role in garden art; even fishponds and moats were transformed into ornamental pools. Fountaineers were also in great demand: Thomas Francini (1571–1651) and his brothers arrived from Florence (*c*. 1598) to build an aqueduct for the Jardins du Luxembourg and hydraulic automata for grottoes at the château of Saint-Germain-en-Laye (Yvelines). For several generations the Francini family worked for royal patrons as fountaineers. At Liancourt (Oise), the bosquets (*c*. 1630) and gardens contained jets and cascades that played continuously. Despite these decorative developments, the traditional association of ornamental gardens with horticulture and agriculture survived, as exemplified in Charles Estienne's popular *Praedium rusticum* (Paris, 1554), the French version of which (Paris, 1564) went through a number of editions. Along with horticultural and agricultural advice, the book contained patterns for ornamental compartments. In an equally famous treatise, *Théâtre d'agriculture et mesnage des champs* (Paris, 1600), Olivier de Serres (1539–1619) included elaborate parterre designs drawn by Claude Mollet I.

Along the Seine to the west of Paris, the steep slopes bordering the river offered handsome sites and vast panoramas for châteaux and terraced gardens. At Saint-Germain-en-Laye, below the old irregular château, a new symmetrical one (*c*. 1595; destr.) was erected halfway down the slope (for illustration *see* SAINT-GERMAIN-EN-LAYE). Eight terraces *à l'italienne* were laid out on sloping ground. This feat required the use of heavy masonry; hence, monumental flights of steps were built. Across the river below, Henry IV (*reg* 1589–1610) had three avenues cut (*c*. 1607) through the hunting grounds of Le Vésinet. The avenues fanned out from the point where the central axis of the new château and gardens reached the opposite bank. River and park were thus brought within one overall view.

In the early 17th century the integration of château, garden, park and landscape was extended further. At Richelieu (Indre-et-Loire), Cardinal de Richelieu (*see* RICHELIEU (ii), (1)) created an extensive ensemble by 1631. This included a new town and a new palace with gardens and a park (*see* RICHELIEU (i) and fig.). The gardens were laid out on a grid-like plan, exceptional for its breadth with an open-ended axis that was crossed in a novel way by a second axis that ran at a right angle to it. At RUEIL (Hauts-de-Seine) Richelieu acquired a simpler country residence, with orchards, vineyards and superb pleasure gardens (1633). Visitors were struck by the skilful way in which these gardens had been laid out on uneven ground, integrated by such architectural improvements as noble flights of steps, terraces and ramps. There were pools on upper and lower levels, a great Italian stepped cascade (see fig. 45), 'natural' groves in the arcadian taste then prevailing, *trompe l'oeil* frescoes, many statues (as at Richelieu), a huge mouth-like blind portico with jets of water to soak the incautious and, from a terrace, 'an excellent prospect towards Paris, the meadows and river', as John Evelyn noted in his *Diary* in 1644.

Among the architects who helped the prevailing taste for garden design was François Mansart (*see* MANSART, (1)). He emphasized the aesthetic role each house played in its integrated domain, opening each one to views from all sides. The château at Balleroy (*c*. 1626; Calvados), built

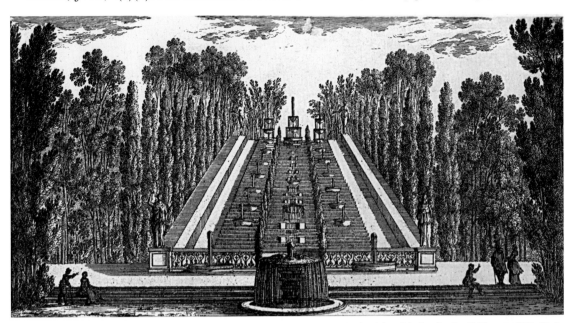

45. Grande Cascade in the garden at Rueil, Hauts-de-Seine, 1633 (destr.); engraving by Adam Pérelle after Israël Silvestre, 1661 (Paris, Bibliothèque Nationale)

at the summit of a slope, was further enhanced by the straight approach to it from the village, which ran over the crest of a hill, then dipped down before finally rising up and into the entrance courtyard. At Maisons (1642–51; Yvelines; see MANSART, (1), fig. 3) the château was displayed on a platform, its main avenue stretching out before and behind the building itself.

(b) André Le Nôtre and late 17th-century garden design, 1656–c. 1700. André Le Nôtre, the son of a head gardener at the Palais des Tuileries, first studied painting under Simon Vouet, then architecture under Mansart. His first major garden project was with the architect Louis Le Vau for the finance minister Nicolas Fouquet at Vaux-le-Vicomte (1656–61; Seine-et-Marne; see ANDRÉ LE NÔTRE, fig. 1; see also VAUX-LE-VICOMTE, §2). There, the uneven ground was made into a masterpiece. The by then traditional arrangement of a strongly marked axis running through a hierarchic sequence of house, parterres, lawns and bosquets was expanded right and left by Le Nôtre with the introduction of secondary vistas. Changes in the ground-level were incorporated into monumental flights of steps, or masked by fountains and cascades. The nearby swampy river was made into a long transverse canal, widened midway below a row of cascades. A seven-arch grotto buttressed the opposite slope, up which the central vista ran to a copy of the Farnese *Hercules* (original, Naples, Mus. Archeol. N.) silhouetted against the sky. At Vaux-le-Vicomte, Le Nôtre's art lay in providing balanced contrasts of open and closed views; light and shade; surfaces of grass, gravel and water; vertical and horizontal lines; and apparent boundlessness and architectural or sculptural features near at hand.

Charles Le Brun had been responsible for arranging the statuary at Vaux-le-Vicomte, which was removed to Versailles following Fouquet's fall from favour in 1661. Le

Vau, Le Brun and Le Nôtre afterwards worked jointly at Versailles (see VERSAILLES, fig. 1 and fig. 2 above). Each time the château at Versailles was enlarged, the gardens were widened proportionally. Around 1678 Jules Hardouin Mansart broadened Le Vau's sunken orangery south of the château's terrace, while Le Nôtre expanded the gardens north of it. The orangery's lateral axis was extended southward to a large body of water highlighting that area of the park. The earth that was removed from it was used in the Potager du Roy (1670), the fruit and vegetable garden supervised by Jean-Baptiste de La Quintinie (1626–88). Le Nôtre's most impressive contribution at Versailles was his widened vista that dipped west from the water parterre of the château's terrace (1674–83), down a grand horseshoe ramp and steps to the immense cross-shaped canal (1668). In between were fountains, including one by Jean Tuby where Apollo figured prominently to symbolize the advent of Louis XIV (*reg* 1643–1715), the Sun King; these were separated by a long sloping green, 'Le Tapis-Vert'. On either side, meagre woodlands were transformed (1680) into 12 bosquets set on a strict grid-like layout. The finely arranged glades were set off by marble statues in leafy recesses and by Baroque fountains. Constructed under François Francini (1617–88), these fountains required water to be pumped to them from local rivers (for further discussion of Le Nôtre's work at Versailles *see* VERSAILLES, §2).

At Louis XIV's more private retreats, of the Grand Trianon (1671–87; see VERSAILLES, fig. 3) or Marly le-Roi (1679–86; destr.; Yvelines; for illustration *see* MARLY), innumerable bedding plants were needed. At Fontainebleau (1645–64; Seine-et-Marne) and the Jardin des Tuileries (1655–72), Le Nôtre reorganized their layouts and enlarged the parterres. At Saint-Germaine-en-Laye he planned the great terrace (1669–73) commanding an

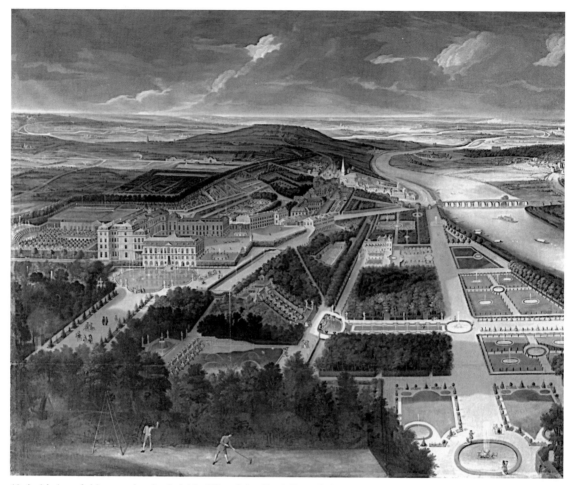

46. Aerial view of château gardens by André Le Nôtre, Saint-Cloud, Hauts-de-Seine, 1665–97; painting by Etienne Allegrain (Versailles, Musée National du Château de Versailles et de Trianon)

immense panorama. His genius was seen at its best where difficult sites were concerned: Chantilly (1662–92; Oise; *see* CHANTILLY, §1(ii)), Saint-Cloud (see fig. 46; *see also* SAINT-CLOUD, §1(ii)), Sceaux (1670–90; Hauts-de-Seine), Dampierre (1675–86; Oise), Maintenon (1676; Eure-et-Loir), MEUDON (from 1679; Hauts-de-Seine), Anet (1681–7; *see* ANET, §2) and elsewhere. He found effective solutions for them—bold perspectives, impressive axes, terraces, large water parterres or long canals, transverse vistas and plunging views, glade and tunnel, shapely bosquets and delicate *broderies*—and by doing so, unassumingly invented landscape architecture.

Le Nôtre's style and practice was codified in *La Théorie et la pratique du jardinage* (Paris, 1709), a famous treatise by Antoine-Joseph Dezallier d'Argenville (*see* DEZALLIER D'ARGENVILLE, (1)). In it, *le jardin à la française* was reduced to order, which resulted in part of Le Nôtre's noble though supple simplicity being lost. His followers and pupils Alexandre-Jean Baptiste Le Blond (*see* LE BLOND, (3)), Claude DESGOTS and Dezallier himself all designed rather stilted gardens, often estranged from 'nature' (e.g. Desgots's alterations to the gardens at the Palais-Royal, Paris). Le Nôtre's influence was felt as late

as *c.* 1775, many houses in and beyond France (as far as Russia) still having gardens laid out *à la française*. But even in his own creations, signs of change can be discerned. A taste for English lawns had led to the design of *compartiments à l'anglaise* (decorative lawns) by about 1650 and of rectangular *boulingrins* (Fr.: 'bowling greens') by 1663.

(c) Landscape gardens in the 18th century. By 1715, France's rural economy was suffering. Enlightened landowners travelled to England and visited well-managed estates. After having returned from England in 1729, Voltaire praised 'wild' Nature, while disparaging dull artful symmetry. In 1729 Jean-Jacques Rousseau first read a French translation of Joseph Addison's description (1712) of an imaginary, pleasant and profitable kind of *ferme ornée*. This term was coined in England but later borrowed by the French to mean a sort of garden–farm. By 1731, Charles-Louis Secondat, Baron de la Brède et de Montesquieu, had started landscaping the grounds of his picturesque castle of La Brède (Gironde) in an English style. From 1700 Louis Liger (1658–1717) published numerous books on husbandry and gardening, while the Jesuits René

Rapin and Jacques Vanière wrote Latin poems celebrating the plainer, more profitable, delights of gardens and the countryside, as opposed to the pomp of Versailles.

Irregular designs for gardens were used before the 18th century. At Versailles, as at Grand Trianon and Marly-le-Roi, a bosquet concealed a 'Chinese'-style maze of twisted paths and rills. By *c.* 1710 Charles Rivière Dufresny (1648–1724) is reputed to have laid out novel and irregular gardens. Nevertheless, it was the published descriptions of Chinese gardens by French Jesuit missionaries who had visited China that began the craze for chinoiseries during the reign of Louis XV (*reg* 1715–74). Anglophile feelings were expressed through *jardins anglais*, while *jardins anglo-chinois* were usually more contrived and less 'English' (see fig. 47). They generally adjoined central gardens *à la française* as surprising sideshows. At Chanteloup (Indre-et-Loire), a 'Chinese' pagoda (1775–8) was a prominent feature of gardens of both types. However, at Le Raincy (Seine-Saint-Denis), the famous Le Nôtre-style gardens of *c.* 1660 were transformed (*c.* 1770) into a vast irregular composition of a rural scene dotted with pavilions or *fabriques*. At Chantilly (1773) and the Petit Trianon (1785; *see* VERSAILLES, §4) mock hamlets were built for play in arcadian settings. Among the more extravagant creations of the time, the garden at Monceau, Paris, was filled with exotic scenes and *fabriques* (*c.* 1775), including a Tartar tent, a Vale of Tombs, a naumachia and a windmill. Le Moulin-Joli (Hauts-de-Seine), laid out on two islands in

the River Seine, was more soberly conceived (*c.* 1760) along regular lines with picturesque side views. The DÉSERT DE RETZ (Yvelines) was also less fanciful, except for a 'Chinese' tea pavilion (begun 1777; destr.) and the house itself (1780; rest.)—built in the form of a huge column that was truncated, fluted and cracked. In the picturesque garden, trees were grouped naturally among the built structures, so that architecture no longer dominated. The house was usually tucked away as a minor element, however essential, in a pastoral setting. MÉRÉ-VILLE (1784–94; Essonne) was designed in the hollow of a surrounding plateau, while the château was up a slope by the village. The river below fed a 'natural' waterfall, tumbling among impressive rocks and caverns. It also meandered under Picturesque-style bridges, spread into lakes and flowed past 'rural' scenes and such imaginative *fabriques* as an 'Egyptian' water-mill, a porticoed dairy, a rotunda, memorial columns and monuments, all devised by Hubert Robert and François-Joseph Bélanger. Between 1777 and 1783, at Bagatelle, in Paris, Thomas Blaikie (1750–1838) shaped the grounds into hillocks and vales adorned with ponds, rocks, cascades and rills, ruins and rare plants.

French *jardins paysagers* (Fr.: 'landscaped parks') were individual creations that seemed to lack some general direction. It was not clear what the prevailing tastes or styles were. In 1771 Thomas Whately's *Observations on Modern Gardening* (London, 1770) appeared in a French

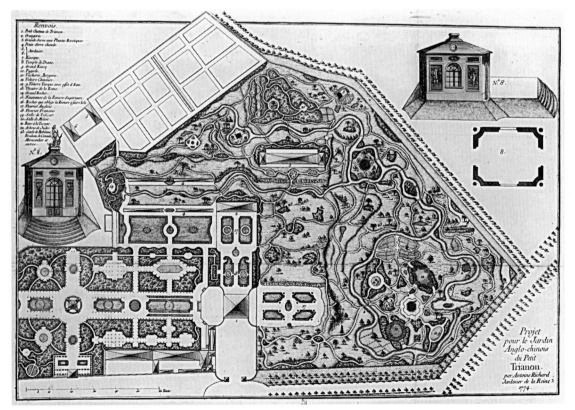

47. Petit Trianon, Versailles, design for a *jardin anglo-chinois*, *c.* 1772 (unexecuted); engraving by George-Louis Le Rouge, from *Cahier 6* (Paris, 1774), pl. 1 (Paris, Bibliothèque Nationale)

edition. In 1774 CLAUDE-HENRI WATELET, who created Le Moulin-Joli, undertook a classification of landscapes. In 1775 Antoine Nicolas Duchesne (1747–1827) pleaded for regular gardens near the houses, and the following year Jean-Marie Morel published his *Théorie des jardins*, a book on 'modern' gardening at last dissociated from architecture, in which pleasure and profit were successfully combined and 'art' was cleverly concealed. At this time ERMENONVILLE (1766–76; Oise) was renowned for its Picturesque gardens. Jean-Jacques Rousseau, who helped to inspire them through his description of Julie's garden in *Julie, ou la nouvelle Héloïse* (Amsterdam, 1761), was eventually buried in the sublime simplicity of the Poplar Island, Ermenonville's central motif. LOUIS-RENÉ GIRARDIN, Rousseau's admirer and last host, had Ermenonville's swamps drained and woodland cleared in the less-productive parts of his estate, adding a few *fabriques*, among which was the famous Temple of Philosophy. Château, farm, fields, village, lakes, streams, lush meadows and game-filled woods formed an Elysium that satisfied all needs. In 1777 Girardin published his own treatise on the composition of 'natural' landscapes around habitations, adding his views on rural management.

In *Les Jardins* (Paris, 1782), a poem on pleasure gardens, Jacques Delille summed up the conceptual confusion of the French gardens of his day, adding that he himself could hardly choose between the designs of William Kent or those of Le Nôtre. Soon after, however, Gabriel Thouin (1747–1829), an exact contemporary of Uvedale Price, an English theorist of the Picturesque (*see* §(iv) below), offered rational solutions to the 'natural' landscaping of gardens which were partly based on wide curvilinear walks and cross vistas. Thouin's ideas opened a new era in French garden art.

BIBLIOGRAPHY

C. Estienne and J. Liébault: *L'Agriculture et maison rustique* (Paris, 1564, rev. 1582); Eng. trans. by R. Surfet as *Maison Rustique, or the Countrie Farme* (London, 1600)

J. Androuet Du Cerceau: *Les Plus Excellents Bastiments de France*, 2 vols (Paris, 1576, 1579/R 1988)

O. de Serres: *Le Théâtre d'agriculture et mesnage des champs* (Paris, 1600, rev. 2/1603)

J. Boyceau de la Barauderie: *Traité du jardinage selon les raisons de la nature et de l'art* (Paris, 1638)

A. Mollet: *Le Jardin de plaisir* (Stockholm, 1651/R Paris, 1981)

C. Mollet: *Le Théâtre des plans et jardinages, contenant des secrets et inventions inconnus à tous ceux qui jusqu'à présent se sont mêlés d'écrire sur cette matière* (Paris, 1652–63)

G. Perelle and I. Silvestre: *Veues des belles maisons de France* (Paris, [c. 1685]); *Veues des belles maisons des environs de Paris* (Paris, 1685); *Veues des plus beaux bastiments de France* (Paris, [c. 1690])

[A.-J. Dézallier d'Argenville]: *La Théorie et la pratique du jardinage* (Paris, 1709, Eng. trans. by J. James, London, 1712)

T. Whately: *Observations on Modern Gardening* (London, 1770); Fr. trans. as *L'Art de former les jardins modernes, ou L'Art des jardins Anglois* (Paris, 1771)

[J.-M. Morel]: *Théorie des jardins, ou L'Art des jardins de la nature*, 2 vols (Paris, 1776, rev. 2/1802)

R. L. Gérardin: *De la composition des paysages, ou Des Moyens d'embellir la Nature autour des habitations, en joignant l'agréable à l'utile* (Geneva, 1777, rev. 3/1805); Eng. trans. by D. Malthus as *An Essay on Landscape; From the French of Ermenonville* (London, 1783)

J. Delille: *Les Jardins, ou L'Art d'embellir les paysages: Poëme* (Paris, 1782; Eng. trans., London, 1789)

A. L. J. de Laborde: *Description des nouveaux jardins de la France et de ses anciens châteaux, mêlée d'observations sur la vie de la campagne et la composition des jardins* (Paris, 1808)

G. Thouin: *Plans raisonnés de toutes les espèces de jardins* (Paris, 1819–20)

M. Poëte: *La Promenade à Paris au 17e siècle* (Paris, 1913)

——: *Au Jardin des Tuileries—L'Art du jardin—La Promenade publique* (Paris, 1924)

E. de Ganay: *Les Jardins de France et leur décor* (Paris, 1949)

A. Marie: *Jardins français classiques* (Paris, 1949)

——: *Jardins français créés à la Renaissance* (Paris, 1955)

H. Honour: *Chinoiserie: The Vision of Cathay* (London, 1961/R 1973)

E. de Ganay: *André Le Nostre, 1613–1700* (Paris, 1962)

A. Marie: *Naissance de Versailles: Le Château, les jardins* (1968), i of *Versailles au temps de Louis XIV* (Paris, 1968–76)

——: *Mansart à Versailles* (1968), ii of *Versailles au temps de Louis XIV* (Paris, 1968–76)

A. Marie and J. Marie: *Mansart et Robert de Cotte* (1976), iii of *Versailles au temps de Louis XIV* (Paris, 1968–76)

D. Wiebenson: *The Picturesque Garden in France* (Princeton, 1978)

W. H. Adams: *The French Garden, 1500–1800* (New York, 1979)

F. H. Hazlehurst: *Gardens of Illusion: The Genius of André Le Nostre* (Nashville, 1980)

A. Marie and J. Marie: *Versailles au temps de Louis XIV, 1715–1745* (Paris, 1984)

K. Woodbridge: *Princely Gardens: The Origins and Development of the French Formal Style* (London, 1986)

DENIS A. LAMBIN

(iii) Spain and Portugal. With the help of Italian and Flemish gardeners, the Spanish king Philip II created gardens in the late Rennaissance style at his hunting lodge of Casa de Campo in Madrid, ARANJUEZ PALACE (*c.* 1562) near Madrid and at his great monastery palace, the Escorial (1563–84). After his annexation of Portugal in 1580, he began a similar garden on the banks of the Tagus River near Lisbon. In 1567 he appointed Juan Plaza as Professor of Botany at Valencia, instructing him to create a botanical garden there. Towards the end of the 16th century the geometrical simplicity of the Rennaissance garden was replaced by a more Mannerist style, characterized by a desire for greater freedom and invention in the use of Classical elements. The most important Spanish garden of the first half of the 17th century was the Buen Retiro (from 1634), near Madrid, laid out for Philip IV to the designs of the Tuscan architect COSIMO LOTTI. Lotti created a grand area for court spectacles and fêtes in imitation of a similar space at the Boboli Gardens in Florence, which he had designed for Cosimo I, Grand Duke of Tuscany. In Portugal, the surviving Mannerist garden of the Palácio do Marquês de Fronteira, near Lisbon, was built by Fernando Mascarenhas, commander of the army that liberated Portugal from Spain in 1640. The brilliance of the glazed tilework here and in other Portuguese gardens is a reminder of the vivid colour that existed in Italian gardens before their architectural frescoes faded.

The influence of André Le Nôtre's great garden at Versailles led to the adoption of the 17th-century French Baroque style of garden design throughout Europe, including Spain and Portugal, and the use of advanced hydraulic and horticultural techniques to produce hitherto unparalleled spatial and decorative effects, the incorporation of ramps to allow vehicular as well as pedestrian circulation and the extension of the lines of the garden into the surrounding landscape became widespread. The complete adoption of the style in Spain came with the accession in 1700 of Philip V, a grandson of Louis XIV. To design the great garden of La Granja de San Ildefonso, Segovia (1720–76), Philip employed the French architect

48. Botanical Garden, Coimbra, Portugal, 1772

René Carlier, a pupil of Robert de Cotte and brother-in-law of Jules Hardouin-Mansart, Louis XIV's architect. His design was executed by the Boutelou family, various members of which held the post of royal gardener for the next 114 years. The fountains were created by RENÉ FRÉMIN and JEAN THIERRY, pupils of the leading French sculptors François Girardon and Antoine Coyzevox. Great avenues of lime trees (introduced from Holland) and horse-chestnuts (imported from France) were planted, the work continuing until Philip's death in 1746. Other major gardens surviving from this period are El Retiro (early 18th century), near Málaga, and Paco de Oca (mid- to late 18th century), near Santiago de Compostela. Although the Portuguese court also began by employing a native architect, Mateus Vicente de Oliveira, to lay out the garden of the summer palace at QUELUZ PALACE (from 1747), he was soon replaced by a French designer, Jean-Baptiste Robillon. Robillon's training as a silversmith resulted in many of the fountains resembling elaborate Rococo table centrepieces.

The expansion of the Portuguese and Spanish colonies during the 18th century led to the establishment of botanic gardens to acclimatize imported plants and study their commercial uses. In Portugal, King Joseph de Braganza created a botanic garden at Ajuda (1768), and his prime minister, the 1st Marquês de Pombal, founded the still flourishing garden at Coimbra (1772; see fig. 48). In Spain, Charles III established botanic gardens in Madrid (1781) and Orotava (1788) on the island of Tenerife. The latter retains some magnificent trees from the early planting. At the end of the 18th century and beginning of the 19th, the Neo-classical style of gardening was represented in Spain by two important gardens with temples, rotundas, sarcophagi and Classical inscriptions: El Laberinto de Horta (1794), near Barcelona, by the Italian Domenico Bagutti, and the Alameda de Osuna (1834–44), near Madrid. Lesser examples survive in Portugal at the Palacio de Seteais (completed 1787), near Sintra, and at Paco do Calhariz (early 19th century) in the Arrabida Hills.

BIBLIOGRAPHY
R. S. Nichols: *Spanish and Portuguese Gardens* (Boston, 1924)
G. Gromort: *Jardins d'Espagne*, 2 vols (Paris, 1926)
C. Villers-Stuart: *Spanish Gardens* (London, 1929)
J. Winthuysen: *Jardines clásicos de España* (Madrid, 1930)
J. H. Harvey: 'Spanish Gardens in their Historical Background', *Gdn Hist.*, iii/2 (1975), pp. 10–21
A. Delaforce: 'Chosen for Perfection: The Gardens of King Philip II (1527–98)', *Country Life*, clxxvii (23 May 1985), pp. 1456–7
J. N. Forestier: *Jardines* (Barcelona, 1985)
H. Carita and H. Cardoso: *Tratado da grandoza dos jardins em Portugal* [Treatise on the magnificence of gardens in Portugal] (Lisbon, 1987); Eng. trans. as *Portuguese Gardens* (London, 1989)
Marquesa de Casa Valdes: *Spanish Gardens* (London, 1987)

S. L. Afonso and A. Delaforce: *Palace of Queluz: The Gardens* (Lisbon, 1989)

P. Bowe: *Gardens of Portugal* (London, 1989)

PATRICK BOWE

(iv) British Isles. There is a sequence of five phases through which the developments of British garden design, planting and use can be followed; however, a history narrated on the basis of major, and therefore inevitably vanguard, examples neglects the fact that at every stage many 'old-fashioned' designs survived alongside newer modes. Also neglected in an overall picture of English gardening is the contribution both of vernacular examples and of those gardens that barely emerged out of a 'second nature', the agrarian phase of human reworkings of the land.

(a) The Elizabethan garden, *c.* 1550–1602. (b) Jacobean and Caroline gardens, 1603–49. (c) Gardens after the Restoration, 1660–*c.* 1700. (d) The new or 'modern' gardening, *c.* 1700–50. (e) The English landscape garden, *c.* 1750–*c.* 1800. (f) The Brownian reaction and aftermath, *c.* 1750–*c.* 1800.

(a) The Elizabethan garden, c. 1550–1602. The English garden of the second half of the 16th century implemented more vigorously some of the new ideas first seen during the reigns of Henry VII (*reg* 1485–1509) and Henry VIII (*reg* 1509–47) in the royal gardens of the palaces at Richmond, Hampton Court (both near London) and Nonsuch. Yet the essential features of a medieval garden—square enclosures, raised beds, arbours, turf seats and possibly a well or decorated cistern—continued to be deployed, though across larger spaces and with more enthusiasm for extravagant display. This included fountains, knots, or patterns of interlacing bands created out of thyme, hyssop or box, with their spaces filled with flowers (see fig. 5 above), all of which were ideally viewed from the palace's *piano nobile*; elaborate arbours and

49. Plan of Kenilworth Castle, Warwickshire, and its garden, 1563–75; from an engraving by William Dugdale: *Antiquities of Warwickshire* (1656)

tunnelled walks created by growing greenery over 'carpenter's work'; and wooden heraldic animals and other symbolic devices.

The spread of such expansive and extravagant garden art under Elizabeth I (*reg* 1558–1603), none of which survives, may be traced from travellers' descriptions of such major gardens as Theobalds Park (1575–85; Herts) and Nonsuch, Surrey (redesigned in 1579–91 by John Lumley, 1st Baron Lumley; *see* NONSUCH PALACE, §2 and fig.) and from a few surviving visual records. There was continued inspiration from the Netherlands, from France (notably in Scotland) and increasingly from Italy. The nobility imitated the example of royal gardens, a development arising from Elizabeth's habit of visiting the country estates of her courtiers. Early publications on gardening, such as Thomas Hill's *The Profitable Arte of Gardening* (London, 1568), with its plans of knots, or *The Gardener's Labyrinth* (London, 1577), also testified to the spread of a new taste for less grandiose gentry properties. In Ireland during the Elizabethan and Jacobean periods, troubles effectively precluded any extensive gardening.

The garden at Kenilworth Castle, Warwicks (see fig. 49), created by Robert Dudley, 1st Earl of Leicester (*see* DUDLEY, (2)) from 1563 on, had obelisks, a terrace and a fountain crowned with his own device. Theobalds featured a marble obelisk, descending stairways, busts of 12 Roman emperors decorating a summer-house, elaborate and profuse knots, a fountain and what was called a 'grotto'. The redesigned appearance of Nonsuch, a result of Lumley's stay in Italy, had emblematic fountains, marble obelisks and a wilderness that was laid out in walks with statuary, inscriptions and additional fountains. Edzell Castle (late 16th century–early 17th; Angus), a Scottish garden, had imagery of planetary deities.

One of the distinctive ways in which the English garden broke out of its medieval enclosure was the introduction of groves or wildernesses: Theobalds Park, for example, had a 'little wood near by' containing a labyrinth, inside of which was a hill, the 'Venusberg', and there was a 'Grove of Diana' at Nonsuch Palace in 1600. The addition of 'naturalistic' elements, often decorated with readable imagery and sometimes with rivers, ponds and an island (as acquired at Theobalds Park in 1602–3 and in the 1620s), complemented the new trend for axial regularity between house and garden. It marked the contest between Art and Nature, one of the many complex ideas for which gardens now became the prime location. The garden could function as an attribute or sign of princely power and magnificence and therefore an apt setting for various spectacles and royal entertainments, such as those of the Earl of Leicester at Kenilworth in 1575; it could also be a conspectus or 'theatre' of God's botanical creation, and even more arcane, allegorical or hermetic significances.

(b) Jacobean and Caroline gardens, 1603–49. During the reign of James I (*reg* 1603–25), the European impact on English and Scottish gardens became even stronger, especially under the enlightened patronage of the Queen, Anne of Denmark, and Henry, Prince of Wales. Both employed Salomon de Caus (*see* CAUS, (1)), who had visited Italy, to work on the gardens at Somerset House (London) and Greenwich Palace (*see* GREENWICH, §1),

both *c.* 1609, and at Richmond Palace in the following years. His brother, Isaac de Caus (*see* CAUS, (2)), also worked extensively in England, where he designed a series of gardens, often decorated with the by then *de rigueur* features of grotto and terracing; one (begun 1632) at Wilton House, Wilts (*see* WILTON, §1) was distinctive for being a completely new layout rather than a series of piecemeal alterations.

This first rage for British gardening was well established by the time of the Civil Wars (1642; 1646–8; 1649–51) and even survived their disruptions. Eloquent testimony to this phase, with its strong Italianate colouring, comes in post-Restoration accounts by John Aubrey and Sir William Temple (1628–99), who were the first to evince any historiological concern for English garden art. Aubrey left a detailed description (Oxford, Bodleian Lib., Aubrey MS. 2) of gardens at Chelsea (from 1622) created by Sir John Danvers (?1588–1655), while Temple's *Upon the Gardens of Epicurus*, written in 1685, contains an even more enthusiastic description of Moor Park, Herts, as it was laid out between 1617 and 1627 for Lucy Russell, 3rd Countess of Bedford. Its axial format, terracing and arcades, grotto and wilderness with 'rockwork and fountains' made it 'most beautiful and perfect'. It lacked only the hydraulically worked automata of the sort found at Wilton. Such devices link the garden to the contemporary quasi-scientific interest in the natural and artificial workings of the world, as represented in the parallel phenomena of cabinets of curiosities and botanical collections: for example, the Tradescants' garden and cabinet in Lambeth (from 1620s; *see* TRADESCANT), the establishment in 1621 of the Oxford Botanical Garden and the grotto at Enstone (late 1620s; Oxon) by Thomas Bushell (1594–1674).

Visual records of contemporary garden taste, for the Caroline period especially, are available in the surviving drawings of masque settings by Inigo Jones, especially *Coelum Britannicum* (1634) and *Luminalia* (London, 1637; *see* JONES, INIGO, §1(ii)); these turn the theatrical uses and format of contemporary gardens into elaborate garden settings for court theatre. Parallel activity in actual gardens and continuing inspiration from the Continent, seen in André Mollet's work for Queen Henrietta Maria at St James's Palace (*c.* 1630) and Wimbledon House (1642; both London), reveals the same repertory of divided staircases, terraces, loggias, groves and vineyards.

(c) Gardens after the Restoration, 1660–c. 1700. While garden design did not entirely cease during the Interregnum (1649–60), the restoration of the monarchy in 1660 spurred a new revival of interest, fuelled especially by many Royalists' forced residence abroad, where they had opportunities to view contemporary garden designs. French styles were now much in vogue: André Le Nôtre was twice tempted (unsuccessfully) to work in England, and John Evelyn translated a major gardening text from the French (*The Compleat Gard'ner*, London, 1693), as did John James, who translated *The Theory and Practice of Gardening* (London, 1712) from the French text by Antoine-Joseph Dezallier d'Argenville. Yet not everyone could work on the huge scale that was characteristic of the French-inspired gardens at Badminton House (*c.* 1682–8; Avon), Boughton House (from 1683; Northants), Castletown (*c.* 1700) or Carton (1687; both Co. Kildare); especially difficult were the long avenues and canals, which were, however, carried out at Hampton Court (*see* HAMPTON COURT PALACE, fig. 2). Certain French elements, such as the *parterre de broderie*, clearly did not suit a simpler English taste which preferred plain grass. Evelyn himself, one of the most knowledgeable and accomplished amateurs, certainly showed a more eclectic, even Italianate,

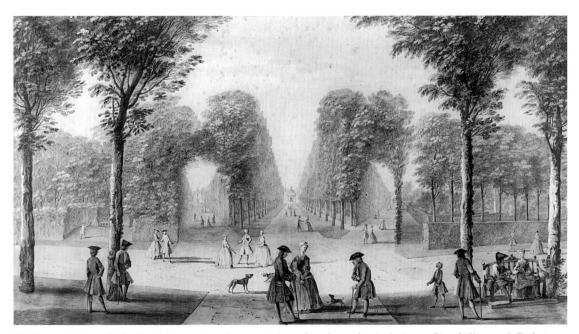

50. Chatsworth House, Derbyshire, the intersection of avenues in the gardens; from a drawing by Jacques Rigaud (Chatsworth, Derbys)

bias in his actual designs for Wotton (1652) and Albury (1677), both in Surrey. However, the professional designers and nurserymen GEORGE LONDON, Royal Gardener to William III (*reg* 1689–1702), and his partner HENRY WISE, Royal Gardener to Queen Anne (*reg* 1702–14), came into prominence in the late 1680s and dominated design for 30 years; they were more open to French taste, between them working at such places as Longleat (from 1683; Wilts), CHATSWORTH HOUSE (from 1686, Derbys; see fig. 50) and Hampton Court (1689–94 and 1698–1702). The emergence of formal gardens during this period was followed by a flourishing vogue for estate portraits, exemplified in paintings or engraved views in English country histories by Johannes Kip and in later editions of John Slezer's *Theatrum Scotiae* (London, 1693).

England's and especially Scotland's and Ireland's debt to garden ideas from abroad was complicated by these countries' accommodations to indigenous sites, uses and climates, such as the milder conditions in Ireland and on the west coast of Scotland, and by the difficulty of distinguishing in practice between competing European styles. Nonetheless, each style was attended by ideological implications: French designs were associated with Louis XIV and absolutist, Catholic power in Europe; Dutch, by contrast, with the Protestant opposition to the French king. It was therefore inevitable that long-established horticultural links with the Netherlands were significantly strengthened by the invitation, in 1688, to the Dutch Stadholder, William of Orange Nassau, to become King of England and Scotland. The examples of William III and his Stuart wife, Mary (*see* ORANGE NASSAU, (6)), both avid gardeners, clearly encouraged landowners to invoke the Dutch practice of landscape gardening, which involved designs on a smaller scale than the French ones, more horticultural display and more use of evergreens, often in topiary form. After the Williamite wars in Ireland (1688–91), Dutch influence, as at Stillorgan (from 1695; Co. Dublin), was strong. Yet at the same time Italian garden designs of the Classical and Renaissance type continued to be invoked, formally in opposition to both Dutch fussiness and French grandeur.

(d) The new or 'modern' gardening, c. 1700–50. Theoretical opposition to French and Dutch regularity by the beginning of the 18th century was matched by fresh, less rigid work in actuality; there was a determination to shape something specially indigenous out of garden art, though this may frequently have been forced on patrons and their designers by the exigencies of a given site, financial resources that would not allow for French-style plans and the priorities given to agricultural reforms, as in 18th-century Scotland.

Anthony Ashley Cooper, 3rd Earl of Shaftesbury, was among the first to call for more 'natural' gardens. Though his ideas have often been misunderstood, it is clear that he wanted garden art to highlight the ideal forms of pure nature through its careful manipulation of natural elements. His ideas were taken up by Joseph Addison, whose famous call to an estate owner to 'make a pretty Landskip of his own possessions' is the earliest plea for the Picturesque in landscape design. ALEXANDER POPE, in his writings, attacked topiary and pleaded for ancient ideas of

gardening, put into practice from 1719 in his own garden at Twickenham (destr.), near London. In addition, STEPHEN SWITZER combined practical experience as a plantsman with design experience and a keen proselytizing zeal in his various publications. Whigs such as Addison and Switzer and Tories such as Pope had their reasons for harkening back to Shaftesbury's call for a national style in the arts. The many landowners who belonged, like Addison and John Vanbrugh, to the fiercely Whig Kit-Cat Club, were keen to make garden art English. It was indeed on some of their estates that the decisive practical implementations of a new style were accomplished, as at Castle Howard (N. Yorks) from 1700, at Stowe (Bucks) from the late 1710s (for illustration *see* STOWE) and at ROUSHAM (Oxon.) in the 1720s; this was equally true at Cirencester (*c.* 1718; Glos).

The new style may be characterized as the determination to involve the natural and cultural landscapes of agrarian land and woods in the planned and artificial experience of gardens. For example, Vanbrugh urged the retention of Old Woodstock Manor at Blenheim, Oxon. (unsuccessfully, as it turned out). The ruins of Rievaulx Abbey, however, were retained at Duncombe Park (1713–18) and those of Fountains Abbey at Studley Royal (1768; both N. Yorks). At Castle Howard (for illustration *see* CASTLE HOWARD), the determination to preserve Wray Wood from elaborate French-style avenues and *ronds-point*, the impossibility of laying out anything more than a segment of the large estate and the consequent incorporation into the garden of the splendid views over the Howardian Hills produced an inspired and pioneering design. The gardens at Penicuik House (*c.* 1720s–1740s, Lothian; see fig. 51) were laid out in a similar manner, with distant hills and foreground meadows providing scenic vistas at the end of terraced walks.

Gardens continued to utilize the whole continental repertory of parterres, avenues, regular bodies of water and fountains, but their locations now within a larger and more loosely designed landscape, as at Stowe and above all at the small and exquisite site of Rousham, signalled a wholly new attitude to garden art. The work of CHARLES BRIDGEMAN, the first of a series of distinguished landscape architects, can be best viewed in this context of a relaxation of the geometry of gardens and an expansion of the range of garden experience and associations. The extensive use of the ditch or ha-ha (not in itself an English 'invention') was the main device for blurring the edges of the immediate garden and the adjacent landscape.

The increase in agricultural expertise and the enclosure movement were two factors that certainly lent support to the new style: since the Restoration, the need for good woodland had been promoted, especially by Evelyn, and the long-standing tradition of deer parks was a handy model for featuring the amenities of an estate as part of its aesthetic whole. Indeed, when Horace Walpole in the 1760s wrote the history of this new phase of what he called 'modern' gardening, he invoked precisely this precedent of deer parks, the abundance of which is testified to by many engraved views *c.* 1700. One important result of this link between agrarian interests and aesthetic design was the *ferme ornée*, of which Woburn Farm (1730s) in

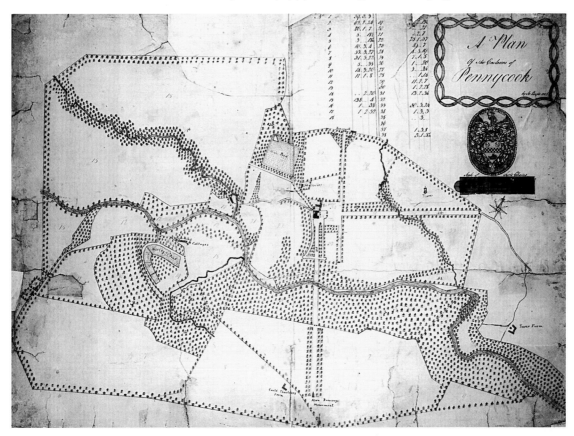

51. Gardens at Penicuik House, Lothian, designed by John Clerk, *c.* 1720–1740s

Surrey is the prime English example and Delville, near Glasnevin (from 1724), an interesting Irish one.

The Palladian Revival in architecture had close connections with the new landscaping, above all through the influence of Richard Boyle, 3rd Earl of Burlington and 4th Earl of Cork (*see* BOYLE, (2)). Sometimes thought to be a paradoxical collocation of Classical building in the midst of naturalistic terrain, the style is better associated with the invocation of Classical garden art mediated through the Italian Renaissance, as in Andrea Palladio's own architecture. Between 1715 and 1750, the frequent occurrence in English gardens of Classical temples, statuary and reminiscences of Roman ruins—often derived from landscape painting, though this has been much exaggerated—was for Pope and others a clear way of securing an apt place for England within the traditions of ancient art. This emphasis on the antique succumbed eventually to a more native insistence on Gothic, even GOTHICK motifs, though for a while the two cohabited as partners in the programme for making gardening 'speak good English', as Switzer noted.

William Kent (*see* KENT, WILLIAM, §§1 and 2(iv)), the second great English landscape architect after Bridgeman, brought to his garden architecture a training both as a history painter and stage designer, as well as a profound love for and knowledge of Italy. The one led him to think of garden pictures as exhibiting some thematic subject; the other encouraged a theatrical instinct for localizing

'events' in garden scenes. Yet he, too, introduced Gothick designs among the Classical imagery at Stowe and Rousham (for illustration *see* ROUSHAM) and suggested their use elsewhere, not only for their formal potential but also for their contributions to the complicated cultural melding of Classical with indigenous traditions. To judge from the considerable numbers of his surviving drawings, his penchant was for somewhat theatrically composed scenes, the boundaries of which were blurred or visually penetrable.

The finest examples of this phase of British landscaping are seen at such places as Chiswick House, London (*see* LONDON, §V, 4), to which Kent contributed, and also at STOURHEAD (*c.* 1745–75; Wilts), Hamilton Palace (early 18th century; Strathclyde) and the somewhat retardataire Powerscourt (from the mid-18th century; Co. Wicklow). Yet the input of amateur designers on these sites, however, is just as crucial; Stowe, for instance, was clearly a group effort in which professionals designed individual buildings. Pope's involvement in many projects, directly or by correspondence, from the 1720s until his death in 1744 is typical of this amateur contribution to garden art; through his friendship with Jonathan Swift, this influence extended also to Ireland.

(*e*) *The English landscape garden, c. 1750–c. 1800.* The professionalism of garden design effectively begins with 'CAPABILITY' BROWN (see fig. 4 above), who trained and worked at Stowe for ten years until his departure in 1751

52. Castle (from 1748) by Sanderson Miller in the park of Hagley Hall, Hereford and Worcestershire

to set up his own business. Although he may be seen as taking previous ideas to their logical conclusion, his inclination towards 'natural' scenery—playing down the incidence of buildings and statuary and the busy ingredients present in a garden such as that at Stowe—must not be misconstrued as some surrender to a pure nature in the manner of Jean-Jacques Rousseau. Brown's supreme skill was to discover the ideal forms of water, trees and earth, even giving a crucial place in the ensemble to the sky, as no other designer had done. That Brown's skills were misunderstood testifies to the decline of Neo-classical concepts, especially among the increasing numbers of gentry who wished to have the latest in landscape design but who cared little for complicated cultural or aesthetic concerns. William Chambers, for example, thought Brown's work differed little from ordinary fields. The Grand Tour, too, ceased to be as crucial an influence on either designs or patrons' inclinations; touring in the British Isles gradually assumed more prominence, so that even if garden art were still thought of as a representative art, the 'nature' it was expected to represent was indigenous scenery. The rich variety of terrain in Scotland and Ireland became an effective constituent of landscape designs in those countries. For 35 years Brown dominated garden design in England. His work extended throughout all parts of the country and ensured a virtual monopoly of naturalistic designs. Although he was prominent, there was a flourishing number of lesser designers, both professional and amateur, who took advantage of the second rage for gardening to grip the British Isles.

A rival tradition to Brown's arose from a series of famous gardens where the associative or poetic impulse, first made famous by Pope's Twickenham, was exploited anew: PAINSHILL PARK (1738–73; Surrey) by Charles Hamilton (1704–86) and the development by Henry Hoare

(*c*. 1743–73; *see* HOARE (i), (1)) of the gardens at Stourhead (for illustration *see* STOURHEAD) are part of this strain, as are THE LEASOWES (1745–63; Warwicks), designed by the poet William Shenstone (1714–63), and the nearby Hagley Hall (mid-18th century; Hereford & Worcs). In these, the mixture of scenery with readable objects (especially less expensive items such as seats or urns) was designed to elicit a strong poetic or associative response in the visitor. The work of SANDERSON MILLER (see fig. 52), a specialist in sham ruins and rustic cascades but also a landscape architect, may be seen as capitalizing on the Gothic strain in Kent's work, giving it a strong associative and Picturesque flavour. The prominence of garden art, whether of the kind proposed by Brown or the more private and poetic types, called forth an extensive literature: historical, as in Walpole's accounts; descriptive, as in Joseph Heely's account in 1777 of The Leasowes and its neighbours Hagley Hall and Enville; theoretical, as in THOMAS WHATELY's *Observations on Modern Gardening* (London, 1770); or practical, as in 'do-it-yourself' publications and pattern books of devices and structures with which to decorate estates.

(f) The Brownian reaction and aftermath, c. *1750–* c. *1800.* Though the second half of the 18th century was dominated by the landscape gardening of 'Capability' Brown, his work did not escape being challenged. Two kinds of emendation were proposed to what was considered by some to be his bland and uneventful scenery. One originated wholly from WILLIAM CHAMBERS, with his Chinese proposals; the other came from proponents of the Picturesque, notably RICHARD PAYNE KNIGHT and UVEDALE PRICE (*see* PICTURESQUE). A third centred around the promotion of the flower garden by William Mason (*see* MASON, WILLIAM (i)).

Chambers had political motives for his attack on Brown, but his prescription of Chinese designs, events and associations in the garden, commented on especially in the *Dissertation on Oriental Gardening* (London, 1772), was a determined attempt to enliven the landscape and awaken curiosity in its visitors. His practical application of these ideas at Kew Gardens (*see* KEW, ROYAL BOTANIC GARDENS OF, §V, 7) elicited in its turn a satirical attack by Mason, but such ridicule did not prevent a plethora of Chinese forms from appearing in landscape gardens, especially in the exportable version of *le jardin anglo-chinois*. Chambers nevertheless also provided Classical structures at Wilton House (1757–9) and Marino (1756–99; Co. Dublin).

An altogether more plausible alternative to Brown's perceived dullness came in the proposals for the Picturesque. These involved reproducing the texture reminiscent of especially engraved or painted landscapes in a busy, intricate, rough design of old trees and bushes, bridges and ruins. In Knight's poem *The Landscape: A Didactic Poem* (London, 1794) the associative potential of such scenery was contrasted with the monotony of Brown's garden designs, and in Price's *Essays on the Picturesque* (London, 1794–1801), the category of 'Picturesque' as distinct from the 'Sublime' and 'Beautiful' was most fiercely promoted. Each proponent created his own Picturesque estate, at Downton and Foxley (from 1770; both Hereford & Worcs) respectively, but it was perhaps the Welsh landscape at Hafod (*c*. 1795–1801; Dyfed) laid out by Thomas Johnes (1748–1816) that most vividly captured the potential of the Picturesque mode. Local topography in Scotland and Ireland also ensured considerable popularity for this type of garden aesthetic.

The debate about the Picturesque also involved HUMPHRY REPTON, who in 1788 had decided to fill the void left by Brown's death. Though he was much influenced by Brown's work and indeed was often called on to intervene in landscapes Brown had created, Repton gradually distanced himself from the other's naturalistic style while also rejecting the absurdities of the Picturesque school. After 1800 he showed an increasing preference for regular and enclosed gardens, and for terracing, raised beds and patterned flower gardens. His great contribution to garden design was probably his 'Red Books' (often bound in red morocco) in which, by means of flaps that could be lifted, he provided clients with watercolour views of their estates as they would look after he had landscaped them. Unlike both Brown and Kent, he was a determined writer, taking parts from his various 'Red Books' for such publications as his *Sketches and Hints on Landscape Gardening* (London, 1795).

BIBLIOGRAPHY

H. Walpole: *History of the Modern Taste in Gardening* (*c*. 1750–70); ed. I. W. U. Chase as *Horace Walpole, Gardenist* (Princeton, 1943)
A. Amherst: *A History of Gardening in England* (London, 1895) [incl. the Parliamentary surveys of earlier gardens such as Theobalds and Wimbledon]
C. Hussey: *The Picturesque: Studies in a Point of View* (London, 1927/R 1967)
O. Sirén: *China and the Gardens of Europe of the Eighteenth Century* (New York, 1950); repr. with intro. by H. Honour (Washington, DC, 1991)
D. Green: *Gardener to Queen Anne: Henry Wise (1653–1738) and the Formal Garden* (London, 1956)
M. Hadfield: *Gardening in Britain* (London, 1960)
C. Hussey: *English Gardens and Landscapes, 1700–1750* (London, 1967)
H. Prince: *Parks in England* (Isle of Wight, 1967)
J. Harris: *A Country House Index* (Isle of Wight, 1971)
S. Orgel and R. Strong: *Inigo Jones: The Theatre of the Stuart Court*, 2 vols (Berkeley and London, 1973) [illus. of garden settings for masques with accompanying libretto descriptions]
J. Dixon Hunt and Peter Willis, eds: *The Genius of the Place: The English Landscape Garden, 1620–1820* (London, 1975, rev. Cambridge, MA, 1988)
B. Henrey: *British Botanical and Horticultural Literature before 1800*, 3 vols (London, 1975)
J. Dixon Hunt: *The Figure in the Landscape: Poetry, Painting and Gardening during the Eighteenth Century* (Baltimore and London, 1976/R 1989)
E. Malins and the Knight of Glin: *Lost Demesnes: Irish Landscape Gardening, 1660–1845* (London, 1976)
P. Willis: *Charles Bridgeman and the English Landscape Garden* (London, 1977)
J. Harris: *The Artist and the Country House* (London, 1979)
R. Strong: *The Renaissance Garden in England* (London, 1979)
A. Brady and E. C. Nelson, eds: *Irish Gardening and Horticulture* (Dublin, 1980)
A. A. Tait: *The Landscape Garden in Scotland, 1735–1835* (Edinburgh, 1980)
The English Landscape Garden, ed. & intro. by J. Dixon Hunt, 29 vols (New York, 1982) [repr. of 34 titles of early garden writings]
D. Jacques: *Georgian Gardens: The Reign of Nature* (London, 1983)
M. Kelsall: 'The Iconography of Stourhead', *J. Warb. & Court. Inst.*, xlvi (1983), pp. 133–43
R. Desmond: *Bibliography of British Gardens* (Winchester, 1984)
J. Dixon Hunt: *Garden and Grove: The Italian Renaissance Garden in the English Imagination, 1600–1750* (London, 1986)
——: *William Kent: Landscape Garden Designer* (London, 1987)
D. Jacques and A. J. van der Horst: *The Gardens of William and Mary* (London, 1988)
The Anglo-Dutch Garden in the Age of William and Mary (exh. cat., ed. J. Dixon Hunt and E. de Jong; Apeldoorn, Pal. Het Loo; London, Christie's; 1988) [special issue of *J. Gdn Hist.*, viii/2–3 1988]
J. Dixon Hunt: *Gardens in the Picturesque: Studies in the History of Landscape Architecture* (Cambridge, MA, 1992)
D. D. C. Chambers: *The Planters of the English Landscape Garden* (New Haven and London, 1993)

JOHN DIXON HUNT

(v) The Netherlands. The art of gardening in the Netherlands during the Renaissance is documented in the engraved pattern-books of Hans Vredeman de Vries, such as the *Hortorum formae* (1587), which gives examples of square or rectangular enclosed gardens on a severely geometrical plan with *berceaux* (vault-shaped trellises). A small pavilion, fountain or tree marks the centre of this type of garden. One well-known example is the Hortus Botanicus of the University of Leiden, laid out by Carolus Clusius (1526–1609) in 1590. A similar garden was laid out *c*. 1620 for Stadholder Prince Maurice of Orange Nassau next to his apartments in the Binnenhof at The Hague. Its main outlines, however, did not consist of the geometrical patterns of 16th-century gardens, but were formed by two large circular *berceaux*. This preference for a simple, straightforward composition came to typify the Dutch classical garden of the 17th century.

Outstanding examples of gardening in the first half of the 17th century are the large country estates of Prince Maurice's brother, Prince Frederick Henry: Honselaarsdijk, near Naaldwijk (from 1620; destr.), the HUIS TER NIEUBURCH, RIJSWIJK (from 1630) and the Huis ten Bosch (1647; *see* THE HAGUE, §IV, 3). The extensive gardens on these estates were all subdivided into large square units, each of which contained a geometric pattern. An axial avenue in each case linked the garden with the house. Water was an important element in Dutch 17th-century

53. Gardens at the Paleis Het Loo, Apeldoorn, 1686 and 1690–92, attributed to Daniel Marot I

gardens. HOFWIJCK in Voorburg, for example, the country estate of the diplomat and poet Constantijn Huygens (i), Prince Frederick Henry's secretary, is set in the middle of a lake near the River Vliet. The front garden is reached via a drawbridge. The estate is divided into a number of rectangular sections by means of canals; drainage canals are indispensable throughout the Netherlands and were thus important in the development of the Dutch garden. Symmetrically organized square islands were part of the designs for the country estates of rich burghers in the mid-17th century, for example in the first estates to be laid out in the dunes, those on the River Vecht, and in the work of Philips Vingboons. In the latter's book of building designs (1648), two large-scale villas are shown at the centre of a group of square islands, surrounded by a circular dyke. The gardens of Castle Amerongen (from 1673) are a good surviving example of this type of simple geometric landscape.

William III's court was important for the dissemination of Baroque gardening concepts in the last quarter of the 17th century. Well-known examples of the style are the gardens of SOESTDIJK (from 1674), HEEMSTEDE (from 1680) and Zeist (1686) in the province of Utrecht, and HET LOO (1686 and 1690–92), Middachten (1695) and DE VOORST (1697) in Gelderland. The central axis that dominates these gardens is aligned on the centre of the house (see fig. 53). In emulation of French models, the axis is drawn out in a long avenue leading to the front of the house, with a seemingly endless central path running through the rear garden. French influence ended the division of the garden into more or less isolated units. Central groups of pools or statuary became the focal points around which the *parterres de broderie* (embroidered parterres) were concentrated, leading to a greater cohesion between the various segments. The parterres consisted of clipped box hedges, red and white gravel and flowers. William III's gardens were located at the edge of the Veluwe, an extensive terrain of sand and heath. To prevent drifting sand from ruining the gardens, each was enclosed by a high barrier of earth that also served as an elevated

walkway, making it possible to see the intricate patterns of the parterres from above. The designs for the interwoven patterns were probably by Daniel Marot I, who lived and worked in the Netherlands from 1686. He also designed the palace interiors and was able to combine house and grounds into a single integrated design.

In the first half of the 18th century garden design was dominated by middle-class country estates such as those on the rivers Vecht and Amstel, in the dunes and in the various polders; these areas had been popular with rich burghers since the mid-17th century. Many new estates were laid out in the first half of the 18th century, while existing ones were altered to conform to the new fashion (e.g. ROSENDAEL CASTLE in Gelderland). William III's large gardens served to some extent as examples. The burghers' gardens were on a smaller scale, but in spite of their smaller size they were just as richly furnished. The result was the meticulously planned, carefully maintained garden, such as that at ZIJDEBALEN, on the bank of a river. Parterres with interwoven patterns, groups of statues, ponds, teahouses, orangeries and corridors of clipped hedges worked out in forced perspective were virtually indispensable elements, no matter how small the available area. An important source of inspiration for many amateur garden architects was *La Théorie et la pratique du jardinage* (Paris, 1709) by Antoine-Joseph Dezallier d'Argenville. The canal journey from Utrecht to Amsterdam, in particular, offered the traveller an unbroken succession of estates displayed like a row of jewel-boxes along the banks of the Vecht and the Gein. There was widespread interest in gardens and in botany: for example, Pieter de la Court van den Voort (1664–1739), a rich Leiden merchant, visited the most important French gardens, raised exotic plants, including the pineapple, on his estate of Berbice in Voorschoten and wrote a handbook on gardening, *Byzondere aenmerkingen* ('Particular remarks'; 1737).

The new fashion for the English landscape garden reached the Netherlands in the second half of the 18th century, albeit by way of Germany. Johann Georg Michael and his son-in-law Jan David Zocher the elder (*d* 1817), the first landscape architects to lay out landscape gardens in the Netherlands, were both Germans. Around 1764, Michael laid out a landscape garden for Jacob Boreel behind the latter's formal garden at Beeckestijn, near Haarlem. It consists of a large scalloped-edged pond surrounded by a wooded area with winding paths. Near Haarlem, Michael also worked on two new landscape gardens, Velserbeek and the Haarlemmerhout. He was assisted from *c.* 1780 by his son-in-law, the first of three generations of landscape architects who continued the development of the landscape style in the 19th century.

BIBLIOGRAPHY

A. G. Bienfait: *Oude Hollandische tuinen* [Old Dutch gardens] (The Hague, 1943)

D. F. Slothouwer: *De paleizen van Frederik Hendrik* [The palaces of Frederick Hendrik] (Leiden, 1945)

J. Balis: *Hortus Belgicus* (Brussels, 1962)

W. Kuyper: *Dutch Classicist Architecture: A Survey of Dutch Architecture, Gardens and Anglo-Dutch Architectural Relations from 1625 to 1700* (Delft, 1980)

H. W. M. van der Wijck: *De Nederlandse buitenplaats* [The Dutch country house] (Alphen aan den Rijn, 1982)

E. de Jong: 'Bibliografie van de Nederlandse tuinarchitectuur, 1960–1983' [Bibliography of Dutch garden architecture], *Kon. Ned. Oudhdknd. Bond.: Bull. KNOB*, lxxxii (1983), pp. 142–62

D. Jacques and A. J. van der Horst: *The Gardens of William and Mary* (London, 1988)

S. van Raaij and P. Spies: *The Royal Progress of William and Mary* (Amsterdam, 1988)

The Anglo-Dutch Garden in the Age of William and Mary (exh. cat., ed. J. Dixon Hunt and E. de Jong; Apeldoorn, Pal. Het Loo; London, Christie's; 1988) [special issue of *J. Gdn Hist.*, viii/2–3, 1988]

<div align="right">K. A. OTTENHEYM</div>

(vi) Germany, Central and Eastern Europe. By the end of the 16th century the ideals of Italian Renaissance garden design had spread into Central Europe. Other influences followed. For example, the Habsburg patron Rudolf II employed Hans Vredeman de Vries, the Dutch engraver of garden pattern books, to modify the royal garden in Prague in the Dutch manner (destr.). Interest in botany as well as horticulture grew rapidly. The Flemish botanist Carolus Clusius (1526–1609), when employed as prefect of the imperial gardens in Vienna (1573–7), introduced the lily, lilac and other plants into cultivation in Europe, and the Italian physician of Ferdinand I and Maximilian II, Pietro Andrea Mattioli (1501–77), pioneered the cultivation of the tulip during his 20 years in Prague. Augustus, Elector of Saxony (*reg* 1553–86), founded a botanic garden in Leipzig in 1580.

Two important gardens were created in Central Europe in the early 17th century. SCHLOSS HELLBRUNN, the principal features of which survive, was designed in 1613 for Marcus Sitticus von Hohenems, Prince-Archbishop of Salzburg, by the Italian architect Santino Solari. In the same year, Elizabeth, the English wife of Frederick V of the Palatinate (*reg* 1610–23), commissioned the Huguenot designer Salomon de Caus (*see* CAUS, DE, (1)) to lay out the Hortus Palatinus at Heidelberg Castle (traces remain, although it is now known mainly through a set of engravings). It was damaged in the Thirty Years War (1618–48), during which period only one garden of note was laid out: that of the Wallenstein Palace (1623–7) in Prague.

After the war, the new Baroque style of gardening was introduced from France, often with the help of French designers. In 1682 Martin Charbonnier (*d* 1720), a pupil of André Le Nôtre, was appointed to transform the garden at HERRENHAUSEN. In 1697 Jean Trehet (*fl* 1688–1723) designed the gardens of the Palais Schwarzenberg in Vienna and in 1701 Simon Godeau (*b* 1632) laid out the gardens of the Schloss Charlottenburg near Berlin. DOMINIQUE GIRARD laid out the gardens of the Belvedere in Vienna and, later, of the Nymphenburg (*see* MUNICH, §IV, 3) and of Schloss Schleissheim, near Munich. At Wilanów (1677–9), Warsaw, French influence arrived indirectly through such Dutch designers as Tylman van Gameren of Utrecht. As late as the mid-18th century, French designers were still being employed: Nicolas de Pigage at Schwetzingen (1753), near Mannheim, and at Schloss

54. Gardens of Veitshöchheim, near Würzburg, 1702–76

Benrath (1756), Düsseldorf, and Jules Robert de Cotte (1683–1767) at Dobříš Castle (1765) in Bohemia. The grandeur of Baroque gave way to the intimate whimsicality of the Rococo style, especially in Germany where Frederick II created the garden of Sanssouci (1745) at Potsdam, and his sister, the Margravine Wilhelmina of Bayreuth, created the two similarly idiosyncratic gardens of Sanspareil (begun after 1744) and the Hermitage, Bayreuth (begun c. 1735). The best-preserved Rococo garden in Germany is, however, that laid out by Adam Friedrich von Sensheim, Prince-Bishop of Würzburg (1755–79), at VEITSHÖCHHEIM (see fig. 54).

By the mid-18th century the English landscape garden was being reproduced outside England. The first landscape garden of major importance in Central Europe was that of Prince Francis von Anhalt-Dessau on his estate of WÖRLITZ. His concept of landscaping extended beyond his park walls to include the countryside itself. Another German exponent of the landscape style was HERMANN LUDWIG VON PÜCKLER-MUSKAU who created the parks of Muskau and Branitz, near Cottbus. These later influenced landscape architecture in the USA, particularly the discipline of country or landscape planning.

Some of Central Europe's landscape parks were planned by imported designers. The Scotsman Thomas Blaikie (1758–1838), who also worked in France, advised on the creation of the park at Schloss Dyck near Düsseldorf. The Irishman Denis McClair (1762–1853) was employed in Poland (e.g. at Pukawy) by the influential promoter of the landscape style, Princess Isabella Czartoryska. Among Central European professional exponents of this style were Simon Bogumik Zug, whose principal work was in Poland where he designed the park at ARKADIA and enlarged the garden at NIEBORÓW, and FRIEDRICH LUDWIG VON SCKELL, best known for the design of the Englischer Garten (1789–95) in Munich.

BIBLIOGRAPHY
G. Ciolek: *Gardens in Poland* (Warsaw, 1922)
D. Hennebo and A. Hoffmann: *Geschichte der deutschen Gartenkunst*, 3 vols (Hamburg, 1962–3)
E. Neubauer: *Lustgärten des Barock* (Salzburg, 1966)
H. Koitzsch and W. Richter: *Barockgarten Grosseditz* (Leipzig, 1967)
K. Heike: *České zámecké parky a jejich dřeviny* [Czech country estates and their plantations] (Prague, 1984)
M. Lutze: *Unsere historischen Gärten* (Frankfurt am Main, 1986)
P. Bowe: *Gardens in Central Europe* (London and New York, 1991)

(vii) Russia. The country estates of the tsars, Kolomenskoye (16th century) and Ismailovo (17th century), which showed some western European influence, survive in part on the outskirts of Moscow, but major advances in garden design did not occur until Peter I introduced Western ideas and style into Russia in the early 18th century. First influenced by the Dutch garden and, secondly, by the French Baroque garden, Peter laid out the Summer Garden (begun 1703) in St Petersburg and the gardens of Peterhof and Strelna, near St Petersburg, with the help of his architects, Johann Friedrich Braunstein (*fl* 1714–26), Domenico Trezzini, Alexandre-Jean-Baptiste Le Blond and his Dutch gardener, Jan Roosen. Similar gardens were laid out by his courtiers, notably Prince Aleksandr Menshikov at Oranienbaum (now Lomonosov; begun 1710).

The reign of the Empress Elizabeth was characterized by palaces and gardens of increasing magnificence. The Italian architect Bartolomeo Francesco Rastrelli designed important Baroque pavilions (1754–61) for her estate at Tsarskoye Selo (now PUSHKIN), near St Petersburg. Aristocratic families also created gardens on their estates. KUSKOVO and ARKHANGEL'SKOYE, near Moscow, laid out by Pyotr Sheremet'yev and the Golitsyn family respectively, are surviving examples. The introduction of the English style of landscape garden into Russia was encouraged by Catherine II, who sent Vasily Ivanovich Neyelov and his son Il'ya Vasil'yevich Neyelov, both architects, abroad to study and employed them both at Tsarskoye Selo. She also commissioned the English landscape gardener John Busch (*fl* 1730s–90s) and the architect Charles Cameron to design the Yekaterinsky Park (1771–8) at Tsarskoye Selo. Her favourite, Prince Grigory Potyomkin, employed the English designer William Gould (1735–1812) to lay out the gardens of the Tauride Palace in St Petersburg. In 1777 Catherine gave the estate of PAVLOVSK to her son, the future Paul I (*reg* 1796–1801). Here, Cameron and his successors, Vincenzo Brenna and Pietro di Gottardo Gonzago, created one of the most perfect combinations of house and park in the world (see fig. 55).

The creation of landscape parks ornamented with Neoclassical buildings was encouraged by the 1785 Charter to the Nobility, but the Neo-classical pavilion was already giving way to more picturesque buildings. The park at Pavlovsk was given a thatched dairy and a rustic charcoal-burner's hut. A new area, the White Birches, was added in imitation of the meadow and forest landscapes of northern Russia. The ensuing movement, giving Russian parks their own characteristic style, was promoted by the architect NIKOLAY L'VOV and the writer Andrey Bolotov (1738–1833), who advocated some formality within the landscape garden and a place for fruit trees, characteristic of Russian gardens.

BIBLIOGRAPHY
A. Kuchumov: *Pavlovsk* (Leningrad, 1980)
A. N. Petrov: *Gorod Pushkin* [The town of Pushkin] (Moscow, 1980)

55. Gardens with the Temple of Friendship (1779–82) by Charles Cameron, Pavlovsk, near St Petersburg

A. N. Petrov, Ye. N. Petrova and G. Pushkin: *Pamyatniki arkhitektury prigorodov Leningrada* [Architectural monuments of the Leningrad area] (Leningrad, 1983)

(viii) Scandinavia. The Renaissance garden was developed in Scandinavia in the mid-16th century by Gustav I of Sweden (*reg* 1523–60), who brought in foreign designers. The garden at the Royal Palace in Stockholm was first laid out *c.* 1550 by the German Hans Friese (*fl* 1545–79) and remodelled in 1563 by the Frenchman Jean Allard. The earliest surviving garden plan in Scandinavia, for Uppsala Castle (*c.* 1572), is by the Italian Franciscus Pahr (*d* 1580). In Denmark, the castle of Egeskov, Fyn, has a Renaissance garden (1550) that has been restored.

As a result of its military success in the Thirty Years War (1616–48), Sweden became a major European power and its monarchs wished to emulate the great gardens in the French Baroque style at the courts of Europe. Queen Christina brought the French royal gardener André Mollet to redesign the Royal Garden in Stockholm (1648–53). Later, the great garden of Drottningholm, Stockholm, was designed by Nicodemus Tessin (*see* TESSIN, (1)) for the Dowager Queen Hedvig Eleanora. It was completed by Nicodemus Tessin the younger. (The latter's collection of garden drawings, many by important French designers, is held in the Kungliga Akademien för de Fria Konsterna, Stockholm.) Frederick IV of Denmark (*reg* 1699–1730), after visiting André Le Nôtre's gardens in France, commissioned the Danish designer JOHAN CORNELIUS KRIEGER to lay out three great gardens in the Baroque style: at Frederiksberg, Copenhagen (begun 1699), Fredensborg, Sjælland (1719–22), and at Hillerød, Frederiksborg Castle

(1720). In 17th-century Norway, circumstances permitted only comparatively simple formal gardens but those at Rosendal Barony, Hardanger (see fig. 56), and Lurøy, Nordland, remain; the latter, lying just below the Arctic Circle, is perhaps the most northerly formal garden in Europe.

During the early 18th-century wars with Russia, the creation of Baroque gardens in Scandinavia ceased. When gardening was revived in the latter part of the century, it was in a lighter Rococo style, as can be seen in the 'Kina' area of the park at Drottningholm and in the delightful estate of Liselund, Møen, in Denmark. The English style of landscape garden was developed in Sweden by F. M. PIPER, whose study drawings of English landscape parks are in the Kungliga Akademien för de Fria Konsterna, Stockholm. His garden design can be appreciated in the royal parks at Drottningholm (1780) and Haga (1785), Stockholm. Meanwhile, the great botanist Carl Linnaeus (1707–78), resident at Uppsala, was devising the system for naming plants that is universally used.

BIBLIOGRAPHY

C. W. Schnitler: *Norske haver i gammel tid* [Norwegian gardens in olden times], 2 vols (Oslo, 1915)
——: *Trädgårdskonstens historie i Europa* [The history of garden design in Europe] (Stockholm, 1917)
G. Martinnson: *En bok om trädgårdar* [A book on gardens] (Stockholm, 1957)
A. Bruun: *Danske haver i dag* [Danish gardens today] (Copenhagen, 1971)
H. Lund: *De kongelige lysthaver* [The royal pleasure gardens] (Copenhagen, 1977)
M. Bruun: *Historic Gardens in Norway* (Paris, 1987)

PATRICK BOWE

56. Rose parterre at Rosendal Barony, Hardanger, Norway, 17th century

(ix) North America. When the Spanish arrived in the 16th century, they destroyed the most sophisticated gardening tradition indigenous to the continent, that of the Aztec Indians (*see* §II, 5 above). The new settlers quickly re-created garden types they had known in Europe, and in Catholic areas these included the utilitarian gardens connected with religious institutions. In the south, fruit trees, kitchen and medicinal gardens were planted in the cloisters and courtyards surrounding the missions; in Quebec, a walled garden at the St Sulpician Seminary in Montreal survives from the building of the monastery in the 1680s. By contrast, the earliest gardens of New Netherland, established as a colony in 1624, were laid out by the Dutch West India Company. At the mansion (*c.* 1685; destr.) built by Peter Stuyvesant, Director-General of the company, on the Battery in Manhattan the axially arranged garden had symmetrical compartments of parterres and orchards in the Dutch classical manner. Influence was not all in one direction: as early as the 1630s 'Jardins de Roi' were established in Quebec as holding areas for native botanicals bound for France. The Château St Louis (begun 1694) had extensive formal gardens to the west. By the 18th century such nurserymen as John Bartram (1699–1777) of Philadelphia, appointed King's Botanist in 1765, were regular suppliers of plants for gardens in England.

In the English-speaking colonies, English gardening traditions were the most influential. At Williamsburg, the capital of Virginia from 1699 to 1781, the formal Anglo-Dutch combination of parterres and geometric topiary at the Governor's Palace has been restored according to the original plan found in the British Museum. In the upper garden, a central axis divides 16 diamond-shaped parterres of periwinkle and 12 cylindrical topiary yaupons; a series of cross-axes and contiguous gardens culminates in a tunnel of American beech and a maze modelled after the one at Hampton Court, although planted in American holly. The terminal feature, a canal, is Dutch in origin. At Mt Vernon, VA, the 'home farm' along the Potomac River built by George Washington (1732–99) and enlarged by him in 1787, the influence of the English landscape garden

is apparent. On the side facing the river, the house is separated from a deer park by a ha-ha. Behind the house are a pair of walled gardens, one for flowers and one for vegetables, divided by a serpentine drive planted with 'clever sorts' of flowering trees and shrubs obtained from Bartram's Nurseries or from Washington's daily riding expeditions in the surrounding area.

In New England there was nothing this grand, although in Newport, RI, the summer colonists competed fiercely to produce the most lavish gardens. Features would include graperies, orangeries, palm, orchid and gardenia green-houses. It is said the Newporter Fairman Rogers ordered his gardener to create a flowerbed to match exactly in pattern and colour his favourite Persian carpet, while at another garden the Shakespeare quotation from *A Winter's Tale*—'This is an art which doth mend nature, change it, but itself is nature'—was spelled out entirely with flowers of varied hues. The earliest type of colonial garden has been reconstructed at Whipple House in Ipswich, MA, where paths paved with crushed clamshells surround raised beds, each boarded, pegged and centred with a rose bush. These are filled with pinks, strawberries and marjoram, such medicinal plants as opium poppies and others on which the settlers depended, as described in 17th-century documents. Few gardens in North America have evolved continuously from the colonial period, although one example can be found at Middleton Place, outside Charleston, SC (see fig. 57), where the first president of the Federal Congress, Henry Middleton, commissioned a formal garden in the French style. A lawn, terraced like an amphitheatre, may have been one of the original features.

BIBLIOGRAPHY

A. Leighton: *American Gardens in the Eighteenth Century: For Use or for Delight* (Boston, 1976)

Voyage de Pehr Kalm au Canada en 1749 (Traduction annotée du journal de route par Jacques Rousseau et Guy Béthune) (Montreal, 1977)

M. H. Ray and R. P. Nicholls: *A Guide to Significant and Historic Gardens of the United States* (Athens, GA, 1982)

E. von Baeyer: *A Preliminary Bibliography for Garden History in Canada* (Ottawa, 1983)

JUDITH A. NEISWANDER

5. AFTER *c.* 1800. From *c.* 1800 gardening increasingly became part of daily life for a large number of people. To meet the needs of a growing gardening public, including working-class window-box gardeners and middle-class do-it-yourself suburban gardeners, a wider variety of garden designs became available, in response to the realization that there was more than one acceptable way to arrange a garden and by the desire to display the exotic flowers and trees that were arriving from overseas. HUMPHRY REPTON started the trend away from the naturalistic landscape style of the 1700s when he declared that gardens were works of art. He reintroduced flowers into the garden, and at Ashridge (1813), Herts, he designed a space composed of a number of small gardens in different styles. The formal garden dominated most of the 19th century; the informal garden led into the 20th century.

(i) The plantsman's garden. (ii) The gardenesque. (iii) Garden design in Europe, before *c.* 1900. (iv) Victorian garden design. (v) Garden design in Britain, *c.* 1890–1945. (vi) Garden design in Australia, Africa and the Americas, before *c.* 1935. (vii) Garden design after 1945.

(i) The plantsman's garden. The British Victorian garden became a formalized floral display that could no longer be

57. Garden at Middleton Place, near Charleston, South Carolina

mistaken for the natural landscape around it. One of the forces behind this design was the flood of new plants arriving from around the world. David Douglas (1798–1834) spent years in North America sending back such hardy conifers as the Douglas fir and Sitka spruce. His discoveries led to collections of pine trees on large Victorian estates and the use of single conifers as specimen trees. The American flowers that John Bartram (1699–1777) had sent to Britain in the late 18th century, including magnolias, rhododendrons and species of lilies and phlox, were grown at the Chelsea Physic Garden, London, at the ROYAL BOTANIC GARDENS OF KEW, and in a few private collections; their colourful blossoms began to influence gardeners to return to the use of flowers in the landscape.

The number of new flowers that arrived from overseas was enormous: from South Africa came gladioli and the pelargonium, an African geranium that has become almost synonymous with Victorian gardening; from Australia and New Zealand came lobelias and species of clematis; from Mexico came dahlias and zinnias; and from South America came gloxinias and fuchsias. China and Japan provided camellias, lilies, primulas, chrysanthemums, hostas and hydrangeas; the Himalaya and Sikkim regions produced a phenomenal selection of rhododendrons; and Assam, on the eastern Indian subcontinent, introduced begonias, crotons, caladiums and the coleus, which became popular for the texture and colour of its leaves. The invention of the Wardian case by Nathaniel Ward (1791–1868) in 1830 had a major impact on plant collecting. Live plants were placed inside a glass case, water was added and the case was closely sealed, except for an occasional change of air; as long as the plants received sufficient light, they would grow within their self-contained environment. This allowed living plants to be transported over far greater distances than had previously been possible.

The development of the glasshouse (or greenhouse) helped to encourage the demand for exotic plants. Tropical plants that could not have withstood the British winter could now flourish in a controlled environment. The increased prevalence of heated glasshouses corresponded with the invention of sheet glass and the end of the glass tax. In the 1830s JOSEPH PAXTON built a large glasshouse at Chatsworth House, Derbys; it was followed by Decimus Burton's Palm House (1844–8) at the Royal Botanic Gardens, Kew. These two glasshouses were high enough to house fully grown trees, thereby increasing interest in and knowledge of tropical plants. Smaller glasshouses were developed for middle-class gardens, making tropical plants available to a wider public. By the 1850s glasshouses attached to the home, known as conservatories, were part of suburban Victorian life.

(ii) The gardenesque. The protagonist in British garden design at the beginning of the 19th century was JOHN CLAUDIUS LOUDON. Although he was a practising landscape designer, producing, for example, Derby Arboretum (1839), his influence came primarily from his writings. He edited five periodicals and wrote 34 books, in which he explained and developed his theories on garden design

58. Gardens with winter bedding, Heckfield Place, Hampshire, 1844; print (London, Linley Library)

and horticulture. Initially he wrote and worked for the landed gentry, but he soon turned his attention to the newly affluent middle class and the layout of their suburban gardens, becoming the first landscape designer to recognize the need for designs for small gardens for town and suburb. His most important written work was his *Encyclopaedia of Gardening* (London, 1822), which at the time of printing was the most definitive book available on the history and theory of garden design; *The Suburban Gardener and Villa Companion* (London, 1838) introduced the idea of the middle-class garden to the general public.

The theory to have the greatest impact on British gardening was the 'gardenesque', which Loudon developed in the early 1830s in response to the influx of new ornamental plants and shrubs. The purpose of gardenesque design was to display the beauty of trees and plants individually. Rather than arranging the trees in large clumps, they were to be planted so as not to touch each other, thus allowing the viewer to appreciate the beauty of each tree. Flowerbeds were to be planted with only one species of flower and were to be in simple shapes. The mixing of different species was, in Loudon's opinion, vulgar. Contained in the gardenesque theory was the idea that the garden should be a work of art and therefore artificial in appearance. To achieve an artistic effect and distinguish the garden from the surrounding countryside, Loudon recommended planting trees and flowers that were non-native to the area.

The worst excesses of the 19th-century garden have been attributed to the gardenesque style. In the wrong hands, Loudon's ideas were carried to an extreme: lawns were broken up by excessive serpentine walkways; simple geometric flowerbeds were replaced by kidney-shaped beds scattered around the lawn with no regard for overall effect; and trees were treated as 'specimens' that were placed in isolation rather than in gentle clumps. Creative in their efforts to display their new plants, gardeners began with massed flower-bedding: large beds were planted with a single colour of flower, primary colours were preferred and beds with high colour contrast were juxtaposed. Scarlet geraniums (the South African pelargonium), purple verbenas and yellow calceolarias were the most popular flowers. The massed flowerbed developed into the bedding system, in which the beds were planted with flowers according to season. The first were planted with summer flowers raised in glasshouses; then came flowers raised outdoors for spring and autumn beds; and in the winter the beds were planted with evergreens in pots (see fig. 58). The bedding system was first used in Phoenix Park, Dublin, in 1826 and remained popular throughout the 1840s and 1850s. The plunging system, another method of bedding plants, is considered one of the excesses of Victorian gardening. Flowers were grown in pots and the pots were then 'plunged' into the beds according to a predetermined design. Since the pots were easily transferable, the beds could be changed often, some as often as 52 times a year. Thus the gardenesque, by which garden design became a means of displaying flowers and trees, turned out to be artistically unsuccessful through over-zealous gardeners. It was replaced in the 1840s by a more formal garden arrangement.

(iii) Garden design in Europe, before c. *1900.* While the British experimented with a variety of garden designs during the 19th century, in Europe there was, in general, a decline in the development of styles unique to any one country. Europe continued to produce gardens in the 18th century British landscape style.

In France, the rise of the British landscape style coincided with the rise of Napolean I (*reg* 1804–14). The landscape style, or *jardins anglais*, with its large areas of lawn and absence of flowerbeds, was less expensive to maintain than the formal French style. The landscape garden was attached to the remaining formal garden, as at the palace of Fontainebleau (1809–12) in Seine-et-Marne. The French were not comfortable with the British landscape style and the *jardin anglais* was developed by Gabriel Thouin (1747–1829). While retaining the informality of grass and trees, Thouin added walkways which were linked to one large allée encircling the lawn. The style reached its peak under Napoleon III (*reg* 1852–70). During the mid-1800s there was a revival of interest in flowers. Enormous beds of a single kind of flower were laid out in the lawn, and British carpet bedding became popular. The late 1800s saw a revival of the formal style of André Le Nôtre. Formal gardens, such as Vaux-le-Vicomte (1656–61; Seine-et-Marne; *see* LE NÔTRE, ANDRÉ, fig. 1; *see also* VAUX-LE-VICOMTE, §2), were restored by Henri Duchêne (1841–1902) and his son Achille-Jean-Henri Duchêne (1866–1947). They also reconstructed other formal gardens, for example Maintenon in Eure-et-Loir and Courances at Essonne.

The British landscape style remained popular in Germany, although by the mid-1800s it was reduced to fit smaller suburban villas. A major change came from the architect Herman Muthesius, who believed that the relationship between house and garden was so strong that the two must be designed by the same person. Fritz Encke (1861–1931) was a leading member of the group called Gartenarchitekten who followed Muthesius's ideas. They emphasized the functional benefits of the garden. Italian garden design reached a low point in the 19th century. Most major gardens were allowed to decay or were converted into the British landscape style. From the mid-1800s new initiatives in garden design were taken by foreign residents, particularly the English and Irish. La Mortola at Ventimiglia, for example, represented a break with traditional classical Italian design. Now known as the Giardino Botanico Hanbury, it was bought by Sir Thomas Hanbury (1832–1907) in 1867 and filled with trees and plants from around the world. In 1983 it came under the care of the University of Genoa.

Russia was also under the influence of the British landscape style. It was popularized by the empress Catherine the Great (*reg* 1762–96). However, the Russian nobility added buildings throughout the garden. Count Vorontson's palace at Alupka in the Crimea consisted of a formal Italianate garden (1830s–1840s) with terraces, flights of steps, statues and fountains followed by a landscape park containing English Tudor, Gothic and oriental buildings. Russian gardens went into decline *c.* 1861 when the abolition of serfdom deprived their owners of cheap labour and made the maintenance of

large estates extremely difficult. A few landscape gardens were laid out. Palanga in Lithuania, on the Baltic Sea, was the palace of Count Tyszkiewicz. The garden (second half of the 19th century), designed by Edouard André, utilized walkways and decorative bridges crossing pools. However, the 1917 Bolshevik Revolution ended the construction of large private gardens. Under Communism the emphasis shifted to public parks.

(iv) Victorian garden design. One of the most successful garden designs to replace the gardenesque was the Italianate, based on gardens of the Italian Renaissance. It was introduced into Britain in 1840 by the architect Charles Barry (*see* BARRY, (1)) at Trentham, Staffs. Barry designed two terraces between the house and the lake: on the upper terrace was a central circular fountain surrounded by flowerbeds; the lower terrace contained two symmetrical rectangular panels of flowerbeds and a walk leading to a balustrade with statuary. Barry's greatest garden, however, was Shrubland Park (1851–4), Suffolk, in which the main terrace incorporates a Swiss cottage, a French garden, a Japanese garden and a fountain garden with massed flowerbeds; four flights of steps, with vases of flowers on the landings, led to a park (see fig. 59). Barry's contribution to the garden was architectural and the planting was left to the head gardeners. The Italianate style, with its terraces, balustrades, flights of steps, statues, vases of flowers and symmetrical display of flowerbeds, was well suited to

provide a bright floral show. William Andrews Nesfield worked in a number of styles, including the Italianate (*see* NESFIELD, (1)). He developed the box parterre based on formal French garden designs, which consisted of elaborate designs laid out in close-clipped boxwood. Nesfield designed the Royal Horticultural Society's Gardens in Kensington, London (*c*. 1861; destr.). They contained three levels of terraces with ornamental beds of coloured gravel and box.

The flowerbeds that were laid out in Victorian gardens came in a multitude of shapes, and not everyone agreed with Loudon that the circular bed was best. It often appeared that garden designers tried to outdo each other in designing complicated multi-coloured flowerbeds. Stars, hearts, kidney shapes and interlocking circles were popular designs, as were complex symmetrical designs composed of multiple flowerbeds. The ribbon border, another feature of mid-Victorian gardening, consisted of a long, narrow bed divided into three rows; the colour of each row was blue, yellow, scarlet or white. In the 1850s, in their quest for the ideal flower display, gardeners developed the raised flowerbed. These included the pyramid bed, which consisted of a pyramid-shaped cone of rubble with flowers, preferably pelargoniums, planted over it, and the pincushion bed, composed of concentric rows of plants arranged in increasing height, the tallest being placed in the centre. (Some claimed they were called pincushions because it

59. Gardens at Shrubland Park, Suffolk, by Charles Barry, 1851–4; from E. Alvano Brooke: *Gardens of England* (1855)

was said that anything could be pushed into them.) A side-effect of the bedding system was the reduction in the variety of plants used in gardens. Rather than displaying large numbers of different plants of the same colour, gardeners found it easier to work with a limited number of favourites. The preference for high-contrast planting through the use of primary colours in beds and ribbon borders was also losing its appeal by the 1860s.

The subtropical garden emerged in the 1860s as an alternative to the bedding system. Subtropical plants chosen for the subdued colours of their leaves were arranged in pincushion beds. The biggest problem was one of survival for unusually cold or windy weather in the summer could damage all the plants. The subtropical garden led to carpet bedding, in which dwarf foliage plants were arranged in complex designs and trimmed to a uniform height. Carpet bedding lasted until the 1880s, when it was replaced by a more informal approach.

The second half of the 19th century saw the compart-mentalization of gardens and an increase in garden fur-nishings. Shirley Hibberd (1825–90), known for his writings on horticulture and garden design, reflected the later Victorian approach to gardening in his *Rustic Adorn-ments for Homes of Taste* (London, 1856/*R* 1987) and *The Amateur's Flower Garden* (London, 1871/*R* 1986). He attempted to reassert the role of the garden as a place to be enjoyed during all seasons, considering it more than a collection of seasonally changeable flowers. While ac-knowledging the necessity of flowers, he encouraged other features in the garden, such as the lawn, which was important for outdoor activities, and recommended ar-bours, summer-houses and shaded seats for reading or conversation. Hibberd divided gardens into sections: formal gardens were placed near the house, with a transi-tional stage leading to the informal areas. His garden designs contained serpentine paths leading to the rose garden, 'American' garden, rockery and other distinctive garden areas. The rose garden, always a Victorian favourite, was planted out of view of the house so as not to provide an unsightly scene when out of season. The American garden was an area devoted to hardy shrubs from North America, the most popular being the rhododendron. Hibberd summarized their popularity in *The Amateur's Flower Garden* (p. 216): 'The money spent on rhododen-drons during twenty years in this country would nearly suffice to pay off the National Debt.' Plots of ground were set apart for the subtropical garden, with its palms, caladiums, begonias and other greenhouse plants. Rock-eries were popular: they could act as a screen to hide objectionable views and were used to display ferns and alpine flowers.

Hibberd approved of ornamentation in the garden as long as it was not excessive. He liked to display flowers and used such devices as vases in raised pots, arches covered with climbing plants and rough wooden baskets filled with flowers and placed on stumps. He had a preference for the rustic style, which he used to frame his garden areas. Arches formed from dead tree-branches were placed on each side of a walk that led to a lawn, in the centre of which stood a fountain or an ornamental stand covered with trailing plants, from which the eye was led to the shrubbery beyond. Hibberd brought a moral

tone to Victorian gardening: he believed that a home could not be considered happy it if did not have some form of garden. The garden was important in developing pure thoughts and refinement of feelings. It also kept husbands away from the taverns and gin houses. Manual labour in the garden was considered good for both body and soul. Similarly, public parks were thought to bring refreshment and culture to the masses (*see* PARK).

(v) Garden design in Britain, c. *1890–1945.* The period from the 1890s to the 1930s, when landscape designers began to break away from the excessive formalization of Victorian gardening, was a time when British garden design lost some of its influence abroad and when North and South America began to develop styles more suitable to their own gardening needs. In the late 19th century in Britain there was a revolt against the formalized bedding system and a movement towards a more informal garden style that was part of a general trend towards naturalism in British artistic thought. Formal flower gardens were equated with industrial mass production. Art critics ad-vocated a return to naturalism, while the Pre-Raphaelite Brotherhood and members of the Arts and Crafts Move-ment wanted a return to a more dignified, simple time, in which manmade products were more important than those made by machine.

William Robinson (1838–1935), a leading proponent of the return to naturalism, advanced his theories in his books *The Wild Garden* (London, 1870) and *The English Flower Garden* (London, 1883), and in the numerous magazines that he edited and published. In *The Wild Garden* Robinson encouraged planting hardy exotic plants where they would thrive without needing further care. His wild gardens contained massed drifts of flowers in meadows and under trees. He strongly disliked ribbon borders, carpet bedding and the seasonal bedding system, condemning them for being unimaginative in their variety of flowers and exces-sively intricate in their designs. The ribbon border, with its predictable rows of three colours and three plants, was considered dull; in response he developed the herbaceous or mixed border filled with a wide variety of perennials.

The Arts and Crafts Movement, which attempted to return dignity to the craftsman, influenced the work of GERTRUDE JEKYLL, EDWIN LUTYENS and Thomas Maw-son (1861–1933). Gertrude Jekyll developed the herba-ceous border to a high artistic level, applying the colour theories she had learnt while training as a painter. In her borders cool colours were placed at either end, with brilliant or warm colours in the centre. She was highly innovative in her arrangement of plants, placing them according to form, texture and colour, making the borders and flowerbeds both subtle and complex in their design. Jekyll is best known for her informal, naturalistic plantings, which are exemplified in her own garden at Munstead Wood (1880s), Surrey, which she described in *Wood and Garden* (London, 1899).

In the 1890s Jekyll entered into a partnership with Edwin Lutyens, an architect who came to garden design through his belief in the Arts and Crafts concept of the unity of house and garden, which, in his opinion, was best achieved if the house and garden were designed by the same person. Lutyens brought a formal approach to the

layout of his gardens. He utilized geometric flowerbeds, sunken ponds, canals, fountains and terraces. In his partnership with Jekyll he provided the framework of the garden and she the planting schemes. One of their most successful ventures was Hestercombe (1904; see fig. 60), Somerset, which contains two gardens: a Dutch garden, and a sunken garden known as the Great Plat. The latter, which is more unusual, uses a grass cross with a sundial in the centre to provide the framework for the garden. The cross and the flowerbeds, which were planted with lilies, bergenias, yuccas, lavender and other flowers, are outlined in stonework. On two sides of the Great Plat are narrow water-channels, or rills, planted with irises, while the third side contains a massive pergola covered with roses and clematis. Other noteworthy gardens by Lutyens are Marsh Court (1901–4), Stockbridge, Hants, Deanery Garden (1899–1901) at Sonning, Berks, and Ammerdown (1902), Somerset, all of which contain features typical of his garden style. The central feature of Marsh Court is an enclosed sunken pool surrounded by steps and flower borders. Deanery Garden (*see* LUTYENS, EDWIN, fig. 1) has a walled orchard in which the lawn is divided by a rill planted with irises. Ammerdown combines three formal gardens. That closest to the house, which contains formal, symmetrical flowerbeds, leads to a circular Italian garden, with formal flower parterres outlined with yew hedging, and thence to the rose garden. Thomas Mawson also used

a formal design for the basis of his gardens. Terraces were placed near the house and there was a transition by steps to the lawns and other parts of the garden. He laid out gardens around the world, including those for the Legislative Building at Regina, Saskatchewan, Canada, and the campus of the University of Saskatchewan, Saskatoon (both 1912).

While Lutyens and Mawson were quietly proceeding to reintroduce formal elements into the garden, REGINALD BLOMFIELD attempted to establish the idea of formal design through his book *The Formal Garden in England* (London, 1892). Blomfield was strongly opposed to the free styles supported by Robinson, advocating instead the separation of garden design from horticulture, arguing that the architectural structure of the garden was the primary element of its design, while plants played a decorative, secondary role. The ensuing argument between Robinson and Blomfield divided British landscape designers. Harold Ainsworth Peto was one of the designers who attempted to follow the middle road (*see* GEORGE & PETO). Strongly influenced by formal Italian gardens, he integrated their main architectural features (temples, terraces, colonnades and flights of steps) into the informal British landscape and successfully added innovative planting. Peto's style is best exemplified by his own garden at Iford Manor (1899–1933), Bradford-on-Avon, Wilts, and the canal garden at Buscot Park (*c.* 1904–11), Berks.

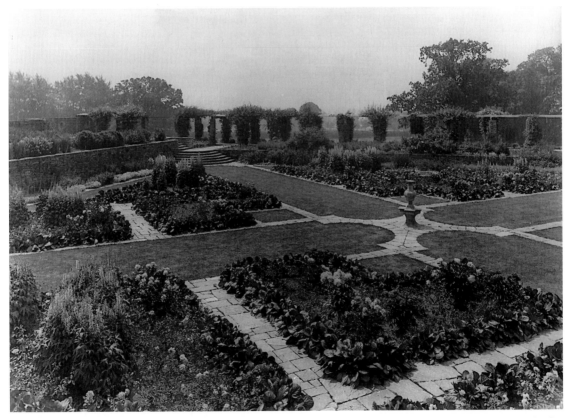

60. Gardens at the Great Plat, Hestercombe, Somerset, by Edwin Lutyens and Gertrude Jekyll, 1904; from *Country Life*, xxiv (17 October 1908)

The small country house garden, as theorized by Loudon and developed by Lutyens, realized its full potential in the gardens of Hidcote Manor, Glos, and Sissinghurst Castle, Kent. Both gardens were laid out by their owners rather than by a professional designer and are important not just for their beauty but for their design. Hidcote was created by Major Lawrence Johnston (1871–1958), who started work on the garden before World War I and continued until his death. It is laid out as a compartmental garden with a central walk of yew hedges and hornbeam trees that leads through a series of garden 'rooms'. While the emphasis of the design is on structure, Johnston was a knowledgeable plantsman who used Jekyll's theories for laying out his flowerbeds. Sissinghurst Castle was bought by Harold Nicolson (1886–1968) and Vita Sackville-West (1892–1962) in 1930, and over the next 20 years its garden was developed into one of Britain's finest. In a relatively small space a series of garden 'rooms' have been created, each different and filled with a rich collection of plants.

(vi) Garden design in Australia, Africa and the Americas, before c. *1935.* British garden design was fashionable throughout the British Empire. Even after achieving independence many countries continued to use British design as the basis for their gardens and made adaptations based on climate, geography and indigenous flora. In Australia, Rippon Lea, near Melbourne, exemplifies a late 19th-century landscape garden laid out around a suburban mansion. The garden consists of a formal terrace, a lake, a rose garden and some of the last surviving examples of private carpet bedding. Dalvui and Mawallock, both in Victoria State, were laid out in the early 1900s by William Guilfoyle (1840–1912). Dalvui is admired for its series of ponds and its luxurious plantings. Mawallock (1909), one of Guilfoyle's last gardens, contains formal terraces with wide expanses of lawn leading to a lake and a grove of trees. In both gardens use is made of native Australian plants.

South Africa produces spectacular gardens based on their plantings. The garden at Groote Schuur, near Cape Town, the former estate of Cecil Rhodes (1853–1902), was laid out in the late 19th century. It was a formal Victorian garden with a series of terraces, a rose garden and carpet bedding. The southernmost tip of South Africa provides an ideal climate for gardens, and much of the history of South African gardening can be found in Cape Town and Stellenbosch. Two of many gardens of prominence are Old Nectar, which resembles Sissinghurst and Hidcote in design, and Rustenberg (both late 19th century to early 20th), which contains a series of small gardens near the house and a wild garden beyond. A new concept

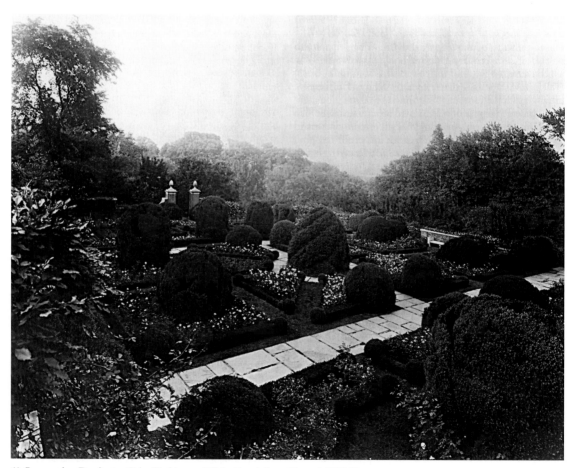

61. Rose garden, Dumbarton Oaks, Washington, DC, by Beatrix Jones Farrand, 1922–33

in South African gardening, the specialized use of indigenous plants, appeared *c*. 1913 in the gardens of the Cape Town area.

In the USA garden design traditionally followed British styles. The 1890s to 1930s was the period of great mansions. These estates generally used the British informal style as the framework, to which were added the formal elements of Italian, French and Spanish designs and a Japanese garden in one corner, the American tendency being to mix styles. Vizcaya (1912–16) in Miami, FL, was typical of this style. Designed by Diego Suarez, it comprises a series of garden 'rooms', each in a different style. There is a Roman cascade, a Venetian bridge and French parterres in the manner of Versailles. Dumbarton Oaks (1922–33), Washington, DC, laid out by BEATRIX JONES FARRAND, comprises a series of gardens that become more informal the further they are from the house, including the Star Garden, named for its astrological motifs, the Pebble Garden, with a pebble mosaic of wheat sheaves, and a rose garden (see fig. 61). The du Pont family has been responsible for three major gardens, each in a different style. Winterthur, DE, one of the finest examples of the English landscape garden in the USA, was laid out in 1927 by H. F. DU PONT, a learned and knowledgeable botanist who continued to develop the gardens up to his death in 1969, adding many rare plants from Asia. Nemours (1932), a du Pont estate in Wilmington, DE, is laid out as a French formal garden in the style of Versailles. Longwood Gardens, Kennet Square, PA, was purchased by Pierre Du-pont, who opened the gardens to the public in 1921. There are over 400 ha, which contain formal Italian and French gardens, numerous conservatories, specialized flower gardens, meadows and an arboretum.

(vii) Garden design after 1945. After World War II garden design went through changes that reflected the decrease in available manpower, the need for low maintenance and the desire for gardens that are suited to a more leisure-orientated lifestyle. GEOFFREY JELLICOE and Russell Page (1906–85) were two British designers who made distinctive contributions to modern garden design. Geoffrey Jellicoe used art as an inspirational basis for his gardens. In his later years he laid out allegorical gardens, such as Sutton Place (1980–84), Surrey, an allegory of creation, life and aspiration. Jellicoe's unique achievement is the Moody Gardens (1992) in Galveston, TX, covering 10 ha in which visitors take a boat ride through a series of gardens depicting the history of civilization. Russell Page was a traditionalist who believed that the style of the garden should suit the house. He was sufficiently flexible to be able to work in both the grand French manner and the informal English landscape style. Page was concerned with the overall framework of the garden and was a knowledgeable plantsman. His gardens include those of the Frick Gallery (1973), New York, and the PepsiCo headquarters (1981–5; see fig. 62) in Purchase, NY, an example of the corporate need to present the correct image to the outside world. Its buildings are situated in a natural landscape and sculpture garden, which are open to the public. The PepsiCo landscape was the final work of Russell Page, who worked on integrating the sculpture

62. Gardens at PepsiCo headquarters, Purchase, New York, by Russell Page, 1981–5

into the landscape and creating an imaginative natural setting.

The advent of the corporate client turned landscape design into a complex collaboration between client, architect, engineer and landscape designer, but there were still individuals who commissioned gardens that would suit their lifestyles. For them, the emphasis was on family life, and the garden was designed to take into account children's play areas, swimming-pools and barbecue grills. The modern California garden was the result, of which THOMAS D. CHURCH and Garrett Eckbo (*b* 1910) are regarded as the pioneering designers. The state's climate allowed the garden to become an informal outdoor room, and the emphasis changed from horticulture to the social role of the garden. Church developed low-maintenance gardens with broad timber decks, raised flowerbeds and shady pergolas, with a place in the garden setting for the automobile. He designed one of the most famous 20th-century gardens, El Novilfero (1947–9) at Sonoma, CA. Situated on a hilltop, with a view that extends the garden into the surrounding countryside, it has a kidney-shaped swimming-pool, epitomizing the increasingly practical rather than entirely ornamental use of water.

In South America and Mexico the late 20th century has brought an assertion of nationalism. Initially gardens were designed in the styles of their colonizers but after independence they experimented with a number of styles, including Italian, French, English, Spanish-Islamic and Chinese. At the end of the 20th century, however, landscape designers were working in styles unique to their cultures. LUIS BARRAGÁN, a Mexican architect who also designed gardens, considered himself a Minimalist, a follower of the artistic theory that everything must be broken down into its simplest forms. He developed a uniquely personal style that contrasts abstract form with the wilder aspects of nature. One of his most famous designs is the Plaza del Bebedero de los Caballos (1958–62) in Las Arboledas, which uses water, a single species of tree and strategically placed walls to provide artistic effect. ROBERTO BURLE MARX was a Brazilian designer who created a national style, using sweeping masses of plants and creating dramatic contrasts in texture and colour. Typical of one aspect of his work is Monteiro Garden

(1948) in Rio de Janeiro, an 'English' landscape planted with native Brazilian flowers and trees chosen and arranged according to their colours. One of the most creative and innovative garden designers of the 20th century, Burle Marx showed that European landscape designers no longer held the most prominent positions in landscape design. In the 20th century garden design became more varied and international.

See also LENNÉ, PETER JOSEPH; MÄCHTIG, HERMANN; and ISLAMIC ART, §II, 7(i)(b).

BIBLIOGRAPHY

M. Allan: *William Robinson* (London, 1982)
T. Church: *Gardens Are for People* (New York, 1983)
E. von Baeyer: *Rhetoric and Roses: A History of Canadian Gardening* (Markham, Ont., 1984)
T. Carter: *The Victorian Garden* (London, 1984)
J. Brown: *Vita's Other World: A Gardening Biography of V. Sackville-West* (Harmondsworth, 1985)
R. Page: *The Education of a Gardener* (New York, 1985)
B. Elliott: *Victorian Gardens* (London, 1986)
P. Goode and M. Lancaster, eds: *The Oxford Companion to Gardens* (Oxford, 1986)
D. Stuart: *The Garden Triumphant: A Victorian Legacy* (London, 1988)
D. Ottewill: *The Edwardian Garden* (New Haven, 1989)
J. Morgan and A. Richards: *A Paradise out of a Common Field: The Pleasure and Plenty of the Victorian Garden* (London, 1990)
P. Cutler: *America in Bloom* (New York, 1991)
J. Davies: *The Victorian Flower Garden* (London, 1991)
F. Frankel and J. Johnson: *Modern Landscape Architecture* (New York, 1991)
M. Griswold and E. Weller: *The Golden Age of American Gardens* (New York, 1991)
——: 'Fashioning an Image of the West Coast Garden', *Pacific Hort.*, Winter (1991), pp. 39–51
M. Mosser and G. Teyssot, eds: *The History of Garden Design* (London, 1991)
M. Schinz and G. van Zuylen: *The Gardens of Russell Page* (New York, 1991)
C. Quest-Ritson: *The English Garden Abroad* (London, 1992)
J. Wolschke-Bulmahn and G. Groening: 'The Ideology of the Nature Garden: Naturalistic Trends in Garden Design in Germany during the Early Twentieth Century', *J. Gdn Hist.*, xii (1992), pp. 73–80
D. Imbert: *The Modernist Garden in France* (New Haven and London, 1993)
M. Laurie: 'The Modern California Garden', *Pacific Hort.* (Summer 1993), pp. 16–25
M. Treib, ed.: *Modern Landscape Architecture: A Critical Review* (Cambridge, MA, and London, 1993)
R. Williams: 'Edwardian Gardens, Old and New', *Gdn Hist.*, xiii (1993), pp. 90–103

VIVIAN A. RICH

Garden, Hugh M. G. *See under* SCHMIDT, GARDEN & MARTIN.

Garden city. Economically and socially independent urban unit of medium size surrounded by a green belt. The term is often loosely applied to various other forms of urban planning. Letchworth, Herts, begun in 1903, was the first garden city proper; it was followed in Britain by Welwyn, Herts (from 1920), and examples in Germany, Russia and France. The garden city idea is usually considered to derive from two quite distinct sources: the social Utopias of such philosophers as Henri de Saint-Simon (1760–1825) and Charles Fourier (1772–1837; *see* FOURIERISM) and the model estates and villages of industrial philanthropists of the second half of the 19th century. British industrialists, such as William Hesketh Lever and George Cadbury, built planned communities for their workers, for example at Port Sunlight (from 1888), near Liverpool, and Bournville (from 1879), near Birmingham, along the lines of picturesque, medieval villages, with strong influence from the Arts and Crafts Movement. These model villages or suburbs were laid out with the health of the residents as a principal consideration; they became the flagships of the emerging international housing reform movement, which attempted to eradicate the insanitary conditions of working-class housing.

In 1882 the Spanish inventor Arturo Soria y Mata (1844–1920) proposed a linear garden city (Ciudad Lineal), 600 m wide, arranged along rail- or tramlines and intended to link the country's main cities. In the USA an industrial suburb was established on Long Island in 1869, while Chicago described itself as a 'garden city' before the fire of 1871. In the UK, Maurice B. Adams, who superseded R. Norman Shaw in the planning and design of Bedford Park, West London (from 1878), a model Arts and Crafts suburb (*see* QUEEN ANNE REVIVAL, fig. 1), described it as the first garden city. However, it was EBENEZER HOWARD who gave the term common currency from 1898 through his book *Tomorrow: A Peaceful Path to Real Reform*. His aim, to curtail urban growth through planned population dispersal, was clearly opposed to suburban developments. He saw garden cities as independent units in social, economic and political terms and was little concerned with architectural style. However, such various groups as the housing reform movement and the protagonists of the emerging discipline of urban planning seized the garden city idea, and Howard's initial concept of economic and social independence quickly lost its importance. From the turn of the century low-density, model cottage housing rapidly became the fundamental principle of garden city planning, largely due to the influence of Raymond Unwin's theories, which he put into practice with his partner Barry Parker (*see* PARKER & UNWIN) at Letchworth (see fig.) and Hampstead Garden Suburb (from 1905), North London. The latter showed how quickly the garden-city concept developed from the initial insistence on economic and social independence to notions of successful layout, planning and design. Unwin, with his strong affiliations to the architecture of the ARTS AND CRAFTS MOVEMENT and the picturesque planning principles of Camillo Sitte, laid down the artistic canon of the garden city movement in the UK. The planning and building according to these principles of Letchworth Garden City (at a site chosen by Unwin and Howard, and commissioned by the Rowntree family through the Garden City Association) from 1902 firmly placed Britain on the forefront of the housing and urban-planning movement in Europe. Letchworth was a socially mixed community, with resident industries to support the inhabitants. Its zoning of land use and strict control over the design and density of housing most closely matched the original concept of the garden city; many of these features were incorporated into the statutory planning provisions of the British Housing and Town Planning Act of 1909. Hampstead Garden Suburb, by contrast, had no industrial or commercial base, being merely a dormitory suburb; yet it was much praised for its architecture, with the central square (unfinished) designed by Edwin Lutyens. Both ideologically and architecturally, Hampstead Garden Suburb directly followed the philanthropic model villages of the late 19th century.

The Garden City Association had been founded in Britain as early as 1899, and Garden City conferences were held at Bournville (1901) and Port Sunlight (1902), propagating the garden city idea, as well as acknowledging the historic link between the two developments. The British Garden Cities Association held the first International Garden City Congress in London in 1904. A series of international conferences following the congress of 1904, resulted in the foundation of the International Garden Cities and Town Planning Association in 1913. In many countries, including Germany, France, Italy, Spain, Holland, Poland, Russia and the USA, garden city associations were set up. The different national associations represented a large variety of different attitudes and philosophies.

The DEUTSCHE GARTENSTADTGESELLSCHAFT, founded in 1902 and active until the 1930s, mounted its first successful project with the establishment (from 1909) of Gartenstadt HELLERAU, near Dresden. The creator was Karl Schmidt (1873–1948), and the overall plan and a series of standard house designs were by Richard Riemerschmid. Like Bournville and Port Sunlight in England, Hellerau was linked to a manufacturing firm (the Deutsche Werkstätten, which produced well-designed, standardized furniture) and was intended to be a community in which artistic endeavour, labour, leisure and education were harmoniously fused. In France, in spite of active promotion of the garden city notion by Georges Benoît-Lévy, a follower of Howard, garden cities near Strasbourg (1912) and at Paris-Jardins de Draveil (1911) were the only schemes initiated before World War I that were comparable with those in other countries. Between 1920 and 1939, however, 16 garden cities were built in the Seine region, starting with the picturesque and becoming increasingly Functionalist (for illustration of an intermediate scheme at Châtenay-Malabry, see PARIS, fig. 12). The Russian Society of Garden Cities founded many projects based on national traditions of peasant-style construction, wooden urban architecture and industrial settlements. The first was Prozorovskaya Station (1913–14) by Vladimir Semyonov, on the railway line from Moscow to Kazan. Other garden settlements were built near Omsk, Khar'kov (Kharkiv), Odessa and Vladivostok and, in accordance with a policy of decentralization around large cities, in the environs of Moscow and St Petersburg (see RUSSIA, §III, 2). In Finland Eliel Saarinen (see SAARINEN, (1)) conceived a plan embodying a redefinition of the function of monuments and public buildings in city centres and the close linkage of garden cities with them.

Until World War I the international garden city movement was still relatively united in following the lead of Britain, the acknowledged pioneer of housing reform, and Unwin's concept of low-density cottage estates. From 1920 Howard initiated the building of the second garden city, Welwyn. The plan and many of the houses were designed by Louis De Soissons in a neo-Georgian manner, formal in the centre, informal in the domestic zones. On the whole, however, the heyday of the garden city idea in the international context was over. The International Garden Cities Association was revived, but it changed its name in 1926. On the Continent, the emergence of rational architecture and planning superseded the picturesque

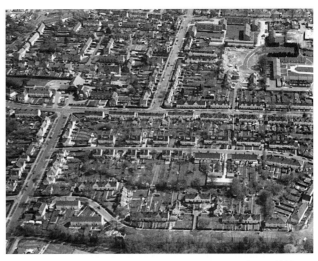

Letchworth Garden City, Hertfordshire, by Parker & Unwin, begun 1903

design principles of the earlier generations. Both the French and Russian garden cities associations began to adopt the more dynamic, linear urban concepts of Soria y Mata instead of the British rural idyll. The concepts of population dispersal in low-density cottage estates and economic decentralization were rapidly replaced by an insistence on modern technology and Functionalist design. In Britain, however, the garden city notion determined the inter-war public housing programme, and continued after World War II with the foundation of the New Towns after the New Towns Act (1946).

See also URBAN PLANNING, §V.

BIBLIOGRAPHY

E. Howard: *Tomorrow: A Peaceful Path to Real Reform* (London, 1898); rev. as *Garden Cities of Tomorrow* (2/1902); Ger. trans. as *Gartenstädte in Sicht*, intro F. Oppenheimer (Jena, 1907)
H. Kampffmeyer: *Die Gartenstadtbewegung* (Leipzig, 1909)
——: *Die deutsche Gartenstadtbewegung* (Berlin, 1911)
C. B. Purdom: *The Building of Satellite towns* (Dent, 1925)
L. Mumford: *The Culture of Cities* (London, 1938)
F. J. Osborne: 'The Garden City Movement: A Revaluation' *J. Town Plan. Inst.*, xxxi (Sept–Oct 1945), pp. 193–207
W. Creese: *The Search for Environment* (New Haven, 1966)
Arch. Rev., [London] clxiii/976 (June 1978) [special issue on garden-city movement]
M. E. Huls: *History of the Garden City Idea: A Bibliography*, Vance Bibliographies, Architecture Series Bibliography No. 1574 (Monticello, IL, 1986)
S. Buder: *Visionaries and Planners: The Garden City Movement and the Modern Community* (Oxford, 1990)

Gardijn, Karel du. *See* DU JARDIN, KAREL.

Gardner, Alexander (*b* Paisley, Scotland, 17 Oct 1821; *d* Washington, DC, 11 Dec 1882). American photographer of Scottish birth. He was apprenticed to a jeweller (*c.* 1835–43) until his interest in optics, astronomy, chemistry, literature and social welfare led him to move to Glasgow. There he took a position as a reporter for the news journal *Sentinel* of which he eventually became editor. He is believed to have been a self-taught photographer. Gardner had plans to found a Utopian socialist community in the USA, but when he emigrated in 1856 it was with a fare

paid for by the photographer Mathew B. Brady. They had met in England in 1851 at the Great Exhibition. Brady appointed him manager of another branch of his gallery in Washington, DC, in 1858, after first giving him a position in his studio in New York.

When the American Civil War broke out in 1861, Brady appointed Gardner to lead a photographic team to accompany the Union armies. Their aim was to make a potentially commercial record of the war. The photographs produced by this group constitute the first comprehensive photographic document of a war in all its aspects and thus a major development in the history of photojournalism. In 1862, however, Gardner argued with Brady over the issue of these photographs being published under Brady's name. Gardner left Brady's employ, taking with him a number of other photographers, as well as his negatives. He established his own studio and gained an appointment as Official Photographer for the Army of the Potomac. The particular privilege he enjoyed in this position enabled him to make documents of some of the most important events and people of the war period. His portraits of *Lincoln* (see W. Welling: *Photography in America: The Formative Years, 1839–1900*, New York, 1978, p. 144) are among the most famous in 19th-century photography, and his series of portraits of the Lincoln assassination conspirators and the views of their subsequent execution are among the masterpieces of photographic reportage. His photographs were direct, informative and unsentimental.

In 1866 Gardner published 100 original photographic prints in two volumes as *Gardner's Photographic Sketch Book of the War*, taken by a team of photographers. Each picture, for example *A Sharpshooter's Last Sleep, Gettysburg, July, 1863* (see Gardner, pl. 40), was individually credited and was accompanied by an explanatory text, most probably written by Gardner himself. Unfortunately, this project was not a financial success due to the national desire to forget the horrors of the event. Gardner also sought to sell his negatives to the government but met a similar lack of interest.

In 1867 Gardner became the Official Photographer for the Union Pacific Railroad. He documented scenes along the lines in Kansas, West Mississippi and Missouri, showing Native American life, railway construction and landscapes. He maintained his portrait studio in Washington, DC, during the 1870s and enjoyed a reputation as one of the most famous photographers of his era.

For further illustration *see* PHOTOGRAPHY, fig. 14.

PHOTOGRAPHIC PUBLICATIONS
Gardner's Photographic Sketch Book of the War, 2 vols (Washington, DC, 1866/*R* New York, 1959)

BIBLIOGRAPHY
R. Taft: *Photography and the American Scene* (New York, 1938)
D. H. Mugridge: *The Civil War in Pictures* (Washington, DC, 1961)
C. Beaton and G. Buckland: *The Magic Image* (London, 1975)
L. Witkin and B. London: *The Photograph Collector's Guide* (London, 1979)

GRANT B. ROMER

Gardner, (Ernest) Arthur (*b* 16 May 1878; *d* Harrow-on-the-Hill, London, 29 Jan 1972). English writer. He inherited both his interest in medieval art and his photographic skills from his father, the antiquary Samuel Gardner. After graduating from King's College, Cambridge, in 1901, Gardner entered the family business, the stockbrokers Laurence, Son and Gardner, with whom he remained for 40 years. His contribution to the study of medieval architecture and sculpture was considerable. He travelled throughout the British Isles and the Continent, building up an impressive photographic record of medieval monuments. This collection, now absorbed by the Conway Library of the Courtauld Institute of Art, London, includes many buildings that have since been destroyed, restored or otherwise transformed, and consequently it is of enormous value to scholars. Gardner's most significant publications were broad surveys of medieval sculpture, which, rather than offering new interpretations of the material, usefully synthesized the findings of other scholars. Many of his works became standard textbooks for students but, by virtue of being so sumptuously illustrated, they also succeeded in making medieval art more accessible to the layman. His first major work, *An Account of Medieval Figure Sculpture in England* (1912), co-written with E. S. Prior, provided the basis of numerous later works such as *English Medieval Sculpture* (1935), 'Alabaster Tombs of the Gothic Period' (1923) and *Minor English Wood Sculpture, 1400–1550* (1958). Other books dealt generally with French sculpture (*Medieval Sculpture in France*, 1931) and architecture (*An Introduction to French Church Architecture*, 1938).

WRITINGS
with E. S. Prior: *An Account of Medieval Figure Sculpture in England* (Cambridge, 1912)
French Sculpture of the 13th Century: 78 Examples of Masterpieces of Medieval Art: Illustrating the Works at Reims (London, 1915)
'Alabaster Tombs of the Gothic Period', *Archaeol. J.*, lxxx (1923), pp. 1–80
Medieval Sculpture in France (Cambridge, 1931)
English Medieval Sculpture (Cambridge, 1935, rev. 3/1951)
An Introduction to French Church Architecture (Cambridge, 1938)
Alabaster Tombs of the pre-Reformation Period in England (Cambridge, 1940)
The Lincoln Angels (Lincoln, 1952)
Wells Capitals (Wells, 1956)
Minor English Wood Sculpture, 1400–1550 (London, 1958)

BIBLIOGRAPHY
Obituary, *King's College Annual Report* (Cambridge, 1972), pp. 36–7

KATHRYN MORRISON

Gardner, Daniel (*b* Kendal, *c.* 1750; *d* London, 8 July 1805). English painter. He was born into a middle-class family and at some time before 1762 was taught by George Romney. This relationship was renewed in 1767 when Gardner moved to London, where he studied at the Royal Academy Schools from 1770 and was awarded a silver medal in 1771. Around 1773 he entered Joshua Reynolds's studio and during his brief time there developed an approach to portraiture that he was to use for the rest of his career. Gardner's pair of oval portraits *The Rev. John Clarke* and *Emma, Mrs John Clarke* (*c.* 1772–3; priv. col., see 1972 exh. cat., nos 34 and 35) are typical examples of his work in pastel and are characterized by a nervous and agitated style. In the mid-1770s he gave more substance to his work by using a mixture of oil, gouache and pastel, and for larger works he used oils. *Lady Jane Halliday and Child* (*c.* 1775; priv. col., see 1972 exh. cat., no. 53) is one of the first paintings for which he used this mixed technique. His most accomplished and charming works are family groups, such as *Mrs John Moore with her Children*

(c. 1780; London, Tate), *Mrs Justinian Casamajor with Eight of her Children* (1779; New Haven, CT, Yale Cent. Brit. A.) and, on a much larger scale, *The Heathcote Family* (c. 1800; Montacute House, Somerset, NT).

BIBLIOGRAPHY
Waterhouse: *18th C.*
Daniel Gardner, 1750–1805 (exh. cat. by H. Knapp, London, Kenwood House, 1972)
HUGH BELSEY

Gardner [née Stewart]**, Isabella Stewart** (*b* New York, 14 April 1840; *d* Boston, MA, 17 July 1924). American patron, collector and museum founder. (All works cited are in Boston, Isabella Stewart Gardner Mus.) The daughter of a wealthy New York merchant and wife of the prominent Boston banker, John L. Gardner jr (1837–98), she bought her first important painting in 1873—a small landscape by the Barbizon painter Charles-Emile Jacque. In the 1870s she also began to collect rare books, manuscripts, autographs and etchings, under the influence of Charles Eliot Norton. Although she continued to buy such pieces until her death, after the 1880s books took second place to art. During a trip to Europe in 1886, she visited the London studios of James McNeill Whistler and John Singer Sargent, both of whom painted her portrait, and it was at that time that she decided to give serious thought to collecting art.

Mrs Gardner purchased her first Old Master painting in 1888—a *Madonna* by Francisco de Zurbarán, which became her personal altarpiece. A summer visit to Venice that year kindled her interest in Venetian architecture, and subsequent travels provided her with the opportunity to study important paintings in London and Paris, while strengthening her enthusiasm for collecting. She became friendly with Bernard Berenson, whom she had met when he was a young Harvard student in 1886–7. She partly underwrote the postgraduate study trip to Europe in which he began his study of early Renaissance Italian painting, and it was largely through his assistance that she created the collection housed in her Boston mansion, now known as Fenway Court. Begun in 1899 and opened to the public in 1903, Fenway Court incorporated antique and Renaissance architectural fragments imported from Italy to create the appearance of a Venetian palazzo that would serve as both a public museum and private residence. The collection includes paintings, sculpture, drawings and prints, furniture, textiles, ceramics and glass. Among its treasures are Titian's *Rape of Europa* (c. 1560), Vermeer's *The Concert* (c. 1662), Raphael's *Count Tommaso Inghirami* (c. 1512), Rubens's *Thomas Howard, Earl of Arundel* (c. 1529–30) and Rembrandt's *A Lady and Gentleman in Black* (1633) and *Self-portrait* (c. 1629). With Berenson's advice, Mrs Gardner bought such important early Italian paintings as Giotto's *Presentation of the Child Jesus in the Temple* (c. ?1320s), the *Annunciation* (c. 1481) by Antoniazzo Romano, *Hercules* (c. 1465) by Piero della Francesca and *The Tragedy of Lucretia* (c. 1504–10) by Botticelli.

Mrs Gardner managed Fenway Court singlehandedly until 1919, when she handed over its direction to Morris Carter, formerly of the Museum of Fine Arts, Boston. Through her friendship with scholars and connoisseurs, she exercised considerable influence on the collecting and exhibition policies of the Museum of Fine Arts and, through that institution, on Boston's cultural life. In her will Mrs Gardner froze her collection so that it would permanently reflect her personality and taste. Fenway Court was established 'as a Museum for the education and enjoyment of the public forever'. On its seal she inscribed a phoenix, symbol of immortality, and the motto: 'C'est mon plaisir'—her justification for a life devoted to the enjoyment and encouragement of art.

BIBLIOGRAPHY
M. Carter: *Isabella Stewart Gardner and Fenway Court* (Boston, 1925/R 1972)
P. Hendy: *European and American Paintings in the Isabella Stewart Gardner Museum* (Boston, 1931, rev. 1974)
A. B. Saarinen: *The Proud Possessors* (New York, 1958)
L. Hall Tharp: *Mrs. Jack* (Boston, 1965)
R. Hedley, ed.: *Drawings: Isabella Stewart Gardner Museum* (Boston, 1968)
L. B. Miller: 'Celebrating Botticelli: The Taste for the Italian Renaissance in the United States, 1870-1920', *The Italian Presence in American Art, 1860-1920*, ed. I. Jaffe (New York, 1992), pp. 1–22
LILLIAN B. MILLER

Gardy Artigas, Joan. *See* ARTIGAS.

Garemijn [Garemyn]**, Jan Antoon** [Joannes Antonius] (*b* Bruges, 15 April 1712; *d* Bruges, 23 June 1799). Flemish painter and draughtsman. He was apprenticed to Roch Aerts (*d* ?1721/39), continued his training at the Bruges Académie and later studied with Louis Roose (1701–65) and the sculptor Hendrik Pulinx. However, his characteristic style, evident from 1730, owed most to Jacob Beernaert. Matthias de Visch (1702–65), whom he succeeded as director of the Académie, introduced Garemijn to the graceful Italian style and to the mannered drawing-room scenes typical of the French masters Antoine Watteau and François Boucher.

Garemijn is perhaps best known for his large, multifigured painting, the *Digging of the Ghent Canal* (?1753; Bruges, Groeningemus.). After his appointment to the Académie, he received many commissions from the clergy, the nobility and the middle class. His religious scenes are conventional and imitate the famous Flemish Baroque masters. More individual are his portrayals of the picturesque aspects of everyday life among the aristocracy, bourgeoisie and working classes. These are colourfully painted, harmonious compositions (e.g. *Afternoon Tea*, 1778; Bruges, Groeningemus.; *see* BELGIUM, fig. 18). He painted few portraits, though some studies of heads of peasant types survive among his many drawings. He was much in demand to decorate panels in salons and dining-rooms, for which he often painted allegories, the Four Seasons being a favourite subject. His paintings and drawings are preserved in the museums of Bruges and in many churches in the city and its environs. In a rather undistinguished period of Flemish painting, he occupies a worthy position.

BIBLIOGRAPHY
A. Janssens de Bisthoven: 'De schilder Jan Garemijn (1712-1799)', *Drie Vlaamse meesters van de XVIIIde eeuw* (exh. cat., Bruges, Stadshallen, 1955), pp. 11–68
B. De Prest: *Directeur Jan Garemijn als kunstschilder* (Bruges, 1970)
D. De Vos: *Groeningemuseum, Bruges: The Complete Collection* (Bruges, 1984), pp. 80–83
W. LE LOUP

Gargallo, Pablo (*b* Maella, Saragossa, 5 Jan 1881; *d* Reus, Catalonia, 28 Dec 1934). Spanish sculptor. He moved with his family to Barcelona in 1888 and at age 13 entered the studio of the sculptor Eusebio Arnau y Mascort (1864–1933) as an apprentice, producing his first works, including a small *Virgin* in plaster (1894; Saragossa, Mus. Prov. B.A.). He took part in exhibitions from 1898 and studied at the Escuela de Bellas Artes de La Lonja from 1900, before visiting Paris on a grant from October 1903 to March 1904. On his return to Barcelona he worked from 1905 to 1910 on commissions from architects to produce the decorations (busts, statues and bas-reliefs) of several public buildings, including the Hospital de Sant Pau i Sant Creu (1904–5) and the Palau de la Música (1904–7), both by Lluís Domènech i Montaner, and the Teatre Bosque (1907). Garagallo's early works were executed primarily in stone, as in the case of *Cleopatra* (marble, h. 880 mm, 1902; priv. col., see Courthion, p. 26), one of a small group of works bearing the fleeting trace of Art Nouveau influence; but during a brief stay in Paris at the end of 1907, when he worked in the studio of the sculptor Robert Wlérick (1882–1944), he used copper for a *Small Mask with a Lock of Hair* (h. 80 mm; Paris, Petra Anguera-Gargallo priv. col., see Courthion, p. 129). Henceforth, although he did not abandon stone, Gargallo favoured materials such as copper, hammered lead or iron, opening the way to a new aesthetic and a new technique in sculpture.

Gargallo lived in Paris again from 1912 to 1914, suffering considerable hardship despite finding some buyers, among them Léonce Rosenberg, for his metal masks, and producing three versions of a portrait of *Picasso* (all h. 210 mm, 1913; stone version, Barcelona, Mus. A. Mod.; bronze version, Paris, Pompidou; terracotta version, Madrid, Mus. A. Contemp.), whom he had first met in Barcelona in 1900. He returned to Barcelona and in 1915 married a young French woman, Magali Tartanson. Over the next two years, temporarily obliged by illness to give up large-scale sculptures, he made jewellery and works in cutout and repoussé copper, for example *Female Torso* (h. 300 mm, 1915; Paris, priv. col., see Courthion, p. 32). In 1920 he was named Professor at the Escola de Bells Oficis. In 1924 he settled in Paris on the Rue Blomet with his wife and his daughter Petra; he moved house several times in search of the ideal studio, which he found at last on the Rue de Vaugirard. His typical works, such as *Kiki de Montparnasse* (bronze, h. 205 mm, 1928; Paris, Mus. A. Mod. Ville Paris), date from this period; they are executed in a late Cubist style, with the volume of the head defined by curved surfaces on to which the features are superimposed as stylized linear elements. Each metal piece is unique, although Gargallo devised a method for producing variants of particular sculptures by using cardboard models; there are, for example, four versions in copper of *Mask of Harlequin Smiling* (all 170×340 mm, 1927; e.g. Philadelphia, PA, Mus. A.). In the late 1920s he executed large sculptures in stone and bronze for Barcelona, which were erected in the Plaça de Catalunya, Barcelona Stadium and Montjuich. During the 1930s he elaborated his characteristic style in sculptures of animals such as *Cock* (iron, h. 510 mm, 1930; New York, Met.) and in other works such as *Greta Garbo* (iron, 1931; Madrid, Mus. A. Contemp.), *Harlequin with Flute* (iron, 1931; Paris, Pompidou;

Pablo Gargallo: *Antinoüs*, iron, 770×400 mm, 1932 (Duisburg, Wilhelm-Lehmbruck-Museum)

see IRON AND STEEL, fig. 7), *Antinoüs* (iron, 1932; Duisburg, Lehmbruck-Mus.; see fig.) and a portrait of *Marc Chagall* (bronze, 1932–3; Paris, Mus. A. Mod. Ville Paris), treated in a linear fashion with internal hollows. Among his last works was a classicizing *Torso of a Young Girl* (pink marble, 1934; Paris, priv. col., see Courthion, 1973, p. 161). The Museo Pablo Gargallo, devoted exclusively to his work, was opened in 1985 in the Palacio de Argillo in Saragossa.

BIBLIOGRAPHY

P. Courthion: *L'Oeuvre complet de Pablo Gargallo* (Paris, 1973) [with cat. rais. by P. Anguera-Gargallo]

A. Cirici: *Gargallo i Barcelona* (Barcelona, 1975)

J. Anguera: *Gargallo* (Paris, 1979)

Gargallo (exh. cat., Paris, Mus. A. Mod. Ville Paris, 1981)

Gargallo: Exposició del centenari (exh. cat. by M. L. Borras and others, Barcelona, Ajuntament, 1981)
Gargallo (exh. cat., Paris, Gal. Marwan-Hoss, 1983; 1989)
El Museo Pablo Gargallo (Saragossa, 1985)
Gargallo (exh. cat., London, Gimpel Fils, 1986)
Gargallo (exh. cat., New York, Arnold Herst & Co. Gal., 1987)
Catalogo del Museo Pablo Gargallo (Saragossa, 1988)
R. O. Fernández: *Gargallo* (Madrid, 1991)
Gargallo (exh. cat., Pontoise, Mus. Pontoise, 1992)

JEAN SELZ

Gargas. Cave site in France, near Montréjeau in the foothills of the central Pyrenees Mountains. It is important for its examples of Palaeolithic cave art (*see also* PREHISTORIC EUROPE, §II, 1 and 2). The cave of Gargas had long been known for its abundance in skeletons of Ice Age fauna when, in 1906, its art was first reported by Félix Regnault, a local scholar. The material recovered in subsequent excavations is housed in the Institut de Paléontologie Humaine, Paris, and the Muséum d'Histoire Naturelle, Toulouse. The cave comprises 530 m of galleries, in two sectors on separate levels. The lower cave originally had a huge porch, which subsequently collapsed; an artificial entry has been punched through to an enormous gallery *c.* 140 m long and 25 m wide, containing many large stalagmitic formations and several side chambers. The upper cave, reached by a modern staircase, is narrower and more tortuous. There are a few paintings (one in the lower cave and four in the upper) of such animals as bison and ibex, and innumerable meandering finger tracings on the ceiling, some of which form animal figures. However, the fame of Gargas rests on its animal engravings and more particularly on its stencilled hand outlines, all of which are located in the lower cave.

The engravings are grouped primarily in side chambers, especially one called the 'Camarin'. Most of the 148 known animal figures have been attributed to the early Gravettian period (*c.* 27,000–*c.* 22,000 BP) through comparison with depictions of a vaguely similar style found on small stone slabs stratified in the cave's occupation layers. Other engravings, including what may be crossbows, are probably Gallo-Roman and medieval in date. There are about 250 stencilled hand outlines, which were produced either by blowing powder over the hand onto a wet wall or by applying the paint around the hand with a pad. More were done in black (often charcoal) than in red, and left hands dominate greatly, as might be expected if the artists were right-handed. Though certainly Palaeolithic, their exact date is unknown. Bone fragments found in fissures next to some hands have been radiocarbon-dated to 26,860 years ago. In contrast to most examples in other caves, the Gargas stencils are dominated by hands with missing finger joints: these include numerous repetitions of the same hands, suggesting that fewer than 20 men, women and children could account for the whole. The meaning of the missing finger joints remains the subject of debate: some scholars suggest ritual mutilation, others a pathological cause such as Reynaud's disease, a condition akin to frostbite that afflicts the fingers. However, many scholars believe that the fingers were not missing at all, merely bent over in a kind of language of gestures or signals: there are stencils of bent thumbs in the cave, and experimenters have managed to duplicate all the Gargas hand-types by bending their fingers.

BIBLIOGRAPHY
G. Malvesin-Fabre, L.-R. Nougier and R. Robert: *Gargas* (Toulouse, 1954)
A. Leroi-Gourhan: 'Les Mains de Gargas: Essai pour une étude d'ensemble', *Bull. Soc. Préhist. Fr.*, lxiv (1967), pp. 107–22
C. Barrière: *L'Art pariétal de la grotte de Gargas* (Oxford, 1976)
——: 'Grotte de Gargas', *L'Art des cavernes* (Paris, 1984), pp. 514–22
M. Groenen: 'Les Représentations de mains négatives dans les grottes de Gargas et de Tibiran (Hautes-Pyrénées): Approche méthodologique', *Bull. Soc. Royale Belge Anth. Préhist.*, xcix (1988), pp. 81–113
M. Suères: 'Les Mains de Gargas: Approche expérimentale et statistique du problème des mutilations', *Travaux de l'Institut d'Art Préhistorique de Toulouse*, xxxiii (1991), pp. 9–200
J. Clottes and others: 'Des Dates pour Niaux et Gargas', *Bull. Soc. Préhist. Fr.*, lxxxix (1992), pp. 270–74
C. Barrière and M. Suères: 'Les Mains de Gargas', *Doss. Archéol.*, 178 (1993), pp. 46–54

PAUL G. BAHN

Gargiolli, Giovanni (*b* Fivizzano, Tuscany, *c.* 1540; *d* Livorno, 1608). Italian architect, active in Bohemia and Austria. In 1585 he entered the service of Rudolf II in Prague. He designed a domed cylindrical grotto (1586–94) lined with rusticated masonry in the Royal Enclosure at Bubeneč. The banded columns on the façade recall Michele Sanmicheli's Porta Nuova (1533–40) in Verona. The complex included a pool and an arcaded gallery treated as a *sala terrena*. He laid out an Italian garden (1588–93) at the Royal Castle at Brandýs nad Labem. Built on four low terraces, it features a secret garden, a summer-house, fountains and a stone terrace with four flights of steps. At Hradčany Castle, Prague, he planned Rudolf's quarters in the south wing, and the Spanish Stables surmounted by a picture gallery (both executed by Ulrico Aostalli). Gargiolli was probably responsible for an extension to the royal garden in Prague, and for the first brick orangery in Europe (1590). In the same year he built the three-wing hunting castle at Lány, near Prague. Also attributed to him is the St Stanislas Chapel in the south transept of Olomouc Cathedral, which features an Italian Mannerist *trompe l'oeil* on the façade. In 1589 he was appointed Hofbaumeister in Vienna and was ennobled in 1593. He settled in Vienna from 1594 to 1598 and then returned to Italy. He is known to have worked on the fortifications of Livorno in 1601.

BIBLIOGRAPHY
J. Krčálová: 'La Toscana e l'architettura di Rodolfo II: Giovanni Gargiolli a Praga', *Firenze e la Toscana dei Medici nell'Europa del '500: Firenze, 1980*, iii, pp. 1029–51
——: 'Die Gärten Rudolfs II' and 'Die rudolfinische Architektur', *Leids Ksthist. Jb.* (1982), pp. 149–60, 271–308
——: *Rudolfínská architektura* [The architecture of Rudolf II] (1989), ii/1 of *Dějiny českého výtvarného umění* [History of Czech fine art] (Prague, 1984–)

J. KRČÁLOVÁ

Gargiulo, Domenico. See SPADARO, MICCO.

Gargoyle [Lat. *gargulio*: 'throat']. Projection from the roof, parapet or buttress of a building that acts as a water-spout, throwing rainwater clear of the wall to prevent damage to the structure. Gargoyles are a particular feature of European Gothic architecture, Gothic Revival buildings and restorations (see fig.) and also occur in Chinese architecture.

Gargoyles by E.-E. Viollet-le-Duc on the north side of Notre-Dame, Paris, 1844–64

Although best known in its European Gothic manifestations, the concept of a water-spout projecting from the roof line, as well as the decoration of that feature, originated considerably earlier. Examples have been cited at Abusir, Egypt, dating to the 5th Dynasty (*c*. 2465–*c*. 2325 BC). In Greece the 7th-century BC wooden Temple of Apollo at Thermon featured terracotta spouts in the form of masks and lions' heads (Thermon, Archaeol. Mus.). In such Roman buildings as the House of the Niobid, the water-spouts were more visually related to Gothic examples: dogs and lions in a crouching position formed the upper part of the gargoyle with water running out between their front paws through the spout below.

Despite the commonly held view that gargoyles do not appear on Romanesque buildings, some instances have been cited, including one original example among the many modern reproductions on Autun Cathedral (begun 1120). Viollet-le-Duc, one of the great producers of gargoyles in the 19th century, mentioned an example of *c*. 1220 at Laon Cathedral as one of the earliest appearances of the type. These early gargoyles are quite simple in form. The spout is divided longitudinally, the upper section simply carved at the end to form the ears, eyes and snout of a beast and the lower section forming its jaw and forelegs, with water flowing from its mouth and body created by the tubular spout. From the simple form at Laon the gargoyle underwent various transformations into the twisted grotesques most commonly understood by the term, often becoming composite figures: human, animal and mythical. They are not restricted to France or even northern Europe. Examples appear on sites as diverse as

Westminster Abbey (from 1245), Siena Cathedral (completed early 1270s), Prague Cathedral (begun 1344) and the Convento do Cristo (*c*. 1515) in Tomar. They are as common on parish churches as cathedrals, for example at St Andrew, Heckington (Lincs), built *c*. 1330.

The idea of these mythical beasts looming down from the heights of mysterious medieval structures particularly caught the fancy of 19th-century Gothic revivalists. Among the most famous series is that on Notre-Dame, Paris, many of which are actually 19th-century 'restorations' or additions. There water issues from the mouths of various beasts via open channels set in their backs. Attempts have been made to link the appearance of gargoyles with medieval legends and biblical texts, but this would seem too literal an interpretation of these fantastic creatures, which demonstrate the predilection of the Gothic age for combining decoration and function.

In China gargoyles were used as decorative water spouts from at least the Ming period (1368–1644); they are found in buildings associated with the imperial tombs at Chang ling, in the Ming and Qing (1644–1911) structures in the Forbidden City, Beijing, and elsewhere. In the Forbidden City marble gargoyles in the form of dragons' heads channel water from the high terraces that support the imperial halls.

BIBLIOGRAPHY
E.-E. Viollet-le-Duc: *Dictionnaire raisonné de l'architecture française du XIe au XVIe siècle*, 10 vols (Paris, 1854–68)
L. B. Bridaham: *Gargoyles, Chimeres, and the Grotesque in French Gothic Sculpture* (New York, 1930)
J. Baltrušaitis: *Réveils et prodiges: Le Gothique fantastique* (Paris, 1961)
R. Sheridan and A. Ross: *Gargoyles and Grotesques* (Boston, 1975)

LISA A. REILLY

Garh Dhanaura. Village and temple site 3 km from Keskal on the Raipur–Jagdalpur road, Bastar District, Madhya Pradesh, India. Sixteen mounds, cleared by the Department of Archaeology and Museums, Madhya Pradesh, and a number of significant images in the surrounding area, are the most notable features of the site. Twelve mounds yielded temples, which follow designs established at Bhongapal (also in Bastar District), namely a sanctum (Skt *garbhagrha*) with a constricted vestibule (*antarāla*) demarcated by brick pilasters, the sanctum being occasionally provided externally with a central projection (*bhadra*) and sometimes with this and a subsidiary offset (*prati*) and corner offset (*karṇa*). The preference is for a sequence of tall, flat mouldings like the base (*vedībandha*) at the Deorani Temple, TALA. Three of the mounds are large and were built in terrace formation, in a sequence of successive squares or rectangles, of diminishing size and rising height. The square or rectangular plan, with an occasional apsidal sanctum, the plinth (*pīṭha*) with tall water-pot moulding (*kumbha*) and heavy roll cornice (*kapota*), the base with narrow recess moulding (*antarapaṭṭa*) in place of torus moulding (*kalaśa*) and the wall (*jaṅghā*) relieved by plain projections and niches are features of the Garh Dhanaura temples that were anticipated at Bhongapal.

In sculpture, a two-armed, seated Kevala Narasimha from Garh Dhanaura (kept at a later Shiva temple at adjacent Keskal) is close in style to examples from Tala and Ramtek. A standing Vishnu on a slab recovered from

one of the 12 mounds dates to the first half of the 6th century. It retains the huge shoulders of 5th-century figures, enhanced by a cylindrical head and tall crown, but the hardening visible in the incipient linear accent below its knees and chest, the sharp curve of the cloth and the dwarfing of the legs seem to follow the style of the Jethani Temple at Tala. The characteristics implicit in this Vishnu image are more pronounced in a second Vishnu (c. late 6th century), which was recovered from the largest terraced temple. The body of this image is longer, as is the crown. The halo is elliptical, further elongating the head. The legs are almost like round columns.

Another group of images from Garh Dhanaura and adjacent sites shows broader, squarer and heavier forms. The most important are a seated Kevala Narasimha with a partially broken left arm recovered from the sanctum of one of the smaller mounds, a slab carved with a standing four-armed Vishnu found at nearby Deo Dhanaura, a two-armed standing ascetic (probably Shiva) carved on a slab located in the forest of Garh Dhanaura and a four-armed Vishnu found at the Chaturbhuj Temple, Badbar, near Keskal. These all display a transition from tightly muscled bodies to a more relaxed form and a squaring of the entire body. Thickening of the legs, waist and head is accompanied by a curbing of the height of the crown and a slight drop in the shoulders.

See also INDIAN SUBCONTINENT, §III, 5(i)(f).

BIBLIOGRAPHY
D. M. Stadtner: *From Sirpur to Rajim: The Art of Kośala during the Seventh Century* (diss., Berkeley, U. CA; microfilm, Ann Arbor, 1977)
KALYAN KUMAR CHAKRAVARTY

Garimberto, Gerolamo (*b* Parma, 1506; *d* Rome, 1575). Italian bishop, antiquarian and collector. He went to Rome some time before 1527, serving as a canon of St Peter's and as vicar of S Giovanni in Laterano (where his mortuary monument remains) before being made Bishop of Gallese by Pius IV in 1562. By this date he had published five books, the first of which, *De reggimenti pubblici delle città*, appeared in 1544. In 1550 Ulisse Aldrovandi recommended his readers to the antiquarian collection 'nella camera di messer Hierolimo Garimberto' in the Palazzo Gaddi on Monte Citorio. In 1562 Garimberto helped to evaluate the antiquities that Paolo Bufalo offered to Cardinal Alessandro Farnese. He also served as archaeological adviser to Cesare Gonzaga, Lord of Guastalla, and to his cousin Guglielmo Gonzaga, 3rd Duke of Mantua. The extensive correspondence (1562–73) with the former and the letters written to the latter in 1572–3 provide a highly readable source of information on the contemporary Roman antiquities market and on Garimberto's relations with such other antiquarians and dealers as Alessandro de' Grandi (*d* after 1590) and Vincenzo and Giovanni Antonio Stampa (active in Rome 1550–80). His own collection of antiquities is documented in detailed inventories of 1567 and 1576 sent to Albert V, Duke of Bavaria, in anticipation of a possible sale. Several of the works described can be related to engravings of items 'in Museo Garimberti', shown in books 3–4 of Giovanni Battista de' Cavalieri's *Antiquarum statuarum urbis Romae* (1594), and of these some can be identified with extant

works as, for example, the *Infant Hercules Wrestling with Snakes* (Turin, Mus. Civ. A. Ant.), the acquisition of which is mentioned in the correspondence with Cesare Gonzaga. The same source documents the major purchase of his career, the collection of the Milanese merchant Francesco Lisca (*d* 1564/5), which he bought in 1565. In 1572 Garimberto wrote to Cesare Gonzaga describing his library of over 2000 books, arranged according to subject and interspersed with busts of many of the authors, his gallery displaying figurines and imperial heads and his loggia containing 'statove grande del naturale' (i.e. life-size statues). He was not the most learned member of the contemporary Roman intelligentsia, but his aspirations were typical and are unusually well documented.

BIBLIOGRAPHY
I. Affò and A. Pezzani: *Memorie degli scrittori e letterati parmigiani*, 7 vols (Parma, 1789–1833), iv, pp. 135–44; vi, pp. 542–7
P. P. Bober: 'Francesco Lisca's Collection of Antiquities: Footnote to a New Edition of Aldrovandi', *Essays in the History of Art*, ii of *Essays Presented to Rudolf Wittkower on his 65th Birthday*, ed. D. Fraser, H. Hibbard and M. J. Lewine (London, 1967), pp. 119–22
C. M. Brown: 'Major and Minor Collections of Antiquities in Documents of the Later 16th Century', *A. Bull.*, lxvi/2 (1984), pp. 496–507
——: 'Paintings and Antiquities from the Roman Collection of Bishop Gerolamo Garimberto Offered to Duke Albrecht Vth of Bavaria in 1576', *Xenia*, x (1985), pp. 55–70
C. Riebesell: *Die Sammlung des Kardinal Alessandro Farnese* (Weinheim, 1989)
C. M. Brown: *Cesare Gonzaga and Gerolamo Garimberto: Two Renaissance Collectors of Greco-Roman Art* (New York and London, 1993)
C. M. BROWN

Garland, Colin (*b* Sydney, Australia, 1935). Jamaican painter. He studied painting first at the National School of Art, Sydney (1953–5) and later at the Central School of Art and Design, London (1959), before emigrating to Jamaica in 1962. He arrived in the island a very competent painter, with the rudiments of his style in place. Inspired essentially by Surrealism and Magic Realism, he also studied the work of various artists who have exhibited a taste for the fantastic, such as Botticelli, Bosch, Giuseppe Arcimboldo and Richard Dadd. He also benefited from his knowledge of the art of John Dunkley and some of the Haitian primitives. Jamaica and Haiti were his principal sources of inspiration. The land and sea, the flora, the birds, fish and the people of varied types and exotic costumes all feature in his surreal juxtapositions. The paintings are hard to decipher and indeed Garland claimed that they are not meant to be unravelled like puzzles, but to be simply viewed as exotic fantasias. However, paintings such as *End of an Empire* (1971; artist's col.) and *In the Beautiful Caribbean* (1974; Kingston, Inst. Jamaica, N.G.) demonstrate his interest in constructing a more coherent iconography. He was also a sensitive portraitist, illustrator and stage designer, although his excursions into these areas were rare.

BIBLIOGRAPHY
P. Archer-Straw and K. Robinson: *Jamaican Art* (Kingston, 1990)
DAVID BOXER

Garland, Nicholas (Withycombe) (*b* London, 1 Sept 1935). English caricaturist and draughtsman. He attended the Slade School of Art, London (1954–7). For some years he was a theatre director and stage manager but gave up this career to earn his living drawing cartoons. The 'Barry

McKenzie' comic strip (1964–74), conceived together with the writer and comedian Barry Humphries for the satirical magazine *Private Eye*, was one of his earliest and most successful creations. From 1966 to 1986 Garland was employed by the *Daily Telegraph* as their first political cartoonist; he later worked for a short time at *The Independent* (1986–91) before returning to his former newspaper. His cartoons have also appeared in several periodicals, for example the *New Statesman & Society* and *The Spectator*, and he has produced many illustrations for books. Garland's work is greatly influenced by the earlier cartoonist 'Vicky' (Victor Weisz, 1913–66) and is reinforced by his literary knowledge. His cartoons, covering a vast gallery of contemporary political figures, provided a perceptive commentary on current affairs for more than three decades. What was probably Garland's most effective cartoon was executed in 1990, shortly after the Conservative minister Nicholas Ridley made an outburst against the German Chancellor Helmut Kohl and consequently had to resign: the biting cartoon depicted Ridley running off with a paintbrush and paint, having daubed a Hitlerstyle moustache on to the Chancellor. Garland was also actively involved in the campaign by the Cartoon Art Trust for a permanent museum in England devoted to cartoon art. He has exhibited widely in England, including at the Cartoon Gallery, London, an important showcase for contemporary humorous art, once run by the cartoonist Mel Calman (1931–94).

PUBLICATIONS

with B. Humphries: *The Wonderful World of Barry McKenzie* (London, 1968)
An Indian Journal (Edinburgh, 1983)
Twenty Years of Cartoons by Garland, intro by A. Howard (Edinburgh, 1984)
Travels with my Sketchbook: A Journey through Russia, Poland, Hungary and Czechoslovakia (London, 1987)
with B. Humphries: *The Complete Barry McKenzie* (London, 1988)
Not Many Dead: Journal of a Year in Fleet Street (London, 1990)

BIBLIOGRAPHY

W. Feaver: *Masters of Caricature: From Hogarth and Gillray to Scarfe and Levine*, ed. A. Gould (London, 1981), p. 212
The Art of Laughter (exh. cat. by L. Lambourne and A. J. Doran, Oxford, Ashmolean, 1992)
M. Bryant and S. Heneage: *The Dictionary of British Cartoonists and Caricaturists, 1730–1980* (Aldershot, 1994)

S. J. TURNER

Garlick, Beverly (*b* Melbourne, 7 Sept 1944). Australian architect. She studied architecture at the University of Melbourne, graduating in 1964. In 1974–85 she worked in the New South Wales Public Works Department, Sydney, on various tertiary buildings. As project architect for the Petersham College of Technical and Further Education (1982) in Crystal Street, Petersham, she was the first woman in New South Wales to receive a merit award from the Royal Australian Institute of Architects for a nonresidential building. Externally the building is four storeys high but internally these storeys tier down to an oasis-like courtyard formed by the new building and the existing buildings. The college is red brick with terracotta tiled roofs facing the courtyard. The choice of domestic materials in the institutional setting was deliberate; the harsh external wall of the building contrasts with the softer internal space with its layers of roofs. Contrasts between enclosed and exposed spaces were a continuing interest for Garlick and are ideas she further explored in her own practice, established in 1987. Much of her work was residential, for example Winnie's House (1987), Torquay, Victoria, and Shirley's House (1991), Sydney; Winnie's House is essentially a 'bent wall' that forms a courtyard to the north giving protection from the southerly winds. The rooms of the house are formed from skillion roofs supported off this face-brick wall. She also designed medium-density housing projects (e.g. at Leichhardt, 1994) and refurbished Sydney's Italian quarter in Norton Street, Leichhardt, in 1994 to accommodate a regular weekend street market, introducing culturally appropriate urban design with such elements as lighting, trees, paving, street furniture and changes in awnings. The project draws its design language from Italian historical precedents but aims at a regional and modern interpretation. Garlick taught design at the University of Sydney (1985–92) and University of Technology, Sydney (1984, 1993–5).

WRITINGS

'Piazza Leichhardta': Parramatta Road Ideas Competition, *Archit. Show* (Oct 1986), pp. 26–31
'Singular Women', *Archit. Bull.* (June 1986), p. 13 [book review]
'Shirley's House, 100 Cecily St, Lilyfield', *Archit. Show* (May/June 1991), pp. 26–8

BIBLIOGRAPHY

N. Quarry: 'Petersham College', *Archit. Australia*, lxxiii/3 (1984), pp. 46–52
P. Middleton: 'Enclosure and the Fair Go', *Archit. Bull.* (Aug 1991), p. 17
D. Jones: 'Designing a Wisma in Indonesia: A Student Project', *Archit. Bull.* (Aug 1994), pp. 6–7 [about project sponsored by Garlick]

ANNA RUBBO

Garner, Sir Harry (Mason) (*b* Wymeswold, Loughborough, 3 Nov 1891; *d* Camberley, Surrey, 7 Aug 1977). English art historian, collector and scientist. After reading mathematics at the University of Cambridge, in 1916 he joined the Royal Aircraft Establishment, where he remained until his retirement in 1952, becoming a distinguished specialist in aeronautics and an expert on metal fatigue. In the 1930s he became interested in Chinese blue-and-white porcelain and soon after began a scientific study of the material. He began collecting Chinese porcelain but in assembling his collection was not solely concerned with scientific aspects. His book *Oriental Blue and White*, the results of his research and a summary of contemporary knowledge on the subject, became a standard reference text. He later became interested in cloisonné enamels, of which he made a notable collection, publishing his research in 1962, the first comprehensive work on the subject. In this he exploded the theory, which had existed since the 17th century, that any piece of cloisonné enamel with a Jingtai reign mark (1450–56) was a genuine 15th-century example. Garner proved that the mark was almost always spurious, having been added later on a plate affixed to the object. He turned next to the much more complex problems of Chinese lacquer, closely examining techniques and distinguishing the different workshops in Sichuan, Zhejiang and Yunnan provinces, work that he completed only a few weeks before his death. He was Honorary Secretary and President of the Oriental Ceramic Society and wrote numerous articles, published in a wide range of art-historical and scientific journals.

WRITINGS

Oriental Blue and White (London, 1954, rev. 3/1970)

'The Use of Imported and Native Cobalt in Chinese Blue and White', *Orient. A.*, n.s., ii/1 (1956), pp. 48–50

'Guri Lacquer of the Ming Dynasty', *Trans. Orient. Cer. Soc.*, xxxi (1957–9), pp. 61–73

Chinese and Japanese Cloisonné Enamels (London, 1962, 2/1970)

'Diaper Backgrounds on Chinese Carved Lacquer', *A. Orient.*, vi (1966), pp. 165–89

'The Origins of the Famille Rose', *Trans. Orient. Cer. Soc.*, xxxvii (1967–9), pp. 1–17

Chinese and Associated Lacquer from the Garner Collection (exh. cat., London, BM, 1973)

Chinese Lacquer (London, 1979)

MARGARET MEDLEY

Garneray [Garnerey]. French family of artists. Among the many pupils of the painter (1) Jean-François Garneray were his three sons (2) Louis Garneray, (3) Auguste Garneray and Hippolyte(-Jean-Baptiste) Garneray (*b* Paris, 23 Feb 1787; *d* Paris, 7 Jan 1858); a daughter, about whom little is known, seems to have worked most closely with Auguste. Hippolyte was a painter and engraver, producing landscapes of Brittany and Normandy (examples in La Rochelle, Mus. B.-A.; Douai, Mus. Mun.; Paris, Louvre).

(1) Jean-François Garneray (*b* Paris, 1755; *d* Auteuil, 11 June 1837). Painter. He was one of Jacques-Louis David's earliest pupils, probably entering his studio in 1782. He worked with David on portrait commissions, most notably on *Dr Alphonse Leroy* (1783; Montpellier, Mus. Fabre), where he was responsible for the clothing and hands, but inexplicably he (or more likely David) chose a pose that seems to deny the sitter a left hand. He did not make his Salon début until 1791; during the French Revolution he drew and painted many important figures, including *Joseph Barra* and *Charlotte Corday* (both untraced; engraving of *Barra* by Pierre-Michel Alix after Garneray, 1794; Paris, Mus. Carnavalet). Garneray was evidently present at Corday's trial, as he recorded how she posed impassively when she realized her portrait was being drawn. The portrait of a deputy to the Convention, *Jean-Baptiste Milhaud* (*c.* 1794; Paris, Louvre), has also been attributed to Garneray on the basis of his signed and dated miniature copy (1794; Paris, Louvre), although it was previously given to David because of a false inscription; later even Garneray's authorship was disputed (see 1989 exh. cat.). After the Revolution, Garneray continued his successful portrait practice and also moved into historical genre. Many of his portraits, for example *Citizen Ol and his Wife* (exh. Salon 1801; Paris, priv. col.), have a Dutch quality, then much in vogue, while his excursions into historical genre indicate both a nostalgia for the *ancien régime* and some relationship with the Troubadour style (e.g. *Diane de Poitiers Asking Francis I to Pardon her Father*, 1817; the *Duc de Montansier Taking the Young Dauphin, Son of Louis XIV, into a Peasant's Cottage*, 1827; both untraced). Towards the end of his life he also produced numerous paintings of church interiors, again invoking a profound debt to Dutch art.

BIBLIOGRAPHY

Bellier de la Chavignerie–Auvray

P. Chaussard: 'Notice historique et inédite sur M. Louis David', *Le Pausanias français: Etat des arts du dessin en France à l'ouverture du XIXe siècle: Salon de 1806* (Paris, 1806), p. 154

J. Renouvier: *Histoire de l'art pendant la Révolution*, i (Paris, 1863), pp. 210–12

G. Brière: 'Sur David portraitiste', *Bull. Soc. Hist. A. Fr.* (1945–6), pp. 172–3

David et Rome (exh. cat., ed. A. Senllaz, V. van de Sandt and R. Michel; Rome, Acad. France, 1981–2), pp. 168–72

La Révolution française et l'Europe, 1789–1799 (exh. cat., ed. J. R. Gaborit and others; Paris, Grand Pal., 1989), ii, pp. 493–4

SIMON LEE

(2) (Ambroise-)Louis Garneray (*b* Paris, 19 Feb 1783; *d* Paris, 11 Sept 1857). Painter, illustrator and museum keeper, son of (1) Jean-François Garneray. He studied briefly with his father, before embarking as an apprentice on the frigate *La Forte*. After narrowly avoiding capture by the English in the Ile-de-France in 1799, he worked briefly as a draughtsman for a boatbuilder in Mauritius and then returned to sea on an expedition to chart the coast of Madagascar. His short but picturesque career at sea ended when he was taken prisoner by the English in 1806. During his confinement in a prison-ship in Portsmouth, Garneray learnt English and made an income by painting portraits. In 1814 he returned to France, took lessons in aquatint from Philibert-Louis Debucourt and was appointed marine painter to Louis de Bourbon, Duc d'Angoulême (1775–1844). He also painted for Charles, Duc de Berri, and exhibited the first of many shipping scenes in 1815. His collaboration with Etienne Jouy on *Vues des côtes de France dans l'océan et dans le Méditerranée* (Paris, 1823), illustrating the ports of France, gave him the opportunity to travel along the French coasts from 1820 to 1823, drawing the views that he later engraved to illustrate the text. In 1827 he was sent to Greece to paint a work commemorating the *Battle of Navarino* (exh. Salon 1831; Versailles, Château).

In 1832, at his own request, Garneray was made keeper of the Musée de Beaux-Arts, Rouen. In this capacity he published the first catalogue of the collection and set up a society to support the museum; he resigned in 1837 following a reprimand for overspending his account. In 1841, again at his request, he was given a place in the Sèvres manufactory, providing models for the painters to copy on to porcelain. He then spent much of his time at Nice (where he had a house), painting marines for Sèvres and for the Salon in Paris. In 1851 he published a colourful memoir, *Les Scènes maritimes*, which ran to several editions. Some of his paintings, also, are autobiographical, for example *Prison Hulks at Portsmouth* (London, N. Mar. Mus.) and the *Battle of the Kent and the Confiance* (La Rochelle, Mus. B.-A.). Most, however, are simple views of boats at sea, filled with light and movement, as in *Fishing* (Rouen, Mus. B.-A.), which he presented to the museum at Rouen in 1832; it shows a boat heaving on a swell against a windswept sky in a manner that recalls the early work of Turner, whose marine paintings he must have known.

BIBLIOGRAPHY

Marseille et les grands ports français vus par Louis Garneray (exh. cat., Marseille, Mus. Mar., 1984)

(3) Auguste(-Simon) Garneray (*b* Paris, 1785; *d* Paris, March 1824). Painter, printmaker, illustrator and designer, son of (1) Jean-François Garneray. He studied with his father and with Jean-Baptiste Isabey. He was appointed

Peintre du Cabinet to Queen Hortense, Josephine's daughter, a title he retained after the fall of the Bonapartes, when Caroline, Duchesse de Berri, appointed him her drawing-master. From 1808 until his death he exhibited many portraits (e.g. *Queen Hortense in her Boudoir*, 1811; Paris, priv. col., see Praz, fig. 162), miniatures and vignettes. He also painted landscapes and illustrated books (Mme de Genlis's *La Duchesse de la Vallière*, 1805; Mme Cottin's *Mathilde*, 1804; the works of Molière and others). Apart from a few lithographs dated 1819, his prints consist entirely of etchings of theatrical costumes, many of which were published in his series *Receuil des costumes de tous les ouvrages dramatiques representés avec succès sur les grands théâtres de Paris* (Paris, 1819–22). He designed costumes for the Académie Royale de Musique, the Opéra and the Théâtre-Français, all in Paris.

Garneray is remembered chiefly for his interior scenes in watercolour. These recall the more familiar work of Isabey, although Garneray's subject is the room itself and Isabey's work has a more pronounced human focus. Garneray's best-known interior, the *Music Room at Malmaison* (Malmaison, Château N.), was begun in 1812 and was finished by his sister in 1832. Others are illustrated and discussed by Praz, including a group dated too late to be by Garneray that may be by his sister.

BIBLIOGRAPHY

M. Praz: *An Illustrated History of Interior Decoration* (London, 1964), p. 196
The Age of Neo-classicism (exh. cat., ACGB, 1972), pp. 704–5

JON WHITELEY

Garni [anc. Gornea]. Armenian village, 30 km east of Erevan in the Abovian district, famous for its pagan and Christian architectural remains. The earliest indications of settlement are the Early Bronze Age (*c.* 2500 BC) foundation courses of Cyclopean masonry (*see* MASONRY, §II) at the site of Garni's fortress, which is strategically situated on a triangular promontory high above the River Azat. An Urartian inscription records its conquest by King Argishti I (*reg* 785–760 BC). The present fortress was probably built in the 3rd century BC, using massive dressed basalt blocks

Garni, peripteral temple, ?second half of the 1st century AD, rebuilt 1978; view from the north-west

reinforced with iron clamps set in lead. Garni is recorded by Tacitus (*Annals* XII.xlv) as the Roman garrison of Gornea in AD 51, shortly after which the fortress was partially dismantled and the garrison expelled (62). If the Greek restoration inscription dated to the eleventh year of the reign of King Trdat is attributed to the first ruler of that name (*reg* 54–60; 63–93) the fortress was largely restored in 77. It consisted of curtain walls interspersed with great square or rectangular towers. A round tower with a rubble core and a dressed stone facing at the entrance to the fortress may be attributed to Trdat III (*reg* 287–98). The fortress suffered in the national revolt of the Armenians against the Sasanians in 451 and may well have been sacked and abandoned during the Arab campaign against Armenia in 640–43. It was restored under the Bagratids in the late 9th century and was maintained as a royal fortress. Extensive finds of glazed and unglazed pottery testify to its continuous occupation at least until the Mongol invasion of 1236. Two Armenian inscriptions dated 1291 and 1315 giving immunity from certain taxes testify to the continuity of urban life in Garni. With the fall of the Ilkhanid regime in the mid-14th century a slow decline began. In 1604 the Safavid shah ʿAbbas I deported most of the population to Isfahan and in 1638 the town was finally destroyed by the Ottomans.

The most renowned monument within the fortress is the peripteral temple (rebuilt 1978; see fig.), orientated north–south, with 24 Ionic columns on a high concrete podium reached by a broad flight of nine steps bounded by low walls with low reliefs showing Atlas figures. The entablature with a markedly projecting architrave and frieze is richly decorated with acanthus fronds, rosettes and standard mouldings, deeply cut and with some undercutting. This indicates that even if the design and ornament are typically Roman the workmen were local, with the requisite experience of carving basalt. The dedication of the temple is disputed. In noting the pronounced similarities to temples such as that at Sagalassos, Trever has dated Garni's temple to the reign of Trajan (98–117) when Armenia was briefly a Roman province, in which case the temple may well have been intended to house a statue of the emperor. The temple was, however, left unfinished, for although sockets were carved for acroteria none appears to have been made. It has also been less convincingly designated to Apollo–Mithras and dated *c.* AD 70 (Arakelian). A complicating factor has been the dating of the restoration inscription of the fortress to AD 77, although the inscription is damaged at certain crucial points. Confusingly, the 5th-century historian Moses Khorenatsi'i attributes the temple, doubtless based on a misreading of the inscription, to Trdat III under the description of a 'cooling house' (i.e. summer palace) for his sister. It has also been identified (Wilkinson) with a funerary structure *c.* AD 150–*c.* 220, possibly for one of the rulers of western Armenia.

To the west of the temple are the remains of a two-storey palace with a grand audience hall originally with a vaulted ceiling resting on eight square axial piers. On its north side are the ruins of a small bath with plastered inner walls, brick hypocaust heating and the remains of a stone mosaic floor finely executed in *opus vermiculatum*

with an elaborate marine scene including sea-gods (identified by Greek inscriptions), nereids, tritons and fish. It shows certain resemblances to mosaics of the second half of the 3rd century AD at Antioch (*see* ANTIOCH (i), §2(iii)); a probable *terminus ante quem* may be the conversion of Armenia to Christianity and the widespread destruction of pagan monuments at the very beginning of the 4th century, since the baths' ruins contained many fragments of broken marble statuary and low reliefs.

Other buildings within the fortress include a domed tetraconch church with a polygonal exterior, which was built in the 7th century AD next to the temple's west wall. The Catholicos Mashtots (*reg* 897–8) added a domed mausoleum to this church. Outside the fortress walls is a church (4th–5th century) with a single four-bay nave ending in a semicircular apse. These and other ruined structures in the surrounding area from the 9th century onwards are all built of volcanic stone, basalt or tufa.

There are also extensive cemeteries, both pagan and Christian. The largest pagan cemetery contains burials datable by associated coin finds between the 1st century BC and the 3rd century AD. The grave goods (Erevan, Hist. Mus. Armenia) included beads, spindle-whorls, locally manufactured pottery, female ornaments and glass, some of which is of fine quality. The Christian cemeteries contain numerous khatchk'ars (commemorative stone crosses); several bear inscriptions of the 9th century, or the 12th–13th century.

BIBLIOGRAPHY
N. G. Buniatov: *Yazycheskiy khram pri dvortse Trdata v kreposti Garni* [The pagan temple attached to the palace of Trdat in the fortress of Garni] (Erevan, 1933)
K. V. Trever: 'K voprosu ob antichnom khrame v Garni (Armeniya)' [The Classical temple at Garni in Armenia], *Sov. Arkheol.*, xi (1949), pp. 285–304
B. N. Arakelian: 'Excavations at Garni, 1949–50' and 'Excavations at Garni, 1951–55', *Contributions to the Archaeology of Armenia*, ed. H. Field (Cambridge, MA, 1968), pp. 13–108, pp. 109–98
A. A. Shahinian: *Arkhitekturniye pamyatniki Garni i Gegarda* [The architectural monuments of Garni and Geghard] (Erevan, 1969)
S. Mnatsakanyan and N. Stepanyan: *Arkhitekturnyye pamyatniki Armyanskoy SSR* [Architectural monuments in the Soviet Republic of Armenia] (Leningrad, 1971)
R. D. Wilkinson: 'A Fresh Look at the Ionic Building at Garni', *Rev. Etud. Armén.*, xvi (1982), pp. 221–4
R. H. Hewsen: 'Aspects of the Reign of Tiridates the Great', *Armenian Studies in Memoriam Haig Bérbérian*, ed. D. Kouymjian (Lisbon, 1986), pp. 322–32
P. Cuneo: *Architettura armena dal quarto al diciannovesimo secolo*, i (Rome, 1988), pp. 128–30, nos 23–5

J. M. ROGERS

Garnier, (Jean-Louis-)Charles (*b* Paris, 6 Nov 1825; *d* Paris, 3 Aug 1898). French architect. A master of the Beaux-Arts style, he established an outstanding reputation, eclipsing the great Neo-classical architects who preceded him and exerting an important influence on succeeding generations in France and also in the USA. His fame is particularly surprising in that it rests to such a large extent on a single work: the Opéra in Paris.

1. Early career, to 1860. 2. The Opéra. 3. Later career and influence.

1. EARLY CAREER, TO 1860. Garnier was the grandson of a blacksmith in the département of Sarthe and the son of a skilled coach-builder who settled in Paris. He enrolled for evening classes at the Ecole de Dessin in the Rue de l'Ecole-de-Médecine (a free course of training that was open to people with a modest income), and then at the age of 15 he joined an independent architect's studio run by Jean Léveil (1801–66), a former pupil of Jean Nicolas Huyot and winner of the Grand Prix de Rome in 1832. Léveil, who was an alcoholic, was imprisoned for debt, but Garnier was accepted into the studio of Louis-Hippolyte Lebas. There he became friendly with Louis-Jules André while also working as a draughtsman for other architects, most notably Viollet-le-Duc, who was at that time completing work at Vézelay. Although he was being taught by one of the last great Neo-classical architects, therefore, Garnier was also aware of a contrasting approach, and he collaborated with Félix-Jacques Duban and Jean-Baptiste-Antoine Lassus on the Sainte-Chapelle as well as preparing a project for the competition to restore Notre-Dame de Paris, of which he was put in charge, with Lassus, in 1844. From this contradictory training Garnier preserved both the artistic emotions acquired from Lebas and the rigorous sense of analysis to which Viollet-le-Duc had accustomed him.

In 1844 Garnier was admitted into the Ecole des Beaux-Arts, and in 1848 he won the Prix de Rome, enabling him to travel. During eight years abroad, he visited Florence, Venice, Siena and Pisa and then went to southern Italy, where, after being impressed by the Etruscan tombs of Corneto, he saw Paestum, Pompeii and Sicily. There he was struck by the fabulous decoration of Palermo and Monreale, examples of which he painted in watercolour with the help of a camera lucida. In 1852 he arrived at the Ecole Française in Athens, from where he travelled on to Aigina with Edmond About to draw up plans of the Temple of Aphaia, and then to Istanbul with Théophile Gautier. On returning to Paris in 1855, Garnier found the city transformed: the space-clearing operations begun under Louis-Philippe between Les Halles and le Châtelet had been successfully completed, and a new landscape of buildings had been planted at the heart of the capital city along with great new boulevards, the new Palais du Louvre, the Avenue Foch and the Bois-de-Boulogne. He worked initially as a deputy inspector of works on the Tour Saint Jacques (under the direction of Théodore Ballu), and then as a site-inspector for the Ecole des Mines, but the disparity between his ambitions and the harsh reality of the profession led to a nervous breakdown, followed by 18 months in a clinic near Paris. His only hope was to find private clients, but fortunately the house that he built in 1859 at 63 (later 75) Boulevard de Sébastopol was praised in the architectural reviews, and the following year he was appointed as the architect responsible for highways in the 5th and 6th arrondissements on the left bank of the Seine. In this capacity he was responsible for the extension of the Boulevard Sébastopol (now the Boulevard St Michel).

2. THE OPÉRA. While beginning a worthy administrative career as a highway architect, Garnier learnt that a public competition was about to be launched for the construction of the new Opéra. The choice of architect was the subject of a dispute between Baron Haussmann (who had entrusted the project to Charles Rohault de Fleury) and the Empress Eugénie (who preferred Viollet-le-Duc), while a rumour suggested that the victor would

be a third party, Crépinet & Boitrel, whose application had been supported by the Director of the Opéra. The academic jury, made up of members of the Institut de France in association with members of the Conseil Général des Bâtiments Civils, eventually short-listed five out of a total of 117 applicants, omitting the most illustrious and likely candidates but including Garnier, along with Paul-René-Léon Ginain, Crépinet & Boitrel, Louis Duc and an architect called Garnaud, who died shortly afterwards. For the second round of the competition Garnier suggested to Ginain that they should collaborate, but Ginain rejected the offer. Garnier was subsequently announced as the sole prize-winner, and an ineradicable hatred developed between the two men.

Using a sense of volume and layout that had previously been defined by Charles Rohault de Fleury, Garnier had the idea of constructing the different parts of the building (the foyer, the auditorium and the fly) in distinct masses and decided to arrange them in tiers in such a way that the perspective varied in depth, gradually increasing the concentration on the façade (see fig. 1). Abandoning the great arched roof-trussing that was dear to François Debret (whose opera house in the Rue Le Pelletier remained the standard model for most of the competitors), Garnier set out the low volume of the foyer in a very emphatic manner, as he did the auditorium and the immense gabled fly tower, which was of an impressive height: more than 60 m high, or three times the height of Parisian buildings at that time (see fig. 2). This analytic and perfectly rationalist vision of spatial volume immediately defined the different functions of the building, but it also created strange disjunctions, the severity of which is reminiscent of the manner in which Léon Vaudoyer arranged masses architecturally in the cathedral of La Major in Marseille.

Garnier's skill in layout was in associating this broken-up sense of space with a continuous and gradual linking up of spaces and points of view, from the furthest point at the Avenue de l'Opéra (the present Place André Malraux) to the nearest (the approach to the Place de l'Opéra between the Rue du 4 Septembre and the crossing of the Boulevard des Capucines). Each important point on the route corresponds to a balanced moment in the visual elaboration of the building, right up to the heart of the building, the great stairway (see STUCCO AND PLASTERWORK, fig. 21). This colossal, brightly lit and multicoloured space, with its imperial flights of stairs with bronze statues and marble columns, culminates in the ivory caryatids at the entry to the theatre boxes. The progression of effects is spectacular and makes the Opéra the most exuberant building of its time and the most characteristic of the Second Empire, although it was not completed until 1875, under the Third Republic. The stairway is in fact the most spectacular element of Garnier's design. This is emphasized by the fact that it is disguised by the gradation of architectural masses on the exterior. This piece of illusionism, the distillation of the skill of the Beaux-Arts system, rivals that of the great Baroque architects. It is not surprising therefore that Viollet-le-Duc was intent on pointing out the defects of the layout, which he criticized mainly for the excessive size of the interior vestibules compared with the relatively small size of the auditorium: 'the auditorium seems to have been made for the stairway rather than the stairway for the auditorium'.

1. Charles Garnier: Opéra, Paris, 1861–75, view from the south

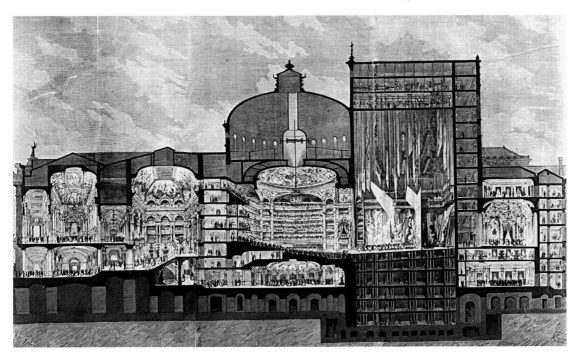

2. Charles Garnier: longitudinal section of the Opéra, Paris, 1861–75; engraving by F. Máulle after K. Fichet and H. Meyer (Paris, Bibliothèque–Musée de l'Opéra): from *Le Journal illustré* (February 1875)

Garnier's use of ornamentation at the Opéra is simultaneously characteristic and banal. As in much architecture of the 19th century there is an excessive use of ornamental keystones in relief patterns on a plain background, but, like all architecture of the time, Garnier's style of ornamentation was contradictory. He pushed figurative realism to extremes, giving the impression that his ornamentation is ready-made, but at the same time he eliminated the effect of this realism by integrating these motifs with a general layout that was so systematically geometrical that it destroyed all sense of the autonomy of décor. The severity of the formal construction reminds the observer constantly of a graphic approach to design and of the subjugation of the applied arts to the architectural structure, in opposition to all classical tradition. In every decorative detail the architect apparently dominated the sculptor (*see also* FRANCE, fig. 12).

3. LATER CAREER AND INFLUENCE. The Opéra was a colossal undertaking that occupied Garnier for 16 years. He never had another such opportunity to show off his talents and largely continued with his official duties as the head of a studio at the Ecole des Beaux-Arts and as a member of the Institut de France. He thus not only taught but also judged those who trained with him, securing prestigious official careers for a few especially brilliant students who won the Grand Prix de Rome and to whom official state commissions for work were offered. He did also continue to undertake some architectural projects. Between 1878 and 1879 he built the elegant Cercle de la Librairie on the Boulevard St Germain, a beautiful example of the rotund style associated with Baron Haussmann, enriched with polychromatic décor that is both seductive

and discreet. On a more monumental scale, the Maison Hachette (1880–81) on the same boulevard, while not possessing the same charm, is a powerfully rhetorical composition that was widely imitated in Parisian architecture at the end of the century.

Also notable is the magnificent Casino (1878–9) of Monte Carlo, where Garnier handled the unexpected combination of plaster façades and polychrome mosaic with astonishing virtuosity. This formal originality, while true to Garnier's artistic temperament, was somewhat excessive, and he was careful later to produce a more restrained effect in the rather disappointing casino in Vittel (1882; destr.) and in the admirable observatory in Nice (1879–86; *see* OBSERVATORY, fig. 4). The latter is a rigorous Palladian construction on which he collaborated with Gustave Eiffel and which is dominated by Frédéric-Auguste Bartholdi's impressive statue of the *Spirit of Science*. Garnier also built two parish churches: at La Capelle-en-Thiérache in the département of Aisne (1883–7) and at Bordighera in Italy (1879–85). Towards the end of his career he spent much of his time away from Paris on the Mediterranean coast, apparently exhausted by the sheer scale of the success that had marked his career. He nevertheless remained an important influence on Parisian architecture at the end of the 19th century.

WRITINGS

A travers les arts (Paris, 1867, R 1985) [with essay on Garnier by F. Loyer]
Le Nouvel Opéra de Paris (Paris, 1878)

BIBLIOGRAPHY

G. Larroumet: *Notice historique sur la vie et les travaux de M Charles Garnier* (Paris, 1899)
C. Moyaux: *Notice sur la vie et les oeuvres de M Charles Garnier* (Paris, 1899)
J.-L. Pascal: *Charles Garnier: Architecte de l'Opéra de Paris* (Paris, 1899)

Charles Garnier et l'Opéra (exh. cat. by A. Laprade, Paris, Opéra, 1961)

J.-F. Revel: 'Charles Garnier: Dernier fils de la Renaissance', *L'Oeil*, xcix (1963), pp. 2–11

M. Steinhauser: *Die Architektur der Pariser Oper* (Munich, 1969)

D. van Zanten: 'Architectural Composition at the Ecole des Beaux-Arts from Charles Percier to Charles Garnier', *The Architecture of the Ecole des Beaux-Arts*, ed. A. Drexler (London, 1977)

FRANÇOIS LOYER

Garnier, Etienne-Barthélemy (*b* Paris, 24 Aug 1759; *d* Paris, 15 Nov 1849). French painter. Although he was given a sound Classical education to prepare for the magistrature, he found a painter's career more alluring. Despite his late start, he had an impeccable record of success in competition with the pupils of Jacques-Louis David, whose influence he mostly resisted. Trained by Louis-Jacques Durameau, Gabriel-François Doyen and Joseph-Marie Vien, he won second place in the Prix de Rome competition in 1787 with *Death of Sedecius* (Le Mans, Mus. Tessé) and first place in 1788 with a strenuously rhetorical *Death of Tatius* (Paris, Ecole N. Sup. B.-A.). Although his stay in Italy was abruptly ended by the Roman crisis of 1793, he completed before his return to Paris the course work and other pictures, including an academic study of *St Jerome* (Troyes, Mus. B.-A. & Archéol.) and several Classical subjects.

While in Italy, Garnier began work on his masterpiece, the *Family of Priam*, for which he completed a painted sketch (Mâcon, Mus. Mun. Ursulines) in 1792. On the

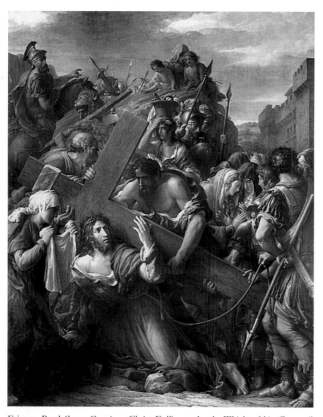

Etienne-Barthélemy Garnier: *Christ Falling under the Weight of his Cross*, oil on canvas, 3.30×2.62 m, exhibited at the Salon of 1848 (Paris, Musée du Louvre)

strength of this he obtained a government grant and a studio in the Louvre where he completed the huge, full-scale version (4.2×5.96 m; Angoulême, Mus. Mun.) eight years later, exhibiting it at the Salon of 1800. This depiction of the grief at Hector's death in combat with Achilles (as described in the *Iliad*), with its high, panoramic view, isolated groups and episodic action, is unlike anything David had painted by 1792; however, the fragmentation, which disturbed critics in 1800 and which was perhaps inspired by Greek art, was later echoed in David's *Leonidas at Thermopylae* (1814; Paris, Louvre).

The success of Garnier's picture established his reputation, and he was included in several major enterprises in the Empire and Restoration. With Pierre-Paul Prud'hon and Léonor Merimée (1757–1836) he was commissioned to decorate the ceiling of the Salle de Diane in the Louvre, where he painted an accomplished but stiff picture of *Hercules with the Deer with the Golden Horns* (*in situ*) in a tympanum. He was included in the group of painters who provided pictures for the sacristy in the church of St Denis, Paris, for which he painted the *Burial of Dagobert I* (*in situ*). In 1808 he painted *Napoleon Studying a Map of Europe in his Study* (Versailles, Château), and in 1810 he was included among the select group competing for the Prix Décennal. His success continued under the Restoration: *Eponina and Sabinus* (Angers, Mus. B.-A.), exhibited in 1814, was bought by Louis XVIII.

Garnier was inevitably drawn into the Restoration commissions for religious pictures, exhibiting in 1827 his *Virgin of Sorrows* (Nantes Cathedral), commissioned for the Madeleine, Paris, but he was too old to keep up with the newer, softer fashions in religious art. His career received a check in 1829, when he failed in his candidature for the directorship of the Académie de Rome, in competition with Horace Vernet. Charles X compensated him with the Légion d'honneur and a pension of 2000 francs. He continued to paint, exhibiting in 1847 his large *Marriage Procession of Napoleon and Marie-Louise in the Tuileries Gardens* (Versailles, Château), completed after 30 years.

As President of the Académie des Beaux-Arts, Garnier delivered eulogies on such painters as Anne-Louis Girodet, Charles Meynier, Antoine-Jean Gros, Carle Vernet, François-Xavier Fabre and Charles Thévenin (1764–1838), some of whom were younger and more supple artists than himself. At his last Salon, in 1848, Garnier exhibited *Christ Falling under the Weight of his Cross* (Paris, Louvre; see fig.), a cramped, crowded, mannered composition, out of step with the early Italian style preferred in contemporary religious art. He was at his best painting the conventional passions and gestures of Greek and Roman mythological characters and was less convincing in his attempts to depict historical figures (e.g. *Henry IV Visiting the Louvre*, exh. Salon 1819; Versailles, Château). Garnier died the last survivor—but also the most forgotten artist—of his generation.

BIBLIOGRAPHY

J. Bottineau: 'Le Décor de tableaux à la sacristie de l'ancienne abbatiale de Saint-Denis (1811–1823)', *Bull. Soc. Hist. A. Fr.* (1973), pp. 255–81

De David à Delacroix (exh. cat., Paris, Grand Pal., 1974), pp. 423–5

JON WHITELEY

Garnier, Louis (*b c.* 1639; *d* Paris, 21 Sept 1728). French sculptor. He was Professeur and later Doyen of the Académie de St Luc in Paris and is sometimes confused in contemporary documents with the sculptor Pierre Granier (1635–1715). Garnier was a bronze specialist employed by François Girardon to repair the waxes bronzes at the Paris Arsenal from 1686 to 1692. He was also responsible for such small bronze groups and statuettes as *Paetus and Arria* (1696–7; Paris, Louvre) and *Bacchus* (before 1699; e.g. Dresden, Skulpsamml.). He also executed funerary monuments in bronze and marble, including the monument for the brain of *James II of England* (1703; fragments, Paris, former Collège des Ecossais, 65 Rue Cardinal-Lemoine), the tomb of *Maximilien Titon du Tillet* (after 1711; destr.) for the chapel of the convent of the Hospitalières at St Mandé and the tomb for the heart of *Louis-François, Maréchal de Boufflers* (1713; fragments, Crillon, Oise, parish church). His best-known work, however, is the remarkable and strikingly original *Parnasse français* (1718–21; Versailles, Château), an elaborate bronze group, over 2 m high, commissioned by Evrard Titon du Tillet and celebrating artists, musicians and writers of the reign of Louis XIV. The King, in the guise of Apollo and seated on top of Mt Parnassus, is surrounded by the three Graces, personified by the poets Antoinette Deshoulières, Henriette de La Suze and Madeleine de Scudéry. Below are statuettes of Corneille, Racine, Molière, Lully, La Fontaine etc. Other notable figures are represented by portrait medallions. Titon later commissioned Augustin Pajou to add Jean-Jacques Rousseau, Prosper Crébillon and Voltaire. Apart from the *Parnasse*, however, few works by the strongly classical Garnier have survived, and the information about him is disappointingly fragmentary.

Lami; Souchal
BIBLIOGRAPHY
Obituary, *Mercure de France* (Oct 1728), p. 2269
J. Guiffrey: *Comptes des Bâtiments du Roi sous le règne de Louis XIV*, 5 vols (Paris, 1881–1901)
I. Colton: *The Parnasse français, Titon du Tillet and the Origins of the Monument to Genius* (New Haven, 1979)
FRANÇOISE DE LA MOUREYRE

Garnier, Pierre (*b* Paris, *c.* 1720; *d* Paris, 1800). French cabinetmaker. He was trained in the workshop of his father, François Garnier. His early work, however, was indistinguishable from that of many of his contemporaries. He became a *maître-ébéniste* on 31 December 1742. He was quick to incorporate the principles of the Neo-classical style, and these ideals governed his furniture during his second period of production. In 1761 he made a table based on designs by the architect Charles de Wailly, which was shown at the annual Salon at the Louvre organized by the Académie Royale de Peinture et de Sculpture. His furniture displayed architectural lines with uprights in the form of fluted pillars, and in general he rejected marquetry in favour of such fine veneers as ebony, mahogany or even Japanese lacquer. His bronze mounts were in the Neo-classical style and included laurel wreaths, triglyphs, lion heads and spiral ferrules. Many pieces survive, among them writing-tables (e.g. 1762–5; Lisbon, Mus. Gulbenkian), commodes (e.g. Stockholm, Kun. Husgerådskam.), secrétaires (e.g. Paris, Louvre) and corner-cupboards (e.g.

of *c.* 1755; Malibu, CA, Getty Mus.). Later he was inspired by English furniture. His clientele included such collectors of furniture in the *Goût grec* as the Marquis de Marigny, the Maréchal de Contades, for whom Garnier furnished the entire château of Mongeoffroy in Mazé, Maine-et-Loire (1771; *in situ*), and the Duc de Choiseul (e.g. desk; Chantilly, Mus. Condé).

BIBLIOGRAPHY
F. de Salverte: *Les Ebénistes du XVIIIe siècle, leurs oeuvres et leurs marques* (Paris, 1923, rev. 5/1962)
J. Viaux: *Bibliographie du meuble (Mobilier civil français)*, 2 vols (Paris, 1966–88)
S. Eriksen: 'Some Letters from the Marquis de Marigny to his Cabinet-maker Pierre Garnier', *Furn. Hist.*, viii (1972), pp. 72–85
JEAN-DOMINIQUE AUGARDE,
JEAN NÉRÉE RONFORT

Garnier, Tony (*b* Lyon, 13 Aug 1869; *d* La Bédoule, 19 Jan 1948). French architect, urban planner and writer. Regarded as a precursor of the Modern Movement in France, paradoxically he was absent from the debates that enlivened architectural and urban-planning circles between World Wars I and II. He built only *c.* 15 works, all in the area around Lyon. A winner of the Grand Prix de Rome and recognized by his profession, he was regularly published in architectural reviews. His fame and influence on the Modern Movement in the 1920s and 1930s was due to a theoretical project for a *Cité industrielle*, sent from Rome while he was a pensionnaire at the Villa Medici. This project was so rich, as much in its city plan (inspired by the site of Lyon) as architecturally, that it had a profound influence on a whole generation of architects led by Le Corbusier and served as an inexhaustible model for Garnier himself, for almost all his future activities.

1. THE 'CITÉ INDUSTRIELLE' AND ITS INFLUENCE. After studying at a technical school, Garnier attended the Ecole des Beaux-Arts in Lyon (1886–9). He next enrolled at the Ecole des Beaux-Arts in Paris where he entered the studio of Paul Blondel and Scellier de Gisors (1889–99). There he followed the Functionalist teaching of Julien Azais Guadet and regularly entered competitions for the Prix de Rome, winning the Grand Prix in 1899 and staying at the Villa Medici until 1904. A non-conformist pupil in Paris, he was the same in Rome, and in a number of provocative commentaries denounced the 'errors' of antique architecture. However, he studied Greco-Roman domestic architecture in detail, and this was an important source of inspiration for his aesthetic and the spatial conception of his future villas.

In 1901 the academy refused Garnier's entry devoted to a *Cité industrielle*, for which he had designed a plan and a general view of the town. Ignoring this opposition, he continued with his work and exhibited it in 1904 in Paris and Rome. Until 1917, the date of its publication as 164 plates preceded by an introduction, he reused and redrew parts of it, making dating for certain drawings problematic. The *Cité industrielle* (see fig.) occupies a site at the junction of a river and a tributary, reminiscent of his native city (*see* LYON, §1(ii)(b)). He designed precise zoning, which clearly separates the town's three functions: work, social life and housing. The industrial zone, centre of urban creation and a better future, occupies the plain and includes

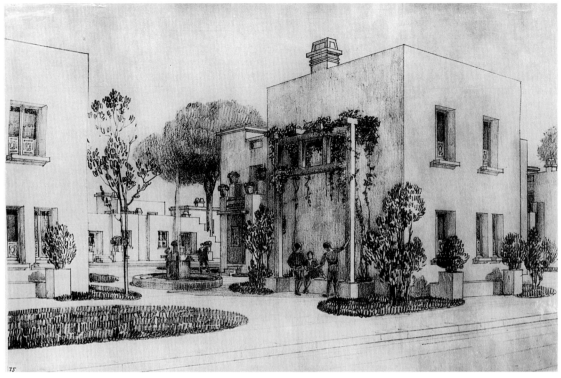

Tony Garnier: 'housing neighbourhood' sketch, 1901–4; from *Une Cité industrielle* (Paris, 1917)

a metallurgical factory, large furnaces and a dam. The city itself is spread out on the plateau overlooking the valley, with administrative services, museums, theatres and sports facilities grouped around the centre. He banished all skyscrapers and intended there to be 'pavilions' or small blocks with a maximum of three or four storeys, surrounded by public gardens. Throughout his career he remained faithful to the pavilion model, with the exception of a few projects situated outside Lyon, which proved abortive.

The ensemble was designed according to a web of orthogonals—the traffic routes—arranged to keep pedestrians separate from cars. The *Cité industrielle* is a green city with no enclosed spaces. The orientation of the housing and its ventilation were carefully studied as were all the city's amenities. A strong stylistic unity emerges from the whole, dominated by cubic volumes and combinations of simple forms in which the porches play a unifying role. The open plans, the roof terraces, the bare walls, often without cornices, created a new formal language, even if Garnier remained attached to classical rules of composition. The entire city was built in concrete and metal, essentially for the main frames of the buildings. At a time when concrete skeletons were still an exception, systematic use of them on the scale of an entire city was evidence of a certain daring.

The project expressed a clear evident Utopian socialist ideal, derived from the theses of Charles Fourier or Robert Owen, and strongly evoked the descriptions of Emile Zola's ideal city in his novel *Travail* (1900). A member of the literary association Amis de Zola, Garnier had read

and appreciated this work to the point of reproducing extracts on the entablature of the assembly hall porches in the *Cité industrielle*. Convinced of socialism's beneficial effects on human relationships, he refused to have in his plan any police or military building, prison or church: he also blended collective and individual housing.

Although the innovative character of Garnier's plan was later recognized, when it was exhibited in 1904 (and again in 1925), and when published in 1917, it did not provoke strong reactions on the part of his colleagues in Paris or Lyon. It was probably as a highly original and misunderstood precursor of LE CORBUSIER that his contribution was rediscovered. Le Corbusier visited Garnier in 1915 and may have seen several plates from the forthcoming edition of the *Cité industrielle*.

2. MAJOR PROJECTS IN LYON. On his return to Lyon in 1905, Garnier used the *Cité industrielle* as a source of ideas from which virtually all his creations would henceforth be drawn. Known for his theoretical urban planning work, he did not, however, hold official posts of any scope in Lyon or elsewhere: he worked on commissions, notably the commission for the planned extension and embellishment of the city of Lyon, but decisions in matters of urban planning were taken by the municipal services of the Road Board. His first creation, the Vacherie de la Tête d'Or, was commissioned from him in 1905 by the mayor, Victor Augagneur, who was impressed and recommended him to his successor Edouard Herriot (1872–1957). This project, which included a dairy, a stable and housing for the cowherd, was distinguished by a more picturesque

style of the cubic and purified agricultural establishments in his *Cité industrielle*. This first and only deviation from the aesthetic line he had laid down for himself can probably be explained by the situation of the building in the park of the Tête d'Or.

Garnier next worked on very large, short-term operations being undertaken by the socialist mayor Herriot, published in 1921 in an anthology *Les Grands Travaux de la ville de Lyon*: the abattoirs of La Mouche (1909–13), Avenue Tony Garnier, the Olympic Stadium (1913–16), Avenue Jean-Jaurès, the Hôpital de la Grange Blanche (1915–30; now Hôpital Edouard Herriot).

Later Garnier also obtained commissions to work on the Tête d'Or Monument to the Dead (1924), the Telephone Exchange (1927) and the Weaving School (1927–34), for which a preliminary project (1915) had been published in the anthology of major projects, and the low-cost housing district Etats-Unis (1928–35). All these works in Lyon, as well as the Hôtel de Ville (1931–4; with Jacques Debat-Ponsan) built in Boulogne-Billancourt, took their main inspiration from buildings in the *Cité industrielle*, from which they also derived their principles of construction, the use of concrete, the clear and rational plans aided by a keen sense of the monumental. Moreover, by their amplitude, the abattoirs of La Mouche and the Hôpital de la Grange Blanche possess a real urban dimension. Garnier linked the various buildings by covered galleries and avenues planted with trees. In the Hôpital de la Grange Blanche, the walkways are underground to facilitate transport of the sick.

Some private commissions and participation in major international exhibitions completed Garnier's career, as well as maintenance work and projects undertaken under the auspices of Bâtiments Civils et des Palais Nationaux: the architect's villa at Saint-Rambert (1909), near Lyon, constructed around a patio; the villa for his wife, also at Saint-Rambert (1909); the Gros villa (1920–33) at Saint-Didier; the Lyon and Saint-Etienne pavilions (1925) at the Exposition Internationale des Arts Décoratifs et Industriels Modernes, Paris; the Vaudrey Telephone Exchange (1928–33; now the Moncey Exchange), Lyon, published in a preliminary version of 1919 in the anthology of major projects in Lyon; and the Chaleyssin factory (1932), Lyon. Throughout his career Garnier's style and ideas revealed great fidelity to the principles and forms set out in the *Cité industrielle*. His unexecuted projects include extending the stock exchange district (1906) in Marseille, abattoirs (1907) in Reims and the Rothschild Foundation (1915). Sadly the archives of Garnier's practice have been largely destroyed.

WRITINGS

Une Cité industrielle: Etude pour la construction des villes (Paris, 1917, 2/1932, rev. Paris, 1978)
Les Grands Travaux de la ville de Lyon (Paris, 1920)

BIBLIOGRAPHY

J. Badovici and A. Morance: *L'Oeuvre de Tony Garnier* (Paris, 1938)
G. Veronesi: *Tony Garnier* (Milan, 1948)
D. Wiebenson: 'Utopian Aspects of Tony Garnier's *Cité industrielle*', *J. Soc. Archit. Hist.*, 1 (1962)
C. Pawlowski: *Tony Garnier et les débuts de l'urbanisme fonctionnel en France* (Paris, 1967)
D. Wiebenson: *Tony Garnier: The 'Cité industrielle'* (New York, 1969)
A. Lagier, P. Rivet and M. Roz: *Tony Garnier (1869–1948)* (Paris, 1983)
L. Piessat: *Tony Garnier* (Lyon, 1988)
R. Jullian: *Tony Garnier: Constructeur et utopiste* (Paris, 1989)

GILLES RAGOT

Garofalo [Tisi, Benvenuto] (*b* Ferrara, 1481; *d* Ferrara, 1559). Italian painter. Active mainly in Ferrara and the district around the Po delta, he was one of the most outstanding figures in Emilian classicism during the first half of the 16th century. In 1497 Garofalo's father paid Boccaccio Boccaccino to teach his son the rudiments of painting. Garofalo's first works were directly influenced by the Cremonese painter, to whom they were formerly even attributed. They consist of a series of small paintings depicting the *Virgin and Child*. The example in the Ca' d'Oro in Venice must have been Garofalo's first painting and reveals not only the lessons learned from Boccaccino, but also signs of the influence of Domenico Panetti (*c.* 1460–before 1513), traditionally recorded as his first master. Another *Virgin and Child* (Assisi, Perkins priv. col.) shows signs of the early influence of Lorenzo Costa the elder, while the example in the Nationalmuseum, Copenhagen, shows a similarity with the early works of his contemporary, Lodovico Mazzolino. A particularly important project in Ferrara during the earliest years of the 16th century, involving numerous highly skilled artists, was the fresco decoration of the oratory of the Concezione. The frescoes (Ferrara, Pin. N.) represent a significant development in the city's art. Garofalo's hand has been identified in the *Presentation in the Temple*, in which he reveals a familiarity not only with local art, but also with the high points of Bolognese classicism, whose greatest exponents were Francesco Francia and Lorenzo Costa the elder. Around 1505, Garofalo's works show a close familiarity with artistic developments in Bologna, in particular the mature style of Costa and the decoration in 1505–6, by Francesco Francia, Costa, Aspertini and others, of the oratory of S Cecilia in S Giacomo Maggiore. Garofalo's *Virgin Enthroned between SS Martin and Rosalia* (Florence, Uffizi), created for Codigoro Cathedral, should be seen within this context, whereas the small altarpiece for the Arcivescovado, Ferrara, although executed at the same time, shows early, if faint, signs of the influence of Venetian painting of the period.

In 1506 Garofalo received payments for work done in the apartments of Lucrezia Borgia in the Palazzo di Schifanoia, Ferrara, and it was probably at this time that he executed the strikingly illusionistic figures of musicians on the ceiling of the Aula Costabiliana in the Palazzo di Ludovico il Moro. This important scheme reveals a complex variety of different visual influences, especially the Mantuan work of Mantegna, the clearest stylistic prototype for the work. It also reveals a more highly evolved sense of perspective, derived from Lombard art, in which Garofalo may well have been influenced by the presence in Ferrara of Cesare di Lorenzo Cesariano. Garofalo's paintings began to reflect a number of qualities reminiscent of the work of Giorgione, and it is possible that he travelled to Venice. This influence can be clearly seen in a series of small paintings, a *Nativity* (Ferrara, Pin. N.) and two versions of the *Adoration of the Magi* (Berlin, Staatl. Museen; Krakow, N. Mus.), which reveal first-hand knowledge of such works by Giorgione as the *Adoration*

of the Magi (London, N.G.). In the large painting created for the Este family depicting *Neptune and Minerva* (1512; Dresden, Gemäldegal.) Garofalo turned his attention to the classicism of Giorgione's final years, as exemplified by the latter's *Female Nude* on the façade of the Fondaco dei Tedeschi, Venice, while still retaining an interest in Mantegna's final style. Between executing the *Neptune and Minerva* and the large *Nativity* (Ferrara, Pin. N.), which can be dated to July 1513, it is possible that Garofalo went to Rome, since the latter painting and also the *Virgin and Child between SS Lazarus and Job* (Ferrara, Pin. N.) from the same year clearly display a familiarity with the new classicism of Raphael, which is still absent from the Dresden painting. This new element was to form the basis of Garofalo's output over a long period, starting with a direct allusion to Raphael's Aldobrandini *Madonna* in his Suxena Altarpiece (Ferrara, Pin. N.; see fig.), executed for S Spirito, Ferrara.

As Garofalo's style became more complex and grandiose and enriched with Classical allusions, his vein of originality seemed to exhaust itself. His activities were, nonetheless, marked by an impressive series of commissions, ranging from a *Virgin with Saints* (1517; London, N.G.), executed for S Guglielmo, Ferrara, to the *Massacre of the Innocents* (1519; Ferrara, Pin. N.) for S Francesco, Ferrara, and in 1519–20, the decoration of two rooms in the Palazzo del Seminario, Ferrara, in which he revived the layout of the ceiling of the Palazzo di Ludovico il Moro, accentuating the perspective arrangement, but weighing it down with excessive ornamentation. In the meantime, documents record Girolamo da Carpi among his collaborators, while Garofalo himself produced a vast number of altarpieces for the main churches in Ferrara. After the large and iconographically complex fresco of 1523, depicting the *Old and New Testament* (Ferrara, Pin. N.) for the refectory of S Andrea, Ferrara, and the polyptych executed for the same church in collaboration with Dosso Dossi, he completed such other works as the *Deposition* (1527; Milan, Brera) and the *Raising of Lazarus* (1534; Ferrara, Pin. N.), all of which mark a phase in which Garofalo was impressed by the work of Michelangelo. In 1537 and 1541 in the company of Battista Dossi, Camillo Filippi and Girolamo da Carpi, Garofalo worked on the decoration of the Este villas of Belriguardo and La Montagnola (both destr.). The faded frescoes executed in 1543 in the church of the Ospedale di Rubiera, commissioned by the Sacrati family, are extant, albeit in poor condition. Despite serious problems with his vision, resulting in total blindness in 1550, Garofalo continued his prolific output throughout the 1540s, executing such works as an altarpiece for S Salvatore, Bologna (1542) and a fresco of the *Last Supper* (1544; Ferrara, Pin. N.). His last dated painting is the *Annunciation* (1550; Milan, Brera).

BIBLIOGRAPHY

Thieme–Becker
E. Sambo: 'Sull'attività giovanile di Benvenuto Tisi da Garofalo', *Paragone*, xxxiv/395 (1983), pp. 19–34 [with bibliog.]
V. Sgarbi: 'Testimonianze inedite del Raffaellismo in Emilia: "Garofalo, Gerolamo da Carpi e Battista Dossi a Belriguardo"', *Studi su Raffaello. Atti del congresso internazionale di studi: Urbino and Florence, 1984*, pp. 596–60
J. Manca: 'Two Copies after a *Massacre of the Innocents* by Ercole de' Roberti', *Master Drgs*, xxv/2 (1987), pp. 143–6

MARCO TANZI

Garouste, Gérard (*b* Paris, 10 March 1946). French painter. He was brought up in Burgundy by an uncle who made untutored stone-carvings. He studied at the Ecole des Beaux-Arts in Paris (1965–72), but, influenced by the work of Marcel Duchamp, temporarily gave up easel painting for theatrical performance and set design. It was not until the early 1980s that his gestural and highly coloured mythological figuration (e.g. *Orion the Classical, Orion the Indian*, 1981–2; Paris, Pompidou) gained recognition as part of a broader eclecticism associated with the Italian Transavanguardia. While retaining similar references, for example in *Untitled* (1986–7; see 1987–8 exh. cat., p. 39), from his *Dante* cycle (1986–7), he developed a more personal and enriched style, which brings passion to his characteristically reduced figures.

BIBLIOGRAPHY

Gérard Garouste: Peintures de 1985 à 1987 (exh. cat. by J. Risset and R. Guidieri, Bordeaux, Mus. A. Contemp., 1987–8)
Gérard Garouste (exh. cat. by R. Giudieri and B. Blistène, Paris, Pompidou; Düsseldorf, Städt. Ksthalle; 1988–9)

VANINA COSTA

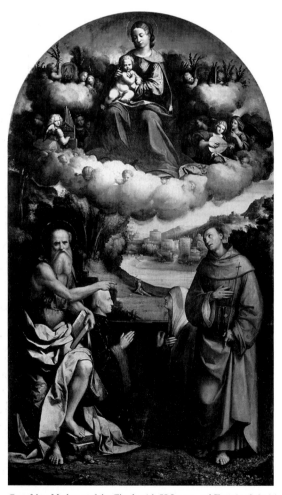

Garofalo: *Madonna of the Clouds with SS Jerome and Francis of Assisi and Two Members of the Suxena Family* (Suxena Altarpiece), oil on panel, 2.46×1.46 m, 1514 (Ferrara, Pinacoteca Nazionale)

Garovaglio. *See* ALLIO.

Garove, Michelangelo (*b* Bissone, nr Lugano, 12 March 1650; *d* Turin, July 1713). Italian architect and engineer of Swiss birth. In his youth he worked with Amedeo di Castellamonte, and from 1669 to 1713 he was in the service of Charles-Emanuel II and then Victor-Amadeus II, dukes of Savoy; after 1684 he was responsible for all ducal projects. He was in the service of the Prior of the Confraternità di S Luca in 1688 and of the Prince of Carignano in 1697–9. He was considered the most creative architect active in Piedmont between the deaths of Guarino Guarini and Castellamonte and the arrival in Turin of Filippo Juvarra.

Although Garove initially trained as a military engineer and retained the title of captain, he also practised as a civic architect, as did many other Piedmontese architects of the 17th century, including Carlo di Castellamonte and Ascanio Vitozzi. Garove completed several of Guarini's unfinished buildings, for example the Castello at Racconigi, where he finished the S-curves of the staircase, the Collegio dei Nobili in Turin, where in 1685 he proposed that construction stop at the first floor, and the Palazzo Carignano, also in Turin. He supervised, together with Gian Francesco Baroncelli (*fl* 1674–94), the construction of the Ospedale di S Giovanni Battista, begun by Amedeo di Castellamonte. Garove played an active role in the second urban expansion of Turin (begun 1673), as his preliminary designs for Piazza Carlina, the main piazza of the enlargement area is attested by (Turin, Archv Stato; Milan, Bib. Ambrosiana).

As a military engineer he is documented (Turin, Archv Stato) as having had responsibility for the fortifications at Cherasco (1683), Cuneo (1691) and Turin (1706). The initial design (Turin, Archv Stato) for the Università was commissioned from him by Victor-Amadeus II in 1713. The columns of the arcade surrounding the large courtyard have banded shafts reminiscent of the order employed by Amedeo di Castellamonte in the vestibule of the Ospedale di S Giovanni Battista.

Buildings entirely by Garove show the influence of his early training and include the Cappella di Beato Amedeo di Savoia (1682; altered) in Vercelli Cathedral. This established his reputation and demonstrates his interest in lighting effects. The most outstanding feature of his Palazzo Asinari di S Marzano (?1684) in Turin is the atrium-like scenographic vestibule on the ground floor. Inspired by the Palazzo Carignano, it has a star-shaped vault supported by four double spiral columns. In his church of S Martino (1684–5) at La Morra, Garove used unplastered brick, the quintessential Piedmontese construction material, for both structure and decoration, again recalling the Palazzo Carignano. S Martino is a large, vigorous building, with broken pediments on the two superimposed orders of the façade. Despite the open centre of the façade, not unlike that of S Maria in Campitelli by Carlo Rainaldi in Rome, the church towers austerely over the piazza in front of it.

BIBLIOGRAPHY
H. A. Millon: 'L'altare maggiore della chiesa di San Filippo Neri a Torino', *Boll. Soc. Piemont. Archeol. & B.A.*, n. s., xiv–xv (1960–61), pp. 83–91

C. Brayda, L. Coli and D. Sesia: *Ingegneri e architetti del sei e settecento in Piemonte* (Turin, 1963)
A. di Baudi Vesme: 'Garove, Michelangelo', *Schede Vesme*, ii (Turin, 1966), pp. 515–16
H. A. Millon: 'Michelangelo Garove and the Chapel of the Beato Amedeo of Savoy in the Cathedral of Vercelli', *Essays in the History of Architecture Presented to Rudolf Wittkower*, ed. D. Fraser, H. Hibbard and M. Lewine (London, 1967), pp. 134–42

MARTHA POLLAK

Garrard. English firm of goldsmiths and jewellers. The firm was founded by GEORGE WICKES *c*. 1730 and taken over by Parker & Wakelin after his retirement in 1760. Robert Garrard (i) (1758–1818), who was not a working silversmith but had been made a freeman of the Grocers' Company of London in 1780 and thereafter had been accountant to Parker & Wakelin, became a partner in the firm in 1792. The joint mark of Robert Garrard (i) and John Wakelin (*fl* 1776–1802) was entered in that year. Wakelin was appointed Goldsmith and Jeweller to George III in 1797 and, upon Wakelin's death, Garrard assumed sole control of the prestigious London-based firm, entering his own mark (RG) that year.

Robert Garrard (ii) (1793–1881), who had also been made a freeman of the Grocers' Company in 1816, and his two brothers, James (1795–1870) and Sebastian (1798–1870), took over the business on the death of their father, Robert Garrard (i), in 1818. Trading as R., J. & S. Garrard or R. Garrard & Brothers, the firm supplied elaborate gold and silver items, including the ducal coronet of Arthur Wellesley, 1st Duke of Wellington, for George IV's coronation in 1821. On William IV's accession in 1830 the firm was appointed Royal Goldsmiths and, in 1843, displaced Rundell, Bridge & Co. (formerly Rundell, Bridge & Rundell) as Crown Jewellers in Ordinary to Queen Victoria. After James Garrard retired in 1835, Robert and Sebastian moved in 1836 to 29 Panton Street as the firm of R. & S. Garrard and, from 1843, with Samuel Spilsbury as the first of several subsequent partners, traded as R. & S. Garrard & Co. until 1909.

In the 1830s and 1840s Garrard supplied pieces in eclectic historicist styles of the period, including Renaissance Revival, Baroque Revival, Rococo Revival and Neo-classicism. The range of rich jewellery included brooches and bracelets in the Gothic Revival and Egyptian Revival styles. The sculptor Edmund Cotterill (1795–1860), Garrard's head of design from 1833, established the firm's reputation for producing elaborate sculptural groups and centrepieces in silver, often with Moorish or Arab and equestrian themes, for example a centrepiece (1846–53; priv. col., see 1991 exh. cat., p. 73) in the form of a group of camels, stallions and Arab figures. The firm also produced outstanding sporting trophies and cups, notably those for horse-racing—the Ascot, Doncaster and Goodwood Cups—and for yachting, for example the America's Cup (1848). In the Great Exhibition in London of 1851 the firm showed pieces in the Queen Anne and Louis XIV Revival styles and a silver-gilt centrepiece (British Royal Col.) with naturalistic figures of Queen Victoria's favourite dogs.

Following Cotterill's death in 1860 W. Spencer became head of design. After the death of Robert Garrard (ii) in 1881 the firm passed to his nephew, James Mortimer Garrard (*d* 1900), who was succeeded by his son, Sebastian

Henry Garrard (1868–1946). Sebastian was the last member of the Garrard family to control the business. After his death in 1946 the company amalgamated with the Goldsmiths' & Silversmiths' Co. and moved to 112 Regent Street, becoming Garrard & Co. Ltd and retaining its royal appointment, including responsibility for the maintenance of the British Crown Jewels.

BIBLIOGRAPHY

Garrard's, 1721–1911: Crown Jewellers and Goldsmiths during Six Reigns and in Three Centuries (London, 1912)

A. G. Grimwade: 'The Garrard Ledgers', *Proc. Soc. Slver Colrs*, i/4 (1961), pp. 1–12

P. Wardle: *Victorian Silver and Silver Plate* (London, 1963)

H. Honour: *Goldsmiths and Silversmiths* (London 1971), pp. 244–8

J. Culme: *Nineteenth-century Silver* (London, 1977)

S. Horsford: 'The Crown Jewellers', *Illus. London News* (1987), pp. 55–7 [supernumerary issue: The Royal Year, 1987]

Royal Goldsmiths: The Garrard Heritage (exh. cat., ed. J. Ogilvy; London, Garrard & Co. Ltd, 1991)

RICHARD RIDDELL

Garrard, George (*b* London, 31 May 1760; *d* London, 8 Oct 1826). English painter and sculptor. After serving an apprenticeship with Sawrey Gilpin, later his father-in-law, Garrard became a student at the Royal Academy Schools, London, in 1778, exhibiting his first sporting picture there in 1781. Though his occasional genre paintings were better received than his many animal subjects (Sir Joshua Reynolds purchased his *View of a Brew-house Yard* from the Academy exhibition of 1784), he initially determined to practise as a sporting artist, probably on the advice of the notorious sportsman Colonel Thomas Thornton (1755–1823) for whom he had worked in the 1780s.

Guided by his patron, the brewer and philanthropist Samuel Whitbread MP (1764–1815), Garrard began to expand his artistic range and by 1800 was attempting to gain additional recognition as a sculptor of both animal and human form. In 1800 he was elected ARA. Joseph Nollekens called Garrard 'a jack-of-all-trades'; Joseph Farington believed that his failure to attain full membership of the Royal Academy, despite strenuous efforts, was directly due to his unwillingness to specialize in one field. With Whitbread's help, Garrard successfully secured a copyright act for the protection of sculptors (1798) in emulation of William Hogarth's campaign for engravers. Garrard's notable sculptures include his unsuccessful but widely publicized series of scale models of cows and oxen, mass-produced in plaster with the support of the Board of Agriculture (examples at Woburn Abbey, Beds), as well as the portrait busts, for example of *Benjamin West* (exh. RA, 1803) and *Humphrey Repton* (exh. RA, 1810).

Among Garrard's best paintings are the equestrian portrait of *Douglas, 8th Duke of Hamilton* (engraved in mezzotint; 1797), *Mr Whitbread's Wharf* (1796; oil on copper), one of his few but historically valuable views of working life in London, and the *Building of Southill* (1803; both at Southill Park, Beds). He also made many outdoor landscape sketches in oil on paper, among them *Coomb Hill* (1791; London, Tate).

Gunnis

BIBLIOGRAPHY

George Garrard (exh. cat., ed. E. Croft-Murray; Bedford, Cecil Higgins A.G., 1961)

Paintings, Politics & Porter: Samuel Whitbread and British Art (exh. cat., ed. S. Deuchar; London, Mus. London, 1984)

STEPHEN DEUCHAR

Garreta, Raimundo Madrazo. *See* MADRAZO, (4).

Garrett. *See* GHEERAERTS.

Garrez, Pierre-Joseph (*b* Paris, 24 Feb 1802; *d* Paris, Nov 1852). French architect. He was probably the son of an inspector in the Conseil des Bâtiments Civils during the Bourbon Restoration. In 1822 he entered the Ecole des Beaux-Arts, Paris, under the aegis of Delespine. He was promoted to the first class in 1823, winning second prize in the Prix de Rome competition in 1829 and first in that of 1830 with a design for a 'maison de plaisance pour un prince'. He spent the years 1831–6 at the Villa Medici in Rome, participating in the vibrant discussion of the second generation of Romantic classicists such as Victor Baltard and Simon-Claude Constant-Dufeux. This is reflected in his remarkable restoration of the Trajanic port of Ostia in 1834, where buildings and urban planning combined to record historical accretion. Like many of the Romantics, Garrez was drawn to the study of French medieval and Renaissance architecture. He toured France extensively and his travel sketches of Italy, France and Germany were much admired at the Salon in the 1830s and 1840s.

Although Garrez took third prize for an austere neo-medieval project in the Avignon Town Hall competition of 1836, his career was at first restricted to restoration, notably of the medieval churches at Moret, near Fontainebleau, and that at Donnemaire-les-Lys (Seine-et-Marne). Only in 1842 did he receive an important commission, when he was appointed simultaneously architect of the extensions to the Ecole des Ponts et Chaussées and Professor of Architecture in that school. The new wing along the Rue des Pré-aux-Clercs was an exquisitely detailed attempt to apply rationalized classicism to a continuous street façade and is characterized by the severe lines and shallow relief and mouldings that Garrez admired in Etruscan, medieval and French Renaissance architecture.

BIBLIOGRAPHY

A. E. Lance: *Dictionnaire des architectes français* (Paris, 1872)

E. Delaire: *Les Architectes élèves de l'Ecole des Beaux-Arts* (Paris, 1907), p. 271

BARRY BERGDOLL

Garrick, David (*b* Hereford, 19 Feb 1717; *d* London, 20 Jan 1779). English actor-manager, patron and collector. He began his acting career in London in 1737, and managed Drury Lane theatre from 1747 to 1776. His increasing fortune inspired him to patronise the arts both as a means of self-advertisement and to enhance his status. In 1755 he bought Fuller House at Hampton, near London, employing Robert Adam to make improvements to the house and Lancelot 'Capability' Brown to design the gardens. Garrick later commissioned Johan Zoffany to paint conversation pieces showing his new estate, such as *Mr and Mrs Garrick by the Shakespeare Temple at Hampton* (*c*. 1762; priv. col., see 1975 exh. cat., no. 83). Zoffany also painted for Garrick a series of theatrical conversation pieces showing the actor in his best roles,

including *Mr Garrick in the Character of the Farmer Returned from London* (exh. London, Soc. Artists GB 1762; priv. col., see 1975 exh. cat., no. 21) and *Garrick as Jaffier and Mrs Cibber as Belvidera in 'Venice Preserv'd'* (exh. London, Soc. Artists GB 1763; priv. col., see 1975 exh. cat., no. 22). These works were exhibited and engraved, serving as publicity for Garrick's performances.

In 1763 Garrick went to Italy, where he commissioned non-theatrical portraits from, among other painters, Angelica Kauffman (1764; Burghley House, Cambs) and Pompeo Batoni (1764; Oxford, Ashmolean), as well as a portrait bust (1764; marble version, Althorp House, Northants) from Joseph Nollekens, who was struggling to find employment in Rome. From Italy Garrick offered his services as an agent to buy pictures for William Cavendish, 4th Duke of Devonshire, but the Duke declined. Garrick was a member of the committee that established the Society of Artists' exhibitions, and in *c.* 1762 he purchased Hogarth's *Election* series (*c.* 1754; London, Soane Mus.) to prevent the artist from being obliged to raffle the paintings. He advised Francis Hayman on the gesture and expression of the characters in his frontispieces for Jennens's edition of Shakespeare's plays (pubd 1770–74). Garrick's friendship with artists such as Hogarth, Reynolds and Hayman combined with his stage popularity inspired over 450 paintings and engravings showing him both in and out of character.

BIBLIOGRAPHY
K. A. Burnim: 'The Significance of Garrick's Letters to Hayman', *Shakespeare Q.*, ix (1958), pp. 148–52
The Georgian Playhouse (exh. cat. by I. Mackintosh and G. Ashton, ACGB, 1975)
L. Bertelsen: 'David Garrick and English Painting', *18th C. Stud.*, xi/3 (1978), pp. 308–24
K. A. Burnim: 'Looking upon his Like Again: Garrick and the Artist', *British Theatre and the Other Arts, 1660–1800*, ed. S. S. Kenny (Washington, DC, 1984), pp. 182–218
S. West: *The Image of the Actor: Verbal and Visual Representation in the Age of Garrick and Kemble* (London, 1991)

SHEARER WEST

Garriga y Roca, Miguel (*b* Alella, Barcelona, 1804; *d* Barcelona, 1888). Spanish architect and urban planner. He studied at the Real Academia de Bellas Artes de San Fernando, Madrid. Among his notable works was the neo-Baroque Gran Teatro del Liceo (1844–8; destr. 1861), Barcelona, built on the grounds of the monastery of the Trinitarians. It had a horseshoe-shaped ground-plan and was later rebuilt by José Oriol Mestres Esplugas, who retained part of the façade design. Garriga y Roca's main interest, however, was in urban planning. In 1857 he offered a proposal for an extension of Barcelona towards the Paseo de Gracia, which mixed the radial system with the orthogonal, in the style of Georges-Eugène Haussmann. The basic grid delivered plots 140×200 m suitable for dwellings and gardens and divided by a rectilinear pattern of streets 10 m wide. Although the plan was approved by the city council, it was replaced by that of Ildefonso Cerdà, which was imposed by the central government in the disputed competition of 1859. In 1864 he received honourable mention in the Exposición Nacional de Bellas Artes for his plans for Barcelona, which included a general plan of the city on a triangular grid, a plan of the Hostafranchs district and a general plan of the old quarter. He also served as architect to the civil government of Barcelona and to the Royal Heritage.

BIBLIOGRAPHY
P. Navascués and others: *Del Neoclasicismo al Modernismo* (Madrid, 1979)

ALBERTO VILLAR MOVELLÁN

Garrison, Edward B. (*b* Chicago, 1900; *d* London, 1981). American art historian. He made a fundamental contribution to the study of medieval Italian painting. His pioneering work mapped out an area of art-historical study through the highly ordered publication of a large body of new or little-known material.

Coming to art history after a business career, Garrison took an MA at the Institute of Fine Arts, New York, in 1945, under Richard Offner's direction. Garrison then travelled extensively in Italy, applying Offner's attributional methods to early panel painting. The resulting publication, *Italian Romanesque Panel Painting: An Illustrated Index*, constituted a concise yet most informative work, which remains a basic tool for the study of medieval painting. Garrison's interests then broadened to include monumental painting and, in particular, manuscript illumination. Between 1953 and 1962 he produced his *Studies in the History of Mediaeval Italian Painting*. This was an idiosyncratic publication, in periodical form, to which Garrison was virtually the only contributor. Definition and categorization of styles and of their chronological developments, and the presentation of much new material, were again major features. His subsequent work, in a variety of journals, reflected his continuing interest in central Italian manuscript studies. The photographic archive that he assembled, the Garrison Collection, is a major resource for study of medieval Italian painting. When it was incorporated into the Courtauld Institute of Art, University of London, in 1962, Garrison became its honorary curator. Apart from this association he was an independent researcher.

WRITINGS
Italian Romanesque Panel Painting: An Illustrated Index (Florence, 1949)
'Toward a New History of Early Lucchese Painting', *A. Bull.*, xxxiii (1951), pp. 11–31
'The Role of Criticism in the Historiography of Painting', *Coll. A. J.*, x (1951), pp. 110–20
Studies in the History of Mediaeval Italian Painting, 4 vols (Florence, 1953–62)

BIBLIOGRAPHY
J. Cannon: 'Bibliography of the Writings of E. B. Garrison', *Burl. Mag.*, cxxiv (1982), pp. 96–7
J. Gardner: Obituary, *Burl. Mag.*, cxxiv (1982), p. 96

JOANNA CANNON

Garrucci, Raffaele (*b* Naples, 23 Jan 1812; *d* Rome, 6 May 1885). Italian writer and Jesuit priest. Virtually self-taught, he had a vast and profound knowledge of Classical and Oriental languages, biblical history and theology, which informed his writings on Classical, Christian and Jewish archaeology. He applied his method of research, based on the study of sources and facts, mainly to Christian iconography and to the topography of catacombs. He made several discoveries, which he shared with other archaeologists and philologists, as his correspondence demonstrates, but he was occasionally critical of some German scholars, especially Theodore Mommsen, at a time when German academics were pre-eminent in this

field. His publications number nearly 120, making him one of the most prolific scholars of his time. One of his earlier works was as editor of the *Hagioglypta* by Joannes Macarius after he had discovered a copy in Paris. After 1858 he began work on his major project, a comprehensive history of Christian art in the first eight centuries; it contained 500 plates illustrating over 2000 works. At the same time, Pope Pius IX commissioned him to write on the monuments of the Lateran Museum. He wrote for several magazines from 1852, mainly *La Civiltà cattolica* and *Bollettino archeologico napoletano*.

WRITINGS
ed.: J. Macarius: *Hagioglypta* (Paris, 1856)
Vetri ornati di figure in oro trovati nei cimiteri dei Cristiani primitivi di Roma (Rome, 1858)
Monumenti del Museo Lateranense (Rome, 1861)
Storia dell'arte cristiana nei primi otto secoli della chiesa, 6 vols (Prato, 1872–81)
Venafro illustrato coll'aiuto delle lapide antiche (Rome, 1874)

OLIMPIA THEODOLI

Garshin, Vsevolod (Mikhaylovich) (*b* Domna estate, nr Donetsk, Ukraine, 14 Feb 1855; *d* St Petersburg, 5 April 1888). Russian writer and theorist of Ukrainian birth. His work began to be published in 1876. He was a supporter of realism in art and was close to the WANDERERS, on whose work he wrote critical essays, mainly analysing their group exhibitions. He posed for a number of paintings by Russian artists. His story *Khudozhniki* ('Artists'), illustrated by Il'ya Repin, was directed against the theory of art for art's sake and expounded the view that art should be socially useful. He was unusually sensitive in his attempts to convey his impressions of art through words.

WRITINGS
Polnoye sobraniye sochineniy [Complete collected works], 3 vols (Moscow, 1934)

BIBLIOGRAPHY
Pamyati Garshina [In memory of Garshin] (St Petersburg, 1988)

V. S. TURCHIN

Garstin, Norman (*b* Cahirconlish, Co. Limerick, 28 Aug 1847; *d* Penzance, Cornwall, 22 June 1926). Irish painter and writer. He attempted various professions, including diamond-mining and journalism in South Africa (1872–7), before becoming an artist. At the Koninklijke Academie, Antwerp (1878–80), under Charles Verlat, in Paris (1881–4) as a student of Carolus-Duran and in Venice (1885) Garstin became friends with future Newlyn school painters. *Saint's House and Field, Tangier* (1885; Plymouth, City Mus. & A.G.), a small oil panel painted *en plein air*, exemplifies both the medium and the suggestive approach he preferred throughout his career. In 1886 he married and settled in Newlyn and then Penzance (1890). Financial pressures forced him to produce portraits and such large anecdotal genre scenes as *Her Signal* (exh. RA 1892; Truro, Co. Mus. & A.G.) for which his talents for simplified forms and surface design were less well suited. Though he exhibited widely, he received little recognition. Garstin supplemented his income by writing, lecturing, teaching and, from 1899, taking art students on summer trips to the Continent. His perceptive, witty articles for *The Studio*, the *Art Journal* and the *Cornhill Magazine* about artists he knew and places he had painted reveal his cosmopolitan taste and experiences. He admired the Japanese aesthetic, and the Impressionists' and Manet's challenge to academic canons. His most famous work, *The Rain it Raineth Every Day* (1889; Penzance, Penlee House Mus. & A.G.), acknowledges his debts to Degas's innovative compositions and Whistler's tonalism. His daughter, Alethea Garstin (1894–1978), was also a painter.

WRITINGS
Contributions to *A. J.* [London] (1884, 1891, 1892), *Cornhill Mag.* (1886) and *The Studio* (1893, 1896–7, 1897, 1900, 1901, 1912)

BIBLIOGRAPHY
Norman and Alethea Garstin: Two Impressionists—Father and Daughter (exh. cat., Penwith, Soc. A., 1978)
Artists of the Newlyn School, 1880–1900 (exh. cat. by C. Fox and F. Greenacre, Newlyn, Orion Gals, 1979), pp. 208–25

BETSY COGGER REZELMAN

Gartman [Hartman], **Viktor (Aleksandrovich)** (*b* St Petersburg, 5 May 1834; *d* Moscow, 4 Aug 1873). Russian architect, designer and artist. He studied at the St Petersburg Academy of Arts (1852–61), where he won the Gold Medal, which allowed him two years' sabbatical leave in Russia and four years' study abroad (1864–8). His subsequent career was brief but richly creative. For his designs for the All-Russian Industrial Exhibition (1870) in St Petersburg, at which he was responsible for some 600 of the projects displayed, from pavilions and showcases to interior decoration, he was made an academician in architecture. An extensive use of timber-framed constructions combining glass, ornament and polychrome fretwork distinguished his work and influenced the design of Russian exhibition halls for decades. His designs for the Moscow Polytechnical Exhibition (1872) were closely linked to his previous work and included a theatre that could be easily assembled. Its façades, with open galleries, were lavishly adorned with fretwork, which also decorated the auditorium, where the canvas curtains were decorated with patterns and motifs similar to those found in peasant needlework. Gartman's timber buildings in rural settings, such as a studio/turret at Abramtsevo and a dacha at Kiroyevo (both 1870–72), are stylistically similar to the exhibition halls, with log walls, elaborate ornamentation of fretted woodwork, and complex compositions and silhouettes. Gartman was inventive and aware of new materials. For the St Petersburg exhibition of 1870 he designed a conference hall (unexecuted) with an extremely ornate façade reminiscent of an Oriental carpet, an effect to be achieved through the use of coloured tiles and specially designed bricks. As elaborate were the walls of the Kiev city gates (abandoned 1869) and the Mamontov printing house (1872) in Leont'yev Lane (now Stanislav Street), Moscow, which show that Gartman was a rationalist and an initiator of the polychrome brick style in Russia. Throughout his life he was also a prolific designer of book covers, interior decoration, furniture and ceramics. In 1870 he designed a production of Glinka's opera *Ruslan and Lyudmila*, and the posthumous exhibition (1874) of his watercolours was the inspiration for Mussorgsky's piano suite *Pictures from an Exhibition*. Always devoted to the use of peasant motifs and models, Gartman's principles were enormously influential throughout Russia in the second half of the 19th century.

BIBLIOGRAPHY
Viktor Aleksandrovich Gartman, arkhitektor [Viktor Aleksandrovich Gartman, architect] (St Petersburg, 1874) [cat. rais.]
I. B.: 'V. Hartman (1834–1873)', *Iskusstvo stroitel'noye i dekorativnoye*, 1–2 (1903)
Y. I. Kirichenko: 'Tri mastera' [Three masters], *Zodchestvo*, ii/21 (1973)
YE. I. KIRICHENKO

Gärtner. German family of architects. (1) Andreas Gärtner achieved a modest career as a minor Neo-classical architect with a local reputation in Koblenz and Munich. His son (2) Friedrich von Gärtner was a court architect to Ludwig I of Bavaria and a prominent exponent of Romantic Classicism.

(1) Andreas (Johann) Gärtner (*b* Dresden, 10 Aug 1744; *d* Munich, 15 Nov 1826). His first important appointment came in 1783, when he was appointed building director in Koblenz to Elector Clemens Wenceslaus of Trier. Gärtner was mainly responsible for the completion (1777–86) of the electoral residence in Koblenz, designed by the French architects Pierre-Michel d'Ixnard and Antoine-François Peyre. He also worked on numerous other minor projects, but he lost his patron when in 1794 Trier was taken by the French and subsequently the Electorate ceased to exist. He moved to Würzburg in 1799 as court architect to the prince-bishop and five years later went to Munich when Würzburg was annexed to Bavaria. Here he was appointed director of the royal works, a position he occupied until he retired in 1818. His work in Munich was overshadowed by that of the more able Karl von Fischer and, from 1814, Leo von Klenze. Andreas Gärtner's best-known public works in Munich are the west front of the royal mint (1809) and a wing of the Bayerishe Akademie der Wissenschaften (1808–11), both rather simple examples of the somewhat dry Neo-classicism of the early 19th century. He was also engaged in the interior decoration of the Residenz in Munich.

(2) Friedrich von Gärtner (*b* Koblenz, 10 Dec 1792; *d* Munich, 21 April 1847). Son of (1) Andreas Gärtner. He studied (1808/9–12) at the reorganized Akademie der Bildenden Kunst in Munich under Karl von Fischer. Then he went briefly to Karlsruhe, where Friedrich Weinbrenner had established an important centre of Neo-classical architecture, and subsequently spent two years in Paris studying with Charles Percier and Pierre-François-Léonard Fontaine. In 1815 he travelled to Italy, where he visited most of the important sites in Rome, Naples and Sicily; later he published two volumes about ancient Roman and Sicilian monuments (1819, 1824).

When Gärtner returned to Munich in 1817 he found Leo von Klenze had a well-established reputation, and for two years he suffered from a lack of commissions. In 1819 he accepted an invitation from C. R. Cockerell to come to London and help with publications of Cockerell's journey through Greece. Gärtner stayed in England less than a year, however, because after the death of Karl von Fischer he returned to take up the vacant chair of architecture at the Akademie in Munich, which he obtained through his father's influence. In 1822 he was appointed artistic director of the Nymphenburg Porcelain Factory, but his only architectural commission was the rebuilding of the porcelain factory (1823–5). His situation improved when the Crown Prince became Ludwig I, King of Bavaria, in 1825 and wanted another architect as a counter-balance to the arbitrary Klenze. Thereafter there developed an important relationship between patron and architect. In 1828 Gärtner was commissioned to design his first great work, the Ludwigskirche on the Ludwigstrasse, the centre of Ludwig's grand project to establish Munich as a city of architectural and cultural prominence (*see* WITTELSBACH, §III(3)). Klenze had presented his project for the new Ludwigstrasse in 1816 and most of the southern part of the street had been built. The northern section of the street (beyond Klenze's Kriegsministerium) was entirely Gärtner's work (see fig.); he designed and built all the public buildings as well as two monuments at each end of the street (see below). Klenze's Neo-classical canon was replaced by Gärtner's new conception of a dynamic contemporary architecture, which stylistically was a combination of classical and Romanesque forms (*see* RUNDBOGENSTIL).

The Ludwigskirche (1829–44) was a unique achievement of its time, the answer to Gärtner's quest for a style that could develop the artistic possibilities he believed were concealed in early medieval architecture. He tried out a series of schemes, the earliest being of a rather dull and dry character. The mature solution was a basilica with transept and a rectangular choir, the street façade dominated by tall, elegant, twin towers; the parsonage and Gärtner's own house were connected to the entrance

Friedrich von Gärtner: Ludwigstrasse, Munich, with the Ludwigskirche (1829–44) and Staatsbibliothek (1832–43); from an engraving by E. Rauch

façade by round-arched arcades, giving a horizontal emphasis to the street front. Compared to the severe, almost geometric forms of the exterior, the interior displays a surprising richness, mainly due to the plasticity of the architectural details and to the novel polychrome decoration. PETER CORNELIUS provided choir and transept with monumental frescoes depicting the Christian creed, dominated by a gigantic *Last Judgement* (1839) on the choir wall above the high altar.

While Gärtner was planning the Ludwigskirche he was also occupied with the Staatsbibliothek in Munich, planned by Ludwig I since 1827. The first site chosen was on the Königsplatz, opposite Klenze's Glyptothek. From 1828, however, Gärtner was planning for a site on the Ludwigstrasse, next to his church. Because of financial problems the building was begun only in 1832 (completed 1843). The three-storey structure of 25 bays, with horizontal accentuation and a severe exterior softened only by polychrome colouring, set the gigantic scale and the artistic character of Gärtner's section of the Ludwigstrasse, although there is some influence from Klenze's adjoining Kriegsministerium. Both buildings clearly derive from the same model—the 15th-century Florentine palazzo—yet Gärtner's building surpasses his rival's both in scale and expressiveness.

Other public buildings in Munich followed, all begun in the 1830s: the Blindeninstitut (1833–5), University (1835–40), Georgianum (1835–40), Damenstift St Anna (1835–9), Max-Joseph-Stift (1837–40) and the Salinengebäude (1838–43). In his design for the latter Gärtner was clearly free of Klenze's influence, mainly due to his short visit to Berlin in 1835, where he had seen Karl Friedrich Schinkel's later works, particularly the rationalist, brick Bauakademie. Inspired by this, Gärtner used glazed bricks and terracotta for the ornament of the Salinengebäude, with the same red-yellow colouring as the Bauakademie. Two final monuments designed by Gärtner completed the rebuilding of the Ludwigstrasse: the Feldherrnhalle (1841–4) at the south end and the Siegestor (1843–52) at the north, closely based at the request of the King on the Loggia dei Lanzi in Florence and the Arch of Constantine in Rome.

As well as undertaking buildings for the King, including the Pompejanum (1841–4), an Italianate villa near Aschaffenburg, Befreiungshalle (begun 1842) in Kehlheim and the Wittelsbach Palace (1843–9) in Munich, Gärtner was appointed curator of historical monuments (1836) and was occupied with several restorations of medieval architecture—Bamberg Cathedral (1835–43), Regensburg Cathedral (1836–9) and the church and cloister at Heilsbronn (1837)—although later opinion regarded the results as deplorable. His only exercise in the Gothic Revival, the Wittelsbach Palace, illustrated his approach to Gothic architecture, which was superficial compared to his deep understanding of Romanesque and Renaissance art.

In 1835 Gärtner, together with Klenze, accompanied the King's younger son, Otto, King of Greece (*reg* 1832–62), to Athens, where he was commissioned to build the new royal residence (1836–41; now the Parliament; *see* ATHENS, fig. 8). Gärtner rejected Schinkel's vision of a reconstructed Acropolis in the schemes of 1834 and designed a very contemporary building. In spite of its

subdued Greek character, dictated by the illustrious site, he maintained the conception that had sustained the Ludwigstrasse buildings: he designed a chaste three-storey cubic block, clearly stressing the horizontal; the slight central projection with its heavy Doric portico, which supports a balcony, gives the building a majestic dignity. On a second visit to Athens (1840–41) he designed and supervised the interior decoration of the new residence, which was the earliest Neo-classical building in Wittelsbach Athens.

Gärtner was appointed director of the Akademie in Munich in 1841; his influence on the young generation of architects was considerable and was greater than that of Klenze. His most able pupil, Friedrich Bürklein, was the architect of the Maximilianstrasse, Munich, which was the most ambitious urban plan of the following period. After Gärtner's sudden death, his uncompleted projects in Munich (Wittelsbach Palace, Siegestor, Campo Santo) were finished to his designs, and the Befreiungshalle (inaugurated 1863) in Kehlheim was completed to an altered design by Klenze.

WRITINGS
Ansichten der am meisten erhalten griechischen Monumente Siciliens (Munich, 1819)
Römische Bauverzierungen (Munich, 1824)
Sammlung der Entwürfe ausgeführter Gebäude Bibliotek und Archiv-Gebäude in München (Munich 1844–5)

BIBLIOGRAPHY
Thieme–Becker
H. Moninger: *Friedrich von Gärtners Originalpläne und Studien* (Munich, 1882)
H. Reidelbach: *Ludwig I und seine Kunstschöpfungen* (Munich, 1888)
O. Hederer: *Die Ludwigskirche in München* (Munich, 1942)
H. Russack: *Deutsche Bauen in Athen* (Berlin, 1942)
H. R. Hitchcock: *Architecture: Nineteenth and Twentieth Centuries*, Pelican Hist. A (Harmondsworth, 1958, 4/1977), pp. 53–4, 68
K. Eggert: *Friedrich von Gärtner: Der Baumeister König Ludwigs I* (Munich, 1963)
H. Karlinger: *München und die Kunst des 19. Jahrhunderts* (Munich, 1966)
O. Hederer: *Friedrich von Gärtner, 1792–1847* (Munich, 1976)
D. Watkin and T. Mellinghoff: *German Architecture and the Classical Ideal, 1740–1840* (London, 1987)
SUSANNE KRONBICHLER-SKACHA

Gärtner, Christoph. *See* GERTNER, CHRISTOPH.

Gärtner, Eduard. *See* GAERTNER, EDUARD.

Gärtner, Georg, II (*b* Nuremberg, *c.* 1575/80; *d* Nuremberg, 1654). German painter and engraver. The son of the artist Georg Gärtner I (*d* 1612), he probably worked with his father until 1612. He executed 44 signed plates illustrating the *Funeral Procession of Margrave Frederick of Brandenburg* (1613; London, BM) and also helped illustrate B. Beseler's natural science compendium, the *Hortus Eichstettensis* (Nuremberg, 1613; complete copy, Nuremberg, Stadtbib.), which he signed appropriately in Latin as 'Georg Hortulanus'. On 8 April 1613 Nuremberg city council commissioned him to work alongside Gabriel Weyer, Paul Juvenel I and Jobst Harrich to restore the wall paintings designed by Dürer for the Nuremberg Rathaussaal (destr. 1945). This restoration was undertaken first in 1613–14, then in a second phase in 1619.

Gärtner's contemporaries praised him as 'felicissimus Dürer imitator', and after the death of Hans Hoffmann in 1591/2 he became the leading Dürer copyist (*see* DÜRER

RENAISSANCE). Unlike other Dürer copyists such as Hoffmann, Gärtner does not seem to have painted in a contemporary 17th-century style, on the evidence of his surviving autograph works. His copy of Dürer's *Man of Sorrows* (1512), which was last listed in the Imhoff inventory (Göttingen, Kstsamml. U.), provides a valuable record of this untraced painting, displaying Dürer's fine and delicate treatment of the beard and hair. Gärtner also combined various figures from different compositions including drawings and prints in order to create his own 'Dürer-style' version, as, for example, in a drawing of the *Man of Sorrows* (Vienna, Albertina). Two additional figures appear on either side of Christ, to the right Pontius Pilate and to the left a henchman. Here Gärtner elaborated on the subject by effectively contrasting the elegant features of Christ against the offensive physiognomy (selected from Dürer's repertory) of the two additional characters in order to emphasize the Saviour's dignity. In another instance Gärtner adapted Dürer's *Praying Fürlegerin* (?1497 or 1506; Frankfurt am Main, Städel. Kstinst. & Städt. Gal.) in his drawing of the *Praying Virgin* (Darmstadt, Hess. Landesmus.) by replacing the praying hands with wrung hands and adding a halo; again the portrait is framed by the typical goldsmith-like foliage motif that probably formed a particular feature of the Gärtner workshop. The drawing technique is close to Dürer's sketches (*c.* 1506) for the *Virgin of the Rose Garlands* (Prague, N.G., Convent of St George) and *Christ among the Doctors* (Madrid, Mus. Thyssen-Bornemisza).

Apart from the drawings and copies after Dürer, some paintings by Gärtner on copper in a Düreresque style are known. For example the small painting of the *Circumcision* (priv. col.; sold London, Sotheby's, 30 Nov 1983, lot 174) displays Düreresque figures such as the Virgin in the background, closely based on Dürer's *Family of St Anne* (*c.* 1514; New York, Met.), although the composition is taken from an engraving of the *Circumcision* (1594; B. 0301.018) set in a chapel of St Bravo' Church in Haarlem by Hendrick Goltzius, who in turn employed figures based closely on one of Dürer's woodcuts (B. 1001.086).

BIBLIOGRAPHY
J. Neudörfer and A. Gulden: *Nachrichten von Künstlern und Werkleuten*, ed. G. W. K. Lochner (Vienna, 1875)
H. Kauffman: 'Dürer in der Kunst und im Kunsturteil um 1600', *Anzeiger des Germanischen Nationalmuseums (1940–1953)* (Nuremberg, 1954), pp. 18–60
F. Anzelewsky: *Albrecht Dürer: Das malerische Werk*, 2 vols (Berlin, 1971, rev. 2/1991)
Dürer-Renaissance (exh. cat., ed. G. Goldberg; Nuremberg, Ger. Nmus., 1971)
Zeichnung in Deutschland (exh. cat., ed. W. Geissler; Stuttgart, Staatsgal., 1979–80)
W. L. Strauss: *Sixteenth-century German Artists (1980)*, 10 [VII/i] of *The Illustrated Bartsch*, ed. W. L. Strauss (New York, 1978–) [B.]

Garzi, Luigi (*b* Pistoia, 1638; *d* Rome, 1721). Italian painter. At the age of 15 he entered the Roman workshop of Andrea Sacchi, from whom he acquired the classical training that served him throughout his career. Among his earliest works is the *Triumph of St Catherine and All Saints* (Rome, S Caterina a Magnanapoli), which clearly shows the influence of Emilian painting, particularly that of Reni. Another early canvas is *St Silvestro Shows Constantine*

Portraits of SS Peter and Paul (Rome, Santa Croce in Gerusalemme). In 1680 Garzi was appointed Regent of the Congregazione dei Virtuosi al Pantheon, and in 1682 he became Principe of the Accademia di S Luca, of which he had been a member since 1670. In the early 1680s he contributed to the frescoed decoration of the vault of S Carlo al Corso, where his works included an *Allegory of Faith*. This was influenced by Giovanni Lanfranco's decoration in S Andrea della Valle, as was his fresco depicting the *Glory of the Eternal Father* (1686; S Maria del Popolo, Cappella Cybo).

Between 1695 and 1697 Garzi decorated the chapel of S Francesco in S Silvestro in Capite, Rome, with a fresco and paintings showing scenes from the *Life of St Francis*; a preparatory sketch for the painting of *St Francis Preaching* has survived (Holkham Hall, Norfolk). In the same period he painted a fresco cycle for S Caterina a Formiello in Naples, responding to the influence of Luca Giordano and Francesco Solimena in an overdoor panel of the *Miracle of St Catherine* and a vault decoration of the *Ecstasy of St Catherine of Siena*. Back in Rome, he repeated this theme in the vault of S Caterina a Magnanapoli (before 1713) but in a more classical style, indebted to Maratti. Among his last works were the nave decoration of the Roman churches of S Giovanni in Laterano, the oratory of S Maria Traspontina (*c.* 1715) and S Paolo alla Regola. A late canvas, *Cincinnatus Recalled from the Fields*, and a preparatory sketch for it survive in the collection at Holkham Hall. This work, influenced by Poussin, reveals his lasting commitment to Roman classicism.

BIBLIOGRAPHY
L. Pascoli: *Vite* (1730–36), ii, pp. 235–45
G. Sestieri: 'Per la conoscenza di Luigi Garzi', *Commentari*, xxiii/1–2 (1972), pp. 89–111
——: 'Luigi Garzi fra seicento e settecento', *Scritti di storia dell'arte in onore di Federico Zeri* (Milan, 1984), ii, pp. 755–65
M. Gregori and E. Schleier, eds: *La pittura in Italia: Il seicento*, 2 vols (Milan, 1989), i, fig. 695; ii, p. 754
MARIO ALBERTO PAVONE

Garzone. Young apprentice, less trained than a journeyman, working in an artist's studio in Italy, especially during the Renaissance and Baroque periods. Such boys often posed for figure studies by the studio master.

Garzoni, Giovanna (*b* ?Ascoli Piceno, 1600; *d* Rome, ?12 Feb 1670). Italian painter. She may have begun her training in Ascoli Piceno. In a letter written in the 1620s, she identified the otherwise unknown Giacomo Rogni as her teacher. The theory that she studied miniature painting in Florence with Jacopo Ligozzi is no longer accepted, although she must have seen his exquisite nature studies when she was later at the Medici court. In 1625, and again in 1630, she was in Venice, where she painted a miniature *Portrait of a Young Man* (1625; The Hague, Willem V Mus.) and wrote a small textbook on calligraphy (Rome, Gal. Accad. N. S Luca). By the late 1620s she had two influential patrons in Rome: Cassiano dal Pozzo and Anna Colonna, wife of Taddeo Barberini. She went to Naples in 1630, to work for the Duque de Alcalá, and was still there a year later, when in a letter to dal Pozzo she expressed her desire to 'live and die in Rome'. However, she spent the next five years in Turin at the court of

Charles Emanuel II, Duke of Savoy. She left Turin in 1637, probably for Florence; documents indicate that she was there from 1643. She continued to work for members of the Medici court after finally settling in Rome in 1651. There she was a loyal supporter of the Accademia di S Luca, to which she bequeathed her property on condition that a monument to her be placed in the Accademia's church, SS Luca e Martina. It was set up in 1698.

Garzoni specialized in the depiction of fruit, vegetables, flowers and occasionally animals, painted with tiny stippled dabs of watercolour on parchment; she also painted portraits and small devotional pictures. She usually selected one type of fruit (grapes, figs) or vegetable (broad beans), showing it close to the picture plane on a slightly uneven surface coloured to suggest earth but with a horizon too close and low for spatial realism (e.g. *Broad Beans, c.* 1650; see 1976–7 exh. cat.). The area above is often untinted. The focus is on the principal object, which she rendered accurately and with considerable compositional flair. She also painted a series of sumptuous bouquets of flowers in glass or porcelain vases, works that display her botanical knowledge and artistic sophistication to best advantage. She was widely admired and was patronized by collectors in Italy and Spain. Almost 40 of her paintings have now been traced in Florentine collections, many in the Palazzo Pitti, and many others were recorded in Medici inventories of the 17th and 18th centuries. Her finest work is a splendid synthesis of art and science rivalled by few specialists in this genre.

BIBLIOGRAPHY

L. Pascoli: *Vite* (1730–36), pp. 201, 451
G. C. Carboni: *Memorie intorno i letterati e gli artisti della città di Ascoli nel Piceno* (Ascoli Piceno, 1830), pp. 203–4
La natura morta italiana (exh. cat., Naples, Pal. Reale, 1964), nos 12–17
A. Cipriani: 'Giovanna Garzoni, miniatrice', *Ric. Stor. A.*, 1–2 (1976), pp. 241–6
Women Artists, 1550–1950 (exh. cat. by A. S. Harris and L. Nochlin; Los Angeles, CA, Co. Mus. A.; New York, Alfred A. Knopf; 1976–7), pp. 134–6
Italian Still Life Painting from Three Centuries (exh. cat. by J. Spike, New York, N. Acad. Des., 1983), pp. 65–70
S. Meloni: 'Giovanna Garzoni miniatora', *Franco Maria Ricci*, 15 (1983), pp. 77–96
A. Mongan: 'A Fête of Flowers: Women Artists' Contribution to Botanical Illustration', *Apollo*, cxix (1984), pp. 264–7
M. Rosci: 'Giovanna Garzoni dal Palazzo Reale di Torino a Superga', *Scritti di storia dell'arte in onore di Federico Zeri* (Milan, 1984), ii, pp. 565–7
Il seicento fiorentino: Arte a Firenze da Ferdinando I a Cosimo III (exh. cat., Florence, Pal. Strozzi, 1986–7), i, pp. 459–65; iii, pp. 97–9

ANN SUTHERLAND HARRIS

Gascar [Gascard; Gascars], **Henri** (*b* Paris, 1634–5; *d* Rome, 18 Jan 1701). French painter. He was perhaps the son of Pierre Gascar, an obscure painter and sculptor. In 1659 he made his first journey to Rome. He had probably returned to Paris by 1667, although he may have been in the Netherlands that year when he executed his fine portrait of *Nicolas Delafond* (St Petersburg, Hermitage), a journalist from Amsterdam. The informality of the pose and the simplicity of the sitter's expression are reminiscent of contemporary Dutch portraits by such painters as Jacob Gerritsz. Cuyp and Ferdinand Bol, but the elegance of gesture and the extremely refined treatment of drapery are entirely French. In 1672 Gascar's *morceau de réception*, a

portrait of *Louis de Bourbon, the Grand Dauphin* (untraced), was rejected by the Académie Royale, a setback that may have been the cause of his departure for England in 1674, although Waterhouse suggested that he may have been a French agent. In London he worked at the court of Charles II, painting the portrait of, among others, *Louise Renée de Penancoet de Kéroualle, Duchess of Portsmouth* (Goodwood House, W. Sussex), with whom he found particular favour. During this period he also painted the double portrait of *Lord Lisle and Dorothy Sidney, Children of the 3rd Earl of Leicester* (Althorp House, Northants), which shows the influence of both Pierre Mignard and Peter Lely. His allegorical portrait of the *Duchess of Grafton* (Providence, RI, Brown U., Bell Gal.), on the other hand, seems to reveal the influence of Willem Wissing. His most astonishing work in the English context is the full-length portrait of *James, Duke of York, as Lord High Admiral* (London, N. Mar. Mus.). The Duke (later James II) is presented in Roman armour in a manner reminiscent of images of Louis XIV, and the colouring has a curious metallic tonality.

Gascar may have travelled through the Netherlands again before returning to Paris in 1679. There he was received (*reçu*) as a member of the Académie Royale in 1680 with portraits of *Louis Elle the Elder* and *Pierre de Sève the Younger* (both Versailles, Château) in which he temporarily abandoned the preciosity of his English period. In 1681 he executed a portrait of *Charles Colbert, Marquis de Croissy* (untraced; engr. Antoine Masson). In April that year he left France for Italy. A portrait of *Prince Maximilian William of Hanover* (Hannover, Fürstenhaus Herrenhausen-Mus.) is signed and dated *Gascar Venetiae 1686*, which suggests a stay of some length. He finally settled in Rome, where he painted an altarpiece representing *St Anthony* (S Maria dei Miracoli; *in situ*). The task of re-establishing Gascar's oeuvre is helped by the existence of engravings after a number of his portraits, including those of the *Duchess of Portsmouth* by Etienne Baudet (1636–1711), of *Charles II* by Pieter van der Banck (1649–97) and of *Violanta Beatrix of Bavaria* by Joseph Anton Zimmermann (1705–97).

BIBLIOGRAPHY

Thieme–Becker
E. Waterhouse: *Painting in Britain, 1530–1790*, Pelican Hist. A. (London, 1953, rev. 2/1977), pp. 103–6

D. BRÊME

Gascon, Ponciano Ponzano y. *See* PONZANO Y GASCON, PONCIANO.

Gaspari, Antonio. *See under* LONGHENA, BALDASSARE.

Gasparini, Paolo (*b* Gorizia, Italy, 1934). Venezuelan photographer of Italian birth. He moved to Venezuela in 1954, working as a photographer of architecture. At the same time he depicted the landscape and the life of the Venezuelan countryside. He was invited to participate in the Fourth Photographic Show in Spilimbergo, Italy, where he won a silver medal. He settled for four years in Cuba, where he worked at the Consejo Nacional de Cultura. His work, based on neo-realism, was influenced by that of Paul Strand, and he was particularly interested in photographing aspects of the social structure. He returned to

Venezuela in 1967 and took part in the Venezuelan Pavilion at Expo 67 in Montreal. He was a founder-member of the Consejo Latinoamericano de Fotografía. Examples of his photography are in MOMA, New York, in the International Museum of Photography at George Eastman House, Rochester, NY, and in the Bibliothèque Nationale in Paris.

PHOTOGRAPHIC PUBLICATIONS
Retromundo (1987)

CRUZ BARCELÓ CEDEÑO

Gasparo Padovano (*fl* Rome, 1483–5). Italian illuminator. He is mentioned as an illuminator, with Bartolomeo Sanvito, in Rome, in the will (1483) of Cardinal Francesco Gonzaga (*see also* MANUSCRIPT, colour pl. III). In 1485 he was in Rome in the service of the Neapolitan cardinal Giovanni d'Aragona (1456–85). He can be identified with the Gasparo Romano mentioned by Pietro Summonte in a letter of 20 March 1524 to Marcantonio Michiel as the illuminator 'al garbo antiquo' (in the antique manner) of a copy of Pliny (untraced) for Giovanni d'Aragona. The same source stated that Gasparo was also an architect and that his style was copied by Giovanni Todeschino (*fl* Naples, 1487–1500). There are no documented works by Gasparo. His Paduan origin, his presence in Rome and his relationship with Sanvito make it likely that he was one of the illuminators who propagated in Rome the antiquarian, classicizing style that originated in Padua and the Veneto region (*see* VENICE §III, 1). Scholars have tentatively identified Gasparo with two anonymous illuminators, the Master of the Berlin St Jerome (Berlin, Kupferstichkab., MS. 78 D. 13) and the Master of the Vatican Homer (Rome, Vatican, Bib. Apostolica, MS. Vat. gr. 1626). In both cases the artists, who are presumed to have come from the Veneto region, worked during the 1480s and 1490s on commissions from Giovanni d'Aragona as well as those mentioned above. The manuscripts of the Master of the Vatican Homer have also been attributed to Sanvito or Lauro Padovano. Those of the St Jerome master, on the other hand, for example a copy of Ovid's *Metamorphoses* (Paris, Bib. N., MS. lat. 8016), have recently been ascribed to the Master of the London Pliny (London, BL, MS. IC. 19662). These works influenced manuscript illumination in Naples and might, therefore, have been executed by Gasparo. Decorated with architectural frontispieces and antiquarian motifs of gems, pearls and cameos, they are characterized by refined metallic tones based on blues, mauves and gold.

BIBLIOGRAPHY
J. J. G. Alexander: 'Notes on Some Veneto-Paduan Illuminated Books of the Renaissance', *A. Ven.*, xxiii (1969), pp. 9–20
J. Ruysschaert: 'Miniaturistes "romains" à Naples', *La biblioteca napoletana dei re d'Aragona: Supplemento*, ed. T. de Marinis, i (Verona, 1969), pp. 263–74
A. Putaturo Murano: 'Ipotesi per Gasparo Romano miniatore degli Aragonesi', *Archv. Stor. Prov. Napoletane*, xiv (1975–6), pp. 95–100
L. Armstrong: *Renaissance Miniature Painters and Classical Imagery: The Master of the Putti and his Venetian Workshop* (London, 1981), pp. 40–49
The Painted Page: Italian Renaissance Book Illumination, 1450–1550 (exh. cat., ed. J. J. G. Alexander; London, RA, 1994)

FEDERICA TONIOLO

Gasperini, Gian Carlo. *See under* CROCE, AFLALO AND GASPERINI.

Gassel, Lucas [Luc] (*b* Helmond, *c.* 1495–1500; *d* Brussels, *c.* 1570). Flemish painter. According to van Mander, he worked in Brussels and was a friend of Domenicus Lampsonius (1532–99), who included Gassel in his *Pictorum aliquot celebrium Germaniae inferioris effigies* (1572). Gassel, whom van Mander described as a good but unproductive painter, belonged to the Joachim Patinir and Herri met de Bles tradition of landscape painters. He preferred panoramic rocky and mountainous views with a

Lucas Gassel: *Landscape with a Copper Mine*, oil on panel, 565×1065 mm, 1544 (Brussels, Musée d'Art Ancien)

high horizon and a plethora of details, but his works have a character of their own and are not mere slavish imitations. The rocks and mountains have less fanciful silhouettes and are generally placed further into the background of the composition. The sparse and generally dark brown foreground flows gradually into the empty blue-green but distinct mountainous distance. The figures in Gassel's paintings are generally of a thick-set build with large heads; yet they add colour to the otherwise dull foreground. By using repoussoir motifs and elements that lead into the composition, he introduced two features from Italian landscape painting, but these often exist in isolation in a landscape where the artist is not prepared to abandon the high horizon and excess of detail. He experimented with the repoussoir motif in the *Landscape with a Copper Mine* (Brussels, Mus. A. Anc.; see fig.) and the *Landscape with Juda and Thamar* (Vienna, Ksthist. Mus.): a few trees on a hill in sharp profile against a light background landscape; however, he was unable to exploit the full potential offered by this convention. Indeed, the repoussoir motif appears to be unconnected to the rest of the landscape, in which individual motifs have their own perspective, resulting in a less than unified whole. A stage further in Gassel's development is evident in the *Landscape with a 'Noli me tangere'* (Prague, N.G., Sternbeck Pal.); here the dark repoussoir foreground is linked by a road to the rest of the landscape. Although the details seem less superfluous, the scene still appears rather artificial, with its strongly horizontal divisions.

The use of proper linear perspective is seen in a number of landscapes by Gassel that appeared in an engraved series published by Hieronymus Cock in the 1560s (Hollstein, vii, p. 89). In the *Landscape with Abraham and the Angels*, for which the preparatory drawing by Gassel—his last dated work—is preserved (1568; Berlin, Kupferstich-kab.), the composition is closed off and dominated by the fairly accurately rendered farm buildings in the middle distance. This rigid linearity is taken to an extreme in the *Landscape with St Jerome* (Hollstein, no. 4), in which all the straight lines seem to have been drawn with a ruler.

BIBLIOGRAPHY

Hollstein: *Dut. & Flem.*
K. van Mander: *Schilder-boeck* ([1603]–1604)
S. de Schrijver: 'Luc Gassel: Peintre paysagiste du XVIe siècle', *An. Soc. Royale Archéol. Bruxelles*, v (1891), pp. 1–16 [off-print]
G. J. Hoogewerff: 'Lucas Gassel: Schilder van Helmond', *Oud-Holland*, liii (1936), pp. 37–47
H. G. Franz: *Niederlandsche Landschaftsmalerei im Zeitalter des Manierismus*, 2 vols (Graz, 1969), i, pp. 108–13; ii, pp. 75–81

HANS DEVISSCHER

Gasser, Hans (*b* Eisentratten, 2 Oct 1817; *d* Pest, 24 April 1868). Austrian sculptor, painter and collector. He was introduced to carving and painting in the workshop of his father, a rural Carinthian cabinetmaker and woodcarver. In 1838 he was allowed to go to Vienna to join his elder brother Franz Gasser, who lived there as a portrait painter; Franz's death that year obliged Hans to earn a living by painting portraits and doing small-scale decorative work while studying at the Akademie and preparing for a career as a sculptor. Some prizes and the support of benevolent patrons enabled him to move to Munich where he hoped to find greater stimulation and better teachers.

There he met Ludwig von Schwanthaler and the painters working for Ludwig I. Gasser had some success with statuettes (e.g. *Wilhelm von Kaulbach*, 1846; Cologne, Wallraf-Richartz-Mus.) and small, delicate groups (e.g. *The Schnorr Daughters*, 1843; Vienna, Belvedere). In 1847 he returned to Vienna on receiving his first commission for architectural sculpture: the façade statues of the Carl Theater (1847; destr. 1951). From this point he worked frequently for the aristocracy and was also in demand at the imperial court. He produced several figural decorations for public and private buildings such as the Arsenal and the Bank- und Börsengebäude in Vienna, contributed to monuments, excelled in portrait busts and tombs and also helped in special commissions such as that from Emperor Francis Joseph for Queen Victoria's bookcase (1851; London, V&A). His growing renown led to further commissions from abroad including those for monuments to the writer *Christoph Martin Wieland* (1857; Weimar Frauenplatz, later known as Wielandsplatz) and to *Adam Smith* (U. Glasgow, Hunterian A.G.). Among Gasser's best works are a *Self-portrait* (*c.* 1855; Vienna, Hist. Mus.), Mozart's tomb monument (1859; Vienna, Cent. Cemetery; later damaged, then slightly altered), a statue of the *Empress Elizabeth* (1860; Vienna, Westbahnhof), a bust of the painter *Carl Rahl* (1866; Vienna, Belvedere) and the fountain figures of the Vienna Opernhaus (1866–8). The latter were almost completed when Gasser died from a festering wound he had received while carving.

Gasser taught briefly (1850–51) at the Vienna Akademie but was dismissed because of his liberal ideals. He gradually built up an important art collection, which formed a picturesque ensemble of diverse forms and styles framed by the *Altdeutsch* architecture of his house. Ill-considered purchases plunged him into debt, resulting in the early loss of many objects; the rest of the collection was dispersed after his death. Among the most famous works were two 16th-century wooden madonnas, one by Tilman Riemenschneider (both now Vienna, Ksthist. Mus.). Gasser's sculptural style combines the more vivid elements of Munich Romanticism with the heritage of Viennese Biedermeier, achieving an organic yet not over-particularizing modelling; and his work was most successful on a small scale. He aimed at realism but tried to avoid superfluous details and any artificial virtuosity. Dramatic and sentimental features, mood and expression were his strong points; and it cannot be doubted that he laid the foundations of a more psychological conception of sculptural representation, independent from the dictates of architecture. Many of his plaster models and sketches are held in the Landesmuseum für Kärnten in Klagenfurt, and some drawings are at the Albertina in Vienna. Several other works, notably portraits, may be seen in the museums of Vienna and Budapest.

BIBLIOGRAPHY

OBL; Thieme–Becker
M. Poch-Kalous: 'Wiener Plastik im 19. Jahrhundert', *Geschichte der bildenden Kunst in Wien: Plastik in Wien* (1970), n.s. VII/i of Gesch. Stadt Wien (Vienna, 1955–)
W. Krause: *Die Plastik der Wiener Ringstrasse: Von der Spätromantik bis zur Wende um 1900* (1980), ix of *Die Wiener Ringstrasse*, ed. R. Wagner-Rieger (Wiesbaden, 1969–81)
A. Rohsmann: *Der Bildhauer Hans Gasser* (Klagenfurt, 1985) [many illus.]

WALTER KRAUSE

Gas station. *See* SERVICE STATION.

Gasteiz. *See* VITORIA.

Gasur. *See* NUZI.

Gatchina. Russian town 45 km south-west of St Petersburg with an important 18th-century palace and park. In 1765 Catherine II (*reg* 1762–96) gave the estate to her favourite, Grigory Orlov, for whom ANTONIO RINALDI built a large palace (1766–81) in Russian Neo-classical style. The main three-storey block, revetted in yellow-grey stone, is flanked by two pentagonal towers that give the building the austere appearance of a fortress. A curved single-storey open gallery linked it with two symmetrical service wings, the kitchen and stables (later the arsenal). In 1783 Gatchina became the property of Pavel Petrovich, Catherine II's son, the future Paul I (*reg* 1796–1801). He commissioned VINCENZO BRENNA to transform the open gallery into blind walls and to build a second storey on top. Brenna also turned the lawn in front of the palace into a drill square enclosed by a moat with drawbridges. Rinaldi's original interior decorations, which made extensive use of murals, stucco moulding and patterned parquet, were altered to give a more military, ceremonial effect, although the White Hall retains Rinaldi's original décor.

The grounds (143 ha), largely to the north of the palace, were laid out in the 1760s by John Busch (*fl* 1730s–90s) as an English-style park; they acquired their final form towards the end of the 18th century under the supervision of the landscape gardener G. Hackett. The focal points of the layout are the Beloye (White) and Serebryanoye (Silver) Lakes, the carp pond and small islands and peninsulas, among which are distributed obelisks, columns and pavilions, such as the Venus Pavilion (1792) and the Birchwood Hut (1790s). In the 1790s Brenna, together with Hackett and F. Helmholz, created the formal Upper and Lower Dutch Gardens and the Private Garden; they are all close to the palace and contain Italianate sculpture. The northwestern part of the park, the Silviya, which includes a maze, was also laid out formally in the 1790s with a design based on a radiating system of alleys. On its periphery are the Bird House (by Andreyan Zakharov, 1797) and the Farm (1796–8). South-east of the park is the landscaped Prioratsky (Priory) Park with the Chornoye (Black) and Glukhoye (Deaf) Lakes. In 1798–9 NIKOLAY L'VOV built the Prioratsky Palace beside Lake Chornoye using the unusual medium of rammed earth. Under Nicholas I (*reg* 1825–55) additions were made to the main palace (1844–52) by R. I. Kuzmin: most notably the height of the wings and of the towers was increased. The palace was badly damaged in World War II but has been carefully restored.

BIBLIOGRAPHY
Y. M. Piryutko: *Gatchina: Khudozhestvennyye pamyatniki goroda i okrestnostyey* [Gatchina: the artistic monuments of the town and its environs] (Leningrad, 1975)
Pamyatniki arkhitektury prigorodov Leningrada: Al'bom-monografiya [Architectural monuments in the Leningrad area: album-monograph] (Leningrad, 1983)
M. I. ANDREYEV

Gate-house. Defensive or semi-defensive structure for the protection of the entrance to a castle, residence or community.

1. Military. 2. Domestic.

1. MILITARY. The defence of the entrance to any fortress, an obvious potential weakness, received much attention from medieval military architects (*see* CASTLE, §I). The paradoxical result was that the gateways of walled towns were usually the strongest points in the enceinte, and similarly also in castles, hence the so-called 'keep-gate-houses' at, for example, Harlech and Beaumaris.

Apart from some gate-houses, such as the 13th-century Constable's Gate at DOVER CASTLE (*see* CASTLE, fig. 3) and the closely related Black Gate at Newcastle upon Tyne, which are so complex as almost to defy analysis, there were three ways to defend the entrance, all of which, including the complex, exploit the mural or flanking tower. An early type of gate-house, persisting also into the later Middle Ages, was a single tower pierced by an entrance passage, making a defensible unit to guard the actual gate. It was found at Le Plessis-Grimoult in Normandy before 1047, and in Norman England in the first generation of castles at, for example, Rougemont Castle (*c.* 1068) in Exeter, Devon; Ludlow (begun *c.* 1085), Salop; and Arundel, W. Sussex. The same could be constructed in timber, such as within the excavated 12th-century site at Penmaen, W. Glam., while later examples in stone included Framlingham (*c.* 1190), Suffolk, Le Coudray-Salbart (early 13th century), Leeds (in its final form dating from the reign of Edward I), Kent, and the Porte St-Lazare (*c.* 1368) in the town walls at Avignon. The tower was usually rectangular in plan; the round or D-shaped tower was occasionally found in the 13th century, for example at Pembroke and Ludlow, Arques-la-Bataille, Bressuire and Le Coudray-Salbart, but did not persist.

The most common and eventually most formidable gate-houses, however, were twin-towered. These evidently did not appear before the 12th century and reached their maximum development and strength in the late 13th century and the early 14th. The two gateways of Henry II's inner bailey (1180s) at Dover, the present King's Gate and Palace Gate, were early prototypes, each with a pair of rectangular towers on the curtain wall, set close on either side of the gate and making an entrance passage between them. Subsequent development can be seen at Beeston (1220s), Ches, where the forward projecting twin towers (here D-shaped in the latest fashion) are bound together at the rear into a unit by a rectangular block with an upper floor to match that of the towers. This created the true gate-house, with an upper floor that contained residential accommodation but also enabled the lengthened gate passage to be defended from above. From Beeston the way was straight to the forbidding splendours of Tonbridge (?*c.* 1265), Caerffili (1268–71), Harlech (1283–95), Beaumaris (1295–1300), the Fort St-André (mid-14th century) at Villeneuve-lès-Avignon (see fig. 1) and to the many great town gates in France and elsewhere, such as the Porte Narbonnaise (late 13th century) at Carcassonne. Rectangular towers were used at Dover, although later cylindrical or D-shaped towers were more

1. Gate-house of the Fort St-André, Villeneuve-lès-Avignon, mid-14th century

usual, with the occasional octagonal variant. Round towers *à bec* occurred in the 13th century at, for example, the Porte Narbonnaise in Carcassonne and the Porte St-Jean at Provins. Rare rectangular towers *à bec* were built at Provins (Porte de Jouy; 13th century) and at Villeneuve-sur-Yonne (early 14th century).

The third method of defending a gateway has scarcely been noticed, perhaps because it did not properly form a gate-house but was simply an arched entrance pierced in the thickness of the curtain wall. This sounds both weak and primitive but in practice was defended and strengthened by at least one mural tower in close proximity. That it was neither primitive nor ineffective, although simple, can be deduced from its widespread occurrence at all dates and its appearance in some of the finest and latest castles. At Chepstow, Gwent, there were no fewer than three examples, two of which survive, all raised in the late 12th century and the earlier 13th, when the castle was being developed and modernized into a first-class contemporary fortress by the Marshall family. At the Tower of London, the present misnamed Bloody Tower was originally, in the 1220s, a water-gate of this type and more than adequately defended by the great Wakefield Tower, of one build with it and then rising sheer and dominant from the water of the Thames. At Conwy, one of the finest castles in Latin Christendom, built by Edward I, who was also responsible for the prodigious twin-towered gate-houses at Harlech and Beaumaris (*see* JAMES OF ST GEORGE), the main outer gateway (west) was again simply an entrance arch and passage (originally with guard-rooms behind) piercing the curtain but defended in practice by the two great angle towers on either side, between which there was no room, as well as no need, for a towered gate-house. Similarly at COUCY-LE-CHÂTEAU, where no expense was spared, the Porte de Laon (1240s) pierced the south-east curtain near an angle tower and the vast *donjon cylindrique* (destr.), without room or need of further protection. Other gateways of this type and disposition are to be found, for example, in southern Italy at Melfi and in France at Clisson (rebuilt 1470) and Bonaguil; the last-named, in its present form (late 15th-early 16th centuries), is a serious fortification designed both to use and resist cannon. It seems very probable, indeed, that the twin-towered gate-house, which basically consisted of two mural towers, one on either side of the entrance, may have originated in this early but persistent type of fortified gateway.

The subsidiary defences of the gateway, after the tower(s), are well known. First, to the field, there may have been a barbican or outwork to keep an enemy at his distance, and then a ditch, moat or pit crossed only by a drawbridge, which, strictly speaking, was usually a turning-bridge or *pont levis*. The gate itself was two-leaved and heavy, strongly reinforced with iron, and there may have been more than one in the longer gate-house passages. The portcullis was a stout grille of timber, iron or both, lowered from above in front of the gate or gates. The vulnerable gates themselves could be further defended by arrow-slits in the projecting flanking towers of the gate-house or in the walls of the passageway, and from above by apertures or 'murder holes' designed at least as much to quench fire brought against the timber gate as to kill assailants. The main defence from above was from the crenellated parapet of the gate-house or curtain, often reinforced by an overhanging gallery of timber hoarding or stone machicolation. The latter was less common in the British Isles than in France but was extensively used, for example at Raglan Castle (15th century), Gwent, and covering the outer gate at Conwy (see above). The great King's Gate at CAERNARFON CASTLE (*c.* 1300; unfinished) was intended to have five gates with six portcullises and its entrance passage to turn through a right angle. Such a 'bent entrance' was rare in Europe (and may have been introduced from the East via the Crusades) but was found also in the Inner or Horseshoe Gate (*c.* 1200) at Pembroke.

The military gate-house evidently acquired a symbolism of its own and, in its influence on domestic gate-houses, long survived both the castle and the walled town (*see* §2 below).

See also BARBICAN; CASTLE, §I; and CURTAIN WALL (i).

R. ALLEN BROWN

2. DOMESTIC. The domestic gate-house typically has some castellated architectural emphasis, with accommodation for at least a porter or gatekeeper, and is therefore more substantial than a simple entrance. The earliest surviving truly domestic gate-house stands before the mortuary temple of Ramesses III (*reg c.* 1187–*c.* 1156 BC) at Medinet Habu, Upper Egypt, with royal accommodation above a grand ceremonial entry (*see* THEBES (i), §VII). Such domestic features were rare in ancient architecture, and domestic gate-houses were common only after the Roman period. Early examples are all monastic, since monasteries, being predominantly isolated outside city walls, required defence from attack. The semi-fortified Buddhist monastery at Hōryūji, Nara, Japan, is entered through the chūmon (Middle Gate; early 8th century), an impressive, two-tiered timber gate-house. Tibetan monasteries were designed as fortresses. Few European monasteries have retained their sense of medieval enclosure; their gate-houses, such as those at Romainmôtier (14th century) and Maulbronn (16th century), are generally late

medieval reconstructions and often unintentionally picturesque. The grand twin-arched gate-house (*c.* 1177; destr.) at Cluny was modelled on regional Roman city gates (*see* CITY GATE, §1). The Torhalle (*c.* 800) at Lorsch Abbey is a monumental, three-arched gate-house with a large chapel-chamber above (for illustration and further discussion *see* LORSCH ABBEY, §2). It was formerly free-standing, forming no part of any defensive enclosure, and served as a grandiose processional approach to the monastic complex. One of the few monastic gate-houses to have survived in continental Europe from later years is at Jumièges Abbey.

Urban monasteries were much commoner in England, and numerous monastic gate-houses have been preserved. The Court Gate (*c.* 1155) of Canterbury Cathedral has a single giant barrel-vaulted entry and a spacious upper chamber: its scale was intended more to impress than to defend. Bury St Edmunds, Suffolk, has a 12th-century gate-house tower and a fortified gate-house, built after rioters had attacked the abbey in 1327 (*see* BURY ST EDMUNDS, §1). Many English monasteries, including those at Ely, St Albans and Norwich, applied for licence to build fortified gate-houses during this unsettled period. The Great Gateway (1300–09) of St Augustine's Abbey, Canterbury, is an early example of a battlemented, twin-towered façade framing a single large arch, porter's lodge within, and a large chamber above. The gate-house (*c.* 1380) at Thornton Abbey, Humberside, is the grandest monastic example in England and resembles a castle. The contemporary unpopularity of the English Church extended to its hierarchy, and many bishops built gate-houses to defend their palaces. One of the simplest survives at the Archbishop of Canterbury's palace (*c.* 1335) at Charing, Kent, with a large carriage arch flanked by a smaller pedestrian entrance, while others survive at Chichester (early 14th century), W. Sussex, and Wells (after 1341), Somerset. Fear of French attacks during the Hundred Years War (1336–1453) prompted the building of yet more monastic gate-houses, for example at Battle Abbey (1339), E. Sussex. A similar situation must have existed throughout warring medieval Europe, although few episcopal gate-houses have survived. The fortified gate-house of the 14th-century Palais des Papes at Avignon hardly counts as domestic, and religious wars and revolution led to the virtual elimination of this class of building throughout Europe.

In secular domestic architecture, a distinction can be made between street façades containing a simple entrance arch leading to an inner yard or court, such as an inn, and a conscious attempt to enhance an entrance by additional architectural motifs, commonly drawn from the world of military architecture. Sometimes a tower-block was raised above the carriage arch, for example at New College (*c.* 1380), Oxford, and the Palais Jacques-Cœur (1443–51) at Bourges, while others imbue military or monastic status to their street façades, with twin turrets and battlements, such as at Queens' College (*c.* 1448), Cambridge (see fig. 2). Educational institutions, with their quasi-monastic origins and planning and urban setting, were among the first secular buildings to feature the gate-house as part of a monumental façade, for example at Winchester College

2. Gate-house and east façade of Queens' College, Cambridge, *c.* 1448

(*c.* 1380). Collegiate gate-houses were most highly developed in Cambridge, where twin-towered, battlemented gate-houses, some with two floors of upper chambers, for example at Trinity College (*c.* 1490) and St John's College (*c.* 1515), contrast with the simpler, turretless gate-towers of Oxford, such as those at All Souls College (*c.* 1440) and Corpus Christi College (*c.* 1505). Perhaps the most splendid institutional gate-houses belong to the late medieval Spanish universities, for example at the university palace at Salamanca (1510–20), although they are closer in spirit to the monumental façades that frame the entrances of later, Renaissance buildings.

Medieval French domestic gate-houses are scarce, the nobility preferring fully fortified residences. One small river gate-house at the Palais de la Cité, Paris, is shown in the depiction of *June* in the Très Riches Heures (*c.* 1411–16; Chantilly, Mus. Condé, MS. 65, fol. 6*v*), while the entrance arch of the north-east wing (1498–1508) at the château of Blois is merely accentuated by sculptural decoration (*see* BLOIS). After the Hundred Years War, usage in France seemed to change from castles to undefended châteaux almost immediately without the intermediate stage of semi-fortified mansions that are so typical of late medieval England, where domestic gate-houses are prominent. Such enormous French châteaux as that at Chambord (begun 1519) stand in enclosed parks and have no other protection. The major façades have no defensive aspects, and gate-houses, where they do occur, become

mere ornamental pavilions, for example at the Palais du Luxembourg (*c.* 1620) in Paris (*see* BROSSE, SALOMON DE, fig. 1).

The more settled nature of English medieval society encouraged landowners to live in rural mansions rather than castles, but some security was still required, usually a moat, an enclosure wall and a defensible gate-house. Early gate-houses tend to be detached from the main house, merely flanked by the enclosure wall or ditch, for example at Markenfield Hall (*c.* 1310), N. Yorks, but when symmetrical planning became fashionable (*c.* 1380), monumental turreted gate-houses were often placed centrally in the entrance façade, for example at Wingfield Castle (*c.* 1385), Suffolk.

In the rectangular courtyard plans of the following century, such as at Oxburgh Hall (1482), Oxborough, Norfolk, the gate-house was often placed directly opposite the hall entrance. Brick, turreted, multi-storey gate-houses became so popular in England that some, such as Deanery Tower (*c.* 1495) at Hadleigh, Suffolk, were built as totally isolated, self-contained houses, while the essence of the castellated gate-house remained even in undefended mansions, for example at Hengrave Hall (1535), Suffolk. The English courtyard plan, with a central, turreted gate-house, remained popular for another century, and echoes of the semi-defensive gate-house still linger in John Webb's plan (1630s–40s; unexecuted) for Whitehall Palace, London.

See also CASTLE, §II,1.

BIBLIOGRAPHY

A. Verdier and F. Cattois: *Architecture civile et domestique au moyen âge et à la renaissance*, 2 vols (Paris, 1852–7)
E.-E. Viollet-le-Duc: *Dictionnaire raisonné de l'architecture française du XIe au XVIe siècle*, 10 vols (Paris, 1854–68)
N. Lloyd: *A History of the English House* (London, 1931)
G. Webb: *Architecture in Britain: The Middle Ages*, Pelican Hist. A. (Harmondsworth, 1956)
W. Swaan: *Art and Architecture of the Late Middle Ages* (London, 1977)
M. Wood: *The English Medieval House* (London, 1981)

FRANCIS WOODMAN

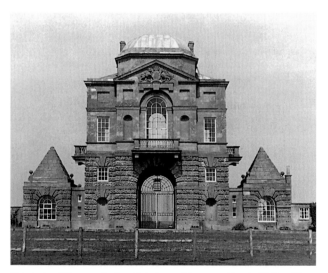

Gate lodge: Worcester Lodge, Badminton, Gloucestershire, by William Kent, 1750

Gate lodge. Gate-keeper's roadside dwelling. It can be a single building, one of a pair or part of an archway, and it is mostly found where the private park drive of a country house meets a public road. Originally built to house employees of the estate it guards, a lodge is usually modest, even spartan, in the accommodation it provides. Yet, because these dwellings marked aristocratic boundaries, the iconography of an upper-class residence was often attached to them, and this was to become a significant feature of suburban 'villa' design in the 19th century and after. Lodges evolved early in the 18th century in response to the changing character of the English park, the wealth and confidence of the landed gentry and the increase in carriage traffic. In the following 200 years professional architects, backed by rich patrons, experimented with designs for housing working-class families in small structures of style and distinction.

The earliest lodges drew upon the styling of ornamental twin garden pavilions common to the gardens of many large Elizabethan and Jacobean houses. These garden buildings became unfashionable when French garden design was adopted in England after the Restoration (1660), but such houses as Bolehyde (nr Chippenham, Wilts), where twin pavilions of *c.* 1680 face the garden and another pair of *c.* 1710 front the road, prove that these small, stylized structures continued to be built.

The popularity of large formal gardens waned after the reign of Queen Anne (*d* 1714). In their place, walled or fenced parks were planted with carefully composed arcadian landscapes; through these the visitor approached the main house along a carriage drive. To protect these private estates, gate lodges were built at their entrances. A family inhabiting a lodge was employed to keep deer and cattle securely within the park confines and to open the gates for swift carriage access. The lodges were expected to suggest the tone of the park; consequently such architects as Colen Campbell, Roger Morris and William Kent began to design them, retaining the ornate character of the old garden pavilions but providing rooms within for a family. Morris's Brington lodges (1732–3) at Althorp, Northants, are a simple classical pair; Kent ranged more widely, from adequate family cottages in Gothick trim (*c.* 1733) at Esher Place, Surrey, to the superb Palladian Worcester Lodge (1750; see fig.) at Badminton, Glos.

In 1747 Sanderson Miller completed the Edgehill Tower on his estate at Radway, Warwicks, as a combined lodge and dining pavilion. This established the Gothick lodge as an appropriate mood-setter to a romantic landscape park. From 1740 onwards pattern books began to offer the gentry lodge designs in other styles, and lodges became a standard feature at major entrances to parks. As the French aristocracy after 1760 favoured an English style of gardening, they too occasionally built gate lodges, but it is essentially a British building type. In the southern states of North America the system of slave ownership never encouraged building isolated cottages on estate boundaries.

All the major 18th-century British architects worked at some time within the unique restraints and demands of gate-lodge design. Robert Adam was responsible for some of great elegance, for example the Isleworth entrance (1773) to Syon House, London, but they offered minimal

comfort for the lodge-keeper. When the industrial wealth and military success of Regency Britain produced a spate of lodges, these often concealed, behind their elegant triumphal façades, two small rooms where an estate pensioner lived wretchedly, the bedroom separated from the living-room by the open carriage way.

The Victorian period was characterized by far greater social concern, and gate lodges usually provided adequate accommodation for a family. Both classical and Gothic styles continued to be used, but a picturesque cottage of composite Elizabethan and Jacobean motifs became more popular. From 1859, when the West Lodge to Trentham Park, Staffs, was built (an extremely early example of free-style Old English), lodges were in the forefront of Arts and Crafts Movement design. C. F. A. Voysey's intensely original South Lodge (1897) to Norney Grange, Shackleford, Surrey, lies at the end of this development and can be considered a prototype for countless 20th-century suburban villas.

BIBLIOGRAPHY

J. Harris: *The Artist and the Country House* (London, 1979) [incl. illustrations of early lodges]
T. Mowl and B. Earnshaw: *Trumpet at a Distant Gate: The Lodge as Prelude to the Country House* (London, 1985)

TIM MOWL

GATEPAC [Grupo de Artistas y Técnicos Españoles para el Progreso de la Arquitectura Contemporánea]. Spanish group of architects. It developed from GATCPAC, a Catalan group formed in 1930 by JOSEP LLUÍS SERT, JOSEP TORRES I CLAVÉ, Sixto Illescas (1903–86) and Juan Baptista Subirana (1904–79). In 1930 GATEPAC was founded as a state body bringing the Catalan group together with a group of architects from central Spain, the most prominent of whom was FERNANDO GARCÍA MERCADAL, and a group from the Basque country that included José María Aizpurua (1904–36) and Joaquín Labayen (1904–74). It remained active until the outbreak of the Spanish Civil War in 1936. GATEPAC was the Spanish representative in CIRPAC and in CIAM, and the architecture designed and promoted by the group can be seen as exemplifying the orthodox Rationalism of the 1930s. Although the young architects who belonged to GATEPAC were all influenced to some extent by Le Corbusier, they also showed a particular preoccupation with the relation of architecture to technical considerations and to social and economic conditions. The group's theoretical concepts were thus closely related to the principles of Neue Sachlichkeit.

The most active of the constituent groups was GATCPAC, which was responsible for the publication of the magazine *A. C. Documentos de actividad contemporánea*. Through this they promoted Modernist architectural ideas within Spain and in other Spanish-speaking countries with articles and reports on the activities and works of the group and other modern architects. They were also closely involved in the process of social and political renewal that Spain was undergoing in the 1930s, drawing up practical proposals for such utopian projects as the 'Ciudad Cooperativa para el Reposo y las Vacaciones' (1933–4), a kind of 'green city' to be built on the coast near Barcelona; the Macià plan (1932–5), an urban project for Barcelona seen as a functional city and drawn up in collaboration with Le Corbusier; or the construction of the Casa Bloc (1932–6) in Sant Andreu, Barcelona, an experimental model housing unit planned for use throughout the city.

WRITINGS

A.C./G.A.T.E.P.A.C., 1931–1937 (Barcelona, 1975) [facs. edn of the group's journal]

BIBLIOGRAPHY

O. Bohigas: *Arquitectura española de la segunda república* (Barcelona, 1970)
F. Roca: 'El G.A.T.E.P.A.C y la crisis urbana de los años 30', *Quad. Arquit. & Urb.*, xc (1972)
J. C. Theilacker: 'La organización interna del G.A.T.C.P.A.C.', *Quad. Arquit. & Urb.*, xc (1972), pp. 6–10
E. Donato: 'Cronología del proyecto C.R.V.', *Quad. Arquit. & Urb.*, xciv (1973), pp. 20–22

JORDI OLIVERAS

Gatta, Bartolomeo della. *See* BARTOLOMEO DELLA GATTA.

Gatteaux. French family of medallists.

(1) Nicolas-Marie Gatteaux (*b* Paris, 2 Aug 1751; *d* Paris, 24 June 1832). He was the son of a locksmith and trained as a gem-engraver under Delorme and de Gros before obtaining a position at the Paris Mint in 1773. Among his early medals were those for the *School of Medicine and Surgery* (1774), the *Death of Louis XV* (1775) and the *Coronation of Louis XVI* (1776). In 1781 he was made Médailleur du Roi and engraved a medal for the *Birth of the Dauphin*. He contributed three medals to the series commemorating the American Revolution—*Horatio Gates*, *Anthony Wayne* and *John Stewart*—and during the same period executed portraits of *Jean-Frédéric, Comte de Maurepas* (1781), *Jean le Rond d'Alembert* (1785) and *Joseph-Jérôme le François de Lalande* (1787). His *Abandonment of Privileges* (1789) was the first of a number of medals produced during the French Revolution, and his portrait of *Franz Joseph Haydn* (1802) was very highly regarded. Among his pupils were Bertrand Andrieu, Nicolas-Guy-Antoine Brenet (1770–1846) and his son (2) Jacques-Edouard Gatteaux.

(2) Jacques-Edouard Gatteaux (*b* Paris, 4 Nov 1788; *d* Paris, 9 Feb 1881). Son of (1) Nicolas-Marie Gatteaux. He trained with his father and also studied sculpture and modelling under Jean-Guillaume Moitte. In 1809 he won the Prix de Rome for medal-engraving. In Rome he formed a friendship with Jean-Auguste-Dominique Ingres and executed a medal commemorating the *Villa Medici*, the home of the Académie de France in Rome. On his return to Paris in 1813 he contributed first to Vivant Denon's medallic history of Napoleon I's reign and then, from 1816, to the *Galerie métallique des grands hommes français*. For the latter he executed 17 portrait medals, including those of *Pierre Corneille, Victor Riqueti, Marquis de Mirabeau, Michel Eyquem de Montaigne* and *Armand-Jean du Plessis, Cardinal de Richelieu*. Among his official commissions were the coronation medals of *Charles X* (1824) and *Louis-Philippe* (1830), and the *Marriage of the Prince Royal* (1837). Gatteaux also executed a number of portrait busts, including posthumous ones of *François Rabelais* (Versailles, Château) and *Michelangelo* (Paris, Louvre), as well as statues. He was notable among French medallists of the first half of the 19th century in executing all but one of his 289 medals from his own designs. The exception

was that for the *Ecole des Beaux-Arts*, after a drawing by Ingres. Elected a member of the Académie des Beaux-Arts in 1845, the younger Gatteaux was an influential teacher, whose most famous pupil was Eugène Oudiné. His fine collection of works of art went, after his death, to the Louvre and to the Ecole des Beaux-Arts.

BIBLIOGRAPHY
DBF; Lami
Biographie des hommes vivants, iii (Paris, 1817), p. 231
F. M. Meil: *Notice sur N.-M. Gatteaux* (Paris, 1832)
C. Gabet: *Dictionnaire des artistes de l'école française du XIXe siècle* (Paris, 1834), pp. 294–5
J. F. Loubat: *The Medallic History of the United States* (New York, 1878)
J. M. Darnis: 'Jacques-Edouard Gatteaux', *Bull. Club Fr. Médaille*, lviii (1978), pp. 194–201

MARK JONES

Gatti, Bernardino [il Soiaro] (*b* ?Pavia, *c.* 1495; *d* Cremona, 1576). Italian painter. In some documents he is said to have come from Pavia. His first documented work, the *Resurrection* (1529; Cremona Cathedral), shows that he had a thorough knowledge of Correggio's work and of the classicizing manner of Raphael and Giulio Romano. Correggio's influence became increasingly apparent, although it was blended with Lombard archaisms, as in the *Virgin of the Rosary* (1531; Pavia Cathedral) and in the *Resurrection with the Virgin and St John the Baptist* and the *Last Supper* (1534–5; both Vigevano Cathedral). In the frescoes of *St George and the Dragon* and scenes from the *Life of the Virgin* (1543; both Piacenza, S Maria di Campagna) he tried to refine his style further, still drawing on Giulio and Correggio but achieving only a somewhat bloodless sentimentality. This is evident in the *Crucifixion* (Piacenza, Municipio).

From 1549 Gatti worked in Cremona. He painted the fresco of the *Ascension* on the vault of S Sigismondo that year, and in S Pietro al Po a large fresco of the *Miracle of the Loaves and Fishes* (1552), notable for its vividly naturalistic portraits, probably suggested to him by Sofonisba Anguissola, with whom he was staying at the time. For the same church he also painted the *Nativity* (*in situ*), one of his most successful works. From 1560 to 1572 he worked on the prestigious commission for the decoration of the cupola of S Maria della Steccata, Parma; this included the *Assumption of the Virgin*, the *Annunciation* and figures of the Apostles. He still drew inspiration from Correggio, although transmuted into stiff and often awkward formulae. He painted the *Annunciation* in S Sigismondo, Cremona, but the monumental canvas of the *Assumption of the Virgin* for the high altar of Cremona Cathedral, a wooden work, was left unfinished at his death.

BIBLIOGRAPHY
A. M. Panni: *Distinto rapporto delle dipinture che trovansi nelle chiese della città e sobborghi di Cremona* (Cremona, 1762)
G. B. Zaist: *Notizie istoriche de' pittori, scultori ed architetti cremonesi* (Cremona, 1774)
G. Aglio: *Le pitture e le sculture della città di Cremona* (Cremona, 1794)
L. Lanzi: *Storia pittorica della Italia* (Bassano, 1795–6)
G. Picenardi: *Nuova guida di Cremona per gli amatori dell'arti del disegno* (Cremona, 1820)
E. Schweitzer: 'La scuola pittorica cremonese', *L'Arte*, iii (1900), pp. 41–71
R. Longhi: 'Quesiti caravaggeschi, ii: I precedenti', *Pinacotheca*, 5–6 (1929), pp. 97–144; repr. in *'Me pinxit' e quesiti caravaggeschi* (Florence, 1968)
A. Venturi: *Storia* (1933), ix/6, pp. 812–24
A. C. Quintavalle: 'Un appunto sulla cultura di Bernardino Gatti', *A. Ant. & Mod.*, vii (1959), pp. 433–6
M. di Giampaolo: 'Disegni di Bernardino Gatti', *Antol. B. A.*, iv (1977), pp. 333–8
I Campi e la cultura artistica cremonese del cinquecento (exh. cat., ed. M. Gregori; Cremona, Mus. Civ. Ponzone, 1985), pp. 145–51
G. Bora: 'Sofonisba Anguissola e la sua formazione cremonese: Il ruolo del disegno', *Sofonisba Anguissola e le sue sorelle* (exh. cat., Milan, 1994), pp. 83–8

G. BORA

Gau, Franz Christian (*b* Cologne, 15 June 1790; *d* Paris, 31 Dec 1853). French architect, writer and archaeologist of German birth. In 1810 he left Coiogne with his lifelong friend J. I. Hittorff for Paris, enrolling at the Ecole des Beaux-Arts in 1811 under the tutelage of the ardent Neo-classicists Louis-Hippolyte Lebas and François Debret. But from the beginning Gau was exposed to a wider field of historical sources, first as assistant site architect under Debret on the restoration of the abbey church of Saint-Denis (1813–15) and then from 1815 in Nazarene circles in Rome, where he met the archaeologist and philologist Barthold Nieburh (1776–1831), who arranged a scholarship for him from the Prussian government and a trip through the eastern Mediterranean. In Egypt Gau undertook an arduous trip down the Nile to visit and record the monuments of Nubia, which he published as the lavish folio *Antiquités de la Nubie*. He noted assiduously every trace of colour on the remains, just as he was to do in 1826 when he completed F. M. Mazois's *Ruines de Pompeii*, findings that were to inspire the theoretical approaches of his pupils Gottfried Semper and Gottlieb Bindesbøll and to serve a fashionable Pompeiian taste in interior décor.

During the late 1820s and the 1830s Gau acquired diverse official posts in Paris. His major works, however, date from the last decade of his career: the transformation of Louis-Adrien Lusson's Customs Hall in the Rue Cauchat, Paris, into the Protestant Eglise de la Rédemption (1842–3), and the design of the Gothic Revival church of Ste Clotilde (1845). Ste Clotilde rapidly became a *cause célèbre* of official recognition of the Gothic Revival in France and precipitated Eugène-Emmanuel Viollet-le-Duc's rejection of the literal Gothic Revival. Although his buildings made little mark, Gau's writings exerted considerable influence on mid-19th-century French and German architecture.

WRITINGS
Antiquités de la Nubie (Stuttgart, 1822–7)
continuation of F. M. Mazois: *Les Ruines de Pompeii*, iii–iv (Paris, 1829–38)

BIBLIOGRAPHY
R. Weigert: 'L'Eglise de la Rédemption, ancienne halle de déchargement de l'octroi', *Gaz. B.-A.*, xxxvi (1949), pp. 279–90
Pompéi: Travaux et envois des architectes français au XIXe siècle, Ecole Nationale Supérieure des Beaux-Arts (Paris, 1981)
A. Falières-Lamy: 'La Basilique Sainte-Clotilde', *Paris et Ile-de-France: Mémoires publiés par la Fédération des Sociétés historiques et archéologiques de Paris et de l'Ile-de-France*, xl (Paris, 1989) [brochure]

BARRY BERGDOLL

Gaucher, Charles-Etienne (*b* Paris, 1741; *d* Paris, 18 Nov 1804). French engraver and writer. He trained as a reproductive engraver with Pierre-François Basan and later with Jacques-Philippe Lebas but soon turned to small-scale engraving. He specialized in the extremely meticulous execution of small portraits; he made more than 100 of these, the most popular being those of *Marie Leczinska, Queen of France* (1768; Pognon and Bruand,

no. 40) after Jean-Marc Nattier and the portrait of the *Comtesse du Barry* (1770; PB 45) after Hubert Drouais. His greatest work was the *Crowning of the Bust of Voltaire at the Comédie Française* (PB 154) after a drawing by Jean-Michel Moreau (i) (1778; Cambridge, Fitzwilliam), on which he worked from 1778 to 1782. Gaucher was also a writer on theory and wrote several articles on engravers for the Abbé de Fontenai's *Dictionnaire des artistes* as well as obituaries of Lebas and Jean-Jacques Flipart for the *Journal de Paris* and several polemical writings in defence of engraving. The Académie des Sciences asked him to write a treatise on the art of engraving; he abandoned this at the onset of the French Revolution, and only his *Essai sur l'origine et les avantages de la gravure* (1798) gives some idea of it.

WRITINGS
Essai sur l'origine et les avantages de la gravure (Paris, 1798)

BIBLIOGRAPHY
L.-A. de Fontenai: *Dictionnaire des artistes* (Paris, 1776)
R. Portalis and H. Draibel [Béraldi]: *Charles-Etienne Gaucher, graveur* (Paris, 1879)
E. Pognon and Y. Bruand: *Inventaire du fonds français: Graveurs du dix-huitième siècle*, Paris, Bib. N., Cab. Est. cat., ix (Paris, 1962), pp. 451–562 [PB]

CHRISTIAN MICHEL

Gaucher, Yves

(*b* Montreal, 1934). Canadian painter and printmaker. He entered the Ecole des Beaux-Arts in Montreal in 1954 and was expelled in 1956 for insubordination. In 1957 he had his first one-man show of paintings and prints at the Galerie l'Echange in Montreal. That year he began studying printmaking under Albert Dumouchel, again at the Ecole des Beaux-Arts in Montreal, where he remained until 1960. In 1959 he won the graphics award at the Salon de la Jeune Peinture in Montreal and until 1964 he devoted himself entirely to printmaking. In 1962 he travelled around Europe and visited Paris, where he was greatly impressed by a concert of Anton Webern's music. This provided the stimulus for the series of three relief prints with rectilinear forms, *In Homage to Webern* (1963; see 1979 exh. cat., pls 1–3), in which Gaucher believed he reached his artistic maturity.

Gaucher resumed painting in 1964, having thoroughly absorbed the work of Rothko, Morris Louis, Barnett Newman and other contemporary American artists. Until 1965 he painted a number of symmetrical, lozenge-shaped abstract works, framed by coloured edges, such as *The Circle of Great Reserve* (1965; Toronto, A.G. Ont.), which formed the series *Square Dances*. In 1966, in the series *Signals/Silences*, he returned to the more usual rectangular format and his palette brightened, as in *Triptych* (1966; Toronto, A.G. Ont.). These were followed in 1967 by the *Ragas* series and in 1968–9 by the *Grey on Grey* series. From 1970 he began to produce abstract works using broad horizontal bands of colour, such as *Red/Blue/Green* (1971; Toronto, A.G. Ont.). After 1976 he experimented with diagonally-organized asymmetric areas of colour. This led in 1978 to the series of *Jericho* works, such as *Jericho I: An Allusion to Barnett Newman* (1978; artist's col., see 1979 exh. cat., pl. 57), based on Barnett Newman's *Jericho* (1968–9).

BIBLIOGRAPHY
Perspective 1963–1976: Yves Gaucher, peintures et gravures (exh. cat., Montreal, Mus. A. Contemp., 1976)
Yves Gaucher: A Fifteen Year Perspective (exh. cat. by R. Nasgaard, Toronto, A.G. Ont., 1979)
Yves Gaucher: Paintings and Etchings (exh. cat. by R. Nasgaard, Paris, Cent. Cult. Can., 1983)
☐

Gaudí (i Cornet), Antoni

(*b* Reus, 25 June 1852; *d* Barcelona, 10 June 1926). Spanish Catalan architect. He was one of the most original designers of his generation. Beginning with a deep interest in Catalonia's medieval history and architecture combined with a respect for craftsmanship and structural logic, he used nature as a source of inspiration for structure as well as ornament to develop a highly personal, organic style characterized by sculptural plasticity, the manipulation of light and the use of mosaics and polychromy. He was later acclaimed as a genius of Catalan *Modernisme*, a style related to Art Nouveau, but his work went far beyond ornament to embrace a more fundamental representation of nature through structural form.

1. Education and early work, to *c.* 1880. 2. Eclecticism to *Modernisme*, *c.* 1880–1900. 3. Mature work, *c.* 1900–15. 4. The Sagrada Familia, to 1926.

1. EDUCATION AND EARLY WORK, TO *c.* 1880. The youngest son of a coppersmith, Gaudí studied at the Escuela de Ciencias, Barcelona (1869), and then entered the Escuela Superior de Arquitectura, Barcelona (1873), graduating in 1878. His background gave him a taste for the practical aspects of architecture, but he also read assiduously, absorbing theories such as the structural rationalism in Viollet-le-Duc's recently published *Entretiens sur l'architecture*. Other formative experiences included study visits to Catalan architectural monuments arranged by Elias Rogent i Amat (1821–77), Director of the Escuela Superior and an exponent of Catalan medieval revival, and attendance at classes on philosophy by Josep Llorens i Barba and on aesthetics by Pablo Milà i Fontenals (1818–84). He also read the authors of the Renaixença, the Catalan Romantic movement. Later, in the 1880s, in an atmosphere of growing Catalan regionalism, he continued to participate in local study trips organized by the Asociació d'Arquitectes de Catalunya or the Asociación Catalanista de Excursiones Científicas, which nurtured his strong feelings for his native region. He travelled abroad only to Tangier, on a project for a Franciscan mission, and to Mallorca, while working on Palma de Mallorca Cathedral. In parallel with his studies, Gaudí worked throughout the 1870s as a draughtsman for such architects as Joan Martorell i Montells (1833–1906), by whose medievalism and Christian ethics he was influenced. Significantly for his future career, between 1877 and 1882 he also worked for Francesc de Paula del Villar i Lozano (1828–1901) on the neo-Romanesque *camarín* chapel of the Virgin in Montserrat Monastery and for Josep Fonseré i Mestres (*d* 1897) on works in the Parque de la Ciudadela, Barcelona, and on the urban plan for neighbouring areas. Drawings of railings, street-lamps and monumental sculptures reveal his taste for ornamental motifs and experimentation, developed through close contact with the different crafts that shaped architecture at this time.

Gaudí's earliest designs as a graduate were for furniture, including an eclectic exercise (1878) for Martorell's neo-Gothic chapel for the Marqués de Comillas, Santander,

and a showcase for the glove manufacturer Esteban Comella at the Exposition Universelle in Paris in the same year. He also won a municipal competition for the design of street furniture in Barcelona. All these projects were significant for his future career. Through his contact with the wealthy Comillas family, he met Comillas's son-in-law, Don Eusebi Güell y Bacigalupi, a textile magnate, and at Güell's house he met the avant-garde members of the Catalan Renaixença and discussed the works of Ruskin and Viollet-le-Duc, who favoured a regional approach to building. His interest in Ruskinian social ideals resulted in designs for a factory, housing and other buildings for the textile workers' cooperative La Obrera Mataronense at Mataro, north-east of Barcelona; these project drawings were also exhibited in Paris in 1878. Only one of the industrial buildings was constructed (1882): the almost parabolic arches that support its simple pitched roof are significant in the development of Gaudí's structural techniques. In spite of his brief professional experience, in 1883 Gaudí was appointed on the recommendation of Martorell to succeed the diocesan architect, del Villar, as Director of Works on the Templo Expiatorio de la Sagrada Familia, Barcelona, where construction had begun the previous year. He worked on this building continuously for the rest of his life and, after an illness in 1910, gradually gave up all other work in favour of it (*see* §4 below).

2. ECLECTICISM TO MODERNISME, *c.* 1880–1900. Gaudí's first important buildings reveal an imaginative experimentation with ornament and construction, exploiting local building techniques, materials and craftsmanship along Arts and Crafts principles, albeit at first with an Islamic flavour. His use of *azulejos* (glazed tiles) in particular helped to revitalize the local art of tile-making. The three-storey Casa Vicens (1883–5), Barcelona, has walls of red earth-coloured rubble with polychromatic counterchange tile banding. Its tall top storey is set back behind a perforated screen supported by highly original Y-headed colonettes; the turreted brick façade of the garden cascade (destr.) had a distinct Mudéjar character reminiscent of the 13th-century brick churches of Castile. Two similar buildings followed: El Capricho (1883–5; *see* POLYCHROMY, colour pl. II, fig. 2), a summer villa near Santander built for another son-in-law of Comillas, which was a heavier design with a façade of rusticated stone at ground-floor level and striped brickwork above; and the lodge, stables and entrance gate (1887) to the Finca Güell, Pedralbes, Barcelona. Here Gaudí used parabolic arches and vaults to develop a complete roofing system for the stables, achieving varied natural lighting effects through the arch openings. Here also is the fantastic wrought-iron dragon gate guarding the entrance to the estate. Both buildings have look-out towers with heavily corbelled platforms reminiscent of early Islamic free-standing minarets, their cylindrical surfaces patterned in rich green *azulejos*.

Gaudí's eclectic period continued with a series of buildings with more restrained medieval-style exteriors, and he began to handle internal space more fluently, while still meeting the rationalist structural principles of Viollet-le-Duc. In particular, the parabolic arch and vault—

important elements in his mature work—were more confidently handled. The Palau Güell (1886–91), a grey-marble urban building of six storeys, presents a simpler façade to the street, but the twin parabolic arches at the entrance and the bay windows, particularly at the rear, have a wealth of wrought-iron ornament; together with the furniture designed for the Güells, this is among the earliest manifestations of the incipient Catalan *Modernisme*, the regional tendency related to Art Nouveau. There is also a series of sculpted roof elements behind the symmetrical parapet gables. The internal areas were unified around a magnificent central space covered with a parabolic vault, naturally lit from above through parabolic arches in the octagonal, pinnacled cupola.

While busy on the Güell house, Gaudí was commissioned by the Bishop of Astorga, who was also a native of Reus, to build the Palacio Episcopal (1887–93) at Astorga, León. Again he organized the building around a central space, to which were added the chapel, library, throne-room and the turrets that give the building its castle-like appearance. The interiors are full of neo-Gothic details in columns, arches and vaulting. While he was in León, friends of Güell commissioned the Casa Fernández-Andrés or Casa de los Botines (1891–4), Plaza de San Marcelo, León. This heavily mural building in rusticated stonework, with corner turrets, is perhaps Gaudí's most direct neo-Gothic essay. Another work of the period, the Colegio Teresiano (1889–94), Barcelona, was far more abstract in its ornamental detail. This four-storey rectangular building, begun by another architect, was constructed of buff-coloured rubble with geometric bands of brickwork and corner pinnacles surmounted by characteristic flowered crosses. The top storey of the façade incorporates a blind arcade of rectilinear parabolic arches between the slender windows and a parapet of gables—tall, elegant, geometric profiles in unadorned brickwork that reflect the structure within. By opening up some of the rooms and admitting light into the building, Gaudí provided a masterly display of interpenetrating views of superimposed, corbelled parabolic arches outlined in red brick and white plasterwork.

Towards the end of the decade and in the early years of the 1900s, Gaudí worked on three projects that foreshadow his highly individual, mature style. The first was an unexecuted project (1892–3) commissioned by the Marqués de Comillas for a monastery and church for the Franciscan missions in Tangier; Gaudí's drawings for this project reveal the origin of the group of parabolic towers later used in the Sagrada Familia. In the Casa Calvet (1898–1904), Barcelona, a commercial and residential building on a narrow urban site, he turned to the Baroque for formal inspiration but amalgamated it with highly decorative, curvilinear *Modernisme* elements, principally in wrought-iron balustrades and lighting and door fixtures. The Torre Bellesguard (1900–02), Barcelona, stands on high ground on the site of the palace of the last king of Barcelona. A tall, four-storey house on a square plan, it was designed in a neo-Gothic castellated style embodying the Catalan cultural resurgence. However, the style was completely reworked and freely interpreted, and Gaudí's experimentation with eccentric, composite columns, arches and vaults and the variety of sculptural rooftop

features marks the end of this phase of his work. The structural rationalism of Viollet-le-Duc is now transcended by a new formal plasticity, in this case held within a traditionally acceptable shell.

3. MATURE WORK, c. 1900–15. The decisive period for Gaudí's work came during the first decade of the 20th century when historicism—always tempered by highly individualistic interpretations—was abandoned, and conventional arcuate structures were dissolved into a new curvilinear architecture already foreshadowed in the Palau Güell. Going far beyond the exuberant use of natural forms in sculpture and wrought-ironwork, which were the hallmarks of *Modernisme*, Gaudí turned to nature to generate structural form. This was first realized in the Park Güell (1900–14), Barcelona, part of a garden city commissioned by Güell in pursuit of the reformist ideals of the Renaixença. The housing was never built, but Gaudí prepared roads and avenues, projecting viaducts from the hillside on an amazing array of rubble columns like tree trunks, angled to carry the structural thrusts directly to the ground. He also built polychromatic entrance lodges of fantastic form and a vast staircase, with fountains, leading to a hypostyle market hall constructed out of the sloping site and supported on 100 massive, quasi-archaic Doric columns. The roof of this structure, a flat, open space

used as a playground, is surrounded by a serpentine bench-balustrade, covered, like the fountains and other elements, with brightly coloured mosaic decoration in abstract designs by Gaudí and Josep Maria Jujol i Gibert (*see* MOSAIC, fig. 4 and colour pl. IV, fig. 2). The result is a playful, exciting and surrealistic environment.

Gaudí worked on two major urban residential buildings in parallel with the park: the Casa Batlló (1904–6) and the Casa Milà (1906–10), both in the Passeig de Gracia, Barcelona. The Casa Batlló reveals Gaudí's confidence and skill in remodelling an existing building. He added a floor to the original Neo-classical five-storey town house and clothed ground and first floors in stone in fantastic, fluid lines like an eroded outcrop of rock. This curvilinear stonework conceals the original rectangular windows within mask-like openings, which are echoed in the iron balustrades of the balconies above. The higher levels of the redesigned façade are covered in an abstract tile mosaic, and the whole undulates upwards to a parapet that is like a wavecrest and changes colour from end to end. Parapet and roof forms echo the gable that dominates the adjoining house by Josep Puig i Cadafalch, but the roof of the Casa Batlló curves in three dimensions and is covered with green ceramic tiles like the scales of a great sea monster. On the fifth floor there is also a tiny roof-garden from which a circular turret rises to break through the parapet. Inside the house, the curved forms of the stairway and its

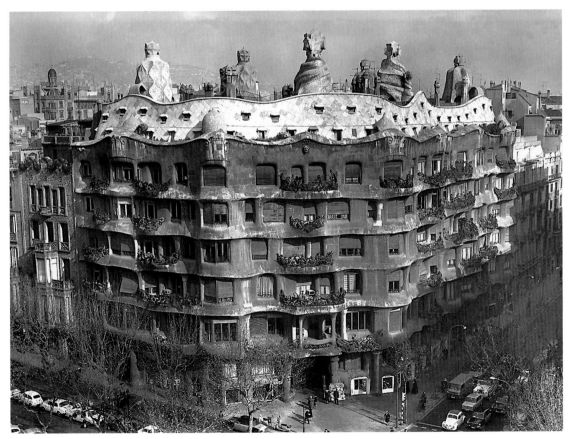

1. Antoni Gaudí: Casa Milà, Barcelona, 1906–10

path up through the building in its skylit, blue and white ceramic-tiled stair-well add to the dynamic analogy (*see* SPAIN, fig. 32).

The Casa Milà ('La pedrera'; see fig. 1) is one of Gaudí's most important achievements. In this ambitious corner project, his approach to the creation of a new architectural organism was unencumbered by any existing work, and the curvilinear planning of the floors around magnificent patio spaces was possible from the outset. Again drawing inspiration from nature, Gaudí presented a rock-face of fluid, curvilinear forms to the street; openings appear to be carved out of the stonework in rounded forms with deep overhangs, giving rise to the building's nickname 'the quarry'. The tiled roof follows the rise and fall of the superstructure of the attic storey as it spans spaces of varying widths on the floors below. The result is a heaving roofscape, and on this stands a fantastic family of chimneys and ventilators sculpted in twisted, faceted, sometimes quasi-figural shapes. The hand-moulded ceilings in the flats, the wrought-iron balustrades and grilles, completed to Gaudí's designs by Jujol, and the walls of the patios, painted by Alexis Clapes (1850–1920), are among the delights of *Modernisme* and contribute to the completeness of Gaudí's most mature secular work.

At this time Gaudí was engaged in restoration work (1904–14; with Jujol and Joan Rubió i Bellver) on Palma de Mallorca Cathedral, which involved moving the choir, transforming the pulpit, modifying the lighting of the main altar and some stained-glass windows and side altars. He also produced a design (1908; unexecuted) for a hotel in New York, which used some motifs from his other work and included a group of parabolic towers some 200 m to 300 m high. But it was an exhibition at the Société Nationale des Beaux-Arts in Paris (1910), coinciding with the completion of the Casa Milà, that brought his work before an international audience. It included drawings, photographs and models of all his principal buildings, including the Sagrada Familia and the chapel for the Colonia Güell (1908–15), a settlement for Güell textile workers at Santa Coloma de Cervelló, near Barcelona, commissioned in 1898. Its form was derived from a unique catenary modelling system, which he invented using wires, canvas, threads and hanging weights to simulate the structural stresses. The interior is created from highly complex ribbed vaults of stone, brick and tile in squat, quasi-parabolic shapes carried on inclined columns of roughly chiselled stone and textured brick. Outside, inclined rubble walls and columns grow out of the ground like trees, with teardrop-shaped windows between their roots. The whole building expressed Gaudí's aim to achieve an organic unity of space, form and structure, in which each element was determined by analogy with nature—an aim reinforced by the exaggeration of the primitivist forms. Only the crypt was completed; it was dedicated in 1915, when Gaudí handed over the work to Francesc Berenguer i Mestres, the associate whose work came closest in character to Gaudí's own and who carried out other work at the settlement. It was the last building to be abandoned by Gaudí in favour of the Sagrada Familia.

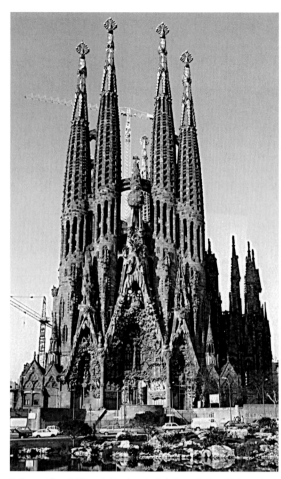

2. Antoni Gaudí: Templo Expiatorio de la Sagrada Familia, Barcelona, 1883–1926

4. THE SAGRADA FAMILIA, TO 1926. The Templo Expiatorio de la Sagrada Familia is Gaudí's masterpiece, and, although only partially completed, it is among the most impressive buildings of the 20th century. He took charge of the works at the age of 31 and continued for the rest of his life; it thus summarizes his evolution as an architect as well as the increasing depth of his spiritual conviction, measured in terms of his increasing dedication to the task. His assistants on the project included Jujol, Berenguer, Rubió, the sculptor Lorenzo Matamala i Pinyol (1856–1927), Gaudí's friend and site supervisor, and Carlos Mani i Roig (1866–1911). The project was initiated by the Asociación de Devotos de San José, founded in 1866 to raise funds to build a church dedicated to St Joseph and the Holy Family. This concept was widened to become a cathedral for the new metropolitan areas of Barcelona, and del Villar's neo-Gothic design had been under construction for more than a year when Gaudí took over in 1883.

Gaudí completed the crypt to del Villar's design in 1891 but began to work on a more grandiose concept for the whole church, including an encircling ambulatory or cloister. By 1893 he had completed the walls and finials of

del Villar's apse and had started work on the façade of the Nativity (see fig. 2): this is where Gaudí's own conception of the structure began to appear, dominated by towers. The triple portals (1903) of the façade, representing Faith, Hope and Charity, rise out of the ground as neo-Gothic elements but are increasingly clothed and then draped in natural forms until the angular Gothic gables are almost concealed by carvings that hang like canopies of stalactites over the porches. This eases the transition through *Modernisme* to the mature individualism of the four great towers named after the Apostles: from south to north, Barnabas, Simon, Thaddeus and Matthew. Only Barnabas was completed before Gaudí's death; the others, which were still below finial level, were completed in 1930 by Domenech Sugrañes i Gras (1871–1938), an assistant of long standing on the Sagrada Familia, and Francisco de Paula Quintana (*b* 1892).

The towers of the Sagrada Familia, which were to house tubular bells, are square at their bases, but above the portals they become cylinders pierced by spirals of columns and narrow, round-headed arches. For acoustic reasons the perforation was continued as the stone columns converged in a series of tall, slender parabolic arches, tied together by thin plates in spirals that produce a ladder-like effect. Above the arches are hexagonal pinnacles; above them are Cubist faceted finials covered with polychromatic Venetian glass mosaics, each surmounted by a three-dimensional haloed cross. The towers and the church show Gaudí's structural aesthetic at work in the idiom of the Gothic cathedral, eliminating the need for flying buttresses. At the same time, his polychrome decoration that had its roots in Oriental traditions provided both the natural motifs inspired by Ruskin and the religious iconology of the church.

For all the virtuoso qualities of the church, however, the little school (1909) built by Gaudí on the site of the Sagrada Familia perhaps best crystallizes the essence of his genius. It has an undulating roof built of *bovedas tabicadas* (Sp.: tile vaults), a technique later developed and widely used in the USA by Rafael Guastavino y Moreno, and walls that are both curved in plan and inclined outwards from the roof to counteract thrust. It is a simple statement of his aesthetic, expressing nature through form, and of his practical genius in adapting traditional materials and methods through the application of contemporary building technology. Gaudí died a few days after being knocked down by a trolley-bus on his way to church, leaving behind him unexecuted drawings for the Sagrada Familia, for the remaining main façades, the crossing and a chapel of the Assumption. He also left behind a body of work that continued to influence an extraordinarily diverse following including Surrealists, Abstract Expressionists, engineers and environmentalists.

For illustration of chairs designed by Gaudí *see* SPAIN, fig. 40.

BIBLIOGRAPHY

J. Rubió: 'Dificultats per arribar a la síntesi arquitectònica', *Annu. Asoc. Arquitectos* (1913), pp. 63–136
I. Puig: *El Temple expiatori de la Sagrada Familia* (Barcelona, 1929)
J. F. Ràfols: *Modernismo y modernistas* (Barcelona, 1949)
J. Bergós: *Antoni Gaudí: L'home i l'obra* (Barcelona, 1954)
C. Martinell: *Gaudinismo* (Barcelona, 1954)
G. Collins: *Antonio Gaudí* (New York, 1960)
J. L. Sert and J. Sweeney: *Antoni Gaudí* (New York, 1961)
E. Casanellas: *Nueva visión de Gaudí* (Barcelona, 1964)
R. Pane: *Gaudí* (Milan, 1964)
C. Martinell: *Gaudí, su vida, su teoría, su obra* (Barcelona, 1967)
J. Bassegoda and J. M. Garrut: *Guía de Gaudí* (Barcelona, 1969)
C. Prevost and R. Descharnes: *La Vision artistique et religieuse de Gaudí* (Lausanne, 1969; Eng. trans., New York, 1971)
Y. Futagawa and M. L. Borras: *Casa Batlló, Barcelona, Spain, 1905–1907* (Tokyo, 1972) [illus.]
O. Bohigas: *Reseña y catálogo de la arquitectura modernista* (Barcelona, 1973, rev. 1983)
G. Collins and M. E. Farinas: *Bibliography of Antonio Gaudí and the Catalan Movement, 1870–1930* (Charlottesville, VA, 1973)
I. Solà-Morales: *Joan Rubió i Bellver i la fortuna del Gaudinismo* (Barcelona, 1975), pp. 120–36
J. Bassegoda Nonell: *Antonio Gaudí: Vida y arquitectura* (Tarragona, 1977)
D. Mower: *Gaudí* (London, 1977)
S. Tarragó: *Gaudí* (Barcelona, 1977)
Artículos manuscritos, conversaciones y dibujos de Antonio Gaudí (Murcia, 1982) [original source mat.]
G. Collins and J. Bassegoda: *The Designs and Drawings of Antonio Gaudí* (Princeton, NJ, 1982)
C. Flores: *Gaudí, Jujol y el Modernismo catalán* (Madrid, 1982)
I. Solà-Morales: *Gaudí* (Barcelona, 1983)
J. Bassegoda: *Gaudí* (Barcelona, 1984)
X. Güell: *Antoni Gaudí* (Barcelona, 1986)
S. Tarragó, ed.: *Gaudí* (Barcelona, 1992)
C. Kent and D. Prindle: *Hacia la arquitectura de un paraíso: Park Güell* (Madrid, 1992)
J. Lahuerta, ed.: *Gaudí* (Barcelona, 1993)

JORDI OLIVERAS

Gaudier-Brzeska [Gaudier], **Henri** (*b* St Jean de Braye, nr Orléans, 4 Oct 1891; *d* Neuville-Saint-Vaast, France, 5 June 1915). French sculptor and draughtsman. He began sculpting in Paris *c.* 1910, taking as his model Auguste Rodin rather than the avant-garde artists of his own generation. When he moved to London in January 1911, having previously visited England on a scholarship in 1906 and again in 1908, his knowledge of contemporary developments in sculpture was slight. He was accompanied by Sophie Brzeska, whose surname he appended to his own. A crucial meeting with Jacob Epstein, when the tomb of *Oscar Wilde* (1912; Paris, Père-Lachaise Cemetery) was still in his studio, strengthened Gaudier-Brzeska's determination to pursue a more experimental direction. He delighted in pitting himself against the cultures that he admired during visits to the British Museum, and his work ranged from carefully carved Classical torsos to deliberately barbaric painted masks.

For a time Gaudier-Brzeska's fascination with selective aspects of tradition gave his work a bewildering diversity; underneath, however, lay a firm and economical grasp of line, exemplified by numerous swift yet decisive drawings of figures and animals. By the autumn of 1913, his friendships with T. E Hulme, Ezra Pound and Epstein all combined to propel him in the direction of greater bareness and a proto-geometrical simplification. The contrast between his *Dancer* (bronze, h. 700 mm, 1913; London, Tate) and *Red Stone Dancer* (red Mansfield stone, 432 mm, *c.* 1913; London, Tate; see fig.) shows the change in his work within a few months, from a graceful variation on the tradition of Rodin towards a startling alternative. *Red Stone Dancer* is stocky and unashamedly pugnacious in impact, with a triangle imposed on her otherwise featureless face and equally geometrical forms on her breasts. The entire body defies anatomical convention by twisting and bending in unlikely directions; in an enthusiastic review Pound declared that 'the "abstract" or mathematical

Henri Gaudier-Brzeska: *Red Stone Dancer*, red Mansfield stone, h. 432 mm, *c.* 1913 (London, Tate Gallery)

the modern sculptor is a man who works with instinct as his inspiring force. His work is emotional. The shape of a leg, or the curve of an eyebrow, etc., etc., have to him no significance whatsoever; light voluptuous modelling is to him insipid—what he feels he does so intensely and his work is nothing more nor less than the abstraction of this intense feeling.

There was also a vein of impish humour in Gaudier-Brzeska's work. Even the *Hieratic Head of Ezra Pound* could be seen, especially from the rear, as a circumcised phallus, for he had no more inhibitions than his friend Epstein about incorporating sexuality in his art. Primitivism gave way to other concerns, however, after the *Head* was displayed at the Whitechapel Art Gallery in May 1914. He continued to ally himself with what he called 'the tradition of the barbaric peoples of the earth (for whom we have sympathy and admiration)', but a new mechanistic emphasis entered his sculpture as well. In *Bird Swallowing Fish* (bronze, 315×310 mm, 1914; U. Cambridge, Kettle's Yard), the two combatants have been transformed into armoured creatures, with angular wings and jutting component parts. The fish is jammed into the bird's mouth like a weapon.

By the summer of 1914 Gaudier-Brzeska had allied himself firmly with both Pound and Wyndham Lewis, and his work was illustrated in the magazine *Blast*. Lewis commissioned him to write a special 'Vortex' article for its pages. Here, he declared his admiration for Epstein, Constantin Brancusi, Alexander Archipenko and Amedeo Modigliani, as well as insisting with militant pride that 'we have crystallized the sphere into the cube, we have made a combination of all the possible shaped masses—concentrating them to express our abstract thoughts of conscious superiority'. In a sequence of small carvings, like *Fish* (cut brass, 25×45 mm, 1914; Celia Clayton priv. col., see Cork 1976, p. 436) and *Ornament/Toy* (bronze, 156×38× 32 mm, 1914; London, Tate), he gave rein to the most aggressive side of his temperament, creating images that chimed with *Blast*'s claim that the Vorticists were 'Primitive mercenaries in the modern world'. Gaudier-Brzeska's signature was on the Vorticist manifesto in *Blast*, and he appeared as a member in the Vorticist exhibition the following year (*see* VORTICISM).

Gaudier-Brzeska's final sculptures can not be described as wholly Vorticist in their implications. One of the finest, *Birds Erect* (limestone, 667×260×314 mm, 1914; New York, MOMA), is a tall carving that seems to move away from mechanistic rigidity towards a rather more organic language. Its exploration of near-abstraction bears out the analysis that Gaudier-Brzeska gave in *Blast*, where he explained that 'Sculptural energy is the mountain./ Sculptural feeling is the appreciation of masses in relation./Sculptural ability is the defining of these masses by planes.' This credo, which later impressed the young Henry Moore when he read it in the 1920s, did not, however, prevent Gaudier-Brzeska from carving a serenely sensual *Seated Woman* (650×700×200 mm, 1914; Paris, Pompidou) in white marble, which displayed his continuing involvement with the figurative tradition. Soon after its completion Gaudier-Brzeska joined the French Army and was killed in action. His obituary was published in the second issue of *Blast*.

bareness of the triangle and circle are fully incarnate, made flesh, full of vitality and energy'.

Pound supported the impoverished Gaudier-Brzeska in a practical way, too, not only by purchasing carvings but also by presenting him with a block of marble for a specially commissioned portrait, *Hieratic Head of Ezra Pound* (915×483×420 mm, 1914; priv. col., see 1983 exh. cat., p. 53). Gaudier-Brzeska, who had never worked on such a large scale before, prepared for the task by producing a bold series of ink drawings (Paris, Pompidou) outlining Pound's essential features with a decisive brush. He told his sitter, while the *Head* was being carved, that 'it will not look like you'. Gaudier-Brzeska's chief inspiration seems to have been the great Easter Island figure *Hoa-Haka-Nana-Ia* (basalt, h. 2.6 m) in the British Museum, and the completed carving exudes the same kind of hieratic severity. Reduced to a few essential planes and masses, the *Head* possesses an awesome stillness that exemplifies Gaudier-Brzeska's declared belief that:

WRITINGS

'Vortex Gaudier-Brzeska', *Blast*, 1 (1914)
'Vortex Gaudier-Brzeska (written from the trenches)', *Blast*, 2 (1915), pp. 33–4

BIBLIOGRAPHY

Obituary, *Blast*, 2 (1915), p. 34
R. Fry: 'Gaudier-Brzeska', *Burl. Mag.*, xxix (1916)
E. Pound: *Gaudier-Brzeska: A Memoir by Ezra Pound* (London, 1916)
H. S. Ede: *A Life of Gaudier-Brzeska* (London, 1930; rev. as *Savage Messiah: A Biography of the Sculptor Henri Gaudier-Brzeska* (London, 2/1971)
H. Brodzky: *Henri Gaudier-Brzeska, 1891–1915* (London, 1933)
M. Levy: *Gaudier-Brzeska: Drawings and Sculpture* (London, 1965)
R. Cork: *Vorticism and Abstract Art in the First Machine Age*, 2 vols (London, 1975–6)
R. Cole: *Burning to Speak: The Life and Art of Henri Gaudier-Brzeska* (London, 1978)
F. Koslow: *The Graphic Work of Henri Gaudier-Brzeska* (diss., Boston U., 1981)
R. Cork: 'Henri Gaudier and Ezra Pound: A Friendship', *Henri Gaudier and Ezra Pound* (exh. cat. by R. Cork, London, Anthony d'Offay Gal., 1982)
Henri Gaudier-Brzeska, Sculptor, 1891–1915 (exh. cat., ed. J. Lewison; U. Cambridge, Kettle's Yard; 1983)
Henri Gaudier-Brzeska (exh. cat., Orléans, Mus. B.-A., 1993)

RICHARD CORK

Gaudin, Henri (*b* Paris, 25 Sept 1933). French architect. He abandoned a career in the navy to enter the Ecole des Beaux-Arts, Paris, and after graduating in 1966 he travelled to the USA and worked in the office of Harrison and Abramovitz. After returning to France in 1969, his only executed works before 1982 were a school (1970–73), Souppes-sur-Loing, and 100 houses (1975–81) at Maurepas; there, in the anonymous context of the new town of Saint-Quentin-en-Yvelines, he translated his love for the compactness of the medieval city into the design of a genuine 'street'. His complex but homogeneous vocabulary of sensuous curves, yielding unexpected contrasts of light and shade, was developed here into a powerful device to create visual intensity and to differentiate each dwelling. The Maurepas project gained him a well-deserved reputation and other residential commissions followed, including those in Evry-Courcouronnes (1982–5) and at 44 Rue de Ménilmontant (1983–6), Paris, in which his critical approach to history finds a practical and original echo. In the late 1980s he began receiving major public commissions (e.g. Amiens, additions to Université de Picardie, 1993; Paris, redevelopment of the Charléty Stadium, first phase completed 1994), which he co-signed with his son Bruno Gaudin.

WRITINGS

La Cabane et le labyrinthe (Liège, 1984)

BIBLIOGRAPHY

Henri Gaudin (Paris, 1984)
'100 Logements à Courcouronnes: Ville nouvelle d'Evry', *Archit. Aujourd'hui*, 244 (1986), pp. 6–11
P. Wislock: 'Archives de Paris', *Architects' J.*, cxciv/19 (1991), pp. 42–7
M. K. Meade: 'Gothic Cité', *Archit. Rev.*, cxciv/1165 (1994), pp. 31–8

ISABELLE GOURNAY

Gaudreaus, Antoine-Robert (*b* Paris, 1682; *d* Paris, 6 May 1746). French cabinetmaker. He became a *maître-ébéniste c.* 1710 and from 1724 became the main supplier to the Garde Meuble de la Couronne. From 1726 until his death, first as Ebéniste de la Reine and then as Ebéniste du Roi, he exercised a virtual monopoly over commissions intended for royal residences, most of which he subcontracted. His strong, personal style is evident in his work, although only about six pieces remain unmodified. Apart from a medal-cabinet (1738; Versailles, Château), on which he collaborated and obviously submitted to the designs of the Slodtz brothers, two of his works are very important. The style of a marquetry commode (1739; London, Wallace; for illustration *see* COMMODE) with bronze mounts by Jacques Caffiéri suggests that he had escaped the Slodtzs' supervision. It follows the dictates of the Louis XV style, employing asymmetrical designs and exaggerated curves and Rococo decoration. The exuberance of this piece was followed by a return to balanced forms, as shown in a lacquered commode (1744; Paris, Bib. N., Cab. Médailles), which could be referred to as being in a 'symmetrical' Louis XV style. Gaudreaus excluded from it the traditional frames that follow the contours of the drawers and the doors, their absence reflecting a strong desire for purity. Gaudreaus transformed aesthetic expression into a dialogue between bronze and lacquer. A third veneered commode (1740–45; London, Wallace), made for Monsieur de Selle, bears witness to Gaudreaus's boldness with both material and form. His widow and his son, François-Antoine Gaudreaus (*c.* 1715–53), continued the workshop until 1751.

BIBLIOGRAPHY

J. Viaux: *Bibliographie du meuble (Mobilier civil français)*, 2 vols (Paris, 1966–88)
D. Alcouffe: 'Antoine-Robert et François-Antoine Gaudreaus, ébénistes de Louis XV', *Antol. B.A.*, n.s., 27–8 (1985), pp. 73–97
J. N. Ronfort: '1744, Choisy et la commode du Roi', *L'Estampille*, ccxviii (1988), pp. 14–29

JEAN NÉRÉE RONFORT

Gauermann, Friedrich (August Matthias) (*b* Miesenbach, Lower Austria, 20 Sept 1807; *d* Vienna, 7 July 1862). Austrian painter. He was the son of the painter and copper engraver Jakob Gauermann (1773–1843) and the brother of the painter Carl Gauermann (1804–29). He was taught painting by his father, who emphasized especially the direct observation of nature. Friedrich Gauermann subsequently studied at the Vienna Akademie (1824–7) in the landscape class of Josef Mössmer (1780–1845). In Vienna Gauermann was especially attracted to the work of such 17th-century Dutch landscape painters as Philips Wouwerman, Jacob van Ruisdael, Allaert van Everdingen, Paulus Potter and Nicolaes Berchem, and he made copies of their paintings. He continued to admire such artists throughout his life, and in his own landscape painting he remained close to their form of realism. Gauermann also made study tours to see art collections in Munich and Dresden in 1827 and 1829.

Gauermann always painted landscapes, generally with the figures of peasants or with animals as staffage, such as he could observe in his native countryside. He made extensive preparation for each painting, producing many sketches of individual motifs as well as composition sketches (Vienna, Akad. Bild. Kst.) largely to assess the treatment of light and colour. In all media (pencil, pen, watercolour and oils) Gauermann's sketches are notable for their vigour and their directness in reproducing nature. Although intended as preparatory material, they may be regarded as works in their own right. Gauermann's early

landscape scenes were generally based on his own experience of nature, although staffage was added from imagination. In the late 1820s, like Ferdinand Waldmüller, Gauermann worked directly from nature, producing fresh, unpretentious landscapes, that have been seen as typical of the Biedermeier era, for example *Landscape near Miesenbach* (before 1830; Vienna, Belvedere). The treatment of light always remained a distinctive feature of Gauermann's work, although it gradually became a virtuoso element in the expression of atmosphere and mood; but human beings and animals were incorporated into the landscapes in a genre-like idyllic way. During the 1830s and 1840s the prevailing taste for greater drama in landscape was reflected in Gauermann's work. By using weather conditions, such as a gathering storm, or a scene of hunting, or animals fighting, Gauermann appealed to stronger emotions, as in *Wild Boar Startled by a Wolf* (1835; London, V&A) and a *Grain Cart in a Thunderstorm on Lake Zell* (1837; Vaduz, Samml. Liechtenstein).

Gauermann had great success from the start of his career. His pictures sold well to both aristocratic and bourgeois collectors (account book of 1822–59 in Vienna, Akad. Bild. Kst.; see Feuchtmüller, 1962). In his later work there was a degree of repetition, due to the large number of commissions he received, and Gauermann resorted to virtuoso effects and to a sweetly sentimental style of mountain landscape painting. Gauermann particularly admired the work of Carl Rottmann and Christian Morgenstern, two Munich painters, and he emulated their style, which stressed the Romantic grandeur of landscape motifs in their own right. Gauermann travelled widely but particularly favoured sketching trips in the mountains of the Salzkammergut, Tirol and northern Italy, generally accompanied by painter friends. Gauermann was widely known among the cultural leaders of Viennese society: his circle included the composer Franz Schubert, the playwrights Johann Nestroy and Ferdinand Raimund, and the artists Friedrich von Amerling and Leopold Kupelwieser.

BIBLIOGRAPHY
Thieme–Becker
Friedrich Gauermanns Handzeichnungen, Ölskizzen und Autographen (exh. cat., Vienna, Akad. Bild. Kst., 1954)
R. Feuchtmüller: *Biedermeier Ausstellung: Friedrich Gauermann und seine Zeit* (exh. cat., Gutenstein-Mariahilfberg, Servitenkloster, 1962), pp. 93–100
Friedrich Gauermann (exh. cat., ed. U. Jenni; Vienna, Akad. Bild. Kst., 1987)
MARIANNE FRODL-SCHNEEMANN

Gauffier, Louis (*b* Poitiers, 1762; *d* Livorno, 20 Oct 1801). French painter. Following his move to Paris, where he became a pupil of Hugues Taraval and a student at the Académie Royale, in 1784 Gauffier shared the Prix de Rome with Jean-Germain Drouais and Antoine-Denis Chaudet (for sculpture), his own work being *Christ and the Woman of Canaan* (Paris, Ecole N. Sup. B.-A.). During his time in Rome (1785–9) Gauffier worked hard, but his health was poor and the results variable. On his return to Paris he was accepted (*agréé*) by the Académie as a history painter. Soon after, he returned to Rome in order to escape the worsening situation in Revolutionary Paris, although he continued to send his Neo-classical works to the Salon. In March 1790 he married Pauline Chatillon (*d*

July 1801), a portrait painter whom he and Drouais had taught.

In 1793 anti-French demonstrations in Rome forced him to flee to Florence, where in order to make a living he abandoned historical, mythological and religious themes, as exemplified by *Abraham and the Three Angels* (Fontainebleau, Château), and began practising as a portrait painter. His sitters were chiefly British and French army officers or diplomats and their wives (e.g. *Elizabeth Fox, Lady Holland*, Montpellier, Mus. Fabre). Occasionally he painted his friends, for example *Coclers Van Wick* (1797; Montpellier, Mus. Fabre), as the painter Philippe-Henri Coclers (1738–1810) was known; and he painted himself and his family, for example *Artist with his Family* (Florence, Pitti). During the late 1790s he continued to earn his living as a portrait painter, with works such as *Dr Penrose* (1798; Minneapolis, MN, Inst. A.), but he also painted a number of landscapes, such as the *View of Vallombrosa* (1799; Paris, Mus. Marmottan), based on sketches made in the countryside near Florence. Behind the rigorous composition and sure line in Gauffier's works, Romanticism can be seen emerging: it is apparent in his treatment of nature and of light, in the juxtaposition of the past and the present, of man and his times. Before the death of his wife, which was quickly followed by his own, Gauffier had been hoping to return to France. One daughter, Faustine Gauffier (1792–1837), later practised as a miniature painter under her married name, Faustina Malfatti.

BIBLIOGRAPHY
L. Moinet: 'Le Peintre Louis Gauffier', *Rev. Saintonge & Aunis*, xv (1895), pp. 436–40
P. Marmottan: 'Le Peintre Louis Gauffier', *Gaz. B.-A.*, n.s. 4, xiii (1926), pp. 281–300
R. Crozet: 'Louis Gauffier, 1762–1801', *Bull. Soc. Hist. A. Fr.* (1941–4), pp. 100–13
M. Sandoz: 'Oeuvres de Louis Gauffier nouvellement apparues', *Rev. des A.*, 4 (1958), pp. 195–8
J. P. Samoyault: 'Note sur un tableau de Louis Gauffier', *Rev. Louvre*, xxv (1975), pp. 334–7
CÉLIA ALEGRET

Gaugain, (Armand-Pierre-)Henri (*b* Rouen, 1799; *d* after 1834). French print publisher and dealer. He was the son of a prosperous Rouen magistrate and may have had family connections with the engraver Thomas Gaugain. Henri Gaugain went to Paris to study law, but in 1826 he entered into partnership with the firm of Lambert & Noël to run a lithographic business in the Rue de Vaugirard. At the same time he opened a shop at 2 Rue Vivienne. His first prints were commissioned from the Romantic generation of artists young in the 1820s—Gustave Boulanger, Ary Scheffer, Camille Roqueplan, Eugène Devéria and Eugène Delacroix (who remembered him with gratitude). They shared the current taste for English literature, and Gaugain published scenes from Walter Scott from 1827 onwards, and in the same year a volume entitled *Souvenirs du théâtre anglais dessinés par MM. Devéria et Boulanger*.

In 1829 Gaugain opened a picture gallery within the elegant arcade known as the Galerie Colbert, naming it the Musée Colbert. His exhibitions, for which he published catalogues, received much critical attention, particularly as there had been no official Salon since 1827. Some important pictures received their first showings there, for

example Delacroix's *Assassination of the Bishop of Liège* (1829; Paris, Louvre), and many of the pictures reflected Gaugain's known tastes: Roqueplan's *Morris the Spy* (Lille, Mus. B.-A.) was exhibited several times and Gaugain simultaneously published a lithograph after it, as he did with another Scott subject, Devéria's *The Dwarfs*, from *The Talisman.* He also hung works in the Neo-classical taste. In 1830 Gaugain was forced to declare himself bankrupt through failure to meet a publishing commitment. In 1831 he was in England and by 1834 back in Rouen. He is said to have left France at that date.

BIBLIOGRAPHY

L. Whiteley: 'Art et commerce d'art en France avant l'époque impressionniste', *Romantisme*, xl (1983), pp. 65–75

B. S. Wright: 'Henri Gaugain et le musée Colbert: L'Entreprise d'un directeur de galerie et d'un éditeur d'art à l'époque romantique', *Nouv. Est.*, cxiv (1990), pp. 24–31

LINDA WHITELEY

Gaugain, Thomas (*b* Abbeville, Somme, 24 March 1756; *d* 1812). French engraver and print-publisher, active in England. He entered the Royal Academy Schools, London, in 1771, with the aim of becoming a painter; he exhibited in 1778–81 at the Royal Academy. In 1780 he began to engrave, initially engraving and publishing his own paintings. Some colour prints that he published were among the few English ones printed from several plates, rather than *à la poupée*. Gaugain built up a successful business; he bought pictures and drawings to engrave as decorative stipples, such as *Selling Guinea Pigs* and *Dancing Dogs* (1789–90), after George Morland, which enjoyed a large sale abroad, and the *Sailor Boy* after William Redmore Bigg, engraved (1791–2) by Thomas Burke. The decline in the export trade probably affected Gaugain more than most print-publishers, as in 1793 his stock of plates was auctioned. He continued to engrave, notably an ambitious Hogarthian set of *Diligence and Dissipation* after ten pictures exhibited in 1796 by James Northcote, but his output was much reduced; his best prints belong to his period as an independent engraver.

BIBLIOGRAPHY

O'Donoghue; Thieme–Becker

Intire Stock of Mr Thomas Gaugain, Engraver (Leaving off Printselling) (sale cat., London, Gerrard, 17 Dec 1793)

A. Graves: *The Royal Academy of Arts*, iii (1905), p. 217

——: *The Society of Artists of Great Britain (1760–1791): The Free Society of Artists (1761–1783)* (London, 1907)

M. Hébert, E. Pognon and Y. Bruand: *Inventaire du fonds français: Graveurs du dix-huitième siècle*, Paris, Bib. N., Cab. Est. cat., x (Paris, 1968), pp. 1–5

DAVID ALEXANDER

Gauguin, Paul (*b* Paris, 7 June 1848; *d* Atuona, Marquesas Islands, 8 May 1903). French painter, printmaker, sculptor and ceramicist. His style developed from Impressionism through a brief cloisonnist phase (in partnership with Emile Bernard) towards a highly personal brand of Symbolism, which sought within the tradition of Pierre Puvis de Chavannes to combine and contrast an idealized vision of primitive Polynesian culture with the sceptical pessimism of an educated European. A selfconsciously outspoken personality and an aggressively asserted position as the leader of the Pont-Aven group made him a dominant figure in Parisian intellectual circles in the late 1880s. His use of non-naturalistic colour and formal distortion for

expressive ends was widely influential on early 20th-century avant-garde artists.

1. Life and work. 2. Working methods and technique. 3. Reputation and influence.

1. LIFE AND WORK.

(i) To 1882. (ii) 1883–7. (iii) 1888: Pont-Aven and Emile Bernard. (iv) 1888: Arles and van Gogh. (v) 1889–91: Pont-Aven, Le Pouldu, Paris. (vi) 1891–3: First visit to Tahiti. (vii) 1893–5: Return to France. (viii) 1895–1901: Papeete. (ix) 1901–3: The Marquesas.

(i) To 1882. His father, Clovis Gauguin, worked on the *National*, a paper with liberal leanings. In 1846 he had married Aline Chazal, whose parents were the engraver André Chazal and Flora Tristan (1803–44), a French socialist writer close to Pierre Joseph Proudhon and George Sand. Flora Tristan's personality, so deeply involved with social struggle that she had acquired mythic status, her egocentricity and her ceaseless travelling prefigure many aspects of her grandson's character. She was the natural daughter of a Peruvian nobleman, Don Mariano Tristan Moscoso, and when Gauguin constructed his image of the 'untamed' artist he often referred to this exotic ancestry. When the revolution of 1848 brought Louis Napoleon to power, Clovis Gauguin, fearing a return to the imperial regime, decided to set off with his family for Lima, where he intended to found a newspaper, but during the crossing he died of a heart attack. Aline Gauguin continued the journey, in order to seek protection for herself and her two children with her uncle, Don Pio Tristan Moscoso.

Until 1855 Gauguin lived the life of a pampered child on his great-uncle's estate in Lima. Then he returned to France where an inheritance allowed his mother to settle first in Orléans, native city of the Gauguin family, and then in Paris. Gauguin pursued his studies but was an indifferent student and at the age of 17 joined a cargo ship sailing between Le Havre and Rio de Janeiro. In 1867 his mother died, leaving the financier Gustave Arosa as guardian of her children. A collector and photographer, friend of Nadar and Camille Pissarro, Arosa was to have a considerable influence on the young Gauguin. Like many collectors at the end of the 19th century, Arosa was attracted to the French painters of the 1830 generation, and he had put together a remarkable collection, including 16 works by Delacroix and numerous paintings by Corot, Courbet and the Barbizon school. It was in this context that Gauguin first became enthusiastic about painting, which he practised as an amateur with Marguerite Arosa, his guardian's daughter. In 1871 Arosa obtained a position for Gauguin as a stockbroker with a bank. The substantial income he earned in this new post removed any anxiety about money, and in 1873 he married Mette-Sophie Gad, a young Danish woman who bore him five children.

Painting began to occupy an increasingly important place in Gauguin's life, thanks to a series of different people. By 1872 he was regularly visiting Emile Schuffenecker, who like himself worked in a bank and was also a painter. The following year he met the Norwegian painter Frits Thaulow, his wife's brother-in-law. Gauguin visited the First Impressionist Exhibition (April–May 1874) and witnessed the stir it caused in the press and in public opinion. However, it was his meeting with Pissarro that

proved the decisive catalyst for his artistic development: probably introduced by Arosa, he was in touch with Pissarro by June 1874 and worked with him at the Académie Colarossi in Paris. Several times during the course of his career Gauguin paid homage to Pissarro who was both a generous teacher and someone who made him appreciate the reality of the struggles faced by avant-garde artists. On his recommendation, Gauguin bought some Impressionist paintings, showing a preference for Cézanne (e.g. *The Castle of Médan, c.* 1880; Glasgow, Burrell Col.) and thus becoming one of his earliest admirers. Pissarro also drew him into the Impressionist circle. Gauguin, who had already exhibited a landscape at the official Salon in 1876, participated in their group exhibitions from 1880 onwards.

Gauguin's early works before about 1878 are in a muted Impressionist style, not yet free of a greyish tonality, which was sometimes reminiscent of the Barbizon school (e.g. *Glade*, 1874; Orléans, Mus. B.-A.) and sometimes of the urban landscapes of Stanislas Lépine (*The Seine by the Pont d'Iéna*, 1875; Paris, Mus. d'Orsay). His meeting with Pissarro encouraged him to adopt a more clearly stated luminosity and it liberated his use of colour in landscapes whose compositions were sometimes inspired by Cézanne

(e.g. *The Gardeners of Vaugirard*, 1879; Northampton, MA, Smith. Coll. Mus. A.). Gauguin, Pissarro and Cézanne painted together in Pontoise in 1881. Gauguin's interiors and still-lifes on the other hand were more influenced by Degas, as can be seen in *Suzanne Sewing* (1880; Copenhagen, Ny Carlsberg Glyp.). When it was shown in 1881 at the sixth Impressionist exhibition, this work, a resolutely unidealized study of the female nude, aroused the enthusiasm of J.-K. Huysmans who wrote: 'among contemporary painters who have studied the nude, none has yet given such a vehement note to reality'.

(ii) 1883–7. Following the stock-market crash of 1882, Gauguin lost his bank job. Having no income, he envisaged supporting himself by his painting and took his family from Paris to Rouen and then to Copenhagen, where he worked as a salesman for a canvas manufacturer. He spent a miserable year in Denmark in 1885: neither his parents-in-law, who took the couple in, nor the Danish public appreciated Impressionist painting. Gauguin organized an exhibition of his work, which the Danish Academy forced to close after five days. He returned to Paris a bitter man in June 1885, accompanied by his son Clovis. He was leading a wretched life at that time despite financial support

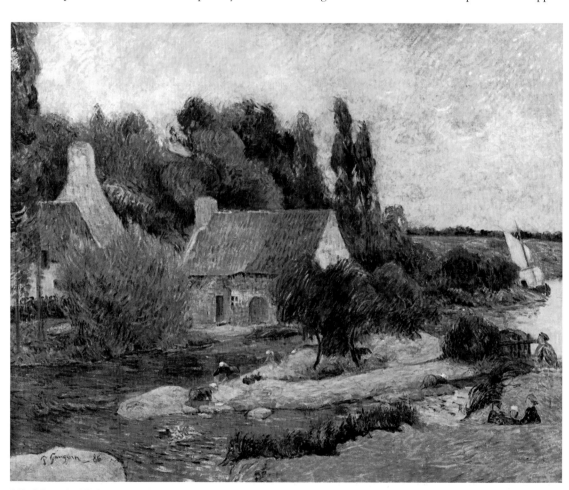

1. Paul Gauguin: *Washerwomen at Pont-Aven*, oil on canvas, 710×900 mm, 1886 (Paris, Musée d'Orsay)

from Schuffenecker. Nonetheless, he continued to paint and in 1886 made the acquaintance of the ceramicist Ernest Chaplet, with whom he then collaborated, for example, on producing a glazed stoneware vase decorated with Breton girls (1886–7; Brussels, Mus. Hôtel Bellevue, see Bodelsen, fig. 9).

Almost penniless, Gauguin took the advice of the Breton painter Felix Jobbé-Duval to seek a less stressful life in the Breton village of Pont-Aven. He went to live there in mid-July 1886, basing himself at the Pension Gloanec. Gauguin's first stay in Brittany, which lasted five months, did not bring about any radical change in his art: he was still painting in the Impressionist technique of divided tones. However, there was distinct progress in his mastery of form at this time: there was a more conscious stylization of figures and landscape elements, and his compositions became both better ordered and more daring (e.g. *Washerwomen at Pont-Aven*, 1886; Paris, Mus. d'Orsay; see fig. 1). According to evidence collected by Charles Chassé, Gauguin frequently talked about synthesis during his first stay in Brittany. He was perhaps developing in conversation the 'synthetic notes' he had written shortly before in Rouen or Copenhagen. At this time the method Gauguin was advocating consisted of making sketches, copies and studies from many different sources and reassembling them in the finished work, a process utterly opposed to the Impressionist *plein-air* painting that had originally inspired him. He was also aiming to produce work in which the colour of Impressionism was allied to the harmony of Puvis de Chavannes. This is what he sought to achieve in a series of pictures produced in Martinique on a visit in 1887 with the painter Charles Laval (1862–94). In *Tropical Vegetation* (1887; Edinburgh, N.G.), the composition, formed by large patches of brilliant colour whose chalky texture is reminiscent of mural paintings, is enlivened by vibrant parallel brush-strokes recalling Cézanne.

(iii) 1888: Pont-Aven and Emile Bernard. During his second stay in Pont-Aven, Gauguin reached full stylistic maturity. He returned to the Pension Gloanec in February 1888, and in August he was again in touch with EMILE BERNARD; Gauguin was then 40, Bernard 20. The two artists had first met two years earlier but had not worked together then, nor even exchanged ideas. However, on this occasion, Gauguin, influenced by Bernard's aesthetics, made the most decisive stylistic change of his career.

After 1887 Emile Bernard had distanced himself from the Seurat-inspired Neo-Impressionism he had previously been practising, so that with Louis Anquetin he could elaborate a new way of constructing pictorial space, CLOISONNISM, which consisted of covering the picture surface with large patches of flat colour, bounded by a clearly marked line, similar to the leading of stained glass (e.g. Bernard's *The Rag-pickers: Iron Bridges at Asnières*, 1887; New York, MOMA). It is probable that Gauguin was already familiar with these experiments, having returned to Paris from Martinique in November 1887 and having seen the exhibition at a restaurant in the Avenue de Clichy organized by Vincent van Gogh, which included cloisonnist paintings by Bernard and Anquetin. However, the works Gauguin executed in Pont-Aven before Bernard

arrived, even if they reflect the growing influence of Japanese prints, were not properly speaking cloisonnist (e.g. *Young Boys Wrestling*, 1888; priv. col., see Rewald, p. 173). It was in August 1888 that, impressed by Bernard's painting *Breton Women in the Meadow* (Paris, Mus. d'Orsay), Gauguin reworked its stylistic features into a picture that marks both his adherence to Cloisonnism and his development beyond it into Symbolism: the *Vision after the Sermon: Jacob Wrestling with the Angel* (1888; Edinburgh, N.G.; see fig. 2). In his *Souvenirs inédits* (1943), Bernard stated:

> Gauguin had simply put into practice not the colour theory I had told him about, but the essential style of my *Breton Women in the Meadow*, having first laid in a completely red ground in place of my yellowish-green one. In the foreground, he put my large figures with the monumental headdresses worn by châtelaines.

Even if it is true that Gauguin borrowed from Bernard the general arrangement of his composition, as well as the monochrome ground, his motive for using these elements was quite different. While Bernard was mainly concerned with a formal stylistic experiment—to present a complex decorative arrangement— Gauguin was bent on depicting the image a sermon creates in the minds of those who hear it. The originality of the *Vision after the Sermon* lies in the fact that the imaginary scene of Jacob wrestling with the angel is located on the same plane as the real people, while at the same time it is separated by the trunk of an apple tree, which bisects the composition diagonally. The colour, more muted than in Bernard's work, is marvellously attuned to the spirit of the scene. Gauguin wrote about it to van Gogh: 'I believe I have achieved in these figures a great rustic and superstitious simplicity.' The painting has inspired numerous interpretations. The 'seers' at prayer have been contrasted with the excluded 'non-seers' set aside on the upper left. The physical resemblance between the preacher and Gauguin has led critics to see the work as an image of how the mystery of art may be revealed by an inspired painter. It was on this picture that in 1891 the critic Georges-Albert Aurier based his famous definition of pictorial symbolism: *Le Symbolisme en peinture: Paul Gauguin*. Pissarro saw the *Vision after the Sermon* as marking Gauguin's definitive break with Impressionism. He wrote to his son Lucien: 'I criticize him for not applying his synthesis to our modern philosophy, which is absolutely social, anti-authoritarian and anti-mystical.' (20 April 1891).

In late September 1888 Gauguin met PAUL SÉRUSIER in Pont-Aven and the following month instructed him how to paint landscape in the new technique of simplified forms and flat colour patches. The result was *The Talisman* (Paris, Mus. d'Orsay), which Sérusier took back to Paris, where it had a decisive impact on his contemporaries at the Académie Julian, notably Pierre Bonnard, Maurice Denis, Edouard Vuillard and Paul Ranson, who were to form the NABIS. Not only did the Nabis copy Gauguin's way of organizing the picture surface and subjective palette, but his quasi-mythical personality was of exemplary value in their eyes.

(iv) 1888: Arles and van Gogh. While he was at Pont-Aven, Gauguin received insistent requests from Vincent

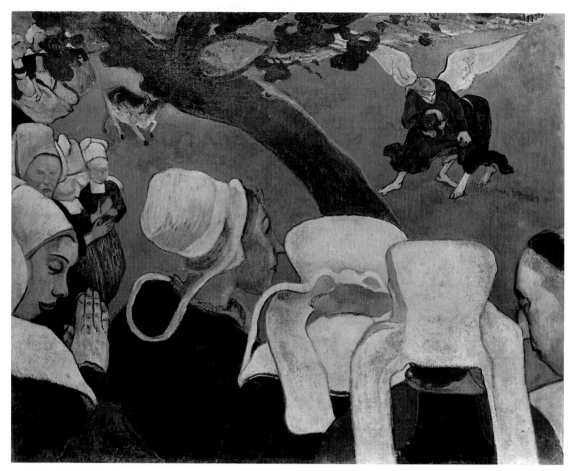

2. Paul Gauguin: *Vision after the Sermon: Jacob Wrestling with the Angel*, oil on canvas, 722×910 mm, 1888 (*Edinburgh, National Gallery of Scotland*)

van Gogh and his brother Theo to join Vincent in Arles, where he had recently gone to live. In exchange for coming to the aid of his brother, whose mental health was already failing, Theo undertook to help Gauguin financially by buying his work. For van Gogh, also in search of exoticism, Arles represented an imaginary Japan. He hoped to set up a studio there that would attract numerous other artists. Gauguin, whom he had admired ever since their first meeting in Paris in 1887, would have been its leader.

Giving in to these appeals, Gauguin reached Arles in October 1888. For two months, the two artists lived under the same roof, endlessly discussing artistic theories and working together, out of doors and in the studio. Even in the first letters he wrote to Bernard at the beginning of his stay, Gauguin seemed already to have decided to distance himself from van Gogh, whose fiery but introverted personality hardly seemed destined to accord with his. Their tastes also differed profoundly, Gauguin wrote: 'Vincent can see Daumiers to do here, while I on the other hand, see coloured Puvis to do, mixed with Japan.' This brief partnership of two exceptional artists is one of the most famous episodes in the history of art: van Gogh's mental health rapidly deteriorated, and he was pushed to the limit of his endurance by discussions in which he and

Gauguin never stopped contradicting each other, and by the impossibility of realizing his dream of a 'studio in the south'; during the night of 23 December, he cut off his left ear, having first threatened his companion with a razor-blade. This was the grotesque and tragic end of an association on which van Gogh had set all his hopes. Three days later Gauguin returned to Paris.

Did Gauguin's stay in Arles, as he complacently noted in *Avant et après*, only benefit van Gogh? In contrast to Gauguin's relationship with Bernard some months earlier, the reciprocal influence of Gauguin and van Gogh, clearly evident in work by them both, did not produce any definitive stylistic upheaval. If it is true that the surface treatment of a painting such as *Human Misery* (1888; Copenhagen, Ordrupgaardsaml.) shows the heavy impasto of van Gogh, Gauguin's Arles series, with its supple animated forms, is really an epiphenomenon in his work.

(v) 1889–91: Pont-Aven, Le Pouldu, Paris. The two years preceding Gauguin's departure for Tahiti (1891) were marked by frequent trips between Brittany, where he sought to discover new landscapes at the Avens and Le Pouldu, and Paris, where he entered Symbolist literary circles. In January 1889 he stayed with Schuffenecker

before returning to Pont-Aven in April. He was invited to exhibit with Les XX in Brussels, but when his 12 submissions were not received as enthusiastically as he had anticipated, he decided not to go to Belgium. At the end of May he was again in Paris, drawn there by the opening of the Exposition Universelle and preparations for the Impressionist and Synthetist painters' exhibition. When the jury of the Exposition Universelle refused to hang the work of Gauguin and his friends, Schuffenecker organized a group exhibition at the Café Volpini on the Champ de Mars, not far from the official art pavilion. Gauguin, Bernard, Laval, Anquetin and Georges-Daniel de Monfreid all took part. Gauguin intervened with Schuffenecker to exclude the Neo-Impressionists (Georges Seurat, Paul Signac, Henri-Edmond Cross and Pissarro), which indicates a new-found awareness of his stylistic identity and his role as the leader of a school, which he insisted on playing from then on. Despite the unquestioned novelty of the works shown, which should at least have ensured a *succès de scandale*, the exhibition was a failure. The national press remained silent and only a few literary friends, such as Félix Fénéon, gave it brief coverage.

Disappointed by this new setback, Gauguin again set off for Brittany at the beginning of the summer, accompanied by Paul Sérusier. Pont-Aven, increasingly invaded by painters, disgusted him, and he took refuge for the winter in Le Pouldu. During this period, the Dutch painter JACOB MEYER DE HAAN worked with him. Gauguin's hatred for anything over-sophisticated, and his search for ever wider horizons, were the signs not just of an inherent instability but also of a frequently expressed desire to safeguard the primitive nature of his art. By December 1889 he was dreaming of leaving for Tonkin and then Madagascar: 'The West is now in a state of decay', he wrote to Bernard.

In 1889–90, even while he was experiencing a succession of failures, Gauguin was gradually gaining considerable notoriety among avant-garde intellectuals who found in his painting an echo of their own preoccupations. During his spells in Paris, he visited Stéphane Mallarmé and his 'Tuesday' group in the Rue de Rome and befriended Aurier, Charles Morice and Jean Moréas. The *Loss of Virginity* (1890–91; Norfolk, VA, Chrysler Mus.), probably painted in Paris just before he left for Tahiti, represents the culmination of an esoteric tendency that characterizes this period. The synthetist stylization is pushed to extremes: for the first time, the landscape is strictly ordered by emphasis on the horizontal to which even a cloud, portrayed as a long pale wisp, must submit. The shape of the cloud is echoed in the foreground by the barely pubescent body of a young girl with her limbs held rigid after a clumsy attempt at defloration. Against her breast she clutches a fox, 'the Indian symbol of perversity' according to Gauguin. As in the *Vision after the Sermon*, the artist artificially juxtaposes two distinct planes in one continuous space. The symbolic foreground appears as the unconscious echo of a real event shown in the distance: a Breton wedding advancing through the countryside. Religious feeling, explicit even in the title of *Jacob Wrestling with the Angel*, is expressed here by a network of more complex symbols, revealing a pagan vision of stages of existence characterized by anxiety and mystery. This search

for the primeval emotion of mankind in ritual links Gauguin with Symbolist artists who were rediscovering legend and myth at this time.

(vi) 1891–3: First visit to Tahiti. While in Le Pouldu during the autumn of 1890, Gauguin made the decision to set off for Tahiti and put all his energy into carrying out this plan. On his return to Paris at the beginning of 1891, Gauguin organized an auction of his paintings in order to raise sufficient funds for his departure. A major event in the world of art and literature, this sale, for which Octave Mirbeau wrote the catalogue introduction, was a success. A benefit evening at the Théâtre des Arts was also organized for him, as well as a farewell banquet presided over by Mallarmé. At that point, Gauguin could legitimately have claimed fame and hoped that his return (for his letters show that he did not intend to remain in Tahiti indefinitely) would be the triumph he had so long awaited.

In June 1891 he arrived in Papeete in French Polynesia, after a two-month voyage. On being confronted with the

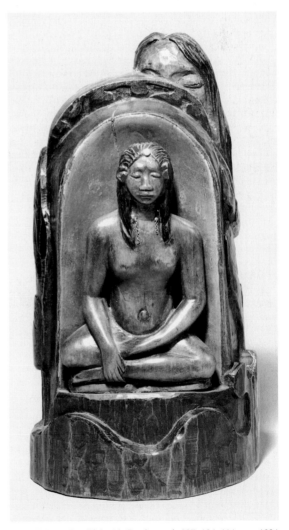

3. Paul Gauguin: *Idol with Pearl*, wood, 237×126×114 mm, 1894 (Paris, Musée d'Orsay)

reality, his illusions rapidly dissolved: the revelation he had expected from contact with an imaginary Eden never came, and the numerous expatriates who inhabited Tahiti created a parody of Europe. His constant moving from place to place was evidence of his dissatisfaction. By the summer he was at Mataiea, having spent several months at Pacca. During the first few months of his stay, he amassed what he thought of simply as studies. He wrote to Sérusier in November 1891: 'Not a single painting yet, but masses of research which may prove fruitful; any number of documents which will be useful for a long time, I hope, back in France.' It was not until June 1892 that his letters indicated real confidence in his work. Such paintings as *Vahiné no te tiare* ('Woman with a flower') (1891; Copenhagen, Ny Carlsberg Glyp.) were still reminiscent of Cézanne, but by 1891 Gauguin was already producing several works showing a new boldness, such as *Women of Tahiti* (Paris, Mus. d'Orsay) in which the abbreviated forms can be read as a jigsaw of coloured patches, and traditional modelling was reduced to a strict minimum.

In Tahiti Gauguin made considerable progress with his sculpture and woodcuts. He borrowed unashamedly, often copying poses from photographs of other works. In Tahiti this process became quasi-systematic. It is apparent in his small-scale wooden sculptures in which the artist blended Oceanic sculpture and iconography often borrowed from Asiatic art. Thus *Idol with Pearl* (1894; Paris, Mus. d'Orsay; see fig. 3), which shelters in a gilded niche a sort of Buddha inspired by the reliefs at Borobudur, shows on its other face two Oceanic *Ti'i* figures (anthropomorphic wooden images), very much like those Gauguin would have seen around him. This assimilation of two cultures shows that Gauguin was in search not of local colour but of a primitive religious spirit, which he believed inseparable from a certain crudity of workmanship. This roughness is also found in his woodcuts (e.g. *Manao tupapau* ('Watched Over by the Spirit of the Dead'), *c*. 1891–3; Paris, Mus. A. Afr. & Océan.; *see* PRIMITIVISM, fig. 2), which appeared in large numbers between 1891 and 1893, most of them on themes already treated in his paintings. Gauguin was eager to submit his increasingly 'untamed' style to European judgement. In June 1892, sick and destitute, he asked to be repatriated to France, but he did not leave Tahiti until June of the following year.

(vii) 1893–5: Return to France. As soon as he arrived in Paris, Gauguin became intensely active. He inherited some money, which gave him enough to live on. At Degas's instigation, Paul Durand-Ruel suggested giving a one-man exhibition of his work from Tahiti, for which Gauguin made feverish preparations until November. He saw himself as permanently on show and affected an ostentatious exoticism verging on the theatrical. His studio became an Oceanic junk-shop, and he took as his mistress a Parisian mulatto, nicknamed Anna the Javanese.

Because the manner in which he drew attention to his artistic beliefs, however genuine, was crude, Gauguin was often dismissed as a charlatan. Attempts to explain and justify his attitude only met with incomprehension. In Tahiti he had written a text that became *Noa-Noa*, in which he related his discovery of the island and its religious traditions. With the help of Charles Morice, who interspersed the text with his own poems, Gauguin put the work into shape, with the intention of having it published, believing it would help people to understand his painting. (It first appeared in the *Revue blanche* in October 1897.) Despite these justifications of his work, his exhibition at Galerie Durand-Ruel in Paris was received with no more than a certain respect. Preoccupied with promoting his work, Gauguin painted little. He produced a few paintings on Tahitian subjects, such as *Mahana no atua* ('Day of God') (1894; Chicago, IL, A. Inst.). At Pont-Aven, from May 1894, his colour acquired a new acidity (e.g. *David's Mill at Pont-Aven*, 1894; Paris, Mus. d'Orsay) and he painted some snow scenes (e.g. *Breton Village in the Snow*, 1894; Paris, Mus. d'Orsay).

It seems that during this period Gauguin set out to compromise the success he could have achieved if he had only been more patient. In Brittany he brought an unsuccessful lawsuit against the innkeeper Marie Henry in order to recover some pictures he had left with her. He had a brawl with some sailors and was forced to stay in hospital with a broken leg. During this time, Anna the Javanese ransacked his Paris studio. Discouraged by the failure of his exhibition and continued humiliation, he decided in September 1894 to leave France permanently. In February 1895 he organized another auction, which he hoped would raise enough money to finance his departure. The catalogue introduction comprises a text by August Strindberg, frankly unfavourable to Gauguin, and the latter's reply, in which once again he extols his 'untamed' aesthetic. Of forty-seven pictures shown, only nine were sold: the failure was self-evident.

(viii) 1895–1901: Papeete. If his letters are to be believed, Gauguin's second departure for Oceania was undertaken in a different frame of mind from his first. It was not just a farewell to 'the European way of life' in the hope of seeing his family again one day, but also to his artistic career. Above all it was peace of mind that he sought in exile: 'I would be able to end my days free and at peace with no thought for tomorrow and without having to battle endlessly against idiots. Farewell painting, except as a distraction.' On his arrival in Papeete in September 1895 he did not find the restfulness he had counted on: his poor health forced him to stay in hospital and his savings ran out. Nonetheless it was a period of intense creativity, during which he painted and sculpted a great deal and seemed to go further in his metaphysical questioning, obsessed by the thought of death: he wrote *L'Esprit moderne et le catholicisme*. Periods of great energy alternated with inactivity for the rest of his life. In April 1897 he learnt of the death of his daughter Aline, to whom he was deeply attached. It seems it was this event that made him decide to commit suicide. He embarked on a picture that represents his last will and testament: *Where do we come from? Who are we? Where are we going?* (1897; Boston, MA, Mus. F.A.; for illustration *see* SYMBOLISM). Painted on hessian sacking, this vast picture, hastily finished in many places, represents in his work a new surface ruggedness, which with its more spontaneous handling influenced his future output. Gauguin reused a number of individual figures and groups from his earlier pictures, transforming

Where do we come from? into a kind of résumé of his work. The figures in the foreground, symbolizing the successive ages of an Edenic existence, are counterbalanced by three figures in the background wearing dark clothes, images of the anguish inherent in religion or knowledge. Gauguin juxtaposed the two sides of his personality, one carelessly turned towards sensuality, and the other towards a profound existential anxiety. Thus this work constitutes the concluding synthesis of his Tahitian pictures on religious themes, such as *Te tamari no atua* ('Birth of Christ, Son of God') (1896; Munich, Neue Pin.), a series that culminates in the scepticism embodied in the questions of the title.

Gauguin tried unsuccessfully to kill himself by taking arsenic. Physically and morally shaken, he took an office job in Papeete, which allowed him to earn a living for a while. He seemed to become detached from his own work. When Maurice Denis wrote to him asking if he would participate in an exhibition of the Nabis in Paris, he replied in June 1899 'I no longer paint except on Sundays and holidays'. No painting by him dated 1900 is known. On the other hand, he expended a great deal of energy bickering with the island's administrative authorities, and he worked on a satirical paper in Papeete, *Les Guêpes*, before founding his own publication *Le Sourire: Journal méchant*, which he edited and illustrated with woodcuts.

(ix) 1901–3: The Marquesas. Gauguin's career can be summarized as the pursuit of an ideal constantly belied by reality. Unsatisfied, he felt the need of new discoveries. He left Tahiti for the island of Hiva Oa in the Marquesas at the end of 1901, seeking a primitive world, unspoilt by any contamination from Europe. The impact of this other world, wilder because, as it seemed, less overrun by colonization, prompted a period of enthusiasm that despite his deteriorating health drove him to produce his last series of works. His financial worries were eased by de Monfreid (his most assiduous correspondent in the final years), the Paris dealer Ambroise Vollard, and the collector Gustave Fayet.

Gauguin was once more attracted to sculpture. Of particular interest are the roughly carved wooden reliefs with which he decorated the doorway of his new hut, the *Maison du jouir* (1901; Paris, Mus. d'Orsay). His painting evolved towards a greater sobriety and a linear treatment of form that gives his late work an austere appearance. In *Savage Tales* (1902; Essen, Mus. Flkwang; see fig. 4), the thinly applied paint barely conceals the canvas, and in many places the weave shows through. Gauguin superimposed formal ideas already present in earlier works by bringing together two Tahitian nudes and a sinister image of his distant friend Meyer de Haan, half-faun, half-cloven-hoofed-devil, but concentrated the composition, re-linking the separated figures by his use of a decorative ground. He also explored a theme treated during his first visit to Tahiti and central to his art: the contrast between savage innocence and civilized knowledge. Although this group of late works is evidence of a stylistic renewal, Gauguin died no longer expecting his work to be recognized or appreciated, though retaining a keen awareness of the liberating role that his painting would play for the next generation.

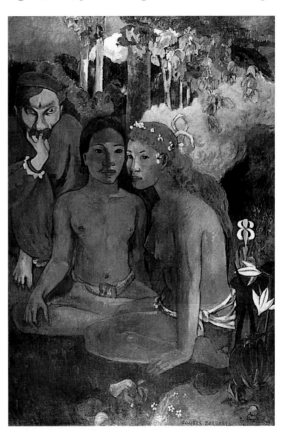

4. Paul Gauguin: *Savage Tales*, oil on canvas, 1300×890 mm, 1902 (Essen, Museum Folkwang)

2. WORKING METHODS AND TECHNIQUE. Starting with relatively banal Impressionist techniques, Gauguin evolved towards an increasingly personal treatment of form and colour, and he adapted his technique to new requirements. According to Henri Delavallée (*fl* 1892–6), a painter who knew Gauguin when he first stayed at Pont-Aven, Gauguin was endeavouring, under the influence of Pissarro, to use Divisionism: 'I only paint with sable brushes. . . ; that way the colour stays thicker: when you use ordinary brushes, two adjacent colours get mixed up; with sables you get juxtaposed colours', he said. In this way he obtained iridescent brushstrokes, which side by side give the stripy effect mentioned by Delavallée. In *Still-life with Ham* (1889; Washington, DC, Phillips Col.), Gauguin organized the whole surface into broad vertical hatching, creating a top paint layer that was homogeneous and fairly thick. From 1892 the vertical stripes became more and more discreet. Then the artist, who was increasingly composing his works with patches of colour bounded by blue outlines, tended to use thinner paint and showed sensitivity to the matt effects obtained by large areas of colour on a canvas whose weave sometimes remained visible (e.g. *Nave nave mahana* ('Days of Delight'), 1896; Lyon, Mus. B.-A.). This tendency increased with time, and in the works from his second visit to Tahiti Gauguin conceived painting in terms of colour alone, to which effects of texture became subordinate; thin impasto,

extreme sobriety of unvarnished surface, all bore similarities to the art of mural painting.

Gauguin's attitude to his subject soon set him apart from the Impressionists. Even though he may have completed a canvas out of doors, his starting-point still remained the study produced in his studio from preliminary drawings, a process attested to by his reuse of identical figures in different works. Even in the elaboration of his work, Gauguin remained entirely traditional. An unfinished oil painting on paper, *Tahitian Women Resting* (1894; London, Tate), makes clear how he drew his composition in charcoal very precisely, outlining his figures quite clearly before starting to paint.

In the field of engraving and sculpture, it is important to stress Gauguin's fondness for the most primitive techniques, which correlates with the deliberate 'savagery' of his art (see fig. 5). He favoured processes in which the artist's hand was clearly visible in the finished work: thus wood was his favourite material for sculpture, and woodcut his preferred graphic medium. Even in 1880, when his work was still academic, he was already attracted by this material (e.g. the *Birth of Venus*, wood, *c.* 1880; Geneva, Petit Pal.). However, it was most probably modelling in clay that had the greatest effect on his conception of sculpted form. In the pots he made after 1886 with Chaplet, Gauguin worked the clay as a sculptor, and for the usual thrown forms he substituted a strange and personal vocabulary, partly inspired by Pre-Columbian art. Gauguin's early ceramics seem to have led him to adopt a

5. Paul Gauguin: *Oviri*, partly glazed stone, h. 750 mm, *c.* 1894 (Paris, Musée d'Orsay)

clearer stylization of form in his paintings. The sculptures and woodcuts made in Tahiti owe their primitive roughness to the extreme economy of means employed. In his woodcuts, Gauguin created effects of astonishing novelty from oppositions of black and white and the use of the woodgrain (e.g. *Be in Love and You Will Be Happy*, *c.* 1893–5; see fig. 6).

3. REPUTATION AND INFLUENCE. Although Gauguin is seen as a Symbolist, his place in the art of his own time as assessed by the critics and art historians of the first half of the 20th century is not without a certain ambiguity. He had turned his back on Impressionism by 1888, yet he remained historically linked to the movement and for this reason figured in various works and exhibitions devoted to it. Moreover, Gauguin's artistic descendants at the beginning of the 20th century did not take up the Symbolist aspect of his work. At the same time, modernist critics, and Fénéon in particular, considered Symbolism residual to Gauguin's strictly pictorial preoccupations, and they attempted to isolate him from his period and the circle with which he was involved.

Gauguin's attitude towards his own work was clear: for him, the relationship between a subject and how it was treated pictorially was of crucial importance. He used colour as an emotional and symbolic language, but at the same time a fascination with the supernatural and with metaphysical inquiry were constant features of his thought. Studies have underlined the influence of theosophy on his work: occultism was widespread among the intellectuals with whom he was friendly. Although his independent nature distanced him from established groups such as the Rosicrucians, Gauguin was familiar with the esoteric writing of Joséphin Peladan, Eliphas Lévi and Edouard Schuré. Because of this, his creative approach cannot be dissociated from the symbolic system on which it relied. For example, he was fascinated by the Buddha figure, which appears in numerous of his paintings and sculpture (e.g. *Savage Tales*). However, his recourse to the model of Asiatic art should be seen not as a simple formal borrowing but as an attempt to give his work a wider spiritual resonance from its earliest conception. In short, if Gauguin belonged to the Symbolist movement by virtue of his focus of interest and even his approach, it should be emphasized that his Symbolism was never the simple transposition of a given idea into paint.

Gauguin held an extraordinary fascination for the Parisian avant-garde and especially for the Nabis, who considered him their spiritual father. Gauguin influenced other leading early 20th-century artists, apart from those who were in direct contact with him. The stylistic changes that determine the maturity of Munch at the time of his stay in Paris in 1889 were probably a result of the discovery of paintings by Gauguin. Likewise the young Picasso owed his change of direction at the end of 1901, which led to his 'blue period', to the influence of the paintings by Gauguin seen at the house of his friend Paco Durio, or at Vollard's. Between 1904 and 1910, Matisse was the artist who came closest, as much in form as in spirit, to Gauguin's aesthetic. A work such as Matisse's *Luxury* (1907; Paris, Pompidou) illustrates the stylistic ties that bound the Fauves (André Derain, Maurice Vlaminck, Albert Marquet

6. Paul Gauguin: *Be in Love and You Will Be Happy*, woodcut, 162×276 mm, *c.* 1893–5 (Chicago, IL, Art Institute of Chicago)

and Matisse) to Gauguin, from whose work they, like the German Expressionists (Alexei Jalenski, Ernst Kirchner, Otto Müller, Max Pechstein), retained an expressive use of colour and linear distortion (*see* FAUVISM). The Gauguin retrospective at the Salon d'Automne of 1906 in Paris brought home to a wide circle of avant-garde artists the full extent of his genius.

Gauguin was naturally not the only source of inspiration for the revolutionary developments in Western art at the beginning of the 20th century; he shared this role with Cézanne and van Gogh. Nevertheless, while it is difficult to establish the relative importance of their influence, it must be said that Gauguin's work provided inspiration for the widest variety of artists.

WRITINGS

J. Rewald and R. Cogniat, eds: *Notes synthétiques* (*c.* 1886) (Paris, 1963) [facs. of sketchbook]
Ancien culte mahorie (*c.* 1892–3), notes by R. Huyghe (Paris, 1951) [facs. of illus. MS.]
'Noa-Noa, voyage de Tahiti', *Rev. Blanche* (15 Oct 1897); as book (Berlin, 1926/R Stockholm, 1947) [facs. of *c.* 1893–4 MS., Paris, Louvre]
Le Sourire: Journal méchant (Paris, 1952) [facs. of per. pubd by Gauguin in Papeete, 1899–1900]
Avant et après (Leipzig, 1918 [facs. of 1903 MS.], rev. Paris, 1923/R Copenhagen, [1951]); abridged Eng. trans. as *The Intimate Journals of Paul Gauguin* (New York, 1921)
Lettres de Gauguin à sa femme et à ses amis, ed. M. Malingue (Paris, 1946)
V. Merlhès, ed.: *Correspondance de Paul Gauguin, documents, témoignages*, i (Paris, 1984) [1873–88]

BIBLIOGRAPHY

MONOGRAPHS AND CATALOGUES

J. de Rotonchamp [Brouillon]: *Paul Gauguin* (Weimar, 1906; Fr. trans., Paris, 1925)
C. Morice: *Paul Gauguin* (Paris, 1920)
M. Guérin: *L'Oeuvre gravé de Gauguin*, 2 vols (Paris, 1927)
H. Perruchot: *La Vie de Gauguin* (Paris, 1948, rev. 1961)
C. Chassé: *Gauguin et son temps* (Paris, 1955)
C. Gray: *Sculpture and Ceramics of Paul Gauguin* (Baltimore, 1963)
M. Bodelsen: *Gauguin's Ceramics* (London, 1964)
G. Wildenstein: *Gauguin: Catalogue*, i (Paris, 1964) [ptgs]
C. Chassé: *Gauguin sans légendes* (Paris, 1965)
Gauguin and the Pont-Aven Group (exh. cat., London, Tate, 1966)
F. Cachin: *Gauguin* (Paris, 1968, rev. 1988)
F. Agustoni and G. Lari: *Catalogo completo dell'opera grafica di Paul Gauguin* (Milan, 1972)
G. M. Sugana and G. Mandel: *L'opera completa di Gauguin* (Milan, 1972) [update of Wildenstein]
B. Thomson: *Gauguin* (London, 1987)
M. Hoog: *Paul Gauguin: Life and Work* (New York, 1987)
E. Kornfeld and E. Morgan: *Paul Gauguin* (Berne, 1988) [cat. rais.]
The Art of Paul Gauguin (exh. cat. by R. Bretell and others, Washington, DC, N.G.A.; Chicago, A. Inst.; Paris, Grand Pal.; 1988–9)

SPECIALIST STUDIES

G.-A. Aurier: 'Le Symbolisme en peinture: Paul Gauguin', *Mercure France* (March 1891), p. 155; repr. in *Oeuvres posthumes* (Paris, 1893)
'Gauguin, sa vie, son oeuvre', *Gaz. B.-A.*, n.s. 6, li (1958) [issue devoted to Gauguin]
S. Lövgren: *The Genesis of Modernism: Seurat, Gauguin, van Gogh and French Symbolism in the 1880s* (Stockholm, 1959, rev. 2/1971)
B. Danielsson: *Gauguin Söderhavsar* [Gauguin in the South Seas] (Stockholm, 1964; Eng. trans., London, 1965)
M. Bodelsen: 'Gauguin the Collector', *Burl. Mag.*, cxii (1970), pp. 590–615
M. Roskill: *Van Gogh, Gauguin and the Impressionist Circle* (London, 1970)
H. R. Rookmaaker: *Gauguin and 19th Century Art Theory* (Amsterdam, 1972)
H. Dorra: 'Munch, Gauguin and Norwegian Painters in Paris', *Gaz. B.-A.*, n.s. 6, lxxxviii (1976), pp. 175–80
M. Herban: 'The Origin of Paul Gauguin's *Vision after the Sermon: Jacob Wrestling with the Angel*', *A. Bull.*, lix/3 (Sept 1977), p. 415
V. Jirat Wasiutyński: *Paul Gauguin in the Context of Symbolism* (New York and London, 1978)
——: 'Paul Gauguin's Paintings, 1886–91: Cloisonism, Synthetism and Symbolism', *RACAR*, ix/1–2 (1982), pp. 35–46
J. Teilhet-Fiske: *The Influence of Polynesian Cultures on the Works of Paul Gauguin* (Ann Arbor, 1983)

C. Boyle-Turner: *The Prints of the Pont-Aven School: Gauguin and his Circle in Britanny* (Washington, DC, 1986)

B. Braun: 'Paul Gauguin's Indian Identity: How Ancient Peruvian Pottery Inspired his Art', *A. Hist.*, ix/1 (1986), pp. 36–54

V. Jirat Wasiutyński: 'Paul Gauguin's Self-portrait with Halo and Snake: The Artist as Initiate and Magus', *A.J.* [New York], xlvi/1 (Spring 1987), pp. 22–8

For further bibliography see J. Rewald: *Post-Impressionism: From van Gogh to Gauguin* (London, 1978), pp. 527–36.

RODOLPHE RAPETTI

Gaul, August (*b* Grossauheim, nr Hanau, 22 Oct 1869; *d* Berlin, 18 Oct 1921). German sculptor. His father was a mason, and he acquired the craftsman's techniques in his father's workshop. Between 1884 and 1888 he received training as an engraver in a silverware factory, at the same time attending courses at the Zeichenakademie in Hanau. In 1888 he went to Berlin, where he became an assistant in the studio of Alexander Calandrelli, who was already a well-known figure. Seeking further professional development, he attended evening courses at the teaching institute of the Kunstgewerbemuseum after 1891.

An event that was significantly to influence Gaul's artistic work was his winning a permanent entry ticket to the Berlin zoo. From then on animal sculptures dominated his work and made him famous. He complemented his daily studies by attending classes given by the animal painter Paul Meyerheim at the Akademische Hochschule, where he was a pupil from 1894. However, it was Peter Breuer (1856–1930), the teacher of the sculpture life class, who discovered Gaul's great talent and presented some of his studies to Reinhold Begas. The latter immediately enrolled Gaul as an assistant in completing a large project of his workshop, the monument to *Emperor William I* for Berlin (1895–6). Gaul first became known to the public as the creator of two of the four lions on the socle of the monument. About this time he joined Begas's studio as a pupil.

August Gaul: Cygnet Fountain, 1908, Kurfürstendamm, Berlin

In 1897, through the Königliche Akademie der Künste, Gaul received the prize of the Paul-Schulze-Stiftung, awarded for his circus relief; this included a scholarship that enabled him to travel to Rome and Florence. Gaul was fascinated by the works of antiquity. In Rome another of Begas's pupils, Louis Tuaillon, introduced him to the circle of Adolf von Hildebrand, whose views on art were of significance for his subsequent works. In him Gaul found a counterweight to his Berlin teacher, Begas.

On returning to Berlin Gaul established his own studio. He became known as an artist who was unwilling to make concessions, after withdrawing from Emperor William II's scheme for the Siegesallee, when he refused to convert a naturalistic edge into a heraldic form. Gaul was a founder-member of the Berlin Secession, and from 1902 he was on the committee, leading to close friendships with artists. After 1901 he was able to make a living from his commissions. His great artistic breakthrough came in 1901 with *Standing Lioness*, which received such acclaim at the Esposizione Internazionale d'Arte Decorativa in Turin in 1902 that the room in which it was shown was called the Sala della Leonessa. It was followed in 1904 by a *Standing Lion* (Berlin, Alte N.G.). During these years he participated in other large international art exhibitions, including the World's Fair at St Louis, MO (1904), and the Venice Biennale of 1905.

Gaul's works reveal a debt to the traditions of the 19th-century Berlin school of sculpture. His lasting artistic interest was animals in their diversity and independence, rather than as subordinates to humans. Years of intense observation of animals at the zoological gardens in Berlin enabled him to render their subtlest traits of character and behaviour. He converted these experiences into an artistic form in which calm and harmony were predominant values. Without humanizing the animal or narrating anecdotes, Gaul enabled the onlooker to empathize with his creations. His output comprises mainly small-format works, with small animals as subjects. His love of creation is reflected in a loving treatment of his subjects, although the works are not primarily emotive. All this distinguishes him fundamentally from the generation of his teacher Begas, who used animals mainly for decoration or to convey allegorical meanings relating to human characteristics.

In 1904 Gaul had become a member of the Königlich Preussische Akademie der Künste and took up a mediating position between the board of management, who tended to follow the official state style, and the Secession. Several fountains were produced as public commissions for Krefeld, Charlottenburg in Berlin (see fig.), Schöneberg and Hamburg; his animal sculptures brought him great popularity among the general public. In 1908 he was awarded the title of professor by the Prussian Ministry of Culture. At the Düsseldorf Kunstausstellung of 1911 he was awarded the major gold medal. When the first Secession entered a crisis after 1911, Gaul joined the newly founded Freie Sezession under Max Liebermann (1913). In the same year he produced the over life-size bronze statue of the god *Mercury* (Hamburg, Ksthalle), for the firm of Klöpper in Hamburg. This was one of the few non-animal subjects by Gaul.

Between 1914 and 1918 Paul Cassirer, who had become the sole distributor of Gaul's works, published satirical graphic works by him, for example the illustrations to accompany an edition of K. W. Rambler's *Alte Tier Fabeln* (1919). To celebrate his 50th birthday the dealer put on a large retrospective of Gaul's work. From 1919 to 1921 Gaul was a member of the purchasing committee of the Nationalgalerie. During this period he became weakened by illness. His appointment as a senator of the Akademie der Künste, the highest distinction for an artist, was made when he was already close to death and he was unable to take up the office. His pupil Max Esser made a simple gravestone at the Dorffriedhof in Dahlem, Berlin, decorated with small bronze lizards.

BIBLIOGRAPHY

Thieme–Becker

F. Stahl: 'August Gaul', *Kst & Kstler*, ii (1904), pp. 89–98

E. Waldmann: *August Gaul* (Berlin, 1919)

Zum 50. Geburtstag August Gaul (exh. cat., Berlin, Cassirer Gal., 1919)

W. Grzimek: *Deutsche Bildhauer des zwanzigsten Jahrhunderts* (Wiesbaden, 1969), pp. 38–58

August Gaul (exh. cat., Grossauheim, 1969)

I. Wirth: *August Gaul: Plastik, Handzeichnungen, Druckgrafik* (Berlin, 1972)

Stilkunst um 1900 (exh. cat., E. Berlin, 1972)

A. Walther: *August Gaul* (Leipzig, 1973)

P. Bloch and W. Grzimek: *Das klassische Berlin* (Berlin, 1978)

P. Bloch and B. Hüfler: *Rheinland Westfalen und die Berliner Bildhauerschule des 19. Jahrhunderts* (Berlin, 1984)

Kunst in Berlin, 1648–1987 (exh. cat., E. Berlin, Altes Mus., 1987)

SIBYLLE EINHOLZ

Gauld, David (*b* Glasgow, 7 Nov 1865; *d* Glasgow, 18 June 1936). Scottish painter, stained-glass designer and illustrator. He attended evening classes at the Glasgow School of Art from 1882 to 1885 while an apprentice lithographer. In 1887 he worked as an illustrator on a Glasgow newspaper and in 1889 provided illustrations for a book of poetry by James Hedderwick. His paintings of this period were realist in subject and low in tone, but these illustrations show an awareness of Pre-Raphaelite technique and symbolism, particularly that of Dante Gabriel Rossetti.

Symbolism of a similar kind appeared in his oil paintings in 1889. In two works, *Music* (priv. col., see Billcliffe, pl. 232) and *St Agnes* (London, Andrew McIntosh Patrick priv. col., see Billcliffe, pl. 233), the change in subject was accompanied by a more colourful palette and more thickly applied paint. Perspective is flattened, and a dark outline surrounds each figure and other objects in the composition. The religious symbolism and outlined technique, which may have influenced his close friend Charles Rennie Mackintosh, almost certainly reflect Gauld's involvement in designing stained-glass panels. Throughout the 1890s he worked freelance for some of the many stained-glass manufacturers in Glasgow. For Hugh McCulloch & Co. he produced a series of eight panels on a theme of music, but his most elaborate work was done for Guthrie & Wells, culminating in a series of windows for St Andrew's Scottish Church in Buenos Aires (*c.* 1905).

In 1895 he visited Grez-sur-Loing, the French village that in the early 1880s had been an Anglo-American artists' colony where several painters of the Glasgow school had spent their early years (*see* GLASGOW BOYS). His paintings of the village and surrounding countryside are cool in tone. On his return to Scotland, Gauld produced similar works, often based on the Galloway town of Kirkcudbright. Gradually his work was given over to paintings of cattle in rural settings, painted in low tones of green, ochre, blue and brown. Gauld dubbed these paintings 'wolf-scarers', but their popularity ensured him a steady income.

Gauld was elected a member of the Royal Scottish Academy in 1924, and in 1935 he was made Director of Design Studies at Glasgow School of Art, reflecting his lifelong interest in the decorative aspects of his art.

BIBLIOGRAPHY

P. Bate: 'The Work of David Gauld', *Scot. A. & Lett.*, ii (1903), pp. 372–83

D. Irwin and F. Irwin: *Scottish Painters at Home and Abroad, 1700–1900* (London, 1975), p. 386 [excellent bibliog.]

R. Billcliffe: *The Glasgow Boys: The Glasgow School of Painting, 1875–1895* (London, 1985) [most comprehensive account and selection of pls]

ROGER BILLCLIFFE

Gaulli, Giovanni Battista [il Baciccio, Baciccia] (*b* Genoa, 1639; *d* Rome, shortly after 26 March 1709). Italian painter. He was a celebrated artist of the Roman High Baroque, whose illusionist ceiling fresco, the *Triumph of the Name of Jesus* (1678–9; Rome, Il Gesù) is one of the most radiant and joyous visions of a triumphant Catholicism. His work, which included frescoes, altarpieces, mythological scenes and portraits, is distinguished by the warm, glowing colour that reveals his Genoese origins.

1. Life and work. 2. Working methods and technique. 3. Contemporary and posthumous reputation.

1. LIFE AND WORK.

(i) The early years, before 1672. (ii) The middle years, 1672–85. (iii) The final years, 1685–1709.

(i) The early years, before 1672.

(a) Altarpieces and frescoes. No works can be securely attributed to Gaulli's youth in Genoa; he left the city before 1658 and based himself in Rome for the rest of his life. Working in Rome for the Genoese art dealer Pellegrino Peri, he met Gianlorenzo Bernini, whose support guaranteed his early success. Gaulli was accepted as a member of the Accademia di S Luca in 1662. His first public commission, the altarpiece *St Roch and St Anthony Abbot Imploring the Intervention of the Virgin and Child on behalf of the Plague-stricken* for the church of S Rocco, shows the profound impression left on Gaulli by the art of his native city. The work in Genoa of Rubens and van Dyck had led painters there, such as Bernardo Strozzi, to work in a broad painterly manner, using dark backgrounds broken by flashes of hot, highly saturated colour. Likewise in S Rocco, Gaulli builds up warm dark colours towards saturation, in glazes over a reddish ground; in the cherub on the left, for example, the whole face is ruddy but where the shadow falls across it, the glow of almost pure red is startling in its intensity. There is also the lingering influence of Genoese Mannerism in the crowded, markedly vertical composition and the elongated figure of St Roch.

Yet in the 1660s Gaulli also experimented with Bolognese classicism. His *Pietà* (1667; Rome, Pal. Barberini) is an early attempt to master this style; the composition is

freely reinterpreted from Annibale Carracci's *Pietà* (Naples, Capodimonte). Here he abandoned the loose painterly manner of the S Rocco altarpiece for a hard, predominantly linear type of modelling, with closed brushwork and an emphasis on detail. In place of the dark warm colours of his earlier canvas, shot through with hues of high intensity, he substituted a cool dry palette, moving everywhere towards grey. In contrast to the rather flaccid treatment of the figures in the S Rocco altarpiece and the somewhat mannered treatment of space, the anatomy of the figures is flawless, the draughtsmanship unfaltering and the treatment of space entirely convincing.

Gaulli's first mature masterpiece is the group of four large pendentive frescoes in the church of S Agnese: *Temperance, Prudence, Faith and Charity* and *Justice, Peace and Truth*. He received the commission in December 1666 thanks to Bernini, who recommended him to the Pamphili family, patrons of the church, and completed it in 1672. As part of his preparations (*see also* §2 below) he travelled in 1669 to Parma to study Correggio's frescoes in the cathedral. His own work drew together all his previous artistic experience. In their pale hues, their essentially linear techniques and their attention to the clarity of detail, they are indebted to Bolognese classicism. Yet these elements, now fully absorbed, have been drawn into the mainstream of the High Baroque, which Gaulli first encountered in Genoa but developed much further in Rome under the guidance of Bernini and the example of Pietro da Cortona. In each fresco the composition is full and abundant, not limited (as the classicists would have preferred) to the figures that would suffice to explain the theme. Instead they are enriched with many gently moving figures in elaborately convoluted, billowing garments and enlivened by putti and angels in full flight. The altarpieces that Gaulli also painted around this time—*St John the Baptist* (*c.* 1670–71; Rome, S Nicolo da Tolentino) and *St Louis Beltrán* (*c.* 1671; Rome, S Maria sopra Minerva)—continue however in the Genoese manner of the S Rocco altarpiece.

(b) Portraits. In his own day Gaulli was admired as a portrait painter, although today we can identify few of his works in this genre. He may have seen portraits by van Dyck in Genoa; his own sometimes suggest the influence of van Dyck's elegance and painterly refinement. Pascoli tells us that he made innumerable portraits 'of all the cardinals, of all the great personages in the Rome of his day, and of the seven popes who reigned from Alexander VII to Clement XI'. His earliest known portrait is that of *Cardinal Paluzzi degli Altieri* (*c.* 1666; Karlsruhe, Staatl. Ksthalle). There followed the half-length portrait of *Alexander VII* (1666–7; Munich, Messinger priv. col., see Enggass, 1964, fig. 111), a more adventurous work. The Pope raises his right hand, and this emphasis on a momentary gesture was admired by Gaulli's contemporaries: the artist himself said that he had been inspired by Bernini, who believed that the sitter revealed himself more truly in movement and in conversation than when motionless and hushed (Pascoli). Probably a little later, he painted a glamorous, intensely romantic *Self-portrait* (1667–8; Florence, Uffizi), for which he posed richly clad in golden jacket and velvet cap. The portrait of *Pope Clement IX*

(1667–9; Rome, Pal. Barberini) perfects the theme of the earlier papal likeness. The Pope, right hand raised, is brought closer to the spectator, on whom he turns an intense gaze.

(ii) The middle years, 1672–85.

(a) Il Gesù, 1672–83. On 21 August 1672 Gian Paolo Oliva, the Father-General of the Jesuit Order, signed a contract with Gaulli commissioning him to fresco the dome, the pendentives and the nave and transept vaults of the church of Il Gesù, Rome. This enormously important commission was won in competition with Giacinto Brandi, Ciro Ferri and Carlo Maratti, and with the support of Bernini, to whom Oliva turned for advice. The nine large frescoes (1672–83) constitute the greatest achievement of the artist's career and his chief claim to fame. The cloud-borne *Vision of Heaven* (1672–5) in the huge dome is badly damaged, but the frescoes on the pendentives (1675–6) have survived in almost perfect condition. Two of these four, the *Four Evangelists* and the *Four Doctors of the Latin Church*, represent the New Law; the other two, the *Leaders of Israel* and the *Prophets of Israel*, the Old. Just as the pendentives form the physical transition that carries the weight and thrust of the dome to the ground below, so the paintings on the pendentives form the metaphysical transition between the vision of heaven in the dome and the congregation on the floor of the church.

The break between these frescoes and the earlier ones at S Agnese is decisive. Except for the smooth surfaces and hard outlines, no trace of Bolognese classicism remains. Deeply saturated hues replace the pale tonalities of the earlier pendentives, powerful rhythms are substituted for gentle movements and the heavy, sharply convoluted, angular garment folds produce highly agitated rhythms, similar to those used by Bernini in his last, most expressionistic phase. In the *Leaders of Israel* (Moses, Abraham, Joshua and Aaron) Gaulli brings together four twisting, tilted, muscular, interlocked figures, the torsos taken from Michelangelo, the garments from Bernini. Churning rhythms surge through the whole composition which, unable to be contained, breaks sharply out and over the gilded frame, casting a painted shadow on the surface of the dome's drum.

The style so successfully developed for the pendentives was transferred to the vault of the great nave and reinterpreted, with still more dramatic compositional devices and on a very much larger scale, in the fresco representing the *Triumph of the Name of Jesus* (1678–9; see fig. 1). In this we see the hosts of heaven kneeling in adoration before the divine light that radiates from the monogram of Jesus, drawing the blessed up to heaven and casting the damned down into hell. The fresco falls into three principal divisions: a hollow disc with the monogram in the centre; an arc of clouds supporting a throng of the blessed that spreads out beyond the frame; and a dark triangular mass containing the fall of the damned. The central zone is populated by an immense group of cherubs rising cylindrically around the mystical light source. Almost all are sharply foreshortened. We see them dangling overhead, shooting upward or plunging down below. In the sections closest to the earth these figures retain their solid forms

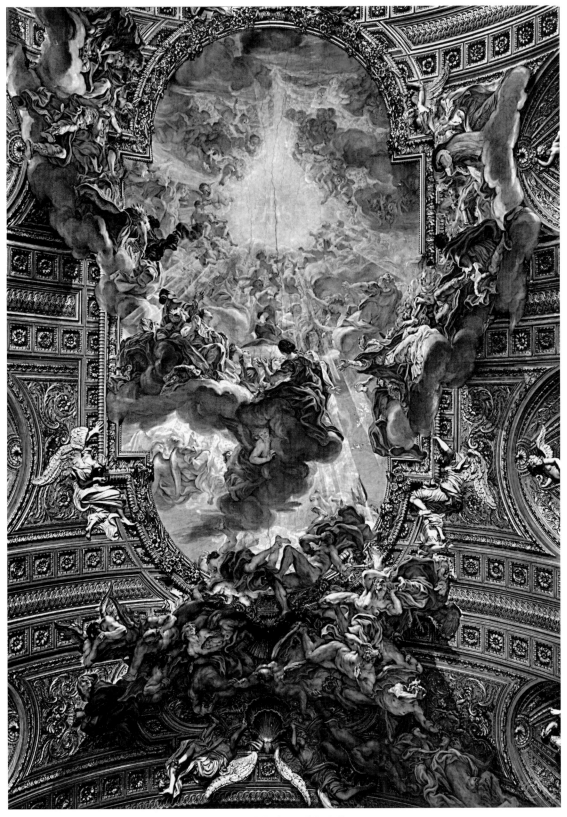

1. Giovanni Battista Gaulli: *Triumph of the Name of Jesus* (1678–9), fresco, Il Gesù, Rome

and pink flesh tints. Above them lies a more numerous host of tiny heads pressing toward the light that dissolves their mass and drains their colour.

Far below we see the second group, the great arc of the blessed, which gives the illusion of being on a level just below the vault of the church and breaks out on either side far over and beyond the frame, covering large sections of the architectural decoration. Borne upward on heavy clouds, these clearly outlined figures still retain the customary attributes of human form: the sense of weight, mass and clearly articulated anatomy—in short all the qualities necessary to give the illusion of their immediate and tangible existence. In contrast to the upper levels, the colours are rich and extraordinarily vital. Granting, as in the theatre, a temporary suspension of disbelief, we gaze upward to witness the miraculous intrusion of a heavenly host within the confines of the earthly church.

A triangle composed of figures of the damned concludes the composition. Hurled over the edge of the frame, they spread out into the upper regions of the church, driven downward in a great torrent by the same light that lifts up the blessed. These figures are the most tangible of all. Their writhing forms, contorted with fear and rage, bulge with muscles whose weight seems to increase the speed of their downward plunge. Some represent specific vices: Simony with a purse and tempietto, Vanity with a peacock, Avarice with a wolf, Heresy with a head swarming with snakes.

The most striking aspect of the *Triumph* is its composition and the blending of architecture, painting and sculpture. Early sources state, and modern critics generally agree, that Bernini played a major role in its development. Precedents are to be found in the ceiling fresco *Angel Concert round the Dove of the Holy Ghost*, designed by Bernini and executed by Guido Ubaldo Abbatini on the vault of the Cornaro Chapel (1647–52) in S Maria della Vittoria, Rome, and more importantly in Bernini's *Cathedra Petri* (1657–66) in St Peter's.

(b) Other commissions. While at work on Il Gesù, Gaulli carried out a number of other commissions, mainly religious works, but also a few mythologies and portraits. His most notable religious work is the *Death of St Francis Xavier* (1676; Rome, S Andrea al Quirinale). The saint, depicted in a highly realistic manner, lies prostrate at the moment of death, his face drained of colour, his head rolled back, his heavy-lidded eyes opening to the celestial vision. Around him, against a field of golden light, float angels and cherubs modelled in pinks and rose. The earthly and heavenly scenes interpenetrate yet are filled with deliberate contrasts, of cool and warm, motionless and motion-filled, dark and light, all giving formal emphasis to the thematic contrast between death and life after death.

Among Gaulli's mythological paintings are the *Bacchanalia* (c. 1675; São Paulo, Klabin priv. col.; see Enggass, 1964, fig. 37)—which echoes the mood of Poussin's early mythological paintings and of Titian's *Bacchus and Ariadne* (London, NG), then in Rome in the Villa Aldobrandini— and a pair painted c. 1680–85, the *Adonis Bidding Farewell to Venus* (Burghley House, Cambs) and the *Death of Adonis* (Oberlin, OH, Oberlin Coll., Allen Mem. A. Mus.). His portraits include the austere and dignified *Gianlorenzo*

Bernini (c. 1673; Rome, Pal. Barberini) and the superb *Cardinal Leopoldo de' Medici* (c. 1672–5; Florence, Uffizi). None of the cardinal's ugliness is withheld, yet this is a sympathetic portrait of a sensitive, contemplative and deeply cultured man, enriched by the remarkable orchestration of the colour. Hunched slightly forward, he looks out at us with partially unfocused, watery eyes, his mouth parted as if he were about to speak, his long delicate fingers toying with the cardinal's hat. The flesh tones are beautifully modelled, but what gives the painting its sense of inner life is the cape, the folds of which create angular, insistent rhythms. To suggest the shimmer of watered silk Gaulli extends his palette through the whole gamut of reds from pink to wine-black. Stripes of crimson overlay soft rose. In the highlights the brushstrokes are especially free, producing a marvellous iridescence.

(iii) The final years, 1685–1709. In the late years, responding to the changing taste of his patrons, Gaulli moved away from the High Baroque and adapted his art to the newly fashionable style, a blend of classicism and Baroque, as practised by Carlo Maratti. His colours became less intense and the rhythms of his compositions lighter. In this period he received fewer large commissions, although he went to Genoa in 1693 to discuss a commission to fresco the Great Hall of the Palazzo Reale, and in 1706–7 was asked to paint three frescoes in the hall of the Minor Consiglio in the Palazzo Reale; neither project was fulfilled.

The large *Birth of John the Baptist* (1698; Rome, S Maria in Campitelli) is a representative example of Gaulli's late style, in which some aspects of classicism are accepted while others are rejected. As at Il Gesù, he models his figures with smooth hard surfaces and strong outlines. The colours are now much less saturated but still bright: there is nothing dull or dry about them. Zachariah's cloak is a pale violet. The woman who holds the infant St John wears a tunic that is exquisitely modulated in tones of pink and rose. This is the palette of the contemporary style, the *Barocchetto romano*, but there is also a significant survival of the Roman High Baroque. The figures crowd the foreground; they are arranged so as to provide recessions along diagonals; and their poses are filled with movement. Most striking of all, especially at this late date, is the use of garment folds based on the late sculpture of Bernini: deep, heavy, angular convolutions that generate tempestuous rhythms and a sense of highly charged emotions.

In 1707 Gaulli completed his last major project, a vault fresco of *Christ in Glory Receiving Franciscan Saints* (Rome, SS Apostoli). This makes a striking contrast to the *Triumph of the Name of Jesus*. Both depict a celestial vision crowded with figures and infused with divine light, and both are set in the same frame, but whereas at Il Gesù the cloud-borne figures sweep out beyond the frame, at SS Apostoli they keep strictly within it, even reinforcing it by turning inward. The field is less crowded, allowing greater clarity for each of the figures; garment folds, while still elaborate, are less expressive. Everywhere the rhythms are weaker, the gestures of the figures more subdued. The rich palette for which the artist won such renown has been drained of intensity: the colours are dull and dry. Yet this is not Gaulli's natural manner. A recently discovered *bozzetto*

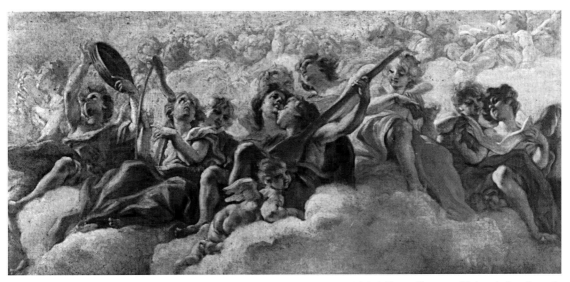

2. Giovanni Battista Gaulli: *bozzetto* for *Angelic Concert*, oil on canvas, 490×980 mm, 1672–3 (Rome, Pinacoteca Vaticana); for a fresco in the dome of Il Gesù, Rome

(Genoa, priv. col., see Enggass, 1981, fig. 1) shows his consummate skill as a colourist even when working with lighter, more delicate tones. His changed style in the fresco was undoubtedly something forced on him to meet the demand of his new patrons for a more classicizing approach.

2. WORKING METHODS AND TECHNIQUE. Gaulli's vast decorative schemes involved long and careful preparation, and before he began work on his frescoes he made many drawings and also a number of rapid oil sketches or *bozzetti* (see figs 2 and 3) as well as more finished modelli. The *bozzetti* show his intimate, instinctive personal style, and a comparison of those for the S Agnese frescoes with the finished work reveals how Gaulli transformed his vivid first impressions into the more monumental style of the Roman High Baroque. In the *bozzetto* for the fresco of *Prudence* (see fig. 3) and *Faith and Charity* (both Rome, 1666–71; Pal. Barberini) the colouristic intensity of his Genoese background bursts forth in full vigour. With hasty strokes he masses brilliant hues, leaving compositional problems for a later phase of the project. In the *bozzetto* for *Prudence* the putto in the centre has a flame-red face and a mouth that is a black hollow, as if he were crying out. The putto below him turns sharply in contrapposto, his head thrust out from the green ground like a carved sphere. Four strokes are enough to block out his leg, plus three touches of red in the shadows, yet these are sufficient to give the whole figure a sense of recoil, like a wound spring released.

When Gaulli translated these early impressions into their final form on the broad surfaces of the pendentives of S Agnese he achieved a brilliant blend of styles that are often thought to be antithetical. Hard, smooth surfaces and closed brushwork are used to construct solid figures that are delineated in considerable detail. The colours are far paler than in the *bozzetti* but more skilfully modulated and more harmoniously distributed. *Cangiantismo* makes

its first appearance in Gaulli's work: the figure of Fame in the fresco of *Temperance* has a mantle that is dark violet in the shadows but turns pale green in the light. Major colour schemes such as this are almost always repeated. Thus the putto in the upper left has a scarf with the same *cangianti*, violet and green, but now with the intensity lowered.

The *Triumph of the Name of Jesus* is particularly remarkable for its successful creation of illusion through technique. The greater part of the composition lies inside the frame, a heavy gilt stucco moulding that projects between

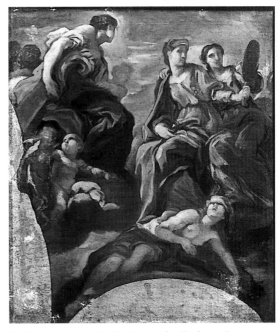

3. Giovanni Battista Gaulli: *bozzetto* for *Prudence*, oil on canvas, 360×475 mm, 1666–71 (Rome, Galleria Nazionale di Palazzo Barberini)

100 mm and 120 mm from the surface of the vault proper. The vault is elaborately panelled with deep coffers inset with rosettes. Thick layers of plaster overlay the mouldings and fill up the coffers, providing a smooth surface on which the painting is carried over and beyond the frame. Other gilded areas of the vault are overpainted with a dark glaze to indicate shadows cast over the architecture by masses of figures and cloud banks that block off the central radiation of light. This technique permits the illusion that a heavenly host floats not only high above us in the sky but also close to the ground within the very nave of the church where we stand.

To the corpus of Gaulli's paintings must be added a very considerable body of surviving drawings. There are more than 300 in the Kunstmuseum in Düsseldorf alone, some two dozen in the Ashmolean Museum in Oxford and smaller but notable collections in the Cabinet des Estampes at the Louvre, Paris, the Kupferstichkabinett of the Staatliche Museen in Berlin, the Print Room of the British Museum in London and in the Royal Collection at Windsor Castle, Berks. The drawings are done in a wide range of media, on various kinds of paper, in pen and ink with or without washes (which may be in any of a variety of colours), with or without highlights, and in a number of different coloured chalks. All would appear to have

4. Giovanni Battista Gaulli: *Innocent XI*, red and black chalk and red wash, heightened with white, 373×246 mm (Windsor Castle, Berks, Royal Collection)

been made as studies for paintings, not as ends in themselves. As a group they provide us with invaluable insights into the way in which Gaulli devised the poses of his figures, often making considerable changes, and the manner in which he developed his compositions. A few of his early pen drawings, such as the *Esther before Ahasuerus* (Oxford, Ashmolean), are done with the greatest rapidity, almost like Rembrandt's, with large ink blotches providing accents. More often the drawings are careful studies of individual figures, many of which are shown sharply foreshortened and in unusual poses. Their variety is evident in the preparatory drawings for the *Adonis Bidding Farewell to Venus*, which include a compositional study in pen and ink on white paper, with transparent grey wash (Windsor Castle, Berks, Royal Col.), a design in black chalk heightened with white on greybrown paper, squared in black chalk, and a study for the figure of Adonis, which delicately captures a transient pose, in pen and brown ink over black chalk, with grey wash on grey-brown paper (both Düsseldorf, Kstmus.). A number of portrait drawings survive, among them the *Portrait of a Man* in black and red chalk (*c.* 1665; Madrid, Prado), *Innocent XI* (see fig. 4) and *Clement X* (both Windsor Castle, Berks, Royal Col.). In the later part of his life Gaulli became fascinated with garment folds done in the manner that Bernini developed for his late sculpture. Seemingly endless studies, among them the *Study for a Figure of the Virgin Mary* (Düsseldorf, Kstmus.), are devoted to what are essentially abstract patterns, filled with the ebb and flow of powerful curvilinear rhythms. For the movement of these garments, in most cases, there is no rational explanation. The design itself is its own reason for being.

3. CONTEMPORARY AND POSTHUMOUS REPUTATION. In his own lifetime Gaulli was a highly successful and wealthy artist, the Principe of the Accademia di S Luca in 1673 and 1674 and the owner of a large house on Via del Parione that still stands today. Between 1670 and 1685 he was probably the most highly praised painter in Rome. He never fell completely out of favour during his lifetime, but from about 1685, when his High Baroque style was no longer fashionable, his popularity declined. He altered his style to meet the new trend, and early critics recognized, and regretted, the marked change in his style during his final phase; Pascoli writes:

> Had he but died after he had painted the pendentives of S Agnese . . . the vault and pendentives . . . of Il Gesù and the other works that he did in those years and some time after, when, while still in his prime, he worked in a manner that was powerful, extravagant and altogether beautiful, he need not have envied even the greatest masters. But then, abandoning this manner and imitating those who denied themselves deep colours, he changed, and the works that he did thereafter, while still beautiful, lost that which gave them a supreme beauty; and whereas before he was the equal of the most famous, he became afterward less than himself.

Gaulli's posthumous fame has fluctuated more or less with the acceptance or rejection of the High Baroque. Up until the late 1760s his paintings were generally admired by Italian critics, but as Neo-classicism came increasingly

to the fore they fell from favour. References to his work during the 19th century and well into the 20th are always brief and often unfavourable. This began to change, but only gradually, in the years between the two world wars. Even in the mid-20th century the Baroque was often viewed with distaste as being uncouthly demonstrative and patently insincere. The Metropolitan Museum of Art in New York, long seen as the flagship of American museums, was said to be unable to work up an interest in Italian Baroque art because the prices were too low. This situation has changed. American museums now bid eagerly and lavishly for the few authentic works by Gaulli that come on the market. A major monograph on the artist appeared in 1964. Though his most important paintings are in fresco and hence unmoveable, other work of his was exhibited at Oberlin in 1967 and continues to attract the attention of scholars and dealers.

BIBLIOGRAPHY

F. Titi: *Nuovo studio di pittura, scultura et architettura nelle chiese di Roma . . .* (Rome, 1708), pp. 17–8, 26, 30–31, 39 [see esp. addendum by F. Posterla]

L. Pascoli: *Vite de' pittori, scultori, ed architetti moderni*, i (Rome, 1730), pp.194–209

A.-J. Dézallier d'Argenville: *Abrégé de la vie des plus fameux peintres*, i (Paris, 1754), pp. 386–92

R. Soprani and C. G. Ratti: *Vite de' pittori, scultori ed architetti genovesi . . .*, ii (Genoa, 1769), pp. 74–90

R. Enggass: *The Painting of Baciccio* (University Park, P.A., 1964 [with complete bibliog. to 1963]

R. Spear: 'Baciccio's Pendant Paintings of Venus and Adonis', *Allen Mem. A. Mus. Bull.*, xxiii (1966), pp. 98–112

An Exhibition of Paintings, Bozzetti and Drawings by Giovanni Battista Gaulli, called Baciccio (exh. cat. by J. Spencer and others, Oberlin Coll., OH, Allen Mem. A. Mus, 1967), pp. 61–137

R. Enggass: 'Baciccio at Oberlin, Some Reflections', *Burl. Mag.*, cix (1967), pp. 184–8

B. Canestra Chiovenda: 'Ancora del Bernini, del Gaulli e della Regina Cristina', *Commentari*, xx (1969), pp. 223–36

——: 'Nuovi documenti su G. B. Gaulli', *Commentari*, xxiii (1972), pp. 174–80

A. T. Lurie: 'A Short Note on Baciccio's Pendentives in the Gesù à propos a New Bozzetto in Cleveland', *Burl. Mag.*, cxiv (1972), pp. 170–73

H. MacAndrew: 'Baciccio's Early Drawings: A Group from the Artist's First Decade in Rome', *Master Drgs*, x (1972), pp. 111–25

H. MacAndrew and D. Graf: 'Baciccio's Later Drawings: A Rediscovered Group Acquired by the Ashmolean Museum', *Master Drgs*, x (1972), pp. 231–59

E. Schaar: 'G. B. Gaullis Düsseldorfer Entwürfe zur Sala del Maggior Consiglio in Genua', *Jb. Hamburg. Kstsamml.*, xvii (1972), pp. 53–66

D. Graf: 'Giovanni Battista Gaullis Ölskizzen im Kunstmuseum Düsseldorf', *Pantheon*, xxxi (1973), pp. 162–80

——: 'Giovanni Battista Gaulli: Entwürfe zur Dekoration des Vorraums der Taufkapelle von St Peter', *Pantheon*, xxxii (1974), pp. 35–47

——: *Kunstmuseum Düsseldorf: Die Handzeichnungen von Guglielmo Cortese und Giovanni Battista Gaulli*, 2 vols (Düsseldorf, 1976)

B. Canestra Chiovenda: 'La *Morte di S Francesco Saverio* di G. B. Gaulli e suoi bozzetti, altre opere attribuite o inedite', *Commentari*, xxviii (1977), pp. 262–72

M. Fagiolo: 'Strutture del trionfo gesuitico: Baciccio e Pozzo', *Stor. A.*, xxxviii–xl (1980), pp. 353–60

R. Enggass: 'Baciccio at SS Apostoli: A New Bozzetto and a New Point of View', *Ars auro prior, Studia Ioanni Białostocki sexagenario dicta* (Warsaw, 1981), pp. 333–5

C. Johns: 'Some Observations on Collaboration and Patronage in the Altieri Chapel', *Stor. A.*, l (1984), pp. 43–7

ROBERT ENGGASS

Gault de Saint-Germain, Pierre-Marie

(*b* Paris, 18 Feb 1756; *d* Paris, 11 Nov 1842). French painter, draughtsman and writer. Born of a Breton family living in Paris (the aristocratic de Saint-Germain was a later addition to his name), he trained *c.* 1774 in the studio of Louis-Jacques Durameau and at the Académie Royale. He became a fashionable painter, receiving numerous commissions from ecclesiastical and private patrons. His surviving paintings include an *Assumption of the Virgin* (Domfront, St Julien) and a full-length portrait of *Maréchal de Richelieu* (Paris, Carnavalet). He met and married a Polish artist, Anna Rajecka (*c.* 1760–1832), who was financially supported by King Stanislav II Poniatowski. He exhibited at the Salon until 1801.

During the Reign of Terror his aristocratic name rendered him suspect and he took refuge in Clermont-Ferrand, where he was appointed teacher of a free course in drawing, then Keeper of Monuments of the Puy-de-Dôme. On returning to Paris in 1797 he dedicated himself to writing. He contributed numerous articles to the daily *Moniteur universel*, as well as producing a work on Nicolas Poussin and an edition of Leonardo da Vinci's treatise on painting, with a biographical introduction and a catalogue of his works. Pierre-Marie was also interested in the state of the contemporary arts, a topic discussed in his *Observations sur l'état des arts dans le XIXe siècle*. His most important book is *Les Trois Siècles de la peinture en France* of 1808, a history of painting in France from the 16th century to the beginning of the 19th.

WRITINGS

ed.: *Traité de la peinture* (Paris, 1803); trans. of Leonardo da Vinci: *Trattato della pittura* (Paris, 1651)

Des Passions et leur expression, sous le rapport des beaux-arts (Paris, 1805)

Vie de Nicolas Poussin (Paris, 1806)

Les Trois Siècles de la peinture en France, depuis François I jusqu'au règne de Napoléon (Paris, 1808)

Observations sur l'état des arts dans le XIXe siècle (Paris, 1815)

BIBLIOGRAPHY

Bellier de La Chavignerie–Auvray; *DBF*

G. Gabet: *Dictionnaire des artistes de l'école française du XIXème siècle* (Paris, 1831)

C. Jeannenat: 'De Gault à Gault de Saint-Germain', *Bull. Soc. Hist. A. Fr.* (1935), pp. 221–35

ANNE LECLAIR

Gaultier, Léonard

(*b* Paris, 1561; *d* Paris, *c.* 1635). French engraver, draughtsman, print publisher and dealer. He was the son of the goldsmith Pierre Gaultier, but probably not, as has been stated, the son-in-law of Antoine Caron and brother-in-law of Thomas de Leu. His first dated engravings (1576; Linzeler, 13–120) form part of a suite of 108 plates illustrating the New Testament. He was a very prolific engraver—his output reached at least 985 prints—and treated various genres, producing religious engravings, allegories, coats of arms and above all portraits and book illustrations. Although he copied the suite of engravings by Agostino dei Musi and B. Daddi after Raphael's fresco cycle the *Loves of Cupid and Psyche* in the Farnesina, Rome (L 163–95), most of his work was from his own drawings. His work was published by a number of print publishers: Pierre Gourdelle (*fl* 1555–88) and, in 1591, by his wife (e.g. the *Salvator Mundi*, L 2, and the *Virgin*, L 125); by Jean Leclerc (e.g. the *Passage of the World*, L 124); by Jean Rabel (1545–1603) (e.g. portrait of *Henri Cajetan*, L 202); by Jacques Honnervogt (*fl* 1608–35), and by 'Veuve Jacquet au Palais' (e.g. portrait of *Catherine de Bourbon*, L 197)—but he most often published his engravings himself. Gaultier also sold prints at the sign of the Fleur de

Lys d'Or in the Rue Saint-Jacques, Paris. His earliest prints show Italian influence (possibly through Etienne Delaune); he then came under German influence and later, with Thomas de Leu, contributed to the creation of a distinctively French school of engraving at the turn of the 16th and 17th centuries.

BIBLIOGRAPHY

A. Linzeler and J. Adhémar: *Inventaire du fonds français: Graveurs du seizième siècle*, Paris, Bib. N., Dépt Est. cat. (Paris, 1932–8), i, pp. 371–428; ii, pp. 325–9 [L]

R.-A. Weigert: *Inventaire du fonds français: Graveurs du XVII siècle*, Paris, Bib. N., Dépt Est. cat., iv (Paris, 1961), pp. 414–549

J. Ehrmann: 'La Vie de l'atelier du graveur Thomas de Leu gendre du peintre Antoine Caron', *Archv A. Fr.*, xxvi (1984), pp. 43–6

M. Grivel: *Le Commerce de l'estampe à Paris au XVII siècle* (Geneva, 1986), p. 304

——: *Dictionnaire des éditeurs d'estampes à Paris sous l'Ancien Régime* (Paris, 1987)

MARIANNE GRIVEL

Gaur [Lakṣmaṇāvatī; Lakhnautī]. Ruined city situated on the international border between Bangladesh and India. The southern suburb, with the most important monument in the area, the Chota Sona Masjid, is in Nawabganj District, Bangladesh. The walled city and the inner citadel to the north, still called Gaur, are in Malda District, West Bengal, India.

1. HISTORY. Before the 12th century Gauda was the name of a kingdom comprising the city and surrounding area. In the 12th century it became the capital of the Sena dynasty of Bengal and was known as Lakṣmaṇāvatī after King Lakshmanasena (*reg c.* 1178–1206). In the 13th century, when the sultans of Delhi conquered parts of Bengal, they made Gaur their capital. It was known as Lakhnautī to Muslim historians. Difficulties in controlling Bengal from Delhi led Sultan Ghiyath al-Din Tughluq (*reg* 1320–25) to divide the region into three administrative units, Lakhnautī, Satgaon and Sonargaon. By the middle of the 14th century Bengal was ruled by independent sultans. Gaur served as a capital for these kings until the 16th century, except for the period from 1342 to the beginning of the 15th century, when the capital was shifted to Pandua, about 32 km to the north-east. Most of the extant ruins date from the 15th century or later.

In the late 15th century and the early 16th Gaur was a thriving urban centre, which the Mughal emperor Humayun called the 'Abode of Paradise' (Pers. Jannatabād). Several factors led to its decline and eventual abandonment. The city was sacked by the Afghan Sher Shah Sur in 1539, and the capital was shifted to Tanda in 1564 by his successors in the region, the Afghan Karrani sultans. Gaur was finally deserted when the Ganga and Mahananda rivers, between which it was located, changed course and moved away from the city.

2. MONUMENTS. Numerous stone inscriptions have been recovered from Gaur, but only a small number were found *in situ*. (Some loose inscriptions have been fixed to original or modern buildings, other examples are in Calcutta, Ind. Mus.; Maldah Mus.; London, BM; Philadelphia, U. PA, Mus.) Among the few monuments that can be dated reliably are the Darasbari Mosque, built by Sultan Yusuf Shah in 1479, and the Chota Sona Mosque (the name refers to the gilding formerly on the domes),

built by Wali Muhammad, a noble of Sultan Husain Shah (*reg* 1494–1518). Both mosques are in the typical multi-domed style of Bengal, with curved cornice and corner towers (*see* INDIAN SUBCONTINENT, §III, 6(ii)(d)). The Darasbari has exquisite terracotta ornamentation, while the Chota Sona is faced with stone carved to resemble terracotta. The central bays of both buildings are covered by curved cradle vaults with down-turned eaves. (This Bengali roof-form is known in Bangla as *chau-chala*.) Another firmly dated monument is the Bara Sona Mosque constructed in 1526 (AH 932) by Sultan Nusrat Shah (*reg c.* 1519–32). Although faced with stone, the surface is not carved. All these mosques had platforms in the north-west corner where royalty or the nobles excluded themselves from the public during prayers.

The Kadam Rasul, a single-domed square building, was constructed by Sultan Nusrat Shah in 1530 (AH 937) to house an impression of the Prophet's foot. The 15th-century Lattan Mosque is extensively embellished with glazed tile. The Lukochuri Darvaza (gateway) and the mosque and tomb of Ni'mat Allah are important Mughal monuments of the 17th century. The internal arrangement of this tomb is similar to the earlier tomb of I'timad al-Daula in Agra, and the later tomb of Bibi Pari in Dhaka. Portions of the massive earthen rampart that surrounded the citadel survive, while the ruined brick enclosure wall is all that remains of the palace.

BIBLIOGRAPHY

Muhammad 'Abid 'Ali Khan: *Memoirs of Gaur and Pandua* (?Maldah, 1912); ed. and rev. H. E. Stapleton (Calcutta, 1930)

A. H. Dani: 'Bibliography of Muslim Inscriptions of Bengal (down to AD 1538)', *J. Asiat. Soc. Pakistan*, ii (1957) [appendix]

S. Ahmed: *Inscriptions of Bengal*, iv (Rajshahi, 1960)

A. H. Dani: *Muslim Architecture of Bengal* (Dhaka, 1961)

G. Michell, ed.: *The Islamic Heritage of Bengal* (Paris, 1984), pp. 65–82

PERWEEN HASAN

Gauricus, Pomponius (*b* Gauro, nr Salerno, *c.* 1482; *d* 1528–30). Italian humanist and writer. He took his surname from the village where he was born, which in the 15th century belonged to the domain of Giffoni near Salerno. In 1501 he moved to Venice and then to Padua, where he attended the university. After 1505 he left Padua and went first to Rome, then to Naples. He remained there from 1512 on, and until 1519 held the chair of Humanities at the university. Until 1526 he served as tutor of the Prince of Salerno and his wife. He was a distinguished poet but his importance for the history of art is based on his *De sculptura*, a substantial Latin treatise written in Padua in 1503 and published in Florence in 1504. It is in the form of a Ciceronian dialogue, in which Gauricus himself instructs two learned interlocutors, the Latinist Raffaele Regio and the philosopher and collector Leonico Tomeo, on the noble art of sculpture. Gauricus presents himself not only as an erudite man but also as an amateur sculptor, a personal friend of Tullio Lombardo, Andrea Riccio and Severo da Ravenna. Much of the treatise is devoted to bronzes, which were popular in Renaissance Padua. His discussion of this topic is divided into two distinct parts: the *ductoria*, or creation of the model in wax or clay, and the *chemiché*, or casting in bronze. The *chemiché* is treated in a relatively imprecise way but the *ductoria*, which in turn is divided into a section

on *designatio* (drawing) and *animatio* (imitation), stimulates a long and detailed analysis. The theoretical interest of the treatise is concentrated on the *designatio*, which goes beyond drawing in the strict sense to include chapters on proportion and perspective, and a long excursus on physiognomy (actually a translation of a text by the Greek Adamantius, known to Gauricus through Giorgio Valla). The two chapters on proportion and perspective, though indebted respectively to the writings of Michele Savonarola and to contemporary workshop practice, make important contributions to the artistic thought of the Renaissance.

In *De sculptura* types of sculpture other than bronze merely serve as the occasion for a show of terminology: for example the antique *encaustum* is identified with the vitreous enamel used by such contemporary sculptors as the della Robbia. This imaginative classification serves mainly as a framework for the last part of the treatise, which is devoted, following Pliny, to sculptors distinguished by the different techniques. Gauricus admired above all the art of Donatello, but was also aware of lesser artists, such as Benedetto da Maiano, and promising youths like Michelangelo and Giovanni Francesco Rustici. The most interesting citations are on north Italian sculptors, from Cristoforo Solari to Giulio Mazzoni (?1525–?1618). The painters Andrea Mantegna and Giulio Campagnola are also mentioned. Gauricus dedicated one of his Latin *Sylvae* (1526) to the latter.

There is no proof that Gauricus directly knew earlier writings on art, with the exception of ancient authors such as Philostratus, Pausanias, Vitruvius and, especially, Pliny, whom he cites abundantly. His own work was very little known by later writers on art, with a few important exceptions such as Albrecht Dürer. He seems to have been known mainly to encyclopedists and antiquarians, for whom numerous editions of *De sculptura* were published in northern Europe from the 16th to the 18th century.

WRITINGS

De sculptura (Florence, 1504); French trans. ed. A. Chastel and R. Klein (Geneva, 1969)
Sylvae (Venice, 1526)

BIBLIOGRAPHY

E. Pèrcopo: 'Pomponio Gaurico umanista napoletano', *Atti & Mem. Reale Accad. Archeol., Lett. & B.A. Napoli*, xvi (1891–3), pp. 145–261
J. von Schlosser: *Die Kunstliteratur* (Vienna, 1924); 3rd Ital. ed. (Florence, 1964), pp. 235–9, 248, 716
R. Klein: 'Pomponius Gauricus on Perspective', *A. Bull.*, xliii (1961), pp. 211–30
Z. Wazbinski: 'Portrait d'un amateur d'art de la Renaissance', *A. Ven.*, xxii (1968), pp. 21–9

MARCO COLLARETA

Gausson, Léo (*b* Lagny-sur-Marne, nr Paris, 14 Feb 1860; *d* Lagny-sur-Marne, 27 Oct 1944). French painter, sculptor, designer and government official. He trained first as a sculptor and engraver, not taking up painting until 1883. While working at the shop of the wood-engraver Eugène Froment (1844–1900) he met Emile-Gustave Péduzzi (Cavallo-Péduzzi; 1851–1917) and Maximilien Luce. By 1886 all three were experimenting with the stippled brushwork and divided colour they had seen in the works of Seurat, Paul Signac and Camille Pissarro and Lucien Pissarro. That year Gausson made his début at the Salon as a sculptor, with the plaster medallion *Profile of a Young Girl* (untraced). He first showed his paintings at the Salon des Artistes Indépendants in 1887 and exhibited there annually thereafter.

Gausson painted regularly until *c.* 1900, with a brief Neo-Impressionist phase from 1886 to 1890; as the critic Fénéon remarked, 'he soon realized that this technique was ill-suited to his temperament'. In paintings such as *River and Bridge at Lagny* (1886; Paris, priv. col., see 1968 exh. cat., p. 59) and *The House* (*c.* 1887; Lausanne, priv. col., see 1979 sale cat., no. 159) Gausson confined the divisionist procedure to certain areas of the canvas, relying on the comparative freedom of Impressionist brushwork to fill in the rest. As a result, these pictures display a certain technical bravado at the expense of pictorial coherence. Nevertheless, many of Gausson's landscapes have a pleasing decorative effect, and such paintings as *Church at Gouvernes* (1887–8; Amsterdam, Rijksmus. van Gogh), rendered in an Impressionist manner, are remarkable for their fidelity to nature.

Gausson exhibited with the Symbolist painters at Le Barc de Boutteville (1891) and again with the Rose+Croix and the Salon des XX (both 1892). With more dexterity than inspiration, he began to imitate the broad, flat colour areas and smooth brushwork of the Nabis, much at variance with the textured surfaces of his Neo-Impressionist paintings. In subsequent exhibitions at the *Revue blanche* (1896), the Salon de Lagny and the Théâtre Antoine (both 1899), he also showed drawings, bronzes, plaster medallions, poster designs and jewellery. An amateur poet, he published a volume of verse entitled *Histoires vertigineuses* (Paris, 1896) under the pseudonym Laurent Montésiste, and he also illustrated the poems of Adolphe Retté (Paris, 1898). In 1900 he received a commission to engrave a plaque commemorating Charles Colinet (Fontainebleau Forest) who had been responsible for the restoration of the Forest of Fontainebleau. After this, however, Gausson worked only sporadically as an artist, his time being occupied largely by a series of government posts at Conakry (Guinea) and later in France.

BIBLIOGRAPHY

F. Fénéon: 'Léo Gausson', *Rev. Blanche*, x (1896), p. 336
Neo-Impressionism (exh. cat. by R. Herbert, New York, Guggenheim, 1968), pp. 58–60
P. Eberhart: 'The Lagny-sur-Marne Group', 'Léo Gausson', *The Neo-Impressionists*, ed. J. Sutter (Greenwich, 1970), pp. 147–52, 165–70
Léo Gausson (sale cat., Paris, Hôtel Drouot, 3 Dec 1979)
M. Hanotelle: *La Vie et l'oeuvre de Léo Gausson, 1860–1944: Un Peintre méconnu du Post-impressionnisme* (diss., U. Paris IV, 1985)
Peintures néo-impressionnistes (exh. cat., Pontoise, Mus. Pissarro, 1985), nos 7–11

PETER J. FLAGG

Gautherot, Pierre [Claude] (*b* Paris, 1769; *d* Paris, July 1825). French sculptor and painter. He studied sculpture with his father, Claude Gautherot (1729–1802); throughout his life he was known as both Pierre and Claude, signing his work with his surname only. He initially specialized in portrait busts of well-known figures such as *Voltaire, Anne-Robert-Jacques Turgot* and *Jean-Sylvain Bailly* (all untraced). In 1787 he entered the studio of Jacques-Louis David and became his close friend. Thereafter he devoted himself completely to painting, initially choosing his subjects from his sculptural practice, as in his copies of portraits of *Voltaire* (after Nicolas de

Largillierre) and *Turgot* (after Joseph Ducreux) (both 1790; St Petersburg, Hermitage). Deléczuze's description of Gautherot in David's studio in 1796 and 1797 mentions that he was an avid Republican and that he wore a blond, powdered wig to disguise a skin disease. At the Salon of 1799 he exhibited *Pyramus and Thisbe* (Melun, Mus. Melun) and a year later another version of that subject (Bagnères-de-Bigorre, Mus. A.). At the Salon of 1802 he treated the fashionable subject of the *Funeral Procession of Atala* (untraced; see Lemonnier, p. 366), taken from the sensationally successful novel by François-René, Vicomte de Chateaubriand. In a scene full of pathos, the mournful cortège has Père Aubry with head bowed, followed by the Indian Chactas carrying the lifeless Atala.

Gautherot painted numerous scenes commemorating Napoleon's military triumphs, including *Napoleon Haranguing his Troops at Lech, 12 October 1805* (exh. Salon 1808; untraced) and *The Emperor Wounded before Regensburg* (exh. Salon 1810; Versailles, Château). In 1809 he was an unsuccessful candidate for admission to the Institut de France. Contemporaries observed that Gautherot's work was weakly coloured, but that his composition and draughtsmanship were extremely proficient. At the Restoration he managed to slip effortlessly from Napoleonic to Bourbon patronage and in 1817 received from Louis XVIII a commission for a *St Louis Curing the Plague-stricken Soldiers in his Camp* (untraced; oil sketch, Paris, Louvre) for the chapel of the Tuileries Palace, Paris.

BIBLIOGRAPHY
Bellier de La Chavignerie–Auvray
E. J. Delécluze: *Louis David: Son école et son temps* (Paris, 1855), pp. 49–53
F. Benoit: *L'Art français sur la révolution et l'empire* (Paris, 1897), p. 310
H. Lemonnier: 'L'Atala de Chateaubriand et L'Atala de Girodet', *Gaz. B.-A.*, 4th ser., xi (1914), pp. 365–6

SIMON LEE

Gauthey, Emiland-Marie (*b* Chalon-sur-Saône, 3 Dec 1732; *d* Paris, 15 July 1806). French engineer and architect. After initial studies in mathematics Gauthey took up architecture. In 1757 he entered the Ecole des Ponts et Chaussées, a school that had been founded 10 years earlier by the great engineer Jean-Rodolphe Perronet. In 1758 Gauthey was engaged by the province of Burgundy to work as an assistant engineer in the Ponts et Chaussées, employed to supervise the construction and upkeep of bridges and roads; he became Inspecteur-Général des Ponts et Chaussées in 1792. During this last phase of his career Gauthey wrote his posthumously published *Traité de la construction des ponts*, the authoritative French work on the subject for the first half of the 19th century.

In his role as an engineer, Gauthey was responsible for the ambitious Canal du Centre linking the rivers Saône and Loire. Planning began in 1767 and construction in 1782. He is chiefly remembered, however, for his 15 or so bridges. Whereas the French tradition (from the late 17th century) of bridge-building involved the use of arches that increase in height from the river-bank to the centre, Gauthey always preferred basket arches of equal size, which supported a horizontal causeway and coping. Although an engineer, he did not aim for technical innovation: his piers, which added up to a fifth of the total span of each bridge, have nothing of the daring slenderness

achieved by Perronet. Gauthey's refinement of his chosen type was, however, taken to a degree previously unknown in France. The arch heads have archivolts or sometimes bosses, which give an animating rhythm to the overall composition, while the cut-waters of the piers are usually engaged pyramids of varying heights. By using coffering with projecting ribs he also lavished attention on the intrados, an often neglected part of a bridge, since it is not usually fully visible. The play of volumes reigns supreme in Gauthey's bridges, no two of which are alike. The best-known include the Pont Gauthey (Pont de Pierre; 1766–70) over the River Thalie, near Chalon-sur-Saône, the Pont de Pierre (1781–6) over the Rue de Baulches, near Auxerre, the Pont des Echavannes (1781–90) at Chalon-sur-Saône and the Pont de Navilly (1782–90) over the River Doubs.

Although the bulk of Gauthey's work was in the public sphere, he also undertook private architectural commissions, notably the château of Chagny (1777–80; destr.), Saône et Loire, and the church of Givry-sur-Saône (1777–91). The latter was strongly influenced by Jacques-Germain Soufflot's Ste Geneviève, Paris, a building Gauthey knew well since he was among the team of experts responsible for advice on its construction.

WRITINGS
M. Navier, ed.: *Traité de la construction des ponts*, 3 vols (Paris, 1809–16)

BIBLIOGRAPHY
Macmillan Enc. Architects
F. de Dartein: *Etudes sur les ponts en pierre remarquables par leur décoration antérieurs au XIXe siècle*, iv (Paris, 1909)
J. J. Read: *Emiland-Marie Gauthey, 1732–1806* (diss., U. Cambridge, 1974)

JEAN MESQUI

Gautier, Amand(-Désiré) (*b* Lille, 19 June 1825; *d* Paris, 29 Jan 1894). French painter and lithographer. He began as an apprentice lithographer but displayed such a talent for drawing that in 1845 his parents enrolled him at the Académie in Lille, where he studied under the sculptor Augustin-Phidias Cadet de Beaupré (*b* 1800). In 1847–50 he worked in the studio of the Neo-classical painter François Souchon (1787–1857). In 1852 he received a scholarship to study at the Ecole des Beaux-Arts in Paris with Léon Cogniet. He frequented the Brasserie Andler where he met many of the artists who exhibited at the Salon, particularly the Realists. Gautier himself made his début at the Salon in 1853 with *Thursday Promenade*. He shared living-quarters with Paul Gachet, a close friend whom he had known from his days in Lille. Gachet, who was a doctor, introduced Gautier to the environment of such hospitals as La Salpêtrière, and this influenced the direction his art was to take. He was authorized to execute a large number of studies of lunatics in the specialized asylum, continuing the tradition begun some 30 years earlier by Gericault with his scientifically realistic series of monomaniacs. Gautier was fascinated by this experience and, as a result, painted his best-known work, the *Madwomen of La Salpêtrière* (destr. 1870). When the painting was exhibited in 1857 at the Salon in Paris, it was a resounding success, acclaimed not only by Maxime Du Camp but also by Jules-Antoine Castagnary, Théophile Gautier and Charles Baudelaire. The originality of its conception and the virtuosity of its technique made the

painting a significant example of Realism, worthy of being placed in the same category as the works of his master and friend Courbet. Their friendship was such that in 1867 Courbet painted Gautier's portrait (Lille, Mus. B.-A.). After his success at the Salon of 1857, Gautier received further praise for the *Sisters' Promenade* (exh. Salon 1859) and a full-length portrait of *Dr Gachet* (exh. Salon 1861; both Lille, Mus. B.-A.). During this time he actively sought a patron, and eventually found one in Louis-Joachim Gaudibert (1838–70), a wealthy shipowner from Le Havre who had already helped Monet and Eugène Boudin. Gautier became friends with these artists who were interested in unconventional ways of painting; he was particularly close to Monet, whom he advised early in the latter's career. He took part in the first Salon des Refusés in 1863, exhibiting *The Adulteress* (1860; untraced). During this time financial needs prompted him to paint portraits for the Salons, where they were favourably reviewed by critics, who compared him to Carolus-Duran. Along with Courbet, he was a member of the revolutionary movement of the Commune and because of his activities was arrested and sentenced in June 1871. He began exhibiting again at the Salon from 1874, showing portraits, still-lifes and religious scenes, and continued to do so until 1888, but these works did not have the conviction of his earlier ones. In his last years he became a recluse in the village of Ecouen and was eventually put in a retirement home by friends.

Gautier was a major figure in French painting from 1850 to 1870, although in later years he was somewhat neglected. He was a major interpreter of the Realist language of Courbet, whose artistic sensibilities he shared, although his contribution as a Realist has been hindered by the fact that many of his earlier works were destroyed in 1870 during the Franco–Prussian war. The review of the Salon of 1864 in *L'Autographe* described him as 'one of those rare artists who was a born painter'.

For illustration of Gautier's lithograph of *La Canebière, Marseilles*, see MARSEILLE, fig. 3.

BIBLIOGRAPHY
Bellier de La Chavignerie–Auvray; Thieme–Becker
F. Verly: *Essai de biographie lilloise contemporaine* (Lille, 1869)
A. M. De Belina: *Nos peintres dessinés par eux-mêmes* (Paris, 1883), pp. 360–61
A. Bloch: *Amand Gautier, 1825–94* (diss., U. Paris IV, 1932)
The Realist Tradition: French Painting and Drawing, 1830–1900 (exh. cat. by G. Weisberg, Cleveland, OH, Mus. A.; New York, Brooklyn Mus.; St Louis, MO, A. Mus.; Glasgow, A.G. & Mus.; 1980–82), pp. 291–2

ANNIE SCOTTEZ-DE WAMBRECHIES

Gautier, (Pierre-Jules-)Théophile (*b* Tarbes, 30 Aug 1811; *d* Paris, 23 Oct 1872). French critic and writer. He pursued a career as a critic of art, as well as of literature and theatre, for nearly 40 years, alongside what he considered to be his true vocation as a poet. A hugely prolific journalist, by the time of his death he was probably the most widely known, respected but somewhat passé art critic in France; he was an unwitting pioneer in the production of art criticism for a mass readership. Visual art played a central role in his literary imagination; this, together with the notion, much discussed in Parisian artistic circles around 1830, of deep affinities between the arts, accounted for an abundance of images drawn from

painting, sculpture and graphic art in his poetry, novels and stories. He saw fulfilment of his role as a critic of art in the making of verbal 'transpositions'; his criticism is characterized by its use of lengthy, colourful and sometimes very effective description, which, in turn, often provided inspiration for his poetry.

Gautier was the son of a tax official; his family moved to Paris in 1814. He received a classical education under the Restoration and in 1829 was briefly enrolled in the studio of Louis-Edouard Rioult (1790–1855), a former pupil of David. His artistic awakening, as he described it in his *Histoire du romantisme* (1874), came about through contact with studio and bohemian life, and with Victor Hugo's Romantic circle. Gautier, conspicuous in a pink waistcoat, was one of Hugo's chief partisans at the stormy first performances of *Hernani* in 1830. He belonged to a generation of younger Romantics that, in the ideological confusion following the July Revolution of 1830, orientated itself by adhering to an idea of the autonomy and freedom of art. The preface to his novel *Mademoiselle de Maupin* (1835) was an early statement of the doctrine of 'l'art pour l'art' (*see* ART FOR ART'S SAKE).

In 1836 Gautier joined *La Presse*, founded that year by Emile de Girardin (1806–81), as its regular art (and subsequently theatre) critic. His often proclaimed experience of the tedium of journalism confirmed him in his conviction of the superiority and self-sufficiency of art, which he increasingly elevated to the status of a cult. From the beginning of his career he championed Ingres as well as Delacroix, maintaining that the critic's task was to enter into the imaginary world of each artist he encountered; only when this was not possible did he feel justified in offering any further critique. As a result he acquired a reputation for critical generosity. He claimed that every artist was the bearer of a microcosmic inner world, through which experience of the outer, perceived world was translated. This translation was necessarily an idealizing one. Delacroix (whose work had prompted the metaphor of the microcosm in 1839) 'transported' Gautier into an other-worldly realm of passion, violence and colour that offered a heightened sense of dramatic truth. Gautier even idealized the idealist Ingres, who came to occupy the 'inner sanctuary' of Gautier's 'temple of art'. Yet Gautier considered himself not as a 'classic'—he retained an early abhorrence for the school of David—but as a modern pagan. He was an ardent supporter of sculpture, which he saw as exiled in an inhospitable age and environment; the naked, idealized human figure was a central metaphor in his mature writing, expressing both the primacy of the life of the senses and a notion of consoling permanence: this came fully to the fore after 1848 and found its most succinct statement in his poem 'L'Art' (1857).

Gautier covered every Salon of Louis-Philippe's reign (except those of 1831, 1835 and 1843) for *La Presse* or other publications, as well as writing on architecture and the applied arts; he contributed to *La Presse* until 1855. In 1854 he joined *Le Moniteur universel*, producing an encyclopedic account of the Exposition Universelle of 1855, published in book form as *Les Beaux-arts en Europe* (1855–6). In 1856 he also took over editorship of *L'Artiste*. Under the Second Empire he was at the centre of the Parisian art and literary world, and friendly with its most

prominent and influential members. With both Delacroix and Ingres enshrined in public consciousness as modern Old Masters, Gautier's art criticism grew increasingly nostalgic in tone. His eclectic approach perfectly qualified him to become the semi-official artistic spokesman for the regime. He played a part in shaping official acceptance of Courbet, whom he praised for his robust use of paint but condemned as a wilful and misguided anti-idealist. His opposition to Manet's *Olympia* (1863; Paris, Mus. d'Orsay), on similar grounds, was more strident, and he expressed rueful incomprehension at the first manifestations of Impressionism. By the late 1860s he had reconciled himself to describing Salons containing a preponderance of genre subjects and nearly three times as many exhibits as the already large Salons of the late 1840s, although he often resorted to ghost-writers. He survived the siege of Paris (1870–71) and wrote his final *Salon* in 1872.

As a traveller and connoisseur, Gautier did much to introduce the French public to the work of foreign artists, living and dead, particularly, in the 1840s, to Goya. (Gautier's *Voyage en Espagne* (1845) contains some of his best descriptive writing.) He also contributed to a mid-19th-century revival of interest in the art of 18th-century France, and to a mid-century Neo-classical revival associated with the painting of Jean-Léon Gérôme and the poetry of the Parnassiens. Through his poetic approach to visual art, and insistence on his right to his own subjectivity, he exercised an important influence on the Goncourt brothers and the young Baudelaire, although he lacked Baudelaire's analytical and moral acuity.

WRITINGS

Mademoiselle de Maupin (Paris, 1835/*R* 1966)
Voyage en Espagne: Tra los montes (Paris, 1845)
Salon de 1847 (Paris, 1847)
Émaux et camées (Paris, 1852/*R* 1872) [definitive edn of Gautier's best-known col. of poems, incl. 'L'Art']
Voyage en Italie (Paris, 1852)
Constantinople (Paris, 1853)
Les Beaux-arts en Europe, 2 vols (Paris, 1855–6)
L'Art moderne (Paris, 1856)
Abécédaire du Salon de 1861 (Paris, 1861)
Trésors de l'art de la Russie ancienne et moderne (Paris, 1861–2)
Les Dieux et les demi-dieux de la peinture (Paris, 1864)
Tableaux de siège: Paris, 1870–1871 (Paris, 1871)
Histoire du romantisme: Notices romantiques: Les Progrès de la poésie française depuis 1830 (Paris, 1874)
Portraits contemporains: Littérateurs, peintres, sculpteurs, artistes dramatiques (Paris, 1874)
L'Orient, 2 vols (Paris, 1877)
Fusains et eaux-fortes (Paris, 1880)
Tableaux à la plume (Paris, 1880)
Les Vacances de lundi (Paris, 1881)
Guide de l'amateur au Musée du Louvre, suivi de la vie et les oeuvres de quelques peintres (Paris, 1882)
Souvenirs de théâtre, d'art et de critique (Paris, 1883)
Regular contributions to *La Presse*, *Moniteur Univl* (after 1869 *J. Officiel*), *Ariel*, *L'Artiste*, *Bien Pub.*, *Cab. Amat. & Antiqua.*, *Cab. Lecture*, *Charte 1830*, *Chron. Paris*, *L'Evénement*, *Le Figaro*, *France Indust.*, *France Litt.*, *Gaz. Paris*, *Gaz. B.-A.*, *L'Illustration*, *Mag. Pittoresque*, *Mercure France*, *Mus. Familles*, *Le Pays*, *Rev. Paris*, *Rev. Deux Mondes* and *Rev. 19e Siècle*

BIBLIOGRAPHY

C. Spoelberch de Lovenjoul: *Histoire des oeuvres de Théophile Gautier*, 2 vols (Paris, 1880)
R. Jasinski: *Les Années romantiques de Théophile Gautier* (Paris, 1929)
J. Richardson: *Théophile Gautier: His Life and Times* (London, 1958)
M. Spencer: *The Art Criticism of Théophile Gautier* (Geneva, 1969)
R. Snell: *Théophile Gautier: A Romantic Critic of the Visual Arts* (Oxford, 1982)
Actes du colloque international. Théophile Gautier: L'Art et l'artiste, 2 vols (Montpellier, 1982)
C. Lacoste-Veysseyre: *La Critique d'art de Théophile Gautier* (Montpellier, 1985) [exhaustive index of artists discussed by Gautier]

ROBERT SNELL

Gautier-Dagoty. French family of engravers. The father of the family, Jacques-Fabien Gautier-Dagoty, is noted for his pioneering work in four-colour engraving and for the publication and illustration of scientific works. His eldest son, Jean-Baptiste-André Gautier-Dagoty, also became an engraver of scientific illustrations. The other four sons likewise were their father's pupils and used his methods.

In 1736 Jacques-Fabien Gautier-Dagoty (*b* Marseille, 1716; *d* Paris, 1785) moved to Paris. There he met the Jesuit scholar and anti-Newtonian colour theorist, Père Louis-Bertrand Castel (1688–1757), who encouraged him to produce in 1737 his first colour print, *Turbinate Shell* (Hébert, Pognon and Bruand, no. 1), from three superimposed plates. In 1738 Jacques-Fabien entered the studio of Jacob Christoph Le Blon; he remained there for only a few weeks, long enough to study the process of colour printing that Le Blon had developed, of superimposing three mezzotinted plates. In order to make use of this method without being accused of plagiarism and to speed up the printing, Jacques-Fabien used an extra plate inked in black or bistre, which gave the tonal values: this was the basic principle of four-colour printing. He was granted a royal licence, which was disputed by Le Blon's heirs until 1748. In 1741 he published in the *Mercure de France* a list of 21 colour prints, claimed to be facsimiles of paintings, that could be supplied on canvas and varnished. He gave up this kind of work in 1745, having made engravings such as *Susanna and the Elders* (HPB 7) and *Bathsheba* (HPB 8; both 1741) after Jean-François de Troy, and the *Tapestry-worker* (HPB 27) and the *Draughtsman* (HPB 28; both 1741) after Jean-Siméon Chardin.

Jacques-Fabien next devoted himself to scientific and documentary publications, probably seeing this as a way of giving a wider circulation to his process. Describing himself as a 'botanist and anatomist', he himself published a number of plates, often in the form of suites, on subjects in natural history such as anatomy, zoology and botany. He felt that the use of colour made it possible to publish valuable scientific texts for the first time. Among his major projects were *Myologie complète en couleur et grandeur naturelle* (1746; HPB 32–51); *Exposition anatomique de la structure du corps humain* (1759; HPB 155–74); *Collection de plantes usuelles, curieuses et étrangères* (four volumes, 1767; HPB 175–214); and illustrations for *Histoire naturelle de la parole* (1776) by Antoine Court de Gébelin (1719–84). He also founded the first French illustrated scientific periodical, the *Observations sur l'histoire naturelle, sur la physique et sur la peinture* (six volumes, 1752–5; HPB 76–135), from which he republished a selection of plates under the title *Collection de planches d'histoire naturelle* (1772). In 1772 he also undertook, in collaboration with Jean-Baptiste-André Gautier-Dagoty, a series of portraits of contemporary figures, the *Galerie universelle contenant les portraits de personnes célèbres de tout pays* (HPB 224–7).

Jacques-Fabien's oeuvre is interesting rather than beautiful: the black plate, often too heavily inked, deprived the

colours of any transparency, and the drawing lacked clarity. Nevertheless his engravings are sought after because of their rarity. He gave full descriptions of his publications in advertisements and in the press, particularly the *Mercure de France*. In 1749 he also wrote the *Lettres concernant le nouvel art de graver et d'imprimer les tableaux* and *Chromagenesis: ou Génération des couleurs contre le système de Newton*.

Jean-Baptiste-André Gautier-Dagoty (*b* ?Paris, ?1740; *d* ?Paris, 1786) was the eldest son of Jacques-Fabien Gautier-Dagoty. He worked in a style very similar to his father's. Like him, he began by engraving reproductions of paintings, such as the *Dutch Schoolmaster* (1755; HPB 1) after Jacob Ochtervelt, and then turned to scientific subjects and portraits, sometimes in collaboration with his father. He engraved 52 plates (1756–7) in the *Observations périodiques sur la physique, l'histoire naturelle et les beaux-arts* (HPB 3–54), a sequel to his father's *Observations sur l'histoire naturelle*. He began a series of royal portraits, the *Monarchie française* (HPB 56–61), in which the plates were etched, rather than mezzotinted, but abandoned it after a few plates, in 1770. He also engraved portraits (HPB 87–91) for the *Galerie universelle* of 1772. He signed himself *Gautier l'aîné* or *Gautier major*.

Arnault-Eloi Gautier-Dagoty (1741–before 1780), the second son, also contributed to scientific publications; notably, he engraved 15 plates to illustrate the *Cours complet d'anatomie* by Nicolas Jadelot (1773; HPB 1–15) and executed the illustrations to the *Mémoire sur des bois de cerfs fossiles* (1775) by Barthélemy Faujas de Saint-Fond (1741–1819). Edouard Gautier-Dagoty (1745–83), the third son, was a member of the Académie de Toulouse. He used his father's technique for reproducing paintings, particularly after Titian, Correggio and Charles Le Brun. He sometimes used as many as six plates instead of four, and he heightened the proofs in gouache. He began a series called *Galerie royale des tableaux* (HPB 3–13), twelve plates of which were published in 1781. But as the work did not meet with the expected success, he moved in 1782 to Italy, to escape financial difficulties. There he made three engravings: the *Madonna of the Chair* (HPB 17) after Raphael, the *Entombment* (HPB 15) after Titian and the *Conspiracy of Catiline* (HPB 16) after Salvator Rosa, from pictures in Florentine collections. He died in Florence.

Louis-Charles Gautier-Dagoty (1746–after 1787), the fourth son, made reproductions of some contemporary paintings including *Dites donc s'il vous plaît* (HPB 4) by Jean-Honoré Fragonard. He also executed in 1776 a portrait of *Marie-Antoinette* (HPB 2) that was much criticized at the time of its publication. Fabien Gautier-Dagoty (1747–after 1784), the fifth son, is known only as the engraver of *c*. 60 prints on mineralogy, which appeared in 1781 under the title *Histoire naturelle: ou Exposition générale de toutes ses parties* (HPB 1–5). He used to add to his signature the annotation *5e fils*.

BIBLIOGRAPHY
Thieme–Becker
H. W. Singer: 'Der Vierfarbendruck in der Gefolgschaft Jacob Christoffel Le Blon', *Mhft. Kstwiss.*, x (1917), pp. 177–89
M. Hébert, E. Pognon and Y. Bruand: *Inventaire du fonds français: Graveurs du dix-huitième siècle*, Paris, Bib. N., Cab. Est. cat., x (Paris, 1968), pp. 34–94 [HPB]
Anatomie de la couleur: L'invention de l'estampe en couleurs (exh. cat., Paris, Bib. N., 1996)

MADELEINE BARBIN

Gautszke [Gauszke], Briccius (*fl* 1476–after 1490). German stonemason and painter. He was trained at Görlitz (1476–77) by the town architect Stephan Aldenberg (*fl* 1461–88). From 1480 to 1490 he worked on the impressive, stylized natural stone decoration of the south façade of the town hall at Breslau (now Wrocław; completed second quarter of the 16th century, restored 1949–53). From 1490 to 1495 he was the senior master of the guild of masons and stonemasons at Kutná Hora, where after 1490 he worked on the façade of the Stone House (1487–1515).

Together with Paul Preusse, he was a leading master of the 'Lausitz Lodge', which originated from the circle of ARNOLD VON WESTFALEN.

BIBLIOGRAPHY
M. Bukowski and M. Zlat: *Ratusz wrocławski* [Wrocław Town Hall], (Wrocław, 1958)
A. Miłobedzki: 'Architektur: Osteuropa', *Spätmittelalter und beginnende Neuzeit*, Propyläen Kstgesch., vii (Berlin, 1972), pp. 370–5

VERENA BEAUCAMP

Gauzfredus (*fl c.* ?1125–50). French wood-carver. His name appears in an inscription (GAUZFREDUS ME F[E]CIT; PETRUS EDI[FICAVIT]), which is no longer complete, carved on the batten of one of the two sets of wooden doors of Le Puy Cathedral, Auvergne (*see* LE PUY). Petrus, named as the builder of the cathedral, may have been the architect or, less literally, one of the bishops associated with its construction, Peter II (1055–73) or Peter III (1145–55). The doors, made of joined and hinged planks of larch, give access to chapels located on either side of the entrance way and under the third bay of the nave. Their decoration is in low relief, and the components of the design are formed of sharply bounded and flattened forms raised above an equally flat ground. The surface of the wood shows traces of polychromy, now much eroded. One set of doors (bottom section restored) is framed by a pseudo-Sufic border and shows scenes of the *Infancy of Christ*; the other is devoted to the events of the *Passion*, culminating in the *Resurrection* and *Pentecost*. Wooden doors executed in a similar style are found at St Gilles, Chamalières-sur-Loire, St Pierre, Blesle, and Ste Croix, Lavoûte-Chilhac (all in the Auvergne), but their imagery is more symbolic than narrative, centring on the *Glorification of the Cross*, and more complex joinery methods were employed. Their attribution to Gauzfredus and their chronological relationship to the Le Puy doors are therefore uncertain.

BIBLIOGRAPHY
N. Thiollier: *L'Architecture religieuse à l'époque romane dans l'ancien diocèse du Puy* (Paris, 1900/R 1979), pp. 64–6
A. Fikry: *L'Art roman du Puy et les influences islamiques* (Paris, 1934), pp. 171–84, 262–7
W. Cahn: *The Romanesque Wooden Doors of Auvergne* (New York, 1974)

WALTER CAHN

Gavarni, Paul [Hippolyte-Guillaume-Sulpice Chevalier] (*b* Paris, 13 Jan 1804; *d* Paris, 24 Nov 1866). French lithographer and painter. He was one of the most highly esteemed artists of the 19th century. Like Daumier, with whom he is often compared, he produced around 4000 lithographs for satirical journals and fashion magazines, but while Daumier concentrated on giving a panoramic

view of public life, it was said of Gavarni that his work constituted the 'memoirs of the private life of the 19th century'. He specialized in genre scenes, in which the protagonists are usually young women, treating them as little dramatic episodes drawn from the light-hearted life of bohemia, dear to the Romantics.

Gavarni was initiated into the art of precision drawing while still very young, being apprenticed to an architect and then to a firm making optical instruments. He was also a pupil at the Conservatoire des Arts et Métiers. His first lithograph appeared when he was 20: a miscellany that accorded well with the taste of the time. His second work, the album *Etrennes de 1825: Récréations diabolico-fantasmagoriques*, also dealt with a subject then in fashion, diabolism. The pattern was set: all his life Gavarni produced works that would have been considered superficial if the delicacy of his line, his beautiful light effects and the wit of the captions he himself composed had not gained him admirers who found his prints both popular in their appeal and elegant. Gavarni also enjoyed writing, producing several plays now forgotten.

From 1824 to 1828 Gavarni stayed in Tarbes in the Pyrénées, where he worked for a geometrician; but he constantly made drawings, especially of local costumes, which he later published in Paris. On this trip he acquired his pseudonym, the 'cirque de Gavarnie'. Back in Paris he had his first taste of success with his contributions to fashion magazines. He was himself extremely elegant and sophisticated, and he adored women. He personified the dandy figure sought out by the Romantics and expressed his personal tastes in his drawings. In March 1831 Balzac introduced him to the paper *La Caricature*, owned by the Republican Charles Philipon, where he joined a team of young graphic artists, most notably Daumier, Jean-Jacques Grandville and Joseph Traviès, who were to raise the status of satirical lithography to new heights. Like them, he produced a few political caricatures directed against Charles X prior to the 1830 Revolution and a few satires against the monarchy in 1832, but he made a speciality of ball and carnival scenes, portraits of actresses and prints of costumes and fancy dress.

In 1833, encouraged by the speed of his success, Gavarni founded his own magazine, *Le Journal des gens du monde*, where, surrounded by artist and writer friends, including Nicolas-Toussaint Charlet, Achille Devéria, Théophile Gautier and Alexandre Dumas, he combined the roles of editor-in-chief, graphic designer and journalist. The magazine was a commercial failure and closed after seven months and eighteen issues. From 1834 he began working on Philipon's principal satirical journal, *Le Charivari*, and after 1837 became a regular contributor both to this and to *L'Artiste*, which since 1831 had been reporting on the art world. It was for *Le Charivari* that he made his main series of lithographs: *The Letter-box*, *Husbands Avenged*, *Students*, *Clichy* (1840–41) (the Parisian debtors' prison to which he had been sent in 1835), *The Duplicity of Women in Matters of the Heart* (1840) and *The Life of a Young Man* (1841). In 1841–3 he made the 'Lorettes' famous: they were young women of easy virtue who haunted the new district around Notre-Dame-de-Lorette in Paris, to which businessmen and numerous intellectuals had been moving.

From the very start of his career in 1829, Gavarni's prints had been published by Tilt in England, where they had been fairly successful. He stayed in England in 1847 and 1851, discovering the wretchedness of the working-class districts of London. There he published his *Gavarni in London* (1849). He began drawing in quite a different way, with greater social commitment and greater bitterness. It was also at this time, no doubt largely under English influence, that he worked in watercolour. On his return to France he published in *Le Paris* the long suite *Masques et visages* over the course of a year and at the rate of a lithograph a day (1852–3). The suite included several series: *The English at Home*, *A Tale of Politicking*, *The Sharers*, *Lorettes Grown Old* and *Thomas Vireloque*. This is perhaps his most important achievement. In it his graphic work is seen at its most lively. His line has become more tense and vigorous, the sense of contrast and movement greater, and the theme (the contrast between appearance and reality) more serious. He became moralistic and critical, often acrimoniously so, and his later work was not a popular success. The image created in the 1830s of a cheerful bohemia in which the lower orders of the bourgeoisie still mingled with the people had disappeared before the confrontation of the working class with the *nouveaux riches*. Gavarni superimposed on his habitual themes a profound disenchantment that owed much to his own aging, in such images as *The Emotionally Sick* (1853; see fig.). He became increasingly reclusive, abandoning lithography in 1859 to concentrate on his garden, only to see it destroyed by the encroachment of the railways.

Gavarni was praised by the critics of his time: Balzac, Gautier, Sainte-Beuve and Jules Janin. Edmond and Jules

Paul Gavarni: *The Emotionally Sick*, lithograph, 194×1602 mm, 1853; from *Masques et visages* (London, British Museum)

de Goncourt, who befriended him after 1851, and of whom he made a lithograph portrait (for illustration *see* GONCOURT, DE), helped to sustain his reputation after his death. They contrasted the elegance of Gavarni's themes favourably with what they considered the triviality of Daumier. This contrast obscured the more fundamental political division implicit in their work between a bourgeoisie faithful to its popular origins and one proud of its rise. For the latter Gavarni was a less dangerous artist than Daumier, although for later generations he appears less representative of the broad popular current that swept across France in the 19th century.

BIBLIOGRAPHY

J. Armelhault and E. Bocher: *L'Oeuvre de Gavarni* (Paris, 1873)

E. de Goncourt and J. de Goncourt: *Gavarni: L'Homme et l'oeuvre* (Paris, 1873)

H. Beraldi: *Les Graveurs du XIXe siècle: Guide de l'amateur d'estampes modernes* (Paris, 1885–92), vii, pp. 5–82

The Studio (1904) [issue dedicated to Daumier and Gavarni]

P.-A. Lemoisne: *Gavarni: Peintre et lithographe*, 2 vols (Paris, 1924)

Inventaire du fonds français après 1800, Paris, Bib. N., Cab. Est., viii (Paris, 1954), pp. 465–581

Paul Gavarni, 1804–1866 (exh. cat. by G. Schack, Hamburg, Ksthalle, 1971)

The Charged Image: French Lithographic Caricature 1816–1848 (exh. cat. by B. Farwell, Santa Barbara, CA, Mus. A., 1989)

MICHEL MELOT

Gavrinis. Neolithic passage grave in Brittany, north-west France, decorated with outstanding megalithic designs (*see* PREHISTORIC EUROPE, §IV, 2 and 3(i)). The tomb is situated on the island of Gavrinis, parish of Larmor-Baden, in the Morbihan Gulf, 13 km south-west of Vannes. It was discovered in 1825, opened in 1832, excavated in 1884–6, and excavated (by C. T. Le Roux) and restored in 1979–84. The grave is covered by a large subrectangular cairn with revetment walls, measuring *c.* 40 m wide×*c.* 8 m high. Beneath the cairn is a square chamber measuring 2.6 m×2.5 m and 1.8 m high entered through a 13.5 m long passage averaging 1.2 m wide by 1.6 m high. Built largely of granite orthostats, the passage opens towards the south-east. It is roofed with granite capstones and paved with granite slabs, with silt-stones at either end. At the tomb entrance is a forecourt, 30 m wide, beneath which most of the artefacts recovered from the site were found. These include stone axes, Neolithic pottery and quartz stones that were apparently used for facing and decorating the slabs. Radiocarbon analysis of eight burnt posts from the final phase of the site has provided a date in the late 4th millennium BC after calibration; soon after this, the forecourt was blocked, preventing further use.

The most significant feature of Gavrinis is the decoration carved on the megaliths in the passage and chamber. In all, 23 of the 29 orthostats are decorated, and these provide a remarkable example of a pecked and incised megalithic art tradition found in a number of areas along the Atlantic coast of Europe. The decoration at Gavrinis consists largely of curvilinear and geometric patterns, with some simple representational motifs. The prevalent designs are 'boxed' U-shapes, concentric arcs, zigzags, parallel lines, spirals, 'yokes' and 'croziers'. A simple axe motif recurs, most effectively on one stone (L9), which is covered with curvilinear patterns, surrounding a panel of 18 long, thin axeheads. The hidden backs of some of the

Gavrinis, decorated orthostat, granite, 3rd millennium BC

orthostats are decorated in an earlier style and have obviously been reutilized from other structures. The concealed upper surface of the chamber capstone shows a continuation of decorative motifs that match those under the capstone of the Table des Marchands passage grave 11 km away (*see* CARNAC). However, it is the coherence of the visible art, particularly its composition in balanced and integrated panels (see fig.), that makes Gavrinis so striking.

BIBLIOGRAPHY

C. T. Le Roux: *Gavrinis et les îles du Morbihan* (Paris, 1985)

P. R. GIOT

Gawra, Tepe. Ancient Mesopotamian mound, north-east of modern Mosul in Iraq. The site, which was excavated by E. A. Speiser (1927, 1931–2 and 1936–7) and Charles Bache (1932–6 and 1937–8), is noted for its informative remains dating to the 4th and 5th millennia BC, including rich graves of the Uruk period and the 'acropolis' of late Ubaid times (see fig.). The archaeological materials are in the Iraq Museum, Baghdad, and the University Museum, Philadelphia.

The upper levels of the site (numbered I–X) have been totally excavated, providing rare evidence of settlement architecture. Levels I–IV are dated to the 2nd millennium BC, with fine examples of Nuzi and Khabur ceramic types. The preceding levels make up a chronological sequence including Ur III (level V), Sargonic (VI), Early Dynastic/Ninevite 5 (VII), Uruk, including Jemdet Nasr

Tepe Gawra, plan of level XIII (the 'acropolis'), late Ubaid period (late 5th millennium BC): (a) main court; (b) Northern Temple; (c) Central Structure; (d) Eastern Shrine

(VIII–XII), late Ubaid (XIII–XIX) and Halaf (XX). Material of the Halaf period was also recovered from soundings at the base of the mound. The most notable objects from the site are those from the brick or stone-built Uruk tombs (4th millennium BC), including decorative objects in gold, a unique electrum wolf's head (Baghdad, Iraq Mus.), beautifully carved stone bowls (of marble, serpentine and, unusually, obsidian), ivory combs, and plaques and beads of lapis lazuli and other exotic materials. Of especial importance, too, is the vast quantity of seal impressions on clay, which constitute a major source for the Ubaid and Uruk periods. The designs include linear and geometric patterns, drilled designs (rare), naturalistic motifs including animals, humans (sometimes in erotic pose), fishes, snakes and scorpions. Of particular significance is the large number of sealings from the 'acropolis' of level XIII, suggesting their possible association with some centralized economy already in Ubaid times. Jemdet Nasr animal stamp-seals were found in level VIII, and cylinder seals are first reported in level VII.

Architecturally of interest are the tripartite, porched Uruk temples; a free-standing arch of late Uruk date (level VIII-A) and a number of public buildings in this same level; the unique Round House of level XI-A with its massive walls; and the Ubaid public architecture, especially the 'acropolis' in level XIII (see fig.). Though only some 30 sq. m, the latter provides the earliest example of planned architecture in the sense of public buildings constructed in deliberate spatial relation to one another, though it is not certain that all were in use simultaneously. The Northern Temple (b) bears a striking resemblance to contemporary structures at ERIDU, but unlike Eridu, where a sequence of temples was built on increasingly high platforms or terraces, the Gawra shrine provides an example of the 'low temple' type (see MESOPOTAMIA, §II, 1). Ninety-nine model bricks of baked clay were discovered

in the Eastern Shrine (d), precisely one tenth of the size of the bricks in the Central Structure (c) and almost certainly used to plan the complex bonding of its piers and pilasters. The tripartite houses of Ubaid levels XIV–XV can be compared with those of Abada and other Hamrin sites; circular structures (*tholoi*) of Halaf type persist in the earliest Ubaid levels.

BIBLIOGRAPHY
E. A. Speiser and A. J. Tobler: *Excavations at Tepe Gawra*, 2 vols (Philadelphia, 1935–50)

JOAN OATES

Gay, Jan Jakub (*b* Warsaw, 1 Dec 1803; *d* Warsaw, 2 Oct 1849). Polish architect. In 1828–30, in conjunction with Antoni Corazzi, he built the Bank of Poland (destr. 1944; rebuilt 1950–54), where a two-storey arcade at the corner of a square sweeps round a central domed rotunda, a design influenced by Jean-Nicolas-Louis Durand. In 1830 he travelled to England, Holland, Germany and France and became acquainted with (and influenced by) the work of such architects as Charles Percier, Pierre-François-Léonard Fontaine and Karl Friedrich Schinkel. In 1838 Gay constructed his own house (destr. 1944) at 18 Grzybowska Street and was the first architect in Warsaw to make architectural use of cast iron and to use sheet zinc as roof covering. In 1839 he travelled to Russia, where he saw Leo von Klenze's plans for the new Hermitage in St Petersburg. Back in Warsaw, working from 1840 for the Main Council of Philanthropic Institutions, he built an apartment house (1840–41) at 28 Bednarska Street. He used cast iron on a large scale for the construction of the Gościnny Dwór (1841; destr. 1939), a covered market, which he built in Warsaw in conjunction with Alfons Kropiwnicki (1803–81). Among Gay's most important works outside Warsaw is a monumental granary (1844) in Modlin, at the confluence of the Vistula and Narew rivers. Gay is considered one of the most important Polish architects of the first half of the 19th century, and he is noted particularly for his progressive constructions.

BIBLIOGRAPHY
S. Sienicki: 'Dom własny architekta warszawskiego przed stu laty' [A Warsaw architect's own house one hundred years ago], *Biul. Hist. Sztuki & Kult.*, iv/4 (1936), pp. 295–307
S. Łoza: *Architekci i budowniczowie w Polsce* [Architects and builders in Poland] (Warsaw, 1954), pp. 89–90

ANDRZEJ ROTTERMUND

Gay, Nikolay (Nikolayevich). *See* GE, NIKOLAY.

Gay, Walter (*b* Hingham, MA, 22 Jan 1856; *d* Le Bréau, Dammarie-les-Lys, nr Fontainebleau, 13 July 1937). American painter and collector. Gay lived all his adult life in and around Paris. He sailed for France in 1876, after a successful exhibition and sale of his still-life paintings at the Williams and Everett Gallery, Boston, which provided funds for his study abroad. Soon after arriving in Paris, Gay entered the atelier of Léon Bonnat, where he remained for about three years. At Bonnat's suggestion, Gay made a trip to Spain in 1879 to study the work of Velázquez. These influences combined to form a style of painterly realism that emphasized fluid brushwork and a high-keyed tonal palette. Gay made his professional début in France in the Salon of 1879 with the *Fencing Lesson* (New York,

priv. col.), an 18th-century costume piece in the manner of Mariano Fortuny y Carbo. The painting received favourable attention from French and American critics, encouraging Gay to continue this subject-matter for several years. During the late 1880s his summer trips to Brittany and Barbizon inspired a series of paintings of French peasants. One of the most successful of these, *The Blessing* (Amiens, Mus. Picardie), was shown at the Salon of 1889 and purchased by the French government.

Around 1895 Gay stopped painting large figural compositions and began to paint interiors, inspired by his love of French furniture and interior decoration. In 1907 he purchased Le Bréau, an 18th-century château near Barbizon. Many of his subsequent paintings, for instance *The Medallions* (c. 1909; Paris, Pompidou), depict rooms in the château and were exhibited to great acclaim in Europe and America. Gay's memoirs were published in New York in 1930. His collection of Old Master drawings, paintings, bronzes and other works of art was donated to the Louvre by his widow in 1938.

BIBLIOGRAPHY
A. E. Gallatin, ed.: *Walter Gay: Paintings of French Interiors* (New York, 1920)
L. Gillet: 'Walter Gay', *Rev. A. Anc. & Mod.*, xxxix (1921), pp. 32–44
Memorial Exhibition of Paintings by Walter Gay (exh. cat., New York, Met., 1938)
Walter Gay: A Retrospective (exh. cat. by G. Reynolds, New York U., Grey A. G., 1980)
M.-E. Jaffrenou: *Catalogue des dessins de la collection Walter Gay conservés au Cabinet des Dessins du Louvre (Ecoles françaises et anglaises)* (diss., Paris, Ecole du Louvre, 1984)

GARY A. REYNOLDS

Gaya. *See* BODHGAYA AND GAYA.

Gay and lesbian art. The phrase 'gay and lesbian' art is something of a misnomer, for, clearly, it is not the art itself that is lesbian or gay; rather, these qualities pertain to individuals and communities associated with this art. But what is the nature of that association? Is it art that depicts lesbians and gay men, art admired by lesbian and gay audiences, or art made by lesbian and gay artists? Even if all of these potentially overlapping categories are admitted to the classification of gay and lesbian art, the problem remains of defining what is meant by the terms 'gay' and 'lesbian'. The history of these terms offers a structure by which to understand debates about the categories of gay and lesbian art.

1. Questions of identity, before the 1890s. 2. Assertion and evasion of identity, 1890s–1960s. 3. An art of identity, 1970s–1990s.

1. QUESTIONS OF IDENTITY, BEFORE THE 1890s. The terms 'gay', 'lesbian' and 'homosexual' are very new. The last two came into medical currency in the translation (1892) of the *Psychopathia sexualis* (1887) by Richard von Krafft-Ebing, while the first has moved from slang to a term of self-definition (OED) only since the 1960s. The invention of these terms is interpreted by many scholars as evidence of important changes in ideas about society, sexuality and individual identity, first around the beginning of the 20th century, and then again 70 years later. The same timetable characterizes the history of feminism, suggesting that identities based on gender and sexuality

are characteristic of, if not unique to, the culture of modern urban capitalism (*see also* FEMINISM AND ART).

Whether the relative novelty of lesbian and gay identity forecloses its relevance to historical research is a matter of controversy. Scholars who apply these terms to premodern or non-Western cultures are sometimes criticized as 'essentialists': those who naively believe that their own experience reflects a human 'essence' and is therefore universal. The danger of essentialism, of course, affects all historical study. When such terms as 'artist' are applied to societies outside contemporary Western culture, there is a risk of imposing the current nuances of those words in the West on peoples whose social and cognitive structures may be significantly different. Although such theoretical pitfalls have not precluded historical attention to artists, however, concern over essentialism has shaped the study of homosexuality, with few historians examining the effects of same-sex attraction on the arts outside modern Western culture. Although by the 1990s scholars were beginning to document the artistic expression of lesbian and gay identity in the modern urban centres of Japan and India, the *Bibliography of Gay and Lesbian Art* of 1994 lists no studies of lesbian and gay art in pre-industrial cultures. By the late 20th century relevant images had been examined only in histories of EROTIC ART, while historians investigating homosexuality in ancient Chinese and Islamic societies, Edo-period Japan, and the indigenous cultures of the Americas have relied on verbal sources.

Many of the arguments over essentialism have focused on the social formation of homosexuality in pre-industrial Europe, beginning with the ancient Greeks and Romans. The numerous Classical vase paintings, carved ornaments, murals and sarcophagi displaying homoerotic imagery have become evidence in debates over the applicability of modern concepts of gay identity to ancient culture. Using primarily textual sources, Halperin (1990) claimed 'Homosexuality and heterosexuality . . . are modern, Western, bourgeois productions. Nothing resembling them can be found in classical antiquity.' In contrast, Richlin (1993), using similar evidence, asserted that 'men identified as homosexuals really existed at Rome', while Boswell (1980 and 1994) argued for the existence of 'gay people' and same-sex marriages in the Middle Ages. At stake is the relevance of the categories of lesbian and gay art advanced above. If there were artists or patrons who perceived themselves as part of a subculture based on sexual identity, this opens the possibility of a wide range of lesbian or gay art, with or without sexual imagery. Potential examples include the homoerotic decorations on Greek and Roman drinking vessels (Dover, 1978; Clarke, 1993), the wall paintings in what was probably a male brothel in the Roman port city of Ostia (Clarke, 1991), and marginalia in some medieval manuscripts (Camille, 1989).

Among the inventions of the Renaissance was one with profound implications for the historical study of lesbian and gay art: the artist's biography. Combined with other documentation, such as legal records, these accounts identify specific artists and patrons who, in contemporary terms, might be considered gay; women's virtual exclusion from the fine arts means that most documentation concerns men. The most obvious case is that of the Sienese

artist Giovanni Antonio Bazzi, who flaunted his derogatory nickname 'il Sodoma', a gesture Saslow (in Dynes and Donaldson, 1992) called 'arguably the first "coming out" statement in Western history'. In a climate of fluctuating tolerance and persecution of homosexual acts, however, others were not so open, and imputations of homosexuality rely on a synthesis of legal accusations, personal letters, and art works made or commissioned. Cases have been made for the homosexuality of the artists Benvenuto Cellini, Sandro Botticelli, Donatello, Leonardo da Vinci and Guido Reni, as well as for Caravaggio and his important patron the Cardinal Francesco Maria del Monte. The most thorough study of homosexuality and the art of the Renaissance is Saslow's work on Michelangelo (1986), whose homoerotic poems and drawings for the young nobleman Tommaso de' Cavalieri are exemplified by his famous *Rape of Ganymede* (Cambridge, MA, Fogg; see fig. 1).

Since the dawn of modern gay consciousness, scholars interested in gay history have seized on such records; in the late 19th century John Addington Symonds's pioneering books on Michelangelo castigated efforts by Michelangelo's family and editors to suppress and distort these documents. Saslow's analysis details Michelangelo's profoundly ambivalent eroticism, which the artist experienced and expressed through the often contradictory lenses of Catholicism and Neo-Platonic philosophy. In this context, the drawing of *Ganymede* expresses Michelangelo's sense of being transported by his love for Cavalieri, but takes its place as a pendant with a drawing of Tityos having his liver perpetually ripped out by a vulture in punishment for

1. Michelangelo: *Rape of Ganymede*, black chalk on off-white laid paper, 361×275 mm, 1532 (Cambridge, MA, Fogg Art Museum)

his lust (Windsor Castle, Royal Lib.). Saslow's study of Michelangelo led him to conclude that, although no records suggest any kind of gay community or self-conscious activist agenda, 'an emerging sense of distinctive homosexual identity' nevertheless characterizes the 16th century and its art. It should be noted that these conclusions refer specifically to gay male identity: in the 16th century powerfully phallocentric definitions of sexuality precluded any explicit articulation of female sexual identity apart from men. The forms of female homoeroticism in the Renaissance were explored by Simons (in Davis, 1994) in a groundbreaking study that reads between the lines of texts and in the subtle gestures in representations of Diana and her nymphs to find 'a woman's world of pleasure' overlooked and ignored by men.

The enormous influence of Renaissance art and its Classical prototypes on the art of the subsequent four centuries ensured the perpetuation of the male nude as a common subject in all forms of art, but especially in the prestigious category of history painting. To modern eyes, the homoerotic overtones of many of these images are inescapable. At the period, however, male nudity was invested with symbolic political and historical meaning, making it impossible to read these very public images simply as statements of the artist's erotic interests (Crow, 1991). Although explicit commentary on the homoerotic implications of these works is absent from the historical record, scholars of the 1990s began looking for sexual subtexts behind such events as the critical reaction to Jacques-Louis David's *Death of Barra* (1794; Avignon, Mus. Calvet) or Ingres's failure to follow up on the themes of *Achilles Receiving the Ambassadors of Agamemnon* (1801; Paris, Ecole N. Sup. B.-A.; Fernandez, 1989; Ockman, 1993). These episodes seem to suggest increasing discomfort with this imagery, particularly around the early years of the 19th century, when social changes made its erotic implications more recognizable.

As relevant to the study of lesbian and gay art as the historical circumstances of earlier ages is the later use of artists and images from the Renaissance and before to mark modern gay identity. The 18th-century German scholar Johann Winckelmann emphasized the homoerotic elements of ancient Greek and Roman sculpture, arguably the first attempt at gay art history. By the end of the 19th century Winckelmann himself had been analysed to similar ends by Walter Pater, and Symonds's biography of Michelangelo established this artist's position as a symbol of modern gay identity. Pictures and reproductions of Michelangelo's monumental *David* (Florence, Accad.), itself a variation on ancient sculpture, subtly identified gay homes and businesses four centuries later. Likewise, St Sebastian, represented in Renaissance painting with his nude body pierced by arrows, became a potent symbol of the plight of modern homosexuals, and visual references to this tradition mark the work of turn-of-the-century gay artists, such as the photographer F. Holland Day, as well as more modern gay painters, such as Keith Vaughan, and such photographers as Arthur Tress. Although in the 1990s historians rejected such assumptions, for pioneering gay scholars such Renaissance artefacts seemed proof of a venerable heritage in a golden age before modern homophobic stigma. Symonds (1893) described Michelan-

gelo's era as one when 'the frank and hearty feeling for a youth of singular distinction. . .gave no offence to society'. Turn-of-the-century photographers like Day and the Baron Wilhelm von Gloeden drew on the conventions of Renaissance art (and its ancient prototypes) to create a body of homoerotic photographs that were distributed through networks of gay men at the same time that they were reproduced in art magazines as tools for practising artists. Such self-consciously gay readings of art from the Renaissance and earlier are, no doubt, highly anachronistic, although no more so than, for instance, Federal American invocations of ancient Greek architecture as a symbol of modern democracy. As this comparison suggests, however, the study of gay and lesbian art in the pre-industrial West cannot be limited to arguments over the sexuality of artists and patrons in these cultures. Art is changed as it passes through generations, and the new meanings that adhere to particular artists and art objects become a relevant part of their history.

2. ASSERTION AND EVASION OF IDENTITY, 1890s–1960s. It is impossible to exaggerate the importance of the 1890s for the formation of modern gay and lesbian identity. The idea of the homosexual, as a distinct category of person, was forcefully articulated in the *Sexual Inversion* (1897) by Havelock Ellis, and that same year Magnus Hirschfeld founded a research centre and activist organization to study and defend homosexuals. Both Ellis in England and Hirschfeld in Germany sought to counter newly harsh and invasive laws against homosexual activity by proving that such behaviour was normal to certain men and women. There is some irony in the symbiotic relationship between stricter social and legal proscriptions against homosexuality and the increasing entrenchment of gay and lesbian identity. This pattern, however, characterizes the development of gay expression in non-totalitarian states from the 1890s to the 20th-century era of AIDS.

The importance of modern notions of homosexual identity is exemplified in a comparison of artists before and after the turn of the century. Although Okuhara Seiko in Japan and Rosa Bonheur in France worked a world apart, these two late 19th-century painters together exemplify conditions before the invention of the modern lesbian identity. Both women made successful careers despite their sex, by acceding to the social status of men. Both adopted men's fashions of dress and deportment, allied themselves with aristocratic patrons, and excelled in conservative styles of painting. Both had long-term domestic relationships with other women, exemplifying a 19th-century trend towards passionate friendships among women (Faderman, 1981). There is no evidence, however, that either ever articulated a specifically sexual identity or imagined a lesbian community.

In contrast, although little more than a generation younger, such artists as photographer Berenice Abbott and painter Romaine Brooks embraced an identity that was specifically lesbian. Both Abbott and Brooks were Americans who established their careers in Paris. A continent away from the censorious oversight of their families, networks of expatriate lesbians formed around such writers as Gertrude Stein, Natalie Barney and Djuna Barnes; the last was also an occasional artist. Brooks's and

Abbott's devotion to this unprecedented lesbian community may be gauged from their portraits of its members, which emphasize the unconventional, often masculine, beauty of their colleagues. In Berlin the painter and printmaker Jeanne Mammen (1890–1976), who was brought up and educated in Paris, chronicled the lesbian clubs with a similar documentary fervour. Although she identified with the culture that her energetic prints and paintings represent (see fig. 2), her work falls into the tradition of mainstream representations of lesbians as symbols of decadent eroticism. This large body of images, including a now-lost painting cited in the 16th-century court of the Comte de Chasteau-Villain (in Faderman), Gustave Courbet's *Sleepers* (1866; Paris, Petit Pal.), Brassaï's photographs of Paris nightclubs in the 1930s, and even the covers of sensationalistic novels about lesbians in the 1950s and 1960s, bears a complicated relationship to the category 'lesbian art'. This work probably says more about its heterosexual authors and viewers than about lesbians. Nevertheless, Mammen's variations on these themes exemplify the way subcultures can internalize and rehabilitate mainstream perceptions, sometimes flaunting what might be considered stereotypes.

Paralleling the lesbian circles of Abbott, Brooks and Mammen were communities of gay artists and intellectuals that arose simultaneously in Europe and North America. The writings of the American poet Walt Whitman, as well as Englishmen like Symonds and Pater, and most famously

2. Jeanne Mammen: *She Represents (Two Women in a Club)*, watercolour and pencil, 420×304 mm, *c.* 1928 (Berlin, private collection)

the Irish expatriate Oscar Wilde, were essential to the early formation of gay identity. In England, under the influence of Pater and Wilde, the Aesthetic Movement developed what is probably the first example of an art movement identified with homosexuality. This early connection was to have long-lasting effects on both gay self-identity and outsiders' perceptions of the connections between male homosexuality and art or decoration. Long after the Aesthetic Movement's nominal decline, its combination of high fashion, artistic refinement and sensuality continued to be the art-world face of gay identity. Art by original Aesthetes, such as Simeon Solomon and Aubrey Beardsley, in its combination of theatrical references, erotic subjects and visual elegance, anticipates the work of later gay artists: the painters Charles Demuth, Paul Cadmus and Jared French (1905–88); the French writer and artist Jean Cocteau; and the photographers Cecil Beaton and George Platt Lynes.

All of these artists were part of urban gay communities where echoes of Aestheticism could be recognized as assertions of a sexual identity that, although not publicly acknowledged at the time, can be readily documented today. The pressures that prevented any franker avowal of gay identity in an era when homosexuality was grounds for forced confinement in prisons and psychiatric hospitals left few options for other gay artists uncomfortable or unwelcome in the white, wealthy subculture derived from Aestheticism. Such art as Marsden Hartley's Cubist portraits of a German officer (c. 1914), Mark Tobey's paintings, and the enigmatic sculptural combines of Jasper Johns and Robert Rauschenberg in the 1950s have long

been admired as examples of abstract modern art. In the late 20th century, however, scholars of gay art have reinterpreted these works, reading their veiled allusions as expressions of another aspect of gay identity: the experience of being 'closeted' or hiding one's sexual identity (see Katz, 1993; Weinberg, 1993; M. Kangas in Dynes and Donaldson, 1992). One example is Johns's *Target with Plaster Casts* (1955; priv. col., see Katz, 1993, p. 203), with its collection of body parts, including male genitals and nipple, each in a compartment with its own trapdoor. As a depiction of closeted sexuality (with the target evoking the martyrdom of St Sebastian), this work has been interpreted as describing Johns's personal situation, and, more generally, the condition of gay Americans during the McCarthy era of homophobic persecution.

If the art world during the first half of the 20th century incorporated two strands of gay expression, echoes of the Aestheticism of the 1890s and evocations of camouflage or dissimulation, commercial art provided another vision of gay identity. In the early part of the century nudist magazines earned a circulation far wider than audiences interested in their nominal ethos of health and fitness. By mid-century, especially around Los Angeles, magazines and photographic agencies devoted to male body-building were creating images that circulated widely, if surreptitiously, to create new visual codes of gay identity. Not only photographers but also illustrators, such as George Quaintance (c. 1915–57) and 'Tom of Finland' (Touko Laaksonen; 1920–91), popularized an iconography of muscled cowboys, bikers, soldiers and sailors, which competed with the Aesthetic model of upper-crust refinement as modes of gay identity.

3. Jess: *Tricky Cad: Case V*, collage of coloured newspaper, clear plastic and black tape on board, 337×641 mm, 1958 (Washington, DC, Hirshhorn Museum and Sculpture Garden)

Both inside and beyond the art world the 1960s disrupted established values. Nowhere was this clearer than in Pop art's challenge to modernist abstraction. Where Abstract Expressionism was identified with heterosexual male virility, part of Pop art's challenge was its deployment of images and attitudes that were also associated with gay culture. At the heart of Pop's gay identification is the notion of 'camp', an exuberant irreverence expressed in equal measure as cynicism towards authoritative values and determination to love that which dominant culture dismisses as trivial. Camp replaced the attitudes associated with the Aesthetic Movement as the art world's clearest expression of gay identity, with Oscar Wilde ceding to Andy Warhol. Although Warhol's early gay-themed work was rejected by galleries, by 1962 the popularity of his paintings of Coca-Cola bottles and Campbell's soup cans ensured an audience for his films, for example *Blow Job* (1963), *My Hustler* (1965) and *Flesh* (1968), and also for his more subtly homoerotic projects: the censored *Thirteen Most Wanted Men* (priv. col., see 1989 exh. cat., illus. 287–301, pp. 287–301) for the World's Fair, New York, in 1964; his silkscreens of such male beauties as Marlon Brando and Elvis Presley; and the male nudes and *Oxidization Paintings* of the 1970s, the latter made with urine on a copper-paint surface in the style of Abstract Expressionist canvases.

Other prominent gay Pop artists include David Hockney, Robert Indiana and Jess (Collins) (*b* 1923). As early as 1953 Jess was collaging comic-strips, such as *Dick Tracy*, to, in his words, 'single out the homoerotics of the original material' (see fig. 3). Indiana's *LOVE* graphic, designed as a Christmas card in 1964, became a symbol of the sexual revolution of the later 1960s, and he later made a series of prints in homage to Marsden Hartley's coded gay portraits. More explicitly, Hockney's gay-themed paintings confirmed the identification of Pop art with a gay sensibility. As an art student, Hockney was inspired by American muscle magazines, which created a vision of southern California as a paradise of homoeroticism. Starting with the *Domestic Scene, Los Angeles* (1963; priv. col., see Livingstone, 1981, fig. 33, p. 51), Hockney borrowed figures from these sources to create cheerful fantasies of gay life. After moving to California, Hockney continued his pictorial celebration of the gay community around Los Angeles, including frankly erotic images of his American lover (see fig. 4). This work marks the first sustained attempt by an artist to picture the forms of modern gay community that had come into being since World War II. By the end of the 1960s, under the influence of the upsurge in feminist and other civil rights movements, this community began emerging from the closet to assert a new form of gay identity, one far more public and politicized than earlier manifestations.

3. AN ART OF IDENTITY, 1970s–1990s. The rise of lesbian art is inseparable from the rise of feminism in the 1970s. The label 'lesbian continuum' was even proposed by feminist poet Adrienne Rich, in 'Compulsory Heterosexuality and Lesbian Existence', to incorporate all 'women-identified experience', which challenges conventional imperatives that women focus on men. By this definition the whole range of feminist activity might fall

4. David Hockney: *Peter Getting out of Nick's Pool*, acrylic on canvas, 1.52×1.52 m, 1966 (Liverpool, Walker Art Gallery)

under the rubric of lesbian art. An early feminist art project such as Judy Chicago's *Dinner Party* (1974–9; see FEMINISM AND ART, fig. 2) exemplifies this proposition: its vaginal symbolism binds its female authors and subjects to one another in a way that includes, but is not limited to, sexuality. Because of such connections, lesbian-identified artists found colleagues and audiences through the women's movement. In 1976 women coordinated a series of exhibitions across the USA under the title of the Great American Lesbian Art Show, and in the following year the third issue of the influential American feminist journal *Heresies* was devoted to lesbian artists.

Prominent within lesbian culture in the USA in the 1970s were artist-writers Harmony Hammond (*b* 1944) and Kate Millet (*b* 1934). Hammond's fabric-wrapped sculptures sought to evoke women's experience through form and texture, rather than through illustration. Similarly evocative was Millet's work, such as the installation *Domestic Scene* (1976), in which a cage enclosing wild grasses was placed on a large rug. The subtlety of both women's work was balanced by the specificity of their writings, which dealt explicitly with their lesbian identities. A different approach is exemplified by the painter Monica Sjoo, whose simple, linear images with prominent titles forthrightly engage themes of lesbian love and matriarchal religion. So challenging are these paintings that the artist has repeatedly been threatened with legal prosecution for blasphemy and obscenity.

Where lesbian art flourished in the context of a vital feminist movement, the much smaller community of gay rights activists offered fewer resources for the analogous development of gay art in the 1970s. Explicitly erotic

images, circulated in the increasing number of gay-porn magazines, were probably the primary visual manifestation of the growing gay community and were exploited by such artists as Robert Mapplethorpe. In the early 1970s Mapplethorpe's youthful Pop-inspired collages manipulated porn images, and later in the decade these magazines provided audiences for his photographs documenting the practices of sexually specialized sub-groups within the gay community. Gay artists with less explicit subject-matter, however, lacked such venues and risked losing teaching careers and exhibition opportunities if they acknowledged their sexual identity. Among the few artists exploring the new politicized gay identity was Mario Dubsky (1939–85). His photomontage mural (1971) for the Gay Artists Alliance Building (destr.) in New York, created in collaboration with John Button (1929–82), celebrated the current gay power demonstrations, while his published series of drawings *Tom's Pilgrim's Progress among the Consequences of Christianity* (1977–8) responded to the blasphemy trial of a London gay newspaper. Overall, however, when in 1980 openly gay New York art critic John Perreault asked, 'Is there gay culture?', he answered, 'Not yet'. More specifically, he acknowledged, 'there's gay male art', but 'it's a secret'.

During the 1980s the secret came out. Under the title *Extended Sensibilities*, the first major exhibition to unite gay and lesbian artists took place at the New Museum, New York, in 1982 and brought the question of 'homosexual sensibility' into mainstream art journals. In London, meanwhile, the Gay Men's Press released a collection of Dubsky's drawings in 1981 and in 1985 began publishing small monographs on gay artists, with the first series featuring Philip Core (1951–89), Juan Davila and Michael Leonard (*b* 1933). Although increasing numbers of artists were willing to be counted as gay, most resisted efforts to define a gay sensibility or to see their art as an expression of their sexual identity. Nicolas Moufarrege (1948–85), whose Pop-inspired constructions reproduced famous paintings in textiles, published a survey of contemporary lesbian and gay artists that challenged assumptions of any unifying sensibility. 'We are faced with artists who happen to be homosexual rather than a particular homosexual aesthetic', he said. One example was the graffiti artist Keith Haring, who, Moufarrege reported, 'accepts his homosexuality but does not see it as his only artistic concern'.

By the end of the 1980s such ambivalence over the artistic expression of gay identity was much less common. One galvanizing event was AIDS, or, more specifically, societal indifference to a disease that struck first at urban gay men. Following the founding of ACT-UP/New York in 1987, similar activist groups sprang up in cities where the art world and the gay community were centred. From the beginning these groups included influential artists and critics. One of ACT-UP/New York's first actions was a shop-window display at the New Museum of Contemporary Art, New York, and the group's graphics established a model for AIDS activists worldwide. Just as the imagery of suffrage protests gave visual form to the feminist identity in the 1890s, so AIDS activist graphics became the public face of gay identity in the 1980s. Both bodies of work convey the anger and determination of the

communities they represented; at the same time both strengthened their communities by asserting a legacy of heroes. Many of the early graphics of ACT-UP/New York echo the style and motifs of such famously gay Pop artists as Warhol and Indiana, along with their predecessors Johns and Rauschenberg. Similar graphics by other AIDS activist groups have quoted artists from Michelangelo to Mapplethorpe. The question of what constitutes 'gay art' is basic to such efforts to define a public identity robust enough to claim political parity with other forms of identity based on such factors as ethnicity and religion. For gay men the AIDS crisis occasioned the need for a public identity, and even artists who earlier had downplayed their sexuality responded. Haring, for instance, by 1989 was designing posters in his signature style for ACT-UP and contributing a lively mural to the Lesbian and Gay Community Center in New York, where ACT-UP met.

Haring's willing accession to the status of gay artist is exemplary of the 1980s, when an explosion took place in the number of artists unambiguously claiming a gay identity in the context of the AIDS crisis. In 1987 reviewers in New York commented on the 'notable presence of gay-content art' at the prestigious Whitney Biennial, connecting this trend to 'the increased prominence of gays in the public eye—mainly due to the nightmare of AIDS' (Meyer). The Biennial of 1991 featured, if anything, even more art related to gay identity and AIDS, including paintings by Haring, David Wojnarowicz (1954–92) and Thomas Lanigan Schmidt (*b* 1948), along with sculpture by Robert Gober and an *AIDS Timeline* created by Group Material, an artists' collaborative. The cultural climate of 1991 is exemplified by the catalogue for the Biennial, which opens with an essay by the curator, titled 'Culture under Siege'. This describes attacks on artists and galleries by right-wing politicians across the USA, frequently over the creation and exhibition of art dealing with homosexuality. Analogous controversies arose simultaneously in Britain over 'Clause 28', which forbade tolerance of any form of gay expression by government-funded institutions. Wojnarowicz and Mapplethorpe became focuses for these debates in the USA, especially when in 1990 a major exhibition of Mapplethorpe's work was closed by the police in Cincinnati and the director of the city's Contemporary Arts Center was tried (and eventually acquitted) on obscenity charges. This history suggests the potential contentiousness surrounding debates over 'gay art'. Whether the category is seen as affirming a community under fire or as threatening the mainstream, the stakes in debates over gay art are very high.

Where gay imagery provoked controversy over censorship and public funding of the arts in the 1980s, similar lesbian imagery was at the centre of debates among feminists over pornography. Some prominent feminists championed censorship of pornographic images of women, while others vehemently opposed such laws, which, when they were enacted in Canada, resulted in the immediate suppression of such lesbian magazines as *On our Backs* (see Segal and McIntosh, 1993; Kiss & Tell, 1994). The problem for lesbians was how to represent a sexual identity without perpetuating conventions that figure lesbianism as titillating for heterosexual men. Documentary photographs of lesbians working or playing

together risk failing to signify as lesbian unless they exploit stereotypes, while sexual images are easily appropriated for the male libido. A decade of responses to this issue were collected in the anthology *Stolen Glances* (1991). Solutions range from the practice of Tee Corinne (*b* 1943), consistent since the 1970s, of using drawing, photographic solarization and other forms of distortion to abstract images of lesbian sexuality into colourful decorations that defy the voyeur's gaze, to recent images by Jill Posener (*b* 1953) and Della Grace (*b* 1957) that confront viewers with explicitly erotic scenes involving powerful women who are clearly not posed for men's pleasure. Addressing the controversy head-on, a group of Canadian artists, operating under the name Kiss & Tell, began in 1990 circulating an exhibition of their lesbian erotica, entitled *Drawing the Line*. Women viewers were given markers and invited to draw the line at the point where they found the pictures disturbing. Many viewers chose to add comments, so each installation turned into a community debate on the nature of sexuality and its representation (see fig. 5). In its acknowledgement of the controversy surrounding sexual identity and imagery, this work may best embody the nature of gay and lesbian art. As a category of historical analysis or lived experience, sexual identity is characterized by change and debate. This dynamism should not be interpreted as a sign of weakness or irrelevance, however. On the contrary, it is because sexual identity is crucial to so many artists and audiences that its visual manifestations arouse such passion and creativity.

BIBLIOGRAPHY

GENERAL

'Lesbian Art and Artists', *Heresies*, i/3 (1977) [whole issue]

J. Perreault: 'Is There Gay Culture? Not Yet', *SoHo News* (25 June–1 July 1980), p. 20

L. Faderman: *Surpassing the Love of Men: Romantic Friendship and Love between Women from the Renaissance to the Present* (New York, 1981)

N. Moufarrege: 'Lavender: On Homosexuality and Art', *Arts* (Oct 1982), pp. 78–87

Extended Sensibilities: Homosexual Presence in Contemporary Art (exh. cat., ed. D. Cameron; New York, New Mus. Contemp. A., 1982)

J. D'Emilio: 'Capitalism and Gay Identity', *Powers of Desire: The Politics of Sexuality*, ed. A. Snitow, C. Stansell and S. Thompson (New York, 1983)

H. Hammond: *Wrappings: Essays on Feminism, Art, and the Martial Arts* (New York, 1984)

E. Cooper: *The Sexual Perspective: Homosexuality and Art in the Last 100 Years in the West* (London, 1986)

J. Meyer: 'Some Gay Themes in the 1987 Whitney Biennial', *Arts*, 62 (Oct 1987), pp. 25–7

D. Greenberg: *The Construction of Homosexuality* (Chicago, 1988)

M. Duberman, M. Vicinus and G. Chauncey, eds: *Hidden from History: Reclaiming the Gay and Lesbian Past* (New York, 1989)

D. Fernandez: *Le Rapt de Ganymeade* (Paris, 1989)

J. Z. Grover: 'Dykes in Context: Some Problems in Minority Representation', *The Contest of Meaning: Critical Histories of Photography*, ed. R. Bolton (Cambridge, MA, 1989)

R. Dellamora: *Masculine Desire: The Sexual Politics of Victorian Aestheticism* (Chapel Hill, 1990)

D. Halperin: *One Hundred Years of Homosexuality* (New York, 1990)

T. Crow: 'Revolutionary Activism and the Cult of Male Beauty in the Studio of David', *Fictions of the French Revolution*, ed. B. Fort (Evanston, 1991), pp. 55–83

Drawing the Line: Lesbian Sexual Politics on the Wall, Kiss & Tell (Vancouver, 1991) [collaborative project by Persimmon Blackbridge, Lizard Jones, Susan Stewart]

5. Kiss & Tell: *Drawing the Line*, installation, 1990

V. Carter: 'Abseil Makes the Heart Grow Fonder: Lesbian and Gay Campaigning Tactics and Section 28', *Modern Homosexualities: Fragments of Lesbian and Gay Experience*, ed. K. Plummer (London, 1992)

W. Dynes and S. Donaldson, eds: *Homosexuality and Homosexuals in the Arts* (New York, 1992) [useful anthology of recent criticism and history]

K. Silver: 'Modes of Disclosure: The Construction of Gay Identity and the Rise of Pop Art', *Hand Painted POP: American Art in Transition, 1955–62* (exh. cat., Los Angeles, CA, Mus. Contemp. A., 1992)

R. Aldrich: *The Seduction of the Mediterranean: Writing, Art and Homosexual Fantasy* (London, 1993)

J. Katz: 'The Art of Code: Jasper Johns and Robert Rauschenberg', *Significant Others*, ed. W. Chadwick and I. de Courtivron (London, 1993), pp. 189–207

A. Richlin: 'Not before Homosexuality', *J. Hist. Sexuality*, iii (1993), pp. 523–73

L. Segal and M. McIntosh, eds: *Sex Exposed: Sexuality and the Pornography Debate* (New Brunswick, 1993)

J. Weinberg: *Speaking for Vice: Homosexuality in the Art of Charles Demuth, Marsden Hartley, and the First American Avant-garde* (New Haven, 1993)

Bibliography of Gay and Lesbian Art, Gay and Lesbian Caucus of the College Art Association (New York, 1994)

W. Davis, ed.: *Gay and Lesbian Studies in Art History* (Binghamton, NY, 1994) [double issue of *Journal of Homosexuality*, xxvii/1–2]

Her Tongue on my Theory: Images, Essays and Fantasies, Kiss & Tell (Vancouver, 1994)

C. Reed: 'Postmodernism and the Art of Identity', *Concepts of Modern Art*, ed. N. Stangos (London, 3/1994)

MONOGRAPHS

W. Pater: 'Winckelmann', *Westminster Rev.* (Jan 1867); repr. in *Studies in the History of the Renaissance*; rev. as *The Renaissance: Studies in Art and Poetry* (London, 1877; rev. 4/1893; ed. D. L. Hill, Berkeley, 1980)

J. A. Symonds: *The Life of Michelangelo Buonarroti* (London, 1893)

A. Breeskin: *Romaine Brooks: 'Thief of Souls'* (Washington, DC, 1971)

M. Dubsky: *Tom's Pilgrim's Progress among the Consequences of Christianity and Other Drawings* (London, 1981)

P. Eliasoph: *Paul Cadmus* (Oxford, OH, 1981)

S. L. Langer: 'Fashion, Character and Sexual Politics in Some Romaine Brooks Lesbian Portraits', *A. Crit.*, i/3 (1981), pp. 25–40

M. Livingstone: *David Hockney* (London, 1981)

P. Core: Paintings, 1975–1985 (London, 1985) [early monograph on gay artist]

P. Taylor, ed.: *J. Davila: Hysterical Tears* (London, 1985) [early monograph on gay artist]

Cecil Beaton (exh. cat., ed. D. Mellor; London, Barbican A.G., 1986)

K. Sykora: 'Jeanne Mammen', *Women's A. J.*, ix (Fall 1988), pp. 28–31

L. G. Zatlin: *Aubrey Beardsley and Victorian Sexual Politics* (Oxford, 1990)

M. J. McClintock: *Okuhara Seiko (1837–1913): The Life and Arts of a Meiji Period Literati Artist* (diss., Ann Arbor, U. MI, 1991)

P. Taylor: 'Love Story', *Connoisseur*, 221 (Aug 1991), pp. 47–51 [about Robert Indiana]

B. Kurtz: 'Haring's Place in Homoerotic Art', *Keith Haring*, ed. G. Celant (Munich, 1992)

J. Saslow: 'Disagreeably Hidden', *The Expanding Discourse: Feminism and Art History*, ed. N. Broude and M. Garrard (New York, 1992) [about Rosa Bonheur]

M. Auping: *Jess: Grand Collage, 1951–1993* (Buffalo, 1993)

F. V. Hooven: *Tom of Finland: His Life and Times* (New York, 1993)

C. Ockman: 'Profiling Homoeroticism: Ingres's *Achilles Receiving the Ambassadors of Agamemnon*', *A. Bull*, lxxv (1993), pp. 259–74

George Platt Lynes: Photographs from the Kinsey Institute (exh. cat. by J. Crump, New York, Grey Gal. & Stud. Cent., 1993)

R. Mayer: 'Warhol's Clones', *Yale J. Crit.*, vii/1 (Spring 1994), pp. 79–109

SPECIALIST STUDIES
Ancient art

K. Dover: *Greek Homosexuality* (New York, 1978) [ground-breaking study using much visual evidence]

J. Clarke: 'The Decor of the House of Jupiter and Ganymede at Ostia Antica: Private Residence Turned Gay Hotel', *Roman Art in the Private Sphere*, ed. E. Gazda (Ann Arbor, 1991)

——: 'The Warren Cup and the Contexts for Representations of Male-to-male Lovemaking in Augustan and Early Julio-Claudian Art', *A. Bull*, lxxv (1993), pp. 275–94

Medieval art

J. Boswell: *Christianity, Social Tolerance and Homosexuality: Gay People in Western Europe from the Beginning of the Christian Era to the 14th Century* (Chicago, 1980) [ground-breaking study, criticized by Halperin as essentialist]

M. Camille: *The Gothic Idol* (Cambridge, 1989)

J. Boswell: *Same-sex Unions in Early Modern Europe* (New York, 1994)

Renaissance art

J. Saslow: *Ganymede in the Renaissance* (New Haven, 1986)

P. Simons: 'Lesbian (In)Visibility in Italian Renaissance Culture: Diana and other Cases of *donna con donna*', *Gay and Lesbian Studies in Art History*, ed. W. Davis (Binghamton, NY, 1994), pp. 81–122

Photography

A. Foster and R. McGrath: *Behold the Man: The Male Nude in Photography* (Edinburgh, 1988)

T. Boffin and J. Fraser: *Stolen Glances: Lesbians Take Photographs* (London, 1991)

A. Ellenzweig: *The Homoerotic Photograph* (New York, 1992)

Art and AIDS

D. Crimp and A. Rolston: *AIDS Demographics* (Seattle, 1990)

C. Saalfield and R. Navarro: 'Shocking Pink Praxis: Race and Gender on the ACT UP Frontlines', *Inside/Out: Lesbian Theories, Gay Theories*, ed. D. Fuss (New York, 1991)

R. Atkins and T. Sokolowski: *From Media to Metaphor: Art about AIDS* (New York, 1992)

J. Miller, ed.: *Fluid Exchanges: Artists and Critics in the AIDS Crisis* (Toronto, 1992)

CHRISTOPHER REED

Gaya Nuño, Juan Antonio (*b* Soria, 29 Jan 1913; *d* Madrid, 6 July 1976). Spanish art historian, critic and teacher. He was one of the most outstanding figures in Spanish art criticism after the Civil War, and he maintained a position favourable to non-establishment art in his writings at a time of rigid academic reaction. Among his publications, numbering over 600, his *Historia del arte español* (1946), *El arte español en sus estilos y en sus formas* (1949) and *Escultura española contemporánea* (1957) are of particular interest, as are some volumes in the Ars Hispaniae series, particularly that on 20th-century art (1957, 2/1977). He took an active part in the revitalization of avant-garde art in Spain, not only through his writings but in numerous other ways; he organized, for example, the Salones de Otoño in the Galeries Laietanes in Barcelona (1948) and gave lectures at the I Congreso de Arte Abstracto held in Santander in 1953. He was important as a historian of artistic thinking in Spain, a subject he studied and chronicled in his book *Historia de la crítica de arte en España* (1975).

WRITINGS
Historia del arte español (Madrid, 1946)
El arte español en sus estilos y en sus formas (Barcelona, 1949)
Escultura española contemporánea (Madrid, 1957)
Historia de la crítica de arte en España (Madrid, 1975)

M. DOLORES JIMÉNEZ-BLANCO

Gaye, Giovanni (Johann Wilhelm) (*b* Tönning, nr Kiel, 8 Nov 1804; *d* Florence, 26 Aug 1840). German art historian. After school in Meldorp and a short attendance at the College of Slesvic, in 1824 he entered the Faculty of Philosophy at the University of Kiel. In 1825 he moved to Berlin, where he studied under such famous figures as Hegel, Wilhelm Humboldt and Leopold von Ranke (1795–1886). He gained his Laureate of Philosophy from Kiel in 1829 with a dissertation on Erasmus of Rotterdam. The rest of his brief life was spent in Italy, travelling around

until 1835 when he settled in Florence. Here his three-volume *Carteggio inedito d'artisti dei secoli XIV, XV, XVI: Documenti di storia italiana* was published in 1839–40. It was a collection of documents covering many aspects of Italian artists' lives: e.g. contracts, personal letters, tax returns, wills, guild statutes and papers relating to municipal works, individual foundations and governing bodies. Most of the documents were from Florentine archives and were transcribed personally by Gaye. Some, such as those relating to Sienese and Mantuan history, were furnished by Italian colleagues, but it is clear from the many annotations, addenda and corrections that Gaye invariably checked the originals to ensure accuracy. The *Carteggio* set a standard for a number of other more narrowly based collections of documents, for example those edited by MICHELANGELO GUALANDI and GAETANO MILANESI.

WRITINGS

Disquisitionis de vita Desiderii Erasmi (Kiel, 1829)
ed.: *Carteggio inedito d'artisti dei secoli XIV, XV, XVI*, 3 vols (Florence, 1839–40); facs. ed. A. von Reumont (Turin, 1961)

BIBLIOGRAPHY

R. Bülck: 'Johannes Gaye: Ein Schleswig-Holsteinischer Kunstforscher', *Mitt. Ksthist. Inst. Florenz*, x/1–4 (1961–3), pp. 95–105

ANABEL THOMAS

Gaynor, John P(lant) (*b* Ireland, *c.* 1826; *d* San Francisco, CA, 1889). Irish architect, active in the USA. The first record of Gaynor is a listing in the city directory of 1851 of Brooklyn, New York. Although he worked as an architect in Brooklyn and New York for 12 years, only one building has been firmly attributed to him: the Haughwout Building (1856–7) at the corner of Broadway and Broome Street, New York, erected for E. V. Haughwout & Co., china, glass and silverware manufacturers and importers. Loosely modelled after the Libreria Sansoviniana in Venice, the Haughwout Building is considered to be one of the masterpieces of cast-iron architecture (*see* UNITED STATES OF AMERICA, fig. 6 and NEW YORK, fig. 1). The street façades have large ground-floor windows flanked by tall Corinthian columns. Above are four storeys with virtually identical round arches set on Corinthian colonnettes and separated by projecting Corinthian columns. The exterior was originally painted a stone colour called (in 1859) 'Turkish drab'. The utilitarian interior consists of large open spaces with wooden beams supported by cast-iron columns. The iron for the store was cast by Daniel Badger's Architectural Iron Works. The design relationship between Badger and an architect such as Gaynor remains unclear. In 1863 Gaynor left New York for San Francisco. He was responsible for several prominent buildings in the Bay area, notably two sumptuous works for Gold Rush millionaire W. C. Ralston—the extension of his house in Belmont, CA (1865–75; now Ralston Hall, College of Notre Dame), and the Palace Hotel (1873–5; burnt 1906). The Palace was famous for its enormous glass-enclosed carriage court fully surrounded by six storeys of Renaissance-inspired balconies.

BIBLIOGRAPHY

'The Haughwout Establishment', *Cosmopolitan A. J.*, iii (1859), pp. 141–7

Illustrations of Iron Architecture Made by the Architectural Iron Works of the City of New York (New York, 1865); *R as Badger's Illustrated Catalogue of Cast-iron Architecture*, intro. M. Gayle (New York, 1981)
W. Weisman: 'Commercial Palaces of New York: 1845–1875', *A. Bull.*, xxxvi (1954), pp. 285–302
D. Gebhard and others: *A Guide to Architecture in San Francisco and Northern California* (Santa Barbara, 1973)
M. Gayle and E. Gillon: *Cast-iron Architecture in New York: A Photographic Survey* (New York, 1974)
R. Bernhardi: *Great Buildings of San Francisco: A Photographic Guide* (New York, 1980)

ANDREW SCOTT DOLKART

Gayrard, Raymond (*b* Rodez, Aveyron, 25 Oct 1777; *d* Paris, 4 May 1858). French sculptor and medallist. He trained in Paris as a goldsmith with Jean Baptiste Claude Odiot before turning to the engraving of medals; about 1808 he joined the workshop of the gem-engraver and medallist Romain-Vincent Jeuffroy. In 1819 he showed his first work of sculpture, a marble statue in Neo-classical style of *Cupid Testing his Arrows* (untraced), at the Paris Salon. In 1823 he became medal-engraver to Charles X, and he remained a prolific engraver of commemorative and portrait medallions throughout his life. He competed unsuccessfully in the competition (1829) for allegorical sculpture for the pediment of the church of the Madeleine, Paris. That same year, however, he received an official commission for two seated marble statues representing the *Power of the Law* and *Universal Suffrage* for the courtyard of the Chambre des Députés, Palais Bourbon, Paris; these ponderous and academic works were not put in place until 1860. Gayrard was largely excluded from major state commissions during the July Monarchy (1830–48) because of his pro-Bourbon sympathies. Instead, he began to devote himself to religious statuary and funerary monuments in a Neo-classical style; among these works is the tomb of his friend *Denis-Antoine-Luc Frayssinous*, minister of ecclesiastical affairs under Charles X (marble, 1844; St Geniez, Aveyron, parish church). He was also a portraitist, and produced several busts and medallions of private clients (examples in Rodez, Mus. Fénaille), as well as small-scale groups of children and animals with moralizing themes, as in *Child, Dog and Serpent* (marble, exh. Salon 1841; Paris, priv. col.). Under the Second Empire (1851–70) Gayrard was much in demand as a medallist, but he received only one official commission, a bust of *Napoleon III* (marble, 1854; Paris, Acad. N. Médec.). His son and pupil Paul Gayrard (1807–55) was also a sculptor, producing popular family groups and statuettes of actors and animals.

BIBLIOGRAPHY

Bénézit; Forrer; Lami; Thieme-Becker
J. Duval: *Raymond Gayrard* (Paris, 1859, rev. Rodez, 1902)

HÉLÈNE DU MESNIL

Gaywood, Richard (*b c.* 1630; *d* ?London, 1680). English printmaker. He was trained by Wenzel Hollar and later collaborated with Francis Barlow for over fifteen years. Despite the fact that as an etcher Gaywood is clearly the inferior of the two, prints (and sometimes drawings) by Barlow have been wrongly assigned to him from time to time. An example of their close working relationship is the large print of Titian's *Venus and the Organist*, which Barlow dedicated to the virtuoso John Evelyn in 1656 (see Evelyn's *Diary*, ed. E. S. de Beer, Oxford, 1955, iii, p. 166,

n. 5); despite the fact that it is signed by 'his friend' Gaywood, Barlow made it clear to Evelyn that he had engraved all the more important elements in the plate. Although Gaywood was included in William Sanderson's *Graphice* (1658), as one of 'Our Excellent Gravers for Prints', he rarely rose above a pedestrian level of skill. For the undated *Democritus and Heraclitus* (example London, BM) Gaywood copied his figures from paintings by Rembrandt van Rijn, one of which was *Judas Returning the Thirty Pieces of Silver* (1629; Mulgrave Castle, N. Yorks); this is probably the earliest English print made after that Dutch master.

BIBLIOGRAPHY

H. Walpole: *Anecdotes of Painting in England* (1762–71); ed. R. N. Wornum (1849)

'The Note-books of George Vertue', *Walpole Soc.*, xx (1932); xxiv (1936); xxix (1947) [index]

R. T. Godfrey: *Printmaking in Britain: A General History from its Beginnings to the Present Day* (Oxford, 1978), pp.22–3

E. Hodnett: *Francis Barlow: First Master of English Book Illustration* (London, 1978)

RICHARD JEFFREE

Gazebo. Garden house built on a terrace, with views to a road outside or the distant countryside. Until the 1830s, when 'belvedere' became the more acceptable term, small turrets on a roof-top were also described as gazebos, as were Maltese mirador windows. The term, with its implied meaning 'I will look out', was coined whimsically in the early 18th century using the Latin future tense ending, but the type of structure it describes developed in the reign of Queen Elizabeth I from the less ambitious forms of the medieval garden mount.

The compact houses of the English Renaissance afforded neither the privacy nor the viewpoints that had been common in the towered domestic castles of the late Middle Ages. Gazebos developed to supply these two advantages, and both Longleat House, Wilts (*c.* 1572), and Hardwick Hall, Derbys (1591–7), have prospect rooms on their roofs. As garden design in this period grew more ambitious, it became usual for these to be built, often in pairs, on a terrace. From there, the parterres could be viewed and, away from prying servants, alfresco meals enjoyed. Governor Spotswood's residence at Williamsburg, Virginia (USA), had matching gazebos built as late as 1740, but in England after 1700 single structures on sites overlooking roads (with their increasing carriage traffic) were more popular. Reginald Blomfield revived the gazebo as a popular garden building type, and the Edwardian gardens of Edwin Lutyens and Gertrude Jekyll often featured them, both singly and in pairs.

See also BELVEDERE and PAVILION, §3.

BIBLIOGRAPHY

R. Blomfield: *The Formal Gardens of England* (London, 1892)

R. Strong: *The Renaissance Garden in England* (London, 1979)

M. Girouard: *Robert Smythson and the Elizabethan Country House* (London, 1983)

TIM MOWL

Gazini. *See* GAGINI.

Gazzar [Elgazzar; Jazzār, 'Abd al-Hādī al-]**, 'Abd al-Hadi al-** (*b* Alexandria, March 1925; *d* 7 March 1966). Egyptian painter. He showed an early interest in art, and at the secondary school of al-Halmiyya in Cairo was taught by the Egyptian painter Hussein Youssef Amin. While at this school, he won a prize for his poster for a government health programme. In 1944 he began to study at the School of Fine Arts in Cairo, and was one of the younger members of the Contemporary Art Group founded in 1946 by Amin. By the late 1940s he was introducing in his paintings literary and philosophical references, as well as highly original and nightmarish images. In 1949 he was arrested with Hussein Youssef Amin because his painting *Hunger* (retitled *Theatre of Life*, 1948; artist's col., see Karnouk, p. 31) was considered an attack on the government. Both were released following the intervention of the Egyptian painters Muhammad Nagy and Mahmud Said.

In 1950 al-Gazzar completed his degree and began to teach at the School of Fine Arts, and from 1958 to 1961 he studied for a degree at the Accademia di Belle Arti, Rome. His first one-man exhibition took place in 1951 at the Museum of Modern Art, Cairo. In 1952 he exhibited with Ibrahim Mas'ud in Cairo, and in 1955 held another one-man exhibition at the Egyptian Academy of Fine Arts, Rome. He also exhibited at the annual 'Salon' in Cairo, and in 1957 at the Contemporary Art Exhibition in the Museum of Modern Art, Cairo. In Alexandria his work appeared at the sixth Biennale in 1966. His last one-man exhibition was held in the Akhnaten Gallery in Cairo. He also exhibited his work abroad, including the Venice Biennale from 1956 to 1960, and the São Paulo Biennale from 1957 to 1961.

Al-Gazzar's themes and images were inspired by a range of subjects, such as Egyptian magic symbolism, the popular arts, urban low life, and later modern science. *Folk Poem* (1953; Cairo, MOMA, see Karnouk, p. 44) reflects his interest in Egyptian themes, and *Night and Day* (1957; priv. col., see al-Sharuni, p. 74), combines images from daily life and from dreams as a background to the pharaonic figure of the goddess Nut. His work also reflected the political preoccupations of his day, whether in international affairs or national problems: *High Dam* (1964; priv. col., see Karnouk, p. 53) records the construction of the high dam at Aswan, and shows his preoccupation with modern science and technology.

BIBLIOGRAPHY

S. al-Sharuni: *'Abd al-Hādī al-Jazzār: Fannān al-asātīr wa 'ālam al-faḍā'* (Cairo, 1966)

E. Naguib: *Themen der ägyptischen Malerei des 20. Jahrhunderts* (Cologne and Vienna, 1980)

L. Karnouk: *Modern Egyptian Art: The Emergence of a National Style* (Cairo, 1988)

S. J. VERNOIT

Gazzini. *See* GAGINI.

Gdańsk [Ger. Danzig]. Polish city and port on the Baltic coast and the Motława and Leniwka rivers. Its history is a story of changing ownership from the dukes of Gdańsk and Pomerania (12th century to 1308) to the Teutonic Knights (1308–1454), the Kingdom of Poland (1454–1795), and Prussia (1793–1918), with two periods of independence (1807–15; 1919–39). Since 1945 it has formed part of Poland.

The town's name first appears as 'urbs Gyddanyzc', AD 997, in the *Life of St Adalbert*. It formed part of the estate of the dukes of Gdańsk and Pomerania, who granted

the town specific privileges in 1235. The church of St Mary was founded in 1240 by Świetopełk II, Duke of Gdańsk (d 1266). In 1308 the dukes invited the Teutonic Order to help defend the town from the Duke of Brandenburg. Once in control of the town and the west bank of the Vistula River, the Teutonic Order maintained occupation of Gdańsk for 146 years. The knights constructed a castle (destr. 1454) and financed the building of the Radunia Canal and the Great Mill. The medieval town was made up of four distinct areas: Main Town, centred on Długi Targ (Long Market; see fig.), the principal market street; Old Town, centred on the residence of the Dukes of Gdańsk and later the Teutonic Knight Commanders; Osiek, the Slav fishing settlement to the north; and New Town, west of Osiek. As the historic nucleus, Main Town was based on a comb-pattern urban layout characterized by a dense network of streets running parallel to the harbour, with no market square. The quays along the Motława functioned as the market-place, and the streets leading to them were used for transporting goods to the merchants' cellars and warehouses. This follows a pattern established at Lübeck and Elbing (Pol. Elbląg).

In 1343, after 74 years of occupation, the Teutonic Order relaxed its grip on the town and granted permission for the construction of fortifications; defensive walls were built (1343–1410), together with sixteen gates, nine of which faced the river. The year 1343 marked the beginning of the first period of important building activity, which lasted to c. 1500. The principal and the most dominating building was St Mary's. The first brick church was built 1343–60 in the heart of the Main Town as a six-bay basilica with a western tower and no transept. In 1379 a contract was signed with Heinrich Underadin (fl 1371–1400) that marked the beginning of a grand plan to construct a new church, with transepts and an enlarged east end and nave, capable of holding 24,000 people. The east end of the church was completed in 1447, and the west end followed

in 1484–1502, with cellular and net vaulting. Many of the original fittings and altars of the church have survived in situ, including the Gdańsk Schöne Madonna of c. 1420 and the giant Pietà by the same sculptor. The church originally housed Master Francke's Last Judgement altarpiece (c. 1435; Warsaw, N. Mus.) and Hans Memling's Last Judgement altarpiece (1467; Gdańsk, N. Mus.; see MEMLING, HANS, fig. 1), which was captured by pirates and donated to the church in 1473. Two important secular buildings in Main Town also belong to this period: the Town Hall and Arthur's Hall (see fig.). The former was built in 1379–82 as a two-storey block with representative rooms on the upper floor. The architectural programme was further developed in 1486–92 with the addition of a third storey, a tall tower and a show gable facing the market street. This development was inspired by the Oosterlingenhuis (destr.) in Bruges (see BRUGES, fig. 2). Arthur's Hall, the meeting place of the guilds and trades, dates from 1380, but was also later rebuilt (see below).

In 1454 the Teutonic Order was overthrown by national events and a popular uprising in Gdańsk, and the city was incorporated into the Kingdom of Poland. A series of royal charters set out by King Kasimir Jagiellon (reg 1446–92) for Gdańsk between 1454 and 1477 stimulated artistic and economic development. After 1454 a further five gates were constructed together with the Crane, a defensive gateway situated on the Motława and incorporating a powerful goods lift. Arthur's Hall was remodelled in 1476–81 using columns from the Teutonic Knights' Castle. The building took the form of a three-aisled hall; the front gable and façade were altered in 1552. Other buildings belonging to this period are the Hall of the Confraternity of St George (1487–94; by Hans Glothau), the double convent of St Brigid (destr. 1840) and the Oliwski Granary.

Renaissance styles, which reached Gdańsk in the mid-16th century, developed quite independently of the mainstream Polish Renaissance style in Kraków. Through its

Gdańsk, Long Market, showing the Town Hall, with Arthur's Hall on the right; engraving, c. 1765, after a drawing by F. A. Lohrmann

location Gdańsk was brought into contact with developments in the Netherlands, and three artists dominated all major projects: the architect Antonis van Obberghen, the sculptor Willem van den Blocke and his son, the sculptor and architect Abraham van den Blocke. The van den Blockes arrived in Gdańsk in 1584 and van Obberghen came two years later. Renaissance building activity in the city tied in with these dates and constituted the second period of significant architectural development. The most important Renaissance building is the Great Arsenal, built in 1601–9 by Obberghen (for illustration *see* OBBERGHEN, ANTONIS VAN). The three-storey brick building has stone detailing with allegorical military emblems based on popular Mannerist models by Hans Vredeman de Vries and Cornelis Floris, both of whom visited Gdańsk. The Mannerist style extended to the city gates, notably Upland Gate (1586–8), designed by Willem van den Blocke, and Golden Gate (1612–14), as well as to the Royal Granary (1606–8; designed by Abraham) and the important residences that lined key arteries. Narrow gabled houses such as the House of the Abbots of Pelplin (1612) follow a type developed in the Netherlands and along the Baltic coast. In 1616–17 Abraham undertook the final, Mannerist remodelling of the façade of Arthur's Hall (see fig.). Willem and Abraham van den Blocke were also responsible for a number of tombs, many of which were commissioned from outside Gdańsk. The city was famous, especially in this period, for its decorative arts (for furniture and metalwork *see* POLAND, §§VI and IX, 1 and 2). The craftsmen working in amber (with their own guild from 1477) produced outstanding ornamental objects, including jewellery, cups, caskets, figurines and furniture inlays, and their craft flourished from the 16th century to the 19th. (For 17th-century painting in Gdańsk *see* POLAND, §III, 3 and BLOCKE, (3).)

From *c.* 1530 the western walls of Gdańsk were replaced by earthworks resistant to artillery bombardment. A further ring of fortifications consisting of 14 towers, 3 gates, a moat and a stone sluice was built in 1620–35 to the designs of Cornelius van den Bosch. These measures proved effective, and assaults on Gdańsk by Swedish forces in 1656, 1657 and 1659 were unsuccessful. Major building activity slowed down in the Baroque period. The Royal Chapel was built (1676–81) to the north of St Mary's as a Catholic statement, at the request of King John Sobieski (*reg* 1674–96). The design of this church is attributed to Tylman van Gameren. It was completed by the historian Barthel Ranisch (*c.* 1648–1701), who took responsibility for the design of numerous other sacred works, including the Carmelite convent (1646–50; destr. 1741), the Jesuit church (1676–77) and the north wing of Corpus Christi (1687–88). Several important granaries were built in this period, for example 53 Chmielna Street (Wisłoujście) and 59 Chmielna Street (Pod Koroną).

The Swedes attacked Gdańsk again in 1734, and once more the siege was resisted. The city continued to improve its defences, and two outlying hills on the outskirts were fortified *c.* 1830, although demolition of the gates and ramparts began in 1870. The medieval centre survived until the mid-19th century. Soon, with the growth of population, the expanding railway network and the promotion of the town to the status of capital of Western

Prussia (1878), streets were widened, burghers' houses and terraces demolished and the fortifications removed. Following the Treaty of Versailles (1919), the Free City of Gdańsk was established as an artificial political creation, consigned to the League of Nations. As a result, Poland developed a rival port in neighbouring Gdynia. On 1 September 1939 the battleship *Schleswig Holstein* opened fire on the Army Depot at Westerplatte on the outskirts of Gdańsk, thus beginning World War II, in the course of which the city was seriously damaged. It was returned to Poland in 1945, with 55% of the buildings in ruins; the Main Town was reconstructed after the war. In 1970 and 1980 Gdańsk witnessed popular uprisings and the rise of the political movement 'Solidarity'. A monument commemorating the events of 1970 was erected in 1980 at the gates of the Lenin Shipyard. It was designed by Bogdan Pietruszka and consists of three giant crosses with anchors and relief sculpture.

BIBLIOGRAPHY
P. Simson: *Geschichte der Stadt Danzig* (Danzig, 1913)
W. Drost: *Die Marienkirche in Danzig und ihre Kunstschätze* (Stuttgart, 1963)
E. Cieślak: *Historia Gdańska* (Warsaw, 1978)
J. Grabowska: *Polish Amber* (Warsaw, 1983)

JACK LOHMAN

Ge [Gay], Nikolay (Nikolayevich) (*b* Voronezh, 27 Feb 1831; *d* Ivanovsky farm [now T. G. Shevchenko farm], Chernihiv region, Ukraine, 13 June 1894). Russian painter. The son of a landowner and grandson of a French nobleman who emigrated during the French Revolution, he initially studied in the departments of mathematics of Kiev and St Petersburg universities (1847–50). In 1850 he enrolled at the Academy of Arts, St Petersburg, from which he graduated in 1857. During his time at the Academy he was strongly influenced by Karl Bryullov and Aleksandr Ivanov. He worked in Rome and Florence (1857–69), in St Petersburg and, from 1876, on his farm in Chernihiv region. He was one of the founder-members of the WANDERERS (Peredvizhniki).

Ge's first important picture was the *Last Supper* (1863; St Petersburg, Rus. Mus.), in which he eschewed the traditional idealized treatment of the religious subject, presenting it as a realistic psychological drama. The work became the focus of public attention, since the opposition of Christ and Judas and the theme of apostasy were connected in the public mind with the discord and division in Russian political movements of the 1850s and 1860s, which lent the subject a topical social and psychological resonance. His other most important accomplishment in this period was the celebrated portrait of the writer and political thinker *Aleksandr Herzen* (1867; Moscow, Tret'yakov Gal.), which is compelling in the peculiar spiritual intensity of its characterization. Ge displayed virtuosity in the handling of dramatic dialogue in his *Peter I Interrogating the Tsarevich Aleksey Petrovich at Peterhof* (1871; Moscow, Tret'yakov Gal.), which embodies wide-ranging historical and philosophical thought on the important years of the Petrine reforms.

Ge gradually came to occupy a unique position in post-Romantic Russian art, anticipating the artistic quests of the 20th century in the passionate expressiveness of his

work. In terms of iconography and ideas the determining influence on Ge from the 1880s onwards was the religious teaching of Lev Tolstoy, who became a close friend. Ge's works moved towards a broad painterly style, pushing contrasts of colour and of light and shade to the limit. His innovations as a painter show him to have been a founder of the 'proto-Expressionist' tendency in Russian art. Notable among the works marking the opening of this new period, *What is Truth?* (1890; Moscow, Tret'yakov Gal.), in which Christ is shown before Pilate who puts his ironic question to him, represents, in the words of Tolstoy, 'an epoch in Christian painting', inasmuch as, instead of 'treating Christ as God', it conveys 'a moral concept of [his] life and teachings' (letter to George Kennan, 3 Aug 1890). The demythologization of Christian doctrine and the rejection of liturgical dogma in order to achieve an earnest ethical and psychological appeal is particularly pronounced in the unfinished *Golgotha* (1893; Moscow, Tret'yakov Gal.) and two versions of a *Crucifixion* (both 1892; untraced). Such works drew sharp criticism from the Church and conservative circles, but religious dissidents often hung reproductions on their walls as 'Tolstoyan icons'. Alongside his religious paintings, Ge produced remarkable portraits with a haunting inner spirituality (e.g. of *Lev Tolstoy*, 1884, and of *N. I. Petrunkevich*, 1893; both Moscow, Tret'yakov Gal.), and he made an original contribution to landscape.

WRITINGS
N. N. Ge: Pis'ma, stat'i, kritika, vospominaniya sovremennikov [N. N. Ge: letters, articles, criticism, reminiscences by contemporaries] (Moscow, 1978)

BIBLIOGRAPHY
V. I. Porudominsky: *N. Ge* (Moscow, 1970)
E. N. Arbitman: *Zhizn' i tvorchestvo N. N. Ge* [The life and work of N. N. Ge] (Saratov, 1972)

M. N. SOKOLOV

Gebeil [anc. Gebal]. *See* BYBLOS.

Gebel, Matthes (*b c.* 1500; *bur* Nuremberg, 22 April 1574). German medallist. On the occasion of being granted the citizenship of Nuremberg in 1523 he was described as a wood-carver. It seems likely that Nuremberg's adoption in 1525 of the Reformed faith obliged Gebel to look for other work, since none now came from the Church. The first medal definitely attributable to him is also one of his most famous: that of *Albrecht Dürer* (Nuremberg, Ger. Nmus.), struck in 1527. It shows the painter with short hair and was to become for future ages the definitive portrait of him in old age. In 1528, after Dürer's death, this medal was reissued with an altered reverse. In 1529 and 1530 Gebel travelled to the imperial diets in Speyer and Worms to obtain commissions for portrait medals.

Gebel did not belong to any guild but was among those practising the 'freie Künste': the fact that in 1534 he was singled out by name in Nuremberg city ordinances concerning medallists who were free craftsmen suggests that he was regarded as the most important Nuremberg medallist of his day, an assumption supported by his works, which include a silver medal of *Georg Hermann* (1529) and a bronze medal of *Georg Kress* (1544; both Nuremberg, Ger. Nmus.). Habich ascribes 350 medals to him, the last dating from 1555, of which only a small

number from the years 1542 and 1543 are marked with the initials MG. They are almost all two-sided and are extremely thin casts in silver, bronze or lead. The portrait sides are distinguished by strong individualization and fine plastic modelling, with highly detailed handling of hair and beards and rich rendering of costume. Gebel was always most careful to establish a connection between portrait and inscription: the reverse of each medal almost always shows the subject's coat of arms, with splendid helm and mantling. There exist numerous models by Gebel, carved in stone from Kelheim or Solnhof, and their fine detail is evidence of his extremely painstaking craftsmanship. Matthes Gebel has been revealed by Hampe's work as the most prolific medallist in Nuremberg in the Renaissance period; previously his medals had been ascribed to Peter Flötner or Ludwig Krug. Occasional variations in the quality of his medals suggest that he had a fairly large workshop, employing several collaborators.

BIBLIOGRAPHY
Forrer; *NDB*; Thieme–Becker
T. Hampe: 'Zu Matthes Gebel', *Festschrift des Vereins für Münzkunde in Nürnberg* (Nuremberg, 1907), pp. 37–48
G. Habich: *Die deutschen Schaumünzen des 16. Jahrhunderts*, i (Munich, 1931), pp. 140–78
W. Vöge: 'Bildwerke deutscher Medailleure', *Jb. Preuss. Kstsamml.*, liii (1932), pp. 141–8
M. Bernhart: 'Kunst und Künstler der Nürnberger Schaumünze des 16. Jahrhunderts', *Mitt. Bayer. Numi. Ges.*, liv (1936), pp. 12–19
A. Suhle: *Die deutsche Renaissance-Medaille* (Leipzig, 1950), pp. 52–62
M. Mende: *Dürer-Medaillen* (Nuremberg, 1983), pp. 82–93, 208–34
H. Maué: 'Nürnberger Medaillen, 1500–1700', *Wenzel Jamnitzer und die Nürnberger Goldschmiedekunst* (exh. cat., ed. K. Pechstein, R. Schürer and M. Angerer; Nuremberg, Ger. Nmus., 1985), pp. 153–4, 443–7
——: 'Die Anfänge der deutschen Renaissancemedaille', *Gothic and Renaissance Art in Nuremberg* (exh. cat., New York, Met.; Nuremberg, Ger. Nmus.; 1986), pp. 106–7, 419–23

HERMANN MAUÉ

Gebel Barkal. *See under* NAPATA.

Gebelein [Arab.: 'the two mountains'; anc. Egyp. Inerti: 'the two hills'; Gr. Pathyris]. Ancient Egyptian site *c.* 28 km south of Luxor on the west bank of the Nile, which flourished from Predynastic times (4th millennium BC) to the Greco-Roman period (*c.* 332 BC–AD 395). Excavations carried out between 1910 and 1937 by the Museo Egizio in Turin uncovered an extensive Predynastic period necropolis that yielded quantities of Naqada II (*c.* 3500– *c.* 3000 BC) types of black-topped ceramic ware, small schist statues of bearded male heads, and a unique textile fragment painted in red, black and white with scenes from a hippopotamus hunt (see fig.). The oldest temple of Hathor known in Egypt was constructed at Gebelein during the 3rd Dynasty (*c.* 2650–*c.* 2575 BC), and worship of the goddess continued at the site into the Roman period. Reliefs and votive objects from the sanctuary are now in the Museo Egizio, Turin. Extensive First Intermediate Period (*c.* 2150–*c.* 2008 BC) remains from Gebelein include the brick tomb chapels of Ini and Iti. Both tombs are decorated with scenes of agriculture and daily life in a regional style characterized by angular, etiolated figures and harsh colour combinations (Turin, Mus. Egizio). A fine painted offering stele of a Nubian mercenary (Boston, MA, Mus. F.A.) is one of the earliest depictions to differentiate Nubians by a darker skin colour. Gebelein's

Gebelein, fragment of painted linen cloth depicting a hippopotamus hunt (entire sheet 0.95×2.00 m), 4th millennium BC (Turin, Museo Egizio di Torino)

continuing importance during the Middle Kingdom is attested by stelae and inscriptions of several kings of the 12th and 13th dynasties (*c.* 1938–*c.* 1630 BC). The evidence for the New Kingdom (*c.* 1540–*c.* 1075 BC) and Third Intermediate Period (*c.* 1075–*c.* 750 BC) is sparser, although there are architectural fragments from the reign of Pinedjem I. The site has also proved to be a rich source of Greco-Roman period papyri.

LÄ

BIBLIOGRAPHY

E. M. Frazer: 'Excavations by the Egypt Exploration Fund at al-Gebeleyn', *Proc. Soc. Bibl. Archaeol.*, xv (1892–3), pp. 496–500
P. Posener-Krieger: 'Les Papyrus de Gébelein: Remarques préliminaires', *Rev. Égyp.*, xxvii (1973), pp. 211–21
E. D'Amicone: 'Arte minore nel Museo Egizio di Torino', *Egitto e società antica: Atti del convegno: Torino, 1984*, pp. 27–40
E. Leospo: 'Un cantiere torinese: La tomba dipinta di Gebelein', *Egitto e società antica: Atti del convegno: Torino, 1984*, pp. 9–19

ELVIRA D'AMICONE

Gebel el-Arak. Ancient Egyptian site on the east bank of the Nile near Nag Hammadi, where a ripple-flaked flint knife dating to the Late Predynastic Period (*c.* 3000 BC; Paris, Louvre, E. 11517) was discovered, an important piece of evidence for the crucial formative phase of Egyptian civilization. The knife was purchased by the French Egyptologist Georges Bénédite in 1894; its original archaeological context is uncertain. Its handle, carved from a single hippopotamus tusk, is decorated on both sides with finely engraved representations in a style that is considered to be more Syrian or Mesopotamian than Egyptian. One face of the handle bears a representation of a variety of wild animals, including two lions held apart by a man wearing a long robe and unusual headgear. Both the costume and the distinctive motif of a man between two beasts are Mesopotamian in origin. The other side has scenes of hand-to-hand fighting between foot-soldiers and a naval battle: both the naval scene and the human 'hero' figure between lions are similar to those depicted in the 'decorated tomb' at Hierakonpolis. The conflict on the Gebel el-Arak handle is between two different types of boat: the familiar crescent-shaped Egyptian papyrus skiff and another type with an almost vertical prow. It has therefore been suggested that the decoration on the knife-handle records a specific military encounter between Egyptians and Near Eastern (or perhaps Libyan) invaders; the wild animals and battle scenes, however, should perhaps be interpreted more loosely as an indication of the widespread conflict that preceded the establishment of a unified Egyptian state.

LÄ

BIBLIOGRAPHY

G. Bénédite: 'Le Couteau de Gebel el Arak', *Mnmts Piot*, xxii (1916), pp. 1–34
J. Vandier: *Les Époques de formation: La Préhistoire* (1952), I/i of *Manuel d'archéologie égyptienne* (Paris, 1952–78), pp. 533–9
H. Asselberghs: *Chaos in beheersing: Documenten uit aeneolithisch Egypte* [Chaos in command: documents from late Neolithic Egypt] (Leiden, 1961), pls xxxviii–lxi
A. L. Kelley: 'The Evidence for Mesopotamian Influence in Predynastic Egypt', *Newslett. Soc. Study Egyp. Ant.*, iv/3 (1974), pp. 2–11
——: 'A Review of the Evidence Concerning Early Egyptian Ivory Knife Handles', *Anc. World*, vi (1983), pp. 95–102
R. M. Boehmer: 'Gebel-el-Arak- und Gebel-el-Tarif-Griff: Keine Fälschungen', *Mitt. Dt. Archaol. Inst.: Abt. Kairo*, xlvii (1991), pp. 51–60

IAN M. E. SHAW

Gebel el-Mawta. *See under* SIWA OASIS.

Gebel el-Silsila [Gabal al-Silsila]. Ancient Egyptian site on a mountain ridge of the Upper Nile valley, *c.* 65 km north of Aswan, directly bordering the river. It is famous for its immense sandstone quarries (open and in galleries), the largest of which are in the east. These supplied the material for many temples in the region of Thebes, from the 18th Dynasty (*c.* 1540–*c.* 1075 BC) to the Roman period (30 BC–AD 395). The sandstone here is very solid and of excellent quality, and it could be quarried easily and in inexhaustible quantities. Shipping was equally easy. In the quarries there are many royal stelae (especially of Amenophis III and IV and Sethos I), commemorative tablets of officials, and innumerable Egyptian and Greek graffiti and quarry marks that attest to those activities. Many graffiti on the west bank date back to the Middle Kingdom and the 11th Dynasty (*c.* 2081–*c.* 1938 BC), some even to the early 6th Dynasty (*c.* 2325–*c.* 2150 BC). The quarries belonged to an ancient settlement called Kheny, located north of the mountain on the east and known since the Middle Kingdom. Here the crocodile god Sebek was worshipped.

The most important monument is the well-preserved speos of King Horemheb (*reg c.* 1319–*c.* 1292 BC) on the west bank, comprising only two rooms, a wide, large portico with a pillared front and a small axial sanctuary. It was dedicated to the Theban triad Amun, Mut and Khonsu, the local gods Sebek, Thoeris and Thoth, and Horemheb himself. All of them are present in a group of seven cult-statues in a niche in the rear wall of the sanctuary, preceded by long rows of other gods in the reliefs of the lateral walls. In the gallery (see fig.) only a small section of the walls was decorated by Horemheb. These reliefs of his triumphant return with his army from a Nubian campaign are, however, famous for their scenery and the exquisite sculpture typical of the post-AMARNA STYLE period. In the subsequent Ramessid period many kings and officials left their memory here all round the walls and pillars in the form of statue niches, stelae and innumerable graffiti.

About 750 m south of the speos, three contiguous, porch-like 'Nile shrines' with nearly identical decoration (Sethos I, Ramesses II and Merneptah) and a large stele (Ramesses III) mark a place of offerings twice a year to the Nile god. North of them is a long line of 32 small funerary shrines, cut in the cliff above the river by high officials of the 18th Dynasty, mostly under Hatshepsut and Tuthmosis III. Another series of shrines, different in form and function and further away from the river, was built high up on the east bank in honour of Amenophis III. Here, in one of the quarries, three monumental ram-headed sphinxes, damaged or unfinished, have been left unshipped.

BIBLIOGRAPHY

LÄ: 'Gebel es-Silsile'

R. A. Caminos and T. G. H. James: *Gebel es-Silsilah: The Shrines* (London, 1963)

JÜRGEN OSING

Gébelin, François (*b* Bordeaux, 27 Feb 1884; *d* Paris, 17 Jan 1972). French historian, archivist, paleographer and writer. He was chief librarian at the Cour de la Cassation. An expert on Renaissance architecture, sculpture and history, he established precise chronologies of events, and

Gebel el-Silsila, speos of Horemheb, gallery (*c.* 1300 BC), view to the north

revised the generally accepted view of the Italian influence on the French Renaissance. In his *Les Châteaux de la Renaissance* he refuted the common assumption that the Italianate architecture seen in France during the reigns of Louis XII and Francis I was built by Italians working in France. He argued instead that much of it was the product of French masons, and maintained that the arrival of Sebastiano Serlio at the French court had led to the dispersal of Italian Renaissance styles among French craftsmen, which had reached a peak in the work of the French architect Pierre Lescot, at the end of Francis I's reign. Under Henry II, a less Italian, more indigenous style was seen. In *Les Châteaux de la France* Gébelin established an encyclopedic history of French châteaux. He claimed that, except for Chambord, none of the Loire châteaux was architecturally original; this he attributed to the fierce jealousy of the royal masons who, eager to maintain their privileged status, were hostile to new styles.

WRITINGS

Les Châteaux de la Renaissance (Pau, 1927)
Les Châteaux de la Loire (Paris, 1931)
Versailles (Paris, 1939)
Le Style Renaissance en France (Paris, 1942)
Les Trésors de la Renaissance: La Sculpture en Italie et en France (Paris, 1947)
Les Châteaux de la France (Paris, 1962)

□

Gebrawi, Deir el- [Dayr al-Gabrawi]. Site in Egypt, *c.* 5 km north of Asyut, that was the necropolis of the governors of the 12th Upper Egyptian nome in the 6th Dynasty (*c.* 2325–*c.* 2150 BC). The nomarchs and other important officials were buried in two groups of rock-cut tombs. The earlier, northern, group comprises 104 tombs, although very few of these preserve any trace of decoration. In time the necropolis was moved eastwards, and this led to the formation of the more important southern group of 52 tombs. The tombs of Ibi and Djau are large and fully decorated, while seven others preserve the names of their owners. The tomb of Ibi (no. 8) has a rectangular chamber, which originally had two square pillars, with a deep niche in the back wall. In addition to the main burial pit there were two others, one of which was intended for

Ibi's wife. The upper parts of all walls are covered in plaster decorated with paintings. The walls to either side of the doorway depict Ibi fishing and fowling; the shorter side walls contain a biographical text, agricultural scenes and a procession with dancing girls; on the back wall are more agricultural scenes and depictions of craftsmen at work. The niche contains false doors, lists of offerings and prayers. Some of the scenes were reproduced in the 26th Dynasty (664–525 BC) in Theban Tomb no. 36.

The tomb of Djau (no. 12) lies to the west of Ibi's and is similar in plan. It lacks the pillars and has a rock ledge in the niche. The content of the painted scenes is also similar and slightly better executed (the decoration was completed by Djau's son, who was buried in the same tomb), and the offering niche contains false doors and offering lists to both Djau and his son. Several of the tombs were later occupied by Christian hermits; near by is the site of the church of St Victor of Antioch.

BIBLIOGRAPHY
N. de G. Davies: *The Rock Tombs of Deir el-Gebrawi* (London, 1902)

PHILIP J. WATSON

Gebtu. *See* KOPTOS.

Gechter, (Jean-François-)Théodore (*b* Paris, 1796; *d* Paris, 11 Dec 1844). French sculptor. Like Antoine-Louis Barye, Gechter was a pupil of François-Joseph Bosio and Baron Gros. His first Salon exhibits in 1824 had heroic Classical and mythological subjects. After 1830 he followed the example of Barye in turning to small-scale sculpture, usually including animals, but without Barye's zoological bias. After being shown at the Salon in 1833, his *Combat of Charles Martel and Abderame, King of the Saracens* (Meaux, Mus. Bossuet) was commissioned in bronze by the Ministry of Commerce and Industry. Although occasionally—as in *The Engagement (Egyptian Expedition, 1798)* (exh. Salon, 1834; untraced)—Gechter treated recent history, his predilection was for elaborately costumed battle or hunting scenes from the medieval or Renaissance period. Usually such pieces, with their frozen groupings, their emphasis on costume and their intricacy, belong to the genre known as Troubadour. Exceptionally Gechter could strike a more emotive note in his statuettes, as in *Death of Tancred* (bronze, exh. Salon 1827; silvered bronze, e.g., Paris, Louvre) or *Wounded Amazon* (bronze, exh. Salon 1840; untraced). Gechter received several important public commissions: a marble relief of the *Battle of Austerlitz* (1833–6) for the Arc de Triomphe; marble allegories of the Rhine and the Rhône for one of the fountains in the Place de la Concorde (1839); a *St John Chrysostom* (marble, 1840) for the Madeleine; and a marble statue of *Louis Philippe* in coronation robes, commissioned in 1839 (Versailles, Château).

BIBLIOGRAPHY
Lami
The Romantics to Rodin (exh. cat., ed. P. Fusco and H. W. Janson; Los Angeles, CA, Co. Mus. A., 1980)
G. Schiff: 'The Sculpture of the "Style Troubadour"', *A. Mag.*, lviii/10 (1984), pp. 102–10

PHILIP WARD-JACKSON

Geddes, Andrew (*b* Edinburgh, 5 April 1783; *d* London, 5 May 1844). Scottish painter and etcher. After his father's death he went in 1806 to study at the Royal Academy Schools in London, but he was largely self-taught when he set up as a portrait painter in Edinburgh in 1810. He was encouraged by his close friend Sir David Wilkie. He went to Paris in 1814 and was then chiefly based in London. In 1827 he married Adela, daughter of the miniaturist Nathaniel Plimer (1757–1822). He visited Rome in 1828 and travelled on the Continent, returning early in 1831. He was influenced by Rubens and Rembrandt and went to Holland in 1839, but his style remained rather linear. He was probably more successful as an etcher than as a painter in oil or watercolour. He painted and etched copies of Old Masters, of which he had a considerable collection, and was able to adopt different styles of painting appropriate to the period of his historical and 'fancy' pictures. He also produced biblical pictures (e.g. *Devotion*, exh. RA 1832; untraced), costume pieces and landscapes. He was elected ARA in 1832. The contents of his studio were auctioned at Christie's, 8–12 April 1845.

BIBLIOGRAPHY
DNB
Mrs Geddes: *Memoirs of the Late Andrew Geddes* (London, 1844)
C. Dodgson: *The Etchings of David Wilkie and Andrew Geddes: A Catalogue* (London, 1936)

ROBIN SIMON

Geddes, Norman Bel. *See* BEL GEDDES, NORMAN.

Geddes, Patrick (*b* Ballater, Perthshire, 2 Oct 1854; *d* Montpellier, France, 17 April 1931). Scottish scientist, urban planner, teacher and writer. He studied in London (1874–8) under the natural scientist Thomas Huxley and from 1878 at the University of Paris. In France he was introduced to the social theories of Frederic Le Play (1806–82) and Elisée Reclus (1830–1905), which shaped his future work decisively. After extensive travels in Europe and South America, Geddes returned to Edinburgh in 1880. From 1889 to 1919 he held the chair of Botany at Dundee University, while working mostly in Edinburgh. He quickly established a reputation as a radical and unconventional thinker. His basic concern was social change and the relationship between society and its environment, which for Geddes were inextricably linked. In his view, only the interaction of social processes and spatial form could bring about social change. Thus he developed the idea of 'civics', the study of social and environmental planning, and he initiated the Edinburgh summer meetings (1887–99), annual summer schools covering a wide range of subjects and promoting the study of civics, sociology and geography.

Geddes tried to put his ideas into practice in the slums of the Edinburgh Old Town, where he worked with philanthropic organizations to improve the environment of its inhabitants. His 'conservative surgery' approach encompassed the conservation of the essential social structure of communities while rehabilitating the physical fabric. He also built the first self-governing halls of residence for Edinburgh University, Ramsay Lodge (1894) and the Arts and Crafts-inspired Ramsay Gardens (1893), a cooperative block of flats in the shadow of Edinburgh Castle. The Outlook Tower (1895), a museum embodying the stages of cultural and environmental evolution, was conceived as the first of a worldwide chain of 'living' museums.

Geddes's theories of urban and regional planning were based on local surveys detailing the interdependence of all aspects of life and their relation to spatial form. He first put this into practice with his survey of Dunfermline, Fife, (1903). This approach exerted a major influence on the emerging discipline of urban planning and on its leading figures, including Patrick Abercrombie and Raymond Unwin. A dedicated internationalist, Geddes organized the first International Conference on Town Planning in London in 1910, and in 1914 he was a founding member of the Town Planning Institute. For its 1910 conference he devised the *Cities and Town Planning* exhibition, which he subsequently took on tour through Britain and Europe. His work in Dublin between 1911 and 1914, which included sitting on the jury for the international competition for a new city plan (won by Abercrombie), provided an example of his holistic approach to urban problems; this relied on philanthropic work, environmental improvements such as 'conservative surgery', landscape design and comprehensive urban planning schemes.

Geddes's work was summarized in his *Cities in Evolution* (1915), which became a major influence on generations of urban planners and urban sociologists, most notably Lewis Mumford. In 1915 Geddes was invited to India where he organized summer meetings and conducted a large number of surveys of such cities as Madras, Bombay and Calcutta; between 1919 and 1924 he also worked in Palestine. He returned to Europe in 1924 for health reasons and settled in Montpellier, where he founded the Collège des Ecossais, housed in a rustic structure incorporating an older medieval tower (completed 1930). The college was a living symbol of his life's work in promoting regional study and providing international halls of residence to support comprehensive studies and the exchange of ideas. His last publication *Life: Outlines of General Biology* (1931) was intended as a final statement of his biological perspective of life and society. One of the most versatile thinkers of modern Britain, combining different disciplines and moving outside mainstream academia, he can be regarded as one of the fathers of urban planning theory and environmental sociology.

WRITINGS

Cities in Evolution (London, 1915)
Life: Outlines of General Biology (London, 1931)

BIBLIOGRAPHY

P. Boardman: *Patrick Geddes: Maker of the Future* (Chapel Hill, NC, 1944)
J. Tyrwhitt, ed.: *Patrick Geddes in India* (London, 1947)
P. Mairet: *A Pioneer of Sociology: Life and Letters of Patrick Geddes* (London, 1957)
M. Stalley, ed.: *Patrick Geddes: Spokesman for Man and Environment* (New Brunswick, 1972)
P. Boardman: *The Worlds of Patrick Geddes: Biologist, Town-planner, Re-educator* (London, 1978)
H. Meller, ed.: *The Ideal City* (Leicester, 1979)
H. Meller: *Patrick Geddes: Social Evolutionist and Town Planner* (London, 1990) [extensive bibliography]

Geddes, Robert (*b* Philadelphia, PA, 7 Dec 1932). American architect. He studied at Yale University, New Haven, CT, and received his architectural training at the Graduate School of Design (1946–50), Harvard University, Cambridge, MA. He taught design at the University of Pennsylvania (1951–65), Philadelphia, and he was appointed Dean of the School of Architecture, Princeton University, in 1965. In 1954 he was co-founder of the firm Geddes Brecher Qualls Cunningham, with offices in Princeton, NJ, and Philadelphia. His work has included a broad range of designs from small houses and playgrounds, to large public and institution buildings. Among the latter are the Pender Laboratory (1958), Moore School of Electrical Engineering, University of Pennsylvania; Temple Beth Sholom (1964), Manchester, CT; Theater and Fine Arts Complex (1966–8), Beaver College, Glenside, PA; Graduate Research Center (1967), University of Pennsylvania; Coatesville public housing (1973), Coatesville, PA; Humanities and Social Sciences Building (1975), University of Southern Illinois, Carbondale; Liberty State Park (1979), Jersey City, NJ; South Wing, J. B. Speed Art Museum (1983), Louisville, KY. His curved Philadelphia Police Headquarters (1962) was an early example of the use of dramatic visual form to create a sense of identity. Unlike many architects of the 1960s, Geddes believed it was the architect's task to embody ethical and aesthetic values in building at both the individual and social levels.

WRITINGS

'The Nature of the Built Environment', *Prog. Archit.*, lv (June 1974), pp. 72–81
'Possibilities in Architecture', *Archit. Rec.*, vii/11 (Nov 1977), pp. 103–8
'The Forest Edge', *Archit. Des.*, lii/11–12 (1982), pp. 2–23
'The Common Ground', *Landscape Archit.*, lxxiii/3 (1983), pp. 64–9

BIBLIOGRAPHY

Contemp. Architects; *Macmillan Enc. Architects*
R. G. Wilson and others: 'Accessing a Decade whose Only Constant Has Been Change', *Architecture* [USA], lxxvii (May 1989), pp. 128–37

LELAND M. ROTH

Gedovius, Germán (*b* Mexico City, 1 May 1867; *d* Mexico City, 16 Mar 1937). Mexican painter and teacher. He studied at the Kunstakademie in Munich from 1884 to 1892. After producing a series of portraits in the manner of Old Masters, such as *Self-portrait in the Style of Rembrandt* (San Luis Potosí, Casa Cult.), a particularly outstanding example, he showed the influence of late 19th-century German Symbolism in paintings such as *Fantasy Palette* (1893; Mexico City, Carolina Reinking priv. col., see 1984 exh. cat., p. 35). There are Symbolist overtones, too, in some of the many portraits painted on his return to Mexico, such as *Dolores Gedovius* (1898; San Luis Potosí, Casa Cult.).

Gedovius was one of the principal proponents of a type of painting evoking the age of the Viceroys from a modern point of view. Among his favourite subjects were the interiors of old convents, usually deserted (e.g. *Sacristy at Tepotzotlán*, 1906; Saltillo, Ateneo Fuente); contemporary figures dressed in the costumes of New Spain, such as the portrait of *Luis Quintanilla* (1901; Guadalajara, Mus. Reg. Antropol. & Hist.); and flower studies depicting traditional Talavera flower vases. He also painted works with allegorical overtones such as *Baroque Nude* (*c*. 1920; Mexico City, Mus. N. A.), in which a figure is surrounded by fragments of retables; the combination here of a religious atmosphere with eroticism bears comparison with the work of decadent poets.

Like Saturnino Herrán, Gedovius painted popular types and customs with the aim of expressing what was then

called the 'soul of the nation'. Stylistically his work encompassed elements of the neo-Baroque and of Post-Impressionism. He exercised considerable influence as a teacher of colouring and composition at the Escuela Nacional de Bellas Artes in Mexico City in the first decades of the century.

BIBLIOGRAPHY

Germán Gedovius, 1867–1937 (exh. cat., essay F. Ramírez, Mexico City, Mus. N. A., 1984)

FAUSTO RAMÍREZ

Geefs, Guillaume (*b* Antwerp, 10 Sept 1805; *d* Brussels, 19 Jan 1883). Belgian sculptor. He was the eldest member of a family of sculptors, which included his six brothers, the most famous of whom were Joseph Geefs (1808–85; Prix de Rome winner in 1836) and Jean Geefs (1825–60; Prix de Rome winner in 1846). He studied at the Antwerp academy under the two Van Geels, father and son, before completing his studies under Jean-Etienne Ramey (1796–1852) at the Ecole des Beaux-Arts in Paris. He travelled to Italy in 1829 and was made a teacher at the academy when he returned to Antwerp. He retained this position until 1840 but settled in Brussels. His first works (exhibited from 1828) were predominantly elegiac in mood. Soon, however, Geefs revealed a realism full of simplicity and power in, for example, the monuments to *General Belliard*, *Frédéric de Merode* (erected in Brussels in 1836 and 1837) and *Peter Paul Rubens* (1841; Antwerp). Geefs was held in high esteem, dominating the Belgian sculptural world of his day.

To satisfy both official and private commissions Geefs set up a factory, in which he employed his brothers and other artists. His output was considerable, but uneven, including a large number of busts, mausolea such as that of *Malibran* (1842; Laeken cemetery) and *Mme Gardel* (1864; Philadelphia) and several statues of *Leopold I* (version, 1853; Brussels, Mus. A. Mod.). He was a member of the Académie Royale de Belgique from 1845 and of the Institut de France from 1850. Geefs took a leading role in the juries that governed teaching and Salon commissions. Notable among those who studied in his studio were Pierre Puyenbroeck (1804–84), Léopold Wiener (1823–91), Félix Bouré (1831–83) and Paul Bouré (1823–48).

BNB

BIBLIOGRAPHY

E. Marchal: 'Essai sur la vie et les oeuvres de Guillaume Geefs', *Annu. Acad. Royale Sci., Lett. & B. A. Belgique* (1886)

E. Bartholeyns: *Guillaume Geefs: Sa vie et ses oeuvres* (Brussels, 1900)

J. van Lennep: 'Geefs, Guillaume', *Académie Royale des Beaux-Arts de Bruxelles* (exh. cat., Brussels, Mus. Royaux B.-A., 1987), pp. 274, 322–35

——: *Catalogue de la sculpture: Artistes nés entre 1750 et 1882: Bruxelles, Musées Royaux des Beaux-Arts de Belgique* (Brussels, 1992), pp. 184–200

——: *Les Bustes de l'Académie royale de Belgique, histoire et catalogue raisonné précédés d'un essai: Le Portrait sculpté depuis la Renaissance*, vi (Brussels, 1993), pp. 308–17

JACQUES VAN LENNEP

Geel, Jan Frans [Jean-François] **van** (*b* Mechelen, 18 Sept 1756; *d* Antwerp, 24 Jan 1830). Flemish sculptor. His work was essentially part of the late Flemish Baroque tradition; yet he was aware of the emerging Neo-classical movement, as is revealed by certain details in his religious works and, above all, by the spirit of his secular commissions. He was a pupil first of the painter Guillaume Herryns and then of the sculptor Pierre Valckx. In 1784 van Geel was appointed an assistant teacher at the academy of art in Mechelen and subsequently devoted himself consistently to teaching, first in Mechelen and then at the Académie in Antwerp. Among his pupils were Jean-Baptiste de Bay (1802–62), Guillaume Geefs, Lodewijk Royer, Joseph Tuerlinckx (1809–73) and his own son Jan Lodewijk van Geel (*b* Mechelen, 28 Sept 1787; *d* Brussels, 10 April 1852), also a sculptor. Jan Frans's first important commission was for statues (1780–90) of *St James*, *St Andrew* and *St Thomas* and the *St Blaise* altar for the church of Onze-Lieve-Vrouw-over-de-Dijle in Mechelen (*in situ*). In 1810 he successfully adapted the pulpit made in 1723 by Michiel van de Voort (i) for the Jesuit church at Leliëndael for Mechelen Cathedral, and, with the collaboration of van de Voort, executed the mausoleum of *Cardinal Thomas-Philippe of Alsace* in the same church. In 1820 Jan Frans executed the pulpit in the church at Hofstade, and the following year, with his fellow artist Jan Baptist van Hool (1769–1837), he designed the pulpit in the church of St Andries in Antwerp. In 1824 van Geel produced statues of *St Jerome* and *St Andrew* for the St Jacobskerk in Antwerp. He also produced the pulpit in the church at Eppegem (destr.) and that of Keerbergen, where he also carved the stalls. The confessionals in the church of Onze-Lieve-Vrouw at Wavre are by him, as are those in the church at Gheel, where he also worked on some of the panelling and produced statues of the *Theological Virtues*. The pulpit and six medallions (destr.) in the church of St Pieter at Zemst were also by van Geel. A number of preparatory terracotta modelli and a signed drawing of a pulpit by van Geel have been preserved (Brussels, Mus. A. Anc.), as have several series of his designs for religious projects (Antwerp, Mus. Vleeshuis, and Mechelen, Stadsmus. Hof van Busleyden). Among his secular works are *Time Stealing Away Youth* (Brussels, Mus. A. Anc.); the *River Scheldt* (Antwerp, Mus. S. Kst) and *Law* (Mechelen, Stadsmus. Hof van Busleyden); the latter is distinctly Neo-classical in style.

Thieme–Becker

BIBLIOGRAPHY

1770–1830: Autour du Néo-classicisme (exh. cat. by D. Coekelberghs, Brussels, Mus. Ixelles, 1985–6), pp. 116–18

DOMINIQUE VAUTIER

Geerarts. *See* GHEERAERTS.

Geertgen tot Sint Jans (*b* ?Leiden; *fl c.* 1475–95). North Netherlandish painter. He was the leading painter in Haarlem during the last quarter of the 15th century.

1. Life and work. 2. Style and influence.

1. LIFE AND WORK. Van Mander, in the *Schilder-boeck*, the principal source for the artist's life, wrote that Geertgen was a disciple of Albert van Ouwater and that, although he was not a member of the Order, he lived at the Commandery of the Knights of St John in Haarlem, from which he took his name. Van Mander described the right wing of a large *Crucifixion* triptych that Geertgen had painted for the high altar of the Commandery church. He also mentioned, without describing it, a work in an Augustinian church in Haarlem, and he attributed to

Geertgen a painting of the exterior of the Grote Kerk (*in situ*). He concluded, 'he died young, at the age of about 28 years'. In the book of obituaries of members of the Knights of St John, the name *Gherijt Gheritsz, fr(ater) de scilder* (the painter) appears in listings for deaths in July, but the year is not recorded. A drawing, probably 17th-century, of a young man (Haarlem, Rijksarchf. N.-Holland) is identified on the reverse as a copy of a self-portrait of the artist Geertgen in a painting, *The Seven Works of Mercy*, executed for the Holy Ghost orphanage, Haarlem.

Van Mander's biography presents two problems. First, it is unlikely that Geertgen was a disciple of van Ouwater, as he was too young to have been his pupil, and Geertgen's *Raising of Lazarus* (Paris, Louvre) bears little resemblance, stylistically or iconographically, to van Ouwater's version of the same subject (Berlin, Gemäldegal.). Second, van Mander's statement that Geertgen died at about 28 years old seems an exaggeration, since his activity can be traced for approximately 20 years.

Geertgen's most important work is the altarpiece for the high altar of the Commandery church. The left wing and centre panel were destroyed during either the iconoclasm of 1566 or the Spanish siege of Haarlem in 1572–3. The exceptionally large right panel (1.75×1.39 m; Vienna, Ksthist. Mus.) has the *Lamentation* on the inner side (see fig. 1) and on the outer side a complex narrative of the *Burning of the Bones of St John the Baptist* and the legendary rescue of certain relics, a thigh bone and finger, by members of the original Knights of St John in the 4th century. According to van Mander, the lost centrepiece was a *Crucifixion*; hence the left wing must have had an *Ecce homo* or *Christ Carrying the Cross* on the interior, and

the story of *John the Baptist*, including the *Baptism* and the *Beheading* of the saint, on the exterior. Two facts are important for dating the altarpiece: the Knights of St John acquired the Baptist's relics from the Ottoman sultan Bayezid II (*reg* 1481–1512) in 1482–3, which could account for the unprecedented story of the relics on the exterior. Also, the Grand Prior of the Order visited Haarlem in 1494, an occasion that would merit the display of a sumptuous new altarpiece.

In the immediate foreground of the *Lamentation* the four Marys are placed around the dead Christ, mourning at the extremities of a cross formed by his rigid body. Mary Magdalene, kneeling to the lower left, repeats the pose she was given in Rogier van der Weyden's *Deposition* (Madrid, Prado), and the Virgin, supporting Christ in her lap, repeats the pose of the Magdalene in the *Lamentation* attributed to Rogier (Brussels, Mus. A. Anc.). Behind this group a triangle of male participants is introduced by the kneeling St John the Evangelist. The figure of Joseph of Arimathea, who kneels to John's left, was directly inspired by the second Magus in the Monforte *Adoration of the Magi* (*c.* 1470; Berlin, Gemäldegal.) by Hugo van der Goes. On the reverse, the story of the relics of St John the Baptist includes one of the earliest examples of group portraiture in Dutch art. In the immediate foreground, Julian the Apostate orders the burning of the Baptist's bones. In the central zone, the Haarlem Knights of St John appear in the guise of the legendary knights who secretly rescued the relics. Five of them, wearing eight-pointed Maltese crosses on their mantles, are clearly portraits and are shown removing the relics from the open sarcophagus. They appear again, at the top right, carrying the bones, on the path into the city. The Commander (?Johan Willem Janssen) stands to the far left of the group behind the tomb. The six figures to the right are servant members of the Commandery. Geertgen is probably the introspective figure to the far right. The members are presented as rows of three-quarter portraits, facing right and left.

Two other works attributed to Geertgen seem to have been painted for the Commandery. The *Holy Kinship* (Amsterdam, Rijksmus.; see fig. 2) is a complex allegory involving the immediate family of Christ and is based on the medieval legend of the three marriages of St Anne, each producing a daughter named Mary, whose offspring included Christ and six Apostles. The Virgin's cousin Elizabeth bore John the Baptist, and they figure prominently in the right foreground of the deep church interior, an unusual addition to the traditional Holy Kinship iconography but one appropriate for the Knights of St John, who dedicated a chapel in their church to Mary, Elizabeth and John the Baptist. The charming *St John the Baptist in the Wilderness* (Berlin, Gemäldegal.) may also have been executed for a member of the Commandery. In this small panel Geertgen displays his skill as a landscape painter: certain aspects recall the carefully composed landscapes of Dieric Bouts I, but Geertgen introduced a more natural extension of space both laterally and in depth and produced a unified vista filtered through a warm golden light. Details such as ferns, flowers and trees are also handled in a softer, more impressionistic fashion.

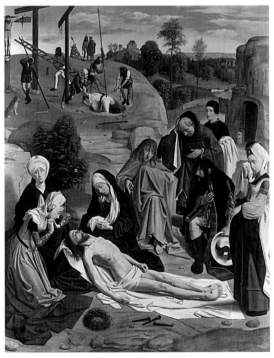

1. Geertgen tot Sint Jans: *Lamentation*, oil on panel, 1.75×1.39 m, *c.* 1484–94 (Vienna, Kunsthistorisches Museum)

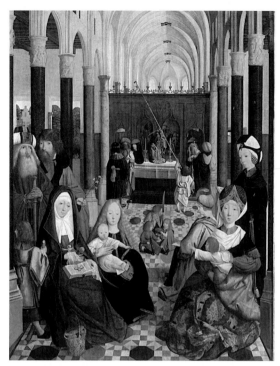

2. Geertgen tot Sint Jans (attrib.): *Holy Kinship*, panel, 1.37×1.05 m, *c*. 1490–95 (Amsterdam, Rijksmuseum)

Geertgen also painted for the Dominicans. In 1478 the Order founded the first Netherlandish Confraternity of the Rosary in Haarlem, introducing a Marian devotion that involved repeated prayers of the *Ave Maria* and the *Paternoster* counted off on beads. Geertgen's broad altarpiece for the Dominican church depicted the legendary institution of rosary devotion by St Dominic, according to the account of Alanus de Rupe, the main spokesman for the new devotion in the Netherlands. The painting is known only from copies (e.g. Leipzig, Mus. Bild. Kst.), but it marked a departure from earlier altarpieces in presenting, rather than a central image, a narrative with individual events alternating from background to foreground across the panel. The foreground scenes take place in two rooms, each with an opening at the rear left revealing a chapel and a landscape in which the background scenes are set. From left to right, the four scenes show St Dominic before a Crucifix, receiving the beads from the Virgin and Child, preaching to the common folk about the rosary and, finally, with an assistant distributing beads to the French queen Blanche of Castile and her entourage. Rosary devotion involved concentration on the joys, sorrows and glories of the Virgin, calling for an intimate response on the part of the faithful. This is reflected in a tiny *Virgin and Child* by Geertgen (Rotterdam, Mus. Boymans–van Beuningen). Several titles have been given to this curious painting, but the designation 'Madonna of the Rosary' encompasses all others. The Apocalyptic Virgin of Revelations 12 forms the core around which swirl three aureoles of light containing music-making angels, angels with the instruments of the Passion and an

innermost circle of seraphim who crown the Queen of Heaven. These correspond respectively to the joys, sorrows and glories of the Virgin. On the left and right, level with the head of the Virgin, are angels displaying rosary beads. The Child vigorously rings two sanctus bells, marking the end of the rosary devotion at the elevation of the Host during Mass.

2. STYLE AND INFLUENCE. Geertgen tot Sint Jans has been called the most 'lovable' of all Netherlandish painters. He created distinctive figure types, and his Virgin is a young maiden with a pure countenance and delicate features. Reddish tints give warmth to the faces, gestures are delicate, and a sweet-sad melancholy pervades his pictures. Much controversy obscures the attribution of his paintings (see especially Châtelet), but the qualities that distinguish a painting by Geertgen are easy to perceive. Owing to the brevity of his career, it is difficult to discern a development in his style. The miniature-like *Virgin and Child* (Milan, Ambrosiana) and the *Adoration of the Magi* (Cleveland, OH, Mus. A.) are usually considered his earliest works. The poetic *Night Nativity* (London, N.G.), based on a composition originating in the shop of Hugo van der Goes, and the *Raising of Lazarus* (Paris, Louvre) are thought to be from his middle period. The *Crucifixion* triptych (*c.* 1484–94) for the Knights of St John forms the pivotal point in any chronology (*see* §1 above). His later works can be characterized as displaying a more colourful and mannered style, typical tendencies in Netherlandish art at the end of the 15th century. In the *Man of Sorrows* (Utrecht, Catharijneconvent), Geertgen has exaggeratedly truncated the figures around the sarcophagus in which the bleeding Christ stands so that it has often been assumed, incorrectly, that the panel has been cut down. Archaic features, such as the bright golden background, underscore the painting's role as an abstracted devotional image (*Andachtsbild*). As are other versions of this subject attributed to Geertgen, the *Adoration of the Magi* triptych (Prague, N.G., Šternberk Pal.) is ultimately derived from the Monforte altarpiece (Berlin, Gemäldegal.) by Hugo van der Goes. The Prague triptych has been dated *c.* 1490 on account of the somewhat pompous mood that the rich colours and costumes evoke in the compressed composition. These traits are especially notable in the elaborate *Tree of Jesse* (Amsterdam, Rijksmus.), in which a colourful ensemble of richly garbed kings of Judah sit among the branches of a tree growing in a convent garden, where a nun kneels. This painting has frequently been attributed to Jan Mostaert because of the frivolous nature of the presentation, but the head types and brushwork support the attribution to Geertgen.

Geertgen's legacy was pervasive in the north Netherlands, and in many respects his Late Gothic style held in check the strong influences of the school of Antwerp Mannerists in Haarlem during the first decades of the 16th century. It was only after the arrival of Jan van Scorel (*c.* 1527–30) that Haarlem painting entered its Mannerist phase. While Geertgen apparently had no apprentices, his style established the mode of painting throughout the north Netherlands at the end of the 15th century. Among his closest followers were the Master of the Brunswick

Diptych, Jan Mostaert in Haarlem and Jacob Cornelisz. van Oostsaner in Amsterdam.

BIBLIOGRAPHY

K. van Mander: *Schilder-boek* ([1603]–1604)

L. Balet: *Der Frühholländer Geertgen tot Sint Jans* (The Hague, 1909)

J. J. H. Kessler: *Geertgen tot Sint Jans: Zijne herkomst en invloed in Holland* [Geertgen tot Sint Jans: his origins and influence in Holland] (Utrecht, 1930)

G. J. Hoogewerff: *De Noord-Nederlandsche schilderkunst*, ii (The Hague, 1937), pp. 138–239

W. Vogelsang: *Geertgen tot Sint Jans* (Amsterdam, 1942)

E. Panofsky: *Early Netherlandish Painting* (Cambridge, MA, 1953), pp. 324–30

Middeleeuwse kunst der noordelijke Nederlanden (exh. cat., Amsterdam, Rijksmus., 1958), pp. 47–62

J. Snyder: 'The Early Haarlem School of Painting, II: Geertgen tot Sint Jans', *A. Bull.*, xlii (1960), pp. 113–32

K. G. Boon: *Geertgen tot Sint Jans* (Amsterdam, 1967)

M. J. Friedländer: *Early Netherlandish*, v (1969), pp. 11–30

A. Châtelet: *Les Primitifs hollandais* (Paris, 1980); Eng. trans. as *Early Dutch Painting* (Oxford, 1981), pp. 93–121

JAMES SNYDER

Geest, Cornelis van der (*b* Antwerp, ?1575; *d* Antwerp, 10 March 1638). Flemish merchant, patron and collector. In 1597 the affluent van der Geest bought two houses near St Walburgiskerk, a fashionable quarter in Antwerp, and from 1609 to 1615 he was Dean of the retail traders' guild there. He mediated on behalf of his parish church with Rubens in 1609–10 for the *Raising of the Cross* (Antwerp, Cathedral) and he also prevented the destruction of Quinten Metsys's tombstone, which he had placed by the cathedral tower. In 1612 he was a founder-member of the Guild of St Luke, to which he belonged until 1627.

Van der Geest's distinguished art collection was depicted by Willem van Haecht II in a signed and dated composition (1628; Antwerp, Rubenshuis) with the punning inscription *Vive l'Esprit* under the coat of arms (Fr. *esprit* = Flem. *geest*; see COLLECTING, fig. 1). The imaginary scene shows several dignitaries who had visited the collection over the years, including the Archdukes Albert and Isabella and many of van der Geest's painter friends such as Rubens and van Dyck (who painted his portrait, *c.* 1621–2; London, NG). The painting indicates the importance of art to van der Geest and his learned circle of connoisseurs and shows that he collected contemporary as well as earlier Flemish, Italian and German masters. Among the identifiable works are Rubens's *Battle of the Amazons* (*c.* 1618; Munich, Alte Pin.), landscapes by Pieter Bruegel the elder, the *Virgin and Child* (Cincinnati, W. E. Edwards priv. col.) and the *Man with Glasses* (Frankfurt am Main, Städel Kstinst. & Städt. Gal.) by Quinten Metsys and the lost painting by Jan van Eyck of a *Woman Bathing* (ex-Pieter Stevens priv. col., Antwerp). Van der Geest died unmarried and childless, and his collection was publicly sold in 1638.

BIBLIOGRAPHY

E. Geudens: *Het hoofdambacht der Meerseniers* [The main trade of the Meerseniers], 4 vols (Antwerp, 1891–1904)

J. S. Held: 'Ars pictoris amator: An Antwerp Patron and his Collection', *Gaz. B.-A.*, n. s. 5, i (1957), pp. 53–84

A. J. J. Delen: 'Cornelis van der Geest: Een groot figuur in de geschiedenis' [Cornelis van der Geest: a great figure in history], *Antwerpen*, v (1959), pp. 57–71

F. Baudoin: 'Een belangrijk aanwinst vor het Rubenshuis: De *Constcamer* van Cornelis van der Geest, geschilderd voor Willem van Haecht' [An important acquisition for the Rubenshuis: the *Constcamer* of Cornelis van Geest, painted by Willem van Haecht], *Antwerpen*, xv (1969), pp. 158–73

VERONIQUE VAN PASSEL

Geest, Wybrand (Symonsz.) de, I (*b* Leeuwarden, 16 Aug 1592; *d* Leeuwarden, *c.* 1662). Dutch painter. He was the son of Symon Juckes de Geest (*d* before 1604), a painter of stained-glass windows. He studied with Abraham Bloemaert in Utrecht and then travelled to France and Italy. There he became a member of the colony of Dutch artists active in Rome that later developed into the Schildersbent, who gave him the nickname 'the Frisian eagle'. He made a copy after Caravaggio's *Mary Magdalene* (untraced) in Rome in 1620 (ex-S. Alorda priv. col., Barcelona; see Arnaud). He returned to Leeuwarden in 1621 and became the favourite portrait painter of the Frisian stadholders and the landed gentry. His marriage to Hendrickje Uylenborch, who was related to Rembrandt's wife Saskia, strengthened his contacts with artistic centres outside Friesland.

De Geest's early work is somewhat conventional, adhering to the style of Michiel van Mierevelt and Paulus Moreelse. Changes in fashion and artistic influences from Amsterdam lent more elegance and refinement to his later works. He is best known for his portraits of children, many of whom are dressed in pastoral costume, in the Utrecht tradition of Moreelse and Bloemaert, and for his life-size full-length portraits of influential Frisian noblemen. His most original works are three life-size group portraits of the Frisian counts of Nassau-Dietz and their relatives (Leeuwarden, Fries Mus.; Amsterdam, Rijksmus.). This series was made around 1630 for the Frisian stadholder Ernst Casimir (1573–1632) and stresses the common descent of all Nassaus and their role in the war against Spain. (Significantly, no prince of the Orange Nassau branch of the family was depicted.) The architectural backgrounds are reminiscent of Moreelse, but the elegant composition, influenced by the work of van Dyck, has no precedent in the art of the northern Netherlands.

Notwithstanding his relation to the Protestant Nassau court, de Geest remained a Catholic; some of his portraits depict Catholic patrons. His *Album amicorum* (Leeuwarden, Prov. Bib. Friesland) is an important source for the circle around Bloemaert and for the members of the Schildersbent. His son, Julius Felix de Geest (known as Julius Franciscus; *d* 1699), was also a painter; two books with botanical drawings and some provincial portraits by him are known. Julius's son, Wybrand de Geest II (*d* before 1716), was a mediocre poet and possibly a draughtsman who published his grandfather's travel guide to Rome, 'Den getrouwen leidtsman in Romen', in his collection of writings *Het kabinet der statuen* (Amsterdam, 1702).

BIBLIOGRAPHY

C. Hofstede de Groot: 'Het vriendenalbum van Wibrand Symonszoon de Geest', *Oud-Holland*, vii (1889), pp. 235–40

J. Arnaud: 'Ribalta y Caravaggio', *An. & Bol. Mus. A. Barcelona*, v (1947), pp. 345–413

A. Wassenbergh: *De portretkunst in Friesland in de zeventiende eeuw* [Portraiture in seventeenth-century Friesland] (Lochem, 1967), pp. 30–45

L. de Vries: *Wybrand de Geest* (Leeuwarden, 1982)

N. C. Sluijter-Seijffert: *Cornelis van Poelenburch* (Leiden, 1984), pp. 27–9

LYCKLE DE VRIES

Geestigheit. *See* CABEL, ADRIAAN VAN DER.

Geffroy, Gustave (*b* Paris, 1 June 1855; *d* Paris, 4 April 1926). French critic, writer and administrator. Although his formal education stopped short of a lycée degree, in his youth he steeped himself in the positivist, socialist and Romantic currents of the day. In the early 1880s he met his mentors: Georges Clemenceau (1841–1929), who preached evolutionary, socialist politics; and Emile Zola and Edmond de Goncourt, who inculcated in him their Naturalist literary theories. Geffroy also formed close friendships with Claude Monet, Auguste Rodin, J.-F. Raffaëlli, Félix Bracquemond and Eugène Carrière, all of whom helped to shape his aesthetic views.

As a journalist covering art, literature and politics from the 1880s to about 1907, Geffroy was an important witness to the cultural life of the early Third Republic. His chief endeavour was the art criticism that he wrote, in the 1880s, for Clemenceau's newspaper *La Justice* and, from 1893, for *Le Journal*. About a third of his output for these and other periodicals was collected in *La Vie artistique* (1892–1903).

Geffroy styled himself a Naturalist critic, and this designation still seems apt. Writing at a time when Symbolist ideas held sway among the avant-garde, he argued that naturalistic art was rich enough in poetry and mystery to satisfy the Symbolist criteria. To support this contention he appealed to scientific theories about the unity of all life governed by the same physical and chemical laws—a viewpoint that intellectual historians have called the 'materialistic pantheism' of the late 19th century. Geffroy was not an avant-garde critic. He championed the Impressionists when the group had disbanded and most of their critical battles had been won, but he also reviewed perceptively works being created and exhibited in the 1880s and 1890s. He was one of the first to understand Monet's series paintings, Rodin's unorthodox poses and the 'unfinished' in Cézanne. Both Rodin and Cézanne, in gratitude for his support, made portraits of Geffroy (1905, bronze; 1895, oil on canvas; both Paris, Mus. d'Orsay). Though not sympathetic to the mystical themes of some Symbolist art, he had an eye for the formal innovations and true-to-life qualities in the work of Seurat, Vuillard, Bonnard, Denis and Gauguin. He also commented significantly on women artists, public sculpture, mural decoration, the applied arts, japonisme, Expositions Universelles and countless minor masters.

Geffroy held strong socialist views concerning the role of art, which shaped his critical judgements and also inspired him to crusade for the cultural education of the masses. In 1894 he proposed a project for a museum of decorative arts for the benefit of workers, the Musée du Soir. The volumes he wrote after 1900 on art history and on the museums of Europe were also part of this work of popularization, as was his novel of 1924, *Cécile Pommier*, the story of a working-class girl's spiritual redemption through study of the history of art. After 1908, when he became director of the Gobelins, he wrote little criticism, devoting himself to commissioning tapestry designs from modern artists. His biography of Monet (1922) is an important, if unreliable, source of first-hand information on the artist.

WRITINGS
La Vie artistique, 8 vols (Paris, 1892–1903)
Claude Monet: Sa vie, son oeuvre (Paris, 1922)

BIBLIOGRAPHY
J. Vallery-Radot: *Gustave Geffroy et l'art moderne* (Paris, 1957)
R. T. Denommé: *The Naturalism of Gustave Geffroy* (Geneva, 1963)
J. C. Paradise: *Gustave Geffroy and the Criticism of Painting* (New York, 1985)
P. Plaud-Dilhuit: *Gustave Geffroy: Critique d'art* (diss., U. Rennes II, 1987)

JOANNE CULLER PARADISE

Gegello, Aleksandr (Ivanovich) (*b* Yekaterinoslav [now Dnepropetrovsk], 22 July 1891; *d* Moscow, 11 Aug 1965). Russian architect of Ukrainian birth. From 1911 to 1920 he studied in the Institute of Civil Engineers, Petrograd (later Leningrad, now St Petersburg), and then, from 1920 to 1923, at the Academy of Arts, Petrograd. From 1915 he worked as assistant to IVAN FOMIN, who had a profound influence on him. Gegello built the residential complexes (1925–7) on Prospekt Stachek and Traktornaya Street, Leningrad, with G. A. Simonov (1893–1974), Aleksandr Nikol'sky and D. L. Krichevsky (1892–1942), which are characteristic of 'Proletarian Classicism' in their restrained, economical forms. In his building of the Gor'ky House of Culture for the Workers of the Moskovsko-Narvsky District (1925–7; with Krichevsky; *see* ST PETERSBURG, fig. 5), Leningrad, he played an important role in the creation of a new type of public building. The nucleus of its symmetrical structure was formed by the 2000-seat amphitheatre, while its architecture is a concise version of neo-classical forms. His career then entered a Constructivist phase with the Botkin Hospital (1927–8) in Leningrad, which was organized in pavilions, and the House of Technical Studies (1930), on a site near his earlier Gor'ky House of Culture, Leningrad. Returning to a modernized neo-classicism, in the 1930s, he designed the Gigant Cinema (1933–5; with Krichevsky) in Leningrad; and between 1935 and 1938 schools on Prospect Stachek, Mokhovaya and Kalyayeva streets, and the baths on Tchaikovsky Street, all in Leningrad. After World War II he was involved in the restoration of the historic Neo-classical buildings of Leningrad. He was also an initiator of mass industrialized construction, as in the large-panelled buildings (1949–51) in the Moskovsky district of Leningrad designed with S. V. Vasil'kovsky (1892–1960). From 1950 he worked in Moscow on theoretical problems.

WRITINGS
Iz tvorcheskogo opyta [From creative experience] (Leningrad, 1962)

BIBLIOGRAPHY
S. O. Chan-Magomedov: *Pioniere der sowjetischen Architektur* (Dresden, 1983); Eng. trans. as S. O. Khan-Magomedov: *Pioneers of Soviet Architecture* (London, 1987), pp. 276, 279, 434

A. V. IKONNIKOV

Geghard Monastery. Armenian monastery *c.* 30 km east of Erevan, set among the wild and impressive rock faces of the deep valley of the River Azat. In the early 4th century AD a monastery known as Ayrivank' ('cave monastery') was founded on this site in a cave. The name Geghard dates from the 13th century, when a fragment of the Holy Lance (Armen. *geghard*; now in Ēdjmiadzin Cathedral, Sacristy) was brought here. The monastery is set in a courtyard (*c.* 100×65 m) surrounded on three sides by walls with towers and on the fourth (north) by a rock

face (see fig.). The earliest monument is the chapel of St Grigor the Illuminator (later dedicated to the Mother of God) which lies outside the monastery walls 100 m to the west and, according to inscriptions, dates from as early as 1160. At the beginning of the 13th century the site became the property of the Zakarid princes under whom the monastery developed. Around 1240 the monastery was purchased by the Proshian princes, who made it their place of dynastic burial. Throughout the Middle Ages the monastery was a major cultural centre and seat of landed proprietors. It has never ceased functioning, and its monuments have been regularly restored, most notably in the 17th and 18th centuries and in 1968–71.

The main church, also dedicated to the Mother of God, was built inside the monastery enclosure by the princes Zak'arē and Ivanē Zak'arian in 1215. It belongs to one of the main types of Armenian church architecture. Its outer rectangular shell encloses a cruciform structure, with a dome supported by spherical pendentives and engaged columns attached to the walls of the four two-storey corner rooms. The building's slender proportions are further enhanced by its tall cylindrical drum topped by a conical dome. Richly carved reliefs decorate the interior of the apse as well as the surrounds of the doors and windows and the exterior of the dome drum. On the west side of the church is a square-planned narthex (*gavit*; 1215–25); its four central columns support a dome with a central opening and stalactite decoration (*see* MUQARNAS), which produces a striking effect of shadow and light.

On the north side, in the rock face against which the narthex is built, two doors lead to several rock-cut rooms mainly of the second half of the 13th century. The earliest and most westerly of these rooms is a chapel built *c.* 1240 by Galdak, whose name is engraved at the base of the dome. The chapel's name of Avazan ('font') derives from the fact that it is carved out of a cave with a spring. It reproduces the architecture of a vaulted roof on two pairs of intersecting arches, while the stalactite vaulting of the apse reflects Islamic influence. Further to the east of this chapel are a family burial vault and a second cave chapel (1283), both with richly carved ornament. The burial vault contains a large composition in high relief depicting the head of an ox holding in its mouth a chain that winds round the necks of two flanking lions, whose heads turn towards the onlooker. The tips of the lions' tails are in the shape of dragons' heads looking upwards. Between the lions and below the chain is an eagle with half-open wings; it holds a lamb in its talons. This sculpture probably depicts the coat of arms of the Proshian family. The interior of the chapel's dome is carved with twelve *Trees of Life*. North of the Proshian vault and on a higher level is the large funerary chapel of Papak and Ṙuzukan' (1288), which is square in plan with four centrally placed columns supporting the dome. These rock-cut rooms were executed with great precision and illustrate a technique rarely found in Armenia.

Geghard is also exceptional for the large number of *khachk'ars* (stone slabs with a cross engraved in the centre) that are carved directly on the rock face, set into the walls of buildings or free-standing on pedestals.

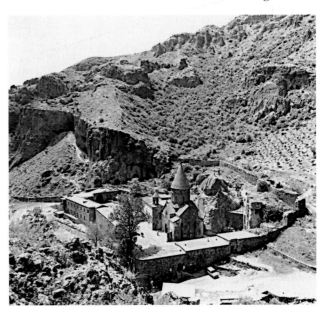

Geghard Monastery, view from the south-east, 13th century; restored 1968–71

BIBLIOGRAPHY
A. Sahinian, A. Manoukian and T. A. Aslanian: *The Geghard Monastery* (1973), vi of *Documenti di architettura armena* (Milan, 1970–)
A. Sahinian: *Garni-Geghard* (Erevan, 1978)
P. Cuneo: *Architettura armena* (Rome, 1988)

PATRICK DONABÉDIAN

Gego [Goldschmidt, Gertrudis] (*b* Hamburg, 1 Aug 1912). Venezuelan architect, sculptor, draughtsman and printmaker of German birth. She studied architecture at the Technische Hochschule in Stuttgart until 1938; one of her principal teachers was Paul Bonatz. The following year she travelled to Venezuela, where she combined her artistic career as a sculptor, draughtsman and engraver with teaching work. In 1952 she adopted Venezuelan nationality. She later began experimenting with the conversion of planes into three-dimensional forms, exploring the media of drawing, watercolour, engraving, collage and sculpture and integrating them into architectural spaces in defiance of artistic conventions. A pioneering example of her integration of art and architecture was her design (1962) for the headquarters of the Banco Industrial de Venezuela in Caracas, which comprised a 10 m tower of interlocking aluminium and steel tubes. Later works that explored the form of the web included *Trunk No. 6* (wire, 1976; artists col., see exh. cat., p. 114). She participated in numerous one-woman and group shows in Venezuela and other countries. In 1980 she was awarded the Premio Nacional de Artes Plásticas in Venezuela. She executed over 850 sculptures, 600 drawings and 60 engravings during her career.

UNPUBLISHED SOURCES
Caracas, Fond. Gal. A. N., Archvs [File G-9]

BIBLIOGRAPHY
M. F. Palacios: 'Conversación con Gego', *Ideas*, 3 (1972), pp. 23–7
Gego (exh. cat. by H. Ossott, Caracas, Mus. A. Contemp., 1977)
J. Calzadilla: *El artista en su taller* (Caracas, 1979)

GUSTAVO NAVARRO-CASTRO

Frank O. Gehry: California Aerospace Museum, Los Angeles, 1982

Gehry, Frank O(wen) (*b* Toronto, 28 Feb 1929). American architect, exhibition designer and teacher. He qualified at the University of Southern California, Los Angeles, in 1954 and attended the Graduate School of Design, Harvard University, in 1956–7. After working in various architectural practices, from 1962 he practised independently in Venice, Los Angeles. His early work focused on the potential of small-scale works to provide a succinct metaphorical statement, as with various exhibition designs for the Los Angeles County Museum of Art and his designs for the Joseph Magnin Stores at Costa Mesa and San Jose (both 1968), CA. In his major works he was interested more in the manipulation of architectural form than in technical innovation, and he was concerned with the conceptual and spatial content of buildings rather than the tighter demands of the architectural brief. Seeking an 'open-ended' approach to architecture, he was influenced by the work of fine artists, but his works of the late 1970s proved that his approach could provide habitable if haphazard buildings, as in the Wagner House (1978), Los Angeles, and his own Gehry House (1979) in Santa Monica, CA (*see* ARTIST'S HOUSE, fig. 7). The latter is composed of apparently casually assembled low-cost corrugated metal panels, steel poles and a canopy of wire mesh fencing. This idiosyncratic, industrialized effect, with the minimum of conspicuous expenditure, was also employed in the converted warehousing that he transformed into temporary accommodation for the Los Angeles Museum of Contemporary Art in 1983.

Influenced by the tradition defined by Colin Rowe in his book *Collage City* (1978), Gehry demonstrated his mastery of architectural collage in the Law School Building (1981) for Loyola University, Los Angeles, an urban infill with a latent sense of classicism alluding to the place of Roman Law in the school's curriculum. In other works a single striking image is employed effectively, for example in the California Aerospace Museum (1982), Los Angeles, where a full-scale F-104 jet fighter is transfixed on the entrance façade (see fig.). Similarly, his design (1986) for the Kobe Fish restaurant in Japan relies on a sculptural representation of a vast fish-like form at the entrance. Many of Gehry's works include expressionist elements, while his innovative approach to questions of architectural form led to his being associated with Post-modernism. From 1972 he taught at the University of Southern California, Los Angeles, and at the universities of Harvard and Yale.

WRITINGS
Projects in Europe (Paris, 1991)

BIBLIOGRAPHY
P. Arnell and T. Beckford: *Frank Gehry: Buildings and Projects* (New York, 1985)
R. Haag Bletter: *The Architecture of Frank Gehry* (New York, 1986)
S. Richardson: *Frank O. Gehry: A Bibliography* (Monticello, IL, 1987)
B. Lacy and S. de Menil, eds: *Angels and Franciscans: Innovative Architecture from Los Angeles and San Francisco* (New York, 1992), pp. 78–102

MICHAEL SPENS

Geiami. *See* AMI, (2).

Geiger. German family of artists.

(1) Willi Geiger. (*b* Schönbrunn bei Landshut, 17 Aug 1878; *d* 1971). Painter and printmaker. He was a pupil of Franz von Stuck at the Akademie der Bildenden Künste in Munich (1902–5). After travels in Spain, Italy and Tunisia, he taught in Munich at the Kunstgewerbeschule (1920–23). From 1928 to 1933 he was a professor at the Staatlichen Akademie für Graphik und Buchkunst in Leipzig and, after World War II, at the Akademie in Munich (1945–51). Geiger was never formally aligned to any specific 20th-century movement. During the years of the Weimar Republic (1919–33) he rejected the programmatic, attempting to develop a figurative style that was clear and workmanlike. Like those of George Grosz and Otto Dix, his subjects were often gruesome: he frequently painted attacks on the devastation brought by war and militarism. Works such as *Spanish Worker's Leader* (1925; Berlin, Neue N.G.) are characterized by an expressive force that is informed by the verism of Dix, rather than the imagery of German Expressionism. The influence of Goya was particularly important, and Geiger's enthusiasm for grim realism led him to illustrate the work of such writers as Honoré de Balzac (1924), Dostoyevsky (1924), Kleist, Lev Tolstoy and Wedekind (1920–23). Working in Munich from 1943, Geiger began a folio of prints, including the etching *War II* (1943; see exh. cat., no. 63), which depicted his account of fascism. His series of pen-and-ink drawings of 1944–5, *A Reckoning* and *Twelve Years* (e.g. *General Staff*, pen and ink, *c.* 1945; see exh. cat., no. 79), published in Munich as prints in 1947, are among the first and most powerful artistic documentations of life in Germany under Hitler's regime. His later work, while still figurative, combines simplified forms and symbolic colour in a surrealistic, visionary way.

BIBLIOGRAPHY
Willi Geiger (exh. cat. by G. Pommeranz-Liedtke, Berlin, Akad. Kst. DDR, 1956)
W. Petzet: *Willi Geiger: Der Maler und Graphiker* (Munich, 1960)

(2) Rupprecht Geiger (*b* Munich, 26 Jan 1908). Painter and architect, son of (1) Willi Geiger. He first studied architecture under the neo-classicist Eduard Pfeiffer (1889–1929) at the Kunstgewerbeschule, Munich (1926–9). He served an apprenticeship as a mason from 1930 to 1932, which was followed by a period of study at the Staatsbauschule in Munich (1933–5). In 1940 Geiger was called up for military service. Self-taught, he started to paint in the Ukraine and in Greece, where he discovered the differing qualities of light and colour that later became the sole subject-matter of his art. Although Geiger resumed work as an architect at the end of World War II, he took part in some of the first post-war exhibitions, including *Extreme Kunst* in the Schaezlerpalais in Augsburg, exhibiting such works as *Surreal Landscape (Dream Picture with Abstract Forms)* (1947; see 1985 exh. cat., p. 31). In the wake of these exhibitions and encouraged by John Anthony Thwaites, the British consul in Munich, a group of artists formed the ZEN 49 group in 1949 with the object of promoting abstract art, although with no attendant ideological programme. Among the founder-members were Geiger, Willi Baumeister, Fritz Winter, Rolf Cavael (*b* 1898), Gerhard Fietz (*b* 1910), Willi Hempel (1905–?1985) and Brigitte Meier-Denninghoff (later Matschinsky-Denninghoff). At that time Geiger was working in complete isolation on abstract trapeziform canvases, for example *E 53* (1948; Hagen, Osthaus Mus.).

In his subsequent periods of creativity Geiger concentrated on simpler shapes such as the rectangle and the circle, so that emphasis lay in the expressive qualities of the colours used. To achieve maximum heightening of colour intensity, with red playing the main role, he combined colours such as pink and red or modulated the fields of colour from light to dark. In 1965 he started using a new spray technique and bright fluorescent colours to achieve the pure tone of colour for which he was striving. From the late 1960s he also constructed a variety of monochrome coloured spaces, including the tent-like environment *Red Spout* (1985; see 1985 exh. cat., p. 87). He was a professor at the Staatliche Kunstakademie in Düsseldorf from 1965 to 1978.

BIBLIOGRAPHY
Rupprecht Geiger (exh. cat., Hannover, Kestner-Ges., 1967)
Rupprecht Geiger, Gemälde und Zeichnungen (exh. cat., Munich, Lenbachhaus, 1978)
Rupprecht Geiger: Retrospektive (exh. cat., essays by H.-P. Riese and others; W. Berlin, Akad. Kst.; Ludwigshafen, Hack-Mus. & Städt. Kstsamml.; Düsseldorf, Städt. Ksthalle; 1985)
ANGELA SCHNEIDER

Geikie, Walter (*b* Edinburgh, 9 Nov 1795; *d* Edinburgh, 1 or 2 Aug 1837). Scottish painter and printmaker. Before he was two years old he was left deaf and dumb by an illness. However, he did benefit from the new approach to teaching the deaf pioneered in Edinburgh by Thomas Braidwood, whose first successful pupil, Charles Sheriff (*c.* 1750–after 1831), had become a painter; it may have been Braidwood who encouraged Geikie in this direction. He studied drawing privately with Patrick Gibson (1782–1829) before enrolling in 1812 at the Trustees' Academy, Edinburgh, where John Graham (1754–1817) was the master. Graham had taught David Wilkie and was succeeded at the Academy in 1818 by Andrew Wilson, a friend of both Wilkie and Geikie. Wilkie was the dominant influence on Geikie's art. Geikie first exhibited in 1815 and contributed to exhibitions in Edinburgh regularly thereafter, becoming an Associate of the Scottish Academy in 1831 and an Academician in 1834.

In spite of his disability Geikie was a lively and sociable person. Like Wilkie he was a gifted mimic and the precise observation of expression and gesture is a feature of his art. According to an anonymous obituarist (*Caledonian Mercury*, 10 Aug 1837), Geikie was colour-blind and this predisposed him to the graphic media that he favoured. He did, however, paint quite extensively. His first dated painting, *Hallow Fair, Whitehouse Toll* (1824, Hopetoun House, Lothian), though badly damaged by fire, reveals a considerable command of oils, but on the whole his painting tends to a greyness that confirms the account of his colour-blindness. Although it is not known who taught Geikie to etch, his forceful and incisive manner of drawing with pencil suggests that Alexander Nasmyth took an interest in his work, for this was very much a feature of

the latter's style and of his teaching. Geikie also engraved and reproduced a set of lithographs. Between 1826 and 1829 he published a set of 87 etchings in parts. He published a second set of 18 etchings in 1831, *Studies from Nature* (repr. 1838), and he may have produced others. The first set provided the bulk of the prints included in the posthumous *Etchings of Scottish Life and Character* (Edinburgh, 1841, rev. 1885). It is by this collection, broadly comic in character, that Geikie is best known: it has been widely accepted as defining his achievement. However, the etchings of 1831, not included in this collection, though still enlivened by humour, are much more ambitious, and along with the drawings associated with them, such as *Girl Peeling Potatoes* (1830; Edinburgh, N.G.), are the high point of his art.

Clumsiness of execution sometimes mars his work in the transition from drawing to etching but it never obscures the sympathetic truthfulness that is his gift, even in such an unpromising subject as a drunk man helped home by his friends (etching, *He's Just Gotten Plenty for ae Day*, 1830). The doctor and psychiatrist Alexander Morison used several drawings by Geikie to illustrate his *Physiognomy of Mental Diseases* (1840). This suggests an interest in the psychology of expression on Geikie's part and hints at the sophistication that underlies his art in spite of its apparent naivety. Geikie also worked as a topographical artist and there are numerous paintings, drawings and engravings by or after him of Scottish scenery; these are unexceptional, but two bound drawings of ruinous or half ruinous buildings in and around Edinburgh are remarkable for their vigour and lack of picturesque quaintness (Edinburgh, Cent. Lib.).

BIBLIOGRAPHY
R. Morris: 'The Etchings of Walter Geikie', *Prt Colr Q.*, xxii (1935), pp. 304–24
D. Irwin and F. Irwin: *Scottish Painters at Home and Abroad* (London, 1975), pp. 193–5
Walter Geikie: Scottish Life and Character (exh. cat. by D. Macmillan, U. Edinburgh, Talbot Rice Gal., 1984)
Painting in Scotland: The Golden Age (exh. cat. by D. Macmillan, U. Edinburgh, Talbot Rice Gal.; London, Tate; 1986–7), pp. 173–4

DUNCAN MACMILLAN

Geisberg, Max (Heinrich) (*b* Münster, Westphalia, 9 Oct 1875; *d* Münster, 5 June 1943). German art historian. He studied art history in Münster, Berlin and Heidelberg, submitting in 1902 a thesis on the Westphalian engraver Israhel van Meckenem (ii). In 1905 he was appointed assistant to the Director of the Kupferstichkabinett, Dresden. After becoming professor in 1911, he contributed decisively to extending and consolidating the collections in Dresden (1911–34) and in Münster, where from 1940 he was Director of the Stadtmuseum. Geisberg was one of the leading experts on graphic art of his time, concentrating his research on two main areas: the art history of Westphalia, particularly Münster, and the development of German graphic art in the 15th and 16th centuries. In both areas he published fundamental works, including a six-volume inventory of the architectural and artistic monuments of Westphalia; a study of the origins of engraving and studies of the German single-leaf woodcut; and German graphic art before Albrecht Dürer.

WRITINGS
Die Anfänge des deutschen Kupferstiches (Leipzig, 1909, rev. 1924)
Der deutsche Einblatt-Holzschnitt in der ersten Hälfte des 16. Jahrhunderts (Munich, 1923)
Bau- und Kunstdenkmäler von Westfalen, 6 vols (Münster, 1932–41)
Geschichte der deutschen Graphik vor Dürer (Berlin, 1939)

NDB

BIBLIOGRAPHY

ELISABETH GUROCK

Geisselbrunn, Jeremias (*b* Augsburg, *c.* 1594–6; *d* Cologne, *c.* 1659–64). German sculptor. In 1608 he was apprenticed in Augsburg to Caspar Meneller and may later have worked for Hubert Gerhard in Munich. He moved to Cologne at some time before 1624 and acquired citizenship. He worked in both wood and stone and in 1628 became a master in the guild of joiners and wood sculptors. However, in Cologne stone sculptors belonged to the masons' guild, which he was not allowed to join until 1636. He was at various times an official both of that guild and of the city's administration.

Geisselbrunn had probably been summoned to Cologne to work on the new Jesuit church of Mariae Himmelfahrt (1618–29), which was being built by Ferdinand von Wittelsbach, Archbishop of Cologne, and his brother Maximilian I von Wittelsbach, Elector and Duke of Bavaria. Geisselbrunn was responsible for most of the sculptural decoration on the church's interior, notably the over life-size wood apostles that are set on consoles in the nave. For these he first made small wooden models (untraced) that bore his monogram and the date 1624 or 1627. This series of statues, which culminated in the figures of the *Salvator mundi* and the *Regina coeli* at the entrance to the choir, was completed by 1631 and was based on the large terracotta apostles and saints that Hubert Gerhard had produced between 1585 and 1595 for the choir of St Michael in Munich. Geisselbrunn adopted several of Gerhard's poses and facial types, as well as his sense of monumental grandeur. However, he made significant changes, such as varying the positions of the figures; thus *St Simon* strikes a casual pose, his right leg unselfconsciously crossed over his left, while *Christ* and the *Virgin* gesture towards each other, thereby creating a spiritual and spatial interaction that dominates the choir entrance. Geisselbrunn somewhat refined Gerhard's heavy, voluminous drapery with its deep folds, developing the flowing movement and the detailing of the material. The face and the hair of *St John the Divine*, perhaps the finest of Geisselbrunn's apostles, are particularly close to those in Gerhard's statue of *St John*, but the expression of spirituality is intensified. Here and in many of his other sculptures of the late 1620s and 1630s, Geisselbrunn conveyed a pathos that recalls the work both of Peter Paul Rubens, whose figures and compositions he occasionally copied, and of the sculptor Georg Petel.

Geisselbrunn's other projects for the Jesuit church include the high altar (wood, 1618), the pulpit (wood, 1630–34) and the decorative carvings of the spandrels and columns. He designed all of these but left most of the carving to assistants. For the pulpit, he made the figures of *Christ* and the *Four Evangelists*, which are close in style to the nave apostles, as well as the *Archangel Michael Vanquishing Satan*. Around 1629 Geisselbrunn made the model for the life-size bronze statue of *St Helena* in Bonn

Minster, formerly attributed to Petel, because of its striking similarity to Petel's statue of *St Mary Magdalene* forming part of the *Crucifixion* group in the Niedermünster parish church in Regensburg.

Geisselbrunn frequently supplied designs and models for other artists. He is documented as the designer of the beautiful shrine in the St Engelbert Chapel in Cologne Cathedral, made between 1630 and 1633 by the goldsmith Conradt Duisbergh. Though small (h. 170–200 mm), the shrine figures such as *Christ*, the *Virgin*, the *Magi* and *St Engelbert* resemble the Jesuit church apostles and pulpit statues. Around 1656 Geisselbrunn also made the model for a silver *Virgin and Child* in St Andreas, Düsseldorf.

Most of Geisselbrunn's religious statues were made for churches in Cologne. Since the city was largely spared the ravages of the Thirty Years War, Geisselbrunn, unlike almost every other sculptor of his time in Germany, continued to receive important commissions throughout the 1630s and 1640s. He is documented (*c.* 1640) as carving the wooden *Virgin and Child* for the Minorite church of Mariae Empfängnis and an *Apostles* cycle (fragments in Eupen, St Nikolaus). He supplied the alabaster *St Helena* (1635) for the altar of St Stephan, while for the church of St Gereon he designed some decorative sculpture (*c.* 1635) and a life-size alabaster Crucifix (1650s). For the church of St Ursula he made the reliquary busts of *St Ursula* (wood and silver, 1643) and two of her fellow martyrs (after 1656). Works attributed to him are found also in the cathedral and the churches of St Kolumba, St Maria in Kapitol, St Maria in Pesch and St Pantaleon. Among his most beautiful works of the early 1650s was the alabaster *Virgin and Child* (Cologne, St Kolumba, destr.) and the wood *St Hubert* (Cologne Cathedral). The *Virgin and Child* yet again recalls Gerhard's work, but in *St Hubert* Geisselbrunn focused on

the subtle facial expression and heightened spiritual character, rather than the overt theatricality of his apostles from the Jesuit church. Geisselbrunn was the leading sculptor in Cologne during the 17th century, and his late works strongly influenced subsequent sculpture in Cologne and its archdiocese.

BIBLIOGRAPHY

E. Roessler-Mergen: *Jeremias Geisselbrunn und die kölnische Plastike des 17. Jahrhunderts* (Bonn, 1942)

H. P. Hilger: 'Eine Silberstatue der Muttergottes nach Jeremias Geisselbrunn', *Pantheon*, xxvii (1969), pp. 299–305

U. Weirauch: *Der Engelbertschrein von 1633 im Kölner Domschatz und das Werk des Bildhauers Jeremias Geisselbrunn* (Düsseldorf, 1973) [the best critical monograph]

H. P. Hilger: 'Zum Werk des Kölner Barock-Bildhauers Jeremias Geisselbrunn', *Beitr. Rhein. Kstgesch. & Dkmlpf.: II. Festschrift Alan Verbeek* (Düsseldorf, 1974), pp. 179–90

B. W. Lindemann: 'Zu Jeremias Geisselbrunns Helenafigur im Bonner Münster', *Z. Dt. Ver. Kstwiss.*, xxxii (1978), pp. 168–73

——: 'Zur stilistischen Entwicklung im Werk des Jeremias Geisselbrunn', *Die Jesuitkirche St Mariae Himmelfahrt in Köln*, Beiträge zu den Bau- und Kunstdenkmälern im Rheinland, xxviii (Düsseldorf, 1992), pp. 299–314

JEFFREY CHIPPS SMITH

Gekkei. *See* MATSUMURA GOSHUN.

Gelati Monastery. Architectural complex founded in 1106 as a monastery and academy on the south bank of the Tskaltsitela River, 12 km from Kutaisi, Georgia. It was founded by King David III the Builder (*reg* 1089–1125) and is generally regarded as the most important centre of medieval Georgian culture and art. Among the many outstanding scholars there was the Neo-Platonist philosopher Ioann Petrisi (*fl c.* 1080–1120), who translated texts of Aristotle and Proclus into Georgian and wrote commentaries upon them. The wealth of the monastery was based on land grants and contributions from the Georgian kings and from private individuals.

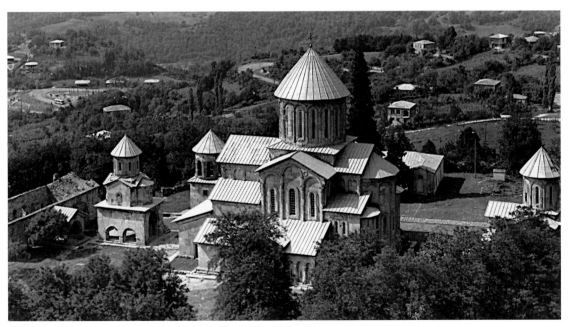

Gelati Monastery, founded 1106

Three churches now remain, together with a bell-tower and the ruins of the academy building (see fig.). The main church (1106–25) is dedicated to the Dormition and has a cruciform plan (35.5×35 m) with three projecting eastern apses and a dome resting on two piers and the corners of the altar apse. Three chapels were subsequently added to the east, south and north sides in the 12th and 13th centuries. The walls are built with hewn stone and decorated on the exterior with a complex system of arches. The interior decoration includes a mosaic (1125–30) in the altar apse of the *Virgin and Child Accompanied by Archangels*. The Virgin's dark blue robe and the archangel's emerald green, lilac and gold attire are set against a gold background, giving a rich palette of colours. The narthex contains 12th-century paintings depicting the Seven Ecumenical Councils; other wall paintings (13th century and later) include many portraits of historic figures such as *David the Builder* (rest. 16th century) and depictions of religious subjects.

To the east of this building lies the smaller, domed cruciform church of St George (13th century), which has 16th-century wall paintings. The church of St Nicholas (13th century) has a domed cross plan of two storeys. The three-tiered bell-tower (13th century) is one of the oldest in Georgia and has a circular arcaded bellcote on the top storey. Originally the 12th-century academy building was a rectangular single-storey hall with large arched windows, to which a portico was added in the 14th century. Part of the south entrance was erected over the tomb of David the Builder.

Among the icons produced at Gelati is the folding triptych of the *Virgin of Khakhuli* (Tbilisi, Mus. A. Georgia), whose main portrait (cloisonné enamel, *c.* 1100–50) is surrounded by complex ornamental patterns chased in gold and silver and smaller Georgian and Byzantine enamels of the 9th to 12th centuries. The monastery is also noted for its production of illuminated manuscripts (Tbilisi, Acad. Sci., Inst. MSS), church plate and traditional dress (Kulāisi, Mus. Hist. & Ethnog.).

BIBLIOGRAPHY
R. Mepisashvili: *Arkhitekturnyy ansambl' Gelati* [The architectural ensemble of Gelati] (Tbilisi, 1966)
A. Alpago Novello, V. Beridze and J. Lafontaine-Dosogne: *Art and Architecture in Medieval Georgia* (Louvain-la-Neuve, 1980)
Gelati: Arkhitektura, mozaika, freski [Gelati: architecture, mosaics, frescoes], foreword by R. Mepisashvili and T. Virsaladze (Tbilisi, 1982)
V. Beridze and others: *The Treasures of Georgia* (London, 1984)

V. BERIDZE

Gelder, Arent [Aert] de (*b* Dordrecht, 26 Oct 1645; *d* Dordrecht, 27 Aug 1727). Dutch painter and draughtsman. He was the son of a wealthy Dordrecht family and probably became a pupil of Samuel van Hoogstraten in 1660. Apparently on the advice of van Hoogstraten, de Gelder moved to Amsterdam and entered Rembrandt's workshop, possibly *c.* 1661. It is commonly assumed that he stayed there about two years. He was Rembrandt's last pupil. After completing his apprenticeship, de Gelder returned to Dordrecht, where he worked for the rest of his long career. Considering that de Gelder was active for more than half a century, his output of just over 100 paintings seems low, probably because he was financially independent. Of those paintings accepted as by him, only 22 are dated, creating considerable problems in establishing a chronology.

De Gelder was influenced most of all by Rembrandt's painting technique. Like that of his famous master, de Gelder's brushwork was sometimes broadly applied and his colours thickly layered. On occasion, he too scratched the paint surface with the blunt end of his brush. By contrast, he hardly ever imitated Rembrandt's compositions, with one exception: the *Ecce homo* (1671; Dresden, Gemäldegal. Alte Meister, see Sumowski, 1983, no. 723 and Moltke, no. 66), an early composition derived from the third or fourth state of Rembrandt's etching of 1655 (A. von Bartsch: *Le Peintre-graveur*, 1803–21; 76). The extent to which de Gelder's artistic personality later developed independently is evident in the composition, subject-matter and colour scheme of a *Temple Entrance* (1671; The Hague, Mauritshuis, s 724, m 54). This becomes more obvious in the paintings he created in the 1680s, when no fewer than 12 dated paintings are recorded. Many of these depict scenes from the Old Testament, for instance *Judah and Tamar*, a theme never dealt with by Rembrandt. Possibly de Gelder knew such a composition by Pieter Lastman, Rembrandt's teacher. Other subjects from the Old Testament played an important role in Rembrandt's oeuvre, although *Esther and Ahasuerus*, so often depicted by de Gelder, was only once dealt with by Rembrandt in a painting of *c.* 1661 (Moscow, Pushkin Mus. F.A.), done at the time de Gelder entered his studio. De Gelder treated the theme nearly a dozen times, a good example being the imposing *Esther at her Toilette* (1684; Munich, Alte Pin., s 743, m 29; see fig.). The story of Esther's life interested de Gelder more than any other biblical event, possibly because of the human dimension. Most of the pictures are centred on the interactions between a few protagonists; however, narrative details are emphasized rather than psychological relationships.

De Gelder also executed numerous portraits during the 1680s, some of which are dated, others datable on stylistic grounds. Some are official commissions, such as the portrait of *Ernestus van Beveren* (1685; Amsterdam, Rijksmus., s 804, m 84), while others are clearly of friends, such as the *Portrait of an Actor* (1687; Detroit, MI, Inst. A., s 791, m 92). De Gelder was a man of independent financial means and thus never worried about securing commissions. From the same decade there is also a fine *Self-portrait* (1685; Frankfurt am Main, Städel. Kstinst. & Städt. Gal., s 749, m 83), which might have been inspired by Rembrandt's *Self-portrait* of two decades earlier (1665; Cologne, Wallraf-Richartz-Mus.).

In the 1690s de Gelder continued to produce paintings of biblical themes as well as some fine portraits, including that of the sculptor *Hendrik Noteman* (1698; Dordrecht, Dordrechts Mus., s 806, m 86). The gradual emergence of 18th-century features is apparent in this work, not only in the sitter's clothing, hairstyle and pose but also in the greater refinement and subtler choice of colours in the painting technique. Early in the 18th century de Gelder's colour scheme changed still further. For the first time a brilliant emerald and other shades of green made their appearance. The previous lack of such colours demonstrates how slowly he abandoned the Rembrandtesque palette. A typical example of this vivid new approach is

Arent de Gelder: *Esther at her Toilette*, oil on canvas, 1.39×1.63 m, 1684 (Munich, Alte Pinakothek)

the large canvas depicting *Ahimelech Giving the Sword of Goliath to David* (Malibu, CA, Getty Mus., s 752, M 20). The same brilliant palette is found in the *Portrait of a Young Man* (Hannover, Niedersächs. Landesmus., s 812, M 94); rather than a specific likeness, it is a spirited description of a seated youth looking out at the viewer.

Towards the end of his life, *c.* 1715, de Gelder created a number of paintings of the *Passion*. Of a projected series of 22 pictures, 12 survive (10 in Aschaffenburg, Schloss Johannisburg, Staatsgal., and 2 in Amsterdam, Rijksmus.). They were probably not painted on commission: de Gelder, a religious man, may simply have been taking stock of his life. The paintings vary greatly in quality, the finest being the *Way to Golgotha* (Aschaffenburg, s 772, M 67). Some of them were inspired in parts by Rembrandt's etchings, transposed into de Gelder's personal idiom.

At the very end of his life de Gelder executed a remarkable and affectionate group portrait of the famous *Doctor Boerhaave of Leiden with his Wife and Daughter* (*c.* 1722; Amsterdam, Rijksmus., s 817, M 100); the apparent bond with the sitter—something very rare in de Gelder's portraits—suggests that the subject might have

been de Gelder's own doctor. The artist was then nearly 80 years old at the time, but his powers of observation were undiminished.

De Gelder did not adopt the artistic trends of the latter half of the 17th century or the early part of the 18th, nor was he interested in painting elegant portraits in the fashionable Flemish style (like Govaert Flinck and Ferdinand Bol). He did not experiment with either the precise 'Fine' painting style of Gerrit Dou or the artificially illuminated candlelit scenes popularized by Godfried Schalcken. Although de Gelder in many ways continued the painterly technique of Rembrandt, his choice of subject-matter, imaginative presentation and brilliant colour schemes reveal a fine aesthetic sensibility, ensuring him a special place in Dutch painting of the 17th and 18th centuries.

BIBLIOGRAPHY

S. van Hoogstraten: *Inleyding tot de hooge schoole der schilderkonst* [Introduction to the great school of painting] (Rotterdam, 1678/R Utrecht, 1969)

A. Houbraken: *De groote schouburgh* (1718–21)

K. Lilienfeld: *Arent de Gelder: Sein Leben und seine Kunst* (The Hague, 1914)

J. Rosenberg, S. Slive and E. H. ter Kuile: *Dutch Art and Architecture, 1600–1800*, Pelican Hist. A. (Harmondsworth, 1966/*R* 1982), pp. 163–6

W. Sumowski: *Drawings of the Rembrandt School*, v (New York, 1981), pp. 2335–444

——: *Gemälde der Rembrandt-Schüler*, ii (Landau, 1983) [S]

The Impact of a Genius: Rembrandt, his Pupils and Followers in the 17th Century (exh. cat. by A. Blankert and others, Amsterdam, Waterman Gal.; Groningen, Groninger Mus.; 1983)

J. W. von Moltke: *Arent de Gelder, Dordrecht 1645–1727*, ed. K. L. Belkin (Doornspijk, 1994) [chapters by C. Tümpel, G. Pastoor and A. Chong; with cat. rais.] [M]

<div style="text-align: right">J. W. VON MOLTKE</div>

Gelder, J(an) G(errit) van (*b* Alkmaar, 27 Feb 1903; *d* Utrecht, 9 Dec 1980). Dutch art historian. He studied in Utrecht with W. Vogelsang, one of the founders of art history as an academic discipline in the Netherlands. At the same time he was, from 1924, assistant keeper at the Museum Boymans in Rotterdam, where he remained active until 1940. After an interlude in The Hague, as director of the Rijksbureau voor Kunsthistorische Documentatie (RKD) and, briefly, of the Mauritshuis as well, van Gelder was appointed to the Utrecht chair of Art History in 1946. The Utrecht Institute for Art History benefited greatly from his qualities as a manager, his numerous international contacts and the inspiring generosity of his teaching. He was a member of the Princeton Institute for Advanced Studies in 1953–4.

Van Gelder's writings include numerous articles and radio talks addressed to the general public. His professional publications testify to his vast knowledge of Dutch painting and, especially, prints and drawings. He studied such neglected aspects of Dutch 17th-century art as monumental painting at the court of Frederick Henry of Orange Nassau, the significance of Peter Paul Rubens and Anthony van Dyck for the Netherlands in the 17th century, and the history of collecting. Together with Ingrid van Gelder-Jost he embarked upon a comprehensive study of the prints after drawings and statues in Jan de Bisschop's *Icones* and *Paradigmata*, which document classical taste in the Netherlands in the 17th century. This was published posthumously.

<div style="text-align: center">WRITINGS</div>

For a complete list of J. G. van Gelder's writings consult J. Bruyn and others (1963) [1925–61], J. Bruyn and others (1973) [1962–72] and *In Memoriam J. G. van Gelder, 1903–1980* (1982) [1973–81]

Jan van de Velde, 1593–1641: Teekenaar-schilder (The Hague, 1933)

Vincent van Gogh: The Potato Eaters in the Collection of V. W. van Gogh, Amsterdam (London, 1947)

'De schilders van de Oranjezaal', *Ned. Ksthist. Jb.*, ii (1948–9), pp. 119–64

'Rubens in Holland in de zeventiende eeuw', *Ned. Ksthist. Jb.*, iii (1950–51), pp. 103–50

'Jan van de Velde, 1593–1641: Teekenaar-schilder, Addenda I', *Oud-Holland*, lxx (1955), pp. 21–40

'Nederlandse prentkunst in de laat-zestiende en zeventiende eeuw', *Kunstgeschiedenis der Nederlanden*, ed. H. E. van Gelder (Utrecht, 3/1959), i, pp. 106–33

Dutch Drawings and Prints (London/New York, 1959) [with 224 pls]

'Anthonie van Dyck in Holland in de zeventiende eeuw', *Bull. Mus. Royaux B.-A.*, viii (1959), pp. 43–86

'De Noordnederlandse schilderkunst in de zestiende eeuw (II)', *Kunstgeschiedenis der Nederlanden* (Antwerp, 4/1963), iv, pp. 602–53

with H. Gerson and S. de Gorter: 'Frits Lugt: Inspirator-organisator-documentator 80 jaar: De activiteiten van de laatste vijftien jaar', *Frits Lugt: Zijn leven en zijn verzamelingen, 1949–1964* (The Hague, 1964), pp. 5–27

'Drawings by Jan van de Velde', *Master Drgs*, v/1 (1967), pp. 39–42

'Lambert ten Kate als kunstverzamelaar', *Ned. Ksthist. Jb.*, xxi (1970), pp. 139–86

'Jan de Bisschop, 1628–1671', *Oud-Holland*, lxxxvi (1971), pp. 201–88

'Tekeningen van Aelbert Cuyp', *Aelbert Cuyp en zijn familie, schilders te Dordrecht* (exh. cat., Dordrecht, Dordrechts Mus., 1977–8), pp. 112–13

'Constantijn Huygens de Jonge als tekenaar', *Boymans Bijdragen: Opstellen van medewerkers en oud-medewerkers van het Museum Boymans-van Beuningen voor J. C. Ebbinge Wubben* (Rotterdam, 1978), pp. 111–28

'Rubens Marginalia I and II', *Burl. Mag.*, cxx (1978), pp. 445–57, 842–4; 'III', cxxii (1980), pp. 165–8; 'IV', cxxiii (1981), pp. 542–6

with I. Jost: *Jan de Bisschop and his 'Icones' and 'Paradigmata': Classical Antiquities and Italian Drawings for Artistic Instruction in Seventeenth Century Holland*, ed. K. Andrews, 2 vols (Doornspijk, 1985)

<div style="text-align: center">BIBLIOGRAPHY</div>

J. Bruyn and others, eds: *Album discipulorum J. G. van Gelder* (Utrecht, 1963), pp. 188–205 [bibliog., 1925–61, by E. Verwey]

——: *Album amicorum J. G. van Gelder* (The Hague, 1973), pp. 361–4 [bibliog., 1962–72]

J. Bruyn: Obituary, *Burl. Mag.*, cxxiii (1981), pp. 236–9

In Memoriam J. G. van Gelder, 1903–1980 (Utrecht, 1982), pp. 69–76 [bibliog., 1973–81]

<div style="text-align: right">J. BRUYN</div>

Geldersman, Vincent. *See* SELLAER, VINCENT.

Geldorp. Flemish family of painters. Most of (1) Gortzius Geldorp's surviving work was painted in Cologne around the turn of the 17th century. His son (2) George Geldorp worked as a painter and art dealer in England in the mid-17th century.

(1) Gortzius Geldorp [Gelsdorp; Gualdorp] (*b* Leuven, 1553; *d* Cologne, 1616). After training in Antwerp, first with Frans Francken (i) and later with Frans Pourbus (i), he became court painter to Charles of Aragon, Duke of Terranova. In 1604 he went with the Duke to the Catholic city of Cologne, where he remained for the rest of his life, working primarily as a portrait painter for the well-to-do. Most of his 70 works are painted on panel. He executed a series of nine family portraits that are mostly signed and/or dated and are inscribed on the back. These date from 1590 to 1610 and are all in the Rijksmuseum, Amsterdam. The sitters were painted either three-quarter-length, half-length or head and shoulders. The earliest of these are *Jean Fourmenois* (1590) and his wife *Hortensia del Prado* (1596) and the latest *Jeremias Boudinois* (1610) and his wife *Lucretia del Prado* (1610). The style of these portraits changed little; they are traditional but painted in a smoother manner and with more colour than portraits by the old Cologne masters. Geldorp also painted versions of existing portraits: for example the portrait of *Elisabeth von Steinrodt* is from a picture painted in Cologne in 1551.

Geldorp's oeuvre also includes religious and mythological scenes. He represented saints and figures from mythology as if they were portraits, often head-and-shoulder length (e.g. *Lucretia*; St Petersburg, Hermitage; and *Solomon and the Queen of Sheba*, 1602; Cologne, Wallraf-Richartz Mus.). The figures have a sweet, pious expression typical of Geldorp. Crispijn van de Passe (i) and Peter Isselburg made engravings after these portraits. For Cologne's town hall Geldorp painted a *Crucifixion* (c. 1597–1602; Cologne, Wallraf-Richartz Mus.), one of his best works, which used to hang over the emperor's throne in the Council Room. The figure of Mary Magdalene to the left of the cross is a later addition.

BIBLIOGRAPHY

M. Rooses: *Geschiedenis der Antwerpse schilderschool* [History of the Antwerp school of painting] (Ghent, 1879), p. 168

R. Wilenski, *Flemish Painters, 1430–1830* (London, 1960), p. 561

Katalog der niederländischen Gemälde von 1550 bis 1800 im Wallraf-Richartz Museum und im öffentlichen Besitz der Stadt Köln, Cologne, Wallraf-Richartz Mus. cat. (Cologne, 1967), pp. 41–6

Katalog Wallraf-Richartz Museum (Cologne, 1986)

M. J. T. M. STOMPÉ

(2) George Geldorp (*b* Spanish Netherlands; *d* London, 1665). Son of (1) Gortzius Geldorp. He was admitted Master in the Guild of St Luke in Antwerp in 1610. In 1613 he married a daughter of Willem de Vos (*fl* 1593–1629). He came to London from Antwerp in 1623. He painted a number of portraits in the Anglo-Netherlandish style, close in conception to the work of Daniel Mijtens (i) or Paul van Somer. The most important are those of *William Cecil, 2nd Earl of Salisbury* and his wife *Catherine* (both 1626; Hatfield House, Herts). The handling is less accomplished and the figures more stiffly articulated than in the work of Mijtens, for example (his feeble draughtsmanship was noted by Sandrart), but the surfaces are decorative and the background of the portrait of the Earl contains an historically important view of Hatfield House with sportsmen in the foreground.

Subsequently Geldorp was closely associated with Anthony van Dyck and specialized in copies of his work. He was also involved with Peter Lely. He became, however, increasingly active as a dealer and impresario. In 1637–8, for example, he acted as intermediary between Everhard Jabach and Rubens in the commission for the altarpiece the *Martyrdom of St Peter* (1638; Cologne, St Peter); he was also involved, at first with van Dyck, in supplying pictures to Algernon Percy, 10th Earl of Northumberland. Early in the Interregnum he put up a scheme, with Lely and Sir Balthazar Gerbier, for a series of pictures to commemorate the achievements of the Long Parliament; and at this time Cardinal Mazarin's agent in London was buying works of art with Geldorp's assistance. On the eve of the Restoration, however, Geldorp was prominent in the efforts to hunt down and reassemble as many as possible of the royal family's possessions, and he was rewarded with the post of picture-mender and cleaner to the king.

BIBLIOGRAPHY

J. von Sandrart: *Teutsche Academie* (1675–9); ed. A. R. Peltzer (1925)

E. Auerbach and C. K. Adams: *Paintings and Sculpture at Hatfield House* (London, 1971), pp. 27, 84–6

OLIVER MILLAR

Gelduinus, Bernardus. *See* BERNARDUS GELDUINUS.

Gel'freykh, Vladimir (Georgiyevich) (*b* St Petersburg, 24 March 1885; *d* Moscow, 7 Aug 1967). Russian architect. He studied from 1906 to 1914 at the Academy of Arts, St Petersburg, under Leonty Benois. In 1911, while still a student, he began to work with Vladimir Shchuko, who introduced him to the World of Art circle, and to their ideas of revival of the artistic traditions of the past. In the post-revolutionary years he worked exclusively with Shchuko. Their early works include: the neo-classical propylaea and extension (1922–3) to the Smol'ny, Petrograd (now St Petersburg); the light wooden pavilions (destr.; see M. Y. Ginsburg: *Stil' i epokha* [Style and epoch]

(Moscow, 1924), table vi) of the foreign section of the All Russian Agricultural Exhibition (1923), Moscow, using a dynamic asymmetry that was close to the compositions of De Stijl; and the dynamic monument to *Lenin* (1925–6) with S. A. Yevseyev (1882–1959) near the Finland Station in Leningrad (now St Petersburg). Their largest projects of the 1930s were the Constructivist style theatre (1930–35), Rostov-on-Don (*see* RUSSIA, fig. 14), and the State Lenin Library (1928–37; now the Russian State Library), Moscow, in which the free asymmetry of the spatial composition is attended by strict vertical rhythms derived from 20th-century neo-classicism. They took part in the third and fourth stages of the competition for the Palace of Soviets, Moscow, and worked on the final project (1933–8; with Boris Iofan; unexecuted); Gel'freykh continued to work on the design after Shchuko's death in 1939.

With Igor' Rozhin, between 1943 and 1944, he designed the Elektrozavodskaya metro station, which is notable for the integrity of its neo-classical composition, and the ground-floor vestibule of the Novokuznetskaya metro station, both in Moscow. With Mikhail Minkus he designed the Prospekt Mira Circle Line metro station (1949–51), Moscow, and the 27-storey Ministry of Foreign Affairs Building (1948–53), Smolensk Square, Moscow. Situated on one of the principal junctions on the Sadovoye Kol'tso (Garden Ring Road), the building has a rectangular plan, stretched out frontally along the ring road and facing an extensive square and, beyond, an esplanade, sloping down to the River Moskva. Supporting pylons in the front create an organic link with the surrounding quarter of Moscow. From 1950 Gel'freykh directed the layout and construction of the western part of Moscow, devoting particular attention to the planning of the pivotal Kutuzov Prospect, and the squares along it.

WRITINGS

'Vosstanovleniye i rekonstruktsiya rostovskogo teatra' [The restoration and reconstruction of the Rostov theatre], *Arkhit. SSR*, 14 (1947), pp. 16–20

BIBLIOGRAPHY

I. Rozhin: 'V. G. Gel'freykh', *Arkhit. SSSR*, 5 (1986), pp. 92–8

A. V. IKONNIKOV

Gell, Sir **William** (*b* Hopton, Derbys, 1 April 1777; *d* Naples, 4 Feb 1836). English Classical scholar, archaeologist and topographer. Educated at Jesus College, Cambridge, he studied at the Royal Academy Schools, was elected Fellow of learned societies in London and, later, honoured by academic institutions abroad. Gell began his travels in Greece and the Troad in 1801, followed rapidly by exemplary publications. His travels continued until 1806, broken only in 1803 when he was sent on a diplomatic mission to the Ionian islands. The Society of Dilettanti appointed him to lead its third Ionian mission (1811–13), instructing him to make architectural measurements of Classical sites in Attica and Asia Minor, the results subsequently being published by the Society in *The Unedited Antiquities of Attica* (1817) and revised editions of *Ionian Antiquities* (1821 and 1840; *see* CHANDLER, RICHARD).

Gell was knighted in 1814, and accompanied Caroline, Princess of Wales, as one of her chamberlains when she

set out on her foreign travels. He left her entourage after its arrival in Italy and resumed his archaeological studies, in particular at the site of Pompeii, which was his main interest throughout his life. His *Pompeiana: The Topography, Edifices and Ornaments of Pompeii* was the first account in English of the site. Between 1814 and 1820 Gell worked also at Rome, where his collaboration with the young and brilliant scholar ANTONIO NIBBY at Rome University resulted in a publication in Italian of the walls of Rome.

Gell went to England in 1820 to give evidence for the defence at the trial of Queen Caroline, later returning to Rome where he continued to explore and record the archaeological sites of the Campagna. Though not endowed with great artistic talent, he was honest and accurate. His sketches and topographical drawings, undertaken by what modern scholars might consider old-fashioned methods (he used a camera lucida), can still usefully be consulted, and his recordings of some Classical inscriptions are the only ones now extant. From 1830 he lived permanently at Naples where, as 'resident plenipotentiary' of the Society of Dilettanti, he reported on archaeological discoveries of interest and the activities of the 'fashionables' of Naples. He was the first to give news of the discovery of Oplontis near Pompeii, where an excavated villa of outstanding beauty is thought to be that of Poppaea, the wife of Nero (*reg* AD 54–68).

Despite crippling gout Gell retained his lively interest in the academic world and entertained a wide social circle with his learning, wit and sometimes flippant conversation. He was able to indulge in his love of music, had an organ installed in his house and was reported as having taught one of his dogs to sing. He died at Naples in his 60th year and was buried in the Protestant cemetery in the tomb of the Margravine of Ansbach, the mother of his closest friend, Hon. Richard Keppel Craven, the tomb taking the form of an Ionic temple.

WRITINGS

The Topography of Troy and its Vicinity Illustrated and Explained by Drawings and Descriptions etc (London, 1804)
The Geography and Antiquities of Ithaca (London, 1807)
The Itinerary of Greece, with a Commentary on Pausanias and Strabo and an Account of the Monuments of Antiquity at Present Existing in that Country, Compiled in the Years 1801, 2, 5, 6 etc (London, 1810/R 1827)
The Itinerary of the Morea, Being a Description of the Routes of that Peninsula (London, 1817 and 1823)
The Unedited Antiquities of Attica (London, 1817)
with J. P. Gandy: *Pompeiana: The Topography, Edifices and Ornaments of Pompeii*, 2 vols (London, 1817–19)
with A. Nibby: *Le mura di Roma disegnate da Sir W. Gell, illustrate con testo note da A. Nibby* (Rome, 1820)
The Topography of Rome and its Vicinity with Map, 2 vols (London, 1834, rev. 2/1846)

BIBLIOGRAPHY

E. Clay and M. Frederiksen, eds: *Sir William Gell in Italy: Letters to the Society of Dilettanti, 1831–1835* (London, 1976)

E. CLAY

Gellée, Claude. See CLAUDE LORRAIN.

Gelli, Giovanni Battista (*b* Florence, 12 Aug 1498; *d* Florence, 24 July 1563). Italian writer. He was closely connected with the Accademia Fiorentina, where he made his mark as the most distinguished 16th-century commentator on Dante. He wrote two works on the visual arts, an academic lecture delivered and published in 1549 and an unfinished series of artists' biographies, which remained unpublished until the end of the 19th century. The 1549 lecture took the form of a commentary on Petrarch's two sonnets (lxxvii and lxxviii) dedicated to the portrait of *Laura* (untraced) by Simone Martini. Gelli interpreted the sonnet 'Per mirar Policleto a prova fiso' as a eulogy of the painting according to Platonic doctrine, and the second sonnet 'Quando giunse a Simone l'alto concetto' as one according to Aristotelian doctrine. After a brief exposition of the fundamental principles of Neo-Platonism, based on the *De dogmate Platonis* of the Greek philosopher Albinos, Gelli explained that the painter had reflected on human nature in order to portray his model's features. However, he believed this mode of vision to be incompatible with the soul's perceptive ability and considered that, while the sonnet was learned and ingenious, it lacked any resonances in reality. The analysis of the second poem is a paraphrase of some extracts from Aristotle's *Physics* and *Metaphysics*. Gelli defined the concepts of form, matter, loss and causality, which he transferred from the natural world to the realm of artistic creation.

Although Gelli bowed to the convention of academic lectures whereby a poem must give rise to a philosophical exposition, this work nevertheless represents a rare meeting of the visual arts with philosophical trends. Neo-Platonism is presented as an appropriate system for expressing aesthetic emotions without, however, explaining them. Aristotelianism, on the other hand, is shown to provide categories that can be used to define an artist's work. The commentary on the sonnets is prefaced by a long introduction on the visual arts. Quoting from Aristotle's *Poetics*, Gelli defined painting and sculpture as imitative arts. He summarized their history along traditional lines: Roman decadence and the Middle Ages were followed by a period of renewal that began in the 14th century and reached its height with Michelangelo. He repeated this account in his *Dell'origine di Firenze*, written before 1546, as well as in the introduction to his *Vite d'artisti*, where he attributed the decline in the art of drawing to genetic and cultural degeneracy caused by the barbarian invasions. In language and literature Gelli gave perfection in art an exclusively Florentine character. His *Vite*—probably intended to go as far as Michelangelo but interrupted at Michelozzo—set out to demonstrate Florentine supremacy in the visual arts and is dominated by the figures of Giotto, Ghiberti, Brunelleschi and Donatello. The work was written independently of and probably earlier than the *Vite* of Giorgio Vasari (i.e. probably between 1540 and 1549). Several passages suggest that it shared a common source with *Il libro di Antonio Billi* and the *Anonimo Magliabechiano* (Kallab). Gelli's notions of artistic development in the arts heralded Vasari's theories, which replaced Gelli's linear progression from Cimabue to Michelangelo with subtler divisions into periods and styles.

WRITINGS

Lezione sopra i due sonetti che lodano il ritratto di Madonna Laura (Florence, 1549); ed. C. Negroni in *Lezioni petrarchesche* (Bologna, 1884), pp. 219–82; extracts in P. Barocchi, ed.: *Scritti d'arte del cinquecento*, i (Milan, 1971), pp. 286–9
G. Mancini, ed.: 'Vite d'artisti di G. B. Gelli', *Archv Stor. It.*, xvii (1896), pp. 32–62

A. d'Alessandro, ed.: 'Dell'origine di Firenze', *Atti & Mem. Accad. Tosc. Sci. & Lett., 'La Colombaria'*, xxx (1979), pp. 61–122

BIBLIOGRAPHY
W. Kallab: *Vasaristudien* (Leipzig, 1908), pp. 182–207
A. de Gaetano: *Giambattista Gelli and the Florentine Academy: The Rebellion against Latin* (Florence, 1976)
F Quiviger: 'Arts visuels et exégèse littéraire à Florence de 1540 à 1560', *Les commentaires et la naissance de la critique: France/Italie (14e–16e siècles)* (Paris, 1990), pp. 165–73

FRANÇOIS QUIVIGER

Gelnhausen Palace. Former imperial palace in Hesse, Germany. It was founded by Frederick I (Barbarossa), Holy Roman Emperor (*reg* 1152–90), who apparently planned it as part of a gradual expansion of his ancestral Hohenstaufen lands. Situated on an island in the River Kinzig, the palace is a fortress protected by water. Next to the palace Frederick founded a new town with a regular street plan and two markets on the great Frankfurt–Leipzig trade route. The palace seems to be the earliest building on the site. The buildings have tended to be dated far too early: between 1150 and 1170 (the date of the town's charter), or up to 1180 (the date of the imperial diet held at Gelnhausen) or 1190. However, a document relating to the deposition of Henry the Lion at the diet of 1180 was drawn up *in territorio Maguntino*, suggesting that it took place in the older castle belonging to Mainz, which presumably stood on another site. Dendrochronological tests have now provided a date of 1182 for one of the foundation piles driven in at the gateway of Gelnhausen Palace. Since the palace rests on approximately 18,000 to 20,000 such piles, which would have taken 15 to 20 years to drive in, this provides a *terminus post quem*. The palace

fell into decay from the 14th century because of disturbances in its foundations, and it has been a ruin for centuries. Nevertheless, almost all the plan is discernible: a surrounding wall of rusticated masonry, a gateway divided into two aisles, each of three bays, with the palace chapel above, a tower built of rusticated masonry connected to the gate-house behind the defensive wall, and the main living quarters set at an angle of 110 degrees to the gate-house (see fig.). Excavations *c.* 1930 revealed the foundations of a building adjoining the living quarters to the east, as well as those of a thick-walled round tower and of the castle guards' houses.

The sequence of building at Gelnhausen Palace was probably as follows: first the defensive wall, followed after 1182 by the lower storey of the gate-house and the tower connected with it. Capitals comparable to the 'double-shield' ones in the gate-house are found in Alsace, the ancestral land of the Hohenstaufen, for example at Marmoutier and, in very similar form, at the entrance to St Andrew's Chapel in Strasbourg Cathedral, which was completed *c.* 1190. Next, after a slight alteration to the north-east corner of the tower, the chapel was built above the gate-house, and at the same time the famous column with its eagle capital was placed in front of the gate-house to support the added thickness of the wall. After a fire in 1195 the living quarters were built with magnificent block capitals, carved with stylized foliage. In addition to the capitals in the gate-house, some of the stylistic sources of other architectural features originate in Alsace: the impost blocks formed of roll and block, the round angle rolls and their ornamental lower ends, and the interlace ornament of the panels flanking the fireplace. There is an identical

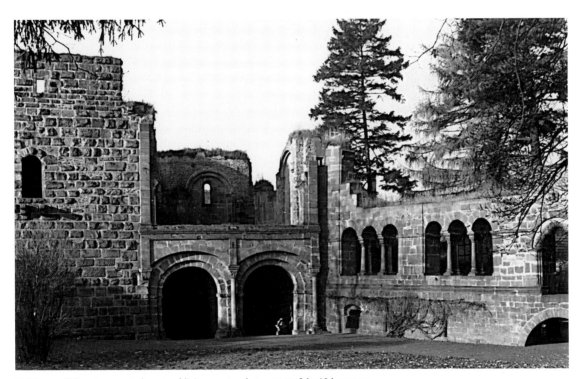

Gelnhausen Palace, tower, gate-house and living-quarters, last quarter of the 12th century

fragment at Kaiserslautern, another fortified palace protected by water. The great richness of the capitals and imposts at Gelnhausen points to southern France (e.g. La Daurade, Toulouse), and the arrangement of the engaged piers in the chapel is found there. A few motifs come from Lorraine. Yet all is combined into a unified whole of very high quality, suggesting the work of a brilliant master from the Upper Rhine who assimilated influences from southern France, Arles and Toulouse, Burgundy, Autun and Alsace.

BIBLIOGRAPHY
L. Bickell, ed.: *Die Bau- und Kunstdenkmäler im Regierungsbezirk Cassel*, i (Marburg, 1901)
G. Binding: *Pfalz Gelnhausen* (Bonn, 1965); review by W. Einsingbach in *Nassau. An.*, lxxviii (1967), pp. 362–7
K. Nothnagel: *Staufische Architektur in Gelnhausen und Worms* (Göppingen, 1971)
W. Einsingbach: *Gelnhausen, Kaiserpfalz: Amtlicher Führer* (Bad Homburg, 1975)

FRITZ ARENS

Gelpke, André (*b* Beienrode, Gifhorn, 15 Mar 1947). German photographer. He studied photography under Otto Steinert at the Folkwangschule, Essen, from 1969 until 1974. During and after his studies he travelled widely, working also as a photojournalist for *Geo* magazine and for the Visum agency, of which he was a co-founder. From 1978 he worked mainly on personal themes and books. His autobiographical and subjective documentations of artificial environments, for example the series entitled *Fluchtgedanken* (Munich, 1983), which deals with the loneliness of the individual, were influential on younger German photographers in the late 1970s and early 1980s. Gelpke is presently professor of photography in Zurich.

PHOTOGRAPHIC PUBLICATIONS
Sex-Theater (Munich, 1981)
Fluchtgedanken (Munich, 1983)
Der Schiefe Turm von Pisa: Reisebilder, 1972–1985 (exh. cat., Brunswick, Mus. Phot., 1985)

BIBLIOGRAPHY
M. Mettner: *Die Autonomisierung der Fotografie* (Marburg, 1987)

HANS CHRISTIAN ADAM

Gem-engraving. Engraved gems are gemstones, whether quartzes or the harder, more precious stones, either engraved in intaglio, as for seals, or cut in cameo to give a raised relief image. In a wider sense gem-engraving encompasses shell cameos and moulded, glass-paste imitations of engraved gems.

See also GEMS and HARDSTONES.

I. History. II. Collections and museums.

I. History.

1. Ancient Egyptian. 2. Greek. 3. Etruscan. 4. Roman. 5. Gnostic. 6. Indian. 7. Islamic. 8. Byzantine. 9. Medieval. 10. Renaissance to 1700. 11. 1701–1800. 12. After 1800.

1. ANCIENT EGYPTIAN. The use of gems, often set in gold, electrum and to a lesser extent silver, in ancient Egypt is attested from the Predynastic period (*c.* 6000–*c.* 2925 BC). The Egyptians chose the stones for their rich colours, not their reflective powers, and the classic trio were blood-red cornelian, turquoise and lapis lazuli. It has

been suggested that these colours represent blood, vegetation and water/sky respectively, and certainly the amuletic protection afforded by ancient Egyptian jewellery was as important as any decorative effect.

Cornelian pebbles could be quite easily picked up from the Eastern desert, whereas turquoise had to be mined laboriously in the Sinai desert. A list of craftsmen from a papyrus (London, BM) notes a *mes'at* or 'purveyor of precious stones', a prospector who roved the desert. There, in addition to cornelian, red jasper and garnets, which can be highly polished and require little working to turn into beads, green feldspar, an alternative to turquoise, occurs in a seam in the Eastern desert, where there is evidence of ancient workings. Lapis lazuli, which had been used for inlays and beads since Predynastic times, was imported from the Euphrates area, whence it had been traded from Badakhshan in Afghanistan. It has been suggested that the Egyptian name for this stone, *khesbed*, is a variant of this toponym. Its presence among grave furnishings testifies to the antiquity of trade routes.

From earliest times natural and artificial substitutes were sought, especially for the expensive imported lapis lazuli. Soapstone was coated with blue and green glazes in Predynastic times, and by the 4th Dynasty (*c.* 2575–*c.* 2465 BC) a crystalline lapis blue material, coloured by copper calcium tetrasilicate, had been developed.

See also EGYPT, ANCIENT, §XIV.

BIBLIOGRAPHY
G. C. C. Maspero: *Catalogue général des antiquités égyptiennes du Musée du Caire* (1901–)
C. Andrews and A. Wilkinson: *Jewellery I, from the Earliest Times to the XVII Dynasty* (London, 1981), vi of *Catalogue of Egyptian Antiquities in the British Museum*
C. A. R. Andrews: *Ancient Egyptian Jewellery* (London, 1990)

LAWRENCE WINKWORTH

2. GREEK.

(i) *Introduction: early seals.* Gem-engraving was widely practised in Bronze Age Greece but thereafter was not significantly resumed until the Late Geometric period (8th century BC), when it was stimulated by Near Eastern and Egyptian contacts. From the later 8th century BC extensive importation of eastern scarabs and scaraboids, and the arrival of immigrant craftsmen, reintroduced in Greece not only the use of seals but also the techniques for cutting them. The earliest Greek seal workshop was established in the Cyclades *c.* 750 BC and produced square, flat plaques with bevelled edges and a central hole, to which a wooden handle was probably attached. They were cut in soft stone, usually white limestone, but occasionally marble, and they were soon imitated in the Argolid. There the material was mostly serpentine, and seals were cut in both the old square shape and various new forms. Some of these were Near Eastern in origin; mainly hemispheres, tabloids, lentoids and discs. The earliest examples were decorated with linear patterns and simplified human figures in the traditional Geometric style. Later, however, such Orientalizing creatures as sphinxes and centaurs were introduced. The repetitive character of this decoration indicates that the seals were ornamental or votive objects rather than official seals for documents or property. From the 7th century BC seals were also produced in the form of

engraved ivory and bone discs (*see* GREECE, ANCIENT, §X, 6(i)). Most of these were dedicated in sanctuaries, and they bear simple decorative designs similar to those on stone seals.

The most significant group of early Greek seals, however, are the Island Gems, manufactured on the Cyclades, mainly on Melos. The cutters of these gems reintroduced the Bronze Age lentoid and amygdaloid shapes, which they copied from rediscovered prehistoric seals. Their material was soft green serpentine, often translucent, and the decoration included animals, sea-monsters and hybrid creatures in the Geometric and Orientalizing traditions. Examples occur outside the Cyclades, in mainland Greece and on Crete. These seals were pierced lengthways and were probably worn on cord bracelets.

(ii) Archaic. By around 575–550 BC, two major new forms, the scarab and its plain variation, the scaraboid, had been introduced from the Near East and Phoenicia. The beetle backs of the scarabs were usually carefully engraved, but without much detail, while a distinctive feature, which clearly reveals Phoenician influence, is a ridge or spine running along the beetle's back. Sometimes, the different parts of the back are framed with hatched borders.

The materials used for Archaic gems were harder than their precursors: cornelian and other varieties of chalcedony. These necessitated the use of new techniques, again borrowed from the East, and the bow drill and cutting-wheel were increasingly employed. Eastern models also influenced the iconography of the earlier groups in particular, which were probably of Cypro-Phoenician origin. These generally depicted horse-bodied Gorgons in eastern dress, winged centaurs and other hybrid creatures, as well as Greek versions of Phoenician themes. Gradually, the increased use of the drill allowed figures to be modelled more robustly and in greater detail, and many seals bore depictions of satyrs, either reclining, carrying women or holding drinking cups. These poses perfectly suited the gems' oval field, and such subjects continued to be used throughout the Archaic period, even after being abandoned by sculptors and vase painters. Especially notable is an agate scarab by the Master of the London Satyr (6th century BC; London, BM; see fig. 1). Similar compositions depicted sphinxes, either alone or with animals or even carrying off youths in the manner of the Theban Sphinx vanquished by Oedipus. Although the motif itself has religious origins, it is unclear whether the gems had any ritual significance.

The Late Archaic artistic interest in the human figure is reflected in many late 6th-century BC gems depicting nude warriors, youths restraining horses and girls by fountains. Artists' signatures of this period are also preserved, including those of Epimenes, on a chalcedony scaraboid found in Egypt (*c.* 500 BC; Boston, MA, Mus. F.A.; see Boardman, pl. 355), depicting a youth and his horse, and Anakles, on a black jasper scaraboid depicting a reclining satyr (*c.* 480–470 BC; New York, Met., see Boardman, pl. 373), which illustrates the progress made in the rendering of anatomical details and complex poses. The iconography of Archaic scarabs strongly reflects artistic developments in East Greek sculpture and coinage, and, through trade

1. Agate scarab by the Master of the London Satyr, 16×22 mm, 6th century BC (London, British Museum)

and colonization, it profoundly influenced West Greek glyptics, as shown by Etruscan gems (*see* §3 below).

(iii) Classical. The evolution of gem production from the Archaic to the Classical period was gradual in terms of shapes, materials, style and subject-matter. Figures became smaller, no longer dominating the field, and their rendering reflected contemporary developments in sculpture and vase painting. Subjects included the heads of gods or humans, single standing male or female figures, a few mythological scenes and some fine animal studies. Some themes new to Greek art were introduced, implying considerable originality on the part of Classical gem-engravers. East Greek sites and the Cyclades continued to be important centres of production, but workshops were also established elsewhere. Such is the homogeneity of Classical Greek art, however, that local styles are hard to identify.

Scarab seals were gradually abandoned in favour of scaraboids, which were rather larger than in Archaic times and usually had sides sloping towards the base to create a crisper impression. A distinctive group had domed backs, sometimes four times the height of their sides. Some stones were set in metal rings, prefiguring Hellenistic practice. Perhaps following the example of the latter, with their decorated convex faces, some scaraboids had devices carved on the back, rather than on the flat face. Other shapes included the cylinder and the sliced barrel. The most common material was smoky-white, grey or blue chalcedony, although cornelian, agate, various types of jasper and rock crystal also occur, and glass paste was used to copy existing gems.

Inscriptions naming the gem's owner or the artist became more common at this time. Owners' inscriptions reveal that women could own gems, as jewels rather than seals. This is confirmed by literary sources, which also describe the use of seals and sealings as a means of identification for labelling property or authorizing documents. Small scarabs and scaraboids were mounted on swivel hoops, either worn on the fingers or around the wrist, and larger ones were worn as pendants. Such temple inventories as those of the Athenian Parthenon indicate

2. Mottled jasper scaraboid signed *Dexamenos epoie* (Dexamenos made me), 21×16 mm, *c.* 450–425 BC, from Kara, Attica (Boston, MA, Museum of Fine Arts); impression of original

that gems, either on their own or mounted in rings, were presented as votive offerings.

The most prominent artist whose signature survives was Dexamenos of Chios (*fl c.* 450–425 BC), to whom numerous unsigned gems are also attributed. His four extant signed works include a scaraboid with a finely detailed male head (Boston, MA, Mus. F.A.; see fig. 2), which epitomizes the High Classical style and places him among the greatest Classical artists.

In the 4th century BC the new developments in sculpture initiated by Praxiteles and Lysippos influenced gem-engravings, anticipating the sophisticated rendering of poses and anatomy on Hellenistic intaglios. Thus some Late Classical gems, such as the blue chalcedony scaraboid depicting a *Nike* erecting a trophy (London, BM, see Boardman, pl. 590), are extremely refined works. As in contemporary vase painting, scenes featuring the daily life of women became increasingly popular. In these, women are depicted caressing herons, bathing, or sitting in the women's quarters (*gynaikonites*). Female nudes also became more common.

A group of scaraboids of Classical date, cut mostly in blue chalcedony and known as 'Greco-Persian' gems, are related to Classical models but do not conform precisely to their features. Produced in Asia Minor for an eastern, non-Greek market by studios strongly influenced by Greek and East Greek styles, their representations of standing figures in Oriental dress, animals and hunting scenes combine both Achaemenid and Greek elements.

(iv) Hellenistic. Gem-engravers were among the many artists patronized by Alexander the Great and succeeding Hellenistic monarchs. Pliny (*Natural History* VII. xxxvii.125) recorded that Pyrgoteles alone was permitted to engrave Alexander's portrait on gems, while portraits of the Successors and their queens appeared on numerous intaglios presented to visiting dignitaries. Collections of gems were also established in Hellenistic times, the most

notable belonging to Mithridates VI, King of Pontos (120–63 BC).

Although already developed in Classical times, the large oval ringstone with a convex face became the most distinctive form of Hellenistic gem, although circular stones were also used for depicting heads, including portraits. As a result of Alexander's conquests in the East, new types of stone became available, including various brightly coloured, translucent garnets and quartzes, while cheaper intaglios for a wider market were cut or cast in coloured glass paste. The main technical innovation was the introduction of the cameo, in which designs were rendered in relief rather than incised. Cameos were usually executed in sardonyx, a type of agate with different coloured layers, which could be cut away to produce a striking contrast between the subject and the background. Circular and broad oval ringstones bore royal portraits, of which the best and most numerous examples come from Ptolemaic Egypt, as well as heads of gods and mythological figures, sometimes based on eastern models. Elongated or pointed oval gems bore single standing figures, often such deities as Aphrodite, Apollo or Dionysus. The finest works, such as the *Nymph* from Tartus (Oxford, Ashmolean, see Boardman, pl. 1002) or *Kassandra* from Chalkis (Boston, MA, Mus. F.A., see Boardman, pl. 1004), are in a sophisticated and delicate classicizing style typical of much late Hellenistic art.

As a result of Roman military campaigns, many Hellenistic gems from the Greek east were carried off to Rome, including the collection of Mithridates, dedicated on the Capitol (?62 BC) by Pompey. In addition, numerous Greek gem-engravers went to Rome, either as slaves or to seek new patrons following the demise of the Hellenistic courts, and by combining their own forms with native Etruscan ones they created a new Roman style of gem-engraving (*see* §4 below).

BIBLIOGRAPHY
A. Furtwängler: *Die antiken Gemmen*, 3 vols (Berlin and Leipzig, 1900)
G. M. A. Richter: *Engraved Gems of the Greeks and the Etruscans* (London, 1968)
J. Boardman: *Greek Gems and Finger Rings* (London, 1970)
P. Zazoff: *Die antiken Gemmen* (Munich, 1983)

DIMITRIS PLANTZOS

3. ETRUSCAN. The art of gem-engraving was practised in Etruria from *c.* 540 BC. The first exponents were immigrant craftsmen from East Greece. Before this date the only known Etruscan gem is a sealstone and a bezel in green serpentine incised with figures in the late Orientalizing animal style (Florence, Mus. Archaeol.) found in the precincts of the Archaic 'palace' at Poggio Civitate (Murlo). Such figures also occur on the earliest gold rings with oval bezels and intaglio devices, and derive from traditions of Phoenician goldwork. Before the establishment of local workshops, gems were imported from Ionian Greece and Cyprus, and the movement of specialized craftsmen from East Greece to Italy can be paralleled in other arts, for example black-figure pottery (*see also* ETRUSCAN, §V, and GREECE, ANCIENT, §V, 5(vii)).

The first gems to be produced were small scarabs (diam. 7–10 mm), engraved in high relief with elaborate anatomical detail. The precise engraving of beetle head,

spine and wings is distinctive when compared with mainland Greek examples; and the oval bezels to the scarabs display equally careful craftsmanship, with figures and vignettes engraved inside a border of geometric patterns. In some cases the spine of the scarab was replaced by a figure in relief, such as Dionysos or a harpy, or by apotropaic masks of gorgons or satyrs, although these should strictly be classed as 'pseudo-scarabs'. The stone was mounted on a gold hoop or ring of twisted gold wire by way of an internal drill-hole running lengthwise. Less common were those set in a band of gold foil and attached to a ring, to be worn as pendants. The favoured stone for Etruscan scarabs was cornelian. Alternatives included agate and sardonyx (a transversely striped type of agate). The cornelian employed in Etruria was always red, whereas Greek cornelian varied in shade from deep red to orange. The consistency of the stone suggests that the Etruscan workshops were supplied from a single source, either indigenous or Eastern.

In addition to the variations in the form of scarab spines, the iconography of the incised bases has attracted scholarly interest, and a chronology has been established based on the style of the incised decoration. The pieces concerned are, however, almost exclusively from existing collections, and few gems have come from controlled excavations. The subject-matter displays a rich hellenizing repertory with a highly mythological content; yet it is only in the late 20th century that the motifs have been considered in a functional sense, as relating to the owner of a particular scarab, who would have used it as a personal seal.

The earliest group of scarabs attributable to a single workshop dates from the Archaic period and consists of eight gems decorated with subjects involving war (Paris, Bib. N., Cab. Médailles; Cambridge, Fitzwilliam; Rome, Villa Giulia; London, BM). The style, sedulously neat, favours solid, fleshy figures, recalling those featured on bronze reliefs from *c.* 530–*c.* 500 BC. Gems of the following generation (one example comes from a tomb at Spina datable to *c.* 470 BC; Ferrara, Mus. N. Archaeol.) are characterized by a more elongated figure style, with the depiction of warrior-gods and episodes linked to the Trojan cycle. One subject that appears on about ten gems of this period is the figure of Athena, armed and either standing or fighting (Florence, Mus. Archaeol.).

A marked increase in production occurred *c.* 480–*c.* 430 BC during the Early Classical or 'Severe' period, and from then several versions of the same subjects can be compared. The style is more plastic but nevertheless closely follows the trends of Greek draughtsmanship (although without solving the problem of foreshortening). The range of subject-matter became much wider, including not only Greek heroes from the Trojan or Theban cycles and the labours of Herakles, but also generic scenes, for example combats, and animals fighting or in heraldic postures. Figures were labelled with inscriptions giving the Etruscanized form of the name of the respective Greek hero. Since the scarabs were not merely ornamental but also served as signatures, it is possible that the engraved hero-motifs may have represented something akin to a coat of arms for their owners. Standing or seated heroes might be used to fill the oval field vertically. They are often shown

in the act of collapsing (e.g. *Capaneus Struck by Lightning*; Hamburg, Mus. Kst & Gew.), in kneeling postures or bending over. There are also groups of two figures in more ambitious designs, for example *Aeneas Kneeling down to Lift Anchises on to his Shoulder* (Paris, Bib. N., Cab. Médailles), *Achilles Standing over the Fallen Penthesilea* and *Perseus Decapitating the Gorgon* (both London, BM). If the composition uses a horizontal field, it may feature such subjects as *Sleep and Death Bearing Away a Fallen Warrior* (Paris, Bib. N., Cab. Médailles) or *Herakles Fighting Kyknos* (London, BM). A cornelian scarab made famous by Johann Joachim Winckelmann depicts five of the seven Theban heroes in assembly, grouped on two levels within the single field of decoration (see fig. 3).

During the rest of the Classical period (*c.* 430–*c.* 330 BC) scarab production continued to increase. The figural style became looser and even more plastic. To the standard mythological repertory were added unnamed athletes and horsemen, as well as a menagerie of overtly heraldic beasts. There were few changes in subject-matter, although single figures became more common than groups. Seated figures, such as Achilles and Odysseus, still occur, as do falling and doubled-up figures, with new episodes including *Ajax Throwing himself on his Sword* (Geneva, Mus. A. & Hist.) and *Odysseus Attempting to Untie the Wineskin of Aiolos* (Paris, Bib. N., Cab. Médailles). Groups of two figures often depict Herakles engaged in his various labours or with his divine protectress Athena. The production of 'a globolo' gems (It. *scarabei a globolo*) began during this period. These are characterized by the execution of figures in small 'globules', for which a round drill was evidently used. Established subjects continued to include the *Seven against Thebes* (London, BM), *Sleep and Death Bearing away a Fallen Warrior* (Naples, Mus. Archaeol. N.), the *Stricken Capaneus* (Paris, Bib. N., Cab. Médailles) and various collapsing or seated heroes. More real and fantastic beasts were depicted, again with a possibly heraldic function: Kerberos, centaurs, the Chimera, Pegasus, sea daemons and composite monsters. The diffusion of these examples, many of which come from central and southern Italy (but one is even known from the Crimea), suggests that workshops were active outside Etruria proper.

3. Cornelian scarab, depicting five of the seven Theban heroes (Parthenopaios, Adrastos, Amphiaraos, Tydeus and Polyneikes) in assembly, diam. 16 mm, Etruscan, *c.* 480–*c.* 450 BC (Berlin, Antikenmuseum)

During the Hellenistic period (*c.* 330–1st century BC) the output of scarabs, done in either 'free' linear or '*a globolo*' style, diminished, and there is a body of engraved gems intended to decorate the bezels of finger-rings. The figures on these gems, generally standing alone, recall Late Classical sculptural types and represent not only male or female divine figures and heroes but also Etruscan *haruspices* (priest-seers). They are set on gold-plated silver rings decorated with animal or floral motifs. However, from this period competition from workshops elsewhere in Italy, especially in Campania and Latium, hastened the decline both in quality and quantity of Etruscan gem production.

BIBLIOGRAPHY
P. Zazoff: *Etruskische Skarabäen* (Mainz, 1968)
J. Boardman: *Greek Gems and Finger Rings* (London, 1970), pp. 152–3, 186–7
W. Martini: *Die etruskische Ringsteinglyptik* (Heidelberg, 1971)
P. Zazoff: *Die antiken Gemmen* (Munich, 1983), pp. 214–59

MAURO CRISTOFANI

4. ROMAN. The use of seals must have expanded enormously in the Roman period judging by the large numbers of intaglios that survive from the late Republic and early Empire. They range from masterpieces of glyptic art to moulded glass copies, but virtually all were set in rings of iron, silver or gold; those of gold were restricted by law to the aristocratic classes, senators and knights—and employed to impress clay or wax in validation of the owners' autograph signatures. The public record office at Cyrene in North Africa, built in the 1st century BC and burnt down in the early 2nd century AD, has yielded hundreds of burnt, and thus fired, cylinder seals (see Maddoli).

In the late Republic and early Empire the most important gems were cut by artists with studios on the Via Sacra near the Forum in Rome. There were many other centres, one of the most important in the West being at Aquileia in North Italy. Virtually every town must have had its own gem-engravers, and indeed some were itinerant, like the gem-cutters and jewellers who buried a cache of intaglios (see Maaskant-Kleibrink, 1992) and unfinished rings and bracelets (London, BM) at Snettisham, Norfolk. It is remarkable that, leaving aside imperial commissions, there was such uniformity of subject-matter and style throughout the Empire at any particular time. Only occasionally, and usually in the East, were such regional themes as local deities depicted.

During the Republic, gems, which were normally easily obtainable chalcedonies such as sard and agate, still displayed archaizing features as found in Etruscan art. Many have cable borders, figures are unnaturally hunched within the ovoid frame of the stone, and detail is frequently applied in the form of circular borings (pellets) of the same stone. There were also influences from the Greek world; this is apparent in the modelling, which is rather richer than is normally seen in Etruscan glyptics, and in the ambitious range of subject-matter: mythology was especially popular, but religious scenes (frequently bucolic), symbols and animals also appear.

From the 1st century BC, Greek gem-engravers working for Roman patrons produced works, including portraits, in the full, Hellenistic tradition. Skopas signed a hyacinth cut with the expressive head of a young man (U. Leipzig, Archäol. Inst.; see Zazoff, pl. 79, no. 9, p. 285, note 109) and Gnaios signed an amethyst portrait of *Mark Antony* (ex-Ionides priv. col.; see Boardman, no. 18). The use of brightly coloured, rare and translucent stones from the East (notably from Afghanistan, Pakistan and India) is notable.

Gem-engraving reached its apogee during this period. Augustus certainly employed Greek gem-engravers, among them Dioskourides (*fl* end of the 1st century BC), who cut a signet for him bearing his portrait (Pliny, *Natural History* xxxvii.8; Suetonius, *Lives of the Caesars: Augustus* L). No less than seven intaglios and a cameo by this artist are known, including one of his best works, a cornelian showing *Diomedes Stealing the Palladium from Troy* (Chatsworth, Derbys; see fig. 4). The head of Diomedes recalls that of Augustus himself and indicates that a style intended to flatter the ruling house was prevalent within the imperial court circle; this was in strong contrast to the restrained, understated works of public propaganda such as the Ara Pacis (*see* ROME, §V, 4).

The finest engraved gems of the period are the great decorative cameos such as the sardonyx *Gemma Augustea* (after AD 10; Vienna, Ksthist. Mus.). This depicts Augustus as Jupiter, accompanied by Jupiter's eagle, seated next to the goddess Roma. Augustus is being crowned by Oecumene (the inhabited Earth) while receiving the salutation of his great-nephew Germanicus and a victorious general (probably Tiberius, who later succeeded him). Below this scene of imperial triumph soldiers erect a trophy above disconsolate captives. This cameo, which presumably belonged to a great noble, is unsigned, although it has been suggested that Dioskourides was the artist. It certainly reveals the close relationship between the art of the imperial court and that prevalent in the late Hellenistic monarchies, as exemplified by the Ptolemaic Farnese Cup (1st century BC; Naples, Mus. Archeol. N.). A feature of both Hellenistic and Roman art was the use

4. Cornelian intaglio cut by Dioskourides, showing *Diomedes Stealing the Palladium from Troy*, 20×18 mm, *c.* end of 1st century BC (Chatsworth, Derbyshire)

of myth and symbol to express political ideas. Thus the largest known cut sapphire from the ancient world shows *Venus Offering Drink to an Eagle* (Cambridge, Fitzwilliam). Venus was said to be the ancestor of the Julian house, while Augustus, as the adopted son of Julius Caesar, could claim her as a forebear; the eagle symbolizes imperial power.

Augustus' immediate successors, most notably Claudius, were depicted on similar State Cameos but in a style that became more restrained, as seen, for example, on the *Gemma Claudia* (?AD 49; Vienna, Ksthist. Mus.; *see* HARD-STONES, colour pl. II, fig. 2) and on the Great Cameo of France (1st century AD; Paris, Bib. N., Cab. Médailles), which depicts Tiberius but may have been made for Claudius. The latter cameos mark the beginning of a change that can also be observed on ordinary intaglio ringstones; in the early 1st century AD these displayed sleek and well-proportioned figures, animals and symbols, but by the Flavian period (AD 70–96) many showed hastier, more linear cutting. During the 2nd century AD intaglios displayed a patterned texture of broad grooves produced using the lap wheel, a very small cutting wheel mounted at the end of a drill. Opaque stones, notably red jasper and nicolo onyx (which is formed in two layers, blue on black) largely replaced translucent gems. This new style of modelling was used in its most advanced form on gems of Severan date (AD 193–235), including cameos, both private cameos, often with motifs signifying good luck, love, betrothal and marriage (see Henig, 1994), and State Cameos such as those showing Julia Domna, wife of the emperor Septimius Severus; one shows her as *Juno Caelestis* (London, BM), another as *Victory* (Kassel, Staatl. Museen). Both are notable for their richly patterned textures. During the 3rd century AD, however, the production of engraved gems seems to have been much reduced throughout the Roman world.

BIBLIOGRAPHY

G. Maddoli: 'Le Cretule del Nomophylakion di Cyrene', *Annu. Scu. Archeol. Atene & Miss. It. Oriente*, xli–xlii (1963–4), pp. 39–145
G. Sena Chiesa: *Gemme del Museo Nazionale di Aquileia* (Aquileia, 1966)
M. L. Vollenweider: *Die Steinschneidekunst und ihre Künstler in spätrepublikanischer und augusteischer Zeit* (Baden-Baden, 1966)
J. Boardman: *Engraved Gems: The Ionides Collection* (London, 1968)
G. M. A. Richter: *Engraved Gems of the Romans* (London, 1971)
M. Henig: *A Corpus of Roman Engraved Gemstones from British Sites*, Brit. Archaeol. Rep. (Oxford, 1974, 2/1978)
M. Maaskant-Kleibrink: *Catalogue of the Engraved Gems in the Royal Coin Cabinet, The Hague: The Greek, Etruscan and Roman Collections*, 2 vols (The Hague, 1978)
P. Zazoff: *Die antiken Gemmen* (Munich, 1983)
M. Maaskant-Kleibrink: *Description of the Collections in the Rijksmuseum G. M. Kam at Nijmegen: The Engraved Gems, Roman and Non-Roman* (Nijmegen, 1986)
M. Henig and M. Whiting: *Engraved Gems from Gadara in Jordan: The Sa'd Collection of Intaglios and Cameos* (Oxford, 1987)
W. R. Megow: *Kameen von Augustus bis Alexander Severus* (Berlin, 1987)
M. Henig: 'The Chronology of Roman Engraved Gemstones', *J. Roman Archaeol.*, i (1988), pp. 142–52
——: *The Content Family Collection of Ancient Cameos* (Oxford and Houlton, 1990)
S. H. Middleton: *Engraved Gems from Dalmatia from the Collections of Sir John Gardner Wilkinson and Sir Arthur Evans in Harrow School, at Oxford and Elsewhere* (Oxford, 1991)
M. Maaskant-Kleibrink: 'Three Gem-engravers at Work in a Jeweller's Workshop in Norfolk', *Babesch* [Leiden], 67 (1992), pp. 151–67
J. Spier: *Ancient Gems and Finger Rings*, Malibu, CA, Getty Mus. cat. (Malibu, 1992)
M. Henig: *Classical Gems: Ancient and Modern Intaglios and Cameos in the Fitzwilliam Museum, Cambridge* (Cambridge, 1994)

MARTIN HENIG

5. GNOSTIC. Gnostic gems, or Greco-Roman magical amulets, as scholars often prefer to call them, account for a significant fraction of the engraved gems found on Roman sites throughout the Empire from the 2nd to the 5th century AD. Like other engraved gems they were worn as pendants and rings as well as carried on clothing as talismans. They were engraved with varying degrees of skill on the hardstones favoured by lapidaries—typically cornelian, jasper and onyx—with the addition of the less attractive but medicinally potent haematite (bloodstone), which was used exclusively for amulets. Unlike other engraved gems these amulets were not used as seals; their inscriptions rarely appear in reverse.

Since the Renaissance, when these objects first attracted collectors, scholars have speculated as to the origin and meaning of their often cursorily executed devices depicting unfamiliar Greco-Egyptianizing deities and obscure, frequently meaningless inscriptions. The surviving Gnostic texts provide few clues to the deities that the amulets illustrate, while they give elaborate cosmogonies and explanations of the creation of man from evil matter, and describe the process by which the Gnostic initiate might achieve gnosis (knowledge) by a hazardous but precisely mapped ascent from evil terrestrial existence, through intervening daimons and aeons to the pleroma (celestial realm). One common amuletic device, a serpentine creature with an irradiated lion's head inscribed CHNOUBIS, was recognized as an evil Gnostic demiurge (creator), elsewhere reputed to be effective in the treatment of stomach ailments. Certainly the deity has its iconographic origins in Egyptian mythology and astrology, but it exists only on these amulets. Similarly, the anguipede—a cock-headed, serpent-legged Roman soldier—lacks description in Gnostic texts, although the creature is invariably accompanied by the inscriptions IAO (a form of the Jewish *Yahweh*) and ABRAXAS, both of which deities are appealed to in the texts. Abraxas (as the anguipede is popularly known) must have been a worthy guardian of the aeons: the cock head suggests solar affiliation, the serpentine legs chthonic attachments, while the Roman breastplate, whip and shield suggest worldly authority.

The urgent desire to attain a vision of Helios (the sun god) in many of the spells in the Greek magical papyrae is perhaps reflected in the number of solar deities illustrated on the amulets. Some show the glorious sun god resplendent in his chariot, on others he sits astride a lion. The Egyptian infant sun Harpokrates is depicted emerging from the opening lotus in a genesis scene set above the primordial waters, sometimes surrounded by triads of animals or adored by the ithyphallic baboon, the first in Egyptian mythology to worship the rising sun. There is a fascination with the gods of a pre-creation era in an otherworldly, cosmic setting. Combinations of shadowy, underworld gods, the mummified Osiris, Anubis and Isis abound. They appear together with Nephthys and sometimes Chnoubis above a stylized uterus locked with a key (see fig. 5). The medical applications of this amulet as a protection against miscarriage and haemorrhage are well

5. Haematite uterine amulet, 17×14×3 mm, Gnostic, 2nd–3rd century AD (Berlin, Ägyptisches Museum)

understood, but the presence of the overseeing pantheon and the inscriptions that always include the name of the guardian of the womb, Ororiouth, the seven Greek vowels indicating the seven known planets and the Jewish magical name Iao, also suggest a cosmological significance.

On an image more familiar to the modern observer a horseman leaps over a recumbent, naked woman who raises her arms against the thrust of his spear. The iconography has been absorbed into the cult of St George, but on the amulets (always of haematite) the horseman is named as Solomon who in the Gnostic and magical texts leaps beyond obstructing demons into the world of the heroized dead. His vanquishing of the woman, who may be Abysou, the demoness of the Abyss, is accompanied by the monotheistic claim 'One God who overcomes evil', while on the reverse a key, similar to that on the uterine amulets, is entitled 'Seal of God'. Useful in their powerful evocation of controlling deities for warding off all evils, these amulets were like passports ensuring the upward mobility of the soul.

BIBLIOGRAPHY

C. Bonner: *Studies in Magical Amulets Chiefly Graeco-Egyptian* (Ann Arbor, 1950)

A. A. Barb: 'Diva Matrix: A Faked Gnostic Intaglio in the Possession of P. P. Rubens and the Iconology of a Symbol', *J. Warb. & Court. Inst.*, xvi (1953), pp. 193–236

——: 'Abraxas Studien', *Hommages à Waldémar Deonna* (Brussels, 1957), pp. 67–86

A. Delatte and P. Derchain: *Les Intailles magiques gréco-égyptiennes* (Paris, 1964)

P. Zazoff: *Die antiken Gemmen* (Munich, 1983), pp. 349–62

MARY K. WHITING

6. INDIAN. From ancient times India has been famous for its gems. India's rulers had an avid interest in gems as a reflection of royal splendour and a symbol of personal wealth and status; gems were also the ultimate present, and sultans and princes competed with one another to possess and give beautiful and important stones. Rulers in other countries were also interested in Indian gems, and the crown jewels of many nations, among them England, Iran and Turkey, include Indian stones. Few ancient Indian jewels, however, survive, because of the Hindu funerary rite of cremation in which a person's possessions are burnt with the deceased. As a result, knowledge of the early history of gems in India is based almost entirely on early texts and representations in sculpture and wall paintings (*see* INDIAN SUBCONTINENT, §VIII, 12).

India maintained its monopoly in the supply of gems throughout antiquity: almost all the significant gems and hardstones of India are listed by Pliny in his *Natural History* (*see* INDIAN SUBCONTINENT, §VIII, 11), and India was the world's only source of diamonds until 1732, when they were found in Brazil, and sapphires, rubies and emeralds were also found in the subcontinent. Most information on early mining derives from Kantilya's *Arthasāstra*, which describes the provenance and qualities of gems and hardstones. Although the 13th chapter of *Narahī*'s medical encyclopedia, *Rājanighantu*, which deals with gems and minerals, describes cut diamonds as 'multi-edged, hexagonal, hundred-cornered, the weapon of Indra, unsplittable', not much attention was generally given to the cutting of stones, and the natural surface of the crystals was usually retained. Gems played an economic role as an important part of the royal income, a fact that led to the development of mining. Hardstones of the region included opal, topaz and hyacinth. Pearls were also valued: according to the *Rājanighantu*, 'the five nobler precious stones are ruby, diamond, pearl, emerald and sapphire'.

As early as the 3rd millennium BC, necklaces and ornamental pieces were being made of certain beautiful minerals and crystals. Finds from sites of the Indus Valley civilization (*see* INDIAN SUBCONTINENT, §I, 2(i)) such as MOHENJO-DARO, Harappa and CHANU-DARO include pieces made of cornelian, lapis lazuli, turquoise and jade; the cornelian and lapis lazuli were Sumerian exports. As very little archaeological material has survived from the middle of the 2nd millennium BC, it is necessary to rely almost exclusively on linguistic data and ancient literature for information on the gems of this period. Since no specific terms for precious stones predating the 7th century AD have been identified, however, researchers have to work with more general words such as *ratna* (wealth, gift or present), *mani* (jewel) and *manikāra* (jeweller).

The ancient Indians attributed great supernatural powers to precious stones, and even the gods were believed to worship images studded with gems: Vishnu, the sustainer, revered sapphires; Agni, the god of fire, venerated diamonds; and Indra, the king of paradise, worshipped rubies. The notion of correspondence between precious stones and planets was also very widespread. According to the *Rājanighantu*, 'ruby is competent to the sun, perfectly stainless pearl to the moon, coral to Mars, faultless emerald to Mercury, topaz to Jupiter, diamond to Venus, sapphire to Saturn, hyacinth to Rahu (a demon), cat's eye to Ketu (a meteor)'. Through their magic power, stones were supposed to exert many wonderful influences, acting as remedies against poison and a number of ailments. Emerald protected the wearer from poisons and stimulated the appetite, diamond was the best general antidote for diseases and sapphire prevented gall-bladder diseases. In the *Kathāsaritsāgara* of Somadeva, Indumati presents a king with a jewel that saves him from poisons, demons, old age and disease. Hindu and Buddhist texts are full of symbolic connections between precious stones and moral

M. Jenkins and M. Keene: *Islamic Jewellery in the Metropolitan Museum of Art* (New York, 1982)
M. Latif: *Mughal Jewels* (Brussels, 1982)
The Indian Heritage (exh. cat., ed. R. Skelton; London, V&A, 1982)
M. Jenkins: *Islamic Art in the Kuwait National Museum* (London, 1983)

NADA CHALDECOTT

7. ISLAMIC. Coloured hardstones and gems, when set and polished, have long been used in goldsmithing and jewellery in the Islamic lands. When carved in reverse and intaglio they served as stamps or seals (*see* ISLAMIC ART, §IX, 14); when carved with a positive inscription, whether intaglio or in relief, they were used as talismans or jewellery. Both cut and uncut gems were mounted, particularly in the form of rings, necklaces and earrings. The use of gems and the techniques employed to work them date back to antiquity, particularly in India (*see* §6 above), and their scientific classification and analysis in Islamic lands continued Greco-Roman practices.

The most important gems used in the Islamic lands were lapis lazuli from Afghanistan, turquoises mined near Nishapur (north-east Iran), rubies from Badakhshan (Afghanistan), sapphires from Sri Lanka and cornelian from Arabia and India. Other stones used included garnet, rock crystal, amethyst, haematite, agate, jasper, onyx, sardonyx and emerald. As in ancient times, gems circulated from one end of the region to the other. The shape into which the stones were cut varied, depending on the properties of the gems and on taste. Most were made round or oval, but some were cut square, hexagonal, octagonal or even heart- or pear-shaped. Some were faceted, while others were rounded (cabochon). As in ancient times, the rarity of certain gems led to the manufacture of numerous imitations; the Muslims were very familiar with the art of making glass and other similar materials resemble precious stones.

Like others, Muslims attributed certain supernatural powers to gems, particularly as their vivid colours made them stand out from their natural surroundings. A large number of texts mention gems and their magical virtues, drawing considerably on ancient works and usually forming part of general treatises on mineralogy. For example, cornelian was used as a medicinal stone to cure toothache, and rings with a cornelian seal were commonly thought to have the property of calming the heart—particularly in combat—and of stopping haemorrhage. Rubies were thought to strengthen the heart and to offer protection against plague and lightning, as well as stopping the flow of blood. Emeralds were considered an excellent specific for use against the bites of vipers; if powdered and swallowed in water, emeralds were thought a cure for all injuries involving venom. Emeralds were also regarded as equally effective against epilepsy and stomach disorders. Like emeralds, turquoise could improve sight, but it was more useful in curing diseases of the eye and scorpion stings. Haematite cured gout and eased childbirth; when powdered and swallowed in hot water or milk it eliminated the effects of poison. Powdered lapis lazuli was used to cure diseases of the eye and all imbalances of the humours. Rock crystal was used to prevent nightmares.

6. Emeralds and rubies set in a pendant of white nephrite jade with a pierced gold frame and a pendent emerald, 57×50 mm, Mughal, first half of the 17th century (London, Victoria and Albert Museum)

or spiritual qualities; in another story in the *Kathāsaritsāgāra* a dish made of emerald enables the spectator to see his previous existence.

The MUGHAL dynasty (1526–1858) maintained the tradition and interest in gems. Under their rule, the interaction between Islam and Hinduism produced some of the most beautiful designs in Indian art. By the 17th century, trade with Europe brought new gems to India, along with European influences on design and European craftsmen and stonecutters. Drilling techniques developed over this period used the wheel and polishing points to produce free-flowing designs of flora and fauna on stones (see fig. 6). Emeralds from Colombia were in great demand not only for their exceptional colour but also for being the symbol of the Garden of Paradise and of the Emerald Mountain, the highest spiritual level in Sufism, an Islamic mystical tradition.

See also INDIAN SUBCONTINENT, §VII, 12.

BIBLIOGRAPHY
G. C. M. Birdwood: *The Industrial Arts of India* (London, 1880)
R. von Garbe: 'Die indischen Mineralien: Nahari's *Rājanighantu*', *Varga*, xiii (Leipzig, 1882)
J. B. Tavernier: *Travels in India* (London, 1889)
A. A. MacDonell: *Vedic Index of Names and Subjects*, ii (London, 1912)
A. Aziz: *The Imperial Treasury of the Indian Mughals* (Lahore, 1942)
M. Wheeler: *The Indus Civilization* (Cambridge, 1953)
S. C. Welch: *Art of Mughal India* (New York, 1963)
C. H. Tawney: '*Kathāsaritsāgāra*' of Somadeva (Delhi, 1968)
G. Y. Wojtilla: 'Indian Precious Stones in the Ancient East and West', *Acta Orientalia Acad. Sci. Hung.*, xxvii/2 (1973), pp. 211–24

BIBLIOGRAPHY

Enc. Islam/2: 'al-Āthār al-'ulwiyya' [The meteorological phenomena]

Ibn Māsawayh (*d* 857): *Kitāb al-jawāhir wa ṣifātuhā* [The book of gems and their properties], ed. 'I. 'A. Ra'uf (Cairo, 1977)

al-Bīrūnī (*d c.* 1050): *Kitāb al-jamāhir fī ma'rifat al-jawāhir* [The sum of knowledge about precious stones], ed. F. Krenkow (Hyderabad, AH 1355/1936–7)

Pseudo-Majrīṭī (11th century): *Ghāyat al-ḥakīm* [Purpose of knowledge]; Ger. trans. by H. Ritter and M. Plessner as *Picatrix: Das Ziel des Weisen* (London, 1962)

Abū'l-Qāsim Jamal al-Din 'Abdallah al-Kashī: *'Arā'is al-jawāhir wa nafā'is al-atā'ib* [1303; gemological treatise], ed. I. Afshar (Tehran, 1967); partial ed. and Ger. trans. by H. Ritter, J. Ruska and R. Winderlich as 'Orientalische Steinbücher und persische Fayencetechnik', *Istanbul. Mitt.*, iii (1935) [whole issue]

J. Clément-Mullet: 'Essai sur la minéralogie arabe', *J. Asiat.*, xi (1868), pp. 5–81, 109–253, 502–22

M. Steinschneider: 'Arabische Lapidarien', *Z. Dt. Mrgländ. Ges.*, xlix (1895), pp. 244–78

E. Wiedemann:'Zur Mineralogie im Islam', *Beitr. Gesch. Natwiss.*, xxx, *Sber. Phys.-Mediz. Soz. Erlangen*, xliv (1912), p. 205

J. Ruska: 'Die Mineralogie in der arabischen Literatur', *Isis*, i (1913), pp. 341–50

'A. Badawi: 'Sirr al-asrār ou al-siyāsa fī tadbīr al-riyāsa' [chapter on stones from a book attributed to Aristotle], *Fontes Graecae doctrinarum politicarum Islamicarum*, i (1954)

LUDVIK KALUS

8. BYZANTINE. The art of gem-engraving continued after the late Roman period. Belief in the protective and healing powers of gems persisted into the Christian era, as indicated by amulets to aid childbirth dated to the late Byzantine period (*c.* 1200; Selçuk, Ephesos Archaeol.

7. Byzantine onyx intaglio depicting Apostle princes, 98×67 mm, early 7th century (Vienna, Kunsthistorisches Museum)

Mus.). A good number of Early Christian intaglios (see fig. 7) and a very small group of low-quality cameos have survived. They reflect contemporary iconography and frequently depict whole scenes, as, for example, on an onyx intaglio of the *Adoration of the Magi* (London, V&A). Rock crystal pendants, probably dating from the 7th or 8th century, are executed in reverse intaglio (i.e. incised from the back, with the incisions sometimes filled with gold leaf) and the carving sealed in by the addition of another piece of rock crystal; they show both secular imperial iconography and Christological scenes (e.g. London, V&A). Curiously, comparatively few intaglios have survived from the period after the restoration of the veneration of images in AD 843, the most active time for the production of Byzantine cameos. Surviving examples show the subject-matter of the cameos (Christ, saints) and were used mostly as seals mounted on rings. Partly because of the uniformly poor standard of the work and partly because they usually have no archaeological context, they are difficult to place and date accurately.

Most Byzantine cameos are datable to the 10th to the 12th century. Some of these can be dated precisely by inscriptions, such as the jasper carving of the standing *Christ Blessing* (late 9th century–early 10th; London, V&A; see fig. 8), with an inscription on the back referring to Emperor Leo VI (*reg* 886–912), and the much larger circular serpentine relief of the *Virgin orans* (London, V&A), which has an inscription around the edge invoking the help of the Virgin for Emperor Nikephoras Botaniates (*reg* 1078–81). Others can be placed reasonably accurately because of their mounts or surroundings, for instance the bloodstone cameo of *St John the Evangelist* set into the front cover of the Gospels of Otto III (Munich, Bayer. Staatsbib., Clm. 4453), which must pre-date the manufacture of the manuscript and its cover *c.* AD 1000. Some Byzantine cameos may be precisely dated by comparison with coin types, such as the early 10th-century coins with the bust-length *Christ Pantokrator* on the obverse.

Just over 200 surviving Byzantine cameos are known, in a range of gems: the most popular materials were bloodstone (also known as heliotrope), jasper, chalcedony and sardonyx. More rarely lapis lazuli and sapphire were employed. They were used to adorn bookcovers and were widely worn as rings and pendants. Most show either single- or double-figure compositions; only a few bear scenes (invariably Christological), such as one showing the *Transfiguration* (Vienna, Ksthist. Mus.). The Virgin and Christ were the most popular subjects, both full-length and in bust form; SS John the Baptist (an especially fine late 10th-century example in Vienna, Ksthist. Mus.), George, Michael, Theodore, Demetrius and the prophet Daniel were also popular. The best pieces are invariably from the 10th and 11th centuries, when the so-called Macedonian Renaissance stimulated a revival of Classical art forms (examples in Baltimore, MD, Walters A.G.; Washington, DC, Dumbarton Oaks; Kassel, Hess. Landesmus.; Vienna, Ksthist. Mus.; Paris, Louvre and Bib. N., Cab. Médailles; London, V&A and BM; Moscow, Hist. Mus. and Kremlin, Armoury; St Petersburg, Hermitage). Imitation cameos were made from moulded glass paste and exported from Constantinople to the West from the 11th century. They were copied in Venice from an

early date and contributed to the spreading of the Byzantine style and iconography into Europe.

BIBLIOGRAPHY

RBK: 'Intaglio'; 'Kameen'
P. Williamson: 'A Byzantine Bloodstone Carving in the Victoria and Albert Museum', *Burl. Mag.*, cxxii (1980), pp. 66–9
——: 'Les Stéatites et les pierres dures', *Splendeur de Byzance* (exh. cat., ed. J. Lafontaine-Dosogne; Brussels, Musées Royaux A. & Hist., 1982), pp. 121–2
——: 'Daniel between the Lions: A New Sardonyx Cameo for the British Museum', *Jewel. Stud.*, i (1983–4), pp. 37–9
S. Trümpler: 'Die byzantinische Marienkamee der Abegg-Stiftung in Riggisberg', *Z. Schweiz. Archäol. & Kstgesch.*, xliii/1 (1986), pp. 9–16 [Ellen Judith Beer Festschrift]

PAUL WILLIAMSON

9. MEDIEVAL. The production of glyptics in Europe declined from the early years of the Early Christian period (4th century AD), probably due to economic and socio-historical causes. The *Strohbündelstil* (straw-bundle style) gems form a stylistically unified group of intaglios that were produced in large numbers from around the 4th to the 5th centuries (e.g. a bloodstone intaglio of the *Annunciation*; Hannover) until around the 13th and 14th centuries (e.g. a bloodstone of the *Annunciation*, Hamburg). They were thus named by H. Wentzel because of the characteristic way in which the stone was cut in layered lines (bundles of straw). The small stones, mainly bloodstone, banded agate, jasper and cornelian, show a simple iconography of predominantly Christian symbols and images; for example scenes of the *Adoration*, the *Annunciation* or angels. Where this genre was practised is not yet clear; its close relationship with Sasanian sealstones and magic gems (abraxas gems) from Egypt suggests prototypes common to all three in the glyptics of the late Roman period. So-called Alsen gems form a special group; they are named after Alsen in Denmark where a cache of them was found, and were probably made between the 8th and 13th centuries in the Germanic area of the lower Rhine. They were made in large numbers—*c.* 100 have been preserved—mainly in northern Europe and are of glass paste in imitation of nicolo (a variety of onyx); a hard needle was used to scratch silhouette-like figures on the surface, which is bluish in colour. The quantity in which they have been found and the scenes depicted (e.g. the *Magi*) suggest a Christian interpretation; they were most probably used as amulets suspended round the neck or from the wrist. The belief in the magic power of hardstones, both engraved and unengraved, was immensely widespread in the Middle Ages among all levels of society; it derived directly from the superstitious belief in the magic effect of astrological and Gnostic symbols and charms (e.g. the abraxas gems) and of the stones themselves, a belief that had especially flourished from the late Classical period. Many medieval writers, for example Bede (673–735) and Rabanus Maurus (*fl c.* 776 or 784–856) describe the special meaning of the allegorical lore relating to precious stones, partly adopted from antiquity.

In the 9th century there was a revival of glyptics in the regions of the Carolingian Empire; the objects produced were all intaglios, almost all made of rock crystal, with such Christian images as scenes of the Crucifixion and Baptism and symbols of the Evangelists. Five seals are also extant, for example the Lothair Seal (Aachen) and the

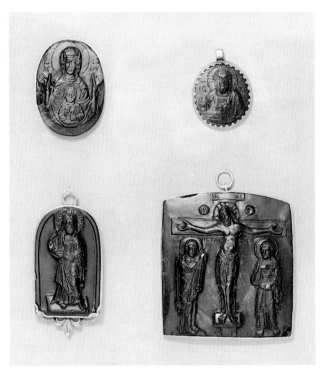

8. Byzantine cameos (clockwise from top left): *Virgin Blachernitissa*, bloodstone, h. 45 mm, late 12th century; *Christ Pantokrator*, bloodstone, h. 37 mm (including rim), late 10th century–early 11th; *Crucifixion with the Virgin and St John*, jasper, h. 65 mm, late 9th century–early 10th; *Christ Blessing*, jasper, h. 47 mm, late 9th century–early 10th (all London, Victoria and Albert Museum)

Norpertus Seal (Florence). Altogether 20 intaglios have been preserved (a further three are untraced), now located in London, Paris, Berlin, Freiburg, Rouen, Venice, Toledo, OH, and the church treasuries of Aachen, Halberstadt and Conques. The outstanding masterpiece, with the largest number of figures and the greatest artistic significance, is the Lothair Crystal (see fig. 9), which was made during the 9th century probably for King Lothair II (*reg* 855–69); other engraved rock crystals, especially those with *Crucifixion* scenes (e.g. Venice, Col. Cini), can be stylistically linked to this. The gems can be linked technically to the production of workshops in Metz, Trier, Aachen and Tours; the 'court school' of artists in this field appears to have died out after 950 (*see* CAROLINGIAN ART, §VII).

Western skill in gem-engraving was re-established in the 13th century, presumably triggered by the Sack of Constantinople in 1204, resulting in large numbers of ancient and Byzantine engraved gems reaching Europe, and Byzantine gem-engravers moving there. From 1200 there were two important countries of production: France and Italy. The number of extant French seals reveals that a fashion for gems started in France during this period; the Classical coin profile was used on cameos, intaglios and seals. There is evidence that gem-engravers had their own guild in Paris in the 13th century. The finest items were intaglios of busts or profiles, which are known to us only from seal-impressions made from them. Generally the production of intaglios declined in favour of cameos

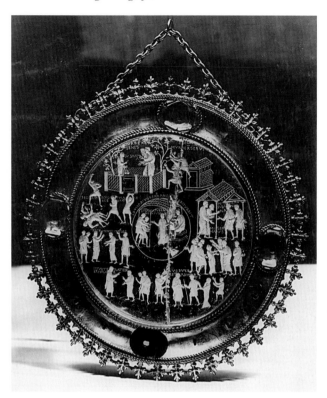

9. Rock crystal intaglio, the Lothair Crystal, illustrating *Susanna and the Elders*, in copper-gilt mount, diam. crystal 115 mm, Carolingian, *c*. 855–69 (London, British Museum)

after the Carolingian period. Among the most typical cameos are the heads and busts in high relief that suggest embossed work engraved on such monochrome stones as chalcedony and sapphire; these date from the second half of the 13th century (examples Paris, Bib. N., Cab. Médailles). A series of sardonyx cameos with biblical scenes is believed to have been made *c*. 1300 and shows typically Gothic stylistic characteristics.

In Italy glyptic art, particularly cameo-cutting, was at its height during the reign of Emperor Frederick II (1212–50) in his hereditary kingdom of Lower Italy and Sicily. The 'Hohenstaufen cameos', a series produced at this time, are mainly made from multi-layered sardonyx. They are more closely related to Classical rather than contemporary French examples and consist of representations of contemporary significance (for example the eagle and the lion, symbols of Hohenstaufen supremacy), Classical themes (e.g. Poseidon; see fig. 10) and portraits of emperors. They include the cameos with dark figures on a light ground (examples include an eagle, a lion, Hercules and the Nemean lion and a female falconer) dating from *c*. 1200–30 and those with a coloured upper layer or pale figures on a dark ground (e.g. an emperor's bust on a cross, *c*. 1250; Brescia). The cameos that portray Classical themes or stylistically imitate antiquity (e.g. *Athena*, Vienna; *Poseidon*, Paris), which were probably made in Upper Italy in the second half of the 13th century, were derived from these Hohenstaufen Italian cameos. Evidence in documents and inventories shows that Frederick II and Pope Boniface VIII (*reg* 1294–1303) also owned collections of gems.

Throughout the medieval period cameos and intaglios were mainly used as pendants or brooches or on rings, and the value of the stone was enhanced by the image represented on it. The large-scale examples known as 'State cameos', which were made for purposes of prestige, were worn as encolpia or were used to decorate such gold religious items as reliquaries; they may also have been presented as honorary gifts to princes of the Church or ambassadors. Ancient cameos and intaglios existed in large numbers in the Middle Ages and were highly valued; they formed a major component of church treasuries and were used to decorate book covers, crosses, reliquaries and other liturgical items such as the Cross of Lothair II (*c*. 985–91; Aachen, Domschatzkam.), made in Cologne and jewelled on the front with an antique cameo of Emperor Augustus.

BIBLIOGRAPHY

EWA: 'Glittica'
E. Babelon: 'La Glyptique à l'époque mérovingienne et carolingienne', *Acad. Inscr. & B.-Lett.: C. R. Séances*, n. s. 4, xxiii (1895), pp. 397–427
A. Furtwängler: *Die antiken Gemmen*, iii (Leipzig and Berlin, 1900), p. 373
E. Babelon: *Histoire de la gravure sur gemmes en France depuis les origines jusqu'à l'époque contemporaine* (Paris, 1902)
H. Gebhart: *Gemmen und Kameen* (Berlin, 1925)
H. Wentzel: 'Mittelalterliche Gemmen, Versuch einer Grundlegung', *Z. Dt. Ver. Kstwiss.*, viii (1941), p. 45
J. Deér: 'Die Basler Löwenkammee und der süditalienische Gemmenschnitt des 12. und 13. Jhs.', *Z. Schweiz. Archaol. Kstgesch.*, xiv (1953), p. 129
H. Wentzel: 'Mittelalterliche Gemmen in den Sammlungen Italiens', *Mitt. Ksthist. Inst. Florenz*, vii/6 (1953), p. 239
——: 'Die mittelalterlichen Gemmen in der Staatlichen Münzsammlung zu München', *Münch. Jb. Bild. Kst*, n. s. 2, viii/3 (1957), p. 37

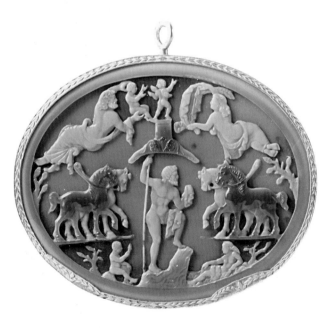

10. Onyx cameo of *Poseidon as Ruler of the Isthmian Games*, in gold setting (early 19th century), diam. 88 mm, southern Italian, first half of the 13th century (Vienna, Kunsthistorisches Museum)

C. Meier: *Gemma Spiritalis: Methode und Gebrauch der Edelsteinallegorese vom frühen Christentum bis ins 18. Jahrhundert*, i (1977)

R. Kashnitz: 'Staufische Kameen: Zum Forschungsstand nach dem Tode von H. Wentzel', *Die Zeit der Staufer*, v (1979), p. 477

G. Friess: *Edelsteine im Mittelalter: Wandel und Kontinuität in ihrer Bedeutung durch zwölf Jahrhunderte* (Hildesheim, 1980)

P. Zazoff: *Die antiken Gemmen* (Munich, 1983), p. 374

G. A. Kornbluth: *Carolingian Treasure: Engraved Gems of the Ninth and Tenth Centuries* (diss., Chapel Hill, U. NC, 1986)

A. Soeda: 'Gods as Magical Charms: The Use of Ancient Gems in the Medieval Christian West', *Survival of the Gods: Classical Mythology in Medieval Art* (1987), p. 185

ALFRED BERNHARD-WALCHER

10. RENAISSANCE TO 1700. The earliest important examples of post-medieval glyptics date from Valois France, but it was in Renaissance and Mannerist Italy that, under the stimulus of a growing passion for collecting ancient gems, the revived craft reached an artistic perfection unrivalled since antiquity. Craftsmen practising in such related occupations as seal-engraving, coin-die cutting and as medallists set up as gem-engravers in North Italian cities and in Rome, which was to dominate gem-engraving until the decline of the craft in the 19th century.

(i) 1400–c. 1500. (ii) c. 1500–1600. (iii) 1601–1700.

(i) 1400–c. 1500. The luxury displayed by Charles V (*reg* 1364–80) and his three brothers, Jean, Duc de Berry, Louis I, 1st Duke of Anjou (*reg* 1356–84), and Philip the Bold, 1st Duke of Burgundy (*reg* 1384–1404), included a profusion of engraved precious stones in regalia, jewellery and seals. Like those preserved in church treasuries, most were of ancient origin, but they also included contemporary portraits. A sapphire intaglio (London, BM) of a frontally seated prince is thought to represent Jean, Duc de Berry, while a cameo (*c.* 1420; St Petersburg, Hermitage), in which the chalcedony profile head is adorned with a garnet crown and an emerald jewel, portrays Charles V's grandson, Charles VII. Disastrous wars probably caused the temporary cessation of the art in northern France, but it flourished at the court of René I, King of Naples and 4th Duke of Anjou. An onyx cameo bust (London, BM) of the King in old age may have been the work of one of his two recorded stone-engravers, Thomas Pigne (*fl* 1476) and Jehan Castel (*fl* before 1480); his accounts reveal commissions for gems depicting biblical themes. Both the revival of gem-engraving in northern France and King René's interest in gems may be attributed to close contacts with Italy, where the study of antiquity was already having a profound impact on the arts.

In Italy gem-engraving, influenced by Classical models, arose in various Italian cities in the wake of humanist learning and collecting of antiquities. Knowledge of ancient gems was disseminated through plaster casts and bronze plaquettes; the excitement they aroused among artists is evident in their influence on sculptures by Donatello and his followers; they are reproduced in paintings and drawings by Botticelli, Giovanni Bellini and Veronese, and on the reverses of medals. They also stimulated contemporary gem-engravers to produce work in the Classical tradition; the techniques of engraving on stone were influenced by learning from Byzantine refugees and from Burgundian craftsmen. They employed the traditional quartzes (hardstones): for intaglio, pale chalcedony, cornelian and sard; for cameo, mostly two- or three-layer agates, for example onyx and sardonyx, and varieties of chalcedony and jasper. They also engraved on lapis lazuli and occasionally on the harder gemstones, such as sapphire or ruby. Turquoise was a particular favourite of Isabella d'Este (i), Marchioness of Mantua, who commissioned gems from Francesco ANICHINI in Venice, already a noted centre for the craft. In 1477 Lorenzo de' Medici, the Magnificent, brought the medallist Pietro de' Neri Razzanti [Petroceni] (1425–after 1480) to Florence to teach gem-engraving, and in Milan Domenico dei Cammei (*d* 1508) engraved a portrait of *Ludovico il Moro* (Florence, Pitti; St Petersburg, Hermitage, attrib.; *see also* §II below). Remarkably naturalistic portraits of old men (London, BM; Vienna, Ksthist. Mus.) were also produced in Milan. Rome attracted artists to the Papal Mint and court: a cornelian intaglio portrait of *Pope Paul II* (1470; Florence, Pitti) by Giuliano di Scipione (*fl c.* 1470) is the earliest preserved Italian gem by a named engraver. Three other gems (Naples, Mus. Archeol. N.) once owned by the Pope, later in the collection of Lorenzo de' Medici, and variants (e.g. Paris, Bib. N., Cab. Médailles) of the ancient *Apollo and Marsyas* gem (Naples, Mus. Archeol. N.), are by unknown contemporary artists. A cameo portrait of *Lorenzo* (Florence, Pitti), probably posthumous, has been attributed to the earliest engraver mentioned by Vasari, Giovanni delle Corniole [Giovanni delle Opere] (1470–c. 1516), whose cornelian intaglio of *Girolamo Savonarola* (see fig. 11) was acquired *c.* 1568 by Cosimo I de'

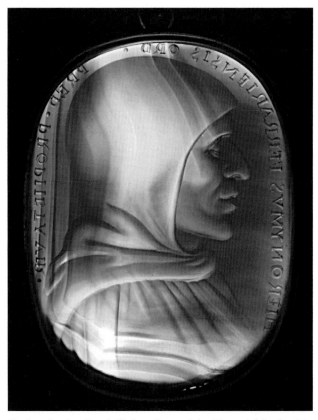

11. Cornelian intaglio of *Girolamo Savonarola* by Giovanni delle Corniole, 327×415 mm, *c.* 1500 (Florence, Palazzo Pitti, Museo degli Argenti)

12. Onyx cameo, *Christ at the Column*, 65×42 mm, north Italian, *c*. 1500 (Vienna, Kunsthistorisches Museum, Kunstkammer)

Medici, Grand Duke of Tuscany. The noble, idealizing style of these busts—very different from Milanese naturalism—reveals the influence of Classical portraiture. Besides motifs from the Antique, biblical subjects were engraved in styles closely related to those of the major arts of the period (e.g. *Annunciation*; St Petersburg, Hermitage; *Christ at the Column*, *c*. 1500; see fig. 12). The work of PIER MARIA SERBALDI DA PESCIA is imbued with the Classical spirit that he absorbed in the circle of Lorenzo. Serbaldi distinguished himself by working in the exceedingly hard porphyry (e.g. dies for a portrait medal of *Pope Leo X*, Florence, Pitti; Paris, Louvre). A cornelian intaglio representing a many-figured *Bacchanal* (Paris, Bib. N., Cab. Médailles), which in subsequent centuries was one of the most admired and copied stones, has been ascribed to Serbaldi.

(ii) c. 1500–1600. After the restoration of the Medici in 1527, Florence once again exercised important patronage; portraits of the assassinated *Alessandro de' Medici* (cameo; Florence, Pitti; rock crystal intaglio; Paris, Bib. N., Cab. Médailles) are ascribed to Domenico di Polo (1480–1547), who engraved a magnificent standing *Hercules* for Grand Duke Cosimo I's seal (Florence, Bargello). Much of the busy trade in gems continued through Venice, where Francesco Anichini remained revered as the leading glyptic artist until his death in 1526. Chalcedony cameo busts of women (e.g. *Cleopatra*; Vienna, Ksthist. Mus.) show the influence of the work of the sculptor Tullio Lombardo

(*see* LOMBARDO, (2)); similar busts, almost or entirely in the round, appear in hyacinth, for example *Lucretia* (Florence, Pitti).

Antique motifs and Classical styles continued to dominate the work of gem-engravers, who also drew on contemporary graphics and plaquettes, which were themselves influenced by Classical art, for models of frieze-like processions and sacrifices, triumphs and bacchanals, hunts and cavalry battles; portraits and contemporary scenes were also depicted in antique mode, for example the confronted *Cosimo I and Eleonora de' Medici* and the *Triumph of Philip II* (both Florence, Pitti) by Domenico Compagni (*fl c*. 1550–86). Matteo del Nassaro (*d* 1547/8) from Verona, who studied in Rome with his compatriot Nicolò Avanzi (1500–*c*. 1550) was an admired gem-engraver of the first half of the century; in 1515 Matteo left Italy to work in France for Francis I. Even his reputation, however, was surpassed by that of the prolific VALERIO BELLI. Belli was renowned for his large, reverse intaglio rock crystal plaques, designed to be seen through the polished surface, for example those forming the casket (1530–32; Florence, Pitti) with scenes of the *Passion* commissioned by Pope Clement VII. His mature work in gems was widely disseminated through reproduction in plaquettes (examples in Florence, Bargello), as was that of his younger rival GIOVANNI BERNARDI, who worked chiefly in Rome, a master of the struck medal as well as of gem-engraving. Bernardi's technique of reverse intaglio resembled that of Belli, but his style is related to contemporary Mannerist art; a rock crystal intaglio of *Tityus* (see fig. 13) is based on a drawing by Michelangelo. Bernardi's work exercised great influence on the newly fashionable vessels in rock crystal and hardstones created in Milan (*see* MILAN, §III, 1), where, under the settled rule of the Spanish Habsburgs, dynasties of craftsmen were established.

A different direction is indicated by the smaller-scale work of Alessandro Cesati. Active in Rome during the mid-16th century, he was employed by the Mint and is reputed to have been a skilful forger of ancient coins; his cameos are distinguished by a virtuoso technique in extremely low relief, for example a portrait of *Henry II* of France in cornelian (St Petersburg, Hermitage).

An exceptionally important commission for Rome was the State Cameo (1565–72; Florence, Pitti) created by Giovanni Antonio de' Rossi for Cosimo I. It was designed to emulate Classical models and depicts the Duke surrounded by his wife and children.

For jewellery, the more colourful and more immediately 'readable' cameos began to be preferred over intaglios, their contrasting layers making a splendid show in badges or pendants, sumptuously mounted in gold, enamel and precious stones (examples of original settings in Vienna, Ksthist. Mus.). As emblems of dynastic power, often destined for gifts, cameo portraits of rulers and their consorts assumed great importance. In addition to portraits in the antique style (e.g. onyx cameo of *Cosimo I* by ?Domenico Poggini; Florence, Pitti), sitters were also shown in contemporary armour or costume, with minutely detailed dress, hairstyles and jewels (e.g. ?*Alfonso II, Duke of Ferrara, and Lucrezia de' Medici*; Paris, Bib. N., Cab. Médailles). Even more striking, naturalistic effects were

achieved in *commesso* cameos, in which differently coloured hardstones were placed in mosaic with enamelled gold and gems to render flesh-tones and costume; in the cameo of *Cleopatra* (Vienna, Ksthist. Mus.) a diamond is used to imitate a mirror. Ottavio Miseroni developed this genre further by adopting a relief mosaic, which he employed for portraits, both real and ideal (e.g. *Lady with a Feather Fan*; Vienna, Ksthist. Mus.), for pagan allegorical figures, and for Christian devotional gems (e.g. *Madonna*; Vienna, Schatzkam.). In *cameos ornés*, details of jewellery are rendered in applied pearls and brilliants, most strikingly on heads of negroes and Moors, their images cut in the dark surface layer of onyx or sardonyx (e.g. *Diana as a Negress*; Vienna, Ksthist. Mus.; *Negro King*; Paris, Bib. N., Cab. Médailles); ideal heads of *Roman Emperors*, sometimes in series of *The Twelve Caesars*, similarly exploit the crisply defined strata of the stones. Another favourite motif consisted of half figures of nude women, for example *Lucretia* (c. 1560–70; Vienna, Ksthist. Mus.) by Jacopo da Trezzo I. Sculpture, plaquettes and prints provided the models for narrative subjects: Francesco Tortorino (*d* before 1595) depicted a cavalry battle after a motif from the Arch of Titus in Rome; his scenes in high relief— *Marcus Curtius at the Bridge*, the *Generosity of Scipio* (attrib.; both Vienna, Ksthist. Mus.) and other subjects from Roman history—were frequently repeated, as they were on plaquettes; earlier intaglios by Valerio Belli were also translated into cameo. Brightly coloured jaspers cut in high relief depicting birds or animals (e.g. St Petersburg, Hermitage) were the speciality of the workshop of Giovanni Antonio Masnago (*fl* late 16th century); minute figures in highly elaborate landscapes and architectural settings, representing Classical or biblical scenes after prints by Etienne Delaune, were engraved by his son Alessandro Masnago (*fl c.* 1575–1612) on polychrome jaspers and agates, as in the *Rape of Proserpina* (Vienna, Ksthist. Mus.); greatly prized by Rudolf II, many are preserved in elaborate mounts (Vienna, Ksthist. Mus.) by Andreas Osenbruck (*fl* 1612–22) and Hans Vermeyen (*d* 1606). Cameos were also employed profusely in a subsidiary role to decorate such gold objects as cups, caskets, mirrors, candelabra and even arms; here one finds ancient and imposing modern cameos intermingled with such hasty and insignificant work as small portrait heads, busts of women with exposed breasts, and roughly cut intaglios of pseudo-Classical heads and figures in cornelian and lapis lazuli. At the end of the century large oval plaques of transparent banded and mottled agates were cursorily engraved in intaglio with Classical figures, often cupids, in a landscape (e.g. Vienna, Ksthist. Mus.; Florence, Pitti).

Matteo del Nassaro was brought by Francis I to Paris, but despite his long activity at court, only two portraits of the King, in intaglio and in cameo (both Paris, Bib. N., Cab. Médailles) can be attributed to him or his school; intaglios representing Roman cavalry battles and lion hunts (attrib.) are in Paris (Bib. N., Cab. Médailles) and the British Museum, London; his works most prized by contemporaries, however, for the exquisite use of coloured jaspers, are lost. In 1531 Nassaro was paid for a vase and for establishing a lapidary mill on a boat on the Seine; this new invention was to become highly important not only for the polishing of gems but for the manufacture of

13. Rock crystal intaglio of *Tityus* by Giovanni Bernardi, l. 60 mm, 16th century (London, British Museum)

luxurious hardstone vessels, which were becoming increasingly fashionable. Catherine de' Medici took many gems with her from Florence to France in 1533 and commissioned many more; therefore, the Italian influence on French gem-engraving remained dominant during the reigns of her sons. Charles IX (*reg* 1560–94) created a special gallery in the Louvre for engraved gems, coins, medals and antiquities. Towards the end of the 16th century, however, the royal collection suffered grievous losses, and it was not until the accession of Henry IV (1589) that more settled times encouraged its re-establishment. By then, three French gem-engravers are documented in the royal archives, although only royal portraits can be attributed to them with any probability. These are portraits of Henry IV, especially a mounted cameo of *Henry IV as Hercules*, and intaglios on emerald and garnet (all Paris, Bib. N., Cab. Médailles), attributed to Olivier Coldoré (*fl* before 1582–?early 17th century) and to Julien de Fontenay (*fl* 1590–1611), who was at Fontainebleau in 1596 and was a salaried court artist in the Louvre in 1608. Portrait gems, signed with the initials of Guillaume Dupré, who also worked for the House of Nassau, are more secure in their attribution, based on the evidence of his medals: for example, a sapphire intaglio of *Maurice of Nassau*, signed with his initials (Paris, Bib. N., Cab. Médailles). Gems were also profusely employed in France to decorate metalwork (e.g. *Sword of Henry IV*; Paris, Louvre).

Less laborious than stone-engraving, the carving of cameos on shell was seemingly an indigenous craft practised in France from the early 16th century until well into the 17th. Tiny, delicate scenes of animals are featured on bracelets (e.g. Paris, Bib. N., Cab. Médailles), but larger

slabs, used for the decoration of cups, priming-flasks and other objects, portray biblical and antique subjects, often accompanied by inscriptions (e.g. Paris, Bib. N., Cab. Médailles; London, BM; Florence, Bargello). These either show naturally contrasting layers of colour or are underlaid with a dark base to make white surface figures more prominent.

The workshop most closely associated with the use of shell cameos on elaborate *Kunstkammer* objects was that of the Nuremberg goldsmith Ludwig Krug, to which a cup set with shell in the Treasury of S Antonio (Il Santo), Padua, has been attributed; Nuremberg has been suggested as a second centre for such cameos, for which drawings and prints by such Northern artists as Dürer, and Italian prints and plaquettes served as models. Besides Classical and fantastic heads and figures, there are also examples of devotional scenes on shell (e.g. *Virgin and Child*, after a plaquette by Moderno; Florence, Bargello). Similar sources also served as models for 16th-century stone cameos of German origin, for example *Judith* (St Petersburg, Hermitage) after an engraving by Barthel Beham. Names of engravers recorded in German goldsmithing centres *c.* 1600 include Georg Höfler (*c.* 1570–1630) of Nuremberg and Valentin Drausch (*d* 1626) of Augsburg, who worked for William V, Duke of Bavaria.

The House of Habsburg was prominent in collecting and patronage, both in Spain and in Austria. Philip II of Spain (*reg* 1556–98) brought Italian gem-engravers to Madrid; Jacopo da Trezzo I moved there from Milan and executed the important custodia (a type of portable tabernacle) for the Capilla Mayor in the Escorial; he also engraved individual gems, including portraits such as that of *Philip II and Don Carlos* confronted (topaz intaglio, Paris, Bib. N., Cab. Médailles); Clemente Birago (*d* 1592) is reputed to have engraved Philip's signet on a diamond, a feat of the greatest virtuosity. But it was Philip's nephew, Emperor Rudolf II, who established in Prague the last great Renaissance centre for gem-engraving (*see* PRAGUE, §III, 2). In constant touch with the workshops of Milan, where Alessandro Masnago cut cameos for him, Rudolf brought Ottavio Miseroni and other members of the family to his court (*see* MISERONI; *see also* HARDSTONES, colour pl. II, fig. 1); their descendants worked in Prague until the last quarter of the 17th century.

A small but remarkable series of Tudor dynastic portraits, culminating in numerous cameos of Elizabeth I, has led to speculations about the involvement of such foreign artists as Olivier Coldoré in their production; although no English workshop is recorded, Richard Atsyll [Astyll], documented in 1539, has been suggested as the artist responsible for portraits of *Henry VIII* and the infant *Edward VI*. Their images are derived from portraits by Hans Holbein the younger and are executed in a refined technique of low-relief cameo on three-layer sardonyx, with intaglio engravings on the reverses (e.g. Windsor Castle, Berks, Royal Col.; Chatsworth, Derbys). Profile cameo portraits of *Elizabeth I*, probably derived from her portrait on the 'Phoenix Jewel' (*c.* 1570–80; London, BM), are known in various sizes on two- and three-layer sardonyx; most portray her in elaborate state dress with jewels, although the face is the official 'mask of youth'; they were designed for diplomatic and personal gifts (fine

examples in Paris, Bib. N., Cab. Médailles; Vienna, Ksthist. Mus.; Windsor Castle, Berks, Royal Col.; St Petersburg, Hermitage). Their number presupposes a busy workshop, possibly based abroad and working from a graphic model. A number of cameos of *St George*, devised as 'Lesser Georges' for the Knights of the Order of the Garter, of the 16th and 17th centuries (e.g. Windsor Castle, Berks, Royal Col.), are probably of English origin.

(iii) 1601–1700. As patrons became increasingly interested in other luxury arts, 17th-century gem-engraving declined artistically, although it was still widely practised. In Italy few engravers' names are recorded, and gems were mostly unsigned, in itself a sign of diminished status. Examples of cursorily cut stones mounted on decorative vessels show the continued use of motifs derived from the Antique, but the age of the Counter-Reformation also found expression in devotional gems, some of considerable size. Cameo busts of *Christ* and *The Virgin*, after Antonio Abondio's medal types, commonly cut on bloodstone (e.g. Paris, Bib. N., Cab. Médailles; London, BM; Vienna, Ksthist. Mus.), date from the first half of the century. More remarkable is a series of 12 rock crystal intaglio plaques depicting the *Life and Passion of Christ*, commissioned by Cardinal Francesco Barberini for a set of candlesticks for St Peter's in Rome from Anna Cecilia Hamerani (1642–78), a member of the Roman family of medallists. In Florence, Giuseppe Antonio Torricelli established a family workshop, but patronage of glyptic artists at this time was more assiduous in centres outside Italy. Foremost among them was Prague, where the Miseroni workshop continued after the death of Rudolf II. Other workshops, probably offshoots of the Prague school, were established near Vienna, where much of their work remains. Gems and shells continued in demand for decorative purposes, for example on a circular lapis lazuli dish, the rim of which is set with a series of *The Twelve Caesars* (Vienna, Ksthist. Mus.).

Imperial portraits show the considerable changes in taste at this time. In contrast with the traditional materials of contrasting layers, transparent or translucent monochrome stones, some of considerable size, were now employed for cameos, as on an amethyst portrait of *Leopold I* (*c.* 1670); the same emperor appears on an emerald of *c.* 1660 (both Vienna, Ksthist. Mus.). Such stones are characteristic of the ostentatious luxury of Baroque court art. Other showy jewels, for example extremely large lockets and pendants with elaborate enamelled gold mounts enriched with precious stones, centre on small cameo portraits in quickly worked ivory or shell, surrounded by a series of tiny ancestral busts or minutely worked coats of arms in shell, turquoise and coral. Long series of similar small portraits in monochrome chalcedonies or shell, depicting such dynasties as the Habsburgs, hang from precious metal 'family trees'; as many as 48, depicting family members of the Habsburgs down to Leopold William, Archduke of Austria, form the links of a necklace (Vienna, Ksthist. Mus.). Similar series of other dynasties are found in shell, but CHRISTOPH DORSCH of Nuremberg continued the production of extensive portrait series in stone and glass seemingly well into the 18th

century (e.g. *The Popes*; Leiden, Rijksmus. Kon. Penning-kab.). In the later 17th century German courts and wealthy bourgeois patrons commissioned a large number of gem-engravings: a rock crystal bowl (1680; Kassel, Hess. Landesmus.) by the Swiss Christoph Labhart stems from a court workshop that also produced chalcedony cameos and figures in the round.

Portraits of members of the Bourbon court are evidence of the continuation of French gem-engraving in the 17th century, although the authors of fine cameo portraits of *Louis XIII* and his consort (*c.* 1630), *Cardinal Richelieu* (both St Petersburg, Hermitage), *Cardinal Mazarin* (*c.* 1659) and a cameo bust of *Louis XIV* (*c.* 1660; both Paris, Bib. N., Cab. Médailles) are unknown. Louis XIV constantly added to the magnificent collection inherited from his uncle, Gaston, Duc d'Orléans (1608–60; *see* §II below), and portraits were engraved on the most precious stones: a ruby cameo of *Madame de Maintenon* (London, BM); a sapphire cameo of *Louis, Le Grand Dauphin* (St Petersburg, Hermitage); and another sapphire cameo of *Elisabeth Charlotte, Duchesse d'Orléans* (Karlsruhe, Bad. Landesmus.). None of these gems, however, can be securely attributed.

In England collecting reached a high point in the 17th century, accompanied by some patronage of contemporary artists (*see* §II below). Portrait cameos were engraved, not only for the Stuart court but also during the Common-wealth (1649–60); for example two cameos of *Oliver Cromwell* (St Petersburg, Hermitage) are ascribed to the medallist Thomas Simon (1618–65), while royalist portraits have been assigned to Thomas Rawlins (e.g. *Charles I*; St Petersburg, Hermitage; Chatsworth, Derbys). Both Simon and Rawlins were pupils of Nicolas Briot. Charles Christian Reisen (*c.* 1637–97), of Danish descent, reputedly engraved a portrait of *Christian XII* of Sweden (untraced). Cameos of *St George* continued to be engraved for 'Lesser Georges' (St Petersburg, Hermitage; Windsor Castle, Berks, Royal Col.).

BIBLIOGRAPHY

DBI; Forrer; Thieme–Becker
G. Vasari: *Vite* (1550, rev. 2/1568); ed. G. Milanesi (1878–85)
P. -J. Mariette: *Traité des pierres gravées*, 2 vols (Paris, 1750)
A. P. Giulianelli: *Memorie degli intagliatori moderni in pietre dure, cammei, e gioje, dal sec. XV fino al sec. XVIII* (Livorno, 1753)
H. Rollett: 'Glyptik', *Geschichte der technischen Künste*, ed. B. Bucher, i (Stuttgart, 1857), pp. 271–356
[A.] Chabouillet: *Catalogue général et raisonné des camées et des pierres gravées de la Bibliothèque Impériale* (Paris, [1858])
C. D. Fortnum: *Notes on Some of the Antique and Renaissance Gems and Jewels in Her Majesty's Collection at Windsor Castle* (London, 1876)
E. Müntz: *Les Arts à la cour des Papes pendant le 15e et 16e siècle*, i (Paris, 1878)
E. Babelon: *La Gravure en pierres fines: Camées et intailles* (Paris, 1894)
——: *Catalogue des camées antiques et modernes de la Bibliothèque Nationale*, 2 vols (Paris, 1897)
——: *Histoire de la gravure sur gemmes en France depuis les origines jusqu'à l'époque contemporaine*, 2 vols (Paris, 1902)
O. M. Dalton: *Catalogue of Engraved Gems of the Post-Classical Periods in the British Museum* (London, 1915)
H. Gebhart: *Gemmen und Kameen* (Berlin, 1925)
E. Kris: 'Camées français au Musée de Vienne', *Aréthusa*, x (1926), pp. 29–34
F. Eichler and E. Kris: *Die Kameen im Kunsthistorischen Museum* (Vienna, 1927)
E. Kris: *Meister und Meisterwerke der Steinschneidekunst in der italienischen Renaissance*, 2 vols (Vienna, 1929)
R. Righetti: *Incisori di gemme e cammei in Roma dal rinascimento all'ottocento* (Rome, 1952)
C. G. Bulgari: *Argentari gemmari e orafi d'Italia—Roma*, 3 vols (Rome, 1958–66)
C. Piacenti Aschengreen: *Il Museo degli Argenti a Firenze* (Milan, 1968)
J. Kagan: *Western European Cameos in the Hermitage Collection* (Leningrad, 1973)
K.-H. Meyer: *Studien zum Steinschnitt des 17. und der ersten Hälfte des 18. Jahrhunderts, unter besonderer Berücksichtigung der Werkstatt am Hofe von Hessen-Kassel in den Jahren 1680–1730* (diss., U. Hamburg, 1973)
J. Kagan: 'Portretnyye kamni epokhi Tyudorov: Problemy interpretatsii, datirovki, atributsii' [Tudor portrait cameos: problems of interpretation, dating, attribution], *Muzey*, i (1980), pp. 29–36
——: 'K istorii gliptiki v Anglii XVII v.' [Towards a history of glyptics in 17th-century England], *Zapadno-yevropeyskoye iskusstvo XVII veka* [Western European art of the 17th century] (Leningrad, 1981)
D. Scarisbrick: 'The Devonshire Parure', *Archaeologia* [*Soc. Antiqua. London*], cviii (London, 1986), pp. 239–54
M. A. McCrory: 'Renaissance Shell Cameos from the Carrand Collection of the Museo Nazionale del Bargello', *Burl. Mag.*, cxxx (1988), pp. 412–26
R. Distelberger: 'Die Kunstkammerstücke', *Prag um 1600: Kunst und Kultur am Hofe Rudolfs II*, 2 vols (exh. cat., Essen, Villa Hügel; Vienna, Ksthist. Mus.; 1988–9)

11. 1701–1800.

(i) 1701–50. (ii) 1751–1800.

(i) 1701–50. There was a major revival in gem-engraving during the early 18th century, partly the result of a widespread interest in the arts of antiquity. The undisputed centre of production was Rome, the main destination for visitors on the Grand Tour, who were as keen to acquire modern copies and gems in the antique taste as they were to obtain ancient originals, so that a new generation of craftsmen found it profitable to settle there. Among many others, the Ferrarese Flavio Sirletti, the Neapolitan Giovanni Costanzi and Anton Pichler (*see* PICHLER) from Brixen (now Bressanone, Italy) successfully established family workshops in Rome that continued through several generations. Accurate copies of devices on ancient gems and coins were based on illustrated publications and casts in wax, sulphur and plaster, which became more abundant as the century progressed and provided the most convenient models; thus Solon's *Medusa* (London, BM) exists in many copies (e.g. plasma intaglio, London, BM)—one of them (untraced) was executed by Giovanni Costanzi's son Carlo Costanzi (*see* COSTANZI, (2)) in 1729. The highest praise bestowed on an engraver was that his works might pass for 'Greek'. Undoubtedly many were taken to be antique, by accident or by design, and were often embellished with fake Greek signatures. Most gems of the period have remained unidentified owing to the dispersal of Italian collections in the 18th century and of Grand Tourists' possessions by their descendants in the 19th.

At first, intaglios were cut on small ovals and simply mounted in rings or fobs, used for sealing and studied in impression; the minerals most commonly used were the traditional sard, cornelian, nicolo, transparent amethyst, rock crystal and citrine. Cameos were rarer and were also generally modest in size; they usually show white heads or figures on a darker, sometimes dyed, background. For the wealthiest patrons, however, engravers could demonstrate their skill by engraving the hardest gems: both Giovanni and Carlo Costanzi reputedly engraved on diamond; Carlo

also worked in emerald, cut a portrait of *Empress Maria-Theresa* on sapphire (untraced) and a *Diadoch* on aquamarine (Bucharest, Roman. Acad.).

A popular new genre depicted the most celebrated ancient sculptures admired by visitors to Rome, Florence and Naples, and thereby supplied artistic and conveniently portable souvenirs: for example Flavio Sirletti engraved a copy of the *Laokoon* (Rome, Vatican, Mus. Pio-Clementino) on amethyst (untraced) for an English duke. Portraits of the Ancients, a taste first stimulated by the humanists' interest in iconography, were popular, copied directly from gems, coins, statues and busts or from illustrated books: Antonio Pichler engraved a *Cicero* and a *Cleopatra*, Giovanni Costanzi a *Nero* on diamond and Carlo Costanzi a *Plato*; but historical portraiture also extended to the increasingly popular genre of 'illustrious men'—especially Italian artists—of the more recent past, for example Pichler's *Raphael* (untraced). Contemporary portraits, no longer a princely preserve, were commissioned in Rome by such Grand Tourists as Sir John Frederick, Bart, a portrait of whom was executed by Carlo Costanzi in 1737 (untraced). Many sitters were depicted in the antique style in 'coin profile'; others, like historical portraits copied from paintings and busts, were shown in contemporary dress and fashionable wigs. Except for such portraits and rare devotional gems, motifs were exclusively Classical. It is significant for the enhanced status of engravers at this time that they usually signed their gems with names or initials, frequently transliterated into Greek, in emulation of the gems published in Philipp von Stosch's *Gemmae antiquae caelatae* (1724), which had awakened interest in the signatures on ancient gems. Some gem-engravers were accorded honours by popes and potentates: Carlo Costanzi was distinguished by Pope Benedict XIII and in 1740 by Benedict XIV, and Giovanni Pichler was created a Knight of the Holy Roman Empire by Joseph II.

Among the foreign gem-engravers who were attracted to Rome during the first half of the century, the most skilful was the German Johann Lorenz Natter, who engraved a portrait of *Cardinal Alessandro Albani* during his stay in Rome. He also spent time in Florence during the 1730s in the circle of Stosch, of whom he engraved two portraits, on emerald and aventurine (both St Petersburg, Hermitage). He worked in London and the Netherlands (important collection in Leiden, Rijksmus. Kon. Penningkab.) and died in Russia. The last Medici Grand Dukes and their Lorrainer and Habsburg-Lorraine successors employed members of the Torricelli family; Francesco Ghinghi engraved Roman emperors in sapphire for Anna Maria Luisa de' Medici and portraits of *Grand Duke Cosimo III* (untraced) and *Philipp von Stosch* (Berlin, Pergamonmus.) before taking up the directorship of the Real Laboratorio delle Pietre Dure in Naples. Stosch also patronized Felix Bernabé, who engraved Classical devices, a *Head of Christ* and an *Ithyphallic Procession* (glass paste in Bucharest, Roman. Acad.). The French gem-engraver LOUIS SIRIÈS, who had settled in Florence in 1722 and became Director of the Real Galleria di Firenze, executed many minutely detailed gems in very low relief for Empress Maria-Theresa, Queen of Hungary and Bohemia (Vienna, Ksthist. Mus.).

14. Sardonyx cameo, *Alliance between France and Austria* by Jacques Guay, set in copper, 34×28 mm, 1756 (Paris, Bibliothèque Nationale, Cabinet des Médailles)

Outside Italy craftsmen continued to find employment in the major cities in Germany and Austria during the first half of the 18th century. Philipp Christoph Becker (1674–1742) worked in Vienna for Joseph I (*reg* 1678–1711) and Charles VI (*reg* 1711–40); Susanna Maria Preissler (1701–65), the daughter of Christoph Dorsch, was active in Nuremberg (sealing-wax impressions of her gems are in The Hague, Rijksmus. Meermanno–Westreenianum). In France François-Julien Barier (1680–1746), who engraved in a minutely detailed style (e.g. *Three Philosophers*, Leiden, Rijksmus. Kon. Penningkab.), was named Graveur du Roi en Pierres Fines to Louis XV; he was, however, succeeded by a far greater artist, Jacques Guay, in the mid-18th century. Guay's work in allegorical scenes celebrating the King's reign (e.g. *Victory at Lawfeldt* and *Alliance between France and Austria*, 1756; see fig. 14) and portraits (e.g. cameo of *Louis XV*; all Paris, Bib. N., Cab. Médailles) is more closely related to the medallic art of the period and the Rococo of François Boucher and Edme Bouchardon, who furnished him with drawings, than the more classicizing gems of the Roman masters.

(ii) 1751–1800. The genres practised earlier continued in the second half of the 18th century, but a search for novelty led to some widening of scope, which included details from popular Renaissance and Baroque paintings and portraits of famous contemporaries. In the last decades of the century cameos for ladies' jewellery, especially bracelets and necklaces, began to take precedence over intaglios. Cameo-engravers found the increasing numbers of cast collections particularly valuable, as intaglios, too, were shown in impression as cameos, making copying easy.

In Rome numerous new engravers such as Gaspare Capparoni joined the younger generation of family workshops. Many of their works continued to be bought by Grand Tourists. There are four signed gems by Giovanni Battista Cerbara in the British Museum, London, among them *Portrait of a Lady*, a genre for which he was much praised. His son Giuseppe Cerbara is represented in the Kunsthistorisches Museum in Vienna and the Museo Nazionale del Bargello in Florence. Angelo Antonio Amastini engraved a *Head of Diomedes* (St Petersburg, Hermitage) and a *Cupid and Psyche* (London, BM), but the foremost engraver of the period was Giovanni Pichler,

eldest son of Anton Pichler (*see* PICHLER). Praised for his fine execution, he was remarkably productive during a short lifetime, engraving almost 400 named devices in cameo and intaglio. He cut a portrait of *Joseph II* (1769; Vienna, Ksthist. Mus.) from life during the Emperor's visit to Rome in 1769, which earned him the titles of Ritter and Gem-Engraver to His Imperial Majesty. Among his most admired gems were figures of maenads and dancers (St Petersburg, Hermitage) after frescoes at Herculaneum, Muses (e.g. *Urania*; see fig. 15) and figures of Venus. His pupils Antonio Pazzaglia and Alessandro Cades (1734–1809) followed in his footsteps, but they were outshone by several artists who had been attracted to Rome from abroad, for example Christian Friedrich Hecker from Saxony, who engraved Classical devices and also a distinguished portrait of *Goethe* in Weimar. Others who made their career in Rome included Natter's pupil Gottfried Krafft (*fl c.* 1750), known as 'il Tedesco', and Hyacinth [Jacinto] Frey (1761–*c.* 1824), who engraved an *Aurora* after Guido Reni. The Englishman Nathaniel Marchant spent 16 years in Rome, where he made his name as a worthy rival to Pichler, specializing in intaglios after ancient sculptures, such as *Bacchus and a Bacchante* (examples in London, BM; see fig. 16; and St Petersburg, Hermitage).

Outside Italy, London became the most important centre of gem-engraving in the second half of the 18th century; connoisseurs and returned Grand Tourists promoted the establishment of a school of gem-engraving through the Society of Arts; they exhibited their works through the Society and at the Royal Academy. George III, although he bought the collection of Joseph Smith, British Consul in Venice, was not noted as a patron, but his brother, William Henry, Duke of Gloucester (1743–1805), his sons, the Prince of Wales (later George IV) and Augustus, Duke of Sussex (1773–1843), and such peers as George Spencer, 4th Duke of Marlborough (1739–1817), and George John, 2nd Earl Spencer (1758–1834), and his

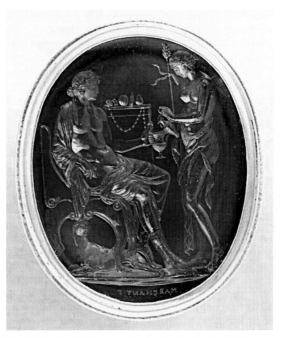

16. Sard intaglio of *Bacchus and a Bacchante* by Nathaniel Marchant, 1772–83 (London, British Museum)

Countess, were among those whom engravers could count on for commissions. English patronage attracted Natter to London, and Giovanni Pichler at one time planned to follow him there. Natter published his important treatise on gem-engraving, *Traité de la méthode antique de graver en pierres fines*, in London in 1754 in both French and English. Outstanding native English artists included EDWARD BURCH, elected among the first Royal Academicians; his erstwhile scholar Nathaniel Marchant, who returned home after making his name in Rome; and the brothers William Brown (1748–1825) and Charles Brown (1749–95), a large part of whose output was executed in London to the commission of Catherine II, Empress of Russia. Catherine also employed a number of German engravers and through her patronage enabled the London manufacturer James Tassie, whose casts from gems and glass pastes gave modern engravers equal prominence with the ancient, to expand his production to almost 16,000 models (collection Edinburgh, N.P.G.; London, V&A; and St Petersburg, Hermitage). In Russia Catherine's daughter-in-law, later Empress Maria Fyodorovna (1759–1828), became an accomplished cameo-engraver, portraying members of the Imperial family (examples in St Petersburg, Hermitage) under the tutelage of Karl von Leberecht (1749/55–1827), Director of the Mint in St Petersburg. Gottfried Benjamin Tettelbach (1750–1813) became gem-engraver to Frederick-Augustus III, Elector of Saxony, and his two sons, Clemens Tettelbach (1776–1851) and Felix Tettelbach (1788–1857), engraved for the Dresden and Russian courts. Members of the Abraham family, such as Philipp Abraham (e.g. portrait of *Catherine the Great*, St Petersburg, Hermitage), and Ascher Wappenstein (e.g. *Empress Maria Ludovica*; Vienna, Ksthist. Mus.) were able to found

15. Sard intaglio of *Urania* by Giovanni Pichler, second half of the 18th century (London, British Museum)

workshops in Berlin and Vienna in the age of the emancipation of the Jews. Friedrich Wilhelm Facius (1764–1843), a protégé of Goethe, became Court Engraver at Weimar.

BIBLIOGRAPHY

P. von Stosch: *Gemmae antiquae caelatae* (Amsterdam, 1724)
J. G. Meusel: *Teutsches Künstlerlexikon oder Verzeichnis der jetzt lebenden Künstler* (Lemgo, 1778)
[G. A. Guattani]: *Memorie per le belle arti*, 4 vols (Rome, 1785–9)
R. E. Raspe: *A Descriptive Catalogue of a General Collection of Ancient and Modern Engraved Gems . . . Taken from the Most Celebrated Cabinets in Europe by James Tassie, Modeller*, 2 vols (London, 1791) [text in Eng. and Fr.]
C. Justi: *Winckelmann, sein Leben, seine Werke und seine Zeitgenossen*, 3 vols (Leipzig, 1866–72), rev. as *Winckelmann und seine Zeitgenossen* (Leipzig, 1923)
E. Babelon: *Histoire de la gravure sur gemmes en France* (Paris, 1902)
R. Righetti: *Incisori di gemme e cammei in Roma dal rinascimento all' ottocento* (Rome, 1952)
L. Pirzio Biroli Stefanelli: 'Roman Gem Engravers of the Eighteenth and Nineteenth Centuries: The Present State of Research', *Jewel. Stud.*, iv (1990), pp. 53–8
G. Seidmann: 'A Very Useful, Curious and Ancient Art: The Society of Arts and the Revival of Gem-Engraving in 18th Century England', *The Virtuoso Tribe of Arts and Sciences—Studies in the Eighteenth Century Work and Membership of the London Society of Arts*, ed. D. G. C. Allan and J. L. Abbott (Athens, GA, and London, 1992), pp. 120–31

12. AFTER 1800. In Italy gem-engravers initially continued to produce work in the Neo-classical taste after 1800, but their lives were disrupted by the French invasion and the political upheavals that followed. Giovanni Antonio Santarelli moved from Rome to Florence in 1797; FILIPPO REGA, after studying with the Pichlers, returned to Naples; Teresa Talani (*fl* 1797–after 1800) of Rome also moved there. These cities, with their splendid antiquities and resident connoisseurs, still offered knowledgeable patronage. In Rome workshops continued as best they could, in part turning to cheaper wares; the workshops of the AMASTINI, Paoletti, Cades and Liberotti families specialized in cast collections. About 1800 gem-engraving received a new impetus, the last of any significance, through the enthusiastic patronage of Napoleon and his entourage. An early portrait by Romain-Vincent Jeuffroy shows *General Bonaparte* (Paris, Bib. N., Cab. Médailles) in uniform, and within a few years Napoleon discovered the full potential of the portrait cameo for propaganda purposes. Italian gem-engravers—among them Antonio Berini (?1790–1861), GASPARE CAPPARONI, NICOLA MORELLI (e.g. cameo of *Napoleon*, 1800; see fig. 17) and GIOVANNI ANTONIO SANTARELLI—were occupied multiplying Napoleon's image, laureate, as the new Emperor Augustus. Other members of Napoleon's court, and the new dynasts he created in his satellite kingdoms, were similarly portrayed in the antique style (e.g. *Letizia Bonaparte* by Morelli; Rome, Mus. Napoleonico). At the same time there was an overwhelming demand for women's cameo jewellery, encouraged by Napoleon's wife Josephine Bonaparte, herself portrayed in a cameo (Vienna, Ksthist. Mus.) by Berini. A newly popular material at this time was shell, which was not only more quickly and cheaply engraved than stone but also offered larger fields for intricate multi-figured scenes suitable for the combs, diadems and belt-clasps of the Empire fashion. Carved coral also began to be used in jewellery, often as small frontal cupids' heads; and from *c.* 1840 lava cameos, often

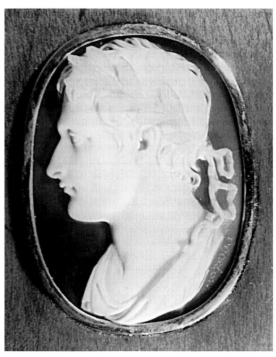

17. Sardonyx cameo of *Napoleon* by Nicola Morelli, 33×24 mm, 1800 (Karlsruhe, Badisches Landesmuseum)

portraits of renowned Italian contemporaries, in shades ranging from white to grey, brown and black (e.g. necklace and bracelet; London, Mus. London), were additional novelties for travellers. Such easily worked substitutes vulgarized the craft and bore the seeds of its gradual decline. Not only shell, but also stone cameos became larger, and included elaborate reproductions of paintings, a genre practised with superb technique in intaglio by GIOVANNI BELTRAMI, who engraved the *Tent of Darius* after the painting (Versailles, Château) by Charles Le Brun with its many figures and recessed planes on a Brazilian topaz (1828; Cremona, Mus. Civ. Ala Ponzone); the modern sculptures of Antonio Canova, Bertel Thorvaldsen and John Gibson (i) replaced Classical statuary as models. In Rome, Antonio Amastini's son Niccolò Amastini assisted his father and continued the workshop after his death; their workshop also produced cast collections after Giovanni Pichler and Nathaniel Marchant.

Several engravers left Italy during this period; Giovanni Calandrelli (1784–1852) established himself in Berlin, where he taught engraving; two of his portraits on amethyst of the Russian tsar *Nicholas I* (*reg* 1825–55) are in the Hermitage, St Petersburg. Giovanni Pichler's half-brother Luigi Pichler was invited by Prince Metternich to direct a school of gem-engraving in Vienna. The two dominant figures of the first half of the 19th century were GIUSEPPE GIROMETTI and BENEDETTO PISTRUCCI. The latter moved to London in 1815, where he became Chief Medallist at the Royal Mint in 1828; his cameos, for example a portrait of *George IV* (Cambridge, Fitzwilliam), commanded large sums. Girometti, the only eminent engraver of the period to remain in Rome, was greatly in

demand for portraiture and depicted numerous contemporary heads of state; he is represented by cameos in Karlsruhe (Bad. Landesmus.), London (BM), New York (Met.) and Vienna (Ksthist. Mus.). Although Girometti and Pistrucci commanded great prestige and large fees during their lifetimes, sustained patronage, which alone could have kept gem-engraving alive, had dwindled by the mid-19th century. Fashion, too easily satisfied by repetitive 'ideal heads' in shell, together with an even greater diffusion and vulgarization through mass-produced glass and ceramic imitations, was the major factor in its decline.

Gem-engraving was, however, continued in Rome by a few skilful engravers, including Girometti's son Pietro Girometti, and Tommaso Saulini and his son Luigi Saulini (see SAULINI). They continued working in both stone and shell, engraving Classical subjects in a more sentimental style after sculptures by Thorvaldsen, for example a sardonyx cameo of *Cupid and Ganymede Playing at Dice* (1831; Copenhagen, Thorvaldsens Mus.) by Tommaso Saulini after designs by John Gibson (i), and *Toilet of Nausicaa*, by Luigi Saulini, in a gold diadem (New York, Met.) made by the Castellani firm of jewellers. They also copied Classical and Neo-classical gems in cameo (e.g. necklace and brooch by Luigi Saulini; New York, Met.). The Saulini were also entrusted with a jugate portrait of *Victoria and Albert* for the badges of the Royal Order of Victoria and Albert, instituted in 1862 (London, V&A; Karlsruhe, Bad. Landesmus.). In the 1860s the firm of CASTELLANI set finely executed matched intaglio copies of ancient stones in its 'archaeological jewellery' (examples in Rome, Villa Giulia). By this time, the production of cameos for the jewellery trade had, however, largely shifted to Paris.

During the Second Republic (1848–52) and Second Empire (1852–70) in France under Napoleon III, large stone cameo medallions for pendants and brooches were in vogue; their vapid 'ideal heads' in high relief, usually depicting *Ceres*, *Bacchus*, nymphs or maenads, had cheaper counterparts in shell cameos. Not untypically for the Second Empire style, Napoleon III commissioned Adolphe David (1828–96) to engrave an *Apotheosis of Napoleon I* (Paris, Mus. d'Orsay) after Ingres, the largest known modern cameo (240×220 mm), which was completed in 1874. Large copies of Renaissance portraits fulfilled a demand for historical jewellery, fashionable during the Romantic period, which were mounted in sumptuous pseudo-Renaissance settings, for example an onyx cameo (c. 1865; London, V&A) of *Marie de' Medicis* by GEORGES BISSINGER, in a pendant setting by Carlo Giuliano (1831–95). Paul Victor Lebas (fl 1852–76) portrayed *Queen Victoria* (1851; London, V&A) in a revived *commesso* technique after a painting by Thomas Sully (1838; London, Wallace). Less ostentatious cameos depict vaguely Classical scenes in a mawkish, sentimental vein (examples in Paris, Mus. d'Orsay), although cameo heads of a more original kind, in ivory and enamel, appeared in Art Nouveau jewellery. Wilhelm Schmidt (1848–1938), born in Idar and trained in Paris, was a cameo-engraver in London until World War I and later moved to New York; he produced gems with Classical subjects and Renaissance portraits for the leading contemporary jewellers, and

experimented with stones as unusual as opal and labradorite (e.g. unsigned cameos in London, Geol. Mus.). In the late 20th century the craft of stone-engraving and shell-carving is still practised by rare enthusiasts; they mainly copy ancient examples in the traditional technique, now using electric rather than foot-driven power. The Russian gem-engraver Peter Zaltsman (b 1952) produced original work in the form of cityscapes of St Petersburg and London engraved on large shell wall plaques designed for transmitted light (examples in Paris, Mus. A. Déc.; St Petersburg, Hermitage).

BIBLIOGRAPHY
G. A. Guattani: *Memorie enciclopediche romane sulle belle arti ed antichità*, 5 vols (Rome, 1806–10)
A. Billing: *The Science of Gems, Jewels, Coins and Medals, Ancient and Modern* (London, 1867, 2/1875)
H. Vever: *La Bijouterie française au 19e siècle*, 3 vols (Paris, 1906–8)
E. Kris: *Catalogue of the Postclassical Cameos in the Milton Weil Collection on Permanent Loan to the Metropolitan Museum* (Vienna, 1932)
C. Gere: 'Intaglios and Cameos', *The Art of the Jeweller: A Catalogue of the Hull Grundy Gift to the British Museum*, ed. H. Tait, 2 vols (London, 1984), pp. 121–39
Catalogue sommaire illustré des arts décoratifs, Paris, Mus. d'Orsay, cat. (Paris, 1988)
L. Pirzio Biroli Stefanelli: *I modelli in cera di Benedetto Pistrucci*, 2 vols (Rome, 1989)
S. Bury: *Jewellery, 1798–1910: The International Era*, 2 vols (Woodbridge, 1991)

II. Collections and museums.

According to Pliny (*Natural History* XXXVII.5–6), the first Roman to collect gem-set rings in *dactyliothecae* (the term used for gem collections until the 18th century) was the dictator Sulla's stepson Marcus Aemilius Scaurus in the 1st century BC, but the fashion spread after Pompey the Great dedicated the gems of Mithridates of Pontus, captured in war (in 61 BC), in the Capitol; Julius Caesar offered six collections in the Temple of Venus Genetrix. The great quantity of extant engraved gems indicates that their possession was widespread in the ancient world. The tradition continued in imperial Byzantium; returning crusaders donated outstanding stones, to be mounted on precious objects, to the treasuries of medieval churches: the Shrine of the Three Kings (late 12th century–c. 1220; see SHRINE, fig. 2) in Cologne Cathedral is embellished with 226 cameos and intaglios. The inventories of Charles V (1380) and his brothers reveal a royal taste for engraved gems in late-medieval France. In Italy Petrarch was one of the earliest humanists to collect gems; in the 15th century Pietro Barbo (later Pope Paul II) owned 821, including the Tazza Farnese (Naples, Mus. Archeol. N.), which, with others from his collection, was later in the possession of Lorenzo de' Medici, who had the letters LAV. R. MED. engraved on many of them (dispersed; the majority in Naples, Mus. Archeol. N.). Outstanding collectors c. 1500 in Italy were Cardinal Domenico Grimani (collection in Venice, Mus. Archeol.) and Isabella d'Este (i), Marchioness of Mantua, who owned the great jugate cameo admired by Rubens, later called the *Cameo Gonzaga* (probably that in St Petersburg, Hermitage), and the Roman Imperial onyx known as the *Mantuan Vase* (Brunswick, Herzog Anton Ulrich-Mus.). In the 16th century Cosimo I, Grand Duke of Tuscany, and the later Medici re-established a collection in Florence (Pitti); the

scholar Fulvio Orsini bequeathed his important collection (Naples, Mus. Archeol. N.) to Cardinal Odoardo Farnese.

In France the collection of Francis I and his sons was dispersed, but Henry IV laid the foundations for a new gem cabinet. No collector, however, of that period could vie with Emperor Rudolf II (*reg* 1576–1612), who expended vast sums on his treasures (*see* HABSBURG, §I(10)). Despite the ravages of the Thirty Years War (1618–48), a great part of his collection survived in Vienna, together with that of his brother and successor Matthias. Queen Christina of Sweden (*reg* 1632–54) built up an important collection (dispersed in the 18th century) first inventoried in 1652, which was greatly enlarged during her exile in Rome. By the 17th century scholarly citizens with antiquarian tastes vied with princes in accumulating both gems and coins, especially in France and the Netherlands. Pierre-Antoine de Rascas, Sieur de Bagarris, who was overseer of Henry IV's gem cabinet, owned *c.* 1000 gems and stimulated the enthusiasm of Nicolas-Claude Fabri de Peiresc. Peiresc planned a publication on gems in collaboration with Rubens, from whom he received a painting (Oxford, Ashmolean) of the Roman Imperial cameo, the *Gemma Tiberiana* (Paris, Bib. N., Cab. Médailles). Rubens sold many of his gems to George Villiers, 1st Duke of Buckingham, favourite of James I; the collection of the Dutch antiquary Abraham Gorlaeus (*b* 1549) was acquired for the King's son, Prince Henry (1594–1612). The greatest English collector of the age, however, was Thomas Howard, 2nd Earl of Arundel (collection dispersed with the Marlborough gems in 1899). In the second half of the 17th century the French royal collection was greatly enriched by Louis XIV's inheritance from his uncle, Gaston d'Orléans, and by many purchases, including the collection of Lauthier d'Aix, which incorporated many stones from that of Peiresc and of Rascas de Bagarris. At the end of the century two German princely collections were published, illustrated by prints: that of the Elector Palatine Charles Ludwig (*Thesaurus Palatinus*, 1685), which, inherited by his daughter Elisabeth Charlotte, later formed the cornerstone of the second Orléans collection, and that of Frederick III, Elector of Brandenburg, in Berlin (*Thesaurus Brandenburgicus*, 1696–1701), both by the antiquarian Lorenz Beger.

During the first half of the 18th century in France the collection of Pierre Crozat (*see* CROZAT, (1)) was outstanding (merged with the Orléans collection; now St Petersburg, Hermitage). However, the connoisseur–collector who exerted the greatest influence during this period was PHILIPP, Baron von STOSCH, a German resident in Rome and Florence, both through his publication of *Gemmae antiquae caelatae* (Amsterdam, 1724) of 70 gems with artists' signatures, and through his own collection of over 3000 stones (Berlin, Staatsbib.), catalogued after his death by Johann Joachim Winckelmann in *Description des pierres gravées du cabinet du feu Baron de Stosch* (Florence, 1760) and later bought by Frederick II, King of Prussia. During the early 18th century there were important collections in Italy, especially in Rome, among them those of the prelate Leo Strozzi (which was merged with the collection of PIERRE-LOUIS-JEAN-CASIMIR, duc de BLACAS D'AULPS, bought by the British Museum in 1867), but they were dispersed during the 18th and 19th centuries as Rome

became the focus of gem-collecting by visitors and agents for European collectors. Among these the British were in the forefront. William Cavendish, 2nd Duke of Devonshire, Henry Howard, 4th Earl of Carlisle, William Ponsonby, 2nd Earl of Bessborough (*d* 1793), and George Spencer, 4th Duke of Marlborough (*d* 1817)—whose collection absorbed the Arundel and Bessborough collections—were among the greatest aristocratic collectors. Of their collections, only that of the Duke of Devonshire is still extant at Chatsworth, Derbys; the Carlisle collection was bought by the British Museum and the Marlborough collection was finally dispersed in 1899; Sir Richard Worsley's is at Brocklesby Park, Lincs, and part of the collection of Algernon Percy, 1st Earl of Beverley, later 10th Earl of Northumberland, is at Alnwick Castle, Northumb. By the end of the century the British Museum, which already possessed gems bequeathed by the founder, Sir Hans Sloane, acquired an important collection, chiefly of Etruscan stones, from Sir William Hamilton and, by bequest and purchase, the gems owned by Clayton Mordaunt Cracherode (1730–99), Charles Townley and Richard Payne Knight. The most successful and one of the most passionate collectors of the second half of the 18th century was Catherine II, Empress of Russia, whose agents bought collections from all over Europe, including the Orléans collection; she eventually owned 10,000 gems (St Petersburg, Hermitage).

Napoleon's imperial aspirations and the Empress Josephine's passion for gem-set jewellery encouraged a renewed enthusiasm for engraved gems, especially cameos. Within a few decades, however, gem-collecting began to fall out of favour. The abundance of modern workshop productions, a disillusionment with collecting through the increasing number of fakes, fuelled by the notorious sale at Christie & Manson, London (29 April 1839) of the part of Prince Stanisław Poniatowski's famous collection that consisted largely of 18th-century intaglios bearing fake Greek signatures (*see* PONIATOWSKI, (2)), and Romanticism's preference for the Middle Ages, all contributed to this decline. Nevertheless, such individuals as Sybille Mertens-Schaaffhausen (1791–1857) in the Rhineland, Bram Hertz, Joseph Mayer (1803–86), Rev. Greville J. Chester (1831–92), the Cambridge scholars Charles William King (1818–88) and Samuel Savage Lewis (1836–91) and Sir Francis Cook (1817–1901) in England, Ritter Tobias Biehler (*fl* 1856–81) in Austria, Count Michel Tyszkiewicz (in Rome from 1865; *d* 1898), Sir William Currie (*d* 1863) of Como, Walther Fol (1832–90) of Geneva and Maxwell Sommerville (1829–1904) of Philadelphia were only some among a number of 19th-century enthusiasts. Scholarship benefited from the gems brought from Cyprus by Luigi Palma di Cesnola (1832–1904) in 1872 and 1876 (New York, Met.) and, above all, from the collecting by Sir Arthur Evans of Roman gems in Dalmatia and of Minoan and Mycenean gems (Oxford, Ashmolean).

Since the late 19th century American collectors and museums have acquired gems in the European market, among which Henry Walters (Baltimore, MD, Walters A.G.) and the Boston Museum of Fine Arts are particularly important. The Getty Museum in California continues to purchase gem collections.

Principal public gem collections are in St Petersburg, Hermitage; London, BM; Cambridge, Fitzwilliam; Paris, Bib. N., Cab. Médailles; Vienna, Ksthist. Mus.; Florence, Mus. Archeol. and Pitti; Naples, Mus. Archeol. N.; Munich, Staatl. Münzsamml.; Berlin, Antikenmus. and Pergamonmus.; Geneva, Mus. A. & Hist.; Leiden, Rijksmus. Kon. Penningkab.; Copenhagen, Thorvaldsens Mus. and Nmus.; New York, Met.; Boston, MA, Mus. F.A.; Baltimore, MD, Walters A.G.

BIBLIOGRAPHY

S. Reinach: *Pierres gravées des Collections Marlborough et d'Orléans, des Recueils d'Eckhel, Gori, Levesque de Gravelle, Mariette, Millin, Stosch* (Paris, 1895)

E. Babelon: *Catalogue des camées antiques et modernes de la Bibliothèque Nationale* (Paris, 1897), pp. cxii–clxxvii

A. Furtwängler: *Die antiken Gemmen*, iii (Leipzig and Berlin, 1900), pp. 402–35

C. Piacenti Aschengreen: *Il Museo degli Argenti a Firenze* (Milan, 1968), pp. 11–26

Il tesoro di Lorenzo il Magnifico: Le gemme (exh. cat. by N. Dacos, A. Giuliano and U. Pannuti, Florence, Pal. Medici-Riccardi, 1972)

M. van der Meulen: *Petrus Paulus Rubens Antiquarius: Collector and Copyist of Antique Gems* (Alphen aan de Rijn, 1975)

C. Gasparri: 'Gemme antiche in età neoclassica: Egmagmata, Gazofilaci Dactyliothecae', *Prospettiva*, viii (1977), pp. 25–35

M. Maaskant-Kleibrink: *Catalogue of the Engraved Gems in the Royal Coin Cabinet, The Hague: The Greek, Etruscan and Roman Collections* (The Hague, 1978) i, pp. 11–54

P. Zazoff and H. Zazoff: *Gemmensammler und Gemmenforscher* (Munich, 1983)

J. Kagan and O. Neverov: 'Lorenz Natter's *Museum Britannicum*: Gem Collecting in Mid-Eighteenth-Century England', *Apollo*, cxx (1984), no. 269, pp. 114–21; no. 271, n. s., pp. 162–9

O. Neverov: *Antichnyye kamei v sobranii Ermitazha* [Antique cameos in the Hermitage collection] (Leningrad, 1988), pp. 5–24

R. Distelberger: 'Steinschneidekunst', *Prag um 1600: Kunst und Kultur am Hofe Kaiser Rudolfs II*, 2 vols (exh. cat., Essen, Villa Hügel; Vienna, Ksthist. Mus.; 1988–9), pp. 457–61

G. Seidmann: 'Eine kurfürstliche Gemmensammlung und ihr Schicksal', *Ruperto-Carola*, xlii/82 (Dec 1990), pp. 25–9

A. Bernhard-Walcher: 'Zur Geschichte der Gemmensammlung', *Die antiken Gemmen des Kunsthistorischen Museums in Wien*, iii (Munich, 1991), pp. 28–38

D. Scarisbrick: 'English Collectors of Engraved Gems: Aristocrats, Antiquaries and Aesthetes', *Classical Gems, Ancient and Modern Intaglios and Cameos in the Fitzwilliam Museum, Cambridge*, ed. M. Henig (Cambridge, 1994), pp. xiii–xxiii

GERTRUD SEIDMANN

Gemito, Vincenzo (*b* Naples, 16 July 1852; *d* Naples, 1 March 1929). Italian sculptor and draughtsman. He was a child of the streets, who was adopted by a poor artisan. In 1861, at only nine years of age, he entered the workshop of the sculptor Emanuele Caggiano (1837–1905) as an assistant and dogsbody. Around this time he formed a close friendship with the painter Antonio Mancini; together they frequented the studio of Stanislao Lista (1824–1908), a sculptor and painter of a more advanced tendency. There Gemito learnt to model in clay and wax, and he is supposed to have been encouraged by Lista to study the life of the streets. After leaving Lista's studio Gemito set up independently in an abandoned convent, working alongside Mancini and the sculptors Achille D'Orsi and Giovanni Battista Amendola (1848–87).

In 1868, as well as entering a statue of *Brutus* for the annual competition of the Neapolitan Istituto di Belle Arti, Gemito showed at the Promotrice di Belle Arti his *Card Player*, a bronze cast of which was acquired by Victor Emmanuel II for the Capodimonte collection. This piece

of low-life realism is remarkably accomplished for an artist in his mid-teens; it represents a Neapolitan urchin seated on the ground, scratching his head as he contemplates his hand of cards. The rugged treatment, conforming to the nature of the subject, is a marked departure from the sentimental approach to Neapolitan genre practised earlier in the century by such foreign artists as Léopold Robert or François Rude. Gemito was, however, less concerned to preach a social message than was D'Orsi in his exactly contemporary group of antique spongers, *The Parasites*; in Gemito's urban genre heads and busts of the following years, it is the pathetic poetry of the subjects that is stressed. In such a work as the *Sick Child* (terracotta, 1870; Naples, Mus. N.S. Martino), the combination of reductive format with an illusionistic facture, contrasting smooth and crusted clay surfaces, anticipates the poetic impressionism of Medardo Rosso. The same qualities distinguish Gemito's portrait head of the painter *Francesco Paolo Michetti* (terracotta, 1873; Florence, Ugo Ojetti priv. col.). A bust of the composer *Giuseppe Verdi* (bronze version, Florence, Pitti), executed in the same year, is more responsive to the subject's aquiline and dramatic aspect.

During the mid-1870s Gemito came under the influence of the painters Domenico Morelli and Mariano José Bernardo Fortuny y Marsal, who spurred him in the respective directions of pronounced chiaroscuro and virtuoso draughtsmanship. A strain of naturalistic bizarrerie is present in a figure of a *Chinese Acrobat*, with his legs in the air (terracotta, 1876; Naples, Minozzi priv. col.). In the same year, a series of adept pen-and-ink studies of nude youths and fisherboys (Naples, Minozzi priv. col.) culminated in the life-size *Little Fisherboy* (plaster, Naples, Capodimonte, see fig.; bronze version, Florence, Bargello), a tense crouching figure examining his catch, which Gemito exhibited, to some acclaim, at the Paris Salon of 1877. He himself travelled to Paris in 1877, staying there for three years, for part of the time as a guest of the French painter Ernest Meissonier; he made contact with French sculptors, particularly Paul Dubois (i), and at the Salon of 1880 he exhibited portraits of both *Meissonier* and *Dubois*. Contact with the world of French academic sculpture may have encouraged Gemito to re-examine Classical sculpture; on his return to Naples, he executed a *Water Carrier* (bronze version, 1881; Rome, G.N.A. Mod.), in which the elaborate, antique style of the fountain base and the figure's artful posture evoke antique genre sculptures from Pompeii and Herculaneum.

The *Water Carrier* was one of the pieces that Gemito exploited commercially when in 1883 he set up his own bronze foundry for lost-wax casting, assisted by the Belgian entrepreneur Baron Oscar du Mesnil. He also edited his personal interpretations of a number of Classical works in the Museo Nazionale di S Martino in Naples. In 1886 Gemito executed his only major public commission, a marble statue of *Charles V, Holy Roman Emperor*, one of a series of eight figures of rulers adorning the façade of the Palazzo Reale in Naples.

After the death in 1881 of his mistress, Mathilde Duffaud, Gemito married a model, Anna Cutolo. Marital jealousy, combined with strenuous labour, caused his mental collapse in 1887, and until 1909 he was a recluse, concentrating entirely on drawing.

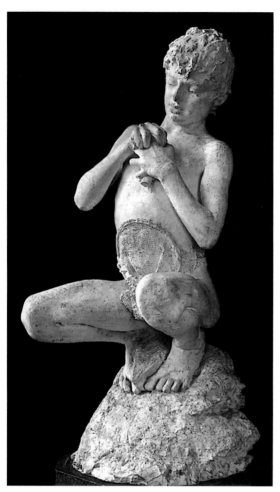

Vincenzo Gemito: *Little Fisherboy*, plaster, h. 1.16 m, 1877 (Naples, Museo e Gallerie Nazionali di Capodimonte)

The sculpture of Gemito's last phase turned away entirely from modern life. In the treatment of mythical subjects he combined an exuberant and uncontrolled sensuality with a concern for small-scale decorative richness, enhanced by the use of precious metals. Often, as in versions of the *Young Neptune* or *The Philosopher*, he reworked old compositions, but at the start of the 1920s new subjects emerged: imaginary portraits of *Alexander the Great*, and the head of *Medusa*. The precious and obsessional quality of Gemito's later work, little of which is to be seen in public collections, has provoked comparison with the decadent sensibility of his admirer, the author Gabriele d'Annunzio; it remains difficult, however, to make a case for it, given the evident failure of Gemito's powers as a sculptor and the increasingly laboured and literal sentimentalism and pornography of his later drawings.

BIBLIOGRAPHY

S. di Giacomo: *V. Gemito: La vita, l'opera* (Naples, 1905)
G. Morisani: *Vita di Gemito* (Naples, 1936)
A. Savinio: *Narrate uomini la vostra storia* (Milan, 1942)
A. Schettini: *Gemito* (Milan, 1944)
R. Causa: *Vincenzo Gemito* (Milan, 1966)
Da Antonio Canova a Medardo Rosso: Disegni di scultori italiani del XIX secolo (exh. cat., ed. Gianna Piantoni; Rome, G.N.A. Mod., 1982)
Temi di Vincenzo Gemito (exh. cat., ed. B. Mantura; Spoleto, 1989)

PHILIP WARD-JACKSON

Gems. Minerals, usually of crystallized matter, used for personal adornment (e.g. JEWELLERY) or for decorating such items as textiles and liturgical objects. Rubies, sapphires, diamonds and emeralds are regarded by the layman as the high monetary value gems, while such stones as opals, topazes, tourmalines and garnets, and the organic gems IVORY, AMBER (ii), JET and CORAL are considered to be of lesser value. The value of any gem is dependent upon its beauty, rarity, quality and size (see colour pl. I): a diamond, for example, may be of lesser value than an emerald of a similar size, and a mediocre to poor-quality ruby may be of a lower value than an example of demantoid, the rare green variety of garnet. Such rare and lesser-known gems as alexandrite and chrysoberyl cat's-eye, two of the members of the chrysoberyl family, can also command very high prices depending not only upon rarity, quality and size but also upon the market in which they are sold: a chrysoberyl cat's-eye sold in England may have a lower market value than if it were sold in Japan.

Gems are tested by gemologists for authenticity in a variety of ways: the refractive index is tested with a gem refractor; the hardness by scratching the surface and measuring the result against the Mohs' scale—talc (1) being the softest and diamond (10) being the hardest. If these methods do not suffice, then the gem can be tested using X-ray diffraction or chemical analysis. In the case of diamond, unlike any other gem, there are internationally recognized quality-grading standards and a clear pricing structure according to the clarity, colour, cut and weight. The most widely accepted system for grading diamonds is that of the Gemological Institute of America (GIA). The top GIA clarity grade is 'Flawless' and the lower grades run down through VVS, VS, SI and L. The top colour grade is denoted by the letter 'D', and with increasing yellowness they run through to 'Z'.

1. SOURCES AND MINING. Such gems as ruby, sapphire, diamond, emerald, topaz and tourmaline are found in the form of crystals, or as water-worn pebbles in sands and gravels. It is as rounded, worn pebbles that such gems as blue, yellow and pink sapphire are found in the alluvial deposits in Sri Lanka, sometimes known as the 'Gem Island'. One of the earliest records of Sri Lanka as a source of gems was in 334 BC, and probably hundreds of thousands of carats of gem-quality sapphire, chrysoberyl, spinel and other gems have been mined there over the centuries. The local miners search the surface of likely mining areas looking for rounded pebbles, often located in rice fields. The miners sink their pits as deep as 15 m in search of the gem-bearing gravel known as illam. The gravel is brought to the surface, washed in baskets, and the gem-bearing material is sorted from the waste.

The mining operations in Sri Lanka are simple, and each pit is operated by comparatively few people. Similar operations take place in Burma, Thailand and Brazil. When local conditions and economics permit, much larger and more mechanized operations take place. An example of

this is the huge sapphire mining operation in the state of New South Wales, Australia, where farmland may be removed to a depth of 15 m to the gem gravels. The gravel is then sorted, and the top soil replaced so that farming can recommence. In the Lightning Ridge opal fields, also in New South Wales, the mining is initially simple: shafts are sunk until an opal seam is discovered and followed. The entire area of Lightning Ridge thus becomes a warren of tunnels. When such tunnel-type mining becomes uneconomic, a larger company will often buy up the claims and resort to an open-cast type of mining to claim the remainder of the opal. In Colombia, large numbers of people are employed to pick through the soft rocks containing veins of emerald bulldozed from the sides of mountains.

Diamond mining can be quite a simple operation using a small dredger to expose the gravels from, for example, the smaller rivers in Brazil, or more complex using huge dredgers containing full recovery plants, bringing up the gravels of the larger rivers. This type of diamond mining of alluvial or placer deposits is known as secondary deposit mining. Primary deposit mining in Australia, South Africa and Russia is a much bigger operation, drilling through the earth to kimberlite. When diamond-bearing kimberlite pipes were first discovered in South Africa, the ground at the surface (yellow ground) was quite easily mined with a pick and shovel. As the depth of the mine increased the yellow ground gave way to a very hard material known as blue ground, which was thought to be barren. It was later discovered that the blue ground was the unweathered form of the yellow ground and still contained diamond. These pipes are mined in a highly mechanized manner in the late 20th century: when a pipe is discovered, huge diggers move in to carry out open-cast mining. When this form of mining becomes uneconomic, shafts are sunk in the country rock around the pipe, and tunnels are then driven into the pipe; the remainder of the mining takes place underground. This can involve miners working at considerable depths: the mines in the Kimberly area of South Africa reach a depth of *c.* 915 m.

On 26 January 1905 the largest rough diamond ever discovered, weighing 3106 carats and known as the Cullinan Diamond, was found in the Premier Mine near Pretoria, South Africa. The largest two stones cut from it are the Star of Africa (the largest faceted diamond in the world), which is set in the head of the Royal Sceptre, and the Second Star of Africa, which is set in the Imperial State Crown, both of which are from the British Crown Jewels, held in the Tower of London.

2. CUTTING. The cutting of diamond requires a knowledge of its hardness and cleavage properties (which are regarded as perfect), and the skill to produce the correct angle between the various portions of the finished stone, and correctly proportioned facets. Various organizations differ about what the ideal measurements for the round brilliant cut should be: one proposal suggests 57.5% for the table facet proportion (100% being the diameter of the stone) and 34.5° for the 'crown angle', which is the angle made between the crown (upper) facets and the line of the girdle.

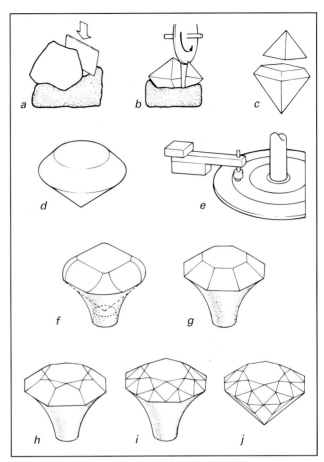

Gem-cutting processes: (a) cleaving; (b) cutting; (c) cut shape; (d) bruted stone; (e) rotating wheel for grinding and polishing; (f)–(j) faceted and polished brilliant-cut stone

As diamond is optically isotropic, for the most part it does not have any directional properties in terms of colour (while diamond is mostly regarded as a 'colourless' stone it is also found in numerous colours, e.g. blue, green, yellow, orange, brown and pink), and therefore the colour factor is not, usually, taken into account during the cutting process. This is different from a great many other coloured stones. Both ruby and sapphire, which are members of the corundum family, are dichroic, and, depending upon the angle of view, a different colour or shade of colour will be seen. Colour and clarity are the most important factors in assessing a faceted ruby or sapphire, but during the cutting process the lapidary's main objectives are to produce the best 'face up' colour from the rough material being worked, while at the same time preserving the maximum weight.

The art of polishing diamonds began in the early 14th century when it was used on stones from India. At that time small facets were polished on crystals using a leather lap. Such a technique inevitably could not achieve the perfectly flat surfaces produced by the modern cutting methods (see fig.), which involve cleaving (dividing) or sawing a rough diamond (a), cutting the stone into the

approximate shape desired (b and c), bruting (grinding or shaping) the top into a circular shape (d) and grinding and polishing on a rotating wheel (e), which yields a finished, multi-faceted gem (f)–(j). A notable example of a diamond with easily observable undulating facet surfaces is the slightly pink 56.71 carat Shah Jahan Diamond.

The modern 58-facet, brilliant cut (see fig. (j)) evolved from the point cut employed during the Middle Ages. This cut is little more than a slight alteration to the angles of the octahedral crystal habit in which diamond is normally found. The first 'true cut' for diamond was the table cut, and it was this cut that dominated throughout the 16th century. The table cut is an octahedral crystal on which one point is flattened to a square table with the opposite point also sometimes flattened to a lesser extent. The rose cut, in which the base is flat and the upper portion multi-faceted sometimes rising to a point, may be as old as the table cut. As more facets were added to the table-cut diamond it passed from the English square cut, to the single cut, the old mine cut, the European round brilliant cut and finally to the modern brilliant cut.

The enhancing of other coloured stones by altering their appearance, as with diamond, started merely by polishing the surface of the stone while keeping the basic crystal shape. An excellent example of this is the Black Prince's Ruby set in the British Imperial State Crown (London, Tower). This is a large polished red spinel, which retains its octahedral crystal shape. Probably originally intended as a turban ornament, the Black Prince's Ruby was drilled several times, once through the entire length of the stone to accommodate the necessary pins and perhaps to thread on to a necklace.

3. OTHER TREATMENTS. The enhancement of gems very often goes beyond the faceting of the crystals. The disguising of flaws and the alteration of colour are two common practices. The flaws in emeralds have been artificially filled with an oil (colourless or dyed green) of a similar refractive index for many years. More recently these flaws have been hidden with the aid of resin. A similar problem with the visibility of flaws in diamond has been solved by two different methods: when there is a black inclusion in the stone, which does not reach the surface, a narrow tunnel is 'drilled' or burnt by a laser into the object; the inclusion is then treated with acid down the laser hole, bleaching it from black to a less visible white. Some fractures in diamonds reach the surface and with the aid of a vacuum process, glass can be made to fill the fracture and make it less visible.

The colour of a gem can be changed or enhanced through staining, heat treatment or irradiation. Many types of chalcedony are stained either to imitate more expensive gems or to produce unnatural colours. Ruby, sapphire, zircon, aquamarine and citrine are examples of stones that may have their colour improved by heat treatment. Diamond, topaz and tourmaline are examples of stones that may have their colour changed by irradiation. In ancient times the drilling of high-value gems was common practice, but in the late 20th century it was considered wasteful and uneconomic.

See also GEM-ENGRAVING and HARDSTONES.

BIBLIOGRAPHY

G. F. Herbert Smith: *Gemstones* (London, 1912, London, rev. 14/1972)
E. H. Kraus and C. B. Slawson: *Gems and Gem Materials* (New York, 1925, New York and London, rev. 5/1947)
R. Webster: *Gems, their Sources, Descriptions and Identification* (London, 1962, rev. 4/1983)
P. E. Desautels: *The Gem Kingdom* (New York, 1971)
P. G. Read: *Gemmology* (Oxford, 1991)

KEN SCARATT

Gendall, John (*b* Exeter, *bapt* 2 Jan 1790; *d* Exeter, 1 March 1865). English draughtsman and painter. He began his working life as a servant to James White of Exeter who, recognizing Gendall's drawing talent, sent him with introductions to London in 1811. He worked for the bookseller and publisher Rudolph Ackermann on experiments in lithography and became the firm's draughtsman for aquatint engravings. Gendall made a series of London views, published as aquatints between 1817 and 1819. From 1820 he excelled in watercolour drawings, some taken from Augustus Charles Pugin's sketches for *Picturesque Views of the Seine* (1821). He also worked at Hastings, Dover and Calais, and in 1824 at Edinburgh. From 1819 to 1827 he contributed views of country houses to the *Repository of Arts*, many of which were republished in *Views of Country Seats* (1830).

Gendall exhibited in the Exeter Art exhibitions of 1821 to 1824, remaining in Exeter in 1824 as a partner in Charles Cole's picture business at 270 High Street. In the 1830s, during Exeter's cultural heyday, he was recognized as an authority on art and was a popular drawing-master with his own premises at Mols Coffee House, Cathedral Yard. The author Richard Ford took lessons and the sculptor Edward Bowring Stephens (1815–82) was a pupil. Gendall's success in the Devon and Exeter Society's exhibitions from 1845 to 1847 encouraged him regularly to contribute paintings of Devon river scenes to the Royal Academy. His colourful sketches in gouache also date from this period. Gendall was honorary curator of the collection that formed the core of the Royal Albert Memorial Museum in Exeter; however he died before the museum was completed.

BIBLIOGRAPHY

G. Pycroft: *Art in Devonshire* (Exeter, 1883)
J. R. Abbey: *Scenery of Great Britain and Ireland in Aquatint and Lithography, 1770–1860* (London, 1952)
John Gendall (exh. cat. by F. Owen, Exeter, Royal Albert Mem. Mus., 1979)

FELICITY OWEN

Gendron, (Etienne-)Auguste [Augustin] (*b* Paris, 17 March 1817; *d* Paris, 15 July 1881). French painter. He entered the Ecole des Beaux-Arts in Paris on 20 October 1827 as a pupil of Paul Delaroche. The title of the picture which he sent to his first Salon in 1840, *Captivity in Babylon* (untraced), recalls the subject of Eduard Bendemann's famous picture of 1832, *Jews in Exile* (Düsseldorf, Kstsamml. Nordrhein–Westfalen). Gendron went to Italy in 1844 at the same time as Delaroche and Jean-Léon Gérôme. From there he sent *A Public Commentary on Dante* (untraced) to the Salon of 1844 and *Willis* (Le Havre, Mus. B.-A.), a vaporous group of spirits, inspired by German literature and also, perhaps, by German art, to the Salon of 1846. The *Willis* made his reputation.

Théophile Gautier was predictably impressed, and in his review of the Salon of 1846 he 'discovered' Gendron as well as most of the painters in Gendron's circle, pupils of Delaroche, who banded together in the late 1840s to form the NÉO-GREC group. It was, perhaps, in the company of Gautier, Gérôme and the Néo-Grecs, rather than in Italy, that Gendron became interested in the ancient world. His debt to Gérôme is particularly evident in *Tiberius at Capri* (exh. Salon, 1852; Marseille, Mus. B.-A.), where the twisting concubines, as Gendron admitted, were copied from Gérôme's *Greek Interior* (1849; untraced). But the ancient world was never more to him than an excuse to paint variations on the theme of the langorous sylphs who decorate *The Voice of the Torrent* (1857; Le Havre, Mus. B.-A.), *Nymphs at the Tomb of Adonis* (exh. Salon, 1864; Toulouse, Mus. Augustins) and *Foolish Virgins* (exh. Salon. 1873; Angers, Mus. B.-A.).

Gendron's reputation as a Salon painter waned after the success of the *Willis* until 1855, when *Sunday in Florence in the Fifteenth Century* (Fontainebleau, Château), an elegantly idealized vision of life in Renaissance Italy, revived interest in his work. The State bought the picture and gave him the Légion d'honneur. This was the highpoint of his career. Although he continued to exhibit pictures of fairies, Greek nymphs and scenes of everyday life from Italian history, he did not repeat the success of 1846 and 1855. There was, however, a decorative quality in his work that was put to good use outside the Salon by the state officials of the Second Empire. In 1850 he was paid for designing a frieze of *Four Seasons* for a Sèvres jardinière; in 1859 the government commissioned him to paint one of the panels in the Salle des Pas-Perdus in the Conseil d'Etat in Paris; in 1861 he painted a ceiling in an antechamber in the Louvre; he worked in the palace of St Cloud (1856); he painted a frieze in the Galerie Pereire in 1864 and decorated the chapel of St Catherine in the church of St Gervais in Paris in 1866.

Gendron's work represents the official side of the delicate art of Jean-Louis Hamon, Henri-Pierre Picou (1824–95) and their circle, which was popular in the Second Empire, particularly during the ascendancy of the Comte de Nieuwerkerke, who supported these artists. The fall of the Second Empire was a severe setback for Gendron. His eight cartouches representing *The Hours of the Day* in the Cour des Comptes, Paris, and his work at the palace of St Cloud were destroyed in the fires of 1871. He died, forgotten, ten years later.

BIBLIOGRAPHY
L'Art en France sous le Second Empire (exh. cat., Paris, Grand Pal., 1979), pp. 360–61

JON WHITELEY

Gendt, Adolf Leonard van (*b* Alkmaar, 18 April 1835; *d* Amsterdam, 28 April 1901). Dutch architect. He was the son of Johan Godart van Gendt, Engineer to the Waterstaat. He received his architectural training at the Koninklijke Academie voor Beeldende Kunsten in Amsterdam and then worked for his father. Between 1855 and 1861 he worked for the Waterstaatswerken in Rotterdam, and from 1861 to 1874 he was employed on the construction of the Staatsspoorwegen in north Holland, building a number of stations along the Amsterdam–Den Helder line. In 1874 he set up as an independent architect in Amsterdam. Initially van Gendt built in a quite eclectic style, for example the Home Economics School for Girls on the Weteringschans in Amsterdam. From the early 1880s the style of his designs acquired a somewhat Viennese character, the most important works including the Concertgebouw (1883–6) on the Van Baerlestraat in Amsterdam. After 1885 van Gendt built mainly in the Dutch Renaissance Revival style. The most important examples of this are the Central Station (1882–9) in Amsterdam, in collaboration with P. J. H. Cuypers (*see* CUYPERS, (1)), and the Amsterdam City Theatre (1891–4) on the Leidseplein. After his death his architectural practice was continued by both his sons Adolf Daniel Nycolas van Gendt and Johan Godart van Gendt.

BIBLIOGRAPHY
Obituary, *Bouwknd. Wkbld*, xxi (1901), p. 166
C. W. Bruinvis: *Levensschetsen van en mededeelingen over beeldende kunstenaars, die te Alkmaar geboren, aldaar gewoond of voor die stad gewerkt hebben* [Life sketches and a communication on visual artists who were born in Alkmaar, lived there and worked for the town] (Alkmaar, 1905)
G. Fanelli: *Architettura moderna* (1968)
H. J. F. Roy van Zuydewijn: *Amsterdamse bouwkunst, 1815–1940* (Amsterdam, 1970), p. 72–6

DIANNE TIMMERMAN, FRANK VAN DEN HOEK

Genealogical and heraldic manuscripts. Manuscript records made by heralds and antiquaries in the pursuit of their professional activities or private studies. They are extremely common, surviving not only in national libraries but also in local and private collections, but very few bibliographic surveys of the material have been made, especially of the many antiquarian drawings of the 16th to 18th centuries. Owing to the subsequent destruction of the originals, these drawings are often primary sources for knowledge of past practices and their importance cannot be too highly stressed. For the use of heraldry in the decoration and illustration of medieval and Renaissance manuscripts *see* HERALDRY, §II, 4.

1. GENEALOGICAL MANUSCRIPTS. While very important collections of royal pedigrees can be found in some early medieval chronicles, specific collections of pedigrees were first made in the later Middle Ages. One fairly common type that links both groups comprises the English scrolls based on Petrus Comestor's *Historia scholastica*, written before 1178 and augmented with descents of the British kings from Geoffrey of Monmouth's *Historia regum Britanniae* (*c.* 1136). The French and Scottish kings were also included, providing a useful reference sheet from the Creation onwards. Many of the copies include the arms attributed to the early kings. By the end of the Middle Ages collections of pedigrees, either in narrative or tabular form, were being compiled in many countries. Some served to glorify the real or legendary ancestors of the family or were written to serve a particular cause, such as the English claim to the crown of France. Some of the family books also served as an abstract of title and could be incorporated in a cartulary.

The kings of arms had a duty to know the arms borne in their provinces, and, since these were hereditary, they began to keep records of pedigrees as well. Not all of these regional surveys were made by the heralds, and a few, such as the *Miroir des nobles de Hesbaye* (*c.* 1353–98),

an account by Jacques de Hemricourt (1333–1403) of the noble families of Hesbay in Liège, exist in many copies. Perhaps the most systematic records surviving are those made by the English kings of arms, or their herald deputies, between 1530 and 1688 (London, Coll. Arms).

The hundreds of pedigree rolls and books compiled for individual families from the 16th century onwards vary greatly in historical value and artistic merit, but the illuminated pedigrees produced by aspirants to the noble chapters and orders of knighthood that required such proofs of nobility are quite accurate. Perhaps the most splendid pedigree book was the *History of the Sovereigns of the Most Honourable Order of the Bath* (London, Coll. Arms), commissioned at a reputed cost of £2000 by the Prince Regent (later George IV) in 1803 from Sir George Nayler (?1764–1831), Garter, but never paid for. Apart from such official compilations, numerous manuscripts record pedigrees compiled by antiquaries and heralds alike in the course of their studies. Although not of legal authority like the official records, they can be very useful.

2. HERALDIC MANUSCRIPTS. Heraldic rolls of arms may be in either a codex or a rotulus (roll). Some are painted, others consist of blazons (*see* HERALDRY, §I), and a few contain both media; the choice seems to be governed by the country of origin and the type of roll. They are most common in Germany, the Low Countries, France and England; hardly any are known from Italy, Spain and Portugal, Scandinavia and Eastern Europe. None survives for Ireland or the Latin kingdoms in the Levant. Only the English, French and German armorials have been catalogued, in no case exhaustively, and only a small number have been printed in adequate editions. The scheme of classification given below is adapted from Wagner (1950).

Illustrative rolls. Collections of arms added to chronicles and other texts to illustrate the persons mentioned in them, such as that in Matthew Paris's compilation of the *Historia Anglorum*, *Chronica majora*, *Abbrevatio chronicarum* and *Liber additamentorum* (before 1260, London, BL, MS. Royal 14 C.VII).

General rolls. Rolls usually beginning with a collection of rulers and continuing with the arms of nobles and gentry. Sometimes these can be grouped by rank, county or province. The 15th-century German books of arms follow a distinctive and fairly consistent pattern wherever they were produced. These rolls, such as Jürg Rugenn's Armorial (*c.* 1492; Innsbruck, Ubib., MS. 545), are most often painted.

Occasional rolls. These record, most often in blazon, the arms of those present at a battle (e.g. Boroughbridge Roll, 1322; London, BL, MS. Egerton 2850), tournament or other special occasion.

Ordinaries. A special type of general roll in which the arms are grouped according to their charges, thus making the identification of unknown coats easier. They appear to be peculiar to England, and the oldest, Cooke's Ordinary (London, Wagner priv. col.), dates from *c.* 1340.

Local rolls. These contain the arms of a county or province, or the feudal tenants of an abbey or lord (e.g. 1373–4; Paris, Bib. N., MS. fr. 20082). Some, such as Hemricourt's *Miroir des nobles de Hesbaye* (see §1 above), give brief accounts of the families concerned.

Order, confraternity and society rolls. A mainly Central European group, doubtless reflecting the importance of the nobiliary and tournament societies there. Some were made in Switzerland for burgesses belonging to a particular trade or town (e.g. *c.* 1439–65; Elgg, Zivilgemeinde, Archv III, 39 or 72).

Family rolls. These depict, sometimes with figures in heraldic dress, the arms borne by members of a particular family (e.g. Clare Roll, *c.* 1456; London, Coll. Arms, Box 21, No. 16). A few have a narrative pedigree, but most have just the arms for the wives.

Attempts have been made to localize some of the early rolls on the basis of the arms they contain, but, even where the result has been convincing, the authorship remains anonymous. Most would have been made for their own use by heralds, but many of the Order rolls are contained in copies of the statutes and would have been made for the knight who was given or who ordered the copy.

Sir Thomas Wriothesley (*d* 1534), Garter King of Arms, had a studio at his house in Red Cross Street, outside Cripplegate, London, which was responsible for a major research programme into English medieval heraldry. The indexes nominum contained in his *Registrum armorum* (London, BL, Add. MS. 45133, fols 117–57), now scattered through many libraries, provided the key to the sources for his 'Letter' rolls, which together made up an alphabet of the old arms. Another series comprised the largest ordinary then in existence, and the same staff also made copies of old rolls that he had borrowed. Apparently completed by about 1530, it was the most ambitious programme then carried out for any herald and lies at the root of current reference books for English arms.

Other collections of arms were made by the heralds in pursuit of their official duties or by other heraldic authorities such as the Office du Juge d'Armes in France before the Revolution of 1789; these are the most authoritative sources. Original grants of arms and books recording them survive from the 15th century onwards in the English College of Arms, London, and are perhaps the longest series of such documents in existence. In continental Europe the heraldic authorities took cognizance only of noble arms; new grants of these normally took the form of patents of nobility and were usually produced by the chancellery of the country. Examples, particularly of the Spanish court, are found in many libraries.

In the late Middle Ages and the Renaissance, the English heralds were also responsible for marshalling funerals of the nobility and gentry at which their arms and crests, banners, standards or pennons were displayed according to the rules for their rank. The certificates of these funerals are also kept in the College of Arms. The obsequies of rulers on the Continent were often organized by scholars and artists rather than heralds and made greater use of the IMPRESA.

Another interesting group of manuscripts beginning in the 16th century, often with very fine illuminations of

arms, is the series of *libri amicorum*, which were compiled mainly by German students as autograph albums during their travels from one university to another. Many hundreds survive, mainly in German and Swiss libraries and in the British Library, London.

Reference has already been made to antiquarian surveys of church monuments and the arms seen on them. Iconoclasm, whether inspired by religious or political ideologies, has conferred on these a greater importance than they would otherwise have had. Even when the tombs survive, such as those at Westminster Abbey in London, the old descriptions often included details of heraldry since lost, and without this information the significance of the whole scheme cannot be understood. Some collections are roughly tricked or blazoned, but others, like Sir William Dugdale's *Book of Monuments* (*c.* 1640; London, BL, Loan MS. 38) or the collection for Bruges (*c.* 1690; Bruges, Rijksarchf, MS. D246) by Ignace de Hooghe and for France (*c.* 1690–1715) by Roger de Gaignières, have highly finished drawings, often of great beauty. Dugdale's book was part of a series designed to preserve the heraldic antiquities of England against the envisaged Civil War. Not only monuments but also seals and rolls of arms were copied and are often the best source for a lost text.

BIBLIOGRAPHY

J. du Cros: *O livro do armeiro-mor* (1509; Lisbon, Arquiv. N.); ed. A. Machado de Faria (Lisbon, 1956)
G. Gatfield: *Guide to Printed Books and Manuscripts Relating to English and Foreign Heraldry and Genealogy* (London, 1892)
E. Freiherr von Berchem, D. L. Galbreath and O. Hupp: *Die Wappenbücher des deutschen Mittelalters* (Basle, 1928)
O. Hupp: *Die Wappenbücher vom Arlberg* (1937), i of *Die Wappenbücher des deutschen Mittelalters* (Berlin, 1937–)
A. R. Wagner: *A Catalogue of English Mediaeval Rolls of Arms*, Aspilogia, 1 (Oxford, 1950); addenda and corrigenda in T. D. Tremlett, H. L. London and A. R. Wagner: *Rolls of Arms: Henry III*, Aspilogia, 2 (London, 1967), pp. 255–81
——: *The Records and Collections of the College of Arms* (London, 1952)
R. Walther: *Das Hausbuch der Familie Melem: Ein Trachtenbuch des Frankfurter Patriziate aus dem 16. Jahrhundert* (Frankfurt am Main, 1968)
G. Saffroy: *Bibliographie généalogique, héraldique et nobiliaire de la France*, 4 vols (Paris, 1968–79)
M. A. E. Nickson: *Early Autograph Albums in the British Museum* (London, 1970)
C. E. Wright: *English Heraldic Manuscripts in the British Museum* (London, 1973)
J. Adhémar and G. Dordor: 'Les Tombeaux de la collection Gaignières: Dessins d'archéologie du XVIIe siècle', *Gaz. B.-A.*, lxxxiv (1974), pp. 1–192; lxxxvii (1976), pp. 1–128; xc (1977), pp. 1–76
F. Menendez Pidal de Navascues: *El libro de la Cofradia de Santiago de Burgos* (Bilbao, 1977)
C. Becher and O. Gamber: *Die Wappenbücher Herzog Albrechts VI von Österreich: Ingram-Codex der ehem. Bibliothek Cotta* (Vienna, 1981)
M. C. Díaz y Díaz, F. López Alsima and S. Moralejo-Alvarez: *Los tombos de Compostella* (Madrid, 1985)

For further bibliography see HERALDRY.

JOHN A. GOODALL

Genelli. German family of artists, of Danish descent. Johann Franz Joseph Genelli (1724–92) was a draughtsman and embroiderer in the service of Empress Maria-Theresa in Vienna until 1774, when he went to Prussia. Janus Genelli (1761–1813), a landscape painter, (1) Hans Christian Genelli and Friedrich Genelli (1765–93), an engraver, were sons of Johann Franz Joseph; (2) Bonaventura Genelli was Janus's son.

(1) Hans Christian Genelli (*b* Copenhagen, 5 April 1763; *d* Alt-Madlitz, 30 Dec 1823). Architect and porcelain designer. He entered the Kunstakademie in Berlin in 1782 to study architecture, and he travelled to Italy in 1786 with his brother Janus to study the monuments of Classical antiquity and the Renaissance. When King Frederick II of Prussia died in 1786, Genelli designed a tomb for him in cooperation with Johann Gottfried Schadow (the project was unrealized). On his return to Berlin, he exhibited drawings of Roman buildings in the Kunstakademie exhibition of 1789. He was subsequently employed in the royal porcelain works in Berlin as a centrepiece designer. In 1792 Genelli became head of the porcelain works and also Inspector of Building and Repair Works at the Mint. In the same year he became a member of the Berlin Kunstakademie, to which he regularly submitted designs, mostly for porcelain. In 1798 Genelli wrote a very progressive memorandum with suggestions for improvements to the work and effectiveness of the Academy. Between 1799 and 1806 he also published several reports, criticisms and book reviews. He began to have a visible influence on artistic life in Berlin, but his architectural designs, for example for a new theatre (1800), were ignored by the authorities. In 1801, dissatisfied with his employment in the Prussian State service, Genelli moved to the hamlet of Madlitz near Frankfurt an der Oder, where he devoted himself to theoretical studies and to designs (1801–23) for private country houses in the style of Classical antiquity and the Renaissance, 95 of which were discovered by Hans Ebert (Leipzig, Graph. Samml. Mus. Bild. Kst.). His only executed work was the Ziebingen house (*c.* 1800) at Frankfurt an der Oder. In this idyllic rural setting Genelli also wrote several major cultural studies, for example on Vitruvius' architecture, which he published in periodicals. His major theoretical work was on the ancient theatre in Athens (1818), which deals with the mutual relationships between dramatic poetry and Classical architecture. Of the porcelain pieces he designed, a large centrepiece of *Zephyr and Psyche* with many figures (1793–8; Schwerin, Staatl. Mus.) and a *Fruit Bowl with Three Nymphs* belonging to a centrepiece entitled *Mount Olympus* (1800; Berlin, Schloss Köpenick) have survived.

UNPUBLISHED SOURCES

Leipzig, Graph. Samml. Mus. Bild. Kst. [95 architectural designs, 1801–23]

WRITINGS

Idee einer Akademie der Bildenden Künste (Brunswick, 1800)
Über das Theater von Athen (Berlin and Leipzig, 1818)

BIBLIOGRAPHY

H. Ebert: 'Über Hans Christian Genelli und seine Beziehungen zum Berliner Kultur- und Geistesleben', *Forsch. & Ber.: Staatl. Mus. Berlin*, xvii (1976), pp. 175–88, pls 18–22, figs 1–6
H. von Einem: *Deutsche Malerei des Klassizismus und der Romantik, 1760–1840* (Munich, 1978), pp. 47–9, 52, 171
H. Ebert: 'Nachträge zur Künstlerfamilie Genelli', *Forsch. & Ber.: Staatl. Mus. Berlin*, xxiii (1983), pp. 106–9, pls 31–4

INGRID SATTEL BERNADINI

(2) (Giovanni) Bonaventura Genelli (*b* Berlin, 26 Sept 1798; *d* Weimar, 13 Nov 1868). Draughtsman and painter, nephew of (1) Hans Christian Genelli. He was educated by his uncle, imbibing in particular the influence of Asmus Carstens, who had been a great family friend. He also studied with the painter Friedrich Bury, and in

1814–19 he attended the Berlin Kunstakademie, studying with Johann Erdmann Hummel. Having completed military service, and receiving a grant for study in Italy, Genelli was able to travel in 1822 to Rome, where he joined the circle of German artists around Joseph Anton Koch, supplying the staffage to some of Koch's works. In Rome he drew inspiration from both antiquity and the High Renaissance, and in his drawings, often with watercolour additions, he derived his subject-matter mostly from Classical poetry and mythology.

Genelli returned to Leipzig to provide frescoes for the 'Roman' house of Dr Hermann Härtel. The unsatisfactory execution in 1831 of the first of Genelli's designs (1830–33; Rotterdam, Mus. Boymans–van Beuningen) made Härtel put an end to the arrangement, however, and Genelli moved to Munich. There he was largely concerned with a series of narrative cycles in the form of line drawings, in most cases subsequently produced as engravings by other artists. The first of these was a series of 24 scenes each from the *Odyssey* and the *Iliad* (1837–44; Marbach, Schiller Nmus. & Dt. Litarchv) and the second a set of 36 illustrations to Dante's *Divine Comedy* (1839–48; Dresden, Kupferstichkab.; see fig. for engraving after Genelli). Genelli also produced narrative cycles on non-mythological subjects that exploited his literary sense: 10 scenes *From the Life of a Witch* (1843; Berlin, Altes Mus.), engraved in 1846, and the 18 scenes *From the Life of a Rake* (1840–50; priv. col.; see Ebert, pp. 104–5), engraved

in 1866. Genelli's last series of this kind, 24 pencil drawings *From the Life of an Artist* (*c.* 1857–61; Leipzig, Mus. Bild. Kst.), executed to illustrate his autobiographical work with that title, contains a scene showing Genelli's 'companions in the hereafter', consisting of the main representatives of German classicism, including Carstens and Koch. Genelli's financial difficulties eased somewhat while he was engaged on six paintings ordered over a period of time for the Munich house of Graf Adolf Friedrich von Schack (1857–68; now all Munich, Schack-Gal.). While two of these, the *Vision of Ezekiel* and *Abraham and the Angel*, are biblical scenes with few figures, the rest are on Classical themes and are resplendent with skilfully arranged figures, showing similarities with the mural. On the whole, Genelli's oeuvre, which consists of over 1600 drawings and watercolours and 14 oil paintings, is extremely unified and shows little development. This results not from Genelli's lack of originality but from his strong dedication to continuing German classicism well into the second half of the 19th century, thus providing a link with Germans working in Rome, particularly Anselm Feuerbach.

BIBLIOGRAPHY
M. Jordan: 'Bonaventura Genelli: Biographische Skizze', *Z. Bild. Kst,* v (1870), pp. 1–19
H. Marshall: *Bonaventura Genelli* (Leipzig, 1912)
U. Christoffel: *Bonaventura Genelli: Aus dem Leben eines Künstlers* (Berlin, 1922)
E. Hempel: 'Bonaventura Genellis Umrisse zu Dantes *Göttlicher Komödie*', *Dt. Dante-Jb.,* xxxiii, n. s. xxiv (1954), pp. 62–86
H. Ebert: *Bonaventura Genelli: Leben und Werk* (Leipzig, 1971)

H. BÖRSCH-SUPAN

Generalić, Ivan (*b* Hlebine, 21 Dec 1914). Croatian painter. A farmer by occupation, his artistic talent was discovered in 1930 by Krsto Hegedušić. He became the most celebrated Yugoslav naive painter and the central figure of a group of naive painters known as the HLEBINE SCHOOL. In the 1930s the simple and expressive folk style and the clear colours in which he depicted peasant scenes with traditional customs, merry festivals, tragic deaths or arduous peasant work came close to the socially critical aesthetic of the committed artists in the group Zemlja (*see* EARTH GROUP). Yet he did not develop this expression of childlike simplicity by drawing on its primary force but by studying painting, focusing particularly on problems of perspective and space and on colour.

After World War II Generalić began to idealize his scenes, turning his native countryside into a melancholic, bucolic world of dream-like visions. His expressiveness is best seen in the *Death of my Friend Virius* (1959; Zagreb, Gal. Primitive A.), evoking the memory of a painter friend who had been shot by the occupiers during the war. The picture was painted in oil on glass, a technique that was largely perfected by Generalić himself on the basis of traditional folk art. Otherwise, treetops seem to have become his trademark; in them, each leaf or twig is painted with the precision of a miniaturist. His later pictures became more monochrome.

BIBLIOGRAPHY
N. Tomašević: *Magični svet Ivana generalića* [The magical world of Ivan Generalić] (Belgrade, 1976)
Ivan Generalić (exh. cat., ed. M. Špoljar; Hlebine, A.G., 1980)

JURE MIKUŽ

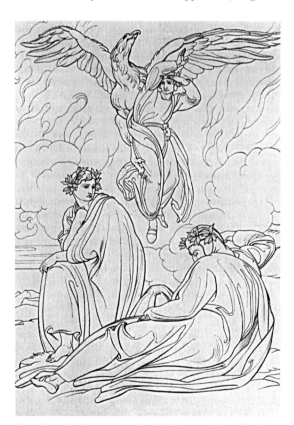

Engraving after Bonaventura Genelli: *Purgatory*, from *Sketches for Dante's Divine Comedy*, Canto 9, verses 13–30 (Leipzig, 1867)

General Idea. Canadian partnership of conceptual artists working as performance artists, video artists, photographers and sculptors. It was formed in 1968 by A. A. Bronson [pseud. of Michael Tims] (*b* Vancouver, 1946), Felix Partz [pseud. of Ron Gabe] (*b* Winnipeg, 1945) and Jorge Zontal [pseud. of Jorge Saia] (*b* Parma, Italy, 1944; *d* Feb 1994). Influenced by semiotics and working in various media, they sought to examine and subvert social structures, taking particular interest in the products of mass culture. Their existence as a group, each with an assumed name, itself undermined the traditional notion of the solitary artist of genius. In 1972 they began publishing a quarterly journal, *File*, to publicize their current interests and work. In the 1970s they concentrated on beauty parades, starting in 1970 with the *1970 Miss General Idea Pageant*, a performance at the Festival of Underground Theatre in Toronto that mocked the clichés surrounding the beauty parade, resulting in the nomination of Miss General Idea 1970. This was followed by the *1971 Miss General Idea Pageant*, which involved the submission by 13 artists of photographic entries that were exhibited and judged at The Space in Toronto.

From 1971 to 1977 General Idea presented a series of performances and exhibitions for the planned *1984 Miss General Idea Pageant and Pavilion*, such as *Going thru the Motions* (Toronto, A.G. Ont., 1975), which included designs for the architectural setting, and a rehearsal for the pageant. Undermining temporal structures, in 1977 they enacted the destruction of the 1984 pavilion by fire at a large site in Kingston, Ontario. This was followed, in the late 1970s and early 1980s, by a series of 'archaeological' exhibitions that documented the destruction and displayed 'retrieved' fragments from the pavilion. The first of these was the exhibition *Reconstructing Futures* in 1977. Later, in works such as *The Unveiling of Cornucopia* (1982; see 1984–5 exh. cat., p. 97) they exhibited such images in the guise of rescued mural fragments. In the late 1980s General Idea turned their attention to the AIDS epidemic through exhibitions and installations.

BIBLIOGRAPHY
General Idea's Reconstructing Futures (exh. cat. by C. Robertson, Toronto, Carmen Lamanna Gal., 1977)
General Idea: 1968–1984 (exh. cat. by J.-C. Ammann, T. Guest and General Idea, Basle, Ksthalle; Eindhoven, Stedel. Van Abbemus.; Toronto, A.G. Ont.; Montreal, Mus. A. Contemp.; 1984–5)

Geneva [Fr. Genève; Ger. Genf; It. Ginevra]. Swiss city and capital of the canton of the same name, with a population of *c.* 154,450. Located at the western end of Lake Geneva (Lac Léman) on both banks of the River Rhône, from 1536 it became a centre of the Reformation under the influence of Jean Calvin (1509–64). Its position on the border with France made the city a centre of French intellectual life, and it is also the headquarters of many international organizations, including the Red Cross, the World Health Organisation and various United Nations bodies.

1. History and urban development. 2. Art life and organization. 3. Cathedral.

1. HISTORY AND URBAN DEVELOPMENT. The oldest traces of human settlement, which consist of buildings on piles in the present harbour area, date from the Neolithic era (*c.* 2500 BC). The first fortified settlement on the hill overlooking the south bank of the Rhône was built *c.* 450 BC: it belonged to the Celtic Allobroges and in 121 BC was incorporated into the province of Gallia Narbonensis by the Romans. The forum was on the site of the Place du Bourg de Four, and from there the through-road travelled north-westwards and crossed the Rhône via the Ile. In 58 BC Julius Caesar—who was the first to mention Geneva (*De Bello Gallico* I.vi.3)—had the bridge destroyed to prevent the Helvetii from advancing further south. Because of attacks by the Alemanni, the *vicus* was fortified in the late Roman period, and in the 4th century AD the settlement became a *civitas*; the first Christian community then developed, building the churches of St Pierre and St Germain (rebuilt; rest.) and becoming a bishopric *c.* 400.

In 443 Geneva became the capital of the Burgundian kingdom; although the settlement grew it still roughly corresponded to the late Roman town. From 888 the town belonged to the second Burgundian kingdom, which fell to the Holy Roman Empire in 1032. The first permanent settlement on the north bank of the Rhône was probably Carolingian: it was a fortified villa with a chapel (later rebuilt as St Gervais).

The prolonged quarrel between the bishops of Geneva and the counts of Genevois ended in 1124 with the Treaty of Seyssel, which declared the bishop sovereign ruler. Work on the present cathedral started in 1150 (*see* §3 below and fig.). The lower town, which was gradually extending towards the Rhône and the lake, was enclosed by expanded city walls in 1364–76. In 1387 Bishop Adhémar Fabri confirmed the citizens' rights, thus initiating Geneva's era as a city republic. Its position at the intersection of important trade routes, its fairs (first mentioned in 1262) and the branches of Florentine banks and merchants operating there gave Geneva a prominence that lasted until the late 15th century. The Hôtel de Ville was begun in the mid-15th century (later additions 16th to 18th centuries).

In the 16th century Geneva allied itself with Fribourg (1519), Berne (1526) and Zurich (1584). In 1536, with the help of Berne, it became an independent republic and extended the city walls to include the north bank of the Rhône and St Gervais. Calvin's ability to reorganize religious and political institutions furthered the cause of the Reformation (*see* CALVINISM). Geneva became a centre of the Reformed Church and a haven for religious refugees, who stimulated the city's economic and cultural life. The Hôtel de Ville was extended by a staircase tower (1555–78) that linked the various parts of the building together. In 1602 Savoy made a last attempt, known as the Escalade, to conquer Geneva. As a result, the fortifications on both sides of the Rhône were massively reinforced with bastions. In the upper town the Maison Turrettini (1617–20), built to plans by Faule Petitot (1572–1629) in the late Renaissance style, became the first aristocratic private mansion in Geneva.

The revocation of the Edict of Nantes in 1685 led to a new influx of Protestant refugees. The Huguenots brought watchmaking and silk-weaving to Geneva, which contributed to its increasing economic prosperity in the 18th

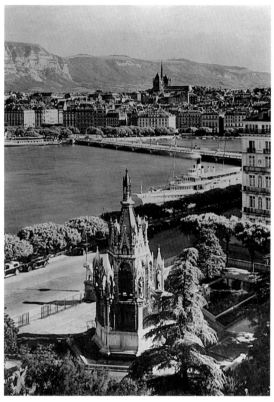

Geneva, showing the Quai du Mont Blanc and the Pont du Mont Blanc; in the foreground, the monument to *Duke Charles II of Brunswick*; in the background the Old Town with the Cathedral (begun 1150)

century. International trade and banking promoted the affluence reflected in the imposing town houses in the upper town and in superb country estates. In 1713–15 the French architect Jean Vennes (*fl* 1700–10) built the Temple de la Fusterie (1707–10), the city's first post-Reformation church. Such mansions as the houses (1720–23) on the Rue de Granges, which are a remarkable example of classicist urban planning, and the Maison Lullin (now Maison de Saussure), built in 1707–12 by the French architect and engineer Joseph Abèille (*fl* 1707–35), are typical examples of the hôtel particulier, built *entre-cour-et-jardin.*

Growing tension between the aristocrats and the people led to the downfall of the regime in 1794 in the wake of the French Revolution. Between 1798 and 1813 Geneva belonged to France, as the capital of the département of Léman. In 1815 it was accepted into the Swiss Confederation as the 22nd canton, but it was not until 1846, with the Revolution of the Radicals, that it achieved democracy. The banks of the lake and the bridges were built up and extended (1815–50), and the old fortifications were razed (1850–88) to be replaced by straight roads and regular plots of land for housing for the upper middle classes, according to plans drawn up by General Guillaume-Henri Dufour (1787–1875) and Léopold Blotnitzki (1817–79). Ring-roads following the course of the former moats were laid out separately with bridges crossing them. The Musée

d'Art et d'Histoire (1909–10), built by John Camoletti (1847–94) and Marc Camoletti (*b* 1857) and inspired by the architecture of the Exposition Universelle in Paris in 1900, was skilfully and impressively adapted to both street levels. Henri Bouchard and Paul Landowski (*b* 1875) made the Reformation Monument (1909–17; for illustration *see* CALVINISM). In a third stage of development (1888–1914) trams were introduced and the suburbs extended. In 1930 the three outlying parishes of Eaux-Vives, Plainpalais and Petit-Saconnex were incorporated into the city.

Important examples of modern architecture include Les Tilleuls, or La Rotonde (1928–9), by Maurice Braillard (1879–1965), a circular building that incorporates residential, commercial and workshop facilities, and Clarté (1931–2), a residential block built after designs by Le Corbusier and his cousin Pierre Jeanneret (1896–1967); the latter was the first steel-frame building in Geneva. The Palace of the League of Nations (completed 1937), built in Fascist monumental style to designs by Henri-Paul Nénot and Julien Flegenheimer, was executed by an international consortium of architects; since 1946 it has been the European headquarters of the United Nations.

BIBLIOGRAPHY
L. Blondel: *Le Développement urbain de Genève à travers les siècles*, Cahiers de Préhistoire et d'Archéologie, iii (Geneva and Nyon, 1946)
L. Deuchler: *Schweiz und Liechtenstein: Kunstdenkmäler und Museen* (Stuttgart, 1966, rev. 3/1979)
E. Deuber-Pauli and others: 'Genf', *Kunstführer durch die Schweiz*, ii (Zurich and Wabern, 1976), pp. 1–37
G. Barbey and others: 'Genève', *Inventaire Suisse d'architecture: 1850–1920*, iv (Berne, 1982), pp. 249–403
A. Brulhart and E. Deuber-Pauli: *Ville et canton de Genève* (Geneva, 1985)

2. ART LIFE AND ORGANIZATION. From the advent of Christianity in the 4th century AD until 1032, when Geneva became part of the Holy Roman Empire, the Burgundian kings and the Church were the most important patrons of the arts. They were succeeded by the bishops and, to a lesser extent, the Counts of Geneva and Dukes of Savoy. In 1444 Konrad Witz painted the *St Peter* altarpiece (partly destr.; Geneva, Mus. A. & Hist.; *see* SWITZERLAND, fig. 5), with a view of Geneva in the background. By and large, artistic output in Geneva throughout the Middle Ages was relatively modest, even allowing for the destruction of many religious works in the iconoclasm that accompanied the Reformation.

In establishing the Academy in 1559, Jean Calvin unwittingly created the nucleus of the city's future museums, because its library collected coins, minerals, scientific instruments and portraits. The altered political and social conditions resulting from the Reformation, in particular the luxury laws, which affected paintings (eventually repealed 1775–6), had a lasting, adverse impact on cultural life; the arts did not develop more freely until the late 17th century. Such arts and crafts as gold- and silversmithing and watchmaking, however, were boosted by the influx of skilled Protestant refugees.

In the 18th century there was an artistic revival, not least because of the arrival of Huguenot refugees. Painting and sculpture were dominated by French influences. JEAN-ETIENNE LIOTARD (the first Genevan painter of international standing), JEAN-PIERRE SAINT-OURS, Adam-Wolfgang Töpffer (*see* TÖPFFER, (1)) and JACQUES-LAURENT AGASSE, all of whom trained in Paris, were among the

most important representatives of the 18th- and 19th-century Geneva school. Others included FIRMIN MASSOT and the HUBER family, while FRANÇOIS TRONCHIN was an important patron.

After a *Kunst- und Wunderkammer* had been set up in the Academy in 1725 for the library's valuable treasures, the Ecole de Dessin (Ecole des Beaux-Arts from 1851) was opened in 1751; it purchased plaster casts of antique statues and drawings by Old Masters and was supported by the Société des Arts (founded 1776). Several private collections of paintings were created, which contained works by foreign and local artists. The first Salon des Artistes was held in 1789, giving contemporary art a new impetus, and featured works by such artists as Jean-Antoine Linck.

The privately financed Musée Rath, the first purpose-built museum in Switzerland, was opened in 1826; it housed the collections belonging to the city and the Société des Arts. Contemporary Genevan art exhibited in the city was initially influenced by Romantic paintings of the Alps by FRANÇOIS DIDAY and Alexandre Calame, and subsequently by the *plein-air*, pre-Impressionist painting developed by Jean-Baptiste-Camille Corot, who stayed in Geneva several times, and by his admirer, Barthélemy Menn. Ferdinand Hodler, who came to Geneva in 1872, attended classes given by Menn at the Ecole des Beaux-Arts and participated successfully in competitions run by the Société des Arts in memory of Calame and Diday.

The Schweizerische Landesausstellung held in Geneva in 1896 strengthened the desire for a large central museum. In 1910 the Musée d'Art et d'Histoire was opened. Built with the help of private funds, it brought various public and private collections together under one roof and was supported by the Société Auxiliaire du Musée (founded 1897). In 1914 Maurice Barraud (1889–1954), along with other Genevan painters, established the Le Falot group, which attracted attention through exhibitions in the famous Galerie Moos and through the arts periodical *L'Eventail* (published between November 1917 and October 1919).

Since World War II, banks, insurance companies and other commercial companies have increasingly sponsored cultural events in Geneva or set up their own art collections. In the late 20th century exhibitions were held at private galleries, and there were also regular, publicly subsidized exhibitions in the Musée Rath, Palais de l'Athénée and Musée d'Art et d'Histoire, which confirmed Geneva's position as the cultural capital of western Switzerland.

BIBLIOGRAPHY
D. Baud-Bovy: *Peintres genevois, 1702–1812* (Geneva, 1903)
W. Deonna: *Les Arts à Genève: Des origines à la fin du XVIIIe siècle* (Geneva, 1942)
——: *Le Genevois et son art* (Geneva, 1945)
A. Neuweiler: *La Peinture à Genève, de 1700 à 1900* (Geneva, 1945)
Dessins genevois de Liotard à Hodler (exh. cat. by A. de Herdt, Geneva, Mus. Rath, 1984)
C. Lapaire: *Musée d'Art et d'Histoire: Genève*, Musées Suisses, i (Geneva and Zurich, 1991; Eng. trans., 1991)

CHRISTIAN BÜHRLE

3. CATHEDRAL. Extensive excavations begun in 1976 revealed a complex history of church building on the site. The first Christian buildings were probably erected in the mid-4th century and included a cathedral to the north and a baptistery. In the late 4th century a second cathedral was added to the south. The north cathedral was enlarged during the 5th century and became the main church. In the 6th century, following the destruction by fire of parts of the complex, the north cathedral (ded. 513–25) was partially rebuilt, and a new church with three apses was built behind the baptistery and enlarged *c.* 1000.

The present structure (see fig. above), dedicated to St Peter, is a transitional Romanesque–Gothic work, begun in the 1160s and finished *c.* 1232. It is small (l. *c.* 70 m) and built to a basilical plan. The two transept towers represent the survival of a Carolingian tradition of building that was common in the Middle and Upper Rhine regions. The general plan was influenced by Cistercian churches, with two rectangular chapels at the east end of each transept. The cathedral retains its carved capitals, which are among the finest Romanesque and Gothic examples of this form of sculpture in Switzerland.

The Chapelle des Macchabées was added to the southwest corner in the early 15th century (rest. 1878) and marks the beginning of the use of the Flamboyant style in Geneva. During the Reformation the cathedral was cleared of most of its ornament, although some stained glass, the choir-stalls, capitals and pulpit remain. The cloisters were replaced by the Hôtel Mallet (1721), designed by Jean-François Blondel. The Neo-classical west portico (1752–6) was built to plans by Benedetto Innocente Alfieri when the original structure showed signs of collapsing. A 19th-century spire between the two irregular towers at the east end replaced a 16th-century bell tower. The lack of cohesion between the earlier foundations and the later, main phase of building has led to structural problems, and the building has needed constant repair, notably in 1750, in 1890 and in the 1970s.

BIBLIOGRAPHY
C. Bonnet: 'The Archaeological Site of the Cathedral of Saint Peter (Saint-Pierre), Geneva', *World Archaeol.*, xviii (1987), pp. 330–40

□

Genga. Italian family of artists.

(1) Girolamo Genga (*b* Urbino or surroundings, 1476; *d* La Valle, nr Urbino, 11 or 31 July 1551). Painter and architect. Vasari stated that he was first apprenticed to Luca Signorelli, probably when the latter went to Urbino in 1494. From *c.* 1498 until 1501 he was active in Pietro Perugino's workshop, where he probably met Raphael. He later went to Florence, remaining there for some years, according to Vasari, before going to Siena, though the sequence of his movements between 1501 and *c.* 1513 is disputed. His career is unlikely to have followed the neat progression implied by Vasari, and it is more reasonable to consider the artist as relatively mobile, moving between different artistic centres.

In 1504 Girolamo Genga is documented working with Timoteo Viti on a fresco cycle of the *Life of St Martin* (destr. 1793) and an altarpiece of *SS Thomas Becket and Martin Venerated by Bishop Arrivabene and Duke Guidobaldo da Montefeltro* (Urbino, Pal. Ducale) for the chapel of St Martin in Urbino Cathedral. The following year they were both paid for painting and gilding a tabernacle (destr.)

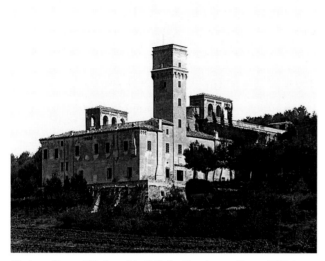

Girolamo Genga: Villa Imperiale, Colle San Bartolo, near Pesaro (1530s)

for the cathedral. In 1507 they shared a commission to paint a silk standard for the *comune* of Urbino, and in 1508 Genga was entrusted with the decorations for the funeral of Duke Guidobaldo I da Montefeltro. Towards the end of 1509 Genga and Viti designed the triumphal arches and other ephemeral decorations for the festivities celebrating the entry into Urbino of Leonora Gonzaga (*d* 1550), consort of Francesco-Maria I della Rovere, 4th Duke of Urbino.

Genga's work in the Palazzo Petrucci, Siena, where he painted alongside Bernardino Pinturicchio and Signorelli, has been dated to 1509, although some scholars suggest a date as early as 1498 or place the project in the years 1503–12. Genga is most frequently linked with the two frescoes (now detached) of the *Ransoming of Prisoners* and *Aeneas' Flight from Troy* (Siena, Pin. N.). He is documented in Siena in 1510, and this date is also assigned to the *Transfiguration* (Siena, Mus. Opera Duomo), painted as a cover for the cathedral organ, in which the influences of Sodoma and Girolamo del Pacchia (1477–1533) are more apparent than those of his earlier teachers.

Genga's name has been linked with the decorations for the inaugural performance of *Calandria* (1506) by Cardinal Bernardo Bibbiena in Urbino on 6 February 1513, as described in a letter by Baldassare Castiglione and an anonymous 16th-century manuscript (Rome, Vatican, Bib. Apostolica, MS. Urb. Lat. 490), but neither source names the artist responsible. Since no traces of the sets have survived, and considering Castiglione's reference to his own role as overseer and director of the enterprise, it is difficult to accept the attribution to Genga without question, although both Serlio and Vasari wrote of his talents in designing theatre sets.

In September 1513 Genga was commissioned by the Augustinian Order in Cesena to paint the altarpiece of the *Dispute on the Immaculate Conception* (Milan, Brera), signing the contract *gironimo da urbino pictore in fiorenza*. He executed the work in Cesena and received the first payment in 1516, by which date he was a resident there.

The altarpiece was installed in S Agostino in 1520. It reflects the influence of Raphael, but more particularly of Michelangelo. A painting of the *Dispute on Original Sin* (Berlin, Bodemus.), stylistically similar to the Cesena Altarpiece, is dated *c.* 1515. In 1518 Genga collaborated with Viti on a fresco cycle of the *Assumption of the Virgin* (destr. 1793) in the church of S Francesco, Forlì. Before 1520 he was commissioned by Agostino Chigi to paint an altarpiece of the *Resurrection* for the oratory of S Caterina da Siena in the Via Giulia, Rome (*in situ*). Its dependence on Raphael's *Transfiguration* (Rome, Pin. Vaticana) is clearly visible (Colombi Ferretti). It is likely that Genga was in Rome in 1520–21.

In August 1522 Genga was invited to Urbino by Francesco-Maria I della Rovere to become court artist and architect. His earliest years in the Duke's service were actually spent in Rome drawing antiquities and acquiring precious building materials, such as columns and slabs of ancient marble and coloured stone. For most of the 1520s his work was limited to the restoration and modernization of the two principal ducal palaces, at Pesaro and Urbino, and the Duchess's residence at Fossombrone. Between *c.* 1529 and 1532 he was commissioned by the Duchess to plan and oversee a fresco cycle in eight rooms in the Sforza Villa Imperiale (*see* PESARO (i), §3). The Duchess also commissioned him to design his first architectural project, a new villa on a difficult hill site further up the Colle San Bartolo (1530s; see fig.). For Francesco-Maria I he restored the Barchetto (destr.), a park located inside the town walls of Pesaro near the Porta Rimini, where, according to Vasari, he designed a small house built to simulate a ruin.

Genga's last major building was S Giovanni Battista, Pesaro, begun in 1543 and continued after his death by his son, (2) Bartolommeo Genga. The Latin-cross plan, with an octagonal choir, barrel-vaulted nave and side chapels, was clearly influenced by Francesco di Giorgio Martini, Donato Bramante and Baldassare Peruzzi. Certain architectural details of the unfinished façade, such as the shallow pilasters, recall those of the earlier Villa Imperiale.

(2) Bartolommeo [Bartolomeo] **Genga** (*b* Cesena, 1518; *d* Malta, July 1558). Architect, son of (1) Girolamo Genga. According to Vasari, he was apprenticed to his father at the age of 18. Around 1538 he was sent from Pesaro to Florence to continue his studies in drawing and painting. While there he came under the influence of Vasari and Bartolomeo Ammanati, two of the leading exponents of Tuscan Mannerism. When he returned to Pesaro three years later, his father decided that he showed more skill in architecture than in painting. Accordingly, Girolamo instructed him in perspective and sent him to Rome to measure antiquities. On his return to the Duchy of Urbino (*c.* 1545), he became the principal military architect to Guidobaldo II della Rovere, Duke of Urbino, who took him on one of his missions for the Republic of Venice, to draw fortifications. Vasari specifically refers to the fortress of S Felice, Verona, where work is documented as under way between late 1546 and 1547. Ferdinand I of Austria, King of Bohemia, saw work executed by Genga in Lombardy and tried to engage his services but was unsuccessful. Back in Pesaro, in 1548, Bartolommeo

prepared a model for the port, but his project was abandoned, probably for lack of funds. His renown as a military engineer spread quickly. Around 1550, while in Rome with the Duke, he made drawings for the fortification of the Vatican Borgo. Also at this time, the Genoese tried to commission him to work on their defence system, but the Duke refused to give his architect leave of absence.

Bartolommeo's activity was not restricted to military projects. In January 1548 he had been in charge of the decorations honouring the arrival in Urbino of Vittoria Farnese, Duke Guidobaldo's second wife. Not much later, he began a major restoration and modernization of the Palazzo Ducale in Pesaro. He enlarged the 15th-century courtyard, installing an entrance portal with access to the principal staircase, the source for which can be found in the central bay of Giovanni Maria Falconetto's Loggia Cornaro in Padua (1524). Despite its more vertical lines, the Pesaro door closely reflects Falconetto's scheme, even including the two *Victories* in the spandrels. Bartolommeo also designed three rooms on the first floor of the palazzo that are remarkable for their ornate ceilings, the elaborate forms of which could have been inspired by his father's ceilings in the Villa Imperiale, though Bartolommeo's designs surpass them in intricacy. He built another apartment of four rooms, which is mentioned by Vasari as the Duke's apartment, in the wing overlooking the Corso.

Bartolommeo succeeded his father as chief ducal architect in 1551 and supervised the continuation of S Giovanni Battista, although the façade was not completed. In the Palazzo Ducale at Urbino he built the suite of rooms on the second floor (1554–7), over the 15th-century apartment of Iole, that served as the Duke's private quarters. In March 1558 he arrived at Malta to design the fortifications of the island and two new cities, one of the few commissions he was allowed to accept outside Urbino, but managed to prepare only one urban design and drawings for some of the buildings.

BIBLIOGRAPHY

B. Castiglione: *Le lettere* (early 16th century); ed. G. La Rocca, 3 vols (Verona, 1978–)

S. Serlio: *Il secondo libro di prospettiva* (Paris, 1545); ed. G. D. Scamozzi (Vicenza, 1618), fol. 47*v*

G. Vasari: *Vite* (1550, rev. 2/1568); ed. G. Milanesi (1875–85), vi, pp. 315–40

F. Milizia: *Memorie degli architetti antichi e moderni*, i (Bassano, 1785), p. 177

B. Patzak: *Die Villa Imperiale in Pesaro* (Leipzig, 1908)

G. Gronau: *Documenti artistici urbinati* (Florence, [1936])

A. M. Petrioli Tofani: 'La *Resurrezione* del Genga in S Caterina a Strada Giulia', *Paragone*, xv (1964), no. 177, pp. 48–58

——: 'Per Girolamo Genga', *Paragone*, xx (1969), no. 229, pp. 18–36; no. 231, pp. 39–56

A. Pinelli and O. Rossi: *Genga architetto* (Rome, 1971)

M. Groblewski: *Die Kirche San Giovanni Battista in Pesaro von Girolamo Genga* (diss., U. Regensburg, 1976)

F. Ruffini: *Teatri prima del teatro* (Rome, 1983)

A. Colombi Ferretti: *Girolamo Genga e l'altare di S Agostino a Cesena* (Bologna, 1985)

D. J. Sikorsky: 'Il Palazzo Ducale di Urbino sotto Guidobaldo II (1538–74): Bartolomeo Genga, Filippo Terzi e Federico Brandani', *Il Palazzo di Federico da Montefeltro: Restauri e ricerche* (exh. cat., ed. M. L. Polichetti; Urbino, Pal. Ducale, 1985), pp. 67–90

S. Eiche: 'La corte di Pesaro dalle case malatestiane alla residenza roveresca', *La Corte di Pesaro*, ed. M. R. Valazzi (Modena, 1986), pp. 13–55

A. Fucili Bartolucci: 'Architettura e plastica ornamentale nell'età roveresca dal Genga al Brandini', *Arte e cultura nella provincia di Pesaro e Urbino*, ed. F. Battistelli (Venice, 1986), pp. 281–92

S. Eiche: 'Girolamo Genga the Architect: An Inquiry into his Background', *Mitt. Ksthist. Inst. Florenz*, xxxv (1991), pp. 317–23

——: 'Prologue to the Villa Imperiale Frescoes', *Not. Pal. Albani.*, xx (1991), pp. 99–119

——: 'Fossombrone, Part I: Unknown Drawings and Documents for the *Corte* of Leonora Gonzaga, and her son, Giulo della Rovere', *Stud. Stor. A.* (1991), pp. 103–28

SABINE EICHE

Gennai. *See* HIRAGA GENNAI.

Gennari. Italian family of painters. The family, which originated in Cento, comprised Benedetto Gennari I (1563–1658); his two sons Ercole Gennari (1597–1658) and Bartolommeo Gennari (1594–1661), who married Lucia, the sister of GUERCINO; Lorenzo Gennari (1595–1665/72), who was descended from another branch of the family; and Ercole's two sons, Cesare Gennari (1637–88) and (1) Benedetto Gennari II. These artists were closely associated with Guercino, and their work, with the exception of that of Benedetto II, has been difficult to identify among the many paintings from Guercino's studio. It seems that neither Ercole nor Lorenzo had an independent career; Bartolommeo, whose style remained close to that of Guercino, had a stronger personality; Cesare, though he too painted very much in Guercino's manner, was the most gifted. These four worked with Guercino in Cento, Lorenzo as his first assistant until 1630, when he left the studio. In 1642 Guercino moved to Bologna, followed in 1643 by Bartolommeo and Ercole, with the latter's family. Bartolommeo, who succeeded Lorenzo as Guercino's assistant, painted some independent works, such as the *Incredulity of St Thomas* (1643–5; Cento, Pin. Civ.). After the death of Guercino, Cesare, with his brother Benedetto II, ran the studio; Cesare's *Penitent Magdalene* (c. 1662; Cento, Pin. Civ.) is characteristic of his accomplished style.

(1) Benedetto Gennari II (*bapt* Cento, 19 Oct 1633; *d* Bologna, 9 Dec 1715). He trained with Guercino in Bologna, and his early works, such as the *Investiture of St Chiara* (1656–7; Pieve di Cento, S Chiara), are close to the style of Guercino. On Guercino's death he and his brother Cesare Gennari directed the studio. In March 1672, motivated by his admiration for Louis XIV, he journeyed to Paris, where commissions from the French nobility encouraged him to extend his stay over 16 months. In Paris he began to keep a diary (Bologna, Bib. Com. Archiginnasio, MS. B 344), which lists his works in chronological sequence. In September 1674 he travelled to London, where commissions to paint royal portraits inaugurated a lengthy period of residence at the court of Charles II and subsequently of James II (*reg* 1685–9). His mythological paintings include four large pictures of scenes from Ovid's *Metamorphoses* (London, Hampton Court, Royal Col.) and Tasso's *Rinaldo and Armida* (c. 1676–8; priv. col., see 1991 exh. cat., p. 467). For the Catholic Queen Catherine he painted devotional pictures and altarpieces, among them the *Annunciation* (1675; Cento, Cassa di Risparmio) and a series of pictures to commemorate important feast days of the Virgin (untraced). A full-length portrait of *James II* (1686; New York, priv. col.,

see Miller, fig. 1) marked his appointment as first painter to that monarch. For this court, which zealously promoted the Catholic faith, he continued to paint the traditional subjects of Catholicism, as for example an *Annunciation* (1686; Sarasota, FL, Ringling Mus. A.), painted as an altarpiece for the chapel in the palace at Whitehall, London. In 1689 he followed James II in exile to the court at Saint-Germain-en-Laye, remaining there until his return to Bologna (1692). In 1709 he became one of the founder-members of the Bolognese Accademia Clementina. Apart from having the most eventful career of the Gennari family, Benedetto II developed, as a portrait painter, an intriguing eccentricity of style and iconography, diverging considerably from its origins in Guercino (1991 exh. cat.; Bagni).

BIBLIOGRAPHY

G. P. Zanotti: *Storia dell'Accademia Clementina*, i (1739), pp. 167–94
L. Crespi: *Felsina pittrice: Vite de' pittori bolognesi* (Rome, 1769), pp. 173–4
M. Levy: *The Later Italian Paintings in the Collection of Her Majesty the Queen* (London, 1964), pp. 21–3
D. Miller: 'Benedetto Gennari's Career at the Courts of Charles II and James II and a Newly Discovered Portrait of James II', *Apollo*, cxvii (1983), pp. 24–9
P. Bagni: *Benedetto Gennari e la bottega del Guercino* (Bologna, 1986)
Il Guercino (exh. cat., ed. D. Mahon; Bologna, Mus. Civ. Archeol.; Cento, Pin. Civ.; Frankfurt am Main, Schirn Ksthalle; Washington, DC, N.G.A.; 1991)

DWIGHT C. MILLER

Genoa [anc. Genua; It. Genova]. Italian city, capital of Liguria. It lies on the shores of the Gulf of Genoa in the north-west of Italy, its urban area extending up into the surrounding hills. Genoa (population *c.* 750,000) is the most important port in Italy and one of the largest in the Mediterranean. Its historic importance as a maritime power, which rivalled that of Venice by the 14th century, is reflected in the city's rich medieval and Renaissance architecture, notably the palaces of its great maritime families. Genoa also became a noted centre of production, particularly of silk and ceramics.

1. History and urban development. 2. Art life and organization. 3. Centre of production.

1. HISTORY AND URBAN DEVELOPMENT. With origins perhaps in the 6th century BC, a Ligurian trading settlement was established at Genoa, which subsequently allied itself with Rome in the 3rd century BC; although destroyed by the Carthaginians (205 BC), it was quickly rebuilt. The outline of the first settlement can be seen on the slopes of the Collina di Castello. The remains of the Ligurian site to the north of the Castello probably indicate the limits of pre-Roman habitation. It is likely, however, that the summit of the hill constituted the principal urban area even in Roman and Byzantine times. After the collapse of the Roman Empire, Genoa was ruled successively by the Goths, Byzantines, Lombards and Franks. The medieval city finally took shape in the period between construction of the first and second city walls (AD 864–1161). The 9th-century walls took in the lower inhabited areas (*civitas*) and the higher (*castrum*) areas of Castello on the northern side of the town, in which direction subsequent major urban growth developed. The arrival of the relics of S Remo in the walled city between 889 and 916 and the transfer of the cathedral from the country church of S Siro to S Lorenzo (987) resulted in the development in the city's Castello quarter of an active canonical community. A new Romanesque cathedral (see fig. 1) was consecrated in 1118 (modified later; rest. 1934). S Siro and the Benedictine abbey of S Stefano (façade 13th–14th century) then became the focal points of suburban colonization encouraged by the Church in the 10th and 11th centuries.

After the establishment (1009) of the 'Compagna Communis' for the emancipation of the *comunes* from imperial and ecclesiastical power, control of Genoa was disputed between powerful local families, notably the SPINOLA, Grimaldi, DORIA and Fieschi, who subsequently became important patrons. The city's rise to maritime power began when, together with Pisa, it acquired the islands of Sardinia and Corsica from the Saracens in 1070. It then took full advantage of the Crusades to develop trade with the East, consolidating its influence with a colony at Byzantium (1204) and, having defeated its rival Pisa in 1284, gaining a monopoly over trade between the Russian empire, Turkey and Egypt. Genoa's mercantile success resulted in enormous demographic and urban expansion. The Ripa Maris (sea-wall), the long colonnade along the port, was begun in 1133 and completed by Giovanni Boccanegra

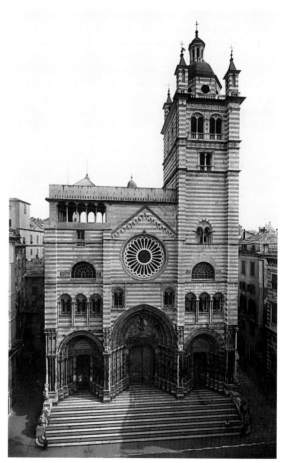

1. Genoa, façade of the cathedral of S Lorenzo, consecrated 1118, campanile 1522

with the Palazzo del Mare (1160) and the new walls (1155–61), which encompassed the quarters of Borgo and the fort of Castelletto. The nobility, engaged in commerce, resided in those quarters sheltered by the Ripa, whereas the monastic orders occupied the few free areas within the city walls.

By the end of the 13th century, medieval Genoa had attained its definitive form. The port was completed with the dockyards at Pré, near the Ospedale di S Giovanni (1180); the Castello, dominated by the Romanesque church of S Maria (11th century), also acquired such civic buildings as the Palazzo Comunale (after 1291), which was later incorporated in the Palazzo Ducale (1806). The urban landscape was characterized by an intricate street-system and conspicuous towers, vying for height with the towers of the city gates (e.g. Porta Sovrana, c. 1155). The predominant building materials were the local light-grey Promontorio stone and slate, skilfully worked by the Lombard 'Maestri Antelami', master builders from the Intelvi Valley near Lake Maggiore, who monopolized construction activity in the city for several centuries. Noble town houses were generally built on several floors above loggias with double barrel vaults. An exception was the house of the wealthy Benedetto Zaccaria, where the court of Henry VII (later Holy Roman Emperor) and his wife, Margaret of Luxembourg, stayed in 1311. The internal spaces of the city expanded significantly only in the 14th century, with the increase in numbers of 'alberghi', a type of inter-family consortium that controlled shared property rights.

The joint claims of Genoa and Pisa on the Greek island of Tenedos (now Bozcaada, Turkey) drew them into conflict with Venice in the Wars of Chioggia (1378–81), from which Genoa emerged defeated. Attempts to arrest the resulting political and commercial decline of the city led to the formation (1407) of the sole trading company, the Casa di S Giorgio, but this was unable to halt its loss of control of trade to the East, which fell to the Turks and Venetians. Protected at first by France and then by the Visconti and Sforza families, Genoa came under the domination of Francis I of France in 1527. A year later it was liberated from the French by Andrea Doria I, one of the greatest of its naval leaders, and by the intervention of Spain, to which the city remained closely linked for the next two centuries.

The revival on a grand scale of Genoese urban politics took place in the 1530s, when the city became a financial centre. While the city walls were being reconstructed (1536), an extraordinary series of noble suburban villas was begun, including the Palazzo Doria (now Doria-Pamphili), built for Andrea Doria I at Fassolo (see fig. 2); from 1528 many artists from both Florence and Rome were employed at the palazzo, which became a model through which the High Renaissance was introduced to Liguria (see §2 below; for further discussion see DORIA, §I(1)). Other villas were built by Galeazzo Alessi, one of the most important architects working in Genoa in the 16th century: these include the Villa Giustiniani (1548; renamed Villa Cambiaso; see ALESSI, GALEAZZO, fig. 1) and Villa Pallavicino (c. 1555; also known as the Villa delle Peschiere; see VILLA, fig. 5). The cubic spatial form of the villas is also seen in Alessi's church of S Maria Assunta

2. Genoa, Palazzo Doria (now Doria-Pamphili), Fassolo, begun c. 1528; photographed before damage in World War II

(1552–1603; see ALESSI, GALEAZZO, fig. 2), his masterpiece, which is perched high up on the hill of Carignano, dominating the southern part of Genoa.

Among the most distinguished urban projects of the 16th century was the creation of the Strada Nuova (1550–58; now Via Garibaldi), instigated by the Grimaldi family in an effort to clean up the area around Castelletto, which was occupied by a public brothel. The Strada Nuova was known as Via Aurea for the magnificence of its buildings, including the Palazzo Doria-Tursi (begun 1565; now Palazzo del Municipio), designed originally for Nicolò Grimaldi by the PONZELLO brothers and executed by Giovanni Lurago (see LURAGO (i), (1)); the Palazzo Podestà (c. 1563–5) by Giovanni Battista Castello (see CASTELLO (i), (1)); and the Palazzo Bianco (c. 1565; enlarged after 1711) by Giovanni Orsolino (d 1597) and Domenico Ponzello. Important buildings constructed there later include the Palazzo Rosso (1671–7), built for the Brignole-Sale family (see BRIGNOLE AND BRIGNOLE-SALE) by Matteo Lagomaggiore. Even in its most resplendent palazzi, however, the Via Aurea remained true to the essence of Alessi's teaching, suggesting a restrained decorum much praised by Vincenzo Scamozzi and Rubens. During this period the Via S Luca, parallel to the Ripa, was widened, and several piazzas were created, for example the Campetto degli Imperiale (1558).

The first two decades of the 17th century were marked by the reconstruction of S Siro (1613) and the 13th-century church of SS Annunziata (1620) in Baroque style, with magnificent frescoed interiors. Abortive attempts were made to double the width of the Via Aurea at this time, but, most importantly, another new monumental street was created at the instigation of the BALBI family: the Via Balbi (1602–13) at Pré, conceived largely by BARTOLOMEO BIANCO. The austere façades of Bianco's Palazzo Durazzo-Pallavicini (1618) and Collegio dei Gesuiti (1634–65; now Palazzo della Università), Via Balbi, stand in stark contrast to their picturesque courtyards with loggias and staircases. Other notable buildings in Via Balbi include the Palazzo Reale (now Balbi-Durazzo), begun

c. 1643 by Pier Francesco Cantone. While convents multiplied inside the city, the Albergo dei Poveri (1654) by Stefano Scaniglia was built outside the walls, which by then reached the Lanterna lighthouse at Carignano. In general, however, architectural activity in Genoa suffered a decline in the second half of the 17th century and in the 18th, although the damage caused by a French bombardment in 1684, together with renewed population growth, was followed by some revival of building work; this produced the Teatro Pallavicini (1702), near S Donato, the first theatre in Genoa, and later the construction of the Strada Nuovissima (1778–86; by Gregorio Petondi) between Via Balbi and Via Aurea. During this time rented accommodation became popular, a logical consequence of mass urbanization.

In the meantime the great geographical discoveries of the 15th and 16th centuries led by Christopher Columbus, a native of Genoa, had significantly reduced the importance of the Mediterranean market. In 1768 Genoa sold Corsica to the French, and in 1796 Napoleon entered the city and the Ligurian Republic was formed. The city was subsequently handed over to the House of Savoy under the Congress of Vienna (1815). The Neo-classical architect Carlo Francesco Barabino, appointed city architect in 1818, was responsible for interpreting the cautious plans for reconstruction, and he carried out several works in 1825–35. His expansion plan (1825; unexecuted) designated zones for residential expansion in the eastern areas of the city (S Vincenzo, Pace, Carignano). The old city, meanwhile, was provided with modern axial roads (e.g. Via Carlo Felice from the Strada Nuova to Via Giulia; and Via Carlo Alberto, a coastal route) as well as civic and institutional buildings (e.g. the Accademia Ligustica di Belle Arti, 1826–31; and Teatro Carlo Felice, 1826–7; rebuilt 1991; for further discussion and illustration *see* BARABINO, CARLO FRANCESCO). Both of these buildings were constructed in the Piazza De' Ferrari, near the Palazzo Ducale and the cathedral, and this became the new cultural centre of the city. In the 1850s the liberal politics of the minister Camillo Cavour (1810–61) stimulated the rise of a dynamic, entrepreneurial bourgeois class, and in the western areas of the city (Sampierdarena, Cornigliano, Sestri) the first iron- and steelworks were built, as well as such mechanical industries as the Ansaldo railway works (1852), the largest factory in Italy. Genoa was linked to the international communications network with the construction of its first railway station (1853) and the expansion of the port (1875–88), which was later also extended to the west (1905). The new area destined to become the focus of commercial activity took shape *c.* 1890 between Piazza De' Ferrari and the Strada Giulia (now the Via XX Settembre).

In 1861 Genoa became part of the kingdom of Italy, and in the following century it concentrated on a vast programme of industrialization, which radically transformed its economy. Under pressure from increasingly chaotic and speculative residential building activities, Genoa expanded, to the detriment of adjoining municipalities. With a regulatory plan of 1877 the expansion of the western areas resulted in the annexation of six boroughs, including Marassi and Staglieno, the latter being the home of the famous Camposanto di Staglieno (1844–

51). Similar aims were pursued in a royal decree of 1926, which extended the metropolitan boundaries to other hill and coastal zones. The historic centre was the subject of Piero Barbieri's improvement plan (1936), based on 'thinning out', but the area was badly damaged by bombing in World War II. The period after 1945 highlighted the inability of local administration to control urban expansion. The policy of decentralization that was favoured during the 1950s for housing estates resulted in the isolation of new quarters (e.g. Forte Quezzi, 1958). The siting of enormous oil refineries in Val Polcevera involved new road construction, necessitating such outstanding feats of engineering as Riccardo Morandi's motorway viaduct (1960–65). Towards the end of the 20th century there was a hesitant renewal of urban-planning activity, concentrating mainly on the improvement of services (e.g. underground, 1990) and on the renovation of traditional places of assembly (e.g. Marassi Stadium, 1990). A plan for the revitalization of the port area was prepared by Renzo Piano for the Columbus celebrations of 1992 and partially carried out.

BIBLIOGRAPHY

E. De Negri and others: *Catalogo delle ville genovesi* (Genoa, 1967)
T. O. De Negri: *Storia di Genova* (Milan, 1968)
G. Giacchero: *Genova e la Liguria nell'età contemporanea*, 3 vols (Genoa, 1970)
P. Torriti: *Tesori di Strada Nuova: La Via Aurea dei genovesi* (Genoa, 1970)
E. Poleggi: *S Maria di Castello e il romanico a Genova* (Genoa, 1973)
N. Lamboglia: 'Le origini di Genova e i problemi del colle di Castello: Archaeologica', *Scritti in onore di A. Neppi Madona* (Florence, 1975), pp. 359–71
T. O. De Negri: *Il Ponente Ligustico incrocio di civiltà* (Genoa, 1977)
G. Petti Balbi: *Genova medievale vista dai contemporanei* (Genoa, 1978)
L. Grossi Bianchi and E. Poleggi: *Una città portuale nel medioevo: Genova nei secoli X–XVI* (Genoa, 1979)
G. Rotondi Terminiello: *Palazzo reale* (Genoa, 1979)
E. Poleggi and P. Cevini: *Genova* (Rome and Bari, 1981)
Il palazzo dell'università di Genova: Il collegio dei Gesuiti nella Strada dei Balbi (Genoa, 1987)
A. M. Matteucci: *L'architettura nella repubblica di Genova: L'architettura del settecento* (Turin, 1988)

GIUSEPPE PINNA

2. ART LIFE AND ORGANIZATION. During the Middle Ages Genoa's artistic output was almost entirely in the hands of artisans from areas outside Liguria, generally those with the closest political, military or economic ties with the city. This was most apparent in the city's sculptural output, which during the 12th and 13th centuries revealed the presence of craftsmen from a wide variety of different cultural areas, both Italian (for example from Lombardy–Como, Lombardy–Emilia and Pisa) and foreign (artists working in the French Early Gothic style or Byzantine artists). During the 14th century, however, the Genoese preferred to commission works by important Tuscan artists: Giovanni Pisano, for example, created the tomb of *Margaret of Luxembourg* (part in Genoa, Mus. S Agostino; statue in Genoa, Pal. Spinola), who died in Genoa in 1311 (*see* PISANO (i), (2)). During the 15th century, architectural sculpture was virtually monopolized by Lombard artists, although Tuscan sculptors were also employed. The same situation prevailed in painting: from the end of the 13th century to the middle of the 14th Tuscan painters who were influenced by Cimabue or Pisan and Sienese–Avignon painters worked in Genoa alongside

Byzantine or Byzantine-influenced artists. The first Ligurian painters did begin to make an appearance at this time, albeit heavily influenced by Tuscan art. During the 15th century, however, painting was almost completely controlled by Lombard artists.

In 1528, after consolidating his power, Andrea Doria I summoned PERINO DEL VAGA to Genoa and, with him, several painters and sculptors from both Rome and Florence to work at the Fassolo workshop, the painters executing an iconographic scheme depicting Classical subject-matter and intended to express Doria's achievements and public recognition (see fig. 3; see also DORIA, §I(1)). The arrival of these artists, including Giovanni Angelo Montorsoli and Baccio Bandinelli, brought High Renaissance art to Genoa, which underwent a total transformation. Many trading and banking families followed Doria's example and commissioned villas and lavishly decorated new town houses. The influx of artists from the most artistically advanced Italian cities continued throughout the century, but from the 1550s the presence was also felt of Genoese artists educated outside the city, who were familiar with the latest artistic developments. A particularly important figure in this respect was the painter LUCA CAMBIASO, who, after studying in Rome, worked in Genoa; he contributed to the modernization of Genoese painting and decoration and introduced Italian Mannerism to the city.

The 'Genoese century', which lasted until c. 1650 and during which there was an extraordinary growth in the wealth of the city, was matched by intensive artistic activity in the decoration of palaces and churches commissioned by a brilliant and cultured ruling class, whose members included the SPINOLA, Grimaldi and BRIGNOLE families in addition to the Doria (see also §1 above). The 17th century marked the golden age of Genoese painting, which expressed itself in an underlying mood of realism, particularly among the first generation of local painters, including BERNARDO STROZZI and Gioacchino Assereto (e.g. Esau Selling his Birthright, c. 1645; Genoa, Gal. Pal. Bianco; for illustration see ASSERETO, GIOACCHINO). During the early decades of the century painting was also influenced by the presence in Genoa of Rubens (1605–6) and van Dyck (1621–7), who painted many portraits of members of local patrician families (e.g. Marchese Balbi, c. 1621–2, and Marchesa Elena Grimaldi Cattaneo, 1623; both Washington, DC, N.G.A.; see PORTRAITURE, fig. 17 and DYCK, ANTHONY VAN, fig. 1); as well as celebrating the ruling class, these also represented powerful status symbols. Artistic education was furthered by such patrons as Prince Gian Carlo Doria, who instituted life classes in his house in the early 17th century (see DORIA, §II(1)).

Baroque art found expression mainly in the fresco decoration of numerous Counter-Reformation churches and patrician residences, both in the city and in the surrounding countryside. One of the most important workshops was that of Domenico Piola (see PIOLA, (1)). A combination of museum and collection, containing originals and copies of works by the great masters, the Casa Piola also produced a considerable number of paintings, frescoes and altarpieces. The workshop was continued by Piola's sons and, more importantly, his son-in-law Gregorio de' Ferrari, who worked with Piola on

3. Perino del Vaga: *Jove Hurling Thunderbolts at the Giants* (c. 1530), fresco, Palazzo Doria-Pamphili, Fassolo, Genoa

frescoes for several buildings, including the Palazzo Rosso (*see* FERRARI, DE', (1)). The Casa Piola coordinated the activities of the different artists involved in decorative projects and often also created furniture and carved wooden furnishings to an overall scheme planned by the painter. Another important artist active in Genoa at this time was Filippo Parodi (*see* PARODI, (1)), perhaps the most typically Genoese sculptor of the Baroque period. The beginning of the 18th century marked a rapid decline in Genoese art, with commissions for the decoration of major buildings again generally being given to artists from outside Genoa, for example Marcantonio Franceschini, who painted a cycle of scenes eulogizing the *Republic of Genoa* (1702–4; destr. 1777) in the Palazzo Ducale.

The Italian Enlightenment led to the birth of Genoa's first public body devoted to art, the Accademia di Pittura e Scultura, a school for young artists sponsored by a group of cultured and enlightened aristocrats. Following the city's conquest by Napoleon, there was widespread suppression of ecclesiastical institutions and extensive dispersal of the city's artistic patrimony. This was, however, matched by the first political debates concerning the need to erect a public museum, reflecting a new appreciation of the role of museums as a public service and the didactic role played by art in the life of the citizens. The first civic museums were in fact established only in the final decades of the 19th century, thanks to a number of donations, most notably by the Brignole-Sale family: Maria, Duchess of Galliera (née Brignole-Sale), bequeathed both the Palazzo Rosso and the Palazzo Bianco, together with her magnificent art collection, to the city in 1874 and 1884 respectively. Genoa in the 19th century was characterized by an extensive restoration campaign affecting many of the city's medieval monuments, conducted by the architect and painter Alfredo D'Andrade. During the late 19th century and early 20th, which marked Genoa's emergence as a middle-class city, many of its monuments were destroyed and much of its artistic heritage was further dispersed.

BIBLIOGRAPHY

E. Gavazza: *La grande decorazione a Genoa* (Genoa, 1974)
F. R. Pesenti: *La pittura in Liguria: Artisti del primo seicento* (Genoa, 1986)
La pittura a Genova e in Liguria, 2 vols (Genoa, 1987)
La scultura a Genova e in Liguria, 3 vols (Genoa, 1987–9)
P. Boccaro: *Andrea Doria e le arti* (Rome, 1989)
E. Gavazza, F. Lamera and L. Magnari: *La pittura in Liguria: Il secondo seicento* (Genoa, 1990)
G. Algeri and A. De Floriani: *La pittura in Liguria: Il quattrocento* (Genoa, 1991)
E. Castelnuovo, ed.: *Niveo de marmore: L'uso artistico del marmo di Carrara dall'XI al XV secolo* (Genoa, 1992)

ANNA DAGNINO

3. CENTRE OF PRODUCTION.

(i) Silk. The trade in silk fabrics and the raw materials for their production has been an important part of the Genoese economy since the Middle Ages. At first Genoa served as a centre of distribution for woven-silk products. There is evidence, however, of local production, of significant quality and quantity, from the mid-13th century. At the beginning of the 14th century numerous weavers exiled from Lucca arrived in Genoa to teach their craft. The arrival of these craftsmen, who were technically advanced and artistically autonomous, substantially increased production in Genoa. The silk-workers, who for over a century had belonged to the Corporazione dei Merciai, acquired their own statutes in 1432.

In the 16th century, partly because of the Turkish threat, which reduced trade with the Near East, the Genoese transferred their investments from foreign trade to the local silk industry. Whereas in Milan participation in the silk trade was prohibited to noblemen, in Genoa it was taken up by members of such important families as the Grillo, Spinola, Di Negro and Grimaldi. Silk manufacturers imported raw silk from the Near East and Messina and from other areas in Italy such as Calabria, Lombardy and Piedmont and then employed specialized workers in small, family workshops to carry out the various operations of spinning, dyeing, spooling and weaving. Relations between the entrepreneur and the different categories of workers were regulated by statutes, which tended to prohibit the weavers from practising their trade independently: they were allowed a limited number of looms and had to remain within the city walls. The quality of the product was maintained by rigidly fixed technical specifications; this also served as a protection against frauds and falsifications. The Consiglio dell'Arte della Seta and its consuls formed a real magistrature in the Republic, which indicates their economic and political power.

Genoese fabrics were widely appreciated in the other Italian and European states; particular specialities were plain and decorated velvets, satins and damasks. Black Genoese velvet was considered incomparable for softness and lustre and was favoured by the European nobility for their clothes; women preferred the crimson damask, of a delicate pinkish tone, which was never successfully imitated, and the precious gold and silver lamé fabrics that can be seen in the splendid portraits by van Dyck. At the end of the 17th century, however, the first signs of a crisis began to appear. This was provoked mainly by foreign competition, especially from France, in markets that until that time had absorbed the Italian exports. The luxury fabrics, especially the velvets, nevertheless remained quite competitive throughout the 18th century.

From the mid-17th century to the end of the 18th the Genoese silk industry turned more and more to the production of furnishing fabrics. Along with damask, lampas (a figured textile, which is heavier than damask) was woven in three or more colours, and in the 18th century 'garden style' polychrome, flower-patterned velvet appeared. Decorative drapery fabrics tended to keep to the same patterns (e.g. the so-called 'palm' damask), while the proportions in the design and the manner of working the background changed.

Following Genoa's loss of independence at the end of the 18th century, when the trade guilds were also abolished, silk production was slowly rebuilt. In Liguria the introduction of mechanized looms, which spread progressively towards the coasts (especially to the east of Genoa), was slower than in such united states as England and France, which encouraged the change from artisan to industrialized production. A limited quantity of high-quality silk, especially plain and *ciselé* velvets (*see* ITALY, fig. 97) and damasks, continued to be produced by hand. This situation of objective retardation continued at the expense of the

workers: although highly specialized, they were isolated by working at home and were economically and culturally unable to bring their technical skills and decorative ideas up to date. Even so, the Ligurian weavers won prizes and recognition at exhibitions in Milan (1881), Turin (1884) and Rome (1887). In the 19th century silk production was restricted to a few centres on the coast east of Genoa, which were still active in the late 20th century: Zoagli specialized in velvets, and damasks, lampas and brocades were produced in Lorsica.

BIBLIOGRAPHY

Antiche stoffe genovesi (exh. cat. by G. Morazzoni, Genoa, Teat. Carlo Felice, 1941)

P. Massa: 'L'arte genovese della seta nella normativa del XVe del XVI secolo', *Atti Soc. Ligure Stor. Patria*, x/1 (1970)

——: *Un'impresa serice genovese della primametà del cinquecento* (Milan, 1974)

——: *La 'fabbrica' dei velluti genovesi: Da Genova a Zoagli* (Genoa and Zoagli, 1981)

ELENA PARMA

(ii) Ceramics. Production of ceramics is documented in Genoa from the Middle Ages. A few jugs from that period, decorated with a dark-green lead glaze incised through to an ochre ground, are extant. These utilitarian, domestic vessels were recovered from archaeological excavations. There are numerous documents referring to 15th-century workshops, which produced items decorated with painted or incised motifs, often in blue on a pale ground. At that time there was also a considerable production of *laggioni*, tiles decorated in a Moorish style in imitation of those imported from Valencia in Spain. In 1528 the manufacture of maiolica became important in Genoa. Production was similar to that of potteries in the Marches and Faenza, due in part to Francesco da Pesaro and Francesco da Camerino from Faenza, who founded the first workshop in the city. They produced tableware and vases with light-blue grounds decorated with calligraphy, grotesques, arabesques or chinoiseries. After the death (1580) of Bartolomeo da Pesaro, son of Francesco, the workshop was taken over by his son-in-law Giovan Antonio Cagnola, who continued to produce fairly high-quality wares. During the 17th century other ceramic workshops were established in Genoa, but these never reached the levels attained in the previous century. The Genoese kilns closed shortly after the mid-17th century as wares in gold and silver were preferred. Savona and Albisola then became the most important centres of maiolica production in Liguria.

BIBLIOGRAPHY

F. Marzinot: *Ceramica e ceramisti di Liguria* (Genoa, 1979)

LUCIANA ARBACE

Genoels, Abraham, II (*bapt* Antwerp, 25 May 1640; *d* Antwerp, 10 May 1723). Flemish painter and etcher. His father was Peeter Genoels, not the minor Antwerp painter Abraham Genoels I (*fl* 1628–37). Abraham II was apprenticed to Jacob Backereel (*c.* 1612–after 1658) by the age of 11 but left in 1655 to join Nicolaas Maerten Fierlants (1622–94) of 's Hertogenbosch, who specialized in perspective paintings. In 1659 Genoels went to Paris after a journey through the northern Netherlands. There, with the help of his cousin Laurent Francken (*fl* 1622–63), he became an assistant to the French academician Gilbert de Sève, in whose workshop he painted background landscapes for tapestry cartoons (untraced), including a series of eight tapestries with children playing, commissioned by the Marquis de Louvois. Genoels also worked on a series of paintings for the château of Chantilly for the Princesse de Condé and on a commission from the English ambassador to France (all untraced). De Sève introduced him to Charles Le Brun, who invited him to work at the Gobelins, of which Le Brun was then director. Le Brun also proposed Genoels for membership of the Académie Royale de Peinture, to which he was received (*reçu*) on 4 January 1665. As Le Brun's assistant, Genoels participated in the execution of many royal commissions, for instance the cycle of five paintings depicting the *History of Alexander* (Paris, Louvre), for which he painted the background landscapes in a conventional and academic style with cool and monochromatic colouring. In 1669–70 he was sent by Louis XIV to Marimont (Moselle) to make sketches of the castle, from which he later produced tapestry cartoons.

In 1672 Genoels returned to Antwerp, where he became a master in the Guild of St Luke. For the guild's council-room he painted a large academic work, *Minerva and the Muses in a Landscape* (Antwerp, Kon. Mus. S. Kst.). He also received a major commission from the Conde de Monterrey, the Governor-General of the Netherlands, for a series of tapestry cartoons (1672–4; untraced) to rival those of the King of France. In 1674, together with, among others, Peeter Verbrugghen (ii), Genoels left for Italy, where he became a member of the Schildersbent (the society of northern painters in Rome) and was given the bent-name 'Archimedes' because of his knowledge of perspective. The bulk of his output during his eight years in Rome consisted of working sketches. However, he painted one portrait and two landscapes (all untraced) for Cardinal Jacopo Rospigliosi. Genoels's earliest dated etchings, mostly landscapes animated with a few figures, also stem from his Roman period. According to Houbraken, Genoels had been taught to etch while in France by Girard Audran, who made etchings after Le Brun's *Alexander* cycle. In 1682 Genoels returned to Antwerp via Paris, where he took on numerous pupils and started a free and highly popular course on architectural geometry and perspective drawing.

None of Genoels's major commissions has survived. The few paintings that have been preserved (e.g. in Antwerp, Amsterdam, Brunswick and Montpellier) are classically structured landscapes, often based on works by Nicolas Poussin, though lacking in depth. The figures have a certain academic grace but are rather characterless. His landscape drawings and etchings are generally of better quality. The compositions are more structured and often include Italianate architecture and small, sketchy figures. The drawings show determination and fluency; he often employed loopy strokes for the foliage. Genoels died a rich man.

BIBLIOGRAPHY

Hollstein: *Dut. & Flem.*; Thieme–Becker

A. Houbraken: *De groote schouburgh* (1718–21), ii, pp. 96–105

E. Fetis: *Artistes belges à l'étranger: Etudes biographiques, historiques et critiques*, i (Brussels, 1857), pp. 215–32

A. Michiels: *Histoire de la peinture flamande et hollandaise*, ix (Paris, 1874), pp. 318–26

F. J. Van den Branden: *Geschiedenis van de Antwerpsche schilderschool*
 (Antwerp, 1883)

HANS DEVISSCHER

Genovés, Juan (*b* Valencia, 1930). Spanish painter. He trained at the Escuela de Bellas Artes de San Carlos in Valencia and became associated with avant-garde movements as a young man, joining the short-lived Grupo Parpalló (1956–9), which sought to inject new energy into Valencian art, and the GRUPO HONDO (1961–4). Like other artists who reacted against *Art informel*, he reintroduced figurative images in his pictures, in his case either through the use of collage or by the incorporation of photographic or cinematic motifs (a method suggested by Pop art).

Genovés has been described as a reporter of Spanish reality observed from its blackest and cruellest point of view, a faithful reflector of the social and political situation especially characteristic of the 1960s. His recurring subjects were anonymous, anguished human beings, seen more as forms than as individual people, or crowds rushing towards the unknown in an undefined space. In *The Focus* (oil on canvas, 1966; Stuttgart, Staatsgal.), for instance, a crowd of diminutive running figures is caught in a circle of light, as if viewed through a telescope or telephoto lens from a great distance.

BIBLIOGRAPHY
Genovés (exh. cat., Frankfurt am Main, Kstver.; Berlin, Haus Waldsee; Stuttgart, Württemberg. Kstver.; Recklinghausen, Städt. Ksthalle; 1971–2)
Juan Genovés (exh. cat., Rotterdam, Boymans–van Beuningen, 1972)

ALBERTO VILLAR MOVELLÁN

Genovesino, il. *See* MIRADORI, LUIGI.

Genpei Akasegawa. *See under* HI-RED CENTER.

Genre. Term derived from the French word for 'kind' or 'variety', referring to a type of picture that shows scenes from everyday life. Until the late 18th century the term embraced what were then seen as the minor categories of art, such as landscape, still-life and animal painting (*les genres*); these were to be distinguished from history painting, which took as its subject the noble deeds of man, drawn from famous literary sources. In 1791 Quatremère de Quincy used the word to describe domestic scenes, and by the mid-19th century this usage was fully established (Stechow and Comer). In Classical antiquity genre was considered a lowly form of art, inferior to history painting; Renaissance theorists inherited and elaborated this attitude, and from the Renaissance until the early 19th century art theorists held that history painting was the noblest form of art, to which all great talents should aspire, while genre was seen as the province of inferior artists. It was not until the early 1800s that genre painting challenged the supremacy of history painting and became the dominant form.

1. Ancient Greece and Rome. 2. Medieval and Renaissance, to 1500. 3. The 16th century. 4. The 17th century. 5. The 18th century. 6. The 19th century. 7. The 20th century.

1. ANCIENT GREECE AND ROME. Although Greek artists did not initially represent secular subjects or motifs from everyday life, from the 6th century BC such themes became increasingly popular with vase painters. Many 6th-century BC vases show banquets and dancing, music and love-making. Sport was a popular subject: athletes are shown with their trainers and pairs of wrestlers and boxers confront one another. There are scenes of work from the world of trading and commerce, such as the workshops of bronzesmiths, potters, carpenters and cobblers; scenes of rural activity, such as the Antimenes Painter's *Olive Harvest* (*c.* 520 BC; London, BM) painted on a neck amphora; and scenes of the domestic life of women, among them fountain-house scenes. The Red-figure artists of the 5th century BC developed such motifs more freely and with greater naturalism, portraying more intimate moments from everyday life. The drinking party and varied and highly inventive scenes of sexual activity were popular. Epiktetos introduced new sexual images, while Douris and the Brygos Painter—whose observations are particularly fresh—were among artists most interested in everyday life. In the later 5th century BC more vases, often small perfume and unguent jars, were intended for women, and the domestic life of women became the dominant subject. Many scenes are associated with weddings, but others show washing, dancing or women with their maids. Other scenes from the 5th century BC were inspired by the theatre, especially by comedy, and small terracotta figures of actors in the padded jackets and phalluses of Greek comedy survive from the 5th and 4th centuries BC.

In the Hellenistic period (*c.* 323–27 BC), as art became more realistic and artists became interested in the individual rather than the ideal, genre motifs became more popular, both in monumental sculpture and in the minor arts. Sculptors created vivid and expressive figures of varying moods and ages: surviving examples include old destitutes, a negro, urchins and fishermen, dwarfs and a battered boxer. The most celebrated of such large-scale marble works include the *Old Woman* (New York, Met.), usually believed to be an original Hellenistic work of the late 2nd or early 1st century BC; the *Old Shepherdess* (Roman copy of an original of the late 2nd or early 1st century BC; Rome, Mus. Capitolino); the *Drunken Old Woman* (Roman copy of late 3rd-century BC original; Munich, Glyp.; for illustration *see* GREECE, ANCIENT, fig. 68); and the *Old Fisherman*, traditionally known as the *Dying Seneca* (black marble Roman copy of an original of disputed date; Paris, Louvre). These works raise many difficulties. Their dates are not universally agreed, and it has been suggested that they are Roman, rather than Hellenistic (Ridgway, 1981, p. 234). It is not clear whether they were votive statues (the old women have been described as Dionysian votives by Smith) or private commissions for decorative genre works. Nor is their mood easy to read, though their objective realism may perhaps be associated with the awareness of the harshness of poverty and rustic life that is expressed in Theocritus' 21st Idyll, *The Fishermen*. Smaller sculptures, too, show genre motifs, such as the popular *Boy Removing a Thorn* or *Spinario* (earliest known version, bronze, 3rd century BC; Rome, Mus. Capitolino; *see* STATUE, fig. 2) and the vividly real *Jockey* (late 2nd or early 1st century BC; Athens, N. Archaeol. Mus.). The small Tanagra figures of 325–200 BC (*see* GREECE, ANCIENT, fig. 154), and those from Myrina in Asia Minor of the 2nd and 1st centuries BC (*see*

GREECE, ANCIENT, fig. 156), made of brightly coloured terracotta, show moments in the lives of ordinary men and women with unusual directness and charm.

Painters of genre subjects are documented by Classical writers. Aristotle (*Poetics* ii. 4), for example, mentions a painter named Pauson (*c.* 430–380 BC), who painted low-life scenes. Aristotle connects these low-life scenes with comedy: 'comedy is inclined to imitate persons below the level of our world, tragedy persons above it' (ii, 116–17). Small pictures of boys and garland-sellers by Pausias are mentioned by Pliny (*Natural History* XXXV.124, 125; XXI.4). The late Hellenistic city of Alexandria was perhaps particularly important to the development of genre. The painter Antiphilos worked there, and Pliny (*Natural History* XXXV.114, 138) described two of his pictures: *Boy Blowing a Fire* and *Women Spinning Wool*. These descriptions became important to Renaissance genre (*see* §3 below).

Scenes of hunting and feasting were popular in Etruscan funerary art (*see* ETRUSCAN, fig. 25), and they remained so in the Italic world. In Roman art the wall paintings of Pompeii and Herculaneum exhibit small scenes from family life, scenes in the street and forum, a baker's shop and men playing dice. Gardens were decorated with genre sculptures. Two mosaics (Naples, Mus. Archeol. N.) from Pompeii, signed by one Dioskourides of Samos, are almost certainly copies of Hellenistic works, perhaps from Alexandria. Both show stage scenes, and the *Street Musicians* is exceptionally vivid in its rendering of movement and gesture.

Pliny's descriptions of genre were important to its later development. He used the word *parerga* to describe the pleasing genre motifs with which a painter might embellish his theme. The word was subsequently adopted by Renaissance writers on art. A Greek painter, Peiraikos, of unknown date, was described by Pliny as one who

> won fame with the brush in painting smaller pictures . . . In mastery of his art but few rank above him, yet by his choice of a path he perhaps marred his own success, for he followed a humble line . . . He painted barbers' shops, cobblers' stalls, asses, eatables and similar subjects, earning for himself the name of painter of odds and ends (*rhyparographos*). In these subjects he could give consummate pleasure, selling them for more than other artists recorded for their large pictures.

Pliny's unease with these humble subjects from everyday life—anticipated by Strabo (*c.* 64 BC–AD 21), who described Protogenes as trivializing his art—was to be echoed by classicizing theorists of the Renaissance, yet later artists modelled themselves on Peiraikos, and history painters continued to envy their popularity and wealth.

2. MEDIEVAL AND RENAISSANCE, TO 1500. In the Middle Ages, although all human activity was viewed from within a theological framework, the motifs from everyday life that appear in marginalia and illuminated books, in misericords and stained-glass windows, in ivories and tapestries, often convey a delight in fresh and direct observation. From the 12th century depictions of the Labours of the Months appear in carved capitals, on the portals of many Romanesque and Gothic churches and in manuscript illumination, richly suggesting daily reality. In England the Luttrell Psalter (*c.* 1340; London, BL. Add.

MS. 42130) is illuminated with lively scenes of agricultural life (*see* LANDSCAPE PAINTING, fig. 2). In Siena in the 14th century, fresco painters sometimes included genre-like incidents, as in Pietro Lorenzetti's *Last Supper* (Assisi, S Francesco; lower church), where two servants wash up before a glowing fire and a little dog licks a plate. At the end of the 14th century calendar scenes, above all the *Très Riches Heures* (*c.* 1416; Chantilly, Mus. Condé) painted by the Limbourg brothers for the Duc de Berry, included naturalistic interior and outdoor scenes (for illustration *see* TRÈS RICHES HEURES). Netherlandish panel painters of the early 15th century shared this preoccupation and created, within the context of religious art, both lovingly detailed interiors and enchanting glimpses of the life of the street. Robert Campin's *Virgin and Child in an Interior* (London, N.G.) and Jan van Eyck's *Arnolfini Marriage* (1434; London, N.G.) show a delight in surface and texture and in the effects of light—such as the flicker of flames against the dappled daylight on a white wall or the gleaming highlights on a brass chandelier—that remained a constant theme of later genre painting. Netherlandish art inspired many Italian painters, among them Antonello da Messina, whose *St Jerome in his Study* (*c.* 1460–65; London, N.G.; *see* ANTONELLO DA MESSINA, fig. 1) was the precursor of many 17th-century renderings of scientists, alchemists, geographers and scholars. Genre scenes also decorated Italian castle walls, as at the castle at Issogne (Piedmont), where the courtyard lunettes are frescoed with scenes of shops.

3. THE 16TH CENTURY. In the 16th century the novelty of new secular themes, introduced in the Netherlands and developed in northern Italy, delighted a public perhaps tired of the idealizing grandeur of Italian Renaissance art. The Renaissance viewer sought theoretical justification for such themes through an avid reading of Classical texts, and in northern Europe the humanist scholar Hadrianus Junius likened Pieter Aertsen to Pliny's Peiraikos (see Sterling, p. 37). In Italy, towards the end of the century, theorists associated bawdy yet didactic genre scenes with moralizing comedy, and Giovanni Paolo Lomazzo described a category of pictures that he called 'composizioni ridicole', whose origins he traced back to the 15th-century painter Michelino da Besozzo. Both Jacopo Bassano and El Greco attempted to recreate Antiphilos' painting of a *Boy Blowing a Fire*.

(i) *Northern Europe.* In northern Europe in the early years of the 16th century, artists created a new kind of didactic allegorical genre, which drew on the language of folklore and proverb and had parallels in the terse satire of Sebastian Brant's *Ship of Fools* (1494) and Erasmus's *Praise of Folly* (1515). Folly and credulity, charlatans and quacks were satirized by Hieronymous Bosch, and his tabletop with *Seven Deadly Sins* (Madrid, Prado) illustrates each sin with a vignette from everyday life. Greed and avarice are condemned in Marinus van Reymerswaele's grotesquely ugly bankers and tax collectors, while Quentin Metsys's *Ill-assorted Lovers* (*c.* 1522–3; Washington, DC, N.G.A.), in which a lecherous old man is robbed by a young woman, introduced themes of mercenary love and the contrast between youth and age, beauty and deformity. Such themes

were popularized in the prints of Lucas van Leyden, and Lucas Cranach I's *The Payment* (Stockholm, Nmus.) suggests their appeal in Germany. In Antwerp Jan Sanders van Hemessen created monumental genre scenes with three-quarter-length figures, which satirized licentious living. In the mid-16th century genre themes became less coarse and exaggerated, and in the 1550s Pieter Aertsen, followed in the 1560s by Joachim Beuckelaer, introduced a new kind of low-life genre scene, showing vast kitchens, markets and shops. Often these have tiny religious scenes in the background (e.g. *Christ in the House of Martha and Mary*, 1565; Stockholm, Nmus; for illustration *see* BEUCKELAER, JOACHIM), which perhaps warn against the pleasures of the flesh; these are suggested by the rich exuberance of foregrounds piled high with the glowing produce of market day or with the succulent sausages and calves' heads of well-stocked butchers' shops. Pieter Bruegel I painted the world of the peasants, who, in harmony with the rhythm of the seasons, labour through the months of the year and enjoy the festivities of harvest time (*see* BRUEGEL, (1), fig. 5). His peasants, although heroic in stature, are coarse and clumsy, and early commentators saw their humour; they may have conveyed to Bruegel's learned patrons a condemnation of human folly. Yet Bruegel's vision transcends such moralizing, and with his art peasant genre scenes attained a new comic grandeur.

(ii) Italy. In Italy in the early 16th century there developed a tradition of idyllic genre scenes, influenced by the Arcadian movement in Italian poetry. Giorgione and his school and the painters of the Veneto, Lombardy and Emilia, such as Giovanni Cariani, Niccolò dell'Abate and Giovanni Girolamo Savoldo, painted scenes of lovers in the countryside, concerts and musical parties, singers, lute players and shepherds with their flutes (e.g. Savoldo's *Shepherd with a Flute*, c. 1527; Malibu, CA, Getty Mus.; *see* SAVOLDO, GIOVANNI GIROLAMO, fig. 1). The mood of such works is often melancholy, and music is shown as the pleasure of a highly cultivated society. An aristocratic society also enjoyed the rustic genre of Jacopo and Francesco Bassano, who presented the Georgic beauty of country tasks, both in religious scenes and in allegorical representations of the Seasons.

The later 16th century witnessed the development, in Cremona and Bologna, of a new kind of bawdy genre, related to comedy, of such subjects as card-players, poultry-vendors, butchers and fishmongers. The *Butcher's Shop* (Rome, Pal. Barberini) by Bartolomeo Passarotti is a gross rendering of a Flemish theme, and low-life street scenes, for example Vicenzo Campi's *Fruit Seller* (see fig. 1), are rich in erotic humour. This tradition formed the precedent to Annibale Carracci's *Bean Eater* (1583–4; Rome, Gal. Colonna; *see* CARRACCI, (3), fig. 1) and *Butcher's Shop* (Oxford, Christ Church Pict. Gal.), which, despite their large scale and the sense of serious and direct observation that they convey, retain elements from a comic tradition. The early genre paintings of Caravaggio, painted in Rome in the 1590s, bear a subtle relation to earlier art. They show such scenes as card-sharpers, fortune-tellers, fruitsellers and musical concerts, often with a lyrical grace and

1. Vicenzo Campi: *Fruit Seller*, oil on canvas, 1.45×2.15 m, *c.* 1580 (Milan, Accademia di Belle Arti di Brera)

spontaneity reminiscent of a Giorgionesque tradition, and with allegorical overtones indebted to north Italian renderings of the Seasons or the Five Senses. Although such pictures as the *Card-sharpers* (Fort Worth, TX, Kimbell A. Mus.; see CARAVAGGIO, MICHELANGELO MERISI DA, fig. 2) and the *Fortune-teller* (Paris, Louvre) follow the Flemish genre tradition in their moralizing intent (warning the viewer against trickery and deceit), yet Caravaggio, and also Carracci, looked forward to the greater realism of the 17th century. Carracci endlessly drew and sketched the life around him, and Caravaggio's insistence on painting directly from the model introduced a revolutionary naturalism into genre. His followers popularized his style throughout Europe.

4. THE 17TH CENTURY. The 17th century saw the rise of classical art theory, and it was in this period that the academic opposition to genre painting, which was to remain dominant until the 19th century, was fully elaborated. Yet early 17th-century artists who felt a renewed interest in nature were increasingly attracted to genre, and in this period such theorists as Giovanni Battista Agucchi and Francisco Pacheco (who defended Velázquez's *bodegones*) displayed tolerance towards scenes of real life. In the writings of Giulio Mancini, however, the concept of a hierarchy of genres based on different kinds of subject-matter ('le varie specie della pittura, nate dalla differenza della cosa imitata') was introduced. This hierarchy, in which everyday life held a low position, hardened into a set of rigid rules and received its fullest elaboration in André Félibien's *Conférences de l'Académie royale de peinture et de sculpture pendant l'année 1667* (Paris, 1668). Later, in the *Entretiens* (1688, pp. 487–8), Félibien wrote that genre lacked nobility, and consequently could give only momentary pleasure; for this reason learned connoisseurs had little interest in it. Italian theorists were also hostile; in 1678 Carlo Malvasia, in his *Felsina pittrice*, published a correspondence of 1651 between Francesco Albani and Andrea Sacchi condemning the Bamboccianti, followers of the Dutch genre painter Pieter van Laer. Thus in Italy, France and Spain, all Roman Catholic countries in which an idealizing art lay at the service of Church and State, genre flourished only spasmodically, and it was in the Protestant Netherlands, where pictures were sold by dealers and the patronage of art rested mainly with the bourgeoisie, that a vast number of paintings and drawings recording daily life was produced.

(i) Italy. In the early 17th century the followers of Caravaggio popularized coarser versions of his genre subjects (e.g. card-sharpers, musical concerts and fortune-tellers), a tradition that petered out after the death of Valentin de Boulogne. In the late 1620s and 1630s northern artists, led by Pieter van Laer, introduced new genre subjects from the street life of 17th-century Rome; van Laer was nicknamed Bamboccio (i.e. ugly doll or puppet) on account of his odd physique, and the low-life scenes that he and his followers painted were termed *bambocciate*. The critic Giovanni Battista Passeri wrote that these artists opened a window on to life and painted what they saw; in fact favourite themes—artists sketching, brigands assaulting travellers, limekilns, country dances, charlatans, street vendors—recurred and established specific compositional types, with an emphasis on lively narrative. The world that they depicted was idealized, with peasants happy at work and at leisure. Such reassuring pictures became immensely popular with aristocratic patrons. Salvator Rosa, who aspired to win fame as a history painter, complained bitterly in his satire *La pittura* that what such patrons hated in life pleased them when it was presented in a picture.

Van Laer's most distinguished followers were Michelangelo Cerquozzi and Michiel Sweerts. Sweerts painted Roman street scenes, tavern scenes and young artists drawing (for illustration *see* SWEERTS, MICHIEL) with an unusual gravity and tenderness and in highly personal colour harmonies of violets, greys, light blues and browns. In Naples genre painters recorded a harsher, darker reality: Jusepe de Ribera produced his vigorously human *Boy with a Club–foot* (Paris, Louvre), and Cerquozzi's *Revolt of Masaniello* (Rome, Gal. Spada) presented a dramatic moment from contemporary history as genre.

(ii) France, Spain and Flanders. In France, after the founding of the Académie Royale in 1648 and Louis XIV's patronage of a courtly and magnificent art, painters were rarely interested in naturalistic genre. In the early 17th century, however, there was a realistic strain in French art. Jacques Callot did vivid picaresque etchings of hunchbacks, gypsies and beggars, moving towards a harsher, more intense feeling in his scenes of the horrors of war, *Grandes Misères de la guerre* (Paris, 1633). The peasant paintings of Louis Le Nain, which Félibien described as 'manière peu noble' (1688, p. 61), present their subjects with an unusual gravity and almost sacramental stillness; the compositions are classically ordered, and the restrained greys and grey-greens create a melancholy air. Le Nain's enigmatic works contrast with the more flamboyant scenes of soldiers painted by his brother Mathieu Le Nain, yet they have something in common with Georges de La Tour's highly personal renderings of Caravaggesque themes. De La Tour's genre scenes develop from the picturesque, detailed naturalism of the *Hurdy–gurdy Player* (Nantes, Mus. B.-A.) to the highly poetic *Woman Crushing a Flea* (c. 1645; Nancy, Mus. Hist. Lorrain), where both the candlelight and the austere, almost geometric simplicity of the forms create an emotional intensity that transcends the subject.

In Spain the early pictures of Velázquez of such peasant subjects as an *Old Woman Cooking Eggs* (Edinburgh, N.G.; see BODEGÓN, fig. 1) and *Two Young Men Eating at a Humble Table* (London, Apsley House) introduced a new and influential naturalism into painting in Seville. It seems likely that Velázquez's interest in painting from nature was indebted to Caravaggio, yet his pictures convey a deeply religious feeling that is Spanish, and the characteristic Spanish objects—the glazed water-jug, the pestle and mortar, the fish and eggs with garlic and pimento—are presented with a grave concentration very different from Caravaggio's provocative naturalism. It has been suggested that Valázquez's naturalism has a parallel in the popular low-life subjects of the Spanish picaresque novel. Such pictures, of tavern and kitchen scenes, with prominent still-lifes, were termed *bodegones* in the 17th century, though the word is now used solely of still-life pictures.

In the middle years of the century Bartolomé Esteban Murillo's *Fruit Eaters* (Paris, Louvre) and *Young Beggar* (Paris, Louvre), which present the children of the poor as charming urchins, transformed Velázquez's direct naturalism into a kind of sentimental genre, to which many 18th-century painters, above all Thomas Gainsborough, were to be deeply indebted.

Flemish genre scenes contrast sharply with Spanish restraint. The heirs to Pieter Bruegel I painted panoramic and riotous peasant wedding scenes and kermesses, in which revellers entertained the aristocratic spectator with their coarse antics. Later, Adriaen Brouwer, who worked both in Haarlem and Antwerp, set such revellers in dark and smoky taverns of extreme squalor and created a kind of small-sized genre scene, of brutally realistic peasants smoking tobacco, quarrelling savagely over cards and enjoying drunken musical parties. They were perhaps intended as a warning against the dangers of unbridled behaviour. Yet there is also a more idealizing strain in Flemish genre, in the medium-sized, often bourgeois scenes of Jacob Jordaens (e.g. *As the Old Sing, so the Young Twitter*, 1638; Antwerp, Kon. Mus. S. Kst.) and Rubens (e.g. his heroic *Peasant Dance*, Paris, Louvre). In the later 17th century a more lyrical note entered low-life painting in the sweetly idealized peasant wedding and dancing scenes of David Teniers II (e.g. *Peasant Fair*, 1649; London, Buckingham Pal., Royal Col.; *see* TENIERS, (2), fig. 2) and David Rijckaert III (for illustration *see* RIJCKAERT, DAVID, III).

(iii) The Netherlands. In 17th-century Holland there occurred an unprecedented flowering of genre painting. A vast number of pictures record, in rich detail and with loving naturalism, the social variety of 17th-century Holland. They embrace rowdy barrack rooms, taverns, inns and brothels, and the well-scrubbed pantries, kitchens, luxurious bedrooms and gleaming hallways of the Dutch upper and middle classes. Poverty and work tend to be absent; these pictures are not a mirror of reality. In the early years of the century artists inherited both the allegoric language and didactic aims of 16th-century genre, and they drew on sayings, proverbs and emblem books in pictures that draw attention to the dangers of drinking, tobacco and licentious living. Many pictures show the stupefied trance of the tobacco smoker or the drunken sleep of the idle maidservant. The vanity of worldly pleasure is a common theme, suggested by scattered rose petals or a curl of smoke. There are many bawdy references to sexual lust: men proposition women with coins or gesture obscenely with their pipes; women entice with oysters or with a raised glass of wine and bared breast; doctors examine the urine of young girls who ail from love's sickness. In the second half of the century emblem and symbol are more delicate, and the meanings more ambiguous. Many pictures represent the domestic virtues, such as the sober piety of an old woman eating a simple meal of bread and herrings, or the harmony and beauty of a whitewashed interior filled with daylight. It should be remembered that a painting is not an emblem and does not fulfil the same needs, and in the later genre of Johannes Vermeer and Pieter de Hooch the beauty of light on a tiled floor or on a pottery jug is at the centre of the work.

The pioneers of Dutch genre worked in Haarlem, where in the second decade of the century Frans Hals and Willem Buytewech, and later Dirck Hals, developed the 16th-century theme of the Merry Company, which, as in Buytewech's *Merry Company* (Rotterdam, Mus. Boymans–van Beuningen), pokes fun at the follies of an over-elegant society. Buytewech's followers included Pieter Codde and Willem Duyster, who also painted guardroom scenes, such as Duyster's dramatically lit *Soldiers beside a Fireplace* (Philadelphia, PA, Mus. A.; for illustration *see* DUYSTER, WILLEM). Savagely realistic peasant scenes were introduced by Brouwer, whose follower Adriaen van Ostade moved towards a less threatening, more picturesque conception of low-life painting. Artists in other centres specialized in different kinds of genre. In Utrecht the Dutch followers of Caravaggio, among them Gerrit van Honthorst, Hendrick ter Brugghen and Dirck van Baburen, popularized half-length, single-figure compositions, both of pastoral, arcadian figures and of theatrically clad, merry drinkers and musicians (*see* BRUGGHEN, HENDRICK TER, fig. 2). Gerard Dou was the foremost exponent of the school of LEIDEN 'FINE' PAINTERS, whose works were characterized by exquisite detail and an exceptionally high finish. Dou painted shadowy interiors, often lit through casement windows on the left, and enveloping single figures—housewives, old men, violinists, artists, scholars and scientists—in a meditative atmosphere. His *Village Grocer* (1647; Paris, Louvre; *see* DOU, GERRIT, fig. 1) is typical. His pupil, Frans van Mieris (i), in such works as *Teasing the Dog* (1661; *see* MIERIS, VAN, (1), fig. 2) and *Boy Blowing Bubbles* (1663; both The Hague, Mauritshuis), elaborated a particularly popular composition, the niche piece, in which figures are set within an illusionistic window frame. Gabriel Metsu also worked at Leiden, but he created a richer art, drawing on more varied sources.

In the middle and later years of the century, now known as the classic period of Dutch genre, the often coarse vigour of the early, innovative period yielded to a new elegance and formal sophistication; it was dominated by Gerard ter Borch (ii) and Jan Steen, and by artists of the school of Delft. Ter Borch created a new type of high-life interior, termed 'polite genre', which celebrated the refinement and elegance of fashionable society. He shows richly furnished interiors, where women wash and dress and, clad in ermine and satin, write and receive letters (*see* BORCH, TER, (2), fig. 2), make music and welcome suitors. The emphasis is on the figures and on the delicate and psychologically mysterious relationship between them; traditional subjects, such as the mercenary lover, are revitalized by a subtle and ambiguous treatment. In sharp contrast, a long tradition of low life and comedy reaches a climax in the art of Jan Steen, who used well-established symbols drawn from proverb and folklore, and often underlined by inscribed titles and mottoes, more openly than any other 17th-century painter. The Doctor's Visit (*see* STEEN, JAN, fig. 1) and the Dissolute Household were favourite themes, and both are presented with a dazzling array of lewd jokes and sexual symbols.

In the period between *c.* 1654 and 1670 Delft became the centre of domestic genre painting. The greatest works of Pieter de Hooch and Johannes Vermeer are a celebration of middle-class domesticity. They show the simple tasks

2. Pieter de Hooch: *The Pantry*, oil on canvas, 605×650 mm, *c.* 1658 (Amsterdam, Rijksmuseum)

of women and children—peeling apples, pouring milk from a jug, watching over the baby's cradle—and are distinguished above all by the beauty of the treatment of space and light, which creates a sense of harmony and peace (for examples *see* VERMEER, JOHANNES). De Hooch painted interiors, such as *The Pantry* (*c.* 1658; Amsterdam, Rijksmus.; see fig. 2), in which the figures seem locked into an elaborate abstract pattern of horizontals and verticals, squares and rectangles; open doors lead the eye in and out of space, and there is a taut relationship between surface and depth. In his courtyard scenes (*see* HOOCH, PIETER DE) he also explored perspective effects, and the beauty of the light in his pictures of both interior and exterior space adds a deep emotional weight to the subject. De Hooch created a convincing illusionistic space for genre figures, and this was developed further by Vermeer, whose compositions emphasize the formal relationship between figures and an abstract geometry of chairs, tables, pictures and windows.

5. THE 18TH CENTURY. In the 18th century, although the academic opposition to genre persisted, the demand for small cabinet pictures grew and genre became increasingly popular. In the Netherlands traditional themes persisted, rendered with new charm by Cornelis Troost. The dominant centres, however, were France and England, while Italian artists made spasmodic, often eccentric contributions. In France and Italy the oppressive grandeur of the Baroque yielded to a lighter, more natural art that showed ordinary people and their society, while in England the new patronage of the middle classes and the growth of the print industry led to the founding of a native school of genre painting. With this went the desire, manifest first in the harsh satire of William Hogarth and later in the edifying narratives of Jean-Baptiste Greuze, that art should have a moral aim.

(i) Italy. In Italy, although there was a persistent tradition of low-life scenes in Emilia, Lombardy and the Veneto, genre tended to appear outside the mainstream of official

art and was created by powerful, non-conformist artists, whose aims, although perhaps linked to a desire for social and ethical reform, are hard to classify. The Genoese Alessandro Magnasco introduced strange subjects, torture chambers, synagogues and Quaker meetings, which he presented as macabre fantasies. In Naples and Rome Gaspare Traversi created disconcerting, ironic bourgeois scenes, such as the *Secret Letter* (Naples, Capodimonte), where expressive figures, oddly related to one another in an irrational space, create an ambiguous mood. In northern Italy the soberly realistic and depressing scenes of peasant life by Giacomo Ceruti, which utterly lack the biblical quality of Le Nain, show a sometimes morbid fascination with a sordid array of beggars, cripples and idiots. His best-known picture of this kind is the *Two Wretches* (early 1730s; Brescia, Pin. Civ. Tosio-Martinengo; for illustration *see* CERUTI, GIACOMO).

A more lasting tradition of genre, however, developed in Bologna. It was initiated by Giuseppe Maria Crespi (ii), and it spread to Venice through Crespi's pupils, Pietro Longhi (ii) and Giovanni Battista Piazzetta. Crespi, encouraged to turn to genre by Grand Prince Ferdinand de' Medici, painted low-life scenes, sometimes with wit and vivacity, as in the *Self-portrait with Family* (1708; Florence, Uffizi), sometimes with sympathy for the life of the labourer. Piazzetta's early pictures are close to Crespi, and throughout his career Piazzetta drew and painted half-length genre figures and fanciful heads, which were widely influential. Around 1740 he painted the *Fortune-teller* (Venice, Accad.) and *Country Idyll* (1745; Cologne, Wallraf-Richartz-Mus.; *see* PIAZZETTA, (2), fig. 3) in which large genre figures are evocatively united in mysterious settings, and become 'fantasy, [or] capriccio, on a genre theme' (Levey).

The small pictures of Pietro Longhi (ii) present a more prosaic record of daily life in 18th-century Venice. He painted such subjects as balls, concerts, dancing lessons, social visits and the apothecary's shop, lavishing attention on the minute details of furnishings and décor. His pictures, so bland in their record of tiny incident and trivial gesture, seem to lack either trenchancy or an idealizing charm, and yet to his contemporaries they fulfilled a desire that art should have some relevance to life, and Gasparo Gozzi defended his realism as equalling in perfection the history paintings of Giambattista Tiepolo. There followed Giandomenico Tiepolo's genre frescoes in the guest house of the Villa Valmarana, near Vicenza (for illustration *see* TIEPOLO, (2)): enchanted scenes that present both an Arcadian rustic world, touched with wit and grace, and the sumptuous elegance of aristocratic Venice.

(ii) France. In early 18th-century France the desire for a new informality took the form of a highly sophisticated pastoral yearning for an idyllic rustic life. Small Dutch and Flemish pictures, particularly the lyrical country scenes of David Teniers, became popular with collectors, and the early genre scenes of Antoine Watteau, such as the *Village Bride* (London, Soane Mus.), which became a frequent subject throughout the century, reveal Watteau's roots in a Flemish tradition. Watteau also created many genre scenes inspired by the theatre and plays and established a category known as the *fête galante*, indebted to the pastoral

tradition of 16th-century Venice and showing lovers strolling, making music or picnicking in a parkland setting. In other works, such as *La Toilette* (*c.* 1720; London, Wallace), Watteau created a kind of erotic genre scene. François Boucher and Jean-Honoré Fragonard were indebted to this work, and Fragonard later painted such titillating genre scenes as *Useless Resistance* (*c.* 1775; Stockholm, Nmus.). In his late works Watteau attained a new realism, and his *L'Enseigne de Gersaint* (1721; Berlin, Schloss Charlottenburg; *see* DRESS, fig. 43), which shows Flemish pictures on the walls and a portrait of Louis XIV being lowered into a packing case, seems to symbolize the end of 17th-century grandeur. Watteau's followers Jean-Baptiste Pater and Nicolas Lancret continued to popularize his themes throughout the 1730s.

This aristocratic genre contrasts sharply with the lower middle-class domestic interiors of Jean-Siméon Chardin, which have their roots in 17th-century Dutch art. Chardin's early genre scenes, such as *The Washerwoman* (1733; Stockholm, Nmus.), often show servants busy on domestic tasks, presented with simple dignity; later, as in the *Morning Toilet* (1741; Stockholm, Nmus.), he painted bourgeois scenes with a hint of anecdote. A traditional language of emblem and symbol, used with delicacy and gravity, adds subtle overtones to Chardin's genre: he painted a boy building a house of cards (*see* CHARDIN, JEAN-SIMÉON, fig. 3), a young man blowing bubbles through a straw, a child with a spinning top—all motifs that suggest the transience of childhood.

In the second half of the century genre painters responded to the cult of *sensibilité*, which laid new emphasis on feeling, and whose devotees demanded that a work of art should elicit a passionate response. In 1761 Jean-Jacques Rousseau published *La Nouvelle Héloïse*, the essential literary expression of *sensibilité*, and Greuze exhibited the *Marriage Contract* (Paris, Louvre; *see* GREUZE, JEAN-BAPTISTE, fig. 2) at the Salon. Here he exhibited the language of the heart where it may seem purest, in the idealized simplicity of family life in a humble rustic home, where all generations gather together. Diderot hailed his art as a new kind of genre, 'la peinture morale', yet Greuze was dissatisfied with the lowly status of genre and in 1769 tried, unsuccessfully, to enter the Académie Royale as a history painter. He was an immensely influential artist and in the 1770s and 1780s had many followers. Among them was Louis-Léopold Boilly, whose early works especially were indebted to Greuze. Boilly was also influenced by 17th-century Dutch genre painting (he owned a collection of works by Metsu and ter Borch), and after 1800 he turned to depicting scenes of popular and street life, providing a chronicle that was often spiced with humour. He also painted historical scenes but was interested more in their human aspect than in any glorification of events or of leaders.

(iii) England. In 18th-century England the academic theory of the hierarchy of the genres remained powerful. British painters aspired to the Grand Manner of Italian art, and Joshua Reynolds's *Discourses on Art* (London, 1778) are a plea for the supremacy of history painting; he liked and collected Dutch genre yet wrote that such artists

3. Francis Wheatley: *Evening*, oil on canvas, 445×545 mm, 1799 (Newhaven, CT, Yale Center for British Art); from the series *Four Times of the Day*

sought distinction from 'some inferior dexterity, some extraordinary mechanical power'.

Yet in the first half of the century the connoisseurs' unthinking admiration for Italian history paintings was boldly challenged by Hogarth. Hogarth wished to elevate genre to the moral seriousness of history painting, and he lamented that 'painters and writers never mention, in the historical way, any intermediate species of subject between the sublime and the grotesque'. His picture narratives of the 1730s, the *Harlot's Progress*, the *Rake's Progress* (London, Soane Mus.) and *Marriage à la Mode* (London, N.G.; *see* HOGARTH, WILLIAM, fig. 4), are an attempt to claim this space between the sublime and the grotesque and to make genre the vehicle of harsh satire. Henry Fielding described him as a 'comic history painter', and Hogarth himself used the phrase 'modern moral subjects'. Hogarth's satiric method is richly varied. He drew on the theatre for his stage-like settings and for a dramatic language of gesture and expression; he titillated the voyeur with scenes of debauchery and spicy topical references to notorious criminals and magistrates of the day; his pictures are intricately crowded with symbols, emblems, inscriptions, names and labels; his satire is aimed not only at vice

but also at the foibles of contemporary society—manners, fashion, taste and furnishings. His pictorial narratives, such as the *Four Times of the Day* (1736) and the didactic series of prints *Industry and Idleness* (1747), were much imitated later in the century. In the 1730s and 1740s the other notable genre achievement was Francis Hayman's decoration of the pavilions of Vauxhall Gardens, where he introduced new motifs from London life, such as the *Milkmaid's Garland*, in a style that softened English realism with a touch of French grace.

In the second half of the century the asperity of Hogarth yielded to a gentler, sweeter style, often influenced by Greuze, and inspired by the aesthetics of *sensibilité*. A society uncomfortably aware of the sufferings of the rural poor and of the afflictions brought about by the agricultural revolution sought reassurance in depictions of an idealized pastoral life. Oliver Goldsmith's *The Deserted Village* (1770), in which the poet laments that 'the rural Virtues leave the land', presents this life as threatened, and a sweet nostalgia hangs over the genre scenes of James Northcote, Francis Wheatley, George Morland and Edward Penny. Wheatley's series the *Four Times of the Day* (Newhaven, CT, Yale Cent. Brit. A.) portrays a happy rural community

and *Evening* (see fig. 3), with a housewife effortlessly churning butter and a yeoman returning to decorously welcoming children in a well-scrubbed kitchen, is characteristic of this moment. His similarly sanitized engravings of *Cries of London* (1793–7; for illustration *see* WHEATLEY, FRANCIS) have enjoyed lasting popularity. At the end of the century genre became increasingly moralizing and didactic; it reflected the moral standards of a middle-class audience, which demanded that the lower classes, as in Morland's the *Comforts of Industry* (1790; Edinburgh, N.G.), should practise thrift and hard work, while the middle classes, as in the same artist's *Benevolent Sportsman* (exh. 1792; Cambridge, Fitzwilliam; for illustration *see* MORLAND, (2)) or in William Redmore Bigg's the *Benevolent Heir* (1797; New Haven, CT, Yale Cent. Brit. A.), display humanitarian charity.

The term 'fancy picture' was widely used in the 18th century and described a kind of sentimental genre of domestic, rural scenes. It was introduced by Philip Mercier at the end of the 1730s, developed in his *Oyster Girl* (*c.* 1745–50; priv. col.; see Johnson, fig. 69) and found its fullest expression in Thomas Gainsborough's pictures of the 1780s, which show pastoral scenes with life-size figures, often children—as in *Cottage Girl with Dog and Pitcher* (1785; Dublin, N.G.; for illustration *see* FANCY PICTURE)—steeped in elegiac sentiment and reminiscent of Murillo.

6. THE 19TH CENTURY. The 19th century saw a widespread reaction against the Grand Manner, and the boundaries between history painting and genre became increasingly blurred. Throughout Europe there was a demand for an art that should have contemporary relevance and that should embrace the life of the common man. Genre became the dominant mode of expression, with new themes expressing the aspirations of an era of often violent political upheaval. Industrialization threatened traditional ways of life, and many picturesque genre scenes recorded, with sociological fervour, the vanishing rituals and quaint customs of regional life. The figure of the peasant—folkloric, pious or threatening—recurs throughout 19th-century art, epitomizing a pure, unchanging existence, remote from the flux and corruption of city life. A graver art, which laid claim to the forms and grandeur of history painting, was created by French Realist artists, who presented both the dignity of the rural labourer and the suffering of the urban worker—of the laundress, the weaver, the ragpicker. Yet artists in Victorian England and Germanic Europe, remote from French political strife, rejected grand gestures and, in response to an increasingly middle-class patronage, created small-scale, intimate scenes of domestic life; in America, too, genre painters rendered the everyday with quiet naturalism. Impressionism, with its optimistic portrayal of modern urban life, offered an alternative vision in the 1870s, but at the end of the century, throughout Europe, artists created an increasingly powerful record, often with biblical overtones, of both rural and urban suffering.

(i) 1800–60. In France in the second quarter of the 19th century, many Realist artists, such as François Bonvin and Théodule Ribot, painted intimate, often charming, genre scenes deeply indebted to Dutch 17th-century art and to Chardin. Yet after 1848, the year of revolutions, genre themes attained a universality and power that transcended an interest in the everyday. Jean-François Millet, Jules Breton and Gustave Courbet challenged the traditional hierarchies by presenting genre themes on the scale and with the seriousness formerly reserved for history painting; Breton wrote, 'we associated ourselves with the passions and feelings of the humble, and art was to do them the honour formerly reserved exclusively for the gods' (see Nochlin, p. 113). Millet's monumental peasants, such as *The Winnower* (1848; Paris, Louvre) and *The Sower* (1850; Boston, MA, Mus. F.A.; *see also* MILLET, JEAN-FRANÇOIS, fig. 3), suggest both the harshness and the biblical virtue of a time-hallowed and primitive way of life; the sheer scale of Courbet's epic Realist pictures *The Stonebreakers* (1849; ex-Gemäldegal. Neue Meister, Dresden) and the *Peasants of Flagey Returning from the Fair* (1850, revised 1855; Besançon, Mus. B.-A. & Archéol.; see fig. 4) claimed a new and weighty significance for such themes. So popular were peasant scenes that after 1850 the term *paysanniste* became widespread. Conservative writers and artists feared the corruption and squalor of city life, and urban scenes were less popular. Yet they attracted graphic artists, and Honoré Daumier created a new genre of urban subject; he satirized the bourgeoisie, while his compassionate images of the oppressed and fugitive, of clowns, laundresses and sad travellers in railway carriages symbolized the condition of modern man.

A sharply contrasting type of genre was created between 1815 and 1848 in the countries of Germanic Europe, where the BIEDERMEIER artists painted small, lyrical works that suggest the tranquillity of the domestic realm; they include Peter Fendi's tearful *Poor Officer's Widow* (Vienna, Belvedere), Georg Friedrich Kersting's *At the Mirror* (1827; Kiel, Christian-Albrechts U.), a haunting study of a figure alone before an open window, and the works of Christen Købke, which create from simple, everyday scenes an intensely romantic poetry. American genre, which was popular in the 30 years before the Civil War, also concentrated on the commonplace; William Sidney Mount's pictures, such as *Bargaining for a Horse* (1835; New York, NY Hist. Soc.; for illustration *see* MOUNT, WILLIAM SIDNEY), quietly convey the abundance of agricultural America, the domain of the Yankee farmer, while Charles Deas idealized such romantic westerners as the trapper and the frontiersman. The pictures of George Caleb Bingham, such as the *Jolly Flatboatmen* (1846; priv. col., on loan to Washington, DC, N.G.A.; for illustration *see* BINGHAM, GEORGE CALEB), are lyrical, classically constructed works that domesticate their subjects.

English genre was more varied, embracing both reassuring and cosy works and those that deal with the moral dilemmas of modern life. Genre was established as the dominant vein by Sir David Wilkie, who, inspired by 17th-century Dutch and Flemish artists and in response to an increasingly middle-class patronage, created panoramic scenes of village fairs and festivals (e.g. the *Penny Wedding*, 1817–19; Brit. Royal Col.; *see* WILKIE, DAVID, fig. 1) and smaller pictures that place greater emphasis on psychological relationships. In these years the tone of genre was optimistic. The popular pastimes of country life had a

4. Gustave Courbet: *Peasants of Flagey Returning from the Fair*, oil on canvas, 2.06×2.75 m, 1850, revised 1855 (Besançon, Musée des Beaux-Arts et d'Archéologie)

reassuring quaintness, and many painters celebrated the sanctity of family life and the innocence of childhood. At the same time the Victorian social scene, in all its variety and self-confident and ebullient materialism, proud of such advances as the railway, was recorded in the panoramic scenes of William Powell Frith, such as *Ramsgate Sands: 'Life at the Seaside'* (1852–3; London, Buckingham Pal., Royal Col.; for illustration *see* FRITH, WILLIAM POWELL). The sheer scale of Frith's pictures and their apparently casual compositions challenged the authority of history painting.

In the 1850s, however, many painters, led by the Pre-Raphaelites, reacted against the triviality of contemporary genre, against that 'softening influence of the fine arts which makes other people's hardships picturesque' (George Eliot). These artists elevated genre, creating works that confronted social injustice and reflected the humanitarian concerns of such contemporary novelists as Charles Dickens and Elizabeth Gaskell. Many treated the sufferings of women, often depicted as melancholy, waiting and isolated, in passionate scenes of love in adversity, such as Arthur Hughes's the *Long Engagement* (1854–9; Birmingham, Mus. & A.G.), and in many farewell scenes. The fallen woman was a frequent subject, most celebrated in William Holman Hunt's the *Awakening Conscience*

(1853; London, Tate). Such Victorian pictures, where compassion is touched with fascinated horror, and the theme enriched with heavy biblical and literary symbolism, contrast sharply with French treatments of the *demi-mondaine*, such as Edouard Manet's *Olympia* (1863; Paris, Mus. d'Orsay). Proletarian themes include Ford Madox Brown's allegorical *Work* (1852–65; Manchester, C.A.G.; *see* BROWN, FORD MADOX, fig. 1) and Henry Wallis's *The Stonebreaker* (1857; Birmingham, Mus. & A.G.), where the heavy symbolism of the autumnal sky contrasts with Courbet's objectivity.

(ii) 1860–1900. In 1863 Charles Baudelaire's *Le Peintre de la vie moderne*, a programme for young contemporary artists, championed the fugitive beauty of modern Paris as the proper subject of art. French Impressionist painters of the late 1860s and 1870s, freed from the biblical symbolism of early Realism, celebrated this urban scene; they painted the crowded boulevards and the railway stations, the world of the theatre, café and brothel, and the holiday atmosphere of the seaside resort and racetrack. Of the Impressionists, Manet and Edgar Degas were most deeply committed to the naturalistic description of contemporary life. Degas's art, in its precise observation of social types and milieu, reflects the concerns of such

naturalist novelists and critics as Emile Zola and Duranty: he painted the milliner, the prostitute, the jockey, the dancer and the laundress, and he recorded the banks, offices and theatres that formed the background to modern life (*see* DEGAS, EDGAR, figs 2–4). In this period the peasant claimed less attention, although Camille Pissarro painted the busy market-places of small rural towns. Impressionism found followers in other countries, where often the genre element became more pronounced, as in James Tissot's scenes of fashionable Victorian life, for example the *Ball on Shipboard* (exh. 1874; London, Tate; for illustraion *see* TISSOT, JAMES), and William Merrit Chase's domestic scenes. The bourgeois interior remained a genre theme throughout the century, austerely Dutch when painted by James McNeill Whistler, richly patterned in the art of the Nabis and a setting for drama in that of Sir William Quiller Orchardson.

The darker side of modern life was not neglected in the 1870s, and artists influenced by the naturalist aesthetic, such as Jean-François Raffaëlli, attempted a methodical study of the poor and unemployed who inhabited the new urban wastelands. In England a group of artists associated with the *Graphic*, a socially conscious weekly—of whom the most prominent were Luke Fildes, Hubert von Herkomer and Frank Holl (ii)—created illustrations that reveal the bitterness of urban poverty. Their paintings of the 1870s and 1880s are dark and sombre works that document such themes in great detail, yet with passion, as in Fildes's *Applicants for Admission to a Casual Ward* (1874; for illustraion *see* FILDES, LUKE) and Holl's *Newgate: Committed for Trial* (1878; both Egham, U. London, Royal Holloway & Bedford New Coll.). In the 1880s a reaction against Impressionism led many artists to search for a more abstract and spiritual art, and the peasant again became a romantic figure, whose way of life seemed hallowed by tradition and who represented purity and innocence. Many artists sought such themes in regions remote from the city, and Paul Cézanne's Provençal peasants, Paul Gauguin's scenes of rural life in Brittany and the works of many artists who frequented artists' colonies, such as that at SKAGEN in Denmark and at Newlyn (*see* NEWLYN SCHOOL) in Cornwall, where they recorded the harsh lives of the fishermen, are part of this impulse. Working-class subjects were presented with increasing social commitment, as in Vincent van Gogh's painting and drawings series (1883–5) of weavers, and Théophile-Alexandre Steinlen's studies of laundresses. Perhaps particularly in Belgium, such themes were characterized by a new ambition and by an almost biblical grandeur. Constantin Meunier, Léon Fréderic and Eugène Laermans created dark, heavily painted and serious scenes, of the peasant, the urban worker, the miner, the fugitive and the immigrant (e.g. Meunier's *Return of the Miners*, 1905; Brussels, Mus. Meunier; for illustration *see* MEUNIER, CONSTANTIN). Their works are harsh, and the frequent use of the religious format of the triptych underlines the universality to which they aspire.

7. THE 20TH CENTURY. By the 20th century the distinction between history painting and genre, which had been central to European art from 1500 to 1900, was no longer relevant. Yet the echoes of traditional aesthetic

debates perhaps lingered on in the tension between abstract and figurative art, and painters drawn to describe everyday life have tended to react against the subjectivity or high seriousness of certain forms of abstraction. Realism often flourished away from the main centres of modernism and was associated either with nationalism or with a desire to convey a uniquely 20th-century drabness and gloom. Twentieth-century genre tends to be conservative in style, and only occasionally, as with Fernand Léger's heroic genre paintings of proletarian subjects, of cyclists, musicians and construction workers, have artists applied to genre an artistic vocabulary derived from a 20th-century artistic movement.

In the early 20th century a group of American painters, the Eight (i), who later developed into the Ashcan school, began to paint commonplace scenes of urban life, such as John Sloan's *Hairdresser's Window* (1907; Hartford, CT, Wadsworth Atheneum; for illustration *see* ASHCAN SCHOOL) and George Bellows's *Stag at Sharky's* (1909; Cleveland, OH, Mus. A.). In England in the same period, the CAMDEN TOWN GROUP recorded working-class life in suburban London, sometimes lyrically, sometimes, as in Walter Sickert's *L'Ennui* (1914; London, Tate), suggesting stifling dullness. A developing nationalism encouraged an interest in native genre in America in the 1930s and 1940s, when painters such as Charles Burchfield and Edward Hopper recorded small-town America, where 'dullness is made God' (Sinclair Lewis), and the anonymity of modern urban life, a waste of offices, cinemas, diners and petrol stations. Regionalist painters present a more optimistic celebration of Midwestern life, as in the country idylls of Thomas Hart Benton, the colourful folk scenes of John Steuart Curry, such as *Baptism in Kansas* (1928; New York, Whitney), and Grant Wood's iconic and satirical *American Gothic* (1930; Chicago, IL, A. Inst.).

The Pop art of the 1950s and 1960s has also been seen as a product of national values and as 'a magnified form of genre painting' (Wilmerding, p. 222). Yet perhaps Pop and, later, Photorealism are more concerned with creating icons of mass media culture; only rarely do they describe the feel of everyday life, as in some of Tom Wesselman's *Great American Nudes* or David Hockney's pictures of young boys swimming in Californian pools. In sharp contrast, British painters of the 1950s known as the KITCHEN SINK SCHOOL painted, in heavy colours and textures, the drabbest moments of modern life. In the following years movements and subjects proliferated, yet the distinction between the celebratory and the drab remains.

BIBLIOGRAPHY

GENERAL

EWA [with bibliog.]

F. Kugler: *Handbuch der Geschichte der Malerei* (Berlin, 1837), ii, p. 187

E. Fromentin: *The Masters of Past Time* (1875; Eng. trans., London, 1948)

E. Dacier: *La Gravure de genre et de moeurs* (Paris and Brussels, 1925)

S. Sitwell: *Narrative Pictures: A Survey of English Genre and its Painters* (London, 1937)

M. J. Friedländer: *Landscape, Portrait, Still-life: Their Origin and Development* (Oxford, 1949)

A. Hauser: *The Social History of Art* (New York, 1951)

C. Sterling: *La Nature morte de l'antiquité à nos jours* (Paris and New York, 1952)

D. Millar: *Street Criers and Itinerant Tradesmen in European Prints* (Stanford, CA, U. A.G. & Mus., 1970) [with bibliog.]

F. Abbate: 'Generi artistici', *Enciclopedia Feltrinelli Fisher Arte*, i/1 (Milan, 1971), pp. 184–227

W. Stechow and C. Comer: 'The History of the Term Genre', *Allen Mem. A. Mus. Bull.*, xxxiii/2 (1975–6), pp. 89–94

H. Langdon: *Everyday Life Painting* (New York, 1979)

H. J. Raupp: *Bauernsatiren* (Lukassen, 1986) [with long bibliog. on peasant subjects from *c.* 1470 to 1570 in Flemish and German art]

ANCIENT GREECE AND ROME

J. Boardman: *Athenian Black-figure Vases* (London, 1974)

N. Himmelmann: *Über Hirtengenre in der Antiken Kunst* (Tübingen, 1980)

B. S. Ridgway: *Fifth-century Styles in Greek Sculpture* (Princeton, 1981)

H. Guiraud: 'Bergers et paysans dans la Glyptique Romain', *Pallas*, xxix (1982), pp. 39–56

H. P. Laubscher: *Fischer und Landleute: Studien zur hellenistischen Genreplastik* (Mainz, 1982)

N. Himmelmann: *Alexandria und der Realismus in der griechischen Kunst* (Tübingen, 1983)

J. J. Pollitt: *Art in the Hellenistic Age* (Cambridge, 1986)

J. Boardman: *Athenian Red-figure Vases: The Classical Period* (London, 1989)

B. S. Ridgway: *Hellenistic Sculpture* (Wisconsin, 1990)

R. Smith: *Hellenistic Sculpture* (London, 1991)

MEDIEVAL AND RENAISSANCE

R. van Marle: *Iconographie de l'art profane au moyen âge et à la renaissance* (The Hague, 1931)

J. C. Webster: *The Labors of the Months* (Chicago, 1938)

C. Gilbert: 'On Subject and Non-subject in Renaissance Pictures', *A. Bull.* (1952), pp. 202–16

S. Epperlein: *Der Bauer im Bild des Mittelalters* (Berlin, 1975)

W. Hansen: *Kalenderminiaturen der Stundenbücher mittelalterliches Leben im Jahreslauf* (Munich, 1984)

THE 16TH CENTURY

G. Lomazzo: *Scritti sulle arti* (Milan, 1584–90); ed. R. P. Ciardi, 2 vols (Florence, 1974), ii, p. 315, ch. xxxiii

H. Junius: *Batavia* (Antwerp, 1588)

L. Baldass: 'Some Remarks on Francesco Bassano and his Historical Function', *A. Q.* [Detroit], xii (1949), pp. 199–219

R. Genaille: 'La Peinture de genre aux anciens Pays Bas au XVI siècle', *Gaz. B.-A.*, xxxix (1952), pp. 243–52

A. Petrucci: *Il Caravaggio acquafortista e il mondo calcografico romano* (Rome, 1956)

R. Wittkower: *L'arcadia e il giorgionismo in umanismo europeo e umanismo veneziano* (Florence, 1963), pp. 473–84

Stampe popolari venete del '500 (exh. cat. by A. Omodeo, Florence, Uffizi, 1965)

B. W. Meijer: 'Esempi del comico figurativo nel rinascimento lombardo', *A. Lombarda*, xvi (1971), pp. 259–66

B. Wind: 'Genre as Season: Dosso, Campi, Caravaggio', *A. Lombarda*, n.s., 42/43 (1975), pp. 70–73

——: 'Annibale Carracci's Scherzo: The Christ Church *Butcher Shop*', *A. Bull.*, lviii (1976), pp. 93–6

K. P. F. Moxey: *Pieter Aertsen, Joachim Beuckelaer and the Rise of Secular Painting in the Context of the Reformation* (New York and London, 1977)

B. Wind: 'Vincenzo Campi and Hans Fugger: A Peep at Late Cinquecento Bawdy Humour', *A. Lombarda*, n.s., 47/48 (1977), pp. 108–14

I Campi e la cultura artistica cremonese del cinquecento (exh. cat., Cremona, Mus. Civ. Ala Ponzone, 1985)

M. N. Sokolov: *Bytovye obrazy v zapadnoevropeiskoj zhivopisi XV–XVII vekov: Realnost i simvolika* [Genre images in European painting of the 15th to 17th centuries: reality and symbolism] (Moscow, 1994)

THE 17TH CENTURY

K. van Mander: *Schilder-boeck* ([1603]–1604])

G. Mancini: *Considerazioni sulla pittura* (MS. *c.* 1621), ed. A. Marucchi and L. Salerno, 2 vols (Rome, 1956)

V. Carducho: *Diálogos de la pintura: Su difesa, origen, esencia, definición, modos y diferencias* (Madrid, 1633); ed. F. Calvo Serraller (Madrid, 1979) [incl. attack on the naturalism of Caravaggio]

F. Pacheco: *Arte* (1649); ed. F. Sánchez Cantón (1956) [bk III, ch. viii on *bodegones*]

S. van Hoogstraten: *Inleyding tot de hooge schoole der schilderkonst, anders de zichtbaere werelt* [Introduction to the academy of painting, or the visible world] (Rotterdam, 1678/*R* Soest, 1969; Ann Arbor, 1980)

C. C. Malvasia: *Felsina pittrice* (1678); ed. G. Zanotti (1841), ii, p. 268

G. B. Passeri: *Vite* (1679); ed. J. Hess (1934)

A. Félibien: *Noms des peintures les plus célèbres et les plus connus, anciens et modernes* (Paris, 1688)

G. A. Cesareo: *Poesie e lettera di Salvator Rosa* (Naples, 1892) [contains Rosa's satire *La pittura*]

Les Peintres de la réalité en France au XVIIe siècle (exh. cat., Paris, Mus. Orangerie, 1934)

M. Liebmann: 'I pittori della realtà in Italia nei secoli XVII–XVIII', *Acta Hist. A. Acad. Sci. Hung.* (1969), pp. 257–79

Les Frères Nain (exh. cat., ed. J. Thuillier; Paris, Grand Pal., 1978–9)

S. Alpers: *The Art of Describing: Dutch Art in the 17th Century* (Chicago, 1983)

G. Briganti, L. Trezzani and L. Laureati: *I Bamboccianti: The Painters of Everyday Life in 17th-century Rome* (Rome, 1983)

M. F. Duranti: *The Child in 17th-century Dutch Painting* (Ann Arbor, 1983)

Masters of 17th-century Dutch Genre Painting (exh. cat. by P. C. Sutton and others, Philadelphia, PA, Mus. A.; Berlin, Gemäldegal.; London, RA; 1984) [with full bibliog.]

S. Schama: *The Embarrassment of Riches* (London, 1987)

I Bamboccianti: Niederländische Malerrebellen im Rom des Barock (exh. cat., Cologne, Wallraf-Richartz-Mus.; Utrecht, Cent. Mus.; 1991)

THE 18TH CENTURY

G. de Lairesse: *Het groot schilderboeck* (Haarlem, 1740/*R* Soest, 1969)

G. Gozzi: *La gazzetta veneta* (Venice, 13 Aug 1760); ed. B. Romani (Venice, 1943), ii, p. 41 [Gozzi on Longhi]

——: *L'osservatore veneto* (14 Feb 1761); quoted in V. Moschini: *Pietro Longhi* (1956), pp. 62–3

A. Quatremère de Quincy: *Considérations sur les arts du dessin en France* (Paris, 1791)

D. Diderot: *Essais sur la peinture* (1795); in *Oeuvres esthètiques*, ed. P. Vernière (Paris, 1959)

M. Levey: *Painting in 18th-century Venice* (London, 1959)

Edward Bird (exh. cat. by S. Robinson, Wolverhampton, A.G.; London, Geffrye Mus.; 1982)

J. Barrell: *The Dark Side of the Landscape: The Rural Poor in English Painting* (Cambridge, 1983)

N. Bryson: *Word and Image: French Painting of the Ancien Régime* (Cambridge, 1986)

E. D. H. Johnson: *Paintings of the British Social Scene from Hogarth to Sickert* (New York, 1986)

Giuseppe Maria Crespi and the Emergence of Genre Painting in Italy (exh. cat. by J. T. Spike, Fort Worth, TX, Kimbell A. Mus., 1988) [with bibliog.]

THE 19TH CENTURY AND AFTER

C. Baudelaire: *The Painter of Modern Life* (Paris, 1863; trans. and ed. J. Mayne, London, 1964)

E. Fromentin: *Les Maîtres d'autrefois* (Paris, 1876; Eng. trans., Boston, 1882; London, 1913)

L. Goodrich: *Art in New England: New England Genre* (Cambridge, 1935)

G. Reynolds: *Painters of the Victorian Scene* (London, 1953)

F. Laufer: *Das Interieur in der europäischen Malerei des 19. Jahrhunderts* (Zurich, 1960)

The Victorian Vision of Italy (exh. cat., Leicester, Mus. & A.G., 1968)

H. Beck: *Victorian Engravings* (London, 1973)

H. W. Williams: *Mirror to the American Past: A Survey of American Genre Painting, 1750–1900* (Greenwich, CN, 1973)

P. Hills: *The Painter's America: Rural and Urban Life, 1810–1910* (New York, 1974)

Painting of the American Frontier (exh. cat. by P. Hills, New York, Whitney, 1974)

J. Wilmerding: *American Art*, Pelican Hist. A. (Harmondsworth, 1976)

J. Gear: *Masters or Servants?* (London and New York, 1977)

The Cranbrook Colony (exh. cat. by A. Greg, Wolverhampton, A.G., 1977)

Derby Day (exh. cat. by L. Lambourne and P. Connor, London, RA, 1979)

L. Lambourne: *Victorian Genre Painting* (London, 1982)

The Substance of the Shadow: Images of Victorian Womanhood (exh. cat. by S. P. Casteras, New Haven, CT, Yale Cent. Brit. A., 1982)

Danish Painting: The Golden Age (exh. cat. by K. Monrad, London, N.G., 1984)

The Pre-Raphaelites (exh. cat., ed. L. Parris; London, Tate, 1984)

M. Jacobs: *The Good and Simple Life* (Oxford, 1985)

The New Painting: Impressionism, 1874–1886 (exh. cat., ed. C. Moffett; San Francisco, CA, Mus. A.; Washington, DC, N.G.A.; 1986)

G. Norman: *Biedermeier Painting, 1815–48* (London, 1987)

American Frontier Life: Genre Paintings and Prints, 1830–61 (exh. cat., Fort Worth, TX, Amon Carter Mus., 1987)

R. L. Herbert: *Impressionism: Art, Leisure and Parisian Society* (New Haven and London, 1988) [with excellent bibliog. on the Impressionists as painters of Parisian genre]

J. Halsby: *Venice: The Artist's Vision* (London, 1990)

E. Johns: *American Genre Painting: The Politics of Everyday Life* (New Haven and London, 1991)

L. Nochlin: *The Politics of Vision* (London, 1991)

HELEN LANGDON

Gensfleisch zur Laden, Johann. *See* GUTENBERG, JOHANN.

Genshirō. *See* KANŌ, (13).

Genthe, Arnold (*b* Berlin, 8 Jan 1869; *d* New Milford, CT, 9 Aug 1942). American photographer of German birth. He studied philology at the universities of Berlin and Jena from 1888 to 1894 and spent a year at the Sorbonne in Paris. In 1896 he emigrated to the USA and opened a portrait studio in San Francisco in 1897. He first achieved wide publicity with his photographs of the earthquake of 1906. He won further acclaim with the publication of *Pictures of Old Chinatown*, a series of photographs taken with the aid of a concealed camera. He also photographed in Japan.

In 1911 Genthe moved to New York, where he established a studio on Fifth Avenue and worked as a freelance photographer for numerous magazines and newspapers, specializing in dance and theatre portraits, such as *Isadora Duncan: 24 Studies*. His later reputation was founded on his portraits of famous personalities. Among his subjects were Greta Garbo and prominent statesmen such as Fridtjof Nansen and Theodore Roosevelt. In his best works faces emerge mysteriously from the darkness, emphasizing atmosphere at the expense of detail. His autobiography *As I Remember* contains an impressive selection of his photographs.

WRITINGS
As I Remember (New York, 1936)

PHOTOGRAPHIC PUBLICATONS
Pictures of Old Chinatown (New York, 1908); also as *Genthe's Photographs of San Francisco's Old Chinatown*, text by John Kuo Wei Tchen (New York, 1984)

Isadora Duncan: 24 Studies (New York, 1929)

BIBLIOGRAPHY
Contemp. Phots

Arnold Genthe, 1869–1942 (exh. cat., New York, Staten Island Inst. A. & Sci., 1975)

Documenta 6, ii (exh. cat. by K. Honnef and E. Weiss, Kassel, Mus. Fridericianum, 1977), pp. 70–71

REINHOLD MISSELBECK

Gentile. *See* PRIMO, LUIGI.

Gentile (di Niccolò di Massio) da Fabriano (*b* Fabriano, *c.* 1385; *d* Rome, before 14 Oct 1427). Italian painter and draughtsman. He was the most important Italian representative of the elaborate Late Gothic style of painting that dominated European painting around 1400. He was a consummate master of naturalistic rendering, narrative invention and detail, and ornamental refinement. He introduced a new relationship between painting and nature through the depiction of three-dimensional space and the representation of natural lighting. This relationship, established at the same time but in much more radical form by Masaccio, was central to the art of the Renaissance.

1. Life and autograph work. 2. Attributions. 3. Working methods and technique. 4. Influence, critical reception and posthumous reputation.

1. LIFE AND AUTOGRAPH WORK.

(i) Fabriano, Venice and Brescia, c. 1385–1420. Fabriano, the artist's birthplace, in the Marches, is roughly halfway between Perugia and Ancona. Although his grandfather, father and uncle served there as officials of various civic and religious organizations, Gentile's early life and apprenticeship are not documented. The first record of him is a payment of 27 July 1408 for a panel (untraced) that Gentile was to paint for Francesco Amadi in Venice. Before his departure for Venice the artist painted a *Virgin and Child* (Perugia, G.N. Umbria) for S Domenico at Perugia, and a *Virgin and Child with SS Nicholas, Catherine of Alexandria and a Donor* (Berlin, Gemäldegal.) for S Niccolò, Fabriano (see fig. 1). Stylistically, both panels are dependent on Lombard illuminated miniatures and on a group of works, datable *c.* 1405 to *c.* 1410, by the itinerant Venetian painter Zanino di Pietro, and may be dated between *c.* 1406 and 1408, the year in which Gentile arrived in Venice.

There he was inscribed in the Scuola di S Cristoforo dei Mercanti, and, according to 16th- and 17th-century guidebooks to Venice, he painted panels for the churches of S Felice, S Giuliano and S Sofia. In 1409 and 1411 the Maggior Consiglio voted funds to repair a cycle of narrative

1. Gentile da Fabriano: *Virgin and Child with SS Nicholas, Catherine of Alexandria and a Donor*, tempera on panel, 1.31×1.13 m, *c.* 1406–8 (Berlin, Gemäldegalerie)

frescoes in the Sala del Maggior Consiglio in the Doge's Palace, begun 1366–7 by Guariento, which depicted the struggle between Pope Alexander III and the Emperor Frederick Barbarossa at Venice and the role of Doge Sebastiano Ziani in securing a papal victory. According to Bartolommeo Fazio, Gentile executed the scene of the naval battle between the Venetians and Barbarossa. Francesco Sansovino reported that Gentile's reputation was such that for this work he was paid the extravagant fee of a ducat a day and that he dressed in open sleeves like a nobleman.

In Venice, Gentile met the Lombard painter and illuminator Michelino da Besozzo, who was there in 1410, and was influenced by his refined, languorous, rhythmically sophisticated style. They probably collaborated, with Pisanello and Jacobello, on the decoration of the Sala del Maggior Consiglio (frescoes destr. 1557). The most important work from Gentile's five years in Venice is the Valle Romita Altarpiece, a polyptych with the *Coronation of the Virgin* (see fig. 2) flanked by *SS Jerome, Francis, Mary Magdalene* and *Dominic* and scenes from the lives of the saints (Milan, Brera). In the sophistication of its colouring, the attention to naturalistic detail and the fluid curvilinear shapes of the design, it is Gentile's first masterpiece. It was probably commissioned by Chiavello Chiavelli (*d* 1412), Lord of Fabriano, who in 1405 bought and rebuilt the monastery of S Maria di Valdisasso, near Fabriano, and who, while in the service of the Venetian Republic, may have contracted Gentile to paint the altarpiece for the new church. Because of the stylistic dependence of the work on Michelino da Besozzo, it is unlikely that it was executed before 1410. Other autograph works from this period are a badly damaged *Virgin and Child* (New York, Met.), a heavily repainted *Virgin and Child* (Ferrara, Pin. N.) and two small panels of *St Peter* and *St Paul* (Florence, I Tatti).

In May 1413 Pandolfo Malatesta, Lord of Fano, Bergamo and Brescia and commander of Venetian forces, was awarded Venetian citizenship and a house on the Grand Canal in recognition of his victory over a Hungarian army led by the Florentine condottiere Pippo Spano. Later that year Pandolfo must have appointed Gentile his court artist, for by January 1414 Gentile had moved to Brescia, where for the next five years he worked on the fresco decoration of the chapel of the Broletto, or court house, of which fragments have recently been recovered (*see* Analli). In *De laudibus Brixiae oratio* (1458) Umbertino Posculo recorded that one of its scenes showed St George slaying the dragon. Gentile's lost composition is perhaps reflected in a painting of *St George and the Dragon* by a Brescian artist (*c.* 1450–75; Brescia, Pin. Civ. Tosi-Martinengo) and may have had as its model a relief (Cesena, Bib. Malatestiana) carved by a Venetian sculptor for Andrea Malatesta (*d* 1416). In November 1418 Gentile painted a panel for Pandolfo as a gift for Pope Martin V, then in Mantua, but who had passed through Brescia in October on his way from his election at the Council of Constance to Rome. On 18 September 1419 Gentile requested a letter of safe conduct for eight people and eight horses in order to join the Pope (who resided in Florence from 26 February 1419 until 9 September 1420) and left Brescia on 22 September.

2. Gentile da Fabriano: *Coronation of the Virgin*, tempera on panel, 1.78×0.79 m, *c.* 1410 (Milan, Accademia di Belle Arti di Brera)

(ii) Florence and Siena, 1420–27. In March and April 1420 Gentile petitioned for exemption from taxes and debts in Fabriano and declared that he wished to live, work and die on his native soil. But between 6 August and 24 October of that year he paid the equivalent of a year's rent for a house in Florence, which suggests that he had settled there before his visit to Fabriano. It was during this visit that he probably received the commission for a double-sided processional standard with the *Coronation of the Virgin* (Malibu, CA, Getty Mus.) on one side and the *Stigmatization of St Francis* (Italy, priv. col., see Christiansen, 1982, colour pl. B) on the other. The two images are very different in conception. The *Coronation of the Virgin* and a roughly contemporary *Virgin and Child* (Washington, DC, N.G.A.) reveal a move away from the gothicizing delicacy of Gentile's earlier work towards the solidity of

form and rich surface tooling of 14th-century Florentine painting. The *Stigmatization of St Francis* shows a much more important development, not only in Gentile's style but also in early 15th-century painting, in the interpretation of the divine light emanating in golden rays from the vision of the crucifix as natural light by which the scene is illuminated.

Gentile's first signed work is an altarpiece of the *Adoration of the Magi* (the Strozzi Altarpiece; Florence, Uffizi; see fig. 3). Its main panel is one of the grandest

pictures of the early 15th century and had a more lasting influence on Italian Renaissance painting than any other work of its time. It was completed in May 1423 and had been commissioned for the sacristy of Santa Trinita by Palla Strozzi, who had built the sacristy as a private chapel for the Strozzi family after the death of his father Onofrio in 1418. The artist's growing mastery of naturalistic illumination and the three-dimensional construction of figures are accompanied, especially in the predella panels of the *Nativity*, the *Flight into Egypt* (both Florence,

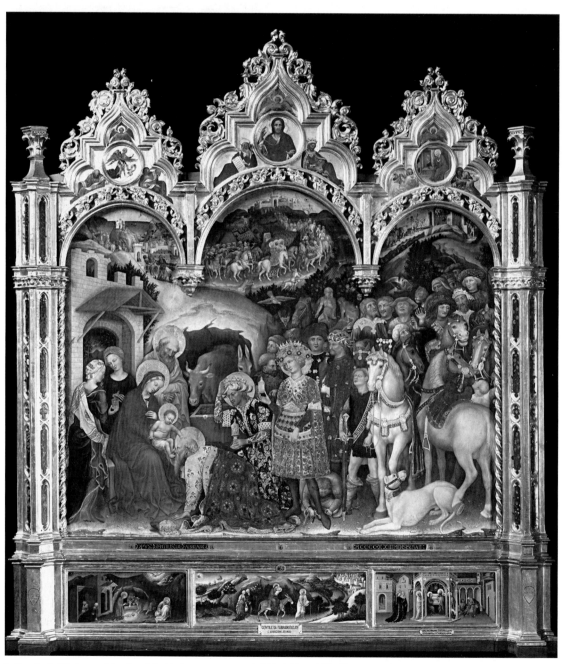

3. Gentile da Fabriano: *Adoration of the Magi*, tempera on panel, 3.00×2.83 m, 1423 (Florence, Galleria degli Uffizi)

Uffizi) and the *Presentation in the Temple* (Paris, Louvre), by perspectival coherence and the suggestion of atmosphere in the rendering of pictorial space. For these accomplishments Gentile was indebted to Donatello's innovations in relief sculpture which he was the first artist to translate into painting.

The main panel of the Strozzi Altarpiece is divided into a crowded foreground, in which the three Magi adoring the child on the left and their retinue of grooms and horses on the right are seen from close up, and a background with three scenes from the journey of the Magi, seen from far away, under the three arches of the frame. By virtue of the consistency of illumination and tonality throughout the composition, the viewer has the illusion of continuous space. The source of illumination in both background and foreground is the star that leads the Magi to their destination. In the left arch they see it in a golden sky above the sea; in the central arch, wider and higher than the arches at the sides, they ride with their retinue through fields and hedges, loosely described in an ebbing light with delicately applied shadows, to the castellated town of Jerusalem; and on the right they are about to enter the gate of Bethlehem. In the foreground the star has come to rest above the Holy Family, where it serves as one of the light sources for the array of figures, horses and other animals. The figure style has little in common with the rhythmic contours, smooth, hard surfaces and bright, clear colours of contemporary Florentine painting. Shapes are conceived not as silhouettes but as bodies or masses in space and light, with loosely rendered and sensitively differentiated surfaces and muted colours. The figures, especially those of the Magi, are lit up by stamped and richly tooled patterns of gold leaf.

Gentile's novel conception of design, light, colour and space is even more clearly in evidence in the predella. In the *Nativity* three sources of light—the moon for the sky, the angel above the hills for the shepherds and the Christ Child for the foreground—are interwoven to form the first convincingly realistic night scene in Renaissance art. In the *Flight into Egypt* gilding on the ground and on the side of the hills behind the figures registers the light of the rising sun, represented as a rounded gilt disk, while the more neutral lighting of the fields and the walled town evoke the cool of morning where the sun has not yet reached.

The *Adoration of the Magi* may also have a humanist meaning. One of the inheritances of the Renaissance from the Middle Ages was the belief that chivalry had been founded in Classical antiquity. The depiction in the *Adoration of the Magi* of a resplendent world of chivalry brought to life for the Renaissance imagination a vision of the ideal world of antiquity that it so passionately sought to recapture.

Gentile's influence on his contemporaries, particularly on Masolino da Panicale, and the number of commissions he now received suggest that in 1423 he was the leading painter of Florence. A small *Virgin and Child* (Pisa, Mus. N. S Matteo) and an altarpiece of the *Virgin and Child with SS Julian and Lawrence* (New York, Frick), important for the consistency in the illumination of the figures, probably date from that year. Perhaps dating from a year later are a fragment of a *Virgin and Child* (Florence, I

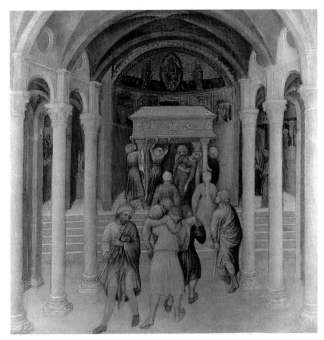

4. Gentile da Fabriano: *Pilgrims at the Tomb of St Nicholas*, tempera on panel, 350×360 mm, 1425 (Washington, DC, National Gallery of Art)

Tatti) and a signed *Virgin and Child* (New Haven, CT, Yale U. A.G.) in which the figures, set against a foliated background (a motif introduced by Gentile into Florentine painting) and surrounded by a window frame, are seen from below.

In May 1425 Gentile completed a polyptych (now dispersed) commissioned by the Quaratesi family for the high altar of S Niccolò sopr'Arno that consisted of a *Virgin and Child with Angels* (London, Hampton Court, Royal Col., on loan to London, N.G.), *SS Mary Magdalene, Nicholas, John the Baptist and George* (Florence, Uffizi) and five predella panels (four in Rome, Vatican, Pin., one in Washington, DC, N.G.A.; see fig. 4). Vasari considered this altarpiece to be the best work by Gentile that he had seen, and it served as a model for Fra Angelico and Domenico Veneziano as well as Bicci di Lorenzo and other minor masters. Its central panel is Gentile's masterpiece in subtlety of lighting, tonal balance and the depiction of three-dimensional form through the control of values of light and dark.

From 22 June to September 1425 Gentile rented a house in Siena and painted a polyptych with the *Virgin and Child with SS John the Baptist, Peter, Paul and Christopher* (destr., last recorded in the 18th century) for the guild of notaries; this was placed beneath a baldacchino on the outside of the guild's palazzo in the Piazza del Campo. Its influence on Sienese painting can be gauged by the naturalism, spatial arrangement of narrative compositions and rich surface texture that appear in the works of Giovanni di Paolo and Sassetta after 1426. Gentile interrupted his work in Siena in order to paint a fresco of the *Virgin and Child* in the south aisle of Orvieto Cathedral, arriving in Orvieto on 25 August 1425. Since

its restoration and the removal of drastic overpainting, the 'Maestà', as it was called, has emerged as one of his most monumental designs and, technically and colouristically, one of his most delicate works (Christiansen, 1989). The Sienese chronicler Sigismondo Tizio recorded in the *Historiarum Senensium* (Siena, Bib. Com. Intronati) that Gentile returned from Orvieto to Siena to finish the polyptych for the notaries' guild.

(iii) Rome, 1427. On completion of the work in Siena, Gentile went to Rome, where from 28 January 1427 he received payments for the fresco decoration of S Giovanni in Laterano, the first major pictorial cycle commissioned by Pope Martin V after his return to the city in 1420. The last payment is dated 2 August 1427, and on 14 October Gentile is referred to as having died. The frescoes were completed by Pisanello and were destroyed in the 17th century. According to Fazio, Gentile began, but did not finish, one scene from the *Life of St John the Baptist*, and painted five tabernacles with grisaille figures of Old Testament prophets in niches between the windows of the clerestory. A drawing of the fresco cycle before 1647 by a follower of Borromini (Berlin, Kstbib. & Mus.) shows the tabernacle with the prophet Jeremiah. Christiansen (1982) has associated a fresco fragment, tentatively identified as a *Head of David* (Rome, Vatican, Mus. Pio-Crist.), with the prophets at S Giovanni in Laterano. This association is questionable, however, because the head is not in grisaille but coloured. Fazio also refers to a panel by Gentile in S Giovanni in Laterano of Martin V and ten cardinals, and Vasari reports that Gentile painted a *Virgin and Child with SS Benedict and Joseph* above the tomb of Cardinal Adimari in S Francesca Romana. A *Virgin and Child* (Velletri, Mus. Capitolare) from SS Cosma e Damiano in Rome and a small, heavily repainted *Stoning of St Stephen* (Vienna, Ksthist. Mus.), which shows Gentile's adventurous compositional skills in the crescent-shaped spatial arrangement of the figures, date from his last two years.

2. ATTRIBUTIONS. There are grounds for the attribution to Gentile of a group of drawings after Roman sarcophagi and other reliefs (Florence, Uffizi, 3S; Milan, Bib. Ambrosiana, 214F, fols. 13r and 15r; Oxford, Ashmolean, 41v; Paris, Ecole N. Sup. B.-A., 2342; Paris, Louvre, 2397v; Rotterdam, Mus. Boymans–van Beuningen, I.523) that were originally part of a sketchbook begun in Gentile's workshop in Rome and continued after his death in the studio of Pisanello. They are stylistically consistent with the posing and rendering of figures in the predellas of the *Adoration of the Magi* and the Quaratesi Altarpiece, and their importance as the first preserved series of systematic studies of the Antique is a reflection of Gentile's interest in Classical art. Testimony for this is his employment of antique prototypes ranging from Roman sarcophagi to reliefs on the Arch of Constantine in the *Adoration of the Magi* and the Quaratesi Altarpiece.

According to the present writer, among paintings attributed to Gentile on the grounds of quality and style, a *Virgin and Child with Angels* (Athens, N.G.) is by Zanino di Pietro; a *St Michael* (Boston, MA, Mus. F.A.) is by the Marchigian painter Pellegrino (di Giovanni) di Antonio (d

1437); a dossal with five panels commissioned by Bernardo Quaratesi for S Niccolò sopr'Arno (on dep. Florence, Pitti) is the work of Francesco d'Antonio; a *Nativity* (Malibu, CA, Getty Mus.) was designed and painted by an assistant in Gentile's workshop during the last few years of his stay in Florence; and a watercolour on parchment of a *Maiden* (Paris, Louvre, 20693) is by an anonymous Lombard artist c. 1400. Two drawings in pen and ink on parchment associated with Gentile—one with a *Seated Woman* on the recto and *St Paul* on the verso (Berlin, Kupferstichkab., Kd.Z.5164), the other with *Two Apostles* on the recto and a drapery study on the verso (Edinburgh, N.G., D.2259)—share stylistic characteristics with figures in the Valle Romita Altarpiece, but it is an open question whether they are by Gentile, by followers, or are copies after him.

3. WORKING METHODS AND TECHNIQUE. Gentile's works reveal a sharp and sensitive eye, but they also show that, in conformity with contemporary artistic practice, he worked not directly from nature, but rather from studies from nature in model-books such as the drawings after the Antique in his own Roman sketchbook. The dog in the right foreground of the *Adoration of the Magi*, for example, has been traced to a Tuscan model-book of c. 1400 (Paris, Louvre, Inv.759–760, fol. 6r). The frontally foreshortened crouching figure removing the spurs from the left foot of the standing Magus reverts to a 14th-century model-book. The identical motif was employed in the figure of the prostrate Holofernes in a fresco from S Andrea in Ferrara, the *Triumph of St Augustine* (Ferrara, Pin. N.) by an Emilian painter of the second half of the 14th century. Gentile's panel paintings and his one surviving fresco display both mastery and delight in the employment of colours and materials described in the early 15th-century painting manual *Il libro dell'arte* by Cennino Cennini.

4. INFLUENCE, CRITICAL RECEPTION AND POSTHUMOUS REPUTATION. During the two decades of Gentile's career his style underwent astonishing and far-reaching changes. In his early works the study of nature was subordinated to, and served as an embellishment for, the medieval conception of art as timeless and symbolic. The exploration of space and of light and shade in his mature paintings reflects the Renaissance notion, first formulated by Alberti in *De pictura* (1435), that painting represents its objects as they are seen in nature. From the late 15th century until the mid-20th Masaccio alone was credited with the introduction of space and of light and shade into Renaissance painting, while Gentile was perceived as the consummate master of the Late Gothic style. Although the view of Gentile as a progressive artist is no longer contested, his relationship to Masaccio remains controversial, largely because of unresolved problems in the chronology of Masaccio's works. Two painters whom Gentile demonstrably influenced were Jacopo Bellini, who was one of his apprentices at the time of the *Adoration of the Magi*, and Domenico Veneziano, who was probably a member of his workshop in Florence as well as in Rome.

Bartolommeo Fazio elevated Gentile above all Italian painters of his time, not only because of his virtuosity but

also because the ornate, naturalistically descriptive style of paintings such as the *Adoration of the Magi* was the pictorial style preferred by humanists. It was also what they admired most in the art of antiquity. The earliest and clearest articulation of this humanist taste is found in the writings of the Greek-born Manuel Chrysoloras (1350–1415), who came to Florence in 1397 at the invitation of Palla Strozzi. He was also his patron's teacher, and Palla's choice of Gentile for the altarpiece of his family chapel was one of the fruits of that teaching.

At the end of the 16th century Francesco Bocchi wrote in his guidebook to Florence, *Le bellezze della città di Firenze* (1591), that Gentile's *Adoration* 'is held in reverence like a work of antiquity and because it proceeds from the first painter in whom was born the wonderful style which is today in flower'. The association of the *Adoration of the Magi* with the Renaissance revival of antiquity challenges the view first articulated by Alberti that identifies the founding of this revival with Brunelleschi, Donatello, Ghiberti, Masaccio and Luca della Robbia. It also raises the question of the relationship between these artists' approach to the Antique and that of Gentile. Another challenge to traditional views in Bocchi's text is his perception of a connection between Gentile's style and the *maniera* style of his own time.

BIBLIOGRAPHY

SOURCES

B. Fazio: *De viris illustribus* (1456) in M. Baxandall: 'Bartholomaeus Facius on painting', *J. Warb. & Court. Inst.* xxvii (1964), pp. 90–107 (100–101)

G. Vasari: *Vite* (1550, rev. 2/1568); ed. G. Milanesi (1878–85), iii, pp. 5–33

F. Sansovino: *Venetia, città nobilissima et singolare* (Venice, 1581)

A. Venturi: *Gentile da Fabriano e il Pisanello* (Florence, 1896), pp. 1–19

R. Sassi: 'La famiglia di Gentile da Fabriano', *Rass. March.*, ii (1923), pp. 21–8

——: 'Altri appunti su la famiglia de Gentile da Fabriano', *Rass. March.*, vi (1928), pp. 259–67

D. Davisson: 'New Documents on Gentile da Fabriano's Residence in Florence, 1420–1422', *Burl. Mag.*, cxxii (1980), pp. 759–63

MONOGRAPHS

A. Colasanti: *Gentile da Fabriano* (Bergamo, 1909)

B. Molajoli: *Gentile da Fabriano* (Fabriano, 1927)

L. Grassi: *Tutta la pittura di Gentile da Fabriano* (Milan, 1953)

L. Bellosi: *Gentile da Fabriano*, Collezione Silvana (Milan, 1966)

E. Micheletti: *L'opera completa di Gentile da Fabriano*, Class. A. (Milan, 1976)

K. Christiansen: *Gentile da Fabriano* (Ithaca, 1982) [includes source material]; review by H. Wohl in *A. Bull.*, lxvi (1984), pp. 522–7

SPECIALIST STUDIES

A. Ricci: *Elogio del pittore Gentile da Fabriano* (Macerata, 1829)

H. Horne: 'The Quaratesi Altarpiece by Gentile da Fabriano', *Burl. Mag.*, vi (1904–5), pp. 470–74

A. Colasanti: 'Un quadro inedito di Gentile da Fabriano', *Boll. A.*, i (1907), pp. 19–20

L. Venturi: 'Un quadro di Gentile da Fabriano a Velletri', *Boll. A.*, vii (1913), pp. 73–5

R. Sassi: 'Arte a storia fra le rovine d'un antico tempio francescano', *Rass. March.*, v (1927), pp. 331–51

R. Longhi: 'Me pinxit: Un S Michele Arcangelo di Gentile da Fabriano', *Pinacotheca*, i (1928), pp. 71–5

R. Sassi: 'Gentile nella vita fabrianese del suo tempo', *Gentile da Fabriano: Boll. Mens. Celeb. Centen.*, vi (1928), pp. 7–13, 33–8

B. Molajoli: 'Bibliografia di Gentile da Fabriano', *Boll. Reale Ist. Archaeol. & Stor. A.*, iii (1929), pp. 102–7

A. L. Mayer: 'Zum Problem Gentile da Fabriano', *Pantheon*, xi (1933), pp. 41–6

E. Lavignino: 'Un affresco di Gentile da Fabriano a Roma', *A. Figurativa*, i (1940), pp. 40–48

W. Suida: 'Two Unpublished Paintings by Gentile da Fabriano', *A. Q.* [Detroit], iii (1940), pp. 348–52

L. Grassi: 'Considerazioni intorno al polittico Quaratesi', *Paragone*, 15 (1951), pp. 23–30

E. Micheletti: 'Qualche induzione sugli affreschi di Gentile da Fabriano a Venezia', *Riv. A.*, xxviii (1953), pp. 115–20

C. Sterling: 'Un Tableau inédit de Gentile da Fabriano', *Paragone*, 101 (1958), pp. 26–33

C. Volpe: 'Due frammenti di Gentile da Fabriano', *Paragone*, 101 (1958), pp. 53–5

B. Degenhart and A. Schmitt: 'Gentile da Fabriano in Rom und die Anfänge des Antikenstudiums', *Münchn. Jb. Bild. Kst*, xi (1960), pp. 59–151

C. Huter: *The Veneto and the Art of Gentile da Fabriano* (diss., U. London, 1966)

B. Davidson: 'Gentile da Fabriano's *Madonna and Child with Saints*', *ARTnews*, lxviii (1969), pp. 24–7, 57–60

C. Huter: 'Gentile da Fabriano and the Madonna of Humility', *A. Ven.*, xxiv (1970), pp. 26–34

B. Davidson: 'Tradition and Innovation: Gentile da Fabriano and Hans Memling', *Apollo*, xciii (1971), pp. 378–85

F. Rossi: 'Ipotesi per Gentile da Fabriano a Brescia', *Not. Pal. Albani*, ii/1 (1973), pp. 11–22

C. Brandi: 'A Gentile da Fabriano at Athens', *Burl. Mag.*, cxx (1978), pp. 385–6

K. Christiansen: 'The *Coronation of the Virgin* by Gentile da Fabriano', *Getty Mus. J.*, 6–7 (1978–9), pp. 1–12

R. Panczenko: 'Gentile da Fabriano and Classical Antiquity', *A. & Hist.*, ii (1980), pp. 9–27

L. Analli: 'Ricognizione sulla presenza bresciana di Gentile da Fabriano dal 1414 al 1419', *A. Lombarda*, 76/77 (1986), pp. 31–54

K. Christiansen: 'Revising the Renaissance: "Il Gentile Disvelato"', *Burl. Mag.*, cxxxi (1989), pp. 539–41

L. Riccetti: '"Dolci per Gentile": New Documents for Gentile da Fabriano's *Maestà* at Orvieto', *Burl. Mag.*, cxxxi (1989), pp. 541–2

GENERAL WORKS

EWA; Thieme–Becker

G. Poggi: *La cappella e la tomba di Onofrio Strozzi nella chiesa di Santa Trinita (1419–1423)* (Florence, 1903)

R. van Marle: *Italian Schools* (1923–38), viii, pp. 1–53

H. Siebenhüner: *Über den Kolorismus der Frührenaissance* (Schramberg, 1935), pp. 45–50

R. Longhi: 'Fatti di Masolino e di Masaccio', *Crit. A.*, (1940), pp. 189–91

B. Degenhart and A. Schmitt: *Süd- und Mittelitalien*, 4 vols (1969–), i of *Corpus der italienischen Handzeichnungen, 1300–1450* (Berlin, 1969–), i/2, pp. 334–45, 639–44

F. Hartt: *History of Italian Renaissance Art* (Englewood Cliffs, 1969, rev. 2/1979), pp. 188–92

D. Davisson: 'The Iconology of the S Trinita Sacristy, 1418–35: A Study of the Private and Public Functions of Religious Art in the Early Quattrocento', *A. Bull.*, lvii (1975), pp. 315–35

H. Wohl: *The Paintings of Domenico Veneziano, ca. 1410–1461: A Study in Florentine Art of the Early Renaissance* (New York, 1980), pp. 7–9

——: 'The Revival of the Arts in Rome under Martin V', *Rome in the Renaissance* (Binghamton, 1983), pp. 171–83

HELLMUT WOHL

Gentile (Partino) da Montefiore (*b* Montefiore dell'Aso, nr Ascoli Piceno, *c.* 1240–50; *d* Lucca, 27 Oct 1312). Italian cardinal and patron. A Franciscan, he graduated in theology from Paris University by *c.* 1295 and in 1296 was made *lector* at the Papal Curia. The earliest evidence of Gentile's lavish patronage is found in his account book (Vatican, Archv Segreto, 313 A), which records payments for embroidery and enamels and (22 Sept 1306) for work by the Sienese goldsmith, Toro. From 1307 Gentile was papal legate in Hungary. One of his earliest important commissions is the funerary monument (1310) to his parents, in S Francesco, Montefiore dell'Aso. It is unique for being both a double tomb (unknown in Italy before

this date) and a secular one, directly emulating papal tomb designs.

Gentile arrived at Assisi in 1312, and the principal works associated with him are found in two chapels in the Lower Church, S Francesco. Only one document can be related to his patronage there: a transaction in his account book, dated 30 March 1312 (fol. 100*r*), records his donation to S Francesco of the considerable sum of 1070 gold florins, 600 of which were was to be employed for a chapel. The general consensus is that this was for the S Martino Chapel, which was decorated with a narrative fresco cycle of the *Life of St Martin* by Simone Martini and is one of the most lavish private chapels of the period (*see* ASSISI, §II, 2(vi) and fig. 6; and MARTINI, SIMONE, fig. 1). The frescoes are thought to have been begun after Gentile's death, and it is not known if the artist was chosen by the Cardinal or by the executors of his will. It does seem, however, that the subject was selected by Gentile, as St Martin was not only a Hungarian by birth and a patron saint of France but also the patron saint of Gentile's church in Rome. Gentile's portrait appears in the central stained-glass window, which is inscribed GE[N]TILIS CARDINAL[IS], and he is also shown kneeling before St Martin, in a fresco above the entrance arch inside the chapel. The patron and saint are on the same scale, an exceptional image in Italian art of this period. Angels bearing shields with the Montefiore arms appear at the top of the three stained-glass windows. All that remains of his patronage of the S Ludovico Chapel, situated opposite, is his portrait in the stained-glass window, showing him kneeling before St Anthony of Padua. Beneath is the inscription D[OMINUS] GENTILI[S], together with his coat of arms. An inventory of 1338 lists fine illuminated manuscripts, crucifixes, altar frontals and liturgical vestments (all unidentified), donated by the Cardinal to S Francesco. Gentile died in Lucca while on a mission to transfer the papal treasure from Assisi to Avignon. He was buried in the S Ludovico Chapel at S Francesco, Assisi.

BIBLIOGRAPHY

R. Ritzler: 'I cardinali e i papi dei frati minori conventuali', *Misc. Francesc.*, lxxi (1971), pp. 18–20
J. Gardner: 'A Double Tomb in Montefiore dell'Aso and Cardinal Gentile', *Acta Hist. A. Acad. Sci. Hung.*, xxv (1979), pp. 15–25
A. S. Hoch: 'A New Document for Simone Martini's Chapel of St Martin at Assisi', *Gesta*, xxiv (1985), pp. 141–6

□

Gentileschi. Italian family of painters. Both (1) Orazio Gentileschi and his daughter (2) Artemesia Gentileschi were highly individual Caravaggesque painters, whose works spread knowledge of Caravaggio's style in Italy and northern Europe. Orazio's eldest son, Francesco Gentileschi (*b* Rome, 31 May 1597; *d* after 1665), was a painter and art dealer who, in the 1620s and 1630s, is recorded as assisting Orazio and Artemesia; none of his paintings survives.

(1) Orazio Gentileschi (*b* Pisa, 1563; *d* London, 7 Feb 1639). Although he was eight years older than Caravaggio, he is nevertheless regarded as a Caravaggesque artist, so deeply was his mature style affected by his knowledge of the younger painter's art. His response to

Caravaggio was intensely poetic, and none of Caravaggio's many gifted followers produced more beautiful pictures.

1. Rome: Early training and public commissions, *c.* 1576–1600. 2. Rome: The impact of Caravaggio, 1600–20. 3. Genoa, Paris and London, 1623–39.

1. ROME: EARLY TRAINING AND PUBLIC COMMISSIONS, *c.* 1576–1600. Gentileschi was the son of a Florentine goldsmith, Giovanni Battista di Bartolomeo Lomi (*d* 1581). He was proud of his father's Florentine origins and must have visited Florence before moving to Rome *c.* 1576–8; throughout his career his work shows his awareness of the clarity and restraint of Florentine painters such as Santi di Tito. In 1593 he was paid for the design of medals for the feast of St Peter, and it is probable that he began his career intending to follow his father's profession and turned to painting in his twenties. Such a change of career would explain why he did not find his characteristic style until he was in his late 30s; his earliest works are executed in a tight, dry manner that gives little indication of the distinction he achieved. A lack of conventional training, especially in the usual methods of preparing multi-figure subjects with composition and detailed figure and drapery studies, would explain a certain stiffness to his poses and figure groups that remains characteristic of his work throughout his career. He may simply have chosen to emulate Caravaggio, who composed his pictures directly on to the canvas. No convincing attributions of drawings have yet been made either to Caravaggio or to Orazio, or to Artemesia, whom he trained.

In 1596 Gentileschi painted a large altarpiece, the *Conversion of Saul*, for S Paolo fuori le Mura, Rome (destr.; the design is recorded in a print of 1610 by Jacques Callot). Several of his earliest commissions were collaborative, decorative projects, where his style had to conform to that of the group, so much so that it is almost impossible to detect his contribution to the painted decoration in the Biblioteca Sistina in the Vatican (*c.* 1588–9) and in the series of Apostles in the transept of S Giovanni in Laterano (*c.* 1600). Only in the altarpieces of the *Triumph of St Ursula* and the *Martyrdoms of SS Peter and Paul* and in the frescoes in the Abbey of S Maria at Farfa (1597–9) do we begin to see the typically smooth contours and surfaces, the sharp-edged but shallow drapery folds and familiar profile faces that are found in his work throughout his career.

2. ROME: THE IMPACT OF CARAVAGGIO, 1600–20. By 1605 Gentileschi had begun to absorb the lessons of Caravaggio's powerful realism. The few traits of Mannerism visible in his first public commissions were eliminated, and instead there are passages that reveal intense observation from life of details such as hands, feet and faces. Gentileschi knew Caravaggio, and in 1603 he was sued for libel with Caravaggio and others by Giovanni Baglione. We know from the libel suit that Orazio had borrowed a pair of swan's wings from Caravaggio, presumably used by both men when painting angels. At the same time he was absorbing the exquisite miniaturism of Adam Elsheimer; in these years he perfected his surface finish, achieving in some small works on copper such minute control

of detail that his early career as a goldsmith is recalled. The impact of Caravaggio is seen in the choice of subject and in the intimate realism of Orazio's *St Francis Supported by an Angel* (*c.* 1600–03; Rome, Pal. Barberini, and Madrid, Prado), while Elsheimer's meticulously observed river shore landscapes shaped Orazio's vision of *St Christopher Carrying the Christ Child over the River* (*c.* 1605; Berlin, Gemäldegal.).

In this period Orazio Gentileschi painted his most Caravaggesque works. Like Caravaggio he chose subjects requiring few figures, which he placed close to the picture plane usually with little setting beyond a suggestive gloom. Unlike Caravaggio he did on occasion provide a landscape vista, though never an elaborate interior view. The focus is on the principal figures observed in a contemplative instant that arrests a drama and on Orazio's masterful depiction of their features and clothes, especially the silvery fall of light on yellow and blue silk and white linen (see fig. 1). His early works display simultaneously a naive, almost clumsy understanding of anatomical structure and an exquisitely refined handling of the painted surface. Silks, brocades, skin, furs, clouds, steel, ropes and pebbles are all lovingly described, but the drawing of hands and faces and the proportions of faces can be eccentric. These deficiencies are less evident after 1610. His long and careful study of the figure gradually led to mastery, though never to a looser, more confident technique. He rarely attempted multi-figure compositions or depicted moving figures.

Most critics believe that the Caravaggesque masterpieces painted before he settled in England were his greatest works. All feature one or two figures eloquently posed, beautifully lit (usually from the right) and sensitively and meticulously painted. The protagonists may lack the psychological intensity of Caravaggio but Orazio offers far more visual pleasure, sometimes to a distracting degree. His *Penitent Magdalene* (*c.* 1605; Fabriano, S Maria Maddelena) shows the saint kneeling in a cave-like setting which is embroidered with dead twigs, bushes, wild flowers, grass and pebbles. The Magdalene herself has magnificent long, golden hair, cascading over her shoulders and down her back, so delicately rendered that the viewer will find it hard to focus on her message of penance. Similarly the beautifully painted sword and minutely described rope sling in *David Slaying Goliath* (*c.* 1605–10; Dublin, N.G.) pull the eye away from the gaze of the youthful hero preparing to behead the stunned giant. In a small variant of this subject, *David Contemplating the Dead Goliath* (*c.* 1610; Berlin, Gemäldegal.), the viewer is enchanted by the fall of the light on striated rock formations and on David's lambskin garment and by the view over a lake to hills and a sky hazed with clouds on the left. Only after admiring these details do we notice Goliath's head in the shadows near David's left leg.

At the same time Orazio Gentileschi continued to work as a decorative painter. In 1609 and 1610 he was employed on various parts of the mosaic decoration of the main dome of St Peter's. From 1611 to 1612 he collaborated with Agostino Tassi on the decoration of the Casino delle Muse (Rome, Gal. Pallavicini; for illustration *see* TASSI, AGOSTINO), the garden casino of Cardinal Scipione Borghese's nearby palazzo (now the Palazzo Rospigliosi-Pallavicini). The two artists also worked together in 1612 on the fresco decoration (destr.) of the Sala del Concistoro in the Palazzo del Quirinale. For the Casino delle Muse, and as a setting for Scipione Borghese's lavish entertainments, Gentileschi painted musicians and audience enjoying a festive concert, within an elaborate illusionist architectural background contributed by Tassi. It has been suggested that one of the concert-goers is a portrait of his daughter, Artemesia. The successful partnership between Tassi and Gentileschi collapsed in 1612, when Tassi was sued for raping Artemesia.

Orazio's sequence of Caravaggesque masterpieces culminates in two outstanding works, *Judith with her Maidservant* (*c.* 1611–12; Hartford, CT, Wadsworth Atheneum) and the *Stigmatization of St Francis* (*c.* 1615; Rome, S Silvestro in Capite). In the former the heads and arms of the two women frame the head of Holofernes. The women look out of the picture to left and right, listening before they begin their escape through the night, eloquently depicted by the uninterrupted surrounding darkness. A soft raking light from the right illuminates the luscious red and gold brocade of Judith's blouse and the blue dress of her servant, who is shown as a young, attractive woman and not as an elderly hag, as was usual. His *Stigmatization of St Francis* rivals Caravaggio's influential *St Francis in Ecstasy* (1591–2; Hartford, CT, Wadsworth Atheneum) in its lyrical intensity. The saint is a slim, standing figure who leans back, supporting himself on a rocky ledge, his extended arms forming a cross with his body. His face, hands and right foot are illuminated by a silver light that seems to be natural moonlight and not a blazing, visionary apparition. The saint's angular pose of transfixed astonishment is an unforgettable image subtly heightened by the fall of his shadow on the faintly lit rocks behind him. This

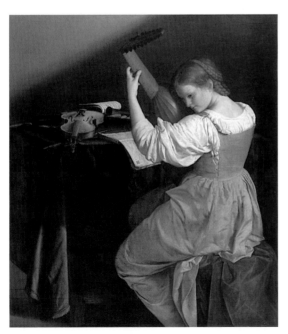

1. Orazio Gentileschi: *Young Woman Playing a Lute*, oil on canvas, 1.43×1.29 m, *c.* 1612–20 (Washington, DC, National Gallery of Art)

painting is one of the masterpieces of Counter-Reformation art. Gianlorenzo Bernini certainly understood its power when he planned his carefully illuminated group in the *Ecstasy of St Teresa* (1645–52; Rome, S Maria della Vittoria) 30 years later.

Around 1616 Orazio painted some frescoes and altarpieces for churches in Fabriano, including the *Madonna Presenting the Child to St Francesca Romana* (*c.* 1617–18; ex-S Caterina Martire; Urbino, Pal. Ducale), and tried unsuccessfully to get commissions in Venice and Urbino in 1617 and 1619.

3. GENOA, PARIS AND LONDON, 1623–39. By 1623 Orazio Gentileschi was in Genoa working for the Duke of Savoy, Charles-Emanuel I; in 1626 he worked for Marie de' Medici in Paris. In 1623 his son, Francesco, accompanied paintings to Turin for the Duke of Savoy, and these works, the *Annunciation* (see fig. 2) and *Lot and his Daughters* (*c.* 1622; Berlin, Gemäldegal.), introduced a new refinement and grace that reflect the taste of a more aristocratic clientele. To keep up with the demands of influential patrons, Orazio started producing autograph variants of some of his more ambitious easel paintings. Most of the works he replicated were large, horizontal canvases featuring reclining female figures, such as *St Mary Magdalene in Penitence* (Vienna, Ksthist. Mus., and New York, Richard L. Feigen priv. col., see Bissell, fig. 116) and *Danae* (*c.* 1621–2; Cleveland, OH, Mus. A., and New

York, Richard L. Feigen priv. col., see Bissell, figs 108, 110). He never copied his own work exactly but varied details of the settings and colour schemes. In some cases the later version is more successful than the first. His meticulous technique could not be hurried, but repeating the design shortened the production time.

The most spectacular of these later compositions with variants is the *Danae*. The colour scheme emphasizes gold, white and flesh tones in a dark setting. Gold coins and ribbons hurtle towards Danae, who reclines on a red velvet couch covered with white linen sheets on a dark, gold satin coverlet. The exquisite refinement of the execution masks with its disciplined control the eroticism of the subject, with which the artist was not totally at ease.

By November 1626 Gentileschi was in London, where he became court painter to Charles I and his queen, Henrietta Maria. In 1627 Francesco and his brother, Giulio, spent several months in Italy buying works of art for Charles I. Orazio's style, in such works as the *Finding of Moses* (*c.* 1630; Madrid, Prado), which Francesco took to Madrid for Philip IV of Spain, was one of increasingly aristocratic refinement. His most ambitious work was the ceiling (1638–9; London, Marlborough House) for the Great Hall in the Queen's House in Greenwich designed by Inigo Jones, where he was assisted by Artemesia. This shows an *Allegory of Peace and the Arts under the English Crown*, a theme in keeping with the flattering courtly language of Inigo Jones's masques.

By this date Orazio was unhappy in England and manoeuvring for an appointment at the court of Philip IV of Spain or with Ferdinand II, the Medici Grand Duke of Tuscany. In a letter to Ferdinand II he lamented that he had not been in Florence for 55 years. He died in London without returning to Italy. Orazio was not a prolific artist; there are about 80 canvases and frescoes known today. As Caravaggism died out in Europe in the 1620s so did awareness of Orazio's contribution, and he has only recently attracted the attention of scholars. Yet his interpretation of Caravaggio's stylistic revolution was important to painters in northern Italy and in France, where the elegance of artists such as Laurent de La Hyre and the Le Nain brothers has been linked to his art; he may also have influenced Simon Vouet, before the French painter's return to Paris from Rome in 1627.

BIBLIOGRAPHY
F. Baldinucci: *Notizie* (1681–1728); ed. F. Ranalli (1845–7), pp. 711–13
R. Longhi: 'Gentileschi padre e figlia', *L'Arte*, xix (1916), pp. 245–314
A. Emiliani: 'Orazio Gentileschi: Nuove proposte per il viaggio marchigiano', *Paragone*, ix/103 (1958), pp. 38–57
C. Sterling: 'Gentileschi in France', *Burl. Mag.*, c/110 (1958), pp. 112–20
M. Chiarini: 'Gli inizi del Gentileschi', *A. Figurativa*, x (1962), pp. 26–8
A. Moir: *The Italian Followers of Caravaggio*, 2 vols (Cambridge, MA, 1967)
R. Ward Bissell: *Orazio Gentileschi and the Poetic Tradition in Caravaggesque Painting* (University Park, PA, and London, 1981) [full bibliog., cat. rais., illus.]

(2) Artemesia Gentileschi (*b* Rome, 8 July 1593; *d* Naples, 1652/3). Daughter of (1) Orazio Gentileschi. She was the first Italian woman whose artistic achievements not only were praised by her contemporaries but also influenced the work of other artists. She spread her firsthand knowledge of the work of Caravaggio beyond Rome to Florence, Genoa and Naples, where, in her exceptional

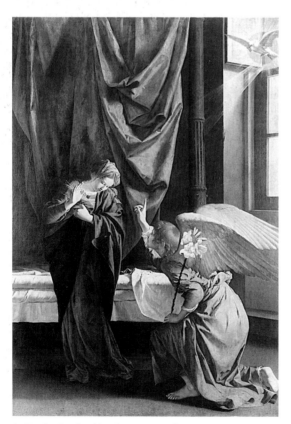

2. Orazio Gentileschi: *Annunciation*, oil on canvas, 2.86×1.96 m, 1622–3 (Turin, Galleria Sabauda)

career, she worked at different times. From the beginning she refused to limit herself to portraits, still-lifes and small devotional pictures, the staples of most women artists in the 16th and 17th centuries, but established herself immediately as an ambitious history painter.

1. EARLY CAREER IN ROME AND FLORENCE. Artemesia learnt most of the craft of painting from her father, Orazio; her palette, the physiognomy of her figures and their costumes all show his influence, especially in her early works. He hired a colleague, Agostino Tassi, to teach her perspective. Like Caravaggio her father worked directly on the canvas using posed models, perhaps scratching into the damp priming paint a few contour lines of the main elements of the composition. She was presumably taught to paint in the same way. The heavy build of her figures and the occasional compositional awkwardness in her early works also betray her lack of conventional training based on drawing from ancient casts, Renaissance prints and paintings and live models, followed by carefully drawn preparation of figure compositions. Like her father, she had a skill at rendering the surfaces of textures and light reflections that often masked poorly understood anatomical details. Yet she demonstrated from the beginning a firm grasp of dramatic narrative, and her first paintings illustrate both her debt to her father and her independent artistic personality. Her first signed and dated painting, *Susanna and the Elders* (1610; Pommersfelden, Schloss Weissenstein), painted when she was 17, is extraordinarily accomplished and addresses two themes that she favoured throughout her career—women heroines and the female nude. Susanna is shown as both vulnerable and anguished; the picture has been eloquently analysed by Garrard who stresses the degree to which the woman's viewpoint has altered the usual narrative strategies.

Around 1611 both father and daughter painted *Judith and her Maidservant* (Oslo, N.G., and Florence, Pitti, respectively). Her painting is a vertical, compressed reworking of his horizontal composition. Orazio gave the servant unusual prominence by placing her next to the picture plane with her back to the viewer. Artemesia retained this figure almost unaltered but moved Judith closer to her, thus concealing more of the principal figure. Judith's facial expression is anxious in Artemesia's canvas but almost serene in Orazio's. Her servant's profile is hidden in shadow, masking her reactions to the unseen threats, while the visible profile of Orazio's servant is almost expressionless. Finally Artemesia's Judith has started to raise her sword, ready to strike any pursuers, while Orazio's Judith has let her right arm with her sword drop to her side. Artemesia's painting lacks the velvety finesse of Orazio's surfaces, but she brings the story to life to a degree that makes elegant finish irrelevant.

It is this sense of the dramatic that separates Artemesia from her father. The particular moment chosen in a familiar story, the arrangement of the figures, their gestures and facial expressions are all orchestrated with a sense of theatre. Artemesia's paintings include a dramatic *Judith Beheading Holofernes*; her father chose only to paint a picture showing Judith and her servant preparing to return home afterwards; and his female nudes are far less erotically charged than those of his daughter.

In 1611 Agostino Tassi took advantage of his role as teacher to seduce or rape her. A gruelling public trial resulted in 1612. Tassi was imprisoned for eight months, and Artemesia was quickly married to a Florentine, Pietro Stiattesi, late in 1612 and moved with him to Florence.

Artemesia's most frequently reproduced canvas, *Judith Beheading Holofernes* (c. 1613–14; Florence, Uffizi), which she painted shortly after the traumatic rape trial in Rome and her move to Florence, is a meticulously realistic interpretation. (A variant of this composition is in Naples, Capodimonte. Technical evidence has led Garrard, 1989, p. 305, to suggest that this is the original.) Artemesia's personal experience is frequently read into the painting, which is seen as a form of visual revenge for her humiliation. These circumstances may well have influenced her choice of subject. However, as her *Judith and her Maidservant* is a reinterpretation of a picture by her father, so this picture is a critical analysis of Caravaggio's *Judith Beheading Holofernes* (1598–9; Rome, Pal. Barberini). Once again her interpretation is far more dramatic than that of her source. She emphasizes the brutal facts of decapitation to such a degree that most people find it hard to look at the picture. Caravaggio's Judith stands so far to the right of Holofernes that she would not have been able to cut his head off, but Artemesia's Judith is more effectively positioned. She grasps her enemy's hair with her left hand and saws vigorously with her muscular right

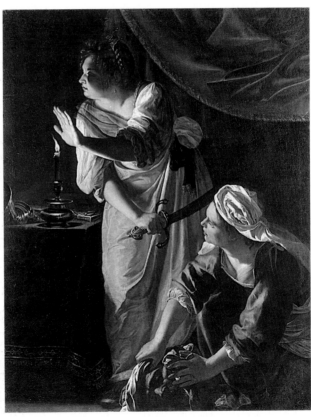

1. Artemesia Gentileschi: *Judith and Maidservant with the Head of Holofernes*, oil on canvas, 1.84×1.42 m, c. 1625 (Detroit, MI, Institute of Arts)

arm, while her servant holds down the victim's arms. Judith's arms seem too large in relation to her head, and the foreshortening of her torso and its relation to these arms is poorly managed, yet the painting has a mesmerizing power and is full of beautifully painted details. It was surely Artemesia's intention to announce her arrival in Florence with a work that could not be overlooked and further that demanded comparison with one of the most celebrated painters of the day whose work was still hardly known outside Rome. She gave this painting to Cosimo II de' Medici and shortly afterwards painted the *Penitent Magdalene* (*c.* 1617–20; Florence, Pitti), almost certainly for his wife, Grand Duchess Maria Maddalena. Artemesia's Magdalene is no meek supplicant but a heroine of powerful stature in a magnificent yellow silk dress.

In 1616 Artemesia became the first woman artist to join the Accademia del Disegno, and in 1615–17 she contributed an *Allegory of Inclination* to the decorations glorifying Michelangelo, painted by prominent Florentine artists for the galleria in Casa Buonarotti. In 1620 she returned to Rome. She made brief trips to Genoa (1621) and to Venice in the 1620s; in Genoa she may have painted the *Lucretia* (*c.* 1621; ex-Genoa, Pal. Adorno; see Garrard, 1989, fig. 38). Her finest treatment of the story of Judith is *Judith and Maidservant with the Head of Holofernes* (*c.* 1625; Detroit, MI, Inst. A., see fig. 1), which shows the heroine with her servant after the decapitation preparing to flee. She adopted a Caravaggesque night setting illuminated by a candle on a table and shows the two women in a moment of frozen action. Judith tells the servant to be still, while they listen in case they have been heard. Her face is partially in shadow, that of her servant more fully lit. Judith wears Artemesia's favourite golden yellow; her servant is in blue and purple. Artemesia's gifts as a story-teller are here supported by a more advanced technique and a surer grasp of anatomical structure.

Baldinucci's brief biography of Artemesia, which is tacked on to his life of her father, says that she painted many portraits. Today only one *Self-portrait* (1630; London, Kensington Pal., Royal Col.) and one portrait of a male sitter, *A Condottiere* (Bologna, Pal. Com.), signed 1622, are universally accepted, although a few other portraits have been attributed to her. The *Self-portrait as an Allegory of Painting* is a powerful and complex work (see fig. 2); that of the *Condottiere* is a more conventional but nevertheless striking image.

2. NAPLES AND LONDON, 1630–52. By 1630 Artemesia was living in Naples. In the 1610s and 1620s she seems deliberately to have chosen subjects that required female nudes so that she could flaunt her skills in an area avoided by most women artists on grounds of decorum until the later 19th century. In Naples her style changed. She painted more traditional subjects and, later than most Italian artists, abandoned the intense chiaroscuro of Caravaggio, probably because fashions had changed, even in Naples. The dominant Spanish influence made the subjects of her early work less saleable, and she painted more conventional religious themes, such as the *Annunciation* (1630; Naples, Capodimonte), the *Birth of St John the Baptist* (1631–3; Madrid, Prado) and the *Adoration of the Magi* (1636–7; Pozzuoli Cathedral). In 1635 her brother, Francesco, took paintings by her to Cardinal Antonio Barberini in Rome and to Francesco d'Este I in Modena.

Reaching London in 1638, Artemesia worked, alongside her ailing father, for three years for Charles I; she assisted Orazio on the ceiling paintings for the Great Hall (1638–9; London, Marlborough House) in the Queen's House in Greenwich. Orazio died in 1639, but Artemesia was still in London in 1641. Her later years are not well documented, but she probably spent most of the last decade in Naples. In these years she painted several versions of *David and Bathsheba* (earliest version from the early 1640s; Columbus, OH, Mus. A.), some for patrons who lived elsewhere. One such patron was Don Antonio Ruffo, for whom, between 1648 and 1650, she painted pictures (untraced) of *Galatea*, *Andromeda Freed by Perseus* and *Diana and Actaeon*. Based on earlier compositions, she produced close variants, such as *Judith and Maidservant with the Head of Holofernes* (late 1640s; Naples, Capodimonte), as did her father, but these lack the forceful impact of her earlier paintings. Several versions of the story of Bathsheba attributed to her are so weak that they must have been done by imitators. Nevertheless the quality of her work declined after 1630. The precise date of her death is not known. A *Susanna and the Elders* of 1652 is recorded in a 19th-century inventory; and she was dead by 1653, when two disrespectful epitaphs about her were published.

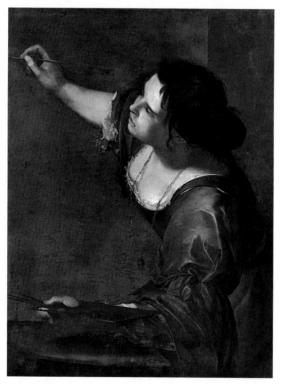

2. Artemesia Gentileschi: *Self-portrait as an Allegory of Painting*, oil on canvas, 965×737 mm, 1630 (London, Kensington Palace, Royal Collection)

3. CRITICAL RECEPTION AND POSTHUMOUS REPUTATION. Artemesia played a significant role in bringing

knowledge of Caravaggio's style to Florence in the 1610s, to Genoa in 1621 and to Naples after 1630, where her palette and elaborately painted drapery seem to have influenced Massimo Stanzione, Bernardo Cavallino and others. The relative silence of contemporary biographers about her achievements and the lack of information about her later years suggest that male artists did not enjoy competing with her and that she had some difficulty making a living. Her correspondence is full of attempts to interest potential buyers in her paintings, clear evidence of her need for patronage. Artemesia, a victim of male violence and yet the creator of powerful images of heroic women, has become a legendary figure in recent years, celebrated by 20th-century feminists and by women artists.

BIBLIOGRAPHY

F. Baldinucci: *Notizie* (1681–1728); ed. F. Ranalli (1845–7), pp. 713–16
R. Longhi: 'Gentileschi, padre e figlia', *L'Arte*, xix (1916), pp. 245–314
A. M. Crinò: 'More Letters from Orazio and Artemesia Gentileschi', *Burl. Mag.*, cii (1960), pp. 264–5
R. Ward Bissell: 'Artemesia Gentileschi: A New Documented Chronology', *A. Bull.*, l (1968), pp. 153–68
Women Artists, 1550–1950 (exh. cat. by A. Sutherland Harris and L. Nochlin; Los Angeles, Co. Mus. A.; Austin, U. TX, A. Mus.; Pittsburgh, Carnegie Mus. A.; New York, Brooklyn Mus.; 1976–7), pp. 118–24
M. Garrard: 'Artemesia Gentileschi's *Self-portrait as the Allegory of Painting*', *A. Bull.*, lxii (1980), pp. 97–112
F. Fox Hofrichter: 'Artemesia Gentileschi's Uffizi *Judith* and a Lost Rubens', *Rutgers A. Rev.*, i (1980), pp. 9–15
M. Garrard: 'Artemesia and Susanna', *Feminism and Art History: Questioning the Litany*, ed. Norma Broude and Mary D. Garrard (New York, 1982), pp. 146–71
——: *Artemesia Gentileschi* (Princeton, 1989) [the most detailed treatment of her career; evaluates the originality of her imagery, with docs, pls and full bibliog.]

ANN SUTHERLAND HARRIS

Gentili, Antonio (*b* Faenza, 1519; *d* Rome, 29 Oct 1609). Italian goldsmith and engraver. After moving to Rome in 1549–50, he was first elected consul of the goldsmiths' guild in 1563 and, after 1584, assayer for the Papal Mint. His workshop executed important commissions for the Farnese family, among which survive a cross and two monumental candlesticks (1570–82; Rome, St Peter's); Cardinal Alessandro Farnese paid 13,000 scudi for these items and presented them to St Peter's, Rome, to be placed on the high altar. In this ensemble, one of the most important of late 16th-century Italian silver, Gentili combines technical expertise with a mastery of the plastic modelling of putti, nudes and caryatids, inspired by the work of Michelangelo. These figures appear in the miniature architectural structures that form the stems of the candlesticks. In the late 17th century the silversmith Carlo Spagna (*fl* 1680) created a triangular base for these pieces, commissioned by Cardinal Francesco Barberini and with volutes framing a scroll with a bee, the symbol of the Cardinal. A fine set of knife, fork and spoon (New York, Met.), the handles of which are chased with various elements from his decorative repertory, has been attributed to Gentili on the basis of a design (New York, Met.) for a similar spoon, signed *Antonio di Faenza*.

For bibliography *see* ITALY, §IX, 1.

ANGELA CATELLO

Gentilini, Franco (*b* Faenza, 4 Aug 1909; *d* Rome, 5 April 1981). Italian painter, illustrator and stage designer. He began his training in Faenza in the workshop of the Italian painter and ceramicist Mario Ortolani (1901–55). After living briefly in Bologna (1927) and Paris (1928) he settled in Rome in 1929, first exhibiting his work at the Venice Biennale in the following year. His paintings at this time, such as *Nude (Susanna after her Bath)* (1929; Faenza, Pin. Com.), were characterized by an emphasis on tonal relationships and on the influence of the Scuola Romana. In 1934 he began to work with growing success as an illustrator for the journals *Quadrivio* and *Italia letteraria*. The contacts he established with Paris were intensified with his move there in 1947, resulting in three one-man shows at the Galerie Rive Gauche (in 1950, 1953 and 1957), and in his paintings he evolved a cautious balance between the representation and the disassembling of the image. Some of his best-known series of paintings date from this time, including his *Cathedrals* (e.g. *Cathedral with Still-life and Dog*, 1960; Rome, Vatican, Col. A. Relig. Mod.), pictures of town squares populated by acrobats and musicians, and later female nudes and a series entitled *Mermaids*.

In his paintings Gentilini drew attention both to the physical qualities of his materials, sometimes mixing his oil paints with sand, and to the linear and graphic elements used in building up the composition. The vaguely fantastic, ironic and melancholic atmospheres that he favoured brought him many offers of work in the theatre, both as a stage designer and costume designer, and also as an illustrator of editions of Franz Kafka's *Metamorfosi* (Rome, 1953), Boccaccio's *Decamerone* (Milan, 1975) and other books.

BIBLIOGRAPHY

A. Moravia: *Gentilini* (Venice, 1952)
A. Jouffroy: *Gentilini* (Milan, 1987)

VALERIO RIVOSECCHI

Gentillâtre [Gentilhâtre], **Jacques** (*b* Sainte-Menehould, Marne, 1578; *d* in or after Nov 1623). French architect, draughtsman, theorist and writer. Around 1600 he worked in the studio of Jacques Androuet Du Cerceau (ii) in Paris. In 1602 he left Paris to work in Troyes and Sedan (Ardennes) and remained from about 1603 to 1610 in Lorraine, where his principal patron was Jean III Du Châtelet, Baron des Thons. At Petit-Thon, Gentillâtre built an important château for him consisting of two wide wings joined by a narrower gallery. The exterior façade is of brick and stone (the brickwork is simulated in paint), and the corners and openings are enhanced by quoins. There is no polychromy on the courtyard façade, which has instead an abundant display of decorative sculpture. The fireplaces are also laden with sculptural motifs.

After staying in Montbéliard (Doubs) and Geneva, he went to Chalon-sur-Saône (Saône-et-Loire) in 1612, staying there until 1622. The Hôtel Virey (1612; now the Sous-préfecture) and the Palais du Bailliage (begun 1613; destr. 1825) were his major works in the town. The Hôtel Virey has an unusual layout, so designed as it was intended to house the Virey family and an important library. The front façade of brick and stone (the rear of the building abuts a Roman wall) is notable for its original and

harmonious articulation and decoration. Such a luxurious and fashionable treatment of a façade is seen here for the first time on a building in Chalon-sur-Saône. While links with the decorative and widely popular late Mannerist style of Du Cerceau are unmistakable, certain motifs are advanced enough to place the building's design on a par with much contemporary architecture being done in Paris. The Palais du Bailliage was also treated with brick and stone, and the refinement of its façade lay in the interplay of planes that corresponded to groups of bays accentuated by quoins. Although small, the projections suggested a plastic treatment characteristic of the Baroque style. From 1613 Gentillâtre extended the château of the barons of Blé d'Uxelles at Cormatin, near Chalon-sur-Saône, by adding two wings to the existing one to make a square. The most remarkable feature is the large grand staircase, which has four newels and three flights rising around a rectangular opening in the centre. The plan and vaulting of the structure are similar to the staircase (from 1615; destr. 19th century) built by Salomon de Brosse at the Palais du Luxembourg in Paris. In 1622 Gentillâtre was living in Lyon, where he constructed the façade of the chapel at the Hospice de la Charité (mostly destr.; now the Post Office), in which he employed copious decorative forms similar to those he had used at the château at Petit-Thons (extensively ruined). After this time there is no record of him.

Gentillâtre achieved high standards as an architect, even though he lived and worked outside of Paris where his talent never had the opportunity to develop fully. Perhaps his greatest significance was as the author of an important album of architectural drawings and decorations (London, RIBA) and of a theoretical treatise on architecture (Paris, Bib. N., MS. fr. 14727). The album of about 300 architectural drawings (to which have been added later on his name and date of birth) consists largely of his own projects, only some of which were actually carried out. One part includes copies of projects by the Architecte du Roi Jacques Androuet Du Cerceau and his studio, while the remainder is made up of drawings, inspired by a wide variety of sources, that on occasion recall the buildings Gentillâtre saw on his travels. His treatise of approximately 600 folio-sized handwritten sheets was intended for architects and engineers and is an adaptation of the Vitruvian model to the more practical demands of his time, reflecting his knowledge of Alberti, Palladio and many others. It is the only one known in France between those of Philibert de L'Orme (1567) and Roland Fréart, Sieur de Chambray (1650).

UNPUBLISHED SOURCES
Paris, Bib. N., MS. fr. 14727 [treatise]

BIBLIOGRAPHY
R. Coope, ed.: Catalogue of the Drawings Collection of the Royal Institute of British Architects: Jacques Gentilhâtre (London, 1972)
L. Châtelet-Lange: 'Jacques Gentillâtre et les châteaux des Thons et de Chauvirey', Pays Lorrain, 2 (1978), pp. 63–95 [and two pages errata including the reconstruction of the plan of the château des Thons, Pays Lorrain, 3 (1978)]
——: 'L'Architecture entre science et pratique: Le Cas de Jacques Gentillâtre', Actes du colloque. Les Traités d'architecture de la Renaissance: Tours, 1981, pp. 397–406
——: 'Jacques Gentillâtre', Mnmts Piot, vii (1989), pp. 71–138

LILIANE CHÂTELET-LANGE

Gentils, Vic (b Ilfracombe, Devon, 19 April 1919). Belgian sculptor. After studying in Antwerp, first at the Koninklijk Akademie voor Schone Kunsten (1934–8) and then at the Hoger Instituut voor Schone Kunsten (1940–42), he progressed from Expressionism towards *Art informel* and went through a neo-Surrealist phase in 1950. By 1954 he was attempting to escape from painting by integrating objects and using a variety of materials in his work. His first reliefs were produced in 1960 and were made up of fragments of old moulded frames and wooden laths blackened by burning. Shortly afterwards he began to make assemblages of mutated objects, investigating the possibilities of wood and extending his pictorial vocabulary by using parts of pianos, as in *Musical Relief* (1963; Brussels, Musées Royaux B.-A.), as well as cupboards, balustrades, pulleys, shoe-trees and hat-blocks.

After 1963 Gentils abandoned pure relief and executed works in which human forms and (from 1965) colour began to reappear. In 1966–7, for example, he produced the 32 pieces of a monumental *Chess Set* (Antwerp, Openluchtmus. Beeldhouwkst Middelheim); this was followed by the *Huysmans-Lenin Monument* (1971), whose 30 elements made him take a further step towards figuration and the art of portraiture. By the mid-1970s the strength of the colours is such that he seemed now to be actually painting in three dimensions.

BIBLIOGRAPHY
Vic Gentils: Monument C. Huysmans en andere portretten (exh. cat., intro. G. Gepts; Antwerp, Kon. Mus. S. Kst., 1974)
L. Bekkers: 'Conversation avec Vic Gentils', Retrospective Vic Gentils (exh. cat., Lille, Mus. B.-A., 1977–8)
Vic Gentils (exh. cat., intro. K. J. Geirlandt; Kruishoutem, Fond. Veranneman, 1985)

PIERRE BAUDSON

Gentz, (Johann) Heinrich (b Breslau, Silesia [now Wrocław, Poland], 5 Feb 1766; d Berlin, 3 Oct 1811). German architect. He studied drawing and architecture in Berlin from 1782 under Karl Philipp Christian von Gontard and Asmus Jakob Carstens. Between 1790 and 1795 he travelled to Italy, England and France, spending three years in Rome and studying Greek temples at Paestum and in Sicily. From 1798 he was Professor of Civic Design at the newly founded Bauakademie in Berlin and in 1810 was appointed Court Building Adviser. Together with his brother-in-law Friedrich Gilly (see GILLY, (2)) and Carl Gotthard Longhans, Gentz was the most prominent representative of Neo-classicism in Prussia prior to Karl Friedrich Schinkel. His chief work was the Royal Mint (1798–1800; destr. 1886), Berlin, which also housed the Bauakademie and the Chief Building Department until 1836. The cuboid *corps de logis* had a battered and rusticated lower floor surmounted by a frieze carved in sandstone and bronzed to a design by Gilly. A plain storey above was articulated by semicircular windows, the apexes of which reached only halfway to the string course, which underlined the corresponding three-light windows of the top floor. The projecting entrance wing displayed two Doric columns beneath a monumental arched window. Gentz's Mint, which made use of antique references without disturbing the ambience of the existing architectural context, served as a model to the younger Berlin architects in about 1800, and they grouped themselves

around Gilly and Gentz in the Privatgesellschaft Junger Architekten (Private Society of Young Architects). Between 1801 and 1803, working in close contact with JOHANN WOLFGANG VON GOETHE, Gentz carried out the interior decoration of the east and north wings of the Schloss at Weimar: the Falkengalerie, the Greek Doric staircase and the Festsaal (banqueting hall), with a free-standing Ionic order derived from the Erechtheion in Athens, are regarded as mature achievements of German Neo-classicism, as was his Schiesshaus (shooting pavilion; 1803–5), which was drastically altered in 1913 (*see also* WEIMAR). The small summer theatre (1802) in Bad Lauchstädt, near Halle, reflects Goethe's ideas on the reform of the theatre and incorporates a barrel-vaulted ceiling with delicate painted ribbing suggesting rippling canvas. Later works in Berlin include a manor house (1804) at Steglitz and one wing (1810) of his Prinzessinnenpalais in Unter den Linden. The mausoleum to *Queen Louise* (1810–11) in the park at Schloss Charlottenburg, Berlin, in the form of a prostyle Doric temple, was designed in collaboration with Schinkel, who was influenced by his colleague's buildings and plans, for example Gentz's design for a monument to *Frederick the Great* and his scheme for replanning the centre of Berlin.

WRITINGS

'Briefe über Sizilien', *Neue Dt. Mschr.*, ed. F. Gentz, iii (1795), pp. 314–22
'Beschreibung des neuen königlichen Münzgebäudes', *Samml. Nützl. Aufs. & Nachr. Baukst betreff.*, i (1800)
Elementar-Zeichenwerk zum Gebrauch der Kunst- und Gewerbe-Schulen der preussischen Staaten (Berlin, 1803–6)

BIBLIOGRAPHY

NDB; Thieme–Becker
A. Doebber: *Lauchstädt und Weimar* (Berlin, 1908)
——: *Das Schloss in Weimar* (Jena, 1911)
——: *Heinrich Gentz* (Berlin, 1916)
A. Jericke and D. Dolgner: *Der Klassizismus in der Baugeschichte Weimars* (Weimar, 1975)
Friedrich Gilly, 1772–1800, und die Privatgesellschaft junger Architekten (exh. cat., ed. R. Bothe; W. Berlin, Berlin Mus., 1984)
H. Reelfs: 'Beymes Steglitzer Rittergut', *Jb. Brandenburg. Gesch.*, xxxvii (1986), pp. 121–68
D. Watkin and T. Mellinghoff: *German Architecture and the Classical Ideal, 1740–1840* (London, 1987)

ADRIAN VON BUTTLAR

Geodesic dome. Structural system designed by R. BUCKMINSTER FULLER in 1946 and patented in 1954. Fuller conceived the idea of a domical grid based upon the Great Circle in the early 1940s while developing his World Map (Dymaxion Map, pubd 1946). For reasons to do with the economical use of resources, even from 1927, the Dymaxion buildings had been designed to take greater advantage of the tensile, as opposed to the compressive, strength of materials. (Fuller called these forces 'energetic'.) For Fuller, the mass required for structural elements in compression was wasteful. It was not until 1946, after the abandonment of the Wichita House project, that he began to apply the lessons of the Dymaxion buildings to the study of his ideal structure, the geodesic dome. It was to be a universal design for any available material that could withstand tensional forces, and capable of being built to any scale, demountable, transportable and easy to erect.

The principles behind statically determinate SPACE-FRAME structures had been known since the late 19th century; Alexander Graham Bell had also built triangulated framed columns in 1907. Fuller, however, exploited the principle of continuous tension and discontinuous compression to devise first the geodesic dome and then tensegrity (tensional integrity) structures, a generalized structural system capable of use in various forms. All are statically indeterminate (or, for Fuller, 'synergetic') structures, dependent to some extent upon intuition and experiment for their success, but the theory that the domes could be built to any scale takes no account of length in relation to buckling, a limitation that applies to all framed structures.

Elegant domes from one quarter to three-quarters of a sphere in shape have been built, their appearance dependent on the disposition of the tetrahedral or octahedral elements and the surface membrane covering them. They were first built at schools of architecture across the USA, but commercial success came in 1956 when the geodesic dome was accepted for general use by the US Marine Corps. Three separate geodesic and tensegrity structures were exhibited at the Museum of Modern Art, New York, in 1959.

By the 1960s the geodesic dome had become the symbol of American ingenuity; it served as the shell for the US Pavilion at Expo 67 in Montreal (see fig.). Domes have been erected world-wide for domestic, scientific, industrial, exhibition and military uses (e.g. for the American Distant Early Warning or DEW radar line).

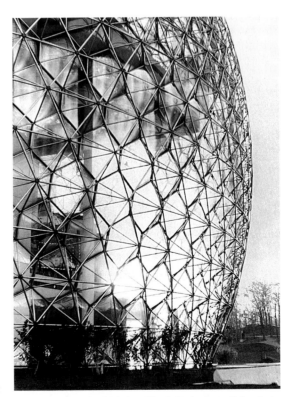

Geodesic dome (detail) designed by R. Buckminster Fuller, Sadao and Geometrics Inc., United States Pavilion at Expo 67, Montreal

BIBLIOGRAPHY
'Geodesic Dome: Fuller's Spidery New Framing System', *Archit. Forum*, xcv/2 (1951), pp. 144–51

RICHARD GUY WILSON

Geoffrin [née Rodet], **Marie-Thérèse** (*b* Paris, 2 June 1699; *d* Paris, 6 Oct 1777). French literary and artistic hostess and patron. She was the daughter of a valet de chambre in the royal service and was orphaned early; aged 14, she married François Geoffrin, a rich bourgeois 34 years her senior, who owned a splendid hôtel particulier in the Rue St Honoré, Paris. In 1730 Mme Geoffrin became a regular guest at the famous literary salon of her neighbour, Mme Claude-Alexandrine Guérin, Marquise de Tencin (1682–1749). Subsequently, she began to entertain literary figures on her own account; following Mme de Tencin's death in 1749, she took over her salon, the members of which included such distinguished men of letters as Voltaire, Montesquieu, Fontenelle (1657–1757), Diderot, Baron von Grimm and d'Alembert (1717–83). They attended her popular literary salon, which met on Wednesdays; an artistic salon, which met on Mondays, included as guests the architect Jacques-Germain Soufflot, the sculptor Edme Bouchardon and the painters Carle Vanloo, Jean-Baptiste Greuze, Hubert Robert and François Boucher, bringing them together with such collectors and connoisseurs as Caylus, Ange-Laurent La Live de Jully, Claude-Henri Watelet and Horace Walpole. Mme Geoffrin was a friend of the Marquis de Marigny, and of Stanislav Poniatowski, later King of Poland. In 1766 she visited his court, and on her way paid a visit to the Empress Maria Theresa of Austria, whose correspondent she was. She also corresponded with Catherine II of Russia. She began collecting works of art in 1750; an inventory lists 69 paintings, most of which she had herself commissioned from her friends. A number of the works were portraits of contemporaries; also included were two paintings by van Loo, the *Spanish Conversation Piece* and the *Spanish Lecture*, which Mme Geoffrin sold to Catherine the Great in 1772. Five paintings by Hubert Robert depicted Mme Geoffrin engaged in various occupations in her own house. Other paintings, including five by François-Hubert Drouais, were idealized portraits of children.

DBF BIBLIOGRAPHY
A. Morellet, A.-L. Thomas and J. d'Alembert: *Eloge de Mme Geoffrin, suivi de Lettres de Mme Geoffrin* (Paris, 1812)
P. de Ségur: *Le Royaume de la rue Saint-Honoré* (Paris, 1898)
G. de Lastic Saint Jal: 'La Reine de la rue Saint-Honoré', *L'Oeil*, xxxiii (1957), pp. 50–57
B. Scott: 'Madame Geoffrin: A Patron and Friend of Artists', *Apollo*, lxxxv (1967), pp. 98–103
D. Wakefield: *French Eighteenth-century Painting* (London, 1984), p. 158

Geoffroi d'Ainai (*b* ?1080–90; *d* Clairvaux, 1140). French monk and architect. His reputation as an architect rests on three contemporary records. They show him to be a senior and trusted member of the Clairvaux community of Cistercian monks who had been at the abbey since its early days (*see* CLAIRVAUX ABBEY). In his role as a companion of St Bernard he was given responsibility for assisting new houses to establish themselves in the Cistercian way of life (see BERNARD OF CLAIRVAUX). The clearest information comes from FOUNTAINS ABBEY, N.

Yorks, to which Geoffroi was sent in 1133 to instruct the monks (none of whom had spent any time within a Cistercian house) in the customs of the Order, its way of life and disciplined attitude to monastic affairs. Serlo, then of Fountains, stated that Geoffroi had performed this task on many occasions: 'he was skilled in ordering and establishing new houses' (see Walbran). Part of these duties included the physical aspects of laying out the buildings, deciding on their disposition and determining their dimensions, whether in timber as at Fountains or in stone as at Clairvaux. The confidence that Bernard placed in Geoffroi is indicated in his letter to Abbot Richard: 'All the matters I have no time to write about I leave to Geoffroi; he will deal verbally with the rest'. When the instruction at Fountains was completed, Geoffroi left behind him a group of monks well able to continue the Cistercian tradition. Adam of Meaux, Robert of Newminster and Alexander of Kirkstall were all monastic founders and, inevitably, builders.

In 1135, after Geoffroi's return to Clairvaux, construction of the new abbey church (Clairvaux II) was started. This had barrel vaults and a straight-ended presbytery, features that occur in the first stone church at Fountains (1136–48). In 1139 Geoffroi was sent to Clairmarais in French Flanders to assist in that abbey's foundation. Again his role may have been as much to give instruction in Cistercian customs as to plan the building. While he was at Clairmarais, old, weak and feeling his end was near, he hurriedly returned to Clairvaux, dying in Bernard's presence, the saint having been forewarned in a dream to return to Clairvaux to comfort his friend. Geoffroi's role as a guide and planner has parallels in the work of Archard at Himmeröd (1138) and Robert at MELLIFONT ABBEY (1142), who were important in standardizing the mental disciplines of daily life and the physical setting in which it was conducted. In architectural terms the similarities are more marked than the regional differences.

BIBLIOGRAPHY
St Bernard: *Epistola*, xcvi, ed. J. LeClerq and H. Rochais (Rome, 1984)
——: *Vita*, IV, 2, 10; ed. in *PL*, clxxxv, col. 327
J. R. Walbran: 'Memorials of the Abbey of St Mary of Fountains', *Surtees Soc.*, xlii (1862) [Serlo: *Narratio*, pp. 46–7]
M. Aubert: *L'Architecture cistercienne en France*, i (Paris, 1947), p. 97
P. Fergusson: *Architecture of Solitude: Cistercian Abbeys in Twelfth-century England* (Princeton, 1984), pp. 39–40
R. Gilyard-Beer and G. Coppack: 'Excavations at Fountains Abbey, North Yorkshire, 1979–80: The Early Development of the Monastery', *Archaeologia* [Soc. Antiqua. London], cviii (1986), pp. 147–58, 174–7

L. A. S. BUTLER

Geoffroy-Dechaume, Adolphe-Victor (*b* Paris, 29 Sept 1816; *d* Valmondois, Val-d'Oise, 25 Aug 1892). French goldsmith, sculptor and museum curator. He studied in Paris, first at the Ecole Gratuite de Dessin and from 1831 at the Ecole des Beaux-Arts, where he was a pupil of David d'Angers and James Pradier. He worked principally as a goldsmith until 1848 but then devoted himself to the study of medieval sculpture. Throughout his career he collaborated on the restoration of many important Gothic buildings in France, notably with Emile Boeswillwald on Laon Cathedral, with Victor-Marie-Charles Ruprich-Robert on Bayeux Cathedral and with Jean-Baptiste-Antoine

Lassus and Eugène-Emmanuel Viollet-le-Duc on the Sainte-Chapelle and Notre-Dame in Paris. At the Sainte-Chapelle he was responsible for the 12 stone statues of the *Apostles* at the base of the spire (*in situ*); from 1848 to 1864 he ran the sculpture studio at Notre-Dame, where among many other works in an elegant neo-Gothic style he executed 12 copper statues of the *Apostles* for the base of the spire (*in situ*). He also contributed to the sculptural decoration of St Clothilde (1854) and St Bernard-de-la-Chapelle (1860), Paris. Although he never exhibited at the Salon, Geoffroy-Dechaume received a number of commissions for commemorative statues and portraits, including a bronze statue of the playwright *François Ponsard* (1870; destr. 1940) for Vienne (Isère), a bronze medallion of *Jean-Baptiste-Camille Corot* for his tomb at Ville d'Avray (1880; *in situ*) as well as marble busts of *Charles-François Daubigny* (1870; Paris, Père Lachaise Cemetery) and *Viollet-le-Duc* (1879; Paris, Mus. Mnmts Fr.). In 1885 he became curator of the Musée de Sculpture Comparée (now the Musée des Monuments Français), Paris.

BIBLIOGRAPHY

Lami; Thieme-Becker

Viollet-le-Duc (exh. cat., intro. B. Foucart, Paris, Grand Pal., 1980), pp. 156–61

MARIE-THERESE THIBIERGE

Geomancy [Chin. *fengshui*: 'wind and water']. Chinese system of beliefs concerning the siting and orientation of buildings. Since its origins during the Han period (206 BC–AD 220) this proto-science has given rise to a vast corpus of literature that in reached maturity in the Song period (960–1279). Geomancy is applied to houses (*yangzhai*) and tombs (*yinzhai*), as close links exist between graves, where the bones of ancestors are stored, and houses, where their spirit tablets are kept in domestic altars. *Yangzhai* geomancy has been an important factor in Chinese architecture since *c.* AD 1000 (*see* CHINA, §II, 5(ii)(c)).

The two main strands of geomancy are the Jiangxi and the Fujian schools. The Jiangxi school, known as the School of Forms, is concerned with determining the most favourable site for a building within the natural environment: an ideal site faces water and is protected at the rear by a hill. The books of the school are lavishly illustrated with diagrams of ideal sites (see fig.). The foremost Jiangxi master was Yang Yinsong (*fl* mid-9th century). The Fujian school was founded in the 11th century by Wang Ji. It stresses the importance of favourable and unfavourable directions for buildings and their component parts, and its rise was closely associated with the spread of the geomantic needle compass during the Song period. Directions are judged to be favourable or unfavourable according to the stars that govern them. The books of the Fujian school are illustrated with diagrams indicating the proper orientation of doors, courtyards and other parts of a house.

The two schools existed side by side. The theories of the Jiangxi school could be put into practice in the countryside, where a favourable site could be chosen freely, while the Fujian school dominated in towns, where the choice of a favourable house-plan and auspicious directions for its various parts were much more important.

Geometric principles used in site design; from *Dili sanzan xuanji xiapuo ji* ('Assembled writings of the immortal old woman of magic calculation'), 1587

Since favourable directions changed every year, the builders of houses and temples might be forced to postpone repairs or building work until a year when the direction of their properties was declared to be lucky. J. J. M. de Groot, who studied geomancy in Fujian Province in the 19th century, wrote that whole streets were demolished and rebuilt during auspicious years. As there were always ritual ways around its restrictions, however, geomancy had only a limited effect on actual buildings. Nonetheless, geomantic literature is important for the study of Chinese architecture, containing something that approaches a theory of architecture and its aesthetics. The following passage from the *Bazhai zaofu zhoushu* ('Complete book of creating good luck in houses of all directions'; 1629) clearly illustrates the relationship between geomancy and aesthetics:

> If the shape is unfavourable, the house definitely will be hard to live in. Whether a house is favourable or unfavourable, unlucky or lucky, can be told by the eye. As a rule, a house is favourable if it is square and straight, plain and neat, and pleasing to the eye. If it is too high and large, or too small and tumbledown, so as to be displeasing to the eye, then it is unfavourable.

Geomantic practices influenced the development of town, temple and tomb planning, garden design and domestic architecture in Korea and Japan, as well as in China (*see also* CHINA, §§II, 4(i)(a) and (iii), 5(ii)(c), 6(ii)(a) and III; KOREA, §II, 3(i) and (iii) and 4; and GARDEN, §VI, 1(iv) and 2). In South-east Asia, houses, and sometimes entire villages, are planned in accordance with rules of orientation based on such geographical dualities as mountain–sea or upstream–downstream, or on the four or eight cardinal points of the compass.

BIBLIOGRAPHY

J. J. M. de Groot: *The Religious System of China*, 6 vols (Leiden, 1892–1910), iii, pp. 935–1056

S. D. R. Feuchtwang: *An Anthropological Analysis of Chinese Geomancy* (Vientiane, 1974)

S. J. Bennett: 'Patterns of the Sky and Earth: A Chinese Science of Applied Cosmology', *Chin. Sci.*, iii (1978), pp. 1–26

M. Freedman: 'Geomancy', *The Study of Chinese Society: Essays by Maurice Freedman*, ed. G. W. Skinner (Stanford, 1979), pp. 313–33

S. Skinner: *The Living Earth Manual of Feng-shui: Chinese Geomancy* (London, 1984)

He Xiaoxin: *Fengshui tanyuan* [The source of *fengshui*] (Nanjing, 1990)

R. Waterson: *The Living House: An Anthropology of Architecture in Southeast Asia* (Singapore, 1991)

K. Ruitenbeek: *Carpentry and Building in Late Imperial China: A Study of the Fifteenth-century Carpenter's Manual 'Lu Ban jing'* (Leiden, 1992)

KLAAS RUITENBEEK

George, Prince of Wales and Prince Regent. *See* HANOVER, (4).

George III, King of Great Britain. *See* HANOVER, (3).

George IV, King of Great Britain. *See* HANOVER, (4).

George, Milton (*b* Asia, Manchester, Jamaica, 23 July 1939). Jamaican painter. He attended the Jamaica School of Art in Kingston part-time for a while although he was essentially self-taught. He started exhibiting in the late 1960s. He was a major exponent of the expressionist trend in Jamaican art. His central theme was the absurdity of the human condition seen from his personal, highly subjective perspective. While his early work is characterized by a gentle melancholy, his mature work has satirical, albeit anguished overtones. The human figure is central to most of his paintings and is usually subjected to caricatural distortion. On occasion, he also experimented with full abstraction. His major subjects were the self, the artist and the art world, the individual versus society, the man–woman relationship. Occasionally he also commented on political issues. Most of his works include self images, in the form of direct self-portraits or projections into other personae such as the Christ figure. Among his major works is a 14-panel work, *Fourteen Pages from my Diary* (1983; Kingston, Inst. Jamaica, N.G.), which presents a pitilessly funny analysis of the artist's relationship with women. He worked mainly in oils and oil pastel on canvas and paper. Often described as 'a painter's painter', his paintings illustrate a sensuous delight in the act of painting itself. A daring colourist, he had an acute sense for the emotional impact of colour and some of his most dramatic paintings verge on the monochromatic and minimalist (e.g. *Judgement*, 1987; priv. col., on loan to Kingston, Inst. Jamaica, N.G.).

BIBLIOGRAPHY

Jamaican Art 1922–82 (exh. cat. by D. Boxer, Washington, DC, Smithsonian Inst.; Kingston, Inst. Jamaica, N.G.; 1983), pp. 21, 77

G. Escoffery: 'The Intimate World of Milton George', *Jamaica J.*, xix/2 (1986), p. 28

VEERLE POUPEYE

George, Walter Sykes (*b* 1881; *d* Delhi, 7 Jan 1962). English architect, active in India. Born of a family of Quaker architects, he was brought up in East Anglia and Manchester, where he worked in the family office. He studied under A. Beresford Pite and W. R. Lethaby at the Royal College of Art, London, and won the Soane Scholarship in 1906. In 1906–11 he was associated with the British School at Athens and participated in several excavations. In 1913 he published a monograph, *The Church of St Eirene at Constantinople*.

Having lost an eye in his youth, George was not accepted for service in World War I. In 1915 he went as Herbert Baker's representative to New Delhi, where he designed a number of houses, St Stephen's College, and St Thomas's Church (1930–31), Paharganj. In 1923 he went into private practice. Major commissions included the reconstruction of Maiden's Hotel in Delhi and the design of the Council Chamber at Simla. He worked extensively at Mandi, Nabba and Jodhpur. He was responsible for the layout of the garden at the British Residency at Kabul and several houses for the rulers of Jhind, Mandi and Bahawalpur at New Delhi. He remained in India after its independence in 1947 and was largely responsible for starting the Delhi School of Architecture. President of the Indian Institute of Architects in 1950–52 and 1957–8, he also founded the Indian Institute of Town Planning.

See also INDIA, §III, 8(i), and DELHI, §I, 8.

BIBLIOGRAPHY

Obituary, *RIBA J.*, n.s. 3, lxix (1962), p. 102

G. Stamp: 'Indian Summer', *Archit. Rev.* [London], clix (1976), pp. 365–72

R. G. Irving: *Indian Summer: Lutyens, Baker and Imperial Delhi* (New Haven and London, 1981)

G. Stamp: 'British Architecture in India, 1857–1947', *J. Royal Soc. A.*, cxxix (1981), pp. 358–79

P. Davies: *Splendours of the Raj: British Architecture in India, 1660–1947* (London, 1985)

PHILIP DAVIES

George of Kolozsvár. *See under* MARTIN AND GEORGE OF KOLOZSVÁR.

George of Poděbrady [Poděbrad; Jiří Poděbradský], King of Bohemia (*b* Poděbrady, 23 April 1420; *reg* 1458–71; *d* 22 March 1471). Bohemian ruler and patron. He was known as the 'Hussite King' for his adherence to the Utraquist movement for Communion in both kinds, being political leader of the Utraquists after the death of Sigismund, King of Bohemia and Hungary, in 1437 and during the reign of Ladislas Postumus (*reg* 1440–57). He was proclaimed Regent in 1452, becoming king after a short period of anarchy. He formed alliances with neighbouring rulers, but in 1466 he was anathematized by Pope Paul II, who in 1469 secured the election of Matthias Corvinus as King of Bohemia. Before his death, however, George secured the subsequent succession of Vladislav II Jagiellon (*see* JAGIELLON, (1)).

King George can be seen holding a gold chalice, the Utraquist symbol, in a statue (*in situ*) that he commissioned for the façade of St Mary of Týn in Prague. His cultural efforts were not, however, as far-reaching as his political activity, partly owing to the state of the kingdom and the scant interest in culture evinced by the Utraquists. Nevertheless, in this period the monasteries and churches that had been destroyed during the Hussite wars were slowly rebuilt and, in view of the unstable political situation, George undertook the fortification of towns and castles. There is evidence of high quality artistic activity during George's reign, in particular at Rožmberk where the influence of German Late Gothic is reflected in the architecture and sculpture.

BIBLIOGRAPHY

R. Urbánek: 'Věk poděbradský' [The Poděbrad period], *České dějiny* [Czech history], iii/1–3 (Prague, 1915–60)

——: *Husitský král* [The Hussite king] (Prague, 1926)

R. Chadraba, ed.: *Dějiny českého výtvarného umění* [A history of Czech fine arts], 2 vols (Prague, 1984)

JAN ROYT

George & Peto. English architectural partnership formed in 1876 by Ernest George (*b* London, 13 June 1839; *d* London, 15 Dec 1922) and Harold Ainsworth Peto (*b* Somerleyton, Suffolk, 11 July 1854; *d* Bradford-on-Avon, Wilts, ?14 April 1933). George was articled to the architect Samuel Hewitt in London (1856–60), and in 1857 he entered the Royal Academy Schools, where he won the Gold Medal two years later. After a few months in the London office of William Allen Boulnois (1823–93), he made a sketching tour of France and Germany. On his return in November 1861 he set up in partnership in London with a fellow Royal Academy student, Thomas Vaughan (?1839–75). By the early 1870s they had established a sound practice, designing commercial, domestic and some ecclesiastical buildings, principally in London and Kent. They designed a villa (1870) for Arthur Richard Wellesley, 2nd Duke of Wellington, at Molino del Rey, Granada, Spain, and in 1874 began their country-house practice with Rousdon, Devon, built for Henry William Peek in an arresting mixture of Franco-Flemish, late Tudor and Old English styles. The securing of commissions from such prestigious clients helped consolidate their growing reputation.

Following Vaughan's early death, George entered into partnership in 1876 with Peto, who was the son of a public works and railway contractor. Peto had spent a year in the offices of Kerslake & Mortimer in London before joining his brother's building firm, Peto Brothers, in 1875. Once the partnership had been formed, the scope of the practice widened dramatically, with many commissions coming through the Peto family's connections. These included their timely speculation in Harrington and Collingham Gardens, Kensington, London, which was one of George & Peto's major architectural successes. Their superbly conceived domestic designs, executed between 1880 and 1888, represent the extreme point of late Victorian individualism. The range of plain Queen Anne Revival houses was extended to include something of the picturesque brio of the old Flemish and German town houses that George sketched and painted in watercolour on his frequent tours to northern Europe. One such house, 39 Harrington Gardens (1882; see fig.), was built for the dramatist W. S. Gilbert.

George & Peto were spectacularly successful throughout the late 1870s and 1880s. Their designs ranged from the picturesque Queen Anne Revival style premises (1875–6) for Thomas Goode & Co. in South Audley Street, Mayfair, London, to the superlative Ossington Coffee Palace (1881–2), Newark-on-Trent, Notts, and interiors for the yacht *Cuhona* (1883). George was particularly alert to the potential of colour in his buildings, and he frequently made imaginative use of terracotta, notably at 52 Cadogan Square (1886–7) and the Albermarle Hotel (1887–8), Piccadilly, both in London; Woolpits (1885–8), Ewhurst, Surrey, Sir Henry Doulton's country house; and St Andrew's (1885–6), Guildersfield Road, Streatham, London. The partnership specialized in designs for country houses, however, and they worked in a variety of revival styles, including mixed early and late Tudor at Stoodleigh Court (1883–6), Tiverton, Devon; Queen Anne at Dunley Hill (1887–8), Dorking, Surrey; Tudor at Shiplake Court (1889–91), Henley-on-Thames, Oxon; Jacobean at Poles

George & Peto: houses in Harrington Gardens, London, 1880s; W. S. Gilbert's house, no. 39, is on the left

(1890–92), Ware, Herts; and Elizabethan at Motcombe House (1892–4), Shaftesbury, Dorset. While many of George's early designs appear elaborate, such as the Franco-Flemish Renaissance style of Buchan Hill (1882–6), Crawley, W. Sussex, there was always an underlying restraint, an aspect of his work that often went unnoticed, although it was occasionally laid bare, as at his own house, Redroofs (1887–8), Streatham Common, London. The partnership's smaller houses, cottages and lodges, such as those on the Clandon Park Estate (1889–92), Guildford, Surrey, and the Haydon Hall Estate (1879–80), Eastcote, Middx, show an informed and sympathetic handling of forms based on local vernacular traditions. These were highly influential prototypes for the modest-sized houses that were favoured by the later English domestic revivalists. The partnership also made designs for furniture, which show a high level of historical expertise and structural integrity. They purchased furniture and furnishings on behalf of clients, sometimes combining these with work by contemporary craftsmen.

In 1892 ill health forced Peto to retire from the partnership and concentrate on landscape gardening and interior design. In 1889 he bought Iford Manor, Bradford-on-Avon, Wilts, where he laid out an Italian garden, partly as a setting for his collection of Gothic and Renaissance statuary. His other garden designs included Buscot Park (*c*. 1904–11), Berks, for Lord Faringdon, gardens for Garinish Island, Glengariff, Co. Cork, Ireland, for John Annan Bryce, and numerous villas and gardens in southern France. His interiors included that for the Cunard liner *Mauretania* (1912; destr. 1934). With Peto's departure, George entered into his final partnership with Alfred Bowman Yeates (1867–1944). Commissions for large country houses continued, for example Crathorne Hall (1903–6), Yarm-on-Tees, Cleveland, and Eynsham Hall (1904–8), Witney, Oxon, and these were more successful than their designs for public commissions, the most distinguished of which were both in London: Golders

Green Crematorium (1901–28), in a Lombard Romanesque style, and Southwark Bridge (1908–21).

George was a watercolourist and etcher of some distinction. He published several volumes of etchings, although it was his perspective drawing in soft sepia pen and wash that was most highly acclaimed. These drawings, widely published in the architectural press, were immensely influential. In 1896 he was awarded the Royal Gold Medal for Architecture, and from 1908 to 1910 he was President of the RIBA. He was made ARA in 1910 and RA in 1917, and in 1911 he was knighted. Among the pupils who passed through his office were Herbert Baker, Robert Weir Shultz, Edwin Lutyens and Guy Dawber who, with his partner A. R. Fox, continued the practice after George's death.

WRITINGS

E. George: 'An Architect's Reminiscences', *Builder* (13 May 1921), pp. 622–3

PRINTS

E. George: *Sketches, German and Swiss* (London, 1870)
——: *Etchings on the Mosel* (London, 1874)
——: *Etchings on the Loire and South of France* (London, 1875)
——: *Etchings in Belgium* (London, 1877, 2/1883)
——: *Etchings of Old London* (London, 1884)
——: *Etchings of Venice* (London, 1888)

BIBLIOGRAPHY

J. W. Gleeson-White: 'The Revival of English Domestic Architecture', *The Studio* (1896), pp. 147–58, 204–15
M. Richardson: 'The Office of Sir Ernest George and Peto', *Architects of the Arts and Crafts Movement*, RIBA Drawings Series (London, 1983), pp. 59–69
H. J. Grainger: *The Architecture of Sir Ernest George and his Partners, c. 1860–1922* (PhD diss., U. Leeds, 1985)
The Survey of London, xlii (London, 1986), pp. 184–95

HILARY J. GRAINGER

Georges II d'Amboise, Cardinal of Rouen. *See under* AMBOISE, D'.

Georgescu, Ion (*b* Bucharest, 18 March 1856; *d* Bucharest, 13 Dec 1898). Romanian sculptor and painter. He studied at the Fine Arts School in Bucharest (1872–7) under Karl Storck and Theodor Aman, then at the Ecole des Beaux-Arts in Paris (1878–80) under Augustin-Alexandre Dumont. In Paris, where he lived until 1882, he also worked in Eugène Delaplanche's studio. In his painting he was guided by Pierre-Auguste Cot (1837–83) at the Académie Julian (*c.* 1881), but the most significant influences on his development were the sculptures of Jean-Baptiste Carpeaux. Georgescu preferred to work in terracotta and bronze; his works in marble were carved from his models by workers at Carrara and especially in Romania. From his period in Paris date the allegorical reliefs *Summer* and *Winter* (both 320×270 mm, 1882; Bucharest, N. Mus. A.) and the statue of *Endymion Hunting* (bronze, h. 1550 mm, 1882; Bucharest, N. Mus. A.), a work of austere realism that shows a precise anatomical knowledge and also the capacity to give the human figure in motion a spiritual significance.

Georgescu was a gifted sculptor of portrait busts, which he modelled with energy and with a powerful intuition of their subjects' individually. Some of them represent writers and artists, whose complex creative personalities attracted him. Among these is the portrait bust of the actor *Mihail Pascaly* (bronze, h. 720 mm, 1882; Bucharest, Mus. N.

Theat.), a work of remarkable romantic pathos. He also executed funerary monuments, such as that to Princess Bălaşa (marble, 1884; Bucharest, Princess Bălaşa Church). A masterpiece of his maturity is the statue of *Gheorghe Asachi* (marble, 1890; Iaşi, Stefan cel Mare Street), which vividly portrays the concentrated expression of the old writer meditating in an armchair. Two large reliefs evoking scenes from Asachi's life decorate the plinth of the monument. A study for this statue (plaster, h. 455 mm, 1886; Galaţi, Mus. A.) gives a different interpretation, revealing the anxieties and contradictions of the model's personality. Georgescu's watercolours are mostly of costumed models, landscapes (e.g. *Massa-Carrara*, 1885; Bucharest, Roman. Acad. Lib.), interior scenes, still-lifes and flowers. He also painted in oils, concentrating on figure studies. From 1887 until his death he taught sculpture at the Fine Arts School in Bucharest.

BIBLIOGRAPHY

N. Petraşcu: *Ion Georgescu* (Bucharest, 1931)
G. Oprescu: 'I. Georgescu', *An. Acad. Române*, n.s. 3, xvii (1948), pp. 1–23
R. Niculescu: 'Ştiri noi despre anii de formaţie ai lui Ion Georgescu' [New information on the formative years of Ion Georgescu], *Stud. & Cerc. Istor. A.*, iv/3–4 (1956), pp. 173–83
——: 'Statuia lui Gheorghe Asachi de Ion Georgescu' [The Gheorghe Asachi statue by Ion Georgescu], *Stud. & Cerc. Istor. A.: Ser. A. Plast.*, xxvii (1980), pp. 41–91

REMUS NICULESCU

George William [Georg Wilhelm], Duke of Calenberg and Celle. *See* WELF, (4).

Georgia, Republic of [Sakartvelos Respublika]. Caucasian country covering an area of 69,700 sq. km in the central and western part of Transcaucasia. In the early 1990s it had a population of *c.* 5 million. It borders Russia to the north, Azerbaijan to the east and south-east, Armenia and Turkey to the south and the Black Sea to the west (see fig. 1). Its capital is TBILISI. Having been incorporated into the USSR in 1921, Georgia became a separate Soviet republic from 1936 but became independent in 1991.

I. Introduction. II. Architecture. III. Sculpture. IV. Painting, mosaics and graphic arts. V. Decorative arts. VI. Patronage and collecting. VII. Museums and institutions.

I. Introduction.

The earliest traces of material culture in Georgia have been recovered from early Palaeolithic contexts in caves in, for example, Abkhazeti, Imereti and Kakheti. A complex tribal society existed by the 5th millennium BC. In the late 2nd millennium BC and the early 1st there is evidence for the formation of two clearly defined regions with homogeneous material cultures in western Georgia (Colchis) and eastern Georgia (Kartli). Invasions from the north in the 8th century BC by the Cimmerians and later by the Scythians, whose handicrafts and constructions are known from excavations (*see* SCYTHIAN AND SARMATIAN ART), accelerated this process, leading to the emergence in the 6th century BC of the Colchian kingdom, the successor to ancient Colchis, and of the Iberian kingdom, in the 4th century BC. Foreign trade had become increasingly active, especially with the establishment of Greek trading posts and colonies on the eastern Black Sea coast in the 6th century BC. In the succeeding centuries strong political and economic ties were maintained with Armenia,

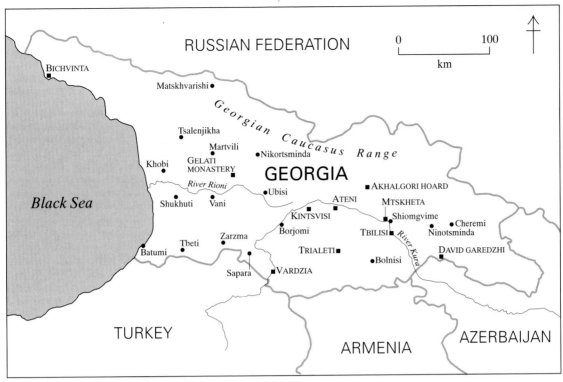

1. Map of Georgia; those sites with separate entries in this dictionary are distinguished by CROSS-REFERENCE TYPE

the Hellenic states of the Seleucids and the kingdom of the Pontus.

In the 1st century BC Georgia was subjugated by Rome, but between the 2nd and 3rd centuries AD first the Iberian kingdom and then the kingdom of Lazica in Colchis regained control. Both kingdoms adopted Christianity as their state religion in the 4th century AD, and there followed the first major period in the development of Georgian culture, from which date the earliest surviving examples of Georgian writing (5th century), the only written member of the South Caucasian (Kartvelian) linguistic family; it is written in a distinctive alphabet with 32 letters. The Arab invasion in the mid-7th century led to the so-called Transitional period, which was marked by the formation of the rival principalities of Kakheti, Ereti, Tao-Klarjeti and Abkhazeti, which vied with each other until the second half of the 10th century.

Georgia was unified into a single feudal state in the early 11th century and reached its political, economic and cultural apogee during the next two centuries. The architecture of this period included churches, palaces and fortresses, and there was considerable production of monumental paintings and icons, manuscript illuminations, sculpture, gold and silver metalwork, enamelling, ceramics and textiles.

The Tatar–Mongol invasions of the second quarter of the 13th century brought this period of florescence to a close, and Georgia was further devastated by the attacks of Timur (reg 1370–1405) and during the struggle between Iran and Turkey for control of Transcaucasia (16th–18th centuries). After this unstable political situation, certain aspects of Georgian art and architecture revived in the 17th and 18th centuries.

With the annexation of eastern Georgia to the Russian empire in 1801 and the gradual inclusion of western Georgia between 1803 and 1864, Georgian art became heavily influenced by that of Russia and more closely in line with European trends. After the Revolution of 1917 and the incorporation of Georgia into the USSR in 1921, Georgian art tended to represent such themes as the people's revolutionary struggle and various historical, military and patriotic subjects.

The most important collection of Georgian art is housed in the State Museum of Art of Georgia (now Tbilisi, Mus. A. Georgia), Tbilisi, which was founded in 1933 and also contains sections on Russian, west European and Iranian art. Many of Georgia's finest illuminated manuscripts are kept in the Institute of Manuscripts at the Academy of Sciences in Tbilisi. The M. I. Toidze people's art studio, which existed until 1929, and the Academy of Arts, which still trains artists and architects, were both founded in Tbilisi in 1922 to foster the arts.

BIBLIOGRAPHY

E. Takaishvili: *Arkheologicheskiye puteshestviya i zametki* [Archaeological travels and notes], 2 vols (Tbilisi, 1907–14)

——: *Arkheologiuri ekspeditsia Letchkum-Svanetshi 1910 tsels* [Archaeological expedition to Lechkhumi and Svanetiya] (Paris, 1937)

——: *Arkheologiuri ekspeditsia Kola-Oltisshi da Changlshi* [Archaeological expedition to Kola-Oltisi and Changly] (Paris, 1938)

——: *Arkheologicheskaya ekspeditsiya 1917-go goda v yuzhnyye provintsii Gruzii* [The 1917 archaeological expedition to the southern provinces of Georgia] (Tbilisi, 1952)

S. Amiranashvili: *Istoriya gruzinskogo iskusstva* [A history of Georgian art] (Moscow, 1963)

V. Beridze: *Dzveli kartveli ostatebi* [Masters of ancient Georgian art] (Tbilisi, 1967)

V. Beridze and N. Yezerskaya: *Iskusstvo Sovetskoy Gruzii: Zhivopis', grafika, skul'ptura* [The art of Soviet Georgia: painting, graphic arts and sculpture] (Moscow, 1975)

R. Mepisaschwili and W. Zinzadse: *Die Kunst des alten Georgien* (Leipzig, 1977)

V. Beridze and N. Yezerskaya: *Srednevekovoye iskusstvo: Rus'–Gruziya* [Medieval art: Russia–Georgia] (Moscow, 1978)

A. Alpago-Novello and others: *Art and Architecture in Medieval Georgia* (Louvain-la-Neuve, 1980)

V. Beridze and others: *The Treasure of Georgia* (London, 1984)

II. Architecture.

The earliest constructions in Georgia include the barrow burials of the 3rd and 2nd millennia BC in the Trialeti area and at Samgori, and the Cyclopean fortresses and settlements with round and oval dwellings (1st millennium BC) in Iberia and Colchis. Excavations have also revealed an acropolis (4th century BC–AD 1st century) near Armazi, a palace and bathhouse (2nd–3rd century AD) at MTSKHETA and various other stone structures pre-dating the official acceptance of Christianity (AD 330s). With the need for churches, Georgian ecclesiastical architecture adopted the central and basilican plans that characterize all Early Christian churches, while retaining distinctive local features. Numerous monasteries and secular buildings, including bridges, baths, forts, houses and towers, were also built between the 5th century and the early 13th, when Georgia was invaded by the Tatars and Mongols.

During the 15th century an effort was made to reconstruct and restore many of the monuments destroyed during these invasions as well as the subsequent 14th-century invasion of Timur. Despite the depredations of Iran and Turkey between the 16th and 18th centuries, the architecture of this period is interesting for its national character. With the annexation of Georgia into the Russian empire (1801), urban architecture increasingly reflected Russian and European styles. Most emphasis was placed on the promotion of urban planning and the construction of civic amenities, and this continued after the Revolution of 1917 and the establishment of Soviet power.

1. 4th–7th centuries AD. 2. 8th–14th centuries. 3. 15th century–early 19th. 4. Mid-19th century and after.

1. 4TH–7TH CENTURIES AD. The building techniques of this period are a direct continuation of earlier practices. Stone, of which there is an abundant supply in Georgia, was the most commonly used material, and several stages can be distinguished in the development of masonry construction. By about the 6th century dry-stone walling was replaced by walls composed of rectangular blocks laid two deep, their dressed faces corresponding to the inner and outer surfaces, and bound together by lime mortar. The use of continuous and level courses of different heights produces a picturesque effect that is further enhanced by the choice of the colourings of the stone. In a few areas dark basalt and granite predominate, otherwise the stone is mostly tuff, sandstone and limestone of light yellow, pink, green, grey with bright flecks, even blood-red. From the end of the century the blocks were separated by a thin core of rubble laid in mortar, which became steadily thicker, at the expense of the stone blocks, until by the 10th century the walls comprise a massive rubble core with ashlar facing.

The development of early Georgian architecture can best be followed by reference to the churches, which are preserved in greater numbers and reflect stylistic changes more clearly than other building types. Architectural features of this period are distinguished by their clarity of line and precision, reaching a peak of development in the late 6th century and the early 7th. It was then too that relief sculpture became an important feature in the design of church façades (*see* §III below).

According to chronicles, the first churches were built by King (Mepe) Mirian III immediately after the official adoption of Christianity *c.* 337. The earliest surviving churches, such as the basilica at Nekresi, the original single-aisled structure at Bodbe and the square-plan building at Cheremi, date to the second half of the 4th century and the early 5th. They are small (*c.* 6–12 sq. m), without domes, and reflect the attempt to combine the local preference for centrally planned structures with the imported basilican form. This is most clearly exemplified by the church at Nekresi: though in a basilican form with three aisles, the central nave is joined to the side aisles by a single arch covering a wide span.

The earliest genuine basilica of any significant size is the church of Sioni (Assumption of the Mother of God; 478–93; vaults rebuilt 17th century) at Bolnisi. Built in turquoise-coloured tuff, it has three aisles divided by arcades of six bays, a projecting semicircular apse and northern and southern annexes. The zoomorphic and geometric reliefs on some of the capitals and walls are among the earliest examples of such ornament. The same basilican plan is also found at Urbnisi, Uriatubani (both 6th century) and the church of Anchiskati at TBILISI (6th century; rebuilt 17th century).

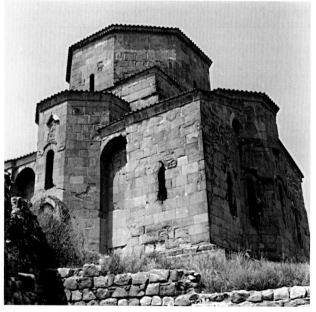

2. Large church of Jvari, Mtskheta, AD 586–605

In the 6th and 7th centuries centrally domed structures became the predominant church type. They appear in various forms: the cross plan with free-standing arms, such as at Shiomgvime (both 6th century) and Samtsevrisi (7th century); the cross within a rectangle, such as at Ikalto (6th century) and the small church of Jvari (mid-6th century; partly destr.) at Mtskheta; and the four-apsed plan, such as at Manglisi (6th–7th century), where it was inscribed within an octagon, and at Dzveli Gavazi (6th century), where the external aspect of the building was determined by the unadorned semicircular apses. A larger and more complicated form of this last plan was used for the cathedral of Ninotsminda (6th century), dedicated to St Nino. There four rectangular chambers with apsidioles were added in the spaces between the arms of the cross, resulting in an exterior formed by eight semicircles, alternately large and small, surmounted by a central dome.

The large, as opposed to small, church of Jvari (586–605; see fig. 2) at Mtskheta is a further development of the type seen in the cathedral of Ninotsminda and represents a peak in Georgian architecture. The large central dome rests on squinches and dominates the interior, which is bound by the four apses of the cross and by four semicircular niches between the arms, each opening into a chamber. This plan, which is characteristically Georgian, inspired the construction of numerous churches, some very similar (e.g. Ateni and Martvili), others less so, as in the small domed church at Dzveli Shuamta (all 7th century). The cathedral at Bana, Turkey (7th century; largely destr. 19th century), represents another type of domed tetraconch employed in the repertory of Georgian churches. Its central four-apse plan was surrounded by a circular ambulatory, on to which the lower part of each apse opened through an arcade.

The further development of Georgian architecture in the 620s and 630s is exemplified by the church at Tsromi. It has an elongated structure with a single eastern apse flanked by two rectangular chapels and a western narthex. The central dome rests on four free-standing pillars and unifies the interior's inscribed cross plan, which is one of the earliest of its kind in Georgia. The church also contains the first perfected example of the motif of two triangular niches in the east façade that later became a compulsory feature of Georgian domed churches.

In addition to churches, the cave monastery at DAVID GAREDZHI was founded in the 6th century, and, as it grew into a broad complex of branching cliff-monasteries, it became an important centre of artistic, cultural and educational activities. Among the few secular buildings to survive from this period are the citadel of Ujarma, parts of that at Tbilisi and the ruins of a palace in Cheremi.

2. 8TH–14TH CENTURIES. The architecture of the region continued to flourish in the aftermath of the invasion of Georgia by the Arabs towards the mid-7th century and the emergence of rival principalities. The search for new types of church and decorative styles reflected the growing power of the independent duchies and princedoms: Abkhazeti, TAO-KLARJETI, Kakheti and Kartli. Increasingly churches were built with a longitudinal east–west axis and the dome placed either centrally or near the altar. A number of monasteries, particularly in Tao-Klarjeti and Kakheti, were constructed with their own churches, workshops, scriptoria and refectories. Among the most notable churches are the domed Sioni (759–77) at Samshvilde, the two-domed church near Gurjaani (8th century) and the cathedral of BICHVINTA (10th century). The ruins of several feudal palaces of the 8th to the 10th centuries have also survived (e.g. in Kakheti) and present a layout that is entirely different to that used in ecclesiastical architecture. They usually had two storeys, the lower containing service quarters and the upper living-quarters and a large reception hall. Other buildings, such as the bathhouse and family chapel, stood apart.

From the end of the 10th century to the early 13th the building of new towns, roads, bridges, palaces, defensive systems and cathedrals was widespread. A major new cliff-monastery was founded at Vardzia (12th century), and the David Garedzhi complex continued to be extended. A dominant church design emerged based on an elongated structure with a dome over the crossing. The multi-faceted drum of the dome is supported by four free-standing pillars, but from the 11th century two of the pillars are sometimes replaced by the corners of the altar walls. Variations within this basic type could employ projecting polygonal or circular apses (e.g. Kaldakhvara and Bichvinta), or galleries and porticos (e.g. Oshki; 958–64). Some examples have a narthex (e.g. the church of Simon Cananaeus in Anakopia), while others do not (e.g. Sinkoti). Proportions are stretched upwards, and a painterly style of architecture is achieved through the harmonious arrangement of exterior mass and inner space, combined

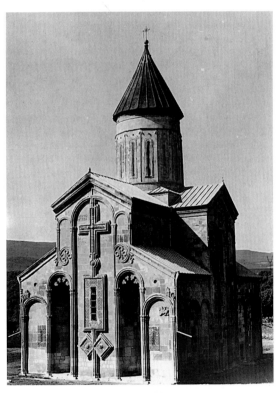

3. Cathedral at Samtavisi, Georgia, 1030

with rich ornamental carvings on the façades (see fig. 4 below) and wall paintings inside. Among the principal monuments are the cathedrals of Kumordo (964), Kutaisi (1003), Alaverdi (early 11th century), Nikortsminda (1010–14), Sveti-Tskhoveli (1010–29) and Samtavro at Mtskheta, and Samtavisi (1030; see fig. 3), as well as the churches in GELATI MONASTERY (1106), Kvatakhevi, Betania (late 12th century–early 13th), Pitareti (1220s), Kintsvisi (*see* KINTSVISI, ST NICHOLAS) and Sapara (1280s). Examples of Georgian architecture from this period are also to be found outside the region at the monastery of the Holy Cross (mid-5th century; rebuilt 11th century), Jerusalem, and at the Georgian monastery of Iviron (founded late 10th century) on Mt Athos. The few surviving churches from the period immediately before Timur's invasions (1386–1403) include those of Daba (1333), near Borjomi, Zarzma (1308) and Sameba on Mt Kazbegi.

3. 15TH CENTURY–EARLY 19TH. Between the 15th and 18th centuries great efforts were made to restore the churches, palaces, forts and dwellings damaged during the invasions of Timur and later by the Iranians and Turks. Church architecture clung to traditional forms but never reached the artistic level of earlier works. Of particular interest are the surviving examples of secular architecture. In mountainous regions an integral part of a dwelling was a multi-storey tower. In East Georgia, in both towns and villages, the common residence was the *darbazi* (hall), a centrally planned structure with a wooden, dome-shaped lantern roof pierced by a small opening at the top to let light in and smoke out (e.g. Uplistsikhe). Examples of the latter type of dwelling in Georgia are known from before the advent of Christianity.

The change in political, social and economic conditions after the incorporation of Georgia into the Russian empire in 1801 greatly influenced the development of architecture and urban building. The capital, Tbilisi, which had retained its medieval appearance with marked Iranian features, owing to the imposition of Iranian rule between the 16th and 18th centuries, was gradually changed into a typical European town. Forts and feudal castles, the main architectural features of the Middle Ages, were demolished, and urban planning was given more emphasis than church building, although the latter continued. Official and public buildings were erected in the Neo-classical style, such as the army headquarters and the seminary (now the Museum of Art of Georgia) in Tbilisi.

In the 1830s and 1860s residential architecture in Tbilisi, Signakhi, Telavi and other cities began to combine classically derived elements, such as door and window frames, balusters, cornices and Tuscan and Doric columns, with local architectural traditions: wide wooden balconies, carved balustrades and balcony arches, open staircases and glassed-in galleries.

4. MID-19TH CENTURY AND AFTER. In the second half of the 19th century European Eclecticism dominated Georgian architecture. From the early 20th century this was superseded by the modern style of architecture as well as a renewed interest in national building types and decorative motifs. Typical examples in Tbilisi include the

Kvashveti Church (1904–10), the Georgian Bank of the Nobility (1912–16; now the National Library of Georgia), the opera house (1880–96), the Rustaveli Theatre and the Hotel Tbilisi.

With the establishment of Soviet power the devising of general plans for the large-scale rebuilding and modernization of Georgian cities became a primary architectural objective. The first city to be redeveloped was Tbilisi (1932–4), followed by Kutaisi, Batumi, Sokhumi, Gori (where Stalin was born) and others. New industrial centres, such as Rustavi, and Black Sea resorts were also founded. Much new housing was constructed after World War II.

The buildings of the 1920s reflected two trends in architecture: on the one hand the stylistic influence of various European forms such as Constructivism and Functionalism and, on the other, the use of purely decorative motifs. By the 1940s the uncritical use of the classical tradition had prevailed to the detriment of a functional solution, as in the rest of the Soviet Union. From the mid-1950s the search for national self-expression became more restricted and related to modern achievements; the synthesis of architecture and other art forms became an important issue. Among the many important architectural works in Tbilisi are the Sports Palace (1961–2; by V. Aleksi-Meskhishvili, I. Kasradze and D. Kajaia), the Philharmonic Concert Hall (1971; by I. Chkhenkeli), the main Post Office (1980; by V. Aleksi-Meskhishvili and T. Mikashavidze) and a new railway station (1987; by R. Bairamashvili, A. Jibladze, I. Kavlashvili and G. Shavdia). Other notable buildings include the Revolutionary Museum (1955; by K. I. Javakhishvili), Batumi, and the numerous sanatoria, rest homes and baths in Borjomi, Gagra, Kobuleti and Tskhaltubo. Since the early 1960s the restoration and adaptation of historic areas within cities have become a major concern.

BIBLIOGRAPHY

G. Lezhava and M. Jandieri: *Arkhitektura Svaneti* [The architecture of Svaneti] (Moscow, 1938)

G. Chubinashvili: *Bolnisskiy Sion* [The Bolnisi Sioni church] (Tbilisi, 1940) [Ger. summary]

——: *Pamyatniki tipa Dzhvari* [Monuments of the Jvari type], 2 vols (Tbilisi, 1948)

R. Schmerling: *Gruzinskiy arkhitekturnyy ornament* [Georgian architectural decoration] (Tbilisi, 1954)

V. Beridze: *Samtskhis khurotmodzgvzeba XIII–XVI saukuneebi* [The architecture of Samtskhe, 13th–16th centuries] (Tbilisi, 1955) [Ger. summary]

T. Gabashvili: *Portalebi kartul arkhitekturashi* [Portals in Georgian architecture] (Tbilisi, 1955)

G. Chubinashvili: *Arkhitektura Kakheti: Issledovaniye razvitiya arkhitektury v vostochnoy provintsii Gruzii v IV–XVIII vv.* [Architecture of Kakheti: research into the architectural development of the eastern province of Georgia in the 4th–18th centuries], 2 vols (Tbilisi, 1959)

L. Rcheulishvili: *Tigva: Sharvanis dedpolis thamaris agmshenenbloba* [Tigva: The building work of Queen Tamar of Shirvan: an essay on the history of Georgian architecture in the 12th century] (Tbilisi, 1960) [Rus. and Ger. summaries]

A. Schmerling: *Malyye formy v arkhitekture srednevekovoy Gruzii* [Small forms in Georgian medieval architecture] (Tbilisi, 1962)

P. Zakaraya: *Drevniye kreposti Gruzii* [Early Georgian forts] (Tbilisi, 1969)

G. Sokhashvili: *Samtavisi* (Tbilisi, 1973) [Rus. and Eng. summaries]

V. Beridze: *Gruzinskaya arkhitektura rannekhristianskogo vremeni, IV–VII vv.* [Georgian architecture in Early Christian times, 4th–7th centuries] (Tbilisi, 1974)

R. Mepisashvili and V. Tsintsadze: *Arkhitektura nagornoy chasti istoricheskoy provintsii Gruzii: Shida Kartli* [The architecture of the mountainous part of the historic province of Georgia: Shida Kartli] (Tbilisi, 1975)

P. Zakaraya: *XI–XVIII saukuneebis kartuli tsentralur-gumbathovani arkhitektura* [Georgian central domed architecture, 11th–18th centuries], 3 vols (Tbilisi, 1975–81)

N. Janberidze and I. Tsitsishvili: *Arkhitektura Gruzii ot istokov do nashikh dney* [The architecture of Georgia from its origins to our times] (Moscow, 1976)

M. Jandieri and G. Lezhava: *Narodnaya bashennaya arkhitektura* [National tower architecture] (Moscow, 1976)

W. Beridse, E. Neubauer and K. Beyer: *Die Baukunst des Mittelalters in Georgien* (Vienna and Munich, 1981)

V. Beridze: *XVI–XVIII saukuneebis kartuli khurotmodzgvzeba* [The architecture of Georgia, 16th–18th centuries], i (Tbilisi, 1983) [Rus. summary]

L. Sumbadze: *Arkhitektura gruzinskogo narodnogo zhil'ya darbazi* [The architecture of the Georgian national dwelling, the *darbazi*] (Tbilisi, 1984)

III. Sculpture.

There is no evidence of developed sculptural production in Georgia before the introduction of Christianity. During the Middle Ages the use of sculpture was limited to reliefs on building façades; only in the late 19th century and the 20th did sculpture in the round develop as an art form.

1. 5TH–14TH CENTURIES. The earliest sculptural reliefs are carved in stone and depict plant and animal motifs, some of which are derived from Early Christian art (e.g. peacocks flanking a cross, a symbol of the Resurrection) and others from local pagan cults. Examples of the latter include a bull's head with a cross between its horns on a capital in the south chapel of the church of Sioni in Bolnisi. In early times the reliefs were nearly always used on the interior of the church to decorate capitals and pillars, but by the late 6th century sculptural reliefs had become an important element in the design of the church façades. The finest example is the sculptured exterior of the Jvari church at Mtskheta, where three reliefs of the donors and one of the *Ascension of the Cross with Angels* lie respectively above the windows of the eastern apse and in the tympanum over the south entrance. The figures in these reliefs are based on three-dimensional images, but this influence gradually gave way to a more flattened, linear style, as in the reliefs (6th–7th century) in the churches of Kvemo Bolnisi, Edzani and Tetri Tskharo, and on stelae from Khandisi (Tbilisi, Acad. Sci., Inst. MSS) and Burdadzori. This style of carving predominated in the 8th and 9th centuries: the decorative linearity of the drapery was emphasized and the proportions of the figures distorted with, for example, enlarged heads or wrists, as in the reliefs of *Prince Ashot I Kuropalati* (*reg* 780–830) from the monastery church (destr.) at Opiza (now Bağcılar) and the stele from Usaneti (both Tbilisi, Mus. A. Georgia).

The most creative period of early Georgian sculpture was between the second half of the 10th century and the first half of the 11th. There was a gradual return to a more realistic modelling of forms with correct proportions; by the 11th century individual parts of the body were being differentiated from the mass of the block, and the figures appear to move more freely in space. The finest work of this kind is on the stone altar screens (11th century; Tbilisi, Mus. A. Georgia) from the churches of Sapara and the monastery of Shiomgvime. On one slab from Sapara are depicted the *Annunciation* and the *Visitation*; the swift movement of the archangel and the Virgin's gesture are freely and naturally conveyed. The reliefs from Shiomgvime are especially interesting for their original subject-matter. On one side are Old and New Testament scenes, including the *Hospitality of Abraham*, the *Trinity* and the *Crucifixion*, and on the other scenes from the lives of the monastery's founder, Shio Mgvimeli, and of St Simeon the Stylite. The sculptor also undertook complex background constructions, including one with many buildings and another of a forested landscape.

In the 10th and 11th centuries every church façade was decorated according to a single artistic programme. Reliefs of single figures or whole scenes are usually located in the triangular spaces between the angles of the gables, the tympanum or near the windows. They sometimes occupy the lunettes of the cross-vaults over the inner porch. The varied subject-matter may include scenes from the Gospels, real and fantastic animals and birds, groups of donors, a single donor holding a model of the church or the construction of the building, as in the cornice of the 10th-century church at Korogo. Plant motifs are also found on many reliefs, either forming a border or woven into the scene itself. Inscriptions occasionally appear on tympana reliefs as an integral part of the design.

The best-preserved examples of integrally sculpted façades appear on the church in Nikortsminda (1010–14). Large representations of *Christ in Judgement*, the *Transfiguration* and the *Second Coming* (see fig. 4) are depicted on the west, east and south façades respectively. Wide, ornamental borders enclose the first two scenes; two mounted saints also flank the frame of the *Transfiguration*. The *Second Coming* lies flat against the wall without any border: the angels bearing Christ are in violent motion,

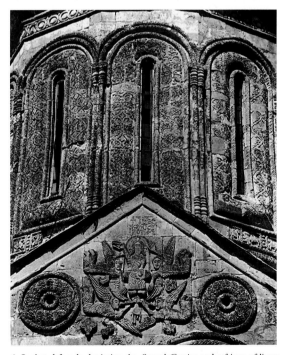

4. Sculpted façade depicting the *Second Coming* and a frieze of lions and gryphons around the base of the dome's drum, Nikortsminda Church, Georgia, 1010–14

with their bodies angularly bent, and the wings, garments and hands are treated ornamentally. Major compositions depicting the *Ascension of the Cross with Angels*, *Christ between Two Warrior-saints* and *Two Archangels* occupy the tympana above the entrances. The vaulted roof of the south portico and the frieze around the base of the dome's drum are covered with lions and gryphons. These carvings and reliefs were executed by several artists using various techniques, some being more sculptural and others more flattened and symbolic, but they are all organically interwoven into the decorative architecture of the façades, portals and roof vaults. The figural reliefs are united by a single theme: the glory of Christ and his Second Coming.

Relief sculptures of archangels, saints, animals and a *Deësis* with a group of donors have also been preserved on the façades and in the gallery of the church in Oshki (960–70). Other interesting reliefs survive on the churches of Khakhuli and Kumurdo, and of Sveti-Tskhoveli at Mtskheta. During the 10th and 11th centuries woodcarving also reached high standards, as evidenced by the ornamental and figurative designs on the wooden doors of the churches of Pkhotreri, Jakunderi and Chukuli.

There was little interest in relief sculpture during the 12th century and most of the 13th. Individual relief compositions were no longer carved on façades; minor figures were reduced to faceless ornament and woven into the general decoration. Despite a revival in relief production in the late 13th century and the 14th, for example on the capitals in the west portico of the church of St Saba, Sapara, it remained of secondary importance.

2. 15TH CENTURY AND AFTER. The situation of the preceding period prevailed during the 15th and 16th centuries, but by the 17th century relief sculptures were commonly used to decorate the façades of forts (entrances and towers), as well as churches. Their naive, but expressive, style was similar to folk art, and the themes depicted were drawn from both the pagan and Christian traditions. One of the most richly decorated buildings of the period is the stone church (late 17th century) in the fortress of Ananuri. Although technically of a fairly high standard, the architect clearly imitated old motifs, compositions or fragments of scenes without fully understanding their meaning.

Throughout the 18th century and much of the 19th there was a steady decline in sculpture. Not until the general artistic revival of the late 19th century and the early 20th did it attract interest as an art form. Whereas sculpture had previously been limited largely to relief carving, rounded forms were now developed, either as monumental works or as statues and busts of individuals. In the decades before 1917 several monuments by foreign artists were erected, such as the statue of *Aleksandr Pushkin* (1892; by F. Hodorovich) in Tbilisi.

A new school of national sculpture was created in the early 20th century by Y. Nikoladze, the first Georgian sculptor of note and a pupil of Rodin. His most renowned work is an allegorical statue of the *Grieving Motherland* (1908–10) at the tomb of the poet I. Chavchavadze (1837–1907) on Mtatsminda Hill in Tbilisi. With the establishment of Soviet rule, sculpture was required to present its subject-matter realistically. The leading sculptors of this

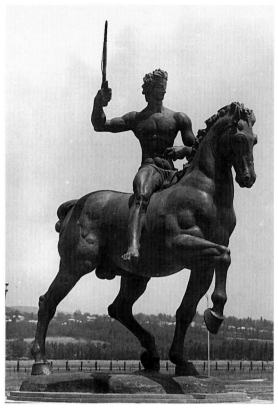

5. M. Berdzenishvili: memorial to the *Glory of Battle*, bronze, fragment from an ensemble at Kutaisi, Georgia, 1979

style included T. Abakelia (1905–53) and N. Kandelaki (1889–1970). Since the 1950s a substantial number of memorials and statues have been erected in towns and villages. These represent a distinctive style in the development of Georgian monumental art and are generally symbolic or have patriotic themes, such as monuments celebrating victory in World War II, war heroes, political activists and renowned artists. Examples include the monument of *Mother Georgia* (h. 16 m, 1958; by E. Amashukeli), depicting a woman holding out a sword to her enemies and a bowl to her friends, a stone obelisk in memory of the *Three Hundred Aragvian Heroes* (1961; by the architect A. Bakradze; both in Tbilisi) and the bronze memorial to the *Glory of Battle* (1979; by M. Berdzenishvili; Kutaisi; see fig. 5).

BIBLIOGRAPHY
N. Chubinashvili: *Gruzinskaya srednevekovaya khudozhestvennaya res'ba po derevu* [Medieval Georgian wood-carving] (Tbilisi, 1958)
A. Vol'skaya: *Rel'efy Shio-Mgvime* [The Shiomgvime reliefs] (Tbilisi, 1975) [Ger. summary]
N. Aladashvili: *Monumental'naya skul'ptura Gruzii* [Monumental sculpture of Georgia] (Moscow, 1977) [Eng. summary]

IV. Painting, mosaics and graphic arts.

The earliest paintings in Georgia date to the Christian period and can be divided into three categories: monumental (including mosaics), manuscript illumination and icons. These clearly reflect Early Christian and Byzantine

influences while preserving local traditions in the use of colour and iconography. In the 19th century these traditional forms were largely superseded by portrait and landscape painting, and the graphic arts were established as an important genre by the early 20th century.

1. Before the 19th century. 2. 19th century and after.

1. Before the 19th century.

(i) Monumental. (ii) Manuscript. (iii) Icon.

(i) Monumental. The floor mosaics in the baths (4th century AD) at Shukhuti, the basilica (5th century AD) at BICHVINTA and the Georgian church (5th–6th centuries AD) near Bethlehem, Palestine, which has an inscription in ancient Georgian, provide the earliest examples of Georgian monumental decoration. Although stylistically similar to other examples of Early Christian art in the Near East, certain motifs and the masterly use of local materials at Shukhuti and Bichvinta indicate the existence of local workshops. Mosaic fragments also survive on the altar conches in the small church of Jvari (mid-6th century) at Mtskheta and at Tsromi (7th century).

The use of wall paintings became widespread in the 8th and 9th centuries. Examples survive only in churches and monastic refectories, although it is recorded that palaces were also decorated with wall paintings. Characteristic traits include a flattening and linearity of form, which tends to be decorative. Among the few works to have survived are those at Telovani (8th–9th centuries), Armazi (864), Dodos-Rka (9th century) in the DAVID GAREDZHI complex, Nesgun (9th–10th centuries) in Svaneti and the cave monastery of Sabereebi (9th–10th centuries).

The finest paintings were produced between the late 10th century and the mid-13th, with a stylistic division in the mid-12th century. During the first period wall painting came into its own, employing a subdued palette and linear style to cover the walls and vaults. Although the treatment of the paintings, such as the placing of the triumphal cross in the dome and the *Deësis* in the altar conch, remained in accord with the theological requirements of the Eastern Orthodox Church, a local iconography also developed. Scenes from the lives of Georgian saints, churchmen, founders, donors and other secular personages were introduced and remained an important feature of later works. Among the most outstanding examples are the large-scale and confidently drawn figures (1080) in the cathedral of Sioni at ATENI, the bodies of which are carefully modelled, while the faces of the Apostles and church fathers are both expressive and individualized. The figure of the Archangel Gabriel in the *Annunciation* is especially dynamic (see fig. 6).

An important school of painting developed in the monasteries of TAO-KLARJETI in south-western Georgia. The solemn grandeur of paintings at Ocktha Eclesia (late 10th century), Oshki (1036), Ishkhani, Khakhuli and Tbeti (all early 11th century) is expressed through the harmonious combination of form and colour. Another school developed at the David Garedzhi complex, where the paintings (9th–14th centuries) in the small rock-cut churches and refectories are more modest and intimate, freely executed in lighter, livelier colours.

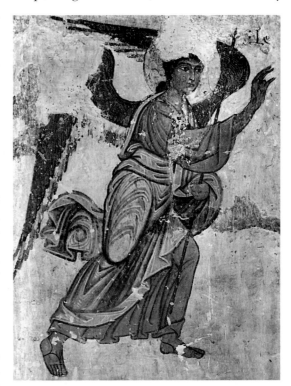

6. Wall painting of the *Annunciation* (detail; 1080), cathedral of Sioni, Ateni, Georgia

The walls of numerous miniature chapels in the western mountainous regions of Racha and, especially, Svaneti are painted both inside and out, sometimes with secular subjects, such as the story of the legendary hero Amirani. Among the primitive, but expressive and brilliantly executed folk art fresco paintings in Svaneti are those by the royal artist Tevdore at Iprari (1096), Lagurka (1112) and Nakipari (1130), and by a certain Mikael Maglakeli at Matskhvarishi (1140). Archangels and mounted saints are particularly popular subjects, expressed in a linear style of drawing that is even more striking than elsewhere in Georgian wall paintings. The beautiful mosaic (early 12th century) in the apse of the main church of GELATI MONASTERY also belongs to this first phase.

In the late 12th century and the early 13th wall painting became more dynamic, decorative and luxuriant in style, with the unbroken coverage of walls and vaults resembling colourful carpets. Important works include the frescoes in the churches at VARDZIA (1184–6), Kintsvisi (late 12th century; *see* KINTSVISI, ST NICHOLAS), where drawing and colour are especially refined, Betania, Bertubani, Timotesubani and Akhtala (all 13th century). Portraits of Queen Tamar (*reg* 1178–1213) appear in all these churches, except Akhtala.

From the second half of the 13th century and in the 14th the influence of the PALAIOLOGAN style is evident in the churches of the Annunciation and the Ascension in Udabno, the David Garedzhi complex, the south chapel of the main church at Gelati (1290s), the large church in the monastery at Safara (1280s) and in the church of

Zarzma (early 14th century). The latter two churches contain interesting group portraits of the Jakeli family, who ruled the province of Samtskhe-Saatabago. This style is also well represented in the work of a certain Gerasime in the village church at Ubisi (14th century) and of Kir Manuil Evgenikos, who was brought from Constantinople in the last quarter of the 14th century, in the village church of Tsalenjikha in western Georgia (see fig. 7). Early 15th-century paintings are found in the church of Nabakhtevi.

During the 16th and 17th centuries damaged wall paintings were restored and new ones painted, as in the main church at Gelati and the many palace chapels of the kings and feudal lords. The numerous individual and group portraits of the ruling families and feudal dynasties produced at this time, such as those in the main nave at Khobi, in a chapel at Tsalenjikha, in Khoni, the north chapel at Gelati and the tower paintings (1678–88) at Sveti-tskhoveli, are of great historical and artistic interest. Despite the naive character of many provincial wall paintings, they nevertheless retain a direct and expressive quality. From the late 16th century Russian and Greek artists were occasionally engaged to decorate Georgian churches, and by the 18th century wall-painting techniques were in decline.

BIBLIOGRAPHY

T. Virsaladze: 'Freskovaya rospis' khudozhnika Mikaela Maglakeli v Matskhvarishi' [The frescoes of the artist Mikael Maglakeli in Matskhvari], *A. Georgica*, iv (1955), pp. 160–231

S. Amiranashvili: *Istoriya gruzinskoy monumental'noy zhivopisi* [A history of Georgian wall painting] (Tbilisi, 1957)

T. Virsaladze: 'Freskovaya rospis' tserkvi Arkhangelov v Zemo-Krikhi' [The frescoes in the church of the Archangels in Zemo-Krikhi], *A. Georgica*, vi (1963), pp. 107–66 [Fr. summary]

N. Aladashvili, G. Alibegashvili and A. Vol'skaya: *Rospisi khudozhnika Tevdore v Verkhney Svaneti* [The paintings of the artist Tevdore in Upper Svaneti] (Tbilisi, 1966) [Eng. summary]

I. Lordkipanidze: *Nabakhtevis mokhatuloba* [The wall paintings of Nabakhtevi] (Tbilisi, 1973) [Rus. and Fr. summaries]

T. Virsaladze: *Rospis' Yerusalimskogo krestnogo monastyrya i portret Shota Rustaveli* [Wall painting in the Jerusalem Crusader monastery and a portrait of Shota Rustaveli] (Tbilisi, 1973) [Fr. summary]

S. Amiranashvili: *Kartveli mkhatvari Damiane/The Georgian Artist Damiane* (Tbilisi, 1974) [Georg., Rus. and Eng. text]

A. Vol'skaya: *Rospisi srednevekovykh trapeznykh Gruzii* [Frescoes in the medieval refectories of Georgia] (Tbilisi, 1974) [Fr. summary]

I. Lordkipanidze: *Stennaya rospis' v Tsalendzhikha i khudozhnik Kir Manuel' Evgenikos* [Wall paintings in Tsalenjikha and the artist Kir Manuil Evgenik] (Tbilisi, 1977)

G. Alibegashvili: *Svetskiy portret v gruzinskoy srednevekovoy monumental'noy zhivopisi* [Secular portraiture in medieval Georgian wall painting] (Tbilisi, 1979) [Fr. summary]

L. Shervashidze: *Srednevekovaya monumental'naya zhivopis' Abkhazii* [The medieval wall paintings of Abkhazeti] (Tbilisi, 1980) [Fr. summary]

N. Aladashvili, G. Alibegashvili and A. Vol'skaya: *Zhivopisnaya shkola Svanetii* [The school of painting of Svaneti] (Tbilisi, 1983) [Fr. summary]

T. Shevyakova: *Monumental'naya zhivopis' rannego srednevekov'ya Gruzii* [Wall painting of the early Middle Ages in Georgia] (Tbilisi, 1983)

(ii) Manuscript. Although the earliest Georgian manuscripts (6th–7th centuries) lack any decoration, an artistic effect is nevertheless created by the beautiful uncial script, the careful placing of the text on the page and the use of initial letters. Most manuscripts are in codex form rather than scrolls, which were used for official documents. From the 10th century paper was used in addition to parchment and by the 16th century had replaced it completely. From the 8th century schools of copyists were established in Tao-Klarjeti and in Georgian monastic centres in Syria, Palestine and on Mt Sinai. Unless otherwise stated all the manuscripts mentioned below are held in the Institute of Manuscripts at the Academy of Sciences, Tbilisi.

The earliest surviving illuminated manuscripts are the Adishi Gospels (897; Mestia, Mus. Hist. & Ethnog.) and the first Jruchi Gospels (text 936, illuminations 940; Tbilisi, Acad. Sci., Inst. MSS, MS. H1660). Though few in number, the illuminations are stylistically related to the Hellenistic tradition, as is shown in the imitation of marble columns and antique capitals. The linear style of drawing, which remained a distinctive feature of later Georgian codices, is already notable.

With the strengthening of Byzantine cultural ties and the foundation of the Georgian monastery of Iveron on Mt Athos in the late 10th century, there was a gradual assimilation of Byzantine manuscript ornament. Only from the 11th century onwards were Georgian Gospel books composed and illuminated according to an ordained system. The canon tables are placed at the beginning of the manuscript, a full-page depiction of the relevant Evangelist precedes each Gospel and the first page of the text bears a decorative heading and initial. Gospel books may also have a separate frontispiece showing a *Deësis* or cross, and numerous illuminations within the body of the

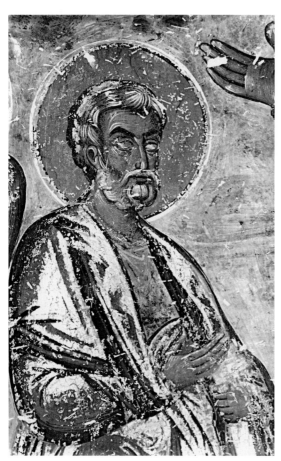

7. Wall painting of the *Apostle Peter* (last quarter of the 14th century) by Kir Manuil Evgenikos, village church of Tsalenjikha, Georgia

text. The varying combination of these elements determines the particular style of each period.

The finest illuminated manuscripts were produced between the late 10th century and the 12th. Some codices were decorated wholly or in part by Greek artists, as for example the Tbeti Gospels (995; St Petersburg, Saltykov-Shchedrin Pub. Lib.), the Zakaria Valashkerteli *Lives of the Saints* (early 11th century; MS. A648), the Gelati Gospels (12th century; MS. 908), which contains more than 250 miniatures, and the Vani Gospels (late 12th–early 13th century; MS. A1335). Most manuscripts, however, were made by Georgian artists who had assimilated the complex techniques of Byzantine illumination. Their drawings are sophisticated, the colouring harmonious, the proportions of the figures classical and the faces filled with spirituality, as in the Alaverdi Gospels (1054; MS. A484) and a song book (12th century; MS. A734; see fig. 8). The decoration includes inventive plant and geometric motifs, as well as animals and birds. The only secular manuscript of the period, a treatise on astronomy (1188), is particularly notable for its illustrations of the signs of the Zodiac.

The 13th-century manuscripts tend towards a strictly linear form, with increasingly complex architectural and landscape backgrounds. The Mokvi Gospels (1300; MS. Q902) reflect the influence of the Palaiologan style on 14th-century manuscripts. In a 15th-century Gospel book (MS. H1665) the biblical scenes are executed in a secular style, with detailed depictions of warfare and the

regalia and apparel of kings and feudal lords; the drawing has become coarser and the colours less subtle.

In the 16th century illumination assumed entirely new features. Religious manuscripts are Post-Byzantine in style, but codices containing chivalric romances show the undoubted influence of Persian (Iranian) art, resulting from the political and cultural pressure then exerted by the country. Multi-figured compositions are flat, brightly coloured and decorative in a style resembling contemporary Iranian illuminations. By contrast, Georgian artists also produced illuminations depicting local subjects in a simpler style and employing a more sober palette.

From the 17th century various elements were adapted and assimilated from the Russian and Western traditions, and there was a tendency to give sculpted volume to form. A notable body of manuscripts from this time comprises illustrated rolls of Shota Rustaveli's poem *The Knight in a Tigerskin*; these may contain several dozen miniature scenes and long margins decorated with wild animals, birds, plants and ornamental motifs. Another renowned manuscript (1646; MS. H599) was produced at the court of the sovereign prince Odishi by the scribe and artist Mamuka Tavakarashvili; the miniatures are naively executed but are expressive and resemble national folk art, with many details relating to daily life, such as costumes, artefacts and architecture, indicating a clear move away from Iranian influence.

Manuscript illumination declined sharply in the 18th century, with crude drawing and colouring. The standard of calligraphy, however, remained high, despite the establishment of the first printing press in Georgia in 1709, and manuscripts were in demand until the 19th century, produced by dynasties of fine calligraphers.

BIBLIOGRAPHY
S. Amiranashvili: *Gruzinskaya miniatyura* [Georgian miniatures] (Moscow, 1966)
——: *Vepkhis-tkaosnis dasuratheba: Miniaturebi shesrulebuli XVI–XVIII saukuneebshi* [Miniatures of the 16th–18th centuries for the poem 'The Knight in a Tigerskin'] (Tbilisi, 1966)
G. Alibegashvili: *Khudozhestvennyy printsip illyustrirovaniya gruzinskoy knigi XI–nachala XIII vekov* [The artistic principle of Georgian illustrated books from the 11th century to the beginning of the 13th] (Tbilisi, 1973) [Fr. summary]
Y. Khuskivadze: *Kartuli saero miniatura XVI–XVIII ss.* [Georgian secular miniatures of the 16th to the 18th centuries] (Tbilisi, 1976) [Rus. and Eng. summaries]

(iii) Icon. Although many Greek icons were imported into Georgia, most were locally made. The earliest surviving work is a 9th-century encaustic icon, the *Virgin of Tsilkani* (Tbilisi, Mus. A. Georgia), which resembles the Byzantine image of the Virgin who Points the Way (Gr. *Hodegetria*) and is painted in a linear, flattened style, with a thick black line encircling the face. Portable icons were also made in mosaic, such as that of *St George* (11th–12th century; Tbilisi, State Mus. Georgia) from the village of Matskhvarishi in Svaneti. Two icons of the Archangels Michael (Church of SS Kvinké and Ivlita, Lagurka) and Gabriel (both late 11th–early 12th century; Mestia, Mus. Hist. & Ethnog.), also from Svaneti, apparently belong to a polyptych with a representation of the *Deësis*. The figures are half-length portraits, and their execution shows a mastery of the technique of multi-layer painting. The

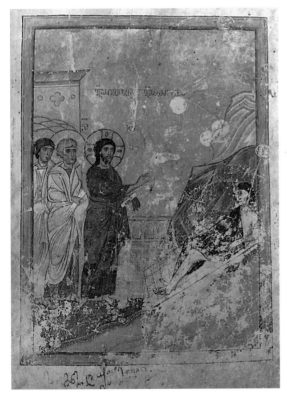

8. Manuscript illumination from a song book, 230×150 mm, early 12th century (Tbilisi, Academy of Sciences, Institute of Manuscripts)

drawing is strikingly elegant, and the thoughtful expressions show real psychological insight.

An icon of equal mastery is a 12th-century *Crucifixion* (Mestia, Mus. Hist. & Ethnog.) which, with its elongated proportions, bent figure of Christ and soft, flowing lines, is imbued with a certain decorative quality. An icon of the *Forty Martyrs* (12th century; see fig. 9) is notable for its striking presentation of complex movement and the deeply tragic facial expressions. A large icon of the *Crucifixion* from Matskhvarishi (early 13th century) is another complex composition that portrays the emotions of the protagonists. In a number of icons from the mountainous Svaneti region, such as the *Virgin and Child* (13th century) from Adishi and *St George* (14th–15th century; both Mestia, Mus. Hist. & Ethnog.) from Nakipari, the heightened emotion and expressiveness are achieved by disregarding proportions and accentuating certain details. Icons of the late 13th century and the 14th reflect the influence of the Palaiologan style, such as the representations of *St Paul* and an archangel in the church of Pkhotreri (14th century; *in situ*), which are distinguished by their dynamic, mobile lines and painterly treatment of light and shade. The late Palaiologan style may be seen in two triptychs (late 14th century; Tbilisi, Mus. A. Georgia) from Ubisi, one bearing figures of saints and the *Dormition of the Virgin*, and the other a large icon (1.76×1.33 m) with scenes from the *Life of the Virgin* and the Old Testament. Within a fully developed spatial setting, the latter composition has many figures in complex poses involving rapid movement.

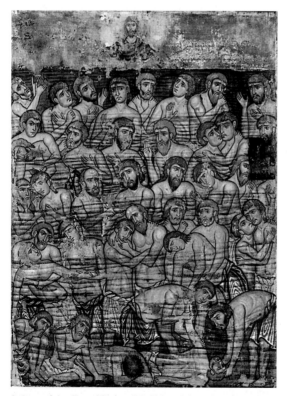

9. Icon of the *Forty Martyrs*, 685×530 mm, from Svaneti, Georgia, 12th century (Mestia Museum, of History and Ethnography)

Icons of the 16th and 17th centuries are of inferior quality, often at the level of simple craftsmanship, although some reflect the influence of Persian and Russian art.

BIBLIOGRAPHY

G. Alibegašvili and A. Volskaja: 'The Icons of Georgia', *The Icon*, ed. K. Weitzmann (London, 1982), pp. 85–127

2. 19TH CENTURY AND AFTER. Portraits in a European style of the family of King Erekle II (*reg* 1744–98) and members of the higher clergy first appeared in Georgia in the late 18th century. They are unsigned but are generally attributed to Russian or western European artists, although some may be by Georgians trained in the European style. During the early 19th century portrait painting rapidly established itself as a major art form, and numerous works were commissioned by the aristocracy and the urban middle classes. The medieval linear, flattened style and Persian influences are still evident, but by *c.* 1850 realism had become the dominant painting style. Among the most notable portrait painters of this period was the Armenian Akop Hovnat'anian (*see* HOVNAT'ANIAN, (1)), who worked in Tbilisi.

In the second half of the 19th century closer links were established with Russian art, and many Georgian artists moved to St Petersburg to study at the Academy of Arts, one of the first being Grigol Maysuradze (1817–85), who studied under Karl Bryullov. In the 1880s a number of realist artists began to make their mark, including Romanoz Gvelesiani (1859–84), Aleksandre Beridze (1858–1917), David Guramishvili (1857–1926) and Gigo Gabashvili (1862–1936). The latter's work was particularly influential, since he was the first Georgian artist to cover a wide range of subjects, both in oils and in watercolour, including portraits, landscapes and scenes of everyday life.

Two very talented painters of this pre-Revolutionary period were MOSE TOIDZE and NIKO PIROSMANASHVILI, whose laconic paintings of debauchery, still-lifes, animals, portraits and historical scenes are imbued with a naive truthfulness and humanity. At the turn of the century democratic and revolutionary ideas found their clearest expression in the graphic arts, which were closely associated with the Georgian press. Several Georgian literary classics were published with graphically decorated pages by G. Tatishvili and pictures by the Hungarian artist MIHÁLY ZICHY, who illustrated Shota Rustaveli's *The Knight in a Tigerskin*.

A new generation of Georgian artists who had studied in Russia and western Europe began their creative careers in the years immediately before and after the Revolution of 1917. These included D. Shevardnadze (1885–1937), a stage designer, portrait painter and founder of the Society of Georgian Artists (1916) and the Georgian State Picture Gallery in Tbilisi (1920), V. Sidamon-Eristavi (1889–1943), who at first concentrated on depicting Georgian historical figures such as Queen Tamar and King Erekle II, DAVID KAKABADZE, L. D. GUDIASHVILI, the portraitist K. Magalashvili (1894–1973) and the talented landscape artist Yelena Akhvlediani. Their portraits, landscapes, stage designs (a new form in Georgian art) and book illustrations continued to be influenced by the latest trends in western European art while remaining attached to the early artistic culture of Georgia. The *Imereti* landscape paintings (e.g.

Imereti Landscape with a Tower, 1919; see fig. 10) by Kakabadze is an important series dedicated to his native province of Georgia; the landscape is presented tectonically in a restrained palette.

Several art associations were established in the 1920s, including the Association of Revolutionary Artists of Georgia (1929–32) and the Association of the Artists of the Revolution (1929–31), whose activities reflected the search for a modern art that could express and interpret the fundamental changes the country was undergoing.

In the early 1930s a number of talented graphic artists and painters graduated from the Georgian Academy of Arts, including U. Japaridze (1906–88), a painter of portraits, lyrical scenes of country life and historical compositions, K. Sanadze (1907–85), A. Kutateladze (1900–72), P. Bletkin (1903–88), the landscape painter S. Mamaladze (1895–1963), K. Grdzelishvili (1902–78), D. Gvelesiani (1890–1949), S. Kobuladze (1909–78), I. Gabashvili (1908–73) and L. Grigolia (1903–78), originator of the art of Georgian book design with I. Sharleman' (1880–1957). The stage designs of I. Gamrekeli (1894–1943), P. Otskheli (1907–37), Simon Virsaladze and Kobuladze were notable achievements.

Immediately after World War II Georgian art was largely preoccupied with the production of pompous and lifeless official compositions, but from the late 1950s artists were allowed greater freedom of expression. Among the better known artists of this period is the mosaicist ZURAB TSERETELI, whose work is found both in Georgia and abroad.

The graphic artist R. Tarkhan-Mouravi (*b* 1921) created a series of illustrations for Georgian folk songs that are conventional, stylized and typified by a sharpness of features (e.g. linocut, 1959; Tbilisi, Mus. A. Georgia). His contemporary A. Bandzeladze (*b* 1927), illustrated the book of the folk poem *A Song about April* (1966), rewriting the text by hand. Bandzeladze also painted portraits of Georgian writers and actors (e.g. the poet *G. Tabidze*, 1952; Tbilisi, Mus. A. Georgia). Portraits with poignant psychological features are typical of the work of Z. Nizharadze (*b* 1928), for example his portrait of *T. Tsitsisvili* (1960–61). He also painted genre scenes with unusual compositions (e.g. *Planting of a Tree*, 1961; Tbilisi, Mus. A. Georgia) and a series devoted to his travels around Italy. A. Gelovani (*b* 1928), a painter of monumental forms, is represented in the Museum of Art of Georgia, Tbilisi, by *Family from Dusheti*, which portrays a peasant family (1963). The painter and set designer N. Ignatov (*b* 1937) created large compositions adorning spacious

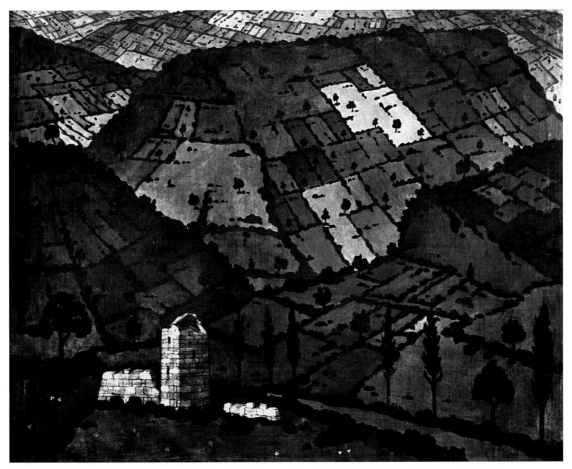

10. David Kakabadze: *Imereti Landscape with a Tower*, oil on canvas, 0.91×1.19 m, 1919 (Tbilisi, Georgian Picture Gallery)

halls (e.g. *A Song about Georgia*, 23×8 m, 1967; Bichvinta-Pitsunda), and sets for performances at the Rustaveli Theatre, Tbilisi.

BIBLIOGRAPHY
V. Beridze: *Gudiashvili* (Budapest, 1975) [Georg., Rus. and Hung. text]
F. Kuznetsov: *Niko Priosmani* (Leningrad, 1984)
N. Janberidze and G. Maskharašvili: *Izobratitei'noye iskusstvo gruzinskoy SSR* [Fine art of Georgia SSR] (Moscow, 1986)
V. Berdize, D. Lebanidze and M. Medzmariašvili: *David Kakabadze* (Moscow, 1988) [Rus. text]

V. Decorative arts.

1. Metalwork. 2. Ceramics. 3. Textiles and embroidery.

1. METALWORK. All the examples of Georgian metalwork mentioned below are housed in the State Museum of Art of Georgia, Tbilisi.

(i) Gold and silver. The art of gold-, silver- and even bronze-working was established in Georgia long before the adoption of Christianity. Excavations of the barrows at TRIALETI (first half of the 2nd millennium BC) and of burials at Akhalgori (4th century BC), Mtskheta, Kldeeti, Bori, Vani and Armaziskhevi (1st–4th centuries AD) have revealed jewellery and vessels of high quality.

Surviving examples of Georgian silver and gold from the 8th to 18th centuries include numerous icons, crosses, chalices and covers for Gospel books and other religious manuscripts. For the first few centuries the mixture of ornamental and figural designs employed in the chasing and repoussé decoration of these objects, and of vessels for domestic use and personal jewellery, parallels that of contemporary stone sculpture (*see* §III, 1 above). Thus 8th- and 9th-century metalwork is characterized by flat carving and a linear manner of expression. The most renowned object in this style is the monumental icon of the *Transfiguration* from the monastery of Zarzma (886; restored 11th century), which is made of embossed, chased and gilded silver on wood.

The finest period of metalwork production was during the late 10th century and the 11th, when a more sculptural rendering of figures and drapery was attempted. The first stage in this development is evident in the processional crosses with images of the *Crucifixion* (973) from the cathedral of Ishkhani and from Brili (late 10th century), the latter by a certain Asat. Another remarkable piece is the embossed and chased gold chalice of Bedia (999), the sides of which depict an arcade enclosing figures of the Virgin and Child, Christ Enthroned and various saints. The donation inscription mentions King Bagrat III (*reg* 975–1014) and his mother, Queen Gurandkht.

Among the most outstanding works of the 11th century are the icon of the *Virgin of Tenderness* (*Eleousa*) with a donor inscription of the Laklakidze family and framed by scenes from the Gospels, the Martvili processional cross (first half of the 11th century), the icons of the *Virgin and Child* from Tsageri and *St George* from Ieli, and a pair representing *SS Nicholas and Basil* (1040) by Ioann Monisdze. The silver tondo of *St Mamay Riding a Lion* (see fig. 11) is set against a smooth background and in such relief that the figures appear to be three-dimensional. These icons are characterized by their decorative composition and wealth of geometric and vegetal ornament,

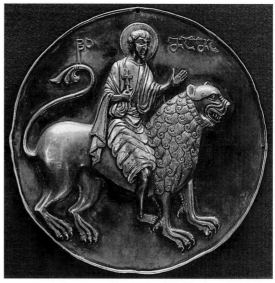

11. Tondo depicting *St Mamay Riding a Lion*, embossed, chased and gilded silver, diam. 200 mm, early 11th century (Tbilisi, Museum of Art of Georgia)

which is conceived with the relief work as part of a unified whole. Colour is inserted through the use of enamel, precious stones and niello.

In the 12th century designs became increasingly decorative with a greater emphasis on coloured insertions. The most striking example of purely decorative chased work is the triptych of the *Virgin of Khakhuli* from GELATI MONASTERY (see fig. 12). The central enamel icon of the Virgin (10th century; *see* §(ii) below) is surrounded by an ornamental pattern of great artistic virtuosity in gold, silver-gilt and silver. Precious stones, relief-painted crosses and 115 enamel icons (8th–12th centuries) are arranged in a rhythmic pattern within this intricately worked surround to create an exceptionally colourful and festive picture.

The traditions of the 11th century were followed by two outstanding artists, Beka Opizari and Beshken Opizari (*see* OPIZARI), in the late 12th century and the early 13th. Beka executed the mounting for the encaustic icon of *Christ the Saviour* (Tbilisi, Mus. A. Georgia) from the Anchi Monastery in southern Georgia. According to an inscription, the icon mounting of embossed, chased and gilded silver studded with gems was commissioned by Queen Tamar. The outer frame is composed of ornamental bands separated at regular intervals by two full-length reliefs of the Virgin and St John the Baptist turning to face the central icon of Christ, a representation of the *Hetoimasia*, and five half-length reliefs of saints. Beka's cover for the Tskarostavi Gospels is decorated with a *Deësis* and *Crucifixion*, which also appear on Beshken Opizari's cover for the Berti Gospels.

In the centuries following the invasions of the Tatars, Mongols and Timur, the art of metalworking declined, the forms depicted became coarse and compositions overloaded. Several fine examples of embossed work, however, were produced in the 16th century by a goldsmith called Mamne, including a gold processional cross from Gelati

12. Triptych of the *Virgin of Khakhuli*, gold, silver, enamel and precious stones, 1.47×2.02 m (when open), 8th–12th centuries (Tbilisi, Museum of Art of Georgia)

and a large, silver gilded altar cross from Chkhari, which has reliefs of the *Deësis* and New Testament scenes. Instead of the usual relief and chasing, the decoration on an exceptional group of gold covers belonging to the Kakheti icons is incised into the metal and interspersed with turquoise insertions. As native metalworking skills continued to decline, an increasing amount of European gold and silver was imported during the 18th century and imitated by local artists, for example in the Atskuri triptych of the *Virgin*, which presents the west European iconographic subject of the Ascension of the Crown. In the 19th century wine vessels, other domestic articles and items for church ritual, such as chalices and censers, continued to be made, but the traditional techniques of embossing and chasing died out in the face of mass-produced wares from Russia.

Since the 1960s there has been a revival in chased metalworking, particularly on brass, copper and aluminium, with works by I. Ochiauri, V. Guruli, D. Kipshidze and G. Gabashvili. The themes depicted are often based on Georgian folklore, national literature and popular imagery; there is also a tendency towards generalization, which imparts a symbolic feel to the images. This is evident in Guruli's *The Tiller* (copper, 1965), with its underlying theme of the relationship between Man and Nature, and two works by Ochiauri, *Homo Sapiens* (brass, 1968) and

A Shepherd (copper, 1966). The latter, bearing a lamb on his shoulders in the manner of the Good Shepherd, symbolizes the principle of the strong defending the weak.

(ii) Enamel. The art of cloisonné enamel developed in the 8th century and remained prominent in medieval Georgian art until the 13th century, with some late examples from the 15th. Georgian enamels are distinguished by their colours and cloisonné technique, and by the drawing, general typology and emotional quality of their imagery. They are closely related to Byzantine enamels (*see* EARLY CHRISTIAN AND BYZANTINE ART, §VII, 7(ii)), while incorporating features found in Georgian metalwork, manuscript illumination and wall paintings. Most enamels bear Greek or Georgian inscriptions and are set into chased metalwork as icons, crosses, individual plaques and medallions. They are usually small, measuring *c.* 30–60 mm along the sides of a lozenge or across a medallion. An exception is the 10th-century central panel of the *Virgin of Khakhuli* triptych (*see* §(i) above and fig. 12). Only the face and hands of the Virgin survive, but it remains the largest enamel in the world (1.16×0.95 m).

An 8th-century quatrefoil on the *Khakhuli* triptych showing the *Crucifixion*, flanked by the Virgin, St John and two angels, is the earliest known Georgian enamel. The faces are rather primitive, the garment folds long and

few, and the background dark. A 9th-century enamel of the *Deësis*, from which the figure of Christ is lost, decorates the central section of a triptych from the church at Martvili. Examples from the 10th century include medallions of the Virgin and SS Paul, Peter, John the Evangelist and John the Baptist on the mounting of a large icon of the Virgin from VARDZIA, a quatrefoil with the *Crucifixion* from Shemokmedi, a *Christ Pantokrator* on the lid of a gold reliquary, a cross with Georgian and Greek inscriptions referring to King Kvirike II (*reg* 929–76) and the central icon of the *Virgin*, both on the Khakhuli Triptych.

As with Byzantine enamels, by the late 10th century gold had replaced emerald green as the ground on most Georgian examples, but the latter show a greater emotional quality and spontaneity of form. Georgian and Byzantine enamels of the 11th century are almost indistinguishable, but in the 12th and 13th centuries there was a return in Georgia to 10th-century imagery, once again emphasizing national characteristics. Freed from the religious and dogmatic severity of Byzantine images, the figures on Georgian enamels are striking for the direct human simplicity of their faces and for occasional anatomical distortions. They are mostly brightly coloured and freely drawn. Many of the faces seem to be portraits. Among the best examples of the first half of the 12th century are the medallions of saints and Evangelists that adorn the mountings of the icons of the *Saviour* from Gelati, the *Virgin* from Khobi, the *Saviour* from Tsalenjikha and the *Virgin* from Martvili. The surviving plaques from a cycle of church festivals are slightly later in date (late 12th–13th century): a *Presentation in the Temple* (122×100 mm) depicting a Georgian church with a lighted candle in the foreground, a detail found only in Georgian versions of this scene; a *Raising of Lazarus* (128×103 mm) including many figures and elements of perspective; and a *Descent of the Holy Spirit* (135×103 mm). The emerald green, brick red and light and dark blue of these enamels are set against a gold background.

From the 13th century enamel production went into decline. Exceptions to this are two 15th-century plaques depicting an equestrian *St George* (145×118 and 171×125 mm), in one of which he is shown slaying the dragon and in the other rescuing the emperor's daughter. Although technically they equal the workmanship of the earlier images, they are artistically inferior. Both show the saint wearing a red tunic with a yellow and blue coat of mail and a dark purple cloak floating in the wind; the horse is white, and the dragon has multicoloured scales with red legs.

BIBLIOGRAPHY

G. Chubinashvili: *Gruzinskoye chekannoye iskusstvo* [Georgian chased metalwork] (Tbilisi, 1959)
S. Amiranashvili: *Georgian Metalwork from Antiquity to the 18th Century* (London, New York, Sydney and Toronto, 1971)
L. Khuskivadze: *Levan Dadianis saokromehedlo sakhelosno* [Levan Dadiani's chasing workshop] (Tbilisi, 1974) [Rus. and Eng. summary]
A. Chkhartishvili: *Mamne Okromchedeli* (Tbilisi, 1978) [Rus. summary]
T. Sakvarelidze and G. Alibegashvili: *Gruzinskiye chekannyye i zhivopisnyye ikony* [Georgian chased and painted icons] (Tbilisi, 1980)
L. Khuskivadze: *Gruzinskiye emali* [Georgian enamels] (Tbilisi, 1981) [Fr. summary]
A. Javakhishvili and G. Abramishvili: *Jewellery and Metalwork in the Museums of Georgia* (Leningrad, 1986)
T. Sakvarelidze: *XIV–XIX saukuneebis kartuli okromehedloba* [Georgian metal chasing work from the 14th to the 19th centuries], 2 vols (Tbilisi, 1987) [Rus. summary]

2. CERAMICS. The painted pottery of the late 3rd millennium BC to the 4th century AD found alongside the gold and silver objects in the barrows at Trialeti and at Akhalgori, Mtskheta, Kldeeti, Bori and Vani (Tbilisi, Mus. A. Georgia; *see* §1(i) above) also shows Hellenistic and Near Eastern cultural influences. Standards declined from the 5th century AD, however, with manufacture limited to unglazed and sparsely decorated wares.

With a recurrence in ceramic production in the 9th century, glazed pottery began to be made in Tbilisi, Dmanisi, Rustavi and many other towns. Between the 9th and 11th centuries large vessels and bowls were made in a variety of slipware, decorated with bands of white slip under a transparent coloured, usually green, glaze or painted in white slip and decorated with coloured spots and dots, a technique similar to that used on Persian sgraffito ware (*see* ISLAMIC ART, §V, 3(iii)). Several kinds of unglazed pottery were also made in the 12th and 13th centuries. Pottery was painted in green, light blue, brown and dark blue, given a colourless glaze and engraved with geometric and plant designs, birds, wild animals, human figures and representational scenes. Simple glazed pottery was used for a range of vessels, from large wine vats and storage containers to tiny household jugs. Some porcelain vessels were made in Georgia, and others were imported from Persia and China. Already by the 12th century coloured and glazed tiles were being used to decorate the brick façades of churches and, for example, the hexagonal and rhomboid floor tiles before the altar in the church of Ozaani (9th century).

Ceramic production declined from the 15th century owing to economic difficulties and began to revive only in the second half of the 18th century. Further development in the 19th century led to the establishment of *c.* 50 potteries, often producing cheap alternatives to metal vessels in the form of simple red crock pottery and vessels decorated with multicoloured glazes for the storage of water and wine, and for other domestic uses.

BIBLIOGRAPHY

Z. Maisuradze: *Kartuli mkhatvruli keramika XI–XIII saukuneebi* [Georgian artistic pottery from the 11th to the 13th centuries] (Tbilisi, 1953)
V. Djaparidze: *Ceramic Manufacture in 11th- to 13th-century Georgia According to Archaeological Materials* (Tbilisi, 1956) [Georg. text; Rus. summary]
M. Mitsishvili: *Glazed Earthenware in Old Georgia, 9th–12th Centuries* (Tbilisi, 1969) [Georg. text]

3. TEXTILES AND EMBROIDERY. The earliest surviving textiles from Georgia are fragments of silk (10th–13th centuries) from Ipkhi, Chazhashi and Iatali in Svaneti. Their animal, bird, plant and geometric motifs resemble those on Persian and Byzantine textiles, but a local origin (or commission) is suggested by Georgian inscriptions. Decorated curtains, richly embellished secular and clerical garments and items of church ritual have also survived from the later medieval period, as have imported patterned woven textiles from Byzantium and Persia. Plain wools and linens were imported from western Europe, which in

the 18th century also supplied printed cottons, the preferred colours being dark red, brown, dark blue, yellow and light blue.

Embroidery underwent considerable evolution in Georgia; examples in silk, gold and silver for religious and secular use survive from the 14th century. The most interesting category comprises palls, derived from the Byzantine EPITAPHIOS, which were mostly commissioned and donated to important churches by the kings and feudal lords between the 15th century and the early 19th. Human figures are generally depicted in preference to the symbolic images, angels, cherubim and seraphim found on Byzantine and Slavonic palls. Already in the 15th century the *Pietà* was generally accompanied by the *Three Marys at the Tomb* and *St Peter at the Tomb*, and sometimes an *Ascension* in the upper section of the cloth. In a practice unknown elsewhere, donors are depicted on some 17th-century palls, and there are close parallels with late Georgian chased votive icons. However, from the 17th century Georgian palls increasingly began to imitate Slavonic examples.

The colouring of these palls also evolved from a restrained palette harmoniously combined with gold, as on the palls of King Giorgi VIII of Georgia (*reg* 1446–65) and King Bagrat III of Imereti (*reg* 1510–65), and the pall from the church at Ubisi (16th century). A tendency to over-emphasize the gold or silver thread from the 17th century was accompanied by a decline in a genuine sense of colour. Richly ornamented borders form part of the overall design of the earlier palls, such as that of Giorgi VIII, but by the 18th century these are notably simpler in design and clearly show foreign influence, for example in the use of European-style medallion busts of the Evangelists. Most palls are silk, or sometimes velvet, and embroidered in drawn gold or gold thread twisted around silk. The relationship between the palls and monumental painting is noteworthy, for in some cases the content and style of the scenes are clearly drawn from church wall painting: at the church at Ubisi, for example, the 16th-century pall imitates the 14th-century wall paintings.

BIBLIOGRAPHY

V. Beridze: *Sur l'histoire de la broderie géorgienne: Epitaphios géorgiens* (Tbilisi, 1983) [Georg. text; Rus. and Fr. summaries]

V. BERIDZE

VI. Patronage and collecting.

Before the Russian annexation of 1801, patronage in Georgia was always closely allied with the endowment of the Church, and most surviving evidence reflects this. Evidence is now severely restricted and must be drawn from inscriptions and donor portraits in churches, manuscript colophons and a few surviving royal charters of the 11th and 12th centuries. Records of medieval secular patronage (mainly palaces with extensive decorative cycles) exist in the *Georgian Chronicle* (a loose rendition of *Kartlis Tskhovreba*), although only the shells of castles and the ruins of the royal palace of Geguti survive to testify to the extent of the work produced.

In general, patrons were restricted to the highest echelons of society: the monarchy, aristocracy and senior Church figures. Almost every Georgian ruler can be associated with individual acts of patronage, varying in scale, but notable royal patrons of architecture, as well as of icon painting, metalwork and manuscripts, include David II (*reg* 990–1000), David III (*reg* 1089–1125) and Queen Tamar (*reg* 1179-1212). These rulers are also recorded as endowing monasteries throughout the East Christian world, including St Catherine on Mt Sinai, the Holy Cross (1038–56) in Jerusalem, St Barlaam at Antioch and Iveron on Mt Athos. Among the more active patrons in the Church hierarchy, the Catholicos Melchisedek (*reg* 1010–29) stands out as a collector of icons from holy centres in Byzantium. Inscriptions in some 10th- to 12th-century Svanetian churches suggest that patronage there was exercised by the lesser nobility, combining their wealth to pay for individual works. In the 15th century the Jakeli family in Samtskhe commissioned much important metalwork. In the 16th century King Levan of Kakheti (*reg* 1520–74) was a significant royal patron, and his portraits survive in many of the churches he endowed, including Gremi. His policies were continued by his son Alexandre II (*reg* 1574–1605).

Collecting in the modern sense of seeking out works of art for aesthetic reasons was really undertaken only after 1801. In the 18th century, however, Vakhtang VI (*reg* 1711–14; 1719–24) attempted to gather together an encyclopaedic collection of Georgian culture, encompassing law codes, historical chronicles and architectural restoration. Vakhtang VI also introduced the first printing press to Georgia.

After the Russian annexation, collecting was undertaken mainly by antiquaries primarily interested in the discovery and recording of buildings and objects. In the mid-19th century figures such as Prince Grigory Gagarin and Marie Félicité Brosset (1802–80) travelled extensively describing and analysing the works of art in the churches they visited. Independently at the end of the 19th century Mikhail Botkin (1839–1914) began collecting Georgian enamels in St Petersburg, and Aleksandr Zvenigorodskoy travelled in Georgia, also collecting enamels. Under Stalin the Botkin collection was transferred to the State Museum of Art in Tbilisi.

In the early 20th century the cataloguing of Georgian art was undertaken more scientifically by such figures as Nikolay Yakovlevich Marr (1864–1934) and Ekvtime Takaishvili (1863–1953), and the brief extension of Russian control into the historic Georgian principality of TAO-KLARJETI (north-east Turkey) allowed expeditions to record monuments in this region, bringing much important 9th- to 11th-century sculpture back to the State Museum of Art. Collecting has since been centralized by the State, allowing for the comprehensive collections in Tbilisi to be formed from all the churches in Georgia.

BIBLIOGRAPHY

M. F. Brosset: *Rapports sur un voyage archéologique dans la Géorgie et dans l'Arménie, exécuté en 1847–1848*, 6 vols (St Petersburg, 1849–51)

N. P. Kondakov: *Die byzantinischen Zellenschmelze der Sammlung Dr Alex. von Swenigorodskoi* (Aachen, 1886)

M. Botkin: *Collection M. Botkine* (St Petersburg, 1911)

N. Marr: *Dnevnik poezdki v Shavshetiyu i Klardzhetiyu* [Journal of a voyage to Shavsheti and Klarjeti] (St Petersburg, 1911)

E. Takaishvili: *Arkheologicheskaya ekspeditsiya 1917-go goda v yuzhnyye provintsii Gruzii* [Archaeological expedition in 1917 to the southern provinces of Georgia] (Tbilisi, 1952)

VII. Museums and institutions.

The museums of Georgia are principally national institutions, devoted to presenting the material evidence of the region's inhabitants since prehistoric times. The foremost museum is the State Museum of Georgia, Tbilisi, which was established in its present form in 1923–9, after the incorporation of the Tsarist Caucasian Museum, founded in 1852. Its collections cover archaeological and ethnographic material from all periods of Georgian history. The ground floor contains Palaeolithic and Bronze Age objects, as well as the collections of gold objects (6th–4th century BC; see §V, 1(i) above) excavated from Akhalgori and Vani in ancient Colchis. The first floor contains a small medieval collection and a larger collection of historical objects from the Tsarist and Independence periods (1801–1923).

The principal art collection is held in the State Museum of Arts, Tbilisi. The museum was founded in 1923 and is housed in a converted hotel (1827–34). The medieval section comprises metalwork, enamels, repoussé and painted icons. Outstanding examples include the icon from Zarzma (886), the processional cross (973) from Ishkhani Cathedral, the gold goblet from Bedia (999), the silver-gilt tondo of *St Mamay Riding a Lion* (early 11th century; see fig. 11 above) and the triptych of the *Virgin of Khakhuli* (8th–12th centuries; see fig. 12 above) from Gelati Monastery. The enamels incorporate the Botkin collection, placed in Tbilisi by Stalin. The first floor contains a large collection of medieval stone-carving from throughout the country, including the carved stone altar screen (11th century) from Shiomgvime Monastery (*see* §III above), and copies of the principal wall paintings in Georgian churches. The museum has strong holdings of 19th-century Russian painting, including works by Ilya Repin, Valentin Serov and Ivan Ayvazovsky, and 19th- and 20th-century Georgian paintings by Lado Gudiashvili, David Kakabadze, Yelena Akhvlediana (to whom are also devoted small house-museums in Tbilisi) and Niko Pirosmanashvili, Georgia's most celebrated painter. There is also a small collection of Western art, including a painting attributed to the 14th-century Florentine Bernardo Daddi.

The House of Georgian Artists in Rustaveli Avenue contains works by contemporary artists. The Museum of Georgian Folk Architecture and Local Lore in the Vake region of Tbilisi, founded in 1960 (opened 1976), contains 'typical' examples of domestic architecture of the 18th and 19th centuries, transferred from throughout Georgia.

Another important collection of medieval art, particularly painted and metalwork icons and repoussé crosses produced locally, is held in the Mestia Museum of History and Ethnography in northern Georgia (Svaneti). The principal manuscript collection is the K. Kekelidze Institute of Manuscripts in Tbilisi. The documents range from ancient papyri to medieval Christian manuscripts and pre-Tsarist documents, and there is also a fine collection of illuminated manuscripts (*see* §IV, 2 above). The icons, medieval sculpture, extensive photographic records and archives held by the G. Chubinashvili Institute of the History of Georgian Art, Tbilisi, were destroyed by fire in 1991. There are many local ethnographic and art museums, notably the Abkhazian State Museum in Suchumi and museums in Kutaisi, Telavi and Akhaltsikhe.

BIBLIOGRAPHY

I. Abuladze, K. Kekelidze and E. Metreveli, eds: *Kartul khelnatsera aghtseriloba* [Description of Georgian manuscripts] (Tbilisi, 1946–)
Au pays de la toison d'or: Art ancien de Géorgie soviétique (exh. cat. by D. Gaborit-Chopin, T. Sanakidze and I. Gagochidze, Paris, Grand Pal., 1982)

ANTONY EASTMOND

Georgian style. Term used to describe the diverse styles of architecture, interior decoration and decorative arts produced in Britain and Ireland during the reigns of George I (1714–27), George II (1727–60) and George III (1760–1820). What might more accurately be named the Georgian period is, on occasion, further subdivided into Early (1714–1730s), Mid (1740s–1750s) and Late (1760s–1790s) periods. The term REGENCY STYLE is applied to works of the period *c.* 1790 to 1830 and refers generally to the period when George, Prince of Wales (later George IV), was Regent (1811–20).

In architecture and interior design, the dominant aesthetic in Britain during the Georgian period was derived from classicism, but it took many different forms. The English Baroque that was current at the beginning of the 18th century was replaced at first by what became known as Palladianism, introduced by *c.* 1715 and championed by RICHARD BOYLE, 3rd Earl of Burlington and 4th Earl of Cork. By the middle of the century the Rococo style had developed, and the increasingly eclectic approach that this helped foster led to the use of the Gothick (and, later, the Gothic Revivial), Chinoiserie and other exotic styles. In the second half of the century, however, most major architectural schemes used some form of Neo-classicism, which was accompanied by the rise of such interior design styles as Pompeian Revival and the Etruscan style. Between 1760 and 1790 Robert Adam (*see* ADAM (i), (3)), WILLIAM CHAMBERS and JAMES STUART were the most notable architects and interior designers, each creating a distinctive and influential style, and they, together with numerous lesser architects and builders, provided an exceptionally wide range of designs and models for public buildings, town houses, country houses, villas and garden buildings.

The most significant survivals of the Georgian period are the vast numbers of plain, well-proportioned, usually astylar, domestic buildings erected throughout the United Kingdom and much of the English-speaking world, particularly the eastern seaboard of North America. These buildings were often modified to suit local conditions or building materials, for example in India, southern Africa and Australia. The plain exteriors often contained elaborate woodwork or plasterwork reflecting current fashions (*see* ENGLAND, §I, 2(iv), and 5(iv) and (v)). Major planning developments were also characteristic of the Georgian period, with uniform facades of terraced houses often designed to present a single monumental unit. Particularly successful examples of these can be seen in the streets, crescents and circuses built in Bath in the middle of the 18th century (*see* BATH (i), §2), most notably by the Wood family (*see* WOOD (ii)). Ideas taken from these developments were influential later in London, Edinburgh and elsewhere.

In the decorative arts the production of gold and silver ware, and to a much lesser degree ceramics, adopted the form and decoration associated with some of these phases.

Furniture production more closely parallelled many of the various styles but is often defined by the designer's name, as in 'Kentian' (*see* KENT, WILLIAM, §2(i)), CHIPPENDALE, Hepplewhite (*see* HEPPLEWHITE, GEORGE), and Sheraton (*see* SHERATON, THOMAS) pieces. The high quality of design and good standards of craftsmanship are especially notable in works of art and in architectural detailing produced throughout the period. What is particularly characteristic of the period, however, is the enormous number of publications, ranging from ornament and pattern books, design books and directories, to manuals for builders and craftsmen, guides for decorators and books on architecture and travel. The extensive range of publications available, added to the experience and knowledge gleaned on the Grand Tour, led to a greater awareness of historical periods and styles, which were drawn on unashamedly and supplied the basis for the revivalist movements. In this, the role played by such amateurs as Richard Boyle and Horace Walpole (*see* WALPOLE, (2)) was extremely influential. In the late 20th century Georgian or NEO-GEORGIAN has come to describe architecture, interiors and works of art produced in an 18th-century fashion that referred back to any of the styles current in the Georgian period.

BIBLIOGRAPHY
J. Summerson: *Georgian London* (London, 1945, rev. 2/1962)
——: *Architecture in Britain, 1530–1830*, Pelican Hist. A. (London, 1953, rev. 7/1983)
The Age of Neo-Classicism (exh. cat., ACGB, 1972)
J. Fowler and J. Cornforth: *English Decoration in the 18th Century* (London, 1974)
Rococo: Art and Design in Hogarth's England (exh. cat., ed. M. Snodin; London, V&A, 1984)
BRUCE TATTERSALL

Georgia Straits. *See* STRAIT OF GEORGIA.

Georgiev, Pencho (*b* Vratsa, 1 Feb 1900; *d* Sofia, 2 April 1940). Bulgarian stage designer, printmaker and painter. In 1925 he graduated in design from the National Academy of Art in Sofia and the following year made a successful début as a stage designer at the Sofia National Opera House with his set for Tchaikovsky's *Queen of Spades*. From 1929 to 1934 he lived and worked in Paris, studying first at Paul Loran's atelier for applied art. Georgiev also became known as a printmaker and painter, exhibiting at the Salon d'Automne in 1929, and his art was favourably reviewed in *Le Journal des arts*, *Matin* and *Temps* by French critics. While in France he executed prints containing a strong social message (e.g. *Unemployed*, etching, 1930; *Clochard*, etching, 1931; *Hotel*, woodcut, 1932). His best-known paintings, among which are *All Souls Day* (1927) and *Disaster* (1931; both Sofia, N.A.G.), also contain strong social criticism. He also did a series of paintings entitled *Bird Sellers* (e.g. *c.* 1930–32; Sofia, N.A.G.). After returning to Bulgaria, Georgiev worked as a stage designer for the Ivan Vazov National Theatre in Sofia, creating more than 30 sets for plays, operas and ballets. His designs were daring and innovative, and he became an opponent of traditional sets, which featured symbolic themes or everyday genre. In 1936 he participated in the fourth Triennale in Milan, showing stage designs for Shakespeare's *Hamlet* and Offenbach's *La Belle Hélène*. He also executed decorative and stylized oil paintings of Bulgarian peasants and prints depicting Bulgarian village life.

BIBLIOGRAPHY
N. Mavrodinov: 'Pencho Georgiev', *Isk. & Krit.*, 5 (1940)
Pencho Georgiev–Album: Zhivopis', grafika, teat'r [Painting, graphics and theatre] (Sofia, 1941) [Album pubd by Union of Bulgarian Artists; intro. by S. Skitnik]
JULIANA NEDEVA-WEGENER

Georgius Matthei Dalmaticus. *See* GIORGIO DA SEBENICO.

Geraardsbergen. *See* GRAMMONT.

Gerada, Mariano (*b* 1766; *d* 1823). Maltese sculptor. He was reputedly trained in Valencia, Spain, where his family had business interests. His work, which included architectural ornament and polychrome wooden processional statues, drew on the tradition of vernacular Maltese sculpture. Its refinement and use of exquisite serpentine curves reveal a knowledge of Gothic devotional images. His sculptures were criticized in his lifetime for their mundane appearance and dance-like stances, but this did not prevent him from obtaining regular commissions from many of Malta's churches. His first important work, the *Prophet Elijah* (1796; Xewkija, Parish Church), has an expressiveness that is absent in his later statues. His masterpiece is probably the exquisite *St Michael the Archangel* (1819) in the Parish Church, Cospicua, where there is also a *Baptism of Christ*, commissioned in 1814 as a cover for the font. His public monuments include the *Lion and Unicorn* fountains in St John's Square, Valletta, and the *Virgin of the Graces* at Zabbar, which marks the site of a skirmish during the Maltese uprising against the French in 1798.

MARIO BUHAGIAR

Geraki. Site of ancient Geronthrai in Laconia, Greece, 40 km south-east of Sparta and occupied by a large modern village. The ancient acropolis is surrounded by Cyclopean walls of the Mycenaean period (*c.* 1300 BC), well-preserved to the north and east. The medieval castle of Geraki, which was built by Jehan de Nivelet in 1254 on the rocky ridge of Parnon 5 km to the south-east, was the headquarters of one of the original twelve Frankish baronies in the Peloponnese. The village, the castle and the surrounding region contain a number of churches of various periods.

In the village there are two 6th-century basilical churches, only one of which has been excavated, and six later churches. Of the latter, the Evangelistria, St Sozon (built above the unexcavated basilica) and St Athanasius are built in the cross-in-square plan and date from the 12th century, while the two-aisled church of St Nicholas dates from the 13th century. St John Chrysostomos, a single-aisled church, and St Theodore, with its barrel-vaulted nave and pointed transverse barrel vault, were founded *c.* 1300. The exteriors are decorated with brick-work patterning and inset with ancient and Early Christian spolia, such as capitals, triglyph fragments and inscriptions. The interior walls of the standing churches, except for St Theodore, are decorated with fragmentary frescoes in a local style. The earliest paintings date to the late 12th century and survive in St Sozon and the Evangelistria, where representations of *Christ Pantokrator*, the *Descent*

into Limbo and the *Evangelists* are of particular interest, revealing influences from Constantinople. The wall paintings in St Athanasius belong to the early 13th century (or possibly earlier) and the early 14th, while those in St Nicholas date from the late 13th century and those in St John Chrysostomos to *c.* 1300, except for an epitaph of 1450. The most common designs are meanders, kufic motifs and crescents containing a star (a Byzantine symbol also found in two of the castle churches).

The castle of Geraki contains the ruins of numerous houses, a single-aisled basilical church and the main three-aisled church of St George. Outside the castle walls are three barrel-vaulted churches with transverse barrel vaults: Hagia Paraskevï, the Theophaneia and the Taxiarques. Their exterior walls are richly decorated with rare brick-work patterning and carvings of Frankish inspiration, while the interiors preserve the remains of 13th-century frescoes. Hagia Paraskevï and St George also have stone shrines bearing paintings of their patron saints. The shrine of the former is crudely carved in a local Gothic style, and the latter's is of high quality with Frankish, Byzantine and Arabic elements, including fleurs-de-lis and a crescent containing an eight-pointed star surrounded by five six-pointed stars. The remaining churches are decorated with late Byzantine wall paintings; those of the Eleoussa are particularly impressive and dated by inscription to 1431.

BIBLIOGRAPHY

R. Traquair: 'Laconia: The Mediaeval Fortresses', *Annu. Brit. Sch. Athens*, xii (1905–6), pp. 262–9, pls ii–vi
A. Xyngopoulos: 'Anaskaphes eis to Geraki' [Excavations at Geraki], *Praktika Athen. Archaiol. Etaireias* (1937), pp. 108–14
J. Lafontaine: 'Le Village "byzantin" de Iéraki', *Reflets Monde*, ix (May 1956), pp. 45–58
E. Kounoupiotis-Manolessos: 'Nees toixographies sto Geraki' [New wall paintings at Geraki], *Actes du XVe congrès international des études byzantines: Athènes, 1976*, ii/1, pp. 305–24
N. Moutsopoulos and G. Dimitrokallis: *Geraki: Hoi ekklesies tou oikismou* [Geraki: the churches of the village] (Thessaloniki, 1981)

G. DIMITROKALLIS, N. MOUTSOPOULOS

Gérard, François(-Pascal-Simon), Baron (*b* Rome, 4 May 1770; *d* Paris, 11 Jan 1837). French painter and illustrator.

1. LIFE AND WORK. He spent most of his childhood in Rome. His talent as an artist revealed itself early and during this period he acquired a love of Italian painting and music, which he never lost. In 1782 his family returned to Paris, where, through the connections of his father's employer Louis-Auguste le Tonnelier, Baron de Breteuil, Minister of the King's Household, Gérard was admitted to the Pension du Roi, a small teaching establishment for young artists which had been founded by the Marquis de Marigny. After 18 months he entered the studio of the sculptor Augustin Pajou, where he remained for two years, before transferring to that of the painter Nicolas-Guy Brenet. He became a pupil of David in 1786 and quickly found special favour with his master.

In 1789 Gérard competed for the Prix de Rome and his entry, *Joseph Revealing himself to his Brethren* (Angers, Mus. B.-A.), was placed second; the winner was Girodet. He did not submit in 1790, being preoccupied with his father's illness and death—after which he returned to Italy with his mother and two younger brothers. Back in Paris

by mid-1791 he became David's assistant in the painting of the *Death of Le Pelletier de Saint Fargeau* (destr.) in 1793 and the following year won first prize in the National Convention's competition on the theme of its historic session of *10th of August 1792* (prize drawing, Paris, Louvre; unfinished canvas, London, priv. col.). Although the project lapsed, his success secured him lodgings and a studio in the Louvre. The design was much praised by David—its composition was inspired by his own *Oath of the Jeu de Paume* (never completed) and through his influence Gérard was spared military service, though only at the cost of sitting on the Revolutionary Tribunal. (He avoided most, if not all, of its sanguinary sessions by feigning illness.)

On the death of his mother in 1793, Gérard married her sister and assumed responsibility for his youngest brother. He urgently needed to earn a living and worked for the publisher Pierre Didot the elder illustrating luxury folio editions of La Fontaine's *Les Amours de Psyché et de Cupidon* (1797), the works of Virgil (1798) and Racine (1801) and *Les Amours pastorales de Daphnis et Chloé* (1800). He was greatly assisted financially by the miniature painter Jean-Baptiste Isabey who commissioned his *Belisarius* (ex-Duke of Leuchtenberg priv. col., Munich), which, having taken only 18 days to paint, brought him acclaim at the Salon of 1795. Immediately afterwards Isabey sold it to Caspar Meyer, Ambassador of the Batavian Republic, at a profit, which he donated to the artist. He also commissioned the superb portrait of himself and his four-year-old daughter (1795; Paris, Louvre; see fig.) which drew attention to Gérard at the Salon of 1796.

Gérard's reputation and success were based on his work as a portrait painter. *Isabey and his Daughter* was widely praised for its superb naturalism, rivalled only by David's *Mme Sériziat and her Son* (exh. Salon 1795; Paris, Louvre). There followed *Larevellière-Lépeaux* (1797; Angers, Mus. B.-A.) and *Comtesse Regnault de Saint-Jean-d'Angély* (exh. Salon 1799; Paris, Louvre), in which personal expressiveness was couched in precise definition of form and soft yet subtle colour. These portraits met with almost universal approval and led in turn to commissions from Bonaparte, his family and entourage, culminating in the official *Napoleon in his Imperial Robes* (Versailles, Château, incl. other versions) and *Mme Récamier* (Paris, Carnavalet), both completed in 1805. On the strength of these, Gérard became the most fashionable portrait painter of his day, surpassing even David. His productivity at this time was phenomenal: between 1800 and 1815 he produced approximately fifty full-length and forty bust-length portraits.

Gérard did not forsake history painting. *Belisarius* was followed in 1798 by *Psyche Receiving Cupid's First Kiss* (Paris, Louvre)—a development of his illustrations to La Fontaine—in which the cool smoothness of the two figures contrasts strongly with the carefully observed landscape setting. This painting was the sensation of the Salon of 1798, and as a result Gérard was commissioned in 1800 to execute one of two paintings (Girodet did the other) on Ossianic themes for the Salon Doré at Malmaison. His uncharacteristically ethereal *Ossian Evoking Phantoms* (1801; original lost; versions at Hamburg, Ksthalle; Malmaison Château N.) was followed by the *Three Ages* (Chantilly, Mus. Condé), shown at the Salon of 1808; in

François Gérard: *Isabey and his Daughter*, oil on canvas, 1.95×1.30 m, 1795 (Paris, Musée du Louvre)

an unusual interpretation, an old man, a baby and a youth are grouped in complex symmetry around the central figure of a woman. In all three pictures a tendency towards the allegorical and anecdotal is pronounced, as is Gérard's interest in landscape (an interest probably absorbed from Girodet and his circle in Rome).

Corinna at Cape Misenum (1819; Lyon, Mus. B.-A.) was commissioned at the suggestion of Madame Récamier by Prince Augustus of Prussia in memory of Madame de Staël and shown at the Salon of 1822. Although the treatment of the figures remains classical, Gérard's propensity for elevating eyes and exaggerating gestures in the manner of Greuze is much in evidence, while passionate emotion and the wildness of the setting lend the picture a romantic aspect well in advance of its time. *St Theresa* (Paris, Infirmerie Marie-Thérèse), a rare venture into religious subject-matter, was conceived in a similarly romantic vein. Painted in 1827, its lachrymose mysticism is well attuned to the *Génie du Christianisme* (1802) of Chateaubriand, whose wife founded the institution for which it was commissioned.

Gérard returned to classical themes intermittently throughout his career but in order to cater for the increasing interest of the French in their own history, many of his history paintings depicted more recent subjects. In 1810 he exhibited the enormous *Battle of Austerlitz*

(Versailles, Château; figures, Paris, Louvre), commissioned by the Emperor and incorporated into the ceiling of the Salle du Conseil d'Etat at the Tuileries in the form of a fictive tapestry being unrolled by winged female figures representing Victory, Fame, Poetry and History. It was removed after the fall of the Empire and replaced by the *Entry of Henry IV into Paris* (exh. Salon 1817; Versailles, Château), an allegory of the Bourbon Restoration and one of Gérard's most successful history paintings. On several occasions thereafter he was commissioned to paint large-scale contemporary history pictures, for example the *Coronation of Charles X* (1827–9; Versailles, Château) and the *Duc d'Orleans Accepting the Lieutenancy-general of the Kingdom* (1834; Versailles, Château). Under the July Monarchy, Gérard resumed work on four allegorical pendentives at the Panthéon, originally commissioned in 1820 but not completed until 1836, and in recognition of his work as a history painter, Louis-Philippe envisaged the creation of a Salle Gérard at the Louvre.

The consistent success of Gérard, particularly as a portrait painter, coupled with his political moderation and circumspection, brought him many honours. Chevalier of the Légion d'honneur from its inception in 1802, he became Premier Peintre to Empress Josephine in 1806, professor at the Ecole des Beaux-Arts in 1811 and a member of the Institut in 1812. Through the influence of Talleyrand, he secured the commission for a full-length portrait of *Louis XVIII* (exh. Salon 1814; Versailles, Château) at the Restoration, became Chevalier of the Order of St Michel in 1816 and Premier Peintre to Louis XVIII in 1817. Two years later he was ennobled.

2. STYLE AND INFLUENCE. In his early years Gérard was markedly influenced by David. This is evident in his illustrations to *Psyché*, where he made much use of nudity, figures seen in profile, archaeological detail, strong diagonal shadow and shallow space; or in the *Three Ages*, where the woman was inspired by the figure of Hersilia in David's *Sabine Women* (Paris, Louvre). His contemporary history pictures show the influence of both David and Gros. His technique always retained its polished quality; indeed, it became more finical than David's own and was thus, by the closing years of his career, greatly at variance with that of Delacroix and his romantic followers. His mature pictures have a grace and independence from the antique which distance him from his master, as do his softer colours and liking for landscape settings. In the case of *Psyche Receiving Cupid's First Kiss*, the finesse of the figures, the clarity of definition and the lack of colour complexity led to his being the only contemporary artist admired by Les Primitifs, while Ingres was much influenced by his *Ossian* in the composition of his *Dream of Ossian* (1813; Montauban, Mus. Ingres) and by some of his portraits.

In portraiture Gérard was a leader from the late 1790s, rivalling David himself for Court favour and even influencing his style. Typical of the free brushwork and superb control of tone in his portraits is *Mme Lecerf* (1794; Paris, Louvre). At the height of his success, the brilliant characterization of his sitters, as striking as that of his English contemporary, Sir Thomas Lawrence (whom he greatly admired), began to decline through sheer pressure of

work; a number of his later portraits are repetitious and uninspired. This is hardly surprising in view of the extent of his oeuvre: over thirty history paintings, more than eighty full-length portraits and innumerable half-lengths and busts. Many of the portraits are in private collections and are known only through prints or the series of 84 freely handled reductions, originally made by Gérard as a record and now at Versailles. He had hardly any pupils but, because of the demands on his time, was compelled to employ assistants, notably Charles de Steuben (1788–1856), Paulin Guérin and Marie-Eléonore Godefroid (1778–1849).

BIBLIOGRAPHY

C. Lenormant: *François Gérard: Peintre d'histoire* (Paris, 1846, 2/1847)
H. Gérard, ed.: *Oeuvre du baron Gérard, 1789–1836*, 3 vols (Paris, 1852–7)
——: *Correspondance de François Gérard* (Paris, 1867) [with an essay on Gérard by A. Viollet-le-Duc]
Lettres addressées au baron François Gérard (Paris, 1880)
G. Hubert: 'L'Ossian de François Gérard et ses variantes', *Rev. Louvre* (1967), pp. 239–48
The Age of Neo-classicism (exh. cat., London, RA; London, V&A; 1972), pp. 66–9, 351–2
A. Latreille: *François Gérard (1770–1837): Catalogue raisonné des portraits peints par le baron François Gérard* (diss., Paris, Ecole Louvre, 1973)
French Painting, 1774–1830: The Age of Revolution (exh. cat., Paris, Grand Pal.; Detroit, MI, Inst. A.; New York, Met.; 1974–5), pp. 431–9
Le Néo-classicisme français: Dessins des musées des province (exh. cat., ed. J. Lacambre and others; Paris, Grand Pal., 1974–5), pp. 61–6 [on Gérard's illustrations for Didot]
R. Kaufmann: 'François Gérard's *Entry of Henry IV into Paris*: The Iconography of Constitutional Monarchy', *Burl. Mag.*, cxvii (1975), pp. 790–805
M. Moulin: 'François Gérard: Peintre du *10 août 1792*', *Gaz. B.-A.*, (May–June, 1983), pp. 197–202
——: 'Daphnis et Chloé dans l'oeuvre de François Gérard, 1770–1837', *Rev. Louvre*, xxxiii/2 (1983), pp. 100–09

PAUL SPENCER-LONGHURST

Gérard, Jean-Ignace-Isidore. *See* GRANDVILLE, J.-J.

Gérard, Marguerite (*b* Grasse, 28 Jan 1761; *d* Paris, 18 May 1837). French painter. After the death of her mother in 1775 she left Grasse to join her elder sister Marie-Anne and her sister's husband Jean-Honoré Fragonard in their quarters in the Louvre in Paris. Marguerite became Fragonard's protégé and lived for the next 30 years in the Louvre, where she was exposed to the greatest art and artists of the past and present. By 1785 she had already established a reputation as a gifted genre painter, the first French woman to do so, and by the late 1780s came to be considered one of the leading women artists in France, the equal of Adelaide Labille-Guiard, Anne Vallayer-Coster and Elisabeth Vigée-Lebrun.

Since she was excluded from exhibiting at the Académie Royale, which allowed only four women members, her work was popularized through engravings by Gérard Vidal, Robert de Launay and her brother Henri Gérard. As a woman, Marguerite Gérard was also deprived of the academic training and study of the nude essential to the professional history painter. However, her informal apprenticeship to Fragonard and her study of the paintings by Dutch 17th-century masters in private and royal collections enabled her to develop a meticulous and sentimental genre style that appealed to both the public and the critics throughout her long career. After the Revolution the Salons were opened to women and Gérard exhibited from 1799 to 1824, winning a Prix d'Encouragement in 1801 and a Médaille d'Or in 1804.

Gérard was also an accomplished portrait painter, specializing at first in small-scale, freely brushed portraits of friends and later in larger, more finished portraits, closer in style to her genre scenes. More than 300 genre scenes and 80 portraits, including several miniatures, have been documented. Since she worked chiefly in oil on canvas, preferring to make preliminary sketches in oil, very few drawings can be reliably attributed to her.

Gérard's genre paintings present an idealized vision of the private world of bourgeois and upper-class women of her period. The embodiments of perfect womanhood, her subjects are depicted in romantic or maternal roles, accompanied by pets and servants and enjoying a leisurely, protected life occupied with their children, their correspondence, their music and drawing. *Bad News* (exh. Salon 1804; Paris, Louvre) is typical of this genre. Unlike her subjects, Marguerite Gérard never married. She pursued her career as an artist for over 50 years and was an astute businesswoman, often lending money to aristocrats at high rates of interest.

The myth that Gérard and Fragonard were lovers has been disproved: she referred to him as her 'good little father' and continued to live with Mme Fragonard for 17 years after the master's death. However, the question of her artistic collaboration with Fragonard during the 1780s remains controversial. Some scholars believe that Fragonard's hand is visible in many works signed by Gérard during the first decade of her career, while others cannot imagine this master of dynamic, spontaneous brushwork painting in the precise, controlled manner of his student. Since Fragonard scholars are still at odds over the style and quantity of his output in the 1780s, agreement over the attribution of many well-known pictures including the *Stolen Kiss* (*c.* 1785; St Petersburg, Hermitage) and the *First Steps of Childhood* (*c.* 1780–83; Cambridge, MA, Fogg) has yet to be reached.

Gérard maintained a level of technical competence and ingratiating sentimentality in her paintings that assured her success. Her ability to reproduce textures and surfaces with *trompe l'oeil* precision and her preference for a glittering palette of silvery colours enhanced by glazes made her genre scenes unique. Gérard's canvases are precursors of the idyllic domestic genre scenes beloved by the public from the 19th century onwards, yet they also convey a sense of the splendid isolation that was the norm for the most fortunate, educated women of her time.

BIBLIOGRAPHY

J. Doin: 'Marguerite Gérard', *Gaz. B.-A.* (1912), pp. 429–30
G. Levitine: 'Marguerite Gérard and her Stylistic Significance', *Baltimore Annu.*, iii (1968)
S. W. Robertson: 'Marguerite Gérard', *French Painting 1774–1830: The Age of Revolution* (exh. cat., Paris, Grand Pal.; Detroit, MI, Inst. A.; New York, Met.; 1974–5), pp. 440–41
——: 'Marguerite Gérard', *Women Artists, 1550–1950* (exh. cat., Los Angeles, CA, Co. Mus. A., 1976–7), pp. 197–8
——: 'Marguerite Gérard et les Fragonard', *Bull. Soc. Hist. A. Fr.* (1977), pp. 179–89
——: *Marguerite Gérard, 1761–1837* (diss., New York U., 1978) [includes complete cat. rais., master bibliog., bibliographies of source and sale materials, biog. outline, etc]
Fragonard (exh. cat. by P. Rosenberg, Paris, Grand Pal.; New York, Met; 1987–8), pp. 573–7

J. P. Cuzin: *Jean-Honoré Fragonard: Life and Work* (New York, 1988), pp. 216–24, 338–40

SARAH WELLS ROBERTSON

Gérard de Lenoncourt. *See* JACQUEMIN, GERARD.

Gerards. *See* GHEERAERTS.

Gerasa [anc. Antioch-on-the-Chrysorrhoas; now Jerash]. Ancient city in Jordan, set in the hills of Gilead *c.* 45 km north of Amman. It flourished from the 2nd century BC to the 7th century AD; the site is in the modern town of Jerash. Founded by Antiochos IV of Syria (*reg* 175–164 BC), Gerasa first rose to importance as Antioch-on-the-Chrysorrhoas during Hellenistic and Roman times. Its location between Pella and Philadelphia ensured its continued prosperity as one of the cities of the Decapolis in Roman Syria. Gerasa's shift to the new province of Arabia in AD 106 sparked its greatest urban flourishing, which continued until its capture by the Persians in AD 614 and the Arabs around AD 635. Although ancient Gerasa remained occupied until the 8th century AD, it was devastated by a major earthquake *c.* AD 746, and later sources suggest that it was abandoned. The site was discovered in 1806 by the German traveller Ulrich Seetzen and briefly described by many 19th-century visitors; the first scientific account was by G. Schumacher in 1902. Excavations conducted from 1928 to 1934 by Yale University exposed large parts of the Roman street-plan and many isolated buildings, including the temples of Zeus and Artemis, a 2nd-century AD triumphal arch and over a dozen Christian churches. In the 1980s several international teams worked at Gerasa under the supervision of the Jordanian Department of Antiquities. The monumental public buildings that still dominate the site constitute one of the best-preserved cityscapes of Classical antiquity. Finds from the early excavations are divided between the Israel Museum in Jerusalem and the Yale University Art Gallery in New Haven, CT, while more recent discoveries are housed at the site and at the Jordan Archaeological Museum, Amman.

BIBLIOGRAPHY

C. H. Kraeling, ed.: *Gerasa: City of the Decapolis* (New Haven, 1938)
I. Browning: *Jerash and the Decapolis* (London, 1982)
R. Pierobon: 'Gerasa in Archaeological Historiography', *Mesopotamia*, xviii–xix (1983–4), pp. 13–35

M. RAUTMANN

1. Roman. 2. Byzantine.

1. ROMAN. Although Josephus may have been exaggerating when he claimed (*Jewish War* IV.487–9) that Gerasa was destroyed during the First Jewish Revolt (AD 70), it was at about this time that an ambitious new city plan was begun, involving the laying out of the main streets and perhaps the construction of the city walls. The north-west gate was completed by AD 75, but the walls seem to be of a later date. They enclosed an irregular area on both banks of the river, bisected by the *cardo* (the main north–south street). The triumphal arch to the south of the city, dedicated to Hadrian in AD 129–30, seems to have been associated with an enlargement southwards of the city that never took place. The arch and the contemporary new south gate both display some unorthodox, perhaps Nabataean, architectural features, such as acanthus bases (*see* NABATAEA). The adjacent hippodrome, one of the few in this part of the Empire, must have been planned at the same time but did not last beyond the 3rd century AD.

Most of the public buildings seem to have been on the gently sloping west bank of the river; the greatly expanding modern town occupies what may have been the largely residential area on the east bank. Inside the south gate are the visible remains of the Temple of Zeus, in the Corinthian order, which dates to the 160s AD but which superseded earlier cult buildings dating to the Hellenistic and early Roman period. Certainly the temenos and the stairs up from the valley date to the earlier 1st century AD. Next to the temple is the large, partially restored southern

1. Gerasa, Temple of Artemis complex, mid-2nd century AD

theatre (late 1st century AD), with a seating capacity of
c. 3000. North-east of the temple and the theatre lies the
Oval Piazza (1st century AD), a paved area surrounded by
an Ionic colonnade filling in a natural valley. From here
the city's finely paved *cardo* leads off to the north. It is
lined by Corinthian colonnades and was perhaps widened
at points in the 160s AD; differing architrave heights
indicate the locations of public buildings. The intersections
between the *cardo* and the southern and northern *decumani*
(the principal cross-streets) were marked by two public
monuments. At the south crossroads was a tetrakionion
(structure with four pillars) of the ?2nd century AD, in this
case consisting of four large piers each surmounted by
four columns, which was later surrounded by a circular
piazza. At the northern intersection stood a tetrapylon
(quadruple gateway) of the Severan period (early 3rd
century AD). The *decumani*, although perhaps laid out
earlier, were only colonnaded in the 160s AD.

The propylaeum to the Temple of Dushares–Dionysus
stands on the west side of the *cardo* in its reused form as
an entrance to the late 4th-century AD Christian cathedral.
Next to it is an elaborately decorated semicircular nym-
phaeum (AD 191) with two tiers of statue niches, which
was roofed by a semi-dome and fronted by giant Corin-
thian columns. Further north is the massive propylaeum
of the Temple of Artemis (completed AD 150). The
monumental scale and plan of the temple complex (see
fig. 1) are typical of oriental sanctuaries of its period. The
octastyle Corinthian temple was approached through a
system of steps and courtyards that started across the
cardo on the east bank of the river. The propylaeum, giving
on to the main street, was fronted by a porch of four huge
Corinthian columns supporting a pediment with an arch
over the central span. The actual entrance consisted of a
vast doorway, with two smaller openings surmounted by
elaborately decorated niches framed by Corinthian col-
umns carrying spurs of entablature. Artemis was the major
Classical deity of Gerasa and appears on coins of the city.
Off the north *decumanus* lies the north theatre (160s AD),
which is smaller than its southern counterpart. Only its
lower tiers of seats belong to the original building, which
was an odeion that doubled as a bouleuterion. It was
enlarged to serve as a theatre in the 230s AD. East of the
cardo are the west baths, which provide fine examples of
Roman vaulting and engineering techniques but remain
unexplored. On the east bank of the river are the remains
of the east baths and an adjacent palaestra. Major construc-
tion projects in the city ceased by the 3rd century AD and
little is known of the later domestic buildings, apart from
the makeshift dwellings erected inside important earlier
monuments.

BIBLIOGRAPHY

J. H. Iliffe: 'Imperial Art in Trans-Jordan', *Q. Dept Ant. Palestine*, xi
 (1945), pp. 1–26
M. Lyttleton: *Baroque Architecture in Classical Antiquity* (London, 1974),
 pp. 241–7
R. Parapetti: 'Architectural and Urban Space in Roman Gerasa', *Mesopo-
 tamia*, xviii–xix (1983–4), pp. 37–84
E. O. Goicoechea: *Excavaciones en al agora de Gerasa en 1983* (Madrid,
 1986)
R. G. Khouri: *Jerash: A Frontier City of the Roman East* (London, 1986)
F. Zayadine, ed.: *Jerash Archaeological Project, 1981–1983*, i (Amman,
 1986)
'Jerash Archaeological Project, 1984–1988', *Syria*, lxvi (1989) [whole issue]
J. Seigne: 'Jérash romaine et byzantine: Développement urbain d'une ville
 orientale', *Studies in the History and Archeology of Jordan*, iv (1992),
 pp. 331–41

J. M. C. BOWSHER

2. BYZANTINE. Like most of Roman Syria, Gerasa
revived after the founding of Constantinople in AD 330.
Abundant quantities of Byzantine coins and pottery, both
local and imported, excavated at the site, reflect the city's
continuing importance in the region's commerce. Its urban
life is further documented by the remains of many civic
and private buildings, and those of at least 15 churches
that were built between the late 4th century AD and the
early 7th. Epigraphic and archaeological sources show that
it remained an urban centre under Persian rule (AD 614–
28) and for about a century under the Umayyads from
c. AD 635.

Most parts of the Roman city were occupied until the
early 8th century AD. Neither an earthquake in the 4th
century AD nor the threat of Arab attack in the mid-5th
century AD, in apparent response to which the 1st-century
AD fortifications were repaired, seriously disrupted local
settlement: the street plan was retained in Byzantine times
and remained passable despite increasing encroachment
from the late 6th century AD. Although the two large
theatres within the walls were apparently no longer in use
by the late 5th century AD, an inscription from the small
theatre to the north of the city records the celebration of
a local theatrical festival in AD 535. A mosaic inscription
of AD 578 documents the continued activities of the local
Blue circus faction, even though at least part of the 2nd-
century AD hippodrome had been converted to domestic
and industrial purposes during the 5th century AD.

Bishops represented the city of Gerasa at the Council
of Seleucia (AD 358) and the Council of Chalcedon
(AD 451), and the epigraphic sources demonstrate that
until the 7th century AD the local bishop remained the
most important patron in the building and decoration of
churches. The episcopal complex (l. *c.* 180 m east–west)
was built on terraces to the south of the Classical Temple
of Artemis and fronted on the *cardo maximus*. A monu-
mental staircase of the 2nd-century AD gave access to the
eastern end of the complex, which in its final form
comprised two basilicas (see fig. 2). At the top of this
entry lies the episcopal basilica (probably late 4th century
AD). A fountain stands in a square colonnaded atrium to
the west of the church. In AD 494–6 a martyrium basilica
dedicated to St Theodore was erected to the west of the
atrium on a higher terrace. Rooms to the north of the
martyrium's atrium have been identified as the clerical
residence. Next to the basilica is a bathhouse built by
Bishop Placcus in AD 454–5 and restored in AD 584, which
was presumably for the use of the clergy.

Most of Gerasa's other churches were also built on a
three-aisled basilica plan and range in length from 29 to
45 m. They were built of local limestone and spolia and
originally had timber roofs on arcades or architraves
supported by reused columns; in the 6th century AD
masonry piers were sometimes employed. The open plan
of churches' chancels, with their multiple doorways and
side chambers often flanking the apse, suggest liturgical
links with Aegean architecture. The churches at Gerasa
do not have galleries and the only closed narthex is that

with four diagonally placed exedrae set within a square shell, similar to the cathedral at Bosra (AD 512). The four central columns may originally have supported a light timber dome. Paired doorways and niches articulate the outer walls.

The decoration of the churches at Gerasa reflects the city's relative prosperity in Byzantine times. Sculptural spoils were readily available from abandoned Classical buildings. Interior furnishings could include benches in the apse and occasionally an ambo or font. Floors are paved with limestone slabs; in the 5th and 6th centuries AD mosaics, many of which are inscribed, were usually employed: favoured subjects include human figures in genre settings, architectural scenes, animals and flowers set in geometric frames and vegetal *rinceaux*. Frontally arranged donor portraits are found at SS Cosmas and Damian, the church of Bishop Isaiah (AD 521) and perhaps the Synagogue church (AD 531).

The small church of Bishop Genesius (ded. AD 611) is the latest of the churches to be dated. Although Byzantine administration ended with the Persian invasions and the Umayyad occupation of Syria, coins, pottery and buildings show that settlement continued under Arab domination. Despite disruption to its central water supply and increasing encroachment on public roads, most parts of the urban site remained inhabited into the 8th century AD, during which time Gerasa possessed a castle, mosque and a mint.

BIBLIOGRAPHY

J. W. Crowfoot: *Churches of Jerash* (London, 1931)

'Gerasa I: Report of the Italian Archaeological Expedition at Jerash: Campaigns 1977–1981', *Mesopotamia*, xviii–xix (1983), pp. 5–134

F. Zayadine, ed.: *Jerash Archaeological Project, 1981–1983*, i (Amman, 1986)

'Jerash Archaeological Project, 1984–1988', *Syria*, lxvi (1989) [whole issue]

M. RAUTMANN

Gerasimov, Aleksandr (Mikhaylovich) (*b* Kozlov [now Michurinsk, Tambov region], 12 Aug 1881; *d* Moscow, 23 July 1963). Russian painter, stage designer and administrator. He studied at the School of Painting, Sculpture and Architecture in Moscow (1903–15) under Abram Arkhipov, Nikolay Kasatkin (1859–1930) and Konstantin Korovin, among others. At the School he emerged as a leader of a group of traditionalists who contended with the avant-garde led by Mikhail Larionov. After service in the army he returned to Kozlov, where he worked as a stage designer and decorated the town for revolutionary festivities. In 1925 he moved to Moscow, where he was a member of the Association of Artists of Revolutionary Russia. The style Gerasimov was using by the mid-1920s in his landscapes and portraits, which was a combination of academic realism and Impressionism, remained practically unchanged throughout his life.

Gerasimov's work is significant as representative of a solemn 'heroic realism' (e.g. *Lenin on the Tribune*, 1929–30; Moscow, Cent. Lenin Mus.), later considered a paradigm of Socialist Realism. He painted a series of pompous official portraits of Soviet leaders (e.g. *I. V. Stalin and K. Ye. Voroshilov in the Kremlin* (1938; Moscow, Tret'yakov Gal.; for illustration *see* SOCIALIST REALISM) but, still feeling himself a pupil of Korovin, tried to express a more lyrical and personal mood in landscapes (e.g. *Summer Rain at Noon*, 1939; St Petersburg, Rus. Mus.),

2. Gerasa, cathedral complex, late 4th century AD–late 5th, plan: (a) monumental staircase; (b) episcopal basilica; (c) fountain atrium; (d) martyrium of St Theodore

added to the small, single-aisled church of Bishop Marianos (AD 570). Two important buildings depart from the basilica plan. The church of the Apostles, Prophets and Martyrs was built at the expense of a certain Marina in AD 464–5 and is of the cross-in-square plan, with four small chambers arranged between the cross arms. Short colonnades extend outward from four large central columns that probably supported a timber roof over the crossing. The church of St John the Baptist, built between the two basilical churches of St George (AD 529) and SS Cosmas and Damian (AD 533), has a circular interior plan

the group portrait of the painters *I. N. Pavlov, V. N. Meshkov, V. K. Byalynitsky-Birulya and V. N. Baksheyev* (1944; Moscow, Tret'yakov Gal.), numerous other portraits, such as that of the ballerina *O. V. Lepeshinskaya* (1939; Moscow, Tret'yakov Gal.), and in his stage designs.

Gerasimov had a stormy career in arts administration, often exercising totalitarian control. He was Chairman of the Executive Committee of the Union of Artists of the USSR (1939–54) and President of the Academy of Art (1947–57) when cultural repression was at its strongest. As a representative of official policy he campaigned against 'cosmopolitanism' and 'formalism' in the late 1940s and he played a major role in the closure of the Museum of Modern Western Art in Moscow.

WRITINGS
Zhizn' khudozhnika [An artist's life] (Moscow, 1963)

BIBLIOGRAPHY
A. K. Lebedev: *A. M. Gerasimov* (Moscow, 1938)
M. P. Sokol'nikov: *Zhizn' i tvorchestvo A. M. Gerasimova* [The life and work of A. M. Gerasimov] (Moscow, 1951)
——: *A. M. Gerasimov* (Moscow, 1954)
I. M. Blyanova: *Aleksandr Gerasimov* (Moscow, 1988)

V. RAKITIN

Gerasimov, Sergey (Vasil'yevich) (*b* Mozhaysk, 26 Sept 1885; *d* Moscow, 20 April 1964). Russian painter. He trained in Moscow, at the Stroganov Institute (1901–7) and the School of Painting, Sculpture and Architecture (1907–12), under Sergey Ivanov and Konstantin Korovin. His early Post-Impressionist sensitivity for the modelling of form through colour was embodied in expressive portraits of social types (e.g. *Front-line Soldier*, 1926; Moscow, Tret'yakov Gal.). The austere, almost monochrome *Oath of the Siberian Partisans* (1933; St Petersburg, Rus. Mus.) contrasts with the optimistic, broadly impressionistic *Collective Farm Holiday* (1937; Moscow, Tret'yakov Gal.), while the experiences of the war years are expressed in the heroic, emotional *Partisan's Mother* (1943–50; Moscow, Tret'yakov Gal.). Gerasimov's work represents a compromise between Socialist Realist tendentiousness and the quick sensitivity of a painting style full of lyrical sincerity. The latter emerged with particular clarity in the poetic and reflective *Mozhaysk Landscapes* (1954; Moscow, Tret'yakov Gal. and elsewhere). The artist's painting style is also used in his book illustrations, such as those for Maksim Gorky's *Delo Artamonovykh* (The Artamonov case, 1939–54; Moscow, Tret'yakov Gal. and other collections). Gerasimov also proved an experienced teacher. He taught at the Surikov Institute of Art in Moscow (1936–50) and at the Moscow Artistic-Industrial High School (1950–64). He was an able and sensitive administrator, holding the position of first secretary of the Board of the Union of Artists of the USSR in the years of thaw between 1958 and 1964, and won a reputation as a genuine liberal.

BIBLIOGRAPHY
S. W. Gerassimow: Album, intro. by T. Stephanowitz (Dresden, 1961)
S. V. Gerasimov: Al'bom reproduktsiy [S. V. Gerasimov: an album of reproductions], intro. by I. Grabar' and A. Chegodayev (Moscow, 1972)
I. Rostovtsev, ed.: *S. V. Gerasimov: Al'bom reproduktsiy* [S. V. Gerasimov: an album of reproductions] (Leningrad, 1975)
S. M. Ivanitsky: *S. Gerasimov: Al'bom* [S. Gerasimov: an album] (Moscow, 1985)

M. N. SOKOLOV

Gerbier, Sir **Balthazar** (*b* Middelburg, Zeeland, 23 Feb 1592; *d* Hampstead Marshall, Berks, 1663). Dutch courtier, miniature painter, architect and writer, of French origin, active in England. The son of a Huguenot émigré, and perhaps a pupil of the artist Hendrick Goltzius, he travelled to London in 1616. William Sanderson, in his *Graphice* of 1658, says that Gerbier 'had little of art, or merit; a common Pen-man who pensil'd the *Dialogue* [?Decalogue] in the Dutch Church, London; his first rise of preferment' (p. 15). Two or three years later he entered the service of GEORGE VILLIERS, 1st Duke of Buckingham, whose miniature portrait he painted in 1618 (London, Syon House), the same year in which he wrote a poem on the death of Goltzius, which features his future friend Rubens. Rubens was to paint a portrait of his wife Debora Kip (daughter of the Dutch-born goldsmith and engraver William Kip), whom Gerbier married not later than 1618 (*Huguenot Soc. Proc.*, 3rd ser., x, p. 194). Gerbier was clearly instrumental in the spectacularly rapid growth of Buckingham's collection of pictures. In 1621 he travelled to Venice and acquired three pictures by the Bassano family, Titian's *Ecce homo* (Vienna, Ksthist. Mus.) and Tintoretto's *Woman Taken in Adultery* (Dresden, Gemäldegal. Alte Meister). In Rome he drew the Farnese *Hercules* (Naples, Mus. N.) so well that Edward Norgate claimed in his *Miniatura* that his drawing was the 'admiration of all Italians who saw it'. In 1622 he was sent to Brussels, his first diplomatic mission, and the following year he is said to have accompanied Buckingham and Prince Charles (later Charles I) to Spain, where he allegedly painted a portrait of the *Infanta Doña Maria*, whom Charles intended to marry; the facts of both visit and painting, however, have subsequently been disputed (see Foskett, p. 286). In 1624–5 he supervised major alterations at Buckingham (later York) House (destr. 1670s) in the Strand, London, and New Hall (destr.), Essex. It has been claimed that he designed the York House water-gate, which survives in the Embankment Gardens, London, but this is more likely to have been at least begun by Inigo Jones (whose pupil John Webb subsequently drew it).

In 1625 Gerbier accompanied Buckingham to Paris on his mission to bring back Henrietta Maria to England. While he was there Gerbier met Rubens; this was the beginning of a life-long friendship. As Keeper of Buckingham House, Gerbier was given lodgings adjacent to those of Orazio Gentileschi, with whom he was soon to quarrel. In 1628, after Buckingham's assassination, Gerbier was naturalized and Charles I took him into his own service. When Rubens travelled to England in June 1629, he lodged with Gerbier, who was then busy supervising completion of Hubert Le Sueur's bronze equestrian statue (now London, Trafalgar Square) of *Charles I* and its garden setting for Richard Weston, 1st Earl of Portland, at his villa (destr.) in Roehampton, London. During his visit Rubens painted the group portrait of Gerbier's family that Gerbier had replicated in a larger version (Washington, DC, N.G.A.; Windsor Castle, Berks, Royal Col.).

In 1631 Gerbier was appointed King's agent in Brussels. Charles knighted him in 1638 and three years later

appointed him Master of Ceremonies. Within two months, however, he was effectively dismissed from this post, having betrayed a Protestant plot to the Habsburgs and then accused Francis Cottington of treason. His hopes of obtaining the post of Surveyor-General to the Works were now destroyed. The current Surveyor, Inigo Jones, apparently was among those who opposed his candidature; no doubt this was the source for the hostility towards Jones's work that pervades Gerbier's subsequent writings. Jones may have already been alienated by Gerbier's organization of the decorative schemes at Greenwich (from November 1639).

In October 1642 Gerbier was questioned by Parliamentary Commissioners in connection with a Royalist plot. In 1643 he left for France, taking his long-suffering family with him. After the execution of Charles in 1649 he returned to England and opened a continental-style academy at Bethnal Green for the sons of gentlemen. The syllabus included foreign languages, horsemanship, anti-Copernican cosmography, architecture, drawing, painting, engraving and the art of fortification. When insufficient numbers turned up to hear his lectures Gerbier published them, together with other pamphlets more specifically designed to curry favour with the new regime led by Oliver Cromwell. These included a scheme proposed jointly with George Geldorp and Peter Lely to decorate the Banqueting Hall with military portraits and the 'memorable achievements' of the Long Parliament.

Given his superior knowledge and contacts, Gerbier no doubt made money during the early 1650s from dealing in the pictures that formerly belonged to Charles I and Buckingham and that Parliament sold off or gave to their creditors. Nevertheless, in 1658 he persuaded the Dutch government to finance a scheme to send him and his family to Guyana in search of a gold mine he had first learnt about while in Spain in 1623. After an extraordinary voyage from which he was sent back by mutineers after the killing of his daughter Catherine, he published an indignant account claiming to have been the victim of a conspiracy.

In 1660 Charles II was restored to the throne, and in that same year Gerbier attempted, unsuccessfully, to recover his post as Master of Ceremonies. He dedicated his *Brief Discourse Concerning the Three Chief Principles of Magnificent Building* to Charles in 1662 as if he still retained the post, and a year later he published the more substantial *Counsel and Advice to All Builders*. By this time he had entered the employment of William, 1st Earl of Craven, designing a large mansion for him (perhaps out of an earlier structure) at Hampstead Marshall, Bucks (1662–5; destr. 1718), of which only the gate-piers survive. As a consequence of Gerbier's death during its construction, the house was completed by William Winde; an engraved bird's-eye view was published by Johannes Kip in *Britannia Illustrata* (1707).

WRITINGS
Balthazar Gerbier, Knight, to all Men that Loves [sic] *Truth* (?Rouen, 1646) [incl. MS notes by Gerbier (B.L.E.510 (1*)]
Brief Discourse Concerning the Three Chief Principles of Magnificent Building (London, 1662)
Counsel and Advice to All Builders (London, 1663)
Subsidium peregrinantibus (Oxford, 1665)

BIBLIOGRAPHY
Colvin; Foskett
F. H. Cheetham: 'Hampstead Marshall and Sir Balthazar Gerbier', *Notes & Queries*, 118, vii (1913), pp. 406–8
H. Ross Williamson: *Four Stuart Portraits* (London, 1949)
E. Croft-Murray and P. Hulton: *Catalogue of British Drawings in the British Museum* (London, 1960), pp. 328–30
L. -R. Betcherman: 'Balthazar Gerbier in Seventeenth-century Italy', *Hist. Today* (May 1961), pp. 325–31
M. J. Power: 'Sir Balthazar Gerbier's Academy at Bethnal Green', *E. London Pap.*, x/1 (1967), pp. 19–33
L. -R. Betcherman: 'The York House Collection and its Keeper', *Apollo*, xcii (1970), pp. 250–59
D. Freedberg: 'Fame, Convention and Insight: On the Relevance of Fornenbergh and Gerbier', *Ringling Mus. A. J.*, i (1983), pp. 236–59
P. McEvansoneya: 'Some Documents Concerning the Patronage and Collections of the Duke of Buckingham', *Rutgers A. Rev.*, viii (1987)
H. Colvin: *The Canterbury Quad, St John's College, Oxford* (Oxford, 1988)
E. Chaney: *The Evolution of the Grand Tour* (London, 1996)

EDWARD CHANEY

Gerçin. *See under* ZINCIRLI.

Geremia, Cristoforo di. *See* CRISTOFORO DI GEREMIA.

Gerhaert [Gerardi], **Nicolaus** [Niclaus; Niclas; Claes] (*fl* 1462; *d* ?1473; *bur* Wiener Neustadt, Austria). Sculptor, probably of Netherlandish origin. Although his known works span scarcely a decade, his innovative handling of traditional themes and his treatment of mass and space made him one of the most influential sculptors in late 15th-century Germany.

Gerhaert is first recorded in Trier, where he signed the tomb of Jakob von Sierck, Archbishop of Trier, in 1462. There is evidence that he was in Strasbourg from 1463 until August 1467, requesting and receiving the rights of a full citizen of Strasbourg on 3 September 1464. In 1466 a *meister niclaus Bildhouw(er)* was mentioned as owning a house in the Oberstrass (today Grand'Rue) in Strasbourg. From 1467 he worked in the service of Emperor Frederick III (1440–93). The inscription (now lost) on his tombstone in Wiener Neustadt was published in 1733 in an evidently bad copy, the date of his death being barely legible. He was mentioned as being deceased in 1489. His son Peter Gerhaert was a goldsmith in Strasbourg, and his daughter Apollonia was married to the goldsmith Georges Schongauer, who was the brother of the painter Martin Schongauer.

The question of his origins is complicated by the two statements *de leyd* (signature, in Trier, of 1462) and *von Leyden* (Strasbourg document of 1464), and by the signature *von leyen* on the Crucifix of 1467 (Baden-Baden, SS Peter und Paul; see fig. 2 below), which have led to controversy as to whether they represent the Dutch town of Leiden or a Moselle-Franconian place name. It has now been established that the name Leyen was occasionally used for the former. The mention of *von Leyden* does not, however, necessarily imply place of birth: it could also have been the artist's previous place of residence. More certain information about Gerhaert's origin occurs in the name that he used on his seal, partly preserved on a Strasbourg document of 1464: *S.Claes.(G)erhaert.soen*. Claes is a pure Low Franconian form, and the present-day Netherlands and the neighbourhood of Cleve were particularly known as Lower-Franconian-speaking areas. The name Claes does not appear in the Middle Rhine and the Moselle.

Gerhaert's artistic style also suggests a Netherlandish origin, in its fresh and accurate observation of nature, and by the delicate rendering of the textures of human skin and dress. Insofar as sources of his style can be identified, they are found in the work of such Netherlandish artists as Claus Sluter and Jan van Eyck. Attempts to find traces of the young Gerhaert's work in the drastically reduced stock of Netherlandish 15th-century sculpture have failed.

1. Before 1463. 2. Strasbourg and related work, 1463–7. 3. After 1467.

1. BEFORE 1463. Gerhaert's first documented work is already that of a mature artist. The tomb of Jakob von Sierck, Archbishop of Trier (*d* 1456), is signed *nicola(us).gerardi. de.leyd(en)* and dated 1462. It was erected in the choir of the Liebfrauenkirche in Trier (removed 1771). The tomb slab (2.53×1.20 m) has been preserved, with the signature and an inscription in Latin verse praising the Archbishop's deeds, and also the over life-size effigy of Sierck in his pontifical vestments (both Trier, Bischöf. Dom & Diözmus.). Two early descriptions show that it was originally a two-tiered monument, the slab supported by four pillars, with a cadaver underneath with toads, snakes and a mouse. From a mention of the tomb in a draft of Sierck's will it seems that the Archbishop himself had decided on this form, for which there are many English forerunners (e.g. the tomb of Bishop Richard Fleming, Lincoln Cathedral, before 1431), but there were probably other examples, perhaps in the Netherlands or in France. That the effigy represents a live man is clear from the powerful and extremely alert facial expression. The accurate representation, with minute attention to the details of the vestments and the hint of a beard, is combined with a feeling for large-scale design. Gerhaert probably spent a considerable time in Trier while completing this work: the monument to Elisabeth von Görlitz (*d* 1451; Trier, Jesuit Church), which may well have been erected during the 1450s, shows Gerhaert's influence.

The high altar of St George's Church, Nördlingen, Germany, which was signed by the painter Friedrich Herlin, is also dated 1462. The carver of the group of wooden shrine figures is not named (*see* MASTERS, ANONYMOUS, AND MONOGRAMMISTS, §I: MASTER OF NÖRDLINGEN), but the crucified Christ strongly resembles Gerhaert's sandstone Crucifix of 1467 in Baden-Baden (see §2 below). This type—the outstreched body, with carefully reproduced anatomical structure, and a prominent openwork crown of thorns—was new to German sculpture. The Nördlingen altar was previously thought to be the work of one of Gerhaert's followers, but when the date 1462 was uncovered in 1971, the question of Gerhaert's authorship was raised, first for the Crucifix and later for the other figures, as well as for the closely related wooden Dangolsheim *Virgin and Child* (Berlin, Dahlem, Gemäldegal.; *see* MASTERS, ANONYMOUS, AND MONOGRAMMISTS, §I: MASTER OF THE DANGOLSHEIM MADONNA). The composition of the Nördlingen standing figures, rich in movement, many-layered and three-dimensional, has stylistic characteristics that are also typical of Gerhaert's known works; but their labile stance, the ornamental richness of their dress, their magnificent locks

and their naively fresh faces, which can portray overwhelming suffering, differ from Gerhaert's reflective and yet worldly figures, whose complicated form conveys their enigmatic nature. Although no authenticated large standing figures and wood sculpture by Gerhaert have survived, it is generally recognized that a knowledge of Gerhaert's style was a prerequisite for the Nördlingen shrine sculptures. This implies that Gerhaert must have been in Strasbourg before 1462. However the absence of accurately dated works by other Strasbourg sculptors at the time does not permit the Nördlingen sculptures to be placed in a closer stylistic and historical context.

2. STRASBOURG AND RELATED WORK, 1463–7. Gerhaert's first authenticated work in Strasbourg was the portal of the New Chancellery. According to the 18th-century antiquary, Abbé Grandidier, it was dated Easter 1463 and signed *Nikolaus von Leiden*. Gerhaert was paid 220 gulden, with 20 gulden for his wife and 4 for his apprentices, and on 14 June 1464 he undertook to maintain the work for the next 20 years. The building was demolished in the French Revolution, but Künast's description of the lost drawing of the portal by J. A. Seupel of 1679 (Will, 1959) gives some details: above was a Virgin and Child, the Virgin crowned by one angel and flanked by two others; below was the municipal coat of arms held by two men in armour, and two busts, of a bearded old man and a younger woman, were probably in the space between them. At the tip of the gable was a stork. After the destruction the busts and the surviving ornamentation from the portal were put in the Strasbourg library, apparently disappearing in the bombardment of 1870. Only the plaster casts (h. 460 mm) of the busts seemed to have survived; however, in 1909 the head of the man reappeared (red sandstone, h. 260 mm; Strasbourg, Mus. Oeuvre Notre-Dame), as did the head of the woman in 1933 (red sandstone, h. 232 mm; Frankfurt am Main, Liebieghaus; see fig. 1). The busts seem to be in the very act of leaning out of windows. The oblique poses and the raised, curved line of the arms of the figures achieve a subtle twisting movement that almost completely obscures the rest of the bodies, which are in a dark hollow space behind the window. The enigmatic pose is matched by their facial expressions. According to a local tradition dating back to 1587, the busts represented Graf Jakob von Lichtenberg and his mistress Bärbel von Ottenheim, a disreputable pair of lovers well known in the city *c.* 1463. Following this tradition Krohm (1991) has interpreted the busts as a pair of ill-matched lovers (*ungleiches Liebespaar*), a popular subject in art at that time, with the man old and ugly and the woman young and beautiful. Religious interpretations, however, predominate: a prophet and a Sibyl, or Emperor Augustus and the Tiburtine Sibyl (Recht, 1970). In Recht's interpretation the Tiburtine Sibyl shows the Emperor a vision of the future ruler of the world, that is the Christ Child with his mother, revealing a thematic gradation of the portal from the urban sphere (city coat of arms) through the imperial to the province of the divine; but conclusive evidence is lacking, because the man is not wearing imperial insignia and his facial expression is more appropriate to a prophet. The motif of half figures appearing at a window had been used by the middle of the

century, on and in the House of Jacques Coeur in Bourges. Gerhaert's figures, however, were the first to lean out over the window sills ('Bärbel' even seems to be looking the observer straight in the eye). This type of Gerhaert bust was to have an important following on the Upper Rhine.

According to Seupel/Künast (Will, 1959), above the date on the portal there was a 'Portrait of the Master Builder' in stone resting on a pedestal. This could have survived in the red sandstone half-length figure of a man, leaning his chin on his hand in thought and holding a broken-off object in his left hand, possibly a pair of compasses (h. 440 mm; Strasbourg, Mus. Oeuvre Notre-Dame). Like the prophet, the figure has folded arms, and there is a space between the arms and the upper body. But here the work is more labile, rising from a narrow base; at the same time the circular movement gives the whole figure unparalleled unity. The representation of a man deep in his own thoughts was an astonishing theme for late medieval art. This sculpture is generally attributed to Gerhaert, and it was classified as a 'self-portrait' before the discovery of Künast's description.

The gravestone of a priest in St John's Chapel, Strasbourg Cathedral, is composed of a group of grey sandstone figures (c. 1.50×1.08 m) in a Late Gothic vaulted niche above a coat of arms since removed, at the sides of which the date 1464 and signature n.v.l. are carved. Half-length figures of the Virgin and the priest are set behind the parapet, while the naked Christ Child is seated on it, reaching out for the priest's hands, so emphasizing the immediate juxtaposition of divine and earthly beings, although the inner distance is perceptible and only Christ's playful gesture tries to bridge it. Rich detailing of skin, hair and dress is conveyed in a masterly manner, imbuing the religious scene with a fresh vigour, which already conforms to the new demand for sensuous illustration. Models for the portrait types, for example the priest, as well as for individual features, have been sought in Netherlandish painting (e.g. Jan van Eyck's *Virgin and Child with SS Donatian and George and the Donor*, 1436; Bruges, Groeningemus.; see EYCK, VAN, (2), fig. 4) and above all in the fragmentary remains of Netherlandish sculpture, such as the stone reliefs in Utrecht (Cent. Mus.). But only in Gerhaert's relief is the earthly being placed on the same level as the Virgin, and without a saint to act as mediator. The usual identification of the Strasbourg monument with Canon Busnang (mentioned in a 17th-century source) remains uncertain (cf. Will, 1988). Recht (1987) suggested that the Strasbourg monument must have had a cadaver, as it was the model for Nikolaus Hagenauer's tomb (begun c. 1490–93; destr.) for Bishop Albrecht of Strasbourg (in the Lady Chapel of the collegiate church, Saverne), which had a cadaver in addition to a wall relief (destr.) with two busts in an architectural frame.

In 1466 a new wooden altarpiece (destr. after 1530) was erected on the high altar of Konstanz Cathedral and consecrated on Whit Saturday of that year. The carver of this work, *Niclaus von Leyden*, brought a lawsuit before the Strasbourg Council on 17 April 1467, alleging that he had done the work 'better and in a more craftsmanlike way' than he had been contracted to do it, and was therefore now demanding a total of 200 gulden. It was settled that Gerhaert should be paid an extra 50 gulden,

but that he must relinquish his original contract to supply the choir-stalls. This work went to the Konstanz cabinetmaker Simon Haider, who undoubtedly made use of Gerhaert's designs (see ISELIN, HEINRICH). Various reconstructions of the high altar, which was probably dedicated to the Virgin Mary, have been proposed. Deutsch (1963/4) drew some conclusions about its architectonic structure from the surviving choir-stalls. Tripps (1992), tracing Hans Syfer's Heilbronn altarpiece back to Netherlandish sources, has suggested that Gerhaert's Konstanz altarpiece exhibits the same type of central panel, with one row of niches for standing figures and another row of smaller niches for busts, introducing it to the art of the Upper Rhine.

The red sandstone Crucifix (corpus h. 2.20 m; see fig. 2) from the Baden-Baden old cemetery (SS Peter und Paul from 1967) is dated 1467 and signed *niclaus . von . leyen*. From the coat of arms on the base, the donor is taken to be Hans Ulrich der Scherer, a Baden-Baden surgeon. The corpus is of the same type as the Nördlingen Christ of 1462, but here the body is even more emaciated, the head particularly emphasized by deeper relief carving of the hair, and the crown of thorns weightier, so that the expression of tranquillity on a face still marked by suffering just overcome seems all the more moving. Numerous Late Gothic stone crucifixes bear witness to the great influence on both style and technique exerted by this extraordinary

2. Nicolaus Gerhaert: Crucifix, red sandstone, h. 2.20 m, 1467 (Baden-Baden, SS Peter und Paul)

1. Nicolaus Gerhaert: head of a young woman, red sandstone, h. 232 mm, from the portal of the New Chancellery, Strasbourg, c. 1463 (Frankfurt am Main, Städtische Galerie Liebieghaus)

work: for example the crucifix in Maulbronn, dated 1473 and signed *C V S* (?Conrat Syfer).

3. AFTER 1467. Gerhaert must have left the Upper Rhine during 1467. On 2 December 1463 and on 5 June 1467 Emperor Frederick III had begged the city of Strasbourg to persuade the sculptor Niclas to go to the imperial court, for the Emperor had ordered 'several tombstones' for which Niclas had already 'received quite some monies'. On 3 August 1467 Gerhaert swore that he would take up this invitation after a month had passed. Two payments by the Emperor for a tombstone in 1468 have been recorded. A letter of recommendation to the Bishop of Passau, dated 2 June 1469, requests that he give the 'master niclas, sculptor from Strasbourg' 98 florins for work done and still to be done for the Emperor. In 1472 a Niclas Steinmetz (stonemason) is mentioned as the owner of a vineyard in Wiener Neustadt. The tomb was finally erected in 1513 in the Stephansdom in Vienna. It remains uncertain whether the burial was originally planned in Wiener Neustadt or in Vienna, and where the tomb slab (3.01×1.65 m), the only part of the tomb that might have been carried out under Gerhaert's supervision, was prepared. A document issued in Vienna in 1479 mentions the 'gravestone which one ... had recently brought here by water' and which one now intended 'to take to the (Wiener) Neustadt'. The assumption that Gerhaert worked on the tomb slab in Passau thereby becomes more likely although the request for payment to the Bishop of Passau is no proof of this.

In contrast to the tomb for Archbishop Sierck, this work was purely for show, and the costly material, of red-and-white flecked marble from Adnet, also produces a rather more ornamental effect. The result, compared to the Trier tomb, is also correspondingly conventional. The lid of the tomb does show signs of Gerhaert's style: in the portrait-like shaping of the Emperor's head, in the deep undercutting that gives dark areas of shadow in the relief,

and also in the crowning baldacchino with its relief of St Christopher; however, the Emperor's pose—the contrapposto standing figure on the one hand, and the cushioned head on the other—is entirely within the medieval tradition of ambiguity between standing and lying. The effigy also seems to be overwhelmed by the sheer scale of the surrounding coat of arms. Further work on the tomb was probably not quite faithful to the original plan. Some of its motifs (e.g. the prince in coronation robes, lions with crowned buckled helmets on their heads and one of them carrying the long sword) were adopted by Veit Stoss for the tomb of King Kasimir IV Jagiellon, inscribed 1492 (Kraków, Wawel Cathedral), the year of the King's death. The tomb of the Empress Eleonora (Wiener Neustadt, Neukloster) was among the 'several tombstones' which Gerhaert was to finish, and it may have been from his workshop.

In his few surviving works Gerhaert emerges as a daring innovator who was able to invest traditional religious themes with more earthly life than before, thus enhancing rather than profaning their significance. Gerhaert's feeling for design seems to be equally original: by reducing the mass and employing dark hollows he created dynamic sculptures in their own clearly defined space. In spite of their highly artistic composition, his figures look natural, and possess an almost classical harmony. South German sculptors, particularly those from the Upper Rhine, adopted Gerhaert's stylistic elements and developed them further into their own highly imaginative and vivacious style, which reached its peak in the composition of the great carved altars from the last third of the 15th century.

BIBLIOGRAPHY

Thieme-Becker

C. Brower and J. Masenius: *Antiquitatum et annalium Trevirensium libri xxv*, ii (Liège, 1670), p. 289

R. Duellius: *De fundatione templi cathedralis austriaco-neapolitani (vulgo zu Wiennerisch-Neustatt)* (Nuremberg, 1733), p. 32

Abbé P.-A. Grandidier: *Ordres militaires et mélanges historiques*, v of *Nouvelles oeuvres inédites* (Colmar, 1900), p. 404

O. Wertheimer: *Nicolaus Gerhaert: Seine Kunst und seine Wirkung* (Berlin, 1929)

H. Rott: *Quellen und Forschungen zur südwestdeutschen und schweizerischen Kunstgeschichte im XV und XVI Jahrhundert*, i: *Bodenseegebiet* (Stuttgart, 1933); iii: *Der Oberrhein* (Stuttgart, 1936–8)

L. Fischel: *Nicolaus Gerhaert und die Bildhauer der deutschen Spätgotik* (Munich, 1944)

J. A. Schmoll [Eisenwerth]: 'Madonnen Niklaus Gerhaerts von Leyden, seines Kreises und seiner Nachfolge', *Jb. Hamburg. Kstsamml.*, iii (1958), pp. 52–102

W. Paatz: 'Nicolaus Gerhaerts von Leiden', *Heidelberg. Jb.*, iii (1959), pp. 68–94

R. Will: 'Le Portail de l'ancienne chancellerie de Strasbourg', *Cah. Alsac. Archéol., A. & Hist.*, iii (1959), pp. 63–70

G. Eis: 'Zum Leben und Werk des Strassburger Bildhauers Nicolaus Gerhaert', *Archv Kultgesch.*, xlii (1960), pp. 294–308

W. Deutsch: 'Die Konstanzer Bildschnitzer der Spätgotik und ihr Verhältnis zu Niclaus Gerhaert', *Schr. Ver. Gesch. Bodensees & Umgebung*, lxxxi (1963), pp. 11–129; lxxxii (1964), pp. 1–113

T. Müller: *Sculpture in the Netherlands, Germany, France and Spain, 1400 to 1500*, Pelican Hist. A. (Harmondsworth, 1966)

Friedrich III.: Kaiserresidenz Wiener Neustadt (exh. cat., Wiener Neustadt, St Peter an der Sperre, 1966), pp. 192–6, 386–7

J. A. Schmoll [Eisenwerth]: 'Marginalien zu Niclaus Gerhaert von Leyden', *Festschrift Karl Oettinger* (Erlangen, 1967), pp. 209–41

R. Recht: 'Études sur Nicolas de Leyde et la sculpture rhénane', *Rev. A.*, ix (1970), pp. 15–26

Spätgotik am Oberrhein: Meisterwerke der Plastik und des Kunsthandwerks, 1450–1530 (exh. cat., ed. E. Zimmermann and others; Karlsruhe, Bad. Landesmus., 1970)

E. D. Schmid: *Der Nördlinger Hochaltar und sein Bildhauerwerk, Rekonstruktion, Stil, Frage des Meisters (Nicolaus Gerhart von Leiden), Datierung, Ausstrahlung im Nördlinger Raum* (diss., U. Munich, 1971)

E. Zimmermann: 'Spätgotik am Oberrhein . . . Forschungsergebnisse und Nachträge zur Ausstellung im Badischen Landesmuseum', *Jb. Staat. Kstsamml. Baden-Württemberg*, ix (1972), pp. 95–114

H. P. Hilger: 'Der Hochaltar von St. Georg in Nördlingen, Bericht über das Colloquium vom 24.–26. Oktober 1972 in St. Georg in Nördlingen', *Kunstchronik*, xxvi (1973), pp. 198–215

M. Ohnmacht: *Das Kruzifix des Niclaus Gerhaert von Leyden in Baden-Baden von 1467: Typus-Stil, Herkunft-Nachfolge*, Europäische Hochschulschriften (Berne, 1973)

A. Schädler: 'Studien zu Nicolaus Gerhaert von Leiden: Die Nördlinger Hochaltarfiguren und die Dangolsheimer Muttergottes in Berlin', *Jb. Berlin. Mus.*, n.s., xvi (1974), pp. 46–82

E. Hertlein: 'Das Grabmonument Kaiser Friedrichs III. (1415–1493) als habsburgisches Denkmal', *Pantheon*, xxxv (1977), pp. 294–305, 334–5

J. Taubert, F. Buchenrieder and K. W. Bachmann: 'Friedrich Herlins Nördlinger Hochaltar von 1462', *Farbige Skulpturen, Bedeutung, Fassung, Restaurierung*, ed. J. Taubert (Munich, 1978), pp. 150–66

M. Baxandall: *The Limewood Sculptors of Renaissance Germany* (New Haven, 1980)

R. Recht: *Nicolas de Leyde et la sculpture à Strasbourg (1460–1525)* (Strasbourg, 1987)

R. Will: 'Le Portrait de Conrad de Bussnang dans la chapelle Saint-Jean: Hypothèse ou certitude?', *Bull. Cathédrale Strasbourg*, xviii (1988), pp. 7–11

Die Dangolsheimer Muttergottes nach ihrer Restaurierung (exh. cat., Berlin, Staatl. Museen Preuss. Kultbes., 1989)

A. Schommers: 'Das Grabmal des Trierer Erzbischofs Jakob von Sierck (+1456), Deutungs- und Rekonstruktionsversuch von Inschrift und Grabaufbau', *Trier. Z. Gesch. & Kst des Landes & Nachbargebiete*, liii (1990), pp. 311–33

E. Zimmermann and others: 'Zuschreibungsprobleme—Beiträge des Berliner Colloquiums zur Dangolsheimer Muttergottes', *Jb. Preuss. Kultbes.*, xxviii (1991), pp. 223–67

J. Tripps: 'Hans Syfer und Niklaus Gerhaert van Leyden: Ein neuer Rekonstruktionsvorschlag zum Konstanzer Retabel', *Z. Württemberg. Landesgesch.*, li (1992), pp. 117–29

EVA ZIMMERMANN

Gerhard [Gerardus] (*fl* 1248; *d* 23 April 1258/61). Architect, active in Germany. He was the first architect of Cologne Cathedral (begun 1248) and probably its designer, since at his death he was described as 'initiator of the new building of the greater church' (*initiator novae fabricae maioris ecclesiae*). In 1257 the cathedral chapter rewarded him for his services as 'the director of our building' (*rector fabricae nostrae*) with a piece of land, larger and longer than others, on which he had already built himself a stone house. Although Gerhard's name suggests a French origin, his building does not reflect the technical innovations of such contemporary French projects as Amiens Cathedral, although he probably saw it under construction. Gerhard developed Cologne Cathedral primarily as a work of art. Recognizing the shortcomings still evident even in the very advanced system of Amiens, he refined the articulation of vaulting ribs and compound piers, using a technology little different from that of the Late Romanesque churches in Cologne, which was far removed from the rational, prefabricated construction of the French cathedrals. The year of Gerhard's death is uncertain, but Master Arnold was not mentioned as his successor until 1271.

BIBLIOGRAPHY
ADB: 'Gerhard von Rile'

J. J. Merlo: 'Zur Chronologie der ersten Dombaumeister von Köln', *Köln. Dombl.*, cccxxxii (1880)

——: 'Die Dombaumeister von Köln', *Bonn. Jb. Rhein. Landesmus. Bonn & Ver. Altertfreund. Rheinlande* (1882), no. 70, p. 93; no. 73, p. 170; no. 74, p. 93; (1883), no. 75, p. 81

P. Clemen: *Der Dom zu Köln*, Die Kunstdenkmäler der Stadt Köln, I/3 (Düsseldorf, 1937)

ARNOLD WOLFF (bibliography with BRODIE NEUENSCHWANDER)

Gerhard, Hubert (*b* 's Hertogenbosch, ?1540–50; *d* ?Munich, before 1621). Dutch sculptor, active in Germany. He worked principally in Augsburg, Munich and Innsbruck as a sculptor in bronze, terracotta and stucco and introduced Giambologna's courtly Mannerist style into southern Germany and the Tyrol. He is perhaps best known for the bronze figures he made for monumental fountains, among which is the Augustus Fountain in Augsburg.

1. Free-standing, relief and decorative sculpture. 2. Monumental fountains.

1. FREE-STANDING, RELIEF AND DECORATIVE SCULPTURE.

(i) *Early career and work in Augsburg for the Fugger family, to 1587.* Although there is only one recorded mention (for 1580 or 1581) of Gerhard's connection with the court workshops in Florence, his style implies that he trained in Italy, probably at Florence. In 1581 he and the Florentine sculptor Carlo di Cesari del Palagio were summoned to Augsburg by the wealthy Fugger family to work on the tomb (since dismantled) of Christoph Fugger (*d* 1579), which was set up in the monastery church of St Magdalena. The two gilded bronze reliefs they made for this tomb—a *Resurrection* (London, V&A) and an *Ascension* (untraced)—were originally framed in red and white marble. A number of surrounding figures were also cast: two standing and two seated prophets, two putti with Instruments of the Passion, and the two larger kneeling angels that supported the structure (all London, V&A). Since these bronzes are Gerhard's earliest authenticated works, they are a crucial guide to his artistic origins. They reveal his debt to Giambologna, a Flemish sculptor who was by then settled in Florence; but in addition, and this is particularly true of the *Resurrection* relief, they show the clear influence of the sculptural traditions of the Low Countries.

From 1582 Hans Fugger employed Gerhard and Palagio at Schloss Kirchheim (built 1578–83), south-west of Augsburg on the River Mindel. The pair sculpted the 12 overlife-size terracotta figures of illustrious men and women that are displayed in niches along the side walls of the Great Hall. Two further terracotta figures, *Hercules* and *Mars*, which flank Kirchheim's main entrance, are ascribed to Gerhard; a third figure by him, *Minerva*, has been destroyed. The economical technique Gerhard employed for these overlife-size terracotta figures—building them up on wood armatures and then firing them—may have been previously introduced into Germany from Italy. Other works at Kirchheim by him and Palagio include the Great Hall's large chimney-piece (1587), which has figures of *Mars*, *Venus* and *Vulcan* as well as atlantids. The figures Gerhard made for Kirchheim were widely imitated in southern Germany, for example at the Michaelskirche, Munich. Later works for Kirchheim, made after Gerhard had moved to Munich, include his *Mars and Venus* fountain (*see* §3 below) and a number of door-knockers (now Hamburg, Mus. Kst & Gew.), which he made in 1598.

(ii) Work in Munich for William V, 1584–97. Gerhard's earliest known works for William V, Duke of Bavaria, were ephemeral figures that he made for Munich's Corpus Christi procession in 1584. He remained in William's service until the Elector abdicated in 1597, although he was still able to accept commissions from elsewhere, notably from the Fuggers and the city of Augsburg. The year before Gerhard established himself in Munich, William had commissioned a new church for the Jesuits, the Michaelskirche, and as a result Gerhard was requested to provide an extensive programme of terracotta statues on the lines of those he had made for Schloss Kirchheim. By 1588 he had produced 14 angels and 12 apostles in his workshop with help from assistants, who at one time or another included Hans Reichle and Hans Krumpper; and after the collapse of the Michaelskirche choir in 1590, he made an additional series of saints, prophets and apostles for it over the following seven years. Several of Gerhard's angels made in the 1580s are undervalued masterpieces of late Mannerist sculpture; their drapery, almost Rococo in its lightness, is quite distinct from the more rigidly stylized effects preferred by Giambologna.

Gerhard's most important contribution to the Michaelskirche's decorative programme was his monumental bronze group of *St Michael and Lucifer* (cast 1588; see fig. 1), which was set up in a niche between the two main entrance doors to the church. He never cast his own bronzes, and this group, along with Gerhard's other figures in this medium in Munich, was cast by Martin Frey, a founder from Kempten. Several bronze figures set up in the gardens of William's complex of new buildings for the Residenz, which was laid out by the court painter Friedrich Sustris, are almost certainly Gerhard's work as well. They include the Italianate *Mercury* (gilded 1587) in the grotto of the 'Grottenhof', influenced by Giambologna's *Mercury* of 1565; the nude *Bavaria* (1594), an over life-size allegorical female figure originally made for a fountain; and the *Perseus* made for the Grottenhof Fountain, which transposed the type of Cellini's *Perseus* (Florence, Loggia Lanzi) into the taste of Gerhard's and Sustris's day. These bronzes show that Gerhard, unlike Giambologna, was not interested in the *figura serpentinata* with its multiple viewpoints; despite their richly decorative details his figures are designed to be studied from a single aspect only.

Gerhard's main involvement in Munich in the 1590s—the tomb William V planned for himself, which was to be erected in the Michaelskirche—was left incomplete at William's abdication. As the founder of this church William required an imposing monument, which was to include numerous over life-size bronze figures as well as reliefs and coats of arms, and he had attempted to speed up the execution of this scheme by bringing in other artists and craftsmen formerly associated with Giambologna. The figure of *Christ on the Cross* was in fact by Giambologna himself, while Reichle made the grieving figure of *Mary Magdalene* (1595), and Felice Traballesi (*fl* 1590s) was possibly responsible for some of the reliefs. Gerhard was entrusted with the main figures to be made for the tomb: those of the Duke and his wife and their Guardian Angels, the *Angel Bearing the Stoup of Holy Water*, a legendary ancestor of the *Duke of Bavaria*, and the *Virgin* (1595), the last of which was to be suspended above the tomb on

1. Hubert Gerhard: *St Michael and Lucifer*, bronze, h. 4 m, cast 1588 (Munich, Michaelskirche)

a crescent moon. Where more than one of each piece was required—for example, four kneeling knights and four heraldic lions were made—Gerhard shared the work with Palagio. Apart from the *Angel Bearing the Stoup*, four reliefs and four candlesticks, all these figures are now to be found scattered throughout Munich: the *Virgin*, which has been widely imitated since it was made, is on a column in the city's Marienplatz; the legendary *Duke of Bavaria* decorates the Wittelsbach fountain in the Residenz; the four kneeling knights guard Krumpper's tomb of *Emperor Ludwig IV* in the Frauenkirche; and the lions flank the Residenz's entrance doorways.

Gerhard was not free to pursue his own artistic inclinations during the years he worked in Munich, since all craftsmen working for William were obliged to follow the designs furnished by Sustris, the court painter. Sustris's designs for Gerhard's *Angel Bearing the Stoup*, for example, have survived, along with others for the Michaelskirche's decorative schemes. No design drawings by Gerhard himself have come to light, nor have any of the modelli he is documented to have made for goldsmiths. Silver

figures at Innsbruck (parish church of St Jakob; now Innsbruck Cathedral), which have been linked with his name, are stylistically unconvincing and unlikely to be his work, and there is no evidence to justify attributions to him of any medals.

(iii) Work in Mergentheim and Innsbruck for Maximilian I, after 1597. The transfer of power to William's son, Maximilian I of Bavaria (*reg* 1597–1651), was accompanied by drastic economies. Having lost his post as court sculptor, Gerhard entered the service of Archduke Maximilian III, Grand Master of the Teutonic Order and brother to Rudolf II. Maximilian had been governing the Tyrol since 1595, but he was still on campaign in 1597. Gerhard worked at the Mergentheim headquarters of the Franconian Teutonic Order from 1599 to 1602. In 1600 he took on Caspar Gras as an apprentice; as his faithful follower, Gras in turn maintained Gerhard's style well into the mid-17th century.

Of Gerhard's own works produced in Mergentheim, nothing seems to have survived: two works in silver, which were presented as dedicatory gifts to Einsiedeln Abbey—a relief of the fortress of Gösswardein in Hungary and a portrait of Maximilian—are untraced; and records refer to wax and terracotta figures (untraced) that Gerhard left behind him when he moved in 1602 to Innsbruck, where Maximilian had chosen to establish himself and his court.

At Innsbruck, Maximilian III clearly sought to emulate the visible achievements of the cities of Munich and Prague, where fine bronze statuary was widely displayed. Gerhard is believed to have made a life-size equestrian statue of Maximilian for Innsbruck before 1610, although all that survives of this subject is a bronze statuette (Frankfurt am Main, Liebieghaus). Since this commission may well have been abandoned at some stage, it seems likely that from 1608 Gerhard's main undertaking at Innsbruck was the free-standing tomb he made for Maximilian (parish church of St Jakob; now Innsbruck Cathedral). This was completed in 1618–20 and set up in the Hofkirche by his pupil, Gras. The tomb's principal bronze figures consist of *Maximilian Kneeling at Prayer*, accompanied by *St George*, his patron saint, and *The Dragon*. A slab supported by four solomonic columns carries at its corners four *Mourning Putti* made by Gras.

In 1613, on account of his age, Gerhard retired from Maximilian III's service and returned to Munich, where Krumpper was already well established as the court's leading sculptor. Records indicate that in 1618, for the brother of the ruling duke, Gerhard made a bronze group depicting the *Miracle of St Eustace* for a garden fountain

2. Hubert Gerhard: Augustus Fountain, bronze, 1589–94, Perlachplatz, Augsburg; from a photograph before World War II

(untraced) at Schloss Neudeck near Munich, where it was to be paired with one of *Susanna and the Elders* (untraced), also perhaps by Gerhard.

2. MONUMENTAL FOUNTAINS. During the period 1586–94 Gerhard produced three monumental fountains, in all of which the influence of Giambologna is pronounced, more so in fact than in his robed figures. The first monumental fountain (erected 1587), which was commissioned by Ferdinand, brother of William V, was originally set up in the public square in front of his palace. The numerous bronze figures on the edge of the basin—four river gods, four standing figures of the *Seasons* and eight small groups of putti and animals—now decorate the Wittelsbach Fountain (Munich, Residenz); a drawing (Augsburg, Stadtarchv) by Simon Zwitzel shows their original disposition. The column of Ferdinand's fountain formerly carried an equestrian figure; this went missing in 1609 when the fountain was transferred to the Residenz and was replaced by Gerhard's figure from the tomb of William V. The novel Italianate style of the original fountain was widely admired in southern Germany and led to further commissions for Gerhard. Augsburg requested one—the Augustus Fountain (1589–94; see fig. 2)—which was set up near the Rathaus in honour of the city's supposed Roman founder. Below the standing figure of Augustus, which is supported by a shaft decorated with maritime imagery (restored in 1749), is the basin at the extremities of which are four figures personifying the Augsburg region's rivers. This fountain is in fact one of the very few works by Gerhard still in its original setting.

Gerhard's third fountain, since dismantled, was commissioned by Hans Fugger for Schloss Kirchheim's courtyard. Its overlife-size bronze group (Munich, Bayer. Nmus.) was cast probably in 1590 and depicts, in a clumsily erotic way, *Mars and Venus Playing with Cupid*. This interlocked seated pair with Cupid at their feet appear cumbersome and ungainly, given the delicacy the theme requires. The supporting marble column was decorated by Gerhard with a coat of arms, dolphins, lion and faun masks and sirens (now Munich, Bayer. Nmus.), while at the edge of the basin were formerly eight reclining figures (presumably nymphs). In 1604 Gerhard repeated his *Mars and Venus* design in the form of a small bronze (Vienna, Ksthist. Mus.) for Emperor Rudolf II.

BIBLIOGRAPHY

NDB; Thieme-Becker

R. A. Peltzer: 'Der Bildhauer Hubert Gerhard in München und Innsbruck', *Kst & Ksthandwk*, xxi (1918), pp. 109–52

A. Legner: *Bildwerke der Barockzeit aus dem Liebieghaus* (Frankfurt am Main, 1963)

M. Baxandall: 'Hubert Gerhard and the Altar of Christoph Fugger', *Münchn. Jb. Bild. Kst*, xvii (1966), pp. 127–44

H. R. Weihrauch: *Europäische Bronzestatuetten* (Brunswick, 1967)

H. Friedel: *Bronze-Bildmonumente in Augsburg, 1589–1606*, Abhandlungen zur Geschichte der Stadt Augsburg, xxii (Augsburg, 1974)

M. Schattenhofer: 'Die öffentlichen Brunnen Münchens von ihren Anfängen bis zum Ende des 18. Jahrhunderts', *Brunnen in München*, ed. O. J. Bistritzki (Munich, 1974), pp. 7–33

E. P. Bowron: *Renaissance Bronzes in the Walters Art Gallery* (Baltimore, 1978)

H. Noflatscher: 'Archivalische Notizen zu Hubert Gerhard und Kaspar Gras', *Innsbruck. Hist. Stud.*, i (1978), pp. 221–6

D. Diemer: 'Quellen und Untersuchungen zum Stiftergrab Herzog Wilhelms V. von Bayern und der Renata von Lothringen in der Münchner Michaelskirche', *Quellen und Studien zur Kunstpolitik der Wittelsbacher vom 16. bis zum 18. Jahrhundert*, ed. H. Glaser (Munich and Zurich, 1980), pp. 7–82

Welt im Umbruch: Augsburg zwischen Renaissance und Barock (exh. cat., Augsburg, 1980) [incl. text by H. R. Weihrauch, ii, pp. 168–81]

D. Diemer: 'Bronzeplastik um 1600 in München: Neue Quellen und Forschungen', *Jb. Zentinst. Kstgesch.*, ii (1986), pp. 107–77; iii (1987), pp. 109–68

—: 'Hubert Gerhard und Carlo Pallago als Terrakottaplastiker', *Jb. Zentinst. Kstgesch.*, iv (1988), pp. 19–141

DOROTHEA DIEMER

Gericault [Géricault], **(Jean-Louis-André-)Théodore** (*b* Rouen, 26 Sept 1791; *d* Paris, 26 Jan 1824). French painter, draughtsman, lithographer and sculptor. He experienced the exaltation of Napoleon's triumphs in his boyhood, reached maturity at the time of the empire's agony and ended his career of little more than 12 working years in the troubled early period of the Restoration. When he died, he was known to the public only by the three paintings he had exhibited at the Salon in Paris, the *Charging Chasseur* (1812; Paris, Louvre; see fig. 1), the *Wounded Cuirassier Leaving the Field of Battle* (1814; Paris, Louvre) and the *Raft of the Medusa* (1819; Paris, Louvre; see fig. 3 below), and by a handful of lithographs.

The work that Gericault left behind is a fragment, difficult to comprehend or fit into the conventional framework of art history. Primarily he sought a pictorial form with which to represent contemporary experience with dramatic emphasis and visual truth. The dangers that beset him on this search were, on the one side, the stylelessness and banality of 'picturesque' realism and, on the other, the stilted artifice of over stylization. Between these two temptations, the Romantic and the Neo-classical, he sought for a middle way: a grand style capable of expressing modern subjects.

I. Life and work. II. Posthumous reputation.

I. Life and work.

1. Training and early work, before 1814. 2. Salon of 1814 and experiments with Neo-classicism, 1814–17. 3. The *Raft of the Medusa* and stay in England, 1817–21. 4. Late works, 1821–4.

1. TRAINING AND EARLY WORK, BEFORE 1814. Gericault was born into a family of the provincial middle class, business-minded, newly enriched by revolution and war and far removed from intellectual or artistic interests. In 1796 his parents moved to Paris, where the boy, a far from brilliant student, attended the Lycée Imperial. At his mother's death in 1808 he came into a comfortable annuity that allowed him, at the age of 17, to plan his future according to his own wishes. An irresistible, precocious vocation for art marked him out as unusual in his family. His widowed father, the very model of a good bourgeois, who was to remain his lifelong companion and housemate, raised objections, but the young Gericault refused to be swayed from his decision.

By his own choice, Gericault's early studies were casual and without clear direction, foreshadowing in their changes of course some of the dilemmas that he was to face in later life. Following a personal impulse, he initially sought

the advice of a fashionable outsider, Carle Vernet, the specialist of equestrian subjects and modish genres. Vernet seems to have regarded Gericault as a clever boy with a taste for art but without serious professional prospects. He allowed him the run of his studio, to rummage and to copy as he pleased, but apparently made no effort to teach him in any systematic way. Few traces survive from this earliest period (1808–9): a youthful *Self-portrait* (*c.* 1808; Paris, Denise Aimé-Azam priv. col., see Eitner, 1983, p. 8), a work of exuberant amateurishness, some paintings of horses, inspired by engravings after Vernet, and a sketchbook filled with a profusion of fantasy drawings of horses (Bazin, ii, pp. 334–55).

In 1810 Gericault left Vernet's casual guidance for a more disciplined course of studies under Pierre Guérin, a rigorous classicist and conscientious teacher who had organized his studio as a private academy in imitation of David's. Here Gericault proved to be a difficult student who, impatient with his master's routines, persevered in regular attendance for only about six months. Guérin recognized the talent of his unruly disciple but warned the other, more docile students against imitating this turbulent nonconformist who possessed, unlike them, the 'stuff of three or four painters' (Clément, p. 25). While in Guérin's studio, Gericault is known to have painted the posing model and can be presumed to have submitted to the other regular exercises of academic training, but virtually nothing of his early school work has been preserved or, at any rate, identified. The very sparse scattering of works that can be dated within the short period of his apprenticeship (1810–11) shows few, if any, traces of Guérin's influence.

In 1811 Gericault took his further education into his own hands, removing himself from Guérin's studio to the galleries of the Louvre, recently transformed into the Musée Napoléon and filled with the art looted from Flanders and Italy. Setting up his easel before paintings by Rubens, van Dyck, Rembrandt, Titian, Caravaggio, Pier Francesco Mola and Salvator Rosa—a wide and for its time unorthodox choice of models—he discovered a richness and vitality in Renaissance and Baroque painting that completed his disenchantment with the reasoned compositions of Davidian classicism. He persisted in his copying of the masters for about four years (*c.* 1811–15), a remarkably sustained effort compared to the brevity of his studies with Vernet and Guérin. Like the vanguard painters of the later 19th century, he developed as an essentially self-trained artist whose school was the museum. Guided by intuitive affinities, he found his teachers among the masters of the past and gradually defined his individuality through his choice of models. Far from stifling his spontaneity, copying seems to have encouraged his love of heavy pigment and sensuous brushwork. After his death, some 62 of his copies of the masters were found in his studio.

When Gericault began his study of art, Neo-classical history painting had already started its decline into sterile routine. The public and the artists themselves were growing weary of the stilted pantomime, the endless parade of antique beauty and nobility, enacted by stock figures draped and helmeted *à l'antique*. The time was ripe for

change. Napoleon, whose interests were not served by far-fetched mythologies, personally intervened to give a national and modern direction to history painting by commissioning prominent artists to record the victories and ceremonies marking his reign. At his instigation, history painting was divided into two official categories of equal rank, the classical and the national. At the Salons, these presented a contrast that was bound to impress artists of Gericault's temperament: on the one side, classical nudity and the pallor of ideal beauty; on the other, scenes of the most urgent modernity, violent action and colour. Gericault strongly favoured the painters of national—that is, modern military—subjects, particularly Antoine-Jean Gros, whose influence at this stage helped to obliterate the last traces of Guérin's instruction.

Barely 21 years old, an unknown, largely self-taught beginner, Gericault brashly presented himself at the Salon of 1812 with his *Charging Chasseur* (see fig. 1), a work of provocative size (2.92×1.94 m) that surprisingly held its own among the exhibition's grand performances. A dashing improvisation, rapidly worked up into a picture of Salon format, it was indebted to Gros in its modernity and use of colour, and beyond this immediate influence it hinted at that of Rubens, whose work Gericault had recently copied at the museum. Though designated a 'portrait' at the Salon, in fact it went beyond the traditional schemes of portraiture, history or genre. The *Chasseur* spurring his horse into the glare of battle was not intended as the likeness of an individual but as an embodiment of the spirit of France in arms on the eve of the Russian campaign. The picture's originality and vigour of execution

1. Théodore Gericault: *Charging Chasseur*, oil on canvas, 2.92×1.94 m, 1812 (Paris, Musée du Louvre)

drew attention to its young author. Gericault was awarded a gold medal at the Salon's close.

The years following this precocious success were troubled and, on the surface, unproductive. Gericault continued his self-training, copied at the Louvre and painted the nude in Guérin's studio. Renouncing the ambitious monumentality and drama of the *Chasseur* for the time being, he indulged a more personal bent by painting intimate studies of thoroughbred horses in the imperial stables of Versailles (*Twenty-four Horses in Rear View*, *c.* 1813–14; Paris, Vicomte de Noailles priv. col., see Eitner, 1983, p. 35) and producing a series of small, brilliantly vivid oil studies of cavalrymen (*Three Mounted Trumpeters*, *c.* 1814; Washington, DC, N.G.A.). A large number of swiftly but precisely pencilled sketches related to these paintings fill the pages of his sketchbooks of the time (e.g. the Chicago Album, Chicago, IL, A. Inst.). These private works, of small scale and delicately realist execution, were apparently not intended to be translated into larger, exhibitable works. They mark the first of several episodes of stylistic relaxation that regularly followed his more strenuous efforts: temporary lapses into a refined descriptive realism and fluent handling that cost him little effort.

2. SALON OF 1814 AND EXPERIMENTS WITH NEO-CLASSICISM, 1814–17. For the Salon of 1814, held shortly after Napoleon's abdication, Gericault reverted to a grand style and heroic dimensions. His *Wounded Cuirassier Leaving the Field of Battle* was planned as a pendant to the *Charging Chasseur* of 1812, which he showed again on this occasion. The ponderous figure of the defeated soldier, solidly sculptural in its metal armour and earthbound weight, lacked the painterly brilliance and dashing modernity of the earlier picture. Neither portrait nor history, the *Wounded Cuirassier* suited none of the recognized categories of subject-matter. It had the puzzling aspect of a fragment torn from its context, isolated, magnified and made to stand for something larger than a particular incident: the wounded straggler, a dark presence among the timid offerings of this first Salon of the Restoration, signified the fall of an empire. The *Wounded Cuirassier* failed to please the critics. Gericault himself was dissatisfied. The picture nonetheless marked an advance on his way towards an art of monumental format and energetic expression. It was followed by other military subjects, of similar style and mood, though of smaller format and entirely private purpose, among them a *Mounted Hussar Trumpeter* (*c.* 1814–15; Williamstown, MA, Clark A. Inst.) and the two versions of the *Portrait of a Carabinier* (both *c.* 1815; Paris, Louvre, and Rouen, Mus. B.-A.), powerful evocations of military valour in defeat.

Gericault's work up to this point had been part of the current of national modernity, one of the two mainstreams that constituted the French school of the time. To the other, the Neo-classical, he owed nothing, despite his brief studies with Guérin. The collapse of the empire in the spring of 1814 did not immediately cause him to change direction. In the course of that year, he bought a commission in the Mousquetaires Gris, a splendidly uniformed royal cavalry of ceremonial rather than military character. This unexpectedly involved him in a brief spell of active service at the time of Napoleon's return from Elba in April 1815, when the Musketeers covered the flight of Louis XVIII to Belgium. Released from service at the frontier, Gericault spent the Hundred Days in hiding.

This inglorious end of Gericault's military adventure interrupted the course of his work and seems to have given him a distaste for the military spectacles that until then had preoccupied him. After the Battle of Waterloo (1815), he may have concluded that the modern, national vein in French art, inextricably involved with the Napoleonic era, was now exhausted. Upsets in his private life, the start of a clandestine love affair with a close relative, may also have contributed to his need for a change. Some time early in 1815 he made an abrupt change in his work, not only abandoning his favourite modern subject-matter but also radically reforming his style. With sudden determination, he turned to the only alternative at hand, the Neo-classical grand style, and with characteristic energy struggled to master an idiom that he had previously avoided. For nearly two years, he inflicted on himself the rigours of the kind of academic regimen that he had earlier refused to accept from Guérin. The progress of this self-training can be followed in the pages of the so-called Zoubaloff Sketchbook (Paris, Louvre), in compositional exercises, and in numerous practice drawings after engravings. By inborn talent a colourist and realist, he deliberately thwarted his more spontaneous tendencies, replaced colour with sharp light–dark contrasts, painterly effect with contour design and, in his treatment of the human figure, limited himself to a vocabulary of rough stereotypes, harsh to the point of crudity and entirely indifferent to natural appearance.

The style Gericault distilled from this self-inflicted ordeal, his 'antique manner', had little to do with conventional classicism, though he used it to express Classical themes. His very personal intent was to gain greater expressive force: more important than the increase in control was the increase in dramatic intensity that his effort at discipline brought him. Unlike his earlier, more casual realism, this new, highly artificial manner lent itself to resonant statements. Romantic in its intensity, borrowed from the tradition of Michelangelo rather than that of David, it expanded his range to include fantasies of terror, cruelty and lust (e.g. the pen-and-wash drawing of an *Executioner Strangling a Prisoner*, *c.* 1815; Bayonne, Mus. Bonnat). There can be no doubt that the main purpose of these efforts was to prepare himself for painting on a monumental scale. For the time being, he tested his grand style in works of modest size (e.g. the portrait of *Alfred Dedreux*, *c.* 1815–16; New York, Met.) and in a series of oil studies of heroic male nudes (e.g. Rouen, Mus. B.-A.; Bayonne, Mus. Bonnat; Brussels, Mus. A. Mod.), culminating in the *Nude Warrior with Spear* (*c.* 1815–16; Washington, DC, N.G.A.). Some of these studies were probably painted by way of rehearsal for the academic Prix de Rome competition of 1816, in which Gericault participated in the hope of winning a stipend for the Villa Medici in Rome. He failed the second round of the contest, precisely that of the study of the live model, and was thus disqualified from competing in the final, decisive trial. From this period of stylistic reorientation also comes the erotic and boldly carved *Satyr and Nymph* (*c.* 1815–16; Rouen, Mus. B.-A.),

2. Théodore Gericault: *Start of the Race of the Barberi Horses*, oil on paper, 449×595 mm, 1817 (Baltimore, MD, Walters Art Gallery)

one of Gericault's few sculptures and an indication of his considerable talent for this medium.

Despite his failure in the competition, Gericault was determined to go to Rome, partly to further his self-education, partly to escape the torments of an unavowable love affair. He arrived in Florence in October 1816 and the following month left for Rome. Overwhelmed by the works of Michelangelo, he 'trembled before the masters of Italy' (Clément, p. 82), began to doubt his own ability and only gradually recovered from this shock. His newly acquired 'antique manner' had by then lost some of its initial harshness; his irrepressible virtuosity was beginning to reassert itself, despite the obstacles he had put in its path. With superb assurance, he drew a series of erotic fantasies based on Classical themes in pen, wash and white heightening: *Leda and the Swan, Centaur Carrying off a Woman* (both 1816–17; Paris, Louvre) and *Satyr and Nymph* (1817; Princeton U., NJ, A. Mus.).

After his long effort of stylistic discipline, Gericault felt the need for fresh experience. Equally impressed by the drama of Italian popular life and the greatness of Italian art, he conceived the idea of treating observations gathered in the streets of modern Rome in an elevated style reminiscent of Michelangelo or Raphael. An event of the Roman carnival of 1817, the traditional race of the riderless Barberi horses in the Corso, gave him the motif he wanted.

He began by recording the *Start of the Race of the Barberi Horses* (1817; Baltimore, MD, Walters A.G.; see fig. 2), as he had witnessed it in the Piazza del Popolo, and the *Recapture of the Horses at the Finish* (1817; Lille, Mus. B.-A.), both turbulent and diffuse crowd scenes in modern settings. In a series of studies he then gradually reduced the panoramic spectacle to a few clearly articulated groups, arranged these in a balanced frieze and stripped the figures of their modern costumes (e.g. *Four Youths Holding a Running Horse*, 1817; Rouen, Mus. B.-A.). The final preparatory design of the *Race of the Barberi Horses* (1817; Paris, Louvre), ready for the transfer to a large canvas, projected a severely stylized composition of athletes struggling with horses, in a setting of undefined location and a time neither ancient nor modern.

Having reached this point, Gericault suddenly abandoned his project and returned to France, a year earlier than planned. He may have begun his painting in the hope of making an appearance at the Salon of 1817 with a work surpassing his previous entries in ambition and careful preparation. Had he carried out his compositional design, he would have produced a work without parallel in its time and probably incomprehensible to Salon audiences: a painting of heroic format and grand style that had no clearly identifiable subject and made no clear reference to history or myth, literature or common reality.

3. Théodore Gericault: *Raft of the Medusa*, oil on canvas, 4.91×7.16 m, exhibited 1819 (Paris, Musée du Louvre)

3. THE 'RAFT OF THE MEDUSA' AND STAY IN ENG-LAND, 1817–21. After his return to Paris in the autumn of 1817, Gericault continued briefly to experiment with timeless heroic subjects, composing a *Cattle Market* (oil sketch, Cambridge, MA, Fogg), another contest of men and animals. He also toyed with the subject of a *Cavalry Battle*, which he alternately cast in an antique version (*c*. 1818; Bayonne, Mus. Bonnat) and a modern version (*c*. 1818; Paris, Louvre). On a larger scale, he improvised a cycle of three mural-sized Italianate landscapes, signifying *Morning* (1818; Munich, Neue Pin.), *Noon* (1818; Paris, Petit Pal.) and *Evening* (1818; New York, Met.). But in the politically charged atmosphere of Paris the timeless visions that had absorbed him in Rome began to fade. His interest in the drama of contemporary life reawakened. Turning his Italian experience to new advantage, he conceived the idea of representing exemplary acts of courage or endurance, taken from the history of the recent wars, with the stylistic elevation with which he had treated Classical themes. Searching for suitable subjects, he followed the news of the day and tried his hand at work of small format and wholly modern character, among them a series of drawings dealing with a sensational crime, the *Murder of Fualdès* (1818; Rouen, Mus. B.-A., Dijon, Mus. B.-A., Lille, Mus. B.-A., and Paris and London, priv. cols, see 1991–2 exh. cat., pls 210, 214–15). The new medium of lithography, recently introduced to France and used mainly for journalistic or illustrative work, offered him a chance to reconcile realistic observation with stylistic

discipline in a series of military subjects, as in *Retreat from Russia* (1818; Paris, Bib. N.). It also allowed him to achieve on a small scale that union of the grand and the natural that he hoped to realize in the more ambitious format of a Salon painting.

The crowning result of these various efforts was the *Raft of the Medusa* (Paris, Louvre; see fig. 3) with which Gericault caused a sensation at the Salon of 1819. The huge canvas (4.91×7.16 m) represents the aftermath of a shipwreck that, three years earlier, had violently agitated public opinion in France. Gericault was initially attracted to this subject because of its sensational actuality and controversiality, but, in the course of giving it pictorial form, he gradually progressed from reportorial realism to a broadly humanitarian statement, putting the emphasis not on the scandalous circumstances of the disaster but on the suffering and struggle of men abandoned to the forces of nature. The problem he had set himself was the extremely difficult one of treating a contemporary occurrence in the exalted language of monumental art: the newspaper story of the wreck of a government frigate and the shameful abandonment of its crew was to be raised to the tragic power of Michelangelo's *Last Judgement* or Dante's *Inferno*.

Before deciding on his composition, Gericault explored the successive episodes of the underlying narrative: the outbreaks of mutiny and cannibalism on the raft, the victims' first, inconclusive sighting of the distant rescue vessel and the final rescue of the few survivors. He finally

chose the moment of highest suspense between hope and despair—the shipwrecked men's desperate effort to be seen by their rescuers—because it offered the most dramatic pictorial effect and expressed the particular significance he wished to give to the event. Once he had found this motif, he gradually developed its compositional form in a series of contour drawings, after which he translated it, by means of several oil studies, into the painterly terms of light and colour. For the execution of the final canvas, he posed studio models in the predetermined positions and painted all the figures directly from the life. To maintain his emotional tension and remind himself of the horror of his subject, he had medical friends furnish him with portions of cadavers on which he based several studies of *Severed Heads* (*c.* 1819; Stockholm, Nmus.) and still-lifes composed of *Dissected Limbs* (1818–19; Montpellier, Mus. Fabre). The *Medusa* was badly hung at the Salon and met with a mixed reception. The critics blamed or praised it for what they supposed to be its political tendency while ignoring its artistic significance.

Disappointed and exhausted after what had been the most strenuous effort of his career, Gericault suffered a nervous collapse in the autumn of 1819. During his convalescence, he made arrangements to have the *Raft of the Medusa* exhibited to the paying public in London in 1820. He had personal reasons for absenting himself from Paris for a time. In 1818, while he was at work on his picture, his mistress—the young wife of an elderly uncle—had given birth to their child. Relaxing in England, during part of 1820 and all of 1821, he renounced the grand manner and, indulging the other side of his artistic personality, played the part of the leisured amateur. He had no projects other than some lithographic experiments and spent the early part of his stay in London in undemanding occupations. Where Rome had roused him to attempt the grandiose, timeless and monumental, London revived his taste for the natural, modern and elegant. With a new lightness of touch, he drew or painted in watercolour horsemen, farriers, waggoners and the animals at the zoo. Struck by the spectacle of slum life, he drew studies of the poor whom he observed in London streets and used some of these for a series of lithographs, *Various Subjects Drawn from Life and on Stone* (London, 1821), which, as a group, constitute the most original work of his English stay. In the *Epsom Downs Derby* (Paris, Louvre), his only highly finished oil painting of this period, he deliberately imitated a popular English type of racing picture, playing in masterly fashion with borrowed foreign conventions. Painted in London in 1821, it is the modern English counterpart to his antique Roman *Race of the Barberi Horses*.

4. LATE WORKS, 1821–4. When Gericault returned to Paris, in the last days of 1821, his health had begun to fail. Frequently ill with what seems to have been a tubercular infection, he suffered from what appeared to his friends as a physical and moral fatigue. A barely concealed urge to self-destruction seemed to guide his conduct. Repeated riding accidents succeeded in breaking what remained of his health, and ruinous speculations and reckless expenditures brought him to the edge of want. His artistic powers were unimpaired, but instead of focusing them on major projects, he spent them on a multitude of enterprises

4. Théodore Gericault: *Gambling Mania*, oil on canvas, 770×615 mm, *c.* 1822 (Paris, Musée du Louvre)

of short duration and small ambition. He had lived most of his life in financial security, without giving much thought to the saleability of his work. The loss of part of his fortune in 1822 forced him to work for the market and to appeal to the tastes of collectors and dealers. This accounts for his large production, in 1822–3, of finished watercolours and small oil paintings of pleasing subjects: horse genres, for the most part, romantic exotica and illustrations of popular, mainly Byronic, literature.

The few works that rise above this level of refined but minor accomplishment all had some private significance and evidently drew on deeper resources of emotional energy. The great achievement of Gericault's last years was not another grand Salon picture but a series of ten portraits of insane men and women, probably the patients of a medical acquaintance, Dr Etienne-Jean Georget (1795–1828), a pioneer of psychiatric medicine, who was the original owner of these paintings. The five surviving portraits of the series (all *c.* 1822) represent victims of various delusions or 'monomanias': *Kleptomania* (Ghent, Mus. S. Kst.), *Gambling Mania* (Paris, Louvre; see fig. 4), *Manic Envy* (Lyon, Mus. B.-A.), *Delusion of Military Command* (Winterthur, Samml. Oskar Reinhart) and *Kidnapper* (Springfield, MA, Mus. F.A.). What purpose these portraits were to serve is unknown. They were painted in a spirit of severe objectivity and may have been intended as a record of Georget's clinical studies. Of hypnotic intensity and boldly spontaneous execution, they have a powerful realism that is entirely unaffected by romantic

sentiment or artistic dramatization. They secure Gericault a place in the vanguard of 19th-century realism, though in their time they remained virtually unknown. They were among the last of his works to reach a wider public and emerged from obscurity only after 1900.

In 1823 Gericault's illness became acute. Aware that he might die, he regretted his many unfinished projects and the waste of his talent on petty enterprises. On his sickbed, his ambition to paint subjects from modern life on a hugely monumental scale returned to him with full force. Too weak for their actual execution, he nevertheless busied himself with the preliminaries for several large compositions, among them the drawings for the *Opening of the Doors of the Spanish Inquisition* (1823; Paris, priv. col., see Eitner, 1983, p. 271) and for the *African Slave Trade* (1823; Paris, Ecole N. Sup. B.-A.), subjects of intense political interest to liberal Frenchmen of the period. Though realized only in drawings, their conception equals that of the *Raft of the Medusa* in ambition and surpasses it in stylistic unity. Amid the seemingly directionless variety of Gericault's late works, the *Portraits of the Insane* and these last monumental projects give strong hints of future possibilities. Had his life not been cut short, his late work would not appear as a subsidence but as the preparation for a new start.

II. Posthumous reputation.

After Gericault's death, an auction dispersed his works the following November. This contained some 220 paintings, mostly studies or sketches, and 16 large lots of drawings and watercolours that included a number of sketchbooks and may have comprised a total of 1600 to 1800 individual sheets. Save for some gifts to friends and relatives, this constituted the bulk of his life's work, as he had sold very little. The *Medusa* entered the Louvre later that year, the *Charging Chasseur* and the *Wounded Cuirassier* in 1848. But, despite the very limited public visibility of his work, his posthumous reputation among artists was great, and his influence, both on the later Romantics (Delacroix) and on the Realists (Courbet), was longlasting. For all its experimental variety, Gericault's work has the coherence of an assertive, unconforming individualism. It stands apart by its freedom from the aesthetic and sentimental stereotypes of his time; there is very little in it of religious or conventionally patriotic subject-matter, even less of past history and literature, and not a trace of amusing anecdote or humour. He took his material mainly from the direct—largely visual—experience of reality or from an empathetic reconstruction of reality, but in giving it form he remained aware of the traditions of art and was able to give his evocations of reality a symbolic resonance. In dealing with contemporary events, he responded to their broadly human aspects rather than to national or partisan interests and at the same time tended to see in them reflections of his own fate. His keenest experience of life was associated with athletic or heroic exertion. The drama of all his larger compositions is generated by conflict, often in the form of physical contest, as in the recurring image of fiery horses mastered by athletes, but sometimes, as in the *Raft of the Medusa*, by an heroic self-assertion in the face of overwhelming adversity.

BIBLIOGRAPHY

C. Clément: *Géricault: Etude biographique et critique* (Paris, 1868, rev. 3/1879/*R* with additions, New York, 1974)
L. Rosenthal: *Géricault* (Paris, 1905)
L. Delteil: *Géricault* (1924), xviii of *Le Peintre-graveur illustré* (Paris, 1906–30)
G. Oprescu: *Géricault* (Paris, 1927)
K. Berger: *Géricault und sein Werk* (Vienna, 1952)
D. Aimé-Azam: *Mazeppa, Géricault et son temps* (Paris, 1956, rev. 3/1980)
L. Eitner: *Géricault: An Album of Drawings at the Art Institute of Chicago* (Chicago, 1960)
The Graphic Art of Géricault (exh. cat. by K. Spencer, New Haven, CT, Yale U. A.G., 1969)
L. Eitner: *Géricault's 'Raft of the Medusa'* (London, 1972)
P. Grunchec: *Tout l'oeuvre peint de Géricault* (Paris, 1978)
Géricault: Tout l'oeuvre gravé et pièces en rapport (exh. cat., Rouen, Mus. B.-A., 1981)
P. Grunchec: *Géricault: Dessins et aquarelles de chevaux* (Lausanne, 1982)
L. Eitner: *Géricault: His Life and Work* (London, 1983)
G. Bazin: *Théodore Géricault: Etude critique, documents et catalogue raisonné*, 6 vols (Paris, 1987–94)
Géricault, 1791–1824 (exh. cat. by L. Eitner and S. A. Nash, San Francisco, CA, F.A. Museums, 1989)
Géricault (exh. cat. by S. Laveissière, B. Chenique and R. Michel, Paris, Grand Pal., 1991–2)

LORENZ EITNER

Gérines, Jacques de (*fl* 1428; *d* 1463/4). South Netherlandish bronze-founder. He is documented in Brussels from 1428, when he became a town councillor. He held the offices of receiver in 1435, churchwarden of Notre-Dame-la-Chapelle in 1438 and 1450, and surveyor of the forests of Soigne (1443) and Brabant (1457–9). In 1450 he was asked to advise Philip the Good, 3rd Duke of Burgundy, on the practicability of diverting a stream from the village of Anderlecht to supply the Coudenberg Palace in Brussels. In 1454 and 1458 he received payments for two royal tombs commissioned by Philip the Good. The first was that of *Louis de Mâle*, Count of Flanders (*d* 1384), destined for St Pierre, Lille. It included effigies of Louis, his wife Margaret of Brabant and their daughter Margaret of Flanders (Philip the Good's grandmother). The tomb was destroyed during and after the French Revolution, but drawings and engravings show that 24 bronze figures (identified through coats of arms and inscriptions as the various descendants of the first two dukes of Burgundy) were set in niches along the sides of the black stone sarcophagus on which the three bronze figures rested. Jacques de Gérines was paid the huge sum of 2000 gold crowns for the tomb, which was inscribed with his name and the date 1455. The second tomb was made in honour of *Joanna of Brabant* (*d* 1406), sister of Margaret of Brabant. The royal accounts show that the tomb consisted of effigies of Joanna and her great-nephew William (*d* 1410), two angels holding the arms of Joanna at her head and 24 weepers. Jacques de Gérines was paid only 60 crowns for all the figures except the effigy of William, which was supplied by Jean Delemer, who was also paid for repairing the images provided by Jacques de Gérines, all for the sum of 100 crowns. The painter Rogier van der Weyden was paid 100 crowns for colouring the images. Jacques de Gérines's small fee is unlikely to have covered the cost of casting bronze figures. As the sarcophagus itself was wooden, it is possible that the figures were wooden models, perhaps those used to cast the figures for the tomb of Louis de Mâle, which may have been refurbished, coloured and placed on Joanna of Brabant's

tomb. Joanna's tomb was destroyed in 1695, but old drawings and engravings reveal that the effigy of Joanna was virtually identical to that of Margaret of Flanders from Louis de Mâle's tomb, and the 24 weepers adorning the sides of Joanna's sarcophagus corresponded closely with those on the earlier monument.

Ten bronze figures (Amsterdam, Rijksmus.) have occasionally been attributed to Jacques de Gérines because they closely resemble certain statues from the tombs of 1454–5 and 1458 but are in reverse. They probably came from the later tomb of *Isabella of Bourbon* (first wife of Charles the Bold), which was erected by her daughter Mary of Burgundy reputedly in 1476/8 in the abbey of St Michael, Antwerp. It was apparently virtually identical to the two earlier tombs, and all but three of the 24 statuettes belonging to it are known to have gone missing in the 16th century. The bronze effigy of Isabella survives in Antwerp Cathedral.

BIBLIOGRAPHY

A. Pinchart: 'Jacques de Gérines, batteur de cuivre du XVe siècle et ses oeuvres', *Bull. Comm. Royale A. & Archéol.*, v (1866), pp. 114–36

J. Destrée: 'Etudes sur la sculpture brabançonne', *An. Soc. Royale Archéol. Bruxelles*, xiii (1899), pp. 310–30

S. Collon-Gevaert: *Histoire des arts du metal en Belgique*, 2 vols (Brussels, 1951)

J. Leeuwenberg: 'De tienbronzen "plorannen" in het Rijksmuseum te Amsterdam: Hun herkomst en de voorbeelden waaraan zij zijn ontleend' [The ten bronze 'weeping figures' in the Rijksmuseum in Amsterdam: their provenance and prototypes], *Oud-Holland*, xiii (1951), pp. 13–59

Flanders in the Fifteenth Century (exh. cat., Detroit, MI, Inst. A., 1960), pp. 264–7

Les Mémoriaux d'Antoine Succa (exh. cat. by M. Comblen-Sonkes and C. van den Bergen-Pantens, Brussels, Bib. Royale Albert 1er, 1977), i, pp. 166–9, 220–21

L. Campbell: 'The Tomb of Joanna, Duchess of Brabant', *Ren. Stud.*, ii/2 (1988), pp. 163–72

KIM W. WOODS

Gerini. Italian family of patrons and collectors. An old Florentine merchant-banking family, it was particularly prominent in the 17th and 18th centuries. The main line became extinct in 1923, but a cadet branch survives in Florence. Carlo Gerini (1616–73), a courtier of Cardinal Giovanni Carlo de' Medici, obtained the title of Marchese in 1640. He began the family tradition of art patronage and collecting. In 1650 he purchased the family palazzo at 42 Via Ricasoli, where he assembled an art collection that included paintings commissioned by him from Salvator Rosa, such as the *Philosopher's Wood* (Florence, Pitti). Carlo may also have been responsible for acquiring paintings by other contemporary artists, including Guercino's *Repentance of St Peter* (Edinburgh, N.G.), which was listed in the Gerini collection in the mid-18th century. Carlo's son Pierantonio Gerini (1650–1707) was a counsellor and diplomat at the court of Cosimo III de' Medici, Grand Duke of Tuscany. In the 18th century the three sons of Pierantonio, Carlo Francesco Gerini (1684–1733), Giovanni Gerini (1685–1751) and Andrea Gerini (1691–1766), made a significant contribution to the cultural life of Florence. Giovanni, for example, compiled a notable ornithological collection, while Andrea distinguished himself by his patronage of the arts.

Like his contemporary, Francesco Maria Gabburri, Andrea Gerini was a regular and generous contributor to the public art exhibitions of Florence. He lent 26 pictures to the St Luke's Day exhibition at SS Annunziata of 1737, among them paintings from the family collection (including 17th-century Flemish pictures) and a new work, presumably a commission, by the Florentine painter Giovanni Domenico Ferretti, the *Liberation of St Peter* (Berlin, Gemäldegal.). Another local artist who enjoyed Andrea Gerini's particular protection was Giuseppe Zocchi, from whom he commissioned two illustrated volumes: *Scelta de XXIV vedute delle principali contrade, piazze, chiese e palazzi della città di Firenze* and *Vedute delle ville e d'altri luoghi della Toscana* (1757), the frontispiece of which (see Ginori Lisci, p. 417) includes portraits of both patron and artist. Gerini combined the patronage of contemporary Florentine art with a taste for Venetian painting, and his collection is known to have included a *Diana and Endymion* by Giovanni Battista Piazzetta, an *Apollo and Daphne* by Giambattista Tiepolo and a view of Venice by Canaletto (all untraced). His taste for Venetian art was encouraged by his friendship with the Venetian collector and connoisseur Anton Maria Zanetti (i), in whose company, inspecting cameos, he was portrayed by Zocchi (Venice, Correr). Zanetti sent Gerini books from Venice and in 1738 also sent him three paintings by Francesco Zuccarelli.

Andrea Gerini's pride in the family collection was reflected in the publication in 1759 of an illustrated catalogue of selected pictures that was reprinted in 1786 by his nephew Carlo Gerini (1733–96). Carlo had earlier commissioned and published an illustrated catalogue (1774) of drawings he possessed by Marcantonio Franceschini and a five-volume catalogue (1767–74) of his father Giovanni's ornithological collection. The family fortunes suffered during the political upheavals of the early 19th century, and in 1818 some items from the collection, by then the property of Carlo's son Giovanni Gerini (1770–1825), were acquired by Grand Duke Ferdinand III; these included the *Philosopher's Wood*. The Gerini collection, which had included 328 paintings and 22 bronzes, was finally dispersed in the 1820s and 1830s, many pictures being sold at the sale of 1825 and that of November 1836 in London.

BIBLIOGRAPHY

Raccolta di stampe rappresentanti i quadri più scelti de' Sigg. Marchesi Gerini (Florence, 1759/*R* 1786)

Formae picturarum archetypae una et viginti Marci Antonii Franchini Bononiensis quae adservantur apud Carolum Marchionem Gerini aere incisae (Florence, 1774)

Catalogo e stima dei quadri e bronzi esistenti nella galleria del Sig. Marchese Giovanni Gerini a Firenze (Florence, 1825)

V. Spreti: *Enciclopedia storico-nobiliare italiana*, iii (Milan, 1930), pp. 406–8

F. Lugt: *Répertoire des catalogues de ventes, 1826–1860* (The Hague, 1953), no. 14500

F. Haskell: 'A Note on Artistic Contacts between Florence and Venice in the 18th Century', *Boll. Mus. Civ. Ven.*, iii/iv (1960), pp. 32–7

L. Ginori Lisci: *I palazzi di Firenze nella storia e nell'arte*, i (Florence, 1972), pp. 415–20

F. Borroni Salvadori: *Le esposizioni d'arte a Firenze dal 1674 al 1767* (Florence, 1974), pp. 147–8

JANET SOUTHORN

Gerini, Lorenzo di Niccolò. *See under* LORENZO DI NICCOLÒ.

Gerini, Niccolò di Pietro. *See* NICCOLÒ DI PIETRO GERINI.

Gerl. Austrian family of builders and architects. Matthias (Franz) Gerl (*b* Klosterneuburg, 1 April 1712; *d* Vienna, 13 March 1765), who received his training under Donato-Felice Allio, designed numerous churches for the archbishop of Vienna, Cardinal Sigismund von Kollonitz, and worked throughout his life for the Piarist Order. In most of his churches he used a combination of the directional nave and the centralized types of plan. He used this ambivalent, centralizing space with a domed middle bay when altering the church of the archbishop's summer residence at Ober-St Veit (1742–5), in his designs for the parish churches of Ollersdorf (1742–6) and Oberlaa (1744–6) and in the design for the pilgrims' church at Heiligenkreuz-Gutenbrunn (1755).

Matthias Gerl's largest building project for the Piarist Order was the completion (1751–3) of the convent and church of Maria Treu in Vienna, the original plan of which was probably by Johann Lukas von Hildebrandt. Gerl produced designs for the Piarist settlements in Gleisdorf (Styria; from 1747), and at St Thekla (1753–7) and St Ivo (1760–62) in Vienna. The Viennese canon (later suffragan bishop) Franz Anton Marxer commissioned Gerl to build the large orphanage (1743–5 and 1759–63) on the Rennweg, Vienna.

As an adviser to the court, in 1751–4 Gerl enlarged the Böhmische Hofkanzlei (1708; by Johann Bernhard Fischer von Erlach) in Vienna, and in 1752 he carried out alterations to the military academy at the fortress in Wiener Neustadt. Commissioned by Bishop Ferenc Bárkóczy, he built the County Hall (1749–56) at Eger in Hungary. The design for the small provost's palace in Eger (1758) is attributed to him, and he completed the Minorite church there (1758–73) to the design of Kilian Ignaz Dientzenhofer.

Joseph Ignaz Gerl (*b* Klosterneuburg, 22 May 1734; *d* Vienna, 1 Feb 1798), nephew of Matthias Gerl, designed numerous buildings for Melk Abbey, and for Abbot Urban of Melk he built the Melkerhof (1769–74), one of the earliest apartment complexes in Vienna. Other large projects were the new building of the Allgemeines Krankenhaus (from 1782) and of the Invalidenhaus in Vienna, and the design of the vast Lyceum (1765–85) in Eger. A typical exponent of *Plattenstil*, he executed numerous buildings for the court, including a design for the Hauptmaut building (1773) and the rebuilding (1782) of the royal Gallizische Adelsleibgarde in Vienna.

BIBLIOGRAPHY
Thieme–Becker
A. Ilg: 'Die Wiener Baumeisterfamilie Gerl', *Mbl. Altert.-Ver. Wien* (1885), p. 29
O. Biba: 'Der Piaristenorden in Österreich: Seine Bedeutung für die bildende Kunst, Musik und Theater im 17. und 18. Jahrhundert', *Jb. Österreich. Kstgesch.*, v (1975), p. 73
G. Holzschuh: *Matthias Gerl und die Sakralarchitektur in Wien und Niederösterreich zur Zeit Maria Theresias* (diss., U. Vienna, 1985)

GOTTFRIED HOLZSCHUH

Gerlach, Johannes (*d* Strasbourg, 10 Jan 1372). German architect. He was possibly the grandson of ERWIN. The mason's workshop of Strasbourg Cathedral appears to have been managed by Erwin's descendants for at least half a century, initially by his son Johannes from 1318 to 1339. It is likely that Gerlach, who succeeded Johannes, also belonged to Erwin's family. In 1338 he and other descendants of Erwin were among those who rendered the fabric accounts of the cathedral. Between 1341 and 1370 he represented the stonecutters in the City Council on many occasions. He was Master of the Works from *c.* 1340 to 1371, and various accomplishments of the workshop during this time can be attributed to him, including the St Catherine Chapel (*c.* 1340–49) and the left wing of the office of works, the Oeuvre Notre-Dame (1347). The third stage of the north-west tower, whose elevation recalls that of the St Catherine Chapel, was built from some time after 1355 to 1365, and it was probably Gerlach who conceived the plans for the Ascension Gallery above the rose window and the belfry between the two towers (drawing preserved in the Musée de l'Oeuvre Notre-Dame). He may have built the gallery himself, although the belfry was built only after 1383.

BIBLIOGRAPHY
DBF; Thieme–Becker
F. X. Kraus: *Kunst und Alterthum im Unter-Elsass* (Strasbourg, 1876), pp. 378–9, 687–93
A. Schulte: 'Zur Geschichte der Strassburger Münsterbaumeister', *Repert. Kstwissen*, v (1882), pp. 271–9
M. Hasak: *Das Münster Unserer Lieben Frau zu Strassburg im Elsass* (Berlin, 1927), pp. 120–26
R. Recht: *L'Alsace gothique de 1300 à 1365* (Colmar, 1974), pp. 54–80

ROGER LEHNI

Germain. French family of silversmiths.

(1) Thomas Germain (*b* Paris, 19 Aug 1674; *d* Paris, 1748). He was the son of the Parisian silversmith Pierre Germain (*d* 1684), who became a master in 1670 and was granted lodgings in the Louvre, Paris, in 1679 as an Orfèvre du Roi. Pierre executed a large number of silver items for the château of Versailles (1680–84), but most of his work is known only from archival evidence. Thomas was at first apprenticed to the painter Louis Boullogne (ii), but during his years in Rome (*c.* 1685–1704) he trained as a silversmith and was active as an independent silversmith by 1697.

Thomas Germain returned to Paris by 1706, became a master in 1720 and in 1723 was granted lodgings in the Louvre as an Orfèvre du Roi. His early commissions were for ecclesiastical silver, but from 1725 he was extensively employed by the French Crown, producing toilet services, candelabra and a complete set of silver for the Dauphin's apartments in 1736.

Thomas Germain executed many pieces of sculptural tableware with naturalistic plant and animal forms (e.g. salt modelled with tortoise, scallop and crab, 1734–6; Paris, Louvre) and excelled in the textured surfaces and vigorous scrollwork of the Rococo style, for example in a pair of wine-coolers (1727–8; Paris, Louvre) in the form of tree-trunks with snails and vine-leaves. Even his more restrained forms, for example a ewer (1736–7; New York, Met.) and tureen and cover (1744–6; Paris, Louvre), reflect the influence of the Roman Baroque. As well as his work for the French Crown, he also executed numerous commissions for royal and aristocratic patrons in Cologne, England, Brazil, Spain, Naples and Portugal. Although much of his silver for Portuguese patrons was destroyed in the Lisbon earthquake (1755), surviving examples include a spectacular surtout (1729–30; Lisbon, Mus. N.

A. Ant.), made for the Duque de Aveiro, and a pair of tureens and stands modelled with boars' head masks (1726–8; Malibu, CA, Getty Mus.), a model of which is depicted in *Silver Platters with Peaches* (Stockholm, Nmus.) by François Desportes. In 1741 Thomas Germain designed and began to build at his own expense the church of St Louis-du-Louvre, Paris (destr. 1810); Jacques-François Blondel published a full description of it and engravings in his *L'Architecture française* (1754). The portrait by Nicolas de Largillierre (1736; Lisbon, Mus. Gulbenkian) of *Thomas Germain and his Wife* shows them with a number of silver items.

<div align="right">CLARE LE CORBEILLER</div>

(2) François-Thomas Germain (*b* 17 April 1726; *d* 23 Jan 1791). Son of (1) Thomas Germain. On the death of his father, he was allowed to take over his father's lodgings in the Louvre, Paris, and was appointed Sculpteur-Orfèvre du Roi. He completed items commissioned from Thomas Germain (e.g. lamp, 1744–54, for Ste Geneviève), Paris and also modified earlier pieces by his father, for example a pair of tureens and stands (1726–8; Malibu, CA, Getty Mus.), which have an inscription on the stands added by François-Thomas in 1764. He also continued to use his father's casting models.

As the head of a large workshop, François-Thomas Germain continued to supply items for the French Crown (e.g. service for the Maisons Royales, 1752), but it is through his work for foreign courts that he is most renowned. In 1756 a large service was ordered by Empress Elizabeth of Russia but was not completed and delivered until 1762. The eight tureens (Lisbon, Mus. N. A. Ant. and Fund. Gulbenkian; Lugano, Col. Thyssen-Bornemisza) in the service vary only in the decoration of the covers, and they closely resemble those in a service produced for Joseph, King of Portugal, ordered in 1756 and executed between 1757 and 1762. François-Thomas Germain's work produced for the Portuguese Crown reveals the number of different styles in which he could work successfully. The coffeepot with decoration of laurel leaves and berries (1757; New York, Met.; *see* PARIS, fig. 26) is in sharp contrast to the tea-kettle and stand (1757–62), which is in a hybrid mixture of chinoiserie and *Goût grec*, while the tureens and platters (see fig.) have boldly modelled putti and animals on the covers. Reflecting the source of wealth of the patron are the biscuit-boxes in the form of sailing vessels supported by dolphins (1757–9), the exotic, partly gilt condiment stand and the salt-cellars depicting putti in Native American dress with feathered crowns (1757–61; all Lisbon, Mus. N. A. Ant. and Pal. N. Ajuda).

Germain's position as Sculpteur-Orfèvre du Roi allowed him to disregard guild regulations, and he produced gilt-bronze objects at the same time as he was working in silver. The surviving signed works by him are the set of four wall lights (1756; Malibu, CA, Getty Mus.) made for the Palais-Egalité (formerly and now Palais-Royal), Paris, residence of Louis Philippe, Duc d'Orléans, and a pair of fire-dogs with Neo-classical elements (1757; Paris, Louvre). In 1756 he also produced the gilt-bronze mounts for the chimney-piece in the Bernstorff Palace, Copenhagen.

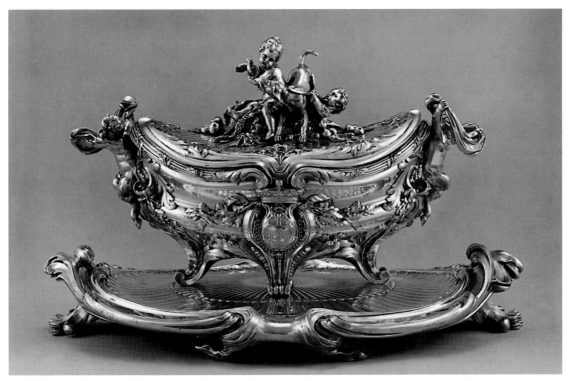

François-Thomas Germain: silver tureen and platter made for Joseph, King of Portugal, tureen h. 325 mm, Paris, 1757–62 (Lisbon, Museu Nacional de Arte Antiga)

Although no other signed gilt-bronzes survive, it seems probable that he produced a significant number.

François-Thomas was declared bankrupt in 1765 and was subsequently dismissed from his royal post and had to vacate his lodgings in the Louvre. He continued, however, to execute work in silver and also began to produce copies of antique vases made of a compositional material imitating porphyry, alabaster and agate and mounted in gilt-bronze. His unsuccessful attempts to regain royal favour led to his visiting England (1770–72), but he returned to Paris and died still in disgrace.

BIBLIOGRAPHY

G. Bapst: *Etudes sur l'orfèvrerie française au XVIIIe siècle: Les Germains, orfèvres-sculpteurs du roy* (Paris, 1887)

Marquês da Foz: *A Baixela Germain da antiga coroa portuguesa* (Lisbon, 1925)

Les Trésors de l'orfèvrerie du Portugal (exh. cat., Paris, Mus. A. Déc., 1954–5)

'A Tureen for the Empress Elizabeth, 1759', *Bull. Philadelphia Mus. A.*, 1 (1955), pp. 28–31

French Taste in the 18th Century (exh. cat. by P. L. Grigaut, Detroit, MI, Inst. A., 1956)

Musées nationaux, département des objets d'art: Catalogue de l'orfèvrerie (Paris, 1958)

F. Dennis: *Three Centuries of French Domestic Silver*, 2 vols (New York, 1960)

C. Fregnac, ed.: *Les Grands Orfèvres de Louis XIII à Charles X* (Paris, 1965)

H. Honour: *Goldsmiths and Silversmiths* (London, 1971), pp. 155–63

G. Wilson: 'Decorative Art Acquisitions', *Getty Mus. J.*, x (1982), pp. 73–8

——: 'Decorative Art Acquisitions', *Getty Mus. J.*, xi (1983), pp. 24–8, 39–45

G. Mabille: *Orfèvrerie française des XVIe, XVIIe et XVIIIe siècles: Catalogue raisonné des collections du Musée des arts décoratifs et du Musée Nissim de Camondo* (Paris, 1984)

H. Müller: *The Thyssen–Bornemisza Collection: European Silver* (London, 1986)

L. d'Orey: *A Baixela da coroa portuguesa* (Lisbon, 1991)

Tesouros Reais (exh. cat., Lisbon, Palácio Nacional da Ajuda, 1992)

C. Perrin: *François-Thomas Germain: Orfèvre des rois* (Paris, 1993)

L. d'Orey: 'L'Histoire des services d'orfèvrerie française à la cour du Portugal', *Versailles et les tables royales en Europe* (exh. cat., Versailles, Château, 1993–4)

BET McLEOD

Germany, Federal Republic of [Deutschland]. Country in northern Europe. It extends from the Baltic Sea and the North German Plain to Lake Constance and the Bavarian Alps and Plateau, and from the North Sea and the French border to the Oder and Neisse rivers and the mountainous eastern regions of the Erzgebirge and the Fichtelgebirge. Bordered by Denmark, Poland, the Czech Republic, Austria, Switzerland, France, Luxembourg, Belgium and the Netherlands, its territory covers 357,000 sq. km of varied landscape and heterogeneous geological composition; more than a quarter is covered by forest. After World War II, from 1949 to 1990, Germany was divided, with Bonn as the capital of West Germany; the historic capital Berlin was restored after reunification in 1990 (East Berlin having served as the capital of East Germany from 1949 to 1990). Other major cities include Hamburg, Munich, Frankfurt am Main, Cologne, Leipzig, Dresden, Hannover, Bremen, Stuttgart and Nuremberg (see figs 1 and 2).

I. Introduction. II. Architecture. III. Painting and graphic arts. IV. Sculpture. V. Interior decoration. VI. Furniture. VII. Ceramics. VIII. Glass. IX. Metalwork. X. Objects of vertu. XI. Textiles. XII. Patronage. XIII. Collecting and dealing. XIV. Museums. XV. Art education. XVI. Art libraries and photographic collections. XVII. Historiography.

DETAILED TABLE OF CONTENTS

I. *Introduction.*

Located at the heart of Europe, Germany has always been a natural melting pot for diverse economic, cultural, political and intellectual forces. The origins of its population in the various Germanic tribes described by Tacitus,

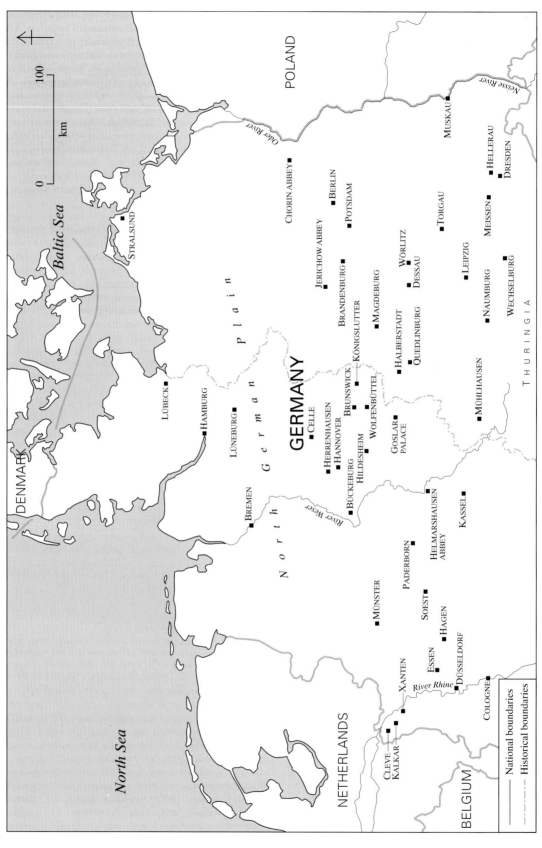

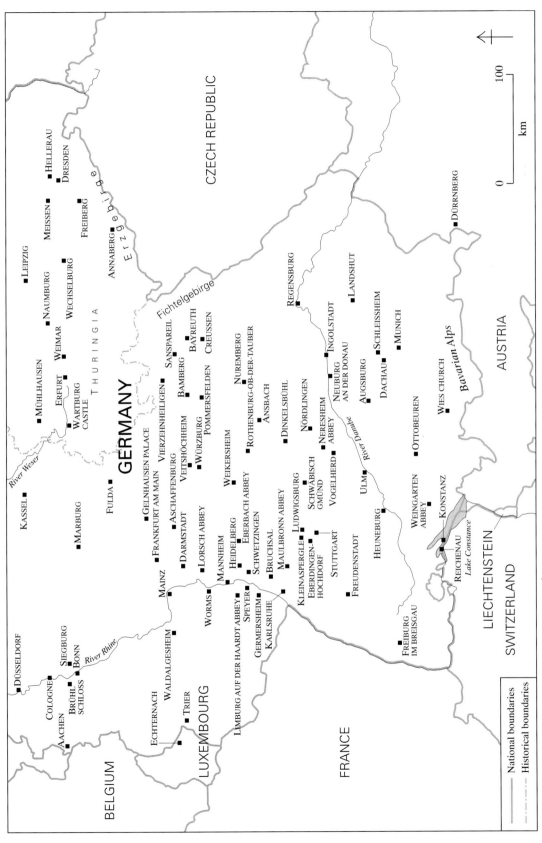

2. Map of southern Germany; those areas with separate entries in this dictionary are distinguished by CROSS-REFERENCE TYPE

however, produced a heterogeneity and particularism still perceptible in Germany's federal constitution and disparate regional characteristics. Before the Christian era, Germans had driven the Celts out of central Europe and thwarted attempts to subsume them into the Roman Empire, but the word *deutsch* does not occur before the 8th century AD, when it denotes the language of the eastern part of the Frankish kingdom. This reached its peak during the reign of Charlemagne, who established a northern European Christian culture modelled on the Roman Empire. After his death (814), his empire was divided into three kingdoms, laying the foundations for later conflicts between France and Germany, whose boundary remained for many centuries a 'fault line' in the middle of Europe.

After the restoration of political stability, Otto I was crowned Holy Roman Emperor in Rome in 962. The high culture of the Holy Roman Empire was dominated by the great monastic seats of learning such as Fulda and St Gall. By the 15th century it had become the 'Holy Roman Empire of the German Nation'. Under the rule of the Ottonian and Hohenstaufen dynasties, Romanesque architecture emerged, to be followed by the great Gothic cathedrals at Strasbourg, Cologne and Freiburg im Breisgau (the absence of natural sandstone in north Germany gave rise to the brick Gothic churches that were a major German contribution to Gothic architecture). During the following Habsburg dynasty, trade and the arts flourished in such cities as Nuremberg.

As the medieval order declined, the 'German lands' became increasingly fragmented: by the late 15th century and the early 16th there were more than 300 German states. Political and cultural contact with Italy had never entirely ceased, and the Renaissance helped shape a Golden Age of German painting (*see* §III, 2 below). After the 1530s the Reformation brought a further division into Protestant and Catholic states, and after the Thirty Years War (1618–48) all moves toward German unity were blocked by France and Sweden. All that remained in the ensuing cultural–political vacuum was a diffuse national consciousness and a nostalgia for the Middle Ages. While other European countries prospered from the acquisition of overseas empires, Germany remained divided and backward. Until well into the 18th century serfdom remained, along with an often harsh feudalism, only partly softened by the more enlightened hedonistic spirit of the Rococo. Prussia in particular adopted Luther's political absolutism and evolved under the Hohenzollern dynasty into a powerful authoritarian military state. The late 18th-century age of classicism in German literature and the arts was an age of continuing political despotism.

The French Revolution brought some permanent changes: the abolition of serfdom, the dissolution of the Holy Roman Empire (1806) and the confiscation of Church lands. But civil rights, equality before the law, security of property, emancipation of Jews and a just administration were very short-lived. After the Congress of Vienna (1815), the new German Confederation consisted of 39 states, with a nominal capital in Frankfurt but without centralized administration. Napoleon's victories had aroused only nationalist resentment in most Germans. Democracy came to be a term of abuse, associated with the hated French, while the German sense of identity

became centred on the Prussian military ethic of order, subordination and discipline. Liberal and radical aspirations were ruthlessly suppressed, contributing to a socially alienated Romantic turn towards nature, the inner life and the medieval heritage. Prussia, which by then included the former Church lands in the Rhinelands bordering France, thereby became responsible for Germany's western border and later, with the rapid industrial expansion of the second half of the 19th century, inherited the industrial might of the Saarland and the Ruhr. The liberal–democratic revolutions of 1848 had little effect on Germany beyond some 18 months of ostensibly constitutional government, which neither achieved any social reform nor brought unity any nearer. On becoming Prussian Chancellor in 1861, Otto von Bismarck (1815–98) correctly predicted that Germany would be unified 'not by majority decisions but by blood and iron'. Prussia established the Second German Empire (1871) by waging three successive wars: against Denmark (1864), Austria (1866) and France (1870).

With its diligence, high educational standards and efficient administration, its rapid economic growth and thriving culture, the Second German Empire set standards for the world. The combination of its authoritarianism and militarism, its Neo-classical pomp and hollow pretence of democracy, reinforcing Germany's traditional contempt for democracy, led directly to the disaster of World War I and doomed to failure the following Weimar Republic, for all its artistic and cultural brilliance and innovative spirit. In 1933 Adolf Hitler, aided by the discontent created by the Great Depression, became Chancellor; his expansionist and genocidal policies led Germany into World War II and to renewed defeat. In 1949 two German Republics emerged: the Federal Republic in the west was established as a liberal–capitalist parliamentary democracy; the Democratic Republic in the east as a communist state under the aegis of the USSR, whose cultural life was substantially dominated by the demands of socialism. Following the collapse of the communist regime in 1989, the two Germanies were reunified in 1990.

RDK

BIBLIOGRAPHY
R. Krautheimer: *Studies in Early Christian, Medieval and Renaissance Art* (London, 1971)
G. Lindemann: *History of German Art* (London, 1971)

DAVID JENKINSON

II. Architecture.

1. Before *c.* 1400. 2. *c.* 1400–*c.* 1600. 3. *c.* 1600–*c.* 1700. 4. *c.* 1700–*c.* 1750. 5. *c.* 1750–*c.* 1800. 6. *c.* 1800–*c.* 1900. 7. After *c.* 1900.

1. BEFORE *c.* 1400.

(i) Carolingian. (ii) Ottonian and Romanesque. (iii) Early Gothic and the introduction of Late Gothic.

(i) Carolingian. Until Carolingian times church building was carried out mainly in the regions of the Roman Empire, and although no large buildings have been preserved, their existence can be deduced from isolated archaeological finds. They were usually small hall churches with narrow rectangular chancels, sometimes with apses. They had a wooden-post or timber-frame construction, sometimes with Roman foundations (*see also* CHURCH, §I). There were also fortifications with ditches and timber-consolidated earth structures, as well as houses built on

piles or above pits for living and agricultural uses. It was only with Charlemagne that the development of true monumental architecture began in Germany (*see* CAROLINGIAN ART, §II). The royal palaces, with halls, chapels, colonnaded walks and residential rooms, show the same clear overall composition as Roman palaces. At the palace in Aachen the chapel (*c.* 790–800 AD) and the royal hall (now the Rathaus) have largely survived (*see* AACHEN, fig. 1). At Aachen the columnar grid with columns and Corinthian capitals taken from Late Antiquity is raised above simple arches on the ground floor as a sign of prestige. The gallery, enclosed by rich latticework and with its own altar, was used in the eastern Roman tradition for baptisms and to accommodate women. The immense niche in the façade in the background of the atrium, which is surrounded by columns and conches, represents a new departure in its monumentality. The Torhalle (gateway) (*c.* 800) at LORSCH ABBEY combines Roman details with Merovingian forms (pedimented pilasters, *opus reticulatum*) in the Romano-Gallic tradition.

Charlemagne's palace (774–87; destr.) at Ingelheim had a three-winged courtyard joined to an exedra, with a colonnade and six round towers placed outside the perimeter wall, also representing a development of ancient Roman models. Between 791 and 819 the modest three-aisled church at FULDA was extended to the west with a large nave and side aisles and given a wide, unbroken transept closed by an apse at the west end. The use here of a double chancel is a Carolingian innovation first found in St Maurice Klosterkirche (*c.* 787), Switzerland. Other churches were built with raised floors, which partly assumed the functions of the individual buildings in a church complex. The development of complicated outer crypts (*see* CRYPT) came to affect the shape of the whole chancel section, and the WESTWORK with several rooms evolved as the second liturgical centre after the chancel. These innovations prefigured future architectural developments, as did the ideal plan of a monastery recorded in the St Gall plan (*see* ST GALL ABBEY, §2 and fig.), which was drawn up specifically for Abbot Gozbert (abbot 816–37) as he prepared to rebuild St Gall Abbey from 830. It has a church with double chancel, semicircular atrium to the west with free-standing round staircase towers, passage crypt and a comprehensive construction plan for a monastery that hardly changed throughout the Middle Ages.

Prestigious monumental architecture came to an end in Germany with the death of Charlemagne in 814. Churches composed of small individual cells were preferred, as built by Benedict of Aniane (*c.* 750–821) at Inda (now Kornelimünster; 814–17; destr.), near Aachen, and by Einhard at Steinbach (815–27), although at Seligenstadt (831–40) Einhard built a large basilica with the nave walls carried on pillars, a continuous east transept, apse and circular crypt. Large schemes were, however, uncommon, even though the westwork introduced at Lorsch (774) was adopted at Corvey an der Weser (873–85), and it reappeared on a large scale at Hersfeld (831–50). The most common plan was the small, single-aisled church with rectangular chancel.

(ii) Ottonian and Romanesque. The art and architecture of the German empire between the mid-10th century and the late 11th is generally classed as Ottonian (*see* OTTONIAN ART), although it overlaps, both stylistically and chronologically, with the much more widely diffused ROMANESQUE style of *c.* 1000–*c.* 1200.

(a) 10th century–late 11th. Otto the Great (*reg* 936–73) revived the imperial conception of architecture and adopted the styles and dimensions of Carolingian buildings. Magnificent buildings were constructed in Saxony, with strict plans and well-balanced structures. The convent church at Gernrode (from 961) adopted the alternating system of supports with emphasis on the middle section, round towers to the west and Byzantine-influenced galleries above the side aisles.

The church of St Michael at Hildesheim (1010–22/3; *see* HILDESHEIM, §2) was the apogee of Ottonian architecture. It has two choirs, a west crypt combining the hall and circular types, two transepts with staircase–towers and towers at the crossing, an alternating system of supports, cushion capitals, alternating impost blocks of light and dark stone (*see* HILDESHEIM, fig. 2) and, for the first time, a crossing separated from the nave and transept by four arches, which determines the plan dimensions. The building's structure, and its rhythmic and centralizing articulation, are prefigured in the westwork of St Pantaleon in Cologne (984; *see* COLOGNE, §IV, 6(i)). The use of antique forms of articulation discernible in St Pantaleon next occurs in the group of buildings at ESSEN MINSTER from the mid-11th century (destr.); here Abbess Theophanu (abbess 1039–58) used part of the Aachen palace chapel as the model for the west chancel of the church she had built. The Aachen palace chapel was also used as a model for numerous centralized buildings of the period, mainly in palaces and castles (e.g. at Bamberg), but also in churches (e.g. at Ottmarsheim).

The 11th and 12th centuries were a period of far-reaching monastic reforms, great pilgrimages and crusades, and they were marked by the efforts of the clergy and the nobility to assert their claims to power and prestige. In almost all regions of the Christian West this led to renewed efforts in architecture. During the 11th century regional artistic styles developed, which frequently spread beyond diocesan, political and tribal boundaries. Under the SALIAN monarchy the Upper Rhine became the leading architectural region, with the construction of the church at LIMBURG AUF DER HAARDT ABBEY (1025/30–42; destr.) and SPEYER CATHEDRAL (1025/30–61). The Limburg church is a basilica with the nave walls carried on columns and the west entrance flanked by towers; the interiors of the long transept and square chancel are articulated with blind arches around the lower windows, a motif influenced by Trier Cathedral (*see* TRIER, §3). In Speyer, this motif embraces the clerestory windows and provides the dominant rhythm, in conjunction with half columns and cushion capitals, a flat-roofed nave and vaulted side aisles. The wide, groin-vaulted crypt with sturdy columns and cushion capitals, comprising several rooms around the central space, has an important successor in St Maria im Kapitol, Cologne (consecrated 1065; *see* COLOGNE, §IV, 3). Here, however, it is underneath a simple basilica with nave walls resting on pillars, and the nave ends in a trefoil shape with

three identical conches and an ambulatory separated by columns.

This type had brilliant successors in the Hohenstaufen period, from the North Rhine as far as Płock in Poland (from 1144). From 1037 Trier Cathedral, enlarged to incorporate Roman elements, was given a tower-flanked west front based on Limburg, with a pilastered west apse, a window cornice prefiguring the dwarf gallery under the eaves and an arcaded walkway between the apse and corner towers as the first genuine dwarf gallery. When Speyer was rebuilt (c. 1090–1120) this gallery—probably influenced by north Italian buildings—was extended to form a magnificent ornamental motif, which then, via the east chancel of Mainz Cathedral, influenced the two-storey chancels on the Lower Rhine in the early and high Hohenstaufen periods. A double chancel and multiple towers are found at the late Salian monastery church of Maria Laach (1093–1156), a complex comprising stereometric buildings accentuated, framed and articulated by pilasters, round arch friezes, blind arches and windows and openings of various shapes.

(b) Late 11th century–early 13th. Late Salian church architecture (1080–1130) is characterized by wide vault spans, skeletal wall construction, differentiated wall articulation, a dwarf gallery under the eaves, outer wall areas framed by pilasters, and by rich ornamentation by stonemasons trained in Lombardy.

In contrast to this lavish ornamentation and the evolution of richly articulated complexes with multiple towers was the architecture of the Cluniac Order, whose centre in Germany was Hirsau. There the main church of SS Peter and Paul was rebuilt in 1082–91. The churches built under the Hirsau reforms have simplified local forms applied to a uniform basic type to preserve regional traditions (Alpirsbach Abbey Church in Swabia, 1095–1125; Paulinzella Abbey Church in Thuringia, 1112–24). They have small crypts, flat ceilings, east bays in the nave joined to the transept, towers above the east bays of the side aisles, flat-ended chancels with side chapels, vestibules and columnar arcades with a rectangular frame.

The simplicity of Cluniac design and some of its structures were also employed in buildings unconnected with the Order, especially in Bavaria and the regions east of the Weser. The Cistercians, who rapidly gained influence, around the mid-12th century, also used simple architectural types without towers. From the early 13th century they imported French Gothic forms (e.g. at MAULBRONN ABBEY; Ebrach, consecrated 1207; Walkenried, 1215–40). Brick construction was developed in the north (e.g. Kalundsborg, end of the 12th century), while the hall church predominated in Westphalia and Bavaria. East of the Elbe, Romanesque architecture only began to establish itself fully around 1150.

About the mid-12th century a rich, fully vaulted Hohenstaufen style was developed in the Rhine–Meuse region and the Upper Rhine. Buildings were articulated externally by pilasters, blind arches, arcades and dwarf galleries (e.g. St Klemens, Schwarzrheindorf, consecrated 1151); and internally by niches and blind arcades (e.g. Bonn Minster, chancel consecrated 1153; Cologne, St Gereon, chancel before 1156). From 1170 onwards this internal articulation

was detached from the wall to form a second shell (Cologne, chancel of Gross St Martin, consecrated 1172; west chancel of St George, before 1188; Xanten, west choir, c. 1180–90). Worms Cathedral (built from c. 1130; consecrated 1181; see fig. 3) demonstrates the development from the dark, heavy masses of early Hohenstaufen–Alsatian buildings (e.g. Lautenbach, 1140–50; Mauersmünster, c. 1150; Rosheim, late 12th century) to the richly articulated, centralizing polygonal form with a rose window in the west chancel, influenced by the early French Gothic. In the early 13th century architectural ornamentation reached an extreme of richness in Swabia and on the Upper Rhine (e.g. cathedral of the Holy Cross, Schwäbisch Gmünd). Knowledge of French Gothic works and the love of a rich surface treatment produced the Late Romanesque buildings of the Lower and Middle Rhine (e.g. Neuss, from 1209; Werden, 1256–75; St Kunibert, Cologne, c. 1215–24; Sinzig, c. 1220–30; Limburg an der Lahn, 1220–35; Gelnhausen, c. 1220–40), but also to such typically Gothic solutions as the centralized decagonal arrangement introduced at St Gereon (1219–27), Cologne. During the 12th century town houses, town gates and especially the Hohenstaufen palaces (e.g. Gelnhausen, Wimpfen) and castles (*see* WARTBURG SCHLOSS; NUREMBERG, §I) gained importance.

(iii) Early Gothic and the introduction of Late Gothic. French GOTHIC, with its emphasis on structure, met in German

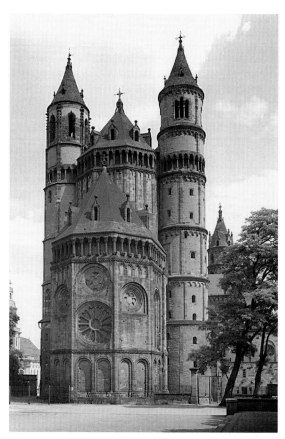

3. Worms Cathedral, west choir, c. 1170–81

areas with strongly traditional ideas of sculptural form. This produced a use of wall passages, which further emphasized the thickness of the wall. The vault responds were applied to the wall without changing its basic structure. The triforium was not adopted, and two-storey wall elevations were preferred (e.g. Liebfrauenkirche, Trier, 1235–40; Elisabethkirche, MARBURG, 1235–83). French influences, however, are evident in individual features of the first German Gothic churches: for example, Cologne Cathedral (from 1248) was strongly influenced by Amiens Cathedral. After the first contact with French Gothic, a closed wall with a simpler elevation became popular, and Cistercian monastic architecture prepared the way for certain elements of the German Gothic (e.g. at Ebrach, Altenberg, Arnsburg, Bebenhausen, Lilienfeld, Marienstatt, Walkenried). The same is true of the mendicant churches with their avoidance of rich double walls, diaphanous structures and in some cases vaulting (e.g. Regensburg Cathedral, from 1250; ERFURT Cathedral, 13th–14th century). The hall church was in these cases preferred to the basilica form. With St Mary's in Lübeck (from *c.* 1251–80) the Gothic style in brick (*Backsteingotik*) became the dominant influence on church architecture in the Baltic region.

The Parler family introduced Late Gothic into Germany in the mid-14th century. This brought with it a simplification of spaces, the introduction of the hall choir (SCHWÄBISCH GMÜND, from 1351; St Sebaldus, in Nuremberg, from 1361, *see* NUREMBERG, §IV, 1 and fig. 6), slender free-standing pillars leading directly into the vault, the merger of the columned area with vaulting, the use of net and stellar vaulting without articulation in bays, and the unified effect of the hall and surrounding walls with fenestration, producing a uniform light. Although the Gothic cathedral style implied a twin-towered façade (e.g. St Maria zur Weise, Soest; Frauenkirche, Munich), single-towered façades were also constructed, with different interpretations according to regional traditions: heavy, closed forms in Westphalia and Lower Saxony; in southern Germany light stone pyramids relieved by tracery (e.g. Freiburg im Breisgau Cathedral, *c.* 1330; Ulm, from 1377). Finally, richly articulated façades at the cross-section of the nave and aisles are to be found (e.g. Frauenkirche, Nuremberg). In the 14th century Gothic articulation and the Gothic genius for vault construction spread to the increasingly important secular architecture.

See also GOTHIC, §II, 2 and VERNACULAR ARCHITECTURE, §II, 1(ii).

BIBLIOGRAPHY
N. Pevsner: *European Architecture*, Pelican Hist. A. (Harmondsworth, 1942, 7/1963)
L. Grodecki and F. Mütherich: *Die Zeit der Ottonen und Salier* (Freiburg, 1973)
H. E. Kubach: *Architektur der Romanik* (Stuttgart, 1974)
L. Grodecki: *Architektur der Gotik* (Freiburg, 1976)
H. E. Kubach and A. Verbeek: *Romanische Baukunst an Rhein und Maas*, 4 vols (Berlin, 1976/*R* 1989)
G. Binding: *Architektonische Formenlehre* (Darmstadt, 1980/*R* 1987)
A. Wiedenau: *Katalog der romanischen Wohnbauten in westdeutschen Städten und Siedlungen* (1983), xxxiv of *Das deutsche Bürgerhaus*, ed. G. Binding (Tübingen, 1959–86)
N. Nussbaum: *Deutsche Kirchenbaukunst der Gotik* (Cologne, 1985/*R* Darmstadt, 1994)
G. Binding: *Masswerk* (Darmstadt, 1989)
M. Untermann: *Der Zentralbau im Mittelalter* (Darmstadt, 1989)

GÜNTHER BINDING

2. *c.* 1400–*c.* 1600.

(i) Late Gothic. (ii) Influence of the Italian Renaissance.

(i) Late Gothic. While Renaissance architecture was reaching its highpoint in Italy, Late Gothic emerged as an independent style north of the Alps. Based on the earlier High Gothic tradition and 14th-century innovations, it was to be the dominant force in German architecture until the 16th century. The growth of urban society gave rise to the construction of numerous churches, especially in the early 15th century. Under Austrian influence, the brick hall church had become the typical form of urban parish church. Buttresses were moved inside the building, and exterior walls created plain and often smooth forms; the single-towered façade was often preferred.

From 1392 Ulrich von Ensingen supervised work at Ulm Minster (begun 1377; *see* ULM, §2(i)). In 1399 he was also commissioned to build the Strasbourg Minster and in 1400 the Frauenkirche at Esslingen. His son Matthäus Ensinger continued his work in Ulm and Esslingen; in 1420 the city of Berne appointed him to rebuild the cathedral. The change from the directional Gothic spatial system, rhythmically articulated in bays, to a hall church interior was associated with an altered conception of space. The Late Gothic church now extended on all sides without directionality, and forms stressing lateral extent were increasingly preferred. Previously separate spaces were merged, and all spatial components woven smoothly together.

The leading master in Bavaria was Hans von Burghausen (*c.* 1350–1432), who built seven churches in which he adopted and developed further the new plan, featuring a hall choir with an ambulatory, used in the cathedral of the Holy Cross (from 1351) in Schwäbisch Gmünd, which was probably built by Heinrich Parler I.

A new rationality is discernible in the chancel of St Lorenz, Nuremberg, with its vigorous net vaulting over the nave and ambulatory. Begun in 1439 by Konrad Heinzelmann, it was completed in 1477 by Jakob Grimm (*d* 1490). Other important churches included St Georg (from 1448) in Dinkelsbühl by Niclas Eseler I and the Frauenkirche in Ingolstadt (from 1465). In 1468 rebuilding started on the Frauenkirche in Munich under Jörg von Halsbach (*c.* 1410–88).

A new spatial ideal was created by simplifying the plan and elevation and unifying the complex. The building of St Martin (begun 1421) in Amberg was an early example of a church without a transept and with chapels between the buttresses, which were drawn into the body of the church, and galleries above. St Anne's (1499–1525), Annaberg, by Peter von Pirna and others, St Wolfgang in Schneeberg (1515–26) by Hans von Torgau and the Marktkirche (1529–54), Halle an der Saale, develop the plan of St Martin, Amberg, further.

Some trends in Late Gothic architecture can be related to the Renaissance: the new concept of space, the increasing stress on the horizontal and, in later buildings, the attempt to achieve a closed space, as well as the rejection of excessive size in favour of proportions based on a

human scale. This did not, however, produce the same three-dimensional modelling of space as in Italy. While the Late Gothic conception of space aimed to reduce and simplify the Gothic system, its decorative principles are conspicuously ornate: tall, pointed towers dissolve into filigree work, and tracery smothers the architecture. Fourteenth-century star and reticulated vaulting had increasingly neutralized the Gothic division into bays, preparing the way for a unified ceiling (*see* VAULT: RIB). Net vaulting as a special form of reticulated vaulting first appeared in the Albrechtsburg in Meissen (after 1471), built by Arnold von Westfalen. Rib configurations lost their structural importance, and vaults became increasingly rich and complex, culminating in star and net vaults with curved ribs sometimes arranged asymmetrically. Inspired by Benedikt Ried's vault in the Vladislav Hall in Hradčany Castle (1493–1502; *see* RIED, BENEDIKT, fig. 2), Prague, Jacob Haylmann completed the ceiling (1525) of St Anne's, Annaberg, with segments of circles forming star shapes. Vaults were given a sense of movement, and, freed of their segmental structure, assumed autonomous vegetal forms. The nave chapels of the Liebfrauenkirche (after 1500), Ingolstadt, show two systems of interwoven curvilinear ribs.

(ii) Influence of the Italian Renaissance. The Italian Renaissance began to affect Germany only around 1500, when the Italian idiom merged with local traditions. Sixteenth-century German architecture shows a fragmented stylistic development; only in the north-west, in the WESER RENAISSANCE of the late 16th century, is a coherent style detectable. A new humanist cultural ideal expressed itself through the study of antiquity. Such treatises as Dürer's *Unterweisung der Messung* (1525) or Gualtherus Rivius's *Vitruvius Teutsch* (1548) introduced both Vitruvius and contemporary Italian architecture as models. The theorists' demands, however, often remained unfulfilled; learned architects were to be found only among foreigners. The Fugger Chapel (1509–18) in St Anna, Augsburg, the plan of which is very probably to be attributed to Albrecht Dürer, the Stadtresidenz (from 1537–43) in Landshut by Sigmund Walch and Bernhard Walch, the Fürstenhof (from 1553), Wismar, possibly designed by Erhard Altdorfer, and Schloss Güstrow (from 1558) by Franciscus Parr (*d* 1580), are among the few Italian Renaissance style buildings in Germany. The majority of the buildings generally show the use of Italian forms as decoration, but the Italian system itself was not adopted. German Renaissance architecture evolved from the Late Gothic style, adhering to tradition. For example the chapel (consecrated 1544) of Schloss Hartenfels near Torgau by Nikolaus Gromann (*fl* 1537–74) follows the Upper-Saxon type, merely having more compact proportions (*see* TORGAU, §2).

(a) Forms, motifs and plans. The influence of Italianate forms in Germany was determined by the way they were transmitted. This occurred primarily through such sources as graphic pattern sheets, engravings of Italian ornament, book title-page surrounds and woodcuts, which were converted by German master builders into stone. Such works as Heinrich Vogtherr I's *Libellus artificiosus* (1538)

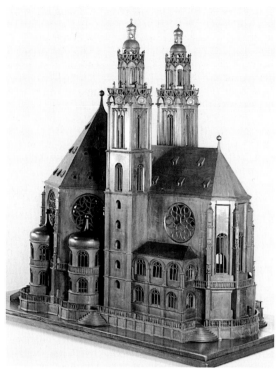

4. Hans Hieber: wooden architectural model (1519) for the Kapelle zur Schönen Maria, Regensburg (Regensburg, Stadtmuseum)

show that new forms were first incorporated as single components, with no feeling for the total composition.

Renaissance motifs thus made their first appearance as applied decoration. The Oktagon crowning the west tower of St Kilian (begun 1513) in Heilsbronn is Gothic in structure, with only the decorative detail deriving from Renaissance forms. In the early 16th century, 14th-century Venetian and Lombard ornamentation, already obsolete in Italy, was widely adopted; its strong sense of movement and decorative richness converged with Gothic tendencies. In the search for a modern idiom, indigenous Romanesque models were also rediscovered and used, for example in the round-arched frieze on the Georgentor (1534) of Dresden Castle.

Besides decorative elements, individual motifs removed from their structural contexts were adopted from Italian architecture. German Gothic buildings were given arcades modelled on Italian arcaded courtyards: the red marble columns (1519) by Stephan Rottaler (*d* 1553) in the episcopal Residenz in Freising are still Gothic in character, whereas the arcades of the Gläserner Saalbau of Heidelberg Castle (1544; probably by Conrad Forster, *fl* 1544–52) have clearer forms. The Bavarian version of the Mint courtyard (from 1563; by Wilhelm Egckl) in Munich became the model for the courtyards of palaces for the country nobility; in 1578 arcades were placed in front of the medieval Burg Trausnitz in Landshut, and the arcaded courtyard (1567–9) of the Plassenburg, near Kulmbach, is swathed in luxuriant modelled decoration. Most Italianate of all were the arcades of the Altes Schloss (begun 1553; destr.) in Stuttgart (for illustration *see* STUTTGART). The

tops of the towers of churches (e.g. cupolas on Frauenkirche, Munich, 1524–5; *see* MUNICH, §IV, 1), palaces and houses were also given a modern, Italian treatment.

A synthesis of old and new is found in the wooden model (1519; simplified in execution; see fig. 4) by Hans Hieber for the Kapelle zur Schönen Maria (now the Neupfarrkirche) in Regensburg. This design combined a nave with a Renaissance centralized hall.

While individual features, ornaments and articulating elements were thus taken singly from Italian Renaissance forms, plans generally remained medieval and irregular, following the picturesque concepts of Late Gothic. The Italian influence became noticeable in the overall composition only around 1550. Rules adopted from Italian theorists now governed the structure: Serlio's writings, the *Vitruvius Teutsch* and Hans Blum's book on columns (1550) propagated the ARCHITECTURAL ORDERS as the core of all architecture. French influence is also seen in individual cases.

(b) Secular buildings. Important architectural projects also included town houses, for example the Tucherhaus (1533–44) and the Hirschvogelhaus (1534) in Nuremberg, and, especially, town halls. The Rothenburg Rathaus (from 1572) is an example of the early Renaissance in Franconia; but the Leipzig Altes Rathaus (*c.* 1480, rebuilt 1556) has a more modern arrangement of the building block (*see* LEIPZIG, fig. 1). The vestibule of the Cologne Rathaus (1569–73) is a unique copy of buildings by Sansovino and Palladio on German soil and was built by a Netherlandish architect. The Rathaus (1574–6) in Emden is an example of Netherlandish classicism.

The nobles' need for self-display, characteristic of Renaissance architecture, was reflected in the rebuilding or replacement of residences, pleasure palaces and hunting-lodges. Examples include the Johann-Friedrich-Bau (1533–6) of Schloss Hartenfels, built by Konrad Krebs and modelled on the Albrechtsburg in Meissen, and various moated castles in Westphalia (e.g. Schloss Horst, 1508).

One of the most important architectural patrons of the time was Elector Otto Henry of the Palatinate (*reg* 1556–9). The Ottheinrichsbau (from 1556; see fig. 5) of Heidelberg Castle is an outstanding example of a work based on pattern books and treatises kept in the library there. In its rhythmical articulation by pilasters and cornices and its regular plan, it is a mature Renaissance work in the Italian sense, although it is characteristic of architecture north of the Alps and is strongly influenced by Netherlandish Mannerism. A concern with antique themes is reflected in the humanistic, astrological façade programme. The invocation of the Roman Empire by the Renaissance also underlies the façade decoration of the Kaiserhaus (1586; destr.) at Hildesheim, with portraits of the Caesars, and the decorative programme of the Antiquarium (1569–71) of the Munich Residenz.

Efforts to clarify the plan, in which French palace design and the theoretical works of Jacques Androuet Du

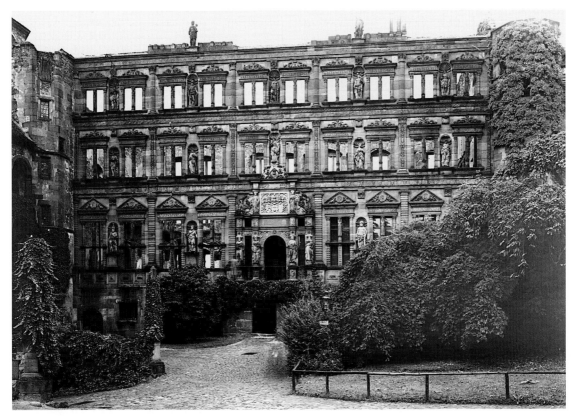

5. Heidelberg Castle, Ottheinrichsbau, court façade, from 1556

Cerceau I were influential, are seen in the layout of square, four-wing palaces with corner-towers built from *c.* 1570, including the Wilhelmsburg (from 1584) in Schmalkalden, Schloss Augustusburg (from 1567), and the Lusthaus (1583–93) in Stuttgart by Georg Beer. Such urban designs as Daniel Speckle's *Architectura von Festungen* (1584)—a similar plan was put into practice in Freudenstadt in 1599—reflect the new principles, as do such burgher houses as the Nuremberg Pellerhaus (1602–7) by Jakob Wolff I, in which a central hallway is flanked by symmetrically arranged rooms (for illustration *see* WOLFF (i),(1)). The most important exponent of late Renaissance style on the threshold of the Baroque was ELIAS HOLL (i), who produced new architectural ideas based on a synthesis of Italian designs and recent developments in Germany.

(c) Protestant and Catholic churches of the Reformation period. Between *c.* 1530 and 1580 church building declined sharply due to the religious upheavals of the Protestant Reformation. Few town churches were built; the first new Protestant buildings were mostly palace churches (e.g. Schloss Hartenfels). Protestant architecture further developed the Late Gothic gallery-church, since it suited the emphasis on preaching.

The Jesuit church of St Michael (from 1583), Munich, by Friedrich Sustris is the opening achievement of the period; its large, barrel-vaulted space has as its precursor the Antiquarium of the Munich Residenz, and the somewhat hazy conception of the vault goes against Italian practice. The gallery here is a dominant element in the articulation of space, and it became a permanent feature in south German Catholic churches for the next two centuries.

Decoration in this period became increasingly luxuriant and unrestrained; scrollwork and Netherlandish interlacing and strapwork hark back to Late Gothic, negating rationality and clarity. Netherlandish influences were particularly felt in northern Germany. In comparison to the Ottheinrichsbau, the Friedrichsbau of Heidelberg Castle shows innovations: while it is tauter and severer, it is simultaneously more vital, powerful and full of movement. A return to elements of Gothic decoration, and to medieval forms in general, characterizes some early 17th-century Jesuit churches, including the Holy Trinity Church (1614–19), Molsheim, St Mariä Himmelfahrt (1618–27), Cologne, and the Jesuit church (1607–16) in Neuburg, designed by Joseph Heintz I.

Stylistically similar are a number of buildings commissioned by Julius Echter von Mespelbrunn, Bishop of Würzburg—for example the pilgrimage church in Dettelbach (1610–14)—which blend Gothic and Baroque elements. The Bishop's main work, however, the new university church (1583–91) in Würzburg, shows Gothic reminiscences in only a few details, being constructed on a Roman model.

See also VERNACULAR ARCHITECTURE, §II, 1(ii).

BIBLIOGRAPHY
W. Lübke: *Geschichte der deutschen Renaissance* (Stuttgart, 1872)
H. Wölfflin: *Die Architektur der deutschen Renaissance* (Munich, 1914)
A. Stange: *Die deutsche Baukunst der Renaissance* (Munich, 1926)
H. Wölfflin: *Italien und das deutsche Formgefühl* (Munich, 1931)
K. H. Clasen: *Deutsche Gewölbe der Spätgotik* (Berlin, 1958, 2/1961)
K. Brix: *Baukunst der Renaissance in Deutschland* (Dresden, 1965)
E. Hubala: *Renaissance und Barock* (Frankfurt am Main, 1968)
H.-R. Hitchcock jr: *German Renaissance Architecture* (Princeton, 1981)
H.-J. Kadatz: *Deutsche Renaissancebaukunst von der frühbürgerlichen Revolution bis zum Ausgang des dreissigjährigen Krieges* (E. Berlin, 1983)
B. Jestaz: *Die Kunst der Renaissance* (Freiburg, 1985)
B. Bushart: *Die Fuggerkapelle bei St Anna in Augsburg* (Munich, 1994)

DORIS KUTSCHBACH

3. *c.* 1600–*c.* 1700.

(i) Architectural theorists and ideal urban plans. (ii) Before the Thirty Years War. (iii) Reconstruction.

(i) Architectural theorists and ideal urban plans. Late Gothic rules of proportions remained the basis of the training of German masons in the 17th century. The early German editions and commentaries on Vitruvius (*see* §2(ii) above) were addressed primarily to patrons and masters of works; they did not contribute directly to training, and their influence was mostly confined to the articulation of architectural elements, hardly affecting the proportions of buildings or the techniques used. In addition to works conceived as collections of exemplary decorative designs, for example Wendel Dietterlin's *Architectura* (1598), pattern books addressed directly to masters of works appeared in increasing numbers in Germany. Such 17th-century theorists as JOSEF FURTTENBACH I aimed to be fairly comprehensive.

In the 18th century, however, there was increasing specialization. Beginning with the works of Joseph Furttenbach II and, above all, the treatises of Leonard Christopher Sturm, numerous specialists wrote on such subjects as agricultural structures, mills, schools etc. Both these and publications on buildings already executed (e.g. Fischer von Erlach's *Entwurff einer historischen Architektur*) contributed to the rapid spread of new architectural concepts (*see* §4(i) below).

As new towns were founded by territorial rulers, numerous ideal urban layouts were developed, stimulated by 16th-century Italian models and especially by the detailed reconstruction of Jerusalem by JUAN BATTISTA VILLALPANDO. Such plans achieved quite original solutions. For the new town of FREUDENSTADT (from 1599) in Württemberg, Heinrich Schickhardt II submitted several designs that implied a knowledge of Italian ideal town concepts. The chosen plan arranged streets in concentric rectangles around a square, at the centre of which the palace was situated at an angle of 45°, with important buildings at right angles to the square. This plan is markedly different from the other new towns of the period. In MANNHEIM (1606) the town was composed of a strict grid pattern of square blocks, a layout later found in simpler form in Ludwigsburg (1709), while Karlsruhe was developed (from 1715) on a radial design with the castle at its centre. In addition to these large schemes, planned settlements for Huguenot exiles from France were established in the 17th century (the villages of Perouse and Serres, both in Württemberg), typically linear in design. Another example was Karlshafen (from 1685) in Hesse by Paul Du Ry (*see* DU RY, (2)). Immigrants from other countries also settled in the Huguenot areas, and in their quarters the architecture of their country of origin was deliberately adopted.

New types of monasteries were developed in the 17th century and the early 18th, and various attempts were made to classify them. These designs, sometimes very complex, seem to have been influenced by the reconstruction of the Temple of Solomon, as disseminated in the works of Villalpando. It cannot be established with certainty how far these monastery designs were affected by publications on the Escorial (1563–84), Spain, which was itself certainly influenced by such reconstructions. (The direct influence of the Escorial can be demonstrated only in the case of Schloss Eggenberg (from 1623), near Graz, in Austria, built by Pietro Valnegro (*d* 1639) and Laurenz van de Sype (*d* 1634).) The most elaborate plans almost entirely enclose the monastery church at the centre of the complex. Such plans were followed by the buildings at Metten, in the first quarter of the 17th century, and Ochsenhausen (from 1614), built to plans by Stephan Huber and completed only in the 18th century. After the Thirty Years War (1618–48) symmetrical plans were developed, with the church on the central axis, as in those partly completed in Weingarten Abbey, Wiblingen and Schussenried.

(ii) Before the Thirty Years War. The period from before the Thirty Years War up to *c.* 1630–35 was one of economic expansion, which gave rise to large-scale building projects. The architecture of this time is influenced by three main factors: first, the monumental treatment of ancient forms, as mediated by the treatises of Palladio and Scamozzi; second, the proliferation across the whole building of luxuriant decoration almost entirely devoid of architectural structure, as, for example, in the façade of the Stadtkirche (1611–15) in Bückeburg (for illustration *see* BÜCKEBURG) by Hans Wulff (such decoration was developed by façade painting and mediated, for example, by Wendel Dietterlin's treatise); and third, the typically German phenomenon of the survival of Gothic tracery, especially in churches. The popularity and growth of the Gothic Revival can be explained only by the training of masons, which until the 18th century was based on the laws of proportion and the constructional principles of Late Gothic architecture. In keeping with the concept of proof prevailing at the time in legal disputes over property, some buildings were deliberately constructed in an old-fashioned style and with clear iconographic meanings to reinforce a claim of ownership or assert an ancient right. Thus, in designing the towers of the Stadtkirche of Freudenstadt, Heinrich Schickhardt II adopted the typical style of 15th-century Württemberg town churches, as seen, for example, in the Stiftskirche at Tübingen. In the towers of the Augustinian church (1604–11) at Polling, Hans Krumpper used the Romanesque style for similar reasons. The use of the Gothic Revival style in such buildings as the Jesuit churches in Molsheim (1614–18) and Cologne (1618–29), both by Christoph Wamser (*d* before 1649), is probably explained by similar intentions in the founders.

(a) Secular buildings. Important stimuli for the development of architecture came from the large residence towns and the more powerful imperial cities. Palace building in the early 17th century was clearly influenced by Serlio, especially his designs for the château of Ancy-le-Franc (1541–50) in France. The palaces constructed in the second half of the 16th century at Wolfegg and Messkirch, and later at Zeil, were shaped by this influence and created a form that remained widespread in Swabia until the 18th century, as in Tettnang (1712), built by Christian Gessinger and rebuilt (from 1753) by Jakob Emele (1707–80). Only Heinrich Schickhardt II's palace plans owe more to the 16th-century German four-winged structures built by Alberlin Tretsch, MARTIN BERWART and BLASIUS BERWART I at the Altes Schloss (from 1553), Stuttgart, and Schloss Göppingen (1556–65). Schloss Scharffeneck (from 1627; destr. 1632), built by Blasius Berwart II, was based directly on the plans for Ancy-le-Franc published by Jacques Androuet Du Cerceau I in 1572.

The castle at ASCHAFFENBURG (1605–14), built by Georg Riedinger, represents a combination of Serlio's ideas and the German tradition, whereas the Willibaldsburg (from 1609) near Eichstätt, built by Hans Alberthal possibly to plans by Elias Holl, and the episcopal palace (from 1635) in Pressburg (now Bratislava) both show an original treatment of northern Italian forms. The building programmes of princely residences show a broad range of influences. Under William V, Duke of Bavaria (*reg* 1579–97), and Maximilian I, Duke of Bavaria (*reg* 1597–1651), Munich was turned into a residence of European standing. Seventeenth-century projects included the enlargement of the Residenz (*see* MUNICH, §IV, 2) and such smaller palaces as Schleissheim (1616–17) by Heinrich Schön I.

As at the Palazzo Ducale in Mantua, the Munich Residenz developed as a synthesis of individual courtyard blocks, while many of its architectural details are derived from northern Italian designs. The west façade (1611–19) is extremely elongated and unified, structured three-dimensionally only by two monumental portals and the bronze group of the *Patrona Boiariae* by Hans Krumpper. The immense wall areas of this and other façades were articulated by architectural painting. The rooms inside the residence are linked in a linear manner: individual sections are often separated by corridors running around the apartments. The electoral castle complex in HEIDELBERG was extended in several stages between 1508 and 1632, incorporating earlier buildings. Apart from the layout of the fortifications, it had no unified plan, the individual parts being designed and built in isolation. The Friedrichsbau (1601–4), built by JOHANN SCHOCH, conforms to 16th-century styles in its adoption of Venetian forms. The new architectural language, however, is apparent in the Englischer Bau (1612–15; largely destr.), for which designs by Inigo Jones may have been used. It has a colossal Tuscan order as articulation on the north façade and a uniform fenestration on the south façade. In Dresden the late medieval castle was extended to serve as a modern residence, on the basis of a four-wing restructuring that had been executed earlier (from 1545).

Treatises were more influential in the design of fortifications than in civil buildings. If Schickhardt's designs for Freudenstadt were somewhat antiquated and of little practical value, such fortresses as the Wülzburg (1588–*c.* 1634) of the margraves of Ansbach near Weissenburg, Bavaria, built by Georg Berwart I, Kaspar Schwabe

(*fl* 1580–92) and Blasius Berwart I, or the Nuremberg fortress of Lichtenau (from 1552), which was given its present form by Jakob Wolff II from 1599, were modern buildings as regards not only military technique but also architectural style. In public buildings, especially those of the imperial cities, the new vocabulary was soon established. Particularly outstanding are the town halls in Augsburg, Nuremberg and Neuburg an der Donau. In the more powerful imperial cities, such as Nuremberg and Augsburg, whole building programmes can be detected. The remodelled Rathaus in Nuremberg (1616–22; destr. 1945; reconstructed; see NUREMBERG, §IV, 3), built by Jakob Wolff II, shows striking similarities to the administrative buildings in Villalpando's reconstruction of Jerusalem. Wolff also erected the house of the municipal architect and some fortifications in 1615.

At the same time Elias Holl I was working in Augsburg, becoming Director of Building Works in 1602. His works there included the rebuilding of the municipal foundry (1601–2), the Zeughaus (1602–7; see fig. 6), the meat market (1606–9), the main store (1611), the grammar school of St Anna (1613–15) and the Rathaus (1614–20; see HOLL (i), (2), fig. 2). These buildings gave Augsburg an entirely new architectural character. Holl's early buildings, for which he may have studied designs by Joseph Heintz I, are distinguished by an unusually pronounced sculptural articulation, which gives individual elements such as window-frames and cornices an almost oppressive weight (as in the armoury façade). The Rathaus, built on

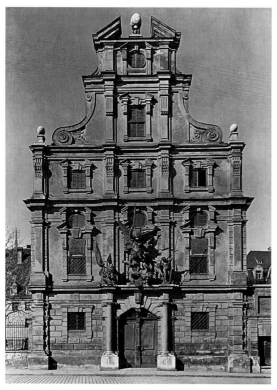

6. Zeughaus, Augsburg, façade design by Joseph Heintz I, built by Elias Holl I, 1602–7

a rectangular plan to form a monolithic cube, renewed the tradition of late medieval town halls while introducing a new stylistic feature in the placing of the principal rooms one above the other.

(*b*) *Churches.* Church architecture of the early 17th century is richly experimental. Designs range from Gothic Revival to the Italian style. The Jesuit church of the Ascension (1610–17) in Dillingen by Hans Alberthal is one of the prototypes of the Baroque wall-pillar church and is of special importance for the later development of Catholic church architecture. One of its immediate successors is the Jesuit church (1617–20) in Eichstätt, also by Alberthal. During the Counter-Reformation some unique buildings were erected, including the Benedictine abbey church (1622–30) in Oberaltaich, built by Ulrich Walchner (*fl* 1614–30) to plans by Abbot Vitus Höser.

Protestant churches, intended primarily for preaching, were characterized by the search for new architectural forms. The Hofkirche (from 1607; now Jesuitenkirche) in Neuburg an der Donau, based on plans by Joseph Heintz I dating from 1603, was conceived as a hall with free-standing pillars and dwarf galleries; its imposing single-towered façade recalls Gothic façades in the Protestant imperial cities of Swabia. Heinrich Schickhardt II's churches (1601–7) in Mömpelgard (now Montbéliard, France) and Göppingen (1618–19) are simple hall churches of monumental dimensions, and, with their strict articulation, may be seen as contemporary interpretations of the Classical temple.

(*iii*) *Reconstruction.* After the devastation of the Thirty Years War there was a serious shortage of architectural craftsmen in Germany. This produced an influx of such Italian craftsmen families as the Luccheses, Luragos, Carlones, Sciascas and Zuccallis into southern Germany; and of mainly Netherlandish masters into the north. The great patrons after the war included the Catholic orders, especially the Jesuits. The works of Carlo Lurago, Francesco Caratti and other Italians in Germany and Bohemia are stylistically indebted to Palladio and Scamozzi; in their small-scale elements and their uniform façades, devoid of articulating emphasis of the more important parts, they fall short not only of contemporary Italian architecture but also of early 17th-century German works. They were, however, significant in introducing elements of the Baroque into Germany.

After the new Salzburg Cathedral, the rebuilt Passau Cathedral (from 1668; see fig. 7) by Carlo Lurago was the most important new church building in the southern German states. The transept and chancel retain the walls of the earlier 15th-century building, but the façade and interior treatment, with a series of domes resting on pendentives in the nave, clearly show Venetian influences. DOMENICO SCIASSIA and his son LORENZO SCIASCA were active in Bavaria. Sciassia built the church and other buildings for the monastic foundation of St Lambrecht (Austria); and Sciasca built the monastery churches of Herrenchiemsee (1676–8) and Weyarn (1688–93; interior altered 1729): wall-pillar churches with low, single-nave chancels of a kind that was later widely adopted in Bavaria. The church of St Kajetan (from 1663) in Munich was built

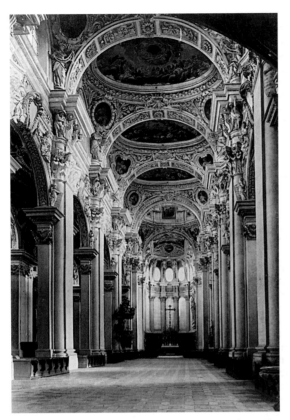

7. Carlo Lurago: Passau Cathedral, interior of the nave, after 1668

to designs by Agostino Barelli (for illustration *see* BARELLI, AGOSTINO). He was succeeded in 1674 by Enrico Zuccalli (*see* ZUCCALLI, (1)), who completed the dome in 1688. The façade (completed 1768) was designed by François de Cuvilliés I. This church gave a new impetus to southern German architecture. Zucalli's designs for the remodelling of the Wallfahrtskirche (from 1673; uncompleted) and the Wallfahrt district of Altötting reveal an exact knowledge of the works of Bernini, and Zuccalli's centrally planned designs proved influential in Bavaria.

Zuccalli was a major influence on Bavarian palace design through his works for Elector Maximilian II Emanuel. At SCHLOSS SCHLEISSHEIM he built the small, Baroque pleasure palace of Lustheim (1684–8) and the Neues Schloss (from 1701). He also extended (from 1702) the Nymphenburg in Munich to designs by Barelli (1674–6) for a plain, five-storey block. The works of Johann Serro (e.g. St Lorenz, Kempten, from 1652) and of ANTONIO PETRINI (e.g. Benedictine abbey church of Haug, Würzburg, 1670–91; destr. 1945; rest. completed 1964) utilize the type of the monumental dome resting on a drum. However, St Lorenz, originally begun by Michael Beer in 1651, is rather indecisive, while Petrini's works adhere firmly to the early Italian Baroque in their strictly conventional treatment of walls and space. In Swabia the designs for the monasteries at Zwiefalten (from 1668) and Obermarchtal (1674) by Tomaso di Comacio (*d* 1678) are especially important in the light of further developments by Beer and Christian Wiedemann (*c.* 1680–1739). Comacio placed

separate buildings accommodating the main official rooms outside the corners of the four-winged structure. The main staircases were located at the intersections of the wings, giving access both to the wings and to the separate official buildings. Carlo Antonio Carlone's designs for the monastery of Niederaltaich (from 1698) are important for the development of Bavarian monastic architecture. Following the same general principle as the great Austrian imperial monasteries, identical wings are grouped around a succession of rectangular courtyards that can be added to at will, and it is impossible to discern the function of each wing from the outside.

See also VERNACULAR ARCHITECTURE, §II, 1(ii).

BIBLIOGRAPHY

J. Braun: *Die Kirchenbauten der deutschen Jesuiten*, 2 vols (Freiburg, 1908–10)

J. Baum: 'Beiträge zur Charakterisierung der deutschen Renaissance-Baukunst', *Z. Bild. Kst*, xx (1909), pp. 149–58

C. Horst: *Die Architektur der deutschen Renaissance* (Berlin, 1928)

E. Reiff: *Anachronistische Elemente in der deutschen Baukunst aus der Zeit von ca. 1650 bis ca. 1680* (Emsdetten, 1937)

A. M. Zendralli: *I magistri Grigioni, architetti e costruttori, stuccatori e pittori dal 16 al 18 secolo* (Poschiavo, 1958)

E. Hubala: 'Palladio und die Baukunst in Deutschland im 17. Jahrhundert', *Boll. Cent. Int. Stud. Archit. Andrea Palladio*, iii (1961), pp. 38–44

R. Wagner-Rieger: 'Architektur und Plastik in Zentraleuropa', *Die Kunst des 17. Jahrhunderts*, ed. E. Hubala, Propyläen-Kstgesch., ix (Berlin, 1970), pp. 279–96

W. Fleischhauer: *Renaissance im Herzogtum Württemberg* (Stuttgart, 1971)

H. Hipp: *Studien zur 'Nachgotik' des 16. und 17. Jahrhunderts in Deutschland, Böhmen, Österreich und der Schweiz* (Hannover, 1979)

E. Hubala: 'Vom europäischen Rang der Münchener Architektur um 1600', *Um Glauben und Reich Kurfürst Maximilian I*, ed. H. Glaser, Wittelsbach und Bayern, ii/1 (Munich, 1980), pp. 141–51

H.-R. Hitchcock: *German Renaissance Architecture* (Princeton, 1981)

H.-J. Kadatz: *Deutsche Renaissancebaukunst* (E. Berlin, 1983)

K. Budde and K. Merten: 'Die Architektur im deutschen Südwesten zwischen 1530 und 1634', *Renaissance im deutschen Südwesten* (exh. cat., Heidelberg, Schloss, 1986), pp. 86–123

G. Skalecki: *Deutsche Architektur zur Zeit des Dreissigjährigen Krieges: Der Einfluss Italiens auf das deutsche Bauschaffen* (Regensburg, 1989)

4. *c.* 1700–*c.* 1750.

(i) Introduction. Architecture in the first half of the 18th century was characterized by many new stylistic features. Traditional forms used by the Vorarlberg masons, for example, were combined with elements from contemporary Italian, but above all French, architecture. The leitmotif of church and secular architecture at this time is the union of the longitudinal and the centralized structure. Areas that received especially elaborate treatment in palaces were the staircase and the adjoining complexes of state rooms that usually formed the core of the building (*see also* SALA TERRENA), while the apartments and less important functions were housed in the wings. In Balthasar Neumann's designs for palaces in Würzburg, Stuttgart and Bruchsal (for illustration *see* BRUCHSAL, SCHLOSS), it is precisely the main, ceremonial staircases that are emphasized (*see* WÜRZBURG, fig. 3 and NEUMANN, BALTHASAR, fig. 1).

Despite the orientation towards Italy and France, diverse regional styles emerged in German architecture. The wall-pillar churches built by the Vorarlberg master masons Michael Thumb and Christian Thumb in Ellwangen (Jesuit college; 1681–3), Schönenberg (pilgrimage church; 1682–6) and Obermarchtal (monastery church; from 1690; with Franz Beer) profoundly influenced church architecture

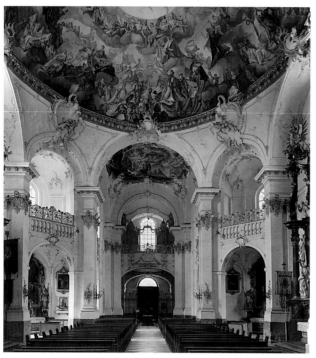

8. Johann Michael Fischer: interior of the Klosterkirche, Rott am Inn, 1759–63

about 1700. This type was further developed by Franz Beer (*see* BEER, (2)) and merged with newer architectural forms. Beer's designs for St Ursen in Solothurn (1708) and the churches in Ehingen (1712–19), Weingarten (from 1715) and Weissenau (1717–21) have wide, uninterrupted spaces and large openings in their walls, combined with a centralized layout, and clearly go beyond the traditional wall-pillar church. Among the smaller churches the type of the hall church with widened chancel, as represented by Peter Thumb (e.g. pilgrimage church, Neubirnau, 1746–58) and Johann Caspar Bagnato, was widely adopted.

In monastic architecture the pavilion system took on special importance, originating in Tomaso di Comacio's designs and in French châteaux but fully developed for the first time in the monastery of Salem (from 1697) by Franz Beer. In these buildings the principal rooms are housed in accentuated pavilions joined by long wings. A characteristic feature is the grouping of communal rooms in one pavilion, and the addition of the imperial or banqueting hall and the abbot's dining-room, the offices and chancelleries in the middle and corner pavilions respectively. This system, probably developed by Beer and realized in exemplary fashion in such monasteries as Kaisheim (1716–21) and Weissenau (from 1708), was widely used throughout Swabia, especially by Christian Wiedemann, whose buildings in Oberelchingen, Wiblingen (from 1714), Roggenburg (from 1731) and Wald (1721–8) show the various possibilities of this system. It was adopted and disseminated by such master builders as Dominikus Zimmermann, Jakob Emele (1707–80) and many others.

The buildings of such stuccoist–architects as Dominikus Zimmermann (*see* ZIMMERMANN, (2)) are characterized by highly decorative motifs that partly supplement the sometimes excessive stucco decoration (*see also* STUCCO AND PLASTERWORK, §III, 10(i)(e)), giving rise to the Bavarian Rococo church. Examples include churches in Steinhausen bei Schussenried (1727–33) and Günzburg (Frauenkirche, 1736–41) and the pilgrimage church of Die Wies (1744–57; *see* WIES CHURCH), all of which were built on centralized plans. Probably the most important of the stuccoist–architects was Donato Giuseppe Frisoni (1683–1735), who became state master builder in Württemberg (1714) and whose principal work was the enlargement and completion of the palace and town of LUDWIGSBURG. From 1715 he made a major contribution to the architecture of the abbey church at Weingarten (*see* WEINGARTEN ABBEY), and he also produced designs for extensions to the monastery at OTTOBEUREN, so contributing to the dissemination of new Italianate forms in southern Germany.

(ii) Regional development. In Bavaria the influence of northern Italian architecture was spread by the works of Enrico Zuccalli, Lorenzo Sciasca, GIOVANNI ANTONIO VISCARDI and especially such Milanese architects as Francesco Maria Ricchini. Viscardi designed centralized churches in Freystadt (Mariahilf, 1700–10) and Munich (Holy Trinity, 1711–18) and the monastery at Fürstenfeld (1691–1703). Under Joseph Effner and François de Cuvilliés I and II, the French influence was strengthened, as in Effner's remodelling of SCHLOSS SCHLEISSHEIM (1719–26), and the Nymphenburg (from 1714) and Residenz in Munich (*see* MUNICH, §IV, 2 and 3). The church buildings of JOHANN MICHAEL FISCHER are shaped to an exceptional degree by his concern with centralized forms, and they reveal a close study of northern Italian and Bohemian models, particularly in the use of the wall-pillar system. This resulted in such original structures as the monastic churches of Altomünster, Ottobeuren and Rott am Inn (1759–63; see fig. 8), while Diessen, Osterhofen and Zwiefalten retained the traditional longitudinal construction. The phenomenon of the painter- and sculptor-architect attained a special flowering in Bavaria with the work of Cosmas Damian Asam and Egid Quirin (*see* ASAM, (2) and (3)), who had worked at Fischer's church of St Anna am Lehel from 1731–5 and had both studied in Rome. Their most important works, characterized by sophisticated spatial intersections and precisely calculated lighting effects, include monastic churches at Weltenburg (from 1716; consecrated 1718) and Rohr (from 1717).

The development of Franconian architecture was influenced by a variety of sources including the Bohemian buildings of Christoph Dientzenhofer (e.g. St Nicholas, Prague, 1703–11), the churches of Johann Dientzenhofer (e.g. Fulda Cathedral, 1704–12) and Balthasar Neumann (e.g. Hofkirche, Würzburg, 1733; churches in Neresheim, from 1747 (*see* NERESHEIM ABBEY), VIERZEHNHEILIGEN, from 1743); and also by the French-influenced buildings of Leopoldo Retti, Johann Wilhelm von Zocha and Friedrich Wilhelm von Zocha, all of whom worked in the margravate of Ansbach. The planning history of the Würzburg Residenz (*see* WÜRZBURG, §2) indicates how

diverse architectural styles were brought together in a completely original design. It can be seen that not only were Viennese ideas introduced through the designs of Johann Lukas von Hildebrandt and Franco-Rhenish forms through those of Maximilian von Welsch, but that the latest French concepts were also introduced by designs of Robert de Cottes and Germain Boffrand, and by Neumann's journey to Paris (1723) and his consultations with members of the Académie Française.

Gabriel de' Gabrieli was Director of Works in the margravate of Ansbach (1705–16). He had also worked in the bishopric of Eichstätt (e.g. the monastery at Rebdorf) and above all in Eichstätt itself, and his style owes much to the late Baroque architecture of northern Italy. Another Italian, Leopoldo Retti, was Director of Works in Ansbach from 1731 to 1735. His buildings include the Neues Schloss in Stuttgart (from 1744), the Orangery (1735) and the Residenz (1731–8) in Ansbach, as well as numerous churches and palaces in the surrounding area, show a dry, academic style based on French models, which was taken up by Friedrich Wilhelm von Zocha in Ansbach and disseminated more widely. Such architects as Johann Jakob Michael Küchel in Franconia and Gottfried Heinrich Krohne in Thuringia were of more local significance; their works, for example Krohne's Schloss Belvedere (1726–32) near Weimar, aimed to achieve a harmonious assembly of fairly small buildings.

The leading architect in the Rhenish bishoprics was MAXIMILIAN VON WELSCH, who was influenced by French forms, as for example at Schloss Biebrich (from 1707) and the Orangery (1722–4) in Fulda. The Rhenish monasteries comprised interpenetrating wings (in contrast with the pavilion type prevalent in southern Germany) and were influenced by 17th-century Netherlandish architecture. The architecture of the mid-German states was particularly influenced by 17th-century Dutch classicism as developed to an exemplary standard by Jacob von Campen. These forms were mediated by such Dutch architects as Paul Du Ry, a pupil of Jacques-François Blondel. The Palais im Grossen Garten (1678–83; partly destr. 1945; in reconstruction) in Dresden, by Johann Georg Starcke, was the first BAROQUE building in the city; based on Parisian models, it clearly shows French influence. In Westphalia Peter Pictorius II, Gottfried Laurenz Pictorius and Johann Conrad Schlaun contributed to the adoption of Netherlandish–French Baroque classicism. The French architects Zacharias Longuelune and Jean de Bodt were active in Saxony. Contemporary French styles were also spread by the work of Andreas Schlüter (e.g. Berlin, Königliches Schloss, from 1698; see SCHLÜTER, ANDREAS, fig. 2) and George Wenzeslaus von Knobelsdorff (e.g. Stadtschloss, Potsdam, 1744–52; destr. 1945; Schloss Sanssouci, 1745–7; see POTSDAM, §2).

In Dresden extensive building work was carried on under Frederick-Augustus II, Elector of Saxony, including one of the most grandiose plans for a residence, of which the best-known building was the Zwinger (1711–28; rest. after 1945) by Matthäus Daniel Pöppelmann and Balthasar Permoser (see DRESDEN, §IV, 2). Pöppelmann's Pillnitz pleasure palace (from 1720) is typical of the Chinese style of the time, which was frequently used for such pleasure houses as the Pagodenburg (1716–19) by Joseph Effner

in the gardens of the Nymphenburg, the Chinese Tower (1790) in the Englischer Garten in Munich, or the Chinese Tea House (1754) by Johann Gottfried Büring in the park of Sanssouci, Potsdam. In Protestant areas the typical Protestant gallery church was developed, usually a simple hall church with galleries often on several floors. Centralized buildings were widely used, often with a programmatic aim, like those known as churches of peace or grace (e.g. Gnadenkirche, Hirschberg, 1709). One of the most architecturally ambitious churches of the 18th century is the Frauenkirche in Dresden, built by George Bähr (1726–43; destr. 1945; for illustration *see* BÄHR, GEORGE). A massive dome with drum was supported on eight slender, freestanding columns, rising above a square plan. The large size of the dome was determined by the architectural requirements of the city (*see* DRESDEN, §IV, 1).

BIBLIOGRAPHY

H. Popp: *Die Architektur der Barock- und Rokokozeit in Deutschland und der Schweiz*, Bauformen Bibliothek, vii (Stuttgart, 1913)

M. Hauttmann: *Geschichte der kirchlichen Baukunst in Bayern, Schwaben und Franken, 1550–1780* (Munich, 1921)

H. Keller: *Das Treppenhaus im deutschen Schloss- und Klosterbau des Barock* (Munich, 1936)

R. Zürcher: *Der Anteil der Nachbarländer an der Entwicklung der deutschen Baukunst im Zeitalter des Spätbarock* (Basle, 1938)

W. Hager: *Die Baukunst des deutschen Barock, 1690–1770* (Jena, 1942)

W. Sahner: *Deutsch-holländische Wechselbeziehungen in der Baukunst der Spätrenaissance und des Frühbarock* (Gelsenkirchen-Buer, 1947)

H. Müther: *Baukunst in Brandenburg bis zum beginnenden 19. Jahrhundert* (Dresden, 1955)

P. A. Riedl: *Die Heidelberger Jesuitenkirche und die Hallenkirchen des 17. und 18. Jahrhunderts in Süddeutschland* (Heidelberg, 1956)

G. Deppen: *Die Wandpfeilerkirche des deutschen Barock unter besonderer Berücksichtigung der baukünstlerischen Nachfolge von St. Michael in München* (diss., U. Munich, 1957)

W. Fleischhauer: *Barock im Herzogtum Württemberg* (Stuttgart, 1958/R 1981)

N. Powell: *From Baroque to Rococo: An Introduction to Austrian and German Architecture from 1580 to 1790* (London, 1959)

B. Rupprecht: *Die bayerische Rokoko-Kirche*, Münchener Historische Studien, Abteilung bayerische Geschichte, v (Kallmünz, 1959)

H. G. Franz: *Bauten und Baumeister der Barockzeit in Böhmen: Entstehung und Ausstrahlung der böhmischen Barockbaukunst* (Leipzig, 1962)

E. Hempel: *Baroque Art and Architecture in Central Europe: Germany/Austria/Switzerland/Hungary/Czechoslovakia/Poland*, Pelican Hist. A. (Harmondsworth, 1965)

H.-R. Hitchcock: *Rococo Architecture in Southern Germany* (London, 1968)

K. J. Schmitz: *Grundlagen und Anfänge barocker Kirchenbaukunst in Westfalen* (Paderborn, 1969)

H. Keller: 'Deutsche Architektur', *Die Kunst des 18. Jahrhunderts*, Propyläen-Kstgesch., x (Berlin, 1971), pp. 83–117, 187–219

C. Schreiber: *Rathäuser des Barock in Franken, Schwaben und Baden* (diss., Berlin, Freie U., 1973)

Vorarlberger Barockbaumeister (exh. cat., ed. W. Oechslin; Einsiedeln, Fürstensaal, 1973)

N. Lieb: *Die Vorarlberger Barockbaumeister* (Munich and Zurich, 1976)

J. Schmitt: *Der Einfluss der Kölner Jesuitenkirche auf die Kollegskirchen im Rheinland und Westfalen* (Frankfurt am Main, 1979)

B. Evers: *Mausoleen des 17–19 Jahrhunderts: Typologische Studien zum Grab- und Memorialbau* (Aachen, 1983)

K. Harries: *The Bavarian Rococo Church: Between Faith and Aestheticism* (New Haven and London, 1983)

ULRICH KNAPP

5. *c*. 1750–*c*. 1800. In the mid-18th century German architecture participated in the gradual disintegration of the international Baroque style. A great deal of building continued in the old style, especially in the Catholic principalities of southern Germany, but it was accompanied by buildings in such imported national architectural styles as French Rococo, Italian Academicism and English

Palladianism. The eclectic character of mid-18th-century German architecture is exemplified by the work of Frederick II of Prussia's architects in Berlin and Potsdam, notably Georg Wenceslaus von Knobelsdorff (*see* POTSDAM, fig. 2) and Karl von Gontard.

In the late 1760s three buildings were commissioned that announced the formation of a characteristic national style and anticipated the development of German Neo-classicism in the 19th century (*see* §6(ii) below). The palace (1769–73) at WÖRLITZ was built for Francis, Prince of Anhalt-Dessau, by Friedrich Erdmannsdorff and has been seen as the first Neo-classical building in Germany, being closely modelled on English Palladian houses. It was conceived as an English country house, or summer residence, and eschewed external decoration, relying instead on the relation of wall, fenestration and a portico. It was the centrepiece of a park to which was later added a Gothic house and an iron bridge modelled on Coalbrookdale in England. A somewhat grander example of nascent Neo-classicism is the monastery of St Blasien (1768–83) in the Black Forest by Pierre-Michel d'Ixnard. Both buildings represent progressive versions of the traditional commissions of palace and church, yet Simon Louis Du Ry (*see* DU RY, (4)) showed how the Neo-classical style could be used to fulfil the unprecedented commission of a public museum in Kassel by the Landgrave of Hesse-Kassel. The Museum Fridericianum (1769–79) was stylistically the most conservative of the three buildings. It nevertheless anticipated the new tasks presented to architects in the following century. They were called on to produce public buildings to serve the needs of a modernizing society, and they did so by an exploration of the limits of a traditional architectural vocabulary.

BIBLIOGRAPHY

T. Mellinghof and D. Watkin: *German Architecture and the Classical Ideal, 1740–1840* (London, 1987)

6. *c.* 1800–*c.* 1900.

(i) Introduction. (ii) Neo-classicism. (iii) Schinkel and the development of *Rundbogenstil*. (iv) Renaissance Revival and late 19th-century developments.

(i) Introduction. Architecture played a key role in the political and industrial modernization of Germany in the 19th century. During this period a traditional rural society scattered across 300 political units transformed itself into a single urban, industrial and politically centralized imperial nation state. Architecture both contributed to and reflected this transition. It sought to shape the national aspirations of German society at the same time as meeting the unprecedented demands for buildings intended for public administration, worship, education, dwelling, recreation and business. The resulting tension between aesthetic and practical demands produced the combination of prosaic function and extravagant façade evident in much of the architecture of this period. German architecture at this time exemplifies the uneasy settlement between traditional forms and modern content; the general problem of accommodating new building types within a traditional stylistic syntax characteristic of 19th-century European architectural history. Architects sought to meet new demands with old styles, masking their use of innovative constructional techniques with traditional façades. For this reason the period has been described as one of 'architectural historicism' and divided chronologically and regionally in terms of such stylistic revivals as Neo-classicism, neo-Renaissance and neo-Baroque. Such stylistic diversity was, however, predicated on innovations in engineering and the use of new materials and building techniques.

The adaptation of traditional forms to new uses was not restricted to buildings designed by architects. Even those factories and storage spaces built by craftsmen or engineers to house industrial production reworked traditional vernacular forms. Early 19th-century machine-houses for factories were often built in the form of churches. The basilica form was also carried over into the first German iron and glass construction, the Royal Prussian Ironworks (1824–30) by Carl Ludwig Althans (1788–1864) at Sayn bei Neuwied. In it the traditional form and new construction techniques are inconspicuously synthesized. This was not the case in much subsequent factory and railway architecture, in which architects added historicist façades intended to conceal the main engineer-designed building.

(ii) Neo-classicism. The period during which Althans was building the Ironworks also marked the zenith of German Neo-classicism. A close relationship existed between the engineering proficiency evinced by Althans's work and the well-known Neo-classical buildings of Karl Friedrich Schinkel in Berlin, Friedrich Weinbrenner in Karlsruhe, and Karl von Fischer and Leo von Klenze in Munich. These architects discovered their architectural vocations in the Berlin Bauschule building (Bauakademie from 1799) established by David Gilly (*see* GILLY, (1)) in 1793. Gilly had considerable experience of provincial civil engineering, and his publications and the curriculum of his school stressed the importance of engineering and technical innovation in architecture. His approach in many respects anticipated Etienne-Louis Durand's subsequent teaching at the Ecole Polytechnique in Paris.

Gilly was also receptive to the stylistic innovations proposed by Neo-classical architects active in Berlin. Foremost among these were Carl Gotthard Langhans, who built the Brandenburg Gate (1788–91), inspired by an engraving of the Propylaia on the Athenian Acropolis; and Karl von Gontard and Friedrich Erdmannsdorff, who had worked on the interior of the Berlin Königliches Schloss in 1787. Stylistic implications of Neo-classicism were taken to their extreme in the work of Friedrich Gilly. Despite a tragically early death, Gilly inspired a generation of architects and defined German Neo-classicism. His largely unexecuted work combined visionary flights with an attention to technical detail. His famed project for a memorial to Frederick the Great (for illustration *see* GILLY, (2)) shows the visionary extreme of Neo-classicism; it was submitted to a competition proposed by the Akademie der Künste of Berlin in 1797, which also attracted entries from Langhans, Heinrich Gentz, Erdmannsdorff and Aloys Hirt. This monumental proposal should, however, be contrasted with other projects for industrial architecture that show Gilly to be ahead not only stylistically but also technically of many German architects of the following century. Nevertheless, Gilly's immediate influence on

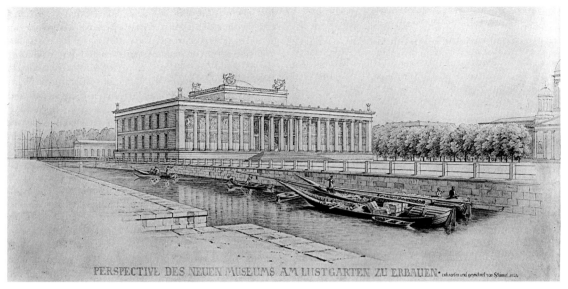

PERSPECTIVE DES NEUEN MUSEUMS AM LUSTGARTEN ZU ERBAUEN.

9. Karl Friedrich Schinkel: perspective drawing for the Altes Museum, Berlin, pen and black ink and wash over pencil, 407×635 mm, 1823 (Berlin, Alte Nationalgalerie)

architecture was stylistic. He inaugurated a monumental, tectonic style that had many imitators at the turn of the century. The most important examples are the Royal Mint (1798–1800; destr. 1886), Berlin, by Gentz (with Gilly's collaboration), and Peter Speeth's women's prison (1811, 1826–7) in Würzburg, which also shows the influence of French revolutionary architecture. With both buildings, however, a severe Neo-classicism serves as a façade to otherwise unremarkable buildings. This was even more pronounced in many provincial buildings erected in the Neo-classical idiom.

With some individual exceptions, this attention to Neo-classicism as a style also describes the more tempered, academic Neo-classicism of Friedrich Weinbrenner in Karlsruhe in the early 19th century, as well as the eclecticism of LEO VON KLENZE. Klenze's remarkable career ranges from the Renaissance Revival Leuchtenbergpalais (1818–21) in Munich to the Glyptothek (1816–30; rest. 1972) through to the Bavarian Hall of Fame (1841–50). Both architects used Neo-classical forms to solve new architectural problems though with varying degrees of success. The style and the substance of the building were often incongruously juxtaposed. Klenze's Alte Pinakothek (1826–36), for example, serves its function as an art gallery well, but its central portico is entirely decorative, the entrance being to the side of the building. His Walhalla (1830–42) near Donaustauf is a late epitome of Neo-classicism. It was intended to be a Greek temple and therefore takes the form both internally and externally.

(iii) Schinkel and the development of Rundbogenstil. The urban planning and architectural achievements of Weinbrenner and Klenze were surpassed by the work of KARL FRIEDRICH SCHINKEL in Berlin. He realized and developed the technical and stylistic innovations proposed by David and Friedrich Gilly. During the Napoleonic Wars there was little building activity in Berlin, in contrast to the southern principalities allied to Napoleon. With the cessation of hostilities, Schinkel, who had resorted to painting dioramas during the wars, was appointed state architect, and he began an architectural career of unprecedented influence. His first building, the Neue Wache (1816; interior rebuilt), is close to the tectonic classicism of Friedrich Gilly's sketches, but his masterpiece, the Schauspielhaus (1818–21; rebuilt 1980s as a concert hall), is marked by the Romantic–Classicist interpretations of this style while remaining true to the Gillys' attempt to unite the style and substance of a building. ROMANTIC CLASSICISM was formed by the union of romantic sentiment with classical motifs and found expression in the monumental architecture of the German Neo-classicists. Schinkel's museum (1823–30; partially restored 1960s; now the Altes Museum; see fig. 9) in Berlin, however, is controversial in this respect: for some historians it is a brilliant formal and technical solution to the problem of exhibiting works of art, while for others it is a building that superimposes an inappropriate Neo-classical façade on a modern building.

During the 1820s Schinkel responded to new demands for inexpensive public buildings as well as to the technical advances being made by engineers in producing factory buildings. His notebooks from a visit to France and England in 1826 evince a growing fascination with buildings not designed by architects, notably factories in Manchester. Schinkel's projects from the 1820s and 1830s sought to meet new demands for such buildings as museums, department stores and warehouses by an extended architectural vocabulary that incorporated the technical and stylistic possibilities opened up by engineers' building activities. Projects realized included the Neue Packhof warehouse complex (1829–32) and the brick Bauakademie (1831–5; destr. 1961), unquestionably Schinkel's most modern building and one that he considered his masterpiece.

Schinkel was adept at working in several historical styles and yet managed both to avoid pastiche and to produce

unmistakably modern buildings. His palace work at Charlottenhof and Klein-Glienecke in 1826 shows his facility in both Neo-classical and Renaissance styles, while Babelsburg (1834) is a clear citation of the Gothic. His Friedrich-Werdersche-Kirche (1824–30), which was originally planned as Neo-classical, emerged as neo-Gothic, while his four parish churches for the new suburbs of a rapidly expanding Berlin are in Neo-classical and Renaissance Revival styles. Of these the Nazarethkirche (1832) and the St-Johannes-Kirche (1832–5) are convincing syntheses of the Classical pediment and Renaissance arch, a synthesis that was being earnestly sought after by the new generation of architects.

Schinkel produced a school of architects who on the whole developed only the stylistic implications of his work. Such followers as Ludwig Persius, Friedrich Hitzig and Friedrich August Stüler remained within a historicist framework and did not develop the revolutionary implications of the façadeless Bauakademie. Stüler did make interesting use of glass and iron in his Neues Museum (1843–50), Berlin, but did not extend its implications into the imposing façade. Similarly, the unexecuted design for a machine-house for the fountains at Potsdam proposed by Persius in 1842 is clothed in the style of a Renaissance villa. However, on the explicit wish of Frederick William IV, the machine-house was built by Persius as a mosque, with the chimney for the steam engine as a minaret. Overall, the reaction of a younger generation of architects against Neo-classicism was stronger among the pupils of the more doctrinaire southern architects. This reaction took the form of the development of a new style in the 1820s, in which arches were favoured over columns and trabeation.

RUNDBOGENSTIL describes both a stylistic programme and a general tendency in public building dominant in Germany in the 1830s and 1840s. It was a transitional style between the Neo-classicism of the early decades of the 19th century and the Renaissance Revival prevalent after the 1840s. In many respects it was anticipated by Klenze and Schinkel, especially in the latter's parish churches, but it was considered by its practitioners to mark a radical departure from the practice of the elder architects. *Rundbogenstil* as an architectural programme was announced by HEINRICH HÜBSCH in his polemic *In welchem Style sollen wir bauen?* (1828), in which he argued for the technical advantages of building with arches. Hübsch succeeded Weinbrenner as Director of Building in Baden in 1829. He opposed the monumental façades of Neo-classicism with the sobriety of such buildings as the Finanzministerium (1829–33) and Technische Hochschule (1833–6; altered) in Karlsruhe. Hübsch's polemic offered a manifesto for an existing and growing tendency in architecture. It was widely represented in official buildings, especially in southern Germany and also in Hamburg. In Munich, Klenze's younger rival Friedrich von Gärtner built the extremely elegant Staatsbibliothek (from 1832) on the Ludwigstrasse, while in Hamburg the Johanneum (1837–40; destr. World War II) by Carl Ludwig Wimmel and Franz Forsmann (1795–1878) showed an evolution of the style. Indeed, Hübsch's attempt to transform style into constructional technique led to the Renaissance Revival

style, which was predicated on this constructional technique.

(iv) Renaissance Revival and late 19th-century developments. Architectural historians distinguish between the Renaissance Revival of the 1830s–1840s and that of the 1860s–1870s. The former, exemplified by the work of GOTTFRIED SEMPER, was closely tied to the liberal nationalism that sparked the revolution of 1848 in which Semper participated in Dresden. He developed the *Rundbogenstil* into the RENAISSANCE REVIVAL; in Dresden his synagogue (1838–41) remains in the earlier style, while the Opera House of the same period modulates the construction into a Renaissance façade that evokes the aristocratic republicanism of the Renaissance cities. This phase of Renaissance Revival incorporates the official sobriety of the *Rundbogenstil* with a celebration of the building's availability to the public.

The Renaissance Revival of the 1860s is of a quite different character. Here the stylistic tropes are more grandiose and imposing and mark the transition to the neo- or Wilhelmine Baroque of the German empire. The late 19th century was a time of unprecedented stylistic eclecticism. The Rathaus (1861–9) in Berlin, built by Hermann Friedrich Waesemann (1813–79), is an extraordinary combination of Renaissance and Flemish details, while the Munich Rathaus (1867–74; second phase 1888; third phase from 1899) by Georg von Hauberisser is built in a formidable neo-Gothic style. The Bavarian castles commissioned by Ludwig II—from Georg von Dollmann's Schloss Linderhof (1874–5) to Neuschwanstein (from 1868; *see* CASTLE, fig. 12) by Eduard Riedel (1813–85) and Dollmann—mark a Rococo Revival more extravagant than the original. The Imperial style of the last decades of the 19th century was overwhelmingly neo-Baroque. Façades with colossal orders were added to buildings ranging from Berlin tenement houses to Friedrich Hitzig's Berlin Exchange (1859–63). The neo-Baroque reached its apogee in two major imperial commissions for central Berlin. The first was the monumental Reichstag building (see fig. 10) by PAUL WALLOT, the design of which won a competition in 1882 and which was built between 1884 and 1894, and Berlin Cathedral (designed 1888; built 1894–1905) by JULIUS RASCHDORFF.

The schemes for the Reichstag and cathedral were accompanied by a growing revulsion among the public, architects and even the Emperor against the architectural gargantuanism that modern building techniques had made possible. Architects began increasingly to abandon stylistic historicism in favour of the search for a new architectural vocabulary appropriate to the advances in architectural technique. The work of such *Jugendstil* architects as August Endell in Munich (e.g. Studio Elvira, 1896–7; destr. 1944; *see* ART NOUVEAU, fig. 4) and Henry Van de Velde in Berlin and Weimar, and such buildings as the Wertheim Department Store (1896–8; destr.; see fig. 11) in Berlin by ALFRED MESSEL, intimate the anti-historicist Modernism that came to dominate 20th-century architecture.

See also VERNACULAR ARCHITECTURE, §II, 1(iii).

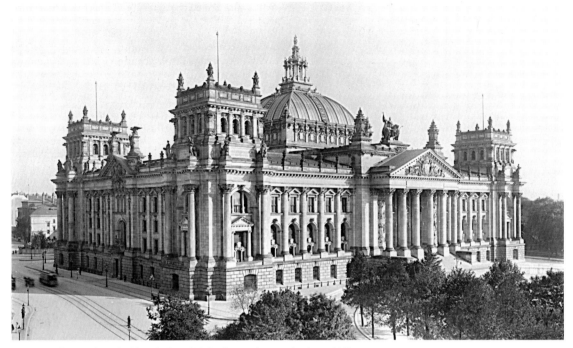

10. Paul Wallot: Reichstag building, Berlin, 1884–94; from a photograph taken *c.* 1905

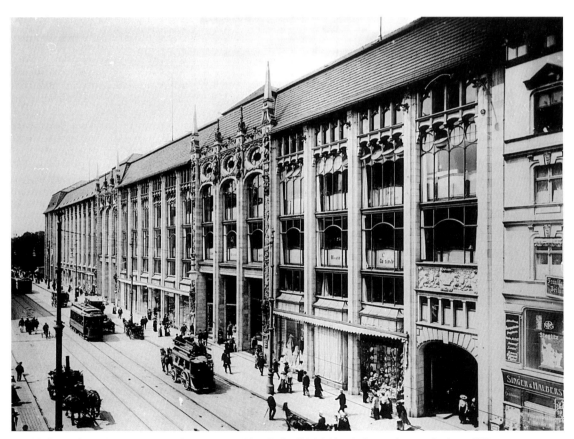

11. Alfred Messel: Wertheim Department Store, Leipziger Platz, Berlin, 1896–8 (destr.); from a photograph taken *c.* 1900

BIBLIOGRAPHY

S. Giedion: *Spätbarocker und romantischer Klassizismus* (Munich, 1922)
W. Hermann: *Deutsche Baukunst des 19. und 20. Jahrhunderts*, 2 vols (Breslau, 1932/*R* Basle and Stuttgart, 1977)
H.-R. Hitchcock: *Architecture: Nineteenth and Twentieth Centuries*, Pelican Hist. A. (Harmondsworth, 1958, rev. 4/1977)
J. Paul: *Einführung in die Architektur des Historismus im 19. Jahrhundert* (n.p., 1974)
K. Döhmer: *'In welchem Style sollen wir bauen?': Architektur Theorie zwischen Klassizismus und Jugendstil* (Munich, 1976)
G. Dresbusch: *Industrie Architektur* (Munich, 1976)
K. Milde: *Neorenaissance in der deutschen Architektur des 19. Jahrhunderts* (Dresden, 1981)

HOWARD CAYGILL

7. AFTER *c.* 1900.

(i) Before World War II. (ii) After World War II.

(i) Before World War II. In the first decade of the 20th century Historicism and academicism were superseded by originality, pathos and authenticity. Although *Jugendstil* remained only a marginal phenomenon in German architecture, it persisted until the beginning of World War I. It informed Josef Maria Olbrich's work on the Mathildenhöhe (1899–1914), Darmstadt, and Henry Van de Velde's designs for the Kunstgewerbe exhibitions at Dresden (1906) and Cologne (1914). It was characterized by organic forms used decoratively and a fanciful approach to proportions. Alongside *Jugendstil* was monumentalism, in which the load-bearing elements of buildings were visible and consciously emphasized. The effect of such features was heightened by contrasting the various building materials and introducing archaic motifs. Architects associated with this style of architecture include FRITZ SCHUMACHER and WILHELM KREIS.

The influence of the English Arts and Crafts Movement was brought to bear by Hermann Muthesius after his return from London (1903; *see also* §V, 5 below). Also, in the wake of the Kunstgewerbe exhibitions the DEUTSCHER WERKBUND was founded (1907), with a number of architect members and an aim of developing cooperation between architect–designers and industry to create a socially cohesive synthesis through the improved design of compatible, mass-produced goods. Urban architecture also required a new, neat functional style due to the immense housing problems in industrial centres. HEINRICH TESSENOW, THEODOR FISCHER and RICHARD RIEMERSCHMID formulated urban plans, garden cities and workers' settlements (e.g. Fischer and Riemerschmid's work at the garden city of HELLERAU, 1909–11), taking over and further developing the concepts of English Arts and Crafts. HANS POELZIG and PETER BEHRENS introduced new purposeful forms into industrial architecture, for example Behrens's AEG turbine factory (1909), Berlin (*see* MODERN MOVEMENT, fig. 1). A conflict developed, however, between those who wished to standardize and industrialize the building process (led by Muthesius) and the advocates of traditional building methods, the Expressionists (led by Van de Velde). Van de Velde demanded that industry should follow artists' craft models and not the other way round, but this position was generally abandoned after World War I.

After World War I most of the younger members of the Werkbund joined the ARBEITSRAT FÜR KUNST, a group of radical architects, artists and critics founded by Bruno Taut in Berlin in 1918. The Gläserne Kette, a correspondence group led mainly by Bruno Taut and Max Taut (*see* TAUT), came into being in 1919 and shared a largely common membership with them. In the immediate postwar years these architects published a number of Utopian urban plans with expressionistic glass architecture, the form of which was conceived as a synthesis of the arts. Due to the economic depression many remained unexecuted, but such ideas posited a claim, which the radical modern age of the Weimar Republic took over. The desire was not so much to be modern as to be ahead of industrial and social development.

In this climate a number of artists' associations were formed along the lines of medieval workshops, bringing together all branches of the arts, and the Staatliches Bauhaus was founded in Weimar in 1919 by the merging by WALTER GROPIUS of the Kunstgewerbeschule and the Kunstakademie (*see* BAUHAUS). The architects who worked and taught there included LUDWIG MIES VAN DER ROHE, LUDWIG HILBERSEIMER and HANNES MEYER. During the Weimar period several architectural trends came to the fore. Expressionism and its aim to free architecture from the confines of the norm (*see* EXPRESSIONISM, §2) were represented by Erich Mendelsohn in such works as his Einstein Tower (1920–24), Potsdam (*see* MENDELSOHN, ERICH, fig. 1). Such architects as HANS SCHAROUN and HUGO HÄRING and the critic Adolf Behne supported the concept of ORGANIC ARCHITECTURE within a modern age. Using expressionistic forms they sought to meet the frequently repeated expectations as regards living needs. In church architecture OTTO BARTNING and Dominikus Böhm (*see* BÖHM (ii), (1) and fig.) were particularly significant.

Expressionism had had some bearing at the Bauhaus in its early period, but it was superseded by an architecture that developed from an aim to produce anonymous, industrially standardized mass settlements—machines for living in—that would liberate people from material worries and enable them to live unfettered lives. Hilberseimer was the most radical representative of this approach, exemplified in his proposals for new towns to house millions. Relatively little was achieved; ERNST MAY, as city architect

12. Walter Gropius (with Adolf Meyer): Bauhaus buildings, Dessau, 1925–6

of Frankfurt am Main, was able to realize only his plans for Römerstadt (1926–30), Praunheim (1927–30) and Westhausen (1930). The thrust of the Bauhaus's teaching evolved, however, influenced by Vasily Kandinsky and El Lissitzky and Russian Constructivism, and by LÁSZLÓ MOHOLY-NAGY and his promotion of Functionalism. By 1925, when the Bauhaus relocated to Dessau, its new outlook was reflected in its new buildings by Gropius (with Adolf Meyer; see fig. 12). Similarly, DER RING had been founded in Berlin by a group of architects whose aim was to promote Modernism. By 1926 the group's membership had widened to encourage the development of a non-rhetorical international architecture, logical as to function and construction, and sometimes described as Neue Sachlichkeit. It was exemplified in the Berlin *Siedlungen* on which many of Der Ring's members collaborated.

The cultural battle between modernists and traditionalists continued, however, and was again highlighted in the Werkbund's Weissenhofsiedlung exhibition of a model housing estate in STUTTGART, in which almost all the internationally known architects participated (for illustration *see* DEUTSCHER WERKBUND). The spokesmen for the conservatives were PAUL BONATZ and PAUL SCHMITTHENNER. Bonatz in particular, in his Stuttgart railway station (designed 1913; completed 1928), represented monumental architecture, which attached great importance to the expressive qualities of the materials and proportions of a building. Schmitthenner was the leading representative of the domestic style in neighbourhood housing, deriving the form and material of his architecture from local traditions. In doing so, he aimed to counteract the loss of tradition and sense of home in modern industrial society. A similar approach inspired the third protagonist of the conservatives, PAUL SCHULTZE-NAUMBURG, who harked back more particularly to the beginning of bourgeois architecture *c*. 1800. Bonatz and Schmitthenner formed Der Block.

Shortly after 1933 the National Socialists ended the struggle between conservatives and modernists. Modernist schools were closed, and the leading representatives of the movement were forced into exile. However, those architects who had hoped for employment as state architects were also disappointed: their provincialism did not satisfy the Nazi aspirations to world power through architecture. The Third Reich had no new architectural programme, following instead the dilettantism of Adolf Hitler, who took as his model the work of PAUL LUDWIG TROOST, characterized for example by the Haus der Deutscher Kunst (1933), Munich. In the absence of any great talent, Troost drew on classicism, and in the mid-1930s Hitler gave him a few commissions for buildings. When Troost died in 1934 ALBERT SPEER became state architect, executing such works as the Reichskanzlei (1939; destr.), Berlin. He set up a building industry capable of realizing the large-scale projects of the Third Reich. By completely transforming Berlin Speer created a model for all German cities (*see* BERLIN, §II, 4). Megalomaniac buildings based on the classical style, constructed on enormous coordinate axes, represented the power and magnificence of the state. Such plans, unqualified in every aspect, remained Utopian. Towards the end of World War II the large architectural

bureaux were occupied with repair work and thus had considerable influence on the post-war reconstruction of devastated towns. The neighbourhood style of architecture continued to be confined to a few settlements. The Modern Movement survived in industrial architecture through the works of HERBERT RIMPL.

(ii) After World War II. Rudolf Wolters, Friedrich Tamms, Helmut Hentrich, Hanns Dustmann and Julius Schulte-Frohline planned the reconstruction of Düsseldorf; Friedrich Hetzelt and Herbert Rimpl worked in Wuppertal; Konstanty Gutschow and Rudolf Hillebrecht (*b* 1910) led the rebuilding of Hamburg and Hannover and influenced the work in other towns. All of these men belonged to the reconstruction bodies established by Speer and possessed the relevant experience. In Düsseldorf and Wuppertal the system of coordinate axes introduced during the Third Reich was retained, but the shapes of the houses and façades were simplified and modernized.

In other towns there were architects who strove to revive the Modern Movement. Hans Schwippert (1899–1973), who had developed a plan for the reconstruction of Aachen as early as 1945, became a pioneer of urban architecture. With dispersed buildings separating traffic and functional areas, the concept of the garden city was revived. It was with this intention that Hans Scharoun drew up a new plan for Berlin (1946; unexecuted), while Gutschow, Hillebrecht and Werner Hebebrand (1899–1966) carried out a similar concept for Hannover (1948), which found its first expression in the *Constructa* project. Another remarkable achievement was the reconstruction of COLOGNE, mainly under the direction (1946–52) of Rudolf Schwarz in collaboration with Wilhelm Riphahn, Franz Ruf and Sep Ruf. They strove to harmonize traditional and contemporary architecture while preserving buildings that had remained unscathed, creating a marked contrast in a new heterogeneous urban plan with buildings repaired in the new formal language. The rebuilding of Münster and Nuremberg followed a similar pattern. Equally respectful and sensitive in his treatment of the differences was Hans Dollgast (1891–1974), whose most important work at this time was the restoration (1952–7) of Leo von Klenze's Alte Pinakothek in Munich.

Alfons Leitl had laid a foundation stone for the post-war Modern Movement with the restoration of Rheydt, which helped to establish this variation of forms against the conservative conceptions of a closed town picture. Forming part of this freer style was the light, soaring glass architecture especially favoured by Paul Schneider-Esleben (*b* 1915), EGON EIERMANN, Bernhard Pfau (*b* 1902), Dieter Oesterlen (*b* 1911) and many others. Efforts were made to link up again with the most recent trends in international architecture, and many influences from the USA, Scandinavia and Italy were reworked. In this connection high-rise architecture also underwent a renaissance, as in the Drei-Scheiben-Haus (1955), Düsseldorf, by HELMUT HENTRICH and Hans Hauser. Most architectural energy was, however, expended on cultural buildings, and church architecture established itself even more as a field for experiment in new ideas. The new, pre-World War II modernist ideas of Bartning and Böhm were

developed by Gottfried Böhm (*see* BÖHM (ii), (2)), RU-
DOLF SCHWARZ and many others, only to end in a general
effort to please all and sundry.

In East Germany, Hermann Henselmann, a former
Bauhaus student, began by collaborating with Scharoun's
Planungskollektiv in Berlin, but, as ideologies polarized,
turned to characteristic Stalinist axial monumentality in
response to Walter Ulbricht's anti-modernist rules for
urban planning (proclaimed 27 July 1950). The first phase
of the Stalin Allee (1952–8; now Frankfurterallee), Fried-
richshain, Berlin, uniform seven- and eight-storey blocks
with standard cornices on both sides of a monumentally
scaled avenue, is characteristic of 1950s reconstruction in
central areas of other East German cities: Wilhelm-Pieck-
Allee (1953–64) in Magdeburg; Rossplatz (1953–9), Leip-
zig; and the Marktplatz (1953–7), Dresden. Rehousing in
the 1950s ranged from Henselmann's nine-storey Hoch-
haus Weberwiese (1951–2), East Berlin, to Ernst May's
Grosssiedlung Neue Var (1957–62), Bremen, both remi-
niscent of Modern Movement blocks of flats of the late
1920s. In continuance of the same tradition was the
Internationale Bauausstellung (Interbau; 1957–61), Han-
saviertel, Berlin: contemporary German architects (Eier-
mann, Schneider-Esleben) and survivors of the heroic
period (Max Taut, Wassili Luckhardt) as well as members
of the international 'old guard' (Le Corbusier, Gropius,
Alvar Aalto, Oscar Niemeyer) designed the individual
Objekte that were disposed across the Tiergarten. Among
the earliest and best-known post-war cultural buildings
were Egon Eiermann's Kaiser-Wilhelm-Gedächtnis-
Kirche (1955–63), isolated in the Breitscheidplatz, and
Scharoun's neo-expressionist Philharmonie (1956–63; for
illustration *see* SCHAROUN, HANS), on the southern edge
of the Tiergarten, both in Berlin. The latter was highly
influential on modern post-war theatre design.

By the end of the 1950s an economic upsurge had made
architecture economically viable, thus causing an even
greater change in the appearance of both large and small
towns than that wrought by war. Development of new
techniques and processes led to new, but rarely futuristic
forms. International attention was, however, gained by
such works as the Olympiapark (1967–72), Munich, by
GUNTHER BEHNISCH and FREI OTTO; Otto designed the
complex construction of the free spanning tent roof with
counterfort masts and perspex skin (for illustration *see*
TENSION STRUCTURE). Other examples of post-war mod-
ernism include Dieter Oesterlen's Historisches Museum
am Hohn Ufer (1960–66), Hannover; the minimalist Neue
Nationalgalerie (1962–8), Berlin, by Mies van der Rohe;
and the Rathaus (1967–71), Bensberg, near Cologne, by
Gottfried Böhm (see fig. 13). At the same time a decisive
influence on the shape of German architecture was Ernest
Neufert, whose views on the standardization and ration-
alization of the building industry reached back into the
Third Reich. This gave rise to the extensive housing estates
of the 1960s, such as the Märkische Viertel in Berlin (*see*
BERLIN, §II, 5) under the direction of Werner Düttmann,
which became a byword for unsuccessful building policy.
There was a general, popular opposition to Modernism at
this time, which concentrated its efforts on the care and
preservation of monuments.

13. Gottfried Böhm: Rathaus (1967–71) incorporating remains of
the Alte Burg (13th century), Bensberg; village houses at front of
photograph

By the 1970s Germany faced a primary aim of aesthetic
urban renovation, with the artistic shaping of museums as
an immediate task, since it had been largely neglected after
the war. Pioneers included HANS HOLLEIN, with the
museum in Mönchengladbach (1972–82; *see* MUSEUM,
fig. 9), and Alexander Freiherr von Branca with the Neue
Pinakothek in Munich. OSWALD UNGERS built the
Deutsches Architekturmuseum (1979–84), Frankfurt, in
the shell of a 19th-century town house, introducing a
geometrical order derived from historical perspective, thus
achieving a proportional rapport between the old and the
new. This methodical Post-modernism also distinguished
the work of JOSEF PAUL KLEIHUES, who was appointed
director of a new International Bauausstellung, held in
Berlin in 1979, and it contrasted with the direct borrowing
of motifs from the history of building. It endorsed a return
to the closed façade complex in the form of line or block
architecture. An international array of architects was
invited to recreate traditional urban typologies including
housing, along lines first proposed by Aldo Rossi and
Giorgio Grassi, who with others such as Rob Krier (*see*
KRIER, (1)) and Hollein were among those commissioned
to design new buildings. Many but not all of the buildings

were completed before the momentous events of the late 1980s resulting in the reunification of Germany. The city of Berlin immediately decided to embark on a programme of reconstruction of the central area, for which a masterplan by Heinz Hilmer (*b* 1936) and Christoph Sattler (*b* 1938) won the competition of 1991. Adjacent buildings next to Schinkel's Schauspielhaus were commissioned from Ungers, Jean Nouvel and I. M. Pei in 1992.

BIBLIOGRAPHY

G. A. Platz: *Die Baukunst der neuesten Zeit*, Propyläen-Kstgesch. (Berlin, 1927)
G. Hatje, H. Hofmann and K. Kaspar, eds: *New German Architecture* (London, 1956)
J. Posener: *Anfänge des Funktionalismus: Von Arts und Crafts zum Deutschen Werkbund* (Berlin, Frankfurt and Vienna, 1964)
A. Teut: *Architektur im Dritten Reich, 1933–1945* (Berlin, Frankfurt and Vienna, 1967)
B. Miller-Lane: *Architecture and Politics in Germany, 1918–1945* (Cambridge, MA, 1968)
W. Pehnt: *German Architecture, 1960–1970* (London, 1970)
——: *Die Architektur des Expressionismus* (Stuttgart, 1973)
H. Schnell: *Der Kirchenbau im 20. Jahrhundert in Deutschland* (Munich and Zurich, 1973)
J. Petsch: *Baukunst und Stadtplanung im Dritten Reich* (Munich and Vienna, 1976)
H. Klotz: *Architektur in der Bundesrepublik* (Frankfurt, Berlin and Vienna, 1977)
J. Campbell: *The German Werkbund: The Politics of Reform in the Applied Arts* (Princeton, 1978; Ger. trans., Stuttgart, 1981)
N. Huse: *'Neues Bauen' 1918 bis 1933: Moderne Architektur in der Weimarer Republik* (Berlin, 1980/*R* 1985)
K. Frampton: *Die Architektur der Moderne: Eine kritische Baugeschichte* (Stuttgart, 1983)
H. Klotz: *Moderne und Postmoderne: Architektur der Gegenwart, 1960–1980* (Brunswick, 1984)
M. Schreiber, ed.: *Deutsche Architektur nach 1945* (Stuttgart, 1986)
H. Schubert: *Moderner Museumsbau* (Stuttgart, 1986)
W. Durth and N. Gutschow: *Träume in Trümmern: Planungen zum Wiederaufbau zerstörter Städte im Westen Deutschlands, 1940–1950*, 2 vols (Brunswick, 1988)
A. Aman: *Architecture and Ideology in Eastern Europe during the Stalin Era* (New York, 1992)
G. G. Feldmeyer: *The New German Architecture* (New York, 1993)
J. Zukowsky, ed.: *Building in Germany between the World Wars* (Munich and New York, 1994)

ACHIM PREISS

III. Painting and graphic arts.

1. Before *c.* 1400. 2. *c.* 1400–*c.* 1600. 3. *c.* 1600–*c.* 1750. 4. *c.* 1750–*c.* 1900. 5. After *c.* 1900.

1. Before *c.* 1400.

(i) Carolingian. Charlemagne made the cultivation of art a part of his ambitious political programme, and the earliest painting in Germany to evince high artistic claims emerged at the end of the 8th century AD (*see* CAROLINGIAN ART, §IV). This entailed replacing the pagan, Germanic sense of form found in ornamentation with a Christian–Roman art of three-dimensional figures and spatial representation. In addition, there was a desire to re-establish the traditions of the ancient Roman Empire. These aims could be achieved only by imitating imported Byzantine art and with the help of Byzantine artists. This explains the lack

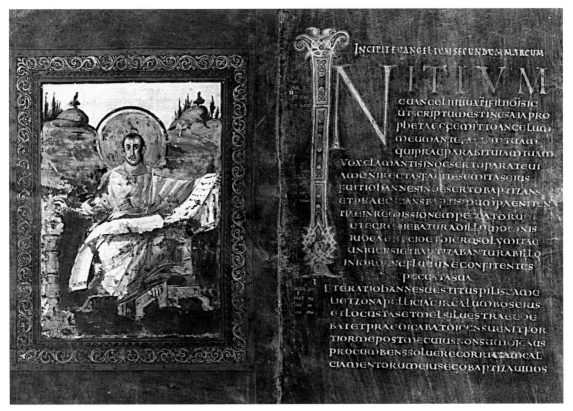

14. *St Mark the Evangelist* and the beginning of the Gospel according to St Mark, gold and silver ink and gouache on purple-dyed vellum, 324×249 mm (page size), from the Coronation Gospels, late 8th century (Vienna, Schatzkammer, SCHK XIII 18, fols 76*v* and 77*r*)

of unity of non-indigenous, Carolingian art, which was centred on the Emperor's residence at Aachen.

Painting was used to adorn the walls of churches and palaces, although only small fragments of the wall paintings survive, for example those in the monastery at Lorsch and in St Maximin in Trier (both mid-9th century; *see* CAROLINGIAN ART, fig. 5). Illuminated manuscripts, however, give a detailed picture of the art produced at the time. They indicate the importance that the Emperor attached to the book as an instrument for education and communication, such that writing and thinking evangelists became the most important motifs. The sumptuous illustrations of the sacred codices reflect their function of making the word of God the basis of Christian culture, while those in works by ancient authors are generally simpler.

The east Frankish manuscripts, the exact origin of which cannot be determined, may be divided into three groups: the most important is the Ada group, named after the donor, Äbtissin Ada, of the main work in Trier (Stadtbib., Cod. 22); the first influential work of this group is the liturgical book produced by the scribe Godescalc (781–3; Paris, Bib. N., MS. nouv. acq. Lat. 1203; *see* CAROLINGIAN ART, fig. 6). The style of these works characteristically combines monumentality and linear clarity with an agitated depiction of space and figures. Distinct from this is the nervous, picturesque and atmospheric style of the second group (formerly known as the Palace school), which is clearly derived from models of Late Antiquity. The main work of this group is the Coronation Gospels (late 8th century; Vienna, Schatzkam.; see fig. 14), in which a feeling for landscape is also apparent. The third group, produced in St Gall Abbey, still owes much to traditional ornamental thinking, but its style led to much inventive ornamentation of initials here and in other schools.

(ii) Ottonian and Romanesque. As the power of Charlemagne's successors waned, the vigour of painting also declined. It began to recover only with the coronation of Holy Roman Emperor Otto I in 962. The 'Ottonian Renaissance' used Carolingian models while absorbing new Byzantine influences (*see* OTTONIAN ART, §IV); Otto II married the Byzantine princess Theophano (*c.* 956–91). The centres of this new artistic flowering were no longer the courts but the monasteries, such as those under Gero, Archbishop of Cologne (*d* 976), and Bernward, Bishop of Hildesheim, on the island of Reichenau, in Trier, and in Fulda, Regensburg, St Gall, Corvey and ECHTERNACH. Ottonian painting is generally distinguished from Carolingian through its heightened spirituality; a more complete fusion of elements from Late Antiquity with the abstract decorative idiom; greater aristocratic dignity; and a more refined use of colour. Some of the best achievements of this epoch are also to be found in manuscript illumination. Outstanding examples are such manuscripts produced on Reichenau as for instance the Bamberg Apocalypse (Bamberg, Staatsbib., MS. Bibl. 140) and the Codex Egberti (Trier, Stadtbib., MS. 24), the principal contributor to which was the MASTER OF THE REGISTRUM GREGORII (*see* MASTERS, ANONYMOUS, AND MONOGRAMMISTS, §I), who later worked in Trier (*see* REICHENAU, §2(ii)). Some relatively well-preserved wall paintings remain in the church of St Georg on Reichenau, on which there is a cycle of the *Miracles of Christ* (before 1000), and in the priory at Neuenberg (1023), near Fulda.

In the Romanesque period (*c.* 1000–*c.* 1200) German painting was not of the same quality as before. The powerful patrons of manuscript illumination were replaced by the reformed monastic orders, and production increased. While such centres as Trier and Echternach faded, others came to the fore, for example Salzburg, Weingarten, Hirsau and Helmarshausen. Sumptuous colours gave way to a sparser treatment, with a limited range of colours or drawing alone. An eagerness to learn and a delight in storytelling extended the range of subject-matter. For example the *Hortus deliciarum* (*c.* 1170; destr. 1870), a manuscript produced in Alsace by Herrard von Landsberg (*c.* 1125/30–95), contained an encyclopedic display of medieval knowledge in 344 images. Fresco cycles, whose artists had a predilection for contrasting Old and New Testament scenes, demonstrate a similar attitude in monumental painting, as in those in the chancel apse of St Gereon in Cologne (end of the 12th century). The unique, painted wooden ceiling in St Michael in Hildesheim, showing biblical scenes in eight panels, dates from the 13th century.

Panel painting began in Germany *c.* 1250, the first known examples being a retable from Soest (Berlin, St Walpurgis) and two slightly later altar wings in Worms (St Paul). The characteristic sharp-edged treatment of drapery folds found in these is also widespread in book illumination in the first half of the 13th century (*see* ZACKENSTIL). The vitality and naturalism so surprisingly displayed by the sculpture of this period (*see* §IV, 1 below) are hardly matched by the painting. The Carmina Burana manuscript (first third of the 13th century; Munich, Bayer. Staatsbib., Cod. Lat. 4660) from Benediktbeuren is, however, an astonishing work, being the first known painting of a forest landscape with animals but without figural scenes.

(iii) Early Gothic. The High Gothic style that spread from France to Germany is seen primarily in the designs of stained-glass windows (*see* STAINED GLASS, §II, 1). The refined new style, with flowing robes and an aristocratic and predominantly youthful expression in the faces, is expressed particularly impressively in book illumination in the Codex Manasse (*c.* 1300; Heidelberg, Ubib., Cod. Pal. Germ. 848), perhaps from Zurich. Small-format altars for private worship, rather like enlarged book illuminations, became more common in the 14th century, Cologne taking the lead in this field.

Under Holy Roman Emperor Charles IV, a centre of courtly culture emerged in Prague. Merging French and Italian influences, its painting combined elegance with monumentality and was modern especially in its elaboration of individual features. In the wake of Charles IV's expanding political activities, this art was widely disseminated: to Silesia, the lands controlled by the Teutonic Order, the Brandenburg Marches, the Upper Palatinate, Franconia and the Baltic and North Sea coasts. In Hamburg Master Bertram from Minden, an important painter influenced in his narrative style by Bohemian art, completed the Grabow Altarpiece (1379–83; Hamburg,

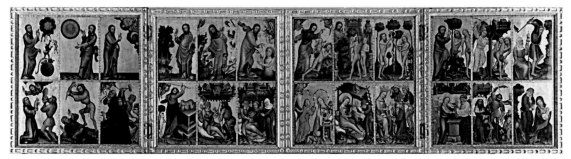

15. Master Bertram: Grabow Altarpiece, panel, 1.8×7.2 m, 1379–83 (Hamburg, Hamburger Kunsthalle)

Ksthalle; see fig. 15) for the Petrikirche. The first German portrait in the form of a panel painting, depicting *Archduke Rudolf* (*c.* 1365; Vienna, Dom- & Diözmus.), also shows features of Bohemian painting.

BIBLIOGRAPHY

P. Clemen: *Die romanische Wandmalerei in den Rheinlanden* (Düsseldorf, 1916)
A. Goldschmidt: *Die deutsche Buchmalerei*, 2 vols (Berlin, 1928)
W. Köhler: *Die karolingischen Miniaturen*, 3 vols (Berlin, 1930–60)
A. Grabar and F. Nordenfalk: *Das frühe Mittelalter vom 4.-11. Jahrhundert* (Geneva, 1957)
H. Schrade: *Malerei des Mittelalters I, vor- und frühmittelalterliche Malerei* (Cologne, 1958)
H. Wentzel: *Die Glasmalerei in Schwaben von 1220 bis 1350*, Corp. Vitrearum Med. Aevi (Berlin, 1958)
A. Boeckler: *Deutsche Buchmalerei der Gotik* (Königstein im Taunus, 1959)
——: *Deutsche Buchmalerei der vorgotischen Zeit* (Königstein im Taunus, 1959)
W. Braunfels, ed.: *Karl der Grosse: Lebenswerk und Nachleben*, 4 vols (Düsseldorf, 1965–7)
H. Fillitz: *Das Mittelalter*, i (Berlin, 1969)
C. R. Dodwell: *Painting in Europe, 800–1200* (London, 1971)
W. Köhler and F. Mütherich: *Die karolingischen Miniaturen*, 2 vols (Berlin, 1971)
O. von Simson: *Das Mittelalter*, ii (Berlin, 1972)
Die Zeit der Stauffer (exh. cat., Stuttgart, Württemberg. Landesmus., 1977)
Die Parler: Die Parler und der Schöne Stil, 1350–1400: Europäische Kunst unter den Luxemburgern (exh. cat., Cologne, Josef-Haubrich-Ksthalle, 1978)

HELMUT BÖRSCH-SUPAN

2. *c.* 1400–*c.* 1600. During this period panel painting, previously of equal importance with manuscript illumination within German painting, became increasingly pre-eminent. In addition the developing format of the ALTARPIECE began to replace wall painting, uniting in a single work sculpture, an architectural frame and painting. Until the advent of oil painting, tempera was used, usually on a support of oak, walnut, conifer or lime. The emergence of printed graphics had taken place towards the end of the Middle Ages, and the new technique of woodcut, freed from tradition, allowed deviation from conventional forms of expression. The oldest woodcuts were single sheets, especially devotional images but also playing cards: they were followed by a broad spectrum of religious and secular themes. With the invention of book printing, the handbill and pamphlet provided scope for woodcuts; in the period of the Reformation (from 1517) the broadsheet took on special importance. Stylistically, there was a development from coarse simple outlines, usually with hand-coloured areas, to intricately detailed works, with increasingly complex internal textures created by hatching and cross-hatching.

(i) 'International' and Late Gothic. (ii) Renaissance.

(i) 'International' and Late Gothic.

(a) Painting. The 'Soft style' of 'International Gothic' shaped the art of the first quarter of the 15th century. Under primarily secular court patronage, an artistic idiom developed that has also been designated the court style. The term Soft style denotes a greater inwardness achieved through formal means, with devotional images conveyed through an idealized beauty. Characteristic of this art are small formats and a delicate and refined, charming grace. Drapery is soft, sometimes doughy, typically with deep folds. Detailed studies of nature are often woven into the decorative patterns. Despite the aesthetic idealization, the ground was prepared for the tendencies towards greater realism of the following period.

Important centres for painting were Cologne (see COLOGNE, §II, 3), north-west Germany and the Upper Rhine area. In Cologne the Master of St Veronica created devotional images in the Soft style. Also in this vein, MASTER BERTRAM, working in Hamburg, was influenced by Bohemian court art, but his delight in narrative, as seen in his altarpiece of the Virgin (1400–10; Hamburg, Ksthalle), reveals a tendency towards greater realism. One of the most important masters was MASTER FRANCKE, who lived in Hamburg. Such paintings as his Englandfahrer Altarpiece (1424; Hamburg, Ksthalle) from St Johannis in Hamburg show the influence of French and Burgundian manuscript illumination. Conrad von Soest, working in Westphalia (probably Dortmund, *c.* 1394–1422), was influenced by Netherlandish art, as is clear from his Nieder-wildungen Altarpiece (*c.* 1414; Bad Wildungen, St Nikolas), which combines International Gothic with a meticulous realism. Close links with Bohemian art are evident in Salzburg and Nuremberg, whereas Bavarian painting developed more extreme forms. An important example of the Soft style in stained glass is found in the windows of the Besserer Chapel (begun 1413) in Ulm Minster.

German art in the following period, up to around the Reformation in the early 16th century, is generally designated Late Gothic or 'old German painting', the latter a term coined by the Romantics for the medieval art that they rediscovered. Iconographically the religious painting of the 15th century was still based on established medieval formulae. Typology played an important part, objects and details being loaded with symbolism (see TYPOLOGICAL CYCLES). The portrait as a new secular theme became an

16. Stefan Lochner: *Presentation of Christ*, panel, 1.39×1.24 m, 1447 (Darmstadt, Hessisches Landesmuseum)

important genre. The first subjects were princes, followed by numerous burgher patrons.

Netherlandish influence was paramount in the 15th century. The surface realism developed by Jan van Eyck and Robert Campin helped to form German painting style. Visual investigation of nature and naturalistic reproduction of reality became guiding principles. After the mid-15th century, particularly under the influence of Rogier van der Weyden and Dieric Bouts, a more three-dimensional depiction of events and figures increasingly replaced the flat treatment of earlier Gothic art. By *c*. 1475 the direct influence of Netherlandish painting receded, and German artists formed their own schools. The diversity of these resulted in a fragmentation into local styles, and narrow guild rules further encouraged regionalism. The previously consistent development towards a naturalistic idiom was disrupted by an emphasis on the autonomy of artistic means and the expression of feeling. In the early 15th century artists in Cologne and northern Germany were highly productive, while southern Germany took the lead just before the middle of the century. Swabia became a leading region: important painters' workshops operated in Ulm, Augsburg, Memmingen and Konstanz.

Lukas Moser, who worked on the Swabian Upper Rhine, painted the Tiefenbronn Altarpiece (dated 1432; Tiefenbronn, nr Pforzheim, parish church of St Mary Magdalene; for illustration *see* MOSER, LUKAS). Its naturalistic tendencies and graphic, genre-like narrative make it an important example of Late Gothic German painting. In Ulm Hans Multscher, who worked primarily as a sculptor but probably also as a painter, appears to have run an extensive

workshop. His Landsberg *Virgin and Child* (1437), Landsberg am Lech, St Maria Himmelfahrt, part of the 'Wurzbach' Altar, with its grandiose, stylized figures (*see* MULTSCHER, HANS, fig. 2), has an expressive vigour verging on ugliness. KONRAD WITZ, who worked mainly in Basle, introduced Netherlandish realism to the Upper Rhine region. Among his successors is the Master of the Darmstadt Passion, who worked in the mid-Rhine region. In Colmar around the mid-15th century Caspar Isenmann developed Witz's art further while also assimilating Netherlandish influences.

The painting of the chief master of Late Gothic in Ulm, Bartholomäus Zeitblom, shows the solemn, immobile calm of Swabian art, its severity and vivid sense of colour. The work of his pupil Bernhard Strigel, who lived in Memmingen, seems to stand on the threshold of Renaissance art. Like Hans Maler, a painter working in Schwaz, his work is one of the last offshoots of medieval Swabian art. The influence of the Ulm school was felt as far afield as Switzerland (e.g. on the work of the Bernese Master of the Carnation). The chief representative of a tendency closer to International Gothic was the Cologne painter known as Stefan Lochner, the grace and elegance of whose work point to the courtly tradition (see fig. 16). He further developed the style of the Master of St Veronica, heightening it in sometimes monumental compositions. The realistic tendencies in his work have an idealizing aspect that aims to reveal a higher reality.

Through their geographical location, Cologne and the Lower Rhine area were the entry-point for the art of the Netherlands around the mid-15th century (e.g. Rogier van der Weyden's Columba Altar, *c*. 1455, Cologne; now Munich, Alte Pin.; *see* VAN DER WEYDEN, (1), fig. 3). This influence was precipitated through the works of the Master of the Life of the Virgin, still heavily marked by the Cologne painting of the Lochner era, and those of the Master of the Glorification of the Virgin, who was close to him in style. The painting of Dieric Bouts influenced the Master of the Lyversberg Passion. In the late 15th century the Master of the St Bartholomew Altar, who probably came from the Netherlands, the Master of the Holy Kinship and the Master of the Legend of St Ursula (ii) continued the tradition of painted altars (as in the Netherlands) in Cologne. In the works of the Master of St Severin and the Master of the Aachen Altar the Mannerist influence of the Antwerp school is already at work.

About the mid-15th century Hamburg had no school or tradition of its own; its masters were mainly from other areas. In 1475 the Westphalian Hinrik Funhof settled there; his workshop was carried on by Absalom Stumme and Henrik Bornemann. In the years after 1435 Lübeck prospered, becoming one of the most important artistic centres. The outstanding masters there were Hermen Rode, who produced the altar (1484) of the Lukas-Bruderschaft der Maler (founded 1473), and Bernt Notke, the head of a large workshop, who worked as a painter and sculptor. The most important representative of Westphalian art was Johann Koerbecke. In the south German centres the influence of Netherlandish painting spread more slowly. While the study of spatial depth was of central interest elsewhere, a realistic style characterized by

ornamental vigour and expressive power emerged in Upper Bavaria. The outstanding figures include the Master of the Polling Panels and the Master of the Tegernsee Altar (the 'Tabula Magna'). Jan Polack, who was town painter in Munich from 1488, continued the tradition of old Bavarian painting for several decades.

The most important centres in Franconia were Rothenburg, Nördlingen, where Friedrich Herlin had his workshop, Bamberg and above all Nuremberg, where the Bohemian tradition remained influential for a long period. Its painting is distinguished by clarity of form and perspective and precise draughtsmanship. In the second half of the 15th century painting there was shaped by Hans Pleydenwurff and his workshop. A second workshop was run by the Master of the Augustinian Altar.

Painting in the South Tyrol was influenced by Italian art. In the works of the outstanding master Michael Pacher, the influence of North Italian painting is combined with a Late Gothic idiom. On the Upper Rhine in Colmar the painter and engraver Martin Schongauer ran a large workshop. Although his works are classified as Late Gothic, they show a new vividness and plasticity of form of almost Classical clarity (*see* §(b) below). Their influence extended far beyond their area of production. His picturesque style of engraving, artistic independence and quality influenced the work of Albrecht Dürer. The Housebook Master, who worked as a painter and engraver in the last quarter of the 15th century, can, like Schongauer, be considered a precursor of the art of the age of Dürer, although his works were less influential. In the late 15th century the workshop associated with Peter Hemmel von Audlam, founded in Strasbourg in 1477, played a leading role in the production of stained glass, which was exported all over Germany; another important centre was Nuremberg.

(b) Graphic arts. Book illustration became one of the important tasks of the woodcut (*see* BOOK ILLUSTRATION, §I). About 1430–70 the block-book, in which text and image were cut from a single block, came into being; the first illustrated books with movable letters were printed by Albrecht Pfister in Bamberg from 1461, but were only widely adopted *c.* 1470. The incunabula were usually works of a popular kind: different kinds of edifying works (mirrors of virtue, *ars moriendi*, dances of death, gardens of the soul, *imitatio Christi*), and travel journals (e.g. by Bernhard von Breydenbach), fables, myths and heroic legends. The most important printing centres were Augsburg, Ulm, Cologne, Lübeck and Nuremberg. In the last decade of the 15th century artistic personalities began to stand out in this field: Michael Wolgemut and Wilhelm Pleydenwurff illustrated Stephan Fridolin's *Schatzbehalter* (1491) and Hartmann Schedel's *Weltchronik* (1493) for the Nuremberg publisher Anton Koberger (*c.* 1445–1513). Dürer's *Apocalypse* (1498), with its full-page illustrations (*see* DÜRER, (1), fig. 4) emancipated from the text, revolutionized book illustration. Also important *c.* 1500 were the book projects of Holy Roman Emperor Maximilian I. The *Gebetbuch Kaiser Maximilians* (Augsburg, 1513), to which Dürer, Albrecht Altdorfer, Hans Burgkmair, Hans Baldung, Lucas Cranach the elder and Jörg Breu the elder

contributed marginal drawings in 1514–15, combines Renaissance innovations with fantastic late medieval illustrations. Burgkmair and Leonhard Beck (i) were involved in ornamenting his novels *Theuerdank* (1510–17) and *Weisskunig* (begun 1505). Other important works of the time were produced by the Master of Petrarch and Cranach the elder.

Around 1420 copperplate-engraving evolved in Germany from goldsmiths' techniques and became one of the most commonly used printing techniques. One of its first exponents was the Master of the Life of the Virgin. Probably because of its origin, it was used first for models and patterns and for copies of paintings; later it was used for original compositions and developed autonomy as a medium. A broad range of subject-matter developed: small images of saints, crude jokes, heraldic or ornamental motifs, playing cards and early examples of erotica. The particularly notable early engravers include the Master of the Berlin Passion, the Upper-Rhenish Master of the Playing Cards, the Master E. S., Martin Schongauer and the Housebook Master, who also used the drypoint technique. Their drawings in pen and ink (see fig. 17) and metalpoint shared the same lively linear and calligraphic style of their prints. The Master with the Banderoles worked as a printmaker in southern Germany, while Israhel van Meckenem (ii) produced an extensive oeuvre of engravings in north-west Germany.

(ii) Renaissance. German painting had formerly been marked by an attachment to contemporary styles on the

17. Martin Schongauer: *Virgin with a Carnation*, pen and ink, 227×159 mm, before 1473 (Berlin, Kupferstichkabinett)

one hand and to regional peculiarities on the other. Although some artists are known by name, they were embedded in the context of local workshops in which the artist's individuality played little part. By the end of the 15th century, artists began to emerge as self-confident personalities, and craftsmen began to lose their anonymity. A significant aspect of this development was the division of the work in the production of woodcuts: the artist's contribution was now limited to drawing, while the actual carving was done by the wood-block carver.

(a) Introduction of Italian idiom. The centres of art were the courts and the towns. Art was also increasingly promoted by an intellectual class of humanists. In the 16th century a new evaluation of art and artists evolved under the influence of the Italian Renaissance (*see* ITALY, §III, 3 and 4). The new interest in antiquity and the Reformation's hostility to images led to a shift towards non-religious subjects and functions. In the secular area, in particular, new subjects, for example from mythology, were depicted. Drawing took on a certain autonomy, breaking free of its merely preparatory function. Its independent status was reinforced through new media (chalk, charcoal, inks, washes, brush-drawing), and it became a collected item.

Although frequently called the 'last medieval mystic', an original 'German' artist in contrast to the 'Italianate' Dürer, MATTHIAS GRÜNEWALD, nevertheless, stands close to the Italian High Renaissance, without adopting Italian models. This is evident in his treatment of the human body, the relation of figure to space and surface and his monumental treatment of form, for example in the *Meeting of SS Erasmus and Maurice* (*c.* 1520–25; Munich, Alte Pin.; *see* GRÜNEWALD, MATTHIAS, fig. 3). His use of colour enabled him to achieve an unsurpassed realism and was also a means of suggesting transcendence, as in the image of the *Resurrection* in the Isenheim Altarpiece (*c.* 1512–15; Colmar, Mus. Unterlinden; *see* GRÜNEWALD, MATTHIAS, fig. 2).

(b) Work and influence of Dürer. Albrecht Dürer in Nuremberg dominated German painting and printmaking in the 16th century (*see* DÜRER, (1)). Though basing his work on Nuremberg painting and influenced by such German masters as Schongauer as well as the art of the Netherlands, he anticipated an Italian-orientated art. His work is animated by a tension between late medieval piety and the Renaissance. The Venetian painters Giovanni Bellini and Andrea Mantegna were fundamentally important, as were Leonardo's science of physiognomy and Alberti's theory of art. In his woodcuts he attained a new mastery through formal refinement and heightened expression, raising the medium to the status of a fully developed art form. Major works include the cycles of the *Apocalypse* (1498; *see* APOCALYPSE, fig. 3), the *Life of the Virgin* (*c.* 1500–11) and the *Large Woodcut Passion* (1510–11). He also produced woodcuts with secular themes, as in the *Triumphal Arch of Emperor Maximilian* (1512–18). In his portrait engravings, his *Engraved Passion* series (1508–12) and his three master engravings *Knight, Death and the Devil* (1513), *Melencolia I* (1514; *see* DÜRER, (1), fig. 9) and *St Jerome in his Study* (1514; *see* ENGRAVING, fig. 4), as well as other works, he created unsurpassed

masterpieces distinguished by their closed pictorial unity. Dürer's theoretical writings were decisive in linking painting and humanism, with a consequent upgrading of the status of the artist. His self-confident artistic persona is reflected above all in his numerous self-portraits (*see* DÜRER, (1), figs 2 and 5).

The art of Dürer was decisive for German painting and graphic art in the 16th century. Hans Suess von Kulmbach, Wolf Traut and Hans Leonhard Schäufelein were among Dürer's closest pupils; his graphic work had its most direct influence on those engravers called the LITTLE MASTERS: Barthel Beham, Sebald Beham and Georg Pencz in Nuremberg and Heinrich Aldegrever in northern Germany. His successors as artists of the woodcut also included Erhard Schön and Hans Springinklee. Apart from artists of the Danube school (*see* §(d) below), Peter Flötner and Hans Baldung in Strasbourg were important engravers of the first half of the 16th century. In the late 16th century Virgil Solis and Jost Amman in Nuremberg and the Strasbourg artist Wendel Dietterlin, creator of the *Architectura* (Nuremberg, 1598), produced important works. Georg Pencz was influenced by Dürer, but he developed his own style in the transition to Mannerism. Hans Baldung worked in Dürer's workshop for a time before going to Strasbourg to start his own. Apart from several altars, he specialized in secular themes: portraits and, sometimes obscure, allegorical images. Mannerist tendencies are seen in the heightened movement, the highlights and the ornateness of his paintings.

Important glass paintings came from the workshop of Veit Hirsvogel in Nuremberg—often after sketches by Dürer—and from Kulmbach and Baldung.

(c) Augsburg as artistic centre. By the early 16th century the free imperial city of Augsburg had developed into a major centre of intellectual and artistic life in Germany. Such important humanists as Conrad Peutinger and Konrad Celtis worked there; the rich merchant dynasty of the Fugger family developed a style of patronage modelled on Italy; and Augsburg painting became predominant. The city was one of the German centres of printing and the home of the Hopfer family of goldsmiths, who played a decisive part in developing the technique of etching, especially Daniel Hopfer I. Hans Holbein the elder (*see* HOLBEIN, (1)) worked there at the end of the 15th century, and, until his departure to Basle in 1515, he was undoubtedly one of the most popular painters of southern Germany. His painting marks a transition to the formal idiom of the Renaissance but is especially important for the development of colour. In 1498 Hans Burgkmair the elder took over his father's painting workshop in Augsburg, where he quickly attained renown. In such works as his altarpiece of *St John on Patmos* (1518; Munich, Alte Pin.; *see* BURGKMAIR, (2), fig. 2) nature has an important expressive function. Already, his early paintings of basilicas (e.g. 1499–1504; Augsburg, Schaezlerpal.) show a new sense of colour, while he later evolved colour effects influenced by the Venetians. At the end of the 15th century he developed the colour woodcut technique for the Augsburg printer Erhardt Ratdolt. The CHIAROSCURO WOODCUT developed by Burgkmair and Cranach the elder around 1506 shows parallels with the technique of drawing on colour-primed paper, which appeared at round

the same time. Leonhard Beck (i) also worked in Augsburg as a painter and illustrator and was influenced by Burgkmair. Ulrich Apt the elder (*c.* 1475–1537), painter and draughtsman for woodcuts and glass paintings, developed Holbein's and Burgkmair's painting further. Christoph Amberger was predominantly a portrait painter and was influenced by Titian.

Augsburg, however, was not the only centre of art at this time. The key representative of Ulm painting in Dürer's time, Martin Schaffner, was also influenced by Italian painting. Jerg Ratgeb, also from Swabia, was influenced by the Housebook Master and Grünewald, as well as south Netherlandish and Venetian painting.

(d) Danube school. Another major painter of the early 16th century was Albrecht Altdorfer (*see* ALTDORFER, (1)), who ran a large workshop in Regensburg. With the Passau painter WOLFGANG HUBER and Lucas Cranach the elder (*see* CRANACH, (1)), he was a chief representative of the so-called DANUBE SCHOOL, which was active on the Danube between Regensburg and Vienna, in the Bavarian–Austrian Alps and the Alpine foothills in the first third of the 16th century. The paintings, drawings and prints are characterized by atmospheric observation and a strong feeling for nature (see fig. 18). In them landscape appears as a subject in its own right for the first time (apart from watercolours by Dürer; *see* DÜRER, (1), fig. 3). One of the

main examples of this new style is the cosmic landscape in Altdorfer's *Battle of Alexander at Issos* (1529; Munich, Alte Pin.; see fig. 19), painted for the cycle of history paintings commissioned by William IV, Duke of Bavaria. In his early years Lucas Cranach the elder was central to the Danube school. In 1505 he became court painter to Elector Frederick the Wise (*reg* 1486–1525) in Wittenberg, where he produced mainly portraits, mythological paintings, allegories and history paintings. In developing a specifically Protestant iconography, however, he also played an important part in the renewal of religious painting, influenced by Martin Luther, depicting such Protestant acts of worship as baptism and confession. Altdorfer, Huber and Cranach were also masters of the woodcut.

(e) Effects of the Reformation. Protestantism accorded a central role to preaching. Few Lutheran altarpieces were produced; Marian themes, portraits of saints and miraculous scenes gave way to depictions of apostles and evangelists. Such themes such as 'Suffer the little children to come unto me' and 'Christ and the woman taken in adultery' were initiated by Cranach, then widely disseminated. Otherwise, Protestantism had a rather negative influence on art. In the second half of the 16th century court art gained precedence over religious art. By *c.* 1550 the impetus that 'old German' painting had given to art at the beginning of the 16th century had been slowly exhausted. The urban schools began to die out; only in a few towns such as Augsburg or Münster (through the tom Ring family) did urban traditions survive. Though Mannerist tendencies had already been evident in the work of such artists as Baldung or Pencz, German art as a whole joined the mainstream of international Mannerism at this time.

Increased court patronage by such figures as Holy Roman Emperor Maximilian I, Albert V, Duke of Bavaria, and William IV, Duke of Bavaria, helped to support numerous artists. Pieter Candid, Friedrich Sustris, Hans Müelich and Christoph Schwarz, for example, worked at the court in Munich. Nevertheless, many were attracted abroad. Hans Holbein the younger settled in Basle in 1519, and from 1537 he was in the service of King Henry VIII in England. Hans von Aachen, Joseph Heintz the elder and Bartholomeus Spranger all worked at the court of the Holy Roman Emperor Rudolf II in Prague—one of the most important centres of art in the late 16th century—while Hans Rottenhammer I was occupied at the imperial court in Venice.

BIBLIOGRAPHY
Hollstein: *Ger.*
M. Lehrs: *Geschichte und kritischer Katalog der deutschen, niederländischen und französischen Kupferstiche im 15. Jahrhundert*, 9 vols (Vienna, 1908–34)
A. Schramm: *Der Bilderschmuck der Frühdrucke*, 23 vols (Leipzig, 1920–43)
M. Geisberg: *Der deutsche Einblatt-Holzschnitt in der 1. Hälfte des 16. Jahrhunderts* (Munich, 1923–30)
C. Glaser: *Die altdeutsche Malerei* (Munich, 1924)
A. M. Hind: *A History of Engraving and Etching from the 15th Century to the Year 1914* (London, 1927/*R* New York, 1963)
E. Buchner: *Das deutsche Bildnis der Spätgotik und der frühen Dürerzeit* (Berlin, 1933)
A. Stange: *Deutsche Malerei der Gotik*, 9 vols (Munich, 1934–61)
F. Winkler: *Altdeutsche Tafelmalerei* (Munich, 1941/*R* 1944)

18. Wolfgang Huber: *Christ on the Cross*, 320×215 mm, pen and ink, *c.* 1529 (Cambridge, Fitzwilliam Museum)

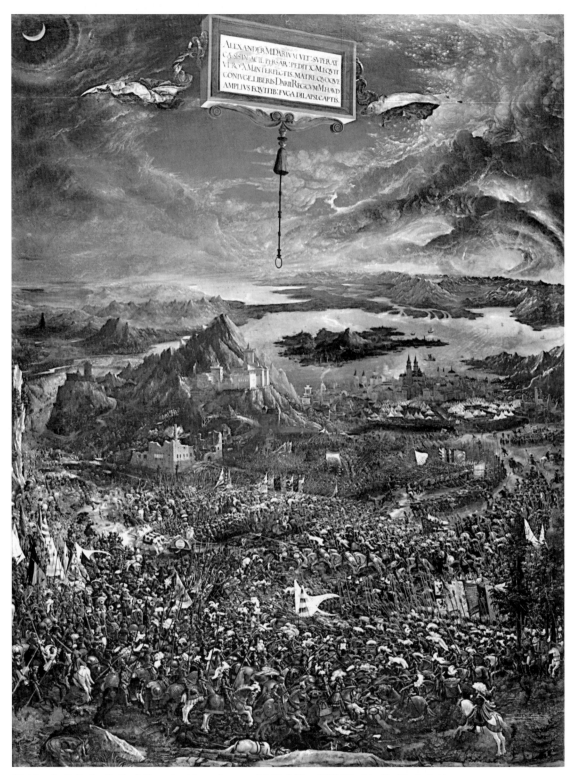

19. Albrecht Altdorfer: *Battle of Alexander at Issos*, oil on panel, 1.58×1.20 m, 1529 (Munich, Alte Pinakothek)

A. Stange: *Deutsche Spätgotische Malerei, 1430–1500* (Königstein im Taunus, 1965)

O. Benesch: *Die deutsche Malerei von Dürer bis Holbein* (Geneva, 1966)

P. Strieder: *Deutsche Malerei der Dürerzeit* (Königstein im Taunus, 1966)

——: *Deutsche Malerei nach Dürer* (Königstein im Taunus, 1966)

A. Stange: *Kritisches Verzeichnis der deutschen Tafelbilder vor Dürer*, 3 vols (Munich, 1967–78)

Albrecht Dürer, 1471–1971 (exh. cat., Nuremberg, Ger. Nmus., 1971)

W. Koschatzky: *Die Kunst der Graphik* (Munich, 1972, rev. 5/1980)

M. Geisberg: *The German Single-leaf Woodcut, 1500–1550*, 4 vols (New York, 1974)

Lukas Cranach: Gemälde, Zeichnungen, Druckgraphik, 2 vols (exh. cat. by D. Koepplin and T. Falk, Basle, Kstmus., 1974/1976)

H. Körner: *Der früheste deutsche Einblattholzschnitt* (Mittenwald, 1979)

Luther und die Folgen für die Kunst (exh. cat., ed. W. Hofmann; Hamburg, Ksthalle, 1983)

Gothic and Renaissance Art in Nuremberg, 1300–1550 (exh. cat., ed. G. Bott, P. de Montebello, R. Kahsnitz and W. D. Wixom; New York, Met.; Nuremberg, Ger. Nmus.; 1986)

P. Strieder: *Tafelmalerei in Nürnberg, 1350–1550* (Königstein im Taunus, 1993)

Stefan Lochner, Meister zu Köln: Herkunft, Werke, Wirkung (exh. cat., ed. F. G. Zehnder; Cologne, Wallraf-Richartz-Mus., 1993)

Lucas Cranach: Ein Maler-Unternehmer aus Franken (exh. cat., ed. C. Grimm, J. Erichsen and E. Brockhoff; Kronach, Feste Rosenberg, 1994)

Bilder aus Licht und Farbe: Meisterwerke spätgotischer Glasmalerei: 'Strassburger Fenster' in Ulm und ihr künstlerisches Umfeld (exh. cat., ed. B. Reinhardt and M. Roth; Ulm, Ulm. Mus., 1995)

German Renaissance Prints (exh. cat. by G. Bartram, London, BM, 1995)

DORIS KUTSCHBACH

3. *c.* 1600–*c.* 1750.

(i) Baroque. (ii) Rococo and court art.

(i) Baroque.

(a) Before the Thirty Years War. Even before the Thirty Years War (1618–48) devastated Germany and depressed the level of its art, painting had lost much of its status through the Reformation, the religious image having been displaced by the word (*see* §2(iii)(e) above). The developing Protestant iconography failed to achieve popularity, and religious art maintained a creditable standard only where Catholicism held sway, above all in Bavaria. The Counter-Reformation, propagated especially by the JESUIT ORDER, exploited the suggestive power of the image. Thus the Jesuit church of St Michael (1583–97) in Munich, the first early BAROQUE, and emphatically Roman, large building in Germany, received important altarpieces by Hans von Aachen, Friedrich Sustris and Pieter Candid. These Mannerist works were partly Netherlandish and partly Italian in origin.

About 1600 the rich commercial city of Augsburg was again demonstrating its wealth in the extravagant Rathaus, the Goldener Saal of which Johann Matthias Kager adorned with ceiling paintings from 1622 (destr. World War II). Johann König, an artist influenced by Adam Elsheimer, and Hans Rottenhammer I worked alongside him at the beginning of the 17th century. Elsheimer, the most important German painter of his time and a reformer of landscape painting, had died in Rome in 1610, after leaving his native Frankfurt am Main *c.* 1598. The other great painter that Germany produced *c.* 1600, the Holstein artist Johann Liss, also died young, in Verona, without having influenced the German art of his time. His ecstatic late figure paintings bridge the sensual and spiritual worlds and seem to anticipate the heightened sensibility of the

18th century. One of Germany's best etchers, Wenceslaus Hollar, also left the country, going to England in 1637.

Apart from Augsburg, a few free imperial cities carried on the tradition of Renaissance painting on a more modest level. Frankfurt was the leading centre in the south-west. While Augsburg dominated in history painting, where the Italian influence was strong, Frankfurt was more open to Netherlandish stimuli, not least through the religious refugees who also settled in the neighbouring Frankenthal, forming the FRANKENTHAL SCHOOL of landscape painters. Still-life was given new importance by Georg Flegel and Peter Binoit (*fl* 1611–24) in Frankfurt and by David Soreau and Isaak Soreau in Hanau. These painters endowed their subjects with an inward, sometimes oppressive gravity through their conscientious, religious treatment. Georg Flegel's pupil Jacob Marrel in turn taught Abraham Mignon (1640–79), the virtuoso flower and fruit painter who went to Utrecht via Antwerp in 1664. Sébastien Stoskopff, a pupil of David Soreau, who worked mainly in Strasbourg, was the most rigorous and inventive German still-life painter. The Strasbourg still-life and portrait painter Albrecht Kauw the elder (1621–81) settled in Berne in 1640, working alongside Joseph Plepp (1595–1642). In Cologne, Gottfried von Wedig (1583–1641) painted still-lifes, while also working as a portrait painter with Gortzius Geldorp. In Nuremberg, the second art centre in southern Germany, a tradition of Renaissance painting going back to Dürer still continued, above all in portraiture, as in the work of Lorenz Strauch, keeping aloof from Mannerist fancy. Between *c.* 1570 and *c.* 1630 there was actually a DÜRER RENAISSANCE.

The most flourishing city in Germany *c.* 1600, apart from Munich, was Dresden, after the electorship of Saxony had passed in 1547 to the Albertine line of the House of Wettin, which resided there. Here too Mannerism in the style of Hans von Aachen flourished, and there were many links between the Dresden art of this time and Prague, Munich and Augsburg. Berlin was far less important. In general, at the beginning of the 17th century, north Germany had few significant painters, Anton Möller I in Danzig being one of the rare exceptions.

(b) After the Thirty Years War. When the task of cultural reconstruction began after the end of the Thirty Years War and painting revived, inspiration was sought first from the Netherlands and Italy and later increasingly from France and England. Study trips to foreign countries were a normal part of a painter's training. Like many others, the painter Joachim von Sandrart of Frankfurt had sought international contacts even earlier, having been to Prague, Utrecht, London, Venice, Rome and Amsterdam. Even before the peace treaty, he seemed a self-confident, worldly artist, a German Rubens, working in Munich, Augsburg and Nuremberg. He painted portraits, allegories and large altarpieces and founded a private academy in Augsburg before taking over the existing one (founded in 1662) in 1674.

Excelling him as a painter, however, was Johann Heinrich Schönfeld, who returned to Augsburg in 1651 after a long stay in Rome and Naples. His sensitive history paintings, allegories and genre works (see fig. 20) seem shrouded in mystery and matched the still subdued mood

20. Johann Heinrich Schönfeld: *Life Class in an Academy*, oil on canvas, 1325×970 mm, after 1660 (Graz, Steiermärkisches Landesmuseum Joanneum)

of the time. His lively brushwork influenced such other history painters as Isaak Fisches (1638–1706), Johann Spillenberger, Hans Ulrich Franck (1603–80) and Franz Friedrich Franck (1627–87). Johann Heiss had a more academic manner. Joseph Werner II, with his similar approach to art, worked in Augsburg from 1667 to 1680. Rembrandt's pupil Johann Ulrich Mayr painted mainly portraits and became Director of the Akademie in 1684.

Augsburg continued the 16th-century tradition of printmaking. The Sadeler, Custos and Kilian families, working primarily as reproductive engravers, spread the artistic ideas of the time and helped the city to exert its influence elsewhere. Schönfeld, Jonas Umbach and Hans Ulrich Franck were outstanding etchers. Augsburg had close links with Munich, ruled by Maximilian, Elector of Bavaria, and then by his son Ferdinand Maria. Nikolaus Prugger was the leading portrait painter there, together with Johann de Pay. Johann Ulrich Loth produced history paintings influenced by the work of Caravaggio. Christopher Paudiss, a pupil of Rembrandt, worked in neighbouring Freising at the end of his life, and Johann Christophorus Storer, a prolific painter of altarpieces, worked in Konstanz until 1671. The development of church architecture in the Catholic south of Germany also fostered the production of altarpieces by numerous painters, even in smaller towns and villages.

In Nuremberg lively artistic activity in all genres was resumed after the Thirty Years War. At its centre was Joachim von Sandrart, who worked there from 1674 until his death (1688). The Prague portrait painter Daniel Preissler (1627–65), progenitor of an extensive family of artists, settled there in 1652. The Dutchman Willem van Bemmel (*fl* 1630; *d* 1708) lived in Nuremberg after 1662; he developed landscape painting, and several later members of his family were artists in Nuremberg. The landscape painter Johann Franz Ermels was his pupil. In Frankfurt the artistic tone was set by the animal painter Johann Heinrich Roos, who also worked as an engraver, and by Matthäus Merian (ii). The latter was a pupil of Sandrart and the son of the etcher Matthäus Merian (i), famous for his topographical works. Frankfurt was, however, outpaced by Hamburg, the burgher artistic centre in the north. In the second half of the 17th century a style of painting heavily dependent on the Netherlands flourished, embracing all genres and typified by the works of Johann Georg Hainz (*fl* 1666–1700), Joachim Luhn, Franz Werner von Tamm, Jacob Matthias Weyer (*fl* 1648–70) and Ottmar Elliger (i).

Rembrandt's pupil Juriaen Ovens worked for the court in Gottorp. In Danzig (now Gdańsk, Poland) outstanding portrait painters worked in the second half of the 17th century, notably Andreas Stech and Daniel Schultz II. The most important German painter of this period, Michael Willmann, came from Königsberg (now Kaliningrad, Russia), but it is characteristic of the fragmentation of cultural life in Germany that he finally produced his main works in the Silesian monasteries of Leubus and Grüssau. His agitated paintings are informed by a deep religious seriousness in which the harrowing experience of the wars is still felt.

(ii) Rococo and court art. The flagging of painting throughout Europe at the end of the 17th century coincided in Germany with the extravagant attempts of the absolutist princes to vie with Louis XIV, King of France. The numerous building projects that resulted from this (*see* §II, 3 above) prompted the development of a monumental figural style of painting that took its models mainly from Italy and that flourished in Berlin, Dresden, Munich, Kassel and Bamberg. Netherlandish influence continued in the work of numerous lesser masters in burgher and court art centres throughout the 18th century, most successfully in the painting of Christian Wilhelm Ernst Dietrich, who worked in Dresden. The most significant achievements of this period, and of the entire 18th century, however, were the astonishingly copious ceiling paintings and altarpieces in the Catholic south, not only in the towns but also in the monasteries and in countless village churches. Whole families of fresco painters worked there, raising the craft of decoration to a high level. Blurring the boundary between court and popular painting, this art developed in close conjunction with the evolution of architecture, which advanced from the simple addition of elements to increasingly intricate spatial structures. Accordingly, fresco programmes changed from cycles of uniform separate paintings to elaborately composed ensembles. Johann Michael Rottmayr, who worked mainly in Austria, was the most important pioneer. The main centres of fresco painting (and of the production of

altarpieces) were Augsburg, with Johann Georg Berg-müller, Matthäus Günther, Johann Evangelist Holzer and Johann Wolfgang Baumgartner; and Munich, with Cosmas Damian Asam and Christian Thomas Winck (see fig. 21). From these places the artists spread in a wide circle as far as Trier, Büren in Westphalia and Hildesheim. Januarius Zick (ii), an extremely prolific producer of frescoes and panel paintings, including works with secular subject-matter, worked finally in Ehrenbreitstein. These painters also collaborated in other south German cities, such as Würzburg, Bamberg and Stuttgart.

The courts needed portrait painters above all. The most important German portrait painter *c.* 1700 was the Bohemian Jan Kupecký, who worked from 1723 in Nuremberg. He combined imposing portrayal with psychological depth, expressed partly through highly inventive compositions. His best works were portraits of citizens and nobles. The same can be said of Balthasar Denner of Hamburg, whose minutely painted close views of elderly faces were well received. In the formal aspects of the court portrait the French example predominated around 1700, overcoming Dutch and English influences, notably from the circle of Van Dyck, transmitted through the Netherlands. French portrait painters worked in several German cities; they included Paul Mignard (1639–91), Martin Maingaud (*fl* 1692–1710) and Joseph Vivien in Munich, Pierre Goudréaux (1694–1731) in Mannheim and Antoine Pesne in Berlin (1711–57), where, with his numerous pupils, he founded a tradition of painting that lasted far into the 19th century. Georges Desmarées in Munich absorbed Venetian as well as French influences. In Mannheim and later Hannover Johann Georg Ziesenis became the leading ROCOCO portrait painter. The multiplicity of German courts, each with their own artistic life, and the traditional cultivation of art in such great burgher cities as Hamburg, Frankfurt, Nuremberg and Augsburg, led to a dispersal of painters in all genres across the whole country; there was no major concentration of outstanding talent at any one place.

Graphic art flourished in conjunction with publishing in the tradition-orientated burgher cities. Foremost among these was Augsburg, where Georg Philipp Rugendas (i), who favoured military scenes, and Johann Elias Ridinger and Johann Esaias Nilson, who created decorative Rococo genre scenes and portraits, were active. In Berlin Pesne's pupils Joachim Martin Falbe (1709–82) and Johann Gottlieb Glume (1711–78), and above all Georg Friedrich Schmidt (1712–75), who had been trained in Paris, produced excellent etchings.

BIBLIOGRAPHY
G. Biermann: *Deutsches Barock und Rokoko*, 2 vols (Leipzig, 1914)
H. Tintelnot: *Die barocke Freskomalerei in Deutschland* (Munich, 1951)
Barock in Nürnberg, 1600–1750 (exh. cat., Nuremberg, Ger. Nmus., 1962)
Deutsche Maler und Zeichner des 17. Jahrhunderts (exh. cat., W. Berlin, Schloss Charlottenburg, 1966)
B. Bushart: *Deutsche Malerei des 17. und 18. Jahrhunderts*, 2 vols (Königstein im Taunus, 1967)
Augsburger Barock (exh. cat., Augsburg, Rathaus and Holbeinhaus, 1968)
G. Adriani: *Deutsche Malerei im 17. Jahrhundert* (Cologne, 1977)
Kunst der Bachzeit (exh. cat., Leipzig, Mus. Bild. Kst, 1985)

21. Christian Thomas Winck: ceiling fresco (1769), pilgrimage church of St Leonhard, near Dietramszell

4. *c.* 1750–*c.* 1900.

(i) Neo-classicism. (ii) The Nazarenes. (iii) Romanticism. (iv) Realism. (v) Urban centres. (vi) *Jugendstil.*

(i) Neo-classicism. In the mid-18th century (earlier in the north than in the south), under the influence of the Enlightenment, an increasingly sober, serious style evolved in contrast to the Rococo. In 1755 JOHANN JOACHIM WINCKELMANN's *Gedanken über die Nachahmung der griechischen Werke in der Malerei und Bildhauerkunst* ushered in NEO-CLASSICISM, which elevated sculpture above painting and clearly defined form above colour. Anton Raphael Mengs (*see* MENGS, (2)), Winckelmann's friend, was regarded as the leader of the new tendency in painting, although he worked almost exclusively in Italy and Spain.

The Seven Years War (1756–63) was a political turning-point, and in art the change was seen most clearly in south and south-west Germany, particularly in religious fresco painting. Augsburg, once the leading art centre of the south, had almost completely lost its importance by the end of the 18th century. It was hoped that a new impetus would come from the academies (*see* §XV below). New institutes were founded in Stuttgart in 1761, in Dresden and Leipzig in 1764 and in Kassel in 1777; the academy in Berlin was renovated in 1786. In other towns schools of drawing sought to spread knowledge of the arts. Mannheim lost its artistic status when Charles Theodore, Elector Palatine of the Rhine, also became Elector of Bavaria and in 1778 moved his court to Munich. This

prepared the ground for this city's flowering as an artistic centre, where in 1797 Alois Senefelder invented lithography, a technique that spread rapidly.

Thus, in the last third of the 18th century, the centres of artistic life were redefined. Dresden, the city with the finest collections, possessed in Anton Graff the best German portrait painter of the time. The draughtsman Adrian Zingg (1734–1816) prepared the way for the development of Dresden landscape painting in the 19th century. He was followed by Johann Christian Klengel. In Leipzig, the other notable centre in Saxony, Adam Friedrich Oeser was a vigorous exponent of Neo-classicism and Director of the academy. He was succeeded (1800–12) by Friedrich Tischbein, the last great exponent in Germany of the emotive society portrait, whose influence spread to The Hague, Paris and St Petersburg. The art of Stuttgart was characterized by a classicism derived from Jacques-Louis David that was applied to history and portrait painting by such artists as Philipp Friedrich von Hetsch, Eberhard Wächter, Johann Baptist Seele and Gottlieb Schick. In Kassel Johann Heinrich Tischbein I was the dominant figure, preserving some Rococo elements in his portraits and history paintings. Similarly conservative in form but boldly experimental in subject-matter was the Berlin painter and etcher Bernhard Rode.

Daniel Nikolaus Chodowiecki, working primarily as an illustrator, disseminated Enlightenment ideas through *c.* 2000 etchings. The most idiosyncratic innovator in German art, Asmus Jakob Carstens, achieved prominence almost exclusively as a draughtsman and moved from Berlin to Rome in 1792. Long after his death (1798) his work was seen as a model for poetic history painting.

During the 19th century, particularly in the first third, Italy (especially Rome) was an important outpost of German art, initiating developments that were adopted at home. Through the classicist enthusiasm for antiquity, Rome had become a meeting-place for German artists. Many stayed there, including Philipp Hackert, a prolific landscape painter who gave the genre new impetus through his unfettered observation of nature, and younger artists such as Johann Christian Reinhart, Johann Martin von Rohden and Joseph Anton Koch.

(ii) The Nazarenes. Napoleon I's conquests and the consequent upheavals in Germany led to a withering of painting but also prompted a rediscovery of 15th- and 16th-century art. In Vienna in 1809 artists opposed to the Akademie formed the Lukasbund. Of them the German artists Friedrich Overbeck and Franz Pforr went to Rome in 1810 to create a new painting style inspired by Dürer

22. Friedrich Overbeck: *Joseph Sold by his Brethren* (1816–18), fresco, 2.43×3.04 m, from the Casa Bartholdy fresco cycle (Berlin, Alte Nationalgalerie)

and Raphael and regenerated by the Christian spirit. The first Lukasbrüder were soon joined by other painters, including Peter Cornelius (1812) and Wilhelm Schadow (1813) and, after the wars of liberation, Philipp Veit (1816) and Julius Schnorr von Carolsfeld and Friedrich Olivier (1817). These reformers came to be called NAZARENES and painted important frescoes with scenes from the *Story of Joseph* in the Casa Bartholdy (Pal. Zucchari) in Rome (1816–18; Berlin, Alte N.G.; see fig. 22). Their work was influential in Germany, and the most important of them later took up key positions in German artistic life. Overbeck was the only leading member of the group who stayed in Rome. A second fresco project undertaken by the Nazarenes was the decoration (1817–29) of three rooms in the Casino Massimo in Rome. Religious painting, particularly that done in the service of the Catholic Church, was guided by the increasingly anaemic ideal of the Nazarenes until the end of the 19th century. A late representative of this tendency was Eduard Jakob von Steinle.

(iii) Romanticism. The Nazarenes' backward-looking Romantic strand should be distinguished from the more progressive ROMANTICISM that evolved in Dresden in the early 19th century in the works of PHILIPP OTTO RUNGE and CASPAR DAVID FRIEDRICH. These artists strove to renew art through the contemplation of nature, which they saw as a divine revelation (see fig. 23). This Romantic landscape painting was centred in north and central Germany, but its influence extended as far as Italy. It was represented by Ferdinand Olivier from Dessau and Karl Friedrich Schinkel, and later the Heidelberg artists Ernst Fries and Carl Philipp Fohr, and Carl Rottmann, the most important landscape painter in Munich. The Romantics' reverential attitude towards nature was often expressed in a painstaking naturalism or by the artist's confining himself largely or wholly to the drawing or the oil sketch, as in the case of Franz Theobald Horny and Heinrich Reinhold. Dürer's example played a part here. In Germany the centre of this school of landscape painting was Dresden, where Ernst Ferdinand Oehme (1797–1855) and Ludwig Richter worked with and were influenced by Carl Gustav Carus. The landscape paintings of the Norwegian J. C. Dahl achieved success in Dresden after 1819.

The Romantics' idealistic impulse to exert an edifying influence on the public through art and poetry was increasingly eroded by commercial pressures. The rapidly growing number of painters trained at the academies in Berlin, Dresden, Düsseldorf and Munich flooded the market with their works. This led to entertainment being given priority over education, and conformity over self-realization. Genre painting thus flourished from the 1820s. Art exhibitions became the most important means of promoting art and were put on by academies and art associations in many cities.

Munich, Berlin and Düsseldorf emerged as the main centres, while Dresden lost importance as a result of Saxony's economic weakness. Dresden's most important artist in the last two-thirds of the 19th century, Ferdinand von Rayski, a portrait painter of European rank, did not stay in the city. Until the mid-19th century in Munich Ludwig I, King of Bavaria, encouraged a monumental

23. Philipp Otto Runge: *Morning,* from his series *Four Times of the Day,* oil on canvas, 109×86 mm, 1808 (Hamburg, Kunsthalle)

style of painting in connection with the extension of his residence. Alongside it a refined school of landscape and genre art, concerned above all with Bavarian landscape and folklore, flourished in the work of Wilhelm Alexander Wolfgang von Kobell (i), Johann Georg von Dillis, Albrecht Adam (iii) and others. Joseph Karl Stieler continued to paint court portraits in the conventional style, while Moritz von Schwind produced poetically Romantic works.

(iv) Realism. In Berlin, apart from a historicizing Romantic genre style represented primarily by Heinrich Anton Dähling (1773–1850), Karl Friedrich Hampe (1772–1848) and Carl Wilhelm Kolbe (ii), a sober depiction of reality was favoured (*see* REALISM (ii)). City views were particularly popular and were produced by Eduard Gaertner, the best painter in this field (*see* BERLIN, fig. 4), Johann Erdmann Hummel and others. Numerous portrait painters benefited from the citizens' desire for self-display, the most important being Franz Krüger. In the 1820s and 1830s the landscape painter Karl Blechen achieved prominence with his spiritualized, Romantic vision of nature. From 1834 Adolph Menzel emerged from the BIEDERMEIER art milieu. An acute observer, he was a painter and draughtsman as well as producing woodcut illustrations, lithographs and etchings. He was by far the most important artist in Berlin in the second half of the 19th century, though he did not have a proportionate influence. Up to his death in 1905 he was the only artist to maintain the generally high standard of German drawing of the first half of the century in the second.

Within a few years after 1826 the DÜSSELDORF SCHOOL flourished as an offshoot of the Berlin school, with

Wilhelm Schadow at its head and the artists who had come to the Rhineland with him, Eduard Bendemann, Julius Hübner, Heinrich Mücke (1806–91), Carl Ferdinand Sohn, Carl Friedrich Lessing and Adolf Schrödter. They were joined by the Rhineland landscape painters Johann Wilhelm Schirmer and Andreas Achenbach (1815–1910) from Kassel, and by Alfred Rethel, the most important history painter of the school. Around the mid-19th century Rethel produced both outstanding woodcuts—for example *Another Dance of Death* (1849; Dresden, Kupferstichkab.), a reaction to the revolution of 1848–9—and monumental paintings, for example frescoes with scenes from the *Life of Charlemagne* (1840–62) for the Rathaus in Aachen.

(v) Urban centres. In other German cities artistic culture flourished in proportion to the interest of the citizens or the ruling princes. In Hamburg, where Philipp Otto Runge had lived up to 1810, an inward, Romantic art persisted until the 1840s through the work of such artists as Julius Oldach and Erwin Speckter, whereas the realistic tendency, above all in landscape and genre painting, was upheld by such artists as Johann Joachim Faber and Hermann Kauffmann. Friedrich Carl Gröger (1766–1838) was a distinguished portrait painter, working in the current styles of classicism and Biedermeier.

In Frankfurt am Main around the mid-19th century, apart from the Nazarene art of Philipp Veit and Eduard von Steinle, a picturesque approach to genre and landscape flourished in the work of Carl Morgenstern (1811–93), Anton Burger (1824–1905), Karl-Peter Burnitz (1824–86), Peter Becker (1828–1904) and others. In 1844–7 Moritz von Schwind and in 1873–99 Hans Thoma lived in this intellectually receptive city, which was a gateway for the influence of the French BARBIZON SCHOOL and Gustave Courbet. This is seen particularly in the work of Victor Müller (1829–71), Otto Scholderer and Louis Eysen.

The grand dukes of Baden and Saxe-Weimar founded art schools in Karlsruhe (1854) and Weimar (1858), attracting artists to those towns. Adolf Schrödter, Carl Friedrich Lessing and Johann Wilhelm Schirmer went to Karlsruhe from Düsseldorf. In Weimar, where Friedrich Preller was still painting landscapes in the heroic style, the Weimar school, including Christian Rohlfs, evolved a style of landscape painting that adhered sensitively to nature. Other centres with a more modest artistic life were Hannover, Brunswick, Schwerin, Kassel and Darmstadt.

In the second half of the 19th century Munich surpassed all other German cities in painting through its receptivity to developments from Belgium and France. Peter Cornelius's pupil Wilhelm Kaulbach, in his history paintings, translated the Nazarene idiom into something worldly and grandiose. Influenced by such Belgian history painters as Louis Gallait (1810–87), this idealist tendency gave way to a style of history painting concerned primarily with authenticity, as seen in the work of Karl Theodor von Piloty. His pupil Hans Makart conveyed historical reality through brilliantly evocative decorative effects, but moved to Vienna in 1869. The work of Gabriel Max is impressive through its psychological depth. Franz von Defregger successfully depicted rural life in the Tyrol. Franz von Lenbach became the leading portrait painter. Carl Spitzweg's gently ironic view of the petty bourgeoisie and his

sumptuous use of colour distinguished his work from the usual genre painting, as practised with great mastery but with little real insight into the world of humble folk by Ludwig Knaus in Düsseldorf and Berlin.

The peasant genre was given new dignity by Wilhelm Leibl, a friend of Courbet. Hans Thoma likewise developed a new monumentality in landscape and genre painting. Poetic and fantastic effects were cultivated by the Swiss Arnold Böcklin. Though active for a time in Munich, he otherwise worked with German artists in Italy, such as Anselm Feuerbach and Hans Reinhard von Marées, who were idealistically returning to the classical heritage in opposition to the commercialized art world in Germany. The most important artist in this group was Marées, whose reformist efforts were acknowledged only in the 20th century.

(vi) Jugendstil. The Franco-Prussian War (1870–71) and the subsequent rise in national self-confidence was not beneficial to German art. Powerful opposition to the official salon painting began in the 1890s, inspired by the new ideals of *Jugendstil* (see ART NOUVEAU). The journal *Die Jugend*, founded in 1891, helped to advance this new aesthetic. In Munich a Secession was formed in 1892 with Wilhelm Trübner, Max Slevogt, Hugo von Habermann (1849–1929), Franz von Stuck and others (see SECESSION, §1). It was followed by such groups as DIE SCHOLLE (1899). Similar developments could be observed in Berlin. Through Anton von Werner a style of painting evolved that was entirely subservient to public taste. Here, too, a Secession was formed in 1898 (see SECESSION, §2), after an anti-establishment 'League of XI', with Max Liebermann, Walter Leistikow, Franz Skarbina (1849–1910) and others, had been formed in 1892. The avant-garde magazine *Pan* was founded in 1895. *Jugendstil* emerged in parallel with the socially critical realism seen characteristically in the etchings of Käthe Kollwitz. William II, King of Prussia and Emperor of Germany, sensing an imminent social upheaval, strenuously supported conservative art, sometimes using draconian measures. Even before World War I, however, this art was hopelessly on the defensive.

BIBLIOGRAPHY

Ausstellung deutscher Kunst aus der Zeit von 1775–1875 (exh. cat., Berlin, Kön. N.-G., 1906)

W. Becker: *Paris und die deutsche Malerei, 1750–1840* (Munich, 1971)

W. Hütt: *Deutsche Malerei und Graphik der frühbürgerlichen Revolution* (Leipzig, 1973)

H. von Einem: *Deutsche Malerei des Klassizismus und der Romantik* (Munich, 1978)

W. Vaughan: *German Romantic Painting* (New Haven, CT, 1980)

W. Hütt: *Deutsche Malerei und Graphik, 1750–1945* (Berlin, 1986)

G. Lammel: *Deutsche Malerei des Klassizismus* (Leipzig, 1986)

P. Betthausen and others, eds: *The Romantic Spirit: German Drawings, 1780–1850, from the Nationalgalerie, Berlin and the Kupferstichkabinett, Dresden* (New York and London, 1988)

H. Börsch-Supan: *Die deutsche Malerei von Anton Graff bis Hans von Marées, 1760–1870* (Munich, 1988)

Caspar David Friedrich to Ferdinand Hodler: A Romantic Tradition (exh. cat., ed. P. Wegmann; Berlin, Alte N.G.; Los Angeles, CA, Co. Mus. A.; New York, Met.; London, N.G.; 1993–4)

German Printmaking in the Age of Goethe (exh. cat. by A. Griffiths and F. Carey, London, BM, 1994)

The Romantic Spirit in German Art, 1790–1980 (exh. cat., ed. K. Hartley and others; Edinburgh, Royal Scot. Acad. and Fruitmarket Gal.; London, Hayward Gal.; Munich, Haus Kst; 1994–5)

HELMUT BÖRSCH-SUPAN

24. August Macke: *Storm*, oil on canvas, 840×1120 mm, 1911 (Saarbrücken, Saarland Museum)

5. AFTER *c.* 1900.

(i) Before World War II. (ii) After World War II.

(i) Before World War II. The early 20th century was characterized by two opposing trends: *Jugendstil* and Expressionism. German Expressionism (*see* EXPRESSIONISM, §1) came into being at the beginning of the 20th century, at about the same time as Fauvism and Cubism in France. Its roots lay in northern Germany, where Emil Nolde (*see* EXPRESSIONISM, fig. 2), Christian Rohlfs and Paula Modersohn-Becker independently developed a visual language characterized both by its naturalism and by an expressive feeling for nature.

In 1905 in Dresden the artists' group DIE BRÜCKE was founded; the most important members were Ernst Ludwig Kirchner (*see* EXPRESSIONISM, fig. 1), Erich Heckel, Karl Schmidt-Rottluff, Max Pechstein and Otto Mueller. Their painting and graphic arts were influenced by the art of Gauguin, van Gogh, Seurat, Munch and Toulouse-Lautrec, as well as by African and Far Eastern art and that of the mentally ill (*see* PRIMITIVISM). This resulted in a radical simplification and sharpening of form and colour. They concentrated on a limited range of subject-matter: figures, and urban and natural landscapes. An important aspect of their work was the use of the woodcut. They took as their model not the fine-lined woodcuts of Dürer's epoch (*see* §2 above), but the coarse early printing of the late Middle

Ages. In 1911 the group moved to Berlin, and in 1913 it dissolved.

The next great phase of German Expressionism was associated with the BLAUE REITER. In 1911 an art almanac and a series of exhibitions with this title were set up in Munich by Vasily Kandinsky and Franz Marc. Other members of the group included Paul Klee (*see* WATER-COLOUR, colour pl. VIII, fig. 2), August Macke (see fig. 24), Alexei Jawlensky and Gabriele Münter, although it was less cohesive than Die Brücke. What distinguished the art almanac was the juxtaposition of pictures and texts from widely differing cultures, regions and periods. Works with Futurist and Fauvist tendencies were included alongside examples of older European art and non-Western art. Another strand of Expressionism developed *c.* 1910 in western Germany and was closely linked with Paris. This comprised the Rheinische Expressionisten, who included Macke and Heinrich Campendonk, and such Westphalian Expressionists as Wilhelm Morgner. Among the 'loners' of the period before World War I were the Austrian Oskar Kokoschka, who belonged to the circle of the periodical DER STURM (founded in 1910 by Herwarth Walden), Ludwig Meidner, Otto Dix, George Grosz, Max Beckmann and Lovis Corinth.

Following its foundation in Zurich in 1916, DADA emerged in Germany in Cologne and Berlin. Its main

exponents there were Hans Arp, Max Ernst, Hans Richter, Kurt Schwitters and Raoul Hausmann. Using such techniques as collage and montage, and also the combination of various media (poetry, music, theatre, film), Dada influentially expanded the concept of art. Though short-lived, it was immensely significant, and elements of its aesthetic remained in the work of, among others, Max Ernst, who joined the embryonic Surrealist group in Paris in 1922. The art of the 1920s was marked by a late phase of Expressionism, as exemplified by the work of Werner Scholz (1898–1982) and Conrad Felixmüller, and by a severely realistic counter-movement, variously called 'Neorealismus', 'Magischer Realismus' and NEUE SACH-LICHKEIT. This last movement concentrated on concrete reality to produce an uncompromising portrayal of the material world. Socially critical and anti-bourgeois, it was based in Berlin and Dresden, and its main exponents were Otto Dix, George Grosz (see fig. 25), Franz Radziwill, Christian Schad and Georg Schrimpf.

25. George Grosz: *Pillars of Society*, oil on canvas, 2.00×1.08 m, 1926 (Berlin, Neue Nationalgalerie)

In 1919 the Staatliches Bauhaus was founded in Weimar by its first director, Walter Gropius (*see* BAUHAUS). Through the Bauhaus, which from the outset was internationally orientated, an attempt was made to synthesize the visual, performing and applied arts. In its first, markedly experimental phase, the dominant influences were the expressive painting of southern Germany, with its tendency to abstraction, and the formalism of Cubism and Futurism. The most important teachers at the Bauhaus were Paul Klee, Lyonel Feininger, Johannes Itten, Oskar Schlemmer and Vasily Kandinsky. Political pressure forced the Bauhaus to move to Dessau in 1925. Here, under the Hungarian László Moholy-Nagy and later Josef Albers, and influenced by the Dutch De Stijl movement, there was a development towards Constructivism and Functionalism. Having moved to Berlin in 1932, in 1933 the Bauhaus was closed.

It was the political attitude towards art of National Socialism from 1933 onwards that caused the most serious break in the development of German art in the 20th century (*see* NAZISM, §2). In 1937, in the exhibition of ENTARTETE KUNST in Munich, art seen by the regime as undesirable was displayed to the public. Such artists as Klee, Rohlfs, Grosz, Dix and many others were from then on forbidden to exhibit, and many of their works were destroyed, confiscated and sold abroad. The artists lived under the threat of deportation to concentration camps. Some painters, such as Nolde and Heckel, tried to come to terms with Nazi art policy, but they were prohibited from painting. Nolde withdrew into 'inner emigration'; in Seebüll during the years of World War II, he secretly painted over 1000 small-format 'unpainted paintings', as he called them.

Other German artists emigrated abroad: Kandinsky (1933), Klee (1933), Kokoschka (1934), Beckmann (1937), Feininger (1937) and many others. The destination of numerous emigrants was Paris, where ABSTRACTION-CRÉATION united the leading exponents of various movements of abstract art. Other German emigrants ended up in the USA, especially in New York. At the same time that *entartete Kunst* was being displayed, works that were acceptable to the National Socialists were also being shown in Munich in the *Grosse deutsche Kunstausstellung*. State art in the Third Reich attached itself to the tradition of 19th-century German art, especially the painting of the Munich school (such as that by Wilhelm Leibl and Franz von Defregger) and the 'heroic landscape' of Romanticism. The realism that characterized official German art from *c.* 1939 may be seen as a misunderstood continuation of Neue Sachlichkeit. Hubert Lanzinger, Elk Eber, Sepp Hilz and Adolf Ziegler were the best-known painters of the Third Reich.

(ii) After World War II. Soon after the war Germany tried to regain entry into the international art world, and the first result was the Klassische Moderne movement. Following the division of East and West Germany, artistic development to a large degree in the two states ran parallel during their first years. In both the first priority was the rehabilitation of those artists condemned as 'degenerate' by the Nazis, and, particularly in the Soviet occupation zone, artists of ASSO (Assoziation Revolutionärer Bildender Künstler Deutschlands), founded in 1926. In West

Germany abstract painting gradually took the place of the Klassische Moderne revival. In East Germany, however, from as early as 1946–7 there was a move towards SOCIALIST REALISM and away from any plurality of styles. This latter change was largely prompted by Soviet cultural functionaries and was essentially unaltered until the reunification of Germany in 1990. This state support for Socialist Realism forced many of the more progressive artists to move to West Germany.

While the art of the Bauhaus, the various types of Expressionism and the painting of Neue Sachlichkeit could be seen as specifically German, the art that arose after 1945, especially in West Germany, was embedded in broader international movements. Besides the influences from Paris (Abstraction–Création), German artists became interested in such American movements as Abstract Expressionism, as well as the work of Cobra, founded in 1948.

A transition to ART INFORMEL took place in West Germany through the work of Willi Baumeister, Ernst Wilhelm Nay, Fritz Winter, Theodor Werner and others. In 1948 the internationally orientated group the Junger Westen was formed in Recklinghausen; its core members, Gustav Deppe (*b* 1913) and Emil Schumacher, aimed at a purist, geometric form of abstraction that resembled Tachism. In 1952 Karl-Otto Götz, Bernhard Schultze, Otto Greis and Heinz Kreutz formed the QUADRIGA group in Frankfurt am Main. Elements of Cobra, Tachism and the action painting of Jackson Pollock were influential.

At first the German reaction to the trends of Pop art and Minimalism was hesitant. Karl Georg Pfahler (*b* 1926) was the first to adopt a hard-edge style. Various avant-garde styles and movements, including Nouveau Réalisme, Kinetic art and Op art, became established in Düsseldorf with the founding of the ZERO group, which, based on GRUPPE 53, achieved notable prominence and was active from 1958 to 1966. Heinz Mack, Otto Piene and Günther Uecker were the most important artists of Zero. The main influences were the ideas of the Bauhaus, especially the kinetic objects of László Moholy-Nagy, Lucio Fontana's slashed canvases, the monochrome pictures of Yves Klein and the works of Piero Manzoni.

German artists absorbed those elements of American Pop art that were linked with the traditions of Neue Sachlichkeit. Konrad Klapheck's meticulously painted typewriters and the Hamburg group ZEBRA (formed in 1965), as well as Gerhard Richter's photographically realistic works, belong to this trend. Richter and Konrad Lueg coined the concept of 'Kapitalistisches Realismus', a style intended as a response to abstraction. Taking an ironic view of petit bourgeois taste, they also referred to the socio-economic factors in the production of art, by allusion to Socialist Realism.

In the early 1960s, after a period in which abstract painting dominated, there was a noticeable return to figuration. Horst Antes carried on the figurative, expressive art of the era before World War II and that of the Grieshaber school. The real development in the figurative painting of the 1960s, however, took place in Berlin through the works of Georg Baselitz and Eugen Schönebeck and through the founding (1961) of the Vision group and the Galerie Grossgörschen 35, an amalgamation of 15 artists, including K. H. Hödicke, Bernd Kobeling (*b* 1938)

26. Markus Lüpertz: *Babylon-Dithyrambisch XII*, distemper on canvas, 1.62×1.30 m, 1975 (Eindhoven, Stedelijk Van Abbemuseum)

and Markus Lüpertz. Hödicke's *Passage* and *U-Bahn* pictures, the 'Saxon landscapes' of Baselitz and the *Motif Paintings* (1970–75) produced by Lüpertz (see fig. 26) made two things clear: painting was dealing with German subject-matter, and, as a medium, had to confront such multimedia art forms as the Happening and the works of the Fluxus movement.

In the 1970s and 1980s there was a revival of expressionist tendencies, as seen in the *heftige Malerei* of Rainer Fetting (*b* 1949), Helmut Middendorf (*b* 1953), Salomé (*b* 1954) and Bernd Zimmer (*b* 1948) and the work of the Neue Wilde group, which included, among others, the members of Mülheimer Freiheit in Cologne, such as Walter Dahn (*b* 1954), Jiří Georg Dokoupil and others. There were, however, alternative approaches. In 1980 A. R. Penck was expatriated from East to West Germany. His 'world pictures', 'system pictures' and '*Standarts*' consisting of signs, symbols and pin men treated critically the social situation in East and West. Anselm Kiefer, Jörg Immendorff and Sigmar Polke created satirical commentaries on West German society and on the German people's coming to terms with the past (see fig. 27). Alongside figuration, abstraction continued. Karl Georg Pfahler and Günter Fruhtrunk pursued the path of geometric abstraction, while other painters, such as Gerhard Richter, Kuno Gonschior (*b* 1935), Raimund Girke (*b* 1930) and Gotthard Graubner worked with such effects as blurring.

BIBLIOGRAPHY

W. Haftmann: *Malerei im 20. Jahrhundert: Eine Entwicklungsgeschichte* (Munich, 1954, rev. 6/1979)

H. Richter: *Dada—Kunst und Antikunst: Der Beitrag Dadas zur Kunst des 20. Jahrhunderts* (Cologne, 1964; Eng. trans., London, 1965/*R* 1978)

27. Jörg Immendorff: *Café Deutschland*, acrylic on canvas, 2.82×3.20 m, 1977–8 (Aachen, Neue Galerie)

Kunst in Deutschland, 1891–1973 (exh. cat. by W. Hofmann, Hamburg, Ksthalle, 1973)

W. Schmied: *Malerei in Deutschland, Österreich und der Schweiz* (Berlin, 1974)

P. Vogt: *Geschichte der deutschen Malerei im 20. Jahrhundert* (Cologne, 1976)

Zero: Bildvorstellung einer europäischen Avant-garde, 1958–1964 (exh. cat. by U. Perucchi-Petri, H. Weitemeier-Steckel and E. Gomringer, Zurich, Ksthaus, 1979)

K. Thomas: *Die Malerei in der DDR, 1949–1979* (Cologne, 1980)

W. M. Faust and G. de Vries: *Hunger nach Bildern: Deutsche Malerei der Gegenwart* (Cologne, 1982)

H. Klotz: *Die Neuen Wilden in Berlin* (Stuttgart, 1984)

1945–1985: Kunst der Bundesrepublik Deutschland (exh. cat. by J. Poetter, W. Berlin, N.G., 1985)

Deutsche Kunst im 20. Jahrhundert: Malerei und Plastik (exh. cat., ed. C. M. Joachimides, N. Rosenthal and W. Schmied; Stuttgart, Staatsgal., 1986)

Zen 49 (exh. cat. by D. Honisch and others, Baden-Baden, Staatl. Ksthalle, 1986)

Die 'Kunststadt' München 1937: Nationalsozialismus und 'Entartete Kunst' (exh. cat., ed. P.-K. Schuster; Munich, Staatsgal. Mod. Kst, 1987)

M. Bleyl: *Essentielle Malerei in Deutschland: Wege zur Kunst nach 1945* (Nuremberg, 1988)

THOMAS KLIEMANN

IV. Sculpture.

1. Before *c.* 1400. 2. *c.* 1400–*c.* 1600. 3. *c.* 1600–*c.* 1750. 4. *c.* 1750–*c.* 1900. 5. After *c.* 1900.

1. BEFORE *c.* 1400.

(i) Carolingian, Ottonian and Romanesque. As with other types of art, sculpture production in Germany in the Middle Ages flourished at different times in various centres. In the early medieval period the area once settled by the Romans around Aachen and Metz in the west became prominent. The beginnings of a distinctive sculptural tradition in the Carolingian period (late 8th century–962) indicate the lingering impact of Christianity's rejection of large-scale pagan sculpture (*see* CAROLINGIAN ART, §III). Documents mention sculpture in stucco and precious metal, although little survives from this period. While the bronze statuette made in Metz of an emperor on horseback (*c.* 860; Paris, Louvre) complies with the traditional antique image of the ruler, it is stylistically closer to contemporary small-scale art.

During the Ottonian period (*c.* 955–late 11th century) Hildesheim, Werden, Fulda and Augsburg and their monasteries also became important centres for sculpture in ivory, wood, stone and bronze (*see* OTTONIAN ART, §III).

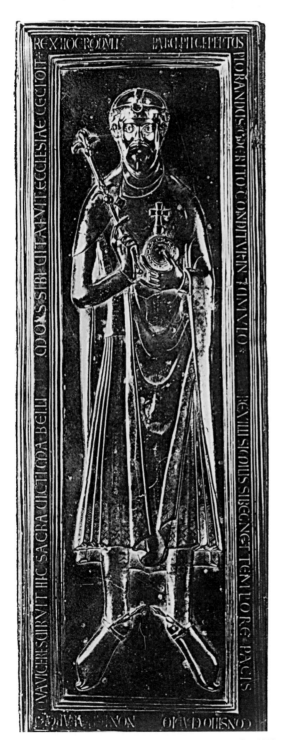

28. Memorial to *Rudolf of Swabia*, bronze, 1.97×0.68 m, after 1080, Merseburg Cathedral

The Gero Crucifix (wood, *c.* 969–76; Cologne Cathedral; *see* CRUCIFIX, §3(i) and fig. 3) provided the model for many crucifixes into the 11th century. Surviving pieces of sculpture from *c.* 1000, for example the Virgins in Essen Minster (980; Essen, Münsterschatzmus.; *see* RELIQUARY, fig. 2) and Hildesheim Cathedral (Hildesheim, Diözmus. & Domschatzkam.), or even the bronze doors at Hildesheim (1015; *see* OTTONIAN ART, §V, 2), are clearly based on manuscript illumination and treasury art. One of the earliest surviving full-length life-size portraits, the bronze memorial to *Rudolf of Swabia* (*d* 1080) in Merseburg Cathedral, also demonstrates this cross-fertilization (see fig. 28).

The largest number of 12th-century works survives in the Rhine–Meuse region, Lower Saxony and the southwest. Generally in the 11th and 12th centuries forms became crisper and structural composition firmer; this is particularly evident in such religious pieces as crucifixes (e.g. bronze crucifix, 1060; Werden, St Liudger) and seated Virgins (e.g. the Imad Virgin; Paderborn, Diözmus. & Domschatzkam.). Large narrative cycles, however, were still rare (e.g. wooden doors, mid-11th century; Cologne, St Maria im Kapitol). Romanesque sculpture flourished in the mid-12th century, taking a variety of forms: for example the ledger on the tomb of *Archbishop Friedrich* (*d* 1152) in Magdeburg Cathedral; gallery reliefs in Gröningen Abbey Church; lecterns in Freudenstadt church; and such architectural sculpture as capitals (Lower Saxony and south-west Germany; *see also* ROMANESQUE, §III, 1(ix) and 2(vi)). Incisively cut, cleanly separated forms yielded around 1200 to a painterly slurring of detail and sculptural softness; stucco became popular, for example choir-screens in the Liebfrauenkirche, Halberstadt, and St Michael, Hildesheim. The association with manuscript illumination continued.

(ii) Gothic. Many Middle German crucifixion groups and choir-screens survive from the first half of the 13th century. The rise of Gothic coincided with the emergence of new centres of production (*see* GOTHIC, §III, 1(iii)), including Strasbourg and Freiburg im Breisgau on the Upper Rhine, Bamberg and then Nuremberg in Franconia, and Swabia in southern Germany. With the advent of French Gothic *c.* 1220, sculpture took on new roles. The figures around portals in the cathedrals of Magdeburg (*c.* 1220; now in choir; *see* MAGDEBURG, §1(ii)) and Bamberg (now in Bamberg, Diözmus.; *see* BAMBERG, §2(ii)) reveal different degrees of dependency on their French models. In the works of the SAMSON MASTER (*see* MASTERS, ANONYMOUS, AND MONOGRAMMISTS, §I) and his circle in Cologne and the Middle Rhine area, or in Upper Saxon works from Freiberg and Wechselburg, the assimilation of French Gothic sculpture goes further still. The realism and drama of the 12 mid-13th-century life-size statues of the Founders in the west chancel of Naumburg Cathedral (*see* NAUMBURG, §1(ii); *see also* MASTERS, ANONYMOUS, AND MONOGRAMMISTS, §I: NAUMBURG MASTER) are exceptional, although the workshop rapidly declined. In south Germany the ERMINOLD MASTER (*see* MASTERS, ANONYMOUS, AND MONOGRAMMISTS, §I) worked in Regensburg from *c.* 1275, influenced

by French cathedral sculpture, as at Paris and Reims. Indeed, contemporary French trends centred on Paris and Reims had a profound impact on German sculpture in the second half of the 13th century. The figures (c. 1290) on the choir piers in Cologne Cathedral (from 1248), depicting *Christ*, the *Apostles* and the *Virgin* (*see* COLOGNE, fig. 8) attest to the high aspirations of the building. Later sculptures in wood reveal how the courtly elegance of Parisian sculpture was reshaped into a local vernacular idiom. The Cologne Cathedral workshop functioned from *c.* 1290, inspired by a calmer style from Lorraine, as in the marble figures on the high altar (see fig. 29), and parts of the oak choir-stalls (1308–11); it influenced the development of sculpture in the Lower Rhine until the second half of the 14th century (*see* COLOGNE, §IV, 1(ii)).

The sculpture on the west portals of Strasbourg Cathedral (*see* STRASBOURG, §III, 2) had a lasting influence in the Upper and Middle Rhine area from Freiburg to Worms, and also to the east. In the draped figures of the *Prophets*, *Virtues* and *Vices* (1275–1300), the bodies are rendered wholly by swathes of material. In the sculpture (*c.* 1340) of the chapel tower at Rottweil, the Strasbourg use of drapery has become graphic and hard-edged, well-suited to the ascetic figures.

A complete stylistic break can be observed from *c.* 1350, with the building of the choir of the cathedral of the Holy Cross, Schwäbisch Gmünd, from 1351 (*see* SCHWÄBISCH GMÜND, CATHEDRAL OF THE HOLY CROSS, §2), which influenced Swabia, Cologne and Nuremberg. Representations of the human figure were characteristically powerful, under life-size, formed simple sculptural volumes and had soft, expressive faces. The geographical spread of artistic inspiration at this time came to depend not only on patrons

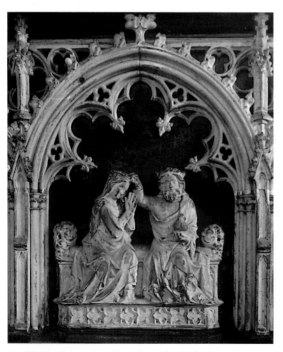

29. Marble figures, h. 2.15 m, from the high altar of Cologne Cathedral, *c.* 1300

but also on links between artists: members of the PARLER family were involved in many important projects. Alongside national and international developments, local sculptural traditions flourished. In the middle and north of Germany 14th-century sculpture—rather sparsely represented—was largely isolated from southern trends. From the late 13th century, however, the carved altar retable developed towards the winged altar form north of the Main, as can be seen in masterpieces of this genre, for example the Doberan, Marienstatt, Cologne, Oberwesel and Hamburg altarpieces.

BIBLIOGRAPHY

H. Beenken: *Bildhauer des 14. Jahrhunderts am Rhein und in Schwaben* (Leipzig, 1927)
R. Wesenberg: *Bernwardinische Plastik* (Berlin, 1955)
——: *Frühe mittelalterliche Bildwerke: Die Schulen rheinischer Skulptur und ihre Ausstrahlung* (Düsseldorf, 1972)
D. Schubert: *Von Halberstadt nach Meissen: Bildwerke des 13. Jahrhunderts in Thüringen, Sachsen und Anhalt* (Cologne, 1974)
P. Kurmann: 'Deutsche Skulptur des 13. Jahrhunderts: Zur Frage nach den Voraussetzungen in Frankreich', *Alte & Neue Kst*, xxvi/xxvii (1978–9), pp. 76–101
R. Budde: *Deutsche romanische Skulptur, 1050–1250* (Munich, 1979)
M. V. Schwarz: *Höfische Skulptur im 14. Jahrhundert: Entwicklungsphasen und Vermittlungswege im Vorfeld des Weichen Stils*, 2 vols (Worms, 1986)
R. Kahsnitz: *Die Gründer von Laach und Sayn: Fürstenbildnisse des 13. Jahrhunderts* (Nuremberg, 1992)
K. Niehr: *Die mitteldeutsche Skulptur der ersten Hälfte des 13. Jahrhunderts* (Weinheim, 1992)
G. Schmidt: *Gotische Bildwerke und ihre Meister*, 2 vols (Cologne and Vienna, 1992)
R. Suckalef: *Die Hofkunst Kaiser Ludwigs des Bayern* (Munich, 1993)
K. Hengevoss-Dürkop: *Skulptur und Frauenkloster: Studien zu Bildwerken der Zeit um 1300 aus Frauenklöstern des ehem. Fürstentums Lüneberg* (Weinheim, 1994)

KLAUS NIEHR

2. *c.* 1400–*c.* 1600.

(i) Development of a German style. (ii) Effects of the Reformation.

(i) Development of a German style. A distinctively German sculptural style emerged in the 15th century and blossomed in the early 16th. Its evolution was tied to the proliferation of religious art in both church and secular settings in the form of civic, corporate and personal commissions.

(a) Introduction. The extent and richness of German religious art of this period, for example carved choir-stalls, tabernacles, crucifixes, carved cycles, tombs, epitaphs and other objects, have been obscured by subsequent destruction caused by the Protestant iconoclasm of the 1520s and 1530s (*see* §(ii) below), and by various wars: for example, all but one of Ulm Minster's 52 altars were destroyed (*see* ULM, §2(i)(b)). In the late 15th century urban workshops arose to meet the demand for sculpture. The workshop of TILMAN RIEMENSCHNEIDER in Würzburg carved at least 143 altars, holy statues, tombs and related works. Though one can speak of a 'German style', it is more accurately a myriad of individual or local trends, each modifying the other. Thus Riemenschneider's influence is evident in most Franconian churches. Early woodcuts and engravings, notably those of Master E. S. and Martin Schongauer, were influenced by sculpture and in turn contributed greatly to the proliferation of specific models and ideas.

The distinctive character of German sculpture developed slowly during the 15th century. The limestone *Virgin* of Krumau Castle (Vienna, Ksthist. Mus.) typifies the refined 'Soft style' in vogue *c.* 1400 (*see also* §III, 2 above).

Its naturalistic pose contrasts with the lyrical, swaying form. Such sweet, doll-like 'Beautiful Madonnas' remained popular in cities throughout the Lower Rhine well into the 1460s. Yet the pear-wood *Virgin and Child*, made *c.* 1420 for St Sebaldus, Nuremberg, reveals a distinctive shift towards natural observation in the weight and form of the Virgin's body, its squatter proportions, and the decreased idealism of her fleshy face.

The fascination with detail and careful observation of forms that characterize the sculpture of Claus Sluter and other Netherlandish masters are evident in the life-size sandstone *Man of Sorrows* (1429) carved for the west portal of Ulm Minster (original now inside) by HANS MULTSCHER (for an illustration of his work *see* PALMESEL). The transmission of Netherlandish art to Germany occurred when Nicolaus Gerhaert of Leiden moved to Trier (by 1462) and to Strasbourg, where he worked between 1463 and 1467. His naturalism, seen in the wooden retable (1466; destr.) for Konstanz Cathedral, greatly influenced other artists in the Upper Rhine region, and the engravings of MASTER E. S. (*see* MASTERS, ANONYMOUS, AND MONOGRAMMISTS, §III) spread the sculptor's style throughout southern Germany. The oak busts (1469–74) by Jörg Syrlin (*see* SYRLIN, (1)) and his team for the choir-stalls in Ulm Minster reveal a familiarity with the art of Multscher and Gerhaert.

(b) Altarpieces. The most characteristic creation of German sculpture from the 1470s was the wooden RE-TABLE or winged altarpiece (*see* ALTARPIECE, §2). Typical are Michael Pacher's St Wolfgang Altarpiece (1471–81; St Wolfgang, parish church; *see* PACHER, MICHAEL, fig. 2), Michel Erhart's altarpiece of *c.* 1493–4 in Blaubeuren Abbey Church (for illustration *see* SCHNITZALTAR), Riemenschneider's *Holy Blood* altarpiece (1501–5; *see* RIE-MENSCHNEIDER, TILMAN, fig. 2) in the Jakobskirche, Rothenburg ob der Tauber, the altarpiece (1511–14; altered) for St Castulus, Moosburg, by HANS LEINBERGER, or the *Coronation of the Virgin* altar (1523–6; see fig. 30) by MASTER H. L. (*see* MASTERS, ANONYMOUS, AND MON-OGRAMMISTS, §III) in Breisach Minster, all *in situ*. Such altarpieces can measure up to 14×7 m. They involved the collaboration of sculptor and painter, although such artists as Michel Pacher or VEIT STOSS combined both skills. However, this was strongly discouraged by the local guild regulations.

The relationship between painters and sculptors became closer *c.* 1500; the spatial articulation and the adroit use of light in Riemenschneider's *Last Supper* in the *Holy Blood* altarpiece derive from painting, while the massing of figures in the extreme foreground and the popularity of highly angular drapery forms in paintings and prints were inspired by sculpture. Although increasingly personal styles were developed by these masters, their altarpieces were typically crammed with figures and rampantly fluid deco-rative elements, each figure compounding the animation in its pose and in the long, flowing drapery folds that swirl across the body. In the work of Master H. L., linear agitation dominates. The multiplicity of surfaces, coupled with deep troughs of the fabric and hair, contribute to the rich interplay of light and dark. This delightfully overzeal-ous use of line partially obscures the figures. The Breisach

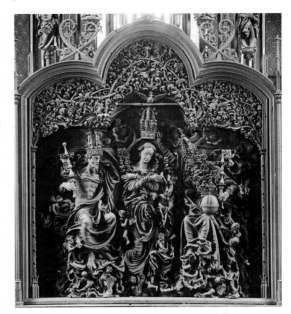

30. Master H. L.: *Coronation of the Virgin* altar (detail), lime-wood, 4.31×3.62 m, 1523–6, Breisach Minster

Altar is also highly theatrical. The playful clamouring of joyous angels celebrating the Virgin's coronation contrasts sharply with the style of Peter Flötner's bronze Apollo Fountain (1532; Nuremberg, Ger. Nmus.; for illustration *see* FLÖTNER, PETER), in which the physical harmony of the nude central figure is emphasized by its clear and forceful athletic stance.

(c) Regional developments, c. *1470–*c. *1530.* During this period distinctive regional styles and important individual workshops emerged. In Swabia, especially in Ulm and later Augsburg, Michel Erhart, Gregor Erhart (*see* ERHART, (1) and (2)), Adolf Daucher, Hans Daucher (*see* DAUCHER, (2)) and Sebastian Loscher (*d* 1548) dominated. In Bavaria and the archdiocese of Salzburg, ERASMUS GRASSER, Hans Leinberger and Loy Hering were active. Veit Stoss, ADAM KRAFT and Peter Flötner worked in Nuremberg, and the VISCHER family ran Germany's foremost brass foundry there. BERNT NOTKE, Claus Berg, Hans Witten (*see* MASTERS, ANONYMOUS, AND MONOGRAMMISTS, §III: MASTER H W), HENNING VON DER HEIDE and later Benedikt Dreyer (*fl* 1506–55) provided works for towns throughout northern Germany and the Baltic. Despite the quantity of sculpture produced along the Rhine, fewer major masters worked there; the most notable included Hans Backoffen (*d* 1519), Niclaus von Hagenau, Conrat Meit (active in the Netherlands), the Master H. L., Hein-rich Douvermann (*fl* 1510–44) and Peter Schro.

(ii) Effects of the Reformation.

(a) Introduction. The Protestant Reformation of the 1520s condemned the traditional Catholic use of religious art as idolatrous and prodigal, and traditional religious art declined until the Catholic Counter-Reformation at the end of the 16th century. Reform rhetoric begat ICONOCLASM. From 1522 tens of thousands of sculptures

were destroyed, making a reconstruction of the history of south-western German late medieval art problematic. Many sculptors, whose livelihoods traditionally depended on the production of altars and holy statues, were without commissions, while staunchly Catholic patrons feared that any new works commissioned would later be destroyed. Cardinal Albrecht von Brandenburg's ambitious renovation of the Neue Stift in Halle during the 1520s and 1530s was the only major church project, and even he had to remove or sell most of the sculptures and paintings before Halle embraced Lutheranism in 1541. LOY HERING succeeded largely by skilfully developing the market for tombs and epitaphs in and around Eichstätt. Peter Dell (*see under* DELL), whose early small reliefs and statuettes exhibited great potential, spent the rest of his career carving attractive if formulaic funerary monuments.

It was in Lutheran Saxony that a Protestant art took root, first in the paintings from the workshop of Lucas Cranach the elder in Wittenberg, and later in such modest sculptural projects as the chapel at Schloss Hartenfels, Torgau (*see* TORGAU, §2), consecrated by Martin Luther in 1544. Lutheran acceptance of the pedagogical benefit of representations of biblical scenes and a few evangelical allegories prompted a dynamic school of sculpture in Dresden. With the support of Augustus I, Elector of Saxony (*reg* 1553–86), the WALTHER family carved stone altarpieces, pulpits, baptismal fonts and funerary monuments for many regional churches during the second half of the century, initiating the revival of religious sculpture in Lutheran northern Germany in the late 16th century and the early 17th.

(b) Exploitation of a new repertory. The Reformation allowed sculptors to develop new types of carving. In the late 1510s HANS SCHWARZ began to popularize portrait medals (already fashionable in Italy and France) in Augsburg, Nuremberg and Worms. It has been estimated that during the 16th century at least 4000 different medals were cast or struck (Habich). Other leading medallists included MATTHES GEBEL, Christoph Weiditz (*see* WEIDITZ, (3)), HANS REINHART and JOACHIM DESCHLER. Small-scale reliefs and statues in wood, stone or metal were produced for collectors in the late 1510s; for instance, Peter Vischer the younger cast several versions of a brass relief of *Orpheus and Eurydice* (e.g. h. 163 mm, *c.* 1516; Hamburg, Mus. Kst & Gew.) and inkpots with allegorical themes (h. 167 mm, *c.* 1516; h. 193 mm, 1525; both Oxford, Ashmolean). Classical subjects and Italianate forms first appeared in the *Kleinplastik* of Augsburg and Nuremberg. Hans Daucher, VICTOR KAYSER and, in Eichstätt, the Hering workshop used fine-grain Solnhofen limestone. Peter Flötner, who frequently collaborated with Nuremberg's goldsmiths, favoured the plaquette (*see* PLAQUETTE, §3(ii)). Such Netherlandish masters as Johann Gregor van der Schardt brought courtly sophistication to Germany, for example in the four fire-gilt *Seasons* (*c.* 1570–75; Vienna, Ksthist. Mus.), which he made with Wenzel Jamnitzer (*see* JAMNITZER, §I(1)), Germany's foremost goldsmith, and in his *Mercury* of 1573 (Stockholm, Nmus.; see fig. 31). Van der Schardt also made naturalistic terracotta portrait busts, for example the life-size *Willibald Imhoff* (1570; Berlin, Skulpgal.) and relief roundels.

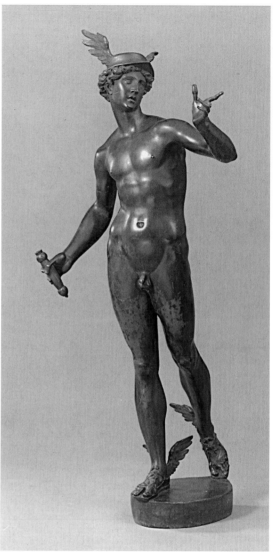

31. Johann Gregor van der Schardt: *Mercury*, bronze, h. 1.14 m, 1573 (Stockholm, Nationalmuseum)

(c) Catholic, Lutheran and secular projects of the later 16th century. After the end of the Council of Trent in 1563, Germany's Catholics once again embraced religious art and gradually renovated many churches. This *renovatio* or revival ultimately proved to be a critical catalyst to German sculpture. Ambitious Catholic clerics and princes initiated significant new commissions. For instance, HANS RUPRECHT HOFFMANN carved various items including the sandstone pulpit (1570–72) for Trier Cathedral. Many sculptural dynasties, such as the Groninger family and the ZÜRN family, were founded. The Dukes of Bavaria expressed their criticism of this revival of the Catholic church through their support of the Jesuits and their artistic patronage in Ingolstadt and Munich. Between 1583 and 1597 William V, Duke of Bavaria, financed the Jesuit church of St Michael in Munich, hiring Italian and Netherlandish sculptors to collaborate with local masters.

Hubert Gerhard's imposing bronze *St Michael and Lucifer* (1588; *see* GERHARD, HUBERT, fig. 1) stands in a niche between the two portals. The interior is dominated by 40 over life-size terracotta statues of *Christ*, saints and angels by Gerhard and Carlo Pallago, and by the high altar with a complex frame (1586–9) carved by WENDEL DIETRICH, which typifies the revival of monumental altarpieces. The bronze Crucifix (1594–5) represents the international character of St Michael. Giambologna contributed the figure of *Christ on the Cross*, and HANS REICHLE, his German assistant, added the grieving *Mary Magdalene*. Around 1600, dozens of sculptures were begun, for example Hans Degler's three lime-wood altars (1604–7) for the choir of the basilica of SS Ulrich and Afra, Augsburg (for illustration *see* DEGLER, HANS).

In Lutheran regions sculpture also thrived. Intricate pulpits were set up in the cathedrals of Schleswig (1560), Lübeck (1568), Ratzeburg (1576) and Magdeburg (1595–7; by Christof Kapup), among others. Sebastian Walther, working occasionally with Giovanni Maria Nosseni, supplied altars and epitaphs to churches throughout Saxony. In both Protestant and Catholic areas many sumptuous tombs and epitaphs were carved.

By the 1590s there were more secular commissions, ranging from portraits and small bronzes or ivories for collectors, to major civic projects. For instance, BENEDIKT WURZELBAUER cast his monumental brass Fountain of the Virtues (1585–9; Nuremberg, nr St Lorenz) in Nuremberg, and Hubert Gerhard and Adriaen de Vries made bronze fountains for Augsburg. Wealthy patricians and nobles engaged sculptors to embellish their new residences. Hubert Gerhard and Carlo Pallago provided terracottas and bronzes for Hans Fugger's new Schloss Kirchheim (built 1578–83; *see* FUGGER, (3)). By the end of the 16th century German sculpture had regained its vitality, although, having entered mainstream European art, it had perhaps yielded some of its distinctive character.

BIBLIOGRAPHY

L. Bruhns: *Würzburger Bildhauer der Renaissance und des werdenden Barock, 1540–1650* (Munich, 1923)
H. Huth: *Künstler und Werkstatt der Spätgotik* (Augsburg, 1925/*R* Darmstadt, 1967)
E. F. Bange: *Die Kleinplastik der deutschen Renaissance in Holz und Stein* (Florence, 1928)
W. Pinder: *Die deutsche Plastik vom ausgehenden Mittelalter bis zum Ende der Renaissance*, 2 vols (Potsdam, 1929)
G. Habich: *Die deutschen Schaumünzen des XVI. Jahrhunderts*, 2 vols (Munich, 1929–34)
E. F. Bange: *Die deutschen Bronzestatuetten des 16. Jahrhunderts* (Berlin, 1949)
A. Schädler: *Deutsche Plastik der Spätgotik* (Königstein im Taunus, 1962)
T. Müller: *Deutsche Plastik der Renaissance bis zum Dreissigjährigen Krieg* (Königstein im Taunus, 1963)
W. Paatz: *Süddeutsche Schnitzaltäre der Spätgotik* (Heidelberg, 1963)
P. Poscharsky: *Die Kanzel: Erscheinungsform in Protestantismus bis zum Ende des Barocks* (Gütersloh, 1963)
J. Rasmussen: *Deutsche Kleinplastik der Renaissance und des Barock* (Hamburg, 1975)
Der Mensch um 1500: Werke aus Kirchen und Kunstkammern (exh. cat., ed. H. Gagel; Berlin, Skulpgal., 1977)
U.-N. Kaiser: *Der skulptierte Altar der Frührenaissance in Deutschland* (Frankfurt am Main, 1978)
H. Schindler: *Der Schnitzaltar: Meisterwerke und Meister in Süddeutschland, Österreich und Südtirol* (Regensburg, 1978)
M. Baxandall: *The Limewood Sculptors of Renaissance Germany* (London, 1980)
R. Laun: *Studien zur Altarbaukunst in Süddeutschland, 1560–1650* (Munich, 1982)
M. J. Liebmann: *Die deutsche Plastik, 1350–1550* (Leipzig, 1982)
B. Decker: *Das Ende des mittelalterlichen Kultbildes und die Plastik Hans Leinbergers* (Bamberg, 1985)
W. Schmid: *Altäre der Hoch- und Spätgotik* (Cologne, 1985)
Natur und Antike in der Renaissance (exh. cat., ed. H. Beck and D. Blume; Frankfurt am Main, Liebieghaus, 1985)
Modell und Ausführung in der Metallkunst (exh. cat. by L. Seelig and others, Munich, Bayr. Nmus., 1989)
Meisterwerke Massenhaft: Die Bildhauerwerkstatt des Niklaus Weckmann und die Malerei in Ulm um 1500 (exh. cat., Stuttgart, Württemberg. Landesmuseums, 1993)
J. C. Smith: *German Sculpture of the Later Renaissance, c. 1520–1580: Art in an Age of Uncertainty* (Princeton, 1994)
The Currency of Fame: Portrait Medals of the Renaissance (exh. cat., ed. S. K. Scher; New York, Frick, 1994)

JEFFREY CHIPPS SMITH

3. *c.* 1600–*c.* 1750.

(i) Introduction. The division of the Holy Roman Empire in the 17th and 18th centuries into a number of small territories favoured the development of regional, often traditional styles. Sculpture in the monastic territories and Catholic states in the south had been placed in the service of the Church and often took the form of extensive ensembles based on religious and secular themes. In the Protestant north sculpture was mainly centred on such secular tasks as architectural decoration, monuments and tombstones. The bidenominational imperial cities, such as Augsburg and Nuremberg, achieved artistic prominence in the 17th century and early 18th. At the beginning of the 17th century sculptors were organized in guilds; there was a strict division between sculptors working in wood and those using stone. Most workshops were in cities, and the guilds exerted a significant influence until the first half of the 17th century, when such struggles against their power as the disputes of the Zürn workshop in Überlingen with Hans Georg Botschlin occurred. Guild organization remained intact, however, until the second half of the 18th century. The number of masters was strictly regulated; a journeyman (as a rule) became a master only by inheritance or by marrying a master's widow.

Towns in south Germany, such as Weilheim, Mindelheim, Schongau and Türkheim, became regional centres, supplying a large area. Many sculptors worked away from home for prolonged periods, for example the masons and stuccoists who came from Graubünden, Lombardy, Vorarlberg or Wessobrunn, and worked on a seasonal basis in Germany. Monastic workshops were established by imperial monasteries in south Germany, while in residential towns such as Munich court sculptors established workshops free from the strict guild laws. Sculptors seeking to evade the guilds' restrictions settled outside towns; Joseph Matthias Götz, for instance, worked at St Nikola near Passau. In the first half of the 17th century and especially from the late 17th century, journeymen would often travel extensively, mostly to Italy, Austria and Bohemia.

Private academies, such as that in Nuremberg (1662), were supplemented by newly established public academies after the early 18th century. The Vienna academy (founded 1705) was influential in southern Germany, and the Augsburg academy was founded in 1710 to ensure the city's position as the leading artistic centre of Swabia. In

Prussia the Berlin academy was founded in 1699; Andreas Schlüter was one of its first directors.

(ii) Regional developments.

(a) Southern Germany. Under William V and Maximilian I, Dukes of Bavaria, Munich grew to be the most important royal seat in the Holy Roman Empire after Vienna. Among the most ambitious achievements were the tombs of *William V* (incomplete) in St Michael's and of *Ludwig IV* (*d* 1347) by Hans Krumpper in the Frauenkirche (*see* KRUMPPER, HANS, fig. 2). During this period Netherlandish sculptors continued to be an important influence. The successors of Hubert Gerhard and Adriaen de Vries (*see* §2 above) included Krumpper, Hans Reichle and Caspar Gras, who worked mainly in bronze. They influenced Bavarian sculptors working in wood, such as CHRISTOPH RODT, Hans Leonhard Waldburger (*c.* 1543–1622), Hans Spindler (*c.* 1597–*c.* 1660) and HANS DEGLER. Netherlandish art also inspired sculptors in smaller towns; for instance, the Netherlander Hans Morinck settled at Konstanz, and his work influenced both Jörg Zürn (as in his altar of the Virgin, 1613–16; Überlingen Minster; *see* ZÜRN, (1), fig. 1) and David Zürn (1598–1666), for example in his *St Catherine* (*c.* 1630; Nuremberg, Ger. Nmus.). In the second quarter of the 17th century a change occurred in ecclesiastical sculpture in the Catholic south, probably connected with the Counter-Reformation's reform of the liturgy. Cycles or ensembles of free-standing sculptures, usually over life-size and highly naturalistic,

became commonplace in churches. These strikingly classical works include the lay altar statues (1633) in the abbey church of Salem by CHRISTOPH SCHENCK, the *Crucifixion* group (1648–53) in Bamberg Cathedral by Justus Glesker and the *Ecce homo* (*c.* 1627–33) and *Salvator mundi* in Augsburg Cathedral by Georg Petel.

The disruption caused by the Thirty Years War (1618–48) led in the second half of the 17th century to stylistic regression in southern Germany, as in the work of Christoph Daniel Schenck and of JOSEPH MATTHIAS GÖTZ, who was influenced by stylistic traditions from Leinberger and by the Roman High Baroque. In the third quarter of the 17th century Upper Austria and the Tyrol became the focus of a new stylistic ideal that was disseminated by the SCHWANTHALER family, Michael Zürn the younger (*fl* 1617–51), Andreas Tamasch (1639–97) and Franz Joseph Feuchtmayer (*see* FEUCHTMAYER, (1)) in southern Germany. Stuccoists and sculptors from northern Italy, in particular Giovanni Battista Carlone and the Allio family (*see* ALLIO, 2(ii)), were involved in formulating the new style. The stucco decoration in the interior of the cathedral of St Stephan in Passau from 1677 by Giovanni Battista Carlone (see fig. 32; *see also* CARLONE (ii), (4)) is an early example of Baroque space decoration, which reached its peak at the pilgrimage church of Neubirnau (1746–50) and the monastery church of Ottobeuren. The work of Diego Francesco Carlone (*see* CARLONE (ii), (7)) at the priory church in Weingarten (from 1723), Ludwigsburg Castle (1719 and 1725) and numerous churches and royal residences in Franconia and Lower Bavaria exerted a lasting influence on the stucco and sculpture of Joseph

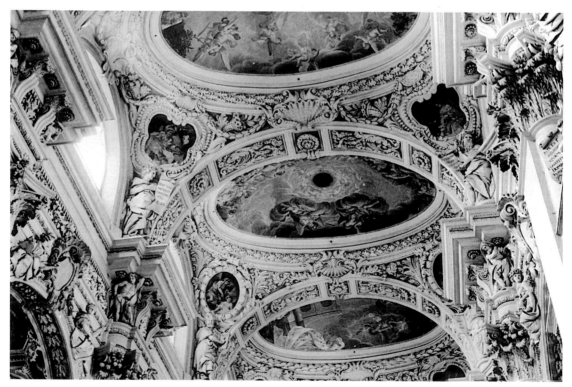

32. Giovanni Battista Carlone II: *Prophets* and stucco ornamentation, from 1677, nave of the cathedral of St Stephan, Passau

Anton Feuchtmayer (*see* FEUCHTMAYER, (3)), Johann Baptist Zimmermann (*see* ZIMMERMANN, (1)), Franz Joseph Ignaz Holzinger and others (*see* STUCCO AND PLASTERWORK, §III, 10(i)(e)). Italian stuccoists such as the Appiani, Bossi, Pozzi, Donato Frisoni and Gasparo Mola contributed to an integration of sculptural and painted architectural decoration sometimes described as *Gesamtkunstwerk*. Standards became increasingly high, as in Egid Quirin Asam's work *c.* 1734 in the monastery church of St Georg and St Martin in Weltenburg (*see* ASAM, (3)) and in the impressive *Vision of Ezekiel* by JOHANN JOSEPH CHRISTIAN in the abbey church of Zwiefalten. Church sculpture enjoyed a variety of settings and featured a striking use of gesture, as in the sculpture by Hans and Christoph Schenk and Zacharias Binder in the abbey church of Salem (*c.* 1625–34; altered).

A preference for forms characterized by the materials used is evident in 18th-century German sculpture, for instance in the *bozzetto*-like statues (*c.* 1750; St Aloysius Gonzaga) by PAUL EGELL, or the sculptures of Ignaz Günther, in which the folds of the drapery exploit the shape of the woodcarver's knife, a technique also used by Joseph Götsch. There were also considerable regional differences in style. Italian and Bohemian sculpture became especially important in Lower Bavaria and Franconia. FERDINAND TIETZ brought Bohemian styles to south Germany. The Flemish sculptor EGID VERHELST I and the Netherlander GUILLIELMUS DE GROF were active in Bavaria, while French and Flemish influences were introduced to Baden by Peter Anton von Verschaffelt (*see* VERSCHAFFELT, (1)). In the 18th century Munich developed into an artistic centre; the workshops of de Grof, Johann Baptist Straub (*see* STRAUB, (1)) and Ignaz Günther influenced numerous Bavarian sculptors. More traditional workshops flourished simultaneously in smaller towns, for example those of Anton Sturm (1690–1757), FRANZ XAVER SCHMÄDL and Christian Jorhan the elder. In Swabia the workshops of Ruez, Reusch, Hops and Hegenauer were influenced by such Tyrolean sculptors as Andreas Etschmann (*d* 1708) and Ignaz Waibl. On Lake Konstanz the Mimmenhausen workshop under Joseph Anton Feuchtmayer, Johann Georg Dirr (*see* DIRR) and JOHANN WIELAND had a marked influence on style in the region. A similar role was played by CHRISTIAN JOHANN WENTZINGER in the Upper Rhine region, and by Johann Peter Wagner (*see* WAGNER, (1)) in Franconia. From the early 17th century until the late 18th there was an unbroken tradition of south German small-scale sculpture, represented by LEONHARD KERN, Sigmund Hescheler, Christoph Daniel Schenck (*see* SCHENCK, (3)), JOHANN CASPAR SCHENCK, Mathias Rauchmiller, IGNAZ ELHAFEN and Paul Egell, among others.

(b) *Central and northern Germany.* In central and northern Germany sculptors followed their own distinctive development, owing to their being given commissions that were undoubtedly also confessional in origin. Such Netherlandish sculptors as Adriaen de Vries, who had been trained in Italy, influenced native artists. The work of the WULFF FAMILY from 1600 on the sculptural decoration of the palace chapel and new parish church in Bückeburg clearly shows the influence of Netherlandish Mannerism.

There were also, however, traditional workshops that mingled Mannerist forms with Late Gothic elements, as in the work of LUDWIG MÜNSTERMAN and his successors Jürgen Kriebel (1580/90–1645) and Gebhard Jürgen Titge (*c.* 1590–1663/4). In Saxony and Thüringen Giovanni Maria Nosseni's work continued to influence local sculptors, and in Saxony–Anhalt Magdeburg exerted a widely felt influence until its destruction in 1631, one of its most important representatives being CHRISTOPH DEHNE. An important figure in the coastal regions and Brandenburg from the mid-17th century was Artus Quellinus the elder; his pupil GABRIEL GRUPELLO influenced early 18th-century sculpture in the Lower Rhine area.

Extensive secular cycles included those by BALTHASAR PERMOSER at the Zwinger in Dresden, and by ANDREAS SCHLÜTER in Berlin. Schlüter also executed decorative sculpture on buildings (Berlin, Zeughaus; *see* SCHLÜTER, ANDREAS, fig. 1) and monumental bronzes, for example his equestrian statue of the *Great Elector* (1697–1700; Berlin, Schloss Charlottenburg). Johann Peter Benkert (1709–69) and Matthias Gottlieb Heymüller were also inspired by the late Baroque, as in their sculptures in the gardens of Schloss Sanssouci in Potsdam (*see* POTSDAM, §2).

In Protestant religious art, especially in the second half of the 17th century, the relief became important, and sculpture attained a classical severity. In Saxony Johann Heinrich Böhm (1626–80) and his successor BALTHASAR STOCKAMER were influential. Alongside the altar sculpture, reduced to a narrow range of subject-matter, costly tombstones in the tradition of 16th- and 17th-century French tombstone art are often found. In Lower Saxony Paul Egell, whose style was assimilated by Johann Friedrich Blasius Zisenis (1715–87), remained active. Egell's style, however, appears incongruous alongside the more classical north German sculpture, illustrating the basic stylistic break between the sculpture of south Germany and that of the north.

BIBLIOGRAPHY

A. Feulner: *Münchener Barockskulptur* (Munich, 1922)

——: *Die deutsche Plastik des siebzehnten Jahrhunderts* (Munich and Florence, 1926)

W. Pinder: *Deutsche Barockplastik* (Königstein, 1933)

M. V. Freeden: *Kleinplastik des Barock* (Stuttgart, 1951)

K. Schwager: *Bildhauerwerkstätten des achtzehnten Jahrhunderts im schwäbischen Voralpengebiet*, i and ii (Tübingen, 1955–63)

G. van der Osten: 'Zur Barockskulptur im südlichen Niedersachsen', *Niederdt. Beitr. Kstgesch.*, i (1961), pp. 239–58

M. Hering Mitgau: *Barocke Silberplastik in Südwestdeutschland* (Weissenhorn, 1973)

V. Loers: *Rokokoplastik und Dekorationssysteme: Aspekte der süddeutschen Kunst und des ästhetischen Bewusstseins im 18. Jahrhundert*, Münch. Ksthist. Abh., viii (Munich and Zurich, 1976)

Barockplastik in Norddeutschland (exh. cat. by J. Rasmussen, L. L. Möller, L. Seeling and others, Hamburg, Kst- & Gewsch., 1977)

J. Rasmussen: 'Barockplastik in Norddeutschland: Nachträge', *Jb. Hamburg. Kstsamml.*, xxiii (1978), pp. 191–208

Himmlische Vettern: Barockskulptur im südlichen Westfalen (exh. cat. by A. Fehr, K. B. Heppe and H. Kurian, Unna, Hellweg-Mus., 1980)

K. Kalinowski, ed: *Barockskulptur in Mittel- und Osteuropa*, Seria historia sztuki, 11 (Poznań, 1981)

E. Zimmerman: '"Kunst-berühmte Bildhauer und Stuccadors": Bemerkungen zur südwestdeutschen Skulptur des 18. Jahrhunderts', *Barock in Baden-Württemberg* (exh. cat., Karlsruhe, Bad. Landesmus., 1981), pp. 25–35

R. Zürcher: 'Architektur als Gesamtkunstwerk: Zwei Beispiele aus dem Spätbarock', *Z. Ästh. & Allg. Kstwiss.*, xxvii (1982), pp. 11–22

K. Kalinowski, ed: *Studien zur europäischen Barock- und Rokokoskulptur,* Seria historia sztuki, 15 (Poznań, 1985)
H. Schindler: *Bayerische Bildhauer: Manierismus, Barock, Rokoko im altbayerischen Unterland* (Munich, 1985)
Bayerische Rokokoplastik vom Entwurf zur Ausführung (exh. cat., ed. P. Volk; Munich, Bayer. Nmus., 1985)

ULRICH KNAPP

4. *c.* 1750–*c.* 1900. The beginning of this period was marked by the publication in 1755 of JOHANN JOACHIM WINCKELMANN's highly influential work, *Gedanken über die Nachahmung der griechischen Werke in der Malerei und Bildhauerkunst.* This was followed by his *Geschichte der Kunst des Alterthums* (1764). Winckelmann's NEO-CLASSICISM emerged when German sculpture was still characterized by elements of the Baroque and Rococo: major commissions for the important centres of religious sculpture in south Germany included the decoration of Rococo churches, for example the monastery church at Schäftlarn (*c.* 1755–64), by Johann Baptist Straub, and the Benedictine Klosterkirche SS Marinus and Anianus (1759–62) at Rott am Inn, by IGNAZ GÜNTHER. Shortly after the mid-18th century there was considerable growth in the production of small-scale Rococo porcelain sculptures (*see* §VII, 3 (i) below). The focal point for Neo-classical sculpture was Rome; the city became an indispensable inspiration for several generations of sculptors. Notable influences on German sculptors included the study of Classical sculpture, the Danish sculptor Bertel Thorvaldsen and Antonio Canova.

The time he spent in Rome (1785–9) and his close friendships with Thorvaldsen and Canova were thus crucially important to JOHANN HEINRICH DANNECKER. In 1790 Dannecker became a professor at the Carlsschule in Stuttgart, native city of Friedrich Schiller, who had been a friend of Dannecker's in his youth. The latter's bust of *Schiller* (marble version, 1796, Weimar, Zentbib. Dt. Klassik; plaster version, 1794, Marbach, Schiller-Nmus. & Dt. Litarchv; see fig. 33) constitutes a major work of portrait sculpture. Similarly formative experiences for the most important German Neo-classical sculptor, Johann Gottfried Schadow, were his stay in Rome (1785–7) and the influence of Canova. Between 1785 and 1815 Schadow produced his major works, including the marble *Princesses Luise and Friederike* (1796–7; Berlin, Bodemus.; *see* SCHADOW, (1) and fig. 1).

Schadow founded a Neo-classical tradition of sculpture in Berlin, which was continued beyond the mid-19th century by his pupil CHRISTIAN DANIEL RAUCH, and through Rauch's pupils ALBERT WOLFF, AUGUST KISS, FRIEDRICH DRAKE and Ernst Rietschel. Munich was another centre of German sculpture (*see* MUNICH, §II, 1). LUDWIG VON SCHWANTHALER made the model for the bronze *Bavaria* (h. 15.75 m) that stands in front of the Ruhmeshalle (1841–50) by Leo von Klenze; it was erected after Schwanthaler's death by Stiglmaier and Ferdinand von Miller the elder (1831–87) in 1850. In Dresden, the third main centre, ERNST RIETSCHEL was a professor at the Akademie from 1832. His bronze monument to *Goethe and Schiller* (1852–6) in Weimar demonstrates his development away from Schadow's Neo-classicism towards realism.

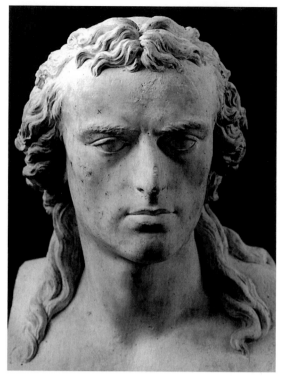

33. Johann Heinrich Dannecker: *Friedrich Schiller*, plaster, h. 550 mm, 1794 (Marbach, Schiller-Nationalmuseum und Deutsches Literaturarchiv)

The main function of sculpture in the 19th century was to serve patriotism and nationalism: the Battle of Leipzig (1813), the March Revolution (1848) and the founding of the Reich (1870) were events that determined the nature of subsequent commissions. For Leo von Klenze's Walhalla (1830–42) at Donaustauf, near Regensburg, Ludwig I, King of Bavaria, commissioned busts of famous characters from German history from renowned artists: Schadow, FRIEDRICH TIECK, Rauch, Dannecker, KONRAD EBERHARD, Randel, von Schwanthaler, MAX VON WIDNMANN and Rietschel, among others. Throughout Germany national monuments to Germania, to Emperor William I and to Otto von Bismarck (1815–98) sprang up after 1870. They were characterized by their grand scale, emotive use of form and by references to German mythology. The Niederwald monument by JOHANNES SCHILLING, officially unveiled in 1883, portrays an over life-size *Germania*. In Thüringen the Kyffhäuser monument to *Emperor William I* was built on a mountain in accordance with the plans of its architect BRUNO SCHMITZ. It was a megalomaniacal tower structure with equestrian statues of *Frederick Barbarossa* and *Emperor William I*. In the second half of the 19th century Reinhold Begas was the leading sculptor (*see* BEGAS, (2)). He had been a pupil of Christian Daniel Rauch in Berlin and turned Rauch's restrained Neo-classicism into a Baroque Revival style. One of his major works is the national monument to *Emperor William I* (h. 20 m, 1892–7) in Berlin. Soon after 1895 the construction of one of the largest 19th-century

sculpture ensembles in Germany began: the Siegesallee (dismantled after World War II) of Emperor William II in Berlin, stretching from the Königsplatz in front of the Reichstag to the Kemperplatz, reviewed nearly 800 years of German rulers in a cycle of 32 monuments. The most important sculptors of the German Reich were involved in this project, which was directed by Begas and completed in 1901: JOSEPH UPHUES, AUGUST KRAUS, Emil Cauer the elder, Otto Lessing (*see* LESSING, (2)), Albert Wolff, GUSTAV EBERLEIN and many others.

While official, and therefore primarily monumental, sculpture continued to lean towards the neo-Baroque style of Begas into the first decade of the 20th century, stylistic counter-movements were initiated by independent sculptors. In 1886 Auguste Rodin completed the *Burghers of Calais* (h. 2 m; version, Calais, Hôtel de Ville). Its revolutionary use of form was a challenge to German Neoclassicism and the Baroque Revival; Rome ceased to be the source of inspiration for German sculptors in Paris. ADOLF VON HILDEBRAND also contributed to the change in sculpture; his influence, more as a theorist than as a sculptor, was felt by artists into the 20th century. In *Das Problem der Form in den bildenden Kunst* (1893) he attempted to trace, with close reference to Renaissance sculpture, the formal laws of sculpture as well as its relationship with architecture. His book offers a theoretical basis for a synthesis of materialist and idealist aesthetics, and lays the foundations for a type of sculpture characterized by rational, constructive and tectonic clarity and explicitness. Some of Begas's pupils, such as LOUIS TUAILLON and AUGUST GAUL, left him to join von Hildebrand.

BIBLIOGRAPHY

H. Beenken: *Das neunzehnte Jahrhundert in der deutschen Kunst: Aufgaben und Gehalte, Versuch einer Rechenschaft* (Munich, 1944)
F. Novotny: *Painting and Sculpture in Europe, 1780–1880*, Pelican Hist. A. (Harmondsworth, 1960/*R* 1978)
G. von der Osten: *Plastik des 19. Jahrhunderts in Deutschland, Österreich und der Schweiz* (Königstein im Taunus, 1961)
M. de Micheli: *La scultura tedesca dell'800*, I maestri della scultura, xciv (Milan, 1966)
K. Lankheit: *Der Stand der Forschung zur Plastik des 19. Jahrhunderts* (Munich, 1968)
H. E. Mittig and V. Plagemann, eds: *Denkmäler im 19. Jahrhundert: Deutung und Kritik*, Studien zur Kunst des 19. Jahrhunderts, xx (Munich, 1972)
W. Hansen: *Nationaldenkmäler und Nationalfeste im 19. Jahrhundert* (Brunswick, 1976)
Malerei und Plastik des 19. Jahrhunderts (exh. cat. by C. von Holst, Stuttgart, Staatsgal., 1982)
M. Prause: *Bibliographie zur Kunst des 19. Jahrhunderts* (Munich, 1984)
H. Scharf: *Kleine Kunstgeschichte des Denkmals* (Darmstadt, 1984)
R. Zeitler: *Die Kunst des 19. Jahrhunderts*, Propyläen-Kstgesch., xi (Frankfurt am Main and Vienna, 1984)
M. Lurz: *Kriegerdenkmäler in Deutschland* (Heidelberg, 1985)

5. AFTER *c.* 1900. Construction of huge monuments continued until the beginning of World War I. The influence of the French sculptor Auguste Rodin spread, and in 1904 the first major exhibition of his work, held in Düsseldorf, aroused much public attention. Such artists as KARL ALBIKER, BERNHARD HOETGER, Wilhelm Lehmbruck and GEORG KOLBE found in the work of Rodin and of Aristide Maillol 'a new naturalness and living warmth in the formal language of sculpture' that was lacking in German sculpture (Hofmann). Throughout the 20th century artists also repeatedly referred back to the

ideas of another initiator of modern sculpture in Germany, Adolf von Hildebrand (*see* §4 above). For Rodin, von Hildebrand and many other artists of the first decade, the concept of truth to materials was important. In opposition to this stood *Jugendstil* (*see* ART NOUVEAU), and particularly the work of MAX KLINGER; in his monument to *Beethoven* (1902; Leipzig, Mus. Bild. Kst.) he attempted to revive polychrome and polylithic sculpture.

From Paul Gauguin's reassessment of primitive sculpture emerged another development represented by ERNST BARLACH, EWALD MATARÉ and the Expressionists (*see* EXPRESSIONISM, §1). Barlach's contribution to Expressionism lay in his veiled and voluminous figures with bulky outlines, for example *Seated Woman* (1911). These are simple in form and were worked from a mainly frontal perspective. By contrast, the delicate, elongated nudes by WILHELM LEHMBRUCK (e.g. *Woman Kneeling*, 1911; Berlin, Neue N.G.) portray mass in a state of disintegration. Members of the group DIE BRÜCKE, active from 1905 to 1913 in Dresden and Berlin, included ERICH HECKEL, KARL SCHMIDT-ROTTLUFF (see fig. 34) and ERNST LUDWIG KIRCHNER; they used wood that was coarsely worked and partially painted in gaudy colours. Although the human form was paramount, the portrayal of humanity by Die Brücke sculptors was no longer a classical or symbolic one. Works by artists in the group resemble exotic idols and are reminiscent of Oceanic and African carvings (*see also* PRIMITIVISM). The planar disintegration of form, which characterized Cubism, did not directly influence German sculptors, but it was filtered through to the artists of the BAUHAUS and to RUDOLF BELLING via Picasso's successors Alexander Archipenko and the Futurist Umberto Boccioni.

In the 1920s the geometric abstraction of the Dutch De Stijl movement and of Soviet Constructivism was discussed in Germany. El Lissitzky and László Moholy-Nagy both became teachers at the Bauhaus, with which Theo van Doesburg also maintained close connections. OSKAR SCHLEMMER also taught sculpture in wood and stone there; his figures and abstract reliefs, building on the achievements of Alexander Archipenko, are characterized by the fusion of concave and convex formal elements. The inclination towards a synthesis of the arts is already suggested in Schlemmer's *Triadisches Ballett* (first performed in 1922; *see* PERFORMANCE ART, fig. 1). Its synthesis of space, figure, music and movement is also found in Kurt Schwitters's Merzbau (begun 1923; destr. 1943; reconstruction 1980–83; Hannover, Sprengel-Mus.), in which the boundaries between architecture and sculpture become blurred (*see* SCHWITTERS, KURT, fig. 2). Similarly, in Schwitters's assemblages and in the *objets trouvés* of the Dadaists MAX ERNST, Hans Arp and RAOUL HAUSMANN, the concept of sculpture itself was being explored and redefined.

German sculpture was profoundly affected from 1933 by the political attitude towards art of the Nazis (*see* NAZISM). The ENTARTETE KUNST exhibition held in Munich (1937) at the Archäologisches Institut displayed works by artists who were deemed to have offended the spirit of Nazism: it contained the work of such Expressionist sculptors as Ernst Ludwig Kirchner, and of Ewald Mataré, Ludwig Gies, Wilhelm Lehmbruck, Rudolf Belling

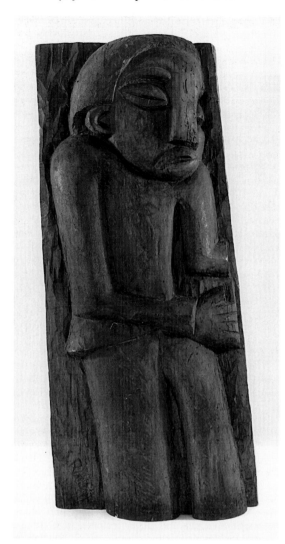

34. Karl Schmidt-Rottluff: *Grieving Figure,* high relief on green-tinted poplar-wood, 800×360 mm, 1920 (Berlin, Brücke-Museum)

and many others. Sculptors condemned by the *Kunstpolitik* often had to work 'underground' or go into exile. Official Nazi art, with its usually over life-size portrayals of the human form, was orientated towards a formal language that was classical yet bereft of content. ARNO BREKER and Josef Thorak (1889–1952) were among the preferred sculptors.

After 1945 German sculpture, which in the first half of the 20th century had mainly been anthropocentric, was characterized by artists' attempts to extricate it from the hero-depiction of the Nazi era. Such artists as GERHARD MARCKS, GUSTAV SEITZ or Heinrich Kirchner continued the classical–humanist tradition initiated by von Hildebrand and supported by Maillol. The human form was portrayed in terms of archaic, austerely shaped figures. Constructivist sculpture in the tradition of Naum Gabo, Antoine Pevsner and El Lissitzky was continued after 1945 by the geometrically rhythmic wire sculptures of

HANS UHLMANN and the tower-like sculptures of the partners MATSCHINSKY-DENNINGHOFF. Sculpture approached abstraction from different directions: Uhlmann and NORBERT KRICKE rejected traditional tendencies, and BERNHARD HEILIGER, KARL HARTUNG and ALFRED LÖRCHER progressed beyond creating forms derived from real objects towards a pure abstraction that had no links with external reality. The work of Joseph Beuys was accompanied by a redefinition of what constituted sculpture. In his work he negated the conventional concept of form by using such soft materials as fat and felt, materials that also had a personal symbolism for him (*see* BEUYS, JOSEPH, fig. 1). The appearance of painter–sculptors at the beginning of the 1980s was reminiscent of the artists of Die Brücke. In the crude working and gaudy, partial painting of their wood sculptures, connections also exist between the works of Ernst Ludwig Kirchner or Erich Heckel and those of GEORG BASELITZ, MARKUS LÜPERTZ or A. R. PENCK.

BIBLIOGRAPHY
W. Hofmann: *Die Plastik des 20. Jahrhunderts* (Frankfurt am Main, 1953)
C. Giedion-Welcker: *Plastik des XX. Jahrhunderts: Volumen- und Raumgestaltung* (Stuttgart, 1955)
H. Richter: *DADA—Kunst und Antikunst: Der Beitrag Dadas zur Kunst des 20. Jahrhunderts* (Cologne, 1964; Eng. trans., London, 1965/R 1978)
W. Grzimek: *Deutsche Bildhauer des 20. Jahrhunderts: Leben, Schulen, Wirkungen* (Wiesbaden, 1969)
Reliefs: Formprobleme zwischen Malerei und Skulptur im 20. Jahrhundert (exh. cat., ed. E.-G. Güse; Münster, Westfäl. Landesmus., 1980)
E. Trier: *Bildhauertheorien im 20. Jahrhundert* (Berlin, 1984)
Kunst der Bundesrepublik Deutschland (exh. cat., W. Berlin, N.G., 1985)
Deutsche Kunst im 20. Jahrhundert: Malerei und Plastik (exh. cat., ed. C. M. Joachimides, N. Rosenthal and W. Schmied; Stuttgart, Staatsgal., 1986)
Die 'Kunststadt' München 1937: Nationalsozialismus und 'Entartete Kunst' (exh. cat., ed. P.-K. Schuster; Munich, Staatsgal. Mod. Kst, 1987)
THOMAS KLIEMANN

V. Interior decoration.

1. Before *c.* 1600. 2. *c.* 1600–*c.* 1700. 3. *c.* 1700–*c.* 1790. 4. *c.* 1790–*c.* 1900. 5. After *c.* 1900.

1. BEFORE *c.* 1600. As few secular buildings from this period have been preserved, information about interior decoration is primarily derived from paintings or prints. From the beginning of the 14th century windows in grand houses were rectangular in shape, with panes of leaded glass supported by stone mullions. In less well-to-do houses only the upper panes were glazed, and wooden shutters were mounted on the inside. Oiled paper or parchment served as a window covering when glass was too costly. Heat was provided mainly by an open hearth or by fireplaces with decorative stone surrounds. In south Germany tiled stoves were used for heating from an early date. Ceilings displayed open timber construction, with the wood left its natural colour or painted with geometric or floral designs. From the beginning of the 15th century coffered wooden ceilings are documented in the south.

Finely plastered walls were painted white or solid colours. In especially wealthy houses in west Germany wooden wainscoting covered the walls up to a third of their height. Initially kept smooth, wall panels came to be decorated with a pattern of carved folds in the French Gothic style. In south-west Germany walls were often

completely panelled and doorframes elaborately carved. Important examples of 14th-century Gothic panelling are in the Rathaus in Überlingen, the Zunftstube der Metzger in Konstanz (now in the Rosgtn Mus.) and the cloister in the Benedictine abbey of Stein am Rhein. An important work of Renaissance panelling carved by PETER FLÖTNER is the Hirsvogelsaal (1532–4; Nuremberg, Stadtmus. Fembohaus) with a Classical tendril-patterned frieze and pilasters enriched with wedding scenes. Another example with perspectival marquetry is the room (Munich, Bayer. Nmus.) from the Schloss Fugger in Donauwörth completed in 1545 by Heinrich Kohn and Franz Kels. Heraldic emblems were sometimes employed; from the end of the Renaissance decorative friezes were also painted on walls. On special occasions walls might be hung with tapestries or patterned fabrics (see fig. 35). Wall niches with wooden doors served as shelves or cupboards, and large rooms might be divided by plank walls into sleeping alcoves.

Floor coverings reflected the social standing of the occupants. Modest houses had floors covered with dirt or local stone. In more noble houses in forested areas, wooden floors were employed; these could be strewn with flowers and leaves during the summer. Square red ceramic tiles were popular; later examples were polygonal in shape with patterned, polychrome glazes. Occasionally these formed large, multicoloured geometric designs. Rugs were used rarely, and small foot-mats constituted a sign of great comfort.

From the end of the Middle Ages modes of furnishing became increasingly differentiated according to the function of the room. The placement of furniture within the room was determined by the sources of light and heat; stone benches were placed under windows, and moveable chairs were set near the fireplace. Such large pieces of storage furniture as linen chests or dressers stood against the walls. The severe simplicity of furnishings is noteworthy: rooms were dominated by a few functional pieces of furniture, and textiles constituted the only luxury, in addition to individual utensils or art objects.

BIBLIOGRAPHY

F. Horb: *Das Innenraumbild des späten Mittelalters* (Zurich and Leipzig, n.d.)
G. Hirth: *Das deutsche Zimmer der Gothik und Renaissance des Barock-Rokoko und Zopfstils* (Munich, 1886)
M. Heyne: *Das deutsche Wohnungswesen von den ältesten Zeiten bis zum 16. Jahrhundert*, 3 vols (Leipzig, 1899–1903)
G. Leinhass: *Wohnräume aus dem 15. und 16. Jahrhundert* (Berlin, 1901)
F. Luthmer: *Deutsche Möbel der Vergangenheit*, Monographien des Kunstgewerbes (Leipzig, 1902)
K. H. Klingenberg: *Vom Steinbeil bis zum schönen Brunnen: Angewandte Künste in Deutschland vom Anfang bis zum Mittelalter* (Berlin, 1964)

For further bibliography *see* §5 below.

2. *c.* 1600–*c.* 1700. The influence of the Italian Renaissance, in addition to the stimulus for new construction provided by the end of the Thirty Years War (1618–48), transformed interior decoration during the 17th century. Printed pattern books led to a rapid diffusion of new forms to remote areas. The model books of Wendel Dietterlin, Georg Haas and Gabriel Krammer from the end of the 16th century were the most important; they contributed to a unified conception of the interior in which, ideally, the floor, wall panelling, window-frames and fireplace were related through the use of ornament.

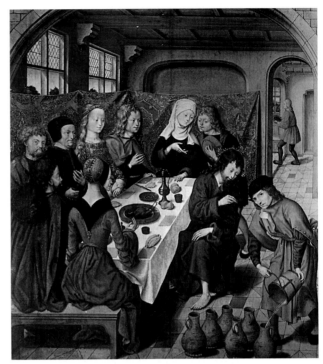

35. Master of the St Bartholomew Altar: *The Marriage at Cana*, oil on panel, 640×575 mm, *c.* 1480–1510 (Brussels, Musées Royaux des Beaux-Arts de Belgique)

Itinerant craftsmen also promoted the diffusion of forms; the marquetry by TÖNNIES EVERS II from the war cabinet room (1594–1613; destr. 1942) of the Rathaus in Lübeck, for example, made use of motifs similar to those from the area of Lake Constance, where the cabinetmaker had worked previously. Nevertheless, southern Germany was strongly influenced by Italy, while French and Netherlandish influences in the west can be traced as far as the Mark Brandenburg and Berlin.

Tall rectangular windows with small coloured leaded panes were widely used, but by the middle of the 17th century glazing with clear glass, which allowed a view outside when the window was closed, became more fashionable. This led to the increased use of light curtains, although interior shutters remained more common until the end of the century. Window sashes were hinged on the sides and could be opened with a batten mechanism. Floors varied by region and social status. In modest houses a smooth chalk floor sufficed; grander houses had floors with complicated designs of stone or glazed polychrome tiles. In such unforested areas as the Mark Brandenburg wooden floorboards remained the privilege of a few. A 17th-century house in Berlin contained only one room with a plank floor, indicating the high value placed on timber in the city. Plank floors were usually strewn with fine sand to keep them cleanly polished. In southern Germany wooden floors were more common. A few examples of parquet floors suggest the influence of French and Italian models. Rugs, imported from Persia or Turkey or made locally, became more popular as floor coverings. From 1680 small rugs woven in a solid colour or with

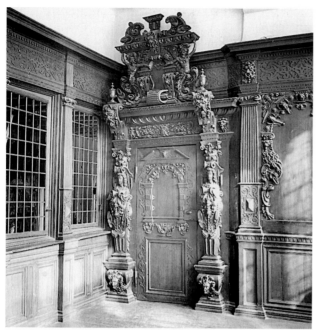

36. Wooden portal of the Güldenkammer by Reinecke Stolling, Servaes Hoppenstede and Evert Lange, *c.* 1610–20, in the Rathaus, Bremen

colourful floral sprays on a plain background were made in Berlin. Rooms were heated primarily by fireplaces on the French model. The fireplace was the major architectural feature of a room and was elaborately decorated in stone, wood or stucco. Cast-iron fire-backs were decorated with foliate ornament, heraldry or figural scenes stamped or moulded in relief. Tiled stoves, often with Classical motifs in bright colours, or iron stoves in similar shapes continued to be used.

At the beginning of the 17th century finely plastered walls were generally painted white or solid colours. Painted murals, Classical ornament or friezes after Italian models were exceptional. Tapestries were popular, as were monochromatic wall hangings. Precious Spanish gilt leather was sometimes used in smaller chambers. At the beginning of the century all types of art objects and curiosities were displayed on the walls on shelves, pedestals and consoles, and paintings were frequently hung indiscriminately. By the end of the century the wall surface became clarified: in the absence of panelling, the wall was divided by regularly spaced framed pictures. In timber-rich areas wall panelling reached its highest development. An example of a unified panelled room is the Truchenzimmer (1600–11) in Schloss Zeil near Wangen in Allgäu by the Swabian master Jörg of Isny. The coffered ceiling, the doorframe and the cornice are decorated with classical consoles, dentil friezes and fluting in dark wood that contrast effectively with the light painted walls. The tiled stove and furniture repeat the classical elements, drawing together the ensemble. The most significant work of the first half of the century is the panelling of the Hornstube in Veste Coburg (1632), the result of a collaborative effort of various court craftsmen. The panelling displays architectural segmentation on a monumental scale: three registers

of panelling are set one on top of the other between vertical elements, and continuous hunting scenes in intarsia are set into the upper fields. The top section is finished by a deeply undercut and pierced relief frieze beneath a coffered ceiling with complex compartmentalization. The architectural elements are partially painted with grotesques.

While the influence of the Italian Renaissance is apparent in southern Germany, in the north exceptional examples of Mannerist figural decoration can be found. The portal of the Güldenkammer (*c.* 1610–20; see fig. 36) in the Rathaus of Bremen by Reinecke Stolling, Servaes Hoppenstede (*d* 1652) and Evert Lange features a fanciful triumphal arch surrounded by a lavishly carved, monumental doorframe. The Door of the Gods (1604–5) in the Goldener Saal of Schloss Bückeburg by Ebert and Johann Wulff (*see* WULFF) makes use of large, free-standing figures in exaggerated contrapposto poses, painted and partially gilt. Towards the end of the century the articulation of the wall became more restrained; panelling from 1678 in Schloss Sigmaringen shows a clearly legible colossal division in the style of Louis XIV, with relief carvings in the upper section only. The Coin Cabinet of the Prince Elector Frederick William in Berlin displays a similar structure with double pilasters crowned by Corinthian capitals in stucco. Consoles support Classical busts above the windows, and coin cabinets were set against the walls.

BIBLIOGRAPHY

G. Hirth: *Das deutsche Zimmer der Renaissance* (Berlin, 1879–81)
W. Pinder: *Innenräume deutscher Vergangenheit* (Königstein and Leipzig, 1924)
W. Stengel: *Alte Wohnkultur in Berlin und der Mark Brandenburg* (Berlin, 1958)
Die Renaissance im deutschen Südwesten zwischen Reformation und dreissigjährigem Krieg (exh. cat., Karlsruhe, Bad. Landesmus., 1986)

For further bibliography *see* §5 below.

3. *c.* 1700–*c.* 1790. French influence was strong throughout this period, and, in some cases, German princes called in architects trained in France to build their residences. The sequence of interior spaces formulated at Versailles was widely adopted as apartments were increasingly tailored to the domestic requirements of residents. The designs of Jean Berain I were important well into the 18th century, although after 1734 pattern sheets by Gilles-Marie Oppenord, Juste-Aurèle Meissonier and Germain Boffrand were in use in German centres. French influence remained the strongest in Bavaria and Prussia, while in the Würzburg Residenz the Italian late Baroque style was followed. In Bavaria Charles VII (*reg* 1726–45) undertook building projects in the palaces of Schleissheim, Nymphenburg and Munich; he appointed François de Cuvilliés I, who had trained under Jacques-François Blondel in Paris, to serve as his architect. The Rococo style in Germany is most clearly represented in the palaces and gardens erected or completed under the Prussian king Frederick II, notably in the rebuilding of Schloss Sanssouci (destr. World War II; reconstructed) and the renovation of major buildings in Potsdam and Charlottenburg. Although Frederick chose French models for his architectural projects, they were executed by German artists.

Changes in social conventions and the trend for more privacy led to the creation of a large number of smaller salons, music-rooms and living-rooms, as well as small

cabinets and reception rooms. Blocks of flats for the middle class were built in cities with greater frequency. These also contained numerous small rooms for entertaining, and the courtly model for interior decoration was imitated to the extent permitted by the economic resources of the individual. Even in city palaces the reception salon was replaced by smaller living-rooms. In addition to the hall on the ground-floor, there were living-rooms on the first floor, and the master bedroom was on the second floor. Service rooms were in the attic or cellar, which also contained the kitchen. Stairways and windows became larger and more commodious in both middle- and upper-class houses. Heating continued to be provided by fireplaces, although the cleaner heat from stoves made of tiles, faience or iron became increasingly the norm (see fig. 37). High windows were filled with clear glass and, on the parterre level, often served as doors.

Walls were painted in light or pastel shades with ornamental motifs in contrasting colours or gilt. The distinct division of the wall (painted, carved or stuccoed) continued but gradually became overgrown with shell and vegetal ornament. Around 1715 the ornament derived from Berain became finer and more delicate, as in the Viktoriensaal in the Neues Schloss, Schleissheim, near Munich. Initially wood panelling was left unpainted, as in

the work of Johann Georg Nestfell at Schloss Wiesentheid near Würzburg in the early 1720s, where flower-patterned marquetry was inlaid into carved gilt frames enriched with tendril motifs. From the 1730s asymmetrical ornament seemed to dissolve the surface and overgrow the walls like plants. At Neues Schloss in Bayreuth the court cabinetmaker Johann Friedrich Spindler and the carver Franz Ignaz Dorsch carried out the wall panelling of the so-called 'Zedernsaal' (*c*. 1755), one of the most important secular interior spaces in Germany. The panelling, made of veined nut-wood, is divided by a row of carved cedar trees with naturalistic trunks. Gilt stems and leaves twist up the lower part of these compartments.

In some cases the division between ceiling and wall was almost completely obscured by ornament that grew over a reduced cornice on to the ceiling. The ornament within the wall compartments, usually carved in wood and painted, was echoed in stucco on the ceiling. Johann Baptist Zimmermann (*see* ZIMMERMANN, (1)), Wenzslaus Myroffski, Joachim Dietrich and Wolfgang Jacob Gerstens (*b* 1722; *d* after 1798) carried out fanciful rocailles for the panelling of the rooms of the Munich Residenz and the Amalienburg, Schloss Nymphenburg (1730–33). The silver and gilt carvings set against a white or yellow background created a unified scheme with the stuccowork of

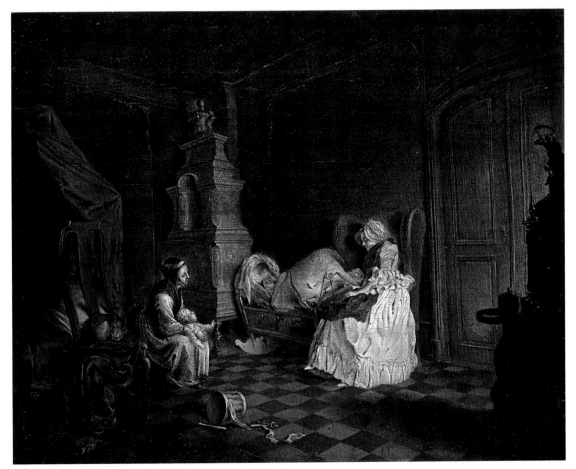

37. Daniel Nikolaus Chodowiecki: *Family Scene*, oil on canvas, 240×310 mm, 1725 (Berlin, Gemäldegalerie)

the ceilings, also silver or gilt. In a seemingly endless sequence, garlands, scallops, swags, vases, swelling cornucopias, putti and graceful female forms were spun out over ceilings and walls. The plane of the wall is visually dissolved by the overgrown ornamentation, an illusion sometimes expanded by mirrors.

The Winter Apartments (destr. World War II) in the Potsdam Stadtschloss were constructed in 1744–5 under the direction of George Wenceslaus von Knobelsdorff and the sculptor Johann August Nahl, who had been called to Berlin in 1741 to be Director of Interior Decoration. They incorporated the King's bedroom, library and office into one unified space. The decoration of this apartment and the Goldene Galerie in Schloss Charlottenburg (completed in 1747; destr. World War II; now reconstructed), Berlin, are major works by Nahl. After 1746 his designs were executed by Johann Michael Hoppenhaupt (i) and Johann Christian Hoppenhaupt. In the dining-room of the Stadtschloss the elaborate wall decorations were made of gilt bronze set against light panelling. The library at Sanssouci was modelled after that in Schloss Rheinsberg, where the King had spent his youth. The space is round, and the interior, in soft brown cedar-wood with gilt-bronze ornaments by the goldsmith C. G. Kelly (after 1750), was carried out by Johann Heinrich Hülsemann after a design by Nahl (see fig. 38). Such characteristic details as herons and palm fronds (also found in the area of Ansbach and Bayreuth) were brought to Potsdam by Nahl and the Hoppenhaupts; these motifs were combined with such fruits as melons, pomegranates and grapes, as well as flowers, branches, emblems and net-like traceries,

all bound together with rocaille ornament. With a rhythm that flows through all parts of the interior, the various areas of the room and the furniture were bound into a unified composition despite the apparent freedom of the design of the separate components.

Mirrors enjoyed a great vogue and were often placed over the fireplace or over a console table; due to technical advances they could be produced in larger sizes. Mirror cabinets were especially popular (see CABINET (i), §4 (ii)). An early example is the mirror cabinet in Merseburg from around 1710. The most important mirror cabinet, that at the Würzburg Residenz, has been reconstructed to the original design by Johann Wolfgang von der Auwera. Above the wainscoting a fine net of framed fields extends over the wall. Grouped around an extremely large central mirror are portraits of women, chinoiseries and allegorical subjects in asymmetrical frames. Another mirror cabinet was carried out for the Margravine Wilhelmina in her Schloss Eremitage in Bayreuth. Irregularly shaped mirrors were combined with chinoiserie ornament on the walls and ceilings, creating an illusionary space. A game-room of the late 18th century in the Schloss der Fürsten von Thurn und Taxis, Regensburg, has a finely detailed colossal order that segments the wall, and arches between narrow pilasters create an arcade. All surfaces are mirrored, seeming to open into infinity.

Other important interiors were the porcelain or chinoiserie cabinets (see CABINET (i), §4(i)); the walls were mounted with consoles or tiny shelves on which Asian, and later European, porcelain was displayed, often in combination with mirrors. An important porcelain cabinet (reconstructed) is in the Schloss Charlottenburg, while in Dresden Frederick-Augustus I, Elector of Saxony, housed his collection of over 57,000 pieces of East Asian and Meissen porcelain in the Japanisches Palais. Cabinets with Chinese lacquered panels lining the walls were also very popular as exotic novelties; an example designed by Johann Jacob Sänger (*b* 1730) in Schloss Ludwigsburg, near Stuttgart, was made between 1714 and 1719. Above a low base, tall rectangular wall compartments were filled to the ceiling with broad lacquer panels. Their carved and gilt frames were crowned by cranes and Chinese figures in brilliant contrast to the black lacquer. Porcelain objects were placed on small consoles on the ribs between the panels. The Chinese House (1747–53; destr. 1822) at Falkenlust (1729–34), in the grounds of Schloss Brühl (nr Bonn), completed by Cuvilliés in 1736, was also important. Here, panels japanned in Germany were placed into large, brightly painted fields surrounded by gilt frames carved with Chinese figures.

Grotto chambers in the Italian style were imitated in a few places; the grotto pavilion in the garden at Falkenlust and the Great Grotto Hall (1763–9) in the Neues Palais at Potsdam are examples. In both rooms the walls were studded with mussel shells, stones, pebbles and pieces of coral, forming a system of wall compartments and evoking a fantastic marine world.

Walls in grand houses could be covered with such textiles as satin, velvet or damask, perhaps embellished with silver or gold braid or fringe. Wall hangings from Flanders or the Gobelins in Paris and, occasionally, expensive silk tapestries from Lyon were also used. During

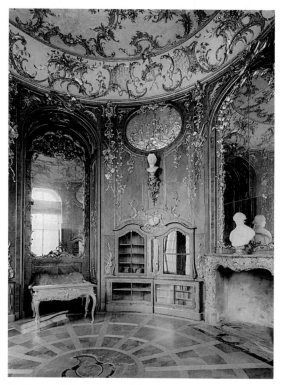

38. Library of Schloss Sanssouci, Potsdam, 1746–7

the first half of the century factories were founded in Germany to imitate these fine-quality materials in wallpaper, which was printed with floral patterns. Leather continued to be used or, for middle-class homes, less expensive oil cloth produced in Berlin. Pictures were hung in regular rows covering large expanses of wall, as in the gallery of Sanssouci.

Stairwells were often painted to look like marble, a technique diffused in Germany by Italian artists. The low wall panelling and doors in the marble room (1720) in Schloss Anhalt were painted in this manner, and the ground-floor of the stairwell designed by Balthasar Neumann in Schloss Brühl has a *faux-marbre* finish on stucco of exceptional quality. Although large representational paintings can be found on the ceilings of some stairwells, walls were rarely decorated in this way, an exception being the trellis with birds rediscovered during the restoration of Schloss Charlottenburg.

In the 18th century wooden planks were generally used for flooring. Parquet floors with multicoloured marquetry are found in such courtly contexts as the mirror and porcelain cabinet in Schloss Weissenstein, Pommersfelden, executed by Ferdinand Plitzner (1678–1724). Blue-and-white Delft-style tiles could be used, as in the summer rooms on the ground-floor of Schloss Brühl. While simple plank floors in middle-class houses were strewn with fine sand, floors in palaces were waxed. As larger rugs became increasingly popular, Savonnerie-style carpets were produced in Germany. In modest houses rugs of woven straw could be found. The use of drawn curtains became more common; these were usually coordinated with the textiles of the walls and furnishings in wealthy establishments. Middle-class households made use of adjustable draperies in light cotton fabrics, as well as Venetian blinds.

In comparison with France and England the Rococo style lasted much longer in Germany, due in part to the advanced age of the aristocratic patrons. Even in the late 1770s Frederick II directed the Hoppenhaupts to carry out Rococo interiors, although elsewhere a renewed interest in classical forms appeared, as well as a rediscovery of the Gothic style of the Middle Ages. The writings of Johann Joachim Winckelmann and Adam Friedrich Oeser unleashed the first reactions against the Rococo, but the Neo-classical style was brought from France by such architects as Philippe de La Guépière, Nicolas de Pigage and Pierre Michel d'Ixnard, who designed buildings in Stuttgart, Schwetzingen, Benrath (near Düsseldorf) and St Blasien. In such smaller courts as Dessau or Weimar classical tendencies were quickly taken up and promoted by an informed intelligentsia. The architect Wilhelm Ferdinand Lipper (*d* 1800) created the Yellow Cabinet (destr. World War II) in the Residenzschloss (now part of the university), Münster, in 1776 in this new style; a room of dignified elegance, the walls were yellow with grisaille paintings in the upper corners, the carved ornament gilt, and the roses of the mirror frames painted in naturalistic colours. Landgrave William IX of Hessen-Kassel (*reg* 1785–1821) had Schloss Wilhelmshöhe (begun 1786) built in Kassel by Simon Louis Du Ry and Heinrich Christoph Jussow. The inspiration for the castle and park came from England, where the Landgrave had family connections. The Rondellzimmer in the Weissenstein

wing, completed around 1790, was derived from prototypes by Robert Adam. The *boiserie* was painted in white and grey, and only a few square panels were emphasized by flat decorative carving. Colour appears only in the painted lintels and the pattern of the parquet floor. In Prussia the Neo-classical style for interiors of official buildings was introduced only after the death of Frederick II in 1786 by his successor, Frederick William II (*see* §4 below).

BIBLIOGRAPHY

H. Schmitz: *Wohnzimmer und Festräume Berliner Baumeister vom Ausgang des 18. Jahrhunderts* (Berlin, n.d.)
C. Gurlitt: *Das Barocke und Rokoko Ornament Deutschlands* (Berlin, 1889)
H. Popp: *Die Architektur des Barock und Rokokozeit in Deutschland und der Schweiz* (Stuttgart, 1913)
W. Kurth: *Die Raumkunst im Kupferstich des 17. und 18. Jahrhunderts* (Stuttgart, 1923)
H. Kreisel: *Die Kunstschätze der Würzburger Residenz* (Würzburg, 1930)
W. Kurt: *Sanssoucci: Schlösser, Gärten, Kunstgewerbe* (Potsdam, 1985)

For further bibliography *see* §5 below.

4. *c.* 1790–*c.* 1900. The widespread acceptance of Neo-classicism in Germany at the end of the 18th century resulted from the efforts of a few princes committed to its diffusion. The style was also promoted by such new publications as the *Journal des Luxus und der Moden*, published in Weimar by Friedrich Bertuch from 1786 to 1826 and later by his son, and *Geschichte und Darstellung des Geschmacks der vorzüglichsten Völker in Beziehung auf die innere Auszierung der Zimmer und auf die Baukunst* (Leipzig, 1796–9) by Joseph Friedrich von Racknitz. The new magazines and books presented the latest fashions in furnishings from Paris, London and Berlin to a new audience, consisting not only of architects and craftsmen but educated middle-class homeowners as well. In addition to Neo-classicism, they featured an expanded range of stylistic choice. Racknitz, for example, gave suggestions for the decoration of Gothic Revival, Turkish, Oriental and Old German (Altdeutsch) rooms. The dissemination of designs was further facilitated from the mid-19th century by industrial fairs and international exhibitions.

When Frederick William II ascended the Prussian throne in 1786, he undertook a series of new building projects in the Neo-classical style with the assistance of such architects as Friedrich Wilhelm Erdmannsdorff, Michael Philipp Boumann, Carl Gotthard Langhans and Karl Philipp Christian von Gontard. Between 1794 and 1796 the Potsdam master carpenter Brendel furnished a sequence of rooms in the small palace on Peacock Island in Berlin; he also built the Gothic Ruin in the palace grounds. The walls of the Great Hall were covered with panelling divided by pilasters; such local woods as elm, black poplar, apple-wood and yew were used, and all the carved decorations, mouldings and doorframes were made of chestnut. The fireplace overmantel was enriched with painted figural carving and delicate tendril ornament. Between 1795 and 1797 Langhans decorated the Winter Apartments in Schloss Charlottenburg (destr. World War II; reconstructed) with unpainted panelling decorated with simple geometric shapes and fluting. The natural beauty of the wood, heightened by the careful selection and matching of colours and grains, was emphasized by the austerity of the ornament. In 1799 the architect Friedrich Gottlieb Schadow (1761–1831) was commissioned by

Frederick William to remodel the Coursaal and the Yellow Room of the Potsdam Stadtschloss (destr. 1945), for which he used *faux-marbre* panels with Classical subjects set into the severely geometric *boiserie*. In the Etruscan Room, completed by the brothers Ludwig Friedrich Catel (1776–1819) and Franz Ludwig Catel in 1803 after designs by Schadow, the walls were veneered with panelling of cypress, mahogany and ebony; scagliola panels were inserted into the upper part of the walls and into the furniture. Slim, flat pilasters with capitals formed like Egyptian lotus leaves divide the walls; the upper third of the wall was decorated with palmette bands. The ceilings were painted in the manner of ancient Greek Black-figure vases.

During the Napoleonic occupation of Germany French schemes of interior decoration were increasingly adopted. King Jerome Bonaparte of Westphalia (*reg* 1807–13), installed by Napoleon in 1807, decorated the Residenz and Schloss Wilhelmshöhe (renamed Schloss Napoleonshöhe during his reign) in Kassel in collaboration with the German architect Heinrich Christoph Jussow and Auguste-Henri Granjean de Montigny, whom Jerome had invited from Paris. Photographs of the interiors (destr. World War II; reconstructed 1960s) indicate that French models by Percier and Fontaine were followed. The palaces were furnished with Empire furniture from Paris. Elements of Empire decoration were also incorporated into the Toskanazimmer (1807–13; destr. 1945) of the Würzburg Residenz by Nicolas-Alexandre Salins de Montfort.

The interiors carried out in Berlin under the direction of KARL FRIEDRICH SCHINKEL, most of which have been destroyed, displayed a strongly classical character that found its purest expression in the work of this architect. Examples include the private apartments in the Königliches Schloss, designed *c.* 1825 for Crown Prince Frederick William and demolished following World War II; in the tea salon the walls were subdivided by Neo-classical sculptures on piers and by panelling, into which were set circular paintings of mythological figures and legends of the Greek gods. Schinkel's classicism was modified by the influence of Percier and Fontaine and the addition of some Louis XVI and Directoire elements. This selective recombination of historical styles prefigured the stylistic pluralism that characterized the domestic design of the late 19th century.

The BIEDERMEIER style developed from the concept of unified decoration and was strongly influenced by the French Empire style and its architects; it affected bourgeois and aristocratic homes alike. The rooms of an apartment followed the traditional sequence: reception rooms, dining-rooms, salons and bedrooms with wardrobes. In the great houses this scheme was extended by the addition of small salons and cabinets. In modest houses the smaller number of rooms served multiple purposes.

The colour schemes of the Biedermeier period coordinated all elements of the decoration; moss green, yellow and red tones were popular, and as the century advanced the colour palette expanded. Simple shapes, smooth contours and plain surfaces were favoured. Walls were often painted a single colour or covered with wallpaper; stripes, sprays of flowers and antique subjects were popular

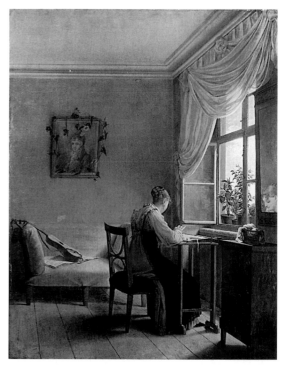

39. Georg Friedrich Kersting: *The Embroiderer*, oil on canvas, 472×374 mm, 1811 (Weimar, Schlossmuseum)

patterns. Whether the walls were painted or papered, the dado and upper border were usually painted in a complementary colour with a patterned or ornamental frieze. The cornice and ceilings were white in contrast to the walls or sometimes had painted decoration. In 1829 the architect Alexis de Chateauneuf (1799–1853) remodelled the house of the Hamburg lawyer Karl Sieveking; one room (now in Hamburg, Mus. Kst & Gew.) was decorated like a ship's cabin, as a remembrance of a voyage that Sieveking had taken The walls were completely panelled, and the large rectangular fields within the panelling were painted with polychromed figures in the Pompeian manner.

Windows and sometimes entire walls might be covered with elaborate draperies in dramatic or complementary colour combinations, already seen in the bedroom designed by Schinkel in 1809 for Queen Louise in Schloss Charlottenburg (see 1991 exh. cat., pl. 36a). While for Queen Louise these foldings were made in white muslin, such complex folds of fabric could sometimes be imitated in papier-mâché and painted. Walls were also decorated with pictures and prints arranged in symmetrical groups. Rooms continued to be heated with stoves, the efficiency of which was constantly improved. Lighting fixtures were located in the middle of the ceiling. Chandeliers of bronze, carved and gilt wood, glass or porcelain were found in more formal houses. In modest apartments table-lamps and candlesticks were used. Furniture made of cherry, nut, mahogany and highly figured woods was popular in the apartments of the Bavarian palaces. Empire and gilt furniture was used only in such *schöne Zimmer* ('beautiful

rooms') as the salon, audience hall and rooms for entertaining. A great variety of decorative objects, busts and souvenirs was displayed in living-rooms. Porcelain figures, objects of silver and cut glass and ornaments even of hair or wax were exhibited in glass cases. In addition to such major pieces of furniture as commodes, secrétaires, sofas and display cabinets, numerous small end-tables and sewing-tables completed the furnishings. Platforms were often set up in window niches, where a chair, stool or bench provided an invitation to linger over the view (see fig. 39).

Oriental carpets were rarely found in middle-class homes; small foot mats, which women embroidered in wool on a canvas backing, were used more frequently. The fashion for wall-to-wall carpeting came from England and was very popular. An innovation of the Biedermeier period was the widespread interest in houseplants, which were displayed in clay pots, in flower troughs or on benches in living-rooms. More well-to-do houses had 'winter gardens' (conservatories), in which all kinds of plants could be raised.

The Gothic Revival style came from England; from the end of the 18th century interiors in the Gothic taste appeared in magazines and pattern books. The interiors of the Gothic House in Wörlitzer Park, near Dessau, were finished in 1790; although classical in form, the house was decorated by Georg Christoph Hesekiel (1732–1818) with a pastiche of medieval fragments, both authentic and reproduction. One of the most important creations of the Gothic Revival in Germany was the library (destr.; now reconstructed) added to Schloss Nassau by Johann Claudius von Lassaulx in 1816. Set within a three-storey octagonal tower, the library has tracery windows and ceilings with groin vaults supported by bundled ribs painted black. In 1833 Schloss Hohenschwangau was decorated for Crown Prince Maximilian II of Bavaria by Domenico Quaglio II. Some of the rooms were painted after designs by MORITZ VON SCHWIND, and fragments of stained glass from medieval buildings were used for some of the windows. Although Gothic in spirit, the furnishing satisfied modern domestic requirements. Friedrich August Stüler (1800–65) and Ludwig Persius carried out work (1850–56) on Burg Hohenzollern; the carved wood panelling of its interiors was decorated with a mixture of Gothic Revival and classical elements, stiffly executed. The furnishing of the Marienburg, near Hannover, carried out in 1864 by the architect Edwin Oppler, is very elaborate. Gothic tracery dominates the wall panelling, and the ceilings, supported by struts, are carved and coffered. Rhäzumas Hall at Schloss Sigmaringen (destr.; rebuilt 1893) was decorated in the Renaissance style with luxuriant carvings on the columns and entablatures. Arrangements of authentic musical instruments were placed over the doors. The library near Schloss Sigmaringen was

40. A lady's sitting-room, Leipzig, 1879–80; from O. Mothes: *Unser Heim im Schmuck der Kunst* (Leipzig, 1880)

carried out in the English Tudor style from 1860 to 1867 by Josef Laur (1817–87). The tall reading-room with three naves displays open rafters with suspended non-structural pointed arches. The furnishings of castles in Austria provided examples of medieval and Renaissance forms; these were published as pattern sheets and were widely circulated. In Prussia Frederick William IV had Stüler and Ludwig Hesse enlarge the Orangerie of Sanssouci between 1851 and 1860. The decoration of the generously proportioned rooms in the Renaissance Revival, Baroque Revival and Empire styles is of the highest quality. A hall hung with 47 copies of paintings by Raphael formed the centre of the building. The furniture of the living-rooms was carried out in the Rococo Revival style.

From the 1880s a heavy Renaissance Revival style with luxuriant carvings, coffered ceilings and intarsia panelling was favoured for the decoration of such official buildings as the Hamburg Rathaus and the Berlin Reichstag (1884–94; destr. 1933, reconstructed 1970s) by Paul Wallot. The highpoint of the revival of historical styles is represented by the palaces that the Bavarian king Ludwig II (*see* WITTELSBACH, §III (4)) built during his reign (1864–86). On an island in the Chiemsee he constructed Schloss Herrenchiemsee on the model of Versailles; Schloss Neuschwanstein was built near Steingaden at the same time. At Schloss Linderhof, under the direction of Julius Hofmann (1840–96), a completely Rococo interior was created. Walls and ceilings were overgrown with gilt carvings and stuccowork, and the floors were carried out in marquetry. Through the overloading of individual parts with Rococo ornament, the lightness and delicacy of the original style was lost.

In the realm of middle-class furnishings, the studio of the Austrian painter HANS MAKART, decorated in 1872 and well known through paintings and photographs, strongly influenced popular taste in Germany (see Thornton, pl. 444). Large pieces of furniture with elaborate carving and upholstery, thick draperies, rugs, numerous pillows and large arrangements of plants and dried flowers created a domestic environment dense with richly coloured patterns and textures (see fig. 40).

BIBLIOGRAPHY

H. Schmitz: *Vor 100 Jahren, 1770–1850: Festräume und Wohnzimmer der deutschen Klassik und Biedermeier* (Berlin, n.d.)
F. Luthmer: *Sammlung von Innenräumen, Möbeln und Geräten im Louis XVI und Empirestil* (Stuttgart, 1897)
J. A. Lux: *Von der Empire- zur Biedermeierzeit: Eine Sammlung charakteristischer Möbel und Innenräume* (Stuttgart, 1906)
F. Luthmer and R. Schmidt: *Empire und Biedermeier Möbel* (Frankfurt am Main, 1923)
S. Harksen: *Wohnräume der Biedermeierzeit* (Potsdam, 1970)
I. Wirth: *Wohnen im Biedermeier: Berliner Innenräume der Vergangenheit* (Berlin, 1970)
Innenräume um 1800 (exh. cat., Frankfurt am Main, Hist. Mus., 1976–7)
H. Ottomeyer: *Das Wittelsbacher Album: Königliche Wohn- und Festräume, 1799–1845* (Munich, 1979)
P. Thornton: *Authentic Decor: The Domestic Interior, 1620–1920* (London, 1984)
A. Wilkie: *Biedermeier, Eleganz und Anmut einer neuen Wohnkultur am Anfang des 19. Jahrhunderts* (Cologne, 1987)
L. De Gröer: *Les Arts décoratifs de 1790–1850* (Paris, 1988)
H. Ottomeyer: 'Von Stilen und Ständen der Biedermeierzeit', *Biedermeier, Glück und Ende: Die gestörte Idylle, 1815–1848* (exh. cat., Munich, Stadtmus., 1988)

Karl Friedrich Schinkel: A Universal Man (exh. cat., ed. M. Snodin; London, V&A, 1991)

For further bibliography *see* §5 below.

5. AFTER *c.* 1900. At the beginning of the 20th century, inspired by developments in England, there was a reaction against the imitation of historical styles and academic conventions in design. In Darmstadt the Grand Duke of Hesse, Ernest Ludwig, had created an artists' colony in 1899 by bringing together the Hamburg-born architect Peter Behrens, the Viennese Secessionist Joseph Maria Olbrich, the painter and furniture designer Hans Christiansen (1866–1945), the interior decorator Patriz Huber (1878–1902) and others; they treated interior decoration and furnishing as part of an overall conception of exterior and interior architecture, in order to ensure the uniformity of the building. In Munich the architects Hermann Obrist, Richard Riemerschmid and August Endell founded the Vereinigte Werkstätte für Kunst und Handwerk. Other workshops were founded in Munich and Dresden; in Berlin a group formed around Otto Eckmann and Karl Stoevg. Bernhard Pankok was working in Stuttgart. In 1904 the Belgian Henry Van de Velde became Director of the Kunstgewerbeschule in Weimar, where his curvilinear style had a decisive effect on the applied arts. Many of these architects and designers created interiors that combined the principles of the Arts and Crafts Movement with *Jugendstil* motifs. Walls were often painted white or in pastel colours or covered with wallpaper in undulating organic designs. Furniture was characterized by softly curving outlines and large, smooth surfaces, either veneered, painted or decorated sparingly with plant motifs (see fig. 41). From Vienna came stylized geometric ornament and folk art elements as additional decorative themes. Artists such as Bruno Paul, Paul Schultze-Naumburg or Heinrich Tessenow, opted for the sober forms of the early Biedermeier period, a conservative trend that was very popular with the public. In his book *Das englische Haus* (1904–5) Hermann Muthesius clarified the relationship between lifestyle and dwelling-place. His work had an extraordinary effect in Germany, where, in the early decades of the century, interiors in the elegant and comfortable style of the new English suburban house were frequently commissioned. Numerous periodicals concerning architecture, interior decoration and the arts and crafts also provided regular and lavishly illustrated information about the latest projects; examples include *Deutsche Kunst, Innendekorationen* and *Moderne Bauformen*.

After World War I a second generation of the Modern Movement was triggered by the influence of the Dutch periodical DE STIJL and by the architects and craftsmen of the BAUHAUS. These groups created furnishings with geometric forms and smooth undecorated surfaces painted in primary colours to meet the physical and spiritual requirements of modern domestic life. Home design was based on Functionalism, the greatest possible correspondence between construction and function, the use of new materials and flexibility in the utilization of space. In the new blocks of flats built by the youthful adherents of this movement the functions of various rooms were carefully integrated. In such model housing estates as the Weissenhofsiedlung, Stuttgart, built by the Deutscher Werkbund in 1927, individual rooms served different purposes; the large room in a flat could be a living-room, a bedroom

41. Dining-room in the house of Peter Behrens, Darmstadt, 1900–01; designed by Behrens, with furniture executed in Hamburg by J. D. Heymann

and a workroom or study. These multiple functions demanded neutral fittings and furniture that were designed to be functional without taking up much space; for example, standardized shelf units were designed to make use of the full width of the wall. Doors had smooth surfaces without frames or mouldings, and ceilings were painted white. East Asian influence was expressed by bare floors and walls, on which an isolated picture might be hung. Large windows gave an unhindered view of nature, and draperies were limited to simple white net curtains. Flooring could be parquet, wooden boards or linoleum, although the hall, kitchen and bathroom were tiled. Carpets of woven wool or coconut matting could be fitted; occasionally Oriental carpets were used. Woven rugs produced to artists' designs were more popular, as were colourful folkloric patchwork rugs. Upright furniture was lower and smaller to suit the reduced proportions of the rooms, and many items of furniture formed part of the interior fittings: cupboards were built-in, and beds were set into niches. A further criterion was the easy mobility of furniture. Marcel Breuer's tubular steel furniture (see fig. 51 below), inspired by the aircraft industry, was characteristic. At the Werkbundausstellungen of 1925 in Berlin, 1927 in Stuttgart and 1929 in Berlin (entitled *Die billige und schöne Wohnung*) the new designs were introduced to the public by Walter Gropius, Breuer, Ludwig

Mies van der Rohe and Hans Poelzig, among others. The new furniture, however, was often expensive and, as a result, remained the preserve of the small, affluent, intellectual clique.

After the National Socialists took over in 1933 the rapid developments of the 1920s were brought to an abrupt halt. The Bauhaus was disbanded, and many of the pioneering architects fled into exile. In a limited way the Nazis adopted some elements of Functionalism, but in general interior decoration degenerated either into a traditionalistic folk arts and crafts style or into monumental classicism.

Architecture and design became subordinate to such state institutions as the Reichsstättenamt and the Reichsamt Schönheit der Arbeit. The decoration (1937–8; destr.) of the Reichskanzlei in Berlin by ALBERT SPEER is a typical example of the interiors created for party ceremonial. Speer attempted to copy the classicism of Karl Friedrich Schinkel: the huge interiors were furnished in a pompous manner with floor-to-ceiling marble wall claddings. Stone or parquet floors were either inlaid with strips of geometric marquetry or carpeted. Lavish furniture of marble, bronze or wood, sometimes inspired by late Louis XVI period works, assumed enormous proportions, the monumental size and extravagant use of materials failing to compensate for the poor quality of design. Subdued

42. Room conception by Ingo Maurer, Munich, 1984

colour schemes in shades of brown reinforced the intimidating and oppressive effect. Working for the Reichsstättenamt, Paul Schultze-Naumburg designed interiors that were reminiscent of the Functionalism of the 1920s, while consciously invoking the peasant craft traditions that were meant to express a specifically Germanic character; his exaggerated use of regional forms and materials conveyed a folksy, nationalistic cottage style. More worldly interiors for the public domain, with streamlined shapes derived from ocean liners, were created by Paul Ludwig Troost.

After World War II and the division of Germany into two states, interior decoration developed differently in the two parts, the dominant pattern being that new ideas from the Federal Republic were imitated after a delay of several years by the poorer Democratic Republic. Developments in the GDR were determined by state institutions, and despite shortages of materials and isolation there were individual attempts to emulate developments in the West. Though the state had determined that a socialist ideal should be the guiding principle, the influence of West Germany and the obligation of the GDR to export goods to this market compelled the country to conform to Western demands and trends. In the Federal Republic the re-establishment of the Deutscher Werkbund in 1950 gave a positive stimulus to the design of interiors. As a consequence of bombing and the influx of refugees, interior design in the immediate post-war years was determined by the pressing need to provide basic, functional housing for the homeless; practical, convertible furniture was created that allowed a single item to be used for a variety of functions: thus a writing-desk could also serve as a bed. From the early 1950s inexpensive decorative

goods such as raffia matting and cane furniture provided a modest start for the furnishing of living-rooms. Pastel shades predominated. The work of such artists as Paul Klee, Piet Mondrian or Willi Baumeister, condemned as decadent during the Nazi rule, inspired 'modern art' patterns for wallpapers and fabrics. In more affluent homes a wall or door surface was hung with pleated material. Colourful mosaics and tiles were used as decoration in entrance halls. Shelving, asymmetrically suspended by ropes, and a reproduction of Vincent van Gogh's *Sunflowers* hung on roughly textured wallpaper painted white were typical of the decoration found in the living-rooms of the young. Foam and other artificial materials enabled furniture to be produced in new organic shapes.

The standardization of furniture shapes and functional interior design were promoted in West Germany by the Hochschule für Gestaltung in Ulm under the direction of Max Bill, a former member of the Bauhaus. From the beginning of the 1960s built-in kitchens began to be popular, followed by modular furniture with seating units that could be combined in various ways. Wood-panelled ceilings, large picture windows, exposed masonry and carpeted floors completed the interior design of the period. With the increasing affluence of West Germany there was a greater demand for choice in decorating styles and materials, and, as living habits became more international, a typically German approach to interior design became more difficult to discern. Some bought expensive furniture by Italian or Scandinavian designers and painted the walls of their homes white, while others bought newly made bulky, dark oak 'Old German' furniture that survived from the vernacular style of the 1930s. An expanding variety of

lifestyles has also contributed to altering domestic forms. Since the 1970s interiors decorated in whimsical style, sometimes with junk or industrial by-products, expressed an attitude of 'anti-design' in reaction to earlier theories of functionalism and practicality (see fig. 42). This unconventional approach to design was taken up by industry and became widespread in a restrained form.

BIBLIOGRAPHY

Möbel und Zimmereinrichtungen der Gegenwart: Eine Sammlung von Möbeln, Dekorationen und Wohnräumen in allen Stilarten, Berlin, 1898–1905 (Berlin, 1898–1905), rev. as *Jugendstil: Möbel und Zimmer um 1900* (Hannover, 1981)

H. Muthesius: *Das englische Haus*, 3 vols (Berlin, 1904–5)

H. Warlich: *Wohnung und Hausrat: Beispiele neuzeitlicher Wohnräume und ihrer Ausstattung* (Munich, 1908)

C. H. Baer: *Deutsche Wohn- und Festräume aus 6 Jahrhunderten* (Stuttgart, 1912)

F. Naumann: *Der deutsche Stil* (Dresden, [1915])

H. Muthesius: *Die schöne Wohnung: Beispiele neuer deutscher Innenräume* (Munich, 1922)

J. Baum: *Farbige Raumkunst: 120 farbige Entwürfe moderner Künstler* (Stuttgart, 1926)

K. M. Grimme: *Die Mietwohnung von heute: Wie richte ich sie ein* (Vienna and Leipzig, 1932)

W. Müller-Wulckow: *Die deutsche Wohnung der Gegenwart* (Königsstein and Leipzig, 1932)

H. M. Wingler: *Das Bauhaus, 1919–1933: Weimar, Dessau, Berlin* (Bramsche, 1962)

A. Silbermann: *Vom Wohnen der Deutschen: Eine soziologische Studie über das Wohnerlebnis* (Cologne and Opladen, 1963)

H. Kreisel and G. Himmelheber: *Die Kunst des deutschen Möbels*, 3 vols (Munich, 1968–83)

S. Muthesius: *Das englische Vorbild: Eine Studie zu den deutschen Reformbewegungen der Architekten in Architektur, Wohnbau und Kunstgewerbe im späten 19. Jahrhundert* (Munich, 1974)

J. Campbell: *The German Werkbund* (Princeton, 1978)

H. Wichmann: *Aufbruch zum neuen Wohnen, deutsche Werkstätten und WK-Verband, 1898–1970* (Basle and Stuttgart, 1978)

A. Bangert: *Der Stil der fünfziger Jahre: Möbel und Ambiente* (Munich, 1983)

G. Selle: '"Es gibt keinen Kitsch—es gibt nur Design": Notizen zur Ausstellung *Das geniale Design der achtziger Jahre*', *Kstforum Int.*, no. 66 (1983)

G. Benker: *Bürgerliches Wohnen: Städtische Wohnkultur in Mitteleuropa von der Gotik bis zum 'Jugendstil'* (Munich, 1984)

S. Günther: *Das deutsche Heim: Luxusinterieurs und Arbeitermöbel von der Gründerzeit biz zum 'dritten Reich'* (Giessen, 1984)

P. Thornton: *Authentic Decor: The Domestic Interior, 1620–1920* (London, 1984)

L. Burckhardt: *Die Kinder fressen ihre Revolution: Wohnen, Planen, Bauen, Grünen: Design ist unsichtbar* (Cologne, 1985)

Die Hochschule für Gestaltung Ulm: Die Moral der Gegenstände (exh. cat. by H. Lindinger, Berlin, Bauhaus-Archv, 1987)

S. Hinz: *Innenraum und Möbel* (Berlin, 1989)

S. Geissler: *Ästethik und Organisation des deutschen Werkbundes im 'dritten Reich'* (Giessen, 1990)

M. Praz: *Histoire de la décoration intérieure* (Paris, 1990)

ULRICH LEBEN

VI. Furniture.

1. Before 1510. 2. 1510–1650. 3. 1651–1769. 4. 1770–1895. 5. After 1895.

1. BEFORE 1510. Few examples of German furniture from this early period have been preserved: information is provided mainly by manuscript illuminations, especially monastic literature. Most extant Romanesque and Gothic furniture is Church property, which has survived better than secular pieces because of the higher esteem in which it was held and its more sturdy construction.

From the beginning of the 12th century chairs with lathe-turned posts were introduced to south Germany from Scandinavia. One of the best-known examples is the bench in Alpirsbach Monastery, which dates from the early 12th century. It has turned front and back posts and similar back rails. The supports under the seat are also turned to give an impressive array of balusters. The stone imperial throne in Goslar Cathedral is a box chair of complex construction that dates from 1150. A typical early example of seat furniture is the folding chair, or 'Faldistorium', from the monastery of Nonnberg, near Salzburg. Although it dates from 1242, the carved lion's head and paws on the crossbars hark back to earlier models. Such chairs were usually intended for dignitaries, and the Nonnberg example is said to have belonged to the Abbess Gertrude. The south German or Alpine scissors chair or armchair, dating from the beginning of the 16th century, constituted an important development towards mobile, or moveable, furniture.

The commonest and most important item of storage furniture was the chest, which serves as an excellent illustration of the stylistic development of furniture. The monumental type with horizontal emphasis predominates. Local differences are reflected in the choice of woods: oak was preferred in north Germany, pine in south Germany and the Alpine regions. The earliest surviving examples are chests or trunks made in the 12th century from a single oak tree in northern Germany. These developed into the commonest medieval types, the front-supported design and the side-supported design, in which the chest has four corner posts, front, back and end panels, a bottom and a lid. The front-supported chest, characteristic of Westphalia, acquired a distinctive appearance from the strikingly thick bands of iron and posts carved with animals and weapons in relief. The abundant use of metalwork originally served to strengthen the panels; subsequently, with improved construction techniques, the iron bands increasingly became merely decorative. The invention of the sawmill in Augsburg in 1320 enabled thinner planks to be cut and led to framed-panel construction. The making of chests later became the responsibility of house-builders, and many were shaped very crudely with an adze. In the 15th century joiners began to specialize in making chests or coffins, which resulted in more refined craftsmanship. A south German type dating from the second half of the 15th century is a simple box chest with carved base. In due course notching, tracery and relief carving replaced painted decoration (for illustration *see* CHEST). Late Gothic decoration was supplemented by the linenfold ornament favoured in the Low Countries. This motif, achieved with a hollow-moulding and rod plane, represents cloth laid in vertical folds and later developed to an X-shaped parchemin adornment. It was particularly adapted for chests of framed-panel construction and was common at the beginning of the 16th century on chests in the Lower Rhine and Cologne district (e.g. of 1500; Leipzig, Mus. Vlkerknd.).

Most tables consisted of two trestles with a board laid across the top. A further development was the folding chest table, which originated in the Alps. These softwood chests were mostly adorned with bas-relief carving. An important innovation was the table with a fixed central pedestal, the best-known example of which is the round

43. Cupboard, pine with walnut, maple and cherry-wood marquetry and remains of painted decoration, 1.67×1.95×0.73 m, from Tyrol, *c.* 1500 (Frankfurt am Main, Museum für Kunsthandwerk)

adornment. Intarsia work, a technique that came from Italy via the Tyrol, was used by Syrlin in the scrolls framing the door panels and the inlaid bands of ornament at the sides. The design of the cupboard is typical of its southern origin.

An important aid in dating is the return of the relatively realistic plant motif from 1475 onwards; it subsequently declined to become more abstract. The use of engraved ornament as a model became more significant, the most important examples being those by Master E. S., MARTIN SCHONGAUER and Daniel Hopfer I.

2. 1510–1650. Under Italian influence German decoration underwent a marked improvement during the early 16th century. Such artists as Albrecht Dürer who travelled to Italy became an important channel for new ideas. The spread of graphic ornament influenced the arrangement and style of furniture: designs by the so-called Little Masters from Nuremberg, Westphalia and the Netherlands were particularly significant. A repertory of ornament derived from antiquity largely replaced religious themes. The new vocabulary included frond work with naked figures, birds, animals, urns, masks and trophies of weapons. In south Germany the new Italian fashion was inspired by the work of Peter Flötner and Virgil Solis, and its application to furniture is particularly striking in cupboards. Until the mid-16th century the two-stage cupboard, with a richly carved band dividing it into two halves, was fashionable. The first phase of the German Renaissance is exemplified in two such cupboards made to designs by Dürer (*c.* 1520; Eisenach, Wartburg-Stift.) and Flötner (1541; Nuremberg, Ger. Nmus.; for illustration *see* CUPBOARD). The ornamental carving shows demifigures amid tendrils, budding blossoms and fruit. The inclusion of picturesque reliefs denotes the final phase of this development. These cupboards derive their artistic significance from their reliefs, copied from engraved sources. Five printed designs for beds by Flötner are known. They are strongly reminiscent of Florentine chests. The typical Late Gothic four-post standing bed reached its most sumptuous expression in the lavishly ornamental examples made at this time.

The chest continued to be one of the most important items of storage furniture until the second half of the 16th century. Typical decoration schemes of north German chests consisted of symmetrical arrangements of motifs without any central emphasis. In Westphalia and in Schleswig-Holstein the fronts of many chests were panelled and carved with biblical scenes. In the Protestant north, following the Reformation, Church commissions ceased; however, domestic pieces with secular themes were still made. One of the most important Renaissance chests in south Germany is the 'Erasmus' chest (Basle, Hist. Mus.), commissioned in 1539 in memory of the great scholar of Rotterdam. Worked in lime and ash, the front is divided into four panels with relief medallions, but the overall shape is characteristic of south Germany and Switzerland. Its sophistication reveals Italian influence. Another south German type is represented by a chest decorated with intarsia depicting architectural prospects (walnut, 1551; Berlin, Staatl. Museen Preuss. Kultbes.). It bears the signature of Master H.S., to whom the first large-scale

table with an incised slate top made to a design by Tilman Riemenschneider (1506; Würzburg, Mainfränk. Mus.). Apart from the simple couch and corner bed, the freestanding bed with bedposts and wooden baldacchino was common in the Late Gothic period. In south Germany and the Alps this type persisted well into the Renaissance, its decoration similar to that of the chest and cupboard.

A typical early example of a cupboard is the Halberstadt Reliquary (1230; Halberstadt Cathedral, Treasury), which is still in use. It is distinguished by the unusually fine quality of the painting of the interior and of the figures of saints on the exterior. Cupboards at this time had a stepped pediment or saddle roof, together with a plinth giving greater stability. More Early Gothic cupboards have been preserved from the north than the south; nearly all are of oak. By the late 15th century, however, the high quality of softwood cupboards in south Germany became artistically significant (see fig. 43), and the area became the centre of fashionable furniture production. The striking achievements of south German woodworkers can be attributed to specialization among craftsmen, who had organized themselves in guilds (the first had been established by Cologne carpenters in 1397). A typical example is the two-stage cupboard with panelled doors and a rich variety of Late Gothic ornament, including carving, parquetry and intarsia. A good example is the bridal cupboard signed by Jörg Syrlin the elder (1465; Ulm, Ulm. Mus.), which has openwork tracery in pewter, cusped decoration and vine and thistle tendrils—the full panoply of Late Gothic

intarsia work in the German-speaking area is attributed. Framed tables became increasingly common, although the trestle table continued to be used. Chair design developed from the Italian stool with four legs. German examples were, however, of stouter construction, with cushions for comfort.

From the mid-16th century the predominant ornament became grotesques, originated by, among others, Flötner. Derived from ancient Roman decoration, the style offered a contrast to the symmetry of earlier motifs. Engravings and woodcuts provided models for woodworkers and goldsmiths. During the second phase of the Renaissance, woodworkers also looked increasingly towards architecture for inspiration, especially the designs of Vitruvius (published in Nuremberg in 1547). The works of contemporary Italian theoretical architects were also translated into German, backed up by publications by various German authors.

The two-stage cupboard depended for its decorative effect on creating the impression of an architectural façade; the finest examples were made at Nuremberg, their most salient characteristic being the absence of inlaid or carved ornament. A Classical-style frieze with metopes and triglyphs now replaced the pewter garland; curved borders gave way to pilasters or free-standing columns, with aediculae taking the place of the ornamental door panels (e.g. two-stage cupboard with 8 doors, c. 1575; Nuremberg, Kaiserburg). After c. 1565 the façade might conceal hidden compartments. Another technical advance was the introduction of veneering, for example the use of wavy-grained Hungarian ash on Nuremberg cupboards. Figured veneering became a highly important decorative technique in south German cabinetmaking (see fig. 44), although it was absent from north German work.

The Gothic tradition lingered on most tenaciously in north Germany and Westphalia. Massive ash furniture with relief carving, frequently following designs by Heinrich Aldegrever or, somewhat later, Auricular designs by Cornelis Floris, predominated until the 17th century. An important type of cupboard consisted of many small compartments with a fall-front in the middle. Its characteristic central compartment gave rise to the *Schenkschive* (e.g. carved oak cupboard, 1575; Erfurt, Angermus.). In north-western Germany and the Rhineland furniture was strongly influenced by Flemish and French styles. The Rhenish dressoir, for example, derived from the French form, still had a medieval shape, but the surface decoration displays such Renaissance ornament as leaf tendrils, cornucopias and masks derived from the engravings of Aldegrever.

In the second half of the 16th century, in the Cologne district, the Late Gothic dressoir developed into an outsize cupboard, its upper stage set back and richly inlaid with geometrical and floral inlay (e.g. oak, 1590; Hannover, Kestner-mus.). The ornament is carefully arranged and often emphasized with a maypole with symmetrical branches, scrolls and leaf motifs. The perspective intarsia of Cologne clearly shows the influence of south Germany and the Tirol, illustrating the spread of this specifically south German style of wood decoration. Augsburg was famous for complex intarsia decoration, notably wood engravings inspired by the painter Lorenz Stoer (*fl* 1555–

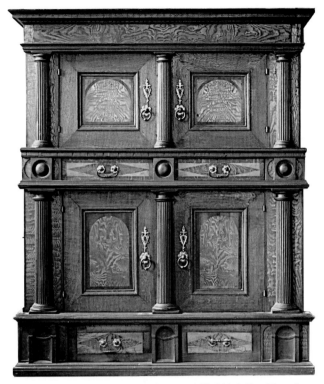

44. Cupboard, oak with Hungarian ash veneer, 1.88×2.19×0.63 m, Nuremberg, mid-16th century (Frankfurt am Main, Museum für Kunsthandwerk)

1621) and his *Geometria et perspectiva* (Augsburg, 1567). One of the most celebrated items of this kind, the *Wrangelschrank* (1566; Münster, Westfäl. Landesmus.), was made to a design of Stoer by an unknown master. Produced at Augsburg, this cabinet cupboard acquired its name from the Swedish count Carl Gustaf Wrangel (1613–76), who subsequently claimed it as war booty. Early cabinets in the Wrangel style were inlaid with scenes of ruins combined with scrolls, clasps, shells, monkeys and birds in different coloured woods. Their picturesque effect was exceedingly well adapted to meet the craving for illusionistic decoration. The secrétaire, with numerous small drawers and compartments, was a speciality of Augsburg cabinetmakers and continued to be much sought after for export until well into the 17th century. Writing-cabinets, mostly with a fall-front enclosing drawers, functioned as repositories for correspondence, jewellery and collections of curiosities.

The early 17th century was a period of transition: furniture with noticeably restrained decoration was created alongside other pieces in an exaggerated Mannerist style. The latter included a special type of cabinet, produced in Augsburg, that resembled a work of art rather than a piece of furniture and was made in such valuable materials as ebony, tortoiseshell, ivory, lacquer and hardstones. These were the work not only of cabinetmakers but also of goldsmiths and sculptors. A splendid example is the ebony cabinet (1625–31; Uppsala, U. Kstsaml.; see fig. 45) with which the town of Augsburg honoured Gustav II Adolf

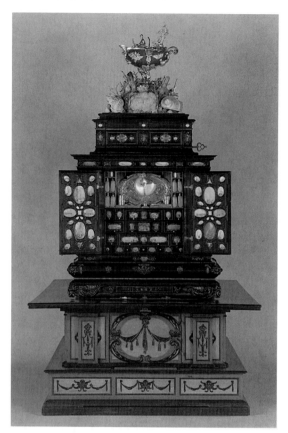

45. Cabinet, carved ebony inset with hardstones and miniatures, crowned with an arrangement of hardstones, shells and coral with a boat-shaped ewer of Seychelles nut and silver figures, 0.98× 1.88×0.86 m, Augsburg, 1625–31 (Uppsala, Universitet Konstsamling)

such old and new motifs as grotesques and leafy embellishment co-exist. The Nuremberg Kleinmeister were very successful in modifying Italian elements: at first this decoration was copied slavishly, but gradually the designs took on a luxurious German personality. The engravings of the Dutch artist Cornelis Floris exerted a powerful influence. His fantastic volutes, which frequently appear like masked faces, derive from late Renaissance scrollwork. One of the most important late exponents of this fleshy Auricular decoration was Friedrich Unteutsch from Frankfurt, who published a book on the art of decoration, *Neues Zieratenbuch den Schreinern Tischlern oder Künstlern und Bildhauern* (Nuremberg, *c.* 1650). His patterns were often used in carving on south German cupboards. A four-door, architecturally styled cupboard from Augsburg (*c.* 1660; Frankfurt am Main, Mus. Ksthandwk; see fig. 46) shows that traditional Renaissance designs were still in use in the mid-17th century. New features added to the typical south German cupboard were Auricular ornament and twisted columns flanking the niches. Early Baroque cupboards rested on flattened ball feet.

Augsburg, in particular, was a principal centre of high-quality furniture production. Cabinet-cupboards using the boulle technique are characteristic of Augsburg. A typical cabinet dated 1680 reveals not only techniques from Italy

of Sweden (*reg* 1611–32). It was conceived by the Augsburg scholar PHILIPP HAINHOFER. Among the craftsmen employed by him to work on the project were the painter Johann König and the silversmith Johannes Lencker (*c.* 1573–1637); the carving was probably carried out by Ulrich Baumgartner (*c.* 1580–1652). The cabinet, which was designed to symbolize in microcosm an entire world, also marked the end of the *Kunst- und Wunderkammer* era of the 16th century.

3. 1651–1769.

(i) Baroque. (ii) Rococo.

(i) Baroque. The Baroque style became established relatively late in Germany because of the devastation and economic decline caused by the Thirty Years War (1618–48). The tradition of the 16th century lingered in the towns, with their craft guilds, longer than among the privileged court craftsmen, who were not subject to strict guild rules. It was primarily south Germany that received artistic stimulus from Italy and, at the end of the 17th century, increasingly from France as a result of foreign artists working at the German princely courts and German craftsmen training and working in Paris. The change in style first affected the vocabulary of ornament, in which

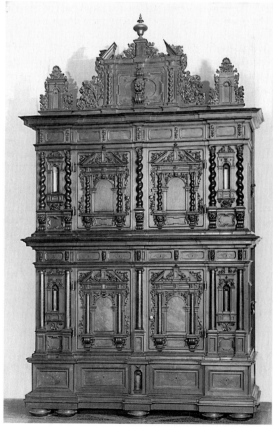

46. Cupboard, after designs by Friedrich Unteutsch, pine body with walnut veneer and carving, 2.22×3.50×0.80 m, Augsburg, *c.* 1660 (Frankfurt am Main, Museum für Kunsthandwerk)

and France but also tortoiseshell inlay of Dutch inspiration. The south German cabinet-cupboard developed from a light, portable travelling item to an important piece of furniture in a room scheme. It later evolved into the secrétaire, which became a valued status symbol. The somewhat over-decorated façades of typical Augsburg cabinets were embellished with four twisted columns headed by a segmental pediment. Panels of marble inlay sometimes featured on the drawer fronts and the central recess. Early cabinets were raised on supports carved as figures. In Augsburg, ebony furniture became a speciality, characterized by excessive decoration. The architectural framework of cabinets was constructed of ebony or black stained wood, but the inlaid decoration differed little from other south German cupboards. Rectangular tables with baluster or twisted column legs following Dutch examples were common in both bourgeois and court settings. A further development was the console table. Regional differences lay in materials and ornament rather than in design. In north Germany oak tables predominated, while in south Germany walnut tables with intarsia were more favoured. Lavish tables produced in Augsburg for the court occupy a special position. They are distinguished by pietre dure, boulle decoration or an overlay of silver sheets. No really sumptuous examples of silver furniture survive because most were melted down during warfare. Silver furniture was produced in Augsburg from the mid-17th century until the first half of the 18th, made by such silversmiths as Johann Jacob Biller (e.g. design for silver table, 1720; see Kreisel and Himmelheber, ii, pl. 311). Thin sheets of silver foil spread over the carcase were then ornamented with engravings and repoussé work. Silversmiths generally designed and decorated the furniture they produced. The silversmith Johannes Rump designed old-fashioned, heavily shaped chairs carved with Auricular motifs and acanthus fronds.

The progressive attitudes of Augsburg and Munich cabinetmakers, whose furniture was influenced by the French Régence style, is evident when compared with Franconian furniture. For instance the basic design of Franconian writing-desks derived from tables on caryatid legs and cabinets with interlace ivory marquetry—a distinctly retrogressive formula. Typical examples of decorative furnishing are a cabinet with filigree ivory marquetry (c. 1715–20; Pommersfelden, Schloss Weissenstein) by Ferdinand Plitzner (1678–1724) after models by Jean Berain I and a somewhat clumsy bureau-cabinet on sculptural legs with Bandelwerk and rocaille intarsia (1745; Würzburg, Mainfränk Mus.) by Carl Maximillian Mattern of Würzburg. The conservative style of Franconian furniture may be due in part to its being commissioned by ecclesiastical patrons, the electors and prince-bishops of the von Schönborn family. In spite of its magnificent mounts it creates a down-to-earth impression. With their precise marquetry, carving and gold-plating, these cupboards are outstanding examples of German furniture.

Sacristy cupboards, used for storing church vessels and vestments, had an upper stage consisting of numerous drawers, clearly modelled on south German cabinets; the lower part normally had doors. They differ from other cupboards in their excessive breadth and height. In the first half of the 18th century walnut veneering and

abundant Bandelwerk intarsia were characteristic. In contrast to France, the cupboard continued to be important in Germany in the 18th century. Regional differences in design are often striking. Among town carpenters, who were organized in guilds, it became their pièce de résistance, and it is often possible to link style, region and craftsman. Those made in the Hanseatic towns of Hamburg and Lübeck, mostly in oak, were influenced by the art of the Netherlands. The Hamburg Schapp cupboard, with its double doors, achieved its typical form c. 1700: ball feet, a plinth with drawers, the main stage having pilasters, panelled doors and a profiled cornice. The pilasters, the spandrels of the door panels and the plinth feature carved detail (e.g. walnut Schapp, 1682; Hamburg, Mus. Kst & Gew.). Lübeck cupboards have curved pediments. A different impression is given by delicately worked cupboards in colourful natural woods from the Aachen-Liège district, which derive from French and Flemish models. Vitrine cupboards came into favour in the Aachen area in the early 18th century. These cupboards from Aachen and Liège, with the upper stage enclosed by double doors and a lower commode section, owe their special character to small relief carvings in the centre and on the canted corners of the cornice and the drawers; the bevelled edges and carved cartouches are an indication of adaptation to the Rococo style (e.g. of 1750; Aachen, Couven-Mus.).

The conservative taste of the north German bourgeoisie in Brandenburg sustained traditional Baroque forms well into the Rococo era. The typical Brandenburg cupboard had small marquetry designs executed in pewter, ivory and box-wood in the centre of the door panels. From about 1725 straight cornices were replaced by an arched pediment with a flattened top. After c. 1786 walnut secrétaires replaced wardrobes as status symbols. Cupboards produced in Frankfurt c. 1700 are also highly distinctive, having an elaborately wave-fronted lower section supporting an upright stage; carving is absent except on the columns and pilaster capitals. The cornice is stepped, the lower part projects forward, and they were invariably made of walnut. This type of cupboard was found throughout the Middle Rhine area and in Saxony.

Lacquer work, originally imported into Europe by English and Dutch trading companies, spread rapidly into European court circles. From 1710 the technique was perfected by Martin Schnell (c. 1675–1740), who had learnt the art in Paris and was active at the Dresden court. His more famous works include an ensemble of red and green lacquer secrétaires (e.g. c. 1730–40; Frankfurt am Main, Mus. Ksthandwk). A typical Dresden feature was the upper stage with mirror doors surmounted by a scrolled pediment. The lower bombé commode stage containing three drawers relates to other Saxon furniture. This type of two-stage bureau-cabinet, which was much favoured elsewhere during the Rococo period, derives from English models. Richly gilded mounts were often ordered for the Dresden court from Paris. The decoration included charming little chinoiserie scenes; with its light construction and exotic decoration this style completed the transition to Rococo.

(ii) Rococo. German cabinetmakers assimilated imported styles with such a sure touch that the Rococo became one

of the richest and most distinctive phases in German art. The making of fashionable furniture was at this time centred on the royal courts. A penchant for sculptural furniture at the Berlin court was already marked under Frederick I, as testified by a carved and gilt bench dated 1696 after a design by the architect Andreas Schlüter. Some of the finest furniture was made in the French style in Berlin, for Frederick II's rebuilding of the palaces of Charlottenburg (1740–46) in Berlin and Sanssouci (1745–7) and the Neues Palais at Potsdam to designs by the architect Georg Wenceslaus von Knobelsdorff and the sculptor Johann August Nahl, who had trained in Paris (see §V, 3 above). Nahl, a typical representative of the Frederican Rococo with his elegant light blue, white and gold furniture, designed sculptural chairs and console tables for the interiors (see fig. 47). The legs of his armchairs have pronounced curves and the arms lively openwork carving. When Nahl left Berlin in 1746 he was replaced by a sculptor from Zurich, Johann Melchior Kambli (1718–83), one of the few cabinetmakers active in Germany whose gilt-bronze mounts can compare with those from Paris. After 1764 he also worked with the brothers Johann Friedrich and Heinrich Wilhelm SPINDLER from the Bayreuth court. The Spindler brothers, who achieved fame for their floral marquetry furniture, were the leading cabinetmakers of the late Rococo in Potsdam. By this time the two-drawer serpentine commode on long legs had become popular. The courtly Rococo is splendidly exemplified by a commode by the Spindler brothers and Kambli with luxurious tortoiseshell veneer, mother-of-pearl marquetry and lavish silver-gilt bronze mounts (c. 1768; Potsdam, Schloss Sanssouci; see fig. 48). Contemporary bourgeois commodes from south Germany were much simpler than the courtly types. The majority had three or four drawers, but the previously straight front became curvilinear and was veneered in walnut enriched with Bandelwerk marquetry, chinoiserie and simple floral inlays. Beds retained a Baroque four-poster shape, but, especially in south Germany, the hangings and bedding were much more lavish. The bed was no longer a ceremonial object, but, by being placed against a wall, acquired a certain homeliness.

Among leading south German patrons at Ansbach, Würzburg, Bamberg and Munich, those at Munich were most influential. The Elector Maximilian II Emanuel (reg 1679–1726) and his son Charles Albert (later Charles VII; reg 1726–45) admired Parisian fashions and installed the French-trained Joseph Effner and François de Cuvilliés I as court master builders. A fluently carved and gilt console table made to Effner's design (1730; Frankfurt am Main, Mus. Ksthandwk) combines elements of the exuberant Italian Baroque with French inspiration. The broad frame is accentuated by a central cartouche, and the sculptural legs are linked by carved members. The twin-drawer, long-legged white and gold commodes made to designs by de Cuvilliés are supported in a similar manner (e.g. 1739; Munich, Amalienburg). While related to commodes at the Berlin court, Munich furniture does not always achieve the same delicacy and elegance of detail. The Martinsburg (1478–82; destr. late 18th century), the electoral archibishop's residence at Mainz, was also a centre for Rococo furniture. Here developed the Cantourgen, an original type of bureau-cabinet and a successor to the cabinet-cupboard, as can be seen from the arrangement of the upper stage. The link between the upper part and the lower commode is the sloping desk unit, the front, side and corners forming a flowing line. The comparatively delicate furniture of Mainz is harmoniously proportioned, high volute feet giving it a typical Rococo lightness.

From 1750 the Neuwied workshop of Abraham Roentgen and his son David (see ROENTGEN) occupies a very special place in the history of 18th-century German furniture. Owing to its extreme refinement, their furniture stands comparison with the best work of the French ébénistes. Their clients included all the great European electoral houses, the princes of the Church and also the bourgeoisie. Furniture produced in the early period by Abraham Roentgen is distinguished by simple shapes of English and Dutch inspiration. Walnut furniture in the Queen Anne style and small gaming-tables with fine intarsia work belong in this phase. David Roentgen further developed marquetry techniques and introduced lavish French styles of cabinetwork. Much of his floral and chinoiserie marquetry was designed by the painter Januarius Zick. The Roentgens' strict religious background in the Moravian Brethren ensured reliable workmanship and fair dealing. David Roentgen succeeded in developing an entirely original range of pieces, one of which (1769; Frankfurt am Main, Mus. Ksthandwk) was designed to look like an ordinary chest but could be transformed into a writing-desk, a dressing-table or a gaming-table, with

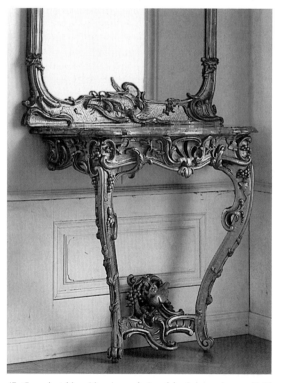

47. Console table with mirror, designed by Johann August Nahl, carved and gilt wood, 930×910×510 mm, Kassel, 1755–60 (Fulda, Schloss Fasanerie)

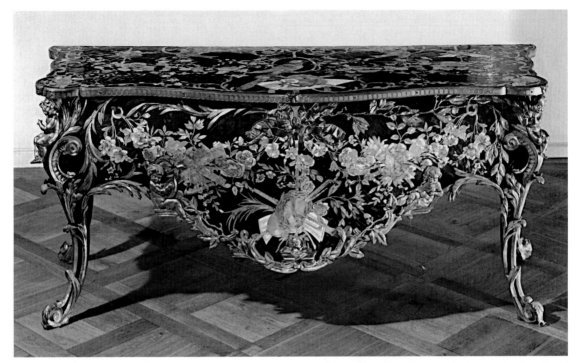

48. Commode, by Johann Friedrich Spindler, Heinrich Wilhelm Spindler and Johann Melchior Kambli, tortoiseshell veneer, mother-of-pearl marquetry and silver-gilt bronze mounts, 1950×845×745 mm, Potsdam, *c.* 1768 (Potsdam, Schloss Sanssouci)

numerous hidden drawers and compartments (*see also* §4 below).

4. 1770–1895. In comparison with England and France, Neo-classicism came to Germany relatively late, first making itself felt *c.* 1770 with the so-called *Zopfstil*, corresponding to the French Louis XVI style, followed by the Empire style and fading with the Biedermeier style. The taste of this perod was profoundly influenced by the social changes that swept away the traditional court society and ushered in a new self-assured bourgeoisie. The French Revolution also hastened the decline of the old guild-dominated trades.

In the *Zopfstil*, early Neo-classical phase, contrasts with the court style were not yet marked; traditional furniture continued to be made but with some updating of ornament. This development can best be illustrated by studying the secrétaire. Serpentine Rococo forms were replaced by rectangular, more architectural designs, while marquetry decoration became confined to the centre of a drawer, door panel or fall-front. The new repertory of ornament included such motifs as festoons, floral bands, paterae vases, metopes and triglyphs. David Roentgen, one of the most important cabinetmakers at the courts, often employed gilt-bronze mounts on his lavish Neo-classical furniture. He gradually reduced floral ornament in favour of finely figured veneers. Despite the German preference for walnut, Roentgen favoured mahogany. The trend towards simplicity was firmly established by the end of the century. A favourite *Zopfstil* design type was the roll-top desk, which had been developed in France and eventually replaced the writing-cabinet or secrétaire. The desk cover,

in the form of a quarter cylinder, retracted when the writing compartment was opened. Simple in outline, most roll-top desks were decorated only with elegant veneers rather than marquetry (e.g. 1785; Malibu, CA, Getty Mus.; for illustration *see* ROENTGEN, (2)). In central and southern Germany in particular, parquetry was used for the front; a similar decorative treatment was used for commodes, which now mostly had two drawers raised on tall straight legs.

In the Aachen and Middle Rhine area carved oak, walnut and cherry-wood furniture was popular. Chair shapes were influenced by English models, especially in north Germany where English furniture pattern books circulated, while in south Germany a variety of original designs were used for chair backs. In north Germany the tendency to retain traditional forms is best seen in large hall-cupboards. Pedimented cupboards with drawers in the lower stage, widely popular in England and the Netherlands, were adopted by Bremen craftsmen. Their simple design, combined with carefully selected timber and delicately carved mouldings, give these cupboards a distinctive character (see fig. 49). By the end of the century veneered furniture had become the norm.

During the Empire period Napoleon I sought to influence fashionable taste in the subjected German areas by means of a deliberate cultural policy. The designs of his two leading architects, Pierre-François Fontaine and Charles Percier, were rapidly assimilated in the Rhineland, but it was not until the 1820s that the re-established courts deliberately adopted the luxurious style of French furniture. At first, owing to widespread poverty, furniture in Germany was extremely austere; simply styled pieces with

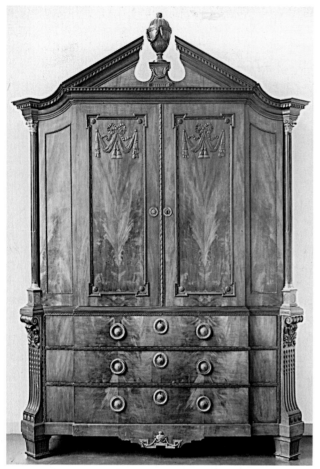

49. Cupboard, mahogany veneer, 2.77×1.88×0.66 m, Bremen, 1780 (Frankfurt am Main, Museum für Kunsthandwerk)

a little carved ornamentation in the classical style predominated. The solid and sober design of German Empire furniture can be readily distinguished from the French furniture loaded with gilt-bronze mounts that was imported for the courts of Westphalia, Kassel and Munich by the relatives of the French Emperor. Owing to the scarcity of mahogany—the preferred wood of the Empire period—walnut or box-wood was often stained to resemble mahogany. Until *c.* 1810 the late style of David Roentgen still exerted a powerful influence on German furniture. He worked in south, central and east Germany on such pieces as cupboards by the Berlin master Johann August Griese or by the Leipzig cabinetmaker Johann Christian Knesing. Typical examples are the enormous *secrétaires à abattant* with lavish temple architecture and small marble columns (e.g. writing-cabinet by Griese, 1801; Potsdam, Neues Pal.).

One of the most original and influential specimens of German furniture was the luxurious boat-shaped bed designed for Queen Louise by Karl Friedrich Schinkel in 1809. Made of pear-wood, it anticipated Biedermeier form (see fig. 50). A round birch table with silver mounts (1809; Würzburg, Residenz (Bayer. Verwalt. Staatl. Schlösser,

Gtn & Seen)), made by the Frankfurt carpenter Johann Valentin Raab to a design by Nikolaus Salin for the Würzburg court, is highly typical of the German Empire style. Its central support is in the form of three large swans on a pedestal. Dolphins and caryatids carved in the round were employed to adorn sets of chairs, and mythological animals were supplemented by other figures. The white and gold furniture at the Berlin and Munich courts was of an imperial character that came to be known as the Néo-Grec style. Cast-iron furniture was introduced by Schinkel, who also designed inlaid mahogany pieces.

In contrast to the imposing character of Empire furniture, the new BIEDERMEIER forms were more domestic and built on a more human scale. Furniture that had a fixed station as part of the architecture of a room was now replaced by more mobile pieces. Alongside the rectangular Empire styles appeared round, half-round and lyre-shaped forms. Such light-coloured, vividly figured veneers as cherry, birch and maple became popular, while for contrast black-stained pear-wood was preferred to metal mounts. The use of finely grained timber to achieve vivid decorative surface effects is a striking feature of Biedermeier furniture. With quartering, shapes like eyes and fountains enlivened veneered furniture. Regional differences became less obvious, although in north Germany there was preference for darker woods, and English influence was stronger than the French inspiration behind south German furniture. The trend towards uniformity was primarily due to the circulation of journals that illustrated English, French and German models. The designs of WILHELM KIMBEL, a cabinetmaker and designer to the royal court, also had far-reaching influence.

The Biedermeier period encouraged an abundance of furniture types, particularly tables. The round Empire table with a central pedestal became a rectangular table with drop leaves and either lyre-shaped supports, curving legs or pillars with carved acanthus. Its models were English Pembroke and sofa-tables. Small sewing-tables, in the form of elaborately fitted boxes on a central column, or globe-shaped work-tables enjoyed considerable popularity. Great importance was also attached to the sofa, which became a classic piece of furniture distinguished by its fine craftsmanship and width. In north Germany large proportions and dark timber were preferred; the south and central German smaller pieces were rounded and more lightly and richly embellished. The same applied to such chairs as the so-called 'English' chair, derived from Roman models with sabre legs. The canapé sofa and chair both appear in the Mainz design book with variants in the ornament of the armrests and backs.

The clothes-press was a popular form of case furniture. In north and central Germany the plinth or cornice often had half-rounds or lozenges. By the end of the century a smaller cupboard, generally with a mirror door, was preferred. Vitrines were widely used for the display of decorative objects. The *secrétaire à abattant* became the standard type of writing-cabinet of the Biedermeier and later periods. No other piece of furniture offered the same scope for architectural treatment. Pedimented examples from north and east Germany resembled antique monuments. South German secrétaires were much smaller, consisting of a lower stage with drawers supporting a

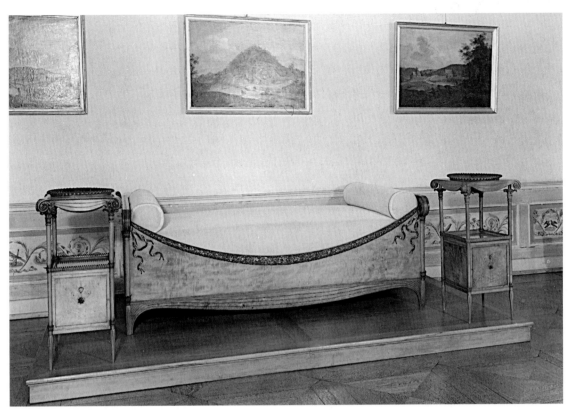

50. Queen Louise's bed by Karl Friedrich Schinkel, pear-wood, 2.02×0.75×1.10 m, 1809 (Berlin, Schloss Charlottenburg)

writing-desk headed by another long, shallow drawer. Architectural and ornamental decoration merged only at the end of the Biedermeier period. A typical example is a secrétaire after a design by Schinkel (1826; Potsdam, Schloss Charlottenhof). The late date of this ample piece is betrayed in the use of fluted ionic columns, in the thin round mouldings surrounding the drawers and writing surface and in the Gothic arrangement of the desk compartment—a decorative combination unknown to pure classicism.

From the 1830s Biedermeier forms were increasingly ousted by the fashion for historicism. Romantic historicism, with its mostly Gothic-style furniture in castles and palaces, was succeeded c. 1850 by the Baroque and Rococo revivals, which depended largely on Viennese models. This early antiquarian furniture often lacked harmonious proportions, due mainly to advances in machine production during the 1840s, when aesthetics were subordinated to technical ingenuity with the result that different styles were frequently mixed together. A characteristic example is a north German easy chair (1880) made in the style of the neo-Renaissance. The turned and shaped front legs are at variance with the straight square back legs, as are the carved fluting and volutes on the armrests and the overall upholstery, while the high back and legs lack any uniformity of proportion or style. The situation is somewhat different with case furniture: after c. 1850 genuine efforts were made to reproduce original period pieces. The Great Exhibition of 1851 in London firmly established historic

styles in the mainstream of furniture design, and leading furniture factories began to produce high-quality individual pieces by returning to traditional craftsmanship. Sculptural furniture was the result, with oak dining-room sideboards in the so-called 'Old German' style very much to the fore. Regional variations were no longer to be expected, although local specialities of manufacture existed. Cupboards up to three metres high consisted of a lower stage enclosed by doors and a set-back upper section leaving a shelf in the middle. Columns and mouldings gave this furniture an architectural character, although every surface was ostentatiously decorated, sometimes combined with sculptural carving in the form of putti and caryatids.

5. AFTER 1895. A reaction to historicism was *Jugendstil*, which had various ideological origins and several centres. The nucleus of the German *Jugendstil* was the Vereinigte Werkstätten für Kunst und Handwerk set up in Munich in 1898 with the idea of returning to high-quality craftsmanship. In contrast to the movement in England, its adherents, among them Bernhard Pankok and Richard Riemerschmid, aimed to work not against, but in cooperation with industry and machines. The Munich workshop produced both luxury furniture and routine cabinetwork. Many of Pankok's designs are sculptural in character and combine a variety of materials. His sideboards are close to traditional types with relief carving in which animals combine with naturalistic plants or abstract organic forms. Both he and Franz von Stuck produced expensive luxury

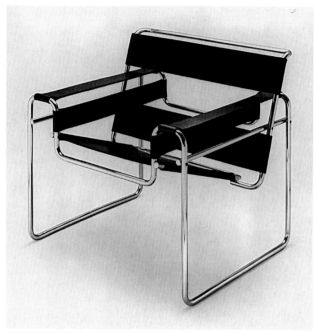

51. 'Wassily' chair by Marcel Breuer, nickel-plated tubular steel, h. 680 mm, 1925 (Munich, Neue Sammlung, Staatliches Museum für Angewandte Kunst)

furniture; von Stuck would typically work in costly materials, for instance embellishing a chair with mother-of-pearl marquetry. Riemerschmid, on the other hand, turned to folk art for his inspiration: his furniture is neat, practical, functional and well suited for mass production (e.g. walnut chair, 1899; London, V&A). Another centre of *Jugendstil* was Darmstadt, where in 1899, Ernest Ludwig, Grand Duke of Hesse, brought in a number of artists and intellectuals to promote and supply the domestic market. An artists' colony was set up in the Mathildenhöhe with the accent on sophisticated living (*see* §V, 5 and fig. 41 above). A white bench designed by Peter Behrens was typical; furniture harked back to the Biedermeier, but the backs show the typically taut, dynamic line of *Jugendstil*. A similar reflection of the two styles is revealed in a sofa (1902; Langen, Jagdschloss Wolfsgarten) by Josef Maria Olbrich, who came to Darmstadt from Vienna. The Belgian architect Henry Van de Velde similarly pointed the way for the German *Jugendstil*. His relatively simple furniture expresses flowing, sinuous plant contours without loss of clarity: this is particularly evident in a large semicircular writing-desk (1897–8; Nuremberg, Ger. Nmus.), in which each movement is answered by a counter movement in the lines. After 1900 the curved line of his furniture was replaced by cubic forms.

Furniture-making became wedded to Functionalism. Such maxims as the right use of materials and respect for technology led to the establishment of the Deutsche Werkstätten für Handwerkskunst in HELLERAU in 1907 and to the BAUHAUS in 1919. The most important personalities at the Bauhaus were Walter Gropius, Marcel Breuer and Ludwig Mies van der Rohe—all leading figures in the development of German furniture after World War

I. The main idea at the Bauhaus was to establish the pre-eminence of high-quality utility furniture from the point of view of both craftsmanship and artistic integrity. A fundamental tenet was that affordable functional furniture should be available to a broad section of the population through mass production. This was the philosophy behind the 'Wassily' chair (1925; see fig. 51) and the 'Barcelona' chair (1926)—two tubular steel chairs with leather upholstery designed by Breuer and Mies van der Rohe respectively. The far-reaching influence on furniture production that the Bauhaus had exercised by 1933, when it was dissolved, has not been realized in furniture production in Germany since World War II.

BIBLIOGRAPHY

F. Hellwag: *Die Geschichte des deutschen Tischlerhandwerks* (Berlin, 1924)
H. Kreisel and G. Himmelheber: *Die Kunst des deutschen Möbels*, 3 vols (Munich, 1968–83)
G. Himmelheber: *Biedermeiermöbel* (Munich, 1974)
M. Bauer, P. Märker and A. Ohm: *Europäische Möbel von der Gotik bis zum Jugendstil*, Frankfurt am Main, Mus. Ksthandwk cat. (Frankfurt am Main, 1976)
E. Redlefsen: *Möbel in Schleswig-Holstein*, Flensburg, Städt. Mus. cat. (Flensburg, 1976, 2/1983)
L. Dewiel: *Möbel-Stilkunde* (Munich, 1980)
A. Feulner: *Kunstgeschichte des Möbels* (Berlin, 1980)
F. Graetz-Windisch: *Möbel Europas*, 2 vols (Munich, 1982)
H.-P. Trenschel: *Meisterwerke fränkischer Möbelkunst: Carl Maximillian Mattern* (Würzburg, 1982)
G. Haase: *Dresdner Möbel des 18. Jahrhunderts* (Dresden, 1983)
S. Mertens: *Barockmöbel aus Württemberg und Hohenlohe, 1700–1750* (Ulm, 1983)
Ornament und Entwurf (exh. cat. by E.-M. Hanebutt-Benz, Frankfurt am Main, Mus. Ksthandwk, 1983)
H. Zinnkann: 'Mainzer Möbel der ersten Hälfte des 19. Jahrhunderts', *Schr. Hist. Mus. Frankfurt am Main*, xvii (1985)
D. Alfter: *Die Geschichte der Augsburger Kabinettschränke* (Augsburg, 1986)
T. Brachert: *Beiträge zur Konstruktion und Restaurierung alter Möbel* (Munich, 1986)
J. Bahns: *Zwischen Biedermeier und Jugendstil* (Munich, 1987)
H. Zinnkann: *Meisterstücke Mainzer Möbel des 18. Jahrhunderts* (exh. cat., Frankfurt am Main, Mus. Ksthandwk, 1988)
Kunst des Biedermeiers, 1815–1835 (exh. cat. by G. Himmelheber, Munich, Bayer. Nmus., 1988)
S. Sangl: *Das Bamberger Hofschreiner Handwerk im 18. Jahrhundert* (Munich, 1990)
H. Ottomeyer: *Zopf- und Biedermeiermöbel*, Munich, Stadtmus. cat. (Munich, 1991)

HEIDRUN ZINNKANN

VII. Ceramics.

1. Stoneware. 2. Earthenware. 3. Porcelain.

1. STONEWARE. German stoneware probably evolved *c.* 1450 in the Rhineland from an earlier fabric (so-called 'early stoneware'), although it is possible that it also emerged in several other places where suitable clays were available and where the kilns had been improved to provide the higher temperatures required to make stoneware. The centres of stoneware production in Germany from the early 16th century—apart from a few smaller pottery towns—were in the Rhineland, the main centres being Cologne-Frechen and Siegburg, in a region south of Aachen with the main centres at Raeren (now in Belgium), Creussen in Franconia, and Waldenburg, Freiberg and Altenburg in Saxony and Muskau and Bunzlau in Silesia. Apart from the production of simple, utilitarian tableware, the highly artistic stoneware made in these centres was used for display, especially in the princely courts. It was a precious as well as useful commodity for trade, being

exported to England, Hungary and Scandinavia, for example.

Closely connected with the development of stoneware is salt glazing, which, possibly developed by the late 15th century in Raeren, was used in most centres of stoneware production to provide a glossy coating. Applied reliefs were used as decoration, starting with small masks, flowers and images of the Virgin after patterns on coins, marzipan models and bracteates. In the 16th and 17th centuries, especially in the centres in the Rhineland, very elaborate and carefully executed relief ornaments determined the appearance of stoneware. They were applied to the vessel sides as imprints from hollow moulds. The designs of most of these figural depictions with religious or profane, mythological or allegorical subjects, as well as heraldic depictions, were probably based on handbills, such as those by Sebald Beham, or on ornamental engravings by Heinrich Aldegrever. Whether the potters translated these patterns into the necessary format and then carved the original moulds themselves cannot be proven in every case; moulds were often exchanged between workshops or even between centres of production. Apart from the applied decorations, *Kerbschnitt* (carved geometric patterns), stamped and scratched designs were also used, sometimes in conjunction with and sometimes as a substitute for the applied mouldings. From the early 18th century in the Westerwald, *Redtechnik* (scratched decoration) and *Knibistechnik* came to the fore. In the latter, imprints from a small, sharp-edged wooden stamp were linked together in waves or ribbons. Painting with cobalt-blue was employed from the end of the 16th century; this became characteristic of some centres, such as Raeren and especially in the Westerwald (e.g. Grenzhausen and Höhr) and its affiliated centres. From the end of the 17th century a manganese glaze was used in addition to the blue for decoration.

The development of Rhenish stoneware began in Cologne in the early 16th century, after an initial development in Siegburg (*see* COLOGNE, §III, 3(ii)). In Cologne the potters first took the artistic lead with areas covered in vines and with applied images. The image of a face below a rim of a usually pear-shaped bottle, the so-called *Bartmannskrug*, became a special characteristic of Cologne stoneware, which is distinguished by a brown slip (see fig. 52). Stoneware production died out in Cologne after the mid-16th century, when, as a result of antagonism, the potters left the city, mainly for Frechen, where production continued. SIEGBURG then became the leading producer in the Rhineland, although some of its primary impulses were taken over from Cologne. Because of the fine, light-fired Siegburg clay the impressed relief decoration was especially remarkable (e.g. *Schnelle*, 1573; Düsseldorf, Hetjens-Mus.). Special forms were the *Trichterbecher* (baluster-shaped beaker with funnel mouth) and, above all, the *Tüllenkannen* (large-spouted pitcher). In Siegburg fine stoneware was produced by only a few families, especially the KNÜTGEN, Vlach, Symons and Oiman.

While the artistic energies at Siegburg began to flag in the early 17th century, very high-quality stoneware, often with large-format vessels, usually jugs and pitchers with applied decoration and a brown slip, developed in the region around Raeren. The renown of Raeren stoneware

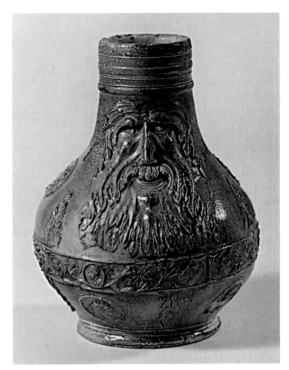

52. Stoneware *Bartmannskrüg*, h. 210 mm, made in Cologne, mid-16th century (Düsseldorf, Hetjens-Museum)

was founded primarily on the work of a few artists. Most came from the Mennicken family, of whom JAN EMENS MENNICKEN was especially outstanding. From *c.* 1590 Raeren and Siegburg potters moved to the Westerwald, and those who remained in Raeren worked wholly in the style used in the Westerwald. There, after this influx, pottery enjoyed an artistic flowering, so that the Westerwald was the main centre of Rhenish stoneware production until the 18th century. The Raeren and Siegburg influences were soon adapted to the characteristic grey ceramic produced by de-oxidizing firing. About the mid-17th century the Westerwald potters produced a form of their own by developing the Raeren jug; the decoration on the spherical or, most often, ovoid body was treated zonally (e.g. jug with pewter lid, third quarter of the 17th century; London, Wallace), and the typical tankard was also developed. From the end of the 17th century and into the 18th, the so-called 'Anna Regina' and 'Georgus Rex' pitchers formed a special group; they were produced for the English market, with the monograms AR and GR. Through potters moving elsewhere, stoneware production of the Westerwald was disseminated to other regions of Germany, above all to the Rhineland around Bonn, Hesse and Bavaria and to Alsace.

During the 17th century stoneware production in CREUSSEN, which seemed to appear quite suddenly *c.* 1600, had an independent position. Very early on its characteristic forms were developed, especially the beehive-shaped jug. Using a dark-brown salt glaze or black-manganese dioxide slip, the large-format applied images are mainly cycles of Apostles and planets, as well as hunting scenes.

From the second third of the 17th century the use of enamelling increased as a result of connections with the glass decorators of Bohemia and the Fichtelgebirge, who were very well known for their enamelled glass. Busts of electors were added as a new form of decoration. It is possible that production in Creussen may have been only in the hands of the Vest family.

From the mid-16th century to the early 17th, Waldenburg was the leading centre of stoneware production in Saxony. Using a brown slip similar to that used in Cologne, Waldenburg stoneware is distinguished by such independent vessel forms as small casks or tankards of an elongated ovoid shape. Waldenburg was superseded as the pottery centre in Saxony by Altenburg, where grey stoneware, produced by firing in a reduction kiln, was produced until the 18th century. Saxon stoneware is frequently mounted with pewter, not only on the foot and rim, but also around the neck of the vessel.

In Silesia, Muskau was an important centre; at the time of its flowering in the 17th and 18th centuries, stoneware was produced both with a brown slip or with a plain grey body. After the mid-17th century it is possible to confuse this type of stoneware with that of the Westerwald, although in Muskau such original elements as twisted swellings and angels' heads were used. The stoneware from Bunzlau, another Silesian pottery centre, is really a hard-fired earthenware with glaze-like slip, which was used as early as the beginning of the 16th century. Melon jugs were an especially characteristic form in the 17th and 18th centuries. From the mid-18th century the typical Bunzlau stoneware with white-grey applied images on a shiny ground was produced.

Competition for stoneware slowly grew during the 17th century in the form of faience and was further intensified after 1710 with the manufacture of hard-paste porcelain at Meissen. From this time, stoneware for display was limited to use in middle-class households. Output was now concentrated on the production of drinking and preserving vessels, while in the 19th century the emphasis switched increasingly to building materials and sanitary and industrial wares. In the 19th-century period of revivals, old forms were reproduced in many places (especially the Westerwald), or new vessels were designed in the Renaissance style. As a reaction against this, *Jugendstil* artists tried to reinvigorate production with contemporary artistic designs based in the craft tradition (e.g. Peter Behrens in Darmstadt and Richard Riemerschmid, who designed for the Reinhold Merkelbach Co., Grenzhausen).

BIBLIOGRAPHY

O. von Falke: *Das rheinische Steinzeug*, 2 vols (Berlin, 1908/*R* 1978)

K. Koetschau: *Rheinisches Steinzeug des 15. bis 18. Jahrhunderts* (Munich, 1924)

B. Lipperheide: *Das rheinische Steinzeug und die Graphik der Renaissance* (Berlin, 1961)

G. Reineking von Bock: *Steinzeug*, Cologne, Kstgewmus. cat. (Cologne, 1971, rev. 3/1986)

J. Horschik: *Steinzeug, 15. bis 19. Jahrhundert: Von Bürgel bis Muskau* (Dresden, 1978)

E. Klinge: *Deutsches Steinzeug der Renaissance- und Barockzeit* (Düsseldorf, 1979)

ANGELIKA STEINMETZ

2. EARTHENWARE.

(i) Before 1800. (ii) 1800 and after.

(i) Before 1800. The first important earthenwares produced in Germany are those generally grouped under the generic title of 'Hafner' wares. These initially started out as insulating bowl-tiles for stoves and were made by stove-makers. The tiles were often covered in a green lead glaze, for the dual purpose of further insulation and decoration. During the 15th century the tiles were decorated with moulded or modelled reliefs, which often took the form of figures in recessed niches. About 1500, polychrome glazes were introduced. The Leupold family in Nuremburg were particularly well known for their black-glazed stove tiles with oil gilding. Paul Preuning (*fl* 1540–50) and Kunz Preuning from Nuremburg made quite fine polychrome jugs decorated with horizontal bands of biblical and allegorical scenes in relief. Useful wares based on the stove tile began to emerge particularly in the 17th century.

The first tin-glazed earthenwares made in Germany were, as in the rest of Europe, inspired by Italian maiolica. Initially it was produced only in small workshops in CREUSSEN, such as those of Lorenz Speckner and Leonhard Schmidt (*d* 1665), who made drug-jars, and workshops in Hamburg (e.g. blue-and-white jug, 1643; London, V&A). Gradually there was a shift towards more widespread production throughout Germany, not least by the potters who had left the Netherlands due to religious persecutions. In 1661 the Dutch immigrants Daniel Behagel (1625–98) and Jacobus von der Walle (*d* before 1693) established the first German faience factory in Hanau (*see* HANAU FAIENCE FACTORY). The designs on the wares are clearly influenced by the blue-and-white wares made in such Dutch towns as Delft, where European and East Asian motifs were combined. Other factories that were soon established included those in Frankfurt am Main (1666), Berlin (1678) and Kassel (1680). Until the mid-18th century this number grew to include, among the most important: ANSBACH (est. *c.* 1708–10), Nuremberg (est. 1712; *see* NUREMBERG, §III, 3), Bayreuth (est. 1719; *see* BAYREUTH, §2), Brunswick (est. 1719), Durlach (est. 1722), Hannover (est. 1732), Oettingen-Schrattenhofen (est. 1735), Fulda (est. 1741; *see* FULDA, §3), Künersberg (est. 1745), Höchst (est. 1746; *see* HÖCHST CERAMIC FACTORY), Göggingen (est. 1748), Crailsheim (est. 1749), Schrezheim (est. 1752), Schwerin (est. 1753) and Ludwigsburg (est. 1758). After the mid-18th century only a few workshops, including those in Magdeburg (est. 1756), Kelsterbach (est. 1758), Proskau (est. 1763) and Mosbach (est. 1770), were established due to the increased competition from porcelain. The establishment of the workshops was in part due to the local ruling aristocracy's initiative and the prestige of owning a faience factory, even though considerable financial contributions and subsidies often had to be paid.

The German faience industry reached its apogee during the 18th century, particularly while porcelain remained for many a prohibitively expensive luxury. Items included jardinières, *cachepots*, candelabra, mirror frames, clockcases, wig-stands and writing implements. Among the most ubiquitous items produced were cylindrical, pear-shaped or narrow-necked jugs and tankards fitted with pewter lids (e.g. *Walzenkrug*, *c.* 1750; Munich, Bayer. Nmus.; see fig. 53). Tablewares included such items as tureens and bowls in the shape of vegetables or animals and birds (e.g. tureen in the shape of a turkey, made at Höchst, 1748–53; Frankfurt am Main, Mus. Ksthandwk)

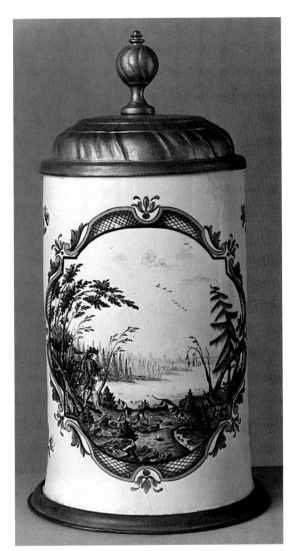

53. Faience *Walzenkrug* painted with enamels, h. 180 mm, made in Künersberg, *c.* 1750 (Munich, Bayerisches Nationalmuseum)

and compote and butter dishes in the shape of fruit. Figures were also made at various factories including Fulda and Höchst. At Schrezheim an astonishing Rococo altar (*in situ*) originally comprising figures, putti, vases and candlesticks (many of which are now lost) was made in 1773–4 by the sculptor Johann Martinus Mutschele for the chapel of St Anthony.

The most popular forms of decoration, executed in polychrome enamels, were coats of arms, landscapes, figures, animals and birds and flowers. Such factories as Crailsheim, Oettingen-Schrattenhofen, Göggingen and Schrezheim are notable for their high-temperature colours, which were used in preference to enamelling. Many factories had particularly characteristic forms of decoration: at the factories in Kellinghusen (from 1763) bold, Baroque flowers were typical; wares from Hanau are often painted with a style of decoration known as *Vögelesdekor*, where a pattern of tiny flowers and dots is interspersed

with fantastic and exotic birds; at factories in Bayreuth, Fulda, Höchst and Ansbach the decoration known as *indianische Blumen*, made popular at Meissen, was employed. At Bayreuth red earthenware tea- and coffee-services covered in dark or pale brown glazes were decorated with gold and silver chinoiseries, inspired by early Meissen stonewares by Johann Friedrich Böttger. Other forms of decoration used in a variety of factories included landscapes or coats of arms enclosed in *Laub- und Bandelwerk* cartouches (e.g. Bayreuth blue-and-white plate, *c.* 1734; Hamburg, Mus. Kst & Gew.), flowers (e.g. *deutsche Blumen*) and birds.

BIBLIOGRAPHY

O. Riesbieter: *Die deutschen Fayencen* (Leipzig, 1921)
G. E. Pazaurek: *Deutsche Fayence- und Porzellan- Hausmaler* (Leipzig, 1925/R Stuttgart, 1971)
K. Hüseler: *Deutsche Fayencen* (Stuttgart, 1956–8)
A. Klein: *Deutsche Fayencen im Hetjens-Museum* (Düsseldorf, 1962)
W. Schwarze: *Alte deutsche Fayence-Krüge* (Wuppertal, 1980)

WALTER SPIEGL

(ii) 1800 and after. During the 19th century earthenware was increasingly superseded for simple utility use by cheap, industrial stoneware and porcelain, which could be mass-produced. Earthenware only continued to be produced in lightly industrialized, rural areas and small towns, where it continued to be made in the traditional manner. The production of tin-glazed earthenware remained in the hands of potters in small workshops. In some regions, despite the further eclipse of earthenware utility goods, there were some developments in the production of decorative ceramics. Such ceramics continued to be made, especially in tourist centres, into the late 20th century.

In north Germany traditional, folk-style faience was produced in some factories in Kellinghusen until 1860. The plates and ornamental vessels decorated with loosely painted flowers in vivid colours were first marketed in small towns and then in rural areas. In Marburg, after 1800, the application of freely formed figurative or geometric decoration became a new way to embellish wares. The production of straight, cylindrical forms shows the influence of contemporary Biedermeier taste (e.g. coffee-pot from Tarburg, 1828; Hamburg, Mus. Kst & Gew.). This earthenware with overlaid decoration, which was also produced in North Hessen as far as Thuringia, and in Alsace, was sold outside the region.

In Silesia the town of Bunzlau was known primarily for vessels that were decorated with blue and brown dots forming the so-called 'peacock's-eye pattern' (e.g. coffee-pot from Bunzlau, *c.* 1900; Berlin, Mus. Dt. Vlksknd.); until the end of the 19th century this type of ware was produced in large quantities. As earthenware has the least utilitarian qualities of any of the ceramic bodies, it was not highly prized in the period of historical revivals, when mass production in factories was most important. Tin-glazed earthenware, faience and majolica, however, did enjoy new popularity as designs in the Renaissance, Baroque and Islamic styles became popular (e.g. 'Holstenschale' by Robert Bichweiler, 1882; Hamburg, Mus. Kst & Gew.).

In the first decades of the 20th century table centre-pieces, stove tiles, building ceramics and sculpture were

made mainly in faience. The Majolikamanufaktur in Karlsruhe (est. 1899) was the leading faience factory, in which almost all the leading artist–potters of the period worked at some time. Only with the revived interest in folklore studies during the second half of the 19th century did simple, glazed earthenware regain esteem as a ceramic material. The source of inspiration for *Jugendstil* ceramics was Japanese and Islamic art, which in turn inspired ceramics designers to reconsider popular indigenous earthenwares, which were admired for their sureness of style and high-quality craftsmanship. One of the first of these designers was Max Laeuger (1864–1952), who, inspired by the rural pottery made in the Black Forest, applied engobe (slip) with a painting horn to vases and ornamental plates from 1893. In 1895 he established the art pottery Tonwerke Kandern at Kandern. There, as at such other workshops as the Schmidt-Pecht workshop (1906–17) in Konstanz, the aim was to produce utility wares for a wide market in the *Jugendstil*. Continuing this idea, after 1907 the DEUTSCHER WERKBUND in Munich strove to influence taste, through its reformist social ideas, by addressing both manufacturers and buyers. To this end earthenware designs for mass production were developed.

After World War I the ceramics workshop of the Bauhaus (est. 1919) in Dornburg, near Weimar, sought to perfect this approach. In particular, Otto Lindig (1895–1966), artistic director from 1922, based his ideas closely on the craft traditions of Thuringian pottery, producing extremely simple vessels in which decoration was omitted to heighten the effect of form (see fig. 54). In translating the Bauhaus's demand for good form into a mass-produced article, Theodor Bogler (1897–1968; in Dornburg from 1920; commercial director from 1924) and Gerhard Marcks, the founder of the Bauhaus ceramics workshop in Dornburg and chief designer there until 1924,

achieved entirely new results. By articulating and accentuating different parts of the vessels (e.g. handles, spouts, necks and lids) in clear stereometric shapes, they took functionalism to its logical conclusion. Although the aim to reach a wide market was not achieved in Dornburg, demand for appropriate designs for the material and an emphasis on form and monochrome glazes created the criteria by which ceramic vessels in all materials were to be judged in the 1930s and 1940s. Regarding earthenware, hand-crafted individual items were now at the forefront of ceramic art. These ideas were taken further after World War II, and commercial art colleges played an important part in spreading these ideas, for example through the teaching of Otto Lindig and his successor Jan Bontjes van Beek (1899–1969) at the Hochschule für Bildende Künste in Hamburg, and Hubert Griemert (1905–1969), first at the Werkkunstschule in Krefeld, then at the Staatliche Werkschule für Keramik in Höhr-Grenzhausen. The work of Richard Bampi (1896–1965), who was the first, *c.* 1950, to produce asymmetrical work and who experimented with viscous glazes and broken, irregular surface textures, was extremely influential. Once again East Asian, especially Japanese, ceramics were inspirational, above all for glazes, which were revered for their own worth.

In the 1950s designers reverted to painting ceramics, especially vases and bowls, using asymmetrical designs and calligraphic brush decoration. At the same time vessels were seen less as functional and more as decorative objects. In the 1960s asymmetry as a design principle was pushed into the background, replaced by vessels with a pronounced side for display or, as a new tendency, forms assembled from separate parts. As this happened the potter's wheel lost its importance as ceramicists moved towards free, abstract sculptural forms. Following tendencies in the fine arts, Cubist and, especially, realistic formal

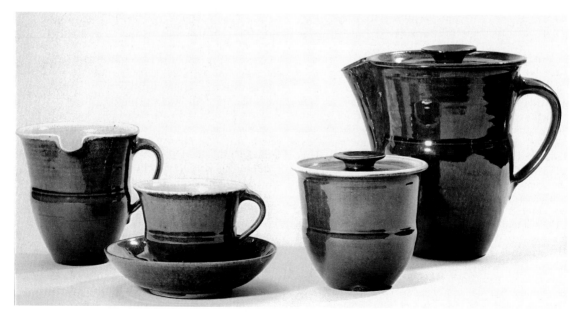

54. Earthenware coffee-service, designed by Otto Lindig, h. 170 mm, made in Dornburg for the Bauhaus, *c.* 1922–4 (Düsseldorf, Hetjens-Museum)

principles were adopted by ceramicists. Against the background of technical improvements in the workshops (more powerful kilns and the improved availability of ceramic materials), and connected with the ever-renewed studies of East Asian ceramics, high-fired ceramics were again highly regarded, so that ceramicists increasingly preferred stoneware and porcelain to earthenware. Since the 1970s, with the interest in the Japanese Raku technique, earthenware regained significance as many ceramicists discovered new expressive possibilities in the special aesthetic of this material.

BIBLIOGRAPHY
E. Meyer-Heisig: *Deutsche Bauerntöpferei: Geschichte und landschaftliche Gliederung* (Munich, 1955)
E. Klinge: *Deutsche Keramik des 20. Jahrhunderts*, Düsseldorf, Hetjens-Mus. cat., 2 vols (Düsseldorf, 1975)
H. Jedding: *Volkstümliche Keramik aus deutschsprachigen Ländern* (Hamburg, 1976)
R. Reineking von Bock: *Keramik des 20. Jahrhunderts in Deutschland* (Munich, 1979)
T. Préaud and S. Gauthier: *Die Kunst der Keramik im 20. Jahrhundert* (Fribourg and Würzburg, 1982)
P. Lane: *Studio Ceramics* (London, Glasgow and Sydney, 1983)
M. Brauneck: *Volkstümliche Hafnerkeramik im deutschsprachigen Raum* (Munich, 1984)

ANGELIKA STEINMETZ

3. PORCELAIN.

(i) Before 1880. (ii) 1880 and after.

(i) Before 1880. In the course of the second half of the 17th century porcelain, a rare and sought-after luxury article imported to Europe from China, became an expensive commodity, which gradually superseded silver in European princely courts. To pay for these imports enormous quantities of gold and silver had to be expended; to keep the money in Germany, the princes supported all attempts to re-invent porcelain in Europe, which JOHANN FRIEDRICH BÖTTGER finally succeeded in doing in Dresden in 1708. Two years later the first factory of genuine porcelain in Europe was founded in Meissen, large-scale production beginning in 1713 (*see* MEISSEN, §3).

The high value attached to porcelain led to the foundation of other factories at German princely courts. At Meissen, Christoph Conrad Hunger (*fl c.* 1717–48) had discovered the secret of the arcanum—the knowledge and techniques used in making porcelain—and sold it to Claudius Innocentius Du Paquier in Vienna in 1717. Joseph Jakob Ringler (1730–1804), the most successful and famous 'arcanist' of the time, came from Vienna. His work was closely bound up with the founding of the Höchst Ceramic Factory (1746), the NYMPHENBURG PORCELAIN FACTORY (1753) and factories in Strasbourg (1751) and Ludwigsburg (*see* LUDWIGSBURG, §2). Ringler was a friend of the arcanist Johann Kilian Benckgraff (1708–58), who in 1751 disclosed the arcanum to Wilhelm Caspar Wegely (1714–64), a Swiss manufacturer working in Berlin who was made director of the FÜRSTENBERG PORCELAIN FACTORY in 1753. From 1762 Benckgraff's pupil Adam Bergdoll (1720–97) was technical director at the FRANKENTHAL PORCELAIN FACTORY (est. 1755). Other porcelain factories were opened at ANSBACH (est. 1757), Kelsterbach (est. 1761), Fulda (est. 1764; *see* FULDA, §3), Kassel (est. 1766; *see* KASSEL, §2), Würzburg

(est. 1775) and in several towns in THURINGIA (est. 1757–90).

In the years following the German creation of porcelain, manufacturers largely based their designs on well-known East Asian vessels and figures and on south German and French silver forms. Painted Chinese and Japanese plant and flower decoration (bamboo, prunus branches, chrysanthemums, peonies and pomegranates etc) were copied, without knowledge of their symbolic meanings, and executed in flat, ornamental areas of glowing colour (e.g. tankard and cover, Meissen, *c.* 1730–35; Boston, MA, Mus. F.A.). About the mid-1730s a genuine European style in porcelain production emerged, after designers had learnt how to take advantage of all the formal possibilities that the malleability of the soft material allowed. The edges of vessels were fashioned and fluted, the bodies were articulated with bosses and recesses, and the surfaces, up to

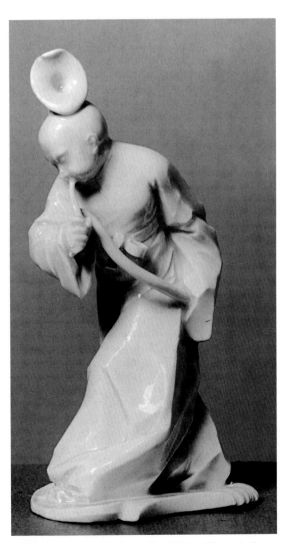

55. Hard-paste porcelain figure of a *Chinese Man with Serpent*, modelled by Franz Anton Bustelli, h. 140 mm, made at the Nymphenburg Porcelain Factory, *c.* 1765 (Frankfurt am Main, Museum für Kunsthandwerk)

then uniformly smooth, were embellished with moulded decoration. Freely modelled sculptural flowers and leaves were applied to the vessels and colourfully painted. In addition to functional handles, knops and spouts, figures in the round, plants and fruits or relief mascarons were also applied.

The sumptuous tableware ordered by the courts and members of the nobility was artistically formed and made to a unified plan as a 'service'. Utilitarian forms and small-scale sculptures were combined to form precious single pieces such as table centrepieces (e.g. *Temple of Love*, made at Meissen, *c.* 1750; Frankfurt am Main, Mus. Ksthandwk), candelabra, vases and clock-cases, snuff-boxes (e.g. of 1745–50; Boston, MA, Mus. F.A.), *nécessaires* and other fashionable items.

Genre scenes for decorating wares were derived from contemporary engravings, or such porcelain painters as Johann Gregorius Höroldt used their own designs. Höroldt's chinoiseries were Germanic in style, inspired by engravings by travellers in East Asia. Cartouches of gold filigree, foliage and scrollwork were used as framing devices for these; other new scenes included views of battles and camps, seascapes and harbour views, vignettes of ladies and cavaliers in the style of Watteau and Johann Esaias Nilson and events from life at the princely courts.

German porcelain factories are particularly notable for their outstanding range and quality of figure production. The most important 18th-century modellers included JOHANN JOACHIM KÄNDLER, who worked at Meissen, and FRANZ ANTON BUSTELLI, who worked at Nymphenburg. The range of porcelain figures was seemingly inexhaustible: court jesters, Chinese figures (e.g. *Chineseman* with Serpent, made at Nymphenburg, *c.* 1765; Frankfurt am Main, Mus. Ksthandwk; see fig. 55; *see also* CERAMICS, colour pl. I, fig. 2), madonnas and saints, allegorical and mythological figures based on Baroque garden sculptures, groups from the *commedia dell'arte* (e.g. *Pantaloon*, *c.* 1755–60; London, V&A), gentlemen and ladies engaged in court pastimes, idylls with shepherds and shepherdesses, street traders, artisans and peasants, children and putti, as well as gods and goddesses from Greek mythology. Biscuit porcelain was increasingly used for Neo-classical subjects, and the sculptor Johann Peter Melchior (1742–1825), who worked at Nymphenburg, Höchst and Frankenthal, was outstanding in this medium (e.g. *Apotheosis of the Electoral Pair*, 1792; Berlin, Schloss Charlottenburg).

The taste for Neo-classicism, however, limited the scope for free invention and favoured the cool, elegant lustre of the material and a painting technique that inclined towards delicacy. The forms of vessels were increasingly severe, while bead mouldings, palmettes and other Neo-classical ornamentation were used. Mythological gods and goddesses from Ovid's *Metamorphoses* were painted after works by Boucher (e.g. breakfast-service, made at Frankenthal, *c.* 1765–70; Frankfurt am Main, Mus. Ksthandwk; see fig. 56), and subjects were taken from contemporary literature (e.g. Goethe's *Werther* or Gessner's *Idylls*). Watteau's cavaliers and ladies gave way to rural and peasant scenes after paintings by David Teniers (ii). The flower remained the most important decorative motif in German porcelain painting; it had developed from the stylized East Asian flowers known as *indianische Blumen* (e.g. on a tankard made at Meissen, *c.* 1730–35; Boston, MA, Mus.

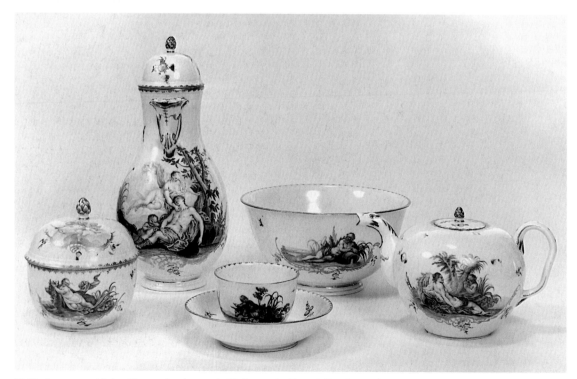

56. Hard-paste porcelain breakfast-service, decorated with figures after François Boucher, made at the Frankenthal Porcelain Factory, *c.* 1765–70 (Frankfurt am Main, Museum für Kunsthandwerk)

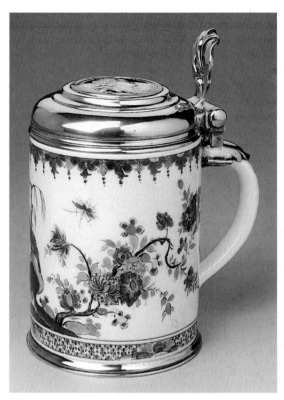

57. Hard-paste porcelain tankard with silver mounts, decorated with *indianische Blumen*, h. 147 mm, made at the Meissen Porcelain Factory, *c.* 1730–35 (Boston, MA, Museum of Fine Arts)

F.A.; see fig. 57) through the *Holzschnittblumen* (based on woodcuts) to the natural-looking *deutsche Blumen* painted in the form of rich bouquets. Towards the end of the 18th century floral wreaths were widely used, together with garlands, bows and ribbons, to frame medallions. In conjunction with flowers there were insects and butterflies and a range of indigenous and exotic birds.

At the beginning of the 19th century the Neo-classical style evolved into the Empire style under the influence of France. Many of the major German factories, however, neither had the resources for the technical innovations that had become necessary, nor were they capable of making the stylistic change on the artistic level. Such factories as Frankenthal (1799) and Ludwigsburg (1824) were closed, and others lapsed into insignificance. Even Meissen had to yield its previously unchallenged supremacy to the factories in Vienna, Sèvres and Berlin.

The new shapes of vessels were copied from French factories. Such models as the goblet-shaped 'Jasmine' cup were copied exactly or, like the egg-shaped 'Paestum' model, were remodelled and adapted. Clarity and simplicity characterize the shapes of vases and services made in the early 19th century. Two stylistic tendencies governed their design: the Greco-Roman and the Etruscan. Ancient amphora types and krater models after the famous 'Medici' Vase and coffee-services with smooth, vase-like forms or using the 'Etrurian' and 'Campanian' forms were produced. As decoration, large gilt areas with matt etched or

lustrous polished ornamentation were favoured, giving the porcelain vessels the appearance of goldsmiths' work (e.g. the 'Prussian' dinner-service, made at the Königliche Porzellan-Manufaktur, Berlin, 1817–19; London, Apsley House; see fig. 58). This quite intentional deviation from the original appearance of the material is seen also in colourfully painted surface decoration, which imitated jewellery, veined marble, wood grain, pietra dura, mosaic or East Asian lacquerwork. The relief ornamentation lacking in the modern vessel forms was simulated by sophisticated painted effects. The fantastic landscapes found on 18th-century porcelain gave way to topographically correct *vedute* after engravings, and silhouettes and antique-style expressive heads in grisaille were superseded by the lifelike portrait in colour, in the style of contemporary miniature painting.

In the 19th century porcelain design continued to detach itself from the influence of the court. A changed economic situation and the start of the Industrial Revolution in Germany demanded considerable financial outlays for the new private firms, which were, from the outset, run on commercial principles, and necessitated the restructuring and modernization of tradition-bound factories. Technicians and chemists took charge, and it was from their achievements—rather than those of the artists—that the factory owners expected financial success. The range of products was geared to a new and much wider stratum of buyers. More and more middle-class households could afford decorative objects and tableware of porcelain, which displaced pewter and stoneware. In decoration an exclusively Romantic attitude was expressed, rejecting the élitist antique style. Among the most popular motifs in addition to flowers were views of landscapes, towns and buildings. On 'personal' cups intended as gifts were painted genre depictions from everyday life in the Biedermeier period (1815–48), portraits of women copied from almanac illustrations, Christian and historical motifs and emblems of happiness, health, friendship and love, with mottoes, dedications and miniature copies of famous paintings. The copies of paintings on porcelain dishes, in widespread use from the mid-19th century, were both artistically and technically proficient. Lithophanes made of thin, unglazed porcelain were introduced; their impressed decoration appeared against the light as a picture composed of light and shade. They were hung in windows or placed in stands, where they were used as screens.

In the 1830s, emanating from Meissen, a hybrid style typical of the whole epoch emerged, combining moulded decoration of naturalistic foliage, Gothic-style tracery and 17th-century Auricular style Baroque ornament, with colourful painted flowers and luxuriant, lustrous gilding. Flowers in combination with gold rocaille became the preferred decoration for tableware and remained fashionable throughout the 19th century. The Neo-classical shapes of vessels made in the first decade of the 19th century were discarded in favour of the rich forms of the Biedermeier style. The predilection for embossed, curved, bell-shaped and large-bellied models gave rise to the Rococo Revival style, based on the idiom of the 18th century; this was particularly noticeable in the field of porcelain figures. Casts were often taken from old models or reconstructed if the moulds no longer existed. They were painted in the

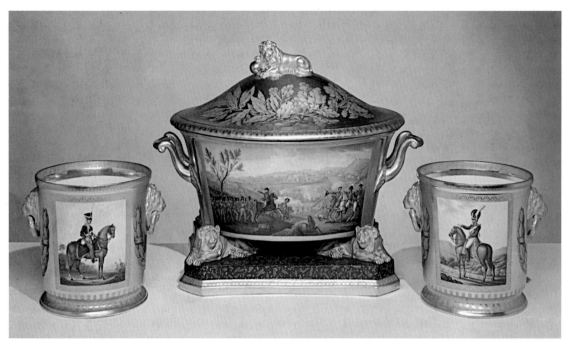

58. Hard-paste porcelain tureen and ice-buckets from the 'Prussian' dinner-service, made at the Königliche Porzellan-Manufaktur, Berlin, 1817–19 (London, Apsley House)

style of the originals but with modern enamel colours, the luminosity of which was a powerful contrast to the delicate charm of the originals.

BIBLIOGRAPHY
F. H. Hoffman: *Das Porzellan der europäischen Manufakturen* (Berlin, 1932, rev. 1980)
S. Ducret: *Deutsches Porzellan* (Fribourg and Herrshing, 1962, rev. 1974)
G. Weiss: *Ullstein Porzellanbuch* (Berlin, Frankfurt and Vienna, 1964, rev. 1973)
L. Schnorr von Carolsfeld and E. Köllmann: *Porzellan der europäischen Fabriken* (Brunswick, 1974)
M. Newman: *Die deutschen Porzellan-Manufakturen im 18. Jahrhundert* (Brunswick, 1977)
WALTER SPIEGL

(ii) 1880 and after. After the stylistic revivals during the 19th century, German ceramic artists, as elsewhere, looked for new forms. They drew their artistic inspiration primarily from a deeper knowledge of East Asian, especially Japanese, ceramics. This formal stimulus was combined with more clearly articulated demands for the upgrading of the arts and crafts into a fully fledged artistic genre. Artists also wanted to reconsider the environment they inhabited, a desire first represented in Germany by the Vereinigte Werkstätte für Kunst im Handwerk in Munich (est. 1897). These endeavours were made possible partly by technological and scientific progress, carried forward in the wake of the industrialization of Europe.

In ceramics this tendency had been fostered by the interest during the historicist period in the revival of ancient techniques. During the 1870s and 1880s at the Königliche Porzellan-Manufaktur in Berlin, in competition with the French factory of Sèvres, experiments were made to widen the palette of underglaze colours and to discover a porcelain that could be fired at low temperatures. In 1881 Hermann Seger (1839–93) in Berlin developed the

ox-blood red glaze, which had been used in China during the Qing period (1644–1911). The transition to the *Jugendstil* was made on these foundations in Germany in the 1890s. The expensive material of porcelain seemed ideally suited to the style's initial luxury-orientated tendency.

At this time the study of the relationship of technology and art gave rise to attempts to design for industrial mass production. In this respect ceramics factories, rather than independent artists, paved the way for the new style. In Germany the newer factories found this easier than the more established ones, the customers of which still expected traditional services and sculptures in the style of the 18th century and the early 19th. Only when the older generation of modellers and painters was superseded was it possible to develop contemporary forms and decoration, first of all at Meissen with the 'Krokus' service and the 'wing-pattern' decoration (1896; e.g. plate, Düsseldorf, Hetjens-Mus.) by Konrad Hentschel (1872–1907) and Rudolf Hentschel (1869–1951). Henry Van de Velde, who designed the 'Whiplash' decoration (1903–4), and Richard Riemerschmid, who designed the 'fishscale' pattern (1904–5), were freelance artists who supplied designs to Meissen, although at the time these were unsuccessful.

By contrast the Königliche Porzellan-Manufaktur in Berlin, under the artistic direction of Theodor Schmuz-Baudiss (1859–1942) from 1908, largely followed the stylistic criteria of the *Jugendstil*. New, more streamlined forms were introduced, which were highly suitable for underglaze decoration. The *Wedding Procession* was designed by the silversmith and sculptor ADOLF AMBERG as a table centrepiece for the wedding of William (1882–1951), Crown Prince of Germany and Prussia, and Herzogin Cecilie von Mecklenburg-Schwerin (1886–1954) in

1905; it was, however, not accepted by the royal household, and instead the design was sold to the Berlin factory and was made into porcelain sculptures between 1908 and 1910 (e.g. *Rider*, 1908; Düsseldorf, Hetjens-Mus.). Everywhere in Germany the underglaze, with muted greys and blues so popular at the Scandinavian factories, especially the Kongelige Porcelaensfabrik and the firm of Bing & Grøndahl in Copenhagen, was adopted. The Nymphenburg Porcelain Factory in Munich sought to produce services in this modern style as well as new versions of old models. Hermann Gradl's design for the 'Moderna' service (*c*. 1900) decorated with algae and fish motifs is an early example of the German *Jugendstil* in Munich. There too such porcelain sculptures as the crinoline figures by Joseph Wackerle (1880–1959) and stylized animal figures by Theodor Kärner (1885–1966) were particularly important. Some of the smaller firms, particularly Gebrüder Heubach in Lichte, specialized in animal sculptures.

About 1905 Philip Rosenthal (1855–1937), who had established the Rosenthal-Porzellan Manufaktur in Selb, Bavaria, in 1879, attempted to put 'Donatello' (1905–10), an undecorated service, on to the market for the first time. Apart from the *Jugendstil* designs, in the first decade of the 20th century aspects of the Biedermeier and Louis XV styles were also adopted. From 1913 Paul Scheurich (1886–1945) produced porcelain sculptures for Meissen in which the playful style of the Rococo was revived, although with heightened gestures and elegance. About 1910 Gerhard Marcks and ERNST BARLACH collaborated with the Schwarzburger Werkstätten in Schwarzburg, which produced, above all, porcelain sculptures influenced by Expressionism (see fig. 59). Between 1910 and 1920, the aesthetic and formal principles of the Deutscher Werkbund (est. Munich, 1907) and of early Expressionism became increasingly important. The Werkbund's demand for collaboration between industry and artists was taken further in the work of the Bauhaus in Weimar from 1919. The Bauhaus's ceramics workshop in nearby Dornburg, which existed until 1925, was first directed by Marcks and later by Otto Lindig (1895–1966). Only a small part of the Bauhaus's functionalist ideals were realized in porcelain, as the new value placed on traditional crafts led to a concentration on the production of earthenware and stoneware. In series-produced services of the 1920s, decoration derived from the angular idiom of Expressionism (e.g. Adelbert Niemeyer's (1867–1932) designs for Meissen) was predominant. Towards the end of the decade forms and decoration became calmer, function now becoming the main criterion as seen in the 'Halle' service (1927) by Marguerite Friedländer (1896–1983).

This calmer idiom was continued in the 1930s and 1940s in plain, timeless forms, especially in the designs of Trude Petri (1906–68) for the Staatliche Porzellanmanufaktur in Berlin (e.g. 'Urbino' service, 1930–31; 'Arkadia', 1938). At this time, as the design 'Arzberg 1382' (1930) by Hermann Gretsch (1895–1950) shows, formal tendencies, primarily a subordination of decoration to form, were clearly emerging, which were to dominate after World War II. Artistically significant porcelain sculpture was produced before World War II principally in the Meissen and Berlin factories.

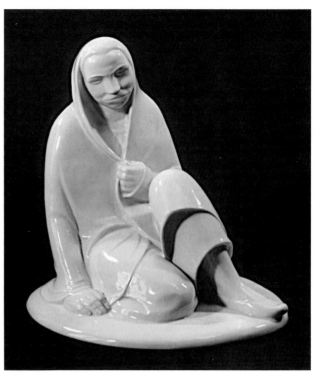

59. Porcelain figure of *Seated Girl*, designed by Ernst Barlach, h. 240 mm, made in the Schwarzburger Werkstätten, *c*. 1910 (Düsseldorf, Hetjens-Museum)

After World War II schools of applied arts became increasingly important as centres of training for designers. Under the pressure of ever-more quickly changing fashions and of increasing competition, from both home and abroad, porcelain firms were forced to become more and more innovative, making use of such specialist designers as Heinrich Löffelhardt, who worked for the firms Arzberg and Schönwald, Upper Palatinate, Bavaria, and the Finnish glass designer Tapio Wirkkala (1915–85), who worked for Rosenthal. To improve their image large porcelain firms produced limited editions of purely artistic items, sometimes in collaboration with artists whose first medium was not ceramics: for example Rosenthal used the designs of Henry Moore, Etienne Hajdu (*b* 1907), Lucio Fontana, Giò Pomodoro and Victor Vasarely. In addition to industrial production, porcelain was increasingly valued by independent ceramic artists as a material for art pottery—especially by Margarethe Schott (*b* 1911), Gotlind Weigel (*b* 1932), Karl Scheid (*b* 1929) and Ursula Scheid (*b* 1932) and Görge Hohlt (*b* 1930) and Albrecht Hohlt (*b* 1928). Some of these artists were commissioned by porcelain firms to produce designs for mass production.

BIBLIOGRAPHY

A. Leistikow-Duchardt: *Die Entwicklung eines neuen Stiles im Porzellan: Eine Betrachtung über die neuzeitliche Porzellankunst in Europa seit 1860* (Heidelberg, 1957)

T. Préaud and S. Gauthier: *Die Kunst der Keramik im 20. Jahrhundert* (Fribourg and Würzburg, 1982)

A. Fay-Hallé and B. Mundt: *La Porcelaine européenne au XIXe siècle* (Fribourg, 1983)

K. H. Bröhan, D. Högermann and R. Niggl: *Porzellan: Kunst und Design, 1889–1939: Vom Jugendstil zum Funktionalismus*, Bestandskatalog des Bröhan-Museums, iv (Berlin, 1993)

ANGELIKA STEINMETZ

VIII. Glass.

1. Before 1600. 2. 1600–1750. 3. After 1750.

1. BEFORE 1600. Early German glass manufacture was influenced by Roman glassmakers, and production was concentrated in the provinces along the Rhine. After the Romans departed in the 5th century AD, there was a notable decline in the use of such sophisticated techniques as enamelling and engraving. The glass produced was a soda-lime glass in various shades of green and yellow, a dull violet and different tones of blue. The shapes of the vessels were very simple; some wares were mould-blown in ribbed moulds, while others were decorated with fine threading or thick, trellis-like trailing. The application of *Nuppen*, or prunts (blobs of glass), anticipated the *Nuppenbecher* of the later medieval period. During the Franconian period, from the 5th century to the 8th, these simple techniques continued to be used, and the influence of Roman glass finally disappeared. Drinking horns and cone-beakers were very popular, and simple beakers without stems or with short, impractical stems were also produced. The most widely produced drinking glass at this time was the *Rüsselbecher* or 'claw-beaker'. Two rows of molten glass blobs were applied to the beaker, blown out into hollow probosces and then fused to the body with pincers. The 'claws' were then decorated with trailing of a contrasting colour (e.g. 5th century; Cologne, Röm.–Ger.-Mus.).

Very little glass from the 8th century to the 12th has survived. Glass fragments excavated from settlements and castles prove not only that there was local production but that the craftsmen were surprisingly skilful and made a variety of vessels during the early medieval period. The use of trailed and applied decoration prevailed, and the *Nuppenbecher* and the related *Krautstrunk* were the most popular forms. From *c*. 1400 glass production moved from the Rhineland to the wooded areas of Hesse, Württemberg, Bavaria, Thuringia, Saxony and Silesia. These areas remained the centres of German glass production for hundreds of years, although the positions of the glasshouses repeatedly changed when wood supplies were exhausted. *Waldglas*, for which the flux was potash, was the main product; it was sometimes colourless but more often green, brown, amber or blue. Wares included simple drinking glasses, small round panes for windows and beads for rosaries. The most mature artistic development of the *Nuppenbecher* was the roemer, which was introduced as a type of wine-glass in the mid-16th century and became widespread in different forms all over Europe. The decoration on such simple beakers as the *Berkemeyer* (a type of roemer), the *Krautstrunk* and the *Maigelein* (a ribbed, hemispherical mould-blown cup) and on such tall, cylindrical beakers as the *Passglas* (a banded, communal drinking glass) and the *Stangenglas* was mainly trailed or blobbed (e.g. early 16th century; London, BM; see fig. 60).

From the mid-16th century there is proof that enamel decoration in bright colours was used. This refined form

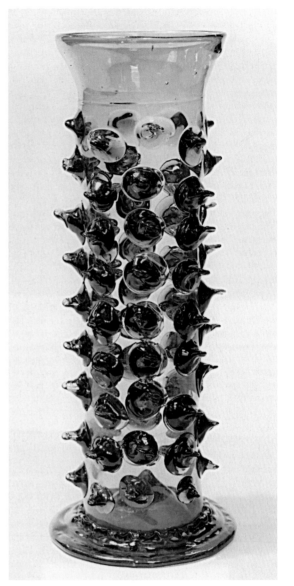

60. *Waldglas Stangenglas* with eight vertical rows of prunts, h. 260 mm, probably made in the Rhineland, early 16th century (London, British Museum)

of decoration was inspired by Venetian armorial wares and was to reach its apogee in Germany during the 17th century. Soda glass was the most commonly used material for enamelled wares; those forms best suited for enamel decoration were *Humpen* (tall, wide, cylindrical beakers for drinking beer or wine) and *Stangenglas*. Decoration included armorial devices, hunting and biblical scenes, the imperial double-headed eagle (*Reichsadlerhumpen*; *see* GLASS, colour pl. VI, fig. 1), which depicted the hierarchy of the Holy Roman Empire, and portraits of the Holy Roman Emperor with the seven Electors (*Kurfürstenhumpen*).

In addition to those glasshouses in the forests, others were established in princely residences and courts and

specialized in the production of luxury glass *à la façon de Venise*, decorated by diamond-point engraving. These glassworks, such as those at Landshut and Munich, were mostly founded and managed by Italian glassworkers. In 1583 William IV of Hesse established a glasshouse in Kassel, which was run by Italians and produced wares that were very similar to those made in Italy and the Netherlands. Although many of these glassworks existed for only a short time, they had a huge effect on the future artistic development of glass in Germany.

2. 1600–1750. During the 17th century there was a transition from the style of glass made *à la façon de Venise* to the style of the High Baroque; there were also technological breakthroughs, although based on proven Venetian methods, in refining processes. Painting with brightly coloured enamels gradually lost its dominant role and was to decline in the course of the 18th century to the level of folk art. Painting on glass with translucent black enamel (*schwarzlot*; see fig. 61), a technique that had spread from the Netherlands in the first half of the 17th century, was applied to glass vessels by such artists as Johann Schaper (1621–70), who worked in Nuremberg from *c.* 1655 to 1670 (*see* NUREMBERG, §III, 3). The predominantly ornamental decoration using foliage and interlacing motifs was dependent on early Viennese porcelain painting. The technique did not, however, attain the scale and importance of coloured enamel painting, and by the early 18th century it was used only by Ignaz Preissler (*see* PREISSLER (ii)) and a few, mostly anonymous painters from the Silesia–Bohemia region. Diamond-point engraving went entirely out of fashion.

All these decorative techniques were replaced by wheel-engraving. The tools needed for grinding and engraving were adopted from rock-crystal engraving, a technique that had spread from Milan to the courts of Munich, Prague and Dresden during the 16th century. The gem-cutter CASPAR LEHMANN, who came from Uelzen in north Germany, is credited with having introduced wheel-engraved glass at the court of Rudolf II in Prague at the beginning of the 17th century. Lehmann's pupil Georg Schwanhardt the elder (1601–67) is regarded as the initiator of wheel-engraving in Nuremberg, although the goldsmith Hans Wessler (*d* 1632), who engraved the plaque showing *Tomyris, Queen of the Messagetae, Cutting off the Head of Cyrus, King of Persia* (1610–20; Corning, NY, Mus. Glass), and others had practised the art there previously. Schwanhardt and his sons Heinrich Schwanhardt (*d* 1693) and Georg Schwanhardt the younger (*d* 1676) and their followers mainly used thin, light goblets *à la façon de Venise*, with slender, single-knopped, baluster stems (e.g. mounted goblet by Georg Schwanhardt the elder, *c.* 1630; Prague, Mus. Dec. A.). The family worked as HAUSMALER as there was no glass industry in Nuremberg; the source of the glass is unknown, although it may have been ordered from Venice or the Netherlands. In Frankfurt am Main a similar situation existed. Johannes Hess (?1590–1674) from the factory in Tambach (est. 1633) in Thuringia worked there; his descendants continued to work in Frankfurt until *c.* 1740.

The glass-engravers, especially those who had mastered the techniques of gem-cutting, required a different metal

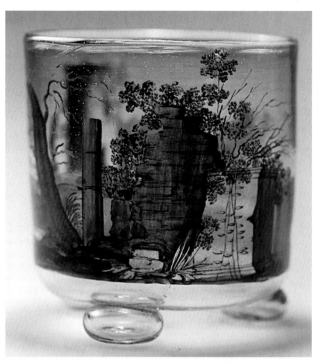

61. Glass beaker enamelled in black (*schwarzlot*), probably by Johann Schaper, h. 100 mm, Nuremberg, *c.* 1665 (Düsseldorf, Kunstmuseum im Ehrenhof)

in order to exploit the possibilities of their art. The thin-walled glass *à la façon de Venise* did not allow deep-relief engraving (*Hochschnitt*) and often could not withstand the pressure of the rotating copper wheel and the heat from the friction it produced. From the Tambach factory's archives it is known, for example, that in 1639 Hess received 27 thalers for six engraved bottles and four others that broke while being worked. While glass was still melted and processed *à la façon de Venise* in many factories, new metals were being experimented with in others. The aim was to discover a metal that could be formed into thick-walled vessels, had the purity and colour of rock crystal and could also be ground and engraved. The secret lay in replacing soda with potash (potassium carbonate) as the flux and adding chalk (carbonate of lime) to stabilize the glass; the glass developed by George Ravencroft in England in 1676 contained lead-oxide instead of chalk (lead glass). During the last quarter of the 17th century experiments carried out in various German and Bohemian factories led to almost simultaneous success; the outcome naturally depended on the experience and enterprise of glassmakers.

Previously it was only the glassmakers who decided the shapes and embellishments of the glasses during production. Glass-cutters were now brought into the creative process, particularly in the case of luxury glass. They gave the vessel its final look, basing their designs on contemporary silverware. The glass-engravers also worked with the aid of ornamental engraving patterns intended primarily for the embellishment of precious metals. The similarity between glass and metal engraving is in some cases so apparent that until recently the Nuremberg goldsmith

Johann Wilhelm Heel (1637–1709) was referred to as a glassmaker and engraver and even had 'Heel decoration', a particular type of decoration, ascribed to him. Held together by the framework of the Baroque style, individual forms evolved under the influence of regional peculiarities, the creativity of the artists and the aesthetic ideas and social pretensions of their aristocratic patrons. These forms gave the products of various factories and workshops their individual character. In addition, the peripatetic lifestyle of glassmakers and decorators ensured that production techniques, shapes and principles of decoration were used by recently established factories and workshops.

In the Electorate of Brandenburg, where three factories were in operation during the second half of the 17th century, the interest of Frederick William, Elector of Brandenburg, was concentrated on the factory in Potsdam, which was founded in 1674 (see BRANDENBURG GLASS-WORKS). There Johann Kunckel (1630–1703), lessee of the factory from 1679, produced the new crystal glass to the highest standards. In 1680 the glass-cutter and engraver Martin Winter (d 1702) from the Silesian region of the Giant Mountains entered the Elector's service. He brought his nephew, the highly talented engraver Gottfried Spiller (1663–1728), with him to Berlin. To facilitate the laborious and time-consuming work of grinding, and particularly of relief-cutting, a water-driven grinding mill was constructed in 1688. The outcome of the combined efforts of Winter and Spiller were masterpieces of the glassmaker's art, which set the standard for Potsdam glass; their influence continued even after the factory was moved to Zechlin in 1736.

Although no glasses can be attributed with any certainty to the court factory in Munich (1677–c. 1702), it is worth mentioning on account of the furnace-master Hans Christoph Fidler. His account books (1677–81) are a unique document, even though much of the glass terminology remains enigmatic. The mention, however, of crystal glass and coloured glasses, including opal, Porcelleinglas ('porcelain' or 'milk' glass) and red, green, blue and marbled glass, indicates that Fidler was an outstanding glass technician and must have previously worked in an important centre of glass production, probably in the Netherlands. Although his earlier and later whereabouts are unknown, he was several times summoned to Bohemia to organize glass production. It is thought that he brought with him the secret formula for ruby-red glass from Bohemia; he did not, however, produce it in Munich, although this is constantly asserted. Maximilian II Emanuel, Elector of Bavaria, took little interest in his court glass factory in Munich and left its administration to court officials. Intrigues, disfavour and envy made Fidler's task more difficult and finally forced him to resign. In Potsdam, however, Frederick William and his successor from 1688, Frederick III, regarded glass production as an economic factor in keeping with Jean-Baptiste Colbert's mercantilism, and saw in artistically decorated glassware a means of glorifying and propagating their prestigious rule. Production therefore comprised coloured-glass beads ('corals') to be used as a cheap exchange currency in the African colonies and splendidly cut, engraved and gilded goblets, which were held in high regard. Such works were not required, however, of Fidler; the Munich court was satisfied with his glass doll's-house tea-sets and other toys for the princes and princesses.

In Saxony the situation was similar to that in Berlin. In Dresden a sense of commerce and ostentation was allied to a taste for pleasure, which expressed itself in sumptuous feasts; the demand for glass was thus correspondingly high. Glass was needed in the form of elegant vessels from which to drink the health of important guests, for expensive hunting and shooting prizes, for personal and official gifts and for self-aggrandisement. The decoration executed by the Dresden glass-engravers was diverse. The blanks were supplied mainly by the glass factory in Dresden (est. 1700), which on the instigation of the natural scientist Ehrenfried Walter von Tschirnhaus (1651–1708) had a cutting-shop attached to it. In Thuringia sophisticated work was produced only in the residencies of the princes and dukes; the many other Thuringian factories produced almost only cheap, simple utilitarian goods, which competed in the export markets with similar Bohemian glass. The factory in Altmünden is another example of how the glass produced in a factory only emerges from anonymity if it is linked, at least temporarily, with the name of an important artist or inventive glassmaker. In this case it was the stepbrothers Johann Heinrich Gundelach and FRANZ GONDELACH; the latter worked for 40 years as an engraver for Charles, Landgrave of Hesse-Kassel, and from 1722 to 1726 as director of the Altmünden factory.

Luxury glass and simple utilitarian goods were produced by the factory in Lauenstein (est. 1701) in the principality of Calenberg. The shapes of the glass and the use of lead crystal for the more sophisticated varieties were reminiscent of English wares; this may be connected to the fact that when the factory was founded an English glassmaker from the Tisac family, who were originally from Lorraine, was employed there. A further peculiarity is the factory's mark: an engraved rampant lion, sometimes accompanied by a C (for Calenberg) on the ground-pontil mark.

3. AFTER 1750. During the second half of the 18th century interest in engraved glass clearly waned. Significant achievements then came almost entirely from the Silesian part of the Giant Mountains. This area had powerfully stimulated the development and spread of glass engraving in the decades before and after 1700 and had close ties to Bohemia until 1742. When Silesia was ceded to Prussia (1763) the established economic links were largely lost. Artistically these changes became apparent c. 1765. Many talented glass-engravers moved to Berlin or changed to engraving seal stones.

Changes were also apparent in taste and style: the Rococo called for differently shaped and ornamented glass. Colourfully painted Porcelleinglas—an economical substitute for expensive porcelain—was increasingly used and provided stiff competition for cut and engraved crystal glass. In place of the aristocratic patrons, the middle class became increasingly dominant; concepts of moderation and thrift now decided the appearance and decoration of glass. Later, under the impact of Neo-classicism, forms were greatly simplified, or some disappeared altogether. Severity and clarity of line restricted the scope for individuality and obliterated regional differences. Almost all the

court factories closed or changed their production to commercial goods.

After the Napoleonic Wars (1803–15) and the Congress of Vienna (1815), avant-garde ideas from English and Irish factories spread to the Continent, influencing the glass of the Biedermeier period. Cutting and faceting became the most elegant forms of embellishment, and their execution became the undisputed domain of the Bohemian glass industry, which maintained its supremacy by technical progress in the development of coloured glass. At first only the Zechlin factory produced glass of a similar quality. In the 1830s, however, a number of factories in the Bavarian Forest, in which Bohemian glassworkers and decorators were employed, also began to produce good-quality glass. The production of the Josephinenhütte (est. 1844) was completely influenced by Bohemian glass. This situation changed little throughout the 19th century. Only two firms gained importance in the production and sale of luxury glass: the glass refinery of Fritz Eckert in Petersdorf, Silesia, produced enamelled 17th- and 18th-century style glass and also *Jugendstil* glass; and the factory founded with Bohemian workers in 1865 in Cologne-Ehrenfeld mainly made high-quality imitations of medieval German and Venetian Renaissance glass.

At the end of the century the centre for high-quality glass gravitated to the Bavarian Forest factories, which until then had played a subordinate role. Based on the model of such Bohemian factories as Lötz Witwe in Klostermühle (*see* GLASS, colour pl. VI, fig. 3), which produced glass designed by Viennese *Jugendstil* artists, the Poschinger factory in Oberzwieselau, for example, had the forms and decoration of its glasses designed by well-known German *Jugendstil* artists. The painter and etcher Karl Köpping from Dresden designed *Jugendstil* glass in Berlin. He is particularly well known for his lamp-worked *Zierglas* (ornamental glass) pieces, which were intended to be used as liqueur glasses (see fig. 62). Engraving was revived in the early 20th century by such artists as Wilhelm von Eiff (1890–1943), who decorated such items as bowls, medals, plaques, beakers, flasks and goblets in bold, Modernist designs. In 1921 the Württembergische Metallwaren Fabrik at Geislingen began to produce art glass under the director Hugo Debach and later Karl Weidmann (*b* 1905). Two of their most successful designs are Ikora-Kristall, in which air bubbles or coloured stripes are captured, and Myra-Kristall, which is simple in form and has iridescent surfaces. The designer Wilhelm Wagenfeld was employed at the Württembergische Metallwaren Fabrik, where he applied the Bauhaus principles of design to the production of industrial glass. During the early 1930s he was employed at the Schott & Gen. Glassworks, where he designed a range of heat-resistant glasswares and, later, Functionalist, undecorated tablewares for mass production (*see* INDUSTRIAL DESIGN, fig. 7).

From the 1960s studio glass was produced by such exponents as Erwin Eisch (*b* 1927), who was inspired after meeting Harvey K. Littleton in the USA in 1957. He produced free- and mould-blown sculptural items that were decorated with gilding, etching and enamelling. Outstanding studio glassmakers working in the late 20th century included Franz Xaver Höller (*b* 1950), who produced geometric, sculptural forms using cold techniques,

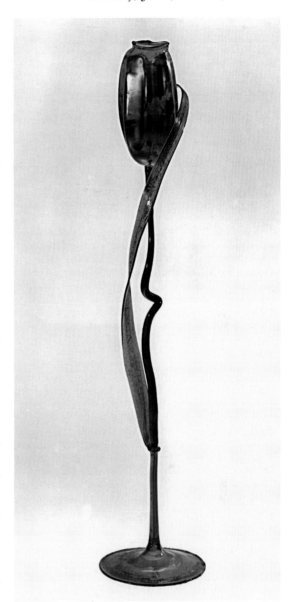

62. *Zierglas* in the form of a tulip, by Karl Köpping, h. 320 mm, Berlin, *c.* 1898 (Düsseldorf, Kunstmuseum im Ehrenhof)

Isgard Moje-Wohlgemuth (*b* 1941), who produced rounded, shell-like forms with luxurious, nacreous surfaces, and Jorg F. Zimmermann (*b* 1940), whose fragile, skeletal works combined wire netting and coloured inclusions.

BIBLIOGRAPHY
C. Friedrich: *Die altdeutschen Gläser* (Nuremberg, 1884)
G. E. Pazaurek: *Moderne Gläser* (Leipzig, 1901)
R. Schmidt: *Das Glas* (Berlin, 1912, rev. 1922)
——: *Brandenburgische Gläser* (Berlin, 1914)
G. E. Pazaurek: *Kunstgläser der Gegenwart* (Leipzig, 1925)
F. Rademacher: *Die deutschen Gläser des Mittelalters* (Berlin, 1933, rev. 1963)
W. B. Honey: *Glass* (London, 1946)
E. Meyer-Heisig: *Der Nürnberger Glasschnitt im 17. Jahrhundert* (Nuremberg, 1963)

A. von Saldern: *German Enameled Glass* (Corning, 1965)

F.-A. Dreier: *Glaskunst in Hessen-Kassel* (Kassel, 1969)

R. Charleston: *Masterpieces of Glass* (New York, 1980)

R. Rückert: *Die Glassammlung des Bayerischen Nationalmuseums*, ii (Munich, 1982)

E. Baumgartner and I. Krueger: *Phoenix aus Sand und Asche: Glas des Mittelalters* (Munich, 1988)

G. Haase: *Sächsisches Glas* (Leipzig and Munich, 1988)

R. von Strasser and W. Spiegl: *Dekoriertes Glas* (Munich, 1989)

WALTER SPIEGL

IX. Metalwork.

1. Gold and silver. 2. Base metals.

1. GOLD AND SILVER.

(i) Before 1520. (ii) 1520–*c*. 1700. (iii) *c*. 1700–1805. (iv) 1806–1914. (v) After 1914.

(i) Before 1520. In the 13th century the goldsmithing workshops of monasteries were dissolved, and the goldsmiths moved to the flourishing towns where there was an increasing demand for liturgical items richly decorated with such architectural motifs as pointed arches, pier buttresses and pinnacles, as well as finials and figures (*see* SHRINE, colour pl. IV, fig. 2). Cast silver decoration gradually displaced the repoussé copperwork and decorative gems still used on the Shrine of St Elizabeth (1236–49; Marburg, St Elizabeth). As with the monstrance, a new type of reliquary emerged (e.g. reliquary cross of St Trudpert, *c*. 1286; St Petersburg, Hermitage), often in the form of a Gothic pointed spire. Triple-aisled shrines, however, continued to be made, for example the Shrine of St Suitbert (*c*. 1300; Düsseldorf, St Suitbert), as well as reliquaries in the form of heads and arms, chalices, crosses (e.g. the Cross of Ottokar, *c*. 1286; St Petersburg, Hermitage) and book covers, for example one from the church of St Blaise in Strasbourg (*c*. 1270; Benedictine abbey of St Paul); it is not usually possible to ascertain in which workshop these pieces were produced. The most prominent centres of production in this period were in the Upper Rhine region, Westphalia, Lower Saxony and north Germany.

In the High Gothic period Cologne, which had had the highest number of goldsmiths in Germany in the Early Gothic period, and towns in the Rhineland re-emerged as centres of gold- and silversmithing, and goldsmiths' guilds were formed, although most of the works made at this time remain anonymous. The earliest surviving German guild statutes are those of Strasbourg (1363; Strasbourg, Archvs Mun.). These and later statutes set out the conditions by which a craftsman could become a master, journeyman or an apprentice goldsmith, as well as the standard of quality of gold and silver products. Gold articles could not generally be of less than 18 carats and silver articles not less than 14 lot. Journeymen were required to spend several years (e.g. eight years for Cologne craftsmen in the 14th century) travelling in Europe; this factor contributed greatly to the stylistic unity of goldsmiths' work.

The use of town marks was made obligatory at this time, and various devices were used: a coat of arms in Strasbourg in the 14th century; a laterally inverted N in Nuremberg in the early 15th century; and crossed keys in Regensburg from 1448. From the mid- to late 15th century it became usual for goldsmiths in many German towns to utilize a maker's mark as well as the town mark. As these makers' marks usually comprise the undeciphered emblems of families or masters' initials, it is not always possible to attribute works to particular goldsmiths, although a number of extant pieces have signatures, for example a *Chormantelschliesse* by Reinecke vam Dressche (1487; Minden, Domschatz).

From the 14th century the demand for secular gold and silver increased. Some outstanding 14th-century objects have survived, for example an immense wine pitcher (before 1353; Kassel, Hess. Landesmus.) from the mid-Rhine region, known as the *Katzenelnbogischer Willkomm*, the form of which imitates that of a barrel. The universities of Heidelberg and Leipzig also own 14th- and 15th-century rectors' sceptres. Most of the tableware, including plates, dishes, goblets, pots and jugs, that was undoubtedly widely produced at this time has been melted down, and most of the surviving works are ecclesiastical. The main works of the period include the Shrine of St Patroclus (1313; destr.; figures, Berlin, Bodemus.), recorded as the work of Master Sigifridus, who worked *c*. 1313 in Soest. The single-nave shrine is conceived as a Gothic church with a transept, with figures standing in front of the closed window niches. Tall monstrances, with long shafts and immense upper parts consisting of delicate architectural motifs, were produced from 1350 to 1520 (e.g. of 1385, Essen, Minster; e.g. of 1370–80, Gerleve, Benedictine Abbey). Cologne was the main centre of production for monstrances and ciboria. Over 2000 Gothic communion chalices survive: in the 13th century their bowls were hemispherical; in the 14th and 15th centuries they became elongated and, about 1500, bell-shaped.

During the Late Gothic period the production of secular goldsmiths' work increased further, and goldsmiths received large commissions from town councils for municipal treasuries: one of the few surviving examples is the treasure of the city of Lüneburg (mid-15th century to early 17th), from which 36 vessels are extant (Berlin, Tiergarten, Kstgewmus.). In the Rathaus at Goslar, a major centre of silver mining, is the Goslar *Bergkanne* (after 1477; see fig. 63), with tiny figures of miners at work mounted on the lid. The embossed vessels of this period are evidence of an extremely refined repoussé technique: goblets, double-goblets, bowls and cups were worked in this manner until the 17th century, and naturalistic forms were created by masters in Nuremberg at the beginning of the 16th century. Some forms are derived from drawings by Albrecht Dürer, for example the Apple Goblet (*c*. 1515; Nuremberg, Ger. Nmus.) with a branch as its stem. A goblet (1520; Budapest, Mus. Applied A.) produced in the workshop of Ludwig Krug of Nuremberg shows early Renaissance features.

In ecclesiastical work monstrances, ciboria and chalices continued to predominate. Numerous extant statuettes, for example the Reliquary of St George (*c*. 1480; Hamburg, Mus. Kst & Gew.) by Bernt Notke of Lübeck, are also notable. The ecclesiastical treasures in the Protestant regions were decimated by the iconoclasm of the 16th century. The *Heiltumsbuch* (1526–7) of Albert of Brandenburg, Elector of Mainz and Archbisop of Magdeburg, however, illustrates the original size of these treasuries. Some 353 richly decorated medieval and Gothic reliquaries

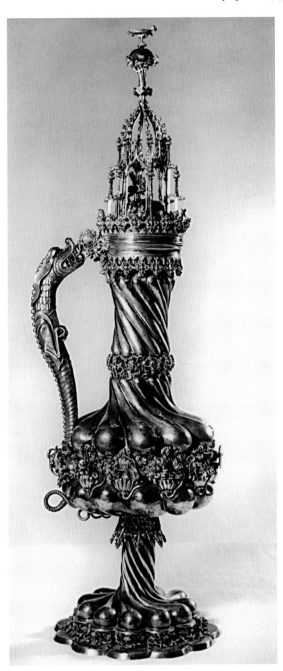

63. Goslar *Bergkanne*, silver and parcel gilt, h. 730 mm, after 1477 (Goslar, Rathaus)

are recorded, but only a negligible part of the works described in this and other books has survived.

BIBLIOGRAPHY

Das Wittenberger Heiltumsbuch mit Holzschnitten von L. Cranach (Wittenberg, 1509); ed. G. Hirth (Munich, 1884)
M. Rosenberg: *Der Goldschmiede Merkzeichen*, 2 vols (Frankfurt am Main, 1890, rev. in 4 vols, 3/1922–8)
J. Lessing: *Gold und Silber* (Berlin, 1907)
P. H. Hahn and R. Berliner: *Das hallesche Heiltumsbuch des Kardinals Albrecht von Brandenburg* (Aschaffenburg, 1931)
Metall im Kunsthandwerk (exh. cat., ed. G. Schade; Berlin, Schloss Köpenick, 1967)
H. Kohlhausen: *Nürnberger Goldschmiede: Kunst des Mittelalters und der Dürerzeit 1240 bis 1540* (Berlin, 1968)
E. M. Link: *Ullstein Silberbuch* (Berlin, Frankfurt am Main and Vienna, 1968)
J. F. Fritz: *Goldschmiedekunst der Gotik in Mitteleuropa* (Munich, 1982)
Der silberne Boden, Kunst und Bergbau in Sachsen (exh. cat., Dresden, Staatl. Kstsammlungen, 1989)
S. Bursche: *Das Lüneburger Ratssilber*, Berlin, Tiergarten, Kstgewmus. cat. (Berlin, 1990)

For further bibliography *see* §(iii) below.

G. REINHECKEL

(ii) 1520–c. 1700. In the 16th and 17th centuries there was no one leading centre of production of gold- and silversmiths' work. There were many towns and villages that became regional centres. The different styles and forms in German goldsmiths' work can generally be explained by geographic and economic factors. The south and west had closer links with Italy and France; the north was more under the influence of the Netherlands. At the beginning of the 16th century the major centres were in the south. Due to the large number of outstanding goldsmiths—LUDWIG KRUG, MELCHIOR BAIER, Wenzel Jamnitzer I and Christoph Jamnitzer (*see* JAMNITZER; *see also* SHELL, colour pl. I, fig. 1) and Johannes Lencker—Nuremberg (*see* NUREMBERG, §III, 2) became the main centre in the 16th century, although its importance declined in the 17th, in spite of the activity of HANS PETZOLT and members of the Ritter family. Augsburg gained importance from the mid-16th century and became the leading centre by the mid-17th century. It maintained preeminence into the 18th century (*see* AUGSBURG, §3(i)). A number of distinguished goldsmiths were active in such smaller towns as Ulm, for example Hans Pflaum, to whom a screw-top bottle (*c.* 1565–70; Nuremberg, Ger. Nmus.) is ascribed, and Adam Kienlin the elder (1628–91), who made a baptismal set (1665; Ulm, Minster), or Lüneburg, for example Jochim Worm (*fl* 1536–58), who made several goblets belonging to the Lüneburg municipal silver collection (Berlin, Tiergarten, Kstgewmus.), and Lutke Olrikes (*fl* from 1508; *d* before 1555), whose two confectionery dishes (Berlin, Tiergarten, Kstgewmus.) were made for the same collection, particularly in the 16th century. In the 17th century Hamburg became a prominent centre for silver (*see* HAMBURG, §2), rivalled to some extent by Lübeck, where Detlef Jürgen Mansfeld (*fl* 1642; *d* after 1673) (dish, Oslo, Kstindustmus.; tankard, Frankfurt am Main, Mus. Ksthandwk) and Hans IV Hintze (*fl* 1658–1707) (dish with Venus and Adonis relief; Lübeck, St Annen-Mus.) worked.

(a) Style and forms. (b) Techniques and ornament. (c) Patronage.

(a) Style and forms. During the early 16th century the Renaissance style became popular throughout Germany, although initially there was no distinctively German adaptation of Italian forms; decoration in this style was limited to the use of moresques, scalloped work and scrollwork on vessels in the latest Gothic style. Gothic beakers and standing-cups continued to be produced.

By the second quarter of the 16th century the transition to the Renaissance style was complete. New types of

drinking vessels appeared: the tazza, the waisted standing-cup in the Renaissance or Mannerist styles and the standing beaker (e.g. by David Winckler (*fl* 1617–35), 1625; Dresden, Grünes Gewölbe). The form of the tazza was inspired by Italian examples. These vessels were also used as salvers, for example two sweetmeat dishes by Lutke Olrikes made for the Lüneburg Council (1541; Berlin, Tiergarten, Kstgewmus.). The frieze engraving on the dishes of tazzas was superseded in the second half of the 16th century by chased relief figural tondi, a type of decoration particularly favoured by goldsmiths in Augsburg (examples in Salzburg Cathedral; Florence, Pitti). The standing-cup is characterized by a body on which two bulbous forms are separated by a cylindrical band. The surfaces are decorated with a wide variety of techniques, for example embossing, engraving and etching (e.g. 'Jupiter' Cup, possibly by Matthäus Hasenbanck (*fl* 1590–1615), 1590; Regensburg, Stadtmus.; see fig. 64). The standing beaker usually consists of a conical form flaring gently outwards towards the rim, with a base and a narrow

stem. Standing beakers are often decorated with abstract, chased ornament or figural scenes. Although not manufactured exclusively in Germany, this form was most widespread in this region until the second half of the 17th century, when a goblet-shaped bowl appeared.

A third type of cup with a pear- or bell-shaped bowl was also produced; most extant examples date from the end of the 16th century and from the first third of the 17th (e.g. the Imhoff Cup by Hans Petzolt, 1626; Lugano, Col. Thyssen-Bornemisza). The shape of the cup is similar to the Gothic columbine cup (i.e. with lobed forms), but without any kinks or folds in the surface of the vessel, and is characterized by a blending of organic forms.

From the end of the 16th century the form of the tankard became more sophisticated. In south Germany sturdy forms with embossed or chased decoration were popular (e.g. tankard by Hieronymus Zainer (*fl* 1587–95), *c.* 1590; Berlin, Schloss Köpenick), whereas in the north and the east oversize types were produced. Coins, or the imprints of coins, were often melted on to the surface (e.g. tankard from Leipzig by Balthasar Lauch (*fl* 1670–before 1725), 1687; Dresden, Grünes Gewölbe). This technique became particularly popular in Berlin and throughout Prussia and east Germany. It can be seen already on early 16th-century dishes and beakers and was later used until the second half of the 19th century on other types of vessels, for example tureens. The Hanseatic flagon, mainly produced in the Baltic area from the second half of the 16th century until the early 18th century, is in the form of an elongated tankard: a tall drinking vessel with a hinged lid and handle that was probably developed in Hamburg or Lübeck (e.g. by Peter I Henniges (*fl* 1607–27), *c.* 1590; Hamburg, Mus. Kst & Gew.). Like the type of tankard produced in north Germany, it is often decorated with engraving, a technique rarely used by south German goldsmiths.

Catholic liturgical vessels continued to be made in traditional forms with fashionable ornament. Protestant objects were adapted from traditional domestic types: the communion cup, for example, is an enlarged chalice. Wine flagons were modelled on secular utensils (e.g. by Johannes Lencker (1573–1637); Augsburg, St Anne); a standard form was not developed. Only in their decoration was any reference made to their liturgical purpose: a lamb often crowned the lid; a relief medallion with a biblical theme—the Resurrection, the Last Supper—was often inlaid into the flagon itself, while others had such scenes engraved on to the surface. Goldsmiths in Augsburg created prototypes for patens in 1536–7, which were needed by the new Protestant liturgical practice, and they remained the often repeated model until the mid-17th century. There was no standard form of flagon, communion plate or paten in the 16th and 17th centuries. Baptismal utensils differ from secular ewers and basins only in their decoration. Designs were mainly of a religious nature; flagons were sometimes crowned with a lamb or a statuette of John the Baptist; the inside of the font was often decorated with a biblical scene, for example the Baptism of Christ, or it could be divided into three compartments representing the Trinity.

The most common type of drinking vessel during the 16th and 17th centuries was the simple beaker without a

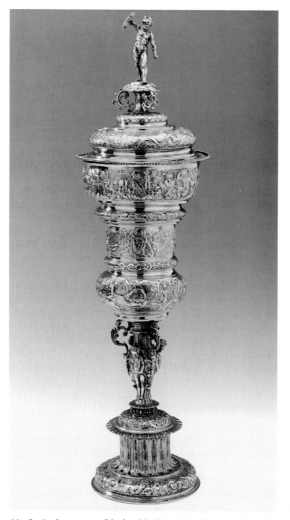

64. 'Jupiter' cup, possibly by Matthäus Hasenbanck, silver gilt, h. 560 mm, Regensburg, *c.* 1590 (Regensburg, Stadtmuseum)

stem or foot, raised from sheet silver and produced in a wide variety of fashionable styles and forms. Beakers were made in pairs, often in the shape of small barrels, and in nests in the 16th century and the early 17th, particularly in southern and central Germany (e.g. set of 1621; Nuremberg, Ger. Nmus.).

Figural drinking cups, popular from the beginning of the 17th century, were modelled in animal or human form and were used as table decorations; they became drinking vessels when the head was removed. Many figures were combined with automata (e.g. 'St George' by Joachim Fries (c. 1579–1620); Dresden, Grünes Gewölbe). These types were produced mainly in Augsburg. MATTHIAS WALBAUM, Fries and Jacob Miller (c. 1550–1618) often used figures of Diana or Europa for these mechanisms. In the first half of the 17th century drinking vessels in the form of equestrian statuettes became fashionable, sometimes portraying contemporary figures, for example King Gustav II Adolf (reg 1611–32) of Sweden (e.g. by Daniel Lang (fl after 1623; d 1635); Frankfurt am Main, Mus. Ksthandwk) and Emperor Ferdinand III.

As well as drinking vessels in their various forms, the ewer and basin also formed part of the lavish tableware popular from the 16th century to the 18th. Utilitarian examples are relatively simple, whereas those with elaborate reliefs on the basin and decorated with enamels and gemstones or inlaid with mother-of-pearl were used for display (e.g. ewer and basin with mother-of-pearl inlay by Nikolaus Schmidt (fl 1582; d 1609), c. 1582; Vienna, Ksthist. Mus. Kstkam.; Dresden, Grünes Gewölbe). Ewers in human or animal form could continue the theme of the relief decoration on the basin (e.g. Europa ewer in the form of the Rape of Europa by Johannes Lencker, c. 1620; Donaueschingen, priv. col.; Paris, priv. col.; see Seling, vol. II, figs 85–6 for a copy of the original) but were of limited practical use. In the second half of the 17th century ewers and basins with a clearly organized structure and decoration were developed. Plain surfaces alternate with areas of ornamentation, which, on the basins, are concentrated mainly in the well and the boss. On helmet-shaped ewers, which were then popular, the foot, the lower third of the ewer and the handle are often elaborately decorated. The use of gadrooning as decorative edging, which occurred increasingly from the 1680s, reveals growing French influence on German gold work.

In the second half of the 17th century embossed decoration, mainly of flowers and foliage, appeared on ornamental salvers (e.g. of 1685–90; Nuremberg, Ger. Nmus.), as well as on ewers and basins. As well as drinking vessels and ewers and basins, such other types of utensils as salts (e.g. by Philipp Warmberger (fl 1564–1614), c. 1590; Augsburg, Städt. Kstsammlungen), spice-boxes, jars, candlesticks and pots were produced. These are, however, found in small numbers and reflect the development of style and ornament less clearly. New forms were introduced from the second half of the 17th century and in the 18th (see §(iii) below), although they were made in few centres: silver furniture (see §VI, 3 above), dinner services, toilet services and travelling sets, for example, were made predominantly in Augsburg (e.g. set of silver furniture, c. 1700; Dutch Royal Col., on loan to Apeldoorn, Pal. Het Loo; toilet service with agate inlay by Tobias

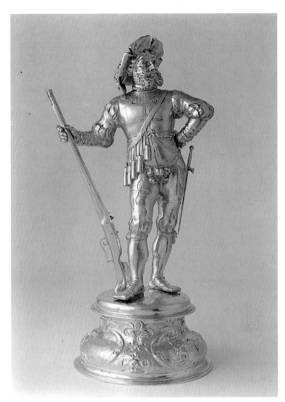

65. Drinking vessel in the shape of a man by Johann Heinrich Mannlich, silver gilt and enamel, h. 520 mm, Augsburg, 1700 (Zurich, Schweizerisches Landesmuseum)

Baur (c. 1660–1735), c. 1690; Nuremberg, Ger. Nmus.). Standing-cups and figural drinking vessels (e.g. by Johann Heinrich Mannlich, 1700; Zurich, Schweiz. Landesmus.; see fig. 65) continued to be prestigious types of plate. In ecclesiastical work, the radial type of monstrance was popular (e.g. by Georg Ernst (fl 1626–51), 1652; Weyaru, former monastery church).

(b) Techniques and ornament. During the 16th and 17th centuries it was rare for craftsmen to specialize in the use of either gold or silver in the smaller towns and it was not common in the cities until the 17th century. Most silver was gilded primarily to protect the metal from tarnishing, but parcel-gilding was also used to provide decorative contrasts. Gold work from this period is frequently enriched by the mounting or inlaying of hardstones, cast reliefs and enamels that came from specialist workshops (many of the enamel medallions mounted on cups made in Augsburg came from Geneva). Translucid enamels were used only on the most elaborate Renaissance or Mannerist pieces by such goldsmiths as Baier and Lencker in Nuremberg and David Altenstetter (1547–1617; see GILDING, colour pl. III, fig. 2) in Augsburg.

Although embossing was the most favoured decorative technique until the 17th century, most objects contain cast parts, for example the bases of standing-cups or the handles of jugs and tankards. For cast stems, bases and

finials goldsmiths drew inspiration from Italian and German bronze Renaissance figures; for example two vases by Lorenz II Biller (1649–1726) decorated with cowering slaves (*c*. 1699; Argentaria, Palazzo Pitti) similar to the figures on the monument to *Ferdinand I* (1624–5) by Giovanni Bandini, show a strong Italian influence. Sketches and drawings were also widely utilized. Designs could be made by the goldsmith as a pattern or as a basis for discussion for an order from a client (e.g. drawing for a pot with lid by Hans Reimer of Munich (*d* 1604), 1572; Munich, Residenz). Designs were also produced by other artists: a number of actual-size models for silver sculptures are extant.

There were usually sheets of designs for ornament in goldsmiths' workshops. In the mid-16th century Renaissance ornament on German gold and silver was derived from designs by engravers in the Netherlands, for example Cornelis Floris. These designs were adapted by Virgil Solis. Moresques, strapwork, scrollwork and sometimes scalloping were used as decoration in the second half of the 16th century, particularly in Augsburg. They were later replaced in certain regions from *c*. mid-16th century until the early 17th century by grotesque ornament, which features in the niellos of Corbinian Saur (*d* 1635), David Mignot (*fl* 1593–6) and others. This type of decoration was also used on champlevé enamel *c*. 1600.

A typical decorative feature of the first half of the 17th century was Auricular ornament, inspired by the work of Adam van Vianen and Paulus van Vianen of Utrecht. The zoomorphic and grotesque character of this ornament appears on the hilt of the Palatinate Sword by Abraham Drentwett II (1653; Munich, Residenz). This was followed in the second half of the 17th century by a preference for naturalistic plant motifs in symmetrical arrangements (e.g. dish on three balled feet with flower decoration by Hans III Lambrecht (*fl* 1630–after 1683), *c*. 1660; Hamburg, Mus. Kst & Gew.). Engravings by Johann Wilhelm Heel (1637–1709) or Johann Conrad Reuttimann (*fl* 1676–81), incorporating arrangements of flowers and foliage, were followed in the last third of the 17th century by acanthus scrolls in which animals often appear. The growing French influence at the end of the 17th century appeared particularly in works of goldsmiths in Augsburg (e.g. mirror frame by Albrecht Miller (1653–1720), *c*. 1700; Paris, Louvre).

(c) Patronage. Commissions for goldsmiths came from many sources. Town and city councils ordered municipal silver—drinking vessels and tableware—usually from local craftsmen. The most impressive extant set of this type consists of 34 pieces from the Lüneburg Rathaus (1536 onwards; Berlin, Tiergarten, Kstgewmus.). Wealthy guilds possessed large and constantly expanding collections of silver, which, apart from the indispensable drinking vessels, also included guild signs and bier or coffin plaques (e.g. the coffin plaque of the Lübeck sailors by Claus Schmidt (*d* before 1694), 1684; Lübeck, Schifferges.). The plate of the marksmen's associations usually included silver chains with figural pendants (e.g. German (?Rhineland) chain, 2nd half of the 16th century; Cologne, Kstgewmus.). The wealthy city council of Nuremberg purchased the elaborate

Mother Earth centrepiece by Wenzel Jamnitzer (*c*. 1549; Amsterdam, Rijksmus.; *see* JAMNITZER, (1), fig. 1).

The greatest demand for silverware, however, came from the courts. While the nobility and the patrician families were able to afford only relatively modest items, ordered directly from the goldsmiths' workshops or offered for sale by the masters at markets or trade fairs (e.g. those in Frankfurt am Main), from the 16th century the German princes collected rare and precious objects. Notable collectors included Archduke Ferdinand II of Austria and Albert V, William V, Dukes of Bavaria, and Maximilian I, Elector of Bavaria, who acquired the basis of the Schatzkammer of the Residenz in Munich. Coconuts, ostrich eggs, nautilus shells and other natural specimens were fitted with sumptuous gold mounts (e.g. silver-gilt trochus shell by Wenzel Jamnitzer, *c*. 1570; Munich, Residenz; *see also* SHELL, colour pl. I, fig. 1); these objects, although appearing to be functional, were decorative pieces. The work of court goldsmiths, who operated outside the jurisdiction of the guilds since, often not being citizens of a town but employees of a lord, they were not subject to the jurisdiction of the civil authorities, was so far removed from the general trends that it had very little influence on the work of goldsmiths elsewhere.

(iii) c. 1700–1805.

(a) Style and manufacture. Goldsmiths in Augsburg dominated the market for gold- and especially silverware in Germany for most of the 18th century. Their reputation also extended to eastern Europe, Italy, Spain and, to a limited extent, France. The requirement that craftsmen from Augsburg serve as journeymen outside Germany, as well as the influx of immigrant craftsmen into the city, resulted in the assimilation of new ideas and the dissemination throughout Europe of the types of gold- and silverware made in Augsburg. This was also facilitated by the numerous pattern books and designs for ornament produced in Augsburg, where many goldsmiths were also active as designers, for example various members of the BILLER and DRENTWETT families, who both published engravings incorporating strapwork in the style of Jean Berain I, combined with long acanthus scrolls, and Johann Erhard II Heuglin (1687–1757). The sculptor Franz Xaver Habermann produced numerous decorative designs, including rocaille motifs, as well as severe classical patterns. The design of wares from Augsburg, characterized by the unity of form and decoration, determined the style of German gold- and silverware throughout the Régence and Rococo periods (*see also* AUGSBURG, §3(i)). French or Dutch silverware, particularly such types of vessels as the three-footed coffeepot, were influential only in western and northern Germany. Outside Augsburg, in the royal capitals of Dresden, Munich, Berlin, Hannover and Kassel, and the religious centres of Cologne and Mainz, court factories producing silverware in the first half of the 18th century mostly operated for only a short period, and products reflected the taste of their owners.

Although the silver buffet (Berlin, Schloss Köpenick) ordered around 1698 by Frederick I, King of Prussia, and completed by Johannes Biller of Augsburg in 1733 followed established tradition, a change in taste followed

Frederick II's accession as King of Prussia in 1740. His preference for French culture manifested itself in gold- and silverware made in Berlin, which was heavily influenced by Parisian models. After the embargo on the import of French wares in 1740 to protect German industry, such Prussian goldsmiths as Christian Lieberkühn the younger (*fl* 1738–64) went to Paris to study. Wares made in Berlin also determined the character of goldsmiths' work made throughout the Kingdom of Prussia. The well-established preference for tableware, including tankards and cups, decorated with coins spread to the north-east, as far as Königsberg (now Kaliningrad) and Danzig (now Gdańsk) (e.g. tankard with coins from Königsberg by Otto Schwertfeger (*d* 1720), 1699; Lüneburg; Ostpreuss. Landesmus.).

A number of goldsmiths were also active in Dresden during the 18th century (*see* DRESDEN, §III, 1). The inspired creations of JOHANN MELCHIOR DINGLINGER for Frederick-Augustus II, King of Saxony, are so elaborate in their design and construction, incorporating pearls, gemstones and enamels, that they were not widely imitated. Other goldsmiths in Dresden, for example Johann Jacob Irminger (?1635–1724; e.g. coffeepot, 1722; Dresden, Grünes Gewölbe; see fig. 66), Christian Heinrich Ingermann (*fl c.* 1750–98) and Carl David Schrödel (*fl* 1753–after 1762), provided the court with French-inspired tableware.

The increased use of porcelain in the mid-18th century, however, gradually, but severely, limited the everyday use of silverware. With the decline of the Rococo style from the 1770s, Paris became the leading centre of production of gold and silver in Europe. German goldsmiths were influenced almost exclusively by French Neo-classical or Empire-style models, and few distinctly German characteristics appear in silverware of this period. Examples of this change in style and design include services (Munich, Residenz) by Johann Alois Seethaler (1775–1835). With the establishment of his large workshop in his home town of Augsburg in 1803/4, in which up to 42 silversmiths were employed, and with the organization of his own large business, he was one of the first German goldsmiths to reject the traditional practices of the craft and its guild regulations before the official dissolution of the goldsmiths' guild in Germany in 1868.

(b) Forms. In the 18th century the types of utensils appropriated for ecclesiastical use were usually produced in fashionable styles, although those made for the Protestant Church have more restrained Rococo decoration. A number of works produced in southern Germany for use in Protestant churches, however, are exceptionally elaborate, for example the baptismal utensils (1745–7; Augsburg, St Anne) designed by Bernhard Heinrich Weyhe (*d* 1782), comprising a circular font with a cut rocaille edge inside of which there is a relief showing the Baptism of Christ, and a flagon inlaid with elaborate rocaille work with a lifted lid inlaid with rocailles. Monstrances, for example the Lepanto-Monstrance (1708; Ingolstadt, Patrician Church of Maria de Victoria) by Johann Zeckel (1691/4–1728), and reliquaries, for example the Fridolin Shrine (Säckingen, Fridolinsmünster) by Emanuel Gottlieb Oernster (*d* 1767), as well as numerous other types of

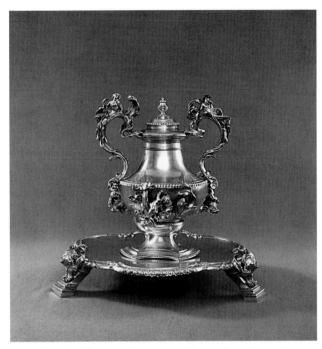

66. Coffeepot by Johann Jacob Irminger, h. 390 mm, diam. 475 mm, Dresden, 1722 (Dresden, Grünes Gewölbe)

liturgical vessels, including chalices, were transformed into *Kunstkammer* objects through the addition of plaquettes, gemstones and enamels. Gold and silver sculpture was also used for ecclesiastical purposes. Figurative reliquaries and life-size devotional figures were supplied by workshops in Augsburg and Munich, following models by such sculptors as Ehrgott Bernhard Bendl (e.g. model for statue of *St Sebastian*, 1714–15; silver figure in Neuburg, St Peter; wooden model in Augsburg, Maximilianmus.), Ignaz Günther (1725–75) or Johann Baptist Straub.

In the field of secular silverware richly decorated drinking vessels, for example standing-cups, beakers or cups in the form of animal or human figures, were no longer the most prestigious types. The greatest demand was for elaborate gold and silver table services. During the 17th century goldsmiths used consistent engraved, cast or embossed ornament on different objects in a set in order to create a unity of decoration between the individual pieces, but in the 18th century the uniform character of a set of silverware was strengthened by the standardization of decorative components, for example profiled rims of salvers and plates and the finials and handles of tea- and coffeepots, tureens, sauceboats and other tableware. Many of these decorative features were designed by sculptors. Goldsmiths in Augsburg made use of this new aesthetic principle in the early 18th century, and in doing so they used and adapted the forms and decoration of other European types of silverware. A characteristic example, similar to English designs, is a coffee service (*c.* 1700; Augsburg, Städt. Kstsammlungen) by Johann Ulrich Baur (1663–1704); this includes a tea- and coffeepot with restrained ornament that combines gadrooning with cut-card work. Around 1720 the standard German vessel for

tea was a squat, full-bellied type of pot, and for coffee, a taller, pear-shaped type. These remained the standard forms, usually with repoussé decoration, although varying with different styles, until the late 18th century. The three-footed tea- and coffeepots used in France and the Scandinavian countries were common in northern and western areas, while they were rarely used in southern and central Germany.

Coffee sets frequently formed part of the larger state dinner services, for example the Hildesheim Service (Munich, Bayer. Nmus.; Hildesheim, Roemer-Mus.), or of the so-called travelling services (e.g. by Johann Erhard II Heuglin of Augsburg, *c.* 1720; Hamburg, Kst- & Gewsch.). The latter are ensembles of diverse silver utensils intended for breakfast or toilet purposes and packed into a special trunk. Large, elaborate trunks accommodating sets of utensils with many pieces for both functions, known as combined travelling services, were already produced by goldsmiths in Augsburg at the end of the 17th century but became highly fashionable in the first half of the 18th century, when they were among the most spectacular products of Augsburg goldsmiths and were ordered by almost all the European courts.

The 17th-century fashion of equipping formal state-rooms with silver furnishings continued in Germany in the 18th century, in contrast to the practice in France. Instead of individual pieces, larger sets of furniture were made, for example the furniture (Nordstemmen, Schloss Marienberg) from the estate of the Dukes of Brunswick, made *c.* 1730 by various goldsmiths in Augsburg, of which the individual pieces are unified through the use of standard forms and decoration. As the influence of French silversmithing increased after the mid-18th century and spread to eastern Europe, German goldware lost its distinctive character. The forms of Parisian silver from *c.* 1770 to *c.* 1800 were widely imitated by German gold-smiths (e.g. the services of Robert-Joseph Auguste). The effects of Rationalism and the Enlightenment also caused a great reduction in commissions for ecclesiastical art, and Neo-classical ecclesiastical works produced in Germany after 1795 are uncommon.

BIBLIOGRAPHY

F. Sarre: *Die Berliner Goldschmiedezunft von ihrem Entstehen bis zum Jahre 1800* (Berlin, 1895)
E. von Czihak: *Die Edelschmiedekunst früherer Zeiten in Preussen*, 2 vols (Leipzig, 1903–8)
E. Hintze: *Die Breslauer Goldschmiede* (Breslau, 1906)
M. Frankenberger: *Die Alt-Münchner Goldschmiede und ihre Kunst* (Munich, 1912)
J. Warncke: *Die Edelschmiedekunst in Lübeck und ihre Meister* (Lübeck, 1927)
A. Häberle: *Die Goldschmiede zu Ulm* (Ulm, 1934)
H. Leitermann: *Deutsche Goldschmiedekunst* (Stuttgart, 1954)
G. Schiedlausky: *Tee, Kaffee, Schokolade* (Munich, 1961)
M. Hasse: *Lübecker Silber, 1480–1800* (Lübeck, 1965)
W. Scheffler: *Goldschmiede Niedersachsens* (Berlin and New York, 1965)
——: *Berliner Goldschmiede* (Berlin, 1968)
——: *Goldschmiede Rheinland-Westfalens* (Berlin and New York, 1973)
G. Schade: *Deutsche Goldschmiedekunst: Ein Überblick über die kunst- und kulturgeschichtliche Entwicklung der deutschen Gold- und Silberschmiedekunst vom Mittelalter bis zum beginnenden 19. Jahrhundert* (Hanau, 1974)
W. Scheffler: *Goldschmiede Hessens* (Berlin and New York, 1976)
C. Hernmarck: *The Art of the European Silversmith, 1430–1830*, 2 vols (London and New York, 1977)
B. Heitmann: *Die deutschen sogenannten Reise-Service und die Toiletten-Garnituren von 1680 bis zum Ende des Rokoko und ihre kulturgeschichtliche Bedeutung* (Hamburg, 1979)
W. Scheffler: *Goldschmiede Mittel- und Norddeutschlands* (Berlin and New York, 1980)
H. Seling: *Die Kunst der Augsburger Goldschmiede, 1529–1868* (Munich, 1980)
H. Hoos: *Augsburger Silbermöbel* (diss., U. Frankfurt am Main, 1981)
W. Scheffler: *Goldschmiede des Ostallgaus* (Hannover, 1981)
A. Gruber: *Gebrauchssilber des 16. bis 19. Jahrhunderts* (Fribourg and Würzburg, 1982)
W. Scheffler: *Goldschmiede Ostpreussens* (Berlin and New York, 1983)
E. Schliemann, ed.: *Die Goldschmiede Hamburgs* (Hamburg, 1985)
Wenzel Jamnitzer und die Nürnberger Goldschmiedekunst, 1500–1700 (exh. cat., Nuremberg, Ger. Nmus., 1985)
Deutsche Goldschmiedekunst vom 15. bis zum 20. Jahrhundert aus dem Germanischen Nationalmuseum (exh. cat., ed. K. Pechstein; Nuremberg, Ger. Nmus., 1987)
Das Lüneburger Tafelsilber (exh. cat., ed. S. Bursche; Berlin, Staatl. Museen Preuss. Kultbes., 1990)
Schätze deutscher Goldschmiedekunst von 1500 bis 1920, aus dem Germanischen Nationalmuseum Nürnberg (exh. cat., ed. K. Pechstein; Nuremberg, Ger. Nmus., 1992)

HANNELORE MÜLLER

(iv) 1806–1914. During the period of French occupation (1806–13) large quantities of plate were confiscated and melted down in Germany, and, even after the establishment of a German confederation in 1814, there were few large commissions for silverware. With the increased prosperity of the middle classes in the early 19th century, however, the favoured criteria for silverware, as well as other decorative arts, were high-quality materials, harmonious proportions and optimum utility, all of which characterize the Biedermeier style. There was a preference for cubic, circular and oval shapes. Manufacturers used squat, bulbous shapes for tea- and coffeepots and jugs; silverware was modelled on simple English tableware. Ornament was restricted to beading, palmettes and leaf motifs. Other forms of decoration, particularly the Gothic Revival and the later Neo-classical styles (e.g. cup with palmettes and Gothic motifs, 1830–31; Hanau, Hist. Mus.) evident in the designs of Karl Friedrich Schinkel, were also popular in the 1820s and 1830s. Goldsmiths also incorporated coral, ivory and hardstones into their work.

In the 1820s and 1830s, due to the widespread introduction of steam-powered machinery from England, new centres of production were established that transformed the manufacture of silverware into a lucrative branch of industry in Germany, particularly in Hanau, where the tradition of goldsmithing had developed from the end of the 16th century. The Staatliche Zeichenakademie founded there in 1772 served as a training centre for silver- and goldsmiths. The manufacture of gold and silver in Pforzheim and Schwäbisch Gmünd also became influential, as did the production of jewellery (*see* §X, 1 below).

The industrialized manufacture of silver during this period altered the forms of silverware, which was increasingly mass-produced. After 1835 the simple cubic shapes used for vessels in the Biedermeier period disappeared. Copies of the ornament and forms of Baroque and Rococo prototypes led to the Rococo Revival, which became increasingly luxuriant. Silverware in the Renaissance Revival and Gothic Revival styles (e.g. cup by Kurz & Laufs, 1860; Hanau, Hist. Mus.; see fig. 67) were also popular. The technique of stamping metal from sheet silver was used for gold- and silverwork in these styles, although

manufacturers as M. H. Wilkens & Söhne of Bremen and Sy & Wagner of Berlin displayed works in a wide variety of revival styles at the International Exhibition of 1862 in London and the Exposition Universelle of 1867 in Paris. The manufacture of electroplated wares was centred in Munich and Geislingen, where the Württembergische Metallwaren Fabrik had been established. From the 1870s the silverware factory of J. D. Schleissner & Söhne in Hanau produced highly prized pieces for use by town councils, which, after the Franco-Prussian War (1870–71) and the resulting increase in prosperity and fervent patriotism, were replacing items that had been destroyed in the early 19th century. The factory produced other lavish vessels in the 'Antique' style. The town councils of Hamburg, Frankfurt am Main and Cologne, for example, competed with each other in acquiring silverware in every available style, keeping local workshops fully occupied. Other goldsmiths who worked for town councils included Gabriel Hermeling in Cologne and Alexander Schonauer in Hamburg. One especially enigmatic goldsmith from this period, however, was the forger Reinhold Vasters (1827–1909) of Aachen, who produced a large number of vessels and decorative items that were held in many collections and believed to be original Renaissance works (see FORGERY, fig. 2).

The steady growth of industrialization and the cessation of war in 1871 resulted in the creation of a newly rich middle class that imitated the taste of the aristocracy. The production of over-elaborate silverware was thus increased, especially the types used for display: for civic celebrations, as presentation pieces, sporting trophies, commemorative pieces or tableware (e.g. Baroque Revival centrepiece by Koch & Bergfeld, 1885; Nuremberg, Ger. Nmus.; see fig. 68). Although the use of the Baroque or Renaissance Revival styles continued, floral motifs were more widely used in the late 19th century, together with a revival of enamelling techniques. Many items in historicist styles continued to be designed and produced by craftsmen with academic training, for example Fritz von Miller (1840–1921).

From the late 19th century the *Jugendstil* was an important catalyst for the revival of handmade silverware in Germany, although industrial manufacture, especially in Pforzheim and Hanau, continued. Such architects as Henry Van de Velde, who worked in Berlin and Weimar, designed and produced silverware characterized by severe, angular contours (e.g. silver tea-kettle; Zurich, Kstgewmus.). Many other designers of silverware were active in Munich and Berlin, important centres of the *Jugendstil* movement. Silver implements in this new style became fashionable among a new, more aesthetically aware generation of the middle class. Wilhelm Lucas von Cranach, a descendant of the Franconian painter Lucas Cranach, worked in Berlin c. 1900 as an outstanding goldsmith and designer, producing superb gold and silver pieces. He exhibited successfully at the Exposition Universelle of 1900 in Paris. Japanese floral art, as well as naturalistic forms in the Mannerist style, influenced his designs, and there is also a discernible inclination towards Symbolism in his work.

Almost all members of the artists' colony established in Darmstadt in 1899 designed silver vessels. As well as

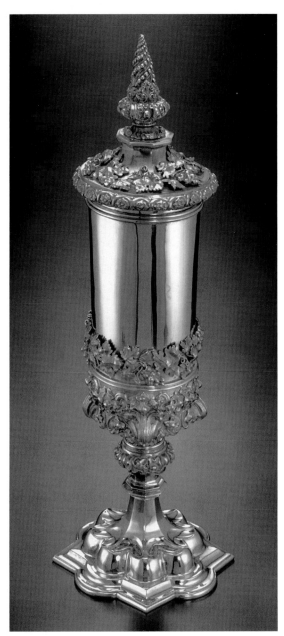

67. Cup by Kurz & Laufs, silver gilt, h. 364 mm, 1860 (Hanau, Historisches Museum)

products were often made of thin gauge metal, and stamped items often had to be filled with cement-like materials to prevent collapse. This technique of 'loading' had been developed by the manufacturers of Sheffield plate in England. About 1860 'machine decoration', a form imported from Paris, was produced in Hanau by the firm of Carl Michel; shapes relating to industrial manufacture, for example cogwheels, bolts and screws, were used decoratively.

From the mid-19th century many German firms participated in the numerous international exhibitions. Such

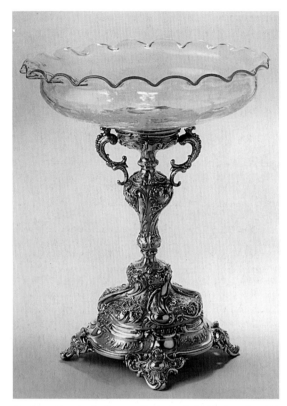

68. Centrepiece in the Baroque Revival style by Koch & Bergfeld, silver and blown engraved glass, h. 390 mm, Bremen, 1885 (Nuremberg, Germanisches Nationalmuseum)

individual pieces, Joseph Maria Olbrich, Peter Behrens and Patriz Huber (1878–1902), among others, produced designs for mass production. There was also a workshop for goldsmithing in Darmstadt run by Karl Berthold in collaboration with Maria Schmidt-Kugel, and their works, influenced by Symbolism, are similar to those of von Cranach. The Deutscher Werkbund was founded in 1907 by pioneering designers of the *Jugendstil*, who aimed to combat the declining quality of mass-produced decorative arts. The most prominent designers of silverware included Richard Riemerschmid and Theodor Wende. The latter was influenced by early 19th-century Neo-classical German silver. Ernst Riegel designed items decorated with rock crystal, enamel and amethyst. The outbreak of World War I in 1914, however, temporarily halted the production of silverware in avant-garde styles.

(v) After 1914. The increase in inflation and the economic crisis in Germany after World War I had a profound effect on the production of silverware. Until the 1930s it was not possible for a class that delighted in ostentatious decoration to become established, and, therefore, no close links between gold- and silversmiths and patrons developed during the 1910s and 1920s. Silverware was bought as an investment, but this activity did not encourage the creation of modern forms. The objectives of the Bauhaus formulated by Walter Gropius in 1919 were not particularly conducive to the invention of varied forms and decoration

in silverware. The designers at the Bauhaus saw their aim as the creation of standard types fulfilling a social necessity. Gold- and silversmiths and base metalworkers, for example Christian Dell (1893–1974) and MARIANNE BRANDT, worked together in one workshop at the Bauhaus and had equal status. Their tutor, Naum Slutzky (b 1898), also set up a workshop in precious metals at the Bauhaus as a private enterprise, where simple chains were made from circles and other geometric shapes in quartz, mother-of-pearl and a variety of metals.

There were few attempts at the traditional centres of goldsmithing—Hanau, Pforzheim and Schwäbisch Gmünd—to assimilate the avant-garde artistic movements of the period, although Expressionism and Art Deco inspired some designs. The company of Wilhelm Müller in Schwäbisch Gmünd had organized competitions for gold- and silversmiths from 1873, the entries for which have been preserved and which clearly illustrate changes in style. After 1919 the 'jagged style' (*Zackenstil*), characterized by figural motifs and an Expressionist use of different coloured enamel, became popular. In 1922 a trade exhibition was held in Munich, where new German applied art, including silver tableware, was displayed. The firm of P. Bruckmann & Söhne exhibited pieces designed by Josef Michael Lock, Karl Wahl, Albert Feinauer and Gerta Schroedter that were in historicist styles. Emil Lettré (b 1876) also showed similar gold items. Later, he and Andreas Moritz (b 1901) became the best-known exponents of elegant but austere forms. Lettré successfully represented German arts and crafts at exhibitions in London in 1925 and in Paris in 1926 and 1937, showing both functional and purely decorative items. Moritz also produced both elaborate repoussé wares and geometric forms in silver.

Such artists as Erich Heckel, Karl Schmidt-Rottluff and Emil Nolde designed and made superb silver items as gifts for friends in the 1920s. In 1924 Hugo Leven (1874–1956), a sculptor and principal of the Zeichenakademie in Hanau from 1910 to 1933, had a piece made to his design that was based on Parisian models. Karl Lang (1892–1958), who had been a pupil of René Lalique in Paris, Alexander Fisher (1864–1936) in London and Peter Carl Fabergé in St Petersburg, created lively decorative compositions using a combination of superb enamelling and figurines in fashionable dress.

Art Deco and Constructivist designs were predominant from 1929 until the mid-1930s, when folkloric trends with runic symbols and swastikas appeared, and a new historicism, inspired by Renaissance silverware or using scrollwork, was established. In 1932 the Gesellschaft für Goldschmiedekunst was founded in Berlin and was influential in Germany in encouraging and promoting the work of German gold- and silversmiths, sculptors in metal, enamellers and jewellers. Its first president was the goldsmith F. R. Wilm. At the instigation of this society, the Deutsches Goldschmiedehaus was established in Hanau as a forum for contemporary work by gold- and silversmiths. A Goldener Ehrenring ('Golden ring of honour') was instituted and awarded annually. This has been presented to a number of well-known European gold- and silversmiths, including Elisabeth Treskow (b 1898; e.g. *Dove of Peace*, 1940; Hanau, Dt. Goldschmiedehaus; see

fig. 69), Herbert Zeitner (*b* 1900) and Lili Schultz (*b* 1895) from Germany, Søren Georg Jensen (*b* 1917) of Copenhagen, Sigurd Persson (*b* 1914) of Stockholm and Max Fröhlich (*b* 1908) of Zurich.

After World War II the production of silverware was largely determined by the personal expression and preference of the artist or craftsman, rather than by the use of silver to display the wealth and status of the patron. As well as the specialist schools of gold- and silversmithing, art schools that provided instruction in this craft, particularly in Munich, were influential in the development of this movement. Franz Rickert (*b* 1904) began teaching classes in the art of goldsmithing in Munich in 1945, and Andreas Moritz continued to play an influential role, as a teacher at the Kunstakademie, Nuremberg, from 1952 and as a maker of austere silverware (e.g. coffeepot, 1968; Nuremberg, Ger. Nmus.; see fig. 70).

Some of the most prominent goldsmiths from the 1950s to the 1970s included Ebbe Weiss-Weingart (*b* 1923), who experimented with the surfaces of gold objects, transforming them into sculptural reliefs; Reinhold Reiling (*b* 1922), who taught at the Staatliche Kunst- und Werkschule in Pforzheim and experimented with surface textures in his decorative work; and Friedrich Becker (*b* 1922), who preferred the use of white gold alloy. His training as a machine builder and aeronautical technician led him to incorporate kinetic features into his work, and his functional pieces are characterized by simple, geometric forms. Hermann Jünger (*b* 1928), who was taught by Franz Rickert and who succeeded him as a teacher of goldsmithing in Munich in 1972, produced works characterized by the use of enamel and gemstones.

Exhibitions and the acquisitions policies of German museums have played an important role in promoting the work of avant-garde silversmiths. In 1970 the Schmuckmuseum, Pforzheim, for example, held a series of exhibitions illustrating contemporary decorative trends in which young German goldsmiths showed inventive designs. *Gold-Silber, Schmuck-Gerät* was another exhibition including innovative designs, held in Nuremberg in 1971. The Deutsches Goldschmiedehaus, Hanau, founded in 1942, was also involved in organizing a series of exhibitions of modern silver.

From the 1970s many goldsmiths have concentrated on the production of jewellery, rather than silverware. Claus Bury (*b* 1946) began to use acrylic glass in his work in London in 1969–70, developing a repertory of forms using strong colours and geometric shapes. A new stylistic vocabulary in jewellery and silverware was invented by Hubertus von Skal (*b* 1942). Like Bury, who eventually turned to large-scale sculpture, von Skal rejected the limited scale of jewellery and silverware in favour of interior design. Gerhard Rothmann (*b* 1941) was also a prominent goldsmith during the 1970s. German goldsmiths were highly involved in avant-garde movements in the 1980s. Most of them were born after World War II, and many were taught by Hermann Jünger and Reinhold Reiling or at the art colleges and schools of goldsmithing at Munich, Nuremberg, Hanau, Pforzheim and Schwäbisch Gmünd.

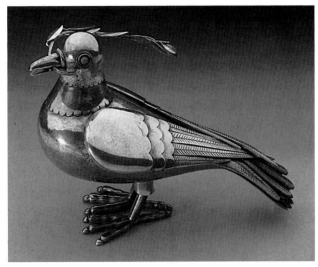

69. *Dove of Peace* by Elisabeth Treskow, silver, gold and lapis lazuli, l. 120 mm, h. 75 mm, Essen, 1940 (Hanau, Deutsches Goldschmiedehaus)

70. Coffeepot by Andreas Moritz, silver with wooden handle, h. 100 mm, Nuremberg, 1968 (Nuremberg, Germanisches Nationalmuseum)

BIBLIOGRAPHY

Hanauer Gold- und Silberschmiedekunst seit 1800 (exh. cat., Hanau, Dt. Goldschmiedehaus, 1961)

S. Grandjean: *L'Orfèvrerie du XIXe siècle en Europe* (Paris, 1962)

Friedrich Becker of Düsseldorf (exh. cat., London, Goldsmiths' Co., 1966)

G. Hughes: *Modern Silver throughout the World, 1880–1967* (London, 1967)

W. Schleffer: *Berliner Goldschmiede: Daten, Werke, Zeiche* (Berlin, 1968)

Y. Hackenbroch: 'Reinhold Vasters: Goldsmith', *Met. Mus. J.*, 19–20 (1986), pp. 163–268

Elisabeth Treskow: Goldschmiedekunst des 20. Jahrhunderts (exh. cat., Cologne, Kstgewmus., 1990)

Silver of a New Era: International Highlights of Precious Metalware from 1880 to 1940 (exh. cat., Rotterdam, Mus. Boymans–van Beuningen, 1992), pp. 132–79

GERHARD BOTT

2. BASE METALS.

(i) Copper alloys. (ii) Pewter. (iii) Iron and steel.

(i) Copper alloys. Copper has been mined in Germany on a limited scale since ancient Roman times. Records confirm

the extraction of copper at Goslar in AD 989; other important mines were located in the Erzgebirge, Hesse, Westphalia, the Eifel, Silesia and at Mansfeld. Calamine (zinc ore) deposits were located in Bohemia and Saxony. In the early Middle Ages copper was worked in centres close to where it was mined, and small-scale production of copper and brass domestic implements developed in Hildesheim, where an important workshop was founded by BERNWARD, Bishop of Hildesheim, in the 11th century, Goslar, Minden, Ilsenberg and Blankenberg. Brass is known to have been produced as early as 1373 in Nuremberg (*see* NUREMBERG, §III, 2(ii)). This city became an important centre following the sack of Dinant in 1466, as many skilled craftsmen from the Meuse region emigrated to Nuremberg, as well as Aachen and Cologne (*see* COLOGNE, §III, 2(ii)), and set up workshops.

Most brass and bronze objects produced in the 15th century were made for ecclesiastical purposes and included magnificent lecterns, church doors, fonts, chandeliers, aquamanilia and lavabos. By the late 15th century and the early 16th improvements in mining technology, financed mainly by the Fugger family of Augsburg, led to the extraction of copper on a large scale. Production of brass and bronze consequently increased, and due to the greater prosperity of the middle classes more domestic ware was manufactured, including cooking pots, skillets, candlesticks, jugs, weights and mortars. Cooking pots of rounded form, with handles for suspension and three feet, were modelled on ceramic forms; early examples tend to be squat, while later pots are more rounded. Bronze kettles of a similar type were also produced. A large number of cast brass ewers (known in Germany as *Schenkanne*) have survived from this period and are of two main types: a bell-shaped body with three legs or a body set on a circular stand with a stem. Both types have plain or zoomorphic spouts. A large proportion of brass and bronze manufactured in Germany was exported via the Hanseatic ports, Antwerp or Amsterdam or sold in the markets and fairs of central Europe.

Nuremberg became the major centre of brass and bronze production and remained dominant until 1618, but thereafter the Thirty Years War reduced its importance. A wide range of objects, including 'nests' of weights, were made in Nuremberg, but the city is perhaps best known for its decorated dishes and bowls (see fig. 71), the production of which flourished in the early 16th century. These were made by specialist craftsmen known as dish or basin beaters.

In the 17th century brass production developed at Brunswick, which also became a major centre. In the 18th century at Iserlohn craftsmen specialized in the manufacture of brass and copper tobacco-boxes, many with cast or engraved decoration, often imitating that found on Dutch boxes. One prominent maker and engraver was Johann Heinrich Giese (1716–61). These boxes were exported to all parts of Europe, particularly Sweden and England. In other brass and bronze works Baroque decoration was dominant until the 1770s, when Rococo designs became popular, and the demand for candlesticks provided a much-needed boost to the industry, which was in decline due to the increased use of such cheaper materials as earthenware. Potsdam was one of the main

71. Brass dish, diam. 393 mm, Nuremberg, 1522 (New York, Metropolitan Museum of Art)

centres for production of Rococo brasswork. Towards the end of the 18th century Neo-classical forms were introduced.

During the late 18th century and the early 19th the manufacture of copper and brass continued on a small scale, with workshops consisting of a master and a few journeymen, in contrast to the large-scale industrialized manufacture in other European countries, particularly England. Competition for makers of utilitarian wares was severe, especially from manufacturers in Birmingham, and many small firms in Germany were forced to close. Some firms, however, including Ebermayer (*c.* 1830–40) of Nuremberg and Hohne & Rosling, whose catalogue of 1839 has survived, continued to produce such domestic ware as smoothing irons.

In the mid- and late 19th century two stylistic trends revived interest in copper, brass and bronze: *Historismus* (Gothic Revival) and the *Jugendstil*. Copper- and brassware in the latter style was produced throughout Germany, although the most important firms operated in Kiel, Freiburg, Munich, Dresden and Magdeburg. The works of Zimmermann & Co., George Poschmann, Christian Wagner and George Gehlert are particularly notable. In the 1920s and 1930s a number of notable metalworkers were active at the Bauhaus in Weimar and later in Dessau, for example MARIANNE BRANDT, who was head of the metal workshop in 1928–9. Her designs are based on pure, geometric forms (e.g. brass ashtray, 1924; Berlin, Bauhaus-Archv; *see* BAUHAUS, fig. 2); in these works functional considerations are less important than aesthetic qualities.

(ii) Pewter. Tin was mined in the Erzgebirge from the early medieval period. Lead deposits were also found in Germany, and thus the German pewter industry developed using local raw materials. It is recorded that pewter was being manufactured in Nuremberg by 1285, at Augsburg from 1324, at Lübeck from 1370 and at Hamburg from 1375, although production had probably commenced in all these centres at a much earlier date. In the Middle Ages pewter was also made in Breslau (now Wrocław), Lüneberg and Munich. Before 1520 most pewter was made for institutional or ecclesiastical use. The production of guild

and church flagons was predominant, although some domestic ware, for example plates, dishes and drinking vessels, was made for the wealthy.

Guild regulations established in the late Middle Ages stipulated the required standards for pewter, based on the proportion of tin to lead, which varied from town to town. There were usually at least two permitted standards: the highest quality pewter, for example that made in Nuremberg, had a ratio of tin to lead of 10:1, while pewterers in Breslau and Württemberg both adopted a ratio of 9:1. Gradually a degree of standardization of quality evolved; the higher standard had a ratio of tin to lead of approximately 10:1 and the lower standard a ratio of 6:1. Detailed systems of marking were also stipulated by the guilds. Although there was much variation, three basic types of mark were used: a town or guild mark, a maker's mark and a quality mark.

In the 16th century increased wealth led to a rise in the demand for domestic pewter, and by the end of the 16th century most noble and middle-class households would have owned both display pewter and plates and dishes for everyday use. Demand for institutional pewter also continued. New centres of production evolved, for example Baden-Baden, Dresden, Düsseldorf, Frankfurt am Main, Hannover, Kiel, Konstanz, Leipzig, Stuttgart, Uberlingen and Würzburg. Most centres developed distinctive local styles, thus it is often possible to identify where an object was made from its style or form, although the use of marks was compulsory in every centre. Pewter measures, for example, were used for the sale of liquids; the standards set by each state or city varied, and thus measures in many different sizes are extant.

In terms of the number of recorded pewterers Augsburg, Lübeck, Nuremberg, Frankfurt am Main and Breslau were the major centres for much of the 17th and 18th centuries. There were, however, generally fewer pewterers than brass-, bronze- or ironworkers; in Nuremberg, for example, it is probable that no more than 75 masters were active at any one time. Some 575 pewterers' names have been recorded from 1400 to 1870 for Nuremberg, compared to almost 2000 members of the founders' guild (*Rotschmiede*) in the same period.

The production of cast and decorated dishes and drinking vessels for display was probably inspired by the production of brass dishes with punched and hammered decoration in Nuremberg (*see* §(i) above). The quality of the casting is the outstanding feature of German display pewter, seen for example in the work of such masters as CASPAR ENDERLEIN. Nuremberg was the main centre of production for this type of pewter, although other well-known craftsmen were active in other towns, for example Isaac Faust (1606–66) in Strasbourg, Johann C. Hunn (second quarter of the 17th century) in Württemberg and George Meyer (end of the 17th century) in Leipzig.

By 1700 pewter was used by all levels of society, and the earlier, simpler designs gave way to more highly decorative pewter in the Baroque and Rococo styles. 'Wrythen' pewter, of fluted or swirling form, was especially common in Frankfurt am Main (*see* FRANKFURT AM MAIN, §3). The demand for coffee and tea utensils also acted as a stimulus to the pewter trade. During the late 18th

century, however, German pewterers suffered from competition from producers elsewhere in Europe, and much Dutch and English pewter was imported. At the same time such other materials as earthenware became more popular for domestic items. By the turn of the 19th century the industry was in decline, with only one or two specialist pewterers active in the formerly important centres, although it was still relatively more important than that in other European countries. Pewter plates and dishes continued in widespread use in rural areas into the late 19th century.

The demand for reproduction pewter provided some impetus to the pewter trade in the mid-19th century, but the popularity of *Jugendstil* pewter, with its flowing lines and floral decoration, in the late 19th century and the early 20th made the survival of the trade possible. The firm of J. P. Kayser & Sohn of Krefeld and Cologne was the outstanding exponent of these new designs (see fig. 72); its products are known as 'Kayserzinn', and many were designed by Hugo Leven (1874–1956). The peak period of production was between 1894 and 1912. The work of the Württembergisches Metallwaren Fabrik, or W. M. F., was important, although of a lower quality. Other firms that produced *Jugendstil* pewter in the early 20th century included that of Walter Sherf of Cologne, the maker of

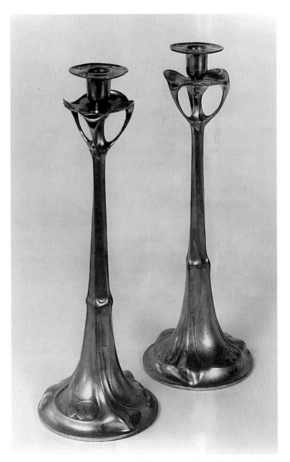

72. Pewter candlesticks by J. P. Kayser & Sohn, Krefeld, *c.* 1900 (London, Victoria and Albert Museum)

'Osiris' and 'Orivit' pewter, and that of F. G. Schmitt in Nuremberg, which made the 'Orion' range.

(iii) Iron and steel. From the Middle Ages iron was mined in several areas, including the Swabian Alps, Bavaria, Franconia, Württemberg and the Erzgebirge. Metalworkers in the Lower Rhine region and south Germany specialized in the production of arms and armour: craftsmen in the area around Cologne, principally at Solingen, were noted for the casting of sword blades in the 15th century, while armour was made in Nuremberg; in these centres workshops were also established for the production of cast-iron domestic objects (e.g. cooking pots) usually in the same style as locally produced ceramic pots. Candlesticks and chandeliers were made for churches and wrought-iron doors for public buildings. Free-standing iron stoves, made of several stove plates riveted together and decorated with biblical scenes, were also popular. In north Germany important centres of iron production included Magdeburg and Lüneberg.

Although cast-iron objects, for example fire-backs and stoves, continued to be made in the Eifel, Siegerland, Hesse and Saxony in the 16th and 17th centuries, the increased demand for brass and bronze candlesticks, cooking pots and chandeliers resulted in a decline in the use of domestic ironware, and blacksmiths concentrated on the production of wrought ironwork. 17th- and 18th-century German wrought ironwork is characterized by the use of round sectioned bars and scrolling designs. The 'Armada' chest (*see* IRON AND STEEL, fig. 1), a type of safe erroneously thought to have been designed to hold bullion for financing the Spanish Armada, was a speciality of German locksmiths. The steel lock mechanism, often elaborately pierced and engraved, covers the whole of the inside of the lid of the chest. In the late 18th century improvements in the technology used for casting iron, which originated in England, spread to Germany, and there was a major expansion in the manufacture of cast iron, some of which was of domestic nature, for example mortars, stoves and cooking pots, but most of which was used industrially. Most of the new foundries that evolved operated on a small scale.

In the 19th century the production of ironwork further increased due to the expansion of industry, but the use of iron for domestic ware declined with a growth in demand for ceramics. The principal ironworking regions were Saxony, Brandenburg, Silesia, Stuttgart, the Rhine Valley and Thuringia. In 1804 the Königliche Eisengiesserei bei Berlin was founded (*see* BERLIN, §III, 2). It first produced commercial castings, but from 1806 jewellery (see fig. 73) was manufactured; designs were supplied by such prominent artists and architects as Karl Friedrich Schinkel. The production of iron jewellery reached a peak in the 1810s, when the citizens of Berlin were encouraged to exchange their gold jewellery for that in iron, often inscribed *Gold gab ich für Eisen*, in order to raise funds for the campaign against the Napoleonic occupation. In the 20th century artistic wrought ironwork was made by Achim Kuhn and Manfred Bergmeister.

See also ROMANESQUE, §VI, 4 and GOTHIC, §V, 4.

BIBLIOGRAPHY

J. Tavenor-Perry: *Dinanderie: A History and Description of Mediaeval Art Work in Copper, Brass and Bronze* (London, 1910)
E. Hintze: *Die deutschen Zinngiesser und ihre Marken* (Leipzig, 1931)
H. U. Haedeke: *Metalwork* (London, 1970)
L. Mory: *Schönes Zinn* (Munich, 1972)
H. U. Haedeke: *Zinn* (Brunswick, 1973)
M. Wiswe: *Hausrat aus Kupfer und Messing* (Munich, 1979)

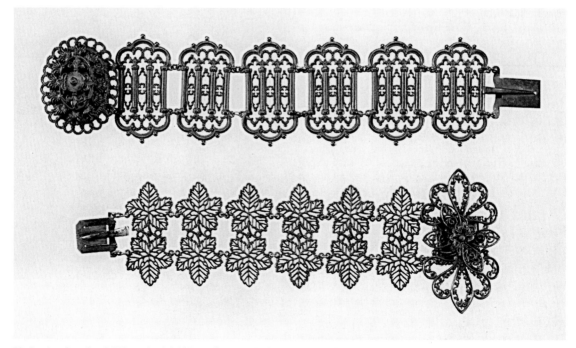

73. Cast-iron bracelets, l. 225 mm (top), l. 186 mm (bottom), Berlin, *c.* 1830 (London, Victoria and Albert Museum)

H. P. Lochner: *Messing* (Munich, 1982)
P. R. G. Hornsby: *Pewter of the Western World* (Exton, 1983)

PETER HORNSBY

X. Objects of vertu.

1. Jewellery. 2. Enamel. 3. Snuff-boxes. 4. Ivory. 5. Hardstones.

1. JEWELLERY. Paintings from the first half of the 15th century by Stephan Lochner and the Cologne school document figural brooches in the Burgundian style richly studded with precious stones, as in *Madonna in the Rose Bower* (Cologne, Wallraf-Richartz-Mus.; *see* LOCHNER, STEFAN, fig. 2). Jewellery of this type was mainly ecclesiastical or devotional, and almost no original pieces survive. Some less elaborate jewels from the 14th and 15th centuries are extant, including several pilgrim's badges made of pewter in such cities as Aachen and Cologne and silver-gilt figurines of saints used in rosaries or as belt-ends. Mother-of-pearl reliefs depicting religious scenes based on engravings by Martin Schongauer from the late 15th century and the early 16th were framed in simple silver or gilt settings and were used as pendants (e.g. Cologne, Mus. Angewandte Kst); similar settings, presumably from south Germany, were used for rock crystals or amulet stones. Gothic forms continued to be used for jewellery until the first half of the 16th century.

Renaissance jewellery was made in such goldsmithing centres as Nuremberg, Augsburg and Munich; the most popular items were hat badges, pendants and rings. Jewellery was an expression of great craftsmanship and design, and many painters of this period also designed jewellery. Albrecht Dürer made several drawings for jewellery (see fig. 74), as did Peter Flötner, Virgil Solis and Matthias Zündt. These were printed and distributed all over Europe and became so popular that they were partly reprinted and continued to be used in the 17th century. An invaluable document concerning Renaissance jewellery in Germany is the *Kleinodienbuch* (1552–6; Munich, Bayer. Staatsbib. Cod. monacensis, icon 429) by Hans Mielich (1516–73) with an illustrated inventory of the jewels belonging to Anna of Bavaria, the wife of Albert V of Wittelsbach. Apart from a few imported pieces most of the jewellery was probably made in the court workshop in Munich; a surviving piece is a collar of the Order of St George (Munich, Residenz). Such engravers as Erasmus Hornick from the Netherlands and Etienne Delaune from France also made drawings for south German jewellers. Fine examples of court jewellery of this period are the jewels found in the tomb of the Palatine-Wittelsbachs of Neuburg in Lauingen on the Danube (Munich, Bayer. Nmus.). In the Baroque era JOHANN MELCHIOR DINGLINGER, a goldsmith and jeweller working in Dresden at the court of Frederick-Augustus I, Elector of Saxony, is an important representative (examples in Dresden, Grünes Gewölbe).

However, it is the cities of Hanau, Schwäbisch Gmünd, Pforzheim, Idar–Oberstein and Neugablonz–Kaufbeuren that are particularly noted for jewellery production. The goldsmithing tradition in Hanau originated with a group of Calvinist Flemings, Walloons and, later, Huguenots, who left their native countries due to religious persecution and first settled in 1554 in Frankfurt am Main. In 1597 they moved to nearby Hanau; the new settlers were mainly

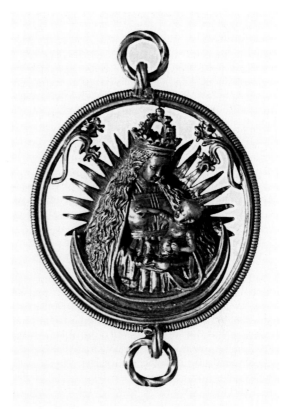

74. Pendant, from a design by Albrecht Dürer, silver and parcel gilt, h. 90 mm, *c.* 1510 (Vienna, Kunsthistorisches Museum)

goldsmiths and in 1610 they founded a guild and laid the foundations for the jewellery trade. In 1736 Landgrave William VIII of Hesse-Kassel in Hanau improved the laws for taxes and customs, and by 1762 the manufacture of jewellery flourished to international standards. To improve the quality of workmanship the 17 firms founded in 1772 the Staatliche Zeichenakademie, which is still extant, to train goldsmiths. In the late 19th century and the early 20th Hanau reached its peak of production, manufacturing handmade jewellery (e.g. Hanau, Dt. Goldschmiedehaus), which is often wrongly classified as French in many collections. Since World War I and especially after World War II the trade declined.

The gold- and silversmithing trade in Schwäbisch Gmünd originated in the 14th century, and documentary evidence from the 16th century proves that there was trade in metalwork with Venice. In the 17th and 18th centuries it was renowned for its production of rosary beads made of alabaster, amber, bone, crystal, wood and silver filigree work. Such religious items as chains, crucifixes and medals were a speciality; the enamelled parts were made in the nearby town of Lorch. In the 18th and 19th centuries folk jewellery was increasingly in demand, and Schwäbisch Gmünd produced silver filigree jewellery for many regions in Germany. In the north individual goldsmiths made folk jewellery in small workshops. During the 19th century several firms in Schwäbisch Gmünd produced gold jewellery in the French style for export

throughout Europe (design books in Schwäbisch Gmünd, Städt. Mus.).

In Pforzheim, known as the 'Gold City', Charles-Frederick, Margrave of Baden-Durlach (*reg* 1738–1817), founded a watch industry in 1767 as an occupation for orphans. The jewellery industry developed soon after, and craftsmen from all over Europe, particularly from Geneva, and Huguenots, were invited to Pforzheim to train. By 1780 Pforzheim was participating in international trade fairs, and in the early 19th century *Quincaillerie* (steel jewellery) and gold jewellery made in Pforzheim was exported world-wide. Between 1918 and 1940 there was an increase in the mass production of jewellery; Theodor Fahrner (1868–1929) manufactured inexpensive jewellery in the Art Nouveau style. Pforzheim maintains an international reputation as a centre producing both expensive and cheaper forms of jewellery.

The history of jewellery in Idar–Oberstein and the surrounding area is closely linked to that of the hardstone agate. It is possible that the Romans imported stones for their jewellery from this region. However, the earliest records of agates in Idar–Oberstein are from the 14th century; polishing of gemstones is documented on the River Idar in the 16th century and in Oberstein in 1609. It was not until 1700 that goldsmiths settled there to make jewellery using such stones as chalcedonies, cornelians, jaspers and quartz in addition to agates. By the 19th century most of the merchandise was exported to London, Birmingham and Paris and a smaller amount to Geneva, Hanau and Pforzheim. In 1830 travellers from Idar and Oberstein discovered agates in Brazil, and in 1834 the first Brazilian agates were imported. Soon afterwards the choice of stones increased as amethysts, citrines, turmalines and emeralds were also imported. The trade flourished, and Idar–Oberstein continues as one of the world's largest centres for the supply of gem- and hardstones.

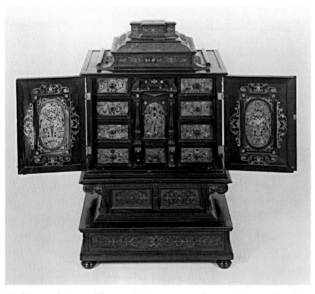

75. Silver and *basse taille* enamel plaques on an ebony cabinet, attributed to David Altenstetter, h. 430 mm, w. 285 mm, Augsburg, early 17th century (ex-Earl of Rosebery private collection)

Since the 16th century the regions of Gablonz, Bohemia and Sudeten have been renowned for their production of glass and, since the 18th century, in the field of jewellery production, for glass beads, buttons and small accessories. The glass industry survived until World War II, despite several political changes. In 1945 the Sudeten Germans were forced to flee; a community of 18,000 refugees settled in Kaufbeuren (temporarily renamed Neugablonz–Kaufbeuren), near Munich. The glass industry for fashion jewellery—Gablonzer Schmuckwaren-Industrie—was established by the settlers and continues to flourish.

In the history of jewellery Germany played an important role in the 20th century beginning with the *Jugendstil* and its renowned artist colony in Darmstadt. Later, the Bauhaus movement (e.g. jewellery by Naym Slutzky (1894–1965)) and the school in Burg Giebichenstein in Halle, which still exists today, gave new inspiration to jewellery design. In the post-war development of avant-garde styles and experiments with new materials goldsmiths such as Reinhold Reiling (1922–83), Claus Bury (*b* 1946) from Frankfurt am Main, Friedrich Becker (*b* 1922) from Düsseldorf and Hermann Jünger (*b* 1928) from Pöring, near Munich, gave contemporary jewellery design new dimensions.

For the history of iron jewellery production *see* §IX, 2 (iii) and fig. 73 above.

BIBLIOGRAPHY

E. Maschke, ed.: *Die Pforzheimer Schmuck- und Uhrenindustrie: Beiträge zur Wirtschaftsgeschichte der Stadt Pforzheim* (Pforzheim, n.d.)
K.-T. Reidenbach: *Achatschleiferei und Wasserschleifen am Idarbach* (Idar–Oberstein, n.d.)
W. Klein: *Sechshundert Jahre Gmünder Goldschmiedekunst* (Stuttgart, 1947)
W. Hegemann: *Hanauer Gold- und Silberschmiedekunst seit 1800* (Hanau, 1962)
P. Scherer, ed.: *Das Gmünder Schmuckhandwerk bis zum Beginn des XIX. Jahrhunderts* (Schwäbisch Gmünd, 1971)
U. von Hase: *Schmuck in Deutschland und Österreich, 1895–1914* (Munich, 1977)
K. Stolleis and I. Himmelheber: *Die Gewänder aus der Lauinger Fürstengruft mit einem Beitrag über die Schmuckstücke* (Munich, 1977)
Ländlicher Schmuck aus Deutschland, Österreich und der Schweiz (exh. cat., ed. G. Bott; Nuremberg, Ger. Nmus., 1982)
B. Marquardt: *Schmuck: Klassizismus und Biedermeier, 1780–1850* (Munich, 1983)
W. Pieper: *Geschichte der Pforzheimer Schmuckindustrie* (Gernsbach, 1989)
C. Weber: *Schmuck der zwanziger und dreißiger Jahre in Deutschland* (Stuttgart, 1990)

ANNA BEATRIZ CHADOUR

2. ENAMEL. During the Renaissance goldsmiths working for German courts adopted the techniques of *en ronde bosse* and *basse taille* enamelling to enhance opulent display groups, magnificent jewels and devotional articles. Silver plaques enamelled in *basse taille* were inset or attached to ebony or ivory articles, as in the ornate display cabinets (see fig. 75), clocks (*see* GILDING, colour pl. III, fig. 2) and boxes made by David Altenstetter (1547–1617). The most renowned German goldsmith of the 16th century, Wenzel Jamnitzer, and his nephew and pupil, Christoph Jamnitzer (*see* JAMNITZER, (2)), produced sumptuous enamelled masterpieces for princely and royal clients, for example the magnificent casket designed to hold writing utensils, of silver, silver-gilt, enamel and rock crystal, made by Wenzel Jamnitzer in 1562 (Dresden, Grünes Gewölbe; *see also* SHELL, colour pl. I, fig. 1). The greatest collections of

late 16th-century German enamelled pieces can be seen in the Grünes Gewölbe, Dresden, and in the Residenzmuseum, Munich.

Champlevé insets were made for early German watches, and from 1630 silver *basse taille* dials became popular; from 1619 to 1624 Valentin Sezenius, of south Germany, created work in the rare technique of enamel *en resille sur verre* (e.g. silver-gilt girdle set with 15 plaques showing rural scenes, 1623; London, V&A). The art of miniature painting on enamel in the pointillé technique was introduced into Germany in the second half of the 17th century. Samuel Blesendorf (*b* Sweden, 1633; *d* 1706) was said to be the first artist in Berlin to make enamel paintings (e.g. miniature of *John Churchill, Duke of Marlborough, c.* 1703; Port Sunlight, Lady Lever A.G.). The Huaud brothers of Geneva, Jean-Pierre (1655–1723) and Amicus (1657–1724), worked in Berlin for Frederick William, Elector of Brandenburg, and his successor, Frederick III, from 1686 to 1700, decorating snuff-boxes and watchcases with enamel miniatures in bright colours depicting figural themes taken from Classical mythology.

In the early 18th century the techniques of *en ronde bosse* and *basse taille* enhanced the spectacular and sometimes bizarre figural groups made for the German courts. Enamels were used extensively by the renowned goldsmith JOHANN MELCHIOR DINGLINGER. Over 130 gilt and enamelled figures, the largest measuring 180 mm high, are used in Dinglinger's exotic display group known as the *Court of Aurangzeb* (1701–8; Dresden, Grünes Gewölbe). Dinglinger's brother, Georg-Friedrich Dinglinger (*b* Biberach, 1666; *d* Dresden, 1720), who was appointed court enameller to Augustus the Strong in 1704, studied enamel painting in Paris and worked in the pointillé style, producing many excellent miniatures. Matheaus Bauer (*fl* 1681; *d c.* 1728) of Augsburg made silver wine-cups and stands decorated with enamel paintings, and Peter Boy the elder (*b* Lübeck, 1645; *d* Düsseldorf, 1727), who worked as a goldsmith and enameller in Frankfurt and Düsseldorf, established a great reputation for his enamel miniatures (e.g. the *Entombment of Christ*, 1716; portraits of the Elector Johann Wilhelm von der Pfalz; Munich, Bayer. Nmus.). In the second half of the 18th century Carl Friedrich Thienpondt (*b* Berlin, 1730; *d* Warsaw, 1796) also excelled in this art. The costly enamelled snuff-boxes made in Berlin and Dresden in the 18th century were decorated *en pleine*, with miniature paintings, or in the *basse taille* technique (*see also* §3 below). The subject range followed the fashions introduced for the decoration of porcelain. DANIEL NIKOLAUS CHODOWIECKI excelled in enamel miniatures depicting mythological themes and *fêtes galantes*. Copper replaced precious metal as a base for watchcases, miniatures, wine-cups, boxes and trinkets if the metal was to be completely covered with enamel. The Berlin workshop founded by Pierre Fromery (*b* 1685; *d* Berlin, 1738), a Huguenot goldsmith, was noted for its enamelled snuff-boxes. Fromery boxes featured opaque or painted enamel grounds with applied silver-gilt repoussé decorations with figural, chinoiserie or floral themes (e.g. snuff-box attributed to Alexander Fromery, son of the founder, *c.* 1740; Budapest, Mus. Applied A.). From the late 1740s the Augsburg workshops produced a cheaper range of enamel boxes and trinkets decorated with simple overglaze paintings applied on a white enamel ground on a copper base. In the second half of the 18th century transfer methods were used to produce black or sepia pictures on opaque white grounds. Designs were again taken from the porcelain industry.

In the 19th century some earlier techniques were revived, spurred by the growth of the Antiquarian movement. Reinhold Vasters of Aachen (1827–1909) was the most gifted and successful restorer and faker of enamelled goldsmiths' work in the medieval and Renaissance styles (*see* FORGERY, fig. 2). At the turn of the 20th century Pforzheim was a leading German centre for the manufacture of gold and silver jewellery and ornaments, and highly skilled emamellers and enamel painters were employed on a wide variety of articles. The output ranged from *plique-à-jour* hair ornaments and large brooches (e.g. octopus and butterfly brooch by L. W. von Cranach, 1900; Pforzheim, Schmuckmus.) in *Jugendstil* designs to painted silver cigarette cases with contemporary subjects. Automata were much in demand at this time, and copies of Swiss mechanical singing-bird boxes with enamelled lids were produced by German manufacturers up to the 1920s. Metalworkers, design-enamellers and innovative jewellers subsequently offered individual pieces ranging from champlevé ecclesiastical vessels and wall plaques made in combination methods to dress jewellery.

BIBLIOGRAPHY

E. Molinier: *Dictionnaire des émailleurs* (Paris, 1885)

G. H. Baillie: *Watches* (London, 1929), p. 131

J. E. T. Clark: *Musical Boxes* (Birmingham, 1948, rev. London, 3/1961), p. 192

W. Holzhausen: *Goldschmiedekunst in Dresden* (Tübingen, 1966)

Thirty Renaissance Jewels and Works of Art from the Collection of the Late Arturo Lopez-Willshaw (sale cat., London, Sotheby's, 13 Oct 1970)

H. Ricketts: *Objects of Vertu* (London, 1971)

A Thousand Years of Enamel (exh. cat. by A. K. Snowman, London, Wartski, 1971)

Einführung in das Grüne Gewölbe (exh. cat., Dresden, Staatl. Kstsammlungen, 1980)

Princely Magnificence: Court Jewels of the Renaissance, 1500–1630 (exh. cat., London, V&A, 1980–81)

S. Bury: *Jewellery Gallery Summary Catalogue of the Victoria and Albert Museum* (London, 1982)

C. W. Clasen: *Peter Boy: Ein rheinischer Goldschmied und Emailmaler der Barokzeit und der Schatzfund von Perscheid* (Cologne, 1993)

ERIKA SPEEL

3. SNUFF-BOXES. Some of the most original engraved designs for snuff-boxes were published in Augsburg during the 17th and 18th centuries, and although the production of gold and silver objects in Augsburg was in decline, snuff-boxes were undoubtedly made there, as well as in Nuremberg, in the late 18th century; owing to their lack of marks, however, these are difficult to distinguish from those made in Dresden. From the mid-18th century boxes were made in a wide variety of forms, for example baskets, trunks, chests, shoes, vases, pocket watches, fruits, animals and even skulls (examples from Dresden in St Petersburg, Hermitage). Many of the designs derive from porcelain models. The two main centres of production were Dresden and Berlin.

(i) Dresden. From the early 18th century in Dresden hardstone boxes were made to which carved hardstone motifs were cemented: flowers or insects were the most popular. The series of boxes with applied carved onyx beetles, agate dragonflies, cornelian ladybirds and quartz

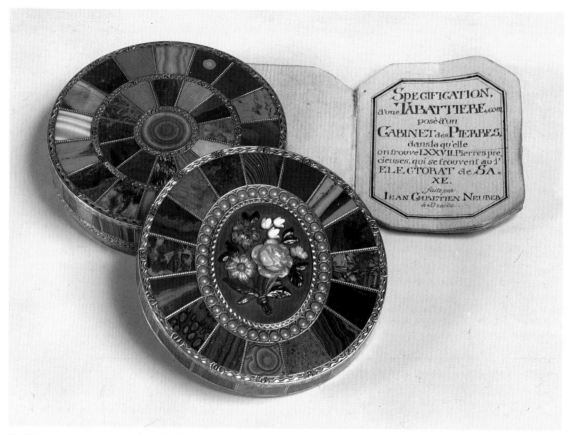

76. Circular box by Johann Christian Neuber, inlaid with 77 varieties of hardstones, diam. 73 mm, h. 22 mm, Dresden, *c*. 1775 (private collection)

butterflies are traditionally attributed to the workshop of Benjamin Gottlob Hoffman. From the mid-18th century the stone-cutters and goldsmiths of Dresden also specialized in the highly skilled technique of inlaid hardstone mosaic that is derived from Renaissance Florentine lapidary work. Boxes in this manner, usually oval or round, are composed of small shaped panels of different hardstones held by a finely wrought gold webbing in the form of a supporting frame soldered to the body of the box. The inlay work is usually of a uniformly high quality, with a smooth surface, and the harmonies of tone and colour of the hardstones are accentuated by the radiating patterns. The cover is often set with a portrait miniature or floral ornament with a border of pearls or inlaid hardstone flowers. Rectangular examples with canted corners are also common.

Heinrich Dattel (whose name was later modified to Taddel; *d* 1769), a master goldsmith recorded in Dresden in 1739 and later Director of the Grünes Gewolbe in Dresden, appears to have been the first to have perfected this *Zellenmosaik* (cell-mosaic) technique. His son-in-law, Johann Christian Neuber (1736–1808), is also associated with this type of lapidary work. He worked for the court of Frederick-Augustus II, Elector of Saxony, and eventually was, like Taddel, appointed Director of the Grünes Gewölbe. Neuber's earliest box is dated 1770 (ex-Grünes

Gewölbe, Dresden). He designed many boxes using local hardstones; numbers are engraved on the slender, gold, skeletal divisions, each referring to a particular small panel. Inside such boxes, which are known as *Stein Kabinetts-tabatieren*, there is often a small booklet listing the different specimens numbered on the box (e.g. box inlaid with 77 varieties of hardstones, *c*. 1775; priv. col.; see fig. 76). These numbered lists are often hidden within a secret compartment or drawer that springs open when a particular part of the box is pressed. Miniatures or carved or engraved gemstones are usually set in the centre of the lids. Neuber's signature sometimes appears in the accompanying booklet, and his surname is often stamped on the box. Some boxes are inscribed *Neuber à Dresde*. Neuber also designed *carnets*, *étuis*, *châtelaines* and centrepieces, as well as at least one table and an elaborate chimney-piece, which were made using the *Zellenmosaik* technique.

Christian Gottlieb Stiehl (1708–92) was Neuber's most celebrated contemporary. His work is often distinguished by the use of *plique à jour* settings for the stones. Neuber's work is generally characterized by rectangular forms that give the appearance of a parquet surface, whereas Stiehl used hardstones with gently curved contours (e.g. of 1770–80; Lugano, Col. Thyssen-Bornemisza).

One of the most prominent patrons in Dresden was Heinrich, Graf von Brühl, Prime Minister to Frederick-Augustus II, Elector of Saxony, and Director of the

Meissen Porcelain Factory from 1733 to 1756. He had no less than 300 complete suits of clothes, each with its own gold-mounted stick and snuff-box.

(ii) Berlin. The production of snuff-boxes in Berlin during the 18th century was promoted by Frederick II, who inherited his love of boxes from his mother, Sophia Dorothea. He was reputed to have owned over 1500 snuff-boxes. It is said that Frederick considered his collection of snuff-boxes as valuable as his paintings and that numerous boxes could be found at strategic points throughout his palaces. On 16 November 1740, in order to protect the native industry, Frederick forbade the import from France of jewelled articles in precious metals, although he could not resist buying some of the most splendid French boxes to augment his own collection, and French influence on design remained strong.

Richly ornamented boxes were made for Frederick II by several goldsmiths between 1742 and 1775; most were supplied by the crown jewellers, the brothers André Jordan and Jean-Louis Jordan, and also Daniel Baudesson (1716–85) at prices ranging from 125 talens for an enamelled box lined in gold to 12,000 talens for one of the most splendid examples. Baudesson was one of the most imaginative designers of snuff-boxes in Germany in the 18th century; there are two outstanding pieces by him in the Metropolitan Museum of Art, New York. Frederick also commissioned pieces from foreign craftsmen, the most prominent of whom was Jean Guillaume George Krüger (1728–91). Born in London, he trained in Paris and in 1753 moved to Berlin, where he founded and led La Fabrique Royale de Berlin. Frederick II personally supervised much of the design and production of snuff-boxes made there.

The boxes made in Berlin are generally large, as they were intended for use at the dinner-table, instead of being carried in the pocket. In contrast to the *Zellenmosaik* technique used in Dresden, goldsmiths and stone-cutters in Berlin specialized in the technique of *Reliefmosaik*, involving the cementing of various decorative motifs carved in ivory, mother-of-pearl, coral, lapis lazuli and other expensive materials to the stone body of the box. This technique had also been used in Florence during the Renaissance. During the 1740s elaborate mythological scenes executed in ivory or mother-of-pearl and tinted green, pink or blue were applied to the covers of snuff-boxes. From the 1740s to the 1760s sprays of flowers and fruits in a variety of coloured hardstones were popular (e.g. 1745–50; Paris, Louvre). From *c.* 1760 allegorical and mythological subjects were revived; the illusion of perspective was reinforced by the application of gold details in layers. Clusters of large diamonds were applied to boxes, backed with gold or silver foil; 18 carat gold was used for the gold mounts. The results were often sumptuous, although some examples were grossly overloaded. One elaborate example (*c.* 1760; Los Angeles, CA, Gilbert priv. col.; see fig. 77) is of carved agate, with large diamonds, gold mounts, gold decoration in relief and a hunting scene after Jean-Baptiste Oudry in hardstones.

Gold snuff-boxes enamelled *en plein* in the style of those made in Paris were also produced in Berlin at this time; these are often characterized by elaborate and richly set diamond thumb-pieces. Much of the finest enamel painting was executed by Daniel Nikolaus Chodowiecki. A gold box enamelled with scenes of the story of Diana by Chodowiecki (1760–65; Paris, Louvre) was possibly made by Baudesson. During the late 18th century elaborate snuff-boxes continued to be made, but by the end of the century, production throughout Germany declined sharply; as in many European countries, the fashion for taking snuff was superseded by that of cigar and cigarette smoking.

BIBLIOGRAPHY

M. Rosenberg: *Der Goldschmiede Merkzeichen*, 3 vols (Frankfurt, 1922–5)

J.-L. Sponsel: *Das Grüne Gewölbe zu Dresden*, 4 vols (Leipzig, 1925)

M. Klar: 'Berliner Golddosen aus Friederizianischer Zeit', *Pantheon*, ix (1932), pp. 60–62

W. Holzhausen: *Johann Christian Neuber* (Dresden, 1935)

R. Norton and M. Norton: *A History of Gold Snuff Boxes* (London, 1938)

77. Snuff-box, carved agate with chased gold mount, set with brilliant-cut diamonds, 105×50×79 mm, Berlin, *c.* 1760 (Los Angeles, CA, Rosalinde and Arthur Gilbert Collection); on the bottom (right), a hunting scene after Jean-Baptiste Oudry in hardstones and coloured gold with a foliate border in coloured gold

H. Schmitz: *Katalog der Ornamentstichsammlung der Staatlichen Kunstbibliothek Berlin*, 2 vols (Berlin, 1939)

H. Berry-Hill and S. Berry-Hill: *Antique Gold Boxes* (New York, 1960)

C. Le Corbeiller: *European and American Snuff Boxes, 1730–1830* (London, 1966)

J. Menzhausen: *The Green Vaults* (Leipzig, 1968)

W. Baer: 'Ors et pierres des boîtes de Frédéric-le-Grand', *Conn. A.*, 346 (Dec 1980), pp. 100–05

S. Grandjean: *Les Tabatières du Musée du Louvre* (Paris, 1981)

G. von Habsburg-Lothringen: *Gold Boxes from the Collection of Rosalinde and Arthur Gilbert* (Los Angeles, 1983)

A. von Solodkoff and G. von Habsburg-Lothringen: 'Tabatieren Friedrichs des Grossen', *Kst & Ant.*, 83 (May–June 1983), pp. 36–42

A. Somers Cocks and C. Truman: *The Thyssen-Bornemisza Collection: Renaissance Jewels, Gold Boxes and Objets de Vertu* (London, 1984)

Gold and Silver Treasures from the Hermitage (exh. cat., Lugano, Col. Thyssen-Bornemisza, 1986)

A. K. Snowman: *18th Century Gold Boxes of Europe* (London, 1990)

A. KENNETH SNOWMAN

4. IVORY. The use of ivory declined significantly in Germany and throughout Europe in the 15th century. In the first half of the 16th century ivory was used less for sculpture but more for such domestic items as cutlery handles or powder horns. A group of display saddles (*c.* 1440; Bologna, Mus. Civ.) of ivory and bone with depictions of love scenes presumably originated in Upper Germany.

In the Baroque period there was a revival of figurative carving. Carved groups and single figures were produced, as were richly worked centrepieces and ceremonial tankards, goblets and bowls decorated with Christian, mythological and allegorical reliefs. Powder flasks, gun stocks, cutlery handles, musical instruments, furniture, sundials and anatomical models were also produced throughout the 17th century. Such artists as Leonhard Kern, Christoph Angermair (see fig. 78), Georg Petel, Ignaz Elhafen and Balthasar Permoser achieved celebrity through the patronage of princely houses.

Numerous workshops were located in southern Germany: that of Kern in Schwäbisch Hall, of Johann Michael Maucher in Schwäbisch Gmünd and of Christoph Daniel Schenck in Konstanz. Nuremberg was a major centre for turning. Locations with a tradition of working in ivory, Nuremberg and Geislingen, for example, were able to maintain production. Munich and Augsburg were the main centres of production of furniture (e.g. throne of the Danish kings, narwhal and ivory, 1662–5; Copenhagen, Rosenborg Castle), board-games (e.g. folding game-board, *c.* 1560–80; Munich, Bayer. Nmus.), musical instruments and weapons, which often incorporated ivory inlay. In the early 17th century caskets, boxes and display cabinets were cased in ivory panels. The coin cabinet (1618–24; Munich, Bayer. Nmus.) of Maximilian I, Elector of Bavaria, by Angermair is the artist's masterpiece (*see* ANGERMAIR, CHRISTOPH, §2 and fig. 2). During the High Baroque period sculpturally carved ivory reliefs were often used on furniture, as on the masterpiece created between 1678 and 1680 by Dominikus and Franz Stainhart, brothers from Weilheim, for the gallery of the Palazzo Colonna, Rome, after a design by Carlo Fontana.

Working at an artist's lathe with a valuable material such as ivory was regarded as a fitting part of the education of young noblemen. Famous turners were engaged as tutors and were often furthered in their careers by their noble

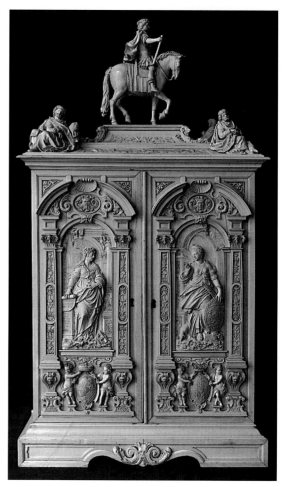

78. Ivory coin cabinet by Christoph Angermair, 812×457 mm, 17th century (Munich, Bayerisches Nationalmuseum)

pupils. In the last years of his life Rudolf II practised turning, taught by Peter Zick I from Nuremberg, and both Maximilian I and Maximilian III Joseph, Elector of Bavaria, owned lathes. The latter is believed to have been the patron of Simon Troger, whose characteristic pieces combining ivory and wood were known as 'Troger figures', later a generic term for all such work (e.g. *Samson Battles with the Lion*, *c.* 1740; Munich, Bayer. Nmus.). Goblets, boxes, chains, rings, counterfeit spheres and centrepieces were sought after as appropriate items for a *Kunstkammer*. The most important 17th-century collections of ivory were owned by the Habsburgs (now in Vienna, Ksthist. Mus.), the Wittelsbachs (Munich, Bayer. Nmus.), the Welfs (Brunswick, Herzog Anton Ulrich-Mus.) and the Wettins (Dresden, Grünes Gewölbe).

The decline in the popularity of ivory in the 18th century can be traced mainly to the foundation of the Meissen Porcelain Factory: porcelain, which could be produced serially, began to supersede ivory. Ivory carvers were able to work in porcelain factories as experienced modellers. Johann Christian Ludwig Lücke, for example, worked from 1728 alternately as a porcelain modeller and as an

ivory-carver in Meissen, Vienna, St Petersburg and Copenhagen.

Graf Franz I von Erbach-Erbach (*b* 1754) introduced ivory-carving in his domain in 1783; in the same year a guild of ivory-carvers was established in the hunting lodge at Eulbach. Erbach became a centre of carving that was highly regarded in the 19th century, and it is the only place in Germany where ivory-carving has continued to be practised up to the present day. Initially decorative items such as boxes, jewellery cases or candlesticks were produced, but *c.* 1850 sophisticated flower brooches began to be made (examples in Erbach, Dt. Elfenbeinmus.). These and hunting brooches were extremely popular; the Erbach 'rose' was awarded a bronze medal at the Weltausstellung of 1873 in Vienna.

In the Biedermeier period ivory-carvers in Germany produced portrait busts, statuettes and medallions and copied antique, medieval or Baroque models. For the Exposition Universelle of 1855 in Paris the sculptor Pierre-Charles Simart created a 3 m high chryselephantine *Athena*, based on the lost statue by Pheidias from the Parthenon, Athens. It attracted a great deal of attention and can be regarded as the stimulus for the renaissance in chryselephantine art that took place in the 19th century. From the last third of the 19th century increasingly large numbers of figural work were produced. The foundation of the Grossherzogliche Fachschule für Elfenbeinschnitzerei und Verwandte Gewerbe, Erbach, in 1892 provided a solid basis for the practical and artistic training of wood- and ivory-carvers. In the late 19th century and the early 20th, ivory continued to be a popular material for luxury items and statuary, for example in the chryselephantine Art Deco figures made by Ferdinand Preiss (1882–1943) in Berlin.

The Deutsches Elfenbeinmuseum Erbach, founded in 1966, maintains Erbach's links with ivory-carving and training and includes in its collection around 200 works of small-scale sculpture, jewellery and utensils in ivory and fossilized mammoth ivory by the sculptor Jan Holschuh (*b* 1909). In the late 20th century a small group of German artists have continued to produce ivory sculpture, domestic items and jewellery. The worldwide ban (Oct 1989) on marketing and working in African ivory has prompted a return to such alternative materials as mammoth ivory and bone.

BIBLIOGRAPHY

C. Scherer: *Elfenbeinplastik seit der Renaissance* (Leipzig, 1905)

J. V. Schlosser: *Elfenbein* (Vienna, 1910)

R. Berliner: *Die Bildwerke in Elfenbein, Knochen, Hirsch- und Steinbockhorn*, Munich, Bayer. Nmus. cat., iv (Augsburg, 1926)

C. Scherer: *Die Braunschweiger Elfenbeinsammlung* (Leipzig, 1931)

E. V. Philippovich: *Elfenbein* (Munich, 1961/*R* 1982)

J. Menzhausen: *Einführung in das Grüne Gewölbe* (Dresden, 1975)

K. Maurice: *Der drechselnde Souverän: Materialien zu einer fürstlichen Maschinenkunst* (Zurich, 1985)

R. H. Randall jr: *Masterpieces of Ivory from the Walters Art Gallery* (New York, 1985)

C. Theuerkauff: *Die Bildwerke in Elfenbein des 16.–19. Jahrhunderts*, ii of *Die Bildwerke der Skulpturengalerie*, Staatl. Museen Preuss. Kultbes. (Berlin, 1986)

H.-W. Hegemann: *Das Elfenbein in Kunst und Kultur Europas* (Mainz, 1988)

B. Dinger and C. B. Heller: *Sammlung Jan Holschuh*, Erbach, Dt. Elfenbeinmus. cat. (Erbach, 1993)

BRIGITTE DINGER

5. HARDSTONES. The artistic use of hardstones in Germany was encouraged by the widespread presence of deposits of precious minerals, concentrated in particular in Bohemia and Saxony. Hardstone-carving was established in Dresden from the end of the 16th century, aided by the patronage of the electoral princes of Saxony. The altar of the church of Penig (1564), Chemnitz, or that of the Kreuzkirche (1574–9) in Dresden (now in the church of Bad Schandau, Dresden) are among the first monumental works to use the jasper, amethyst and serpentine found locally. In 1579 the court sculptor GIOVANNI MARIA NOSSENI created a series of 12 chairs (e.g. in Dresden, Schloss Pillnitz) for Augustus, Elector of Saxony; they were made of ebony inlaid with jasper and with seats of serpentine. Hardstone-carving continued and improved throughout the 17th century due to the activity of numerous craftsmen, for example the goldsmith Samuel Klemm (*fl* 1644–78), who made the extraordinary 'Miner's coat' (Dresden, Grünes Gewölbe) studded with gems and hardstones from Saxony; it was worn at a parade in 1678 by John-George II (*reg* 1656–80). In the 18th century the selection of available stones increased due to the discovery of new deposits, and hardstone-carving in Dresden became internationally renowned through the careers of the cameo specialist Johann Cristoph Huebner (*fl* until 1733) and Johann Melchior Dinglinger (e.g. centrepiece, 1727–8; Dresden, Grünes Gewölbe). Their fame was exceeded by Johann Christian Neuber (1736–1808), who produced small, refined items for an international clientele (see §3 and fig. 76 above).

Augsburg was an important centre of hardstone-carving from the late 16th century. Philipp Hainhofer provided the principal courts of Europe with objects of art and ingenious pieces of furniture created in Augsburg, often to his own designs. *Kunstkammern* in particular, through their rich use of different decorative materials, provided ample scope for the use of hardstones either as a background for miniature oil paintings—the specialists were Johann König and ANTON MOZART—or arranged in mosaics inspired by those of Florence and Prague. Important surviving examples are the monumental 'German' cabinet (1619–26; Florence, Pitti), made by Ulrich Baumgartner (*c.* 1580–1652) and presented in 1628 by Archduke Leopold V, Count of Tyrol (1586–1632), to Ferdinando II de' Medici, and an ebony cabinet (1625–31; Uppsala, U. Kstsaml.; see fig. 45 above) conceived by Hainhofer. The production of hardstone plaques and mosaics continued in Augsburg until at least the mid-1660s, as can be seen from several ivory cabinets (examples in Paris, Louvre; Copenhagen, Rosenborg Slot; London, Buckingham Pal., Royal Col.) with mosaics reflecting subjects from Florence and Prague. Throughout Germany *pietra paesina*, a type of limestone from the Arno, was extremely popular as a decorative material due to its fantastically patterned graining. Small plaques of *pietra paesina* were used in the decoration of cabinets; they appear in the earliest productions of Hainhofer (e.g. cabinet, *c.* 1630–40; Copenhagen, Rosenborg Slot) and continued to be popular throughout the 17th century (later examples in Nuremburg, Ger. Nmus., and Brunswick, Herzog Anton Ulrich-Mus.).

Landgrave Charles of Hesse-Kassel established a specialized workshop at his court in Kassel; at the end of the 17th century he invited Francesco Mugnai (*d* 1710) from Florence to the workshop, where he worked until his death. He produced several large cameos and an unfinished table-top with an *Athena* in hardstone relief against an inlaid landscaped background (Kassel, Hess. Landesmus.). Hardstone-carving at Kassel was continued by such German artists as Johann Christoph Labhardt and Johann Albrecht Lavillette (1667–1743), originally from Dresden, who both specialized in small-scale mosaic reliefs.

Frederick II of Prussia made widespread use of both gem- and hardstones in the interior decoration and furnishings of his palaces in Potsdam. He imported hardstone inlaid table-tops from Florence and commissioned the fantastic Great Grotto Hall (1763–9) in the Neues Palais. This is a work of German production and taste; it is encrusted with blocks and chips of hardstones and precious minerals and inspired by similar Italian creations.

For the use of hardstones in jewellery *see* §1 above.

BIBLIOGRAPHY

W. Holzhausen: *Das Grüne Gewölbe zu Dresden* (Dresden, 1937)
K. E. Meyer: *Studien zum Steinschnitt des 17. und der ersten Hälfte des 18. Jahrhunderts unter besonderer Berücksichtigung der Werkstatt am Hofe von Hessen-Kassel in den Jahren 1680–1730* (diss., U. Hamburg, 1973)
R. Sachse and G. Rhode: *Der Grottensaal im Neuen Palais* (Potsdam, 1984)
D. Alfter: *Die Geschichte des Augsburger Kabinettschranks* (Augsburg, 1986)
W. Quellmalz: *Die edlen Steine Sachsens* (Leipzig, 1990)
A. M. Giusti: *Pietre Dure: Hardstone in Furniture and Decoration* (London, 1992)

ANNAMARIA GIUSTI

XI. Textiles.

The development of Germany's textile industries reflects the problems of a country composed for centuries of a number of semi-independent states. Although its native fibres of wool and linen were used to produce superb embroideries, tapestries and woven cloths, its textiles assumed a major role in international trade only at certain periods. Germany has, however, played a prominent part in the production of textile machinery and the development of new techniques.

1. Embroidery. 2. Silk. 3. Tapestry. 4. Carpets. 5. Other.

1. EMBROIDERY. The oldest important surviving German embroidery is the cover from the reliquary of St Ewalde (Cologne, St Kunibert), a Cologne work from the second half of the 10th century. The blue linen is embroidered with silk thread and narrow, couched strips of gilded leather, in a design that shows the temporal world guided by Christ with the heavenly cosmos. From the early 11th century come the imperial cloaks in Bamberg (Bamberg, Diözmus.). These magnificent south German pieces, possibly from Regensburg, are embroidered with silk and gold on a silk ground. They were commissioned for and by the Holy Roman Emperor, Henry II, and his wife, Kunigunde (*d* 1033). They exemplify the deep religious faith of the medieval period. The cloak with star motifs combines zodiacal signs associated with Christ and the Virgin with other constellations to form a total picture of the heavenly vault ruled by Christ. One of the other cloaks, that of Kunigunde, has rows of roundels that illustrate Christ

Incarnate with scenes from the Old Testament, while another cloak features rows of enthroned rulers.

Two chasubles and a cope (St Paul im Lavanttal, St Paul; Vienna, Österreich. Mus. Angewandte Kst) from the late 12th century and the third quarter of the 13th, originally from the Benedictine monastery of St Blasien in the Black Forest, are worked in chain and plait stitch. The embroidery, which completely covers the linen, contains numerous scenes from the New Testament and the lives of the saints. The Rupertsberg Antependium, a mid-Rhenish work of *c.* 1230 (Brussels, Musées Royaux A. & Hist.; *see* EMBROIDERY, fig. 1), displays a dignified monumentality in its figures that bears comparison with wall and panel painting. Two important antependia survive from *c.* 1300. The Upper Rhenish one in Anagni Cathedral shows the Tree of Life; above and below are roundels containing prophets, Old Testament kings, St Peter and the Virgin Mary. The Franconian antependium (Munich, Bayer. Nmus.) comes from Bamberg Cathedral and is embroidered with large roundels containing the *Three Magi* and the *Virgin and Child Enthroned*. Both pieces have linen grounds entirely covered with silk embroidery and couched gold thread.

During the 13th and 14th centuries Germany was famous for its white linen embroidery (*opus teutonicum*), which was worked in Lower Saxony, Lübeck and Hesse. This whitework, which was sometimes relieved with touches of colour in silk and dyed linen thread, was used for altar covers and antependia and also for the veils with which churches were draped during Lent. The large figurative subjects were drawn by local artists. Two fine 14th-century examples from Altenberg Monastery, Hesse, can be studied in the Metropolitan Museum of Art, New York, and the Cleveland Museum of Art, Cleveland, OH. The whitework from Lower Saxony shows great variety in its wealth of motifs and images and in the technique, in which many different stitches are combined with cut and drawn work. This can be seen in the antependium from Heiningen with the *Deësis and Saints* (*c.* 1260; Helmstedt, Stift Marienberg), in which satin, brick, stem and cross stitches are used with drawn thread work. Others are less elaborate: the altar cloth with enthroned kings and animals in six-lobe tracery (*c.* 1300; Isenhagen Monastery) has brick, stem and patterned satin stitches on a plain ground.

At the same period embroiderers in Lower Saxony also produced brightly coloured work in silk and in wool. The Hildesheim Cope (*c.* 1310–20; London, V&A), which is in silk, is decorated with overlapping circles containing grisly scenes of the martyrdom of various saints. Two early wool embroideries survive in Wienhausen Convent, near Celle; they date from *c.* 1300 and are worked in a form of couching known as convent stitch. The first, which is fragmentary, is embroidered with ogival compartments containing seated prophets, the second with the *Story of Tristan* in 23 scenes with explanatory captions. Bead embroidery was also carried out in Lower Saxony in the 13th and 14th centuries. It was worked in seed pearls, coral and coloured glass beads, with the addition of stamped gilded metal in the form of plaques, stars and rosettes (e.g. two late 13th-century antependia: *Christ in Glory*, Hannover, Kestner-Mus.; the *Coronation of the Virgin*, Halberstadt Cathedral, Treasury).

Wool embroidery in convent and stem stitch was also practised on the Upper Rhine. The Malterer Hanging (*c.* 1320–30; Freiburg im Breisgau, Augustinmus.) comes from the convent in Adelhausen. It shows the dangers of worldly love, as demonstrated by the so-called wiles of women, with pairs of male and female figures. The unicorn is shown at the end as a symbol of divine love. Wool embroideries were also worked for domestic use in the later 14th century and the 15th to increase comfort in the house.

During the 14th century and the early 15th the influence of Bohemian art extended as far as Saxony and Brandenburg and throughout south Germany (e.g. the antependium with the *Coronation of the Virgin with Saints* from the Dominikanerkirche, Pirna, *c.* 1350; Dresden, Mus. Ksthandwerk). Embroideries reflected the style of paintings, with graceful Gothic figures wearing softly draped garments. They were worked with coloured silks on grounds of gold threads often couched in whorls or diaper patterns. The influence of Bohemia was felt as far north as Danzig (now Gdańsk), where a set of cope orphreys depicting the *Life of St Mary Magdalene* (Lübeck, St Annen-Mus.) was worked for the church of Our Lady as late as the second quarter of the 15th century.

Only a few of the embroideries that survive from the 15th and 16th centuries are of outstanding quality, though special mention should be made of the relief embroideries with bead decoration that were used as trimmings for vestments and small altars. They were made in south Germany and Austria in the late 15th century and the early 16th. Many other pieces, however, intended for private and domestic purposes, are of merely utilitarian standard. At the end of the 16th century the courts and other secular and ecclesiastical patrons began to support the art of embroidery, though in many areas the Thirty Years War interrupted this patronage. Church and monastery vestments were renewed, and embroidery was also used for room decoration and elegant dress. In the late 17th century and the early 18th embroidery with silk, gold and silver thread was produced in south Germany in court and monastic workshops and by independent professional embroiderers, to whom a particular oeuvre can sometimes be attributed (see fig. 79). This work fully bears comparison with French and Italian products. Another form of embroidery known as *point de Saxe* or Dresden work emerged in Saxony in the 18th century in imitation of lace. The fine white embroidery was executed first on linen and later on cotton cambric.

High-quality silk and metal-thread embroidery continued to be produced during the 19th century, for example for the furnishings of Ludwig II's Schloss Herrenchiemsee. At the end of the century one of the earliest expressions of the *Jugendstil* was found in the embroideries of HERMANN OBRIST, Joseph Maria Olbrich and their contemporaries. In the late 20th century individual textile artists turned to embroidery as an expressive medium. Their work encompassed a wide range of forms from abstract and stylized images expressed through traditional techniques to large-scale, free-standing, mixed media pieces.

See also BEADWORK, §2(iii).

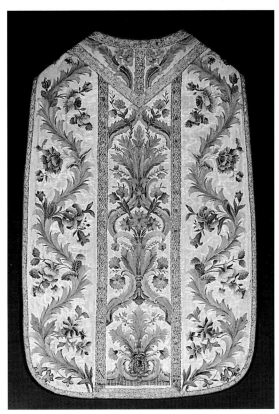

79. Chasuble embroidered with the coat of arms of Maximilian III Joseph, Elector of Bavaria, white silk moiré ground with applied silks and silk embroidery, Munich, 1745–50 (Munich, Schloss Nymphenburg)

2. SILK. The Witgarius Cingulum (Augsburg) from the third quarter of the 9th century is proof that tablet-weaving in silk was already practised in Germany during the Carolingian period; the cingulum has a red inscription on a gold ground with yellow-green edges. An example of late 10th-century work is provided by the stole from Neumagen (Trier, Bischöf. Dom- & Diözmus.) with the Lamb of God, the symbols of the Evangelists and half-length figures of the Twelve Apostles; pure silk, tablet-woven bands of a slightly later date, *c.* 1000, are preserved in Augsburg and Speyer (both Diözmus.). Tablet-weaving of the 11th to 13th centuries used gold and linen thread as well as silk. This work must have been produced in various places, but its common German origin is suggested by inscriptions (e.g. the dedication of Queen Hemma on the Witgarius Cingulum; the ?*Ailbecunde* on the Augsburg band; and the name *Odilia*, that of the weaver, on a stole of *c.* 1200; London, V&A). This assumption is supported by stylistic similarities, for example in the figures on the Neumagen stole and the biblical scenes and Christian symbols on other stoles and maniples from the 12th and 13th centuries.

By the 12th century silk, linen and metal threads were also used to weave patterned bands up to 200 mm wide on narrow looms. The patterns include stylized birds and animals, rosettes and lines of diamonds, right angles,

80. Chasuble, half-silk woven with a main warp of linen and a weft and pattern warp of silk, Cologne, 15th century (Brunswick, Herzog Anton Ulrich-Museum)

century, and as the designs of the half-silks and the wool-mix fabrics are sometimes more or less identical it can be assumed that they were produced in the same place. These fabrics have been found in vestments from north Germany and Scandinavia, and the only city in north Germany with archival records of a significant silk-weaving industry is Cologne. This, and its long history of wool and silk weaving and dyeing, makes Cologne the only possible production centre. The mixed fabrics were made of fine or coarse yarns, mostly woven in weft compound twill in varying qualities. The range of motifs shows only slight variations in design and the use of different weft colours. In the half-silks undyed or blue linen thread was used for the main warp. Linen and hemp were also used in the wool-mix fabrics. (Examples of early half-silks and wool-mix textiles can be seen in the Herzog Anton Ulrich-Museum, Brunswick, and the Treasury of Halberstadt Cathedral.)

Light silk fabrics with a tabby binding were woven from the 13th century, not only in Cologne but in other centres. The dialect of a motto in a coloured silk damask of the mid-16th century (fragments in Riggisberg, Abegg-Stift.) links this fabric and others to the Aachen, Cologne and Lower Rhine region. In the 16th century there were some silk-weavers in Augsburg as well as a large number of linen- and fustian-weavers. In the late 17th century Dutch Mennonite and French Huguenot refugees revived the German silk-weaving industry. From the mid-18th century those based in Berlin and Potsdam received particular support from Frederick the Great. Remnants of original wall-covering fabrics in the palaces at Potsdam include half-silk satins, silk damasks and other silks with complex weaves and rich patterns that also used metal threads. In the second half of the 18th century silk and half-silk napkins (*Koffeetücher*), often brightly coloured, were among the products of the damask-weavers in Silesia and Saxony, who worked mainly in linen (*see* §5 below).

Silk weaving was gradually established at Krefeld, where, during the 18th century, production was largely controlled by the von der Leyen family. From the 1830s velvet and plush, plain, striped and chequered silks and some mixed silks have been woven in Krefeld. The manufacture of patterned silk ties became a very successful branch of the industry. The Krefeld industry has supported technical and design training from 1855 when a weavers' school was founded. This was followed by a school for dyeing and weaving (1895) and the Textilforschungsanstalt (1920). These were amalgamated with the Textilingenieur-schule (1938), of which an important part was the department of textile art; its collection of historic textiles formed the basis of the town's Textilmuseum. Since World War II the industry has combined technical innovation with good design to produce modern fabrics that sell throughout the world.

3. TAPESTRY.

(i) Before 1375. (ii) 1375–1529. (iii) 1530–1800. (iv) After 1800.

(i) Before 1375. Early medieval inventories of cathedral, monastery and parish church property frequently mention *tapetia*, *dorsalia*, *bancalia* and *scamalia*, that is tapestries,

meanders and crosses. A number of bands were sometimes sewn together to make pouches, and because these were often used to hold relics, they survive in church collections (e.g. Augsburg, Diözmus.; Maastricht, Schatkamer St-Servaasbasiliek; Passau, Domschatz- & Diözmus.) and museums (e.g. Frankfurt am Main, Mus. Ksthandwk).

By *c.* 1300 Cologne had become a centre for the production of more complex patterned bands woven in a weft-faced compound twill with coloured silk patterns often on grounds of gold thread (gilt membrane around a linen core). The main warp of linen and a linen secondary weft, visible only on the reverse side, produced a solid fabric. In the 15th century the braids were further enriched with embroidery. These Cologne bands, which were widely exported, retained their popularity into the early 16th century. Among the earliest 13th-century examples are two horizontal pieces *c.* 75–80 mm wide (Berlin, Tiergar-ten, Kunstgewmus.): one bears a coat of arms and the name of an abbess, Julia, who has not yet been identified. Coats of arms and stylized plant motifs were popular at this period, but they were later joined by Christian subjects, including the *Annunciation*, the *Crucifixion* and figures of Christ, the Virgin and saints. These designs suggest that the bands were intended for both liturgical and secular purposes.

In the 14th and 15th centuries half-silk and wool-mix fabrics were produced. Their patterns (see fig. 80) were derived from Italian silks, particularly those of the 14th

backcloths for choir-stalls, benches and pews (Ger. *Rück-laken*), long seat covers (Ger. *Banklaken*) and small pieces for individual seats. But were the *tapetia* large tapestries hung on the walls or between the piers and columns of the nave? Did they differ from *dorsalia* in their greater height? Or were *tapetia* also the carpets spread on the floors? Much remains unknown because so few of the tapestries that were evidently abundant at that period have survived.

The oldest surviving German tapestry is a Cologne work from the third quarter of the 11th century. It was found in the 19th century in St Gereon, Cologne, and fragments of it can be seen in London (V&A), Lyon (Mus. Hist. Tissus) and Nuremberg (Ger. Nmus.). It has a linen warp, a feature that is associated with medieval German tapestries—including those from German-speaking Switzerland and Alsace—and clearly differentiates them from those of France, the Low Countries and Italy. Undyed linen and coloured wool, in two shades of red and three of blue-green, were used for the weft. The field, which was enclosed by a border on all sides, featured a series of medallions, each containing a griffin attacking a bull with an eagle above. This design is based on contemporary silks from Byzantium and the Middle East, hence the repeat, which is inappropriate to the tapestry-weaving technique and is not found on later tapestries.

The next tapestries to survive date from the mid-12th century and later (all Halberstadt Cathedral, Treasury); with them are associated rare examples (now in Halberstadt and Quedlinburg) of the knotted-pile weaving that took place in the region at that period (*see* §4 below). The oldest tapestry contains scenes from the *Story of Abraham and Isaac*. Its size (1.20×c. 10.65 m) suggests that it was originally intended for the south wall of the Ottonian west transept. The accompanying Latin inscriptions point to the fulfilment of the Old Testament in the New, the coming of Christ and his redemption of sinful mankind. The final image (see fig. 81), of the Archangel Michael personifying divine omnipotence, concludes the iconography; the figures are monumental and expressive, and the bold outlines of the forms and figures, against a dark blue ground, emphasize the shapes of the coloured areas. A companion piece, which is now lost but is known from 18th-century oil copies (Halberstadt Cathedral, Treasury), may have culminated in a representation of the Archangel Gabriel. The second surviving piece (*c.* 1170–75) is known as the *Apostles* tapestry. Christ in Glory is enthroned in a central mandorla supported by the archangels Michael and Gabriel and flanked by the Apostles. There is greater complexity in the pictorial detail and in the weaving. This tapestry was probably intended for the screen that closed off the eastern end of the Ottonian Cathedral. In 1179 the cathedral was destroyed by fire, and when it was rebuilt in the 13th century the screen was replaced by a triumphal cross with the Apostles. Thus the *Apostles* tapestry quickly lost its intended function and, like the *Abraham and Isaac*, it was later hung in the choir-stalls. The *Charlemagne* tapestry (*c.* 1230–40) is rather different. With a vertical format of originally *c.* 2.4×1.87 m, it is one of the few medieval tapestries woven with a vertical warp. Only three-quarters of the tapestry has survived. The tall,

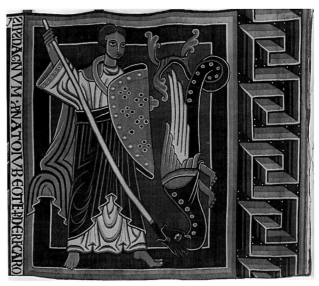

81. Archangel Michael, detail from the tapestry of the *Story of Abraham and Isaac*, 1.20×c. 10.65 m, *c.* 1150 (Halberstadt Cathedral, Treasury)

diamond-shaped central field encloses the enthroned figure of the Emperor Charlemagne, who was venerated in Halberstadt not only as a saint but also as the founder of the bishopric. At his feet sit Cato and Seneca. The Latin inscription surrounding the Emperor points to the transience of authority and power, beauty and youth, while the words of the two wise men recommend the benefits of charity. The top corners, now missing, may have contained Cicero and Boetius representing truthful speech and the virtue of silence. The *Charlemagne* is more colourful than the two earlier tapestries; another development is the delight in embellishment and the greater substance of the figures. Like the knotted works that survive at Halberstadt and Quedlinburg, it exemplifies the medieval belief that the wisdom of antiquity was anchored in the Christian faith.

Virtually no tapestries survive from the period between the mid-13th century and *c.* 1375, apart from the Upper-Rhenish *Rücklaken* from the Dominican convent of Adelhausen (*c.* 1330; Freiburg im Breisgau, Augustinmus.). It bears two rows of quatrefoils containing dragons and pairs of parrots.

(ii) 1375–1529. The two outstanding German tapestries from the late 14th century come from Alsace on the Upper Rhine and from Nuremberg. The profane subject-matter of the large Alsatian tapestry, *Courtly Games* (*c.* 1385; Nuremberg, Ger. Nmus.), clearly enjoyed equal status with Christian themes in the Upper Rhine region. By contrast, the Nuremberg tapestry, *Twelve Wise Men* (*c.* 1380; Nuremberg, Ger. Nmus.), is an example of the preponderance of Christian subjects in that locality. The figures, arranged in six pairs, are engaged in debate, commencing with the praise of God; they are surrounded by banners with mottoes in Nuremberg dialect. The tapestry shows western influences, both artistic and technical, assimilated into the local style.

Tapestry production, probably shortlived, took place in Regensburg about 1400. One example (*c.* 1400; Regensburg, Mus. Stadt) shows the *Battle of the Virtues and the Vices*, a popular theme in the Middle Ages. Another, somewhat later tapestry (*c.* 1410–20; Regensburg, Mus. Stadt), which survives only in fragments, depicts *Frau Minne* (the Queen of Love). She sits enthroned, surrounded by pairs of lovers placed in several rows, each pair in one of the six colours of love.

In Nuremberg in the early 15th century smaller tapestries were produced, mainly antependia (e.g. the *Adoration of the Magi, c.* 1420–30, Berlin, Tiergarten, Kstgewmus.; *Seven Tormented Female Martyrs, c.* 1430, Cologne, Kstgewmus.; scenes from the *Legend of the Holy Cross, c.* 1430–40, Nuremberg, Ger. Nmus.; see fig. 82). One series (*c.* 1420–30; Nuremberg, Ger. Nmus.) depicts the *Miracles of St Sebaldus*, a local saint of Nuremberg. The large antependium from the high altar of the Dominikanerkirche in Nuremberg (*c.* 1460; Nuremberg, Ger. Nmus.), which shows the *Virgin and Child with Saints*, was probably made in the workshop of the Dominican nuns. This workshop was recorded in contemporary documents and is distinguished by its woodcut-like treatment of form. Secular themes were also produced (e.g. the *Garden of Love, c.* 1460; Nuremberg, Ger. Nmus.). Of all these tapestries, only the *St Sebaldus* reaches the height of 1 m, but the tapestry palls of the period range in height from 2.42 m to as much as 2.9 m. In keeping with their function they show the *Last Judgement* or the *Crucifixion*. The Würzburg pall (*Crucifixion, c.* 1460–65; U. Würzburg, Wagner-Mus.) was influenced by contemporary Netherlandish painting and tapestry-weaving. In the impressive characterization of each of the many figures around the cross, their spatial grouping and the linking of the scene with the landscape that leads into the space beyond (which replaces the previous dark-blue ground), a new sense of realism imbues the whole work, ably supported by the weaving technique.

Three tapestries from the third quarter of the century (scenes from the *Life of the Virgin* and the *Story of Joseph*, both Harburg, Schloss; the *Prodigal Son*, Nuremberg, Ger. Nmus.) show how the Nuremberg style absorbed the new realism in its own way, without being subordinated to it. Two other tapestries, the *Adoration of the Magi with SS Erasmus and Ursula* (*c.* 1470–75) and the *Death of the Virgin* (*c.* 1480; both Glasgow, Burrell Col.), go further in their fine vertical hatching and soft colour accents in delicate shot silk. By this time, however, Nuremberg patrons had come to prefer Netherlandish tapestries, so local production declined and was extinct by 1500, though it was carried on for a short time by Dominican nuns in Bamberg and Benedictine nuns at Eichstätt.

On the Upper Rhine, with workshops in the main towns of Basle, Strasbourg and Freiburg, the situation was quite different (*see also* SWITZERLAND, §XI, 1, and FRANCE, §XI, 1(ii)). Here, profane subjects were preferred: local legends and stories and the ever-present world of wildmen and fabulous beasts provided allegories for the activities and amusements, joys and sorrows of human beings. This subject-matter may possibly have muted the western influences, with the result that the new tendencies only gradually penetrated the imagery of tapestry-weaving on the Upper Rhine. With different nuances at different centres, the tapestries of this region are characterized by a delight in narrative and descriptive detail and by a decorative treatment that can sometimes permeate the entire composition. The dark blue or red backgrounds are overlaid with vine-scroll decoration or with branches, leaves and blossoms, whereas in Nuremberg the grounds were a plain dark blue to form a uniform foil for the picture and its figures.

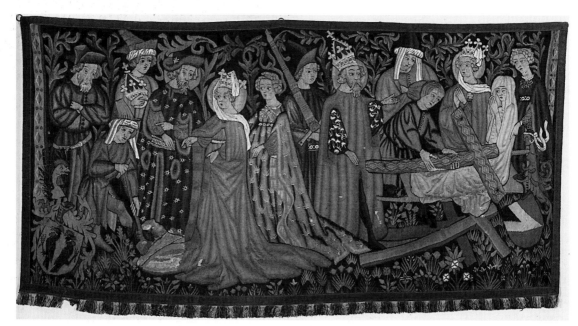

82. Tapestry of scenes from the *Legend of the Holy Cross*, 850×1800 mm, Nuremberg, *c.* 1430–40 (Nuremberg, Germanisches Nationalmuseum)

The style of the Upper Rhine merged into that of the Middle Rhine, particularly in Mainz. Stylistically this transition must have been fluid: the Middle Rhine favoured the same profane subject-matter as the Upper Rhine, but the figures differed in their delicacy and litheness, and the presentation in its movement and subtle gradations of colour (e.g. the *Story of William of Orleans, c.* 1415; Frankfurt am Main, Mus. Ksthandwk). The large tapestry in Marburg with the *Story of the Prodigal Son* (*c.* 1430; Marburg, Umus. Kultgesch.) is more closely related to mid-German art in its coarse texture and vigorous narrative style. The harsher idiom of the *Life of the Virgin* (Gelnhausen, Marienkirche) from the end of the 15th century derives from the art of the Middle-Rhenish Housebook Master, who had been trained in the Netherlands.

Curiously, only one fragment, the *Tree of Jesse* (ex-London, priv. col.; art market, 1992), has survived from Cologne and the Lower Rhine from the first seven decades of the 15th century, but there are a few finely executed tapestries in wool, silk and metal threads from the last three decades of the century that are clearly related to Cologne painting. No large 14th- or 15th-century tapestries have survived from north Germany. The two parts in the Treasury of Halberstadt Cathedral, which together are almost 14 m long, were not produced until *c.* 1500. They show scenes from the *Life of the Virgin* on a red vine-scroll ground.

(iii) 1530–1800. On the Middle and Upper Rhine the late medieval tradition continued into the 16th century, though the biblical and other images took on secular features and developed into genre-like narratives. The fragmentary pew cover from the Middle Rhine, for example, with the *Story of the Queen of France and the Disloyal Marshal* (1554; Hamburg, Mus. Kst & Gew.) shows more spatial depth, and the costume has been adapted to current fashions, but the 15th-century idiom and delight in simple narrative are still discernible. In Nuremberg, however, this tradition had been broken about the turn of the century, and as a result the Netherlandish weavers who had come to Germany (usually on account of their Protestant faith) were able to establish themselves at a number of places. Frankenthal in the Palatinate gave refuge to both Flemish and Walloon refugees, whose work included the *Metamorphoses of Ovid* (1603; Munich, Bayer. Nmus.).

In Lower Saxony tapestry-weaving took place in Lüneburg and Hamburg. The scenes from antiquity on the long *Rücklaken* depicting the *Story of Massinissa and Sophonisbe* (*c.* 1530; Lüneburg, Mus. Fürstentum) were seen in the Rathaus as examples of civic virtues: courage, discipline, lawfulness, patriotism, conjugal fidelity, kindness and reliability. Another Lüneberg work is the *Tobias* series (*c.* 1560; Hannover, Kestner-Mus.), while the upright-format *Healing of the Blind Man* (*c.* 1535; Hannover, Kestner-Mus.), although for a Lüneburg family, is likely to have been executed in Hamburg. Among the Netherlandish weavers who worked in Hamburg from the second half of the 16th century, Joost van Hersele I and his son Joost van Hersele II (*fl* 1589–1621) are remarkable. The latter produced two series (*Roman History, c.* 1600; Bückeburg, Schloss; the *Story of Alexander the Great, c.* 1610;

Vienna, Ksthist. Mus.) in the style of Brussels and Antwerp.

The Brussels style also provided a starting point for tapestry-weaving in Wismar when Johann van Ophorn, under the patronage of the Dukes of Mecklenburg, arrived *c.* 1550. The *Queen of Sheba before Solomon* and *Esther and Ahasuerus* were popular subjects, and subsidiary scenes were often added around the main image. Another Brussels weaver, Boldewin, produced several tapestries with the *Sacrifice of Abraham* (e.g. 1600; Hildesheim, Pelizaeus-Mus.). He worked in Wolfenbüttel, Lower Saxony, from 1590. In Lüneburg, Hamburg and Wolfenbüttel, as well as in other places in north Germany, many cushion-covers were woven. Inspired by Netherlandish art, they featured angels, vases of flowers, verdures, scenes such as *Pyramus and Thisbe* and Old Testament subjects set in panoramic views. In the course of the 17th century these cushion-covers assumed a stiff, rustic style, which continued into the 18th century. A Netherlandish weaver, Seger Bombeck, worked in Leipzig and Torgau from 1545 to 1552, and later in Dresden, in the service of the Elector of Saxony, until 1559. Although the borders suggest a Flemish schooling, his tapestries reflect the spirit of the Cranach school influential in Saxony at that time (e.g. the full-length portrait of *Elector Augustus, c.* 1550; New York, Met.; large verdure with the Wittenberg coat of arms, *c.* 1550, Nuremberg, Ger. Nmus.).

The founding of the first tapestry manufactory in Munich at the beginning of the 17th century was closely linked to the building activities of the Duke, later Elector Maximilian I of Bavaria. Since it was cheaper for him to produce the wall hangings for his Residenz on the spot than to import them, he summoned Hans van der Biest from Enghien to set up a workshop. Although the enterprise existed only from 1604 to 1615, and continual disagreements with the weavers (from Brussels) proved disruptive, it nevertheless produced extraordinarily good work, mainly through the efforts of Peter Candid (*see* CANDID, PETER, §2), who was responsible for the cartoons (e.g. the *Acts of Duke Otto of Bavaria, Months, Seasons, Night* and *Day, Grotesques*; Munich, Residenz).

A century later, in 1718, a new manufactory was set up in Munich under Maximilian II Emanuel, this time with Parisian weavers. Their principal work was a series depicting the *Acts of the Dukes of Bavaria* (1726–53; Munich, Residenz), but they also produced upholstery, firescreens and portraits, and completed or altered series that had been woven in Brussels and Beauvais. In 1765 another Parisian, Jacques Sentigny, took over the manufactory, to be joined in 1769 by Joseph Chedeville; they worked on a series designed by THOMAS CHRISTIAN WINCK (the *Four Seasons,* 1765–75; Munich, Bayer. Nmus.). The royal manufactory was closed in 1799, though Sentigny and Chedeville continued to operate independently.

In Würzburg, too, the manufactory (1721–*c.* 1775) was founded in conjunction with the building activity of the prince-bishops from the House of Schönborn. Andreas Pirot (*fl* 1728; *d* 1763), who probably came from a Frankenthal tapestry-weaving family, produced the two series of *Chinese Scenes* and *Burlesques* (examples in Würzburg, Residenz) after designs by the Bamberg court painter Johann Joseph Scheubel the elder, partly inspired by

Beauvais tapestries. In Schwabach and Erlangen, however, the weavers were Huguenot refugees, who had been taken in by the Protestant margraves of Ansbach and Bayreuth after the revocation of the Edict of Nantes in 1685. In Schwabach, Michel de Claravaux (*d* 1688) began working in 1685. Later, Jean Peux was the master weaver. His *Grotesques* (*c.* 1730; Coburg, Veste Coburg) are adaptations in the German style of Jean Berain I's engravings by the second generation weavers, born in Germany. In Erlangen, Jean Dechazaux I (*d* 1728) and Jean Dechazaux II (*d* 1779) worked in a similar style (e.g. tapestries with the *Elements* and *Greek Gods*, completed 1721; Bayreuth Neues Schloss; *Grotesques*, *c.* 1730; Regensburg, priv. col.).

The refugees who went to Berlin in 1685 included the tapestry-weaver Pierre Mercier (*d* 1729) from Aubusson. In the following years he produced an extensive series of tapestries from sketches by various Berlin painters, featuring the exploits of Frederick William of Brandenburg, the Great Elector. In 1714, after the succession to the throne of Frederick William I of Prussia, Mercier went to Dresden. His place in Berlin was taken by his nephew, Jean Barraband II (1687–1725), who had been working previously for private clients (e.g. a series of *Chinese Grotesques*, 1708; Chevening, Kent). In 1720 Barraband was joined by Charles Vigne (*d* 1751), and themes with *commedia dell'arte* figures, chinoiseries, the fables of La Fontaine, hunting and genre scenes were taken as models. In Dresden, Pierre Mercier worked from designs by L. Sylvester on a series (untraced) depicting the travels in France of Prince Friedrich Augustus (1716–19).

(iv) After 1800. In 1818 Joseph Chedeville, in Munich, completed *Achilles with the Daughters of Lycomedes* after a design by Winck dating from 1791. There was then no further interest in tapestry production in Germany until the end of the 19th century. In 1896 the Schule für Kunstweberei in Scherrebek (Schleswig-Holstein) was founded at the instigation of Justus Brinckmann (1843–1915), Director of the Museum für Kunst und Gewerbe, Hamburg. As in Norway, where during the 1880s tapestry-weaving had been revived with folk models of the 17th and 18th centuries, high looms were used. Although the Scherrebek workshop had to close for financial reasons as early as 1903, it produced tapestries of small and medium format to designs by outstanding artists of the German *Jugendstil*, including Otto Eckmann, Alfred Mohrbutter (1867–1916) and Hans Christiansen.

Soon, private tapestry workshops were set up in Lübeck, Kiel, Berlin and elsewhere. Between about 1920 and 1940 a generation of younger weavers emerged from the workshops of such artists as Alen Müller-Helwig (*b* 1901) and Hildegard Osten (*b* 1909) in Lübeck, and, in addition, a number of art colleges and craft schools now included tapestry-weaving in their textile courses. In the textile course run by Gunta Stölzl at the Bauhaus between 1925 and 1931, Gobelins (with the warp hidden by the weft) and half-Gobelins (tabby-bound, with the warp not hidden by the weft) were designed and executed. The Gobelin-manufaktur in Munich, which had been founded in 1908, made a name for itself in the 1930s and 1940s with large, decorative tapestries for ocean liners. In 1941 a manufactory was founded in Nuremberg, at the suggestion of Irma

Goecke (1895–1976), with the aim of creating and promoting a modern German style in emulation of that of France. German and foreign artists were engaged as designers. Woty Werner (1903–71) wove her own designs so she could work out the details while she sat at the loom. Since the 1970s German textile artists have followed the international tendency of rejecting traditional tapestry-weaving in favour of three-dimensional creations and 'textile objects' (*see* FIBRE ART).

4. CARPETS. It is impossible to know whether the *tapetia* (*see* §3(i) above) mentioned in the medieval church inventories were woven or knotted, whether they lay on the floor or were hung. However, the two knotted fragments in Halberstadt Cathedral Treasury, one of which depicts Virtues and wise men of antiquity, are evidence that carpets were knotted in Lower Saxony by the middle of the 12th century. The famous carpet in nearby Quedlinburg (Quedlinburg, Convent Church, Treasury) was donated *c.* 1200 by Agnes of Meissen (*d* 1203–5), abbess of the Quedlinburg convent. It is said to have been made by the nuns to serve as a carpet before the high altar. Now in fragments, it originally measured 7.4×5.85 m. Within a broad border there were five rows of scenes, one above the other, depicting the wedding of Mercury after a text by Martianus Capella, a poet of the 5th century AD who was popular in the Middle Ages. Like the Halberstadt carpets, it has a hemp warp and weft and knots tied around a single warp.

In the 15th and 16th centuries in the Upper and Middle Rhine regions knotted pile was sometimes used to highlight details in woven tapestries, but three large fragments (New York, Met.; London, V&A; Nuremberg, Ger. Nmus.), probably south-west German work of *c.* 1500, 1530 and 1540, are exclusively knotted. They show respectively the *Annunciation, Pyramus and Thisbe at the Well* and a symmetrical foliage pattern surrounded by floral borders. A knotted carpet (Berne, Hist. Mus.) with coats of arms, the names Simon Wurstemberger and Philipp Marchat and the date 1555 confirms that this technique was used in the Upper Rhine region, probably in imitation of Turkish carpets, which were then greatly prized.

Two Savonnerie manufactories of the 18th century should be mentioned. The Kurkölnisch factory (Bonn, *c.* 1715–94) produced upholstery and large hangings with chinoiserie motifs within Rococo borders, as well as small pieces with portraits, flowers and still-lifes. The Kurpfälzisch factory (Mannheim, 1756–62; Heidelberg, 1762–98) produced knotted wall hangings.

In the early years of the 20th century hand-knotted and machine-woven carpets were designed by Peter Behrens, August Endell, Richard Riemerschmid and others, and after 1920 such artists as GUNTA STÖLZL designed hand-knotted and hand- and machine-woven carpets for the Bauhaus. A typical Stölzl design of 1928 (London, V&A) is composed of geometric blocks of strong colour—squares, diamonds, triangles and oblongs. Also in the 1920s Bruno Paul, the influential head of the Vereinigte Staatschulen für Freie und Angewandte Kunst in Berlin, designed Art Deco rugs with Ernest Boehm (1890–1963). They have geometric and floral patterns in muted shades, but with interesting juxtapositions of light and dark. Since

the end of World War II the commercial production of machine-woven carpets has been dominant, and the periodic involvement of architects and painters in designing for the mass market has resulted in such ventures as the 'Diologue' range of the early 1990, issued by Vorwerk of Hameln (nr Hannover).

5. OTHER. Wool- and linen-weaving were widely practised, and woollen cloth was among the most important exports from Cologne as early as the 12th century.

(i) Linen damask. Linen damask was woven from the 16th century, probably first in Augsburg, which had a flourishing linen and fustian industry dating back to the late Middle Ages. Dates from the whole of the 17th century are found on white linen damask from Schleswig-Holstein, while some white and blue linen damasks from Danzig (now Gdańsk) are dated 1609 (Nuremberg, Ger. Nmus.; Krefeld, Dt. Textilmus.) and 1677 (Warsaw, N. Mus.). The rise of damask-weaving in Saxony began in the third quarter of the 17th century in Gross-Schönau (*see* LINEN DIAPER AND DAMASK). Its output grew rapidly, and in the 18th century production spread into Silesia. The damask, which was exported to many countries, was quite different from the products of Flanders and the Netherlands; its designs included the seasons, the continents, the virtues, such Classical scenes as *Orpheus and the Beasts*, biblical and genre scenes, hunts, flowers, town views, coats of arms and contemporary events (e.g. the treaties of Hubertusburg, 1763, and Teschen, 1779).

(ii) Printing. Contrary to earlier belief, it is now clear that European textile printing was practised only from the late 14th century. It emerged at the same time as woodcut printing on paper (*see* WOODCUT, §II, 2). The patterns, which were printed on linen, were based on those of Italian woven silks, but for some items—chasubles and antependia for example—the figures of saints and scenes from the *Crucifixion* and *Annunciation* were used. Sometimes the same patterns were used on paper, parchment and leather. Printed textiles played a subordinate role during the 16th and 17th centuries, but in 1689, soon after the start of mordant-dyeing in the Netherlands and England, Jeremias Neuhofer of Augsburg learnt its secret. Augsburg remained a leading centre during the 18th century; a very important business was that founded by Johann Heinrich Schüle (1720–1811). His high-quality prints were mostly mordant-dyed with hand-painted (pencilled) details in red, brown, silver and gold. In the north the first enterprises had been set up in Bremen and Hamburg, the latter since *c*. 1690. Printing also flourished in Berlin, Plauen and Chemnitz, where some of the most successful cotton-weavers branched out into cotton printing in 1754 and 1770. During the second quarter of the 19th century cotton printing was developed at Elberfeld and Krefeld as an offshoot of the dyeing industry. At first the designs were closely based on those of France, but gradually they became more distinctively German. From the 1880s grounds of mixed silk and cotton were used. Krefeld became a major centre for the manufacture of rollers for the industry from 1900. Since World War II German printed furnishing textiles with both traditional and avant-garde designs have served an international market.

(iii) Knitting. The early establishment of knitting is indicated by the Buxtehude *Virgin and Child* (*c*. 1400; Hamburg, Ksthalle) by Master Bertram of Minden, in which the Virgin is shown using four needles to knit a seamless jacket for the Christ Child. Guild regulations from 1563 and later survive for several towns, and among the masterpieces required by guild statutes were the spectacular large wall hangings or table covers of the late 17th century and the 18th (examples in London, V&A; Nuremberg, Ger. Nmus.). The hand-knitters' staple output, however, consisted of stockings, caps, gloves, woollen shirts and trousers.

(iv) Lacis and lace. Hand-made decorated net (lacis) was made in Germany from an early period: the earliest dated examples are the hair-nets and coifs from the coffins of female saints acquired in 1271 for the abbey of Sint-Truiden (*in situ*) in Belgium. Other surviving coifs and bags worked in coloured silk are decorated with geometric, heraldic, animal and bird motifs in silk and metal threads (London, V&A; Nuremberg, Ger. Nmus.). The continuing popularity of the technique is shown by the predominance of lacis designs in the pattern-books published in Germany from *c*. 1523 onwards. Many of the large-scale furnishings of the 16th and 17th centuries (e.g. London, V&A) were made with plain linen thread or coloured silk and have patterns that relate to those of contemporary embroideries and woven textiles. Although less fashionable in the 18th and 19th centuries, lacis continued to be made for household furnishings, for example in the Vierlande in north Germany, where elements of 17th- and 18th-century designs were kept alive to the end of the 19th century.

Lace-making was introduced during the first half of the 16th century, and bobbin lace-making became widely established on a domestic and small-scale commercial basis. The only area in which lace was made commercially over a long period was in the Erzgebirge of Saxony. The lace was influenced both by the developments in the high fashion laces of the Netherlands and by the more solid, often tape-based, laces of northern Italy. The lace was used to trim furnishings, vestments, underwear and dress. During the second half of the 19th century the growing international interest in lace, coupled with the need to relieve rural unemployment, resulted in a government-sponsored revival of the Erzgebirge industry. The lace, made in white, black and coloured threads in a wide range of styles and techniques, was shown successfully at the Weltausstellung of 1873 in Vienna. The impact of the important Zentralspitzenkurs in Vienna was also felt. Johann Hrdlicka, who taught there and at the Vienna Kunstgewerbeschule, produced Art Nouveau designs from 1899 to 1907 for both needle and bobbin lace, which were widely executed, for example *c*. 1900 by W. Horner of Gossengrün. Lace schools modelled on the Kunstgewerbeschule were opened to teach both traditional techniques and new styles of design; some, such as the Schlesische Spitzenschule Hoppe-Siegert of Hirschberg, survived into the 1930s. Interest in the technique as an art form at the end of the 20th century has its roots in the

inter-war period, in the work of such artists as Leni Matthaei (1873–1981). Her controlled, perfectly executed geometric laces (e.g. Hamburg, Mus. Kst. & Gew.) are much sought after.

(v) The Bauhaus. Using the looms from Henry Van de Velde's Kunstgewerbeschule, the weaving workshop was one of the first sections of the BAUHAUS to begin production. Ida Kerkovius (1879–1970) learnt to weave, and transferred to the loom Johannes Itten's theories about colour and design. In 1921 GEORG MUCHE took over as artistic director of the workshop, and as a result of his promotion, textiles made a major impact at the first Bauhaus exhibition (Weimar, 1923). At first, one-off tapestries, carpets and woven lengths were produced by individual artists, but when GUNTA STÖLZL replaced Muche in 1927 greater emphasis was placed on commercial production. There was already a strong link with the furniture workshop, with structural but decorative straps and upholstery yardage being produced for use on chairs. Now designs were sold to manufacturers and produced under licence by Polytextil Gesellschaft of Berlin and others. When Stölzl moved to Switzerland in 1931, she was briefly replaced by the weaver Anni Albers (*see* ALBERS, (2)). In 1932 Mies van der Rohe invited Lilly Reich (1885–1947) to take over, but with the increasing emphasis on architecture, the weaving workshop became less important within the Bauhaus. Outside, however, its ideas, particularly those relating to colour, had been absorbed by some commercial producers and, through them, entered into people's homes.

BIBLIOGRAPHY

GENERAL

I. Radewaldt: *Bauhaustextilien* (Hamburg, 1986)

300 Jahre Hugenottenstadt Erlangen (exh. cat. by C. Friederich, Erlangen, Stadtmus., 1986) [incl. frame-knitting, tapestries and glove-making]

L. von Wilckens: *Die textilen Künste von der Spätantike bis um 1500* (Munich 1991)

EMBROIDERY

A. Lotz: *Bibliographie der Modelbücher* (Leipzig, 1933)

L. von Wilckens: 'Zwölf gestickte Wandbehänge aus Dresden', *Pantheon*, xx (1962), pp. 69–76

G. von Bock: *Perlstickerei in Deutschland bis zur Mitte des 16. Jahrhunderts* (Bonn, 1966)

L. von Wilckens: 'Ein Jahrhundert Lübecker Gold- und Seidenstickerei seit um 1365', *Anz. Ger. Nmus.* (1970), pp. 7–26

——: 'Zwei hessische Leinenstickereien der zweiten Hälfte des 13. Jahrhunderts', *Festschrift für Peter Wilhelm Meister* (Hamburg, 1974), pp. 121–6

——: 'Unbekannte Buchmalerei und Leinenstickerei des 14. Jahrhunderts im Umkreis von Lübeck', *Niederdt. Beitr. Kstgesch.*, xv (1976), pp. 71–98

——: 'Das goldgestickte Antependium aus Kloster Rupertsberg', *Pantheon*, xxxv (1977), pp. 3–10

——: 'A Middle Rhenish Embroidery of about 1430', *Cieta Bull.*, xlv–xlvi (1977), pp. 13–15

D. Heinz: 'Germany', *Needlework: An Illustrated History*, ed. H. Bridgeman and E. Drury (London and New York, 1978), pp. 185–217

N. Gockerell: *Stickmustertücher*, xvi of *Kataloge des Bayerischen Nationalmuseums München* (Munich, 1980)

L. Seelig: *Kirchliche Schätze aus bayerischen Schlössern: Liturgische Gewänder und Geräte des 16. bis 19. Jahrhunderts* (Munich, 1984)

——: 'Münchner Stickereien des 18. Jahrhunderts: Beispiele einer wenig beachteten Gattung des Kunsthandwerks', *Kst & Ant.*, iii (1988), pp. 72–80

SILK AND OTHER WOVEN FABRICS

E. Sauermann: *Schleswigsche Beiderwand* (Frankfurt am Main, 1909)

E. Scheyer: *Die Kölner Bortenweberei des Mittelalters* (Augsburg, 1932)

H. Kisch: 'Prussian Mercantilism and the Rise of the Krefeld Silk Industry: Variations upon an Eighteenth-century Theme, *Trans. Amer. Philos. Soc.*, n.s. lviii/7 (1968) [whole issue]

K. Paepke: *Seiden in Sanssouci: Textile Raumausstattungen des 18. und 19. Jahrhunderts*, Sanssouci-Bildhefte 2 (Potsdam, 1982)

L. von Wilckens: 'Kölner Textilien', *Ornamenta Ecclesiae* (exh. cat., ed. A. Legner; Cologne, Schnütgen-Mus., 1985), ii, pp. 440–45

——: 'Gemusterte Gewebe des Mittelalters aus Köln', *Anz. Ger. Nmus.* (1986), pp. 27–33

——: 'Die Stola aus Neumagen in Trier', *Z. Kstgesch.*, li (1988), pp. 301–12

TAPESTRY

B. Kurth: *Die deutschen Bildteppiche des Mittelalters*, 3 vols (Vienna, 1926)

H. Göbel: *Die germanischen und slawischen Länder*, 2 vols (1933–4), III of *Wandteppiche* (Leipzig, 1923–34)

H. Huth: 'Zur Geschichte der Berliner Wirkteppiche', *Jb. Preuss. Kstsamml.*, lvi (1935), pp. 80–99

L. L. Baron Döry: 'Schwabacher und Berliner Groteskentteppiche', *Z. Kstwiss.*, xi (1957), pp. 91–108

——: 'Würzburger Wirkereien und ihre Vorbilder', *Mainfränk. Jb. Gesch. & Kst*, xii (1960), pp. 189–216

L. von Wilckens: 'Der Michaels- und der Aposteltteppich in Halberstadt', *Kunst des Mittelalters in Sachsen: Festschrift Wolf Schubert* (Weimar, 1967), pp. 279–91

G. Himmelheber: '"Fait à Munich": A Short-lived Tapestry Workshop', *Apollo*, lxxxx (1969), pp. 385–9

H. Rossmeissel: 'Die Gobelinwirkerei in Schwabach', *600 Jahre Stadt Schwabach, 1371–1971* (Schwabach, 1971), pp. 323–32

Kunsthandwerk in Schleswig-Holstein (exh. cat. by E. Schlee, Schleswig, 1974), pp. 6–14

Textile Objekte (exh. cat. by B. Mundt, Berlin, Staatl. Museen Preuss. Kultbes., 1975)

L. von Wilckens: 'Nürnberger Bildteppiche um 1460–65', *Anz. Ger. Nmus.* (1976), pp. 31–8

A. Völker: 'Die Tapisserieankäufe des Kurfürsten Max Emanuel und die Anfänge der Münchner Wandteppichmanufaktur', *Zur Geschichte und Kunstgeschichte der Max-Emanuel-Zeit*, i of *Kurfürst Max Emanuel: Bayern und Europa um 1700*, ed. H. Glaser (Munich, 1976), pp. 265–73

B. Volk-Knüttel: *Wandteppiche für den Münchner Hof nach Entwürfen von Peter Candid*, Forschhft, ii (Berlin and Munich, 1976)

L. von Wilckens: 'Über ein gewirktes Kölner Antependium in Manchester', *Kst & Ant.*, iv (1978), pp. 34–9

——: *Bildteppiche*, Regensburg, Stadtmus. cat. (Regensburg, 1980)

——: 'The "Wise Men" Tapestry in Berlin', *Cieta Bull.*, lix–lx (1984), pp. 61–6

C. Cantzler: *Bildteppiche der Spätgotik am Mittelrhein, 1400–1550* (Tübingen, 1990)

CARPETS

K. Hahm: *Ostpreussische Bauernteppiche* (Berlin, 1932)

E. B. D. S. Dreczko: *Die Kurkölnische und Kurpfälzische Savonneriemanufaktur, 1715–1798: Mit einem einleitenden Überblick über handgeknüpfte Teppiche in Europa* (Bonn, 1978)

L. von Wilckens: 'Ein deutscher Knüpfteppich gegen 1540 und andere Textilien des 16. Jahrhunderts mit verwandter Funktion', *Anz. Ger. Nmus.* (1982), pp. 31–40

——: 'The Quedlinburg Carpet', *Hali*, lxv (1992), pp. 97–105, 128

OTHER

M. Schuette: *Alte Spitzen* (Brunswick, 1963), pp. 207–15

I. Turnau and K. G. Ponting: 'Knitted Masterpieces', *Textile Hist.*, vii (1976), pp. 7–59

I. Turnau: *Historia dziewiarstwa europejskiego do początka XIX wieku* [The history of knitting to the beginning of the 19th century] (Warsaw, Kraków and Gdańsk, 1979)

L. von Wilckens: 'Der spätmittelalterliche Zeugdruck nördlich der Alpen', *Anz. Ger. Nmus.* (1983), pp. 7–18

XII. Patronage.

1. BEFORE *c.* 1500. Members of the upper aristocracy and holders of high church office were the main patrons until the 12th century. The patronage of palaces, monasteries, cathedrals and such arts as book illumination and ivory began to become established during the reign of the

King and Holy Roman Emperor Charlemagne (*reg* AD 768–814), through those associated with his court chapel, and other bishops and abbots (*see* CAROLINGIAN ART). It can be seen at work in such foundations as the palace in AACHEN with its palace chapel, the architecturally important buildings for imperial abbeys at Corvey, Fulda, Hersfeld or Lorsch, and the basilicas of EINHARD in Seligenstadt and Steinbach. The adoption of antiquity introduced by Charlemagne in the spirit of a *renovatio imperii* (*see* §§II, III and IV above) had a major impact on the formation of style. The Ottonian and Salian dynasties that followed took over the model of Carolingian patronage to implement their imperial ideas, strengthening it through the Ottonian–Salian system of imperial bishops: for example Archbishop Willigis built a new cathedral in MAINZ; Archbishop Poppo built a new cathedral in Trier. The figure of a court architectural supervisor first emerged in the 11th century when Bishop Benno II of Osnabrück (*see* BENNO) acted on behalf of Henry IV, Holy Roman Emperor. Rulers, landowners and town dignitaries began to regard constructions for public purposes (e.g. bridges, town fortifications) as part of their normal responsibilities. A good example of a patron's influence on the development and planning of a town is the work of Bishop Meinwerk (1009–36) of PADERBORN, responsible for the cruciform layout of monasteries. Around 1000 BERN-WARD, Bishop of Hildesheim, emerged as a patron whose universal mastery of the liberal arts and of mechanical skills was reflected in the foundations he set up in Hildesheim. The fully developed role of Court and Church as donors and founders encouraged all fields of small-scale art (*see* §III above).

From the 12th to the 13th centuries there was a considerable expansion both in the social classes of patron and in the types of commissions. The growing role of the provincial rulers is reflected in the foundation of towns and the endowing of private monasteries, often linked with such new orders as the Premonstratensians or Cistercians (e.g. Maria Laach endowed by Pfalzgraf Heinrich II, or the Cistercian monastery at Altenberg endowed by Count von Berg in 1133). The upsurge in popularity of retrospective figural tomb monuments, for example the donors' statues in the west choir at Naumburg (*see* NAUMBURG, §1(ii)), promoted appeals to the tradition whereby local rulers acted as patrons. Another change was the increasing number of commissions from the nobility. Above all, there were the first notable commissions from rich townspeople: according to a document of 1144 Hermann, a burgher of Cologne, was the founder of St Mauritius; there were also initiatives from the priests of smaller churches (e.g. renovation of St Peter in Buben-heim, Palatinate, by Godefried, 1163).

From the 13th century the 'extension of the contributory structure' (Warnke) became a noticeable feature in large buildings and their furnishing. Churchmen and nobles were joined by civic fraternities and guilds, patrician families and private individuals as donors of, for example, windows in churches. Up to the 16th century town halls, guild houses and hospitals were built as monuments of civic pride. The councils whose members generally came from the patrician class also strove to take over the patronage of important town churches or to install burghers as procurators to direct the ambitious building measures and foundations. Some foundations and the changes of style within the Late Gothic period provide proof of great aesthetic awareness on the part of the patrons. Competition and cooperation between the various social groups and individual personalities continued to be important. Those who endowed the great wave of Late Gothic 'florid' carved altars, for example, came from both the patrician and the merchant class, and were sometimes even well-to-do tradesmen.

2. *c.* 1500–*c.* 1800. By the early 16th century there had been an extraordinary increase in the number of endowments in general. Holy Roman Emperor Charles IV was a great patron (*see* LUXEMBOURG, House of, (3)). Architectural commissions and endowments also came from the WITTELSBACH and WETTIN families. Artists did, however, produce uncommissioned works to ensure they had their own stock. The diversity can be seen in the early 16th century both in the large commissions awarded by Holy Roman Emperor Maximilian I (*see* HABSBURG, §I(3)) or Cardinal Albert of Brandenburg (*see* HABSBURG, §I(14)) whose main commissions were connected with the reconstruction and endowment of the cathedral at Halle, and those of the great patrician and merchant families in Nuremberg and Augsburg and their dealings with humanist circles (Willibald Pirckheimer and others) and the artists closely associated with them. These people expressed themselves through their great town houses and their furnishings, in endowments for churches and chapels, and also in Nuremberg, for example, in the development of the portrait medals of the Renaissance.

Wide-ranging patronage extending far beyond Augsburg is associated with the rise of the FUGGER family in particular, who rose from the status of weavers and merchants to imperial counts. Royal patronage was also important for an artist's career (e.g. Lucas Cranach the elder was court artist to the Wettins). In the mid-16th century the main thrust of patronage shifted to the early absolutist princes and their courts, who built town palaces and summer palaces. In Bavaria in particular, where the Counter-Reformation was promoted by the Wittelsbachs, their influence was also to have a decisive impact on monastic and church buildings (e.g. the Jesuit church of St Michael in Munich).

The heyday of Baroque patronage began in the aftermath of the Thirty Years War, taking the form of competition for prestige between the imperial court in Vienna with its *Reichsstil*, the princes, the upper aristocracy and the abbots of great abbeys, all fired with enthusiasm for building and decoration. Towns were developed as royal residential towns (e.g. Ansbach, Dresden, Würzburg); others were founded, such as LUDWIGSBURG by Duke Eberhard-Ludwig (*see* WÜRTTEMBERG, (1)) and KARLS-RUHE as the setting for the official residence of Charles III, Margrave of Baden-Durlach (*see* ZÄHRINGEN, (2)). The unique patronage exercised by the von SCHÖNBORN family had a decisive impact on architecture and the fine arts in south and west Germany for a century. The number and variety of the commissions spurred artists on to enormous productivity in all the different arts, and also

resulted in some new discoveries (e.g. porcelain; *see* §VII, 3 above). The craft skills of such towns as Augsburg and Nuremberg were largely used in the service of this Court and Church. FRANCIS, PRINCE OF ANHALT-DESSAU, who was interested in the Enlightenment, was responsible for creating the first important German landscaped park in WÖRLITZ, which was started in 1764. Middle-class patronage could not compete on equal terms, although some town houses belonging to prominent citizens were built, and interest was directed towards genre paintings, particularly portraits.

3. AFTER *c.* 1800. In the 19th century changes towards increasingly middle-class values determined the nature of the commissions awarded. This was expressed in the great weight given to such communal building projects as town halls, law courts and libraries, as well as for industrial and residential buildings. Private investors or companies also commissioned new buildings. Civic patronage influenced by Historicism covered the task of furnishing public buildings with monumental art. Art societies were established, which, as collective patrons, played a great part in creating a new middle-class cultural openness. In 1855 they were involved in founding the Vereinigung für Historische Kunst, which devoted itself to nurturing history painting as a major genre for patronage. In almost every field middle-class self-assertion rivalled the efforts of the new kings. In this interplay of middle-class civic patronage and royal patronage the principles and procedures (e.g. competitions) of modern Germany's art sponsorship came into being. Such patronage together with middle-class monument societies were responsible not least for the increasing 19th-century flood of statues and monuments, usually with a nationalist or patriotic theme (*see* §IV, 4 above). Nationalist ideas had generally become a significant factor in Germany by this time, and efforts were made to raise the aesthetic level in the fields of the applied arts and industry, which were heavily influenced by Historicism. Extensive commissions for monumental furnishings and for new church buildings designed under the influence of Historicism served to defend the role of the churches. The aristocracy and upper middle classes continued to be the main customers for uncommissioned painting. Their patronage also helped promote museums through their generous endowments (*see* §XIV below).

The artistic Secessions and the movement for design reform in the applied arts and machine-made goods attracted support *c.* 1900 from liberal, upper middle-class and intellectual circles open to modern ideas. Paul Cassirer marked the emergence in Germany of a new type of art dealer, who entered into contracts with artists as a means of encouraging their work. Some sectors of modern industry turned to the new designers (e.g. AEG and the architect PETER BEHRENS). The avant-garde Erster Deutscher Herbstsalon arranged by Herwarth Walden and artists from the Blaue Reiter had Bernhard Köhler sr, manufacturer of rubber stamps, as its patron and benefactor. While modern architecture in the Weimar Republic was fostered mainly by communal policies for social reform, the marked decline of any state policy for art led to the dominance of private patronage for modern work in the creative arts, made possible by an expansion in art dealing. The return of a policy of state commissions in the Third Reich, ideologically motivated and artistically selective, ran counter to this trend, as did to some extent the state-directed art policy of the Socialist Realism in the German Democratic Republic, in which other social organizations or industrial enterprises were drawn in to act as patrons to correct the results of a modernism that were criticized as liberalistic.

4. SINCE 1945. Corporate patronage developed alongside the traditional forms of commissioning in the public field from 1945. The BDI (Bundesverband der Deutschen Industrie), founded in 1951 to award grants and art prizes primarily to young artists, has been active. The first exhibition, *Ars viva in Aachen*, of artwork by those awarded grants took place in 1955. Philipp Morris GmbH has sponsored an art prize since 1977. Exhibitions have been sponsored and museums established, for example the furniture company Vitra International's Vitra Design Museum at Weil am Rhein (opened in 1989).

Corporate art collections, primarily of modern art, have been built up at Deutsche Bank AG between 1984 and 1988 for its new headquarters in Frankfurt am Main. Other companies to have done this include Degussa AG Frankfurt am Main, IBM Deutschland, Siemens and BMW. Gerhard Merz's interior design in 1985 for the Munich-based Matuschka group created a form of corporate identity. Bayerische Hypotheken- und Wechselbank have held exhibitions of modern art since 1982, and the so-called Hypo-Kulturstiftung (Hypo Culture Foundation) was an initiative of board member Hans Fey.

BIBLIOGRAPHY

N. Lieb: *Die Fugger und die Kunst im Zeitalter der Spätgotik und der frühen Renaissance* (Munich, 1952)
——: *Die Fugger und die Kunst im Zeitalter der hohen Renaissance* (Munich, 1958)
L. Dehio: *Friedrich Wilhelm IV. von Preussen: Ein Baukünstler der Romantik* (Munich and Berlin, 1961)
P. E. Schramm and F. Mütherich: *Denkmale der deutschen Könige und Kaiser* (Munich, 1962)
P. Hirschfeld: *Die Rolle des Auftraggebers in der Kunst* (Munich and Berlin, 1968)
F. Petri, ed.: *Bischofs- und Kathedralstädte des Mittelalters und der frühen Neuzeit* (Cologne and Vienna, 1976)
M. Warnke: *Bau und Überbau: Soziologie der mittelalterlichen Architektur nach den Schriftquellen* (Frankfurt am Main, 1976)
R. Kroos: 'Liturgische Quellen zum Kölner Domchor', *Kölner Dombl.*, xxxxiv–xxxxv (1979–80), pp. 35–202
W. Braunfels: *Die Kunst im Heiligen Römischen Reich deutscher Nation*, 3 vols (Munich, 1979–81)
H. Glaser, ed.: *Quellen und Studien zur Kunstpolitik der Wittelsbacher vom 16. bis zum 18. Jahrhundert* (Munich and Zurich, 1980)
Stadt im Wandel: Kunst und Kultur des Bürgertums in Norddeutschland, 1150–1650 (exh. cat., ed. C. Meckseper; Brunswick, Herzog Anton Ulrich-Mus., 1985)
H. Hoffmann: *Buchkunst und Königtum im ottonischen und frühsalischen Reich* (Stuttgart, 1986)
H. Ludwig: *Kunst, Geld und Politik um 1900 in München: Formen und Ziele der Kunstfinanzierung und Kunstpolitik während der Prinzregentenära, 1886–1912* (Munich, 1986)
F. Unterkircher: *Maximilian I: Ein kaiserlicher Auftraggeber illustrierter Handschriften* (Hamburg, 1986)
G. Binding: *Bischof Bernward als Architekt der Michaeliskirche in Hildesheim* (Cologne, 1987)
Romantik und Restauration: Architektur in Bayern zur Zeit Ludwigs I: 1825–1848 (exh. cat., ed. W. Nerdinger; Munich, Stadtmus., 1987)
F. Möbius and H. Sciurie, eds: *Geschichte der deutschen Kunst, 1200–1350* (Leipzig, 1989)

G. Mietke: *Die Bautätigkeit Bischof Meinwerks von Paderborn und die frühchristliche und byzantinische Architektur* (Paderborn and Munich, 1991)

Die Gründer von Laach und Sayn: Fürstenbildnisse des 13. Jahrhunderts (exh. cat., ed. R. Kahsnitz; Nuremberg, Ger. Nmus., 1992)

HARALD OLBRICH

XIII. Collecting and dealing.

The preferences of individuals, particularly for foreign works of art, have historically been of greater influence on German collecting and dealing than an interest in national art and heritage. The first noteworthy collector was the King and Holy Roman Emperor Charlemagne, who adopted Roman heritage to underline his central power (*see* CAROLINGIAN ART), importing an equestrian statue (destr.) of Theodoric (*reg* 493–526) from Ravenna and antiquities and coins from all parts of Italy. A German art market began to develop in the 16th century, and until the 19th century it was principally concerned with buying works of art from abroad. This perhaps contributed to German art history emphasizing the topoi of such early national heroes as Holbein, Dürer, Hans Baldung and Albrecht Altdorfer, while neglecting the evolution of the German idiom of two centuries, from Lucas Cranach the elder to the Romantic painters. This internationalism was based partly on the particularism that characterized German history until Napoleon's triumph in 1806, through which petty princes had the opportunity to build collections of personal taste and/or for public grandeur. Various members of the WETTIN, WITTELSBACH and HOHENZOLLERN families in particular became well known as noble collectors, but there were also interesting collections in provincial parts of Germany. According to a catalogue of 1721, the picture gallery of Lothar Franz von SCHÖNBORN in Pommersfelden near Bamberg consisted of 505 paintings, notably works of the Netherlandish schools.

A great import of Dutch and Flemish art and artists to Germany in the 17th and 18th centuries was due partly to dynastic connections and also to a taste for the elaborate realism of Dutch portrait painting. Frederick William, Elector of Brandenburg (*reg* 1640–88; *see* HOHENZOLLERN, (3)), had studied at Leiden University and married the Dutch princess Louise Henriette in 1646. One year later he bought 49 portraits by the Amsterdam court painter Gerrit van Honthorst. The Elector had an extreme preference for still-life painting, especially the work of Daniel Seghers, who sent him a flower-piece, which Frederick William paid for by giving him some reliquaries from Berlin Cathedral (*Jahrbuch der Königlich-preussischen Kunstsammlungen*, ii, 1890, p. 122). The Elector's court painter Hendrik de Fromantiou (1633/4–1694 or 1700) was his favourite art agent; he sent him to the Lely sale in London and several times to Amsterdam, where he attended a trial against the art dealer Gerrit Uylenburgh, who had offered Italian paintings of inferior value and quality to the Berlin Court in 1671. Mainly Dutch and Flemish art constituted the collection of the Archbishop and Elector of Cologne Clemens August (*see* WITTELSBACH, §I(9)), who was interested in still-lifes; northern European art also characterized the paintings in the Kassel gallery of Landgrave William VIII (*reg* 1751–80; *see* HESSE-KASSEL, (2)), where works by Rembrandt, van Dyck,

Rubens and Wouwerman formed the focus of a particularly good collection. William VIII built the nucleus of this by purchasing the renowned cabinet of Valerius Röver in Delft in 1750 for 40,000 guilders. The art dealer Gerard Hoet (ii), who described the paintings in his famous *Catalogus of naamlyst van schilderijen* (1752), acted on behalf of the Landgrave, accepting a provision of 5%.

Under Elector Palatine John William (*reg* 1690–1716; *see* WITTELSBACH, §II(3)) the Düsseldorf residence became the Rhenish centre of collecting. The Flemish painter Jan Frans van Douven (1656–1727) became John William's art agent using progressively greater sums of money to acquire paintings in the European art centres (5000 thaler in 1706; 12,180 thaler in 1713; 19,000 thaler in 1715). After John William's death the collection was published in a two-volume catalogue by Nicolas de Pigage (1778), who recorded forty Rubens, seventeen van Dycks, seven Dous, Rembrandt's six-piece Passion cycle, and works by Tintoretto, Titian, Domenichino, Reni and Raphael (col. now in Munich, Alte Pin.).

International art transactions were also the basis of the Saxon collections, the roots of which were in the *Kunstkammer* in Dresden (founded *c.* 1560). Frederick-Augustus I, Elector of Saxony and later King of Poland (*reg* 1694–1733; *see* WETTIN, (7)), had a universal taste in collecting antiquities, paintings, works of art and porcelain. His son Frederick-Augustus II (*reg* 1733–63; *see* WETTIN, (8)) refined and crowned the electoral collections by acquiring 268 paintings of the Wallenstein collection once owned by Albrecht Wenzel Eusebius von Wallenstein (1583–1634), and 100 pictures from Francesco III, Duke of Modena (*reg* 1737–80). He paid 25,000 scudi for Raphael's *Sistine Madonna* in 1754. Frederick-Augustus II left state affairs to his prime minister HEINRICH, Graf von BRÜHL, who was also an insatiable collector. The inventory of 1742 lists more than 4700 pictures; most of these were imported from Venice, Paris, Amsterdam, Antwerp, Vienna, London and Madrid. Frederick-Augustus II was a bad politician, losing the Seven Years War, yet one of the greatest German connoisseurs, constantly outbidding his economical enemy Frederick II, King of Prussia (*reg* 1740–86; *see* HOHENZOLLERN, (7)), who once wrote to his Berlin counsellor Johann Ernst Gotzkowsky: 'I buy what I can pay at a reasonable price, but what is too expensive I leave to the King of Poland.' Frederick II's early collecting activities were dedicated to the until-then neglected French art; his collection of paintings by Antoine Watteau, Jean-Siméon Chardin, Nicolas Lancret and Jean-Baptiste Pater was the most comprehensive outside France. In 1742 he bought the antiquities of Melchior de Polignac on the Paris market for 80,000 livres. Frederick also collected jewellery and gold boxes (*see* §X, 3(ii) above) and acquired an important part of the print and coin collection of Baron Philipp von Stosch, which was highly esteemed by Johann Joachim Winckelmann. The King's efforts were overshadowed, however, by a high proportion of faked art that was sent by him through agents mainly from Paris. He was one of the last of the princely collectors of miscellanea, being an equal adherent to antiquities of the Classical period, Old Master paintings and contemporary art.

During the late 18th century the idea of art collecting as a mirror of absolutism came to an end in Germany.

The last German king with importance as a collector was Ludwig I of Bavaria (*reg* 1825–48; *see* WITTELSBACH, §III(3)). During his Grand Tour at Rome he became a friend of the sculptor Berthel Thorvaldsen and began to collect antiquities, the greatest of which were the statues from the collection of Pius VI (*reg* 1775–1800), the marbles of the Bevilacqua collection, the Barberini *Faun* and the sculptures from the gable of the Aegina temple. Private, bourgeois collecting gained prominence at this time; this was directed towards protection and preservation as well as investment. Such collections in the 18th century often concentrated on bibliophily and prints, coins and medals. Exceptions to this were the painting and drawing collections of the Berlin engraver Daniel Nikolaus Chodowiecki, the Berlin merchant Benjamin Ephraim and the founder of the Kunstakademie in Düsseldorf, LAMBERT KRAHE.

During the first half of the 19th century a surge in interest for the Romanesque and Gothic periods led to the revival of national schools of religious painting and sculpture in the collections of members of the Rhenish *haute bourgeoisie*, above all the Cologne professor FERDINAND FRANZ WALLRAF and the brothers Sulpiz and Melchior BOISSERÉE. It was, however, the Jewish upper-middle classes who had the greatest influence on German collecting in the 19th century, beginning with the ascent of the ROTHSCHILD family in Frankfurt am Main. The prosperity of an industrial nation with a seemingly inexhaustible flow of money was coupled with a new feeling for the investment potential of works of art. The Berlin-based WILHELM BODE, a highly influential museum director, advised such collectors as Marcus Kappel, James and Eduard Simon, Richard von Kaufmann and Oscar Huldschinsky, whose collections were put up for public sale in the first three decades of the 20th century. The exodus of these national treasures began in 1906 when the widow of the Berlin banker Oscar Hainauer sold the whole collection for 4 million goldmark to the New York dealers Duveen Brothers. In this wealthy period Berlin became an important centre with the emergence and growth of auction houses, of which Lepke (founded 1853) and PAUL CASSIRER were the most important. At the zenith of this 'goldmark era' there were international auctions, for example the Lanna sale of decorative arts (1909). The most prominent of these was the painting and sculpture sale of the Richard von Kaufmann estate that in the depths of World War I raised an exorbitant 12 million goldmark. Much of the art collected during the 'golden' period of 1860–1914 went by sale to international dealers and collectors, particularly American collectors such as J. Pierpont Morgan, Benjamin Altman, Joseph E. Widener and Henry Clay Frick.

In the 1920s Berlin was very much the capital of the German art market: a handbook published in 1926 includes the addresses of 16 auctioneers, 81 art galleries, 79 art and antique dealers and 11 specialists for Chinese and Japanese art. The most important dealers of modern art in this period were Ferdinand Moeller, HERWARTH WALDEN, ALFRED FLECHTHEIM (who opened a gallery in Düsseldorf in 1913) and Justin K. Thannhauser, whose main gallery, the Moderne Gallerie Heinrich Thannhauser, was established in 1909 in Munich, the second German art market centre in the early 20th century. Like Berlin,

where such progressive collectors as Carl Bernstein and Eduard Arnhold had a distinguished taste for French Impressionism and the art of Die Brücke, the Munich intelligentsia was also passionately interested in Post-Impressionism and work of Der Blaue Reiter. By 1924 there were 66 collectors throughout Germany who had bought van Gogh paintings, and 6 important Picasso collectors, including the poet Rainer Maria Rilke. These efforts, however, came to a violent end in 1933 when it was established by Nazi law that every German artist and art dealer had to become a member of the Reichskammer der Bildenden Künste, which accepted only 'Aryans'. This marked the end of Jewish dealing and collecting in Germany, a loss that still persists.

The following 12 years were overshadowed by the confiscation of 'degenerate art' (*see* ENTARTETE KUNST) from German public collections culminating in the notorious Luzern Fischer sale of 1939. During World War II the Nazis (especially Hermann Göring for his private collection and Hitler for his planned mammoth museum at Linz) looted art from private collections and art dealers in the occupied countries, mostly from the Netherlands and France, the largest art plunder since Napoleon's raids in Europe and Egypt. On the other hand, after the fall of the Third Reich there was a considerable loss of national patrimony; a list published in 1965 details *c.* 8000 paintings that were destroyed or plundered during World War II and shortly after. Some pieces were housed secretly in Russian state museums, the Berlin Priamos treasure and the Bremen Dürer collection included.

After the war the German art market recovered slowly. The first German art and antiques fair was held in 1956 in Munich, while 18 progressive galleries established the first European fair for modern art in Cologne in 1967. By the late 20th century there were seven major art fairs every year in Germany. From 1948 to 1962 the auction scene was dominated by the sales of Roman Norbert Ketterer's Stuttgarter Kunstkabinett, which was the centre of the economic and cultural reparation for German Impressionism and Expressionism. In the 1990s 14 major auction houses existed, which organized sales, mostly in spring and autumn. The centres of German art dealing are Munich, Berlin, Cologne and Düsseldorf. In the late 20th century particularly notable German collectors included PETER LUDWIG, the Stuttgart entrepreneur Rolf Deyhle, who collected medieval sculpture and paintings of the 19th and 20th centuries, and the Berlin real estate magnate Erich Marx, who possessed the largest collection of work by Joseph Beuys and other contemporary art.

BIBLIOGRAPHY

H. Sachs: *Sammler und Mäzene* (Leipzig, n.d.)
G. F. Waagen: *Kunstwerke und Künstler in Deutschland*, 2 vols (Leipzig, 1843–5)
H. Seidel: 'Die Beziehungen des Grossen Kurfürsten und König Friedrichs I zur niederländischen Kunst', *Jb. Kön.-Preuss. Ktsamml.*, ii (1890)
J. von Schlosser: *Die Kunst- und Wunderkammern der Spätrenaissance* (Leipzig, 1908/*R* Brunswick, 1978)
A. Donath: *Psychologie des Kunstsammelns* (Berlin, 1918)
F. Lugt: *Répertoire des catalogues de ventes publiques* (The Hague, 1923–38)
P. Seidel: *Friedrich der Grosse und die bildende Kunst* (Leipzig and Berlin, 1924)
W. von Bode: *Mein Leben* (Berlin, 1930)
H. Wilm: *Kunstsammler und Kunstmarkt* (Munich, 1930)
L. Brieger: *Die grossen Kunstsammler* (Berlin, 1931)

G. Händler: *Fürstliche Mäzene und Sammler in Deutschland von 1500–1620* (Strasbourg, 1933)

W. Treue: *Kunstraub unter Napoleon* (Berlin, 1976)

C. Herchenröder: *Die Kunstmärkte* (Düsseldorf, 1979)

W. Schmidt: 'Kunstsammeln im augusteischen Dresden', *Barock in Dresden* (exh. cat., ed. W. Schmidt; Essen, Villa Hügel, 1986), pp. 191–202

R. Lenman: 'Painters, Patronage and the Art Market in Germany, 1850–1914', *Past & Present*, no. 123 (1989), pp. 163–80

K. Wilhelm: *Wirtschafts- und Sozialgeschichte des Kunstauktionswesens in Deutschland vom 18. Jahrhundert bis 1945* (Munich, 1990)

CHRISTIAN HERCHENRÖDER

XIV. Museums.

Germany played an important role in the origin and development of museums in Western culture that was paralleled and variously influenced by similar developments in Renaissance Italy, Napoleonic France and post-war Europe. While the concept of the art museum as an institution for the preservation, interpretation and public display of cultural artefacts did not develop until the 19th century, several of Germany's modern museums can claim descent in part or whole from earlier ecclesiastical and, more importantly, princely treasuries dating from the late Middle Ages (*see* MUSEUM, §I). In the course of this evolution, Germany produced the first known printed catalogue (Munich, 1567) and autonomous museum structure (Kassel, 1769–79). (*See also* §§XII and XIII above.)

1. Precursors and early museums, up to the 19th century. 2. Growth and evolution, up to the mid-20th century. 3. World War II, partition, reunification and its aftermath.

1. PRECURSORS AND EARLY MUSEUMS, UP TO THE 19TH CENTURY. Prior to the Renaissance, collecting and storing valuable objects were haphazard and restricted to the Church and nobility. As collections grew, they became too large to be housed in strong-rooms or treasuries and overflowed into semi-public places such as castle armouries. Augustus I of Saxony (1526–86), for example, used three entire rooms in his palace in Dresden to house his collections. Albert V, Duke of Bavaria (*see* WITTELSBACH, §I(3)), whose collections of ancient and modern art work, musical instruments and geological specimens numbered 4000 items, eventually required a checklist or catalogue. This was published as *Musaeum Theatrum* (Munich, 1567) by Dr Samuel Quickeberg, who categorized the collection according to purpose or material. Albert V's collection was typical for its breadth and atypical for its orderliness. Furthermore he was ahead of his peers in that he had a special room built for the display of statuary, the Antiquarium (1569–85), a wide barrel-vaulted corridor in the Residenz in Munich. It was inspired by the Italian Renaissance *galleria* (*see* ITALY, §XIV).

A less calculated accumulation and more haphazard display of objects in other German collections of the 16th and 17th centuries is more characteristic. The rooms in which these various objects were stored became known as *Kunst- und Wunderkammern* (*see* KUNSTKAMMER and CABINET (i), §2). During the course of the 17th and 18th centuries galleries and museums became standard features in palaces throughout Germany and the rest of Europe. There might be separate galleries for painting, Classical sculpture, coins, prints, scientific apparatus and ethnographic material, for example. Thereafter theoretical and practical interests began to focus more on the display space itself. Newly constructed galleries such as the Stallhof (1722–5) in Dresden followed the Italian Renaissance *galleria* model as first seen in Munich. In the book *Der geöffnete Ritterplatz* (*c.* 1704), attributed to Leonhard Christoph Sturm, a theoretical model for the proper design of a court museum is included. Similarly, Francesco Algarotti, an Italian nobleman and art agent for Frederick I, King of Prussia, and Frederick-Augustus II, Elector of Saxony, had evidently drawn a museum plan for Dresden as early as 1742. This proposed a balanced Renaissance structure with Corinthian columns that stood independent of the palace.

In this manner, the Museum Fridericianum, the first independent museum structure in Europe, was built in a public square in the Hessian city of Kassel between 1769 and 1779. Named after its patron, the Landgrave of Hesse-Kassel, Frederick II, this Neo-classical structure was designed by Simon Louis Du Ry to house in separate rooms the Landgrave's library, mineral collection, musical instruments, mechanical devices and art collection. It also contained a study for Frederick and primarily served him and his court. During the second half of the 18th century, there was an increased emphasis at the courts of Germany on painting galleries and rooms for the display of Classical antiquities and plaster casts. Some were evidently semi-public.

In 1772 the Swiss art dealer and engraver Christian von Mechel was called to Düsseldorf to reorganize the painting collection. He did this along the line of schools of painting arranged in chronological order. This 'proto' art-historical shift in the organization was emphasized in the visitor catalogue that accompanied the collection, which included general information for the viewer and numbers assigned to each painting. Mechel was invited to Vienna in 1777 to do the same for the imperial collections, and most major German collections thereafter followed Mechel's didactic pattern and purpose.

2. GROWTH AND EVOLUTION, UP TO THE MID-20TH CENTURY. This didactic approach to collections eventually evolved into a scholarly involvement in museums. Furthermore, awakening nationalism in Germany in the 19th century increased the desire to preserve as much of the nation's past as possible. The rise of an educated middle class and the invention of tourism also placed pressures on princes to open collections to a larger audience and in a more systematic fashion.

In Munich, the Bavarian Crown Prince and later King Ludwig I took the lead among the German nobility in opening his collections to a wider audience by establishing two museums, the Glyptothek (1816–30) and Pinakothek (Alte Pinakothek, 1826–36; Neue Pinakothek, 1846). These were built to house, respectively, his sculpture and painting collections as public institutions in the city. Construction of the Glyptothek took place shortly after Ludwig had visited London and seen the British Museum and the Parthenon Marbles. The Musée des Monuments Français in Paris probably also influenced his decision to establish this museum. He commissioned Leo von Klenze, who had been Court Architect in Kassel, to design a classical structure to house the King's sculpture collection

(*see* KLENZE, LEO VON, fig. 1). This museum (which stands on the Königsplatz) was designed as a single-storey Classical temple form with a central portico supported by eight unfluted, Ionic columns, which Klenze based on recent archaeological evidence. Ludwig conceived the museum as a public institution opened, as he stated, free of charge to the Bavarian people. It displayed both Classical antiquities collected since the time of Duke Albert V, as well as many new acquisitions by Ludwig, including the Aegina Marbles and modern sculptures by Antonio Canova, Christian Daniel Rauch and Ludwig von Schwanthaler. The museum was opened to the public, although Klenze included a private banqueting hall and a portico at the back of the building for carriages of the King and his noble guests. As if to remind the public that they were the guests of the King, attendants in the galleries wore the extravagant livery of the royal household. Klenze was also the architect of the Neo-classical Alte Pinakothek (*see* MUSEUM, fig. 5), built to house the Wittelsbach hereditary collections of paintings as well as Ludwig's numerous purchases (mainly of paintings by such Italian masters as Raphael and Canaletto).

The situation in Prussia somewhat paralleled that of Bavaria. During the reigns of kings Frederick II (*reg* 1740–86) and Frederick William II (*reg* 1786–97), their art collections had been opened for several days a week to artists who wished to copy the works of Old Masters. In 1797 Aloys Hirt, professor of fine arts in Berlin, delivered a speech in which he called on the King to unite the dispersed royal collections. It was his desire to see the collections displayed, not as mere ornaments for the palaces that had limited audiences, but rather as a publicly accessible, precious 'heritage for the whole of mankind'. The King responded by asking Hirt to develop a plan to establish a museum for 'public instruction and the noblest enjoyment', that would be open to artists throughout the week, so that they might continue to learn from the 'patterns' of the past, and to the general public at weekends. After several years of delay, the architect Karl Friedrich Schinkel was selected during the reign of King Frederick William III (*reg* 1797–1840) to design the royal museum in Berlin (now known as the Altes Museum; *see* SCHINKEL, KARL FRIEDRICH, fig. 1). Construction began in 1823, and the museum was completed and opened in 1830. Schinkel's building carried the idea of the museum as a temple to its most severe and most influential form. The interior rooms are organized around a central rotunda that was influenced by the Pantheon in Rome. Antiquities were installed on the ground floor, paintings on the upper floor. Mechel's chronological and stylistic arrangement was eventually seen as the proper organization of the collection. Schinkel even designed, as needed, historically accurate frames in the style of each painting's period. The arrangement of the collections was determined by a committee chaired by Wilhelm, Freiherr von Humboldt, and including Schinkel and Gustav Friedrich Waagen, later the museum's first Director. Their goal, as summarized in a memorandum written by Schinkel and Waagen, was 'to awaken in the public a sense of fine art as one of the most important branches of human civilization'. Along with their chronological and period arrangements of the collections, the committee also divided the collection into several classes,

according to quality, a practice still maintained in many museums. Classes ten and above were not shown and were considered merely curiosities outside the mainstream of art history. These, tellingly, included all paintings by Italian Mannerists.

Along with the continuation, expansion and increased public display of noble collections in such princely cities as Munich and Berlin, learned societies of scholars and wealthy burghers began to organize public collections in such cities as Bonn, Bremen, Cologne and Hamburg. These new foundations included the Kunsthalle of Bremen (1845/54), Hamburg (1850/63–69) and Kiel (1857), and the Wallraf-Richartz-Museum in Cologne (1856–61; *see* COLOGNE, fig. 4). During this period the German Heimatmuseum also came into being under similar impetus. For example the Museum Vaterländischer Altentümer (now the Rheinisches Landesmuseum) in Bonn was established in 1820 'so that', according to the catalogue published in 1970 to celebrate the museum's 150th anniversary, 'through education and affection, the citizens should develop an enthusiastic interest in the German past and a willingness to work towards the growth and strengthening of the State'. The Germanisches Nationalmuseum in Nuremberg (1852) and Bayerisches Nationalmuseum in Munich (1854) were later established along similar lines.

Following unification and the establishment of a national capital in Berlin, museums continued to be seen as cultural institutions that played an important role in moulding a national identity and educating the citizenry. The success of this education resulted in directions in public collections and taste that did not always coincide with that of the rulers. German Emperor William II in Berlin and the Austro-Hungarian Emperor Francis-Joseph in Vienna both witnessed their increasingly informed citizenry expressing a mind of their own in these matters, particularly with reference to avant-garde art. During these prosperous years Germany's public collections grew under the direction of such individuals as Alfred Lichtwark in Hamburg and Fritz Wichert in Mannheim. Funds for acquisitions often came from private citizens and businessmen. The Berlin Museum was particularly active at the turn of the century in buying major works of art. Wilhelm Bode, Director-General of the Prussian museums, developed the idea of the *Museum-Inseln* in Berlin that had been begun by Frederick William IV on an island in the Spree. It provided a concentration of different types of museums that was unique in Europe.

North American collectors also became increasingly evident in the European art market at this time, resulting in increased prices and the export of important works of art by German, as well as French and Italian masters to the USA. Following World War I, the flow of art from Germany increased. Many German collectors and museums were forced, for financial reasons, to sell works of art from their collections: for example, much of the former royal house of Hanover's collection (the Guelph Treasure) went to the Cleveland Museum of Art, Ohio. Under Adolf Hitler, however, German collections in general turned increasingly towards retaining and expanding their holdings of works of art by German artists and any major European artists whose work was considered to have

contributed to the evolution of German art and civilization. Non-German works of art, even if they were of great quality, were sold to raise funds for the purchase of lesser works by German artists. Italian paintings, including several works from the Alte Pinakothek by Raphael and Canaletto and a panel from Duccio's *Maestà* in Berlin, were sold in this way. The centralized authority of the Nazis allowed such confiscation from public (and private) collections throughout the country and, later, from the conquered countries of France, the Netherlands, Belgium etc. Hitler was very enthusiastic about the museum-island concept in Berlin, and with the architect Albert Speer proposed its expansion. He also held the goal of establishing a Führermuseum in Linz. Unrealized, it was to house the masterpieces of European art from German and foreign collections that he had confiscated. Avant-garde art was censored, destroyed or sold by the Nazis following public display in such institutions as the newly constructed Haus der Kunst (1937) in Munich, under the title of 'degenerate art' (*see* ENTARTETE KUNST).

3. WORLD WAR II, PARTITION, REUNIFICATION AND ITS AFTERMATH. During World War II, Allied bombing of Germany destroyed many museum structures. Munich, Berlin and Dresden were particularly hard hit; the Glyptothek, Alte Pinakothek and the Residenzmuseum in Munich were severely damaged, all museums on Berlin's Museum Island and most in Dresden were destroyed. The Nazis had removed most art collections prior to the attacks; nevertheless, over 8000 important paintings were destroyed or lost between 1939 and 1945. Shortly after the arrival of Allied troops in Germany, much of the confiscated or hidden art was discovered in over 1000 underground repositories in Germany and Austria. Those discovered in the western sectors controlled by the French, British and American forces were placed under the supervision of the Monuments, Fine Arts and Archives Service of the American and British armies and taken to a number of collecting points to be repatriated or returned to their original owners, including museums throughout Europe. Unfortunately, it later became clear that both individuals and institutions in the West received works of art that slipped through the post-war relocation net. In the section of Germany controlled by Russian troops, the treatment of discovered collections was not so forthright. Major works of art from German museums were transferred to Moscow, according to the Soviet authorities, to be cleaned. As the Cold War progressed, however, the USSR returned these German collections to the restored East German museums, although this too seems to have been in parts selective. (Some treasures that were later discovered in Russia became in the late 20th century the subject of continuing negotiations on the basis of art for aid.)

While the Western allies proceeded to establish democratic institutions in West Germany, the Communist leaders of East Germany brought all cultural institutions under their aegis. Museums in West Germany fell mainly under the control of their respective cities and federal states, with a high degree of cooperation among institutions; they were perceived as educational institutions and also as focal points for the increasing international tourism that followed the war. In East Germany the idea of the museum as an institute for instilling political awareness and to educate the citizenry became the focus of museums. Regardless of their differences, museums in both countries took a leading role in providing a sense of cultural continuity and value in the war-scarred and psychologically disorientated nation.

During the 1950s and 1960s most German museums were restored to their former appearance. The Alte Pinakothek in Munich was restored (1952–7) by Hans Döllgast (1891–1974), so that the effect of the inverted, cone-shaped impact of the bomb that exploded in its centre has been preserved in the exterior masonry as a war memorial. The work of Josef Wiedemann (*b* 1910) on the Glyptothek (1967–72) includes a new, austere brick interior but a restored exterior. Many new museums were also constructed in West Germany during the decades following the war, designed by German as well as non-German architects in the major international architectural styles. These include the International Style Neue Nationalgalerie (1965–8) in Berlin by Ludwig Mies van der Rohe and the Städtische Kunsthalle (1966–8), Bielefeld, by Philip Johnson; and the Post-modernist rebuilding of the Neue Pinakothek (1974–81) in Munich by Alexander von Branca (*b* 1919) and the new Staatsgalerie (1977–82) in Stuttgart by James Stirling and Michael Wilford.

After the 1950s there was increased professionalization of museums and museum staff in areas of conservation and preservation, display, housing and study in West Germany. A national, professional organization, the Deutscher Museumsbund, was established at this time, and many German museums also participated on an international scale through membership in the International Council of Museums (ICOM). This resulted in West Germany's full participation in the several large-scale international exhibitions that were mounted in the 1970s and 1980s, including *Nuremberg: 1300–1500: Art of the Gothic and Renaissance*, which took place in 1986 in the Germanisches Nationalmuseum in Nuremberg and the Metropolitan Museum of Art in New York. After East and West Germany reunited in October 1990, museums in the eastern states of the enlarged Federal Republic accepted the institutional model of international cooperation and an awareness of the role of museums for tourism. The effects of unification in Germany are most evident in the rationalization of the duplicated institutions of Berlin under the Preussischer Kulturbesitz. During the 1990s this was the subject of considerable debate, with a widely held ideal of the return to the integration of the different aspects of culture on the *Museum-Inseln*, actively opposed by Wolf-Dieter Dube, Director of the Kulturbesitz. He favoured the further expansion of the Dahlem complex (former West Berlin). In February 1991 plans to this effect were set in motion with a proposal for a new gallery to be built on the Kemperplatz. European art was thereby concentrated at Dahlem, with the archaeological museums alone on the island. This apparent parallel financial imbalance in favour of West Berlin raised considerable controversy, although it was somewhat offset by the conversion of the former station, the Hamburger Bahnhof, as a museum of contemporary art.

BIBLIOGRAPHY

J. von Schlosser: *Die Kunst- und Wunderkammern der Spätrenaissance* (Leipzig, 1908/*R* Brunswick, 1978)

V. Scherer: *Deutsche Museen: Entstehung und kulturgeschichtliche Bedeutung unserer öffentlichen Kunstsammlungen* (Jena, 1913) [incl. interior photos of museums before World War II destruction]

V. Plagemann: *Das deutsche Kunstmuseum, 1790–1870: Lage, Baukörper, Raumorganisation, Bildprogramm*, iii of *Studien zur Kunst des 19. Jahrhunderts* (Munich, 1967)

H. Seling: 'The Genesis of the Museum', *Archit. Rev.*, 141 (1967), pp. 103–14

B. Mundt: *Die deutschen Kunstgewerbemuseen im 19. Jahrhundert* (Munich, 1974)

K. Hudson: *A Social History of Museums: What the Visitors Thought* (London, 1975)

B. Wurlitzer: *Museen, Galerien, Sammlungen, Gedenkstätten [D.D.R.]* (Berlin and Leipzig, 1983)

G. Stelzer and U. Stelzer: *Bildhandbuch der Kunstsammlungen in der D.D.R.* (Leipzig, 1984)

H. Klotz and W. Krase: *New Museum Buildings in the Federal Republic of Germany* (Stuttgart and New York, 1985)

Der deutsche Museumsführer in Farbe: Museen und Sammlungen in der Bundesrepublik Deutschland und West-Berlin (Frankfurt am Main, 1986)

C. H. Smyth: 'Repatriation of Art from the Collecting Point in Munich after World War II', *The Third Gerson Lecture, University of Groningen: The Hague, 1988*

Mus. J. (March 1990) [special issue on East German museums in Berlin and Potsdam]

'Berlin: The Fate of 28 Museums', *A. Newspaper*, ii/5 (1991), p. 5

K. H. Jansen: 'War Thefts: Kunstraub! The Sacking of Germany', *A. Newspaper*, ii/5 (1991), pp. 10–11

G. A. Marsan: 'Reunited Germany: The Painful Westernising of the 751 Museums Once behind the Wall', *A. Newspaper*, ii/6 (1991), p. 6

——: 'The Last Fifteen Years: The Ninety-five Museums Built in West Germany', *A. Newspaper*, ii/13 (1991), pp. 6–7

D. Janes: 'Uniting a Divided Past', *Mus. J.*, xciii/10 (1993), pp. 23–5

DAVID ALAN ROBERTSON

XV. Art education.

The history of art education in Germany to some extent parallels the country's cultural–political history. For a long time the group of provinces that are now known as Germany followed the artistic trends of its more confident European neighbours. In the 17th century private academies had been little more than extensions to established artists' studios. During the 18th century municipal governments and rulers acquired new influence, and they took on the patronage of art education, as an expression of burgeoning self-confidence and national culture. At first academies of fine art aped those in Paris and Rome; schools of applied art and design looked to London. Gradually, though, during the Industrial Revolution of the 19th century, Germany emerged as a major trading power, and with this change in status, the cultural and economic significance of art education changed. The commercial power of applied arts soon became a key weapon in the battle for national competitive advantage, and this role eventually led to a keenly developed sense of social and political responsibility among architects and designers in the 20th century.

1. 17th–18th centuries. 2. 19th–20th centuries.

1. 17TH–18TH CENTURIES. One of the earliest known German art schools was founded in Nuremberg by JOACHIM VON SANDRART in 1674 or 1675. Germany was not known for its artists during this period, and Sandrart is one of the few to have achieved a European reputation during his lifetime. He travelled widely, studying at Utrecht

and working in England, before settling in Amsterdam, Augsburg and finally Nuremberg. Sandrart's school was modelled on the studios he had encountered in his travels, and compares with similar private schools elsewhere in Europe. Sandrart's prospectus described the 'Teutsche Academie der Edlen Bau- Bild- und Malerey-Künste', but it appears that, at the outset at least, the curriculum extended to little more than life drawing, although the architect Elias von Gedeler (1620–93) taught there briefly. The municipal council of Nuremberg offered the school premises in the Franciscan monastery, and later (in 1703, after Sandrart's death) in the convent of St Katharine. A year later, the engraver Johann Daniel Preissler (*see* PREISSLER (ii), (1)) became the new director. In this period, painters were regarded much as other craftsmen, and were obliged to submit a 'masterpiece' and pay dues to the guild in order to work at the Nuremberg school, although this requirement was relaxed in the late 1730s in order to attract more prominent artists to the city. In spite of this concession, however, Nuremberg gradually declined in importance as a regional centre during the 18th century, with a consequent decline in the status of its school.

During the 18th century the academy at Augsburg also enjoyed some brief success, thanks to the participation of several well-known painters and engravers. It was established in 1710 as a municipal school but, despite a brief flurry of activity, went into decline and did not re-emerge as an institution of any significance until it was revived 70 years later.

The private academy at Dresden, run by the court painter SAMUEL BOTTSCHILD in the 1680s, was a relatively minor institution, compared to the grand schools in Italy and France. After Bottschild's death, it was revived by his former pupil Heinrich Christoph Fehling and in 1705 was provided with just enough funding from the authorities to pay for a model. As with the handful of similar institutions recorded at this time in Germany, it apparently flourished briefly during the first two decades of the 18th century, only to drift into obscurity over the following decades, until it was reformed in 1765 under the direction of CHRISTIAN LUDWIG VON HAGEDORN, with a robust and forthright commercial thrust.

While a number of the early German academies had been founded as private enterprises and were absorbed into the municipal bureaucracy in the early 1700s, the Berlin academy had from the outset an altogether bolder set of ambitions. At the turn of the 18th century Frederick I, King of Prussia, set out to make his capital the cultural equal of Paris and Rome, by redeveloping the city and establishing various grand institutions, including the art academy, which came into being in 1697, under the painter JOSEPH WERNER II. While primarily intended to help bring about the cultural elevation of Prussia, the Berlin academy also had a clearly commercial purpose. Frederick I had been profoundly influenced in his aims by the philosophy of Gottfried Wilhelm Leibniz (1646–1716), who championed a mercantilist justification for investing in education. He believed that the country's balance of payments could be improved by putting the fine arts and sciences at the disposal of trade and industry, an idea that has remained current in German art education ever since.

Initially, the Berlin academy enjoyed excellent facilities and tuition from its four rectors, including ANDREAS SCHLÜTER, architect and sculptor to the King. Its first golden age was short-lived, however; Frederick I's successor, Frederick William I, had little sympathy for its cultural aims and cut its grant and those of the court painters. The academy rapidly diminished in importance, despite an attempt to revive it in the 1730s. Its fallow period continued into the reign of Frederick the Great, who was unimpressed by its output. He had absorbed some of Voltaire's antipathy to the traditional academic approach to teaching in general, an attitude that was gaining momentum across Europe during the late 18th century. The Berlin academy was eventually reformed to bring it into line with the new ideas about art and teaching, and its industrial focus was sharpened. Friedrich Anton Freiherr von Heinitz (1725–1802), the new director, gave an address to the academy in 1788, in which he reiterated its role in the cultural and commercial development of Prussia, by making specific reference to France and England's ability to derive wealth from art when applied to industry.

2. 19TH–20TH CENTURIES.

(i) Introduction. The rise of an anti-academic faction among artists during the later 18th century overlapped with the earlier development of an overtly commercial role for academies of art, and the two tendencies gave rise to some interesting anomalies and contradictions. On the one hand, there were the critics of the traditional schools with their system of learning by copying from engravings and plaster casts. This faction was spearheaded by writers such as Schiller and Goethe and painters such as ASMUS JAKOB CARSTENS, who, ironically, developed many of his ideas in a protracted and acrimonious exchange of letters with Heinitz at the Berlin academy, when he was benefiting from one of that institution's scholarships. On the other hand, gradual changes in the economic and political structure of the region, including the decline in importance of the provincial aristocracy, and the rise of manufacturing and trade, meant that artists could no longer rely on court patronage.

Ultimately, the two tendencies could not co-exist. The mercantilist tendency was taken to its logical conclusion of completely separate training for fine artists and commercial artisans, at first in Vienna, where a Manufaktur-Schule was established in 1758, and in the following years more widely across Germany, for example in the Staatliche Zeichenakademie founded by 17 firms in Hanau in 1772 for the training of gold- and silversmiths. Ultimately, a clear distinction developed among specialized trade schools, art and craft schools and fine art academies, such as those at Dresden and Düsseldorf (*see also* DÜSSELDORF SCHOOL). Meanwhile, in the first half of the 19th century, the anti-academy movement achieved its zenith with the NAZARENES, a group of artists under the leadership of FRIEDRICH OVERBECK at Sant'Isidoro in Italy. The Nazarenes lived and worked together like a medieval guild, under deliberately spartan conditions, forsaking the sentimental in art just as in life. They and their followers had a profound impact on art education in Germany from *c.* 1830 onwards. Their favoured system of 'Meisterklassen'

and the master–pupil system of education gradually supplanted the academic tradition of copying from drawings and engravings at most of the major academies in Germany.

(ii) Trade schools. It was the development of the Gewerbeschulen (trade schools), whose specific brief was to bring art to industry, that first put the German art education system under the European spotlight. With a few exceptions, German art education before the first half of the 19th century had generally been content to aspire to the standards set by Italy, France and England. By the 1830s, however, its education system had become sufficiently specialized, and indeed sufficiently successful, to start attracting serious foreign attention. Ironically, given its already pre-eminent place in the Industrial Revolution, Britain showed the keenest interest: the Scottish painter WILLIAM DYCE led an investigation into the applied art education institutions in France, Prussia, Bavaria and Saxony on behalf of the London School of Design in 1837.

Dyce favoured the Bavarian system, which presented the clearest manifestation of the Nazarene ideal. Elementary classes focused on observational drawing of geometrical solids, as well as the principles of linear perspective; expression was restricted to outline only, and colour and tone were forbidden. This regime continued through to the 30 secondary Gewerbeschulen, to which students could graduate and where they also studied languages, history and sciences. The best of these trainees then progressed to one of three specialized polytechnics, at Augsburg, Nuremberg and Munich, where the stress lay on practical instruction in the techniques of industrial production. Significantly, the Prussian schools lay not under the jurisdiction of any educational body, but under the Privy Councillor of Finance, and instruction was free. A further innovation, and one whose significance was not lost on Dyce, was the importance placed on student access to museums of art and crafts.

(iii) The Gründerzeit *and the early 20th century.* By the time the various independent states that made up the region known as Germany unified to create the Second German Empire in 1871, art education had become strongly associated with the training of artists and artisans to work in industrial production. Fine art training continued in the traditional academies, but it was in applied arts and crafts that the German education system really made its mark. The significance of its efforts was both economic (as a manufacturing nation, Germany came to rival Britain in this period) and cultural, since the art education system was crucial in helping to unify the previously diverse regions and to promote the German Empire as a world power.

Perhaps the most important figure in the development of educational philosophy in German art schools in the *Gründerzeit* ('foundation period') was HERMANN MUTHESIUS, a Prussian civil servant who in 1896 was appointed as cultural attaché to the German Embassy in London. He was deeply impressed by the breadth and the vitality of British applied arts. In 1903 he returned to Berlin to take up a post in the Prussian trade ministry, where his particular responsibility was the reform of art

and design education. One of his first actions was to introduce workshop training into the schools of applied art; the aim was to bring the student an awareness of the direct relationship between form, process and raw materials.

Muthesius secured the appointment of people sympathetic to his belief in workshop training and working directly with raw materials, for example the architect PETER BEHRENS, who became the director of the Düsseldorf school in 1903, and HANS POELZIG, appointed to the Royal School of Arts and Crafts at Breslau in the same year. This, together with his crucial role in the establishment of the Deutscher Werkbund, an association of manufacturers and designers, in 1907, gave Muthesius a uniquely powerful role in the rapid advances in art training in Germany.

From *c.* 1900 to 1914 Germany became a focus for new ideas in art and design education. It is ironic, however, that it was not until Germany had been ruinously defeated in World War I and was in the midst of a period of chronic political instability that it achieved the summit of its international standing with the formation of the BAUHAUS in 1919. Through a combination of brilliant self-promotion by its first director, WALTER GROPIUS, and the recruitment of some of the most important designers of the 20th century, the Bauhaus earned a reputation out of all proportion to its relatively meagre output of students and its brief, 14-year existence. In many ways, the Bauhaus represented the logical drawing-together of many of the ideas in German art education: its master–pupil teaching system and its early allusions to the medieval craft guilds harked back to the Nazarenes, while its uncompromising and strident (if ultimately fruitless) determination to meet the industrial age head-on by designing for machine production can be seen as a 20th-century reflection of the commercial exigencies also encountered much earlier, for example by Hagedorn at the Augsburg academy in the 1760s (*see* BAUHAUS, fig. 1). Far from attempting to create and perpetuate a division of labour between artist and artisan, however, the Bauhaus sought to fuse all the disciplines into a unified whole, with architecture at its apex. Ultimately, it became a victim of a hostile political environment and was closed by the Nazis in 1933.

(iv) Developments after World War II: The Hochschule für Gestaltung at Ulm. After the demise of the Bauhaus, the Nazis' antagonistic and repressive attitude to what they saw as decadent modernism ensured that Germany was no longer in a position to lead the theory and practice of art and design education. It was not until several years after the end of the war that the seeds were sown for a new and radical institution, the Hochschule für Gestaltung (HfG) at Ulm. It was set up by Inge Aicher-Scholl (*b* 1917) in 1953, in memory of her brother and sister, who were executed by the Nazis during the war. Its buildings, designed by its first rector, MAX BILL, were officially opened in 1955. The HfG project had the support of Walter Gropius, and several ex-Bauhaus staff taught there in the early years; there are obvious parallels to the Bauhaus during its formative period. Significantly, though, there was no provision for fine art in its four departments of

Industrial Design, Visual Communication, Building and Information.

Towards the end of the 1950s the HfG moved increasingly towards a curriculum based on science and objectivity, under the leadership of a new rector, TOMÁS MALDONADO. Scientists and academics were brought in to teach the subjects of a new design practice: applied psychology, logic, mathematics, sociology and political history. In late 1962, however, the school suffered another *coup d'état*, this time led by Otl Aicher (1922–91) and the practical design tutors, who felt that science and scientific methods of design were beginning to turn the school into an academy of theory. In the meantime, the HfG had managed to establish an international reputation for excellence in its design and rigour in its approach and undertook prestigious commissions from such major international companies as Lufthansa, Olivetti and Braun.

In 1968, 15 years after its inauguration, the Ulm school closed, amid bitter accusations of betrayal on all sides. The staff who had survived the two abrupt changes of direction had become disillusioned with the constant financial battle to keep the school afloat in the face of bad publicity and of implacable hostility on the part of the local government. Many of the students had become highly politicized, finally occupying the buildings and renaming it the Karl Marx School. In the end it was the student revolution in Paris in May 1968 that sounded the final death-knell for the school. Ulm's historical significance is that it indirectly helped West Germany to return to political and economic prominence; by the time of its closure, however, affluent consumer society had become hostile to its Nazarene-like abhorrence of extravagance and ostentation.

Meanwhile, the ex-*Bauhäusler* MART STAM was busy establishing an overtly functionalist agenda for artists and designers in the new German Democratic Republic in the east. He was appointed to the directorship of the Dresden Akademie der Künste und Hochschule für Werkkunst in 1948, but his ideas on proletarian design and education were paradoxically too radical for a deeply conservative state socialist government, and he moved to Amsterdam in 1953. East German art and design educationalists struggled on with the irreconcilable conflicts of cultural development in a command economy, but their efforts were hampered by an official policy, promoted by the director of the Staatlicher Kommission für Kunstangelegenheiten, Walter Heisig, which favoured a kind of mythical folk-culture not too far removed from some of the ideas of the Nazis, and it was not until 1964 that the Bauhaus was once again acknowledged as a part of German design theory.

The reunification of Germany in 1990 brought unforeseen challenges and problems, but also opportunities. In the 1990s German economic ascendency in Europe and its consequent political power may have brought about a confidence and stability that have not prompted its art education system to remain in the vanguard of either theory or practice.

See also ACADEMY.

BIBLIOGRAPHY

N. Pevsner: *Academies of Art Past and Present* (Cambridge, 1940)

R. Banham: *Theory and Design in the First Machine Age* (London, 1960)

C. Schnaidt: *Hannes Meyer: Buildings, Projects and Writings* (London, 1965)

H. M. Wingler: *The Bauhaus: Weimar, Dessau, Berlin, Chicago* (Cambridge, MA, 1969)

U. Conrads: *Programmes and Manifestos on Twentieth Century Architecture* (London, 1970)

S. MacDonald: *The History and Philosophy of Art Education* (London, 1970)

J. Heimbucher and P. Michels: *Bauhaus–HfG–IUP: Dokumentation und Analyse von drei Bildungsinstitutionen im Bereich der Umweltgestaltung* (diss., U. Stuttgart, 1971)

H. Bayer, W. Gropius and I. Gropius, eds: *Bauhaus, 1919–1928* (New York, 1975)

K. Frampton: 'Ideologie eines Lehrplans', *Archithese*, 15 (1975), pp. 26–43

J. Heskett: *Industrial Design* (London, 1980)

H. M. Wingler: *Bauhaus-Archiv Museum für Gestaltung Sammlungskatalog* (Berlin, 1981)

P. Erni: *Die gute Form* (Baden, 1983)

G. Naylor: *The Bauhaus Reassessed* (London, 1985)

A. Forty: *Objects of Desire* (London, 1986)

J. Heskett: *Design in Germany, 1870–1918* (London, 1986)

R. Kinross: 'From Bauhaus to their House', *Blueprint*, 41 (1987), pp. 61–2

H. Lindinger, ed.: *Hochschule für Gestaltung Ulm: Die Moral der Gegenstände* (Berlin, 1987)

H. Wichmann, ed.: *System-Design Bahnbrecher: Hans Gugelot* (Basle, 1987)

G. Bertsch and E. Hedler: *Schönes Einheits-Design* (Cologne, 1990)

DOMINIC R. STONE

XVI. Art libraries and photographic collections.

The origins of art libraries in Germany were in the small book collections of the art academies, the first of which was founded at the end of the 17th century; the courts at this time also often had extensive collections of books on architecture, art theory and topography, as well as inventories of other royal houses, and some of these later formed the core of important general libraries. In the 19th century noteworthy specialist libraries for art research were developed, usually in museums, and institute libraries were founded, although these did not become significant until the 20th century. The development of museum libraries from small reference libraries for the curators to comprehensive subject libraries for the public took place in the 1920s.

The largest collection of art literature in Germany is in the Kunstbibliothek of the Staatliche Museen zu Berlin Preussischer Kulturbesitz. (The art library has 230,000 volumes and 1000 current periodicals, while the museum libraries have 300,000 volumes.) The art library (founded 1867) contains the Lipperheide costume library, bibliophile editions and also a collection of graphic art and photographs. Since 1972 the Deutsche Forschungsgemeinschaft has supported the acquisition of literature on the art of Anglo-Saxon, Scandinavian and Latin American countries up to 1900 and the architecture of the 20th century. In addition to photographs on architecture and fine art the Bildarchiv of the Preussischer Kulturbesitz also has reproductions on history and portraits. In total there are *c.* 7 million picture documents available.

The library of the Germanisches Nationalmuseum in Nuremberg was founded in 1852 as a museum collection and research establishment for all its departments. The collection (480,000 volumes, 1550 current periodicals) covers literature on art and cultural history, local and regional studies of German-speaking countries and areas once colonized by Germans, and history and folklore from prehistoric times. This library is also responsible for the editing of the bibliography *Schrifttum zur deutschen Kunst*, begun in 1933. The Zentrale Kunstbibliothek in Dresden (founded 1946 and run by the Staatliche Kunstammlungen) is based on the library of the arts and crafts school, which was founded in 1876. The central library and the 11 department libraries have 80,000 volumes and 100 current periodicals. In Leipzig there is the library of the Museum für Bildende Künste, founded in 1837 (60,000 volumes), and the library of the Museum des Kunsthandwerk (38,000 volumes).

The Kunst- und Museumsbibliothek und Rheinisches Bildarchiv in Cologne (250,000 volumes, 950 current periodicals) was founded in 1957 and in addition to general art books collects literature on 20th-century art, the art of the Benelux countries and the history of photography. The Bildarchiv, which became part of the Kunst- und Museumsbibliothek in 1975, has over 300,000 negatives relating to art in Cologne and the Rhineland. The library of the state art collections in Karlsruhe includes the collections of the Staatliche Kunsthalle and the Badisches Landesmuseum (170,000 volumes, 650 current periodicals). The libraries of the Kunsthalle and the Museum für Kunst und Gewerbe in Hamburg each have over 130,000 volumes. Other museum libraries in Bonn, Altenburg, Brunswick, Bremen, Düsseldorf, Frankfurt am Main, Kassel and Stuttgart also have extensive collections.

The Zentralinstitut für Kunstgeschichte in Munich (320,000 volumes, 1100 current periodicals) was founded in 1946. Originally established from the collections of the Nazi libraries of confiscated books, the library rapidly expanded through both extensive gifts and purchases. Main points of the collection are source documents on architectural theory and literature on the emblems and arts of France and the east and south-east European countries; a bibliography of journals on the latter has been printed since 1965. Its photograph library and Bildarchiv der Deutschen Kunst, which was founded in 1961, together have more than 360,000 photographs. The Heidelberg University Library has been collecting—as comprehensively as possible—German and foreign literature on art history since 1949 (in accordance with the directives of the inter-regional DFG—Deutsche Forschungsgemeinschaft).

As part of the acquisition plan of the former German Democratic Republic, the Sächsische Landesbibliothek in Dresden was made responsible for art history in 1956. Among its tasks was the publication of certain reference books on art-historical literature in East Germany, until 1989 the *Bibliographie bildender Kunst, Bibliographie illustrierter Bücher der DDR* and *Standortverzeichnis von Zeitschriften und Serien zur bildenden Kunst in den Bibliotheken der DDR*. There are large collections of literature on art history in art colleges and universities throughout Germany, for example in the Bibliothek der Hochschule für Bildende Künste in Dresden and the Bibliothek der Leipziger Hochschule für Graphik und Buchkunst (26,000 volumes). The central library of the Hochschule der Künste in Berlin has a particularly large collection with 250,000 volumes, and the library of the Kunsthistorisches Institut in Bonn has 140,000 volumes and 350 current periodicals. In addition to a library, all university institutes

also have a reproduction and slide collection for teaching and research (not usually open to the public). The photograph collection of the Kunsthistorisches Institut (180,000 photographs, 180,000 slides) is at the head of the collections that were demanded by the art historians' congress in Vienna in 1873. Some general libraries include good collections on art, for example the Bayerische Staatsbibliothek in Munich, the Deutsche Bibliothek in Frankfurt am Main, the Deutsche Bücherei in Leipzig and the Staatsbibliothek zu Berlin Preussischer Kulturbesitz. Of the regional libraries that were often begun with royal collections it is worth mentioning the collection of the Württembergische Landesbibliothek in Stuttgart.

A major centre for documents is the Bildarchiv Foto in Marburg, founded in 1929 as a department of the Preussisches Forschungsinstitut für Kunstgeschichte. The picture archive has 900,000 negatives on the fine arts of Europe with particular emphasis on Germany, France, Italy, Spain and the Netherlands; it also has 10,000 colour slides of Western paintings. It publishes the *Marburger Index*, which contains 800,000 photographs on microfiche relating to architecture and fine art in Germany. The photographs are taken from the Bildarchiv Foto Marburg, the Rheinisches Bildarchiv, the photograph collections of numerous monument offices, regional educational film hire services, museums, libraries and archives. In addition the picture archive published the *Index photographique de l'art en France* in 1979 with 100,000 photographs on microfiche. The photograph department of the Allgemeine Deutscher Nachrichtendienst (A.D.N. Zentralbild) in Berlin has 6 million photographs. The Deutsche Fotothek in the Sächsische Landesbibliothek in Dresden has 1,200,000 photographs on art and history, culture and technology.

BIBLIOGRAPHY

M. Prause: *Verzeichnis der Zeitschriftenbestände in den kunstwissenschaftlichen Spezialbibliotheken der Bundesrepublik Deutschland und West-Berlins* (Berlin, 1973)

U. Schäme: 'Art Literature in the Libraries of the German Democratic Republic', *ARLIS Newsletter* (22 March 1975), pp. 12–18

Deutsche Kunstbibliotheken: Berlin, Florenz, Köln, München, Nürnberg, Rom (Munich, 1975)

W. Gebhardt: *Spezialbestände in deutschen Bibliotheken: Bundesrepublik Deutschland einschl. Berlin (West)* (Berlin, 1977)

E. Rücker: 'Kooperative Erwerbungspolitik deutscher Kunstbibliotheken: Ein Programm der Deutschen Forschungsgemeinschaft', *Kunstchronik*, xxxi (1978), pp. 437–46

A. Burton: 'A Study Tour of Art Libraries in Germany during Sept. 1979, Part 1', *A. Libs J.*, v (1980), pp. 33–42

EDUARD ISPHORDING

XVII. Historiography.

The development of art history as a specialist subject took place so early in Germany that Erwin Panofsky's statement that for a long time German was the mother language of art history is often quoted. From the 15th century artists themselves had justified their work on theoretical as well as historical grounds. As the collections of both royalty and private citizens grew, there developed a demand, mainly from the middle class, for the critical appraisal of individual works of art by connoisseurs and critics. Art began to be treated as a social institution. In this context JOHANN JOACHIM WINCKELMANN developed the model of a scientific historiography of fine art; in his *Geschichte der Kunst des Alterthums* (Dresden, 1764) he postulated

that political freedom as well as climatic and social conditions and skills had been a basic prerequisite for the burgeoning of the arts in ancient Greece. He took a model of styles already familiar from the field of rhetoric and gave it a historical context. With his attempts to describe individual works, he provoked criticism from aesthetic and literary specialists, archaeologists, connoisseurs and critics of art alike.

Before long the ideals of national identity and cultural prosperity overlaid the premises laid down by Winckelmann. It was in Germany in particular that 'philosophical' painters, as Charles Baudelaire called them, and sculptors and architects whose work reinforced such ideals enjoyed great success. Until the second third of the 19th century the historiography of art was still universal in emphasis, relating to the history of the world. In his lectures the philosopher GEORG WILHELM FRIEDRICH HEGEL had mapped out a historical aesthetic. Carl Schnaase (1798–1875), a lawyer and an art historian, exploited this model in his *Geschichte der bildenden Künste*, the first volume of which was published in 1843. Preparatory work for Hegel's lectures and Schnaase's books had been carried out particularly by Carl Friedrich von Rumohr (1785–1843) with his research into the critical sources of Giorgio Vasari's *Le Vite de' più eccellenti pittori, scultori ed architettori...* (Florence, 1550, rev. 2/1568), which was then being published for the first time in a German translation. Franz Theodor Kugler (1808–58), a historian and politician in cultural affairs who published the *Handbuch der Kunstgeschichte* in 1842, saw this and other publications as suitably complementing Schnaase's concept of world history.

At the same time a large number of more or less independent scholars and artists were examining the history and development of individual monuments without reference to Hegel, motivated by a sense of culture and tradition. This led to inventories of regional treasures, the first scientifically based museum catalogues and travel guides. The Swiss historian JACOB BURCKHARDT wrote *Der Cicerone* (1855), an examination of Renaissance art that was influential in Germany in this respect. Other writers contributed to the widening of general knowledge among the public at large with the first monographs devoted to the life and works of individual 15th- to 17th-century artists. In this they adhered to the idea of growth, the burgeoning and decay of individual styles, so that German research became concentrated on the easily delimited Gothic and Renaissance periods.

After the popular Revolution in 1848 there was an increasingly aesthetically based approach to the writing of history, and thus to research in the history of art to the extent that the latter was henceforth accepted as a separate subject at universities. After chairs for the history of art had been created as early as 1855 in Zurich and 1860 in Vienna, long-term professorships in the history of art were agreed at the university in Bonn (1862), the polytechnics in Stuttgart (1865) and Karlsruhe (1868), and the universities of Strasbourg (1871), Leipzig (1872) and Berlin (1873). The first full professors immediately set up their own art history departments. Until the end of the 19th century the directors and custodians of museums still

came primarily from the ranks of artists and were suspicious of the university-based academic training; their successors were subsequently recruited increasingly from the departments created by the first professors.

Although the heyday of art history writing in Germany is often held to have been in the reign of William II, King of Prussia and Emperor of Germany (*reg* 1888–1918), this argument cannot really be sustained. It is true that during his reign, strictly historico-philological research was carried out modelled on Vienna; CARL JUSTI and ADOLF GOLDSCHMIDT can be named as its most important representatives. (It is also true that connoisseurship, particularly in the person of Wilhelm Bode, the Director-General of the Prussian museums, yielded fruitful results.) The underlying principles for a strictly scientific writing of art history were being developed at that time in the form of *Kunsthistorische Grundbegriffe* (Munich, 1915) by the Swiss historian HEINRICH WÖLFFLIN and in the form of the paradigmatic iconological research of ABY WARBURG. (It must also be added that such progress would have been inconceivable without the lively scholarly exchange of ideas and information and contributions from their colleagues in Switzerland, Austria and Italy, especially Jacob Burckhardt, Alois Riegl, Franz Wickhoff, Giovanni Morelli and Adolfo Venturi.) It was, however, only during the crisis in the liberal arts in the decade following World War I that the development and dissemination of German writing on art history achieved an amazing tempo and a striking social range. The exchange of ideas between nations, particularly with French colleagues, contributed to this, as did the loss of a level of general education among the population that could be taken for granted. The two factors prompted a variety of reactions among German art historians: the distinction was blurred between so-called periods of burgeoning and periods of decadence; the way in which the concept of the history of styles was formulated was sharpened; iconographic research was intensified. Work continued with as much dedication as ever on the *Allgemeines Lexikon der bildenden Künstler...* (Leipzig, 1907–50), edited by Ulrich Thieme and Felix Becker (*see* THIEME-BECKER). People subscribed to the very popular Propyläen-Kunstgeschichte series (Potsdam, 1923–9). The *Handbuch der Kunstwissenschaft* (Munich, 1914–32) founded by Fritz Burger, which had a different methodology, was continued with even greater enthusiasm. In such popular picture books as the *Blaue Bücher* and in the forewords and afterwords of learned publications homage was paid to the supposed pre-eminence of German art. Following a different line of argument, however, the case was also put for maintaining the traditionally international scope of research; the *Kritische Berichte zur kunstwissenschaftlichen Literatur* (Leipzig, 1927–34) was the organ of this line of thought. The Kulturwissenschaftliche Bibliothek Warburg, with its courses and lectures (both 1923–32), and the *Zeitschrift für Ästhetik und allgemeine Kunstwissenschaft* (from 1905) and its conferences promoted interdisciplinary dialogue.

During the 1930s, under the tyranny of Nazism, many art historians lost their posts or voluntarily left the country; most of the specialists who remained endeavoured to make their scholarly activities harmonize with Nazi ideology. However, with a few exceptions, art historians were not taken seriously by the Nazis, and many were left with little to do except organize the protection of works of art during World War II. After the war German historians were at first preoccupied with the reconstruction of destroyed museum buildings and the return of their collections. The isolation of German scholars at the beginning of this period caused them to implement an old idea: the founding of a national specialist association. Until then there had been only national committees for the International Congresses of the History of Art, which had been held since 1873, and since 1908 there had been an association for the promotion of art historical research, the Deutscher Verein für Kunstwissenschaft, which had been open to anyone.

Until the 1960s the professors, museum directors and custodians of monuments, as the main spokesmen for research and teaching of art history, made no secret of their conservative stance and their pessimism about the state of culture. They cultivated a historiography of art that was intelligent but not creative; even the iconology that had been driven out of Germany was accepted back only hesitantly. Then with the coming of a new generation, the student movement and a general change in the perception of history the specialist area was opened up to the inter-disciplinary questioning of the social sciences in particular, then of general historical research; consequently methodology shifted to systems of styles, the hermeneutic, semiotic, psychological, sociological and feminist analysis of individual works of art, the careers of certain artists and the relatively autonomous history of art.

BIBLIOGRAPHY

W. Waetzoldt: *Deutsche Kunsthistoriker*, 2 vols (Leipzig, 1921–4)
J. Jahn, ed.: *Die Kunstwissenschaft der Gegenwart in Selbstdarstellungen* (Leipzig, 1924)
J. Hermand: *Literaturwissenschaft und Kunstwissenschaft* (Stuttgart, 1965)
U. Kultermann: *Geschichte der Kunstgeschichte* (Düsseldorf, 1966, rev. Munich, 1990)
H. Dilly: *Kunstgeschichte als Institution* (Frankfurt am Main, 1979)
L. Dittmann, ed.: *Kategorien und Methoden der deutschen Kunstgeschichte, 1900–1930* (Stuttgart, 1985)
H. Dilly: *Deutsche Kunsthistoriker, 1933–1945* (Munich, 1988)
H. Dilly, ed.: *Altmeister moderner Kunstgeschichte* (Berlin, 1990)
M. Sitt, ed.: *Kunsthistoriker in eigener Sache* (Berlin, 1990)

HEINRICH DILLY

Germersheim. Small west German town at the confluence of the Rhine and Queich rivers, which was refortified, like many other frontier towns, after the Napoleonic Wars. In the 1840s the town was encircled by fortifications designed by Friedrich Ritter von Schmauss (1792–1846). Influenced by the French military engineers Marc-René de Montalembert (1714–1800) and Lazare Carnot (1753–1823), he built them not with bastions but with powerful multi-gun caponiers and casemated batteries covering and flanking straight faces of wall retrenched by defensible barracks. This was the German system of polygonal fortification, and, although it was different from the bastion system that had dominated military architecture for three hundred years, there were still arguments about its effectiveness in war.

These fortifications were dismantled in accordance with the provisions of the Treaty of Versailles (1919), but fine remnants survive, including the central sector of the Beckers Front with a caponier, ravelin, flank batteries and

redoubts, all carried out in a combination of precise brickwork and rusticated masonry. The Ludwigs Tor or gate of 1840 uses military symbolism on the façade, but the sides are pierced by powerful gun embrasures to defend it. Some of the sturdy defensible barracks remain. Everywhere the impression is of fine craftsmanship and robust design, intended by its dignity and expression of martial character to deter an assailant.

BIBLIOGRAPHY
J. Probst: *Geschichte der Stadt und Festung Germersheim* (Speyer, 1898/*R* Pirmasens, 1974)

QUENTIN HUGHES

Germigny-des-Prés. Oratory in Loiret département, France, near the abbey of Saint-Benoît-sur-Loire.

1. ARCHITECTURE. According to an inscription dated between the 9th century AD and the 11th, the small oratory of Germigny-des-Prés was consecrated on 3 January 806. It was built to serve the summer palace of THEODULF, Bishop of Orléans, Abbot of Fleury (Saint-Benoît-sur-Loire) and close associate of Charlemagne. The palace, situated to the west, was presumably destroyed by a documented mid-9th-century fire, no doubt owing to one of the Viking raids that plagued the area during that time. The fire also affected the oratory, which became a priory of Saint-Benoît-sur-Loire in the mid-11th century. In the 15th or 16th century, with the addition of a western nave, it was converted into a parish church. The 'restoration' of 1867–76 by Jean-Juste-Gustave Lisch (1828–1910) involved the wholesale and inaccurate reconstruction of the building, but, although many original features were then destroyed, the essentials of the architectural concept may still be grasped from old drawings and information revealed by the excavations of 1930.

The oratory originally had a centralized plan similar to that found in Byzantine and Armenian architecture (e.g. the 7th-century churches at Ẹdjmiadzin), which may have shared the same Late Antique source, although direct contact must be ruled out. Centralized Visigothic buildings may also have played an influential role, but the presence of Spanish influence is more detectable in the elevation than in the plan. The origins of Theodulf, a Goth, in Spain or Septimania (Provincia Narbonensis) may be responsible for this.

The oratory is a cross-in-square building, buttressed from the outset, with a square tower rising over the central, and slightly largest, of nine vaulted bays. This tower is supported by four square piers, which break up the internal space and are joined by horseshoe arches, suggestive of Spanish influence (see fig.). The walls above these arches, between the central and axial bays, are pierced by triple-arched openings with columnar supports. The tower, which was lowered and erroneously given a cupola by Lisch, replaced a lantern and belfry that may have been rebuilt in the 11th century but certainly existed originally, as bells are documented. Horseshoe arches also spring from the impost blocks of the central piers to the outer walls, where they are received by free-standing columns on high plinths. The corner bays are vaulted with small domes on squinches, perhaps inspired by Late Antique models, while the central bays on each side of the building have raised barrel vaults and windows above apses, which,

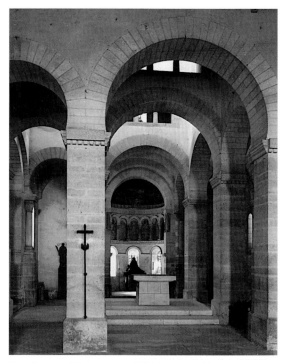

Germigny-des-Prés, consecrated 806, interior looking east

disconcertingly, differ from one another in size and contour. The semicircular north apse is slightly offset to the west owing to a doorway to its east, which was eliminated by Lisch but originally had a gabled lintel and fluted jambs. The south apse is larger than the north and horseshoe-shaped in plan, reflecting the form of the arches in the elevation. Before their 19th-century reconstruction, masonry evidence recorded by Georges Bouet (see *Bull. Mnmt*, lxxxv (1868), pp. 569–88) showed that these lateral apses had been rebuilt, probably after the mid-9th-century fire. The corner bays flanking the east apse, the smallest of the four axial apses, once opened into lateral absidioles; all three were horseshoe-shaped, as was the larger west apse, which was destroyed to make way for the nave. The west apse, facing the altar, may have served as a lodge for Theodulf in the manner of Charlemagne's lodge in the palatine chapel (*c.* 800; now the cathedral) at Aachen. It was later pierced to contain the main entrance of the oratory, a transformation that altered its form.

Although the east apse is not the largest of the axial apses, its liturgical importance is emphasized by its decoration: its entry arch is carried by short, twin colonnettes placed high in the wall; the conch contains a now fragmentary mosaic depicting the *Ark of the Covenant* (see §3 below); beneath this runs a blind arcade that was also decorated with mosaics, and in the lowest zone are three round-headed windows and two niches.

The walls of the oratory were constructed from undressed stone from Fay-aux-Loges and Briare (both Loiret), laid in regular courses with reddish-brown mortar, but the piers and arches were composed of well-cut ashlar. The interior was originally plastered and lavishly decorated with mosaics and stucco. Fragments of stucco and stone

sculpture were removed in 1878 (now in Orléans, Mus. Hist. & Archéol. Orléanais). The reconstruction of the oratory may have deprived it of much of its allure, but the building remains one of the most important, if atypical, Carolingian buildings surviving in France.

See also CAROLINGIAN ART, §II.

2. SCULPTURE. The oratory depended largely on its mosaics and stuccowork for ornamental effect and incorporated only a small amount of architectural stone sculpture. The imposts of the four central piers were simply moulded or carved with fluting supported by guttae; only those on the south-east and north-west piers are original, retained during the 19th-century reconstruction because they carry inscriptions. The baskets of the capitals of the free-standing columns flanking the lateral apses are truncated, inverted pyramids carved with flat, ribbed leaves on each angle. Their abaci are simply carved with a die and small volutes. The capitals flanking the main, eastern apse are more elaborate, possessing bells with cable motifs around their rims and large palmette-like leaves on the angles. Most of the stucco decoration was lost before or during the 19th-century restoration, but some fragments survive (Orléans, Mus. Hist. & Archéol. Orléanais). Pre-restoration drawings reveal the original location of many fragments, including sections of archivolt decoration consisting of *rinceaux*, hook and cable motifs, and foliage capitals. These surprisingly gauche fragments lack the regular, polished appearance of the 19th-century stucco now decorating the apse and cupola. Other sculptures include in the oratory an 11th-century pillar *piscina* and some late medieval wood-carving.

KATHRYN MORRISON

3. MOSAICS. The oratory was once extensively decorated with mosaics, but only that adorning the conch of the eastern apse survives, apart from some insignificant fragments in the blind arcades beneath. Watercolours made in 1869 show that at least the apse wall and the barrel vault on the chancel bay bore mosaics, and, according to Vieillard-Troiekouroff (1959), the large dedicatory inscription formerly to be seen at the base of the dome, which recorded Theodulf's patronage, may also have been executed in mosaic. A drawing by Lisch (1873; see Clemen) showing large cherubim in the spandrels at the base of the main dome is likely to be a reconstruction rather than a record of the original state (Grabar). The provenance of *c.* 100 kg of mosaic paste found in the church in 1867 has not been established.

The apse mosaic of Germigny-des-Prés is the only figural mosaic on a gold ground to survive from the Carolingian period. Its programme largely follows the biblical description of the temple of Solomon according to 1 Kings 6:19–35: here is found not only the apse motif of the *Ark of the Covenant* flanked by large cherubim (the roof of which is adorned by smaller gold cherubim, following Exodus 25:18–20) but also the reference to walls adorned with further cherubim, palm trees and floral motifs, as recorded by the 19th-century drawings of the decoration of the chancel bay. Some scholars have connected the restriction of the decoration to the biblical account of the Holy of Holies, supplemented only by a depiction of the Right Hand of God between the nimbi of the large angels, to the iconoclastic tenor of the *Libri Carolini*, a text associated with Theodulf.

Traces of the three restorations carried out on the apse mosaics since 1841 are discernible in places, for example in the hand of God and the roof of the Ark. The animated figure style seems to be preserved fairly reliably, however, as is suggested by parallels in manuscripts associated with the Court School of Charlemagne, although it seems to surpass that of the lost mosaics in the palatine chapel at Aachen, known only from drawings (*see* CAROLINGIAN ART, §IV, 2). If the 19th-century renovation of the dedicatory inscription on the south-eastern pillar is trustworthy, the mosaics at Germigny were probably produced *c.* 806. They would thus be slightly later than the Aachen mosaics, which must have influenced them. The unusual floral motifs have parallels in Umayyad and Mozarabic ornamentation, and some scholars have attributed this to Theodulf's north Spanish (Visigothic) origins.

BIBLIOGRAPHY

P. Clemen: *Die romanische Monumentalmalerei in den Rheinlanden* (Düsseldorf, 1916), pp. 54–8

J. Hubert: 'Germigny-des-Prés', *Congr. Archéol. France*, xciii (1930), pp. 534–68

A. Grabar: 'Les Mosaïques de Germigny-des-Prés', *Cah. Archéol.*, vii (1954), pp. 171–83

A. Khatchatrian: 'Notes sur l'architecture de l'église de Germigny-des-Prés', *Cah. Archéol.*, vii (1954), pp. 161–9

K. J. Conant: *Carolingian and Romanesque Architecture, 800–1200*, Pelican Hist. A. (Harmondsworth, 1959, rev. 4/1978)

M. Vieillard-Troiekouroff: 'Tables des canons et stucs carolingiens', *Stucchi e mosaici alto medioevali. Atti dell'ottavo congresso di studi sull'arte dell'alto medioevo: Milano, 1959*, pp. 154–78

P. Bloch: 'Das Apsismosaik von Germigny-des-Prés: Karl der Grosse und der Alte Bund', *Karl der Grosse: Lebenswerk und Nachleben*, iii (Düsseldorf, 1965), pp. 234–61

M. Vieillard-Troiekouroff: 'Nouvelles Etudes sur les mosaïques de Germigny-des-Prés', *Cah. Archéol.*, xvii (1967), pp. 103–12

J. Hubert, J. Porcher and W. F. Volbach: *L'Empire carolingien* (Paris, 1968); Eng. trans. as *The Carolingian Renaissance* (New York, 1970), pp. 11–15

W. Grape: 'Karolingische Kunst und Ikonoklasmus', *Aachen. Kstbl.*, xlv (1974), pp. 49–58

P. Jouvellier: 'Les Fragments décoratifs carolingiens de Germigny-des-Prés conservés au Musée historique de l'Orléanais', *Etudes ligériennes d'histoire et d'archéologie médiévales: Saint-Benoît-sur-Loire, 1969* (Auxerre, 1975), pp. 432–5

M. Vieillard-Troiekouroff: 'Germigny-des-Prés: L'Oratoire privé de l'abbé Théodulphe', *Doss. Archéol.*, xxx (1978), pp. 40–49

V. H. Elbern: 'Die "Libri Carolini" und die liturgische Kunst um 800: Zur 1200-Jahrfeier des 2. Konzils von Nikaia 787', *Aachen. Kstbl.*, liv-lv (1986–7), pp. 15–32 (19)

MATTHIAS EXNER

Gernsheim. British historians and collectors. Helmut Gernsheim (*b* Munich, 1 March 1913; *d* 20 July 1995) was brought up in a family of historians. He took a diploma at the Bayerische Staats-Lehr-und Versuchsanstalt für Licht-bildwesen in Munich (1934–6) and studied colour photography at Uvachrome in Munich (1936–7) so that he could emigrate to England and support himself. In Britain in 1937 he became one of two professional colour photographers, worked in the dye-transfer process of Uvachrome and exhibited his black-and-white work. He was interned in Australia in 1940–41 as a German prisoner-of-war, and there studied and lectured on the history of photography, published in 1942 as *New Photo Vision*. Back in London, under the direction of Rudolf Wittkower at the Warburg

Institute, he made complete photographic surveys of historic buildings and monuments for the National Buildings Record. He published his wartime work in 1949 as *Focus on Architecture and Sculpture, an Original Approach to the Photography of Architecture and Sculpture.*

In 1938 Helmut Gernsheim met Alison Emes (*b* London, 1910; *d* 27 March 1969), who had trained as a historian of English social history at Birkbeck College, University of London; they married in 1942. Soon afterwards Helmut Gernsheim was encouraged by the American historian of photography Beaumont Newhall (*b* 1908) to rescue the then unappreciated incunabula of photography. He began this task in January 1945, initially acquiring cased daguerreotypes and ambrotypes for 5–10 shillings each, as well as paying 1–5 guineas for albumen prints by Julia Margaret Cameron and calotypes by Hill and Adamson; he also began assembling a major research library. These activities were later aided by Alison Gernsheim's modest inheritance, by her research in the British Museum reading room and her collaboration with her husband on 20 books and 160 articles between 1947 and 1968. She was meticulous in her research, studying fashion to help date photographs and as a background for her book *Fashion and Reality* (1963).

The subjects of the Gernsheims' pioneering monographs and other studies were generated by their remarkable collecting discoveries. After acquiring over 200 of Julia Margaret Cameron's finest photographs and the accompanying documentary material, they published in 1948 what was probably the first scholarly monograph in the history of photography. Their unearthing of an album of Lewis Carroll's photographs led them to further research and publication in 1949 of a book about the author's heretofore unknown pastime. They developed a very successful exhibition of early photographs, *Masterpieces of Victorian Photography*, for the Festival of Britain in 1951; the exhibition was held at the Victoria and Albert Museum in London and stimulated the revival of interest in Victoriana. The Gernsheims' encyclopedic *History of Photography from the Camera Obscura to the Beginning of the Modern Era* was first published in 1955; it stressed the importance of British photographers to the development of photographic techniques and invested photography itself with greater respectability as an art form. Between 1952 and 1963 the Gernsheims toured their exhibition *One Hundred Years of Photography* in the UK and abroad, but were unsuccessful in negotiations with officials in several countries to establish a national collection of photography. However, in 1963 the University of Texas in Austin bought the Gernsheim collection of 33,000 vintage photographs, 4000 books and journals and 350 pieces of photographic equipment, and thus made it accessible to both scholars and to the public. The Gernsheims moved to Castagnola, Switzerland. One of their ongoing projects was the systematic photographing of all of the world's major collections of Old Master drawings, to form a documentary archive that was sold to museums and libraries by subscription. Following Alison Gernsheim's death in 1969, Helmut Gernsheim enlarged and revised his previous studies and lectures, and returned to writing. He also continued to champion what he considered to be the world's first camera image, *View from his*

Window at Gras (*c*. 1826–7; Austin, U. TX, Human. Res. Cent., Gernsheim Col.), attributed to Nicéphore Niépce.

WRITINGS

H. Gernsheim: *New Photo Vision* (London, 1942)
——: *Julia Margaret Cameron: Her Life and Photographic Work* (London, 1948, rev. Millerton, 1975)
——: *Lewis Carroll, Photographer* (London and New York, 1949)
——: *Focus on Architecture and Sculpture, an Original Approach to the Photography of Architecture and Sculpture* (London, 1949)
H. Gernsheim and A. Gernsheim: *History of Photography from the Camera Obscura to the Beginning of the Modern Era* (Oxford, 1955)
A. Gernsheim: *Fashion and Reality* (London, 1963)
Creative Photography, 1826 to the Present from the Gernsheim Collection (exh. cat. by H. Gernsheim and A. Gernsheim, Detroit, MI, Inst. A., 1963)
H. Gernsheim: *Incunabula of British Photographic Literature: A Bibliography of British Photographic Literature, 1839–75 and British Books Illustrated with Original Photographs* (London and Berkeley, 1984)

BIBLIOGRAPHY

'Mrs Alison Gernsheim, Photo-historian and Biographer', *The Times* (7 April 1969)
P. Hill and T. Cooper: 'Helmut Gernsheim', *Dialogue with Photography* (New York, 1979), pp. 160–210

DIANE TEPFER

Gerolamo di Bartolomeo Strazzarolo da Aviano. *See under* GIROLAMO DA TREVISO (i).

Gerolamo di Giovanni Pennacchi. *See under* GIROLAMO DA TREVISO (i).

Gérôme, Jean-Léon (*b* Vésoul, Haute-Saône, 11 May 1824; *d* Paris, 10 Jan 1904). French painter and sculptor.

1. LIFE AND PAINTED WORK. Gérôme's father, a goldsmith from Vésoul, discouraged his son from studying to become a painter but agreed, reluctantly, to allow him a trial period in the studio of Paul Delaroche in Paris. Gérôme proved his worth, remaining with Delaroche from 1840 to 1843. When Delaroche closed the studio in 1843, Gérôme followed his master to Italy. Pompeii meant more to him than Florence or the Vatican, but the world of nature, which he studied constantly in Italy, meant more to him than all three. An attack of fever brought him back to Paris in 1844. He then studied, briefly, with Charles Gleyre, who had taken over the pupils of Delaroche. Gérôme attended the Ecole des Beaux-Arts and entered the Prix de Rome competition as a way of going back to Italy. In 1846 he failed to qualify for the final stage because of his inadequate ability in figure drawing. To improve his chances in the following year's competition, he painted an academic exercise of two large figures, a nude youth, crouching in the pose of Chaudet's marble *Eros* (1817; Paris, Louvre), and a lightly draped young girl whose graceful mannerism recalls the work of Gérôme's colleagues from the studio of Delaroche. Gérôme added two fighting cocks (he was very fond of animals) and a blue landscape reminiscent of the Bay of Naples. Delaroche encouraged Gérôme to send *The Cockfight* (1846; Paris, Louvre) to the Salon of 1847, where it was discovered by the critic Théophile Thoré (but too late to buy it) and made famous by Théophile Gautier. The picture pleased because it dealt with a theme from Classical antiquity in a manner that owed nothing to the unfashionable mannerisms of David's pupils. Moreover, it placed Gérôme at the head of the NÉO-GREC movement, which consisted largely

of fellow pupils of Gleyre, such as Henri-Pierre Picou (1824–95) and Jean-Louis Hamon.

Gérôme abandoned his attempt to win the Prix de Rome and, although the ambition to paint a perfect nude never left him, he turned to the art market to exploit his popular success. In 1848 he exhibited a frieze-like composition, *Anacreon, Bacchus and Amor* (1848; Toulouse, Mus. Augustins), which was bought by the State, and he was listed among the finalists in the competition for a figure of the Republic with a monumental allegory (Paris, Mairie Lilas). His *Greek Interior* (1850; untraced), a brothel scene in the Pompeian manner of Ingres's *Antiochus and Stratonica* (1840; Chantilly, Mus. Condé), was bought by Prince Napoléon-Jerôme Bonaparte, whose Paris house Gérôme helped to decorate in the Pompeian style (1858). In 1853, his *Idyll* (Brest, Mus. Mun.), a picture of two Greek adolescents (probably Daphnis and Chloë) with a young deer, returned to the formula of *The Cockfight*. With his *Idyll*, he also exhibited *Nations Bringing their Tribute to the World Fair in London* (Sèvres, Mus. N. Cér.), a frieze of figures inspired by Delaroche's Sorbonne mural and commissioned in 1851 to decorate a vase (now London, St James's Pal., Royal Col.) given by the Emperor to Prince Albert. Gérôme developed this theme in a huge composition, the *Age of Augustus* (1855; Paris, Mus. d'Orsay), commissioned by the Comte de Nieuwerkerke in 1852, that combines the birth of Christ below with a host of conquered nations paying homage to Augustus, an ironic contrast between Bethlehem and Rome, inspired

by a passage in Bossuet's *Histoire universelle* (1681) and, like Delaroche's Sorbonne mural, by Ingres's *Apotheosis of Homer* ceiling in the Louvre (1827).

Having received the down payment for the *Age of Augustus* in 1853, Gérôme went to Constantinople with the actor Edmond Got, the first of several journeys to the East that provided themes for many pictures. The sight of regimented Russian conscripts in Romania, making music under the threat of a lash, became *Recreation in the Camp* (sold London, Sotheby's, 25 Nov 1987, lot 19), a modest picture, characteristically ironic, which was more appreciated at the Exposition Universelle of 1855 than his huge masterpieces. He was then hovering on the edge of an official career. A commission to decorate a room in the Conservatoire des Arts et Métiers in Paris (destr. 1965) was followed by a more important commission to decorate the chapel of St Jerome in the church of St Séverin, Paris, completed in 1854. The effect of the pale, flat colours in the *Last Communion of St Jerome*, clearly outlined against a black ground, reflects the influence of Ingres's school on the religious and allegorical works painted by Gérôme and his friends in this period. However, Gérôme did little more like this.

Gérôme's skill as an ethnographer, noticed by the critics in 1855, developed after his first trip to Egypt in 1856. He showed the results at the Salon of 1857. *Plain of Thebes, Upper Egypt* (1857; Nantes, Mus. B.-A.) was the first of many pictures of Arab religion and justice, North African animals and landscape that he composed over the next 40

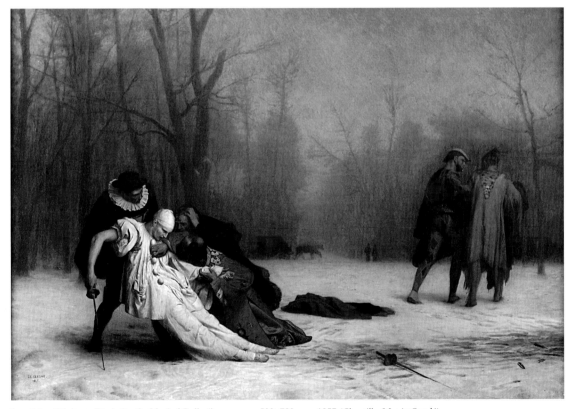

Jean-Léon Gérôme: *Duel after the Masked Ball*, oil on canvas, 500×720 mm, 1857 (Chantilly, Musée Condé)

years. He also exhibited a scene from modern life, *Duel after the Masked Ball* (1857; Chantilly, Mus. Condé; see fig.), which Gérôme described as 'a picture in the English taste', inspired, perhaps by a recent duel in Paris, perhaps by the fashionable Pierrot shows at the Théâtre des Funambules.

In 1859 Gérôme returned to painting Classical subjects, exhibiting *King Candaules* (Ponce, Mus. A.), a solitary figure of *Caesar* (untraced) lying below Pompey's statue and a picture of gladiators, *Ave Caesar* (untraced). Delaroche's *Assassination of the Duc de Guise* (1835; Chantilly, Mus. Condé) was the common source of all these. Ingres's *Antiochus and Stratonica*, the immediate source of *King Candaules*, was painted as a pendant to the *Duc de Guise*, and Gérôme's *Caesar* was an enlarged detail, taken from a photograph of a more complex picture inspired by Delaroche's composition, that had been commissioned by Adolphe Goupil, the print editor, to sell in reproduction as a pendant to the *Duc de Guise*. *Ave Caesar* employs a similar composition and was probably intended as an ironic companion to the picture of the dead Caesar. Gérôme returned to this idea in the *Death of Marshal Ney* (Sheffield, Graves A.G.), which he exhibited in 1867, insisting on his right as a historian to tell the truth, despite official pressure to withdraw a picture that raised painful memories. The limits of Gérôme's repertory were fixed by the end of the Second Empire. History, Greek mythology, Egypt and animals gave him the themes of the many pictures that he exhibited and the many more that he sold through Goupil in the last decades of his life. The Salon became less important to Gérôme as a way of publicizing his work, although he returned very successfully to the Salon in 1874 with *Eminence grise* (Boston, MA, Mus. F.A.).

Gérôme's deity was Truth. In 1896 he painted *Truth Rising from her Well* (Moulins, Mus. Moulins), inspired by La Fontaine. His greatest ambition was to achieve the transparency of an illusion and to describe his subject with the accuracy of contemporary historians. Like a number of painters in this period, Gérôme believed that photography offered an alternative to the old formulae. 'Thanks to it', he said in 1902, 'Truth has at last left her well.' The smooth, highly coloured surface of his pictures and his ingenious effects of light appear photographic. His technique was also admirably suited to the photographic reproductions of his work sold by Goupil.

2. SCULPTURE. Gérôme surprised the public at the Exposition Universelle of 1878 by exhibiting a large bronze gladiator trampling on his victim (Paris, Mus. d'Orsay), which was taken from his painting *Pollice verso* (Phoenix, AZ, A. Mus.), completed in 1872 with the help of casts from the museum at Naples. The idea of making sculpture from his picture was perhaps inspired by the figurines that Antonin Mercié and Alexandre Falguière made for Goupil after Gérôme's *Dance of the 'Ālmah* (1863; Dayton, OH, A. Inst.) and *Phryne in Front of the Judges* (1861; Hamburg, Ksthalle), and also by his lifelong ambition to imitate the works of nature. He moved from modelling to carving marble, turning the theme of his early *Anacreon, Bacchus and Amor* (1848; Toulouse, Mus. Augustins) into an accomplished marble statue (exh. Salon, 1878; Copenhagen, Ny Carlsberg Glyp.) that succeeds in creating the illusion of swaying movement and rippling drapery in the hard stone. He then turned to colour, aware of contemporary experiments in tinting marble in imitation of an antique practice. His best surviving tinted statue, *Dancer with Three Masks* (Caen, Mus. B.-A.), combining colour and movement, was exhibited in 1902. He also experimented with mixed media, assembling a charming *Dancer* (Geneva, priv. col.) from tinted marble, ivory and bronze, inlaid with gemstones and paste, which he exhibited in 1891. The following year he exhibited a disagreeable life-size statue of *Bellona* (Toronto, Inn on the Park), made from bronze and ivory, and a tinted group of *Pygmalion and Galatea* (San Simeon, CA, Hearst Found.). (His sculpture also provided inspiration for his pictures. In several late paintings Gérôme depicted himself in the role of Pygmalion, the sculptor who could turn marble into flesh through the intervention of a goddess, as in *Pygmalion and Galatea* (1890; New York, Met.).)

3. TEACHING AND INFLUENCE. In 1853 Gérôme moved into the group of studios in the Rue Notre-Dame-des-Champs, the 'Boîte à Thé', which became a meeting place for artists, actors and writers in the 1850s. Gérôme's studio housed a theatre where George Sand gave entertainments and Berlioz, Rossini, Princess Mathilde Bonaparte, Gautier, Brahms and Turgenev were visitors. Gérôme remained at the Boîte à Thé until his marriage in 1863 to Marie Goupil, daughter of the dealer and print editor whose international empire, based in the Rue Chaptal, made several of Delaroche's pupils rich and famous. Although Gérôme was a close friend of the Comte de Nieuwerkerke and welcome at the imperial court, and although he received a handful of state commissions, of which the *Reception of the Siamese Ambassadors* (1861–4; Versailles, Château) was the most important, his career as an official artist was limited. Nor was he an academic artist, although his attitudes to subject-matter owed much to his early academic training. His appointment as one of three professors at the Ecole des Beaux-Arts in 1863 followed government reforms carried through despite intense opposition from the Academy. He was not then a member of the Institut, although he was elected, at the fifth attempt, in 1864. His influence was extensive at the Ecole, where his sardonic wit, lax discipline and clear-cut teaching methods made him a popular and respected master. In the longer term, his well-known hostility to the work of Manet, Monet, Rodin, Puvis de Chavannes, Jules Dalou and many others, made his influence unfashionable and ineffective. His art could be dry and disagreeable, but it sometimes had a colour and vivacity that was never equalled by his imitators, and his attitude to subject-matter, often misanthropic, tinged with irony, had a refined emotional strength rarely matched by his fellow Orientalists.

BIBLIOGRAPHY
E. Galichon: 'M. Gérôme, peintre ethnographe', *Gaz. B.-A.* (1868), pp. 147–51
C. Timbal: 'Les Artistes contemporains: Gérôme', *Gaz. B.-A.*, n.s. 2 (1876), pp. 218–31, 334–46
F. Field Hering: *Gérôme: His Life and Works* (New York, 1892)
C. Moreau-Vautier: *Gérôme: Peintre et sculpteur, l'homme et l'artiste* (Paris, 1906)

Gérôme and his Pupils (exh. cat., Poughkeepsie, NY, Vassar Coll. A.G., 1967); review by G. Ackerman in *Burl. Mag.*, cix (1967), pp. 375–6
Jean-Léon Gérôme (1824–1904) (exh. cat., Dayton, OH, A. Inst., 1972)
Jean-Léon Gérôme, 1824–1904: Sculpteur et peintre de l'art officiel (exh. cat., Paris, Gal. Tanagra, 1974)
The Romantics to Rodin (exh. cat., ed. by P. Fusco and H. W. Janson; Los Angeles, CA, Co. Mus. A., 1980), pp. 285–92
Gérôme (exh. cat., Vesoul, Mus. Mun. Garret, 1981)
G. M. Ackerman: *The Life and Work of Jean-Léon Gérôme* (London, 1986)
JON WHITELEY

Gerona. *See* GIRONA.

Gerritsz., Pieter. *See under* MASTERS, ANONYMOUS, AND MONOGRAMMISTS, §I: MASTER OF ALKMAAR.

Gersaint, Edmé-François (*b* Paris, 1694; *d* Paris, 24 March 1750). French *marchand-mercier*, picture dealer and publisher. His marriage to Marie-Louise Sirois (1698–1725) in 1718 brought him into the circle of Antoine Watteau's intimate friends and determined the future course of his activities. One of the witnesses to the marriage, the painter Antoine Dieu, was also a picture dealer, whose stock and business Gersaint had bought before the marriage. He took possession of Dieu's shop, Au Grand Monarque, on 15 April 1718. These premises were destroyed by fire only a few days later, but Gersaint was able shortly afterwards to set up his business on the Pont Notre-Dame. His father-in-law, the master glazier Pierre Sirois (1665–1726), frequently exhibited pictures on his own premises and occasionally worked in association with Dieu. Sirois was also an early patron and friend of Watteau, who recorded his features in *Sous un habit de Mezzetin* (*c.* 1716–18; London, Wallace), and published ten prints after his work. Gersaint maintained this connection: after Watteau returned from London in 1720, in poor health, he took up residence with Gersaint. On Watteau's own initiative (to 'stretch his fingers', as he put it), he painted for Gersaint *L'Enseigne de Gersaint* (1720; Berlin, Schloss Charlottenburg; *see* DRESS, fig. 43). The dealer soon afterwards took charge of the division of Watteau's drawings and of his remaining financial affairs, and Watteau died in his arms on 18 July 1721. During the next decade, Gersaint published 15 prints after paintings and drawings by Watteau, and 31 arabesques, often in collaboration with Louis de Surugue (1686–1762). The arabesques, as he explained, lent themselves particularly well to the embellishment of screens and furniture. After the death of his wife, he married Marie-Anne Pelletier, a merchant's daughter, in 1725. By the early 1730s, his interests included shells, lacquer and porcelain. He made a number of journeys to the Netherlands in search of stock in 1733, 1734, 1736 and 1739, which resulted in a series of catalogues of the curiosities, as well as the prints and drawings, that he was offering for sale. In 1740, in keeping with his new tastes, he changed the name of his shop to La Pagode and ordered a trade card from Boucher, which was engraved by the Comte de Caylus. Soon afterwards, he began to direct sales of important collections, beginning with that of QUENTIN DE LORANGÈRE in 1744, to whom Gersaint had earlier sold his own collection of shells.

For Gersaint the quality of a painting was always more important than the attribution, and he used his catalogues as the vehicle for his thoughts on painting and collecting. In his writing he maintained the superiority of the Italian school although, paradoxically, his activities did much to spread the taste for Dutch and Flemish art. He made a catalogue raisonné of Rembrandt's etchings, which was published posthumously in 1751. In his introduction to the catalogue of the Quentin de Lorangère sale (which also contains his biography of Watteau), he described the pleasures of the life of a 'curieux', to whom his friends' collections were always open when his own palled. It was to this small, amateur world that Gersaint belonged, by habit and taste, although his lively and informative catalogues set a standard that persisted in the later 18th century, when the art market was dominated by a handful of highly professional dealers.

WRITINGS
Catalogue raisonné des diverses curiosités du cabinet de feu M. Quentin de Lorangère (Paris, 1744) [includes 'Abrégé de la vie d'Antoine Watteau', repr. in *Vies anciennes de Watteau*, ed. P. Rosenberg (Paris, 1984)]
Catalogue raisonné d'une collection considérable de diverses curiosités en tous genres contenues dans le cabinet de feu Monsieur de la Mosson (Paris, 1745)
Catalogue de la vente Angran de Fonspertuis (Paris, 1747)
Catalogue raisonné de toutes les pièces qui forment l'oeuvre de Rembrandt (Paris, 1751)

BIBLIOGRAPHY
E. Dacier, J. Hérold and A. Vuaflart: *Jean de Jullienne et les graveurs de Watteau*, 4 vols (Paris, 1921–9)
E. Duverger: 'Réflexions sur le commerce d'art au XVIIIe siècle', *Stil und Überlieferung in der Kunst des Abendlandes*, iii (Berlin, 1967), pp. 65–88
K. Pomian: *Collectionneurs, amateurs et curieux, Paris, Venise: XVIe–XVIIIe siècle* (Paris, 1987), pp. 163–94
M. Préaud and others: *Dictionnaire des éditeurs d'estampes à Paris sous l'Ancien Régime* (Paris, 1987)

Gershuni, Moshe (*b* Tel Aviv, 1936). Israeli painter and printmaker. He studied at the Avni Art Institute in Tel Aviv from 1960 to 1964 and taught at the Bezalel Academy of Art and Design in Jerusalem (1972–7) and at the Art Teachers' Training College in Ramat Hasharon (from 1978). Taking as his subject-matter the cultural, social and political myths that embody Israeli life, Gershuni was one of the first Israeli artists to practise conceptual art and performance art in the late 1960s, first questioning the nature of art and later the structure of society as manifested in cultural and political coercion; at the Venice Biennale in 1980 he exhibited an installation, *Red Sealing/Theatre*, in which an entire room was devoted to texts in Hebrew on the theme of 'Who Is a Zionist and Who Is Not?'. His themes in the 1980s ranged from the unknown soldier to the plight of the Jew forced to assimilate into a hostile society. His *I Am a Soldier* series (e.g. *Soldier! Soldier!*, 1981; see 1986 exh. cat., no. 11) incorporates these and other phrases into an exuberantly expressionist handling of paint explicitly reminiscent of blood. Gershuni touched also on such issues as immigration and the transplantation of European into Israeli culture; to these ends he often included images of waving flags in paintings such as *Arise! Ye Starvelings from Your Slumbers* (1984; Switzerland, Charles Majorkas priv. col., see 1986 exh. cat., no. 14), representing them with fluid and luridly coloured brushstrokes, or linked political dramas with timeless allusions to the Hebrew Bible. He explored similar themes and gestural techniques in screenprints and in large etchings

such as the *Kaddish* series, for example *Honoured* (790×760 mm, 1984; Jerusalem, Israel Mus.).

BIBLIOGRAPHY

Moshe Gershuni (exh. cat. by T. Deecke and I. Levi, Münster, Westfäl. Kstver., 1983)

Moshe Gershuni, 1980–1986 (exh. cat. by I. Levi and Y. Zalmona, Jerusalem, Israel Mus., 1986)

Moshe Gershuni: Malereien auf Papier (exh. cat. by S. Breitberg-Semel, Munich, Gal. Hasenclever, 1987)

Moshe Gershuni, Prints (exh. cat. by I. Levi, Tel Aviv, Mus. A., 1990)

Moshe Gershuni, Prints (exh. cat. by Arik Kilemnik, Ramat Gan, Beit Immanuel Mun. Mus., 1992–3)

SUSAN T. GOODMAN

Gerson, Horst (Karl) (*b* Berlin, 2 March 1907; *d* Groningen, 10 June 1978). Dutch art historian of German birth. He studied art history in Vienna, Berlin and Göttingen. From 1929 to 1930 he was employed in The Hague as an assistant to Cornelis Hofstede de Groot. His dissertation on Philips Koninck was defended in 1932 at Göttingen and was later published. In 1933 Gerson returned to The Hague, where he became a volunteer in the recently founded Rijksbureau voor Kunsthistorische Documentatie (RKD). Later projects included the preparation of his study of the influence of Dutch 17th-century art outside the Netherlands, which was published in 1942. Gerson became a Dutch citizen in 1940 and five years later was appointed curator at the RKD; in 1946 he became the Assistant Director and in 1954 Director. In all of these capacities he made significant contributions to the development of the institution into an internationally respected and indispensable centre for the study of Dutch art history. In the meantime, he regularly produced books, articles and contributions to catalogues and reference works. In 1965 he was appointed professor of art history at the University of Groningen and resigned his post at the Rijksbureau. During the six years of his professorship, he published his *Rembrandt Paintings* and the new edition of Bredius's *Rembrandt: The Complete Edition of the Paintings*, both of which attracted considerable attention because of Gerson's radical reduction of the number of autograph works.

WRITINGS

Philips Koninck (Berlin, 1936)

Ausbreitung und Nachwirkung der holländischen Malerei des 17. Jahrhunderts (Haarlem, 1942)

with E. H. ter Kuile: *Art and Architecture in Belgium, 1600–1800*, Pelican Hist. A. (Harmondsworth, 1960)

Rembrandt Paintings (Amsterdam and New York, 1968)

ed.: A. Bredius: *Rembrandt: The Complete Edition of the Paintings* (New York, rev. 3/1969)

Ned. Ksthist. Jb., xxiii (1972), pp. 513–20 [full bibliog.]

BIBLIOGRAPHY

K. G. Boon: Obituary, *Jb. Kon. Ned. Akad. Wet.* (1978), pp. 163–72 [incl. suppl. to publications listed in *Ned. Ksthist. Jb.*]

J. G. van Gelder: Obituary, *Burl. Mag.*, cxx (1978), pp. 756–9

Obituary, *Oud-Holland*, xcii (1978), pp. 225–6

L. de Vries: Obituary, *Jb. Maatsch. Ned. Lettknd. Leiden* (1978–9), pp. 49–57

J. G. van Gelder and others: *Redes uitgesproken bij de herdenking van Horst Karl Gerson (1907–1978)* [Address given in memory of Horst Karl Gerson (1907–1978)] (Groningen, 1981)

RUDOLF E. O. EKKART

Gerson, Wojciech (*b* Warsaw, 1 July 1831; *d* Warsaw, 25 Feb 1901). Polish painter. He studied (1844–50) at the School of Fine Arts in Warsaw under Jan Feliks Piwarski (1794–1859) and Chrystian Breslauer (1802–82), and then at the Academy of Arts in St Petersburg (1853–5) under Alexey Markov (1802–78). During a stay in Paris (1856–7) he trained for three months at Léon Cogniet's studio, before returning to Warsaw in February 1858. Gerson was among the founders of the Towarzystwo Zachęta Sztuk Pięknych (Society for the Encouragement of Fine Arts), the first exhibition-organizing body in Warsaw, which was set up in 1860. He also influenced a generation of artists from his position as Chief Professor to the Drawing Class at the School of Fine Arts. Gerson led the class until 1896, teaching life drawing, which he believed to be the foundation of art, and discouraging copying and imitation. A number of outstanding 19th-century Polish artists, both the more conservative and those of the avant-garde, studied under Gerson.

Gerson's own work developed in a number of different directions. During sketching trips in the Polish countryside with his students in the 1850s he made landscape and genre studies. After 1863 he took up subjects from history and painted large-scale scenes of a patriotic character: *Lamentable Mission* (1866; Kraków, N. Mus.), concerning the German mission to the Pomeranian Slavs, and the *Princess's Dowry: Polish Prisoners Released from Lithuanian Captivity* (1894; Warsaw, N. Mus.). From 1885 Gerson painted striking mountain landscapes in the Tatras; *Mountain Cemetery* (1894; Warsaw, N. Mus.) is among the foremost achievements of Polish Realism. Gerson's Tatra landscapes reveal his concern with the treatment of light and his articulate response to the contribution of detail to overall atmosphere, as in his record of weather conditions, especially just before a storm. In *Rest after a Bathe* (1895; Warsaw, N. Mus.) Gerson depicted the female nude, a subject rarely treated in Polish art at that time. Gerson also painted genre scenes, portraits and religious subjects for churches, and he produced lithographs and drawings which were published in albums and books and illustrated journals. He was also active as a painter of murals, and he designed stage costumes and settings. He wrote articles on art and art theory, and in 1876 he translated Leonardo da Vinci's *Trattato della pittura* into Polish. He also took an interest in ethnography, archaeology and architecture.

BIBLIOGRAPHY

SAP; Thieme–Becker

A. Čelebonović: *Peinture kitsch ou réalisme bourgeois: L'Art pompier dans le monde* (Paris, 1974), pp. 12–13

J. Zielińska: 'Wojciech Gerson', *Bull. Mus. N. Varsovie/Biul. Muz. N. Warszaw.*, xix/4 (1978), pp. 120–26

Wojciech Gerson (exh. cat., Warsaw, N. Mus., 1978)

A. Ciechanowiecki: 'Ein seltsamer Garten', *Polnische Malerei des 19. Jahrhunderts: Romantik, Realismus und Symbolismus* (exh. cat., Lucerne, Kstmus., 1980)

JANINA ZIELIŃSKA

Gerstein, Noemí (*b* Buenos Aires, 10 Nov 1908; *d* Buenos Aires, 30 Nov 1993). Argentine sculptor. She began her studies in 1934 under the Argentine sculptor Alfredo Bigatti (1898–1964), and in 1950–51 she studied in Paris under Ossip Zadkine with a French government grant. After working in a conventional figurative style she gradually assimilated the language of the avant-garde, for example in an extraordinary series of *Maternities* (1952–6; *Mother and Son*, version, iron and bronze, h. 350 mm, 1953) in which forms are defined by rhythmic relationships

between hollows and volumes. In 1953 she won first prize in the international section of a London-based competition for a monument to the *Unknown Political Prisoner*, representing the theme with an abstract work (version, steel and bronze, 450 mm, 1953; Buenos Aires, Acad. N. B.A.). This was followed by an expressive symbolic marble carving entitled *The Scream* (1956; Buenos Aires, Mus. N. B.A.).

In the late 1950s Gerstein began to use iron and other metals soldered together into exaggerated vertical shapes. These were followed by works made of soldered bronze tubes, sometimes on a monumental scale, for example *Young Girl* (1959; New York, MOMA) and the aggressive *Samurai* (1959; Buenos Aires, Mus. N. B.A.). One such work was awarded a prize in 1962 at the international sculpture competition run by the Instituto Torcuato Di Tella in Buenos Aires.

In 1964 Gerstein began using metal fragments or industrial elements placed on a background of sheet metal to create landscapes or humorous scenes, and she also produced doors, iron gates and fountains. From the 1970s she deployed polished bronze hemispheres in different combinations: closed or open, grouped rigidly together or loosely arranged.

BIBLIOGRAPHY
E. Rodríguez: *Noemí Gerstein* (Buenos Aires, 1955)
O. Svanascini: *Noemí Gerstein* (Buenos Aires, 1962)

NELLY PERAZZO

Gerstl, Richard (*b* Vienna, 14 Sept 1883; *d* Vienna, 4 Nov 1908). Austrian painter and draughtsman. He studied at the Akademie der Bildenden Künste in Vienna under Christian Griepenkerl (1839–1916) and Heinrich Lefler. Gerstl's early and passionate interest in music led him in 1905 to frequent the circle around the composer Arnold Schoenberg. An unhappy romantic attachment to the latter's first wife, Mathilde, was the cause of his suicide. Gerstl's work included life-size portraits of friends and relatives, numerous self-portraits as well as a series of small-scale landscapes, which are among the most accessible of the works created by this sensitive, nervous and complex artist. Apart from a few examples, most of Gerstl's drawings and sketches on paper disappeared after his death. Around 70 paintings exist. Gerstl's main interest was in figure painting. *Self-portrait Semi-nude before a Blue Background* (1901–2; Vienna, priv. col., see 1983–4 exh. cat., no. 1) bears a startling similarity to Edvard Munch's *Puberty*. This artistic and spiritual influence seemed to be impressively overcome, however, in the double portrait of the *Fey Sisters* (1905; Vienna, Belvedere). For these and later works Gerstl painted in a late-Impressionist or pointillist style. Other examples include portraits of his father, his brother in a lieutenant's uniform, *Arnold Schoenberg* (*c*. 1905–6; Vienna, Hist. Mus.) and *Smaragda Berg* (*c*. 1905–6; priv. col., see 1983–4 exh. cat., no. 12).

In the last two years of his life Gerstl created remarkable pictures that seemed to be far in advance of contemporary painting, including the portrait of the *Composer Alexander von Zemlinsky* (*c*. 1907–8; priv. col., see 1983–4 exh. cat., no. 35) or the group portrait of the *Schoenberg Family* (*c*. 1908; Vienna, Mus. 20. Jhts). Schoenberg encouraged Gerstl to paint. In this work Gerstl attempted to achieve in painting a similar effect to that which Arnold Schoenberg achieved in his early atonal music: Gerstl's painting was spontaneous and lively, almost becoming non-representational. His exceptional interest in music meant that he avoided contact with other artists. He never exhibited during his lifetime, and financial security through his affluent father meant that he never needed to sell any work. It was not until 23 years after his death that he was somewhat mistakenly hailed as an 'Austrian van Gogh'. The comparatively small number of surviving works has limited the extent to which he is considered significant, although he is certainly a key figure for Austrian Expressionism and for early expressive art in general. Important one-man exhibitions of Gerstl's paintings and drawings took place at the Neue Galerie in Vienna (1931), the Galerie Gurlitt in Berlin, the Kunstverein in Cologne and the Suermondt-Museum in Aachen. His work was also exhibited at the Austrian pavilion of the Venice Biennale in 1956, at the Vienna Secession in 1966, and in 1983–4 to mark his centenary at the Historisches Museum in Vienna.

BIBLIOGRAPHY
W. Born: 'Richard Gerstl', *Belvedere*, x/11 (1931)
W. Hofmann: 'Der Wiener Maler Richard Gerstl', *Kstwk*, x/1–2 (1956–7), pp. 153–7
O. Breicha: 'Gerstl, der Zeichner', *Albertina-Stud.*, iii/2 (1965), pp. 99–101
O. Kallir: 'Richard Gerstl: Beiträge zur Dokumentation seines Lebens und Werkes', *Mitt. Österreich. Gal.*, xviii/62 (1974), pp. 125–93
Richard Gerstl (1883–1908) (exh. cat. by O. Breicha, R. Kassal-Mikula and W. Deutschmann, Vienna, Museen Stadt, 1983–4)
O. Breicha: *Richard Gerstl* (Salzburg, 1993)

OTTO BREICHA

Gerthener [Gertener], **Madern** (*b* Frankfurt am Main, *c*. 1360; *d* Frankfurt am Main, 1430/31). German architect and sculptor. He was one of the most important architects of the generation following the Parler family. His work in Frankfurt and the middle Rhine Valley exerted a lasting influence on the Late Gothic architecture and architectural sculpture of the early 15th century, extending over a wide area. His style was influenced by the formal vocabulary of the Parlers, and he ranks as an important exponent of the *Schöne Stil c.* 1400. He was born into a respected family of stone masons: with his father, Johann, he occupies the second place among stone masons on a list of inhabitants of Frankfurt dated 1387. Presumably he trained in his father's workshop, and as there is no evidence that he was in Frankfurt between 1387 and 1391 he may have gained wider experience through travel during those years. He probably visited the workshops in Nuremberg, Prague, Ulm and Vienna, all closely associated with the Parlers. His eventual contact with the art of the Burgundian court is now considered less significant.

Gerthener first reappears in the Frankfurt tax rolls in 1392. By 1395 he was a permanently salaried mason in the employ of the imperial city. In 1408/9 he became Master of the Works at the cathedral of St Bartholomäus in Frankfurt, and he remained Master of the Works for both the city and St Bartholomäus until his death, his high status matched by his social and financial position. Shortly before 1400 Gerthener married Adelheid Gulden zum Schusshan, a member of an influential Frankfurt family. Decreases in his considerable taxes in the 1420s should

probably be seen as the result of partial exemptions and privileges granted by the city. In 1391 he had already inherited two houses in Frankfurt, and in later years he increased his property holdings considerably. From 1398 he owned the Karthäuser Hof. In April 1400 Gerthener and his wife acquired a garden plot (and later a house) within the newly completed walls of the city (Ringshausen).

Documentary evidence for Gerthener's activity both in Frankfurt and elsewhere is sparse. His first public commission for a civic building was perhaps the construction of the former Leinwandhaus (1395/6; mainly destr. 1944) in Frankfurt. He worked on the bridge over the River Main at Frankfurt until 1399, and he is still mentioned in connection with the bridge's construction in 1406, 1409 and 1411. His activities as a civil engineer included the construction of a bridge at Bonames in 1409/10. He was certainly also prominently involved in the renewal of Frankfurt's defences. Construction of the Eschenheimer Turm, which was begun in 1400, was completed in 1427 under his direction. In 1411 he reinforced the city walls between the River Main and the Bockenheimer gate. The Galgenwarte (a watch-tower) was built in 1414 during his period of service and became the model for fortifications built by the Frankfurt militia in the 15th century. Some buildings can be attributed to Gerthener on stylistic grounds. Around 1410 he may have been involved in building the so-called Nürnberger Hof in Frankfurt, the trading centre for the Nuremberg merchants; the arched entrance was given a sumptuous vault. He probably drew up plans for rebuilding the following churches: the former Carmelite church, beginning in 1424; the Leonhardskirche in 1425 (see FRANKFURT AM MAIN, fig. 1); and the south façade of the Liebfrauenkirche (1425), which was designed as a show façade.

Gerthener's most outstanding achievement in Frankfurt was the Cathedral of St Bartholomäus. He vaulted the transepts and crossing from 1408, completing their construction in 1411. The foundation-stone of an imposing west tower was laid in 1415, but after numerous interruptions of work in the Late Gothic period and a fire in 1867 the tower was only finally completed, still to his plans, in 1869. His artistic importance is primarily revealed in the striking cupola-like top of the tower and the richly decorated north and south portals (1416; see fig.). The tower plans A, B and C (Frankfurt am Main, Hist. Mus.) are probably later versions of Gerthener's sketches made by one of his successors (Ringshausen, 1968), although the outstanding quality of the drawing of plan A, which is dated 1420–40 (Pause) and shows the elevation of the cathedral tower seen from the west, may indicate that, if not by Gerthener himself, it is the work of a close associate.

Gerthener's work outside Frankfurt is poorly documented. The 50 florins paid out in Gelnhausen in 1407 are presumably to do with a commission for Rupert, Holy Roman Emperor (reg 1400–10). The so-called Ruprecht building in Heidelberg Castle (begun c. 1400) and the sacristy of Speyer Cathedral (begun 1409) are ascribed to Gerthener, and in 1414 he was commissioned to build the west choir of the Katherinenkirche, Oppenheim. Gerthener and his workshop were probably entrusted with the so-called Memorial gate in the cathedral cloister in Mainz from 1425. Gerthener's skills were already appreciated in

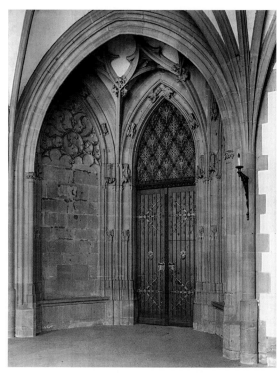

Madern Gerthener: north portal, tower of cathedral of St Bartholomäus, Frankfurt am Main, 1416

Strasbourg in 1419, when, with other important south German masters, he was called there to advise on the continuation of work on the cathedral tower after the death of Ulrich von Ensingen. As late as October 1430 Gerthener was paid with wine for inspecting the construction of a bridge in Nied (now part of Frankfurt). He may also have spent some time that year in Ulm, where the accounts books indicate payments to a 'matern von Frankfurt'.

Gerthener's importance as a sculptor is difficult to determine owing to the lack of a certainly attributable homogeneous body of work. His workshop contained up to seven highly qualified sculptors and stone masons working either according to his designs or on their own commissions. Sculptures documented as by his own hand are the reliefs of the city and imperial eagles for the Eschenheimer Turm in Frankfurt (1427) and a keystone carved in 1409, depicting the Frankfurt eagle, for the transept vault of the cathedral. An entry in the Frankfurt Baumeisterbücher (accounts), concerning a statue of the *Virgin* in the possession of the foreman, cannot definitely be associated with his sculptural activity. Some works have, however, been attributed to him on grounds of style (Kniffler): an epitaph to the village mayor (Stadtschultheiss), *Siegfried von Marburg Going to Paradise* (c. 1410; Frankfurt am Main, Nikolaikirche), and the tomb memorial to *Archbishop Johann II of Nassau* (d 1419; Mainz Cathedral).

Gerthener's style is marked by a synthesis of contrasting elements. The plain socle of the tower of the cathedral of St Bartholomäus, for example, contrasts markedly with

the tower itself, with its richly decorated octagon decorated with a dense crown of bundled finials, and the steep, slender pyramid of its spire. The vaults and tracery forms show ideas borrowed from the Parlers and interpreted in a personal way: the Parlers' tri-radial vault of the south transept of Prague Cathedral is transformed in the narthex of the portal at Frankfurt into halved star shapes or to rose blossoms used as tracery infill. By using arching ribs he produced here probably the first traceried vault pattern on the Continent. His innovative tracery designs, composed of entangled rod-like forms (e.g. at St Bartholomäus, the tympana of the side walls of the narthex; in Mainz Cathedral cloister, the Memorial gate), anticipate the development of the tracery and branch decoration (*Astwerk*) of 15th-century Late Gothic architecture and decoration. The plan (Vienna, Akad. Bild. Kst., MS. 10931) shows ideas for tracery that are excellent examples of his typical 'rod-work'; in it the edges of the foiled and bubble shapes incorporated into the tracery are reinterpreted as vegetable forms, composed of rod-like elements and given little foliate cusps. His ideas were largely taken up by the men trained in the circle of the Frankfurt workshop, and this led directly to the development of an independent school of building in the middle Rhine Valley during the first half of the 15th century.

BIBLIOGRAPHY

W. K. Zülch: *Frankfurter Künstler, 1223–1700*, Veröffentlichungen der historischen Kommission der Stadt Frankfurt, 10 (Frankfurt am Main, 1935/*R* 1967), pp. 48–53

A. Feulner: 'Der Bildhauer Madern Gerthener', *Z. Dt. Ver. Kstwiss.*, vii (1940), pp. 1–26

R. Wallrath: 'Eine Visierung des Baumeisters und Bildhauers Madern Gerthener', *Jb. Preuss. Kstsamml.*, lxiv (1943), pp. 73–88

F. W. Fischer: *Die spätgotische Kirchenbaukunst am Mittelrhein, 1410–1520*, Heidelberg. Kstgesch. Abh., n. s. 7 (Heidelberg, 1962), pp. 15–64

M. Backes: *Hessen*, Hb. Dt. Kstdkml. (Munich, 1966/*R* 1975, rev. 1982)

D. L. Ehresmann: *Middle Rhenish Sculpture, 1380–1440* (diss., New York U., 1966), pp. 174–260

——: 'The Frankfurt Three Kings Portal: Madern Gerthener and the International Gothic Style on the Middle Rhine', *A. Bull.*, 50 (1968), pp. 301–8

G. J. Ringshausen: *Madern Gerthener: Leben und Werk nach den Urkunden* (diss., U. Göttingen, 1968)

P. Pause: *Gotische Architekturzeichnungen in Deutschland* (diss., U. Bonn, 1973), pp. 117–28

Kunst um 1400 am Mittelrhein: Ein Teil der Wirklichkeit (exh. cat., ed. H. Beck, H. Bredekamp and W. Beeh; Frankfurt am Main, Liebieghaus, 1975), pp. 49–56

G. J. Ringshausen: 'Kunst und Wirklichkeit um 1400', *Städel-Jb.*, n. s., vi (1977), pp. 209–30

G. Kniffler: *Die Grabdenkmäler der Mainzer Erzbischöfe vom 13. bis zum 16. Jahrhundert: Untersuchungen zur Geschichte, zur Plastik und zur Ornamentik*, Diss. Kstgesch., 7 (Cologne and Vienna, 1978), pp. 51–93

Die Parler und der Schöne Stil, 1350–1400 (exh. cat., ed. A. Legner; Cologne, Schnütgen-Mus., 1978), i, pp. 232–3

B. Schütz: *Die Katharinenkirche in Oppenheim*, Beitr. Kstgesch., 17 (Berlin and New York, 1982), pp. 267–313

N. Nussbaum: *Deutsche Kirchenbaukunst der Gotik* (Cologne, 1985), pp. 201–4

FRANZ BISCHOFF

Gertler, Mark (*b* Spitalfields, London, 9 Dec 1891; *d* Highgate, London, 23 June 1939). English painter. He was the son of Polish Jews and was brought up in Whitechapel in severe poverty until his father's furrier workshop became moderately successful. As a child he knew nothing of art except advertisements and the work of pavement artists. He was 14 before he heard of any art institutions,

and his career was determined by the discovery of W. P. Frith's *Autobiography* in a secondhand bookshop. In 1906 he began attending art classes at the Regent Street Polytechnic in London, as well as a series of talks on Dutch and Flemish painting. His earliest still-lifes show the influence of Dutch 17th-century painting and the work of Chardin. Gertler left the Polytechnic for financial reasons in 1907 and apprenticed himself to Clayton and Bell, a firm of glass painters. In 1908 he won a prize in a national art competition and, on the strength of this, successfully applied for financial assistance from the Jewish Educational Aid Society, using William Rothenstein as a referee. That autumn he entered the Slade School of Fine Art, where he was taught by Henry Tonks and Philip Wilson Steer. He won several prizes and scholarships and fell in love with Dora Carrington. This and other friendships established at the Slade introduced him into a society that gave him a new perspective on his own family background. While writing delightedly to others of his 'nice friends among the upper classes', his paintings—portraits and family groups—celebrated the enclosed world, the poverty and hardship of a Jewish ghetto. The most outstanding of these are portraits of his mother (e.g. *The Artist's Mother*, 1911; London, Tate).

Gertler's prospects were additionally helped *c*. 1910–20 by his friendship with the civil servant and patron Edward Marsh. Gertler was open to a wide variety of artistic and literary influences at this time, particularly enjoying the novels of Dostoyevsky. Although he experimented with a degree of abstraction while interest in Post-Impressionism was at its height, he did so in order to introduce a barbaric and symbolic note into his essentially realist art. His aim, he once told his friend Dorothy Brett, was 'to paint a picture in which I hope to express all the sorrow of life'. His masterpiece is a savage indictment of war: entitled *Merry-go-round* (1916; London, Tate), it portrays a mechanistic nightmare in which rows of serried figures spin forever. Its harsh colour and violent mood announce his dissatisfaction with much English Post-Impressionism which he declared an abject imitation of the French example, 'too refined for us—too sweet. We must have something more brutal today.'

Behind *Merry-go-round* lay not only Gertler's hatred of war but also the tension created by his relationship with Dora Carrington, who had transferred her affections to the biographer Lytton Strachey. Frustrated and often depressed, Gertler struck a melancholy vein in paintings done at Garsington, the home of Lady Ottoline Morrell, where he mixed with artists and writers such as D. H. Lawrence and Aldous Huxley. After the stridency of *Merry-go-round* and other war-time paintings, his work became gentler during the 1920s, using subtle colour schemes and more persuasive rhythms. He began to concentrate on still-lifes and nudes, employing in paintings such as the *Queen of Sheba* (1922; London, Tate) a neo-classical style related to that used by Picasso and Renoir. Dogged by tuberculosis (necessitating long periods in sanatoria), anxious about his work and depressed at his lack of success, he took his own life in 1939.

WRITINGS

Mark Gertler: Selected Letters, ed. N. Carrington (London, 1965) [with intro. by Q. Bell]

BIBLIOGRAPHY

Mark Gertler, 1891–1939 (exh. cat. by J. Woodeson, Colchester, Minories, 1971)

J. Woodeson: *Mark Gertler: Biography of a Painter, 1891–1939* (London, 1972)

Mark Gertler: The Early and the Late Years (exh. cat., London, Ben Uri A.G., 1982)

FRANCES SPALDING

Gertner [Gärtner], Christoph (*b* ?Arnstadt, *c.* 1575–80; *d* after 1623). German painter and draughtsman. From stylistic evidence he must have spent some time around 1600 in the circle of the court painters to Emperor Rudolf II in Prague. In 1604 he was engaged as court painter by Henry Julius, Duke of Brunswick-Wolfenbüttel; he worked at the Duke's residence at Wolfenbüttel until 1621, then entered the service of the Protestant archbishop Christian William of Brandenburg. Gertner is exemplary among those painters of the era who carried a training at the imperial court to provincial, usually Protestant, courts, not without a certain loss of quality. The individuality of his art can best be seen in his drawings, about 40 sheets being known. Their formal qualities, the style of his figures and the iconographic treatment derive from Rudolf's court painters Hans von Aachen and Joseph Heintz I. However, with the artists he headed at Wolfenbüttel, Philipp Rudolf Hübner (*c.* 1585–after 1625), Sebastian Schütz (*c.* 1595–after 1631), Hans Georg Wolff (*c.* 1590–1618/19) and Blasius Maler of Würzburg (*fl c.* 1627), and under the influence of the art of Joachim Wtewael and Abraham Bloemaert, Gertner gradually developed an unmistakable ornamental style of his own.

The only paintings unquestionably known to be Gertner's are a monogrammed *Danaë* on slate (1608; Wolfenbüttel, Stadt- & Kreisheimatmus.), a *Last Judgement* (1610; Bückeburg, Schlosskapelle), a *Pair of Lovers with the Reaper* on slate (Prague, N.G.), another *Last Judgement* (Wolfenbüttel, St Johannis), a *Crucifixion* (1613; Wobeck, St Georg), *Venus and Cupid* and *Diana* (both 1610; Wolfenbüttel, Stadt- & Kreisheimatmus.) and a portrait of *Frederick Ulrich, Duke of Brunswick* (1615; Wolfenbüttel, Landesmus. Ges. & Vlkstum), of whom there is also a miniature (1620; Wolfenbüttel, Herzog August Bib.). His latest known painting is a *Bordello Scene* (ex-art market, Bremen, 1990), signed and dated 1623, after a composition by Hans von Aachen (versions: Linz, Oberösterreich. Landesmus.; Karlsruhe, Staatl. Ksthalle). Also attributable to Gertner are miniatures on an alchemist manuscript (Wolfenbüttel, Herzog August Bib., Cod. Helmst. 340). Sketches survive for 21 untraced canvases of *Virtues and Vices*, commissioned *c.* 1617 by Graf Anton Günther von Oldenburg (1583–1617) for a coffered ceiling in the Great Chamber of Schloss Oldenburg (Oldenburg, Niedersächs. Staatsarchiv).

Thieme–Becker

BIBLIOGRAPHY

F. Thöne: *Wolfenbüttel: Geist und Glanz einer alten Residenz* (Munich, 1963)

H. Geissler: *Zeichnung in Deutschland: Deutsche Zeichner, 1540–1640* (exh. cat., Stuttgart, Staatsgal., 1979–80), ii, pp. 118–21

J. Zimmer: 'Christoph Gertner, Hofmaler in Wolfenbüttel: Eine neu entdeckte Danae und ein vorläufiges Werkverzeichnis', *Niederdt. Beitr. Kstgesch.*, xxiii (1984), pp. 117–38

Schriften des Weserrenaissance museums, Schloss Brake, 2 vols (Munich, 1989)

JÜRGEN ZIMMER

Gertner [Gärtner], Peter (*b c.* 1495–1500; *d* after 1541). German painter. On 12 January 1521 he received citizenship of Nuremberg, where he is thought to have studied under Wolf Traut. Like Traut, he used an austere graphic line and dry, bright colours. While in Nuremberg he painted a *Portrait of a Man* (1523; Heidelberg, Kurpfälz. Mus.; stolen 1974) and a portrait of *Hans Geyer* (1524; Raleigh, NC Mus. A.). By 1527 he was working for Kasimir, Markgraf zu Brandenburg-Kulmbach, Burgrave of Nuremberg (1481–1527); he later painted a memorial picture of the Margrave with his wife Susanna (untraced; copy, Heilbronn, Protestant Pfarrkirche). When Susanna then married Otto Henry, the future Elector Palatine, in 1529, Gertner went with her to the court of Neuburg an der Donau. A portrait of her (*c.* 1530; Berchtesgaden, Schlossmus.) was followed by portraits of Otto Henry and other members of the house of Wittelsbach (1531–9; mostly in Munich, Bayer. Nmus.) which took 'maister Peter, Hofmaller' to various German courts. That of *Count Palatine Philip the Warlike* (1530; Munich, Bayer. Nmus. and Bayer. Staatsgemäldesammlungen) includes a view of Vienna during the Turkish siege. Gertner also painted such religious works as the *Crucifixion* (1537; Baltimore, MD, Walters A.G.), but it is chiefly his court portraits that are fascinating for their precise rendition of clothes and jewellery. They were prepared by adding colour to pen-and-ink drawings. Pictorially complete modelli, painted on parchment, served the studio as a basis for producing replicas. Gertner's signature was the monogram PG with a gardener's spade.

BIBLIOGRAPHY

L. Fudickar: *Die Bildniskunst der Nürnberger Barthel Beham und Peter Gertner* (diss., U. Munich, 1942)

P. Wescher: 'A Religious Painting by Peter Gaertner in the Walters Art Gallery', *J. Walters A.G.*, xvii (1954), pp. 71–5

——: 'An Unknown Portrait by Peter Gaertner', *NC Mus. A. Bull.*, i/3 (1957), pp. 1–4

K. Löcher: 'Peter Gertner—ein Nürnberger Meister als Hofmaler des Pfalzgrafen Ottheinrich in Neuburg an der Donau', *Neuburg. Kollktbl.*, 141 (1993), pp. 5–133

KURT LÖCHER

Gerung [Geron], Matthias [Mattis; Matheus] (*b* Nördlingen, *c.* 1500; *d* Lauingen, 1569/70). German painter, miniature painter, and woodcut and tapestry designer. He was probably the son of Matthias, a Nördlingen shoemaker known as Geiger (*d* 1521), and probably served an apprenticeship in Nördlingen with Hans Schäufelein. By 1525 he was established as an artist in Lauingen, then part of the Duchy of Neuburg, where he appears annually in the tax register until 1568. From 1531 to 1567 he served as the city's weighmaster. He was married to Anna Reiser, perhaps the daughter of the Lauingen painter Matthes Reiser (*d c.* 1519), and they had two sons, Hans (*fl* 1564/5), a goldsmith in Lauingen, and Ambrosius (*fl* 1568).

Gerung's major patron was Otto Henry, later Elector Palatine of the Rhine. Between 1530 and 1532 Gerung illuminated the spaces left empty for New Testament scenes in Otto Henry's large unfinished 15th-century Bible (divided between Munich, Bayer. Staatsbib. and Heidelberg, Kurpfälz. Mus.). He modelled the Bible's Apocalypse miniatures on Dürer's woodcut series from 1498, but his compositions lack Dürer's dramatic effects. Gerung may

also have designed tapestries for Otto Henry. One such tapestry, the *Turkish Siege of Vienna in 1529* (1543; untraced), contained the signature *Mathis Gerung von Nördlingen, Maler zu Lauing. O.W.O.N.* (there is a hypothesis that these initials, which accompany Gerung's monogram on several paintings as well, may stand for the motto 'O Welt, O Not'). But attributions to Gerung of designs for other tapestries for Otto Henry are now considered tenuous.

Of the 84 woodcuts ascribed to Gerung, 48 display his monogram, which was mistaken in the 17th century for that of Matthias Grünewald. Preparatory drawings for five of these have been identified, including the richly framed *Crucifixion* (Hollstein, no. 72; drawing, Vienna, Mus. Angewandte Kst) used for Otto Henry's Protestant *Kirchenordnung* (Nuremberg, 1543). At the core of Gerung's graphic work is a group of 58–60 woodcuts (1536–58) that illustrate Lorenz Agricola's translation of Sebastian Meyer's commentary on the Apocalypse (written Zurich, 1544; unpublished; MS., Munich, Bayer. Staatsbib.). In this manuscript, a pair of Gerung's woodcuts accompanies a given apocalyptic passage—one illustrating the text itself and a corresponding print satirizing the Catholic Church. The polemical counterpart to the *Adoration of the Seven-Headed Beast*, for instance, is *The Pope and a Turk as Demons Enthroned in Hell* (see fig.), showing these figures as the apocalyptic beasts from Revelation 13, with tails intertwined to signify their unified heretical threat to

Christendom. At least one of Gerung's polemical prints may have encountered controversy. Several symbols of the Catholic hierarchy were removed from the second state of the *Stairway to Salvation* (H 39), a large single-leaf woodcut showing Catholics excluded from heaven, to mitigate the censure of the Church. Yet Gerung's patronage was not confined to Protestants, since he also designed the woodcuts to the *Missale secundum ritum Augustinensis ecclesie* (Dillingen, 1555) for the Augsburg bishop Cardinal Otto Truchsess von Waldburg (1514–73).

Dated paintings with Gerung's monogram include the *Camp of Holofernes* (1538; Madrid, priv. col.), the *Judgement of Paris and Destruction of Troy* (1540; Paris, Louvre), an *Allegory of Justice Asleep and Enchained* (1543; Karlsruhe, Staatl. Ksthalle), *Lauingen's City Council Paying Homage to Charles V in 1546 at his Camp at Weihgäu* (1551; Lauingen, Heimathaus) and a *Giving of Alms* (1553; Höchstadt, Pfarrkirche). In his major historical painting in Lauingen, which was commissioned by the city, Gerung portrayed himself sketching among numerous figures in contemporary dress, in a broad, calm landscape rising to a high horizon. It is similar in organization to several of Gerung's other paintings and to the series of historical paintings made slightly earlier (1528–40) for the Bavarian duke William IV by such artists as Albrecht Altdorfer and Melchior Feselen. Among the paintings securely attributed to Gerung are the Gotha Altarpiece (*c.* 1530; Gotha, Schloss Friedenstein), a large Protestant polyptych, and *Melancolia in the Garden of Life* (1558; Karlsruhe, Staatl. Ksthalle).

Gerung's style reflects the influence of both the Dürer school and, in its less dramatic qualities, the nearby Augsburg artists. This provincial master freely borrowed figures and compositions from such artists as Dürer, the Master of Petrarch, Christoph Amberger and the Cranach workshop. His originality lies in his allegorical subjects and satires. His last dated work is from 1558.

BIBLIOGRAPHY

Hollstein: *Ger.*; *NDB*; Thieme–Becker

C. Dodgson: 'Some Drawings by Matthias Gerung', *Graph. Kst.*, n. s. 1 (1936), pp. 81–5

R.-C. Sonderband, ed.: *Ottheinrich. Gedenkschrift* (Heidelberg, 1956), pp. 141–71 [A. Stemper: 'Die Wandteppiche'], 172–8 [F. von Juraschek: 'Der Thronend-Wandelnde des Matthias Gerung']

S. Béguin: 'Deux tableaux allemande des collections du Louvre', *Rev. A.*, ix (1959), pp. 25–30

H. Wichmann, ed.: *Bibliographie der Kunst in Bayern*, iv (Wiesbaden, 1973), pp. 183–4

W. L. Strauss: *The German Single-Leaf Woodcut, 1550–1600*, i (New York, 1975), pp. 249–332

R. W. Scribner: *For the Sake of Simple Folk: Popular Propaganda for the German Reformation* (Cambridge, 1981), pp. 112–13, 161, 181–2, 241, 267; n. 94

Luther und die Folgen für die Kunst (exh. cat., ed. W. Hofmann; Hamburg, Ksthalle, 1983), nos 16, 42, 46–7, 70–72, 77–8

C. Müller: 'Die Melancholie im Garten des Lebens: Matthias Gerungs "Melancolia 1558" in Karlsruhe', *Jb. Staatl. Kstsamml. Baden-Württemberg*, xxi (1984), pp. 7–33

Die Renaissance im deutschen Südwesten (exh. cat., Karlsruhe, Bad. Landesmus., 1986), nos C17, F10–11, G1, H73, Q2

P. Roettig: *Reformation als Apokalypse: Die Holzschnitte von Matthias Gerung im Codex germanicus 6592 der Bayerischen Staatsbibliothek in München* (Berne, 1991)

JANE S. PETERS

Matthias Gerung: *The Pope and a Turk as Demons Enthroned in Hell*, woodcut, 238×162 mm, *c.* 1550 (London, British Museum)

Gervex, Henri(-Alexandre) (*b* Paris, 10 Sept 1852; *d* Paris, 7 June 1929). French painter. His artistic education

began with the Prix de Rome winner Pierre Brisset (1810–90). He then studied under Alexandre Cabanel at the Ecole des Beaux-Arts in Paris, where his fellow pupils included Henri Regnault, Bastien-Lepage, Forain, Humbert (1842–1934) and Cormon; and also informally with Fromentin. Gervex's first Salon picture was a *Sleeping Bather* (untraced) in 1873: the nude, both in modern and mythological settings, was to remain one of his central artistic preoccupations. In 1876 he painted *Autopsy in the Hôtel-Dieu* (ex-Limoges; untraced), the sort of medical group portrait he repeated in 1887 with his *Dr Pean Demonstrating at the Saint-Louis Hospital his Discovery of the Hemostatic Clamp* (Paris, Mus. Assist. Pub.), which celebrated the progress of medical science with a sober, quasi-photographic realism. Gervex's most controversial picture was *Rolla* (1878; Bordeaux, Mus. B.-A.), refused by the Salon of 1878 on grounds of indecency, partly because of the cast-off corset Degas had insisted he include. The painting shows the central character in a de Musset poem, Jacques Rolla, who, having dissipated his family inheritance, casts a final glance at the lovely sleeping form of the prostitute Marion before hurling himself out of the window. As his friend, Manet, had done the year before with his rejected *Nana* (1877; Hamburg, Ksthalle), Gervex exhibited his work in a commercial gallery, with great success.

In 1881 Gervex was chosen to decorate the town hall of the 19e arrondissement in Paris. He painted the subjects selected in a sombre palette and realist style: *Civil Marriage* (the wedding of the son of the mayor who had organized the competition; exh. Salon, 1881), *The Docks of La Villette* (bare-chested workers unloading coal on the canal; exh. Salon, 1882) and *The Charity Office* (poor people queuing for state assistance on a winter's day; exh. Salon, 1883). The final ceiling panel, which features two muscular men in the foreground about to slaughter an ox, employed dramatic *di sotto in sù* recession (reduced sketch, exh. Salon, 1905). For the Exposition Universelle of 1889 Gervex collaborated with Alfred Stevens (i) and many assistants to produce *Paris Pantheon of the Nineteenth Century*, a vast panorama (20×120 m) of a gathering in the Tuileries Gardens, which included the most famous French rulers, writers, artists, hostesses and politicians from Napoleon to those more recently deceased. It was subsequently cut up and sold. Gervex did other major decorative paintings in a more baroque style for the ceiling of the Hôtel de Ville in Paris (*Music across the Ages*; exh. Salon, 1891) and *France Receiving the Nations* over a decade later for the Elysée Palace.

In 1890 Gervex, like many of the most distinguished academic artists of the day, broke with the official Salon to become a founder-member of the Société Nationale des Beaux-Arts, with which he exhibited regularly until 1922. Throughout his long career he was enormously popular and honoured: he was made a member of the Légion d'honneur in 1882, Officer in 1889 and Commander in 1911, and a member of the Institut in 1913. His success in his own lifetime and his subsequent neglect both resulted in part from his exceptional facility. He adopted the appearance of the Impressionist style without quite comprehending its essence. A late series of pictures (1914–21), inspired by World War I, apply his bravura technique to powerful subjects and are worthy of reconsideration.

Gervex had an extremely agreeable personality and numbered among his many friends artists and writers of more avant-garde tendencies than himself, such as Renoir, Manet, Degas and Guy de Maupassant. Zola used him and de Maupassant as his models for the shrewd and ambitious painter Fagerolles in *L'Oeuvre* (1886). Gervex appears in Renoir's *La Moulin de la Galette* (1876; Paris, Mus. d'Orsay) and Degas's *Six Friends at Dieppe* (1886; Providence, RI Sch. Des., Mus. A.). He was also a resolute ally of Manet in his last years and defender of his posthumous reputation. Jacques-Emile Blanche was Gervex's most notable pupil.

BIBLIOGRAPHY
J. Reinach: *Peinture de Alfred Stevens et Henri Gervex* (Paris, 1889)
J. Bertaut: *Henri Gervex: Souvenirs, recueillis par Jules Bertaut* (Paris, 1924)
The Realist Tradition: French Painting and Drawing, 1830–1900 (exh. cat. by G. P. Weisberg, Cleveland, OH, Mus. A., 1981), pp. 15–17, 219–20, 292–3 [biog. adapted from J.-F. de Canchy]
Le Triomphe des mairies (exh. cat. by T. Burollet, Paris, Petit Pal., 1987), pp. 116–18, 406–7

JAMES P. W. THOMPSON

Gerzso, Gunther (*b* Mexico City, 17 June 1915). Mexican painter and printmaker. He was sent by his parents to Cleveland, OH, to study stage design. On his return to Mexico in 1935 he joined the national film industry and worked for years on a large number of films. Soon afterwards he began to concentrate on painting; he had Julio Castellanos and Juan O'Gorman as mentors but was essentially self-taught. He was particularly influenced by Wolfgang Paalen and other Surrealist artists who arrived in Mexico during World War II. The impact of Surrealism was evident in the paintings shown at his first exhibition in 1950, by turns dramatic, witty and erotic. His feeling for colour was already much in evidence.

Still following Paalen's example, though without imitating him, in the mid-1950s Gerzso moved towards abstraction, basing his first such paintings on prehispanic architecture, as in *Landscape at Papantla* (1955; Mexico City, Mus. A. Carrillo Gil). Even after 1960, when he began to concentrate on subtle relationships of colour within a geometric structure, he continued to hint at sensory and even erotic responses. While linear elements dominate the compositions of his mature and meticulously executed paintings and screenprints (e.g. *The House of Tataniuh*, 1978; Washington, DC, MOMA Latin America), even in these works colour alludes to hidden levels of experience.

BIBLIOGRAPHY
L. Cardoza y Aragón: *Gunther Gerzso* (Mexico City, 1972)
O. Paz and J. Golding: *Gerzso* (Neuchâtel, 1983)

XAVIER MOYSSÉN

Gesamtkunstwerk [Ger.: complete, unified or total work of art]. Term first used by RICHARD WAGNER in *Das Kunstwerk der Zukunft* (1849) to describe his concept of a work of art for the stage, based on the ideal of ancient Greek tragedy, to which all the individual arts would contribute under the direction of a single creative mind in order to express one overriding idea. However, the term is applied retrospectively to projects in which several art forms are combined to achieve a unified effect, for example

Roman fora, Gothic cathedrals and some Baroque churches and palazzi.

The concept of a synthesis of the arts expressing one dominant idea, usually either religious or political, can be traced back to ancient times, and it finds its most successful visual expression in works that use an architectural framework. The monumental funerary complexes of ancient Egypt are probably the earliest examples of such works of art combining architecture, sculpture, wall carvings and the use of colour and ritual for the glorification of a ruler. The mortuary temple (*c.* 1458 BC) of Queen HATSHEPSUT, at Deir el-Bahri, near Thebes (*see* THEBES, fig. 4), presents a strong concept of central planning in the layout, with a long processional avenue leading up to the altar sanctuaries. A similar centralizing tendency is evident in Roman architecture and urban planning. Conscious groupings of buildings, such as that of the Forum Romanum complex in Rome (*see* ROME, fig. 18), resulted in a public environment that was not only functional but was also an expression of monumental imperialism. In Gothic architecture, the development of the rib vault and flying buttress opened up the space inside the church and allowed for large stained-glass windows. This extra dimension of light, as well as the upward thrust of the moulded piers and pointed arches, the placement of sculptures and paintings, the decoration of the altar and the words and music of the service all combined to create an enhanced spiritual experience. Such an effect is created in the Lady chapel (1321–49) of Ely Cathedral (*see* ELY, §1(iv)), a true *Gesamtkunstwerk*.

In the Baroque period, there was a reliance on the creation of illusion, which demanded that the space of the church and all details of architecture, sculpture, painting, colour, ornament and lighting be orchestrated to produce an otherworldly effect that was to enhance the beholder's faith. The Gothic 'master mason' was replaced by the 'artist–genius' of the Baroque: as early as 1682, Filippo Baldinucci referred to Gianlorenzo Bernini (*see* BERNINI, (2)) as the first artist who had tried to integrate architecture, sculpture and painting to create 'un bel composto'. This integration culminated in the Cornaro Chapel (1647–52) in S Maria della Vittoria, Rome. Ecclesiastical examples of the Baroque *Gesamtkunstwerk* in the Germanic countries are the Abbey Church (1702–14) at Melk (*see* MELK ABBEY), Austria, by JAKOB PRANDTAUER and the Benedictine Abbey church (1741–85) at Zwiefalten, Germany, by JOHANN MICHAEL FISCHER. At this time secular architecture also aspired to the concept of harmonious union of all parts, often including the building's surroundings: in the case of the Gartenpalast in der Rossau (1689–1711; today the Museum Moderner Kunst) in Vienna, the patron, John Adam, Prince of Liechtenstein, planned not only the building and the interiors but also the gardens.

By the late 19th century, the growing isolation of individual art forms from one another, and man's alienation from his increasingly industrialized environment, meant that Wagner's idea of a *Gesamtkunstwerk*, which seemed to sum up late Romantic aspirations, was eagerly taken up in Symbolist and Post-Impressionist circles. Inspired by Baudelaire's theory of 'correspondences', such visual artists as Gauguin, Odilon Redon, Paul Sérusier and Ferdinand Hodler explored the unconscious, as well as

the links between the various art forms, in an attempt to arrive at an all-embracing, universal language of art. Architects and decorative artists of the Viennese Secession (*see* SECESSION, §3) were influenced by Mackintosh's Glasgow School of Art (begun 1896; *see* MACKINTOSH, CHARLES RENNIE, fig. 1) and his links to the Gothic craft traditions revived by William Morris, Philip Webb and others. The Secession artists conceived their 14th exhibition (1902) in Vienna as more than just the 'purposeful design of an interior' (Ernst Stöhr, catalogue of the 14th exhibition of the Union of Creative Artists of Austria, Secession Vienna, 15 April to 27 June 1902): here, Josef Hoffmann's architectural framework was successfully combined with Max Klinger's polychromed sculpture, the *Beethoven* monument (1902; Leipzig, Mus. Bild. Kst.), the *Beethoven Frieze* (1902; Vienna, Sezession; rest. 1985) by GUSTAV KLIMT and a musical performance of Beethoven's *Ninth Symphony* to create a *Gesamtkunstwerk* in homage to the German composer. The interior of Hoffmann's Palais Stoclet (1905–11; *see* HOFFMANN, JOSEF, fig. 2) in Brussels again brought together the work of various artists into an impressive and unified project. Another interior conceived as a *Gesamtkunstwerk* was the 'Pallenberg-Saal' (1900; Cologne, Kstgewmus.; mostly destr.) by MELCHIOR LECHTER, which was created in honour of, and had numerous references to, Wagner, Nietzsche and Arnold Böcklin.

In the 20th century, artists have attempted to realize the concept of the *Gesamtkunstwerk* in various ways. For Gropius, under whose direction the Bauhaus (1919–33) brought together such major artists as Kandinsky, Klee, Lyonel Feininger, László Moholy-Nagy and Oskar Schlemmer, the *Gesamtkunstwerk* was the building itself and everything contained within (that is, all the arts brought together under the auspices of architecture). Apart from such custom-designed interiors as Schlemmer's *Lackkabinett*, conceived in 1941–2 but not executed until 1987 at the Kunstverein für die Rheinlande und Westfalen in Düsseldorf, the *Gesamtkunstwerk* was exemplified in artistic collaborations masterminded by one creative individual, such as Apollinaire, in his book *Bestiaire ou cortège d'Orphée* (Paris, 1911), for which Raoul Dufy provided woodcut illustrations, or in the LIVRE D'ARTISTE, such as Kandinsky's *Klänge* (Munich, 1912), where text and illustrations are by a single artist. In the stage production *Der gelbe Klang* (1912), Kandinsky came even closer to Wagner's original concept of the *Gesamtkunstwerk*. It offers a loose combination of movement, song, speech, shapes and colour, all conceived by the artist. Ballet and other stage performances, often combined with such additional creative media as film, have provided opportunities for visual artists to devise or participate in combined events of music, drama and visual arts, each of which could be described as a *Gesamtkunstwerk*. Examples of such productions are Serge Diaghilev's ballet *Parade* (1917), with sets and costumes designed by Picasso; the ballets *La Création du monde* (1923) and *Ballet mécanique* (1924) by FERNAND LÉGER; and Schlemmer's *Triadisches Ballett* (1922; for illustration *see* SCHLEMMER, OSKAR).

It has been suggested that the cinema is the real successor of Wagner's ideas, not only in its role of providing a seamless fusion of the visual and aural arts

Oswald Mathias Ungers: Deutsches Architekturmuseum, Frankfurt am Main, 1979–84

but also by providing for the spectator's complete emotional involvement (Wyss). Müller explores the idea of the museum as the real *Gesamtkunstwerk* of the 20th century, as it has taken over the role of temple and cathedral and has the potential to provide within the framework of Postmodernist architecture an environment of spiritual harmony. As examples of this 'return to an architecture of "narrative content"', he cites Oswald Mathias Ungers's Deutsches Architekturmuseum (1979–84) in Frankfurt am Main (see fig.) and Hans Hollein's Städtisches Museum Abteiberg (1982) in Mönchengladbach (*see* MUSEUM, fig. 9). All these examples have one thing in common: they attempt to fuse different art forms into one work of art and to provide a complete alternative reality. This, nevertheless, relates to experiences and concerns that are timeless and fundamental to human life and provides the spectator with an experience of aesthetic transcendence. The striving for the perfect, harmonious whole of the *Gesamtkunstwerk* is still the ultimate aspiration of many visual artists.

BIBLIOGRAPHY

W. Kandinsky: *Klänge* (Munich, 1912; Eng. trans. by E. R. Napier, New York, 1981)

O. von Simson: *The Gothic Cathedral: Origins of Gothic Architecture and the Medieval Concept of Order* (New York, 1956, rev. 1962)

J. M. Stein: *Richard Wagner and the Synthesis of the Arts* (Detroit, 1960/R Westport, 1973)

H. Schaefer: *Principles of Egyptian Art* (London, 1974)

I. Lavin: *Bernini and the Unity of the Visual Arts*, 2 vols (New York and London, 1980)

H. Szeeman, ed.: *Der Hang zum Gesamtkunstwerk—Europäische Utopien seit 1800* (Frankfurt am Main, 1983)

R. Wagner: *Dichtungen und Schriften*, ed. D. Borchmeyer, vi (Frankfurt am Main, 1983) [contains Richard Wagner's *Das Kunstwerk der Zukunft* (1849)]

J. Krause: 'Melchior Lechter's Pallenberg-Saal für das Kölner Kunstgewerbemuseum: Ein Kultraum der Jahrhundertwende im Zeichen Nietzsches und Georges', *Wallraf-Richartz-Jb.*, xlv (1984), pp. 203–30

O. Brusatti: 'Erlösung der Menschheit durch die Künste—Gustav Klimts Beethovenfries', *Du*, 6 (1985), pp. 50–57

K. von Maur, ed.: *Vom Klang der Bilder* (Munich, 1985)

M. Müller: 'Vom "Schönen Schein"', *Werk, Bauen & Wohnen*, lxxii (1985), pp. 48–60

R. Preimesberger: 'Berninis Cappella Cornaro: Eine Bild-Wort-Synthese des 17. Jahrhunderts?', *Z. Kstgesch.*, xlix (1986), pp. 190–219

L. Feinberg: 'Symbolism and the Romantic Tradition', *Allen Mem. A. Mus. Bull.*, xliii (1987), pp. 5–17

J. Svestka: 'Oskar Schlemmer: Il Gabinetto delle Lacche, 1941–42/1987', *Domus*, 690 (1988), pp. 77–80 [It. and Eng. text]

B. Euler-Rolle: 'Wege zum "Gesamtkunstwerk" in den Sakralräumen des österreichischen Spätbarocks am Beispiel der Stiftskirche von Melk', *Z. Dt. Ver. Kstwiss.*, xliii/1 (1989), pp. 25–48

F. Whitford: *Bauhaus* (London, 1989)

B. Wyss: 'Ragnarök of Illusion: Richard Wagner's "Mystical Abyss" at Bayreuth', *October*, liv (1990), pp. 57–78

B. Millington, ed.: *The Wagner Compendium* (London, 1992)

INGRID MACMILLAN

Gesell, Georg. *See* GSELL, GEORG.

Gesellius, Lindgren, Saarinen. Finnish architectural partnership formed in 1896 by Herman Gesellius (1874–1916), ARMAS LINDGREN and Eliel Saarinen (*see* SAARINEN, (1)), the year before they graduated from the Polytekniska Institutet in Helsinki. It dissolved in 1907, although Lindgren left the office in 1905. National and international recognition came in 1900, when they designed the Finnish pavilion for the Exposition Universelle in Paris, having won the competition for its design in 1898. The design linked a number of international influences as well as particularly Finnish elements (motifs such as bears, squirrels and pine cones) and forms from Art Nouveau. It also included neo-Romanesque elements reminiscent of the H. H. Richardson school in the USA. The interior of the pavilion's cupola was decorated with paintings by Akseli Gallen-Kallela. The overall effect was of an Arts and Crafts ambience. It was one of the first examples of the architecture of NATIONAL ROMANTICISM. In the Pohjola Insurance Company building (1899–1901), Helsinki, classicism was again abandoned in favour of motifs taken from the medieval period and from nature. The exterior is dominated by a strongly rusticated soapstone, expressive of the developing style. Three blocks of flats in Helsinki followed: Fabianinkatu 17 (1900–01); Olofsborg (1900–02); Eol (1901–3). In them a plastic, asymmetrical massing is related to innovations in interior planning: the linear sequence of rooms typical of representational middle-class homes gave way to a freer, more open ordering of space.

The firm's biggest project was the National Museum of Finland (1902–11), Helsinki, won in a competition. Volumes are arranged asymmetrically, articulated by a tall tower of campanile proportions, and in an attempt to give different parts an appearance that will reflect the period of the collection they contain, Finnish historical motifs are used throughout. Backed by plentiful commissions, the firm was able to build their studio and homes (1902–4; now partially changed) in the countryside near Kirkkonummi: a large group of buildings, it was called Hvitträsk after the lake by which it is situated, and it contained work spaces as well as accommodation for the architects and their families. Local materials, powerful granite bases, timber superstructures and red pitched roofs expressed

the new spirit of Romanticism. All the families of the partnership as well as artist friends contributed to a collective creation and cooperated in designing and making the furnishings and decoration. Hvitträsk was carefully merged with the surrounding countryside, and this freely implemented ideal environment is one of the most complete expressions of the vision of the time.

Some of the characteristics of Hvitträsk, such as the non-axial plan, the articulation of volumes, polychromy and the vaulted spaces of varying heights were developed in the main building of Suur-Merijoki (1901–3; destr.), Viipuri province (now the Vyborg area, Russia), which was under construction at the same time. Their considerable budget allowed them to design all the interiors, including the furniture, textiles and lighting fixtures. Medieval references were joined with contemporary European influences. In the next few years, however, design attitudes in Finnish architecture changed as represented by the partnership's return to symmetry and more integrated volumes in the Nordic Bank (1903–4; destr. 1934), Helsinki.

In 1904 Saarinen participated as an individual in the competition for Helsinki Railway Station and Lindgren moved away from Hvitträsk the next year. The work continued nevertheless between Gesellius and Saarinen with Haus Remer (1905–7; destr.), Alt-Ruppin, Mark Brandenburg, Germany, which was dominated by a central axis both in its volume and in its plan, and in the interior spaces by vertical articulation and a more restrained use of colour than previously.

BIBLIOGRAPHY
A. Christ-Janer: *Eliel Saarinen, Finnish American Architect and Educator* (Chicago, 1948, rev. 2/1979), pp. xiii–xiv, 11–32, 141–2
Saarinen in Finland: Gesellius, Lindgren, Saarinen, 1896–1907, Saarinen, 1907–1923 (exh. cat., Helsinki, Mus. Fin. Archit., 1984)
M. Hausen and others: *Eliel Saarinen: Projects, 1896–1923* (Helsinki, 1990)
PEKKA KORVENMAA

Gessi, Francesco (*b* Bologna, 1588; *d* Bologna, 1649). Italian painter. He was first a pupil of Giovan Battista Cremonini and then of Denys Calvaert; *c.* 1615 he entered the workshop of Guido Reni. The progressive influence of Reni on his work can be seen in the development from paintings such as *St Charles Adoring the Holy Nail* (1612; Bologna, S Maria dei Poveri) and the frescoed *Death of St Roch* (1614; Bologna, oratory of S Rocco), to the small altarpiece of the parish church of Pianorso (Modena) and the *Virgin of the Rosary* at Castelnuovo ne' Monti (Reggio Emilia). The first two works are characterized by an archaizing naturalism, while in the second two the elegance of Reni is touched with fantasy, resulting in a style similar to that of Gessi's contemporary, Mastelletta. This individual element in his style was suppressed for those important commissions where he was working under Reni's direct supervision, as in the frescoes (1615–20), commissioned by Cardinal Pietro, for the chapel of Aldobrandini the Holy Sacrament in Ravenna Cathedral or the *Redeemer Raising His Hand in Blessing* (1620) for the main altar of the church of S Salvatore in Bologna; for these works he was able to imitate his master's style perfectly.

In 1621 Gessi went to Naples with Reni to make an agreement, which later fell through, over the decoration of the treasury chapel in the cathedral, and he returned there alone between 1624 and 1625, perhaps against Reni's wishes. He failed, however, to obtain the coveted commission. While the earliest sources (Malvasia) stress his loyalty to his master, to the degree that his work becomes confused in the general academic following of Reni, recent critics have preferred to draw attention to the degree of autonomy that he showed with regard to Reni. His independence is already evident in the small altarpiece of the *Virgin with Saints* (Milan, Brera), and can be seen in later paintings executed in the 1620s, such as the *Temptation of St Thomas Aquinas* (Reggio Emilia, Mus. Civ. & Gal. A.), the *Agony in the Garden* (Bologna, Pin. N.) and the two canvases for Perugia Cathedral (*Agony in the Garden* and *Capture of Christ*). In the *Virgin Immaculate* (1632–3) in S Nicolo at Carpi, the lighter brushstrokes that he learned from Reni are used to render the surface quality of the skin, in a way that attracted the attention of Simone Cantarini when he visited Reni's workshop, *c.* 1635.

The late works are characterized by unusually forceful expressive elements and a denser and more shadowy application of paint (e.g. the *Miraculous Draught of Fishes*, 1645; *Christ Driving the Money-changers from the Temple*, 1648; both Bologna, S Girolamo della Certosa; *St Jerome in Ecstasy*, 1648; Naples, Pin. Girolamini).

BIBLIOGRAPHY
C. C. Malvasia: *Felsina Pittrice* (1678); ed. G. Zanotti (1841), pp. 245–9
M. Cellini: 'Francesco Gessi', *La pittura in Italia: Il seicento*, ed. M. Gregori and E. Schleier, 2 vols (Milan, 1988, rev. 1989) [with bibliog.]
A. Pellicciari: 'La pratica del disegno all'interno della scuola reniana attraverso l'esperienza grafica di Sementi e Gessi', *Boll. A.*, lviii (1989), pp. 1–26
DANIELE BENATI

Gessner. Swiss family of artists and writers.

(1) Salomon Gessner (*b* Zurich, 1 April 1730; *d* Zurich, 2 March 1788). Painter, etcher, writer and poet. In 1746 his father, Konrad Gessner, a bookseller, sent him to live in the country at Berg am Irchel, where he became aware of the healing effect of the natural landscape and of late Baroque society's estrangement from nature. While working for the Spener booksellers in Berlin (1749–50), he tried to paint fantastic landscapes but failed owing to his poor mastery of oil painting. After his return to Zurich in 1751 he concentrated on poetry and, later, a form of lyrical prose. His first sketches from nature, inspired by the pastoral lyrics of Barthold Hinrich Brockes (1680–1747), were published as illustrations to his *Idyllen* (Zurich, 1756). His prose *Der Tod Abels* (Zurich, 1758) expressed a moralistic criticism of civilization that was widely influential and it was soon translated into many languages, including English (London, 1761).

In 1757 Gessner's friendship with Judith Heidegger (1736–1818), whom he later married, gave him access to her father's art collection and he copied engravings and drawings, especially 17th-century Dutch and Roman landscapes. His self-taught evolution as a draughtsman is recorded in *Briefe über Landschaftsmalerey an Herrn Fuesslin* and two volumes of studies (Zurich, Ksthaus); a third volume of classical figure studies is untraced. His intention was to free the pastoral landscape from late Baroque eclecticism, declaring that the study of nature was the

basis of landscape painting and emphasizing the importance of composition, based upon the work of Poussin, Gaspard Dughet and Claude. He supplied more than 400 illustrations and vignettes for books published by the family firm, for example for the writings of Jonathan Swift (8 vols, Hamburg and Leipzig, 1756–66), Shakespeare's *Plays* (8 vols, Zurich, 1762–6) in the German version by Christoph Martin Wieland (1733–1813), and Samuel Butler's *Hudibras* (Hamburg and Leipzig, 1765), for which he drew upon Hogarth's designs for the same poem (London, 1726).

Gessner's first two series of landscape etchings in the Dutch and classical styles (1764 and 1769) still display the eclecticism of Christian Wilhelm Ernst Dietrich. Ink-brush drawings from the 1760s, however, combine ideas from the work of Adam Friedrich Oeser with nature studies from the hilly landscape of eastern Switzerland. The full-page figure compositions made for both the French and German editions of his collected works (Zurich, 1772–7) are among the finest examples of early classicist book illustration.

Gessner's first autonomous watercolour and gouache landscapes, mostly in a vertical format, were made between 1777 and 1781. Picturesque details derived from his sketchbooks, such as streams, woodland scenes and overgrown orchards, were merged into Arcadian fantasy landscapes, usually populated by dryads, nymphs, satyrs and other elemental spirits. The evocative, mural-like arrangement is characteristic of Neo-classical–Romantic landscape painting and creates a picturesque impression rendered more complex intellectually by the emphasis on the depiction of plants, trees and stones. In *Arcadian Music* (1781; Zurich, Ksthaus; see fig.), for example, he peoples a refreshing nature scene with ideal figures and uses formal analogies and colour correspondences to point to a symbolic, inward experience of nature, which he perceived as a harmony of opposites.

After 1784 Gessner mostly worked in a horizontal format, which provided a more spacious foreground. Foliage, especially in his works in gouache, for example *The Wood* (1784; Zurich, Ksthaus), appears as opaque and glazed shades of green superimposed to produce an effect of colour flooded with light, contrasting with the deep, heavy earth tones, in a manner that points to 19th-century realist landscape painting.

WRITINGS

Schriften, 5 vols (Zurich, 1770–72) [includes *Briefe über Landschaftsmalerey an Herrn Fuesslin*]
Briefwechsel mit seinem Sohne (Berne, 1801)

BIBLIOGRAPHY

H. Wölfflin: *Salomon Gessner: Mit ungedruckten Briefen* (Frauenfeld, 1889)
P. Leeman-van Elck: *Salomon Gessner: Sein Lebensbild mit beschreibenden Verzeichnissen seiner literarischen und künstlerischen Werke* (Zurich, 1930)
Salomon Gessner: Schriften, Radierungen, Zeichnungen, Malereien, Porzellan (exh. cat., ed. W. Wartmann; Zurich, Ksthaus, 1930)
D. Roskamp: *Salomon Gessner im Lichte der Kunsttheorie seiner Zeit: Ein Beitrag zum Problem Klassizismus und Romantik im 18. Jahrhundert* (diss., U. Marburg, 1935)
R. Strasser: *Stilprobleme in Gessners Kunst und Dichtung* (diss., U. Berlin, 1936)
Maler und Dichter der Idylle: Salomon Gessner, 1730–1788 (exh. cat., ed. M. Bircher; Wolfenbüttel, Herzog August Bib., 1980, rev. 1982)
M. Bircher, B. Weber and B. von Waldkirch: *Salomon Gessner* (Zurich, 1982)

(2) (Johann) Konrad Gessner (*b* Zurich, 2 Oct 1764; *d* Zurich, 8 May 1826). Painter and etcher, son of (1) Salomon Gessner. He first trained with his father and with the amateur artist Salomon Landolt (1741–1818), under whose guidance he discovered his talent as a painter of horses and battle scenes. In 1784–6 he pursued his studies at Dresden with Adrian Zingg (1734–1816), Anton Graff and Johann Christian Klengel. He copied from paintings by Philips Wouwerman, Abraham Bloemaert, Georg Philipp Rugendas I and Salomon van Ruysdael, adopting the dark-toned realism of the latter as an effective contrast to the picturesque chiaroscuro of the groups of horsemen in such paintings as *Mounted Battle* (1786; Zurich, Ksthaus). In the watercolour landscape *Schloss Nossen* (1785–6; Zurich, Ksthaus) Gessner's style develops beyond that of Zingg, with his lively use of line reinforcing the strong sense of mood conveyed by the brushwork.

From 1787 to 1789 Gessner was in Rome, from where he made sketching trips to the Abruzzi; many of his landscapes were bought by English tourists.

After returning to Zurich, he joined an independent society of artists (founded 1787) that organized exhibitions and laid the foundation for the collection of the Zurich Kunsthaus. In 1796 Gessner went to London, where he published 30 etchings of horse studies, *Malerische Darstellung der vorzüglichsten Truppen Europas* (1801). He made experiments in etching on stone. Between 1799 and 1803 he sent landscapes and horse paintings to the Royal Academy, London. He lived for the major part of those years on the Scottish estate of his patron Mitchell (Horner), where he worked intensively on animal painting. There he

Salomon Gessner: *Arcadian Music*, gouache over pencil, 360× 283 mm, 1781 (Zurich, Kunsthaus Zürich)

produced his major works, which are distinguished from the earlier ones by a more spacious composition and a lighter palette. His favourite subjects were hunting scenes, mail coaches, stable interiors, smithies and village taverns. Many paintings and watercolours from this period remain in English and Scottish private collections. *Horses in a Storm* (1798), *Horses at a Pool* (1800), *Landscape with Horses* (1800) and *Soldiers Playing at Cards in a Stable* (1800) are all in the Victoria and Albert Museum, London. Gessner spent his last years, from 1804 to 1826, as a respected painter in Zurich. There is an important collection of his watercolours and etchings at the Zurich Kunsthaus.

WRITINGS

S. Gessner: *Briefwechsel mit seinem Sohne* (Berne, 1801)

BIBLIOGRAPHY

J. J. Horner: 'Das Leben Conrad Gessners von Zürich', *Neujbl. Zürch. Kstges.* (1928)

A. Federmann: 'Der Maler Conrad Gessner', *Neue Zürch. Ztg* (15 June 1930)

Von Gessner bis Turner (exh. cat., ed. B. von Waldkirch; Zurich, Ksthaus, 1988)

BERNHARD VON WALDKIRCH

Gesso. White coating used as a ground for painting (*see* GROUND) and in the preparation of wood for gilding. It comprises glue-size (*see* SIZE), mixed with either calcium sulphate (a form of gypsum), which produces the soft gesso that was used in Italy in the Renaissance, or calcium carbonate (chalk), which produces a hard gesso that was used in northern Europe. It is inflexible and absorbent and, once dry, may be worked to produce a smooth surface. Variations on the basic recipe occur, notably the inclusion of white pigment to increase its brilliance. *Gesso grosso* is a traditional form made from burnt gypsum and hide glue. The glue slows down the setting action of the plaster and makes it considerably harder when dry. Similar compositions are used in decorative plasterwork. *Gesso grosso* is comparatively coarse and was used as a base coat on wooden panels being prepared for tempera painting (*see* TEMPERA, §1). It would be covered with several coats of *gesso sottile*, another traditional form made by steeping burnt gypsum in an excess of water and stirring it to prevent setting. *Gesso sottile* is fine, soft and smooth; it was originally bound with parchment glue for use. Cennino Cennini, writing in the 14th century, describes the use of these materials, as does Pacheco, who, writing in the 17th century, refers to them as *yeso grueso* and *yeso mate*.

In ancient Egypt, small gesso-coated panels were employed for writing and painting, and also for late Egyptian mummy portraits in encaustic (examples in London, BM). Little gessoed panels are described as reusable drawing surfaces, and gessoed card may occasionally have been used as a support for miniature painting. Such materials were used for temporary record keeping throughout the Middle Ages and Renaissance. A prepared surface of hard gesso was also used in conjunction with metalpoint. From the Byzantine era until the late Renaissance gesso was applied in layers to wooden panels to produce a thick, luminous ground. Its smooth finish suited the detailed style, small brushstrokes and translucent paint of the tempera technique. Its use as a base (under bole) for water gilding was exploited to the full on icons and altarpieces (*see* GILDING, §II, 1) by such Sienese artists as Simone Martini, who also used carved and punched gilded gesso to add surface detail to haloes and decorative textiles (*see* MARTINI, SIMONE; *see also* PUNCH). Gesso, often in the form of a chalk ground suitably modified to reduce its absorbency, was also employed in oil painting on panel, where its smooth surface and strangely reflective quality was exploited by such artists as Robert Campin, Jan van Eyck (e.g. the *Arnolfini Marriage*, *c.* 1434; *see* EYCK, JAN VAN, fig. 4), Rogier van der Weyden and Antonello da Messina. The stability of gesso on wood may have helped preserve such works. Gesso applied to canvas must be kept thin and should be used only to fill the pores of the cloth; Cennini describes such preparation for painted banners. Many of Titian's paintings in oil are on a gesso ground, probably coated with glue. However, the comparative instability of canvas and the comparative inflexibility of gesso make them incompatible, particularly on a large scale, and it was the widespread adoption of canvas and oil paint that led to a decline in the use of gesso. Since the 19th century, however, there has been a steady revival of interest in its use not only in painting but also in the decorative arts. From the early 1940s the American painter Andrew Wyeth started to use egg tempera on gesso board in such paintings as *Christina's World* (1948; New York, MOMA); David Tindle (*b* 1932) also used the traditional tempera on panel technique. Conservation research has highlighted the potential superiority of the traditional gesso ground on panel. Gesso is also used as a filler and surface coating for wooden sculpture, furniture and picture frames, where it not only serves as a ground for a painted finish or gilding (*see* GILDING, §§I, 1(i) and II, 2 and 3, and ENGLAND, fig. 51) or carving but also suppresses the wood grain and any roughness of finish. It may be worked as low relief carving or cast as small motifs for decorated panels (*see* PASTIGLIA) or sculpture. In sculpture, the term gesso may be a direct reference to plaster. It is also applied to a modern acrylic primer known as 'acrylic gesso'.

BIBLIOGRAPHY

C. Cennini: *Il libro dell'arte* (MS.; *c.* 1390); trans. and notes by D. V. Thompson jr (1933)

R. J. Gettens and M. E. Morse: 'Calcium Sulphate Minerals in the Grounds of Italian Paintings', *Stud. Conserv.*, i (1954), pp. 174–89

J. Ayres: *The Artist's Craft: A History of Tools, Techniques and Materials* (London, 1985)

J. Stephenson: *The Materials and Techniques of Painting* (London, 1989)

Art in the Making: Italian Painting Before 1400 (exh. cat. by D. Bomford and others; London, N.G., 1989)

J. Dunkerton and others: *Giotto to Dürer: Early Renaissance Painting in the National Gallery* (London, 1991)

JONATHAN STEPHENSON

Geste, Vasily (Ivanovich). *See* HASTIE, WILLIAM.

Gestel, Leo [Leendert] (*b* Woerden, 22 Nov 1881; *d* Hilversum, 26 Nov 1941). Dutch painter and draughtsman. As the son of the director of an art school, he trained first as an art teacher at the Rijksnormaalschool, Amsterdam, with evening classes at the Rijksacademie (1900–03), before becoming an artist. For several years he managed to earn a living by illustrating books, by contributing drawings to newspapers and by designing advertising leaflets for his uncle Dimmen Gestel, an artist and printer who had painted outdoors with van Gogh. His friends

called him Leonardo, a nickname that he adopted in a shortened form. For a short period Gestel's development ran parallel to that of his former classmate Jan Sluijters. Gestel's work, like Sluijters's, is characterized by a variety of styles including a form of Divisionism, seen in *Autumn Tree* (1911; The Hague, Gemeentemus.), Fauvism, Cubism, Futurism and Expressionism. On the whole, however, Gestel's paintings are more deliberate in style and spiritual in content. He was one of the leading figures of the avant-garde in 1909 with Piet Mondrian and Sluijters, and in 1911 he was among the most important Dutch representatives at the first international exhibition of the Moderne Kunstkring, from which two of his nudes were excluded, but his role was less outspoken than that of Sluijters.

Within Gestel's oeuvre the Cubist/Futurist paintings occupy a prominent place. The division of the picture plane, which characterized the work of Paul Cézanne and the early Cubists, was something that naturally fitted in with Gestel's constant tendency to give his work a clear and sound structure by using a distinctive pattern. His paintings vary from stylized, angular figure pieces with an open composition, such as the portrait of the poet *Jacques Rensburg* (1913; Amsterdam, Stedel. Mus.), to the fully abstract landscapes and still-lifes with flowers, painted in the same year, which are made up of bristling patches of colour (e.g. *Bloemen* and *Landschap*, both 1913; Amsterdam, Stedel. Mus.). Like Sluijters, he always used traditional, naturalistic themes as a starting-point for such studies. This stylistic phase reached its climax in a large series of landscapes painted in Mallorca in 1914. His mountain landscapes, orchard and harbour views are painted in a well-balanced rhythm of intersecting cube and circle fragments. They make up the most consistent translation—albeit a derivative one—of French Cubism into Dutch painting.

The close-knit structure of the Mallorca series recurs in various forms in the bolder landscapes painted between 1915 and 1922 in Bergen, Koedijk and De Beemster. In comparison with the finely drawn light-hearted Spanish panoramas these landscapes with trees and fields, painted in an expressionist manner, in which one can see the influence of Henri Le Fauconnier, are heavier in style and tend to be rather melancholic in atmosphere (e.g. *The 'Perseverance' Farmstead, c.* 1916; Bergen, Kom.). The same applies to the still-lifes with flowers. With this work Gestel was for a short period the leading painter of the Bergen school during World War I. He introduced the art collector Piet Boendermaker (1877–1947) to the group; with Johannes Fredericus Samuel Esser (1877–1946) he was the first to be interested in buying Gestel's avant-garde work.

The monumental human figure, which dominated Gestel's late work, first appeared during a two-year stay in Zinnwald, Germany, and Positano and Taormina, Italy, where he otherwise made mostly bleak landscapes in black chalk (1923–4). In the period that followed he produced pastels in pale colours and with flat shapes of the Leie region in Flanders, homeland of his friend Gust. De Smet (1877–1943), whom he had met in Holland during World War I. In Belgium he became fascinated by the world of circus and variety theatre, which inspired him to make pictures in tempera, mainly of horses. This genre, which depended heavily on the artist's imagination and the

subject's expressive power, finally provided Gestel with, in his own words, 'an individual style'.

After a fire in his studio in Bergen, which destroyed a large body of his work, Gestel moved to Blaricum, where he spent the final period of his life (1929–41). There he devoted himself to drawing heads of peasants, fishermen, horses and female figures, using the massive, sculptural style that was typical of the work of many artists during the 1930s, for example Frits van den Berghe (1883–1939) and Gust. De Smet. In the last 20 years of his life he suffered deteriorating health and periods of severe depression, which often forced him to abandon his work for long periods. Various monumental commissions were left incomplete at his death.

BIBLIOGRAPHY
W. van der Pluym: *Leo Gestel: De schilder en zijn werk* (Amsterdam/Antwerp, 1936)
A. Klomp: *In en om de Bergense school* [In and around the Bergen school] (Amsterdam, 1944), pp. 13–55
A. B. Loosjes-Terpstra: *Moderne kunst in Nederland, 1900–1914* (Utrecht, 1959), pp. 88–94, 138–50
A. Venema: *De Bergense school* (Baarn, 1976), pp. 62–82
G. Imanse and others: *Van Gogh tot Cobra: Nederlandse schilderkunst, 1880–1950* (Amsterdam, 1981)
Leo Gestel als modernist (exh. cat., Haarlem, Frans Halsmus.; 's Hertogenbosch, Noordbrabants Mus.; 1983)
H. Henkels: *La Vibration des couleurs: Mondrian, Sluijters, Gestel* (The Hague, 1985)
M. Estourgie-Beijer and E. Heuves: *Leo Gestel: Schilder en tekenaar* (Zwolle, 1993)

MAUREEN S. TRAPPENIERS

Gestoso y Pérez, José (*b* Seville, 1852; *d* Seville, 1917). Spanish writer, museum founder and art historian. He studied law and then entered the Corporation of Archivists (Cuerpo de Archiveros) and became a lecturer in the Escuela de Bellas Artes, Seville. The creation of the Museo Arqueológico Provincial de Seville was due to his efforts. He was Vice-Director of the Academia de Buenas Letras, Vice-President of the Academia de Bellas Artes, both in Seville, and a member of the Real Academia de Bellas Artes de S Fernando, of the Real Academia de la Lengua and of the Real Academia de la Historia, all in Madrid. His life was dedicated entirely to his studies, resulting in the publication of around 100 books, dealing with historical, archaeological and artistic subjects relating to Spain and the Americas, between 1883 and 1916. Several of these, for example the *Historia de los barros vidriados sevillanos desde sus orígenes hasta nuestros días* (Seville, 1904), were the first major studies on these subjects and continue to be used as primary reference sources. Among his other important writings are: *Pedro Millán: Escultor sevillano* (Seville, 1884), *Sevilla monumental y artística* (3 vols; Seville, 1899–1902) and *Ensayo de un diccionario de los artífices que florecieron en Sevilla desde el siglo XIII al XVIII inclusive* (3 vols; Seville, 1899–1908).

CARLOS CID PRIEGO

Gestural painting. *See* ACTION PAINTING.

Gesture. Usually, a stance or movement of the body, or part of it (mainly the hand), that expresses an emotional condition (or character) or is by convention understood to convey an established meaning. The study of gestures as represented in works of art poses specific problems; it

can often be difficult to distinguish represented stances and movements that deserve to be called gestures from similar movements that are not meant to convey an emotion or a meaning but are part of the representation of an action. The stooping posture of Sisyphus carrying the heavy stone is not a gesture, it is part of the action represented; while the bowed stance of the defeated barbarian or the drooping pose and inclined head of the melancholic are indeed gestures. Gestures in art have yet to be comprehensively and systematically studied. They may be most usefully classified into those that express emotions ('expressive gestures') and those that convey established meanings in ritualized patterns ('symbolic gestures').

1. EXPRESSIVE GESTURES. These have a very wide range (*see also* EXPRESSION, §1), reaching from unintentionally manifested emotions to symbolic gestures performed with such emotional intensity that they become 'expressive'. The exposure of an emotion may be beyond the individual's control, or even knowledge, so that it is possible almost to speak of 'symptoms': for example, blushing as a manifestation of shame, growing pale as showing fear, turning red with anger. Renaissance theorists of art considered such non-intentional bodily manifestations of emotion as gestures significant for the artist. Colours show the *moti interiori* (internal movements or impulses) according to Giovanni Paolo Lomazzo (*Trattato della pittura*, 1586, iii, 1). Facial expression in the visual arts is in fact almost exclusively confined to showing the emotions. At least since the Renaissance artists and critics have known that in representations of the face the artists can express only emotions. Charles Le Brun reflected a venerable tradition when, in his *Méthode pour apprendre à dessiner les passions* (Amsterdam, 1702), he adduced models for the facial rendering of emotions only. The limitation to passions is made clear in the title.

At the other end of the scale of emotion expressed through gesture are motifs that have acquired much of a symbolic configuration but have often preserved so much of an immediate expressive power that it is hard to separate them from the class of showing emotions. The motif of the defeated foe, kneeling down and stretching out his arms in supplication towards the victor on horseback, common in Roman art, is one of many examples. Both the kneeling posture and the stretching out of the arms are codified gestures, well understood in the political ceremony and imagery of the Roman empire; in some representations, however, they possess such a high degree of expressive immediacy that the spectator is apt to forget their conventional character. Another example is the benedictory pope in some Renaissance pictures. The movement of blessing is, of course, a ritualized gesture, but when the artist emphasizes the emotional expression of the pope's face, the whole configuration becomes an expression of emotion.

Since antiquity, stance, gestures and facial expression were conceived as means to evoke the spectator's emotional response, and therefore the study of them formed part of ancient rhetoric, as in Quintilian's *Institutio oratoria*

(xi, 3, 67ff). In later periods, especially since the Renaissance, the expression of emotions by gestures was considered one of the meritorious achievements of art. Alberti declared that 'the *istoria* will move the soul of the beholder when each man painted there clearly shows the movement of his own soul. . . These movements of the soul are made known by movements of the body' (*De pictura*, 1435). The examples Alberti gives are all of emotional gestures: weeping, laughing, anger, happiness. Leonardo famously stated that a painting that does not show the emotions is 'twice dead' (*Trattato della pittura*). In the art literature of the following centuries the value of showing the emotions by means of gestures is stressed time and again.

2. SYMBOLIC GESTURES. These are actions performed deliberately, usually on specific, predetermined occasions, and in a specific context (e.g. ecclesiastical); their form is frequently prescribed in minute detail. While symbolic gestures usually lack the spontaneity characteristic of expressive emotional movements, they have the advantage of clearly conveying a distinctly understood message or evoking a meaning already known to the audience. As a rule, they are products of a specific culture and hence do not have the almost universal significance of emotional gestures. As Panofsky pointed out in the introduction to *Studies in Iconology* (New York, 1939), an Athenian of the 5th century BC would not understand a modern gentleman lifting his hat to greet somebody; this conventional movement is the product of certain conditions and habits that prevailed in medieval society. But while conventional gestures do not have the wide appeal and universal intelligibility of expressive movement, they have the advantage of clear legibility.

Social life abounds in conventional gestures. They are of a very wide range, reaching from finger- and hand-movements in deaf-mute sign language to elaborate ecclesiastical ceremonies. For the visual arts it was mainly two domains of conventional gesture that became of particular importance: on the one hand political action and ceremony ('political' in a broad sense), on the other religious—mainly ecclesiastical—ritual. In both, gestures are codified, their meaning clearly determined. Both tend to employ clear, easily remembered movements, often of considerable emotional appeal.

Simple forms of symbolic gesture are found everywhere; many are small body movements (usually limited to a single limb) that have acquired the status and character of a sign, e.g. the pointing index finger. Tikkanen in *Zwei Gebärden mit dem Zeigefinger* showed how variegated were the functions and contexts of this unassuming gesture in art. Some of the most famous works of European art show how this sign motif could be transformed into a spontaneous, expressive gesture (Leonardo's *St John*, *c*. 1515; Paris, Louvre; God's hand in Michelangelo's *Creation of Adam*, 1508–12; Rome, Vatican, Sistine Chapel). Symbolic gesture is also used in works of art as a principal instrument of status identification. In these cases, the general configuration of the scene represented is complex and usually includes several figures. Here it is appropriate to use the term 'gestural situations' (see Brilliant).

3. THE FUNCTIONS OF GESTURE. Gestures in art form a system of motifs that has a certain similarity to language: they make a continuity that transcends the limit of periods and creates continuous traditions that are not interrupted by shifts in style. Gestures of wailing, for example, have survived from the art of ancient Egypt to the imagery of modern times; the gestures performed in taking an oath (particularly in allegiance to some 'heroic' cause) are found in Roman art, in classicism and in modern political imagery. The wide reach and the varieties of these continuities remain to be explored.

The formal articulation of certain gestures expressive of moods or social actions contribute to making the work of art clearly 'readable' by the audience familiar with the gestures. In this respect, gestures form part of what is called the 'symbolism' of images. Another aspect worthy of study is the tendency of certain art forms, and the artistic imagery of certain periods, to use and emphasize the one or the other type of gesticulation. Thus Roman state monuments tend to give prime importance to conventional, ritual gestures. Renaissance art, which tried to manifest 'the movements of the soul', preferred 'expressive' gestures. Among art movements of modern times, Expressionism clearly concentrates on body movements that are not intentionally performed. Analysis of the gestures represented may thus manifest some of the intellectual and stylistic leanings of the artistic creations of periods and art forms.

BIBLIOGRAPHY

K. Sittl: *Die Gebärden der Griechen und Römer* (Leipzig, 1890/*R* 1980)
W. Wundt: *Die Sprache* (1900; trans. as *The Language of Gesture*, The Hague, 1973), i of *Volkerpsychologie*
K. von Amira: 'Die Handgebärden in den Bilderhandschriften des Sachsenspiegels', *Sber. Akad. Wiss. München*, xxiii/2 (1905), pp. 161–263
J. J. Tikkanen: *Die Beinstellung in der Kunstgeschichte: Ein Beitrag zur Geschichte der künstlerischen Motive* (Helsinki, 1912)
——: 'Zwei Gebärden mit dem Zeigefinger', *Acta Societatis Scientiarum Fennicae*, 43 (1913)
R. Brilliant: *Gesture and Rank in Roman Art: The Use of Gesture to Denote Status in Roman Sculpture and Coinage* (New Haven, CT, 1963)
E. H. Gombrich: 'Ritualized Gesture and Expression in Art', *Philos. Trans.*, ser. B, ccli (London, 1965), pp. 391–401
——: 'Action and Expression in Western Art', in *Non-verbal Communication*, ed. R. A. Hinde (Cambridge, 1972), pp. 373–93
M. Schapiro: *Words and Pictures: On the Literal and the Symbolic in the Illustration of a Text* (The Hague and Paris, 1973)
J. Benthall and T. Polhemus, eds: *The Body as a Medium of Expression* (London, 1975)
M. Barasch: *Gestures of Despair in Medieval and Early Renaissance Art* (New York, 1976)
R. Suntrup: *Die Bedeutung der liturgischen Gebärden und Bewegungen in lateinischen und deutschen Auslegungen des 9. bis 13. Jahrhunderts* (Munich, 1978)
B. Fehr: *Bewegungsweisen und Verhaltensideale* (Bad Bramstedt, 1979)
F. Garnier: *Le Langage de l'image au moyen âge: Signification et symbolique* (Paris, 1982)
M. Barasch: *Giotto and the Language of Gesture* (Cambridge, 1987)
J.-C. Schmitt: *La Raison des gestes dans l'occident médiéval* (Paris, 1990)

MOSHE BARASCH

Getty, J(ean) Paul (*b* Minneapolis, MN, 15 Dec 1892; *d* Sutton Place, nr Guildford, Surrey, 6 June 1976). American businessman, collector and patron. Born into a wealthy family, he followed his father into the oil business. This was his chief occupation and made him one of the richest individuals in the world. In 1912 he visited East Asia, where he purchased some pieces of carved ivory, bronzes and lacquer. However, Getty did not begin to collect actively until the 1930s: the Depression dictated relatively low prices, and this presented an opportunity to acquire a small art collection, for investment. In 1931 he purchased his first painting of value, a landscape by Jan van Goyen, and two years later he acquired ten paintings by Joaquín Sorolla y Bastida. Around this time he also developed a fondness for Renaissance paintings. (Unless otherwise stated, all objects mentioned are in the J. Paul Getty Museum, Malibu, CA.)

In the late 1930s Getty began to collect 18th-century French furniture and tapestries, 16th-century Persian carpets and 17th-century Savonnerie carpets. In 1938 he bought many major pieces of French furniture at the Mortimer Schiff sale in London, thereby acquiring the basis of a significant collection. Later that year he purchased the Ardabil Carpet (*c.* 1540; Los Angeles, CA, Co. Mus. A.) and several paintings, including Rembrandt's portrait of *Marten Looten* (1632; Los Angeles, CA, Co. Mus. A.) and Thomas Gainsborough's portrait of *James Christie* (1778). In 1949 Getty published *Europe in the Eighteenth Century*, which contains a substantial chapter on French decorative arts.

After World War II, Getty began to collect again in the early 1950s, partly to furnish his several homes. He left California for Europe in 1951, never to return to the United States. He started to donate works of art from his private collection to various museums, including, most notably, Rembrandt's *Marten Looten* and the Ardabil Carpet to the Los Angeles County Museum of Art. In 1954 he established a modest museum in his own name in a wing of his home at Malibu, CA, opening his collection to the public for the first time. Getty developed a keen interest in ancient Greek and Roman marble and bronze sculptures, mosaics and murals. He made his first important purchases of antiquities in the early 1950s, buying the life-size Pentelic marble Lansdowne *Herakles* (Roman, *c.* AD 135) and three sculptures from the collection of Thomas Bruce, 7th Earl of Elgin. In 1955 Getty published *Collector's Choice*, describing his feelings on art and the contemporary art market.

Between 1958 and 1968 Getty's interest was centred on Sutton Place (1521–6), his Tudor mansion near Guildford, Surrey. He continued to acquire art through a subsidiary corporation, Art Properties, Inc. Gradually, he evolved the idea of a major new art museum, the design of which was to be based on the Villa dei Papiri, Herculaneum, destroyed in AD 79 when Mt Vesuvius erupted: the new J. Paul Getty Museum opened in 1974, near the original house in Malibu. It houses distinguished collections of Classical antiquities and French decorative arts from the early years of the reign of Louis XIV to the Empire period. Getty died without seeing the museum, but he was later buried in the grounds; he bequeathed a vast legacy to the museum, including his private collection.

WRITINGS

Europe in the Eighteenth Century (Santa Monica, 1949)
with E. Le Vane: *Collector's Choice* (London, 1955)
My Life and Fortunes (New York, 1963)
The Joys of Collecting (New York, 1965)
As I See it: An Autobiography (London, 1976)

BIBLIOGRAPHY
R. Hewins: *J. Paul Getty: The Richest American* (London, 1961)
R. Lund: *Getty: The Stately Gnome* (London, 1977)
T. A. Marder, ed.: *The Critical Edge: Controversy in Recent American Architecture* (Cambridge, MA, 1985) [excellent bibliog. on Getty Mus.]
The J. Paul Getty Museum Handbook of the Collections (Malibu, 1986)
The J. Paul Getty Museum Guide to the Villa and its Gardens (Malibu, 1988)
STEPHEN F. THORPE

Geyer, (Karl Ludwig) Otto (*b* Charlottenburg [now Berlin], 8 Jan 1843; *d* Berlin, 25 March 1914). German sculptor. He trained for several years at the Akademie der Künste in Berlin and studied with the sculptor Hermann Schievelbein. On the latter's death in 1867 Geyer took over one of his studios and then worked as an independent sculptor in Berlin. He first showed sculptural works at the exhibition of the Akademie in 1868 and then regularly took part in exhibitions in Berlin. In 1891 he took up a teaching post at the Technische Hochschule in Berlin-Charlottenburg (being awarded a professorship in 1893) and he published several educational essays on human anatomy and issues in the politics of education.

Geyer's main sculptural work was produced in the years between 1870 and 1885. He made numerous portrait sculptures, some monuments (all destr.), religious reliefs and statues for church decoration, funerary sculpture, small-scale sculptural works, commemorative medals and parts of table centrepieces. His principal works, however, are reliefs for the decoration of public buildings. Of particular interest are three figurative friezes: the large-scale, painted stucco *History of German Culture*, concerning Germany from the introduction of Christianity, with St Boniface, to the foundation of the German Empire in 1871 (Berlin, Alte N.G., partially destr.); 36 terracotta reliefs, completed with the help of assistants, showing the *History of Berlin from its Foundation in the 13th Century until the Kaiser's Proclamation in 1871*, including 10 on the theme of *Life and Work in the Medieval City* (all 1875–7; Berlin, Rathaus). Geyer's last figurative frieze, in coloured stucco, was made in 1880 with Emil Hundrieser for the glass-covered courtyard of the Kunstgewerbemuseum in Berlin (now Berlin, Gropiusbau, partially *in situ*), and shows a procession with representatives of various peoples, bringing Borussia, the personification of Prussia, the products of their art and industry. Such works, combining the traditions of late classicism with the observation of reality, are typical of the Wilhelmine period.

BIBLIOGRAPHY
Thieme-Becker
J. Hildebrand: *Das Leben und Werk des Berliner Bildhauers Otto Geyer (1843–1914) dargestellt unter besonderer Berücksichtigung seiner historischen Figurenfriese* (diss., Berlin, Freie U., 1975)
Rheinland-Westfalen und die Berliner Bildhauerschule des 19. Jahrhunderts (exh. cat., Bottrop, Mod. Gal.; Cappenberg-Selm, Schloss Cappenberg; 1984)
Ethos und Pathos (exh. cat., W. Berlin, Staatl. Museen Preuss. Kultbes., 1990)
JOSEPHINE HILDEBRAND

Geyger, Ernst Moritz (*b* Rixdorf, Berlin, 9 Nov 1861; *d* Marignolle, nr Florence, 1941). German sculptor, printmaker and painter. He studied painting at the Akademie der Künste in Berlin from 1877 to 1882. From 1885 onwards he concentrated on printmaking, in which he was self-taught, and by 1886, when he received a gold medal for the oil painting *Bacchus* (untraced, see Rapsilber, p. 22), exhibited in Munich, he had already abandoned painting. From 1888 onwards, again studying on his own, he turned to sculpture and in 1894 he also gave up printmaking. Between 1888 and 1894 Geyger stayed first in Switzerland and then in Italy, and, having declined the offer of a teaching post in Dresden, he went to Paris, from where in 1895 he moved to Florence. In 1896 he settled at the Villa Marignolle, where he established a sculpture studio, although not altogether abandoning his Berlin studio. From 1918 Geyger taught printmaking at the Charlottenburger Hochschule für Bildende Künste in Berlin, but he continued to spend most of the year in Florence.

Geyger first achieved renown as a printmaker with an ambitious etching after Botticelli's *Primavera* (Florence, Uffizi). His second print, *Apes' Disputation*, a satire on Darwinism, also aroused admiration. Animals were one of Geyger's principal subjects in sculpture too: his first large sculptural work was *Hippopotamus Attacked by a Lion* (priv. col., see Rapsilber, pp. 44 and 46), notable for the painstaking effort in working the surface to emphasize texture and bring out the contrast between the lion's fur and the hippopotamus's thick hide. The connections between Geyger's work as a printmaker and sculptor are evident in the role played by line in his sculptural work. This is especially clear in his very precise approach to the treatment of large surfaces, for example in the large *Marble Bull* (untraced, see Rapsilber, pp. 54–6) or the tall bronze *Archer* (Potsdam, Schloss Sanssouci; see 1981 exh. cat., no. 28). Geyger was especially drawn to experiment with new or specialized techniques. For large-scale sculptural work he often worked in copper, and for small-scale works in bronze and silver he used the lost-wax process to achieve maximum retention of detail. The finesse and delicacy of his jewellery and ornamental objects are especially notable. Particularly charming is a mirror with a fully sculpted statuette, *Youth as a Caryatid* (e.g. Berlin, Tiergarten, Kstgewmus. and Hamburg, Mus. Kst & Gew.).

Geyger also produced sculpture for public monuments, for example the Fairy-tale Fountain, commissioned in 1915 and erected in 1935 in the von-der-Schulenburg-Park, near Sonnenallee in Berlin-Neukölln. Geyger always based his figures on the observation of nature, but he was able to adapt them in an idealizing manner. Although rather different from most of his German contemporaries, he is in many respects comparable with the 19th-century French sculptor Jean-Baptiste Carpeaux, especially in his large-scale work, while his highly decorative small-scale work is very close to French Art Nouveau examples.

BIBLIOGRAPHY
M. Rapsilber: *E. M. Geyger: Berlin, Florenz und sein künstlerische Schaffen in Studien und ausgeführten Werken: Malerei, Radierung, Plastik, Bronzen, Kleinkunst* (Darmstadt, 1904)
J. Guthmann: 'E. M. Geyger als Bildhauer', *Münch. Jb. Bild. Kst*, iv (1909), pp. 177–87
U. Köcke: *Katalog der Medaillen und Plaketten des 19. und 20. Jahrhunderts*, Bremen, Ksthalle cat. (Bremen, 1975), p. 54
Sculpture from the David Daniels Collection (exh. cat., text by M. M. Parsons, Minneapolis, MN, Inst. A., 1979–80)
Was ist Kleinplastik. Das kleine Format in der Bildhauerkunst (exh. cat. by G. Gerkens, Bremen, Ksthalle, 1981)
Ethos und Pathos: Die Berliner Bildhauer Schule, 1786–1914, i (exh. cat., ed. P. Bloch, S. Einholz and J. Von Simson; Berlin, Hamburg. Bahnhof, 1990), pp. 109–10
ELKE OSTLÄNDER

Geymueller, Heinrich von (*b* Vienna, 12 May 1839; *d* Baden-Baden, 19 Dec 1909). Austrian architect, engineer, architectural historian and writer. He studied engineering in Paris and in 1860 entered the Bauakademie, Berlin, where he was a pupil of Friedrich Adler. He made two study trips to Italy in his youth. He devoted himself mainly to historical research, renouncing his practical activities as an architect. Many of his numerous studies are still invaluable reference works for scholars of French and German architecture of the 15th and 16th centuries. Geymueller was profoundly influenced by the Swiss art historian Jacob Burckhardt. His *Les Projets primitifs pour la basilique de Saint-Pierre de Rome* (1875) was based on the discovery and study of previously unpublished drawings by Bramante and Raphael for St Peter's in Rome. He collaborated with Karl Martin von Stegmann in writing, and then edited, *Die Architektur der Renaissance in Toscana* (1885–1907), a comprehensive work that had originally been the idea of four young German artists who had joined together to form the Società S Giorgio. Geymueller's advice was also sought on various restoration projects, such as the façade of Milan Cathedral (1885) and the castles of Chillon (1892), Switzerland, and Hohkönigsburg (1899; now Haut-Koenigsbourg), Alsace. In 1909 he donated his collection of drawings by Florentine architects to the Uffizi Gallery, Florence. He lived mainly in Paris, Lausanne and Baden-Baden.

WRITINGS
Notizen über Entwürfe zu St Peter in Rom (Karlsruhe, 1868)
Les Projets primitifs pour la basilique de Saint-Pierre de Rome (Paris, 1875)
Cento disegni di architettura, d'ornamento e di figure di Fra Giocondo (Florence, 1882)
Documents inédits sur les manuscrits et les oeuvres d'architecture de la famille de Sangallo (Paris, 1885)
with K. M. von Stegmann: *Die Architektur der Renaissance in Toscana*, 11 vols (Munich, 1885–1907)
Les Du Cerceau: Leur vie et leur oeuvre (Paris and London, 1887)
Friedrich II von Hohenstaufen und die Anfänge der Architektur der Renaissance in Italien (Munich, 1908)
J. Durm, ed.: *Nachgelassene Schriften* (Basle, 1911)

PETER BOUTOURLINE YOUNG

Gezer, Hüseyin (*b* Mut, 1920). Turkish sculptor and writer. After completing his education in 1940, he taught for one year and then began his military service. In 1944 he entered the sculpture department of the Fine Arts Academy in Istanbul, where he was a student of Rudolf Belling. From 1948 to 1950 he lived in Paris on a bursary and studied under the sculptor Marcel Gimond (*b* 1894) at the Académie Julian. When he returned to Turkey he became an assistant teacher in the sculpture department of the Fine Arts Academy and also began to assist with the administration and management, eventually becoming Director. From 1969 to 1976 he also directed the Museum of Painting and Sculpture in Istanbul. As a sculptor he concentrated on figural works and made an important contribution to statue art in Turkey. He was responsible for a number of monuments to *Atatürk* including those at Geyve (1961), Karabük (1961), Akhisar (1962), Antalya (1964), and in Ankara at the Hacettepe University campus (1971) and the Parliament Building (1981). His other sculptures included a range of busts and figures. Certain works such as *Love of a Brother* (plaster, 890×110 mm; Istanbul, Mimar Sinan U., Mus. Ptg & Sculp.) demonstrate

a more stylized and abstract rendering of figures. He also wrote about Turkish art.

WRITINGS
with N. Berk: *50 Yılın Türk resim ve heykeli* [50 years of Turkish painting and sculpture] (Istanbul, 1973)

BIBLIOGRAPHY
S. Tansuğ: *Çağdaş Türk sanatı* [Contemporary Turkish art] (Istanbul, 1986), pp. 322–4, 326, 388–9

□

Ghaffari [Ghaffārī]. Persian family of painters. A distinguished family of government officials and jurists from Kashan, it had many members who were also artists. For several decades beginning in 1749, Muʿizz al-Din Muhammad Ghaffari served as governor of Kashan, Jawshaqan, Qum and Natanz for the Zand ruler of Shiraz, Karim Khan (*reg* 1750–79). Muʿizz al-Din's son (1) Abu'l-Hasan Mustawfi Ghaffari became court secretary to Karim Khan and was a noted painter of polychrome watercolours and wash drawings. His great-nephew (2) Abu'l-Hasan Ghaffari was the greatest painter of the Qajar dynasty and was awarded the title 'Painter of the Kingdom' (Pers. *Sāniʿ al-mulk*), by which he is often known. He introduced a realistic style based on European painting, and this style was continued by his nephew (3) Muhammad Ghaffari, who was known under the title 'Perfection of the Kingdom' (*Kamāl al-mulk*) and was the most notable painter in Iran in the late 19th century and early 20th.

BIBLIOGRAPHY
G. Scarcia: 'Sulla famiglia Gaffārī di Kāšān e sul contributo all'evoluzione della pittura persiana degli ultimi 150 anni', *AION*, xii (1962), pp. 198–203
B. W. Robinson: 'Persian Painting in the Qajar Period', *Highlights of Persian Art*, ed. R. Ettinghausen and E. Yarshater (Boulder, 1979), pp. 331–62
——: 'Persian Royal Portraiture and the Qajars', *Qajar Iran*, ed. E. Bosworth and C. Hillenbrand (Edinburgh, 1983), pp. 291–310
L. S. Diba: 'Persian Painting in the Eighteenth Century: Tradition and Transmission', *Muqarnas*, vi (1989), pp. 147–60
B. W. Robinson: 'Persian Painting under the Zand and Qājār Dynasties', *From Nadir Shah to the Islamic Republic* (1991), vii of *The Cambridge History of Iran* (Cambridge, 1968–91), pp. 870–90

(1) Abu'l-Hasan Mustawfi Ghaffari [Abū'l-Ḥasan Mustawfī Ghaffārī] (*d c.* 1797–8). As court secretary (*mustawfi*) to Karim Khan Zand, Abu'l-Hasan Mustawfi began to compose the *Gulshan-i Murād* ('Garden of desire'), one of the most important historical sources for the period, which was finished by his son Muhammad Baqir, the painter, in 1796. Neither of the two surviving manuscripts (Tehran, Malek Lib., MS. 4333, and London, BL, Or. MS. 3592) is illustrated, but many of Abu'l-Hasan Mustawfi's watercolours and drawings, including portraits of his family and historical figures, have been preserved by his family. Several, including one dated 1782, show his father Muʿizz al-Din Muhammad seated and smoking a pipe. A miniature dated August 1794 depicts his great-grandfather Qazi ʿAbd al-Muttalib riding a mule *en route* to the coronation of Nadir Shah Afshar (*reg* 1736–47). A portrait dated 1793–4 (see Diba, fig. 6) depicts the Safavid ruler *Safi I* (*reg* 1629–42), and another painting done the following year is a posthumous portrait of *Karim Khan* and his groom in the royal square. The artist's latest work, dated 1797–8, is a portrait of his grandfather Qazi Ahmad seated

in a garden with a boy sleeping in the background. Abu'l-Hasan Mustawfi signed his works *al-mustawfi*, but other unsigned paintings, such as a watercolour (Geneva, Prince Sadruddin Aga Khan priv. col.) of Shah 'Abbas II receiving the Mughal ambassador, can also be attributed to the artist. His impressive compositions continue the tradition of late Safavid court painting, but he was a perspicacious observer of contemporary events, and his eye for detail distinguishes his style from the decorative and charming but sometimes vapid work of his contemporaries.

BIBLIOGRAPHY
Enc. Iran.: 'Abu'l-Hasan Mostawfi'
M. A. Karīmzāda Tabrīzī: *Ahvāl u āthār-i naqqāshān-i qadīm-i īrān* [The lives and art of old painters of Iran] (London, 1985), no. 58

(2) Abu'l-Hasan Ghaffari [Abū'l-Ḥasan Ghaffārī] (*b* 1817; *d* 1866). Great-nephew of (1) Abu'l-Hasan Mustawfi Ghaffari. He studied with MIHR 'ALI and, like his teacher, was particularly effective in portraiture. Abu'l-Hasan also acknowledged a debt to his great-uncle, for his earliest works are signed *Abu'l-Hasan thānī* ('the second'). In 1842 he painted an oil portrait of the Qajar monarch *Muhammad* (*reg* 1834–48), who appointed him court painter. From 1846 to 1850 the artist was sent to study painting in Italy, and his fine lithographed portrait of *Tsar Peter the Great*, made for a Persian translation of Voltaire's history published in Tehran in 1846, is based on a European painting. On his return to Iran, he was made Painter Laureate (Pers. *naqqāsh-bāshī*) and he supervised the painting department of the Dar al-Funun, the college founded in Tehran by Nasir al-Din (*reg* 1848–96; *see* TEHRAN, §2). Abu'l-Hasan was put in charge of the illustration for a Persian translation of *The Thousand and One Nights* (Tehran, Gulistan Pal. Lib., MSS 12367–72). This was the most lavish manuscript produced during the Qajar period: the six folio volumes contain 1134 illustrated pages, with two to six separate paintings per page. For this monumental task, which was completed by 1855, he led a team of 34 painters, preparing preliminary sketches (some in London, BL, Or. MS. 4938) and executing some of the finest paintings. The manuscript set the style for book illustration for the rest of the Qajar period (*see* ISLAMIC ART, §III, 4(vi)(b)). Abu'l-Hasan's most impressive work is a set of seven large oil panels (Tehran, Archaeol. Mus.) prepared for the Nizamiyya Palace in Tehran in 1857. The paintings depict Nasir al-Din enthroned in state surrounded by his sons, courtiers and foreign ambassadors, an arrangement based on the mural (1812–13; destr.) by 'ABDALLAH KHAN for the Nigaristan Palace showing Fath 'Ali Shah (*reg* 1797–1834). Each figure in the Nizamiyya panels is a lifelike portrait, and Abu'l-Hasan concentrated most of his attention on the faces. Preliminary sketches for many of the figures are also in the Archaeological Museum in Tehran. On 19 May 1861 Abu'l-Hasan was named Sānī' al-Mulk ('Painter of the Kingdom') and given a building in which to establish his own school of painting.

In his last years, Abu'l-Hasan was more occupied with administration than with painting. In 1861 he was appointed director of printing and editor of the government periodical, which was renamed *Rūznāma-yi dawlat-i 'aliya-yi Īrān* ('Newspaper of the lofty state of Iran'). It was copiously illustrated with his incisive, and sometimes merciless, lithographed portraits of princes, statesmen and generals and scenes of daily life. In 1864 he was put in charge of all printing establishments in Iran, and in 1866, shortly before his death, he took over the directorship of three more official journals and was made Under-Secretary in the Ministry of Science. Abu'l-Hasan's strength was portraiture, and his brilliant characterizations of tiny princes and debauched ministers in richly patterned robes and tall fur hats bring to life the dissipation and corruption that forshadowed the fall of the Qajar dynasty.

BIBLIOGRAPHY
Enc. Iran.: 'Abu'l-Ḥasan Khān Gaffārī'
Y.Zuka: 'Mīrzā Abū'l-Ḥasan Khān, Sānī' al-Mulk Ghaffārī', *Hunar va Mardum*, x, pp. 14–27; xi, pp. 16–33 [in Persian]
M. A. Karīmzāda Tabrīzī: *Ahvāl u āthār-i naqqāshān-i qadīm-i īrān* [The lives and art of old painters of Iran] (London, 1985), no. 56

(3) Muhammad Ghaffari [Muḥammad Ghaffārī] (*b* Kashan, ?1852; *d* Nishapur, July 1941). Nephew of (2) Abu'l-Hasan Ghaffari. He studied at the Dar al-Funun, the art school founded in Tehran by the Qajar monarch Nasir al-Din (*reg* 1848–96), and in 1892 received the title Kamāl al-Mulk ('Perfection of the Kingdom'). Like his uncle, he was sent to study in Europe, and, after his return to Iran, he established an art school in 1911. He painted a great many portraits, landscapes and genre scenes. One of the finest (Tehran, Firuz priv. col.; see Robinson, fig. 38b) is a large portrait of *Nasir al-Din*, which exemplifies the artist's dignified and impressive, but completely Europeanized, style. He is buried in a magnificent tomb on the outskirts of Nishapur, near the tombs of the poet and mystic Farid al-Din 'Attar (1145–1221) and the astronomer and poet 'Umar Khayyam (*d* 1131).

BIBLIOGRAPHY
M. A. Karīmzāda Tabrīzī: *Ahvāl u āthār-i naqqāshān-i qadīm-i īrān* [The lives and art of old painters of Iran] (London, 1985), no. 1117
B. W. Robinson: 'Persian Painting under the Zand and Qājār Dynasties', *From Nadir Shah to the Islamic Republic* (1991), vii of *The Cambridge History of Iran* (Cambridge, 1968–91), pp. 887–9

SHEILA S. BLAIR

Ghaga-shahr. *See* KUH-I KHWAJA.

Ghana, Republic of [formerly the Gold Coast]. Country in West Africa on the Gulf of Guinea, bordered by Côte d'Ivoire to the west, Burkina Faso to the north and Togo to the east. The capital is Accra. Ghana became independent in 1957. English is the language of government, while Ahan and Ewe are also national languages.

1. Geography and cultural history. 2. Architecture. 3. Painting. 4. Sculpture. 5. Patronage and art institutions.

1. GEOGRAPHY AND CULTURAL HISTORY. The south of Ghana is situated on a narrow coastal plain, while the north comprises tropical forest and savannah. The total land area is about 240,000 sq. km.

By the 14th century AD most of the major ethnic groups that constitute the present population of 14,753,900 (UN estimate, 1990) had settled in various parts of the country and had formed independent city states with distinctive artistic cultures. These states unsuccessfully combated Arab and European cultural encroachments and were brought together as a British colony during the last quarter of the 19th century. Little unity was achieved, resulting in a cultural division into Muslim north and Christian south.

The attainment of independence rekindled national pride, and it was accompanied by a revival of indigenous cultural traditions. Ghanaian craftsmen have continued to produce such traditional products as carved wooden figures, miniature brass sculptures, terracotta statues, brightly woven kente cloth and patterned fabrics (*see* TEXTILE, colour pl. VIII, fig. 1) known as *adinka*. Traditionally produced to fulfil daily needs and ceremonial functions, in the late 20th century these craft products were also made for the tourist market.

This article covers the art produced in the region since colonial times. For art of the region in earlier periods *see* AFRICA, §VII, 3. *See also* AKAN and ASANTE AND RELATED PEOPLES.

2. ARCHITECTURE. Ghanaian architecture has long been receptive to foreign influences. In the 15th century European and Arab traders built slave castles and mosques. They combined such traditional building practices as the use of brick and laterite soil and the adherence to standard ground-plans, including such non-local elements as painted or low-relief geometric designs and moulded latticework, which had an Islamic source, and long corridors and verandahs derived from European ecclesiastical models. The resulting stylistic fusion is evident in 20th-century Ghanaian buildings. The colonial government made neo-classical and Islamic decorative architecture the hallmark of its administrative buildings, while at the beginning of the 20th century Ghanaians commissioned prestigious sandcrete houses designed with fluted pillars and arches framing and supporting abridged and long, winding verandahs. A change of style occurred when new government institutional buildings were designed by foreign architects under Ghanaian government directions. Between 1951 and 1954 the English architect James Cubitt designed several schools and colleges. In the following years Ghanaian architects, trained in Europe, took over and designed some of the same modern structures. The most famous was Adegbite, who designed the ten-storey State House in Accra. Gradually Ghanaian architecture developed a modernist style with its own character. Typically, this style features low-relief, decorative concrete motifs set in banisters and security walls, and the construction of self-contained homes with courtyards, combining conventional utilitarian demands with modernist aesthetics.

3. PAINTING. The nationalism that led to a revival of traditional arts (*see* §1 above) also inspired an artistic development that romanticized folk life and glamorized indigenous customs. These ideas were expressed in modern academic compositions or realism, rather than in the reworking of traditional techniques, and artists no longer followed formalized conventions: they expressed themselves freely in individual styles that could be identified with individual names and given titles and dates. During the 1950s and 1960s Ghanaian painters produced works instilled with a sense of indigenous pride and dignity, which treated themes from Ghana's folk culture, touching on pageantry, market scenes and domestic life. Although conforming to techniques of modern academic realism, the figures, and especially the head, neck and limbs, were defined using oval shapes in consonance with traditional Ghanaian ideals of beauty. The painter and sculptor Kofi Antubam (1922–64) produced paintings that display these characteristics, particularly in the dominant black outline of his figures. His works also show strong organization and rhythm in their composition. Other artists working at this time include the designer of Ghana's coat of arms, Amon Kotei; Owusu-Dartey; the designer of the national flag, Theodosia Okoh; and E. V. Asihene, best known for his mural painting in the National Parliament House in Accra. Kotei and Owusu-Dartey enhanced the realism of their work through the use of light and shade.

1. Ablade Glover: *Disorderly, Orderly*, oil on canvas, *c.* 0.76×1.50 m, 1988

In the 1970s academic realism gave way to the 'Sculptural Idiom'. The chief exponent of the trend was Kobina Bucknor, who described it as a 'two-dimensional painting idiom transformed from three-dimensional sculpture idiom' (Fosu, p. 129). It allowed experimentation with traditional Ghanaian aesthetic concepts and the free interpretation of the past. Such artists as Charlotte Hagan, E. K. Tetteh and Bucknor disregarded conventional rules of perspective, proportion and realism. Instead, they created stylized representations of abstract symbologies characterized by elongations and mask-faced motifs in rhythmic movements fused with backgrounds. The artists who emerged in the 1980s were unencumbered by nationalist fervour. Their work was more spontaneous in conception and less experimental in execution. Two representatives of this generation are Ablade Glover and Ato Delaquis. Coincidentally, both based their work on crowds, especially in open markets, lorry stations and at ceremonial events. Stylistically, however, Glover's crowds differ by being more concentrated, fused into backgrounds of roof tops; his figures are abstract impressions in thickly applied and intense colour (see fig. 1). Glover is well known both within Ghana and internationally. His work was featured in the exhibition *Contemporary African Artists: Changing Traditions* (1990) at the Studio Museum in Harlem, New York, and the Venice Biennale of the same

year. Ato Delaquis, on the other hand, used cheerful colours to define individuals in his crowds, and his compositions show a strong sense of design and order. During the 1990s many younger artists were beginning to make an impact with works that indicated a willingness to explore new ways of expressing the spirit of modern Ghana.

4. SCULPTURE. During the 1950s there was a dramatic departure from Ghana's classical sculptural traditions in works of modern composition and monumental scale. Expressionistic exaggeration of form appeared in Kofi Antubam's oval-shaped figures and in the works of Vincent Kofi. Oku-Ampofo, who received a medical training in Britain and returned to Ghana after World War II, created figures with sinuous limbs and slanting beaded eyes. In the 1970s realism became apparent in the work of such sculptors as Saka-Acquaye and Azii Akator, the latter producing monumental outdoor statues of historical personalities. El Anatsui (*b* 1944) worked in wood, clay and glass and incorporated photography into his exhibitions. In the early 1990s he belonged to the Aka group of artists in eastern Nigeria, where he also exhibited and taught.

Another sculptor who has received much international attention is Kane Kwei (*b* 1924). Although he had no

2. Kane Kwei: Mercedes-Benz-shaped coffin, wood and enamel paint, l. 2.65 m, 1989 (Rotterdam, Museum voor Volkenkunde)

formal education, he was apprenticed to a carpenter and made such traditional items as language staffs, palanquins and coffins. For his uncle's funeral he made a special coffin in the shape of a boat to represent the uncle's life as a fisherman. The idea was popular, and local customers began to order these representational coffins. Vivian Burns, an American dealer, published and exhibited his work in San Francisco in 1974, and Kwei began to receive commissions from tourists and foreign museums (e.g. Rotterdam, Mus. Vlkenknd.). His designs are limited to such set models as a boat, fish or whale for fishermen; a hen with chicks for women with large families; an aeroplane for great travellers and a white Mercedes-Benz for successful business people (see fig. 2). In the early 1990s there were few significant developments in sculpture.

5. PATRONAGE AND ART INSTITUTIONS. By the early 1990s the bulk of Ghana's patronage came from foreigners, especially diplomatic personnel, and from members of the Ghanaian government, foreign-based commercial enterprises and individual Ghanaians. The tourist market continued to provide the incentive for much traditional art and craft work, although commissions for local customers were still important in this field. The Arts Council was founded in 1958. Based in Accra, its purpose is to promote and develop the arts and to preserve the traditional arts. The council includes a research section, and at the end of the 1980s a national archive was planned.

Permanent exhibitions have been held at the Ghana National Museum, Accra, the Centre for National Culture, Accra, the National Cultural Centre Museum, Kumasi, and the Museum of the African Studies Centre, Legon. The most active exhibitors of modern Ghanaian art have been the Loom Gallery, Accra, and some of the foreign embassies in Accra. Both the College of Art of the University of Science and Technology, Kumasi, and the College of Education, Winneba, have held annual art exhibitions. The Mobil Oil Company sponsors the annual publication of an art journal, *Image*, by the College of Art. Other regularly published arts magazines are *Sankofa* by the Ghana Arts Council and the privately owned *Uhuru*.

The major teaching institution is the prestigious College of Art of the University of Science and Technology, Kumasi, which has trained almost all of the modern professional artists of Ghana and is the only degree-granting institution. It offers a BA in Studio Art and an MA in Art Education and African Art. The College of Art, Winneba, offers art diploma courses. There are also two privately organized vocational schools: the Kumasi College of Art and Industry and Ghanatta College of Art, Accra.

BIBLIOGRAPHY

K. Antubam: *Ghana Arts and Crafts* (Accra, 1961)
——: *Ghana's Heritage of Culture* (Leipzig, 1963)
V. A. Kofi: *Sculpture in Ghana* (Accra, 1964)
A. A. Y. Kyerematen: *Panoply of Ghana* (London and Accra, 1964)
L. Grobel: 'Ghana's Vincent Kofi', *Afr. A.*, iii/4 (1970), pp. 8–11, 68–70, 80
Image [Kumasi], i- (1972–)
M. W. Mount: *African Art: The Years since 1920* (Bloomington and London, 1973/*R* 1989)
National Museum of African Art Handbook (Accra, 1973)
V. Burns: 'Travel to Heaven: Fantasy Coffins', *Afr. A.*, vii/2 (1974), pp. 24–5
K. Bucknor: *Ten Years of Sculptural Idiom* (Accra, 1975)
Sankofa, i- (1977–)
The Arts of Ghana (exh. cat. by H. M. Cole and D. H. Ross, Los Angeles, UCLA, Wight A.G.; Minneapolis, MN, Walker A. Cent.; Dallas, TX, Mus. F.A.; 1977–8)
C. Kristen: 'Sign-painting in Ghana', *Afr. A.*, xiii/3 (1980), pp. 38–41
El Anatsui: *Sculptures, Photographs and Drawings* (Enugu, 1982)
K. Fosu: *20th Century Art of Africa* (Zaria, 1986)
Sculptures in Wood: 'Thoughts and Processes' by El Anatsui and Ndubisi Onah (exh. cat., Lagos, Ist. It. Cult., 1988)
Uhuru (1989–)
E. Nii Quarcoopome: 'Self-decoration and Religious Power in Dangme Culture', *Afr. A.*, xxiv/3 (1991), pp. 56–65, 96
'Kane Kwei: Coffin Maker', *Africa Explores* (exh. cat. by S. Vogel, New York, Cent. Afr. A., 1991), pp. 97–100, 108–11
J. Kennedy: *New Currents, Ancient Rivers: Contemporary African Artists in a Generation of Change* (Washington, DC, and London, 1992), pp. 88–92
T. Secretan: *Il fait sombre: Va-t'en* (Paris, 1994); Eng. trans. by R. Sharman as *Going into Darkness: Fantastic Coffins from Africa* (London, 1995)

KOJO FOSU

Gharapuri. *See* ELEPHANTA.

Ghassul, Teleilat el- [Teleilat Ghassul]. Site of a Chalcolithic settlement in Jordan that flourished *c.* 4600–*c.* 3600 BC. The site is at the north-east corner of the Dead Sea, 5 km east of the River Jordan and between 290 and 300 m below sea level. The Chalcolithic culture of Palestine and Jordan was first recognized at Teleilat el-Ghassul, which remains the type site for the period. Excavations at the site were conducted by the Pontifical Biblical Institute of Rome under Mallon and Köppel (1929–38), by Robert North (1960), and by the British School of Archaeology in Jerusalem (1967) and the University of Sydney (1975–8), both under the direction of Basil Hennessy. Renewed excavations in 1994–5 by the University of Sydney were directed by S. J. Bourke. Important finds from the excavations include wall paintings, ceramics and stonework. The major collections are in the Jordan Archaeological Museum in Amman, the Rockefeller Museum and the collection of the Pontifical Biblical Institute in Jerusalem, and in the Nicholson Museum of Antiquities at the University of Sydney.

In the 5th millennium BC the area was marshy and supported a wide variety of plant and animal life. The settlement at Teleilat el-Ghassul was large (20–30 ha) and rich. Its economy was based on agriculture and included the herding of domestic sheep, goats, cattle and pigs and the cultivation of wheat, barley, flax and legumes. Olives, which were an important part of the diet, were probably imported. The settlement was ideally sited as a trading centre, as it lay across major north–south and east–west routes, and it may also have had a religious significance; religion evidently inspired much of the art found there.

The original architecture of the site was round, semi-subterranean and poor, but soon after the first occupation the inhabitants began constructing substantial rectangular structures, including two well-constructed shrines in a walled enclosure. Houses were of the longhouse type, up to 15 m in length, with the width rarely exceeding 4 m, and they were solidly constructed of mud-brick on stone foundations. Inside, the walls were often lined with a white lime plaster and painted with geometric and naturalistic patterns. The wide range of colours, in varying shades of red, green, black, white and yellow, were mineral-based. The walls were frequently recoated and repainted and, in

some instances, more than 20 plasterings were noted. These painted rooms may have been domestic shrines that were ceremonially repainted every year. They occur in all phases of occupation associated with the rectangular architecture. One of the earliest paintings (see fig.) shows a procession of richly garbed figures approaching what appears to be a building, perhaps the cult centre already mentioned. A similar construction appears in the background of another wall painting that is dominated by a large, eight-pointed star.

The pottery is individual, technically superb and decorated in a most attractive manner with the same paints as those used in the wall paintings. A great variety of elaborately decorated cult vessels, including some in appealing animal and human shapes, were found in the main religious area of the settlement. The flaked- and ground-stone industries were also technically accomplished and many of the flaked-stone products are of artistic merit.

The inhabitants of Teleilat el-Ghassul passed on their outstanding technical and artistic skills to their immediate successors in the Late Chalcolithic period (*see* SYRIA-PALESTINE, §I, 2(iii)).

BIBLIOGRAPHY

A. Mallon, R. Köppel and R. Neuville: *Teleilat Ghassul*, i (Rome, 1934)

R. Köppel and others: *Teleilat Ghassul*, ii (Rome, 1940)

R. North: *Ghassul 1960 Excavation Report* (Rome, 1961)

J. B. Hennessy: 'Preliminary Report on a First Season of Excavations at Teleilat Ghassul', *Levant*, i (1967), pp. 1–24

D. C. Elliott: 'The Ghassulian Culture in Palestine', *Levant*, x (1978), pp. 37–54

J. B. Hennessy: *Teleilat Ghassul: Its Place in the Archaeology of Jordan* (1982), i of *Studies in the History and Archaeology of Jordan* (Amman and London, 1982–), pp. 55–8

D. Homès-Fredericq and J. B. Hennessy, eds: *Archaeology of Jordan, II. 1: Field Reports: Surveys and Sites*, A–K (Leuven, 1989), pp. 230–41

J. B. HENNESSY

Ghaybi [Ghaybī Tawrīzī; Ghaybī al-Shāmī; Ghaibi]. Arab potter. The name is also applied to a pottery workshop active in Syria and Egypt in the mid-15th century. All the products are underglaze-painted in blue and black. A rectangular panel composed of six tiles decorated with a lobed niche in the mosque of Ghars al-Din al-Tawrizi, Damascus (1423), is signed '*amal ghaybī tawrīzī* ('the work of Ghaybi of Tabriz'), suggesting that he was associated with Tabriz, a noted ceramic centre in north-west Iran. As the interior of the mosque and tomb is decorated with 1362 unsigned but related tiles, Ghaybi must have been the head of a workshop in Damascus. A fragment of a bowl with a typical Egyptian fabric (New York, Met., 1973.79.9) bears the name *ghaybī al-shāmī* ('Ghaybi the Syrian'), suggesting that the potter later moved from Syria to Egypt. A square tile from a restoration of the mosque of Sayyida Nafisa in Cairo (Cairo, Mus. Islam. A.) is signed by Ibn Ghaybi al-Tawrizi, suggesting that Ghaybi's son was active as a potter in Egypt. Another fragment (New York, Met., 1973.79.20) signed Ibn Ghaybi and counter-signed Ghaybi in the foot indicates that Ghaybi became the name of a workshop.

BIBLIOGRAPHY

A. Abel: *Gaibi et les grands faïenciers égyptiens d'époque mamelouke* (Cairo, 1930)

R. Riefstahl: 'Early Turkish Tile Revetments in Edirne', *A. Islam.*, iv (1937), pp. 249–81

Teleilat el-Ghassul, wall painting showing a procession, h. *c.* 500 mm, *c.* 4000 BC; from a reconstruction drawing (Amman, Jordan Archaeological Museum)

J. Carswell: 'Six Tiles', *Islamic Art in the Metropolitan Museum of Art*, ed. R. Ettinghausen (New York, 1972), pp. 99–125

M. Jenkins: 'Mamluk Underglaze-painted Pottery: Foundations for Future Study', *Muqarnas*, ii (1984), pp. 95–114

Ghazna [now Ghaznī]. City in eastern Afghanistan that served as the capital of the Ghaznavid dynasty from 977 to 1163. In pre-Islamic times the city was a Buddhist centre, and excavations have uncovered remains of a stupa and clay and terracotta Buddhas. In AD 977 the Samanid slave commander Sebüktigin (*reg* 977–97) rose to power in Ghazna and founded the Ghaznavid dynasty (*reg* 977–1186). Ghazna became the capital of an empire that at the death of Sebüktigin's son Mahmud (*reg* 998–1030) stretched from western Iran to the Ganges valley. The city commanded a dominating position on the borderland between the Islamic and Indian worlds and was an important entrepôt for trade. It was also a centre of literature and art: the poet Firdawsi (940–1020), for example, composed the *Shāhnāma* ('Book of kings') at the court of Mahmud *c.* 1010.

According to the late 10th-century geographer Muqaddasi, Ghazna was a thriving frontier town with many markets. It had a citadel (modern Bala-Hisar) with the ruler's palace in the centre. The suburbs had more markets and houses for the wealthy, some of which have been excavated on the hill to the east of the town. Both Mahmud and his son Mas'ud I (*reg* 1031–41) added lavish palaces with gardens and pavilions. With the booty acquired from his victories in India in 1018, Mahmud ordered a new mosque called the 'Bride of the Heavens' (Arab. *'arūs al-falak*). It was attached to a large madrasa containing a library of books seized in his campaigns. Other major constructions ordered by Mahmud included stables to house 1000 elephants and irrigation projects such as the Royal Dam (Pers. *band-i sultān*), which still survives a few kilometres north of the town. Most of these works were

probably done with corvée labour imported from Persia or India.

Ghazna continued to prosper in the late 11th century, despite the loss of Persian territory to the Saljuqs. To the east of the town, Mas'ud III (*reg* 1099–1115) constructed a bazaar and a large palace with a rectangular court (50×32 m) paved in marble. The court is surrounded by 32 niches and iwans on the four sides, with an additional throne-room beyond the south iwan. In plan, it resembles Mahmud's palace at LASHKARI BAZAR, but the palace at Ghazna is distinguished by an extraordinary inscription in floriated kufic that extends for 250 m around the court. The text is a Persian poem extolling the virtues of the Sultan and the glories of his palace and was apparently composed specifically for the new construction. Near the palace Mas'ud built a magnificent flanged tower. It was originally 44 m high, but the upper section with semicircular flanges fell in the earthquake of 1902 and only the lower stellate section (20 m) remains. Built of brick, the tower is superbly decorated with brick patterns, stucco and terracotta panels. Mas'ud's tower was the model for one built by his son Bahramshah (*reg* 1118–52) some 600 m to the west, and the type was repeated at such other sites as Jam and Delhi (*see* DELHI, §III, 1). Earlier travellers identified these constructions as victory towers, but this is unlikely and their original function remains unclear.

In the early 12th century Ghazna was twice occupied by Saljuq armies, and in 1150–51 it was sacked by the Ghurid ruler 'Ala' al-Din Husayn (*reg* 1149–61) in an orgy of destruction that earned him the epithet 'World Burner' (Pers. *jahānsūz*). Although Ghazna recovered somewhat, it fell from Ghaznavid possession in 1163 and a decade later became the Ghurid capital under Mu'izz al-Din Muhammad (*d* 1206). In 1215–16 it was taken by the Khwarazmshahs, only to be sacked in 1221 by the Mongol army of Genghis Khan. This event marked the end of Ghazna's period of glory, and coins ceased to be minted there. When the Mughal prince Babur took Ghazna in 1504, it was a small town. In the 20th century, however, it regained some importance as an administrative centre and provincial capital.

Enc. Islam/2 BIBLIOGRAPHY

S. Flury: 'Das Schriftband an der Türe des Mahmud von Ghazna, 998–1030', *Der Islam*, viii (1918), pp. 214–27
——: 'Le Décor épigraphique des monuments de Ghazna', *Syria*, vi (1925), pp. 61–90
J. Sourdel-Thomine: 'Deux Minarets d'époque seljoukide en Afghanistan', *Syria*, xxx (1953), pp. 108–21
A. Bombaci and U. Scerrato: 'Summary Report on the Italian Archaeological Mission in Afghanistan', *E. & W.*, n. s., x (1959), pp. 3–55
U. Scerrato: 'Islamic Glazed Tiles with Moulded Decoration from Ghazni', *E. & W.*, n. s., xiii (1962), pp. 263–87
A. Bombaci: *The Kūfic Inscription in Persian Verses in the Court of the Royal Palace of Mas'ūd III at Ghazni* (Rome, 1966)
R. Pinder-Wilson: 'The Minaret of Mas'ūd III at Ghazna', *Stud. Islam. A.* (London, 1985), pp. 89–102

☐

Ghaznavid. Islamic dynasty that ruled in Afghanistan, Transoxiana, eastern Iran and northern India from AD 977 to 1186. The founder was Sebüktigin (*d* 997), a Turkish slave employed by the Samanid dynasty, who eventually defied their authority and set up his own principality with its capital at GHAZNA, now in Afghanistan. His son Mahmud (*reg* 998–1030) transformed this principality into a highly militarized empire. At first this expansion was achieved at the expense of the Samanid, Buyid and Qarakhanid dynasties, but Mahmud's streamlined military machine also had a more ambitious target: 17 near-annual raids were launched between 1001 and 1024 against northern India, an ongoing holy war that made Mahmud's name a byword for religious orthodoxy. It also brought vast booty and briefly made Ghazna a famous metropolis, with a fabulous mosque prinked out in gold, alabaster and marble, a university, madrasas, libraries, aqueducts and other public works. These campaigns also tilted Ghaznavid policies away from Iran, a weakness successfully exploited by the Saljuq dynasty at the battle of Dandanqan (1040), which ended Ghaznavid ambitions in the west.

Despite his Turkish heritage, Mahmud enthusiastically adopted the Sasanian-inspired Perso-Islamic tradition of government, with its belief in the divine right of the ruler, inaccessibility and the natural opposition between ruler and ruled, as well as such institutions as the espionage system, the vizierate and army reviews. His assumption of the title *sulṭān*, originally a prerogative of the caliph, expressed Mahmud's claim to absolute authority. The land was divided into military fiefs to pay for the standing professional army, which was largely Turkish and well equipped with horses, camels and elephants. Leading intellectuals of the day were virtually kidnapped to add lustre to the royal court, and laureates produced endless panegyrics in Mahmud's honour. Yet when the great poet Firdawsi (*d* 1020) presented his life's work, the *Shāhnāma* ('Book of kings')—the epic that encapsulated Iranian culture and is still regarded as the masterpiece of Persian literature—Mahmud's reward was too little and too late: the poet had died. The dynasty lost ground in the 12th century to the Ghurids, a dynasty controlling the mountainous centre of Afghanistan. Ghazna fell in 1163, and the Ghaznavids were pushed ever further to the east, eventually surrendering their last Indian possession, their capital at Lahore, to the Ghurids in 1186.

Ghaznavid architecture, although tantalizingly rare, is notable for its excellent quality and for the variety of its forms, many unattested elsewhere in the Iranian world (*see* ISLAMIC ART, §II, 5(i)(c) and figs 32 and 33). Monuments include the *ribat* of 'Ali ibn Karmakh near Multan (Pakistan), the great ceremonial arch at Bust (Afghanistan), the two-tiered flanged and cylindrical minarets of Ghazna and the palatial complexes at Ghazna (early 11th century) and LASHKARI BAZAR (*c.* 1030–*c.* 1130). These follow Abbasid modes in their immense scale, domed cruciform halls and frequently shoddy mud-brick construction, but also use what was to become a distinctively Persian schema, the four-iwan courtyard plan. Ornamental brickwork and terracotta (e.g. the mausoleum of Salar Khalil/Baba Khatim in northern Afghanistan) and inscriptions (including a lengthy verse panegyric of the sultan at Ghazna) dominate the decorative repertory, supplemented by stone and marble carved with themes of Indian inspiration (e.g. arch form, monkeys, elephants and female dancers) as well as booty brought from India. Indian materials and forms were also used for mihrabs, tombstones, cenotaphs (e.g. those of Sebüktigin and Mahmud), fountains and balustrades.

The Ghaznavids introduced cursive script to monumental epigraphy and developed many different kinds of kufic script, including some of notably baroque character. Distinctive green-glazed Ghaznavid pottery is associated with Bust and Bamiyan, some lustreware has been found at Ghazna, and the Ghazna palace has yielded some monochrome glazed tiles with animal motifs. Large collections of cast, engraved and inlaid bronzes in Afghan museums are probably local. But in this medium, as in Koranic calligraphy, the characteristics of a distinctive Ghaznavid style have yet to be identified. Some idea of Ghaznavid manuscript illumination can be gained from a manuscript (Leiden, Rijksuniv., MS. 437) formerly in the library of the Ghaznavid amir 'Abd al-Rashid (*reg* 1050–53), and the royal library certainly possessed illustrated books. Fragmentary frescoes of the caliphal bodyguard have been discovered at Lashkari Bazar, and the same theme reappears in marble (e.g. Copenhagen, Davids Samml.), but the masterpiece of Ghaznavid carving is the pair of doors from Mahmud's tomb (Agra, Taj Mahal Mus.), with densely carved stellar cartouches and even a stylized bull's head in the arabesques.

BIBLIOGRAPHY

S. Flury: 'Das Schriftband an der Türe des Mahmud von Ghazna (998–1030)', *Der Islam*, viii (1918), pp. 214–27

——: 'Le Décor épigraphique des monuments de Ghazna', *Syria*, vi (1925), pp. 61–90

J. Sourdel-Thomine: 'Deux minarets d'époque seljoukide en Afghanistan', *Syria*, xxx (1953), pp. 108–36

U. Scerrato: 'Islamic Glazed Tiles with Moulded Decoration from Ghazni', *E. & W.*, n. s., xiii (1962), pp. 263–87

A. Bombaci: *The Kūfic Inscription in Persian Verses in the Court of the Royal Palace of Mas'ūd III at Ghazni* (Rome, 1966)

S. M. Stern: 'A Manuscript from the Library of the Ghaznawid Amir 'Abd al-Rashid', *Paintings from Islamic Lands*, ed. R. Pinder-Wilson (London, 1969), pp. 7–31

J. Sourdel-Thomine: 'Le Mausolée dit de Baba Hatim en Afghanistan', *Revue Etud. Islam.*, xxxix (1971), pp. 293–320

C. E. Bosworth: *The Ghaznavids: Their Empire in Afghanistan and Eastern Iran, 994–1040* (Beirut, 1973)

——: *The Later Ghaznavids* (Edinburgh, 1977)

D. Schlumberger and J. Sourdel-Thomine: *Lashkari Bazar*, 3 vols (Paris, 1978)

J. Sourdel-Thomine: 'A propos du cénotaphe de Mahmūd à Ghazna (Afghanistan)', *Essays in Islamic Art and Architecture in Honor of Katharina Otto-Dorn*, ed. A. Daneshvari (Malibu, 1981), pp. 127–35

E. Baer: 'Wider Aspects of Some Ghaznavid Bronzes', *Riv. Stud. Orient.*, lix (1985), pp. 1–15

T. Allen: 'Notes on Bust', *Iran*, xxvi–xxviii (1988–90)

H. Edwards: 'The Ribāt of 'Ali b. Karmākh', *Iran*, xxix (1991), pp. 85–94

S. S. Blair: *The Monumental Inscriptions of Early Islamic Iran and Transoxiana* (Leiden, 1992)

ROBERT HILLENBRAND

Gheeraerts [Garrett; Geerarts; Gerards; Gheerhaerts]. Flemish family of artists, active also in England. Egbert [Hegghebaert] Gheeraerts (*d* 1521) was a painter in Bruges. His son (1) Marcus Gheeraerts (i) was an etcher in Bruges, Antwerp and London, where he also painted portraits. (2) Marcus Gheeraerts (ii), the son of Marcus (i), was one of the most important portrait painters in England between 1590 and 1620.

BIBLIOGRAPHY

R. Poole: 'Marcus Gheeraerts, Father and Son, Painters', *Walpole Soc.*, iii (1913–14), pp. 3–8

(1) Marcus Gheeraerts (i) (*b* Bruges, *c.* 1520; *d* ?London, *c.* 1590). Printmaker and painter. He probably

received his initial training from his stepfather, Simon Pieters (before 1552–1556), whom his mother married after the death of his father Egbert. Marcus was admitted into the Bruges Guild of St Luke only in 1558, and it is therefore assumed that he first worked in another town or had a further period of training, perhaps with the Brussels painter Bernard van Orley and, after van Orley's death in 1543, in Antwerp with Hieronymus Cock or another engraver, at which time he met Lucas de Heere and Philipp Galle. Gheeraerts's pupil in Bruges was Melchior d'Assonville (*fl* 1518–1621).

Few paintings can be attributed to Marcus (i) with certainty. In 1561 he was commissioned to complete a triptych with the *Passion* (Bruges, Onze-Lieve-Vrouwekerk), ordered from Bernard van Orley for Margaret of Austria's priory church at Brou. Gheeraerts's share was considerable but is now difficult to detect because the work was damaged by the Calvinists and restored in 1589 by Frans Pourbus the younger. In Bruges Gheeraerts was commissioned to paint and decorate the panels and enclosure around the mausolea of Charles the Bold and Mary of Burgundy (Bruges, Onze-Lieve-Vrouwekerk).

Gheeraerts the elder is known mainly as an etcher and designer of engravings. The *Map of Bruges* (1562; Hollstein, no. 197) that he etched on ten copper-plates (Bruges,

Marcus Gheeraerts (i): *Allegory of the Iconoclasts*, etching, 430×315 mm, 1566 (London, British Museum)

Rijksarchf) was very profitable: the Bruges town council ordered 40 impressions (e.g. Bruges, Gruuthusemus.), intending to promote the advantages of the city as a port and trading town, and many reprints were made in subsequent centuries. He also achieved considerable renown for his etched illustrations for *De warachtige fabulen der dieren* ('Authentic animal fables'; Hollstein, nos 1–108), an edition of Aesop with Flemish text by Edewaerd de Dene, printed by Pieter de Clerck in Bruges in August 1567 (two copies in Bruges, Stadsbib.). His decision to use the new technique of etching resulted in prints that are much more detailed and expressive than they would have been had they been engraved. Each print features one or more animals in the foreground, sometimes accompanied by figures, and each is depicted as realistically as possible, probably often from life. The finely detailed background scenes also contributed to the work's popularity: these are Flemish river scenes and townscapes permeated by a special light and rendered in short hatched strokes. The landscapes look very reminiscent of the work of Joachim Patinir.

The etched political print of the *Allegory of the Iconoclasts* (1566; see fig.; *see also* ICONOCLASM) is a satire on the Catholic Church's practices, which suggests where Gheeraerts's sympathies lay. He portrayed the iconoclasts mercilessly, and in 1568 he was banished from Bruges because of his Reformist beliefs and fled to London with his young son (2) Marcus Gheeraerts (ii). There, after the death of his first wife, he married Suzanna de Critz, whose younger brother, John de Critz the elder, became court painter to Queen Elizabeth I in 1605. Gheeraerts himself carried out much decorative work at the court of Elizabeth I and probably also painted portraits, none of which can be securely identified, although the portrait of *Queen Elizabeth I* (Welbeck Abbey, Notts) is attributed to him. In London he had a pupil called Hans Delavauld.

Gheeraerts (i) was again active in Flanders from 1577, the year in which he is mentioned in the Antwerp archives. He was responsible for the etchings in numerous books and many engraved designs for Philipp Galle and Gerard de Jode (i), a few of which survive (e.g. the *Unlucky Painter*; Paris, Bib. N.). These clearly show his talent for drawing and composition. Gheeraerts was still a member of the Antwerp Guild in 1585 and 1586, but he probably spent the last years of his life in London.

PRINTS
E. de Dene: *De warachtige fabulen der dieren* [Authentic animal fables] (Bruges, 1567); ed. W. Le Loup (Bruges, 1978)

BIBLIOGRAPHY
Hollstein: *Dut. & Flem.*
A. Schouteet: *Marcus Gerards, de zestiende-eeuwsche schilder en graveur* (Bruges, 1941)
E. Hodnett: *Marcus Gheeraerts the Elder of Bruges* (London and Antwerp, 1971)

(2) Marcus Gheeraerts (ii) (*b* Bruges, 1561; *d* London, 19 Jan 1635–6). Painter, son of (1) Marcus Gheeraerts (i). He spent his early years in Bruges, where his father was active as a painter and printmaker, but at the age of seven they moved to London. Marcus (ii) was trained as a painter there by his father and by the painter Lucas de Heere, who had also left Flanders for religious reasons, remaining in London until 1577. It is likely that at the end of the 1580s Marcus (ii) again spent some time in the Low Countries, since his early paintings reveal the influence of the Antwerp school and chiefly the work of Frans Pourbus the elder.

In 1590 Marcus (ii) married Magdalena de Critz, the sister of his stepmother Suzanna. This brought him into close contact with John de Critz the elder, who was also trained by Lucas de Heere. It is not known whether Marcus Gheeraerts the younger, like his brother-in-law, became a court painter, but he certainly obtained many commissions from the English court, both for portraits and for decorative and heraldic work. His portraits conform to the conventions of 17th-century portrait painting, in which the depiction of richly embroidered clothes decorated with expensive lace was very important. Yet his sensitive technique, which makes his paintings radiate with a quite unique atmosphere, distinguishes him from his contemporaries and followers. Together with Isaac Oliver, the well-known miniature painter who married Gheeraerts's sister Sara in 1602, Marcus (ii) instigated the break from the firmly two-dimensional and linear tradition of Nicholas Hilliard and Robert Peake. With a tender, romantic and fanciful style that became highly valued in England under Queen Elizabeth I, Gheeraerts and Oliver were the first to convey a sense of sweet melancholy in their portraits. A similar style is evident in the work of the young Cornelis Jonson van Ceulen I, who was possibly Gheeraerts's pupil.

So many portraits have been attributed to Gheeraerts that there is a strong possibility of some of them being the work of his father. Eight signed portraits by Marcus (ii) are known, but a further twenty-two can be attributed to him with certainty on the basis of the handwriting of the inscriptions found on most of the paintings: it was Gheeraerts's personal custom to put into the background of each portrait a sonnet or the date and age of the sitter. The portrait of *Sir Henry Lee* (*c.* 1590–1600; Ditchley Park, Oxon) depicts Gheeraerts's first important English patron in three-quarter length, with one hand on his hip and one on his dog Bevis who had saved his life; this event was recalled in a poem that can be read in the background. It was Sir Henry who commissioned Gheeraerts to paint a portrait of *Elizabeth I* (1592; London, NPG; see fig.). This is the largest portrait of the Queen, though it has been cut back on both sides; it was painted on the occasion of her visit to Sir Henry at Ditchley. The Queen, by then beginning to age, appears in a richly decorated costume and is fully made-up. She holds a fan in her right hand and gloves in her left and stands on a map of England with her feet on the site of Ditchley. At the centre right is a sonnet, proclaiming her more glittering than the sun. The poem was probably written by Sir Henry, who also determined the whole iconography of the painting. The Queen is presented as the embodiment of England itself, so powerful that she can cause a storm to disappear and the sun to shine, as is happening in the background. She wears an earring in the shape of the heavenly sphere, a symbol long associated with her. Gheeraerts and his workshop used this first portrait as a model for other versions, later on with a number of variations.

Marcus Gheeraerts (ii): *Elizabeth I, Queen of England*, oil on canvas, 2.41×1.52 m, 1592 (London, National Portrait Gallery)

The portrait of *Robert Devereux, 2nd Earl of Essex* (*c.* 1596; Woburn Abbey, Beds) was painted soon after the return of the Earl's expedition to Cadiz. The canvas recalls this event with the inclusion of a town on fire in the background. This and the portrait of the Queen from Gheeraerts's early period are his masterpieces. Another painting from the early years is the *Lady in Fancy Dress* (1590–1600; London, Hampton Court, Royal Col.). It presents a lady dressed as a Persian maid. Her costume is inspired by the Virgo Persica from Jean-Jacques Boissard's *Habitus variarum orbis gentium* (Antwerp, 1581). The symbolism of the painting as well as the sonnet in the cartouche express her troubled love. In the signed and dated half-length portrait of *William Camden* (1609; Oxford, Bodleian Lib.), Gheeraerts portrayed the most important antiquarian and historian of the age in the same way that Abraham Janssen had painted the Flemish Classical scholar Justus Lipsius. Gheeraerts's portrait was subsequently engraved.

After the death of Elizabeth I in 1603, James I's wife, Anne of Denmark, was pleased to be portrayed by Gheeraerts, a good example being the portrait (*c.* 1605–10; Woburn Abbey, Beds) in which Anne is depicted more as a real woman than as a queen. The portrait was probably commissioned as a gift for her best friend, Lucy Harington,

Countess of Bedford. Gheeraerts fell out of favour with the Queen after 1617, and Paul van Somer became her favourite painter. From 1620 Gheeraerts's commissions came mainly from scholars and from the gentry rather than the court. He continued to work in a style that in a certain sense had become old-fashioned but still met with much success. The signed and dated portrait of *Richard Tomlins* (1628; Oxford, Bodleian Lib.) makes it clear that he was still unable to place a figure entirely convincingly in the picture space, for the sitter comes too far into the foreground. Gheeraerts was one of the few painters in the Stuart period who occasionally showed his sitters gently smiling, as does Tomlins in this picture.

Gheeraerts (ii)'s last works are the portraits of *Charles Hoskins* and his wife *Anne Hale* (both 1629; J. Hoskins Master priv. col., see Strong, 1969, pp. 276, 287). Mr Hoskins is portrayed in a painted oval, a practice also often found in Cornelis Jonson's portraits. Mrs Hoskins's portrait is distinguished by a very sensitive and delicate use of colour, typical of Gheeraerts's late work. Although he gradually lost his position to van Somer and to Daniel Mijtens I, with their more bourgeois and intellectual portraits, his work continued to enjoy success for a long time and was often engraved. Hollar's engraving (1644) after a *Self-portrait* (1627; London, BM) by Gheeraerts gives his date of death as 1636.

BIBLIOGRAPHY

C. H. Collins Baker: *Lely and the Stuart Painters: A Study of English Portraiture before and after van Dyck*, i (London, 1912), pp. 21–5

O. Millar: 'Marcus Gheeraerts the Younger: A Sequel through Inscriptions', *Burl. Mag.*, cv (1963), pp. 533–41

R. C. Strong: 'Elizabethan Painting: An Approach through Inscriptions, Marcus Gheeraerts the Younger', *Burl. Mag.*, cv (1963), pp. 149–50, 152–7, 159

——: *The English Icon: Elizabethan and Jacobean Portraiture* (London, 1969), pp. 269–304, 350–51

The Elizabethan Image: Painting in England, 1540–1620 (exh. cat. by R. C. Strong, London, Tate, 1969), pp. 63–78

R. C. Strong: *Gloriana: The Portraits of Queen Elizabeth I* (London, 1987)

ELS VERMANDERE

Ghendt, Emmanuel Jean de (*b* Saint-Nicolas [now St Niklaas], nr Antwerp, 23 Dec 1738; *d* Paris, 17 Dec 1815). Flemish printmaker. At 18 he became a pupil of Michiel van der Voort II, a painter and engraver in Antwerp. In 1766 Ghendt entered the workshop in Paris of Jacques Aliamet. He subsequently became one of the Abbeville school of printmakers in Paris, who were popularizing Dutch paintings through such prints as *Village Pleasures* and the *Return to the Village* after Nicolaes Berchem, the *Plentiful Harvest* after Isaac de Moucheron, and the *Prince of Orange Strolling through the Village of Scheveningen* (1777) after Adriaen van de Velde. Jean-Baptiste-Pierre Le Brun commissioned Ghendt to engrave Jan Steen's painting of *Skittle Players Outside an Inn* (London, N.G.) for the first instalment of prints produced for the *Galerie des peintres flamands, hollandais et allemands* (Paris, 1792–6). Ghendt also engraved many delightful book illustrations, which piquantly convey the charm and affectations of contemporary Parisian life. During the 1760s and early 1770s he engraved the drawings of such masters as Charles Eisen and Gravelot. His best vignettes of the 1780s and 1790s are based on designs by Clement-Pierre Marillier, and

those of his late period include charming pieces after Jean-Michel Moreau *le jeune*.

BIBLIOGRAPHY

Portalis–Beraldi

M. Hébert, E. Pognon and Y. Bruand: *Inventaire du fonds français: Graveurs du dix-huitième siècle*, Paris, Bib. N., Cab. Est. cat., x (Paris, 1968), pp. 117–215

V. Atwater: 'A Catalogue and Analysis of Eighteenth-century French Prints after Netherlandish Baroque Paintings' (diss., Seattle, U. WA, 1988)

VIVIAN ATWATER

Ghent [Flem. Gent; Fr. Gand]. Belgian city, capital of East Flanders, situated at the confluence of the Leie (Fr. Lys) and Scheldt (Flem. Schelde; Fr. Escaut) rivers, with a population of *c.* 232,500.

I. History, urban development and art life. II. Centre of tapestry production. III. Buildings.

I. *History, urban development and art life.*

1. History and urban development. 2. Art life.

1. HISTORY AND URBAN DEVELOPMENT.

(i) Before the 14th century. Archaeological finds date back to Palaeolithic times but the first significant settlement was Gallo-Roman. A cemetery and an area used by craftsmen have been excavated in the Eenbeekeinde district in the suburb of Destelbergen. This may comprise only the eastern part of a more extensive, straggling settlement. The site of Ghent has always been important; its name is derived from the Celtic place-name 'Ganda', meaning 'river mouth' or 'confluence'. The confluence area was certainly inhabited from the 1st to the 3rd centuries AD, but Gallo-Roman remains found further afield support the theory that at this time there were a number of different centres. According to later accounts, a late Roman *castellum* was built in the 4th century AD as protection against Germanic attacks, but the area remained settled after the fall of the Roman Empire.

The next significant event in the city's development was the foundation of two abbeys by Amand of Maastricht (584–679). According to Verhulst a small monastery (*cellula*) was initially established between 629 and 639 on the Blandijnberg (Fr. Mont Bland; 29 m high) on ground obtained by Amand from Dagobert I (*reg* 623–39). This *cellula* soon became a double monastery (for both men and women) called Blandinium. It is traditionally believed that Amand also founded a church in Ganda next to the confluence. The relics of St Bavo (*c.* 589–654) were translated here (920–30) and the abbey of St Bavo grew around the church, probably in the ruins of the *castellum*.

The Merovingian population, initially hostile to Christianity, probably lived on a hill of alluvial sand (now Zandberg, Hoogport, Kalandeberg and Gouvernementstraat) to the west of the upper Scheldt. Both monasteries were secularized by Charles Martel (*reg* 714–41) and declined in the 8th century, but flourished under the lay abbot Einhard in the first half of the 9th century. In 811 Charlemagne visited Ghent to inspect the fleet that he had built there as defence against the Vikings, who nevertheless destroyed St Bavo Abbey 40 years later. They returned in 879 and camped in the abbey until November 880. It is likely that the abbey of St Peter (founded 629–39) was also destroyed at this time; it was rebuilt in the last decades of the 9th century, whereas the reconstruction of St Bavo's did not begin until the late 10th century.

The first written record of a trading post dates from *c.* 865, when the worship of Bavo 'in portu Ganda' is mentioned. This port appears to have grown throughout the 9th century, possibly as the focus of an established settlement between the two abbeys. Excavation has revealed the Carolingian port on the left bank of the Scheldt, apparently surrounded by a semicircular wall enclosing *c.* 7 sq. ha. Significantly, the oldest parish church, St Jan (later St Bavo Cathedral; *see* §III, 1(ii) below) was located in the centre of this area. Documents confirm that the church was consecrated in 947 by Transmar, Bishop of Tournai and Noyon (*reg* 937–50); but it is possible that this was a reconsecration rather than a foundation.

By the 10th century the city's rapid expansion had rendered the enclosure redundant. Development occurred at this time on the banks of the Leie, and Oudburg Island became an important centre. Leatherworkers ('coriarii') worked in the north-eastern area. In the south-west of the island, Baldwin Iron-Arm, Count of Flanders (*reg* 862–79), erected fortifications; traces of a square wooden building, and of the castle church, later St Veerlekerk (both *c.* 10th century; mostly destr.), probably represent the earliest stage of building. In the 11th century a stone keep (Gravensteen Castle, rest.; *see* BELGIUM, fig. 2) was built on the same site. As described in written sources, this '*domus lapidea*' was rectangular (*c.* 13.5×31 m); it is partially preserved in the present castle, which essentially dates from *c.* 1180. The presence of this building fostered trade and house construction along the banks of the Leie, creating the Koornlei and the Graslei (rest.), where an inland port gradually developed. The city's oldest market, the Vismarkt (now the Groentemarkt), was near by.

The 9th- and 10th-century port settlements grew towards each other and continued to develop. Land leases were bought, the first merchants' guilds were founded (12th century), the city's own chamber of aldermen was established (beginning of 12th century) and larger city walls were built (12th century). An area 80 sq. ha in the form of a basin was surrounded by a moat, which was constructed utilizing natural waterways supplemented by canals, including Ketelvest, Houtlei and Ottogracht (end of 11th century). There were at least four fortified gates: the Brabantpoort, Ketelpoort, Torenpoort and the Steenbrug gate. New parish churches were built: St Jacobskerk, St Niklaaskerk (both possibly before 1100) and St Michielskerk (early 12th century). The abbeys were not originally integrated into the port, but developed into independent units, around which the villages of St Baafsdorp and St Pietersdorp developed.

From the 12th century fortified houses (*stenen*) were built of local Tournai limestone, for example the Gerard Duivelsteen (*c.* 1245; rest.); they belonged to the 'virii hereditarii', a group of patricians who frequently formed the city magistrature. From 1228 this body consisted of an oligarchical structure of three groups of thirteen men, the so-called 'XXXIX'. They enlarged the city, usually by purchases or gifts of land. Protection of this land was a continual problem, and new fortified gates and ramparts were built during the 13th and 14th centuries enclosing *c.* 644 sq. ha. The population was now about 56,000; city

churches were rebuilt in stone and a number of new monasteries were founded, including the Cistercian abbey and hospital of Byloke in 1201 (*see* §III, 2 below), and such mendicant orders as the Franciscans (*c.* 1226), the Dominicans (*c.* 1228), the Calced Carmelites (1272) and the Augustinians (1296) also settled in Ghent. St Elisabeth Begijnhof and the Klein Begijnhof were both founded in 1234.

(ii) 14th century and later. In the 14th century, the patrician hegemony crumbled. The Senlis Ordinance of 1301 established a new system of government, consisting of 13 legislative aldermen and 13 civil aldermen (*see* §III, 3 below). In the first half of the 14th century, the Belfort (belfry), symbol of the city's independence, and the Prinsenhof, residence of the counts of Flanders (destr. apart from the Dankere Poort), were built. The growth of the city, however, was somewhat hindered by social unrest and several wars. Ghent lost its unique trading position in the cloth market. The Aartevelde family led the struggle for Flemish independence from France, which continued under the Burgundians. Despite adversity and defeat, in the 14th and 15th centuries such new buildings as houses (Grote Moor), guildhouses and guildhalls (33 Hoogpoort), churches, hospitals and beguinages were constructed. A

new, larger town hall, demonstrating the city's power, was begun in the first decades of the 16th century (*see* §III, 3 below). But these grandiose plans remained unrealized and Ghent's pride was broken by Emperor Charles V (*reg* 1530–56), although he had been born there. Charles ordered Donato Buoni de Pellizuoli to design a prison fortress, the Spanjaardskasteel (destr. from 1576), on the strategic site of the Leie–Scheldt confluence then occupied by the abbey of St Bavo (*see* §III, 1(i) below), which had to be destroyed. The second half of the 16th century was marked by the Wars of Religion. Calvinists ruled Ghent from 1577 to 1584; a new series of ramparts was built around the city. Their triangular form defined the city's territory until the end of the 18th century (see fig. 1). By the end of the 16th century the population had dwindled to *c.* 30,000. In the 17th century Ghent once again expanded under Archduke Albert (1559–1621) and Archduchess Isabella (1566–1633) of Austria, and its population had risen to *c.* 52,000 by 1690. The city at this time had *c.* 7000 houses and 500 streets. It occupied 26 islands, linked by bridges, and was sometimes compared with Venice (see fig. 2). The wars waged by Louis XIV resulted in another decline in the early 18th century; but a period of relative prosperity ensued under Austrian rule (1714–92). The first factories were constructed and an emerging

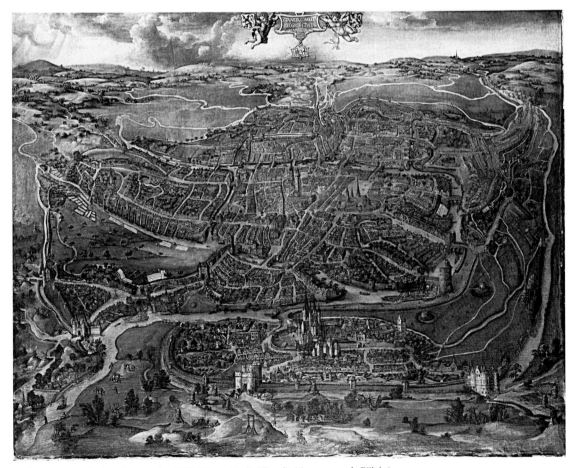

1. Ghent, panoramic view; from a print, 1534 (Ghent, Oudheidkundig Museum van de Bijloke)

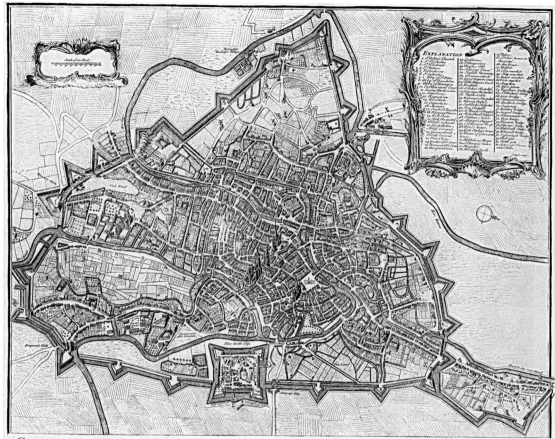

GHENT a large CITY and CASTLE in FLANDERS, twice taken by ỹ *DUKE* of *MARLBOROUGH* Viz. in ỹ Year 1706,&1708.

2. Ghent, plan from Laquin de Thoyars: *The History of England*, iv (London, 1743–7), Book XXVI

merchant class built such lavish houses as the Hôtel Falligan (1755; *see* BELGIUM, fig. 6). The destruction of the ramparts started at the end of the 18th century, and Emperor Joseph II (*reg* 1765–90) ordered the abolition of various ecclesiastical foundations.

Under the government of the southern Netherlands by France from 1794 until 1814, Ghent became the capital of the Scheld département. Dutch rule (1814–30) was fairly favourable for Ghent. The state university was founded in 1816, and the economy revived when Lieven Bauwens (1769–1822) brought stolen machinery from England and started textile production. Many abandoned buildings, for example monasteries, were taken over by industry. In 1819–31 the 1st Duke of Wellington built a fortress called the Citadel in south Ghent; only one gate survives. The construction of the Terneuzen Canal (1822–7), capable of taking large ships, allowed the expansion of Ghent's harbour and made the city one of the most important industrial centres of Belgium. After a few difficult years around the secession of Belgium (1830), Ghent's irrepressible growth continued. Tolls were abolished in 1860, and the city expanded towards its outlying communities. In the 1870s the site of the Citadel became the Citadelpark. A redevelopment plan by LOUIS CLOQUET, covering the old city centre, was executed before

1913, when the World Fair was held in Ghent; old buildings were restored and new streets and squares were built. Railway traffic increased rapidly, and St Pieters Station was built in 1913. The city increased its area in 1977 by combining ten outlying communities into a new satellite town. The most significant factor in Ghent's appearance remained water in the form of the rivers and canals that provide reflections of the castle walls, spires, bridges and a variety of houses.

2. ART LIFE. Ghent's art life has always been overshadowed by that of Antwerp, although many outstanding artists have been trained in, inspired by, and worked in the city; this is attested by the fact that the medieval Guild of St Luke and St John for painters and illuminators outlived the Middle Ages by several centuries. Wall paintings dating from the 12th, 13th and 14th centuries survive in different conditions in various ecclesiastical buildings around the city (*see* §III, 2 below), and important lost works are documented (*see* BELGIUM, §III, 1 and MARKS, fig. 2). Ghent's goldsmiths and silversmiths were renowned for their skill and produced a variety of objects from the 13th century (*see* BELGIUM, §IX, 1). Tapestries were woven in the city from the 14th century (*see* §II below); the

metalworkers and the tapestry-weavers had their own guilds.

The close links between Ghent and Bruges are reflected by the use of the term 'GHENT-BRUGES SCHOOL' to describe the style of manuscript illumination that flourished in the area *c.* 1475–*c.* 1550; illuminators working in Ghent included Sanders Bening and the MASTER OF MARY OF BURGUNDY (*see* MASTERS, ANONYMOUS, AND MONOGRAMMISTS, §I), who influenced Juan de Flandes, among others. The last was active in Spain, and Gerard Horenbout and his family moved to England after working in Ghent *c.* 1487–1522; the travels of such artists, who were sometimes invited to the courts of foreign monarchs, spread Ghent's reputation as an important artistic centre of production. That reputation was reinforced by the association with the city of such acclaimed artists as Hubert van Eyck, who worked in Ghent and was buried in the cathedral; his work includes the *Adoration of the Lamb* altarpiece (for further discussion and illustration *see* EYCK, VAN, (1)), which was completed after his death in 1426 by his brother Jan van Eyck (unveiled 1432; Ghent, St Bavo Cathedral). In the 16th century the public servant and poet MARCUS VAN VAERNEWIJCK described the altarpiece and other works of art in the city. Joos van Wassenhove painted 40 escutcheons for St Bavo in 1467. He is tentatively identified with JUSTUS OF GHENT who is usually thought to have painted the *Calvary* triptych (Ghent, St Bavo Cathedral) before going to Italy. Hugo van der Goes worked in Ghent before entering a monastery.

Ghent became increasingly receptive to new ideas. In 1621 JAN JANSSENS brought the style of Caravaggio to his native city after visiting Italy. His contemporary, ANTOON VAN DEN HEUVEL, became a master in the painters' guild in 1628. ADOLPHE PAULI was town architect, producing buildings in both Gothic and Romanesque Revival styles in the 1850s and 1860s. JEAN-BAPTISTE CHARLES FRANÇOIS BETHUNE lived in Ghent from 1858 and was a major figure in the Belgian Gothic Revival; he founded the St Luke School of Arts and Crafts in Ghent in 1862. He influenced both ARTHUR THÉODORE VERHAEGEN, who trained at Ghent University, and Louis Cloquet (see above). Museums (*see* BELGIUM, §XIV), including the Museum voor Hedendaagse (Museum of Contemporary Art) and the Museum voor Sierkunst (Museum of Decorative Arts), preserve the city's artistic heritage as well as encouraging the work of contemporary artists.

BIBLIOGRAPHY
M. van Vaernewijck: *Van de beroerlicke tijden in de Nederlijden: En voornamelijk in Ghent, 1566–1568* [About the troubled times in the Netherlands, in particular in Ghent, 1566–1568] (MS diary in 10 vols; 1566–8; Ghent U.); ed. F. Vanderhaeghen (Ghent, 1872–81)
V. Fris: *Bibliographie de l'histoire de Gand depuis l'an 1500 jusqu'en 1850* (Ghent, 1921)
M. Gysseling: *Gent vroegste geschiedenis in de spiegel van zijn plaatsnamen* [Ghent's earliest history reflected in its place names] (Antwerp, 1957)
H. van Werveke and A. Verhulst: 'Castrum en Oudburg te Gent', *Hand. Maatsch. Gesch. & Oudhdknd. Gent*, xiv (1960), pp. 2–62
E. Dhanens: *Retabel het Lam Gods in de Sint Baafskathedraal te Gent* (Ghent, 1965); Eng. trans. as *Van Eyck: The Ghent Altarpiece* (London, 1973) [Eng. version omits documents]
S. J. de Laet: 'Les Fouilles de Destelbergen révèlent les origines gallo-romaines de la ville de Gand', *Archeologia*, xxx (1969), pp. 57–69
F. de Smidt: 'De Sint-Niklaaskerk te Gent archeologische studie', *Acad. Anlct.: Kl. S. Kst.*, xxiii (Brussels, 1969) [whole issue]
A. Verhulst: 'De vroegste geschiedenis en het ontstaan van de stad Gent' [The earliest history and establishment of the town of Ghent], *Hand. Maatsch. Gesch. & Oudhdknd. Gent* (1972), pp. 5–39
G. van Doorne: *De Gentse stadsversterkingen tijdens het Calvinistisch bewind* [The fortifications of the town of Ghent during the Calvinistic administration] (diss., U. Ghent, 1975)
Gent Duizend jaar kunst en cultuur: Architektuur, keramiek, koper en brons, izerwerk, tin, meubelkunst, tapijtkunst, Part III [Ghent: a dozen years of art and culture: architecture, ceramics, copper and bronze, iron, tin, furniture, tapestry, part III] (exh. cat. by G. Milis-Proost and others, Ghent, Cent. Kst. & Cult., 1975)
J. Decavele, R. de Herdt and N. Decorte: *Gent op de wateren en naar de zee* (Antwerp, 1976)
R. van Driessche: *De Sint-Pietersabdij te Gent: Archeologische en kunsthistorische studie* (Ghent, 1980)
M.-C. Laleman: 'Vroeg middeleeuwse bewoningssporen te Gent' [Early middle age traces of habitation in Ghent], *Vroeg middeleeuwse bewoning en verdediging in de Scheldevallei* (Ghent, 1980), pp. 11–12
D. Callebaut, P. Raveschot and R. van de Walle: 'Het Gravensteen te Gent', *Conspectus MLMLXXX: Archaeologia Belgica*, ccxxxviii (Brussels, 1982), pp. 112–16
G. Deseyn: *Gids voor oud Gent* (Antwerp and Weesp, 1984)
A. Verhulst: 'Leie en Schelde als grens in het portus te Gent tijdens de Xde eeuw' [The Leie and Scheldt as a frontier in the port of Ghent during the 10th century], *Feestbundel Maurits Gijsseling* (Leuven, 1984), pp. 407–19
N. Poulain, ed.: *Gent en architektuur: Trots, schande en herwaardering in een overzicht* [Ghent and architecture: pride, shame and revaluation in an overview] (Bruges, 1985)
A. Verhulst: 'Het ontstaan van de steden in Noordwest-Europa: Een poging tot verklarende synthese' [The development of towns in northwest Europe: an attempt at an explanatory thesis], *Acad. Anlct.: Kl. Lett.*, i (1987), pp. 57–83
J. de Maeyer, ed.: *De Sint-Lucasscholen en de neogotiek* (Leuven, 1988)
J. Decavele, H. Balthazar and M. Boone, eds: *Gent, apologie van een rebelse stad: Geschiedenis, kunst, cultuur* [Ghent: an apology from a rebel town: history, art, culture] (Antwerp, 1989)

FRIEDA VAN TYGHEM

II. Centre of tapestry production.

Around 1300 there were already tapestry-workers in Ghent, but their guild was not recorded as a fully independent organization in the city books until 1336. The Ghent tapestry-weavers' guild, together with that of Bruges, is therefore the oldest of its kind in Belgium. During the 15th century tapestry production and trade flourished in Ghent. In the following century there was a decline, and numerous complaints were made about the quality of the work. During the same period the influence of OUDENAARDE, spread in part by the emigration of weavers from the city, grew rapidly. Production remained at a very low level in the 17th century. Towards the middle of the century, however, the board of magistrates made a concerted effort to revive the industry, as the circumstances were favourable; for example heavy military expenses were a particular burden for such smaller cities as Oudenaarde.

On 31 July 1655 Frans de Moor (1608–before 1685), his son-in-law Jan d'Olieslaegher I (1621–1685) and Daniël van Coppenolle (*d* 1672), all from Oudenaarde, signed an agreement with the aldermen of Ghent. They wished to move with their families and apprentices to Ghent, but required various financial and other advantages as compensation. For at least ten years de Moor was the most important tapestry-weaver in Ghent. He was in charge of a wide-ranging trade, particularly with Paris, which, however, declined in his later years. His sons Cesar de Moor (1637–*c.* 1679) and Alexander de Moor (1644–*c.* 1679),

like his son-in-law d'Olieslaegher, were also tapestry-weavers. The last, particularly, produced numerous series of wall hangings for various western European countries, but most of his work went to England. In contrast, nothing is yet known about the work of van Coppenolle. Even before the death of his father, Jan d'Olieslaegher II (1657–1712) was also active in tapestry production and trade. In connection with these activities, he travelled repeatedly to England, but at this time the trade was in serious difficulties; in its first few years, his business went bankrupt. His place was taken by other weavers from Oudenaarde who had emigrated to Ghent between 1684 and 1699.

Few Ghent wall hangings have survived. The *Last Supper* (Nuremberg, Ger. Nmus.) has been ascribed by Göbel to a Ghent weaver. He also credited the cartoon, with some reservations, to the Ghent painter Lucas de Heere. On somewhat stronger evidence, attempts have been made to credit work to Adriaan van der Gracht (*c.* 1520–1575), one of the few Ghent tapestry-workers from the second half of the 16th century who is known by name; the tapestry depicting the *Encounter of David and Goliath* (Ghent, Mus. Sierkst) has been tentatively credited to his workshop. Unfortunately, the tapestry is not well preserved, and the borders, probably including the weaver's monogram, are lost. A series of *Landscapes* (Loches, Château) with the signature CAD Moor may have come from the workshop of Cesar and Alexander de Moor.

BIBLIOGRAPHY

M. Duverger: 'De externe geschiedenis van het Gentse tapijtweversambacht' [The external history of the Ghent tapestry weaving industry], *A. Textiles*, ii (1955), pp. 53–104
E. Duverger: *Jan, Jacques en Frans de Moor, tapijtwevers en tapijthandelaars te Oudenaarde, Antwerpen en Gent (1560 tot ca 1680)* [Jan, Jacques and Frans de Moor, tapestry weavers and dealers in Oudenaarde, Antwerp and Ghent] (Ghent, 1960)
J. Duverger: 'Adriaan van der Gracht (ca 1520–1575): Een bijdrage tot de tapijtnijverheid te Gent in het midden van de 16e eeuw' [A contribution to the tapestry industry in Ghent in the mid-16th century], *A. Textiles*, viii (1974), pp. 29–46
——: 'Tapijtwerk van Frans, Cesar en Alexander de Moor of uit hun omgeving' [The tapestry work of Frans, Cesar and Alexander de Moor or their associates], *A. Textiles*, viii (1974), pp. 123–41
E. Duverger: 'Tapijtwerkers en tapijtwerk te Gent' [Tapestry workers and tapestry work in Ghent], *Gent: Duizend jaar kunst en cultuur*, iii (Ghent, 1975), pp. 501–57

ERIC DUVERGER

III. Buildings.

1. St Bavo. 2. Byloke Abbey and Hospital. 3. Town Hall.

1. ST BAVO. The abbey of St Bavo was founded in the 7th century AD outside the walls, and it was destroyed in 1540 when Charles V built the new citadel (destr.; *see* §I, 1 above). In 1539 the chapter had been moved to the parish church of St Jan, which was rededicated to St Bavo. This building achieved Cathedral status in 1559.

(i) The abbey church. The abbey church, founded in the 7th century by St Amand, was destroyed by fire in 813, and restored or rebuilt. It was devastated by the Vikings in the mid-9th century, the monks taking refuge at Saint-Omer, then at Laon. After their return in the 10th century, they undertook the complete renewal of the church. Its first stone was laid in 985 by Abbot Odwin, but the work was finished only in the mid-12th century. At the destruction in 1540 the sanctuary was preserved as a garrison chapel, but even that was soon demolished by the Calvinists. Of the abbey buildings there survive only the cloister with its *lavatorium*, the adjoining north wall of the church and the surrounding conventual buildings, dating essentially from the 12th century.

The excavations of 1943 by Brother Firmin de Smidt enabled him, with the additional evidence of old depictions, to reconstitute the church's main outlines (see fig. 3). It was a major Romanesque monument of the region, measuring 111 m. Construction began with the choir and transepts. The choir had a flat eastern termination and the east end was laid out on two levels in connection with a

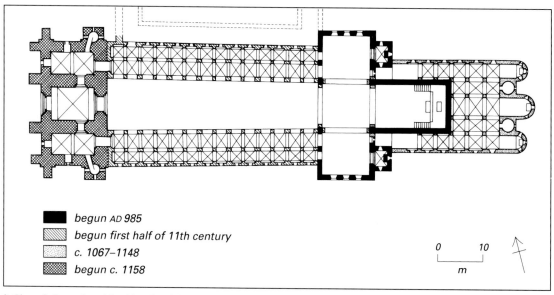

begun AD 985

begun first half of 11th century

c. 1067–1148

begun c. 1158

0 10
 m

3. Ghent, St Bavo, plan of the abbey church, begun AD 985, showing building phases

cult of relics. There was probably a regular crossing, and the transept had two square eastern chapels, separated from the main sanctuary by an intervening space. The long 14-bay nave, which was consecrated in 1067, was built in the first half of the 11th century. It was flanked by double aisles, the only parts of the building to be vaulted. The inner aisles had a gallery. The arcade was constructed on the alternating system, here columns and rectangular piers. In 1068 a crossing tower was built with two stair turrets in the spaces between the sanctuary and the transept chapels. Simultaneously or immediately after a huge outer crypt of five aisles was added to the sanctuary, enveloping it on three sides. Consecrated in 1148, the crypt was laid out on two levels, connected by stairs, which rose above roof level, inserted in the turrets between the three eastern chapels. A great rectangular façade block with a large transverse roof was begun about ten years later. The original plan provided for a square tower over the central bay and stair turrets at its north-east and south-east corners. Early illustrations show that the block was completed in a lighter, Gothic design.

The Romanesque church was connected stylistically both to the Holy Roman Empire, and to France. The relic tribune, the groin-vaulted outer crypt and the arrangement of towers flanked by turrets placed symmetrically at either end of the nave linked the building to currents in Ottonian architecture that were themselves heirs to Carolingian traditions; but the wooden-roofed, galleried nave depended on north French prototypes. The façade block itself, despite its Ottonian structure, was touched by southern influences, as seen in its central portal and massive projecting buttresses.

(ii) The cathedral. After the transfer of the chapter to the parish church of St Jan, and the re-dedication to St Bavo, the parish church was raised to collegiate rank by Pope Paul III. In 1550 the Emperor granted a considerable sum for the completion of the building, which was finished nine years later. At this time, a chapter of the Order of the Golden Fleece was held in the church, which now became a cathedral.

A chapel dedicated to St Jan is documented in the 10th century, and of its Romanesque successor part of the crypt, which extended under the choir, survives. Both crypt and choir originally comprised four aisles, the centre ones opening on to a semicircular apse, while the outer aisles terminated in flat walls with small semicircular apses. The supports were octagonal columns of Tournai stone. The supports in the outer aisles alternate, with narrow piers elongated transversally and clusters of three shafts, also disposed transversally. The crypt was modified and enlarged to support the Gothic choir. The long-held belief, based on modern documents, that the Gothic choir was begun in 1228 is belied both by the style of the building and a Gothic pier in the crypt, which rests on a funerary slab executed *c.* 1230. The first campaign dated only to the early 14th century; it included the five straight sanctuary bays, their aisles and adjoining chapels, and the hemicycle. At the end of the 14th century and the beginning of the 15th this was circled by an ambulatory with five radiating chapels. The façade block was built between 1462 and 1534. The slightly projecting transepts and the four-bay

aisled nave were inserted between the existing parts between 1533 and 1559, and the choir was vaulted in 1628. According to early illustrations there was a crossing tower flanked by four corner turrets.

The sanctuary elevation has three storeys. The piers are *piliers cantonnés*, the shaft facing the central vessel rising unbroken from the floor to the vault springing, suggesting that the sanctuary was always meant to be vaulted. The unglazed triforium arches are subdivided and inscribed in rectangular frames. There is Rayonnant tracery in the clerestory windows, which have an exterior passage under deep arches. Although the side chapels have preserved their exterior gables, the radiating chapels have been re-roofed, with an effect of heaviness accentuated by the absence of flying buttresses.

The nave elevation now has two storeys. The clustered piers are without capitals on three sides, continuing the mouldings of the arcade and vault uninterruptedly downwards. The window frames descend to what would have been the triforium floor, where a parapet runs in front of a plain wall. In the upper part of this quasi-niche is a clerestory window with flamboyant tracery. The nave vaults have a less complex rib pattern than those in the transepts or aisles, which are star-shaped, but diagonal ribs have been omitted throughout. In the nave, tiercerons form a lozenge pattern which, despite the preservation of thin transverse ribs, blurs the division into bays. Everything in this part of the building has been designed to accentuate the effects of thinness and lightness: the very high arcades, the thin walls and the veil-like vault.

The fine tower in front of the church is octagonal. From the third storey, the buttresses are set diagonally to make the transition to the octagonal turrets that flank the fifth and last level of the tower. St Bavo contains many works of art, of which the most prestigious is the Ghent Altarpiece, executed between 1423 and 1432 by Hubert and Jan van Eyck for the Ghent patrician Jodocus Vijd and his wife Elisabeth Boorluut (*see* EYCK, VAN).

BIBLIOGRAPHY

F. de Smidt: 'Opgravingen in de Sint-Baafabdij: De Abdijkerk', *Cult. Jb. Prov. Oostvlaanderen*, x/2 (1956)

——: *Krypte en koor van de voormalge Sint-Janskerk te Gent in het licht van de jongste archeologische opzoekingen* (Ghent, 1959)

E. Dhaenens: *Sint-Baafskathedraal, Ghent* (Ghent, 1965)

F. de Smidt and E. Ohanens: *De Sint-Baafskathedraal te Gent* (Tielt and Amsterdam, 1980)

JACQUES THIEBAUT

2. BYLOKE ABBEY AND HOSPITAL. The former Cistercian abbey of Byloke, now the Archaeological Museum of Ghent, and its nearby hospital, contain structures important for the history of medieval architecture in Flanders. The Gothic timber roof of the hospital ward is especially significant for the technological development of large-scale roof framing in halls without supports or tie-beams.

(i) History. The hospital, originally founded in 1201 by Ermentrude Uttenhove of Ghent, was relocated at its present site in 1228 under the joint patronage of Ermentrude and the Count and Countess of Flanders. Construction began in April, and in the same year the convent of Cistercian nuns was founded *c.* 200 m to the north-east. The convent, originally a daughter house of Oudenbosche

at Lokeren, which managed the hospital, began its autonomous existence directly under Abbot Drogo of Clairvaux in 1234. The religious community, including lay brothers and sisters who served the hospital, prospered until the late 15th century. The abbey was ravaged during the religious wars in the 16th century but revived and was substantially repaired and expanded between 1585 and 1620. The new construction resulted in a second quadrangle of conventual buildings tangential to the north-east of the old cloister; the new work also included a church and infirmary for the sisters. Of the 17th-century additions, the most interesting is the well-preserved house of the abbess. A new refectory with an elaborate ceiling was added in the early 18th century. The community of nuns and its hospital survived until its dissolution in March 1798, when the hospital was placed under civil administration. Now abandoned and poorly preserved, the hospital remains under the jurisdiction of the city of Ghent. The abbey complex was converted into a museum in 1833 and underwent a general restoration in 1924–5.

(ii) Byloke Abbey. Although none of the 13th-century work survives, the medieval plan remains nearly intact. The oldest portions, all of brick, are along the east and south ranges of the large cloister, comprising the chapter house, dormitory above, and refectory; both the dormitory and the refectory retain their early 14th-century timber vaults.

The refectory, of *c.* 1325, is a spacious first-floor hall (31×10 m) with a pointed timber vault (13.7 m high). Timber transverse arches spring from engaged masonry columns with foliate capitals set between the windows; the skilful blending of wood construction, painting and stone demonstrates the builder's interest in an integrated interior. There are also several iron tie-bars. The gable walls are ornamented with 14th-century frescoes, a rare example of early painting in Ghent, discovered during the restoration of 1924. The *Last Supper* (for detail *see* BELGIUM, fig. 10) is depicted on the east wall with *Christ* and the *Virgin* enthroned above within a quatrefoil frame. On the west wall flanking the chimney are frescoes of *St Christopher* and *St John the Baptist*. The refectory exterior provides a fine example of Flemish Gothic brickwork combining blind and openwork tracery.

(iii) Byloke Hospital. The hospital and its attached chapel form an L-shape; the structures are joined by an integrated, twin-gabled façade at the west face. The three-bay chapel originally opened into the first two bays on the south flank of the ward, but this arcaded entrance is now blocked. The chapel has a 14th-century timber vault (rest. ?18th century), but no internal furnishings remain. A separate ward (the 'Craeckhuys') for the critically ill was added behind the east end of the hospital *c.* 1490; it has six bays and is covered by a panelled timber vault.

The roof of the 11-bay infirmary (now encumbered by partitions) is architecturally the most important timber structure at Byloke (see fig. 4). It covers the ward (16×55 m), the internal span of which is exceeded only by 2 m at the late 13th-century aisleless hospital (internally 18×100 m) at Tonnerre, Burgundy. The masonry dates to 1228–34 and occupies only 8 m of the overall height of

22 m. The walls (*c.* 1 m thick) are buttressed at approximately 5 m intervals. Although considerable masonry support for the roof was designed, the walls have deflected outwards, possibly as a result of the roof thrust, and were reinforced by three iron ties *c.* 1640.

The Byloke roof is a monumental two-tiered structure of steep pitch (*c.* 60°) forming a great trefoil arch. Two distinct types of framing were employed. The lower half, beneath the collar-beam, is made of heavy short principals the massive timber blades of which are tenoned into the collar-beam and extend well below the wall-head. This heavy principal frame occurs every seven rafter couples. The lower portion of the framing is set into the wall and rests on masonry corbels (later remodelled). The members of this lower frame form a nearly semicircular arch with a profile enhanced by a slender torus moulding of wood that is attached in sections to the curved braces. The lower frame, employed to cope with the exceptional span, functions structurally to reinforce the principal rafter and to carry the load of the purlin and collar plates.

The upper half of the roof and common rafters represent the second type of construction. The rafter couples are of closely spaced, light-sectioned members of nearly uniform section. The upper framing rests on plates carried on the collar-beams and at the gable ends by large hammerbeam brackets; the entire series of arched frames forms a 'wagon-roof' resembling a barrel vault. The common rafters, extending from the roof peak to the wall-head, are in three sections and joined by scarfing. Otherwise, pegged mortise and tenon joints are used throughout the structure.

Leading scholars of Flemish medieval roofs (Janse and Devliegher) have disputed the date of the roof, doubting that such an extraordinary span could have been built in 1228, and proposed a date of *c.* 1300. There is, however, no documentary evidence of rebuilding, and the use of open roofs with short principals supporting a superimposed truss had appeared in Flanders in the second half of the 13th century at St John's Hospital, Damme. Recent dendrochronological dating places the roof in the mid-13th century.

BIBLIOGRAPHY

A. van Lokeren: 'Historique de l'hôpital de la Biloke et de l'abbaye de la Vierge Marie, à Gand', *Messager Sci.* (1840), pp. 188–226

4. Ghent, Byloke Hospital, begun 1228, roof of the infirmary

J. B. Lavaut: *Inventaire des archives de l'abbaye de la Byloke, 1164–1807* (Ghent, 1881)

E. Serrure: *Monographie de l'hôpital de la Biloque de Gand* (Bruges, 1881)

A. Verhaegen: *L'Hôpital de Byloke à Gand* (Ghent, 1889)

L. Van Puyvelde: *Un Hôpital du moyen âge et une abbaye y annexée: La Biloke de Gand* (Ghent, 1925)

J. Walters: *Geschiedenis der zusters der Bijloke te Gent*, 2 vols (Ghent, 1929–1930)

F. Van Hove: 'Etude de reconstruction de l'état primitif des bâtiments . . . de Biloke', *Bull. Soc. Hist. & Archéol. Gand*, viii (1931), pp. 5–25

A. de Schryver [Schrijver]: 'L'Abbaye et hôpital de la Byloke à Gand', *Congr. Archéol. France*, cxx (1962), pp. 116–28

H. Janse and L. Devliegher: 'Middeleuwse bekappingen in het vroegere graafschap Vlaanderen', *Commission Royale des monuments et des sites*, xiii (Courtrai, 1962), pp. 301–80

Province de Flandre orientale, VIII of *Monasticon belge*, iii, (Liège, 1980), pp. 329–53

H. Janse: *Houten kappen in Nederland, 1000–1940*, Rijksdienst voor de monumentenzorg, Bouwtechniek in Nederland 2 (Delft, 1989), pp. 177, 195

LYNN T. COURTENAY

3. TOWN HALL. During the 13th century the governing body of Ghent, consisting of 13 aldermen, met in an alderman's house, but after the imposition of a bicameral city government in 1301 two meeting rooms became necessary. A number of 13th- and 14th-century cellars survive from the houses that were gradually bought up by the city magistrature for the site of the Town Hall, which is in the heart of the old city, bordered by the Hoogpoort, Botermarkt, Poeljemarkt and Stadhuissteeg.

The foundation stone of the new building, which lies in the centre of the present-day complex, was laid on 4 July 1482. The simple stone building, with step gables, contains two substantial chambers. The ground floor was used for meetings of the legislative aldermen and is still used for meetings of the so-called Collatie, a more extensive municipal body. The Collatiezolder, later called the Arsenaalzaal, still contains a number of original elements, including the pointed wooden barrel vault and a sculptured fireplace on the south side, executed in 1484 by the sculptor Joos sHotters (*fl* second half 15th cent.).

The next major building initiative took place in 1517 when Rombout Keldermans II and Domien de Waghemakere (*d* 1542) were approached for plans for a completely new structure. The surviving documents and sketches for the façade (Ghent, Mus. Byloke) show that the new chamber for the legislative aldermen was planned along the Hoogpoort, with the civil aldermen's chamber forming a shorter wing at right angles along the Botermarkt. Owing to both historical and financial circumstances, only a quarter of this majestic design, the portion destined for the legislative aldermen, was actually realized. The interior consists of a large hall on the ground floor where the court convenes, with a striking floor decoration in the form of a labyrinth. The handsome, single-cell aldermen's chapel and the chapel chamber were added; on the first floor, reached by a staircase, is the throne-room, which was not inaugurated until 1635, when it was vaulted. The exterior of the finished portion (see fig. 5) is remarkable for its luxuriant sculptural decoration, concentrated around niches that were intended for statues of the counts and countesses of Flanders. The 19 small sculptures that now stand there, however, are the result of a wave of neo-Gothicism *c.* 1900.

5. Ghent, north façade of Town Hall, after 1517

The legislative aldermen's chamber was repeatedly expanded in the course of the 16th century, the additions including a new dining-room, which is now a reception room. The Late Gothic façade along the Hoogpoort was extended in 1580–82 by a sharply contrasting piece of Renaissance architecture. The so-called Bollaertskamer, designed by Joos Rooman (*fl* 1552–81), exhibits a remarkable superimposition of three different colonnades in the French and Italian manners. Between 1595 and 1618 a new chamber for the civic aldermen was planned along the Botermarkt and Poeljemarkt in a strongly classicizing design, including a series of Tuscan, Ionic and Corinthian three-quarter columns. The local architects were, in succession, Loys Heindrickx (*d* 1598), Arent van Loo (*fl* 1583–1603), and Lieven Plumion (*d* 1617) and his son Pieter Plumion (*d* 1652).

In the 17th and 18th centuries smaller projects were carried out, mostly on the west side of the complex, where interesting chimney-pieces and stuccoed ceilings have been preserved. The Late Gothic portion was adapted in the Empire style in the early 19th century under the supervision of JEAN-BAPTISTE PISSON, but these alterations were removed in the course of subsequent restorations. Later restorers chose to preserve the Town Hall in all the diversity of its historical evolution.

BIBLIOGRAPHY

F. van Tyghem: *Het stadhuis van Gent: Voorgeschiedenis, bouwgeschiedenis, restauraties, beschrijving, stijlanalyse* [Ghent Town Hall: Origins, architectural history, restorations, description, stylistic analysis], 2 vols (Brussels, 1978)

FRIEDA VAN TYGHEM

Ghent, Justus of. *See* JUSTUS OF GHENT.

Ghent–Bruges school. Term referring to the manuscript illumination of the southern Netherlands (modern Belgium) from approximately the last quarter of the 15th century until the mid-16th. It was first used by Destrée (1891), who referred to 'manuscripts decorated in the

Ghent–Bruges manner', and by Durrieu in an article of the same year. Durrieu also defined the Ghent–Bruges school as that of the Grimani Breviary (Venice, Bib. N. Marciana, MS. lat. I. 99), but this second definition has never found a niche in the study of southern Netherlandish manuscript illumination. Some thirty years later, Winkler suspected that the predominant role in Flemish illumination was taken more by Bruges than by Ghent, and he accordingly referred to the 'Ghent–Bruges' or 'Bruges school'.

Although the term 'Ghent–Bruges school' is almost universally accepted, a more accurate term would be the 'so-called Ghent–Bruges school', because this style of illumination was also practised in other centres; in this context Destrée in a later publication mentioned the Duchy of Brabant and the County of Hainault, although it is not clear why he referred specifically to these two areas and he did not provide any supporting evidence. Whatever the case may be, a gradual and remarkable change did indeed take place in southern Netherlandish illumination between *c.* 1475 and *c.* 1485, replacing the courtly style of *c.* 1440–74 that is found in manuscripts connected with the court of Philip the Good and his son Charles the Bold, who ruled in succession over the southern Netherlands. The luxurious manuscripts executed for the Burgundian court were frequently preceded by a prologue and an initial miniature or frontispiece that shows the patron ceremoniously receiving the book from the hands of the scribe, translator or author, who is usually shown in a kneeling position—for example, the *Chronicles of Hainault* of Philip the Good (*c.* 1450–1500; Brussels, Bib. Royale Albert 1er, MS. 9242–4; for illustration *see* BURGUNDY, (3)). The text or full-page miniature was usually surrounded by a broad decorative border that acted as a frame, the white, undyed parchment or paper being sprinkled with acanthus leaves and flowers and including occasional comical illustrations. The motto and arms of the patron were also often illustrated.

Around 1475–85 a significant change took place in both the miniatures and the marginal decorations. The wooden, clumsily painted stock-figures were replaced by realistically painted figures, shown as accurately as possible in an intimate interior setting or a colourful landscape. Sometimes the human figures were painted on a larger scale, and gradually more half- or full-length portraits appeared (see fig.), following the example of Netherlandish panel painters. The work of Hugo van der Goes of Ghent was often copied by the illuminators of the Ghent–Bruges school, and they also frequently copied their own work and that of their colleagues. The miniatures are also characterized by their attractive, bright colouring and the increasing use of pastel shades, which contrasts sharply with the palette of their predecessors, who worked mainly in primary colours.

The stylistic change in the miniatures also affected the marginal decorations. Instead of using uncoloured parchment as a background and ornament consisting chiefly of acanthus leaves, they were decorated with *trompe l'oeil*. Flowers and other objects threw shadows on the painted backgrounds of the borders, giving a three-dimensional effect. The decorative margin, particularly the generous bottom and outer margins, became broader. The back-

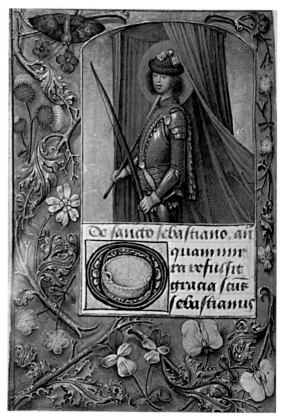

Ghent–Bruges school, circle of the Master of Mary of Burgundy: *St Sebastian*, from a Book of Hours, *c.* 1485 (Brussels, Bibliothèque Royale Albert 1er, MS. IV 40, fol. 124*v*)

grounds were at first ornamented only with golden-yellow, then later also with a variety of colours that transformed the margins into veritable botanical gardens. Different types of flowers, usually scattered about informally, cast their shadows on the coloured parchment and gave the borders of the pages an impression of depth and space (*see* BOOK OF HOURS, fig. 1). The inventiveness of these miniaturists was soon imitated, with varying degrees of success, in other European countries. Although the Netherlandish illuminators first concentrated on realistic floral decorations, they soon began to fill the borders with other objects (*see* BORDER, MANUSCRIPT, fig. 3), including architectural elements, the *Arma Christi*, pilgrim-badges, miniature animals, death's-heads, precious stones, little narrative scenes, inscriptions, rabbit-warrens, peacocks' tails and shells. Shortly after 1500 there began to appear in both miniatures and marginal decorations a number of Renaissance motifs that can be found earlier in the work of such painters as Hans Memling and Gerard David: arabesques, cartouches, medallions, grotesques, putti and garlands of fruit. From around the second decade of the 16th century, miniatures also appeared without marginal decoration; instead, the illustrated border was replaced by an ordinary fluted, gilded frame, so that the illumination resembled a miniature painting.

Very few illuminators are known by name; they include, for example, Gerard Horenbout and Simon Bening (*see*

HORENBOUT, (1), and BENING, (2)), while the work of others, for example Sanders Bening (*see* BENING, (1)), cannot be identified. Other masters are named after the manuscripts associated with them, for example the MASTER OF THE DRESDEN PRAYERBOOK, the MASTER OF THE PRAYERBOOKS OF *c.* 1500 and the MASTER OF MARY OF BURGUNDY (*see* MASTERS, ANONYMOUS, AND MONOGRAMMISTS, §I).

BIBLIOGRAPHY
J. Destrée: 'Recherches sur les enlumineurs flamands', *Bull. Comm. Royale A. & Archéol.*, xxx (1891), pp. 263–98
P. Durrieu: 'Alexandre Bening et les peintres du Bréviaire Grimani', *Gaz. B.-A.*, v (1891), pp. 353–67; vi (1891), pp. 55–69
F. Winkler: *Die flämische Buchmalerei des XV. und XVI. Jahrhunderts* (Leipzig, 1925, rev. Amsterdam, 1978)
——: 'Neuentdeckte Altniederländer I: Sanders Bening', *Pantheon*, xxx (1942), pp. 261–71
La Miniature flamande: Le Mécénat de Philippe le Bon, 1445–1475 (exh. cat., ed. L. M. J. Delaissé; Brussels, Bib. Royale Albert 1er, 1959)
G. Dogaer: L'"Ecole ganto-brugeoise", une fausse appellation', *Miscellanea Codicologica F. Masai dicata* (Ghent, 1979), pp. 511–18
A. von Euw and J. M. Plotzek: *Die Handschriften der Sammlung Ludwig*, ii (Cologne, 1982)
T. Kren: 'Flemish Manuscript Illumination, 1474–1550', *Renaissance Painting in Manuscripts: Treasures from the British Library* (exh. cat., ed. T. Kren; Malibu, CA, Getty Mus.; New York, Pierpoint Morgan Lib.; London, BL; 1983–4), pp. 1–85
J. H. Marrow: 'Simon Bening in 1521: A Group of Dated Miniatures', *Liber Amicorum Herman Liebaers* (Brussels, 1984), pp. 537–59
G. Dogaer: *Flemish Miniature Painting in the 15th and 16th Centuries* (Amsterdam, 1987)
Flämische Buchmalerei (exh. cat., ed. D. Thoss; Vienna, Österreich. Nbib., 1987)
GEORGES DOGAER

Gheorghiu, Ion (Alin) (*b* Bucharest, 29 Sept 1929). Romanian painter and sculptor. From 1948 to 1954 he studied under Camil Ressu at the Nicolae Grigorescu Academy of Art in Bucharest. He was one of the younger generation of artists who, at the beginning of the 1960s, began to detach themselves from the dogma of Socialist Realism that had dominated the art of the 1950s. He found inspiration in primitive peasants' icons painted on glass, a type of folk art that was for some artists a source of inspiration for new form, even before World War II. The simple and pleasing lines of this art, as well as the flatness of form and enamelled brilliance of colour, influenced him greatly. He gradually abstracted his images, nevertheless retaining references to such patterns found in nature as the shapes of shells and the whorled corollas of flowers. At the same time he was preoccupied with portraying the suggestion of rhythm and a vibration recalling the act of growth and the proliferation of life (e.g. *Still-life with Sea-crab*, 1964; artist's col.). His systematic quest for chromatic possibilities produces a sensitivity to colour that, in his non-representational paintings, always has a reference point in nature (e.g. *Farm Landscape*, 1964; artist's col.). Many of his paintings have the general title of *Hanging Gardens*. He also makes abstract sculptures in cast bronze or coloured marble (e.g. *Chimera*, white marble; Bucharest, N. Mus. A.), producing works that incorporate natural patterns and rhythms similar to his paintings.

BIBLIOGRAPHY
M. Moraru: *Ion Gheorghiu* (Bucharest, 1966)
O. Barbosa: *Dicţionarul artiştilor plastici români* [Dictionary of Romanian plastic artists] (Bucharest, 1976)
Ion Gheorghiu (exh. cat., preface D. Hăulică, Bucharest, Mus. A., 1976)
V. Drăguţ and others: *Pictura romaneasca in imagini/Romanian Painting* (Bucharest, 1977) [Eng. and Roman. text]
D. Grigorescu: *Ion Gheorghiu* (Bucharest, 1979)
V. Florea: *Pictura românească contemporană* [Contemporary Romanian painting] (Bucharest, 1982)
IOANA VLASIU

Gherardi [Tatoti], Antonio (*b* Rieti, Sept 1638; *d* Rome, May 1702). Italian painter and architect. He changed his surname only after his arrival in Rome *c.* 1656. With the help of his first patron, Bulgarino Bulgarini, he was able eventually to study with Pier Francesco Mola and Pietro da Cortona, in whose studio he presumably received his training as both painter and architect.

1. PAINTINGS. Gherardi's earliest documented works, three tapestry cartoons depicting *Episodes from the Life of Urban VIII* (1663–6; Rome, Pal. Barberini), were executed in connection with Cortona's workshop and show him almost completely dependent on his master's style. He then undertook an extensive study tour of northern Italy, probably in 1667–8, apparently spending most of this time in Bologna, Lombardy and Venice before returning to Rome with a distinctive manner derived from his study of the works of Veronese. His cycle of paintings and frescoes depicting *Scenes from the Life of the Virgin* (1668–70) in the vault of the small Roman church of S Maria in Trivio is a fusion of the lighting of Caravaggio with the colour and illusionism of Veronese. The works are animated by dynamic compositional patterns typical of the High Baroque but are more pointedly faithful to Venetian 16th-century sources than to any recent Roman examples. Gherardi was in fact attempting to reinvigorate the style he had inherited from Cortona by returning to it some of the more energetic aspects of its own roots.

Gherardi's reliance on Veronese is even more notable in his frescoes of the *Scenes from the Life of Esther* (1673–4) in the Palazzo Naro, Rome, but by the late 1670s he was already relaxing the High Baroque energy in his work and developing a personal kind of classicism, which he seems to have perceived as more consistent with contemporary taste. Typical of his work in this vein is the *Body of Christ Adored by Patron Saints of Savoy* (1680–82; Rome, SS Sudario). The rich, painterly, typically Venetian treatment of draperies survives from his earlier style, but whereas such passages had previously been animated by exuberant currents of movement, they now fall in heavy, motionless folds, and the mood of the entire picture is one of hushed stasis. The remainder of Gherardi's career as a painter is marked by this classicizing restraint, often dependent on Bolognese sources. For example, his *St Cecilia* (1689–90) in a chapel that he himself designed in the church of S Carlo ai Catinari, still has elements of colour and execution reminiscent of Veronese, but its general conception is based on a *Coronation of the Virgin* (1607; London, N.G.) by Guido Reni.

2. ARCHITECTURE. From the time of his first major commissions, following his return from Venice, Gherardi began to establish himself as an architectural decorator and architect as well as a painter, eventually specializing in designing entire chapels, for which he would also provide

the altarpiece. In this he seems to have harboured ambitions of becoming a 'universal genius' in the mould of Bernini. At S Maria in Trivio, Rome, he not only filled the vault with paintings but also designed the stucco relief over the tribune arch and was probably responsible for restructuring the entire apse. Whatever formal training he had in these matters was presumably obtained in Cortona's workshop. Indeed, what little survives of another of his early ventures as a chapel architect, the chapel of S Francesco Solano (1674–8) in the church of S Maria in Aracoeli, shows that at this stage he was very dependent on Cortona's vocabulary of decorative concepts and motifs. His first distinctive work as an architect is the Ávila Chapel (1678–80; see fig.) in S Maria in Trastevere, Rome. Here it is evident that if at about this time he had

abandoned his commitment to High Baroque style as a painter, he had as an architect redoubled it. Conceived as a kind of miniature church within a church, the chapel is a complex blend of motifs inspired by the works of Bernini and Borromini. Its most unusual feature is the use of a small, dramatically foreshortened colonnade, approximately 3 m deep, interposed between the altar itself and the altarpiece (depicting *St Jerome in the Desert*), which is also by Gherardi. This recess, which appears much deeper than it actually is, forms part of a two-storey apsidal complex illuminated in several places from concealed sources. The centre of the chapel is lit by an elaborate outsized lantern in the form of a small Ionic temple, which appears to be borne aloft by stucco angels in the vault. The work as a whole demonstrates an understanding of, and sympathy with, the deliberately theatrical expressive ideals of the mid-17th century.

Gherardi's late masterpiece, the larger and even more elaborate chapel of St Cecilia (1691–1700) in the church of S Carlo ai Catinari, Rome, is in a similarly dramatic style. In the Ávila Chapel the balance between motifs inspired by Borromini and those by Bernini had been fairly evenly balanced. In the chapel of St Cecilia, however, Gherardi relied much more on the latter, and the work is dominated by a rich and exuberant encrustation of figurative sculpture. A dense population of stucco angels and putti seems to flutter through the chapel, carrying various garlands, swags and draperies, singing and playing musical instruments. The chapel was designed for the Congregation of Musicians (the forerunner of the Accademia di S Cecilia), and the many musical motifs (and, no doubt, the riotously festive character of the entire work) were intended to express the nature of their profession as well as the iconography of their patron saint. The feature of greatest architectural interest is the lantern. Rising above a shallow oval cupola, it forms a space the size of a small room and extends well beyond the rim of the oculus, and it is brilliantly lit from a concealed window in its back wall. Life-size musician angels are perched on a balustrade surrounding the oculus, and a low relief in the ceiling of the lantern shows St Cecilia ascending into Heaven. This dramatically illusionistic treatment is Gherardi's expansion on ideas derived from Bernini's high-altar chapel at S Andrea al Quirinale (1658–70), Rome. It represents the earliest use in Rome of a double cupola with concealed light source, which also appears at about the same time in Carlo Fontana (iv)'s baptismal chapel at St Peter's and later in the monastic church (1717–21) at Weltenburg by Cosmas Damian Asam and Egid Quirim Asam.

The chapel of St Cecilia was one of the last large-scale expressions of the High Baroque to appear in Rome. Other, better-known architects of Gherardi's generation, such as Carlo Fontana (iv), had already largely reduced the legacy of Bernini and Borromini to a repertory of decorative motifs, however, to be utilized within a more conservative, classicizing context. Gherardi's work therefore had no repercussions in Rome at the time but may well have served as an inspiration to foreign architects, especially those from Germany and Austria, in the early 18th century.

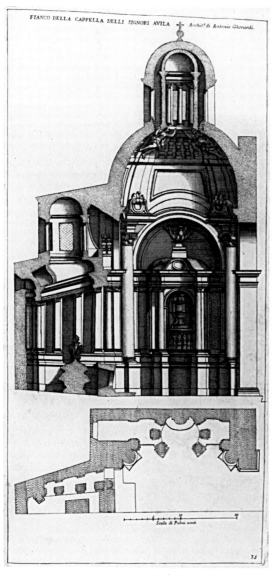

Antonio Gherardi: side elevation of the Ávila Chapel (1678–80), S Maria in Trastevere, Rome; from G. de Rossi: *Disegni di varii altarii* (Rome, ?1685) (London, British Library)

BIBLIOGRAPHY
A. Mezzetti: 'La pittura di Antonio Gherardi', *Boll. A.*, xxxiii (1948), pp. 157–79
P. Portoghesi: *Roma barocca* (Cambridge, MA, 1970), pp. 303–4 [excellent plates of the chapels]
T. Pickrel: *Antonio Gherardi: Painter and Architect of the Late Baroque in Rome* (diss., U. Kansas, 1981)
——: 'Antonio Gherardi's Early Development as a Painter', *Stor. A.*, xlvii (1983), pp. 57–64
——: 'L'Elan de la musique: The Chapel of S Cecilia and the Congregazione dei Musici', *Stor. A.* (in preparation)

THOMAS PICKREL

Gherardi, Cristofano [Cristofano dal Borgo; il Doceno] (*b* Borgo San Sepolcro, 26 Nov 1508; *d* Florence, 4 April 1556). Italian painter. In 1529, after studying with Raffaello dal Colle, he went to Florence, where he became one of Vasari's most steadfast followers. His figurative training provided him with a minute, analytical language, which he often grafted on to Vasari's compositional schemes to produce an effect of refined elegance. His works bear the stamp of the Tuscan-Roman Mannerism of Giulio Romano, Perino del Vaga and Francesco Salviati, not to mention its originators Michelangelo and Raphael. The first work he completed under Vasari was the *sgraffito* decoration, in 1534–5, of the garden façade of the Palazzo Vitelli alla Cannoniera, Città di Castello. In 1537, accused of plotting against the Medici, he was exiled from Florence. In the following years, in collaboration with Raffaello dal Colle and Dono Doni (*d* 1575), he executed the frescoes (destr.) of the Rocca Paolina, Perugia. Between 1537 and 1554 he produced the important cycle of mythological paintings for the Castello Bufalini, San Giustino, and between 1539 and 1542 he and Stefano Veltroni (*fl* 1536–51) painted the frescoes of grotesques and views of the principal Olivetan monasteries in the refectory of the Convent of Monte Oliveto, San Michele in Bosco. In 1546, after a period in Rome and Naples, Gherardi again worked with Vasari, on 18 panels depicting scenes from the *Old and New Testaments*, the *Four Evangelists* and the *Doctors of the Church* for the sacristy of S Giovanni Carbonara, Naples. In 1554 he was pardoned by Cosimo I de' Medici and was able to return to Florence. There, alongside Vasari, he began his last work, the frescoes (1555–9) depicting allegorical and mythological subjects in the Quartiere degli Elementi, Palazzo Vecchio. These, however, remained incomplete after Gherardi's sudden death.

BIBLIOGRAPHY
Thieme–Becker
G. Vasari: *Vite* (1550, rev. 2/1568); ed. G. Milanesi (1878–85)
P. Barocchi: *Complementi al Vasari pittore* (Florence, 1964), pp. 269–77
C. Monbeig Goguel: 'Gherardi senza Vasari', *A. Illus.*, v/48 (1972), pp. 130–41
A. Ronen: 'Palazzo Vitelli alla Cannoniera: The Decoration on the Staircase', *Commentari*, n. s., xxvi/1–2 (1975), pp. 56–88
——: 'The Pagan Gods: A Fresco Cycle by Cristofano Gherardi in the Castello Bufalini, San Giustino (II)', *Ant. Viva*, xvii/6 (1978), pp. 19–30
S. Béguin: 'Pour Cristofano Gherardi', *Giorgio Vasari tra decorazione e storiografia artistica. Convegno di Studi: Arezzo, 1981*, pp. 409–15
A. Ronen: 'Prometheus Creating the First Man: Drawings by Cristofano Gherardi and Cherubino Alberti', *Jb. Zentinst. Kstgesch.*, 5/6 (1989/90), pp. 245–52
——: 'Gherardi's Frescoes in the Apollo Room in the Castello Butalini: Their Sources and Iconography', *Stor. A.*, lxxviii (1993), pp. 129–55

MARINA GAROFOLI

Gherardi, Filippo (*b* Lucca, 1643; *d* Lucca, 1704). Italian painter. His career is inextricably linked to that of GIOVANNI COLI, with whom he collaborated until Coli's death in 1681. The phases of their training and careers are identical. He studied first with his father Sebastiano Gherardi, then with the Lucchese artist Pietro Paolini, and later, and most importantly, in the Roman workshop of Pietro da Cortona. Around 1662 he went to Venice, where, together with Coli, he was one of a circle of Baroque artists who, heavily influenced by the art of Veronese, sought to breathe new life into the tradition of Venetian painting. Still in collaboration with Coli, he painted the canvases for the library of the monastery of S Giorgio Maggiore (1664–8). In Rome in 1669 the two artists painted the frescoes on the dome of S Nicola da Tolentino. In 1672 they were back in Lucca (paintings in S Tommaso in Pelleria) and in 1675 again in Rome, working on the ceiling of Santa Croce dei Lucchesi (1675–7) and, more importantly, the gallery in the Palazzo Colonna, where they created a series of frescoes deeply influenced by Cortona and Veronese (*see* ITALY, fig. 68). In 1678 they returned to Lucca to paint a fresco of the *Glory of the Trinity* in the cathedral. Gherardi completed it alone following Coli's death in 1681.

The *Miracle of the Transfer of the Holy House of Loreto* (1681; Lucca, S Maria Corteorlandini) marked the beginning of Gherardi's independent career. It reveals a marked dilution of the bright colours found in his earlier collaborative works. This cooler, more calculated style also emerges in his *Virgin and Saints with the Souls in Purgatory* (Lucca, chiesa del Suffragio); whereas his vividly coloured frescoes (1687–90) for the vault and apse of S Pantaleo, Rome, suggest the influence of Giovanni Battista Gaulli's decoration of the chiesa del Gesù (Rome). His final works, however, the two scenes from the *Life of St Paul* (Lucca, S Paolo), are less vividly Baroque than these works and develop Cortona's style in a cooler, more classicizing vein especially in the scene of *The Martyrdom*.

For bibliography *see* COLI, GIOVANNI.

UGO RUGGERI

Gherardini, Alessandro (*b* Florence, 16 Nov 1655; *d* Livorno, 1723). Italian painter. He was a pupil of Alessandro Rosi (1627–1707), who had trained with Cesare Dandini and was influenced by Pietro da Cortona. Around 1675 he went to Pontremoli, a Tuscan city, the art of which was closer to that of the neighbouring regions of Emilia and Liguria. There Gherardini painted a *Transfiguration* (Pontremoli, S Cristina) and a fresco in Palazzo Negri of *Samson Destroying the Temple* (destr.). He travelled extensively in northern Italy, spending a period in Parma, where he worked in the Charterhouse. By 1688 he was back in Florence, where, for Grand Prince Ferdinand de' Medici, he decorated a chapel in the Palazzo Pitti and a ceiling with the *Assumption* in the Villa Medici at Castello. The *Discovery of Moses* (Bamberg, Neue Residenz, Staatsgal.) and *Solomon and Sheba* (Schleissheim, nr Munich, Neues Schloss) probably date from the same period. They reveal a knowledge of Venetian painting, especially the work of Veronese, but this influence was soon replaced by that of Luca Giordano, who during Gherardini's

absence had carried out some important works in Florence, including the decoration of the cupola of the chapel of S Andrea Corsini in S Maria del Carmine and of the gallery of the Palazzo Medici (now the *prefettura*). Giordano's influence is apparent in Gherardini's first public work in Florence, the *Triumph of Faith* on the vault of S Jacopo tra i Fossi (drawing, Vienna, Albertina), as well as in his works in Pontremoli of this period, the *Miracle of St Nicholas of Bari* (1689; Pontremoli, Pal. Dosi; drawing, Parma, Bib. Palatina) and two allegories in the Villa Dosi at Chiosi of the *Theological Virtues* and the so-called *Allegory of War*.

During the 1690s Gherardini worked, sometimes in collaboration with the *quadraturista* Rinaldo Botti (*fl* 1650–1740), in several Florentine palaces, his liveliness of style and independence from more official and academic tendencies (represented by Pietro Dandini and Anton Domenico Gabbiani) being popular with many patrons. In 1692 he painted the cupola of S Giovannino dei Cavalieri and between 1692 and 1696, with Dandini and Gabbiani, decorated six rooms in Palazzo Corsini (drawings for some of the latter, Copenhagen, Stat. Mus. Kst) and the ceiling of the *salone* of Villa Corsini. He was employed in Palazzo Orlandini (*c.* 1694), Villa Palmieri (*c.* 1697) and Palazzo Ginori (1698). In 1697–8 he was again in Pontremoli, decorating the ground-floor *salone* of the Villa Dosi in collaboration with the *quadraturista* Francesco Natali (*d* 1723). During the same decade he painted several religious works for Florentine churches, including the *Coronation of the Virgin with St Augustine and St Monica* (*c.* 1694; S Spirito), *St Anne, the Virgin and a Prophet* (S Giovanni di Dio), *Birth of the Virgin* (S Frediano in Cestello), the *Virgin Holding out Jesus to the Saint* (1697; Santa Trìnita) and the *Death of St Joseph* and *Rest on the Flight into Egypt* (1699; S Pietro a Varlungo). Around 1700 Gherardini painted his largest and most important fresco, the *Vision of St Romuald* on the ceiling of S Maria degli Angeli, Florence (see fig.). This is undoubtedly his masterpiece, in which the various influences from northern Italian art, especially that of Venice, Parma and Genoa, have been blended and refined to create luminous and spacious compositions that anticipate the style of painting characteristic of the later years of the 18th century. The work provided an example and a stimulus, prior to Sebastiano Ricci's stay in Florence, for the more painterly approach in Florentine art, taken most notably by Matteo Bonechi and Ranieri del Pace, both of whom had trained with Giovanni Camillo Sagrestani.

From the turn of the century Gherardini was active throughout Tuscany. In 1701 he painted various works for the Vallombrosa Abbey and in 1703 decorated the bedroom of Cardinal Francesco Maria de' Medici (*d* 1711) in his Villa Lappeggi, near Florence. In the same year he appears to have turned briefly to the more official and classicizing stream of Florentine painting, represented by Gabbiani, Tommaso Redi and Benedetto Luti, in which the emphasis is on *disegno*. This tendency can be seen in Gherardini's *Crucifixion* (1703; Bagno di Romagno, S Maria Assunta) and in his decoration of the gallery of Palazzo Giugni with an *Allegory of the Arts* of the same date. In both these works, Gherardini adopted a compositional scheme reminiscent of earlier Florentine painters, such as Raffaello Volterrano and Giovanni da San Giovanni, with the figures arranged in a longitudinal progression. This was only a temporary phase, however. The ceiling of S Elisabetta delle Convertite, Florence (*c.* 1704), a *Deposition* and a fresco of *St George in Glory* (1705; S Giorgio sulla Costa) as well as the great vault of S Verdiana in Castelfiorentino (1708) are painted with Gherardini's usual fluency and ease of expression. His *Self-portrait* (Florence, Uffizi) and various cabinet paintings and frescoes on tile (Verona, Castelvecchio; Bologna, Pin. N.; Washington, DC, Georgetown U. A. Col.; London, V&A; San Miniato, Mus. Dioc. A. Sacra) also belong to this period.

Gherardini's growing disenchantment with Florence *c.* 1710 is attributable partly to legal wrangles and perhaps also to his failure to share in prestigious commissions such as the decoration of Palazzo Capponi (begun 1705), and of S Jacopo sopr'Arno (begun 1709). However, these difficulties seem to have stimulated his inventiveness and compositional freedom, as is evident in the *St Francis of*

Alessandro Gherardini: *Vision of St Romuald* (*c.* 1700), vault fresco, S Maria degli Angeli, Florence

Paola (1711; Volterra Cathedral). After a stay in Genoa in 1713, where he painted *St Pius V* (S Maria di Castello), Gherardini returned to Tuscany. The works of the last years of his life are characterized by chromatic richness, brightness of light effects and rapid brush strokes, all features that derive from Ligurian painting. To this period belong the *Seven Sorrows of the Virgin* (1715; Florence, S Firenze) and his last dated works from 1723: the *Rest on the Flight into Egypt* and the *Deposition* (Livorno, S Jacopo d'Acquaviva) and a *Sleeping Cupid* (Florence, Col. Com. Raffaello Stianti), based on a work by Caravaggio.

About 50 drawings by Gherardini are known, and of these less than half are connected with paintings. They are in various media, including pen and ink, pencil, and red chalk. His achievement lay in his development of a recognizable personal style, which was constantly evolving and which provided a valuable example of freedom and innovation for the Florentine fresco painters of the succeeding generation, such as his pupil Sebastiano Galeotti.

BIBLIOGRAPHY

M. Marangoni: 'La pittura fiorentina nel settecento', *Riv. A.*, viii (1912), pp. 61–102

M. M. Pieracci: 'La difficile poesia di un ribelle all'Accademia: Alessandro Gherardini', *Commentari*, iv (1953)

G. Ewald: 'Il pittore fiorentino Alessandro Gherardini', *Acropoli*, iii (1963), pp. 81–132

70 pitture e sculture del '600 e '700 fiorentino (exh. cat., ed. M. Gregori; Florence, Pal. Strozzi, 1965)

L. Bertocchi and G. C. Dosi Delfini: *Lettere di pittori e scultori dei secoli XVII–XVIII* (Pontremoli, 1970)

S. Rudolph: 'Mecenati a Firenze tra sei e settecento, iii: Le opere', *A. Illus.*, vi/59 (1973), pp. 279–92

R. Bossaglia, V. Bianchi and L. Bertocchi: *Due secoli di pittura barocca a Pontremoli* (Genoa, 1974)

M. Mosco: *Itinerario di Firenze barocca* (Florence, 1974)

S. Meloni Trkulja: 'Alessandro Rosi e gli inizi del Gherardini', *Ant. Viva*, xiv (1975), pp. 17–26

Dessins baroques florentins du musée du Louvre (exh. cat., ed. F. Viatte and C. Monbieg-Goguel; Paris, Louvre, 1981–2)

S. Meloni Trkulja: 'L'attività tarda di Alessandro Gherardini sulla costa tirrenica e un nuovo acquisto delle gallerie fiorentine', *Ant. Viva*, xxiv (1985), pp. 75–81

SILVIA MELONI TRKULJA

Gherardo delle Notti. *See* HONTHORST, GERRIT VAN.

Gherardo di Giovanni del Fora. *See* FORA, DEL, (1).

Gherardo Fiammingo. *See* HONTHORST, GERRIT VAN.

Gherarducci, Don Silvestro dei (*b* 1339; *d* Florence, 5 Oct 1399). Italian illuminator. He was a Camaldolese brother at the monastery of S Maria degli Angeli, Florence, of which he became Prior in 1398. The importance of the scriptorium was noted by Vasari in his *Vita* of Lorenzo Monaco; the latter's entry into the monastery in 1391 completed a triumvirate of painters, Don Silvestro, the eldest painter in the group, Don Simone Camaldolese and Don Lorenzo, that constituted the most important late medieval school of painters in Florence.

Several paintings on panel, including a *Crucifixion* (New York, Met.) and a *Noli me tangere* (London, N.G.), have been attributed to Don Silvestro, but his greatest contribution, and his considerable renown, was as a manuscript illuminator. Many manuscripts by him were dismembered during the Napoleonic era, however, and many of his greatest illuminated initials are dispersed among various collections. One of the most impressive is an initial with *Christ and the Virgin in Glory* (*c.* 1380; Cleveland, OH, Mus. A.): vigorous figures clothed in heavy draperies are set in a clearly articulated letter, which has a complex spatial arrangement similar to those in contemporary panel paintings. Earlier initials, such as a *Consecration of a Church*, dated 1370–77 (Florence, Bib. Medicea-Laurenziana, Cod. Cor. 2), and the similarly dated *Resurrection* (a cut folio; Chantilly, Mus. Condé), exhibit the same traits in increasingly mature productions. The *Ascension of Christ* of 1390, another cut folio (New York, Pierpont Morgan Lib.), represents a final expression of his style.

BIBLIOGRAPHY

G. Vasari: *Vite* (1550, rev. 2/1568); ed. G. Milanesi (1878–85)

M. Levi D'Ancona: '"Don Silvestro dei Gherarducci" e il "Maestro delle Canzoni"', *Riv. A.*, xxxii (1957), pp. 3–37

——: *Miniatura e miniatori a Firenze dal XIV al XVI secolo* (Florence, 1962)

M. Boskovits: 'Su Don Silvestro, Don Simone e la "Scuola degli Angeli"', *Paragone*, cclxv (1972), pp. 35–61

——: *Pittura fiorentina alla vigilia del rinascimento, 1370–1400* (Florence, 1975)

DOMENICO G. FIRMANI

Gheyn, de. Dutch family of artists. Jacques de Gheyn I (*b* on board ship on the Zuyder Zee, 1537–8; *d* Antwerp, ?1581), the first of three generations of artists of the same name, was a glass painter, engraver and draughtsman. He is known to have designed stained-glass windows in Antwerp and Amsterdam, but these are now lost, as are the miniatures he executed. A few allegorical etchings and drawings survive, but these are also ascribed to his son (1) Jacques de Gheyn II. The latter, the most renowned artist of the family, was a gifted draughtsman and engraver, whose work spans the transition from late 16th-century Mannerism to the more naturalistic style of the early 17th century. His importance lies in his originality and creative inventiveness, which was allied to a poetic imagination, and in his role as a recorder of contemporary events at a time when the new Dutch Republic was creating a national identity. He was held in high regard by the central Dutch government and the court of Prince Maurice of Orange Nassau and by the representatives of the Dutch cities in the States General. His son, (2) Jacques de Gheyn III, was a close follower, and it is often difficult to distinguish their work. De Gheyn III is best known for his etchings.

(1) Jacques [Jacob] de Gheyn II (*b* Antwerp, 1565; *d* The Hague, 29 March 1629). Draughtsman, engraver and painter. He was taught first by his father and then from 1585 by Hendrick Goltzius in Haarlem, where he remained for five years. By 1590–91 de Gheyn II was in Amsterdam, making engravings after his own and other artists' work (e.g. Abraham Bloemaert and Dirck Barendsz.). There he was visited several times by the humanist Arnout van Buchell [Buchelius]. De Gheyn received his first official commission in 1593—an engraving of the *Siege of Geertruitenberg* (Hollstein, no. 285)—from the city and board of the Admiralty of Amsterdam. In 1595 he married Eva Stalpaert van der Wiele, a wealthy woman from Mechelen. From 1596 to 1601–2 he lived in Leiden, where he began collaborating with the famous law scholar Hugo de Groot [Grotius], who wrote many of the inscriptions for the

artist's engravings. During this period he also began working for Prince Maurice of Orange. In 1605 de Gheyn was a member of the Guild of St Luke in The Hague, where he remained until his death. Once he had settled in The Hague, de Gheyn's connections with the House of Orange Nassau were strengthened. Among other commissions, he designed the Prince's garden in the Buitenhof, which included two grottoes, the earliest of their kind in the Netherlands. After the Prince's death in 1625, de Gheyn worked for his younger brother, Prince Frederick Henry.

Although originally a Catholic, de Gheyn seems to have turned to Calvinism and gradually abandoned orthodox Catholic themes. His subject-matter was also influenced by his contact with the newly established university at Leiden. He never travelled to Italy and, apart from an interest in Pisanello, there is little evidence in his work (except in his garden designs) of the influence of Classical antiquity or the Italian Renaissance, both of which were so attractive to many of his northern contemporaries. Much information about both de Gheyn II and de Gheyn III is provided in the autobiography of Constantijn Huygens the elder, secretary to Frederick Henry. Jacques II is also mentioned by van Mander, for whom he worked as a reproductive engraver. Van Mander wrote of de Gheyn II, among other things, that he 'did much from nature and also from his own imagination, in order to discover all available sources of art'. Indeed, some of his images are completely fictitious, while others are based on reality. Often his works are a mixture of these two components.

1. Drawings. 2. Prints. 3. Paintings.

1. DRAWINGS. Altena (1983) catalogued 1502 drawings by de Gheyn II, including designs that survive only in prints. For his drawings de Gheyn used a quill pen and dark brown ink with white heightening, black or red chalk or brush and wash. Those intended to be reproduced as prints are often indented with a metal stylus for transfer on to the plate. Before 1600 his style was clearly dominated by the influence of Goltzius, whose small silverpoint and metalpoint portraits on ivory-coloured tablets de Gheyn imitated, although he used a yellow ground and rendered his sitters more gracefully and dynamically than the simple and unadorned portraits of Goltzius. The majority of de Gheyn's portraits date from before 1598. He was particularly skilled in his use of both the pen and the brush. While his free, sketchy studies in pen and ink are usually made without wash, his preparatory drawings for engravings, such as those for the *Exercise of Arms* (c. 1597; various locations, see Altena, 1983, nos 346–459), commissioned by Prince Maurice of Orange and published in The Hague in 1608, are elaborately washed and sometimes heightened with white. Initially de Gheyn's drawings imitated Goltzius's engraving style, as can be seen in the *Portrait of a Young Man Holding a Hat in his Hand* (Berlin, Kupferstichkab.), which may, according to Altena, represent Matheus Jansz. Hyc. De Gheyn's draughtsmanship, like that of Goltzius, belongs to the tradition of Dürer, Pieter Bruegel the elder and Lucas van Leyden; it is also related to the undulating graphic style of Venetian woodcuts by Titian and Domenico Campagnola.

In his landscape drawings de Gheyn was also influenced by Paul Bril and Hans Bol. These seem to have been based mostly on his imagination and contain no evidence of direct visual contact with nature. In some cases, such as the grand *Mountain Landscape* (New York, Pierpont Morgan Lib.), which reflects a type of alpine landscape traditionally associated with Pieter Bruegel, it is difficult to distinguish reality from fantasy. De Gheyn did not make realistic landscapes in the style of Goltzius, but occasionally accurate elements of the Dutch landscape appear in the background of his narrative scenes with figures. An exceptional case is his *Landscape with a Canal and Windmills* (Amsterdam, estate of J. Q. van Regteren Altena, see Altena, 1983, iii, p. 59), which he made after the drawing by Hans Bol (1598; London, BM).

Around 1600 de Gheyn gradually began to dissociate himself from the influence of Goltzius. His pen lines are more fluent, sometimes grow quite wild and tend to have a recognizable curly rhythm. The extensive use of hatching and crosshatching reflect his skill as an engraver. He rarely used red chalk, preferring black chalk and occasionally the combination of chalk with pen and ink, as in the *Studies of a Donkey* (c. 1603; Paris, Fond. Custodia, Inst. Néer.).

De Gheyn II also produced carefully coloured drawings on parchment in a naturalistic style. In these he would often use watercolour as well as bodycolour, with occasional highlights in gold. A splendid example is the *Old Woman on her Deathbed with a Mourning Cavalier* (1601; London, BM). This miniaturist technique can be best compared with the English 'Arte of Limning', described in a treatise by Nicholas Hilliard, and it is possible that, through Constantijn Huygens, de Gheyn may have known these colourful miniatures. A magnificent album from 1600–04 (Paris, Fond. Custodia, Inst. Néer.), once in the possession of Rudolf II, consists of 22 watercolour drawings on parchment, executed in this miniaturist technique. Among the almost photographic representations of natural objects are flowers, mostly roses, insects and also a crab and a mouse. The studies are part of a long-standing tradition of natural history illustrations, of which Dürer, Joris Hoefnagel and Georg Flegel were key exponents. The scientific value of the album leaves lies in the fact that they represent rare examples or newly cultivated varieties of flower. The famous scholar Carolus Clusius is thought to have been de Gheyn's adviser in these matters. As in other works, symbolism apparently plays an important role in this album.

De Gheyn also represented the female nude in drawings. Two of the seven known examples are certainly after the same model (Altena, 1983, ii, nos 803 and 804); the others seem more or less realistic in conception. Together with similar works by Goltzius, they are among the earliest nudes in Dutch art. Another iconographic innovation by de Gheyn was the realistic portrayal of domestic scenes, as in the drawing of *Johan Halling and his Family* (1599; Amsterdam, Rijksmus.) and the *Mother and Son Looking at a Book by Candlelight* (c. 1600; Berlin, Kupferstichkab.). Such genre scenes were not to be painted regularly on a larger scale in Holland until the 17th century.

A number of de Gheyn's drawings are allegorical, although often unclear or complex, for example the

1. Jacques de Gheyn II: *Archer and Milkmaid*, pen and brown ink with grey wash over red chalk, 390×323 mm, *c.* 1610 (Cambridge, MA, Fogg Art Museum)

2. Jacques de Gheyn II: *Standard-bearer*, engraving, proof state, 286×194 mm, 1589 (Amsterdam, Rijksmuseum)

Allegory of Equality in Death and Transience (1599; London, BM) and the related engraving (Hollstein, no. 98), for which the 16-year-old Hugo de Groot wrote the caption. Also allegorical in meaning is the *Archer and Milkmaid* (*c.* 1610; Cambridge, MA, Fogg; see fig. 1), a preparatory study for a print that carries the legend 'Beware of him who aims in all directions lest his bow unmasks you'.

Perhaps de Gheyn's most original inventions iconographically were his '*spookerijen*' ('spooks'), the drawings of sorcery and witchcraft. The meaning of, for example, the *Two Withered Rats* (1609; Berlin, Kupferstichkab.) or of his drawings of monstrous, crawling rats remains a mystery. The enormous *Witches' Sabbath* (Stuttgart, Württemberg. Landesbib.) is reminiscent of the work of Hans Baldung and of contemporary literature on witchcraft. His drawings of strange knotted tree trunks, surely imaginary rather than realistic, are related to the grotesque ornamental style, for the curious, gnarled bark seems to contain hidden figures. There are also some drawings that seem to fall outside any particular iconographical category; they are strange, fantastical scenes, sometimes bordering on the magical, such as the *Naked Woman in Prison* (Brunswick, Herzog Anton Ulrich-Mus.), the meaning of which, if any, is unclear.

2. PRINTS. The 430 engravings and etchings catalogued by Hollstein include prints after de Gheyn's own designs as well as those of other artists. From 1585 until the end of the 16th century he imitated Goltzius's burin manner in his engravings; the lines cut into the copperplate vary in thickness, with the density of the hatchings and crosshatchings suggesting passages of light and dark as well as volume. In some cases dots intensify the density of crosshatchings. Before Goltzius's departure for Italy in 1590, de Gheyn was already using this engraving technique, known as the 'zebra effect', in his series of *Standard-bearers* (1589; Hollstein, nos 144–5). A proof state of one of these plates (Amsterdam, Rijksmus.; see fig. 2) shows de Gheyn's masterly handling of the burin. He also used a finer engraving technique with short hatchings, strokes and dots, as can be seen in the portrait of the numismatist *Abraham Gorlaeus* (1601; Hollstein, no. 313); this old-fashioned type is reminiscent of the portraits of learned humanists at the time of Hans Holbein.

As in the drawings, after *c.* 1600 a gradual change took place. De Gheyn's engraving style became more mature, with lines more evenly spread over the whole of the copperplate. His exceptional talent is seen at its height in the *Fortune-teller* (Hollstein, no. 105), datable shortly after 1600. He more or less abandoned engraving after 1600, but this print can only have been made by him. The tree is certainly based on one of his preparatory tree studies. He depicted relatively few biblical or mythological subjects in his engraved work, preferring, instead, to concentrate on series depicting contemporary events, for example the *Battle of Turnhout* (1594; Hollstein, no. 286) and his striking large print of *Prince Maurice's Land Yacht* (1603; Hollstein, no. 63).

The most important change after 1600 was that de Gheyn began to experiment with etching, a technique that was not fully exploited in its own right until the work of

Rembrandt in mid-century. Even though with etching it is not possible to vary the thickness of lines, de Gheyn's etching style hardly differs from that of his engraving. According to Burchard, there are two etchings certainly by Jacques de Gheyn II: the *Farm at Milking Time* (Hollstein, no. 293), which looks like a Venetian-style woodcut, and the *Happy Couple* (Hollstein, no. 97), which is remarkable for its effective division of light and dark, achieved by, among other things, a fine use of stippling. However, these attributions are not universally accepted. Konrad Oberhuber attributed the *Happy Couple* to de Gheyn III (*Jacques Callot und sein Kreis*, exh. cat., Vienna, Albertina, 1968–9, pp. 67–8); and Altena (1983) described the *Farm at Milking Time* as 'Anonymous after J. de Gheyn II'. They may have been made after drawings (both Amsterdam, Rijksmus.) by Jacques de Gheyn II. The engravers Jan Saenredam and Zacharia Dolendo were both pupils of de Gheyn II.

3. PAINTINGS. Like Goltzius, Jacques de Gheyn II did not take up painting until *c*. 1600, about the time he stopped engraving. Of the 47 works catalogued by Altena (1983), at least 21 survive, while the rest are known from documents and old sale catalogues. The figure paintings are reminiscent of the drawings but lack the conception behind the large academic nudes painted by Goltzius, as well as his 'burning' reddish-brown colour. The unnaturally posed *Seated Venus* (*c*. 1604; Amsterdam, Rijksmus.) is closer to the Mannerist style of Bartholomäus Spranger than to examples from antiquity or the Renaissance. De Gheyn's history paintings have not been extensively studied. The best known is his painting of *Prince Maurice's White Horse* (1600; Amsterdam, Rijksmus.), the artist's first commission from the Prince. There are also a few paintings with obscure subjects, such as the *Woman in Mourning Clothes Lamenting over Dead Birds* (Sweden, priv. col., see Altena, 1983, ii, no. P16).

De Gheyn's best-known paintings, the *vanitas* still-lifes and flower-pieces with butterflies, caterpillars, shells and the like, which are painted in the Flemish tradition, are of better quality. The earliest, the still-life *Allegory of Mortality* (1603; New York, Met.; *see* VANITAS, fig. 1), bears the explanatory caption: HVMANA VANA. In such works as the *Bouquet in a Glass Vase* (1612; The Hague, Gemeentemus.), the roses are almost withered and recall the emblematic motto 'rosa vita est'. The unsigned painting on copper of a *Vase of Flowers* (ex-Brian Koetser Gal., see Altena, 1983, ii, no. P31) is a special case: all the flowers recur in the Paris album of miniatures. His flowers, mostly roses and tulips, are all on the verge of withering and are painted with a dynamism not found in freshly cut flowers; this could also be an allusion to the transience of life. This stylization of nature often recurs in the artist's oeuvre.

(2) Jacques de Gheyn III (*b* ?Amsterdam, ?1596; *d* Utrecht, 5 June 1641). Draughtsman, etcher and possibly painter, son of (1) Jacques de Gheyn II. He worked in The Hague and later in Utrecht, where he became canon of the St Mariakerk. In 1618 he was travelling in England with Constantijn Huygens the elder, and in 1620 he went to Sweden, taking eight of his father's works. His drawings are sometimes indistinguishable from those of his father.

The work of Jacques de Gheyn III is generally of less importance than his father's, with the exception of some of the early etchings, for example the dramatically lit series of *Seven Wise Men from Greece* (1616; Hollstein, nos 10–17), or the *Triton Blowing a Shell* (Hollstein, no. 23) and a few drawings in which he did not imitate his father. Jacques III's etching style was still largely based on the engraving technique used by Goltzius and by his own father, but the dramatic treatment of light and dark seems related to the tenebrist style of Adam Elsheimer and of his follower Hendrik Goudt, who was active in Utrecht from 1611.

De Gheyn III's later works suggest a sudden breakdown, something also indicated in Huygens's autobiography, in which he deplored the apparent inertia of an artist who had shown such promise as a young man. Few works are known from after the death of his father. Although a number of paintings have been attributed to de Gheyn III, some were certainly painted by other artists, such as the *Schoolmaster with Three Children* (untraced, Altena, 1983, p. 233) by Willem van Vliet (*c*. 1584–1642). Jacques de Gheyn III also collected: he owned works by Rembrandt, who painted his portrait (1632; London, Dulwich Pict. Gal.).

BIBLIOGRAPHY

Hollstein: *Dut. & Flem.*K. van Mander: *Schilder-boeck* ([1603]–1604), fols 293v–295r

C. Huygens: *De jeugd van Constantijn Huygens door hemzelf beschreven* (MS., 1629–31); ed. A. H. Kan (Rotterdam and Antwerp, 1946)

L. Burchard: *Die holländische Radierer vor Rembrandt* (diss., U. Halle, 1912)

J. Q. van Regteren Altena: *Jacques de Gheyn: An Introduction to the Study of his Drawings* (Amsterdam, 1936)

J. R. Judson: *The Drawings of Jacob de Gheyn II* (New York, 1973)

F. Hopper Boom: *An Album of Flower and Animal Drawings by Jacques de Gheyn II* (diss., Rijksuniv. Utrecht, 1976)

J. Q. van Regteren Altena: *De Gheyn, Three Generations*, 3 vols (The Hague, 1983); review by E. K. J. Reznicek in *Oud-Holland*, cii (1983), pp. 78–87

Dessins et gravures de Jacques de Gheyn II et III (exh. cat. by C. van Hassel and M. van Berge-Gerbaud, Paris, Fond. Custodia, Inst. Néer., 1985)

Jacques de Gheyn II, 1565–1629: Drawings (exh. cat. by A. W. F. M. Meij and J. A. Poot, Rotterdam, Mus. Boymans–van Beuningen; Washington, DC, N.G.A.; 1985–6)

Dawn of the Golden Age: Northern Netherlandish Art, 1580–1620 (exh. cat., ed. G. Luijten and others; Amsterdam, Rijksmus., 1993–4), p. 305, *passim*

E. K. J. REZNICEK

Ghezzi. Italian family of artists. They came from the Ascoli Piceno region of the Marches. Sebastiano Ghezzi (*c*. 1590–1650) was a minor painter, wood-carver and architectural engineer in Ascoli Piceno and may have been a pupil of Federico Zuccaro. His son (1) Giuseppe Ghezzi was a painter, illustrator and administrator, though best known is Giuseppe's son, (2) Pier Leone Ghezzi, whose witty caricatures of prominent figures in Roman society have won him lasting renown.

BIBLIOGRAPHY

V. Martinelli, ed.: *Giuseppe e Pier Leone Ghezzi* (Rome, 1990)

(1) Giuseppe Ghezzi (*b* Comunanza, nr Ascoli Piceno, 1634; *d* Rome, 1721). Painter, illustrator and administrator. First taught by his father, after 1650 he may have been a pupil of Lorenzo Bonomi (1603–66) in Fermo. Some surviving works in and around Ascoli Piceno have been

attributed to his early oeuvre, including an altarpiece of *St Thomas of Villanueva*, inscribed and dated 1669 (Marrovale, S Agostino). He emigrated to Rome in the late 1660s. Among the first works he executed there is the altarpiece (before 1674) representing the titular saint for the church of S Maria del Suffragio (*in situ*). This picture reflects Ghezzi's rapid assimilation of contemporary Roman painting, especially the styles of Pietro da Cortona and Giovanni Battista Gaulli. In 1674 he became a member of the Accademia di S Luca, and thereafter executed numerous altarpieces in Rome, notably the *Departure of St Paul* (1676; Rome, Pal. Barberini). Two of his most highly regarded pictures were executed between 1695 and 1702 for the Chiesa Nuova at S Maria in Vallicella, Rome: the *Creation of Adam* and the *Resurrection of the Dead* (both *in situ*). These exhibit his mature pictorial style, his impassioned use of chiaroscuro and his gift for dramatic composition.

After *c.* 1700 Giuseppe Ghezzi produced few pictures. Among his students in Rome were his son Pier Leone Ghezzi, Antonio Amorosi and Pietro Bianchi. Giuseppe Ghezzi was perhaps best known in the contemporary art world of Rome for his distinguished administrative talents: from 1678 to 1719 he held the influential post of Permanent Secretary to the Accademia di S Luca. During this period he executed a few portraits of fellow academicians, including a posthumous portrait of *Federico Zuccaro* (before 1696; Rome, Accad. N. S Luca), but his compilation and publication of the academy's reports were of far greater significance. Such publications, for example *Le pompe dell' Accademia del Disegno* (Rome, 1702), often included portraits, illustrations and frontispieces engraved after his designs. From 1682 onwards he co-ordinated the prestigious annual picture exhibition at S Salvatore in Lauro, was a member of the Society of Arcadia, a protégé of popes and ambassadors and a personal adviser to Rome's most prominent art collectors. He was also a respected restorer of Old Master paintings. His *Self-portrait* (red chalk, *c.* 1720–22; Stockholm, Nmus.) illustrates his 'Life' in Nicola Pio's *Vite*.

BIBLIOGRAPHY

N. Pio: *Vite* (1724); ed. C. Enggass and R. Enggass (1977), pp. 107–8
L. Pascoli: *Vite* (1730–36), ii, pp. 199–211
F. Haskell: 'Art Exhibitions in Seventeenth-century Rome', *Stud. Seicent.*, i (1960), pp. 107–21
S. Susinno: 'I ritratti degli academici', *L'Accademia di San Luca* (Rome, 1974), pp. 201–70 [Giuseppe's pubns for the academy are listed, pp. 420–21]
G. Incisa della Rocchetta: *La collezione dei ritratti dell'Accademia di San Luca* (Rome, 1979)
F. Pansecchi: 'Giuseppe Ghezzi: Tre quadri fuori sede', *Scritti di storia dell' arte in onore di Federico Zeri*, ed. M. Natale (Milan, 1984), pp. 724–9 ☐

(2) Pier Leone Ghezzi (*b* Comunanza, nr Ascoli Piceno, 28 June 1674; *d* Rome, 6 March 1755). Painter, draughtsman, antiquarian and musician, son of (1) Giuseppe Ghezzi. He has been described as the first professional caricaturist (Clark), yet he also painted decorative frescoes and created a new type of anecdotal and realistic history painting. As a portrait painter, his works are distinguished by their fresh naturalism. He enjoyed a privileged relationship with Pope Clement XI and his family, and was patronized by the Roman nobility, high churchmen and French aristocrats in Rome. It is their world, and that of the British Grand Tourist, that he portrayed—with humour yet without malice—in his many caricatures.

He was trained by his father in a cultural environment dominated by the Roman classical tradition, as represented most notably in the art of Carlo Maratti, Giovanni Battista Gaulli and Pietro da Cortona. Pio relates that Giuseppe Ghezzi, possibly jealous of his son's natural facility, made him draw from the model entirely in pen, without making corrections. This practice perhaps encouraged Ghezzi's skill in rendering the model in a few rapid penstrokes. In 1695 he won first prize in the competition run by the Accademia di S Luca, Rome.

1. Religious works, history paintings and decorative frescoes. 2. Portrait painting. 3. Drawings.

1. RELIGIOUS WORKS, HISTORY PAINTINGS AND DECORATIVE FRESCOES. Pier Leone Ghezzi's first documented work is the signed and dated *Landscape with St Francis* (1698; Montefortino, Pin. Com.). Very close to this date he collaborated with Antonio Amorosi, a student of Giuseppe Ghezzi, in the *Virgin of Loreto* for the church of S Caterina at Comunanza (*in situ*). In 1705 Ghezzi was elected Accademico di Merito at the Accademia di S Luca, and in 1708 he was made painter of the Camera Apostolica for Clement XI. This position involved him acting as curator of the papal collections, superintending the decorations for ceremonial occasions and the manufacture of tapestries and mosaics, and overseeing architectural sites and the decoration of buildings. He was also a member of the Society of Arcadia.

Ghezzi's most important official commissions date from between 1712 and 1721. Six large canvases of scenes from the *Life of Clement XI* (1712–15; Urbino, Pal. Ducale), painted for the *salone* of the papal palace at Castelgandolfo brought to history painting a new informality and documentary realism; they are characterized by a naturalistic description of setting and figures, and by a lively interest in anecdote. In contrast, the *Election of St Fabian* (*c.* 1712; *in situ*) for the Albani Chapel in S Sebastiano fuori le Mura, Rome, and the frescoed *Martyrdom of St Ignatius of Antioch* (*c.* 1716; *in situ*) over the nave arcade in S Clemente, Rome, remain within the academic tradition, with an emphasis on dramatic gesture and a theatrically Baroque treatment of space. The most important artistic enterprise of Clement XI's reign was the rebuilding and redecoration of the church of S Giovanni in Laterano, Rome, to which Ghezzi contributed a highly academic oval canvas of the *Prophet Micah* (1718; *in situ*) as one of a series of 12 paintings for the nave.

After the death of Pope Clement XI in 1721, the Falconieri family, especially Alessandro (made cardinal in 1724), became Ghezzi's chief patrons. In these years he also developed contacts with French culture, through the Académie de France at Rome, and through Cardinal Melchior de Polignac (1661–1742), French ambassador to the Holy See, who became his patron and friend. He collaborated with Giovanni Paolo Panini, who encouraged a new interest in the picturesque; together they designed the theatrical displays mounted by the Académie de France in Rome to celebrate the birth of the Dauphin in 1729.

For Alessandro Falconieri, Ghezzi painted decorative fresco cycles, in the castle of Torrimpietra (1712–32) and in the Villa Falconieri at Frascati (1724–34; *in situ*). At the castle, in 1725, he decorated the *salone* with *Benedict XIII's Visit to the Torrimpietra*, and the adjacent small chapel with the *Death of St Giuliana Falconieri*. Two further rooms were decorated with the *Falconieri Family Taking a Country Walk* and the *Flight into Egypt*. The perspective views and landscape backgrounds are by Francesco Ignazio Borgognone and suggest that the ideal happiness of villa life is reflected by an idyllic natural world. The figures are fashionably dressed, and for the most part drawn from life, conveying Ghezzi's interest in narrative and witty allusion. In 1725 Cardinal Falconieri restored the chapel of S Filippo Benizi in S Marcello, Rome, to which Ghezzi contributed an altarpiece, in an academic style, of *St Filippo Benizi Presenting SS Alessio Falconieri and Giuliana Falconieri to the Virgin*.

In the Villa Falconieri at Frascati landscape became a dominant theme. In the Stanza della Ringhiera, on the first floor, Ghezzi painted a panoramic *Landscape with Six Figures* in light and airy colours. In 1727 he decorated a room on the ground-floor with a series of wittily observed family portraits, showing the figures strolling or conversing in an illusionistic colonnade. An apartment on the first floor is decorated with scenes of outdoor life with small, almost caricatured figures. In the same period, and revealing his inclination for theatrical settings, Ghezzi painted the *Return of the Prodigal Son* (Minneapolis, MN, Inst. A.) and the *Lateran Council* (1725; Raleigh, NC Mus. A.).

The monumental *Miraculous Intervention of St Filippo Neri on behalf of Cardinal Orsini* (*c*. 1728; Matelica, S Filippo) was painted for Cardinal Orsini, by then Pope Benedict XIII. Though incorporating academic figures, it retains an emphasis on precise descriptive realism and employs bright and vivid colour. The *Death of St Clement* and *St Clement and the Lamb* (both Rome, Pin. Vaticana) were painted in 1728, and in 1731 Ghezzi painted *St Emygdius and other Saints from the Marches* for S Salvatore in Lauro, Rome (*in situ*). This is an unusual composition, in which a circle of peasant-like saints, floating in mid air, crowd around the standing St Emygdius, whose arm is raised in benediction. Ghezzi's last work on a religious theme is the highly naturalistic *St Giuliana Falconieri between SS Filippo Benizi and Alessio Falconieri*, commissioned by Pope Clement XII for S Maria dell'Orazione e Morte, Rome (1737; *in situ*).

Ghezzi's last great decorative project is the cycle of wall paintings in tempera of *Landscape Views*, painted for the gallery of the papal palace at Castelgandolfo (1747; *in situ*). Here the landscape is the principal theme and reflects Ghezzi's connections with such distinguished Jansenists as Cardinal Domenico Passionei, who believed that in nature the soul could recapture its lost purity. In his final years Ghezzi accepted no further commissions for history painting, being by then much involved in the study of the Antique. An exception, however, was the small, privately commissioned *Diogenes before Alexander* (1725–31; Rome, priv. col., see Rybko, 1990, pl. 73) for the antiquarian Baron von Stosch, who shared his scholarly interest in antiquity.

2. PORTRAIT PAINTING. Ghezzi painted portraits throughout his life, even after he had ceased to accept commissions for history and decorative paintings. His portraits were mainly of members of the Roman Curia, of men associated with the Accademia di S Luca or of distinguished members of the French community in Rome. They constitute his most representative work, and introduce a new directness and informality into portraiture. The paintings are comparatively small, executed in rapid and free brushstrokes and conveying the sitter's character and state of mind. The portraits before 1720, although based on the Roman models of Maratti and on the painterly works of Gaulli and Passeri, became increasingly spontaneous, intimate and intense. Examples include a *Self-portrait* (*c*. 1702; Florence, Uffizi; see fig. 1) and the elegant and intimate portrait of the Pope's nephew, *Carlo Albani* (*c*. 1705; Stuttgart, Staatsgal.), which demonstrates Ghezzi's delicate interpretation of character and his anticipation of the Rococo. The naturalistic and warmly coloured portrait of *Pope Clement XI* (Rome, Pal. Braschi) is datable to between 1708 and 1712. In the portrait of *Cardinal Annibale Albani* (*c*. 1712; Milan, priv. col., see Lo Bianco, *Pier Leone Ghezzi*, pl. 11), he moved towards more decorative and expressive contrasts of light and shade; the *Self-portrait* (Florence, Uffizi) of 1719 is a highly personal, lyrical work, in which Ghezzi emphasizes his rank of Cavaliere.

Other of Ghezzi's portraits from between 1710 and 1720 include the portraits of *Benedetto Falconcini* (Worcester, MA, A. Mus.) and *Pompeo Aldrovandi* (Bologna, Bib. U.), which are distinguished by their use of a close viewpoint and by their psychological power. From 1720 Ghezzi responded to the new Rococo style of Benedetto

1. Pier Leone Ghezzi: *Self-portrait*, oil on canvas, *c*. 1702 (Florence, Galleria degli Uffizi)

Luti, Sebastiano Conca and Panini. His works became less dramatic, and he created a quieter naturalism and more luminous tones. In this he was influenced by French portraitists in Rome, an influence particularly apparent in the portraits included in the frescoes for the Falconieri family in their villa at Frascati. The new transparency of his colour is particularly indebted to the portraits of Pierre Subleyras.

The *Self-portrait* (Florence, Uffizi) of 1725 is close in style to the works of William Hogarth. The *Portrait of a Lady as a Shepherdess* (Rome, Lemme priv. col., see Lo Bianco, *Pier Leone Ghezzi*, pl. 43), suggestive of Arcadian Rome, and the portrait of an *Augustinian Nun* (Toledo, OH, Mus. A.) date from the end of the 1720s. The elegant and romantic portrait of the sculptor *Edme Bouchardon* (Florence, Uffizi) dates from 1732, and in the 1740s Ghezzi painted the *Portrait of a Gentleman* (Rome, priv. col., see Lo Bianco, *Pier Leone Ghezzi*, pl. 60), which has an aura of French sophistication. The *Self-portrait* (1747; Rome, Accad. N. S Luca) is a noble and idealized work that retains none of his earlier interest in realism.

3. DRAWINGS. Ghezzi was the first professional caricaturist and produced thousands of drawings throughout his lifetime. Pio reported that in making 'portraits, exaggerated depictions of people and caricatures, he achieved the most original results' (Pio, p. 154). The earliest caricatures date from 1693 and were collected by the artist himself, after 1730, in several volumes, entitled *Mondo nuovo* (Rome, Vatican, Bib. Apostolica, MSS Ott. 3112–19). The intention of these caricatures was not sarcastic or subversive and entailed no moral judgement. He depicted the aristocrats, artists and churchmen who protected him and were his patrons, and who formed the society in which he won such success (see fig. 2; *see also* CARICATURE, fig. 1 and GRAND TOUR, fig. 1). His talent lay in his ability to capture the essential features of a sitter with a few rapid strokes of the pen and watercolour and, without malice, to create comic characters.

Also in the Biblioteca Apostolica, from the Guglielmi collection, are other caricatures from Ghezzi's early career, dating from *c.* 1702. These comprise portraits of members of Roman society, scenes from the Commedia Italiana and popular scenes, such as the *Capuchin Friar and Charming Lady* (*c.* 1702), though Ghezzi, rooted in a cultivated and aristocratic milieu, showed little interest in the world of the poor. The series entitled *Pulcinella* is particularly beautiful. Ghezzi's caricatures from after 1721 were executed in series with a documentary, rather than a comic, purpose, and are less successful than the lively and spontaneous creations of the artist's youth. Some of these later caricatures (1749–52) are bound into a volume (Rome, Gab. N. Stampe, Cod. 2606).

2. Pier Leone Ghezzi: *Baron von Stosch Receiving Roman Antiquaries*, pen and ink, 270×395 mm, 1725 (Vienna, Graphische Sammlung Albertina)

From 1720 Ghezzi also made many drawings after the Antique—cameos, coins and vases—bearing witness to the contemporary interest in archaeology, restoration and collecting. The most famous volumes of such drawings are: one in the British Museum, London, with drawings made for Passionei and Stosch between 1740 and 1750; the volumes in the Ottoboniano Foundation (Rome, Bib. Apostolica, MSS 3100–10); and the Manoscritto Lanciani (Rome, Bib. Ist. N. Archeol. & Stor. A.). He was also commissioned by Cardinal Annibale Albani in 1726 to make drawings for the *Pontificale romano* and for the *Vita del Papa Clement XI*. These are now known only through engravings executed in a highly finished, clear style, which emphasizes their didactic purpose. In addition to his drawings, Ghezzi also left a diary (Rome, Bib. Casanatense, MS. 3765), which survives only in part, and contains interesting notes on the life and society of Rome between 1731 and 1734.

BIBLIOGRAPHY

N. Pio: *Vite* (1724), ed. C. Enggass and R. Enggass (1977), pp. 154–5
L. Pascoli: *Vite* (1730–36), ii, pp. 205–8
L. Lanzi: *Storia pittorica della Italia*, 3 vols (Rome, 1795–6), ii, p. 239
P. Zani: *Enciclopedia metodica critico ragionata delle belle arti*, 28 vols (Parma, 1822), Pt. I, ix, p. 368
M. Loret: 'Pier Leone Ghezzi', *Capitolium*, xiii (1935), pp. 291–307
M. Abruzzese: 'Note su Pier Leone Ghezzi', *Commentari*, vi/4 (1955), pp. 303–8
A. M. Clark: 'Pierleone Ghezzi's Portraits', *Paragone*, xiv/165 (1963), pp. 11–21; also in *Studies in Roman 18th-century Painting* (Washington, 1981), pp. 11–19
C. Mancini: 'Le memorie del cav. Leone Ghezzi scritti da sè medesimo da gennaio 1731 a luglio 1734', *Palatino*, xii (1968), pp. 480–86
J. Gilmartin: 'The Paintings Commissioned by Pope Clement XI for the Basilica of S Clemente in Rome', *Burl. Mag.*, cxvi/855 (1974), pp. 306–12
D. Bodart: 'Pier Leone Ghezzi the Draftsman', *Prt Colr*, vii/31 (1976), pp. 12–31
E. Olszewski: 'The New World of Pier Leone Ghezzi', *A. J.* [New York], xliii (1983), pp. 325–30
A. Lo Bianco: 'La vita di Clemente XI Albani in venti incisioni da disegni di P. L. Ghezzi', *Committenze della famiglia Albani: Note sulla villa Albani Torlonia* (Rome, 1985), pp. 13–41
——: *Pier Leone Ghezzi* (Palermo, 1985) [with bibl1og.]
G. Sestieri: *La pittura del Settecento* (Turin, 1988), pp. 40–43
A. M. Rybko: 'Pier Leone Ghezzi', *La pittura in Italia: Il Settecento*, ed. G. Briganti, 2 vols (Milan, 1989, rev. 1990), ii, pp. 732–3 [see also essays by L. Barroero: i, pp. 388–9, 399; M. R. Valazzi: i, pp. 373–5]
A. Pampalone and A. L. Bianco: 'I pittori di paesaggio del Seicento a Roma', *Giuseppe e Pier Leone Ghezzi*, ed. V. Martinelli (Rome, 1990)
A. M. Rybko: 'La quadreria ad Albano del cardinal Benedetto Pamphilj', *L'arte per i papi e per i principi nella campagna romana: Grande pittura del '600 e del '700* (exh. cat., Rome, Pal. Venezia, 1990), ii, pp. 275–98

RAFFAELLA BENTIVOGLIO RAVASIO

Ghezzi, Biagio di Goro. See BIAGIO DI GORO GHEZZI.

Ghiață, Dumitru (*b* Colibași, 22 Sept 1888; *d* Bucharest, 3 July 1972). Romanian painter. He initially worked as a laboratory assistant at a medical institution; there he was encouraged in his painting by the scientist and collector Ion Cantacuzino. He also received encouragement in 1909–13 from the painter Arthur Verona whose studio he frequented. In 1913 he received a grant to study in Paris at the Académie Ranson and the Académie Delecluse, but after returning to Romania in 1914 he was obliged to continue in his old profession, although his paintings had already been shown at the Official Salon and elsewhere in Bucharest. His early paintings were mainly landscapes (e.g. *Landscape*, 1922; Bucharest, N. Mus. A.) and townscapes,

showing street corners with old houses; he avoided the picturesque, conveying instead an atmosphere of ruggedness and sobriety. After *c.* 1930 his paintings of peasants and of rural scenes (e.g. *Group of Housewives*, 1930; Sibiu, Brukenthal Mus.) have the same severe and austere line dominating them. The draughtsmanship is vigorous, the tones saturated and the impasto abundant. He also painted fairground scenes and still-lifes (e.g. *Still-life with Apples*, 1961; Bucharest, N. Mus. A.).

BIBLIOGRAPHY

A. E. Baconsky: *D. Ghiață* (Bucharest, 1967)
M. Preutu: *Dumitru Ghiață* (Bucharest, 1977)

ALINA-IOANA ȘERBU

Ghiberti. Italian family of artists. (1) Lorenzo Ghiberti was the leading bronze-caster in Florence in the early 15th century and the head of a highly influential workshop, which became a kind of academy of Florentine art. He was renowned both for his monumental bronze sculptures and for his development of a new type of pictorial low relief, which culminated in the panels of the Gates of Paradise for the Baptistery, Florence. About 1415 Lorenzo married Marsilia, the 16-year-old daughter of a woolcarder; their two sons, Tommaso Ghiberti (*b c.* 1417; *d* after 1455) and (2) Vittorio Ghiberti I both worked in Lorenzo's studio, although Tommaso is not mentioned in the documents after 1447. In 1443 Tommaso collaborated with another of Lorenzo's assistants on the execution of the tabernacle for Michelozzo's *Baptist* (Florence, Mus. Opera Duomo) on the silver altar of the Baptistery. In Lorenzo's last years Vittorio played an increasingly important role as his partner. Vittorio's son, (3) Buonaccorso Ghiberti, was an artist and engineer whose *zibaldone* (sketchbook-notebook) includes numerous architectural and technical plans. Buonaccorso's son Vittorio Ghiberti II (*b* Florence, 3 Sept 1501; *d* Ascoli Piceno, 1542) was active as a sculptor, painter and architect.

(1) Lorenzo (di Cione) Ghiberti (*b* Florence, 1378; *d* Florence, 1 Dec 1455). Bronze-caster, sculptor, goldsmith, draughtsman, architect and writer. He was the most celebrated bronze-caster and goldsmith in early 15th-century Florence, and his many-sided activity makes him the first great representative of the universal artist of the Renaissance. His richly decorative and elegant art, which reached its most brilliant expression in the Gates of Paradise (Florence, Baptistery), did not break dramatically with the tradition of Late Gothic, yet Ghiberti was undoubtedly one of the great creative personalities of early Renaissance art; no contemporary artist had so deep an influence on the art and sculpture of later times. His art, in which idealism and realism are fused, reflects the discovery of Classical art as truly as the realism of Donatello, and to label Ghiberti a traditionalist is to define the Renaissance art of the early 15th century one-sidedly in terms of increased realism. His competition relief of the *Sacrifice of Isaac* (1401; Florence, Bargello) determined the development of low relief not only in the 15th century but through the stylistic periods of Mannerism and Baroque, and up until the work of Rodin in the 19th century. Ghiberti's writings, *I commentarii*, which include his autobiography, established him as the first modern historian

of the fine arts, and bear witness to his ideal of humanistic education and culture. He was wealthier than most of his contemporary artists, and he owned considerable land and securities.

I. Life and work. II. Working methods and technique.

I. Life and work.

Lorenzo's father, Cione Paltami Ghiberti, was the son of a notary but seems to have been a somewhat dissolute character. In 1370 he married Mona Fiore, the daughter of a farm labourer, at Pelago, near Florence, but they soon separated and she went to live with Bartolo di Michele (*d* 1422), known as Bartoluccio, whom she married when Cione Paltami died (1406). Bartoluccio taught Lorenzo the goldsmith's art (Lorenzo became a master of the goldsmith's guild in 1409) and was evidently close to his stepson, who variously signed his name as Lorenzo di Bartolo, Lorenzo di Bartoluccio or Lorenzo di Bartolo Michele. Their close relationship is further demonstrated by their collaboration, until Bartolo's death, on the making of the bronze doors (now the north doors) of the Baptistery in Florence.

According to Ghiberti's autobiography, written towards the end of his life, he left Florence in 1400 in the company of an eminent (but unnamed) painter to enter the service of Lord Malatesta of Pesaro, for whom he and his companion painted a room. He returned to Florence on hearing of a competition that was to be held for the design of bronze doors for the Baptistery, and his success in this competition determined the course of his professional life. He is thus best known to posterity as a sculptor, most notably of the Baptistery doors, but his career also included work as an architect, goldsmith and painter, apart from his significant contribution as a writer.

1. Sculpture. 2. Architecture, painting and goldsmith's work. 3. Writings.

1. SCULPTURE.

(i) The north doors of the Baptistery, Florence, 1400–24. (ii) Bronzes for Orsanmichele, Florence and the Siena reliefs, 1413–27. (iii) The *Gates of Paradise* for the Baptistery, Florence, 1426–52. (iv) Other works, from 1425.

(i) The north doors of the Baptistery, Florence, 1400–24. In announcing a competition (winter 1400–01) to design doors for the Baptistery, the Arte di Calimala (Cloth-dealers' and refiners' guild) sought to fulfil a project that had been in abeyance since Andrea Pisano had completed a set of bronze doors (1336; *in situ*), at which time the intention had been to adorn the two remaining portals in a similar way (*see* FLORENCE, §IV, 1(ii)(c)). Ghiberti's autobiography gives a vivid account of the competition (*see also* COMPETITION, §II). Seven artists took part in the final stages: the conservative artists Simone da Colle (*fl c.* 1401), Niccolò di Luca Spinelli (1397–1477), Francesco di Valdambrino and Niccolò di Piero Lamberti and three protagonists of a newer style: Ghiberti, Brunelleschi and Jacopo della Quercia. The prescribed task was a relief depicting the *Sacrifice of Isaac*. Evidently the jury laid down precise specifications, since the connection of the sacrifice scene with a group of servants waiting at the foot of the mountain is not part of the iconographical tradition. Vasari supposed that the theme was chosen for its variety of motifs: single figures and groups, nude and clothed figures, an animal and, above all, a landscape setting. Of the reliefs submitted, only those of Ghiberti (*see* COMPETITION, fig. 4) and Brunelleschi have survived (Florence, Bargello). Both are bronze, partly gilded and measure 465×400 mm (including frame). Ghiberti's is the earliest work securely attributed to him. Artistically the two panels could not be more different. Brunelleschi divided the plaque into two tiers, one above the other, with the figures placed alongside or above one another in the pictorial field. The parts are linked together by the action, which embraces every detail of the scene. Ghiberti's version, on the other hand, gives an impression of unity and of objective calm. Unity is achieved by the incorporation of all parts of the design in a single landscape and by the treatment of space: the figure of the servant, below left, and the angel, upper right, which seems to fly in obliquely from the depth of the scene, form the two extremities of a diagonal that contains in itself the nucleus of a pictorial development of the relief ground. Ghiberti was less interested in a powerful representation of the event than in achieving aesthetic perfection in each detail and in the whole, an endeavour that resulted in some figures of great beauty, such as the naked Isaac or the servant turning away from the spectator, who was to inspire Verrocchio, two generations later, in his group of *Christ and St Thomas* (*c.* 1468–83; Florence, Orsanmichele). Yet in their relation to antiquity Brunelleschi's and Ghiberti's works are close. In neither case is ancient art a constituent feature of the design; rather, antique forms are used as 'quotations', for example in the variation on the *Spinario* (Rome, Mus. Conserv.) in the right-hand servant in Brunelleschi's work, or Ghiberti's Isaac, which probably derives from a Roman torso. It is profitless to compare the two reliefs from the point of view of 'modernity'. Brunelleschi's expressive realism and Ghiberti's idealized forms both represent basic attitudes that remained constant in the development of art in the early 15th century. The 'pictorial' treatment of a unified relief space was perhaps the more modern solution at the time and was to develop into the more markedly pictorial reliefs of the *Gates of Paradise*. The jury were doubtless also influenced by Ghiberti's technical superiority. His relief, unlike that of Brunelleschi, was cast in one piece, apart perhaps from the figure of Isaac, which may have been cast separately; he therefore required less material and incurred less expense. The 'palm of victory' was awarded to him 'by all the experts, and by all those who had competed with me'.

It is not known when, or why, the decision was taken to substitute New for Old Testament themes. A source of 1402 or 1403 (Krautheimer and Krautheimer-Hess, 1956, Document 33), which cannot be dated more precisely, records this change of programme, and that the 'story of Abraham' (the competition relief) was to be gilded and kept for a later door. The contract between the Arte di Calimala and Ghiberti for the execution of the doors was signed on 25 November 1403. As Ghiberti did not keep to the original terms, by which he was to deliver three reliefs a year for a fee of 200 gold florins, a stricter agreement was drawn up on 1 June 1407: he was to accept no other commissions without the consent of the consuls

of the Arte di Calimala, and must work on the door full-time. On 19 April 1424 the doors were completed (see fig. 1) and set up in the main portal of the Baptistery, opposite the cathedral façade, replacing Andrea Pisano's doors, which were removed to the west portal.

The plan of the doors was similar to that of Pisano's, consisting of 28 reliefs in seven horizontal rows of four, each framed in a diamond-shaped quatrefoil. The events read from left to right, extending over both wings of the door, and from the bottom upwards. The two bottom rows represent the Latin fathers of the church (*St Augustine*, *St Jerome*, *St Gregory* and *St Ambrose*) and seated figures of the *Four Evangelists*. The third row begins the narrative of the *Life of Christ* from the *Annunciation* to *Pentecost*, in an order different from that of Pisano's portal. The panels are divided by latticework enriched by varied floral ornament and by individual medallion heads. As in Andrea Pisano's portal, the figures, architecture and landscape details are gilded and gleam against the dark background. Ghiberti signed his work OPUS LAURENTII FLORENTINI above the scenes of the *Nativity* and the *Adoration of the Magi*; the head above-left of the signature may be presumed to be a self-portrait, that above-right to be (2) Vittorio Ghiberti I.

Ghiberti worked on the doors for over 20 years, and the reliefs illustrate the evolution of his style. Initially he worked in Pisano's manner, with the figures powerfully modelled yet firmly linked to the background, and the relief ground functioning as a neutral closing-off surface (e.g. the *Annunciation*). In line, more or less, with the chronology of the narrative, he progressively departed from this practice, the figures becoming less attached to the background and appearing to be almost in the round (the *Temptation in the Wilderness*, *Christ Driving the Money-changers from the Temple*, the *Flagellation*, *Christ before Pilate*). At the same time there is a developing sense of the organic structure of bodies in motion. The relief space is extended towards the spectator and the ground gradually put to 'pictorial' effect. Increasingly more delicate gradations of the height of the relief, and perspectival constructions, make the landscape or architecture seem to extend into the background far beyond the limit set by the quatrefoil framing. The ground is transformed from a closing-off surface into a 'picture' of optically indefinite depth (*Christ among the Doctors*, the *Baptism*, the *Entry into Jerusalem*, the *Capture*). The consequences of this development are seen even in apparently trivial details, such as the changing design of the brackets beneath the scenes that have an architectural setting. While in the *Annunciation* Ghiberti started out with the clearly defined architectonic form of Pisano's brackets, gradually he filled the underside of the front stage with plants and rocks so that the extent of the projection can no longer be seen. In general the reliefs that were probably executed latest, including *Christ before Pilate* and *Pentecost*, show a tension between high and low relief that almost transcends the quatrefoil framework. If, despite stylistic variation, the door as a whole makes a comparatively unified impression, there are probably two main reasons for this: first, the highly decorative quatrefoil frames did not permit further development of the background, and, second, Ghiberti deliberately refrained from making too radical a break with his initial concept of the relief so as to avoid a disturbing lack of harmony. Between 1423 and 1426 Ghiberti worked on the bronze jambs and lintel that frame the door; these are decorated with a varied array of flowers, fruits and tiny animals. The reliefs of the inner jamb introduce a new type of very shallow relief and an elegant stylization of natural forms.

(ii) Bronzes for Orsanmichele and the Siena reliefs, 1413–27. While work was proceeding on the bronze doors, Ghiberti undertook various other commissions. The years between 1413 and 1427 were years of rapidly growing fame and prosperity. In 1423 he was enrolled in the painters' guild, and on 20 December 1426 in the stone masons' guild. Some of his work took him outside Florence; he went to Siena, and in 1424 to Venice to avoid the plague that had broken out in Florence. In *I commentarii* he mentioned a visit to Rome, which may have taken place between 1425 and 1430.

In 1413 Ghiberti was working on an over life-size bronze statue of *St John the Baptist* for the Arte di Calimala, to be placed on the east side of the guild hall of Orsanmichele, Florence (*in situ*). The casting began on 1 December 1414. The signature on the hem of the saint's cloak reads LAURENTIUS GHIBERTUS MCCCCXIV, the date probably referring to the completion of the model. Documents confirm that the niche architecture is entirely by Albizzo di Piero (*fl* 1411). This statue is of great historical

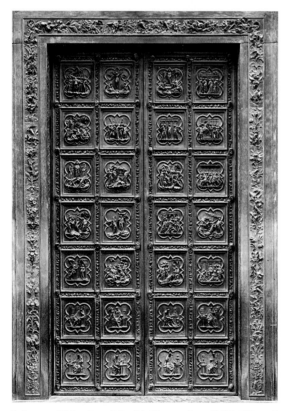

1. Lorenzo Ghiberti: partially gilded bronze doors (1403–24), north side of the Baptistery, Florence

importance. It is the first monumental bronze figure of modern times and is thus an extraordinary technical achievement. Above all, it represents a stage of the Late Gothic style that is without parallel in early 15th-century Florentine sculpture. The saint is enveloped in voluminous swirling drapery with deep folds and furrows. The multiple curves and undulations, frequently moving counter to one another along the axis, give the figure its prevailing line and produce a graceful, almost dancing, effect that is in delightful contrast to its material weight. The heritage of Late Gothic, then in its last stages, is unmistakable; some features are reminiscent of types of sculpture, such as the 'Beautiful Madonnas', from north of the Alps. However, there is a clear departure from the medieval type of draped figure. Far from neglecting the articulation of the body underneath the ample robe, Ghiberti succeeded in creating an impression of the body and its clothing as two largely independent layers of equal importance. The nearest comparable approach to the treatment of figures is to be found in his reliefs of the *Adoration of the Magi* and *Christ among the Doctors* on the doors of the Baptistery, both probably executed at a fairly early stage. (This would confirm the evidence that work on the bronze doors was slow to start.)

By *c.* 1415 Ghiberti was recognized as the best Florentine sculptor in bronze. On 21 July 1419 the wealthy Arte di Zecca (Money-changers' guild), responsible for the west side of Orsanmichele, commissioned from him an over life-size bronze statue of *St Matthew* (see fig. 2). A detailed contract was drawn up on 26 August and gave Ghiberti the permission (which he did not use) to cast the figure in two parts, the head and the remainder. The statue was to be about the same size as that of *St John the Baptist* and to be completed within three years. The date *1420* on the hem of the saint's cloak is probably that of the preparation of the model; Ghiberti received his final payment on 6 March 1423. The design of the niche in which the statue stands can also be regarded as Ghiberti's work: in a contract dated 2 May 1422 the masons Jacopo di Corso (*b c.* 1382) and Giovanni di Niccolò were directed to execute the niche in accordance with Ghiberti's drawing and instructions. Although some basic motifs are repeated from the statue of *St John*—a wide horizontal fold in front of the hip, a long furrow extending from the left hip to the right foot, cascades of drapery by the leg that takes the weight, and the modelling of the hair—nonetheless *St Matthew*, with its approach to antique contrapposto, represents a new stage in Ghiberti's development. The garment is no longer an equal partner of the body; it is less voluminous and serves to articulate the saint's pose and attitude. Compared to the strict frontality of St John, St Matthew's body is slightly turned on its axis, giving an effect of movement. Here Ghiberti was making use of impressions from Donatello (*St Mark*, 1411–13) and Nanni di Banco (*Four Crowned Saints*, *c.* 1414; both Florence, Orsanmichele). The niche is the only piece of monumental architecture known to be by Ghiberti. Its shallowness was dictated by the architecture of the church (the steps leading to the upper storey are located inside the corner pillar), but presumably Ghiberti's design was hardly affected by this limitation. The antique composite

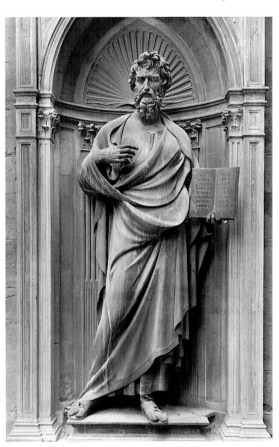

2. Lorenzo Ghiberti: *St Matthew*, bronze, over life-size, 1419–22, west side of Orsanmichele, Florence

capitals articulate the figure's shoulders; the cornice between the vertical and vaulted parts of the niche marks the junction of the head and body; the fluted pilasters at the back confirm the lateral contours of the body; the shell-like ornament of the vaulting may be taken as suggesting a halo. In contrast to the earlier statues at Orsanmichele, the figure and architecture are closely related to each other; the niche, however, does not enclose the statue but acts rather as a frame, its flatness contrasting with the three-dimensional modelling of the figure. The same tension is present between high and low relief as in the later panels of the bronze doors of the Baptistery. The statuesque appearance of *St Matthew* can also be compared with figures in what are thought to be late reliefs in the bronze doors: the figure seen from behind in *Christ before Pilate* or that of Christ in the *Road to Calvary*.

Two reliefs for the font of the Baptistery in Siena (*St John the Baptist before Herod* and the *Baptism*, fire-gilded bronze, each 790×790 mm; *in situ*; see fig. 3) suggest the development of Ghiberti's art. In spite of ample documentary evidence, the complex history of the commission presents some difficulties. In June or July 1416 Ghiberti was paid the cost of travelling to Siena, where he advised on the erection of the font. He visited Siena twice more, and on 21 May 1417 was commissioned to execute two bronze reliefs within 10 to 20 months. He did not keep to

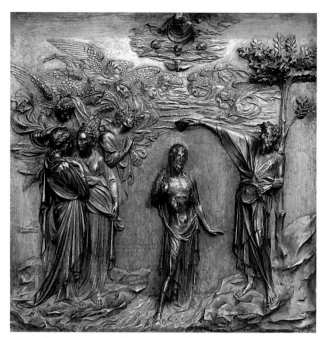

3. Lorenzo Ghiberti: *Baptism*, fire-gilded bronze relief for a font, 790×790 mm, *c.* 1416–27 (Siena, Baptistery)

the *Baptism*, on the other hand, Ghiberti accomplished the harmonization of the picture planes and the gradation of modelling that were characteristic of his latest reliefs.

(iii) The 'Gates of Paradise' for the Baptistery, Florence, c. 1426–52. Ghiberti was now at the peak of his fame, and he received the most important commission of his career. Evidently impressed by the doors he had just completed (2 Jan 1425), the Arte di Calimala entrusted him with a commission for a third pair of doors for the Baptistery (see fig. 4). In the same year Leonardo Bruni suggested a scheme (Krautheimer and Krautheimer-Hess, 1956, Document 52), similar to that of the two older doors, for twenty-eight reliefs in seven rows of four each, depicting eight prophets and twenty Old Testament episodes. It may be supposed that the reliefs were intended to be enclosed within quatrefoils and that the competition relief of the *Sacrifice of Isaac* (1401) was to be incorporated. However, this plan was abandoned—it is not known why or when, nor at whose direction it was changed. As finally executed, the door is divided into ten large, nearly square panels, each illustrating a number of episodes and set within borders richly decorated with small figures and heads. The outer frame is ornamented with leaves, birds and animals. The programme must have been decided on soon after the commission was awarded, as the ten scenes were already rough cast by 4 April 1436 (or possibly 1437). Ghiberti wrote in his autobiography: 'I was given a free hand to execute [the doors] in whatever way I thought best.' This was presumably more than mere rhetoric.

this timetable, and the reliefs were still unfinished in 1425. A document of 16 April 1425 states that he was working personally on one of them, while the other was in the hands of Giuliano di ser Andrea (*fl* 1403–27). Only on 15 November 1427 was the cost of sending the two bronze reliefs to Siena refunded. The Siena reliefs differ from the later panels of the bronze door in the strong emphasis placed on the background, whether it represents an interior space as in *St John the Baptist before Herod*, or a heavenly scene with clouds and angels as in the *Baptism*. But there are also notable differences between the two Siena reliefs, which foreshadow a decisive turn in Ghiberti's artistic development after 1425. Whereas the scene depicting St John and Herod is dominated by the three-dimensional figures in the foreground, in the *Baptism* only the four principal figures are in high relief, the rest of the relief being shallow. Accordingly the actual depth of the space in front of the figures in the latter is not great, and appears even less because of its steepness. We may suppose that the model for the relief of *St John before Herod* is contemporary with the last panels of the bronze doors, while the *Baptism* dates from 1426–7 at the earliest. In addition, it seems probable that different hands were involved in the execution of the two reliefs. Despite its delicacy of detail, *St John the Baptist before Herod* is not of the same quality as the *Baptism* or the late panels of the bronze doors. The abrupt termination of the architecture on the right gives an unbalanced effect; the figures are unusually elongated; the individual forms of the palace are more delicate than in any other background architecture by Ghiberti; and the slight perspectival distortions are also unexpected, in comparison with the exemplary relief of *Christ before Pilate* on the bronze doors. This could be a largely independent work by Giuliano di ser Andrea. In

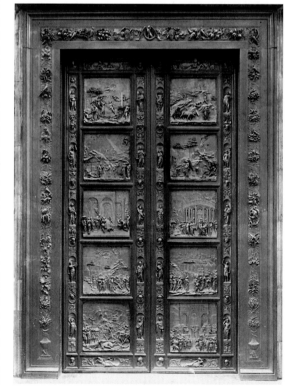

4. Lorenzo Ghiberti: *Gates of Paradise* (*c.* 1426–52), gilded bronze, Baptistery, Florence

When he received the commission, Ghiberti was working on the two reliefs for the font at Siena. Evidently he used these to convince his patrons that a larger format, free from the constraint of the decorative framework, was better suited to narrative scenes. It is certainly not by chance that the dimensions of the Siena reliefs are almost exactly the same as those of the *Gates of Paradise* or that gilt covers the whole surface of these panels. There are signs of a new self-confidence on the artist's part, as he began to free himself from craft constraints, and of a corresponding change in the relationship between artist and patron. The ten reliefs were completed by 7 August 1447 and the following years devoted to the framing; the gilding was completed on 16 June 1452. On 13 July 1452 the consuls of the Arte di Calimala decided that the new doors would replace Ghiberti's first set in the main portal of the Baptistery, and the earlier doors would be reinstalled on the northern side. The new doors were to adorn the main entrance 'stante la sua bellezza'. This is the first recorded occasion on which 'beauty' is referred to as a purely aesthetic category, independent of the subject of a work. That two portals adorned with eminently suitable themes for a Baptistery (the *Life of St John the Baptist* on those by Pisano) or for the main entrance to any church (the *Life of Christ*) should give place to a set of Old Testament scenes is remarkable, and indicates that artistic merit was beginning to be rated higher than content. It also provides evidence to support the conjecture that the artistic perfection of Ghiberti's competition relief had swayed the jury's decision in 1401. This second set of bronze doors has become known in art history as the *Gates of Paradise*. Vasari reported that Michelangelo thought the door worthy to adorn the entrance to Paradise, but the name may have referred to the relief of *Genesis*, which was especially admired, judging by the frequency with which its individual motifs were borrowed in subsequent painting. A third possible explanation for the name is that there may formerly have been a parvis between the cathedral and the Baptistery.

At first sight, Ghiberti's two sets of doors seem, both as a whole and in detail, to represent opposed functions: the older door gives the impression of shutting out, while the *Gates of Paradise*, in which the small quatrefoil reliefs have given place to large panels resembling spacious pictures, rather suggest an entrance through the wall. But it may be doubted that there was in fact a break in Ghiberti's artistic development, as is so often stated; rather that the new conception of the *Gates of Paradise* was a logical evolution of the old. *Christ before Pilate* in the old door and *Jacob and Esau* in the new have many similarities. In both cases we find the illusionistic treatment of the ground as a space extending far into the picture; the tension between high and low relief, with many gradations; the almost three-dimensional handling of the foreground, and the mobility of the figures. Admittedly, the new format of the reliefs provided an opportunity for the flowering of these tendencies. The new problems of design that confronted Ghiberti in the *Gates of Paradise* were chiefly those of uniting several scenes within ordered compositions and organizing the relief space in continuously connected layers. Here, too, Ghiberti's style evolves continuously throughout the sequence of panels, from *Jacob and Esau*

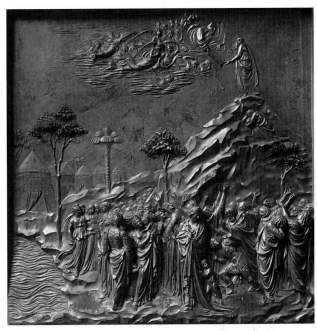

5. Lorenzo Ghiberti: *Moses on Mt Sinai*, detail from the Gates of Paradise (*c.* 1426–52), gilded bronze, Baptistery, Florence

and *Cain and Abel*, through *Genesis* and *Moses on Mt Sinai* (see fig. 5), to *David and Goliath* and *Solomon and the Queen of Sheba*. The front stage is increasingly reduced, while the background receives increasing emphasis, with a growing preference for shallow relief. Correspondingly, there is a slight diminution of scale in the foreground figures. This combination of sculptural and pictorial techniques tends to resolve the tension between high and low relief and thus unify the ensemble. The medallion heads in the borders marking the corners of the reliefs show more individuality than those in the older door and reflect Ghiberti's interest in Classical art. The statuettes of Old Testament figures beside the reliefs belong to the incunabula of the genre of small bronzes. The floral ornamentation reveals a direct perception of nature that had a far-reaching effect on 15th-century sculpture and painting. With justified pride, Ghiberti added after his signature above the second row of reliefs: MIRA ARTE FABRICATUM. The two medallion heads on the central framing strip at the level of this inscription are, on the left, Ghiberti himself (see fig. 6) and, on the right, his son Vittorio.

(iv) Other works, from 1425. During the execution of the *Gates of Paradise*, Ghiberti received a number of prestigious commissions. On 2 April 1425 the Arte di Lana (Wool guild) decided to replace their marble statue of *St Stephen* at Orsanmichele, which dated from 1340, with a bronze figure and a new tabernacle; clearly they did not wish to be outdone by the rich guilds of the Calimala and Zecca. Ghiberti received the commission in that year, and the statue, originally partly gilded, remains *in situ* on the west side of Orsanmichele. The model for the statue was completed on 5 August 1427, and the whole work, including gilding, on 1 February 1429. Critics have generally been reserved in their praise of *St Stephen*. It is true

6. Lorenzo Ghiberti: self-portrait on the *Gates of Paradise* (c. 1426–52), gilded bronze, Baptistery, Florence

that the statue does not represent any further progress in Ghiberti's move towards 'modern' contrapposto, begun in his *St Matthew*. As in the statue of *St John the Baptist*, the pose and movement are chiefly expressed in the soft undulations of the voluminous garment. However, the unity of composition is much more emphasized than in the statue of *St John*, and the sensitive modelling of the head, perhaps influenced by that of Donatello's *St Louis* (Florence, Mus. Opera Santa Croce), is unsurpassed by any other of Ghiberti's works.

Between 1425 and 1427 Ghiberti executed the bronze tomb slab of *Leonardo Dati* (*d* 1425), general of the Dominican Order (Florence, S Maria Novella), the head of which may have been worked from a death-mask. The bronze shrine of *SS Protus, Hyacinth and Nemesius* (Florence, Bargello), commissioned by Cosimo and Lorenzo de' Medici, was installed in S Maria degli Angeli in 1428. It was broken up during the Napoleonic period and subsequently reassembled, except for the base (an inscription on which was recorded by Vasari), which remains untraced. The front, with two hovering angels supporting a wreathed medallion, combines high and low relief in the style of the early parts of the *Gates of Paradise*. The composition may be derived from antique sarcophagi. The most important of the commissions executed by Ghiberti during his work on the *Gates of Paradise* was the bronze shrine of *St Zenobius* (Florence Cathedral), commissioned by the Arte di Lana (*see also* COMPETITION, §II). The contract of March 1432 specified the precise size, materials

and weight, and laid down that the work should be finished by April 1435. In fact it took a whole decade. Bronze for the casting of two reliefs was paid for on 22 October 1434. It is unlikely that the models for the side panels were completed by then, as a new contract of April 1439 refers to those panels as having only just been begun. Ghiberti received the final payment for the work on 30 August 1442. The scene of the *Miracle of the Servant* (left narrow side) was probably completed first. As in the later panels of the *Gates of Paradise*, the front stage is minimal and slopes rapidly upwards to the vertical relief plane. The figures are in low relief; the ensemble is highly compact. These features appear even more strongly on the opposite relief, showing the *Miracle of the Ox-cart*. The final stage of the development is seen in the reliefs on the two long sides. The plaque on the side that is away from the spectator depicts *Angels Bearing a Wreath*, with the groups of angels shown in varying degrees of relief, from high to very shallow. The tension between high and low relief that distinguished the shrine of 1428 is here resolved. The main relief, on the side that faces the spectator, shows the *Miracle of the Strozzi Boy*, and in this the relief projects immediately from the front edge. Even the nearest rows of figures are tied in with the ground to a greater extent than in the late reliefs of the *Gates of Paradise*. The composition combines lively freedom in individual figures with the strict regularity that characterizes Ghiberti's late style. This brief sketch of Ghiberti's relief technique is also borne out by the gilt-bronze shutter showing *God the Father*, cast in 1450 (probably with much workshop assistance) for Bernardo Rossellino's marble tabernacle (Florence, S Egidio). A large bronze relief of the *Assumption of the Virgin* (Sant' Angelo in Vado, S Maria dei Servi), occasionally attributed to Ghiberti, is now regarded as the work, under his influence, of a master from the Marches.

In the late 1440s Ghiberti gradually retired from business. Tax returns from 1427, 1431, 1433, 1442 and 1447 show him as owning houses and land to an increasing extent, and he made a will in November 1455. In 1442 he acquired a manor house, and in 1452 the Calimala paid him and Vittorio for the *Gates of Paradise* by giving them the workshop and house where the doors had been cast.

2. ARCHITECTURE, PAINTING AND GOLDSMITH'S WORK. Knowledge of Ghiberti's work as an architect is patchy. In 1406–8 he was already advising on the construction of Florence Cathedral. A document of September 1418 indicates that he employed four assistants to produce a model for the dome, which was submitted on 13 December together with models by other masters. On 11 August and 3 October 1419 he was paid for preparing models of the dome, one being made of small bricks. The final competition between Brunelleschi and Ghiberti for the construction of the dome evidently took place at the end of March or beginning of April 1420. On 16 April of that year Ghiberti, Brunelleschi and the master mason Battista d'Antonio (*fl* 1420–39) were appointed to supervise the construction, each being paid 3 gold florins a month. On 24 April 1420 Ghiberti and Brunelleschi received another 10 gold florins for a model of the dome, apparently their joint work. In the following years Ghiberti remained associated with the work, on the same monthly

salary. From 4 April 1426 onwards Brunelleschi received 100 gold florins a year for full-time work on the dome, while Ghiberti's fee for part-time work remained at 36 gold florins a year. The last payment to Ghiberti in this connection was not made until 30 June 1436. What part he had in its final design and technical construction is not clear, though the relatively large amount paid to him over 16 years suggests that it was more than a merely advisory function. He himself writes in his autobiography: 'And especially in the building of the dome Filippo [Brunelleschi] and I were competitors for 18 years at the same salary; thus we executed the said dome.' On 14 August 1436, in competition with Brunelleschi and others, Ghiberti submitted a model for a lantern for the dome; nothing is known of its design. Other attributions remain hypothetical: the only indications we have of his architectural style are the niche for the statue of *St Matthew* at Orsanmichele, which employs a composite style of antique and Late Gothic elements, the tabernacle (Florence, Mus. S Marco) designed in 1432 for an altar for the Arte di Linaiuoli (Linen-workers' guild), and the architectural settings of the reliefs. On this basis he may, however, be considered the probable designer of the portal of the Strozzi Chapel (1423–4) in Santa Trinita, Florence, with its slender fluted shafts decorated with foliate garlands and of the façade of the sacristy (1417–24) of that church. This is all the more likely since, on 4 January 1420, Ghiberti was appointed a supervisor of the wood-carving work in the Strozzi Chapel, so that there is evidence of his connection with the church.

Ghiberti's ascertainable work as a painter is confined to the design of important stained-glass windows: he supplied (probably in 1404) a cartoon of the *Assumption* for the central rose window in the cathedral façade, and in 1412 designs for the flanking windows, representing *St Stephen* and *St Lawrence*. On 4 April 1424 he was paid for two designs for windows in the first bay of the cathedral, representing *Joachim Expelled from the Temple* and the *Death of the Virgin*. In October 1436 he received a final payment for designs for four windows in the St Zenobius chapel of the cathedral choir. Finally, he designed three of the round windows in the drum of the cathedral dome: on 7 December 1443 he was paid for the *Presentation in the Temple* and on 11 September received final payments for *Christ on the Mount of Olives* and the *Ascension*. Judging by its stylistic affinity to these windows, and also according to Vasari, the façade window of the *Crucifixion* in Santa Croce, Florence, was also designed by Ghiberti, probably *c*. 1450.

There is no evidence of Ghiberti's work as a goldsmith, beyond what is stated in his autobiography and referred to in documents. In 1417 he supplied a design for two silver candlesticks for Orsanmichele; in 1419 he designed a mitre for Pope Martin V during the latter's stay in Florence (both untraced). In 1428 he set, for Cosimo de' Medici, an antique cornelian engraved with the *Flaying of Marsyas*, and in ?1441 he made a mitre (untraced) for Pope Eugenius IV.

Ghiberti's work has hardly been touched by problems of attribution. There has been dispute as to the authorship of a drawing comprising studies for a *Flagellation* (Vienna, Albertina). It is probably not a sketch for the relief on the first set of bronze doors, but a late 15th-century work. The statuettes of *St Andrew* and *St Francis* on a reliquary containing St Andrew's arm (Città di Castello, Pin. Com.) are derived, certainly, from figures on the first bronze doors but are hardly by Ghiberti's own hand. It may be doubted whether the angels on the silver-gilt reliquary of St James (Pistoia, Mus. Cap.) are from Ghiberti's workshop.

3. WRITINGS. Ghiberti's *I commentarii*, which are divided into three books, were begun *c*. 1447 and remained incomplete at his death. They are outstanding among 15th-century writings on art, both in their ambition to discuss the development of art from antiquity to modern times and in their humanistic belief in the supremacy of ancient art. Book 1 deals with the art of Classical antiquity, drawing widely on the writings of Vitruvius and Pliny. It stresses the perfection of ancient art and the importance to the sculptor of a knowledge of both the liberal arts and theoretical sciences. Ghiberti admired ancient art, as Pliny had done, for its naturalism, and there is a long section, derived from Pliny, on ancient bronze statuary and its origins in clay modelling. Book 2, the most fascinating section, contains a history of modern art, from its death in the Dark Ages to its resurrection by Giotto, who 'abandoned the crudeness of the Greeks and rose to be the most excellent painter in Etruria' (*see* GIOTTO, §I, 2(ii)). Ghiberti then outlined the history of Florentine and Sienese painting and sculpture in the 13th and 14th centuries, with a new emphasis on style rather than anecdote. He particularly praised Sienese painters, above all Ambrogio Lorenzetti, who had created naturalistic settings, and to whom his own art was indebted. The book culminates in an account of his life, the earliest example of an artist's autobiography, which is primarily a chronological list of his works. The third book is a discussion of the sciences necessary to a sculptor, including optics, anatomy and, inspired by Vitruvius, the theory of human proportion.

II. Working methods and technique.

Ghiberti had superb technical gifts, and his workshop became the training-ground for a generation of Florentine artists. The two sets of bronze doors for the Baptistery in Florence, the north doors and the *Gates of Paradise*, were cast by the lost-wax process. For the reliefs of the north doors, Ghiberti made separate wax models for the figures and for the ground plaque with setting. The frame, and the 28 reliefs, were cast separately; the reliefs are therefore hollow sheets, although some of the most three-dimensional figures, such as the Christ in the *Crucifixion*, were cast separately. There followed the longer process of chasing the reliefs. Ghiberti's second contract, of 1407, stipulates that he was himself to execute the wax models and to carry out the chasing of the cast 'particularly on those parts which require the greatest perfection, like hair, nudes and so forth'. That this, his first main work, took proportionately much longer to complete than had the bronze doors of Andrea Pisano, has often been explained by Ghiberti's meticulousness, or by his simultaneously working on other prestigious commissions. However,

Bruno Bearzi's technical investigations since World War II have disproved these suppositions. Andrea Pisano's reliefs were cast by experts from Venice, a city where the classical tradition of bronze-casting remained alive; their rough casts were of high quality, and the chasing therefore relatively easy. In the early 15th century the situation was different, and Ghiberti had to rediscover the lost-wax process. The rough casts of his reliefs were coarse, and the chasing and polishing were lengthy and laborious; Bearzi actually speaks in this connection of 'sculpture in bronze'. In the later panels Ghiberti began to use a shallower relief, and Donatello's concept of *rilievo schiacciato* was probably inspired by this. In 1423 the decision was taken to fire-gild the doors (Poggi, 1948). The gilding highlights the heads, figures and settings, creating a rich contrast with the dark bronze of the background. For the *Gates of Paradise* the panels were cast in one piece and fire-gilded; but here the gilding, as in the Siena reliefs, covers the entire surface, creating a delicate play of light and shade. Again much of the effect of the doors depends on the high quality of the chasing, which occupied 27 years, and which is particularly evident in *Cain and Abel* and *Isaac*. In these panels, too, the technical device of shallow relief finds its richest expression.

St John the Baptist on the Orsanmichele, the first monumental bronze figure of modern times, was an extraordinary technical achievement. The figure was cast as a single piece, and the difficulties of casting necessitated laborious polishing and chasing, including incisions in the drapery up to a depth of 50 mm. The statue is distinguished by the extraordinary detail and decorative beauty of the chasing of the hair, beard and goatskin. The casting of the over life-size bronze statue of *St Matthew* was only partly successful, and certain parts had to be recast. There is no evidence as to which these were, nor can it be discerned from the figure; conceivably it was the open book of the Gospel and the right hand, held away from the body. A coloured drawing (Paris, Louvre) associated with the third Orsanmichele statue, that of *St Stephen*, was probably made in the workshop, at Ghiberti's direction, to give the patron an idea of the work. The intention, shown in the drawing, to introduce antique elements into the Late Gothic niche, was not carried out.

Documentary sources have revealed much evidence about Ghiberti's studio, the progress of his works, his assistants and business practices. The initial contract for the north door of the Baptistery stipulated that he was to work with Bartolo di Michele and might employ other masters if he wished. By 1407, when the second, more stringent, contract was drawn up, Ghiberti already had a workshop of considerable size; a document, not precisely dated, in the Spoglie Strozziane (extracts from the papers of the Arte di Calimala, transcribed in Krautheimer and Krautheimer-Hess) lists 11 assistants, including Giuliano di ser Andrea and Donatello. A second document, of after 1407, gives 25 names, although we must assume that changes were frequent. Among others, Bernardo Ciuffagni and Paolo Uccello worked in Ghiberti's shop for a time (*c.* 1420), as did Michelozzo di Bartolomeo. Michelozzo is also mentioned in 1422, in connection with the casting of the *St Matthew*. Many assistants are also listed during the period when the *Gates of Paradise* were being made. In 1437, in addition to Michelozzo, there is Ghiberti's son, Vittorio, and three unnamed goldsmiths. In 1443 Ghiberti's son, Tommaso, was active in his father's workshop. On 24 January 1444 Benozzo Gozzoli was engaged to work on the new door. In the late years Vittorio played an increasingly dominant role.

The influence of this workshop, which brought together goldsmiths, sculptors, painters and bronze-casters, was widespread, and Ghiberti's art was further disseminated by the help he himself described giving to 'many painters, sculptors and stonecarvers' for whom he 'made very many models in wax and clay'. In short, although Ghiberti's proud boast that 'Few works of importance were made in our city that were not designed or devised by my hand' contains an element of rhetoric, it is also a just claim to a creative versatility that sets him apart from all other artists of his generation.

WRITINGS

J. von Schlosser, ed.: *Lorenzo Ghibertis Denkwürdigkeiten (I commentarii)*, 2 vols (Berlin, 1912)

BIBLIOGRAPHY

SOURCES

G. Vasari: *Vite* (1550, rev. 2/1568); ed. G. Milanesi (1878–85)
G. Guasti: *Santa Maria del Fiore* (Florence, 1887)
A. Doren: *Das Aktenbuch für Ghibertis Matthäusstatue an Or San Michele zu Florenz*, It. Forsch. Ksthist. Inst. I (Berlin, 1906)
G. Poggi: *Il Duomo di Firenze*, It. Forsch. Ksthist. Inst. II (Berlin, 1909)

MONOGRAPHS AND EXHIBITION CATALOGUES

L. Planiscig: *Lorenzo Ghiberti* (Vienna, 1940, rev. Florence, 1949)
J. von Schlosser: *Leben und Meinungen des florentinischen Bildners Lorenzo Ghiberti* (Basle, 1941)
L. Goldscheider: *Ghiberti* (London, 1949)
R. Krautheimer and T. Krautheimer-Hess: *Lorenzo Ghiberti* (Princeton, 1956, rev. 3/1982)
G. Brunetti: *Ghiberti* (Florence, 1966)
G. Marchini: *Ghiberti architetto* (Florence, 1978)
M. Wundram: 'Lorenzo Ghiberti', *Neue Zurich. Ztg*, ccxxxix (1978)
Lorenzo Ghiberti: Materia e ragionamenti (exh. cat., Florence, Accad. and Mus. S Marco, 1978)

SPECIALIST STUDIES
Specific works

F. Gregori and T. Patch: *La porta principale del Battistero di Firenze* (Florence, 1773)
A. Schmarsow: 'Ghibertis Kompositionsgesetze an der Nordtür des Florentiner Baptisteriums', *Abh. Philol.-Hist. Kl. Kön. Sächs. Ges. Wiss.*, xviii/4 (1879)
H. Kauffmann: 'Eine Ghiberti-Zeichnung im Louvre', *Jb. Kön.-Preuss. Kstsamml.*, I (1929), pp. 1–10
W. Lotz: *Der Taufbrunnen des Baptisteriums zu Siena* (Berlin, 1948)
G. Poggi: 'La ripulitura delle porte del Battistero fiorentino', *Boll. A.*, xxxiii (1948), pp. 244–57
B. Albrecht: *Die erste Tür Lorenzo Ghibertis am Florentiner Baptisterium* (diss., U. Heidelberg, 1950)
R. Salvini: *Lorenzo Ghiberti: Le Porte del Paradiso* (Milan, 1956)
M. Wundram: *Ghiberti-Paradiestür* (Stuttgart, 1963)
G. von Österreich: *Die Rundfenster des Lorenzo Ghiberti* (diss., U. Fribourg, 1965)
R. Krautheimer: *Ghiberti's Bronze Doors* (Princeton, 1971)
U. Mielke: 'Zum Programm der Paradiestür', *Z. Kstgesch.*, xxxiv (1971), pp. 115–34
D. F. Zervas: 'Ghiberti's *St Matthew* Ensemble at Or San Michele: Symbolism in Proportion', *A. Bull.*, lviii (1976), pp. 36–44
B. Bearzi: 'La tecnica usata dal Ghiberti per le porte del Battistero', *Lorenzo Ghiberti nel suo tempo: Atti del Convegno Internazionale: Firenze, 1980*

Other

H. Brockhaus: *Forschungen über Florentiner Kunstwerke* (Leipzig, 1902)
J. von Schlosser: 'Über einige Antiken Ghibertis', *Jb. Ksthist. Samml. Allhöch. Ksrhaus.*, xxiv (1903), pp. 125–59
W. Bode: 'Lorenzo Ghiberti als führender Meister unter den Florentiner Tonbildnern der ersten Hälfte des Quattrocento', *Jb. Kön.-Preuss. Kstsamml.*, xxxv (1914), pp. 71–89

G. Sinibaldi: 'Come Lorenzo Ghiberti sentisse Giotto e Ambrogio Lorenzetti', *L'Arte*, xxxi (1928), pp. 80–82

H. Gollob: *Ghibertis künstlerischer Werdegang* (Strasbourg, 1929)

R. Krautheimer: 'Ghibertiana', *Burl. Mag.*, lxxi/413 (1937), pp. 68–80

W. R. Valentiner: 'Donatello and Ghiberti', *A.Q.* [Detroit], iii (1940), pp. 182–214

R. Krautheimer: 'Ghiberti and Master Gusmin', *A. Bull.*, xxix/1 (1947), pp. 25–35

M. Wundram: *Die künstlerische Entwicklung im Reliefstil Lorenzo Ghibertis* (diss., U. Göttingen, 1952)

U. Middeldorf: 'L'Angelico e la scultura', *Rinascimento*, vi/2 (1955), pp. 179–94

M. Salmi: 'Lorenzo Ghiberti e la pittura', *Scritti in onore di Lionello Venturi* (Rome, 1956), i, pp. 223–7

M. Wundram: 'Albizzo di Piero: Studien zur Bauplastik von Or San Michele in Florenz', *Das Werk des Künstlers: Festschrift für H. Schrade*, ed. H. Segers (Stuttgart, 1960), pp. 161–76

G. Marchini: 'Ghiberti "ante litteram"', *Boll. A.*, l/3–4 (1965), pp. 181–93

U. Middeldorf: 'Additions to Lorenzo Ghiberti's Work', *Burl. Mag.*, cxiii/815 (1971), pp. 72–9

D. F. Zervas: *System of Design and Proportion Used by Ghiberti, Donatello and Michelozzo in their Large-scale Sculpture-architectural Ensembles* (diss., Baltimore, MD, John Hopkins U., 1973)

S. Euler-Künsemüller: *Bildgestalt und Erzählung: Zum frühen Reliefwerk Lorenzo Ghibertis* (Frankfurt am Main and Berne, 1980)

B. Nagel: *Lorenzo Ghiberti und die Malerei der Renaissance* (Frankfurt am Main, Berne and New York, 1987)

(2) Vittorio Ghiberti I (*b* Florence 1418 or 1419; *d* Florence 1496). Bronze-caster and sculptor, son of (1) Lorenzo Ghiberti. His birthdate is given differently on two of Lorenzo's tax declarations (9 July 1427 and 26 Jan 1431). He no doubt served his apprenticeship in his father's workshop. In 1437 he is mentioned as assistant to his father on the *Gates of Paradise* at the handsome salary of 100 gold florins per annum. In the ensuing years he seems to have become his father's partner. On 24 January 1444 he signed, on the latter's behalf, the contract engaging Benozzo Gozzoli as an assistant; and from 1451 he is always mentioned together with his father in the documents relating to final work on the doors. His head is portrayed next to his father's, on the right-hand central framing strip of the *Gates of Paradise* at the level of the inscription (*see* (1) above). On 12 February 1453 Lorenzo and Vittorio received the commission for the bronze frame of Andrea Pisano's door, which Vittorio apparently executed himself. It was completed between 1462 and 1464, and payments for it are recorded only after Lorenzo's death, the first being in April 1456. Although Vittorio lived until 1496, nothing is known of further works by him. His personal style can be judged only by the frame of the Pisano door. The floral details stand out boldly from the relief ground, and the softer modelling of the *Gates of Paradise*, for instance, gives way to pointed, angular forms. The figures of Adam and Eve are distinguished by elongation and an emphasis on anatomical detail rather than regard for the general effect. Beauty of line gives place to affectation and refinement.

MANFRED WUNDRAM

(3) Buonaccorso (di Vittorio) Ghiberti (*b* Florence, 10 Dec 1451; *d* Florence, 16 July 1516). Engineer and draughtsman, son of (2) Vittorio Ghiberti. He was involved in artillery-making in 1487 and 1495, and in 1504 he helped to move Michelangelo's *David* from the workshop to its place in front of the Signoria. His signed *zibaldone* of 220 folios (Florence, Bib. N. Cent., MS. Banco Rari 229) was begun in the 1470s. Its contents fall into two groups. The first contains drawings and texts copied from his grandfather Lorenzo's notebooks. These include: extracts from Vitruvius translated into Italian; copies of illustrations from a Late Antique Vitruvius; festival apparatus and hoists, cranes and tools invented and designed by Filippo Brunelleschi; notes on metallurgy and on foundry methods for casting and repairing bells; and sundry records of building material prices and payments to workmen. The second category comprises drawings arranged at random, dating from between *c.* 1470 and *c.* 1500. The subject-matter of these drawings ranges from tombs, equestrian statues and candelabra to architectural subjects such as church façades, Roman capitals and entablatures, a series of 13 fantasy buildings *all'antica* and the Marzocco Tower in Livorno. Of the numerous drawings of machinery and equipment, many are copied from Roberto Valturio's *De rei militari* (Verona, 1483) or are related to those of Francesco di Giorgio (hoists, cranes, trebuchets and scaling ladders, as well as a mechanism for hauling obelisks). The *zibaldone* passed into the hands of Cosimo Bartoli, as did Lorenzo's *I commentarii*, and perhaps other notebooks from Lorenzo's *scriptorio* that Buonaccorso had inherited in 1455. This type of sketchbook–notebook was common in artists' workshops but survives intact only rarely.

BIBLIOGRAPHY

R. Corwegh: 'Der Verfasser des kleinen Kodex Ghiberti', *Mitt. Ksthist. Inst. Florenz*, i (1911), pp. 156–67

G. Scaglia: 'Drawings of Brunelleschi's Mechanical Inventions for the Construction of the Cupola', *Marsyas*, x (1960–61), pp. 45–68

——: 'Drawings of Machines for Architecture from the Early Quattrocento in Italy', *J. Soc. Archit. Historians*, xxv/2 (1966), pp. 90–114

——: 'Fantasy Architecture of *Roma antica*', *A. Lombardo*, xv (1970), pp. 9–24

——: 'A Miscellany of Bronze Works and Texts in the *Zibaldone* of Buonaccorso Ghiberti', *Proc. Amer. Philos. Soc.*, cxx/6 (1976), pp. 485–513

——: 'La Torre del Marzocco a Livorno in un disegno di Buonaccorso Ghiberti', *Lorenzo Ghiberti nel suo tempo. Atti del convegno internazionale di studi: Firenze, 1978*, pp. 463–80

——: 'A Translation of Vitruvius and Copies of Late Antique Drawings in Buonaccorso Ghiberti's *Zibaldone*', *Trans. Amer. Philos. Soc.*, lxix/1 (1979), pp. 3–30

GUSTINA SCAGLIA

Ghiglia, Oscar (*b* Livorno, 23 Aug 1876; *d* Florence, 24 June 1945). Italian painter. When he worked in Livorno he frequented the studio of Ugo Manaresi (1851–1917) and other local painters. After moving to Florence in 1900, his friendship with Giovanni Fattori heightened his sense of observation, while Amedeo Modigliani alerted his attention to Symbolism and to the Secessionist movement in the city. A self-portrait shown at the Venice Biennale of 1901 (see Stefani, pl. 1) underlined his ability in portraiture, which he practised largely until 1908. He worked closely with the writer Giovanni Papini and the literary circle of the reviews *Leonardo* and *La Voce*, and in 1907 he exhibited in the Secessionist section of the Primaverile Fiorentina, an exhibition salon, with Giovanni Costetti (1878–1949), Giuseppe Graziosi (1879–1942) and Llewelyn Lloyd (1879–1949).

Embittered by an unfulfilled promise of a whole room at the Venice Biennale of 1905, Ghiglia abstained from public exhibition for 15 years, chiefly supported by the

collector Gustavo Sforni (1889–1940). In 1909 he visited Sardinia and during World War I worked at Castiglioncello in Tuscany. In 1919 he returned to Florence, where his work was championed by the critic Ugo Ojetti. In 1926 he participated in the first exhibition of the group Novecento Italiano in Milan and in 1929 showed at the Galleria Pesaro, Milan, with his sons Paolo Ghiglia (1905/6–1979) and Valentino Ghiglia (1903–60). In his work he combined a modular articulation of picture space with a tactile approach to his subjects, often still-lifes, in which an ordered simplicity belies metaphysical undertones. He compiled an important monograph on Giovanni Fattori in 1913.

WRITINGS
L'opera di Giovanni Fattori (Florence, 1913)

BIBLIOGRAPHY
U. Ojetti: 'Oscar Ghiglia', *Dedalo*, i/1 (1920–21), pp. 114–32
P. Stefani: *Oscar Ghiglia e il suo tempo* (Florence, 1985)
Prima dell'avanguardia: Da Fattori a Modigliani (exh. cat., ed. R. Monti and G. Matteucci; Aosta, Tour Fromage, 1985)

PAUL NICHOLLS

Ghika [Chatzikyriakos-Ghikas]**, Niko** [Nicos] (*b* Athens, 26 Feb 1906; *d* Athens, 3 Sept 1994). Greek painter, printmaker, illustrator, stage designer and theorist. While still a schoolboy he studied drawing under Konstantinos Parthenis. In 1922 he enrolled at the Sorbonne in Paris for a course in French and Greek literature, but soon moved to the Académie Ranson where he studied painting under Roger Bissière and printmaking under Demetrios Galanis. He first exhibited at the Salon des Indépendants at the age of 17. His first one-man exhibition, at the Galerie Percier, Paris (1927), was enthusiastically reviewed by Tériade in *Cahiers d'art*. His first one-man exhibition in Athens was at the Galerie Strategopoulos in 1928.

Ghika returned to Athens in 1934 and became closely involved with aesthetic and educational issues, specifically the popular art movement and the search for Greekness in art. In 1936–7 he edited the *Third Eye*, an avant-garde magazine in which he was able to introduce new aesthetic trends into Greek cultural life. In collaboration with the leading architects in Greece, he became actively concerned with the problem of urbanism and the restoration of traditional architecture. As a leading member of several cultural and artistic societies and a theoretician of art, he wrote and lectured extensively on art and education. From 1941 to 1958 he was professor of drawing and composition in the School of Architecture of the National Technical University of Athens.

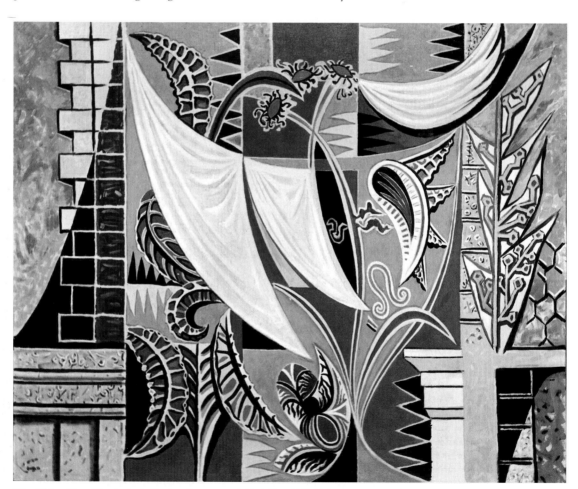

Niko Ghika: *Sheets Hanging in the Garden*, oil on canvas, 1.30×1.63 m, 1954 (Athens, National Gallery)

In the late 1930s Ghika was preoccupied with combining Greek subjects with the formal experiments pursued by the Cubists, as in *Fruitshop Apollo* (priv. col., see Papastamos, p. 92). Later he adopted a kaleidoscopic technique, creating compositions of complex, often calligraphic patterns, as in *Balcony with Iron Rail* (1954; Paris, Pompidou). His subjects were landscapes, mythological and allegorical figures, portraits, interiors and domestic scenes, such as *Sheets Hanging in the Garden* (1954; Athens, N.G.; see fig.). He used a variety of techniques, including encaustic on wood, tempera and oils. His geometrical spaces, which made reference to Byzantine art, were often imbued with a metaphysical significance. His compositions have the intentional rigidity and minuteness of detail of Byzantine mosaics. In his open-air scenes he stressed the Greekness of nature by alluding to Classical and oriental pictorial traditions. In his sparklingly coloured and carefully composed landscapes he not only managed to capture the dazzling Mediterranean light, but also introduced a modernist spirit into viewing the classic Greek landscape. Between 1937 and 1960 he contributed costume and set designs for theatrical and ballet productions in Greece, and in 1961 he designed sets and costumes for Stravinsky's *Persephone* at Covent Garden in London. He was also a printmaker and contributed many illustrations for literary texts.

BIBLIOGRAPHY
C. Zervos and others: *Ghika: Paintings, Drawings, Sculpture* (London, 1964)
Ghika (exh. cat., ed. B. Robertson; London, Whitechapel A.G., 1968)
D. Papastamos: *Painting, 1930–40: The Artistic and Aesthetic Vision of the Decade* (Athens, 1982), pp. 85–95

FANI-MARIA TSIGAKOU

Ghika-Budeşti, Nicolae (*b* Iaşi, 12 Dec 1869; *d* Bucharest, 16 Dec 1943). Romanian architect, restorer, architectural historian and teacher. He studied engineering (1889–93) at the School of Roads and Bridges, Bucharest, and later studied at the Ecole des Beaux-Arts, Paris, in the studio of Victor Laloux, where he obtained a diploma in 1901. After 1906 he was active in the Romanian Historical Monuments Commission, researching the ancient historical architecture of Romania. He was among the promoters of the 'neo-Romanian' style, along with Ion Mincu, Petre Antonescu, Constantin Iotzu (1884–1962) and Grigore Cerchez (1850–1927). Ghika-Budeşti's most significant building is the Museum of National Art (1912–38; now the Romanian Peasant Museum), Bucharest. Built of traditional stone, brick and tiles, it is remarkable both for a compositional balance characteristic of traditional Romanian architecture and for its monumental dimensions. At the same time the human scale is retained by the incorporation of various decorative elements: dogtooth motifs, mouldings, niches, balustrades and ornamental tendrils reminiscent of the Brâncoveanu period (*c.* 1700). In other works, such as the new wing (1928–30) of the University of Bucharest, with Alexandru Baucher (1877–1935), the heavy appearance is indebted mostly to contemporary eclecticism and the necessity of integrating the building in the formal ensemble of University Square. Ghika-Budeşti founded a school for the restoration of architectural monuments by scientific methods and was a pioneer of Romanian architectural history. Between 1908 and 1938 he was a professor at the High School (later Academy) of Architecture, Bucharest, and from 1930 an honorary member of the Romanian Academy.

WRITINGS
Evoluţia arhitecturii în Muntenia şi Oltenia [The evolution of architecture in Wallachia and Oltenia], 4 vols (Bucharest, 1927)
Contributions to *Buletinul Comisiunii Monumentelor Istorice* (1927–36) [esp. studies on the archit. of Wallachia and Oltenia]

BIBLIOGRAPHY
G. Ionescu: *Arhitectura pe teritoriul României de-a lungul veacurilor* [Architecture of Romania through the centuries] (Bucharest, 1982), pp. 554, 559, 609–10

CODRUŢA CRUCEANU

Ghinghi, Francesco (*b* Florence, 1689; *d* Naples, 29 Dec 1766). Italian gem-engraver and medallist. He may have been descended from an old Sienese family who had settled in Florence in 1340. His uncle Vincenzo Ghinghi was also a gem-engraver. By 1704 he was studying drawing under Francesco Ciaminghi (*d* 1736) and modelling with the sculptor Giovanni Battista Foggini. He was taught gem-engraving with the assistance of Ferdinando de' Medici, and acquired a position in the Medici court as gem-engraver to the Grand Duke Cosimo III, establishing his reputation with a chalcedony cameo portrait of his patron (untraced). Among other portraits were those of the collector Baron Philipp von Stosch (*c.* 1717; Berlin, Antikenmus.) and of Cosimo's sons Ferdinando de' Medici and Gian Gastone de' Medici (untraced). For the Electress Palatine Anna Maria Luisa de' Medici he cut cameos of *Hadrian* and *Trajan* in large violet sapphires, and for Cardinal Gualtieri a copy of the *Venus de' Medici* (Florence, Uffizi) in an amethyst (untraced), which later passed to Frederick-Augustus III, Elector of Saxony (later Frederick-Augustus I, King of Saxony). Ghinghi was also the master of Felix Bernabé. On the death of the last Medici, Gian Gastone, in 1737, and through the intervention of the 3rd Conde de Montemar (1671–1747), another patron, he moved to Naples in the employ of Charles VII (later Charles III of Spain). Charles, of whom he produced a chalcedony cameo portrait (untraced), appointed him director of the Real Laboratorio delle Pietre Dure, a post he retained until the end of his life. Several of his works were reproduced in the cast collection of James Tassie (Edinburgh, N.P.G., and St Petersburg, Hermitage).

BIBLIOGRAPHY
A. L. Millan de Grandmaison: *Introduction a l'étude de l'archaeologie des pierres gravées et des medailles* (Paris, 1826)
E. C. F. Babelon: *Histoire de la gravure sur gemmes en France depuis les origines jusqu'à l'époque contemporaine* (Paris, 1902)
A. Gonzalez-Palacios: 'Un'autobiografia di Francesco Ghinghi', *Antol. B. A.*, i/3 (1977), pp. 271–81

□

Ghirlandaio [Bighordi, Bigordi; del Ghirlandaio, Ghirlandajo, Grillandai]. Italian family of artists. (1) Domenico Ghirlandaio and (2) Davide Ghirlandaio are first mentioned in the 1457 Florence tax declaration (*catasto*) of their grandfather Currado di Doffo Bigordi and stated to be nine and six years old respectively. Their brother (3) Benedetto Ghirlandaio is recorded as ten years old in the tax declaration of 1470. Their father Tommaso (*b* 1422) had three other children, and the extended family lived

near S Lorenzo on the Via dell'Ariento, Florence. They also owned a small farm near San Martino a Scandicci, outside Florence, which was worked by a labourer and produced a modest yield of grain and wine. The tax declarations of 1470, 1480 and 1498 reveal a prosperous family of artisans and small businessmen.

In 1457 the family was probably engaged in trading crafted goods, including leather and cloth. The tax declaration of 1457 lists Currado as a toll-collector, while two of his three sons, Antonio (*b c.* 1418) and Tommaso, had a shop dealing in small quantities of silk and related objects (*setaiuoli a minuto*). In the 1480 tax declaration, Tommaso, who seems to have expanded the business, is listed as a *sensale* (general broker). There is no evidence that he worked as a goldsmith, although Vasari, the major source for information on the family, credited him with making silver votives and lamps (untraced) for SS Annunziata, Florence. Vasari attributed the family surname to Tommaso's invention of hair ornaments by this name. Again, this is unlikely, although Tommaso may have been involved in trading these items, as one Nicholo delle Grillande, who is documented as producing such ornaments, is listed as a debtor to the family in 1457. Tommaso is briefly listed as 'del Ghirlandaio' in 1452 and 1453, but Domenico had adopted the name by 1472, when he is listed in the *Libro rosso* of the Compagnia di S Luca as 'Domenicho di Tomaso del Grilandaio dipintore'. Davide is first mentioned with the name in 1476, in records of payments for work at the Badia, Passignano, and documents throughout their careers regularly refer to the brothers as 'del Ghirlandaio'. The name's permanence was acknowledged in the fresco depicting the *Birth of the Virgin* (1486–90; Florence, S Maria Novella), where the names BIGHORDI and GRILLANDAI are inscribed in gilded letters on the wood panelling behind St Anne's bed.

Like their slightly older contemporaries, Andrea Verrocchio and the Pollaiuolo brothers, the Ghirlandaio family worked in several different media. This, and the ability to collaborate with artisans of varying specialities, was fundamental to the nature of their art, which successfully perpetuated the craft tradition of the 15th century. Domenico was by far the most important and talented member of the family. Apart from a few minor individual commissions, Davide's role appears to have been to assist his brother in their busy workshop, as did BASTIANO MAINARDI, who married their sister Alessandra (*b c.* 1450) in 1494. Benedetto pursued an independent career in France, returning to Florence about the time of Domenico's death. Domenico's son (4) Ridolfo Ghirlandaio, although not as successful in business, remained active until 1542. His style alternates between moments of great originality, built on an awareness of Fra Bartolommeo, Andrea del Sarto and, above all, Raphael, and an innate conservatism reflecting his long association with his uncle Davide Ghirlandaio.

(1) Domenico Ghirlandaio (*b* Florence, 1448–9; *d* Florence, Jan 1494). Painter, mosaicist and possibly goldsmith. He was head of one of the most active workshops in late 15th-century Florence. He developed a style of religious narrative that blended the contemporary with the historical in a way that updated the basic tenets of early

Renaissance art. Domenico's documented material situation—prosperous, land-owning—conflicts with Vasari's description of him as unconcerned with wealth and business, and he emerges as an enterprising, versatile craftsman, the artisan and bourgeois nature of his life making him perfectly suited to satisfying the tastes and aspirations of his patrons. He was called to Rome in 1481 to work in the Sistine Chapel, and throughout the 1480s he received prestigious fresco commissions, culminating in 1485 with that to decorate the Tornabuoni Chapel in S Maria Novella, Florence. Many panel paintings, either autograph or workshop productions, were also produced at this time. He received no further fresco commissions after completing the work in S Maria Novella in 1490, but several projects for mosaic decoration date from this period.

I. Life and work. II. Working methods and technique.

I. Life and work.

1. Training and early works, before *c.* 1470. 2. *c.* 1470 and after.

1. TRAINING AND EARLY WORKS, BEFORE *c.* 1470. Domenico was admitted to the confraternity of S Paolo on 12 May 1470. The matriculation book states that he 'sta all'orafo', that is, he was apprenticed to, or was practising as, a goldsmith. Vasari stated that Domenico was trained in his father's profession as a goldsmith; although probably mistaken about Tommaso's trade, he seems to have been correct about Domenico's. Payments made to Domenico in 1481 for designing and gilding candlesticks (untraced) for Florence Cathedral and in 1486 for the valuation of a silver censer (untraced) made by Andrea di Leonardo di Pavolo for Santa Trinita, Florence, indicate some competence in goldsmithing. Vasari's statement that Domenico was a pupil of Alesso Baldovinetti appears to be supported by the *Memoriale* (1513; Florence, Bib. N. Cent., Cod. Baldovinetti, no. 244) of Francesco Baldovinetti, Alesso's fourth cousin, although this reference is ambiguous.

No securely documented works by Domenico exist before 1475, but many frescoes and panel paintings can be attributed to his first years on stylistic grounds. One of his earliest independent works is a fresco in S Andrea a Brozzi, near Florence, depicting the *Baptism* in the lunette and below, between painted pilasters and simulated marble slabs, the *Virgin and Child Enthroned with SS Sebastian and Julian*. The scenes reveal the various components of Ghirlandaio's early style. The lower scene is modelled on Antonio and Piero Pollaiuolo's panel of *SS James, Vincent and Eustace* (1467) for the Cardinal of Portugal's Chapel in S Miniato al Monte, Florence. The format of figures standing on a narrow, paved terrace before a balustrade with glimpses of a panoramic landscape was reworked by Ghirlandaio into a *sacra conversazione*, introducing a shell niche to emphasize the Virgin and Child and clarifying the relationships between the figures. The style points clearly to another early and influential source, Verrocchio, whose nearly contemporary *Virgin and Child* (*c.* 1468; Berlin, Gemäldegal., 108) is recalled in the facial types and draperies, the strong light and the compacted mass of figures. The drive towards a rectilinear ordering of the composition and the unity of real and depicted space is

strikingly apparent in the Brozzi paintings; these qualities emerge repeatedly in his paintings in a manner unequalled in Verrocchio's contemporary work.

The composition for the *Baptism* is often thought to have been modelled on Verrocchio's *Baptism* (c. 1475–85; ex-S Salvi, Florence; Florence, Uffizi) but is closer in format and detail to a niello engraving (before 1464; Paris, Louvre) attributed to Maso Finiguerra. The pose of Ghirlandaio's St John is also close to Baldovinetti's early panel for the silver chest of SS Annunziata (c. 1449; Florence, Mus. S Marco), and the arrangement of the attendant angels on the left is reminiscent of Antonio Pollaiuolo's reliquary cross (1457; Florence, Mus. Opera Duomo) for the Florentine Baptistery. It is therefore possible that Ghirlandaio's composition precedes rather than derives from that of Verrocchio, or is at least indebted to a common source. The figure style of the *Baptism*, however, is similar to that of the *Virgin and Saints* below and shows an awareness of Verrocchio's style generally, if not the S Salvi picture in particular.

In the *Baptism*, Ghirlandaio's cautiously creative approach to his models suggests that, in spite of a bias towards Verrocchio, his artistic temperament had already been formed. While these early scenes show that he was aware of the latest developments in Florentine art, they also reveal the possible lingering influence of early training with Baldovinetti, perhaps between 1460 and 1468, thus vindicating Vasari's assertion. Ghirlandaio's figures recall Baldovinetti in their simplified contours and schematized modelling. The Brozzi *Virgin* shares with Baldovinetti's contemporary works, such as the figures (1466) in the Cardinal of Portugal's Chapel or the *Trinity* panel and fresco fragments (early 1470s) from Santa Trinita, Florence, a tautness of outline and slenderness of figure that separate them from the aggressive plasticity and incisive drawing of Verrocchio's contemporary work. A date of c. 1468–70 may be assigned to the Brozzi fresco, a period that appears also to coincide with Ghirlandaio's closest involvement with Verrocchio's workshop.

Ghirlandaio could not have absorbed his capacity for clear spatial organization and balanced figural arrangement solely from Baldovinetti, and neither Verrocchio nor Antonio Pollaiuolo seems to be the source of this aspect of his work. It is possible that Ghirlandaio looked for inspiration to the tradition of intarsia work. He may have designed the figures of *SS Peter and Paul* for the entrance arch in the north sacristy of Florence Cathedral, for which Finiguerra and Baldovinetti provided designs and Giuliano da Maiano created the architectural settings and ornament. This may be Ghirlandaio's first link with Maiano's family, with whom he collaborated throughout his career, and might also explain the source for this distinctive component of his style. He has also been attributed with the design of an *Annunciation* intarsia, part of a large cupboard in S Maria Primerana, Fiesole. This is similar to his early drawing of the *Annunciation* (Florence, Uffizi) and recalls Finiguerra's design in the north sacristy of Florence Cathedral. Ghirlandaio's few early drawings, such as the pen sketch for the *Annunciation* intarsia and the slightly later cartoon for the Ognissanti *Pietà* (Florence, Uffizi; *see* §2(i)(a) below), declare even more clearly than his early

paintings his debt to the classical strain in early 15th-century Florentine art, especially to Masaccio and Donatello, and to its later adherents, such as Verrocchio.

2. c. 1470 AND AFTER.

(i) Frescoes. (ii) Panel paintings. (iii) Illumination and mosaics.

(i) Frescoes.

(a) Early maturity, c. *1470–c. 1480.* In the 1470s Ghirlandaio's work is marked by increasingly large and schematized plastic forms occupying ample, fully articulated space. The incisive drawing of his earliest works, influenced by Verrocchio, is also simplified. The hallmarks of his style, visible even in the Brozzi frescoes—clear, rectilinear spatial order, block-like plastic form and sculpturesque rendering of light and texture—remain unchanged.

The frescoes over the Vespucci altar on the right wall of the nave in the church of the Ognissanti are probably Ghirlandaio's first major work. They are dated on stylistic grounds to 1470–71, although external evidence is often cited to place them a year or two later, and are a marked advance over the Brozzi frescoes. In the lunette of the *Madonna of Mercy*, in particular, the masterfully foreshortened group of members of the Vespucci family gathered under the Virgin's protective cloak shows that Finiguerra's designs in the cathedral sacristy had been profitably studied. In the *Pietà* below, on the other hand, a Netherlandish prototype has been less successfully assimilated, and this, with the last-minute inclusion of the portrait head second from the left, results in a less harmonious composition.

The frescoes depicting *SS Barbara, Jerome and Anthony Abbot* in S Andrea, Cercina, north of Florence, were probably executed in 1473–4. Here Ghirlandaio successfully resolved the challenge of working in the curving apse of the south aisle and achieved the harmonious blend of painted and real space characteristic of his work. The north sacristy in the cathedral is a conspicuous precedent for the arrangement of figures in a barrel vault, with St Barbara flanked by figures in small niches, but his adaptation allows for both the isolation of the single figures and their unification by the architectural frame and the site. In these frescoes his figures have become more elongated, and draperies articulate volume with a new clarity and conviction.

Ghirlandaio's earliest documented works are the eight lunette frescoes with busts of the *Church Fathers* and *Classical Philosophers* (1475–6) in the Biblioteca Latina (now Biblioteca Apostolica) in the Vatican Palace, Rome. Such a prestigious commission, the occasion for his first trip to Rome, suggests that he had already achieved some reputation. Although Davide seems to have been chiefly responsible for the execution, the design was undoubtedly Domenico's. Neither the illusionistic conception nor the use of painted architecture to forge the link between real and depicted space is new to his art, but the total effect nonetheless reveals the impact of Roman illusionistic wall decoration. The decorative vocabulary takes on a new richness and an explicitly classical note, as seen, for example, in the urns flanking the figures, the fruit and flower garlands that frame the lunettes and the painted

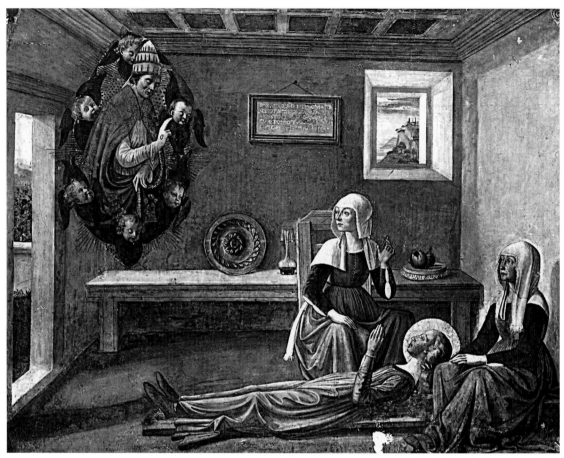

1. Domenico Ghirlandaio: *Vision of St Fina* (*c.* 1477–8), fresco, chapel of St Fina, Collegiata Pieve, San Gimignano

acanthus friezes below. The figures, for example *St Jerome*, are broader-shouldered than those at Cercina but are deprived of commensurate weight and plasticity by the weak execution. Far from changing his stylistic development, contact with the Roman tradition reinforced the tendencies inherent in his own style. Some of his figures may owe their new monumental ambition to the influence of Melozzo da Forlì, then active in Rome.

Domenico had returned to Florence by spring 1476. His first new commission was to fresco the *Last Supper* in the refectory of the Badia, Passignano. Painted in collaboration with Davide between June and September 1476, it was his largest work to date. Its general format is clearly indebted to Andrea Castagno's version of the subject (1447; Florence, Cenacolo S Apollonia), but the painting is linked more explicitly to the actual space of the room, thereby creating a more compelling effect of depth and atmosphere. The monumental effects of the Vatican Library busts are further developed in the figures, whose grave yet animated faces have taken on greater mass than those in his earliest works and assume normal proportions.

Ghirlandaio's first monumental fresco cycle was executed in the chapel of St Fina in the Collegiata Pieve, San Gimignano. A payment on 30 November 1477 probably refers to work in the chapel, and the style of the frescoes confirms the date of *c.* 1477–8. The *Evangelists* in the vault, the *Church Fathers* in the lunettes and the half-length figures of prophets in the spandrels above the altar and entrance arch display greater mass and movement than the Passignano Apostles. The basic components of his narrative style are clearly visible in the scenes below. On the right, the *Vision of St Fina* (see fig. 1) recalls the work at Passignano in its general composition, yet the free disposition of the figures, the atmospheric unity and glimpses of lush landscape through the door and window lend the space a more fluid and unified character. The figures assume calm, understated poses in harmony with the simple domestic interior, but their plasticity is nonetheless sure and convincing, and the drapery takes on a new fluidity. The self-contained space of the *Vision* scene is a perfectly calculated field for the depicted event. The figures, elegantly disposed in the uncluttered room, display seemly surprise and awe at the saint's vision, while sunshine steals through the window and door as a natural counterpart to the divine apparition. In the *Funeral of St Fina*, the rich, classical ornamentation of the massive, semi-domed apse records the impact of Ghirlandaio's Roman sojourn. The huge structure articulates the space, and the broad figural arrangement, rich in secondary incident, complements the outward embrace of the curving apse. Individual

figures turn and gesture with a new expansiveness. Faces, too, show a typological maturity beyond even those at Passignano. The portraits of the three men at the right display a new, incisive drawing style and richness of description beyond the early Vespucci family portraits at the Ognissanti. As in the *Vision* scene, the atmospheric effects and the tall towers of the cityscape glimpsed beyond lend the whole a new breadth and airiness.

Unlike the doll-like stage-sets of Benozzo Gozzoli's frescoes (1463–5) in nearby S Agostino, Ghirlandaio's architecture creates an ample field for narrative action. Truncated at the top, the structure in the *Funeral* towers over the figures and implies space beyond the frame. He also integrated the scene into the actual space of the chapel by harmonizing his painted architecture in mass and decorative detail with Giuliano da Maiano's architecture. The interpolation of invented architecture with identifiable landscape or city views is a familiar device in Ghirlandaio's later works. Similarly, the mingling of portraits and invented figures became a hallmark of his style. While none of the elements present in the S Fina frescoes is new to narrative painting, his synthesis is innovative, and the tone of the work, grave yet celebratory, is distinctively his.

Two further frescoes in the Ognissanti, Florence, both dated 1480, mark Ghirlandaio's stylistic maturity. While *St Jerome* demonstrates his ability to describe objects and surfaces in detail, the *Last Supper* shows his conquest of figural mass and clear spatial organization: its integration of depicted with actual space is the culmination of his researches throughout the 1470s. At about this time he also painted the frescoes reportedly of the *Life of the Virgin* and *Life of St John the Baptist* (both destr.) that decorated the tomb of *Francesca Tornabuoni* in S Maria sopra Minerva, Rome. Francesca, wife of the prominent Florentine citizen Giovanni Tornabuoni, had died on 23 September 1477, and the tomb by Verrocchio and frescoes by Ghirlandaio were produced some time after. This was his first commission from the Tornabuoni family, who were to become his most important patrons, and it was the first casting of the themes that he later treated in S Maria Novella, Florence (*see* §(ii) below).

(b) Mature works, c. 1480–90. The prestigious fresco commissions that Ghirlandaio received during the 1480s confirmed his stature as one of the foremost painters in Florence. In 1481–2, with Perugino, Botticelli and Cosimo Rosselli, he was working in Rome, called there to execute the figures of popes and Old and New Testament scenes in the newly constructed chapel of Sixtus IV (the Sistine Chapel) in the Vatican Palace (*see* ROME, §V, 14(iii)(b)). He painted the *Calling of SS Peter and Andrew* for a fee of 250 ducats, as well as the *Resurrection* (repainted) on the entrance wall and a large number of standing popes. Although the Sistine Chapel frescoes were probably planned by Perugino, their format and style were informed by Florentine conventions and were entirely compatible with the narrative style seen in Ghirlandaio's earlier works. The commission enabled him to work on an extended cycle of frescoes and on a monumental scale. The sumptuousness of the paintings, especially the extensive use of gold, was to reappear in his future works.

Between 17 September 1482 and 7 April 1484 Ghirlandaio, newly returned from Rome, received payments for frescoes in the Sala dell'Orologio (Sala dei Gigli) of the Palazzo della Signoria, Florence. Botticelli, Perugino and Piero Pollaiuolo were also commissioned to work there, but only Domenico completed his contribution, creating his most monumental decorative scheme thus far: an entire wall was used to depict a painted triumphal arch, through the central arch of which, under a star-studded vault, can be seen an enthroned St Zenobius, patron saint of Florence, flanked by two deacons. To left and right, standing on a painted ledge above an actual door and window, sculpturesque figures of Roman heroes are silhouetted against the sky. The richness of the painted architectural detail, harmonizing with Giuliano da Maiano's frieze and ceiling and Benedetto da Maiano's sculpted doorway, as well as explicitly Roman details taken from coins and sculpture, mark a new phase in the early Renaissance use of Classical themes and motifs.

The frescoes depicting the *Life of St Francis* (*see* ITALY, fig. 103) in the chapel of Francesco Sassetti in Santa Trinita, Florence, were probably commissioned in 1478–9 but executed considerably later. By April 1478 Sassetti had begun negotiations to acquire the rights to the chapel, and before May 1479 Ghirlandaio had executed some drawings. The different worlds of the sacred, the antique and the contemporary are given equal weight in these frescoes, and this skilful blend produced the finest display of his mature style so far.

Ghirlandaio's most monumental and last significant fresco cycle is of scenes from the *Life of the Virgin* and *Life of St John the Baptist*, which Giovanni Tornabuoni commissioned for the family chapel in S Maria Novella, Florence, on 1 September 1485, just as Ghirlandaio was finishing the Sassetti Chapel in Santa Trinita (dedicated on Christmas Day 1485). The project eventually included designs for an altarpiece and stained-glass windows. The contract, extraordinarily detailed and providing for the patron's control over every facet of the design and execution, stipulated that work was to begin in May 1486 and be completed by May 1490. A further document of 7 April 1489 extended the deadline by a year, although not all of this was needed as the frescoes were finished and the chapel dedicated in December 1490. The frescoes are on a grander scale than those in the Sassetti Chapel and once more achieve a synthesis of sacred narrative with personal history. The best-known example of this is the scene depicting the *Birth of the Virgin* (*see* ITALY, fig. 30), in which Ludovica Tornabuoni, daughter of the patron, leads a group of women on a formal visit to the newly delivered St Anne, who reclines in a comfortable contemporary Florentine interior. The rich imagery of the Tornabuoni frescoes (Danti and Ruffa) is the crowning achievement of Ghirlandaio's career.

Other important frescoes by Ghirlandaio are known only from documentary sources or survive in fragmentary condition. The only occasion on which he is documented as working directly for the Medici was when, with Perugino, Botticelli and Filippino Lippi, he decorated Lorenzo de' Medici's villa at Spedaletto, near Volterra, executing a fresco of *Vulcan's Forge* (still extant mid-19th century). He also worked on frescoes (destr.) for the chapel of

Giovanni Tornabuoni's Villa Lemmi, Chiasso Macerelli, and at the church of Cestello, Florence, for Lorenzo Tornabuoni.

(ii) Panel paintings. The earliest of Ghirlandaio's panel paintings, the *Virgin and Child with SS Peter, Clement, Sebastian and Paul* (*c.* 1475–80; Lucca Cathedral), is similar in format to the early fresco at Brozzi (*see* §1 above), but both figures and space are carefully orchestrated to emphasize depth and introduce variety. In spite of his efforts, the tooled gold curtain and patterned carpet reinforce a two-dimensional effect. The light and colour are delicately handled, the latter warm and harmonious. The contrasts of complementary colours, especially red and green, seen also at Brozzi and in the Vespucci altar frescoes in the Ognissanti, are suffused in a golden glow.

In December 1478 Ghirlandaio was paid for two paintings destined for Pisa, one of which may be identified with one of two altarpieces of the *Virgin and Child with Saints* (both Pisa, Mus. N. S Matteo). The better-preserved panel, with figures of SS Elizabeth, Stephen, Rose and an unidentified saint, is largely by Domenico, while the other appears to be by Davide. The autograph panel testifies to Domenico's awareness of contemporary stylistic developments. The central figural composition recalls Leonardo's *Virgin and Child with a Vase of Flowers* (Munich, Alte Pin.), but Domenico does not imitate the rich handling of light and texture that is so striking in Leonardo's picture. Significantly, Domenico was not abreast of Leonardo's latest innovations, which broke decisively with Quattrocento precedents: by *c.* 1480 Leonardo had completed the Benois *Madonna and Child* (St Petersburg, Hermitage), while the pen-and-ink studies of the *Virgin and Child with a Cat* (London, BM; *see* LEONARDO DA VINCI, fig. 8) were probably made soon after. Ghirlandaio was instinctively

drawn to Leonardo's less mature composition, which is more in harmony with his own style and temperament.

The altarpiece of the *Virgin and Child with Saints* (ex-S Giusto fuori le Mura, Florence; church destr. 1529, altarpiece now Florence, Uffizi) is documented from 1485 but was probably finished soon after the Pisan works. It is the last of the important undocumented or undated early works, and its similarity to the later Ognissanti frescoes confirms a date of 1479–80. The work was influenced by the Pistoia Cathedral altarpiece, which was commissioned from Verrocchio between 1474 and 1479 but remained unfinished in 1485. Whereas the latter is characterized by understatement, Ghirlandaio's altarpiece is explicit, with figures carefully and clearly ordered in space, and with balanced placing of strong local colour to provide unity and emphasize surface design. Light lends atmospheric unity without obscuring volume, colour or his characteristic precision of surfaces and forms. Of the many portraits by Ghirlandaio and his workshop, the *Portrait of an Old Man and a Boy* (Paris, Louvre), probably dating from *c.* 1485, best exemplifies Ghirlandaio's portrait style. The old man's facial deformity—carefully studied in a preparatory drawing (*c.* 1480; Stockholm, Nmus.; *see* DRAWING, fig. 2)—contrasts with the child's smooth visage, yet the fondness of their embrace binds them together.

While fully engaged as a fresco painter until near the end of his career, the remarkable number of panel paintings executed by Ghirlandaio and his workshop (*see* §II, 2 below) testifies to the secure commercial success of their business. In addition to frescoing the walls of the Sassetti Chapel in Santa Trinita, he was commissioned to execute the altarpiece of the *Adoration of the Shepherds* (see fig. 2), with its prominent Classical sarcophagus and triumphal arch. Its iconography was probably devised by the humanist Bartolomeo della Fonte (1445–1513). The *Adoration* is entirely autograph and shows Domenico's characteristic skill in synthesizing many sources of inspiration, including Classical sculpture, the monumental frescoes of the Sistine Chapel and Flemish painting: the figures of the shepherds reflect the influence of Hugo van der Goes's Portinari Altarpiece (the *Adoration of the Shepherds*, late 1470s; Florence, Uffizi) which had arrived in Florence in 1483.

On 23 October 1485 Ghirlandaio was commissioned to paint a panel, within 30 months, for the chapel in the Ospedale degli Innocenti, Florence. The panel, depicting the *Adoration of the Magi* (Florence, Gal. Osp. Innocenti), was not completed until March 1489. The predella, originally part of his commission, was reallocated on 30 July 1488 to BARTOLOMEO DI GIOVANNI, who also painted the *Massacre of the Innocents* in the panel's background.

Several dated panels survive from the later 1480s and 1490s. The tondo of the *Adoration of the Magi* (1487; Florence, Uffizi) was painted for Giovanni Tornabuoni and listed in the inventory of his palazzo, while the portrait of *Giovanna degli Albizzi Tornabuoni* (1488; Madrid, Mus. Thyssen–Bornemisza) was inventoried in the possession of her husband, Lorenzo Tornabuoni. The double-sided altarpiece, flanked by saints in shell niches, for the Tornabuoni Chapel in S Maria Novella was probably commissioned in 1487 or 1488; it was removed and dismembered in the 19th century. The front central panel of the *Virgin and Child in Glory with Saints* (Munich, Alte Pin.; with

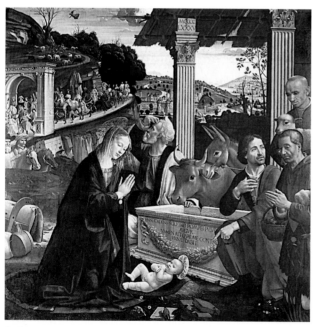

2. Domenico Ghirlandaio: *Adoration of the Shepherds*, tempera on panel, 1.67×1.67 m, 1485 (Florence, Santa Trinita, Sassetti Chapel)

two side panels, *St Lawrence* and *St Catherine of Siena*) is largely autograph. The rear panel of the *Resurrection* (Berlin, Bodemus.) is a workshop production. Vasari's statement that the altarpiece was finished after the artist's death is substantially correct, as recently discovered records indicate that the altarpiece was installed in the chapel in May 1494, four months after Ghirlandaio's death. Numerous other panels, made either for Florence or near by, such as the *Visitation* (1491; Paris, Louvre), or for provincial customers, for example the *Coronation of the Virgin* (1484–6; Narni, Pin. Com.) and *Christ in Glory* (1492; Volterra, Pin. Com.), reveal varying degrees of workshop intervention.

(iii) Illumination and mosaics. Domenico was primarily a painter, but documentary evidence, and some extant works, show that he also worked in other media. His earliest dated work may be an illumination of the *Invention of the True Cross*, inscribed *Domenico Corradi* and dated 1473 (Rome, Vatican, Bib. Apostolica, MS. Ross. 1192, *c.* 16). He is recorded in 1470 as being connected with goldsmithing (*see* §1 above), a profession that often overlapped with that of the illuminator, and his brother (3) Benedetto was also active in the 1470s as an illuminator. Facial and drapery details correspond well with Ghirlandaio's autograph early work, and there is a similar handling of figural and spatial relationships.

Ghirlandaio's activity as a mosaicist reflects the renewed interest in this art, apparently fostered by Lorenzo de' Medici. Vasari stressed the permanence of the medium, and its antique associations undoubtedly added to its prestige. In December 1486 Ghirlandaio evaluated Baldovinetti's restoration of the mosaics in the Florentine Baptistery. The first recorded mosaic commission to Domenico and his workshop was in 1489 for the Porta della Mandorla of Florence Cathedral and was completed by 22 April 1490. Although he received no major fresco commissions during the 1490s, his workshop is frequently recorded in connection with mosaic work. In 1491 Domenico, Davide, Botticelli, Monte di Giovanni (di Miniato) del Foro and his brother Gherardo di Giovanni (di Miniato) del Foro were commissioned to execute mosaics (most destr.) for the vault of the chapel of St Zenobius in Florence Cathedral. Payments are also documented for restoration work at the cathedrals of Pisa (1492–3) and Pistoia (1493–4; apse destr. 1620).

II. Working methods and technique.

1. TECHNIQUE. The corpus of Ghirlandaio's drawings is unusually rich and varied for a 15th-century artist. Their survival provides a relatively complete view of his working method, from his first designs to his finished works. He certainly began with small-scale sketches of whole compositions. Exactly which of his surviving drawings represent preliminary ideas is debated. The sketch (London, BM) for the *Birth of the Virgin* in S Maria Novella is probably a first sketch. Including both figures and architecture, its consistent graphic style and multiple pentiments fix the basic elements of the composition. He used intermediary sketches of figures, singly and in groups, to establish the relationship of the figures and their poses and costumes, as, for example, in the drawing (London,

BM; see fig. 3) for the *Naming of the Baptist*, also for S Maria Novella. More detailed studies of faces and costumes also survive. Once individual details had been resolved, he probably made another drawing of the whole composition, fixing the perspective design, reintegrating the figures into the architectural setting and unifying the lighting. This stage is perhaps represented by the drawing (Berlin, Kupferstichkab.) for the *Confirmation of the Rule* in the Sassetti Chapel. At this point the transition to the actual surface to be painted was made. In his earlier works it is unlikely that he made a full-scale cartoon of the whole surface to be painted, but he may well have adopted this method as his frescoes became larger and more complex in the 1480s. He used cartoons in conjunction with *sinopie*, and the latter, except for the earliest instance at Brozzi, themselves show dependence on cartoons. In the absence of surviving cartoons or visible *sinopie* for the great fresco cycles of the 1480s, however, the procedure he followed in his mature works remains uncertain.

All Ghirlandaio's frescoes are executed largely in *buon fresco*, with passages of secco and gilding on the *intonaco* and on raised wax decoration. His contemporaries recognized his sound technique, and inspection of the frescoes confirms their remarkable durability. Technical examination of his frescoes in the Sistine, Sassetti and Tornabuoni chapels shows the consistency of his technique. The pattern of *giornate* is regular, starting from the upper left and proceeding down the wall. Architectural elements were generally positioned either by snapping a cord or by scoring the *intonaco* directly with a straight edge. Figures were either transferred from full-scale cartoons by pouncing or by incising the major lines of the cartoons. In the latter parts of the decoration of S Maria Novella he seems to have preferred the incising method, perhaps for its greater speed and efficiency.

Individual figures were executed with great variety of stroke and technique; sometimes underpainting and drawing remain visible. Frequently the figure was sketched on the *intonaco* in red pigment, and underpainting, to adumbrate the lighting, was brushed in before the final, top layers of pigment were laid down. These top layers, especially for the most prominent figures, were often composed of a web of strokes, using white and light pigments in the highlights and tiny, reddish-brown strokes to indicate features. Such descriptive details as hair are often deftly indicated with an almost impastoed freedom of touch. Frequently tell-tale dots of dust are visible, indicating the use of a cartoon. Drapery, on the other hand, was painted more freely, with large sweeps of the brush. Frequently the contours indicated by the incised cartoon are ignored by last-minute improvisations. This varying technique for different parts is registered in the pattern of *giornate*: frequently one or two heads make up one *giornata*, indicating the care with which these were painted, while *giornate* for drapery are larger and those for landscape and architecture are larger still.

Ghirlandaio's tempera technique was similar to that used in his frescoes. He always worked on prepared panels with a mixture of tempera and oil. Incisions visible in the gesso made with the aid of a straight edge or other device indicate the adumbration of the general composition. While skin tones and the broad modelling of drapery were

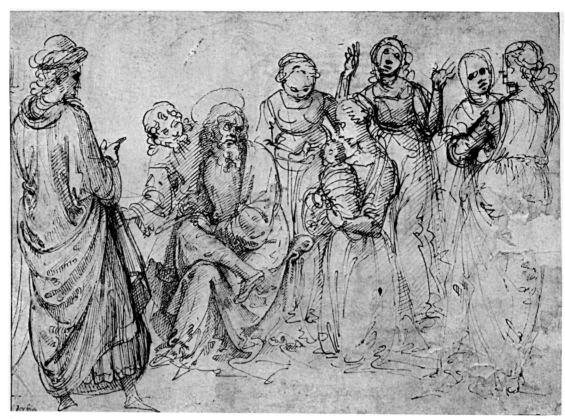

3. Domenico Ghirlandaio: study for the *Naming of the Baptist*, pen and brown ink, 185×263 mm (London, British Museum)

laid in over an underdrawing on the gesso, descriptive details and highlights were meticulously executed in tempera with the tip of the brush. He seems to have varied this technique only once, using tempera with an unusually large mixture of oil in his undated altarpiece of the *Virgin and Child with Saints* (Florence, Uffizi), but the isolation of this technical experiment indicates the fundamental suitability of his usual technique to his aesthetic ends.

Ghirlandaio's drawings reveal a rich variety of techniques, ranging from pen-and-ink studies and metalpoint drawings highlighted with white on coloured prepared papers, to brush drawings in tempera on linen; the latter technique was particularly associated with Leonardo but was certainly used by several artists associated with Verrocchio's shop. This variety corresponds to the different function of the drawings, from planning whole compositions to studying the play of light on the edge of a drapery fold. The drawings demonstrate, as does his painting technique, Ghirlandaio's sure command of the materials of his craft.

2. WORKSHOP ORGANIZATION. Much speculation has centred on the organization of Domenico's workshop and his participation in the works created in it. The long list of artists cited by Vasari as being trained in his shop (including Michelangelo) and the obvious variation in quality in some of the works associated with his name, has led to endless conjecture over attributions. Few convincing

identifications of assistants' hands have been made. Examination of the S Maria Novella frescoes suggests that at most four hands were at work in the major scenes, even in the uppermost, least visible parts.

Vasari credited Domenico's brother Davide and Bastiano Mainardi with a large role in the workshop's production. In the contract with Giovanni Tornabuoni for the frescoes in the choir of S Maria Novella, both the sequence in which Domenico and Davide are named and the manner in which they are described imply a secondary position for Davide. Moreover, payment was made exclusively to Domenico. The contract of 1490 between Domenico and Davide and the Franciscan friars of S Francesco di Palco, near Prato, specifies that Domenico was to design the saints and colour the faces, a stipulation found in several surviving contracts. Other documents, while not specifying the division of labour, provide clues as to how this was done. The payments listed in Platina's register in the Vatican, for example, suggest that, although Domenico was given the commission, he did not supervise it to completion. Only the first payment was made to Domenico, while subsequent payments were made to Davide. Similarly, five of the payments made to the brothers for the *Last Supper* at Passignano were to Davide alone, compared with two to Domenico and two to both brothers. In other payments, Domenico is even less involved, although on occasion Davide is not mentioned at all. It is clear that the degree of collaboration between

the brothers varied greatly. At times Davide seems to have been only an adjunct to his brother, yet even when he did assume a more active role he remained subordinate to Domenico. Probably Davide's role (and the size and composition of Domenico's workshop) expanded and contracted to suite the current workload. While the independent style of Mainardi is somewhat clearer owing to the survival of early paintings by him in S Agostino, San Gimignano, details of his participation in Ghirlandaio's workshop remain obscure. That contracts were made solely with Domenico for work that clearly included workshop participation (e.g. the Sistine Chapel) is not surprising. Unless he clearly stipulated otherwise, a patron would be satisfied with any painting or fresco issuing from Domenico's workshop, in the knowledge that the formal contract ensured that Domenico was legally responsible for the quality of the final work, including the competence of assistants. Throughout the 1480s Domenico was extraordinarily busy with large commissions, yet after 1490 there is evidence of only smaller projects.

DBI; EWA

BIBLIOGRAPHY

EARLY SOURCES

G. Vasari: *Vite* (1550, rev. 2/1568); ed. G. Milanesi (1878–85), iii, pp. 253–83; vi, pp. 531–40

L. Landucci: *Diario fiorentino dal 1480 al 1516* [MS; Florence, Bib. Marucelliana]; ed. I. del Badia (Florence, 1883; Eng. trans., London, 1927)

G. Milanesi: Documenti inediti dell'arte toscana dal XII al XVI secolo', *Buonarroti*, n. s. 2, ii (1887), pp. 335–8

G. Bruscoli: *'L'Adorazione dei Magi': Tavola di Domenico Ghirlandaio nella chiesa dello Spedale degli Innocenti* (Florence, 1902)

C. von Fabriczy: 'Aus dem Gedenkbuch Francesco Baldovinettis', *Repert. Kstwiss.*, xxviii (1905), pp. 540–45

J. Mesnil: 'Portata al catasto dell'avo e del padre di Domenico Ghirlandaio', *Riv. A.*, iv (1906), pp. 64–6

R. G. Mather: 'Documents Mostly New Relating to Florentine Painters and Sculptors of the Renaissance', *A. Bull.*, xxx (1948), pp. 47–9

H. Glasser: *Artists' Contracts of the Early Renaissance* (New York, 1977)

GENERAL WORKS

J. A. Crowe and G. B. Cavalcaselle: *A New History of Painting in Italy, from the Second to the Sixteenth Century* (London, 1864–6); ed. E. Hutton (London, 1909), ii, pp. 441–71

A. Venturi: *Storia*, vii/1 (1911), pp. 713–70

R. van Marle: *Italian Schools*, xiii (1931), pp. 1–268

E. Borsook: *The Mural Painters of Tuscany* (London, 1960, rev. Oxford, 1980)

B. Berenson: *Florentine School* (1963), i, pp. 71–7; ii, pls 954–98

MONOGRAPHS

E. Steinmann: *Ghirlandaio* (Bielefeld and Leipzig, 1897)

G. S. Davies: *Ghirlandaio* (London, 1908)

P. E. Küppers: *Die Tafelbilder des Domenico Ghirlandajo* (Strasbourg, 1916)

J. Lauts: *Ghirlandaio* (Vienna, 1943)

M. Chiarini: *Ghirlandaio* (Milan, 1966)

E. Micheletti: *Domenico Ghirlandaio* (Florence, 1990)

DRAWINGS

H. Egger: *Codex Escurialensis: Ein Skizzenbuch aus der Werkstatt Domenico Ghirlandaios*, 2 vols (Vienna, 1906/R 1975)

F. Ames-Lewis: 'Drapery "Pattern"-drawings in Ghirlandaio's Workshop and Ghirlandaio's Early Apprenticeship', *A. Bull.*, lxiii (1981), pp. 49–62

J. Cadogan: 'Linen Drapery Studies by Verrocchio, Leonardo and Ghirlandaio', *Z. Kstgesch.*, xliii (1983), pp. 367–400

——: 'Reconsidering Some Aspects of Ghirlandaio's Drawings', *A. Bull.*, lxv (1983), pp. 274–90

——: 'Observations of Ghirlandaio's Method of Composition', *Master Drgs*, xxii (1984), pp. 159–72

——: 'Drawings for Frescoes: Ghirlandaio's Technique', *Drawings Defined*, ed. K. Oberhuber and T. Felker (New York, 1987), pp. 63–76

SPECIALIST STUDIES

J. Mesnil: 'L'Influence flamande chez Domenico Ghirlandaio', *Rev. A. Anc. & Mod.*, xxix (1911), pp. 59–85

B. Berenson: 'Nova Ghirlandajana', *L'Arte*, xxxvi (1933), pp. 165–84

C. L. Ragghianti: 'La giovinezza e lo svolgimento artistico di Domenico Ghirlandaio', *L'Arte*, vi (1935), pp. 167–98, 341–73

N. Dacos: 'Ghirlandaio et l'antique', *Bull. Inst. Hist. Belge Rome*, xxxiv (1962), pp. 419–53

M. Levi d'Ancona: 'Una miniatura firmata di Domenico Ghirlandaio e un'altra qui attribuita a Benedetto Ghirlandaio', *Scritti di storia dell'arte in onore di Mario Salmi*, ii (Rome, 1962), pp. 339–61

E. Borsook and J. Offerhaus: *Francesco Sassetti and Ghirlandaio at Santa Trinita, Florence: History and Legend in a Renaissance Chapel* (Doornspijk, 1981)

P. Porcar: 'La Cappella Sassetti in S Trinita a Firenze: Osservazioni sull'iconografia', *Ant. Viva*, xxiii (1984), pp. 26–36

A. Garzelli: 'Problemi del Ghirlandaio nella cappella di Santa Fina: Il ciclo figurativo nella cupola e i probabili disegni', *Ant. Viva*, xxiv (1985), pp. 11–25

P. Simons: 'Patronage in the Tornaquinci Chapel, Santa Maria Novella, Florence', *Patronage, Art and Society in Renaissance Italy*, ed. F. W. Kent and P. Simons (Oxford, 1987), pp. 221–50

C. Danti and G. Ruffa: 'Osservazioni sugli affreschi di Domenico Ghirlandaio nella chiesa di Santa Maria Novella in Firenze', *Le pitture murali*, ed. C. Danti, M. Matteini and A. Moles (Florence, 1990), pp. 39–58

(2) Davide Ghirlandaio (*b* Florence, 14 March 1452; *d* Florence, 11 April 1525). Painter and mosaicist, brother of (1) Domenico Ghirlandaio. Most of his professional career was linked to that of his brother. His date of birth is recorded in the baptismal records of Florence Cathedral, and in 1472 he is listed with Domenico in the *Libro rosso* of the Compagnia di S Luca. On 3 January 1472 he was admitted to the confraternity of S Paolo. His collaboration with Domenico is documented from 1480, when he is listed in his father's tax declaration as being 29 years old and described as Domenico's '*aiuto*', but a precise definition of his role as assistant is unclear. Suggestions range from considering him a financial adviser (the source of which is an anecdote in Vasari) to an alter ego of his brother. His participation in Domenico's painting commissions is well documented (*see* (1) above), but a clear view of his own early style is impossible to establish owing to the lack of independent commissions documented to him. The earliest such commission, a panel of *St Lucy and a Donor* (1494; Florence, S Maria Novella), shows a style that differs from Domenico's largely in terms of its inferior quality. Both figure and drapery style show Domenico's imprint, but the drawing and modelling are both simpler and stiffer. Vasari recorded other works by Davide, including a fresco of the *Crucifixion with Saints* (Florence, Cenacolo S Apollonia), the facial types, drapery and figure styles of which show similarities with the S Maria Novella *St Lucy*.

The most numerous of Davide's documented commissions were in mosaic and included the façades of Orvieto and Siena cathedrals (1491–3 and 1493 respectively; both mosaics destr.). The mosaic of the *Virgin and Child Enthroned with Two Angels* (Paris, Mus. Cluny) was formerly signed and dated 1496 (see Chastel). Vasari also mentioned work in stained glass and mosaic for Montaione in Valdelsa. In stained glass Davide's only documented commission (1495; destr.) was for the tribune of Pisa Cathedral.

After Domenico's death Davide took over commissions from his brother's workshop, including the high altar for S Maria Novella and an altarpiece depicting *SS Vincent*

Ferrer, Sebastian and Roch (Rimini, Pin. Com. & Mus. Civ.), commissioned by Elisabetta da Rimini. He also took in Domenico's children and trained his eleven-year-old nephew (4) Ridolfo, who rapidly became an important member of Davide's shop. Davide made his will in 1513: most of his comfortable estate was left to his wife and, having no children of his own, his sisters, nephews and nieces.

BIBLIOGRAPHY
G. de Francovich: 'David Ghirlandaio', *Dedalo*, xi (1930–31), pp. 65–88, 133–51
A. Chastel: 'Une Mosaïque florentine du XVe siècle', *Rev. des A.*, 2 (1958), pp. 97–101

(3) Benedetto Ghirlandaio (*b* Florence, 1458–9; *d* Florence, 17 July 1497). Painter, brother of (1) Domenico Ghirlandaio and (2) Davide Ghirlandaio. His birthdate is deduced from his father's 1469 tax declaration, in which he is stated to be ten years old. The 1480 declaration says that Benedetto, now 22 years old, had given up working as an illuminator owing to trouble with his eyesight. He was admitted to the confraternity of S Paolo on 29 January 1479. According to Vasari, Benedetto spent many years in France, and documents confirm his presence there by the autumn of 1486. The one painting reasonably attributable to him is a panel of the *Nativity* (Aigueperse, Notre-Dame), inscribed with his name and an illegible date. The panel is painted in a thoroughly Frenchified version of Domenico Ghirlandaio's style, in which the thin, stiffly drawn forms, reminiscent of Davide's rather than Domenico's work, are clad in a veneer of Flemish detail. Benedetto returned to Florence about the time of Domenico's death. His participation in the decoration of the Tornabuoni Chapel in S Maria Novella, Florence, often posited, is therefore impossible.

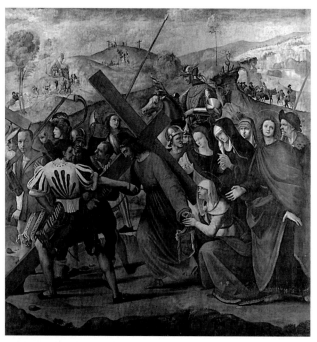

Ridolfo Ghirlandaio: *Procession to Calvary*, oil on canvas, transferred from panel, 1.66×1.62 m, *c*. 1504–10 (London, National Gallery)

BIBLIOGRAPHY
G. de Francovich: 'Benedetto Ghirlandaio', *Dedalo*, vi (1925–6), pp. 708–39

JEAN K. CADOGAN

(4) Ridolfo Ghirlandaio (*b* Florence, 4 Feb 1483; *d* 6 Jan 1561). Painter, son of (1) Domenico Ghirlandaio. He probably learnt his craft from his father and remained with his uncle (2) Davide Ghirlandaio when the latter took over the workshop in 1494. Ridolfo's first documented work is the *Virgin of the Sacred Girdle* (1509; Prato Cathedral), which was commissioned in 1507 from Davide and Ridolfo but probably mostly painted by the latter. The upper part still shows Domenico's influence, whereas the lower section reflects, somewhat clumsily, the more modern style of Fra Bartolommeo, with whom Ridolfo studied, according to Vasari. An interest in Piero di Cosimo is also apparent in the use of light and the sometimes disquieting landscapes of the earlier works that may be attributed to Ridolfo with certainty. This is particularly evident in *SS Peter and Paul* (Florence, Pitti), commissioned from Davide in 1503 but attributable to Ridolfo on the basis of style, the *Virgin and Child between SS Francis and Mary Magdalene* (1503; Florence, Accad.) and the *Coronation of the Virgin* (1504; Paris, Louvre), which was inspired by Domenico's altarpiece of the same subject (1484–6; Narni, Pin. Com.). Another very interesting work that may be dated to the first decade of the 16th century is the *Procession to Calvary* (London, N.G.; see fig.), which shows signs of Ridolfo's study of Leonardo's lost cartoon of the *Battle of Anghiari*.

Ridolfo's training also included links with Raphael during the latter's stay in Florence (1504–8). Vasari related that they became friends and that Raphael entrusted Ridolfo with the completion ('the blue robe') of one of his paintings, identified by Milanesi as *La Belle Jardinière* (Virgin and Child with the infant St John; Paris, Louvre). Some of Ridolfo's portraits, such as the *Portrait of a Woman* (Florence, Pitti), also show stylistic evidence for the link with Raphael.

Ridolfo returned to a conservative formula in the *Adoration of the Shepherds* (Budapest, Mus. F.A.), signed and dated 1510, and thereafter alternated between this style and one of great originality. This perhaps reflects the general crisis in Florentine painting, in which light should be viewed his frescoes, begun in 1514 and ornamented by Andrea Feltrini, for the Cappella della Signoria in the Palazzo Vecchio, Florence. On several occasions Ridolfo was appointed painter for the workshop of Florence Cathedral. In 1515 he was given an official commission to decorate the Cappella dei Papi in the convent of S Maria Novella, Florence, assisted by Feltrini and the young JACOPO DA PONTORMO. The *Miracle of St Zenobius* and *Translation of the Body of St Zenobius* (both Florence, Cenacolo Andrea del Sarto S Salvi) were painted in 1517 for the saint's confraternity and were designed to flank Mariotto Albertinelli's *Annunciation* (completed 1510; Florence, Accad.). They are among Ridolfo's greatest achievements and demonstrate his ability to create evocative, theatrical scenes. This talent was also used in commissions for festive decorations, such as those for the wedding of Lorenzo de' Medici, Duke of Urbino, in 1518. The *Pietà between Two Saints* (1521; Colle di Val d'Elsa, S

Agostino) marked a return to the solemnity of Fra Bartolommeo and Andrea del Sarto. About this time Ridolfo began working with his gifted pupil Michele Tosini, collaborating on a series of altarpieces listed by Vasari, including the *Virgin, St Anne and Other Saints* (Florence, Santo Spirito) and the *Virgin and Child with Four Saints* (Florence, S Felice). These works are of uneven quality, probably owing to commercial pressures.

Ridolfo's activities during his final decades were progressively reduced by gout. His paintings included a portrait of *Cosimo I as a Young Man* (1531; Florence, Pal. Vecchio) and the grotesque decorations (1542) in the Camera Verde of the Palazzo Vecchio. His last fresco, the *Last Supper* (1543) in the refectory of S Maria degli Angeli, Florence, is a rather feeble tribute to that by Andrea del Sarto (1526–7; Florence, Cenacolo Andrea del Sarto S Salvi).

BIBLIOGRAPHY

DBI: 'Bigordi, Ridolfo'

G. Vasari: *Vite* (1550, rev. 2/1568); ed. G. Milanesi (1878–85), iv, p. 328; vi, pp. 531–48

E. Maggini: *Un classicista fiorentino: Ridolfo Ghirlandaio* (Florence, 1968)

S. Meloni Trkulja: 'Ridolfo del Ghirlandaio', *Il primato del disegno* (exh. cat., ed. L. Berti; Florence, Pal. Strozzi, 1980), p. 186

A. Brown: 'A Contract for Ridolfo Ghirlandaio's "Pietà" in S Agostino, Colle Val d'Elsa', *Burl. Mag.*, cxxx (1988), pp. 692–3

W. M. Griswold: 'Early Drawings by Ridolfo Ghirlandaio', *Master Drgs*, xxvii (1989), pp. 215–22

D. Franklin: 'Ridolfo Ghirlandaio's Altar-pieces for Leonardo Buonafé and the Hospital of S Maria Nuova in Florence', *Burl. Mag.*, cxxxv (1993), pp. 4–16

ANDREA MUZZI

Ghirlandaio, Michele di Ridolfo del. *See* TOSINI, MICHELE.

Ghirri, Luigi (*b* Scandiano, Reggio Emilia, 5 Jan 1943). Italian photographer. He became interested in photography in 1970, when he began to take pictures in collaboration with conceptual artists. From 1972 his images were widely exhibited and published both at home and abroad. His use of colour to create surprising images out of everyday life and common surroundings combined acute wit with formal elegance. A major figure in post-war Italian photography, he published several books, including *Kodachrome* (Modena, 1978), *Luigi Ghirri* (Parma, 1979), *Luigi Ghirri* (Milan, 1983) and *Capri* (Turin, 1983). He wrote regularly for several Italian periodicals and taught at Parma University.

PHOTOGRAPHIC PUBLICATIONS

Kodachrome (Modena, 1978)

Luigi Ghirri (Parma, 1979)

Luigi Ghirri (Milan, 1983)

Capri (Turin, 1983)

BIBLIOGRAPHY

CP

I. Zannier: *70 anni di fotografia italiana* (Modena, 1979)

MARGHERITA ABBOZZO HEUSER

Ghirza. Site of Romanized Berber settlement on the banks of the Wadi Ghirza, 240 km south-east of Tripoli, Libya. The site consists of 38 buildings from the 4th and 5th centuries AD, some still preserved up to a height of 7 m. Half a dozen of them are in the form of impressive castle-like structures, two or three storeys high, with interior courts; this type of farm building, once thought to have had a quasi-military role, is typical of the Tripolitanian pre-desert area from the second half of the 2nd century AD onwards. Smaller houses are either single-roomed or have two or three rooms set end to end. One building is a Semitic-type temple probably dedicated to Baal, with an open court and rooms ranged around it. Cisterns, two wells and rubbish middens have also been identified, the last showing that barley, figs and many other crops were present. The settlement seems to have been occupied until the early 6th century AD and then abandoned, although the temple was briefly reused as a house from *c.* 1000 to *c.* 1050, apparently by a merchant and his family. The dry conditions have resulted in the rare survival of 81 fragments of textiles from this period.

Two extensive cemeteries accompany the settlement. Over 400 tombs are visible on the surface, but there are also 14 monumental tombs, probably all of the 4th century AD; most of them are in the form of temples ('temple-tombs') raised on platforms. One in the north cemetery, for example, has a Doric frieze combined with Ionic capitals; others have free-standing Corinthian columns. Barbarous sculptures, as charming as they are naive, executed in exceptionally flat relief, contain a wealth of funerary symbolism, including the standard pagan symbols of the Greco-Roman world (such as the peacock, the siren and the figure of Victory) and mythological scenes (such as the Labours of Hercules); scenes of ploughing, sowing, reaping and hunting are also shown. The names in the Latin inscriptions on the tombs are all Libyan, except for one family name (Marcius). The south necropolis also has monumental tombs, including one of the obelisk type frequent in Tripolitania. Despite the Roman architectural form of the tombs and the Latin inscriptions, there is no denying the essentially Libyan character of this settlement: the tombs were erected by prosperous Libyan farmers, semi-Romanized and apparently bilingual.

BIBLIOGRAPHY

O. Brogan and D. J. Smith: 'The Roman Frontier Settlement at Ghirza', *J. Roman Stud.*, xlvii (1957), pp. 173–84

——: *Ghirza: A Libyan Settlement in the Roman Period* (Tripoli, 1984)

R. J. A. WILSON

Ghisi. Italian family of artists. (1) Giorgio Ghisi was the most important reproductive engraver of the generation following Marcantonio Raimondi (*see* ENGRAVING, §II, 3). His brother (2) Teodoro Ghisi spent most of his life in Mantua working as a painter and had a particular interest in the study of nature.

(1) Giorgio Ghisi (*b* Mantua, 1520; *d* Mantua, 15 Dec 1582). Engraver and damascener. His teacher was probably Giovanni Battista Scultori, after whose designs and in whose style he engraved two *Scenes from the Trojan War* (see 1985 cat. rais., nos 7 and 8). His six earliest prints, from the early 1540s or before, are after designs by Giulio Romano. They are lightly engraved in rather flat perspective, the figures often silhouetted against dark backgrounds, the shading lines not necessarily defining volume, and with an effect of intense flickering light, in the style of Scultori. Ghisi is recorded as being with Giovanni Battista Bertani in Rome during the reign of Pope Paul III (1534–49). There he may have met Antoine Lafréry, who published four of his engravings during the 1540s, and

many others throughout his life. Probably after his return from Rome he made an engraving on ten separate plates after Michelangelo's *Last Judgement* (Rome, Vatican, Sistine Chapel), his model probably being a drawing by Marcello Venusti.

Around 1550 Ghisi travelled to Antwerp, where he made five large engravings for the publisher Hieronymus Cock at his publishing house, Aux Quatre Vents. Two of these, the *School of Athens* (1985 cat. rai. 11) and the *Disputation on the Holy Sacrament* (1985 cat. rai. 13), were after Raphael's frescoes in the Stanza della Segnatura of the Vatican and introduced these great works of the Italian High Renaissance to northern Europe for the first time in large-scale reproductions of high quality (Riggs). These engravings show a growing mastery of the medium, with shading lines following the contours of the forms, and more substantial figures.

Ghisi was in Paris from *c.* 1556 until at least 1567. He worked after designs by Luca Penni, then in Paris, and after several of Primaticcio's designs at Fontainebleau, as well as after Perino del Vaga, Polidoro da Caravaggio, Giulio Romano and Bertani. Here he achieved his mature style, producing densely engraved and richly embellished compositions, filling backgrounds and blank spaces with his own designs of flora, townscapes and landscapes. In 1559–60 he became one of the first printmakers to be granted a French royal privilege for single plates. In Paris he produced his most famous print, the *Allegory of Life* (formerly called the *Dream of Raphael*, 1561; 1985 cat. rai. 28), an enigmatic, compelling image, large, dark and dreamlike, complex and crowded with figures, animals, monsters, plants and water.

After 1567 Ghisi returned to Mantua, where he produced two highly ornamental scenes (*c.* 1570; 1985 cat. rai. 42–3) after drawings by his brother (2) Teodoro Ghisi, the equally ornamental *Cupid and Psyche* (1573–7; 1985 cat. rais. 50) after Giulio Romano, and the set of six large and imposing *Prophets* and *Sibyls* (1985 cat. rai. 44–9) after Michelangelo's frescoes in the Sistine Chapel. From *c.* 1575 all but one of his works were of religious subjects. The exception was his engraving (1985 cat. rai. 58) of the Farnese *Hercules* (Naples, Capodimonte). The religious works, five of them published by Lafrery in 1575, vary a great deal in quality; but the *Flight into Egypt* (1985 cat. rai. 59), apparently dated 1578, shows that his control remained undiminished.

Towards the end of his life, Giorgio was employed by the Gonzaga family as keeper of jewels and precious metals and overseer of work on the Gonzaga wardrobes. As a damascener, he is known by only two signed pieces, a richly embossed and damascened parade shield (London, BM), dated 1554, when he was probably in Antwerp, and a dagger hilt (1570; Budapest, N. Mus.).

BIBLIOGRAPHY
G. B. Bertani: *Gli oscuri e dificili passi del'opera ionica di Vitruvio* (Mantua, 1558), leaf Ev*r*
C. d'Arco: *Di cinque valenti incisori mantovani del secolo XVI e delle stampe da loro operate* (Mantua, 1840), pp. 97–116
C. Huelsen: 'Das Speculum Romanae Magnificentiae des Antonio Lafreri', *Collectanea Variae Doctrinae Leoni S. Olschi* (Munich, 1921), pp. 121–70
H. Zerner: 'Ghisi et la gravure maniériste à Mantoue', *L'Oeil*, lxxx (1962), pp. 26–32, 76
P.-J. Mariette: 'Catalogue de l'oeuvre gravé des Ghisi', ed. J. Adhémar, *Nouv. Est.*, ix (1963), pp. 367–85
T. Riggs: *Hieronymus Cock: Printmaker and Publisher* (New York, 1977)
Incisori mantovani del '500—Giovan Battista, Adamo, Diana Scultori e Giorgio Ghisi—dalle collezioni del Gabinetto Nazionale delle Stampe e della Calcografia Nazionale (exh. cat. by S. Massari, Rome, Calcografia N., 1980–81)
G. Albricci: 'Il *Sogno di Raffaello* di Giorgio Ghisi', *A. Cristiana*, lxxi (1983), pp. 215–22
S. Boorsch, M. Lewis and R. E. Lewis: *The Engravings of Giorgio Ghisi* (New York, 1985) [cat. rais.; all prints illustrated]
S. Boorsch and J. Spike, eds: *Italian Masters of the Sixteenth Century (1986)*, 31 [xv/iv] of *The Illustrated Bartsch*, ed. W. Strauss (New York, 1978–)

MICHAL LEWIS

(2) Teodoro Ghisi (*b* Mantua, 1536; *d* 1601). Painter, draughtsman, illustrator and naturalist, brother of (1) Giorgio Ghisi. He was custodian of the Palazzo del Te, Mantua, where his natural history collection attracted a visit in 1571 from Ulisse Aldrovandi, for whom he executed some animal paintings, including those of two parrots. At around the same time he created the designs for Giorgio's engravings of *Venus and Adonis* and *Angelica and Medoro*. In 1576 he and Giorgio acquired a house in Mantua, where Teodoro worked for Guglielmo Gonzaga, 3rd Duke of Mantua, and Vincenzo I, 4th Duke of Mantua. Between 1579 and 1581 he contributed to the decoration of the Galleria dei Mesi in the Palazzo Ducale and probably worked with Lorenzo Costa the younger in the Sala dello Zodiaco there. Around 1579 he executed the *Visitation* for the cathedral at Carpi, and in 1586–7 he worked in the Palazzo di Goito (destr.). From 1587 to 1590 he was court painter to Guglielmo Gonzaga's brother-in-law Archduke Charles II of Austria (1564–90), in Seckau and Graz, where he painted the altarpiece *Symbolum apostolorum* (1588; Graz, Alte Gal.), showing the *Creation of Eve*, surrounded by depictions of articles of the Nicene Creed. He received a life pension from the Archduke in 1589 but returned to Mantua in 1590. There he and IPPOLITO ANDREASI decorated the cathedral for Bishop Francesco Gonzaga, with frescoes that accorded with the dictates of the Counter-Reformation. The evangelists' animal symbols attest to Teodoro's continuing interest in nature. He indulged this further in his illustrations for Pietro Candido Decembrio's *De animantium naturis* (Rome, Vatican, Bib. Apostolica, MS. Urb. lat. 276). In general his work is more realistic than imaginative.

BIBLIOGRAPHY
Thieme–Becker
A. Neviani: 'Di uno sconosciuto naturofilo italiano della seconda metà del cinquecento', *Atti della Pontificia Accademia delle Scienze, Nuovi Lincei: Rome, 1933*, pp. 358–62
C. Tellini Perina: 'Teodoro Ghisi: L'immagine fra maniera e controriforma', *La scienza a corte: Collezionismo eclettico natura e immagine a Mantova fra rinascimento e Manierismo* (exh. cat. by D. A. Franchini and others, Rome, 1979), pp. 239–68
——: 'Per il catalogo di Teodoro Ghisi', *A. Lombarda*, n. s., 58–9 (1981), pp. 47–51
C. M. Pyle: *Das Tierbuch des Petrus Candidus: Codex Urbinas Latinus 276: Eine Einführung*, Codices e Vaticanis selecti (Zurich, 1984), pp. 77–105
——: 'A New Sixteenth-century Depiction of the Aurochs (*Bos primigenius* + 1627): Evidence from Vatican MS. Urb. lat. 276', *Archv Nat. Hist.* (in preparation)

CYNTHIA M. PYLE

Ghisilieri [Ghislieri]. Italian family of patricians, churchmen, patrons and collectors. One of the old patrician

families of Bologna, the Ghisilieri claimed kinship with Michele Ghisilieri, who became Pope Pius V. They erected palaces, chapels and other memorials in Bologna, including the Palazzo Ghisilieri (begun 1491; façade destr. 1943; rebuilt) that subsequently passed to the Malvasia family and was let for use as an inn, the Albergo Brun, in the early 19th century, and the Ghisilieri Chapel in the church of S Francesco. As important as their commissions was their active support of artistic education in Bologna in the 17th century. In 1646 Ettore Ghisilieri (*c.* 1605–76) established in his palace an academy that was frequented by the most famous painters of the day, such as Guercino, whose pictures for Ettore included *St John the Baptist* (1644) and *St Jerome* (1649; both Bologna, Pin. N.), which formerly decorated the church of S Maria della Galliera in Bologna to which Ettore bequeathed them. Among other devotional works in the bequest were pictures by Elisabetta Sirani, some of which are still *in situ* in the church. In 1686 Francesco Ghisilieri established the Ottenebrati academy, under the direction of Giovan Battista Bolognini (1612–88), Lorenzo Pasinelli, Emilio Tartuffi and Conte Carlo Cesare Malvasia. Francesco also collected the work of local artists, including Giuseppe Maria Crespi, Gian Gioseffo dal Sole and Gian Antonio Burrini.

One of the most notable patrons of early 18th-century Bologna was the Marchese Antonio Ghisilieri, whose commissions included a *Madonna and Child and St Pius V* by Giovan Pietro Zanotti, a sculpture of *Diana* by Giuseppe Mazza and a matching *Apollo* by Angelo Gabriello Piò, and a series of seven room decorations for the Palazzo Ghisilieri by Carlo Giuseppe Carpi (1676–1730) and Giacomo Antonio Boni; the theme of the planets reflected Antonio's interest in astronomy. The family died out in the 19th century.

BIBLIOGRAPHY

V. Spreti: *Enciclopedia storico-nobiliare italiana*, iii (Milan, 1930), pp. 422–4

E. Calbi and D. Scaglietti Kelescian, eds: *Marcello Oretti e il patrimonio artistico privato bolognese* (Bologna, 1984), pp. 234, 235

L. Salerno: *I dipinti del Guercino* (Rome, 1988), pp. 11, 294, 317, 330, cat. nos 217, 243, 259, 340

JANET SOUTHORN

Ghislandi [Galgario], **Giuseppe** [Fra Vittore] (*b* Bergamo, *bapt* 4 March 1655; *d* Bergamo, Dec 1743). Italian painter. He was the most gifted Italian portrait painter of the late Baroque, celebrated both for his fanciful character heads and for his portraits, mostly of people from every level of society in Bergamo. He was the son of a *quadratura* specialist, Domenico Ghislandi (*fl* 1656–72), and Flaminia Mansueti; his brother Defendente was also a painter. Between 1670 and 1675 he studied first with Giacomo Cotta (*d* 1689) and then, for four years, with Bartolomeo Bianchini (Tassi). No works survive from this period. Ghislandi was in Venice from 1675 to 1688, where he became a friar of the Order of Minims and joined the monastery of S Francesco di Paola. After returning briefly to Bergamo, he remained in Venice from *c.* 1689 to 1701/2, working in the studio of Sebastiano Bombelli. His portrait of *Bartolommeo Manganoni* (Narbonne, Mus. A. & Hist.) may be dated to between 1693 and 1696 and is close in style to Bombelli.

Having refused an invitation from the distinguished patron Cardinal Pietro Ottoboni to move to Rome, Ghislandi settled permanently in Bergamo in 1702, living in the Convento del Galgario, from which he took his name. A series of portraits of members of the Rota family date from immediately after his return from Venice (Tassi). The portrait of *Lodovico Rota* (Budapest, Mus. F.A.) is a grand, aristocratic work that echoes both Bombelli and the international style of Jan Kupecký (who was active in Venice from 1687), whereas the spatial complexity of his double portrait of *Marchese Giuseppe Maria Rota and Capitano Brinzago of Lodi* (Bergamo, priv. col., see Gozzoli, pp. 30–31) looks back to Giovanni Battista Moroni; the heavy impasto also reflects an awareness of 16th-century Venetian painting.

Before 1709 Ghislandi visited Milan. The lively realism of his *Oletta's Barber's Shop Sign* (*c.* 1709; Bergamo, Accad. Carrara B.A.) is influenced by Salomone Adler (*d* 1709), an artist working in the city at that time, whose art was indebted to Rembrandt. Adler, whose training and style were international, was an important yet sporadic influence on Ghislandi, most obviously in his character heads. There followed, before the end of 1710, a series of portraits of the Secco Suardo counts, of which the most important is that of *Conte Gerolamo Secco Suardo* (1710; Bergamo, Accad. Carrara B.A.). The series is refined and courtly, reflecting the elegance of Bombelli rather than the lively informality of Adler. Ghislandi's *Self-portrait* (1712; Bergamo, priv. col., see Gozzoli, p. 45) admirably demonstrates his more incisive and psychologically revealing style of portraiture, which is evident, too, in his portraits of contemporary artists, for example that of *Andrea Fantoni* (before 1734; Bergamo, priv. col., see Gozzoli, p. 166).

Although isolated in his monastery in Bergamo, Ghislandi was well known in Italy and in Europe. He visited Bologna *c.* 1717, and was elected to the Accademia Clementina in that year. He was in contact with Bolognese artistic circles and it seems likely that he knew the art of Giuseppe Maria Crespi, whose use of impasto is close to his. Between 1719 and 1733 Ghislandi visited Milan to paint a series of official portraits (untraced) of the governors of Milan, among them *Conte Gerolamo Colloredo* and *Conte Wirico Filippo Lorenzo di Daun*. Yet Ghislandi was most celebrated for his character heads, those 'bizarre, whimsical heads that have caused such a stir, even beyond the Alps' (Tassi, p. 61). These heads, often of young painters and sculptors, or boys in turbans or tricorns, were painted with great freshness and immediacy, and include the *Portrait of a Young Boy (L'Allegrezza)* (before 1720; Milan, Mus. Poldi Pezzoli), and the *Young Painter* and *Young Sculptor* (both Milan, Castello Sforzesco). Such works attracted prestigious collectors, among them Prince Eugene of Savoy, who owned four heads (Tassi), and Marshal Johann Matthias von Schulenberg, who possessed 11 works by Ghislandi, both portraits and heads, of which only a *Portrait of an Unknown Man* survives (Hannover, Niedersächs. Landesmus.). Ghislandi was in contact with contemporary artists such as Sebastiano Ricci, with whom he exchanged rare painting materials, and Giambattista Tiepolo, who visited him while working on the Colleoni Chapel in Bergamo (1732–3).

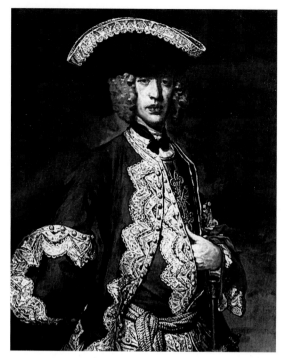

Giuseppe Ghislandi: *Gentleman with a Tricorn Hat*, oil on canvas,
1.09×0.93 m (Milan, Museo Poldi Pezzoli)

The chronology of Ghislandi's works is complicated by the almost total absence of any documented works. His portraits of *Conte Giovanni Domenico Albani* and *Contessa Paola Calepio Albani* (both 1724; Milan, priv. col., see Gozzoli, pp. 67, 68, 159), court portraits that exploit to the full the physical properties of paint, are rare dated works. The portrait of *Francesco Maria Bruntino* (Bergamo, Accad. Carrara B.A.), antiquarian, bookseller, dealer and collector, is distinguished by an affectionate realism that contrasts with the psychological remoteness with which Ghislandi portrayed the *Knight of the Order of St John of Jerusalem*, the so-called *Gentleman with a Tricorn Hat* (Milan, Mus. Poldi Pezzoli; see fig.). This work is tantamount to a judgement, characteristic of the Age of Enlightenment, on the moral degeneracy of the contemporary nobility. Ghislandi's portraits convey a wide range of feelings, from the friendly affability of his portrait of a *Gentleman in Red* (Milan, Mus. Poldi Pezzoli) to the harsh and penetrating realism of his portrait of *Clelia Bondui* (Rome, priv. col., see Gozzoli, p. 168). His late works, which include a *Self-portrait* (1732; Bergamo, Accad. Carrara B.A.) and his portrait of *Francesco Biara* (1736; Bergamo, priv. col., see Gozzoli, p. 94), are characterized by a dissolution of form reminiscent of Titian's late style. This is perhaps no accident, for Ghislandi apparently destroyed a *Head* by Titian by peeling off the layers of paint to discover the secret of that artist's expressive handling.

BIBLIOGRAPHY

F. M. Tassi: *Vite de' pittori, scultori ed architetti bergamaschi* (Bergamo, 1793); ed. F. Mazzini (Milan, 1969–70), ii, pp. 57–69
L. Pelandi: *Fra Galgario* (Bergamo, 1934)
A. Locatelli Milesi: *Fra Galgario* (Bergamo, 1945)
I pittori della realtà in Lombardia (exh. cat. by R. Longhi, R. Cipriani and G. Testori, Milan, Pal. Reale, 1953)
G. Testori: 'Il Ghislandi, il Ceruti e i veneti', *Paragone*, v/57 (1954), pp. 15–33
Mostra di Fra Galgario e del settecento a Bergamo (exh. cat. by F. Mazzini, Bergamo, Pal. Ragione, 1955)
Fra Galgario nelle collezioni private bergamasche (exh. cat. by R. Pallucchini, Bergamo, Gal. Lorenzelli, 1967)
G. Testori: *Fra Galgario* (Turin, 1970)
M. T. Gozzoli: 'Vittore Ghislandi, detto Fra Galgario', *I pittori Bergamaschi dal XIII al XIX secolo: Il settecento*, i, ed. R. Bossaglia (Bergamo, 1982), pp. 3–195 [with bibliog. and illus.]

UGO RUGGERI

Ghisleni, Giovanni Battista. *See* GISLENI, GIOVANNI BATTISTA.

Ghislieri, Michele. *See* PIUS V.

Ghisolfi, Giovanni (*b* Milan, 1623; *d* Milan, 1683). Italian painter. He first trained with his uncle, Antonio Volpino. In 1650, together with his friend Antonio Busca, he travelled to Rome, where he studied the great compositions of Pietro da Cortona and for some time frequented the studio of Salvator Rosa. In 1661 he returned to Lombardy and worked at the Certosa di Pavia, decorating a whole chapel with frescoes showing *Legends of St Benedict* (*in situ*), and later providing a canvas of *St Bruno*, which is now in the Certosa library. In the background of this picture Ghisolfi painted a sloping landscape in a style very close to that of Pietro da Cortona. In the following years he evidently established a reputation for landscape paintings with architecture and ancient ruins. In 1664 he was called to Vicenza to execute, in the Palazzo Trissino Baston and the Palazzo Giustiniani Baggio, an extensive series of decorative landscape frescoes (partially destr.; known through photographs). Numerous preparatory drawings for these exist (Haarlem, Teylers Mus.; Windsor Castle, Berks, Royal Col.). In the same period Ghisolfi collaborated with Antonio Busca on a series of decorative frescoes in the gallery of Palazzo Borromeo Arese at Cesano Maderno, near Milan, and later, with Federico Bianchi, in the Villa Litta Modigliani (1680) at Varese. Both these works have been gravely damaged by decay and later repaintings. The *Liberation of St Peter from Prison* (Milan, S Maria della Vittoria) is one of his few religious works, in an unadventurous style, close to Busca. At the end of the 1660s Ghisolfi went to Varese, where he frescoed the fourth chapel of the sacromonte and covered the vaults of the Basilica of S Vittore with airy frescoes in the style of Cortona, depicting the *Legends and Glory of St Victor*.

Ghisolfi's reputation today rests on his capriccios, small landscapes with ruins and romantic figures, which anticipate the style of Giovanni Paolo Panini. His canvases are preserved in many European galleries, among them the National Gallery of Scotland, Edinburgh (e.g. *Landscape with Ruins, Ruins and Figures*), and the Gemäldegalerie Alte Meister, Dresden (e.g. *Harbour Scene*).

BIBLIOGRAPHY

M. G. Rossi: 'Note su Giovanni Ghisolfi e su Giacinto e Agostino Santagostino', *Commentari*, xiv (1963), pp. 54–68
A. Busiri Vici: 'Giovanni Ghisolfi pittore di rovine romane', *Palatino*, viii/9–10 (1964), pp. 212–21
M. Bona Castellotti: *La pittura lombarda del seicento* (Milan, 1985), pp. 112–14 [with bibliog.]

W. Meijer: 'Disegni di Giovanni Ghisolfi per affreschi in due palazzi vicentini', *Paragone*, xxxviii/443 (1987), pp. 26–33
E. de Pascale: 'Ghisolfi, Giovanni', *La pittura in Italia: Il seicento* (Milan, 1989), ii, pp. 762–3 [with bibliog.]

MARCO CARMINATI

Ghisoni, Fermo (di Stefano) [Fermo da Caravaggio] (*b* Caravaggio, *c.* 1505; *d* Mantua, 1575). Italian painter. He trained with Lorenzo Costa the elder and worked under Giulio Romano in Mantua on the decoration of the Palazzo del Te (payments for the Sala di Psiche and the Sala dei Giganti between 1527 and 1534), in the Palazzo Ducale on the apartment built for Margherita Paleologo (1534) and in the Corte Nuova (Sala di Troia; 1538). Vasari mentioned him as one of the ablest executors of Giulio's designs. Works assigned to him on the basis of style include the *Virgin and Child with Saints* (Mantua, Mus. Dioc.) and three paintings for S Benedetto in Polirone (1538–42; two *in situ*, one, Mantua, church of Ognissanti). Although compared with the inventions of Giulio these works reflect a lack of originality typical of Mantuan painting in this period, their simplified and less anti-classical style reflects the patrons' requirements. Ghisoni was in Venice in 1545 and probably in Rome the following year. On his return to Mantua he painted altarpieces of *St Lucy* and *St John the Evangelist* (both 1552; Mantua Cathedral) for Cardinal Ercole Gonzaga. He was influenced by Mannerist ideas in this period through his collaboration with Gerolamo Mazzola Bedoli on the *Adoration of the Shepherds* (Paris, Louvre) for S Benedetto in Polirone. He worked for Ferrante Gonzaga, Prince of Guastella, and in the 1560s painted a series of portraits for the *studiolo* of Ferrante's son Cesare (Vasari). He also executed the altarpiece of the *Crucifixion* for S Andrea, Mantua. His last work, the organ shutters with the *Annunciation* and *SS Peter and Barbara* (Mantua, S Barbara), shows the influence of Giovanni Battista Bertani in the use of perspective and realistic detail.

BIBLIOGRAPHY
G. Vasari: *Vite* (1550, rev. 2/1568); ed. G. Milanesi (1878–86), vi, pp. 487–9
R. Berzaghi: 'Committenze del cinquecento: La pittura', *I secoli di Polirone*, i (San Benedetto, 1981), pp. 295–311
M. Tanzi: 'Fermo Ghisoni', *Pittura tra Adda e Serio*, ed. M. Gregori (Milan, 1987), pp. 238–9
R. Berzaghi: 'Fermo Ghisoni', *Pittura a Mantova dal Romanico al settecento*, ed. M. Gregori (Milan, 1989), pp. 240–41
Giulio Romano (exh. cat. by A. Belluzzi, K. Forster, H. Burns and others, Mantua, Mus. Civ. Pal. Te, and Pal. Ducale, 1989)

MATILDE AMATURO

Ghissi, Francescuccio (di Cecco) [Francescuccio da Fabriano] (*fl* 1359–74). Italian painter. He was the leading 14th-century painter from the Marches after Allegretto Nuzi. The overall pattern of his activity is unknown. His surviving panels all depict the Madonna of Humility. Frescoes in S Francesco in Sanseverino were recorded but are now lost. Between his earliest known work, the signed *Madonna of Humility* (1359; Fabriano, S Domenico), and the *Madonna of Humility with an Angel* (1374; Montegiorgio, S Andrea) his draughtsmanship and facial modelling became more assured and the design of the basic triangular

group more elegant. Another example (Fermo, S Domenico) shows the richness of his decorative repertory in the painted cloth and in the elaborately foliated gold ground.

Ghissi's dependence on Nuzi is always clear, in the shared facial types and in details such as the way the turned lining of the Virgin's mantle in the Montegiorgio panel rolls into a shiny, tapering tube, a mannerism seen in several of Nuzi's panels. Ghissi shared Nuzi's taste for rich embroidered draperies to clothe the Virgin, though these are described without modelling. Ghissi's Virgins recall those of Bernardo Daddi rather as Nuzi's do, but the angels of the *Madonna of Humility with Two Angels* (Ascoli Piceno, S Agostino) suggest first-hand experience of Daddi's art. Ghissi's poise and refinement are seen at their best in the small *Madonna of Humility* (Rome, Pin. Vaticana), where the Virgin is exquisitely silhouetted against the gold.

BIBLIOGRAPHY
A. Colasanti: 'Note sulle antiche pittori Fabrianesi: Allegretto Nuzi e Francescuccio di Cecco Ghissi', *L'Arte*, ix (1906), p. 262
R. van Marle: *Italian Schools*, v (1925), pp. 169–76
B. Berenson: *Central and North Italian Schools*, i (1968), p. 166
G. Donnini: *Per Francescuccio di Cecco Ghissi* (Sassoferrato, 1970)
M. Boskovits: *Pittura umbra e marchigiana fra Medioevo e rinascimento* (Florence, 1973)
G. Donnini: 'Un'aggiunta al Ghissi e alcune considerazioni sul pittore', *Commentari*, xxiv (1973), pp. 26–33
E. N. Lusanna: 'Pitture del trecento nelle Marche', *La pittura in Italia: Il Duecento e il Trecento*, ed. E. Castelnuovo (Milan, 1986), pp. 414–22

JOHN RICHARDS

Ghiyāth al-Dīn Baysunghur. *See* TIMURID, §II(7).

Ghorid. *See* GHURID.

Ghulam [Ghulām] (*fl c.* 1580–1620). Indian miniature painter. At least two signed early works are known by the Mughal painter Ghulam (Pers.: 'slave'). Inscriptions on paintings reading 'the slave of Shah Salim' (e.g. Los Angeles, CA, Co. Mus. A., L.69.24.259) indicate that he worked for Prince Salim, the future emperor Jahangir (*reg* 1605–27), who took the title Shah in 1599, holding court in Allahabad from 1599 to 1604. Later signatures, in which Ghulam is preceded by the honorific *mīrzā*, occur, for example, on three works in an *Anvār-i Suhaylī* ('Lights of Canopus'; 1604–10/11; London, BL, Add. MS. 18579). Ghulam's style is derived from Iranian sources and bears similarities to that of the Persian artist Aqa Riza (*see* AQA RIZA (i)). His figures tend to be generalized, showing little concern for the actuality of the physical world. Several paintings within the sphere of artists related to Aqa Riza have been attributed to Ghulam.

BIBLIOGRAPHY
J. V. S. Wilkinson: *The Lights of Canopus* (London, 1929)
Ivan Stchoukine: 'Un Bustan de Sa'di illustré par des artistes moghols', *Rev. A. Asiat.*, xi (1938), pp. 68–74
The Grand Mogul: Imperial Painting in India, 1600–1660 (exh. cat. by M. C. Beach, Williamstown, MA, Clark A. Inst.; Baltimore, MD, Walters A.G.; Boston, MA, Mus. F.A.; New York, Asia Soc. Gals; 1978–9)
The Imperial Image: Paintings for the Mughal Court (exh. cat. by M. C. Beach, Washington, DC, Freer, 1981)

JEFFREY A. HUGHES

Ghurid [Ghuri; Ghorid]. Dynasty that ruled portions of Afghanistan and north-west India *c.* 1030–1206. It originated in the Ghur region of Afghanistan; its first fully

historical figure is 'Izz al-Din, who paid tribute to Saljuq and GHAZNAVID rulers. Ghaznavid power declined after the death of Mahmud (*reg* 998–1030), and the Ghurids assumed independence. Under 'Ala' al-Din Husayn (*reg* 1149–61) the Ghurids captured and sacked Ghazna and forced the last of the Ghaznavids to Lahore. 'Ala' al-Din was succeeded by his son Sayf al-Din (*reg* 1161–3), on whose death the principality of Ghur passed to his cousin Ghiyath al-Din Muhammad (*reg* 1163–1203). In 1173 Ghiyath al-Din appointed his brother Shihab al-Din (better known as Mu'izz al-Din Muhammad) to rule from Ghazna and turned his own attention to campaigns in the west. Together the brothers established an empire stretching nearly from the Caspian Sea to north India. Mu'izz al-Din, known in Indian history as Muhammad ibn Sam or simply Muhammad of Ghur, drove the Ghaznavids from Lahore in 1186, and captured DELHI and AJMER after defeating the Rajputs in 1192. Muhammad of Ghur's officers extended Ghurid conquests further into India. The Indian territories were formally part of the Ghurid kingdom until Muhammad's death in 1206, at which time an independent Indian Sultanate ruling from Delhi was established. Art under the Ghurids is well typified by the minaret at Jam, a brick tower 60 m high profusely decorated with geometric patterns and interlocking bands of inscriptions. This style of decoration, ultimately Saljuq in origin, was carried to India where it had a considerable impact.

Enc. Islam/2 BIBLIOGRAPHY
Minhaj al-Din 'Uthman al-Juzjani: *Ṭabaqāt-i Nāṣirī* [History of Naṣir] (*c.* 1259–60); Eng. trans. by H. G. Raverty, 2 vols (London, 1881/*R* New Delhi, 1970)
W. K. Fraser-Tytler: *Afghanistan* (Oxford, 1953)
M. A. Ghafur: *The Ghurids* (diss., U. Hamburg, 1959)
A. Maricq and G. Wiet: *Le Minaret de Djam, la découverte de la capitale des sultans Ghorides (XIIe–XIIIe siècles)* (Paris, 1959)
C. E. Bosworth: 'The Early Islamic History of Ghur', *Cent. Asiat. J.*, vi (1961), pp. 116–33
C. Kieffer: 'Les Ghorides, une grande dynastie nationale', *Afghanistan*, 3 pts (Kabul, 1961–3)
 R. NATH

Giacchino miniatore. *See* GIOACCHINO DI GIGANTIBUS DE ROTTENBURG.

Giacomelli, Mario (*b* Senigallia, Ancona, 1 Aug 1925). Italian photographer. A self-taught painter from the age of 13 and a printer by profession, he began working as a photographer in the early 1950s and quickly developed an intense and personal style, rendering poetic, dream-like visions in strongly contrasting blacks and whites. From the start he worked on a range of themes that closely reflect his concerns for the life of the rural communities of his birthplace; he also extensively documented the often miserable living conditions of the old, poor and sick, with great intensity of feeling and uncompromising directness. Although he sometimes worked on commissions, mainly for the national television company, his best works spring from the need to exorcise his personal obsession with decay, death and old age. Consequently, he intensely disliked documentary photography and printed only the images that reveal his experience, rejecting those that appear to be 'just taken by the camera'. He generally used a simple twin-lens reflex Kobel press camera, with an 80 mm lens and no exposure meter, allowing himself the maximum technical freedom in the taking and developing of the images. He regarded landscape as a subject comparable to the human face and explored its possibilities throughout his career.

 BIBLIOGRAPHY
Breve omaggio a Mario Giacomelli (exh. cat., ed. P. Monti; Novara, Civ. Gal. A. Mod., 1966)
J. Szarkowski: *Looking at Photographs: 100 Pictures from the Collection of the Museum of Modern Art* (New York, 1973)
A. C. Quintavalle: *Mario Giacomelli* (Milan, 1980)
Mario Giacomelli: A Retrospective, 1955–1983 (exh. cat., ed. A. Crawford; Cardiff, Oriel Ffotogal., 1983)
 MARGHERITA ABBOZZO HEUSER

Giacometti. Swiss family of artists.

 BIBLIOGRAPHY
Giacometti: Giovanni, Alberto, Diego, Augusto (exh. cat. by B. Stutzer, Mexico City, Cent. Cult. A. Contemp., 1987)

(1) Giovanni Giacometti (*b* Stampa, 7 March 1868; *d* Glion, nr Montreux, 25 June 1933). Painter and printmaker. Although not as famous as his son (3) Alberto Giacometti, he ranks as one of Switzerland's noteworthy early modernists. Son of a rural innkeeper, he received no early artistic training. After secondary school (1884–6) in Schiers, near Chur, he studied painting in Munich, where he met Cuno Amiet. From October 1888 they studied together for three years in Paris, primarily painting and drawing at the Académie Julian. Returning in 1891 to Stampa, Giacometti worked in obscurity, mainly painting but also producing some etchings. Between 1894 and 1899 he was encouraged by Giovanni Segantini, from whom he learnt the divisionist technique of systematic parallel brushstrokes, as in *Mother and Child under Flowering Tree* (1900; Chur, Bündner Kstmus.). In 1897 the influence of Ferdinand Hodler, with whom he and Amiet had a joint exhibition in Zurich in 1898, is evident in *Panorama of the Muotta Muragl* (1897–8; Chur, Bündner Kstmus.). Through publications, occasional trips, and especially Amiet's visits, Giacometti assimilated recent stylistic innovations from France. In 1904–5 he developed a more avant-garde style, for example in *Piz Duan* (1905; Chur, Bündner Kstmus.), reflecting the flattened forms and bold colours of the Pont-Aven group. In 1907 Giacometti was inspired by the works of Paul Cézanne, which he saw with Amiet in the Salon d'Automne in Paris. In 1907–8 he copied paintings in Swiss private collections by Van Gogh. These sources inspired him to develop more dynamic and assertive brushstrokes, and his mature style, a variant of Fauvism, emphasized two-dimensional space and form and high-keyed, strongly contrasted colours. In the next ten years Giacometti created his most vividly coloured and freely brushed compositions, such as *Bridge in the Sun* and *Rainy Day at Capolago* (1907; Chur, Bündner Kstmus.), *The Lamp* (1912; Zurich, Ksthaus) and *Midsummer's Fire Dance* (*c.* 1912–18; Chur, Bündner Kstmus.). In 1907–8, inspired by his contact with Die Brücke artists, he began to make woodcuts in the German style, which he often enhanced with colours. Some, such as *Nude Boys Wrestling* and *Children of the Sun* (*c.* 1912–13; Chur, Bündner Kstmus.), relate to his paintings. Gradually he achieved public recognition, particularly with one-man exhibitions at the Kunsthaus in Zurich (1912) and the

Kunstmuseum in Berne (1920). Around 1916 his technique gradually evolved away from vigorous brushwork towards more lyrical description, as in the *Sculptor and his Model* (1923; Zurich, Ksthaus); this mature style strongly influenced his son Alberto. The paintings of his late years express his love of colour but lack the energy and bravura of his earlier work.

BIBLIOGRAPHY

E. Köhler: *Giovanni Giacometti: Leben und Werk* (PhD thesis, U. Zurich, 1968)

Giovanni Giacometti: Katalog des graphischen Werke, Chur, Bündner Kstmus. (Chur, 1977)

Ausstellung Giovanni Giacometti zum 50. Todestag: Werke im Bündner Kunstmuseum (exh. cat. by H. Diggelman, G. Germann and B. Stutzer, Chur, Bündner Kstmus.; Zurich, Schweizer. Inst. Kstwiss.; 1983)

(2) Augusto Giacometti (*b* Stampa, 16 Aug 1877; *d* Zurich, 9 July 1947). Painter and decorative artist, cousin of (1) Giovanni Giacometti. He displayed an early talent for drawing while still in secondary school in Schiers, near Chur. In 1894–7 he studied at the Kunstgewerbeschule in Zurich, followed by four years in Paris. There he studied at the Ecole Normale d'Enseignement de Dessin under Eugène-Samuel Grasset, whose Art Nouveau designs based on plants inspired Giacometti to create abstract line and colour patterns, such as *Mountain Stream* (1900; Chur, Bündner Kstmus.). Leaving Paris in 1901, he went to study early Renaissance painting in Florence, where he settled until 1915. While there he began painting large-scale colour abstractions in a lyrical or painterly mode. Although *May Morning* (Basle, Kstmus.) was later dated by the artist to 1910, other paintings indicate that the transition to abstraction occurred in 1912: *Midsummer* and *Stampa* (both Chur, Bündner Kstmus.) are recognizable images executed in a Fauvist mode, while *Ascent of Piz Duan* (Zurich, Ksthaus) of the same year crosses over into abstraction, as does *Colouristic Fantasy* (1913; St Gallen, Kstmus.). His paintings of 1914–17 are purely non-objective; their overall patternings consist of 'explosions' of pure colours in free-form compositions, whose nebulous forms suggest the infinities of both micro- and macrocosmic space, as in *Chromatic Fantasy* (1914; Zurich, Ksthaus), *Summer Night* (1917; New York, MOMA) and *Fantasy on a Potato Blossom* (1917; Chur, Bündner Kstmus.). These paintings, with their use of sophisticated, exuberant colour to create evocative or emotive effects, suggest comparisons with the early abstractions of Kandinsky, but Giacometti eschewed reliance on line, preferring instead more miasmic and stippled forms. He continued to create works in this style during the following decades, for example *Memory of an Italian Primitive II* (1927; Chur, Bündner Kstmus.). These paintings later earned him a place in history as one of the pioneers of abstraction, although during his lifetime he gained fame primarily through his decorative work. After settling in Zurich in 1915 he worked on many public commissions, particularly stained-glass windows and mosaics. His early abstractions were rediscovered through exhibitions in Switzerland in 1959, when they were perceived as having remarkable affinities with European Tachism and *Art informel*, as well as with American colour field painting, for example that of Rothko, Sam Francis and Clyfford Still. However, Giacometti's lyrical colourist compositions had spiritual and symbolist intentions significantly different from post-war Abstract Expressionist styles.

WRITINGS

Die Farbe und ich (Zurich, 1933)

Von Stampa bis Florence, 2 vols (Zurich, 1943 and 1948) [memoirs]

BIBLIOGRAPHY

E. Poeschel: *Augusto Giacometti* (Zurich, 1922, rev. 1928)

M. Gauthier: *Augusto Giacometti* (Paris, 1930)

Augusto Giacometti (exh. cat. by F. Mayer, Berne, Ksthalle; rev. Chur, Ksthaus; 1959)

Augusto Giacometti: Ein Leben für die Farbe (exh. cat. by H. Hartmann, Chur, Bündner Kstmus., 1981)

Augusto Giacometti, 1877–1947: Schilderijen, Aquarellen, Pastels, Ontwerpen (exh. cat. by H. van der Grinter and B. Stutzer, Nijmegen, Mus. Commanderie St Jan, 1986)

(3) Alberto Giacometti (*b* Borgonovo, nr Stampa, 10 Oct 1901; *d* Chur, 11 Jan 1966). Sculptor, painter, draughtsman and printmaker, son of (1) Giovanni Giacometti.

1. Early studies and works, to 1927. 2. Surrealist period, 1927–34. 3. Interim period, 1935–45, and emergence of mature style, 1946–55. 4. Crisis of 1956–7 and late works, 1958–65.

1. EARLY STUDIES AND WORKS, TO 1927. He began drawing around 1910–12, followed by painting and sculpting in 1913–15. While at secondary school in Schiers, near Chur (1914–19), he developed his drawing style primarily through portraiture. In 1919–20 in Geneva he studied painting at the Ecole des Beaux-Arts and sculpture at the Ecole des Arts et Métiers but was more impressed by subsequent visits to Italy (1920–21), where he worked without formal instruction. In sculpture he worked in an academic mode, while in painting he emulated his father's Post-Impressionist and Fauvist style, which he thoroughly mastered by late 1921, as in *Self-portrait* (Zurich, Ksthaus). Consequently in January 1922 he began studying sculpture in Paris under Emile-Antoine Bourdelle at the Académie de la Grande Chaumière, where he continued intermittently for five years. In 1925 he ceased drawing and painting to concentrate on sculpture, and his brother (4) Diego Giacometti joined him in Paris. In 1927 they moved into the studio at 46, Rue Hippolyte-Maindron in Montparnasse, where Alberto worked for the rest of his life, with annual visits to his family in Switzerland.

Giacometti made few noteworthy sculptures before 1925, when he turned to more avant-garde sources. After some interest in the formal simplicity of Brancusi's style, for example in *Torso* (1925; Zurich, Ksthaus), he turned to Cubism, emulating the works of Jacques Lipchitz and Henri Laurens in his own sculptures of 1927, usually titled simply *Composition (Man)* or *(Man and Woman)*. He also turned to African art for inspiration, resulting in his first important sculptures: *Man and Woman* of 1926 (exhibited in the Salon des Tuileries, Paris) and *Spoon Woman* of 1926–7 (both Zurich, Ksthaus). These totemic sculptures consist of radically simplified forms; their rigid frontality and use of male and female nudes as sexual types or symbols were to have long-lasting implications for Giacometti's later work.

2. SURREALIST PERIOD, 1927–34. Giacometti's first period of extraordinary creativity began in 1927; during the next seven years he produced sculptures in a wide

variety of styles. In 1927–8 he modelled flattened compositions, including a series of portrait heads of his parents (see 1987 exh. cat., pp. 159–61) and a group of plaques, notably *Gazing Head* (Zurich, Ksthaus) and several entitled *Woman* (e.g. Washington, DC, Hirshhorn). The plaques reflect a new conceptual approach to sculptural form and space, as Giacometti reduced a head or figure to a few highly abstracted elements on the surface of a flat rectangle.

The plaques attracted the attention of André Masson, through whom Giacometti met Max Ernst, Miró, the French writer Georges Bataille and others who encouraged him to move toward Freudian themes of sexuality, violence and fantasy. As he incorporated this new orientation, he worked increasingly in open, geometrically structured compositions of linear elements, as in *Three Figures Outdoors* (1929; Toronto, A.G. Ont.) and *Reclining Woman who Dreams* (1929; Washington, DC, Hirshhorn), whose semi-abstract imageries convey phallic innuendoes. The following year he began making more three-dimensional constructions of mixed media, notably *Suspended Ball* (iron and plaster, 1930; Zurich, Ksthaus; *see* SURREALISM, fig. 2), whose kinetic sexual implications prompted André Breton to enrol Giacometti into the 'official' Surrealist group. An active member from 1930 until 1935, Giacometti emerged as the Surrealists' most innovative sculptor, extending the parameters of sculpture both conceptually and stylistically. In addition to modelling in plaster, he made constructed sculptures with varied and fragile materials, for example suspending elements such as plaster or glass in delicate structures of extremely thin wood and string. Many sculptures of 1931 to 1933 exceed the traditional definitions of sculpture by coming tantalizingly close to other 'categories': *No More Play* (Dallas, priv. col.) and *Man, Woman, Child* (Basle, Öff. Kstsamml.) resemble table-top toy games with movable figures in abstracted landscapes, while *Surrealist Table* (Paris, Pompidou) approaches furniture design with strange permutations. (At the time Giacometti also did commissions for the interior designer Jean-Michel Frank.) *Palace at 4 a.m.* (New York, MOMA) resembles a miniature architectural stage set, filled with evocations of the artist's own dreams, including the skeleton of a pterodactyl and a spine suspended in a cage. *Flower in Danger* (Zurich, Ksthaus) threatens imminent destruction of fragile beauty, while *Woman with her Throat Cut* (Venice, Guggenheim) conveys the aftermath of gruesome violence, including an element of voyeurism, as the viewer stands enthralled by the sculpture's extraordinary forms. *Hands Holding the Void* (*The Void*; 1934; New Haven, CT, Yale U. A.G.; see fig. 1) presents an enigmatic image of unfulfilled metaphysical longing, as the figure grasps at nothingness. In nearly all his Surrealist sculptures, empty space plays an active role, both compositionally and psychologically.

During 1930–36 Giacometti participated in many exhibitions, including *Miró-Arp-Giacometti* (Galerie Pierre, Paris, 1930), his first one-man show (Galerie Pierre Colle, Paris, 1932), and Surrealist group shows around the world (Galerie Pierre Colle, Paris, 1933; Galerie Charles Raton, Paris, 1936; Museum of Modern Art, New York, 1936; New Burlington Galleries, London, 1936; and others in Brussels, Zurich and Copenhagen). However, precipitated

1. Alberto Giacometti: *Hands Holding the Void* (*The Void*), plaster, h. 1.56 m, 1934 (New Haven, CT, Yale University Art Gallery)

by his work on the figure in the *Invisible Object* (1934; Washington, DC, N.G.A.), in 1935 he rejected Surrealism to return to representational art based on study from life.

3. INTERIM PERIOD, 1935–45, AND EMERGENCE OF MATURE STYLE, 1946–55. For the next decade Giacometti struggled through a period of frustrated effort, as he tried to capture the experience of perception, including subjective effects of spatial distance, without lapsing into a merely descriptive style. He returned to drawing, often copying older art. He sculpted busts repeatedly as his model posed for days or weeks, and by 1939 he was making obsessively reductivist plasters, some so small that they crumbled into dust. Although his efforts in Paris and, during World War II, in Geneva (1942–5) produced only a few significant works, they laid the groundwork for his

post-war style. *Woman on a Chariot* (1942–3; Stuttgart, Staatsgal.) prefigures his later female nudes, while the *Artist's Mother* and *Still-life with Apple* (1937; priv. cols, see Lamarche-Vadel, pp. 75–7) mark the start of his post-war linearist painting style.

Only after his return to Paris in late 1945 were Giacometti's frustrated efforts redirected into producing his mature style, and so began his second phase of intense creativity. Many factors may have contributed to provide the necessary catalysts: the vitality of post-war Paris, the renewed help and support of his brother Diego, his friendship with Jean-Paul Sartre, and his love affair and domestic life with the young Annette Arm, whom he had met in Geneva in 1943 and married in Paris in 1949. Among these converging stimuli was a radical alteration of perception (see Charbonnier for the artist's recollections), which caused him to 'see' figures as if at a distance, attenuated and undifferentiated, a vision that he translated into masterpieces of sculpture during the post-war years. Vestigial traces of Surrealist eeriness are found in some, notably *The Nose* (Washington, DC, Hirshhorn), *Hand* (Zurich, Ksthaus) and *Head of a Man on a Rod* (New York, MOMA). His best-known post-war sculptures portray single or grouped figures, all startlingly skeletal in proportions and often mounted on large or heavy bases. In bronzes such as the various *Tall Figures* (Washington, DC, Hirshhorn; Zurich, Ksthaus), *Four Figures on a Base* (Pittsburgh, PA, Carnegie) and *The Chariot* (New York, MOMA), his rigid female nudes stand like symbols of the irreducible essence of humanity, unapproachable and indestructible. His males appear to know their purpose or destination and so are portrayed in motion, as in *Man Pointing* (New York, MOMA) and the energetically striding figures in *Man Walking in the Rain* (New York, priv. col.) and *Three Men Walking* (Zurich, Ksthaus). The post-war sculptures often suggest an urban setting, as in *City Square* (New York, MOMA), *Woman Walking between Two Houses* and *Man Crossing a Square* (both Zurich, Ksthaus), and they nearly always incorporate a palpable sense of empty space surrounding the individual figures.

Giacometti's figures, with their seeming emaciation, anonymity and isolation in space, immediately struck a responsive chord in critics and collectors. His sculptures were perceived as appropriate metaphors for the human condition of post-war Europe: the horror of the concentration camps, displaced persons, destroyed lives. On a more philosophical level, critics also viewed Giacometti's art as Existentialist, an interpretation introduced by Sartre in his two essays on Giacometti's art (1948 and 1954). This Existentialist interpretation of his sculptures and paintings was the norm during the artist's lifetime and precipitated a reaction by formalist critics (see Kramer). Both the contextual and historical interpretations of his art have much validity, but they limit his work to a kind of philosophical illustration, whereas his art expresses a more personal and universal *Angst* than one specifically of his time and place.

After 1950 Giacometti narrowed his compositional range, eschewing multi-figure compositions and urban contexts for single figures and busts. After 1952 he modelled many busts of Diego based on life studies and memory. They range from relatively naturalistic portrayals to those characterized by a distorting vertical 'pull' or tension coupled with sharp contrasts between frontal and profile views, as in *Large Bust of Diego* (1954; Zurich, Ksthaus). Both his busts and standing nudes are characterized by expressionistically modelled surfaces and fixed frontal stares, both of which tend to keep the viewer at a distance.

During the post-war period of intense productivity, Giacometti drew constantly and painted regularly after a hiatus of 20 years. His drawing style consisted of rapidly executed, often continuous lines that swirl around, over, and through his subject, never quite defining it yet conveying a sense of its mass and mystery. The earliest post-war drawings have heavy reworkings, often obscuring facial features in an expressionist vortex of lines. Around 1954, just as he narrowed his range of compositions in sculpture and painting, he expanded his drawing scope. His pencil drawings of portraits, nudes, still-lifes and interiors from the mid-1950s display a fusion of power and delicacy, as lines interweave in geometrically structured traceries overlaid with darker smudgings and greyed shadows in a ceaselessly moving realm where nothing appears solid or stable. His mature painting style developed from that linear drawing method, as he used very thin brushes like pencils. Many of his post-war paintings have a virtuosic bravura of these black, white, red, and yellow lines, as in *Portrait of the Artist's Mother* (1950; New York, MOMA), *Diego Seated* (1948; Norwich, U. E. Anglia, Sainsbury Cent.), *Annette in the Studio with 'The Chariot'* (1950; London, priv. col., see 1969–70 exh. cat., p. 93), *Diego in the Red Plaid Shirt* (1954; New York, priv. col., see Lamarche-Vadel, p. 97) and *Annette* (Stuttgart, Staatsgal.). In many compositions the figures appear in understated tension with the surrounding space, subtly isolated from contact with surroundings, interpreted by Sartre as beings in the void of existence.

Giacometti's post-war work brought him immediate international acclaim. He had an exhibition at the Pierre Matisse Gallery in New York in early 1948 and again in late 1950 and May 1958. In Paris the Galerie Maeght presented his work in mid-1951, May 1954 and June 1957. Museums acquired his work, and the Kunsthalle in Berne mounted a one-man show in 1954; the next year he had separate retrospectives at the Arts Council Gallery in London and the Solomon R. Guggenheim Museum in New York.

4. CRISIS OF 1956–7 AND LATE WORKS, 1958–65. Continuing his narrowly prescribed formats in sculpture and painting, primarily busts and standing female nudes, Giacometti worked steadily during the 1950s. Of particular note are the 15 (10 surviving) standing female sculptures made for exhibitions in Berne and Venice in 1956. Gradually, however, Giacometti experienced increasing anxieties about his inability to accomplish fully in his work what he set out to do. This neurosis culminated in late 1956, while he was painting portraits of a visiting Japanese professor of philosophy, Isaku Yanaïhara (Paris, Pompidou; Chicago, IL, A. Inst.; priv. cols). The crisis of self-doubt initially and most visibly affected his painting, with which he became obsessed. The rapid bravura linearity of the post-war years in works such as *Annette* (1949; priv.

col., see 1969–70 exh. cat., no. 136) yielded to indecisiveness, to obsessive overpainting and obliteration, so that his canvases became increasingly characterized by grey miasmas overwhelming the figure (or object), as in *Large Standing Nude* (1958; Düsseldorf, Kstsamml. Nordrhein-Westfalen, see Lamarche-Vadel, p. 113).

After the crisis period, Giacometti continued to suffer deeply but his work in all media became stronger, especially from 1959 to 1962. These late works are characterized by tremendous intensity and expressive execution. In 1959–60 he made a group of large sculptures (originally commissioned for the Chase Manhattan Plaza in New York but never finalized), as a summation of the three major themes of his oeuvre: the *Large Standing Woman I–IV*, which average 2.74 m in height, the *Monumental Bust* and the life-size *Walking Man I–II* (see fig. 2). From 1962 to 1965 he worked on a series of 10 busts of Annette and others of Diego and the Romanian-born photographer Elie Lotar (1905–69). All have disturbingly obsessive gazes, vigorously modelled surfaces and distorted silhouettes; their staring faces, often deeply scored by cuts from the modelling knife, peer forward as if seeking to penetrate beyond their own reality. In his paintings some linearity returned but in a subtly different way, merging with the grey nebulous space to produce a sculptural yet ghostly three-dimensionality, in tandem with a gestural expressiveness. Along with a number of paintings of Annette in 1960–62 (e.g. Washington, DC, Hirshhorn), many of his most powerful late paintings depict a young prostitute called Caroline, of whom he was enamoured (e.g. 1962; Basle, Kstmus.). He also painted a series of 'dark heads' of Diego, modest in scale but haunting and almost morbid in effect (e.g. *Head of Diego*, 1961; Boston, MA, Mus. F.A.).

During the last years of his life, public fame claimed a significant amount of Giacometti's time, as collectors, dealers, young artists, curators and the media flocked to his tiny studio. Both Matisse and Maeght presented successful exhibitions of his work in 1961, followed by a major showing of over 100 works at the Venice Biennale in 1962. The Kunsthaus in Zurich (1962–3), the Phillips Collection in Washington, DC (1963), the Museum of Modern Art in New York (1965) and the Tate Gallery in London (1965) all showed large retrospectives. Early in 1963 he had surgery for stomach cancer, and he became increasingly unwell though he continued to work.

2. Alberto Giacometti: *Walking Man I–II*, bronze, h. 1.82 m, 1960 (Buffalo, NY, Albright–Knox Art Gallery)

WRITINGS

G. Charbonnier, ed.: 'Alberto Giacometti', *Le Monologue du peintre* (Paris, 1959), pp. 159–70 [transcripts of two radio interviews with Giacometti]
J. Dupin and M. Leiris, eds: *Alberto Giacometti: Ecrits* (Paris, 1990) [reprint of Giacometti's pubd writings and several interviews, as well as some of his previously unpubd writings]

BIBLIOGRAPHY

Alberto Giacometti (exh. cat., New York, Pierre Matisse Gal., 1948) [incl. artist's letter and handwritten checklist of early works, and J.-P. Sartre's essay 'The Search for the Absolute']
Giacometti (exh. cat., New York, Pierre Matisse Gal., 1954) [incl. J.-P. Sartre's essay 'The Paintings of Alberto Giacometti']
J. Dupin: *Alberto Giacometti* (Paris, 1962)
H. Kramer: 'Reappraisals: Giacometti', *A. Mag.*, xxxviii/2 (1963), pp. 52–9
Alberto Giacometti: Sculpture, Paintings, Drawings, 1913–65 (exh. cat. by D. Sylvester, London, Tate, 1965)
Alberto Giacometti (exh. cat., Paris, Mus. Orangerie, 1969–70)

R. Lust: *Giacometti: The Complete Graphics and Fifteen Drawings* (New York, 1970)
R. Kohl: *Alberto Giacometti* (Stuttgart, 1971; Eng. trans., New York, 1971) [standard monograph with comprehensive bibliog. to 1970 and best selection of primary sources]
G. Soavi: *Disegni di Giacometti* (Milan, 1973)
M. Brenson: *The Early Works of Alberto Giacometti, 1925–1935* (PhD thesis, Baltimore, Johns Hopkins U., 1974)
R. Krauss: 'Giacometti', *Primitivism in Twentieth Century Art*, ii (exh. cat., ed. W. Rubin; New York, MOMA, 1984), pp. 502–33

B. Lamarche-Vadel: *Alberto Giacometti* (Paris, 1984)
J. Lord: *Giacometti* (New York, 1985) [biography]
Alberto Giacometti: Le Retour à la figuration, 1934–47 (exh. cat. by C. Derouet and others, Geneva, Mus. Rath; Paris, Pompidou; 1986)
Alberto Giacometti (exh. cat. by R. Hohl and others, W. Berlin, N.G., 1987)
Alberto Giacometti (exh. cat. by V. Fletcher, Washington, DC, Smithsonian Inst., 1988) [incl. essay by Giacometti's nephew, S. Berthoud]
Alberto Giacometti (exh. cat., ed. K. M. de Baranano; Madrid, Cent. Reina Sofia, 1990)
C. Klemm: *Die Sammlung der Alberto Giacometti-Stiftung*, Zurich, Ksthaus cat. (Zurich, 1990)
V. Fletcher: *Alberto Giacometti: The Paintings* (PhD thesis, New York, Columbia U., 1994)
D. Sylvester: *Looking at Giacometti* (London, 1994)

(4) Diego Giacometti (*b* Borgonovo, nr Stampa, 15 Nov 1902; *d* Paris, 15 July 1985). Furniture designer and sculptor, son of (1) Giovanni Giacometti. He had an unfocused youth, not completing secondary school (1917–19) in Schiers, near Chur, and wandering from job to job. In 1925 he joined his brother Alberto Giacometti in Paris, where he readily helped with the technical aspects of his work, carving stone and making plaster and bronze casts. After assisting with his brother's commissions for the interior decorator Jean-Michel Frank in the 1930s, Giacometti began to create his own body of work. He studied sculpture briefly at the Académie Ranson in 1942 and then did commercial decorative work. By 1949 he received commissions for bases and stands, which led in the mid-1950s to his first designs for chairs and tables in the openwork geometric style associated with his name. The linear supports of his furniture were invariably adorned with animal motifs, usually small and whimsical. A few of these became independent sculptures, notably *Head-waiter Cat* (1961–7; priv. col.) and *Ostrich* (1977; priv. col., see Marchesseau, pp. 121–3). At first, each of his designs was unique, with the structural or decorative elements varied, but some were later made in multiples. He received sizeable commissions, including chairs, lamps and a café bar for the Fondation Maeght in Saint-Paul-de-Vence (1962–4); light fixtures for the Kronenhalle restaurant in Zurich (1964); and doors, a wall relief and lectern for the St Roseline Chapel at La Celle Roubard in the Var region (1968). His last and most important commission was from the Musée Picasso in Paris (1984–5), for which he made furniture and light fixtures in bronze and white polymer resin.

BIBLIOGRAPHY
F. Francisci: *Diego Giacometti: Catalogue de l'oeuvre* (Paris, 1986)
D. Marchesseau: *Diego Giacometti* (Paris, 1986; Eng. trans., New York, 1987)

VALERIE J. FLETCHER

Giacomo, Scilla. *See* LONGHI, SILLA.

Giacomo [Jacopo] di Mino del Pelicciaio (*fl* 1342–*c.* 1396). Italian painter. His life is well documented, although he left only two signed and dated panels, a *Virgin and Child* (1342; Sarteano, SS Martino and Vittoria) and a triptych, formerly in S Antonio, Fontebranda, near Siena, of the *Mystic Marriage of St Catherine* (1362; Siena, Pin. N.). To these are normally added the catalogue of paintings attributed by Longhi to the Master of the Ordini, painter of the vault frescoes of the *Founders of the Religious Orders* in S Francesco, Pisa, and various works added to Longhi's list by Donati. Giacomo's career was exceptionally long and apparently successful: he appeared second in the list of Sienese painters for 1355 and first in that of 1389. Several public commissions for paintings executed by him are recorded, as well as his tenure of various civic offices. He probably died in or before 1396 (Frinta).

Giacomo's father may have been the Mino Parcis da Siena, recorded in 1321 as a collaborator of Pietro Lorenzetti, whose influence is sometimes apparent in Giacomo's paintings. Early works such as the *Virgin and Child* of 1342 and a polyptych of the *Virgin and Child Enthroned with Four Saints* (*c.* 1345; Siena, Pin. N.), however, reflect the painting tradition of Lippo Memmi in the rather stolid, frontally staring saints, perhaps tempered by the more refined and introspective art of Naddo Ceccharelli (*fl* 1340s), whose own influence is apparent in the figures of the Virgin. The development of Giacomo's art from these rather timid beginnings to the triptych of 1362 is considerable, the later painting exhibiting a more inventive and assured figure design, a richness of decoration and a more exuberant Gothic line (e.g. in St Michael's draperies). These characteristics are also seen in a fragmentary fresco of the *Maestà* (Virgin and Child enthroned), formerly in S Francesco, San Miniato del Tedesco (San Miniato, Mus. Dioc. A. Sacra), and in a panel of the *Coronation of the Virgin* (Montepulciano, Mus. Civ.) widely (though not universally) attributed to Giacomo, which, judging from the shared punch designs, suggests some contact with the Ovile Master (Frinta).

BIBLIOGRAPHY
R. Longhi: 'Il Maestro degli Ordini', *Paragone*, vi/65 (1955), pp. 32–3
B. Berenson: *Central and North Italian Schools*, i (London, 1968), pp. 322–3
P. P. Donati: 'Aggiunte al "Maestro degli Ordini"', *Paragone*, xix/219 (1968), pp. 67–70
L. Bellosi: 'Jacopo di Mino dell Pelliciaio', *Boll. A.*, lvii/2 (1972), pp. 73–4
M. S. Frinta: 'Deletions from the Oeuvre of Pietro Lorenzetti and Related Works by the Master of the Beata Umiltà, Mino Parcis da Siena, and Jacopo di Mino dell Pelliciaio', *Mitt. Ksthist. Inst. Florenz*, xx (1976), pp. 271–300
P. Torriti: *La Pinacoteca Nazionale di Siena: I dipinti dal XII al XV secolo* (Genoa, 1980), pp. 144–7

JOHN RICHARDS

Giacomotti, Félix(-Henri) (*b* Quingey, Doubs, 19 Nov 1828; *d* Besançon, 10 May 1909). French painter. He entered the Ecole des Beaux-Arts in Paris at 18 as a pupil of François-Edouard Picot. Italian by descent, he took French citizenship in 1849, giving him the right to compete for the Prix de Rome. In 1851 he won second place and took the prize in 1854 with *Abraham Washing the Feet of the Three Angels* (Paris, Ecole N. Sup. B.-A.), a luminous, natural, delicately coloured composition. He studied Raphael in Italy in company with William-Adolphe Bouguereau, his former classmate in Picot's studio, whose influence mingled with that of Raphael in the pictures of Greek mythology that Giacomotti exhibited in Paris in the 1860s and 1870s. His success on his return to Paris was rapid. In 1861 the State purchased his *Martyrdom of St Hippolytus* (Besançon, Mus. B.-A. & Archéol.) for the museum in Besançon, a dramatic composition more like an artist's idea of a scene from Homer than a work of religious

significance. His *Agrippina Leaving Camp* (Lille, Mus. B.-A.), an expressive, understated work, was commissioned by the State for the Lille museum in 1862. Shortly after completing this work his brightly coloured *Amymoné* (Lille, Mus. B.-A.), reflecting memories of Raphael's *Galatea* (Rome, Villa Farnesina), was bought in 1865 for the Musée du Luxembourg, Paris. The State, however, could not buy everything he did, and there was little private interest in large pictures of ancient history. He painted at least two religious commissions, the Chapel of St Joseph in Notre-Dame-des-Champs and the Chapel of Catechism in St-Etienne-du-Mont, in Paris. Giacomotti turned to portraits for a livelihood and spent his last years as keeper of the Besançon museum.

BIBLIOGRAPHY

A. Estiguard: *Giacomotti: Sa vie, ses oeuvres* (Besançon, 1910)

P. Grunchec: *Le Grand Prix de peinture: Les Concours des Prix de Rome de 1797 à 1863* (Paris, 1983), pp. 182–3

JON WHITELEY

Giambellino. *See* BELLINI, (3).

Giamberti. *See under* SANGALLO, DA.

Giambologna [Bologna, Giovanni; Boulogne, Jean] (*b* Douai, 1529; *d* Florence, 1608). Flemish sculptor, active in Italy. Born and trained in Flanders, he travelled to Italy in 1550 to study the masterpieces of Classical and Renaissance sculpture. On his way home he visited Florence (*c.* 1552) and was persuaded to settle there under the patronage of the Medici Dukes, eventually becoming their court sculptor.

He grafted an understanding of the formal aspect of Michelangelo's statuary on to a thorough reappraisal of Greco-Roman sculpture, as it was being daily revealed in new excavations. Particularly influential were the ambitious representations of figures and groups in violent movement, and the technical finesse of late Hellenistic work, most of which had not been available to earlier generations (e.g. the Farnese *Bull*; Naples, Mus. Archeol. N.; excavated in 1546).

For half a century Giambologna dominated Florentine sculpture, carving an ever more impressive series of statue groups in marble: *Samson Slaying a Philistine* (1560–62), *Florence Triumphant over Pisa* (1563–75), the *Rape of a Sabine* (1582), *Hercules Slaying a Centaur* (1595–1600). In addition, Giambologna produced several extraordinary bronze statues, *Bacchus* (before 1562), *Mercury* (*c.* 1565) and *Neptune* (1566), culminating in his equestrian monument to *Cosimo I, Grand Duke of Tuscany* (1587–93). The last was copied shortly afterwards for the kings of France and Spain.

By *c.* 1570 Giambologna had become the most influential sculptor in Europe; apart from the fame that his monumental statues in Florence inevitably brought, his style was disseminated in the form of small bronze reproductions of his masterworks, or statuettes, which he composed independently as elegant ornaments for the interior. These were used by the Medici as diplomatic gifts for friendly heads of state, and were also eagerly purchased by European collectors as examples of sophisticated

Florentine design. They were especially favoured in Germany and the Low Countries and were prominently illustrated in paintings of fashionable gallery interiors there.

Another important way in which Giambologna's reputation and style spread was through the movement of his pupils and assistants. Many of them, like himself, were from the Low Countries; travelling to Italy, they worked for a while in his studio in Florence (which became something of an international entrepôt) and then returned homewards, sometimes with a recommendation from him to a particular patron in the north of Europe.

For compositional subtlety, sensuous tactile values and sheer technical virtuosity, Giambologna's work is virtually unequalled in any period or country.

I. Life and work. II. Working methods and technique. III. Character and personality. IV. Critical reception and posthumous reputation.

I. Life and work.

1. Background and early study. 2. Statues, statue groups and fountains. 3. Statuettes. 4. Narrative reliefs. 5. Equestrian monuments. 6. Architecture and ornament.

1. BACKGROUND AND EARLY STUDY. Giambologna began his training as an apprentice to Jacques Du Broeucq, a notable Flemish sculptor who at the time was engaged in carving the rood screen (*c.* 1544) for Ste Waudru, Mons, a major monument in the history of sculpture in Flanders. It was an ornamental edifice made colourful by the use of alabaster for the statues and narrative reliefs, and black touchstone for the architectural elements. It was demolished later, but the sculptural components were disposed around the abbey and are easily visible. Giambologna would have learnt from Du Broeucq how to compose figures and carve the relatively soft alabaster. He would also have gained an initial enthusiasm for the Italianate style, which Du Broeucq had developed after visiting Italy, and the inspiration to visit Rome himself, after the rood loft at Ste Waudru was completed in 1550. Also at this time he would inevitably have become familiar with the work of the local wood-carvers, who produced great retables in oak with numerous figures, and with that of the brass-founders of Dinant. The fine casting techniques of 'Dinanderie', as their products are generically called, may have inspired Giambologna later in life, when he began to produce bronze statues and statuettes serially.

By the mid-16th century a journey to Rome had become a fashionable necessity for any aspiring young artist from northern Europe, and Giambologna assiduously studied ancient sculpture there for two years from 1550, making models in wax and clay. One of these he showed to the elderly Michelangelo, who criticized it for having too high a finish, before the fundamental pose had been thoroughly worked out. This lesson was never forgotten, and Giambologna became an assiduous maker of models, of which many have survived.

Giambologna began his journey home to Flanders (1552) by going north to Florence, where he could see more masterpieces of the 15th century and study Michelangelo's work better than in Rome. A rich and perspicacious patron of the arts, BERNARDO VECCHIETTI, offered him accommodation and financial support if he would prolong his stay in Florence. Before long Vecchietti

introduced him to the Medici, who ruled the city. Thus it was that Giambologna settled down to make his career in Florence, shortly afterwards becoming a court sculptor.

2. STATUES, STATUE GROUPS AND FOUNTAINS. Uncertainty surrounds the identification of a marble *Venus*, which he carved for his patron Vecchietti, but its success aroused the interest of Prince Francesco de' Medici (later Grand Duke of Tuscany; reg 1574–87), who gave him a coat of arms to execute for a recently completed building (1558/9) and, from 1561, provided him with a monthly salary. An early commission by Giambologna for the Medici was the casting of a bronze figure of Florence for the Fountain of the Labyrinth at the Villa di Castello (now in Villa La Petraia, near Florence), from a model that had been left unfinished at the death in 1550 of a previous court sculptor, Niccolò Tribolo. The motif of the girl wringing out her hair is mentioned by Vasari in his description of the model that Tribolo had made, and it is not impossible that Giambologna merely reproduced this model in bronze rather than invent the sophisticated and attractive composition, as has usually been claimed. The spiral axis and contrast of rounded curves and sharp angles formed by the elbows and knees, which were to be the hallmark of his treatment of compositions involving a single figure (e.g. *Apollo* and *Astrology* statuettes), may thus be derived ultimately from a study of Tribolo's work. Certainly Giambologna would have taken note of the light-hearted, and sometimes grotesque, figures by Tribolo and his associate Pierino da Vinci in the gardens, grottoes and fountains of Il Castello, as well as similar work in the Boboli Gardens. Early in the 1560s he modelled and cast two (or possibly three) *Fishing Boys* (Florence, Bargello) for a small fountain in the gardens of the Casino Mediceo, near S Marco, Florence. These were inspired by Michelangelo's mischievous painted putti on the ceiling of the Sistine Chapel, Rome, and by Guglielmo della Porta's baby angels on his monument to *Pope Paul III* (*c.* 1550; Rome, St Peter's).

In 1560 a commission for a Fountain of Neptune for the Piazza della Signoria, Florence, which had previously been allocated to Baccio Bandinelli, fell vacant on his death. A competition was held to decide which of the available sculptors should receive the commission. Bartolomeo Ammanati won, through influence at the Medici court and the support of Michelangelo from Rome, but the young Giambologna's full-size model (destr.) was highly praised by another great sculptor, Leone Leoni, in a letter to none other than Michelangelo.

In view of this achievement, Giambologna received his first major commission from Prince Francesco de' Medici, for an over life-size group in marble depicting *Samson Slaying a Philistine* (1560–62; London, V&A; *see* ITALY, fig. 55). The subject and treatment were derived from a project of Michelangelo's from the 1520s involving *Samson and Two Philistines*; this got no further than the stage of a model and is known only from a series of bronze aftercasts (e.g. Florence, Bargello, sometimes attributed to Pierino da Vinci). These bronzes represent the stage of Michelangelo's compositional thinking that immediately followed the *Victory* (*c.* 1530/33; Florence, Pal. Vecchio), when he was engaged on an abortive project for a free-standing

group to match his own earlier *David* (1501–4; Florence, Accad. B.A. & Liceo A.). Francesco's and Giambologna's intention was therefore to render in marble (as originally intended) what might have been Michelangelo's most magnificent sculptural composition, embodying as it did all his theoretical ideals: a pyramidal or conical volume, with a flame-like contour to suggest movement, and three figures unified in action. Giambologna created a distinct variation on the theme, however, by removing the third, dead, figure from the base, thus enabling him to pierce the lower part of the pyramidal block of marble with a series of interstices, which penetrate daringly into and through the depths of the block. The technical problems involved in excavating the marble to this extent were enormous, but Giambologna welcomed the opportunity of demonstrating his virtuosity, in imitation of such Hellenistic groups as the Farnese *Bull* (Naples, Mus. Archeol. N.), which he had seen in Rome.

Later (1569–70) Giambologna created an oddly shaped basin, with monsters supporting it, for a fountain that he crowned with his earlier group of *Samson*. It is quadrilobed in plan, with four great fungus-like protrusions instead of the normal circular basin; bronze monkeys cavorted in niches below. His most important later fountain, carved in marble, was designed for the piazza in front of the Pitti Palace and later erected on the axis of the Boboli Garden behind, only to be moved early in the 17th century to its present site on the Isolotto, near the Porta Romana. The finial was a great marble figure of *Neptune*, probably reflecting his early model made in connection with the competition for the Fountain of Neptune for Piazza della Signoria. The original marble statue is now preserved in the Bargello. Lower down the stem are perched three crouching river-gods holding upturned urns, which pour water, above a huge granite tazza, which had been the raison d'être of the commission. This represented the ocean, which was believed in those days to surround the earth, and so the complex is called the Fountain of the Ocean to distinguish it from the several other fountains of Neptune.

Three years after the competition for the Fountain of Neptune in Florence, the authorities in Bologna approached Giambologna to make a statue of *Neptune* and many subsidiary figures and ornaments for a fountain designed by Tommaso Laureti that they were erecting in the centre of their city. The young sculptor's full powers seem to have been released in the making of this Fountain of Neptune (completed 1566; *see* FOUNTAIN, fig. 3), perhaps because the artistic milieu of Bologna was less competitive than that of Florence. He was able to give rein to his imagination and sure sense of composition in the mighty figure of *Neptune* itself, with its energetic pose and sharp turn of the head. At the feet of Neptune are four boys struggling with dolphins, which spout water, interspersed with grotesquely puffing heads of childlike wind-gods, also spouting water. At the four corners of the pedestal below are four sensuous figures of Sirens, with bulbous curving fishy tails for legs, expressing water from their full breasts into the basin below. In between are many grotesque masks and shells articulating the several smaller basins.

During his stay in Bologna Giambologna produced the earliest of several versions of a flying figure of *Mercury*, which has become his most celebrated statue. It was sent to Maximilian II, Holy Roman Emperor, by Francesco I de' Medici as a gift, in preparation for his marriage to Margherita of Austria. A version of similar size in the Museo Nazionale del Bargello, Florence, is a later cast (1580), which has never left Italy, but Maximilian's *Mercury* must have been almost identical, to judge from its correspondence with a small bronze statuette in Bologna, which probably reflects Giambologna's initial wax sketch-model. The origins of the beautiful, balanced pose may be found in bronzes of the 15th century by Antonio del Pollaiuolo and Andrea del Verrocchio, as well as in the statuette of *Mercury* on the base of Benvenuto Cellini's statue of *Perseus with the Head of Medusa* (1545–53; Florence, Loggia Lanzi; *see* CELLINI, BENVENUTO, fig. 6), and on the reverse of a medal by Leone Leoni. Giambologna's superior control of the means of suggesting movement through the lithe pose and taut musculature, however, gives his figure a feeling almost of flight, which has often been emulated but never surpassed.

While Giambologna was engaged on the Bolognese projects, two events occurred that conspired to suggest to the Medici the next major marble sculpture that they required him to create. The death of Michelangelo in 1564 led to their being given by his heir the nearly finished group of *Victory* that had remained locked up in his studio ever since he had left Florence in 1534. Furthermore, the wedding of Prince Francesco de' Medici to Joanna of Austria in the following year required grandiose decorations for the Palazzo Vecchio, Florence. The idea was thus conceived of commissioning Giambologna to create an allegorical group as a pair to Michelangelo's *Victory*; its subject was to be politically relevant, *Florence Triumphant over Pisa*. Giambologna was thereby led to reconsider the problem of uniting two figures in an action group, which Michelangelo had tackled in the 1520s as part of his scheme for the tomb of *Pope Julius II* (Rome, S Pietro in Vincoli). Virtually all the sculptors of the mid-16th century had tried their hand at this challenging type of composition, and Giambologna's creative powers were therefore being put to a severe test. A tiny preliminary model in wax (*see* MODELLO, fig. 5) and a larger one in terracotta (London, V&A; see fig. 1) show his first thoughts on the subject, while a full-scale working model in plaster (Florence, Accad. B.A. & Liceo A.) was ready in time to be painted white to resemble marble and exhibited at the wedding. A marble version (Florence, Bargello) was carved considerably later (1575), and then largely by his assistant, Pietro Francavilla. The original little wax model is wonderfully spontaneous, its elongated proportions corresponding with those of Michelangelo's *Victory*, which it had to match. Its destination against a wall in the Salone del Cinquecento meant that it would be seen only from the front and sides, but its axis was arranged spirally, within a block of marble of pyramidal shape, like the *Victory*.

Not truly a fountain, but presiding over a pond, into which the main figure appears to press water from a fish, is Giambologna's most extraordinary creation, an allegory of the *Apennines* (in the shape of a crouching, hoary old man; 1570–80), made for the gardens of the Grand-Ducal

1. Giambologna: *Florence Triumphant over Pisa*, terracotta modello, h. 380 mm, 1565 (London, Victoria and Albert Museum)

Villa Demidoff (destr.) at Pratolino, near Florence (*see* MANNERISM, fig. 1). This is a colossal edifice, which was designed to look as though it were carved out of the living rock, but was actually constructed out of brick and volcanic lava over an iron armature. It is so big that there are chambers in its torso, with window-slits through which people could mysteriously hail other visitors, causing fright and mirth. It is thus a characteristic product of the age of Mannerism.

Giambologna's third great marble group, the *Rape of a Sabine* (1582; Florence, Loggia Lanzi; see fig. 2), represented the climax of his career as a figure sculptor, combining three figures into a cohesive group, an idea that had obsessed Michelangelo without his ever having

sculpture is a masterpiece of virtuosity, pushing to its furthest limits the technique of undercutting, which Giambologna had observed in Hellenistic carving, and the use of which distinguishes his work so sharply from Michelangelo's.

In 1584 Giovanni Paolo Lomazzo published his *Trattato dell'arte de la pittura* (Milan), in which he wrote:

> Michelangelo once gave this advice … one should always make the figure pyramidal serpentine and multiplied by one, two or three … A figure has its highest grace and eloquence when it is seen in movement … And to represent it thus there is no better form than that of a flame, because it is the most mobile of all forms and is conical. If a figure has this form it will be very beautiful … the figure should resemble the letter S.

Published a year after the unveiling of Giambologna's masterpiece, the *Rape of a Sabine*, Lomazzo's criteria of excellence in figure composition apply with uncanny exactness to the style of Giambologna. Michelangelo's ideas had obviously been current in artistic circles long before they were set in print, and Giambologna must have been familiar with them from the outset of his career in Italy. Indeed, when one reviews his total production it seems that he may have set out deliberately and methodically to achieve the effects recommended by Michelangelo and contemporary theorists. The series of monumental marble sculptures that span his career are the embodiment of Michelangelo's proposal that a figure may be multiplied by one, two or three.

3. STATUETTES. There are few points of reference in the enormous production of statuettes by Giambologna and his principal assistant in bronze making, Antonio Susini (*see* SUSINI, (1)). Many were original, small compositions rather than reductions from his full-scale statues (as might have been expected). There are nearly 100 models directly associable with him on stylistic grounds, but by no means all are documented. The use of piece-moulds permitted the reproduction of a given original model in some quantity. Furthermore, moulds could be taken from an existing statuette, so that it could be copied too. Individual casts are therefore difficult to date. Only a dozen statuettes bear signatures and none has a date inscribed. Descriptions in inventories are often too generalized to enable identification of particular models, let alone individual examples. There are, however, two lists, drawn up after Giambologna's death, that purport to contain the authentic compositions, and broadly speaking they correspond, but give a total of some 20 models only, which falls far short of the actual number known.

Probably the earliest major statuette is the *Mercury* (*c*. 1565; Bologna, Mus. Civ.; see fig. 3), apparently cast from Giambologna's wax sketch model for the monumental statue (1563) destined for the Università degli Studi, Bologna. The next important statuette, and one of the few that is dated by documents, is the *Apollo* (1572–5; Florence, Pal. Vecchio) that was Giambologna's contribution to a series of eight gods or goddesses by different sculptors made to decorate niches in the walls of the private study/collector's cabinet of Francesco I de' Medici. This *Apollo* is a serpentine composition inspired by Michelangelo and his follower Tribolo, with a mellifluous interplay

2. Giambologna: *Rape of a Sabine*, marble, 1582 (Florence, Loggia dei Lanzi)

been permitted to realize it in marble. Giambologna's first thoughts are embodied in a bronze group with a standing man and a woman raised in his arms, which he produced in 1579 for Ottavio Farnese, 2nd Duke of Parma and Piacenza (*reg* 1550–86). 'The subject', wrote Giambologna to this patron, 'was chosen to give scope to the knowledge and a study of art', suggesting that it was a conceptual rather than a narrative composition. Giambologna's contemporaries subsequently compelled him to identify the particular episode that was shown in the full-scale marble sculpture, by supplying a bronze relief with an unambiguous narrative to go below it, to act as a sort of visual label.

The development from a group of two to one with three figures is plotted in preliminary wax models (London, V&A). The three figures are linked psychologically by the directions of their glances, as well as formally by the arrangement of their limbs and bodies. The spiral composition means that the group cannot be fully comprehended from any single viewpoint. Technically, the

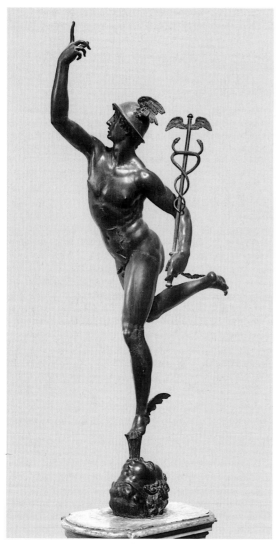

3. Giambologna: *Mercury*, bronze, *c.* 1565 (Bologna, Museo Civico)

bulls and groups showing them attacked by lions, as well as centaurs in combat with Hercules, or the *Centaur Nessus Abducting Deianeira* (*c.* 1576; Rome, Gal. Colonna). A further extension of Giambologna's repertory in bronze was a commission in 1567 for a series of life-size—and extremely life-like—figures of birds (e.g. *Turkey* (see fig. 4), *Eagle, Owl*; all Florence, Bargello) to decorate a grotto at the Medicean Villa di Castello. For these he invented an 'impressionistic' rendering in the original wax of plumage, which was faithfully translated by skilful casting into the final bronze versions. He treated similarly the fur of some *Monkeys* (*c.* 1570; Aranjuez, Jard. Príncipe), which he made to go in niches under the fountain basin that he carved as a mounting for his earlier marble group of *Samson*. Giambologna's vivacious and sympathetic studies of birds and animals, from the life, pointed the way for the French school of 'animaliers' in the 19th century.

4. NARRATIVE RELIEFS. By 1580 the Counter-Reformation movement in the Roman Catholic church was having an impact on the art world. Giambologna, hitherto a sculptor of pagan themes, had to evolve a clear relief style for depicting religious narrative. A skilful amalgam of Italian quattrocento precedents and contemporary relief style in his native Flanders resulted in the successful cycles of bronze panels showing the *Passion* (1585–7; Genoa, U. Studi) for the Grimaldi Chapel, Genoa, and those showing the *Life of St Antonio* (1581–7; Florence, S Marco). Under his aegis a cycle of *Passion* reliefs (1590) was supplied for the church of the Holy Sepulchre, Jerusalem, and later a

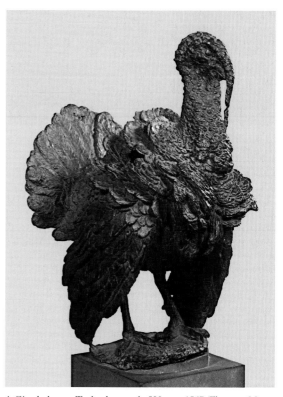

4. Giambologna: *Turkey*, bronze, h. 590 mm, 1567 (Florence, Museo del Bargello)

of curves in the contours of torso and thighs, contrasted with zigzag lines created by bent knees and elbows. The climax of this type of composition is the gilt *Astrology* (early to mid-1570s; Vienna, Ksthist. Mus.), which represents a mirror image of the *Apollo*, adapted to a female body; as these figures are revolved, there is a subtle merging of angular and curved forms, which gives a highly sophisticated progression of views.

For most of his male figures in action, notably his statuette of *Mars* (*c.* 1565–70; priv. col., see Avery, 1987) and an entire series of the *Labours of Hercules* (*c.* 1577–after 1590), Giambologna resorted to open poses, with limbs centrifugally penetrating the space around the figures, in a way that exploited the tensile strength of bronze. Another amusing sideline was a series of genre figures of country folk: *The Fowler, The Shepherd, The Bagpiper* (all *c.* 1580–1600) and *The Duck-girl* (1574; priv. col.). Apart from the human figure, Giambologna's repertory included animals, particularly horses walking or rearing, individual

number of pupils collaborated on the three pairs of bronze doors (c. 1600) for the western façade of Pisa Cathedral. He also created three historical reliefs for the base of his equestrian statue of *Cosimo I* (see below).

Giambologna developed a highly logical relief style, which owed more to Donatello in its rendering of perspective than to his immediate predecessors, Baccio Bandinelli and Benvenuto Cellini, whose fascination with Mannerist surface patterns had militated against clarity. He used architectural settings in perspective to establish a sense of space, and the figures are grouped in distinct blocks within them, related to the various elements of their surroundings. They are often dramatically separated by vistas, which plunge into space. The narrative is thus set out in a clear and comprehensible fashion, showing clear links with the compositions of panels in the oak retables that Giambologna recalled from the days of his youth in Flanders, or more recent ones that he might have known from drawings brought from Flanders by apprentices (e.g. the reliefs of Cornelis Floris on his rood loft in Tournai Cathedral).

5. EQUESTRIAN MONUMENTS. Having achieved by the 1580s a complete mastery of the human form, Giambologna turned to the subject that had fascinated the ancient Greeks and Romans almost as much, the horse. He addressed the subject with a scientific approach derived from anatomical dissections culminating in a large bronze model of a *Flayed Horse* (U. Edinburgh, Talbot Rice Gal., Torrie Col.). This enabled him to create his masterpiece in bronze, the equestrian statue of *Cosimo I, Grand Duke of Tuscany* (1587–93; Florence, Piazza della Signoria; see fig. 5). It was an immediate success and was replicated on the much reduced scale of statuettes, with a variety of different riders, ranging from the *Grand Duke Ferdinando I* (1600; Vaduz, Samml. Lichtenstein) to the *Emperor Rudolf II* (c. 1600; Stockholm, Nmus.) and *Henry IV, King of France* (c. 1600–04; Dijon, Mus. B.-A.). A full-size variant showing Ferdinando himself was commissioned shortly afterwards for Piazza SS Annunziata (1601–8); others followed for the kings of France and Spain.

Giambologna was responding to the challenge of antiquity (*Marcus Aurelius*, Rome, Piazza del Campidoglio; *Horses*, Venice, S Marco) and of the Renaissance (Donatello: *Gattamelata*, Padua, Piazza S Antonio; Verrocchio: *Colleoni*, Venice, Piazza SS Giovanni e Paolo). He would also have been aware of Leonardo da Vinci's abortive projects for equestrian monuments in Milan, and of a great bronze horse in Rome, cast by Daniele da Volterra from a design by Michelangelo, which was still awaiting a rider (later exported to Paris and destroyed in the French Revolution). His chosen model of horse was compact and rotund, with a short body and well-rounded rump, its contours enlivened by the raised front hoof and wildly curling mane, as well as by the sinuous tail (*see* EQUESTRIAN MONUMENT). The lively character and alertness of the beast are conveyed by its swollen veins, rolling eyes and pricked-up ears.

After the equestrian monument had been unveiled, to great public acclaim, Giambologna set to work on his last autograph marble carving, which also had an equine component, for it depicted *Hercules Slaying a Centaur*

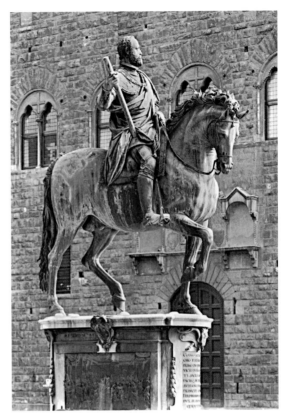

5. Giambologna: *Cosimo I, Grand Duke of Tuscany*, bronze, 1587–93, Piazza della Signoria, Florence

(1595–1600; Florence, Loggia Lanzi; *see* STATUETTE, fig. 2). It originally stood on a street corner and was set high on a pedestal, which conditioned the way in which it was to be viewed—it must have looked more imposing than it does in its present location. The vigorous torsions of the bodies of victor and victim, the compressed springing of the horse-body and the excited thrashing of the tail (which is daringly undercut) build up a highly dramatic composition. Indeed, it was a proto-Baroque sculpture that was to be influential on Bernini.

6. ARCHITECTURE AND ORNAMENT. In his most imposing painted portrait by Francavilla (c. 1570; priv. col., on loan to Edinburgh, N.G.), Giambologna chose to have himself portrayed as an architect, seated in polite apparel at a table, with a pair of dividers poised on a plan; his sculptural activity is alluded to only in the background, in a vignette of his studio with large models seen through a doorway or internal window. The more gentlemanly pursuit was traditionally held in higher social and intellectual esteem, but in Giambologna's case the pretension was based on solid achievement, which has, however, been overshadowed subsequently by his sculptural prowess.

The dual role had been normal since the later Middle Ages and Renaissance, as sculpture was so closely allied to the building that it was used to decorate, and the example of Michelangelo was sufficient to stimulate an artist with the worldly ambition of Giambologna. His principal

projects were the town palace in Florence and nearby country seat—the Villa Il Riposo—of his patron Vecchietti; the Grimaldi Chapel in Genoa; the Salviati Chapel in S Marco, Florence; and his own funeral chapel in SS Annunziata, Florence. All show a distinct, personal style of Mannerist architecture, evolved from the work of Vasari, Bartolomeo Ammanati and ultimately Michelangelo. Smaller projects included a wooden model for the façade of Florence Cathedral, the Altar of Liberty (1579) in Lucca Cathedral, and altars or tombs elsewhere. Other insights may be gained by an examination of the architectural settings and background vistas of his narrative reliefs (*see* §4 above).

Giambologna's role in creating the 'auricular' style of semi-abstract but organic-looking ornament should not be underestimated: the basin and pedestal of the fountain of *Samson Slaying a Philistine* are the classic example (*see* §2 above), but other fascinating forms appear in bases, pedestals and mouldings throughout his career, providing a repertory on which his successors were to draw.

II. Working methods and technique.

1. Sketch-models. 2. Studio organization. 3. Patrons, collectors and connoisseurs.

1. SKETCH-MODELS. More sketch-models (*bozzetti*) for sculptures by Giambologna have survived than by any other Renaissance artist. Like many sculptors—although unlike Michelangelo—he seems to have preferred to invent his compositions in three-dimensional form from the outset, instead of resorting to the standard two-dimensional approach of a graphic artist. The few drawings by him are not exploratory, but depict in a fairly finished state whole projects, such as fountains or the design of a chapel. By examining the evidence that the models (mostly London, V&A) provide, and reading contemporary accounts of the technique and use of models written by Cellini, Vasari and Raffaelle Borghini, it is possible to reconstruct Giambologna's working procedure.

For his statue of *Florence Triumphant over Pisa* all the stages survive (London, V&A; Florence, Accad. B.A. & Liceo A.). He began with tiny models of wax, which he built up round an armature of iron wire or a nail, demarcating the volumes and establishing the form ('disegno'). The anatomical forms are usually attenuated and 'mannered' at this stage. Such models are about 100–200 mm high. Subsequently they were 'fleshed out', a process that began at the next stage, in clay: a model of 400–500 mm high (about a Florentine *braccio*) was built up, with more naturalistic proportions, giving an accurate idea of the general appearance of the final statue. If necessary, small separate studies of such details as heads might be made to refine the expressions. An excitingly direct and rapid technique of modelling distinguishes most of Giambologna's terracottas, although there are also a few highly finished ones, for presentation to his patrons. From the terracotta, a full-scale model (*modello grande*) was then produced in clay by a process of enlargement, probably using some mechanical aids, such as a grid

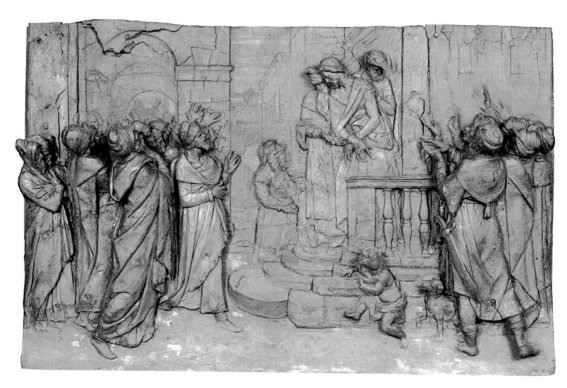

6. Giambologna: *Ecce homo*, wax modello for a relief from the *Passion* series in the Grimaldi Chapel, Genoa, 483×737 mm, *c.* 1580 (London, Victoria and Albert Museum)

system in three dimensions, to permit accurate enlargement. Two such full-scale models—whitewashed over—survive, for *Florence Triumphant over Pisa* (*see* §I, 2 above) and the *Rape of a Sabine* (both Florence, Accad. B.A. & Liceo A.).

For the narrative reliefs that Giambologna cast in bronze in later life, he used a carpenter's approach: he made a backboard out of planks of wood, and then nailed to it a wedge-shaped board at the bottom, to create the illusion of a floor, sloping up and backwards towards a vanishing point. Over this construction he spread a thin layer of red wax, into which he inscribed the details of an architectural setting, building forward from it colonnades and other forms where desired, or cutting away the wax to reveal the wood behind to indicate the furthest distance. Then, around a few projecting nail-heads to help the wax adhere and hold together, he peopled this stage with tightly massed groups of bystanders, often with strongly projecting figures, almost in the round, standing out at either side to close the composition effectively. A protagonist, for example Christ, would be placed at a focal point, carefully emphasized by the architectural setting, or divided from an opponent by a distant vista plunging into the background. The distance would often be emphasized, even exaggerated, by the small size of mysterious observers seen fleetingly in the architectural background.

From such original wood and wax models, for example those for the *Passion* reliefs of the Grimaldi Chapel, Genoa (*c.* 1580; London, V&A; see fig. 6; Brisbane, Queensland A.G.), assistants would make piece-moulds in plaster, which could be safely removed without damaging the master-model, and then reassembled, creating a hollow, negative image into which molten wax could be poured to produce a separate model for use in the foundry (which would then be melted down in the process of lost-wax casting).

Giambologna's models, of which he was justifiably proud, have survived despite their inherent fragility because not only he, but also his contemporaries, preserved and displayed them as works of art in their own right, either in special cabinets or on shelves or brackets round the walls. It was a phenomenon of the High Renaissance and afterwards that artists' sketches or models were considered prime examples of their creative genius. They were sometimes preferred for their very spontaneity to the finished works that evolved from them, for the latter might become deadened by too laborious a working up. This was especially true of sculpture, for which the necessary technical processes of carving or casting are exhausting and lengthy, and often involved other hands.

2. STUDIO ORGANIZATION.

(i) Marble sculpture. It was standard practice in the Italian Renaissance, as in most other periods and places, for a sculptor to delegate work to more or less skilled assistants and apprentices. Men at the quarries would hew blocks to roughly the dimensions and shape required (some drawings by Michelangelo have survived, showing blocks needed for the statues in the New Sacristy, Florence): the larger the statue, the greater the need to reduce the bulk and weight of the block before transport began, to save

effort and hence expense, and to reduce the risk of breakage. The blocks were slid down the precipitous slopes from the quarries of Carrara or Pietrasanta on sleds, with the help of ropes, rollers and levers; put on board ship to travel by water as near as possible to their destination; and then loaded on to ox-carts (or specially constructed wheeled crates) for delivery to the sculptor's studio (this was best undertaken in the spring, to take advantage of high water in the River Arno and cooler weather).

Once in the studio, the block would be set up near the full-scale model, so that measurements could be transferred and constantly checked throughout the carving, which might take months, sometimes even several years. Masons (*scarpellini*) roughed out the general shape of the figure(s) and then the sculptor and his foreman would take over to remove the final superfluous 'layers' of marble and reveal the statue as it had been envisaged in the model (or, on occasion, vary it as they chose, or according to necessity, if hidden flaws appearing in the block forced a change of design, or a slip of the chisel accidentally cut off too much marble).

The younger and/or poorer the sculptor, the more of the laborious hewing out he would have to undertake in person, both to gain experience and to save having to pay assistants; skilled labour was relatively cheap, however, and so could be afforded quite early in a normal career. Some information about Giambologna's situation can be gleaned from archival documents. As early as 1560, at an early point in his career, he enjoyed the help of Carlo di Cesare 'del Palagnio' (1540–98), when making the huge clay model of *Neptune* in the competition for the fountain figure in Florence. For the huge amount of carving involved in the four statues and subsidiary components on his Fountain of the Ocean, he employed in 1574–5 Jacopo di Zanobi Piccardi and his son Andrea di Zanobi Piccardi (both active *c.* 1574–1600), who were skilled carvers from the quarry town of Rovezzano. Jacopo later helped to install the statues on the Altar of Liberty in Lucca Cathedral, and thereafter on occasion selected and paid for various blocks of marble for Giambologna at Carrara (e.g. in 1595 for *Hercules and the Centaur*). Piccardi had an independent standing and was employed by other sculptors too. Through his good offices, Giambologna's most important apprentice and eventual successor as court sculptor to the Medici, Pietro Tacca of Carrara, was introduced to the Florentine studio in 1592 (*see* TACCA, (1)).

Before Tacca, Giambologna's principal associate had been PIETRO FRANCAVILLA, a fellow Franco-Fleming who had been born in Cambrai in 1548. He trained principally under a wood-carver in Innsbruck and then went to Florence *c.* 1570, with a letter of introduction to Giambologna, but was free to conduct business on his own account too. However most of his 'independent' statues betray compositional ideas from Giambologna. He signed several statues jointly, having been responsible for carving them in marble from models by Giambologna: *Grand Duke Ferdinando I* (1594; Pisa and Arezzo); *Grand Duke Cosimo I* (1595; Pisa, Piazza dei Cavalieri); and *St Matthew* (1599; Orvieto, Mus. Opera Duomo). When Francavilla left for Paris in 1601, Tacca was ready to assume his role as foreman of the elderly Giambologna's studio.

(ii) Bronze-casting. Giambologna was quick to exploit the additional scope for statues with limbs outflung in dramatic movement that was offered by the tensile strength of bronze, as opposed to the fragility and weight of marble, which militated against such compositions. Furthermore, strength and stability could be increased by a firm armature of iron running up inside the hollow castings. He must have been aware of the formidable array of brass sculpture and ornament produced in the Meuse valley around Dinant in his native country; even Cellini praised the excellence of the foundrymen of Liège above all others. He could not have learnt the technology, however, for sculptors were in a different trade guild and demarcation lines were strict.

When Giambologna arrived in Italy he would have noted the former glories of the bronze sculpture of the quattrocento and perhaps registered surprise that Michelangelo did not, after his early days, work in the medium, exclusively preferring marble. Soon after Giambologna's arrival in Florence he saw Cellini unveil his monumental group in bronze of *Perseus with the Head of Medusa* (*see* §I, 2 above) and was doubtless inspired to emulate it, as well as the statuettes and narrative relief in bronze that were set below it. Cellini was a goldsmith by training and therefore expert in foundry work, but Giambologna had no such advantage. Among his earliest statues, however, are several in bronze, for example *Bacchus* and *Mercury*; it is probable that he subcontracted their casting, as was normal practice. He also used bronze to preserve many of his original wax sketches and subsequently to reproduce them in some numbers, for sale as figurines and larger statuettes; exactly where and by whom they were produced is not recorded.

The first components of the Fountain of Neptune for Bologna were cast in Florence by Zanobi Portigiani while his son Fra Domenico Portigiani (1536–1601) produced most of the statues and reliefs (1581–7) for the Salviati Chapel in S Marco, Florence, and some reliefs for Jerusalem. To cast the equestrian statue of *Cosimo I*, Giovanni Alberghetti, a professional artillery founder, was employed, in view of the enormity and political importance of the task; this particular commission is correspondingly well documented. For smaller casting jobs, sometimes in precious metal, professional goldsmiths were employed, and in 1581 one of these, Antonio Susini, was hired on the orders of Jacopo Salviati to help finish and polish the bronzes for his chapel. Susini was to become Giambologna's most important assistant in the serial production of bronze statuettes to satisfy the demands of collectors. He evolved a distinctive personal style, consisting of great precision in details, such as the irises and pupils of the eye, or the nails of fingers and toes, as well as the curls of hair and the channelled folds of drapery. Susini eventually set up independently but was allowed the use of Giambologna's models, and on one occasion the master even purchased a finely finished cast from him. Susini also produced some of his own models, but they were usually indebted to Giambologna's, sometimes simply being on a different scale, or a mirror-image. Several of the foreign journeymen who stayed for a while in the studio also gained experience by cleaning and finishing bronzes: for example, Adriaen de Vries was first documented as helping to cast two crucifixes (1581), later becoming independent and gradually evolving a freer style of modelling that was all his own. He was Giambologna's follower as favourite sculptor of Rudolf II, Holy Roman Emperor, in Prague. Hans Reichle was also a member of Giambologna's workshop between 1588 and 1595 and afterwards took his style north to Munich.

Giambologna's earlier, initialled, or otherwise documented, statuettes were frequently unique, or nearly so (for replicas of them appeared only later, with the arrival of Susini). They may be assumed to be 'autograph' (i.e. all his own work), apart from the purely technical foundry process: the original wax model was by the master (it was probably actually consumed in the lost-wax casting), and the bronze, when cold, was then finished personally by Giambologna. A statuette of *Mars* (priv. col.) initialled 'I.B' under one foot is a good example. Its 'painterly' surface and waxy-looking details of hair, fingers, toes etc, reflect the appearance of the original wax model, almost down to the marks of the sculptor's fingers. Many other casts exist, however, and some can be associated on stylistic criteria with Antonio Susini. Others, which differ minutely, may be the work of other craftsmen: there is one documented case, after Giambologna's death, of bronze statuettes by Giambologna himself and by Susini being borrowed back from their owner by Pietro Tacca, to reproduce in bronze as a Medicean diplomatic gift for the Prince of Wales (1611).

In some cases even the name of Giambologna actually inscribed on an item seems not to be a signature in the usual sense, as a guarantee that he actually finished it, but rather a statement of his authorship of the initial model and, presumably, his approval of the particular cast. It was added to satisfy a foreign patron, who wanted to be reassured that he had got 'the real thing', and was not being fobbed off with a 'copy'. There are therefore grave problems, which can be resolved only by connoisseurship, in the study of bronze statuettes made from Giambologna's designs.

3. PATRONS, COLLECTORS AND CONNOISSEURS. Giambologna's earliest and lifelong patron was Bernardo Vecchietti, a prominent banker and courtier, who acted as a personal adviser and friend of Francesco I de' Medici. Vecchietti apparently spotted the talent of the young Flemish emigré when he arrived in Florence *c.* 1551, and offered him lodging and subsistence. This perspicacious—even if self-interested—generosity secured for Florence and the Medici the services of a man who was to become the major sculptor in Europe during the second half of the century. Vecchietti also collected the sculptor's sketch-models avidly, thereby setting a new fashion and guaranteeing their preservation for posterity. Other models were kept by the Medici, by a master mason with whom Giambologna occasionally worked, by such aristocratic patrons as the Gondi and Salviati, and by the artist himself.

While successive Medici Grand Dukes, Cosimo I, Francesco I and Ferdinando I, were his greatest patrons, Giambologna also worked for the Holy Roman Emperors Maximilian II and Rudolf II (who granted him a coat of arms) and the popes (one of whom knighted him). Several other prominent nobles, Italian, German and Austrian,

coveted his services, notably the Duke of Urbino, the Dukes Albert V and William V of Bavaria and the Electors Augustus I and Christian I of Saxony. At the height of his career Giambologna and his assistants produced equestrian monuments for the kings of France and Spain and were solicited for one from as far afield as England, by King James I. Indeed, Henry, Prince of Wales, and King Charles I were avid collectors of his bronzes, as later were the French king Louis XIV and his courtiers, André le Nôtre and Cardinal Richelieu.

The English have always been excited by the Italianate elegance and bravura of Giambologna's work. Charles I and George Villiers, 1st Duke of Buckingham, imported in 1623 the only major monumental marble ever to have left Italy, *Samson Slaying a Philistine*, which eventually reached the Victoria and Albert Museum, London, in 1956. That museum has also gradually acquired, from the date of its foundation in 1852, the finest collection of sketch-models in the world. Many of these reached England much earlier, during the age of the Grand Tour, with the noted connoisseur William Locke of Norbury Park. His collection (sold anonymously at Christie's, London, in 1775) included many models, and these passed successively through the hands of such artist–admirers as the sculptor Joseph Nollekens—whose style, especially in his small terracotta models, was visibly influenced by them—and Thomas Lawrence.

III. Character and personality.

Details of the character and private life of Giambologna are scanty, as he confided little to paper apart from business. Unlike Michelangelo, he had few intellectual, spiritual or philosophical pretensions and was not given to theorizing about his art. He was barely literate and never mastered Italian properly. Instead, he strove for perfection in composition and technique. His business-like approach—quite the opposite of that of the neurotic genius Michelangelo—endeared him to his princely patrons, who received the works they had ordered finished and on time. He was by temperament ideally suited to the role of court sculptor that he rapidly assumed under the Medici. He affected to be unconcerned about money and to care only for glory, by which he meant rivalling the reputation of Michelangelo.

He coveted signs of official recognition, such as the gentleman's coat of arms he was awarded by Emperor Rudolph II in 1588, and, towards the end of his career, he solicited, and ultimately received (1599), a knighthood from the pope. He immediately modelled a self-portrait bust with the cross of the Knights of Christ proudly emblazoned on his tunic; its size was miniature, presumably to indicate a certain modesty. Three casts are known (Amsterdam, Rijksmus.; Dijon, Mus. B; Florence, priv. col. of the late Sir John Pope-Hennessy), so his image was presumably distributed to patrons and friends.

Giambologna must have been a good and inspiring teacher to have attracted over the years so many young sculptors of various nationalities to study under and to work for him. He must have been self-disciplined and well organized to run his large establishment, and to supervise the simultaneous production of so much marble sculpture and bronze casting.

IV. Critical reception and posthumous reputation.

Giambologna was accorded a brief biography in the second edition of Vasari's *Vite* (1568), under the heading of the Accademici del Desegno (members of the recently founded Grand-Ducal Academy of Design). Vasari qualified him as a 'truly exceptional young man' and enumerated his works to date; he also mentioned that Vecchietti and others were collecting his models. In 1584 Raffaelle Borghini, in his book about the arts *Il Riposo* (the title of which is taken from the name of Vecchietti's suburban villa, where the discussions it recounts took place), gave a fuller biography than Vasari had done, probably because he benefited from verbatim information from the sculptor, the protégé of Vecchietti. An illuminating passage about the technique of making models for sculpture is also included. A century later, in 1688, Filippo Baldinucci published a complete biography, subsuming the earlier, partial ones and adding detail from reliable sources and from the Medicean archives. It gives more anecdotes and passes occasional shrewd judgements. Baldinucci also printed an invaluable list of the authentic models produced as bronze statuettes.

The bronze statuettes disseminated all over Europe by the 17th century spread Giambologna's fame everywhere: plaster casts appeared in many artists' studios, especially in his native Flanders, and they were studied by painters, as well as sculptors, as part of their artistic education.

Giambologna's work remained popular and his masterpieces were remarked on in most guidebooks and tourists' accounts of Florence (e.g. John Evelyn's *Diaries*). In 1752 Joshua Reynolds visited his former workshop (the Grand-Ducal sculpture studio, by then much less active) and praised the original full-scale models for the Fountain of the Ocean, hazarding the remark: 'I think him greater than M. Angelo and I believe it would be a difficult thing to determine who was the greatest [sic] sculptor'. Within 20 years of Reynolds's high praise William Locke was recorded as possessing 'among a goodly number of original models by several old masters, many in wax and clay by Giambologna, most of which came from the celebrated collection of Bernardo Vecchietti'. When Locke's collection was put up for sale at Christie's, London, in 1775, the greatest artists of the day vied to possess them, including the sculptor Nollekens, for obvious reasons, and, interestingly, Richard Cosway, Benjamin West and Thomas Lawrence. Evidently, Reynolds's enthusiasm sufficed to give the models and their creator a fresh allure for the English, which they have retained ever since, due to their final gathering together in the Victoria and Albert Museum, London.

During the early 19th century, under the influence of Neo-classicism, the work of Giambologna waned in popularity, apart from certain compositions such as the *Mercury*, which (paired with a variety of modern female partners) was continually reproduced, as an ornament for the domestic interior (so potent is its imagery that it continued to be used in the 20th century in a variety of

contexts concerning rapid communication: on some air-mail postage stamps of Australia in the 1930s; on the cap-badge of the Royal Signals Regiment of the British army; and as the symbol of Interflora); or his *Rape of a Sabine*, which was available for purchase as a tourist souvenir in various materials, such as alabaster or *verde di Prato* marble, complete with the relief on its base.

The reappraisal of Giambologna in the 20th century was motivated by civic pride in his native city of Douai, long since part of France: Desjardins published a luxury monograph in 1883, with much new documentation from the archives of Florence. The next stride forward, half a century later, was the doctoral thesis by Gramberg (1928; pubd 1936) charting Giambologna's early career, which is still somewhat speculative. The major contribution was post-war, in a well-researched monograph (including a catalogue raisonné) based on her doctoral thesis by Elisabeth Dhanens (1956). Another doctoral thesis, by Holderbaum (1959; pubd 1983), concentrated on eluci-dating the origins and appeal of Giambologna's style. An exhibition of the bronze statuettes, as nearly complete as proved possible, was held in Edinburgh, London and Vienna in 1978–9, and its catalogue remains the standard work on that vital aspect of his oeuvre. A fully illustrated survey of the current state of knowledge on Giambologna was published by Avery in 1987.

BIBLIOGRAPHY

EARLY SOURCES

G. Vasari: *Vite* (1550, rev. 2/1568); ed. G. Milanesi (1878–85)

R. Borghini: *Il Riposo* (Florence, 1584), pp. 585–9; facs., ed. M. Rossi (Milan, 1967), 2 vols

F. Baldinucci: *Notizie* (1681–1728); ed. F. Ranalli (1845–7)

GENERAL

B. Wiles: *The Fountains of Florentine Sculptors and their Followers from Donatello to Bernini* (Cambridge, MA, 1933)

H. Keutner: 'Über die Entstehung und die Formen des Standbildes im Cinquecento', *Münchn. Jb. Bild. Kst*, n. s. 2, viii (1956), pp. 159ff

J. Pope-Hennessy: *Italian High Renaissance and Baroque Sculpture* (London, 1963)

J. Pope-Hennessy with R. Lightbown: *Catalogue of Italian Sculpture in the Victoria and Albert Museum* (London, 1964)

L. Berti: *Il principe dello studiolo* (Florence, 1967)

C. Avery: *Florentine Renaissance Sculpture* (London and New York, 1970)

K. J. Watson: *Pietro Tacca, Successor to Giovanni Bologna: The First Twenty-five Years in the Borgo Pinto Studio, 1592–1617* (diss., University Park, PA State U., 1973)

V. L. Bush: *Colossal Sculpture of the Cinquecento, from Michelangelo to Giovanni Bologna* (New York and London, 1976)

K. Langedijk: *The Portraits of the Medici, 15th–18th Centuries* (Florence, 1980)

C. Avery: *Studies in European Sculpture, I* (London, 1981)

M. Bury: 'Bernardo Vecchietti, Patron of Giambologna', *I Tatti Stud.*, I (1985), pp. 13–56

C. Avery: *Studies in European Sculpture, II* (London, 1987)

MONOGRAPHS

A. Desjardins: *La Vie et l'oeuvre de Jean Boulogne, d'après les manuscrits inédits recueillis par Foucques de Vagnonville* (Paris, 1883)

W. Gramberg: *Giovanni Bologna: Eine Untersuchung über die Werke seiner Wanderjahre* (Berlin, 1936)

E. Dhanens: *Jean Boulogne, Giovanni Bologna Fiammingo* (Brussels, 1956); review by H. Keutner in *Kunstchronik*, xi (1958), pp. 325–38

J. Holderbaum: *The Sculptor Giovanni Bologna* (New York and London, 1983)

A. Avery: *Giambologna: The Complete Sculpture* (Oxford, 1987)

SPECIALIST STUDIES

Marble statues and models

H. Keutner: 'Il San Matteo nel Duomo di Orvieto: Il modello e l'opera eseguita', *Boll. Ist. Stor. A. Orviet.*, xi (1955)

J. Pope-Hennessy: 'A New Work by Giovanni Bologna', *V&A Mus. Bull.*, 2 (1966), pp. 75–7

——: 'Giovanni Bologna and the Marble Statues of the Grand-Duke Ferdinando I', *Burl. Mag.*, cxii (1970), pp. 304–7

D. Heikamp: 'Scultura e politica: Le statue della Sala Grande di Palazzo Vecchio', *Le arti del Principato Mediceo* (Florence, 1980), pp. 201–54

M. Campbell: 'Observations on the Salone dei Cinquecento in the Time of Duke Cosimo I de' Medici, 1540–74', *Firenze e la Toscana dei Medici nell'Europa del 500* (Florence, 1983)

M. Baker: '"A Peece of Wondrous Art": Giambologna's *Samson and a Philistine* and its Later Copies', *Antol. B.A.*, n. s., 23–4 (1984), pp. 62–71

M. P. Mezzatesta: 'Giambologna's "Altar of Liberty" in Lucca: Civic Patriotism and the Counter-Reformation', *Antol. B.A.*, n. s., 23–4 (1984), pp. 5–19

L'Appennino del Giambologna (exh. cat.; ed. A. Venzzosi; Pratolino, Villa Demidoff, 1985; rev. 1990)

C. Acidini Luchinat: *Fiorenza in villa* (Florence, 1987)

——: *Risveglio di un colosso* (Florence, 1988)

A. Standati, ed.: *Risveglio di un colosso* (Florence, 1988)

C. Avery: 'Giambologna's *Julius Caesar*: The Rediscovery of a Master-piece', *Art and Tradition: Masterpieces of Important Provenances* (exh. cat., Munich, Konrad O. Bernheimer, 1989), pp. 46–65, 108–9

——: 'When is a "Giambologna" not a "Giambologna"?', *Apollo*, cxxxi/340 (1990), pp. 391–400

M. Bury: 'Giambologna's *Fata Morgana* Rediscovered', *Apollo*, cxxxi/336 (1990), pp. 96–100

Giambologna's Cesarini Venus (exh. cat. by A. Radcliffe, Washington, DC, N.G.A., 1993–4)

Bronzes: general

W. Bode: *The Italian Bronze Statuettes of the Renaissance* (London, 1908–12, rev. New York, 1980)

J. Mann: *Sculpture*, London, Wallace cat. (London, 1931)

Italian Bronze Statuettes (exh. cat., ACGB; Amsterdam, Rijksmus.; Florence, Pal. Strozzi; 1961–2)

H. Weihrauch: *Europäische Bronzestatuetten* (Brunswick, 1967)

M. Campbell and G. Corti: 'A Comment on Prince Francesco de' Medici's Refusal to Loan Giovanni Bologna to the Queen of France', *Burl. Mag.*, cxv (1973), pp. 507–12

K. Watson and C. Avery: 'Medici and Stuart: A Grand Ducal Gift of "Giovanni Bologna" Bronzes for Henry, Prince of Wales (1612)', *Burl. Mag.*, cxv (1973), pp. 493–507

R. Bauer and H. Haupt: 'Das Kunstkammerinventar Kaiser Rudolfs II, 1607–1611', *Jb. Ksthist. Samml. Wien*, lxxii (1976)

Giambologna, Sculptor to the Medici, 1529–1608 (exh. cat., ed. C. Avery and A. Radcliffe; ACGB, 1978); review by J. Montagu in *Burl. Mag.*, cxx (1978), pp. 690–94

Giambologna, 1529–1608: Ein Wendepunkt der europäischen Plastik (exh. cat., ed. C. Avery, A. Radcliffe and M. Leithe-Jasper; Vienna, Ksthist. Mus., 1978)

B. Jestaz: 'A propos de Jean Bologne', *Rev. A.*, 46 (1979), pp. 75–82

Firenze e la Toscana dei Medici nell'Europa del cinquecento, Il Primato del disegno (exh. cat., Council of Europe exh., Florence, 1980)

Liechtenstein: The Princely Collections (exh. cat., New York, Met., 1985)

Die Bronzen fürstlichen Sammlung Liechtenstein (exh. cat., Frankfurt am Main, Liebieghaus, 1986)

Renaissance Master Bronzes from the Collection of the Kunsthistorisches Museum, Vienna (exh. cat. by M. Leithe-Jasper, Washington, DC, Smithsonian Inst., 1986)

Il seicento fiorentino: Arte a Firenze da Ferdinando I a Cosimo III (exh. cat., ed. G. Guidi and D. Marcucci; Florence, 1986), pp. 422–8, nos 4.1–4.6

H. Keutner: 'Appendice: Bronzi moderni', *Catalogo della Galleria Colonna in Roma: Sculture* (Rome, 1990), pp. 277–304

L. O. Larsson: *European Bronzes, 1450–1700* (Stockholm, 1992)

Bronzes: complexes or individual examples

J. del Badia: *Cosimo de' Medici modellata da Giovanni Bologna e fusa da Giovanni Alberghetti: Documenti inediti* (Florence, 1868)

F. Kriegbaum: 'Ein Bronzepaliotto von Giovanni Bologna in Jerusalem', *Jb. Preuss. Kstsamml.*, xlvii (1927), pp. 43–52

H. Keutner: 'Die Tabernakelstatuetten der Certosa zu Florenz', *Mitt. Ksthist. Inst. Florenz*, v (1955), pp. 139–44

——: 'Der Giardino Pensile der Loggia dei Lanzi und seine Fontane', *Kunstgeschichtliche Studien für Hans Kauffmann* (Berlin, 1956), pp. 240–50

——: 'Two Bronze Statuettes of the Late Renaissance', *Register* [Lawrence, U. KS], i (1957), pp. 117ff

A. Ronen: 'Portigiani's Bronze 'Ornamento' in the Church of the Holy Sepulchre, Jerusalem', *Mitt. Ksthist. Inst. Florenz*, xiv (1970), pp. 415–42

G. Corti: 'Two Early Seventeenth Century Inventories Involving Giambologna', *Burl. Mag.*, cxviii (1976), pp. 629–34

R. Tuttle: 'Per l'iconografia della fontana del Nettuno', *Il Carrobbio*, iii (1977), pp. 437–45

M. W. Gibbons and G. Corti: 'Documents Concerning Giambologna's Equestrian Monument of *Cosimo I*, a Bronze Crucifix and the Marble Centaur', *Burl. Mag.*, cxx (1978), pp. 508–10

B. Jestaz: 'La Statuette de *La Fortune* de Jean Bologne', *Rev. Louvre* (1978), pp. 48–52

A. F. Radcliffe: 'Giambologna's Twelve Labours of Hercules', *Connoisseur* (Sept 1978), pp. 12–19

C. M. Brown: 'Giambologna Documents in the Correspondence Files of Duke Vincenzo Gonzaga in the Mantua State Archives, *Burl. Mag.*, cxxiv (1982), pp. 29–31

M. Bury: 'The Grimaldi Chapel of Giambologna in San Francesco di Castelletto, Genoa', *Mitt. Ksthist. Inst. Florenz*, xxvi (1982), pp. 85–128

C. W. Fock: 'The Original Silver Casts of Giambologna's Labours of Hercules', *Studien zum europäischen Kunsthandwerk, Festschrift Yvonne Hachenbroch* (Munich, 1983), pp. 141–5

M. W. Gibbons: *Giambologna's Grimaldi Chapel: A Study in Counter-Reformatory Iconography and Style* (New York, 1984)

A. Lefebure: 'Un singe en bronze de Jean Bologne', *Rev. Louvre*, 3 (1984), pp. 184–8

H. Keutner: *Giambologna e il Mercurio volante*, Florence, Bargello cat. (Florence, 1984)

O. Raggio: 'Bust of Grand Duke Francesco I de' Medici', *Notable Acquisitions, 1983–84*, New York, Met. cat. (New York, 1985)

M. E. Flack: *Giambologna's Cappella di Sant'Antonio for the Salviati Family: An Ensemble of Architecture, Sculpture and Painting* (New York and London, 1986)

C. Acidini Luchinet, ed.: *Fiorenza in Villa* (Florence, 1987)

M. W. Gibbons: *Giambologna: Narrator of the Catholic Reformation* (Berkeley, Los Angeles and London, 1995)

CHARLES AVERY

Giambono [Bono; Zambono], **Michele** [Michele di Taddeo di Giovanni Bono] (*b* Venice, *c*. 1400; *d* Venice, *c*. 1462). Italian painter. He was heir to the Late Gothic style as practised in Venice, and his art represents the most complete development of that style by a Venetian painter. He was seemingly not interested in the forms of antique art and did not seek the kind of verisimilitude practised by such fully Renaissance artists as Giovanni Bellini. His style remained Gothic, as did his vision, but he created unusual combinations of images that anticipate the novel kind of subject-matter later used by Giovanni Bellini. Until the mid-19th century he was known primarily for his designs for the mosaics in the Mascoli Chapel, S Marco, Venice, but he is now also recognized as an accomplished panel painter.

1. Life and work. 2. Working methods and technique.

1. LIFE AND WORK. Giambono may have belonged to a family of artists living in Treviso at the end of the 14th century and could have received his training in that workshop. He was, however, a Venetian, as the extant signatures on his works attest. He is first documented in Venice in November 1420, when he was already established as a painter and living in the parish of S Angelo. In 1422 he joined the Scuola di S Giovanni Evangelista.

Giambono must have enjoyed a considerable personal and professional reputation, for on a number of occasions he was called on to evaluate works by his contemporaries.

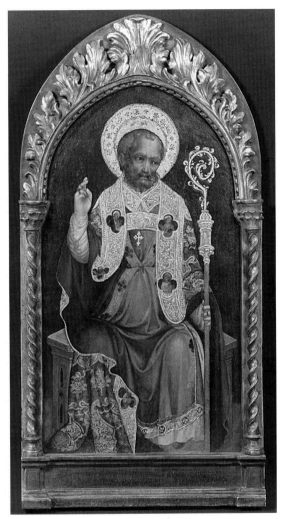

1. Michele Giambono: *Male Saint*, tempera on panel, 825×455 mm, *c*. 1440 (Oxford, Ashmolean Museum)

In April 1430, for example, he and two other artists judged a painting of *St Michael* (untraced) that Jacopo Bellini had made for the church of S Michele, Padua, to be worth 35 gold ducats; in the summer and autumn of 1453 he took part in the arbitration between Donatello and the son of Gattamelata concerning the price to be paid to the sculptor for his equestrian monument to *Gattamelata* outside the Santo, Padua.

One of Giambono's earliest surviving works is the *Man of Sorrows with St Francis* of the 1420s (New York, Met.), and his first major known altarpiece is the polyptych of the *Virgin and Child with Saints* (*c*. 1430; Fano, Pin. Civ. & Mus. Malatestiano). In this work his style is fully developed; the figures seem to float above the ground on which they are meant to stand, and there is very little suggestion of anatomical structure beneath the drapery.

In 1440 the city of San Daniele di Friuli and the church of S Michele there jointly commissioned Giambono and Paolo Amadeo, a woodcarver, to make a partially carved and partially painted altarpiece, as well as two candelabra

for acolytes and two angels to be placed above the altar. For these objects the two artists were to receive 95 gold ducats, but they were required to deliver the works at their own cost and risk, thus substantially reducing their net wages. The sole surviving portions of this altarpiece may be the *St Michael Archangel* (Florence, I Tatti) and the *Virgin and Child Enthroned* (Venice, Ca' d'Oro). The *St Michael* is one of Giambono's best works. The rhythmical, undulating curves of the angel's dalmatic and the thin, translucent veils of crimson paint with which it is depicted unite to lend the image a luminous, shimmering quality; the opaque cerulean blue of the background perfectly harmonizes with the rich crimson and deep old gold of the dalmatic, creating a mellow effect. Giambono's fascination with line is evident in many other paintings, for instance the *Male Saint* (*c.* 1440; Oxford, Ashmolean; see fig. 1), in which he employed patterns borrowed from 15th-century Venetian textiles, such as brocades and damasks. These patterns, derived from vegetal forms, are highly abstracted and stylized. The *Male Saint* is probably the central panel from a dismembered polyptych to which *St Gregory the Great*, *St Augustine* and the *Man of Sorrows* (all Padua, Mus. Civ.) may also have belonged.

Giambono's success as an artist parallels that of Lorenzo Monaco in Florence and lies largely, but not exclusively, in his enhancement and accentuation of the decorative and rhythmical elements of the Late Gothic style, never allowing facial expression to overshadow the decorative elements. He derived his facial types from works by Gentile da Fabriano and Pisanello, both of whom worked in Venice for short periods during the first quarter of the 15th century. In conceiving the faces of his mature male figures, as in the *Man of Sorrows* (*c.* 1440; Padua, Mus. Civ.), he generally followed a formula in which the eyes are set wide apart, emphasizing the bridge of the nose, with the brow stereotypically furrowed into sections and the mouth turned down at the corners and almost always slightly open. Nevertheless, it is likely that at some time he studied human heads and faces and then typified them according to received formulae.

Another feature of Giambono's style is his careful depiction of nature. In the *Virgin and Child Enthroned* (*c.* 1445; Budapest, Mus. F.A.) the vegetation is treated with attention and is used to create abstract patterns. In two panels dating from the 1450s, both of the *Virgin and Child* (Rome, Pal. Barberini; see fig. 2; and Venice, Correr), birds are drawn with an uncommon accuracy of detail. The *Virgin and Child* in Rome shows a balance between the decorative, natural and expressive elements of his style: the bold pattern of the background cloth of honour is played against the delicate patterns of the haloes and of the border of the Virgin's mantle; these patterns are, in turn, relieved by the relatively unbroken colours of the Virgin's mantle, the cloth over her head and that in which the Child is wrapped. At the centre of the panel, emerging from the rhythmical nexus, are the faces of the Virgin and Child, both imbued with an expression of seraphic joy. Giambono never tried to fuse these disparate elements as did true Renaissance artists; rather he sought their harmonious co-existence.

Giambono was probably himself not a mosaicist, but he was responsible for the designs of several of the scenes

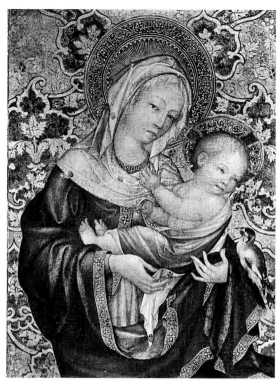

2. Michele Giambono: *Virgin and Child*, tempera on panel, 570×390 mm, 1455 (Rome, Palazzo Barberini)

from the life of the Virgin on the vault of the Mascoli Chapel in S Marco, Venice. Since the 16th century these mosaics have been cleaned and restored on several occasions, but Giambono's contribution to them can still be identified. He designed the *Birth of the Virgin*, the *Presentation of the Virgin in the Temple* and the *Annunciation* (on the altar wall) as well as the decorative borders and the three tondi with the *Virgin and Child*, *David* and *Isaiah* at the top of the vault. He also designed the figures in the *Visitation*, but not the architecture, and the nine disciples at the foot of the Virgin's bier in the *Death of the Virgin*; the rest of the figures, and perhaps the architecture, were drawn by Andrea del Castagno, who was in Venice in 1442–3. The mosaics were probably executed between *c.* 1443 and *c.* 1450.

Certain documents provide a glimpse of the kind of demands Giambono's patrons made on him. In May 1447 Giovanni di ser Francesco, a syndic and proctor of the church of S Agnese, Venice, commissioned him to make a painting (untraced) for the high altar, which was to be similar in form, fabrication, decoration and framing to the *Coronation of the Virgin* of 1444 by Giovanni d'Alemagna and Antonio Vivarini in the Ognissanti Chapel of S Pantaleone, Venice (*in situ*). Giambono was to finish the painting before Easter 1448, or, unless illness prevented its completion, he would forfeit 30 of the 130 ducats he was to be paid. He was also to make his painting wider than the original (by *c.* 300 mm). Two weeks later he subcontracted with Francesco Moranzone for the frame of the altarpiece, which was to be of the same quality as

the original. The altarpiece may be recorded in a drawing (London, BL, MS. Add. 41600, fol. 90 *v*) by an anonymous 15th-century artist. It has been proposed that the *Coronation of the Virgin* (Venice, Accad.), formerly attributed to Giambono, is the work of Antonio Vivarini and Giovanni d'Alemagna and not the work intended for S Agnese (Land, 1977).

Although Giambono's style was influenced throughout his career by the art of his contemporaries, his figures share certain general characteristics with late 14th-century art in Venice. The melancholic expression of his figures, as in, for example, the *St James* polyptych (*c.* 1455; Venice, Accad.), is similar to the expression of the figures in altarpieces by Lorenzo Veneziano and in the sculptural group on the iconostasis in S Marco by Jacobello and Pierpaolo dalle Masegne. His use of richly patterned drapery parallels Lorenzo's employment of the same device, just as the graceful, delicately curving lines of the forms find an echo in the figures by the dalle Masegne brothers. Because Giambono's style is basically linear, his figures are always relatively flat in appearance, the result of his emphasis on contour. Indeed, the contours of his forms were of such interest to him that his figures, such as those in the *St James* polyptych, tend to be first discerned almost as silhouettes against a gold-leaf background.

In one of Giambono's late and most successful works, the *St Chrysogonus* (*c.* 1460; Venice, S Trovaso), linear pattern is masterfully wedded to the composition as a whole. The complex swirls of the saint's banner and his cape as it unfurls behind him suggest a centripetal movement around the centre of the composition. Indeed the movement that might be expected from a figure on horseback is not conveyed by the horse itself, but by the pattern of flying cloth and the strong diagonal thrust of the saint's lance. Naturalism is confined to the depiction of the details of horse and vegetation but is not a principle of vision informing every aspect of the painting.

Giambono may have been the teacher of Giovanni d'Alemagna, who in 1433, before he became the partner of Antonio Vivarini, seems to have painted the fresco of the *Annunciation* around the Cortesia Sarego monument in S Anastasia, Verona. This fresco has been attributed to Giambono, but the attribution is far from unanimous. He seems also to have influenced Carlo Crivelli, whose penchant for intricate patterns and elegant line is close to Giambono's.

Giambono made significant contributions to Venetian iconography by inventing novel combinations of conventional images in his paintings. His *Man of Sorrows with St Francis* of the 1420s (New York, Met.) is an early example of his innovations in the treatment of Franciscan subject-matter, in which the theme of the saint's stigmatization is fused with that of a Pietà. In his only extant narrative panel, the *Stigmatization of St Francis* (*c.* 1440; Venice, Col. Cini), the saint's vision on Mt Alverna is connected to the theme of the Man of Sorrows. Both of these panels express in new ways the likeness between the stigmatized saint and the crucified Christ described by some of St Francis's biographers. Another example is the *Veil of Veronica* (*c.* 1450; Pavia, Pin. Malaspina), in which the head of Christ is slightly tilted to one side and his eyes are half-closed, both features that are found in traditional images

of the Man of Sorrows. Giambono thus presented Christ both as the Holy Face miraculously imprinted on Veronica's cloth and as the Man of Sorrows, thereby enriching the traditional allusion of the sudarium to the Passion.

Vasari did not mention Giambono, but Francesco Sansovino in his guide to Venice (1581) noted two altarpieces in S Alvise, one on the high altar and the other in the chapel of S Agostino.

2. WORKING METHODS AND TECHNIQUE. Giambono seems to have employed the same procedure in creating his paintings throughout his career. First, he made a preparatory drawing, seemingly done with a pen or small brush and ink, on the white gesso ground of the panel. Then, over these preliminary preparations for the figure, he would put on layers of translucent colours, so that in the *St James* polyptych, for example, the underdrawing is visible through the paint, which presumably is tempera. His backgrounds are always either cerulean blue (probably lapis lazuli) or gold leaf, which in some panels is punched to create a geometrical pattern. Occasionally he also used flat gold leaf in the drapery of his figures, painting over it with thin paint to create a textile pattern. His drapery, particularly the borders of copes on his ecclesiastical figures, is sometimes decorated with raised and gilded gesso, and other objects, such as books and keys, are embossed and covered with gold leaf, both practices that give his works a tactile quality like that of a low relief. Throughout his career he employed two separate colour schemes, one predominantly crimson and cerulean blue, as in the panels of *?St Gregory the Great* and *?St Augustine* (both *c.* 1440; Padua, Mus. Civ.), and the other comprising bright pink, orange, green, blue, yellow, red and lavender, as in the *St Peter* (*c.* 1440; Washington, DC, N.G.A.).

There are no known drawings on paper certainly by Giambono, but he was fundamentally a draughtsman, not only because he began his paintings with a drawing, but also because one of the most aesthetically pleasing features of his paintings is the expressiveness of his line, which at its best is spontaneous and vivacious, qualities usually found only in drawings on paper.

BIBLIOGRAPHY

Thieme–Becker: 'Bono, Michele di Taddeo'

F. Sansovino: *Venetia città nobilissima et singolare* (Venice, 1562), fol. 62*r*

J. A. Crowe and G. B. Cavalcaselle: *A History of Painting in North Italy* (London, 1871, rev. by T. Borenius, 2/1912), pp. 12–15

E. Sandberg-Vavalà: 'Michele Giambono and Francesco dei Franceschi', *Burl. Mag.*, li (1927), pp. 215–21

——: 'The Reconstruction of a Polyptych by Michele Giambono', *J. Warb. & Court. Inst.*, x (1947), pp. 20–26

B. Berenson: *Venetian School* (1957), i, pp. 82–3

M. Muraro: 'The Statues of the Venetian *Arti* and the Mosaics of the Mascoli Chapel', *A. Bull.*, xliii (1961), pp. 260–74 [discusses dating of mosaics]

E. Packard: 'The Madonna of Humility', *Bull. Walters A.G.*, xvii/3 (1964), n.p. [with x-ray and ultraviolet photographs showing underdrawing]

N. Land: *Michele Giambono* (diss., Charlottesville, U. VA, 1974)

——: 'Michele Giambono's *Coronation of the Virgin* for S Agnese in Venice: A New Proposal', *Burl. Mag.*, cxix (1977), pp. 167–74 [discusses drawing after lost original]

C. Pesaro: 'Per un catalogo di Michele Giambono', *Atti Ist. Ven. Sci., Lett. & A.*, cxxxvi (1977–8), p. 29 [surveys all documents]

N. Land: 'Two Panels by Michele Giambono and Some Observations on St Francis and the Man of Sorrows in Fifteenth-century Venetian Painting', *Stud. Iconog.*, vi (1980), pp. 29–41

——: 'A New Proposal for Michele Giambono's Altarpiece for S Michele in S Daniele in Friuli', *Pantheon*, iv (1981), pp. 304–10
——: 'A New Panel by Michele Giambono and a Reconstructed Altarpiece', *Apollo*, cxix (1984), pp. 150–65
P. Humfrey: 'The Venetian Altarpiece of the Early Renaissance in the Light of Contemporary Business Practice', *Saggi & Mem. Stor. A.*, xv (1986), pp. 67–82
N. Land: 'Michele Giambono, Cennino Cennini and *Fantasia*', *Ksthist. Tidskr.*, lv (1986), pp. 47–53 [artist's work evaluated in relation to art theory]

NORMAN E. LAND

Giampiccoli. Italian family of engravers and etchers.

(1) Giuliano Giampiccoli (*b* Belluno, 3 May 1703; *d* Belluno, 10 Dec 1759). He was the nephew of Marco Ricci. About 1735 he moved to Venice, where he worked for the publisher Joseph Wagner, and in 1740 he took charge of the engraving department of the copperplate printers Remondini of Bassano. He employed both engraving and etching techniques in his *Racolta di 12 paesi inventate e dipinte dal celebre Marco Ricci* (examples Venice, Correr, see 1983 exh. cat., figs 206, 207), and in the five large landscapes (e.g. Venice, Fond. Querini-Stampalia), also after Ricci, from another set of twelve (completed by Francesco Bartolozzi) for Joseph Wagner. His most important work was the series after Ricci of landscape views (36 landscapes with 2 frontispieces) published *c.* 1740 and reprinted with additions in 1775 by Teodoro Viero (48 landscapes and 4 frontispieces): 42 of these prints were etched in collaboration with Giambattista Tiepolo (see 1983 exh. cat., figs 209–19).

Giuliano also produced engravings, after drawings and paintings by Giuseppe Zocchi, Antonio Balestra, Marcantonio Franceschini, Francesco Zuccarelli and Tiepolo, and engraved book illustrations, for example the plates for Pasquali's edition of *Delle commedie di Carlo Goldini avvocato veneto* (Venice, 1761–77).

(2) Marco Sebastiano Giampiccoli (*b* Venice, 18 July 1737; *d* Venice, 23 June 1809). Son of (1) Giuliano Giampiccoli. A mediocre artist, he produced 42 views of Venice, after Canaletto, Michele Giovanni Marieschi, Pietro Antonio Novelli (1729–1804) and Francesco del Pedro (1740–1806), and 24 views of Venetian churches. He also published a series of *c.* 50 etched views of panoramas and piazzas of important Italian cities, especially those in the Veneto (for examples see 1983 exh. cat., figs 222–3) and was active in the field of book illustration and cartography.

BIBLIOGRAPHY
Thieme–Becker
L. Alpago Novello: 'Gli incisori bellunesi', *Atti Reale Ist. Ven. Sci., Lett. & A.*, xcix (1939–40), pp. 483–523
Da Carlevarijs ai Tiepolo: Incisori veneti e friulani del settecento (exh. cat., ed. D. Succi; Gorizia, Mus. Prov. Pal. Attems; Venice, Correr; 1983), pp. 178–94
Giambattista Tiepolo: Il segno e l'enigma (exh. cat., ed. D. Succi; Gorizia, Mus. Prov. Stor. & A., 1985), pp. 34–5, 79–110, 124–5
E. de Nard: *Marco Sebastiano Giampiccoli: Un caso di omonimia* (Belluno, 1986)

DARIO SUCCI

Giampetrino, il. *See* RIZZOLI, GIOVANNI PIETRO.

Gian [Giovanni] **Cristoforo Romano** (*b* Rome, *c.* 1465; *d* Loreto, 31 May 1512). Italian sculptor and medallist. He was the son of Isaia da Pisa. Some scholars have followed Vasari in suggesting that he was trained by his father or by Paolo Romano, but Isaia stopped work and Paolo died too early to have had any significant influence on him. It is likely that he studied with Andrea Bregno, who worked in Rome from 1446 to 1506. He may have been in Urbino before 1482, working at the Palazzo Ducale with the Lombard master Ambrogio d'Antonio Barocci. Several doorframes in the palazzo have been attributed to him. He then probably went to the Este court at Ferrara. In 1490 he carved a portrait bust of *Beatrice d'Este* (Paris, Louvre), the daughter of Ercole I d'Este, Duke of Ferrara, for her betrothal to Ludovico Sforza, Duke of Milan. The attribution of this bust derives from a letter of 12 June 1491 from Isabella d'Este, requesting that Ludovico send Gian Cristoforo, who had done Beatrice's portrait, to Mantua to work for her. The bust is inscribed with the imprese of a sieve surrounded by a diamond ring. The sieve was a symbol of Ludovico, the diamond of Ercole; entwined they suggest marriage and the hope of fertility. This bust is the sculpture most securely attributed to Gian Cristoforo and, with his medals, provides the basis for the assessment of his style.

In 1491 Gian Cristoforo went to Milan, probably in the wedding entourage of Beatrice d'Este. In that year he began work on his major surviving commission, the tomb of *Giangaleazzo Visconti, 1st Duke of Milan* at the Certosa di Pavia (*see* PAVIA, §2(i)). Despite ample documentation and Gian Cristoforo's signature carved on the front, it has not been possible to distinguish his work on the tomb from that of his collaborators: it is likely that he assigned most of the carving to other sculptors, particularly Benedetto Briosco. Similarly it seems that Gian Cristoforo supervised, either personally or in letters, the many other monumental sculptures and portraits attributed to him.

After the completion of the *Visconti* tomb and the death of Beatrice d'Este, Gian Cristoforo left Milan for the court of Isabella d'Este in Mantua, arriving in September 1497. Several Mantuan works, including a marble doorframe for Isabella (between her second *studiolo* and her grotta) and a terracotta bust of her husband *Francesco II, 4th Marchese of Mantua Gonzaga* (*c.* 1498; Mantua, Pal. Ducale), have been attributed to him. Also from this period is the tomb of *Pier Francesco Trecchi* (Cremona, S Agata), which was designed for S Vincenzo, Cremona. He was in Venice in 1503 and possibly in Rhodes before this.

In 1505 Gian Cristoforo was back in Milan, staying at the house of the doctor and anatomist Marc'Antonio della Torre. His letters to Isabella d'Este refer to designs for the tomb of *Osanna Andreasi* (destr. ?1797), which she had commissioned for S Domenico, Mantua. Also in 1505 he was called to Rome by Pope Julius II. Letters from Isabella indicate that he was to act as her agent in seeking antiquities in Rome. Although letters refer to sculpture of this period, only medals have been securely identified. Three medals by him are noted in a letter of 1507 from Giacomo d'Atri, Mantuan ambassador to Naples, to Isabella d'Este in Mantua. These depict *Isabella d'Este* (gold, *c.* 1498; Vienna, Ksthist. Mus.; see fig.), which is set in a gold frame with enamel and diamonds that spell her name, *Isabella of Aragon* (e.g. London, BM) and *Pope Julius II* (e.g. London, BM). Between 1507 and 1510 Gian

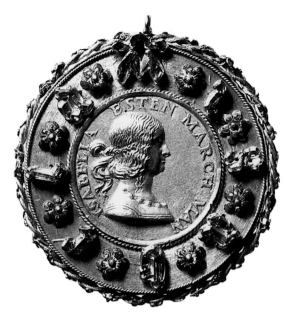

Gian Cristoforo Romano: *Isabella d'Este*, gold medal, diam. 89 mm, *c.* 1498 (Vienna, Kunsthistorisches Museum)

Cristoforo travelled to Urbino, Naples and possibly Mantua and Fossombrone. In December 1510 he was in Loreto and by March 1511 he was working on the S Casa there, a project that seems to have occupied him until his death. No work on the S Casa has been identified as his, and indications are that he worked on the architecture of the church rather than the S Casa itself (Weil-Garris). Gian Cristoforo is further documented as a courtier, musician, antiquary, poet and writer on literature and art. This wide range of activities, as well as his travels and periods of illness (probably syphilis), might account for his small output.

BIBLIOGRAPHY

Thieme–Becker: 'Romano, Giovanni Cristoforo'

G. Vasari: *Vite* (1550, rev. 2/1568); ed. G. Milanesi (1878–85), ii, p. 650

A. Venturi: 'Gian Cristoforo Romano', *Archv Stor. A.*, i (1888), pp. 49–59, 107–18, 148–58

A. Bartolotti: *Figuli, fonditore e scultori in relazione con la corte di Mantova nei secoli XV, XVI, XVII* (Milan, 1890)

A. Luzio and R. Renier: 'Delle relazione di Isabella d'Este Gonzaga con Ludovico e Beatrice Sforza', *Archv Stor. Lombardo*, II/vii (1890), pp. 74–119, 346–399, 619–674

G. de Nicola: 'Falsificazione di documenti per la storia dell'arte romana,' *Repert. für Kstwiss.* xxxii (1909), pp. 55–60

A. Venturi: 'Gli studi su Gian Cristoforo Romano, scultore', *Atti del I. Congresso nazionale di studi romani: Roma, 1929*, pp. 553–9

G. F. Hill: *A Corpus of Italian Medals of the Renaissance before Cellini* (London, 1930)

C. Brown: 'Gleanings from the Gonzaga Documents in Mantua: Gian Cristoforo Romano and Andrea Mantegna', *Mitt. Ksthist. Inst. Florenz*, xvii (1973), pp. 153–9

A. S. Norris: *The Tomb of Gian Galeazzo Visconti at the Certosa di Pavia* (diss., New York U., 1977)

K. Weil-Garris: *The Santa Casa di Loreto: Problems in Cinquecento Sculpture* (New York, 1977)

A. Nova: 'Dall'arca alle esequie: Aspetti della scultura a Cremona nel XVI secolo', *I campi e la cultura artistica cremonese del cinquecento* (Milan, 1985), pp. 409–30

A. S. Norris: 'Gian Cristoforo Romano: The Courtier as Medalist', *Stud. Hist. A.*, xxi (1987), pp. 131–41

ANDREA S. NORRIS

Gianetti, Matteo. *See* GIOVANETTI, MATTEO.

Gianfattori, Carlo Ferrante. *See* CARLO, FERRANTE.

Gian Gastone, Grand Duke of Tuscany. *See* MEDICI, DE', (30).

Giani, Felice (*b* San Sebastiano Curone, 17 Dec 1758; *d* Rome, 10 Jan 1823). Italian painter and draughtsman. He was a prolific painter who, with a team of artists and craftsmen, decorated palaces and public buildings in Rome, Venice, many cities in Emilia Romagna (especially Faenza), and in France. He worked in a distinctive Neo-classical style, creating sumptuous, richly coloured rooms, the paintings on walls and ceilings being surrounded with a wealth of antique ornament. Despite the turbulent era of revolution and war (1789–1815) he never lacked commissions, for which he chose subjects from the literature and history of Greece and Rome that were symbolic both for him and for his patrons. He was a prodigiously talented draughtsman, who drew constantly, both out of doors and in the studio.

1. Painting. 2. Drawing.

1. PAINTING.

(i) *Before 1798.* He first studied in Pavia with Carlo Antonio Bianchi and Antonio Galli-Bibiena. In 1778–9 he attended the Accademia Clementina, Bologna, where he won a prize, and from 1780 to 1783 continued his studies in Rome at the Accademia di S Luca. In an autograph note (New York, Cooper-Hewitt Mus.) he referred to Pompeo Batoni, Cristofero Unterberger and the architect Giovanni Antonio Antolini as his teachers; he also associated with Giuseppe Cades. In 1785–7 he shared rooms with Francesco Caucig (1762–1828) and the two artists drew together in Rome and in the surrounding countryside. Giani sketched many Roman views (e.g. *Tomb of the Horatii and Curiatii*; Rome, Bib. Ist. N. Archeol. & Stor. A.), and drew vivid sketches of the life of artists in Rome (e.g. *Osteria miserabilissima*, Rome, Bib. Hertz.).

Giani's knowledge of Roman remains, which helped to forge his Neo-classical style, is evident from his earliest commissioned works. These came from Faenza in 1786 and 1787: in 1786–7 he decorated the Galleria dei Cento Pacifici with the *Triumph of Titus* (now damaged); in 1787 two rooms in the Palazzo Conti Sinibaldi with scenes from early Roman history and various gods and mythological figures (all *in situ*). Both decorations show the voluminously draped classical figures in antique-inspired surroundings that are characteristic of Giani's art. Having created his personal Neo-classical mode, he never changed it, and thus there is no evident development in his art.

Between 1787 and 1793 Giani worked in the richly decorated apartments created in the Palazzo Altieri, Rome, under the direction of the architect Giuseppe Barberi (1746–1809). Barberi's Noble Cabinet is one of the finest of Neo-classical rooms, uniting classical architecture, marble friezes, furniture, painted decorations, framed paintings and stuccowork. Here Giani played a minor role, contributing figures to landscape paintings and perhaps designing the frieze of putti executed by Vincenzo Pacetti. In the

Winter Bedroom the major decorations (*in situ*) are entirely his. In the curve of the vault he painted long narrow panels showing a series of triumphs; of Venus, of Prosperity, of Eros and of the Arts. The colours are beautifully limpid and light, the draperies billowing, the figures animated. The inspiration is from Raphael, the immediate model being the latter's decoration in the Vatican Loggie. The ceiling is of light-coloured, elegant stuccos, with painted putti in the vault compartments. In the Oval Boudoir all the decoration (*in situ*) is attributable to Giani, including three paintings: *Atalanta and Hippomenes, Diana and Actaeon* and the *Judgement of Paris*. Again, the whole effect is of richness, elegance and lightness. In the Summer Bedroom he painted the centre roundel of *Paris and Helen* on the ceiling; in the Pompeiian Room, the putti on Pompeiian red walls (all *in situ*). There is a letter of 1792 in which Giani mentions that he has recently visited Naples, and a sketchbook (Rome, Bib. Ist. N. Archeol. & Stor. A.) contains many copies of Pompeiian wall paintings. In Rome Giani also led the liberal academy, the Accademia dei Pensieri, which was active from *c.* 1790 to *c.* 1796 and included such members as Anne-Louis Girodet and François-Xavier Fabre.

Further work in Faenza followed, for which Giani organized a team of artists, usually four: himself, Gaetano Bertolani (1758/9–1856), a decorative painter, Antonio Trentanove (*c.* 1745–1812), a sculptor in stucco, and one other. Giani's team was responsible for the entire ensemble in a room or suite of rooms, including the furniture, but usually not the architecture. Once a commission was finished, the entire team moved on together to the next project. Between 1794 and 1796 his team decorated the Palazzo Laderchi, where Giani's paintings of the *Story of Psyche* are framed by elegant stuccos and set off by panels painted with grotesques (all *in situ*). The artists stayed in a house in Brisighella, near Faenza, which still exists, and an album of drawings, *Da Faenza a Marradi* (1794; Forlì, Bib. Com. Saffi), contains views of the house, of Brisighella and of the artists enjoying country relaxations. Some of these, such as *Giani and his Friends at the Casa Brisighella*, reveal Giani's informal and Bohemian character.

(ii) From 1798. Giani was involved with revolutionary and pro-French causes, as is evidenced by two paintings, the *Triumphal Arch* and the *Altar of the Fatherland* (both Rome, Pal. Braschi), which record the Festa della Federazione in Rome on 20 March 1798; and two drawings, *Monument with Standing Figure* and *Equestrian Monument* (both *c.* 1801; New York, Cooper-Hewitt Mus.), which are connected with Antolini's unrealized project for a Foro Bonaparte in Milan. His politics furthered his artistic career, since many of his patrons were of his persuasion and played a powerful role in the links between Italy and France.

From 1800 Giani and his team were occupied with commissions in Rome and Venice, and in the Veneto and Emilia Romagna. Perhaps their finest work was the decorative ensemble created (1804–5; *in situ*) in four rooms on the *piano nobile* of the Palazzo Milzetti, Faenza, which is a tribute to the classical learning of the patron, Conte Francesco Milzetti. In the octagonal anteroom Giani's central ceiling painting, *Apollo in his Chariot*,

forms the splendid climax to a rich array of stucco reliefs, painted simulated reliefs and painted lunettes in grisaille showing winged putti bearing the symbols of the four seasons and of the zodiac. The Galleria d'Achille, the principal room for entertainments, displays Giani's austerely Neo-classical paintings in the flattened lunettes over the end walls and on the vaulted ceiling. Grisaille paintings and stuccos enrich the walls and frame the five richly coloured ceiling paintings illustrating the Homeric story of Achilles in the Trojan War. In the smaller Sala di Numa, Giani painted 18 scenes from the life of Numa Pompilius, the second king of ancient Rome, and in the Sala d'Ulisse the story of Ulysses' return to Ithaca, framed by borders of grotesque decoration.

In 1805 Giani was part of a team that decorated a triumphal arch celebrating the Emperor Napoleon's entry into Bologna (eight drawings; New York, Cooper-Hewitt Mus.) and in 1807 he decorated rooms in the Ala Napoleonica, Venice. Antonio Aldini (1755–1826), one of the Bolognese delegation that greeted Napoleon, commissioned Giani (1805) to decorate the Palazzo Aldini in Bologna with scenes from Roman history (*in situ*); in 1810 Giani also decorated Aldini's celebrated Neo-classical villa (now Villa Aldini) overlooking Bologna (decorations untraced).

Giani's outstanding decoration in Bologna was that of the Palazzo Marescalchi, commissioned by Ferdinando Marescalchi (1754–1816), who, like Aldini, was pro-French and represented the Kingdom of Italy at the court of Napoleon in Paris. The oval dining-room (1810) is the finest part of this work, and, since no architect is mentioned in the documents, Giani may himself have designed the oval space with its loggia-like corners formed of eight pairs of free-standing Corinthian columns and eight Corinthian pilasters, fitted into the rectangular room. The paintings (*in situ*) show scenes from the early part of Virgil's *Aeneid*, with an oval *Banquet of Aeneas and Dido*, apposite for a dining-room, in the centre of the panelled ceiling. Around it are four oval paintings and two octagons. The painted grotesque decorations, in the style of Raphael, are by Bertolani, and the exquisite stuccos, for which Giani made the drawings, are by Marc'Antonio Trefogli (1782–1854), who had replaced Trentanove.

In 1811 Giani was elected to the Accademia di S Luca, Rome. In 1812 he decorated rooms in the Palazzo Quirinale, Rome, for a projected visit of Napoleon. Among these are ceiling pictures, the *Triumph of War* and the *Triumph of Peace* (*in situ*). In 1812–13 he was in France, where he decorated the villa at Montmorency belonging to Aldini, then Secretary of State for the Kingdom of Italy, and carried out decorations at the Tuileries palace and at Malmaison (all destr.). Many drawings of the park at Montmorency survive from this visit (Bologna, Pin. N.). There followed further commissions in the cities of Emilia Romagna, among them the decoration of the Palazzo Sampieri (1815) and the Casa Martinetti (1820) in Bologna, and of the Palazzi Cavina (1816) and Pasolini dall'Onda (1817–18) at Faenza. He was honoured in his own time and in 1819 was made a member of the Accademia dei Virtuosi del Pantheon. The decoration (1821; destr.) of the ceiling of the Teatro Valle in Rome was one of his last works. Giuseppe Valadier, the architect for the project,

included a large engraving and a description of it in his book on his own works, *Opere di architettura e di ornamento ideate ed eseguite da Giuseppe Valadier* (1833). In 1822 Giani was working in Faenza, but a fall and an injured finger caused him to return to his house in Rome, where he died the following year.

Although Giani occasionally painted in gouache, in oil on canvas and in encaustic, his preferred medium was tempera on plaster. There is a great effect of richness and colour in his paintings, though the palette in general tends towards lighter colours than those of oil painting. Rosy and pale flesh tones contrast with rather acid greens and blues, and with warm yellows, oranges and reds in the flowing draperies. The paintings appear to be drawings in colour, with the point of the brush used in various colours to draw contours and shading lines. Few easel paintings by Giani are now known.

2. DRAWING. Giani made very accomplished drawings in black chalk (e.g. *Venetian Architectural Capriccio*, ?1807–14; New York, Cooper-Hewitt Mus.), but his most extensively used medium was pen and brown ink and wash, often over very sketchy drawing in black chalk. A few drawings have watercolour, and a splendid oversized drawing (1821; New York, Cooper-Hewitt Mus.) for the ceiling of the Teatro Valle shows a central figure of Victory and some of the surrounding Muses in delicate watercol-

2. Felice Giani: *Apollo in his Chariot*, pen and brown ink on paper with grey-brown wash over traces of black chalk, 313×296 mm, 1802 (New York, Cooper-Hewitt Museum, Smithsonian Institution, National Museum of Design)

our. In general, however, colour harmonies for paintings do not seem to have been studied thoroughly in the drawings. Certain very large drawings with brown wash may have been intended as virtuoso pieces in themselves, such as *Alexander and Diogenes* (New York, Cooper-Hewitt Mus.) and *The Greeks in the Cave of Polyphemus* (New York, Cooper-Hewitt Mus.; see fig. 1). In this connection may be mentioned Giani's participation in 1803 in the Accademia della Pace in Bologna, where artists gathered weekly to make drawings on a designated subject and submitted these works to their fellow artists for criticism.

Many of Giani's drawings are of figure subjects he was to paint as part of decorative schemes. Some show these compositions in the context of a compartmented ceiling; others indicated work to be executed by fellow artists of the scheme. The Cooper-Hewitt Museum, New York, has 32 *bozzetti* for the decorations (1804–5) in the Palazzo Milzetti, Faenza. Many of these free and spontaneous drawings are squared off and many, such as the drawing for *Apollo in his Chariot* (New York, Cooper-Hewitt Mus.; see fig. 2), are strikingly close to the finished paintings. A drawing for the ceiling of the Sala d'Ulisse shows all nine scenes on one sheet, accompanied by captions.

There are also numerous sketchbook pages, large and small, after works by other artists, or of architecture and decorative schemes, often bearing detailed inscriptions of colours and materials. Examples in the Cooper-Hewitt Museum include a sketchbook page, inscribed 1818, with sketches of architecture and sculpture, and other pages with copies of pictures by Correggio. Giani seems to have continued this practice throughout his career.

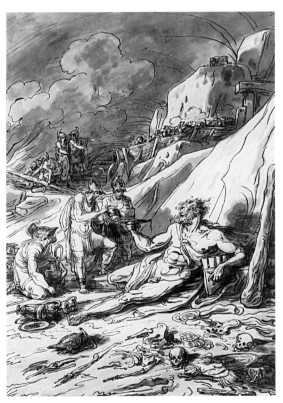

1. Felice Giani: *The Greeks in the Cave of Polyphemus*, pen and brown ink and brown-grey wash over pencil, 533×387 mm (New York, Cooper-Hewitt Museum, Smithsonian Institution, National Museum of Design)

BIBLIOGRAPHY
G. Valadier: *Opere di architettura e di ornamento ideate ed eseguite da Giuseppe Valadier* (Rome, 1833), pp. 9, 14

F. E. Golfieri: 'Felice Giani', *Paragone*, i/7 (1950), pp. 23–8

G. Raimondi: 'Felice Giani o del Romanticismo', *Paragone*, i/11 (1950), pp. 17–25

S. Rudolph: 'Felice Giani: Da Accademico "de' Pensieri" a Madonnero', *Stor. A.*, 30–31 (1977), pp. 175–86

S. Acquaviva and M. Vitali: *Felice Giani* (Faenza, 1979) [with bibliog.]

A. Ottani Cavina: 'Felice Giani e la Francia: La decorazione di Palazzo Baciocchi', *Florence et la France sous la Révolution et l'Empire* (Florence and Paris, 1979), pp. 273–86 [with illus.]

L'età neoclassica a Faenza (exh. cat., ed. A. Ottani Cavina; Faenza, Pal. Milzetti, 1979), pp. 3–79, pls 1–151

K. Rozman: 'The Roman Views of Felice Giani and Francesco Caucig', *Master Drgs*, xviii/3 (1980), pp. 253–7, figs 1–3

M. Vitali and P. D. Massar: 'Un gruppo di bozzetti di Felice Giani nel Cooper-Hewitt Museum di New York', *Paragone*, xxxi/363 (1980), pp. 21–47, pls 23–50

A. M. Iannucci: 'Palazzo Milzetti a Faenza: Storia ed immagine', *Boll. A.*, lxvi/10 (1981), pp. 1–40 [with 54 figs]

L. Danila: 'Inediti di Felice Giani a Iesi', *Romagna A. & Stor.*, viii (1983), pp. 77–84 [7 figs]

E. Gentile Ortona: 'Giani e la pittura pompeiana: Un album di disegni dell'Istituto Nazionale di Architettura e Storia dell'Arte', *Boll. A.*, lxix/24 (1984), pp. 79–100 [31 figs]

P. D. Massar: 'A Drawing by Felice Giani after Michelangelo', *Master Drgs*, xxii/3 (1984), pp. 318–19, fig. 1, pl 42

A. Ottani Cavina: 'Giani, la residenza neoclassica. L'elite filofrancese: Un episodio a Bologna', *Antol. B. A.*, 33–4 (1988), pp. 24–32, pls 1–16

——: *Felice Giani* (in preparation)

PHYLLIS DEARBORN MASSAR

Giannotti, Tommaso. *See* RANGONE, TOMMASO.

Gianotis, Bernardino Zanobi de. *See* ZANOBI DE GIANOTIS, BERNARDINO.

Giant order. *See* ORDERS, ARCHITECTURAL, §II.

Giaquinto, Corrado (*b* Molfetta, nr Bari, 8 Feb 1703; *d* Naples, 18 April 1766). Italian painter. He was a leading exponent of the Rococo school that flourished in Rome during the first half of the 18th century.

1. Life and work. 2. Working methods and techniques.

1. LIFE AND WORK.

(i) Molfetta and Naples, 1703–27. Giaquinto began his training in the studio of Saverio Porto (*c.* 1667–*c.* 1725), a provincial painter in Molfetta. In March 1721 he left for Naples, where, except for a brief return to Molfetta (Feb 1723–Oct 1724), he lived for the next six years. According to De Dominici (1745), Giaquinto's earliest biographer, once in Naples the artist entered the studio of Nicola Maria Rossi, a follower of Francesco Solimena. While Solimena's monumental and complex style influenced Giaquinto throughout his career, there is no documentary evidence to suggest that Giaquinto entered Solimena's flourishing studio. However, close contact between Solimena and Giaquinto during these formative years is indicated by several autograph paintings modelled after the master's work. Giaquinto's *Visitation* (Naples, Pucci priv. col.) appears to have been copied from Solimena's altarpiece of the same subject for S Maria Donnalbina. Other early studies after Solimena include *Europe, Asia and America* (Rome, priv. col., see Bologna (1979), p. 61) and the *Archangel Michael* (Rome, Vatican Pin.). Equally important to the development of Giaquinto's mature style were the luminous fresco decorations that Luca Giordano painted for the Certosa di S Martino, Naples, in 1704.

(ii) Rome and Turin, 1727–40. In March 1727 Giaquinto left Naples for Rome. During the 1730s he worked as an independent artist, modifying his robust Neapolitan style to reflect the classicizing Rococo taste exemplified in the works of the followers of Carlo Maratti such as Sebastiano Conca. Giaquinto's reputation was firmly established in 1733, when he completed an extensive fresco cycle in the nave and cupola of the French church of S Nicola dei Lorenesi, Rome. In these frescoes the Baroque stylistic traditions developed by Pietro da Cortona, Maratti and Giordano were masterfully synthesized and updated. The critical success of this commission prompted two invitations to the Savoy court in Turin in June 1733 and *c.* 1735. Although both visits were brief, his contacts with the works of contemporary artists of the French, Venetian and Neapolitan schools, such as Carle Vanloo, Giovanni Battista Crosato and Francesco De Mura, were important for the perfection of his elegant Rococo forms and pastel palette. Giaquinto's first major commission in Turin was in 1733, for the frescoes depicting the *Triumph of the Gods* (destr. World War II), *Apollo and Daphne* and the *Death of Adonis* for the Villa della Regina (both *in situ*). When he returned to Turin *c.* 1735 he decorated a small chapel dedicated to St Joseph (designed by Filippo Juvarra for the church of S Teresa) with two large oils, the *Rest on the Flight into Egypt* and the *Death of St Joseph*, and a vault fresco, *St Joseph in Glory*. The epitome of Giaquinto's exquisite Turinese style, however, is found in his *Aeneas* cycle, a series of six oils which were moved from Turin to their present location in the Palazzo Quirinale, Rome, in the late 19th century. In Rome Giaquinto continued to paint in this sophisticated style, examples of which can be found in the *Virtues* (*c.* 1733–5), a small ceiling fresco for the Palazzo Borghese, and the *Assumption of the Virgin* (1739), an altarpiece commissioned by Cardinal Ottoboni for the church of the Assumption, Rocca di Papa.

(iii) Rome, 1740–53. The 1740s represent Giaquinto's most significant decade in Rome. The artist was admitted into the Accademia di S Luca in 1740. Some time thereafter he established a studio and was put in charge of training all the Spanish students sent to the papal city to perfect their craft. Giaquinto's most important commissions during this decade were his large decorative programmes for the churches of S Giovanni Calabita (*c.* 1741–2) and Santa Croce in Gerusalemme (*c.* 1744), which established his international reputation as the leader of the Roman Rococo school. During this period his style moved away from the previous Rococo forms of the 1730s towards a more solid classicism that pays homage to the tradition of the Grand Style as exemplified by Maratti, the last great master of the Roman Baroque. Classicizing tastes were especially strong during the 1740s when Pompeo Batoni and the Frenchman Pierre Subleyras established reputations in Rome. Giaquinto's mature Roman style is evident in his nave fresco for S Giovanni Calabita, *St John of God Healing the Plague Victims*, and in his altarpiece for S Maria dell'Orto, the *Baptism of Christ* (1750). Both examples convey a heightened sense of solemnity, which the artist achieved through the use of simplified compositional arrangements and figure types reminiscent of Maratti shown in postures of quiet repose. Other important commissions included the

vault fresco of *God the Father Presenting the Tablets to Moses* (1743; Rome, S Lorenzo in Damaso, Ruffo chapel) and such large canvases as the *Transportation of the Relics of SS Eurychetes and Acutius* (1744; Naples Cathedral).

In 1748 Giaquinto and his studio, which included his most successful student, Antonio González Velázquez, were commissioned by Ferdinand VI of Spain to decorate the Trinitarian church of Santa Trinità degli Spagnoli, for which he painted the altarpiece the *Holy Trinity Freeing a Captive Slave* (1750). The artist's professional relationship with the Spanish crown was reinforced in 1753 when Giaquinto was summoned to Madrid by Ferdinand VI. In August 1752 the court painter Jacopo Amigoni had died, and a successor was needed to fresco the ceilings of the new Palacio Real.

(iv) Spain, 1753–62. Giaquinto's nine-year stay in Spain, where he established himself as Europe's foremost fresco painter after Giambattista Tiepolo, was the highpoint of his career. His prominence within the artistic hierarchy at the Bourbon court recalled the influence exercised by Charles Lebrun at Versailles. Soon after his arrival at court in June 1753, Giaquinto was appointed to three posts: First Painter to the King, Director of the Academia de S Fernando and Director of the royal tapestry factory of S Barbara, Madrid. His position as Director-in-Chief of the court's artistic affairs caused Giaquinto's influence to extend to the next generation of Spanish artists, including Francisco Bayeu and Francisco de Goya. His influence was all the greater because his tenure coincided with the decoration of the new Palacio Real, the most important artistic project of the 18th century in Spain. Here Giaquinto's role extended far beyond his contribution as a painter: he designed many of the sculptures and stuccos in the areas of the palace where he worked; in addition he had many administrative duties, involving frequent meetings with the Secretary of State and other ministers in charge of the palace works. He was responsible for the well-being of a huge workforce and was often called upon to grant commissions and settle price disputes between court artists and palace administrators. Despite his powerful position, however, he was untyrannical by nature and managed to form a smooth working relationship with the architect Giovanni Battista Sacchetti, the sculptors Giovanni Domenico Olivieri and Felipe de Castro and the painters Antonio González Velázquez and José de Castillo, who worked under him at court.

Giaquinto's first royal commission (Oct 1753) was to restore Luca Giordano's fresco of the *Institution of the Order of the Golden Fleece* in the throne room of the palace of the Buen Retiro, Madrid. The vibrant colours and dazzling brushwork of Giordano's Spanish frescoes had a decisive effect on Giaquinto, who possessed a similar talent for brilliant pictorial effects. Though not securely dated, his first autograph works in Spain were probably a series of large oil paintings depicting the Old Testament history of Benjamin for the Sala de Conversatión (now the Comedor de Gala) at the palace of Aranjuez, near Madrid. Important works for other royal sites included the *Holy Trinity and Saints* (*c.* 1755–60; Valladolid, Mus. N. Escul.), which, along with a series of small oils of the *Life of Christ* (*c.* 1755–60; Madrid, Prado; Madrid, Escorial,

Casita Príncipe), was commissioned for the private oratories of Ferdinand VI and Barbara of Braganza at the palace of the Buen Retiro. Giaquinto also supervised the decoration of the royal monastery of Las Salesas Reales, Madrid, where his students Antonio and Luis González Velázquez frescoed the cupola of the church (*c.* 1756). Giaquinto's own work at Las Salesas was limited to one altarpiece in the church, *SS François de Sales and Jeanne de Chantal* (completed Oct 1757; *in situ*).

Stylistically, Giaquinto's frescoes at the new Palacio Real are his most impressive works. In June 1754 he was asked to paint the vaults above the entrance, choir and presbytery of the royal chapel along with its cupola and pendentives, work that was not carried out until 1758–9. His luminous colours, dynamic brushwork and masterly composition are manifest in the chapel's cupola, where dramatic groups of figures are interposed with delicate swirls of pastel clouds. Equally impressive are two large vault frescoes, one above the grand staircase of the palace, *Spain Rendering Homage to Religion and the Catholic Church* (modello, *c.* 1759; Saragossa, Mus. Prov. B.A.; see fig. 1), and the other in the Hall of Columns, the *Birth of the Sun and Triumph of Bacchus* (*c.* 1761–Feb 1762).

Shortly after completing the Hall of Columns, Giaquinto was commissioned to fresco the vault in the adjoining Hall of the Halbadiers (Feb 1762), but later the same month he was granted leave of absence to return to Naples for medical treatment. Eventually the task of completing this commission was given to Tiepolo, who had been called to Spain in 1761 by Charles III to fresco the throne room of the new Palacio Real. After Giaquinto left Madrid his artistic and administrative duties at the royal palace, academy and tapestry factory were assumed by Anton Raphael Mengs, who arrived at court in September 1761. It has generally been assumed that the arrival of Tiepolo and Mengs at court denoted Giaquinto's fall from favour and prompted his swift departure from Madrid in early 1762. However, documentary evidence indicates that Giaquinto intended to return to Spain to resume his duties at court but was prevented from doing so by continued ill-health.

(v) Naples, 1762–6. Giaquinto remained in Naples until his death in 1766. During this time he retained his position as First Painter to Charles III and continued to work for the Spanish monarchy, establishing a close working relationship with the Royal Architect Luigi Vanvitelli, through whom he was commissioned to execute one in a series of allegorical subjects for a tapestry cycle destined for the Stanza del Belvedere in the royal palace, Naples (*Allegory of War*, 1763; Caserta, Pal. Reale). His most important commission, however, and his major collaboration with Vanvitelli, was for a large Marian cycle in the sacristy of the royal church of S Luigi di Palazzo (Jan 1764–July 1765). The simplified composition, monumental figures and elegant postures of the S Luigi altarpieces, including the *Marriage of the Virgin* (Pasadena, CA, Norton Simon Mus.), the *Visitation* (Montreal, Mus. F.A.; see fig. 2), the *Purification at the Temple* (Cambridge, MA, Fogg) and the *Rest on the Flight into Egypt* (Detroit, MI, Inst. A.), indicate that during his last years Giaquinto reiterated and amplified

1. Corrado Giaquinto: *Spain Rendering Homage to Religion and the Catholic Church*, oil on canvas, 1.68×1.54 m, *c.* 1759; modello for vault fresco above the grand staircase of the new Palacio Real, Madrid (Saragossa, Museo Diocesiano de la Seo)

his Roman style of the 1740s to suit the developing Neoclassical tastes of the 1760s. With the advent of Neoclassicism, Giaquinto's reputation plummeted and was not restored until Moschini's pioneering article (1924) and d'Orsi's monograph (1958).

2. WORKING METHODS AND TECHNIQUE. Giaquinto's artistic talents were evolutionary rather than revolutionary. From the beginning of his career he developed an array of stock figure types and compositional formulae, which he continued to revise and perfect until he achieved

executed, Giaquinto's brushstrokes are always precisely controlled. The sumptuous texture of his oil sketches is modified in his large-scale canvases, where the colours tend to be deeper and the surface treatment smoother. However, the lighter pastel coloration, luminosity and rapid brushwork of the artist's oil sketches are apparent in his dynamic fresco technique, which reached an apex of sophistication and refinement in the cycles painted on the large vaults of the New Royal Palace in Madrid.

A true assessment of Giaquinto's oeuvre and his working methods and technique has been obscured by the existence of a large number of drawings, oil sketches and *modelli* executed in his style by his Italian and Spanish followers. The problem is complicated by Giaquinto's tendency to reuse his own established figure types and compositional formulae and occasionally to produce replicas of his own paintings. Other problems of authenticity arise from the lack of information about the organization of his Roman studio and about the numerous lesser-known artists who worked under him in Spain; the hands of distant followers in Naples and Sicily who worked in a similar manner, into the early 19th century also need to be identified. The precise relationship of studio replicas and close adaptations to Giaquinto's autograph paintings can only be judged on the basis of handling and quality: these criteria show that the majority were executed by pupils and followers who failed to achieve the precision of the master's brushwork or the subtlety of his pastel colours.

2. Corrado Giaquinto: *Visitation*, oil on canvas, 3.05×2.02 m, *c.* 1764-5 (Montreal, Musée des Beaux-Arts/Museum of Fine Arts)

a level of exquisite refinement. His preference for familiar pictorial motifs rather than more innovative visual solutions suggests an academic sensibility that belies the spontaneity of conception suggested by his lively preparatory drawings and oil sketches.

Although Giaquinto was a conscientious artist, he did not make minutely detailed studies that closely anticipate a final work. In his youth he produced the usual academic life studies, executed in oil or in chalk. From early in his career, he used quick schematic chalk drawings to work out the poses and gestures of individual figures, the arrangement of drapery and of figure groups. Studies for large-scale compositions, such as altarpieces and frescoes, were often executed in greater detail in pen and ink. However, his final compositions were seldom fully planned and, significantly, the more finished drawings were not squared for transfer. As he matured as an artist, Giaquinto often worked out his pictorial ideas directly in oil sketches painted on copper or canvas. Starting with a ground of pearly grey, he applied a rich selection of delicate pastel hues such as deep coral, sea green, turquoise, lilac and lemon yellow. The consistency of paint varies from an opaque buttery paste to transparent pigmented glazes; built up consecutively, these result in a luxuriant surface that seems to shimmer with silvery light. Although rapidly

BIBLIOGRAPHY

B. De Dominici: *Vita dei pittori, scultori ed architetti napoletani*, iii (Naples, 1745), pp. 722–3 [first biography]

V. Moschini: 'Giaquinto artista rappresentativa della pittura tarda-barocca a Roma', *L'Arte*, xxvii (1924), pp. 104–23 [pioneering study]

M. d'Orsi: *Corrado Giaquinto* (Rome, 1958) [only monograph, but outdated]

M. Volpi: 'Corrado Giaquinto e alcuni aspetti della cultura figurativa dell '700 in Italia', *Boll. A.*, n. s. 4, xliii (1958), pp. 263–82

——: 'Traccia per Giaquinto in Spagna', *Boll. A.*, n. s. 4, xliii (1958), pp. 329–40

A. Videtta: 'Disegni di Corrado Giaquinto nel Museo di S. Martino', *Napoli nobilissima*, ii (1962), pp. 13–28; iv (1965), pp. 174–84; v (1966), pp. 3–18; vi (1967), pp. 135–9 [useful illus. and documentary material from the largest col. of Giaquinto's drawings]

M. Laskin: 'Corrado Giaquinto's *St Helena and the Emperor Constantine presented by the Virgin to the Trinity*', *Museum Monographs*, i (St Louis, 1968), pp. 29–40 [disc. of commission and iconographical programme for Santa Croce in Gerusalemme, Rome]

P. Amato and H. Olsen, eds: *Atti del convegno di studi su Corrado Giaquinto: Molfetta, 1969* [documentation of Giaquinto's Italian and Spanish oeuvre]

P. Amato: 'Corrado Giaquinto: Documenti inediti del *Tabularium Vicariatus Urbis*', *Studi di Storia Pugliese in Onore di Giuseppe Chiarelli*, iv (Galatina, 1976), pp. 229–50 [documentation of Giaquinto's early years in Molfetta and Naples]

J. Urrea Fernández: *La pintura italiana del siglo xviii en España* (Valladolid, 1977) [most complete list of Giaquinto's Spanish paintings incl. documentation and bibliography]

F. Bologna: 'Solimena al Palazzo Reale di Napoli per le nozze de Carlo di Borbone', *Prospettiva*, xvi (1979), pp. 53–67 [disc. of Giaquinto's early copies after Solimena]

L'Art européen à la cour d'Espagne au XVIIIème siècle (exh. cat., Paris, Grand Pal., 1979) [disc. of Giaquinto and his Spanish students, incl. bibliography]

I. Cioffi: 'Corrado Giaquinto's "Rest on the Flight into Egypt"', *Bull. Detroit Inst. A.*, l/1 (1980), pp. 5–13

P. Amato, ed.: *Atti del convegno internazionale di studi: Corrado Giaquinto, 1703–66* (Molfetta, 1981) [additional documentary and iconographical studies of Giaquinto's Italian commissions, incl. useful catalogue of works now in French provincial museums]

The Golden Age of Naples: Art and Civilization under the Bourbons, 1734–1805 (exh. cat., Detroit, MI, Inst. A., 1981) [essay on Giaquinto's late Neapolitan career, incl. catalogue entries and good illus. of the S Luigi di Palazzo altarpieces]

I. Cioffi: 'Corrado Giaquinto's Studies for the Sculptural Decorations Planned for the Staircases of the New Royal Palace in Madrid', *Master Drgs*, xxii/4 (1984), pp. 434–40 [incl. illus. of drawings attributed to Giaquinto]

C. Siracusano: *La pittura del settecento in Sicilia* (Rome, 1986) [disc. of Giaquinto followers in Sicily]

I. Cioffi: [review of *Painting in Spain During the Later Eighteenth Century* (London, N.G., 1989)], *Apollo*, cxxx (1989), pp. 117–18

——: *Corrado Giaquinto at the Spanish Court, 1753–1762. The Fresco Cycles at the New Royal Palace in Madrid*, 3 vols (diss. New York U., Inst. F.A., 1992) [disc. of Giaquinto's work at the New Royal Palace, Madrid, and his role in the development of late 18th-century Spanish ptg]

——: [review of *Corrado Giaquinto, capolavore delle corte in Europa* (Bari, Castello Svevo; Rome, Pal. Venezia; 1993)], *Burl. Mag.*, cxxv (1993), pp. 588–9

IRENE CIOFFI

Giardini, Giovanni (*b* Forlì, 1646; *d* Rome, 1721). Italian draughtsman, silversmith, bronze-caster and gem-carver. Between 1665 and 1668 he was apprenticed to the silversmith Marco Gamberucci (*fl* 1656–80) in Rome. In 1675 he qualified as a master silversmith and rapidly achieved a position of prestige in the silversmiths' guild. He ran a productive workshop, in which he was joined in 1680 by his brother Alessandro Giardini (*b* 1655). In 1698 he was appointed bronze-founder for the Papacy. Only a few of his works in silver have survived, most of them church furnishings that escaped the depredations of the Napoleonic army. These show a strong sense of form and a technical mastery that earned him important commissions from the papal court, including an imposing papal mace in silver and parcel-gilt (*c.* 1696; London, V&A), a tabernacle in silver, gilt copper, porphyry and rock-crystal (1711; Vienna, Ksthist. Mus.) and a cross and two candlesticks in silver and malachite (1720; Pavia, priv. col.), which were made for the chapel of Cardinal Francesco Barberini in St Peter's, Rome. When the body of Queen Christina of Sweden was exhumed in 1965 in St Peter's, a set of pieces by Giardini was found: the Queen's silver sceptre, crown and funerary mask of 1689 (Rome, St Peter's). Giardini's reputation, however, is based on his pattern-book designs for sacred and secular objects, which were engraved on copper by Maximilian Limpach of Prague and published in Prague in 1714 as *Disegni diversi*. They were reprinted in Rome in 1750 with the title *Promptuarium artis argentariae*. This is the finest 18th-century collection of patterns for silversmiths. The objects are divided into different types, with varied and original decorative designs. They reflect the influence of late Baroque sculpture and architecture, especially the work of Bernini and Francesco Borromini from which they derive their long curving lines and their repertory of naturalistic ornament. Although many of Giardini's patterns represent pure caprices that would be difficult to execute in precious metal, they were the most important source of inspiration for Roman artistic silver production throughout the 18th century, and they continued to be influential into the 19th.

BIBLIOGRAPHY
C. G. Bulgari: *Argentieri, gemmari e orafi d'Italia*, i (Rome, 1958)
S. Fornari: *Argenti romani* (Rome, 1969)
H. Honour: *Orafi e argentieri* (Milan, 1972)

ANGELA CATELLO

Gibberd, Sir **Frederick** (*b* Coventry, 7 Jan 1908; *d* Harlow, Essex, 9 Jan 1984). English architect. He was articled to Crouch, Butler and Savage in Birmingham and studied at Birmingham School of Architecture (1925–9). He was in private practice in London from 1930 and became a prominent practitioner of the Modern Movement in Britain, concerned with modernist principles of function, materials and construction. His earliest major work was Pullman Court Flats (1935) in Streatham, London, one of the largest of the blocks of flats designed in the International Style in the 1930s. He modified this style for the flats he built at Park Court, Penge, and Ellington Court, Southgate, both in London (1936). During World War II Gibberd taught at the Architectural Association School, London, and was Principal from 1942 to 1944. He was also influential in the design of prefabricated houses, particularly the design for the British Iron and Steel Federation, which was first erected on a trial estate in Northwood, Middx, in 1944 and used extensively in the rebuilding of Coventry after the war.

In 1946 Gibberd was appointed Principal Architect–Planner for Harlow New Town, Essex, a post he held until 1972. Many architects were brought in to build housing in picturesquely planned neighbourhoods; development was mostly low-rise, with one of the few exceptions being Gibberd's blocks of flats, The Lawns (1949). Gibberd also designed the Civic Centre (1947) and Orchard Croft housing estate (1952) in Harlow. In 1948 he rebuilt a bombed area of the London borough of Poplar; renamed the Lansbury Estate, this was the urban equivalent of Harlow, in stock brick with many traditional features including a market square. It featured as a 'live architecture' exhibition at the Festival of Britain in 1951.

Much of Gibberd's activity in the 1950s and 1960s was in building civic centres and replanning historic cities such as Stratford-on-Avon, St Albans, Leamington Spa and Nuneaton. In this work, as in Harlow, he was particularly concerned with planning for human needs, and he concentrated civic and retail amenities around squares and pedestrian ways. He also built schools, colleges and research buildings, designed power stations using a bold grasp of landscaping and from 1950 to 1969 was involved in the development of Heathrow Airport, London. An unusual building in his career became the one by which he is perhaps best known: the completion in 1967 of the Roman Catholic Metropolitan Cathedral of Christ the King, Liverpool, which he won in competition with a design incorporating a boldly centralized plan that promised to be cheap to build. The tent-shaped design (see fig.), with a circular lantern crowned with spikes, bore no resemblance to the design proposed by Sir Edwin Lutyens for a cathedral on the site; this was abandoned after the crypt had been built. Gibberd also entered enthusiastically into the commissioning of stained glass and other works of art.

Major works executed towards the end of Gibberd's career included the Inter-Continental Hotel in London (1968) and the conversion of Coutts Bank in the Strand, London, a building originally designed by John Nash; he inserted a glazed façade into the centrepiece of the Strand frontage, creating in 1969 one of the first examples of an office atrium in Britain. He also caused surprise with the

Frederick Gibberd: Metropolitan Cathedral of Christ the King, Liverpool, completed 1967

London Central Mosque (1969) in Regent's Park, which incorporated a gilded onion dome and minaret. He created a notable garden at his house at Harlow, with many pieces of sculpture. Gibberd was knighted in 1967 and became a Royal Academician in 1969. He won numerous awards for his work, including the European Architectural Heritage Award (1975) and the Royal Town Planning Association's gold medal (1978).

WRITINGS

The Architecture of England (London, 1938, rev. 5/1965)
Town Design (London, 1953, rev. 6/1970)
with F. R. S. Yorke: *Modern Flats* (London, 1958, rev. 1961)
with B. H. Harvey and others: *Harlow: The Story of a New Town* (Stevenage, Herts, 1980)

BIBLIOGRAPHY

A. Aldous: 'The Gibberd Touch', *Architects' J.*, clxvii/2 (1978), p. 56
Obituary, *Building*, ccxlvi/2 (1984), p. 14

ALAN POWERS

Gibbons, Grinling (*b* Rotterdam, 4 April 1648; *d* London, 3 Aug 1721). English wood-carver and sculptor. He is widely regarded as England's foremost decorative wood-carver. Numerous myths have grown up about him, together with many optimistic attributions. He was the son of English merchant parents settled in Rotterdam, and he probably learnt to draw and to carve both wood and stone in the studio of Artus Quellinus (i) in Amsterdam. It is also likely that he had ample opportunity to become familiar with the work of Dutch and Flemish still-life and flower painters, such as Jean-Baptiste Monnoyer and Justus van Huysum I, a study that is reflected in much of his carved relief work in wood, which depicts a wide range of ornamental motifs, including flowers, fruits, musical instruments, etc.

Contemporary accounts of Gibbons's early life are inconsistent, but Vertue noted that he came to England in 1667 and went first to York. There he may have worked for the Etty family, the leading building craftsmen in the city. By 1671 he was settled at Deptford, near London, where he was working as a ship-carver when the diarist John Evelyn claimed to have discovered him carving a wooden relief copy of a *Crucifixion* by Tintoretto. This may have been the relief after the *Crucifixion* in the Scuola di San Rocco, Venice. This relief, a competent work but lacking Gibbons's later virtuosity, was offered to Charles II, but his Catholic queen, Catherine of Braganza, declined it; Evelyn claimed that it was he who brought Gibbons to the King's notice, and it may also have been through him that Gibbons was introduced to Christopher Wren and Hugh May, for both of whom he later worked.

A number of other carved wood reliefs have been attributed to Gibbons in his early years, including a *Last Supper* (Burghley House, Cambs), a *Battle of the Amazons* (Warwick Castle) and the *Valley of Dry Bones* (Deptford, London, St Nicholas). However, only the ambitious panel of the *Stoning of St Stephen* (London, V&A), with its foreground figures carved almost in the round, can be given to him with any certainty; it is carved from lime-wood and lance-wood glued together. Several relief portraits in wood, including that of *Sir Christopher Wren* (London, RIBA), are also traditionally attributed to Gibbons in the early stages of his career, but all these works are overshadowed by the virtuosity of his mature and documented output.

Gibbons received numerous important commissions throughout the latter part of his career, both before and after his appointment in 1693 as Master Carver to the Crown. Although he worked for private clients, such as Charles Seymour, 6th Duke of Somerset, for whom he executed the famous Carved Room (*c.* 1692; see fig.) at Petworth House, W. Sussex, much of his decorative work was carried out for the Crown under the supervision of Christopher Wren, the Surveyor-General. In the 1690s Gibbons worked at Kensington Palace, London, and at Hampton Court, near London, but his best carving of this kind survives in the Royal Apartments at Windsor Castle, Berks, where he worked from 1677 to around 1682. While some of the carvings at Windsor were displaced in early 19th-century reorganizations, enough exists of Gibbons's sumptuously carved Baroque panelling, overdoors, chimney-pieces and picture frames to justify Evelyn's statement that the ensemble was 'stupendous and beyond all description'.

Perhaps the finest single piece of Gibbons's carved work is the signed lime-wood relief of the *Attributes of the Arts*, garlanded in naturalistic fruit and flowers (Florence, Pitti), presented in 1682 by Charles II to Cosimo III de' Medici, Grand Duke of Tuscany. A second signed relief (Modena, Gal. & Mus. Estense), said to have been sent to Modena by James II, is similar but less refined. Among Gibbons's other important surviving works in wood are the oak decorations (1696–7) of the choir of St Paul's Cathedral, London, another project on which he was associated with Wren.

Grinling Gibbons: carved trophy, softwood, *c.* 1692 (Petworth House, W. Sussex, National Trust)

Most of Gibbons's carved work in wood is made up of softwood laminations (lime-wood, pear-wood or lance-wood), which are glued together and held with iron nails. This technique, acceptable at the time, has since given trouble in conservation; his carving in oak (e.g. the bishop's throne at St Paul's) could not be laminated satisfactorily and cracks have appeared. Gibbons used perhaps as many as 300 different gouges and chisels to achieve his astonishing effects: one long chisel is still known as a 'Gibbons'.

Gibbons also ran a flourishing business as a sculptor in stone, marble and bronze, producing architectural decoration, as at Blenheim Palace, Oxon (1708–16), as well as more than 40 statues and monuments of varying quality. However, it is not at all clear how closely he was involved in the design and execution of the statuary known to have come from his workshop. The size of his team of assistants is not known, but a little more is now known of the exact role of his sometime collaborator Artus Quellinus (iii), who was in England from *c.* 1682 until his death in 1686; Quellinus kept money due to the partnership, and in 1683 Gibbons proceeded against him in Chancery. Among surviving works from Gibbons's workshop are the bronze statues *all'antica* of *Charles II* (*c.* 1681–2; London, Royal Hosp.) and *James II* (1686; London, Trafalgar Square), and the impressive Baroque marble funerary monuments to *Baptist Noel, 1st Viscount Campden* (erected 1686; Exton, Leics, St Peter and St Paul) and to *Henry Somerset, 1st Duke of Beaufort* (*d* 1699; Great Badminton, Avon, St

Michael). More elaborate than either of these are Gibbons's unbuilt designs for tombs for *Mary II* (with Wren, 1695; Oxford, All Souls Coll., Codrington Lib.) and for *William III and Mary II* (1702; London, BM), which would have been the grandest Baroque funerary monuments in England.

UNPUBLISHED SOURCES

London, V&A [a reliable list of Gibbons's monuments is given in J. Physick's revised typescript of R. Gunnis: *Dictionary of British Sculptors, 1660–1851* (London, 1953)]

BIBLIOGRAPHY

H. A. Tipping: *Grinling Gibbons and the Woodwork of his Age, 1648–1720* (London, 1914) [excellent illus., but text superseded by Green]

'The Note-books of George Vertue', *Walpole Soc.* [indexed in xxx (1948–50)]

E. S. de Beer, ed.: *Diary of John Evelyn*, 6 vols (London, 1955)

D. Green: *Grinling Gibbons: His Work as Carver and Statuary, 1648–1721* (London, 1964)

M. Whinney: *Sculpture in Britain, 1530–1830*, Pelican Hist. A. (Harmondsworth, 1964); rev. J. Physick (Harmondsworth, 1988)

G. Beard: *The Work of Grinling Gibbons* (London, 1989), pp. 51–9

GEOFFREY BEARD

Gibbs, Henry Hucks, 1st Baron Aldenham (*b* Bloomsbury, London, 31 Aug 1819; *d* Aldenham, Herts, 13 Sept 1907). English collector. His family have been recorded since the reign of Richard II and the judge Sir Vicary Gibbs was his great-uncle. Gibbs was educated at Rugby School and entered Exeter College, Oxford, in 1838. He graduated with a 3rd-class BA in Classics in 1841 and was awarded an MA in 1844. He joined the merchant-banking firm of Antony Gibbs and Sons (a business started by his grandfather in 1789) in 1843 and by 1875 had succeeded his uncle as head of the firm. From 1853 to 1901 he was also a director of the Bank of England and, from 1875 to 1877, its governor.

Gibbs began as a collector of Bibles, but by 1876, when he wrote his own catalogue of the collection, it included illuminated manuscripts, for example a French Book of Hours with 30 large miniatures of *c.* 1440, and a noteworthy selection of early printed books, particularly by English authors, such as a first edition of Shakespeare (1623), a copy of the *Vision of Piers Plowman* (1561) and the *Workes* of Chaucer (1561), as well as Bibles, among which was a New Testament in English of 1550.

Gibbs was interested in early works of English literature. In 1869 he edited the *Romance of the Chevelere Assigne* for the Early English Text Society and in 1873 prepared the *Hystorie of the Most Noble Knight Plasidas* for the Roxburghe Club. He is known to have had a remarkable memory and, in addition to his interests in philology and lexicography, in 1880 he helped to settle the final form of the New English Dictionary published by Oxford University Press with its editor, Sir James Murray. From 1882 to 1902 Gibbs was also active in financing the restoration of St Albans Cathedral, particularly the altar-screen. A prominent Conservative, he was one of the founders of the *St James Gazette* (1880) and briefly MP for the City of London. He was made High Sheriff of Hertfordshire in 1884, Fellow of the Society of Antiquaries in 1885 and a trustee of the National Portrait Gallery in 1890. Gibbs was created 1st Baron Aldenham in 1896. At his death his estate was valued at £703,000.

WRITINGS

Catalogue of the Books at St Dunstan's, Regents Park and Aldenham House, Hertfordshire (London, 1876)

Catalogue of Some Printed Books and Manuscripts at St Dunstan's, Regents Park and Aldenham House, Hertfordshire (London, 1888)

An Account of the High Altar Screen in the Cathedral Church of St Albans (St Albans, 1890)

BIBLIOGRAPHY

DNB

JACQUELINE COLLISS HARVEY

Gibbs, James (*b* Aberdeen, 23 Dec 1682; *d* London, 5 Aug 1754). Scottish architect.

1. Training and architectural career. 2. Style and influence.

1. TRAINING AND ARCHITECTURAL CAREER. Gibbs was the younger son of an Aberdeen merchant, Patrick Gibb(s), and was brought up a Roman Catholic. He was educated at the Grammar School and at Marischal College in Aberdeen. Shortly before 1700 he left Scotland for the Netherlands, where he stayed with relatives before making his way through France to Italy, visiting Milan, Venice, Bologna, Florence, Genoa and Naples. He arrived in Rome in the autumn of 1703 and registered at the Pontifical Scots College, apparently with the intention of training for the priesthood. Within a year, however, he left to become a pupil of Carlo Fontana, then the most influential architect in Rome. His father had suffered financial hardship as a result of the 1688 Revolution, so that Gibbs had to rely on the charity of friends for his income, probably supplementing it by guiding and drawing for British tourists.

These contacts with potential patrons proved useful when Gibbs arrived in London late in 1708. He was befriended by a fellow Catholic, John Erskine, 11th Earl of Mar and Secretary of State for Scotland, whose house in Whitehall Gibbs remodelled in 1710 (destr.). For Mar's brother-in-law, Thomas Hay, 7th Earl of Kinnoul, he made designs for a Baroque mansion on an X-plan, remarkably similar to Germain Boffrand's 1711 scheme for La Malgrange, Nancy, and prefiguring his fellow-pupil Filippo Juvarra's Palazzina di Stupinigi (1729–33). In 1713 Mar lobbied hard and effectively, helped by Christopher Wren, Robert Benson, Baron Bingley (1676–1731), and Robert Harley, 1st Earl of Oxford, to secure for Gibbs a post as surveyor to the Fifty New Churches Commission in London. In this capacity he designed the church of St Mary-le-Strand, but the death of Queen Anne in August 1714 caused an apparent setback. Harley was dismissed from government and imprisoned, while Mar, deprived of office, joined the Jacobite rebellion of 1715. The Tory–Jacobite taint led to Gibbs's dismissal when the Commission was re-formed in December 1715. By this time a rival Scottish architect, Colen Campbell, was intriguing against him, putting it about that Gibbs was a disaffected papist and attacking (in the preface to *Vitruvius Britannicus*, i, 1715) the Italian Baroque masters who had formed his style. Gibbs denied Campbell's accusations (though in fact he remained a covert Catholic to the end of his life) and persuaded the Commission to let him complete St Mary-le-Strand.

The cosmopolitan sophistication of the church in The Strand established Gibbs's credentials at a time of considerable flux in English architectural taste. Although he was denied further advancement in the Office of Works, owing to its progressive Palladianism, his Tory and Scottish admirers ensured that he did not lack commissions. By 1716 he was remodelling the forecourt of Burlington House in Piccadilly, London (before being supplanted by Campbell), and building Sudbrook Park at Petersham, Surrey, for John Campbell, 2nd Duke of Argyll (1678–1743). There followed a commission from the former Secretary of State for Scotland, James Johnston (1655–1737), for a splendid octagon room (*c.* 1716) at his house in Twickenham, London. From 1713 he had begun remodelling the house of Edward Harley, later 2nd Earl of Oxford, at Wimpole, near Cambridge, and was working on the sumptuous mansion (1716–19; destr. 1747) of James Brydges, 1st Duke of Chandos, at Canons, Middx. By 1720 he had become (as Horace Walpole described him) 'the architect most in vogue'. The success of St Mary-le-Strand won him a yet more prestigious church commission, for St Martin-in-the-Fields (1720–26; see fig. 1), London, which in turn led to the commission for All Saints (1723), Derby. Gibbs was one of seven leading architects invited in 1720 to submit designs for the new Radcliffe Library in Oxford, although he initially lost the commission to Nicholas Hawksmoor. The following year work began on his scheme for the Cambridge University Senate House (completed 1730). Other major public buildings of the 1720s included the Fellows' Building (1724–30) at King's College, Cambridge, and St Bartholomew's Hospital (begun 1728), London.

Gibbs's country-house practice also flourished, with a steady flow of designs for both mansions and garden buildings. In particular, friendship with Charles Bridgeman, the Royal Gardener, led to a number of fruitful

1. James Gibbs: St Martin-in-the-Fields, London, 1720–26

collaborations and commissions for a wide variety of ornamental buildings, at Wimpole, Cambs (1719 onwards), Tring, Herts (*c.* 1724 onwards), and notably at Stowe, Bucks (including the Boycott Pavilions, 1728–9; Temple of Friendship, 1739–41; and Gothic Temple of Liberty, 1741–7).

With the help of his involvement in the development of the Harley Estate (1723 onwards) in Marylebone, London, Gibbs moved rapidly, though with some reverses, from penury to prosperity. His reputation was boosted by the publication of his *Book of Architecture* (1728) and *Rules for Drawing the Several Parts of Architecture* (1732). In 1746 George Vertue reported that 'he has fortund very well. . .by his industry and great business of publick & private works'. Gibbs was able to amass a considerable collection of paintings and sculpture, including works by Canaletto, Giovanni Paolo Panini, Sebastiano Ricci, Watteau and Michael Rysbrack, and he belonged to several art clubs, including Edward Harley's Society of Virtuosi, where he mingled with prospective clients as well as with the artists and craftsmen with whom he regularly collaborated on his building projects, among them Rysbrack, Bridgeman, John Wootton, James Thornhill, Benjamin Timbrell (*d* 1754) and Isaac Mansfield.

In the 1740s ill-health and concentration on the Radcliffe Library (or Camera) project (awarded to Gibbs on the death of Hawksmoor in 1736) led to a drop in his output. He died a wealthy bachelor, leaving his library and architectural drawings to Oxford University. There are eight volumes of Gibbs's drawings in the Ashmolean Museum, Oxford.

2. STYLE AND INFLUENCE. Gibbs was an architect in the same mould as Wren and William Talman: flexible, pragmatic, undogmatic, open to influence from a range of sources that encompassed contemporary French and Italian Baroque, the Antique and the Palladian. He was perhaps happiest when drawing directly on his Italian experiences, and indeed no British architect of his generation could produce designs so close to the contemporary European mainstream. St Mary-le-Strand was influenced by a number of Roman Baroque sources (e.g. the palazzi Nano, Falconieri and Barberini; the vaults of Il Gesù and S Nicola da Tolentino, and Carlo Fontana's apse at SS Apostoli) as well as by Palladio and Inigo Jones. The work of Borromini provided motifs for the interior of the Cambridge Senate House and for the chapels at Canons and Wimpole. The forecourt of Pierre-Alexis Delamair's Hôtel de Soubise (1705–9) in Paris is recalled in the quadrant arcades (destr. 1868) of Burlington House. Even considerably later in his career, when the Palladian influence was stronger, continental reminiscences still occurred, as in the porch vaults and reading-room dome of the Radcliffe Library (1737–48).

Gibbs's interest in the Antique is illustrated by two unexecuted schemes he prepared for the Fifty New Churches Commission, one (1713) in the form of a peripteral temple, the other (1714) based on the Temple of Fortuna Virilis in Rome. Externally St Martin-in-the-Fields is essentially a temple form, with the surprising addition of a tall Wren-inspired steeple. Interpolated between the giant order are windows and doors with Baroque blocked architraves, now known as 'Gibbs surrounds'. Internally Gibbs created a characteristically suave synthesis of antique basilica with the influence of Wren and the Italian Baroque. The elegant vault is enriched by luscious but disciplined plasterwork (frescoes were originally envisaged). The same approach can be observed at the Radcliffe Library (see fig. 2) where, after initially proposing an unadventurous but practical rectangular building, Gibbs was instructed to adopt and elaborate the domed rotunda form bequeathed by Hawksmoor. The result is Gibbs's finest building, again drawing on a wide range of sources and at once richer and more elegant than his predecessor's design but also less powerfully original.

Gibbs's own library contained several editions of Palladio, Vincenzo Scamozzi and Vitruvius, as well as many other books on the buildings of ancient Rome. The influence of Palladio and English Palladianism is felt throughout his career, but never in pure and undiluted form. He was an early exponent of the Thames-side villa. At Sudbrook Park, Surrey, begun for the 2nd Duke of Argyll *c.* 1715, he adopted Palladio's idea of a cube-shaped hall sandwiched between porticos *in antis*; although the house was explicitly called a villa, the result is nevertheless more Baroque than Palladian because of the architectural vocabulary employed. The villa designed for Matthew Prior in 1720 was closer to the Palladian form but was never built. The significance of this aspect of Gibbs's work is questionable, since few of his villa designs were built, and they were not published until 1728, by which time the true Palladians were firmly in fashion.

Although Gibbs's interiors could be as restrained as his exteriors, a number of them are characterized by sumptuous Baroque or rocaille stuccowork, executed and almost

2. James Gibbs: Radcliffe Library (or Camera), Oxford, 1737–48

certainly designed by Swiss–Italian craftsmen from the Ticino area, for example the Artari family (Giovanni Battista and his sons Giuseppe and Adalberto), Giovanni Bagutti, Francesco Vassalli and Francesco Serena. While it is doubtful that Gibbs was responsible for importing any of these artists into England (Bagutti was first employed by Vanbrugh at Castle Howard, N. Yorks, in 1710–12), their work contributes considerably to the effect of the Twickenham Octagon (finished in 1721), St Martin-in-the-Fields, the Cambridge Senate House, Ditchley House (Oxon), the Radcliffe Library and Ragley Hall (Warwicks, begun 1751; completed after Gibbs's death); it is noticeable that the idiom changed remarkably little during the 30-year span represented by these buildings.

Gibbs was responsible for promoting the English career of another immigrant craftsman, the Flemish sculptor Michael Rysbrack. He was employed on many of Gibbs's major commissions for monuments in the 1720s, notably that to *Katharine Bovey* (1727–8) in Westminster Abbey and that to *Edward Colston* (1728–9) in All Saints, Bristol. Gibbs was the first British architect to produce a significant number of sculptural monuments. His important and much-publicized series in Westminster Abbey began in 1721 with the monument to *John Holles, 1st Duke of Newcastle* (executed by Francis Bird and erected in 1723), the design of which was drawn from Carlo Rainaldi's polychrome altarpiece in the church of Gesù e Maria (1671–80) in Rome. It was Gibbs's largest and most celebrated monument and was the first to introduce a Baroque idiom to the Abbey. His successive monuments there (e.g. *Matthew Prior*, 1721–3, and *James Craggs*, 1724–7, executed by Giovanni Battista Guelfi) introduced further Baroque innovations to the English funerary repertory and provided fertile models for imitation by provincial masons.

Gibbs was given unanimously favourable obituaries, though an inevitable reaction to his work later set in: Stephen Riou in 1768 considered that he had 'thrown no new light upon the art' of architecture; Horace Walpole found his buildings correct but mechanical; while James Dallaway censured him for 'crowding every inch of surface with pretty decorations'. His principal architectural heirs were members of the Smith family of Warwick, the contractors employed on several of his buildings (notably Ditchley and the Radcliffe Library) and themselves architect–builders of a large number of country houses in the Midlands.

Through the medium of his two main publications, however, Gibbs's influence spread much further afield, both in Britain and abroad. *A Book of Architecture* was the first British publication to be devoted entirely to the work of a single architect. Consciously aimed at 'such Gentlemen as might be concerned in Building, especially in the more remote parts of the Country, where little or no assistance for Designs can be procured', its 150 plates presented the full range of his output, a wider variety of designs than was available in other contemporary pattern books. Its successor, *Rules for Drawing*, was intended to facilitate in craftsmen a proper grasp of the basic vocabulary of Classical architecture. The features depicted in its 64 plates are markedly more Palladian and less Baroque than those in *A Book of Architecture*, and it followed

Palladio in taking the diameter of the column as the module, though it simplified his supporting system of fractions. These books (and the plagiarizing imitations by Batty Langley and others) disseminated a very wide range of building types and motifs. The results are seen not only in the provinces but in British colonies abroad. The steeple of St Martin-in-the-Fields, in particular, found imitators from Massachusetts to Madras, and the design of the church as a whole was treated as a model for Anglican worship throughout the English-speaking world. Thomas Jefferson drew on the books for his designs for Monticello (begun 1767), VA, and their easy availability through American booksellers and libraries meant that Gibbs was perhaps the architect most admired by a generally conservative building world until the end of the century.

UNPUBLISHED SOURCES
Soane Mus., London [MS. memoir, which may be autobiographical]

WRITINGS
A Book of Architecture Containing Designs of Buildings and Ornaments (London, 1728, 2/1739)
Rules for Drawing the Several Parts of Architecture (London, 1732/R Farnborough, 1968, 2/1738, 3/1753)
Bibliotheca Radcliviana (London, 1747)

BIBLIOGRAPHY
Colvin
A. Cunningham: *The Lives of the Most Eminent British Painters, Sculptors and Architects*, iv (London, 1831)
'The Note-Books of George Vertue', *Walpole Soc.*, xxii (1934), pp. 17, 133
M. Whiffen: 'The Architectural Progeny of St Martin-in-the-Fields', *Archit. Rev.* [London], c (1946), pp. 3–6
J. Summerson: *Architecture in Britain, 1530–1830*, Pelican Hist. A. (Harmondsworth, 1953, rev. 1969)
J. Holloway: 'A James Gibbs Autobiography', *Burl. Mag.*, xcvii (1955), pp. 147–51
B. Little: *The Life and Work of James Gibbs, 1682–1754* (London, 1955)
G. Beard: *Craftsmen and Interior Decoration in England, 1660–1820* (Edinburgh, 1981)
T. Friedman: *James Gibbs* (New Haven, 1984)
A. Laing: 'Foreign Decorators and Plasterers in England', *The Rococo in England* (London, 1984)

ROGER WHITE

Gibelin, Esprit-Antoine (*b* Aix-en-Provence, 17 Aug 1739; *d* Aix-en-Provence, 23 Dec 1813). French painter, draughtsman, sculptor, medallist and writer. He first trained under Claude Arnulphy at Aix, leaving for Rome *c.* 1761. He remained in Italy for ten years, studying the works of Raphael and other Old Masters (see fig.) as well as Polidoro da Caravaggio, whose monochrome frescoes Gibelin later imitated in France. In 1768 he won a prize at the Accademia di Belle Arti, Parma, with his *Achilles Fighting the River Scamander* (*in situ*; preparatory drawing in Stockholm, Nmus.). On his return to Paris in 1771 he was commissioned to execute a large number of monochrome frescoes as well as two paintings, *The Blood-letting* (1777; preparatory drawing at Poitiers, Mus. B.-A.) and *Childbirth*, for the new Ecole de Chirurgie, now the Faculté de Médecine (*in situ*). His works made over the next few years include the *Genius of War* and *Mars* for the pediments of the two south wings of the Ecole Militaire, Paris, and a painting of *St Francis Preaching*, which he donated to the Capuchin Monastery (now the church of St Louis d'Antin) on the Chaussée d'Antin (*in situ*).

During the French Revolution Gibelin was a staunch Republican, and he was elected colonel of the militia in Aix-en-Provence in 1789, remaining in that city for several

Esprit-Antoine Gibelin: *An Offering to Priapus*, pen and black ink with grey wash on white paper, 390×500 mm, *c.* 1770 (Lille, Musée des Beaux-Arts)

years. By 1795 he was back in Paris, where he obtained lodgings in the Louvre, later transferring to the Sorbonne. In the course of the next 12 months he was made an associate member of the Institut de France and a director of a new school of painting at Versailles. He exhibited only three times at the Salon (1795, 1804, 1806) before returning in 1808 to Aix, where he was entrusted with reorganizing its academy.

An erudite artist, Gibelin wrote a number of essays on art, notably *La Nécessité de cultiver les arts d'imitation.* He also designed and executed medals, among which was one struck to honour the French Constitution (1795) and another in honour of American Liberty (drawing and terracotta model at Chauny, Mus. N. Coopération Fr.-Amér.). Among his works as a sculptor is the terracotta low relief of *Jephthah's Daughter* (Aix-en-Provence, Mus. Arbaud) while, as an engraver, his prints include the *Public Good* and the allegorical *Coalition* and *Unison* (both *c.* 1800). Several albums also survive of Gibelin's drawings executed in Rome and Paris (France, priv. col.).

WRITINGS
Discours sur la nécessité de cultiver les arts d'imitation (1799)
Mémoire sur la statue antique surnommée le 'Gladiateur Borghèse' (1806)
Observations critiques sur un bas-relief antique conservé dans l'hôtel de ville d'Aix et sur la mosaïque découverte près des bains de Sextius (1809)

BIBLIOGRAPHY
Bellier de La Chavignerie-Auvray; Thieme-Becker
T.-B. Emeric-David: *Vie des artistes anciens et modernes* (Paris, 1872)
Autour de David: Dessins néo-classiques du Musée des beaux-arts de Lille (exh. cat., Lille, Mus. B.-A., 1983), pp. 104–5

ANNIE SCOTTEZ-DE WAMBRECHIES

Gibon Sengai. *See* SENGAI GIBON.

Gibraltar [anc. Calpe]. British crown colony occupying a peninsula 4 km long on the southern coast of Spain and with a population in the 1990s of *c.* 30,000. Because of its strategic location, on a large tilted slab of limestone ('the Rock') jutting out into the strait separating the Atlantic Ocean from the Mediterranean Sea, it has always played an important role in the maritime control of the approaches to the two seas, and to the Phoenicians it represented the boundary of the known world. In AD 711 the peninsula was captured by Tarik ibn Zijad for the Umayyad caliphate. Some fortifications have survived from the Moorish period that followed, most notably the Moorish Castle, begun *c.* 742, and the series of box-shaped defences that face the flat isthmus joining Gibraltar to Spain. In 1462 the peninsula was captured by the Spanish, who subsequently built strong fortifications along the coast facing the isthmus. In 1704 Gibraltar was seized by the British, who *c.* 1770 strengthened the defences built by the Spanish, adding the large King's Bastion with its many guns aiming out to sea. In 1782 Sergeant-Major Henry Ince (1737–

1809), a sergeant in the Soldier Artificer Company, proposed tunnelling into the north face of the Rock, and subsequently a maze of tunnels was cut, forming an elaborate system that was extended during World War II. Within the perimeter individual batteries did not need to be protected against infantry assault, but in the second half of the 19th century, because of the danger of naval bombardment, their fronts were strengthened with masonry and iron plating. These iron-faced casemates can be seen on the modified coastal bastions now hedged in by the reclaimed land of the dockyard. At the end of the century the main batteries were moved on to the knife-edged ridge of the upper Rock.

The buildings of the town, largely rebuilt in the late 18th century, show Spanish, English and Moorish influences, with sash windows protected by jalousies to exclude the sunlight, and iron balconies. There are also fine, long barrack-blocks with graceful cast-iron verandahs. The early 19th-century Guard-house, opposite the Governor's residence, has a classical portico, its proportions modelled on St Paul's, Covent Garden, London, but much of the architecture, although it possesses charm, lacks the proportional discipline of Georgian architecture.

BIBLIOGRAPHY

Save Gibraltar's Heritage: An Inquest Report (London, 1982)
Q. Hughes and A. Migos: *Strong as the Rock of Gibraltar* (Gibraltar, 1995)

QUENTIN HUGHES

Gibson, Sir **Donald (Evelyn Edward)** (*b* Northenden, nr Manchester, 11 Oct 1908; *d* 22 Dec 1991). English architect. He trained at the School of Architecture and Town Planning, University of Manchester, spent a year in the USA and qualified in 1932. While working for two and a half years at the Building Research Station in the mid-1930s he realized the architectural implications of technology and building programmes. These issues preoccupied him throughout his career. He taught briefly at the School of Architecture, University of Liverpool, then worked for the Isle of Ely County Council, being promoted to the new post of Coventry City Architect in 1938. Coventry, then the fastest-growing city in Britain, had huge housing and planning problems that were exacerbated by savage bombing in November 1940. Gibson masterminded the rebuilding of the town, which because of its central pedestrian area, its cathedral and its schools and housing, became a paradigm for British post-war planning.

Between 1955 and 1958 Gibson was County Architect for Nottinghamshire, where he initiated and promoted the influential CLASP system of prefabricated school-building to combat subsidence. He then moved into central government, first as Director General of Works for the War Office (1958–62) and then, after an amalgamation carried out under his auspices, as Comptroller General of the Ministry of Public Building and Works (1967–9). Gibson upheld the causes of responsive, publicly-controlled methods of industrialized building and of improved status for British architects in public employment. He was knighted in 1962 and was President of the Royal Institute of British Architects in 1964–5.

WRITINGS

'Buildings without Foundations: A Lecture on the Problems of Building on Moving Ground', *RIBA J.*, lxv (1957), pp. 47–59

BIBLIOGRAPHY

S. Lambert: 'Men of the Year: Donald Gibson', *Architect's J.*, cxxi (1950), p. 77
S. Wheeler: 'Sir Donald Gibson: Pioneer of Dual Use', *Architect's J.*, cxlvii (1968), pp. 1492–5
N. Jackson and J. Thomas: 'Presidents of the RIBA: 1964–5 Sir Donald Edward Gibson (1908–)', *J. RIBA*, xci (1984), p. 63
A. Saint: *Towards a Social Architecture* (London, 1987)

□

Gibson, John (i) (*b* Conway, north Wales, *bapt* 19 June 1790; *d* Rome, 27 Jan 1866). English sculptor. He worked in Rome and was the central figure of the Anglo-Roman school and one of the leading exponents of Neo-classicism in the 19th century. He had English, American and Italian patrons and was honoured by academies throughout Europe. Two of his brothers, Solomon Gibson (*c*. 1796–1886) and Benjamin Gibson (1811–51), were also sculptors.

John Gibson was the son of a Welsh market gardener who settled in Liverpool in 1799. The young Gibson was apprenticed to a firm of Liverpool cabinetmakers and in 1805 began working for S. & T. Francey, stonemasons of Brownlow Hill. He trained under the sculptor F. A. Legé (1779–1837) and from 1810 exhibited drawings and models at the Liverpool Academy. One of his earliest public works was the monument to *Henry Blundell* (marble, 1813; Sefton, Liverpool, St Helen), which was signed by the firm. Gibson's first patron was the Liverpool banker and connoisseur William Roscoe, who commissioned a bas-relief of *Alexander Preserving the Works of Homer* (terracotta, 1810; Liverpool, Libs & A.) for his library at Allerton Hall. Gibson became a frequent visitor to Allerton, where he made copies from the Old Master drawings in Roscoe's collection and learnt 'to form [his] style upon the Greeks'. To pursue his studies of the Antique he went in 1817 to London, where he met John Flaxman, and later in that same year he travelled to Italy.

In Rome, Gibson was introduced to Antonio Canova who received him kindly and offered to support him; he studied at Canova's academy and at the Accademia di S Luca. He made a copy after Canova's statue of the pugilist *Damoxenos* (Rome, Vatican, Mus. Pio-Clementino) and under Canova's guidance produced his first original work in Rome, the *Sleeping Shepherd Boy* (plaster model, 1818; London, RA). Gibson later received instruction from Bertel Thorvaldsen, and these two 'masters', the leading sculptors of Neo-classicism, were to be his formative influences. Like them, Gibson sought to achieve 'ideal' beauty in sculpture through the study of the human form, perfected according to the standards of Greek, or Greco-Roman, sculpture. The writings of Johann Joachim Winckelmann and other Neo-classical theorists, including Sir Joshua Reynolds and Flaxman, informed his work.

In 1819 Gibson received his first commission in Rome from William Spencer Cavendish, 6th Duke of Devonshire, for a group of *Mars and Cupid* (marble, 1821; Chatsworth House, Derbys) and he soon became a favourite of English collectors in Rome. Among them, the connoisseur Sir George Beaumont commissioned *Psyche*

and the Zephyrs (marble, 1822; untraced) and Sir Watkin
Williams-Wynn, 5th Baronet, *Cupid Drawing his Bow*
(marble, 1826; untraced). Algernon Percy, Lord Prudhoe
(later 4th Duke of Northumberland), acquired the marble
version of the *Sleeping Shepherd Boy* (1830–34; Liverpool,
Walker A.G.) and Charles Anderson-Pelham, 1st Earl of
Yarborough, the *Nymph Untying her Sandal* (marble, 1831;
Lincoln, Usher Gal.). By the 1830s Gibson was the leader
of a colony of British sculptors working in Rome that
included Richard James Wyatt, Lawrence Macdonald and
Joseph Gott. He also helped the next generation of
sculptors in Rome, among them Henry Timbrell (1806–
49), William Calder Marshall and Mary Thornycroft (1814–
95). Gibson declined many offers of work in London,
writing in 1831: 'I thank God for every morning that
opens my eyes in Rome', though he exhibited at the Royal
Academy from 1816 to 1851 and was elected an ARA in
1833 and RA in 1838.

Gibson visited England in 1844 and 1850 to execute
statues of *Queen Victoria*, one of them for the House of
Lords (marble, 1850–55), and to supervise the installation
in Liverpool of statues of *William Huskisson* (bronze,
1844–6; Liverpool, St James's Cemetery) and of *George
Stephenson* (marble, 1851; Liverpool, St George's Hall). By
this time he was receiving many of his commissions from
patrons in Liverpool, particularly from the wealthy indus-
trialists and merchants of the city. The shipping heir Henry
Sandbach (1807–95) and his wife Margaret, the daughter
of Roscoe, commissioned a number of works between
1839 and 1865, including the *Hunter and Dog* (marble,
c. 1842) and *Aurora* (marble, 1839; both Cardiff, N. Mus.).
The ironmaster Richard Vaughan Yates (1785–1856), the
bankers Richard Naylor (1814–99) and John Naylor (1813–
89) and the manufacturers Richard Alison and Robert
Preston (1820–60) were also Gibson's patrons. For Pres-
ton, Gibson produced his best-known work, the *Tinted
Venus* (polychromed marble, 1851–6; Liverpool, Walker
A.G.; see fig.), which gained notoriety at the 1862 London
International Exhibition. With its painted details and
waxed finish, it was criticized by many contemporaries for
displaying an unnecessary realism, while others saw it as
being over-decorative. To Gibson though, who worked
on it for many years, it was an attempt to demonstrate the
Greek principle of sculptural polychromy. Gibson pro-
duced other coloured sculptures, including *Cupid Tor-
menting the Soul* (marble, 1822; untraced) and *Pandora*
(marble, 1856; London, V&A). He had a busy studio and
often produced many versions of his designs; the *Cupid
Disguised as a Shepherd Boy* (marble version, 1837; Liver-
pool, Walker A.G.), for example, was repeated eight times
for different patrons and the *Tinted Venus* is known in
several replicas. He employed Italian modellers and carv-
ers, his principal carver being Baini (*fl* 1829–60), and in
the 1840s his brother Benjamin Gibson worked as a studio
assistant. The Liverpool sculptor Benjamin Edward
Spence (1822–66) also worked with Gibson, and the
American sculptor Harriet Hosmer became his pupil in
the 1850s.

In the second half of the century Gibson was one of
the few remaining exponents of the so-called 'pure' style
in sculpture, maintaining Neo-classical notions of the ideal
in a period when naturalism, or 'verismo', and modern

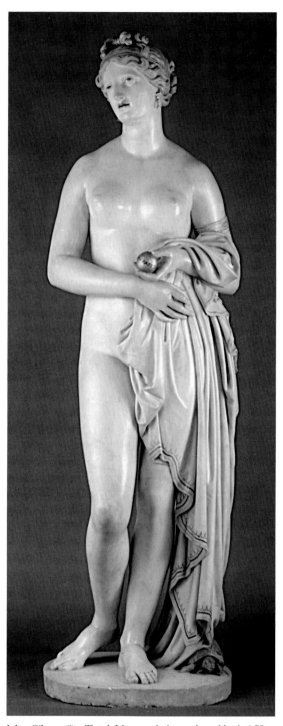

John Gibson (i): *Tinted Venus*, polychromed marble, h. 1.75 m,
1851–6 (Liverpool, Walker Art Gallery)

subjects were in fashion in both Italy and England. Gibson
regarded 'novelties in sculpture' as 'signs of ignorance'
and was a consistent opponent of the use of modern
costume in portraiture: 'The human figure concealed
under a frock-coat and trousers is not a fit subject for

sculpture', he wrote. His work appealed particularly to conservative taste, although his critical reputation remained secure in his lifetime. Moreover, the quality of his work, by comparison with that of many of his contemporaries, was high: it was notable for its technical excellence, subtlety of composition, clarity of form and delicate modelling. Gibson is represented by his biographers as an unworldly and impractical man—as Harriet Hosmer wrote: 'He is a god in his studio but God help him out of it'—but he seems to have had some business acumen and became one of the wealthiest of Victorian sculptors. He left most of his fortune, some £32,000, to the Royal Academy, together with the statues and models from his studio. In 1864 he was granted the Légion d'honneur by the French government and after his death was honoured by a marble statue (destr.) at the Glyptothek in Munich, alongside those of Canova, Thorvaldsen (both *in situ*) and Pietro Tenerani (destr.). The largest holdings of Gibson's sculpture are in the collections of the Royal Academy of Arts, London, the National Museum of Wales, Cardiff, and the Walker Art Gallery, Liverpool.

Benjamin Gibson produced marble replicas of his brother's work in Rome and several original designs for sculpture; he was an authority on Greek and Latin literature and acted as John Gibson's translator of Classical texts. Solomon Gibson contributed regularly to the Liverpool Academy exhibitions in the early 19th century. *Venus Mourning the Death of Adonis* (terracotta, *c.* 1812; Liverpool, Walker A.G.) is one of his few known works.

UNPUBLISHED SOURCES
London, RA, Gibson Papers, GI/1-GI/5
Aberystwyth, N. Lib. Wales, Mayer Papers, MSS 4914D, 4915D, 6757D

BIBLIOGRAPHY
DNB; Gunnis
John Gibson: Imitations of [his] Drawings, Engraved by G. Wenzel and L. Prosseda (n.p., n.d.)
E. Strutt: *The Story of Psyche* (London, 1851) [with designs in outline by Gibson]
Engravings from Original Compositions Executed in Marble by John Gibson (London, 1861) [drawn by P. Guglielmi]
Obituary, *A. J.* [London], v (1866), pp. 91–2, 113–15
Obituary, *The Athenaeum* (1866), p. 172
E. Eastlake: *Life of John Gibson* (London, 1870)
A. Graves: *The Royal Academy of Arts*, ii (London, 1905–6, rev. 1970), p. 230
T. Matthews: *The Biography of John Gibson, RA, Sculptor* (London, 1911)
J. B. Hartman: 'Canova, Thorvaldsen and Gibson', *Eng. Misc.*, vi (1955), pp. 205–35
H. Fletcher: 'John Gibson: An English Pupil of Thorvaldsen', *Apollo*, xcvi/128 (Oct 1972)
E. S. Darby: 'John Gibson, Queen Victoria, and the Idea of Sculptural Polychromy', *A. Hist.*, iv/1 (March 1981)
B. Read: *Victorian Sculpture* (New Haven and London, 1982)
P. Curtis, ed.: *Patronage and Practice: Sculpture on Merseyside* (Liverpool, 1989), pp. 32–59
MARTIN GREENWOOD

Gibson, John (ii) (*b* Castle Bromwich, Warwicks, May 1817; *d* London, 23 Dec 1892). English architect. He was articled first to J. A. Hansom (1803–82) during the building of Birmingham Town Hall, a design Gibson was to recall for Todmorden Town Hall (1860–75). From 1835 to 1844 he worked in Charles Barry's office, absorbing the ripe but restrained Renaissance palazzo style that was to prove most useful to him. In 1844 he won a competition for the National Bank of Scotland in Glasgow (completed 1847, re-erected 1902 as Langside Public Hall). In 1849 he established his reputation in London with the Imperial Assurance Building (destr.) at the corner of Broad Street and Threadneedle Street. A rewarding association with the National Provincial (now National Westminster) Bank began in 1864 when he designed their grand, single-storey City of London headquarters in Bishopsgate. Over the next 20 years he designed banks for them at Southampton (1867), Bury St Edmunds (1868), Birmingham (1869), Newcastle upon Tyne (1872), Gateshead (*c.* 1873), Middlesbrough (1874), Stockton-on-Tees (1874–6), Sunderland (1876), Durham (1879) and Lincoln (1883). In London the former bank at 212 Piccadilly (1873) and Child's Bank (1879) in Fleet Street are his.

Gibson's variations on English styles from medieval to Jacobean were less assured when applied to country houses. They included houses for the Fielden family—Dobroyd Castle, Todmorden, W. Yorks (1865); Nutfield Priory, Surrey (1872–4)—and additions for the Lucys at Charlecote, Warwicks (1847–67). Ecclesiastical work included a neo-Norman Baptist chapel in Shaftesbury Avenue, London (1845), some Gothic parish churches in Oxfordshire and Warwickshire and the Molyneux mausoleum at Kensal Green cemetery, London. In 1890 the RIBA awarded him its Royal Gold Medal.

BIBLIOGRAPHY
DNB
J. *RIBA*, xci (1984), p. 87 [biographies of Royal Gold Medallists]
PRISCILLA METCALF

Gibson, Ralph (*b* Los Angeles, CA, 16 Jan 1939). American photographer. In 1956 he joined the navy and in 1957 entered the Naval Training Center in Pensacola, FL, where he studied photography. After his discharge in 1960 he moved to San Francisco where, in the following year, he studied photography at the San Francisco Art Institute. After working as an assistant to Dorothea Lange (1961–2), in 1963 he moved to Los Angeles, where he began work as a freelance photographer. He moved to New York in 1966, and from 1967 to 1969 he assisted Robert Frank on the film *Me and My Brother*. His photographs of this early period were in a documentary style influenced by Frank, Henri Cartier-Bresson and William Klein. Starting with *The Strip* (Los Angeles, 1966), he began to publish his work in book form, though the reception of his first volumes was poor. In 1969 he established a studio in New York and in the same year founded the Lustrum Press, which he directed. Soon afterwards he used it to publish three books that established his reputation: *The Somnambulist* (1970), *Déjà-Vu* (1973) and *Days at Sea* (1974). The control he exercised over each publication enabled him to organize the images associatively in the manner of a dream sequence. Both the individual black-and-white photographs, printed in high contrast, and their arrangement made use of inexplicable juxtapositions, reflecting the influence of Surrealism.

In 1975 Gibson shifted the emphasis away from books towards exhibitions, joining Castelli Graphics in that year. His exhibition *Quadrants* (New York, Castelli Graph., 1976) consisted of photographs of details of the human figure or of architectural features, each taken at the same distance and with the same camera settings (see *Tropism*, pp. 54–69). Another series, *L'Histoire de France* (1972–

86; see *Tropism*, pp. 114–35), was conceived as a fragmentary record of French life and culture; this group included his first colour photographs, taken in 1979, although he otherwise continued to work in black and white. In the 1980s he began to publish books again, for example *L'Anonyme* (New York and London, 1986), which concentrates on the female nude.

PHOTOGRAPHIC PUBLICATIONS

The Somnambulist (New York, 1970)
Déjà-vu (New York, 1973)
Days at Sea (New York, 1974)
Tropism: Photographs by Ralph Gibson (Oxford, 1987) [incl. afterword by M. Barth]

BIBLIOGRAPHY

Contemp. Phots
J. Kelly, ed.: *Nude: Theory* (New York, 1979), pp. 73–94, 173

☐

Gibson, Richard [Dick; Dwarf] (*b* ?1615; *d* London, 23 July 1690). English miniature painter. He is said to have received some instruction in painting from Francis Cleyn, director of the Mortlake tapestry works. He entered the service of the Lord Chamberlain, Philip Herbert, 4th Earl of Pembroke, and had attracted the attention of Charles I by 1639, when he was asked to make a miniature copy, after Peter Oliver, of Titian's *Venus and Adonis* (Burghley House, Cambs). It seems likely that a group of mid-17th century portrait miniatures signed on the back with the initials DG is by Gibson, signing himself as *Dick* or *Dwarf Gibson*; many of these portraits are of descendants of the Earl of Pembroke and the related Capel and Dormer families, for example *Charles Dormer, 2nd Earl of Carnarvon* (Badminton House, Glos), who were important patrons of his close friend Peter Lely. Gibson copied in miniature a number of Lely's portraits (for example *Anne Hude, Duchess of York*; London, Wallace) for Charles II, and Lely painted a double portrait of *Gibson and his Wife* (Fort Worth, TX, Kimbell A. Mus.). Gibson became drawing-master to Princess Mary and Princess Anne, daughters of James II, and accompanied Mary to the Netherlands on her marriage to William of Orange in 1677. He was frequently in The Hague until 1688 when, on the accession of William III, he returned to England. The miniatures assigned to Gibson are characterized by the thick pigment and parallel striations that give his work an impastoed quality. His daughter, Susan Penelope Gibson (1652/5–1700), became well known as a miniature painter under her married name of Rosse.

BIBLIOGRAPHY

G. Reynolds: *Samuel Cooper's Pocket-book* (London, 1975)
J. Murdoch and V. J. Murrell: 'The Monogrammist DG: Dwarf Gibson and his Patrons', *Burl. Mag.*, cxxiii (1981), pp. 282–9
J. Murdoch and others: *The English Miniature* (New Haven and London, 1981), pp. 129–35

GRAHAM REYNOLDS

Gibson, Thomas (*b* ?London, *c.* 1680; *d* London, 28 April 1751). English painter and copyist. He was an established portrait painter by 1711, when he was appointed a founding director of Godfrey Kneller's Academy in London; among his pupils there was George Vertue. Gibson's sitters included a number of important public figures: *Dr Henry Sacheverell* (1710; Oxford, Magdalen Coll.), *John Flamsteed* (1712; Oxford, Bodleian Lib.), *Sir Robert Walpole* (untraced; engr. G. Bockman), *Archbishop*

William Wake (Oxford, Christ Church Pict. Gal.) and *Archbishop John Potter* (London, Lambeth Pal.). His most constant patron was John, 1st Earl Poulett (1663–1743), who commissioned a great number of originals and copies. Gibson's career was interrupted in 1729–31 by serious illness, and he was obliged to sell his collection and for a time retire to Oxford. After resuming his practice he was patronized by Augusta, Princess of Wales, who in 1742 commissioned a group portrait of her four children, as well as her own portrait (both British Royal Col.).

Gibson kept his prices low, thus incurring the rancour of some of his rivals. Much of his output was depressingly pedestrian, although on occasion he could produce more distinguished work. He closely imitated Kneller in his early work; sometimes, as in *James Johnston* (London, Orleans House Gal.), it is difficult to decide whether the work is an original by Kneller or a copy made after him. Ultimately, however, Gibson lacked the older painter's vivacity and sense of colour. In mid-career Gibson adopted a different manner, frequently involving elaborate accessories and backgrounds; his heads in these portraits tend to be flat and lifeless. Among his best work is, appropriately, the portrait of *George Vertue* (1723; London, Soc. Antiqua.), in which Kneller's influence was tempered by Gibson's own personal sympathy.

BIBLIOGRAPHY

Waterhouse: *18th C.*
R. L. Poole: *Catalogue of Portraits in the Possession of the University, Colleges, City and County of Oxford* (Oxford, 1912–25)
'The Note-books of George Vertue', *Walpole Soc.*, xviii (1930), xxii (1934), xxiv (1936), xxvi (1938) [indexed in xxix (1947)], xxx (1955), pp. 32, 35, 37, 168
S. J. Hardman: *Lord Poulett's Paintings in Georgia* (Decatur, 1978)

RICHARD JEFFREE

Gide, André (*b* Paris, 22 Nov 1869; *d* Paris, 19 Feb 1951). French writer. His opinions were formed by his knowledge of Stéphane Mallarmé and Symbolism, and he counted figurative art among the *Nourritures terrestres* (Paris, 1897). This work, together with the novel *Les Faux-monnayeurs* (Paris, 1926), confirmed him as an intellectual master to several generations in search of freedom. Although he did not write extensively about the aesthetic of his era, Gide was associated with painters throughout his life, especially those he met in the 1890s, such as Gauguin, Denis, Bonnard, Redon and Van Rysselberghe. He also collected works by these artists, buying Denis's important group portrait of the Nabis, *Homage to Cézanne* (1900; Paris, Mus. d'Orsay; for illustration *see* DENIS, MAURICE), in 1901. In the previous year Jacques-Emile Blanche, a lifelong friend, had similarly portrayed a group of writers in *André Gide and his Friends at the Exhibition of 1900* (1900; Rouen, Mus. B.-A.). Gide's opinions were widely influential among artists. He was co-founder and editor of the *Nouvelle Revue française*; he contributed in the 1890s to *La Revue blanche*; he wrote criticism for the *Gazette des beaux-arts* and was on the selection panel for the Exposition de l'Art Décoratif at the Salon d'Automne in 1910. In 1909 he commissioned René Piot to decorate the library of his Villa Montmorency in Auteuil with the mural *The Fragrance of the Nymphs*. The choice of illustrators for de luxe editions of his works suggests his proximity to the more established artists of the avant-garde over many

years. Notable examples are *Le Voyage d'Urien* (Paris, 1893), with lithographs by Denis, *Le Prométhée mal enchaîné* (Paris, 1920), with illustrations by Bonnard, *Paludes* (Paris, 1926), with lithographs by Roger de la Fresnaye, and *Theseus* (Paris, 1949), with lithographs by Massimo Campigli. He was not particularly moved by Cubism or by abstract tendencies, but the anarchic defiance of some of his writings, notably *Les Caves du Vatican* (1914), was influential on the writers around André Breton who helped found Surrealism in 1924. Among his writings, Gide's short historical essay on *Poussin* (Paris, 1945) is ill-assured and relies heavily on the work of André Félibien. However, the *Lettres à un sculpteur* (1952), published posthumously, show that he was not insensible to formal creativity and to the difficulties of the artist.

WRITINGS

Oeuvres complètes, 15 vols (Paris, 1931–9)
Journal, 1889–1939 (Paris, 1939)
Lettres à un sculpteur (Paris, 1952) [incl. letter from Mme André Gide and preface by R. Genglaise]*Journal, 1939–1949* (Paris, 1952)

BIBLIOGRAPHY

C. Martin: *La Maturité d'André Gide* (Paris, 1972)
P. Masson: *André Gide: Voyage et écriture* (Lyon, 1983)

HENRI BÉHAR

Gideon, Sampson (*b* London, 1699; *d* nr Erith, Kent, 17 Oct 1762). English financier and collector. A stockbroker of Portuguese extraction and one of the most successful Jews of his generation in England, Gideon was a major subscriber to government loans and a financial adviser to Henry Pelham, Chancellor of the Exchequer, and to Pelham's brother, Thomas, 1st Duke of Newcastle. He formed a small but highly distinguished collection of pictures for Belvedere, the house near Erith in Kent, to which a 'great room' attributed to Isaac Ware was added soon after 1751. The bulk of the collection was probably acquired in the 1740s and 1750s, and his taste for Old Master pictures exemplified the artistic fashions of the mid-18th century. His collection included Rubens's *Gerbier Family* (Washington, DC, N.G.A.), Murillo's *Immaculate Conception* (Melbourne, N.G. Victoria) and *Flight into Egypt* (Detroit, MI, Inst. A.), and two gallery interiors by David Teniers (ii) (see 1985 exh. cat., no. 291), purchased at or after the Carignano sale, which began in Paris on 3 June 1742. There are contemporary accounts of the collection by Dodsley (1761) and Mrs Lybbe Powys (1771). In recognition of Gideon's financial services, his son Sampson was made a baronet at the age of 13 in 1759: he was created Baron Eardley in 1786. Belvedere was remodelled for him by James 'Athenian' Stuart. The collection was sold by his descendant Sir Culling Eardley at Christie's, 30 June 1860: a number of works were then bought in but the collection was eventually completely dispersed.

BIBLIOGRAPHY

R. Dodsley and J. Dodsley: *London and its Environs Described*, i (London, 1761), pp. 271–4
G. F. Waagen: *Galleries and Cabinets of Art in Great Britain* (London, 1857), pp. 275–84
E. J. Climenson: *Passages from the Diaries of Mrs. Philip Lybbe Powys of Hardwick House, Oxon* (London, 1899), pp. 150–51
The Treasure Houses of Britain: Five Hundred Years of Private Patronage and Art Collecting (exh. cat., ed. G. Jackson-Stops; Washington, DC, N.G.A., 1985), no. 291

FRANCIS RUSSELL

Giedion, Sigfried (*b* Prague, 14 April 1888; *d* Zurich, 9 April 1968). Swiss architectural historian, critic, teacher and writer. The son of a Swiss industrialist, he first studied mechanical engineering in Vienna. In 1913 he began to study art history in Zurich, continuing in Munich under Heinrich Wölfflin and producing his dissertation, *Spätbarocker und romantischer Klassizismus*, in 1922. The impressions he gained on his visit to the Bauhaus at Weimar in 1923 and his first meeting with Le Corbusier in 1925 were decisive for his future career. He developed lifelong friendships with the foremost architects of the Modern Movement, including Le Corbusier, Walter Gropius and Karl Moser, and in 1928 he was among the founders of the Congrès Internationaux d'Architecture Moderne, becoming its secretary general and a convinced proponent of its aims (*see* CIAM). His convictions were expounded mainly in his publications, including his ground-breaking study of the French engineering tradition, *Bauen in Frankreich* (1928), which played down aesthetic influences and had a wide influence on views of the history of the Modern Movement; it also established his reputation as a proponent of modern architecture, and during the next few years he stressed the exclusion of aesthetic considerations from the deliberations of CIAM.

Giedion was not only an idealistic theorist of a new architecture. For him the construction of low-cost housing was a priority for architects and during the 1930s, in addition to his work for CIAM, he was involved in commissioning such projects from Swiss members of CIAM; examples include the Werkbundsiedlung (1928–32), Neubühl, and the multi-family houses (1936) at Doldertal. In 1938–9 he was invited to lecture at Harvard University, Cambridge, MA, and these lectures were later elaborated into his best-known and most influential publication, *Space, Time and Architecture* (1941), one of the first and most important products of a historiography that links the analysis of modern architecture with that of the past. In it he gave due weight to the theoretical and aesthetic as well as formal and technological origins of architecture and urban design along what he called a fundamental axis of development from the Renaissance to the present. In 1946 Giedion became a professor at the Technische Hochschule, Zurich. Other important works include *Mechanization Takes Command* (1948), which was expressive of the need for a humanizing attitude towards progress. In 1951 his edited version of the post-World War II activities of CIAM appeared, followed by his own collected papers, *Architecture, You and Me* (1956). In the 1960s he sought to systematize the historical view and to turn to account the knowledge and experience of the architectural past for the present under a concept he called the 'Eternal Present'; this was expressed in a trilogy, the last book of which was published posthumously in 1970. Like Le Corbusier, Giedion also looked for answers to the banality of mediocre architecture, and in perceiving the interaction of humans and architecture he saw not only a chance to solve architectural problems but also to influence the development of humankind and the world in general.

WRITINGS

Spätbarocker und romantischer Klassizismus (Munich, 1922)
Bauen in Frankreich: Bauen in Eisen, Bauen in Eisenbeton (Berlin, 1928)

Space, Time and Architecture: The Growth of a New Tradition (Cambridge, MA, 1941, rev. 3/1967)
Mechanization Takes Command: A Contribution to Anonymous History (New York, 1948, 2/1969)
ed.: A Decade of New Architecture (Zurich, 1951)
Walter Gropius: Work and Teamwork (New York, 1954)
Architecture, You and Me: The Diary of a Development (Cambridge, MA, 1956, 2/1958)
The Eternal Present: The Beginnings of Art (New York, 1962)
The Eternal Present: The Beginnings of Architecture (New York, 1964)
Architecture and the Phenomenon of Transition: The Three Space Conceptions in Architecture (Cambridge, MA, 1970)
Many contributions to Neue Zürch. Ztg (1930–65)

BIBLIOGRAPHY
Hommage à Giedion: Profile seiner Persönlichkeit (Basle, 1971)
M. Steinmann, ed.: CIAM: Dokumente, 1928–39 (Basle, 1979)
S. Georgiadis: Sigfried Giedion: Eine intellektuelle Biographie (Zurich, 1989); Eng. trans. by C. Hall (Edinburgh, 1993)
Sigfried Giedion, 1888–1968: Der Entwurf einer modernen Tradition (Zurich, 1989)

BARBARA KÜNG

Gierdegom, Josephus Franciscus van. See VAN GIERDEGOM, JOSEPHUS FRANCISCUS.

Gierowski, Stefan (b Częstochowa, 21 May 1925). Polish painter. Between 1945 and 1948 he studied painting at the studios of Władysław Jarocki (b 1879), Zbigniew Pronaszko and Karol Frycz (b 1877) at the Academy of Fine Arts, Kraków. He also studied art history. He lived in Warsaw from 1949, where he taught painting at the Academy of Fine Arts from 1961. He took part in the exhibition at the Arsenal in Warsaw in 1955. Although regarded by some critics as continuing Polish colouristic painting, his work transcends the aesthetic principles of his older friend Jan Cybis (b 1897). The form of Gierowski's coherent and systematically developed oeuvre, which since the mid-1950s consisted exclusively of abstract works, was influenced rather by his collaboration with experimental graphic artists and poster designers in the early 1950s and the painting of Marek Włodarski or Tadeusz Makowski.

Gierowski's abstract paintings, which have numbers instead of titles, are usually grouped in one- or two-year cycles devoted to the fundamental problems of painting, namely 'space and symbol', 'space, light, matter', 'the margins of the picture space', 'the intrusion of line in space' and so on. Some of his pictures involve scientific concepts of space, and some of his series have been compared with matter painting, Op art or minimal art, although his canvases contain a considerably more developed colouristic complex than these tendencies. In the 1980s Gierowski's work showed an increasingly metaphysical slant (e.g. the series Ten Commandments, 1987). His work manages to synthesize Polish traditions of colourism and the avant-garde with the later trends represented by the Arsenalists. Both his paintings and his teaching were instrumental in bringing about the revival of painting among the younger generation of graduates from the Warsaw Academy of Fine Arts in the 1970s and particularly in the 1980s (for example Gruppa).

BIBLIOGRAPHY
Stefan Gierowski: Malarstwo [Stefan Gierowski: painting] (exh. cat., Łódź, Office A. Exh., 1977)
B. Kowalska: 'Stefan Gierowski', Twórcy-postawy [Authors and attitudes] (Kraków, 1981)
Z. Taranienko: 'Materia to także światło' [Matter is also light], Rozmowy o malarstwie [Talks on painting] (Warsaw, 1987)

WOJCIECH WŁODARCZYK

Giersing, Harald (b Copenhagen, 24 April 1881; d Valdal, 15 Jan 1927). Danish painter and teacher. He studied in Copenhagen at the Kongelige Danske Akademi for de Skønne Kunster (1900–04) and at Kristian Zahrtmann's art school (1904–6). In 1906–7 he visited Paris, where his experience of Impressionism and Expressionism was to have a lasting influence on his style, and on that of a generation of Danish artists through his ten years of teaching in the art school he founded in Copenhagen in 1917. In his paintings he united simplicity of composition and an individual use of colour that reflected his study of light. He was also influenced by the pointillist technique of the Neo-Impressionists, for example in a number of works painted in 1907–8, such as Portrait of the Artist's Father (Copenhagen, Stat. Mus. Kst). Subsequently his style was influenced by the work of Matisse, and he approached the monumental in his use of a broad, dark outline. In such paintings as Football Players: Sophus Heading (1917; see fig.), Cubist spatial qualities are combined with the dynamism of Futurism.

In his large-scale figure paintings Giersing also strove towards further simplification, working with a more restricted colour scheme. In the 1920s he painted a large number of fine portraits and female studies, concentrating on a synthesis of black against light, either without any detail or with the sketched suggestion of facial and bodily

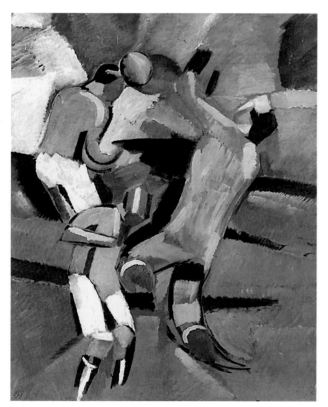

Harald Giersing: Football Players: Sophus Heading, oil on brown cardboard mounted on plywood, 1.49×1.2 m, 1917 (Århus, Kunstmuseum)

features, as in *Seated Mandolinist with Dark Green Background* (1922; Copenhagen, Stat. Mus. Kst). Giersing also painted landscapes, inspired in his bold rhythms and in his colour schemes by his affection for the Danish countryside and by his knowledge of the Danish landscape tradition. His large-scale, *plein-air* paintings, some depicting the area north of Furesø and others the highway and churchyard motifs of Fyn, show a serenity and a tenderness in his view of nature, as in *The Road to Fåborg* (1920; Copenhagen, Stat. Mus. Kst).

Throughout his career Giersing maintained a personal equilibrium in the face of the many artistic movements that influenced his work. He became respected for his independence and for his influence on his contemporaries and on younger Danish painters.

WRITINGS

P. Uttenreiter, ed.: *Om Kunst* [On art] (Copenhagen, 1934)

BIBLIOGRAPHY

H. Rostrup: *Harald Giersings tegniger* [Harald Giersing's drawings] (Copenhagen, 1957)

J. Zibrandtsen: *Moderne dansk maleri* (Copenhagen, 1969), pp. 133–42

H. Bramsen, ed.: *Dansk kunsthistorie*, v (Copenhagen, 1975), pp. 76–9

Portrætter og figurbilleder af Harald Giersing, 1881–1927 (exh. cat. by L. Gottlieb, Copenhagen, Stat. Mus. Kst, 1981)

RIGMOR LOVRING

Gierymski. Polish family of painters and illustrators.

(1) Maks(ymilian) Gierymski (*b* Warsaw, 9 Oct 1846; *d* Bad Reichenvall, Bavaria, 16 Sept 1874). In 1865 he studied in Warsaw for several months under Rafał Hadziewicz (1803–86) and Chrystian Breslauer (1805–82); he was also influenced by the work of Juliusz Kossak, with whom he was acquainted. His earliest landscape oils date from this period (e.g. *Forest Landscape*, 1866; Kraków, N. Mus.), as well as military scenes such as *Artillery on the Gallop* (1867; Warsaw, N. Mus.). Having won a state scholarship, he studied at the Akademie der Bildenden Künste in Munich from July 1867 until October 1868, and at the same time he worked for the battle painter Franz Adam (1815–86) in his private studio. He was interested in contemporary German art and, above all, in 17th-century Dutch and Flemish painting and contemporary French painting. Alongside Józef Brandt, he played a leading role in the community of Polish artists studying in Munich who were influenced in particular by the work of the Barbizon school. Gierymski soon won the recognition of Munich critics and picture-dealers, and in 1868 he was elected a member of the Kunstverein. From 1868 Gierymski sent paintings to exhibitions in Poland, particularly to Warsaw, and also returned to Poland on several occasions, getting to know the landscape of the country south of Warsaw and re-creating it in his paintings with simplicity and feeling (e.g. *Dawn Landscape*, 1869; Warsaw, N. Mus.). Gierymski also produced genre scenes at this time, such as *Praying on the Sabbath* (1871; Liberec, Reg. Gal.), depicting the poor Powiśle district of Warsaw.

An important element in Gierymski's oeuvre was his depiction of events from the Polish Uprising of 1830: in *Aide-de-camp* (*c*. 1869; Warsaw, N. Mus.) he tried to convey the monotonous rhythm of soldiers marching. Gierymski also painted several works drawing on themes from the Rising of January 1863, in which he had participated as a youth (*see* POLAND, fig. 9). These scenes are often set in the landscape around Warsaw, as in *Partisan Scene by Night* (1866–7; Warsaw, N. Mus.). In keeping with contemporary fashion, Gierymski also painted hunting pictures: colourful cavalcades of riders in stylized 18th-century costumes in a Polish landscape. He began producing such compositions with the *Duel of Tarlo and Poniatowski* (1869; untraced), continuing with numerous variants of similar scenes from 1871 to 1874, including *Cavalcade in a Birch Wood* (1870–71) and the *Hunt* (1871; both Warsaw, N. Mus.). Gierymski also worked as an illustrator, from 1867 for the Warsaw periodicals *Tygodnik Illustrowany* and subsequently *Kłosy*, and from 1868 for the German periodical *Münchner Bilderbogen*. In 1873 he went to Venice and Verona with his brother (2) Aleksander Gierymski, and he was much impressed by the use of colour in Venetian paintings. In the last 18 months of his life, seriously ill with lung disease, he travelled to Merano and Bad Reichenvall to recuperate, continuing to work intermittently until several months before his death.

WANDA MALASZEWSKA

(2) Aleksander (Ignacy) Gierymski (*b* Warsaw, 30 Jan 1850; *d* Rome, 6–8 March 1901). Brother of (1) Maks Gierymski. He studied (1867) at the Warsaw Drawing Class, then (1868–73) at the Akademie der Bildenden Künste in Munich under Georg Hiltensperger (1806–90) and Alexander Strähuber (1814–82), and later under Karl Theodor von Piloty. While in Munich he contributed illustrations to Polish, German and Austrian magazines. On a visit to Venice and Verona in 1871 he was especially impressed by the work of 15th-century Venetian artists; this new enthusiasm was reflected in his prize-winning painting of a subject set by the Munich Akademie, a scene from Shakespeare's *Merchant of Venice* (1872; destr., see Starzyński, pl. 4). After accompanying his dying brother Maks to various spa towns and other locations, he settled in Rome in mid-1874. Two genre scenes from this period, *Roman Tavern* and *A Game of Mora* (both 1874; Warsaw, N. Mus.), show the influence of Dutch painting. Gierymski remained in Italy until 1879, mostly resident in Rome. He largely produced studies based on Italian Renaissance painting (e.g. *Italian Siesta*; Warsaw, N. Mus.) and *plein-air* studies for his painting *The Bower* (1st version 1874–80; destr. by artist; 2nd version 1882; Warsaw, N. Mus.). The long series of studies he produced for this work, (e.g. *Begonias*, 1876–80, Łódź, Mus. A.; and *Second Study for the Bower*, Warsaw, N. Mus.) were often deliberately presented as finished works.

Gierymski returned to Warsaw in 1879, remaining there until 1884. During this period he was occupied largely with recording some of the city's poorest quarters and their inhabitants (e.g. *Jewish Woman with Lemons*, 1881; Bytom, Mus. Upper Silesia; and *Powiśle*, 1883; Kraków, N. Mus.). The three versions of the scene of Jewish celebration at dusk at the river's edge, *Feast of the Trumpets* (1884, Warsaw, N. Mus.; 1888 and 1890, both untraced, see Starzyński, pls 53 and 54), all concentrate, characteristically, on changing conditions of light and colour at twilight. In the autumn of 1884 Gierymski went to Vienna, moving to Italy in 1885 on a commission from the Warsaw illustrated magazine *Kłosy* to provide drawings of Polish

monuments and relics in Italy. He visited Bologna, Padua, Venice, Florence and Ferrara, and he settled for a time in Rome. He was again in Warsaw between 1886 and 1888 but then returned to Munich. Trips to the Tyrol, where he dedicated himself to *plein-air* studies, brought a new conviction of the need to convey the intensity of colour seen in such settings. Works such as *View of the Surroundings of Kufstein Castle* (version 1889; Warsaw, N. Mus.) are especially remarkable for their use of pure, intense colours, especially greens.

Equally significant during the next few years were Gierymski's nocturnes, set in impressive urban architectural complexes (e.g. *Max-Josephsplatz in Munich at Night*, 1890; and *Bridge in Munich, c.* 1890; see fig.; both Warsaw, N. Mus.), which show a concern for the interplay of artificial and natural light emanating from various points. Similar works were painted during Gierymski's three years in Paris, where he went in 1890. The *Paris Opéra at Night* (1891; Warsaw, N. Mus., and Poznań, N. Mus.) and the *Louvre at Night* (1892; Poznań, N. Mus.) show his use of an impressionist technique, independently developed, while in *Evening by the Seine* (1892–3; Kraków, N. Mus.; oil sketch, Warsaw, N. Mus.) the technique applied is almost divisionist. At this time he also painted a *Self-portrait with Palette* (ex-Warsaw, N. Mus.) for the gallery of the Polish collector Ignacy Korwin Milewski. Gierymski spent 1893–4 in Kraków, where he painted mainly landscape and genre scenes and attempted to reconcile the realistic rendering of the subject with his deep interest in exploiting a wealth of colour and effects of light (e.g. *Boy*

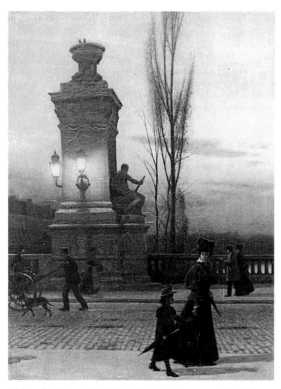

Aleksander Gierymski: *Bridge in Munich*, oil on canvas, 810×600 mm, *c.* 1890 (Warsaw, National Museum)

Carrying a Sheaf of Corn, destr., see Starzyński, pl. 92). In 1894 he left Poland for good and was from then on almost constantly on the move, after 1897 travelling mostly in Italy. Architecture, always of interest to him, played a large role in his late works, both in scenes painted in palaces and churches, such as the *Interior of S Marco in Venice* (1895; Warsaw, N. Mus.) and in views of cities, usually shown in brilliant sunlight and with a predominance of pink colouring, such as *View of Verona* (1900; Warsaw, N. Mus.). Equally meticulous landscapes, however, were the products of his most accomplished late work: invariably he showed deserted locations with an air of brooding stillness, as in *Italian Park* (1895–7; Katowice, Sil. Mus.). Although his art was shaped by his independent, painstaking researches, his development was erratic, shaped by a life of acute neurosis, which culminated in his death in a Roman asylum for the insane.

WRITINGS

J. Starzyński and H. Stępień, eds: *Maksymilian i Aleksander Gierymski: Listy i notatki* [Maksymilian and Alexander Gierymski: letters and notes] (Wrocław, 1973)

BIBLIOGRAPHY

PSB; *SAP*; Thieme–Becker
A. Sygietyński: *Album Maksa i Aleksandra Gierymskich* [The album of Maks and Aleksander Gierymski] (Warsaw, 1886)
S. Witkiewicz: *Aleksander Gierymski* (L'vov, 1903, rev. Kraków, 2/1974)
Venezia e la Polonia nei secoli dal XVII al XIX (exh. cat., Venice, Fond. Cini, 1965)
J. Starzyński: *Aleksander Gierymski* (Warsaw, 1967; Eng. trans., 1971)
Maksymilian Gierymski, 1846–1874: Malarstwo, rysunek [Maksymilian Gierymski, 1846–1874: paintings and drawings] (exh. cat., Warsaw, N. Mus., 1974)
M. Masłlowski: *Maksymilian Gierymski i jego czasy* [Maksymilian Gierymski and his times] (Warsaw, 1976)
W. Juszczak: *Modernizm, malarstwo polskie* [Modernism, Polish painting] (Warsaw, 1977), pp. 28, 38, 56–60, 62, 335 [biog. notes and cat. by M. Liczbińska]
Polnische Malerei von 1830 bis 1914 (exh. cat., Kiel, Christian-Albrechts U., Ksthalle; Stuttgart, Württemberg. Kstver.; Wuppertal, Von der Heydt-Mus.; 1978–9), pp. 210–11
H. Stępień: *Malarstwo Maksymiliana Gierymskiego* [The painting of Maksymilian Gierymski] (Wrocław, 1979)
La Peinture polonaise du XVIe au début du XXe siècle, Warsaw, N. Mus. (Warsaw, 1979), pp. 163–79
E. Clegg: 'The City at Night: Aleksander Gierymski in Munich and Paris', *Apollo*, cxxx/334 (1989), pp. 379–84, 397

ZOFIA NOWAK

Gies, Ludwig (*b* Munich, 3 Sept 1887; *d* Cologne, 27 Jan 1966). German medallist and sculptor. He trained as a sculptor and architectural draughtsman in Munich, attending the Kunstgewerbeschule and the Akademie (1910–13). He exhibited sculpture with the Munich Secession and was one of the foremost exponents of the German Expressionist medal of World War I, along with Karl Goetz, Hans Lindl, Erzsebert von Esseö (*b* 1883) and others. His medals, cast in iron and bronze, eschew the smooth elegance of Art Nouveau in favour of simple, primitive forms and rough castings more in keeping with their subjects. Some are propaganda pieces in praise of German military strength, but many deal with the suffering caused by war: men are rendered as small, stick-like figures in *The Bomb* (iron) and *The Lusitania* (bronze), both of 1916; his *Refugees* plaquette (iron, 1915) is a tragic symbol of universal suffering, while the *Dance of Death* medal (iron, 1917), showing a skeleton leading a group of soldiers, is perhaps his most enduring image. In his later medals

Gies adopted a simpler, more linear style and found his subjects in religious themes, scenes from daily life and portraits. He also executed designs for porcelain, such as the *Holy Family* medal (*c.* 1955), and mosaics. From 1918, when he completed his military service, until his dismissal in 1937 he taught at the Kunstgewerbeschule, Berlin, and from 1950 he taught at the Werkschule, Cologne.

For an illustration of a World War I medal by Ludwig Gies *see* MEDAL, fig. 7.

BIBLIOGRAPHY
Thieme–Becker; Vollmer
A. Hoff: *Plaketten und Medaillen von Ludwig Gies* (Krefeld, n.d.)
L. Forrer: *Biographical Dictionary of Medallists* (London, 1902–30), vii, p. 357
M. Jones: *The Dance of Death* (London, 1979)
B. Ernsting: 'Ludwig Gies: The Munich Years', *Medal* (1988), no. 13, pp. 58–72
Ludwig Gies, 1887–1966 (exh. cat., ed. B. Ernsting; Leverkusen, Schloss Morsbroich; Berlin, Kolbe Mus.; Niebüll, Richard-Haizmann Mus. Mod. Kst.; 1990)

PHILIP ATTWOOD

Giesler, Hermann (*b* Siegen, 2 Aug 1898; *d* Düsseldorf, 20 Jan 1987). German architect. He studied architecture at the Kunstgewerbeschule in Munich (1919–23). From 1923 he worked as an assistant architect in Augsburg and Berlin, working independently from 1930 and becoming District Architect at Sonthofen in 1933. The following year construction of the Ordensburg Sonthofen began, his first commission for the National Socialist party. The design of the building followed historical models, medieval castles and monasteries, and it was constructed following the regionally specific forms of *Heimatschutzarchitektur*. More commissions for the Nazis soon followed, including designs for Gauforums (Nazi assembly and parade grounds) in Weimar and Augsburg, and the plans for the Hohe Schule of the NSDAP on the Chiemsee. With these buildings and projects Giesler established himself as a designer of large, integrated sites, and in 1938 he was appointed Chief of Planning for the Capital City of the Movement by an edict of Adolf Hitler, working directly under his command.

Giesler's task was to integrate the large buildings of Munich—some of which had already been begun or designed—into an overall plan. The task was comparable to the work of Albrecht Speer in Berlin. Comprehensive traffic planning provided the basis for this general development plan, with an orbital motorway, a circular road within the city, two large axis roads, routes for trams and underground trains, reorganized railway installations and a river port. The centrepiece of the plan was the Grosse Strasse, an east–west axis flanked by large buildings, with a 250 m-high party monument and the gigantic cupola construction of the new central railway station. In addition he had planned a vertical north–south axis as Speer had already done for Berlin. Outside the city centre various new residential areas were projected. The unfinished plan was to have been completed by 1950. Giesler used the neo-classical style of official architecture in the Third Reich. In his designs emphasis is placed on the buildings as individual entities and in relation to each other, while the details are of minor importance. Apart from the plans for Munich, Giesler also worked on a second development project for Linz from 1940, as well as being involved in

military activities. After World War II Giesler worked as an independent architect in Düsseldorf.

WRITINGS
Ein anderer Hitler, Bericht seines Architekten Hermann Giesler, Erlebnisse, Gespräche, Reflexionen (Leoni, 1977)

BIBLIOGRAPHY
J. Petsch: *Baukunst und Stadtplanung im Dritten Reich, Herleitung, Bestandsaufnahme, Entwicklung, Nachfolge* (Munich, 1976)
H.-P. Rasp: *Eine Stadt für tausend Jahre, München-Bauten und Projekte für die Haupstadt der Bewegung* (Munich, 1981)
W. Durth: *Deutsche Architekten: Biographische Verflechtungen, 1900–1970* (Brunswick, 1986)

ROLAND WOLFF

Gifford, Sanford Robinson (*b* Greenfield, NY, 10 July 1823; *d* New York, 24 Aug 1880). American painter. He grew up in Hudson, NY, and attended Brown University between 1842 and 1844. He moved to New York in 1845 and studied with the British watercolourist and drawing-master John Rubens Smith (1775–1849), who probably taught him portraiture and topographical rendering. Gifford also enrolled in figure drawing classes at the National Academy of Design and attended anatomy lectures at the Crosby Street Medical College. After a year studying the human figure, he decided to specialize in landscape painting. An admirer of the work of Thomas Cole, he took a sketching trip during the summer of 1846 and visited some of that artist's haunts in the Berkshire and Catskill Mountains. Gifford's earliest works show the combined influence of Cole's style and his own nature studies (e.g. *Summer Afternoon*, 1853; Newark, NJ, Mus.). He first exhibited his work at the National Academy of Design in 1847, the same year the American Art-Union accepted one of his landscapes for distribution through engraving to its members. The next year the Art-Union showed eight of Gifford's canvases. The National Academy elected him an associate in 1851 and an academician in 1854.

Like most American landscape painters of his day, Gifford decided to supplement his training with European travel, and he left for England in 1855. There he studied the work of Turner and Constable. That autumn he went to France and spent over a year studying in Paris, Fontainebleau and Barbizon, where he was strongly impressed with the work of Jean-François Millet. Before returning home, he toured Germany, Switzerland and Italy, where Albert Bierstadt joined him. Paintings from this trip, such as the *Lake of Nemi* (1856–7; Toledo, OH, Mus. A.), reveal his departure from the dark hued, meticulous compositions of his HUDSON RIVER SCHOOL predecessors, such as Cole, in favour of landscapes painted with barely noticeable brushstrokes and bathed in light that diffuses topographical detail. In the autumn of 1857 Gifford took a studio at the Tenth Street Studio Building in New York, where he painted for the rest of his life. On his annual summer trips, usually with fellow landscape painters, to the Catskills, the Adirondacks and a great variety of scenic locations in Maine, New Hampshire and Vermont, he made pencil sketches that he later developed into oil paintings. He favoured the Catskills and produced numerous paintings of the area. *Kauterskill Clove* (1862; New York, Met.; see fig.) is one of his finest works and shows the successful culmination of his experiments with the dissolution of form in atmospheric light. While serving in the Civil War,

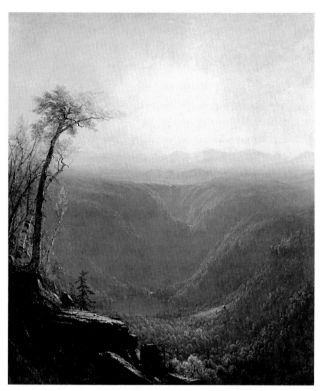

Sanford Robinson Gifford: *Kauterskill Clove*, oil on canvas, 1.22×1.01 m, 1862 (New York, Metropolitan Museum of Art)

he produced such works as *Bivouac of the Seventh Regiment at Arlington Heights, VA* (1861; New York, Seventh Regiment Armory), in which his fascination with effects of light is equally apparent.

Between summer 1868 and autumn 1869 Gifford visited Italy, Greece, Egypt, Syria, Jerusalem and other countries in the Near East. This trip inspired many of his later paintings, for example the *Ruins of the Parthenon, 1868* (1880; Washington, DC, Corcoran Gal. A.). Shortly after his return he accompanied Worthington Whittredge and John Frederick Kensett to the Rocky Mountains and continued on to Wyoming with Ferdinand V. Hayden's survey expedition. He travelled in the western USA, British Columbia and Alaska in 1874. He died six years later of pneumonia, after a trip with his wife to Lake Superior. In 1881 the Metropolitan Museum of Art in New York mounted a large memorial exhibition of Gifford's work, accompanied by a catalogue listing 739 of his paintings, which confirmed his position as a major member of the second generation of the Hudson River school. He has subsequently been seen as an important exponent of LUMINISM (i).

BIBLIOGRAPHY
Sanford Robinson Gifford (1823–1880) (exh. cat. by N. Cikovsky jr, Austin, U. TX, Huntington A.G., 1970)
I. S. Weiss: *Sanford Robinson Gifford, 1823–1880* (New York, 1977)
Sanford R. Gifford, 1823–1880 (exh. cat. by S. Weiss and I. S. Weiss, New York, Alexander Gal., 1986)

CARRIE REBORA

Gigante, Giacinto (*b* Naples, 11 July 1806; *d* Naples, 29 Nov 1876). Italian painter and printmaker. In 1816 he was introduced to painting by his father Gaetano Gigante, a decorator and landscape painter in the tradition of Jacob Philipp Hackert. Giacinto's brothers Achille Gigante and Ercole Gigante also became landscape painters. His training in the style of Hackert, together with the practice of technical drawing carried out at the Neapolitan Reale Ufficio Topografico (where he was employed in 1820) offered him a detailed knowledge and understanding of landscape, based on direct visual contact and precision of detail and far from the conventions of classical composed landscape. Also in 1820, however, he came to know the German painter Jakob Wilhelm Huber (1787–1871) who, along with a large colony of foreign painters in Naples, worked in the classical and picturesque landscape tradition. Huber's picturesque style was based on perspective, and from him Gigante learnt both watercolour technique and the use of the CAMERA LUCIDA, with which he established the essential lines of the landscape and its picturesque and monumental characteristics. In 1821, at Huber's studio, he met the Dutch painter Anton Sminck Pitloo, who became his teacher for a few years and who directed him towards painting directly from nature in a Romantic spirit. In 1823 Gigante enrolled at the Reale Istituto di Belle Arti in Naples and took part the following year in its drawing competition, which he won. In 1826 he exhibited four canvases at the first Esposizione di Belle Arti, set up by Ferdinand IV of Bourbon. Gigante did not fit in well with the life of the Istituto, however, and left early, although later being nominated honorary professor there.

Considered the major exponent of the SCUOLA DI POSILLIPO, Gigante distinguished himself in watercolour and tempera painting. The precision of the views in the early works is remarkable, as in *Lake Lucrino* (1824; Naples, Mus. N. S Martino) and *Pompei* (1835; St Petersburg, Hermitage). The landscape acquired a lively, romantic air, due to the convincing treatment of atmosphere rather than reliance on any literary allusion. Gigante was also expert in various techniques of engraving and in lithography with which he experimented, both with Huber and at the Ufficio Topografico. Between 1829 and 1834 he collaborated on the volumes of the *Viaggio pittorico nel regno delle due Sicilie*, published by Cuciniello and Bianchi; and in 1832 he provided the drawings for the French version of the same work, *Esquisses pittoresques et descriptives de la ville et des environs de Naples*. In the same year he came into contact with Russian aristocrats and diplomats residing in Naples who were to become from then on his most faithful patrons. In 1845 he went to Palermo on a commission for the Tsarina Alexandra and the following year he was commissioned to paint two large canvases (untraced) for Tsar Nicholas I.

In Gigante's mature period, from the 1840s onwards, he refined his treatment of light and progressed in the rendering of atmosphere through the use of mixed techniques: pencil and white lead, pen and wash, watercolour, white lead and tempera on coloured paper. Works painted using the latter technique include *Houses on the Hill* (1841; Naples, Capodimonte) and *Villa at Quisana* (1854; Naples, Gal. Accad. B.-A.). During the unrest in 1848 Gigante took refuge in Sorrento, leaving behind ample artistic documentation of the coast in various media. This includes

Giacinto Gigante: *The Coast at Amalfi with a Stormy Sea*, oil on canvas, 300×420 mm, *c*. 1850 (Naples, Museo e Gallerie Nazionali di Capodimonte)

the tempera painting *Capodimonte di Sorrento* (1850; Naples, Capodimonte), the watercolour *Vico Equense* (1848; Naples, Mus. N. S Martino) and the oil painting *The Coast at Amalfi with a Stormy Sea* (*c*. 1850; Naples, Capodimonte, see fig.). Having become associated with the Bourbon court in 1850, he became, the following year, painting teacher to the Bourbon princesses and was made a Cavalier of the Royal Order of Francis I. He remained a supporter of the Bourbons, yet at the celebration of Garibaldi's entry into Naples he executed a sketch (Naples, Mus. N. S Martino) for a large work on this theme (untraced). With the Unification of Italy the new king, Victor-Emmanuel II, commissioned a tempera painting, *Interior of the San Gennaro Chapel in the Cathedral*, which was completed in 1863 and shown at the Exposition Universelle in Paris in 1867. Gigante returned to Paris in 1869–70, but his Parisian experience left no trace in his painting, which was by now settled into its own formula. The final phase of Gigante's work consists mainly of figure studies and interiors, for example *In the Choir of S Andrea delle Monache* (1864; Naples, Mus. N. S Martino) and *Courtyard with Washerwomen at Capaccio* (1868; Sorrento, Mus. Correale, Terranova).

BIBLIOGRAPHY

Thieme–Becker

G. Carelli: *Giuseppe Mancinelli e Giacinto Gigante* (Naples, 1877)

S. Ortolani: *Giacinto Gigante* (Bergamo, 1930) [with illus. & bibliog.]

M. Biancale: 'Giacinto Gigante', *Vita Artistica* (1932), pp. 38–48

M. Limoncelli: *Giacinto Gigante* (Naples, 1934) [illus.]

A. Schettini: *Giacinto Gigante* (Naples, 1956) [illus.]

S. Ortolani: *Giacinto Gigante e la pittura di paesaggio a Napoli e in Italia dal '600 all '800* (Naples, 1970)

Giacinto Gigante e la scuola di Posillipo: La collezione Angelo Astarita al Museo di Capodimonte (exh. cat., ed. R. Causa and N. Spinosa; Naples, Pal. Reale, 1972)

L'immagine di Capri (exh. cat., ed. R. Causa; Capri, Certosa di S Giacomo, 1980–81)

Napoli e la Campania Felix: Acquarelli di Giacinto Gigante (exh. cat., ed. R. Causa; Naples, 1983) [with illus. & bibliog.]

MARIANTONIETTA PICONE PETRUSA

Gigantibus. *See* GIOACCHINO DI GIGANTIBUS DE ROTTENBURG.

Gigli, Ottavio (*fl c*. 1840–90). Italian collector and man of letters. Though Roman by birth, he lived for at least part of his life in Florence and took a deep interest in Florentine culture. In the 1840s he compiled and edited a collection of prose works by the 15th-century Florentine Feo Belcari (1410–84), *Prose di Feo Belcari* (Rome, 1843–5), and later published an edition of the *Novelle* (Florence, 1861) of the poet Franco Sacchetti (*c*. 1335–after 1398). At the same time, he formed a notable collection of Florentine 14th-century and Renaissance sculpture. Among his most celebrated possessions was the marble statue discovered in Florence and believed for many years to be a lost *Cupid* (or *Apollo*) by Michelangelo (London, V&A), but now attributed to Valerio Cioli and identified as a *Narcissus*. It once belonged to the sculptor's Roman patron Jacopo Galli.

In Florence, Gigli also acted as agent for the Marchese Giampietro Campana, art collector and Director of the Monte di Pietà, the deposit bank for the papal government in Rome. In 1857 Campana was found guilty of misusing the funds in his care in order to build up an art collection, and his possessions were put up for sale together with 124 sculptures owned by Gigli, who had pledged them to the Monte di Pietà. Sixty-nine of these works were purchased in 1862 by J. C. Robinson, Superintendent of the South Kensington Museum (now the Victoria & Albert Museum) and were brought to London.

BIBLIOGRAPHY

A. M. Migliarini: *Museo di scultura del risorgimento raccolta e posseduta da O. Gigli* (Florence, 1858) [illus.]

J. Pope-Hennessy: *Catalogue of Italian Sculpture in the Victoria and Albert Museum*, 2 vols (London, 1964), ii, pp. 452–5

JANET SOUTHORN

Gigliardi, Domenico. *See* GILLARDI, DOMENICO.

Gignous, Eugenio (*b* Milan, 4 Aug 1850; *d* Stresa, 30 Aug 1906). Italian painter. He attended the Accademia Brera in Milan from 1864, studying landscape painting under Luigi Riccardi (1808–77). He was influenced by the example of Gaetano Fasanotti (1831–82) and Carlo Mancini (1829–1910) and, subsequently, by the work of Antonio Fontanesi and the painters of the Scuola di Rivara. Of Gignous's early work, the portraits of the 1870s were influenced by the work of his friends among the Scapigliati, Tranquillo Cremona and Daniele Ranzoni. Until he married in 1881, Gignous travelled and exhibited extensively, showing work at the Weltaustellung in Vienna in 1873 and the Exposition Universelle in Paris in 1878. Important paintings from this period include *Rustic Courtyard at Colombera* (1870; Milan, Mus. Milano) and *Flowers in the Cloister* (Milan, Brera).

In 1879 Filippo Carcano introduced Gignous to the landscape around Lake Maggiore, and this provided Gignous with motifs from the early 1880s onwards. During the 1880s Gignous also painted in Liguria and in Venice, exhibiting his work successfully (e.g. *Calm*, 1884; Rome, G.N.A. Mod.). In 1886 he settled in Stresa on Lake Maggiore, where he painted impressionistic views of the region, becoming the chief representative of the landscape school emerging there in the 1890s. He still visited Liguria regularly in winter and occasionally went to work in Venice. Later works include the landscape *Monte Rosa at Macugnaga* (1896; Rome, G.N.A. Mod.).

BIBLIOGRAPHY

A. Massara: 'Medaglioni—Eugenio Gignous', *Verbania*, i–ii (1909), pp. 5–9

A. Francini: 'Eugenio Gignous, 1850–1906', *Pinacotheca*, ii (1928), pp. 97–109

N. Colombo, ed.: *Eugenio Gignous* (Milan, 1985)

P. Nicholls: *Eugenio Gignous, pittore a Stresa* (Intra, 1986)

PAUL NICHOLLS

Gignoux, Régis-François (*b* Lyon, 1816; *d* Paris, 6 Aug 1882). French painter, active in America. He was educated at Fribourg, the Académie de St Pierre in Lyon and the Ecole des Beaux-Arts in Paris, where he studied under Paul Delaroche. About 1840 he settled in New York and became a skilled exponent of the HUDSON RIVER SCHOOL. Gignoux's work is distinguished by its delicate touch and velvet colour, recalling that of François Boucher, yet he demonstrated an impressive resilience in applying his talents in a thoroughly American idiom. *On the Upper Hudson* (priv. col., see J. K. Howat: *The Hudson River and its Painters*, New York, 1971, p. 93, colour pl. 43), one of Gignoux's finest paintings, shows the subtly modulated palette, diaphanous atmosphere, fine articulation of foreground forms and a cadence of light and shadow that characterize his style. Gignoux's work was widely collected during his lifetime, and he achieved a reputation for his distinctive winter scenes; for example, *Winter Scene in New Jersey* (1847; Boston, MA, Mus. F.A.) was purchased by Maxim Karolik. Gignoux exhibited frequently at the National Academy of Design, New York (1842–68), the Boston Athenaeum (1845–62) and the Pennsylvania Academy of the Fine Arts, Philadelphia (1855–68). He was the founding president of the Brooklyn Art Association (serving from 1861 to 1869) and exhibited there between 1860 and 1884. He returned to Paris in 1870.

BIBLIOGRAPHY

H. T. Tuckerman: *Book of the Artists: American Artist Life* (New York, 1867/R 1966)

C. Clement and L. Hutton: *Artists of the Nineteenth Century and their Works* (Boston, 1894)

JOHN DRISCOLL

Gigoux, Jean(-François) (*b* Besançon, 6 Jan 1806; *d* Paris, 11 Dec 1894). French painter, lithographer, illustrator and collector. The son of a blacksmith, he attended the school of drawing in Besançon. He left for Paris and in 1828–9 frequented the Ecole des Beaux-Arts while executing various minor works. He made his début at the Salon in 1831 with a number of drawings. He established himself at the Salons of 1833 and 1834 with such sentimental compositions as *Henry IV Writing Verses to Gabrielle*, *St Lambert at Versailles*, *Count de Comminges*, *Fortune-telling* and such portraits as *Laviron* and *The Blacksmith* (1886; unless otherwise stated, all works are in Besançon, Mus. B.-A. & Archéol.; many drawings in Lille, Mus. B.-A. and Rouen, Mus. B.-A.). His portrait of the *Phalansterist Fourier* (1836) confirmed the success he had achieved as a history painter with the *Last Moments of Leonardo da Vinci* (1835).

In 1836 Gigoux travelled to Italy with his students Henri Baron and François-Louis Français. His friendships with Hygin-Auguste Cavé, the Directeur des Beaux-Arts, and with the influential Charles Blanc advanced his career and made it easier for him to obtain commissions, producing numerous portraits and religious subjects. He executed several works for the Musée d'Histoire at Versailles, including the *Capture of Ghent* and *Charles VII*. The subject-matter of the *Death of Manon Lescaut* (1845; destr.) and *Israelites in the Desert* (1845; Ivry-sur-Seine, Dépôt Oeuvres A.) reflects a period when Gigoux was out of favour: in addition to rejections from the Salon in 1837, 1840 and 1847, he attracted much adverse criticism. In 1848 and 1849 he drew various portraits and sold to Charles Blanc his painting *Antony and Cleopatra Testing Poisons on Slaves*, which had been refused for the Salon in 1837 (Bordeaux, Mus. B.-A.).

Unlike his friend Théophile Thoré, Gigoux supported the Empire and became involved in official art, producing

such works as *Galatea and Pygmalion* (1857) and *Napoleon Visiting the Bivouacs on the Eve of Austerlitz* (1857). He executed two vast compositions, later destroyed, for the Conseil d'Etat in Paris, the *Grape Harvest* (1853) and *Harvest* (1855), and the *Flight and Rest in Egypt, Entombment* and *Resurrection* for a chapel in SS Gervais and Protais in Paris (*in situ*). Among his later works are *Poetry of the Midi* (1867; Narbonne, Mus. A. & Hist.) and *Father Lecour* (1875), which continued his earlier academic style.

Between 1830 and 1850 Gigoux executed a large number of lithographs of such contemporary figures as *Arsène Houssaye, Eugène Delacroix, Xavier Sigalon, François Gérard* and *Antoine-Louis Barye* and his friends *Pierre-Jean David d'Angers* and *Mme de Balzac* and her daughter. After 1850 these became more fluid, as in *Julia, the Beautiful Englishwoman* and *Memory*. He also illustrated various publications, including Petrus Borel's *Champavert, contes immoraux* (1833) and *Lettres d'Abailard et d'Héloïse* (Paris, 1839), and enjoyed a great success with Alain-René Le Sage's *Gil Blas* (1835). Gigoux was also involved in Jules-Gabriel Janin's *La Normandie* (Paris, 1844) and *Les Français peints par eux-même* (Paris, 1840) among other works. Gigoux was a major collector of paintings, prints and drawings from the Renaissance onwards and owned works by such artists as Dürer, Chardin, Hogarth, Gericault and David. Apart from a few sales and donations to the Louvre and to the Ecole des Beaux-Arts, he left the major part of his collection to the town of Besançon.

WRITINGS
Causeries sur les artistes de mon temps (Paris, 1885)

BIBLIOGRAPHY
A. Estignard: *Jean Gigoux: Sa vie, ses oeuvres, ses collections* (Paris and Besançon, 1895)
H. Jouin: *Jean Gigoux et les gens de lettres à l'époque romantique* (Paris, 1895)
P. Brune: *Dictionnaire des artistes et ouvriers d'art de la Franche-Comté* (Paris, 1912)
R. Marin: *Le Peintre Jean Gigoux (1806–1894)* (MA thesis, Paris, U. Paris IV, 1987)
Jean Gigoux, dessins, peintures, estampes: Oeuvres de l'artiste dans les collections des musées de Besançon (exh. cat., Besançon, Mus. B.-A. & Archéol., 1994)

RÉGIS MARIN

Gil, Jerónimo Antonio (*b* Zamora, Spain, 2 Nov 1731; *d* Mexico City, 18 April 1798). Spanish printmaker and medallist, active in Mexico. He was one of the first students at the Academia de S Fernando in Madrid (founded 1752), training as a painter, medallist and printmaker and gaining the diploma of Académico de Mérito in engraving. The finest works he carried out in Spain were the medals for the proclamation of Charles III (1762) and for the Montepío de los Cosecheros de Málaga; the latter won him the post of Senior Engraver at the Casa de Moneda in Mexico City.

Gil arrived in Nueva España (now Mexico) in 1778. Perhaps because his Neo-classical training clashed with the dominant Baroque style, he established a fine arts academy, initially at the Casa de Moneda; after long negotiations it was officially founded in 1784 by Charles III as the Real Academia de San Carlos de Nueva España. Gil was its director until his death, working energetically both as its administrator and as an artist. In 1787 he engraved portraits of the *Count of Galvez and his Son* and

the *Marquis of Sonora* (see Romero de Terreros, nos 211 and 215). He also designed medals commemorating the pledge of Charles IV and Mary Louise (1790), the Academia (1785) and the inauguration of the equestrian statue of Charles IV (1796).

WRITINGS
Las proporciones del cuerpo humano, medidas por las más bellas estatuas de la antigüedad (Madrid, 1780)

BIBLIOGRAPHY
M. Romero de Terreros: *Grabados y grabadores en la Nueva España* (Mexico City, 1948)
M. Toussaint: *Arte colonial en México* (Mexico City, 1962)

XAVIER MOYSSÉN

Gilabertus (*fl* mid-12th century). French sculptor. He is known from two inscriptions recorded before their accidental destruction in 1864: GILABERTUS ME FECIT and VIR NON INCERTUS ME CELAVIT GILABERTUS ('Gilabertus, no ordinary man, made me'). They were located at the base of figures representing SS Thomas and Andrew, each carved in high relief on one corner of square-sectioned limestone uprights. These sculptures were salvaged with six other reliefs representing the other ten Apostles from the cloister of St Etienne, Toulouse (*see* TOULOUSE, §2(iii)), destroyed after 1812. Originally assembled in the municipal museum (now the Musée des Augustins) as if they formed the splayed jambs of a portal, the sculptures have been variously dated between 1125 and 1160 on the basis of comparison with sculpture elsewhere in Europe. The finely modelled heads and attenuated bodies, which are defined by delicately chiselled drapery falling in sheer folds, have caused the reliefs signed by Gilabertus in particular to be seen as precursors of the style of column-statues at Saint-Denis Abbey and Chartres Cathedral. While these reliefs differ significantly from the others because of the serene posture and oblique setting of the figures, the master's hand has also been detected in other figures of the group characterized by crossed legs. This last feature and the haloes with rosettes have also suggested that Gilabertus's art inspired the work of Nicholaus, whose decoration of the west portal of Ferrara Cathedral is dated by an inscription to 1135. The original location of these reliefs on a chapter house portal is questionable, however; they are better suited to the corners and walls of an interior space such as the *sacellum* mentioned when they were first described in the 19th century. Furthermore, the exceptional style of the Gilabertus reliefs, although related in some ways to regional art, at Moissac for example, has also been explained as inspired by the art of the Ile-de-France rather than anticipating it.

See also ROMANESQUE, §III, 1(iii)(c).

BIBLIOGRAPHY
O. Grautoff: 'Der Meister Gilabertus', *Repert. Kstwiss.*, xxxvii (1915), pp. 81–6
A. Kingsley Porter: 'La Sculpture romane en Bourgogne', *Gaz. B.-A.*, n. s. 4, ii (1920), pp. 61–80
L. Seidel: 'A Romanesque Forgery: The Romanesque "Portal" of Saint-Etienne in Toulouse', *A. Bull.*, l (1968), pp. 33–42
L. Lautard-Limouse: 'Gilabertus, sculpteur roman toulousain', *Archeologia*, lxxvii (1974), pp. 40–49
M. Durliat: 'Nicholaus et Gilabertus', *Nicholaus e l'arte del suo tempo*, i (Ferrara, 1985), pp. 151–66

THOMAS W. LYMAN

Gilbert, Sir **Alfred** (*b* London, 12 Aug 1854; *d* London, 4 Nov 1934). English sculptor, medallist, goldsmith and draughtsman. He was the most famous and, briefly, the most successful English sculptor of the late 19th century and a leading figure in the NEW SCULPTURE movement. His three major monumental works, the Jubilee Monument to *Queen Victoria*, the Shaftesbury Memorial in London, with its widely known figure of *Eros* (see fig. 1), and the tomb of *Prince Albert Victor, Duke of Clarence* (see fig. 2 below), though stylistically and technically adventurous, were more successful in their individual parts than in their total composition. Gilbert incurred heavy debts, culminating in bankruptcy in 1901, which together with his slow working methods and his disregard for the feelings of his patrons, led to 25 years of relatively unproductive self-exile in Belgium. He returned to London in 1926 to execute his last important commission, the monument to *Queen Alexandra*.

1. Life and work. 2. Working methods and technique. 3. Personality and critical reception.

1. LIFE AND WORK.

(i) Training and early work, before 1850. The son of musicians, he originally intended to become a surgeon but, after failing his entrance examination to Middlesex Hospital, London, he enrolled in Thomas Heatherley's art school in 1872. The following year he entered the Royal Academy Schools and was apprenticed to a succession of sculptors. The most important of these was Joseph Edgar Boehm who soon recognized Gilbert's talent and encouraged him to complete his training at the Ecole des Beaux-Arts in Paris. There his masters were Pierre-Jules Cavelier and Emmanuel Frémiet. Gilbert's earliest major works, the *Kiss of Victory* (1878–81; Minneapolis, MN, Inst. A.) and *Mother Teaching Child* (1881–3; London, Tate), are both life-sized marbles. The *Kiss of Victory*, which portrays a winged allegorical figure supporting a nude youth, is close both stylistically and technically to the work of Antonin Mercié and Gustave Doré while the *Mother Teaching Child* reflects the robust, domestic realism of Jules Dalou and Eugène Delaplanche.

A visit to Italy in 1878 had a radical impact on Gilbert's work. His interests shifted from the contemporary French academic style to the Florentine Renaissance and Mannerism, and especially the sculpture of Donatello and Benvenuto Cellini. The bronze statuette *Perseus Arming* (737 mm, 1882; London, V&A) was a cheeky challenge to Cellini's *Perseus and Medusa* which, Gilbert claimed, 'failed to touch my human sympathies'. He substituted a personal twist to the story of Perseus and to the statuette, which portrays a svelte adolescent, caught in an anxious and utterly unclassical turning movement. Among its admirers was Frederic Leighton, himself a major innovator in English sculpture. He commissioned Gilbert's next statuette, *Icarus* (bronze, 1884; Cardiff, N. Mus.; *see* STATUETTE, fig. 5), a free variation on Donatello's *David*. This work is still larger (1067 mm), technically finer—through being directly cast by the lost-wax method—and stylistically assured. Both the *Perseus Arming* and the *Icarus* were immediately successful and influential.

(ii) Sculpture, medals, goldsmith's work and jewellery, 1885–1901. Gilbert returned to London in 1885 and in the following year was elected ARA. Over the next 15 years he received many further commissions. The three most important were the Winchester Jubilee Monument to *Queen Victoria* (1887–1912; Winchester, Great Hall), the memorial to *Anthony Ashley-Cooper, Earl of Shaftesbury*, with its statue of *Eros* (1885–93; London, Piccadilly Circus), and the tomb of *Prince Albert Victor, Duke of Clarence* (1892–1928; Windsor Castle, Berks, Albert Memorial Chapel). All three works show Gilbert's strengths and weaknesses: superb in parts, they are less successful in their total effect. The *Queen Victoria* monument fuses the realism characteristic of the New Sculpture with the fantasy that Gilbert, in particular, injected into the movement. The enthroned portrait of the Queen herself is the most successful part, at once imperious and imperial. It inspired Thomas Brock's portrait for the *Queen Victoria* monument (1901–24; London, The Mall). Gilbert's treatment of the Queen's drapery has been likened to that of the then unfashionable Gianlorenzo Bernini in his tomb of *Urban VIII*. Still more original were Gilbert's decorative accessories for the monument, which culminate in a

1. Alfred Gilbert: *Eros* (the Shaftesbury Memorial), aluminium, h.1.88 m, 1885–93, Piccadilly Circus, London

suspended crown of lilies and tendrils, signifying the Queen's spiritual authority. With some justification the critic Claude Phillips found the accessories over-profuse, resulting in the absence of 'that monumental simplicity which is the primary requisite of a work in this class'. Gilbert's reaction to Phillips's criticism indicates his head-strong character—'utter rot and balderdash', he said.

The Shaftesbury Memorial (see fig. 1) incorporates the figure of *Eros*, the best-known and best-loved statue in London. Like the *Queen Victoria*, individual parts are more impressive than the whole. The bronze pedestal looks like a shapeless mass of molten lava at a distance, but close up its ecstatic dolphins and helmeted putti reveal Gilbert's imaginative choice of subject-matter. Above soars the aluminium figure of Eros; as with the earlier statuettes, Gilbert adapted an Italian model, in this case Giambologna's *Flying Mercury*, and has given it his customary adolescent litheness. Its iconography shows Gilbert's inventiveness which, in its way, is as modern as Rodin's contemporary monument to *Honoré de Balzac*. Instead of producing a realistic portrait statue of Shaftesbury, Gilbert, through Eros, alludes to Shaftesbury's love of humanity. The history of the Shaftesbury Memorial was a personal and financial disaster for Gilbert. Not having effected a legally binding agreement with the Memorial Committee, he was led to undertake the casting at his own expense and this plunged him into debt at a comparatively early stage of his career. The memorial itself was coolly received at the time of its unveiling, with prudish attacks made by public and press alike on Eros's nudity and more justifiable criticism of the work's ludicrously small scale in relation to its surroundings.

The Shaftesbury Memorial fiasco was in turn dwarfed by the protracted, comi-tragic 36-year saga of the tomb of *Prince Albert Victor, Duke of Clarence* (see fig. 2). It commemorates the eldest son of the Prince of Wales (later Edward VII) who died aged 28 in 1892. More than with any previous work, Gilbert displayed his worst faults: his idealizing respect for the subject, which led him into a tortuous, dithering perfectionism; his disregard of time and money, setting and scale; and his unconscious but still callous disregard for the feelings of the bereaved. The tomb comprises a recumbent effigy of the duke in military uniform; as in the *Queen Victoria* monument, the subject is being crowned, but in this instance by a life-sized angel. The work is surrounded by an intricate bronze grille, featuring 12 pairs of pirouetting angels and 12 poly-chromed figures of saints (*see* POLYCHROMY, colour pl. IV). Characteristically, Gilbert employed a multiplicity of materials: for the duke's effigy, marble, bronze, aluminium and brass, and for the statuettes of saints, ivory and bronze. By 1901 the tomb was complete except for five of the saints, which Gilbert could and would not execute, despite Edward VII's offer of rooms at Windsor. Gilbert was by this time hemmed in by personal and financial problems, both largely of his own creation. To alleviate the latter, he sold replicas of the saints' figures and, ignoring the royal veto, he published photographs of the replicas in the *Art Journal*, accompanied by acknowledgements to their owner. This was despite the fact that the tomb had not yet been dedicated or consecrated. It was to remain unfinished for more than 25 years.

As a work of art the tomb dwarfs its surroundings in the Albert Memorial Chapel, a fault opposite to that manifest in the Shaftesbury Memorial. Once again, individual parts within the work demonstrate Gilbert's remarkable inventiveness. The realism of the Duke's effigy contrasts surprisingly effectively with the decorative fantasy of the crown and the grille. The individual figures of saints range from the *Virgin Mary*, smothered in a rose-bush (*see* POLYCHROMY, colour pl. IV), to the figure of *St George*, a descendant of the *Perseus Arming*, clad in aluminium armour. Realist, Symbolist, Art Nouveau (which Gilbert fiercely but unconvincingly repudiated), Gothic and Renaissance elements within the tomb can all be detected, but the guiding genius is the artist's.

Other major works contemporary with the three discussed above repeatedly confirm Gilbert's originality and uneven genius. These include the *Enchanted Chair* (plaster, 1886; destr.), a highly decorative work containing elaborate personal symbolism; a life-sized marble statue of *James Prescott Joule* (1890–4; Manchester Town Hall), which continues the realist tradition of Boehm's *Thomas Carlyle*; and a remarkable half-length bronze bust of *John Hunter* (1893; London, St George's Hospital). Other portrait busts of this period include those of *G. F. Watts* (bronze, 1888; London, Tate) and the rapidly executed and lively head of the pianist *I. J. Paderewski* (plaster, 1891; Manchester, C.A.G.). During the 1890s Gilbert produced a

2. Alfred Gilbert: tomb of *Prince Albert Victor, Duke of Clarence*, bronze, marble, aluminium, ivory and brass, 3.23×1.98×1.75 m, 1892–1901, with additions 1926–8 (Windsor Castle, Berks, Albert Memorial Chapel)

group of portraits of children, among them the bronze bust of *Thoby Prinsep* (1898; priv. col., illus. 1986 exh. cat., no. 85), which capture youthful vulnerability and innocence with the greatest sensitivity.

Gilbert's activities as a goldsmith also became increasingly important during this period. His works include the enormous (1120 mm) silver epèrgne (1887–90; London, V&A), presented to Queen Victoria as a Golden Jubilee gift by officers of the army, and the silver gilt mayoral chain for Preston Corporation (1888–92; Preston Town Hall). Many of his designs in pen, ink and watercolour for goldsmith's work and jewellery are preserved in the so-called van Caloen album (Loppem, Sticht. van Caloen). Gilbert's sculptural training and intimate knowledge of casting techniques were brought to bear on these works so that they are justifiably regarded as part of his sculpture. In turn his sculpture, in particular the tomb of the *Duke of Clarence*, can certainly be regarded as an enlarged version of goldsmith's work. Related to Gilbert's practice as a goldsmith and as a portrait sculptor are his cast and struck medals. These include the cast bronze profile portrait medal of the landscape painter *Matthew Ridley Corbet* (1881; Paris, Mus. d'Orsay), a work in the idiom of P.-J. David d'Angers, and the struck bronze medal designed to commemorate the jubilee of the Art Union in 1887 (e.g. London, BM).

At the height of his career Gilbert also played an energetic part in Royal Academy activities. His election as Royal Academician (1892) was followed by his appointment as Professor of Sculpture in 1900. His lectures in the latter capacity were highly popular with students but proved too incoherent and disordered for publication. In his private life, Gilbert thoroughly enjoyed socializing and extravagance. His tendency to undercharge for works and his inability to complete them spelt disaster, however, the more so as the material costs of sculpture and metalwork were high.

(iii) Later career, 1901–34. The exasperation of long-suffering patrons, from Edward VII downwards, and his bankruptcy in 1901, induced Gilbert to live abroad in self-imposed exile. An exposure of him in the sensationalist newspaper *Truth* led him to the unprecedented step of resigning from the Royal Academy in 1908. Gilbert's 25 years of exile, spent in an impoverished state mainly in Bruges, were largely unproductive, the sculptor having burnt himself out in frenetic activity in the years up to 1901.

Nevertheless, in the early years of his exile, he produced two works of distinction and startling originality. The first was the memorial to *Mr and Mrs Percy Plantagenet Macloghlin* (bronze and marble, 1905–9; London, Royal Coll. Surgeons England), which is usually known by the Latin title *Mors Janua Vitae*. This consists of a double half-length portrait of the Macloghlins, arms entwined, gazing fondly at the cinerary casket that was to contain their commingled ashes. The portrait is mounted on an altar-like substructure decorated with bronze low relief panels representing aspects of the couple's love for one another. The second is the elaborate bronze chimney-piece *A Dream of Joy during a Sleep of Sorrow* (1908–13; Leeds, C.A.G.) commissioned by Mr and Mrs Sam Wilson

for their house outside Leeds. The two-tier structure, with its grotesque fusion of tortuous symbols, was designed to contain in the overmantel a painted portrait of Mrs Wilson. Perhaps more appropriately in a sculpture that reflects every major work by Gilbert as well as his private feelings and neuroses, the artist eventually inserted his own painted portrait of his second wife Stéphanie Gilbert (watercolour and gouache, 1919–21; Leeds, C.A.G.).

It was not until the mid-1920s that Gilbert's fortunes changed. Thanks to the lobbying of the journalist and his future biographer Isabel McAllister (1870–1945), and to the generosity of Lady Helena Gleichen (*d* 1947) in providing him with a studio, in 1926 Gilbert made a comeback to London and sculpture. He completed the tomb of the *Duke of Clarence*, filling it with the five remaining statuettes of saints. With their rough, impressionistic textures comparable to the late work of Donatello, these make a strange contrast to their carefully finished neighbours of the 1890s. Gilbert's revitalized career culminated with a final major commission, the monument to *Queen Alexandra* (1926–32; London, Marlborough Gate). In its swirling forms and emotional intensity, it is closely related to much earlier works that represent Gilbert at his most Art Nouveau, such as the *Resurrection of Christ* reredos (1890–1903; St Alban's Cathedral). On the monument's completion in 1932, Gilbert was restored to membership of the Royal Academy and received a knighthood.

2. WORKING METHODS AND TECHNIQUE. Gilbert was by instinct a modeller, preferring to work out his ideas in clay. Nevertheless a certain number of works on paper exist, including the designs for goldsmith's work in the van Caloen album and rapid compositional drawings in conté crayon such as that for a lost statuette of *Atalanta* (1931; Cardiff, N. Mus.). In addition Gilbert occasionally painted in watercolour and gouache, as in the cases of the portrait of Stéphanie Gilbert set into the Leeds chimney-piece, the illuminated page representing his statuette of *St George* in *The Tomb of the Duke of Clarence Presentation Book* (1894; Loppem, Jean van Caloen Foundation) and the lively sketch for a lost statuette of *Circe* (1912; London V&A).

Few 19th-century artists were more fascinated than Gilbert with the technical aspects of sculpture and metalwork. In the 1880s he played a crucial part in reviving interest in the lost-wax process of bronze casting (*see* BRONZE, §II). Gilbert acquired his knowledge of the process through reading Cellini and with the assistance of the founder Sabatino de Angelis (*b* 1838) in Naples and, on his return to London, the founder Alessandro Parlanti (*fl* 1885–93). Works such as *Perseus Arming* and *Icarus* were both probably cast in the first instance using the high-quality but high-risk direct method, straight from the wax model. The process emphasized their lithe elegance. The critical success of these early works inevitably led Gilbert to the indirect casting method, enabling him to produce multiple bronzes from plaster moulds. Such was the quality of his workmanship, however, that it is usually impossible to establish which method was used.

From his early interest in the lost-wax process, Gilbert moved on to coloured (gold-painted) bronze, together

with the use of semi-precious stones, in his memorial to *Randolph Caldecott* (1885–7; London, St Paul's Cathedral). Making the crown for the *Queen Victoria* monument required Gilbert to teach himself to become a goldsmith. By the 1890s he was employing further new materials and techniques. The most famous instance was the Shaftesbury Memorial, in which the Eros figure was almost certainly the first time that aluminium was used in a public sculpture (*see* ALUMINIUM, §2(ii)). The memorial also reflects Gilbert's growing interest in polychromatic effects, the aluminium of Eros contrasting in turn with the green bronze of the pedestal and the golden bronze of the basin. For smaller-scale works, Gilbert undertook many experiments on alloys in conjunction with Sir William Chandler Roberts-Austen (1843–1902), Professor of Metallurgy at the Royal College of Mines. The outcome could be remarkable; in the statuette *Charity* (1899; London, V&A), a selective pickle applied to the flesh areas creates a warm effect, offset by the surrounding drapery.

Gilbert's notorious tardiness in completing his works might well have been caused by their sheer complexity, or it might have come about through his obvious fascination with working methods and techniques. Certainly Gilbert regarded himself as being an alchemist as well as an artist.

3. PERSONALITY AND CRITICAL RECEPTION. The most famous English sculptor of his generation, Alfred Gilbert was also the most flamboyant, erratic, villainous and, at times, brilliant. The rise, fall and rise of his career seems paradigmatic of the last phase of Romanticism. Perhaps for this reason, Gilbert's contribution to sculpture was less substantial than that of his contemporary Hamo Thornycroft, whether in terms of enduring influence, guidance of younger sculptors or consistent achievement. In comparison Gilbert appears an uneven, flawed genius with the unevenness and flaws frequently undermining the genius. However, his sculpture took risks that neither Thornycroft nor any other contemporary could hope to rival, and it succeeds in moving the spectator accordingly. When told that the English placed Gilbert beside Cellini, Rodin replied: 'Better than that. Better than that.'

BIBLIOGRAPHY

J. Hatton: 'The Life and Work of Alfred Gilbert R.A., M.V.O., LL.D.', *A. J.* [London] (1903) [Easter issue]
I. McAllister: *Alfred Gilbert* (London, 1929)
A. Bury: *Shadow of Eros: A Biographical and Critical Study of the Life and Works of Sir Alfred Gilbert, R.A., M.V.O., D.C.L.* (London, 1954)
L. Handley-Read: 'Alfred Gilbert: A New Assessment', *Connoisseur*, clix (1968)
M. Roskill: 'Alfred Gilbert's Monument to the Duke of Clarence: A Study in the Sources of Later Victorian Sculpture', *Burl. Mag.*, cx (1968), pp. 699–704
Victorian High Renaissance (exh. cat., ed. R. Dorment; Minneapolis, MN, Inst. A.; Manchester, C.A.G.; New York, Brooklyn Mus.; 1978–9), pp. 42–52, 157–203
R. Dorment: 'Alfred Gilbert's Memorial to Queen Alexandra', *Burl. Mag.*, cxxii (1980), pp. 47–54
B. Read: *Victorian Sculpture* (New Haven and London, 1982)
S. Beattie: *The New Sculpture* (New Haven and London, 1983)
R. Dorment: *Alfred Gilbert* (New Haven and London, 1985)
Alfred Gilbert: Sculptor and Goldsmith (exh. cat., ed. R. Dorment; London, RA, 1986)

MARK STOCKER

Gilbert, Araceli (*b* Guayaquil, 13 May 1914). Ecuadorean painter. She studied in Santiago, Chile, at the Escuela de Bellas Artes (1936–9) and at the Escuela de Bellas Artes in Guayaquil, Ecuador (1942–3). Between 1944 and 1946 she studied with the French Purist Amédée Ozenfant in New York. During this period her work changed considerably, with flatter forms organized in synthetic, chromatic planes (e.g. *Composition with Masks*, 1947; Quito, priv. col.). Her contact (1950–52) as a studio assistant with Jean Dewasne and Edgar Pillet (*b* 1912), co-directors of the Atelier d'Art Abstrait in Paris, was decisive, as was her involvement with Auguste Herbin. In her one-woman show in 1953 at the Galerie Arnaud in Paris, she presented mature work: the violent colours on large surfaces were sensual and balanced by their rational abstraction; she adopted the square patterns of Mondrian with no restriction on the use of colour. From 1955, however, when she exhibited at the Museo Nacional de Arte Colonial in Quito, Ecuador, her work became abstract in the tradition of *Art informel*, breaking with rigid geometry, incorporating organic elements and creating illusions of volume within carefully controlled movement (e.g. *Variations in Red*, 1955; Guayaquil, priv. col.); with works such as this she pioneered the style of *Art informel* in Ecuador, breaking the dependence on Indigenism that had been so dominant. In the 1960s the spaces in her works became larger and the geometric treatment became more complex, as in *Requiem for Sidney Beche* (1965; Guayaquil, priv. col.). In the following decade she incorporated more rectilinear elements while maintaining the strength of her tropical colours.

BIBLIOGRAPHY

Abstract Currents in Ecuadorian Art (exh. cat. by J. Barnitz, New York, Cent. Inter-Amer. Relations, 1977), pp. 15-19
J. Barnitz: *Latin American Artists in the US before 1950* (New York, 1981)

ALEXANDRA KENNEDY TROYA

Gilbert, Cass (*b* Zanesville, OH, 24 Nov 1859; *d* Brockenhurst, Hants, 17 May 1934). American architect. He belonged to a group of turn-of-the-century architects who developed an American interpretation of the French Beaux-Arts tradition. He did not rigidly follow Beaux-Arts doctrine, however, choosing instead to support the American Academy in Rome, adopting the point of view of his mentors McKim, Mead & White and Daniel H. Burnham. Gilbert's work following the World's Columbian Exposition (Chicago, 1893) is characterized by its Beaux-Arts monumentality and its reliance on diverse contemporary and historical precedents. He drew on their stylistic associations to forge powerful architectural images for institutional and corporate patrons.

The son of a land surveyor, Gilbert began his architectural career in 1876 as a draughtsman for Abraham Radcliffe in St Paul, MN. In 1878 he enrolled at the Massachusetts Institute of Technology, Cambridge, then under the direction of William Robert Ware, who had modelled its design curriculum on that of the Ecole. Gilbert toured England, France and Italy the following year and sketched the composition, motifs and ornament of major buildings, an activity that inspired him as a designer and continued throughout his career. In 1880 he entered the office of McKim, Mead & White in New York, working on domestic projects under Stanford White until 1882, when he returned to St Paul.

After acting briefly as McKim, Mead & White's Western representative, Gilbert formed a partnership with James Knox Taylor (1857–1929) in 1884. Gilbert's practice followed the path forged by the McKim, Mead & White office, although he was aware of the CHICAGO SCHOOL. His design for the Charles P. Noyes house (1889) in St Paul, for example, resembles that by Charles McKim for the H. A. C. Taylor house, Newport, RI (1883–5; destr. 1952). When Gilbert's partnership with Taylor was dissolved in 1891, he explored the possibility of forming a partnership with Burnham, as a successor to John Wellborn Root, but the association did not materialize.

In 1895 Gilbert won national recognition with his design for the Minnesota State Capitol (completed 1903) in St Paul. Inspired by the Capitol in Washington, DC, and McKim, Mead & White's Rhode Island State House in Providence, it has a dome modelled on that of St Peter's in Rome, a projecting entrance pavilion adapted from Richard Morris Hunt's triple-arched entrance façade for the Metropolitan Museum of Art in New York and wings resembling Anges-Jacques Gabriel's extensions to Versailles. Gilbert skilfully assembled these elements in an excellently proportioned composition. The Capitol's programme of allegorical decoration illustrates the themes of culture and progress with works such as the mural *The Civilization of the Northwest* by Edward Simmons (1852–1931) and Daniel Chester French's sculpture *The Progress of the State* (both *in situ*).

Gilbert's next major opportunity to define an institutional image with architecture and art arose with his commission for the US Custom House (1899–1906) at the foot of Broadway in Lower Manhattan, New York, which he secured after moving his office to that city. Its façade recalled recent Parisian public buildings in the ornamental detailing of its entablature and window surrounds and the planar rustication of its base. The sculptural decoration, designed to represent the role of the port of New York in the nation's emergence as a commercial power, includes French's *Four Continents* (*in situ*).

Gilbert's plan for Washington, DC (1900), foreshadowed the McMillan Plan (1901–2) and exemplifies his espousal of the ideals of the City Beautiful, although not on so grand a scale as Burnham. For the Minnesota Capitol he designed three monumentally scaled approaches to the building (1903–6, unexecuted). He also proposed a plan for the centre of New Haven, CT (1907–10, unexecuted), as part of a large-scale project prepared with Frederick Law Olmsted, in which two broad avenues would connect the historic green with a new civic centre and a new railway station. Gilbert's campus plans, including the University of Minnesota (1908) in St Paul, the University of Texas (1909–14) in Austin and Oberlin College (1912), OH, are influenced by City Beautiful aesthetic principles. The campus buildings, however, often allude to local heritage and culture; the composition of the library at the University of Texas (1910) is influenced by the Lonja at Saragossa, Spain, and shows Spanish sources in its detailing.

Although Gilbert believed public buildings should employ classical precedents, he thought that modern building types, such as the skyscraper, railway station and bridge, could reflect their uses and construction. This assumption was based on his knowledge of the functionalism associated with the Chicago school, which he included in his repertory of available sources and styles. Gilbert's design for the US Army Supply Base in Brooklyn, New York (1918–19), has bold, unornamented concrete masses suitable for its utilitarian purpose. His designs for the West Street Building (1905–7) and the Woolworth Building

Cass Gilbert: Woolworth Building, New York, 1910–13

(1910–13; see fig.), both in Manhattan, express structure with soaring verticals of ivory-coloured glazed terracotta, set off by darker spandrels, that culminate in efflorescent Gothic ornament.

The Woolworth Building, at 233 Broadway, facing City Hall Park, was conceived by its patron Frank Woolworth both as a profit-producing skyscraper and as the administrative capital of an empire of five-and-dime stores. Gilbert based the building's composition on the Late Gothic city hall of the Low Countries, a type with both commercial and civic associations, and selected its motifs and ornament from High Gothic and Flamboyant cathedrals. At the time of its completion the tallest building in the world (241.4 m), it has an interior that rivalled contemporary ecclesiastical interiors, and which is notable for its monumental cross-shaped arcade, Byzantine in inspiration, ornamented with the mural paintings *Labour* and *Commerce* by Carl Paul Jennewein (1890–1978).

Gilbert's career after World War I can be interpreted as a conservative reaction to the modernistic tendencies increasingly discernible in American architecture. After the death of his colleagues, McKim (in 1909), White (1906) and Burnham (1912), he continued to uphold during the inter-war years the vision of architecture they once shared. As architect, with the engineer Othmar H. Ammann, of the only bridge to span the Hudson River at Manhattan, the George Washington Bridge (1927–31), Gilbert unsuccessfully advocated encasing its open steel towers with a sculpted granite veneer, to evoke the solidity of stone. His Supreme Court Building (1928–35) in Washington, DC, influenced by Theophil van Hansen's Parliament Building in Vienna, is replete with allegorical sculpture and inscriptions concerning justice and the law, is deliberately historicist, and among the last of such classical monuments erected near Washington's Mall.

WRITINGS

with F. L. Olmsted: *Report of the New Haven Civic Improvement Commission* (New Haven, 1910)

BIBLIOGRAPHY

M. Schuyler: *The Woolworth Building* (New York, 1913)
R. A. Jones: *Cass Gilbert, Midwestern Architect in New York* (diss., Cleveland, OH, Case W. Reserve U., 1976)
P. A. Murphy: *The Early Career of Cass Gilbert, 1878 to 1895* (thesis, Charlottesville, U. VA, 1976)
C. McMichael: *Paul Cret at Texas* (Austin, 1983)
G. Blodgett: 'Cass Gilbert, Architect: Conservative at Bay', *J. Amer. Hist.*, lxxii (1985), pp. 615–36
S. Irish: *Cass Gilbert's Career in New York, 1899–1905* (diss., Evanston, IL, Northwestern U., 1985)
G. Fenske: *The 'Skyscraper Problem' and the City Beautiful: The Woolworth Building* (diss., Cambridge, MA, MIT, 1988)

Gilbert, C(harles) P(ierrepont) H(enry) (*b* New York, 29 Aug 1860; *d* Pelham Manor, NY, 25 Oct 1952). American architect. He attended Columbia University, New York, and studied architecture at the Ecole des Beaux-Arts in Paris. In the mid-1880s he established an architectural office in New York after briefly practising in the new mining towns of Arizona and California. Gilbert's early work reflected contemporary Richardsonian Romanesque and Shingle style tendencies, but it soon exhibited the historical authenticity favoured by leading New York architects, many of whom also trained at the Ecole des Beaux-Arts, such as Richard Morris Hunt, McKim, Mead

& White, and Carrère & Hastings. Gilbert's practice consisted predominantly of the luxurious city and country houses he designed for wealthy patrons in New York's Upper East Side. The styles of these houses varied, but Gilbert was especially known for his 'French Renaissance' city houses, which resembled the châteaux of the Loire Valley. These he designed for the corporate executive Isaac D. Fletcher (1899; 2 East 79th Street, corner of Fifth Avenue), the investment banker Felix M. Warburg (1908; 92nd Street and Fifth Avenue) and the entrepreneur Frank W. Woolworth (1901; 80th Street and Fifth Avenue, destr. 1925). A later design by Gilbert, the investment banker Otto Kahn's mansion (1918; 91st Street and Fifth Avenue), was based on the Palazzo della Cancelleria in Rome. It resembled McKim, Mead & White's earlier Villard Houses (1882–5) but showed an even greater archaeological exactitude. Gilbert also received commissions for row houses, including the 'French Renaissance' E. C. Converse house (1900; 3 East 78th Street) and the 'Georgian' Harvey Murdock house (1901; 323 Riverside Drive). Although he specialized in houses, Gilbert occasionally designed commercial buildings, including the 13-storey Italian Savings Bank Building (1925) in Manhattan's Lower East Side.

For an illustration of Gilbert's houses in Brooklyn *see* NEW YORK, fig. 2.

BIBLIOGRAPHY

'Some Designs by C. P. H. Gilbert', *Archit. Record*, ix/2 (1899), pp. 165–72
S. B. Landau: 'The Row Houses of New York's West Side', *J. Soc. Archit. Hist.*, xxxiv/1 (1975), pp. 19–36
R. A. M. Stern, G. Gilmartin and J. M. Massengale: *New York 1900* (New York, 1983), pp. 316, 321, 325
J. Tauranac: *Elegant New York* (New York, 1985), pp. 60–63, 181–3, 216–18, 222–5

GAIL FENSKE

Gilbert, Emile(-Narcisse-Jacques) (*b* Paris, 3 Sept 1793; *d* Paris, ?25 Oct 1874). French architect. He was the leading designer of utilitarian buildings in France in the mid-19th century. As a strong believer in the social purpose of architecture, he devoted his career to improving living conditions through his soberly rational yet classicist designs for prisons, asylums and hospitals. Opposed to the fashionable and decoratively eclectic classicism of Charles Percier and Pierre-François-Léonard Fontaine and their followers, Gilbert and his work influenced both contemporary Neo-classicists (e.g. Guillaume-Abel Blouet) and Romantics (e.g. Henrie Labrouste).

As a youth Gilbert was torn between following his father as an architect and pursuing his strong interest in mathematics. In 1811, aiming for a career in engineering, he entered the Ecole Polytechnique, Paris, where he studied under Jean-Nicolas-Louis Durand. Durand's courses on architecture, which taught engineering students a classically inspired but functional system of composition, returned Gilbert's interest to architecture and defined the basis of his later rationalism. In 1813 Gilbert switched to the Ecole des Beaux-Arts, Paris, as a student of Barthélemy Vignon (1762–1846), and he won the Prix de Rome in 1822 with a project for an opera house that was strongly influenced by Durand. His period of study (1823–7) at the Académie de France in Rome, which overlapped with

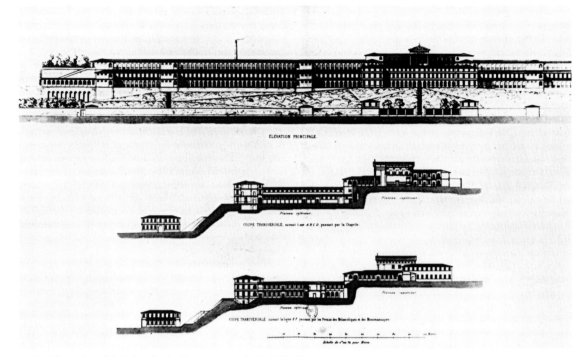

ÉLÉVATION PRINCIPALE

COUPE TRANSVERSALE suivant l'axe A B C D passant par la Chapelle

COUPE TRANSVERSALE suivant la ligne E F passant par le Presu des Épileptiques et des Rhumatismaux

Emile Gilbert: plan of Asile des Aliénés, Charenton, near Paris, 1838–45

those of both Blouet and Labrouste, was marked by a Romantic ferment among the students, yet Gilbert's fourth-year *envoi*, a restoration study (1826) of the so-called Temple of Jupiter at Ostia, was conservative and conventional. After his return to Paris, Gilbert served as the Premier Inspecteur des Travaux under Blouet on the completion (1832–6) of the Arc de Triomphe in Paris (begun 1806 by Jean-François-Thérèse Chalgrin).

In 1836 Gilbert and Jean-François-Joseph Lecointe (1783–1858) were appointed as joint architects for the Prison de la Nouvelle Force (Prison Mazas; 1843–50; destr. 1898) in Paris. Based on the leading contemporary theory of penal reform (*see* PRISON), the building adapted Jeremy Bentham's (1748–1832) semicircular Panopticon to a radial plan of six wings (each containing 210 cells on three floors) that spread in a fan shape from a central observation hall. It also embodied the 'separation' system of solitary confinement that was initiated in John Haviland's Eastern State Penitentiary (1821–5), Philadelphia, PA, which was praised in the reports of two French study missions to the USA (G. de Beaumont and A. de Tocqueville: *Notes sur le système pénitentiaire* and *Système pénitentiaire aux Etas-Unis et de son application en France*, Paris 1831 and 1833; and F.-A. Demetz and G.-A. Blouet: *Rapports . . . sur les pénitenciers des Etats-Unis*, Paris, 1837). Although the Prison de la Nouvelle Force was anticipated in France by the pseudo-panopticon design of Louis-Hippolyte Lebas's Prison de la Roquette ('La Petite Roquette'; 1825–36), Paris, Gilbert and Lecointe were more directly guided by the reports, particularly that of Blouet, with whom they consulted. The prison's plan permitted the supervision of all the cell blocks from the central hall, while the system of individual cells sought to

reform the criminal without the use of physical punishment: isolation in comfortable and hygienic cells, with heating, ventilation, running water and a lavatory, was supposed to allow the inmates to reflect and repent.

Equivalent reforms led to Gilbert's commission to build the new Asile des Aliénés (1838–45) at Charenton, near Paris. The asylum was laid out on a hillside as two terraced wings that extended to either side of a central courtyard through a series of pavilions (see fig.). These were linked by colonnades around secondary courts that opened to views of the countryside. Men and women were segregated to either side of the central courtyard, and the insane were further segregated in the various pavilions. In his design Gilbert was scrupulously faithful to a new theory about the nature and treatment of insanity developed by Jean-Etienne-Dominique Esquirol (1772–1840), who was the leading French alienist and chief physician of the Charenton asylum from 1826. The open courts and the use of deep moats instead of walls to isolate the asylum answered Esquirol's belief in the therapeutic value of peaceful and unconfined surroundings in the treatment of insanity (*see* ASYLUM). At the same time, the asylum's modular grid plan was inspired by Durand's teachings, as was the austerely classical vocabulary, culminating in the Greek Doric chapel in the central courtyard.

In 1853 Gilbert was elected to the Académie des Beaux-Arts; he ran the Blouet *atelier libre* from 1853 to 1855 and served as president of the Société Centrale des Architectes Français from 1854 to 1857. His appointment (1860–69) as one of the four chief architects of Paris overlapped with three more utilitarian projects. In 1855 he became the architect of the Prefecture of Police in Paris, which was designed and built (1862–76) in the wake of police reforms

in collaboration with Arthur-Stanislas Diet, Gilbert's son-in-law, who took over its construction in 1869. In 1861–3 Gilbert built the Nouvelle Morgue (destr. 1914) in Paris, and in 1864 he designed the new Hôtel Dieu, Paris, which was built by Diet in 1865–76. Hospital reforms, including a belief in the hygienic value of ample ventilation (*see* HOSPITAL, §1), influenced this design, which was also indebted to Durand in both its classical vocabulary of arcaded courts and its tripartite modular subdivision of the square plan. The hospital, however, revealed the limitations of Gilbert's rational classicism. The design's majestic regularity proved functionally inadequate even before the building's completion, and it had to be modified by Diet (*see* DIET, ARTHUR-STANISLAS). By the mid-1860s an exhausted Gilbert increasingly delegated the responsibilities of his practice to Diet and he retired in 1870.

BIBLIOGRAPHY
Bauchal; Bellier de La Chavignerie—Auvray
P. Abadie: 'Notice sur M. Gilbert', *Institut de France. Académie des beaux-arts* (Paris, 1876)
E. Delaire, D. de Penanrum and F. Roux: *Les Architectes élèves de l'Ecole des beaux-arts* (Paris, 1895, rev. 2/1907)
L. Hautecoeur: *Architecture classique*, vi (1955); vii (1957)
B. Foucart: 'Architecture carcérale et architectes fonctionnalistes en France au XIXe siècle, *Rev. A.* [Paris], xxxii (1976), pp. 37–56
R. Middleton and D. Watkin: *Neoclassical and 19th Century Architecture* (New York, 1980), pp. 219–23
W. Szambien: *Jean-Nicolas-Louis Durand, 1760–1834: De l'imitation à la norme* (Paris, 1984), pp. 137–8
D. van Zanten: *Building Paris: Architectural Institutions and the Transformation of the French Capital, 1830–1870* (Cambridge, 1994)

CHRISTOPHER MEAD

Gilbert, Sir John (*b* Blackheath, 21 July 1817; *d* Blackheath, 5 Oct 1897). English illustrator and painter. While articled to his father's estate agency for two years, he spent his time sketching City of London costumes and liveries and regimental uniforms. This meticulous historical knowledge helped when he became a full-time artist in 1836, exhibiting oils at the Royal Society of British Artists and the British Institution, both in London. From 1842 he was the first artist to contribute historical scenes to the *Illustrated London News*, making a total of 30,000 illustrations in 40 years. Gilbert found ample employment in book illustration, his classical draughtsmanship being ideal for such publications as Howard Staunton's *Shakespeare* (1856–60). He began to paint in watercolour in 1851, developing mastery as a colourist and in working on a large scale; he was elected to the Old Water Colour Society in 1854 and was its President in 1871. He became an ARA in 1872 and an RA in 1876. Gilbert's paintings, such as *Arrival of Cardinal Wolsey at Leicester Abbey, 1530* (1891; London, V&A), are faultlessly executed and imaginative but their historical content seems heavily Victorian. He had immense prestige in his lifetime and was among the highest paid illustrators.

BIBLIOGRAPHY
M. Hardie: *Watercolour Painting in Britain*, iii (London, 1968), pp. 94–6

SIMON HOUFE

Gilbert, John Graham. *See* GRAHAM-GILBERT, JOHN.

Gilbert, (Charles) Web(ster) (*b* Cockatoo, Victoria, 18 March 1867; *d* Melbourne, 27 Sept 1925). Australian gcsculptor. After inauspicious beginnings and apprenticeship to a pastry cook, Gilbert was led, through his skill in modelling cake decorations, to attend part-time drawing classes at the National Gallery School, Melbourne (1888–91). He also enrolled in night classes at the Victorian Artists' Society, where he found sympathetic encouragement from the sculptor Charles Douglas Richardson (1853–1932). At that time there was no instruction available in the traditional techniques of sculpture so Gilbert taught himself, continuing to earn his living as a chef at a fashionable Melbourne restaurant. In 1914, aged 47, Gilbert left for London to see the work of the great European sculptors of the past, but the outbreak of World War I only weeks after his arrival left him stranded in England. Too old for either military service or art school, he went on working at his sculpture, submitting it each year to the Royal Academy exhibitions. In 1917 his marble bust *The Critic* was purchased for the Tate Gallery under the terms of the Chantrey Bequest, and *The Sun and the Earth* (Melbourne, N.G. Victoria) was exhibited at the Royal Academy in 1918. His finest work in marble, it clearly reveals his debt to Rodin and to late 19th-century English sculpture.

When Gilbert returned to Australia in 1920 he found himself in great demand as a sculptor of war memorials, the two most important being a bronze memorial to the Australian Imperial Forces, 2nd Division, commissioned in 1920 for Mont St Quentin, near Péronne, Somme (destr. World War II), the other the bronze ANZAC Light Horse memorial, commissioned in 1923, at Port Said Public Gardens, Egypt. Gilbert established himself as one of the leading Australian sculptors immediately following World War I. His output was small and limited in scope, which is not surprising given his time-consuming work as a chef, the interruptions of war and the fact that the large demand for war memorials precluded the production of more creative work. Gilbert's large bronze memorial to the explorer Matthew Flinders, which stands outside St Paul's Cathedral, Melbourne, was unveiled a month after his death.

BIBLIOGRAPHY
A. McCulloch: *Encyclopedia of Australian Art*, i (Melbourne, 1968), p. 497
G. Sturgeon: *The Development of Australian Sculpture, 1788–1975* (London, 1978), pp. 80–85
K. Scarlett: *Australian Sculpture* (Melbourne, 1980), pp. 215–22

GRAEME STURGEON

Gilbert and George. British sculptors. Gilbert Proesch (*b* Dolomites, Italy, 17 Sept 1943) and George Passmore (*b* Plymouth, Devon, 8 Jan 1942) met in 1967 as students at St Martin's School of Art in London. By 1969 they were reacting against approaches to sculpture then dominant at St Martin's, which they regarded as elitist and poor at communicating outside an art context. Their strategy was to make themselves into sculpture, so sacrificing their separate identities to art and turning the notion of creativity on its head. To that end Gilbert and George became interchangeable cyphers and their surnames were dispensed with.

Although working in a variety of media, Gilbert and George referred to all their work as sculpture. Their early work took the form both of what they called *Postal*

Sculptures and work in which they presented themselves as 'living sculptures'. One early *Postal Sculpture* (1969; see Jahn, p. 86), consisting of a drawn image of themselves looking out of their window at falling snow, accompanied by a text ('as we began to look we felt ourselves being taken into a sculpture of overwhelming purity life and peace a rare and new art-piece'), was typical in taking quotidian banality as the stuff of art. A similar equation between their art and their life was proposed in other 'living sculptures', such as *Our New Sculpture* (1969), *Underneath the Arches* (1969) and the *Red Sculpture* (1975), which focused attention on their own stylized actions and on their image as old-fashioned gentlemen. Between 1970 and 1974 they also made drawings (referred to as *Charcoal on Paper Sculptures*) and paintings to give a more tangible form to their identity as 'living sculptures'. These are competent yet awkward and manifestly unartistic in execution, drawn from projections of photographic images as part of their consistent rejection of traditional techniques.

In 1971 Gilbert and George made their first 'photo-pieces', which remained their dominant form of expression. The earliest of these consisted of small fragments of black-and-white photographs arranged in irregular patterns, such as *Balls or the Evening before the Morning after* (1972; London, Tate), in which the theme of drunkenness is embodied in the disjointed oval form in which the elements are placed. By 1974 they were working on a larger scale, with areas of flat colour and with the elements more formally regimented in grid patterns. Although continuing to feature themselves and a cross-section of men from their society, they gradually shifted the emphasis of their subject-matter away from their own experiences of life. Instead they concentrated on the inner-city reality that confronted them on the street and on the structures and feelings that inform life (e.g. *Death, Hope, Life, Fear*, 1989; London, Tate), such as religion, class, royalty, sex, hope, nationality, death, identity, politics and fear. Their belief that they are making an 'Art for Life's Sake' and an 'Art for All' was, at the beginning of the 1990s, given a renewed emphasis through their exhibitions mounted in Moscow (1990), Beijing and Shanghai (1993) as well as by the tour of their 'Cosmological Pictures' to ten cities within eastern and western Europe (1991–3). These exhibitions underline their belief that art can still positively break down barriers between people and open up society to new ways of thinking about the world.

See also Erotic art, fig. 9.

BIBLIOGRAPHY
C. Ratcliff: *Gilbert & George: The Complete Pictures, 1971–1985* (London, 1986)
W. Jahn: *The Art of Gilbert & George* (London, 1989)

ANDREW WILSON

Gilbert Islands. *See* Kiribati.

Gilcrease, (William) Thomas (*b* Robeline, LA, 8 Feb 1890; *d* Tulsa, OK, 6 May 1962). American oil magnate, patron and collector. He started the Gilcrease Oil Company in 1922 on land he had received in the Indian land allotments before the creation of the State of Oklahoma in 1907. With the profits from his company Gilcrease began collecting material relating to the development of American culture in the late 1930s. Of partly Indian descent, he felt he owed a debt to the Indian heritage that had allowed him to obtain his wealth. He therefore specialized in collecting the art of the American West, acquiring over 200 works each by George Catlin, Alfred Jacob Miller and Thomas Moran. At the time of his death Gilcrease owned over 10,000 works of art (paintings, drawings, prints and sculpture) by over 400 American artists, spanning 500 years. The art collections were supplemented by large anthropological and archival sections. In 1955 Gilcrease deeded his collection to the City of Tulsa. He eventually gave the museum building and the acreage surrounding it, so as to form the Thomas Gilcrease Institute of American History and Art.

BIBLIOGRAPHY
A. B. Saarinen: *The Proud Possessors* (London, 1959), pp. 307–25

ANNE ROBERTS MORAND

Gild. *See* Guild.

Gil de Hontañón. Spanish family of architects. They were important in the change from Gothic to Renaissance architecture in 16th-century Spain, working mainly in Castile. (1) Juan Gil de Hontañón (i) linked the Hispano-Flemish (Isabelline) style of Late Gothic to the beginnings of Plateresque, which was further developed by his son (2) Juan Gil de Hontañón (ii). Another, illegitimate, son (3) Rodrigo Gil de Hontañón is regarded as particularly representative of Spanish Renaissance architecture.

(1) Juan Gil de Hontañón (i) (*b* ?Carasa, Cantabria, *c*. 1480; *d* Salamanca, 11 May 1526). From his early youth he lived in Rascafría, Madrid, and he may have worked under the direction of Juan Guas on the building of the Paular convent, a Hispano-Flemish building that has many links with the monastery of El Parral, Segovia. In 1500 he was working on a portal at Sigüenza Cathedral. In 1503 he designed S Antolín, Medina del Campo (Valladolid). This is a hall church, a type that became popular in the 16th century.

During the first decade of the 16th century, Juan was Master Mason of Palencia Cathedral; in 1508, thanks to the intervention of the bishop, he was granted a royal pardon for his part in the death of Andrés de Segovia. During this period, he worked on S Clara, Briviesca (Burgos), where he followed the model of the Capilla del Condestable in Burgos Cathedral; the parish church of Coca is also attributed to him because its trefoil plan is based on that of El Parral.

After the lantern of Seville Cathedral collapsed in 1511, Juan was appointed Master of the Works until 1517, rebuilding the destroyed parts and planning a new transept in 1513. He also advised on the construction of the Capilla Real at Granada; and from 12 May 1513 until his death he directed work on the New Cathedral in Salamanca, having already contributed to preparations for the architects' meeting there in 1512. In 1521 he contributed to the design of a chapel for Dean Cepeda in S Francisco, Zamora (destr.), and he also worked on the plans for the new cathedral in Segovia, which his son Rodrigo took over on his death (*see* Segovia, §2(ii)).

Juan's work establishes the link between the Hispano-Flemish style of Toledo and the beginning of the Plateresque style in Salamanca, though he himself continued to work in the Gothic style.

(2) Juan Gil de Hontañón (ii) (*fl* 1521–31). Son of (1) Juan Gil de Hontañón (i). He was a pupil of his father and later collaborated with him. He is documented at the New Cathedral of Salamanca from 1521 and he was Master Mason there from 1526 to 1531. Since he worked with his brother Rodrigo, his personality has been somewhat overshadowed, but it is presumed that he contributed to the buildings directed by Juan de Alava in Santiago de Compostela. In Salamanca, the convent of Sancti Spiritus, with its fine Plateresque façade, is attributed to him.

(3) Rodrigo Gil de Hontañón (*b* Rascafría, Madrid, Feb 1500; *d* Segovia, 31 May 1577). Son of (1) Juan Gil de Hontañón (i).

1. LIFE AND ARCHITECTURAL WORK. He was the most prolific architect of his time in Castile, whether in providing plans, directing operations or giving information about them. In the first phase of his career he followed the Hispano-Flemish style of his father, but from *c.* 1533 he introduced Italian Renaissance forms, particularly in his civil architecture, which led to his becoming Master of the Works at the cathedrals of Segovia, Palencia, Plasencia and Astorga, Master Mason at the New Cathedral of Salamanca and the most prominent architect of the Spanish Renaissance.

From 1521 to 1529 Rodrigo was working, initially with his father, at Segovia Cathedral. At the same time he worked on the Colegio Fonseca, Salamanca, and he was employed at the beginning of work on the Colegiata in Valladolid, where he became Master of Works in 1537. He also worked on the parish church of S Sebastián, Villacastín, on the chapel of Dean Cepeda, Zamora (destr.), and on the church in Mota del Marqués (Valladolid), where his contribution to the palace of Don Rodrigo de Ulloa was recorded in 1541. During the 1530s, he was employed at several other churches and, at Santiago de Compostela, on the cathedral cloister and the courtyards of the Hospital Real. In 1538 he was appointed Master at Salamanca Cathedral; in collaboration with Fray Martín de Santiago, he also began work on the Palacio de Monterrey, Salamanca, one of the most characteristic buildings of 16th-century classicism in Spain (see fig.), and on the Casa de la Salina. At the same time he worked on S Esteban, Salamanca, and on the façade of Alacalá de Henares University, where he probably designed the Patio Trilingue.

In 1541 Rodrigo was appointed Master of the Works at Palencia Cathedral, a post that, from 1544, he held concurrently with that of Plasencia Cathedral, while he also built the churches of Santa Cruz, Medina de Rioseco, and Santiago, Cáceres. In 1553 he became Master of the Works at Astorga Cathedral, with which he was connected until 1559. During this period he also worked on the church of La Magdalena in Medina del Campo and, in 1562, designed the municipal slaughterhouse. In 1559 he designed the magnificent Palacio de los Guzmanes in León

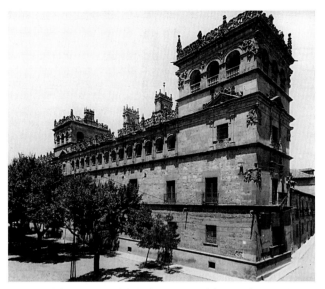

Rodrigo Gil de Hontañón: Palacio de Monterrey, Salamanca, begun 1538

and, the following year, was nominated Master of the Works of Segovia Cathedral, where he was buried.

During the last phase of his life Rodrigo contributed to the Colegio de Santiago (or Colegio del Rey) in Salamanca, the towers of S Hipólito de Támara in Fuentes de Nava and Oviedo Cathedral. He also contributed to the churches of La Magdalena and S Benito in Valladolid, the latter with a monumental portico, Los Sanos Juanes in Nava del Rey and, probably, S Luis at Villagarcía de Campos.

2. WRITINGS. In 1681 the Salamanca architect Simón García completed his *Compendio de arquitectura y simetría de los templos conforme a la medida del cuerpo humano* (Madrid, Bib. N., MS. no. 8884), which includes much of a manuscript by Rodrigo Gil de Hontañón; the latter was in turn inspired by the work of Rodrigo's father, Juan Gil de Hontañón (i). This was made clear by Simón García himself. This text, which is of fundamental importance for the knowledge of technical and aesthetic aspects of 16th-century Spanish Gothic architecture (*see* MASON (i), §IV, 4), is divided into 76 chapters, which, except for the chapter dealing specifically with the New Cathedral of Salamanca, provide rules for the design and construction of the different parts of a building. It also includes a mathematical justification for the proportions not only of a building as a whole but also of its different elements. Many drawings are included, a considerable number of which are attributed to Rodrigo. Ideas of proportion were based on proportions of the human body, which were used to determine the beauty and perfection of the various architectural elements. The ideas were based on Vitruvian concepts, to which there are references.

The module for the measurements of a church is based on the human face, which is divided into 3 parts, each of which is subdivided into 4 sections. The human figure as a whole is equivalent to 10 faces, divisible into 120 facial quarters. This determines that the chancel of the church corresponds to 15 quarters, 3 of which correspond to the thickness of the wall and supports, leaving 12 for the open

space. In the same way the text specifies that the nave corresponds to the body, the transepts to the length of the arms, and the niches at the far ends to the forearms. The interior space of the side chapels reflects the palm of the hand, while the wall and supports correspond to the length of the fingers. Following these proportions, if the central vessel measures 30 units, the aisles will each measure 15 and the chapels between the supports $7\frac{1}{2}$. This proportion varies for geometric reasons and 'not for reasons related to the human body'; in churches that have 5 aisles, if the main nave measures 9 units, then the two inner aisles must measure 6 and the outer ones 4, in accordance with the chosen proportions. Thus, a church measuring 160 m in length must be 80 m wide, 40 m of which correspond to the central vessel while the two aisles each measure 20 m. Its height must be midway between 80 m, the total width, and 40 m, the width of the nave (i.e. 60 m).

The principle that the main vessel should be equal in height to the total width of the church is fundamental. The design should also incorporate aisles of equal height in order to counter pressure and suppress the need for flying buttresses, thus opening the way to the characteristic columnar hall church of the 16th century. A chapter of special interest is the one devoted to towers, which 'signify a complete body without the arms', determining that they must measure 2 faces in width and 10 in height, allowing a third for the depth of the foundations. Other chapters specify rules for the design and proportions of the piers, supports etc and rib vaults, where a distinction is drawn between the supporting elements (the ribs) and the supported (the webs), as well as many other widely differing considerations in praise of precise scientific knowledge used to obtain fine and valid architecture.

See also VITRUVIUS, §1.

BIBLIOGRAPHY

S. García: *Compendio de arquitectura y simetría de los templos conforme a la medida del cuerpo humano* (1681; Madrid, Bib. N., MS. no. 8884); facs. ed. (Salamanca, 1941)
W. Ortiz de la Torre: 'Arquitectos montañeses: Juan y Rodrigo Gil de Hontañón', *Bol. Bib. Menéndez Pelayo*, v (1923), p. 215
——: *Juan y Rodrigo Gil de Hontañón* (Santander, 1927)
G. Weise: 'Die Hallenkirchen der Spätgotik und der Renaissance in mittleren und nordlichen Spanien', *Z. Kstgesch.*, n.s., iv (1935), pp. 214–27
J. Camón Aznar: 'La intervención de Rodrigo Gil en el manuscrito de Simón García', *Archv Esp. A.*, xiv (1940–41), pp. 300–05
E. Ortiz de la Torre: 'Sobre los arquitectos Juan y Rodrigo Gil de Hontañón y Juan de Rasines', *Archv Esp. A.*, xiv (1941), pp. 315–17
J. Camón Aznar: *La arquitectura plateresca*, 2 vols (Madrid, 1945)
F. Chueca Goitia: *La catedral nueva de Salamanca* (Salamanca, 1951)
M. Pereda de la Reguera: *Rodrigo Gil de Hontañón* (Santander, 1951)
F. Chueca Goitia: *Arquitectura del siglo XVI*, A. Hisp., vii (Madrid, 1952), pp. 369–84
G. Weise: *Alt- und Neukastilien*, i of *Spanische Hallenkirchen der Spätgotik und der Renaissance* (Tübingen, 1953)
M. Villalpando: 'Orígenes y construcción de la catedral de Segovia', *Estud. Segov.*, xiv (1962), pp. 391–408
C. Chanfon Olmos: *Simón García: Compendio de arquitectura y simetría de los templos* (Churubusco, 1979)
M. A. Castilla Oreja: *Colegio mayor de San Ildefonso de Alcalá de Henares: Génesis y desarrollo de su construcción* (Madrid, 1980)
A. Bustamante: *La arquitectura clasicista del foco vallisoletano, 1541–1560* (Valladolid, 1983)
J. D. Hoag: *Rodrigo Gil de Hontañón en la arquitectura española del siglo XVI* (Madrid, 1985)

JOSÉ MARIA AZCÁRATE RISTORI

Gildemeester, Jan (Jansz.) (*b* Lisbon, 1744; *d* 1799). Dutch merchant and collector. His father, Jan Gildemeester the elder (1705–79), was a merchant and Consul-General in Lisbon until *c.* 1755, when he returned to Amsterdam, where he set up a trading company with his sons Daniel and Jan the younger. As a wealthy trader and bachelor, Gildemeester the younger had the opportunity to build an important art collection. He began to collect paintings at an early age, from at least 1768, but he had acquired his first prints and drawings even earlier. In 1778 the Dutch Republic named him agent and Consul-General to Portugal, although he remained in Amsterdam. In 1792 he moved from the Keizergracht to the Herengracht in Amsterdam, where his extensive art collection had a setting worthy of it. Adriaan de Lelie's painting of the collection (1794–5; Amsterdam, Rijksmus.) gives an accurate record of the display of the paintings, which were spread all over the house. Gildemeester's taste followed the contemporary Dutch fashion: his collection included the best representatives of Dutch and Flemish 17th- and 18th-century art: works by Jan van Huysum (e.g. *Flowers in a Terracotta Vase*, 1736–7; London, N.G.), Adriaen van Ostade, David Teniers (ii), Rubens, Jan Steen, Philips Wouwerman, Adriaen van de Velde (e.g. *The Shepherdesses*, Windsor Castle, Berks, Royal Col.), Gerrit Dou, Gabriel Metsu, Adriaen van der Werff and Jan Wijnants. In addition, he owned Vermeer's *Astronomer* (Paris, Louvre). Gildemeester also collected many works by contemporaries, including Egbert van Drielst and Jan van Os (1744–1808). Gildemeester owned five works by Adriaan de Lelie, including a *Self-portrait in the Artist's Studio* (?Amsterdam, priv. col.). Juriaen Andriessen painted wall hangings commissioned by Gildemeester for his house. At his death, Gildemeester's collection, consisting of about 300 paintings, 31 art books and a folder of drawings and 14 portfolios of prints, including a collection of mezzotints by English engravers, was sold at auction. He was also an amateur draughtsman and copied flower- and fruit-pieces by such artists as Jan van Huysum.

BIBLIOGRAPHY

F. Lugt: *Ventes*, i (1938), 6102, 6156
C. J. de Bruyn Kops: 'De Amsterdamse verzamelaar Jan Gildemeester Jansz.', *Bull. Rijksmus.*, xiii (1965), pp. 79–114

J. A. VAN DER VEEN

Gilding. The decoration of works of art and architecture with gold or silver or other metals. Traditionally the term describes the application of thin sheets of metal to a surface by means of an adhesive; it is also possible to use the metal in powdered form.

I. Materials and techniques. II. Uses. III. Conservation.

I. Materials and techniques.

1. Leaf. 2. Powder. 3. Fire gilding.

1. LEAF.

(i) Types and application. The earliest application of gold as decoration was in Mesopotamia and in Predynastic Egypt. In gilded figures from Ur (dating from before 2500 BC) and from Egypt (*c.* 2400 BC), sheet gold was nailed to a wooden core, but by 1500 BC leaf gold was

being applied to a variety of materials, notably ivory (known as chryselephantine work; *see also* GREECE, ANCIENT, §IV, 1(iii)(g)). Silver leaf has been extensively used, both on its own and, covered with a golden yellow transparent coating, as a substitute for gold, despite the fact that it tarnishes. Written sources from as early as the late 3rd century AD describe the tinting of metals in imitation of gold, as well as the alloying of gold and silver with base metals. Gold may be naturally or deliberately coloured by the presence of traces of metals such as copper, iron or silver. These also alter its hardness. Gold leaf is obtained today in various shades and degrees of hardness, pure 24 carat gold being the softest. Tinted silver was widely used on polychrome sculpture, in interior decoration and on furniture, notably in 17th- and 18th-century Europe (*see* §II, 3 below). Tin leaf, which does not tarnish, was coloured to imitate gold in addition to being used alone. Leaf is also now produced from white gold, palladium and platinum; aluminium may be used as a cheap alternative.

A laminated leaf, resembling gold leaf, was made by placing a thin sheet of gold over a similar sheet of silver (or tin) and hammering the two together. The gold–silver laminate is known as *Zwischgold* (Ger.), *partijtgoud* (Dut.) or *or parti* (Fr.); according to Skaug (1993), the Italian *oro di metà* refers to the same material. Unlike pure gold leaf, however, it tarnishes, as the thin gold cannot protect the silver below. The gold–tin leaf was rather more robust than gold leaf and has been identified in 14th- and 15th-century Italian mural paintings (*see* §II, 1 below). Gold-coloured alloys used for leaf include the copper–zinc *Schlagmetall* ('beaten metal') or 'Dutch metal', used from the 19th century. The use of copper–tin alloy leaf (now blackened) has been reported in the frescoes (*c.* 1305) attributed to Giotto and his school in the Arena Chapel, Padua; this may correspond to the little-known *orpello* ('tinsel'), occasionally referred to in 14th- and 15th-century Italian documents.

The manual method of hammering gold into leaf is known as goldbeating (see fig. 1), and medieval European guild statutes indicate that it was a separate, although related, trade to that of goldsmiths and other workers in precious metals. Although the process was successfully automated in the 1920s, the basic procedure has remained essentially unchanged over the centuries. A small gold ingot is pressed between steel rollers to give a continuous ribbon 25μm thick and about 50 mm wide; 200 squares (50×50 mm) cut from it are interleaved with sheets of parchment 100 mm square; this pack or 'cutch', bound in parchment, is beaten until the gold extends to the edges of the parchment. The pieces are quartered and the process repeated. The gold is quartered again; 800 pieces are placed in a 'shoder' of goldbeater's skins (prepared from ox gut) and beaten, this procedure being carried out twice. Lastly, the leaf is beaten in a 'mould' of very thin skins, cleaned with calcined gypsum powder. It is cut, on a leather cushion, into pieces 80 mm square and inserted loose between sheets of rouged tissue into a book containing 25 leaves. According to Cennino Cennini, late 14th-century Italian goldbeaters could obtain 145 leaves, similar in size to modern leaf, from a Venetian ducat, which, at that time, weighed about 3.5 g. The thickness of such leaf can be

1. *The Goldbeater*, woodcut by Jost Amman from Hans Sachs: *Eygentliche Beschreibung aller Stände* (Frankfurt am Main, 1568) (London, British Library, fol. J. iv)

estimated to have been about 0.2μm (0.0002 mm). Modern leaf can be even thinner—*c.* 0.1μm if machine made, *c.* 0.05μm if hand beaten. At this thickness it is translucent, transmitting greenish light. Transfer gold leaf (patent gold) is loosely attached to sheets of tissue by pressing and can be used only for oil gilding. It was first made in strip form in the early 20th century, providing a more convenient format for gilding vehicles; in the 1930s a method of sputtering gold on to the waxed paper carrier was devised. Modern foil is manufactured by vaporizing the gold; the carrier film is polyester. It can be obtained with a brilliant metallic finish and is used extensively in manufacturing industries for gold decoration.

An artefact can be gilded using simple, unpigmented adhesives; the choice depends partly on the effect desired and the nature of the substrate. Resin-like substances and oil/resin varnish mixtures have been used for gilding textiles. In Japan, for example, gold or silver leaf was applied to cloth during the Momoyama period (1568–1600) using a technique copied from imported Chinese textiles (*see* JAPAN, §XI, 2(vi)). Such plant gums as gum arabic have been widely employed for gilding materials as diverse as ivory, wood, parchment and paper (*see* PAPER, DECORATIVE). Other simple adhesives have included beaten egg white (glair), used in manuscript illumination and for gilding leather (*see* §II, 5 below), and shellac, also used for the latter. The use of such other substances as garlic juice is recorded in historical sources.

Water gilding and oil or mordant gilding are the two main methods of applying gold leaf used, notably on easel and wall paintings, furniture and sculpture, since medieval times. Water gilding was certainly known in Europe by the early 12th century. This method is used where a shining burnished finish, imitating solid metal, is desired, for example in the gold backgrounds of icons and medieval altarpieces (*see* §II, 1 below) and in manuscript illumination. Gold applied using an oil mordant cannot be burnished, as the adhesive holds the gold too firmly; it therefore appears yellower and has a diffusely reflecting surface. This difference in appearance may be exploited by using both types of gilding in the same piece of work.

In water gilding the object is usually coated with several layers of gesso or chalk mixed with parchment size. When this is hard, it is scraped and polished to a perfectly smooth finish. A soft, slightly greasy, reddish-coloured clay, known as bole, mixed with dilute size, is then applied and, when dry, burnished or polished. A sheet of leaf is placed on a padded leather gilder's cushion, cut to size if necessary and picked up using a gilder's tip—a thin, flat, hair brush (see fig. 2; in medieval times, tweezers and card would have been used). The bole is moistened with water to which a little size may be added. The leaf is held above it, just touching the surface, and is sucked on to the bole by capillary action. It may be patted down afterwards if necessary. When the work is dry, the gold is burnished; modern burnishing tools are usually made of agate, but in earlier times haematite and even dogs' teeth were used.

For oil gilding a mordant, consisting principally of linseed oil heated with a lead drier, is used; frequently a natural resin varnish is also incorporated. The mordant may be pigmented (e.g. with yellow ochre), which not only enables the design seen on the surface to be decorated but may also help to disguise small flaws in the gilding. The mordant is painted on and left until tacky, when the gold is applied; this technique is used for delicate linear designs or lettering (*see* CHRYSOGRAPHY).

Gold and silver leaf were applied to, or encased in, glass to produce the gold and silver tesserae that profoundly influenced the character of post-Antique and medieval mosaics (*see* MOSAIC, §I, 2). According to medieval sources, such as the *Compositiones variae* (Lucca, Bib. Capitolare, MS. 490), the leaf was placed on a small thick sheet of glass, and covered with a very thin glass sheet and heated in a furnace until the glass began to melt; later sources suggest the use of powdered glass, giving a very thin surface layer. After cooling, the surface of the thinner glass was polished with emery powder or a similar abrasive. The slab was then broken into square tesserae. Variations in the appearance of the gold could be obtained by the deliberate use of brownish or greenish glass, rather than colourless, and by applying the tesserae upside down, with the thicker glass at the top.

See also GOLD, §2(iv).

BIBLIOGRAPHY
C. Cennini: *Il libro dell'arte* (MS.; *c.* 1390); ed. F. Brunello (Vicenza, 1971); Eng. trans. and ed. by D. V. Thompson, as *The Craftsman's Handbook:*

2. Water gilding tools and materials (from left to right, top): gilder's cushion, bole (in lump form and ground in dilute size solution); (from left to right, bottom): gold leaf, gilder's knife, gilders' tips (one cut from parchment)

The Italian 'Il libro dell'arte' (New Haven, 1933, *R*/New York, 1960), pp. 60–63, 79–89, 96–8, 100–04, 106–8, 112–13, 118–19

W. Lewis: *Commercium philosophico-technicum*, 2 vols (London, 1763–5), i, pp. 38–229

C. Singer, ed.: *A History of Technology*, 7 vols (Oxford, 1954–78), i, pp. 581–2, 623–62, 677; ii, pp. 174, 342–3

S. M. Alexander: 'Medieval Recipes Describing the Use of Metals in Manuscripts', *Marsyas*, xii (1964–5), pp. 34–51

C. S. Smith and J. G. Hawthorne: 'Mappae Clavicula: A Little Key to the World of Medieval Techniques', *Trans. Amer. Philos. Soc.*, n.s., lxiv (1974), pp. 3–122 [especially p. 48]

B. J. Sitch: 'Transferable Gold Coatings: Historical and Technical Aspects of their Development', *Gold Bull.*, xi (1978), pp. 110–15

E. D. Nicholson: 'The Ancient Craft of Gold Beating', *Gold Bull.*, xii (1979), pp. 161–6

P. MacTaggart and A. MacTaggart: *Practical Gilding* (Welwyn, 1984)

M. Matteini and A. Moles: 'Le tecniche di doratura nella pittura murale', *Le pitture murali: Tecniche, problemi, conservazione*, eds C. Danti, M. Matteini and A. Moles (Florence, 1990), pp. 121–6, 148–9

A. Meyer: 'Mosaik', *Reclams Handbuch der künstlerischen Techniken*, ii (Stuttgart, 1990), pp. 399–498 [especially pp. 427–9]

D. Bigelow, E. Cornu, G. J. Landrey and C. van Horne, eds: *Gilded Wood: Conservation and History* (Madison, 1991)

Gilding and Surface Decoration: Preprints of the UKIC Conference Restoration '91: London, 1991

E. Skaug: 'Cenniniana: Notes on Cennino Cennini and his Treatise', *A. Crist.*, lxxxi/754 (1993), pp. 15–22

(ii) Decoration. A burnished water gilded surface may be decorated by the use of ornamental punches and incised lines while the gesso is fresh enough to be sufficiently flexible. The punch is held at right angles to the gilded surface and tapped lightly with a hammer, thus indenting the gesso ground without breaking the surface. Combinations of punches, the designs of which may range from simple circles or rings to complex rosettes and leaf shapes, are used to create patterns (*see also* PUNCH). A stylus may also be used to indent lines, often combined with patterns produced by a punch. Rich and complex textural effects may thus be achieved. This technique probably evolved from the use of iron punches and gravers to produce raised decoration in sheet metal and from blind tooling (decorative punching without the use of gold), which developed in Europe for the decoration of leather, particularly for book bindings, certainly by the 11th century AD (*see* BOOKBINDING, §II). Gold-tooling of leather, although a very old technique in the Middle East (see colour pl. II, fig. 1; *see also* ISLAMIC ART, §III, 7), reached Europe only in the 15th century; 'gilt' leather, however, had been produced in the late 14th century (*see* LEATHER, §2(ii)). In China, metal leaf was used in conjunction with the lacquer to decorate Tang mirrors in such Southern Song (1127–1297) techniques as *qiangjin*, in which gold leaf was tooled into depressions incised into the surface of the lacquer (*see* CHINA, §IX, 3 and 4).

Metal leaf can also be painted, either with opaque paint or with translucent glazes; opaque and transparent paints can also be used together. Opaque paint may be used to paint a design over gold, but its most effective use is in the sgraffito technique: areas of colour are painted over the gold and then scraped off when the paint is partly dry, revealing the gold beneath in the desired pattern. Richly detailed effects may be obtained, particularly in the representation of brocades and other textiles, for example in 14th- and 15th-century European altarpieces where egg tempera paint has been applied to burnished gold (*see* §II,

1 below; *see also* TEMPERA, colour pl. V, fig. 4). Transparent glazes are applied thinly, in an oil-based medium, to reduce the brilliance of the metal as little as possible. They were widely used on painted altarpieces and in 17th- and 18th-century Europe on polychrome sculpture, leather items and other decorative objects. Gamboge, saffron and the evaporated juice from certain species of aloe were among the yellow colorants; red colorants included lac dye and dragon's blood. Annatto gave an orange, and green could be obtained using verdigris. A number of synthetic organic dyestuffs are available; certain pigments, such as alizarin crimson or Prussian blue, are also suitable.

BIBLIOGRAPHY

E. Skaug: 'Punch Marks—What Are they Worth? Problems of Tuscan Workshop Interrelationships in the Mid-fourteenth Century: The Ovile Master and Giovanni da Milano', *La pittura nel XIV e XV secolo: Il contributo dell'analisi tecnica alla storia dell'arte: Atti del XXIV congresso internazionale di storia dell'arte: Bologna, 1979* (Bologna, 1983), pp. 253–82

R. E. Straub: 'Tafel- und Tüchleinmalerei des Mittelalters', *Reclams Handbuch der künstlerischen Techniken*, i (Stuttgart, 1984), pp. 189–98, 229–36

Art in the Making: Italian Painting before 1400 (exh. cat. by D. Bomford and others, London, N.G., 1989–90), pp. 24–6, 130–35

C. Cession: 'The Surface Layers of Baroque Gildings: Examination, Conservation, Restoration', *Cleaning, Retouching and Coatings: Preprints of the Contributions to the IIC Brussels Congress, 1990*, pp. 33–5

2. POWDER. Recipes for powdering gold (and other metals) appear as early as the 3rd century AD and include amalgamation of gold leaf with mercury and grinding leaf with salt. Shell gold (so called because of the traditional method of storing it in mussel shells) was made by grinding leaf gold with honey (a method known since at least the 14th century) and mixing it with a gum or other appropriate medium so that it could be used as a paint (*see* §II, 1 below). Powdered gold was used in such Chinese techniques as *maiojin* ('painting in gold') and *tiangi* ('filled-in lacquer') to decorate lacquer in the Song period (AD 960–1279; *see* CHINA, §IX, 4); it may also be strewn or dusted lightly over an adhesive to give a glittering appearance, a technique much used on East Asian lacquerware (for further discussion *see* LACQUER, §I, 1(ii)(h) and JAPAN, §X, 1(iii)(c) and fig. 177). Powdered gold suspended in varnish was also used in early bookbinding decoration (*see* §II, 5 below). Mosaic gold—*aurum musicum* or *purporino* (It.)—is a gold-coloured tin sulphide prepared by prolonged heating of tin–mercury amalgam, sulphur and sal ammoniac. By the 14th century recipes for the material abounded, although its use has seldom been confirmed in practice. One rare example is the metal rail in Francesco del Cossa's painting of *St Vincent Ferrer* (*c.* 1473; London, N.G.). It is thought to have been used as a substitute for real powdered gold, mainly in the illumination of manuscripts and in miniature paintings. The now widely used bronze powders were developed in the 19th century and are used predominantly in the decorative arts, in particular on furniture, picture frames and mirrors (*see* §II, 3 below). These powders are generally copper–zinc alloys, their colour depending on the relative proportions of the two metals present. Aluminium flake powders may be used instead of silver.

BIBLIOGRAPHY

C. Cennini: *Il libro dell'arte* (MS.; *c.* 1390); ed. F. Brunello (Vicenza, 1971); Eng. trans. and ed. by D. V. Thompson, as *The Craftsman's Handbook:*

The Italian 'Il libro dell'arte' (New Haven, 1933, R/New York, 1960), pp. 101–2

S. M. Alexander: 'Medieval Recipes Describing the Use of Metals in Manuscripts', *Marsyas*, xii (1964–5), pp. 37-43

P. E. Rogers, F. S. Greenawald and W. L. Butters: 'Copper and Copper Alloy Flake Powders', *Pigment Handbook*, ed. T. C. Patton, 3 vols (New York, 1973), i, pp. 807–17

R. Rolles: 'Aluminium Flake Pigment', *Pigment Handbook*, ed. T. C. Patton, 3 vols (New York, 1973), i, pp. 785–806

A. Smith, A. Reeve and A. Roy: 'Francesco del Cossa's *St Vincent Ferrer*', *N. G. Tech. Bull.*, v (1981), pp. 44–57

F. Ames-Lewis: 'Matteo de' Pasti and the Use of Powdered Gold', *Mitt. Ksthist. Inst. Florenz*, xxviii (1984), pp. 351-62

JO KIRBY

3. FIRE GILDING [Mercury, amalgam or parcel gilding].

(i) Technique. This method of gilding made use of the property of mercury readily to form an amalgam with gold and was usually applied to copper or silver. The technique as practised in the medieval period was described in detail by Theophilus in *De diversis artibus*, and many 19th-century workshop manuals (e.g. those by Spon and Thorpe) contain detailed accounts of this process. There were two basic methods: applying either gold leaf or a gold–mercury amalgam to a surface that had already been treated with mercury.

In both methods the metal had to be carefully cleaned free of all grease and scratch-brushed to key the surface; then mercury was applied. In the more remote past metallic mercury was vigorously worked into the surface with a short, stiff brush until the surface was uniformly covered. From the 18th century the usual practice was to dip the cleaned metal into a solution of mercuric nitrate, which precipitated mercury on to the surface in a thin, continuous layer. This process was known as quicking.

In the first method of fire gilding thin sheets of gold were laid on to the prepared surface, vigorously burnished and then heated to drive off the mercury. This seems to be the process described by Pliny in his *Natural History* (xxxiii.32; Rackham, 1968, p. 77). In the second process an amalgam of mercury and gold was first prepared by heating mercury to about the temperature of boiling water and then adding about half the weight of pure gold filings, stirring with an iron rod until the amalgam had the consistency of butter (hence the term 'butter of gold'). The health hazards of handling mercury were recognized even in medieval times, and the prepared amalgam was stored under water. The amalgam was then applied to the freshly quicked surface by brushing. When the piece was covered it was gently warmed to evaporate the mercury, while the gilding continued to be worked with a stiff brush to ensure even coverage. Alternatively the amalgam could be carefully applied and brushed in with a wire brush that had itself been quicked to promote even coverage, then heated in a closed furnace. In the latter process, however, the piece had to be kept under constant observation, periodically moved and the amalgam layer worked if necessary to keep the gilding even as it formed. The freshly gilded surface had a rather matt, granular appearance, which could then be further treated by scratch brushing, burnishing or by the use of chemicals to produce the desired colour and texture.

(ii) History. The technique of fire gilding has been identified on metalwork from China in Han burials of the 3rd century AD (Lins and Oddy, 1975; *see also* CHINA, §VI, 2), and on some Hellenistic metalwork (Craddock, 1977), including items (Thessaloniki, Archaeol. Mus.) from the tomb of Philip II, King of Macedonia (*reg* 359–336 BC), at Vergina (Assimenos, 1983). The use of mercury gilding at an early date in China is to be expected, given the importance attached to mercury and mercury-based gold elixirs (potable gold) by the Daoist philosophers and alchemists (Needham, 1980). Oddy (1982) has doubted the existence of mercury gilding in the West before the Romans, and certainly leaf gilding was prevalent until well into the Imperial period, when gold plating of bronze statuary and of architectural fittings became extremely popular. Fire gilding provided a much more durable bond than could be achieved with leaf gilding, and, although it could not be used on ordinary bronze, the greater resistance to corrosion and reduced maintenance costs on exterior metalwork in particular made fire gilding prevalent, although it never completely superseded the other methods.

Even in the early medieval period, when supplies of mercury must often have been difficult to obtain in Europe, fire gilding was the favoured method for gilding metalwork and remained so until the mid-19th century, when, in common with most other traditional plating techniques, it was challenged and rapidly replaced by electrogilding. Although it continued for some time to be favoured for applications where either its durability or the special surface effects were required on work of the highest quality, the process has become virtually extinct in Europe and North America because of the extra cost and stringent health regulations. Fire gilding is still used in Tibet, however, although in other countries where traditional metalworking methods still thrive, for example Nepal, and where amalgam gilding was practised until the late 20th century (Oddy, 1981), it has now been replaced by electrogilding (*see* ELECTROPLATING).

See also GOLD, §2(iv).

BIBLIOGRAPHY

Theophilus: *De diversis artibus* (MS.; 12th century); ed. and trans. J. G. Hawthorne and C. S. Smith (Chicago, 1963/R 1979)

E. Spon: *Workshop Receipts* (London, 1882/R 1932)

E. Thorpe: *Dictionary of Applied Chemistry* (London, 1890–93)

H. Rackham: *Pliny: The Natural History* (London, 1968)

P. Lins and W. A. Oddy: 'The Origins of Mercury Gilding', *J. Archaeol. Sci.*, ii (1975), pp. 365–73

P. T. Craddock: 'Copper Alloys Used by the Greeks II', *J. Archaeol. Sci.*, iv (1977), pp. 103–23

J. Needham: *Science and Civilization in China*, v/4 (Cambridge, 1980)

W. A. Oddy, M. Bimsom and S. La Niece: 'Gilding Himalayan Images', *Aspects of Tibetan Metallurgy*, ed. W. A. Oddy and W. Zwalf, BM Occas. Pap., 15 (London, 1981), pp. 87–103

W. A. Oddy: 'Gold in Antiquity', *J. Royal Soc. A.*, cxxx (1982), pp. 1–14

K. Assimenos: 'Technological and Analytical Research on Precious Metals from the Chamber Tomb of Phillip II', *Preprints of the Second International Symposium: Historische Technologie der Edelmetalle: Meersburg, 1983*

P. T. CRADDOCK

II. Uses.

1. Painting. 2. Sculpture. 3. Furniture and woodwork. 4. Metalwork. 5. Bookbinding.

1. PAINTING. Gilding in painting is particularly associated with the embellishment of such religious works as

the ICON and the ALTARPIECE, where it serves to glorify the subject-matter and, because of the cost and effort involved, symbolizes an act of devotion on the part of the patron or artist. It serves a similar function in the illumination of religious manuscripts. The secular applications include the illumination of early books (for a description of the technique see MANUSCRIPT, §III, 3), gold writing (for discussion and illustration see CHRYSOGRAPHY), miniature paintings, heraldic devices, dynastic portraiture and allegorical and mythological paintings, where gilding ranges from mere decoration to an ostentatious display of wealth.

In icon painting gold leaf was applied to a wooden surface using the water gilding technique (see §I, 1(i) above) on a layer of red bole that helped to bind it to the wooden surface. The small overlapping pieces of leaf could then be burnished to provide a shining gold ground (e.g. icon of the *Annunciation*, late 12th century; Mt Sinai, Monastery of St Catherine; for illustration and further discussion of techniques see EARLY CHRISTIAN AND BYZANTINE ART, §VI and fig. 68; see also ICON, colour pl. II, fig. 1). In the 14th century the example of the Byzantine icon was developed in Italy where the altar became the primary setting for panel painting. Such altarpieces made extensive use of gold and silver leaf throughout the 14th century and into the 15th, when these materials were used in Northern Europe as well as Italy (e.g. *Virgin and Child Enthroned, with Four Angels* by Quinten Metsys, c. 1490–95; London, N.G.; see also colour pl. III, fig. 1). A variety of techniques was used to provide surface decoration on gilding. Gilded haloes were often tooled with patterned and incised punches (for discussion and illustration see PUNCH) or with freehand incised lines. Prior to gilding, raised patterned surfaces were built up of pastiglia or gesso to provide such detail as patterns on haloes or embroidery on garments. In the workshop of SIMONE MARTINI, for example, this technique was used to imitate such metallic dress accessories as buckles and belts. In oil gilding, mordants of varying thicknesses and made of a variety of materials (see §I, 1(i) above) could be painted on and, while still tacky, were coated with gold leaf to provide details that stood proud of the surface, in particular highlights and decoration on textiles. These oil-gilded details could not be burnished and therefore remained matt, and the contrast between burnished water gilding and matt oil gilding in close proximity provided another decorative device. For example, in the Rucellai *Madonna* (begun 1285; Florence, Uffizi; see DUCCIO, §I and fig. 1), Duccio uses mordant gilding on the throne and the child's robe against a water-gilded ground, a further decorative device being the haloes patterned with a burin or composite rosette punches. In the technique known as imitation relief brocade, tin foil, which had been pressed into a mould of a brocade pattern, was subsequently tinted, painted and then applied to the surface of a painting with an adhesive to imitate costly garments. The sgraffito technique, in which paint was applied over gold leaf and, when dry, scraped away to expose the gold beneath (see TEMPERA, §1(i) and colour pl. V, fig. 4), was also used to create details on textiles.

The decorative relief technique was also used in conjunction with gilding in wall painting. An early example is

gilded stucco in the Aula of Isis (c. 20 BC), Rome, and was used in medieval wall paintings. Notable examples are Simone Martini's *Maestà* (1315–16; Siena, Palazzo Pubblico; see WALL PAINTING, colour pl. II, fig. 2), painted in a decorative *secco* method (see WALL PAINTING, §I) and the wall paintings in Sainte-Chapelle, Paris, which also incorporated glazed metal leaf (for illustration and further discussion see GOTHIC, §IV, 4(i) and (iii) and fig. 67). Gilding was also used in other wall-painting traditions, for example Islamic wall paintings of the Safavid period (1501–1732) and 18th- and 19th-century Thai wall paintings.

For finer, more delicate highlights and detail, shell gold or silver—the metal ground to a powder with egg white or a solution of gum (see §I, 2 above)—was applied with a brush, a technique also used in manuscript illumination and miniature painting. Shell gold was used in this way by Botticelli, whose illusionistic use of gold also included the sgraffito technique described above (see BOTTICELLI, SANDRO, §II).

By the 16th century altarpieces had less gilding, and Botticelli was one of the last Italian artists to make extensive use of gold in painting. In Britain, however, gold continued to be used in painting in the enclosed environment of the Tudor court, and gilding played an important part in Spanish and German painting until well into the 16th century.

BIBLIOGRAPHY
C. Cennini: *Il libro dell'arte* (MS; c. 1390); ed. F. Brunelli (Vicenza, 1971); Eng. trans., ed. D. V. Thompson, as *The Craftsman's Handbook: The Italian 'Il libro dell'arte'* (New Haven, 1933, R New York, 1960), pp. 60–63, 79–89, 96–8, 100–04, 106–8, 112–13, 118–19
D. V. Thompson: *The Materials and Techniques of Medieval Painting* (New Haven, 1936/R New York and London, 1956)
Z. Veliz: *Artists' Techniques in Golden Age Spain* (Cambridge, 1968)
Art in the Making: Italian Painting before 1400 (exh. cat. by D. Bomford and others, London, N.G., 1989–90)
J. Dunkerton and others: *Giotto to Dürer: Early Renaissance Painting in the National Gallery* (London, 1991)

JONATHAN STEPHENSON

2. SCULPTURE. Gold has been applied to sculpture as protection against corrosion (see §4 below), for embellishment and as a mark of religious devotion; gilding was also applied to some 19th-century non-metal sculptures to imitate the highlights on bronze sculptures (e.g. model for the tomb of the Duke of Clarence and Avondale KG, polychrome plaster on a marble base, 1592–4; Windsor, memorial chapel). It may cover the sculpture completely (e.g. gilt-bronze effigy of *Richard Beauchamp, Earl of Warwick*, d 1439; Warwick, St Mary) or cover only parts of it (e.g. gilded mantle on the *Annunciation* and *Passion*, polychromed limestone altarpiece, 1525; London, V&A). It may be used to highlight a feature (e.g. *dhoti* of the wooden sculpture of the *Bodhisattva Guanyin*, China, Jin period, 1115–1234; London, V&A) or to provide decorative pattern (e.g. robe of a tomb guardian figure, earthenware, China, Tang period, 618–907; London, V&A).

Sheet gold decorations were applied to figures in Predynastic Egypt before 2500 BC (see §I, 1(i) above), in China in the 7th and 6th centuries BC, and similar techniques were used in chryselephantine work in Ancient Greece (see GREECE, ANCIENT, §IV, 1(iii)(g)) and in Ancient Rome (see ROME, ANCIENT, §IV, 1(iii)(a) and fig. 64). Water gilding (see §I, 1(i) above) was used in the

Archaic period in Ancient Greece to apply gold leaf as detail on bronze sculptures and sometimes to cover the whole statue (*see* GREECE, ANCIENT, §IV, 1(iii)(f)); in Japan it was used to apply gold leaf to lacquer (*shippaku*). Water gilding was also used for the great Gothic lime-wood altar pieces (e.g. the Herlin altarpiece, 1466). In Ancient Rome small gilded cult images were produced in terracotta and plaster, and leaf was used to highlight such details as eyes on bronze statues, and hair and eyes on marble statues (*see* ROME, ANCIENT, §IV, 1(iii)(a)). In Japan gilding was applied to statues of clay, wood and lacquer (*see* JAPAN, §V, 1(ii) and fig. 48); it was also used extensively in the Burmese wood-carving tradition (see colour pl. II, fig. 2; *see also* BURMA, §IX, 16 and fig. 27). Leaf applied by the oil gilding technique (*see* §I, 1(i) above) cannot be burnished and may be used to provide decorative patterns (e.g. robes on figures, 1216–20; South Portal, Lausanne Cathedral). Gold-silver laminate leaf (*see* §I, 1(i) above) was used as a cheaper form of gilding (e.g. reredos of the high altar, 1508; Schwabach, SS Johann und Martin) even though it tarnished. Powdered gold can be painted on sculpture in the form of shell gold (*see* §I, 2 above); or, in the Japanese *kindei nuri* technique, strewn over animal adhesive, or in *fundami nuri*, sprinkled over the surface of a sculpture dampened with lacquer. Fire gilding (*see* §I, 3 above) was used for ceramic sculptures. In China there

are dated gilt-bronze Buddha images from as early as AD 38 (*see* CHINA, §III, 1 and fig. 62), and in Korea small gilt-bronze Buddha images were produced from the 4th century AD (*see* KOREA, §III, 1(i) and figs 20 and 21); in Japan, too, fire gilding was used for bronze Buddhist sculptures (*see* JAPAN, §V, 3(i)(b) and figs 57 and 58). Fire gilding was also used to produce the four life-size gilt-bronze statues of horses in S Marco, Venice (Venice, Mus. S Marco), looted from Constantinople in 1204.

Gilding on sculpture can be modified in colour and texture. The colour of the foundation clays or boles to which the gold leaf is applied will affect the colour of the gilding, and gilded metal may be modified in colour by the application of transparent or translucent coloured glazes (e.g. *Allegory of Fame* by Louis-Ernest Barrias, artist's col.; *see also* GLAZE). Opaque pigment may be applied over gold to create a pattern or be scratched away to reveal the gold beneath using the sgraffito technique. Gold can be applied to textured surfaces, complex patterned areas of carving (including carved gesso), or applied to modelled relief work in gesso (e.g. crucifix at Gotland, Hemse church, 1170–90) or clay. Water-gilded gesso can be stamped or punched with a design (*see* §I, 1(i) above), and gilded bronze sculpture has also been decorated with a punched pattern (e.g. tomb effigy of *Richard II*, completed *c.* 1396; London, Westminster Abbey).

Gilded decorations in various materials have been stuck on to sculpture: they include gilded paper spots, as on the mantle of the Virgin on the Boppard Altarpiece (first quarter 16th century; London, V&A); embossed paper; gesso and composition materials; lead (e.g. gilded reliefs on the robe of St Margaret, altarpiece, North German, early 16th century; London, V&A), gilded lead–tin alloys and inset glass with coloured and gilded backgrounds. Among the most opulent gilded decorations applied to sculpture are the imitation relief brocades (*see* §1 above) that simulate sumptuous fabrics as used, for example, on the 15th-century limestone tomb effigies of *William, 9th Earl of Arundel, and his Wife Joan Nevill* (Arundel, Fitzalan Chapel; *see* POLYCHROMY, colour pl. V, fig. 2).

For an illustration of a gilded stucco vault *see* VENICE, fig. 7.

BIBLIOGRAPHY
C. R. Ashbee, trans.: *The Treatises of Benvenuto Cellini on Goldsmithing and Sculpture* (New York, 1967), pp. 96–7
G. Savage: *Porcelain through the Ages* (London, 1969)
M. Broekman-Bokstijn and others: 'The Scientific Examination of the Polychromed Sculpture of the Herlin Altarpiece', *Stud. Conserv.*, xv (1970), pp. 388–90
K. Kamasaki and K. Nishikawa: 'Polychromed Sculptures in Japan', *Stud. Conserv.*, xv (1970), pp. 280, 282
P. Tångeberg: 'The Crucifix from Hemse', *Maltechnik, Rest.*, xc (1 Jan, 1984), p. 28
A. Broderick and J. Darrah: 'The Fifteenth-century Polychromed Limestone Effigies of William Fitzalan, 9th Earl of Arundel, and his Wife Joan Nevill, in the Fitzalan Chapel, Arundel', *J. Church Mnmts Soc.*, i/2 (1986), p. 71, pl. 4

A. BRODERICK

3. FURNITURE AND WOODWORK. The use of gold leaf as a surface decoration for furniture and woodwork not only gave a rich lustre unrivalled by any other material but also had the practical side-effect of reflecting light. When gilt furniture (e.g. carved and gilt wood chair; see fig. 3) and *boiseries* (e.g. Music Room from Norfolk House, completed 1756; London, V&A) were at the height of

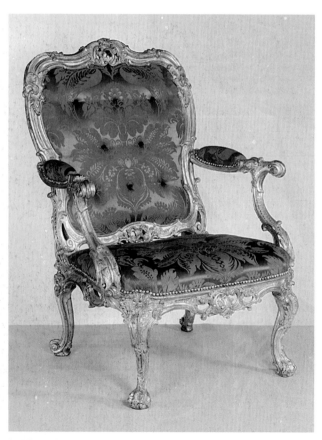

3. Gilt wood armchair designed and carved by Matthias Lock, English, *c.* 1760 (London, Victoria and Albert Museum)

fashion, houses were illuminated by candles, and gilded surfaces, often burnished, reflected the light and increased the candlepower. With the introduction of electricity, the use of gold decoration diminished and, in the late 20th century, virtually disappeared.

The high cost of gold encouraged gilders to seek cheaper substitutes and many 17th-century pieces were silvered and then lacquered with a yellow varnish to simulate gold. The Victorians introduced an alloy of copper and zinc (*Schlagmetall*) or copper and tin, which closely resembled gold leaf in colour and reflective powers but could only be applied with quick drying oil and had to be lacquered to prevent tarnishing. This metal leaf was largely used for decorating high ceilings, but was occasionally used to decorate picture frames. Gold-coloured bronze powders have also been used on furniture and picture frames as a substitute for gold leaf (*see* FRAME, §I). With the advent of colour printing on paper, these powders became so fine that, when skilfully applied, it was difficult to distinguish them from gold leaf.

Oil gilding (*see* §I, 1(i) above) was generally used on surfaces that were exposed to the elements, for example wrought ironwork, stone and sometimes wood. It may also be used for the decoration of furniture in contrast to water gilding, or to obtain a particular effect; for example oil gilding an oak surface without the usual gesso foundation accentuates the flecks and rays in the grain, a technique often employed by the Victorians. Fire gilding (*see* §I, 3 above) was used to produce ORMOLU, gilt bronze decorative objects such as furniture mounts, some of the finest of which were used on 18th-century French furniture (*see* FRANCE, §IX, 2(iii)(a) and fig. 83).

Textured surfaces, ranging from silversand to rice and sago, were used with gilding to obtain differing light reflection. Stippled, cross-hatched or stamped gesso was used to obtain this effect (e.g. medallion with 'grain d'orge' on a French *boiserie*, carved and gilded oak, *c.* 1703–7; Malibu, CA, Getty Mus.). Although there are some examples of oil-gilded chairs, furniture was generally water gilded and burnished (*see* §I, 1(i) above). By the late 17th century furniture of carved wood was gilded using gesso ground, which suited the low relief ornament fashionable in the early 18th century (*see* ENGLAND, fig. 51). Flat water gilding was sometimes coated with ormolu size, often coloured to give a particular hue, for protection. Burnished gold leaf was generally left unprotected in order to retain the maximum lustre on the highlights.

See also ITALY, §VI, 3 and fig. 79.

BIBLIOGRAPHY
P. Verlet: *Les Bronzes dorés français du XVIIIe siècle* (Paris, 1987)
D. Bigelow, ed.: *Gilded Wood: Conservation and History* (Madison, CT, 1991)

MALCOLM GREEN

4. METALWORK. Metals have been plated with gold for three reasons: embellishment, protection and deception. The earliest surviving example of gilding on metal occurs on the heads of some silver nails (*c.* 3000 BC; London, BM) from Tell Brak, on which the gold foil covering the heads grips the silver with the edge. Many different methods of attaching gold foil were evolved using adhesives or pressing the edges into specially prepared grooves, sometimes even filling the groove with lead into which pins could be driven to hold the foils. The techniques of true leaf gilding, introduced in the late 2nd millennium BC, and mercury gilding, introduced about a thousand years later, resulted in a much more continuous gilding but at the same time used far less gold than foil gilding, and so gilding on metalwork became much more prevalent.

A leaf- or mercury-gilded surface gives considerable protection against corrosion, an important consideration for metal sculptures or metal architectural features that were exposed to weathering. Thus Hill (1969) suggested that Roman statuary bronze was gilded in order to preserve the shining appearance of polished metallic surfaces with a minimum of maintenance. This advantageous aspect of gold plating is still exploited, as electrical contacts are often gold plated in order to keep them free from tarnish and thus conducting.

Surface platings by their very nature conceal the metal beneath, and thus soldered joins and other repairs can be hidden by gilding. Base metal can be given the appearance of solid gold by a good continuous plating, or an alloy with only a little gold can be made to appear much richer by surface treatment. How much this was done in the past with the specific intent to deceive, rather than just to embellish, is difficult to assess, except in the case of coinage, where there have been plated forgeries that quite clearly were intended to deceive (Craddock, 1990). For example, among the well-known hoard of 15th-century gold nobles and jewellery found at Fishpool, Notts, were several forgeries (London, BM) made by wrapping a gold foil around a silver blank and striking this in a coin die. In general, however, there were great problems in creating convincing forgeries of gold coins, not least because of the great density of gold. In the past platinum was quite inexpensive, and as it has a similar density to gold it was an ideal substrate for plated false coins; many of this type were made in the 19th century in Spain and Russia.

BIBLIOGRAPHY
D. K. Hill: 'Bronze Working', *The Muses at Work*, ed. C. Roebuck (Cambridge, MA, 1969)
P. T. Craddock: 'The Art and Craft of Faking', *Fake?* (exh. cat., ed. M. Jones; London, BM, 1990), pp. 247–90

P. T. CRADDOCK

5. BOOKBINDING. Both the covers and the edges of the leaves of books can be decorated with gold. Gilded decoration is found primarily on covers made of leather, but also on those of parchment, paper and cloth. In early examples the gold, in the form of powder suspended in varnish, was applied to the covers with a brush; there are examples extant from the Middle East (6th or 7th century AD), and an apparently unique European example from northern France (late 12th century; both New York, Pierpont Morgan Lib.), though this technique was not widely used in Europe. Islamic binders (*see* ISLAMIC ART, §III, 7; *see also* colour pl. II, fig. 1) also set gilded, punched dots into the leather covering, a technique found in 15th-century Spanish and Italian work as a direct result of Islamic influence. The technique known as gold tooling, which involves pressing heated engraved tools through gold leaf on to glair painted on to the surface, is also of

Islamic origin. The earliest known example is on a Koran (Marrakesh, Bib. Ben Youssef) written in Morocco in 1256; the technique is first found in Europe in the second half of the 15th century, both in Spain and Italy (arriving through both Naples and Venice). The earliest designs in both countries also derive from Islamic work, especially the use of intricate interlace patterns and arabesques. From Italy, the technique spread northwards, reaching France by 1507, the date of a gold-tooled binding on a manuscript (Paris, Bib. N.) dedicated to Louis XII, and England some 20 years later. Parisian binders in the 1530s quickly established a pre-eminence in Europe in both design and technique that continued into the 20th century (see BOOK-BINDING, colour pl. IV, fig. 3).

Books decorated elaborately by hand-tooling were largely the preserve of the wealthy and form a tiny proportion of the total output of bindings. At different times various European countries, other than France, produced work of particularly high quality, for example English bindings of the second half of the 17th century, often using East Asian textile designs with applied pigments and onlays of coloured leathers. Some bindings made in Dublin in the mid-18th century have a splendour and inventiveness not equalled elsewhere, and a notable group of immigrant German binders working to Neoclassical designs in London at the end of the 18th century and beginning of the 19th produced work of great elegance and the highest quality (see BOOKBINDING, §II).

As the production of books increased from the 17th century, less elaborate forms of gold tooling became commonplace. From the same period more libraries adopted the method of shelving books vertically with their spines outwards, and this in turn led to a concentration of gold tooling on the spine, with tooling on the boards found only on their edges and/or a narrow border, if at all. In 1832 a successful machine for blocking designs in gold on bookcloth was developed, and elaborate gilt designs became available for the mass market for the first time, although large numbers of hand-tooled leatherbound books continued to be produced to very conventional designs by the large commercial binderies.

In the 19th century there was, in common with other decorative arts, both renewed interest in earlier designs and remarkable technical skill in fine binding, resulting in books that are technically perfect but often somewhat sterile in design and character. Both the Arts and Crafts Movement and Art Nouveau had a fundamental influence on design and on the elevation of binding design as an art form.

The application of gold to the edges of the leaves of a book is known as edge-gilding, but its early history is obscure, as few examples survive intact. Some paintings, for example van Eyck's *Lamb of God* (Ghent, St Bavo), show that gilt and gauffered edges were executed in the early 15th century. Edge-gilding became usual for fine and presentation bindings thereafter, sometimes combined with other decorative techniques. In England the earliest example of the practice of gilding only the top edge of leaves dates from 1851, and this technique did not become common until the end of the 19th century. Gold and silver gilt clasps and bosses, in use from at least the early Middle Ages, would not normally be made by binders but by specialist craftsmen.

BIBLIOGRAPHY

E. P. Goldschmidt: *Gothic and Renaissance Bookbindings*, 2 vols (London, 1928, 2/Amsterdam, 1967)
G. D. Hobson: *Bindings in Cambridge Libraries* (Cambridge, 1929)
H. Thomas: *Early Spanish Bookbindings* (London, 1939)
G. D. Hobson: *English Bindings in the Library of J. R. Abbey* (London, 1940)
L.-M. Michon: *La Reliure française* (Paris, 1951)
M. Craig: *Irish Bookbindings, 1600–1800* (London, 1954)
D. Miners: *The History of Bookbinding, 525–1950 AD* (Baltimore, 1957)
B. Middleton: *A History of English Craft Binding Technique* (London, 1963/R 1978)
H. M. Nixon: *Bookbindings from the Library of Jean Grolier* (London, 1965)
——: *Sixteenth-century Gold-tooled Bookbindings in the Pierpont Morgan Library* (New York, 1971)
——: *English Restoration Bookbindings* (London, 1974)
——: *Five Centuries of English Bookbinding* (London, 1978)
M. M. Foot: *A Catalogue of North-European Bindings* (1979), ii of *The Henry Davis Gift* (London, 1979–83)
P. Needham: *Twelve Centuries of Bookbindings, 400–1600* (New York, 1979)
G. Bosch, J. Carswell and G. Petherbridge: *Islamic Bookbindings and Bookmaking* (Chicago, 1981)
A. R. A. Hobson: *Humanists and Bookbinders* (Cambridge, 1989)

NICHOLAS PICKWOAD

III. Conservation.

The conservation of an object with surface decoration of gold leaf, as distinct from its restoration, requires considerable skill and familiarity with the practical techniques involved. Where necessary, any damage or deterioration that was caused by earlier treatments should be repaired using original techniques and materials, but fair wear and tear resulting from the aging of the object should not be disturbed.

All water- and oil-gilded surfaces, with the possible exception of burnished gold, will have been protected with a coat of parchment size or weak rabbit skin size when the object was originally gilded. In order to clean the gilding of surface dirt, it is possible to use a solution made from Quillaia bark (Panama wood). The crushed bark is left for 24 hours in water and then strained ready for use. It is used cold with a soft brush and soft, natural sponge. This solution will not work on all objects; some gilded surfaces will require a solution of weak ammonia in lukewarm water on a cotton-wool swab, which may need an added liquid detergent before it is effective. It is advisable to test each solution on a remote corner of each separate object. Water-gilded surfaces may require a different solution from oil gilding on the same object. Most cleaning will remove the coat of protective size, which must be replaced. Should the object have been previously restored, there may be areas of new gold that have been colour toned to blend with the original. This colour toning could be removed in error during a cleaning process, and even the professional conservator must be very wary.

Conservation of gilding often requires the removal of several later layers of gilding to reveal the original. Before this kind of work is undertaken, the object should be examined to reveal the original methods of application. If the original layer is water gilding and the subsequent layers are oil paint or oil gilding, the later layers may be removed using a non-caustic, spirit-soluble solvent stripper that

contains methylene chloride for quick evaporation. If the original is covered by later layers of water gilding with gesso foundation, however, they must be removed by careful scraping or chipping. The leather worker's bent awl is a very useful tool for this purpose: the spring steel of the awl enables the conservator to flick off the later layers, using very little finger pressure and without damage to the original, but the skill required takes many hours of practice (see fig. 4). After stripping, the original gilding may need some restoration, and, where this is necessary, it should blend in, remaining faithful to the original methods and colours.

Many gilded objects have sculptural or relief ornamentation that is made from 'gilder's compo': a composition of glue, resin, whiting and linseed oil. This is usually applied after the surface has been prepared with gesso and is attached with an adhesive. The compo will shrink with age, producing cracks in the ornamentation that will allow moisture from the cleaning process to attack the gesso foundation. Extra care must be exercised when cleaning this type of surface. Gilded surfaces are extremely susceptible to moisture, and therefore humidity controlled storage is beneficial. Storage in a damp atmosphere will break down the stable structure of the gesso, causing disintegration. Consolidation of perished gesso has been been successfully attained using Paraloid B72, a co-polymer of methyl acrylate and ethyl methacrylate, in Toluene. This mixture has now largely replaced parchment size for this purpose.

It is essential to match the various colours of foundation clays and boles so that when the gold is 'distressed' the wear and tear of the object may be simulated. Where burnished gold is involved, the act of rubbing with the agate stone will darken the bole colour, which will eventually show after distressing. Colour toning, after gilding, to simulate age, must be carried out with a translucent wash, thus retaining the lustre of the leaf. To ensure reversibility, oil gilding should be toned with parchment size as the mordant, while water gilding may be toned with oil colour or wax as the mordant. The surface craquelure of antique water-gilded gesso can be simulated by cutting the gesso with a sharp tool to create the necessary pattern, but it is possible to create the craquelure by applying gesso to a strip of cloth which, when dry, may be cracked by bending round a right angle, and then attached to the surface of the object. Subsequent layers of clay and bole will not cover these applied cracks, and a fair simulation is created. Pipe clay, a by-product from coal mining, mixed with earth colours and parchment size, will enable the conservator to manufacture any bole colour to match and blend with the original burnishable bole. Matt gold size is manufactured from the same materials but a little glycerin is added to prohibit the burnish.

Powdered gold in solution with gum arabic is another material useful for simulating a particular effect brought on by wear and tear of age. It is an expensive material, but the use of cheaper bronze powders as a substitute should be avoided because of their tendency to oxidize. Generally, bronze powder merely delays proper conservation and will add to the eventual costs when it has to be removed at a later date. Most leaf is manufactured to *c.* 84 mm square to allow a 76 mm surface when laying. After

4. Conservation of gilded wood, using a leather worker's awl to remove layers of water gilding and gesso to reveal the original gilding

distressing, the size of the leaf will be revealed on burnished gold because of the overlaps, and it is therefore important to match the size of the gold leaf when blending restoration to the original.

See also CONSERVATION AND RESTORATION.

BIBLIOGRAPHY
C. Cession: 'The Surface Layers of Baroque Gildings: Examination, Conservation, Restoration', *Cleaning, Retouching and Coatings: Preprints of the Contributions to the IIC Brussels Congress, 1990*, pp. 33–5
D. Bigelow, ed.: *Gilded Wood: Conservation and History* (Maddison, CT, 1991)
MALCOLM GREEN

Gilduin, Bernard. *See* BERNARDUS GELDUINUS.

Gilio da Fabriano, Giovanni Andrea (*b* Fabriano; *d* Fabriano, 1584). Italian ecclesiastic and writer. He seems to have passed almost his whole life in Fabriano, where he was canon of S Venanzo, and from 1579 until his death was a hermit in the hermitage of S Vincenzo. Between 1550 and 1580 he published various works, almost all in Venice. The most important of these is the *Topica poetica* (1580), a vast resumé of ancient rhetoric for the use of contemporary writers. His works are dedicated to high-ranking personages, which makes it hard to understand the scarcity of biographical information on him.

Gilio da Fabriano dealt directly with figurative art only in the second of his *Due dialogi*, published in Camerino in 1564 and dedicated to Cardinal Alessandro Farnese. This dialogue involves six young literary men of the Marches, and purportedly takes place in the garden of the villa of one of them during the spring of 1562. Stimulated by the beauty of the surrounding flowers, the learned company recognizes that painting is a subject worthy of interest; but they begin at once to discuss the 'errors' and 'abuses' committed by contemporary artists in their works.

These errors and abuses, according to Gilio da Fabriano, lie in a systematic and stubborn affront to the principle of decorum, recommended so strongly in Horace's *Ars poetica*. Instead of sticking scrupulously to the subjects

that they are depicting, the contemporary painters are concerned only to demonstrate their artistic ability. The dialogue proposes to remedy this state of affairs. From the start it makes a clear programmatic distinction between the 'poetic' painter, the 'historical' painter and the 'mixed' painter. Based ultimately on Aristotle, this distinction is used to provide a rational foundation for the different degrees of artistic freedom that may be allowed to the three artistic genres. Whereas a wide margin of fantasy can be allowed in pure poetic inventions, and to some degree also in paintings of secular history, religious history requires a scrupulous respect for the text, which the painter is called on simply to translate into images. Artists must renounce their own 'caprices' and adhere to the 'truth of the subject'.

The rigid rules that constitute the theoretical kernel of Gilio da Fabriano's treatise are accompanied by a whole series of important direct references to specific works of contemporary art. For him the paintings of Raphael in the Villa Farnesina, of Michelangelo in the Vatican and of Giorgio Vasari in the Cancelleria represented, respectively, products of the 'poetic' painter, the 'historical' painter and the 'mixed' painter. Fabriano is interested mainly in 'historical' painting. A large section of the dialogue consists of a detailed iconographic analysis, illustrated by a print, of Michelangelo's *Last Judgement* (Rome, Vatican, Sistine Chapel), condemning the freedom with which the artist has depicted Christ without a beard, Mary frightened, resurrected souls kissing each other, and many other details that are extraneous or actually contrary to the Church's teachings. While Gilio da Fabriano recognized Michelangelo as the culmination and the model of the art of his time, he saw him above all as an artist of dangerous formal individualism. Resolutely condemning Michelangelo's 'licence', he praises the scrupulous fidelity to the subject of earlier painters, whose example, in his eyes, should be emulated. The matter is not straightforward, however, as Gilio da Fabriano, a literary man as well as a cleric, is unwilling to wholly reject the artistic patrimony of the High Renaissance. The dialogue therefore proposes a 'regulated mixture', i.e. a reasonable compromise, between the iconographic reliability of the earlier art and the formal resources of contemporary painting, which had been enriched by the achievements of antiquity.

Gilio da Fabriano's dialogue was contemporaneous with the Council of Trent's deliberations regarding images, and it is inspired by the same demands for reform. It makes wide use of earlier Catholic polemicists, such as Conrad Braun. Later Catholic writers, from Raffaele Borghini to Antonio Possevino, obviously held Gilio da Fabriano in great esteem. It is more difficult to evaluate the reciprocal impact of Gilio da Fabriano and contemporary artists, although many late 16th-century painters in Rome produced works that display his ideal of a balanced compromise.

WRITINGS
Due dialoghi (Camerino, 1564); ed. P. Barocchi (Florence, 1986)
Topica poetica (Venice, 1580)

BIBLIOGRAPHY
R. Sassi: 'Biografia di scrittori fabrianesi', *Cronaca religiosa di Fabriano*, vii (1909–10), pp. 100–03
J. von Schlosser: *Die Kunstliteratur* (Vienna, 1924); 3rd Ital. ed. (Florence, 1964), pp. 425, 431, 722

A. Blunt: *Artistic Theory in Italy, 1450–1600* (Oxford, 1940, rev. 1956), pp. 111–15, 118, 121–3, 126–7, 136
F. Zeri: *Pittura e Controriforma* (Turin, 1957, rev. 1970), pp. 30–32, 47–8, 75, 77, 86 (n.), 113–14
P. Barocchi, ed.: *Tratti d'arte del cinquecento tra Manierismo e Controriforma*, 3 vols (Bari, 1960–62), ii, pp. 1–115, 521–32, 569–614
G. Previtali: *La fortuna dei primitivi dal Vasari ai neoclassici* (Turin, 1964), pp. 21–8, 31–2, 45, 72 (n.), 94, 190
P. Barocchi, ed.: *Scritti d'arte del cinquecento*, 3 vols (Milan and Naples, 1971–7), i, pp. 303–25, 834–62, 1095–7
R. de Maio: *Michelangelo e la Controriforma* (Bari, 1978)

MARCO COLLARETA

Gilioli, Emile (*b* Paris, 10 June 1911; *d* Paris, 19 Jan 1977). French sculptor and tapestry designer. His parents were of Italian origin and he spent most of his youth at Reggiolo in Italy, where he began to learn the trade of blacksmith. After living from 1928 to 1930 in Nice, where he also worked with an Italian decorative sculptor called Chiavacci and took evening classes at the Ecole des Arts Décoratifs, he moved to Paris to do his military service in 1930 and from 1931 studied at the Ecole des Beaux-Arts. In 1937 he assisted Robert Couturier on the decoration of the Pavillon de l'Elégance for the Exposition Universelle, but he began to find himself as a sculptor only while in Grenoble from 1940 to 1945 during the German Occupation, with the encouragement of the Director of the museum there, Andry-Farcy, and the abstract painter Henri-Jean Closon (1888–1975); he then turned to a more avant-garde style that became increasingly abstract although still based on the human figure, as in *Grief Crouching* (marble, h. 280 mm, 1943; see Carandente, p. 35). On his return to Paris in 1945 he was closely associated for some years with Constantin Brancusi, Jean Dewasne, Jean Deyrolle, Serge Poliakoff and other leading post-war abstract artists. His abstract sculptures are mostly of an extremely pure, almost crystalline form and are executed in various kinds of stone including marble, or in highly polished bronze (e.g. *Sphere*, h. 650 mm, 1947; Paris, Pompidou). He also carried out commissions for churches and public monuments, including a huge *Monument to the Resistance* (concrete, 15×20×4 m, 1973) on the Glières plateau in the Haute Savoie near Annecy, and he designed a number of abstract tapestries, such as *Nocturne* (1970; see Carandente, p. 118).

BIBLIOGRAPHY
I. Jianou and H. Lassalle: *Gilioli* (Paris, 1971)
Gilioli (exh. cat. by G. Viatte, Paris, Pompidou, 1979)
G. Carandente: *Gilioli* (Milan, 1980)

RONALD ALLEY

Gill, André [Gosset de Guines, Louis-Alexandre] (*b* Paris, 17 Oct 1840; *d* Charenton, 1 May 1885). French draughtsman. The illegitimate son of the Comte de Guines and orphaned at an early age, he was recommended by the journalist Nadar to Charles Philipon, who hired him to work on the *Journal amusant* in 1859. At that time he signed himself *André Gil*; this changed to *Gill* in 1862. He was very successful during the Second Empire (1852–70) and made a speciality of large caricatures, full of power and movement, that covered the opening pages of satirical magazines — mainly *La Lune*, an opposition journal created by François Polo in 1865, when Napoleon III's regime was becoming more liberal. Gill's attacks reinforced

the current of hostility against the regime in the late 1860s. Many of his prints were censored. On 17 November 1867 he drew the Emperor in the guise of Rocambole, a brigand and assassin who was the hero of a popular newspaper serial, and *La Lune* was banned. It was immediately replaced by a new journal, *L'Eclipse*, on which Gill continued to work. Under the Commune (1871) he was appointed Curator at the Musée du Luxembourg. He created two magazines, *Gill Revue* (1868) and *La Parodie* (1869), and in 1876 founded his own republican journal, *La Lune Rousse*. Arrogant and disordered in his life, Gill died in the lunatic asylum at Charenton on the outskirts of Paris.

BIBLIOGRAPHY

C. Fontanes: *Un Maître de la caricature, André Gill, 1840–1885*, 2 vols (Paris, 1927)
Inventaire du fonds français après 1800, Bib. N., Dépt Est. catalogue, ix (Paris, 1955), pp. 111–36

MICHEL MELOT

Gill, (Arthur) Eric (Rowton) (*b* Brighton, 22 Feb 1882; *d* Harefield, Middx [now in London], 17 Nov 1940). English sculptor, letter-cutter, typographic designer, calligrapher, engraver, writer and teacher. He received a traditional training at Chichester Technical and Art School (1897–1900), where he first developed an interest in lettering. He also became fascinated by the Anglo-Saxon and Norman stone-carvings in Chichester Cathedral. In 1900 Gill moved to London to become a pupil of William Douglas Caröe (1857–1938), architect to the Ecclesiastical Commissioners. He took classes in practical masonry at Westminster Institute and in writing and illuminating at the Central School of Art and Design, where he was deeply influenced by the calligrapher Edward Johnston. Johnston's meticulous training was to be a perfect preparation for Gill's first commissions for three-dimensional inscriptions in stone, the foundation stone for Caröe's St Barnabas and St James the Greater in Walthamstow, London, and the lettering for the lychgate at Charles Harrison Townsend's St Mary's, Great Warley, Essex. Further commissions followed after Gill left Caröe in 1903 to work with E. S. Prior of the Art Workers' Guild. He also undertook his first typographical work, for example for Heal's advertisements.

After his marriage in 1904 to Ethel (later known as Mary) Moore, Gill was elected to the Arts & Crafts Exhibition Society, and in 1906 he began teaching writing and illumination at the Central School and monumental masonry and lettering for masons at the Paddington Institute. His enthusiasm for stone-carving was increased by visits to Rome (1906), to Bruges and to Chartres Cathedral (1907), which was to be a lasting source of inspiration. In 1907 Gill moved with his family to Ditchling in Sussex, which until 1924 was to be the setting for an artistic community (formalized in 1920 as the Guild of St Joseph and St Dominic). Influenced by William Morris, the Guild included Johnston, David Jones, the printer Hilary Pepler and the artist Desmond Chute. At Ditchling Gill encouraged craftsmen to pursue their skills in wood-engraving, calligraphy, weaving, silverwork, stone-carving, carpentry, building and printing. In 1916 Pepler established there the St Dominic's Press, which was to print some of Gill's earliest writings and engravings.

During this period Gill maintained his links with artistic circles in London, developing important friendships with Sydney Carlyle Cockerell, Roger Fry, Augustus John, H. G. Wells, Ananda Coomaraswamy (who introduced him to Hindu philosophy), William Rothenstein and especially Jacob Epstein, with whom he shared an interest in African carving, Indian sculpture and erotic art. In 1910 he worked on the lettering for Epstein's tomb of *Oscar Wilde* (installed 1912; Paris, Père-Lachaise Cemetery). In the same year he began direct carving of stone figures. These included *Madonna and Child* (1910; Cardiff, N. Mus.), which Fry described in 1911 as a depiction of 'pathetic animalism'. Such semi-abstract sculptures showed Gill's appreciation of medieval ecclesiastical statuary, Egyptian, Greek and Indian sculpture, as well as the Post-Impressionism of Cézanne, van Gogh and Gauguin.

Eight works by Gill were included by Fry in the Second Post-Impressionist Exhibition (1912–13) at the Grafton Galleries in London, and his growing reputation, together with his conversion to Catholicism (1913), led to a commission from Westminster Cathedral for the *Stations of the Cross* (14 stone reliefs, h. 1.5 m each, 1914–18; *in situ*). His Catholicism inspired other biblical works, including the controversial war memorial at the University of Leeds, *Christ Driving the Money Changers from the Temple* (1922–3), and *Creation* (8.5×2.1 m, 1937), for the League of Nations building in Geneva. His best-known commission on a secular subject was *Prospero and Ariel* (1931) for the BBC at Broadcasting House, Langham Place, London.

From 1924 to 1928 Gill and his wife sought to recreate the Ditchling community at Capel y Ffin, a deserted monastic building in the Black Mountains of Wales, though its impracticality and remoteness persuaded them to move nearer to London, to Pigotts, near High Wycombe. At Capel and at Pigotts, Gill worked on carvings, on the writing of pamphlets, essays and books, and on engravings, of which he produced over 1000 during his career. Among his finest achievements in the medium are the engravings for the Golden Cockerel Press at Waltham St Lawrence, near Twyford, Berks (*see* BIBLE, fig. 7). Gill's highly original typeface designs (e.g. his 'Gill Sans', 1927), commissioned in many cases by Stanley Morison of the Monotype Corporation, had a lasting influence on 20th-century printing. In 1938 Gill designed the brick church of St Peter the Apostle at Gorleston-on-Sea, Norfolk.

WRITINGS

Autobiography (London, 1940)
W. Shewring, ed.: *Letters of Eric Gill* (London, 1947)

BIBLIOGRAPHY

E. R. Gill: *Bibliography of Eric Gill* (London, 1953)
J. F. Physick: *The Engraved Works of Eric Gill* (London, 1963)
E. R. Gill: *The Inscriptional Work of Eric Gill: An Inventory* (London, 1964)
R. Speaight: *The Life of Eric Gill* (London, 1966)
M. Yorke: *Eric Gill: Man of Flesh and Spirit* (London, 1981)
C. Skelton, ed.: *The Engravings of Eric Gill* (Wellingborough, 1983)
F. MacCarthy: *Eric Gill* (London, 1989)
Eric Gill: Sculpture (exh. cat. by J. Collins, London, Barbican A.G.; Newtown, Oriel 31; Leeds, C.A.G.; 1992–3) [incl. Gill's essays 'Sculpture' (1927) and 'The Future of Sculpture' (1929)]

STEPHEN STUART-SMITH

Gill, Irving (John) (*b* Tully, NY, 26 April 1870; *d* Carlsbad, CA, 7 Oct 1936). American architect. The son

Irving Gill: Walter Luther Dodge House, Los Angeles, 1914–16

of a building contractor, he was trained in Chicago in the offices of the architects Joseph Lyman Silsbee and Adler & Sullivan. Health considerations prompted his move to San Diego in 1893. Establishing an independent practice there, Gill remained in southern California for the rest of his life. Most of his commissions were for houses, apartment complexes and institutional buildings in residential districts.

Much of Gill's early work follows popularized conventions for American middle-class suburbs; it is commodious, efficient and picturesque but seldom inspired. He produced more distinctive work after 1900 as a result of pursuing the rustic simplicity advocated by proponents of the Arts and Crafts Movement. Sizeable dwellings such as the Marston House, San Diego (1904), possess a clear, purposeful order in their composition and detail. On the other hand, modest dwellings such as the Cossitt House, San Diego (1906), are often imbued with a studied casualness.

By 1910 Gill had developed his own style, which remained constant until the end of his career. His approach was in part reductivist. Decorative details such as eaves and mouldings are pared away, leaving uninterrupted surfaces inside and out. Yet his method relied more on creating a lucid, geometric order, in both form and space, predicated on what he had come to regard as the immutable basics in design: the straight line, circle, cube and arch. The result may be a scheme composed with insistent regularity, as is the Women's Club, La Jolla (1912–14; for illustration see SAN DIEGO), or may appear to have been erected piecemeal, for example the Fulford House, San

Diego (1910). Yet neither size nor use determines expression. In this respect a complex such as the Bishop's School, La Jolla (1909–10, 1916), is analogous with such substantial residences as the Walter Luther Dodge House, Los Angeles (1914–16; see fig.), or with Gill's numerous experiments in low-cost housing, for instance Buena Vista Terrace, Sierra Madre (1910). Eschewing a hierarchy based on class or function was seen by Gill as a commitment to democratic values. At a time when the use of reinforced concrete was still a novelty, concrete became Gill's favourite material as it can be easily moulded, is durable and is conducive to attaining simple effects. He also refined tilt-slab construction techniques and developed his own steel door and window casings, bull noses and lath.

Gill sought to revitalize what he regarded as long-standing values. His imagery owes a major debt to Spanish architecture in California and to traditional work in the Mediterranean basin. He intended the plainness of exterior surfaces to be softened by vines and extensive surrounding foliage, and aimed to foster an atmosphere of home life not only in all types of house but also in churches, clubs and schools. When the Arts and Crafts Movement lost impetus after World War I, Gill's practice quickly eroded, and he received little work and scant recognition during his last 15 years.

WRITINGS
'The Home of the Future: The New Architecture of the West: Small Homes for a Great Country', *Craftsman*, xxx (1916), pp. 140–51, 220

BIBLIOGRAPHY
'A New Architecture in a New Land', 'The Bishop's School for Girls: A Progressive Departure from Traditional Architecture', *Craftsman*, xxii (1912), pp. 465–73, 653–6

E. Roorbach: 'Celebrating Simplicity in Architecture', *W. Archit.*, xix/4 (1913), pp. 35–8

'Talkative Houses: The Story of a New Architecture in the West', *Craftsman*, xxviii (1915), pp. 448–55

'Garden Apartment-houses of the West', *Architect & Engin. CA*, lviii/1 (1919), pp. 73–7

E. Roorbach: 'A California Home of Distinguished Simplicity', *House Beautiful*, xlix (1921), pp. 94–5, 142

Irving Gill (exh. cat., ed. E. McCoy; La Jolla, Mus. Contemp. A.; Los Angeles, Co. Mus. A.; 1958)

E. McCoy: *Five California Architects* (New York, 1960/R 1975), pp. 58–101

H. M. Ferris: 'Irving John Gill, San Diego Architect, 1870–1936', *J. San Diego Hist.*, xvii/4 (1971), pp. 1–19

W. H. Jordy: *American Buildings and their Architects: Progressive and Academic Ideals at the Turn of the Twentieth Century* (Garden City, NY, 1972/R New York, 1986), pp. 246–71

B. Kamerling: 'Irving Gill: The Artist as Architect', *J. San Diego Hist.*, xxv/2 (1979), pp. 151–90

RICHARD LONGSTRETH

Gill, S(amuel) T(homas) (*b* Perritorn, Somerset, 21 May 1818; *d* Melbourne, 27 Oct 1880). Australian painter of English birth. Educated at Dr Seabrook's Academy, Plymouth, and employed as a draughtsman and watercolour painter by the Hubard Profile Gallery in London, he had some experience of the English watercolour tradition before he departed in 1839 for South Australia. In 1840 he established a studio in Adelaide, working primarily in watercolour, which suited the immediacy of his style; he completed many views of the city as well as portraits. His best works were the landscapes that record the explorations of the South Australian desert, their immediacy and fluency of style comparable to the finest Australian landscape artists of the day. Gill's reputation rests largely on the appeal and interest of the documentary side of his work, seen for example in *Sturt's Overland Expedition leaving Adelaide, 10 August 1844* (watercolour, 1844; Adelaide, A.G. S. Australia).

In 1852 Gill travelled to the Victorian goldfields, where he sketched life on the fields with spontaneity and humour. He lived in Sydney from 1856 to 1864 and spent the remainder of his life in Melbourne. During the 1870s his work became less skilled, and his subjects (landscapes, cityscapes and portraits) repetitive. However, his scenes of stockmen, Aborigines and pioneers from this period formed a basis for the bush mythology prevalent in late 19th-century Australian art. His final years as an alcoholic ended in an undignified death on the steps of the Post Office.

BIBLIOGRAPHY

R. M. Bowden: *S. T. Gill: Artist* (Melbourne, 1971)

G. Dutton: *S. T. Gill's Australia* (Melbourne, 1981)

S. T. Gill: The South Australian Years, 1839–1852 (exh. cat. by T. Appleyard, B. Fargher and R. Radford, Adelaide, A.G. S. Australia, 1986)

BRIDGET WHITELAW

Gillardi [Gilliardi; Gigliardi; Gilardi], **Domenico** [Zhilyardi, Dementy (Ivanovich)] (*b* Montagnola, nr Lugano, 5 July 1785; *d* Milan, 27 Feb 1845). Italian architect, active in Russia. He was the most talented member of several generations of the Gillardi family of architects who worked in Russia. He was the son of Giovanni Battista Gillardi (1755–1819), who worked in Russia from 1787 to 1817. Domenico moved to Russia in 1796 and studied with his father, and then in St Petersburg under Giuseppe Ferrari (1811–70), A. Porto and K. Scotti, and from 1802 to 1806 in the Accademia in Milan. From 1806 to 1810 he studied art in Rome, Florence and Venice. He first worked in Russia as an assistant to his father, and in 1817 he succeeded his father as architect to the Moscow department of the Foundling Hospital.

Gillardi's work embodies the architectural principles of late classicism (the Empire style), combined with a fine understanding of the traditions of Russian architecture and city building. His buildings are characterized by harmonious combinations of architectural masses, the contrasting use of richly articulated architectural forms and large flat areas of wall, with an elegant conciseness of detail and decoration.

Gillardi's works played a large role in determining the appearance of Moscow, as it was restored after the fire of 1812. From 1817 to 1819 he restored the buildings of Moscow University (1782–93; by Matvey Kazakov) and the Razumovsky House (also known as the English Club and now the Central Museum of the Revolution) to their monumental and stately forms. Between 1818 and 1823 he rebuilt the Vdovy Dom (Widows' House; now the Institute for the Advanced Training of Physicians) and in 1818 the Yekaterina School (now the Central House of the Soviet Army). The architect's greatest public buildings were for the Foundling Hospital, including the Council of Guardians (Opekunsky Soviet; 1821–6; now the Academy of Medical Sciences), on which he worked in collaboration with AFANASY GRIGOR'YEV, and the Technical Academy (1827–32; formerly Sloboda Palace; now the Bauman Higher Technical Academy). In Gillardi's residential buildings, monumentality is combined with intimacy, features generally characteristic of private residences in Moscow after the fire of 1812. Features of urban buildings, which form part of an overall street, are combined with specific features from palace estates, evident, for example, in the Lunin House (1818–23; now the Museum of Oriental Art), the House of Grigory Gagarin (1820s; now the A. M. Gorky Institute of World Literature) and the estate of the Usachov–Naydenovs (1828–31) on the River Yauza. An interest in nature is a characteristic of Gillardi in his building projects for estates. In the 1820s, for the Golitsyn princes, he rebuilt the Kuz'minki estate, which was then outside the town but is now a suburb of Moscow. To the central part of the building he added the clarity of the Empire style, but he distributed new buildings picturesquely about the park. Among these, the majestic stables with the Musical Pavilion were particularly important. The memorial complex of the mausoleum (1813) of the Volkonsky princes in Sukharovo, near Moscow, and the mausoleum (1832) of the counts Orlov on the Otrada estate, near Serpukhov, are also noteworthy among Gillardi's rural commissions.

Gillardi was a highly talented interior designer. He developed the best traditions of ceremonial classical interiors, for example in the Assembly Hall of the university and the interior of the Council of Guardians, Moscow, in collaboration with the sculptors and decorative painters G. T. Zamarev, Ivan Vitali, S.-P. Campioni, S.-I. Ul'delli and others. In 1832 he returned to Italy, where he lived in Montagnola and Milan until his death.

BIBLIOGRAPHY

G. Martinola: *J. Gilardi a Mosca* (Bellinzona, 1944)

Y. A. Beletskaya and Z. K. Pokrovskaya: *D. I. Zhilyardi* (Moscow, 1980; It. trans., Lugano, 1984)

Y. A. BELETSKAYA, Z. K. POKROVSKAYA

Gillberg, Jakob (*b* Ölme, nr Kristinehamn, 26 May 1724; *d* Stockholm, 15 Oct 1793. Swedish printmaker and draughtsman. He enrolled at Uppsala Universitet in 1747 but soon became interested in art. He learnt the basics of the engraving technique and studied under Jean Eric Rehn in Stockholm in 1749. He was employed at the Fortifikation in 1751 but continued his studies with Rehn and at the Kungliga Akademi för de Fria Konsterna. In 1751 he executed a series of engravings of Olof Tillaeus, the Dean of Stockholm Cathedral, and his family after the originals by Petter Landsberg (1706–63) and in 1754 portraits of *Adolf Frederick, King of Sweden* (*reg* 1751–71) and *Lovisa Ulrica, Queen of Sweden.* He received a military scholarship to study at the Ecole des Beaux-Arts in Paris (1755–8) as the protégé of Carl Gustav Tessin and Alexander Roslin, and with their assistance he was appointed military draughtsman in 1757. Laurent Cars taught him engraving in the CRAYON MANNER, a technique of stippling the plate to produce a print similar to a chalk drawing. An example of a work done in this style is *Rice Bathhouse* (or *A Matter of Joy for Hell's Furies*, 1755). He brought back the technique to Sweden in 1758, hoping to be appointed Royal Engraver. He was unsuccessful in this attempt, so instead he founded a private engraving school where princes and wealthy dilettantes could be taught. When the Statliga Gravyrskola (State Engraving School) was founded in 1764, he became a teacher there with Per Gustaf Floding, and he was appointed a professor at the Akademi in 1768. Besides working privately for patrons, he engraved portraits of *Gustav III, King of Sweden* and his wife *Queen Sophia Magdalena* in 1773 and their son *Crown Prince Gustav Adolf* (later Gustav IV Adolf) in 1781. His practice of drawing slowly and meticulously was carried over into his engravings, where small, short strokes together with long parallel lines are evident. He also produced copperplate engravings after his own drawings for the *Kronprinsens abc-bok* (Crown Prince's abc book; Stockholm, 1780). In 1792 he was appointed Master of Drawing at the Krigs-akademi (War Academy). His son Jakob Axel Gillberg (1769–1845) was a miniature painter.

BIBLIOGRAPHY

G. Jungmarker: *Jakob Gillberg: Beskrivande förteckning över Jakob Gillbergs gravyrer* [Descriptive list of Jakob Gillberg's engravings] (Stockholm, 1929)

E. Hultmark, C. Hultmark and C. D. Moselius: *Svenska kopparstickare och etsare, 1500–1944* [Swedish copperplate engravers and etchers, 1500–1944] (Uppsala, 1944), pp. 116–18

A.-G. WAHLBERG

Gille, Christian Friedrich (*b* Ballenstedt am Harz, 20 March 1805; *d* Wahnsdorf, nr Dresden, 9 July 1899). German painter, engraver and lithographer. Between 1825 and 1833 he studied engraving under Johann Gottfried Abraham Frenzel, lithography under Louis Zöllner and painting under Johan Christian Dahl at the Hochschule für Bildende Künste, Dresden. Dahl encouraged in Gille an appreciation for the natural formations and changing conditions of light that had inspired Dahl's friend and mentor, the Romantic painter Caspar David Friedrich. Gille, however, did not adopt Friedrich's tendency to find mystical significance in these phenomena. Gille's prints are highly descriptive in style and include Saxon landscapes, genre scenes, animal studies and portraits of celebrated men. His paintings and sketches, in oils, watercolour and pen and brown ink, were mostly of landscapes, many with animal staffage. His style changed relatively little over the years, and few of the paintings are dated.

Like Dahl, Adolph Friedrich Erdmann Menzel and Karl Blechen, Gille was among the pioneers of a realistic form of landscape painting. His empirical approach is especially evident in the undated *Waterfall* (Hamburg, Ksthalle), which is characterized by fluid light and dark passages, harmonious colouring and smooth gradations of tone. Gille habitually painted *en plein air*, recording intimate views of nature. In this he paralleled the Barbizon school, but his use of spontaneous broken brushstrokes in certain passages established the illusion of the light reflecting surfaces of objects, such as the meadow in the foreground of the *Landscape Study* of 1833 (Hamburg, Ksthalle), and anticipated the technique of the French Impressionists.

BIBLIOGRAPHY

K. Gerstenberg: *Christian Friedrich Gille* (Dresden, 1927)

H. Keller: 'Lob der deutschen Landschrift: Zu Bildern Christian Friedrich Gilles', *Mus. Heute* (1948)

H. Zimmerman: 'Christian Friedrich Gille: Ein Wegbereiter der realistischen Landschaftsmalerei', *Jb. Staatl. Kstsamml.* (1961–2)

RUDOLF M. BISANZ

Gilles, Jean-François. *See* COLSON, JEAN-FRANÇOIS.

Gilles, Werner (*b* Rheydt, nr Mönchengladbach, 29 Aug 1894; *d* Essen, 22 June 1961). German painter. He was the fourth of nine children, and the cramped conditions of his childhood home aroused in him early on a wish for freedom; his later life proved correspondingly unsettled. In 1913 he took a study trip to the Netherlands with Otto Pankok. In 1914 he received a scholarship for the Akademie in Kassel. During World War I he was a soldier in Russia and France. From 1921 to 1923 he attended the Weimar Akademie as well as studying under Lyonel Feininger at the Bauhaus, where he became friends with Gerhard Marcks and Oskar Schlemmer. Having worked in a restrained Expressionist style that was partly influenced by the abstract works of Vasily Kandinsky, he developed his own form of figuration, perhaps influenced by Henri Matisse and Marc Chagall.

Gilles's extensive, almost nomad-like travels began during his student years. From 1921 to 1925 he visited Italy several times; from 1927 to 1930 he lived alternately in France, Italy and Germany. Winning the Prix de Rome in 1931 led him to return to Italy. The years 1933–5 were spent in Berlin and on the Baltic Sea. In 1936, on Ischia, Gilles became friends with Eduard Bargheer (1901–79) and, in Berlin, with another German painter, Werner Heldt (1904–54). From 1937 to 1941 he was drawn yet again to Italy; from 1941 to 1944 he lived in Berlin, in the Rhineland, in south Germany and on the Baltic. In 1949, after service in the war, a stay in military hospital, and residence in several parts of Germany, he settled in Munich. From 1951, he regularly spent summers at Sant'

Angelo on Ischia, for it was there that he found a suitable setting for his world of archaic images.

Gilles's themes encompassed Greek myths (especially Orpheus as a Classical resurrection mystery), the Old and New Testaments, Christian legends of the saints, figures from world literature, and above all, landscapes, which, as the artist expressed it, are the most musical element in the visual arts. His works are, however, dreams and visions, which have been translated into well-composed and often stylized forms and structures. Thus nature becomes the means of expressing moods and, beyond that, a manifestation of transcendental powers. The various phases in his works correlate with biographical ups and downs and different artistic trends. The expressive landscapes of the 1920s and the Surrealistic compositions that began to appear in 1928, and which can be traced to the literature of French Symbolism (e.g. the *Rimbaud* cycle, 12 watercolours, 1933–5; Essen, Mus. Flkwang), can be seen as freely determined, if somewhat problematic, expressions of the artist's inner self. The temporary concentration on the traditional themes of landscape and still-life at the beginning of the 1930s must, on the other hand, be considered as a reaction to external circumstances, namely the repressive *Kulturpolitik* accompanying the rise of Nazism. Even here the works are iconographically orientated towards earlier art. Moreover, the elemental, romantic conception of the landscape in the pictures that were painted during the first sojourn on Ischia can be regarded as an escapist introversion, which in some ways held him back.

Following the compositions depicting the confrontation of humanity and the elemental powers of nature, Gilles painted figurative island landscapes such as *Ural Landscape* (1931; Bremen, Ksthalle), which evoke an untouched, primeval and almost archaic world. In them he transformed the natural formations of the earth into decorative abstract patterns. He spent the first years of World War II on Ischia and in Palinuro and again produced works that clearly reflect a retreat from contemporary events: arcadian views of southern landscapes, partly combined with figural scenes of nude fishermen such as *Three Youths by the Sea* (1941; Hamburg, Ksthalle). In this search for a lost paradise, characterized by ancient or Classical rather than Christian ideas, Gilles, probably unknowingly, aligned himself with the tradition of the 19th-century German artists in Rome. In 1949, after service in the war and residence in several parts of Germany, he settled in Munich. In 1951 he became an honorary member of the Akademie der Bildenden Künste in Munich, and in 1955 he was made a member of the Akademie der Künste in West Berlin.

BIBLIOGRAPHY

A. Hentzen: *Werner Gilles* (Cologne, 1960)

K. Ruhrberg: *Werner Gilles* (Recklinghausen, 1962)

Werner Gilles: 60 Werke, Ölbilder, Aquarelle, Pastelle, Zeichnungen (exh. cat., Düsseldorf, Gal. Vömel, 1980)

M. Schwengers: *Werner Gilles: Stilistische und ikonographische Studien zu seinem Werk* (Cologne, 1985)

DOMINIK BARTMANN

Gillespie, John Gaff. *See under* SALMON & GILLESPIE.

Gillespie Graham [Gillespie]**, James** (*b* Dunblane, Perthshire [now in Central], 11 June 1776; *d* Edinburgh, 21 March 1855). Scottish architect. Gillespie added his wife's surname of Graham to his own on his father-in-law's death in 1825. In 1800 he was appointed to supervise work on the islands of Skye and North Uist, including schools, churches, piers, inns and a proposed new town at Kyleakin, for Alexander, 2nd Baron MacDonald. His first major commission was for the County Buildings, Cupar, Fife (1810; altered 1835–40). The austere Neo-classicism of this design was repeated at Gray's Hospital, Elgin, Morayshire (now Highland) (1815), where a Tuscan portico and compound dome terminate the western axis of the town. Blythswood House, Renfrewshire (1818; destr. *c*. 1929), a Greek Revival mansion on the banks of the River Clyde, had an Ionic tetrastyle portico over a semi-basement. Gillespie Graham's largest commission was an extension of the Edinburgh New Town, built in the 1820s on land owned by the 10th Earl of Moray. The main elements of the plan, which combined ideas from Bath and John Nash in London, were a crescent (Randolph Crescent), then an ellipse (Ainslie Place) and finally, in Moray Place, a circus 187 metres in diameter, where the classical proportions are enhanced by Doric columns instead of the pilasters used elsewhere. Gillespie Graham laid out the town of Birkenhead, Cheshire (1828–44), the centre of which, Hamilton Square, had stone terraces, after the fashion of those in Edinburgh, on three sides leaving an open side for the proposed town hall.

The style most favoured by Gillespie Graham was the Gothic Revival. He designed St Mary's Roman Catholic Church, Edinburgh (1813), and St Andrew's Roman Catholic Chapel, Glasgow (1814). St Andrew's was the first Gothic Revival church in Scotland to have a nave and aisles closely imitating the medieval precedent and fully expressed in elevation. These works were instrumental in promoting Gothic as the style for churches in Scotland.

The gradual appearance of Gothic architectural texts enabled Gillespie Graham to combine the principles of the Picturesque with a more accurate Gothic syntax, so that throughout the 1820s and 1830s he remained in the forefront of the Gothic Revival in Scotland. His position was strengthened when he met the young A. W. Pugin in London in 1829. The extent and nature of his collaboration with Pugin has only recently been examined, but it was always known that Gillespie Graham's entry for the Houses of Parliament competition in 1835 was drawn up by Pugin. Pugin supplied drawings for Murthly Castle, Perthshire (1829; destr. *c*. 1950); an early example, copied from various English models, of Jacobean Revival. Through his social connections Gillespie Graham secured numerous commissions in Perthshire. The most grandiose was the embellishment (1838–9) of Taymouth Castle, near Aberfeldy, where the Regency Gothic decoration of the state rooms was given, with Pugin's help, a more scholarly gloss.

Their other collaborative works included the steeple at Montrose, Angus (1832), based on that at Louth, Lincs, the refurbishment of the chapel at Heriot's Hospital, Edinburgh (1834), and Tolbooth St John's, Edinburgh (1839). The site of the Tolbooth church, at the head of the Royal Mile, is very compressed (40×20 m), so the

entrance porch is set in the base of an elaborate 74 metre steeple. The porch leads to a central corridor with committee rooms on either side, above which is the church, a galleried hall with a plaster rib-and-panel ceiling. From a distance the silhouette of Tolbooth St John's is a striking landmark on the Old Town skyline.

In his last important domestic work Gillespie Graham adopted the Scottish Baronial style then gaining popular acceptance. Brodick Castle, Isle of Arran (1844), and Ayton Castle, Borders (1851), display bartisans and crow-steps, and have lavish ceilings copied from early 17th-century models.

BIBLIOGRAPHY
Colvin
J. Macaulay: 'James Gillespie Graham in Skye', *Bull. Scot. Georg. Soc.*, iii (1974–5), pp. 1–14
——: *The Gothic Revival, 1745–1845* (Glasgow, 1975)
——: 'The Architectural Collaboration between J. Gillespie Graham and A. W. Pugin', *Archit. Hist.*, xxvii (1984), pp. 406–16

JAMES MACAULAY

Gillet, Nicolas-François (*b* Metz, 31 March 1712; *d* Poissy, 7 Feb 1791). French sculptor, active in Russia. He studied with Lambert Sigisbert Adam (ii) and at the Académie Royale, Paris. In 1746 he left for the Académie de France in Rome, remaining in Italy until 1752. Among works executed in Italy was a stucco high relief of *St Augustine*, inspired by Roman Baroque examples, for the choir of S Luigi dei Francesi, Rome (1752; *in situ*). On his return to Paris he was accepted (*agréé*) by the Académie Royale in 1753 and received (*reçu*) as a full member in 1757, on presentation of a marble statuette representing *Paris the Shepherd* (Paris, Louvre) as a graceful adolescent. In the same year he travelled to Russia at the invitation of Ivan Shuvalov, President of the newly founded Academy of Fine Arts in St Petersburg.

Gillet was professor of sculpture at the Academy for nearly 20 years, forming a whole generation of Russian sculptors including Fedot Shubin, Mikhail Kozlovsky, Feodosy Shchredin and Ivan Prokof'yev. Although he was a gifted teacher, establishing a life class in 1760 and making the copying of casts after the Antique obligatory from 1769, his own work was disappointing and none of his major projects—an equestrian monument to Peter the Great, a mausoleum for Peter the Great, a monument to Catherine II—was executed. He was in the end overshadowed by Etienne-Maurice Falconet, who was brought to St Petersburg to execute the equestrian monument to *Peter the Great* (bronze, erected 1782; St Petersburg, Decembrists' Square). However, Gillet worked as a decorator at the Winter Palace in St Petersburg, under the supervision of Bartolomeo Francesco Rastrelli, and at the Palace of Pavlovsk, and his portrait busts are moderately successful. Although his posthumous portrait of *Peter the Great* (marble, *c.* 1760; St Petersburg, Hermitage) is rather dull and conventional, his bust of *Count Ivan Shuvalov* (marble, 1759; St Petersburg, Hermitage) has a certain elegance, with its flattering pose and fine display of the Count's decorations, and is an impressive example of a late Baroque official portrait, despite the bland and expressionless features.

By 1779 Gillet was again in Paris, but the rest of his career is obscure.

Lami
BIBLIOGRAPHY
D. Roche: 'Les Sculpteurs russes élèves de Nicolas-François Gillet', *Rev. A. Anc. & Mod.*, xxix (Paris, 1911), pp. 33–48, 125–38
L. Reau: *Histoire de l'expansion de l'art français moderne, le monde slave et l'Orient* (Paris, 1924), pp. 125–9
D. Lavalle: 'Le Choeur de l'église Saint-Louis-des-Français', *Fond. N. Rome Pont.*, lii (1981), pp. 291–4
La France et la Russie au siècle des lumières (exh. cat., Paris, Grand Pal., 1986–7), pp. 248, 253

GUILHEM SCHERF

Gilliam, Sam (*b* Tupelo, MS, 1933). American painter. He studied at the University of Louisville, KY (1952–6; 1958–61). Gilliam's first works showed the influence of Emil Nolde and Paul Klee and of the Abstract Expressionist Nathan Oliveira. After marrying Dorothy Butler in 1962, he settled in Washington, DC. There he established contact with Gene Davis (*b* 1920), Tom Downing (*b* 1928) and Howard Mehring (*b* 1931), who represented a second wave of artists associated with colour-field painting. Gilliam became well known for his colour-field paintings and became the most prominent African American abstract painter, with seven one-man exhibitions at the Jefferson Place Gallery, Washington, DC, between 1965 and 1973 (*see also* AFRICAN AMERICAN ART, §3 and fig. 4). Characteristic works of the 1960s include *Petals* (1967; Washington, DC, Phillips Col.), in which loose canvas is stained with patterns of colour achieved by pigments poured over before it is folded and restretched to give a symphonic resonance. Later works, such as *Dark as I Am* (1971–2) and the series *Jail Jungle* (1968–74) created sculptural assemblages from vigorously textured, mixed-media compositions. The scale of his works increased to vast size: *Autumn Surf* (1973; San Francisco, CA, MOMA) was executed on 100 m of polypropylene to give a connected environmental experience. In his densely layered paintings of the late 1970s, such as *Coffee Thyme* and *Black-Blues-Muse* (both New York, Carl Solway Gal.), Gilliam attempted to achieve an expressive intensity of colour, while paying homage to Jackson Pollock and to Jasper Johns, claiming a place in the epic tradition of American painting.

BIBLIOGRAPHY
Sam Gilliam: Indoor and Outdoor Paintings, 1968–78 (exh. cat., Amherst, U. MA, U. Gal., 1978)
J. Beardsley: *Modern Painters at the Corcoran: Sam Gilliam* (Washington, DC, 1983)
Sam Gilliam (exh. cat. by D. C. Driscoll, Washington, DC, Smithsonian Inst., 1987)

□

Gillick. English sculptors and medallists. Ernest George Gillick (*b* Bradford, 1874; *d* London, 25 Sept 1951) studied at the Nottingham School of Art. He exhibited at the Royal Academy in London from 1904 and was elected an ARA in 1935. Much of his work is in the form of busts, statuettes, reliefs and decorative objects, but he also produced pieces on a grander scale, for example his work on the exterior decoration of the Victoria and Albert Museum, London (commissioned 1904). He designed the reverses of a number of British service medals and executed the model for the Mayoralty seal of the City of London. The Royal Academy prize medal of 1936 (bronze) is also by him. His wife, Mary Gillick [née Tutin] (*b* Nottingham, 1881; *d* London, 27 Jan 1965), trained at the Nottingham School of Art from 1899 to 1902 and at the

Royal College of Art, London, from 1902 to 1904. They married in 1905 and from then on shared a studio in Chelsea, often working in collaboration, as in the memorial to *Frederick Denison Maurice* (Cambridge, St Edward's). Mary Gillick first exhibited at the Royal Academy in 1911. Besides her larger relief work in bronze and stone she produced many portrait medallions, such as those of the sculptor George, Frampton's son *Meredith Frampton* (bronze, 1924; London, BM) and *Eric Arthur Huntington-Whiteley* (bronze, 1934; Oxford, Ashmolean). She modelled the head of Queen Elizabeth II for the first issue of coins of that reign (1953).

BIBLIOGRAPHY
Forrer
R. McQuade: 'Biographical Notes on Mrs Mary Gillick', *Can. Numi. J.*, xxviii (1983), p. 477
D. Pickup: 'The Inner Temple War Medal', *The Medal*, xxv (1984), pp. 73–5

PHILIP ATTWOOD

Gillies, Sir W(illiam) G(eorge) (*b* Haddington, East Lothian [now Lothian], 21 Sept 1898; *d* Temple, Lothian, 15 April 1973). Scottish painter. His studies at Edinburgh College of Art were interrupted from spring 1917 to 1919 by his induction into the Army. In 1922 he and nine fellow students, including William Crozier (1893–1930) and William MacTaggart (1903–before 1934), founded an exhibition society called the 1922 Group, through which they promoted their work in annual exhibitions at the New Gallery in Edinburgh for about ten years. In 1924 a travelling scholarship enabled Gillies to study in Paris under André Lhote and in Italy.

Gillies painted some still-lifes and portraits but specialized in Scottish landscapes such as *Winter Dusk* (1961–3; U. Glasgow, Hunterian A.G.), which were generally painted in oils in the studio from drawings and watercolour sketches executed *in situ*. Until the early 1930s his palette was muted, earthy and almost monochrome; later, partly under the influence of Bonnard and of Fauvism, it became higher-pitched in colour and tone. His best work is characterized by a simplified and lyrical naturalism and by a strong decorative sense of design.

BIBLIOGRAPHY
W. G. Gillies, Retrospective Exhibition (exh. cat. by T. E. Dickson, Scot. A.C., 1970)
T. E. Dickson: *W. G. Gillies* (Edinburgh, 1974)
William Gillies and the Scottish Landscape (exh. cat. by M. Mackay and V. Keller, Scot. A.C., 1980)
William Gillies: Watercolours of Scotland (exh. cat. by P. Long, Edinburgh, N. Gals., 1994)

MONICA BOHM-DUCHEN

Gillis [Gilis], Anthoni-Frans [Antoine-François] (*b* Dôle, *bapt* 7 June 1702; *d* Tournai, 16 Nov 1781). Flemish sculptor and painter of French birth. He was the son of François Gillis, a Flemish wood-carver, and at the age of 15 he became a pupil of Michiel van der Voort I in Antwerp. After becoming a master sculptor in 1723, Gillis moved to Valenciennes, where he was appointed city sculptor in 1724. At the same time he was studying painting with François Eisen and submitted a *Christ* (untraced) as his masterpiece. He executed work for religious foundations and churches in Valenciennes and in 1729 he produced decorations for the city's celebrations on the birth of a Dauphin. From 1756 he was in Tournai,

where he created statues, for example of *Ste Theresa* and *St Anthony*, in the French taste as models for porcelain manufacturers. His most notable work is a porcelain bust of *Prince Charles of Lorraine, Stadholder of the Netherlands* (1756; Brussels, Mus. A. Anc.), which, although unflattering to its subject, is probably an accurate portrait. In 1757 Gillis and his son Jean Michel Gillis founded an academy of arts in Tournai.

BIBLIOGRAPHY
Thieme–Becker
H. Hénault: 'Quelques notes sur Antoine-François Gillis', *Réun. Soc. B.-A. Dépt.*, xxii (1898), pp. 740–67
E. Soil de Moriamé: *Les Porcelaines de Tournay* (Tournai, 1910)

IRIS KOCKELBERGH

Gillot, Claude (*b* Langres, 28 April 1673; *d* Paris, 4 May 1722). French draughtsman, printmaker and painter. He was the son of an embroiderer and painter of ornaments, who doubtless trained him before he entered the Paris studio of Jean-Baptiste Corneille about 1690; there he learnt to paint and etch. In 1710 he was approved (*agréé*) by the Académie Royale; he was received (*reçu*) as a history painter five years later, on presentation of the *Nailing of Christ to the Cross* (Noailles, Corrèze, parish church). Although he painted other elevated subjects, including a *Death of the Virgin* (1715; untraced) for his native Langres, he was most active as a draughtsman and printmaker specializing in theatre and genre scenes, as well as bacchanals and designs for decorations. Gillot's principal source of inspiration was the popular theatre; he is said to have run a puppet theatre, to have written plays and once to have been in charge of sets, machinery and costume for the opera. This interest was to have a profound effect on the art of his principal pupil, Antoine Watteau (*see* WATTEAU, (1)), who entered his studio before 1705 but with whom he quarrelled some time before he was approved by the Académie.

Although the chronology of Gillot's career is unclear, his best-known drawings and etchings date probably from 1700 to 1710. It was then that he created his strange, frieze-like bacchanals, peopled by satyrs and bacchantes, which were recognized by such contemporaries as Pierre-Jean Mariette as innovative works. These subjects also inspired his paintings, few of which are traceable today (though 33 paintings were included in the inventory of his studio at the time of his death); their compositions are now known chiefly through engravings, such as that by Isaac Sarrabat of *Harlequin God Pan* (Populus, no. 486). Two surviving paintings of burlesque theatrical subjects, the *Cabmen's Dispute* and *Master Andrew's Tomb* (both Paris, Louvre), are stiff and static in treatment when compared with the light and spontaneous touch of the drawings of the same subjects (Paris, Louvre; see fig.).

The numerous surviving drawings by Gillot (large holdings in Paris, Louvre; Chantilly, Mus. Condé; Berlin, Kstbib. & Mus.) employ a variety of techniques, among them pencil, black and red chalk, pen, wash, watercolour and gouache, both separately and in combination. He obtained extraordinary effects with red chalk in particular, which he also used to touch up his etchings. Watteau, who took up Gillot's fairground and theatrical subject-matter and style, used a more limited range of graphic media, but he imitated Gillot's manner closely during his years of

Claude Gillot: *Master Andrew's Tomb*, pen and ink with red chalk wash, 150×218 mm (Paris, Musée du Louvre)

apprenticeship, so that red chalk drawings made by the two artists in the period *c.* 1705–8 are sometimes hard to distinguish. All have elongated figures with pointed toes and wide-set eyes, executed with rapid strokes. Equally close at this period are the arabesque designs and gambolling putti of the two. It was, perhaps, the older man's dislike of this excessive closeness (Watteau's painting *Harlequin, Emperor of the Moon* (Nantes, Mus. B.-A.) is based on an untraced Gillot drawing known through an engraving (P 345) and was once attributed to him) that led to their quarrel and parting *c.* 1709.

Gillot was a prolific illustrator. He drew and engraved plates for almanacs with such titles as the *Great Winter of the Year 1709* (P 11) and *Ceres Afflicted to See the Sterile Earth* (P 12). He provided vignettes for the libretti of the operas *Amadis* (P 487–92) and *Thésée* (P 493–8) in 1711, as well as illustrations for the 1713 and 1716 editions of Nicolas Boileau's poem *Le Lutrin* (P 262–7 and 269–74). Most importantly, in 1719 he drew, etched and engraved 68 vignettes for the quarto edition of Houdard de La Motte's *Fables nouvelles* (P 31–98) and 115 for the duodecimo edition (P 99–213). The drawings for these are in the Musée Condé, Chantilly. Gillot's series of 60 drawings (Brussels, Bib. Royale Albert 1er, Cab. Est.) of the *Life of Christ* were engraved by Gabriel Huquier (P 282–341); they are charming compositions but lack any feeling for the sacred. They do, however, shed light on the variety of subjects treated by Gillot.

Gillot's decorative designs, which feature imaginative combinations of architecture, arabesques, scroll- and shell-work with figures in various kinds of fancy dress, for use on panelling, harpsichord cases, screens, hangings, gunstocks etc, achieved a wide circulation in suites of engravings by himself and others. They include the imaginative *Nouveaux desseins d'arquebuserie* (P 214–19), the *Livre de portières* (P 220–25) and the *Livre de principes d'ornements* (P 366–77). The latter, with its various sequels, was published posthumously by Huquier. Gillot was commissioned, in the year before his death, to make watercolour and wash costume designs for the ballet *Les Eléments*, in which the young Louis XV danced. The designs are

collected in the *Nouveaux desseins d'habillements à l'usage des ballets opéras et comédies* (P 394–478), with 80 plates, engraved by François Joullain several years after Gillot's death.

Gillot was recognized by his contemporaries as having played a key role in the development of a distinctively contemporary genre, the *fête galante* (*see* FÊTE CHAMPÊTRE), which was brought to maturity by Watteau. With his prolific and very varied output, he was also one of the artists who most influenced the LOUIS XV STYLE. Despite this, he died in poverty. Nicolas Lancret and the engraver François Joullain were his pupils.

BIBLIOGRAPHY

E. Dacier: 'Gillot', *Les Peintres français du XVIIIe siècle*, ed. L. Dimier, i (Paris and Brussels, 1928), pp. 157–215
B. Populus: *Claude Gillot (1673–1722): Catalogue de l'oeuvre gravé* (Paris, 1930) [P]
H. J. Poley: *Claude Gillot: Leben und Werk, 1673–1722* (Würzburg, 1938)
N. Villa and others: 'Hommage à Claude Gillot, Langres, Musée du Breuil, 1973', *Cah. Haut-Marnais*, cxiii (1973) [whole issue]
Watteau, 1684–1721 (exh. cat., ed. M. Morgan Grasselli and P. Rosenberg; Paris, Grand Pal.; Washington, DC, N.G.A.; W. Berlin, Schloss Charlottenburg; 1984–5)
M. Eidelberg: 'Watteau in the Atelier of Gillot', *Antoine Watteau: Le Peintre, son temps et sa légende*, ed. F. Moureau and M. Grasselli (Paris and Geneva, 1987), pp. 45–57

MARIANNE ROLAND MICHEL

Gillott, Joseph (*b* Sheffield, 11 Oct 1799; *d* Edgbaston, Birmingham, 5 Jan 1872). English manufacturer, patron and collector. Born in humble circumstances, Gillott moved to Birmingham *c.* 1821 to work in the light steel trade. In 1823 he married Maria Mitchell, and they worked together, eventually developing and adapting machinery to mass-produce steel pen-nibs (patent granted 1831), from which Gillott made a considerable fortune. This allowed him to build up a remarkable collection of Old Masters and contemporary paintings. He filled three galleries in his Birmingham house and one in London with an everchanging assortment of paintings and drawings that he bought chiefly through dealers and agents, sometimes exchanging pictures for wine, pen-nibs, horses, musical instruments or jewels. He owned Sassoferrato's copy after Raphael's lost painting of the *Virgin with the Pink* (Detroit, MI, Inst. A.) and 17th-century Dutch and Flemish pictures, including Aelbert Cuyp's *Milking Cows* (1645–50; Dublin, N.G.) and paintings by David Teniers, as well as works by Rubens, Bartolomé Esteban Murillo, Domenico Tintoretto, Joshua Reynolds and Thomas Gainsborough (*Horses and Cattle by a Wood (Repose)*, *c.* 1777–8; Kansas City, MO, Nelson-Atkins Mus. A.). From the early 1850s Gillott concentrated on contemporary genre and landscape paintings, except Pre-Raphaelite examples. He had a notable collection of works by J. M. W. Turner, including *Calais Sands* (exh. RA 1838; Bury, A.G. & Mus.), and by William Etty, including *Bivouac of Cupid* (exh. RA 1838; Montreal, Mus. F.A.). He regularly commissioned John Linnell, owning among other works his *Noah: Eve of the Deluge* (1848; Cleveland, OH, Mus. A.), T. S. Cooper, Francis and Thomas Danby, William Henry Hunt and Thomas Webster. After Gillott's death 525 works were sold at Christie's in six days (April, May 1872)

for over £164,000. Gillott's papers belong to the J. Paul Getty Trust.

DNB

BIBLIOGRAPHY

J. Chapel: 'The Turner Collector: Joseph Gillott 1799–1872', *Turner Stud.*, vi/2 (1986), pp. 43–50

——: 'Gillott Papers', *Walpole Soc.* [in preparation]

JEANNIE CHAPEL

Gillow. English family of furniture retailers. Robert Gillow I (1704–72) became a freeman of the town of Lancaster in 1728 and married Agnes Fell in 1730. They had two sons, Richard Gillow I (1734–1811) and Robert Gillow II (1745–95). Richard studied architecture in London and returned to Lancaster, whereas Robert managed the London showrooms that were established in Oxford Street in 1769. The Lancaster branch engaged in a variety of activities, making furniture for the home and export markets and importing sugar, rum and, to a lesser degree, tropical woods from the West Indies. They also did architectural joinery and made billiard-tables, encouraged by the vogue for this game from the 1770s and by the proximity of the Cumbrian slate mines. The opening of their London branch attracted more customers and brought closer contact with the latest smart fashions. However, the cost of transport had to be set against the cheaper labour rates of Lancaster, and to reduce this overhead, consignments were dispatched for final assembly in London. To encourage trade, discounts were offered for joint dispatches and travelling salesmen, armed with lavishly illustrated manuscript pattern-books, actively promoted the firm's wares. The Gillows were shrewd in producing a neat, rather conventional range of furniture derived from the designs of James Wyatt, the most fashionable architect of the last two decades of the 18th century, and from plates in the pattern-books of George Hepplewhite and Thomas Sheraton. They avoided the height of fashion, supplying instead pieces that would appeal to the burgeoning middle classes of Liverpool and Manchester, who valued good, solid, well-made furniture. Crossbanding and carving were kept to a minimum, but painted furniture that harmonized with upholstery and wallpaper was widely used from about 1770 until the 1800s, when rosewood became more fashionable. From about 1780 the firm took to stamping some of its furniture with GILLOWSLANCASTER, and in 1785 the Lancaster side of the operation branched out into upholstery. At the end of the 18th century the firm manufactured several novel types of furniture, including the Davenport, the whatnot and the 'Imperial Extending Dining Table', which was brought out by Richard Gillow in 1800. In the vogue for historical revivals that developed towards the end of the Napoleonic Wars, Gillows produced 'Gothic', 'Old English' or 'Elizabethan', and 'Antique' (Greek Revival) furniture. There was an increasing market for reproduction furniture, which clients would add to their original sets. A few items of Chippendale-style furniture, based on designs in Thomas Chippendale the elder's *Gentleman and Cabinet-maker's Director*, were also made, such as the Gothic 'Salisbury' Antique table.

As well as the provincial middle classes, Gillows' customers included such elevated patrons as the 1st and 2nd earls of Wilton at Heaton Hall, Lancs, and the 3rd Marquess (later Duke) of Westminster (one of their most lavish employers) at Eaton Hall, Ches; industrialists, including Sir Robert Peel the elder and Peter Drinkwater; and fellow Roman Catholic families, such as the Blundells of Ince Blundell, Lancs, and the Towneleys of Towneley Hall, Lancs. Important collections of their furniture survive at Tatton Park, Ches, Broughton Hall, N. Yorks, and at Lotherton Hall, Leeds (originally made for Parlington Hall, W. Yorks). The last Gillow to be directly involved with the firm was Richard Gillow II (1806–66), grandson of Richard Gillow I, who retired in 1830.

An extensive archive of the business of Gillow & Co. is housed in London at the Westminster City Library. It covers every aspect of the operation, including sketchbooks of *c.* 1770–1800, journals, day-books, cash-books, salary ledgers, packing-books, jobbing-books (some containing samples of fabrics and wallpapers), 'estimate sketch books' and a few 'regulation books'. There is also a large collection of drawings at the Lancaster City Museum.

BIBLIOGRAPHY

N. Goodison: 'Gillows Clock Cases', *Antiqua. Horology*, v/10 (1969), pp. 348–61

N. Goodison and J. Hardy: 'Gillows at Tatton Park', *Furn. Hist.*, vi (1970), pp. 1–40

I. Hall: 'Patterns of Elegance: The Gillows' Furniture Designs', *Country Life*, clxiii (8 June 1978), pp. 1612–15; (15 June 1978), pp. 1740–42

S. C. Nichols: 'Furniture Made by Gillow and Company for Workington Hall', *Antiques*, cxxvii (1985), pp. 1353–9

G. Beard and C. Gilbert, eds: *Dictionary of English Furniture Makers, 1660–1840* (Leeds, 1986)

JAMES YORKE

Gillray, James (*b* London, 13 Aug 1756; *d* London, 1 June 1815). English draughtsman and engraver. During his career he engraved over 1500 prints and invented, almost single-handed, the genre of British political caricature. In his lifetime he was feared and admired; his reputation waned in the strait-laced moral climate that succeeded the Regency. In 1831 the *Athenaeum* described him as a 'caterpillar on the green leaf of Reputation'.

Gillray was the only surviving child of James Gillray, a Scot who was the sexton of the Moravian settlement in Chelsea, and he briefly attended at the Moravian school in Bedford, leaving in 1764. In the early 1770s he was apprenticed to Henry Ashby (1744–1818), an engraver of trade cards, bills and certificates. Gillray claimed to have joined a travelling theatre on leaving Ashby, but by 1775 he was back in London, engraving satirical prints for the print-publisher William Humphrey (?1740–?1810). In 1778 he enrolled as a student at the Royal Academy Schools, where the pre-eminent engraver Francesco Bartolozzi was among the lecturers. During his studies he supported himself by continuing to work as an engraver.

Gillray's first attributable political satire, *Grace before Meat* (see Hill, 1965, pl. 27), appeared in November 1778. During the next six years he developed his characteristic style and in the process transformed the nature of British caricature. From the 1750s to the 1780s caricature had been largely the preserve of the amateur, influenced by the Italian tradition of *caricatura* and limited to the depiction of types, rather than individuals. Political caricature depended heavily on emblems and attributes to identify subjects and personalities. Gillray, following James

Sayers, was among the first satirists to exaggerate the subjects' facial features, while retaining a recognizable likeness. By 1784 he was widely acknowledged as the leading caricaturist in Britain. In 1780 Gillray executed two highly finished prints illustrating Henry Fielding's novel *Tom Jones* (H 1965 pls 21, 22), which reveal his academic training; for several years, until 1789, he pursued parallel careers as caricaturist and as engraver of portrait, fancy and historical paintings, the latter trade being both more lucrative and more respectable.

Between mid-1783 and late 1785 Gillray abandoned satire and concentrated entirely on stipple engravings, producing two illustrations for Oliver Goldsmith's *The Deserted Village* (1784) and, in the same year, a large sentimental plate recording a maritime disaster, the loss of the *Nancy Packet* (H 1965 pl. 25). In 1785, disappointed by his exclusion from John Boydell's *Shakespeare Gallery*, he wrote to Benjamin West, an artist he later satirized, offering to engrave any of his paintings. The failure of his portrait print of *William Pitt the Younger* (H 1965 pl. 24), issued early in 1789, caused Gillray to abandon further attempts at 'serious' subjects; and he took his revenge against the artistic establishment in a magnificent print of 1789, *Shakespeare Sacrificed, Or the Offering to Avarice* (H 1965 pl. 31), in which Boydell is savagely caricatured and Henry Fuseli, Joshua Reynolds, John Opie, George Romney, West and James Northcote are parodied.

From the late 1780s until 1795 Gillray's political prints reflected either public opinion or commissioned propaganda; his own political opinions were subjugated to the needs of the market. Many of his best plates satirized the royal family. Attacks on the Prince of Wales (later George IV) had already begun in 1782 with *Monuments lately Discover'd on Salisbury Plain* (see Hill, 1966, pl. 51), which exploited the Prince's attentions to the Countess of Salisbury, and the monarchy provided the inspiration for Gillray's three great stipple engravings of 1792: *A Connoisseur Examines a Cooper* (H 1965 pl. 39) and *Temperance Enjoying a Frugal Meal* (H 1966 pl. 57), dealing with George III's parsimony, and *A Voluptuary under the Horrors of Digestion* (H 1966 pl. 57; see fig.), which mercilessly anatomizes the profligacy of his son.

After a period of initial optimism following the fall of the Bastille on 14 July 1789, English public opinion turned against the French Revolution and Gillray's anti-republican designs culminated in the horrific satire, the *Zenith of French Glory: A View in Perspective* (H 1966 pl. 8), issued on 12 February 1793, 22 days after the execution of Louis XVI, by which time France had declared war on England. Gillray's sympathies were firmly behind the British Government. Together with Philippe Jacques de Loutherbourg he worked on two patriotic commissions in 1793 and 1794, providing sketches and likenesses for Loutherbourg's paintings, the *Grand Attack on Valenciennes* (Easton Neston, Northants), and the *Victory of Lord Howe on 1 June 1794* (London, N. Mar. Mus.). In 1795 Gillray engraved several political prints based on designs by John Sneyd (1763–1835), a close friend of the politician George Canning. When Gillray was arrested in the following year for blasphemy because of his parody of the Nativity in *The Presentation,* or *The Wise Men's Offering* (H 1965 pl. 66), it was probably Canning who persuaded the authorities to

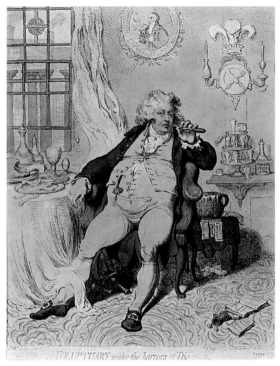

James Gillray: *A Voluptuary under the Horrors of Digestion*, hand-coloured stipple engraving, 337×273 mm, 1792 (London, Victoria and Albert Museum)

drop the charge. Canning, well aware of the value of publicity, used Sneyd to encourage Gillray to caricature him in the *Promis'd Horrors of the French Invasion* (October 1796; H 1966 pl. 15). In recognition of Gillray's help, in 1797 Canning secured for him an annual pension of £200. From this time, Gillray's political cartoons and personal circumstances depended largely on his loyalty to Canning and the latter's changing political fortunes.

Probably disillusioned with domestic politics, Gillray concentrated from 1801 to 1805 on social satire (e.g. the *Pic-nic Orchestra*, 1802; H 1966 pl. 97), with the important exception of his anti-Napoleonic cartoons. These began after hostilities with France were resumed in May 1803, and they established a prototype for caricatures of 'Boney' that was widely copied by Gillray's competitors. A celebrated example is the *Plumb-pudding in Danger* (1805; H 1965 pl. 96; *see* CARICATURE, fig. 2), in which Pitt and Napoleon carve up the globe between them. Gillray's dependence on political patronage compromised his attacks on the royal family. In 1803 the Prince of Wales opened an account with William Humphrey's sister Hannah Humphrey (*d* 1818; Gillray's publisher, with whom he lodged from 1793), and purchased all his prints between 1803 and 1810 with the exception of three that depicted the Prince's morganatic wife, Mrs Maria Anne Fitzherbert (1756–1837). The Prince was not above suppressing an edition: he bought up completely *Tug of War* (*c.* 1802) and virtually all of *L'Assemblée Nationale* of June 1804 (H 1965 pl. 114). In 1806 he intervened to have his portrait removed from *Pacific Overtures* (H 1965 pls. 112, 113).

After 1806, the year in which Gillray first exhibited signs of a nervous illness, no further royal subjects appeared, possibly as the result of a bribe. By 1810 he was insane and remained so until his death.

BIBLIOGRAPHY

T. M'Lean: *Illustrative Description of the Genuine Works of Mr James Gillray* (London, 1830)

T. Wright, ed.: *The Works of James Gillray, the Caricaturist* (London, n.d., c. 1873)

M. D. George: *English Political Caricature: A Study of Opinion and Propaganda*, 2 vols (Oxford, 1959)

D. Hill: *Mr Gillray the Caricaturist* (London, 1965) [H 1965]

——: *Fashionable Contrasts: Caricatures by James Gillray* (London, 1966) [H 1966]

M. D. George: *Hogarth to Cruikshank: Social Change in Graphic Satire* (London, 1967)

James Gillray (1756–1815): Drawings and Caricatures (exh. cat., intro. by D. Hill, ACGB, 1967)

English Caricature, 1620 to the Present (exh. cat., ed. R. Godfrey; London, V&A, 1984)

☐

Gilly. German family of architects and writers of Huguenot descent. (1) David Gilly established an influential school of architecture in Berlin. His son (2) Friedrich Gilly was one of the leading Prussian representatives of Neoclassicism before Karl Friedrich Schinkel, whom he influenced.

(1) David Gilly (*b* Schwedt an der Oder, 7 Jan 1748; *d* Berlin, 5 May 1808). As a Prussian civil servant he served first as County Architect and from 1779 as Superintendent of Works for Pomerania. His duties included the design of buildings of all types, from churches to mills, as well as civil engineering projects. In 1783 Gilly set up a private architectural school at Stettin, where he combined progressive teaching grounded in French rationalism with the realities of provincial building construction. He moved to Berlin in 1788 at the request of Frederick William II, King of Prussia, to take up the post of Head of Building Control. Carl Gotthard Langhans was also persuaded to move there, and under these two architects a Franco-Prussian school began to develop. Gilly was patronized by the royal family, and his works in the 1790s include Schloss Paretz (1796–1800), near Potsdam, and Schloss Freienwalde (1798–9), 50 km north-east of Berlin. The latter, built as a summer home for Frederica, the Queen Mother (1751–1805), is an elegant two-storey, five-bay classical box with giant Tuscan pilasters, while Schloss Paretz, commissioned for the Crown Prince—who in 1797 succeeded to the throne as Frederick William III—is a more self-conscious attempt to accommodate a low Neo-classical building to a rustic setting. In addition to building a new village and church in its vicinity, Gilly provided Schloss Paretz with a landscape park, which included a Gothick belvedere, grotto and Oriental pavilion. His finest building is Vieweg House (1800–07), built in the Burgplatz at Brunswick, Lower Saxony, commissioned by Friedrich Vieweg to serve both as a home and as offices for his publishing company. The nine-bay Burgplatz entrance is fronted by a heavy Doric portico, while one longer side elevation displays more mannered features, including recessed centre bays, unmoulded window surrounds and an eccentric pattern of rustication at ground-floor level.

During his time in Berlin, Gilly continued to teach and write. The Bauschule that he founded in 1793—re-established as the Bauakademie in 1799—developed into one of the finest schools in Europe. Pupils there included Schinkel, Leo von Klenze, Friedrich Weinbrenner, Carl Ludwig Engel and Karl Haller von Hallerstein. Gilly's illustrated journal *Sammlung nützlicher Aufsätze und Nachrichten die Baukunst betreffend*, which he founded and edited (1798–1806), is of equal importance. With issues that ranged from construction methods and costings to architectural history and book reviews, Gilly initiated a type of periodical to which all later architectural journals and magazines are indebted.

WRITINGS

Über Erfindung: Construction und Vortheile der Bohlen-Dächer (Berlin, 1797)

Handbuch der Landbaukunst, 2 vols (Berlin, 1797–8)

Praktische Anweisung zur Wasserbaukunst (Berlin, 1809–18)

BIBLIOGRAPHY

NDB

W. Herrmann: *Deutsche Baukunst des 19. und 20. Jahrhunderts*, i (Basle, 1932/R 1977)

M. Lammert: *David Gilly: Ein Baumeister des deutschen Klassizismus* (Berlin, 1964)

D. Watkin and T. Mellinghoff: *German Architecture and the Classical Ideal, 1740–1840* (London, 1987)

ROBERT WILLIAMS

(2) Friedrich Gilly (*b* Altdamm, nr Stettin [now Szczecin, Poland], 16 Feb 1772; *d* Karlsbad [now Karlovy Vary, Czech Republic], 3 Aug 1800). Son of (1) David Gilly. He received his first lessons at the private architectural school run by his father in Stettin and often accompanied his father on official tours in the Prussian provinces. From 1788 he was an inspector in the Königliche Baubehörde, the same year he began studies at the Akademie der Bildenden Künste in Berlin. His teachers there included Carl Gotthard Langhans, Friedrich Wilhelm von Erdmannsdorff, Christian Bernhard Rode, Daniel Chodowiecki and Johann Gottfried Schadow. Schadow produced a posthumous bust of *Friedrich Gilly* (1801; Berlin, Akad. Kst.). Gilly first made his name with a group of sepia drawings of the 14th-century Schloss Marienburg in east Prussia (now Malbork, Poland); exhibited at the Akademie in 1795, they were published by Frick between 1799 and 1803 as a series of aquatints. This Romantic enthusiasm on Gilly's part for medieval buildings contributed to a renewed interest in construction in brick and to the beginning of provisions for the conservation of historic monuments in Prussia.

In 1797 Gilly travelled to France, England and Austria on a study-trip. The drawings he made in France (ex-Tech. Hochsch., Berlin, 1945) reveal his wide-ranging interests in architecture and reflect the mood at that time of the Directoire. They include views of the Fountain of Regeneration, the Rue des Colonnes—an arcaded street of baseless Doric columns leading to the Théâtre Feydeau—the chamber of the Conseil des Anciens in the Tuileries and Jean-Jacques Rousseau's grotto (Berlin, Altes Mus.) in its landscaped setting at Ermenonville, Oise. A sheet of portrait sketches that includes *François Soufflot* (*d* 1802) and *Julien-David Le Roy* proves that while in Paris he made contact with members of the Académie Royale. One personal project influenced by this visit, Gilly's series of sketches for building an ideal city (ex-Tech. Hochsch.,

Berlin, 1945), is a synthesis of the utopian monumentality of French Grand Prix designs and the idealized forms of Greek architecture.

In 1797 Gilly submitted a design (Berlin, Altes Mus.; see fig.) in the competition for a monument to *Frederick II, King of Prussia*, which Gilly intended should be built in the Leipziger Platz, Berlin. He began his preliminary drawings with Roman models in mind but gradually developed an ideal scheme, based on Greek examples of the 5th century BC, raised on a high podium of several stages. A statue of Frederick, heroically naked in the stance of Zeus, was intended to stand in its cella above the vaulted crypt. The tension that would have been created by this representation of death and transfiguration was to have been enhanced by Gilly's wish to use contrasting light and dark stones for the lower and upper parts and in the top-lighting of the mausoleum itself. Gilly's explanatory notes confirm that the temple was indeed intended to stir the emotions and spiritually elevate those viewing it. In his aesthetic attitude and in the pathos of his architectural symbolism Gilly was close to French Neoclassical architecture, for example, Etienne-Louis Boullée's unexecuted designs for Isaac Newton's cenotaph (1784; for illustration *see* BOULLÉE, ETIENNE-LOUIS), although Gilly's work lacks its abstract quality and huge scale. The influence of Gilly's design for Frederick's monument continued into the 1830s, with Leo von Klenze's Walhalla built near Regensburg (1830–42). In the event the competition of 1797 was won by Langhans, although Frederick William II's death the same year dashed any hopes Langhans might have had for seeing his project carried out.

Of equal importance were Gilly's unexecuted designs (*c.* 1798; ex-Tech. Hochsch., Berlin, 1945) for the Schauspielhaus, Berlin. (The version executed in 1800–02 in the Gendarmenmarkt was to Langhans's plans; after a fire it was replaced in 1818 with a new building by Karl Friedrich Schinkel.) These designs were based on his intensive studies of contemporary French theatre construction. The notes and sketches that he made in Paris include 14 theatres, including the Odéon and Théâtre Feydeau. Gilly's auditorium for his projected Schauspielhaus, which he closely based on Ledoux's theatre in Besançon (1775–84), was conceived with 'democratic' seating—a semicircular amphitheatre but having a circle and a royal box—and was strictly separated from the stage by a great proscenium arch. This clear separation of parts having different functions was reflected in the building's external form: the cube of the stage and back-stage areas and the half-cylinder of the auditorium, with a Doric portico marking the entrance and arcaded passages curving back from it to enclose the auditorium, form a dramatic composition of masses in strong contrast to the elegant and sparingly applied Greek ornament. The theatre (1799–1800; destr. 1838) in Königsberg (now Kaliningrad, Russia), begun to Gilly's plans but much altered during construction, was relatively conventional by comparison.

Other work by Gilly, sometimes uncommissioned, was more modest. His designs (1796) for rebuilding the Nikolaikirche in Potsdam (which had been burnt down) in the form of a cube with a Doric portico surmounted by a cupola were not implemented, but they did influence Schinkel's later replacement building (1826–49; *see* POTSDAM, fig. 1). Gilly also produced a fairly large number of designs for country houses as well as for pavilions in the parks and gardens of country houses designed by his father, including those (1798–1800) in the park at Schloss Bellevue, Berlin. Of his own country house designs, only the Villa Mölter in the Tiergarten, Berlin, was built (1799–1801; destr. 19th century), being modelled on François-Joseph Bélanger's Bagatelle (1775) in the Bois de Boulogne near Paris; Gilly published an illustrated description of Bélanger's masterpiece during construction of his Villa Mölter. By contrast, the Palais Lottum (1800; destr. 1906) in the Behrenstrasse, Berlin, was more in keeping with the city's domestic tradition during Frederick's reign. Gilly was also interested in interior decoration; in 1795, for example, he furnished five rooms at Schloss Schwedt an der Oder for Prince Louis Ferdinand of Prussia.

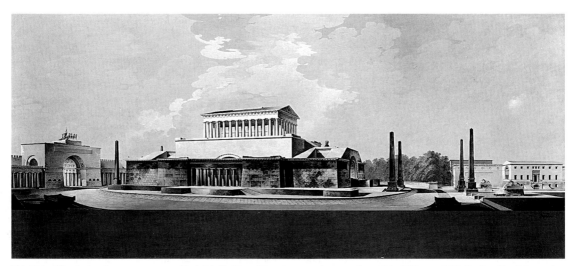

Friedrich Gilly: design for a monument to *Frederick II, King of Prussia*, pen and watercolour, 596×1352 mm, 1797 (Berlin, Altes Museum)

In 1798 Gilly was appointed Senior Court Building Inspector; the following year he became Professor of Optics and Perspective at Berlin's newly founded Bauakademie. Infectiously enthusiastic, during the last two years of his life he was also a keen member of a coterie of young architects, Schinkel and Langhans among them, who met in the spirit of a Platonic academy. They discussed various questions relating to architecture and set themselves competition projects, among them a stock exchange, a hunting lodge and a museum. In addition he began publishing articles in the periodical founded by his father, *Sammlung nützlicher Aufsätze und Nachrichten die Baukunst betreffend*. Gilly's sudden death in 1800 cut short a career of great promise. Nevertheless, with his brother-in-law Heinrich Gentz, he came to be considered a leading exponent of Neo-classicism in Prussia. His drawings, ranging from rapid pen sketches to highly finished watercolours, reveal him to have had great artistic talent. Of his realized designs, only one—posthumously built—survives: the ruinous Greek Revival mausoleum (1800–02; mostly destr. after 1942) at Dyhernfurth near Breslau (now Wrocław, Poland), conceived by Gilly in the form of a prostyle Greek temple.

WRITINGS
'Beschreibung des Landhauses Bagatelle bey Paris', *Samml. Nützl. Aufs. & Nachr. Baukst betreff.*, i (1799), pp. 106–15
'Einige Gedanken über die Nothwendigkeit, die verschiedenen Theile der Baukunst, in wissenschaftlicher und praktischer Hinsicht, möglichst zu vereinigen', *Samml. Nützl. Aufs. & Nachr. Baukst betreff.*, ii (1799), pp. 3–12
'Beschreibung des Landsitzes Rincy unweit Paris', *Samml. Nütz. Aufs. & Nachr. Baukst Betreff.*, ii (1799), pp. 116–22

PRINTS
Schloss Marienburg in Preussen (Düsseldorf, 1799–1803)

BIBLIOGRAPHY
K. Levezow: *Denkschrift auf Friedrich Gilly, königlichen Architect und Professor der Academie der Baukunst zu Berlin* (Berlin, 1801)
W. Niemeyer: 'Friedrich Gilly, Friedrich Schinkel und der Formbegriff des deutschen Klassizismus in der Baukunst', *Mitt. Dt. Kstgewver. Hamburg*, vii (1912–13)
H. Schmitz: *Berliner Baumeister vom Ausgang des 18. Jahrhunderts* (Berlin, 1914)
A. Moeller van den Bruck: *Der preussische Stil* (Munich, 1916), pp. 109–29
J. Ponten: *Architektur die nicht gebaut wurde* (Stuttgart, 1925)
H. Riemer: *Friedrich Gilly's Verhältnis zum Theaterbau* (diss., U. Berlin, 1931)
A. Oncken: *Friedrich Gilly, 1772–1800* (Berlin, 1935, rev. 2/1981)
A. Rietdorf: *Gilly: Wiedergeburt der Architektur* (Berlin, 1940/R 1943) [incl. Gilly's architectural writings]
H. Beenken: *Schöpferische Bauideen der deutschen Romantik* (Mainz, 1952)
W. Salewski, ed.: *Schloss Marienburg in Preussen: Das Ansichtswerk von Friedrich Gilly und Friedrich Frick* (Düsseldorf, 1965)
T. Nipperdey: 'Nationalidee und Nationaldenkmal in Deutschland', *Hist. Z.*, ccvi (1968), pp. 529–85
J. von Simson: *Das Berliner Denkmal für Friedrich den Grossen* (Berlin, 1976)
Fünf Architekten des Klassizismus in Deutschland (exh. cat. by J. P. Kleihues and others, Dortmund, Mus. Ostwall, 1977)
J. Posener: 'Friedrich Gilly, 1772–1800', *Berlin 1789–1848: Facetten einer Epoche* (exh. cat., E. Berlin, Akad. Kst. DDR, 1981)
H. Reelfs: 'Friedrich und David Gilly in neuer Sicht', *Sber. Kstgesch. Ges.*, 28/29 (1981), pp. 18–23
J. Traeger: 'Architektur der Unsterblichkeit in Schinkels Epoche', *Wiss. Z. Ernst-Moritz-Arndt-U. Greifswald*, xxxi/2-3 (1982), pp. 31–5
Friedrich Gilly (1772–1800) und die Privatgesellschaft junger Architekten (exh. cat. by R. Bothe and others, W. Berlin, Berlin Mus., 1984)
D. Watkin and T. Mellinghoff: *German Architecture and the Classical Ideal, 1740–1840* (London, 1987)
H. Reelfs: 'Friedrich Gilly und der Park des Schlosses Bellevue', *Mitt. Pückler-Ges.*, vi (1989), pp. 41–62
Revolutionsarchitektur: Ein Aspekt der europäischen Architektur um 1800 (exh. cat., ed. W. Nerdlinger, K. J. Philipp and H.-P. Schwarz; Frankfurt am Main, Dt. Architmus., 1990)

ADRIAN VON BUTTLAR

Gilman, Arthur Delavan (*b* Newburyport, MA, 5 Nov 1821; *d* New York, 11 July 1882). American architect, urban planner and writer. He was educated at Trinity College, Hartford, CT, travelled in Europe and practised with Boston architect Edward Clarke Cabot (1818–1901) before establishing his own office in Boston in 1857. With an article of 1844, written apparently before he had been to Europe, he became the first American architect to encourage the use of Charles Barry's Italian palazzo style. He later promoted French Second Empire forms, as is evident from the mansard-roofed former Boston City Hall (1862–5; interior altered, 1969–70; now offices and restaurant), School Street, designed in partnership with Gridley J. F. Bryant. While in Boston, Gilman was responsible for the plan of the Back Bay (1856), a residential area focused around Commonwealth Avenue, a French-inspired boulevard. He also designed several houses in this district, most notably the palazzo-like Harbridge House (1859–60), Arlington Street, and one of Boston's major mid-19th-century churches, the brownstone Arlington Street Church (1859–61), which fused a classicism reminiscent of James Gibbs's work with an Italianate sensibility.

In 1866 Gilman moved to New York, where his most important work, one of the most significant in the history of American architecture, was the Equitable Life Assurance Company Building (1868–70, with Edward Kendall and George B. Post; destr. *c.* 1912), Broadway. This 35-m high, mansard-roofed Second-Empire structure, which recent research has shown had seven-and-a-half storeys, is often identified as the first skyscraper; although it had load-bearing walls, rather than a steel frame, it was the first building to exploit the elevator's potential for allowing the most prestigious offices to be on the upper floors.

WRITINGS
'Downing on Rural Architecture', *N. Amer. Rev.*, lvi (1843), pp. 1–17
'Architecture in the United States', *N. Amer. Rev.*, lviii (1844), pp. 436–80
'Landscape Gardening', *N. Amer. Rev.*, lix (1844), pp. 302–29
'The Hancock House and its Founder', *Atlantic Mthly*, xi (1863), pp. 692–707

BIBLIOGRAPHY
DAB; *Macmillan Enc. Architects*
W. Weisman: 'Commercial Palaces of New York: 1845–1875', *A. Bull.*, xxxvi (1954), pp. 285–302
——: 'A New View of Skyscraper History', *The Rise of an American Architecture*, ed. E. Kaufmann jr (New York, 1970), pp. 113–60
S. B. Landau and C. W. Condit: *The New York Skyscraper* (New Haven and London, in preparation)

ANDREW SCOTT DOLKART

Gilman, Harold (*b* Rode, Somerset, 11 Feb 1876; *d* London, 12 Feb 1919). English painter. He developed an interest in art as a boy, during a period of convalescence. He spent a year at the University of Oxford, but left on account of his health to work as a tutor with an English family in Odessa. On his return in 1896 he attended Hastings School of Art and then the Slade School of Fine Art, London (1897–1901). Afterwards he spent over a

Harold Gilman: *An Eating House*, oil on canvas, 572×749 mm, *c.* 1913 (Sheffield, Graves Art Gallery)

year in Spain, copying paintings by Velázquez in the Prado. He also married an American painter, Grace Canedy, whom he met in Madrid. They settled in London, but after the birth of a daughter made a long visit to Canedy's family in Chicago where a second daughter was born and Gilman came under pressure to join his father-in-law's business.

Around this time the two dominant influences on Gilman's art were Velázquez and Whistler, as seen in the sure sense of tone and use of direct painting in *The Thames at Battersea* (1907–8; Kirkcaldy, Fife, Mus. & A.G.). In 1907 he met Walter Sickert and became a founder-member of the Fitzroy Street Group; he also joined the Allied Artists' Association in 1908. By September 1908 he was living at Letchworth, Herts, which became the subject of works by him and by Spencer Gore. In 1911 he was a founder-member of the CAMDEN TOWN GROUP. By this time his style reflected an awareness of the work of Vuillard, for example in paintings such as *Old Lady* (?1911; Bristol, Mus. & A.G.), while the subject of the nude reclining on a bed was one treated also by Sickert.

Gilman's understanding of Post-Impressionism soon exceeded that of Sickert and he began to use stronger colour, thicker impasto and compositional designs almost claustrophobic in their rigidity. The care with which Gilman composed his paintings can be seen in *An Eating*

House (*c.* 1913; Sheffield, Graves A.G.; see fig.), where the surface bears evidence of a grid that has either been kept in position while the picture was painted, or imposed at a late stage while the paint was still wet. The sense of privacy conveyed by this picture is characteristic of Gilman's work as a whole: the faces of the eaters are hidden beneath cloth caps and behind wooden partitions, one of which runs the entire width of the picture, creating a barrier between the viewer and the scene.

Gilman further affirmed his independence from Sickert in 1914 by exhibiting with Charles Ginner as a 'Neo-Realist'. He married again in 1917 and the following year went to Nova Scotia on a commission from the Canadian War Records. One of his last works, *Interior* (1917–18; Brit. Council), of a woman seated on a double bed, indicates his use of strong patterning and a preference for intimate subject-matter. His career was terminated by the influenza epidemic of 1919.

BIBLIOGRAPHY
Harold Gilman (exh. cat., London, Tate, 1954)
Harold Gilman, 1876–1919 (exh. cat., essays R. Thomson and A. Causey; ACGB, 1981)
For further bibliography *see* CAMDEN TOWN GROUP.

FRANCES SPALDING

Gilmor, Robert, jr (*b* Shadwell, MD, 24 Sept 1774; *d* Baltimore, MD, 30 Nov 1848). American collector and

patron. His father was Baltimore's leading merchant and financier. He was one of the first Americans to collect European and American art on a large scale. During his lifetime as many as 500 paintings and 2500 prints and drawings passed through his hands. It is estimated that he owned between three and four hundred paintings at any one time. Dutch and Flemish painting formed the bulk of his collection, but he also accumulated English, French, Spanish and Italian works, though many were of doubtful attribution. A posthumous sale catalogue listed one painting as by Raphael or Leonardo da Vinci. Gilmor began patronizing American artists in the early 1800s. An amateur landscape painter himself, he was attracted to the work of William Groombridge (*fl* 1773–96), Francis Guy, Thomas Doughty and especially Thomas Cole. He also bought from portrait painters (Charles Willson Peale, Gilbert Stuart, Thomas Sully, Henry Inman, John Wesley Jarvis and John Trumbull), as well as genre and history painters (Washington Allston, John Gadsby Chapman, Charles Cromwell Ingham and William Sidney Mount). Hoping to encourage an American school of sculpture as well as painting, he was the first to commission a large-scale work from Horatio Greenough, a recumbent *Medora* (1831–3; Baltimore, MD, Mus. A.). Gilmor was well-read in aesthetics and contemporary art literature, and his letters to Cole form an important chapter in the early history of American taste. His collection was dispersed at two auctions some time after his death (Baltimore, F.W. Bennett, 10 Nov 1863 and 13 April 1875).

UNPUBLISHED SOURCES

Baltimore, MD Hist. Soc. Mus. [collection of travel journals, letters, a diary and Gilmor family memorabilia]

BIBLIOGRAPHY

A. W. Rutledge: 'Robert Gilmor, Jr.: Baltimore Collector', *J. Walters A.G.*, xii (1949), pp. 18–39

H. S. Merritt, ed.: 'Correspondence between Thomas Cole and Robert Gilmor, Jr.', *Baltimore Annu.*, ii (1967), pp. 41–102

ALAN WALLACH

Gilpin. English family of artists and writers. Capt. John Bernard Gilpin (1701–76) was a landscape painter whose elder son (1) William Gilpin became an early and influential theorist of the Picturesque movement. His younger son (2) Sawrey Gilpin was an animal painter who attempted, unsuccessfully, to raise the lowly reputation of the genre. Sawrey's son (3) William Sawrey Gilpin was a landscape watercolourist and garden designer.

(1) Rev. William Gilpin (*b* Scaleby, Cumbria, 4 June 1724; *d* Boldre, Hants, 5 April 1804). Writer, printmaker, clergyman and schoolmaster. After leaving Queen's College, Oxford, he was briefly curate of Irthington, near Carlisle, and then for 25 years headmaster of Cheam School, Surrey. His earliest recorded analysis of landscape (1748) was of the gardens at Stowe, Bucks, pre-dating Edmund Burke's essay of 1756 on *The Sublime and the Beautiful*. Although Gilpin preferred the beauty of nature to the beauty of art, his critical faculties were developed by many years of collecting prints. His *Essay on Prints*, published anonymously in 1768, which had influence on the Continent, contained his earliest definition of the Picturesque. This idea was further worked out in Gilpin's notes on a series of summer holiday tours made between

1768 and 1776 in many regions of Britain. The accounts of these tours, originally intended for private circulation but later published, were influential for the next 50 years through the aesthetic guidance that they offered to amateur artists and travellers. Illustrated with his own aquatints, they offered laymen the apparatus for assessing both art and landscape. Gilpin's most important work was *Observations Relative Chiefly to Picturesque Beauty . . . of Cumberland and Westmoreland* (1786); its inspiration came from the ruins of Scaleby Castle, from his familiarity with the Lake District and from his father.

Gilpin suggested that the Sublime and the Beautiful were not appropriate standards of taste in art criticism; he added his distinct third category, the PICTURESQUE. Originally a term of judgement applied to the landscape paintings of Claude or Poussin, it became for Gilpin a means of determining whether a landscape in nature was fine enough to be depicted by artists. By stressing composition and chiaroscuro, he aspired to train the eye of his readers to appreciate the essential ruggedness, roughness and deformity of a landscape, rather than its beauty: a notion that is historically important for its influence upon Romanticism. Gilpin's theory was developed in the 1790s by Uvedale Price, Richard Payne Knight and Humphry Repton. The architecture of John Nash (i) was also affected by this movement. Praised by the poet Thomas Gray, Gilpin was criticized by others, who ridiculed him for 'improving' on nature and for giving a dubious dignity to the sketching activities of the less gifted. He corresponded with the writers on the Picturesque who succeeded him, and he seemed relatively unperturbed by the shifts of emphasis and definitions that they introduced. The fashion for the Picturesque was satirized by William Combe (1741–1823) in *Dr Syntax in Search of the Picturesque* (1812) with illustrations by Thomas Rowlandson; gentler jibes appeared in Jane Austen's *Sense and Sensibility* and *Northanger Abbey*.

WRITINGS

An Essay on Prints: Containing Remarks upon the Principles of Picturesque Beauty . . . (London, 1768, 5/1802) [first two edns pubd anon.]

Observations on the River Wye and Several Parts of South Wales, etc. Relative Chiefly to Picturesque Beauty; Made in the Summer of the Year 1770 (London, 1782, 5/1800)

Observations Relative Chiefly to Picturesque Beauty Made in the Year 1772, on Several Parts of England, Particularly the Mountains and Lakes of Cumberland and Westmoreland (London, 1786, 5 [recte 4]/1808)

Remarks on Forest Scenery, and Other Woodland Views (London, 1791, 6/1887)

BIBLIOGRAPHY

C. Hussey: *The Picturesque—Studies in a Point of View* (London, 1927/R 1967)

W. D. Templeman: *William Gilpin* (Urbana, 1939)

The Rev. William Gilpin and the Picturesque (exh. cat., London, Kenwood House, 1959)

C. P. Barbier: *William Gilpin: His Drawing, Teaching and Theory of the Picturesque* (Oxford, 1963)

P. Bicknell: *The Picturesque Scenery of the Lake District, 1752–1855: A Bibliographical Study* (Winchester, 1990)

DAVID A. CROSS

(2) Sawrey Gilpin (*b* Carlisle, 30 Oct 1733; *d* London, 8 March 1807). Painter, watercolourist and etcher, brother of (1) William Gilpin. After initial artistic tuition from his father, he was apprenticed in London in 1749 to the marine painter Samuel Scott and remained with him for almost nine years. No extant marines can be confidently

ascribed to Gilpin alone, though he is thought to have assisted Scott in the execution of some commissions during the 1750s. During this period Gilpin's sketches of horses and carts in Covent Garden reportedly brought him to the attention of William Augustus, Duke of Cumberland, by whom he was briefly employed around 1759. His watercolour studies made at Cumberland's stud-farm have been compared (and sometimes confused) with those of his fellow-employee Paul Sandby.

In the 1760s Gilpin combined teaching drawing at Cheam School, Surrey (of which his brother William Gilpin was headmaster), with a career as a sporting and animal painter in London, in which latter sphere he was overshadowed by George Stubbs. Encouraged by Stubbs's publicly exhibited lion and horse subjects, which endeavoured to raise the lowly reputation of animal art, from 1768 Gilpin attempted a number of 'animal history' pieces—notably four pictures illustrating episodes from Jonathan Swift's *Gulliver's Travels*, *Gulliver and the Houyhnhnms* (1768–72; York, C.A.G.; New Haven, CT, Yale Cent. Brit. A., see fig.; Southill Park, Beds). Public reaction was cool, however, and he devoted much of his later career to conventional sporting and animal painting, returning only occasionally to more elevated themes.

Gilpin worked extensively for the rakish Colonel Thomas Thornton (1755–1823), contributing widely to his collection of contemporary sporting pictures (and Old Master fakes) at Thornville Royal, N. Yorks; *Death of the Fox* (exh. RA, 1793; version at Southill Park), for example, is a large work in the style of Frans Snyders. Though Gilpin, who lived at Thornville for a period, was reported to exhibit a particular 'gaieté de coeur [while] . . . enjoying the felicity of the Colonel's parties', he was a sober and responsible gentleman in old age, befriended and employed by the philanthropist Samuel Whitbread MP (1758–1815) at Southill Park, together with his son-in-law and pupil George Garrard. Gilpin's *Duncan's Horses*, an illustration of a scene from Shakespeare's *Macbeth*, provided the design for one of Garrard's five low-relief overdoors (exh. RA, 1798) in the entrance hall of Whitbread's home.

Gilpin, who, like Stubbs, continued working well past the age of 70, never quite fulfilled the promise apparent in his early work. About 1759 he produced a set of expressive etchings of horses' heads to illustrate a manuscript by William Gilpin, 'On the Characters of Horses' (some of which were finally published in the latter's *Remarks on Forest Scenery, and Other Woodland Views*; London, 1791). This work indicates that Gilpin's grasp of the problems of the visual representation of the emotions of animals was as sophisticated as that of Stubbs, but he never exploited it fully. Although his early works in pencil and watercolour were adept enough to prompt his brother

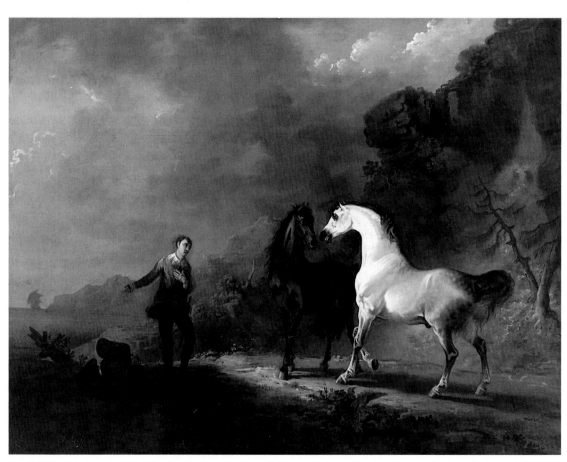

Sawrey Gilpin: *Gulliver Addressing the Houyhnhnms*, oil on canvas, 1.04×1.39 m, 1769 (New Haven, CT, Yale Center for British Art)

to advise him to give up painting in oils in favour of drawing, he seems to have lacked the confidence to do so. Aware of his limitations, he frequently collaborated with other artists such as George Barret and Philip Reinagle, hiring them to paint landscape backgrounds for his paintings or himself supplying animal staffage for theirs (e.g. the cattle in J. M. W. Turner's *Sunny Morning*; exh. RA, 1799). Gilpin was elected ARA in 1795, and he narrowly and controversially defeated William Beechey to become RA in 1797.

BIBLIOGRAPHY

C. Barbier: *William Gilpin: His Drawings, Teaching and Theory of the Picturesque* (Oxford, 1963)

J. Farington: *Diaries*, ed. K. Garlick, A. Macintyre and K. Cave, 14 vols (London, 1978–84)

Paintings, Politics and Porter: Samuel Whitbread and British Art (exh. cat., ed. S. Deuchar; London, Mus. London, 1984)

STEPHEN DEUCHAR

(3) William Sawrey Gilpin (*b* 1762; *d* Sedbergh, Yorks, 1843). Watercolourist and landscape gardener, son of (2) Sawrey Gilpin. He almost certainly received his early training from his father. A rare drawing, *An Arabian Stallion Walking to Right* (New Haven, CT, Yale Cent. Brit. A.), suggests that he may have intended to follow his father's career as an animal painter, but any such aspiration was soon abandoned and his work is almost exclusively devoted to the English landscape. He practised as a drawing master and does not appear to have exhibited until 1797, when he showed the *Village of Rydal, Westmoreland* (London, V&A) at the Royal Academy. Three years later he exhibited a *Park Scene* (London, V&A), his final Academy entry. Gilpin's early technique of painting in wash over careful pencil drawing is conservative, and his style and subjects are similar to those of Humphry Repton. Gilpin's later pictures are more painterly and show an awareness of the work of Thomas Girtin.

By 1804 Gilpin's reputation was sufficiently established for him to be included in the group of successful watercolour painters who, unhappy at their treatment by the Royal Academy, resolved, on 30 November, to establish the Society of Painters in Water-colours, later known as the Old Watercolour Society to distinguish it from the New Society founded in 1832. Gilpin was elected President but resigned in the following year on his appointment as Drawing Master to the Royal Military College at Great Marlow. He continued, however, to exhibit at the Society until 1815, showing a total of 86 works.

In 1815 Gilpin resigned his post at the Royal Military College, which had by then moved to Sandhurst, and abandoned the profession of painter for that of landscape gardener. Although he had no practical training in gardening, his change of career was not particularly surprising. The great majority of his pictures were landscapes drawn from nature and worked up later; a sketchbook of *Landscape Studies in Hampshire* (London, V&A) is typical of his work done *en plein air*. As a landscape gardener he could improve nature by practice rather than in theory. He himself saw the connection clearly, stating in his book *Practical Hints for Landscape Gardening*, published in 1832, his intention to 'apply the principles of painting to the improvement of real scenery'. Furthermore his uncle

William Gilpin, the champion of the Picturesque, must have been an early and important influence.

Gilpin was immensely successful and dominated garden design in Britain for 20 years. He was more imaginative, indeed more picturesque, than his predecessors 'Capability' Brown and Repton, and more sensitive to the natural terrain and indigenous foliage of the grounds he designed. His commissions included Clumber Park, Notts; Hawarden, Flints; Bicton, Salop; and Sudbury, Derbys. He also worked in Scotland and Ireland.

See also GARDEN, §VIII, 5.

WRITINGS

Practical Hints for Landscape Gardening with Some Remarks on Domestic Architecture as Connected with Scenery (London, 1832)

BIBLIOGRAPHY

DNB

M. Hadfield, ed.: *British Gardeners: A Biographical Dictionary* (London, 1980)

DAVID RODGERS

Gilpin, Laura (*b* Colorado Springs, CO, 20 April 1891; *d* Santa Fe, NM, 30 Nov 1979). American photographer. Although she accepted commercial assignments, such as portraiture and architectural work, she was committed to chronicling the people and land of the Southwest. After studying photography in New York between 1916 and 1918 under Clarence H. White, she returned to Colorado. Through most of the 1920s she followed the romantic soft-focus tradition of her teacher and the pictorialists. In 1931 she was introduced to the Navajo community at Red Rock, AZ, by her lifelong friend Elizabeth Forster. She began to make a lasting document of the land and people that she found around her. Her style changed, her photographs becoming increasingly hard-edged, recording the culture of the Navajo and their relationship to the land in a straightforward, empathetic manner. Two decades of this work culminated in the publication of *The Enduring Navaho*.

Gilpin distinguished herself from many of her contemporaries by continuing to use platinum printing paper, which gave her prints a rich tonal quality, and by her devotion to landscape photography, a genre pursued by few other women. Her other publications include *The Pueblos: A Camera Chronicle*, *Temples in Yucatan: A Camera Chronicle* and *The Rio Grande: River of Destiny*. The major collection of her work is at the Amon Carter Museum in Fort Worth, TX.

PHOTOGRAPHIC PUBLICATIONS

The Pueblos: A Camera Chronicle (New York, 1941)

Temples in Yucatan: A Camera Chronicle (New York, 1948)

The Rio Grande: River of Destiny (New York, 1949)

The Enduring Navaho (Austin, 1968)

BIBLIOGRAPHY

T. Pitts: 'The Early Work of Laura Gilpin, 1917–1932', *Cent. Creative Phot.*, xiii (April 1981), pp. 7–37

M. Sandweiss: *Laura Gilpin: An Enduring Grace* (Fort Worth, 1986)

E. Forster and L. Gilpin: *Denizens of the Desert*, ed. M. Sandweiss (Albuquerque, 1988)

MARTHA A. SANDWEISS

Giltlinger. German family of artists. Its main representative, (1) Gumpolt Giltlinger I, from Augsburg, was a painter of panels and stained-glass windows. His son Gumpolt Giltlinger II (*fl* 1520; *d* 1547) was the father of Christoph Giltlinger I (*fl* 1554–96), who was trained by

Christoph Amberger and was the grandfather of Christoph Giltlinger II (*fl* 1591–1608). Florian Giltlinger (*c*. 1490–1547) and his son Andreas Giltlinger (*fl* 1563; *d* after 1580) were of greater significance, as painter and glass painter respectively, than the descendants of Gumpolt Giltlinger I, but their relationship to them has not been established.

(1) Gumpolt Giltlinger I (*fl* Augsburg, 1481; *d* Augsburg, 1522). Painter. All works documented as his seem to be destroyed or untraced. They include a *St Michael* panel (1481–4) for Augsburg Cathedral; the high payment of 400 guilders suggests the esteem in which the artist was held, as does his frequent introduction of apprentices to the guild between 1483 and 1500 (only Hans Burgkmair I and Jörg Breu I would perform this role as frequently). Besides small commissions, for instance for the master builder's office in the Augsburg Rathaus (1488) and for flags etc (1502–4), Giltlinger chiefly worked for the Augsburg monastery of SS Ulrich and Afra, under Abbot Johannes von Giltlingen. Here he painted altar panels, such as one (1493) for the Fugger family and another in the Marienkapelle for the Stammler family, and also frescoed the refectory with views of the Holy Land (1495). In 1496 he executed a panel for the Abtskapelle, and in 1497 one for the St Simpert altar. It can be assumed that all of these works fell victim to the iconoclastic attacks of 1537. The surviving wings of the St Simpert altar, formerly attributed to Giltlinger, have proved to be mid-16th-century works.

On the other hand, there is evidence to show that Giltlinger did create the glass window panels of saints (1496) for the Abtskapelle in SS Ulrich and Afra. Here, in the *Virgin* panel, he evidently executed a design by Hans Holbein (i). A further surviving work is a *Daniel* window panel in the Pfarrkirche of Schwaz, commissioned in 1506 by the local mining brotherhood. Two other glass panels in Schwaz, a *Virgin and Child* and an *Immaculata*, are free from Holbein's influence. Their style can also be seen in the saints and the Virgin between two canonized popes in the second apsidal chapel of Augsburg Cathedral; but attribution to Giltlinger remains uncertain.

BIBLIOGRAPHY
Thieme–Becker
A. Stange: *Deutsche Malerei der Gotik*, viii (Munich, Berlin, 1957), pp. 56ff
Hans Holbein der Ältere und die Kunst der Spätgotik (exh. cat., Augsburg, Rathaus, 1965), p. 123, no. 115

HANS GEORG GMELIN

Gimignani. Italian family of artists. Alessio Gimignani (1567–1651), a pupil of Jacopo Ligozzi, was a respected painter in his home town of Pistoia; his most important surviving work is the *Martyrdom of St Bartholomew* (Pistoia, S Bartolomeo in Pantano). His son (1) Giacinto Gimignani painted altarpieces and frescoes, as well as producing etchings, but was best known for his classicist easel pictures of biblical and historical themes. A more Baroque style was developed by Giacinto's son (2) Ludovico Gimignani, who painted altarpieces and frescoes in Roman churches.

(1) Giacinto Gimignani (*bapt* Pistoia, 23 Jan 1606; *d* Rome, 9 Dec 1681). Painter and etcher. He is traditionally said to have been trained by his father. From 1630 he is documented in Rome, and from 1632 he worked under the direction of Pietro da Cortona for the Barberini family. His first surviving work, also documented by drawings, is the frescoed lunette of the *Rest on the Flight to Egypt* (1632) in the chapel of the Palazzo Barberini, while his earliest signed and dated painting is the *Adoration of the Magi* (1634; Rome, Coll. Urbano Propaganda Fide, chapel). During the reign of the Barberini pope Urban VIII (*reg* 1623–44), he painted many pictures for the Barberini circle, among them a fresco of the *Vision of Constantine* in the ambulatory of the baptistery of S Giovanni in Laterano (*in situ*), under the direction of Andrea Sacchi. His early training with Cortona influenced his brilliant colour and painterly surfaces, yet he was also responsive to the more austere art of Domenichino and Sacchi, to the refined mythologies of Alessandro Turchi and to Nicolas Poussin and his French contemporaries in Rome. Gimignani developed an individual classicist style, and the intense colour and balanced compositions of his many easel paintings of biblical and Classical themes, such as *Rachel Hiding the Idols* (1640s; Florence, Gal. Corsini), are closest to Poussin. His works were popular with French patrons, among them François Annibal d'Estrées (1573–1670), who commissioned *Rinaldo and Armida in the Enchanted Forest* (1640; Bouxwiller, Mus. Ville). With Giovanni Francesco Romanelli he played a decisive role in introducing the Roman Baroque style to France. In the 1640s Gimignani also began to produce etchings, as reproductions of his paintings and as book illustrations, such as those for F. Strada's *De bello Belgico: Decades duae* (Rome, 1647). In 1648 he assisted Cortona in the decoration of the Palazzo Pamphili, Rome.

In the early 1650s Gimignani also worked in Florence, where he produced tapestry cartoons for the Arazzeria Medicea, such as the *Entry of Johanna of Austria into Florence* (tapestry, 1654; Florence, Uffizi) and a ceiling fresco of *Parnassus* (1654) in the Palazzo Niccolini, Florence (*in situ*). Between 1652 and 1654 he painted 25 pictures based on Classical or biblical themes for the Palazzo Rospigliosi in Pistoia (*in situ*). In the late 1650s Gimignani painted frescoes in Lucca (S Agostino) and altarpieces for churches in the Marches (e.g. Fano, Camerino). He then returned to Rome, where in the 1660s he worked, with his son Ludovico and under the direction of Gianlorenzo Bernini, for Pope Alexander VII. Altarpieces such as the *Glory of St Thomas of Villanova* (1661; Castel Gandolfo, S Tommaso da Villanova) and the *Death of St Anthony Abbot* (*c*. 1665; Ariccia, Collegiata dell'Assunta), painted for churches built by Bernini, reveal the influence of the more Baroque style of Ludovico and Bernini. Giacinto's late works include frescoes in the apse of S Maria dei Monti (?1676; *in situ*) and the *Supper at Emmaus* in the former refectory of the Barnabite monastery of S Carlo ai Catinari (1678; *in situ*), both in Rome, and altarpieces for churches in Perugia and Amelia.

(2) Ludovico Gimignani (*b* Rome, 19 or 25 May 1643; *d* Zagarolo, 16 June 1697). Painter, son of (1) Giacinto Gimignani. His career was determined by an early association with Gianlorenzo Bernini and Giulio Rospigliosi, who became Pope Clement IX. His first works, carried out under his father's supervision, were for churches built by Bernini for Pope Alexander VII. They

include the *Holy Family* (1665; Ariccia, Collegiata dell' Assunta), an accomplished work influenced by Bernini and close to the style of Giovanni Battista Gaulli and Guglielmo Cortese. Giulio Rospigliosi paid for him to travel to Venice and Modena in 1668, accompanied by Gaulli and bearing letters of recommendation from Bernini, a journey that deeply influenced his development as an artist. Ludovico's scenes from the *Life of St Maddalena dei Pazzi* (oil on canvas, 1669; Rome, S Maria di Montesanto) and from the *Life of St Pietro d'Alcantara* (oil on canvas, 1669; ex-Palazzo Pallavicini, Rome), painted to celebrate the canonization of the two saints, were influenced in form and expression by Bernini's treatments of saintly ecstasy. He carried out important commissions for altarpieces in the Roman churches of Il Gesù, S Luigi dei Francesi, S Maria in Campitelli and S Maria delle Vergini, and painted many frescoes, for example in S Carlo al Corso and the Palazzo Madama, also both in Rome. Gimignani's most ambitious project was the supervision, after Mattia de Rossi's death, of the refurbishment of S Silvestro in Capite, Rome, for which he produced altarpieces, frescoes in the apse and transepts and stucco decorations in the nave. He made designs for a number of tombs, including one for Queen Christina of Sweden in St Peter's, as well as that of *Cardinal Agostino Favoriti* (*d* 1682) in S Maria Maggiore, which was sculpted by Filippo Carcani. Drawings left in his estate are held in the Gabinetto Nazionale delle Stampe, Rome.

BIBLIOGRAPHY

L. Pascoli: *Vite* (1730–36), ii, pp. 298–308 [mainly Ludovico]

G. Di Domenico Cortese: 'Profilo di Ludovico Gimignani', *Commentari*, xiv (1963), pp. 254–66

D. Cortese: 'Per corso di Giacinto Gimignani', *Commentari*, ii–iii (1967), pp. 186–206

U. Fischer Pace: *Giacinto Gimignani (1606–1681): Eine Studie zur römischen Malerei des Seicento* (diss., U. Freiburg im Breisgau, 1973)

——: 'Les Oeuvres de Giacinto Gimignani dans les collections publiques françaises', *Rev. Louvre*, v–vi (1978), pp. 343–58

M. Carter Leach and R. W. Wallace: *Italian Masters of the 17th Century* (1982), 45 [XX/ii] of *The Illustrated Bartsch*, ed. W. L. Strauss (New York, 1978–), pp. 94–121

U. V. Fischer Pace: *Disegni di Giacinto e Ludovico Gimignani, nelle collezioni del Gabinetto Nazionale delle Stampe*, Rome, Gab. N. Stampe cat. (Rome, 1979)

D. Miller: 'Giacinto Gimignani's *Allegory of Fortune*', *A. Bull.*, lxviii (1986), pp. 144–9

Seicento: Le Siècle de Caravage dans les collections françaises (exh. cat., Paris, Grand Pal.; Milan, Pal. Reale; 1988–9), pp. 232–5

Italian Etchers of the Renaissance and Baroque (exh. cat., ed. S. Welsh Reed and R. Wallace; Boston, MA, Mus. F.A., 1989), pp. 200–01 [Giacinto]

J. M. Merz: *Pietro da Cortona* (Tübingen, 1991), pp. 230–32, 339–40

URSULA VERENA FISCHER PACE

Gimmi, Wilhelm (*b* Zurich, 7 Aug 1886; *d* Chexbres, Vaud, 29 Aug 1965). Swiss painter, printmaker and illustrator. He studied at the Académie Julian in Paris (1908–10), then taught at the Kunstgewerbeschule in Zurich. In 1910 he met Hans Arp, Walter Helbig (1878–1968), Hermann Huber (1888–1968), Paul Klee and Oskar Lüthy (1882–1945), with whom in 1911 he founded the Moderner Bund, characterized by its open attitude to modern European trends. He later travelled through Italy, Belgium and the Netherlands before settling in Paris, where he lived until 1940. His earliest paintings were influenced by Post-Impressionism, followed (until 1914) by a colourful form of Cubism. He took part in the Salon

d'Automne from 1919 and the Salon des Indépendants from 1921; his first individual exhibitions, at Berthe Weill's gallery, were an undoubted success, confirmed in the mid-1920s by a double contract with the dealers Antoine Druet and Jacques Rodrigues-Henriques.

Gimmi's return to Switzerland in 1940, settling by Lake Geneva, did not result in any noticeable break in a particularly consistent life's work, characterized throughout by a kind of 'elementary and unpolished grandeur' and dominated by the constant recurrence of a few favourite themes: portraiture, including several portraits of the novelist *James Joyce* (e.g. 1947; Lausanne, U., Sémin. Angl.), figures and nudes depicted in interiors, winegrowers drinking, and landscapes. Gimmi received major commissions for murals during the last 12 years of his life (e.g. 1956; Zurich, Ecole Poly. Féd.), and his efforts were crowned by the Prix de la Ville de Zurich in 1962. He also executed a large number of engravings and illustrations, particularly for works by Charles Ferdinand Ramuz (1878–1947) and Gottfried Keller.

BIBLIOGRAPHY

P. Cailler: *Catalogue raisonné de l'oeuvre lithographié de Wilhelm Gimmi avec une étude du peintre de Georges Peillex* (Geneva, 1956)

G. Peillex and A. Scheidegger: *Wilhelm Gimmi* (Zurich, 1972)

G. Peillex: *Wilhelm Gimmi: Catalogue raisonné des peintures* (Zurich, n.d. [1978])

Wilhelm Gimmi (1886–1965): De l'esquisse à l'oeuvre (exh. cat., Vevey, Mus. Jenisch, 1993)

Gimson, Ernest (William) (*b* Leicester, 21 Dec 1864; *d* Sapperton, nr Cirencester, 12 Aug 1919). English architect and furniture-maker. From 1881 to 1886 he was an architectural apprentice to Isaac Barradale in Leicester, studying in the same period at Leicester School of Art. On the suggestion of William Morris, whom he heard lecture to the Secular Society in Leicester, Gimson moved to London and became articled to J. D. Sedding. While in London he met W. R. Lethaby, Ernest Barnsley and his brother Sidney Barnsley (1865–1926), fellow architectural students who shared an interest in traditional craftsmanship and furniture design. He also served on the committees of the Arts and Crafts Exhibition Society and the Society for the Protection of Ancient Buildings. As a member of the Art Workers' Guild, he studied chairmaking with Philip Clissett (1817–1913) at Bosbury, near Ledbury, and plastering with the London firm of Whitcombe and Priestley; examples of his plasterwork can be seen at Avon Tyrell, Christchurch, Hants (1892), Pinbury Park, Glos (1903), and the Council Chamber, Bradford (1907).

Gimson's furniture is noted for its simplicity, its truth to materials and its functionalism, particularly evident in an English walnut store cabinet (1902; London, V&A) and oak kitchen dresser (1902; Cheltenham, A.G. & Mus.). He used woods local to Sapperton, particularly ash, oak, elm, deal and fruitwoods, making much of their colour and natural markings. Methods of construction such as exposed pins, joints and dovetails were often utilized as a feature of the design. Ornamental details such as holly and ebony stringing, or inlay in bone or mother-of-pearl, were integrated into the total conception of each piece and taken beyond a mere decorative trimming.

In 1890 Gimson, with his friends Lethaby, Sidney Barnsley and Detmar Blow, together with Mervyn Macartney (1853–1932), Reginald Blomfield and Colonel Mallet, formed a small furniture-making firm called Kenton and Company. It became well-known for furniture 'of good design and good workmanship' and exhibited at the third Arts and Crafts Exhibition at the New Gallery, London, in October 1890, and at the Kenton & Co. Exhibition at Barnard's Inn in December 1891. After the liquidation of Kenton & Co. in 1892 Gimson and the Barnsley brothers moved to the Cotswolds to design and make furniture. They lived at Ewen, near Cirencester, and then at Pinbury Park, part of Lord Bathurst's estate, subsequently moving at the turn of the century to cottages of their own design at Sapperton. Nearby at Daneway House, Gimson established a workshop where he employed a skilled team of cabinetmakers, including Ernest Smith and Percy Burchett, working under a chief foreman, Peter van der Waals (1870–1937). Here he trained village craftsmen to understand and produce the finest cabinet work and metalwork to his design. This laid the foundations for the move of C. R. Ashbee and the Guild of Handicraft from London to Chipping Campden in 1902. Gimson also had a close friendship with two other artists who had dedicated their lives to reviving neglected crafts: the musician Arnold Dolmetsch and the folk music collector Cecil Sharp.

Gimson is less known as an architect, but the buildings he designed did have an important influence on 20th-century architects such as Edwin Lutyens and C. F. A. Voysey. His houses and cottages are characterized by the traditional use of natural materials and the way in which they blend into their surroundings. This can be seen in the cottages he designed for members of his family in Charnwood Forest, Leics, especially Stoneywell Cottage and Lea Cottage at Ulverscroft (1898–9; see Comino, figs 105 and 108), though the houses he designed in Leicester, The White House (1897; see Comino, fig. 54), Clarendon Park, and Inglewood (1892; see Comino, fig. 39), 32 Ratcliffe Road, are equally fine. The Hall and Library (1910 and 1920) at Bedales School, Petersfield, show well his capacity to use domestic detail in an institutional setting. As a furniture-maker Gimson produced considerably more than either of the two Barnsley brothers, but all three had a profound influence on furniture design in the 20th century. Sir Nikolaus Pevsner described Gimson as 'the greatest English artist craftsman'. The Gimson tradition was furthered by Sidney Barnsley's son Edward Barnsley, who trained a succession of craftsmen at his workshop in Froxfield, Hants, over more than fifty years, and Gordon Russell, who carried the tradition forward on a commercial basis through his furniture firm in Broadway, Glos.

BIBLIOGRAPHY

W. Lethaby, F. Griggs and A. Powell: *Ernest Gimson: His Life and Work* (Stratford on Avon, 1924)
R. Alexander: *The Furniture and Joinery of Peter Waals* (Chipping Campden, 1930)
N. Pevsner: *Pioneers of Modern Design* (London, 1936/R 1960)
L. Lambourne: 'The Art and Craft of Ernest Gimson', *Country Life*, cxlvi (Aug 1969)
G. Naylor: *The Arts and Crafts Movement* (London, 1971)
A. Service: *Edwardian Architecture* (London, 1977)
A. Carruthers: *Ernest Gimson and the Cotswold Group of Craftsmen* (Leicester, 1978)
M. Comino: *Gimson and the Barnsleys* (London, 1980)

BARLEY ROSCOE

Ginain, Paul-René-Léon (*b* Paris, 5 Oct 1825; *d* Paris, 7 March 1898). French architect and teacher. He entered the Ecole des Beaux-Arts, Paris, in 1843 and studied under Louis-Hippolyte Lebas, winning the competition for the Prix de Rome in 1852. The measured drawings and studies he sent from Rome, Athens and Taormina, Sicily, demonstrate Ginain's real talent as a landscape painter. On his return from Italy in 1857, he was appointed to a junior official post in the Conseil des Bâtiments Civils and was involved in the building of the north wing of the Palais du Louvre under Hector-Martin Lefuel in the 1850s. In 1860, in the competition for the preliminary plan for the new Paris Opéra, his submission was classed first, but he lost to Charles Garnier on the second round. The following year, he joined the Public Works Department of the City of Paris, and he became architect for the 6e arrondissement for the next 30 years. In this capacity he enlarged the town hall in the Place St-Sulpice, in a style sympathetic to the original smaller building by F. Rolland and Paul-Frédéric Levicomte (1806–81). Between 1867 and 1876 he built the church of Notre-Dame-des-Champs on Boulevard Montparnasse, the nave-and-aisles plan of which is clearly expressed on the façade. The decoration of the church, however, is somewhat cold and sparse. Among Ginain's most important private commissions was the Palais Galliéra, built in 1878–94 to house the collections of the Duchesse de Galliéra, who then changed her mind and left them to the city of Genoa. Situated in the Avenue du Président-Wilson, the building is richly decorated with Hellenic and French Renaissance references. It is now the Musée de la Mode et du Costume.

The last major site on which Ginain worked was the faculty of medicine in the University of Paris. It is here that his greatest works are to be found: the library (1879) of the Ecole de Médecine on Boulevard St Germain, and the administrative offices that surround the original Ecole de Chirurgie, designed by Jacques Gondoin in 1771–6. Here he freely adapted Classical Greek architecture to a modern building (completed in 1900). His use of the Ionic order in particular was a fine example of the attempt of the academic school to renew the Classical tradition. The caryatids on the main portal are by Gustave-Adolphus-Désiré Crauk. During the last 20 years of his life Ginain sat on almost every committee and architectural jury of any importance, and in 1881 he was elected a member of the Institut.

BIBLIOGRAPHY
Thieme–Becker
C. Duprez: Obituary, *Bull. S.A.D.G.* (1898), pp. 146–52

VINCENT BOUVET

Gindelach, Matthäus. *See* GUNDELACH, MATTHÄUS.

Giner, Tomás (*fl* 1458–80). Spanish painter. He lived in Saragossa, working in the service of Prince Ferdinand of Aragon (later Ferdinand II) from 1473. In 1458 he collaborated with Francí Gomar (*fl* 1443–78), sculptor to Archbishop Dalmau de Mur (1431–56), on an altarpiece

representing the *Pentecost, SS Martin and Tecla* for the chapel of the archbishop's palace in Saragossa. He was commissioned to paint the side and central panels and a crowning section, but the two surviving panels (Saragossa, Pal. Arzobisp.) probably come from the centre and right side of the altarpiece. Gomar's high alabaster base forming the predella (New York, Cloisters) is decorated with reliefs of the titular saints. In November 1459 Giner is mentioned as the painter of the high altar retable of S Salvador, Saragossa. He also executed the altarpiece of *St Vincent Martyr* (1462–6) for the same cathedral, of which the main panel survives (Madrid, Prado). In 1466 he painted the altarpiece of the *Virgin and Child* for the hermitage of La Corona, Erla (Saragossa), and that of *St Lawrence* for the parish church in Magallón (Saragossa), the main panel of which is still in the church. Giner's painting is elegantly coloured and is notable for its formality and the deep spirituality conveyed by the faces and poses of the sacred figures. This naturalistic Gothic style is similar to that of the Catalan painter Jaume Huguet, with whom Giner has been connected. Giner's influence was felt in Aragon until the end of the 15th century.

BIBLIOGRAPHY

M. C. Lacarra Ducay: 'Una obra recuperada: El retablo de la Corona de Erla (Zaragoza)', *Rev. Zaragoza*, ii (1979), pp. 14–17

——: 'San Lorenzo de Magallón (Zaragoza), obra restaurada de Tomás Giner', *Cuad. Estud. Borjanos*, vii (1982), pp. 235–41

R. S. Janke: 'The Retable of Don Dalmau de Mur y Cervelló from the Archbishop's Palace at Saragossa: A Documented Work by Francí Gomar and Tomás Giner', *Met. Mus. J.*, xviii (1984), pp. 65–80

M. C. Lacarra Ducay: 'Aportaciones al catálogo de la obra de Tomás Giner, pintor de Zaragoza', *Artigramma*, 10–11 (1993–4)

——: 'Informaciones sobre Tomás Giner, pintor de Zaragoza (1458–1480): Miscelánea homenaje a Don Juan Ainaud de Lasarte', *Bull. Mus. N.A. Catalunya*, ii (1994–5)

M. C. LACARRA DUCAY

Ginés, José (*b* Polop, Valencia, ?1768; *d* Madrid, 14 Feb 1823). Spanish sculptor. His work bridged the Spanish traditions of the 17th and 18th centuries and the Neoclassicism of the reigns of Charles IV and Ferdinand VII. Ginés studied at the Academia de Bellas Artes de S Carlos, Valencia, and later, with a bursary, at the Real Academia de S Fernando, Madrid. He was commissioned by Charles IV for works such as *Birth of the Prince, Adoration of the Shepherds* and the powerful *Massacre of the Innocents* (all 1789–94; Madrid, Real Acad. S Fernando). The latter work comprises numerous groups of polychromed, terracotta figures, perhaps with close to 6000 pieces; these naturalistic works convey a sense of horror and drama.

Ginés was made honorary court sculptor in 1794, academician in 1814 and first court sculptor to the King and director of the Real Academia de S Fernando in 1816 and 1817 respectively. He never left Spain, and his *Venus and Cupid* (San Sebastián, Mus. Mun. S Telmo) shows his interpretation of Neo-classicism. Among other works by Ginés are four Evangelists (1794; Madrid, Pal. Real, Chapel), various royal portraits and numerous allegorical pieces honouring the monarchs.

BIBLIOGRAPHY

M. Ossorio y Bernard: *Galería biográfica de artistas españoles del siglo XIX* (Madrid, 1869, 2/1883–4/*R* 1975), pp. 288–9

E. Pardo Canalís: *Escultores del siglo XIX* (Madrid, 1961), pp. 50–60, 188–97

J. A. Gaya Nuño: *Arte del siglo XIX*, A. Hisp., xix (Madrid, 1966), pp. 70–71

J. M. Azcárate: *Guía del Museo de la Real Academia de San Fernando* (Madrid, 1988)

J. Fuster: *José Ginés, escultor de cámara honorario de Carlos IV, primer escultor de cámara de Fernando VII (1768–1823)* (Alicante, 1980)

M. E. Gómez-Moreno: *Pintura y escultura españolas del siglo XIX*, Summa A., xxxv (Madrid, 1993), pp. 23–6

OSCAR E. VÁZQUEZ

Ginés de Aguirre, Andrés (*b* Yecla, Murcia, 1727; *d* Mexico City, 1800). Spanish painter and teacher. He entered the Real Academia de Bellas Artes de S Fernando in Madrid in 1745 and applied unsuccessfully for a scholarship to go to Rome. He was awarded an allowance by Ferdinand VI, however, which enabled him to continue his studies and to make copies of paintings in the royal collections, including works by Guido Reni and Diego Velázquez. In 1760 he painted a portrait of the new king, *Charles III* (untraced). In 1764 he was made a supernumerary academician and became an Académico de Mérito in 1770, later joining the group of painters working for the Real Fábrica de Tapices de S Bárbara. In 1785 he was appointed assistant to Mariano Salvador Maella, with whom he collaborated in the restoration of the royal portraits, and the following year he was promoted to Director of Painting in the Academia de S Carlos in Mexico City. Disagreements with the director general, conflict with the viceroy and his dislike of the climate all made life in Mexico difficult for Ginés de Aguirre, but he made a great success of his work as a teacher and trained many young painters who worked with him until his death.

Ginés de Aguirre painted both in fresco and oils in Spain and Mexico, and his work was influenced at different stages by Corrado Giaquinto and Anton Raphael Mengs. In Spain he painted frescoes in the church of the Asunción in Brea de Tajo (Madrid) in 1777, depicting the *Annunciation, Nativity* and *Presentation in the Temple* in the dome, the *Four Doctors of the Church* on the pendentives and the *Holy Trinity* in the apse. In Mexico City he painted frescoes (destr.) on the pendentives of the cathedral sacristy. His tapestry cartoons, such as the *Port of Alcalá* and the *Port of San Vicente* (both 1785; Madrid, Prado), are outstanding for their range of colours and high standard of drawing and show a wide knowledge of themes by Philips Wouwerman and David Teniers (i). His many *costumbrista* scenes showing everyday life in Madrid are similar in style to those of José del Castillo, Ramón Bayeu and Francisco Bayeu, Maella and Goya, all of whom produced designs for the Real Fábrica de Tapices.

BIBLIOGRAPHY

E. Tormo: 'El pintor murciano Andrés Ginés de Aguirre', *Bol. Junta Patrn. Mus. Prov. B.A. Murcia*, 2 (1923), pp. 1ff

——: 'Adición al estudio sobre el pintor yeclano Aguirre', *Bol. Junta Patrn. Mus. Prov. B.A. Murcia*, 3 (1924)

J. L. Morales y Marín: 'Artistas murcianos de los siglos XVII y XVIII en la Corte', *Murgenta*, 50 (1978), pp. 70–80

C. Rodríguez de Templeque: 'Ginés Andrés de Aguirre: Pintor de fresco', *Cuad. A. Colon.*, 1 (1986), pp. 85–96

JUAN J. LUNA

Gingee. Fort *c.* 132 km south-west of Madras in Tamil Nadu, India. The fort was begun under the CHOLA dynasty, who erected a citadel on the hill known as Rajagiri. By the mid-15th century the hills of Rajagiri, Chandragiri and

Krishnagiri had been incorporated into a triangular complex by an outer curtain wall that defends all three. Inside, a further system of walls protects the citadel on Rajagiri and the usable high ground on Chandragiri and Krishnagiri. Supplementary walls seal off the outer wall halfway between Chandragiri and Krishnagiri, and a series of diagonally disposed gates, moats and courts make the fort difficult to enter and easy to defend. The fortifications at Gingee were repaired and extended by viceroys of the VIJAYANAGARA kings during the early 17th century. Most of the buildings in the fort, including the multi-storey, temple-like Kaliyana Mahal, the temple of Ranganatha and several stone granaries also date from this period; their architectural style recalls that of Hampi (anc. Vijayanagara). In 1644 Gingee was briefly taken by 'Abdallah Qutb Shah (reg 1626–72) of Golconda (see QUTB SHAHI), but from 1648 to 1677 it was controlled by the Sultans of Bijapur (see 'ADIL SHAHI); Persian inscriptions record the construction of bastions and other structures during the 1650s. In 1677 Gingee was captured by the Maratha chief Shivaji (reg 1674–80), who built additional ramparts and bastions. Gingee was controlled by the French from 1750 until 1761, when it was acquired by the British; on the eastern side of the fort are gun emplacements, living-quarters and sentry-boxes built by the French.

See also MILITARY ARCHITECTURE AND FORTIFICATION, §VIII.

BIBLIOGRAPHY
S. Toy: The Strongholds of India (London, 1957)
B. S. Baliga: South Arcot, Madras District Gazetteers (Madras, 1962)
G. Michell: 'Courtly Architecture at Gingee under the Nayakas', S. Asian Stud., vii (1991), pp. 143–60

WALTER SMITH, CHRISTOPHER TADGELL

Ginkhuk. See under INKHUK.

Ginner, Charles (Isaac) (b Cannes, France, 4 March 1878; d London, 6 Jan 1952). British painter of French birth. He left school at 16 and sailed in a steamer belonging to his uncle round the Mediterranean and the South Atlantic. On his return to Cannes he was briefly employed in an engineer's office before leaving for Paris where he worked for an architect. His family had opposed his growing interest in art and not until 1904 did he begin to study painting at the Académie Vitti under Paul Gervais (1859–1934), who disliked Ginner's bright palette so much that the student was obliged to leave. He went to the Ecole des Beaux-Arts and then returned to Vitti's where he was again ridiculed for his enthusiasm for van Gogh, who remained the single most important influence on his work.

In 1908 Ginner sent work to the Allied Artists' Association in London, where he met Harold Gilman and Spencer Gore. In 1909 he visited Buenos Aires and had his first one-man exhibition at the Salon Costa. When he settled in London in 1910 he became a regular visitor to Sickert's 'Saturdays' in Fitzroy Street, his interest in Post-Impressionism affiliating him with the CAMDEN TOWN GROUP, of which he was a founder-member. An example of his work of this period is Café Royal (1911; London, Tate). He also joined the London Group in 1913 and the Cumberland Market Group in 1914 and in April of that year he held a joint exhibition with Gilman at the Goupil Gallery. The catalogue contained Ginner's essay 'Neo-Realism', first published in the magazine, New Age (1 Jan 1914), from which it would seem that Ginner was anxious to dissociate himself and Gilman from the more academic tendencies inherent in English Post-Impressionism. What he meant by 'Neo-Realism' can be inferred from his condemnation of the Naturalist, who 'copies nature with a dull and common eye', having 'no personal vision, no individual temperament...no power of research'. Ginner's realism, on the other hand, is always recognizably his. He sought out shapes and patterns in everyday city scenes and landscapes that had for him formal and emotional significance. One characteristic, which became his signature, was the use of a small, regular touch of thick paint, a method that can give his paintings the appearance of densely worked embroidery. His almost mechanical technique was used in Leeds Canal (1914; Leeds, C.A.G.) to delineate barges, timber yards and factory chimneys.

During World War I Ginner served as a private in the Ordnance Corps, then as a sergeant with the Intelligence Corps and finally as a lieutenant working for the Canadian War Records, making drawings of a munition factory in Hereford. He performed again as an Official War Artist during World War II, specializing in harbour scenes and paintings of bomb-damaged London. He lived in various places, including Hampstead, all of which he painted in a style which, once established, never altered.

BIBLIOGRAPHY
W. Baron: The Camden Town Group (London, 1979), pp. 24–8, 31–6, 42–6, 53, 56
Charles Ginner (exh. cat., London, F.A. Soc., 1985)
For further bibliography see CAMDEN TOWN GROUP.

FRANCES SPALDING

Ginsberg, Jean (b Częstochowa, Poland, 20 April 1905; d Paris, 14 May 1983). French architect of Polish birth. He was educated in Warsaw and Berlin and went to Paris in 1924 to study at the Ecole Spéciale d'Architecture, graduating in 1929. While there, he worked for short periods in the offices of Le Corbusier and André Lurçat. In 1930 he opened his own office in Paris. After a two-year association (1930–31) with Berthold Lubetkin, he formed a partnership with Franz Heep, who had also worked for Le Corbusier, which lasted until 1945. Ginsberg's family sponsored his first residential design (1930–31) at 25 Avenue de Versailles, Paris, a block of flats with ribbon windows and communal roof garden that was the first successful attempt to adapt the design principles of Le Corbusier's villas to the typology of the infill building in Paris. Across the street, at 42 Avenue de Versailles, he built another block (1933–4) that was remarkable for the design of its streamlined penthouse and bold corner treatment. Both were widely published in architectural journals and were followed by similar projects in the 16e arrondissement of Paris featuring compact plans well suited to the requirements of the Machine Age in place of the bourgeois room arrangements traditional in this area. With these buildings Ginsberg played an important role in popularizing the ideas of the Modern Movement in the field of housing. After World War II his residential practice expanded considerably, ranging from small suburban developments influenced by Scandinavian models, to

tower blocks such as the Tour Mille Fiori (1960–63), Monte Carlo, to large low-cost *grands ensembles* or housing estates in the Corbusian tradition, including some in Meaux and Argenteuil; he also continued to work on infill buildings in the 16e arrondissement of Paris, such as 37–9 Boulevard Murat (1967). His work was characterized by careful planning, attention to detail and a search for impeccable workmanship using industrialized components. In 1965 he won the competition to plan the Israeli city of Asdod (with Pierre Vago and Martin van Treeck; unexecuted). Other work included government offices in Paris, the Embassy of Finland (1962), Paris, a technical university (completed *c.* 1979; with others), Libreville, Gabon, and the Les Speluges complex (1971–8) below the casino at Monte Carlo.

BIBLIOGRAPHY
'Jean Ginsberg: Réalisations et études récentes', *Archit. Aujourd'hui*, xxxi/89 (1960), pp. 16–34
J. C. Garcias: 'L'Immeuble de rapport et les autours de la modernité: Les Années trente à Paris: L'Oeuvre de Jean Ginsberg', *Tech. & Archit.* [Paris], 331 (1980), pp. 64–6
P. Dehan: *Jean Ginsberg* (Paris, 1987)

ISABELLE GOURNAY

Gintsburg [Ginsburg], **Il'ya** [Eliash] **(Yakovlevich)** (*b* Grodno [now in Belarus'], 27 May 1859; *d* Leningrad [now St Petersburg], 3 Jan 1939). Russian sculptor, teacher and writer. His talents were first discovered in 1870 by Mark Antokol'sky in Vil'na (now Vilnius, Lithuania). Antokol'sky subsequently brought him to St Petersburg as his child prodigy and trained him for the Academy of Arts, which he eventually entered in 1878. While still a student, he began to develop an interest in small, highly detailed sculptures of figures in a narrative context, and this type of work would predominate throughout his career. He also executed full-length portraits of such eminent contemporaries as Lev Tolstoy, Vasily Vereshchagin, Dmitry Mendeleyev and Anton Rubinstein, many of whom he knew personally, almost all of whom would be depicted engaged in an action related to their profession (e.g. *Tolstoy at Work*, bronze, 1891; Moscow, Tolstoy Mus.; the *Artist Vasily Vereshchagin at Work*, bronze, 1892; Moscow, Tret'yakov Gal.). Despite the proximity of his style and subject-matter to the paintings of the WANDERERS, with whom he exhibited only in 1895, his rejection of both classical idealism and Impressionism, combined with an apparent indifference to technical innovation, did not prove attractive to his contemporaries. His concentration on everyday and contemporary aspects, while open to charges of being anecdotal, marked, through its rejection of traditional themes and approaches, a new and significant development in Russian sculpture, and he emerged as a leading exponent of the Russian realist school. His characteristic works include *Boy about to Bathe* (bronze, 1886; St Petersburg, Rus. Mus.) and *On the Seesaw* (bronze, 1901; Moscow, Tret'yakov Gal.). After the Russian Revolution of 1917 he became a teacher and was appointed Professor of Sculpture (1918–23) at the Petrograd State Free Art Studios (Svomas). From 1923 he was a member of the ASSOCIATION OF ARTISTS OF REVOLUTIONARY RUSSIA (AKhRR).

WRITINGS
Iz moyey zhizni [From my life] (St Petersburg, 1908)
Iz proshlogo: Vospominaniya [From the past: reminiscences] (Leningrad, 1924)
E. N. Maslov, ed.: *Skul'ptor I. Gintsburg: Vospominaniya, stat'i, pis'ma* [The sculptor I. Gintsburg: reminiscences, essays and letters], intro. by A. K. Lebedev (Leningrad, 1964)

BIBLIOGRAPHY
Katalog vystavki skul'ptury akademika I. Ya. Gintsburga [Catalogue of exhibition of sculpture by the academician I. Y. Gintsburg] (exh. cat., Petrograd, Acad. A., 1918)
Skul'ptura i risunki skul'ptorov kontsa XIX–nachala XX veka [Sculpture and sculptors' drawings from the end of the 19th century to the beginning of the 20th], Moscow, Tret'yakov Gal. cat. (1977), pp. 312–27

JEREMY HOWARD

Ginzburg, Moisey (Yakovlevich) (*b* Minsk, 23 May 1892; *d* Moscow, 7 Jan 1946). Belarusian architect, urban planner, theorist and teacher. His age and background prepared him ideally for a central position among the architects who led the Modernist avant-garde in the USSR in the 1920s. He is best known for his leadership, with Aleksandr Vesnin, of the Constructivist architectural group from 1925 to 1931, but he was a consistently influential figure in Soviet architecture from the early 1920s until his premature death after World War II. Ginzburg insisted on constant re-evaluation and innovation in three key dimensions: architecture must tackle new social tasks; it must create new 'spatial organisms' to facilitate, reflect and catalyze those tasks; and it must harness the new technologies of mass production and the new building materials to achieve fulfilment of those tasks. A new 'style' would be the aesthetic correlate and result of these innovations.

1. THE FORMATIVE YEARS, TO 1925. The son of an architect in Minsk, with limited access as a Jew to higher education in Russia, Ginzburg attended the Ecole des Beaux-Arts in Paris and the Ecole d'Architecture in Toulouse before joining the studio of Gaetano Moretti at the Accademia di Belle Arti, Milan. Here he was exposed not only to Moretti's historicism but also simultaneously to the conflicting influence of Marinetti's Futurism. After graduation in 1914, he underwent a more technical training at the Riga Polytechnic, then evacuated for the war to Moscow, where he graduated as an 'engineer–architect' in 1917. At the time of the Revolution he therefore lacked the building experience of Vesnin and the other younger professionals educated in Imperial Russia, but he had a familiarity with international thought and developments not available either to them or to the Soviet-educated generations whom he later influenced by his writing and teaching. Unlike most leaders of the Russian avant-garde in the 1920s, Ginzburg did not spend the years immediately after the Revolution amid the fervour of artistic innovation in Moscow or Petrograd (now St Petersburg). On leaving the Riga Polytechnic he undertook a private commission for the Lokshin House (1917), Yevpatoriya, near Sevastopol' in the Crimea. This was an assembly of cubic volumes with deep eaves that owed something to Frank Lloyd Wright, whose work Ginzburg had encountered while in Milan, and perhaps something also to H. P. Berlage, but its composition is still dominated by the axial symmetries of Ginzburg's classical schooling. While

in the Crimea, Ginzburg headed the new organization for the preservation and conservation of art works and architecture threatened by the Civil War. The area fell to the Bolsheviks in 1921, and that year he returned to Moscow.

There Ginzburg entered the architectural and aesthetic debates through the long-established Moscow Architectural Society (MAO) and the newly formed Russian Academy of Artistic Sciences (RAKhN). In 1923 he edited both issues of MAO's short-lived new journal *Arkhitektura*. He also started writing serious polemical journalism with two powerful editorials, 'The Aesthetics of Contemporaneity' and 'Old and New'. These were strongly influenced by Le Corbusier's ideas expressed in *L'Esprit nouveau*, with Ginzburg presenting his own version of the argument that 'contemporary architecture must seek its sources of inspiration in the best achievements of engineers and industrial architecture'. In seminars at RAKhN he presented ideas that he turned into two books, *Ritm v arkhitekture*, a mainly historical study, and *Stil' i epokha*. In the latter Ginzburg argued for the relevance of the machine as a prototype for generating the new spatial organisms of the new society's buildings. Drawing on the ideas of Oswald Spengler (1880–1936) Heinrich Wölfflin and Paul Frankl, he showed that every 'new' society in history created an architecture that was 'constructive' before reaching 'maturity' and declining into 'decadence'. As he presented it, a 'constructive' logic of clear assembly of parts and fresh intellectual 'constructs' doubly characterized emerging socialism in the 'epoch of the machine'. *Stil' i epokha* became the principal manifesto of architectural Constructivism, its arguments being regarded as 'proof' of the appropriateness of Constructivism to the new Soviet era.

2. CONSTRUCTIVISM, 1925–32. In December 1925, with Vesnin and other architect members of the Constructivist literary and artistic group LEF, Ginzburg founded the Union of Contemporary Architects (Rus. *Obedineniye sovremennikh arkhitektorov*; *see* OSA). He co-edited the group's journal *Sovremennaya arkhitektura* during its five-year existence (1926–30), presenting examples of Western Modernism alongside their own projects. In a series of theoretical articles he developed what he called the 'functional method of design', which he saw as the essence and embodiment of Constructivism in architecture. Ginzburg wrote that by systematically 're-evaluating form … in response to the changing preconditions' ('Konstruktivizm kak metod laboratornoy i pedagogicheskoy raboty' [Constructivism as a method of laboratory and teaching work], *Sovremennaya Arkhit.*, vi (1927), pp. 160–66) the architect was able to produce 'logical buildings, unconstrained by models handed down from the past' ('Novyye metody arkhitekturnogo myshleniya' [New methods of architectural thinking]; in Cooke, 1990).

Ginzburg had a number of intellectual debts. His key concept of a 'new spatial organism' as a 'social condenser', that is as a positive catalyst to new social relations, owes much to Aleksey Gan's critique of the inherited capitalist city in his *Konstruktivizm* (1922). His insistence on generating the new material objects of a socialist culture from first principles, by logical techniques and objective testing,

probably derives from the influence of Aleksandr Bogdanov. The analyses of organizations through movement patterns follow the time-and-motion studies of Aleksey Gastev (1882–1941). Ginzburg's essentially linear 'method' was typical of the mechanically deterministic models of social action then in vogue. As an attempt to view the design process holistically, however, it was broader in scope and more sophisticated than anything comparable in the USSR at that time, or in the practice of Westerners with whom Ginzburg and his colleagues felt sympathy, such as Hannes Meyer in Germany or Le Corbusier in France.

During the 1920s Ginzburg taught in the VKHUTEMAS, Moscow, and the Moscow Higher Technical College (MVTU). He was a prolific designer, entering innovative projects for most of the significant contemporary Soviet architectural competitions. The steel-and-glass or frame-and-infill treatments of his earlier projects suggest influence from Gropius and other Germans, for example the competition projects for the House of Textiles (1925), the Russgertorg Headquarters (1926), and the Orgametal Headquarters (1926–7), none of which were ever built. His first completed housing building (1926) for Gosstrakh, Moscow, set the direction of his later work, following the International Style of Le Corbusier's Five Principles. His most sophisticated housing development was that for employees of Narkomfin (Finance Commissariat; 1928–30; with I. F. Milinis; see fig.), Moscow. This project combined communal amenities with new spatial models of semi-communalized, minimal flats devised in studies

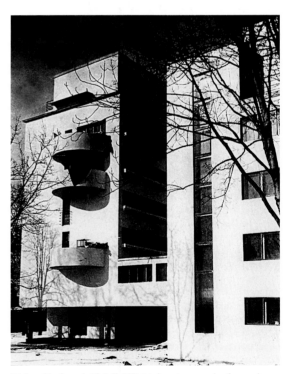

Moisey Ginzburg (with I. F. Milinis): housing complex for employees of Narkomfin (Finance Commissariat), Moscow, 1928–30; main block with apartments (left), linked block of communal facilities (right); from a photograph of c. 1930

for the Stroikom (Building Committee of the Russian Republic). It also demonstrated to the backward Russian building industry modern techniques of frame and hollow-block construction with integrated utilities. His building (1927–31) for the Kazak Republican Government in Alma-Ata demonstrated his belief that local traditions should be maintained by continued use of their proven solutions to climatic and other conditions, not by superficially applied 'style'. During 1930 Ginzburg and his team used the logical and holistic approach of their 'method' to question whether the nodal 'town' form remained a valid settlement pattern for Soviet socialism at that date: his 'Green Town' competition scheme (1930; with Mikhail Barshch and others) explored the resulting theory of a 'disurbanist' dispersal of cities under the impact of technology.

3. SOCIALIST REALISM, 1932–46. With its vast glazed hemispherical dome, Ginzburg's entry (1932; unexecuted) for the third stage of the Palace of Soviets competition represents a last venture in a functionally planned complex of entirely Modernist technology and composition. Through this competition the Bolshevik Party finally dissolved the independent architectural groups, such as OSA, and took hold of stylistic matters in Soviet architecture. When an official Union of Soviet Architects was formed in 1932, Ginzburg's unquestioned professional standing ensured him a place on its board. His building designs of later years attempted to reflect the new official 'method' of Socialist Realism, based on a 'critical assimilation of the heritage' that was semantic rather than functional. He focused increasingly on the application of his analytical and holistic approach to regional and sub-regional planning, for example in the Ufa industrial region (1931) and the development plan (1932–4) for the southern coast of the Crimea. From 1933 he led a design studio in Narkomtyazhprom (the Heavy Industry Commissariat). At the viciously anti-Modernist First Congress of Soviet Architects (1937), he focused on policy for his other long-established concern, the industrialization of housing construction.

When the Soviet Academy of Architecture was formed in 1939, Ginzburg was among its first academicians. As a popular professor in its post-graduate school, his influence was transmitted directly to another generation. History and technology continued to co-exist productively in his work: he was a founder-editor of and principal contributing author for the Academy's multi-volume *Vseobshchaya istoriya arkhitektury* [History of world architecture] and in 1941–5 headed the Academy's Sector for Standardization and Industrialization of Construction, responsible for planning post-war rehousing and reconstruction. As a specialist on the Crimea, he was appointed chief architect and planner for Sevastopol after its liberation, but he died as the work began.

WRITINGS
Ritm v arkhitekture [Rhythm in architecture] (Moscow, 1923)
Stil' i epokha [Style and epoch] (Moscow, 1924; Eng. trans., with intro. by A. Senkevitch, Cambridge, MA, and London, 1982)
Zhilishche [Housing] (Moscow, 1934)
'Mass production housing proposals in the USSR', *Archit. Assoc. J.* (1944), pp. 114–116

BIBLIOGRAPHY
S. O. Khan-Magomedov: *M. Ya. Ginzburg* (Moscow, 1972)
A. Senkevitch: *Soviet Architecture, 1917–1962: A Bibliographical Guide to Source Material* (Charlottesville, 1972)
S. O. Chan-Magomedov: *Pioniere der sowjetischen Architektur* (Dresden, 1983); Eng. trans. as S. O. Khan-Magomedov: *Pioneers of Soviet Architecture* (London, 1987)
C. Cooke: *Russian Avant-garde: Theories of Art, Architecture and the City* (London, 1995) [incl. Eng. trans. of several texts]

CATHERINE COOKE

Gioacchino [Giocchino] **di Gigantibus de Rottenburg** [Gioacchino d'Alemagna; Giacchino miniatore] (*fl* 1453–85). German illuminator, active in Italy. He may originally have come from Rothenburg ob der Tauber. He went to Rome via Florence in 1453 and illuminated books for Pope Pius II. Between 1460 and 1469 he stayed at Siena several times in the papal retinue and was occasionally employed by the cathedral chapter. On 1 April 1471 he was appointed as scribe and illuminator in the library of King Ferdinand I of Naples, and payments to 'Gioacchino di Gigantibus' are recorded on both 23 March and 1 April 1471. He copied a volume of Plutarch in 1473 and works by Pliny and Ovid in 1474. Two further manuscripts, also produced for the King of Naples, are dated 1476: *Super libros sententiarum quaestiones* (London, BL, Add. MSS 15270–73) by the 9th-century scholar John Scotus Erigena and Cardinal Bessarion's *Adversus calumniatorem Platonis* (Paris, Bib. N., MS. lat. 12946). He received a payment for the latter book as early as 9 November 1473 and is last mentioned at Naples on 15 November 1480. He returned to the papal court in the following year, serving under Sixtus IV, for whom he copied and illuminated a Psalter (London, V&A, MS. 1028), and also Innocent VIII. Payments for the illumination of books in the papal library are recorded on 17 August 1484 and 20 September 1485.

BIBLIOGRAPHY
Thieme–Becker: 'Gigantibus'
F. de Mély: *Les Primitifs et leurs signatures* (Paris, 1913)
P. d'Ancona: *La miniatura fiorentina* (Florence, 1917)
J. Ruysschaert: 'Une Annonciation inspirée de Roger de la Pasture dans un manuscrit romain de 1459', *Mélanges d'archéologie et d'histoire de l'art: Offerts au professeur Jacques Lavalleye* (Leuven, 1970), pp. 249–58

O. LOHR

Giocondo (da Verona), Fra Giovanni (*b* Verona, 1433; *d* Rome, 1 July 1515). Italian engineer, architect, epigraphist and scholar. He was much sought after for his technical skills, particularly his expertise in hydraulics and military engineering, while his wide-ranging interests in archaeology, theology, urban planning and philology earned him the regard of his contemporaries; Vasari described him as 'un uomo rarissimo ed universale'. He was almost certainly a Franciscan friar, but it is not known where he acquired his architectural training. Given his lifelong and profound study of Classical architecture and inscriptions, Vasari's assertion that he spent time in Rome as a youth is plausible. One of his earliest endeavours was to compile a collection of Latin inscriptions. The first version (1478–*c.* 1489), which included drawings and was dedicated to Lorenzo de' Medici, became an important and much-copied reference work; it was also a major source for the *Corpus inscriptionum latinarum*, the principal 19th-century compilation. A fine copy survives (Rome,

Giovanni Giocondo: *Vitruvian Man*, woodcut, 1511

Vatican, Bib. Apostolica, MS. Vat. lat. 10228), transcribed by Giocondo's friend and sometime collaborator, the eminent Paduan calligrapher, Bartolomeo Sanvito.

The first secure documentary reference to Giocondo is in 1489 when he was paid for inspecting the ancient ruins at Pozzuoli with the poet and art collector Jacopo Sannazaro (1455–1530). While working for the Duke of Calabria (later Alfonso II, King of Naples), Giocondo made trips to examine the remains of ancient buildings in Naples and its environs (e.g. Castel Mola, now Formia; Gaëta) and was probably consulted on other projects, including, perhaps, the planning of the city (see Hamberg). According to Pietro Summonte (letter 20 March 1524), Fra Giocondo acted as architect-in-chief for over two years supervising the completion of the villa of Poggio Reale (begun 1487; destr.) after the death (1490) of Giuliano da Maiano. On 30 June 1492 Giocondo was paid by the Neapolitan treasury for 126 drawings on paper (copies possibly preserved in Florence, Uffizi) to illustrate two manuscripts (untraced) of treatises by Francesco di Giorgio Martini, 'uno darchitectura et altro dartigliaria et cose appartenenti a guerra'. This contact with the work of Francesco di Giorgio is significant, given Giocondo's subsequent interest in Vitruvius.

As a result of the deteriorating political situation, Giocondo left Naples and in May 1495 entered Paris in the retinue of Charles VIII, King of France. In 1498 he was described as 'deviseur des bastiments' to the King; he later also worked for Louis XII. He may have been involved in the construction of the Pont Notre-Dame (1500–05) and, according to Leonardo da Vinci (undated note, Paris, Inst. France, MS. K., fol. 100*r*), Giocondo also made hydraulic apparatus for the fountains at the château of Blois. During his stay in Paris he gave a series of illustrated public lectures on Vitruvius' treatise *On Architecture*; this legacy of interest in Vitruvius was developed in France, most notably by the French humanist Guillaume Budé.

A document of 5 June 1506 records that Giocondo was in Venice employed as Chief Architect to the Council of Ten. In this capacity and as a hydraulics expert, he was involved in a number of projects in the Veneto and made a tour of inspection of several towns of the Venetian terra firma. He submitted proposals (unexecuted) for the rebuilding of the old Rialto Bridge (destr. 1514) and its immediate vicinity. His ambitious scheme is described in detail by Vasari who claimed to have seen a drawing of the project. Giocondo was employed *c*. 1506 on the systemization of the Brentella Canal, designed to prevent the Venetian canals silting up; he also planned the land reclamation surrounding the Villa Barco (1491–2; destr. *c*. 1820), Altivole, and was asked to prepare a scheme for regulating the waters of the Bacchiglione, near Limena. While in Venice, Giocondo edited a number of Classical texts for his friend the publisher Aldo Manuzio, to whom he presented a manuscript of the letters of Pliny the younger. In 1509 Giocondo worked on the fortifications of Padua and in 1509–11 on those of Treviso. For the latter he is traditionally thought to have designed the fortified city walls (completed 1513) with bastions and rounded, projecting gun platforms.

In 1511 Giocondo's definitive edition of Vitruvius' *On Architecture* was published by the printer Giovanni Taccino and dedicated to Pope Julius II. The text, the earliest version to be illustrated, was accompanied by 136 of Giocondo's own woodcuts (see fig.); although crudely executed, they are clear in conception and *all'antica* in character. Giocondo was the first to comprehend properly the various types of peripteral temple classified by Vitruvius and to publish in full the Greek epigrams in Book VIII. Giocondo's knowledge as an archaeologist, his active interest in Classical architecture and his meticulous philological approach resulted in a substantial contribution to the understanding of the corrupted text, which subsequently became highly influential. In addition, he emphasized the treatise's practical application, aiming to make its contents relevant to contemporary architects and engineers by including, for example, a glossary of terms to clarify Vitruvius' technical terminology. Reprinted in 1513 in a smaller format with Sextus Julius Frontinus' *De aquaeductibus urbis Romae* and an additional four illustrations, the book was this time dedicated to Giuliano de' Medici. Antonio da Sangallo the younger owned a copy of the second edition, and both Raphael and Cesare Cesariano consulted it when producing their own versions of the work. Other writings include an undated fragment, in Italian, of a treatise on epigraphic alphabets, *Fragmenta de literis* (Munich, Bayer. Staatsbib., Cod. it. 37c, fols 90–97*v*), partly written in Giocondo's own hand. He intended it to be an exhaustive survey, serving as a practical handbook for stonecutters, architects and calligraphers. Despite his advanced years, Giocondo was invited by Pope Leo X to Rome and on 1 November 1514 was appointed architect at St Peter's, together with Raphael and Giuliano da Sangallo. During this period, he is also documented in

Venice (5 March 1514), still involved with plans for the Rialto. Giocondo died in Rome on 1 July 1515.

Several buildings have been attributed to Giocondo, although there is no documentation to support this: most notably the Loggia del Consiglio (1493), Verona; the design of the Villa Barco, Altivole, of which only a loggia survives; and the Fondaco dei Tedeschi, Venice; his name is also associated with the Pontano Chapel (1492), Naples. There survive autograph drawings of architectural studies and geometric constructions (e.g. Venice, Bib. N. Marciana, MS. lat. XIV.171; Florence, Bib. Medicea–Laurenziana, MS. Plut. 29.43) and further, attributed drawings (Florence, Uffizi; St Petersburg, Hermitage, Album B). Despite these attributions, the surviving evidence implies that Giocondo acted more as a technical adviser rather than as an architect concerned with design.

WRITINGS
ed.: *M. Vitruvius, per iucundum solito castigatior factus, cum figuris et tabula, ut iam legi et intellegi possit* (Venice, 1511, rev. 1513)

BIBLIOGRAPHY
G. Vasari: *Vite* (1550, rev. 2/1558); ed. G. Milanesi (1878–85), v, pp. 261–73
R. Brenzoni: *Fra Giovanni Giocondo Veronese, Verona 1435–Roma 1515* (Florence, 1960)
L. A. Ciapponi: 'Appunti per una biografia di Giovanni Giocondo da Verona', *Italia Med. & Uman.*, iv (1961), pp. 131–58
P. G. Hamberg: 'Vitruvius, Fra Giocondo and the City Plan of Naples', *Acta Archaeol.* [Copenhagen], xxxvi (1965), pp. 105–25
M. Muraro: 'Fra' Giocondo da Verona e l'arte fiorentina', *Florence and Venice: Comparisons and Relations: Acts of Two Conferences at Villa I Tatti: Florence, 1976–7*, ii, pp. 337–9
P. N. Pagliara: 'Una fonte di illustrazioni del Vitruvio di Fra Giocondo', *Ric. Stor. A.*, vi (1977), pp. 113–20
L. A. Ciapponi: 'A Fragmentary Treatise on Epigraphic Alphabets by Fra Giocondo da Verona', *Ren. Q.*, xxxii/1 (1979), pp. 18–40
——: 'Fra Giocondo da Verona and his Edition of Vitruvius', *J. Warb. & Court. Inst.*, xlvii (1984), pp. 72–90
V. Fontana: 'Fra' Giocondo e l'antico', *Antonio da Sangallo il Giovane, la vita e l'opera: Atti del XXII congresso di storia dell'architettura: Roma, 1986*, pp. 423–4
——: *Fra Giovanni Giocondo architetto, 1433–c. 1515* (Vicenza, 1988)
——: 'Fra' Giovanni Giocondo a Venezia, 1506–1514', *Venezia A.*, ii (1988), pp. 24–30

Gioffredo, Mario Gaetano (*b* Naples, 14 May 1718; *d* Naples, 8 March 1785). Italian architect and theorist. He began his training in 1732 with the architect Martino Buoncore, whose style he later dismissed as 'Gothic'. However, Buoncore had a good architectural library, in which Gioffredo studied the writings of Palladio, Vitruvius and Vincenzo Scamozzi. During the same period he studied with the painter Francesco Solimena, believing an understanding of the human body to be an essential part of architecture.

Gioffredo qualified as an architect in 1741, after being examined by Giovanni Antonio Medrano (*b* 1703), one of the kingdom's engineers. Unfortunately his technical education was somewhat neglected, and he earned for himself the sobriquet 'l'imprudente architetto napoletano' after Luigi Vanvitelli was called in to work on his Villa Campolieto (1762), Resina, and the Palazzo Casacalenda (*c.* 1766), Naples, both of which were in danger of collapse.

Gioffredo's architectural knowledge was largely acquired from books and from the direct study of ancient buildings. In the preface to his treatise *Dell'architettura* (1768) he mentioned several visits to Rome and other places to examine, measure and draw buildings. During one visit to Rome he entered the competition for the façade of S Giacomo degli Spagnuoli, which he won, beating Ferdinando Fuga and Vanvitelli. However, his design remained unexecuted. In 1746 he visited Paestum, the first architect to do so; on his return to Naples he reported this to Conte Gazzola, for whom he later measured and drew the three temples. It is possible that he also produced some of the engravings of Paestum for Paolantonio Paoli's *Rovine della città di Pesto* (1784).

Gioffredo's first major work (1746) was for the Duca di Paduli at the Palazzo Partanna in Naples, and it may have led to his commission to design the new Palazzo Reale at Caserta, although he was later replaced there by Vanvitelli. The palazzo had a fine doorway flanked by free-standing columns supporting a balcony. It was altered in the 19th century by Antonio Niccolini. From 1754 Gioffredo was working on the restoration of SS Marcellino and Festo, Naples, where he broke away from the contemporary Neapolitan fashion for polychromy and inlay. Instead the marble he used was cut so that its natural grain formed symmetrical or regular patterns. His masterpiece, Santo Spirito (1757–74), Naples, was originally built in the early 17th century, and Gioffredo was required to incorporate the arcade of the earlier church into his restoration. His solution was to impose colossal Corinthian columns in front of the nave piers, surmounted by a massive horizontal entablature. Any possible heaviness is offset by the use of plain white stucco throughout the building. He left little room for painted decoration, as he intended the interior to be dominated by the pure abstract decoration of the architecture.

In *Dell'architettura* Gioffredo propounded that architecture was based on rules that could be deduced from the buildings of the Ancients. This argument was followed by a scathing attack on his contemporaries and the Baroque for the ways in which they contorted and misused Classical elements. He believed there was an infinite number of designs laid down by the Ancients and therefore no need to resort to capricious and strange details or ideals. Even in his treatise, however, the engravings of the orders are still not strictly conventional, with masks and swags introduced into the Ionic order.

Only the first part of the work, containing Gioffredo's exposition of the orders, was published; the other two parts would have covered the use of the orders in religious, civil and private buildings. Despite his staunch belief in the ultimate authority of the Ancients and the five orders, Gioffredo's roots were firmly in the Baroque tradition, as his work at S Caterina da Siena, Naples, illustrates. The strictly classical interior contrasts with the open porch, which is essentially Baroque in character, with its rounded corners and flowing lines.

WRITINGS
Dell'architettura (Naples, 1768)

BIBLIOGRAPHY
P. N. Signorelli: 'Regno di Ferdinando IV', *Napoli Nobilissima*, n. s., ii (1921), pp. 14ff [unpubd contemp. account, incl. biog. of Gioffredo]
F. Fichera: *Luigi Vanvitelli* (Rome, 1937), p. 177
R. Pane: *Architettura dell'età barocca in Napoli* (Naples, 1939)

C. S. Lang: 'The Early Publications of the Temples at Paestum', *J. Warb. & Court. Inst.*, xiii (1950), p. 49

A. Venditti: *Architettura neoclassica a Napoli* (Naples, 1961)

A. Blunt: *Neapolitan Baroque and Rococo Architecture and Decoration* (London, 1978)

<div align="right">ALICE DUGDALE</div>

Giolfino, Nicola [Niccolò] (*b* Verona, 1476; *d* Verona, 1555). Italian painter. Born into a family of sculptors active in Verona during the 15th and 16th centuries, he was the son of Nicolò Giolfino (*b c.* 1450). He was trained in the workshop of Liberale da Verona along with Gian Francesco Caroto, and his earlier works, such as the altarpiece depicting the *Pentecost* (1518; Verona, S Anastasia), show a linear quality and hard surface compared to that of his master.

Giolfino's importance as a fresco painter is established in his decoration, between 1512 and 1522, of the Cappella di S Francesco, S Bernardino, Verona, where, in an attempt to reproduce consistent illusionism, he skilfully used scenographic techniques to organize complex episodes of the *Life of St Francis*. In the (damaged) scene of *St Francis Renouncing his Inheritance*, the architecture is used to create a foreground stage, and a view of the River Adige to the upper left conveys a sense of spaciousness. In Giolfino's frescoes depicting scenes from the *Old Testament* in S Maria in Organo, Verona, dating from the 1530s, the forms are smoother and more intensely coloured than in earlier works.

The Cappella degli Avanzi, S Bernardino, contains several important works in oil by Giolfino. On the upper left wall are a *Resurrection, Christ before Pilate* and *Christ Nailed to the Cross*. All have rather slender, static forms and appear to be earlier than his *Arrest of Christ* (1546) on the lower right, with its more powerful, muscular forms and heightened activity. Giolfino began with an eccentric yet conservative style, still related to Late Gothic art, with slender forms and agitated draperies. His mature work is characterized by more robust, active forms and an intensity of colour that seems to favour malachite greens and vermilion. Giolfino was probably the teacher of Paolo Farinati.

BIBLIOGRAPHY

G. Vasari: *Vite* (1550, rev. 2/1568); ed. G. Milanesi (1878–85)

C. Ridolfi: *Meraviglie* (1648); ed. D. von Hadeln (1914–24)

B. dal Pozzo: *Le vite de' pittori, scultori e architetti veronesi* (Verona, 1718), pp. 58–9

A. Avena: 'Le origini dei Giolfino', *Madonna Verona*, v/1 (1911), p. 49

M. Repetto: 'Profilo di Nicola Giolfino', *A. Ven.*, xvii (1963), pp. 51–63

B. Berenson: *Central and North Italian Schools* (1968), i, pp. 170–72

M. Repetto: 'Nicola Giolfino', *Maestri della pittura veronese*, ed. P. Brugnoli (Verona, 1974), pp. 153–60

M. Repetto Contaldo: 'Novità e precisioni su Nicola Giolfino', *A. Ven.*, xxx (1976), pp. 73–80

<div align="right">DIANA GISOLFI</div>

Gioli, Paolo (*b* Sarzano di Rovigo, 12 Oct 1942). Italian photographer. He studied at Rovigo and Venice. Originally an experimental painter and printmaker, from 1968 he began to carry out research into photographic, film and video techniques. He was especially interested in combining new creative techniques with older ones and in re-examining, from this point of view, the history of photography. From 1969 he worked with the pinhole technique, which he combined, from 1977, with Polaroid materials on special supports (drawing paper, silk, wood), and from 1978 he also used the Cibachrome process. His images are largely self-referential interpretations of basic technical principles and examinations of basic photographic language.

PHOTOGRAPHIC PUBLICATIONS

Spiracolografie, preface A. Gilardi (Milan, 1980)

BIBLIOGRAPHY

P. Dragone: 'Paolo Gioli: Imagery di un immaginatore di immagini', *Diaframma/Fot. It.*, 232 (Dec 1977)

Paolo Gioli: Hommage à Niépce (exh. cat. by P. Jay, M. Chomette and J. F. Chevrier, Chalon-sur-Saône, Mus. Nicéphore Niépce, 1983)

Paolo Gioli: Gran positivo nel crudele spazio stenopeico (exh. cat. by P. Costantini and I. Zannier, Venice, Mus. Fortuny, 1991)

<div align="right">PAOLO COSTANTINI</div>

Gionima, Antonio (*b* Venice, 4 March 1697; *d* Bologna, 17 June 1732). Italian painter. The son of the painter Simone Gionima (1655/6–?1730), he was a pupil of Aureliano Milani. Among his first works were the five paintings in tempera depicting scenes from the *Life of St Dominic* (destr.), commissioned from Milani in 1710 for the church of the Mascarella, but executed by his pupil some years later. When Milani left Bologna for Rome in 1719, Gionima entered the studio of the genre painter Giuseppe Maria Crespi and quickly became his most important follower. He did not immediately abandon Milani's lessons, however, and the *Seven Sorrowful Mysteries* (1719; Bologna, Cassa di Risparmio), painted for the church of the Serviti, still shows Milani's Bolognese academicism, although there is in addition a Venetian warmth of colouring that Gionima must have learnt from Crespi. In the same year, Gionima painted the *Reception of James Stuart by Cardinal Gozzadini at Imola* (Rome, Mus. N. Castel S Angelo), possibly as a companion piece to Crespi's *Meeting of James Stuart and Prince Albani* (Prague, N.G., Šternberk Pal.), which it surpasses in brilliance and delicacy of colour.

The chronology of the remainder of Gionima's brief career remains uncertain. During the 1720s he produced a large number of religious and mythological works, often of small format and with few figures. Among the larger paintings of this period are the *Judith Presented to Holofernes* (Minneapolis, MN, Inst. A.), the *Adoration of the Shepherds* and the *Presentation of the Virgin* (both Bologna, Intend. Finanza), which demonstrate the artist's individual interpretation of late Bolognese classicism.

BIBLIOGRAPHY

R. Roli: 'Per Antonio Gionima', *A. Ant. & Mod.*, xi (1960), pp. 300–07

——: *Pittura bolognese, 1650–1800: Dal Cignani ai Gandolfi* (Bologna, 1977), pp. 108–10

□

Gion Nankai [Gion Mitsugu; Hōrai, Nankai] (*b* Kii Province [now Wakayama Prefecture], 1677; *d* Kii Province, 1751). Japanese painter, calligrapher and poet. Along with Sakaki Hyakusen and Yanagisawa Kien, he is regarded as one of the pioneers of literati painting (*Bunjinga* or *Nanga*; see JAPAN, §VI, 4(vi)(d)) and is also celebrated as a poet and calligrapher in the Chinese style (*Karayō*). He was the eldest son of a doctor and Confucian scholar and as a youth accompanied his father to Edo (now Tokyo), where he studied Confucian texts and Chinese poetry with

Kinoshita Jun'an (1621–98). Nankai returned to Kii in 1697 but in 1700 was banished for some unspecified offence. Because he was highly regarded as the finest Chinese-style poet of his day and as an accomplished calligrapher, Nankai was pardoned in order to participate in receptions for the Korean mission of 1710. Three years later he was appointed the official teacher in the clan Confucian academy.

Nankai took up painting in the Chinese literati manner shortly after his pardon in order to supplement his poetry and calligraphy. He was primarily self-taught and more influenced by Chinese woodblock-printed books than by imported Chinese paintings themselves. He was also influenced by immigrant Chinese monks of the Ōbaku sect, many of whom were fine calligraphers and some of whom also painted. Nankai became the prototype of the literati artist, painting as a form of personal expression and devoting himself to literati landscape themes, as in the hanging scroll *Landscape after Tang Yin* (first half of 18th century; see Yonezawa and Yoshizawa, pl. 8), and depictions of what were known as the 'four gentlemen' (bamboo, plum, orchid and chrysanthemum), for example the hanging scroll *Plum* (Tokyo, Govt Cult. Cent.).

Nankai was more skilled at calligraphy and poetry than at painting. He was adept in all five Chinese scripts and worked in a style that shows the influence of the Yuan-period (1279–1368) artist Zhao Mengfu and masters of the late Ming period (1368–1644), as seen in such hanging scrolls as *Poems by Du Fu* (Virginia, Shōka priv. col.). However, Nankai's position as a pioneer of literati painting brought him his greatest fame. His work is inconsistent in style: he was more interested in exploring the Chinese literati tradition than in achieving personal success as a painter. He influenced such later literati masters as Ike Taiga.

BIBLIOGRAPHY
S. Umezawa: *Nihon Nanga shi* [The history of Japanese *Nanga*] (Tokyo, 1919)
K. Tanaka: *Shoki Nanga no kenkyū* [Research on early *Nanga*] (Tokyo, 1962)
Y. Yonezawa and C. Yoshizawa: *Bunjinga* [Literati painting], Nihon no bijutsu [Arts of Japan], xxiii (Tokyo, 1966); Eng. trans. and adaptation by B. I. Monroe as *Japanese Painting in the Literati Style*, Heibonsha Surv. Jap. A., xxiii (New York and Tokyo, 1972–7)
S. Katō, Y. Natada and Y. Iriya: *Gion Nankai, Yanagisawa Kien* (1975), xi of *Bunjinga suihen* [Selections of literati painting], ed. J. Ishikawa and others (Tokyo, 1974–9)
Gion Nankai (exh. cat., Wakayama, Prefect. Mus. A., 1986)

STEPHEN ADDISS

Giordani, Pietro (*b* Piacenza, 1 Jan 1774; *d* Parma, 2 Sept 1848). Italian writer, critic and administrator. He was an intellectual typical of the late Enlightenment, with a Classical education and strong political and civic passions. After a brief experience as a Benedictine monk he abandoned religion and became strongly anti-clerical, earning his living in Milan and Cesena as an administrator in various public offices and as a teacher. He was loyal to Napoleon and between 1808 and 1815 was secretary of the Accademia di Belle Arti, Bologna. During that period, partly through his friendship with Conte Leopoldo Cicognara, Giordani developed his interest in the visual arts. After the defeat of Napoleon he co-edited the *Biblioteca italiana ossia giornale di letteratura, scienze ed arti* in Milan

(1815–18) but was exiled first to Piacenza (1818–24) and then to Florence (1824–30), where he joined the intellectual circle around the review *Antologia*.

Giordani's writings were mainly occasional pieces on linguistic, artistic and literary subjects, as well as lectures for the Accademia, reviews and eulogies of illustrious persons in the cultural field. Despite the hostility aroused by his liberalism, he was well known as an educator and master of language. He idealized the Greek and Latin classics, and also the great Italian writers of the 14th century; he condemned the use of dialect because of its provincial and anti-educational character. He was also responsible for discovering the importance of the poet Giacomo Leopardi. In his many essays in art criticism he avoided discussion of technique, preferring to emphasize the moral and civic significance of works of art; for example, in 1806 he wrote with admiration of Giovanni Antonio Antolini's abandoned project of 1801 for the Foro Buonaparte in Milan, which was to have symbolized the functions of the new bourgeois city near the medieval Castello Sforzesco. In his lecture *Della più degna e durevole gloria della pittura e della scultura* (26 June 1806) at the Accademia in Bologna, he summarized the history and theory of the visual arts, which he saw as educating humanity for civil society. He repeated similar ideas in reviews of Cicognara's works, in letters to Antonio Canova (who was his ideal artist), in comments on the paintings of Gaspare Landi and Vincenzo Camuccini (1811), and on the sculpture of Lorenzo Bartolini (1824) and Pietro Tenerani (1826). Towards the end of his life Giordani was forced to move again, this time to Parma (1830), where he was imprisoned briefly, until his death, deeply disappointed by the failure of the revolutionary movements of 1848.

WRITINGS
Opere, 16 vols (Modena, 1821–7)
P. Papa: *Scritti d'arte di Pietro Giordani* (Florence, 1924) [anthol. and comment.]

BIBLIOGRAPHY
I. della Giovanna: *Pietro Giordani e la sua dittatura letteraria* (Milan, 1882)
G. Ferretti: *Pietro Giordani sino ai quarant'anni* (Rome, 1952)
S. Timpanaro: 'Le idee di Pietro Giordani' and 'Giordani Carducci e Chiarini', *Classicismo e illuminismo nell'800 italiano*, ed. Nistri-Lischi (Pisa, 1965, rev. 2/1969), pp. 41–132
R. Schippisi: *Capitoli giordaniani*, Biblioteca Storica Piacentina (Piacenza, 1992)

FRANCO BERNABEI

Giordano, Luca (*b* Naples, 18 Oct 1634; *d* Naples, 3 Jan 1705). Italian painter and draughtsman, active also in Spain. He was one of the most celebrated artists of the Neapolitan Baroque, whose vast output included altarpieces, mythological paintings and many decorative fresco cycles in both palaces and churches. He moved away from the dark manner of early 17th-century Neapolitan art as practised by Caravaggio and his followers and Jusepe de Ribera, and, drawing on the ideas of many other artists, above all the 16th-century Venetians and Pietro da Cortona, he introduced a new sense of light and glowing colour, of movement and dramatic action. He was internationally successful and travelled widely, working in Naples, Venice, Florence and Madrid.

1. Life and work. 2. Working methods and technique. 3. Critical reception and posthumous reputation.

1. LIFE AND WORK.

(i) Training and evolution from naturalism to Baroque, before 1665. (ii) The mature years, 1665–92. (iii) Spain and the final Neapolitan period, 1692–1705.

(i) Training and evolution from naturalism to Baroque, before 1665. He was the son of the painter Antonio Giordano (*c.* 1597–1683). It is probable that he began his career some years before his first documented works of 1653. His early development was deeply influenced by Ribera, with whom he may have trained (or with someone in his circle). The *St Luke Painting the Virgin* (Ponce, Mus. A.), perhaps Giordano's first major work, in which the saint is a self-portrait, is reminiscent of Ribera's art from *c.* 1637. Giordano was also attracted by Ribera's half-length paintings of philosophers, and himself painted many images of philosophers; the *Crates* (1660; Rome, Pal. Barberini; see fig. 1) is an impressive example of these dramatic and powerfully naturalistic works. The careful study of physiognomy and expression suggests that Giordano may also have been aware of the treatise *De humana physiognomonia* (1586) by Giambattista della Porta. Giordano made his first journey to Rome about 1652. In Rome he absorbed the Baroque art of Pietro da Cortona, whom he may have met, and made many studies (in red chalk on red prepared paper) after the works of Roman High Renaissance artists.

In 1653 Giordano returned to Naples; in the late 1650s, drawing on his ceaseless experiments with other styles, he created an exuberantly Baroque style that brought new

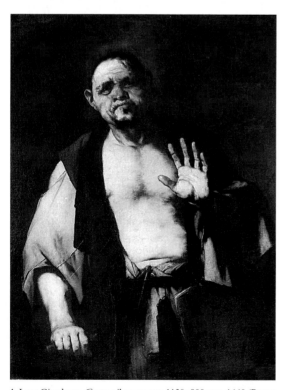

1. Luca Giordano: *Crates*, oil on canvas, 1130×900 mm, 1660 (Rome, Palazzo Barberini)

light and colour to Neapolitan painting. His *Virgin of the Rosary* (1657; Naples, Capodimonte) for the church of the Solitaria, Naples, is almost a homage to Mattia Preti, whom he admired both for his tragic grandeur and for his boldness and freedom. Yet the warmth of the faces also suggests the influence of Peter Paul Rubens, whose art he may have admired in the Chiesa Nuova in Rome and studied in private collections in Naples. Rubens had a lasting influence on the work of Giordano, who expressed his admiration for the Flemish artist in his *Rubens Painting an Allegory of Peace* (Madrid, Prado). In 1658, the year of his marriage to 12-year-old Margherita Dardi, Giordano painted two impressive and celebrated altarpieces for S Agostino degli Scalzi, Naples, both of which glow with warm Venetian colour and light: *St Thomas of Villanova Distributing Alms* and the *Ecstasy of St Nicholas of Tolentino* (both *in situ*). In a group of more restrained works, painted before 1660 and including the *Calling of St Matthew* and the *Calling of St Peter* (both Naples, Certosa di S Martino), the *Feast of Herod* and the *Marriage at Cana* (both Naples, Capodimonte), the influence of Veronese's rich banquet scenes predominates, although Giordano may also have been interested in similar themes by Preti, such as his *Feast of Herod* (Toledo, OH, Mus. A.; see PRETI, MATTIA, fig. 2). The lighter palette of two works from 1664, the *Virgin with SS Joachim and Anna* and the *Rest on the Flight into Egypt* (both Naples, S Teresa a Chiaia), suggests that Giordano had also studied works by Nicolas Poussin in Neapolitan private collections; the more tender sentiment draws close to the style of Guido Reni.

(ii) The mature years, 1665–92. According to Baldinucci, in 1665, the year in which Giordano joined the Neapolitan painters' confraternity, he travelled to Florence and afterwards to Venice, where he stayed for about six months. It may have been on this visit that he won the commission for altarpieces for the Venetian church of S Maria della Salute. In the period between 1665 and 1676 he gradually transformed his long study of the art of Pietro da Cortona into a highly personal idiom in which various other influences are evident. The *Assumption of the Virgin* (1667) clearly reflects Titian, while the *Birth of the Virgin* and the *Presentation in the Temple* (before 1674 according to Boschini; all Venice, S Maria della Salute) unite Venetian sources with the art of the Roman Baroque. In the *Virgin of the Rosary* (1672; Crispano, S Gregorio Magno) Giordano experimented with the style of Cortona, as he did yet more freely in his many easel paintings of mythological subjects, such as the celebrated *Galatea* (before 1677; Florence, Pitti; see fig. 2). Yet Giordano's style remained varied, and he continued to produce pictures in the style of Ribera, such as the *St Sebastian Cured by St Irene* (Philadelphia, PA, Mus. A.; see fig. 3) and the *Assumption of the Virgin* (New York, Hisp. Soc. America). Giordano's imitation of Ribera's style reveals his sensitivity to the tastes of his Neapolitan patrons.

In the late 1670s Giordano began a series of great fresco cycles. In 1677 he was commissioned to paint large frescoes divided by a heavy late Mannerist framework on the nave vault of the Benedictine abbey of Montecassino (destr. World War II; see Ferrari and Scavizzi, 1992, pls 339–54). His severely classical scenes of the *Life of St Benedict* (1677–8) are treated as *quadri riportati* and are

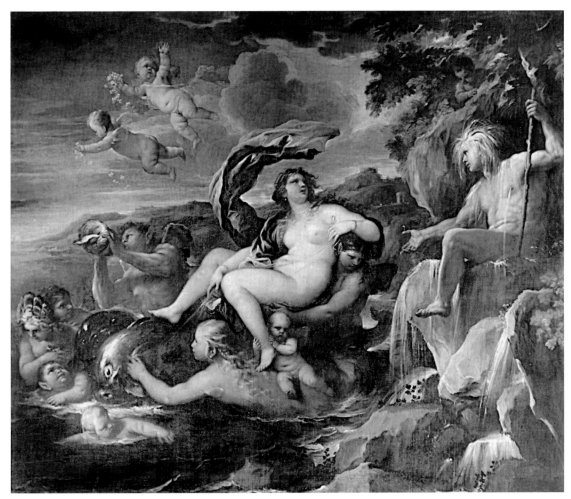

2. Luca Giordano: *Galatea*, oil on canvas, before 1677 (Florence, Palazzo Pitti)

reminiscent of the style of Domenichino. There followed the *St Bridget in Glory* (1678) in the Neapolitan church of S Brigida, inspired by Giovanni Lanfranco's fresco in the chapel of S Gennaro in Naples Cathedral; the daringly foreshortened figures in Giordano's pendentives were intended to give a sense of depth to the very low dome. The cycle of the *Life of St Gregorio Armeno* (*c.* 1678–9), in the Neapolitan church of the same name, moves away from the austere style of Montecassino, and the scenes are linked by a free compositional rhythm. The narratives fall between devotional history and legend and are deeply influenced by Cortona, both in their narrative style and in the light touch and transparent colour.

Even after Giordano returned to Naples, he frequently worked for clients in Florence, where his art was popular with such collectors as Andrea, Ottavio and Lorenzo del Rosso, the Sanminiati family and Pietro Andrea Andreini. Andreini visited Naples (*c.* 1678) and brought back to Florence a small group of works by Giordano, among them the *Apollo and Marsyas* (Florence, Mus. Bardini), which spread his fame in the city. Early in 1682 Giordano himself arrived in Florence, having visited Rome, where

he doubtless admired Giovanni Battista Gaulli's fresco in the dome and vaults of the church of Il Gesù. He stayed with the del Rosso family, who commissioned many works. In Florence, Giordano frescoed the *Glory of St Andrea Corsini* (1682) in the small dome of the Corsini Chapel in S Maria del Carmine. In this work he was again inspired by Lanfranco yet also responded to the recent work of Giovanni Battista Beinaschi (1636–88) in SS Apostoli, Naples, while the handling of the paint suggests Jacopo Bassano. The three oil sketches that Giordano prepared for this dome were retained by the patron (two Florence, Gal. Corsini; one untraced).

In the same period Giordano won the commission from Marchese Francesco Riccardi (1648–1719) to decorate the library and the gallery of the Palazzo Medici–Riccardi, Florence. He began to work on the vault of the gallery, but then returned to Naples (1683–4), completing the ceiling between 1685 and 1686. In this Neapolitan interlude, the most important work was the stupendous *Christ Driving the Money-changers from the Temple* (1684) covering the entrance wall of the Gerolamini Church in Naples, a huge fresco that draws on both Veronese and

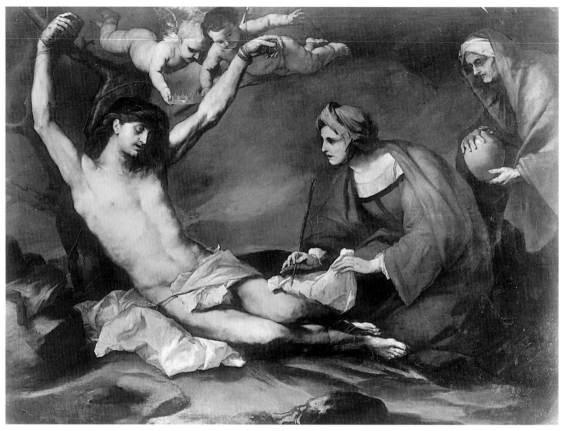

3. Luca Giordano: *St Sebastian Cured by St Irene*, oil on canvas, 1.88×2.58 m (Philadelphia, PA, Museum of Art)

Lanfranco. Christ is set against brilliant light at the centre of a magnificent architectural setting, and figures seem to cascade into the space of the church across the illusionistic temple steps. Giordano then returned to Florence and completed the vault of the gallery at the Palazzo Medici–Riccardi. The theme of this iconographically complex ceiling unites an *Allegory of Human Progress* with an *Allegory of the Medici Family*, the previous owners of the palace. In the centre of the ceiling, in a burst of light, is an *Apotheosis of the Medici*; along the ceiling's cove the idea of progress is conveyed through mythological scenes (set in landscapes) that are fresh and idyllic in mood and deeply influenced by Cortona's radiant frescoes in the Sala della Stufa in the Palazzo Pitti, Florence. Giordano also worked directly for the Medici while in Florence, painting for Cosimo III a *Triumph of Bacchus* (*c.* 1665; untraced) and an *Allegory of Peace between Florence and Fiesole* (*c.* 1682; Florence, Pitti); the latter work reveals the developments in the organization of style and landscape elements made in the Medici–Riccardi frescoes.

Thus Giordano oscillated between two styles in Florence, a powerful Baroque in his religious art and a more elegant classicism in his secular decorations. He returned to Naples in 1686, and his religious works of the middle 1680s, such as the *Destiny of the Virgin* (1685; Rome, S Maria in Campitelli) and the *Virgin of the Rosary* (1686;

Naples, Capodimonte), betray the influence of both Cortona and Bernini in their illusionism, theatrical lighting effects, figure types and drapery style.

(iii) Spain and the final Neapolitan period, 1692–1705. On 22 April 1692 Giordano left for Spain, summoned by Charles II, who appointed him court painter in 1694. His first Spanish work was the decoration (1692–4) of the vault of the imperial staircase at the Escorial with *St Lawrence in Glory, Adored by Charles V and Philip II.* Deeply affected by the Roman Baroque of Gaulli and Bernini, Giordano created a sense of infinite space, flooded with golden light and filled with tumultuous figures. The scene is observed by the reigning royal family seen from behind a balustrade below; these acutely observed portraits suggest Giordano's response to Diego Velázquez. To set off his fresco from the austere 16th-century architecture, Giordano also painted a continuous frieze showing the *Battle of St Quentin*, which served as a transitional zone between the vault and the wall frescoes by Luca Cambiaso (*see* ESCORIAL, fig. 4). In the same years Giordano frescoed the vaults of the side aisles and the main vault of the monastery church at the Escorial; a new sense of airy space is conveyed by the lightly sketched figures in the distance, while larger, more monumental figures are concentrated around the edges of the composition.

In 1696 Giordano painted a series of scenes from the *Life of the Virgin* for the monastery of S Jeronimo,

Guadalupe (*in situ*), which were rapidly executed and show Giordano drawing close to the lyrical art of Murillo. In 1697 he frescoed the ceiling of the Buen Retiro, Madrid, with the *Foundation of the Order of the Golden Fleece*, which has a freer sense of fantasy, in which the dominant rhythms of Gaulli and Lanfranco are fragmented and the figures scattered against an airy and transparent sky. There followed the decoration of the ceiling of the sacristy of Toledo Cathedral (begun early 1698; *see* TOLEDO CATHEDRAL, fig. 4), in which Giordano darkened his palette and returned to the more three-dimensional style of the Roman Baroque, suggesting, in his use of feigned architecture, an awareness of Andrea Pozzo's illusionistic decoration of S Ignazio, Rome. Nonetheless, his increasingly refined decorative motifs continue to anticipate later developments. The scenes from the *Life of St Anthony* (1698–1700; Madrid, S Antonio de los Portugueses o Alemanes) are more sombre in tone and draw closer to Preti. This was Giordano's last public commission in Spain. After the death of Charles II in 1700, he worked only for private patrons, although Philip V greatly admired his art.

On 8 February 1702 Giordano left Madrid and returned to Naples. A renewed contact with Francesco Solimena encouraged his interest in Preti, who had deeply influenced Solimena, and six canvases in the church of the Gerolamini, Naples, with the central scene representing the *Meeting of SS Carlo Borromeo and Filippo Neri* (1704; *in situ*), show his response to the dramatic contrasts of light and shade that distinguish Preti's art. In the same period he decorated the small dome of the Cappella del Tesoro in the Certosa di S Martino with scenes from the *Life of Judith* and other Old Testament heroines (1704); four *bozzetti* (two, St Louis, MO, A. Mus.; one, Barnard Castle, Bowes Mus.; one, ex-Morassi priv. col., Milan) associated with this work survive. The narrative, from the *Triumph of Judith* to the *Massacre of the Amalekites*, unfolds continuously around the four sides of the dome, in separate yet integrated scenes (see fig. 4). Giordano's desire to concentrate the narrative elements around the frame, leaving open skies of pure light in the centre, was here fulfilled. It is an airy vision that anticipates the Rococo, and even the decorative details, such as the exquisite monochrome putti that decorate the feigned base, have an 18th-century sense of grace. Yet the fresco retains a grandeur and passion that are truly characteristic of the 17th century, and these qualities link it to Giordano's final works, left incomplete on his death, which in other ways are quite different. These include the darkly shadowed, visionary pictures, the *Marriage at Cana* and the *Multiplication of the Loaves and Fishes* (Naples, Donnaregina Nuova), and the frescoes in the sacristy of the church of S Brigida, all of which were completed by Giordano's pupil Giuseppe Simonelli (*c.* 1650–1710). The fresco in S Brigida had been planned prior to the Spanish period but begun only after Giordano's return to Naples. Giordano executed little himself, but nonetheless the fresco has an intensity and passion that look forward to Goya.

2. WORKING METHODS AND TECHNIQUE. The most striking aspect of Giordano's technique was his legendary speed of execution; in his many brilliantly coloured frescoes his touch is rapid and fluent. His speed and

4. Luca Giordano: *Life of Judith* (1704), fresco, Cappella del Tesoro, Certosa di S Martino, Naples

capacity to improvise reached a climax in his Spanish period; the Prior of the Escorial wrote to Charles II (Bottineau, p. 252; Colton, in 1987 exh. cat., p. 113):

> Today your Giordano has painted ten, eleven, twelve figures three times life size, plus the Powers, Dominions, Angels, Seraphim and Cherubim that go with them and all the clouds that support them. The two theologians he has at his side to instruct him in the mysteries are less ready with their answers than he is with his questions, for their tongues are too slow for the speed of his brush.

To facilitate his gift for improvisation, Giordano is said to have brought half-nude models with him on to the scaffold (1987 exh. cat., p. 113).

Giordano prepared his works in drawings and oil sketches and was a prolific draughtsman. His early compositional studies, such as the three drawings of *St Sebastian Succoured by the Holy Women* (Florence, Uffizi; Vienna, Albertina), are influenced by Ribera's drawings, yet Ribera's compact forms are replaced by Giordano's more tremulous line. In the early years Giordano also copied the works of other artists, using red chalk on red prepared paper, again in the style of Ribera; these drawings include the *St Mark* (priv. col.; see 1984 exh. cat., p. 92) after Domenichino's pendentive in S Andrea della Valle, Rome, and the *Standing Man Seen from the Rear* (London, BM), which is copied from a scene by Polidoro da Caravaggio. In the middle years Giordano's drawings became more dramatic and freely handled, enlivened by vigorous wash, while the more abundant late drawings are mainly in black chalk and grey wash and concentrate on simplified forms, as in the compositional study, *A Miracle of St Anthony of Padua* (Ann Arbor, U. MI Mus. A.).

Giordano made numerous small oil sketches in connection with his fresco cycles. Four such sketches (New York,

priv. col., see Ferrari and Scavizzi, 1992, fig. 376; Dunkirk, Mus. B.-A.; Rome, priv. col., see Ferrari, 1966, fig. 170; Strasbourg, Mus. B.-A.) for the frescoes in S Gregorio Armeno demonstrate the various stages in his creative thought. One of the oil sketches (New York) corresponds closely to the finished work, while the others show Giordano working out the composition and colour. The oil sketch of the *Three Fates* (Manchester, C.A.G.) for the central vault of the gallery of the Palazzo Medici–Riccardi dates to 1682, while a dozen others associated with the decoration of the library and gallery are documented to 1685 (ten, London, Mahon priv. col., see 1984 exh. cat., pp. 318 and 319; one, London, Sir Emmanuel Kaye priv. col.; and another, Beverly Hills, CA, Frederick W. Field priv. col., sold London, Christie's, 5 July 1991, lot 23 [bought in]). It is not clear how Giordano used such sketches, and their status remains controversial; some scholars believe them to be *ricordi*, while others consider them modelli (Millen, 1976; Ferrari, 1990).

Giordano controlled a large workshop; de Dominici stated that he had around 30 skilled assistants, all working in close association with him. His pupils Giuseppe Simonelli and Nicola Maria Rossi worked according to the ideas and *bozzetti* provided by Giordano, while Domenico di Marino (*fl* 1676–83), who was a good colourist, sketched out Giordano's ideas on the final support using drawings alone. Giordano's pupils also made copies of his sketches, and, according to de Dominici, Aniello Rossi (1660–1719), who himself copied Giordano's sketches for the destroyed frescoes in the Alcázar in Madrid, was instrumental in distributing copies made by Simonelli, Anselmo Fiammingo and Raimondo de Dominici (1645–1705).

Giordano's pupils also played a large role in some of his fresco cycles, such as that for the cupola of S Brigida. De Dominici criticized the uneven quality of Giordano's work, saying that he painted with three brushes—gold, silver and copper—to satisfy three different classes of patrons. It is, however, likely that this unevenness was due to his workshop and that many works were copies of his originals or paintings by assistants that were simply retouched by the master (Colton, in 1987 exh. cat.).

3. CRITICAL RECEPTION AND POSTHUMOUS REPUTATION. Although Giordano's art was not universally understood and appreciated in his lifetime, his fame was nonetheless enormous. His first great supporter was the merchant and collector Gaspar Roomer, part of whose collection was inherited by Ferdinand van den Einden (the remainder was sold by Giordano himself). Other patrons, besides Cosimo III de' Medici and Charles II, included the French king Louis XIV, the Schönborn family of Pommersfelden and the Elector Palatine John William. On Giordano's death, his son inherited the huge sum of 300,000 ducats.

Giordano's many pupils failed to rival his achievement, and during his lifetime his influence was initially more important in Venice than in Naples or Rome. The classical painter Francesco di Maria bitterly opposed his style, which he referred to as 'heretical', and in 1664 a letter from Giacomo di Castro (*fl* 1664) to the collector Antonio Ruffo (V. Ruffo, 1916, p. 288) described Giordano as a virtuoso imitator of the styles of other artists. This view,

which failed to appreciate his creativity, became a critical cliché. In the middle years of the 17th century it was resisted only by Francesco Solimena, who was more of a friend than a pupil and who absorbed from Giordano the concept of a rich and varied relationship with tradition. In Rome, as is clear from the *Relatione della vita di Luca Giordano pittore celebre* (1681; Florence, Bib. N. Cent., Cod. II–II–110, cc. 88–9), which some consider to have been written by Giordano himself (Ceci, 1899), his paintings were little appreciated, perhaps because of their fundamental difference from the Roman Baroque.

In the late years of the 17th century and the early years of the 18th, Giordano's Neapolitan reputation fluctuated. In the 1690s Paolo de Matteis was deeply influenced by him, although his style is more elegant and graceful. Even in the 18th century, when de Matteis had adopted a more classical style, his decorative works were still influenced by Giordano's frescoes (1704) in the Cappella del Tesoro of the Certosa di S Martino, Naples; Giordano's art also formed the starting-point for the graceful style of Corrado Giaquinto. In the early 18th century the dominant tone was set by Solimena's classicizing art, and Giordano was less appreciated; this transition can be pinpointed to the biography written by de Dominici and published in the *Vite* of 1742–5, where the tone is much less enthusiastic than in the first biography he wrote, which was published with the second edition (1728) of Bellori's *Vite*.

It was in Venice, as recorded by Marco Boschini, that the fame of Giordano spread most rapidly. Venetian artists were attracted by the warmth and colour that Giordano absorbed from Rubens, by his Baroque sense of space and by the contrasts of light and dark inspired by Ribera. His art heralded the Rococo, and this aspect was developed by Sebastiano Ricci, who shared his passion for Veronese. In the 18th century his reputation stood high, though it was foreigners who most appreciated his work. In 1756 Charles-Nicolas Cochin admired Giordano as the precursor of the Rococo, and Jean-Honoré Fragonard engraved some of his works as illustrations to the *Voyage pittoresque* (1781–6) of the Abbé de Saint Non.

However, with the advent of Neo-classicism, the fortunes of Giordano declined, to rise again in the early 20th century, against the background of renewed interest in the 17th and 18th centuries. The contributions of many scholars (Longhi; Bologna; Arslan) culminated in the impressive monograph by Oreste Ferrari and Giuseppe Scavizzi in 1966, of which a revised and expanded edition was published in 1992.

WRITINGS

Relatione della vita di Luca Giordano pittore celebre fatta sotto il 13 agosto 1681; ed. G. Ceci, *Napoli Nob.*, viii (1899), pp. 166–8

BIBLIOGRAPHY

EARLY SOURCES

M. Boschini: *Le ricche miniere della pittura veneziana* (Venice, 1674)

G. Cinelli, ed.: rev. edn (Florence, 1677) of F. Bocchi: *Le bellezze della città di Firenze* (Florence, 1591)

C. Celano: *Notizie del bello, dell'antico e del curioso della città di Napoli per i signori forestieri … divise in dieci giornate* (Naples, 1692); ed. G. B. Chiarini, 5 vols (Naples, 1856–60)

A. A. Palomino de Castro y Velasco: *Museo pictórico* (1715–24)

B. de Dominici: 'Vita del cavaliere Luca Giordano pittore napoletano', in G. P. Bellori: *Le vite de' pittori, scultori ed architetti moderni* (Rome, 2/1728)

——: *Vite* (1742–5)

F. S. Baldinucci: 'Vita di Luca Giordano pittore napoletano'; ed. O. Ferrari: 'Una "vita" inedita di Luca Giordano', *Napoli Nob.* (1966), pp. 89–96, 129–38

GENERAL

W. Arslan: *Il concetto di luminismo e la pittura veneta barocca* (Milan, 1946)
Opere d'arte nel Salernitano dal XVII al XVIII secolo (exh. cat., ed. F. Bologna; Salerno, 'Aula di S Tomaso' presso il duomo, 1954–5)
C. Lorenzetti: 'Interferenze della pittura napoletana con la pittura veneziana', *Venezia e l'Europa: Atti del congresso internazionale di storia dell'arte: Venezia, 1955*, pp. 368–73
O. Ferrari: 'Le arti figurative', *Stor. Napoli*, vi (Naples, 1967–82), pp. 1223–363
M. Levey: *The Seventeenth and Eighteenth Century Italian Schools*, London, N.G. cat. (London, 1971), pp. 114–17, nos 1844 and 6327
F. Büttner: *Die Galleria Riccardiana in Florenz*, Kieler Ksthist. Stud., ii (Kiel, 1972), pp. 27, 229
Italian Baroque Paintings from New York Private Collections (exh. cat., ed. J. Spike; Princeton U., NJ, A. Mus., 1980), no. 25, pp. 66–8
Painting in Naples from Caravaggio to Giordano (exh. cat., ed. C. Whitfield and J. Martineau; London, RA, 1982)
Civiltà del seicento a Napoli, 2 vols (exh. cat., Naples, Capodimonte, 1984) [biog. and cat. entries by O. Ferrari]
A Taste for Angels: Neapolitan Painting in North America, 1650–1750 (exh. cat., New Haven, CT, Yale U. A.G., 1987) [essays by Robert Enggass, pp. 41–55; J. Colton, pp. 113–60]
A. Brejon de Lavergnée: *Musées de France: Répertoire des peintures italiennes du XVIIe siècle* (Paris, 1988), pp. 171, 174, 177, 179
O. Ferrari: *Bozzetti italiani dal manierismo al barocco* (Naples, 1990)

MONOGRAPHS

E. Petraccone: *Luca Giordano* (Naples, 1919); rev. by R. Longhi in *L'Arte*, xxiii (1920), pp. 92–5
O. Benesch: *Luca Giordano* (Vienna, 1923) [drgs]
O. Ferrari and G. Scavizzi: *Luca Giordano*, 3 vols (Naples, 1966, rev. 1992)

SPECIALIST STUDIES

A. de Rinaldis: 'Su alcuni disegni di Luca Giordano', *Ausonia*, xi (1910), pp. 148–9
V. Ruffo: 'La galleria Ruffo nel secolo XVII in Messina', *Boll. A.: Min. Pub. Istruzione*, x (1916), pp. 21–2, 95–6, 165–6, 237–8, 284–5, 369–70
R. Longhi: 'Un ignoto corrispondente del Lanzi sulla galleria di Pommersfelden (scherzo 1922)', *Proporzioni*, iii (1950), pp. 216–30
——: 'Due "mitologie" di Luca Giordano', *Paragone*, xxxv (1952), pp. 41–3
——: 'Il "Goya romano" e la "cultura di Via Condotti"', *Paragone*, liii (1954), pp. 28–39
S. L. Ares Espada: *Il soggiorno spagnolo di Luca Giordano* (diss., U. Bologna, 1954–5)
Y. Bottineau: 'A propos du séjour espagnol de Luca Giordano, 1692–1702', *Gaz. B.-A.*, lvi (1960), pp. 249–60
A. Griseri: 'Luca Giordano "alla maniera di..."', *A. Ant. & Mod.*, ii (1961), pp. 417–37
Luca Giordano in America (exh. cat., ed. M. Milkovich; Memphis, TN, Brooks Mus. A., 1964)
H. Wethey: 'The Spanish Viceroy, Luca Giordano and Andrea Vaccaro', *Burl. Mag.*, cix (1967), pp. 678–86
S. Meloni Trkulja: 'Luca Giordano a Firenze', *Paragone*, cclxvii (1972), pp. 25–74
R. Millen: 'Luca Giordano in Palazzo Riccardi', *Paragone*, cclxxxix (1974), pp. 22–45
Paintings by Luca Giordano (exh. cat., London, Heim Gal., 1975), cat. nos 8, 17, 18
S. Meloni Trkulja: 'Nuove notizie su Luca Giordano (e sul Volterrano)', *Paragone*, ccxv (1976), pp. 78–82
R. Millen: 'Luca Giordano in Palazzo Riccardi II: The Oil Sketches', in *Kunst des Barock in der Toskana: Studien zur Kunst unter den letzten Medici* (Munich, 1976), pp. 296–312
R. López Torrijos: *Lucas Jordán en el casón del Buen Retiro: La alegoría del toisón de oro* (Madrid, 1984)
R. Pane: 'Altre tele e un disegno di Giordano', *Seicento napoletano: Arte, costume, ambiente*, ed. R. Pane (Milan, 1984), pp. 293–7
V. Pacelli: 'Qualche inedito e un bozzetto poco noto di Luca Giordano', *Ricerche sul '600 napoletano* (Milan, 1988), pp. 156–7

DANIELA CAMPANELLI

Giorgi, Bruno (*b* Mococa, São Paulo, 6 Aug 1905). Brazilian sculptor of Italian origin. In 1911 he moved from São Paulo to Rome, where he began studying sculpture from 1920 to 1922. He moved to Paris in 1935 to complete his studies under Aristide Maillol and at the Académie de la Grande Chaumière. Returning to Brazil in 1939, he lived first in São Paulo and from 1942 in Rio de Janeiro, where he worked with the architect Oscar Niemeyer, producing the granite monument to *Youth* (1946) for the outdoor garden of the Ministry of Education in Rio de Janeiro. In the 1960s he again collaborated with Niemeyer and produced several sculptures for the new city of Brasília, including the bronze *Two Warriors* (1961) in the Praça dos Três Poderes and the marble *Meteor* (1965) for the Ministry of Foreign Affairs in the Palácio dos Arcos (*see* BRAZIL, fig. 10). He was named best national sculptor in the 1953 São Paulo Biennial. His work constantly oscillated between the figurative stylization of his women, warriors and musicians and an abstract reductionism influenced by the organic qualities of Barbara Hepworth's work and to a slight extent by Baroque sensuality. The Museu Manchete (Rio de Janeiro) houses several of his marble sculptures and his bronze *Chimera* (1966).

BIBLIOGRAPHY
P. M. Bardi: *Profile of the New Brazilian Art* (Rio de Janeiro, 1970)
F. Aquino: *Museu Manchete* (Rio de Janeiro, 1982)
W. Zanini, ed.: *História geral da arte no Brasil*, ii (São Paulo, 1983)
Bruno Giorgi (exh. cat. by J. Klintowitz, Rio de Janeiro, Gal. Skulp., 1985)

ROBERTO PONTUAL

Giorgio da Gubbio. *See* ANDREOLI, GEORGIO.

Giorgio d'Alemagna (*d* between 12 Feb and 9 March 1479). Italian illuminator, probably of German descent. He is documented from 1441 to 1462 in the Este court at Ferrara, working first under Lionello d'Este, Marchese of Ferrara, and then Borso d'Este. He was granted citizenship of Ferrara in 1462. His earliest documented works were executed in Ferrara, where in 1445–8 he participated in the decoration of a Breviary for Lionello d'Este (sold London, Christie's, 8 Dec 1958, lot 190, p. 32; later dismembered). His illuminations for a Missal for Borso d'Este (Modena, Bib. Estense, MS. lat. 239), executed between 1449 and 1457, include that of the *Crucifixion* (fol. 146r; see fig.). In 1453 he decorated the *Spagna in Rima* (Ferrara, Civ. Bib. Ariostea, MS. Cl.II 132). The stylistic relationship between this work, the Missal and the Breviary is problematic. Some scholars attribute only the *Spagna in Rima* to Giorgio, assigning the other works to an anonymous Master of the Missal of Borso d'Este. In Lionello's Breviary (for example the folios sold London, Sotheby's, 25 April 1983, lot 133, p. 199) Giorgio worked in a Late Gothic Emilian style similar to that of the anonymous frescoes at Vignola painted for Niccolò III d'Este. After 1450 his style took on Renaissance characteristics. In the Missal, Giorgio showed familiarity with the art of Francesco Squarcione and Donatello as transmitted through the work of Michele Pannonio, then active in Ferrara. He also knew the work of Piero della Francesca, who in 1451 was in Rimini and later in Ferrara. Giorgio's stylistic vocabulary recalls that of his contemporary Taddeo Crivelli and also the early works of Cosimo Tura. Giorgio's illuminations are of remarkably high quality; the

Giorgio d'Alemagna (attrib.): *Crucifixion*, 280×220 mm, illumination from the Missal of Borso d'Este, 1449–57 (Modena, Biblioteca Estense, MS. lat. 239, fol. 146*r*)

drawing is clear and lively, with Late Gothic rhythms that give a dynamic quality to the figures and an intense expressiveness to the faces. The landscapes are characteristically fantastic: full of pointed rocks, hills and coloured stones, within a fine, carefully worked out colour scheme.

The stylistic connection with Crivelli and Tura is supported by documents that mention Giorgio as a painter. In 1452 he painted panels with scenes of the *Passion* for a reliquary gilded by Cosimo. One of the panels may be the *Crucifixion* (Dublin, N.G.). In 1459 he contributed to the BIBLE OF BORSO D'ESTE (Modena, Bib. Estense, MS. lat. 429), executed in 1455–61 principally by Crivelli and Franco dei Russi. Gathering Z in the first volume (fols 212–221*v*) can be attributed to Giorgio because of its resemblance to the style of his son Martino da Modena (*fl* 1477–89), who was also an illuminator, and because of its stylistic resemblance to some initials in a copy of Virgil's *Works* (Paris, Bib. N., MS. lat. 7939A) executed by Giorgio between 1458 and 1459. In these works Giorgio approaches the style of Guglielmo Giraldi, another illuminator active in Ferrara during this time.

Many of Giorgio d'Alemagna's documented works are untraced. The illuminations in Giovanni Bianchini's *Tabulae astrologiae* (Ferrara, Civ. Bib. Ariostea, MS. Cl.I No. 147), which are close to the style of the Missal but with a courtly language reminiscent of Flemish illumination, have been tentatively attributed to him. During the 1460s and 1470s Giorgio d'Alemagna appears to have participated in the decoration of another Missal (Milan,

Castello Sforzesco, MS. 2165). Between 1473 and 1476 he executed some illuminations (untraced) for the choirbooks of Modena Cathedral. He is credited with a single folio (fol. 2125) depicting *St John the Evangelist* in the Cini Foundation, Venice, and the Albergati Bible (New Haven, CT, Yale U., Bienecke Lib., MS. 407) has also been attributed to him.

BIBLIOGRAPHY
H. J. Hermann: 'Zur Geschichte der Miniaturmalerei am Hofe der Este in Ferrara', *Jb. Ksthist. Samml. Allhöch. Ksrhaus.*, xxi (1900), pp. 117–271
G. Bertoni: *Il maggior miniatore della Bibbia di Borso d'Este 'Taddeo Crivelli'* (Modena, 1925)
M. Boskovits: 'Ferrarese Painting about 1450: Some New Arguments', *Burl. Mag.*, cxx (1978), pp. 370–85
Corali miniati del quattrocento nella Biblioteca Malatestiana (exh. cat., ed. P. Lucchi; Cesena, Bib. Malatestiana, 1989)
Le Muse e il principe: Arte di corte nel rinascimento paolano (exh. cat., Milan, Mus. Poldi Pezzoli, 1991)
F. Toniolo: 'I miniatori estensi', *La miniatura estense*, ed. H. J. Hermann (Modena, 1994), pp. 207–54
The Painted Page: Italian Renaissance Book Illumination, 1450–1550 (exh. cat., ed. J. J. G. Alexander; London, RA, 1994)

FEDERICA TONIOLO

Giorgio da Sebenico [Georgius Matthei Dalmaticus; Giorgio di Matteo; Giorgio Orsini; Juraj Matejev Dalmatinac] (*fl c.* 1441; *d* Sebenico [now Šibenik], 10 Oct 1473). Dalmatian sculptor and architect. He came from Zara (now Zadar). He was possibly apprenticed to Giovanni Buon (i) and may have worked with his son Bartolomeo Buon (i) in Venice. The extent of Giorgio's contribution to their workshop has not been firmly established, but one piece likely to have been created by him is the base with putti supporting the baptismal font (*c.* 1430–40) in S Giovanni in Bragora, Venice. He is first documented on 22 June 1441, when he was summoned from Venice to be Master of the Works of St James's Cathedral in Šibenik. With the aim of transforming the existing simple basilica with nave and aisles (begun 1431) into a more imposing structure, he planned a raised east end with a narrow transept and possibly a dome over the crossing, but his project was only partially realized. The central and side apses (1443–9, 1456–9), which are built from large blocks of carved stone, are polygonal on the outside and have high basements capped by a protruding frieze of 74 highly individual human heads that contrasts with the simplicity of the elevations above. The latter are articulated with simple pilaster strips and fluted shell niches, and, while lacking the classical detail of contemporary Tuscan architecture, they nevertheless create a Renaissance ambience. The sacristy (1452–4), boldly supported on three slender piers to the south of the east end, is similar in construction and wall articulation, but has more Gothic detail. The tetraconch baptistery (*c.* 1443–6) forms a compact, cryptlike space beneath the apse on the south side. Its decoration combines Gothic forms (e.g. interlaced tracery) with figurative reliefs on the circular ceiling that show the influence of early Renaissance works in Florence (e.g. by Luca della Robbia). Giorgio's first authenticated sculptures belong to this early period at the cathedral; they include the frieze of heads facing the piazza (*c.* 1443–4), two putti holding a scroll (1443; see fig.), situated on the exterior of the north apsidal chapel and resembling the shield-bearers on the Porta della Carta (1438–42) of the

Giorgio da Sebenico: east end (begun 1443) of St James's Cathedral (begun 1431), Šibenik

Doge's Palace (*see* VENICE, §IV, 6(i)), and the three putti supporting the font (1444) in the baptistery. The impetuous figures of *St James* and *St Peter* (*c.* 1441–3; Šibenik, Relig. A. Col.) rank among his finest achievements in freestanding statuary.

Giorgio was also active in other Dalmatian cities. Next to the church of St Euphemia (destr.) in the Benedictine nunnery at Split he built a chapel to house the tomb of *Archbishop Rainerius* (1444–8; now Kaštel Lukšić, St Mary). The tomb consists of a sarcophagus, over which an angel assisted by four putti holds a canopy; they unveil the effigy of the Bishop, who is theatrically lamented by a woman sculpted in low relief. The depiction on the sarcophagus of Rainerius's death by stoning in 1180 is an experiment in multi-figure relief unique in mid-15th-century Venetian sculpture: it is almost entirely made up of figures borrowed from Ghiberti, Luca della Robbia and Donatello, and is strangely incoherent in style and iconography. The tomb of *St Anastasius* (from 1448; Split Cathedral) resembles in its architectural articulation the tomb of *St Domnius* (1427; Split Cathedral) by Bonino da Milano (*d* 1429), as the contract specified, but in the figure sculptures Giorgio followed his own models. In Zadar he constructed the choir-screen (1444–9; destr) for the church of St Francis and carved the tomb of *Archbishop*

Lorenzo Venier (*c.* 1449), of which only small fragments survive (Zadar, N. Mus.).

After 1450 Giorgio was active also in Ancona, where he mostly worked in the florid manner of late Venetian Gothic. His portal (1450–59) for S Francesco delle Scale, Ancona, which is Late Gothic, was inspired by the Porta della Carta and by the original layout of the south balcony window (1400–04) of the Doge's Palace, Venice, by Pierpaolo dalle Masegne. The façade of the Loggia dei Mercanti in Ancona (1451–4; for illustration *see* ANCONA) is noteworthy for its open structure, elaborate Gothic detailing and its sculptural decorations, which include a relief of a *Riding Knight* (the emblem of Ancona), executed after 1452 in collaboration with Andrea Alessi. The façade also incorporates four statues of *Virtues* in the niches of the upper piers: *Fortitude*, *Hope* and *Temperance* are represented as armour-clad heroines, and a nude *Charity*, caressing five unruly putti, is reminiscent of Jacopo della Quercia's statues of *Acca Larentia* and *Rhea Silvia* on the Fonte Gaia in Siena. Although her nakedness has no equivalent in mid-15th-century Tuscan sculpture, it is possible that the figure of *Charity* reflects a lost Tuscan model. The portal of S Agostino in Ancona (commissioned 1460; completed and modified after 1493) recalls that of S Francesco delle Scale but may have been inspired by the contemporary parts of the Arco Foscari of the Doge's Palace in Venice. Its relief of *St Augustine*, which is mainly Giorgio's work, is remarkable for its quality of agitated, gyrating movement. In the 1460s his workshop resumed work on the east end of Šibenik Cathedral (exterior of the north transept; apse interiors, 1465–7). The architectural style is a hybrid pseudo-Renaissance, while the figurative ornamental carvings reveal the influence of Donatello's followers in Padua; it is not clear why Giorgio should have abandoned the exuberant Gothic style of his Ancona works in favour of a classicizing decorative repertory, although as Master of the Works he must have approved of this. It has been suggested that Giorgio or his assistants were also responsible for the unfinished relief of the *Entombment* (Šibenik, Nova Crkva (S Maria di Valverde)), which may reflect a lost composition of exceptional expressiveness and iconographic originality from Donatello's circle.

From June 1464 until November 1465 Giorgio was employed in Dubrovnik on various fortification projects, such as the tower of St Catherine and Michelozzo di Bartolomeo's Minčeta bastion. He also advised on repairs to the Rector's Palace, which had been damaged in 1463. The portal of the palace incorporates two imposts with four reliefs, probably carved by an assistant (*c.* 1464), who presumably copied a series of fashionable motifs that Giorgio had obtained: *Venus and Mars Embracing*, dancing putti (in the style of Donatello), music-making putti (quoted after Niccolò Pizzolo) and three nude warriors (in the style of Antonio del Pollaiuolo). Next to the palace Giorgio erected the portal of the gate to the Porta Ponte, bearing his statue of *St Blaise* (1465; Lapad, Hist. Inst. Croat. Acad. Sci. & A.), an impressive example of his late style. In 1466, for the new city of Pag, where his workshop was active from 1449, he supplied the plans for the Bishop's Palace (rebuilt) and designed the façade of the collegiate church (unexecuted). Apart from a journey to

Rome in 1470–71, he spent his last years in Ancona and Šibenik, where he left the cathedral to be finished, after 1475, by Niccolò di Giovanni Fiorentino. Although his style was firmly based on the Venetian Late Gothic tradition, Giorgio was fascinated by the Florentine Renaissance, the influence of which is apparent in his figure sculptures.

BIBLIOGRAPHY

P. Gianuizzi: 'Giorgio da Sebenico, architetto e scultore vissuto nel secolo XV', *Archv Stor. A.*, vii (1894), pp. 397–454 [works in Ancona]

D. Frey: 'Der Dom von Sebenico und sein Baumeister Giorgio Orsini', *Jb. Ksthist. Inst. Ksr.-Kön. Zent.-Komm. Dkmlpf.*, vii (1913), pp. 1–169 [indispensable source of inf.]

H. Folnesics: 'Studien zur Entwicklungsgeschichte der Architektur und Plastik des XV. Jahrhunderts in Dalmatien', *Jb. Ksthist. Inst. Ksr.-Kön. Zent.-Komm. Dkmlpf.*, viii (1914), pp. 27–196

C. Bima: *Giorgio da Sebenico: La sua cattedrale e l'attività in Dalmazia e in Italia* (Milan, 1954)

C. Fisković: *Juraj Dalmatinac* (Zagreb, 1963) [excellent pls]

Simpozij u povodu 500. obljetnice smrti Jurja Dalmatinca [Symposium on the occasion of the 500th anniversary of the death of Giorgio da Sebenico]: *Šibenik, 1975* [proceedings published in *Radovi Inst. Povijest Umjetnosti*, iii-vi (1979–82)]

C. Fisković: 'Georges le Dalmate (Juraj Dalmatinac), architecte et sculpteur', *Interpretazioni veneziane: Studi di storia dell'arte in onore di Michelangelo Muraro* (Venice, 1984), pp. 121–31

I. Fisković: 'Za Jurja Dalmatinca i Veneciju' [For Giorgio da Sebenico and Venice], *Prilozi Povijesti Umjetnosti Dalmac*, xxvii (1988), pp. 145–80

D. Kečkemet: *Juraj Dalmatinac i gotička arhitektura u Splitu* [Giorgio da Sebenico and Gothic architecture in Split] (Split, 1988)

J. Höfler: *Die Kunst Dalmatiens: Vom Mittelalter bis zur Renaissance, 800–1520* (Graz, 1989), pp. 197–215, 254–66 [comprehensive survey]

S. Kokole: 'Auf den Spuren des frühen Florentiner Quattrocento in Dalmatien: Das toskanische Formengut bei Giorgio da Sebenico bis 1450', *Wien. Jb. Kstgesch.*, xxxii (1989), pp. 155–67

J. Höfler: 'Doslej neobjavljeni likovni vir za apsidalne niše šibeniške stolnice Jurija Dalmatinca' [A hitherto unknown pictorial source for the apsidal niches of the Šibenik Cathedral], *Prilozi povijest unjetnosti u Dalmaciji*, xxxii (1992), pp. 445–57

J. Kovačić: 'Dvije hvarske skulpture iz 15. stoljeć' [Two 15th-century sculptures in Hvar], *Prilozi povijesti umjetnosti u Dalmaciji*, xxxii (1992), pp. 425–34

I. Chiappini di Sorio: 'Giorgio da Sebenico', *Scultura nelle Marche*, ed. p. Zampetti (Florence, 1993), pp. 257–68

I. Fisković: 'Georgius Matthei Dalmaticus ad Ancona', *Marche e barocco* (Ancona, 1993), pp. 85–100

F. Mariano: 'Giorgio di Matteo da Sebenico in Ancona', *Marche e barocco* (Ancona, 1993), pp. 61–73

STANKO KOKOLE

Giorgioli, Francesco Antonio (*b* Viggiù, Italy, ?1655; *d* Meride, Ticino, 15 Nov 1725). Swiss painter of Italian birth. He came from a family of sculptors in wood, and his early training was probably as a sculptor. He was in Milan in 1678 and in Rome from 1680 to 1683. He was active in Switzerland in 1686, working on ceiling frescoes for the chapel of S Carlo Borromeo near Lostallo. From 1687 to 1689 he travelled, via Venice and Vienna, to Warsaw, where he worked as a court painter. He went to Ticino in 1690 and stayed in Eisenberg, Coburg and Weimar in Germany from 1691 to 1692. By *c*.1700 he had become a leading painter of frescoes in Switzerland: his skill as an illusionistic decorative artist and his ability to integrate his works into an architectural scheme were much admired.

Giorgioli created his most important cycles of oil paintings for the Benedictine churches at Pfäfers (1694), Muri (*c*.1705) and Rheinau (1708–9). In Säckingen in Germany he produced ceiling frescoes and an altarpiece

for the Nonnenstiftskirche St Fridolin, as well as a series of Classical scenes, for example *Diana and Actaeon* and the *Judgement of Paris* (both 1721), for the pavilion in the grounds of Schloss Schönan. He frequently collaborated with stucco artists from Ticino, as well as with Giovanni Betini in Schloss Willisau in Lucerne and with Pietro Neurone and Giovanni Battista Neurone in the Stiftskirche of Beromünster (1692; destr.). Giorgioli's work is mediocre compared to other artists of the period, but he was the first major exponent of the Italian Baroque in Swiss fresco painting.

BIBLIOGRAPHY

J. Gantner and A. Reinle: *Die Kunst der Renaissance, des Barock und Klassizismus* (1956), iii of *Kunstgeschichte der Schweiz von den Anfängen bis zum Beginn des 20. Jahrhunderts* (Frauenfeld and Leipzig, 1936–62), pp. 315–16

E. Keller-Schweizer: *Francesco Antonio Giorgioli: Ein Beitrag zur Geschichte der schweizerischen Barockmalerei* (diss., U. Zurich, 1972)

MATTHIAS FREHNER

Giorgione [Zorzi da Castelfranco; Zorzon] (*b* Castelfranco Veneto, ?1477–8; *d* Venice, before 7 Nov 1510). Italian painter. He is generally and justifiably regarded as the founder of Venetian painting of the 16th century. Within a brief career of no more than 15 years he created a radically innovative style based on a novel pictorial technique, which provided the starting-point for the art of Titian, the dominant personality of the 16th century in Venice. Although he apparently enjoyed a certain fame as a painter of external frescoes, Giorgione specialized above all in relatively small-scale pictures, painted for private use in the home. A high proportion of his subjects were drawn from, or inspired by, mythology and secular literature.

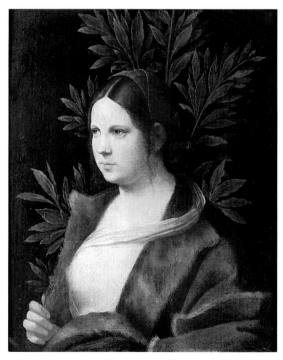

1. Giorgione: *Laura*, oil on canvas glued to panel, 410×336 mm, 1506 (Vienna, Kunsthistorisches Museum)

Landscape played an important role in many of his compositions, and particular attention was often paid to the representation of storms, sunsets and other such natural phenomena. Giorgione was evidently also prized as a painter of portraits, many of them 'fancy' portraits, or views in close-up of the kind of poetic or mythological figure also seen in his narratives. His exploitation of a taste for such works within a circle of aesthetically sophisticated Venetian patricians in turn provided the context for the creation of an entirely novel range of pictorial images.

The extreme difficulty experienced by even the earliest commentators on Giorgione's art in interpreting much of his subject-matter is matched by equally severe problems of chronology and attribution, to the extent that the artist's name has become virtually synonymous with mystery. The difficulties surrounding his work are due in part to the brevity of his career and to the almost complete lack of documented commissions; but to a large extent, too, they are inherent in the peculiar character of his art, which typically tends towards poetic suggestiveness rather than the explicit statement and seeks to evoke a mood rather than to present a clear narrative.

The situation is further complicated by Giorgione's very success in capturing the imagination of his contemporaries, since even in his lifetime his manner was imitated and adapted by his younger colleagues, with the result that the outlines of Giorgione's own personality had become blurred within a few decades of his death. Any modern attempt to interpret his art and to compile a catalogue of his surviving autograph works is bound, therefore, to be more than usually subjective; and experience has shown that it stands little or no chance of gaining universal critical acceptance. What is not in doubt, however, is Giorgione's greatness as an artist; and few critics would dissent from the view that the handful of works that make up his uncontested oeuvre are to be numbered among the most hauntingly beautiful paintings of the Italian Renaissance.

I. Life and work. II. Working methods and technique. III. Critical reception and posthumous reputation.

I. Life and work.

1. Documentary evidence and early sources. 2. Style, attribution, chronology. 3. Interpretation of meaning. 4. Giorgione and his public.

1. DOCUMENTARY EVIDENCE AND EARLY SOURCES. In view of the proverbial mystery surrounding Giorgione's life and work, any discussion of his art must begin by taking careful stock of the information that may reasonably be inferred from contemporary inscriptions and documents and from the earliest written sources. These may be summarized as follows:

(i) Inscriptions. No works by Giorgione are signed, but two carry apparently contemporary inscriptions on their backs that both confirm their authorship and provide dates: the *Laura* (Vienna, Ksthist. Mus.; see fig. 1), dated 1506, and the *Portrait of a Man* (San Diego, CA, Mus. A.; see fig. 2). The date on the latter has been read by Pignatti (1969) as 1510, but the last two digits are badly abraded, and 1506 is equally possible.

(ii) Documents. Only two pairs of documents referring to Giorgione in his lifetime are known; a third pair dates

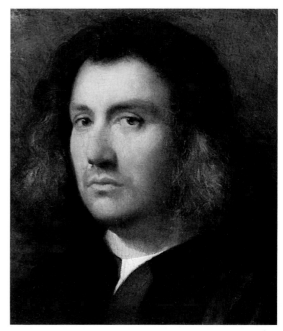

2. Giorgione: *Portrait of a Man*, oil on panel, 299×266 mm (San Diego, CA, San Diego Museum of Art)

from immediately after his death. All of them call him Zorzi (Venetian for Giorgio) da Castelfranco, thereby also naming his birthplace.

(a) Between August 1507 and January 1508 Giorgione painted a canvas for the Sala dell'Udienza (audience chamber) in the Doge's Palace, Venice. This work was almost certainly destroyed in one of the fires that gutted the palace in 1574 and 1577.

(b) In December 1508 Giorgione was paid for his recently completed fresco decoration of the façade of the Fondaco de' Tedeschi, the German warehouse next to the Rialto Bridge, Venice. By the 18th century the frescoes had faded badly; by the early 20th century a single, barely legible fragment of a *Female Nude* remained (detached 1937; Venice, Ca' d'Oro). Some idea of Giorgione's decorations may be gained from early descriptions by Vasari and others and from a series of engravings of individual figures (including the one corresponding to the surviving *Female Nude*) made in the 18th century by Anton Maria Zanetti (i).

(c) In October 1510 the Marchese of Mantua, Isabella d'Este, wrote to her agent in Venice asking him to acquire for her a picture of a night scene ('una nocte') by Giorgione. The agent replied that the artist had recently died of the plague; neither of the two night scenes known to him was available for purchase, and nor indeed were any other works by the artist. No surviving night scene by Giorgione is known.

(d) In March 1508 the silk merchant Jacopo di Zuanne was permitted by the Scuola di S Rocco to commission an altarpiece for a small chapel dedicated to the Cross in the

church of S Rocco (Anderson, 1977). The work is identifiable with the *Christ Carrying the Cross* (Venice, Scu. Grande S Rocco), which must, therefore, date from 1508–9 (1509 being the recorded date of a dedicatory inscription). It is also frequently attributed to Titian, but the evidence both of the sources and of scientific examination tends to support an attribution to Giorgione.

(iii) Sources.

(a) Michiel. The *Notizie* (notebooks) of the Venetian patrician and connoisseur Marcantonio Michiel, compiled between 1521 and 1543, and containing descriptions of the most important private art collections in Venice, provide the most detailed and reliable source of information on the work of Giorgione. Three works listed by Michiel as by Giorgione are certainly identifiable with existing pictures: *The Tempest* (Venice, Accad.; see fig. 3); the *Boy with an Arrow* (Vienna, Ksthist. Mus.) and the *Three Philosophers* (Vienna, Ksthist. Mus.; see fig. 4). Michiel added that the last painting was completed by Sebastiano del Piombo. A fourth work, the *Sleeping Venus* (Dresden, Gemäldegal. Alte Meister; see fig. 5), is generally identified with a picture attributed by Michiel to Giorgione, but of which he said that a figure of Cupid (now overpainted) and the landscape were completed by Titian; a minority of critics, however, attribute the work in its entirety to Titian. Greater doubts attach to the identification of a number of other works listed by Michiel, while several more are evidently lost. One of these, however, a *Finding (or Birth?) of Paris*, is recorded in an engraving of 1658 by David Teniers I; and since Michiel specifies that this was an early work, the engraving provides a useful

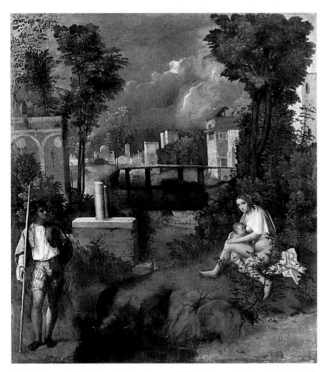

3. Giorgione: *The Tempest*, oil on canvas, 830×730 mm (Venice, Galleria dell' Accademia)

point of reference for other putative early works. In connection with another lost work, a *St James*, Michiel implies that he thought that the S Rocco *Christ Carrying the Cross* (see above) was by Giorgione.

Michiel's notes are chiefly of value for the guidance they provide on attributions to Giorgione, but they have also been used as a key to interpreting his subject-matter. Michiel is frequently vague about what Giorgione's pictures are supposed to represent, and it has sometimes been assumed—probably incorrectly—that this vagueness reflects a lack of clear intention of the part of the artist himself.

(b) Inventory of the collection of Domenico Grimani, 1528. This includes a *Self-portrait of Giorgione as David with the Head of Goliath*. The work is recorded in an engraving of 1650 by Wenceslaus Hollar; a surviving painted fragment (Brunswick, Herzog Anton Ulrich-Mus.) is sometimes regarded as Giorgione's original, and sometimes as a copy. The reference to 'Zorzon' in the inventory provides the earliest known instance of the use of the nickname by which the artist has subsequently always been known.

(c) Vasari. The earliest biography of Giorgione was included in the first edition of Vasari's *Vite* (1550). It provides the generally accepted information that the artist was born in 1477 or 1478. A twin theme of the revised version of the biography in the second edition (1568) is that Giorgione was the first exponent of the *maniera moderna* in Venice, and that he formulated this under the direct inspiration of Leonardo da Vinci. Although the latter claim has often been dismissed as an example of Vasari's Tuscan chauvinism, and it is true that he does not properly explain how Giorgione came to know the art of Leonardo, the visual evidence tends to support the author's claim—despite the fact that his first-hand knowledge of Giorgione's works was evidently quite limited. Vasari did not, for instance, have access to the private collections described by Michiel, and two of the public works he described in the greatest detail—the high altarpiece of S Giovanni Crisostomo (*in situ*) and the *Storm at Sea* in the Scuola di S Marco (now Ospedale Civile; *in situ*)—he later (1568) gave to Sebastiano del Piombo and to Palma Vecchio respectively. Although some scholars still hold that Giorgione was responsible at least for the design of these works, the documentary and circumstantial evidence tends to vindicate Vasari's change of mind in both cases. In the case of a third work discussed in detail, the S Rocco *Christ*, Vasari significantly retained his earlier attribution to Giorgione (although he inconsistently also gave it to Titian in his *Life of Titian*). Vasari also provided full accounts of the documented Fondaco de' Tedeschi frescoes and of another painted façade (untraced); and he lists a number of portraits by Giorgione, including the *Self-portrait as David*, and others that are no longer identifiable, including one of *Caterina Cornaro*, the ex-Queen of Cyprus.

(d) Inventories of the Vendramin collection, 1567–9 and 1601 (see Ravà, 1920; Anderson, 1979b). In addition to *The Tempest* already described by Michiel, these include the picture of an old woman identifiable as *La Vecchia* (Venice, Accad.) as a work by Giorgione. Another possible

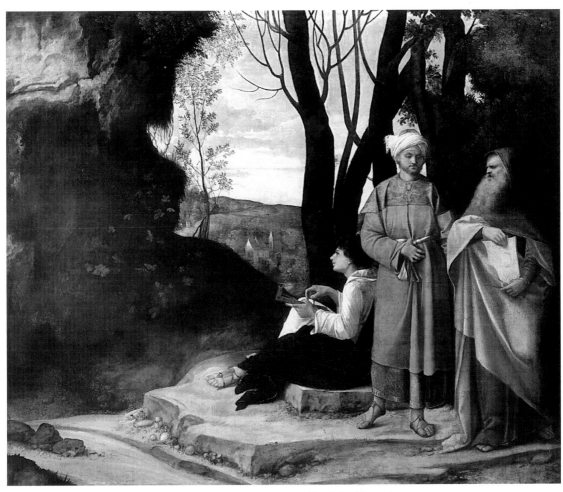

4. Giorgione: *Three Philosophers*, oil on canvas, 1.23×1.44 m (Vienna, Kunsthistorisches Museum)

identification is *The Concert* (formerly called *Samson*) in the Mattioli private collection, Milan (see Ballarin, 1993 exh. cat.).

(e) Ridolfi. By the end of the 16th century, all first-hand memory of Giorgione had faded, and accounts of his life and work were increasingly coloured by myth. In his biography of Giorgione, Ridolfi (1648) listed no less than 66 attributions, very few of which had any basis in reality; a notable exception is the altarpiece that is still in the cathedral of Giorgione's home town of Castelfranco, the *Virgin Enthroned with SS George and Francis* (the Castelfranco Altarpiece; see fig. 6), a work unanimously accepted by modern criticism. Ridolfi may also have been correct in ascribing to Giorgione a number of further Venetian façade decorations, none of which survive.

2. STYLE, ATTRIBUTION, CHRONOLOGY.

(i) The problems. (ii) Building an oeuvre. (iii) Artistic achievement.

(i) The problems. If the severest criteria of attribution are adopted—that is to say, the acceptance of only those surviving works documented by early inscriptions or in contemporary sources—only four works, *The Tempest*, the *Boy with an Arrow*, the *Laura* and the *Portrait of a Man* in San Diego, can be said to qualify with a reasonable degree of certainty as wholly by Giorgione. Of the other certainly identifiable works listed by Michiel, the *Three Philosophers* and the Dresden *Venus* were described as having been completed by Sebastiano and Titian respectively, while his reference to the S Rocco *Christ Carrying the Cross* leaves room for doubt as to whether he was talking about the original or a pupil's copy.

The condition of these works is extremely variable. The *Laura* and the S Rocco *Christ*, for example, have each been severely abraded, and the former has been cut down by as much as a third at the bottom. On the other hand, the recent cleaning of the so-called *Three Ages of Man* (Florence, Pitti) seems to have laid to rest previous critical doubts about its quality, and hence its attribution to Giorgione (Lucco, 1989 exh. cat.). There also exists a handful of other undocumented works, including the *Judith* (St Petersburg, Hermitage), the Castelfranco Altarpiece and the *Portrait of a Young Man* (Berlin, Gemäldegal.), which virtually every modern critic agrees to be by Giorgione.

5. Giorgione: *Sleeping Venus*, oil on canvas, 1.09×1.75 m (Dresden, Gemäldegalerie Alte Meister)

The basis for a chronology of Giorgione's work is equally insecure. Only the *Laura*, a relatively uninformative picture, bears a date; and a previously accepted dating of the Castelfranco Altarpiece to *c.* 1504, by reference to the tombstone of Matteo Costanzo, son of the probable patron of the work, has been shown to be undependable (Anderson, 1973). The loss of the documented painting for the Doge's Palace and the frescoes for the Fondaco de' Tedeschi (completed in 1508) present a particularly severe problem, since there is no secure alternative evidence of Giorgione's handling of large and complex figural compositions in the last three years of his life. The remaining fragment from the Fondaco provides little guidance, while the useful 18th-century engravings by Anton Maria Zanetti (i) inevitably transpose Giorgione's originals with respect to medium, scale and Zanetti's own style.

When we realize that the early careers of Titian and Sebastiano, the other two leading painters to participate in the stylistic revolution of the period 1500–10, are even less well authenticated, it is easy to see why the attribution and chronology of works from this decade have provided so much room for dispute. Dogmatic assertions of attribution and dating are to be distrusted. The best the historian can accomplish is to recognize that a number of more-or-less internally consistent models for Giorgione's career can be constructed, and to accept with due qualification the model that sits least uncomfortably with the evidence. It is unfortunate that the most consistent model(s) for Giorgione's oeuvre can cause difficulties for the construction of similar models for Titian, Sebastiano and their lesser contemporaries. If Giorgionesque works of major quality are ousted from the canon of Giorgione's paintings,

e.g. the *Concert champêtre* (Paris, Louvre; *see* FÊTE CHAMPÊTRE, fig. 1), they need to be located satisfactorily within the careers of another master.

(ii) Building an oeuvre. The *Laura* of 1506 (see fig. 1 above), particularly as reconstructed on the basis of its depiction by David Teniers II in one of his interior views, the *Painting Gallery of Archduke Leopold William* (Madrid, Prado), demonstrates an amplitude of figure style and emotional subtlety that place Giorgione's style firmly within the characteristics of High Renaissance portraiture as pioneered by Leonardo and Raphael. The handling of the oil medium, allowing for the surface damage, exhibits delicate freedom and warm colourism. The selectively applied highlights are composed from thin ribbons and points of impasto, while the modelling of the flesh on the canvas support is achieved with broken touches of paint that tend to dissolve the linear boundaries of forms and permit a subdued radiance of light in the shaded areas. The San Diego *Portrait of a Man* (see fig. 2 above) similarly illustrates Giorgione's interest in exploiting the suggestive qualities of oil paint in such a way that the play of light on forms is evoked through painterly means. This effect is particularly apparent in the economical streaks of impasto that describe the man's untidy bunches of hair.

The evocation of light on surfaces through varied paint handling is also apparent in the Castelfranco Altarpiece (see fig. 6). The 'grainy' treatment of the lit and shaded areas of the Virgin's flesh—conveying a scattered radiance of colour—is contrasted with separate blobs of impasto in the strong highlights of the gold brocade and with the

absorbent, matt quality of her green dress. However, such effects are achieved in a less fluent manner than in the *Laura*, and the medium has been identified as the relatively old-fashioned tempera. The figure style also displays a less developed technique than the *Laura* or the engravings after the Fondaco frescoes. The figures possess a delicate, almost 15th-century air, and the composition is assembled from a series of discrete units. Although the orthogonal lines of the perspective construction focus with fair precision on a single vanishing point (Castelfranco, 1955), the point lies at an improbably high position, and the deeper horizontal intervals of the tile pattern are erratically placed. There is no indication in Giorgione's other works that he was particularly concerned with accurate control of perspectival structures or with other aspects of correct *disegno* in the manner of Raphael and the Central Italian painters.

If Vasari was right in placing Giorgione's birthdate in 1477–8, his career is likely to have begun in the mid-1490s; in which case the manifestly early Castelfranco Altarpiece is likely to date from *c.* 1500 or even earlier. Often associated with this work are the *Holy Family* (Washington, DC, N.G.A.) and the *Adoration of the Magi* (London, N.G.), both of which exhibit the same virtues and defects. The suggestive delicacy of handling and colouristic delights foreshadow the later works, while the articulation of the figures, insecurities of structure and assertive description of drapery folds provide unevenness of pictorial effect. Probable early portraits include the beguilingly romantic *Young Man* in Berlin and the youthful *Francesco Maria della Rovere* (Vienna, Ksthist. Mus.; see Ballarin, 1993 exh. cat.). More marginal attributions in this early period are the *Virgin and Child* in the Ashmolean Museum, Oxford (also occasionally, but improbably, dated later in his career; or else identified, and perhaps more plausibly, as the earliest surviving painting by Sebastiano); the *Judgement of Solomon* and the *Trial of Moses* (both Florence, Uffizi), closely related paintings that share many of the characteristics of 'early Giorgione' but are full of stylistic inconsistencies. The range of the inconsistencies in paint handling, figure type and facial expression (within each picture and between them) is so great as to make it difficult to assign them to one artist. They may be eclectic compilations of Giorgionesque motifs by one or more imitators of Giorgione's earlier style.

The most substantial and developed of the paintings which can be reconciled with the *Holy Family* and *Adoration of the Magi* is the Allendale *Adoration of the Shepherds* (Washington, DC, N.G.A.). Although it may have been subject to later additions (the angels' heads?), the refined sentimentality of the figures and meandering pastoral delights of the landscape represent a generally credible step in Giorgione's development. A further step may be represented by the *Judith* in the Hermitage, first attributed to Giorgione only in the 19th century but now almost universally accepted. Although some internal inconsistencies in handling and structure remain, they are subordinated to a colouristic and atmospheric unity that is characteristic of his mature work.

In March 1500 Leonardo is known to have paid a brief visit to Venice. Although Giorgione may well have already been acquainted with his work, the personal presence of Leonardo in the city seems to have made a strong impact on the Venetian, and two of his works that most explicitly approach Leonardo's style—the Vienna *Boy with an Arrow* and the Pitti *Three Ages of Man*—may probably best be dated to around this time. In both pictures, the half-length figures emerge from a dark background, with their forms softened by an unprecedentedly soft *sfumato*; while the latter—actually representing a musical subject—includes a contrast of physiognomic types that is strongly reminiscent of Leonardo.

Perhaps dating from an intermediate phase between these works and the *Laura* of 1506 are the crucial reference points of *The Tempest* (see fig. 3 above) and the *Three Philosophers* (see fig. 4 above). Once allowance has been made for differences in figure scale and condition, *The Tempest* can probably be most readily aligned with the style of the *Laura*. The handling of paint in the flesh, foliage and architectural detail retains some of the characteristics of the Castelfranco Altarpiece. However, recent interpretations of the allegorical meaning of *The Tempest* have relied on a date no earlier than 1509. The small size of the work makes comparison with the Fondaco frescoes a hazardous undertaking, but the relatively simple and awkwardly articulated poses in *The Tempest* are difficult to reconcile with the phase of his career following his experiments with complex postures on a large scale in 1508.

Whether we date *The Tempest* to *c.* 1505–6 or 1509 makes a radical difference to our model of the final phase

6. Giorgione: *Virgin Enthroned with SS George and Francis* (the Castelfranco Altarpiece), tempera on panel, 2.00×1.52 m (Castelfranco Veneto, S Liberale)

of his career. If the earlier date is accepted, the way is open for a 'late' style that could include such works as the *Concert champêtre* and the *Virgin and Saints* (Madrid, Prado); or, according to an alternative model, the Mattioli *Concert* and the *Two Singers* (Rome, Gal. Borghese). A late date for *The Tempest* leaves little room for any of these pictures and, indeed, presents considerable problems with respect to the San Diego *Portrait*, the S Rocco *Christ* and the generally attributed *La Vecchia*. On balance, it seems that fewer problems are created by a rather earlier dating for *The Tempest*.

It might seem obvious that the paintings apparently completed by Sebastiano and Titian, the *Three Philosophers* and *Sleeping Venus* (see fig. 5 above), would be late works, left unfinished on Giorgione's death. However, a late date for Giorgione's part in the *Three Philosophers* is difficult to sustain, since the relatively simple poses seem to belong to his work before the Fondaco frescoes. The element in this picture that speaks most clearly of Sebastiano's vision is the seated figure, in which the attempt to describe the structure of facial features and hands appears to belong more with his concept of form. The *Venus*, by comparison, can be reconciled with the surviving fragment of the Fondaco decoration and represents a figure style of considerable rhythmic sophistication. The landscape in this latter picture may be regarded as characteristically Titianesque (even if one does not accept the minority attribution of the whole work to Titian), and it is possible that the rather waxy folds of the white cloth were also contributed by the younger master.

If *La Vecchia* joins the S Rocco *Christ* in the last two years of Giorgione's life, his 'late' style may be characterized as exploiting a highly individual form of suggestive realism. In this he may have been responding both to the works painted by Dürer on his second visit to Venice and to the increased Venetian awareness of Central Italian art, as reflected at this time in Sebastiano's work. The directness of Giorgione's 'late realism' is, however, more apparent than actual. He remains resolutely attached to the inference of form through a painterly evocation of light and colour. The descriptive *La Vecchia* is a partial exception to this rule, but it is a subject that makes specific, descriptive demands and may be one of his most direct responses to Dürer's paintings.

If the problematic *Concert champêtre* (*see* FÊTE CHAMPÊTRE, fig. 1) is indeed by Giorgione, it too must belong to the last phase of his brief career. Many critics—perhaps the majority of present-day authorities—prefer to see this picture as an early work by Titian; and indeed, there are numerous points of stylistic contact with the documented frescoes in the Scuola del Santo, Padua, of 1510–11 and with several other works universally attributed to him. Such critics argue that none of Giorgione's extant pictures show a comparable complexity of figure composition or dominance of the figures over their landscape surroundings. But dealing with an artist of such genuinely revolutionary qualities as Giorgione, the historian is extremely unwise to draw rigid boundaries round the possible parameters of his style; and on balance, it seems more reasonable to side with those critics who see the pervasively poetic mood of the *Concert champêtre* as intrinsic to Giorgione's own artistic personality and foreign to the more extrovert Titian. In either case, the picture may be regarded as the most advanced and complex manifestation of the traits apparent in *The Tempest* and the Fondaco fresco, and as a seminal work in the Giorgionesque revolution in form, colour, meaning and expression.

(iii) Artistic achievement. It would also be misleading to allow the historical problems of reconstructing Giorgione's career to obscure the quality and nature of the revolution that he led during the first decade of the century. Giorgione took the first steps in the realization of the potential for oil paint to be handled in a manner that did not suppress its qualities as paint. Rather, he used varied paint application to evoke a coherent visual world of light and colour. He inaugurated a tradition of painterly colour that could stand as an alternative to the Florentine tradition in general and Leonardo's system of light and shade in particular. Although Vasari attributed Giorgione's 'soft-focus' effects to Leonardo's influence, the Venetian achieved his qualities quite differently. Instead of the systematic veiling of colour and form found in Leonardo's paintings, Giorgione used broken touches in the highlights and radiant, even hot, tones in the shadows to achieve a suggestive impression of the elusiveness of light and colour in the natural world. The pictorial unity achieved through paint and colour was placed in the service of a new form of unity between man and nature. The encyclopedic rapture for exquisitely painted natural detail that characterized Giovanni Bellini's *St Francis in Ecstasy* (*c.* 1480; New York, Frick) has given way to a sense in which the figures and landscape belong together—in the same atmosphere, the same light and within a single, credible scene, rather than as an aggregate of separate observations.

These forms of unity were essential in Giorgione's new forms of expression. The small, enigmatic, poetic pictures, which have always been regarded as most archetypally Giorgionesque, rely for their effect on the deliberate subversion of explicit narrative or overt symbolism in favour of a prevailing mood. His paintings were clearly made to appeal to what may be called a romantic sensibility. The ability of his (predominantly young?) patrons to attune themselves to the romantic mood is likely to have been more important to both artist and patron than any more literal meanings that the paintings may have possessed.

3. INTERPRETATION OF MEANING. The problems of reading the content of Giorgione's pictures extend beyond the obvious question of finding textual keys to their narrative or symbolism. In some instances we cannot even be sure what kind of interpretative key we require. In the extreme case of *The Tempest*, the work has been variously interpreted as a mythology (e.g. 'The Infancy of Paris', Richter, 1937), as a religious painting (e.g. 'The Legend of St Theodore', de Grummond, 1972), as an allegory of virtues (Wind, 1969), as referring to events in Venetian history (Howard, 1985, and Kaplan, 1986) and as a free poetic invention with no preconceived subject.

It cannot be doubted that Giorgione possessed an unusual attitude to subject-matter. Even the apparently straightforward Castelfranco Altarpiece departs from the norms in the illogicality of its architectural setting, its

prominent pastoral features, the uncanonical colour scheme and the languorous romanticism of the saints. Even when his various frescoes on the façades of Venetian houses and palaces were still plainly visible, early commentators such as Vasari found them difficult to interpret; it is clear, nevertheless, that their iconography was based on a range of mythological and literary sources similar to that of his cabinet paintings. In these smaller-scale, private paintings his treatment of subject-matter often appears to be almost wilfully subversive. The picture called by Michiel the *Birth of Paris*, for example (untraced but reliably recorded in a copy by David Teniers I), has been called by others the *Finding of Paris*, but actually it corresponds precisely to neither incident in Paris's infancy. Rather it works a free pastoral variation on the theme of Paris as a baby in nature, accompanied by the two shepherds, an elderly flute-player, a scantily-dressed woman and other figures indulging in rural dalliance. It is a fantasia around the theme, much in the manner of a musical fantasia or improvised poem.

Giorgione's pictures of single, half-length or bust-length figures are equally original. He seems to have invented the romantic image of androgynous boys in the possible guise of cupid or shepherd (e.g. the Vienna *Boy with an Arrow*). Novel formats for portraits include those showing the sitter with his back to the viewer, as in the *Man in Armour* (Vienna, Ksthist. Mus.), and/or accompanied by a secondary figure, such as a page. There is no precedent for his *Self-portrait with the Head of Goliath*, with its enigmatic combination of introspective melancholy and outward challenge. The two paintings that present the severest problems of interpretation are the *Three Philosophers* and *The Tempest*. It is disconcerting that Michiel, who almost certainly had direct access to the original patrons of some of Giorgione's pictures, should provide such limited clues. The former painting is described as 'philosophers in a landscape, two standing and one sitting who contemplates the rays of the sun with that rock executed so miraculously', and the latter as 'the small landscape on canvas with the storm, with the gypsy and soldier'.

The *Three Philosophers* (see fig. 4 above) was to be found in the house of Taddeo Contarini, who also owned Bellini's *St Francis in Ecstasy*. Although Bellini's picture may have entered Contarini's collection after Giorgione's death, it is tempting to view Giorgione's painting as a homage to (and criticism of?) the *St Francis*. In any event, a comparison assists in interpreting the subject of Giorgione's work. Bellini's painting is deeply involved with light: the brilliant natural light of the landscape and the burst of divine light that attracts the saint's rapture. Giorgione's seated philosopher similarly seems to be the privileged witness to a directional shaft of light from the top left of the picture. Given Giorgione's oblique treatment of standard subjects, it becomes feasible to interpret the figures as the three biblical Magi who are about to embark on the first steps towards their mission.

The meaning of *The Tempest* (see fig. 3 above) is one of the *causes célèbres* of art history. The problems have only been exacerbated by the evidence of the X-ray examination (Morassi, 1939), which showed Giorgione's remarkably free approach to the setting-up of the subject: a seated female nude was revealed to lie beneath the standing male figure on the lower left-hand side. The main recent tendencies in interpretation have been to approach *The Tempest* as an allegory, either in pure terms or as applied to contemporary events. Wind's allegorical interpretation would have us see two virtues—*fortezza* (Strength, symbolized by the broken columns) and *carità* (Charity, suckling a child)—under threat from the vagaries of *fortuna* (Fortune as a storm, in terms of the shared meaning of the word). The political interpretations broadly accept this approach but additionally identify the buildings as making reference to a specific city. Kaplan (1986) identifies the small, barely discernible heraldic motifs on the buildings as the Venetian lion and the Paduan *carro* (the largely obsolete heraldic device of a carriage used by the da Carrara rulers) and accordingly reads the whole composition as an allegory of the recapture of Padua from imperial troops in 1509. Even by Giorgione's standards, these heraldic motifs are so hidden and the *carro* so recondite a motif as to cast doubt on whether the whole meaning of the picture could hinge on their being noticed.

In the face of such arcane complexities, the return by Settis (1978) to an interpretation of the work as a relatively straightforward episode from the Old Testament, or by Büttner (1986) as a mythology (Ceres and Iasion), have an obvious appeal. Yet no literal interpretation of this kind has ever won general acceptance, and perhaps the most satisfactory way of approaching *The Tempest* and similar Giorgionesque pictures is to regard them as poems in paint, or *poesie*. That is to say, the painter and his public regarded them as visual analogues to poetry and as sharing much of poetry's generic content (pastoral, amatory, mythological etc.). Further, while the painting might evoke, or allude to, a particular text or range of texts, it was not intended as a precise textual illustration. On the contrary, the task of the painter, like that of the writer, was to create a new, and ultimately autonomous, poetic invention (Anderson).

4. GIORGIONE AND HIS PUBLIC. The private, domestic nature of Giorgione's art, and the difficulty of his subject-matter, implies that he was supported by a type of patronage very different from that traditional in late 15th-century Venice, which was devoted to large-scale religious works and, on a more intimate scale, to Madonnas and other half-length devotional subjects. Vasari's remark that Giorgione began his career by painting Madonnas and portraits—pictures of a type associated with Giovanni Bellini—before moving on to his more original subjects seems inherently plausible; so, too, is Ridolfi's information that in his early career Giorgione decorated pieces of furniture with mythological themes drawn from Ovid, furniture-painting being the one context in which older painters such as Bellini and Cima had previously represented secular subjects.

It appears that Giorgione began by painting relatively conventional small-scale works for an existing market and then developed a radically novel range of subject-matter as a taste for his art grew among collectors. His portraits, with their emphasis on private thoughts and emotions rather than public image, evidently struck an increasingly sympathetic chord with a new generation of Venetians. Michiel provides the names of the collectors who owned

pictures by Giorgione in the 1520s and 1530s, and modern research has succeeded in unearthing a certain amount of information about some of them. Giovanni Ram, for example, who owned the *Boy with an Arrow*, was a Catalan merchant and also owned pictures by Titian, Rogier van der Weyden and Jan van Scorel; while Andrea Odoni, who owned an untraced *St Jerome in a Moonlit Landscape* by Giorgione, and whose portrait by Lorenzo Lotto is now at Hampton Court, England, was a connoisseur and antiquary from a wealthy mercantile family of Milanese origin. But it is not clear how many of such collectors actually commissioned their works from Giorgione: thus, while Ram may have, Odoni certainly did not. The only collector in Michiel's list whom we know definitely to have had direct contact with Giorgione was the original owner of the *Three Philosophers* and the *Finding of Paris*, Taddeo Contarini, since he is mentioned in the correspondence of Isabella d'Este in 1510 as the owner of a night-piece by the artist. Despite a recent attempt (Settis, 1978) to identify him with the brother-in-law of another early owner of pictures by Giorgione, Gabriele Vendramin (1484–1552), Frizzoni (editor of Michiel, 1884) was probably correct in identifying the patron mentioned by Michiel as Taddeo Contarini of SS Apostoli, who is recorded as having held office in the Council of Ten and as a Savio di Terra Ferma. He died in 1545 and so would have been still relatively young at the time of Giorgione's death. The same is true of Vendramin himself, the owner of a thriving soap-works as well as of an important art collection that included *The Tempest* and *La Vecchia*; and it may well be that he, too, was a direct employer of Giorgione.

The identification of such individuals has obvious relevance for the interpretation of Giorgione's subject-matter; too little, however, is known of the cultural and intellectual interests even of Contarini and Vendramin to permit definite conclusions to be drawn in this connection. Some critics have claimed that they were steeped in humanist learning, and that they are likely to have encouraged a type of art that was self-consciously recondite, incorporating complex philosophical ideas that would have been comprehensible only to an intellectual élite. Other critics, however, have pointed out that they were not in the first place academics but merchants and administrators, and that they are more likely to have regarded their collections as an undemanding source of pleasure and of relaxation from the cares of business.

The only other direct employer of Giorgione about whom some information is known is Tuzio Costanzo, the donor of the Castelfranco Altarpiece. Costanzo was a Sicilian *condottiere*, who entered the service of Queen Caterina Cornaro in Cyprus and then accompanied her to her court in exile at Asolo, not far from Giorgione's birthplace in the Veneto. Since Vasari mentions that Giorgione painted a portrait of the ex-Queen, and also that he possessed musical accomplishments much in demand at social gatherings, several critics have inferred that the painter was in close contact with the court at Asolo, and also therefore with the various poets and intellectuals who met there, including the celebrated Pietro Bembo and others associated with the currently fashionable vogue for pastoral poetry. The prominence of landscape in so many of Giorgione's works, and their characteristic mood of mystery and poetry, have thus often come to be interpreted as painted equivalents of such contemporary literary successes as Jacopo Sannazaro's *Arcadia* (Wittkower, 1963). Yet here again, Giorgione's supposed contacts with the literary circle at Asolo are by no means proved, and other critics consider that the mood of Arcadian nostalgia, which does indeed appear in certain Venetian paintings of the period, is actually foreign or peripheral to the central works of Giorgione's maturity. Such critics point out that Bembo's collection in Padua, which is also described by Michiel, did not contain any works attributed to Giorgione himself.

II. Working methods and technique.

With his concentration on small-scale works with subjects that closely reflected the personal interests of particular clients, Giorgione had no need of a large-scale, well-organized workshop of the kind run by Giovanni Bellini and later by Titian. It is possible, in fact, that he had no direct pupils at all, and that he only employed assistants in the context of fresco painting. Even so, Titian seems to have been employed at the Fondaco de' Tedeschi as an independent master rather than as an assistant; and Michiel's remark that Titian was responsible for completing the *Sleeping Venus* (see fig. 5 above) should probably be interpreted as meaning that he did so after Giorgione's death rather than as a pupil in his shop.

The highly personal and innovative character of Giorgione's pictorial technique was not, in any case, one that would easily have lent itself to the use of studio assistants. In his *Life of Titian*, Vasari correctly identifies the essence of Giorgione's technical revolution as a method of creating form directly out of colour, dispensing with preparatory drawings on paper. This is in complete contrast to the traditional method as practised in Venice by Giovanni Bellini, where the exact position of every major form had been carefully worked out in the preliminary design, and the paint was then applied methodically in thin, flat layers, with the colour planes remaining strictly within their predetermined contours. Bellini had made use of the newly introduced oil medium to achieve a greater luminosity of colour and a greater softness of tonal transition; but it was Giorgione who first realized the full versatility and malleability of the medium, applying the paint unevenly and expressively, making the forms seem to emerge out of, and to fuse with, one another, thus evolving his composition in the very process of pictorial execution. Although Giorgione sometimes used the traditional panel support, particularly in apparently early works such as the Castelfranco Altarpiece (see fig. 6 above) and the St Petersburg *Judith*, he increasingly turned to canvas, with its comparatively rough, textured surface, as the natural complement to his expressive brushwork and impastoed highlights.

Many aspects of Giorgione's innovative technique are evident to the naked eye, but our knowledge of it has been considerably expanded by the scientific tests made on a number of his pictures during the course of the last half-century. X-ray photographs have proved to be particularly informative, since by penetrating the upper paint layers, they have revealed the artist's often quite radical changes of mind (pentiments) during the course of execution. An

exceptionally dramatic case is that of *The Tempest* (see fig. 3 above), with the revelation that a female nude had been replaced by a standing male figure (*see* §I, 3 above). But other, more recently developed methods of analysis, such as infra-red photography and the study of paint layers in cross-section, have revealed new information about Giorgione's technique that is hardly less relevant to the broader problems of chronology, attribution and meaning. Tests on the Castelfranco Altarpiece undertaken in 1978, for example, have shown that in many aspects of its technique (including the use of tempera) it remains a comparatively traditional work and hence is likely to have preceded the much more radically experimental *Tempest*; while the tendencies in the latter towards a freer and more direct application of paint, and towards a more restricted palette, are taken further in *La Vecchia*, suggesting that this may be even later in date. *La Vecchia* is very close technically to the S Rocco *Christ*, a work that is often attributed to Titian but which lacks the much more complicated pictorial structure and extraordinarily wide colour range of an undisputed early work by Titian such as the *St Mark Enthroned* (Venice, S Maria della Salute; see Lazzarini, 1978 exh. cat.). However, the technical evidence regarding dating and attribution is rarely conclusive and is just as open to differing interpretations as traditional methods of stylistic analysis. Scientific investigation of the *Concert champêtre*, a notoriously problematic work, has merely fuelled the controversy about whether it is by Giorgione, Titian or by the two artists in collaboration. Equally controversial is the interpretation of Giorgione's intentions regarding his subject-matter on the basis of pentiments revealed by X-rays. Thus, for some critics the replacement of a female nude with a clothed male in *The Tempest* proves that Giorgione approached his subjects in a spirit of pure fantasy; while for others the female nude is merely an earlier version of the gypsy figure that the painter subsequently decided to place on the right of the composition.

In view of Giorgione's technical procedures, it is only to be expected that drawings by him should be extremely rare. The only universally accepted example is a *?Shepherd in a Landscape* (Rotterdam, Mus. Boymans–van Beuningen); the recent revelation that the city walls in the background do not represent, as was previously thought, the artist's home town of Castelfranco, but rather Montagnana, does not seem to have shaken confidence in the attribution. The drawing, which is not connected with any known picture, is executed in red chalk, a medium that lends itself perfectly to the kind of suggestive *sfumato* also found in Giorgione's handling of paint. A number of other drawings have also been attributed to Giorgione with varying degrees of plausibility; and it has also been suggested that certain engravings by Giulio Campagnola and Marcantonio Raimondi are based on designs by Giorgione (Oberhuber in Levenson, Oberhuber and Sheehan, 1973; Oberhuber, 1993 exh. cat.). But the whole field of Venetian drawing and engraving in the early decades of the 16th century is highly problematic; and the suggestion, which also carries implications for the study of Giorgione's chronology, remains controversial.

III. Critical reception and posthumous reputation.

Giorgione's impact on Venetian painting was sudden and profound. Although his work may have been little known outside an inner circle of connoisseurs as late as *c.* 1507, it was so highly prized by the time of his death in 1510 that Isabella d'Este in Mantua was unable to acquire a single example of it. For a brief spell between *c.* 1508 and the definitive emergence of Titian *c.* 1516 as the new artistic leader, Giorgione's influence dominated Venetian painting. Not only were Venice-based painters such as Sebastiano del Piombo, Lorenzo Lotto, Palma Vecchio, Giovanni Cariani and Paris Bordone all deeply influenced by his example, but so too were other North Italians, such as the Brescian Giovanni Girolamo Savoldo and the Ferrarese Dosso Dossi. The most important of the Giorgioneschi was Titian himself, of whom Vasari observed that he succeeded in imitating the manner of Giorgione so well that it was often difficult to distinguish their hands. The truth of the remark is borne out by the lively controversy that still surrounds the attribution of such works as the *Concert champêtre*. Even after the superficial aspects of Giorgionism had disappeared from Titian's work, such as the treatment of themes connected with music, poetry and love, more fundamental aspects remained, such as the new painterly freedom of technique; and through Titian they became a vital force in the wider European tradition.

Giorgione was already recognized as one of the great painters of modern times in Baldassare Castiglione's *Il libro del cortegiano* (1528), where he is listed together with Leonardo, Raphael, Mantegna and Michelangelo. He appears in similarly exalted company in Paolo Pino's *Dialogo di pittura* (1548), where he is presented as the hero of Venetian pictorialism, practising a style of dazzling verisimilitude. It is again this aspect of Giorgione that received the highest praise from Vasari, who, although disapproving of his method of painting without drawing, regarded the innovative softness and suggestiveness of his handling as admirably natural; and Vasari paid him the high compliment of placing his Life close to the beginning of Part III of the *Vite*, between those of the other great pioneers of the *maniera moderna*, Leonardo and Correggio. Vasari also provided some of the basic ingredients of the 'myth of Giorgione' by describing him as a person of gentle and courteous manners, fond of social gatherings where his talents as a singer and lutenist were much in demand, and whose love of a lady brought him to his premature grave. Carlo Ridolfi (1648), while as a fellow-Venetian intent on defending Giorgione from Vasari's Tuscan-inspired strictures on his technique, took over and elaborated on the romantic aspect of the Giorgione legend, portraying him as a poet of the paint brush, who re-created in his pictures an Ovidian Golden Age, with happy men and women dallying among pleasant pastures and shady groves. It was on the basis of this alluring image that the *Concert champêtre* was first attributed to Giorgione in the later 17th century by Jean-Baptiste-Pierre Le Brun in the inventory he made of Louis XIV's collection.

Giorgione and the mystery associated with him was predictably a subject of the deepest fascination to the

19th-century Age of Romanticism. Lord Byron was instrumental in having the *Judgement of Solomon* (Kingston Lacy, Dorset, NT) brought to England—a work now almost universally attributed to Sebastiano del Piombo but which was authoritatively listed by Ridolfi as by Giorgione. John Ruskin, closely identifying Giorgione with the spirit of Venice itself, made him a hero of Book V of *Modern Painters* (1860)—without, however, knowing a single example of his work. The climax of this romantic, intuitive approach is marked by Walter Pater's essay 'The School of Giorgione' (1877), a poetic evocation of the spirit of Giorgionism, in which Giorgione's art is made the basis for the famous dictum of the Aesthetic Movement that 'all art constantly aspires towards the condition of music'. Yet even before Pater had written his essay, a new approach to the artist had begun to take shape, founded on more objective criteria. Michiel's *Notizie* had been rediscovered and published as early as 1800, and during the course of the 19th century several of the most important pictures attributed to Giorgione by Michiel, including *The Tempest*, came to public attention for the first time. The process of stripping away the layers of legend accumulated over centuries, and of attempting to establish an authentic corpus, was begun by J. A. Crowe and Giovanni Battista Cavalcaselle (1871), who now reattributed the *Concert champêtre* to Sebastiano del Piombo and replaced it with *The Tempest* and the *Three Philosophers* as the essential touchstones for all attributions to Giorgione. Their approach was continued by Giovanni Morelli, who first reidentified the Dresden *Venus* (1880) and who made a number of convincing new attributions on the basis of this radically revised image of Giorgione's art.

Giorgione studies in the earlier part of this century were characterized mainly by disputes between 'expansionist' critics such as Carl Justi (1908), who was able to reconcile a rather large number of works with the newly redefined image of the artist, and the 'contractionist' critics such as Tancred Borenius (editor of Crowe and Cavalcaselle, 1912) and Louis Hourticq (1919), who were unable to accept more than the canonical handful. The severe problems of interpretation posed by Giorgione's pictures also divided critics into a quite different pair of opposing camps, according to whether they agreed with Pater in viewing them as purely lyrical utterances, analogous to music, without any literary subject (Venturi, 1913), or whether, on the contrary, they regarded them as dense with learned allusions, the meaning of which would become clear once the right key was found (Ferriguto, 1933; Wind, 1969).

The considerable amount of scholarly discussion generated by the celebrations of the fifth centenary of Giorgione's birth in 1978 showed that these debates are far from settled. Indeed, new archival research on the artist's patrons and new methods of scientific investigation of his pictures have in many ways made the problems even more complex. Another result of the centenary year was to throw into relief another growing dichotomy in Giorgione studies, this time relating to an assessment of his place in the history of art, and of the very nature of his creative achievement. One view, perhaps best represented by an essay by Rudolf Wittkower (1963), and tending to be shared by northern European and American scholars, takes an Arcadian view of Giorgione and retains a certain

sympathy for the romantic interpretation of Walter Pater. According to this view, Giorgione is a painter of poetic, dream-like idylls that evoke a bittersweet nostalgia for a far-off Golden Age; artistically he is the forerunner of Claude and Watteau. His most characteristic work is the Dresden *Venus*, and even if the *Concert champêtre* is not actually by him, it is a perfect specimen of the Giorgionesque spirit. Against this view is one developed by Roberto Longhi during the 1930s, and now shared by the overwhelming majority of Italian scholars, which insists that the *Concert champêtre* is entirely characteristic of the 'chromatic classicism' of the early Titian and has nothing whatever to do with Giorgione. Returning to Vasari, Longhi (1946) dismissed as fanciful the stories of lutes and love and concentrated instead on Vasari's praise of Giorgione's verisimilitude. For Longhi, Giorgione's greatness lay in a powerful naturalism, which led not to Claude and Watteau but through Lombard painting to Caravaggio and Velázquez.

In 1978 (conferences at Castelfranco and Venice) Carlo Volpe expanded upon and reinforced Longhi's interpretation, referring to the *Self-portrait as David*, with its melancholy expressiveness and the gruesome trophy of the decapitated head, to the shadowy, introverted San Diego *Portrait of a Man*, to the veristic *La Vecchia*, and to the Pitti *Three Ages of Man* as all central to a proper understanding of the artist. Similarly Alessandro Ballarin (at Castelfranco in 1978 and in 1993 exh. cat.) has redefined the character of Giorgione's late work by insisting on the correctness of Longhi's attributions to the master of the Borghese *Singers* and the Mattioli *Concert*. There is clearly much in this view that the opposing camp does not properly take into account; few critics would deny, for instance, that a fundamental work such as *The Tempest* is characterized rather by brooding disquiet than by idyllic serenity. Yet the Longhian view is equally one-sided and chooses to ignore the gentle languor of the equally fundamental Dresden *Venus*, which, somewhat perversely, it tends to attribute to Titian. Giorgione's artistic personality thus remains far from clearly defined, even after a century of investigation by modern art-historical methods. But it is perhaps a measure of his range and greatness, as well as of his expressive ambiguity, that his work should have given rise to such diverse but creative interpretations by other artists in the past and by historians in the present.

BIBLIOGRAPHY

EARLY SOURCES

M. A. Michiel: Venice, Bib. N. Marciana, Ital. XI 67 (7351), pub. as *Notizia d'opere di disegno nella prima metà del secolo XVI* (MS.; 1521–43); *Notizie d'opere di disegno* (MS.; c. 1520–40); ed. G. Frizzoni (Bologna, 1884); Eng. trans. by P. Mussi, ed. G. C. Williamson as *The Anonimo* (London, 1903/R New York, 1969)

P. Pino: *Dialogo di pittura* (Venice, 1548); ed. R. Pallucchini and A. Pallucchini (Venice, 1946)

G. Vasari: *Vite* (1550, rev. 2/1568); ed. G. Milanesi (1878–85), iv, pp. 91–100 [*Giorgione*]; vii, pp. 425–8 [intro. to *Life of Titian*]

C. Ridolfi: *Meraviglie* (1648); ed. D. von Hadeln (1914–24)

M. Boschini: *Le miniere della pittura veneziana* (Venice, 1664)

A. M. Zanetti: *Della pittura veneziana* (Venice, 1771)

GENERAL

J. A. Crowe and G. B. Cavalcaselle: *A History of Painting in North Italy* (London, 1871, rev. T. Borenius, 1912)

W. Pater: *The Renaissance: Studies in Art and Poetry* (London, 1877, rev. 4/1893; ed. D. L. Hill, Berkeley, 1980) [incl. 'The School of Giorgione' of 1877]

I. Lermolieff [G. Morelli]: *Die Werke italienischer Meister in den Galerien von München, Dresden und Berlin* (Leipzig, 1880)

L. Hourticq: *La Jeunesse de Titien* (Paris, 1919)

H. Tietze and E. Tietze-Conrat: *The Drawings of the Venetian Painters in the 15th and 16th Centuries*, 2 vols (New York, 1944)

R. Longhi: *Viatico per cinque secoli di pittura veneziana* (Florence, 1946)

K. Clark: *Landscape into Art* (London, 1947)

C. Gilbert: 'On Subject and Not-subject in Italian Pictures', *A. Bull.*, xxxiv (1952), pp. 202–16

E. H. Gombrich: 'The Renaissance Artistic Theory and the Development of Landscape Painting', *Gaz. B.-A.*, xli (1953), pp. 335–60; also in E. H. Gombrich: *Norm and Form* (London, 1966), pp. 107–21

A. R. Turner: *The Vision of Landscape in Renaissance Italy* (Princeton, 1966)

S. Freedberg: *Painting in Italy, 1500–1600*, Pelican Hist. A. (Harmondsworth, 1971)

J. Levenson, K. Oberhuber and J. Sheehan: *Early Italian Engravings from the National Gallery of Art* (Washington, DC, 1973)

T. Pignatti: 'The Relationship between German and Venetian Painting in the Late Quattrocento and Early Cinquecento', *Renaissance Venice*, ed. J. Hale (London, 1973), pp. 244–73

J. Wilde: *Venetian Art from Bellini to Titian* (London, 1974)

D. Rosand: *Painting in Cinquecento Venice* (New Haven, 1982)

L. Lazzarini: 'Il colore nei pittori veneziani tra il 1480 e il 1580', *Bull. A.*, 6th ser., no. 5 (1983), suppl., pp. 135–44

M. Lucco: 'Venezia fra quattro e cinquecento', *Storia dell'arte italiana*, v (1983), pp. 447–77

J. Shearman: *The Early Italian Pictures in the Collection of Her Majesty the Queen* (Cambridge, 1983) [attrib. of Hampton Court *Shepherd* to Titian]

N. Huse and W. Wolters: *Venedig: Die Kunst der Renaissance* (Munich, 1986); Eng. trans. as *The Art of Renaissance Venice* (Chicago, 1990)

M. Lucco: 'La pittura a Venezia nel primo cinquecento', 'La pittura nelle provincie di Treviso e Belluno', *La pittura in Italia: Il cinquecento*, 2 vols, ed. G. Briganti (Milan, 1987, rev. 1988), i, pp. 149–70, 197–218

H. Wethey: *Titian and his Drawings* (Princeton, 1988)

P. Humfrey: *Painting in Renaissance Venice* (New Haven and London, 1995)

MONOGRAPHS, EXHIBITION CATALOGUES, SYMPOSIA, COLLEC-
TIONS OF ESSAYS

C. Justi: *Giorgione* (Berlin, 1908)

L. Venturi: *Giorgione e il Giorgionismo* (Milan, 1913)

A. Ferriguto: *Attraverso i misteri di Giorgione* (Castelfranco, 1933)

G. M. Richter: *Giorgione da Castelfranco* (Chicago, 1937) [with cat., illus., doc. and bibliog. to 1936]

Giorgione e i giorgioneschi (exh. cat. by P. Zampetti, Venice, Accad., 1955); review by G. Robertson in *Burl. Mag.*, xcviii (1956), pp. 272–7

V. Lilli and P. Zampetti: *Giorgione*, Class. A., xvi (Milan, 1968) [with cat. and illus., many in colour]

E. Wind: *Giorgione's 'Tempesta'* (Oxford, 1969)

T. Pignatti: *Giorgione* (Venice, 1969, rev. 1978; Eng. trans. 1971) [with cat., doc., bibliog. and illus., some in colour]

Giorgione a Venezia (exh. cat. by A. A. Ruggeri, Venice, Accad., 1977)

Ant. Viva, xvii/4–5 (1978) [issue devoted to Giorgione]

L. Mucchi: *Caratteri radiografici della pittura di Giorgione* (Florence, 1978)

S. Settis: *La Tempesta interpretata* (Turin, 1978); Eng. trans. as *Giorgione's 'Tempest': Interpreting the Hidden Subject* (Chicago, 1990)

La Pala del Castelfranco (exh. cat. by L. Lazzarini, Castelfranco Veneto, Casa Giorgione, 1978)

Giorgione: Atti del convegno internazionale di studio per il 5 centenario della nascita: Castelfranco Veneto, 1978

Giorgione e la cultura veneta tra '400 e '500: Atti del convegno: Roma, 1978

Giorgione e l'umanesimo veneziano: Atti del convegno: Venezia, 1978

R. C. Cafritz, L. Gowing and D. Rosand: *Places of Delight: The Pastoral Landscape* (Washington, DC, 1988)

'Le tre età dell'uomo' della Galleria Palatina (exh. cat., Florence, Pitti, 1989)

Leonardo and Venice (exh. cat., ed. P. Parlavecchia; Venice, Pal. Grassi, 1992)

Le Siècle de Titien (exh. cat., Paris, Grand Pal., 1993)

SPECIALIST STUDIES

C. Ravà: 'Il camerino delle anticaglie di Gabriele Vendramin', *Nuovo Archv Ven.*, n. s., xxxix (1920), pp. 155–81 [1567–9 inventory of Vendramin collection]

P. Paschini: 'Le collezioni archeologiche dei prelati Grimani del cinquecento', *Rendi. Pont. Accad. Romana Archeol.* (1926–7), pp. 149–90

J. Wilde: 'Röntgenaufnahmen der *Drei Philosophen* Giorgiones und der *Zigeunermadonna* Tizians', *Jb. Ksthist. Samml. Wien*, vi (1932), pp. 141–54

A. Morassi: 'Esame radiografico della *Tempesta*', *Arti: Rass. Bimest. A. Ant. & Mod.*, i (1939), pp. 567–70

C. Gamba: 'Il mio Giorgione', *A. Ven.*, viii (1954), pp. 172–7

G. Castelfranco: 'Note su Giorgione', *Boll. A.*, xl (1955), p. 298

H. Ruhemann: 'The Cleaning and Restoration of the Glasgow Giorgione', *Burl. Mag.*, xcvii (1955), pp. 278–82

R. Wittkower: 'L'Arcadia e il giorgionismo', *Umanesimo europeo e umanesimo veneziano* (Florence, 1963); Eng. trans. as 'Giorgione and Arcady', *Idea and Image* (London, 1978), pp. 161–73

N. T. de Grummond: 'Giorgione's *Tempest*: The Legend of St Theodore', *L'Arte*, xviii–xx (1972), pp. 5–53

J. Anderson: 'Some New Documents Relating to Giorgione's Castelfranco Altarpiece and his Patron Tuzio Costanzo', *A. Ven.*, xxvii (1973), pp. 290–99

T. Fomiciova: 'The History of Giorgione's *Judith* and its Restoration', *Burl. Mag.*, cxv (1973), pp. 417–20

M. Muraro: 'The Political Interpretation of Giorgione's Frescoes on the Fondaco de' Tedeschi', *Gaz. B.-A.*, lxxxvi (1975), pp. 117–84

T. Pignatti: 'Il paggio di Giorgione', *Pantheon*, xxxiii (1975), pp. 314–18

J. Anderson: 'Giorgione, Titian and the *Sleeping Venus*', *Tiziano e Venezia: Convegno internazionale di studi: Venezia, 1976*, pp. 337–42

——: 'The *Christ Carrying the Cross* in San Rocco: Its Commission and Miraculous History', *A. Ven.*, xxxi (1977), pp. 186–8

R. Salvini: 'Leonardo, i fiamminghi e la cronologia di Giorgione', *A. Ven.*, xxxii (1978), pp. 92–9

J. Anderson: 'L'Année Giorgione', *Rev. A.*, xliii (1979), pp. 83–90

——: 'A Further Inventory of Gabriele Vendramin's Collection', *Burl. Mag.*, cxxi (1979), pp. 639–50

C. Cohen: 'Pordenone not Giorgione', *Burl. Mag.*, cxxii (1980), pp. 601–7

C. Hornig: 'Unterzeichnungen Giorgiones', *Pantheon*, xxxviii (1980), pp. 46–9

M. L. Krumrine: 'Alcune osservazioni sulle radiografie del *Concerto campestre*', *Ant. Viva*, xx/3 (1981), pp. 5–9

F. Benzi: 'Un disegno di Giorgione a Londra e il *Concerto campestre* del Louvre', *A. Ven.*, xxxvi (1982), pp. 183–7

A. Ballarin: 'Giorgione e la Compagnia degli Amici: Il "Doppio Ritratto" Ludovisi', *Storia dell'arte italiana*, v (1983), pp. 479–541

W. S. Sheard: 'Giorgione's *Tempesta*: External vs. Internal Texts', *Italian Culture*, iv (1983), pp. 145–58

D. Howard: 'Giorgione's *Tempesta* and Titian's *Assunta* in the Context of the Cambrai Wars', *A. Hist.*, viii (1985), pp. 271–89

F. Büttner: 'Die Geburt des Reichtums und der Neid der Götter: Neue Überlegungen zu Giorgiones *Tempesta*', *Münchn. Jb. Bild. Kst*, xxxvii (1986), pp. 113–30

P. Kaplan: 'The Storm of War: The Paduan Key to Giorgione's *Tempesta*', *A. Hist.*, ix (1986), pp. 405–27

C. Hornig: *Giorgiones Spätwerk* (Munich, 1987)

J. Hale: 'Michiel and the *Tempesta*: The Soldier in a Landscape as a Motif in Venetian Painting', *Florence and Italy: Renaissance Studies in Honour of Nicolai Rubinstein*, ed. P. Denley and C. Elam (London, 1988), pp. 405–18

W. S. Sheard: 'Giorgione's Portrait Inventions *c.* 1500: Transfixing the Viewer', *Reconsidering the Renaissance*, ed. M. A. di Cesare (Binghamton, NY, 1992), pp. 141–76

PETER HUMFREY, MARTIN KEMP

Giori, Cardinal Angelo (*b* Capodacqua, nr Camerino, 11 May 1586; *d* Rome, 8 Aug 1662). Italian patron. Of humble birth, he travelled on foot from Camerino to Rome, where he attracted the attention of Cardinal Maffeo Barberini (later Pope Urban VIII), who took him under his protection, and when he was pope, appointed him to various responsible offices. The position of trust he enjoyed within the Barberini court is revealed in his prominent place in the papal entourage in Andrea Sacchi's *Urban VIII Visiting the Gesù during the Centenary Celebrations of the Jesuit Order, 1639* (1641; Rome, Pal. Barberini). Following his ordination as a priest, Giori was created a cardinal on 16 July 1643.

During Urban VIII's pontificate (1623–44) he took charge of a number of major artistic projects, including the pope's tomb, by Bernini, in St Peter's and the restoration of the Lateran baptistery (S Giovanni in Fonte) and its decoration by the painter Andrea Sacchi and assistants. Giori himself became a patron of Sacchi, who painted his portrait (untraced, see Sutherland Harris, pl. 135, cat. 66) and the altarpiece of *SS Francis de Sales and Francis of Paola* for the new church of S Maria in Via, Camerino, built (1639–43) at Giori's expense on an oval plan possibly supplied by Sacchi. Giori's inventory of 1658 also mentions a painting of *Noah* by Sacchi. Other contemporary artists listed include Francesco Albani, Guercino, Giovanni Lanfranco and Poussin.

Most striking is the number of paintings Giori owned by Claude Lorrain. Between 1638 and 1643 Giori commissioned seven or possibly eight pictures from Claude, including the *Seaport* (1639; London, N.G.), the *Seaport with the Landing of Cleopatra in Tarsus* (c. 1642) and its pendant *Landscape with Samuel Anointing David King of Israel* (1643; both Paris, Louvre). Four of these commissioned works hung in a room overlooking the garden in his Roman palazzo; numerous landscapes were displayed in the same room, among them works by Albani and Jan Both. When the Barberini family were disgraced after the death of Urban VIII, Giori remained in Rome, where he supervised the completion of the papal tomb and the Lateran baptistery paintings. His collection, bequeathed to his heirs, was eventually dispersed. The Giori family in Camerino became extinct on the death of the last male heir in 1739.

BIBLIOGRAPHY

L. Cardella: *Memorie storiche de' cardinali della Santa Romana Chiesa*, vii (Rome, 1793), pp. 40–42

B. Feliciangeli: *Il Cardinale Angelo Giori da Camerino e G. L. Bernini* (Sanseverino-Marche, 1917)

M. Röthlisberger: *Claude Lorrain: The Paintings* (London, 1961), pp. 153, 168, 174, 187, 204, 211

S. Corradini: 'La collezione del Cardinale Angelo Giori', *Antol. B.A.*, i (1977), pp. 83–8

A. Sutherland Harris: *Andrea Sacchi* (Oxford, 1977), pp. 80, 87–8, 90, 92, 95

JANET SOUTHORN

Giornata [It.: 'day's work']. Term used in true fresco painting for the area of wet plaster that could be painted in a single day's work. The extent of each *giornata* is often obvious from the seams in the surface of the fresco (for further discussion and illustration see FRESCO, §4 and fig. 4).

See also PONTATA.

RUPERT FEATHERSTONE

Giosafatti. Italian family of sculptors and architects. Antonio Giosafatti, a sculptor and architect, came to Ascoli Piceno from Venice in 1587; his son, Silvio Giosafatti (?1598–?1658), designed the coat of arms for Ascoli Piceno. (1) Giuseppe Giosafatti, son of Silvio, and (2) Lazzaro Giosafatti, Giuseppe's eldest son, brought the influence of Gianlorenzo Bernini to the Marches, where the Baroque style came late and had a more reserved character—sober, balanced and free of exaggeration. Giuseppe's other sons, Lorenzo Giosafatti (1696–1780) and Pietro Giosafatti (1699–1785), were also artists, but not as well known as their brother, with whom they often collaborated.

(1) Giuseppe Giosafatti (*b* Ascoli Piceno, 1643; *d* Ascoli Piceno, 7 July 1731). He was sent to Rome to study with his cousin, Lazzaro Morelli. Morelli, also from Ascoli Piceno, worked with Bernini, and through him Giuseppe worked as one of Bernini's assistants on the *Cathedra Petri* (1657–66; Rome, St Peter's; *see* BERNINI, GIANLORENZO, fig. 2). In 1663 Giuseppe returned to Ascoli Piceno to begin work on the reconstruction of the Palazzo Comunale in the Piazza Arringo, a project that lasted the rest of his life. He modified Giovanni Battista Cavagna's original design of 1610 to create the side and front façades. Later, with the help of his son Lazzaro, he sculpted female caryatids to flank the windows of the second storey, and similar male figures to flank the windows of the third and top storey. Among his other major works, all in Ascoli Piceno, are the altar of the Crucifix in S Maria del Carmine (1668); the façade of the chiesa dell'Angelo Custode (1684); the façade of S Maria del Carmine (1687); altars in S Francesco, S Agostino and S Venanzio (1697); the crypt for S Emidio in the cathedral (1704–8); a marble group of the *Virgin with St Thomas the Apostle* in S Tommaso; a marble statue, *Purity*, and the altar of the Madonna of the Rosary (1720–35), both in S Pietro Martire; the caryatid façade of the Palazzo Lenti (these last four works in collaboration with Lazzaro); the entrance gate to the Casa Odoardi garden, including flanking female busts; and his most admired work, the Tempietto di S Emidio alle Grotte. This last was built between 1704 and 1708 as a tribute to the patron saint of Ascoli Piceno after the earthquake of 1703. The first storey has a semicircular portico with a dome supported by eight Doric columns. Its style reflects Bernini, as well as Pietro da Cortona's S Maria della Pace in Rome.

(2) Lazzaro Giosafatti (*b* Ascoli Piceno, 1694; *d* Ascoli Piceno, 17 April 1781). Son of (1) Giuseppe Giosafatti. He was sent to study with Camillo Rusconi in Rome, where he did stucco decorations in SS Simone e Giuda. He returned to Ascoli Piceno *c.* 1718 to work with his father. His major work is a sculptural group for Ascoli Piceno Cathedral, *St Emidio Baptizing St Polisia* (1725–30; *in situ*). In 1731 he executed the altar of the Madonna of Peace in S Agostino (sketch, Ascoli Piceno, Pin. Civ.). His high relief terracotta *bozzetto* of *St Emidio in Glory* is in the Pinacoteca Civica, Ascoli Piceno. A similar *bozzetto* (Baltimore, MD, Walters A.G.), dated 1757 and signed LG, has been attributed to Lazzaro by Rosenthal. His style, like that of Pierre Legros the younger and Filippo della Valle, both of whom he knew in Rome, combined classical and Baroque elements. While his father's style was more severe, Lazzaro exemplified the Italian Rococo.

BIBLIOGRAPHY

Bénézit; Thieme–Becker

C. Mariotti: *Ascoli Piceno* (Bergamo, 1913), pp. 122–8

G. Rosenthal: 'An Italian Rococo Relief in Bernini's Tradition', *Walters A.G. Bull.*, v (1942), pp. 57–67

G. Fabiani: *Artisti del sei–settecento in Ascoli* (Ascoli, 1961), pp. 35–54

BRUCE M. LOEFFLER

Giottino (i) [Giotto di Maestro Stefano] (*fl* mid-14th century). Italian painter. This name is usually given to the painter of the large-scale panel of the *Lamentation* (Florence, Uffizi) from the Florentine church of S Remigio. It was first attributed to him by Vasari and is probably to be dated in the 1360s. It shows the influence of Giovanni da Milano in the palette, poses and physical types of the figures around the dead Christ, and of Nardo di Cione in the standing saints behind. Although several other works have been ascribed to Giottino, the only one that is generally accepted is a fresco of the *Virgin and Child with Saints* (Florence, Depositi Gal.), formerly in a tabernacle on the Via del Leone in Florence and believed to be identical with that described by 16th-century sources as being in the Piazza di Santo Spirito and by Giottino.

The identity and artistic personality of Giottino are still uncertain. Most modern historians identify him with the Giotto di Maestro Stefano who was listed in the Florentine painters' guild in 1368 and was working on the decoration of two rooms in the Vatican in 1369 alongside Giovanni da Milano, Giovanni and Agnolo Gaddi and others, but this is only conjecture.

Vasari has been the source of much confusion, since he conflated the works of at least three different artists under the invented name of Tommaso di Stefano, nicknamed Giottino. These works included all that Ghiberti had ascribed to a painter called Maso (most notably, the frescoes in the S Silvestro Chapel, Florence, Santa Croce, now generally given to Maso di Banco), as well as the works given by 16th-century sources to Giottino. To these Vasari added numerous other paintings, including frescoes in Assisi that are now generally attributed to Puccio Capanna. In view of Vasari's obvious fabrication it is remarkable that historians cling to the name of Giottino, since it would be more accurate to refer to the Master(s) of the S Remigio Lamentation.

BIBLIOGRAPHY
G. Vasari: *Vite* (1550, rev. 2/1568); ed. G. Milanesi (1878–85), i, pp. 621–30
K. M. Birkmeyer: 'The *Pietà* from San Remigio', *Gaz. B.-A.*, lx (1962), pp. 459–80
L. Marcucci: 'Dal "Maestro di Figline" a Giottino', *Jb. Berlin. Mus.*, v (1963), pp. 14–43
D. G. Wilkins: *Maso di Banco: A Florentine Artist of the Early Trecento* (New York and London, 1985)

BRENDAN CASSIDY

Giottino (ii). *See* HUMBERT DE SUPERVILLE, DAVID PIERRE.

Giotto (di Bondone) (*b* ?Vespignano, nr Florence, 1267–75; *d* Florence, 8 Jan 1337). Italian painter and designer. In his own time and place he had an unrivalled reputation as the best painter and as an innovator, superior to all his predecessors, and he became the first post-Classical artist whose fame extended beyond his lifetime and native city. This was partly the consequence of the rich literary culture of two of the cities where he worked, Padua and Florence. Writing on art in Florence was pioneered by gifted authors and, although not quite art criticism, it involved the comparison of local artists in terms of quality. The most famous single appreciation is found in Dante's verses

(*Purgatory* x) of 1315 or earlier. Exemplifying the transience of fame, first with poets and manuscript illuminators, Dante then remarked that the fame of Cimabue, who had supposed himself to be the leader in painting, had now been displaced by Giotto. Ironically, this text was one factor that forestalled the similar eclipse of Giotto's fame, which was clearly implied by the poet. About the same date, Giotto's unique status was suggested by his inclusion, unprecedented for an artist, in a world chronicle (*c.* 1312–13) by Riccobaldo Ferrarese (*see* §I, 2(i) below). The artist's name first became synonymous with 'the best painting' in a poem by the Florentine Cecco d'Ascoli (*d* 1327) and, more subtly, in several observations by Petrarch (for comments from Boccaccio onwards *see* §III below).

I. Life and work. II. Working methods and technique. III. Critical reception and posthumous reputation.

I. Life and work.

The basis on which Giotto's life is reconstructed and works are attributed to him is provided by the combined information derived from administrative documents and early literary and historical sources. Discussion of these will be followed by that of the works themselves.

1. Documents. 2. Early commentators. 3. Works.

1. DOCUMENTS. Most of the documents concerning Giotto are mundane reports about property transfers, which are more numerous than those for any other contemporary artist and reflect his financial success (see Previtali). Legal records cite Giotto as 'of' Vespignano, a village *c.* 20 km north of Florence, and name his father as Bondone. Giotto's death on 8 January 1337 (1336 in the Florentine calendar system) was reported by the contemporary chronicler Giovanni Villani. In 1373 the chronicle was rewritten and expanded by Antonio Pucci, who gave Giotto's age at death as 70. This statement is the main basis for the consensus about his birth in 1266, although it has also been placed ten years earlier (Ragghianti) or later (Brandi, 1969, based on Vasari). Several records narrow the possibilities. Giotto must have been an established adult when first recorded on 25–6 May 1301 as a house owner. A witness to this document, Martino di Bondone, quite possibly Giotto's brother, is not recorded later, but in 1295 he had been documented in arrangements for his future wife's dowry, suggesting his early adulthood. Giotto's father died before 8 December 1313, when Giotto is described as the emancipated (legally independent) son of the late Bondone, but probably after 1311 when the term 'late' is not used. Bondone must have lived to an advanced age for the period and become a father at an unusually early age for Giotto to have been born *c.* 1267–8; an even earlier birthdate would call for very unlikely cases. A document of 15 September 1318 records Giotto's emancipated son, Francesco, as his father's business agent, assigning land to his sister, Donna Bice, while she was a member of the third order of St Dominic; they were thus both adults. Even if in 1318 the emancipated Francesco was only 21, Giotto is unlikely to have been born any later than the mid-1270s, and an earlier date is more probable. Pucci's statement about Giotto's age at his death should

1. Giotto: frescoes (1303–6), Arena Chapel, Padua; view to the west

not be valued simply because it is the earliest account we have; the age of 70 it provides may represent merely a rounded-up estimate, more common then than now. In 1376 Benvenuto da Imola, the commentator on Dante, wrote that Giotto was 'still rather young' when he painted the Arena Chapel in Padua (*c.* 1305; see fig. 1). If he defined the term as Dante did, that would mean under 35, thus suggesting a birthdate of 1270 or later. In 1568 Vasari wrote that Giotto died at 60, and this has been the basis on which some scholars have suggested a birthdate of 1276. The statement is, however, unsupported and might even be a slip for 70. The consideration of all these documents together seems to indicate 1267–75 for Giotto's birthdate, and more likely the earlier years of this period.

Following the Florentine document of 1301, other sources record Giotto's presence in Padua, Assisi, Florence, Rome, Naples and Milan. The first of these, dating from 1303–6, concern the Arena Chapel in Padua (*see* §3(i) below). Property owned by Giotto in Florence is mentioned in 1305 and 1307, without implying his presence in the city. On 4 January 1309 a citizen in Assisi paid a debt owed by himself and Giotto, reasonably suggesting the artist's previous stay there. In Florence records show Giotto present on 23 December 1311 and then in 1312, 1313, 1314, 1315, and again in 1320 and 1325. Most concern minor business, but of particular interest is a will of 15 June 1312 in which money was left to light a lamp under a crucifix in S Maria Novella by 'the superior painter Giotto', and to do the same under a painting in the Dominican church at Prato 'which the said' testator 'had painted by the notable painter Giotto di Bondone of Florence'. The latter clause, often overlooked since the work is lost, gives weight to the writer's attribution of the former work to Giotto; it is generally identified as the *Crucifix* still in the church (*see* §3(iii) below). On 12 November 1312 Giotto rented out a loom (*telarium francigenum*, not a painter's stretcher), suggesting his varied business activity. His appointment on 8 December 1313 of an agent in Rome to recover property he had left there, including beds, confirms that he had worked there before. In 1320 he is listed with other painters in the Arte dei Medici e Speziali.

There survive for the period 1328–33 numerous records of Giotto's work for the Angevin court in Naples. Giotto was paid a salary on 8 December 1328, 5 August 1329 and 2 January 1330; on 20 January 1330 Robert I, King of Naples, granted him the title *familiare*. On 20 May 1331 he was paid for expenses incurred between September 1329 and the end of January 1330 for materials, including gold, gesso and ass's leather, used while painting the King's Chapel in the Castelnuovo, and a panel, executed at home. The money also covered salaries paid by Giotto to other 'masters', both painters and 'servants'. The King's last payments were in 1332 and 1333. Back in Florence, on 12 April 1334 the city council named Giotto Chief of Works for the cathedral, city walls, fortifications and other projects, on the grounds that he was the best master in the world and so should be retained in the city. Villani reported that the cathedral campanile was begun on 18 July 1334, but he also noted that the government sent Giotto to Milan to serve its ruler, Azzo Visconti (*see*

VISCONTI (i), (1)), a journey from which he returned to die on 8 January 1337. A record in Florence of 15 September 1335 may precede the trip to Milan or mark a temporary visit home during it. Posthumous records include the 1361 entry in the obit book of Old St Peter's, Rome, which states that Cardinal Giacomo Gaetani Stefaneschi had paid a large amount for the high altarpiece and for the façade mosaic, called the 'Navicella', and that Giotto was the artist (*see* STEFANESCHI). Boccaccio's *Decameron* (*c.* 1353) provides an anecdote of Giotto coming to Florence by horse from his native region where he had been inspecting his property. This is consistent with the many other records of his seven children, nearly all concerning land they owned in that region, and contributes to our understanding of Giotto's private life.

2. EARLY COMMENTATORS. There are normally three bases on which works are attributed to an artist of this period: signatures, contractual documents and early written sources. The evidence for Giotto is unusual. Three paintings are agreed to bear his signature, but two (and sometimes the third) are usually rejected and attributed to distinct members of his workshop, an indication that signed works cannot be used as the criterion for his oeuvre (*see* §II, 1 below). The sole documents of a contractual nature concern two lost panels (the Prato one of 1312 and the Naples one of 1330; *see* §1 above) and the Naples Castelnuovo chapel frescoes, the minor surviving fragments of which are also always regarded as by assistants. Thus all the works that form the basis for our knowledge of Giotto's work (before the addition of stylistically similar attributions) emerge from early written sources. These are not always reliable, especially in the case of a famous artist who attracts hopeful attributions very quickly. Nevertheless, there is consistency among the reports and among works cited in them, which show a single style.

(i) Written sources, to *c.* 1450. (ii) Ghiberti's *I Commentarii*.

(i) Written sources, to c. *1450.* The earliest reports chiefly refer to Padua. About *c.* 1313 Francesco da Barberino, an allegorical poet, praised Giotto for his image of *Envy* in the Arena Chapel. About 1312–13 the chronicler Riccobaldo included in his *Compendium Romanae historiae* a short paragraph on Giotto, reporting his 'admired' works in Franciscan churches in Assisi, Rimini and Padua, and also those in the Arena Chapel in Padua and in the town's civic palace, the Palazzo della Ragione. With the exception of Rimini, all these places are found in other early reports. The three locations in Padua recur in local reports: the chronicler Giovanni da None (*d* 1346) described the vault of the civic palace as having zodiacal imagery by Giotto; Benvenuto da Imola, the commentator on Dante, reported the work in the Arena Chapel; and in 1447 the local chronicler Michele Savonarola (*c.* 1385–1464) included the Arena Chapel and the Franciscan church, Il Santo, specifying that Giotto's work was in the chapter house (he omitted the civic palace, which had burnt in 1420). As a visitor, Ghiberti also discussed these two monuments (*see* §(ii) below). Early Florentine reports are surprisingly thin: apart from the will of 1312 concerning the crucifix in S Maria Novella (*see* §1 above), there is only Giovanni Villani's mention of the supervision of the cathedral and

2. Giotto: *Joachim and the Shepherds* (1303–6), fresco, Arena Chapel, Padua

work on its campanile. Villani's report in 1340 that in 1335 Giotto was sent to work for the ruler of Milan may helpfully be combined with a report, also of 1335, by the Milanese chronicler Galvanno Fiamma (or Flamma) of paintings in the Palazzo di Azzone Visconti (destr.) on the theme of Worldly Glory, although Giotto is not named. The link is confirmed later by Ghiberti's report that Giotto painted a *Worldly Glory*, although in this case no location is given (*see* §(ii) below). The early reports about Rome are those noted in the obit book of 1343 (*see* §1 above).

A commentary on Dante of 1334, the so-called 'Ottimo', shows marked consistency with all these reports in stating that Giotto's main works were in Florence, Padua, Rome, Naples and Avignon. Of places cited earlier, only Ricco-baldo's references to Assisi and Rimini are omitted, quite possibly because this commentator's knowledge did not reach back to Giotto's youth. On the other hand, Avignon is included, and 15th-century sources suggest that works by Giotto were sent to the papal court there, which would be plausible, but the matter can be taken no further.

Boccaccio, with a special interest in secular imagery, described paintings of *Worldly Glory*, the *Zodiac* and *Loves of Men of Antiquity*, the last-named in a royal hall (possibly to be identified with the Great Hall or Sala dei Baroni of the Castelnuovo in Naples), with remarks that seem to assign them to Giotto. The latter cycle reappears in two other written reports: an anonymous sonnet sequence describing it in detail, but without Giotto's name, and Ghiberti's *I Commentarii*, which names Giotto but provides no details. Petrarch praised Giotto's work in the Castelnuovo chapel of St Barbara in Naples and a *Virgin and Child*, otherwise unknown, which he owned himself, a gift from a Florentine friend (*see* PETRARCH, FRAN-CESCO). A single report (*c.* 1395) by an anonymous commentator on Dante of works in Bologna has no clear links to known paintings. Around the same time, however, Filippo Villani included in his lives of famous Florentines— the *Liber de origine Florentiae et eisdem famosis civibus*—a short biography of Giotto, the first time a painter had been included in such a work. The author was defensive

on the point and emphasized Giotto's significance in painting the portrait of Dante in an altarpiece for the Palazzo del Podestà (now the Bargello, Florence), which is never otherwise reported. Besides that he cited only the *Navicella*, allowing the inference that it was Giotto's most famous work, a status confirmed by Alberti, who mentioned it in his *De pictura* (1435) as the only example of modern art, along with many others from antiquity.

(ii) Ghiberti's 'I Commentarii'. A significant change of approach appears in Ghiberti's *I Commentarii*, begun *c.* 1447 but surely based on notes collected over his lifetime. His autobiography, the first by an artist, is prefaced by a survey of Florentine and other artists from Cimabue onwards. In the account of Giotto his list of 40 works is astonishing, both in comparison with the few works cited by earlier writers and with any list in this period of any artist's works.

(a) The canon. Several factors make Ghiberti's canon resemble a catalogue raisonné in completeness and reliability: the 40 works, which include several large fresco cycles, might plausibly comprise most of what Giotto achieved; it has no incorrect attributions (Bellosi, 1974); and of works previously mentioned, it omits only one that can be assumed to have been of major scale and that had been cited with any specificity—S Francesco, Rimini—which is also omitted by all other accounts after 1312. Excluded from the list are the already destroyed *Zodiac* cycle in the Palazzo della Ragione, Padua, the generic allusions to work in Avignon and Bologna, and three apparently small panels, the documented ones of Prato

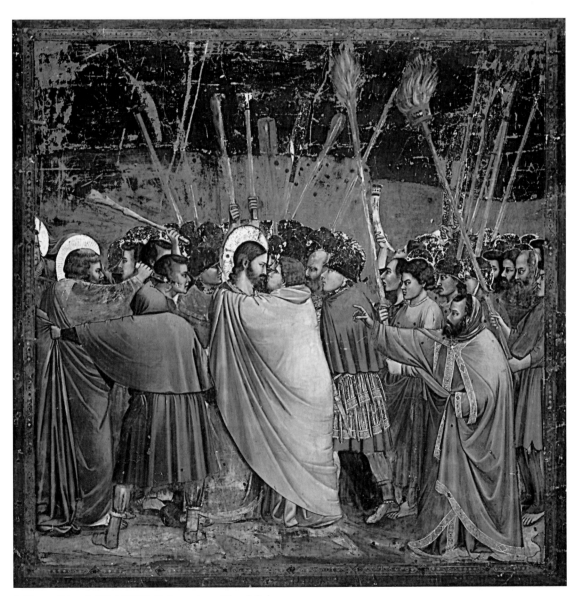

3. Giotto: *Betrayal of Christ* (1303–6), fresco, Arena Chapel, Padua

and Naples and Petrarch's *Virgin and Child*, along with two of the three signed works, which all other sources also omit. Furthermore, Ghiberti named at least nine and perhaps all of the ten works previously cited that had received relatively exact identifications and that were major in scale: the two surviving works in Padua; the two from Old St Peter's, Rome; the Naples chapel; the 'lower part', as he puts it, of S Francesco, Assisi; the *Worldly Glory*, cited without location probably because already lost; and, in Florence, the cathedral campanile and the S Maria Novella *Crucifix*. He also cites the tenth, the Bargello altarpiece, if we take his allusion to 'the Bargello Chapel' to include it as well as the frescoes there, not previously recorded. (This assumes an emendation, plausible if not allowed for in the scholarship, of the writer's Castel dell'Ovo to Castelnuovo for the chapel cited in Naples; otherwise, Ghiberti omitted that well-known chapel and cited a work otherwise never noted.) Hence the list of 40 works includes 31 not named before. Of these, five are located outside Florence: the work from S Maria degli Angeli in Assisi, the cycle of *Famous Men* in the Great Hall of the Castelnuovo, Naples (perhaps the same that Boccaccio had glancingly noted as a cycle of the *Loves of Men of Antiquity*), the frescoes at St Peter's, Rome, and a crucifix and panel from S Maria sopra Minerva, also in Rome. The works in Florence, the essential basis for our knowledge of Giotto's work there, include two more at S Maria Novella, two at S Giorgio sulla Costa, two at the Palazzo di Parte Guelfa, two at the Bargello (the chapel frescoes and the *Commune Cheated*), eight at the church of Ognissanti, three in the Badia, eight in Santa Croce (four frescoed chapels and four altarpieces), and the drawings for the campanile sculpture. Of the 40 references, 38 are quite specific, only two merely noting 'other works' in the same buildings with others and so precluding identification (the Palazzo di Parte Guelfa and S Maria Novella).

Of equal importance, over half the works cited survive, contrary to the impression often given (e.g. Oertel) that Giotto is known only through a small fraction of his output. Three works survive only in copies: one, the Bargello *Commune Cheated*, in differing and thus problematic copies (perhaps the best one in a relief sculpture on the tomb of Bishop Tarlati in Arezzo); a second, *Worldly Glory*, in three very consistent copies (in illustrations in two manuscripts of Petrarch's *De viris illustribus*, Paris, Bib. N.; and one in Darmstadt, Hess. Landes- & Hochschbib.; see Gilbert, 1977); and a third, design drawings for the campanile sculpture, surviving in the sculpture itself (Florence, Mus. Opera Duomo; see FLORENCE, §IV, 1(iii)(b)). Two more works survive only in small fragments: the frescoes of the Badia chapel of St Mary Magdalene and those of the chapel in the Castelnuovo, Naples. One work survives in a combination of fragments and many consistent copies: the *Navicella* (fragments, Boville Ernica, S Pietro Ispano; Rome, Grotte Vaticane). The other survivals, however, are complete or nearly so: the Arena Chapel, including its *Crucifix* (Padua, Mus. Civ.); the frescoes at S Francesco, Assisi, regardless of which cycle there Ghiberti meant; the Stefaneschi Altarpiece (Rome, Pin. Vaticana; for illustration *see* PREDELLA) from Old St Peter's, Rome; the Badia Altarpiece (*Virgin*

and Child with Saints, Florence, Uffizi); the Bardi and Peruzzi frescoes at Santa Croce, Florence (*see* §3(ii) below); the signed *Coronation of the Virgin* from the Baroncelli Chapel of the same church (*see* §II, 1 below); three works from the church of Ognissanti, the *Crucifix* (*in situ*), the *Madonna* (Florence, Uffizi; *see* §3(ii) below) and the *Death of the Virgin* (Berlin, Gemäldegal.); the S Giorgio sulla Costa *Virgin and Child* (Florence, Museo Diocesano); the Bargello Chapel; the S Maria Novella *Crucifix* (*in situ*; *see* §3(iii) below) and the campanile sculptures.

Three more surviving works may or may not be identified with ones named by Ghiberti. A second of the four Santa Croce altarpieces he listed may be the one in Raleigh (Raleigh, NC Mus. A.) with *St John the Baptist* and *St John the Evangelist*, which would match the dedication of the Peruzzi Chapel to those two saints. The main doubt cited, that this is a shop work, does not seem relevant to this question (*see* §(b) below). Often overlooked are the fragmentary workshop frescoes (rest.) in the chapter house of Il Santo, Padua, attributed to Giotto by Michele Savonarola in 1447 and perhaps by Riccobaldo in 1313, which may be identifiable with those Ghiberti cites as 'at the Franciscans'. The objection that Riccobaldo's citation of 'the church' could not allude to these works in the adjacent friary perhaps seeks an unlikely specificity from him, the more so since his text simply refers to the Franciscan churches of three towns, except that one manuscript places Giotto's work in a 'chapel outside S Antonio' in Padua (Hankey). The chapter house shares a connecting door with the church sacristy, and no work by Giotto within the church building was known to the alert Savonarola, so the chapter house frescoes seem very likely to be the work cited by the other two commentators.

The third uncertain case is Giotto's altarpiece, now dispersed among various museums, comprising the *Virgin and Child* (variously dated 1315–30; Washington, DC, N.G.A.), *St Stephen* (Florence, Mus. Horne), *St Lawrence* and *St John the Evangelist* (Chaalis, Mus. Abbaye) and a lost figure. As suggested by Schmarsow, even when aware only of the *St Stephen* panel, this could be identified as the third of the four Santa Croce altarpieces cited by Ghiberti, since it would have been appropriate for the chapel dedicated to SS Lawrence and Stephen (Pulci–Beraldi Chapel). The chapel's frescoes of those saints' martyrdoms by Giotto's pupil, Bernardo Daddi, of before *c.* 1330, recall the situation in the Baroncelli Chapel in the same church, where the signed altarpiece by Giotto's workshop accompanies frescoes by another of Giotto's pupils, Taddeo Gaddi, of around the same time (*see* GADDI (i), (2) and fig. 1); pupils may have inherited commissions when the master went to Naples in 1328. If this dispersed altarpiece, generally agreed to be at least in part by Giotto's own hand, is not on Ghiberti's list, it would be almost the only surviving large-scale work he omitted, so it seems plausible that it is one of those he named. That consideration apparently supported earlier proposals (Longhi and others) to identify this work with another entry on Ghiberti's list, the Badia Altarpiece (now firmly identified in another way with the painting in the Uffizi; see above), or else with still another, the Peruzzi Chapel altarpiece, because the dispersed work includes one *St John the Evangelist* and

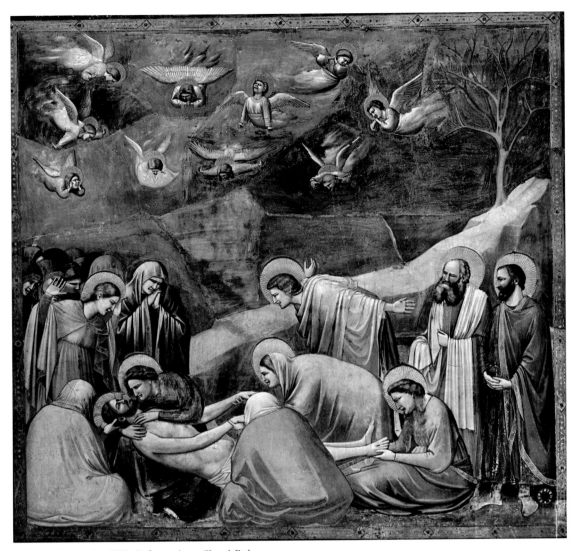

4. Giotto: *Lamentation* (1303–6), fresco, Arena Chapel, Padua

might have included the other. However, the Raleigh altarpiece, with both saints John, fits the Peruzzi dedication as well, if not better, just as the dispersed altarpiece fits the Pulci Chapel.

(b) Critical significance. The great value of Ghiberti's list is that, apart from the Arena Chapel, he was the first to cite all the works of Giotto on which is based our chief image today of the artist: the Ognissanti *Madonna* and the Bardi and Peruzzi chapels' frescoes, followed probably by the Berlin *Death of the Virgin* as the next most important. (The *Madonna* had been attributed to Giotto before Ghiberti, in a manuscript document of 1418, but this would not have established the attribution.) The fewer works on his list that are now lost may be considered of proportionately less importance in Giotto's achievement since a number were smaller, simpler and repetitive images (two more crucifixes, a half-length *Virgin and Child* and

another with two saints). In Giotto's secular work, however, loss outweighs survival since no original is preserved: two major works cannot be reconstructed (the Palazzo di Parte Guelfa fresco and the *Famous Men* of Naples), while three others are known only in copies—the *Commune Cheated*, the *Worldly Glory*, and the zodiacal frescoes from the civic palace (Palazzo della Ragione) in Padua, lost before Ghiberti made his list. There survives only the cathedral campanile sculpture, with its partial inclusion of secular figures.

Ghiberti's canon is helpful only if it is understood that his idea of a work by Giotto included work of his shop, for example the Ognissanti *Crucifix*, unanimously attributed to workshop hands. Ghiberti stated that all forty works were 'made' by Giotto, yet just six were 'by his hand'. There is thus a large group of works by him but not by his hand, a reflection of contemporary business patterns. Hence, in discussions on the difference between master and shop the wrong criteria have been applied, and

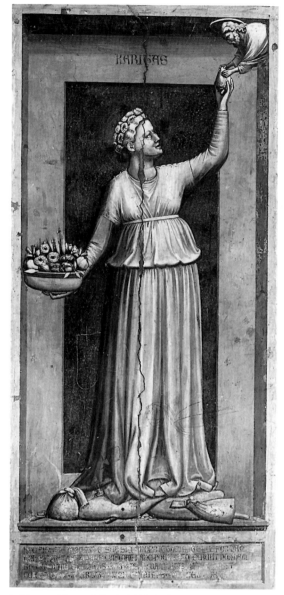

5. Giotto: *Allegory of Charity* (1303–6), fresco, Arena Chapel, Padua

in attributing works. This needs to be emphasized, especially when considering whether to accept Vasari's most famous novelty, his identification of Giotto's work at S Francesco, Assisi, as being the cycle in the Upper Church of the *Legend of St Francis* (*see* §3(iii) below).

3. WORKS. The discussion that follows will focus on the two most critical areas concerning Giotto's work: the Arena Chapel, Padua, on which all other attributions to this artist are based, and the frescoes of S Francesco at Assisi. Giotto's major works in Florence are also discussed here; for paintings attributed to his workshop *see* §II, 1 below.

(i) The Arena Chapel and early works. (ii) Major Florentine paintings. (iii) Assisi and related works. (iv) Stylistic sources.

(i) The Arena Chapel and early works. Giotto's frescoes in the Arena Chapel (Capella degli Scrovegni) at Padua comprise his earliest work of known date and that on which our idea of his art is chiefly based. Generally agreed to be dated to *c.* 1305, further research has shown that the work may be dated no earlier than 1303, when the building was evidently under construction (for details of the building and its dating *see* PADUA, §4(ii)), and no later than 1306, when a set of six choir-books for Padua Cathedral (now Padua, Bib. Capitolare), which contain copies from some of Giotto's scenes, was begun; they include a copy of the *Lamentation* fresco, one of the last to be painted since it is low on the wall. The view that the frescoes might be as late as 1310 (Gnudi) is supported by the fact (Borsook) that in 1306 the choir-book project was still in progress with only two of the six volumes (A15, A16) completed, though the remainder had been partly done. The few miniatures in the first two volumes that show the same scenes as Giotto's paintings do not echo his designs, and the first to copy him are more than midway through the third volume. This would be significant only if it were further argued that before that point work on the set of books was interrupted for four years or more, implausible in general and more so since the work was being done at the cathedral. Further, a phrase of the 1306 document, wrongly transcribed in publication, shows that the set had then continued beyond volume two ('alia vero pars non est ligata neque completa'). On the assumption that the work went on normally, 1306 is firm as the latest date for the originals that were copied in the choir-book.

Calculated by the *giornate* (seams between different days' work; *see* §II, 2 below), the frescoes were painted in 852 days, some of them of course the simultaneous work of assistants painting, for example, decorative borders, but the work surely took most of the years 1304–5, apart from days with temperatures below freezing, when fresco work is not practical (and preparatory drawing might be done). Giotto's painting (see fig. 1) covers the whole vault and walls of the nave (but excluding the small choir): the entrance wall (193 days) with the *Last Judgement*; the vault (88 days) with 33 small figures in medallions and ornamental bands; the long south (245 days) and north (250) walls with narrative scenes; and the choir arch with the *Annunciation* (76 days, plus the panel painting of *God the Father* inserted at the top). The arrangement with the large *Last Judgement* on the entrance wall, as at Torcello Cathedral, and long narrative biblical sequence on the

Ghiberti's statements have been interpreted as false attributions and thus unreliable. Of perhaps even greater importance in judging Ghiberti is the fact that not a single work attributed to Giotto after Ghiberti has obtained full acceptance. This is a natural result both of the broad coverage of Ghiberti's work and of the loss of a live critical tradition after more than a century. After him no new attributions were even attempted until Vasari in 1550, and some of his attributions can be proved to be false. This is the case with the work Vasari described in most detail, a fresco cycle of the life of S Michelina, the subject of which died later than Giotto. The fact that these frescoes are lost has made them little considered by scholars, who have thus ignored this strong evidence for Vasari's unreliability

sides, as at S Angelo in Formis (nr Naples), reflects the Italian version of Byzantine church decoration. The large, immobile imagery of the *Judgement* is made less dominant, however, notably by reducing most of its figures to the size of those on the narrative walls; the Apostles, somewhat larger, lead to the central larger figure of Christ, whose isolation renders him less overwhelming. Giotto also rejected the hierarchical scaling of Gothic imagery, such as is found in cathedral portals, which often focused on the Last Judgement and always gave the narrative a minor role. Although Giotto favoured Western models in most respects, here he was influenced by the greater concern with narrative action evident in Byzantine art, and he went even further to make it the vehicle of his message. The 'story' became the artist's chief material, as Alberti defined it a century later for Giotto's heirs in Florence.

On the two lateral walls, the three tiers of scenes for the most part neatly cover six sections of the narrative: at the top the *Life of Joachim and Anna* on one side, and the *Life of the Virgin* on the other; in the middle the *Infancy of Christ* on one side (*see* PERSPECTIVE, colour pl. VIII, fig. 1 for an illustration of the *Flight into Egypt*), his *Ministry* and *Miracles* on the other; at the bottom both sides have scenes of the *Passion*. The *Passion*, however, beginning on the middle level, thus diminishes the emphasis on the *Miracles*, just as in the Church's liturgical year. Thus *Infancy* and *Passion* dominate. The lack of emphasis on the *Miracles* (in contrast with Duccio's contemporary work) and the added attention to the Virgin and her parents, a rare element, are evidence of Giotto's most basic novelty: the attention to the human condition rather than to the supernatural. Christ emerges not from a diagrammatic Tree of Jesse but from a warm extended family; his ancestry and Old Testament analogues are not abolished but are removed to the small vault and wall medallions (see below).

In the cycle of the *Life of the Virgin* the events of her wedding are extended over four scenes only moments apart, three of which have the same architectural setting; this is Giotto's only use of a device adopted by Duccio for several *Passion* sequences. The fourth scene, the Virgin's return to her parents' house after the wedding, is a rare image and emphasizes her virginity. The detailed story of the Virgin's parents begins with Joachim's expulsion from the temple because of his childlessness and ends with his return and reunion with his wife, Anna, at the city gate, which is a metaphoric image of the conception of their daughter, as the Annunciation is of Christ's. Most of this narrative echoes the text of Jacopo da Voragine's *Golden Legend* and has clear moral messages.

An exception is the second scene, showing the grieving Joachim arriving in the mountains (see fig. 2), which bears little relation to that text, apart from the short phrase 'and he went to his shepherds'. It seems to carry little doctrinal weight, but it has been reasonably viewed as a statement of purely human values by Giotto and has been a favourite example by which to expound his artistic procedures. As in Byzantine painting, there is less naturalism here in the landscape than in the figures. A dramatic scene is created by showing the interaction of a few sharply individualized figures, like a tableau in a play. The paint surface is treated in an innovative fashion, with soft effects of flesh and

cloth in gradually shifting light and shade, suggesting the roundness of organic bodies. Joachim is slightly larger than the secondary figures, the shepherds, and his form more solidly shown as a single, unarticulated unit, which emphasizes his greater physical and dramatic weight. His lowered head, merging into his body and suggesting grief, is noted by the shepherds, who also observe one another, giving the scene weight and moment and ultimately its resulting humanity. A more formal and less affective tone is found in a few scenes with a strong tradition of symbolic meaning, for example the *Baptism* and the *Crucifixion*. Among the *Passion* scenes, the well-known *Betrayal of Christ* and the *Lamentation* (see figs 3 and 4) also present the interaction of a few figures at a point of stress.

Giotto's involvement with the physical and human is striking when faced with inevitable references to the supernatural, and he tended to evade such references. In the *Raising of Lazarus*, one of only two miracle scenes included, Lazarus is depicted still dead, eyes fixed with centred pupils, contrary to Giotto's practice, thus without implying the suspension of the laws of nature. (The follower of Giotto who painted this scene in Assisi, in the Magdalene Chapel, reverted to the traditional gazing eyes.) The same considerations prompted Giotto's solution to

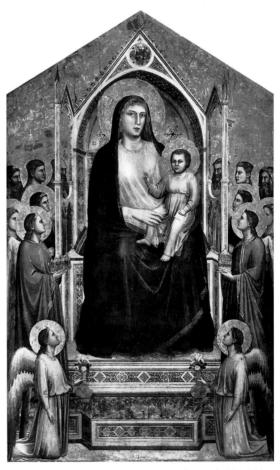

6. Giotto: Ognissanti *Madonna*, tempera on panel, 3.25×2.04 m, *c.* 1310 (Florence, Galleria degli Uffizi)

depicting flying angels and the Christ of the Ascension, which he reduced to half-figures trailing off below the waist into cloudy forms. This may have been influenced by Giotto's portrayal of a natural phenomenon, Halley's comet of 1301, which is shown, in its first accurate representation, with its tail, as the star guiding the Magi. His inventive imagery for the allegorical figures of *Virtues* and *Vices* on the dado level of the walls may reflect similar preoccupations. These are represented not as real people but as monochrome sculptures in grisaille (see fig. 5), inspired by the pulpits of Nicola and Giovanni Pisano, which include series of allegorical figures on their lowest levels. At the same time Giotto's figures physically embody or enact their virtues, rather than symbolizing them with attributes.

The *Last Judgement*, often considered a 'relative failure' (Battisti), charts its hierarchy of figures not through relative size but in a clearly diagrammatic way. The damned in Hell are a notable exception, caricatured as tiny figures in their vivid tortures, but they are so crudely executed that Giotto is usually thought not to have had a part in their design or execution. Among them, the larger figure of *Satan* shows in his mask-like frontality that he is not part of the physical human world. This frontality is also seen in the large *Virgin* of the vault, where she is is shown as Queen of Heaven. The small medallions in the frames between scenes all present in very reduced, almost vestigial form, imagery that had played a leading role in earlier Gothic cycles. The most interesting are those adjacent to ten of the scenes of the *Life of Christ*, showing analogous events from the Old Testament or elsewhere, such as *Moses Receiving the Tablets of the Law*, adjacent to the *Pentecost*, in which the Holy Spirit descends on the Apostles. The juxtaposition of Old and New Testament scenes is limited to the two lower tiers of the windowless wall, perhaps suggesting that this was a device used to fill extra space. In addition, there are busts of saints: on the top tier the *Twelve Apostles* with eight others whose identical attributes link them with the thirty-three heads in the vault, together representing the forty generations of the ancestors of Christ from *Abraham* (at the top of the choir arch), with *Christ* himself. At the ends on the lower two tiers are four female saints, the *Four Evangelists* and *Four Doctors of the Church*.

Two works are stylistically placed earlier than the Arena Chapel. One is the S Maria Novella *Crucifix* (*in situ*), although this applies only to the central figure; it will be discussed in connection with the Assisi problem (*see* §(iii) below), to which its side figures are closely linked. The other is the *Virgin and Child* in S Giorgio sulla Costa, Florence, also linked to Assisi as it is stylistically related to the *Virgin* on the entrance wall there. It has the same simple massiveness as Giotto's later *Virgin* panels, if a more linear contour, but does not show the metallic surfaces evident in the Assisi paintings. The S Giorgio *Virgin* may either be the earliest work by Giotto's own hand, or the later work of a more conservative workshop assistant echoing Giotto's Ognissanti *Madonna* (*see* §(ii) below).

(ii) Major Florentine paintings. The *Madonna* (Florence, Uffizi; see fig. 6), from the church of Ognissanti, is generally dated to *c.* 1310. Giotto's version updated the type of colossal enthroned Virgin altarpiece produced by Cimabue (e.g. Santa Trìnita *Madonna*; Florence, Uffizi) and Duccio (e.g. Rucellai *Madonna*; Florence, Uffizi; *see* DUCCIO, fig. 1). The modelling of the figure is like that in the Arena Chapel, but here the lack of motion, appropriate to an icon, almost excludes emotional interrelations between figures and adds to the effect of dominating weight; some emotion is suggested by the intense gaze of the angels towards the Virgin. The visibility of figures through the arcaded sides of the throne, a device inspired by Duccio, emphasizes the human figures and the secondary role of the architecture, and also looks forward to the use of space developed in later works. The most notable of the later *Virgin and Child* panels (Washington, DC, N.G.A.) also focuses on human, rather than supernatural, elements, with the Child using all his fingers to grasp one of his mother's instead of blessing, suggesting physical attachment and dependency while also depicting proportionate scale.

At Santa Croce the two surviving cycles of frescoes are in the chapels of the Bardi and Peruzzi families, respectively devoted to seven scenes of the *Life of St Francis* (one outside over the entrance arch; see fig. 7 and FRAN-CISCAN ORDER, fig. 1) and to three scenes each of the *Life of St John the Baptist* (see fig. 8) and the *Life of John the Evangelist*. Both cycles have been assigned widely divergent dates anywhere between the Arena Chapel frescoes (1303–6) and Giotto's trip to Naples (1328–33). Each has been considered earlier than the other on the basis of subjective views of Giotto's stylistic evolution. Since St Louis of Toulouse, represented in the Bardi Chapel, was canonized in 1317, the chapel is often held to be necessarily later, although it was not uncommon for uncanonized saints to be depicted. If a date around 1320 is most often favoured for the Bardi paintings, the date for the Peruzzi works ranges from much earlier (*c.* 1313; Previtali) to much later (Borsook). The most notable difference between the two works is technical, the Peruzzi paintings being executed on dry plaster (secco), while in the Bardi Chapel the fresco technique on wet plaster was used (*buon fresco*). Why secco painting should have been selected has been little discussed: it might be because *buon fresco* cannot be executed in freezing weather and was generally not scheduled for the winter; the busy artist might have been able to include it in his schedule only by making use of that season. That would also permit a dating of the two chapels in the same years, which has been argued on the grounds that they share the same internal stylistic evolution from top to bottom (Gilbert, 1968). It is generally agreed that, compared to the Arena Chapel frescoes, both cycles in Santa Croce show greater emphasis on the representation of space, independent of the figures, which all occupy well-proportioned buildings. The inclusion of crowd scenes, with several examples of public chorus-like responses to the hero's dramatic gesture, are possible because of the larger expanses of wall in Santa Croce. Sometimes they are set in everyday contexts, such as a monastery courtyard or a public square, and sometimes indoors with fewer figures and the space divided in two, a motif borrowed from Duccio.

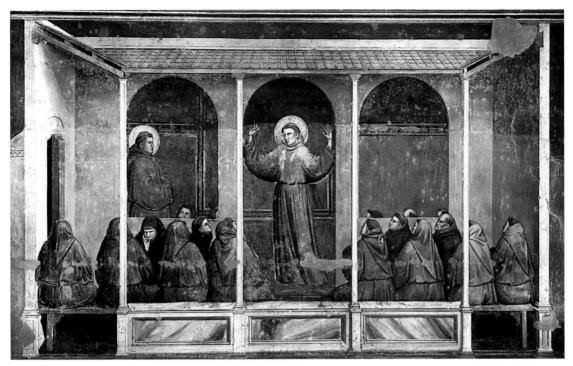

7. Giotto: *Apparition of St Francis at Arles* (*c.* 1320), fresco, Bardi Chapel, Santa Croce, Florence

(iii) Assisi and related works. The most controversial question about Giotto is whether or not he painted, as first stated by Vasari, the 28 scenes of the *Legend of St Francis* running around the two sides and one end of the Upper Church of S Francesco, Assisi. In the literature on Giotto this matter dominates. Scholarship is divided into two camps, although there has been some degree of compromise towards intermediate positions.

(a) The Assisi debate. (b) The *Isaac* scenes and the S Maria Novella *Crucifix*.

(a) The Assisi debate. The early sources from Riccobaldo onwards agree that Giotto painted in S Francesco at Assisi. Its omission from 'Ottimo's' reliable list of 1334 of the places where Giotto worked should not be overlooked (as it often is), but it is not strong evidence against the attribution. After a visit to Assisi in 1459, Pope Pius II, in a very rare reference by him to an artist, spoke of the 'double church, one over the other', adorned with paintings by Giotto, 'known as the greatest painter of his time'; this suggests that Giotto's presence was locally renowned. The first more precise report is Ghiberti's, which states that Giotto painted 'almost all the part below' in the basilica (*I Commentarii*, ii). If Ghiberti meant the Lower Church, he would have intended the four cycles there that are, by general agreement, attributed to Giotto's workshop (those in the crossing, the north (right) transept, the S Nicola Chapel and the Magdalene Chapel; *see* ASSISI, §II, 2 (v)). These cycles can be reasonably treated as 'almost all' of the painting there, especially if the primitive or provincial painting is discounted. If, however, Ghiberti meant the lower wall area of the Upper Church, this would indicate

the *St Francis* cycle and exclude the Lower Church. While some Italian scholars argue that the meaning 'lower church' for 'the part below' is not possible linguistically (Gnudi), others (Supino) have adopted that meaning. Gnudi further proposed to exclude the Lower Church from consideration on the grounds that all the Giotto workshop painting there is later than 1313, the year by which Riccobaldo had already cited work by Giotto in the church; however, since Gnudi's publication, the S Nicola Chapel, very close in style to the Arena Chapel, has been firmly dated to no later than 1307 (Meiss).

Vasari's support for Giotto's authorship of the *St Francis* cycle is agreed to be of limited significance, but until the 19th century it was not challenged; similarly, the cycle was unrivalled as the main visible representative of this famous artist's work since the *Navicella* mosaic was mostly destroyed, the Santa Croce frescoes whitewashed in the later 18th century, after long being hard to make out as their condition deteriorated, and the Arena Chapel privately owned and only locally known. Thus Vasari's statement, made glancingly in the first edition of his *Vite* in 1550 and with precision in the 1568 edition, received wide acceptance. Following doubts by some 19th-century scholars it was forcefully opposed in the early 20th century by Rintelen and Offner in particular (*see also* MASTERS, ANONYMOUS, AND MONOGRAMMISTS, §I: MASTER OF THE LEGEND OF ST FRANCIS). Some of their arguments, such as the much later dating proposed by Rintelen and Offner's 'idealizing' description of the stylistic qualities, have been abandoned. The principal remaining objection to the attribution was well defined by Bellosi: this is the difference between the Assisi cycle's 'incisive and almost metallic'

drawing style and surface texture and the 'soft and fluid' approach in the undisputed Arena Chapel frescoes. For some, such factors differ too much for the works to be by the same master, while others counter that the dates of the two cycles may be far enough apart to account for the differences. Gnudi (1956), in particular, argued that the Arena Chapel frescoes were executed *c.* 1310, explicitly commenting in a footnote that this would 'better explain' the dissimilarity in style to Assisi. The recently discovered reference (no later than 1310) to Giotto (Thomann, 1991) by the notable science writer in Padua, Pietro d'Abano, also suggests this date. In his commentary on the pseudo-Aristotelian work *Problems* he answers the question 'why do images of people exist' by saying that they show an individual's character especially when by an artist 'such as Giotto', who is able to represent them 'in all respects'. This strikingly suggests the people in the Arena scenes. Since Gnudi, the firmer evidence from the Padua choir-books, supporting the traditional 1304–5 date for the Arena Chapel paintings (*see* §(i) above), renders the differences in style more difficult to explain. The most logical surrebuttal by Bellosi (1985) was to infer an earlier date for the Assisi work, in 1291–2. The evidence for this revision—costume details and influence on other works—does not seem completely reliable; none of the other work is firmly dated, and Brandi in response noted the long persistence of costume types. The combination of the early dating with Giotto's authorship involves other difficulties (see below) and the date has not generally been adopted. The one remaining, if daring, stance for those advocating Giotto's work at Assisi is that taken by Previtali,

who stated that the cycles could be by the same hand even if only about three years apart.

As a compromise, the supporters for Giotto's authorship of the *St Francis* cycle have shifted ground and, following earlier tentative suggestions, proposed that most of the cycle is by Giotto's assistants and thus unlike the Arena Chapel, which is agreed to be autograph. This is in addition to the wide agreement to attribute the last three scenes in Assisi (XXVI–XXVIII), and probably scene I as well, to a distinct artist, frequently identified as the ST CECILIA MASTER (i) (*see* MASTERS, ANONYMOUS, AND MONOGRAMMISTS, §I), whether or not the latter was working under Giotto's general direction. Gnudi (1956) has proposed that only scenes II–VII are 'fully autograph' (see fig. 9), VIII–XIX only partly so, and those from XX onwards completely independent of Giotto. There is wide acceptance for the artist of scenes XX–XXV as a distinct personality, sometimes called the Master of the Obsequies of St Francis or the Master of the Funeral Rites, from a theme recurrent in his scenes. In these scenes Giotto's ideas, having been 'interpreted in a personal way' (Gnudi), cannot be distinguished even as to general layout. From scene XIII onwards other assistants' ideas are 'dominant', although according to Gnudi they 'respect Giotto's ideas'. For Previtali, Giotto was always present but was forced 'for some reason to speed up' and so grouped his assistants in two teams working simultaneously. One assistant first appeared in scene VI, a second 'Sienizing' one in scene XI, where he is 'almost autonomous', while scenes XIII and XVIII–XXII are by an assistant Previtali named the 'Worst Helper'; the last scenes show 'almost independent'

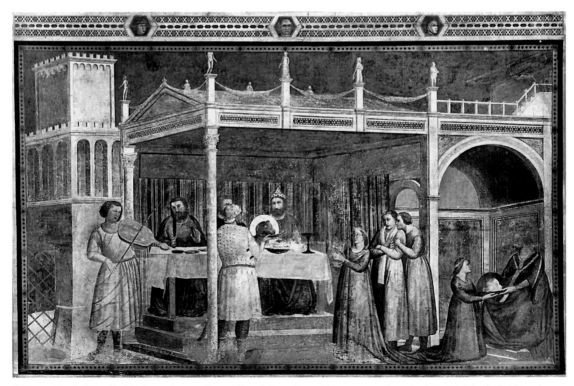

8. Giotto: *Feast of Herod* (*c.* 1320), mural *a secco*, Peruzzi Chapel, Santa Croce, Florence; scene from the *Life of St John the Baptist* cycle

work by the artist usually, but for Previtali wrongly, called the St Cecilia Master. These writers do not, however, specify how different tasks were distributed within each more or less collaborative scene; Bellosi suggested such assignments in his captions, indicating that at Assisi about a tenth of the work is by Giotto himself, in comparison with half at Padua (all but minor details) and more than that in his comparisons with Cimabue and others. This leaves the argument that the strong collaborative role for assistants in the *St Francis* cycle reflects standard 'medieval' practice with little support. Furthermore, for the work to be by Giotto and a crew using his style, it would have to be dated at a time after Giotto was an established master, a conclusion hard to reconcile with a date in his early youth.

Both opposing groups have thus naturally sought firm bases for dating. Those supporting Giotto's authorship of the *St Francis* frescoes have pointed to the image in scene I of the local Torre del Comune, which lacks the top storey added in 1305, and hence must have been painted earlier. Other examples of inaccuracies in the representation of buildings, however, make this line of argument dubious. The most convincing evidence of the date by which the Assisi cycle must have been painted is the existence of a copy dated 1307 of scene XIX, the *Stigmatization of St Francis*, in an altarpiece (Boston, MA, Isabella Stewart Gardner Mus.) by Giuliano da Rimini. Those who think the cycle is reatively late and too close to the Arena Chapel cycle to be by the same artists, cite motifs that occur frequently in the Arena Chapel and only once at Assisi suggesting that the latter is a later copy; the combination of a boy shown in lost profile with another onlooker has often been used as such an example.

(b) The 'Isaac' scenes and the S Maria Novella 'Crucifix'. An intermediate position has been taken by those who do not support Giotto's authorship of the *St Francis* cycle by attributing to him some of the upper tier of frescoes of biblical scenes on the same walls (ignoring Ghiberti's reference), especially the two scenes representing the aged Isaac, *Isaac Blessing Jacob* and *Isaac and Esau* (*see* MASTERS, ANONYMOUS, AND MONOGRAMMISTS, §I: ISAAC MASTER and fig.). Suggested by some 19th-century writers, this attribution was more influentially proposed by Meiss. Although the drawing style is not like that in the Arena Chapel frescoes, and is as sharp and metallic as the *St Francis* cycle, the simplicity of the intense drama is compatible with the approach at Padua and has suggested to some that this is the young Giotto working *c.* 1290–95. The *St Francis* cycle would then be by the master's assistants, cruder executants of his drawing style, overseen by him while he painted above. It is thus argued that the *Isaac* scenes are of such high quality that if they are not by Giotto, he cannot be held to be the stylistic innovator as is always supposed. This assumes, however, that the work, in a style that probably would have emerged *c.* 1290, is itself to be given this date rather than allowing for later work by the same artist retaining his same style. In the latter case the work could reflect, rather than anticipate, the Arena Chapel in its dramatic force.

The attribution to Giotto of the *Isaac* scenes seems strongly supported by the similarity of the S Maria Novella

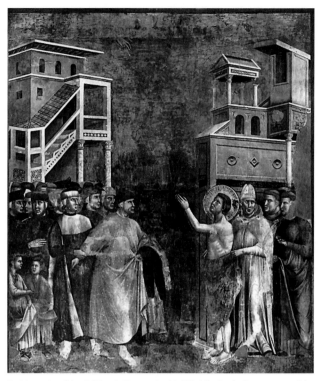

9. Giotto (attrib.): *St Francis Renouncing his Worldly Goods* (first quarter of the 14th century), fresco, Upper Church, S Francesco, Assisi

Crucifix (*in situ*; see fig. 10), attributed to Giotto in the early sources. On the other hand, some (Toesca and others) have seen in it the work of two hands, a view occasionally rejected (Bonsanti, 1988) but most often overlooked. The heads of *St John* and the *Virgin* at the terminals are by the same hand as the *Isaac* scenes, while the central *Christ* matches the softer modelling of the mature Giotto; the usual arrangement of an assistant painting the less important figures would readily apply here. This implies that the painter of the *Isaac* frescoes was an assistant to Giotto, an older one who had not been trained in his shop. In the frescoes he could well have used Giotto's designs, which would account for the brilliance of their dramatic composition. He would have headed a large team of artists at Assisi, whose relationship to Giotto varied.

A date after 1304 (copies of the Arena Chapel figures) and before 1307 (dated copy of the Assisi *Stigmatization*) would be consistent with the commission by the Franciscan official in charge to 1304, Giovanni da Murrovalle. It would also suggest that Giotto, busy at the Arena Chapel, handed over the Assisi work to his associates. A remarkable support for this argument is Vasari's attribution of the S Maria Novella *Crucifix* to two hands, the only such instance in his *Vita* of Giotto. It is often held that such statements about minor artists are more credible than attributions to great ones, the more so in this case since Vasari's informants about the second artist he names, Puccio Capanna, were descendants of this artist in Assisi, who said that their forefather had come from Florence to

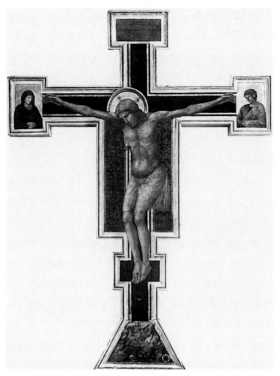

10. Giotto and his workshop: *Crucifix*, tempera on panel, 5.78×4.06 m, *c.* 1300 (Florence, S Maria Novella)

live there. It could then be plausible that Puccio visited Assisi to supervise the frescoes. However, the historical Puccio Capanna has now been firmly identified as the hand responsible for the frescoes of the following generation that Longhi labelled STEFANO FIORENTINO, a pupil of Giotto. Yet since Vasari frequently included errors, especially of the wrong generation or date, in data that were otherwise well based, it would be consistent if the Capanna family's claim that their painter ancestor helped on the *Crucifix* were true of a generation earlier than Puccio, thus making the Isaac Master 'Cappana Senior'.

(iv) Stylistic sources. Praise of Giotto began by claiming that he was not indebted to his predecessors; his naturalism was contrasted with the Byzantine 'Greek manner' of CIMABUE, with whom he is traditionally thought to have trained. The notion of a rigid, lifeless Byzantine art, however, has been challenged, and such works as Cimabue's Assisi *Crucifixion* fresco have been shown to stress similar dramatic human concerns to those found in Giotto's work; differences occur in the drawing of the figures, where Byzantine conventions are rejected by Giotto and a more naturalistic style, much influenced by French Gothic sculpture and Classical Roman work, is adopted. The dramatic Macedonian style of 13th-century Byzantine art has been added to this range. A major precursor of Giotto's soft modelling of figures, and of his fresco technique, is the work of Pietro Cavallini in Rome. His art, greatly influenced by Early Christian styles, is characterized by tranquil, statuesque figures. Giotto's work

is thus a synthesis of Cavallini's painting qualities and Cimabue's dramatic narrative style.

Although the difference of medium has sometimes argued against the idea that the great Tuscan sculptors of the 13th century anticipated Giotto's work, Nicola Pisano's Classical body forms, as well as Giovanni Pisano's great dramatic compositions of passion and crisis, were certainly major stimuli. Giotto's most intimate source may be in work of the less prominent Arnolfo di Cambio, who was active in Florence in Giotto's youth, and whose style reveals a greater emphasis on simple mass. Favoured Giotto motifs anticipated by Arnolfo are the figure leaning forward attentively with powerful shoulders in a tightly pulled robe, for example in the small Perugia Fountain (five figures, Perugia, G.N. Umbria), and the contrast within one work of a frontal icon and a mobile narrative group, as found in the lunette of Florence Cathedral façade (destr.), which recurs in Giotto's *Navicella*.

II. Working methods and technique.

1. WORKSHOP. The loss of Giotto's large, late works in Naples and Milan is the more regrettable as they evidently differed from those that survive, since some were of secular subject-matter and others involved large, unified schemes. Allegorical subjects with frontal protagonists seem to have been more prominent than in earlier works; the large allegorical cycle of the Florence campanile provides some indication of this phase. Giotto was by this stage a famous master, a status that may account for two works of *c.* 1330 with his signature, which were, however, painted by his assistants: the Baroncelli Chapel *Coronation of the Virgin* (Santa Croce, *in situ*; *God the Father* panel; San Diego, CA, F.A. Gal.); the *Virgin and Child with Saints* (Bologna, Pin. N.). Only one earlier signature is known, on the *Stigmatization of St Francis* (Paris, Louvre) usually dated *c.* 1300, which was previously (and often thought originally) at S Francesco, Pisa. It is striking, therefore, that Riccobaldo's report of 1312 on Giotto's work, emphasizing Franciscan work in various cities, does not name Pisa; he is sometimes believed to have obtained his information at a Franciscan conclave in 1310, and he is generally held to have been so well informed that the cities he named were in the order in which Giotto visited them to work. The omission of Pisa is thus incompatible with the picture's attribution to Giotto or his shop, unless the value of Riccobaldo's whole text is questioned, or, more plausibly, the painting is dated later, after he wrote; the inclusion in it of copies of Assisi scenes would fit this hypothesis well and strengthen the case for shop execution.

The two other signed works are both inscribed as by 'magister' Giotto, not a usual form for any artist's signature, particularly notable in the light of Boccaccio's comment that Giotto 'refused to be called Master'. The term would thus imply Giotto's assistants and probably indicates that the works were produced when he was away in Naples. The earliest biography of Giotto, by Filippo Villani in 1395, commented on Giotto's influence on several pupils, Taddeo Gaddi, Maso di Banco and Stefano Fiorentino, all of whom became the leading painters of Florence in their time. Their styles are distinct in a way that the style of the

workshop painting in Giotto's oeuvre is not. Nevertheless, it has conventionally been held that these artists did not break new ground but only recycled some aspects of their teacher's work, thus only underlining his greatness and continuing influence; some attempts have been made to qualify this view.

2. TECHNIQUE. Giotto's only known mosaic, the *Navicella* (*Christ Walking on the Waves*), survives only in fragments and was quite probably executed to his design by a specialist. All his other work is in fresco or secco on plaster walls, or in tempera on panel, unless the relief sculptures of the campanile, evidently based on his drawings, are included. The fresco technique, in which small areas of plaster were painted while still wet, was new in Giotto's time. Cimabue and others had applied the thin coat of plaster all at once to the whole wall, which normally dried long before the painting was complete, often resulting in the later loss of paint. Cavallini, just before Giotto, is perhaps responsible for making advances in the technique by applying wet plaster in areas small enough to be painted in one day. This assured very durable results, and also left the slight seams between patches of different days' work (*giornate*). These *giornate*, easily visible in Giotto's work, differ greatly in size depending on the complexity of what was being painted, and might range from the head of a protagonist to several spectators, or even the upper half of a fresco consisting of sky. Study of these has permitted the count of the days required to paint the Arena Chapel frescoes, recorded above. The most interesting findings about Giotto's technique are the absence of true fresco on wet plaster in the Peruzzi frescoes, and a large revision in one of the Arena Chapel frescoes, *Christ Driving the Money-changers from the Temple*; the revision has partly peeled off, as the bonding to a previous coat of pigment is less secure. This seems to have been a rare case. Until further research is done, the most useful clues to Giotto's technique are the instructions in the handbook of CENNINO CENNINI, who was trained by a pupil of Taddeo Gaddi.

III. Critical reception and posthumous reputation.

Giotto's reputation after his death did not decline. In Boccaccio's *Decameron* Giotto is introduced as a character and defined as the first painter not only to revive art after many centuries when it had been lost but also to imitate nature well enough to deceive. This formula, of Classical derivation, is the first to give Giotto a role in the broad history of art and was one that persisted. In 15th-century Florence Ghiberti perceived Giotto again as an innovator who had replaced the 'Greek' (i.e. Byzantine) manner of Cimabue by studying nature (*see also* §I, 3(iv) above). Alberti in 1435 offered the first close analysis of a work in such a way as to suggest its appeal: he described the different gestures and poses of the figures in the *Navicella*, and how these evoke aspects of fear. In the late 15th century Leonardo da Vinci's only note on past artists states that Giotto was admirable because he followed nature but criticizes his followers until Masaccio, who similarly returned to nature. Here Giotto is admired and yet is superseded by later progress, a viewpoint enforced by

Vasari's *Vite* of 1550. In this Giotto is portrayed as the great master of the first of the three ages, succeeded and improved by Masaccio and then by Leonardo. Thus Giotto had become interesting only as a historical pioneer, a position he retained for the next several centuries (see Baccheschi). Simultaneously, serious criticism took the form of the destruction of major works, the *Navicella* and the four whitewashed fresco cycles in Santa Croce, only two of which were recovered in the 19th century.

Giotto's status began to benefit *c.* 1800 from historicism in general (e.g. in the writings of Johann David Passavant, 1820, who called him unsurpassed) and, more practically, from Italian political nationalism. The first removal of whitewash, *c.* 1841, was from the Bargello Chapel frescoes, but only because they included a portrait of Dante. Nevertheless, this stimulated similar restoration programmes at the Bardi and Peruzzi chapels, and in 1880, after a long campaign, the Arena Chapel became public property. Such developments became the basis for Giotto's renewed reputation, most obviously in Ruskin's essays on the Arena Chapel and Santa Croce cycles. Giotto was once again seen as a great master who embodied principles that interested critics; thus in the 1890s Berenson found him the ideal creator of 'life-enhancing' tactile values, which made him compatible with emerging formalism and with the era of Cézanne. Occasional reflections of Giotto, as in the works of Paul Gauguin and Diego Rivera, are conveyed with simplified shapes that express the high value of a simpler society, indicating a continuing trace of the notion of Giotto as belonging to a less evolved culture. More broadly, probably most 20th-century artists (other than those who eschew any consciousness of the high culture of past Western civilization) treat with great respect Giotto's formal skills as a modeller and his capacity to communicate the human condition, although generally his interest in narrative drama and religion hold little interest. A typical comment is that of Henry Moore, who on a visit to Italy found little sculpture to admire but said that the 'sculpture' of Giotto compensated by its greatness.

BIBLIOGRAPHY

EARLY SOURCES

Riccobaldo Ferrarese: *Compendium Romanae historiae* (written *c.* 1312–13); ed. A. T. Hankey (Rome, 1984)
G. Boccaccio: *The Decameron* (written *c.* 1353); Eng. trans. by G. H. McWilliam (Harmondsworth, 1972)
C. Cennini: *Il libro dell'arte* (written 1390s; publd Rome, 1821); Eng. trans., ed. D. Thompson (New Haven, 1935)
G. Vasari: *Vite* (1550, rev. 2/1568); ed. G. Milanesi (1878–85)
L. Ghiberti: *Commentarii* (1912)

GENERAL

J. Crowe and G. B. Cavalcaselle: *A History of Painting in Italy* (London, 1854)
J. Ruskin: *Mornings in Florence* (London, 1875)
B. Berenson: *The Florentine Painters of the Renaissance* (New York, 1896/R 1909)
P. Toesca: *La pittura fiorentina del trecento* (Verona, 1929)
Pittura italiana del duecento e del trecento (exh. cat. by G. Brunetti and G. Sinibaldi, Florence, Uffizi, 1937)
P. Toesca: *Il trecento* (Turin, 1951), pp. 442–99
R. Oertel: *Die Frühzeit der italienischen Malerei* (Cologne, 1953; Eng. trans., London, 1968)
E. Borsook: *The Mural Painters of Tuscany* (London, 1960; rev. Oxford, 2/1980)
J. Lafontaine-Dosogne: *Iconographie de l'enfance de la Vierge dans l'empire byzantin et en occident*, ii (Brussels, 1965)

L. Bellosi: *Buffalmacco o il trionfo della morte* (Turin, 1974)

P. Hills: *The Light of Early Italian Painting* (New Haven, 1987)

MONOGRAPHS

H. Thode: *Giotto* (Leipzig, 1899)

F. Perkins: *Giotto* (London, 1902)

F. Rintelen: *Giotto und die Giotto-Apokryphen* (Munich, 1912)

O. Sirén: *Giotto and Some of his Followers* (London, 1917)

I. Supino: *Giotto* (Florence, 1920)

R. Salvini: *Giotto: Bibliografia* (Rome, 1938)

T. Hetzer: *Giotto* (Frankfurt, 1941)

G. Gnudi: *Giotto* (Milan, 1956)

E. Battisti: *Giotto* (Geneva, 1960)

D. Gioseffi: *Giotto architetto* (Milan, 1963)

E. Baccheschi: *L'opera completa di Giotto* (Milan, 1966; Eng. trans., 1969)

G. Previtali: *Giotto e la sua bottega* (Milan, 1967, rev. 1974) [most complete set of docs]

Giotto e il suo tempo. Atti del congresso internazionale per la celebrazione del VII centenario della nascita di Giotto: Assisi, Padova, Firenze, 1967

F. Bologna: *Novità su Giotto* (Turin, 1969)

R. Salvini and C. de Benedictis: *Giotto: Bibliografia*, ii (Rome, 1973) [up to 1970, with addenda of items before 1938 missed in vol. i; incl. 1307 doc.]

L. Schneider, ed: *Giotto in Perspective* (Englewood Cliffs, 1974) [col. of important stud. by various authors]

B. Cole: *Giotto and Florentine Painting* (New York, 1976)

L. Bellosi: *La pecora di Giotto* (Turin, 1985)

G. Bonsanti: *Giotto* (Padua, 1988)

PADUA

J. Ruskin: *Giotto and his Works in Padua* (London, 1854)

U. Schlegel: 'Zum Bildprogramm in der Arenakapelle', *Z. Kstgesch.*, xx (1957), pp. 125–46

W. Euler: *Die Architekturdarstellung in der Arena-Kapelle* (Berne, 1967)

J. H. Stubblebine: *Giotto: The Arena Chapel Frescoes* (New York, 1969)

C. Bellinati: 'La cappella di Giotto all'Arena a le miniature dell'antifornario "giottesco" della cattedrale', *Da Giotto a Mantegna* (exh. cat., ed. L. Grossato; Padua, Pal. Ragione, 1974)

D. Giunta: 'Appunti sull'iconografia della storia della Vergine nella cappella degli Scrovegni', *Riv. Istituto nazionale d'archeologia e storia dell'arte*, xxiii/xxiv (1974–5), pp. 79–139

Boll. A., lxiii (1978) [issue ded. to stud. on the conservation of the Arena Chapel, Padua]

M. Lisner: 'Farbgebung und Farbikonographie in Giottos Arenafresken', *Mitt. Ksthist. Inst. Florenz*, xxix (1985), pp. 1–78

G. Basile: *The Arena Chapel Frescoes* (London, 1993)

ASSISI

R. Offner: 'Giotto, non-Giotto', *Burl. Mag.*, lxxiv (1939), pp. 259–68; lxxv (1939), pp. 96–113

R. Longhi: 'Stefano Fiorentino', *Paragone*, 13 (1951), pp. 18–40

R. Fisher: 'Assisi, Padua, and the Boy in the Tree', *A. Bull.*, xxxviii (1956), pp. 47–52

J. White: 'The Date of the Legend of St Francis at Assisi', *Burl. Mag.*, xcviii (1956), pp. 344–51

M. Meiss: *Giotto and Assisi* (New York, 1960)

G. Palumbo, ed.: *Giotto e i giotteschi in Assisi* (Rome, 1969)

A. Smart: *The Assisi Problem and the Art of Giotto* (Oxford, 1971)

V. Martinelli: 'Un documento per Giotto ad Assisi', *Stor. A.*, xix (1973), pp. 193–210

H. Belting: *Die Oberkirche von San Francesco in Assisi* (Berlin, 1977)

E. Battisti: 'Body Language nel ciclo di San Francesco di Assisi', *Roma anno 1300. Atti della IV settimana di storia dell'arte medievale dell' Università di Roma 'La Sapienza': Roma, 1980*, pp. 675–88

L. Bellosi: 'La barba di San Francesco', *Prospettiva*, xxii (1980), pp. 11–34

H. Belting: 'Assisi e Roma', *Roma anno 1300. Atti della IV settimana di storia dell'arte medievale dell'Università di Roma 'La Sapienza': Roma, 1980*, pp. 93–101

G. Bonsanti: 'Giotto nella cappella di S Nicola', *Roma anno 1300. Atti della IV settimana di storia dell'arte medievale dell'Università di Roma 'La Sapienza': Roma, 1980*, pp. 199–209

I. Hueck: 'Il Cardinale Napoleone Orsini e la cappella di S Nicola nella basilica francescana ad Assisi', *Roma anno 1300. Atti della IV settimana di storia dell'arte medievale dell'Università di Roma 'La Sapienza': Roma, 1980*, pp. 187–98

L. Schwartz: *The Fresco Decoration of the Magdalen Chapel in St Francis at Assisi* (diss., Bloomington, IN U., 1980)

D. Schönau: 'The Vele of Assisi', *Meded. Ned. Hist. Inst. Rome*, 44–5 (1983), pp. 99–109

J. H. Stubblebine: *Assisi and the Rise of Vernacular Art* (New York, 1985)

SPECIALIST STUDIES

J. Gy-Wilde: 'Giotto-Studien', *Jb. Ksthist. Samml. Wien*, vii (1930), pp. 45–94

A. Schmarsow: 'Zur Masolino-Masaccio Forschung', *Kstchron. & Kstlit.*, n. s., lxiv (1930/31), pp. 1–3, n. 1

U. Procacci: 'La patria di Giotto', *A Giotto il suo Mugello* (Borgo San Lorenzo, 1937, rev. Florence, 1967), pp. 2–5 [incl. 1301 and 1305 docs]

W. Päseler: 'Giottos Navicella und ihr spätantikes Vorbild', *Röm. Jb. Kstgesch.*, v (1941), pp. 51–162

R. Oertel: 'Wende der Giotto-Forschung', *Kstgesch.*, ii (1943–4), pp. 1–27

R. Longhi: 'Giudizio sul dugento', *Proporzioni*, ii (1949), pp. 52–4

C. Mitchell: 'The Lateran Fresco of Boniface VIII', *J. Warb. & Court. Inst.*, xiv (1951), pp. 1–6

P. Murray: 'Notes on some Early Giotto Sources', *J. Warb. & Court. Inst.*, xvi (1953), pp. 58–80

C. Ragghianti: 'Inizio di Leonardo', *Crit. A.*, n. s., i (1954), pp. 1–18

C. Brandi: 'Giotto recuperato a San Giovanni Laterano', *Scritti in onore di Lionello Venturi* (Rome, 1956), pp. 55–85

F. Zeri: 'Due appunti su Giotto', *Paragone*, 85 (1957), pp. 75–87

C. Gnudi: 'Il passo di Riccobaldo Ferrarese relativo a Giotto', *Studies Dedicated to William Suida* (London, 1959), pp. 26–30

U. Procacci: 'La tavola di Giotto della chiesa della Badia', *Scritti in onore di Mario Salmi* (Rome, 1962), pp. 9–45

A. Romanini: 'Giotto e l'architettura gotica in alta Italia', *Boll. A.*, l (1965), pp. 160–80

L. Tintori and E. Borsook: *Giotto: La cappella Peruzzi* (Turin, 1965)

C. Gilbert: 'L'ordine cronologico degli affreschi Bardi e Peruzzi', *Boll. A.*, liii (1968), pp. 192–7

C. Brandi: 'Percorso di Giotto', *Crit. A.*, xvi (1969), pp. 3–80

M. Trachtenberg: *The Campanile of Florence Cathedral* (New York, 1971)

C. Gilbert: 'Cecco d'Ascoli e la pittura di Giotto', *Commentari*, xxiv (1973), pp. 19–25

J. Gardner: 'The Stefaneschi Altarpiece: A Reconstruction', *J. Warb. & Court. Inst.*, xxxvii (1974), pp. 57–103

C. Gilbert: 'The Fresco by Giotto in Milan', *A. Lombarda*, n.s., 47–8 (1977), pp. 31–72

I. Hueck: 'Giotto und die Proportion', *Festschrift W. Braunfels* (Tübingen, 1977), pp. 143–55

G. Kreytenberg: 'Der Campanile von Giotto', *Mitt. Ksthist. Inst. Florenz*, xxii (1978), pp. 147–84

R. Olson: 'Giotto's Portrait of Halley's Comet', *Sci. American*, ccxl (1979), pp. 160–70

J. Gardner: 'The Louvre Stigmatization and the Problem of the Narrative Altarpiece', *Z. Kstgesch.*, xlv (1982), pp. 217–47

M. Zucker: 'Figure and Frame in the Paintings of Giotto', *Source: Notes Hist. A.*, i/4 (1982), pp. 1–5

A. T. Hankey: 'Riccobaldo of Ferrara and Giotto: An Update', *J. Warb. & Court. Inst.*, liv (1991), p. 244

J. Thomann: 'Pietro d'Abano on Giotto', *J. Warb. & Court. Inst.*, liv (1991), pp. 238–44

Uffizi, Stud. & Ric., viii (1992) [issue ded. to the stud. on the Ognissanti Madonna]

CREIGHTON E. GILBERT

Giovanetti [Gianetti; Giovanetto] **(da Viterbo), Matteo** (*b* ?Viterbo, *c.* 1300; *d* Rome, 1368–9). Italian painter. His name first appears in papal letters of 1322 and 1328 in relation to his duties as a priest in S Luca in Viterbo, north of Rome. In 1336 Pope Benedict XII (*reg* 1334–42) appointed him prior of S Martino in Viterbo, and in 1348 he was nominated as archprior of Verceil in Provence. All his surviving work as a painter was done in and around Avignon, the seat of the papacy from 1309 to 1377. He also worked in Rome. Although Matteo is frequently described as a follower of the Sienese school—and particularly of Simone Martini, whose last years were spent in Avignon—there is no documentation to confirm this. It is uncertain when Matteo first came to Avignon: in 1343 'Magister Matteo' was one of the painters paid for the decoration of the Tour de la Garde-Robe, the pope's

private chambers. In 1346 Matteo is described as 'painter to the pope', and his name appears continuously on papal registers and accounts until 1368.

Matteo supervised a workshop made up of Italian and French painters (Roques) who were responsible for painting the interior of the Palais des Papes (*see* AVIGNON, §3(ii)(b)). While some mural painting had begun under Benedict XII, it was his successor Clement VI (*reg* 1342–52) who entrusted Matteo with the decoration of the newly constructed palace. Over the next 20 years Matteo supervised the painting and executed much of it himself. Much of this work has been lost as a result of fires (1392 and 1413), neglect after the papacy's return to Rome, and the conversion of the palace into a barracks for Napoleon's troops. Enough survives, however, to assess his artistic contribution.

Matteo's role in the earliest (1343) and best-preserved frescoes, the hunting and fishing scenes in the Chambre du Cerf, is uncertain, but he was responsible for most of the other series of paintings in the palace. From 1344 to 1345 he painted the Tour St Michel and the chapel of St Martial with scenes from the lives of the saints. Above the altar in the chapel of St Martial he also painted a *Crucifixion* (see fig.). While only the *sinopie* of the Tour St Michel paintings remain, the St Martial frescoes reveal Matteo's considerable gifts and innovations: his fresh and lively colours, his use of perspective and spatial illusionism, his sense of drama and human interaction, his skills in individualizing figures, and a restrained elegance associated with Sienese painting. These qualities are also found in the scenes from the *Lives of SS John the Baptist and John the Evangelist* in the chapel of St Jean. These frescoes, painted from 1346 to 1348, possibly with considerable assistance from other painters (Colombe), are the only survivors of a fire that destroyed Matteo's extensive work in the

banqueting hall (Grande Tinel) and in the consistory, where the College of Cardinals met. Matteo's work in the Great Audience Hall (1353) was left unfinished, and only 20 figures of *Prophets* on the arches remain, in poor condition; the huge *Last Judgement* and *Crucifixion* frescoes have entirely disappeared, and the *Coronation of the Virgin* has almost vanished; nothing remains of his last work in the palace (1365–6), the frescoes in the apartments called 'Rome', built during the Papacy of Urban V (*reg* 1362–70).

Besides working in the Palais des Papes, Matteo painted several frescoes and altarpieces for the private palace of Clement VI in Villeneuve-lès-Avignon (some frescoes survive in poor condition); for Innocent VI (*reg* 1352–62) he painted frescoes in the chapel of Innocent VI in the Charterhouse at Villeneuve-lès-Avignon (e.g. the *Crucifixion*, 1356; for an illustration of the *Virgin and Child Adored by Innocent VI, see* VILLENEUVE-LÈS-AVIGNON, §1). His paintings (1346) for the residence of Cardinal Napoleone Orsini in Villeneuve-lès-Avignon do not survive, but frescoes with strong stylistic affinities to his work were uncovered during the demolition of an 18th-century mansion in the Rue du Gal, Avignon (Thiebaut). A few small panel paintings have also been attributed to him (e.g. a *Crucifixion*; priv. col., see Volpe, pls 43–4). He died in Rome, where he had been called to take part in the decoration of the Vatican Palace.

BIBLIOGRAPHY

E. Müntz: 'Fresques inédites du XIVe siècle du Palais des papes à Avignon et de la chartreuse de Villeneuve', *Gaz. Archéol.*, x (1885), p. 393–5

R. André-Michel: 'Matteo di Viterbe et les fresques au palais pontifical d'Avignon', *Bib. Ecole Chartes*, lxxiv (1913), pp. 341–9

L.-H. Labande: *Le Palais des papes et les monuments d'Avignon au XIVe siècle*, 2 vols (Marseille, 1925)

G. Colombe: 'Au Palais des papes: Les fresques de Saint-Jean sont-elles de Matteo de Viterbe?', *Gaz. B.-A.*, n.s. 6, viii (1932), pp. 37–50

C. Volpe: 'Un'opera di Matteo Giovanetti', *Paragone*, 119 (1959), pp. 63–6

M. Roques: *Les Peintures murales du sud-est de la France (XIII–XVIe siècles)* (Paris, 1961)

E. Castelnuovo: 'Les Fresques italiennes d'Avignon', *L'Oeil*, 97 (1963), pp. 22–31

S. Gagnière: *Le Palais des papes d'Avignon* (Paris, 1965)

E. Castelnuovo: *Matteo Giovanetti al Palazzo dei papi ad Avignone* (Milan, 1966)

R. Mesuret: *Les peintures murales du sud-ouest de la France du XIe au XVIe siècle* (Paris, 1967)

J. Thiébaut: 'Peintures murales récemment découvertes à Avignon', *Bull. Mnmtl.*, cxxx/2 (1972), pp. 157–8

M. Laclotte and D. Thiébaut: *L'Ecole d'Avignon* (Paris, 1983)

PAULA HUTTON

Giovanni, Agostino di. *See* AGOSTINO DI GIOVANNI.

Giovanni, Antonio di Agostino di ser. *See* ANTONIO DA FABRIANO.

Giovanni, Apollonio di. *See* APOLLONIO DI GIOVANNI.

Giovanni, Bartolomeo di. *See* BARTOLOMEO DI GIOVANNI.

Giovanni, Benvenuto di. *See* BENVENUTO DI GIOVANNI.

Giovanni, Berto di. *See* BERTO DI GIOVANNI.

Giovanni, Bertoldo di. *See* BERTOLDO DI GIOVANNI.

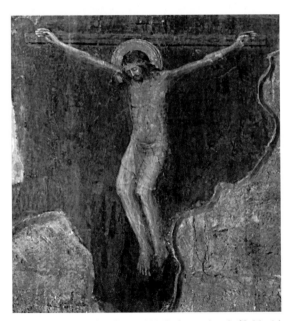

Matteo Giovanetti: *Crucifixion* (1344–5), fresco, chapel of St Martial, Palais des Papes, Avignon

Giovanni, Gualtieri di. *See* GUALTIERI DI GIOVANNI.

Giovanni, Leonardo di Ser. *See* LEONARDO DI SER GIOVANNI.

Giovanni, Matteo di. *See* MATTEO DI GIOVANNI.

Giovanni, Mino di. *See* MINO DA FIESOLE.

Giovanni Agostino da Lodi [Pseudo-Boccaccino] (*fl c.* 1467–1524/5). Italian painter and draughtsman. The identification of a particular hand has resulted in the removal of a group of paintings from those formerly attributed to Boccaccio Boccaccino of Cremona (whence the name 'Pseudo-Boccaccino'). This resulted from the discovery of the signature of Giovanni Agostino da Lodi on a small panel painting of *SS Peter and John* (*c.* 1495; Milan, Brera) and was confirmed by another on a drawing, *Allegory of Prudence* (sold New York, Sotheby's, 16 Jan 1986, lot 36). These works suggest that he was an intermediary between the perspective art of Lombardy during the last decade of the 15th century and the Venetian style of Giovanni Bellini, Giorgione and the other painters of their circle. A lengthy stay in Venice is attested by a payment made in 1504 and by the presence of important paintings in the Veneto, such as the *Virgin and Child Enthroned with Four Saints* (Murano, S Pietro Martire), *Christ Washing the Feet of the Disciples* (1500; Venice, Accad.) and the *Virgin and Child with SS Roch and Nicholas* (Bribano, S Nicola), in which his style was enriched by elements inspired by Dürer. His career thus appears to have run parallel with Gerolamo Romanino, Altobello Melone and those artists whose works reveal a fusion of Milanese, Venetian and northern European influences. After returning to Lombardy, Giovanni Agostino da Lodi executed paintings at Gerenzano (*in situ*), in the Certosa di Pavia (*in situ*; thus confirming his importance in contemporary Lombard art) and for S Maria della Pace, Milan (now in Milan, Brera).

BIBLIOGRAPHY

A. Puerari: *Boccaccino* (Milan, 1957)

M. Lucco and M. Natale: *Cena in Emmaus: Giovanni Agostino da Lodi* (Milan, 1988)

F. Moro: 'Giovanni Agostino da Lodi ovvero l'Agostino di Bramantino: Appunti per un unico percorso', *Paragone*, xl (1989), no. 473, pp. 23–61

MARCO TANZI

Giovanni Angelo di Antonio da Camerino. *See under* MASTERS, ANONYMOUS, AND MONOGRAMMISTS, §I: MASTER OF THE BARBERINI PANELS.

Giovanni Antonio da Brescia (*b* ?Brescia, *c.* 1460; *d* ?Rome, *c.* 1520). Italian engraver. His career can be traced through 27 engravings with his signature (usually IO.AN.B or IO.AN.BX) and many others attributed to him. He appears to have begun work in the circle of Andrea Mantegna, and a number of engravings of the Mantegna school are generally assigned to him, including three prints after Mantegna's *Triumph of Caesar* (B.17b, 18b, 19b) and a version of the *Four Dancing Ladies* (B. 29b). This early phase probably ended about 1506, when the school dispersed after the death of Mantegna. A transition period is suggested by a group of prints that demonstrate the technical conventions of Mantegna with stylistic influence from the work of Benedetto Montagna: *Nativity* (B. 4); *Virgin and Child* (B. 9); *St Barbara* (B. 12); and *Justice* (B. 27; see fig.). In the *Virgin and Child* the view of a distant landscape may have been inspired by the engravings of Albrecht Dürer, which arrived in northern Italy in this period. Giovanni Antonio executed four copies of Dürer's engraving of the *Satyr Family* (1505), one dated 1507 (B. 39).

Evidence of Giovanni Antonio's arrival in Rome is provided by two works in which he reverted to his early style. The first, of uncertain attribution, is a portrait of *Pope Leo X* (B. 35), which cannot have been executed before 1513, when his papacy began. The second engraving, signed IO.AN.BRIXIAS, a *Venus* (B. 22), according to the inscription, represents a statue that had recently been discovered in Rome. The figure and draperies recall his earlier works, but the technique of the landscape is close to that of Dürer, although it is probably derived from an

Giovanni Antonio da Brescia (after Andrea Mantegna): *Justice*, engraving, 317×170 mm, *c.* 1507 (London, British Museum)

engraving by Marcantonio Raimondi, who absorbed Dürer's style. The *Venus* landscape is the first manifestation of Marcantonio's influence on Giovanni Antonio, which continued throughout the rest of his career. In 1516 Giovanni Antonio produced the latest of his signed and dated engravings (B. 25), one of a series of four illustrations from Virgil's *Aeneid* (B. 23–6), copied from four designs engraved on a single plate by Marcantonio. In his later works his technique became more disciplined, as can be seen from a group of engravings probably produced *c.* 1515–20 (B.1–3, 7, 16, 29). Two of these are based on works by other artists that can be dated: the *Abraham and Melchizedek* (B.1), derived from a fresco by Raphael in the Vatican *Loggie*, completed in 1519; and the *Discovery of Joseph's Cup* (B. 2), after a drawing by Baldassare Peruzzi of *c.* 1520 (London, BM). These are his latest known works.

BIBLIOGRAPHY

Thieme–Becker
A. M. Hind: *Early Italian Engraving: A Critical Catalogue with Complete Reproduction of All the Prints Described*, v (London, 1948), pp. 33–54
J. A. Levenson, K. Oberhuber and J. L. Sheehan: *Early Italian Engravings from the National Gallery of Art* (Washington, DC, 1973), pp. 235–64
M. J. Zucker: *Early Italian Masters (1980), Commentary* (1984), 25 [XIII/ii] of *The Illustrated Bartsch*, ed. W. L. Strauss (New York, 1978–)
[B.]

Giovanni Antonio da Padova. *See* PÁDUA, JOÃO ANTÓNIO BELLINI DE.

Giovanni Cristoforo Romano. *See* GIAN CRISTOFORO ROMANO.

Giovanni da Campione. *See under* CAMPIONESI.

Giovanni da Castel Bolognese. *See* BERNARDI, GIOVANNI.

Giovanni [di Bartolo Bettini] **da Fano** (*fl c.* 1450–70). Italian illuminator. In 1462 he is recorded in Rimini living in the house of Francesco Antonio degli Atti, brother-in-law of Sigismondo Pandolfo Malatesta, ruler of Rimini, at whose court he was active. Giovanni illustrated copies of Basinio de' Basini's *Hesperides* (1449–57), an epic poem portraying Malatesta engaged in a struggle against Alfonso I, King of Naples and Sicily, for the domination of Italy. Presentation manuscripts (e.g. Oxford, Bodleian Lib., MS. Canon. Class. lat. 81; Paris, Bib. Arsenal, MS. 630; Rome, Vatican, Bib. Apostolica, MS. lat. 6043) were lavished by Malatesta on his allies. These codices include between 19 and 22 coloured drawings, with variations between copies, which are remarkable for their immediacy; one, for example, depicts a fortress by moonlight, another the Tempio Malatestiano under construction. Some scenes are within illusionistic marble frames. Two of the compositions bear the inscription OP. IOANNIS PICTORIS FANESTRIS. Giovanni also illustrated, with pen drawings, copies of Roberto Valturio's *De re militari*, which dealt with war machines and strategy while exalting Malatesta. This treatise, begun soon after 1449–50, was completed by 1461 when Matteo de' Pasti was sent to Constantinople with a presentation copy for the Ottoman ruler, Muhammad II. Francesco Sforza, Duke of Milan, also received an exemplum with an accompanying letter, dated 9 June 1464,

from Bishop Angelo Geraldini, specifying that the illustrator involved in the production of this series was from Fano. Several other Riminese manuscripts of the *De re militari* are extant (e.g. 1462; Rome, Vatican, Bib. Apostolica, MS. Urb. lat. 281; 1463; Paris, Bib. N., MS. lat. 7236; 1465; Modena, Bib. Estense, MS. lat. 447; 1466; Venice, Bib. N. Marciana, MS. lat. VIII. 29; 1470; Milan, Bib. Ambrosiana, MS. F. 150. sup.).

BIBLIOGRAPHY

C. Ricci: *Il Tempio malatestiano*, 2 vols (Milan and Rome, 1925)
——: 'Di un codice malatestiano della *Esperide* di Basinio', *Accad. & Bib. Italia*, i/5–6 (1928), pp. 20–48
E. Rodakiewicz: 'The "editio princeps" of Roberto Valturio *De re militari* in Relation to the Dresden and Munich Manuscripts', *Maso Finiguerra*, v (1940), pp. 14–81
O. Pächt: 'Giovanni da Fano's Illustrations for Basinio's Epos *Hesperis*', *Stud. Romagn.*, ii (1951), pp. 91–103 [app. by A. Campana]
The Painted Page: Italian Renaissance Book Illumination, 1450–1550 (exh. cat., ed. J.J.G. Alexander; London, RA, 1994)

PATRICK M. DE WINTER

Giovanni da Fiesole, Fra. *See* ANGELICO, FRA.

Giovanni d'Agostino. *See under* AGOSTINO DI GIOVANNI.

Giovanni d'Alemagna (*fl* 1441; *d* 1450). German painter, active in Italy. He collaborated with Antonio Vivarini on various important religious paintings in Venice and Padua (*see* VIVARINI, (1)). Although it is difficult to distinguish the two artists' contributions, Giovanni is associated with the *St Jerome* (1444; Baltimore, MD, Walters A.G.), which carries the signature 'Johannes'. This painting suggests that Giovanni's work was generally flatter and more decorative than Antonio's more naturalistic style.

Giovanni d'Alesso d'Antonio. *See* UNGHERO, NANNI.

Giovanni Dalmata [Giovanni di Traù; Ioannes Stephani Duknovich de Tragurio; Ivan Duknović] (*b* in or nr Traù, Dalmatia [now Trogir, Croatia], *c.* 1440; *d* after 1509). Dalmatian sculptor, active in Italy and Hungary. He probably trained as a mason in a local workshop near Trogir. He moved to Rome in the 1460s, by which time his style was fully developed. Initially he may have worked with Paolo Romano. His earliest works include the side portal of the Palazzo Venezia, Rome, built for Cardinal Pietro Barbo (later Pope Paul II), and the lunette and other sculptures on the façade of the tempietto at Vicovaro. In 1469 he carved the *Annunciation* and statues of *St John the Baptist* and *St John the Evangelist* on the altar of the Madonna della Palla in S Giovanni at Norcia (Umbria).

In Rome Giovanni collaborated on many works with two of the foremost sculptors of the day: Andrea Bregno and Mino da Fiesole. His style, however, preserved its individuality, and he apparently did not attempt to match his work to that of his collaborators. With Bregno he worked on the tomb of *Cardinal Giacomo Tebaldi* (*d* 1466; S Maria sopra Minerva) and that of *Cardinal Bartolomeo Roverella* (1476–7; S Clemente). With Mino da Fiesole he worked on the tomb of *Pope Paul II* (*d* 1471; tomb 1474–7; Old St Peter's, destr.; fragments, Rome, Grotte Vaticane; Paris, Louvre). Its original appearance is known

from an engraving (A. Chacon: *Vitae pontificium*, 1677). It was the largest and most elaborate papal tomb of its date and incorporated more figure sculpture than any contemporary Roman monument. Originally it was in the form of a triumphal arch flanked by two columns, with the carved effigy of the recumbent Pope (by Giovanni) lying on a sarcophagus, surrounded by carved reliefs of personifications of Virtues and historiated reliefs above and below. Giovanni was responsible for the reliefs of the *Resurrection* and the *Creation of Eve* beneath the bier, the large relief of *God the Father in Glory* above it and a statue of *Hope*, which he signed. Giovanni's style is original and forceful, showing a knowledge of Classical sculpture, but he had a greater sense of drama and characterization than his collaborators. Typical of his style are the vigorous modelling and triangular forms of the drapery in the figure of *Hope*. Also with Mino, Giovanni collaborated on an altar in the sacristy of S Marco, Rome (1474; *in situ*), but he alone was responsible for the tomb of *Cardinal Bernardo Eroli* (*d* 1479; fragments, Rome, Grotte Vaticane).

From 1481 Giovanni was employed in Hungary by King Matthias Corvinus. Many of his works there have been destroyed, but a bas-relief of the *Virgin with Two Female Saints* (Budapest, Mus. F.A.), the octagonal fountain and the statue of *Hercules with the Hydra of Lerna*, both in Visegrad Palace, and some decorative fragments in the Palace at Buda survive. He was presented with a castle by the King in 1488 but never took possession of it. On the King's death in 1490, Giovanni returned to Italy. He never lost contact with Dalmatia, and the signed statue of *St John the Evangelist* (Trogir Cathedral, chapel of the Blessed John of Trogir) is a masterpiece of his sophisticated style. A statue of *St Thomas* in the same chapel is also his late work. Other works of his in Dalmatia include the bas-relief of a humanist in the courtyard of the Palazzo Cippico, Trogir, and the statue of *St Mary Magdalene* in the Franciscan convent at Drid.

Giovanni was also active in Venice; in 1498 he was commissioned to carve a large altar for the Scuola Grande di S Marco, but it was never executed; a portrait bust of *Carlo Zeno* (Venice, Correr) and a bas-relief of the *Virgin and Child* (Padua, Mus. Civ.) probably date from this time. Also attributed to him is the bust of the humanist *Francesco Cinzio* (London, V&A) and fragments from the tomb of *Luka Baratin*, Bishop of Zagreb (Zagreb, Hist. Mus. Croatia). In 1503 he offered his services to the city of Dubrovnik, but they were rejected. His last works are the monument of the *Blessed Girolamo Gianelli* (1509; Ancona Cathedral) and the sarcophagus of the *Blessed Gabriele Ferretti* (1509; Ancona, Mus. Dioc.); he also worked on the portal of the convent of S Francesco, Ancona.

Together with Francesco Laurana, Giovanni was one of the two great Dalmatian sculptors of the 15th century who spent most of their career away from their native country. Traces of Giovanni's influence are evident in early 16th-century Dalmatian sculpture.

BIBLIOGRAPHY

Thieme–Becker
H. Tschudi: 'Giovanni Dalmata', *Jb. Kön.-Preuss. Kstsamml.*, iv (1883), pp. 169–90
C. Fabriczy: 'Giovanni Dalmata: Neues zum Leben und Werke des Meisters', *Jb. Kön.-Preuss. Kstsamml.*, xxii (1901), pp. 224–52
P. Meller: 'La fontana di Mattia Corvino a Visegrad', *Annu. Ist. Ung. Stor. A.*, i (1947), pp. 47–73
K. Prijatelj: *Ivan Duknović* (Zagreb, 1957)
——: 'Profilo di Giovanni Dalmata', *A. Ant. & Mod.*, vii (1959), pp. 283–97
J. Balogh: 'Ioannes Duknović de Tragurio', *Acta Hist. A. Acad. Sci. Hung.*, vi (1961), pp. 51–78
C. Fisković: 'Ivan Duknović Dalmata', *Acta Hist. A. Acad. Sci. Hung.*, xiii (1967), pp. 267–70
——: 'La scoperta del portale e del putto di Ivan Duknović a Trogir', *Actes du XX congrès international d'histoire de l'art: Budapest, 1972*, pp. 853–6
R. Cordelli: 'Un'opera inedita di Giovanni Dalmata a Norcia (Umbria): L'altare della *Madonna della Palla*', *Acta Hist. A. Acad. Sci. Hung.*, xxvii (1981), pp. 233–46
——: 'Aggiunta all'articolo "Un'opera inedita di Giovanni Dalmata"', *Acta Hist. A. Acad. Sci. Hung.*, xxviii (1982), pp. 263–4
I. Fisković: 'Duknović Ivan (Ioannes Dalmata, Giovanni da Trau)', *Likovna enciklopedija Jugoslavije*, i (Zagreb, 1984)
K. Prijatelj: 'Duknovićev sarkofag Gabrielea Ferrettija Uanconi', *Vjesnik Archeol. & Hist. Dalmat.*, lxxxvi (1994), pp. 293–8

KRUNO PRIJATELJ

Giovanni dal Ponte [Giovanni di Marco] (*b* Florence, 1385; *d* Florence, 1437–8). Italian painter. He was reputed to have been a student of Spinello Aretino. He acquired the name dal Ponte due to the location of his studio at Santo Stefano a Ponte, Florence. He joined the Arte dei Medici e degli Speziali in 1410 and the Compagnia di S Luca in 1413. Outstanding debts brought him a prison sentence in 1424, but he still owed money to a carpenter three years later. By the late 1420s he had opened his own studio and formed a partnership with the painter Smeraldo di Giovanni (*c.* 1365–after 1442). Giovanni dal Ponte's varied and prolific production, which continued until his death, included fresco cycles, panels and the decoration of small objects. A number of allegorical panel paintings and cassoni are attributed to him. The animated, stylized figures in the *Seven Liberal Arts* (1435; Madrid, Prado) are shown in a garden dotted with naturalistic flowers and plants. His early work shows the impact of the Late Gothic style. The composition of the *Coronation of the Virgin* (?1420; Chantilly, Mus. Condé) recalls the famous altarpiece of the same subject (1413; Florence, Uffizi) by Lorenzo Monaco, while the treatment of drapery suggests the influence of Lorenzo Ghiberti's sculpture. Giovanni assimilated the discoveries of his contemporaries. In the *Virgin and Child with Angels* (*c.* 1427–8; Cambridge, Fitzwilliam, 551) the bulky figures derive from Masaccio. However, his late *Virgin and Child with Angels* (*c.* 1434–5; San Francisco, CA, de Young Mem. Mus.) shows a return to a decorative, linear style.

See also CASSONE, §1.

BIBLIOGRAPHY

C. H. Shell: *Giovanni dal Ponte and the Problem of Other Lesser Contemporaries of Masaccio* (diss., Cambridge, MA, Harvard U., 1958)
B. Berenson: *Florentine School*, i (1963), pp. 90–92
F. Guidi: 'Per una nuova cronologia di Giovanni di Marco', *Paragone*, xix/223 (1968), pp. 27–46
——: 'Ancora su Giovanni di Marco', *Paragone*, xxi/239 (1970), pp. 11–23
C. Shell: 'Two Triptychs by Giovanni dal Ponte', *A. Bull.*, liv (1972), pp. 41–6
C. Mack: 'A Carpenter's *catasto* with Information on Masaccio, Giovanni dal Ponte, Antonio di Domenico, and Others', *Mitt. Ksthist. Inst. Florenz*, xxiv (1980), pp. 366–8

F. G. Bruscoli: 'Una tavola di Giovanni di Marco da San Donato a Porrona', *Scritti di storia dell'arte in onore di Federico Zeri*, ed. M. Natale, i (Milan, 1984), pp. 60–67

C. Frosinini: 'Proposte per Giovanni dal Ponte e Neri di Bicci: Due affreschi funerari del Duomo di Firenze', *Mitt. Ksthist. Inst. Florenz*, xxxiv (1990), pp. 123–38

EUNICE D. HOWE

Giovanni d'Ambrogio (*fl* Florence, 1382–1418). Italian sculptor and architect. He is not to be identified with the craftsman of the same name who was employed to construct the piers of Florence Cathedral in 1366. Giovanni d'Ambrogio's work provided a decisive impetus for the emergence of Renaissance sculpture; he has been described as the 'true mentor of Donatello, and even more so of Nanni di Banco' (Wundram).

Giovanni d'Ambrogio is first mentioned on 23 May 1382 (Florence, Archv Opera Duomo, Delib., ii, 1, n. 14, c. 15) in connection with a payment at Florence Cathedral. Between 1383 and 1386 he made the large seated figures of *Justice* and *Prudence* for the Loggia dei Lanzi in the Piazza della Signoria, Florence. He worked on lintels, sills and similar items for S Cecilia, Florence, and for the chapel of the Sacro Cingolo at Prato Cathedral (*c.* 1388).

Giovanni d'Ambrogio received a commission for three statues for the façade of Florence Cathedral in 1388. He sculpted two pieces (1391–3) for the jambs of the Porta della Mandorla at the cathedral and in 1394 contributed a console block and other items for the doorframe. In 1395–6 he made a large statue of *St Barnabas* for the cathedral façade. From 1397 to 1400 he was absent from Florence. He took over as Master of the Cathedral Works in Florence in 1401, continuing in this post until 1418, except for the period from 1413 to 1415. During this period the choir, chapels, tribunes and drum of the crossing dome were built; he was eventually relieved of his duties because of his age.

Giovanni d'Ambrogio's fine craftsmanship is evident in his earliest authenticated works: in the cycle of marble reliefs illustrating the Virtues at the Loggia dei Lanzi, *Justice* and *Prudence* stand out for their monumentality, the sureness with which the figures are constructed, the quiet yet fluid drapery style, the classical balance between the forms and the skilled integration of the figures with the background. He may earlier, *c.* 1380, have executed two small statues of prophets made as a pair (Florence Cathedral, Porta dei Cornacchini; Florence, Mus. Opera Duomo; Kreytenberg, 1972).

On the basis of their style, Kauffmann ascribed the six pieces that make up the jambs of the Porta della Mandorla to each of the four sculptors recorded as having worked on them, attributing the lower and upper blocks on the left jambs to Giovanni, an attribution supported by their dimensions, which are cited in the contract. The three half-figures of angels on these blocks (1391–2 and 1393) clearly reveal stages in a fast-moving development towards the emergence of the body as an independent entity beneath the draperies. The uppermost angel can no longer be regarded as a Gothic figure; the contrapposto pose is evidence of the influence of antique sculpture, also apparent in the subject-matter of the small figures of Hercules and Apollo, which are framed by acanthus leaves laid out in the shape of a lyre and separated by two reliefs with angels.

Giovanni d'Ambrogio later executed the reliefs on the left side of the doorframe, while the sections in the middle and on the right were executed by Piero di Giovanni Tedesco (Kauffmann), except for the right-hand block of the lintel, which can be ascribed to Giovanni d'Ambrogio and his son Lorenzo (Kreytenberg, 1976). It is only in the section made by Giovanni d'Ambrogio that several small depictions of Hercules and half-figures of the Muses appear (Himmelmann, 1985), indicating the sculptor's interest in humanism; it is clear that no comprehensive iconographic programme for the decoration was prepared in advance.

The reliefs on the upper and lower blocks of the left-hand jamb show similarities to an *Annunciation* group (Florence, Mus. Opera Duomo; Schmarsow, 1887), which Kauffmann attributed to Giovanni d'Ambrogio. Although these statues have also been attributed to such early Renaissance sculptors as Nanni di Banco and Jacopo della Quercia because of the resemblance of the heads to antique sculpture, the conception of the figures is Gothic, stylistically related to the angels on the lower block of the left-hand jamb of the Porta della Mandorla; they may have been made by Giovanni d'Ambrogio for the portal tympanum in 1391–2 (Kreytenberg, 1972). The development in which the body becomes more independent of its draperies in Giovanni d'Ambrogio's three angel reliefs is further apparent in the monumental statue in contrapposto pose (Florence, Mus. Opera Duomo) that Wundram (1960) convincingly identified as the statue of *St Barnabas* made by Giovanni for the cathedral façade in 1395–6.

After 1401 Giovanni d'Ambrogio's duties as Master of the Cathedral Works may have prevented him from devoting time to sculpture. The only other work by him at the cathedral is the left section of the tympanum frame on the Porta della Mandorla (*c.* 1405) and a remarkable console figure in the north tribune (*c.* 1408). He probably also executed the three small statues of prophets for Orsanmichele (Florence, Bargello), possibly during the break in his responsibilities as Master of the Cathedral Works in 1413–15; in them is apparent the old sculptor's familiarity with the early work of Donatello (Kreytenberg, 1972).

BIBLIOGRAPHY

K. Frey: *Die Loggia dei Lanzi zu Florenz* (Berlin, 1885), pp. 229, 232–4, 236, 302–04, 307
C. Guasti: *Santa Maria del Fiore* (Florence, 1887)
A. Schmarsow: 'Vier Statuetten in der Domopera zu Florenz', *Jb. Preuss. Kstsamml.*, viii (1887), pp. 137–53
G. Poggi: *Il duomo di Firenze* (Berlin, 1909)
O. Wulff: 'Giovanni d'Antonio di Banco und die Anfänge der Renaissanceplastik in Florenz', *Jb. Preuss. Kstsamml.*, xxxiv (1913), pp. 99–164
H. Kauffmann: 'Florentiner Domplastik', *Jb. Preuss. Kstsamml.*, xlvii (1926), pp. 141–67, 216–57
G. Brunetti: 'Giovanni d'Ambrogio', *Riv. A.*, xiv (1932), pp. 1–22
G. Poggi: 'La cappella del sacro cingolo nel duomo di Prato e gli affreschi di Agnolo Gaddi', *Riv. A.*, xiv (1932), pp. 355–76
C. Seymour jr.: 'The Younger Masters of the First Campaign of the Porta della Mandorla, 1391–1397', *A. Bull.*, xli (1959), pp. 1–17
M. Wundram: 'Der Meister der Verkündigung in der Domopera zu Florenz', *Beiträge zur Kunstgeschichte: Eine Festgabe für H. R. Rosemann* (Munich, 1960), pp. 109–25
G. Kreytenberg: 'Giovanni d'Ambrogio', *Jb. Berlin. Mus.*, xiv (1972), pp. 5–32
——: 'Giovanni Fetti und die Porta dei Canonici', *Mitt. Ksthist. Inst. Florenz*, xx (1976), pp. 155–6

L. Becherucci: 'Convergenze stilistiche nella scultura fiorentina del tre-cento', *Jacopo della Quercia fra gotico e rinascimento* (Florence, 1977), pp. 30–36

G. Kreytenberg: 'La prima opera del Ghiberti e la scultura fiorentina del trecento', *Atti del convegno internazionale di studi. Lorenzo Ghiberti nel suo tempo: Firenze, 1980*, i, pp. 59–78

N. Himmelmann: *Ideale Nacktheit* (Opladen, 1985), pp. 62–72

G. KREYTENBERG

Giovanni d'Ambrogio, Pietro di. *See* PIETRO DI GIO-VANNI D'AMBROGIO.

Giovanni da Milano [Giovanni da Como] (*fl c.* 1346–69). Italian painter. He is first recorded on 17 October 1346, listed as Johannes Jacobi de Commo among the foreign painters living in Florence. There follows a gap of at least 12 undocumented years until his inscription as Johannes Jacobi Guidonis de Mediolano with the Arte dei Medici e Speziali between 1358 and 1363. A tax return dated 26 December 1363 declares his ownership of land in Ripoli, Tizzana (nr Prato) and a house in the parish of S Pier Maggiore, Florence.

Giovanni's first signed work, a polyptych (Prato, Pin. Com.), coincides with the renewed period of documentation. It has a *terminus ad quem* of 1363 since, according to the inscription, it was commissioned by Francesco da Tieri, prior of the Ospedale of Prato from 1334 until his death in 1363. The polyptych shows the *Virgin and Child Enthroned* (in poor condition) flanked by *SS Catherine and Bernard* and *SS Bartholomew and Barnabas* (to whom the church of the Ospedale was dedicated). The main tier was supported by a double predella. The first, similar to that of Bernardo Daddi's S Pancrazio polyptych (now Florence, Accad.), shows scenes from the saints' lives in the main tier above, with the *Annunciation* in the centre; the second

shows scenes from the *Life of Christ.* The polyptych is the work of a mature painter, although it is not known with whom Giovanni trained. Vasari mistakenly thought him to have been a pupil of Taddeo Gaddi. The expressive figures are elegant but have a Giottesque monumentality and subtle colouring.

Also datable to *c.* 1363 is one of Giovanni's most important works, the polyptych (now dismembered; see fig. 1) made for the Ognissanti in Florence, where it was seen by Vasari and correctly attributed, perhaps indicating that it was originally signed. It was commissioned to replace Giotto's Ognissanti *Madonna* (Florence, Uffizi; *see* GIOTTO, fig. 6) and was more than twice its width. It showed paired standing saints: on the left, *SS Catherine and Lucy*, *SS Stephen and Lawrence* and *SS John the Baptist and Luke*, and on the right, *SS Peter and Benedict*, *SS James the Greater and Gregory* (all Florence, Uffizi) and two missing saints. In the spandrels above the saints are roundels depicting the *Creation*; the *Creation of the Animals and Birds*, for example, is aptly placed above the dove whispering into Pope Gregory the Great's ear. A cut-down fragment showing the *Coronation of the Virgin* (500×500 mm; ex-Inst. Torcuato Tella, Buenos Aires) is thought to have been part of the main central panel (Gregori). A pinnacle with *SS John, Peter and the Trinity* (Venice, priv. col.) may have been positioned above it (Boskovits). The surviving arched predella panels show female virgin saints, male martyrs, apostles, patriarchs and prophets (Florence, Uffizi). The central and right-hand predella panels are missing.

Giovanni's first signed and dated work is a panel of the *Man of Sorrows* (Florence, Accad.), inscribed 1365 and bearing the arms of the Strozzi and Rinieri families. The single panel is unusual in combining the almost full-length figures of the Virgin, Mary Magdalene and St John the Evangelist supporting the dead Christ. In the same year Giovanni was given an extension to complete frescoes already begun in the Guidalotti (now Rinuccini) Chapel in Santa Croce, Florence, showing scenes from the *Lives of the Virgin and St Mary Magdalene*. In fact, he painted only the upper two registers; the cycle was completed by Matteo di Pacino (*fl* 1360–74). Also from *c.* 1365 is the dismembered polyptych with *Christ Enthroned* (Milan, Brera), flanked by *Eleven Saints* (Turin, Gal. Sabauda) on the left; the right side is lost. The pinnacle panels, showing the *Virgin, St John the Baptist* and *Christ of the Apocalypse* (London, N.G.; see fig. 2), link with the apocalyptic texts carried by the *Christ* in the main panel. The original location is unknown, although the Pelagio Chapel in S Maria degli Angeli, Florence, has been suggested. It has also been proposed that this altarpiece may reflect the Stefaneschi Altarpiece (Rome, Pin. Vaticana), attributed to Giotto, and may date to after 1369, the final date of documentation for Giovanni da Milano, when he was working with Giottino and the sons of Taddeo Gaddi in Rome for Pope Urban V.

All of Giovanni's surviving documented works come from Tuscany. A *Virgin and Child* (Scandicci, S Bartolo in Tuto), published by Proto Pisani in 1983, may belong with a standing *St Francis* (Paris, Louvre) and *St Anthony Abbot* (cut down, Williamstown, MA, Williams Coll. Mus. A.), as well as with two *Annunciation* pinnacles (Pisa, Mus.

1. Giovanni da Milano: Ognissanti Polyptych, tempera on panel, 2.05×2.12 m, *c.* 1363 (Florence, Galleria degli Uffizi)

Giovanni da Milano was an original and accomplished painter. In his clear crisp linearity he was influenced by Simone Martini, and it has been suggested that he could have visited Avignon in the early years for which he is unaccounted. A trip to Lombardy has also been suggested. Although more refined than the Master of the Fogg Pietà, he has much in common with him, particularly in the Giottesque bulk of his figures and drapery modelling. His works, although evidently influenced by contemporary Florentine painters, are notably lacking in the profusion of decorative detail and particularly in the comparative absence of luxury textiles rendered in *sgraffito*. His forms tend to be elegant but simple, and the figures are often fashionably clothed.

BIBLIOGRAPHY

G. Vasari: *Vite* (1550, rev. 2/1568); ed. G. Milanesi (1878–85)
A. Marabottini: *Giovanni da Milano* (Florence, 1950)
M. Boskovits: 'Notes sur Giovanni da Milano', *Rev. A.*, 11 (1971), pp. 55–8
M. Gregori: 'Storia di un politicco', *Paragone*, xxiii (1972), no. 265, pp. 3–35
Giovanni da Milano (exh. cat., ed. L. Cavadini; Como, Com. Valmorea, 1980) [excellent bibliog.]
R. Proto Pisani: 'Un inedito di Giovanni da Milano: La tavola di San Bartolo in Tuto', *Boll. A.*, 6th ser., lxviii/19 (1983), pp. 49–58

DILLIAN GORDON

Giovanni da Modena [Giovanni di Pietro Falloppi] (*fl* 1409; *d* before 1455). Italian painter. He is first recorded in Bologna in 1409; the following year he was paid for the hangings for an important funeral in S Francesco, Bologna. His major surviving work is the fresco decoration of the Bolognini Chapel in S Petronio, Bologna, commissioned in Bartolomeo Bolognini's will of 1408. It is attributed to Giovanni on the basis of his later work (1420–21) in the neighbouring chapel of S Abbondio. Bolognini stipulated that there should be a *Paradise*, in which Giovanni shows rows of saints seated on benches, contemplating the Coronation of the Virgin, an *Inferno* 'as horrible as possible' and a *Journey of the Magi*. On the altar wall Giovanni, assisted by Jacopo di Paolo (who painted the altarpiece and stained glass), depicted the *Legend of St Petronius*, bishop and protector of Bologna. The fresco of the installation of a bishop (perhaps Giovanni di Michele of Bologna, *reg* 1412–17) by the anti-pope John XXIII suggests a dating of *c.* 1412–20. The *Petronius* scenes are set against details of Bologna's townscape; the embarkation and papal scenes recall illuminations of Bolognese shipping law and canon law manuscripts respectively. The hollow-cheeked faces and dark shadows probably show the influence and assistance of Jacopo di Paolo. The *Departure of Petronius* reflects Giotto's *Visitation* (Padua, Scrovegni Chapel), though this echo may be via Tomaso da Modena, another likely influence on Giovanni. Volpe has shown a similarity between the *Inferno* scene and those of the Master of the Brussels Initials. But the architectural style, the rocky gorges, the pinks and greens and the long oval faces with dreamy eyes show that Giovanni's style was above all adapted from Agnolo Gaddi's, adding an International Gothic interest in the fashionable, lavish and exotic that was probably fuelled by contact with the art of the Visconti court and with foreign visitors in Bologna. Such details as pointed Hungarian hats, baggy-brimmed

2. Giovanni da Milano: *Christ of the Apocalypse*, tempera on panel, 940×375 mm, *c.* 1365 (London, National Gallery)

N. S Matteo), and may have been painted for a Pisan church. A number of small, unusual panels have also been attributed to Giovanni: for example the *Pietà*, in which the Virgin holds the dead Christ in front of the tomb (ex-Le Roy priv. col., Paris; Paris, du Louart priv. col.).

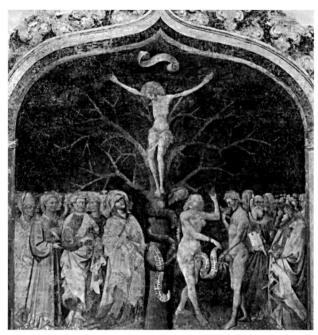

Giovanni da Modena: *Crucifixion: Mystery of the Fall and Redemption of Man* (1420–21), fresco, S Abbondio Chapel, S Petronio, Bologna

boots, extravagantly curled beards and a jester wearing bells appear alongside stewards driving flies from camels. The panels of *SS Cosmas and Damian* (Berlin, Gemäldegal.) can be closely associated with these frescoes in date and style.

The frescoes of 1420–21 in the S Abbondio Chapel in S Petronio, Bologna, show two mystic *Crucifixions*: one of Christ on a tree between Adam and Eve, prophets, the Virgin and saints (see fig.), and the other on a cross, the arms of which crown a personification of the Church on one side and stab a personification of the Synagogue on the other (an anti-Semitism aimed at locally established Jewish colonies). The *Crucifixions* are set in foliate Venetian arches above an illusionistic colonnade framing shields of the aldermen of Bologna. In these scenes Giovanni's style becomes broader and more angular. The intensified drama is particularly evident in the faces of the Virgin and St John in a Crucifix of the same period from S Francesco, Bologna (Bologna, Pin. N.), in which Christ's face is hidden by a striking frontal foreshortening. A slightly later work, the *Stigmatization of St Francis with Three Saints* (Florence, Fond. Longhi) again shows Giovanni's fashion-consciousness. Several frescoes in the aisles of S Petronio, Bologna, and frescoes of the *Madonna* in S Giovanni al Monte and S Maria dei Servi, Bologna, belong to the 1420s to 1430s, while a dismembered polyptych (Bologna, Compagnia Lombardi; Ferrara, Pin. N.) shows the much bolder, coarser style of the 1440s.

Giovanni is last recorded painting a canvas of S Bernardino of Siena, commissioned in 1451 (Bologna, Pin. N.), and the decorations of the Cappella di S Bernardino in S Francesco, Bologna, dated 1455–6. The scenes of the saint's life are shown in perspective niches around the central image of S Bernardino, whose wizened features suit Giovanni's angular style ideally.

BIBLIOGRAPHY

R. Longhi: *Officina ferrarese* (Rome, 1934, rev. 3/1975)
S. Bottari: *La pittura in Emilia nella prima meta del '400*, ed. C. Volpe (Bologna, 1958)
L. Castelfranchi Vegas: *International Gothic Art in Italy* (London, 1968)
F. Filippini and G. Zucchini: *Miniatori e pittori a Bologna: Documenti del secolo XV* (Rome, 1968)
R. Longhi: *Lavori in Valpadana* (Florence, 1973)
S. Padovani: 'Materiale per la storia della pittura ferrarese nel primo quattrocento', *Ant. Viva*, xiii (1974), pp. 3–21 (3–5)
C. Volpe: 'La pittura gotica: Da Lippo di Dalmasio a Giovanni da Modena', *La basilica de S Petronio* (Bologna, 1983), pp. 213–94
P. Montiani Bensi and M. R. Montiani Bensi: 'L'iconografia della *Croce vivente* in ambito emiliano e ferrarese', *Mus. Ferrar.: Boll. Annu.*, 13–14 (1985), pp. 161–82
R. D'Amico and R. Grandi, eds: *Il cantiere di San Petronio* (Bologna, 1987)
Il tempo di Nicolò III: Gli affreschi del Castello di Vignola e la pittura tardogotica nei domini estensi (exh. cat., ed. D. Benati; Vignola, Rocca, 1988)

ROBERT GIBBS

Giovanni da Monte Cassino (*fl* 1278–82). Italian illuminator. The treasury documents of Charles I, King of Naples and Sicily (*reg* 1266–85), record that when the German illuminator Minardus was not available, the King had directed that the monk Giovanni da Monte Cassino should be his substitute. Giovanni thus illuminated a translation into Latin of Rhazes's medical encyclopedia *al-Hāwī* (Paris, Bib. N., MS. lat. 6912). In August 1282 Johannes de Nigellis, royal physician and librarian, paid him two and a half ounces of gold for two and a half months of work ('faciendis ymaginibus') on this mammoth treatise and perhaps also on another text. Giovanni, not recorded at the abbey of Monte Cassino itself, worked from the palace of the archbishop of Naples. His small compositions set within initials are explicative, with gesticulating figures on gold grounds, framed by stiff acanthus ornaments or tendrils. His work suggests roots in the scriptoria of the Latin Kingdom of Jerusalem but recast to reflect the French-influenced illumination favoured at the Angevin court. Most remarkable are the three miniatures on folio 1 depicting the Prince of Tunis giving the Arabic text to Angevin envoys, the presentation to Charles I, and the King commissioning the translation from Farag Moyse of the School of Salerno. Attributed to Giovanni is the illustration, with simplified compositions, of another copy of the same treatise entitled in Latin *Liber continens* (Rome, Vatican, Bib. Apostolica, MSS lat. 2398–9).

BIBLIOGRAPHY

P. Durrieu: 'Un Portrait de Charles I d'Anjou roi de Sicile, frère de Saint Louis, peint à Naples par le miniaturiste Jean, moine de Mont-Cassin, dans un manuscrit aujourd'hui à la Bibliothèque nationale de Paris', *Gaz. Archéol.*, xi (1886), pp. 192–201
C. C. Coulter: 'The Library of the Angevin Kings at Naples', *Trans. & Proc. Amer. Philol. Assoc.*, lxxv (1944), pp. 141–55
G. Léonard: *Les Angevins de Naples* (Paris, 1954)
A. Daneu Lattanzi: 'Una "bella copia" di al-Hawi tradotto dall'arabo di Farag Moyse per Carlo I d'Angio (MS. Vat. Lat. 2398–2399)', *Miscellanea di Studi in memoria di Anna Saitta Revignas* (Florence, 1988), pp. 149–69

PATRICK M. DE WINTER

Giovanni da Napoli. *See* MARIGLIANO, GIOVANNI.

Giovanni da Nola. *See* MARIGLIANO, GIOVANNI.

Giovanni (di Giuliano) da Oriolo (*b* Oriolo, nr Faenza; *d* Faenza, before 24 Sept 1474). Italian painter. His oeuvre is known through one painting, the signed profile portrait of *Lionello d'Este* (London, N.G.). Stylistically similar to Pisanello's *Portrait of Lionello d'Este* (*c.* 1441; Bergamo, Gal. Accad. Carrara), Giovanni's painting probably dates to the same period or slightly later. There is a payment to 'Magistro Johanni de Faventia' dated 21 June 1447, which may refer to the portrait. He returned to Faenza in 1449 and soon after was commissioned to paint portraits of Astorgio II Manfredi's two daughters, Elisabetta and Barbara (untraced). He is recorded as court painter in Faenza and is described as 'pictor publicus' and 'magister' in 1461. In 1452 'Marcius' is given as his second name; later the family name Savoretti appears. He is said to be dead in a document of 24 September 1474. Giovanni di Giuliano da Oriolo should not be confused with his compatriot Giovanni (di Andrea) da Riolo (*fl* 1433), nor with Giovanni Pietro da Oriolo, who painted in Asolo.

BIBLIOGRAPHY
G. Ludwig: 'Archivalische Beiträge zur Geschichte der venezianischen Malerei', *Jb. Kön.-Preuss. Kstsamml.*, xxvi (1905), p. 157 [suppl.]
G. Ballardini: *Giovanni da Oriolo pittore faentino del '400* (Florence, 1911)
R. Buscaroli: *La pittura romagnola del quattrocento* (Faenza, 1931), pp. 61, 71–5, 255
A. Venturi: *Storia* (1901–40), VII/i, p. 268
M. Davies: *The Earlier Italian Schools*, London, N.G. cat. (London, 1951, 2/1961/R 1986)

KRISTEN LIPPINCOTT

Giovanni (di Pietro) da Pisa (i) (*fl* 1401–23). Italian painter. He is first documented in 1401 in Genoa, where he became Deputy of the Painters' Guild in 1415. Two signed works by him are extant: a triptych depicting the *Virgin and Child with SS John the Baptist and Anthony Abbot* (1423; San Simeon, CA, Hearst Found.) and a polyptych depicting the *Virgin and Child with Four Saints* (Barcelona, Mus. A. Catalunya). Whereas the former shows close contacts with the art of the many Pisan painters (e.g. Turino di Vanni) present in Genoa between 1410 and 1420, the latter shows a stronger influence of Taddeo di Bartolo, active in Liguria between 1393 and 1398, and is probably therefore the earlier work. Close to the Barcelona *Virgin and Child*, but considered slightly earlier, is a polyptych partially reconstructed by Algeri from dispersed panels (e.g. Genoa, S Fede; Pavia, Pin. Malaspina). Giovanni's first known work has been identified as the polyptych fragment depicting *Four Saints* (Portoria, nr Genoa, convent of the Annunziata), where the Pisan influences of his formative years blend with Ligurian elements derived from Barnaba da Modena and Taddeo. Algeri proposed the attribution to Giovanni of the polyptych depicting *St Lawrence with Four Saints* (Moneglia, S. Giorgio) because of its similarities with the Portoria panel.

BIBLIOGRAPHY
F. R. Pesenti: 'Un apporto emiliano e la situazione figurativa locale', *La pittura a Genova e in Liguria dagli inizi al cinquecento*, i (Genoa, 1970, rev. 1987), pp. 65–6, 70
M. Migliorini: 'Persistenze pisano–senesi nella pittura genovese del primo quattrocento: Un inedito di Giovanni di Pietro da Pisa', *Stud. Stor. A.*, ii (1978–9), pp. 97–103
E. Rossetti Brezzi: 'Nuove indicazioni sulla pittura ligure–piemontese tra '300 e '400', *Ric. Stor. A.*, ix (1978–9), pp. 13–24
M. Natale: 'Pittura in Liguria nel quattrocento', *La pittura in Italia: Il quattrocento*, ed. F. Zeri, i (Milan, 1987), pp. 15–20 (15–16)

G. Algeri: 'Nuove proposte per Giovanni da Pisa', *Boll. A.*, xlvii (1988), pp. 35–48

VITTORIO NATALE

Giovanni da Pisa (ii) [Giovanni di Francesco] (*fl* 1444; *d* ?Venice, *c.* 1460). Italian sculptor. In a document of February 1447 he is named as a member of Donatello's Paduan workshop, where he apparently worked between 1444 and 1449, engaged on the high altar in Il Santo together with Donatello's other assistants, Niccolò Pizzolo, Urbano da Cortona, Antonio Chellini (*fl* 1446; *d* after 1464) and Francesco del Valente (*fl* 1447). Though his role is not specified, Giovanni probably assisted in the modelling and casting of the bronzes and later may also have assisted on Donatello's pulpits in S Lorenzo, Florence. On 8 July 1447 Giovanni was paid for work on the terracotta altar in the Ovetari Chapel of the church of the Eremitani, Padua. Although Michiel attributed the altarpiece to Giovanni, the design and execution are evidently the work of Pizzolo, from whom the altarpiece was commissioned, and Giovanni's role was minor. Puppi suggested that he made a small-scale model of the altarpiece. Also attributed to Giovanni, probably erroneously, are three reliefs of the *Virgin and Child* (Padua, Eremitani, Ovetari Chapel, included in terracotta altar; Padua, S Giustina; Venice, S Maria Mater Domini), all of which are indebted to Donatello.

BIBLIOGRAPHY
Thieme–Becker
M. A. Michiel: *Notizia d'opera del disegno* (MS. before 1552); ed. T. Frimmel as *Der anonimo morelliano* (Vienna, 1888), p. 26
A. Venturi: *Storia* (1901–40), vi, pp. 332, 448–50
A. Cotton and R. Walker: 'Minor Arts of the Renaissance in the Museo Cristiano', *A. Bull.*, xvii (1935), pp. 118–62
L. Puppi: *La chiesa degli Eremitani a Padova*, ii (Vicenza, 1970), pp. 79–80
Da Giotto a Mantegna (exh. cat., ed. L. Grossato; Padua, Pal. Ragione, 1974), no. 96

STEVEN BULE

Giovanni d'Arbosio. *See* JEAN D'ARBOIS.

Giovanni da Rimini (*fl* 1292–1336). Italian painter. Legal documents mention a Giovanni 'painter', then 'master', living in Rimini between 1292 and 1336. It is likely that they refer to the artist identified on the basis of the *Crucifix* (3.0×2.3 m; Mercatello, S Francesco), inscribed JOHES PICTOR FECIT HOC OPUS/FR. TOBALDI and dated 1309 or 1314 (Volpe); the earlier date is largely accepted today.

Like most 14th-century Riminese crosses, including three others attributed to the same artist, the Mercatello *Crucifix* is derived from that attributed to Giotto in S Francesco, Rimini. Nevertheless, the more elongated proportions, the more schematic anatomical description of the Mercatello Christ and the slightly archaic decorative background betray Giovanni's 13th-century roots. His style is still characterized by the aristocratic aloofness and rich chromatic range of the Italo-Byzantine tradition.

Two small paintings are generally accepted as Giovanni's earliest work. The *Virgin and Child with Five Saints* (Faenza, Pin. Com.) is probably the surviving half of a diptych; the simple, two-tier structure, present in many provincial productions, and the evenly spaced, remote figures of the lower register emphasize the close embrace of Virgin and Child above. The Child presses his upturned

face against the Virgin's, grasping her thumb with one hand and gently touching her cheek with the other. The formality of his gold-striated tunic contrasts with the tenderness of his pose. The second work, a divided diptych (Rome, Pal. Barberini, and Alnwick Castle, Northumb.), shares with the *Virgin and Child* a jewel-like finish and refined palette. Following the tradition of the Romanesque panels of Umbria and the Marches, like many other Riminese Trecento panels, the diptych is divided into numerous small scenes. The miniaturistic style and unusual iconography, such as the two-register *Coronation of the Virgin* and the *Sermon of St Catherine*, are typical of the artist.

The severely damaged frescoes of the *Life of the Virgin*, *Augustinian Saints* and *Two Female Donors* in the Campanile Chapel of S Agostino, Rimini, although not documented, are generally attributed to Giovanni. They form one of the earliest large-scale productions of the school of Rimini, datable within the first decade of the 14th century. The *Presentation in the Temple* illustrates the widely spaced, tranquil designs favoured by the artist: four grave, noble figures echo the impossibly slender columns of the architecture. The fresco is strongly reminiscent of Giotto's *Marriage of the Virgin* in the Arena Chapel, Padua, but the main inspiration is late Classical art, perhaps absorbed through the work of Giotto. The total iconographic correspondence between some of the S Agostino scenes and the equivalent scenes in the Lower Church, S Francesco, Assisi, reinforces the possibility of a common Giottesque prototype.

Giovanni da Rimini was once confused with GIOVANNI BARONZIO, but his oeuvre was identified and reconstructed with increasing critical acclaim after the first exhibition of Riminese painting in 1935. The formation of the Riminese school in the 14th century was not the result of one particular personality, but its beginnings were shaped and defined by Giovanni, the most accomplished of the early local masters.

BIBLIOGRAPHY
La pittura riminese del trecento (exh. cat. by C. Brandi, Rimini, Mus. Com., 1935)
C. Brandi: 'Giovanni da Rimini e Giovanni Baronzio', *Crit. A.*, ii (1937), pp. 193–9
M. Bonicatti: *Trecentisti riminesi* (Rome, 1962)
C. Volpe: *La pittura riminese del trecento* (Milan, 1965)
Restauri nelle Marche (exh. cat., ed. R. Trinci; Urbino, Pal. Ducale, 1973), i, pp. 534–7

DOINA LITTLE

Giovanni da San Giovanni [Giovanni Mannozzi] (*b* San Giovanni Valdarno, 20 March 1592; *d* Florence, 6 Dec 1636). Italian painter and draughtsman. He was the most distinguished of the artists working in fresco in 17th-century Florence. An eccentric personality, he was attracted by the charm and informality of northern art and by a satirical approach to Classical themes. He went to Florence in 1608 to study in the workshop of Matteo Rosselli, where he learnt both fresco and oil painting techniques and drew extensively (Baldinucci). In 1615 he painted two ceiling canvases of *Putti Supporting the Impresa of Michelangelo* for a room in the Casa Buonarroti and in the same period frescoed the dome of the church of the Ognissanti, Florence (completed 1615), with a choir of musician angels. He also painted five lunettes showing scenes from the *Life of St Francis* in the cloister (completed 1619; *in situ*). In 1616 his frescoed decoration of an *Allegory of Florence* (destr.; preparatory drawing, Florence, Uffizi, G.D.S. U. 1122F) on the façade of Cosimo II de' Medici's house in Piazza della Calza won him unexpected and lasting fame. His early works also included several tabernacles, made for patrons in the town and in the surrounding countryside. The *Virgin and Child with Saints* (1616; Florence, Via Faenza) and the delle Stinche Tabernacle, a *Gentleman Distributing Alms among Prisoners* (*c.* 1616; Florence, Via Ghibellina), survive.

From 1619 to 1620 Giovanni worked on the decoration of the façade of the Palazzo dell' Antella, Florence, where with Giulio Parigi he directed a team of painters that also included Filippo Tarchiani, Filippo Napoletano, Domenico Passignano and Ottavio Vannini. Giovanni executed a watercolour (Florence, Uffizi, n. 1088E; *see* FAÇADE DECORATION, fig. 1) showing the entire plan of the decoration. On this façade, at the request of the patron, Donato dell'Antella, he copied Caravaggio's *Sleeping Cupid* (dated 1608; Florence, Pitti), at that time in the possession of the dell'Antella family. Also in 1619 he painted the *Martyrdom of St Blaise* for S Biagio, Montepulciano (now Montepulciano, S Agnese), and in 1620 the Caravaggesque *Beheading of St John the Baptist* (San Giovanni Valdarno, S Maria delle Grazie). In 1621, for the Brancadoro family, he also decorated the exquisite little chapel of their palazzo, now the Palazzo Mainoni-Guicciardini at Vico di Val d'Elsa, with episodes from the *Life of the Virgin* (see Banti, pls 23–9). These small scenes, in light and delicate colours, are set in lyrical, pastoral landscapes enriched with ruins and small Classical temples, close in style to the Roman landscapes of Agostino Tassi, Pietro Paolo Bonzi and Filippo Napoletano. In the same period Giovanni frescoed the little chapel at the convent of the Crocetta, Florence, with an unusual *Rest on the Flight into Egypt* (*c.* 1621; reconstructed Florence, Accad. B.A. & Liceo A.), which shows Mary and Joseph dismounting from their donkey at an inn and tenderly conveys the charms of rustic life. Moonlit landscapes in the scenes from the *Life of St Paul* (*c.* 1621; Volterra Cathedral, Inghirami Chapel) suggest a response to the new vision of Adam Elsheimer. His rare easel pictures explore unusual themes, such as the *Wedding Night* (*c.* 1620; Florence, Pitti) and *Venus Combing Cupid's Hair for Fleas* (Florence, Pitti). In *c.* 1621 Giovanni went to Rome with his pupil Benedetto Piccioli and with Francesco Furini, with whom he at first lived in severely reduced circumstances. In 1623 the Florentine Cardinal Giovan Garzia Mellini commissioned him to decorate the apse of SS Quattro Coronati, Rome, with a *Glory of Saints*. The patronage of Cardinal Guido Bentivoglio and Marchese Enzo Bentivoglio ensured his introduction to the most cultivated Roman circles, and for such patrons he explored curious subjects, such as the *Parish Priest Arlotto Playing a Practical Joke on some Huntsmen* (Kedleston Hall, Derbys) and the *Marriage Contract* (*c.* 1627; Rome, Pal. Barberini), both influenced by northern artists and by the Bamboccianti. His love of the bizarre and the fanciful found expression in the decoration he painted in the Palazzo Bentivoglio (1623–7; renamed Pal. Rospigliosi-Pallavicini; *in situ*). Here, in contrast to the ideal beauty of

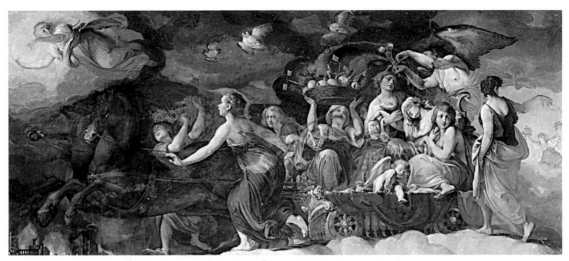

Giovanni da San Giovanni: *Chariot of the Night* (1623), fresco, Palazzo Rospigliosi–Pallavicini, Rome

Guido Reni's *Aurora* (1614), he painted his playful *Chariot of the Night* (1623; see fig.) with sleepy figures and macabre nocturnal creatures, such as bats and owls. In 1627 he decorated three rooms on the ground floor with more gracefully classical friezes showing the rapes of *Europa*, *Amphitrite* and *Proserpina*, and a ceiling fresco, *Perseus Holding the Head of Medusa*. On the *piano nobile* he painted another ceiling fresco showing the *Death of Cleopatra*. In 1628 he moved to the Bentivoglio's Emilian territories at Gualtieri, where, together with Ippolito Provenzale (*d* 1664), he frescoed two large scenes from the history of the Bentivoglio family in the Palazzo Bentivoglio, now the Palazzo Comunale (*in situ*).

By the time of his return to Florence in 1628, Giovanni had become Tuscany's leading fresco decorator. In 1629 he painted large frescoes of scenes from the lives of saints in the abbeys at Settimo (Florence) and Fiesolana (*in situ*). These were followed by 14 lunettes of significant miracles in the Basilica della Madonna della Fontenueva at Monsummano (Pistoia). In *c*. 1630 he decorated the courtyard of the Villa del Pozzino at Castello for Giovan Francesco Grazzini with stories taken from a popular version of Apuleius' *Metamorphoses, or the Golden Ass* (destr.). He accompanied these light-hearted, often licentious, rustic scenes, fitting for a country villa, with verses 'composed after great study, in a low comic vein' (Baldinucci). These were evidently not his only verses, for a book of satiric rhymes, mocking the artists of his day, was burnt by the artist's wife after his death. His ceiling fresco *Stillness Pacifying the Winds* (1632; Florence, Villa La Quiete; see Banti, pl. 83) again renders a mythological theme with sophisticated irony. In his mature period he accentuated the dazzling whites of his oils and frescoes, as in the *Mystic Marriage of St Catherine* (1634; Florence, Pitti) and the fresco *Venus Crying for Cupid* (1634; Florence, Pal. Amerighi). Around this time, with such works as *La Pittura* (*c*. 1634; Florence, Pitti), Giovanni rediscovered the technique of fresco painting on small reed mats or on tiles.

In 1635, assisted by Baldassare Franceschini (with whom he had worked on a fresco in S Felice, Parigi), Giovanni started the decoration of the *salone* at the Palazzo Pitti, and before his premature death he had completed three mocking and gently satirical wall frescoes—*Time and Muhammad Destroy the Heritage of the Ancient World*, the *Destruction of Mt Parnassus* and the *Inhabitants of Parnassus Guided to Tuscany*—and the ceiling fresco, the *Union of the Medici and della Rovere Families*. The frescoes, painted to celebrate the wedding of the Grand Duke Ferdinand II and Vittoria della Rovere, suggest that the brilliance of the age of Lorenzo the Magnificent, when Classical culture was reborn in Tuscany, would return with the marriage of the new Grand Duke, a ruler dedicated to peace.

BIBLIOGRAPHY

F. Baldinucci: *Notizie* (1681–1728); ed. F. Ranalli (1845–7), iv, pp. 191–278

O. H. Giglioli: *Giovanni de San Giovanni (Giovanni Mannozzi), 1592–1636: Studi e ricerche* (Florence, 1949)

G. Briganti: 'Appunti su Giovanni da San Giovanni', *Paragone*, i/7 (1950), pp. 52–7

F. Zeri: 'Giovanni da San Giovanni: *La notte*', *Paragone*, iii/31 (1952), pp. 42–7

G. Briganti: 'La burla del Pievano Arlotto di Giovanni da San Giovanni', *Paragone*, iv/34 (1953), pp. 46–8

M. Gregori: 'Arte fiorentina tra "maniera" e "barocco"', *Paragone*, xv/169 (1964), pp. 11–23

A. Barsanti: 'Una vita inedita di Francesco Furini', *Paragone*, ccxci/25 (1974), pp. 79–99

E. Borea: 'Nota sui capricci di Giovanni da San Giovanni agli Uffizi', *Prospettiva*, 4 (1976), pp. 35–8

M. Campbell: 'The Original Program of the Salone di Giovanni da San Giovanni', *Ant. Viva*, iv (1976), pp. 3–25

A. Banti: *Giovanni da San Giovanni pittore della contraddizione* (Florence, 1977) [incl. cat. rais. by M. P. Mannini]

Giovanni da San Giovanni (1592–1636) (exh. cat. by M. P. Mannini and C. d'Afflitto, Sesto Fiorentino, Vico d'Elsa, 1978)

M. P. Mannini: 'Alcune lettere inedite e un cicco pittorico di Giovanni da San Giovanni', *Rev. A.*, ii (1986), pp. 191–216

MARIA PIA MANNINI

Giovanni da Verona, Fra (*b* ?Verona; *fl* 1476; *d* ?Verona, 1525–6). Italian intarsia artist. He entered the Olivetan Order at Monte Oliveto Maggiore near Siena in 1476, and after ordination (1477–9) he was sent to the monastery of

S Giorgio, Ferrara, where he learnt the art of wood inlay from Fra Sebastiano da Rovigno, called 'Schiavone'. Giovanni then worked as a wood-carver in Perugia (1480–84). The first large project of which substantial traces survive is the choir of S Maria in Organo, Verona, where he decorated the lectern, candelabrum and choir-stalls with architectural motifs, still-lifes, figures of saints and a *Crucifixion* (1494–9). In this work he can already be seen moving away from the Venetian and Ferrarese intarsia tradition in which he was trained towards solutions that are softer and more classical in line. Between 1502 and 1504 he worked on the great choir complex at Monte Oliveto Maggiore (now divided between the abbey church and Siena Cathedral), the intarsia panels of which, featuring birds, fountains, diverse objects and views of Siena, represent the high point of his creativity and skill.

Between 1506 and 1510 Giovanni divided his time between Naples and Fondi. He produced intarsia work for the choir of S Anna dei Lombardi, Naples, where he showed a keen interest in architectural motifs. One of the choir-stalls exhibits a view of Donato Bramante's Tempietto (1502) at S Pietro in Montorio, Rome. He also produced the seat backs (*c.* 1513) for the Stanza della Segnatura in the Vatican Palace, and the communicating door between it and the Stanza di Eliodoro. Except for the door (heavily rest.), his work was removed in the mid-16th century by Pope Paul III. Giovanni's intarsia work in the choir of S Maria fuori Porta Tifi, Siena, later dismantled and partly transferred to Monte Oliveto, shows that he adopted the expressive language of Roman classicist painters. His last work was on the wardrobes (1519) in the sacristy of S Maria in Organo, Verona, and the choir-stalls (1523) of Villanova del Sillaro Abbey, near Milan (now in Lodi Cathedral).

BIBLIOGRAPHY

Thieme–Becker

P. Lugano: 'Di fra Giovanni da Verona, maestro di intaglio e di tarsia e della sua scuola', *Bull. Sen. Stor. Patria*, xii (1905), pp. 147–61

M. Ferretti: 'I maestri della prospettiva', *Situazioni momenti indagini: Forme e modelli*, ed. F. Zeri, Storia dell'arte Italiana, 11 (Turin, 1982)

MARCO CARMINATI

Giovanni del Biondo (*fl* 1356–99). Italian painter. In 1356 he was granted Florentine citizenship as 'Iohannes Biondi de Casentino pictor'. Tax records show that he was resident in Florence from 1359 until his death, when his relatives assumed responsibility for his tax liabilities. The early sources, including Ghiberti and Vasari, do not mention him at all, despite the fact that he seems to have been extremely prolific, as a large number of his works survive. Only two of these are signed and dated: a small panel of the *Virgin and Child* (1377; Siena, Pin. N.), and the altarpiece (1392) for S Francesco Figline Valdarno. He was paid for this work in 1391, and the central panel with the *Virgin and Child* survives. A 17th-century source records another altarpiece (untraced) painted for S Sofia in Castelfiorentino, which bore the artist's name and the date 1360. His style is sufficiently distinctive, however, for a significant number of works to be ascribed to him with confidence. Since several of these are dated, his development can be followed fairly closely.

His early career, and possibly his apprenticeship, began in the workshop of Andrea and Nardo di Cione. He assisted the latter in the frescoed decoration of the Strozzi Chapel in S Maria Novella, Florence, and his hand is generally recognized in the *Four Latin Doctors of the Church* on the entrance arch and in the Dominican allegories in the vault. It was, however, the more severe, hieratic style of Andrea di Cione, known as Orcagna, that particularly influenced Giovanni's early independent works. His triptych showing the *Presentation in the Temple* flanked by panels with *St John the Baptist* and *St Benedict* (1364; Florence, Accad. Dis.) is distinguished by the same emphatic linearity, dramatic chiaroscuro in the male faces, striking colour juxtapositions and delight in ornament as in Andrea di Cione's Strozzi Altarpiece (1357; Florence, S Maria Novella).

In the *Virgin with Saints* (1372; Florence, Santa Croce), and the *Coronation of the Virgin* (1373; Fiesole, Mus. Bandini; see fig.), the severity gives way to a less sombre mood achieved by a more earthy characterization of the saints, a lighter palette and an increased interest in surface decoration. This is expressed both in the material richness of brocaded gowns, cloths of honour and sumptuous book covers, and in the stylization of details such as facial lines and hands to form decorative patterns. These paintings also display the facial types that make Giovanni's work readily recognizable; the young male and female saints, particularly the Virgin, have pale, broad faces, their cheeks tinged with pink, while the older saints are given more varied features, with jutting jaws that sometimes make them appear like caricatures of rustics.

Giovanni was primarily a panel painter; his style changed little in his later career, although he seems to have

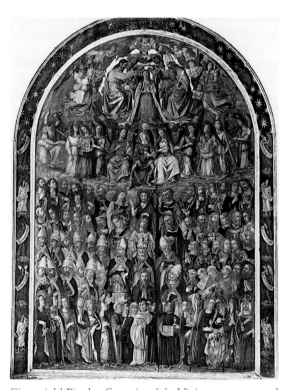

Giovanni del Biondo: *Coronation of the Virgin*, tempera on panel, 1373 (Fiesole, Museo Bandini)

employed assistants to help with his numerous commissions. His Rinuccini Altarpiece (1379; Florence, Santa Croce) and the altarpiece for the Cavalcanti Chapel in S Maria Novella (Florence, Accad. Dis.) betray several hands of varying proficiency. The diminution in quality in some of the later works has led to a general depreciation of Giovanni as a painter, but his achievements as a colourist alone place him among the more enterprising painters of the second half of the 14th century.

BIBLIOGRAPHY

R. Offner: 'A Ray of Light on Giovanni del Biondo and Niccolò di Tommaso', *Mitt. Ksthist. Inst. Florenz*, vii (1956), pp. 173–82

R. Offner and K. Steinweg: *Corpus*, IV/iv (1967); IV/v (1969)

M. Boskovits: *La pittura fiorentina alla vigilia del rinascimento, 1370–1400* (Florence, 1975)

BRENDAN CASSIDY

Giovanni dell'Opera. *See* BANDINI, GIOVANNI.

Giovanni di Balduccio [Giovanni Balducci] (*b* ?Pisa; *fl* 1317/18–49). Italian sculptor. He is first documented in 1317/18 in the cathedral workshop in Pisa, where he was being paid a modest daily wage. In 1349 he was asked, while living in Milan, to take charge of the cathedral works in Pisa, but he was still resident in Milan towards the end of 1349, and he may have died there soon afterwards. His style is known from four signed works, which have formed the basis for a reconstruction of his oeuvre: the tomb of *Guarniero degli Antelminelli* (*c*. 1327–8) in S Francesco, Sarzana; the pulpit in S Maria del Prato in San Casciano, near Florence; the shrine of St Peter Martyr (dated 1339) in S Eustorgio, Milan; and the architrave (1347) from the main portal of S Maria di Brera, Milan (fragments in Milan, Castello Sforzesco). Giovanni developed a distinctive, slightly mannered modelling style based on that of Giovanni Pisano, but he made no attempt to adopt the latter's powerful plasticity and dramatic expressiveness. Through his work in Milan, he introduced into Lombardy the formal vocabulary of Tuscan Gothic sculpture, of the kind that had been developed by Nicola and Giovanni Pisano and by such Sienese sculptors of the early 14th century as Gano di Fazio and Tino di Camaino.

Although it is probable that Giovanni di Balduccio was apprenticed in Giovanni Pisano's workshop, it cannot be proven that he was involved in the execution of the pulpit in Pisa Cathedral. The earliest sculptures attributed to him comprise some of the monumental heads on the exterior of the Camposanto near the Piazza del Duomo in Pisa (Tolaini, 1956), two supporting figures there (Carli, 1943) and two near life-size marble statues of the *Annunciation* in S Michele, Coreglia Antelminelli (Ragghianti, 1960); there are no grounds for the attempt to identify these statues as works of Lupo di Francesco (Burresi, 1982 exh. cat.).

The signed wall tomb of *Guarniero degli Antelminelli* in S Francesco, Sarzana, comprises a sarcophagus supported on consoles, a death chamber surmounted by a tabernacle and a baldacchino covering the whole, following Sienese models. The statue of the *Virgin and Child* in the tabernacle is a copy; the original (Philadelphia, PA, Mus. A.) was purloined in 1916. The tomb was probably executed in 1327–8: the child died in 1327, not in 1322 as first supposed by Targioni Tozzetti in 1768 (Seghieri, 1983

exh. cat.), and the coat of arms on the tomb incorporating the lozenges of the Wittelsbach family was granted to the child's father, Castruccio Castracane, in 1327 by Emperor Ludwig when he made him Duca di Lucca. The pose of the angels holding a curtain in the death chamber corresponds to that of two surviving angels from a tomb in Genoa (Genoa, Mus. Com.), which was probably made by Giovanni di Balduccio *c.* 1325 (Tolaini, 1958; Seidel, 1975).

About 1329 Giovanni di Balduccio executed a seated *Virgin and Child* for S Maria della Spina, Pisa (Carli, 1943), and capitals with human heads for the large cloister at the Dominican convent of S Caterina in Pisa (Seidel, 1979), two of which survive (Pisa, Mus. Opera Duomo; Frankfurt am Main, Liebieghaus). The tomb set in the entrance wall of the Cappella Baroncelli (begun 1328) in Santa Croce, Florence, comprises a sarcophagus under a baldacchino in an opening covered by a grille, so that it can be viewed from two sides. The sides of the sarcophagus are by an unknown sculptor who worked in the manner of a goldsmith, but the marble sculptures above are probably the work of Giovanni di Balduccio and an assistant and date from *c.* 1330–31. During the following years, Giovanni continued to practise in and near Florence; he was responsible for a cycle of reliefs with the *Apostles* and *Virtues* for Orsanmichele (two of these, Washington, DC, N.G.A.; Florence, Bargello), which stem from a tabernacle of the miraculous picture that existed before that of Orcagna and was made by Giovanni di Balduccio in 1333/4; the signed pulpit in S Maria del Prato in San Casciano, a church that was then dependent on the Florentine Dominicans, and finally the two statues of the *Annunciation* at the entrance to the Cappella Baroncelli (Valentiner, 1935).

Giovanni di Balduccio may have been summoned to Milan in 1334 by Azzo Visconti to make a tomb for a member of his family; a few fragments of the tomb from S Tecla have been preserved in the Castello Sforzesco (Baroni, 1944; Cipriani, Dell'Aqua and Russoli, 1963; Carli, 1989). From 1335 Giovanni was working with assistants on the free-standing shrine of St Peter Martyr in the Dominican church of S Eustorgio, Milan, which is signed and dated 1339. As in Nicola Pisano's Arca di S Domenico (1264–7) in Bologna, the sarcophagus is supported by caryatid figures (probably executed by Giovanni di Balduccio himself) and surmounted by a tabernacle. The compositions of the sarcophagus reliefs are noticeably old-fashioned; they are obviously based on those of the reliefs on the Arca di S Domenico, probably on the patrons' instructions (Baroni, 1944; Cipriani, Dell'Aqua and Russoli, 1963). The sculptor must have made a marble polyptych in Bologna around 1331 for the church in Rocca near the Porta di Galliera. Five reliefs and statues have survived from this (Bologna, Mus. S Stefano; Bologna, Mus. Civ. Med.; priv. col.; Faenza, Pin. Com.; Marseille, Mus. Grobet-Labadié); the polyptych had been brought to S Domenico during the 14th century. The tomb of *Azzo Visconti* (*d* 1339) in S Gottardo in Corte, Milan, is probably only a workshop piece. The sculptures on the Porta Ticinese and the Porta Orientale and the signed and dated architrave (1347) on the main door of S Maria di

Brera (Baroni, 1944) mark stages in the deterioration of Giovanni's artistic powers in the 1440s.

BIBLIOGRAPHY

T. Tozzetti: *Relazione di alcuni viaggi in Toscana*, xii (Florence, 1768)

W. R. Valentiner: 'Observations on Sienese and Pisan Trecento Sculpture', *A. Bull.*, ix (1927), pp. 177–220 (214–20)

F. Filippini: 'L'antico altare maggiore in San Domenico attribuito a Giovanni Pisano', *Bologna*, xiii/4 (1935), pp. 19–23

W. R. Valentiner: 'Giovanni Balduci a Firenze e una scultura di Maso', *L'Arte*, vi (1935), pp. 3–29

C. Ragghianti: 'Aggiunta a Giovanni di Balduccio', *Crit. A.*, v/23 (1940), p. xiv

E. Carli: 'Sculture pisane di Giovanni di Balduccio', *Emporium*, xcvii (1943), pp. 143–54

C. Baroni: *Scultura gotica lombarda* (Milan, 1944), pp. 63–93

C. Gnudi: 'Un altro frammento dell'altare bolognese di Giovanni di Balduccio', *Belli A.*, i (1947), pp. 165–81

W. R. Valentiner: 'Notes on Giovanni Balducci and Trecento Sculpture in Northern Italy', *A. Q.*, x (1947), pp. 40–60

E. Tolaini: 'Alcune sculture della facciata del Camposanto di Pisa', *Crit. A.*, n.s. 3, iii/18 (1956), pp. 546–54

——: 'La prima attività di Giovanni di Balduccio', *Crit. A.*, n.s. 3, v/27 (1958), pp. 188–202

C. Ragghianti: 'Arte a Lucca: Spicilegio', *Crit. A.*, n.s. 3, vii/37 (1960), pp. 61–3

R. Cipriani, G. A. Dell'Aqua and F. Russoli: *La Cappella Portinari in Sant'Eustorgio a Milano* (Milan, 1963)

M. Seidel: 'Studien zu Giovanni di Balduccio und Tino di Camaino', *Städel-Jb.*, v (1975), pp. 37–84

——: 'Die Skulpturen des Giovanni di Balduccio aus S Caterina in Pisa', *Städel-Jb.*, vii (1979), pp. 13–32

Castruccio Castracani degli Antelminelli in Lunigiana (exh. cat., ed. F. Bonatti and M. Luzzati; Sarzana, Palazzo Berghini and S Francesco, 1981), pp. 71–80

R. Grandi: *I monumenti dei dottori e la scultura a Bologna (1267–1348)* (Casalecchio di Reno, 1982), pp. 141–3

Il secolo di Castruccio: Fonti e documenti di storia lucchese (exh. cat., ed. C. Baracchini; Lucca, S Cristoforo, 1983), pp. 13–20, 168–73 [incl. entries by M. Seghieri and M. Burresi]

E. Carli: 'Giovanni di Balduccio a Milano', *Mill. Ambros.*, iii (1989)

G. KREYTENBERG

Giovanni di Benedetto da Como (*fl c.* 1378). Italian illuminator. An inscription in the Hours of Blanche of Savoy (Munich, Bayer. Staatsbib., Clm. 23215, fol. 1*v*) names him as responsible for painting and arranging the manuscript. The Hours contain the coat of arms of Galeazzo II Visconti and his wife, Blanche of Savoy. The fact that the opening of a prayer for Galeazzo's soul displaced the planned miniature on folio 213*v* implies that the illumination was incomplete at the time of Galeazzo's death in August 1378. No other work by Giovanni in any medium is known.

The subdued range of colours, technique and layout of the miniatures, with the scene above a *basamento*-like panel as in contemporary chapel decoration (e.g. Oratory of Mocchirolo; Milan, Brera), suggest that Giovanni also worked on a monumental scale. Furthermore, the miniatures of the *Legend of Joachim and Anna*, unusual in manuscript illustration, had precedents in Lombard mural cycles. One of the border styles in the Hours is a more surprising borrowing from contemporary English manuscripts made for Humphrey de Bohun, 7th Earl of Hereford; he had been part of the 1366 embassy that had negotiated the marriage of Lionel, Duke of Clarence, and Violante, the daughter of Galeazzo and Blanche. The English border type was one of many features from the Hours of Blanche of Savoy adopted by the Master of Latin 757. Blanche's Hours have particular significance as the first of the group of Lombard Books of Hours that is the earliest known group of Italian Hours.

BIBLIOGRAPHY

P. Toesca: *La pittura e la miniatura nella Lombardia dai più antichi monumenti alla metà del quattrocento* (Milan, 1912/R Turin, 1966)

Arte lombarda dai Visconti agli Sforza (exh. cat., ed. G. Belloni and others; Milan, Pal. Reale, 1958), pp. 25–6

K. Sutton: 'Codici di lusso a Milano: Gli esordi', *Il millennio ambrosiano*, ed. C. Bertelli (Milan, 1989), pp. 110–39

KAY SUTTON

Giovanni di Bertino (*b* first half of the 15th century; *d* ?Florence, *c.* 1471). Italian stone mason and decorator. He was the son of Bertino di Piero, a Florentine stone mason who in 1412 had executed the doors of Orsanmichele, Florence. Giovanni's brother, Piero, was in Carrara in 1442, working for Filippo Brunelleschi, and was in charge of the preparation of marble sections for the lantern of Florence Cathedral. Some time later, Giovanni was employed to finish some of the capitals on the columns of the nave in S Lorenzo, Florence (1448), although specific carvings by him have not been identified. In April 1454 Giovanni was in charge of the decoration of the church beside the Ospedale del Ceppo at Pistoia, where he was described as *disegnatore*. Both this project and S Lorenzo were works by Michelozzo di Bartolomeo. From around 1457 Giovanni worked on the façade designed by Leon Battista Alberti for S Maria Novella, Florence (*see* FLORENCE, fig. 20). The work was commissioned by the Arte del Cambio (Bankers' guild) and Giovanni Rucellai, the latter recording in his account book works of art in his private collection by Giovanni. The portal, executed by him, incorporated rich decorations of inlay and low reliefs featuring emblems of the Rucellai and Medici families along with relief carvings of fruit, ribbons and spirals. The beauty of the work established Giovanni's fame in his own lifetime and was recorded by Fra Domenico da Corella in his poem, *Teotocon* (1464–9). Among Giovanni's late works are some corbel capitals of the Composite order carved in *pietra serena* for S Bartolomeo at Monteoliveto near Florence (1469). Giovanni's name is listed in the registers of the Arte del Maestri di Pietra e Legname (Stone and Woodworkers' guild) until 1471.

Thieme–Becker

BIBLIOGRAPHY

F. Mandelli, ed.: *Nuova raccolta d'opuscoli scientifici e filologici*, xix (Venice, 1770), p. 455 [includes the *Teotocon* by Fra Domenico da Corella]

G. Mancini: *Vita di Leon Battista Alberti* (Florence, 1882, rev. 2/1911), pp. 460–61

I. Hyman: *Fifteenth Century Florentine Studies: The Palazzo Medici and a Ledger for the Church of San Lorenzo* (diss., New York U., 1968), pp. 385–6

L. Gai: 'Interventi rinascimentali nello Spedale del Ceppo', *Contributi per la storia dello Spedale del Ceppo di Pistoia* (Pistoia, 1977), pp. 108, 124

FRANCESCO QUINTERIO

Giovanni di Bicci. *See* MEDICI, DE', (1).

Giovanni di Bonino. *See under* MASTERS, ANONYMOUS, AND MONOGRAMMISTS, §I: MASTER OF THE FOGG PIETÀ.

Giovanni di Consalvo [Master of the Chiostro degli Aranci] (*fl* Florence, *c.* 1436–9). Italian painter of Portuguese or Spanish descent. He was probably the author of ten scenes from the *Life of St Benedict*, frescoed in the lunettes of the upper loggia of the cloister (called the

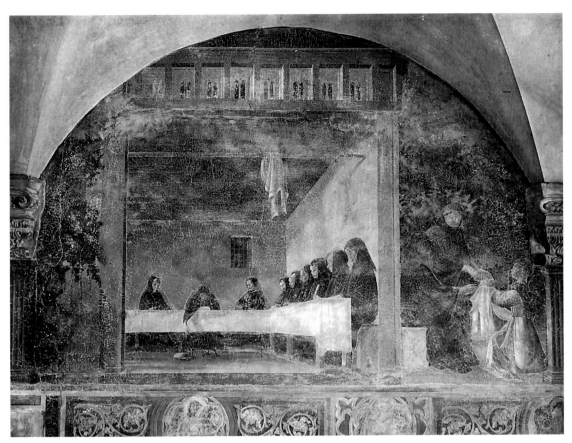

Giovanni di Consalvo: *Miracle of the Poisoned Bread* (1436–9), fresco, 2.18×3.06 m, Chiostro degli Aranci, the Badia, Florence

Chiostro degli Aranci) of the Badia, a Benedictine abbey in Florence. The scenes are arranged along two walls so that they seem to take place beneath the loggia; the lunettes are divided from each other by fictive painted fluted pilasters. The fourth scene in the sequence was damaged and replaced by a fresco of *St Benedict in the Wilderness* by Agnolo Bronzino. Beneath the lunettes runs a decorative frieze with busts of Benedictine saints set in tondi. A Latin inscription, painted between the scenes and the frieze, describes the scenes and names the saints. Two extra lunettes of scenes from the life of the Longobard king, Totila, are of mediocre quality and are by another hand, although dating from only shortly after the scenes of St Benedict. In 1956, and again in 1978, the frescoes were restored and the *sinopie* revealed (the frescoes and the *sinopie* are both displayed at the Badia).

The only document that connects the frescoes to Giovanni di Consalvo, by whom no other works are known, records that he was reimbursed for money spent on painting materials between September 1436 and February 1439 while working at the Badia. Other documents (found by G. Poggi; see Salmi, 2/1938) record that payments were made to the 'painter who is painting the cloister' but do not name him. The dates accord well with the small scale of the cycle, with the style of the paintings and with the fact that the building of the cloister had only recently been completed. Another document names Fra Macario Chonverso, a Benedictine monk at the Badia, who, in October 1439, had been taught to paint at S Domenico, Fiesole, near Florence, where Fra Angelico was working. Salmi attributed the lunette scenes of St Benedict to Fra Macario on the grounds that only he could have been influenced by Angelico; to Consalvo he attributed only the frieze of saints, which he described as provincial and slightly Flemish in character. However, since the restoration, it is obvious that the saints and the lunettes are by the same hand. It is possible that Fra Macario was responsible for the scenes of Totila, although they do not show the influence of Angelico. Berenson attributed the St Benedict scenes to the Master of the Castello Nativity, but this seems unlikely both from a chronological and a stylistic point of view. An argument in favour of Giovanni di Consalvo's authorship is the fact that at the time the cloister was frescoed another Portuguese, Gomez Ferreira da Silva, was Prior of the Badia (Battelli).

By framing the scenes with painted pilasters, the painter created a perspectival framework that echoes the loggia in which they are set. The same device was used by Masolino and Masaccio at the Brancacci Chapel (Florence, S Maria del Carmine). The artist was evidently aware of Filippo Brunelleschi's principles of perspectival construction and, in the *Miracle of the Poisoned Bread* (see fig.), made use of Paolo Uccello's virtuoso system of construction. The

decorative frieze beneath the scenes is also close to Uccello's illusionist techniques and similar to that in the chapel of the Assumption, Prato Cathedral, attributed either to Uccello or his close follower, the Prato Master. However, the figures retain Gothic elements and the architecture is not always perspectivally correct. The buildings in the scenes of *St Benedict Leaving Norcia, The Young Monk Tempted by the Devil* and *St Benedict Breaking the Glass of Poisoned Wine* are curiously eclectic in character and recall Pisanello's and Gentile da Fabriano's imaginary Late Gothic city views, but they also possess exotic elements, perhaps of Iberian origin. Such architectural forms can also be found in Angelico's predella panels (1433) for the Linaioli Tabernacle and in the view of a city in the background of his *Deposition* (both Florence, Mus. S Marco). Certainly the strongest influence is that of Angelico: Berti (1968 exh. cat.) suggested that the Badia artist collaborated on the predella with scenes from the life of St Nicholas (Rome, Vatican, Pin.) from a polyptych by Angelico of 1437. Other documents state that a 'Giovanni di Portogallo' was among the most important disciples of Fra Angelico in 1435 (Berti, 1968 exh. cat.). This suggests that the Badia artist's style was formed at S Domenico: the simplification of the architecture, the compositional system and the landscapes with large sickle-shaped rocks all recall Angelico's work. The simplified forms of the figures and their juxtaposition to each other also show his influence, as does the rational use of light (e.g. the still-life on the table in *St Benedict Takes the Habit and Adopts the Hermit's Life*). The scene of the *Miracle of the Broken Sieve* may even be derived from a lost painting by Angelico and foreshadows the scenes in Angelico's frescoes in the chapel of St Nicholas (Rome, Vatican) of almost 20 years later. The architecture has much in common with that of Michelozzo de Bartolomeo—the mullioned windows in the frescoes are similar to those at S Marco—and the church façade in the *Miracle of the Wine* recalls that of Michelozzo's church of S Marco.

The Badia painter was also influenced by other Florentine masters. Salmi (*Masaccio*, Milan, 2/1947, p. 163) noticed an echo of Masaccio in the figure of St Benedict who is signalling silence in the lunette above the door leading to the Chiostro degli Aranci. Vasari attributed the fresco to Angelico (2/1568, ed. G. Milanesi, 1878–85, vol. ii, pp. 513–14), but stylistically it must be the work of Giovanni di Consalvo (Chiarini, 1963). In the scene of the *Miracle of the Wine* he seems to have absorbed the jovial spirit of Filippo Lippi's fresco of the *Scene of Carmelite Rule* (Florence, S Maria del Carmine). The landscapes are an important element in the scenes and are used to emphasize their mood. The horizon is generally high, either creating a foreshortened effect or a bird's eye view; spatial depth is emphasized both by architectural elements and by the atmospheric use of light evident where the blue paint (painted *a secco* over a red undercoat) still survives. Finally, some of the faces achieve the status of real portraits. All these traits would seem to confirm the complex cultural and stylistic background of this painter who synthesized Florentine and Flemish elements. Attempts to attribute further works to him have been unconvincing. These include a painting of the *Marriage of the Virgin* (Florence, I Tatti; see Meiss, 1961) and three

small panels of saints, one of *St Lawrence* (Baltimore, MD, Walters A.G.; called School of Tuscany; attributed to Battista di Gerio by Boskovits, see F. Zeri: *Italian Paintings in the Walters Art Gallery*, Baltimore, 1976, vol. i, no. 93) and the other two of *St John the Baptist* and an unidentified saint (both sold London, Sotheby's, 26 March 1969, lot 128).

BIBLIOGRAPHY

Colnaghi

A. Neumayer: 'Die Fresken im "Chiostro degli Aranci" der Badia fiorentina', *Jb. Preuss. Kstsamml.*, xlviii (1927), pp. 25–42

B. Berenson: *Italian Pictures of the Renaissance* (Oxford, 1932), p. 343

M. Salmi: *Paolo Uccello, Andrea del Castagno, Domenico Veneziano* (Rome, 1936, rev. Milan, 2/1938), pp. 18–19, 139

G. Battelli: *L'abate Dom Gomez Ferreira da Silva e i Portoghesi a Firenze nella prima metà del quattrocento: Relazioni storiche fra l'Italia e il Portogallo* (Rome, 1940), p. 149

R. Longhi: 'Il Maestro di Pratovecchio', *Paragone*, iii/35 (1952), pp. 12, 20, 30 (n. 3), 34 (n. 13)

Mostra di affreschi staccati (exh. cat., ed. U. Baldini and L. Berti; Florence, Forte Belvedere, 1957), pp. 68–70

M. Salmi: *Il Beato Angelico* (Spoleto, 1958), pp. 67, 126

IIa mostra di affreschi staccati (exh. cat., ed. U. Baldini and L. Berti; Florence, Forte Belvedere, 1958), pp. 41–4

E. Borsook: *The Mural Painters of Tuscany* (London, 1960, rev. Oxford, 2/1980), pp. 80, 84, n. 20

M. Chiarini: 'Di un maestro "elusivo" e di un contributo', *A. Ant. & Mod.* (1961) pp. 134–7 [issue dedicated to Longhi]

M. Meiss: 'Contributions to Two Elusive Masters', *Burl. Mag.*, ciii (1961), p. 57

M. Chiarini: 'Il Maestro del Chiostro degli Aranci: Giovanni di Consalvo, Portoghese', *Proporzioni*, iv (1963), pp. 1–24

The Great Age of Fresco: Giotto to Pontormo (exh. cat. by M. Meiss and L. Berti, New York, Met., 1968), pp. 150–55

N. Rosenberg Henderson: 'Reflections on the Cloister degli Aranci', *A. Q.*, xxxii (1969), pp. 393–410

E. Sestan, M. Adriano and A. Guidotti: *La Badia Fiorentina* (Florence, 1982), pp. 120, 139–40, n. 218–23 [A. Guidotti]

MARCO CHIARINI

Giovanni di Cosma. *See under* COSMATUS.

Giovanni di Domenico Battaggio. *See* BATTAGGIO, GIOVANNI DI DOMENICO.

Giovanni di Francesco (del Cervelliera) (i) [Master of the Carrand Triptych] (*b* Florence, 1412; *d* Florence, 28 Sept 1459). Italian painter. His date of birth is deduced from an entry in the *catasto* (land registry declaration) of 1435, in which the artist gave his age as 23 (Levi d'Ancona). Toesca first identified Giovanni di Francesco as the author of a group of works previously attributed to the Master of the Carrand Triptych (Weisbach), who was named after the triptych formerly in the Carrand collection, of the *Virgin and Child with SS Francis, John the Baptist, Nicholas and Peter* (Florence, Bargello), from S Nicolò, Florence. The scenes from the *Life of St Nicholas* (Florence, Casa Buonarroti) probably formed the predella. The identification was based on a document relating to a payment for the fresco of *God the Father with the Holy Innocents* over the door of the church of the Ospedale degli Innocenti, Florence (1458–9; *in situ*).

On the basis of a document of 1439, Fredericksen identified Giovanni di Francesco as the author of a triptych painted for the nuns of the Convento del Paradiso at Pian di Ripoli, near Florence, the earliest notice of his activity as a painter. Fredericksen proposed that the Paradiso Triptych could be identified as the *Virgin and Child with SS Bridget and Michael*, known as the Poggibonsi Altarpiece

(Malibu, CA, Getty Mus.), ascribed by Longhi to the anonymous MASTER OF PRATOVECCHIO (*see* MASTERS, ANONYMOUS, AND MONOGRAMMISTS, §I). He accordingly suggested that the Master's work should be given to Giovanni di Francesco; however, this view is difficult to sustain given the stylistic disparity of the two groups of paintings, and the hypothesis has not been generally accepted (Laghi, Bacarelli).

The document of 1439 reveals that Giovanni di Francesco was the nephew of the painter Giuliano di Jacopo Lorino and the cousin of another painter, Jacopo di Antonio. Vasari claimed that the two cousins were both pupils of Andrea del Castagno, but this should be discounted as Castagno was ten years younger than Giovanni di Francesco. Giovanni probably received his training *c.* 1430. He does not appear in any of the numerous documents relating to his uncle, but this does not exclude the possibility that he was active in his workshop in a minor capacity.

Stylistically, Giovanni di Francesco's early paintings, for instance the *Nativity* (Berea Coll., KY), appear to be derived from Uccello's work of the 1440s, such as the stained-glass window of the same subject in Florence Cathedral. They are also close to the problematic frescoes in the chapel of the Assumption in Prato Cathedral (before 1435), given by some scholars to Uccello and by others to the Prato Master, and to the fresco of the *Nativity* (before 1437; Bologna, S Martino) attributed to Uccello (see C. Volpe: 'Paolo Uccello a Bologna', *Paragone*, xxi/365, 1980, pp. 3–28). From Uccello, Giovanni di Francesco absorbed a fascination with perspective, a taste for linear definition, a marked sense of form and a predilection for intense facial expressions, qualities evident in the Carrand triptych and in the *Crucifixion* in S Andrea a Brozzi, near Florence.

In 1450 Giovanni di Francesco was owed the considerable sum of 40 florins by Filippo Lippi for his contribution to a collaborative work (untraced). The two painters worked together again in 1455 (Marchini). Lippi's influence on Giovanni is particularly evident in two predella panels, one of the *Adoration of the Magi* (Montpellier, Mus. Fabre) and the other of *SS James and Anthony Abbot Blessing a Donor* (Dijon, Mus. B.-A.). The latter panel formed part of a dismembered triptych comprising the *Virgin and Child* (Florence, Pitti), *St Anthony Abbot* (ex-Contini-Bonacossi priv. col., Florence) and *St James* (Lyon, Mus. B.-A.).

An altar frontal of *St Biagio*, dated January 1453 (NS 1454), was painted for S Biagio at Petriolo, near Florence, where the painter's family owned land. Both this work and the *St Anthony of Padua* (Berlin, Gemäldegal.) display an affinity with Castagno's *Assumption of the Virgin* (1449–50; Berlin, Gemäldegal.; *see* ANDREA DEL CASTAGNO, fig. 1) and his frescoes from the Villa Carducci (Florence, Uffizi). It is possible that Giovanni di Francesco may have worked with Castagno on a similar basis during the time he was collaborating with Lippi, and this may have been the reason that Vasari believed he was Castagno's pupil. Giovanni di Francesco was also influenced by Domenico Veneziano and, to a certain extent, by Piero della Francesca (Longhi). This is evident in his taste for minutely detailed decorative elements in the Flemish style and in the luminosity of his colours, qualities present in the Carrand

Triptych. Uccello's influence is still present in his late works such as the Innocenti lunette and the *terra verde* frescoes in the loggia of the Palazzo Rucellai, Florence, depicting biblical stories (Salvini); the latter were probably left unfinished at the artist's death and were completed by Pier Francesco Fiorentino.

Giovanni di Francesco also produced works of a more artisan quality, such as the *Virgin and Child with Saints* (Philadelphia, PA, Mus. A.) and a frame decorated with prophets holding scrolls (Berlin, Kaiser-Friedrich Mus., destr.). *Portrait of a Lady in Profile* (New York, Met.), showing the influence of Lippi, has also been attributed to him.

BIBLIOGRAPHY

G. Vasari: *Vite* (1550, rev. 2/1568), ed. G. Milanesi (1878–85), ii, p. 682
W. Weisbach: 'Der Meister des Carrand Triptychon', *Jb. Preuss. Kstsamml.*, xxii (1901), pp. 45–8
P. Toesca: 'Il pittore del trittico Carrand: Giovanni di Francesco', *Rass. A.*, xvii (1917), pp. 1–14
R. Longhi: 'Ricerche su Giovanni di Francesco', *Pinacotheca*, i (1928), pp. 34–48
V. Giovannozzi: 'Note su Giovanni di Francesco', *Riv. A.*, xvi (1934), pp. 334–65
R. Kennedy: *Alesso Baldovinetti* (New Haven, 1938), p. 215
R. Longhi: 'Il Maestro di Pratovecchio', *Paragone*, iii/35 (1952), pp. 10–37
M. Levi d'Ancona: *Miniatura e miniatori a Firenze dal XIV al XVI secolo* (Florence, 1962), pp. 144–6
B. Berenson: *Florentine School* (London, 1963), i, pp. 87–8
F. R. Shapley: *Paintings from the Samuel H. Kress Collection: Italian Schools, XIII–XV Century* (London, 1966), p. 104
F. Zeri and E. Gardner: *Italian Paintings: Florentine School* (exh. cat., New York, Met., 1971), p. 113
B. Fredericksen: *Giovanni di Francesco and the Master of Pratovecchio* (Malibu, 1974)
G. Marchini: *Filippo Lippi* (Milan, 1975)
——: 'Una curiosità sul Lippi', *Archv Stor. Pratese*, 51 (1975), pp. 171–5
M. Horster: *Andrea del Castagno* (London, 1980), pp. 198–9
R. Salvini: 'The Frescoes in the Altana of the Rucellai Palace', *Giovanni Rucellai e il suo zibaldone, II: A Florentine Patrician and his Palace*, Studies of the Warburg Institute (London, 1981), pp. 241–52
A. Laghi: 'Giovanni di Francesco, trittico Carrand', *San Niccolò Oltrarno: la chiesa, una famiglia di antiquari* (Florence, 1982), pp. 63–5
[G. Bacarelli and others]: *Il 'Paradiso' in Pian di Ripoli* (Florence, 1985), p. 100
Disegni Italiani del tempo di Donatello (exh. cat., ed. A. Angelini; Florence, Uffizi, 1986), pp. 32–3

ANNA PADOA RIZZO

Giovanni di Francesco (ii). *See* GIOVANNI DA PISA (ii).

Giovanni di Gherardo da Prato (*b* Prato, nr Florence, 1360; *d* Prato, *c.* 1442). Italian poet and architect. He received his education in the liberal arts at the University of Padua, specializing in optics with Biagio Pelacani. He frequented the cultivated circles of Florentine society as well as lively clubs (*brigate*) such as the Burchiello, where he participated in collective poetry writing. For the *Geta e Birria* (1413–25) his co-authors included Filippo Brunelleschi. In September 1414 Giovanni was appointed Capitano di Orsanmichele. In May 1417 he was invited by the Reformatori dello Studio to hold the annual Dante lectures. In 1420 he is recorded in the second group of superintendents for the construction of the dome of Florence Cathedral. In this period the relationship between Giovanni and Brunelleschi underwent a change, which was reflected in a defamatory sonnet, *O forte fonda e nizza di ignoranza*, against Brunelleschi who had patented a costly but impractical riverboat for transporting marble on the River Arno. In 1425 Giovanni was paid by the Cathedral

Works for several drawings and a model of the dome. From these, a parchment with three drawings survives (Florence, Archv Stato) together with two reports in which he criticized the incorrect angulation of the rows of bricks in the dome. Giovanni insisted on the need to pierce additional windows in the dome. He advocated three on each side of the octagonal drum, beneath the incurvature. While this would have provided additional light it would have weakened the structure of the dome. In 1425, the Dante lectures having been abolished by Florence, Giovanni retired with his sister to his villa at Prato, where he wrote the novel *Il paradiso degli Alberti* (*c.* 1426).

WRITINGS
Il paradiso degli Alberti (*c.* 1426); ed. A. Wesselofsky, 2 vols (Bologna, 1867)

BIBLIOGRAPHY
Thieme–Becker
C. Guasti: 'Un disegno di Gio di Gherardo da Prato, poeta e architetto concernente alla cupola di Santa Maria del Fiore', *Belle arti: Opuscoli descrittivi e biografici* (Florence, 1874), pp. 107–28
H. Saalman: 'Giovanni di Gherardo da Prato's Design Concerning the Cupola of S Maria del Fiore in Florence', *J. Soc. Archit. Hist.*, xviii (1959), pp. 11–20
F. D. Prager and G. Scaglia: *Brunelleschi: Studies of his Technology and Inventions* (Cambridge, MA, and London, 1970), p. 152
E. Battisti: *Filippo Brunelleschi* (Milan, 1976), pp. 324–7, 365
G. Tanturli: 'I rapporti del Brunelleschi con gli ambienti letterari fiorentini', *Proceedings of the conference, Filippo Brunelleschi, la sua opera e il suo tempo: Florence, 1977*, pp. 125–44
H. Saalman: *Filippo Brunelleschi: The Cupola of Santa Maria del Fiore* (London, 1980)

FRANCESCO QUINTERIO

Giovanni di Guido. *See under* RAINERIUS.

Giovanni di Marco. *See under* GIOVANNI DAL PONTE.

Giovanni di Nicolò (da) Barbagelata. *See* BARBAGELATA, GIOVANNI DI NICOLÒ.

Giovanni di Paolo (di Grazia) (*b* Siena, *c.* 1399; *d* Siena, 1482). Italian painter and illuminator. With Sassetta and Domenico di Bartolo, he was one of the greatest Sienese painters of the 15th century. He created a lyrical figural style capable of conveying both exaltation and pathos.

1. TO 1430. Giovanni was born probably towards the end of the 14th century, as he was given significant commissions as early as 1420. His training is not recorded, but certain influences can be inferred. An early contact with Lombard culture is suggested by a document showing that on 5 September 1417 he received a payment from Fra Niccolò Galgani (*d* 1424), librarian of S Domenico, Siena, for miniatures in a Book of Hours (untraced) for the wife of Cristoforo Castiglione (1345–1425). Castiglione, a Milanese professor of law at Pavia, was from 1400 to 1404 a member of the supervising board of works of Milan Cathedral. He and his wife lived in Siena *c.* 1415–19, and it is possible that they introduced Giovanni to Lombard book illumination. Throughout his career Giovanni executed book illuminations as well as panel paintings. In 1420 he received payments for two paintings (untraced): one, of an unknown subject, was for the Sienese convent of S Domenico; and the other, of the *Blessed Catherine of Siena*, was ordered by Franceschino Castiglione, probably the son of Cristoforo, for the monastery of S Marta in Siena. These were works of some importance, which

suggests he was already an established artist. The first work securely attributed to him is a box with a panel painting of the *Triumph of Venus* (Paris, Louvre), dated 1421. An exquisite and rare work in good condition, it shows his early interest in the refined, subtle style of Paolo di Giovanni Fei and has echoes of Paduan art, especially in the box's elegant border of deer and wild boar.

In the early 1420s Giovanni painted the first of four altarpieces for S Domenico, Siena: the panel with *Christ Suffering and Triumphant* (Siena, Pin. N.). This was probably for the altar commissioned by the Bishop of Grosseto, Francesco Bellanti, whose coat of arms is on the back. The Pecci Altarpiece (dispersed) for S Domenico is signed and dated 1426. Its central panel, the *Virgin and Child with Angel Musicians* (see fig. 1) is in the parish church of Castelnuovo Berardenga near Siena; two of the side panels,

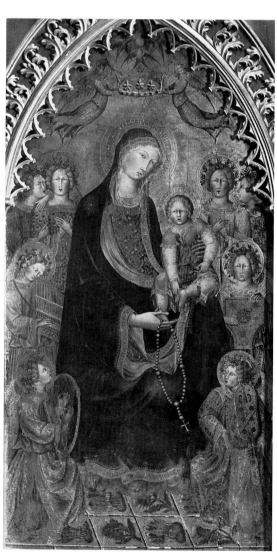

1. Giovanni di Paolo: *Virgin and Child with Angel Musicians*, egg tempera on panel, 1700×830 mm, 1426 (Castelnuovo Berardenga, parish church); central panel of the Pecci Altarpiece

St John the Baptist and *St Dominic*, are in Siena (Pin. N.), and four of the five predella sections, representing the *Passion of Christ*, are in the Walters Art Gallery (Baltimore, MD). The fifth, central section of the predella, with the *Crucifixion*, is in Altenburg (Staatl. Lindenau-Mus.). This is the first work in which Giovanni's poetic figurative style is fully defined. Also from this period is the *St Jerome* (Siena, Pin. N.). In these paintings Giovanni shows a strong (if idiosyncratic) adherence to the late Gothic tradition, with its sinuous lines and decorative details. Also apparent is his interest in the forms used by such earlier artists as Taddeo di Bartolo (already evident in the Pecci altarpiece), or the sculptor Domenico di Niccolò.

At this early stage Giovanni's work shows no interest in art outside Siena, especially in the new developments in Florence. Rather, his attention seems to have been directed to the great Sienese models of the early 14th century, from Simone Martini to Ambrogio Lorenzetti, and to the expression of his own particular view of reality. He had an intense, fertile imagination and a highly individual way of using line—nervous and impetuous—which boldly distorted and abstracted natural forms. In his later works this became impressionistic and grotesque, negating all earthly beauty. Although he does not seem to have absorbed Florentine spatial and compositional innovations, Giovanni was clearly attracted by the precious new style introduced to Siena in 1425 by Gentile da Fabriano in his polyptych (untraced) for the guild of notaries. The influence of Gentile is already evident in the Pecci altarpiece, in such motifs as the garlands worn by the angels and the garden carpet at the Virgin's feet. Gentile's art is first reflected strongly in the Branchini altarpiece (Pasadena, CA, Norton Simon Mus.), painted for S Domenico in 1427, and it remained an important element in Giovanni's figurative language until after the 1460s, even in periods when he drew ideas from other artists.

2. 1430–50. Giovanni's interest in Gentile is clear in the predella of the Fondi altarpiece for S Francesco, Siena, and in the *Madonna della Misericordia* for the Servite church there (both painted in 1436). It is still apparent in his wonderful illustrations (1438–44) for Dante's *Divine Comedy* (London, BM), and in the paintings of *Paradise* (see fig. 2) and the *Creation, and the Expulsion from Paradise* (both New York, Met.). These small panels, with two of the artist's most evocative narrative scenes, are undisputed masterpieces of 15th-century Sienese painting. They may have belonged to the predella of the Guelfi altarpiece, the last he painted for S Domenico, and dubiously identified with a *Virgin and Child with Saints* (Florence, Uffizi), signed and dated 1445.

Having joined the Sienese painters' guild, the Ruolo dei pittori, in 1428, Giovanni became its Rettore in 1441. The *Crucifixion* (Siena, Pin. N.) for a cloister chapel of the church of the Osservanza in Siena was painted in 1440. This work shows the first signs of Sassetta's influence, with a tendency towards monumentality of form and compactness of composition that can also be seen in other works datable to the mid 1440s, when Giovanni collaborated with Sano di Pietro on a panel (untraced) for the Compagnia di S Francesco. The influence of Sassetta also appears in the *Crucifix* of S Pietro Ovile, the *Crucifixion*

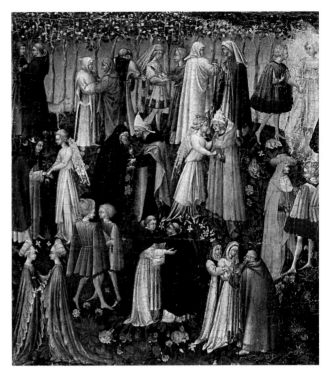

2. Giovanni di Paolo: *Paradise*, tempera on canvas, transferred from panel, 469×406 mm, *c.* 1440 (New York, Metropolitan Museum of Art

in the hermitage of S Leonardo al Lago (his only fresco), and the Antiphonal (Siena, Bib. Com. Intronati, MS. G.I.8) made for the convent of Lecceto. The Antiphonal, and other illuminations Giovanni executed for Lecceto, including three miniatures for a Gradual in the same series (MS. H.I.2), mark a period of intense creativity. The scenes are rendered with great immediacy and narrative conciseness, and are richly adorned with anthropomorphic initials and luxuriant foliage. The elegant Gothic line, with none of the agitated quality of the earlier works, has a strong flowing rhythm that does not detract from the expressive intensity.

From the 1440s Giovanni, who had reached maturity artistically, created numerous fine works, many dated. Typically, he returned to themes he had used earlier, for which he devised imaginative new solutions. He also depicted narrative subjects that were seldom, if ever, treated in Sienese art, including scenes from the lives of SS Catherine of Siena, Ansanus, John the Baptist, Clare and Galganus, as well as the passages from Dante already mentioned. In 1445 he painted the *Coronation of the Virgin* (Siena, S Andrea; signed and dated); he returned to this subject, perhaps a decade later, to produce another, splendid version (New York, Met.).

Between 1447 and 1449 Giovanni executed an important commission for the guild of the Pizzicaiuoli, an altarpiece for S Maria della Scala, Siena. The central panel, which depicts the *Presentation in the Temple* (Siena, Pin. N.), reflects Ambrogio Lorenzetti's treatment of the subject, then visible in Siena Cathedral, as well as motifs and gestures from Gentile da Fabriano's predella panel on

the same theme (1423; Paris, Louvre). The original arrangement of this polyptych is still debated. Other panels (dispersed) include ten scenes from the *Life of St Catherine* (Cleveland, OH, Mus. A.; Detroit, MI, Inst. A; New York, Met.), the *Crucifixion* (Utrecht, Catharijneconvent), and several images of Sienese saints. Some writers suggest that the St Catherine scenes were not part of the original structure but were added later, after her canonization.

3. FROM 1450. In the 1450s Giovanni's style seems to show a stronger influence of Sassetta, with more clearly defined volumes and spatial relations. These features are already evident in the architectural backgrounds of his most ambitious narrative cycle, the scenes from the *Life of St John the Baptist*. The 12 panels, of which 11 survive (Chicago, IL, A. Inst.; Münster, Westfäl. Landesmus.; New York, Met.; Paris, Louvre; Pasadena, CA, Norton Simon Mus.) were originally arranged in four vertical rows, perhaps as part of a cabinet (*custodia*) housing a sacred object or reliquary. They were painted on both sides; traces of an *Annunciation* are discernible on the back of the first panel, the *Annunciation to Zacharias*. A closer adherence to the style of Sassetta is apparent in the *St Nicholas* altarpiece (Siena, Pin. N.), dated 1453. The imposing central figure contrasts with the slender saints at the sides, and all the figures are depicted with conciseness of gesture, strong verticality in the drapery, and severe dignity of expression. His interest in Sassetta proved fertile, and around 1450–55 he produced some of his greatest works, including the altarpiece the *Virgin and Child with SS Peter Damian, Thomas, Clare and Ursula* (Siena, Pin. N.), and perhaps four predella panels with scenes from the *Life of St Clare* (Berlin, Gemäldegal.; Houston, TX, Mus. F.A.; New Haven, CT, Yale U. A.G.). The silvery sheen of the surface, the purity of line, and the severe nobility of the figures are particularly beautiful in these paintings. References to Sassetta are no longer evident in the altarpiece Giovanni painted in 1463 for Pius II's new cathedral in Pienza (*in situ*). Although by this date his skill had begun to decline, he was still capable of producing such fine works as the *Last Judgement* (Siena, Pin. N.). This wonderful painting, with its pure Sienese flavour, seems to sum up his experiences, from the Late Gothic style of Gentile da Fabriano to the Renaissance art of Fra Angelico, who painted a similar sequence (Florence, Mus. S Marco). The figure of Christ the judge anticipates the gesture of Christ in the *Last Judgement* (Rome, Vatican, Sistine Chapel) painted by Michelangelo, who may have known it through a fresco (untraced) by Masaccio. The small figures appear to be surrounded by a silvery radiance, and the whole composition, notably a gorgeous Paradise strewn with flowers and golden fruits, is superimposed on a drawing of exceptional purity and elegance. In his final phase of activity, in which workshop intervention is prominent, Giovanni was still able to create the imaginative and original colouring of the predella of the San Galgano altarpiece (*c.* 1470; Siena, Pin. N.). The altarpiece for S Silvestro di Staggia (Siena, Pin. N.), once signed and dated 1475, is his last documented work.

BIBLIOGRAPHY

E. Romagnoli: *Biografia cronologica de' bellartisti senesi* (Siena, *c.* 1835/R Florence, 1976), iv, pp. 309–30

G. Milanesi: *Documenti per la storia dell'arte senese* (Siena, 1854), i, p. 48; ii, pp. 241–2, 301, 340, 372, 389

G. Borghesi and L. Banchi: *Nuovi documenti per la storia dell'arte senese* (Siena, 1898), pp. 135–6, 182–3, 233

A. Venturi: *Storia* (1901–40), VII/i, pp. 498–501

R. Van Marle: *The Development of the Italian Schools of Painting*, ix (The Hague, 1927), pp. 390–465

J. Pope Hennessy: *Giovanni di Paolo, 1403–1483* (London, 1937)

P. Bacci: 'Documenti e commenti per la storia dell'arte', *Le Arti*, i (1941), pp. 3–39

C. Brandi: *Giovanni di Paolo* (Florence, 1947)

E. Carli: *I pittori senesi* (Milan, 1971), p. 27

M. Meiss: 'A New Panel by Giovanni di Paolo from his Altarpiece of the Baptist', *Burl. Mag.*, cxvi (1974), pp. 73–7

Il gotico a Siena (exh. cat. by G. Chelazzi Dini and others, Siena, Pal. Pub.; 1982), pp. 358–71

La pittura in Italia: Il quattrocento (Milan, 1987), i, pp. 316–25; ii, p. 643

Painting in Renaissance Siena, 1420–1500 (exh. cat. by K. Christiansen, L. B.Kantor and C. B. Strehlke, New York, Met., 1988–9), pp. 168–242

C. B. Strehlke and others: *La pittura senese nel rinascimento* (Milan, 1989), pp. 182–256

P. Torriti: *La pinacoteca nazionale di Siena* (Genoa, 1990), pp. 215–43

GIOVANNA DAMIANI

Giovanni di Pietro (i). *See* GIOVANNI DA PISA (i).

Giovanni [Nanni] **di Pietro (di Giovanni) (ii)** (*b c.* 1403; *fl* 1439–68; *d* before May 1479). Italian painter. He was the brother of VECCHIETTA, who, along with MATTEO DI GIOVANNI, influenced his style. Giovanni di Pietro is first documented in 1452 collaborating with the much younger Matteo in gilding a statue by Jacopo della Quercia for Siena Cathedral. Giovanni and Matteo had a formal partnership and the following year are recorded as sharing living quarters. It is difficult to reconstruct Giovanni's activities before the period of his partnership with Matteo. In 1439 the Spedale della Scala, Siena, paid a certain 'Nanni di Pietro', perhaps Giovanni, for frescoes (destr.) for the 'Pellegrinaio di mezzo'. Other collaborative projects with Matteo include the decoration (1454) of the organ shutters in Siena Cathedral and, with Matteo and a team of other artists, the decoration (1457) of the chapel of S Bernadino in the same cathedral. In 1463 Giovanni was paid for a tabernacle and a predella painting for the Compagnia di S Ansona (fragments in Esztergom, Mus. Christ.; Merion Station, PA, Barnes Found.; Florence, Uffizi; and London, N.G.). Although the altarpiece is usually attributed entirely to Matteo, Giovanni's hand can now be recognized in those parts (all Sansepolcro, Mus. Civ.) that once surrounded Piero della Francesca's *Baptism* (London, N.G.). Three surviving predella panels with scenes from the *Life of the Virgin* from another collaborative effort by Matteo and Giovanni, the altarpiece of the *Annunciation with SS John the Baptist and Bernardino* (Siena, S Pietro Ovile; still largely *in situ*), are considered Giovanni's masterpieces. These comprise the *Birth of the Virgin* (Paris, Louvre), the *Virgin Returning to the House of her Parents* and the *Marriage of the Virgin* (both Philadelphia, PA, Mus. A.); a fourth scene, the *Presentation of the Virgin in the Temple*, is lost. As well as the predella scenes, Giovanni is thought to have painted the central *Annunciation* (copied after Simone Martini) and the pinnacle with the *Crucifixion*. The two lateral panels of *St Bernardino* and *St John the Baptist*, attributed to the so-called Master of the Ovile Annunciation in 1947 by Pope-Hennessy, are probably by

Matteo, as are the pinnacles of the half-length saints, *St Paul* and *St Peter*.

BIBLIOGRAPHY

R. van Marle: *Italian Schools* (1923–38), ix and xvi
Edgell: *A History of Sienese Painting* (New York, 1932)
J. Pope-Hennessy: *Sienese Quattrocento Painting* (London and Oxford, 1947), p. 29, pls 50–53
C. B. Strehlke: 'Sienese Painting in the Johnson Collection', *Paragone*, xxxvi/427 (1985), pp. 3–15
Painting in Renaissance Siena, 1420–1500 (exh. cat. by K. Christiansen, L. B. Kanter and C. B. Strehlke, New York, Met., 1988–9), pp. 264–9, nos 45a, 45b and 46

S. J. TURNER

Giovanni di ser Giovanni Guidi. *See* SCHEGGIA.

Giovanni di Stefano

(*b* Siena, *bapt* 20 June 1443; *d* Siena, before 1506). Italian bronze-caster, sculptor and engineer. He was the son of the painter SASSETTA. In 1466 he worked together with the goldsmith Francesco di Antonio di Francesco (*fl* 1440–80) on a silver reliquary for the head of St Catherine of Siena (untraced); by that date he was referred to as a sculptor. In 1477 Federigo II da Montefeltro, Duke of Urbino, wrote to the governors of Siena commending Giovanni's work for him as a military engineer. In 1481–2 Giovanni made the marble intarsia of the Cumaean Sibyl for the pavement of Siena Cathedral. Giovanni's only marble statue, the elegant if somewhat mannered *St Ansanus*, made for the chapel of St John the Baptist in the cathedral (*in situ*), must date from after the construction of the chapel in 1482. By the mid-1480s Giovanni had moved to Rome, where he worked on the tomb of *Cardinal Pietro Foscari* (*d* 1485) in S Maria del Popolo. Originally the tomb was free-standing; now only the marble base and bronze recumbent figure survive. The figure is refined and delicate, with an emphasis on surface pattern; the base incorporates antique motifs. The attribution to Giovanni of the two bronze candle-bearing angels for the high altar of Siena Cathedral (*in situ*) is open to question, and they would appear to be the work of two different hands. Giovanni di Stefano was involved in a legal dispute with his assistants in Siena in 1498 for which Urbano da Cortona acted as one of the arbitrators. At that date, Giovanni was in charge of a workshop of stone-carvers, not bronze-casters.

BIBLIOGRAPHY

Thieme–Becker
G. Milanesi: *Documenti per la storia dell'arte senese* (Siena, 1854–6), ii, pp. 274, 280, 332, 335, 362, 378, 415, 458–9, 464; iii, pp. 70, 290
F. E. Bandini-Piccolomini: 'L'urna della testa di Santa Caterina', *Misc. Stor. Sen.*, i (1893), pp. 168–9
R. H. H. Cust: *The Pavement Masters of Siena, 1369–1562* (London, 1901)
P. Schubring: *Das Plastik Sienas im Quattrocento* (Berlin, 1907)
A. Monferini: 'Il ciborio lateranense e Giovanni di Stefano', *Commentari*, xiii (1962), pp. 182–212
C. Del Bravo: *Scultura senese del quattrocento* (Florence, 1970), p. 87; review by C. Freytag in *Pantheon*, xxx (1972), pp. 249–50 and by J. Paoletti in *A.Q.* [Detroit], xxxvi (1973), p. 105
M. Kühlenthal: 'Das Grabmal Pietro Foscaris in S Maria del Popolo in Rom, ein Werk des Giovanni di Stefano', *Mitt. Ksthist. Inst. Florenz*, xxvi (1982), pp. 47–62

JOHN T. PAOLETTI

Giovanni di Traù. *See* GIOVANNI DALMATA.

Giovanni di Turino. *See under* TURINO DI SANO.

Giovanni Fiorentino, Niccolò di. *See* NICCOLÒ DI GIOVANNI FIORENTINO.

Giovanni Francesco da Rimini

(*b* Rimini, ?*c.* 1420; *d* Bologna, 1470). Italian painter. He was first mentioned in the statutes of the painters' guild of Padua in 1441 and 1442. Documents of 1442 and 1444 show that he had connections with Francesco Squarcione and was already established as an independent painter. He was recorded in Bologna from 1459 to 1470. There he executed a painting of the *Virgin and Child* (Bologna, Mus. S Domenico) for the Pepoli Chapel, S Domenico, signed and dated 1459, and a *Virgin and Child with Two Angels*, signed and dated 1461 (London, N.G.). From 1459 until 1464 he was engaged in the decoration (destr.) of the tribune of S Petronio, Bologna; around that time he was also commissioned, with Tommaso Garelli, to fresco the S Brigida Chapel in S Petronio, a commission that appears not to have been carried out. All his other Bolognese works are lost (Filippini and Zucchini).

On the basis of the two signed and dated paintings, Ricci reconstructed Giovanni Francesco's oeuvre. The chronology of the works is problematic. The fact that he was in Padua at the beginning of the 1440s makes it likely that, after an initial training in Rimini, he worked around Padua and the Veneto in the circle of Jacopo Bellini, Antonio Vivarini and Giovanni d'Alemagna. The influence of these painters is evident in the series of 12 scenes from the *Life of the Virgin* (Paris, Louvre; formerly attributed to the school of Gentile da Fabriano), to which the two panels of the *Annunciation* (Columbus, OH, Mus. A.) belong. This is also true of the *Nativity* (Paris, Louvre), two paintings of the *Adoration of the Christ Child* (Le Mans, Mus. Tessé; Atlanta, GA, High Mus. A.), the tondo of *God the Father with Angels* (ex-Cook col., see *Burl. Mag.*, cxviii (1976), p. 657, fig. 32) and the *Pietà* (Hannover, Niedersächs. Landesmus.). All these works date from between 1441 and 1450. Giovanni Francesco increasingly borrowed motifs from Squarcione and Mantegna, as well as from the Florentine artists working in the Veneto, including Uccello, Castagno, Donatello and, in particular, Filippo Lippi. The possibility that Giovanni Francesco lived in Florence for a while is strengthened not only by the apparent influence of Florentine art on his work after 1450 but by the provenance of the panel of *St Vincent Ferrer* (Florence, Accad.), painted for the convent of the nuns of S Domenico del Maglio, near Florence. Two predella panels with a *Miracle of St Nicholas* (Paris, Louvre) and a *Miracle of St James* (Rome, Pin. Vaticana) are painted with a more rigorous sense of space compared with his Paduan work, and with a sureness of style that may have been acquired from direct contact with Filippo Lippi, Alesso Baldovinetti, Pesellino and Giovanni di Francesco.

Attributed works dating from Giovanni Francesco's Bolognese period (1459–70) include the *Adoration of the Christ Child* (Bologna, Pin. N.), the *Baptism of Christ* (Rome, Blumenstihl priv. col.) and the *Miracle of St Dominic* (Pesaro, Mus. Civ.). It has been suggested that he may have spent the years 1464–70 in Umbria and the Marches because several of his works are in or from that region. These include the large triptych of the *Virgin and Child with SS Jerome and Francis* (Perugia, G.N. Umbria), the *Virgin and Child* (Ljubljana, N.G.), the *Virgin and Child* (S Benedetto del Tronto, Brancadoro priv. col.) and the *Virgin and Child* (Baltimore, MD, Walters A.G.).

These works have, however, been dated by Zeri (1976) to the early 1450s.

BIBLIOGRAPHY

Bolaffi; Thieme–Becker

C. Ricci: 'Giovanni Francesco da Rimini', *Rass. A.*, ii (1902), pp. 134–5

——: 'Ancora di Giovanni Francesco da Rimini', *Rass. A.*, iii (1903), pp. 69–70

M. Logan Berenson: 'Ancora di Giovanni Francesco da Rimini', *Rass. A.*, vii (1907), pp. 53–4

G. Fiocco: 'I pittori marchigiani a Padova nella prima metà del quattrocento', *Atti Ist. Veneto Sci., Lett. & A.*, ii (1932), pp. 1359–70

M. Urzi: 'I pittori registrati negli statuti della Fraglia Padovana dell'anno 1441', *Archv Ven.*, xii (1932), pp. 212, 223

B. Berenson: *Central and North Italian Schools* (1968), i, pp. 183–4

F. Filippini and G. Zucchini: *Miniatori e pittori a Bologna* (Rome, 1968), pp. 89–90

S. Padovani: 'Un contributo alla cultura padovana del primo rinascimento: Giovan Francesco da Rimini', *Paragone*, xxii/259 (1971), pp. 3–31 [with bibliog.]

C. Joost-Gaugier: 'A Contribution to the Paduan Style of Giovanni Francesco da Rimini', *Ant. Viva*, 3 (1973), pp. 7–12

F. Zeri: *Italian Paintings in the Walters Art Gallery*, i (Baltimore, 1976), pp. 207–8

——: *Tuji slikarji od. 14 do. 20 stoletja* (Ljubljana, 1983), pp. 100–01

SERENA PADOVANI

Giovanni (di Francesco) Toscani. *See* TOSCANI, GIOVANNI.

Giovanni Zenone da Vaprio (*fl* Milan, 1430–6). Italian painter and illuminator. He was one of a large family of painters and illuminators working in Milan in the 15th century. He appears frequently in the registers of the building works of the city's cathedral and as a creditor of the influential Borromeo family. First recorded in 1430 as the painter of two altarpieces for the cathedral, he is mentioned again in 1433 and 1444 for the gilding of sculpture and in 1442, 1446 and 1448 for further paintings. None of these works survives.

In 1445 and 1446 Giovanni was paid by Vitaliano Borromeo for the illumination of family *imprese*. However, Cipriani has suggested that these payments were for a group of decorated diplomas (Milan, Trivulziana) granted to the Borromeo family in 1445, and on this basis says that the designs may be by the much better-known Master of the Vitae Imperatorum. A miniature of Filippo Maria Visconti in Galessio da Correggio's *Historia Angliae* (Paris, Bib. N., MS. lat. 6041) has also been connected with Giovanni. Less convincing are the attempts to identify da Vaprio as the Master of the 'Giuochi Borromeo', a mid-15th-century painter of a fresco cycle of courtly games in the Palazzo Borromeo in Milan. Although Giovanni appears with great frequency in the family registers, the sums are always small amounts of money, which probably indicate a continuous flow of minor decorative commissions.

BIBLIOGRAPHY

Annali della Fabbrica del Duomo, appendix 2 (Milan, 1885), pp. 25, 29, 31, 37, 40, 43, 52, 61, 65–7, 69, 222

G. Biscaro: 'Note di storia dell'arte e della cultura a Milano dai libri mastri Borromeo, 1427–1478', *Archv Stor. Lombardo*, xvi (1914), pp. 71, 108

R. Cipriani: 'Giovanni da Vaprio', *Paragone*, lxxxvii (1957), pp. 47–53

G. Consoli: *I giuochi Borromeo ed il Pisanello* (Milan, 1966)

E. SAMUELS WELCH

Giovannoni, Gustavo (*b* Rome, 1 Jan 1873; *d* Rome, 15 July 1947). Italian architect, urban planner, writer and architectural historian. After graduating in civil engineering from the University of Rome (1895), he took a diploma in public hygiene, before studying art and architectural history in Rome under Adolfo Venturi. In 1899 he was appointed assistant under Guglielmo Calderini in the Engineering School and in 1905 was appointed professor of general architecture. A strong technical as well as art-historical background took him into the conservation field and thus into major projects for urban redevelopment. In 1910 he became president of the Associazione Artistica tra i Cultori dell' Architettura (AACA), founded in Rome in 1890 with the aim of extending the awareness of the historic and artistic heritage and to promote conservation initiatives. This aspect of his career is reflected in such early schemes as that for the Caprera quarter of Rome (1907–11), which overlapped with his work for the Peroni brewery, a factory (1909) and a company headquarters (1913), putting into practice his belief in the *architetto integrale*, able to encompass both artistic and technical skills. It was no accident that his research interests focused on the work of Antonio da Sangallo (ii), who combined careful archaeological knowledge with exceptional practical skills. This Renaissance concept of the architect inspired Giovannoni's approach to architectural education, and in 1918, through the AACA, he was instrumental in the establishment of the Scuola Superiore di Architettura and eventually the new Istituto Universitaria where he lectured in the restoration of historic monuments, becoming Dean from 1931 to 1935.

With Marcello Piacentini, Giovannoni founded the periodical *L'Architettura e arti decorative* (1921), which became the bulletin of the AACA, and when the profession was institutionalized in 1923 the periodical was recognized as its official publication. Characteristic of this period are his neo-Baroque designs for the Chiesa del Sacre Cuore (1922), Salerno, and for the Chiesa degli Angeli Custodi (1923), Montesacro, Rome. In the 1920s he prepared planning proposals for towns such as Assisi, Celano and Ostia, and more significantly, major planning and redevelopment schemes for the centre of Rome. Despite his vigorous position on conservation, his plan for the oldest part of the city, prepared in 1913, suggested the area be 'thinned out' in the interests of hygiene and traffic management. 'Old city—new building', a slogan in his publications, became the recurrent theme for reconciliation, and he was responsible with others for schemes that sanctioned the reshaping of large areas of the city: one of his own proposals, exhibited in Rome with the work of La Burbera group in 1929, would have made incursions on areas of Baroque Rome in order to rebuild parts of them in a monumental style. These, together with his definitive plan for the centre of Rome (1930; with Piacentini), inspired by Mussolini's demands, seem to be the last of his major planning activities. His objection to the destruction of the Spina del Borgo quarter (redeveloped as Via della Consolazione) in the early 1930s was in opposition to Fascist policy. Thus, at the very time when the transformation of Rome was at its most intensive, he turned his attention to his work as a teacher and scholar. Subsequently he founded the Centro di Studi per la Storia dell' Architettura (1935) and the periodical *Palladio* (1937) and edited the architectural entries for the *Enciclopedia*

Italiana. He became President of the Accademia di S Luca, and for 30 years (until his death) he was a member of the Consiglio Superiore per la Direzione di Antichità e Belle Arti. It was only from the 1960s that it became possible to lay aside his polemical separation from the Modern Movement and conspicuous role under Fascism in order to reassess the obvious importance of his writings and influence as a teacher.

WRITINGS

'Il diradamento edilizio dei vecchi centri: il quartiere della rinascenza a Roma', *Nuova Antol.*, clxvi (July–Aug 1913)
'Building and Engineering of Ancient Rome', *The Legacy of Rome* (Oxford, 1923)
Questioni di architettura nella storia e nella vita (Rome, 1925)
Vecchie città ed edilizia nuova (Turin, 1931)
Antonio da Sangallo il Giovane (Rome, 1959)

BIBLIOGRAPHY

G. De Angelis d'Ossat: *Gustavo Giovannoni: Storico e critico dell' architettura* (Rome, 1949)
A. Curuni: *Riordino delle carte di Gustavo Giovannoni* (Rome, 1979)
A. Del Bufalo: *Gustavo Giovannoni* (Rome, 1982)

GUIDO ZUCCONI

Giovenone, Giovanni [Giovan] **Battista** (*b* Vercelli, *c.* 1525; *d* Vercelli, 1573). Italian painter. He probably trained in the workshop of his father, Pietro, a woodcarver who was the brother of a painter, Gerolamo Giovenone (*c.* 1490–1555). His work is documented from 1546, the date on the earliest of his two certain paintings, the *Martyrdom of St Agatha* in SS Quirico e Giulitta in Trivero Matrice (Vercelli), which he signed with Francesco di Gattinara. This schematic composition is painted in a somewhat archaic style. The second secure work, which is of much higher quality, is the *Mystic Marriage of St Catherine* (Vercelli, Mus. Civ. Borgogna), signed and dated 1547, painted for S Francesco, Vercelli. It reflects the influence of Gaudenzio Ferrari, one of his principal models, and is a variation of Ferrari's painting of the same subject in Novara Cathedral. The figure of St Lawrence is almost certainly a portrait, and the background landscape, with a play of light among the trees, shows a sensitive use of colour. A drawing (Turin, Accad. Albertina, no. 357) linked to this painting by Griseri has been attributed to Gerolamo Giovenone (see 1982 exh. cat.). The *Virgin and Child with SS John the Baptist* and *Anthony and a Supplicant* in SS Quirico e Giulitta in Trivero Matrice was ascribed to Giovanni Battista by Sciolla on the basis of a payment recorded in 1548 for two altarpieces, of which one has been identified as his *Martyrdom of St Agatha*. This attribution was rejected by Ghisotti, however, who proposed to add to his oeuvre a drawing of *St Dorothy Presenting a Supplicant* (Turin, Accad. Albertina), formerly attributed to Ferrari. Documents dated later than his secure works indicate that Giovenone also worked as a *plasticatore*, carving small wooden reliefs. Apart from Ferrari, Giovanni Battista was influenced by Gerolamo Giovenone, Bernardino Lanino (*c.* 1512–83) and Ottaviano Cane (1495–1576), whose daughter he married. There is a certain dryness in his modelling, especially of drapery, but he is notable for his sensitivity to light and colour, and for his interest in landscape and portraiture.

BIBLIOGRAPHY

A. Griseri: 'I Gaudenziani', *Gaudenzio Ferrari* (exh. cat., Vercelli, Mus. Civ. Borgogna, 1956), pp. 138–9
G. C. Sciolla: *Il biellese dal medioevo all'ottocento* (Turin, 1980), p. 156
S. Ghisotti: 'Giovan Battista Giovenone', *Gaudenzio Ferrari e la sua scuola* (exh. cat., ed. G. Romano; Turin, Accad. Albertina, 1982), pp. 123–8

FRANCESCA CAPPELLETTI

Giovio, Paolo (*b* Como, April 1483; *d* Florence, 11 Dec 1552). Italian historian, physician, humanist and collector. He belonged to the Zanobi, one of the oldest and most prominent families in Como, and was devoted to his cultural patrimony, especially to Como's great historians, the elder and younger Pliny. His guardian and mentor was his elder brother, Benedetto Giovio (1471–*c.* 1545), a prominent civic figure, local historian and antiquarian who, among other projects, was involved with Cesare Cesariano on the translation and annotation of Vitruvius' *De architectura* (Como, 1521). In compliance with his brother's wishes, Paolo trained as a physician in Pavia and Padua (1498–1507), studying with Marc'antonio della Torre and Pietro Pomponazzi. The university environment of Lombardy and the Veneto exposed him to contact with artistic enterprises of the early 16th century and with those who promoted them. For instance, della Torre apparently collaborated with Leonardo da Vinci on an illustrated anatomical text during Giovio's studentship.

By 1512 Giovio was in Rome, as physician to Pope Julius II; he later became physician to Clement VII and Paul III, being rewarded in due course with the bishopric of Nucera. He began to devote himself to the writing of history, taking advantage of his position at the centre of cultural and political affairs. In 1514 Pope Leo X appointed him to the faculty of the university, pleased with a piece he had written on contemporary Italy; the piece was later published as part of Giovio's two-volume *Historiarum sui temporis* (Florence, 1551–2). He remained at the papal court for most of his career, moving among the great political and intellectual figures of the day and becoming a member of the Accademia della Virtù and the Accademia degli Intronati. Besides chronicling current affairs, he wrote medical texts, an influential dialogue on imprese (Rome, 1555) and numerous biographies, including the first of Michelangelo, Raphael and Leonardo. These were initially published in G. Tiraboschi's *Storia della letteratura italiana* (Parma, 1772–82).

Giovio collaborated with artists over the designs for three large-scale decorative projects, including one of the most important fresco cycles of 16th-century Florentine art: the historical allegories alluding to the family history of the Medici, executed by Andrea del Sarto, Franciabigio and Pontormo in the *salone* of the Villa Medici at Poggio a Caiano (begun 1520). He also provided designs for the façade of Tommaso di Cambi's palazzo in Naples (*c.* 1540), depicting the virtues and deeds of the Emperor Charles V, and a programme for Giorgio Vasari's frescoes (1546) celebrating Pope Paul III in the Sala dei Cento Giorni of the Palazzo della Cancelleria in Rome. Giovio served in an advisory capacity to the Fabbrica of St Peter's (1535–41) and to that of Milan Cathedral. In addition he designed imprese and devices for his patrons, wrote with admirable sensitivity on the styles of some contemporary artists (e.g. his perceptive appreciation of Dosso Dossi's landscape painting) and acted as an intermediary between artists and potential patrons. In particular he was also responsible for

launching Vasari's career in Rome and encouraging him to undertake the writing of his *Vite*. He then edited the work and arranged for its publication in Florence.

The only major artistic ventures Giovio undertook on his own behalf were the formation of his celebrated portrait collection and the building of a villa-museum in Borgovico, north of Como. He probably started collecting portraits after his arrival in Rome; by the time of his death the collection was singular by virtue of its size and content. It comprised over 400 portraits of illustrious and infamous Europeans, past and contemporary, and a number of subjects from the dynasties of the Near and Middle East, and elsewhere. They were probably mostly acquired, as was then common, in return for services rendered to patrons and acquaintances. They tended to be workshop reproductions of varying quality, but the collection nonetheless won great renown. Giovio's villa was built in 1537–8 in anticipation of his retirement, near the site of Pliny the elder's villa, La Commedia. It was Vitruvian in style, lavishly decorated and dedicated to Pliny's memory; it became Giovio's summer retreat and the setting for most of his collection. After his death the building and its contents remained largely intact until 1569, when the first of several serious floods occurred. What was left undamaged was gradually dispersed, and the building was demolished in 1615. The portraits are known today from painted copies made for Cosimo I de' Medici (Florence, Uffizi), Federico Borromeo (Milan, Ambrosiana) and Ferdinand of Tyrol (*reg* 1564–95) (Innsbruck, Schloss Ambras); also from the woodcuts by Tobias Stimmer illustrating editions of Giovio's *Elogia virorum bellica virtute illustrium veris imaginibus* and *Elogia veris clarorum virorum imaginibus* (Basle, 1575 and 1577 respectively) and Nicolaus Reusner's *Icones sivé imagines vivae literis claris* (Basle, 1589). Giovio's *Elogia* were written in his later years to embellish his portrait collection, commemorating in words the deeds and characters of the subjects of the paintings. It was a project that admirably reflected his interest in art as it related to history.

Giovio's position at the court of Paul III weakened in the 1540s as a result of his perceived allegiance to the policies of Charles V. He reconsolidated his position with the Medici, aided in this by the fact that Cosimo I was just then trying to bring the finest artists and intellectuals to Florence. Hence Cosimo became Giovio's last patron, overseeing the completion and publication of his most important writings. He also arranged Giovio's funeral, honouring him with an elaborate ceremony and burial in S Lorenzo, Florence. A commemorative statue, which now stands at the foot of the stairs to the Biblioteca Laurenziana, Florence, was made by Francesco da Sangallo in 1560.

Conte Giovanni Battista Giovio (*b* Como, 10 Dec 1748; *d* Como, 17 May 1814), great-great-grandson of Benedetto Giovio, also became a prolific writer. His interest in the arts is apparent in his *Trattato dell'arte de la pittura* (Lugano, 1776) and in his *Elogi italiani* (Venice, 1778–84), in which he praised Andrea Palladio and Francesco Algarotti as well as his own family.

WRITINGS
Elogia veris clarorum virorum imaginibus apposita quae in Musaeo Comi spectantur (Venice, 1546); It. trans. by L. Domenichi as *Le iscrittioni poste sotto le vere imagini degli uomini famosi le quali a Como nel Museo si veggiono* (Florence, 1552)
Elogia virorum bellica virtute illustrium veris imaginibus (Florence, 1551); It. trans. by L. Domenichi as *Gli elogi: Vite brevemente scritte d'huomini illustri di guerra, antichi e moderni* (Florence, 1554)
Dialogo dell'imprese militari e amorose di Paolo Giovio Vescovo di Nucera (Rome, 1555)
G. G. Ferraro, ed.: *Pauli Iovii opera: Epistolarum*, 2 vols (Rome, 1956–8)
R. Meregazzi, ed.: *Pauli Iovii opera: Gli elogi degli uomini illustri (letterati, artisti, uomini d'arme)* (Rome, 1972) [reprints Latin editions of 1546 and 1551]
M. L. Doglio, ed.: *Dialogo dell'imprese militari e amorose* (Rome, 1978)

BIBLIOGRAPHY
G. B. Giovio: *Elogi italiani*, ed. A. Rubbi (Venice, 1778–84); v; viii, pp. 7–107; xi
F. Fossati: 'Il Museo Gioviano e i ritratti di Cristoforo Colombo', *Period. Soc. Stor. Prov. & Ant. Dioc. Como*, ix (1892), pp. 87–104
K. Frey, ed.: *Il codice magliabechiano* (Berlin, 1892), pp. lxii–lxxix
E. Müntz: 'Le Musée de Paul Jove: Contribution pour servir à l'iconographie du moyen âge et de la renaissance', *Mém. Acad. Inscr. & B.-Lett.*, xxxvi/2 (1898), pp. 249–343
A. Luzio: 'Il Museo Gioviano descritto da A. F. Doni', *Archv Stor. Lombardo*, xxviii (1901), pp. 143–50
L. Rovelli: *L'opera storica ed artistica di Paolo Giovio: Il museo di ritratti* (Como, 1928)
E. Zanolari: *L'erudizione storica di un patrizio comasco del sec. xviii* (Sondrio, 1950)
P. O. Rave: 'Paolo Giovio und die Bildnisvitenbücher des Humanismus', *Jb. Berlin. Mus.*, i (1959), pp. 119–54
——: 'Das Museo Giovio zu Como', *Misc. Bib. Hertz.* (1961), pp. 275–84
T. C. P. Zimmerman: 'Paolo Giovio and the Evolution of Renaissance Art Criticism', *Cultural Aspects of the Italian Renaissance: Essays in Honor of Paul Oskar Kristeller*, ed. C. Clough (Manchester, 1976), pp. 406–24
M. Gianoncelli: *L'antico museo di Paolo Giovio in Borgovico* (Como, 1977)
Z. Waźbiński: 'Museaum Paolo Giovio w Como: Jego geneza i znaczenie' [The Paolo Giovio Museum in Como: its origins and significance], *Acta U. Nicolai Copernici*, xc (1979), pp. 115–44
Atti del convegno Paolo Giovio: Il Rinascimento e la memoria: Como, 1983
R. Pavoni: 'Paolo Giovio, et son musée de portraits à propos d'une exposition', *Gaz. B.-A.*, n. s. 5, cv (1985), pp. 109–16
L. Klinger, L. Raby and J. Raby : 'A Portrait of Two Ottoman Corsairs from the Collection of Paolo Giovio', *Atti del primo simposio internazionale sull'arte veneziana e l'arte islamica. Venezia e l'Oriente Vicino: Venezia, 1986*, in *Ateneo Ven.*, ix (1989), pp. 47-59
L. S. Klinger: *The Portrait Collection of Paolo Giovio* (diss., Princeton U., NJ, 1990)
T. C. P. Zimmerman: *Paolo Giovio: The Historian and the Crises of Sixteenth-century Italy* (Princeton, 1995)

LINDA S. KLINGER

Giral. French family of architects. They were of peasant origin from a small village near Montpellier. Antoine Giral (*b c.* 1640; *d* 1721) was a mason who married into a family of architects in Montpellier; after 1680 he also qualified as an architect, although he practised mainly as a building contractor. His work, often in collaboration with his brothers-in-law, ranged from the construction of the Hôtel de Ganges and the Jesuit College of Montpellier to the restoration of the Pont du Gard. Of his six surviving children, three became architects: Jean Giral (*b* 1679; *d* 1755), Jacques Giral (*b* 1684; *d* 1749) and Etienne Giral (i) (*b* 1689; *d* 1763). Jean Giral was the best known of Antoine Giral's sons. He was trained as an apprentice in the family business but was also influenced by AUGUSTIN-CHARLES D'AVILER, who carried out several projects in Montpellier and the Languedoc. Jean was responsible for the plans for rebuilding the cathedral choir of St Pons. He supervised the construction of the church of St Jean-de-Bruel (1701–10), the Jesuit church of Montpellier (now Notre-Dame-des-Tables), built over a long period from

1707, and the chapel of the Hôpital-Général (from 1751). He also built les Halles des Poissons et des Herbes (1747–50). Other work included plans for the Château de la Mogère (1715) and modernization of the bishop's palace at Montpellier, where he designed a monumental arch and doorway and a small summer house on the ramparts. The scope of his influence was not limited to Montpellier but extended as far as Rouergue. One of his sons, David Giral (*b* 1710; *d* 1753), was also an architect.

Jacques Giral began his career as a painter, winning first prize at the Académie Royale, Paris, and a bursary from Louis XIV to study at the Académie de France in Rome (1712–14). On his return to Montpellier, he opened his own painter's workshop where his assistants included the artist Joseph-Marie Vien (before 1740). Jacques also became involved in architecture, and the Hôtel de Cambacérès-Murles (1723), Montpellier, can be attributed to him. He probably worked on several occasions with his elder brother Jean Giral. Etienne Giral (i) was for a long time assistant to his brothers. He was above all an entrepreneur of public works, and he began the construction of the Promenade du Peyrou (1717–18), Montpellier, for the installation of a statue of *Louis XIV*. His two sons, Jean-Antoine Giral (*b* St Jean-de-Bruel, 1713; *d* Montpellier, 1787) and Etienne Giral (ii) (*b* 1723; *d* 1799), took over both his business and that of their uncles.

Jean-Antoine Giral, who remained perhaps the best-known member of the family, worked for many years under his father on public works. On the death of his uncle Jean, he took over his business and demonstrated his own talent as an architect, producing several accomplished works. He was a remarkable urban planner and designed a direct east-west road, aimed at giving more space to the old town of Montpellier. This project was only partially carried out a century later. Again at Montpellier, he proposed the definitive layout of the Cours des Casernes to the south of the city. He also conceived a plan to transform and enlarge the port at Sète (1779), not begun until half a century later. He was in charge of a large number of projects in Montpellier, including the Hôtel Hagueneau (1753–60) and the Hôtel de St Côme (1753–7), the anatomy lecture theatre of the Master Surgeons of Montpellier. Jean-Antoine's best-known work is the Promenade du Peyrou (1765–72), with a water tower in the form of a Classical temple at the western end of the upper terrace and magnificent steps leading to the lower terraces (for illustration *see* MONTPELLIER). Works in other parts of the Languedoc included the restoration of Alès Cathedral and the building of several monumental bridges (1776–87) using Venetian techniques; he also provided plans for the Hôtel de Ganges at Ganges. All these works earned him the title of Architecte de la Province. Jean-Antoine's son-in-law and pupil Jacques Donnat (*b* 1742; *d* 1824) continued his work and maintained the presence of the Giral family in Montpellier into the first quarter of the 19th century. Etienne Giral (ii) contributed to the businesses of his father and brother for many years, collaborating with his brother Jean-Antoine in tendering for the construction of numerous roads. From 1763 he abandoned architecture and public works for mining research; he also set up a glassworks which became one of the most important in the area. The work of the Giral

family was influenced directly or indirectly by d'Aviler, but also shows an awareness of contemporary Parisian and Italian architecture. During almost a century and a half they exercised a substantial influence on the architecture of Montpellier and the Languedoc in general.

WRITINGS
E. Giral and J.-A. Giral: *Mémoires pour la ville et port de Cette* (Montpellier, 1767)

BIBLIOGRAPHY
Bauchal; Thieme-Becker
L. Hautecoeur: *Architecture classique*, iv (Paris, 1952)
W. G. Kalnein and M. Levy: *Art and Architecture of the Eighteenth Century in France*, Pelican Hist. A. (Harmondsworth, 1972)
A. Blanchard: 'Les Giral, architectes montpellierains', *Mém. Soc. Archéol. Montpellier*, xviii (1988)

ANNE BLANCHARD

Giraldi [del Magro], **Guglielmo** (*fl* 1445–89). Italian illuminator. The son of a tailor, Giovanni, he is documented continuously in Ferrara from 1445 to 1477. With Taddeo Crivelli, he was the favourite illuminator of Borso d'Este, Duke of Ferrara, and one of the most important Ferrarese personalities in Renaissance book decoration. He was also active in Urbino, where in 1480 he is recorded working for Federigo II da Montefeltro, Duke of Urbino. Many documented works by Giraldi remain untraced.

Giraldi's early style is known from signed miniatures in the copy of Aulus Gellius's *Noctes Atticae* (Milan, Bib. Ambrosiana, Cod. Scotti; see fig.) made in Bologna in 1448. Late Gothic stylistic elements persist in the frontispiece miniature, characterized by the hooked folds of the drapery and the expressiveness of the faces. The bright light and chromatic range are Giraldi's additions and are close to Florentine techniques, especially those of Domenico Veneziano. Scholarship is divided as to whether the spatial construction, which is realistic but perspectivally inaccurate, reveals the influence of Paolo Uccello or Piero della Francesca.

Through his study of Piero della Francesca and his contact at the Este court with the painter Cosimo Tura, Giraldi reached full stylistic maturity in the 1450s. In this period he illuminated the only surviving folio of Borso d'Este's Breviary (1454–9), now the frontispiece of the Book of Hours of Louis of Savoy (Paris, Bib. N., MS. lat. 9473), and a copy of Virgil made in 1458 (Paris, Bib. N., MS. lat. 7939 A). The historiated initials and monochrome vignettes that Giraldi contributed to this volume are regarded as his finest work.

Giraldi's style reveals numerous borrowings from Tura in its elongated figures in contorted poses, the tortuous drapery and the rocky landscapes. It is characterized by a highly skilful rendering of space achieved through meticulous perspectival draughtsmanship and a way of modulating light by the use of colour that he probably learnt from Piero della Francesca. The strong pinks and deep blues and greens are typical, as is the almost classical sense of measure and balance that distinguish his style from that of Crivelli.

Some miniatures in the Bible of Borso d'Este (Modena, Bib. Estense, MS. V. G. 12–13, lat. 422–3) may be attributed to Giraldi on stylistic grounds (e.g. vol. ii, fols 106*r*–113*v*). The high quality of his work is apparent in the four volumes of another Bible commissioned by Borso d'Este

Guglielmo Giraldi: detail of miniature from Aulus Gellius's *Noctes Atticae*, 1448 (Milan, Biblioteca Ambrosiana, Cod. Scotti)

for the Certosa di Ferrara (*c.* 1462–76), and in the choir-books for the same monastery (both Ferrara, Mus. Civ. A. Ant. Pal. Schifanoia). The first, autograph, volume of the Bible contains miniatures that in terms of their size, quality and chromatic splendour are really small paintings, also interesting for their naturalistic friezes with architectural inserts. The inferior quality of the second and third volumes indicates the presence of assistants, who executed the entire fourth volume and also worked on the choir-books. A Psalter and a Hymnal for Ferrara Cathedral (1472; Ferrara, Mus. Duomo) are documented as the work of Giraldi. On stylistic grounds various other works have been attributed to him: a copy of Plautus (Madrid, Bib. N., MS. Vit., 22.5), executed for the Gonzaga family; the *Trattato del ben governare* (Milan, Castello Sforzesco, MS. 86), which is stylistically closer to Crivelli; and the *Libro del Salvatore* (Modena, Bib. Estense, MS. it. 353), which was produced by assistants.

After 1477 Giraldi's name no longer appears in Ferrara, and he was probably employed in Urbino, where he participated in the decoration of a copy of Dante's *Divine Comedy* (*c.* 1480; Rome, Vatican, Bib. Apostolica, MS. Urb. lat. 365). The style of this manuscript differs from that of the first volume of the Certosa Bible only in its closer connection with the work of Francesco del Cossa, an influence that is already visible in Giraldi's late Ferrara works. Among Giraldi's followers was his nephew Alessandro Leoni, who, in 1475, collaborated with him on a Psalter (Modena, Bib. Estense, MS. lat. 990).

BIBLIOGRAPHY

F. Hermanin: 'Le miniature ferraresi della Biblioteca Vaticana', *L'Arte*, iii (1900), pp. 341–73

H. J. Hermann: 'Zur Geschichte der Miniaturmalerei am Hofe der Este in Ferrara', *Jb. Ksthist. Samml. Allhöch. Ksrhaus.*, xxi (1900), pp. 117–271

G. Bertoni: *Il maggior miniatore della Bibbia di Borso d'Este 'Taddeo Crivelli'* (Modena, 1925)

M. Bonicatti: 'Contributo al Giraldi', *Commentari*, viii (1957), pp. 195–210

M. Salmi: *Pittura e miniatura a Ferrara nel primo rinascimento* (Milan, 1961)

Dix siècles d'enluminure italienne (VI–XVI siècles) (exh. cat., ed. F. Avril, Y. Zaluska and others; Paris, Bib. N., 1984)

Le muse e il Principe: Arte di corte nel rinascimento padano (exh. cat., Milan, Mus. Poldi Pezzoli, 1991) [notes by F. Avril]

The Painted Page: Italian Renaissance Book Illumination, 1450–1550 (exh. cat., ed. J. J. G. Alexander; London, RA, 1994)

FEDERICA TONIOLO

Giralte, Francisco (*b* ?Palencia, *c.* 1510; *d* Madrid, before 4 April 1576). Spanish sculptor of Netherlandish origin. Around 1534 he was a pupil of Alonso Berruguete, with whom he collaborated on the choir stalls of Toledo Cathedral. In 1542 he produced the wooden altarpiece for the church of S Pedro in Cisneros, Palencia, and made another for the Corral Chapel in the Magdalena, Valladolid; both are bold, densely crowded compositions. Giralte opened an independent workshop in the town of Palencia in 1545 and lived there until 1550 when, after an unsuccessful dispute with Juan de Juni over the contract for the altarpiece of S Maria de la Antigua in Valladolid, he moved to Madrid. He was contracted by the Bishop of Plasencia, Gutierre de Vargas Carvajal, to carve the wooden altarpiece

for his chapel, the 'Capilla del Obispo', formerly part of S Andrés (destr. 1936), Madrid. The design of the work is old-fashioned and clearly shows the influence of Berruguete. Giralte also carved the Bishop's tomb and that of the Bishop's parents, *Francisco de Vargas* and *Inés de Carvajal*, all in alabaster. The tombs demonstrate Giralte's mastery of the Italian style and his highly refined technique. His technical skill is also evident in the wooden altarpiece in the church of S Eutropio in El Espinar, Segovia, and especially in the alabaster tomb of *Pedro Ponce de Leon* (1573; Plasencia Cathedral). Giralte drew inspiration from a wide range of sources but combined this eclecticism with a tortured Mannerism that found expression in his vigorously modelled figures.

Ceán Bermúdez
BIBLIOGRAPHY
G. Weise: *Spanische Plastik aus sieben Jahrhunderten*, iii (Tübingen, 1929)
M. Gómez Moreno: *La escultura del renacimiento en España* (Barcelona, 1931)
A. Martin Ortega: 'Datos sobre Francisco Hernández y Francisco Giralte en Madrid', *Bol. Semin. Estud. A. & Arqueol.* (1957), p. 65
——: 'Más sobre Francisco Giralte, escultor', *Bol. Semin. Estud. A. & Arqueol.* (1961), pp. 123–30
J. M. Caamaño Martínez: 'Francisco Giralte', *Goya*, 76 (1966–7), pp. 230–39
F. Portela Sandoval: *La escultura del renacimiento en Palencia* (Palencia, 1977)
J. M. Parrado del Olmo: *Los escultores seguidores de Berruguete en Palencia* (Valladolid, 1981)

MARGARITA ESTELLA

Girard, Dominique (*fl* 1715; *d* Munich, 1738). French landscape designer and engineer, active in Germany. He trained under André Le Nôtre at Versailles, from where he was seconded by Louis XIV to serve Maximilian II Emanuel, the exiled Elector of Bavaria, who was then building the château of Saint-Cloud. On being restored to power, Maximilian II Emanuel took Girard back with him to Munich to oversee the landscaping of his estates; Girard was appointed Fountain Engineer and Inspector of Works in 1715. His principal work for the Elector was at Schloss Nymphenburg, where he and Charles Carbonet (*fl* 1700–15; also a pupil of Le Nôtre) replanned and enlarged the park, laying down a series of formal gardens, pavilions and spectacular fountains about the central axis of the Würm canal. Girard and Carbonet also worked for Maximilian II Emanuel at SCHLOSS SCHLEISSHEIM. The Neues Schloss (1701–27) and gardens were designed together to enhance each other. The project was intended to supersede Schloss Nymphenburg as a symbol of princely ambition, but it was never completed. In 1717, and again in 1719 and 1722, Girard was invited by Prince Eugene of Savoy to Vienna to build the waterworks at the Belvedere (*see* VIENNA, §V, 6 and fig. 17). He linked the two Baroque palaces with a magnificent garden, designed in accordance with the plans of the Prince's architect, Johann Lukas von Hildebrandt. A formal terraced park, it uses much of the axial planning that Le Nôtre had pioneered at Versailles: long walkways, cascades, symmetrical flights of stairs and hedges create a heroic approach to the palaces. In 1728 Girard worked at the court of Clemens-August, Elector of Cologne, for whom he designed the park at Falkenlust, Brühl, where, in conjunction with François de Cuvilliés I, he linked the palace more coherently with the surrounding squares and gardens.

BIBLIOGRAPHY
Thieme–Becker; Vollmer

Girard d'Orléans (*fl* 1344; *d* Paris, 6 Aug ?1361). French painter. In 1344 he coloured a litter for Louis de Châtillon, Count of Blois, and subsequently entered the service of Philip VI (*reg* 1328–50); by 1348 Philip contributed to an endowment made by Girard to the chapel of his confraternity in the church of the Holy Sepulchre in Paris. During the reign of John II, Girard, referred to as 'dilecto nostro familiari Gerardo de Aurelianis, pictori, hostiario aule nostre' and granted the further title of Valet de Chambre, became artistic factotum. He designed the furnishings for such events as the initial chapter of the Order of the Star at Saint-Ouen. Girard accompanied John II during his captivity in England, where he executed paintings, coloured a throne and a saddle and provided chess pawns. The inventory of Charles V at Vincennes (1380) identifies two works by Girard: a silk grisaille and a quadriptych. The latter may have commemorated the Treaty of Calais (1360) and be the painting mentioned in an earlier inventory as portraying Charles V, Emperor Charles IV, John II and King Edward III of England. Girard was buried at the Charterhouse in Paris, where, according to a contemporary document, 'magister Aurelianensis, pictor, . . . fecit pulchram imaginem beatae Virginis'. Although no documented works by Girard survive, the panel painting probably depicting *King John II* (*c.* 1350–60; Paris, Louvre; *see* GOTHIC, fig. 66) has been attributed to him.

Girard may have been related to several other painters bearing the name Orléans who are recorded in France from the 13th century to the 16th, many of them in the royal service. They included EVRARD D'ORLÉANS, JEAN D'ORLÉANS and François d'Orléans (*fl* 1407–22), who was painter to the Dauphin, Louis de Guyenne, in 1414–15, and in 1422 made the royal effigy for Charles VI's obsequies.

BIBLIOGRAPHY
V. Dufour: *Une Famille de peintres parisiens des XIVe et XVe siècles* (Paris, 1877)
B. Prost: 'Liste des artistes mentionnés dans les états de la maison du roi et des maisons des princes du XIIIe siècle à 1500', *Archvs Hist., A. & Litt.*, i (1889–90), pp. 425–37
——: 'Recherches sur les "peintres du roi" antérieurs au règne de Charles VI', *Etudes d'histoire du moyen âge dédiées à Gabriel Monod* (Paris, 1896), pp. 389–404

PATRICK M. DE WINTER

Girardet, Edouard(-Henri) (*b* Le Locle, Switzerland, 30–31 July 1819; *d* Versailles, 5 March 1880). Swiss painter and engraver. He was the son of the engraver Charles-Samuel Girardet (1780–1863) and the brother of the painters and engravers Karl Girardet (1813–71) and Paul Girardet (1821–93). At an early age he joined his brother Karl in Paris, studying painting with him and attending the Ecole des Beaux-Arts. He had practised the techniques of wood-engraving from the age of nine and concentrated increasingly on the graphic arts after 1835. In 1836 he started work as a draughtsman for Jacques-Dominique-Charles Gavard's *Les Galeries historiques de Versailles* (Paris, 1838–49), a project that continued for the next 12 years. He made his début at the Salon in 1839 with the *Communal Bath* (1839; Neuchâtel, Mus. A. & Hist.), and

he continued to submit works until 1876. These included such genre paintings as the *Paternal Blessing* (1842; Neuchâtel, Mus. A. & Hist.) and a number of engravings and aquatints after such artists as Paul Delaroche, Horace Vernet and Jean-Léon Gérôme. Several of these engravings were published by the firm of ADOLPHE GOUPIL. In 1844 Girardet and his brother Karl were commissioned by the Musées Nationaux de Versailles to travel to Egypt to paint a historical scene from the Crusades. Girardet responded with the *Capture of Jaffa* (1844; Versailles, Château). He also travelled to England and frequently visited Switzerland, though most of his time was spent in France. In 1857 he finally settled in Paris and devoted himself largely to copperplate-engraving.

DBF BIBLIOGRAPHY
H. Béraldi: *Les Graveurs du XIXe siècle*, vii (Paris, 1888), pp. 154–6
G. Vapereau: *Dictionnaire universel des contemporains* (Paris, 1858, rev. 6/1893) □

Girardin, Louis-René [René-Louis], Marquis de (*b* Paris, 24 Feb 1735; *d* Vernouillet, 20 Sept 1808). French landscape designer and writer. He inherited a considerable fortune, which allowed him to develop his interests as a *seigneur-philosophe*. In 1754 he joined the army and, following the cessation of the Seven Years War in 1763, entered military service at Lunéville under the exiled King of Poland, Stanislav I Leszczyński. Between 1761 and 1766 Girardin also travelled in Italy, Germany and England, where he visited several English landscape gardens, including Stowe, Blenheim and the Leasowes.

In 1766, following the death of Stanislav, Girardin settled at ERMENONVILLE, Oise, where during the next decade he laid out an influential Picturesque landscape garden. Shortly after its completion he published *De la composition des paysages* (1777), in which he codified his own accomplishments and presented his theory of landscape gardening. Although this treatise reveals his intimate understanding of the associationist aesthetics of contemporary French and English garden theory, as found for example in Thomas Whately's *Observations on Modern Gardening* (1770) or Claude-Henri Watelet's *Essai sur les jardins* (1774), Girardin's work remains a practical guide to the composition of natural landscape according to the precepts of landscape painting. His views are not without philosophical import, although these largely derive from Jean-Jacques Rousseau's *Julie, ou la Nouvelle Héloïse* (1761) and the same author's *Du contrat social* (1762). Girardin's agricultural experiments and concern for improving the rural conditions of the town of Ermenonville further demonstrate his empathy with Rousseau (who died at the estate). Although Girardin's Ermenonville was one of the follies of the *ancien régime*, it was also a clear reflection of the enlightened and philanthropic thinking of its improving owner and of the dominant lines of enquiry in late 18th-century aesthetics.

WRITINGS
De la composition des paysages (Paris, 1777)
Guide d'Ermenonville (Paris, 1786)
Lettre à Sophie sur les derniers moments de J.-J. Rousseau (Paris, 1824)

DBF BIBLIOGRAPHY
A. Martin-Decaen: *Le Dernier Ami de Jean-Jacques Rousseau: Le Marquis René de Girardin* (Paris, 1912)
D. Wiebenson: *The Picturesque Garden in France* (Princeton, 1978), pp. 70–75
 SUSAN B. TAYLOR

Girardin, Maurice (*b* Paris, 1884; *d* Paris, 1951). French collector and dentist. He trained in the USA as a dentist and practised this profession in Paris, but from 1918 he devoted himself primarily to collecting modern art. For a period of about three years from 1920 he provided financial backing for the Galerie de la Licorne in Paris, but he was essentially a collector whose love of possession led him to hoard pictures and to sacrifice his comforts to this pursuit. His fairly broad tastes encompassed Cubism, the paintings of Maurice Utrillo and Bernard Buffet, and Oceanic objects, but his greatest enthusiasm was reserved for expressive artists who engaged with the tragic aspects of the human condition, beginning with Georges Rouault and followed by Marcel Gromaire, whom he supported under contract throughout the 1920s, and Bernard Buffet, whom he 'discovered' in 1948. Wishing to preserve the unity of his collection, he bequeathed it in its entirety to the City of Paris, although about one quarter of it was kept back by the family, who auctioned some of it off. This bequest now forms the core of the early 20th-century holdings of the Musée d'Art Moderne de la Ville de Paris.

BIBLIOGRAPHY
Collection Girardin (sale cat.; Paris, Gal. Charpentier, 10 Dec 1953)
Collection Girardin (sale cat.; Paris, Hôtel Drouot, 26 Feb 1954)
La collection Girardin (exh. cat., Paris, Petit Pal., 1954)
P. Cabanne: *Le Roman des grands collectionneurs* (Paris, 1961; Eng. trans., London, 1963), pp. 219–34
Gromaire (exh. cat., Paris, Mus. A. Mod. Ville Paris, 1980)
Masques et sculptures d'Afrique et d'Océanie (exh. cat., Paris, Mus. A. Mod. Ville Paris, 1986)
 MALCOLM GEE

Girardin, Nicolas-Claude (*d* 1786). French architect. He was a pupil of Etienne-Louis Boullée and won third prize in the competition of the Académie Royale d'Architecture in 1772 with a design for a palace. Girardin assisted Boullée on the renovation (1773) of the former hôtel of the Marquise de Pompadour (now the Palais de l'Elysée) in the Rue du Faubourg Saint-Honoré, Paris, for the financier Nicolas Beaujon. Girardin succeeded Boullée as architect to Beaujon, and from 1781 to 1783 he renovated the park of Beaujon's Palais Evreux, which bordered the Avenue des Champs-Elysées. In this picturesque rustic setting he built a luxurious country house named La Chartreuse, together with a chapel dedicated to St Nicolas. This had a façade in a stripped geometrical style learnt from Boullée, with no portico and virtually no mouldings around the doors and cornice. Inside, the rectangular nave was decorated with two rows of Doric columns, while a rotunda formed by eight Ionic columns surrounded the altar. Girardin also built the Hospice Beaujon (1784; now the Préfecture de Police) opposite the chapel. It is a massive, functional building, soberly decorated. Joint-lines in the stonework give emphasis to the façades, solid consoles support the cornice and two Doric columns mark the entrance across a square courtyard. This former orphanage is the only remaining evidence of the building

activities of Beaujon and Girardin in the Roule district of Paris. Girardin also worked for the financiers Taillepied de Bondy and Lepelletier de la Garenne, and in 1785 he built the château of Boulayes at Tournan-en-Brie. Here, the long façade is articulated with a giant order of Corinthian columns framing the arched windows of the ground floor and the rectangular windows of the *piano nobile*.

BIBLIOGRAPHY

C. Fournel: *L'Hôpital Beaujon: Histoire depuis son origine jusqu'à nos jours* (Paris, 1884)

R. Dupuis: 'La Chartreuse et le quartier Beaujon', *Bull. Soc. Hist. Paris & Ile-de-France*, 62nd year (1935), nos 3 and 4, pp. 97–132

M. Gallet: *Paris: Domestic Architecture of the 18th Century* (London, 1972)

VALÉRIE-NOËLLE JOUFFRE

Girardon, François (*b* Troyes, 10 March 1628; *d* Paris, 1 Sept 1715). French sculptor and collector. He was the most eminent sculptor in France during the last three decades of the 17th century, playing a vital part in the creation of the French classical style and, through his role as dominant sculptor on the royal works of Louis XIV, helping to disseminate this style in France, as well as turning it into a model for emulation throughout Europe.

1. Early stuccowork and sculpture for Versailles. 2. Sacred and commemorative projects. 3. Stylistic renewal in the later years. 4. Collecting.

1. EARLY STUCCOWORK AND SCULPTURE FOR VERSAILLES. Girardon was the son of a founder, Nicolas Girardon, and he began his apprenticeship in the workshop of Claude Baudesson, a sculptor and cabinetmaker in Troyes. While working with Baudesson at the château of Saint-Liébaut at Estissac, Aube, *c.* 1647, he was noticed by the chancellor, Pierre Séguier, who paid for him to go to Rome to complete his artistic education. About 1650 he returned to Troyes, arriving in Paris the following year, when Séguier found him a place in the workshop of François Anguier and Michel Anguier. At the start of his career he seems to have worked with Gilles Guérin, for whom in 1653–4 he carved nine portrait medallions of aldermen at the Hôtel de Ville, Paris (marble; destr. 1871), as well as some of the decoration of Louis XIV's bedchamber at the Louvre, Paris (gilt wood; *in situ*). He was noticed by Charles Le Brun, the Premier Peintre du Roi, and a long and productive professional association began soon after. Girardon was approved (*agréé*) by the Académie Royale in 1656 and received (*reçu*) as a full member in 1657, at the same time as Thomas Regnaudin and Gaspard Marsy. His *morceau de réception* was an oval profile medallion of the *Virgin of Sorrows* (marble, 1656–7; Paris, Louvre), in which he displayed both the sensitivity of modelling and the mannerist inclination that were to be characteristic of his work in relief throughout his life. This marked the start of a successful academic career, and he rose steadily through the hierarchy, becoming Professeur in 1659, Adjoint au Recteur in 1672 and Recteur in 1674, and in 1695 succeeding Pierre Mignard as Chancelier, a rare honour for a sculptor.

Girardon's first major commission was in 1659 for Nicolas Fouquet at the château of Vaux-le-Vicomte, Seine-et-Marne, where in conjunction with Nicolas Legendre he executed the elaborate stucco decorations designed by Le Brun (*in situ*). In 1663–4 he gave decisive proof of his mastery of stucco work through that executed on the vault of the Galerie d'Apollon at the Louvre (*in situ*). Here, although he was working under the direction of the architect Louis Le Vau and following Le Brun's designs, his supple, elegant style is clearly distinguishable from that of his collaborators, Regnaudin and the Marsy brothers. From then on Girardon was in constant employment on Louis XIV's great programme of building, gradually rising to a position of pre-eminence among the sculptors employed by the Bâtiments du Roi and supplying models for and supervising the execution of much of the sculpture made for the château of Versailles, the park at the Château de Marly, Yvelines, and the Dôme of the Invalides, Paris, before about 1700.

Girardon's stucco work of 1666 in the Grand Appartement du Roi at the palace of the Tuileries, Paris, was destroyed in 1871, but most of his sculpture made from 1666 onwards for Versailles survives *in situ*. Between 1666 and 1675 he executed, with the help of Regnaudin, the group of statues known as *Apollo Tended by the Nymphs* for the Grotto of Thetis (marble; moved to the Bosquet des Bains d'Apollon, 1774). This group, with its obvious

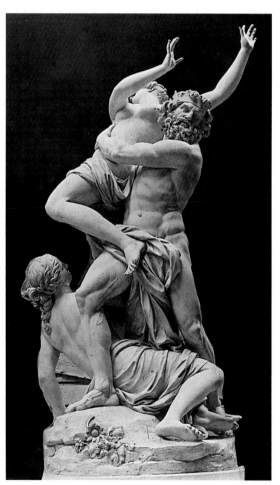

1. François Girardon: *Rape of Persephone*, marble, h. 2.60 m., 1677–99 (Versailles, Musée National du Château de Versailles et de Trianon)

derivations from antique sources modified by the harmonious and skilful disposition of the parts, may be considered the manifesto of the classical style that was to predominate at Versailles in the 1660s and 1670s. From 1667 Girardon designed the models for many of the fountains in the park at Versailles, including the Pyramid Fountain and the *Bain des nymphes* (both lead, formerly gilded; 1668–70). In the latter, the admirably fluid character of his relief modelling is apparent in the famous relief of bathing nymphs. In 1668 Girardon went twice to the dockyards at Toulon to supervise the decoration of the French royal fleet (drawings; Paris, Ecole N. Sup. B.-A., and Amsterdam, priv. col.; see Souchal, ii, pp. 28–9) and made a second visit to Italy. On his return he continued his work at Versailles, and in 1672–7 he contributed the Saturn Fountain (lead, formerly gilded) to the group of four Fountains of the Seasons; he was also active in the copying and restoration of antique marbles to decorate the gardens. However, among his most important contributions were the pieces he supplied as part of the so-called 'Grande Commande' of 1674, including one of the most powerful sculptures at Versailles, the great statue of a bearded old man representing *Winter* (marble, 1675–83; *in situ*), and the marble group of the *Rape of Persephone* (1677–99; see fig. 1). The latter, with its marble relief base, is the major sculpture of Girardon's maturity and originally stood in the centre of Jules Hardouin Mansart's Colonnade. In its confident handling of the complicated interlocking of three bodies, this work rivals similar groups by Bernini and marks the point at which French sculpture liberated itself from the imitation of Italian Baroque models to set a lead that was to be followed throughout Europe.

2. SACRED AND COMMEMORATIVE PROJECTS. Girardon was also active for private patrons, producing funerary monuments including that to *Anne-Marie de Bourbon, Princesse de Conti*, in St André-des-Arts, Paris (wall tomb, marble and bronze, 1672–5; destr. 1790s;

2. François Girardon: funeral monument to *Cardinal de Richelieu*, marble, 4.60×1.70 m, 1675–94 (Paris, chapel of the Sorbonne)

principal relief figure, New York, Met.); that to *Marie de Landes*, mother of Guillaume de Lamoignon, in St Leu-St Gilles, Paris (wall tomb, marble, before 1677; destr. 1790s; bas-relief, Troyes, Mus. B.-A. & Archéol.); and that to the *Castellan Family* (marble, 1678; Paris, St Germain-des-Prés). His most ambitious and successful funerary monument is that to *Cardinal de Richelieu* in the chapel of the Sorbonne, Paris (see fig. 2). The Cardinal is depicted expiring in the arms of Piety, while a weeping statue of Christian Doctrine is seated at his feet. One of the most handsome of 17th-century French tombs, its allegory displays an intellectual ambition unusual in French sculpture of the time.

The other great work of Girardon's maturity was the colossal bronze equestrian statue of *Louis XIV* commissioned by the King for the Place Louis le Grand (now Place Vendôme), Paris. Intended as the prime ceremonial representation of the sovereign in the heart of his capital, it depicted him in Roman armour and full-bottomed wig, hand outstretched in a gesture of command, astride a prancing horse. It was destroyed in 1792 (fragment, Paris, Louvre) but is known through a number of bronze reductions of which that in the Louvre seems to have been made under Girardon's personal direction. In 1688 he was responsible for modifying Bernini's marble equestrian statue of the King so as to represent Marcus Curtius (Versailles, Château).

After 1685 Girardon devoted much time to providing models for other sculptors employed by the Bâtiments du Roi at Versailles and the Louvre, and in the 1690s he oversaw the sculptural decoration of the Dôme of the Invalides, Paris, enjoying the confidence of Pierre Mignard, who replaced Le Brun as Premier Peintre, and François Michel Le Tellier, Marquis de Louvois, who succeeded Jean-Baptiste Colbert as Louis XIV's principal adviser. For Louvois he began a smaller bronze equestrian statue of the King intended for the château of Meudon, Hauts-de-Seine, but cast after Louvois's death for the Maréchal Louis-François de Boufflers (1644–1711) and installed at the Château de Boufflers, near Beauvais, in 1700 (destr. 1792). Girardon was also responsible with Martin Desjardins for Louvois's tomb in the church of the Capucines, Place Vendôme, Paris (1693–1702, marble and bronze; now Tonnerre, Hôpital).

3. STYLISTIC RENEWAL IN THE LATER YEARS. Girardon perhaps owed his pre-eminent position at the height of his career as much to his capacity for stylistic renewal as to his undoubted abilities as a manager of men. In the last two decades of the 17th century his art began to move away from the classicism of the early *Apollo* group and the moderated Baroque of such works as the *Rape of Persephone* towards a lively and elegant style, adumbrated in the fluidly modelled reliefs of his early career. This tendency is exemplified by works on an heroic scale, such as the stone groups of *Hercules at Rest* (1679) and the *Victory of France over Spain* (1680–82) at Versailles, as well as in works on a more modest scale, such as the bronze vases decorated with reliefs of the *Triumph of Thetis* and the *Triumph of Galatea* (1683; Paris, Louvre), or the bronze relief of the *Entombment* that once formed part of the Louvois funerary chapel (Paris, Notre-Dame). It was

at this time, in the period of his greatest success, that Girardon gave a number of works to his native town, Troyes, including a monumental bronze Crucifix for the church of St Remy (1686–90; *in situ*) and a magnificent marble portrait medallion of Louis XIV for the Hôtel de Ville (1687; *in situ*).

Among other late works of note are the bronze relief of *Carlo Borromeo Administering Communion to the Plague-stricken* (*c.* 1690; originally Paris, St Nicolas-du-Chardonnet, now Troyes, Mus. B.-A. & Archéol.) and a number of busts (a genre in which he could not readily compete with his younger rival Antoine Coyzevox, including the forceful but ponderous portraits of *Louis XIV* and *Maria Theresa* (both marble, *c.* 1691; Troyes, Mus. B.-A. & Archéol.). The surviving fragments of the imposing tomb surmounted by a *Descent from the Cross* that Girardon designed around 1700 for himself and his wife, the flower painter Catherine Duchemin (1630–98) (marble, 1703; originally Paris, St Landry, now St Marguerite), perhaps shows a decline in the artist's powers of invention. After 1700 he found himself eased out of his pre-eminent position by the architect Jules Hardouin Mansart, who controlled all public works, and by 1709 he was exhibiting signs of senile decay.

Although at the beginning of his career Girardon looked towards the art of antiquity for inspiration, he treated his sources with freedom in his search for ease and harmony of contour and disposition. When he later turned to contemporary Italian sculpture as a model, he rejected the full-blooded Baroque drama of Bernini in favour of a style modified by his experience of Classical art and his early training in a fluid and graceful Mannerist idiom, which brings his sculpture closer to that of Alessandro Algardi and François Du Quesnoy. Although by about 1700 his influence on French sculpture was being supplanted by the more dynamic style of Coyzevox, most of the sculptors who worked at Versailles and the other major state building projects of the reign of Louis XIV were marked by his work. Among his pupils was Sébastien Slodtz.

4. COLLECTING. During his career Girardon built up a substantial sculpture collection, and he also owned a few paintings, drawings and prints. In his later years, when his work was out of favour, his collection became his abiding passion. There are three main sources of information regarding this aspect of his career: a series of 13 engravings entitled the *Galerie de Girardon* (e.g. Paris, Bib. N., Cab. Est.), which were commissioned by Girardon himself, a description from 1713 and a posthumous inventory from 1715 (both Paris, Archvs N.). The first 12 of the engravings were produced sometime before 1709 by Nicolas Chevallier (*d* 1720) after drawings jointly executed by René Charpentier and Gilles-Marie Oppenord. The thirteenth engraving, again after Charpentier and Oppenord, was engraved by Franz Ertinger (1640–*c.* 1710) and is probably later. Charpentier drew the sculptures themselves, while Oppenord was responsible for designing the imaginary architectural settings in which they are displayed. Though the settings are fictive, the sculptures depicted were selected from those owned by Girardon. More detailed than the 1713 description, which was written for legal purposes, is the 1715 inventory. This was drawn up with

the help of the sculptors Nicolas Coustou and Corneille van Clève and covers the entire collection. From these documents some of the sculptures can be identified.

At the time of his death Girardon's collection comprised about 800 sculptures, ranging from plaster and wax models to notable antique and contemporary sculptures in bronze and marble. It was second only to that owned by Louis XIV, and several of the pieces in the collection came from that of Armand-Jean du Plessis, Duc de Richelieu. Most of it was housed in the Louvre, where Girardon had an *appartement* allocated to him, and the remainder was kept in one of the artist's properties in the Rue de Cléry. According to the inventory, there were 66 antique sculptures (e.g. the bust of *Cybele*—then described as being of *Isis*; Paris, Bib. N., Cab. Médailles) and a number of contemporary copies of antique pieces, together with busts of notable figures from the Classical past. Of later sculptures, there were several small bronzes produced by Giambologna's workshop (mostly under the supervision of Antonio Susini), such as the small version of the *Rape of the Sabines*, works by François Du Quesnoy (including numerous terracottas) and Michel Anguier, as well as some after Michelangelo (e.g. a copy of the figure of Moses from the tomb of *Julius II*). As would be expected, Girardon's own sculptures were also represented. Among the paintings, the majority were by Charles Le Brun, while the most important drawings were the set on the *Life of St Bruno* (Paris, Louvre) by Eustache Le Sueur. Though Girardon had thought of bequeathing his collection to his native town of Troyes, it in fact passed to his heirs, who dispersed it through sales some years after his death.

BIBLIOGRAPHY
Mariette; Souchal; Thieme–Becker
P. J. Grosley: 'Biographie de Girardon' (MS., 1742), *Mémoires inédits . . . des membres de l'Académie Royale*, ed. L. Dussieux and others, i (1854), pp. 295–306
A.-N. Dézallier d'Argenville: *Vies des fameux architectes et sculpteurs* (1788)
Corrard de Breban: *Notice sur la vie et les oeuvres de F. Girardon* (Troyes, 1851)
P. Francastel: *Girardon* (Paris, 1928)
M. Oudinot: 'F. Girardon: Son rôle dans les travaux de sculpture à Versailles et aux Invalides', *Bull. Soc. Hist. A. Fr.* (1937), pp. 204–48
Mignard et Girardon (exh. cat., Troyes, Mus. B.-A. & Archéol., 1955)
F. Souchal: 'La Collection du sculpteur Girardon d'après son inventaire après-décès', *Gaz. B.-A.*, n. s. 5, lxxxii (1973), pp. 1–98
D. Walker: *The Early Career of François Girardon, 1628–1686: The History of a Sculptor to Louis XIV During the Superintendence of Jean-Baptiste Colbert* (diss., U. New York, 1982)
FRANÇOIS SOUCHAL

Girardus. *See under* ANSELMUS.

Giraud, Jean-Baptiste (*b* Aix-en-Provence, 21 June 1752; *d* Bouleau, Seine-et-Marne, 13 Feb 1830). French sculptor and writer. He worked for a goldsmith in Paris before devoting himself to sculpture, in which he was self-taught. Thanks to an allowance from an uncle who had adopted him, he was able to study sculpture in Italy in the early 1780s; there he struck up a friendship with Jacques-Louis David. On his return he was approved (*agréé*) by the Académie Royale in Paris in 1788, and was received (*reçu*) as a member in the following year. On coming into a fortune, he returned in 1790 to Italy, where he lived until 1793, chiefly in Florence, Rome and Naples. He brought back with him what was the richest collection in France of plaster casts after antique sculpture, which he exhibited to the public at his house in the Place Vendôme, Paris.

When, in 1796, Napoleon plundered some of the best-known antique sculptures of Rome, Giraud protested about their removal.

Giraud produced very few works of his own, exhibiting at the Salon only in 1789. His Neo-classical works include *Dying Achilles* (marble, 1789; Aix-en-Provence, Mus. Granet) and a *Dog* (1827; Paris, Louvre). His passion for the theory of Classical art appears to have discouraged him from practising. He contributed to the most popular work of art history in France of that period, the *Recherches sur l'art statuaire, considéré chez les anciens et chez les modernes* (1805) by Toussaint-Bernard Emeric-David. He also took part in a competition organized in 1801 for the restoration to Italy of the *Laokoon* (Rome, Vatican, Mus. Pio-Clementino), which was then in the Louvre in Paris. As a result of this, he conceived the idea of a museum of modern art, the Musée Olympique de l'Ecole Vivante des Beaux-arts, which was never implemented.

BIBLIOGRAPHY

Lami; Thieme–Becker

B. Fillon: 'Lettre de David à Wicar (sur Giraud)', *Nouv. Archvs A. Fr.*, (1874–5), pp. 401–4

M. Shedd; *T. B. Emeric-David and the Criticism of Ancient Sculpture in France, 1790–1839* (diss., Berkeley, U. CA, 1980), pp. 61–101, 186–246 [includes complete bibliog.]

——: 'A Neo-classical Connoisseur and his Collection: J. B. Giraud's Museum of Casts at the Place Vendôme', *Gaz. B.-A.*, n. s. 5, ciii (1984), pp. 198–206

P. Durey: 'Le Néo-classicisme', *La Sculpture française au XIXème siècle* (exh. cat., Paris, Grand Pal., 1986), pp. 288–90, 292

PASCAL GRIENER

Girault, Charles-Louis (*b* Cosne, Nièvre, 27 Dec 1851; *d* Paris, 1932). French architect and writer. He trained in the studio of Honoré Daumet, whom he much admired, at the Ecole des Beaux-Arts, Paris, where he won numerous awards. Having been placed second in the competition for the Prix de Rome in 1879, he was successful the following year with a project for a 'home for sick and infirm children'. His originality was already apparent in his first major commission after his return from Rome, the Palais de l'Hygiène (destr.) at the Exposition Universelle, Paris, of 1889. His building was in an academic style reminiscent of ancient Rome and based directly on the exercises in imaginary reconstruction that were required of Prix de Rome winners. Girault thus proclaimed his suitability for undertaking *grands projets*. In 1896 he built a crypt at the Institut Pasteur, Paris, to receive the ashes of the famous scientist Louis Pasteur. He modelled it on the 5th-century Mausoleum of Galla Placidia in Ravenna and adorned it with marble and mosaics.

At the Exposition Universelle, Paris, of 1900, Girault was able to put some of his ideas on urban planning into practice by laying out the main entrance, aligned with the new Pont Alexandre III and the late 17th-century dome of the Hôtel des Invalides. He also erected two structures that were intended to outlast the exhibition: the Petit Palais, which was entirely his own work, and the Grand Palais (*see* PARIS, fig. 10), of which he was principal architect, working in partnership with HENRI-ADOLPHE-AUGUSTE DEGLANE, Albert Louvet (1860–1936) and Albert-Théophile-Félix Thomas (1847–1907). The two buildings flank the broad Avenue Alexandre III, just off the Avenue des Champs-Elysées and near the colonnades designed (*c.* 1755) by Anges-Jacques Gabriel for the former Place Louis XV (now Place de la Concorde). The façades are interpretations of 18th-century French architecture and the Petit Palais in particular is an obvious allusion to the stables of the château at Chantilly, which were built (1721–35) by Jean Aubert and restored by Daumet in the late 19th century. The Petit Palais, which was intended to accommodate collections of historic French art at the Exposition Universelle and then to become a museum, is arranged around a central courtyard, with an entrance hall and two vast galleries with sumptuous paved floors. Behind exterior façades built entirely of stone, the Grand Palais is in fact one great iron-framed hall. Its plain interior décor centres on a grand staircase leading to the upper galleries.

With this type of work, Girault came to the attention of Leopold II, King of Belgium, a wealthy client for whom he worked on some major public buildings, including the château at Laeken (enlarged 1901–11) and the Palais du Congo (1901–10) in Tervuere, both on the outskirts of Brussels, and the triumphal arch of the Palais du Cinquantenaire (1904–10) in Brussels. Girault thus created in Belgium a type of official architecture reminiscent of his creations in Paris, in opposition to the growth of the locally popular Art Nouveau style.

WRITINGS

Notes sur la vie et l'oeuvre de Honoré Daumet (Paris, 1919)

BIBLIOGRAPHY

A. Louvet: 'Charles Girault', *Architecture* [Paris], xlvi (1933), pp. 253–62

L. Hautecoeur: *Architecture classique*, vii (1957), pp. 468–72

D. Wordsdale: 'Le Petit Palais des Champs-Elysées: Architecture and Decoration', *Apollo*, cvi (1978), pp. 207–11

JEAN-PAUL MIDANT

Girault de Prangey, Joseph-Philibert (*b* Langres, Haute-Marne, 1804; *d* Courcelles, nr Paris, 1892). French photographer and draughtsman. A wealthy landowner and scholar who travelled widely, he made numerous sketches of Islamic architecture (untraced; engravings, Granada, Casa Tiros) and he took many very fine landscape photographs. During his travels in Italy, Asia Minor, Greece, Lebanon and Egypt (1841–5) he produced more than 900 daguerreotypes, which were used to illustrate his book on the Arabic monuments of the Middle East; he also photographed French monuments (e.g. *La Tour St-Jacques, Paris*, 1841; see Berger-Levrault, pl. 72). His work remained completely unknown until the plates (London, H. and A. Gernsheim priv. col.) were rediscovered in 1952. One of the earliest French landscape photographers, he devoted much of his time to his home at Courcelles, where he became a recluse after 1846. His only known contemporary exhibition was in Granada in 1833.

WRITINGS

Monuments arabes et mauresques de Cordoue, Séville et Grenade (Paris, 1836)

Monuments arabes d'Egypte, de Syrie et d'Asie Mineure (Paris, 1846)

BIBLIOGRAPHY

Regards sur la photographie en France au XIXe siècle, Berger-Levrault (Paris, 1980)

H. Gernsheim: *The Origins of Photography* (London, 1982), pp. 83–6

PATRICIA STRATHERN

Girieud, Pierre(-Paul) (*b* Paris, 1876; *d* Nogent-sur-Marne, 1948). French painter. He spent his childhood in

Marseille and Cassis, with no specific artistic education. He arrived in Paris in 1900 and was soon one of a group of determinedly innovative artists, including Picasso, with whom he exhibited in 1901 at the Collège d'Esthétique Moderne in Paris. From 1902 to 1921 he exhibited regularly at the Salon d'Automne and the Salon des Indépendants, Paris. During this time he met a number of Gustave Moreau's pupils, who would later form the Fauvists, and in 1901 exhibited his work at Berthe Weill's gallery in Paris, where he was invited to show again on several occasions in the future. He made two journeys to Italy, in 1905 and 1907, which inspired a series of paintings on Siena and San Gimignano. In 1908 he exhibited the *Temptation of St Anthony* at the Golden Fleece Gallery in Moscow and organized an important exhibition at Daniel-Henry Kahnweiler's in Paris. The following year he joined the Neue Künstlervereinigung München, whose chairman was his friend the American painter Adolph Erbslöh (1881–1947), and he was included in the group's first show in December 1909 at the Moderne Galerie Heinrich Thannhauser in Munich. He also became a friend of Kandinsky and Vladimir Bechtejeff. He exhibited in 1910 in Prague, and in 1912 in Budapest, Cologne and Zurich. He returned to Marseille in 1911 after a stay in Munich, where he showed again at the Moderne Galerie Heinrich Thannhauser. It seems likely that he introduced his painter friends in Marseille to the new pictorial researches being carried out in Russia, and above all in Munich by the circle of Kandinsky. Some of them, especially the French painter Mathieu Verdilhan (1875–1928), clearly showed the influence of the Blaue Reiter. Girieud provided a connecting link between them and the European avant-garde. He moved into 12 Quai de Rive neuve, next door to his friend Alfred Lombard, and together they organized the Salons de Mai in Marseille in 1912 and 1913. In 1914 Girieud exhibited his work at the Galerie Rosenberg in Marseille. After World War I he had a studio in Paris close to Lombard's. He returned regularly to the Midi, which was his source of inspiration for numerous landscapes. He received several official commissions for the Exposition International des Arts Décoratifs and for the Université de Poitiers. He designed a fresco for Cairo Art School, where he gave courses on the art of fresco. In 1945 he became a professor at the Ecole des Beaux-Arts in Nantes.

BIBLIOGRAPHY
C. Malpel: *Notes sur l'art d'aujourd'hui et peut-être de demain*, preface L. Lacroix (Toulouse and Paris, 1910)
A. Alauzen di Genova: *La Peinture en Provence* (Marseille, 1984)
ERIC HILD-ZIEM

Giriktepe. See *under* PATNOS.

Girnar. See JUNAGADH AND GIRNAR.

Girodet (de Roussy-Trioson) [Girodet-Trioson], **Anne-Louis** (*b* Montargis, Loiret, 29 Jan 1767; *d* Paris, 9 Dec 1824). French painter.

1. Life and work. 2. Working methods and technique.

1. LIFE AND WORK.

(i) Before c. 1795: Paris and Rome. Girodet was named 'de Roussy' after a forest near the family home, Château du Verger, Montargis. He took the name Trioson in 1806, when he was adopted by Dr Benoît-François Trioson (*d* 1815), his tutor and guardian and almost certainly his natural father. Girodet took lessons with a local drawing-master in 1773 and by 1780 was studying architecture in Paris, where he became a pupil of the visionary Neo-classical architect Etienne-Louis Boullée. Boullée persuaded Girodet to study painting under Jacques-Louis David, and Girodet joined David's atelier in late 1783 or early 1784. He belonged to the highly successful first generation of David's school, which included Jean-Germain Drouais, François-Xavier Fabre, François Gérard, Antoine-Jean Gros and Jean-Baptiste-Joseph Wicar. David's pupils showed great stylistic uniformity, based on a close emulation of his elevated Neo-classicism, and Girodet's early compositions are distinguishable from those of his contemporaries only by their slight quirkiness and excessive attention to detail.

Girodet's competition paintings for the Prix de Rome from 1786 to 1789 show David's influence in their austerity and formal economy, their subordination of colour to line and the sculptural plasticity of the figures. No prize was awarded in the competition of 1786, and when Girodet tried again in 1787 with *Nebuchadnezzar Putting to Death the Children of Zedekiah* (Le Mans, Mus. Tessé) Fabre denounced him for cheating and he was disqualified. Girodet's reaction to this was extreme, displaying the unpleasant temperament which later developed into vindictiveness, paranoia, arrogance and hatred of criticism that soured his relationships with both patrons and fellow artists. To his abiding hatred of Fabre he was to add jealousy of Gérard and an openly contemptuous attitude to David.

Girodet was placed second in the Prix de Rome of 1788 with the *Death of Tatius* (Angers, Mus. B.-A.), and finally won in 1789 with *Joseph Recognized by his Brothers* (Paris, Ecole N. Sup. B.-A.), which shows a more sensuous and yielding treatment of the figures. In the same year he painted a *Deposition* (1789; Church of Montesquieu-Volvestre, Haute-Garonne) commissioned by a Capuchin convent. This vast canvas (3.35×2.35 m) was thought to have been destroyed during the Revolution but was rediscovered in 1953. It is of considerable importance in that it was painted at a period notably unsympathetic to the production of religious paintings. It is a night scene, set in the interior of a cave, and demonstrates an early strain of Romanticism in Girodet's art. He had a lasting interest in sepulchral subjects, which permitted melancholy introspection: most notable was his *Burial of Atala* (1808; Paris, Louvre; see PARIS, fig. 21).

Girodet's departure for the Académie de France in Rome was delayed by the outbreak of the Revolution of 1789, and since like David he was an avowed Republican, he made drawings of the fall of the Bastille and its aftermath (Paris, Bib. N., Est. B6 Rés.41). Girodet arrived in Italy in 1790 and stayed until 1795 although his studies were disrupted by ill-health and political upheaval. In addition to drawings from the Antique and several accomplished landscape paintings he produced two major compositions in Rome. In 1791 he transformed a compulsory *pensionnaire*'s life-study exercise into an original and impressive mythological painting, the *Sleep of Endymion*

1. Anne-Louis Girodet: *Sleep of Endymion*, oil on canvas, 1.97×2.60 m, 1791 (Paris, Musée du Louvre)

(Paris, Louvre; see fig. 1). In many respects this was the most successful painting of his career; when it was sent to the Paris Salon of 1793 it made his reputation. It demonstrates Girodet's ideas concerning originality, creativity and individuality. He claimed that the idea of the Zephyr and the depiction of the goddess Diana as a moonbeam were entirely his creations, and in thus stressing the role of imagination, he was opposing the imitative basis of Neo-classicism. He was at pains to point out how little *Endymion* resembled the paintings of David and how much it represented his own unique, poetic vision. David had considered Girodet to be his most talented and promising pupil. However, when in Rome Girodet embarked on a deliberate refutation of David's precepts: the elongated figure of Endymion exudes eroticism. The moonlit setting and *sfumato* effects are influenced by Leonardo and Correggio, and the painting exhibits the eclecticism and complexity against which David had warned him before he left for Rome.

In 1792, as a homage to his guardian Trioson, Girodet painted *Hippocrates Refusing the Gifts of Artaxerxes* (U. Paris V, Fac. Médec.), which adheres more closely to Neo-classical precepts although still incorporates bizarre and recherché elements, particularly in its illustration of Johann Kasper Lavater's physiognomic theories. Apart from *Endymion* and *Hippocrates*, the most important paintings

produced by Girodet in Italy were the *Giuseppe Favrega, Doge of Venice* (1795; Marseille, Mus. B.-A.) and *Self-portrait Aged 28* (1795; Versailles, Château).

(ii) From c. *1795: Paris.* On his return to Paris in 1795 Girodet drew the illustrations for Pierre Didot's editions of Virgil (1798) and Racine (1801) and also made his name as a portrait painter. His three-quarter-length portrait of *Jean-Baptiste Belley* (1797; Versailles, Château), the black Deputy to the Convention from Saint Domingue (now Haiti), is one of the outstanding portraits of the Revolutionary period. Belley, an ex-slave, is shown leaning against a bust of the Abbé Raynal, a prominent campaigner against slavery who had died in 1796.

In 1799 Girodet was awarded a Prix d'Encouragement and a state commission for the 'patriotic' subject of the assassination of the French plenipotentiaries at Rastatt. His conditions for undertaking the commission were extravagant and it was abandoned. This was the first of many official commissions that he never executed, or finished years after the agreed date. His disinclination to undertake such work was due to his preference for subjective themes allowing imaginative scope and, after 1815, to his improved financial position.

In 1799 also, Girodet was guilty of a more disruptive professional impropriety. The fashionable actress Anne-

Françoise-Elisabeth Lange commissioned him to paint her portrait. Sitter and artist argued, Girodet destroyed the original portrait and replaced it at the Salon with an allegorical rejoinder satirizing Lange with complex and highly detailed symbolism. This scurrilous painting, *Mlle Lange as Danaë* (Minneapolis, MN, Inst. A.), caused a scandal, ruined Lange's career and disgraced Girodet. The portrait is ethically and stylistically at odds with David's standards and employs an exaggerated Mannerism derived from Bronzino.

Surpassing *Mlle Lange* in extravagance, eclecticism and complexity of effect was Girodet's next major painting, the *Apotheosis of French Heroes who Died for the Country during the War for Liberty*, more commonly known as *Ossian and the French Generals* (Malmaison, Château N.). It was commissioned in 1800 by Charles Percier and Pierre-François Fontaine to decorate the Salon Doré of Napoleon's country retreat at Malmaison and was based on James Macpherson's Ossianic legends. Gérard was also working on an Ossianic subject for Malmaison. In an effort to outdo Gérard and prove his own originality Girodet spent 15 months on a highly complex politico-allegorical work which combined Ossianic figures with the ghosts of generals killed in the wars of the Revolution. Girodet intended it as a topical allusion to the Treaty of Lunéville (1801) but by the time it was shown in the Salon of 1802 the political climate had changed with the Peace of Amiens (March 1802), and the work that Girodet saw as his masterpiece met with incomprehension. Napoleon disliked the painting, David saw it as evidence of Girodet's insanity and critics termed it 'the fruits of a mind in delirium'. It confirms Girodet's claim to originality but demonstrates also his tendency to produce works of an ephemeral interest. Forty named figures are included in *Ossian and the French Generals* (see fig. 2), although the composition is relatively small (1.92×1.84 m). The baroque accumulation of figures and the extravagance of the conception marks a complete break with Neo-classical composition.

Girodet's interest in Ossianic subjects continued with his *Death of Malvina* (Varzy, Mus. Mun.), painted *c.* 1802, and with a number of illustrations to the *Poems of Ossian* including a series of eight also dated *c.* 1802 at the Musée de Montargis. After the failure of the *Ossian* painting, Girodet produced a number of portraits including those of *Doctor Larrey* (Paris, Louvre) and *Charles-Marie Bonaparte* (Ajaccio, Mus. Fesch; replica of 1805, Versailles, Château), both shown at the Salon of 1804. In the Salon of 1806 he showed the *Deluge* (Paris, Louvre), which he insisted had nothing to do with the biblical event and was again intended to demonstrate originality. He felt that the small scale of *Ossian* had contributed to its failure and compensated with the monumental *Deluge* (4.31×3.41 m) showing five full-length figures linked in agonized contortions on a slippery rock. The treatment of the figures combines the influence of David with that of Michelangelo. Many critics found the work unnecessarily horrific, but it won the Prix Décennal of 1810, beating David's *Intervention of the Sabines* which came second. In 1807 Girodet produced two portraits that offer proof of his excellence in the genre; those of *An Indian* (Montargis, Mus. Girodet) and *Chateaubriand* (Saint-Malo, Château).

The following year he had his greatest success since *Endymion* with the *Burial of Atala* (Paris, Louvre), inspired by Chateaubriand's novel *Atala* (1800), a key work of the Catholic Revival in France. Girodet's painting perfectly matched the poetic and exotic tone of Chateaubriand's text, and the *Burial of Atala* was one of the most popular works of the Salon of 1808. Also dated 1808 is an undistinguished Napoleonic work commissioned by Vivant Denon, *Napoleon Receiving the Keys to Vienna* (Versailles, Château). More successful and original was a second Napoleonic work, the *Revolt at Cairo* (Versailles, Château), one of the outstanding works of the Salon of 1810, and an important example of early Romantic orientalism.

From 1808 Girodet was involved with a series of decorative allegorical and mythological paintings for the Empress Josephine at the château of Compiègne. These occupied him intermittently until 1821 but are mediocre in execution. In 1812 he was commissioned to paint 36 portraits of *Napoleon in his Coronation Robes* for the imperial courts. By 1814 he had completed 26 (e.g. Montargis, Mus. Girodet; Barnard Castle, Bowes Mus.). In 1815 Dr Trioson died, leaving Girodet a considerable inheritance. From this point until his death he produced little of importance, concentrating on portraits, such as *The Violinist Boucher* (1819; Versailles, Château), and *Hector Becquerel* (1820; Montargis, Mus. Girodet), and on drawings illustrating Anacreon and Virgil. He spent an increasing amount of time composing didactic poems about painting (e.g. *Les Veillées* and the epic *Le Peintre*) and writing discourses on aesthetics. He made a last attempt to attract attention at the Salon of 1819 with *Pygmalion and Galatea*, which he hoped would equal *Endymion* in its erotic, enchanting effects, but the work was unexceptional and made little impact. His last two exhibited works, at the Salon of 1824, were portraits of the Vendée generals *Bonchamps* and *Cathelineau* (both Cholet, Mus. A.), originally commissioned in 1816. The 1824 exhibition was the first of the great Romantic Salons, overtly opposed to Neo-classicism. Girodet had anticipated significant elements of Romanticism with his insistence on originality and individualism, his deviation from Classical sources and ideals, and his liking for the irrational and extreme. In the latter part of his career, however, he became reactionary and conservative in his politics and his art and was intolerant of Romantic painting which he considered careless and 'unfinished'.

2. WORKING METHODS AND TECHNIQUE. Girodet's innovative theories and themes were not matched by any appreciable stylistic or technical developments. His style remained recognizably influenced by David although his ingenious artificial atmospheric effects (the glaucous moonlight of *Endymion*, the golden lighting of *Mlle Lange*, *Ossian and the French Generals* lit by meteors, and the *Deluge* by lightning) differed significantly from David. In Italy he had started painting at night and continued this unusual practice throughout his career using a system of artificial light set up by his pupil Antoine Claude Pannetier (1772–1859). His Romantic, subjective themes, allied to academically correct execution, resulted in his work attracting contradictory classifications, ranging from 'icy Neo-classicism' to 'visionary Romanticism'. A survey of his oeuvre reveals an unusual eclecticism covering the major

2. Anne-Louis Girodet: *Ossian and the French Generals*, oil on canvas, 1.92×1.84 m, 1802 (Malmaison, Musée de Malmaison)

preoccupations of the time. Girodet systematically researched his subjects and made numerous preparatory drawings. His oil sketches were used mainly to establish effects of lighting and atmosphere and show little of the detail of the finished works, as exemplified by the sketches for *Mlle Lange* (Montargis, Mus. Girodet) and *Ossian and the French Generals* (Paris, Louvre). The preliminary drawings and his literary illustrations, particularly those for the *Aeneid*, demonstrate his outstanding draughtsmanship.

Girodet accepted his first pupils on the strength of the reputation he had made with *Endymion*. Although his atelier was fashionable, it was generally recognized that he was not a successful teacher. His originality and individuality, which he considered crucial to his own work, were

not teachable. Instead, his pupils concentrated on imitating his refined academicism, exaggerating the smooth finish and highly descriptive appearance of his canvases. They assisted him on major commissions such as the portraits of Napoleon and produced copies and replicas of his work. This has sometimes led to confusion of attribution, but Pérignon's catalogue (1825) is a reliable guide to original works.

Girodet's followers rarely distinguished themselves, and his most outstanding pupils were Léon Cogniet, Alexandre Colin (1798–1875), Théodore Gudin, Achille and Eugène Devéria, Pierre Delorme, Henri-Guillaume Chatillon (1780–1856) and Hyacinthe Aubry-Lecomte. Many of his pupils were involved in the new process of lithography,

using it to make reproductions of Girodet's work, such as Aubry-Lecomte's numerous prints of Girodet's illustrations and paintings, including a suite of 16 lithographs of the principal heads from *Ossian and the French Generals*. The Musée Girodet at Montargis has an important collection of Girodet's paintings and drawings.

WRITINGS

Oeuvres posthumes de Girodet-Trioson, peintre d'histoire: Suivies de sa correspondance, précédées d'une notice historique, ed. P. A. Coupin (Paris, 1829) [contains the epic didactic poem *Le Peintre* and its embryonic form, *Les Veillées*]

BIBLIOGRAPHY

Catalogue des tableaux, esquisses, dessins, et croquis de M. Girodet-Trioson, peintre d'histoire, membre de l'Institut (sale cat. by M. Pérignon; Paris, 11–25 April 1825)

J. Adhémar: 'L'Enseignement académique en 1820: Girodet et son atelier', *Bull. Soc. Hist. A. Fr.* (1933), pp. 270–83

G. Levitine: *Girodet-Trioson, an Iconographic Study* (diss., Harvard U., 1952)

——: 'L'Ossian de Girodet et l'actualité politique sous le Consulat', *Gaz. B.-A.*, n. s. 6, xlviii (1956), pp. 39–56

Girodet (exh. cat., ed. J. Pruvost-Auzas; Montargis, Mus. Girodet, 1967) [reviewed by J. de Caso, *A. Bull.*, li (1969), pp. 85–9 and P. Ward-Jackson, *Burl. Mag.*, cix (1967), pp. 660–63]

G. Levitine: 'Girodet's New Danaë: The Iconography of a Scandal', *Minneapolis Inst. A. Bull.*, lviii (1969), pp. 69–77

P. Bordes: 'Girodet et Fabre, camarades d'atelier', *Rev. Louvre*, vi (1974), p. 393

De David à Delacroix: La peinture française de 1774 à 1830 (exh. cat., ed. P. Rosenberg; Paris, Grand Pal., 1974), pp. 447–54

Le Néo-classicisme français: Dessins des musées de Provence (exh. cat., ed. A. Sérrulaz, J. Lacambre and J. Vilain; Paris, Grand Pal., 1974), pp. 68–77

Ossian (exh. cat., ed. H. Toussaint; Paris, Grand Pal., 1974)

G. Bernier: *Anne-Louis Girodet, Prix de Rome 1789* (Paris, 1975) [excellent plates]

S. Nevison Brown: *Girodet: A Contradictory Career* (diss., U. London, 1980)

N. MacGregor: 'Girodet's Poem *Le Peintre*', *Oxford A. J.*, iv/1 (1981), pp. 26–30

Girodet, dessins de Musée, Montargis (exh. cat. by J. Boutet-Loyer, Montargis, Mus Girodet, 1983)

STEPHANIE NEVISON BROWN

Girolamo da Cremona [Girolamo di Giovanni dei Corradi] (*fl* 1451–83). Italian illuminator and painter. He probably trained in the circle of Francesco Squarcione in Padua. It is possible that Girolamo is the Gerolamo Padovano described as illuminating manuscripts for S Maria Nuova, Florence, in Vasari's *Vita* of Bartolomeo della Gatta. Girolamo's first known works are an historiated initial P showing the *Baptism of Constantine* (1451; Paris, Mus. Marmottan) and a letter M inscribed *Ieronimus. F.* with *St Catherine before Maxentius* (London, V&A, MS. 1184), both probably excised from the same Antiphonal. The style of these compositions is eclectic and includes figures with little articulation that appear to derive from Antonio Vivarini's types, combined with studied spatial effects probably learnt from Donatello's main altar at S Antonio, Padua. A subsequent but near contemporary work possibly by Girolamo is the miniature of *St Maurice* in the *Life and Passion of St Maurice* (1452/3; Paris, Bib. Arsenal, MS. 940, fol. 34*v*), commissioned by Jacopo Marcello as a gift for René I, 4th Duke of Anjou. Girolamo's fame soon spread beyond Padua and he was summoned to Ferrara to contribute miniatures (formerly assigned to Marco di Giovanni dell'Avogaro; *fl* 1449–76) to the BIBLE OF BORSO D'ESTE (Modena, Bib. Estense, MS. V. G.12–13, lat. 422–3) produced between July 1455 and December 1461. During his activity in the Estense capital, Girolamo

was influenced by the stage-like settings and abstracted backgrounds of Jacopo Bellini, who had been the painter favoured by Leonello d'Este, Marquis of Ferrara.

In 1461 Girolamo moved to Mantua, where, on the recommendation of Mantegna, he completed by 1466 a lavish Missal (Mantua, Mus. Dioc.) for Barbara of Hohenzollern, Marchioness of Mantua (1422–81), which had been started by Belbello da Pavia in a pristine Gothic style. The work was reassigned to Girolamo in spite of Belbello's entreaties and offer to complete the volume without compensation. Girolamo's close contact with Mantegna was apparently crucial in his obtaining the commission, and the illuminator's work in the Missal demonstrates Mantegna's growing influence on his development. In a letter written in 1461 as Girolamo was hired, the patroness praised his work as that of a young (*un zovene*), talented illuminator, from which it may be inferred that the artist was then probably in his twenties. In Mantua, Girolamo's style matured and became crisply descriptive in the rendering of sculptural forms, even in such details as rock formations and foreground pebbles; but he also adopted Belbello's brilliant palette in an artful and sophisticated manner. Probably dating to 1461–3, and thus of his Mantuan period, are the miniatures he produced along with Franco dei Russi and Jacopo da Mantova (*fl* 1460–65) in an Antiphonal (London, Soc. Antiqua., MS. 456, fols 1*r*, 19*v*, 27*v*) for the church of SS Cosma e Damiano (destr. 1587), originally adjacent to the Mantuan palace. In the miniature of the *Martyrdom of the Saints*, the low vantage point and the steep foreshortening reflect the influence of Mantegna's Ovetari Chapel frescoes (mostly destr. 1944) in the Eremitani, Padua.

Girolamo's Mantuan output demonstrates his excellent craftsmanship in the rendering of a calm, ordered world composed of well-delineated, metallic-like forms and static, svelte figures clad in pleated draperies with long tubular folds, and with small, roundish heads marked by high curved foreheads, wide-bridged noses, and receding chins. The tonalities in his often repetitive compositions are judiciously juxtaposed to maximize the effect of opulence. Also characteristic are his borders, which are enlivened by numerous and illusionistically modelled representations of rubies, amethysts, cameos and other gems enhanced by involved goldsmithswork and gilt chiaroscuro scrolls, as well as prominent shadow-casting pearls. His framed compositions are surrounded by bevelled borders adapted from panel painting.

In 1466 both Girolamo and Mantegna are recorded in Florence. Girolamo subsequently went to Siena, where he was intermittently active from February 1470 until 1474, illustrating choir-books with large historiated initials and borders in collaboration with LIBERALE DA VERONA and Venturino Mercanti da Milano (*fl* 1467–79), for both the monastery of Monte Oliveto Maggiore outside Siena and Siena Cathedral. Girolamo's contribution for the former is in *Corale* M (1472; Chiusi, Mus. Cattedrale), and for the latter in a number of Graduals and Antiphonals (Siena, Bib. Piccolomini, MSS 16.1, 17.2, 18.3, 19.4, 23.8, 28.12, 3.C, 10.L, 12.N). Other works datable to this period are initials I and R showing an *Angel Blowing a Trumpet* and the *Resurrected Christ* (fol. 199*r*; see fig.), respectively in an Antiphonal (Cleveland, OH, Mus. A., Acc. 30.661) and

Girolamo da Cremona: *Resurrected Christ*; cutting from an Antiphonal, ink, tempera and gold on parchment, 559×432mm, *c.* 1470–80 (Cleveland, OH, Cleveland Museum of Art, Acc. 30.661, fol. 199*r*)

a cutting from a Psalter of an initial O (or D) with *God the Father Enthroned* (New Haven, CT, Yale U.A.G., Acc. 1954.7.2). The miniatures Girolamo produced in Siena are compositionally his most complex and stylistically his most dynamic. He played an essential role in introducing such Sienese artists as Benvenuto di Giovanni to a sympathetic, innovative style that combined skilful coloration with clear drawing in a finely descriptive technique. Furthermore, he introduced north Italian architectural motifs to the Sienese school.

Between 1473 and early 1475 Girolamo was also in Florence, participating with Gherardo di Giovanni da Miniato (1444/5–97) and Mariano del Buono di Jacopo on the illustration of a manuscript (Florence, Bargello, MS. 68), copied in 1473 and intended for the Camaldolese hospital of S Maria Nuova. During this period he also produced the illustrations in a manuscript of Pseudo-Lull's *Trattato di alchimia* (Florence, Bib. N. Cent., MS. Banco Rari 52). In 1475 the peripatetic Girolamo is mentioned in two letters from Benedetto Capperello to Lucrezia de'Medici as active in Venice and working on a Missal for her. Three sets of cuttings are cited as having been excised from the Missal (untraced): border decoration with deer, a roundel with deer and an initial C showing a *Priest Celebrating Mass* (Philadelphia, PA, Free Lib., Lewis MS. 27:27–29); a miniature (affixed to a cradled panel) of the *Deposition* (New York, Met., Acc. 49.7.8); and two miniatures, the *Epiphany* and *Presentation in the Temple* (Paris, Wildenstein priv. col.). Also of Girolamo's Venetian

period are the first part (up to fol. 180*v*) of a remarkable Carthusian Breviary (Oxford, Bodleian Lib., MS. Canon. Liturg. 410) with large architectural motifs, and a Cluniac Psalter (Oxford, Bodleian Lib., MS. Liturg. 72) with impressive gold scrolls enlivened with fauna. Other manuscript illumination attributed to Girolamo, which appears to belong to his late period in Venice, is in a Breviary for the charterhouse of Montello (Treviso, Bib. Com., MS. 888), a religious treatise *Theologica mistica* produced for a nun (Venice, Bib. N. Marciana, MS. it. I. 61), and a miniature of the *Crucifixion* (ex-Eugene Schweitzer priv. col., Berlin).

The bulk of Girolamo's late work seems to have been devoted to the illustration of incunabula for Venetian book publishers. Occasional single copies of texts printed on parchment and destined for bibliophiles had miniatures added by Girolamo. He produced frontispieces for volumes printed by Nicolas Jenson: Eusebius's *De evangelica praeparatione* (1470; London, BM, Inc. IB 1912); Gratian's *Decretals* (1474; London, BM, Inc. IC 19678); St Augustine's *City of God* (1475; New York, Pierpont Morgan Lib., ChL 760); another *Decretals* (1477; Gotha, Forschbib.); and Plutarch's *Lives* (1478; vol. I: Paris, Bib. N., Vélins 700; vol. II: New York, Pierpont Morgan Lib., ChL 767). His work in these large volumes consists of rich acanthus borders in which are lodged pearls, precious stones in mounts, and medallions with deer and water fowl at rest or in flight, similar to those in the Cluniac Psalter. The last known productions of this artist are two outstanding frontispieces and some 19 large initials, each enlivened with a bust or cameo within a setting, executed for an edition of Aristotle's *Works*, printed in two volumes in 1483 by Andrea dei Torresani d'Asola and Bartolomeo de Blavis (New York, Pierpont Morgan Lib., ChL 907). Here Girolamo, in a softened and more luminous style, probably engendered by contact with Venetian artists, created especially spectacular *trompe l'oeil* effects. In the first frontispiece, images are shown as if through torn blank areas of the page, while in the second, the text appears like a tapestry, tied to the façade of a Renaissance palace from which Aristotle, Averroës and their followers glance out, with deer, playful satyrs and putti below. These ornamental inventions were subsequently imitated by Venetian illuminators.

Of the several panel paintings once attributed to Girolamo (e.g. in the cathedrals at Viterbo and Arsola, and in S Francesca Romana and the Palazzo Venezia, Rome) all, save a rather bland *Annunciation* (Siena, Pin. N., no. 309) and perhaps a *Virgin and Child with Angels* (Perugia, G.N. Umbria), have been reattributed by post-1950 scholarship to Liberale da Verona. In miniature painting, the individual work of the two artists is at times just as difficult to distinguish, as they seem to have made a concerted effort to converge towards a uniform style on the choir-books in Siena, in fact cooperating in numerous instances on the same miniature (e.g. Siena, Bib. Piccolomini, MS. 16.1, fol. 23*v*), with Girolamo's style influencing Liberale's freer, nervous manner, but benefiting in turn from the latter's creative compositions. Girolamo's sense of monumentality and space transformed the scope of book illumination from subordinate decoration into a form closer to small

panel paintings; he is thus justly considered outstanding among north Italian illuminators of the period.

BIBLIOGRAPHY

G. Vasari: *Vite* (1550, rev. 2/1568); ed. G. Milanesi, iv (1878–85), pp. 584–5

M. Salmi: 'Girolamo da Cremona miniatore e pittore', *Boll. A.*, n. s. 1, i (1922–3), pp. 385–404, 461–78

M. Levi D'Ancona: 'Postille a Girolamo da Cremona', *Studi di bibliografia e storia in onore di Tammaro De Marinis*, iii (Verona, 1964), pp. 45–104

B. Berenson: *Central Italian and North Italian Schools* (1968), i, pp. 189–93; ii, pls 866–75, 877–8

M. Levi D'Ancona: *The Wildenstein Collection of Illuminations: The Lombard School* (Florence, 1970)

M. G. Ciardi-Dupré: *I corali del Duomo di Siena* (Milan, 1972)

F. Bisogni: 'Liberale o Girolamo?', *A. Illus.*, vi (1973), nos 55–6, pp. 400–08

M. Righetti: 'Indagine su Girolamo da Cremona miniatore', *A. Lombarda*, 41 (1974), pp. 32–42

H. J. Eberhardt: *Die Miniaturen von Liberale da Verona, Girolamo da Cremona und Venturino da Milano in den Chorbüchern des Doms von Siena: Dokumentation, Attribution, Chronologie* (Munich, 1983)

Painting in Renaissance Siena, 1420–1500 (exh. cat., ed. K. Christiansen, L. B. Kanter and C. Brandon Strehlke; New York, Met., 1988–9) [entries by K. Christiansen]

PATRICK M. DE WINTER

Girolamo da Fiesole. *See* JÉRÔME DE FIESOLE.

Girolamo da Sermoneta. *See* SICIOLANTE, GIROLAMO.

Girolamo [Gerolamo] da Treviso [*il vecchio*] **(i)** (*fl* Treviso, *c.* 1475–97). Italian painter. The identity of this painter is uncertain. A group of paintings produced in Treviso between *c.* 1475 and 1497 are signed *Hieronymus Tarvisio*; several of them are also dated. Documents show that there were two painters who might have used this signature, both active in Treviso at the same time, both of whom died in 1497. They are Girolamo di Bartolomeo Strazzarolo da Aviano (documented 1476; *d* between 29 May and 26 Oct 1497) and Girolamo di Giovanni Pennacchi (1455–before 15 May 1497), the elder brother of the painter Pier Maria Pennacchi. Unfortunately, no extant painting is securely documented as the work of either man. Because an inscription on the back of *St Jerome in the Wilderness* (Bergamo, priv. col., see Zocca, p. 389) says that it was painted in Padua, and Girolamo Pennacchi stated in his will of 17 July 1496 that he had previously worked in Padua, the oeuvre has been ascribed to him; conversely, it has also been given to Girolamo Strazzarolo da Aviano, because in September 1496 he was given a barrel of wine in payment at Paese, near Treviso, where an altarpiece of *St Martin and the Beggar* (*in situ*), signed *Girolamo da Treviso*, is dated 1496: it is assumed that the wine was in part payment for the painting. Federici, followed by Coletti and Nepi Scirè, identified the artist as Girolamo Strazzarolo da Aviano; Biscaro, Paoletti and Ludwig and Zocca claimed he was Girolamo Pennacchi; Fiocco and Longhi divided the oeuvre between the two men.

The works are in a Paduan, Mantegnesque style; the earliest appears to be the *St Jerome in the Wilderness*, signed and dated 1475. A panel of the *Death of the Virgin* (1478; Treviso, Cassa di Risparmio), a *Pietà* (Lovere, Gal. Accad. B.A. Tadini) and a *Dead Christ with Angels* (Milan, Brera) are in the same tempera technique and the same Mantegnesque style.

After 1480 the artist veered towards a style that imitates Alvise Vivarini; to this period belong two paintings of the *Virgin and Child* (Budapest, Mus. F.A.; Portland, OR, A. Mus.) and a panel fragment of the head of St Anthony Abbot (Treviso, Mus. Civ. Bailo). The signed and dated *Virgin and Child Enthroned with SS Sebastian and Roch*, known as the Pala del Fiore (1487; Treviso Cathedral), shows the influence of Bartolommeo Montagna. Thereafter the artist apparently reverted to a more retardataire style evident in the lunette of the *Transfiguration* (Venice, Accad.), part of a destroyed altarpiece of 1488 (the only painting ascribed by Fiocco to Strazzarolo da Aviano; the rest he gave to Pennacchi); the same stylistic development is visible in the *Virgin and Child with Four Saints*, called the Pala di Collalto (1494; Venice, Accad.), an altarpiece (Treviso Cathedral) from San Vigilio, near Montebelluna, and the *St Martin and the Beggar*, signed and dated 1496.

BIBLIOGRAPHY

D. M. Federici: *Memorie trevigiane sulle opere di disegno. . .*, i (Venice, 1803)

L. Crico: *Lettere sulle belle arti trevigiane* (Treviso, 1833)

J. A. Crowe and G. B. Cavalcaselle: *A History of Painting in North Italy*, ii (London, 1871, rev. 2/1912, ed. T. Borenius)

G. Biscaro: 'Note e documenti per servire alla storia delle arti trevigiane', *Culture & Lavoro* (1897)

P. Paoletti and G. Ludwig: 'Neue Beiträge zur Geschichte der venezianischen Malerei', *Repert. Kstwissen.* (1899)

G. Fiocco: 'Pier Maria Pennacchi', *Riv. Regio Ist. Archeol. & Stor. A.* (1929)

E. Zocca: 'Girolamo da Treviso il vecchio', *Boll. A.*, xxv (1931–2), pp. 388–97

R. Longhi: *Viatico per cinque secoli di pittura veneziana* (Florence, 1946)

L. Coletti: *Pittura veneta del quattrocento* (Novara, 1953)

G. Nepi Scirè: 'Appunti e chiarimenti su Gerolamo da Treviso il vecchio (Gerolamo Aviano o Gerolamo Pennacchi?)', *Not. Pal. Albani*, iii (1973), pp. 27–39 [with documents]

MAURO LUCCO

Girolamo (di Tommaso) da Treviso [*il giovane*] **(ii)** (*b* Treviso, *c.* 1498; *d* Boulogne-sur-Mer, 1544). Italian painter, draughtsman, sculptor and military engineer. He is first documented in 1523 in Bologna but had probably arrived there *c.* 1520. Between 1515 and 1520 he produced an engraving (initialled) of *Susanna and the Elders* and a series of drawings that were engraved by Francesco de Nanto, depicting scenes from the *Life of Christ*. A series of paintings, some of them initialled, were attributed to him by Coletti and this attribution is now generally accepted. The group includes two small canvases (transferred from panels that were initialled HIRTV) representing *Isaac Blessing Jacob* and *Hagar and the Angel* (both Rouen, Mus. B.-A.), the monogrammed *Sleeping Venus* (*c.* 1520–29; Rome, Gal. Borghese; see fig.), which contains an echo of Marcantonio Raimondi's so-called *Dream of Raphael* (B. 274, 359), the initialled *Female Nude* (Vienna, Ksthist. Mus.), derived from a drawing by Raphael (London, BM) that was engraved by Raimondi (B. 234, 311), the *Holy Family with Simeon* (Ca' Morosini, parish church), the *Noli me tangere* (Bologna, S Giovanni in Monte) and the *Christ in Limbo* (Munich, Alte Pin.). These would be early works but they already show that Girolamo's Venetian style was modified by his response to the classicizing art of Emilia, and particularly by the work of Giacomo Francia and Marcantonio Raimondi, who united the classicism of Raphael with the fantasies of northern European engravers.

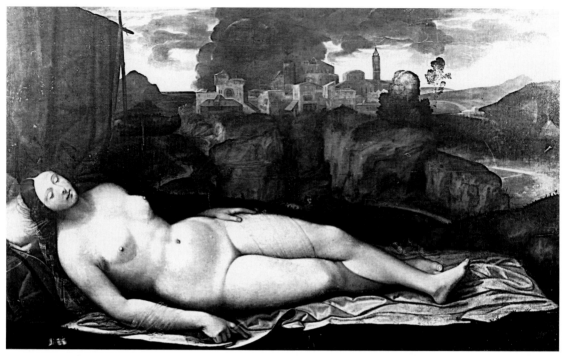

Girolamo da Treviso (ii): *Sleeping Venus*, oil on canvas, 1.30×2.12 m, *c.* 1520–29 (Rome, Galleria Borghese)

In 1524 Girolamo collaborated in the sculptural decoration of the right-hand portal on the façade of S Petronio in Bologna, carving marble reliefs of *Jacob's Sons Presenting him with Joseph's Bloodstained Garment* and the *Cup Found in Benjamin's Sack*. Between the end of 1525 and May 1526 he made eight signed grisaille wall paintings in oil, depicting *Miracles of St Anthony of Padua* in the Guidotti Chapel of the same church. In 1527–8, according to Vasari, he frescoed the façade of the Casa Doria in Genoa, and immediately afterwards may have been involved in the decoration of the Palazzo del Te in Mantua with Giulio Romano (Mancini). In Venice in 1531–2 he provided an altarpiece (untraced) for S Salvatore and painted frescoes on the façade of the house of Andrea Odoni, the antiquarian and collector whose portrait was painted by Lorenzo Lotto (London, Hampton Court, Royal Col.).

In 1533, in Faenza, Girolamo decorated the apse of the church of the Commenda with a beautiful fresco, the central part showing the *Virgin and Child Enthroned with SS John and Catherine of Alexandria, with Mary Magdalene Presenting the Donor*. The *sinopia* shows that the artist originally planned to have four saints beside the throne of Mary. Two sheets of preparatory drawings have survived (Florence, Uffizi). These and the painting itself show a matured style in which Girolamo re-elaborates stylistic devices and formulae found in the work of Correggio, Parmigianino, Bartolomeo Ramenghi Bagnacavallo and Garofalo.

According to Vasari, Girolamo also took part in the decoration of the Magno Palazzo commissioned by Bishop Bernardo Clesio (1485–1539) in the castello of Buonconsiglio in Trent, but there is no other documentary evidence for this. Sometime between 1529 and 1538 the artist produced the fresco, now fragmentary, in the oratory of S Sebastiano at Castelbolognese (Ravenna), the *Adoration of the Magi* (London, N.G.) from a cartoon by Baldassare Peruzzi for the Bentivoglio family, and, for S Salvatore, Bologna, the *Presentation of the Virgin with St Thomas of Canterbury* (*in situ*), which is strongly influenced by the Venetian paintings of Sebastiano del Piombo. This painting, for which there is also a preparatory drawing (Florence, Uffizi), was executed for the English students' chapel, a commission that probably led to the invitation from King Henry VIII for the artist to work at the English court as a military engineer. While in Britain he produced the satirical grisaille of the *Evangelists Stoning the Pope* (London, Hampton Court, Royal Col.), and the anti-papal and anti-imperial drawing of the *Triumph of Death over Church and State* (sold London, Christie's, 23 June 1970, lot 52). Vasari reported that Girolamo was killed by a cannon shot while the English were besieging Boulogne-sur-Mer.

BIBLIOGRAPHY

G. Vasari: *Vite* (1550); ed. L. Bellosi and A. Rossi (Turin, 1986), pp. 687, 762–4, 867

——: *Vite* (1568); ed. P. della Pergola, L. Grassi and G. Previtali (Milan, 1962–6), iv, pp. 264, 403–10; v, pp. 358, 360, 395; viii, p. 218

I. B. Supino: *Le sculture delle porte di S Petronio in Bologna* (Florence, 1914), pp. 37, 41, 47–51, 64

L. Coletti: 'Gerolamo da Treviso il Giovane', *Crit. A.*, i (1935–6), pp. 172–80

P. Pouncey: 'Girolamo da Treviso in the Service of Henry VIII', *Burl. Mag.*, xcv (1953), pp. 208–11

K. Oberhuber: *Marcantonio Raimondi*, 26 [XIV/i], 27 [XIV/ii] of *The Illustrated Bartsch*, ed. W. L. Strauss (New York, 1978) [B.]

The Genius of Venice, 1500–1600 (exh. cat., ed. J. Martineau and C. Hope; London, RA, 1983), pp. 172–3

A. Tempestini: 'Contributo a Girolamo da Treviso il giovane', *Mus. Ferrar.: Boll. Annu.* (1983–4), pp. 111–18

P. Casadio: 'Un affresco di Girolamo da Treviso il giovane a Faenza', *Il Pordenone. Atti del convegno internazionale di studio: Pordenone, 1985*, pp. 209–15
A. Speziali: 'Girolamo da Treviso', *Pittori bolognesi del cinquecento*, ed. V. Fortunati Pierantonio (Casalecchio di Reno, 1986), i, pp. 147–83 [excellent bibliog. and pls]
V. Mancini: 'Un insospettato collaboratore di Giulio Romano a Palazzo del Te: Gerolamo da Treviso', *Paragone*, xxxviii/453 (1987), pp. 3–21
A. Tempestini: 'Un *Cristo al limbo* di Girolamo da Treviso il giovane (1498–1544)', *Ant. Viva*, xxviii/2–3 (1989), pp. 15–18

ANCHISE TEMPESTINI

Girolamo da Udine (*fl* 1506–12). Italian painter. Girolamo's only authenticated surviving work is a *Coronation of the Virgin with SS John the Baptist and John the Evangelist* (ex-S Francesco dell'Ospedale, Udine; Udine, Mus. Civ.) signed *Opus ieronimi Utinensis*. He is almost certainly the same Girolamo, son of Bernardino da Verona (1463–1528), who signed a contract to paint a chapel in SS Biagio e Giusto in Lestizza, near Udine, in March 1511 and who died the following year. Attempts to associate him with a document of 1539 have been shown to be mistaken. Girolamo must have been resident for most of his career in Venice, since the style of the *Coronation* is very close to that of Cima da Conegliano. The fairly literal borrowing of the figure of the Baptist from its counterpart in Cima's *Rest on the Flight to Egypt* (c. 1495–8; Lisbon, Mus. Gulbenkian) suggests a date of about 1500 for the *Coronation* and confirms that Girolamo had access to the contents of Cima's workshop. Another work in the style of Cima that is generally attributed to Girolamo is an *Adoration of the Shepherds* (Worcester, MA, A. Mus.), in which the stylization of the draperies and the timid little figures with button-like eyes bear a close resemblance to the figure types in the *Coronation*. Girolamo may have been responsible for several other variants on designs by Cima; he also seems occasionally to have collaborated with his compatriot Giovanni Martini da Udine (*fl* 1497–1535), for example on the lunette (Udine, Mus. Civ.) of Giovanni's documented St Ursula altarpiece of 1503–7.

Thieme–Becker
BIBLIOGRAPHY
V. Joppi: 'Contributo quarto ed ultimo alla storia dell'arte nel Friuli', *Misc. Stor. Ven.*, n.s. 2, xii A (1894), p. 24
G. M. Richter: 'Italian Pictures in Scandinavian Collections', *Apollo*, xix (1934), pp. 128–9
B. Berenson: *Venetian School* (1957), p. 90
M. Levi d'Ancona: *The Iconography of the Immaculate Conception in the Middle Ages and Early Renaissance* (New York, 1957), p. 31
L. Coletti: *Cima da Conegliano* (Venice, 1959), p. 66
Prima mostra del restauro (exh. cat., ed. A. Rizzi; Udine, Castello, Salone Parlamento, 1963), pp. 70–71
L. Lanzi: *Storia pittorica dell'Italia*, ed. M. Capucci (Florence, 1968), ii, p. 63
P. Zampetti: *A Dictionary of Venetian Painters* (Leigh-on-Sea, 1970), i, pp. 56–7
F. Zeri: *Italian Paintings in the Walters Art Gallery* (Baltimore, 1976), i, pp. 258–9
A. Tempestini: *Martino da Udine detto Pellegrino da San Daniele* (Udine, 1979)
——: 'Tre schede venete', *Itinerari*, i (1979), p. 78
L. Menegazzi: *Cima da Conegliano* (Treviso, 1981)
P. Humfrey: *Cima da Conegliano* (Cambridge, 1983)

PETER HUMFREY

Girolamo del Crocifissaio. *See* MACCHIETTI, GIROLAMO.

Girolamo [Gerolamo] di Bartolomeo Strazzarolo da Aviano. *See under* GIROLAMO DA TREVISO (i).

Girolamo di Giovanni da Camerino (*fl* 1449–73). Italian painter. His first known painting is a fresco, dated 1449, of the *Virgin and Child with SS Anthony of Padua and Anthony Abbot* (Camerino, Mus. Pin. Civ.). The influence of Piero della Francesca, who was active in Urbino during the late 1440s, is evident in the fresco's dramatic play of light and the geometric simplicity of its figures. On 21 November 1450 Girolamo entered the painters' guild in Padua. His hand was identified by Longhi in the frescoes of *St Christopher and the King* (destr. 1944) in the Ovetari Chapel in the Eremitani, Padua. His arrival in the city just after the death of Giovanni d'Alemagna and the withdrawal of Antonio Vivarini from the contract to decorate the chapel suggests that Girolamo went to Padua in order to apply for the new commission.

The *Annunciation* and *Pietà* (Camerino, Mus. Pin. Civ.), executed shortly after Girolamo's return to Camerino, show the influence of Mantegna's use of architectural perspective: the interior of the Virgin's chamber in Girolamo's *Annunciation* is clearly inspired by Mantegna's work in the Ovetari Chapel. The figure of the Angel Gabriel, on the other hand, is derived from the Paduan works of Filippo Lippi, who had worked in Padua around 1434.

Girolamo's art shows little stylistic development since he was by nature an eclectic. His work has been compared with that of Giovanni Boccati, also from Camerino, and Berenson even suggested that Girolamo studied with Boccati, but this seems unlikely since they were of the same generation. Girolamo's last dated work is a large polyptych of the *Virgin and Child with Saints* (1473; Montesanmartino, nr Macerata, Madonna del Pozzo). Works by him continue to be discovered in the Marches.

BIBLIOGRAPHY
B. Berenson: 'Girolamo di Giovanni da Camerino', *Ant. Viva*, vii (1907), pp. 129–35
R. Longhi: 'Lettere pittoriche: Roberto Longhi a Giuseppe Fiocco', *Vita Artistica*, i (1926), pp. 127–39 (136)
L. Serra: 'Girolamo di Giovanni da Camerino', *Rass. March.*, viii (1929–30), pp. 246–68
F. Zeri: *Due dipinti, la filologia e un nome* (Turin, 1961), pp. 74–80
P. Zampetti: *La pittura marchigiana del '400* (Milan, 1969), pp. 90–95 [with catalogue of works]
A. Paolucci: 'Per Girolamo di Giovanni da Camerino', *Paragone*, xxi/239 (1970), pp. 23–41

ELIOT W. ROWLANDS

Girolamo di Romano. *See* ROMANINO, GEROLAMO.

Giroldo (di Jacopo) da Como [Giroldo da Lugano] (*fl* 1267–74). Italian sculptor. In 1267, Giroldo executed the monumental rectangular font in the cathedral at Massa Marittima. His name is preserved in the inscription on the upper border of one of the sides of the font: HOC OPVS EST SCVLPTVM A MAGISTRO GIROLDO. Hewn from a single block of travertine marble, each side is divided by trefoil arches between which are carved reliefs of *Christ Blessing* flanked by the *Virgin and St John the Baptist*, *SS Regolo and Cerbone* and scenes from the *Life of St John the Baptist*. A second secure work is a marble relief, possibly from a pulpit, of the *Annunciation* (San Miniato Cathedral), which is dated 1274 and signed GIROLDVM QVONDAM IACOBI DE CVMO, SVB A D. M. CC. L. XX. IIII. The only other autograph work is a marble relief panel in the abbey of S Maria, near Montepiano. It shows the *Virgin and Child*

Enthroned flanked by standing figures of *SS Peter and Paul* and *St Michael the Archangel*, inscribed GIROLDO ME FECE. This relief is undated, but its style suggests it may be the earliest of the three works. Attributions to Giroldo include sculptural fragments of standing figures in niches (Lucca, Villa Guinigi), originally from S Frediano, Lucca, and probably from an altar, as well as a lavabo in the cathedral at Massa Marittima.

BIBLIOGRAPHY
M. Salmi: *Scultura romanica in Toscana* (Florence, 1928), pp. 113–14
L. Gronchi: 'Le sculture altomedievali di Massa Marittima, I', *Crit. A.*, xv/95 (1968), pp. 55–68
E. Carli: *L'arte a Massa Marittima* (Siena, 1976), pp. 36–8

Girometti, Giuseppe (*b* Rome, 7 Oct 1780; *d* Rome, 17 Nov 1851). Italian gem-engraver, sculptor and medallist. He was one of the most important gem-engravers of the first half of the 19th century. In 1812 he was elected to the Accademia di S Luca in Rome as an engraver of hardstones and was awarded numerous prizes. In 1822 he was appointed, together with Giuseppe Cerbara, as Head Engraver at the papal mint. His early sculptures include four statues for Foligno Cathedral and several portrait busts (Florence, Pitti). He produced an enormous amount of glyptic and medal work and executed more than 60 medals for popes Pius VII, Leo XII, Pius VIII, Gregory XVI and Pius XI, as well as at least 15 medals for private clients and public institutions. He adopted a number of Classical elements, creating an original style that helped to revive the Roman art of medal-making.

Girometti engraved hardstones mainly in cameo: large stones with several layers of colour were particularly popular at the time, especially those engraved with such mythological or Classical subjects as *Bacchantes* (New York, Met.; Rome, Vatican, Bib. Apostolica) or *Primavera* (Paris, Bib. N., Cab. Médailles). He often reproduced such famous antique gems as *Diomedes with the Palladium* (London, BM) and *Jupiter Smiting the Giants with a Thunderbolt* (versions Florence, Pitti; Rome, Vatican, Bib. Apostolica), and copied works by such contemporary sculptors as Antonio Canova, Bertel Thorvaldsen, Pietro Tenerani and John Gibson (i). He also produced a series of portraits commissioned in part by the Duc de Blacas d'Aulps that represented such famous figures as *Plato*, *Socrates*, *Richelieu* and *Racine*. Other works include five cameos with the busts of *Leonardo*, *Titian*, *Michelangelo*, *Correggio* and *Raphael* (sold London, Christie's, 8 June 1982, lot 141) and a series of portraits of contemporary figures largely comprising the sovereigns and rulers of the period (London, BM, V&A).

Pietro Girometti (*b* Rome, 20 Sept 1811; *d* Rome, 13 July 1859), the son of Giuseppe, was also a medallist and engraver. He was particularly well known for having executed some medals for the iconographical series of famous Italian men begun in 1843 in collaboration with Nicola Cerbara, with whom he produced 16 pieces (see A. Gennarelli: *Il Saggiatore*, i, 1844, p. 272; ii, 1845, pp. 301–6). From 1838 he worked as an engraver at the papal mint and succeeded his father as Head Engraver. His medals are particularly valuable for their portraits; his gem-engraving, however, is more difficult to judge, as it is easily confused with his father's work.

BIBLIOGRAPHY
Forrer; Thieme–Becker
P. E. Visconti: *Notizie delle opere dell'incisore in pietre dure ed in conj cav. Giuseppe Girometti* (Rome, 1833)
H. Le Grice: *Walks through the Studii of the Sculptors at Rome* (Rome, 1841), pp. 163–77, 283
R. Righetti: *Incisori di gemme e cammei in Roma dal Rinascimento all'ottocento* (Rome, n. d.), pp. 51–3, 59–60, pl. V
——: *Biblioteca Apostolica Vaticana, opere di glittica dei Musei Sacro e Profano* (Vatican City, Rome, 1955), pp. 47–8, table XVII, 1 and 3
——: *Gemme e cammei delle collezioni comunali* (Rome, 1955), pp. 89–92
G. C. Bulgari: *Argentieri, gemmari e orafi d'Italia, Roma*, i (Rome, 1958), p. 552
Le gemme Farnese (Naples, 1994), figs 22 and 145

LUCIA PIRZIO BIROLI STEFANELLI

Girona [Sp. Gerona]. Capital of the province of Girona in Catalonia, Spain. The city (population *c.* 87,000) is bisected by the River Oñar. Girona was a fortified Iberian settlement, whose ruined walls, dating from the 4th and 5th centuries BC, are preserved. The site was taken over by the Romans, who named it Gerunda; sections of the Roman city remain. Girona passed to the Visigoths and subsequently to the Muslims, the Franks and the Aragonese. The first cathedral was founded by Charlemagne in AD 786 but was destroyed by the Moors. The 12th-century church and cloister of S Pedro de Galligans (now Mus. Arqueol.), both with rich sculptural decoration, the 12th-century church of S Nicolás (rest.) and the cloister of the monastery of S Daniel date from the flourishing Romanesque period. Parts of the 11th-century structure of the cathedral (then a mosque) were incorporated into the 14th-century rebuilding (*see* §1(i) below). Other fine examples of Catalan Gothic include the church of the monastery of S Domingo (1253–1349). A school of goldsmiths was active in Girona in the 13th and 14th centuries (*see* SPAIN, §IX, 1(i), and GOTHIC, §V, 8); they produced high-quality work, examples of which are kept in the cathedral. The famous Jewish quarter in the old town declined from the 15th century. The medieval city is well preserved, with many restored mansions, although little of the old walls remain, for they were largely destroyed during the French siege of 1809. The former Palacio Episcopal (rebuilt 1642) now houses the Museu Diocesà de Girona. The city became an industrial centre in the 20th century.

BIBLIOGRAPHY
The Town of Gerona: Past and Present (Girona, 1931)
J. Pla Cargol: *Gerona arqueologica y monumental* (Girona, 1945)
M. Aurell: *Girona dins la formacio de l'Europa medieval* (Girona, 1985)

1. CATHEDRAL.

(i) Architecture. There was a large mosque on the site, which was converted into the cathedral *c.* 1015. In the 11th century the north tower (Torre de Carlemany) was added, and *c.* 1080–1120 the Romanesque cloister, an irregular quadrilateral in plan, was built. The chapter resolved to rebuild the church from the east end in 1312, and by 1347 a new chevet with seven radiating chapels and a short choir of one and a half bays had been completed in French style under several masons, including Jacques de Faveran (1309–36) from Narbonne. Work lapsed until

1395, however, when it was proposed to build a new chapter house; members of the chapter opposed the idea, arguing that the cathedral church should be completed first. In 1416 Guillermo Boffiy (*fl* 1416–27) produced a plan to complete the cathedral with a nave the same width (22.25 m) as the 14th-century choir and aisles, wider than any comparable European project since Roman times; Faveran may have initiated this plan (Harvey). Despite a tradition of wide, aisleless churches in south-western France (e.g. Albi Cathedral, w. 17.7 m), Boffiy's plan was considered so daring that in 1416 the chapter appointed a commission of 11 architects to establish its safety and feasibility (*see* MASON (i), §IV, 3(ii)). The argument that a single-cell nave would be lighter and cheaper than a nave and aisles may have swayed the chapter, although only five members of the commission supported the idea, and Boffiy commenced work in 1417 with ANTONI CANET. The lateral thrust of the immense vault is taken by buttresses, the lower parts of which are inside the church. There are two polygonal chapels to each bay, fitted in between the buttresses. Above these are a low triforium gallery and very large traceried windows, one to each bay. The east end of the nave is filled by the choir with its flanking aisles, seen as if in section. The four-bay nave was not completed until 1598. The immense flight of stairs leading to the west front dates to the 1680s, and the Baroque west portal was not added until 1730–33 by Pedro Costa (*d* 1761).

BIBLIOGRAPHY

G. E. Street: *Some Account of Gothic Architecture in Spain* (London, 1865, rev. 2/1869/*R* 1912), ii, pp. 92–105, 319–32
J. Harvey: *The Cathedrals of Spain* (London, 1957), pp. 149–50
M. Oliver: *La catedral de Gerona* (León, 1973)

STEPHEN BRINDLE

(ii) Sculpture. The Romanesque capitals and friezes in the cloister are the cathedral's most remarkable sculptural ensemble. There are 58 figurative capitals, 10 of which illustrate scenes from the New Testament, while the panels at the corners of the cloister depict some isolated Old Testament scenes and relate two Old Testament cycles: from the *Creation* to the *Flood*, and from *Abraham and the Three Angels* to *Jacob Taking Refuge with Laban*. The rendering of space and anatomical form is unexceptional, but the expressive realism and acute sense of drama reveal the work of a great master. Particularly notable are the enraptured Adam in the *Creation of Eve*; the *Temptation*, where the serpent licks at Eve ingratiatingly; the detailed treatment of the carpenters with their adzes in *Building the Ark*; the vigour with which Christ plucks Adam from Hell in the *Descent into Limbo*; and the well-preserved frieze recounting the *Life of Jacob*, where the dynamic scenes of the angels on *Jacob's Ladder* and *Jacob Wrestling with the Angel* are vividly conveyed. The iconography derives from illuminated Bibles, such as those known to have been produced in Catalonia at the time, although it cannot be convincingly linked with a known manuscript or tradition. If the carvings were made a little before the mid-12th century then they are earlier than or contemporary with sculpture in the cloister of S Pedro de Galligans and that by Arnau Gatell (*fl c.* 1190) at S Cugat in Vallès Occidental (nr Barcelona), although clearly by a different hand.

The transition from Romanesque to Gothic is apparent in the work of MASTER BARTOMEU, who worked in the cathedral in the second half of the 13th century. He is believed on stylistic grounds to have carved the *Virgin of Bellull* tympanum, which, with other works, seems to show the influence of the cloister carvings. The magnificent retable (1324) carved in wood and covered with silver and enamels is also traditionally attributed to Bartomeu. It was enlarged in 1357–8 by Pere Berneç (Pedro Bernés, *fl* 1345–98) of Valencia together with Ramon Andréu. The late medieval tombs are the remaining foci of sculptural interest in the cathedral. Pere Oller carved that of *Bishop Berenguer de Anglesola* (*d* 1408), with its expressive mourners; the tomb of *Bernat de Pau* (early second half of the 15th century) has been ascribed on grounds of style and quality to Lorenzo Mercadante. Both are made of a white stone with traces of polychrome decoration.

BIBLIOGRAPHY

J. Bassedoga: *La catedral de Gerona* (Barcelona, 1889)
C. Cid Priego: 'La iconografía del claustro de la catedral de Gerona', *An. Inst. Estud. Gerund.*, vi (1951), pp. 5–118
L. Font: *Gerona: La catedral y el Museo Diocesano* (Girona, 1952)
P. Palol: *Gerona* (Barcelona, 1953)
J. Marques Casanovas: *El claustro de la catedral de Gerona* (Girona, 1962)
E. Junyent: *Catalunya romànica*, ii (Monserrat, 1976), pp. 115–37
M. A. Alarcia and others: *Girona: Museu d'Art* (Girona, 1989)

FELIPE FERNANDEZ-ARMESTO

(iii) Stained glass. The stained-glass windows in the cathedral, located in the choir clerestory, ambulatory and nave, date from the 14th to the 16th centuries; fragments and unmounted panels of the same period also survive (Girona, Mus. Catedralicio). The group of stained-glass windows in the choir, dating from the first half of the 14th century and made by the Master of the Sanctuary, consists of four three-light windows (each 4.62×1.68 m) and seven two-light windows (each 4.55×0.96 m), all with tracery. Ten original windows survive, depicting Marian themes. The style is linear, with some conservative elements characteristic of 13th-century stained glass (e.g. the architectural ornamentation and chromatic density). The figures, framed by niches, have schematized faces and static poses (see fig.); backgrounds are plain and the colour scheme is dominated by harmonies of red and blue. Floral and geometric motifs appear in the tracery head. The paint is opaque, rough and very thickly applied, but a clearer grisaille was used in some areas, as described by Theophilus in *De diversis artibus*. The glass was cut into small pieces and coloured in the pot-metal (large sheets of monochrome glass); the leads, with narrow, sharply angled flanges, are original. A whitewashed glazing table (Girona, Mus. A.) used for the axial window of the *Annunciation* survives, and ultraviolet light has revealed images of the Virgin and one of the Apostles represented in the window.

The 11 stained-glass windows in the ambulatory (each 4.55×1.76 m with three traceried lights) were executed *c.* 1358 by Guillem Le Tungard (*fl* 1357–9), a glazier from Coutances. The seven central windows depict the *Passion*, the lateral windows bear *Prophets* (north side) and *Apostles* (south side). They are richly coloured and show minute attention to detail, with a profusion of architectural elements. The grisaille is painted with small strokes to shape the volumes of the figures, especially the faces, and

Girona Cathedral, two-light choir window, the *Virgin and Child*, detail from the *Adoration of the Magi*, c. 1348

the silver-stain technique is employed (*see* STAINED GLASS, §I, 4).

The stained glass in the nave dates from the 15th and 16th centuries. The window showing the *Apostles* (15.3×2.7 m) consists of four traceried lights, in which the Apostles are placed in three rows, each with his attribute and name. The contract of 1437 records that the window was made by Antoni Thomas (*fl* 1437–9) of Toulouse. The style is naturalistic; volumes are suggested by chiaroscuro, and the abundant architectural ornamentation is shown in perspective. Silver-stain is again used.

According to the contract of 1522, the window of the *Sibyls* (13.68×2.87 m) was made by the Catalan glazier Jaume Fontanet. Its four traceried lights bear the four *Sibyls*, *Evangelists* and *Latin Fathers* (SS Augustine, Ambrose, Gregory and Jerome) in three rows. In concept the composition is in the Gothic tradition, but the style and ornamental motifs (classical capitals, shells etc) are Renaissance. The colours are pale green, yellow and greyishblue rather than blue and red; and the thin glass, cut in large pieces, has a regular surface.

BIBLIOGRAPHY
J. Ainaud de Lasarte: *Cerámica y vidrio*, A. Hisp., x (Madrid, 1952)
J. Marqués i Casanovas: 'Els vitralls de la seu de Girona', *Rev. Girona*, xcvii (1981), pp. 32–55
P. Freixas i Camps: *L'art gotic a Girona: Segles XIII–XIV* (Barcelona, 1983)
J. Vila-Grau: *El vitrall gotic a Catalunya: Descoberta de la taula de vitraller de Girona* (Barcelona, 1985)
——: 'La Table de peintre-verrier à Gérone', *Rev. A.*, lxxii (1986), pp. 32–4

J. Ainaud de Lasarte and J. Vila-Grau: *Els vitralls de la catedral de Girona*, Corp. Vitrearum Med. Aevi, España, VII/ii (Barcelona, 1987)
JOAN VILA-GRAU

Gironella, Alberto (*b* Mexico City, 26 Sept 1929). Mexican painter. He was self-taught as a painter but well versed in philosophy, literature and 20th-century avant-garde art. Like other young Mexican painters in the 1950s, he sought to break with local traditions, basing his art instead on Spanish Baroque painting and on the work of Francisco de Goya. His favourite themes were love and death, time, bullfighting, eroticism and painting itself, as in *The Glutton* (1958; Washington, DC, MOMA Latin America), an image of a seated skeleton with overtones of the court portraits of Diego Velázquez. In the 1960s and 1970s he produced an important series about queens, for example *Queen Riqui* (Mexico City, Mus. A. Mod.), in which the figure undergoes various metamorphoses. *The Burial of Zapata and Other Burials* (both 1972; Mexico City, Pal. B.A.) were part of a politically and artistically controversial exhibition; these were followed by a series on Baroque themes, for example *The Gentleman's Dream* (1977; Mexico City, Fund. Cult. Televisiva), demonstrating his preoccupation with eroticism and the passage of time.

BIBLIOGRAPHY
R. Eder: *Gironella* (Mexico City, 1981)
M. Martínez Lambarry: *Tradición y ruptura en la pintura de Alberto Gironella* (diss., Mexico City, U. N. Autónoma, 1988)
MARGARITA MARTÍNEZ LAMBARRY

Girón y Guzmán, Pedro Téllez, Duque de Osuna. *See* OSUNA, (1).

Girón y Pacheco, Pedro de Alcántara Téllez. *See* OSUNA, (2).

Giroux. French family of restorers, dealers, cabinetmakers and painters. François-Simon-Alphonse Giroux (*d* Paris, 1 May 1848) was a pupil of Jacques-Louis David and became a picture restorer, founding his business in Paris at the end of the 18th century. He specialized in genre paintings of medieval ruins and troubadours and bought particularly from a younger generation of artists such as Louis Daguerre, Charles-Marie Bouton (1781–1863), Charles Arrowsmith (*b* 1798) and Charles Renoux (1795–1846), all of whom painted church interiors. Giroux also admired Gothic art and became the official restorer for Notre-Dame, Paris. His daughter Olympe Giroux and son Alphonse-Gustave Giroux succeeded him in his business. Another son, André Giroux (*b* Paris, 30 April 1801; *d* Paris, 18 Nov 1879), was a painter. François-Simon-Alphonse's firm publicized its stock by holding exhibitions of Old Master paintings and contemporary art and by publishing catalogues of works both for sale and for hire from their premises. After 1828 the firm produced a series of elaborate pieces of furniture in a range of styles from Egyptian to Louis XV, some of which were commissioned by members of the royal family. This was their most lasting achievement, and by 1834 the firm was listed under the heading 'ébéniste' in the *Annuaire du Commerce*.

In 1838, François-Simon-Alphonse Giroux left the business to his son Alphonse-Gustave Giroux, after which the firm changed in character. Alphonse-Gustave greatly

expanded the thriving business and under his direction it became associated entirely with furniture, particularly small decorative pieces. In 1857 he opened new quarters in the Boulevard des Capucines; he sold his business and retired in 1867. Several pieces made by the firm from the 1840s to the 1860s, including a small secrétaire for Empress Eugénie, are now in the Musée Nationale du Château de Compiègne et Musée du Second Empire, Compiègne.

André Giroux exhibited at the Salon in Paris from 1819 and in 1825 won the Prix de Rome for a landscape, *Kalydonian Boar Hunt*. In 1837 he received the Légion d'honneur, and from 1836 to 1844 he also showed at the Akademie der Künste in Berlin. He is best known for his landscapes of Italy, France and the Swiss and Austrian Alps (e.g. *Souvenir of the Ravin de Golling*, exh. Salon 1863). He also painted views of the coast of Brittany and the environs of Paris, especially Fontainebleau. His style is somewhat crisp and dry, and the staffage of his paintings was often done by Xavier Leprince (1799–1826).

BIBLIOGRAPHY

D. Ledoux-Lebard: *Les Ebénistes parisiens, 1795–1830* (Paris, 1951)
From Revolution to Second Empire (exh. cat., London, Hazlitt, Gooden & Fox, 1978) [André Giroux]
Théodore Caruelle d'Aligny (1798–1871) et ses compagnons (exh. cat. by M. M. Aubrun, Orléans, Mus. B.-A.; Dunkirk, Mus. B.-A.; Rennes, Mus. B.-A. & Archéol.; 1979) [André Giroux]

LINDA WHITELEY

Girsu. *See* TELLOH.

Girtin, Thomas (*b* London, 18 Feb 1775; *d* London, 9 Nov 1802). English painter, draughtsman and printmaker. With his rival, J. M. W. Turner, he extended the technical possibilities of watercolour and in doing so demonstrated that watercolours could have the visual impact and emotional range of oils. Although close in style throughout the 1790s, by 1800 Turner and Girtin were beginning to diverge: whereas the former dissolved forms to express his idea of Nature in a state of flux, the latter sought out a landscape's underlying patterns to convey his awe of Nature's permanence as well as its grandeur. Girtin's reduction of landscape to simple and monumental forms, his panoramic compositions, his bold palette of browns and blues, and his sensitivity to natural effects such as cloud formations, were to influence watercolour painters as diverse as John Varley, Cornelius Varley, Peter De Wint and John Sell Cotman.

1. Early life, to 1796. 2. Sketching tours, 1796–1801. 3. London panorama and Paris etchings, 1801–2.

1. EARLY LIFE, TO 1796. Girtin was the son of a brushmaker of Huguenot descent. In 1788 he was apprenticed to the topographical watercolour painter Edward Dayes, who taught him the traditional method of watercolour painting—making a light pencil outline, laying in shadows in grey and then adding local colours, mostly pastel shades of blue, green and pink. One of Girtin's tasks as an apprentice was to make watercolours after pencil sketches of medieval ruins by the antiquary James Moore (1762–99; examples at New Haven, CT, Yale Cent. Brit. A.). In the spring of 1794 he exhibited his first watercolour at the Royal Academy, a view of *Ely Cathedral* (Oxford, Ashmolean), based on a sketch by Moore. The

same year he toured the Midlands with Moore, producing watercolours, such as that of *Peterborough Cathedral* (Oxford, Ashmolean; *see* TOPOGRAPHY, fig. 2), which show a sense of architectural drama, with light playing over intricate façades. These were produced in the studio from pencil sketches done on the spot. It was usual for Girtin to make more than one version of a composition (there is a slightly later version of *Peterborough Cathedral* in U. Manchester, Whitworth A.G.).

Late in 1794 Girtin began attending the evening 'Academy' of Dr Thomas Monro in Adelphi Terrace, London, and he remained there until *c.* 1798. With J. M. W. Turner, Girtin was employed for 3s. 6d. a night to copy drawings by John Robert Cozens and others in Monro's collection. Girtin drew the outlines, and Turner added the washes (examples London, Tate). In 1795 Monro petitioned Joseph Farington to secure Girtin a place at the Royal Academy Schools, but he never attended.

2. SKETCHING TOURS, 1796–1801. In the autumn of 1796 Girtin made the first of his sketching tours, which became a feature of his professional life. He travelled to York, Ripon and Durham, along the Northumbrian coast to Lindisfarne, and reached Jedburgh in southern Scotland on 2 October. Sketches from this tour marked a shift in Girtin's attitude to landscape. Instead of composing close-up views of picturesque ruins in the manner of Dayes, he preferred to show a more distant view of buildings within a panoramic landscape, as typified by his sketch of *Jedburgh* (London, BM). The influence of John Robert Cozens is apparent in a watercolour of *Lindisfarne Castle* (1796; New York, Met.), with its poetic exploration of the effects of clouds and drifting smoke. Here he abandoned the grey underpainting of traditional watercolour practice in favour of painting in local colours, with shadows glazed over lighter areas. The palette of strong blues and browns breaks with the pastel tonality of his earlier watercolours.

In 1797 Girtin exhibited ten watercolours, mostly subjects from his northern tour, at the Royal Academy. His summer tour that same year was to Somerset, Dorset and Devon. In contrast to the sublime scenery of the 1796 tour, he concentrated on the gently undulating coastlines of Dorset and Devon, studying their maritime economy. In such pencil sketches as *Kingswear* (New Haven, CT, Yale Cent. Brit. A.), with its rounded hill and foreground barred by smooth water, he abandoned the landscape format widely adopted by painters after Claude, with its dark repoussoirs and a central road or river leading the eye into the landscape, and also the roughness and variety deemed essential by 18th-century theorists of the Picturesque. *Above Lyme Regis* (Ottawa, N.G.) also depicts landscape without dramatic features. From 17th-century Dutch panoramic views Girtin learnt to impose pattern on the West Country's amorphous terrain by manipulating hedgerow lines and cloud shadows. He lightened his palette at this period to include bright greens, gold and sky-blue, and he adopted a brown-flecked laid cartridge paper in preference to the thin white wove paper of his earlier work. Highlights, such as clouds in sunlight, were managed by leaving the paper blank, the slight roughness of the cartridge paper creating a pleasing texture, as in

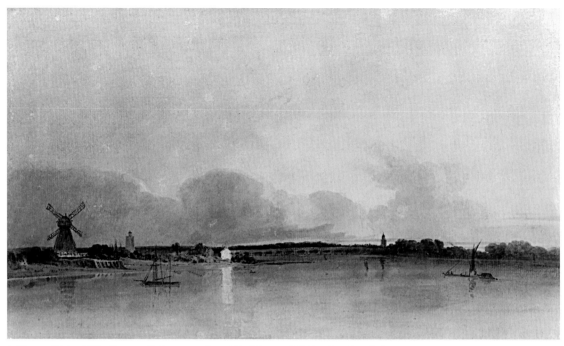

1. Thomas Girtin: *White House at Chelsea*, watercolour, 293×509 mm, 1800 (London, Tate Gallery)

Totnes (1797; London, BM). From *c.* 1797 he also experimented with gouache highlights in Chinese white but largely abandoned this practice by 1800.

In the summer of 1798 Girtin toured north Wales, exhibiting a view of *Beddgelert* (possibly the large watercolour in the L. J. E. Hooper priv. col.) at the Royal Academy in 1799. He also journeyed to Yorkshire in 1798, probably staying at Harewood House with his pupil Edward Lascelles (1764–1814), eldest son of the Earl of Harewood. This was the period at which Girtin and Turner, already recognized as rival leaders of the English watercolour school, were closest in style. In *Warkworth Castle* (1798; New Haven, CT, Yale Cent. Brit. A.), Girtin's palette of warm browns derives from the sonorous colouring of 17th-century Dutch landscape oils, suggesting that watercolour could rival oil, and he expressed the energy of nature by a broken, flickering touch, similar in handling to Turner's 1798 Royal Academy exhibit *Warkworth Castle; Thunderstorm Approaching* (London, V&A).

By 1799 Girtin was sufficiently well established as a watercolour painter to attract society pupils such as Lady Gower and Amelia Long, Lady Farnborough, and to be invited by Lord Elgin to accompany him as draughtsman on a diplomatic mission to Constantinople (now Istanbul), an invitation he declined because the salary was only £30 a year. In May 1799 he attended the first meeting of the Sketching Society or 'Brothers', a group of professional and amateur artists, including Robert Ker Porter, Louis Francia, Paul Sandby Munn (1773–1845) and George Samuel (*d c.* 1823), who met weekly to make monochrome wash drawings inspired by a passage of poetry. They hoped by this exercise to establish a school of 'historic landscape' and thus raise the status of landscape painting in the hierarchy of artistic genres. The Society, which probably met only in the winter months, was attended by Girtin until 1801.

In 1800, the year he married Mary Ann Borrett, Girtin again visited Yorkshire and also probably stayed with his patron Sir George Beaumont at Benarth near Conwy in North Wales. His use of watercolour at this time, at once abstract and naturalistic, broke new ground, as in the unfinished watercolour sketch of *Rhuddlan Castle* (Stanford, CA, U. A.G. & Mus.), with its bold horizontal washes, or *Ouse Bridge* (New Haven, CT, Yale Cent. Brit. A.), typical of his later work with its concentration on monumental architecture, sombre colouring and broad washes textured with brown ink and brush-tip. Also dating from this year is one of Girtin's best-known and technically most accomplished watercolours, the *White House at Chelsea* (London, Tate; see fig. 1).

The following year Girtin made a final visit to Yorkshire. He executed four large watercolours of the Harewood estate for Edward Lascelles, including two views of Harewood House (Harewood House, W. Yorks). These are in essence Romantic country-house portraits, with the grandeur of the house enhanced by dramatic lighting effects over the panoramic landscape. He visited Henry Phipps, 1st Earl of Mulgrave, at Mulgrave Castle, N. Yorks, making studies of shipping near Whitby in his hatched, expressive pencil style (Oxford, Ashmolean). *The Estuary of the River Taw, Devon* (New Haven, CT, Yale Cent. Brit. A.), in which the control of fluid, horizontal washes, giving a sense of breadth and spatial recession, seems far too sophisticated for work done on his 1797 West Country tour, suggests that Girtin returned to Devon in 1801, although there is no documentary evidence for this. In 1801 his first oil painting, *Bolton Bridge, Yorkshire* (untraced), was favourably received at the Royal Academy

exhibition; he was likened by critics to Richard Wilson, and his rivalry with Turner was commented on. The only oil by Girtin to survive is *Guisborough Priory* (New Haven, CT, Yale Cent. Brit. A.), painted with thin horizontal washes in a technique that derived from his watercolour practice. No doubt he was tempted to experiment in this medium because exhibiting in oil was necessary for advancement within the Royal Academy. But in November 1801, when Girtin was a candidate for Associateship of the Royal Academy, he failed to gain a single vote.

3. LONDON PANORAMA AND PARIS ETCHINGS, 1801–2. During 1801 Girtin embarked on his *Eidometropolis* or circular PANORAMA painting of London, taken from the roof of the British Plate Glass Manufactory near Blackfriars Bridge. The *Eidometropolis* was exhibited at Wrigley's Great Rooms, Spring Gardens, London, from August 1802 to early 1803, with an admission charge of 1s. The panorama is now lost, but sketches for it (London, BM; London, Guildhall Lib.; ex-Tom Girtin priv. col.) show Girtin's subtle response to the shifting lights and atmosphere in different parts of the city. A review in the *Monthly Magazine* makes it clear that Girtin succeeded in transferring these impressions to the large canvas: 'the view towards the east appears through a sort of misty medium, arising from the fires of the forges, manufactories

&c. which gradually lessens as we survey the western extremity'.

Leaving his wife in the late stages of pregnancy, Girtin went to Paris in November 1801, remaining there until May 1802, although he was already ill with tuberculosis and had been advised by Sir George Beaumont to go to Madeira for his health. Like so many British travellers, he must have been anxious to take advantage of the opportunity offered by the Peace of Amiens (1 October 1801) to see the artistic treasures that Napoleon had brought back from Italy and had installed in the Louvre. He also wished to see if he might exhibit his *Eidometropolis*, an idea he eventually abandoned, writing to his brother John on 9 April 1802 shortly before returning: 'I think the panorama here does not answer' (MS. letter, Tom Girtin priv. col.). The visit resulted instead in a series of panoramic pencil sketches (London, BM) and a few watercolours, including *Porte St Denis* (London, V&A; see fig. 2), in which free, blotted washes brilliantly evoke the bustling city and the textures of urban architecture. Girtin made a tour of the city and its suburbs with the playwright and radical Thomas Holcroft, who noted the speed and facility with which Girtin made pencil sketches. Holcroft also recorded the artist's remarks on landscape—for example Girtin rejected a view near the village of Montmorency as unsuitable for a picture: 'the objects did not form masses:

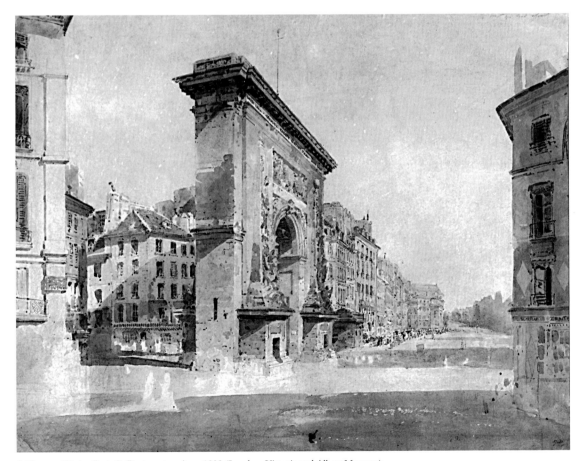

2. Thomas Girtin: *Porte St Denis*, watercolour, 1802 (London, Victoria and Albert Museum)

they were scattered, and water was wanting; to him an almost insuperable defect'. On his return to London, Girtin made soft-ground etchings of *Twenty of the most Picturesque Views in Paris and its Environs*, with aquatint added by specialists in that medium. These were published in 1803, after Girtin's death, by his brother and widow.

Girtin achieved his masterpieces in watercolour in 1802 with *Storiths Heights* and *St Vincent's Rocks* (both ex-Tom Girtin priv. col.). These sombre and emotive works convey a communion of artist and landscape by reducing natural forms to austere patterns. They show Girtin taking the watercolour medium far beyond the limitations of 18th-century topographical drawings and giving his landscapes an intensity that is in keeping with the ideas of Romanticism. That year Girtin died at his studio in the Strand, recognized as Turner's rival for the leadership of the British landscape school.

BIBLIOGRAPHY
Obituary, *Gent. Mag.*, lxxii/2 (Dec 1802), p. 1163; *Gent. Mag.*, lxxiii/1 (Feb 1803), pp. 187-8
T. Holcroft: *Travels from Hamburg, through Westphalia, Holland and the Netherlands, to Paris*, ii (London, 1804), pp. 488–98
'Recollections of the Late Thomas Girtin', *Lib. F.A.*, iii (1832), pp. 307-19
L. Binyon: *Thomas Girtin: His Life and Works* (London, 1900)
R. Davies: *Thomas Girtin's Watercolours* (London, 1924)
J. Mayne: *Thomas Girtin* (Leigh-on-Sea, 1949)
T. Girtin and D. Loshak: *The Art of Thomas Girtin* (London, 1954)
Thomas Girtin (exh. cat., ed. F. Hawcroft; U. Manchester, Whitworth A.G.; London, V&A; 1975)
Thomas Girtin (exh. cat., ed. S. Morris; New Haven, CT, Yale Cent. Brit. A., 1986)

SUSAN MORRIS

Gisant [Fr.: 'recumbant']. Effigy on a tomb showing the deceased person as a lying corpse, sometimes very macabre.

□

Gisbert Pérez, Antonio (*b* Alcoy, Alicante, 19 Dec 1834; *d* Paris, 27 Nov 1901). Spanish painter and museum director. From 1846 he studied at the Real Academia de S Fernando, Madrid, under José de Madrazo y Agudo and Federico de Madrazo y Küntz. While working in Rome on a grant (1855–60), he came into contact with the circles around the Academia Española de Bellas Artes. He belonged to the generation of post-Romantic and Realist Spanish painters whose works are eclectic in genre. However, because of his training, milieu and political beliefs, he produced primarily history paintings. These are linear and superbly drawn, but, though incorporating many erudite references, they lack colour and luminosity. His finest works include *Communards on the Scaffold* (1860; Madrid, Pal. de las Cortes) and the *Execution of Gen. Torrijos and his Comrades* (1888; Madrid, Casón Buen Retiro). The latter, among the best of its type, looks back to Goya's renowned *Third of May* (1814; Madrid, Prado). Gisbert Pérez also painted genre and religious subjects and some fine portraits. Some of these portraits are Romantic in style (e.g. *A Romantic*, 1858; Valencia, Mus. B.A.), while others are clearly Realist (e.g. *Don Salustiano Olózaga*, 1867; Madrid, Pal. de las Cortes). He was the first Director of the Museo del Prado in Madrid from 1868 until 1873, when he moved permanently to Paris.

BIBLIOGRAPHY
F. Abad Abad: *El pintor Gisbert y su Minué* (Alcoy, 1962)
A. Espi Valdes: 'Suplicio de los comuneros de Castilla: Un cuadro de polémica', *A. Esp.* (1962), pp. 65–72
——: *Los pintores de Alcoy y el cuadro de historia* (Alcoy, 1963)
——: 'Gisbert: Primer director del Museo Nacional del Prado', *A. Esp.* (1963-7), pp. 112–18
T. Agustin Rubio: '*El fusilamiento de Torrijos' de A. Gisbert* (Alcoy, 1968)
C. Reyero Hermosilla: *La pintura de historia en España* (Madrid, 1989)
La pintura de historia del siglo XIX en España (exh. cat., ed. C. Reyero Hermosilla; Madrid, Prado, 1992-3)

GERARDO PÉREZ CALERO

Gisel, Ernst (*b* Adliswil, nr Zurich, 8 June 1922). Swiss architect. After training as an architectural draughtsman and studying (1940–42) at the Kunstgewerbeschule, Zurich, he worked in Alfred Roth's office (1942–5). He then opened his own office, initially in partnership with Ernst Schaer. Gisel executed an extraordinary number of buildings, many of them landmarks of late 20th-century Swiss architecture. His Parktheater (1949–55), Grenchen, represents one of the first attempts to reintroduce international trends after wartime isolation had turned Swiss architecture towards traditional vernacular styles. The project is clearly related to contemporary Scandinavian architecture, in particular Alvar Aalto's town hall in Säynätsalo. Gisel's early school buildings, for example Letzi School (1952–4) and Auhof School (1954–7), both in Zurich, are distinguished by their strictly orthogonal layout. In the Gymnasium (1969–72), Vaduz, one of Gisel's key works, this is supplemented with freer configurations of semicircular and staggered buildings. The school in Engelberg (1965–7), built in exposed concrete, has a convincingly sculptural quality, its sharp-edged forms creating a dialogue with the mountainous landscape. Gisel also played a leading role in the boom in ecclesiastical architecture during the 1960s. His churches in Effretikon (1958–61) and Reinach (1961–3) are monumental, sculptural buildings, which dramatize their setting, as does the small Bergkirche (1963), Rigi-Kaltbad, clinging to the steep slope like a fir. His church (1988–90) in the Grünau district of Zurich stands out from the surrounding high-rise estates by its very lack of ostentation. In addition to other municipal buildings, such as a youth hostel (1965) in Zurich and a swimming-pool and Kongresshaus (1966–9) in Davos, Gisel designed numerous residential complexes, including one at Märkisches Viertel (1964–9), Berlin. His later work is characterized by collage-type ensembles composed of various architectural components, executed mostly in brick and defined by their urban environment, for example Stadelhoferpassage (1980–83), Zurich, and the Rathaus (1982–6), Fellbach. He also produced striking single entities, such as the bank (1980–81) in Herisau—one of his few works with regional references—and an old people's home (1989) in Zurich, clad entirely in natural slate. Gisel taught at the Eidgenössische Technische Hochschule in Zurich (1968–9) and the Karlsruhe Technische Universität (1969–71), and he participated in various exhibitions, including the Milan Triennale of 1973 organized by Aldo Rossi.

BIBLIOGRAPHY
T. Dannatt, ed.: *Architect's Y-b.*, 10 (1962), pp. 124–71
A. Roth and W. A. Haker: 'Ernst Gisel', *A + U*, 81 (1977), pp. 3–76

Werk, Bauen & Wohnen, 7–8 (1982), pp. 18–71 [special issue]
B. Maurer and W. Oechrlin, eds: *Ernst Gisel: Architekt* (Zurich, 1993)

BRUNO MAURER

Gislebertus (*fl c.* 1120–40). Burgundian sculptor. An inscription on the west tympanum of St Lazare, Autun (now Autun Cathedral), reads GISLEBERTUS HOC FECIT ('Gilbert made this'). It is cut in square and uncial capitals contemporary with the other inscriptions on the tympanum, all of which refer to the Last Judgement (*see* AUTUN, §2(ii)). The inscription is generally thought to represent the signature of the sculptor, but the verb *facio* can also refer to donors; Oursel noted that a contemporary Autun charter was witnessed by a chaplain, Gillebertus, but in any case the name Gilbert was a common one.

The style of the sculptor of the tympanum can be recognized on numerous capitals in the choir, transept and nave, as well as (apparently) on the north doorway, now largely destroyed: his figures are thin and elongated, with tiny, oval heads; draperies are divided into plain surfaces bounded by bands of raised, ribbed folds; the hems are wind-blown; there is lavish use of beading and drilling (e.g. the pupils of the eyes); the relief is parallel to the surface of the block and seldom in several planes; and the fields of the pilaster capitals are treated as 'frames', which dictate the compositions, even to the point of distorting the poses (*see* AUTUN, figs 1 and 2). Gislebertus's activities at Autun, culminating in the west door, probably date from *c.* 1120–40. The sculpture is unusually uniform in style, but views differ on precisely how much can be attributed to one sculptor.

According to Grivot and Zarnecki, Gislebertus began his career at Cluny Abbey (this remains hypothetical), developed his style at Autun and then worked at other churches, most notably Ste Madeleine, Vézelay (*see* VÉZELAY, fig. 2), with his influence manifest in such places as Chalon-sur-Saône Cathedral and Notre-Dame, Beaune. His work at Autun was probably not restricted to St Lazare, since certain reliefs (Autun, Mus. Rolin) usually attributed to its mutilated north door could have come from other buildings in the town. The hypothesis that Gislebertus was also the architect of St Lazare is based on the conspicuous emphasis given to sculpture throughout the building and the fact that his arrival there coincided with a change of design in the apse.

BIBLIOGRAPHY

D. Grivot and G. Zarnecki: *Gislebertus, Sculptor of Autun* (London, 1961, rev. 1965); reviews by F. Salet in *Bull. Mnmt.*, cxix (1961), pp. 325–43, and cxxiv (1966), pp. 109–12
R. Oursel: 'Autun', *Dictionnaire des églises de France*, ed. J. Brosse, iia (1966), pp. 8–12 (11)

For further bibliography *see* AUTUN, §2.

NEIL STRATFORD

Gisleni [Gislenius; Ghisleni], **Giovanni Battista** (*b* Rome, 1600; *d* Rome, 3 May 1672). Italian architect, stage designer and musician, active in Poland. He arrived in Poland before 1632, being court architect first to King Sigismund III, then to Vladislav IV and John II Kazimir. Between 1643 and 1654 Gisleni was noted at the Polish court not only as a singer and composer but also as a director and designer of ephemeral decorations. His immense though mostly unrealized architectural and decorative oeuvre is chiefly known from three collections: the album *Varii disegni d'architettura inventati e delineati da Gio: Gisleni Romano . . .* (London, Soane Mus.); 12 loose drawings (Milan, Castello Sforzesco); and a sketchbook containing his own designs, copies after modelbooks, and designs by other architects (Dresden, Kupferstichkab.; '*Skizzenbuch des G. Chiaveri*').

Gisleni's architectural projects were relatively limited in scale compared to the grander early Baroque palaces of the court architects Matteo Castelli and Constante Tencalla. The residences he built for the nobility then settling in Warsaw combined elements of the Italian villa and the north European castle, sometimes reduced to the scale of the small wooden-built house—a type that served for vernacular architecture for two centuries. Churches by Gisleni were usually single-naved, with a wall-pillared interior common in the north, to which new Baroque articulation had been applied (e.g. Brigittine church of the Holy Trinity, Warsaw, *c.* 1652–5; destr.). His outstanding work, the Benedictine church in Płock (1632; destr.), had a small rectangular interior, the massive pilasters of which harmonized with the marble portals and altars; their Roman, linear-framed forms and moderate ornamentation, deriving particularly from the work of Carlo Maderno, were echoed in the tombs, catafalques, retables etc. Among his interiors the Marble Room (destr. 1939–44; rebuilt 1971–84; *see* WARSAW, fig. 5) in the Royal Palace, Warsaw, utilized multicoloured marbles and gilded stucco.

Gisleni travelled to Rome in 1650, stayed there in 1656–62, being elected to the Accademia S Luca in 1656, and returned to settle in 1668; these visits affected his ephemeral decorations. Those for the funeral of Prince Charles Ferdinand Vasa (1613–55), in the Jesuit Church, Warsaw, drew on contemporary Roman classicism and theatricality, with an illusionistic deployment of a giant pyramid, colonnades and light-effects in the manner of Bernini and Cortona. A similarly Roman profusion of forms and expressive motifs characterizes his later decorative works, interiors and sepulchral compositions, with their macabre Roman motifs of skeletons, pyramids of skulls etc. The motif of *Death* as an imprisoned skeleton appears in his tomb monument (1670; Rome, S Maria del Popolo).

WRITINGS

Varieta de prospetti veduti nella Chiesa Cathedrale del Regio Castello di Cracovia . . . (Kraków, 1649)
Descriptio theatri in exequiis Varsaviae solenniter celebratis erecti quum sepulturae daretur corpus Serenissimi Domini Caroli Ferdinandi Poloniae et Sueciae Principis . . . (Danzig, 1655)

BIBLIOGRAPHY

SAP; Thieme–Becker
L. Pascoli: *Vite* (1730–36), ii, pp. 532–41
N. Miks-Rudkowska: 'Zbiór rysunków G. B. Gisleniego, architekta XVII wieku, w Sir John Soane's Museum w Londynie' [The collection of designs by G. B. Gisleni, 17th-century architect, in Sir John Soane's Museum in London], *Biul. Hist. Sztuki*, xxiii (1961), pp. 328–39
——: 'Theatrum in exequiis Karola Ferdynanda Wazy: Z badań nad twórczościa G. B. Gisleniego' [Theatre in the funeral of Charles Ferdinand Vasa: from studies of the works of G. B. Gisleni], *Biul. Hist. Sztuki*, xxx (1968), pp. 419–44
J. Lilejko: 'Władysławowski Pokój Marmurowy na Zamku Królewskim w Warszawie i jego twórcy—Giovanni Battista Gisleni i Peter Dankers de Rij' [The Marble Room of Ladislas IV in the Royal Palace in Warsaw,

and its builders—Giovanni Battista Gisleni and Peter Dankers de Rij],
Biul. Hist. Sztuki, xxxvii (1975), pp. 13–31

A. Miłobędzki: *Architektura polska XVII wieku* [Polish architecture of the 17th century] (Warsaw, 1980), pp. 183–7, 190, 257–8, 340

N. Miks-Rudkowska: 'Pałac Bogusława Leszczyńskiego w Warszawie i jego twórca G. B. Gisleni' [The Palace of Bogusław Leszczynski in Warsaw and its creator, G. B. Gisleni], *Biul. Hist. Sztuki*, xlvi (1984), pp. 187–202

M. Karpowicz: 'Giovanni Battista Gisleni i Francesco de' Rossi: Z dziejów współpracy architekta i rzeźbiarza' [Giovanni Battista Gisleni and Francesco de Rossi: story of the cooperation between an architect and a sculptor], *Kwart. Archit. & Urb.*, xxxxvi (1991), pp. 3–21

ADAM MIŁOBĘDZKI

Gismondi [Perugino], **Paolo** (*b* Perugia, *c.* 1612; *d* ?Rome, ?1682–5). Italian painter. In Perugia he studied with Giovanni Antonio Scaramuccia (1580–1633) but then moved to Rome, where he became a pupil of Pietro da Cortona whose style he proficiently followed throughout his career. In 1641 he became a member of the Accademia di S Luca. According to Titi and Pascoli, he frescoed the tribune (*St Agatha Received into Glory* and four *Allegorical Figures*) and the central aisle (scenes from the *Life of St Agatha*) in S Agata dei Goti (Rome), perhaps during the 1660s (all *in situ*). Surviving documents for S Agnese in Piazza Navona (Rome) show that he executed frescoes in the sacristy there in 1664, including: *St Agnes in Glory*, *Purity* and *Religion* on the vault and a now partially damaged representation of the *Virgin in Glory with Angels* above the altar (*in situ*). In 1668 he was nominated for membership of the Congregazione dei Virtuosi al Pantheon and also executed frescoes in S Giovanni a Porta Latina (Rome), including the *Condemnation of St John the Evangelist* (*in situ*; badly restored 1912) in the tribune vault. Morelli suggested that he had also painted altarpieces for churches in Perugia, but this aspect of his career remains unsubstantiated and the paintings either do not survive or are presently of uncertain attribution, including two in the church in Madonna di Bagno, near Deruta (Umbria).

Thieme–Becker
BIBLIOGRAPHY

G. F. Morelli: *Brevi notizie delle pitture, e sculture che adornano l'augusta città di Perugia* (Perugia, 1683/R 1973), p. 186

F. Titi: *Ammaestramento utile, e curioso di pittura, scultura ed architettura nella chiesa di Roma . . .* (Rome, 1686), pp. 59, 110, 248

L. Pascoli: *Vite de' pittori, scultori ed architetti perugini* (Rome, 1732), pp. 202–3

R. Longhi: 'Lettera aperta al Professore G. Giovannon', *L'Arte*, xxviii (1925), pp. 224–5

E. Waterhouse: *Baroque Painting in Rome* (London, 1937), pp. 72–3

JUDITH L. CARMEL

Gisors. French family of architects. Members of the Gisors family occupied prominent administrative positions in the French architectural establishment during the late 18th century and the 19th and were responsible for the construction and maintenance of many public buildings in Paris and other French cities. They were not particularly innovative as designers, but they had considerable authority in official discussions regarding standards of design and professional practice. Jacques-Pierre Gisors (*b* Paris, 12 May 1755; *d* Paris, 17 April 1818) studied architecture with Charles-Axel Guillaumot (1730–1807) and Etienne-Louis Boullée. He won the Prix de Rome in 1779, but personal circumstances cut short his visit to Italy. On his return to Paris, he built several hôtels and châteaux and in 1787 prepared a proposal for a monument to *Louis XVI* on the Pont Neuf. He served as a delegate to the second assembly of the Représentants de la Commune (1789–90). His political connections led to commissions for the assembly hall (1793; destr.) for the Convention in the Palais des Tuileries, designed with Etienne-Chérubin Leconte (*b* 1766); and the assembly hall (1795–7) for the Conseil des Cinq-Cents (now the Chambre des Députés) in the Palais-Bourbon. From 1811 Gisors worked for the Conseil Général des Bâtiments Civils designing a variety of utilitarian buildings in Paris, including the Abbatoir de Grenelle (1811; destr.).

Jacques-Pierre's cousin (Alexandre-Jean-Baptiste-)Guy de Gisors (*b* Paris, 20 Sept 1762; *d* Paris, 6 May 1835) attended the Académie Royale d'Architecture and was a student of Jean-François-Thérèse Chalgrin. He collaborated with Jacques-Pierre on the work at the Palais-Bourbon, but his most important work as a designer is the basilican church of St Vincent (1810) in Mâcon, Seine-et-Loire. He also played an important role in the planning of Napoléonville (1808; now Pontivy, Morbihan). Most of his career was devoted to administrative positions, including Architecte du Corps Législatif et des Archives Nationales (1811), Inspecteur Général des Bâtiments Civils (1811–32), Architecte des Casernes des Sapeurs-Pompiers de Paris (1824–31), member of the Conseil Consultatif des Bâtiments de la Couronne (1825–30) and architect (1831–5) to Louis-Philippe (*reg* 1830–48). In 1821 he was made a member of the Légion d'honneur.

The most distinguished member of the family was Alphonse(-Henry) de Gisors (*b* Paris, 3 Sept 1796; *d* Paris, 18 Aug 1866), a nephew of Guy. He studied architecture with Charles Percier at the Ecole des Beaux-Arts and with his uncle, who secured a position for him with the Bâtiments Civils in 1822. Alphonse was awarded second place in the Prix de Rome competition of 1823 and the following year was promoted to Architecte des Bâtiments Civils. He employed the classical style of Percier in a number of fire stations, theatres, town halls and other public buildings in Paris and in provincial cities. Among these are the Hôtel de la Préfecture and the Hôtel de Ville (both *c.* 1828) in Ajaccio, Corsica. In 1835–41 he remodelled the Palais du Luxembourg in Paris to accommodate the Chambre des Pairs. His additions include a new building parallel to and replicating the south façade, a monumental staircase and an assembly room. Gisors served as architect of the Ministère de l'Instruction Publique in 1839–53. In this capacity he provided the ministry with a new office building (1840) and the Ecole Normale Supérieure (1841–7), both in Paris, the latter inspired by High Renaissance Roman palazzi. He held a number of other administrative positions, including Architecte de l'Académie de Médecine (1846–8) and Inspecteur Général des Bâtiments Civils. In 1836 he was made a member of the Légion d'honneur, and in 1854 he was elected to the Institut de France.

Louis(-Henry-Georges Scellier) de Gisors (1844–1905), a grandson of Alphonse, followed the latter's career in government service. He attended the Ecole des Beaux-Arts as a student of Louis Hippolyte Lebas and Paul-René-Léon Ginain, worked in the office of Charles Garnier

on the Paris Opéra and received second prize in the Prix de Rome competition of 1872. He drew freely on the classical languages of ancient Roman, French and Italian Renaissance architecture in the detailing of his buildings but remained faithful to the principles of composition he had learnt at the Ecole des Beaux-Arts. Among his major works was the central postal warehouse in Paris (1882; destr.).

BIBLIOGRAPHY

E. Joyant: 'Les Gisors: Architectes', *Bull. Soc. Hist. A. Fr.* (1937), pp. 270–93

L. Hautecoeur: *Architecture classique*, v–vii (1953–7)

B. Foucart and V. Noel-Bouton: 'Les Projets d'église pour Napoléonville (1802–1809) de Guy de Chabol à Guy de Gisors', *Bull. Soc. Hist. A. Fr.* (1971), pp. 235–52

RICHARD CLEARY

Gittard, Daniel (*b* Blandy-en-Brie [now Blandy-les-tours], Seine-et-Marne, 14 March 1625; *d* Paris, 15 Dec 1686). French architect. He was from a family of carpenters that supplied the château of Vaux-le-Vicomte with building timber, and received his first commissions from the religious orders of the Counter-Reformation and their devout patrons connected with Nicolas Fouquet. He designed novices' quarters (destr. 19th century) and the chapel at the Institution de l'Oratoire, Paris (1655; now St Vincent-de-Paul hospital), and the convent for the Benedictine Sisters of the Holy Sacrament, Paris (1658; destr. after 1796), financed by Queen Anne of Austria. For Fouquet himself, he fortified Belle-Isle, Morbihan (1660–61).

Although Gittard retained landed and professional interests in his native Brie (he restored the church of St Aspais, Melun, in 1676), he moved to Paris, buying an architect's commission in the Bâtiments du Roi as early as 1655; throughout his life he was to engage in building- and property-speculation in the parish of St Sulpice as did Louis and François Le Vau on the Ile Saint-Louis. His plans for the huge new church of St Sulpice were preferred to those of Louis Le Vau: Gittard supplied the general design and built the sanctuary, ambulatory, apsidal chapels, transept and north portal (1670–78), after which work was suspended for lack of funds. The nave and side-chapels were built in 1719–45 by Gilles-Marie Oppenord and Giovanni Servandoni, to Gittard's designs.

Gittard was also employed by Louis II de Bourbon, Prince de Condé—the Grand Condé—and his son, Henri-Jules. Gittard undertook the architectural side of André Le Nôtre's garden at the Condé château at Chantilly (from 1663), which included forecourt, terraces, garden staircases, pavilions, hydraulic buildings and an orangery (partly destr.). He collaborated with Claude Perrault on the Hôtel de Condé, Paris (destr. *c.* 1770), and he restored and completed their suburban château of Saint-Maur, Val-de-Marne (*c.* 1673–82; destr. 1796). The Condé commissions extended to their buildings in Burgundy where they were governors. Gittard designed the diocesan seminary in Autun (1675; now Lycée Militaire), and began modernizing the former Palais Ducal (Palais des Etats) in Dijon (1682–4; now Musée des Beaux-Arts); he designed a wing for the Palais Ducal, the south esplanade, a terraced wall and a Doric portal (destr. 1782).

Gittard also undertook private commissions in Paris. His best-documented hôtel (1670–71; destr. 1875) was built for the heirs of Olivier Selvois, a financier formerly of Fouquet's circle, and was let until 1714 to Claude, 1st Duc de Saint-Simon and his son Louis, 2nd Duc de Saint-Simon, author of the *Mémoires*. Documentary evidence suggests, however, that he was not responsible, as suggested by Hautecoeur, for the Hôtel Lully.

A much-consulted member of the Académie Royale d'Architecture from its foundation in 1671, Gittard nevertheless received no royal commissions, perhaps because of his early connection with Fouquet; but the city authorities entrusted him, along with Claude Perrault, with the design for the Porte St Antoine triumphal arch (1670; unfinished and destr.). His last Parisian work was the church of St Jacques-du-Haut-Pas (1674–85), where he tried to impose some of his boldest formulae on Jansenist patrons.

Gittard's handling of mouldings and his fondness for domes and colossal orders have been compared to Louis Le Vau's. Nevertheless, many features of his style were remarkably original: elongated proportions and a virtuoso handling of oval-domed vaulting patterns, set on straight or circular lines, are found in the chevet of St Sulpice and the nave of St Jacques; an interest in Gothic vaulting was expressed in debates at the Académie d'Architecture about St Sulpice, while a concern for local building traditions was manifested in the use of Burgundian polychrome glazed tiles at Autun. Gittard had a care for expressiveness that at times verged on the expressionistic: he invented a 'French Order' based on bunches of sunflowers for St Sulpice in 1674, and designed for St Jacques bulbous, thorny, club-shaped spires (unbuilt), in allusion to the saint's martyrdom. It is perhaps Gittard's exclusion from royal commissions and the alteration or destruction of many of his works that have prevented a proper appreciation of his qualities as an architect.

BIBLIOGRAPHY

J. Hérauld de Gourville: *Mémoires de Gourville*, ed. L. Lecestre, ii (Paris, 1894–5), pp. 63–7

G. Macon: *Les Arts dans la maison de Condé* (Paris, 1903), pp. 9, 19–30

L. Hautecoeur: *Architecture classique*, II/i (1948), pp. 5, 168–174

F. de la Moureyre: *Saint-Jacques-du-Haut-Pas* (Paris, 1972)

H. Himelfarb: 'L'Hôtel de Saint-Simon, Rue des Saints-Pères, et son architecte Daniel Gittard (1625–1685)', *Cah. Saint-Simon*, i (1973), pp. 14–29

Y. Beauvalot: 'A l'origine des projets de Jules Hardouin-Mansart pour le Palais des Etats à Dijon, une oeuvre de Daniel Gittard: Le Portail du Logis du Roi', *Mém. Commn Ant. Dép. Côte-d'Or*, xxxi (1978–9), pp. 317–57

D. Brisolier: 'Historique du Lycée militaire d'Autun', *Rev. Hist. Armées*, ii (1985), pp. 97–105

HÉLÈNE HIMMELFARB

Giudice, del. Italian family of gold- and silversmiths. Filippo del Giudice (*fl* Naples, 1707–86), who belonged to an ancient family of goldsmiths, was for over 40 years the chief silversmith of the Deputazione del Tesoro of Naples Cathedral, for which his most important works were executed. These include the two monumental silver candelabra (1749), known as the *Splendori*, with embossed allegorical figures of the *Virtues* and putti in the round, a small gilt-bronze statue of the *Virgin*, which also dates from the mid-18th century, and the cast and chased silver reliquary bust (1757) of *St Mary Magdalene*, after a model

by the sculptor Giuseppe Sanmartino. Between 1761 and 1763 Filippo del Giudice made replacements for most of the liturgical items—crosses, altar-cards, candlesticks, vessels with embossed flowers and missal bindings—of the side altars in the Treasury Chapel of the cathedral. From 1774 the name of Filippo appears along with those of his sons Giuseppe del Giudice and Gennaro del Giudice (both *fl* Naples, 1774–1801) in documents concerning the commission for two silver statues (untraced) for the Regine Chapel in Forio d'Ischia, after a clay model by Sanmartino. In the last years of his career Filippo del Giudice maintained and periodically repaired the silver objects in the Treasury Chapel of the cathedral. Giuseppe and Gennaro were appointed silversmiths of the Treasury of Naples Cathedral in 1786. They executed important commissions for the Deputazione del Tesoro, including the two frontals for the side chapels, decorated with simple motifs in a classical style. The brothers also produced a silver bust of *St Stephen* (1785; Nusco Cathedral), based on a model by Salvatore Franco, a follower of Sanmartino, and a silver figure of *St Vitus* (1787; Forio d'Ischia, S Vito); the latter piece is based almost entirely on a model by Sanmartino. In 1797, four years after Sanmartino's death, the brothers used one of his drawings and the corresponding preparatory model for the group *Tobias with the Archangel Raphael* (Naples Cathedral), a work of exquisite, formal elegance. Giuseppe and Gennaro both served as consuls of the silversmiths' guild. They also had the contract for minting silver coins in Naples, which was renewed after the revolution of 1799.

For bibliography *see* ITALY, §IX, 1.

ANGELA CATELLO

Giudici [Giudice], **Johannes Franciscus** [Carlo Giovanni Francesco] (*b* Dolzago, 5 Jan 1747; *d* Rotterdam, 17 May 1819). Italian architect, active in the Netherlands. He worked in Rotterdam from the age of 25, designing his first important work there, the Roman Catholic St Rosaliekerk (1777; destr. 1940). The church was built without a steeple as these were not permitted until 1795. The interior, however, modelled on Jules Hardouin Mansart's chapel at Versailles and using free-standing Corinthian columns, was all the richer. Giudici was appointed architect for the admiralty of Rotterdam in 1781. In 1785 he produced the design for St James's Hospital in Schiedam. The Protestant church of the hospital is sited on one side of a large courtyard, opposite the entrance to the street. The practice of building along three sides of a courtyard with a dominant middle range was adopted more frequently in the Netherlands in the 18th century. Giudici was probably inspired by the building for the States General in Brussels, which had just been completed. His design for the church, giving the main church entrance the form of a columned portico, is remarkable, as it was the first time that columns with such an intercolumniation had been used in the Netherlands. Like that of Jacob Otten-Husly and Leendert Viervant II, Giudici's work represents the modest Neo-classicism typical of the Netherlands during the last quarter of the 18th century.

BIBLIOGRAPHY

S. J. Fockema Andrea and others: *Duizend jaar bouwen in Nederland* [A thousand years of building in the Netherlands], ii (Amsterdam, 1957)

R. Meischke: 'Het Sint Jacobsgasthuis te Schiedam' [The St James's Hospital in Schiedam], *Bull. Kon. Ned. Oudhdknd. Bond*, xiii (1960), pp. 21–46

PAUL H. REM

Giudicis, Francesco di Cristofano. *See* FRANCIABIGIO.

Giuliani, Giovanni (*b* Venice, 1663; *d* Heiligenkreuz, nr Vienna, 5 Sept 1744). Italian sculptor, active in Austria. He must have received his training in Venice but is documented as working with Andreas Faistenberger (1647–1736) in Munich from 1680. He moved to Vienna in 1689 and worked for the Viennese aristocracy, producing decorative statuary for their palaces and gardens. He became the most important representative of the Italian late Baroque in Vienna. His work reflected the decorative idiom found in northern Italy and was combined with an animated quality that appealed to popular taste and resulted in a wide following, especially among decorators of monasteries in the Vienna area. His sculptures harmonize particularly well with the early buildings of Johann Bernhard Fischer von Erlach, and they worked together in Vienna on Prince Eugene's Winterpalais on the Himmelpfortgasse, where Giuliani carved figures of atlantids for the staircase. Between 1700 and 1701 he sculpted figures for the attic storey on the stables of the Liechtenstein Schloss Eisgrub in Moravia. He provided sculpture for the doorway and vestibule figures (1705) for Domenico Martinelli's Liechtenstein Stadtpalais, Vienna, for which he had earlier (1697) made figures for the attic storey.

Of the many groups of statues Giuliani executed for the gardens of the Liechtenstein Palais, at Rossau, Vienna, and the Kaunitz Palace in Slavkov, Moravia, only a few remnants have survived. He followed antique models, in accordance with the fashion set by the classical French gardens; some small antique sculptures were available in the Liechtenstein collections. Others were sent to Vienna as *modelli* by Massimiliano Soldani from Florence or Giuseppe Mazza from Bologna. The self-contained antique figures with their smooth surfaces could be viewed from any angle; they were transformed by Giuliani into picturesque, delicate figures intended to be viewed from one angle, with a fluctuating surface to convey the impression of movement. Giuliani formed the basic types in clay, keeping these *bozzetti* as rough reminders. They are characterized mainly by attributes and could serve as models more than once, even, as at the Palais Trautson in Vienna, for sculptures made by one of Giuliani's followers. Most (145) of the surviving *bozzetti* are kept in the chapter of the Cistercian monastery at Heiligenkreuz, which Giuliani entered as a lay brother. He had to relinquish his secular commissions, put himself at the service of the community and bequeath his collection of models to the order. Within the monastery he made the high altar (1694–6; destr.; known from surviving model and figures), two choir altars (destr.) and choir-stalls (1707–9; *in situ*). Above the backrests of the stalls are reliefs illustrating the *Life of Christ*, and along the top are busts of secular and spiritual notables. In the cloisters are picturesquely conceived groups showing *Christ Washing the Feet of the Disciples* (1705). Giuliani trained Georg Raphael Donner and was allocated journeymen, whom he used increasingly in his later years to execute his projects.

BIBLIOGRAPHY

D. Frey, ed.: *Die Denkmale des Stiftes Heiligenkreuz*, xix of *Österreichische Kunsttopographie* (Vienna, 1919–37)

E. Baum: *Giovanni Giuliani: Entwicklung und Ableitung seines Stils* (Vienna and Munich, 1964)

G. Schikola: 'Wiener Plastik der Renaissance und des Barocks', *Geschichte der Bildenden Kunst in Wien, Plastik in Wien*, vii/1 of *Geschichte der Stadt Wien* (Vienna, 1970), pp. 85–162

E. Baum: *Katalog des Österreichischen Barockmuseums im Unteren Belvedere in Wien* (Vienna, 1980), pp. 177–90 [with extensive bibliog.]

INGEBORG SCHEMPER-SPARHOLZ

Giuliano, Duc de Nemours. *See* MEDICI, DE', (8).

Giuliano, Giovanni di. *See* GIOVANNI DA ORIOLO.

Giuliano da Rimini (*fl* 1307–24). Italian painter. A 16th-century inventory of the church of the Eremitani, Padua, mentions his signature, and that of a collaborator 'Petruccio', on a lost altarpiece dated 1324. His only secure work is the dossal (1.64×3.0 m; Boston, MA, Isabella Stewart Gardner Mus.) inscribed ANNO DNI MLLO CCC SETTIMO JULIANUS PICTOR DEARIMINO FECIT OCH OPUS TEMPORE DNI CLEMENTIS PAPE QUINTI, from the Franciscan church of S Giovanni Decollato, Urbania, Marches, later transferred to Urbania Cathedral. The *Virgin and Child in Majesty*, surrounded by kneeling female donors, occupies the central section; the eight lateral compartments separated by twisted columns contain six standing figures of saints and two devotional scenes: the *Stigmatization of St Francis* and *St Mary Magdalen Praying in the Desert*. The dossal appears to be the work of a painter who trained in the Italo-Byzantine manner of the late 13th century, to which the 'science' of the new style found in the frescoes of S Francesco, Assisi, was grafted almost as an intellectual exercise. While the *Virgin and Child* relates to a large group of Riminese paintings, which may depend on a local prototype by Giotto, the dossal also includes direct quotations from S Francesco. In spite of a certain monumentality, the figures reflect only a limited interest in depth and volume, and, like other Riminese 14th-century painters, Giuliano was more concerned with surface pattern and rich colour. The simple symmetry of the design is unified and enlivened by the use of balanced colour contrasts. The *Crucifixion* fresco (Forlì, Pin. Civ.) is one of the few attributions generally accepted as a later work.

BIBLIOGRAPHY

La pittura riminese del trecento (exh. cat. by C. Brandi, Rimini, 1935)

M. Bonicatti: *Trecentisti riminesi* (Rome, 1962)

C. Volpe: *La pittura riminese del trecento* (Milan, 1965)

Restauri nelle Marche, i (exh. cat., Urbino, Pal. Ducale, 1973), pp. 60–65

DOINA LITTLE

Giuliano d'Arrigo. *See* PESELLO.

Giulio Romano [Pippi] (*b* Rome, ?1499; *d* Mantua, 1 Nov 1546). Italian painter and architect. He was trained by Raphael, who became his friend and protector, and he developed into an artist of consequence in the third decade of the 16th century. His authority derived from his artistic lineage, attunement to the needs of courtly patrons and a style that blended modern sensibilities with the forms of Classical art. His greatest achievements were the monumental fresco programmes and architectural projects that he conceived and oversaw. Giulio's contemporaries particularly praised the facility and inventiveness of his drawing, a view upheld by 20th-century writers. Most of his career was spent in Mantua, as court artist for Federico II Gonzaga, 5th Marchese and 1st Duke of Mantua (*reg* 1530–40). The Palazzo del Te, designed for Federico, is a *tour de force* of Mannerist architecture and decoration. Giulio's Mantuan workshop was modelled on the organizational structure of Raphael's; it did not, however, generate the sort of independent and highly skilled artist that Giulio himself exemplified.

I. Life and work. II. Working methods and technique.

I. Life and work.

1. In Raphael's workshop, to 1520. 2. Works following the death of Raphael, 1520–24. 3. Works for Federico Gonzaga, 1524–40. 4. Other projects of the 1530s and 1540s.

1. IN RAPHAEL'S WORKSHOP, TO 1520.

(i) Artistic formation. Vasari provided the earliest information about Giulio's beginnings as an artist. This account indicates that he began his apprenticeship as a boy, but then it jumps to a description of him already working at a responsible level, as an assistant to Raphael in the Stanze (papal apartments) in the Vatican. Vasari's remarks firmly set the origins of Giulio's art within Raphael's workshop as it carried out the decoration of the papal apartments from 1509 to 1517, but they leave unclear the particulars of his first steps within that milieu. His early development is difficult to trace in detail since it took place during the production of these monumental projects. His artistic formation, then, can be discussed convincingly only within the context of a workshop system, where the sum of individual efforts was intended to add up to the idea of the master. The more efficient and successful the result, the less is the likelihood that the work of individual hands can be identified. A more promising path for the investigation of Giulio's early development is to explore the indications provided in Vasari's biography of him; this is an authoritative source, since Vasari knew Giulio and interviewed him on at least one occasion. His account records instances of collaboration between Raphael and Giulio, both as a method of teaching and as a business practice, and also points to aspects of the division of labour in Raphael's organization. Such remarks provide the clearest guidance for a consideration of Giulio's earliest work, which, however, cannot be isolated as a distinct corpus.

(ii) The Stanze. Chronologically, Vasari posited Giulio's first significant participation as Raphael's assistant to the decoration of the third room, the Stanza dell'Incendio in the papal apartments (completed by 1517), identified by its scene of the *Fire in the Borgo*. He described Giulio's painting there as extensive, noting particularly the dado with a fictive relief of bronze figures flanked by grisaille elements. Singled out for description and praise, the dado must have been a milestone in Giulio's apprenticeship. He later provided Marcantonio Raimondi with drawings of the dado figures, which the engraver used as the basis for a series of prints. Giulio's involvement in the transfer of these drawings into prints can be taken as further evidence

that he had a significant role in the production of this part of the room's decoration. It is reasonable to assume that during work in the Stanza dell'Incendio, Giulio, who was about 17, would have been supervised in the painting of the narrative scenes, executing the master's designs, but allowed more autonomy in carrying out the ornamental dado. While the use of fictive sculpture was an established tradition in fresco painting—and certainly Giulio was adhering to a given programme—it is notable that experimenting with the representational possibilities of the medium was a concern that continued in his later work. As a novice fresco painter, he also must have delighted in the opportunity to explore ideas used by Michelangelo in the Sistine Chapel (Rome, Vatican), with its compelling display of multiple levels of fiction in the bronze and grisaille figures.

(iii) The Loggia of Leo X. Giulio's development in the composition of figural groups can also be studied in the series of narrative scenes from biblical subjects in the Loggia of Leo X (Rome, Vatican). This is the other grand project that Vasari cites, with particular praise of Giulio's abilities, as an arena of major activity during the artist's years of apprenticeship. Payments made directly to the assistants of Raphael in 1518 and 1519 record not only the dates of the work but also that it was a collaborative effort of the workshop. A significant site, contiguous to the Stanze, the Loggia was intended to be part of a monumental façade for the Vatican Palace. Its decoration demonstrated Raphael's ability to conceive a highly synthetic decorative ensemble and to orchestrate its realization through a startlingly large number of assistants. Although there is no general agreement about the attribution of specific portions of the Loggia to Giulio, this should not prevent recognition of its seminal influence on the artist's genesis. Both for the successful blending of antique and modern idioms and for the strategic employment of specialized assistants, the decorative campaign for the Loggia was the model for Giulio's career as a court artist.

In the complex programme of the Loggia, the arches are covered with elaborate stuccowork and the intervening walls with whimsical motifs in the Classical grotesque manner, while the vaults bear Old Testament scenes. According to Vasari, labour was divided into two main categories, with two protagonists: Giovanni da Udine for the stuccowork, and Giulio Romano for the figural scenes. Vasari's life of Raphael also indicates that Giulio's responsibilities as the chief assistant for the paintings mimicked Raphael's own with regard to the entire shop: he functioned more as a creative manager than as a simple executant of the images. Giulio's supervision of the realization of the biblical episodes indicates his place in the hierarchy of the shop, and it is clear that after Raphael's death Giulio was recognized as a key figure among all the workshop collaborators and assistants for the production of narrative scenes of epic character. His later success in realizing vast fresco cycles, including intricate decorative elements, attests to his close study of the overall strategy of Raphael's handling of complex commissions.

(iv) Easel paintings. In addition to his participation in large-scale fresco projects, Giulio also collaborated with Raphael on numerous easel paintings. His collaboration was always anonymous, however, as a member of the shop, and uncertainty about attribution also surrounds this aspect of his earliest output. The question is vexing since it is known that he was substantially involved in some commissions, yet his precise contribution cannot be established. With this in mind, it is interesting to consider the portrait of *Joanna of Aragon* (Paris, Louvre), completed in 1518. Vasari noted this as one of the works commissioned by Leo X and presented by Cardinal Bernardo Bibbiena to the King of France from Raphael, who completed them with the aid of Giulio. The portrait received enthusiastic response for its elegant presentation of the sitter, to the extent that copies were made and the preparatory studies were in demand by collectors. When he sent one such study to Alfonso I d'Este, Duke of Ferrara, Raphael let it be known that the drawing was by a pupil without, however, naming him. Raphael thus retained the authorship but denied the execution. This is the most useful way to understand Giulio's professional circumstances at this time, when he had extensive autonomy in production but lacked an individual artistic identity. It is generally accepted that Giulio painted the portrait of *Joanna* (most persuasively argued by Joannides). The composition departs from Raphael's practice of concentration on a figure placed close to the viewer's space and is more discursive in presentation. The detachment of the figure from the viewer, spatially and psychologically, is reinforced by the artifice of her gestures and her impassive expression. The summary handling of the subject's delicate features, with detail and visual excitement lavished on her costume and surroundings, is an approach echoed in Giulio's later style. The construction of a complex spatial setting, including areas of deeper space with secondary figures, is another compositional strategy employed by Giulio in later works. The composition, probably worked out by Giulio under Raphael's tutelage, became an influential portrait type, of which many Mannerist variations were made. Perhaps due to the concentration on rendering Joanna's material splendour, the figure itself lacks volume, and there is some dissonance between its form and the space it inhabits; these are possible indications that it is the work of a young artist, struggling with an ambitious and innovative format.

A mature treatment of a similar scheme can be seen in Giulio's portrait of *?Isabella d'Este* (London, Hampton Court, Royal Col.). Here the tentative explorations of the earlier work are codified: the flowing forms of the sitter's gown have become a major pictorial motif, engulfing the foreground with dynamic patterns, and the bulk of the figure convincingly anchors it in the surrounding, compartmentalized space.

As Giulio's talents developed under the pressure of Raphael's work, he quickly achieved the skill required to carry out autonomous commissions and the prestige necessary to receive them. However, it is not clear whether he was at liberty to accept independent employment during Raphael's lifetime. This question is suggested by a major work, the *Stoning of St Stephen* (Genoa, S Stefano), painted by Giulio between 1519 and 1521. The Datary of Pope Leo X, Giovanni Matteo Giberti (1495–1543), commissioned the altarpiece to decorate the church, for which he had just received a benefice. Giberti was a close friend of

Giulio, as well as a powerful presence in the papal court, reasons that may have been enough for a breach of protocol. Certainly Giberti wanted to obtain as quickly as possible a work intended to mark an addition to his stature. When the benefice was pronounced in 1519, Raphael himself was engaged on a major Medici commission, the *Transfiguration* (Rome, Pin. Vaticana), and was therefore not available. It is compelling to imagine that Giberti had Giulio in mind from the start; whether he approached him directly or through Raphael is uncertain. On the basis of a drawing, however, it has been suggested (Ferino Pagden, 1989 exh. cat.) that the commission was given first to Raphael and passed to Giulio after the former's death in 1520.

The composition of the *St Stephen* altarpiece emulates the bipartite division of Raphael's *Transfiguration* and shares the motif of a prominent seated figure in the left foreground, gesticulating towards the central action. The striking array of antique structures in the background is, however, a strong statement of Giulio's own *fantasia*. His particular blend of imaginative reconstruction and recognizable elements from ancient ruins was designed so that the viewer could delight in the exoticism of a colossal stage-set while discerning its origins in such monuments as the Market of Trajan, the Milvian Bridge and Trajan's Column. The drama of the first martyrdom found a particular response in Giulio's sensibilities. He depicted with brio the straining muscles, violent expressions and agitation of the group of ruffians throwing rocks, and accentuated the action through an emphatic pattern of light effects. Vasari called it most beautiful in composition, invention and grace, never outdone by Giulio himself.

2. Works following the death of Raphael, 1520–24.

(i) Sala di Costantino. (ii) Villa Madama. (iii) Villa Lante. (iv) Palazzo Stati Maccarani. (v) Fugger Altarpiece.

(i) Sala di Costantino. Raphael's death in 1520 caused a scramble among artists ambitious to capture his lapsed commissions and disappointed patrons. Giulio's ascendancy was not guaranteed. He was, in official terms, the inheritor of Raphael's shop in partnership with Giovan Francesco Penni, but the successful running of the shop depended on convincing the buyers of the continued quality of the product. His first great battle to prove himself as Raphael's replacement was with Sebastiano del Piombo for the decoration of the Sala di Costantino in the Vatican. The dispute, initiated in the summer of 1520, was complicated by Michelangelo's shadowy participation on behalf of Sebastiano. The competition between the two camps was for artistic primacy in the court of Leo X. The Pope eventually awarded the commission to Raphael's shop, which claimed to have Raphael's drawings for the project, a claim that proved decisive, if not necessarily true. Nevertheless, scaffolding had been erected for the preparation of the walls as early as 1519, and it has been argued persuasively that Raphael conceived the underlying scheme for the frescoes, with its alternations between fictive tapestries and illusionistic architectural spaces articulated by massive thrones (Quednau). It is unclear how far the work progressed during the two years before the death of Leo X. When it was resumed after the brief papacy of Adrian VI (1522–3), the project was under the direction of Giulio, who saw it to completion in 1524. In addition to consolidating his artistic pre-eminence at the papal court, work on the Sala di Costantino gave Giulio the satisfaction of supervising the completion of the decoration of the papal apartments, the site of his own beginnings as an artist.

The two frescoes in the room that most clearly expand the lessons of Raphael's interest in classical form and motifs are the *Adlocutio* (Vision of Constantine) and the *Battle of the Milvian Bridge*. In the presentation of these scenes of Constantine's military exploits, Giulio drew heavily on imagery from Trajan's Column (AD 113; Rome, Foro di Traiano). The archaeological nature of Giulio's borrowings was noted with approval by Vasari. The armour of Giulio's soldiers is copied from that of their ancient counterparts; the image of Constantine on a rearing horse, triumphant in battle, echoes the relief depicting the Trajanic period in the Arch of Constantine (AD 315; Rome, Foro Romano). Giulio's knowledge and assimilation of ancient pictorial vocabulary reinvented the Roman past for the papal court, replacing the more monumental and abstract vision of Raphael. In contrast to Raphael, Giulio delighted in introducing spirited witticisms and distracting detail into even the most monumental compositions. Thus a vividly painted dwarf is prominent in the serious *Adlocutio*, and part of the visual pleasure of the *Battle* is to pick out the incidental episodes of struggle and defeat, of bellicose encounters. In this great fresco cycle, the first to be dominated by Giulio's control, the artist shows his sensibilities to be elaborative and excursive. He achieves an overall effect and grandeur that compensates for any weaknesses in individual passages.

(ii) Villa Madama. In addition to the extensive programme for the decoration of the last of the Vatican Stanze, a major architectural project of Raphael's passed to Giulio for completion. Giulio's training in architecture was probably analogous to that in painting: he assisted Raphael at levels of increasing responsibility, gaining mastery while performing the tasks allotted to him. Since Raphael was appointed architect to the pope in 1514, Giulio's apprenticeship in this arena must date from his earliest years under Raphael's tutelage. As with painting, his first steps as an architect are indistinguishable in the works of his master, and similar questions of authorship arise. Thus for the luxurious residence later known as the Villa Madama, built for Cardinal Giulio de' Medici, the future pope Clement VII, Raphael developed the plan with such accomplished collaborators as Antonio da Sangallo the younger, aided by assistants, notably Giulio, in measures that it is impossible to quantify with certainty. With Raphael's death, Giulio's mounting prestige was such that the Cardinal gave the commission to him. It has been argued that the plan was conceived by Giulio independently, which suggests he was integral to the project from the start, working closely with Raphael during the initial stages (Frommel, 1989 exh. cat.).

The projected structure was to be built on a colossal scale, with a courtyard at its core, thus imitating ancient Roman prototypes. Unusual for the Renaissance, the

courtyard was to be circular, with adjoining vestibules, one opening on to a grandiose loggia overlooking a garden. Notably, the project also included the construction of an outdoor theatre on a sloping hillside, in the ancient manner. Although only a portion of the vast complex was completed under Giulio's efforts, the results were stunning, both for their invention and richness of effect. The two principal façades, for example, were designed asymmetrically, with the small stretch of wall on the garden façade both dissolved and continued by the articulation of the adjoining, monumental loggia. Although in this instance rooted in Raphael's project, similar unexpected juxtapositions were an important element in Giulio's later architectural work in Mantua. The loggia of the villa (*see* RAPHAEL, fig. 9) was richly decorated *all'antica* in stucco and fresco by Giulio himself and Giovanni da Udine, reminiscent in its components and visual effect of the splendour of the Vatican Loggia (*see also* UDINE, GIOVANNI DA, and fig.). Progress on the decoration of the villa almost foundered at one point due to the constant battle of wills between Giulio and Giovanni da Udine, and the Cardinal despaired of negotiating peace between the two 'cervelli fantastichi'. One aspect of Raphael's genius was the smooth implementation of collaborative effort, and it became clear that despite its collective talent, the workshop could not survive without him.

(iii) Villa Lante. In addition to the completion of Raphael's unfulfilled commissions, Giulio immediately received independent architectural assignments. In 1520–21 he had the opportunity to capitalize on the fashion for classical suburban villas, which the Villa Madama had helped to create, when Baldassare Turini commissioned a residence (now known as the Villa Lante) on the Janiculum Hill. The setting suggested a classical conceit: it was the site of a villa thought to be owned by the Roman writer Martial (*c.* AD 40–104; Frommel, 1989 exh. cat.), a link that Turini wanted to celebrate. Giulio's capacity to enunciate modern building language through an antique vocabulary gave him perfect credentials for Turini's task. (His role in the design of the villa is controversial; it has been suggested that the project was begun by Raphael (D. Coffin: *The Villa in the Life of Renaissance Rome*, Princeton, 1979, p. 262).) The design acknowledged the building's ancient predecessor by following the outline of its ruins and the loggia (later enclosed) on its extant foundations (Frommel, 1989 exh. cat.). The details of the structure, however, were not calculated to conform to the Roman canon. The villa is high and narrow, with vertical continuity stressed in the placement of the orders, which are delicately scaled and without massive projection. The pristine Doric order of the ground-floor is surmounted by elegantly shallow Ionic pilasters, whose volutes swell only

1. Giulio Romano: Palazzo Stati Maccarani (now Palazzo Di Brazzà), Rome, *c.* 1522–3

slightly from the surface of the wall. The lightness conveyed by the dainty proportions of the orders is apparent also in the simplified entablature—just an architrave and cornice—and is continued in the tall, narrow arches of the loggia. The canonic orders here begin to be treated visually as independent from their structural purposes, and this liberation offered the architect new expressive possibilities.

(iv) Palazzo Stati Maccarani. Following the Villa Lante, *c.* 1522–3 Giulio took up the commission from a Roman patrician, Cristoforo Stati, to construct an urban palazzo facing the Piazza S Eustachio. In contrast to the villa commissions with their concern for beauty of setting and explicit ancient prototypes, here Giulio was faced with the conversion of the site of several smaller houses into one unified structure, with the inclusion of income-producing shops at the street-level. The resulting Palazzo Stati Maccarani (now the Palazzo Di Brazzà) is a massive three-storey building surrounding an interior courtyard, with five bays composing its principal façade (see fig. 1). The shops on the ground-floor are marked with dynamic, rusticated keystones and voussoirs that burst out in the shape of a fan over the flat-arched entrances. The energy that explodes from the expansive forms and rusticated blocks of the lowest floor leads into a much more restrained *piano nobile*, with its paired pilasters and shallow aediculae framing the windows in stately niches. In the uppermost floor the vigorous physicality that sweeps the ground-level has become completely enervated; even the doubled pilasters, here without architraves, bases and pedestals, almost sink into the wall, merely echoing the articulation of the façade below. The refined effect of the third storey is that of a ghostly grid, in very low relief.

The Palazzo Stati Maccarani provides a clear measure of the rapidity with which Giulio came into his own in architectural design. Although essentially the palazzo fits into the line of development pioneered by Donato Bramante and developed by Raphael, Giulio's variation establishes a different dialogue among the architectural forms, animates them with the tension of contrast and provides a kind of commentary on architectural practice by calling attention to it through the manipulation of its vocabulary.

(v) Fugger Altarpiece. In the aftermath of Raphael's death, Giulio also executed independent commissions for easel paintings, a format that he used extensively during his apprenticeship, but seldom later. A major work of his last years in Rome is an altarpiece, the *Holy Family with SS James, John the Baptist and Mark* (Rome, S Maria dell' Anima; see fig. 2), commissioned by the German banker Jakob Fugger II, perhaps *c.* 1522.

Although the subject is traditional, commemorating both the client's patron saint and that of the chapel, the arrangement of the figures is somewhat surprising. The saints seem to move in and out of the foreground and middle ground at various angles to the emphatically asymmetrical placement of the Virgin and Child. The asymmetry is accentuated by the twisting pose of the Virgin, who is out of alignment with the front of her draped throne. A striking pattern of deep shadows and metallic lights complicates even further the strange balance of this spatial organization. Giulio's penchant for visual digression appears in the detailed architectural fantasy of

2. Giulio Romano: *Holy Family with SS James, John the Baptist and Mark*, oil on canvas, ?*c.* 1522 (Rome, S Maria dell' Anima)

the background, in which is depicted the curious motif of an old woman holding a distaff and a hen and chicks. The luminous openness of this structure provides a foil for the intensity of the crowded foreground of the painting; its free play with the architectural forms of antiquity was later realized in three dimensions when Giulio constructed the Palazzo del Te in Mantua.

3. WORKS FOR FEDERICO GONZAGA, 1524–40.

(i) Move to Mantua and appointment as court artist. (ii) Palazzo del Te. (iii) Palazzo Ducale.

(i) Move to Mantua and appointment as court artist. As Giulio's reputation grew in the years after the death of Raphael, competition for his services increased. From at least 1522, serious efforts were made by the ruler of Mantua, Federico II Gonzaga, 5th Marchese and 1st Duke (*see* GONZAGA, (9)), to lure the artist from Rome to his court in northern Italy. The negotiations were conducted through the Mantuan ambassador, Baldassare Castiglione, who persuaded Giulio to leave Rome in the autumn of 1524. Giulio's universal training must have been a compelling factor in the court appointment, but it is clear that his talent as an architect was Federico's first concern. Even before he moved to Mantua, Federico had commissioned him to make a model for an expansion of a villa (destr.) in the Gonzaga holdings at Marmirolo. The success of this work led to Federico's redoubled efforts to secure the artist's residency in his court. In Mantua, Giulio's ascendancy was swift but not automatic; during the first two

years he established himself with credibility but without fanfare, and proved the quality and range of his capacities.

A sequence of documents attests to Giulio's rapid rise in official standing. In a series of declarations Federico honoured him with citizenship and special privileges, awarded him a house and appointed him Superior General of the Gonzaga buildings for the entire Mantuan state; further declarations bestow benefices and grant tax exemptions. In November 1526 a climax was reached when Giulio received the title of Superior of the Streets, with attendant possibilities for further income and powers of management. Thus Federico publicly established the terms for an extremely close working relationship with his court artist, one that endured throughout his lifetime. Federico and Giulio were close in age, shared fundamental aspects in their cultural formation and had highly compatible aesthetic sensibilities, all of which contributed to one of the most fruitful patronage partnerships in the Renaissance. Giulio's work for Federico included everything from designs for silverware to directing the renovation and construction of buildings. He oversaw projects for urban renewal, advised on engineering problems, produced stage sets for court entertainments and devised and managed the execution of elaborate fresco programmes. None of Federico's needs was too trivial to command Giulio's attention or too grandiose to exhaust the artist's invention.

(ii) Palazzo del Te. The first sustained project that Giulio carried out for his patron was the transformation of a utilitarian structure on an island site known as the Te into a sumptuous setting for leisure activity and courtly entertainment. The Isola del Te, just outside the city, housed stables for the prized breed of Gonzaga horses; the production of a luxury commodity was thus at the core of the programme for a pleasure villa. The project developed gradually, from a modest villa incorporating extant structures into a palazzo embellished with increasingly imposing architectural forms to keep pace with the architect's fertile imagination and the patron's increasing rank within the politics of the Holy Roman Empire (Forster and Tuttle, 1971). Again there was a close match between Giulio's preferred approach, composite and incremental both in conceptualization and process, and his patron's escalating ambitions, backed by resources that came in spurts. Construction and decoration of the Palazzo del Te took place over about a decade, from the mid-1520s with several interruptions.

The Palazzo del Te is in the shape of a square, with four wings, each cut by a loggia, assembled around an open courtyard. This imposingly large central space originally held a labyrinth, which was both decorative and symbolic, as the labyrinth was a Gonzaga emblem. The exterior of the palace is low and compact, with massive rusticated blocks and Doric pilasters as the controlling forms.

On both the north façade (see fig. 3) and west façade, the pilasters extend past the ground-floor through the mezzanine level, so becoming linked visually. These façades are highly textured, with differing thicknesses of the rusticated elements, as well as varying protrusions of the pilasters, their podia and bases, the keystones and voussoirs and the horizontal bands and friezes. The most monumental exterior is the east façade, with its majestic, triple-arched loggia that originally overlooked reflecting pools and an expanse of garden. The courtyard façades continue the themes introduced on the northern and western exteriors, but with a more vigorous projection: the pilasters have swelled into engaged columns, and the entablatures are heavy and deep. Motifs of movement create a cultivated dissonance; keystones jut upwards to split the pediments, and sections of the frieze drop out of register, taking with them slabs of the architrave below. These motifs have been interpreted as manifestations of artistic *Angst* or Mannerist neurosis, but they are more properly seen as a sophisticated dialogue with the Classical canon and as expressive forms meant to embellish the architecture. Moreover, in the context of Giulio's stylistic development, many elements of the Palazzo del Te's energy and whimsy were tentatively explored in the Palazzo Stati Maccarani and other early works (*see also* GROTTO, fig. 1).

The interior plan of the palazzo is determined by four blocks of apartments on the ground level, separated by loggias. These suites, which were elaborately decorated, were destined for Federico's private use or for the pleasure of his guests. Giulio marshalled imagery from a spirited variety of sources: Classical texts in the Sala di Ovidio; astrological texts in the Sala dei Venti; imperial splendour in the Sala degli Stucchi and the Sala di Cesare. In one vast hall Giulio used a subject appropriate to the site; the walls are decorated with frescoes of Federico's favourite horses, studied from life.

The equine portraits, set in front of landscapes, alternate with fictive niches with statues of Olympian deities, an ensemble indicating the ruling presences on the Isola del Te. The diversity of subject-matter and the plethora of decorative ideas give the rooms marvellously different

3. Giulio Romano: north façade of the Palazzo del Te, Mantua; pen and brown ink drawing by Ippolito Andreasi, 182×842 mm, *c.* 1567–8 (Düsseldorf, Kunstmuseum im Ehrenhof)

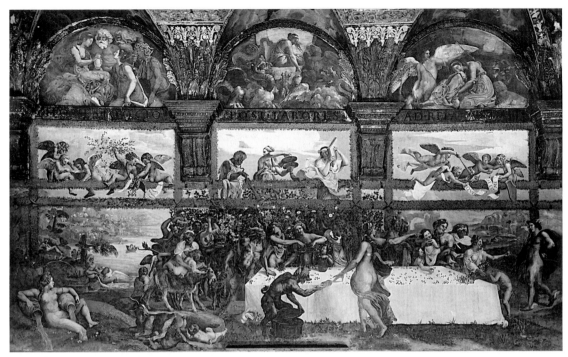

4. Giulio Romano: *Wedding Feast of Cupid and Psyche* (1528), fresco, Sala di Psiche, Palazzo del Te, Mantua

5. Giulio Romano: *Study of Olympian Deities*, pen and brown ink, brush and brown wash, heightened with white, over black chalk, 502×920 mm, for the Sala dei Giganti, Palazzo del Te, 1532–4 (Paris, Musée du Louvre)

characters and attest to Giulio's delight in sheer inventiveness.

Two rooms are particularly impressive: the Sala di Psiche and the Sala dei Giganti. Mythological eroticism lies behind the story of Psyche's tribulations at the hands of Venus. In the room dedicated to the unfolding of her story, Giulio created an environment sparkling with colour and elaborately embellished, with the ceiling compartmentalized into octagons, lozenges and squares, each holding a panel painted with an episode of the narrative. Related or analogous stories appear on the walls in fresco (see fig. 4), with an emphasis on the erotic in both theme and

presentation. The Sala di Psiche was evidently a showpiece; the images display much virtuosity in their compositions and conception, while an inscription along the walls records Federico as the proprietor and augurs his enjoyment of leisure hours.

The conspicuous enjoyment of relaxation is also a theme in the Sala dei Giganti (see fig. 5; see also WALL PAINTING, fig. 6). This was conceived as a show of ingenuity in its fabrication and decoration. The subject of Jupiter's victory over the rebel giants is presented as a threat to the viewer's well-being, as the painted lightning bolts hurled from the ceiling appear to destroy the very structure of the supporting walls.

The theatrical result was surely intended to rival the degree of illusionism and the viewer's complicity in its game in Mantegna's Cameri degli Sposi in the Gonzaga's urban palazzo. In its original presentation the decoration of the Sala dei Giganti was completely continuous, so that ceiling, walls, floor and closed doors coalesced into one collapsing environment. Giulio ensured that the spectral fantasy attained maximum effect by constructing the room as an echo chamber, with a fireplace (since walled over) providing an eerie, flickering effect. Part of one of the later stages of decoration in the Te, the Sala dei Giganti shows Giulio sufficiently confident and autonomous to unleash a highly individualized fantasy for the amusement of his patron.

(iii) Palazzo Ducale. The playfulness indulged in the decorations of the Palazzo del Te was licensed by its function as a suburban villa, used for relaxation and the passing of leisure hours. When faced with the task of coordinating new construction and embellishment within the core of the Gonzaga's urban residence, Giulio eschewed the currents of eroticism and frivolity and turned instead to themes of history, militarism and courtly decorum. The result was the formation of an elegant state apartment, a coherent unit of reception halls, smaller, intimate spaces and loggias, ensconced within the enormous complex of structures that together formed the Palazzo Ducale. The work was carried out over three years, from 1536 to the end of 1538, with several significant breaks. Giulio again had full artistic control over all aspects of the project, carefully monitored by his patron. As in all of his projects for Federico, Giulio had to contend with severe restrictions on the site itself, limited resources and urgent deadlines for completion. With inventiveness that both incorporated and transcended the considerable restraints, he realized a suite of rooms that became a paradigm for 16th-century courtly environments.

In its most formal and stately aspects, the Appartamento di Troia (named after the subject-matter of its major room) culminated in a reception hall bound by a monumental loggia. The loggia, like most of these Renaissance structures, has been enclosed to form a gallery. In its original form it was airy and grandiose, with a series of dignified arches that opened on to a vast courtyard. The walls of the Loggia dei Marmi, as its name indicates, incorporated niches that held marble statues and stuccos, either antique or replicas fabricated in Giulio's shop. From this loggia one entered the Sala di Troia, a formal stateroom with frescoes on all the walls and around the ceiling, depicting epic, Homeric subjects (see fig. 6). The style is classicizing in its grandeur and in its content, appropriate to the dynastic function of the room. With the exception of the Sala dei Cavalli, conceived similarly to that in the Palazzo del Te, the other spaces in the apartment are much smaller in scale and private in nature. Their decoration, like that of the Palazzo del Te, shows delight in a variety of materials and formats and is uniformly courtly in motif, with imagery of birds and hunting falcons, or elegant ensembles punctuated by antique busts.

The decoration of the Appartamento Ducale was of such consequence that collaborators of the highest calibre were involved. Taking up one of the practices of Raphael that he was otherwise not disposed to follow, Giulio engaged a distinguished colleague for the project. For the Room of the Caesars, Titian provided 11 portraits of Roman emperors, on canvas, while Giulio painted the

6. Giulio Romano: *Sinon Overseeing the Construction of the Trojan Horse* (1538), fresco, Sala di Troia, Palazzo Ducale, Mantua

twelfth portrait and furnished the setting for them. The disposition of the entire room, with the allegorical fresco on the ceiling, stuccoed frames, niches, grotesque ornament, as well as narrative panels complementary to the portraits, was created to act as foil for Titian's contribution. That Giulio's more illustrious colleague commanded special consideration is clear from the correspondence about the paintings that was sent directly from Federico himself.

4. OTHER PROJECTS OF THE 1530s AND 1540s. Giulio's impressive position in Mantua was acquired at the cost of severe restrictions in the commissions that could be carried out for patrons other than the Gonzaga. His incumbency in Federico's court implied his constant availability; it also identified him completely with his lord, so that his services became a political benefice that Federico could generously bestow or vengefully withhold. Even an old friend of high standing could not presume upon the employment of Giulio, as Giovanmatteo Giberti discovered in 1534. Giberti, the patron and close friend of Giulio's Roman years, was at this time the Bishop of Verona, and he requested the decoration of the apse of his cathedral. Although Giulio was not allowed the liberty to carry out the commission, he devised the composition and furnished drawings for an *Assumption of the Virgin*, which was then painted by a local artist, Francesco Torbido (*in situ*).

The fireworks of Giulio's design, analogous to the illusionism and high drama of the contemporary Sala dei Giganti, are not rendered in Torbido's translation. The idea, however, was masterful. Giulio envisioned a redefinition of the actual apse through a simulated structure of a coffered half dome, whose supporting cornice is surmounted by a balustrade. This forms the precarious setting in which the Twelve Apostles react to the vision of the Virgin's sudden movement towards the heavens. Clouds with angels in agitated motion rupture the coffered surface of the vault, and the apostles tumble and gesticulate in their surprise. The fictive boundary of the balustrade barely contains the monumental figures, whose limbs and drapery thrust beyond it. One apostle topples backward, testing the empathy of the viewer into whose space he is in danger of tumbling.

One of the most significant projects that Giulio undertook outside of the constant flow of Federico's commissions was the reconstruction of a house in Mantua to be used as his own residence. The house was purchased in 1538, but it is likely that its transformation of it began in earnest only in 1540, after the death of Federico. In any case, the Casa Pippi was completed by 1544, when Vasari saw it and recorded in astonishment its lordly presence and handsome façade, with its sequence of brightly coloured pediments and lunettes.

The façade was extended in 1800, and there has been confusion about the configuration of Giulio's original project. However, a drawing of the façade by Giulio has been identified (Magnussen). His alterations to the property included establishing a series of six bays, with a portal of imposing dignity in the third bay from the left. In place of the wide windows above the other bays, the arch over the doorway frames a shallow niche, where a statue of *Mercury* is displayed. The statue functions as a sort of shop-sign, a symbolic allusion to the profession of the owner of the house (Forster and Tuttle, 1973). This personal theme is continued in the frescoes Giulio painted in the *salone*, where Prometheus, the prototypical artist, figures among the Olympian deities. Letters specify that Giulio's studio was on the ground floor of the Casa Pippi; thus the entire configuration of the house can be understood as a statement of his dual role. He expressed his seigniorial status in the size and elegance of his house and proclaimed his professional identity in the components of its decoration.

The application of Giulio's exuberance and sophistication to religious commissions, as seen in the *Assumption of the Virgin*, was apparently well received. In 1540 the Benedictines of San Benedetto Po, near Mantua, entrusted him with the extensive renovation of their abbey church. The medieval structure was a conglomeration of spaces and styles, following earlier renewals. Thus Giulio's task was to reconcile a number of disharmonious elements and to impose a visual coherence, using a modern, i.e. *all'antica*, manner. He accomplished this by adding framing elements at each end of the church, a vestibule and ambulatory, and new chapels on the right side for balance.

Giulio's true mastery of illusionism is apparent in the interior, where he masked the irregular placement of the side chapels and their bays with a succession of Serlian windows framed by Corinthian pilasters that imposes a visual rhythm strong enough to disguise the discrepancies in their spacing. In his astute management of structures with complicated building histories, Giulio always retained as many original elements as possible and brought them into harmony with key elements of contemporary architectural language.

The church of San Benedetto Po had strong links to the Gonzaga family. Giulio's engagement there was one of the increasing number of religious works that he undertook after the death of Federico Gonzaga, during the regency of Cardinal Ercole Gonzaga. The Cardinal reaffirmed both Giulio's status at court and his control over all artistic matters and became in his turn a keenly interested patron. When fire damaged Mantua Cathedral in April 1545 (Tafuri, 1989 exh. cat.), the Cardinal set Giulio to work on a major reconstruction, envisaging the aggrandizement of the church as a memorial to his reign. Once more Giulio had the challenge of imparting increased majesty and a modern look to a Romanesque church without altering its basic form. His project included the rebuilding of the choir and restructuring of the nave, enlarging it to five aisles. Rows of splendid Corinthian columns, finely detailed and made of Veronese marble, define both the central nave and the side aisles. Vasari remarked on the beauty of the Cathedral's renovation in the account of his visit to Mantua, and recounts the following exchange (*Vite*, Eng. trans., 1987, p. 231):

> The cardinal then asked Giorgio what he thought of Giulio's works, and he replied, in Giulio's presence, that they were so excellent that he deserved to have a statue of himself put up on every corner of the city, and that since he had brought about the renewal of Mantua, half of the state itself would not be enough reward for his labours and talent. And to this the cardinal replied that Giulio was more the master of the state than he was himself.

II. Working methods and technique.

Giulio's art was grounded in the emulation of antique forms. His goal was to forge a modern style that improved on the achievement of the ancients, using Raphael's mode and methods of realization. In this approach, *disegno* was the conceptual basis for all the visual arts. Giulio developed his ideas in a sequence of intensely worked drawings—compositional sketches, figure studies, *modelli* and cartoons—and brought the concept to life. After this crucial work, he usually orchestrated rather than participated in the manual execution, whether in fresco, on panel or in architectural construction. The function of drawings as intellectual property is clearly illustrated in an incident that occurred while Giulio was employed by Federico Gonzaga. One of the assistants stole a group of Giulio's drawings and fled to Verona. The Duke himself immediately wrote to officials there, demanding the imprisonment of the thief and stating that the drawings were of great significance to him, since they were to be used in his buildings, and he did not want them copied. The ideas of his court artist were 'patented' as representations of himself.

Contemporaries greatly admired Giulio's virtuoso drawing technique. He could give form to concepts with lightning speed (Vasari), and he could spontaneously execute variations on antique motifs as though he had the originals in front of his eyes (Armenini, p. 226). Vasari denigrates Giulio's painting in comparison to his draughtsmanship: 'It can be affirmed that Giulio always expressed his concepts better in drawings than in his finished works or paintings, since in the former we see more vivacity, boldness, and emotion' (*Vite*, p. 212). Vasari also added a complaint about the amount of black pigment that Giulio 'always loved to use when colouring' (p. 213), which he thought diminished the perfection of his final product. It is interesting that he makes this point when describing the scene of the *Adlocutio* and in his discussion of the Fugger Altarpiece, thus indicating that the technique was used both for frescoes and easel paintings.

Vasari's *Vita* of Giulio gives another detail about his working process, as carried out in the decoration of the Palazzo del Te: 'it is true that subsequently nearly all the work was retouched by Giulio, so it is as if it were all done by him' (p. 220), specifying that he learnt this system from Raphael. The master's presence was crucial to the final product, for which he took full responsibility. This is apparent from a letter (Mantua, Ist. Gonzaga, busta 2937) that Federico Gonzaga sent to Ercole II d'Este, Duke of Ferrara, in April 1537, promising to allow Giulio a visit only at the end of the month, since the artist was overseeing the preparation of some rooms, and without his presence the work could not continue. In addition to the need for the master's final touches, it seems that his continuous presence was necessary because the decorative or construction programmes were approached piecemeal. There is evidence that Giulio's works developed by increments, with decisions and additions made along the way, rather than established in every detail at the inception of the project. A letter (Talvacchia, 1988) indicates that this was the case in the decoration of the Sala di Troia: Giulio mentions his anticipation of the next group of subjects from his literary advisor and promises new and exciting ideas for the paintings still to be executed.

It has been suggested that Giulio was less competent with some of the engineering aspects of his architectural projects, while masterfully in control of the design elements (Belluzzi and Forster, exh. cat. 1989). The same process of conceptual elaboration through detailed drawings, of individual elements as well as overall composition, can be followed in extant drawings of his architectural projects. Wherever possible, he incorporated existing fragments into the fabric of the new structure, as much for ideological as for practical or economic reasons. This is clear in his proposal for the renovation of the Basilica in Vicenza, in which he stressed that it would be a mistake to demolish the historical structure unnecessarily. Giulio's conservative historicism is an interesting contrast to his approach to the use of materials, which is characterized by an exuberant aesthetic of the inauthentic. The illusionism inherent in his use of substitute materials, developed in response to the lack of local building-stone in Mantua, created its own aesthetic. A majestic palazzo that appeared to be a mass of heavy rusticated stone was in fact a core of bricks sheathed in stucco. The contradiction between the viewer's perception of a building and its physical reality was another concept central to Giulio's creations.

Giulio's mastery of illusionism elicited the awe of his contemporaries. Vasari particularly praised the *di sotto in sù* passages in the Sala di Psiche, and Armenini's treatise includes a lyrical appreciation of the ceiling in the Sala dei Giganti, where: 'The gods are foreshortened *di sotto in sù* and spring from the vault through the force of contours in a manner which makes them stand out with so much relief that they appear as if alive, and not painted. Thus, Giulio gave marvellous form to art and judicious propriety to the subject'. The system that Giulio evolved for illusionistic ceiling painting was regarded as a paradigm, as indicated in Cristoforo Sorte's *Osservationi nella pittura* (passage translated in Hartt, 1958). Sorte recounts his experiences as an apprentice painter in Mantua, when Giulio's assistants were executing his designs in the Sala di Troia. Their method involved the application of a grid to a mirror that reflected the model to be painted, a system that depended on the careful placement of the mirror in relation to the model and to the viewpoint of the painter. According to Sorte, this system attained the best results.

Giulio's greatest technical skill was demonstrated in his drawings, which are notable for their incisiveness and abundance of invention. His formidable talent as a designer was most successfully realized in his architectural projects and in the ensemble of his complex decorative programmes. The immediate influence of his work was marked in the architectural treatises of Andrea Palladio and Sebastiano Serlio and in the move towards an increasing elaboration of illusionistic fresco painting.

For further illustrations *see* GROTTO, fig. 1 and ORDERS, ARCHITECTURAL, fig. 6.

BIBLIOGRAPHY

EARLY WORKS

G. Vasari: *Vite* (1550, rev. 2/1568); ed. G. Milanesi (1878–85) [Eng. trans. of 2nd edn by G. Bull, abridged, Harmondsworth, 1987]

C. Sorte: *Osservationi nella pittura* (Venice, 1580)

G. B. Armenini: *De' veri precetti della pittura* (Ravenna, 1586; Eng. trans. by E. J. Olszewski, New York, 1977)

MONOGRAPHS

C. D'Arco: *Istoria della vita e delle opere di Giulio Pippi Romano* (Mantua, 1838/*R* 1986, 2/1842)

F. Hartt: *Giulio Romano*, 2 vols (New Haven, 1958/*R* New York, 1981); review by J. Shearman in *Burl. Mag.*, ci (1959), pp. 456–60

Studi su Giulio Romano (San Benedetto Po, 1975)

P. Carpeggiani and C. Tellini Perina: *Giulio Romano a Mantova* (Mantua, 1987)

Atti del convegno internazionale di studi su 'Giulio Romano e l'espansione europea del rinascimento': Mantova, 1989

Giulio Romano (exh. cat. by A. Belluzzi, K. Forster, H. Burns and others, Mantua, Mus. Civ. Pal. Te and Pal. Ducale; 1989)

SPECIALIST STUDIES

Palazzo del Te

E. H. Gombrich: 'The Sala dei Venti in the Palazzo del Te', *J. Warb. & Court. Inst.*, xiii (1950), pp. 189–201

G. Paccagnini: *Il Palazzo Te* (Milan, 1957)

J. Shearman: 'Osservazioni sulla cronologia e l'evoluzione del Palazzo del Te', *Boll. Cent. Int. Stud. Archit. Andrea Palladio*, ix (1967), pp. 434–8

K. Forster and R. Tuttle: 'The Palazzo del Te', *J. Soc. Archit. Hist.*, xxx (1971), pp. 267–93

A. Belluzzi and W. Capezzali: *Il palazzo dei lucidi inganni: Palazzo Te a Mantova* (Florence, 1976)

E. Verheyen: *The Palazzo del Te in Mantua: Images of Love and Politics* (Baltimore, 1977)

B. Allies: 'Palazzo del Te: Order, Orthodoxy and the Orders', *Archit. Rev.*, clxxiii (1983), pp. 59–65

Palazzo Ducale

G. Paccagnini: *Il Palazzo Ducale di Mantova* (Turin, 1969)

B. Talvacchia: *Giulio Romano's Sala di Troia: A Synthesis of Epic Narrative and Emblematic Imagery* (diss., Stanford U., 1981)

——: 'Narration through Gesture in Giulio Romano's Sala di Troia', *Ren. & Reformation*, n. s., x (1986), pp. 49–65

M. Annaloro: *La rustica di Giulio Romano in Palazzo Ducale a Mantova* (diss., U. Florence, 1986–7)

B. Talvacchia: 'Homer, Greek Heroes and Hellenism in Giulio Romano's Hall of Troy', *J. Warb. & Court. Inst.*, li (1988), pp. 235–42

Other specific architectural projects

C. L. Frommel: 'La Villa Madama e la tipologia delle ville romane nel rinascimento', *Boll. Cent. Int. Stud. Archit. Andrea Palladio*, xi (1969), pp. 47–64

K. Forster and R. Tuttle: 'The Casa Pippi: Giulio Romano's House in Mantua', *Architectura*, ii (1973), pp. 104–30

C. L. Frommel: *Der römische Palastbau der Hochrenaissance*, 3 vols (Tübingen, 1973)

R. Lefevre: *The Villa Madama* (Rome, 1973)

N. Dacos: *Le Logge di Raffaello* (Rome, 1977, 2/1986)

H. Lilius: *Villa Lante al Gianicolo: L'architettura e la decorazione pittorica*, 2 vols (Rome, 1981)

M. Tafuri: 'Osservazioni sulla chiesa di San Benedetto in Polirone', *Quad. Pal. Te*, iii (1986), pp. 11–24

B. Magnussen: 'A Drawing for the Façade of Giulio Romano's House in Mantua', *J. Soc. Archit. Hist.*, xlvii (1988), pp. 179–84

Other

H. Dollmayr: 'Raffaels Werkstätte', *Jb. Ksthist. Samml. Allhöch. Ksrhaus*, xvi (1895), pp. 231–63

——: 'Giulio Romano und das klassische Altertum', *Jb. Ksthist. Samml. Allhöch. Ksrhaus*, xxii (1901), pp. 178–220

P. Carpi: 'Giulio Romano ai servizi di Federico II Gonzaga', *Atti & Mem. Accad. N. Virgil. Mantova*, n. s., xi–xiii (1918–20), pp. 35–101

E. H. Gombrich: 'Zum Werke Giulio Romanos', *Jb. Ksthist. Samml. Wien*, n. s., viii (1934), pp. 79–104; ix (1935), pp. 121–50; Eng. trans., *Quad. Pal. Te*, i (1984), pp. 23–79

F. Hartt: 'Raphael and Giulio Romano: With Notes on the Raphael School', *A. Bull.*, xxvi (1944), pp. 67–94

E. H. Gombrich: 'The Style *all'antica*: Imitation and Assimilation', *Acts of the XXth International Congress on the History of Art: New York, 1961*, pp. 31–41

M. Laskin: 'Giulio Romano and Baldassare Castiglione', *Burl. Mag.*, cix (1967), pp. 300–03

J. Shearman: 'Giulio Romano: Tradizione, licenze, artifici', *Boll. Cent. Int. Stud. Archit. Andrea Palladio*, ix (1967), pp. 354–68

R. Quednau: *Die Sala di Costantino im Vatikanischer Palast* (Hildesheim and New York, 1979)

Splendours of the Gonzaga (exh. cat., ed. D. Chambers and J. Martineau; London, V&A, 1981)

C. Gould: 'Raphael versus Giulio Romano: The Swing Back', *Burl. Mag.*, cxxiv (1982), pp. 479–87

P. Joannides: 'The Early Easel Paintings of Giulio Romano', *Paragone*, xxxvi/425 (1985), pp. 17–64

A. Belluzzi: 'Giulio di Raffaello da Urbino', *Quad. Pal. Te*, viii (1988), pp. 9–20

BETTE TALVACCHIA

Giunta Pisano [Giunta di Capitino] (*fl* 1236–54). Italian painter. He was one of the most important and influential figures in Italian painting of the first half of the 13th century. He is known to have signed four painted Crucifixes, three of which survive (Assisi, S Maria degli Angeli; Bologna, S Domenico; and Pisa, ex-S Ranierino, now Mus. N. S Matteo). The fourth, painted for S Francesco, Assisi, bore the inscription, 'Brother Elias had me made, Giunta Pisano painted me, in the year of our Lord 1236, Jesus Christ have mercy on the prayers of pious Elias . . .'. The first generally accepted documentary reference to the artist originates from Rome in May 1239 and testifies that his son, the priest Leopardo, was in the city with Giovanni Pisano, a pupil of Master Giunta. This suggests that Giunta was involved in a commission in Rome (Verani). His name also appears in documents from Calci and Pisa dated 28 January 1241 and 28 August 1254. The latter describes him as Giunta di Capitino (*Juncta Capitinus pictor*), a name that recurs in the fragmentary inscription at the foot of the *Crucifix* in S Maria degli Angeli ([IU]NTA PISANUS [CAP]ITINI). This is the only known variant of the painter's name, and it is therefore unlikely that the Giunta di Guidotto mentioned in a document of 30 January 1229 is Giunta Pisano. According to a document of 1257, Giunta was by then dead, but this reference cannot be securely linked to the artist.

Giunta Pisano's painting has usually been studied on the basis of the three surviving signed Crucifixes. That in S Maria degli Angeli has been thought to date from *c.* 1236 during the artist's presumed visit to Assisi in the course of which he executed the lost *Crucifix* for Brother Elias. The next stage in Giunta's career would then be represented by the *Crucifix* in Pisa, in which the artist can be seen to have rejected the influence of Byzantine painting. The *Crucifix* in Bologna, considered the most mature expression of Giunta's art, has been dated *c.* 1250. In it the dramatic accents, typical of his poetic style, seem to subside into a context of subtle refinement.

This reconstruction of Giunta's career was re-examined by Boskovits in an attempt to widen the number of works attributable to the painter. The most important new attribution concerns the altarpiece depicting *St Francis and Six Scenes from his Life* from S Francesco, Pisa (now Pisa, Mus. N. S Matteo; see fig.). Garrison had also noted the importance of this work for 13th-century Pisan painting and its probable connection with Giunta. It is usually considered dependent, both iconographically and chronologically, on a panel in S Francesco, Pescia, which is signed by Bonaventura Berlinghieri and dated 1235. Boskovits, however, argued that the greater narrative and compositional simplicity of the Pisan work suggested that it was the prototype for the altarpiece at Pescia; in which

Giunta Pisano (attrib.): *St Francis and Six Scenes from his Life*, tempera on panel, 1.63×1.29 m (Pisa, Museo Nazionale di S Matteo)

seem to show: these both depict *St Francis and Four Scenes from his Life* (Rome, Pin. Vaticana, and Assisi, Tesoro Mus. Basilica S Francesco).

The decisive nature of Giunta Pisano's influence is clearly discernible: in Pisa itself, one of his close followers was the painter of the Crucifix from S Paolo Ripa d'Arno (Pisa, Mus. N. S Matteo), which is often attributed to Giunta himself; in Florence, Coppo di Marcovaldo and the painter Garrison called the S Maria Primerana Master were influenced by him, as were the so-called Borgo Crucifix Master in Bologna and the S Chiara Master at Assisi. Giunta Pisano's importance in the development of medieval Italian painting has long been overlooked, and only a few critics have fully realized the historical influence of his art. Yet the fame he enjoyed in his lifetime and his visits to other major Italian artistic centres of the period point to the conclusion that he was a leading artistic figure and in his work for the Franciscan Order occupied a position which can be compared to that, many years later, of Cimabue and subsequently Giotto.

BIBLIOGRAPHY

C. Brandi: 'Il crocifisso di Giunta Pisano in San Domenico in Bologna', *L'Arte*, vii (1936), pp. 71–91
R. Longhi: 'Guidizio sul duecento', *Proporzioni*, ii (1948), pp. 32–54
E. B. Garrison: *Italian Romanesque Panel Painting: An Illustrated Index* (Florence, 1949), p. 19
H. Buchtal: *Miniature Painting in the Latin Kingdom of Jerusalem* (Oxford, 1957), p. 49
E. Carli: *Pittura medioevale pisana* (Milan, 1958), pp. 30–36
C. Verani: 'Giunta Pisano ha soggiornato a Roma', *L'Arte*, n. s., xxiii (1958), pp. 3–4
F. Bologna: *La pittura italiana delle origini* (Rome, 1962)
M. Boskovits: 'Giunta Pisano: Una svolta nella pittura italiana del duecento', *A. Illus.*, 55–6 (1973), pp. 339–52
E. Sindona: *Cimabue e il momento figurativo pregiottesco* (Milan, 1984)
A. Caleca: 'Pittura del duecento e del trecento', *La pittura in Italia: Le origini*, ed. E. Castelnuovo (Milan, 1985)
A. Tartuferi: *Giunta Pisano* (Soncino, 1992)

ANGELO TARTUFERI

case the date of 1235 on the latter represents a *terminus ante quem* for the execution of the Pisan *St Francis*. The argument that the subjects represented in the Pisan altarpiece became known only after the publication, *c.* 1250, of Tommaso da Celano's *Trattato dei miracoli*, which had prevented the attribution of this work to Giunta (Caleca), ignores the obvious point that such stories must have been widely known well before that date. Among the authenticated paintings by Giunta, the Assisi Crucifix is stylistically closest to the *St Francis* altarpiece. According to Boskovits's reconstruction, the Bologna Crucifix, in which Giunta's style seems noticeably more courtly and refined than in the painting in Assisi, would then come some years later, when a similar refinement can be seen in contemporary painting. If the Assisi Crucifix is dated before 1230 the most likely dates for the Bologna Crucifix would lie between 1235 and 1240. The Pisan Crucifix must then be seen as belonging to a later period of Giunta's career and represents an authentic turning-point in his style. The dramatic nature of the figure of the dead Christ, accentuated by strong contrasts of light and dark, the extraordinary freshness and freedom in the planning of the design, particularly in the figures of the two mourners, all point to a new stylistic direction.

The source of this development may lie in Byzantine painting of the 13th century, which was characterized by its rediscovery of the classical tradition. The striking similarity of Giunta's paintings to the illustrations in some illuminated manuscripts from S Giovanni d'Acri in Palestine, which had been noted by Buchtal, was also emphasized and discussed in detail by Boskovits. It is likely that Giunta Pisano was aware of the revival in Byzantine painting of the 1240s, and that this influenced his final period, as two paintings attributed to Giunta by Boskovits

Giunti [Giunta; Giuntalochi; Giuntalodi], **Domenico (di Giovanni)** (*b* Prato, 25 Feb 1505; *d* Guastalla, nr Parma, 28 Oct 1560). Italian architect and painter. The son of Giovanni Giunti, a candlemaker, and of Chiara Miniati, he trained as a painter under Nicolò Soggi (*b c.* 1480; *d* before 1552), a follower of Perugino. Vasari noted that Giunti's face is represented in a fresco by Soggi in SS Annunziata, Arezzo. Information on Giunti's career as a painter is very scarce, however, and it is very difficult to identify works by him. A portrait of 1526 is known, however, as is a later copy of a work by Sebastiano del Piombo. It is known (Deswarte-Rosa, 1988) that Giunti worked from 1532 to 1535 in Rome for the Portuguese ambassador, Don Martinho, after which he came into contact with Antonio Salamanca's etching studio, designing for it the allegorical portrait of an *Old Man* (1537; B. XIV, 400; incorrectly attributed to Baccio Bandinelli) and, later, some perspective views of such Roman monuments as the Colosseum and the Pantheon. It is likely that his work as a designer and copier of the paintings of famous masters led him to frequent the imperial circle in Rome and to establish a connection with the Gonzaga family.

In fact, it was more as an architectural designer and for his versatility that Giunti was engaged in 1540 by Ferrante Gonzaga, Viceroy of Sicily, in whose service he remained

for the next 20 years. Initially, he was responsible for the design of fortresses and defences for Sicily, although Antonio Ferramolino (*d* 1550) was principally responsible for their construction. Giunti appears to have remained in Sicily until 1546 and during this period worked mainly in Palermo on the personal urban projects of Gonzaga, such as the restructuring of the Castello a Mare (destr. 1922), at the mouth of the harbour, and the designing of a suburban villa with a garden. In 1546, when Gonzaga was appointed Governor of Milan, Giunti accompanied him and continued to operate predominantly as a civil architect rather than as a military one. In particular, he was in charge of the transformation of the apartments (destr.) in the Palazzo Ducale and he prepared the ephemeral decorations and temporary triumphal arches for the entry of the future Philip II of Spain at the end of 1548. Around this time Gonzaga also initiated a programme for the renovation of the urban centre of Milan based on criteria of architectural decorum and ease of circulation; it was to be under the control of Giunti, assisted by Nicolò Secco (1513–58), man of letters and seneschal. This programme became amalgamated with a grand project to build a new system of fortifications for the city.

Giunti's most significant work for the Governor, however, was La Gonzaga, known later as Villa Simonetta (now the Scuola Civica di Musica; see fig.), outside the old city walls. This was erected around the earlier villa La Gualtiera, which dated from the late 15th century and had been purchased in 1547 from the Cavaliere Cicogna. The villa (heavily damaged in World War II) was given a U-shaped plan, with the lateral arms embracing a forecourt, in front of which was a fish-pond that separated it from a large formal garden. The entrance façade facing Milan was treated as a three-storey loggia following antique models: for the ground floor the composition of the Colosseum and, more generally, the strucure of the Septizonium, although it is closer chronologically to the loggias of the Vatican. Somewhat ambiguous in its typology, the building is part villa and part urban palazzo (*see also* MILAN, §I, 3 and fig. 4).

Documentary evidence suggests that between 1549 and 1551 Giunti designed and erected the church of S Paolo Converso (alle Monache), Via S Eufemia, which has a long rib-vaulted nave delimited by lateral chapels and divided into two by a transversal wall. Evidence also suggests that in 1552 he began work on the Franciscan church of S Angelo, Via della Moscova, replacing an earlier church destroyed during the building of the new city walls. The plan follows the lines of a Latin cross. The spacious nave has no aisles but contains eight chapels on either side. These are divided from each other by narrow walls, which on the nave flank are fronted with fluted Ionic pilasters supporting a continuous horizontal entablature. A plain attic storey leads to the great barrel vault of the nave, which is penetrated with large circular windows above each chapel. Also attributed to Giunti (Mezzanotte) is the massive Palazzo Cicogna (destr.), Milan, and it seems he was also consulted (together with Cristoforo Lombardo and Vincenzo Seregni) on the construction of the Loggia at Brescia. Overall, Giunti's work was an integral part of the new climate of building fervour, encouraged by

Domenico Giunti: garden façade of La Gonzaga (later the Villa Simonetta), Milan, after 1547; from an engraving by Marcantonio dal Rè (Milan, Museo Civico di Milano)

Gonzaga, and shows elements of confrontation and reciprocal exchange of ideas with the most up-to-date aspects of the local artistic environment, in particular with the work of Cristoforo Lombardo.

Although Gonzaga was removed from his post as viceroy, Giunti continued to work for him and in 1556 was working on modest renovations to the family's properties in the area of Mantua, including the palazzi at Mantua and Pietole. Most importantly, he was in charge of building the new town of Guastalla, an estate purchased by Ferrante in 1539. This was laid out on a pentagonal plan with a rigid urban and social structure, as can be seen from Giunti's surviving architectural drawing (1553; Parma, Archv Stato). However, it was only from 1556 that he worked constantly on the Guastalla project. Giunti continued as the Gonzaga's architect at Guastalla, working for Ferrante's son Cesare until his death, by which time the external walls had been completed and work was commencing on the town centre. In his will, Giunti bequeathed 9000 scudi to assist young men from Prato to study at Pisa. In recognition, the town of Prato commissioned Fermo Ghisoni to paint his portrait (in the Palazzo Comunale, Prato).

BIBLIOGRAPHY
G. Vasari: *Vite* (1550, rev. 2/1568); ed. G. Milanesi (1878–85): 'Soggi, Nicolò'
G. Miniati: *Narrazione e disegno della terra di Prato* (Florence, 1596), pp. 136–40
M. dal Rè: *Ville di delizia, o siano palagi camperecci dello stato di Milano*, i (Milan, 1726)
I. Affò: *Istoria della città e del ducato di Guastalla*, 4 vols (Guastalla, 1785–7) [esp. vols ii and iii]
A. von Bartsch: *Le Peintre-graveur* (1803–21) [B.]
G. Campori: *Gli artisti italiani e stranieri negli stati estensi* (Modena, 1855)
C. Guasti: *Commentari alla vita di Nicolò Soggi* (Florence, 1874)
C. Pini and G. Milanesi: *Scrittura d'artisti italiani* (Florence, 1876)
C. Baroni: 'Domenico Giunti architetto di don Ferrante Gonzaga e le sue opere in Milano', *Archv Stor. Lombardo*, n.s. 3, lxv (1938), pp. 326–57; also in *Palladio*, ii (1938), pp. 128–45
——: *Documenti per la storia dell'architettura a Milano nel rinascimento e nel barocco*, 2 vols (Florence, 1940, Rome, 2/1968)
U. Tarchi: *La villa detta 'La Simonetta' nel suburbio di Milano* (Rome, 1953)

P. Giovio: *Lettere*, ed. G. G. Ferrero, ii (Rome, 1958)

P. Mezzanotte: 'L'architettura milanese dalla fine della signoria sforzesca alla metà del seicento', *Storia di Milano*, x (Milan, 1961–8), pp. 561–645

M. Hirst: 'Sebastiano's *Pietà* for the Commendador Mayor', *Burl. Mag.*, cxiv/834 (1972), pp. 585–95

L. H. Heydenreich and W. Lotz: *Art and Architecture in Italy, 1400–1600*, Pelican Hist. A. (London, 1974), pp. 291–3

A. Scotti: 'Per un profilo dell'architettura milanese (1535–1565)', *Omaggio a Tiziano* (exh. cat., Milan, Pal. Reale, 1977), pp. 97–121

S. Deswarte-Rosa: 'Domenico Giuntalodi: Peintre de D. Martinho de Portugal à Rome', *Rev. A.*, 80 (1988), pp. 52–60

——: 'Les Gravures de monuments antiques d'Antonio Salamanca, à l'origine du Speculum Romanae Magnificentiae', *An. Archit. Cent.*, i (1989), pp. 47–62

S. Leydi: 'I Trionfi dell'Aquila Imperialissima', *Schifanoia*, ix (1990), pp. 9–55

N. Soldini: 'La costruzione di Guastalla', *An. Archit. Cent.*, iv–v (1992–3), pp. 57–87

NICOLA SOLDINI

Giurgola, Romaldo. *See under* MITCHELL/GIURGOLA.

Giusti, Alessandro (*b* Rome, 1715; *d* Lisbon, 1799). Italian sculptor, active in Portugal. He studied drawing and painting under Sebastiano Conca and sculpture under Giovanni Battista Maini in Rome. There, around 1744, he was appointed by Manuel Pereira de Sampajo (1692–1750), at the time Portuguese Minister to the Holy See, to supervise the assembly of the chapel of St John Baptist in S Roque, Lisbon; this had been commissioned in 1742 by John V of Portugal (*reg* 1706–50) and arrived in dismantled form, having been made in Rome by Luigi Vanvitelli and Nicola Salvi. Giusti had already made four reliquaries for the chapel, and in Lisbon he directed this project between 1747 and 1748. Also in Lisbon he carved a marble bust of *John V* (*c*. 1745; Lisbon, Pal. N. Ajuda), which was influenced by Gianlorenzo Bernini, for the library of the new Palacio das Necessidades. This was first made in carved and gilded wood and was also cast in bronze (Mafra, Pal. N.). It depicts a splendidly majestic monarch, the personification of royal grandeur, wearing court armour and crowned with a laurel wreath, and is accompanied by symbols of the Arts and Sciences. It is a work that also commemorates the King's important role as a patron of the arts as well as the consistency of his taste, which was predominantly Italian. Giusti also carved statues for the chapel of the Palacio das Necessidades in Lisbon, including the figures of *St Philip Neri*, *St Luis de Sales* and *St Peter*, the last of which is sited on the façade and corresponds to the statue of *St Paul* by his chief rival in Rome, José de Almeida, whose angular style contrasts with Giusti's own more fluid style.

Giusti's principal work belongs to the reign (1750–77) of Joseph, King of Portugal, when the painted altarpieces on canvas from Italy in the palace-convent at MAFRA were found to be deteriorating from damp, and it was decided to replace them with marble low reliefs. In 1750 Giusti was appointed sculptor to the King, from whom he received 60,000 réis a month and a bonus on completion of each relief. This project was the second major sculptural programme at Mafra, the first being the installation (*c*. 1735) of Italian sculpture imported for the narthex and nave of the basilica.

Giusti was assisted at Mafra by two masons, Pedro António Luquez, who had worked with Gian Antonio Bellini at Padua, and Francisco Alves Ganada. The first

retable was installed in 1775 in the Capela dos Santos Bispos; the relief depicts *St Bonaventure and St Louis of Toulouse in Ecstasy before a Vision of the Virgin and Child*, surrounded by clouds and Baroque angels (see fig.). The second retable made by Giusti for the Capela do Santo Cristo (1777) represents the *Crucifixion*, a theatrical scene in which gesture and facial expression convey the grief and despair of the three Marys and St John the Evangelist. In the relief of the *Virgin of the Rosary* for the retable in the chapel of Nossa Senhora do Rosário (1779), the Baroque composition, with its strong diagonal direction, is effectively conveyed both by the gestures of the figures and by the upward direction of their gaze. There is the same mastery in the grouping and related attitudes of the figures, surrounded by clouds and with a multitude of angels, in the relief for the retable of the Capela das Santas Virgens (1781), where the figures include St Elizabeth of Portugal and St Elizabeth of Hungary.

In the retable of the Santos Mártires (1783) the two zones, earthly and heavenly, are linked by the ascending lines suggested by the gaze of the Martyr Saints towards the Virgin, who appears on a cloud. Similar triangular compositional devices are used in the retable for the Capela dos Santos Confessores (1785) with St Bernardine, St Louis and St Ivo worshipping the Virgin above. In the Capela da Sagrada Família the composition of the retable

Alessandro Giusti: *St Bonaventure and St Louis of Toulouse in Ecstasy before a Vision of the Virgin and Child* (1775), marble relief from retable, Capela dos Santos Bispos, Mafra

of 1789 resembles a crowded theatrical scene with saints connected with the Holy Family grouped around the Virgin and Child and St Joseph. Giusti's last work at Mafra was the retable for the Capela da Coroação de Nossa Senhora (1790), which was unfinished because he became blind in 1791. Nevertheless, it shows his characteristic theatricality in the scene with accompanying angel musicians.

At Mafra, Giusti founded and directed the Mafra school, which was fundamental for the development of Portuguese sculpture, and in particular of stone sculpture, in the second half of the 18th century and the early 19th. There his principal assistant and pupil from 1756 was Joaquim Machado de Castro, and the scale of the work at Mafra required the training of a large team. Many of the stone sculptors also became part of the school in Lisbon founded after the earthquake of 1755.

BIBLIOGRAPHY

C. Volkmar Machado: *Collecção de memórias*, xii (Lisbon, 1823)
Ayres de Carvalho: *A es cultura de Mafra* (Mafra, 1950)

JOSÉ FERNANDES PEREIRA

Giustiniani (i). Italian family of collectors and patrons. Of Genoese origin, the Roman branch included Giuseppe Giustiniani (*d* 1599), ruler of the island of Chios, who moved to Rome with his two sons and three daughters in 1566 when the Turks reconquered his territory. He embarked on a new career as papal banker, which enabled him to buy in 1590 the palace near S Luigi dei Francesi that is still known as the Palazzo Giustiniani and in 1595 the papal fief and palazzo (the modern Palazzo Giustiniani-Odescalchi) of Bassano di Sutri, Lazio, which was created a marquisate by Pope Paul V in 1605. His sons, (1) Cardinal Benedetto Giustiniani and (2) Marchese Vincenzo Giustiniani, were among the most distinguished Roman collectors of their day. Their enormous collection of ancient marble statues and of paintings was held in the two family palazzi; the best marbles were published in a collection of engravings, *Galleria Giustiniana* (1631). Vincenzo left all his property to Andrea di Cassano Giustiniani of Messina, who married Maria Pamphili, a niece of Pope Innocent X. The dispersal of the collection began in 1720, when a large number of ancient marbles was sold to Thomas Herbert, 8th Earl of Pembroke. Other works were sold individually until 1812, when the nucleus of 73 paintings, including four works by Caravaggio, was acquired by Frederick William III, King of Prussia (*see* HOHENZOLLERN, (10)). The direct line of the Roman Giustiniani became extinct in 1826.

BIBLIOGRAPHY

C. P. Landon: *Catalogue de la collection Giustiniani* (Paris, 1812)
A. Paillet and H. Delaroche: *Catalogue historique et raisonné de tableaux par les plus grands peintres . . .* (Paris, 1812)
Palazzo Cenci: Palazzo Giustiniani, intro. F. Cossiga (Rome, 1984) ☐

(1) Cardinal **Benedetto Giustiniani** (*b* Chios, 1554; *d* Rome, 23 March 1621). He was the elder son of Giuseppe Giustiniani and lived with his brother (2) Vincenzo Giustiniani at the Palazzo Giustiniani, where they built up a collection of Renaissance and Baroque painting and of ancient sculpture. Their tastes coincided closely, especially over Caravaggio and the Caravaggesque works being produced in Bologna and Rome. Benedetto pursued a highly successful career in the Church and was made a cardinal in 1589. As titular cardinal of St Prisca, Rome, he preserved the church's antiquities and oversaw its decoration in the jubilee year of 1600; frescoes (*in situ*) were executed there by Anastasio Fontebuoni (*c*. 1580–1626). He patronized Bernardo Castello, a painter from his native Genoa, who in 1604 executed an altarpiece for the Giustiniani Chapel in S Maria sopra Minerva, Rome. Through Benedetto, Castello won a commission for an altarpiece (1605) in St Peter's, Rome. Benedetto also favoured Giovanni Baglione, and in 1603 Baglione's *Sacred Love Subduing Profane Love* (1602–3; Berlin, Gemäldegal.) was dedicated to the Cardinal, who rewarded him with a gold chain. Baglione later made a second version of the picture (Rome, Pal. Barberini) and the two hung opposite each other in the Palazzo Giustiniani. Caravaggio painted a three-quarter-length portrait of *Benedetto* (untraced) and was recommended by him to Laerzio Cherubini (?1556–1626), for whom he painted the *Death of the Virgin* (Paris, Louvre) for S Maria della Scala, Rome. As papal legate to Bologna (1606–11), Benedetto commissioned Lorenzo Garbieri to decorate a chapel dedicated to Carlo Borromeo in S Paolo Maggiore, Bologna. For this Garbieri produced three oil paintings featuring scenes from the *Life of St Carlo Borromeo* (1611; *in situ*) and frescoed the vault of the chapel (later repainted). According to Malvasia, Garbieri continued to execute paintings for Benedetto after the latter had returned to Rome.

BIBLIOGRAPHY

G. Baglione: *Vite* (1642); ed. V. Mariani (1935)
C. C. Malvasia: *Felsina pittrice* (1678); ed. G. Zanotti (1841)
——: *Le pitture di Bologna* (Bologna, 1686); ed. A. Emiliani (Bologna, 1969)
L. Cardella: *Memorie storiche de' cardinali*, v (Rome, 1793), pp. 259–65 ☐

(2) Marchese **Vincenzo Giustiniani** (*b* Chios, 13 Sept 1564; *d* Rome, 28 Dec 1637). Brother of (1) Benedetto Giustiniani. He was one of the most informed and perceptive art patrons of his day, with an understanding of artistic abilities and styles that set him apart from his contemporaries. As Benedetto entered the Church, it was Vincenzo who inherited the family business and became one of the richest men in Rome. Yet his style of living was not flamboyant for one of his wealth. He shared the interests of his social circle, as is demonstrated in a series of short discourses in the form of letters, on etiquette, music, hunting and painting (before 1618); also on sculpture and architecture (*c*. 1625–30). The letters on the visual arts offer advice to prospective patrons and reveal both Giustiniani's fascination with the tools and techniques of art and the knowledge he gained from patronage and travel. From March to September 1606 he toured Germany, Flanders, England and France with companions, including the painter Cristoforo Roncalli, and acquired a European outlook on the arts that was maintained through such acquaintances as Thomas Howard, 2nd Earl of Arundel, whom he met in Rome in 1613.

The inventory of the Palazzo Giustiniani (dated 9 February 1638) listed over 500 pictures. Many were by, or attributed to, 16th-century artists, including Luca Cambiaso, Raphael, Titian and Veronese, whose *Dead Christ*

Supported by Two Angels (Berlin, Gemäldegal.) was one of the finest, but contemporary art formed the bulk of the collection. Giustiniani is best known for his patronage of Caravaggio, to whom he may have been introduced by Cardinal Francesco Maria del Monte, who lived near the Palazzo Giustiniani. He owned 15 paintings by Caravaggio, including the first version of the *St Matthew and the Angel* (1602; Berlin, Kaiser-Friedrich Mus., destr. 1945), commissioned, but not accepted, for S Luigi dei Francesi, and the *Victorious Love* (*c.* 1603; Berlin, Gemäldegal.; see fig.), the erotic character of which, unusual in Giustiniani's collection, was apparently concealed behind a curtain in the 1630s. Vincenzo's *Letter on Painting* placed Caravaggio, with Annibale Carracci and Guido Reni, in the highest category of painters, those capable of achieving a just balance between imagination and truth-to-life. His regard for these artists was extended to their followers. In 1609, for example, he commissioned decorations at the Bassano palace from Francesco Albani, who painted frescoes illustrating the myth of Phaëthon, and Domenichino, who frescoed the ceiling of the Sala di Diana with scenes from the goddess's life. Paintings by both artists hung in Giustiniani's collection, alongside works by other followers of Caravaggio, such as Jusepe de Ribera, and northern European painters, some of whom (e.g. David de Haan (*d* 1622) and Nicolas Régnier) lodged in the Palazzo Giustiniani in Rome. In the 1630s Giustiniani was a patron of Claude Lorrain, Pietro Testa and Nicolas Poussin, whose *Massacre of the Innocents* (Chantilly, Mus. Condé)

he owned. He was also a collector of sculpture, with a remarkably large and miscellaneous collection. The best-known piece was the *Minerva Giustiniana* (Rome, Vatican, Braccio Nuo.). Unlike his contemporary, Cassiano dal Pozzo, his interest in antiquities was not primarily archaeological but that of the collector and connoisseur. Among the collection's contemporary pieces was a bronze statuette of *Mercury* (copy *c.* 1629; Vaduz, Samml. Liechtenstein) by François Du Quesnoy. He was a patron of Du Quesnoy and, as his *Letter on Sculpture* demonstrates, well aware of young sculptors' need for generous support. An illustrated catalogue of his collection, *Galleria Giustiniani*, was published in 1631, an event commemorated by Angelo Caroselli's painting of *Pygmalion* (Berlin, Kaiser-Friedrich Mus., destr. 1945). The preparation of this catalogue was supervised by Joachim von Sandrart, who recorded that while he was staying at the Palazzo Giustiniani he sketched in the grounds with Claude Lorrain.

In the *Letter on Architecture* Giustiniani urged patrons to acquaint themselves with the rudiments of architecture, for he had limited faith in contemporary architects though he employed or consulted several, including Carlo Maderno and Girolamo Rainaldi. It is likely that Giustiniani himself had a hand in designing the buildings he commissioned, including the garden casino (*c.* 1608) and, in the 1620s, the church of S Vincenzo at Bassano di Sutri. He was certainly responsible for the landscaping of his Bassano gardens, described in the *Letter on Architecture*, and for choosing evocative names such as Mount Parnassus and Avenue of Aesculapius for the different parts.

BIBLIOGRAPHY

Galleria Giustiniana (Rome, 1631)

J. von Sandrart: *Teutsche Academie* (1675–9); ed. A. R. Peltzer (1925)

G. Bottari and S. Ticozzi: *Raccolta di lettere sulla pittura, scultura ed architettura scritte da più celebri personaggi dei secoli XV, XVI e XVII*, vi (Milan, 1822), pp. 99, 121, 129, 145 [incl. Giustiniani's writings on painting, sculpture and architecture]

A. Banti, ed.: *Europa milleseicento: Diario di viaggio di B. Bizoni* (Milan, 1942)

J. Hess: 'Lord Arundel in Rom und sein Auftrag an den Bildhauer Egidio Moretti', *Eng. Misc.*, i (1950), pp. 197–220

M. V. Brugnoli, I. Faldi, P. Portoghesi and I. Toesca: 'I palazzi Giustiniani a Bassano di Sutri e a Roma', *Boll. A.*, n. s. 3, xlii (1957), pp. 222–308 [issue devoted to Giustiniani's palaces and their decoration]

L. Salerno: 'The Picture Gallery of Vincenzo Giustiniani', *Burl. Mag.*, cii (1960), pp. 21–2, 93–104, 135–48

F. Haskell: *Patrons and Painters: A Study in the Relations between Italian Art and Society in the Age of the Baroque* (London, 1963, rev. New Haven, 1980)

JANET SOUTHORN

Caravaggio: *Victorious Love*, oil on canvas, 1.56×1.13 m, *c.* 1603 (Berlin, Gemäldegalerie)

Giustiniani (ii). Italian family of potters. They were active in Naples from the beginning of the 18th century to the end of the 19th. During the 18th century important family members included Ignazio Giustiniani (1686–*c.* 1742), who specialized in the production of tin-glazed earthenware wall tiles decorated with festoons and naturalistic elements; an outstanding example of his work is the tiled floor (1729) in the church of S Andrea delle Dame in Naples. During this period some members of the family were active in Cerreto Sannita, where they worked on such elaborate projects as the panel (1727) set in the tympanum of the congregation of S Maria in San Lorenzello, which is signed and dated by Antonio Giustiniani. Nicola Giustiniani, known as Bel Pensiero (1732–

1815), is regarded as one of the most important Neapolitan potters of the period. His work includes two maiolica plaques (1758; Graz, Mus. Kstgew.) painted with ruins inspired by the work of Leonardo Coccorante (1680–1750). The family became increasingly active in Naples during the early 19th century producing utilitarian earthenwares, terracotta garden wares, reproduction antique vases, plates and such services as the 'Etruscan' service (Naples, Mus. N. Cer.); they also produced porcelain for a short while. Work produced by the family during the 19th century was highly regarded and was awarded prizes at both national and international exhibitions. Wares are often marked with the monograms FMNG or FGN or alternatively with a G or with the surname in full.

BIBLIOGRAPHY

N. Vigliotti: *I Giustiniani e la ceramica cerretese* (Marigliano, 1973)
F. Apolloni Ghetti: 'Maioliche Giustiniani a Roma', *Strenna Romanisti* (1978), pp. 13–25
M. Rotili: *La manifattura Giustiniani* (Naples, 1981)
G. Donatone: *La terraglia napoletana* (Naples, 1991)

LUCIANA ARBACE

Giustino del fu Gherardino da Forlì (*fl* 1362–after 1384). Italian scribe and ?illuminator. He was active in Venice. He signed the text of the Antiphonary of S Maria della Carità (1365; Venice, Bib. N. Marciana, Cod. lat. II. 119), as follows: *Qui cupis actorem* (sic) *origine venetus huius Noscere Iustinum operis et nomine condam Gherardini fuit forlivensis magistri natus.* The wording suggests that he may have been entirely responsible for the production of the manuscript, including its illumination. Levi D'Ancona has attributed a major group of later 14th-century Venetian illumination to Giustino on this assumption, including several political documents such as the *Promissione* of Doge Michele Morosini (1382; Venice, Bib. N. Marciana, Cod. lat. X. 189) and two major narrative cycles, in the *Leggenda dei santi e della venuta a Venezia di Papa Alessandro III* (Venice, Correr, MS. I 383) and in the *Historia troiana* (Genoa, Bib. Bodmeriana). Giustino's border decoration of foliage spirals and linking poles and miniatures with blue backgrounds, steep architectural foreshortening and close-set facial features framed by dark shadows are derived from Bolognese illumination of *c.* 1320–50; his style, however, is distinguished by sharp Gothic drapery and softer modelling. This conservatism may reflect his father's Romagnole origins as well as official Venetian practice. The triangular faces, large eyes and flattened noses of Giustino's figures were probably inspired by Guariento, whose lost frescoes in the Doge's Palace may have influenced the compositions of the Correr manuscript (Levi D'Ancona). Simon considered that the architectural and compositional features in the *Historia troiana* were borrowed from Altichiero's frescoes in the oratory of S Georgio, Padua, and therefore dated *c.* 1379–84 or later: it is certainly later than the *Papa Alessandro*. Although Giustino's figures lack the majesty of Altichiero's and his buildings are simpler in detail with little spatial cohesion, his work has a simple elegance of execution and narrative charm.

BIBLIOGRAPHY

R. Pallucchini: *La pittura veneziana del trecento* (Venice and Rome, 1965), pp. 218–20, pl. xxxi, figs 685–6, 695–8
M. Levi D'Ancona: 'Giustino del fu Gherardino da Forlì e gli affreschi perduti del Guariento nel Palazzo Ducale di Venezia', *A. Ven.*, xxi (1967), pp. 34–44
H. Buchtal: *Historia troiana* (London and Leiden, 1971)
B. Degenhardt and A. Schmitt: *Venedig* (1980), II/i of *Corpus der italienischen Zeichnungen* (Berlin, 1968–), pp. 48–74
R. Katzenstein: *Three Liturgical Manuscripts from San Marco: Art and Patronage in Mid-Trecento Venice* (diss., Cambridge, MA, Harvard U., 1987; microfilm, Ann Arbor, 1988)
R. Simon: 'Little and Large: Manuscript Reflections of Altichiero's Frescoes', *Apollo*, cxxxiv (1991), pp. 299–300

ROBERT GIBBS

Giusto, Andrea di. *See* ANDREA DI GIUSTO.

Giusto da Guanto. *See* JUSTUS OF GHENT.

Giusto d'Andrea (di Giusto) (*b* 1440; *d* Florence, 1496). Italian painter, son of the painter ANDREA DI GIUSTO. He was apprenticed to Neri di Bicci in 1458 and spent at least two years in Neri's workshop, interrupted by a period of three months when he worked for Filippo Lippi in 1460. In that year he enrolled in the Compagnia di S Luca. He joined Benozzo Gozzoli in San Gimignano in 1464 to gain experience in fresco and agreed to work for expenses only. Giusto recorded his own part in the decoration of the choir of S Agostino, San Gimignano (1464–5), which included female saints in the window splays (destr.), four apostles in the entrance arch soffit, a large part of the frieze and the first small scene in the vault (possibly a reference to one of the scenes in the lunette of the window wall). He possibly assisted Gozzoli with the execution of two contemporary frescoed altarpieces dedicated to St Sebastian (San Gimignano, S Agostino and the Collegiata) and a panel representing the *Virgin Enthroned with Four Saints* (San Gimignano, Mus. Civ.). Giusto's final collaboration with Benozzo was at Certaldo, where he was responsible for the sinopia and painting of the *Deposition of Christ* in the frescoed tabernacle of the Giustiziati (1467–8). The combined influence of Neri di Bicci and Benozzo Gozzoli is evident in the altarpieces attributed to Giusto d'Andrea such as the *Virgin and Child with Saints* (Munich, Alte Pin.). He displayed little invention in his adaptation of their sturdy figures, formalized features and conventional settings.

BIBLIOGRAPHY

Neri di Bicci: *Le ricordanze (10 marzo 1453–24 aprile 1475)* (Florence, Uffizi, MS.2); ed. B. Santi (Pisa, 1976)
G. Vasari: *Vite* (1550, rev. 2/1568); ed. G. Milanesi (1878–85), vol. ii, pp. 89–90, vol. iii, p. 54, n. 4
J. W. Gaye: *Carteggio* (1839–40/R1961), i, pp. 212–13
O. Sirén: *A Descriptive Catalogue of the Pictures in the Jarves Collection Belonging to Yale University* (Oxford, 1916), pp. 101–5
A. Padoa Rizzo: *Benozzo Gozzoli, pittore fiorentino* (Florence, 1972), pp. 64–5

AILSA TURNER

Guisto de' Menabuoi. *See* MENABUOI, GIUSTO DE'.

Giyan, Tepe. Site near Nahavand in the Zagros Mountains in central western Iran. It was an important settlement in prehistoric times and during the Bronze Age and Iron Age (*c.* 5000–*c.* 600 BC; *see* IRAN, ANCIENT, §I, 2(i)(b)–(ii)). It was excavated (1931–2) by G. Contenau and Roman Ghirshman and was the type site for the cultural sequence in the area before the excavation of GODIN

TEPE. Finds are divided between the Louvre, Paris, and the Archaeological Museum, Tehran. Few coherent architectural remains have been found. The earliest period, Giyan V (a–d), yielded largely unstratified Chalcolithic pottery characterized by handmade chaff-tempered buff wares, both plain (generally red-slipped) and decorated, with geometric and, occasionally, naturalistic painted designs or surface modelling. Designs on stone stamp seals (humans, animals, scorpions and geometric patterns) parallel material from TEPE GAWRA in the west; stemmed goblets and painted decoration on pottery are similar to examples from various sites including TEPE SIALK further east. These comparisons show that Giyan V conflates at least five chronologically and culturally distinct assemblages from between *c.* 4800 and *c.* 3000 BC.

More than 100 graves are of Bronze Age or Iron Age date. The burials were of individuals and contained pottery and metal artefacts (mainly bronze jewellery). The Bronze Age graves (Giyan IV–II) date from *c.* 2100 to *c.* 1400 BC. The characteristic monochrome painted buff ware pottery had geometric and sometimes naturalistic motifs in bands on the neck and shoulder of vessels. Shapes included tripod vases (Giyan III) and slender painted goblets (Giyan II). The Iron Age graves (Giyan I) date from *c.* 1400 to *c.* 600 BC (Iron I–III), and some provide typological links with the Bronze Age. The fine burnished grey wares in the earlier Iron Age graves (Iron I–II) are comparable to

contemporary material in north-west Iran. In the early 1st millennium BC the site was fortified and included a large building with possible Assyrian parallels.

BIBLIOGRAPHY
G. Contenau and R. Ghirshman: *Fouilles du Tepe-Giyan, près de Nehavand, 1931 et 1932* (Paris, 1935)
R. C. Henrickson: 'Giyan I and II Reconsidered', *Mesopotamia*, xviii–xix (1983–4), pp. 195–220
E. Henrickson: 'An Updated Chronology of the Early and Middle Chalcolithic of the Central Zagros Highlands, Western Iran', *Iran*, xxiii (1985), pp. 63–108
ROBERT C. HENRICKSON

Giza [anc. Egyp. Ineb hedj]. Egyptian governorate just west of Cairo, site of a major royal necropolis of the Old Kingdom capital of Memphis. The necropolis (see fig.), containing the 4th Dynasty (*c.* 2575–*c.* 2465 BC) pyramid complexes of Cheops, Chephren and Mycerinus (*see* PYRAMID, §1) and their associated satellite burials, is divided by a broad wadi into two areas: the higher plateau, with the pyramid complexes, Great Sphinx and mastaba fields, and other private tombs on an escarpment to the south-west. Although Giza's period of greatest importance was during the Old Kingdom (*c.* 2575–*c.* 2150 BC), the site underwent revivals in the New Kingdom (*c.* 1540–*c.* 1075 BC) and the Saite period (*c.* 664–525 BC). Most of the tombs were robbed in antiquity, and much of the original casing of the monuments has been quarried away, considerably altering their appearance. In the late 20th

Giza, aerial view of the necropolis

century the site has come under threat from rising ground water, which is slowly destroying the monuments.

See also PYRAMID, §1(iii).

1. ROYAL MONUMENTS. The Great Pyramid of Cheops (*reg c.* 2551–*c.* 2528 BC; *see* PYRAMID, fig. 1) originally measured 230×230×146 m high and was the central element of a complex of buildings comprising a mortuary temple abutting the pyramid and connected by a causeway to a valley temple: the mortuary temple has been destroyed, and both the causeway and the valley temple have since disappeared under the modern village of Nazlet el-Simman. The pyramid was basically constructed of rough limestone masonry, although some of the internal chambers were faced with granite. The exterior was given a polished casing of fine white limestone from the royal quarries at Tura (near modern Helwan); some of the casing blocks remain *in situ* at the base of the pyramid. It may also have been surmounted by a pyramidal capstone of the type known from other sites such as Dahshur. Although its internal chambers are undecorated, the mortuary temple at the eastern face of the pyramid was probably adorned with the high-quality reliefs later used as infill for the pyramid of Ammenemes I at el-Lisht. Also on the eastern side are three subsidiary pyramids used for the burials of queens. During the 21st Dynasty (*c.* 1075–*c.* 950 BC), one of these, that of Queen Henutsen, was refurbished into a temple to Isis, worshipped locally as a necropolis goddess. In 1925 George Reisner excavated the opulent burial of Cheops' mother Hetepheres I, the only substantially unplundered royal tomb of the Old Kingdom, which was found in a shaft beside the causeway (*see* HETEPHERES I, TOMB OF). Five pits arranged around the main pyramid originally contained ritual boats; one, excavated in 1954 by Kamal el-Mallakh, yielded the excellently preserved components of a dismantled cedarwood river vessel measuring over 43 m long. Reconstructed and conserved by Ahmed Youssef Mostafa, it is now displayed in a special museum on site. It is debatable whether the vessel was actually used during the King's funeral to transport the body to the valley temple, or whether it had a purely symbolic function relating to the journey of the dead King through the cosmos.

The pyramid complex of Chephren, Cheops' son and successor (*reg c.* 2520–*c.* 2494 BC), measures 214.5×214.5×143.5 m and is partly enclosed by a natural limestone escarpment which was utilized for carving out some of the subsidiary burials of the royal family and courtiers. In addition to the usual components of pyramid, mortuary temple, causeway and valley temple, the complex included an innovative feature in the form of the Great Sphinx. This is a monumental sculpture (l. 80 m, h. 21 m) in the form of a human-headed lion wearing a royal headcloth (*see* SPHINX, fig. 1). Constructed from a natural outcrop supplemented with limestone blocks, it lies north of the causeway of Chephren and adjacent to his valley temple. It was originally painted, and a secondary figure, of which almost no trace remains, seems to have been carved on the chest. Although the Sphinx formed an integral part of Chephren's pyramid complex, its exact significance is unknown. In front of it are the ruins of a small temple

built of granite-faced limestone (*see* EGYPT, ANCIENT, §VIII, 2(i)(a) and fig. 22). During the decline of the necropolis in the Middle Kingdom (*c.* 2008–*c.* 1630 BC) and Second Intermediate Period (*c.* 1630–*c.* 1540 BC), the temple became engulfed by sand. Tuthmosis IV (*reg c.* 1400–*c.* 1390 BC) erected a red granite stele (*in situ*) recording his clearing of the temple and enclosed the area around the Sphinx with a wall into which stelae dedicated to various deities were set, among them some indicating that the Sphinx may have been a pilgrimage centre and oracular shrine. In the New Kingdom the Sphinx became associated with Harmachis, a manifestation of the sun-god, and with Hauron, a Canaanite deity worshipped in Egypt from the Second Intermediate Period. Over time, the Sphinx suffered considerable erosion and attempts were made to restore it in the Ptolemaic period (304–30 BC). In the Roman period (30 BC–AD 395) the temple was completely covered by sand, which also engulfed the figure itself until it was cleared by Giovanni Battista Caviglia in 1816.

In general, however, the complex is much better preserved than that of Cheops: parts of the mortuary temple survive, while the valley temple has been substantially reconstructed, and the entire length of the causeway can be traced. The valley temple at the end of the causeway, beside the Sphinx, is an austerely beautiful building, square in plan, with twin entrances, battered exterior walls and a central T-shaped hall lined with monolithic piers which supported a flat roof; the contrast in colour between their pink granite casing and the polished white calcite floor is highly effective. In places the temple's granite facing was carved with hieroglyphic inscriptions in sunk relief displaying great mastery of the hard stone; they are among the earliest known examples of this technique. The spaces between the piers may have been occupied by the magnificent seated hardstone statues of Chephren found in the temple (e.g. Cairo, Egyp. Mus., JE 10062; *see* EGYPT, ANCIENT, §IX, 3(iii)(a)); fragments of 23 similar statues were found in a pit in an antechamber.

Also dating to the reign of Chephren, the mastaba of Queen Meresankh III (*fl c.* 2500 BC) is in the cemetery east of the Great Pyramid. It is notable for its richly decorated subterranean tomb chapel, which has a superb offering niche containing ten engaged statues of the Queen and members of her family; some of the figures retain their original polychrome decoration.

The pyramid of Chephren's successor MYCERINUS is smaller (105.0×105.0×65.5 m) but better-preserved; again, some of its granite casing has survived. To the south are three small subsidiary pyramids. The valley temple was probably unfinished when Mycerinus died, and it shows evidence of having been hastily completed in mud-brick; nonetheless, when excavated by Reisner in 1906–9 it yielded some superlative statuary, including the dyad of Mycerinus and Queen Kamerernebty II (Boston, MA, Mus. F.A.), and the triads of Mycerinus between gods and personified nomes (e.g. Cairo, Egyp. Mus., JE 46499). All the female divinities in these statues have the features of the Queen. As in the other complexes, the valley temple is linked to the mortuary temple abutting the east side of the pyramid by a causeway. To the south of the causeway is the mastaba of Queen Khentkawes (*fl c.* 2460 BC), who

was probably Mycerinus' daughter. It resembles the Mastaba Faraun of Shepseskaf at Saqqara in that it has a superstructure shaped like a sarcophagus mounted on a high socle, but in this case the core of the podium is constructed from an outcrop of rock. The priests of Khentkawes' mortuary cult lived in a cluster of mud-brick buildings around the enclosure wall; there was also a large unplanned town which housed the priests of the offering cults and other personnel associated with the royal funerary complexes (*see* EGYPT, ANCIENT, §VIII, 4(iii)).

2. PRIVATE MONUMENTS. Numerous burials of private individuals, many of whom had held office in the Giza necropolis during their lifetimes, are associated with the royal burials. These mastabas and rock-cut tombs were gifts from the king in return for loyal service and may have been constructed by royal craftsmen. The original mastaba fields lying to the west, south and east of the Great Pyramid were laid out in regular lines, but later cemeteries grew up more haphazardly. Most of the tombs conform to a standard plan comprising a storeroom, an offering room and a burial chamber (*see* EGYPT, ANCIENT, §VIII, 2(ii)(b)); a chapel in the superstructure contained one or more offering stelae by means of which the deceased and members of his family could enjoy sustenance in the next world (*see* STELE, §2). Outstanding examples include those of Upemnefert (Berkeley, U. CA, A. Mus.) and Nefertiabet (Paris, Louvre). The wealth of detail lavished on the depiction of animals and birds in these 4th Dynasty stelae gives an impression of the precision of Old Kingdom painting, little of which has survived. The mastabas of the western field have yielded a number of the sculptures known as 'reserve heads' (*see* EGYPT, ANCIENT, §IX, 2(i)(k)). Fine decorated mastabas include those of Khufukhaf, Qar and Idu, which contain conventional but well-executed funerary scenes.

In the 26th Dynasty (664–525 BC) the cults of Cheops, Chephren and Mycerinus were temporarily revived, and the priests were buried in tombs, now badly damaged, near the enclosure of Chephren.

BIBLIOGRAPHY
LÄ (Cheops; Chephren; Mycerinos; Sphinx; Taltempel)
Herodotus: *Histories* II. c and cxxiv–cxxv
G. Belzoni: *Narrative of the Operations and Recent Discoveries in Egypt and Nubia* (London, 1820), pp. 255–81
H. Vyse: *Operations Carried on at the Pyramids of Gîseh in 1837*, 3 vols (London, 1840)
W. M. F. Petrie: *The Pyramids and Temples at Gizeh* (London, 1885)
U. Holscher: *Das Grabdenkmal des Königs Chephren* (Leipzig, 1912)
C. S. Fisher: *The Minor Cemetery at Giza* (Philadelphia, 1924)
S. Hassan: *Excavations at Giza*, 10 vols (Cairo and Oxford, 1929–60)
H. Junker: *Giza: Grabungen auf dem Friedhof des alten Reiches bei den Pyramiden von Gîza*, 12 vols (Vienna and Leipzig, 1929–55)
G. A. Reisner: *Mycerinus: The Temples of the Third Pyramid at Giza* (Cambridge, MA, 1931)
A. Pochan: 'Observations relatives au revêtement des deux grandes pyramides de Giza', *Bull. Inst. Egypte*, xvi (1934), pp. 214–20
A. Fakhry: *Sept tombeaux à l'est de la Grande Pyramide* (Cairo, 1935)
G. A. Reisner: *A History of the Giza Necropolis*, 3 vols (Cambridge, MA, 1942–55)
I. E. S. Edwards: *The Pyramids of Egypt* (Harmondsworth, 1947, rev. 2/1972)
J.-P. Lauer: 'Le Temple funéraire de Khéops à la Grande Pyramide de Guizeh', *An. Service Ant. Egypte*, xlvi (1947), pp. 245–59
S. Hassan: *The Sphinx: Its History in the Light of Recent Excavations* (Cairo, 1949)
J.-P. Lauer: 'Les Grandes Pyramides d'Egypte étaient-elles peintes?', *Bull. Inst. d'Egypte*, xxxv (1953), pp. 377–96
Z. Nour, Z. Iskander and others: *The Cheops Boats*, i (Cairo, 1960)
H. Kayser: *Die Mastaba des Uhemka* (Hannover, 1964)
H. Goedicke: *Re-used Blocks from the Pyramid of Amenemhat I at Lisht* (New York, 1971)
D. Dunham and W. K. Simpson: *The Mastaba of Queen Mersyankh III* (Boston, MA, 1974)
C. M. Zivie: *Giza au deuxième millénaire* (Cairo, 1976)
W. K. Simpson: *The Mastabas of Kawab and Khafkhufu I and II* (Boston, MA, 1978)
B. J. Kemp: *Ancient Egypt: Anatomy of a Civilization* (London, 1989)

DOMINIC MONTSERRAT

Gla. Site in the east Kopais in central Greece north-north-west of Thebes. A low flat-topped rock near the converging point of the Late Bronze Age drainage dikes, it was first settled in Neolithic times. It was occupied again *c.* 1300 BC after the construction of the dikes and fortified with a 5.5 m thick serrate Cyclopean wall. This was pierced by four gates (west, north, south-east and south), flanked by thickenings of the wall that project at the South Gate to form bastions. Guardrooms were built inside the gates. Within the enceinte there is a central enclosure, bisected by an east–west cross-wall. The north part contains an L-shaped double residential building consisting of two identical wings divided into apartments connected by corridors and having megaron-like units at both ends. The building had monolithic thresholds and low stone walls with a mud-brick superstructure, covered—as were the floors—with plain or painted lime plaster. Roofs were sloped, covered with terracotta tiles. Similar in construction but simpler (fewer plaster floors, no monolithic thresholds) are two duplicate building complexes along the east and west sides of the south enclosure, both *c.* 145 m long. They served as crop storehouses and administrative quarters.

The duplex residence, the vast storage areas, the predominantly plain household pottery and the few surviving artless frescoes show that Gla was not a palace but a stronghold built to safeguard the drainage system and the agricultural produce of the plain. It was destroyed by fire in the late 13th century BC, never to be settled again.

BIBLIOGRAPHY
F. Noack: 'Arne', *Mitt. Dt. Archäol. Inst.: Athen. Abt.*, xix (1894), pp. 405–40
A. de Ridder: 'Fouilles de Gla', *Bull. Corr. Hell.*, xviii (1894), pp. 271–310
J. G. Frazer: *Pausanias's Description of Greece*, v (London, 1913), pp. 120–28
J. Threpsiadis: 'Excavations at Arne (Gla) in the Kopais', *Praktika Athen. Archaiol. Etaireias* (1955), pp. 121–4; (1956), pp. 90–92; (1957), pp. 48–53; (1958), pp. 38–42; (1959), pp. 21–5; (1960), pp. 23–38; (1961), pp. 28–40 [in modern Gr.]
S. E. Iakovidis: 'Excavations at Gla', *Praktika Athen. Archaiol. Etaireias* (1981), pp. 92–5; (1982), pp. 105–8; (1983), pp. 99–101; (1984) (in preparation) [in modern Gr.]
——: *Late Helladic Citadels on Mainland Greece* (Leiden, 1983), pp. 91–107
——: *Gla I: The 1955–1961 Excavation*, Library of the Archaeological Society at Athens, cvii (Athens, 1989) [in modern Gr. with Eng. summary]

☐

Glackens, William J(ames) (*b* Philadelphia, PA, 13 March 1870; *d* Westport, CT, 22 May 1938). American painter and illustrator. He graduated in 1889 from Central High School, Philadelphia, where he had known Albert C.

Barnes, who later became a noted collector of modern art. He became a reporter–illustrator for the *Philadelphia Record* in 1891 and later for the *Philadelphia Press*. In 1892 he began to attend evening classes in drawing at the Pennsylvania Academy of Fine Arts, studying under Thomas Anshutz. In the same year he became a friend and follower of Robert Henri, who persuaded him to take up oil painting in 1894. Henri's other students, some of whom were referred to as the Ashcan school, included George Luks, Everett Shinn and John Sloan, also artist-reporters; together with Henri they formed the nucleus of THE EIGHT (ii).

Glackens and Henri shared a studio in Philadelphia in 1894 and travelled together in Europe in 1895. On returning to the USA in 1896, Glackens followed Henri's lead in moving to New York and supported himself by producing illustrations for the *New York World* and the *New York Herald*, as well as through book illustrations. In 1898 he and Luks went to Cuba to report on the Spanish–American War for *McClure's Magazine*. On his return to New York, Glackens began to concentrate increasingly on painting. For subject-matter he turned to city parks and café scenes. Like Henri, he admired Diego Velázquez and James McNeill Whistler and adopted the broad brushstrokes of Frans Hals and Edouard Manet. He was particularly drawn to the theatrical aspects of urban life, as in *Hammerstein's Roof Garden* (1902; New York, Whitney).

By 1905 Glackens had adopted a style of high-keyed Impressionism, seen in *Chez Mouquin* (1905; Chicago, IL, A. Inst.). This painting, inspired by *A Bar at the Folies-Bergère* by Manet, shows James B. Moore, owner of the Café Francis where the Ashcan painters often met. With him is one of his 'daughters', as he called his numerous young female companions, at Mouquin's, a French restaurant under the Sixth Avenue elevated railway in New York. In the mirror behind the couple can be seen Glackens's wife, Edith, and his future brother-in-law, Charles Fitzgerald, a critic for *The Sun*. The painting is one of several attempts on the part of the Ashcan painters to depict themselves in bohemian American settings (compare, for example, John Sloan's *Yeats at Petitpas'*, 1910; Washington, DC, Corcoran Gal. A.).

Glackens became increasingly interested in Auguste Renoir's use of colour, seen for the first time in *Nude with Apple* (1910; New York, Brooklyn Mus.), and soon discarded urban themes in favour of studio models, still-lifes, landscapes and seaside subjects, for example *Bathers at Bellport* (1912; Washington, DC, Phillips Col.). In 1910 Glackens was contacted by ALBERT C. BARNES. Glackens urged him to consider collecting Impressionist and Post-Impressionist paintings instead of those of the Barbizon school, as he had been doing. Barnes agreed and in 1912 sent Glackens to France with £20,000 to buy art for him as he saw fit. Glackens returned with works by Cézanne, Renoir, Degas, van Gogh, Monet, Gauguin, Sisley, Camille Pissarro, Seurat and others, forming the nucleus of the Barnes Foundation Collection in Merion Station, PA.

In 1913 Glackens served as Chairman for selecting American art for the Armory Show, in which he also exhibited, and he was the first President of the Society of Independent Artists (1917). There was no notable development in Glackens's art after this date, and he continued to paint until his health began to fail. One of his late works was *Soda Fountain* (1935; Philadelphia, PA Acad. F.A.).

WRITINGS
'The American Section: The National Art', *A. & Dec.*, iii (March 1913), pp. 159–64
'The Biggest Exhibition in America', *Touchstone*, i (June 1917), pp. 164–73, 210

BIBLIOGRAPHY
I. Glackens: *William Glackens and the Ashcan Group: The Emergence of Realism in American Art* (New York, 1957)
W. I. Homer: *Robert Henri and his Circle* (Ithaca, 1969)
B. B. Perlman: *The Immortal Eight* (Westport, 1979)
J. Zilczer: 'The Eight on Tour, 1908–1909', *Amer. A. J.*, xvi (Summer 1984), pp. 20–48
R. J. Wattenmaker: 'William Glackens's Beach Scenes at Bellport', *Smithsonian Stud. Amer. A.*, ii/2 (1988), pp. 75–95
T. Glackens: *William Glackens and the Eight: The Artists who Freed American Art* (New York, 1992)

M. SUE KENDALL

Glair. Term for egg white, a colloidal solution of albumen, used as an adhesive for gilding or as a painting medium in manuscript illumination from at least the 17th century. Until the 19th century it was employed occasionally as a varnish for egg tempera and oil painting.

RUPERT FEATHERSTONE

Glaize, Auguste-Barthélemy (*b* Montpellier, 15 Dec 1807; *d* Paris, 8 Aug 1893). French painter. He was trained by Eugène Devéria and Achille Devéria and made his first appearance at the Salon, in 1836, with *Luca Signorelli da Cortona* (Avignon, Mus. Calvet) and *Flight into Egypt* (untraced), the first of a number of religious pictures painted in the 1840s in the pleasant, sentimental manner of Eugène Devéria's religious work. The *Humility of St Elizabeth of Hungary* (exh. Salon, 1843; Montpellier, St Louis), *Conversion of the Magdalene* (1845; Nogent-sur-Seine, parish church) and *Adoration of the Shepherds* (1846; Quesnoy-sur-Airaine, parish church) belong to an idea of the Rococo common in the 1840s. Glaize's interest in 18th-century French art is also evident in *Blood of Venus* (exh. 1846) and *Picnic* (both Montpellier, Mus. Fabre). This element was less obvious in the 1850s. In 1852 he exhibited a scene of the savage heroism of the *Women of Gaul: Episode from the Roman Invasion* (Autun, Mus. Rolin), one of the first pictures on a theme that appealed to a new interest in the history of Gaul in the Second Empire. Increasingly, he adopted subject-matter favoured by the NÉO-GREC painters. His *Pillory* (Marseille, Mus. B.-A.), exhibited at the Exposition Universelle of 1855, showing victims of misery, ignorance, violence and hypocrisy from all ages, was probably inspired by Jean-Louis Hamon's *Human Comedy* (1852; Compiègne, Château). *What One Sees at 20* (exh. 1855; Montpellier, Mus. Fabre), a vaporous allegory in the same vein, was bought by the State. *Love for Sale* (Béziers, Mus. B.-A.), exhibited in 1857, is a neo-Pompeian composition on a theme painted by Henri-Pierre Picou (1824–95) two years earlier.

The State characteristically rewarded Glaize for his success in 1855 by commissioning a picture of the *Distribution of the Eagles in 1852* (Versailles, Château), which was unsuited to his talent. The picture was not a success and brought official disfavour. By 1863 he was in financial

difficulty. He retired to the country to paint portraits for a living and missed the Salon for the first time since 1836. He recovered ground in 1864 with *The Reefs* (Amiens, Mus. Picardie), an allegorical picture of idle nudes drifting on a boat below a pink sunset, which was bought by the State for the Musée du Luxembourg, Paris. In this period he was commissioned to paint the walls of chapels in St Sulpice, St Gervais, St Jacques du Haut-Pas and Notre-Dame de Bercy in Paris, of which the two most important, the chapel of St John the Evangelist in St Sulpice and the chapel of St Geneviève in St Gervais, were painted in a dry, flat manner suggesting a debt to the school of Ingres.

Glaize's many allegorical and religious pictures brought a less reliable income than portraits, and he apparently had difficulty selling his work to private collectors. However, he was patronized by Alfred Bruyas, a fellow native of Montpellier, who commissioned a portrait (Montpellier, Mus. Fabre) in 1848 and a picture of his study in which Bruyas, his father and friends admire a picture on an easel (1848; Montpellier, Mus. Fabre), as well as a last portrait, painted in November 1876, a few weeks before Bruyas's death.

Glaize's son, (Pierre-Paul-)Léon Glaize (*b* Paris, 3 Feb 1842; *d* 1932), was also a painter, trained by Jean-Léon Gérôme and his father. He came second in the Prix de Rome competition of 1866. He painted genre scenes, portraits and history paintings, including murals for the Salle des Fêtes of the Mairie of the 20th arrondissement (1883; *Triumph of the Revolution* and *Great Men of the Revolution before the Tribunal of Posterity*), and for the Salon des Arts in the Hôtel de Ville (1889), both in Paris.

BIBLIOGRAPHY
L'Art en France sous le Second Empire (exh. cat., Paris, Grand Pal., 1979), p. 364
Le Triomphe des mairies (exh. cat., Paris, Petit Pal., 1986), pp. 170–71, 296–7 [Léon Glaize]
B. Foucart: *Le Renouveau de la peinture religieuse en France (1800–1860)* (Paris, 1987), p. 268

JON WHITELEY

Glanum, triumphal arch and monument of the Julii, late 1st century BC or early 1st century AD

Glantschnigg [Glandschnegg; Glandschnig; Glantschnig; Landschneck], **Ulrich** (*b* Hall, Tyrol, 18 Aug 1661; *d* Bozen [Bolzano], 24 Nov 1722). Austrian painter. He was a tanner's son and settled in Bozen in 1686. He trained with a local painter called Deutenhofer, then in the studio of Heinrich Frisch in Meran (Merano). It was not until he worked with Johann Carl Loth in Venice and encountered Caravaggio's work that he achieved a distinctive style, most powerfully expressed in such genre pictures as the *Scene in a Cellar* (1715; Innsbruck, Tirol. Landesmus.). He introduced the everyday life of the lower and middle classes of the Tyrol into his paintings, transposing even biblical themes into a Tyrolean setting. Thus in the *Adoration of the Shepherds* (1716; Innsbruck, Tirol. Landesmus.) servant girls and shepherds are depicted in the peasant garb of the Bozen district.

Glantschnigg's work, with its emphatic contrasts of light and dark, shows a concise approach to the subject learnt from Loth, eschewing subsidiary scenes, embellishments and learned allusions. His tendency to secularize subject-matter and his awkward transposition of details, almost verging on the naive, also characterize his main work, the allegorical ceiling paintings (1702) in the chancellor's room in the Merkantilpalast (Palazzo Mercantile) in Bozen. Glantschnigg worked prolifically, travelling in Italy, Switzerland and as far as Munich, but died in poverty. He remains an outstanding representative of South Tyrolean painting *c.* 1700.

BIBLIOGRAPHY
B. Bushart: *Deutsche Malerei des 17. und 18. Jahrhunderts* (Königstein, 1967), p. 23

HANNES ETZLSTORFER

Glanum. Gallic site just south of the modern town of Saint-Rémy-de-Provence, France, which occupies the entrance to a craggy defile in the Alpilles range. It was urbanized by Greek colonists (perhaps from Massalia) in the 3rd or 2nd century BC; in the Roman period (1st century BC–3rd century AD) its position on the main route to Italy no doubt contributed to its development, particularly an extensive building programme in the Augustan period.

Glanum retains some traces—rare in Gaul—of the Hellenistic town, including well-built, spacious houses very similar to those in Delos and Campania. The House of the Antai, axially arranged around a large colonnaded court with 12 Ionic columns, is the best example; its rooms were handsomely decorated with painted walls and mosaic floors. The House of Attis is a smaller version of the same type. Between the two what appears to have been originally a market-building has preserved a splendid altar bearing a dedication by the priestess Loreia to the ears of the Bona Dea. The interesting complex at the southern end of the site includes a sanctuary of the god Glan and his female relatives the Glanicae on the western hillside, connected to an ancient spring in the valley below by a series of staircases and platforms. A nymphaeum, with large cistern, was built around the spring, constructed from beautifully cut blocks of local stone. Temples to Hercules and Valetudo (good health) were later built on either side of the nymphaeum. Part of the Hellenistic

bouleuterion also survives; it has tiered seating and is rectangular in plan (such buildings are usually curved).

In the Roman period large public buildings were erected, including a spacious forum, a basilica and public baths. The triumphal arch and the monument of the Julii on the northern edge of the town, popularly known as 'les Antiques', are the best preserved of the public monuments (late 1st century BC or early 1st century AD; see fig.). The triumphal arch is finely decorated, on an unusually large scale, with male and female Gallic captives, and trophy trees behind. The decorative detail is also of high quality. The monument of the Julii that stands close to the arch is a beautifully preserved example of a 'tower-tomb'. It has three main storeys: the rectangular base bears relief panels of crowded conflict scenes; the middle section is in the form of a miniature four-sided arch, which carries a detailed entablature with a frieze of tritons and sea-griffins surrounding a central disc (presumably representing the sun); the third storey consists of a tholos with free-standing columns supporting an entablature and conical roof, with two toga-clad figures inside. The monument as a whole displays a typical Roman blend of the trabeated and arcuated styles of architecture, and of curved and rectilinear shapes, but with a richness of decorative detail characteristic of Provence.

BIBLIOGRAPHY

O. Brogan: *Roman Gaul* (London, 1953)
H. Rolland: *Fouilles de Glanum, 1947–1956* (Paris, 1958)
——: *Le Mausolée de Glanum* (Paris, 1969)
P. Mackendrick: *Roman France* (London, 1972)
H. Rolland: *L'Arc de Glanum* (Paris, 1977)
A. L. F. Rivet: *Gallia Narbonensis* (London, 1988)
A. King: *Roman Gaul and Germany* (London, 1990)
F. Salviat: *Glanum*, Guides archéologiques de la France, 19 (Paris, 1990)
J. Bromwich: *The Roman Remains of Southern France* (London, 1993)

JEFFREY HILTON

Glarner, Fritz (*b* Zurich, 20 July 1899; *d* Locarno, 18 Sept 1972). American painter of Swiss birth. Brought up in France and Italy, he studied at the Regio Istituto di Belle Arti in Naples from 1914 to 1920. Three years later he moved to Paris, where he studied at the Académie Colarossi intermittently between 1924 and 1926 and became acquainted with modernist artists, including Hans Arp, Sophie Taeuber-Arp, Alexander Calder, Theo van Doesburg, Jean Hélion, Fernand Léger, Piet Mondrian and Georges Vantongerloo. During the late 1920s and 1930s Glarner's work consisted largely of semi-abstract still-lifes and interior scenes such as *Painting* (1937; Zurich, Ksthaus), in which flat, hard-edged areas of colour are used to indicate the simplified forms of a table in the corner of a room. Although right angles predominate, a limited number of diagonal edges and overlapping forms serve to establish a sense of spatial recession and indicate the naturalistic origin of the imagery.

Glarner married Louise Powell, an American, in 1928 and spent nine months in New York between 1930 and 1931. Despite a one-artist show at the Civic Club there and participation in a group exhibition in 1931 organized by Katherine Dreier (An International Exhibition Illustrating the Most Recent Development in Abstract Art, Buffalo, NY, Albright–Knox A.G.), he was unable to find an audience for his increasingly abstract work and therefore returned to the more receptive environment of Paris. During the next five years he joined Abstraction–Création and, while living in Zurich from 1935 to 1936, the Allianz group of progressive Swiss artists. When the Spanish Civil War broke out in 1936 Glarner returned to New York; he became an American citizen in 1944 and from 1957 lived in Huntington, Long Island. For several years from 1938 he participated in the annual exhibitions of the American Abstract Artists, an organization also joined by his most influential friend and colleague, Mondrian. Because of Glarner's indebtedness to the Neo-plastic style, he has rightly been associated with Burgoyne Diller, Charmion von Wiegand, Ilya Bolotowsky and other followers of Mondrian in America, but at the same time he also became acquainted with other exiled European artists as well as many of the Americans who became known as Abstract Expressionists.

Glarner's mature style began to emerge in the mid-1940s in such paintings as *Peinture relative* (New Haven, CT, Yale U. A.G.). This work conveys a sense of infinite space through the organization of overlapping geometric forms in a square format. Rectangular planes of different sizes and colours (black, grey and the primaries) interact with both the white ground of the canvas and the black lines projecting from the edges of the painting into the centre. In a gradual process that can be discerned in such pictures as *Relational Painting, Tondo No. 1* (1944; Zurich, Ksthaus), his first painting in a round format, Glarner abandoned the sense of spatial depth in favour of a more strictly organized surface structure based on an irregular grid.

In the late 1940s Glarner perfected what he called his 'relational paintings' in which the canvas was covered with numerous rectangles, each divided into two unequal wedges of colour. Due to the dynamic, 15° slant of their shared edges, these wedges seemed to pulsate back and forth with a rhythmic energy reminiscent of Mondrian's last paintings. In 1958 Glarner was commissioned to paint a huge mural in this style for the lobby of the Time-Life Building in New York and in 1961 another mural for the Dag Hammarskjöld Library in the United Nations Building. He also decorated the walls and ceiling of the dining-room in Nelson Rockefeller's New York apartment. His last mural (1967–8) was designed for the Hall of Justice in Albany, New York. Around that time he completed work on a portfolio of lithographs, *Recollection* (1964–8), recapitulating the development of his 'relational painting' style. In 1971 Glarner moved to Locarno.

BIBLIOGRAPHY

D. Ashton: 'Fritz Glarner', *A. Int.*, vii/1 (1963), pp. 48–54
Fritz Glarner, 1944–1970 (exh. cat., San Francisco, CA, Mus. A., 1970) [with essay by N. Edgar]
Fritz Glarner (exh. cat., Berne, Ksthalle, 1972) [with essays by M. Bill and C. Huber]
M. Staber: *Fritz Glarner* (Zurich, 1976)
D. Hnikova: *Fritz Glarner im Kunsthaus Zurich*, Sammlungsheft 8 (Zurich, 1982) [cat. of large col. mostly donated by Glarner's widow]
Fritz Glarner (exh. cat., Lugano, Mus. Cant. A., 1993) [with essays by M. Staber, L. Arici and R. Koella]

NANCY J. TROY

Glaser, Milton (*b* New York, 26 June 1929). American graphic designer and illustrator. At the age of 13 he began taking life classes with Moses and Raphael Soyer in New

York and subsequently attended the High School of Music and Art, New York (1943–6). He studied painting, typography and illustration at the Cooper Union for the Advancement of Science and Art, New York (1948–51), with the aim of becoming a comic-strip artist and spent two years (1952–3) at the Accademia di Belle Arti, Bologna, working under Giorgio Morandi and drawing extensively from plaster casts. Drawing remained central to his subsequent career in graphic design. Important early influences were the prints of Félix Valloton and Art Nouveau decoration, and he particularly admired Picasso's gift for working in both an abstract and realistic vein. In 1954 he founded, with Seymour Chwast, Edward Sorel (*b* 1929) and Reynold Ruffins (*b* 1930), the Push Pin Studios in New York. In 1955, with Chwast and Ruffins, he became founder-editor of *Push Pin Graphics* magazine. Rejecting the precisionist school of graphic design then prevailing, Glaser introduced an eclectic, narrative style full of historical references that amalgamated illustration with vintage typography. His flattened, heavily outlined images were borrowed at random from the Italian Old Masters, 19th-century illustration, comics, advertising and all manner of visual ephemera. He designed posters, record-sleeves, book illustrations, magazine covers and small advertisements in a witty, inventive style characterized by miscellaneous juxtapositions and revivalist frivolity (e.g. poster of antique head for the School of Visual Arts, New York, offset lithograph, 1964; London, V&A).

From the 1960s and to the mid-1970s Push Pin graphics dominated advertising and the print media, and Glaser's work became something of a fashionable cult. He advocated the reintroduction of basic drawing studies in art colleges and from 1961 lectured at the Pratt Institute, Brooklyn, NY, and the School of Visual Arts, New York. He was an active board member of several art-affiliated organizations. By the late 1960s his forms had become flatter and more brightly coloured, inspired by Pop and Op art (e.g. *Mahalia Jackson* poster, offset lithograph, 1967; New York, MOMA), and he restyled a number of American and European journals in this more contemporary manner. Between 1968 and 1976 he was art director of *New York Magazine*, which he helped to introduce. In 1970 the Musée des Arts Décoratifs, Paris, held a major retrospective of Push Pin Studio graphics. By the mid-1970s, however, Glaser had left Push Pin to follow his new interests in furniture, consumer-product and interior design, as well as to widen his involvement in print. From 1975 to 1977 he was a vice-president and design director of the *Village Voice* newspaper, New York. Among the numerous sign systems he produced was that for the newly refurbished Rainbow Room, Rockefeller Center, New York, in 1987.

BIBLIOGRAPHY

The Push Pin Style (exh. cat., intro. J. Snyder; Paris, Mus. A. Déc., 1970) [bilingual text]

Images of an Era: The American Poster, 1945–75 (exh. cat. by M. Cogswell and others; Washington, DC, Corcoran Gal. A.; Houston, TX, Contemp. A. Mus.; Chicago, IL, Mus. Sci. & Indust.; New York U., Grey A.G.; 1976)

M. Friedman and others: *Graphic Design in America: A Visual Language* (Minneapolis and New York, 1989)

□

Glasgow. Scottish city situated on the estuary of the River Clyde. At the turn of the 19th century it was known as 'the Second City of the Empire' owing to its prosperity, the result of successful overseas trade, shipbuilding and heavy engineering, and its large population (over 1,000,000 by 1914). Despite its industrial decline since the 1920s and much redevelopment, it retains a fine Victorian and Edwardian centre and suburbs, engulfed in 20th-century public housing.

1. History and urban development. 2. Art life and organization. 3. Cathedral.

1. HISTORY AND URBAN DEVELOPMENT.

(i) Before 1750. (ii) 1750–1918. (iii) After 1918.

(i) Before 1750. Glasgow's origins are medieval. Its urban area seems to have grown from two separate settlements, one by the Clyde, and one around the shrine of St Kentigern, popularly St Mungo (*d* AD 612), on the hill north of it, where the first cathedral was consecrated in 1136 (*see* §3 below). By the 15th century the cathedral was surrounded by the bishop's castle (12th–15th centuries), St Nicholas's Hospital (late 15th century) and 32 prebendal houses. A long street connected this upper town with the riverside settlement, where it met two east–west streets (Gallowgate and Trongate) at Glasgow Cross. Another street curved south-west to a bridge, first built in 1285 and rebuilt in stone in 1339. Two friaries were established north of the Cross (Blackfriars (Dominican), 1246; Greyfriars (Franciscan), 1479) and, more important, the University (founded 1451) was built there between 1460 and 1475. By the mid-16th century, the two settlements were conjoined. Slight expansion but considerable rebuilding took place in the lower town thereafter. Tall tenements with uniform stone fronts rose along the main streets after a great fire swept through the neighbourhood of Glasgow Cross in 1652, and after about 1660, merchants built individual mansions in large gardens west of the West Port (destr. 1749). Most notable of these was the Shawfield Mansion, a proto-Palladian villa designed by COLEN CAMPBELL in 1711 (destr. *c.* 1795).

Only fragments of pre-18th-century Glasgow survived 18th- and 19th-century rebuilding, especially the clearance and realignment of streets by the City Improvement Trust after 1866. The cathedral and one of the prebendal houses (Provand's Lordship, 1471) are the only visible evidence of the upper town. Near the river, there are only three disassociated steeples (17th century but still predominantly Gothic) that belonged to the Tolbooth (1625–7, by John Boyd) and the Tron Church (completed 1630–36), both in Trongate, and to the Merchants' House (1665) in Bridgegate. Fragments of the college (begun in 1654, destr. 1860s) were incorporated in the University's buildings of 1865–6 on Gilmorehill.

(ii) 1750–1918. Development was accelerated during the 18th century by great increases in the tobacco and cotton trades, particularly after the Clyde was made navigable up to Broomielaw, west of the merchant city, in 1770–71, and the Forth and Clyde and the Monklands canals were completed in the 1780s. Mansions and gardens were swept away by speculators, sometimes the merchants who had originally built them. Between 1750 and 1793 all the streets

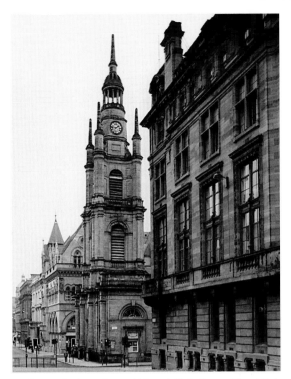

1. Glasgow, Buchanan Street: (right to left) the former Liberal Club, by Campbell Douglas and A. N. Paterson, 1907–9; St George's Tron, by William Stark, 1807–9; the former Stock Exchange, by John Burnet sr, 1875–7; and the former Western Club, by D. & J. Hamilton, 1839–42

west of High Street and Saltmarket as far as Jamaica Street and Buchanan Street had been laid out piecemeal following the lines of the long medieval plots (known locally as riggs), but they were not built up until the early 19th century, by which time industry had infiltrated. The long, straight streets were closed by a mansion of 1778–80, which was transformed by DAVID HAMILTON in 1827–32 into the Greco-Roman Royal Exchange, and other public buildings and churches, notably Trades' Hall (completed 1794), Glassford Street, by Robert Adam; Hutchesons' Hall (1802–5), Ingram Street, by David Hamilton, in a mixture of English Baroque and French Neo-classicism; William Stark's revived Baroque St George's Tron (1807–9; see fig. 1), Buchanan Street; and Thomas Rickman's Gothic Revival Ramshorn Church (1824–6), Ingram Street. Residential development east of Saltmarket was discouraged by neighbouring industry, despite two new churches, St Andrew's (1739–56), St Andrew's Square, by Allan Dreghorn (1706–64), modelled on James Gibbs's St Martin-in-the-Fields, London, and the Episcopal St Andrew-by-the Green (1750–52), Turnbull Street, by two local masons, William Paull and Andrew Hunter, and the improvements made to the common land (Glasgow Green) in the 1750s. A tenement in Gallowgate (1771) and a mansion (c. 1780) in Charlotte Street are the remains of the housing in the area.

The distinctive grid of streets of Glasgow's city centre (see fig. 2) originated in the late 18th century. In 1772 the Corporation commissioned a layout of their Ramshorn lands from James Barry (fl 1772–89). This was Glasgow's first attempt at planned growth, late by English standards but only some five years after the plans for Edinburgh's New Town had been drawn up by James Craig (1744–95). Although not executed, Barry's ideas seem to have inspired the grid of streets centred on a large square (George Square). The Corporation's adjacent Meadowflat lands and the Campbells' Blythswood estate were subsequently developed according to two separate but harmonious plans (possibly devised by Craig in 1792), each with a grid of streets aligned east to west with individually designed terraces of houses. By the 1830s these stretched as far west as Blythswood Square (enclosed by terraces of 1823–9 in a straightforward classical style by John Brash (d 1838–9)) and survive in the square's neighbourhood in reasonable concentration; building continued west until the 1860s. In the 1820s the grid was extended south of St Vincent Street to a plan by James Gillespie Graham, and north over Garnethill, where villas gave way in the 1840s to smart tenements (i.e. flatted dwellings). Across the Clyde, where another bridge had been built in 1768, three residential suburbs adjacent to the old village of Gorbals were developed, also to grid plans: Tradeston and Hutchesontown from 1791 and Laurieston from 1801. Only the names of these suburbs, and Carlton Place, with two terraces of 1802–4 and 1813–18 by Peter Nicholson, have survived comprehensive redevelopment.

Glasgow began to creep even further west in the 1830s and to engulf existing settlements such as Partick, with Partickhill mostly covered with villas by the 1850s, an early outpost. Nearer in, terraces fronted by pleasure gardens, such as Lynedoch Crescent and Claremont Terrace, north of Sauchiehall Street, set the pattern for further development, especially along the Great Western Road, which opened in 1841. The West End (or Kelvingrove) Park, designed by Joseph Paxton, formed part of a grand layout conceived in 1851 and designed by CHARLES WILSON, with terraces of middle-class houses encircling the hill east of the Park, and the Lombardic towers of Wilson's Free Church College (1856–7) and the tower of Park Church (1856–8, by JOHN THOMAS ROCHEAD) accenting them dramatically. Villas and terraces (e.g. Crown Circus, 1858) began to appear at Dowanhill, according to James Thomson's plan of 1850. Kelvinside was mostly built up between 1840 (when Decimus Burton produced his plan, revised in 1858 by James Salmon I, 1805–88) and 1880, with terraces along Great Western Road and villas to the north around the Botanic Gardens. These terraces are the most ambitious in Glasgow, notably Charles Wilson's Kirklee Terrace (1845), Rochead's Grosvenor Terrace (1855), and Great Western Terrace (1867) by ALEXANDER THOMSON. The University was re-established on Gilmorehill in a building by George Gilbert Scott the elder, designed in 1864. Scott was one of the few Englishmen to be employed in the city; the architects of 19th- and 20th-century Glasgow were predominantly Scottish and almost all local. Middle-class tenements, of a size and sophistication comparable with English mansion flats, filled the last estates to be developed in the 1890s (Hillhead, laid out c. 1850, and Hyndland) and spread west round Victoria Park, opened in 1887.

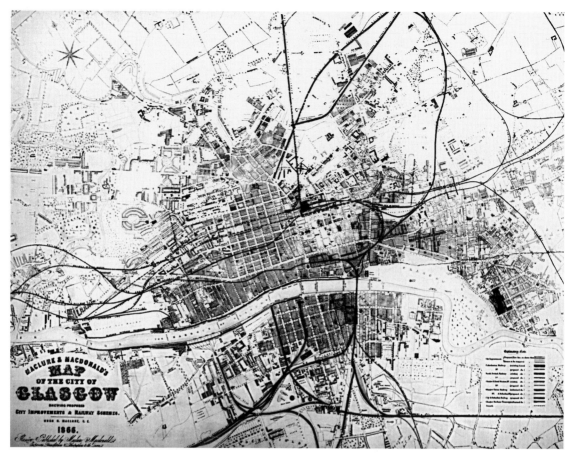

2. Glasgow, map by Maclure and Macdonald, 1866

A scatter of suburbs sprang up south of the Clyde. The first three were Pollokshields, Langside and Queen's Park (Strathbungo), all three with varying participation by Alexander Thomson. Tenements grew up along the main routes, and dozens of villas were built in West Pollokshields and at Cathcart.

Industrial growth spread east, both north and south of the Clyde. Almost nothing remains of the former varied industries and few of their associated buildings, except the Venetian-style carpet factory of 1889 by WILLIAM LEIPER on Glasgow Green and the North British Locomotive Co. offices of 1909 by James Miller (1860–1947) at Springburn (both reused). The Clyde was, of course, the focus of trade and industry. Impressive tobacco warehouses, such as those in James Watt Street, were built from 1848, replacing the ropeworks by the Broomielaw. Shipbuilding, established at Stobcross in 1818, transformed Govan from 1840 and Scotstoun from 1861. These industrial districts were characterized by the plainest four-storey sandstone tenements, built between 1850 and 1914, which offered minimal accommodation, often a single room; most have now been cleared, though pockets of them survive, for example in Govanhill, Partick and Scotstoun.

The city centre east of Blythswood was largely rebuilt between 1845 and 1914. Many of the finest buildings were warehouses, for example the sophisticated façades of

Grosvenor Buildings (1859–66), Gordon Street, and Egyptian Halls (1871–3), Union Street, both by Alexander Thomson. The Ca' d'Oro (1872, by John M. Honeyman, 1831–1914), Gordon Street, is the most elaborate of Glasgow's cast-iron buildings, of which Gardner's warehouse (1855–6), Jamaica Street, by John Baird I (1798–1859) is technically and aesthetically outstanding. In the streets just west of George Square banks and offices replaced houses. George Square itself was transformed when its terraces gave way to commercial buildings in the 1870s and in the 1880s, when the opulent City Chambers (1882–90; see fig. 3) by WILLIAM YOUNG filled the east side.

Architects of this period continued to work in a wide range of styles. Italianate styles remained popular for institutions (e.g. Charles Wilson's Royal Faculty of Procurators (1854–6), Nelson Mandela (St George's) Place), banks (e.g. John Gibson (ii)'s National Bank, 1847, re-erected in Langside Avenue) and warehouses (e.g. James Salmon I's 81 Miller Street, 1849–50). With the building of the City Chambers, the style merged into Baroque Revival. Alexander Thomson continued the Greek style in his highly individual way, in his later work (e.g. St Vincent Street Church, 1857–9; for illustration see THOMSON, ALEXANDER) mixing Egyptian and Assyrian motifs with forms derived from Karl Friedrich Schinkel. A more

chaste Greek style appeared as late as 1885–6 at H. & D. Barclay's St George's-in-the-Fields. Gothic was almost exclusive to churches, with the Stock Exchange (1875–7), Buchanan Street, by John Burnet sr (1814–1901) a notable exception (fig. 1 above). Examples include the first archaeologically convincing Gothic church, the Independent Chapel (1849–52; now St Matthew Blythswood), Bath Street, by John T. Emmett (*d* 1856), and the French Gothic style used by Campbell Douglas (1828–1910) at Crosshill-Queen's Park (1872–3). As in England, interest in indigenous styles grew later in the century, and medieval and 17th-century Scottish buildings were used as sources.

In the last decades of the 19th century the colour and scale of Glasgow buildings altered. After 1890 red sandstone from south-west Scotland took the place of the very local cream and grey sandstone. Commercial buildings also reached a much greater height (up to seven storeys), often rebuilt on the earlier small plots. Mixed Renaissance and Baroque styles offered a freedom well adapted to the new scale (e.g. Connal's warehouse (1898–1900) in West George Street, by James Thomson (1835–1905)). The more inventive architects, such as SALMON & GILLESPIE and Burnet, Son & Campbell, used classicism much more loosely, often with a wealth of figure sculpture and stained glass. Examples of these Free Style buildings range from James Salmon II's St Vincent Chambers (1899–1902), Buchanan Street, with strong Art Nouveau influence, to the later Glasgow work of J. J. BURNET and his partner John A. Campbell (1859–1909) (e.g. Burnet's Athenaeum extension (1891–3), Nelson Mandela (St George's) Place, with its American-influenced severity). Charles Rennie Mackintosh was the only faithful adherent to the so-called GLASGOW STYLE, with its blend of Art Nouveau forms and Arts and Crafts ideas. His development is best seen in the Glasgow School of Art (begun 1896) in Renfrew Street (for discussion and illustration *see* MACKINTOSH, CHARLES RENNIE, §3 and fig. 1). His style was rarely imitated, but it appears in diluted form throughout the city, as in the work of Henry E. Clifford (1852–1932). Govan, which was annexed to Glasgow in 1912, demonstrated its prosperity with its grandiose Town Hall (1897–1901) by John Thomson (1859–1933) and Robert Douglas Sandilands (*c.* 1860–1913), the Elder Library (1901–3) by J. J. Burnet and the Pearce Institute (1902–6) by Rowand Anderson. After 1914, American classicism became particularly popular in Glasgow, probably encouraged by the city's strong trade links with the USA and the visits made to it by architects and their patrons.

(iii) *After 1918.* The city's greatest expansion occurred after 1918, when large tracts were annexed for Corporation housing. The first housing schemes were at Riddrie (a mix of tenements and cottages, 1919–27) and at Mosspark (begun 1920) and Knightswood (begun 1921), designed on garden suburb principles. Many similar cottage estates followed in the late 1920s and the 1930s, but by then most of the council housing was low-cost tenements (e.g. at Blackhill, Haghill, Possilpark) to rehouse slum-dwellers. Particularly novel were the prefabricated concrete houses and flats of Modern Movement appearance built at Penilee during World War II. The Clyde Valley Plan of 1946 promoted overspill, but the City Plan of 1951 prescribed

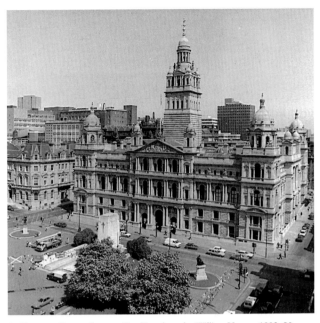

3. Glasgow, George Square, City Chambers, by William Young, 1882–90

comprehensive redevelopment and four great peripheral housing schemes (Drumchapel, Easterhouse, Castlemilk, Pollok), envisaged over-optimistically as satellite townships. Built during the following decade, they housed at very low density about 10,000 people each, in walk-up pitched-roofed blocks. High-rise buildings were tried early at Crathie Drive (1946–54), Partick, and Moss Heights (1950–54), Cardonald, and came into their own when work began in 1957 on the Comprehensive Development Areas. Among the most far-reaching were the redevelopment of Townhead with housing and an education campus that included Strathclyde University and two towers reminiscent of Le Corbusier (the Colleges of Commerce and of Building and Printing, 1963–4) by Wylie, Shanks & Partners; that of Gorbals (destr. 1994), with dramatic slab blocks by Spence, Glover & Ferguson, and others by ROBERT MATTHEW, JOHNSON-MARSHALL & PARTNERS (1959–62); and Anderston Cross (completed 1973) with its megastructure by Richard Seifert Co. Partnership. The tide against high-rise building turned visibly in the early 1970s when the first tenements were rehabilitated. In the areas still being rebuilt in the 1980s and 1990s, building is low rise or remedial. In the city centre, boxed in by the ring road, begun *c.* 1960, the only major rebuilding has been in the areas affected by the new road, along the two main shopping streets and on the site of St Enoch's Station (destr. 1977). The façades of most of the Victorian and Edwardian buildings remain, but their interiors have been remodelled for new office accommodation. In Pollok Park the building (opened 1983; by Barry Gasson Architects; *see* SCOTLAND, fig. 7) to house the collection of William Burrell is made of glass, stainless steel and traditional pink stone from Dumfries and Galloway.

BIBLIOGRAPHY

Municipal Glasgow: Its Evolution and Enterprises Scotland, Corporation of the City of Glasgow (Glasgow, 1914)

A. Gomme and D. Walker: *Architecture of Glasgow* (London, 1968, rev. 1987) [comprehensive bibliog.]
J. M. Kellett: 'Glasgow', *Historic Towns*, ed. M. D. Lobel, i (London, 1969)
J. R. Hume: *The Industrial Archaeology of Glasgow* (London and Glasgow, 1974)
M. A. Simpson: 'The West End of Glasgow', *Middle Class Housing in Britain*, ed. M. A. Simpson and H. Lloyd (London, 1977)
F. Wordsall: *The Tenement: A Way of Life* (Edinburgh, 1977)
F. A. Walker: 'The Glasgow Grid', *Order and Space in Society*, ed. T. A. Markus (Edinburgh, 1982)
A. Gibb: *Glasgow: The Making of a City* (London, 1983)
E. Williamson, A. Riches and M. Higgs: *Glasgow*, Bldgs Scotland (Harmondsworth, 1990)

ELIZABETH WILLIAMSON, MALCOLM HIGGS

2. ART LIFE AND ORGANIZATION. As Scotland's largest city, Glasgow has played a significant role in the country's art life. The Foulis Academy (1753–75), established by ROBERT FOULIS, marked the city's first contribution to art and art education. It pre-dated the Royal Academy in London by 15 years and held Glasgow's first public art exhibition in 1761. Throughout the 19th century increased prosperity was reflected in the growth of interest in and development of art activity. In the first half of the 19th century three exhibiting societies existed: the Glasgow Institution for Promoting and Encouraging the Fine Arts in the West of Scotland (1821–2), the Glasgow Dilettanti Society (1828–38) and the West of Scotland Academy (1841–53). In 1841 the Association for the Promotion of the Fine Arts, later renamed the Glasgow Art Union, was founded to encourage interest in the arts. It attracted subscribers from throughout Britain and overseas. The Royal Glasgow Institute of the Fine Arts, founded in 1861, is the city's longest surviving art organization. Its success led it to build its own galleries in 1879 (see fig. 4), and its annual exhibitions were particularly important to artists from the west of Scotland. It also strove to draw its audience from all sectors of the community. The growing interest in the fine arts led to the establishment of further exhibiting societies and clubs.

The Glasgow Art Club was founded in 1867 and the Scottish Society of Watercolour Painters in 1878. The Glasgow Society of Lady Artists, founded in 1882, was the first women's society of its kind in Scotland.

Until the 19th century many native artists were attracted away from Glasgow and, like most other Scottish artists, moved to England or abroad, and in the 19th century Edinburgh, through the Royal Scottish Academy, became the cultural centre, with artists again drawn away from Glasgow. The first notable painter born in Glasgow to retain close ties with the city was the landscape painter John Knox (1778–1845), followed by the portrait painters John Graham-Gilbert and Daniel Macnee and the landscape painter Horatio McCulloch, though both Macnee and particularly McCulloch also spent much time in Edinburgh. The first concerted attempt to challenge the dominance of the Royal Scottish Academy over art in Scotland was made by the GLASGOW BOYS at the end of the 19th century. The artists of this group were particularly influenced by the Realist painting of Jean-François Millet and Jules Bastien-Lepage as well as that of the Barbizon school. Such art as well as other contemporary continental art, though especially French and Dutch, could be seen at the exhibitions of the Glasgow Institute and in the galleries of such dealers as Craibe Angus (1830–99) and Alexander Reid. These two dealers had a tremendous importance in Glasgow, selling to enlightened local collectors. In addition to the painting of the Glasgow Boys and those associated with them, there was a dynamic and progressive design movement embodied in the GLASGOW STYLE. Incorporating elements of the Arts and Crafts Movement as well as of Art Nouveau, this style was epitomized by the work of CHARLES RENNIE MACKINTOSH, the Macdonald sisters, Herbert MacNair and others. An important focus and driving force for the Glasgow Style was the Glasgow School of Art (*see* MACKINTOSH, CHARLES RENNIE, fig. 1)

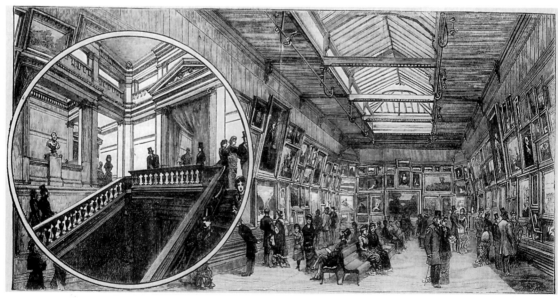

4. *The Galleries of the Royal Glasgow Institute of the Fine Arts*; engraving from *Descriptive and Biographical Industries of Glasgow: Facts, Figures and Illustrations* (London, Glasgow, Leeds and Bradford, 1888), p. 57

under Francis Newbery (1855–1946), who took over as Director in 1885. Indeed, from the 1880s up to the early years of the 20th century there was a surge of artistic activity in Glasgow.

In the early 20th century further small exhibiting societies, such as the Glasgow Society of Painters and Sculptors (1919), were founded. In 1939 the innovative artist J. D. Fergusson settled in Glasgow. Fergusson founded the New Art Club in 1940 and the New Scottish Group in 1943, and through these he helped to coordinate the efforts of many avant-garde artists, such as Donald Bain (1904–79), Millie Frood (1900–88), Josef Herman and Jankel Adler. Later in the 20th century other exhibiting societies were founded, including the Glasgow Group (1958) and the Glasgow League of Artists (1971). A strong figurative school developed in Glasgow in the 1980s, incorporating the varied work of such artists as Stephen Campbell (b 1953), Adrian Wiszniewski (b 1958), Peter Howson (b 1958) and Ken Currie (b 1960).

Throughout the 19th century numerous local collectors existed in Glasgow, their increasing prosperity matching that of the city as a whole. In many cases their collections were bequeathed to the city, so forming the basis of the municipal museums. The coach-builder Archibald McLellan (1796–1854) left his collection of 17th-century Dutch and Flemish and 16th- and 17th-century Italian paintings to the city, and these were housed in the so-called McLellan Galleries in the city centre. While the city's paintings continued to be held there, in 1870 Kelvingrove House was bought to hold the municipal collections of other items. After expansion in 1876 it was decided to house all the collections in one large complex at Kelvingrove. The International Exhibition of 1888, held in Kelvingrove Park, was designed to raise money for the project, and the new building was opened in 1901, an event celebrated by a second International Exhibition at Kelvingrove that year. The Glasgow Art Gallery and Museum, as it became, contains a wide range of exhibits, including jewellery, ceramics and other decorative arts. The extensive fine art collection is strongest in 17th-century Dutch painting, 19th-century French painting and Scottish art from the 18th century onwards. Based largely on bequests, it incorporates the collections of such local businessmen as William Euing (1788–1874), James Reid of Auchterarder (1823–94), James Donald (1830–1905) and William McInnes (1868–1944).

The most extraordinary of the collectors in Glasgow was WILLIAM BURRELL, who donated his diverse collection to the city in 1944. Housed in a purpose-built museum in Pollok Park that opened in 1983 (see SCOTLAND, fig. 7), the Burrell Collection contains outstanding holdings of Persian, Caucasian and Indian rugs, Chinese ceramics and bronzes, Late Gothic and early Renaissance works from northern Europe and 19th-century French paintings. Also in Pollok Park is Pollok House, which, together with the park, was donated to the city in 1967. It contains a notable collection of Spanish pictures by El Greco, Murillo, Goya and others, formed by Sir William Stirling-Maxwell. The other important museum in Glasgow is the Hunterian Museum in the University of Glasgow, which opened in 1808 and was originally based on the collection of WILLIAM HUNTER. Whistler's sister-in-law Rosalind Philip (d 1958)

donated and bequeathed an extremely substantial collection of the American artist's work to the Hunterian, which also holds numerous items by Mackintosh, the Macdonalds and MacNair, as well as over 10,000 prints ranging from the 15th century to the present. The exhibitions held in the public institutions in Glasgow are complemented by those organized by the commercial art galleries, which flourished particularly from the late 1970s. In addition to these more exclusive arenas, in the latter part of the 20th century participation in broader community and public art projects also expanded in Glasgow.

BIBLIOGRAPHY
R. Brydall: *Art in Scotland: Its Origin and Progress* (Edinburgh, 1889)
J. L. Caw: *Scottish Painting: Past and Present, 1620–1908* (Edinburgh, 1908)
I. Finlay: *Art in Scotland* (Oxford, 1948)
H. Miles: 'Early Exhibitions in Glasgow: I, 1761–1838', *Scot. A. Rev.*, viii/3 (1962), pp. 26–30
——: 'Early Exhibitions in Glasgow: II, 1841–55', *Scot. A. Rev.*, viii/4 (1962), pp. 26–9
Glasgow University's Pictures: A Selection of Paintings, Drawings, Prints and Other Works from the Hunterian Museum, University of Glasgow (exh. cat. by A. McLaren Young and others, London, Colnaghi's, 1973)
D. Irwin and F. Irwin: *Scottish Painters at Home and Abroad, 1700–1900* (London, 1975)
R. Marks and others: *The Burrell Collection* (London and Glasgow, 1983)
R. Billcliffe: *The Glasgow Boys: The Glasgow School of Painting, 1875–1895* (London, 1985)
G. Hancock and others: *Glasgow Art Gallery and Museum* (London and Glasgow, 1987)
J. Burkhauser, ed.: *Glasgow Girls: Women in Art and Design, 1880–1920* (Edinburgh, 1990)
W. Hardie: *Scottish Painting, 1837 to the Present* (London, 1990)
D. Macmillan: *Scottish Art, 1460–1990* (Edinburgh, 1990)

GEORGE FAIRFULL SMITH

3. CATHEDRAL. The early church history of Glasgow is associated with the mission of St Kentigern (or Mungo). Although most of the information on him comes from unreliable 12th-century hagiographic *Lives*, it is likely that he was bishop of an area corresponding to the British kingdom of Strathclyde, and that the centre of his diocese may have been in Glasgow. No early artefacts have been found in the vicinity of the cathedral, dedicated to St Mungo. The diocese was re-established between 1114 and 1118 by the future King David I. John (1114 or 1118–47), the first of the new line of bishops, built a church that was sufficiently far advanced for consecration in 1136; a plastered voussoir in the crypt, with painted decoration including a palmette motif, may come from the later work on this building. Its west front was found by excavation in 1992. Major extensions to John's church were undertaken by Bishop Jocelin (1174–99), who commissioned one of the *Lives* of Mungo, probably intending to develop the cult of the saint. Work was in progress in 1181, and a fragment of wall with a respond surviving in the crypt of the later cathedral suggests Jocelin built a cruciform extension to the eastern limb. This would have provided lateral chapels to the area around the saint's tomb in the crypt and flanking the high altar above. A fire interrupted this operation, but enough was complete for consecration in 1197.

Building came to a halt after Jocelin's death, and when work started again it was to a different plan. The new design is datable stylistically to the early 13th century and involved the truncation of the existing transept-like chapels

and the provision of non-projecting transepts further west, thus effectively extending the eastern limb while leaving the tomb towards its east end. At the same time the lower outer walls of the nave were laid out to the plan that was to be retained in the final building campaign, albeit probably without the two western towers at this stage.

Construction of the western limb was halted yet again, and a new plan adopted at the instigation of Bishop William Bondington (1233–58). Work was certainly under way by 1242, when the faithful of the kingdom were exhorted to contribute. Bondington did much to enhance the dignity of the cathedral foundation, and his chief concern for the building was probably to accommodate the augmented complement of clergy fittingly within an architecturally distinct choir, which might also provide an appropriate setting for the saint's shrine. The plan chosen for the new choir was an aisled main space of five bays, with a rectangular eastern ambulatory, off which opened a straight rank of four chapels (see fig. 5). Such a plan, which had been first developed for the needs of the Cistercian order, was unusual for a secular cathedral but admirably met Glasgow's needs with relative economy. In the crypt the central space was further subdivided to provide twin focuses on the saint's tomb and on the Lady Chapel to its east. This subdivision was created by a masterly use of spatial modelling that has few parallels for its date, ingeniously masking the fact that the eastward extension of the choir had left the tomb awkwardly

5. Glasgow Cathedral, view from the south-east, 13th century

towards its west end. The area of the tomb is enclosed within a ciborium of vaulting carried on four piers, while the Lady Chapel occupies the full width of the central space and is capped by a slightly domical vault. By 1301 there was a shrine of St Mungo in the choir above, probably intended from the start to complement the tomb in the crypt, but the logic of the ambulatory plan would presumably require it to be placed, not directly over the tomb, but in the eastern bay of the main vessel, with the high altar to its west.

Two ancillary structures projected from the north side of the choir: at the north-east corner was a two-storey chapter house block, and against the western bay was another two-storey block with a sacristy on the upper floor (destr.) and a treasury below. Soon after work began on these a third laterally extending range was apparently started against the unfinished south transept. This four-bay projection, for which the only contemporary Scottish parallel was at Iona, was probably linked with Mungo's cult but was left incomplete after the walls of its crypt had reached only to main floor level.

The elevations of the choir are in the tradition established at Lincoln Cathedral, with two pairs of triforium openings to each bay, although its mason evidently knew of the latest developments on this theme, such as at Rievaulx Abbey (N. Yorks). The Scottish example of Jedburgh Abbey was probably considered in the design of the continuous clerestory arcade. Covering the central space is a delicately cusped and heavily restored wooden barrel ceiling. The eastern limb features stiff-leaf foliage of high quality and a remarkable range of plate-traceried windows.

Work reached the transepts, which were pierced by some of the earliest but most ambitious bar traceried windows in Scotland, around the 1260s. The nave, built towards the end of the 13th century, was necessarily different from the choir in having to accommodate a bay rhythm pre-ordained by the early 13th-century lower walls, and the chosen design cleverly exploited this tighter spacing. Above the arcades the triforium and clerestories were strongly linked by pairs of embracing arches in each bay, a solution that represents a development on themes seen earlier at, for example, St David's and Pershore (Hereford & Worcs); this also paralleled contemporary approaches to linkage of these storeys at such buildings as York Minster. Like the choir, the nave was originally covered by a wooden barrel ceiling, but this has been replaced by an open-timber roof. At some stage asymmetrical towers were added to the west front, projecting fully to the west and partly to the sides; these were destroyed in 1846 and 1848.

The last structural works at the cathedral of which significant traces remain were the rebuilding of the central tower and spire and the repair of the upper chapter house following lightning damage about 1400. The re-ordering of the choir and feretory, with the addition of the stone pulpitum, followed c. 1420. Robert Blackadder (1483–1508), the first archbishop of Glasgow, added much to his cathedral, including the vault over the lower stage of the projection from the south transept and a pair of altar bases in front of the pulpitum. The cathedral remained in

use through the Reformation of 1560 and was progressively subdivided to meet the needs of three separate congregations. From the 1830s attempts were made to restore the cathedral and remove the divisions. This, unfortunately, led to the destruction of the two western towers and the surviving part of the medieval nave ceiling, apart from its more beneficial effects.

BIBLIOGRAPHY

D. MacGibbon and T. Ross: *The Ecclesiastical Architecture of Scotland*, ii (Edinburgh, 1896), pp. 160–203

G. Eyre-Todd, ed.: *The Book of Glasgow Cathedral: A History and Description* (Glasgow, 1898)

T. L. Watson: *The Double Choir of Glasgow Cathedral: A Study of Rib Vaulting* (Glasgow, 1901)

P. M. Chalmers: *The Cathedral Church of Glasgow: A Description of its Fabric and a Brief History of the Archi-episcopal See* (London, 1914)

C. A. R. Radford and E. L. G. Stones: 'The Remains of the Cathedral of Bishop Jocelin at Glasgow (*c.* 1197)', *Antiqua. J.*, xliv (1964), pp. 220–32

D. McRoberts: 'Notes on Glasgow Cathedral: The Medieval Treasury of Glasgow Cathedral; Our Lady of Consolation; the Lady Chapel of Glasgow Cathedral', *Innes Rev.*, xvii (1966), pp. 40–47

G. Hay: 'Notes on Glasgow Cathedral: Some Architectural Fragments in the Lower Church', *Innes Rev.*, xviii (1967), pp. 95–8

D. McRoberts: 'The Crossing Area of Glasgow Cathedral in the Middle Ages', *J. Soc. Friends Glasgow Cathedral* (1967), pp. 9–12

J. Durkan: 'Notes on Glasgow Cathedral: The Medieval Altars, General Considerations; Medieval Consistory House; The Medieval Library', *Innes Rev.*, xxi (1970), pp. 46–69, 73–6

E. L. G. Stones: 'Notes on Glasgow Cathedral: Evidence from the Scottish Record Office', *Innes Rev.*, xxi (1970), pp. 140–52

J. Durkan: 'The Great Fire at Glasgow Cathedral', *Innes Rev.*, xxvi (1975), pp. 89–92

R. Fawcett: *Glasgow Cathedral* (Edinburgh, 1985)

——: 'The Blackadder Aisle at Glasgow Cathedral: A Reconsideration of the Architectural Evidence for its Date', *Proc. Soc. Antiqua. Scotland*, cxv (1985), pp. 277–87

——: 'Glasgow Cathedral', in E. Williams, A. Riches and M. Higgs: *Glasgow*, Bldgs Scotland (Harmondsworth, 1990), pp. 108–35

RICHARD FAWCETT

Glasgow Boys. Loosely associated group of Scottish artists, active principally in Glasgow in the late 19th century. In 1890 the critics of an exhibition of Scottish painting at the Grosvenor Gallery, London, identified several common traits in the work of those artists associated with Glasgow and gave them the sobriquet 'Glasgow school'. These artists, none of them over 35 and not all born or living in Glasgow, preferred the more familiar term 'The Boys', which did not imply the close stylistic ties and unity of purpose of the term 'school'.

By the end of the 1870s the Royal Scottish Academy in Edinburgh firmly controlled the artistic establishment of Scotland. All Academicians and Associates were expected to live in Edinburgh and the Academy manipulated the artistic taste of Scotland by rejecting all works submitted to its annual exhibitions that did not conform to its own narrow preferences. To many of the younger generation of painters working in Glasgow (those born in the 1850s and 1860s) this situation was unacceptable. They were ambitious both professionally and socially but had no wish to move to Edinburgh or conform to the taste of the Academy. Glasgow was the largest and most prosperous city in Scotland and by 1900 was second only to London in the British Empire, and they wished to exploit the opportunities offered them by the large and active group of collectors and patrons living in the city. Although London would usually offer them refuge (and many Scottish painters had settled there rather than confront the Academy), these Glasgow artists considered that they should be allowed to paint and live as and where they wished.

In rejecting academic taste, a primary source for the work of the Glasgow Boys was the realism of Scottish painters such as Thomas Faed, who avoided excessive sentiment and pathos while recording the life of mid-19th-century Scotland. From Faed and his contemporaries came a more painterly handling and strength of colour that had become a feature of Scottish painting by 1880. French Realism had a particular impact, notably the work of Jean-François Millet and the Barbizon school, whose paintings could be seen regularly at the Glasgow Institute of the Fine Arts and in the dealers' galleries in Glasgow. The development of this style of painting by Jules Bastien-Lepage was crucial to the Boys, and almost all adopted his naturalist palette, handling and compositions. The square brushstrokes and the signatures in large block capitals became as important to the Boys as they were to Bastien-Lepage. Finally, the tonal harmonies and sense of pattern of James McNeill Whistler, whose portrait of *Thomas Carlyle* (1872; Glasgow, A.G. & Mus.) was bought for the city of Glasgow in 1890 on the Boys' recommendation, along with his insistence on the independence of the artist in choice of subject, was to prove most lasting of all as many of the group turned to portraiture after 1890.

By 1885 three separate groups of progressive artists could be identified in Glasgow. W. Y. MACGREGOR and James Paterson (1854–1923) had been painting together in a low-keyed manner since 1876, selecting Realist subjects from the towns and countryside of Scotland. Slightly older (and wealthier) than the other painters of the group, they offered encouragement, assistance and a studio in which to gather in Glasgow. The second group was centred around James Guthrie, Joseph Crawhall, George Henry and E. A. Walton. Since 1880 these painters had worked together during summer painting tours in Scotland and England. After discovering the work of Bastien-Lepage, probably in 1882, they concentrated on painting, in a naturalist manner, single figures or small groups of rural labourers seen at their daily tasks. A third group, including John Lavery, William Kennedy (1859–1918), Thomas Millie Dow (1848–1919) and Alexander Roche (1861–1921), had studied in Paris (usually at the Académie Julian) and then painted at Grez-sur-Loing. Here a number of British and American painters adopted the French naturalist manner pioneered by Bastien-Lepage.

In 1885 all three groups came together in the annual exhibition of the Glasgow Institute and were able for the first time to consider each other's work. Although naturalism had become their predominant style, by 1887 the painters began to follow separate paths. Their realistic paintings of rural life did not sell easily and Lavery began to paint scenes of middle-class life, which were more popular and gained him new commissions. Like Guthrie, Walton and, later, Henry, he gradually moved towards portraiture. The group diversified even more as Henry introduced another young painter to the group, E. A. Hornel. Together they explored a more Symbolist manner in the late 1880s and 1890s, their palette inspired by the Edinburgh painter (but honorary Glasgow Boy) Arthur

Melville. By the time of the exhibition at the Grosvenor Gallery in 1890 several of the Boys were considering leaving Glasgow. The success of this exhibition established them in London and led to invitations to show in Munich, Berlin, St Petersburg, Barcelona, Venice, Paris, Pittsburgh, Chicago, St Louis, New York and elsewhere in Europe and North America. This growth in fame and reputation ensured that by 1900 only two or three of the school remained in Glasgow, the others settling mainly in Edinburgh and London as they achieved artistic respectability and social success. They had, however, overcome the dominance of the Royal Scottish Academy, which dropped its residential and stylistic restrictions in 1888 with the election of Guthrie, who was to become President in 1902.

BIBLIOGRAPHY

D. Martin: *The Glasgow School of Painting*, intro. F. H. Newbery (London, 1897)

G. B. Brown: *The Glasgow School of Painters* (Glasgow, 1908)

J. L. Caw: *Scottish Painting: Past and Present, 1620–1908* (Edinburgh, 1908)

The Glasgow Boys, 2 vols (exh. cat., ed. W. Buchanan; Edinburgh, Scot. A.C., 1968–71)

D. Irwin and F. Irwin: *Scottish Painters: At Home and Abroad, 1700–1900* (London, 1975) [with excellent bibliog.]

Guthrie and the Scottish Realists (exh. cat., ed. R. Billcliffe; Glasgow, F.A. Soc., 1982)

R. Billcliffe: *The Glasgow Boys: The Glasgow School of Painting, 1875–1895* (London, 1985) [most comprehensive account and selection of pls]

ROGER BILLCLIFFE

Glasgow style. Term denoting the style of works of art produced in Glasgow from *c.* 1890 to *c.* 1920 and particularly associated with CHARLES RENNIE MACKINTOSH, HERBERT MACNAIR and the MACDONALD sisters, Frances and Margaret. The style originated at the Glasgow School of Art, where Francis H. Newbery (1853–1946) became director in 1885. Influenced by the ARTS AND CRAFTS MOVEMENT, Newbery had a commitment to excellence in art that combined functionalism with beauty while encouraging individuality and experimentation among his students. Within three years he had brought in the Century Guild of Artists' chief metalworker, William Kellock Brown (1856–1934), to teach modelling and metalwork at the School. Kellock Brown had an intimate understanding of A. H. Mackmurdo's approach to art, as articulated in the journal *The Hobby Horse* (launched in spring 1884), which voiced a desire for the unification of the old with the new and for an artistic relationship between abstract lines and masses that would reflect the harmonious whole found in nature. The development of the style was given further impetus by the fact that Celtic revivalism had already taken root in Glasgow, later coming to fruition with the publication of Patrick Geddes's review *The Evergreen* in the mid-1890s. In addition, an understanding of such contemporary European art movements as Symbolism and ART NOUVEAU became possible when the first issue of *The Studio* appeared in 1893. These factors combined to provide Newbery's students at the School with the fertile ground needed for the emergence of an innovative and distinctive art.

The new style appeared as early as the autumn of 1893 in a student exhibition that featured the works of Herbert MacNair, Charles Rennie Mackintosh, Margaret Macdonald and Frances Macdonald, whose painting *Ill Omen*

(1893; U. Glasgow, Hunterian A.G.) epitomizes the style and was probably hung in the exhibition. The art produced by these artists, known as The Four, represents the core of the Glasgow style. Glasgow critics considered the art to be eccentric, inspired by Aubrey Beardsley and William Blake, individual and 'weirdly new' (the reference here being to the New Woman) but nonetheless remarkable. Later, when The Four and their contemporaries exhibited at the Vienna Secession (1900) and the Turin Esposizione Internazionale d'Arte Decorativa (1902), German critics commented on the 'alien aspects' of the art but also on its poetic, mystical and spiritually expressive qualities. Purples, greens and blues complemented the elongation and distortion and added to the perceived mystery of the work. Although plant forms, particularly the rose, provided an impetus for design, it was a unique linear style that characterized paintings, furniture, metal panels, needlework, bookbinding, gesso panels, interior design and (with Mackintosh) architecture, and reflected the Scots' eclecticism but also their originality. The narrow, tall, white Mackintosh chairs and the slender, elongated women on Margaret Macdonald's embroidered panels demonstrate an understanding of continental Art Nouveau but move a step beyond the floreated curves most often associated with that style.

Although The Four and Francis H. Newbery are central to an understanding of the Glasgow style, several other Glaswegian artists, including JESSIE NEWBERY, Talwin Morris (1865–1911), JESSIE M. KING and James Guthrie, also produced art that is representative of this style. By the end of World War I the Glasgow style was supplanted by a burgeoning modernism.

BIBLIOGRAPHY

The Glasgow Style, 1890–1920 (exh. cat., Glasgow, Museums & A. Gals, 1984)

J. Burkhauser, ed.: *'Glasgow Girls': Women in Art and Design, 1880–1920* (Edinburgh, 1990)

W. Eadie: *Movements of Modernity: The Case of Glasgow and Art Nouveau* (London, 1990)

JANICE HELLAND

Glass. In layman's terms, glass is understood to refer to the manmade silica-based material used to make such items as window panes, bottles and drinking vessels. To the materials scientist, however, the term glass refers to a specific state of matter, often called the 'glassy' state; its defining property is that, regardless of its chemical composition, the material has solidified from the liquid state without forming any crystals, and thus at the atomic level lacks the regular ordered structure of normal crystalline solid materials. The 'glassy' state of matter is therefore the random, three-dimensional network of atomic bonds in the liquid state, which is preserved in the solid state; glass is therefore sometimes described as a 'super-cooled' liquid. It is a truism of science therefore that almost anything can be made into a glass if it is cooled down fast enough from the liquid state to prevent the formation of crystals as the material solidifies; the required rate may very well be measured in millions of degrees per second.

Occasionally, and under fairly dramatic circumstances, glass is formed in nature. Some volcanoes produce the mineral obsidian, a natural form of black glass, which when viewed in very thin section can be seen to be a

translucent grey. It has been used by Native Americans to make carvings and tools, as large quantities were formed by the vast volcanoes that made up the Jemez Mountains of northern New Mexico. Natural glass is also formed when lightning strikes a sandy desert during a violent electrical storm. The immense energy discharged at the point of contact causes the sand to vaporize down the electrical path the lightning takes, leaving a fulgurik, a tube of melted sand, which solidifies without crystallizing to form an almost pure silica glass.

BIBLIOGRAPHY
F. Nenburg: *Ancient Glass* (London, 1962)
R. Hurst Vose: *Glass* (London, 1975)
G. Beard: *International Modern Glass* (London, 1976)
H. Newman: *An Illustrated Dictionary of Glass* (London, 1977)
R. J. Charleston: *Masterpieces of Glass, a World History, from the Corning Museum of Glass* (New York, 1980)
F. Mehlman: *Phaidon Guide to Glass* (Oxford, 1982)
R. J. Charleston: *English Glass, the Glass Used in England,* c. *1400–1940* (London, 1984)
D. Klein and W. Lloyd: *The History of Glass* (London, 1984)
D. Barag: *Catalogue of Western Asiatic Glass in the British Museum* (London, 1985)
B. Klesse and H. Mayr: *European Glass from 1500–1800* (Vienna, 1987)
D. Klein: *Glass, a Contemporary Art* (London, 1989)
H. Tait, ed.: *5000 Years of Glass* (London, 1991)

I. Materials. II. Processes. III. Decorative techniques. IV. Uses. V. Conservation.

I. Materials.

1. BATCH. Sand, the main constituent of manmade glass, is silicon dioxide, often referred to as silica, which has a melting-point of *c.* 1720°C. The melting-point (fusion point) of pure silica can be significantly lowered by over 1000°C by adding alkalis that serve as fluxes, notably the carbonates of sodium and potassium. A simple binary composition of silica and sodium carbonate (soda) will produce a non-durable glass, which will react easily with water. Some silica and potassium carbonate glass rapidly and completely dissolves in water. These binary compositions can be made durable by the simple and relatively low concentration of calcium carbonate (lime). Simple glass of the soda–lime–silica type is by far the most common type manufactured; the composition generally approximates to 75% silica, 15% soda and 10% lime. Glass of this type is suitable for windows and such industrially made wares as bottles; it is not, however, very suitable for handworking as it hardens very quickly on cooling (short working-range) owing to its relatively high lime content.

For handworking, glassmakers require a glass with an extended working-range, which allows sufficient time for the various forming processes to be completed without the need for constant reheating (annealing). This has been achieved in different ways depending on the materials available. Glassmakers based around the Mediterranean seaboard during the Roman period worked glass with a soda content frequently over 20% and lime significantly less than 10%. Soda was easily available either being imported directly from Egypt or prepared by burning certain types of littoral plants.

Early northern European glassmakers burnt beechwood or oak in pits and used the potassium-rich ash (potash) as the flux. Characteristically potassium imparts a longer working-range to glass than sodium. Throughout England, samples from furnace sites as wide apart as Surrey and Yorkshire indicate that medieval glassmakers mainly used a flux with a very high concentration of lime, sometimes as high as 22%. The glass produced had to be worked while extremely hot as it tended to crystallize if left for any significant period below 1290°C.

For several centuries glassmakers made use of lead in glass in a wide range of concentrations to achieve glass that was highly suitable for handworking. During the 1990s the use of such toxic, heavy metals in glass as lead and barium became a controversial issue because of environmental considerations, and the possibility of lead leaching out of the glass container into its contents. The benefits derived from the use of lead are that it imparts a very long working-range to the glass, especially when it completely replaces lime, and that lead, being a heavy metal, increases the density of the glass, which in turn raises the refractive index of the glass, thereby making the glass far more brilliant.

It was the introduction of lead into the manufacture of English glass by GEORGE RAVENSCROFT in 1676 that eventually gave rise to the cut-glass industry in England. Full lead-crystal contains a minimum of 30% lead and is fluxed with potassium; when cut and polished it is sparkling and brilliant. Lead is also used, albeit in much lower concentrations, by glass artists, simply as a means of achieving highly workable glass: for example many glass compositions contain concentrations of lead in the range of 4%–10%.

2. COLOUR. Hot liquid glass is a universal solvent for oxides of every element. A group of elements known as transition metals share the characteristic of having incomplete inner electron shells. Metal-oxides from this group frequently have a colouring effect when dissolved in glass. Usually it becomes more difficult to achieve certain colours proceeding from blue in the spectrum. Not all colours, however, are produced by oxides of transition metals: particularly at the red end of the spectrum no transition-metal oxide dissolved in glass will create a red colour. Other colouratic techniques involve the precipitation of a metal in the glass as a mass of colloidal particles each containing between 50 and 200 atoms, another involves the formation of sulphides or sulpho-selenides of particular metals.

Glass can be made opaque white by the deliberate growing of a large mass of crystals within the glass, and throughout the history of glassmaking many different chemical means of achieving this have been used. The most important technique in use at the end of the 20th century is the inclusion of a considerable quantity of fluorine into the batch, which on cooling forms a mass of crystals that are fluorides of every element in the glass.

Blues are very easily achieved: cobalt oxide is the basis of a strong, rich blue. Copper oxide dissolved in glass produces a huge variety of colours depending on the concentration and the level of oxygen allowed to remain in combination with the copper. Fully oxidized copper oxide (cupric oxide) in a pure soda–lime glass gives a pure, sky blue, which becomes increasingly turquoise if the glass contains either lead, boron or titanium. At concentrations

of *c.* 0.2%, and if carefully stripped of its oxygen using a small quantity of tin as a reducing agent, colloidal particles of metallic copper will precipitate to produce a very rich, translucent red. The ancient Egyptians' only method of producing an opaque, blood-red glass was by the precipitation of crystals of the intermediate cuprous oxide. The Venetians discovered that it was possible to precipitate crystals of pure metallic copper in glass, which grew as optically perfect, small flat 'mirrors', dispersed randomly throughout the glass, imparting a sparkling effect. This became known as 'aventurine' from the Italian *per avventura* (by accident), and it continues to be one of the most difficult types of glass to manufacture.

Green glass can be made by the addition of iron, and in very high concentrations is the means by which the dark-green, protective glass used by welders is produced. Chromium (a metallic agent) also produces green glass, which varies from a yellowish-green, if the glass is fully oxidized, to an emerald-green if the oxygen level is reduced. Most commercial green bottles are produced by a mixture of iron and chromium.

Yellow glass can be made in a variety of ways. A greenish-yellow can be made by the addition of a small amount of uranium oxide, which makes Vaseline glass. If a low concentration of silver is dissolved in glass, a clear, golden yellow is produced. The colour is created by the precipitation of colloidal particles of silver in the glass, which occur when the glass is cooled. Straw-yellow is produced using the iron/manganese system employed by the north-European medieval glassmakers; it is, however, difficult to achieve and is not now used commercially. Lime-yellow glass is produced by forming cadmium sulphide in the glass, which in high concentrations creates an opaque, lemon-yellow.

Orange glass is extremely difficult to produce reliably. It is a modification of cadmium sulphide, achieved by the addition of selenium and can be made either transparent or opaque depending on the concentration. This technology was introduced at the end of the 19th century and is notoriously unpredictable.

Red glass is very difficult to produce; apart from the use of copper, there are three methods of making red glass: first is by a further addition of selenium to cadmium sulphide glass, which produces either a translucent or opaque glass; this method is the only known way of making bright red, opaque glass. Gold dissolved in glass in very low concentrations of *c.* 0.02% imparts a transparent, pinkish red; the higher the lead content, the redder the glass. The colour is produced by a colloidal dispersion of the metal in the glass. A very intense, transparent red can be made by forming antimony sulphide in a batch; this method, however, is extremely difficult, and creates such an intense colour that it is of technical interest only.

BIBLIOGRAPHY

W. A. Weyl: *Coloured Glasses* (Sheffield, 1951)
G. O. Jones: *Glass* (London, 1956)
H. Rawson: *Inorganic Glassforming Systems* (London, 1967)
C. R. Bamford: *Colour Generation and Control in Glass* (Amsterdam, 1977)
M. B. Wolf: *Chemical Approach to Glass* (Amsterdam, 1984)
R. G. Newton: 'Eighth W. E. S. Turner Memorial Lecture', *Glass Technol.*, xxvi (1985), pp. 93–103

PETER WREN HOWARD

II. Processes.

1. Glassmaking. 2. Furnaces.

1. GLASSMAKING.

(i) Casting. The purpose of casting is to fill the void of a mould of the desired shape with molten glass, using heat to fuse it. This process usually takes place inside a kiln. The processes are slow and labour intensive and normally used to create 'one-off' or expensive, limited-edition items. Casting was first developed in Mesopotamia *c.* 700 BC and inspired by the process of casting used to make gold and silver objects. The early vessels are almost exact replicas of the metal originals. Casting continued to be used until Roman times but was eventually replaced by blowing (*see* §(iii) below). The main problem with casting is that the nature of glass is, even at its most liquid, 100 times more viscous than water and therefore resistant to flowing into a mould. How the glass is introduced into the mould and in what form are of basic importance, and it is generally variations of these that give the cast objects their particular qualities. The three main requirements for casting an object are a mould, glass and heat.

The complexity of a cast form and the necessary levels of heat usually mean that the moulds are destroyed every time a cast is made. They are often refractory based, being amalgams of castable materials, which can include plaster, crystobolite and clay. Moulds are produced by pouring a castable mixture around an image (often wax) and leaving a hole in the base. When the castable mix is solid the wax can be steamed out; this technique is known as the lost-wax (*cire perdue*) process. The void is then filled with glass. This can be introduced in a variety of forms: hot liquid, small marbles, sintered fragments or fine powder depending on the shape to be filled, internal colour effects or required surface qualities. After the glass has cooled, the mould can be broken away. This technique was used to make small glass sculptures in ancient Egypt (*see* EGYPT, ANCIENT, fig. 108).

The mould is usually placed in a kiln and filled with glass prior to heating. The kiln is heated until the glass becomes sufficiently molten to fill the details in the mould. At a high temperature—usually *c.* 1000°C—the glass can be topped up with more glass as the mould is filled. Alternatively liquid glass can be poured into an empty mould from a previously heated crucible. After filling, the mould is slowly brought down to room temperature (annealing) to release the strain in the glass. The thicker the cast, the longer and more carefully this must be done. On cooling the mould is broken away to reveal the glass cast. Casts are invariably finished by grinding, polishing, engraving or acid working to remove minor imperfections and to improve and vary the surface quality (*see* §III below).

Although the process of making glass known as *pâte-de-verre* had been known in ancient Egypt during the 18th Dynasty (*c.* 1540–*c.* 1292 BC), the term was only coined in the late 19th century to describe a range of variations of casting used by individual artist–craftsmen, especially in France. The objects made often resembled gems or hardstones. Glass powder, coloured with metal oxides, was carefully packed into a mould to ensure an accurate

dispersal of colour into the fine details. The precise technique varied, but consisted of personal methods of filling moulds, types and form of glass used and subtleties of firing. Important exponents included Gabriel Argy-Rousseau (*b* 1885), Albert-Louis Dammouse (1848–1926) and François Emile Décorchement (1880–1971). *Pâte-de-verre* casting was largely discontinued during the 1920s, but was revived in the late 20th century.

(ii) Moulding. At its most simple, this method involves a negative mould (usually metal) with an opening into which molten glass is introduced; the exposed area of the glass is pressed with a plunger to force the molten liquid into the form and detail of the mould. Originally developed by the Romans, press-moulding was used to make low-relief plaques for architectural use as this basic method did not allow for undercuts or for the manufacture of hollow objects. This method remained unchanged—except for the occasional substitution of metal for clay moulds—until the 19th century when the first simple pressing machine was developed. The market, however, needed cheap, easy to produce, decorative containerware and the process had to become more complex in order to produce three-dimensional forms. The press consisted of a base plate and plunger, which were brought to bear on each other by the use of a hand-operated side lever (see fig. 1). The moulds, invariably metal, consisted of three main parts: the base mould, fitted to the base plate of the press, provided the exterior shape of the object; the plunger, fitted to the plunger arm, formed the interior of the object; and the cap ring, a plate fitted in between the two, which helped to form the rim and allow for small variations in the amount of hot glass fed into the mould. The hot glass was placed in the base mould, the cap ring placed on top

1. Hand-operated glass press showing the base mould being filled with glass and the plunger being lowered; engraving from Apsley Pellatt: *Curiosities of Glassmaking* (London, 1849)

and the plunger brought down by the lever, through the cap ring to squeeze the glass against top and bottom moulds. The lever press was capable of quickly producing vast numbers of identical pieces with the minimum of skill. The first patented press was in operation in the USA in 1829. There were, however, limitations: pressed glass suffers from an irregular surface caused by chilling. Designers countered this with such strategies as covering the entire surface with delicate, decorative detail as in American 'Lacy' glass (*see* UNITED STATES OF AMERICA, fig. 45) or acid etching to create a frosted effect.

As demand grew the simple side-lever press developed into a more complex version in order to facilitate greater speed and the production of more sophisticated and varied objects. The press became automated and was run by compressed air; moulds became multi-partite allowing for the production of heavily undercut and complex shapes. The high cost of the metal moulds gradually became prohibitive and after 1945 pressing was less adventurous.

Flat-glass production developed from crudely hand-pressed and polished sheets in the 17th century to continuous pressing in the 19th and 20th centuries, achieved by forcing hot glass through pre-set metal rollers. This allowed for the development of patterned glass by the use of indented rollers. The centrifuge process is a 20th-century development, where the mould, after being filled with hot glass, is rotated at speed. The centrifugal force pushes the glass into the required shape without the use of a plunger. In slumping pre-cut sheet glass is placed on a mould and heated until it softens and deforms under its own weight into the desired shape. This method is used to make architectural feature windows and simple repetitive decorative items, which are often enamelled at the same time as the glass is deformed. The press-and-blow technique is a combination mass production machine technique, where form and texture can be pressed into the glass prior to its final inflation in a mould.

(iii) Blowing. This technique was developed around the Syro-Palestinian region during the 1st century BC, possibly in response to the growing need for containers for use in trade throughout the Mediterranean. It rapidly became the dominant method of forming glass and especially of making vessels until the 19th century, when many of the basic processes were supplanted by automation, during the Industrial Revolution.

The usual means of blowing hot glass is through a hollow, metal tube (blowing-iron) *c.* 135 mm long and 17 mm in diameter. This is dipped into a crucible containing molten glass, through an opening in the furnace; by rotating the iron a mass or 'gather' of viscous glass is accumulated at one end blocking the hole. This mass can be inflated by blowing, and hot glass can be added to it in a variety of ways. The conversion of this glass bubble (parison) into the desired form requires great skill and often the combined efforts of a team. The master craftsman (gaffer), as head of the workshop, gradually forms the object on the blowing iron and is supported by a range of assistants (servitors) who provide him with constant backup and materials (see fig. 2).

There are many ways in which the basic parison can be given useful form. The most simple is mould-blowing

2. Furnace and lehr with glassblowers gathering, blowing and marvering glass, surrounded by such tools as palettes, pontils and pucellas; miniature from the *Surname-i Humayun* ('Humayun's circumcision ceremony'), *c.* 1582 (Istanbul, Topkapı Palace Museum, MS. H. 1344)

when it is introduced into a mould made from clay, wood or metal depending on the numbers required and inflated. This causes the glass to harden by cooling rapidly as it touches the mould and assumes the shape of the mould. Mould-blowing is an excellent method for manufacturing repetitions of the same form with the minimum of skill and time. It is also possible to create forms that are impossible by ordinary hand manipulation. It was first introduced by Roman glassmakers *c.* AD 25 and the most popular items were flasks in the shape of a head or a bunch of grapes (*see* ROME, ANCIENT, §VIII, 2(ii)). Further gathers of hot glass can be added, initially as blobs, from which the gaffer can form such details as handles or rims using a variety of such simple tools and devices as pucellas (used to form the diameter of the object) and pincers. Objects made without moulds are known as 'free' blown or 'off-hand' blown and require a more complex set of procedures and greater levels of skill.

Any container that has been made from a single parison has to be removed (cracked off) from the blowing iron at the point of inflation. Once cooled this roughened area is smoothed and polished to provide the vessel opening. This method, however, has formal limitations, and to convert a bubble into such an open shape as a dish or plate requires the transfer of the still hot parison on to a solid iron (pontil iron) at a point directly opposite its

connection to the blowing iron with a spot of hot, sticky glass. When adhered to the pontil the parison is broken from its original iron and is therefore attached only to the pontil; the open end can then be flared out. These procedures are very time-consuming, and once glass is gathered from the furnace it immediately cools and solidifies. To carry out more than simple mould-blowing the object being worked must be periodically reheated to restore malleability to the glass. A special furnace (glory hole) is used for this reheating. This process of shaping must be accompanied by the constant, skilled movement of the glass on the iron to keep it central, while forming and decorating the glass with various tools. The process can be extended by further additions of hot glass. These may include other parisons to create complex amalgams to form rims, feet, stems and handles, all of them created from hot, liquid glass using skill, simple tools and the constant centrifugal movement of the blowing iron.

Much of the forming is carried out while the gaffer sits in a special chair (bench) to which are attached two horizontal rails; along these the blowing iron is rolled back and forth with one hand, to keep the mass central, while the other hand is used to tool the glass.

After forming, the cooled object is rigid but full of stress and therefore has to be gradually brought from *c.* 550°C to room temperature (annealing) in a lehr (fig. 2). The exact timing depends on the thickness of the glass, but is usually a minimum of 12 hours. When cold the glass is ready for decorating (*see* §III below).

BIBLIOGRAPHY

H. McKearin and G. S. McKearin: *Two Hundred Years of American Blown Glass* (New York, 1948)
H. Anderson: *Kiln-fired Glass* (London, 1971)
H. Littleton: *Glass Blowing: A Search for Form* (New York, 1971)
A. Pepper: *The Glass Gaffers of New Jersey* (New York, 1971)
A. Polak: *Glass: Its Makers and Public* (London, 1973)
R. Flavell and C. Smale: *Studio Glass Making* (New York, 1974)
F. Kulasiewicz: *Glass Blowing: The Technique of Free-blown Glass* (New York, 1974)
P. Rothenberg: *The Complete Book of Creative Glass Art* (New York, 1974)
C. Lattimore: *English 19th Century Press Moulded Glass* (London, 1979)
J. S. Spillman: *American and European Pressed Glass in the Corning Museum of Glass* (New York, 1981)
K. Cummings: *The Technique of Glass Forming* (London, 1986)
R. Slack: *English Pressed Glass, 1830–1900* (London, 1987)

K. CUMMINGS

2. FURNACES. The main requirements of a glass-melting furnace are first that it should be constructed from materials able to withstand both the heat and the corrosive attack of the glass. This has generally been met either by using alumina-rich clays (fire-clay) or stone with a high silica content (e.g. sandstone). Secondly, the furnace should be capable of reaching and maintaining the temperatures required for the conversion of the fluxed sand to a homogenized liquid. The most commonly used fuel for the furnace has been wood, but coal-fired furnaces pioneered in England at the beginning of the 17th century were used for a while until they were replaced by gas-fired furnaces; there are a few instances of those using electricity; wood and diesel oil are used only in exceptional cases.

Glass-melting furnaces for craftsmen fall into two types: the tank and the pot furnace. The tank furnace is more simple to construct, but is less efficient to run. The walls

of the tank act as the container for the glass, and the heat is transferred into the glass through the top surface; the five remaining glass surfaces shed heat into the tank. The pot furnace contains a crucible made from alumina-rich, clay-based materials, which is placed in the combustion chamber, preferably with a gap between the base of the pot and the furnace floor; heat is then transferred into the glass from all directions. This has been the most common type of glass furnace used throughout history.

Wood-fired furnaces can reach quite high temperatures; the fuel is introduced in the form of long, thin sections with the greatest possible surface area. This time-consuming process causes the fastest possible rate of combustion. The development of coal-fired furnaces involved the use of fire grates, which could be loaded with enough fuel to burn for 10 to 15 minutes and the air was drawn through from underneath the grate.

Gas is the easiest fuel to use and has led to dramatic improvements in thermal efficiency in glassmakers' furnaces. Combustion uses oxygen from the air, but 80% of air is nitrogen, which plays no part in the process, merely absorbing nearly three-quarters of the heat produced and then being exhausted as very hot waste gas. The improvements in glass craftsmen's furnaces were due to the recovery of the heat in the waste gases, and returning it to the furnace by preheating the air supply. When done well this reduces the fuel used by more than 50%, and makes a very substantial contribution to ensuring the economic viability of operating craft-based art-orientated workshops. This technique is called recuperation.

The handworking of glass can be a lengthy process and the glass often requires reheating, to return it to a workable state. The special furnace used by glassmakers is called a glory hole. This horizontal cylindrical furnace is generally run at c. 100°C higher than the glass furnace during glassworking. The skill of a glassmaker largely depends on the successful use of a glory hole to reheat parts of the semi-formed article.

A peculiarity of glass is that it does not have a fixed melting-point; it changes slowly between the liquid and solid states between 450°C and 370°C. If glass is cooled too quickly the outer parts of the glass set solid, while the inner parts are still liquid; the different rates of contraction can cause enormous permanent stresses in the article, sufficient to cause it to fracture. To avoid this, glassmakers slowly cool the finished glass articles in additional chambers called annealing furnaces.

BIBLIOGRAPHY

R. J. Charleston: 'Glass Furnaces through the Ages', *J. Glass Stud.*, xx (1978), pp. 9–34

K. Cummings: *The Technique of Glass Forming* (London, 1980)

PETER WREN HOWARD

III. Decorative techniques.

The ways to decorate glass are many and varied. Some techniques may be used only on specific metals depending on how hard, malleable or plastic the glass is and what pressure it can withstand. This article deals with the methods by category. Such potentially decorative techniques as moulding and colouring are discussed in greater detail in §§I and II above.

1. Hot-working. 2. Cold-working. 3. Coloured glass. 4. Painting. 5. Other.

1. HOT-WORKING. This section deals specifically with decoration created while the glass is in a plastic, malleable state.

(i) Moulded and pressed. Some of the simplest and most effective ways of decorating glass may be carried out during these forming processes. The molten metal is forced into the receptacle of the desired shape either by blowing, casting or pressing. These techniques are discussed in full in §II above.

(ii) Combing and trailing. Molten glass is gathered on to a metal or wooden rod covered with a hard core of clay, sand and animal dung (core-forming). Soft glass of a different colour is then trailed on to the vessel and wound around from top to bottom. After reheating the trailed thread is tooled and combed with a pointed instrument into festoons and then marvered (rolled) on a flat surface to even out the wall thickness. Combed decoration was one of the earliest forms of decoration used on glass and was first used in Mesopotamia and extensively employed by the Egyptians (see EGYPT, ANCIENT, fig. 107; see also colour pl. IV, fig. 2). The same basic technique was also employed to create designs that were not marvered into the body; items with this type of decoration date from the late 1st century AD in the Ancient Near East (see ANCIENT NEAR EAST, §II, 2). Trailing was used to great effect on Roman glass, particularly with 'snake-thread' trails. In the Merovingian and Carolingian periods long, vertical and spiral trails, nipped together to form a lattice pattern, were extensively used.

(iii) Prunts. To create this type of decoration blobs of molten glass are dropped on to the surface of the glass randomly or in a pattern. They were made in a variety of forms and sizes and left either plain or sometimes impressed with a stamp to create such forms as 'raspberries', which are often a feature on the roemer (see ENGLAND, fig. 69). The 'claw beaker' or *Rüsselbecher* was formed by drawing out the applied blob of glass into a hollow proboscis, pulling it out and fusing it to another part of the object; these vessels were made extensively in northern Europe during the Frankish period (5th–8th century AD). The claws were sometimes further decorated with trails (e.g. beaker, 6th century; London, BM). From the medieval period the Rhenish glassmakers decorated beakers with rows of prunts (e.g. *Stangenglas*, early 16th century, London, BM; see GERMANY, fig. 60). Finger cups (*Daumenglas*) were formed using the same basic principle but the applied blobs were flattened and then drawn inwards when the glassblower inhaled through the blow-pipe so that the blobs intruded creating convenient indentations for the fingers.

(iv) Air bubbles and twists. Accidental or deliberate inclusions of air in the glass have been used to decorative effect since glassmaking began. Trapped single or multiple air bubbles, for example, are one of the simplest methods of decorating a stem. A 'teardrop' stem is formed by indenting (pegging) a small depression in the still plastic rod of glass, which is then engulfed with a gob of molten glass to trap the air; the ductile rod is then drawn out so that the air

forms the shape of a teardrop. To create a single air-twist stem the same principle is used and the rod twisted so that the air bubble becomes a helix. To produce a multiple air-twist stem the top of the malleable glass rod is tweaked with tools to create furrows; the shape is then immersed in molten glass, which seals in the pockets of air; the pontil is then securely held while the other end is rotated to create shafts of twisted air throughout the stem; the process can be repeated many times to produce more twists. Opaque-white or coloured strands of glass can be imbedded in transparent glass by rolling a gather of glass over canes set at regular intervals, marvering and blowing the gather into the desired form. Stems of this type of decoration were known as cotton-twist stems (*see* ENGLAND, fig. 70). The generic term for decoration using imbedded tapers of opaque-white or coloured glass is *filigrana* (filigree) and although first used in Murano during the early 16th century (*see* VENICE, fig. 10), it was probably inspired by the rolled edges used to decorate mosaic glass made during the Hellenic period in Europe (*see* GREECE, ANCIENT, §X, 5).

2. COLD-WORKING. Once the object has been formed and allowed to cool and harden, it can be decorated by incising, the techniques for which are discussed below, or painting (*see* §4(i) below).

(i) Incising.

(a) Engraving. This technique involves cutting a design on to a glass surface, using such sharp implements as flints, diamond needles or wheels; the process is similar

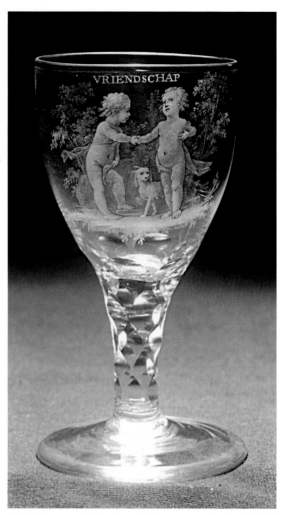

4. Stipple-engraved wine glass with facet-cut stem, by David Wolff, h. 140 mm, from the Netherlands, *c.* 1784–95 (Oxford, Ashmolean Museum)

to gem-engraving. The method of wheel-engraving was first used to decorate Roman glass from the third quarter of the 1st century AD; the process involves cutting patterns on the surface of the glass using discs of hard materials (e.g. copper) and an abrasive (e.g. emery). Suitable metals for wheel-engraving are potash lime glass and lead glass invented by the English glassmaker George Ravenscroft in 1676. Caspar Lehmann, a gem-engraver working in Prague at the court of Rudolf II, is credited as being the first glass-engraver in modern times to have used wheel-engraving. The two types of wheel-engraving are high-relief engraving (*hochschnitt*), where the ground is cut back leaving the design in relief, and intaglio (*tiefschnitt*), where the design is formed by incisions into the surface (see fig. 3). Diamond-point engraving involves creating a design by lightly scratching on to the surface of the glass with a diamond point. The technique was possibly first used in ancient Rome and in Venice in the 16th century and by glassmakers imitating the Venetian style (*see*

3. Wheel-engraved glass plaque depicting *Perseus and Andromeda*, by Caspar Lehmann, 250×180 mm, from Bohemia, *c.* 1605 (London, Victoria and Albert Museum)

PLATE I

Gems

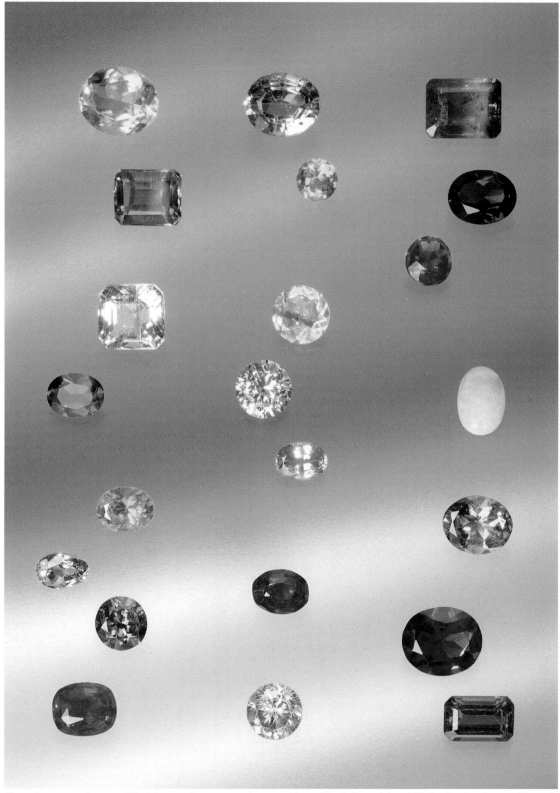

Gems, from top to bottom: (*left*) citrine, amethyst, aquamarine, emerald, sapphire (yellow, pink and blue), ruby; (*centre*) topaz (blue and gold), diamond (yellow, white and pink), red spinel, zircon; (*right*) tourmaline (red and green, green, and rubellite), opal, peridot, garnet (pyrope and hessonite)

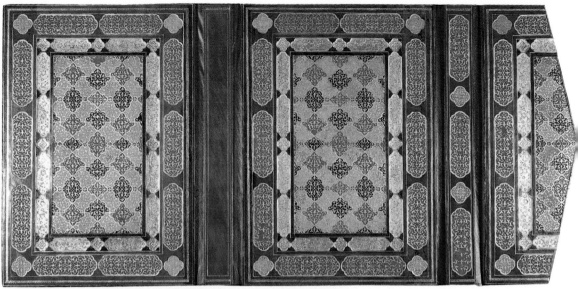

1. Islamic book cover, black leather with gilding, 475×991 mm, from Herat, Afghanistan, 16th century (Lisbon, Museu Calouste Gulbenkian)

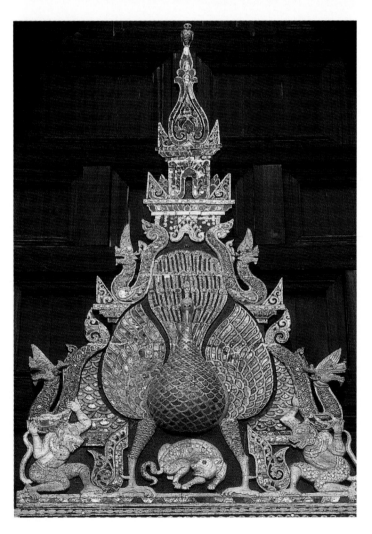

2. Lanna-style pediment (15th–18th centuries), gold leaf on carved teak, h. c. 2 m, Wat Pan Tao, Chiang Mai, Thailand

PLATE III Gilding

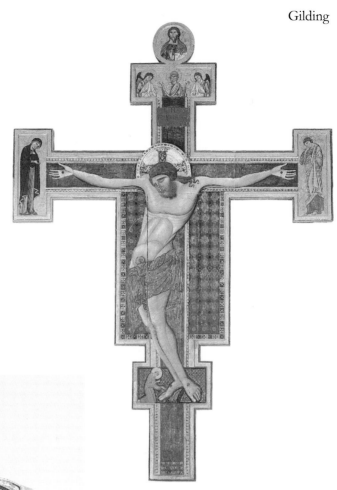

1. *Crucifix* by the Master of St Francis, paint and gilding on panel, incised and punched decoration, 1272 (Perugia, Galleria Nazionale dell'Umbria)

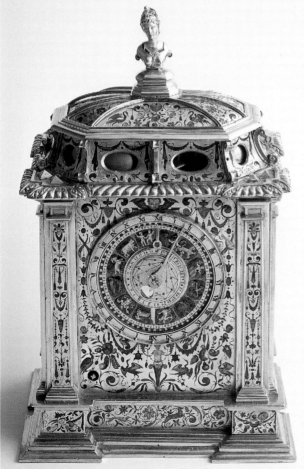

2. Table clock, silver with gilding and *basse taille* enamel, h. 218 mm, case by Cornelius Gross, enamel by David Altenstetter, from Augsburg, *c.* 1570–75 (Vienna, Kunsthistorisches Museum)

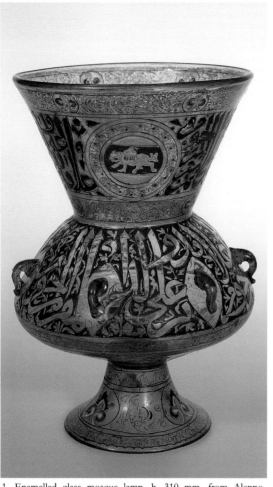

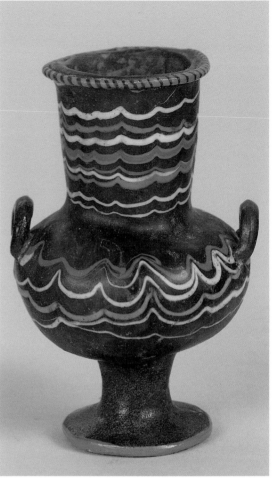

1. Enamelled glass mosque lamp, h. 310 mm, from Aleppo, Syria, 14th century (Lisbon, Museu Calouste Gulbenkian)

2. Core-formed glass unguent bottle (*krateriskos*), h. 98 mm, from Egypt, New Kingdom, 18th Dynasty, 1400–1350 BC (Toledo, OH, Museum of Art)

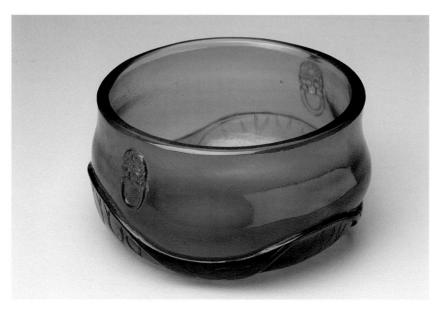

3. Glass bowl, diam. 70 mm, from China, Qing dynasty, 19th century (Boston, MA, Museum of Fine Arts)

PLATE V

Glass

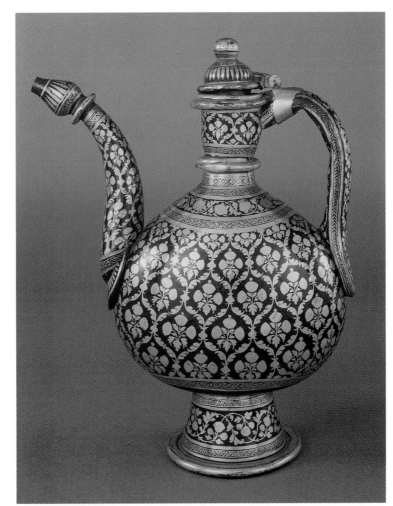

1. Glass ewer with gold paint, h. 280 mm, from India, 18th century (London, British Museum)

2. Relief-cut glass bowl encased in silver gilt with gold cloisonné enamel and gemstones, h. 60 mm, diam. 186 mm, from Iran or Iraq, 9th–10th centuries (glass bowl); with 11th-century Byzantine enamelling and late 10th-century and ?15th-century metalwork (Venice, Tesoro di San Marco)

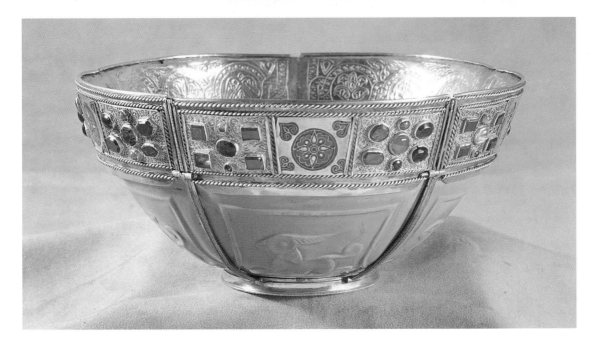

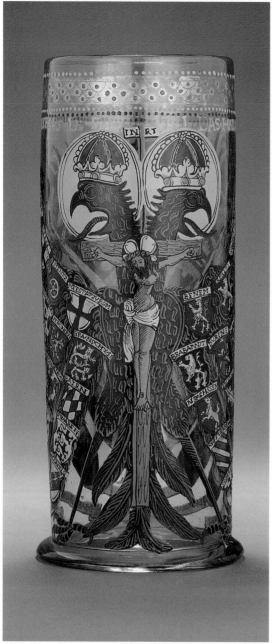

1. Enamelled glass *Reichsadlerhumpen*, h. 268 mm, probably from Bohemia, 1571 (London, British Museum)

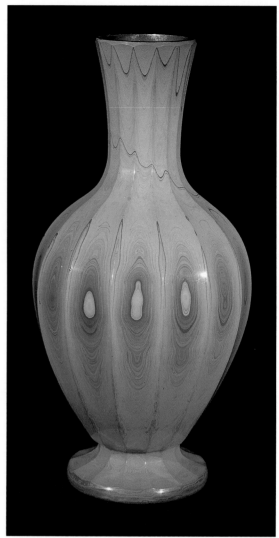

2. Lithyalin glass vase by Friedrich Egermann, h. 305 mm, *c.* 1830–40 (Corning, NY, Museum of Glass)

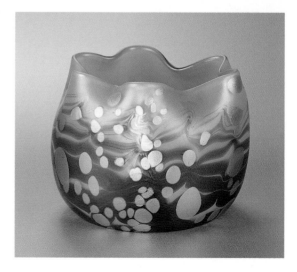

3. Glass bowl with iridescent decoration, h. 90 mm, from the Lötz Witwe Factory, Klostermühle, Bohemia, *c.* 1900 (Düsseldorf, Kunstmuseum im Ehrenhof)

PLATE VII

Glass

1. Core-formed glass alabastron, h. 200 mm, from the east Mediterranean region, probably 1st century BC (London, British Museum)

2. Glass sculpture by Harvey K. Littleton: *Eye*, h. 358 mm, 1972 (Düsseldorf, Kunstmuseum im Ehrenhof)

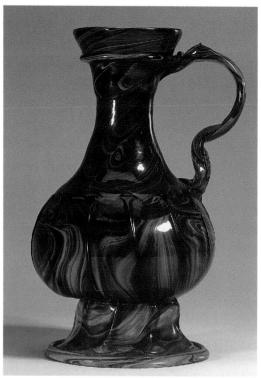

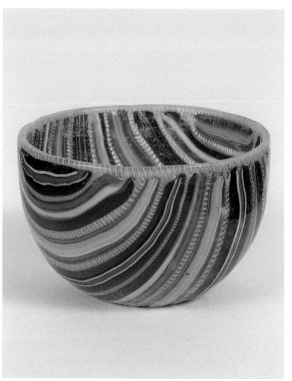

1. 'Chalcedony' glass jug, h. 333 mm, from Murano, *c.* 1500 (London, British Museum)

2. Hemispherical glass bowl, h. 56 mm, diam. of rim 94 mm, probably from Italy, late 1st century BC–early 1st century AD (Toledo, OH, Museum of Art)

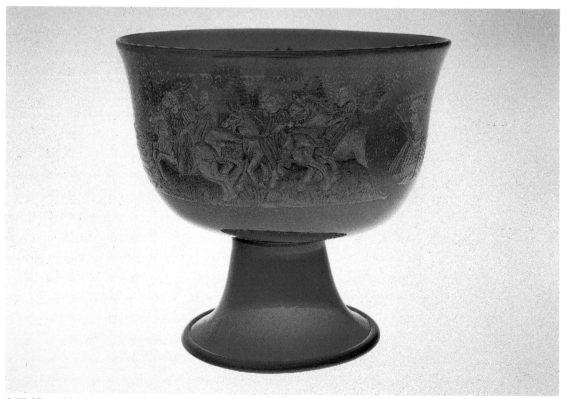

3. Wedding goblet, known as the Barovier Cup, glass with enamel decoration, h. 180 mm, from Italy, 1460–80 (Murano, Museo Vetrario)

ENGLAND, fig. 68). Another form of diamond-point engraving, known as stipple-engraving, was introduced *c.* 1621 by Anna Roemer Visscher (1583–1651) in Holland and was developed during the 17th century. A diamond point is set into a hammer and very gently tapped on to the surface of the object creating a series of dots; highlighted areas contain a high concentration of dots, while dark areas have few or no dots (see fig. 4).

(b) Cutting. This process involves faceting or cutting furrows in a variety of decorative designs by subjecting the glass to a rotating iron or stone disc and abrasives. The technique was used in Mesopotamia during the 5th and 6th centuries and was very common in Roman times. It reached its apogee in England and Ireland during the late 18th and 19th centuries when lead glass—the most suitable metal for deep cutting—was available (*see* IRELAND, fig. 21).

(c) Cameo and cased glass. The creation of this type of glass decoration was first introduced around the beginning of the 1st century AD after the invention of glass blowing. There are two basic ways to achieve cameo glass: the first is by the dip-overlay method in which a gather of glass of one colour is partially dipped into molten glass of another colour, so that it is covered in a thin layer of glass (flashing); the two are fused together during annealing and when cold the outer casing of glass is cut back to reveal the layer beneath. The Romans perfected this

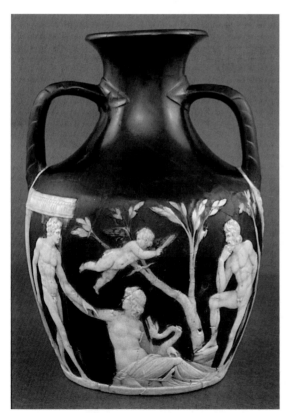

5. Cameo-glass amphora known as the Portland Vase, h. 240 mm, Roman, early 1st century AD (London, British Museum)

technique between the 1st century BC and the 1st century AD; the most famous example of this method is the Portland Vase (see fig. 5). The second method, called 'casing', involves glass of one colour being fused to the inside surface of another, differently coloured glass. This method can be repeated many times to produce multiple layers of glass. The outer casing is made first by blowing a gather and opening it up at one end and placing it in a mould. A second gather is then blown into it and the layers fuse together. The outer layer is thicker than that used for flashed glass and is known as overlay. Cameo decoration was extensively employed on Chinese snuff-bottles during the 18th century (*see* CHINA, §XIII, 10). During the 19th century the term 'plating' was used in the USA to describe casing. Cameo glass was popular in the Art Nouveau period when the leading exponent was EMILE GALLÉ.

(d) Etching. This technique was first introduced in Europe during the 17th century and was extensively used in the 19th century using hydrofluoric acid. The glass is first covered with an acid resist (usually wax) and a design is cut through. The item is then immersed in an acid bath and the exposed design is corroded. The finish is either satin or very matt depending on the length of immersion. For an overall, matt surface the whole item can be immersed, unprotected, into the acid. This technique has been largely superseded by sand blasting.

(e) Sand blasting. This technique involves subjecting the surface of the glass, which was partly covered by a steel template, to a jet of air containing sand, crushed flint or powdered iron. It was invented in 1870 by Benjamin Tilghnman in Philadelphia and proved to be a highly effective method of decorating. It has largely replaced acid etching as it is both safer and cheaper.

3. COLOURED GLASS. This is achieved either by accidental discolouration owing to impurities in the batch or through the deliberate addition of metal oxides. (For a full discussion of the oxides required to achieve coloured glass *see* §I above.) Early glass was often coloured in order to imitate such hardstones as agate, lapis lazuli, jasper, turquoise, chalcedony or porphyry. In order to create the opaque, marbled effect of some of these stones, differently coloured opaque glass is briefly mingled in a melting pot before being gathered and shaped. The process was first used in the eastern Mediterranean from the 2nd century BC. The process was revived in Venice during the early 15th century, when chalcedony glass was produced (see colour pl. VIII, fig. 1). During the 19th century variegated, polychrome glass was very popular throughout Europe; the most notable exponent of this technique was the Bohemian glassmaker Friedrich Egermann (1777–1864) who in 1828 created 'Lithyalin' glass, which imitated the appearance of hardstones through the combination of both opaque and translucent glass; the surface of the finished items very often has the appearance of wood grain (see colour pl. VI, fig. 2).

Mosaic glass refers to glass objects rather than the panels made from tiny tesserae embedded in floors, walls and ceilings (*see* MOSAIC). This process involves fusing

together varicoloured blobs of glass and drawing them out into thin canes. Once cooled the canes are sliced horizontally. The slices are then applied to a mould of the desired shape and then another mould is fitted over in order to keep the slices in position while in the furnace. The surface of the cooled object is ground smooth.

Another method for making such objects as mosaic, hemispherical bowls is by arranging the slices of cane on a flat fireproof clay surface and firing them in the furnace until fused. The disc of glass is then surrounded by a twisted cane of glass and reheated; while still soft it is placed over a clay form and reintroduced into the furnace where it slides down around the mould. Once cooled the object can be ground smooth and polished. This process is known as slumping.

Mosaic beads are made by rolling small blobs of glass over a flat surface covered with tiny slices of the cane. The sections are caught up and marvered into the parent glass and once cooled the beads can be smoothed and polished. *Millefiori* (It.: 'thousand flowers') glass is made using the same basic techniques as those for making mosaic glass. The gathers to make the canes are arranged so as to resemble flowers and when sliced are embedded in a matrix of molten, coloured or colourless glass. The basic technique was probably first introduced in northern Mesopotamia during the 15th century BC (e.g. fragment of a beaker from Tell el-Rimah, mid-15th century BC; London, BM). It was also used with a degree of sophistication by the Hellenistic glassmakers during the second half of the 3rd century BC (*see* GREECE, ANCIENT, §X, 5). The technique reached its apogee in Venice where it was reintroduced and reinvented at the end of the 15th century.

4. PAINTING.

(i) Cold painting. Lacquer colours or oil paints can be applied to glass but are not fired. They are sometimes applied to the back of the object in order that the decoration be protected, otherwise it is liable to rub off. The colours are usually applied to objects too large to fit into the muffle kiln or to those that cannot withstand a second firing to fix the colours.

(ii) Enamelling. Enamel colours are metallic oxides mixed with finely ground glass suspended in an oily medium. While the item is fired at a low temperature (700–900°C) in a muffle kiln, the medium is fired away and the colours are fused as a film on the surface of the object (see colour pl. VI, fig. 1). Enamelling was used on both Roman and Byzantine glass and was combined with extensive gilding on Islamic glass (*see* ISLAMIC ART, §VIII, 5; *see also* colour pl. IV, fig. 1). The *Hausmaler* refined the Dutch method of decorating with transparent, black enamel (*schwarzlot*) during the 17th century (*see* NUREMBERG, §III, 3). After *c.* 1810, thick opaque enamels were largely superseded by transparent, polychrome enamels developed in Bohemia.

(iii) Lustering. In order to achieve an overall lustrous effect the surface of the glass is painted with an oily medium in which metallic oxides of gold, silver, copper or platinum dissolved in acid are suspended. The glass is then fired in a reducing atmosphere and a thin film of metal is fused to the surface. This technique was first used in Egypt from

the 9th century AD. Lustre-painted glass is also known as iridescent glass and was used to great effect during the ART NOUVEAU period in Europe and the USA by such artists as Louis Comfort Tiffany (*see* TIFFANY, (2)), and at such factories as LÖTZ WITWE in Bohemia (see colour pl. VI, fig. 3).

(iv) Staining. Pigments of various colours can be brushed on to the surface of the glass in order to give the impression of stained glass. In the late 13th century silver chloride was brushed on to small panes of glass and fired for use in stained-glass windows (*see* STAINED GLASS). The technique was used on early Islamic glass, and during the 9th century silver chloride was used to produce a yellow stain on Bohemian glass. Glass with staining can be cut through in order to reveal the colourless, transparent glass beneath.

(v) Gilding. This process involves applying gold in the form of leaf, paint or powder to the surface of glass. Gilding can be used alone, with enamelling or with engraving. Gold can be used to decorate the edges of objects or more extensively to create a series of intricate motifs or scenes. It can be applied to the surface of the object in a number of ways using a suspension of honey or mercury or a fixative. With honey gilding the gold leaf is mashed up with the sticky substance, painted on to the object and fired at a low temperature; the deposit is a very soft lustrous gold. The process of mercury gilding involves applying an amalgam of gold and mercury on the surface of the glass; when the mercury burns away, the gold is deposited on the surface. Gold applied in both of these ways can be burnished. Cold gilding or oil gilding involves applying gold leaf to a surface already brushed with linseed oil. This form of decoration is not very permanent and easily rubs off.

(vi) Gold engraving. This form of decoration involves engraving gold leaf with a fine needle and applying it to the outer surface of the glass. Unless it is somehow protected, however, the gold will rub off. One of the ways to ensure the longevity of the gold leaf is by sealing it between two layers of glass. The process involves applying gold leaf to the surface of a usually clear, colourless object, covering it entirely with another sheet of glass and fusing the two layers together. The earliest known examples of this type of decoration are Hellenistic (e.g. Canosa bowls *c.* 200 BC; London, BM; *see* GREECE, ANCIENT, fig. 165). During the first half of the 18th century, the technique became particularly popular in Germany and is known as *Zwischengoldglas*. In France the technique is known as *verre églomisé* (for illustration *see* SALT). Gold leaf can also be protected by a layer of varnish or metal foil.

5. OTHER.

(i) Ice glass. This decorative glass, the surface of which appears frosted or cracked, is achieved by one of two methods: the first involves plunging a blown gather of glass in a tub of water and then quickly reheating it; the second method involves rolling the gather of glass on a clay or metal surface on which randomly placed fragments of glass have been positioned so as to adhere to the gather. The technique was first introduced in Venice during the 16th century.

(ii) Sulphides. During the 19th century, cut glass was sometimes further decorated with small cameo-like encrustations known as sulphides. These opaque-white ceramic medallions usually depicting busts or figures were embedded on the sides or bottoms of clear, often colourless, glass objects. The technique was invented by Barthélemy Desprez (*fl* 1773–1819) in France. The technique was also extensively used to decorate paperweights.

BIBLIOGRAPHY

R. J. Charleston: 'Dutch Decoration of English Glass', *Trans. Soc. Glass Technol.*, xli (1957), pp. 229–43
——: 'Wheel Engraving and Cutting: Some Early Equipment', *J. Glass Stud.*, vi (1964), pp. 83–100; vii (1965), pp. 41–54
D. C. Davis and K. Middlemas: *Coloured Glass* (London, 1968)
P. Jokelson: *Sulphides: The Art of Cameo Incrustation* (New York, 1968)
R. J. Charleston: 'Enamelling and Gilding on Glass', *Glass Circ.*, i (1972), pp. 18–32
T. H. Clarke: 'Lattimo: A Group of Venetian Glass Enamelled on an Opaque White Ground', *J. Glass Stud.*, xvi (1974), pp. 22–56
J. Spillman and E. S. Farrar: *The Cut and Engraved Glass of Corning, 1868–1940* (Corning, 1977)
V. I. Evison: 'Anglo-Saxon Glass Claw Beakers', *Archaeologia* [Soc. Antiqua. London], cvii (1982), pp. 43–76
S. M. Goldstein, S. Rackow and J. K. Rackow: *Cameo Glass Masterpieces from 2000 Years of Glassmaking* (Corning, 1982)
J. S. Spillman: *Pressed Glass, 1825–1925* (Corning, 1983)

IV. Uses.

1. Decorative arts. 2. Architecture. 3. Sculpture.

1. DECORATIVE ARTS. Glass has been manufactured throughout history for the production of decorative arts by many different cultures and civilizations. The ability of glass to be shaped into an endless variety of forms, cut and coloured has ensured its popularity. The history and use of glass as a decorative art are covered in detail in this dictionary under the relevant countries and civilizations.

Glass has often been regarded as a luxury commodity and the earliest use of glass reflects this attitude. Such items as amphoriskoi and alabastra were made from glass as containers for expensive oils, perfumes and unguents. Beads, at first made in blue and black glass and later in a variety of colours and decorated with stripes and spots and later zigzags and chevrons, were first made in Egypt during the 5th Dynasty (*c.* 2465–*c.* 2325 BC); they were threaded into necklaces and bracelets (*see* BEADWORK). Other early uses of glass included gaming-pieces, amulets, pendants and such small sculptures as sacred bulls and rams and shabtis. During the New Kingdom (*c.* 1540–*c.* 1075 BC) glass inlays were made for jewellery and furniture and for setting in gold or other precious metals (*see* EGYPT, ANCIENT, §XVI, 8, and JEWELLERY, colour pl. IV, fig. 2). In China, glass was first used in the Western Zhou period (*c.* 1050–771 BC), to make mosaic beads, eyebeads (*bi*) and decorative hairpins (*see* CHINA, §XIII, 10). Glass beads were also made during the iron age in Europe, as were gaming-pieces, bracelets and inlays for jewellery (*see* PREHISTORIC EUROPE, §VI, 7 and CELTIC ART). The Romans used glass for a variety of purposes and many examples are extant. Glass was used extensively to make tesserae for mosaics (*see* MOSAIC). Glass was also the principal source for the tesserae needed for mosaics and *opus sectile* panels used in Early Christian and Byzantine art to decorate walls and ceilings (*see* EARLY CHRISTIAN AND BYZANTINE ART, §VII, 4; *see also* ICON, colour pl. II, fig. 3).

Because of the refractive nature of glass, it is supremely suitable for lighting fixtures (*see* LIGHTING). Although many early lamps were made of terracotta or bronze, glass examples are known from the Roman period (e.g. lamp, 2nd century AD; London, BM). Particularly fine Islamic mosque lamps, many of which have survived, were made towards the end of the 13th century. These three-sectioned lamps (spread base, bulbous body and flared neck) were fitted with rings so that they could be suspended from the ceiling (see colour pl. IV, fig. 1). Many were decorated with enamelled and gilded arabesques, Arabic inscriptions in cursive script (*naskhi*), heraldic devices, flowers and foliage (*see* ISLAMIC ART, §VIII, 5). As the skill of the glassmaker developed, lighting fixtures became increasingly sophisticated and intricate. The CHANDELIER took numerous forms: simply decorated upward branches soon gave way to such intricately decorated chandeliers known as *ciocche* made by the Venetian glassmaker Giuseppe Lorenzo Briati (1686–1772). During the late 18th century and early 19th, the basic form was suspended with numerous pendants and cascades of cut and multi-faceted drops, which sparkled brightly and created a magnificent display when the candles were lit.

Glass has been used to make mirrors since at least the 1st century BC, when mirrors were made of silvered glass in Egypt. The Roman glassmakers backed their mirrors with a metallic substance or a dark resin to create a reflective surface. By the 16th century the Venetians had produced a superior mirror backed with an amalgam of tin and mercury; the process was known as silvering (*see* MIRROR). Mirrors were in great demand from the 17th century and were framed with lavish surrounds of wood decorated with paint, lacquer, gilding, ivory or precious metals. Such was the expense of glass in the 17th and 18th centuries that rulers, eager to show off their wealth, would sometimes decorate whole rooms with panels of glass (*see* CABINET (i), §4(ii)); the most famous room is the Galerie des Glaces at the château of Versailles (*see* VERSAILLES, §1 and fig. 2). Coloured glass inlays have been used as a way of decorating furniture since they were first employed in this capacity in ancient Egypt and were used to decorate drawer fronts on some bureaus in Venice during the 18th century. During the 19th century press-moulded drawer handles were widely produced in both Europe and the USA and even entire pieces of furniture were made of glass (e.g. toilet-table, designed by Voronikhin, 1804; Corning, NY, Mus. Glass). During the 19th century, many unlikely items were made entirely of glass (e.g. birdcages and clock-cases), some specifically for the international exhibitions in order to demonstrate the virtuosity of the factory or maker; one of the most outstanding examples was the glass fountain (destr. 1936), made by F. & C. Osler of Birmingham, that formed the centrepiece of the Crystal Palace in London where the Great Exhibition of 1852 was held. The PAPERWEIGHT, another 19th-century invention, was extremely popular throughout Europe; it was made in a variety of forms and decorated using a wide range of techniques from cutting to decorative inclusions.

BIBLIOGRAPHY

A. Pellatt: *Curiosities of Glassmaking* (London, 1849)
F. Buckley: 'Old Glass Lamps and Candlesticks', *Country Life* (April 1929), pp. 492–4; (May 1929), pp. 710–12

G. M. Crowfoot and D. B. Harden: 'Early Byzantine and Later Glass Lamps', *J. Egyp. Archaeol.*, xvii (1931), pp. 196–208

P. Hollister: *The Encyclopedia of Glass Paperweights* (New York, 1969)

B. Morris: *Victorian Table Glass and Ornaments* (London, 1978)

R. Grover and L. Grover: *Art Glass Nouveau* (Tuttle, Rutland Vermont, 1979)

V. Arwas: *Glass, Art Nouveau to Art Deco* (London, 1980)

R. von Strasser and W. Spiegel: *Dekoriertes Glas: Renaissance bis Biedermeier: Katalog Raisonné der Sammlung Rudolph von Strasser* (Munich, 1989)

SIMON COTTLE

2. ARCHITECTURE. Glass has long played a central role in architecture, particularly in the West, where it has been highly valued for both its functional and aesthetic attributes. Its ability to provide transparent weatherproofing has made it an indispensable component in buildings, from its use in windows to the development of iron-and-glass skeletal structures in the 19th century and glass curtain walls in the 20th. At the same time, its transparency, reflective properties and the brilliant effects of coloured glass were fundamental to the creation of some of the most celebrated buildings in the western world. Flat glass for windows was traditionally made by the cylinder and the crown processes. In the former, glass was blown and swung into a cylindrical form; the ends were pierced and opened, the cylinder split longitudinally, flattened by reheating and then polished. Crown glass was made by blowing glass into a globe and then spinning it into a flat, circular shape, the maximum thickness being at the centre where a distinctive 'bull's eye' was left by the pontil iron; only small panes could be cut from the circle, but the glass was brilliant and clear, needing no further polishing. These methods were not significantly improved until the 17th century (when plate glass was introduced), with further developments in the 19th and 20th centuries (when drawn sheet and float glass were introduced). In the 15th century only the wealthy could afford glass in architecture. By the end of the 20th century it had become one of the cheapest building materials available and, in response to the pressures of developing technology and commercial and functional requirements, it was increasingly related to the development of architectural form itself.

(i) Before 1800. (ii) 1800–1913. (iii) 1914 and after.

(i) Before 1800. In the architecture of the ancient Mediterranean civilizations, glass played a very minor role. This was partly because glass-making techniques then available were suited only to the production of small artefacts, but there was also a lack of functional imperatives: the climate in the Near East, Egypt and southern Greece required interiors to be protected from heat and sun while admitting air, and this was achieved by small, unsealed openings. Roman techniques for making flat glass suitable for windows, albeit rather coarse and translucent, were introduced, according to Seneca (*d* AD 65), in his own lifetime (*Letters*, XC.xxv). It was used for conservatories and greenhouses, as well as for windows in houses for the wealthy (e.g. at Pompeii; before AD 79). Nevertheless window glass was scarce and costly, and other window coverings, including translucent marble or mica, oiled fabrics or parchment, or simply curtains or shutters, were common until the Middle Ages.

In Early Christian and Byzantine religious architecture, glass was used both in windows and, more significantly, in wall mosaics (*see* MOSAIC, §I). The shimmering glass surfaces of the mosaics (sometimes incorporating metallic foil) not only served a decorative and symbolic role (*see* LIGHT, §5) but also reflected light around the dark interiors, for example in the 6th-century AD churches of S Apollinare Nuovo and S Vitale in Ravenna (*see* RAVENNA, §2). This concept was taken much further in medieval stained-glass windows, particularly in the Gothic period (*see* STAINED GLASS). In this, the first great age of glass architecture, inaugurated at Saint-Denis Abbey (*c.* 1135–44), the walls of Gothic churches were progressively opened up to incorporate huge windows, often filled with coloured glass bearing the Christian message, the illuminated images irradiating the interior with deep glowing colour. It was an appropriate development for the darker, colder climates of northern Europe, and one that was made possible in an age of general insecurity only because of the sanctity of the Church. Medieval glass was available only in small pieces, was of poor quality and often admitted relatively little light. Transparency was not essential, however, and the flaws diffused the light, enhanced the colours and made the glass sparkle. Some of the finest medieval stained glass is found at Chartres Cathedral (begun *c.* 1194; *see* CHARTRES, figs 5 and 6), the Sainte-Chapelle (1243–8; *see* PARIS, figs 34 and 36; *see also* STAINED GLASS, colour pl. I) and King's College Chapel (1448–1515; *see* CAMBRIDGE, figs 4 and 5). The latter two buildings, which appear as almost entirely glazed skeletons, are two of the first 'glass boxes' in architecture.

From the 15th century, as architectural patronage extended beyond the Church into the secular world, and political turmoil eased, glass came to be widely used in the palaces of the aristocracy and throughout society as a whole. Glass produced by the cylinder process remained rather translucent, although transparent panes were available by the more expensive crown-glass process, a technique perfected in Venice and spread throughout Europe in the 16th century. The size of flat sheets was restricted, but by the beginning of the 16th century glazed windows were commonplace. In Italy, windows were often relatively small, as in the Renaissance Palazzo Farnese (begun 1514; *see* PALACE, fig. 1), Rome, by Antonio da Sangallo (ii). By comparison, those in northern Europe were much larger, and in Elizabethan England they were often combined with oriels and projecting bays to maximize the lighting of interiors. In such buildings as Hardwick Hall ('more glass than wall'), Derbys, built in 1590–97 by Robert Smythson, the English nobility made glass a feature of architectural expression (*see* COUNTRY HOUSE, fig. 2). The large Renaissance windows in the Banqueting House (1619–22), London (*see* JONES, INIGO, fig. 1), were replaced in 1685 by the first recorded examples of sliding sashes filled with brilliantly clear crown glass. Large, beautifully proportioned, double-hung sash windows set with lustrous glass panes, with glazing bars that were moulded to reduce contrast, became one of the most prominent features of 18th-century English Georgian architecture.

In the 17th century, more creative uses of glass in architecture emerged, allied to the Baroque manipulation of light. Glazed windows in a variety of shapes and sizes were used to achieve complex lighting effects, as in Guarini's diaphanous domes at the Chapel of SS Sindone,

Turin Cathedral, and S Lorenzo, Turin (both begun 1668; *see* GUARINI, GUARINO, fig. 1; *see also* ITALY, fig. 20). At the same time, silvered-glass mirrors were often employed in combination with windows, thus enhancing and reflecting the light in an overall spatial composition. For example, at the Galerie des Glaces (1678; by Jules Hardouin Mansart) at the château of Versailles, the external wall is reduced almost to an arcade of large, round-headed windows, while the corresponding spaces on the opposite interior wall are lined with mirrors.

The invention of plate glass in France in the late 17th century and of improved cylinder-glass processes in the 18th century facilitated the use of larger panes and larger windows. Plate glass was thicker (and therefore stronger) and flatter, although it was less brilliant than crown glass and needed grinding and polishing to provide a smooth surface; it was employed for large-scale fenestration until the invention of float glass in the 1950s.

More lavish use of glass in architecture can be seen in the development of orangeries lined with huge glass windows; an early purpose-built example is that at Kensington Palace, London (1704; probably by Nicholas Hawksmoor and John Vanbrugh; for illustration *see* OR-ANGERY). Extensive glazing appeared in many 18th-century palaces, for example the Zwinger (1711–28), Dresden (for illustration *see* PÖPPELMANN, MATTHÄUS DANIEL), which grew out of a drawing for an orangery; the Palazzo Madama (1718–21), Turin, by Filippo Juvarra (*see* ITALY, fig. 21); and Sanssouci (1745–7; by Georg Wenceslaus von Knobelsdorff), Potsdam (*see* POTSDAM, fig. 2), where the vineyard terrace was also covered with glass in cold weather.

(ii) 1800–1913. New opportunities for the use of glass in architecture were introduced in the early 19th century with the development of iron structural techniques (*see* IRON AND STEEL, §II, 1). Early fully glazed structures were built for horticultural purposes (*see* GREENHOUSE; *see also* CONSERVATORY), which exploited the 'greenhouse effect'—the opacity of glass to long-wave energy re-radiated from interiors. Among the most beautiful were the Great Stove or conservatory (1836–40; destr. 1920), Chatsworth House, Derbys, by JOSEPH PAXTON (see fig. 6), which used a ridge-and-furrow pattern of glazing with wooden glazing bars and sheet glass; and the Palm House (1845–8; rest. 1984–91; for illustration *see* KEW, ROYAL BOTANIC GARDENS OF) by DECIMUS BURTON and the engineer Richard Turner (*c.* 1798–1881). The Palm House was built after the removal in 1845 of the British excise duty on glass, which had kept the cost of glass high there and inhibited its use. Removal of the tax was a prime cause for the origins in Britain of a second age of glass architecture in the mid-19th century, in which some of the best-known structures to exploit the new techniques were designed by engineers and others rather than architects. Perhaps the most outstanding was the Crystal Palace (1851; destr. 1936), London, designed by Paxton and the engineers Fox & Henderson. This great glasshouse (for illustration *see* PAXTON, JOSEPH) also employed new construction techniques, being prefabricated off-site and erected in only six months (*see also* RATIONALIZED CONSTRUCTION, §2 and fig. 1).

The Crystal Palace was followed by many spectacular, often long-span iron-and-glass daylit structures built to satisfy the growing demands of transport, industry and commerce. Notable examples include glass-vaulted railway stations, such as Paddington Station (1852), London, by Isambard Kingdom Brunel and Matthew Digby Wyatt (*see* RAILWAY STATION, fig. 2); glass-domed commercial exchanges, such as the Corn Exchange (1860–62), Leeds, by

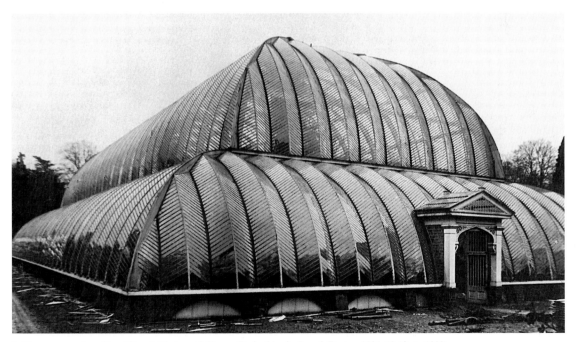

6. Glass conservatory (Great Stove), Chatsworth House, Derbyshire, by Joseph Paxton, 1836–40 (destr. 1920)

Cuthbert Brodrick (*see* IRON AND STEEL, fig. 3); and glass-vaulted shopping arcades, such as the Galleria Vittorio Emanuele II (1863–77), Milan (for illustration *see* MENGONI, GIUSEPPE).

Glass-vaulted roofs continued to be employed in the early 20th century, as in the banking hall of the Postsparkasse (1904–6), Vienna (*see* WAGNER, OTTO, fig. 2). Meanwhile, large glass shop-fronts framed in cast iron had also been introduced, especially in the USA, and from the 1890s, following the introduction of load-bearing structural frames of iron and steel (and, later, reinforced concrete), glass began to be more widely used as an infill element for walls in other buildings. Early examples include the Reliance Building (1889–95), Chicago, by Burnham & Co. (*see* SKYSCRAPER, §2(i) and fig. 1); the Carson Pirie Scott Store (1898–1904), Chicago (*see* SULLIVAN, LOUIS, fig. 2); the AEG Turbine Factory (1908–9), Berlin, by Peter Behrens (*see* MODERN MOVEMENT, fig. 1); and the Fagus Factory (1911–13), Alfeld an der Leine, by Walter Gropius and Adolf Meyer, in which the glazing turned around the corners of the building, anticipating the glass curtain wall. This approach was facilitated by the advent in the early 20th century of continuously drawn sheet glass, which greatly increased the production of glass while reducing its cost. Sheet glass is, however, relatively thin and contains distortions, and plate glass continued to be used for very large panes.

(iii) 1914 and after. If the architects of the 19th century had been slow to realize the potential of glass to create a new architectural aesthetic, the opposite was true of those of the early 20th century. Glass was seen not only as an important functional material for the new industrial age but also as a material offering new concepts of architectural form. This view is exemplified in the influential *Glasarchitektur* (1914) by the German writer PAUL SCHEERBART, a paean in praise of glass founded on his belief in its essential symbolic and material relationship to the brave new world to come: a world of freedom and light admitted by glass. The text was dedicated to Bruno Taut, whose crystalline Glass Pavilion for the *Werkbundausstellung* (1914), Cologne, was an expression of this concept; built for the glass industry and inscribed with epigrams by Scheerbart, it featured a faceted, pointed glass dome and glass-block walls (for illustration *see* TAUT, (1)). Such ideas were explored in the Gläserne Kette ('glass chain'), a short-lived correspondence network instigated in 1919 by Taut with other architects. Among them was Gropius, whose Model Factory at the Werkbund Exhibition (with Adolf Meyer) had used glass to create the 'corner posts' of the building in the form of staircase enclosures, inverting the traditional relationship between solid and void.

With the potential of the new glass technology (including the development of continuous plate-glass production in the 1920s) came further visionary projects, most famously the expressionist glass skyscraper projects (1919–21) of Ludwig Mies van der Rohe, in which floors were cantilevered out from central supporting cores and enclosed by shimmering, transparent glass curtains unimpeded by framing. Here the ambiguous form-making nature of glass was fully exploited, maximizing the transparency of the material and the play of reflections. While

these projects were effectively unrealizable (the fixing and suspension techniques were not then available), Le Corbusier's concept of the '*mur neutralisant*' was realized, if only partially, in his Cité de Refuge (1929–33), Paris. The five-storey window walls to the dormitory blocks were designed to be double-glazed, sealed and the cavity air-conditioned, but the cheaper ventilation system and single glazing finally installed were unable to prevent overheating due to the 'greenhouse effect', and opening windows had to be introduced. Industrial buildings continued to employ glass extensively, as in the Van Nelle Factory (1925–31), Rotterdam (for illustration *see* BRINKMAN, (2)); the Boots Wets Factory (1930–32), Beeston, Notts (for illustration *see* WILLIAMS, OWEN); and the Dodge Half-Ton Truck Plant (1937; by Albert Kahn), Detroit (*see* UNITED STATES OF AMERICA, fig. 9).

Glass was used in a different way at the church of Notre-Dame-du-Raincy (1922–3; *see* PERRET, fig. 1), near Paris, where walls of precast-concrete elements filled with coloured glass echoed the medieval concept of the glass cage. At the Maison de Verre (1928–32; see fig. 7) by Pierre Chareau and Bernard Bijvoet, a wall of gridded glass blocks admits soft, diffused light from a typical Parisian courtyard. The concept of continuous, horizontal strip ('ribbon') windows was emphasized by Le Corbusier, as in the Villa Savoye (1929–31), Poissy (*see* VILLA, fig. 10), while Mies van der Rohe used huge plates of glass to form transparent walls for freely planned houses that merged inside with outside. In his German Pavilion (1929) at the Exposición Internacional, Barcelona, for example, glass walls (some transparent, some opaque) were fixed in a light metal framework between the floor and roof planes, a concept further developed in the Farnsworth House (1945–50), Plano, IL (*see* MIES VAN DER ROHE, LUDWIG, figs 1 and 3). The latter was the inspiration for Philip Johnson's Glass House (1949), New Canaan, CT, an entirely glazed pavilion set among trees, so that the landscape appears to form the boundary of the rooms. In these buildings the architectural concept is derived from the use of glass.

Beautiful as they were, these glass houses were ultimately less influential than Mies van der Rohe's tall office and apartment buildings, which perfected glass and metal-framed architecture. These included the Lake Shore Drive Apartments (1948–51), Chicago (*see* UNITED STATES OF AMERICA, fig. 10), and the Seagram Building (1954–8; with Philip Johnson), New York, in which purpose-made bronze-tinted plate glass fills a gridded frame of beautifully detailed bronze. These and other buildings, notably those by Skidmore, Owings & Merrill, such as Lever House (1950–52), New York (*see* INTERNATIONAL STYLE, fig. 2), contained the seeds for a rather less felicitous phase of glass architecture, in which the glass curtain wall—to Mies a shining form-maker—became, to the commercial property developers of Europe and North America in particular, the ideal, cheap solution to the cladding of framed office buildings, its thinness maximizing rentable floor area. A striking variation to this approach was provided by Frank Lloyd Wright's research tower (1944–50) at the Johnson Wax Building, Racine, WI, where bands of glass tubing were used to accommodate the rounded corners of the building.

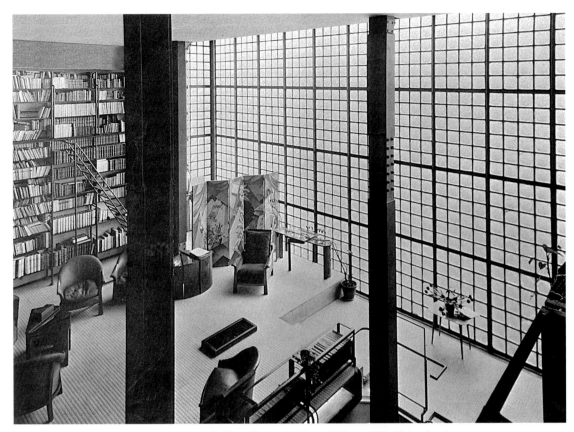

7. Glass-block wall of the Maison de Verre, Paris, by Pierre Chareau and Bernard Bijvoet, 1928–32; interior view

The enduring popularity of glass curtain walls, however, was stimulated by the development in the 1950s of the float glass process, in which a continuous ribbon of molten glass is floated on to a surface of molten tin, providing a fine, fire-finish that needs no further polishing. Flat glass became plentiful and cheap, in thicknesses from 3 mm to 24 mm, and float glass thereafter generally superseded sheet and plate glass. With the increasing use of glass in large buildings, the failings inherent in the material began to be addressed. One of the most serious is thermal performance, resulting in heat gain due to the 'greenhouse effect', exacerbated in warm climates, and heat loss by conduction in cold climates. Heat gain requires excessive input of energy for air-conditioning, particularly in the sealed environment of the skyscraper, and this led to the development of sun-shading devices, initiated earlier in the *brises-soleil* devised by Le Corbusier and used, for example, on the exposed façade of the Ministry of Education and Health (1937–43; by Lúcio Costa, Oscar Niemeyer and others), Rio de Janeiro (*see* BRAZIL, fig. 5); other types of structural sun-shading were also developed, for example in Australia (*see* AUSTRALIA, §II, 2). Attempts in the 1950s and 1960s to control solar heat gain using heat-absorbent tinted glass and reflecting coated glass were limited in effect and often produced rather gloomy interiors; the continuous nature of the float process inhibited variations in colour, leading to a limited range of green, blue, bronze or grey tinted glass. This period did,

however, produce techniques to overcome some of the other failings of single sheets of glass, including the hazards of breakage: such developments as laminated, heat-toughened and wired glass for structural strength and fire-resistance, as well as multiple glazing (recommended in 1914 by Scheerbart) for thermal and acoustic performance, were accelerated by legislation in many countries in relation to safety and energy conservation.

Glass continued to be employed expressively in churches, as in Oscar Niemeyer's cathedral (1958–87; see fig. 8) at Brasília, which evokes the skeletal structure of the Gothic cathedral. Glass roofs using factory glazing evocative of the 1920s appeared in such works by JAMES STIRLING as the Engineering School (1959–63; with James Gowan), University of Leicester, and the History Faculty Building (1964–7), Cambridge. The development of new techniques in the 1960s and 1970s, however, revolutionized the use of glass, particularly in commercial architecture. Thin-film technology allowed the development of new types of reflective or mirror glass that are better at controlling the flow of radiant energy and do not interfere with the basic float process. New bolt-fixing methods also became available, together with translucent silicone sealants for jointing. Used in combination with toughened glass, these permitted the realization of the frameless glass curtain, as opposed to the curtain wall carried in mullions and transoms, and the shimmering glass skins prefigured in Mies van der Rohe's visionary projects of the 1920s

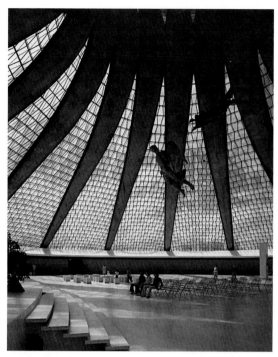

8. Glass and concrete structure of the cathedral, Brasília, by Oscar Niemeyer, 1958–87

were finally achieved. His curvilinear project is echoed in the low-rise Willis Faber & Dumas Building (1974; by Foster Associates), Ipswich, which has a reflective glass cladding suspended from the structure to form a smooth glass curtain that is curved to follow the street line (for illustration *see* CURTAIN WALL (ii)). More prismatic geometric forms appeared in such buildings as the John Hancock Tower (1967–76), Boston, and Allied Bank Plaza (1986; now First Interstate Tower), Dallas, both by I. M. Pei & Partners, and the Pacific Design Center (1975), Los Angeles, by CESAR PELLI. The use of mirror glass in such large buildings has the capacity to diminish their bulk by apparently dissolving them into their surroundings or merging them with the sky (see fig. 9).

Collaboration between architect and glassmaker is an important factor in achieving special effects in many buildings. At the Museum of Glass (1976; by Gunnar Birkerts & Associates), Corning, NY, thin-film technology was used to produce an almost soft feel to the glass overpanels, which are made in patterned glass backed with a stainless-steel coating. At the Lloyd's Building (1977–86), London (for illustration *see* ROGERS, RICHARD), a patterned glass with a multitude of tiny lenses produces a beautiful sparkle. This building also incorporates a triple-glazed air-handling skin. For the Pyramide (1985–9) at the Louvre, Paris (*see* PYRAMID, fig. 4), where the architects I. M. Pei & Partners wanted a 'water-white' glass, a chemical composition used for optical glass was employed. The quasi-structural use of glass was also increasingly exploited, as in the glazed enclosure designed by Philip Johnson and John Burgee (*b* 1933) for the Crystal Cathedral (1980), Garden Grove, CA—an enormous envelope of glass

supported on a delicate steel space-frame (*see* IRON AND STEEL, fig. 5). One of the most widespread developments in glass architecture of the late 20th century was the use of the glazed atrium to provide a daylit space at the centre of a large building, particularly in hotels, where the concept was introduced by JOHN PORTMAN; in such buildings as the Marriott Marquis Hotel (1985), Atlanta, the atrium rises more than 40 storeys (*see* HOTEL, fig. 2). With this concept, architects reinterpreted the glazed conservatories and halls of the 19th century. Glass was increasingly used as part of a new approach to energy-efficient buildings using passive solar control. At the same time, continuing technological developments (e.g. much stronger, machinable ceramic glass and chromogenic variable transmission films) ensured glass a role at the forefront of new developments in architecture.

See also WINDOW; LIGHTING.

BIBLIOGRAPHY

P. Scheerbart: *Glasarchitektur* (Berlin, 1914/*R* Munich, 1971); Eng. trans., ed. D. Sharp (London, 1972)
N. Davey: *A History of Building Materials* (London, 1961)
D. B. Harden: *Domestic Window Glass: Roman, Saxon, Medieval*, Studies in Building History, ed. E. M. Jope (London, 1961)
R. McGrath and others: *Glass in Architecture and Design* (London, 1961)
E. Schild: *Zwischen Glaspalast und Palais des Illusions* (Berlin, 1967)
P. R. Banham: *The Architecture of the Well-tempered Environment* (London and Chicago, 1969)
M. Hennig-Schefold: *Transparenz und Masse* (Cologne, 1972)
J. Hix: *The Glass House* (London, 1974)
H. J. Cowan: *The Master Builders: A History of Structural and Environmental Design from Ancient Egypt to the Nineteenth Century* (New York, 1977)
R. H. Bletter: 'Interpretations of the Glass Dream: Expressionist Architecture and the History of the Crystal Metaphor', *J. Soc. Archit. Historians*, xl (1981), pp. 20–43
M. Foster, ed.: *Architecture: Style, Structure and Design* (New York, 1982), pp. 146–65

9. Reflective glass cladding of the Reunion Hotel, Dallas, TX, by Welton Becket & Associates, 1976–7

S. Koppelkamm: *Glasshouses and Wintergardens of the 19th Century* (London, 1982)
M. Wigginton: *Glass in Architecture* (London, 1990)

MICHAEL WIGGINTON, VALERIE A. CLACK

3. SCULPTURE. The contemporary metamorphosis of glass as a medium for making sculpture began in the 1950s as part of a general movement to explore its possibilities for artistic expression. Generally 20th-century art works in glass revealed the influences of the various modern movements in painting and sculpture, ranging from Cubism to Pop art. The main tendency among sculptors, painters and craftsmen, however, was to exploit the malleability and unique properties of glass: its hardness, brilliance, transparency and unlimited colour range. Glassmakers of the 1950s and 1960s were fascinated by the decorative glassware from the Art Nouveau and Art Deco periods, with its rich infusions of abstract colour effects, which they saw as relevant to Abstract Expressionist painting. Small, highly original decorative glass sculptures and figures produced from *c.* 1900 to the 1930s were also influential. Most were produced in France by such glassmakers as François-Emile Décorchemont (1880–1971), Gabriel Argy-Rousseau (*b* 1885) and the Belgian, Georges Despret (1862–1952), all of whom regularly exhibited their glass at the Paris Salons (e.g. purple *pâte-de-verre* mask by Despret, h. 110 mm, *c.* 1905; priv. col.). The thick-walled, sculptural vases and bowls created in heavy blown glass by MAURICE MARINOT between 1920 and 1937 were an uncompromising example of artistic independence and a pointer to future possibilities. Such enhancing 'accidents' as bubbles, impurities in the batch and embedded skeins of colour, as well as such surface abrasion techniques as acid-etching and deep wheel-cutting derived from well-established practices, were owed to the research and experimentation of Marinot and others between the two world wars.

The studio glass movement first took root in Europe among painters, sculptors and glass designers who worked independently, away from the factory environment or in workshops attached to factories. At such large glassmaking factories as those of the DAUM brothers in Nancy, the Royal Leerdam Glassworks near Utrecht in the Netherlands and the Barberini and Fratelli Toso families in Murano, Venice, professional craftsmen produced glass sculpture from designs by well-known artists (e.g. Jean Cocteau, *Face (Reality)*, glass figure, h. 305 mm, 1966; New York, Mr & Mrs Arnold A. Saltzman priv. col., see 1973 exh. cat., p. 11). Some painters and sculptors also created independent pieces under factory conditions, among them Paul Jenkins, who in the 1960s worked in Italy with the Fucina degli Angeli factory (e.g. *Buddha's Tooth*, coloured glass, h. 382.5 mm, 1969; priv. col., see 1973 exh. cat., p. 30). By the early 1960s the movement had spread to the USA, led by HARVEY K. LITTLETON, who established two glass workshops at the Toledo Museum of Art, OH. Littleton employed a range of techniques from blown glass to assemblages of cut, softened (slumped) glass sheets and rods (e.g. *Amber Crested Form*, 1976; New York, Met.; see fig. 10; *see also* UNITED STATES OF AMERICA, §VIII, 3 and colour pl. VII, fig. 2). Much modern glass sculpture in the USA was the

10. *Amber Crested Form* by Harvey K. Littleton, blown glass, h. 419 mm, 1976 (New York, Metropolitan Museum of Art)

product of individual workshops using small furnaces and developing new formulae for creating glass that could be melted at lower temperatures. During the 1970s methods were greatly refined. Pieces were free- or mould-blown and surfaces were smoked, sandblasted or electroplated. Styles were frequently playful, replete with allusions to nature or the human figure, as in *Rage* (h. 458.5 mm, 1972; artist's col., see 1973 exh. cat., p. 31) by Roberto Moretti (*b* 1930); this depicted an abstracted, blown-glass man with arms comically upraised. Abstract forms, however, predominated and sculptors took full advantage of the medium's fluid, expressionistic qualities as well as its clarity.

Abstract work was vital to modern glass sculpture produced in Europe and Scandinavia and exhibited throughout the world. Some of the finest of this was inspired by the achievements of the designers at the Orrefors Glasbruk at Orrefors Småland in Sweden, among them Sven Palmqvist (1906–84), whose glass screen *Light and Dark* (Geneva, Un. Int. Télécommunic.) is a notable example of the sculptural use of 'Ravenna' glass (*see* SWEDEN, §VIII). The Danish glassmaker Per Lütken (*b* 1916) gained similar renown for his more utilitarian

designs, such as his smoked glass 'duckling' vases (Fensmark, Holmegaards Glasværker; *see* DENMARK, §VIII, and fig. 19); in Finland, Tapio Wirkkala (*d* 1985) produced glass pieces inspired by the Finnish landscape. In Germany such glass artists as Erwin Eisch (*b* 1927), who became known in the 1950s as a Pop artist, redeveloped his techniques to make such sculptures as *Pop Piece* (artist's col., see Klein and Lloyd, p. 264). Most Czech glassmakers worked independently while also designing for Bohemian and other European glass factories. Věra Lišková (*b* 1924) employed the lampwork technique, forging items from long, multiple strands from the gather (e.g. *Porcupine*, l. 280 mm, 1972–80; Corning, NY, Mus. Glass); while Marian Karel (*b* 1944) carved and polished geometric structures from blocks of optical glass (e.g. *Cube*, h. 180 mm, 1980; artist's col., see 1981 exh. cat., p. 126). Modern glass sculpture brought new direction to a material once dominated by utilitarian traditions.

BIBLIOGRAPHY

J. E. Hammesfahr and C. L. Strong: *Creative Glass Blowing* (San Francisco, 1968)
American Glass Now (exh. cat. by O. Wittmann, Toledo, OH, Mus. A. and elsewhere, 1972–4)
International Glass Sculpture (exh. cat. by K. M. Wilson, A. Gasparetto and R. M. Willson, Coral Gables, FL, U. Miami, Lowe A. Mus., 1973)
New Glass: A Worldwide Survey (exh. cat. by R. Lynes and others, Corning, NY, Mus. Glass and elsewhere, 1979–81)
Czechoslovakian Glass, 1380–1980 (exh. cat. by D. Hejdová and others, Corning, NY, Mus. Glass; Prague, Mus. Dec. A.; 1981)
D. Klein and W. Lloyd, eds: *The History of Glass* (London, 1984)

☐

V. Conservation.

1. DETERIORATION AND PREVENTION OF DAMAGE. Although glass can be formulated and toughened in such a way that it can withstand high temperatures, the glass used for creating objects of art tends to be brittle and susceptible to thermal shock. Its hardness, and thus the ease with which it becomes scratched or worn, varies and decorative applications of enamel, paint or gilding may be subject to flaking or wear. Some of the recipes used through the history of glassmaking have produced glass that is chemically unstable. The glass may suffer from diminished transparency owing to fine surface crizzling, and small pieces of glass may spall off the surface. In certain conditions the surface becomes sticky, or beads of moisture appear. This type of deterioration is referred to as glass 'disease' or glass 'sickness' (see fig. 11). In some cases where manganese has been used as a decolourant in the glass batch the glass may take on a pinkish hue because of oxidation of the manganese. It is thought that the composition of 'sick' glass is unstable owing to an inadequate level of lime and too much alkali, which causes the glass to be susceptible to hydrolytic attack. Alkalis leach out on to the surface where they form hydroscopic salts. In conditions of high humidity this produces a weeping effect. If the glass is subjected to low relative humidities these salts crystallize and water, which has replaced the alkalis in the glass network, will dry out, causing the glass to crizzle.

Water may corrode glass vessels that have contained liquids for an extended period and a milky or iridescent surface is deposited on the inside. Deterioration may also

11. Wine glass showing symptoms of glass disease, h. 127 mm, diam. 86 mm, Venetian, 17th century (London, Victoria and Albert Museum)

occur when glass has been buried, which results in surface pitting or the formation of weathering crusts. Weathering crusts are usually opaque and may be iridescent, and have a tendency to flake off.

Damage is preventable through careful handling and controlled storage conditions. Fingerprints may attract dirt and moisture, and the acid from skin can cause corrosion. Glass should be stored in dust-free display cases, and controlled conditions of relative humidity (42–45%) are recommended for glass that shows signs of glass disease. This is important as in the late 20th century there are no other methods of preventing deterioration of 'sick' glass. The temperature should be kept reasonably stable and bright lights that heat up the case should be avoided. Stacking of glass objects should also be avoided, and there should be sufficient space between objects to allow safe handling.

2. EXAMINATION. Glass objects are examined in order to define the nature of any damage or deterioration, and to establish the composition and methods of manufacture. Most damage and old restorations are clearly visible to the naked eye. Microscopes are useful for examining the surface in detail and for examining inclusions in the glass. Air bubbles, which are usually elliptical, will indicate which way the metal was stretched during forming. X-radiography may be used for examining the structure of opaque

glass, and ultraviolet light will sometimes provide information as to the composition of the glass. Various analytical techniques can be used to provide detailed information about the composition of glass.

3. CLEANING. Sound glass may be washed in warm water with the addition of non-ionic detergent. (Detergents that have a high phosphate content, such as those used in dish-washers, can cause clouding of lead glass, and spots or rings on high-alkaline soda glass when used in hot water.) This is followed by careful rinsing and drying. If vulnerable decoration is present or if there are any old restorations, the object is cleaned using cotton-wool swabs dipped in water. Drying may be aided by swabbing with industrial methylated spirit. If the surface is friable a brush may be used instead of cotton-wool swabs to avoid snagging any flakes.

'Sick' glass with sticky or weeping surfaces may be rinsed in de-ionized water to remove surface dirt and salts but must be dried thoroughly using industrial methylated spirit. Weathered layers from archaeological glass are not usually removed as this alters the dimensions of the object and removes any surface decoration. Excess dirt is removed with a dry brush. Ultrasonic cleaning tanks can be safely used to remove dirt from inaccessible places provided the glass is undecorated and sound.

4. BONDING. The smooth edges of glass make bonding difficult and the transparency makes total concealment impossible. Greatest success is achieved when an adhesive that has a refractive index as close as possible to that of the glass is used. The adhesive should also be water white, durable and reversible without damage to the object. A range of epoxy resins, acrylic and vinyl polymers and cellulose nitrate adhesives are used.

The edges of the glass are degreased with solvent before applying the adhesive, which must be spread evenly over the glass to avoid air bubbles in the joint. Depending on the adhesive used, the joints are then held in place with adhesive tape, hand-held or propped in position while the adhesive cures. Alternatively, when there are multiple breaks, the object can be assembled 'dry' with tape and afterwards a low viscosity adhesive fed in along the joints. Care is taken to avoid applied surface decoration if tape is used.

Occasionally such breaks as those in the stems of glasses or vases may need the added strength of a dowel. This is usually made of glass or perspex and is inserted with adhesive in holes made with a drill and diamond burr.

5. RESTORATIONS. When material is missing from a glass object, it may be reassembled on a glass or perspex support. Alternatively small chips or larger missing areas may be filled: an ideal filling material for glass should be transparent and colourless. It should adhere well to the glass, should not shrink and should be capable of being polished to a high shine. It should also be durable and reversible without damage to the object. Those most commonly used are acrylic, polyester and epoxy resins.

Preformed polymethacrylates are cut out, heated and bent to the required shape. They are then secured in position with adhesive. Other materials used are liquid until cured and are usually used in conjunction with a mould made from dental wax, clay or silicone rubber. If the object is coloured, dyes or pigments are mixed into the casting material and if the glass is opaque, such fillers as fumed colloidal silica are added to give the desired effect. After it has cured the filling may be polished using abrasive pastes or a polishing burr on a small dental drill. Any surface decoration is painted on to the surface of the cured resin with dyes or pigments mixed into acrylic or epoxy resins, or one of the lacquers commonly used for retouching ceramics. Gilding is replicated using gold leaf, gold or bronze powders.

BIBLIOGRAPHY

M. Bimson and A. E. Werner: 'The Danger of Heating Glass Objects', *J. Glass Stud.*, vi (1964), pp. 148–50
R. M. Organ: 'The Safe Storage of Unstable Glass', *Mus. J.*, lvi (1965)
R. Errett: 'The Repair and Restoration of Glass Objects', *Bull. Amer. Group IIC*, xii (1972), pp. 48–9
R. Newton: *The Deterioration and Conservation of Painted Glass*, Corp. Vitrearum Med. Aevi (Oxford, 1974)
R. H. Brill: 'Crizzling: A Problem in Glass Conservation', *IIC Conference: Conservation in Archaeology and the Applied Arts: Stockholm, 1975*
J. C. Ferrazzini: 'Reaction Mechanisms of Corrosion of Medieval Glass', *IIC Conference: Conservation in Archaeology and the Applied Arts: Stockholm, 1975*
S. Davison: 'The Problems of Restoring Glass Vessels', *The Conservator*, ii (1978)
N. Tennent: 'Clear and Pigmented Epoxy Resins for Stained Glass Conservation', *Stud. Conserv.*, xxiv (1979)
S. M. Bradley and S. E. Wilthem: 'The Evaluation of Some Polyester and Epoxy Resins Used in the Conservation of Glass', *Preprints of ICOM Committee for Conservation, 7th Triennial Meeting: Copenhagen, 1984*
S. Davison: 'A Review of Adhesives and Consolidants Used on Glass Antiquities', *IIC Conference: Adhesives and Consolidants: Paris, 1984*
R. Errett, M. Lynn and R. Brill: 'The Use of Silanes in Glass Conservation', *IIC Conference: Adhesives and Consolidants: Paris, 1984*
P. Jackson: 'Restoration of Glass Antiquities', *Preprints of ICOM Committee for Conservation, 7th Triennial Meeting: Copenhagen, 1984*
N. Tennent and J. Townsend: 'Factors Affecting the Refraction Index of Epoxy Resins', *Preprints of ICOM Committee for Conservation, 7th Triennial Meeting: Copenhagen, 1984*
——: 'The Significance of the Refractive Index of Adhesives for Glass Repair', *IIC Conference: Adhesives and Consolidants: Paris, 1984*
S. Davison and P. Jackson: 'The Restoration of Decorative Flat Glass: Four Case Studies', *The Conservator*, ix (1985)

SUSAN BUYS

Glasshouse. *See* GREENHOUSE.

Glass painting. Method of producing pictures and ornamental designs on the back of a clear glass panel to be viewed from the opposite side in reflected light. Unlike translucent stained glass, the reverse painted decoration is not fused to the support by firing. The powdered colours are mixed with a binding substance and applied directly to the glass, which becomes an integral part of the picture by providing both the base and the transparent cover for the artwork when the panel is turned. The layer of pigment adheres firmly to the smooth surface, and the colour retains the freshness reminiscent of enamels.

The process begins with a drawing of the subject, positioned under a suitable glass surface. The outline of the pattern is traced and filled in with a blend of colours to fit the design. Working with opaque pigments, the artist has to reverse the standard procedure and begin the painting by exactly placing the highlights and fine details that would normally be put down last. The image must be developed around these fixed points, and corrections by

covering the error with additional pigment cannot be made. The laborious method of painting backward is not employed when thin layers of translucent colours are superimposed following a standard production sequence.

Cold painting on glass was known in the Roman world: numerous fragments of polychrome images have survived, but complete objects are rare. An important example of the latter is a circular plate of colourless glass (diam. 210 mm, *c.* 3rd century AD; Corning, NY, Mus. Glass) reputedly found in southern Syria. The shallow dish of the plate is reverse-painted on the exterior with the *Judgement of Paris* in black, white, shades of grey, yellow, brown and violet on a red background. This technique seems to have been forgotten until the Renaissance, and the sudden flowering of reverse-painted flat glass in northern Italy at this time was without apparent precedent.

In the 14th century unfired pigment was used on the reverse of small glass panels in reliquaries and house altars. Through the following centuries glass painting, in combination with gold-leaf engraving, was found on a vast assortment of devotional objects and ornaments (extensive holdings in Turin, Mus. Civ. A. Ant.). Luxury goods from Lombardy reached the Low Countries and the Rhineland, but a variety of painted glass objects was eventually produced in the area, including the major manufacturing centres at Nuremberg and Augsburg. The secular use of glass painting evolved during the 17th century, with elaborate mirrors, wall pictures and panelled cabinets featuring in patrician houses and princely collections. Glass painting became a recognized European art form. In Switzerland, for example, Carl Ludwig Thuot (*c.* 1677–88) executed a notable *Adam and Eve* (1686; Zurich, Schweizer. Landesmus., see fig.).

Towards the end of the 18th century a cottage industry was established in the German and Austrian countryside to meet the demand for inexpensive religious pictures sold at markets and church festivals. For most of the 19th century small village workshops produced extraordinary numbers of reverse paintings on glass (examples in Munich, Bayer. Nmus.; Vienna, Mus. Vlkerknd.) using popular prints as patterns, and the wholesale distribution of these works reached far beyond regional boundaries. Between 1852 and 1864 a single family workshop in Sandl, Austria, produced 386,000 pictures. By 1900 chromolithography had replaced the painting tradition, but the colourful pictures are collected and valued as folk art.

For further illustration *see* SENEGAL, fig. 2; *see also* GRISAILLE.

BIBLIOGRAPHY

H. W. Keiser: *Die deutsche Hinterglasmalerei* (Munich, 1937)
G. M. Ritz: *Hinterglasmalerei* (Munich, 1972)
L. Schmidt: *Hinterglas* (Salzburg, 1972)
W. Brückner: *Hinterglasmalerei* (Munich, 1976)
S. Pettenati: *I vetri dorati graffiti e i vetri dipinti* (Turin, 1978)

RUDY ESWARIN

Glass print. *See* CLICHÉ-VERRE.

Glastonbury Abbey. Former Benedictine monastery in Somerset, England. Glastonbury has attracted myths and romance for centuries, and the endurance of such thoughts has continued in its attraction to contemporary 'alternative' cultures. The site itself encourages such ideas, for the 'island' of Glastonbury is a group of low hills set in flat meadows dominated by the extraordinary outcrop, Glastonbury Tor, visible 30 km away. The area has been constantly inhabited from Mesolithic times and the lake villages here and at Meare indicate extensive pre-Roman settlement. Excavation has partly revealed a substantial Celtic Christian cemetery, surrounded by a ditch, southwest of the medieval Great Church, containing mausolea and wattle oratories, one of which at least, the 'Vetusta Ecclesia' (ancient church), existed until 1184. When William of Malmesbury wrote his discerning history *De antiquitate Glastonie ecclesie* (*c.* 1125), Joseph of Arimathea and King Arthur, with St Patrick, St David and many British saints, had become part of the Glastonbury tradition, although it was later medieval writers who greatly expanded such legends to promote pilgrimages and the primacy of the Abbey as the earliest Christian site in England. Arthur was first associated with Glastonbury in the *Life of St Gildas* (*c.* 1150). In 1190 bones discovered between two 'pyramids' to the south of the present Lady chapel were supposedly identified as Arthur's by an inscribed lead cross. In 1278 they were ceremonially reinterred in front of the high altar by Edward I.

Until its Dissolution in 1539, Glastonbury was one of the greatest and wealthiest abbeys in Europe. Given its vast wealth and the recorded library lists, the Abbey must have been a substantial patron of the arts in the west of England; nevertheless, but few illuminated manuscripts

Glass painting by Carl Ludwig Thuot: *Adam and Eve*, after Dürer's *Fall of Man*, reverse painting on glass panel, 268×205 mm, 1686 (Zurich, Schweizerisches Landesmuseum)

or other works of art can now be positively identified as Glastonbury work.

1. Before 1184. 2. Later history.

1. BEFORE 1184. Although nothing earlier than 1184 now stands on the Abbey site, from the descriptions in William of Malmesbury's history and the results of various small scale excavations, some attempt can be made to reconstruct the principal early building phases. As all the known churches are superimposed, the archaeological evidence is incomplete and difficult to interpret; the existing published information is open to some interpretation. After the Saxon conquest of Somerset, Ine, King of Wessex (reg AD 688–726), built a stone church in honour of Our Lord, SS Peter and Paul, probably towards the end of his reign. William of Malmesbury thought three earlier churches stood to the west of it, including the wattle 'Vetusta Ecclesia'. As the present Lady chapel is a direct replacement of that church and Ine's building stood east of that, there may well be further Celtic churches to find west of the Great Church (though a crypt dug out in the late 15th century removed all evidence for the 'Vetusta Ecclesia' itself).

The ground-plan of Ine's church was reminiscent of Kentish 7th-century churches, with a rectangular nave (11×6.4 m), perhaps ending in an apse and flanked north and south by large porticus, 3.6 m wide. Fragments of painted plaster and traces of an opus signinum floor indicate a highly decorated interior. Later in the 8th century the east end was extended to include a crypt, further porticus were built flanking the west end of the nave and an atrium was added, probably linked to the 'Vetusta Ecclesia', to create a complex of buildings nearly 60 m long.

The monastic revival in mid-10th-century England was closely associated with Dunstan, who eventually became Archbishop of Canterbury (reg 960–88). As Abbot of Glastonbury (after c. 940), Dunstan began to build a cloister (55×36.5 m) in what came to be the standard Benedictine manner, but because of extensive burials, it was detached from the church and set against the southern boundary wall of the cemetery. Dunstan also considerably enlarged the church by raising a central tower over Ine's chancel (perhaps destroying the crypt) and adding an east end with porticus as square as it was long. Although monasteries are found elsewhere, Glastonbury apparently has the first regular cloister in England, albeit set apart from the monastic church.

No further major buildings seem to have been undertaken until after the Norman Conquest of 1066, when Abbot Turstan (reg c. 1077/8–1100) began a new church after his return from exile in 1087. His successor, Herluin (reg 1100–18), thinking Turstan's church did not correspond to the greatness of Glastonbury, razed it and began again. Little is known of these Romanesque churches, because the building begun in 1184 apparently re-used their foundations. HENRY OF BLOIS (Abbot in 1126–71 and Bishop of Winchester from 1129) extensively rebuilt the monastery, but only a few fine quality sculpture fragments survive. The most important of these are the richly foliated blue lias cloister capitals, which are related to those of Henry's palace at Wolvesey, Winchester, and the west portals of Saint-Denis Abbey, Paris.

2. LATER HISTORY.

(i) Lady chapel. On 25 May 1184 fire reduced the whole monastery at Glastonbury to a heap of ashes. The abbacy was vacant, but Adam de Domerham, a Glastonbury monk writing c. 1218, recorded that soon afterwards Henry II appointed Ralph FitzStephen, builder of Witham Abbey, as Custodian. Ralph first replaced the 'Vetusta Ecclesia' with the church of St Mary 'with squared stone and most beautiful workmanship, omitting no kind of ornament'. According to John of Glastonbury, writing c. 1340, Bishop Reginald consecrated this chapel on 11 June 1186. The incomplete sculpture of the south doorway is some corroboration of this very fast building campaign, made the more remarkable for the high degree of decoration to this four-bay, vaulted rectangle (20×9 m). Built of cream-coloured Doulting limestone, the lower walls inside and out were decorated with detached dark-blue polished lias stone shafts supporting intersecting arcading (see fig. 1). Throughout, the emphasis is on rich plastic form; the undercut chevrons of the vault ribs and windows, acanthus and crocket leaf capitals and sculpted bosses (paterae) set into areas of blank wall similar to the work of the west bays of Worcester Cathedral. The arches of the two

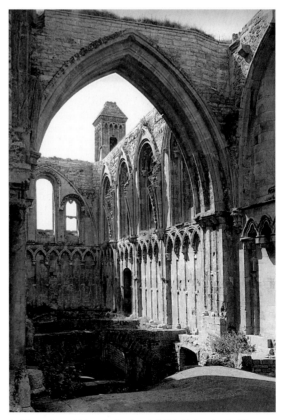

1. Glastonbury Abbey, Lady chapel (1184–6), interior looking west from the galilee (c. 1240)

doorways, particularly the north pilgrims' door, are arranged in the manner of Malmesbury Abbey, with small figured scenes set within foliage shapes (*see* MALMESBURY ABBEY). Orders two and four of the north doorway have relief sculptures of the *Infancy of Christ*, while inhabited scrolls occupy orders three and five. Foliate scrolls adorn the first, third and fifth orders of the south doorway, while the second order has two medallions depicting the *Creation of Eve* and the *Fall*. The remainder of this order and the fourth order are uncarved, which has led to the untenable suggestion that the doorways were executed *in situ* as late as 1230. Internal analysis shows that the sculpture and architecture are contemporary, a view supported by the figure style, which retains some patterned conventions alongside classicizing naturalism, like the contemporary north-west portal of Sens Cathedral. The Glastonbury Master probably trained as a metalworker and, like his Mosan contemporary Nicholas of Verdun, took his inspiration from nature, especially for the label stops.

(ii) Great Church. This was apparently begun immediately after the fire of 1184. The galilee linking the west end with the Lady chapel is stylistically of *c*. 1240, but as Abbot Adam de Sudbury (*reg* 1324–34) completed the vaulting of the nave and decorated it with beautiful painting, perhaps the west end was not fully completed until the 14th century. As the monastery has been used as a quarry for building stone since the Dissolution, little fabric now survives to any height. Enough of the eastern crossing piers and adjacent walling survives to demonstrate the elevation of the building begun *c*. 1184 and the re-casting of the east end credited to Abbot Walter Monington (*reg* 1342–74). The latter has obscured the plan of the original east end and the fragmentary survival of the choir aisle walls are distinctly ambiguous in date. If Adam de Domerham's claim that Ralph laid out a church 400 feet (121 m) long by 18 feet (24.5 m) wide can be believed, after 1184 there was a six-bay rectangular choir, with an ambulatory and four chapels beyond the high gable. Limited excavation has tentatively suggested that the original choir was just four bays long. Monington's work perhaps imitated Gloucester Cathedral in using Perpendicular tracery screens to disguise the earlier fabric, but the stimulus was more likely to be the recently rebuilt choir of nearby Wells Cathedral. The transepts had two bays with eastern aisles and two rectangular chapels on each arm, and the nave was nine bays long.

While no high vaulting survives at Glastonbury, the three-storey elevation was clearly arranged between strong vertical bay divisions linked to the Early Gothic rib vaults (see fig. 2). Within each bay, the main arcade and false triforium are linked below a giant order, visually similar to Oxford Cathedral of *c*. 1160. The clerestory contains a wall passage, the nook shafts of the triple windows unusually being of blue lias. All the arches are pointed, with fleshy crocket capitals, but there is still much use of complex chevron and sculpted wall bosses. The accomplishment and integration of vaulting in the elevation suggests familiarity with ribbed vaults, and the use of linked storeys can be paralleled in similar experiments elsewhere in England and northern France. West country Gothic buildings continued to experiment with linking,

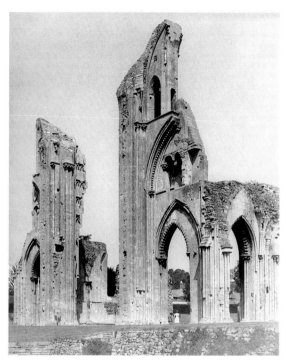

2. Glastonbury Abbey, Great Church (begun 1184), view looking east towards the transepts and choir

but the horizontal emphasis of Wells Cathedral seems to have become more acceptable to English taste. With the addition of an apsidal axial chapel, the Edgar Chapel (destr.), in the early 16th century, the Great Church reached a final length of *c*. 182.5 m.

(iii) Monastic buildings. Little can now be seen of this enormous establishment (the cloister was 41.25 m square), but the mid-14th-century abbots' kitchen is one of the best preserved medieval examples in Europe. It is *c*. 10 m square; the fireplaces are placed across each corner and the octagonal stone roof rises to a tall, decorated lantern.

BIBLIOGRAPHY

William of Malmesbury: *De antiquitate Glastonie ecclesie* [MS.; *c*. 1125]; ed. J. Scott (Woodbridge, 1981) [incl. English translation]

Adam de Domerham: *Historia de rebus gestis Glastoniensibus* [MS.; *c*. 1218]; ed. T. Hearne, 2 vols (Oxford, 1727)

John of Glastonbury: *The Chronicle of Glastonbury* [MS.; *c*. 1340]; ed. J. P. Curley (Woodbridge, 1985)

R. Willis: *Architectural History of Glastonbury Abbey* (Cambridge, 1866)

W. H. St John Hope: 'On the Sculptured Doorways of the Lady Chapel of Glastonbury Abbey', *Archaeologia*, lii (1890), pp. 85–8

H. M. Taylor and J. Taylor: *Anglo-Saxon Architecture*, i (Cambridge, 1965), pp. 250–57

A. Gransden: 'The Growth of the Glastonbury Traditions and Legends in the Twelfth Century', *J. Eccles. Hist.*, xxvii (1976), pp. 337–58

C. A. R. Radford: 'Glastonbury Abbey before 1184: Interim Report on the Excavations, 1908–64', *British Archaeological Association Conference Transactions: Medieval Art and Architecture at Wells and Glastonbury: Wells, 1978*, pp. 110–34

English Romanesque Art, 1066–1200 (exh. cat., ed. G. Zarnecki; London, Hayward Gal., 1984), cat. 149

G. Zarnecki: 'Henry of Blois as a Patron of Sculpture', *Art and Patronage in the English Romanesque*, ed. S. Macready and F. H. Thompson (London, 1986), pp. 159–72

L. Abrams and J. P. Carley, eds: *The Archaeology and History of Glastonbury Abbey* (Woodbridge, 1991)

RICHARD HALSEY, with MALCOLM THURLBY

Glauber, Johannes [Jan; Polidor(o)] (*b* Utrecht, *bapt* 18 May 1646; *d* Schoonhoven, nr Gouda, 1726). Dutch painter, draughtsman and printmaker of German descent. In the mid-1660s he served a nine-month apprenticeship with Nicolaes Berchem in Amsterdam and then found employment copying Italian paintings for the Amsterdam art dealer Gerrit Uylenburgh. In 1671, accompanied by his sister Diana (1650–after 1721) and brother Jan Gottlieb (1656–1703), both painters, Glauber embarked on an extended journey to Italy. *En route* he worked for the Flemish painter and art dealer Jean-Michel Picart in Paris for one year, and possibly met Abraham Genoels II and Jean-François Millet at this time. About 1672–4 Glauber studied with the expatriate Dutch landscape painter Adriaen van der Cabel in Lyon. Glauber was in Rome by 1675, and on joining the SCHILDERSBENT received the nickname 'Polidor' in recognition of his artistic debt to the landscapes of Polidoro da Caravaggio. A member of the third generation of DUTCH ITALIANATES in Rome, Glauber became friends with Karel Dujardin and Aelbert Meyeringh; the latter accompanied him on subsequent travels to Padua, Venice, Hamburg and finally Copenhagen, where Glauber spent six months in the service of the Danish Count Ulrik Frederik Gyldenløve (1638–1704).

Glauber returned to Amsterdam in 1684 and resided with the history painter and theoretician Gérard de Lairesse, who in *Het Groot Schilderboek* (Amsterdam, 1707) cited Glauber as one of the few contemporary landscape painters worthy of emulation. Glauber shared de Lairesse's classicizing tastes and presided with him at meetings of the literary society Nil Volentibus Arduum. He also etched a series of thirty prints after compositions by de Lairesse. Most importantly, however, the two artists collaborated on numerous commissions during the 1680s, including decorative projects for the stadholder William III of Orange, later King William III of England and Scotland, and for the wealthy Dutch bourgeoisie, with de Lairesse providing the staffage for Glauber's Italianate landscapes. Products of this successful partnership include landscapes with mythological scenes, for example *Landscape with Mercury and Io* (*c*. 1685-7), for the palace at Soestdijk, near Hilversum (figures by de Lairesse and Dirk Maas; now The Hague, State Col.), and for the audience hall at Het Loo (*Arcadian Landscape*; *c*. 1685; Apeldoorn, Pal. Het Loo), and four paintings for the Amsterdam home of Jacob de Flines (e.g. *Italian Landscape with Shepherd and Shepherdess*, *c*. 1687; Amsterdam, Rijksmus.). As well as the several other decorative landscape cycles mentioned by Houbraken, Glauber painted Italianate landscapes of a more modest format.

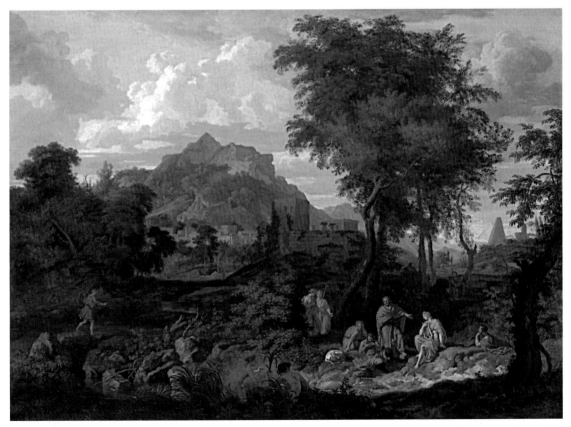

Johannes Glauber: *Landscape with King Midas Judging the Musical Contest between Pan and Apollo*, oil on canvas, 673×908 mm (Boston, MA, Museum of Fine Arts)

Possibly in connection with his work for the stadholder's court, Glauber joined the painters' confraternity Pictura in The Hague on 12 December 1687, although he continued to live in Amsterdam. He married Susannah Vennekool, sister of the architect Steven Vennekool, on 28 March 1704. In 1721 Glauber retired to the Proveniershuis in Schoonhoven, where he died.

The scarcity of dated works hampers an accurate reconstruction of Glauber's stylistic development. His two dated works—a landscape drawing in black chalk of 1685 (Dresden, Kupferstichkab.) and a painting of 1686, *Landscape with Shepherds and Flute Player* (Paris, Louvre)—show the influence of Gaspard Dughet in their strong diagonal compositions and cool, subdued colouring. Dughet's impact is also evident in Glauber's use of specific motifs and themes; for example, his *Storm Landscape* (Vienna, Ksthist. Mus.) is inspired by the tempestuous landscapes perfected by Dughet. Glauber's series of six etchings after landscape compositions by Dughet, as well as his own compositions in a similar vein, probably also date from the late 1680s, when Dughet's influence seems to have been strongest in his work.

Other, presumably later works, such as the *Ideal Landscape with Obelisk* (Brunswick, Herzog Anton Ulrich-Mus.), or the *Landscape with King Midas Judging the Musical Contest between Pan and Apollo* (Boston, MA, Mus. F.A.; see fig.), are closer to the landscapes of Nicolas Poussin in their strict, almost geometric organization of planar space and the use of figures robed in clear primary colours to accent the grey-green tonalities of the surrounding landscape. Glauber was perhaps the most popular proponent of idealized classical landscape in the Netherlands during the late 17th and early 18th centuries and became known as the 'Poussin de la Hollande'.

BIBLIOGRAPHY

Hollstein: *Ger.*, x, pp. 65–130

A. Houbraken: *De groote schouburgh* (1718–21), iii, pp. 216–19

D. P. Snoep: 'Gerard de Lairesse als plafond- en kamerschilder' [Gérard de Lairesse as ceiling and mural painter], *Bull. Rijksmus.*, xviii (1970), pp. 159–217

A. Zwollo: *Hollandse en Vlaamse veduteschilders te Rome 1675–1725* [Dutch and Flemish *vedutisti* in Rome] (Assen, 1973), pp. 10–19

C. Kämmerer: *Die klassisch-heroische Landschaft in der niederländischen Landschaftsmalerei, 1675–1750* (diss., Berlin, Freie U., 1975), pp. 81–100

MARJORIE E. WIESEMAN

Glaubitz, Jan Krzysztof (*b c.* 1700; *d* Wilno (now Vilnius), 30 March 1767). Lithuanian architect. Sources show that he lived in Vilnius from 1738. Glaubitz's first works were the reconstruction (1738–43) of the Protestant church in Vilnius and the rebuilding (1738–62) of the Jesuit church of St John, the latter with an elegant four-storey façade in which the play of light is dramatized by the contrast between projecting clusters of columns and recessed windows. In 1740–46 he completed the church of the Knights Hospitaller in Stołowicze, while in 1741–2 he rebuilt the church of St Catherine, Vilnius, giving it the type of two-tower façade with delicate detailing that became his hallmark. In 1748–9 he built a palace (destr.) in Struń near Połock for Metropolitan Florian Hrebnicki, and in the same year he began the reconstruction (completed 1765) of the Basilians' church of St Sophia in Połock and the Dominican church (completed 1766) in

Zabiały-Wołyńce. Other churches usually attributed to Glaubitz include those of the Carmelites in Mścisław, the Missionaries in Vilnius (1750–57) and the Basilians in Berezwecz (1756–64; destr. 1960s). The latter is one of the most outstanding works of Rococo architecture in Central Europe. The Basilians' church in Vilnius was reconstructed during the 1770s to Glaubitz's plans of 1761. Glaubitz was the leading representative of Vilnius Rococo architecture; his buildings are characterized by their slender proportions, elegant, elaborately crowned towers and dynamically undulating façades.

BIBLIOGRAPHY

S. Lorentz: *Jan Krzysztof Glaubitz: Architekt wileński XVIII w.* [Jan Krzysztof Glaubitz: Vilnius architect of the 18th century] (Warsaw, 1937)

——: 'Architekt kościoła w Berezweczu' [The architect of the church in Berezwecz], *Biul. Hist. Sztuki*, xlvi (1984), no. 4, pp. 395–6

ANDRZEJ ROTTERMUND

Glaukias of Aigina (*fl* first quarter of the 5th century BC). Greek sculptor. According to Pausanias, Glaukias executed four bronze statues commemorating athletic victories at Olympia: none survives. The first was a chariot and portrait of *Gelon of Syracuse* erected following his victory in Olympiad 73 (488 BC; Pausanias: VI.ix.4–5); a portion of this statue's inscription has been recovered (see Dittenberger and Purgold, no. 143). The second depicted *Theagenes*, son of Timosthenes of Thasos, who won the pankration at Olympia, probably in Olympiad 76 (476 BC; Pausanias: VI.xi.2–9); Glaukias' statue was only one of many erected throughout Greece in honour of Theagenes' 1400 athletic victories. The Olympia statue was heavy enough to kill a man when it fell on him. The third was a statue of *Philon of Korkyra*, who won two boxing victories in Olympiads 72 and 73 (492, 488 BC; Pausanias: VI.ix.9). The fourth was a statue of the boxer *Glaukos of Karystos*, which was commissioned by his son (date disputed; Pausanias: VI.x.1–3 and Suidas on Glaukos). The style of Glaukias' statues cannot be determined, and no one has attempted to attribute any known types to him.

BIBLIOGRAPHY

Pausanias: *Guide to Greece*

W. Dittenberger and K. Purgold: *Die Inschriften von Olympia* (Berlin, 1896)

C. Robert: 'Die Ordnung der olympischen Spiele und die Sieger der 75.-83. Olympiade', *Hermes*, xxxv (1900), pp. 141–95 (165, 172)

VIRGINIA C. GOODLETT

Glaze. A transparent or semi-transparent paint layer, applied either directly over the ground or over an underpaint to modify the colour of the ground or underpaint. With the use of appropriate glazes the tonal range of a colour can be extended to give a greater contrast between highlights and shadows. Since the glaze is transparent, the colour of the underpaint or ground, which is generally lighter, plays a part in the final optical effect.

The term 'glaze' is often used imprecisely to mean any thinly applied paint layer, particularly the final finishing touches to a painting. However, these can include combinations of pigments and media that are normally opaque or semi-opaque: it is simply the thinness of application that allows the underlying layers to contribute to the optical effect. Properly, thin layers of opaque colour

applied to modify the underlying colours should be called 'scumbles'.

Glazes are usually made by combining pigments and paint media that have similar or identical refractive indices (*see* PIGMENT, §I): that is, they transmit light to a similar or equal degree so the light is not bent or refracted at the interface between the medium and the pigment particle. Media such as egg tempera, glue distemper, casein, gouache and some paints based on synthetic resins have refractive indices that are lower than those of any artists' pigments: therefore they cannot be used to make truly transparent glazes. At best, the paint layers can only be translucent. Drying oils, however, have higher refractive indices, approaching those of certain pigments. Their refractive indices can be raised further by the addition of natural resins, usually those used in varnish making, for example copal, sandarac, pine resins, mastic and dammar.

Pigments that form transparent or semi-transparent glazes when combined with drying oils fall into three groups. The first contains pigments with refractive indices close to those of drying oils. They include several blue pigments (e.g. natural and artificial ultramarine, smalt and Prussian blue), but they are not completely transparent because their refractive indices are still slightly higher than those of the oil-based media. The second, and perhaps most important, group comprises the red and yellow LAKE pigments. The red and yellow dyestuffs from which they are made do not themselves have low refractive indices, but when they are to be used as transparent lakes they are precipitated on to colourless substrates of low refractive index, traditionally alum (hydrated alumina) or chalk (calcium carbonate). The third group consists of pigments that are wholly or partially soluble in the paint medium. Since there is no longer any interface between pigment and medium to refract and scatter the light, the refractive index of the pigment is irrelevant. This group includes copper resinate (verdigris dissolved in an oil-resin medium), such coloured resins as gamboge and dragon's-blood, and the various bituminous brown pigments.

1. HISTORY. In medieval painting glazes composed of pigments in oil-based media seem to have been used principally in conjunction with gilding (*see* GILDING, §I, 1), both on panel paintings and on polychrome sculpture. Recipes for the glazing of tin leaf with yellow pigmented oil varnishes to imitate gold leaf can be traced back to at least the 8th century AD, and descriptions of painting with coloured oil glazes over metal leaf are given by Theophilus in the 11th century and by Cennino Cennini at the end of the 14th century. Similar techniques were also used in the painting of glass. Oil-based glazes have been identified on 13th- and 14th-century paintings from northern Europe, in particular England (e.g. the Westminster Retable, London, Westminster Abbey) and Norway (especially altar frontals; see Dunkerton), and from Italy. In the Italian examples egg tempera remains the principal paint medium: the oil glazes are associated with the decoration of gilding or with the use of copper resinate (*see* PIGMENT, §V, 2).

In the early 15th century northern European artists, particularly such Netherlandish painters as Jan van Eyck, Robert Campin and Rogier van der Weyden, began to use transparent oil glazes over lighter opaque underpaints to obtain rich saturated colours but also, by varying the thickness of the glazes, to achieve relief and greater tonal variation in the modelling of forms. Modelling by means of glazes is one of the main features of early Netherlandish oil painting. These glazing techniques were transmitted to southern Europe. They first appeared in Italy in the mid-15th century and were soon widely adopted, above all in Venice, where Antonello da Messina pioneered their use, and after him Giovanni Bellini applied them to great effect. In the 16th century, as the handling of oil paint became freer, so the use of glazes became less ordered and systematic. In the late 16th century and the 17th, when coloured grounds were frequently employed, the opaque underpaint was sometimes omitted, the transparent shadows being applied directly over the ground. By adding other pigments to act as driers, it was also possible to apply glazes with some bulk and impasto (as opposed to the repeated thin applications of Netherlandish painting).

Changes in art education in the 18th and 19th centuries led to the breakdown of the master–apprentice craft tradition. As a result, to imitate the depth and saturation of earlier works, particularly the greatly admired Venetian paintings of the 16th century, painters increasingly experimented with unsuitable and often impermanent materials in their glazes. These included bituminous brown pigments, which may never dry, and media containing wax or soft resins more often used for varnish making. Later, 19th- and 20th-century attitudes to the optical and physical properties of oil paint meant that few painters have consciously or deliberately employed oil-glazing techniques. Some colour-field painting involves the superimposition of thin layers of colour, but these occur more as dilute washes and stains than as medium-rich and transparent glazes.

The glazes on many paintings have changed with time: the red and yellow lake pigments are prone to fade, particularly where thinly applied; blue and brown glazes can darken and become more opaque than intended; and copper resinate can discolour from its original bright green to a warm reddish brown. Glazes can also be damaged by conservation treatments, especially by cleaning and by the sometimes over-hot irons used in the past for flattening blistered paint and relining canvases. A glaze on a 19th-century painting that contains wax or a soft resin may be soluble in the solvents that are used to dissolve the discoloured varnish. Glaze layers on earlier paintings, which consist principally of oil, may be no more soluble than other areas of paint, but they are vulnerable to damage because they are often very thin. Thickly applied glazes, on the other hand, may have dried poorly, developing a wrinkled surface and wide drying cracks, or they may have become brittle and consequently tend to flake.

See also CERAMICS, §I, 5.

BIBLIOGRAPHY

Theophilus, also called Rugerus: *De diversis artibus* (?1110–40); Eng. trans. by J. G. Hawthorne and C. S. Smith as *On Divers Arts* (Chicago and London, 1963)

C. Cennini: *Il libro dell'arte* (*c.* 1390); Eng. trans. and notes by D. V. Thompson jr as *The Craftsman's Handbook: 'Il libro dell'arte'* (New Haven, 1933/*R* New York, 1954)

C. L. Eastlake: *Materials for a History of Oil Painting* (London, 1847); *R* as *Methods and Materials of the Great Schools and Masters* (New York, 1960)

R. Mayer: *The Artist's Handbook of Materials and Techniques* (New York, 1940, rev. 4/1982/*R* London, 1987)

R. J. Gettens and G. L. Stout: *Painting Materials: A Short Encyclopaedia* (New York, 1942, rev. 1966)

D. Bomford, C. Brown and A. Roy: *Art in the Making: Rembrandt* (London, 1988)

J. Dunkerton and others: *Giotto to Dürer* (London, 1991)

JILL DUNKERTON

Glazunov, Il'ya (Sergeyevich) (*b* Leningrad [now St Petersburg], 10 June 1930). Russian painter, stage designer and draughtsman. He studied at the Repin Institute of Painting, Sculpture and Architecture in Leningrad from 1951 to 1957. His early works caused heated debate as they went against the official Socialist Realism style of the early 1950s. Since then his work, principally in oils (sometimes including decorative appliqué work), pastels, tempera and charcoal, has attracted increasing attention and has been exhibited widely, surrounded by public acclamation and mass-media debates. The cycle *Eternal Russia* is dedicated to Russian, principally medieval, culture. The works in the cycle, for example the sub-cycle *Kulikovo Field* (1980), display intense and vibrant colours and epic patriotic concepts. The more lyrical cycle *City of the 20th Century*, begun earlier, depicts the emotional life of the individual, estranged and isolated in the modern megalopolis. The sections *Vietnam* (1967), *Chile* (1969) and *Nicaragua* (1973) are journalistic graphic dispatches. Russian literature plays an important part in his art and he illustrated works by, among others, Dostoyevsky, whose views on art and culture he considered his permanent sources of inspiration. He painted numerous portraits of contemporaries, for example *Federico Fellini* (1963; Fellini priv. col.) and *Indira Gandhi* (1973). With his wife, the costume designer Nina A. Vinogradova-Benois (1936–86), Glazunov designed stage sets, including that for Rimsky-Korsakov's *Tale of the Invisible City of Kitezh* at the Bolshoy Theatre in Moscow in 1983. His aesthetic programme, combining flagrant political non-conformity and emphatic anti-revolutionary feelings with nationalistic and romantic stylistic traditionalism, found exhaustive expression in his monumental canvases. These include the *Mystery of the 20th Century* (1970–72), *100 Centuries* (or *Eternal Russia*, 1986) and the *Great Experiment* (1990; Moscow, Malakhov, priv. col.), which present an assembled panorama of Russian and world history from antiquity to perestroika. From 1987 he ran the All-Russian Academy of Painting, Sculpture and Architecture in Moscow, which he himself established. Its aims were to strengthen and promote the classical traditions of Russia and world art.

WRITINGS

Our Culture—A Tradition (Moscow, 1991)

BIBLIOGRAPHY

I. Yazykova: *Il'ya Glazunov* (Moscow, 1972; Ger. trans., Leipzig, 1975)

Il'ya Glazunov (Moscow, 1978)

Pisatel' i khudozhnik: Proizvedeniya russkoy klassicheskoy literatury v illyustratsiyakh I. Glazunova [Writer and artist: works of classical Russian literature illustrated by I. Glazunov] (Moscow, 1979)

Il'ya Glazunov (Moscow, 1986)

N. YA. MALAKHOV

Glebova, Tat'yana (Nikolayevna) (*b* St Petersburg, 28 March 1900; *d* Stary Petergof, 1985). Russian painter, illustrator and stage designer. She studied at the St Petersburg Academy of Arts (1924–7) under Aleksandr Savinov (1881–1942), though her most influential teacher was PAVEL FILONOV, who had temporarily been given a studio in the Academy at that time. Filonov's system of Analytic art attracted many followers, who formed the collective MAI (Mastera Analyticheskogo Iskusstva: Masters of Analytic Art) in 1925, of which Glebova became a leading member. She based her evocation of the inner world of the object on the forms of naive art and on colour given psychological intensity, as in *Sketch for the Painting 'Prison'* (1927; St Petersburg, Rus. Mus.). She participated in MAI's exhibitions, theatrical productions and graphic work, notably the illustration of the Finnish epic *Kalevala* (Moscow, 1933), and during this period collaborated closely with Alisa Poret (1902–84). Glebova remained one of Filonov's most loyal followers, even after the official closure of MAI in 1932. Like many MAI members, she also worked for the children's publisher Detgiz and the magazines *Yozh* ('Hedgehog') and *Chizh* ('Siskin') in Leningrad (now St Petersburg). Books illustrated by Glebova include Samuil Marshak's *Machty i kryl'ya* ('Masts and sails'; Leningrad, 1931) and H. G. Wells's *The First Men in the Moon* ('Pervyye lyudi na lune'; Leningrad, 1939). An example of her interpretation of Filonov's theory of 'made painting' is to be seen in her designs for the Maly Opera Theatre production of Wagner's *Die Meistersinger von Nürnberg* (Leningrad, 1932; now St Petersburg, priv. col.). During World War II she was evacuated with her future husband, the artist Vladimir Sterligov (1904–73), to Alma-Ata, Kazakh SSR (now Almaty, Kazakhstan) and there organized several exhibitions of her work (1943) as well as designing the costumes for the film *Zhambul* (Alma-Ata, 1943). The influences of Sterligov's training under Kazimir Malevich led Glebova to a unique synthesis of the formal principles of Suprematism and the psychological approach of Analytic art in her paintings of the 1960s, as in *Promuzika* (1962) and *Madrigal* (1967; both St Petersburg, priv. col.).

WRITINGS

'Souvenirs sur Filonov', *Cah. Mus. N. A. Mod.* (1983), no. 11, pp. 118–23

'Vospominaniya o Pavle Nikolayeviche Filonove' [Reminiscences of Pavel Nikolayevich Filonov], *Panorama Isk.*, 11 (1988), pp. 108–27

BIBLIOGRAPHY

Tat'yana Nikolayevna Glebova (exh. leaflet, Leningrad, Rus. Mus., 1981) [article by Ye. Kovtun]

Pavel Filonov und seine Schule (exh. cat., ed. J. Harten and J. Petrova; Düsseldorf, Städt. Ksthalle, 1990)

JEREMY HOWARD

Gleeson, James (*b* Sydney, 21 Nov 1915). Australian painter, writer, critic and administrator. He studied at the East Sydney Technical College from 1934 to 1936 and was represented in the first Contemporary Art Society exhibition in 1938. Gleeson is widely regarded as Australia's leading Surrealist, often compared in style to Dalí. His work is frequently described as macabre, threatening and erotic, and his forms range from the recognizable to indeterminate imagery from the darker depths of the mind, as in the *Siamese Moon* (1951; Melbourne, Joseph Brown Gal.). Gleeson is highly praised for his superb brushwork and use of colours and textures. Apart from painting, he

produced drawings, watercolours, pastels and collages. He wrote numerous books on Australian art and monographs on William Dobell and Robert Klippel.

BIBLIOGRAPHY

R. Millar: *Civilized Magic* (Melbourne, 1974)
L. Klepac: *James Gleeson: Landscape out of Nature* (Sydney, 1987)

CHRISTINE CLARK

Gleeson, William (*b* Mildura, Victoria, 30 Jan 1927). Australian painter, printmaker, teacher and glass artist. He was first employed as an apprentice by the prominent stained glass firm Brooks, Robinson & Co. in Melbourne. During his ten-year association with this firm, he undertook part-time studies in painting and drawing at various Melbourne art institutes, including the Art School attached to the National Gallery of Victoria and the Technical College, and at the privately run George Bell School, which at the time presented a more progressive approach to the subject than was espoused at the larger institutes. With his training Gleeson was well-placed to investigate the innovative use of glass as a medium for artistic expression. In line with the notion of truth to material, he virtually abandoned the traditional process of staining glass in favour of a method of creating abstract compositions by overlaying, fusing and acid-etching sheets of coloured glass. Using these techniques he was able to achieve a subtle tonal range. Although Gleeson was awarded an impressive sequence of window commissions including the cycles for the Burwood Presbyterian church, Victoria (1963), and the Anglican church in Elizabeth, South Australia (1980), his major achievement lies in his development and promotion of various kiln-working techniques that anticipated the processes of casting, fusing and slumping and revolutionized studio glass practice during the 1980s. Much of Gleeson's work takes the form of free-standing, regular structures incorporating a textural glass relief within a metal or mixed-media armature. In 1961, as a lecturer in painting at the Melbourne Institute of Technology, Gleeson was responsible for establishing a course in glass studies that was the first of its kind in Australia. Through these auspices Gleeson was highly influential in his encouragement of a fundamentally sculptural approach to glass. At the same time he remained a staunch advocate of the application of innovative artistic concepts in glass to contemporary architectural schemes.

BIBLIOGRAPHY

J. Zimmer: *Stained Glass in Australia* (Melbourne, 1984)
Glass from Australia and New Zealand (exh. cat., ed. J. Zimmer; Darmstadt, Hess. Landesmus., 1984)

GEOFFREY R. EDWARDS

Gleichmann, Otto (*b* Mainz, 20 Aug 1887; *d* Hannover, 2 Nov 1963). German painter and printmaker. After his academic training in Düsseldorf, Breslau (now Wrocław) and Weimar, he served in the trenches on the French and Russian fronts. In 1917 he found that the critic Theodor Daubler (1876–1934) shared his animistic vision of cosmic order. Drawn by favourable reception of his graphic works, he became a member of the Hannover Secession in 1918, settling in the city permanently in 1919. The spiritual unity of man, animal and organic life is expressed in the fantasy landscape painting *Shining: Falling* (1920; Hannover, Kstmus.), which shows his early style of strong contours

and areas of overlaid sombre colour influenced by the artists of Die Brücke and Der Blaue Reiter. His provisional use of nervous linear gestures is exemplified in two portfolios of lithographs published by Paul Cassirer in 1919, *Judas Maccabaeus* and *Antiochus*. Around 1921 he adopted the circus, cabaret and ballroom as settings for such candid portraits of loneliness as *The Stage* (1923; Berlin, Gal. Brusberg). An effective combination of media is attained in the watercolour with gouache *Bayoneted Man* (1923; Los Angeles, CA, Co. Mus. A.).

During the mid-1920s Gleichmann moved into a more lyrical and luscious painterly approach in which anonymous spectral figures appear in an atmosphere of arresting stillness, as is seen in the oil painting *Bitter Carnival* (1925; Hannover, Kstmus.). In the 1950s he adopted a brighter palette and more decorative approach, which lacked the introverted and pessimistic resonance of his Expressionist works.

BIBLIOGRAPHY

T. Daubler: 'Otto Gleichmann', *Kunstblatt*, ii/5 (1918), pp. 150–52
L. Beil: 'Otto Gleichmann', *Cicerone*, xiii/10 (1921), pp. 297–302
L. Zahn: 'Über den Wert der Kritik', *Ararat*, ii (1921), pp. 130–32 [artist's statement in response to questionnaire]
R. Lange: *Otto Gleichmann* (Göttingen, 1963)
Otto Gleichmann, 1887–1963: Zum 100. Geburtstag (exh. cat., Hannover, Sprengel Mus., 1987)

TIMOTHY O. BENSON

Glei'eh. *See under* HADITHA REGION.

Gleizes, Albert (*b* Paris, 8 Dec 1881; *d* Avignon, 23 June 1953). French painter, printmaker and writer. He grew up in Courbevoie, a suburb of Paris, and as a student at the Collège Chaptal became interested in theatre and painting. At 19, his father put him to work in the family interior design and fabric business, an experience that contributed to a lifelong respect for skilled workmanship. The first paintings he exhibited, at the Société Nationale des Beaux-Arts in Paris in 1902, were Impressionist in character, but the work accepted within two years at the Salon d'Automne showed a shift to social themes, a tendency that accelerated until 1908. Compulsory military service from 1903 to 1905 thrust him into the company of working-class people, arousing a permanent sense of solidarity with their aspirations and needs. The results were immediately apparent in the Association Ernest Renan, which he helped to establish in 1905, a kind of popular university with secular and socialist aims. He was also one of the founders of a community of intellectuals based near Paris, the ABBAYE DE CRÉTEIL, which functioned from November 1906 to February 1908. He remained interested during these years in social art, but his paintings became flatter and more sombre, more simplified and with an increased emphasis on structure. Through the circle of poets associated with the Abbaye de Créteil, Gleizes met Henri Le Fauconnier, whose portrait of *Pierre-Jean Jouve* (1909; Paris, Pompidou) made a decisive impression on him, confirming his exploration of volume. His friends soon included Jean Metzinger and Robert Delaunay, with whom he exhibited alongside Le Fauconnier and Fernand Léger at the Salon d'Automne in 1910; the critic Louis Vauxcelles wrote disparagingly of their 'pallid' cubes. The five artists, plus Marie Laurencin, encouraged by Guillaume Apollinaire, Roger Allard, Alexandre Mercereau and Jacques Nayral,

Albert Gleizes: *Brooklyn Bridge*, oil on canvas, 1.02×1.02 m, 1915 (New York, Solomon R. Guggenheim Museum)

determined to group themselves together at the Salon des Indépendants in 1911. Manipulating the rules and helping to elect Le Fauconnier chairman of the hanging committee, they showed together in a separate room, marking the emergence of CUBISM. Gleizes's portrait of *Jacques Nayral* (oil on canvas, 1.62×1.14 m, 1910–11; London, Tate), one of his first major Cubist works, dates from this period.

Given his developed sense of mission and group action, Gleizes welcomed the idea of a generation of young artists, drawn from all classes and countries, revolutionizing the bourgeois canons of art by carrying the painter to the centre of society; in his view the artist–craftsman performed an essential service of seeing and thinking for humanity, rather than serving merely as an ornamenter. Partly in this quasi-heroic and proselytizing spirit, he and Metzinger planned a book, *Du Cubisme* (Paris, 1912), in which they strove to reconcile different goals and methods in painting. Parts of their text were read during the summer of 1912 to the circle around the Duchamp brothers, known as the PUTEAUX GROUP, and it was published before the conclusion in October of the *Salon de la Section d'Or* (*see* SECTION D'OR (ii)), where Gleizes exhibited his epic Cubist painting *The Harvesters* (ex-Guggenheim, New York; for illustration see 1964 exh. cat., fig. 34). In 1912 he also took part in the second exhibition of the Moderne Kunstkring (Amsterdam, Stedel. Mus.). Gleizes's conviction that artists could explain themselves as well as or better than critics caused him to write and grant interviews during the years when *Du Cubisme* was enjoying wide circulation, but much of this communication within a continuously expanding circle of artists was destroyed by the outbreak of World War I. Gleizes, a pacifist, was conscripted in August 1914. While serving at Toul in Lorraine he continued to paint; during 1914–15 he created

not only works such as *Landscape at Toul* (1915; Paris, Pompidou) but also his first abstract pictures (e.g. *Composition*, 1915; see 1964 exh. cat., fig. 72) and the majestic *Portrait of an Army Doctor* (1915; New York, Guggenheim). On his demobilization in September 1915 he married Juliette Roche and sailed for New York, where he lived and worked until early 1919, apart from a long voyage to Barcelona from late spring to the autumn of 1916, from which he returned to New York via Cuba and Bermuda by spring 1917. He made direct allusion to one of the landmarks of New York in *Brooklyn Bridge* (1915; New York, Guggenheim; see fig.), one of his most abstract pictures of this period. A serious break in his style occurred only in late 1917, when his production stopped almost completely. Increasingly preoccupied with the folly of war and harbouring doubts about humanity's capacity to manage its affairs, he turned to writing poems, prose sketches and a treatise on painting and collectivity entitled *En attendant la victoire: L'Art dans l'évolution générale*, none of them published. As a close friend of both Francis Picabia and Marcel Duchamp, he was an intimate observer of the origins of Dada in New York, which he later contended was born of despair and disillusionment. His own organizational efforts were directed towards the re-establishment of a European-wide movement of abstract artists in the form of a large travelling exhibition, the *Exposition de la Section d'Or*, in 1920; it was not a success. Cubism, with which most of the exhibitors were associated, was *passé* for younger artists, although Gleizes, on the contrary, felt that only its preliminary phase had been investigated.

By 1920 Gleizes had developed a style based on his first abstract pictures of 1915, characterized by dynamic intersections of vertical, diagonal, horizontal and circular movements, austere in touch but loaded with energetic pattern. He sought to clarify his methods further in *La Peinture et ses lois* (Paris, 1923), in which he deduced the rules of painting from the picture plane, its proportions, the movement of the human eye and the laws of the universe. This theory, later referred to as translation-rotation, ranks with the writings of Mondrian and Malevich as one of the most thorough expositions of the principles of abstract art, which in his case entailed the rejection not only of representation but also of geometric forms. Based from 1923 in his wife's native town, Serrières, south of Lyon, he was contemptuous of the revivalism and classicizing tendencies of the *rappel à l'ordre* and also of Surrealism. Disappointed that the thrust of early modernism had been blunted, he laid the blame on the structure of society, but his initial enthusiasm for the Russian Revolution soon waned, and he was drawn instead to the study of pre-Renaissance art. His investigations of Romanesque, Gothic, Byzantine and Arabic art reinforced his own practices in painting (e.g. *Painting with 7 Elements* (1924–34; Paris, Pompidou)) and led to a major study, *Vie et mort de l'occident chrétien* (Sablons, 1930), first published as articles in 1928–9.

Convinced that Western society was on the verge of collapse and determined to rescue what he could, in 1927 Gleizes established the artistic, agricultural and intellectual commune of Moly-Sabata in Sablons, across the river from Serrières, where he continued to live. He continued

to write and lecture and exhibited regularly at Léonce Rosenberg's Galerie de l'Effort Moderne in Paris; he was also a founder, organizer and director of ABSTRACTION-CRÉATION. From the mid-1920s to the late 1930s much of his energy went into writing. Two of his most important books, *Vers une conscience plastique: La Forme et l'histoire* (Paris, 1932) and *Homocentrisme* (Sablons, 1937), reveal his hopes for humanity and his conviction that only art could save the world, by returning to communal, early Christian principles.

Gleizes was long aware that easel painting was somewhat at odds with his philosophy of art as a rejuvenating social force, and he came to see even the largest pictures as only preparatory studies for murals. His first opportunities to produce such works came in 1937–8, first for the Exposition Internationale des Arts et Techniques dans la Vie Moderne and then (in collaboration with Jacques Villon) for the auditorium of the Ecole des Arts et Métiers; the latter was rejected by the school authorities as too abstract, but immense panels by Gleizes survive as *Four Legendary Figures of the Sky* (San Antonio, TX, McNay A. Inst.). Other examples of this ambitious public style include *The Transfiguration* (1939–41; Lyon, Mus. B.-A.). At the beginning of World War II, he and his wife retreated to their farm near St Rémy-de-Provence and established a commune from which for the next 14 years no serious student or artist was turned away. During the war he worked on a more modest scale on jute, with a sensual touch reminiscent of his first Cubist period. After converting to Roman Catholicism in 1941, he eliminated the references to traditional Christian iconography that had appeared in his paintings since the mid-1920s. Around 1943 he began a series of paintings entitled *For Meditation* (e.g. 1944; see 1964 exh. cat., fig. 170), in which he synthesized his rich experience. In 1950, at the suggestion of the French critic Jacques Lassaigne, he published a set of 57 etchings illustrating Pascal's *Pensées* (Casablanca, 1950). Drawing on all his previous work for the motifs, he explored in visual form questions concerning the sufficiency of reason, the verifiability of experience, the plausibility of revelation and the exercise of free will.

WRITINGS

with J. Metzinger: *Du Cubisme* (Paris, 1912; Eng. trans., London, 1913; rev. Paris, 1947)
La Peinture et ses lois (Paris, 1923/R Aix-en-Provence, 1961)
Kubismus (Munich, 1928)
Vers une conscience plastique: La Forme et l'histoire (Paris, 1932)
Homocentrisme (Sablons, 1937)
Souvenirs: Le Cubisme, 1908–14: Extraits (Lyon, 1957)

BIBLIOGRAPHY

Albert Gleizes (exh. cat. by D. Robbins, New York, Guggenheim, 1964) [with comprehensive bibliog. of writings by and on Gleizes]
Zodiaque, xxiv, 100 (1974) [issue ded. to Gleizes]
Dessins d'Albert Gleizes (exh. cat., intro. P. Georgel; Paris, Mus. N. A. Mod., 1976)
P. Alibert: *Albert Gleizes: Naissance et avenir du Cubisme* (Saint-Etienne, 1982)
L'Art sacré d'Albert Gleizes (exh. cat., ed. A. Tapié; Caen, Mus. B.-A., 1985)

DANIEL ROBBINS

Glendalough. Site of an early Christian monastery in Co. Wicklow, Ireland. Set in a steep valley on the eastern edge of the Wicklow Mountains, the monastery owed its origin to St Kevin (*d* AD 618), who chose this wild, lonely spot

Glendalough, monastery enclosure, showing St Kevin's 'Kitchen', *c.* 1050–1130, and the round tower and cathedral ruins, both 10th or 11th century

as the site of a hermitage. A century later it had become a flourishing monastery, teeming with pilgrims and students; it retained its vitality until the end of the 12th century despite the sequence of fires, plunderings and other disasters mentioned in the annals. The chief relics of the ancient monastery are an impressive round tower and the ruins of at least nine Romanesque or pre-Romanesque churches scattered for about 2 km along the valley (see fig.). The intractable archaeological and chronological problems associated with the monuments are compounded by the restorations and rebuildings carried out by the Board of Works in 1875–9.

It is generally agreed that St Kevin's original hermitage lay to the west, beside the upper lake; some interesting structures on the cliff side include the foundations of a *clochán* (beehive hut) like those in many eremitic sites in the west of Ireland, as well as the ruins of two small churches, Temple-na-Skellig and Reefert (both of which, however, post-date St Kevin's life by several centuries).

The main monastery was situated some distance away, below the lower lake and at the confluence of two streams. The enclosure is entered through a double-arched gateway of almost Roman pretensions, a unique reminder of how impressive the approach to an early Irish monastery could be. The heart of the precinct is now submerged beneath an accumulation of relatively modern graves, which has wrecked any chance of serious archaeological investigation. The largest church is the cathedral, originally a single-cell structure (14.63×9.15 m internally) with antae, to which a Romanesque chancel was added *c.* 1200. Changes in masonry in the nave and the re-use of old material suggest a complex history. A date in the 10th or 11th century is now accepted by most scholars for the existing fabric. This is also the favoured date for the round tower (30.48 m high), one of the most elegant in the country, with an especially subtle batter of 1:77. Other churches in the enclosure include St Kevin's 'Kitchen', so named because of its pepper-pot tower, and the Priests' House, a tiny Romanesque chapel absurdly rebuilt either in the 18th or 19th century. Beyond the main precinct are three more

churches: Trinity to the east, St Mary's to the west and the small Augustinian priory of St Saviour (founded 1162) about 800 m along the river to the east. Trinity originally had a round tower attached to the west end of the nave (it fell in 1818), and St Saviour's has interesting Romanesque decoration.

Several of the churches retain lintelled doorways with inclined jambs in the standard Irish fashion. That at St Mary's is made of seven huge blocks of granite and is surrounded by an architrave band reminiscent of Anglo-Saxon strip-work. The lintels on the cathedral and St Kevin's Kitchen were reinforced with relieving arches, a rare feature in Ireland. The chancel arches at Reefert and Trinity (both *c.* 1100) are among the earliest examples in Ireland, where the understanding of arch construction arrived late. Perhaps because of uncertainties over arch construction, plans are of the utmost simplicity, the chief distinction being the absence or presence of chancels (which did not become a normal feature until the 12th century): at Reefert and Trinity the chancel was an integral part of the original building, whereas in the cathedral, St Kevin's Kitchen and St Mary's it was added. Structurally the most interesting building is St Kevin's Kitchen (*c.* 1050–1130), which was covered by a barrel vault and surmounted by a corbelled roof of stone, a distinctively Irish form of construction. The chancel at St Saviour's priory may have been similar, but otherwise the churches were not vaulted. Although the early dates once accorded to the monuments at Glendalough can no longer be sustained, and there is no trace of what must have been several centuries of timber building, the site occupies a crucial position in the study of early church architecture in Ireland.

See also ROMANESQUE, §II, 6(ii).

BIBLIOGRAPHY

H. G. Leask: *Glendalough, Co. Wicklow: Official Historical and Descriptive Guide* (Dublin, 1950)
——: *Irish Churches and Ecclesiastical Buildings*, i (Dundalk, 1955)
Lord Killanin and M. V. Duignan: *The Shell Guide to Ireland* (London, 1962, rev. 2/1967)
F. Henry: *Irish Art in the Early Christian Period to 800 AD* (London, 1965)
——: *Irish Art in the Romanesque Period, 1020–1170 AD* (London, 1970)
L. Barrow: *Glendalough and St Kevin* (Dundalk, 1972)
G. Mettjes: *Frühmittelalterliche Klöster in Irland: Studien zu Baugeschichtlichen Problemen am Beispiel von Glendalough* (Frankfurt am Main, 1977)
G. L. Barrow: *The Round Towers of Ireland* (Dublin, 1979)

ROGER STALLEY

Glesker [Glesscker; Klesecker; Klessecker; Klessger], **Justus** (*b* Hameln an der Weser, *c.* 1610–20; *d* Frankfurt am Main, 2 Dec 1678). German sculptor and ivory-carver. He was the son of Jost Glesker, also a sculptor, recorded as working in Hameln from 1607. After visiting Italy, where he studied ancient statues and other works of art, mainly in Rome, and travelling in the Netherlands (probably in the 1630s), Justus settled in Frankfurt am Main in 1648. Probably on the recommendation of Matthäus Merian (ii), a painter from Frankfurt, he was commissioned to produce the *Crucifixion* figures (1648–53) for the east choir in Bamberg Cathedral, where, mounted on a triumphal arch, they crowned the altar to SS Henry I and Cunegunda. The over life-size, gilt limewood figures of

Christ, the *Virgin*, *St John* and *St Mary Magdalene* represent the most important of Glesker's early works. Stylistically, the influence of the Flemish sculptor François Du Quesnoy, who lived in Rome, is striking, but there are also echoes of north Italian sculpture *c.* 1600, as well as the work of Rubens and the southern German sculptors Hans Reichle and Georg Petel. The altar was dismantled during the restoration (1829–37) of Bamberg Cathedral, but in 1912 the *Crucifixion* group was returned to the Cathedral and in 1917 was erected at the high altar in the west choir.

Glesker created numerous other sculptures for Bamberg Cathedral, including an over life-size, gilt statue of the *Risen Christ* (delivered 1649; Bamberg, Diözmus.), probably produced for the rood altar in the west chancel; two angels (1649–50; Frankfurt am Main, Hist. Mus.) for the altar of St Maurice; and a figure of *St Peter* (1649–50; untraced) to crown the altar to St Peter. Four limewood angels (Bamberg, Diözmus.), sculpted in the round for the canopy of the high altar in the west choir, are also extant although lacking some original features. The high altar, modelled on Bernini's Altar of the Confession (1633; Rome, St Peter's), was presumably designed by Glesker.

In 1654 Glesker was awarded the freedom of the city of Frankfurt am Main; in its civic register (Frankfurt am Main, Inst. Stadtgesch. Stadtarchv) he is recorded as a 'fine art sculptor'. He worked on a commission for Mainz Cathedral between 1662 and 1664, creating a side altar for Canon Peter Jakob von Partenheim (*d* 1662). His commissions from 1669 to 1671 for the Barfüsserkirche Alt St Paul in Frankfurt are also recorded, although no works have been preserved. On the remarriage of Glesker's widow an inventory of his estate was drawn up in which the works from the sculptor's studio are recorded. These included small sculptures and ivory works, for example a Crucifix, a *St Sebastian*, a *Man of Sorrows*, cabinet-pieces such as the allegorical figure of *Abundance*, tankards and mugs. However, none of Glesker's ivory work authenticated by a signature or documentary evidence has been preserved, nor can any small sculpture be definitely attributed to him.

BIBLIOGRAPHY

Thieme–Becker
J. von Sandrart: *Teutsche Academie* (1675–9); ed. A. R. Peltzer (1925)
A. Feulner and T. Müller: *Geschichte der deutschen Plastik* (Munich, 1953), pp. 505–7
E. Herzog and A. Ress: 'Der Frankfurter Bildhauer Justus Glesker', *Schr. Hist. Mus. Frankfurt am Main*, x (1962), pp. 53–148
C. Theuerkauff: 'Justus Glesker oder Ehrgott Bernhard Bendl? Zu einigen Elfenbeinbildwerken des Barock', *Schr. Hist. Mus. Frankfurt am Main*, xiii (1972), pp. 39–76
Die Altäre des Bamberger Domes von 1012 bis zur Gegenwart, iv of *Veröffentlichungen des Diözesanmuseums Bamberg* (exh. cat., ed. R. Baumgärtel-Fleischmann; Bamberg, Diözmus., 1987), pp. 126–47

O. LOHR

Gleyre, (Marc-)Charles(-Gabriel) (*b* Chevilly, nr Lausanne, 2 May 1806; *d* Paris, 5 May 1874). Swiss painter and teacher, active in France. While many of his pictures appear academic in technique and subject, they often treat subjects that are new or imaginatively selected in a manner that betrays varied artistic influences. With his contemporaries Paul Delaroche and Thomas Couture, he helped to create the *juste-milieu* compromise style of painting.

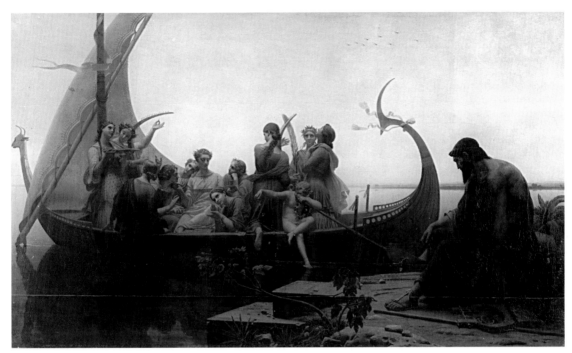

Charles Gleyre: *Evening*, or *Lost Illusions*, oil on canvas, 1.56×2.38 m, 1843 (Paris, Musée du Louvre)

Adept in classical and biblical subjects, Gleyre also ventured into historical iconography, employing Swiss rather than French historical events, as well as genre motifs and sometimes obscure original themes. His influence was immense through his art and his teaching, which helped to form the Néo-Grec school of the Second Empire.

Gleyre's earliest artistic training was in the decorative arts in Lyon, where he was sent after the death of his parents. In 1825 he went to Paris, where he enrolled in the studio of Louis Hersent and augmented his education with classes in watercolour under R. P. Bonington. Having perfected his drawing technique, Gleyre set out for Rome in 1828. (He was not eligible to compete for the Prix de Rome because of his Swiss nationality.) Gleyre lived in abject poverty during his six years in Rome, but the stay was extremely valuable as it permitted him to study closely the major Classical and Renaissance monuments, which remained crucial sources for his art and theory throughout his life.

In 1834 Horace Vernet, Director of the Académie de Rome, recommended Gleyre to accompany an American traveller, John Lowell jr, on an extensive trip to the Near East, serving both as companion and artistic recorder. The two remained together for more than nineteen months, visiting Greece, Turkey, Rhodes, Egypt and Sudan. Gleyre produced a mass of drawings and watercolours at virtually every important site; immediate, sometimes remarkably spontaneous, and always brilliantly coloured, they reveal Gleyre as a draughtsman of exceptional talent and also provide a unique record of significant archaeological sites (some no longer extant), costumes and exotic Near Eastern and North African physiognomies (e.g. *Turkish*

Woman ('Angelica'), Smyrna, 1834; Lausanne, Pal. Rumine). The majority of these works are in the Lowell Institute, Boston (on loan to Boston, MA, Mus. F.A.). They were not well known to Gleyre's contemporaries, and Gleyre himself, although having spent more time in the Near East than most other Orientalist painters of the period, rarely made use of them in his later paintings. In November 1835 Gleyre, almost blind from ophthalmia, decided to withdraw from the assignment, finally returning to Paris in 1838.

Gleyre's first efforts on his return to France were in a decidedly academic manner. His most important commission at that time was for the decoration of the stairway of the château de Dampierre, where he worked with the Flandrin brothers and Ingres for the Duc de Luynes. After the murals were completed in 1841, some were intentionally effaced on the orders of Ingres, who was responsible for the overall decorative scheme; the reason for this was never wholly explained. Gleyre's first genuine success was with *Evening*, or *Lost Illusions* (1843; Paris, Louvre; see fig.), which became the sensation of the Paris Salon of 1843. This sombre allegory of the human condition, deriving from memories of Egypt but wedded to classical iconography, typifies Gleyre's approach in its dreamy, romantic air, but also with its tightly controlled technique and sense of traditional composition, at once appealing to both academic and romantic tastes. The painting was bought by the government, thrusting on the painter an uncomfortable celebrity. In 1845 Gleyre won a first-class medal in the Salon with his *Parting of the Apostles* (Montargis, Mus. Girodet) and also embarked on a curious series of paintings depicting primeval history in accord with contemporary literary and scientific interest in ancient

history (e.g. *The Elephants*, *c.* 1849; Lausanne, Pal. Rumine). However, in 1849, at the height of his career, Gleyre withdrew from exhibiting in the French Salons because of his Republican ideals which clashed with the policies of Louis Napoleon. Gleyre also refused official French commissions and declined the Légion d'honneur, a measure of his staunch independence.

Despite his increasing reclusiveness and misanthropy, in the 1850s Gleyre received various commissions from the city of Lausanne for works depicting aspects of local history. His *Major Davel* (Lausanne, Pal. Rumine, destr.) represented the last moments of the Vaudois hero before his execution in 1723 in a manner that established a universal symbol of political freedom and courage. The *Romans Passing under the Yoke* (1858; Lausanne, Pal. Rumine), commissioned as a pendant, illustrates the Helvetic victory over the Roman legions and demonstrates Gleyre's resourcefulness in dealing with a vast composition of over 50 figures based on a historical event. Both works achieved the status of Swiss national icons and were reproduced in virtually every medium, but neither canvas was shown in France during his lifetime.

Gleyre's later works are marked by a search for new subjects from traditional classical and biblical sources. The most significant is *Pentheus* (Basle, Kstmus.), completed in 1864 on a commission from the city of Basle. The composition is unusually dynamic, with strong, diagonal movement, dramatic lighting and animated figures. Gleyre's last completed canvas, the *Return of the Prodigal Son* (1873; Lausanne, Pal. Rumine), illustrates a well-known theme, but in a manner that is unusually tender and poetic: the son is shown being welcomed home by his mother rather than, as was traditional, his father. Gleyre also added unusually revealing gestures and expressions, as well as exotic details, which enliven the time-worn subject.

A crucial aspect of Gleyre's career was his activity as a teacher. In 1843 he took over from Delaroche one of the most famous ateliers in Paris, which had belonged to Jacques-Louis David and Antoine-Jean Gros, maintaining it until the outbreak of the Franco-Prussian War in 1870. In many ways Gleyre's atelier was a unique institution. It was run like a republic, in which each student had an equal voice in the daily activities and the general programme. Gleyre refused to accept payment for his efforts but requested instead a contribution for the rent and modelling fees. Gleyre offered practical instruction in drawing and painting, as well as theory, providing the customary correction of student work twice a week. Because of the liberal regime that prevailed in the atelier, as well as Gleyre's well-founded reputation as a solid, conscientious teacher, the atelier was among the most popular in Second Empire Paris. His most important pupils included the Impressionists Claude Monet, Auguste Renoir, Alfred Sisley and Jean-Frédéric Bazille, who all attended briefly in 1863. Gleyre also trained more conservative French painters, such as Jean-Léon Gérôme and Jean-Louis Hamon, and two generations of Swiss artists, including Albert Anker, Auguste Bachelin, Albert de Meuron (1823–97) and Edmond de Pury (1845–1911).

BIBLIOGRAPHY

C. Clément: *Gleyre: Etude biographique et critique* (Geneva, 1878) [incl. cat. rais.]
Charles Gleyre ou les illusions perdues (exh. cat., Winterthur, Kstmus., 1974)
W. Hauptman: 'Allusions and Illusions in Gleyre's *Le Soir*', *A. Bull.*, xl (1978), pp. 321–30
L. F. Robinson: *Marc-Charles-Gabriel Gleyre* (diss., Baltimore, Johns Hopkins U., 1978)
Charles Gleyre, 1806–1874 (exh. cat., New York U., Grey A.G., 1980)
W. Hauptman: 'Delaroche's and Gleyre's Teaching Ateliers and their Group Portraits', *Stud. Hist. A.*, xviii (1985), pp. 79–119

WILLIAM HAUPTMAN

Globe. Three-dimensional cartographic representation of the earth, other heavenly bodies or the apparent celestial sphere.

1. Introduction. 2. Celestial globes. 3. Armillary spheres. 4. Lunar globes. 5. Terrestrial globes.

1. INTRODUCTION. In contrast to a map, a globe represents its original virtually free from distortion, although for technical reasons it can be produced only in small sizes: a globe of 320 mm diameter, for example, represents the earth to a scale of *c.* 1:40 million. From the 16th century to about the mid-19th it was customary to make globes in pairs, a terrestrial and a celestial globe of identical size and mounting. Early globes have a rotatable sphere and meridian ring suspended within a wooden stand with a fixed horizon ring. Terrestrial globes are commonly mounted with the axis tilted 23.5° from the vertical to simulate the inclination of the earth relative to the sun. The stands usually follow contemporary taste in furniture design with varying levels of decoration, often reduced when the globe was intended principally as a scientific instrument. Globes were produced in a wide variety of materials, including glass, metal (brass, copper or silver), marble, porcelain and ivory. The most common material used was pasteboard covered with plaster to obtain a perfect spherical form; the skin on small globes may be as thin as 5 mm. Globes are built around a wooden skeleton, of greater or lesser complexity according to the diameter: the most basic form is a simple wooden axis. Calculations and measurements are made using an hour-indicator fixed to the north pole, showing celestial time, and a quadrant, which is a metal strip that may be moved along the meridian ring; a compass is often mounted on the stand. With such equipment, and in conjunction with gradations (degrees and calendar) marked on the horizon ring, globes can be used to calculate, with a minimum of mathematical knowledge, many astronomical occurrences and mathematical–geographical ones, such as sunrise, sunset and the position of important fixed stars, for any spot on the earth's surface throughout the year. An example that combines precise gradations with Chinese decorative dragon designs on the legs of the stand is depicted on a silk tapestry (1794; London, N. Mar. Mus.) showing the transport of British gifts to the Emperor Ch'ien-lung (1736–96).

On early globes and later individual examples (so-called 'manuscript globes') the map design was drawn, painted or engraved directly on to the surface (see fig. 1). From the early 16th century the designs were printed on prepared paper segments, which were cut to shape, moistened and glued to the globe's surface. Albrecht Dürer, Heinrich

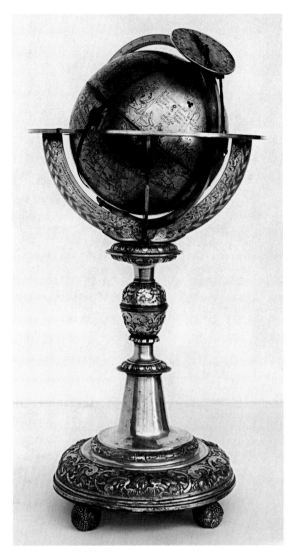

1. Celestial globe with built-in timepiece by Daniel Scheyrer, brass, diam. 210 mm, from Steyr, Upper Austria, 1624 (Vienna, Österreichische Nationalbibliothek)

Glarean (1488–1563) and Vincenzo Coronelli (1650–1718), a Venetian Franciscan friar, were among those who planned these 'global gores'. Twelve strips were usually made, each of 30° of longitude (more rarely 18–20°), which covered the whole globe, starting at the prime meridian. In order that they might be positioned as accurately as possible the strips were truncated near the beginning of the polar circles (c. 67° 30'), and the remaining areas covered with further paper segments, the 'polar caps'. A segment of 10° was cut from the polar caps and the edges aligned, producing a flattened, curved cone only 350° in circumference, which nevertheless showed the entire polar region. During the 16th century woodcut reproduction, which was relatively crude, was replaced by copperengraved printing for maps and globes, enabling much greater precision and more decorative elements to be incorporated. In the 19th century the increasing use of

lithography led to mass production, although until the invention of colour lithography maps were coloured by hand, with precision not always a priority.

A globe-map almost always has a graticule, comprising at least the equator, the Tropics of Cancer and Capricorn, the polar circles, colures and a prime meridian (usually reckoned at first from Hierro, the most westerly of the Canary Islands, but later also from Greenwich etc); most also incorporate the ecliptic (the apparent annual course of the sun through the zodiac). Cartouches, devised in changing contemporary taste, often bear the title of the globe, the name of its maker, publication details and notes on geography, ethnography and the history of discoveries; occasionally there are also dedications to important persons. Globes often had accompanying textual commentary. In the early 16th century this took the form of short textbooks on mathematical geography or astronomy, while later introductions to the use of globes were provided.

During the era of the voyages of discovery terrestrial globes became outdated very quickly. Celestial globes also soon needed revision, for the positions of the fixed stars shift by about 1.5° of longitude per century owing to the slow gyration of the earth's axis, known as precession. The finest Renaissance and Baroque globes, however, have survived because they were often both scientific instruments and decorative display furniture in formal settings. Sometimes globe-maps were brought up to date with newly prepared individual sections stuck over the appropriate areas. This was the case, for example, with a mid-17th-century terrestrial globe (diam. 680 mm) made by the Amsterdam publishers Blaeu, which had mistakenly placed an island called 'California' off the west coast of North America, and with the second edition of Johann Gabriel Doppelmayr's terrestrial globe (diam. 120 mm), which bore new segments over the entire Pacific area following the expeditions of Captain James Cook (1728–79).

In the Renaissance there was a desire for larger, more attractive and technically more ambitious globes. In 1576 Philipp Apian (1531–89) and Heinrich Arboreus (c. 1530–after 1577) produced a pair of spectacular manuscript globes (diam. 770 mm; Munich, Bayer. Staatsbib.) for Albert IV, Duke of Bavaria (reg 1550–79). Several artists collaborated in its making, including Hans Donauer (i); the stars are indicated by gold studs. The most magnificent globes ever made are Baroque and are often of considerable dimensions, such as the Gottorp 'Giant' Globe (diam. 4 m; 1652–8; St Petersburg, Zool. Mus.) by the engineer Andreas Busch (c. 1620–after 1664) that was scientifically conceived by the oriental traveller and librarian Adam Olearius (1603–71); this shows the earth on the outside and the heavens on the inside. The highpoint of Baroque globe-making is to be seen, however, in the work of Coronelli, who made a pair of globes (diam. 3.86 m; 1680) of surpassing beauty for King Louis XIV that are displayed in pieces in the Orangerie at Versailles, and a number of globes (diam. 1.1 m) based on these with engraved segments.

During the 18th century cartography and globe-making were approached in a radically new way, stimulated by the rationalist ideas of the Enlightenment, especially in France. More precise geodesic methods and astronomical measurements enabled both the earth and the heavens to be

represented more objectively, and globes were gradually transformed from *objets d'art* into purely utilitarian tools.

2. CELESTIAL GLOBES. A celestial globe does not show the constellations as seen from the earth, but in mirror image; to obtain the accustomed view it is necessary to imagine oneself inside the globe at its centre. Celestial globes were known in antiquity: Ptolemy (*fl* 2nd century AD) described them and their use in his astronomical treatise *Megale (mathematike) syntaxis* (commonly known, from the Latin version of its Arabic title, as the *Almagest*), in which he gave an account of the geocentric system and the constellations. The marble Farnese Atlas (2nd century AD; Naples, Mus. Archeol. N.), which is probably a Roman copy of a Greek original, bears a celestial sphere (diam. 680 mm) on the surface of which are shown the constellations described by Ptolemy; the individual stars are not depicted but may have been painted on. During the Middle Ages in Europe globes were also used by, for example, Alcuin (*c.* AD 735–804) at the court of Charlemagne and by Gerbert of Aurillac (later Pope Sylvester II; *reg* 999–1003). The oldest extant Islamic example dates from 1080 (diam. 180 mm; Paris, Bib. N.), and about a dozen further examples are known, mostly small and made of brass; sometimes (e.g. Tehran, Archaeol. Mus.) the stars are marked but not the constellations. The most important is the engraved gold and silver globe of Muhammad al-'Urdi (diam. 140 mm; 1279; Dresden, Staatl. Math.-Phys. Salon).

Derived from a different interpretation of cosmology, Chinese celestial globes of brass or wood were normally a dome set in a box to represent the horizon. The first true example (diam. 722 mm; destr.) was probably made by Qian Luozhi in AD 440. It was divided into 28 lunar mansions, and the stars of the three schools of astronomers were represented by white, black and yellow pearls; the sun, moon and five planets were marked on the ecliptic.

In the late Middle Ages celestial globes were introduced in south Germany and Vienna. A celestial sphere (diam. 170 mm; Bernkastel-Kues, St Nikolaus Hosp.), acquired by Nicholas of Cusa (1401–64) in Nuremberg in 1440, shows only 44 stars. Around 1480 Hans Dorn (1430–1509), a Dominican friar, made a decorated celestial globe of gilt-brass (Kraków, Jagiellonian U. Lib.) for Martin Bylica (1433–93), astronomer to King Matthias Corvinus of Hungary. In 1493 Johann Stöffler (1452–1531) made a wooden sphere held together with metal bands (480 mm; Nuremberg, Ger. Nmus.). The celestial globe (diam. 410 mm) produced by Gerard Mercator (1512–94), of which nine examples are known, shows the constellations in antique tradition, with unclothed human figures. Petrus Plancius (1552–1622), a Dutch theologian, introduced new constellations on his globe of *c.* 1598 (diam. 355 mm; Zerbst, Gym., destr.), which was engraved by Jodocus Hondius the Elder (1563–1612); he included the Giraffe, Unicorn and such biblical references as the River Jordan. This is also the earliest known globe to have shown the constellations of the south pole, including the Peacock, Bird of Paradise and Phoenix, which had been charted by Pieter Dirkszoon Keyser (*d* 1597) and Frederik Houtman (1571–1627) during the first Dutch voyage to South-east Asia (1595–7). In order to remain competitive,

Willem Janszoon Blaeu (1571–1638), probably the most important Baroque Dutch cartographic publisher, had to update an almost finished celestial globe (intended as a counterpart to his terrestrial globe of 1599) before finally publishing it in 1603. The constellations drawn by Jan Saenredam are partly clothed with animal skins. Blaeu's attractive celestial globes (diam. 680 mm) dating from or after 1616 show constellations reminiscent of those depicted on the Farnese Atlas, which had just been discovered.

During the late 17th century and the early 18th attempts were made to replace the pagan constellations with Christian images. On one celestial globe (diam. 480 mm; Vienna, priv. col.) Amanzio Moroncelli (1672–1719) stuck biblical figures over the conventional pagan figures, replacing, for example, Orion with the hunter Nimrod. Erhard Weigel (1625–99), on the other hand, transformed constellations into coats of arms: his globes (e.g. diam. 355 mm; Nuremberg, Ger. Nmus.) show, for example, the elephant of Denmark instead of the Great Bear, and the Habsburg double-headed eagle instead of Orion. The lusty figures on Coronelli's globes (diam. 1.1 m) are once more unclothed, and the heavenly bodies are mostly seen from a geocentric viewpoint. The Amsterdam publishers Gerard Valck and Leonardus Valck (1675–1746) introduced new constellations based on the stellar catalogue of Johannes Hevelius (1611–87), including Hunting Dogs, Small Lion and Lizard.

The most accurate celestial globes of the 18th century were made in France by Nicolas Bion (*c.* 1652–1733) and in Nuremberg by Johann Gabriel Doppelmayr, who, following the work of Ignace-Gaston Pardies (1636–73), charted the paths of comets. New constellations in the southern hemisphere were postulated by the Abbé Nicolas Louis de Lacaille (1713–62); these were first depicted on a globe (diam. 310 mm; 1775) by Joseph Jérôme Le Français de Lalande (1732–1807) and engraved by Jean Lattré (*fl* 1743–93). In accordance with Enlightenment scientific taste they were given such names as Glazing Oven and Telescope. On the globe (diam. 310 mm; 1804) devised by Johann Elert Bode (1747–1826) the constellations are represented by thin lines, and the individual stars are more clearly defined than before. By the mid-19th century the use of increasingly powerful telescopes had led to the discovery of countless new stars. While retaining the traditional names of the constellations on technical mnemonic grounds, astronomers henceforth distinguished them in a linear fashion, by dotted lines running along the lines of latitude and longitude, and accordingly all decorative elements were removed from celestial globes.

3. ARMILLARY SPHERES. An armillary sphere (Lat. *armilla*: 'bracelet') is a special form of celestial globe for the determination of the positions of the stars, comprising a combination of mobile and fixed metal rings that denote the astronomical circles. They were used in antiquity, further developed in the Middle Ages by the Arabs and then reached the Christian West. A brass armillary sphere made in China by Zhang Heng (AD 78–139) formed part of an elaborate astronomical clock that was driven by waterpower. The sphere was lost *c.* AD 317 but was recovered in AD 418, although by then all its marks of gradation

moon always turns the same side towards the earth, only one half bears a map. Russell also produced globes and segments in relief, although none has survived. Serial production of lunar globes began in Vienna with Joseph Riedl von Leuenstern (1786–1856) and the publishing house of Schöninger.

5. TERRESTRIAL GLOBES. About 500 BC precise observations enabled members of the community founded at Croton, southern Italy, by Pythagoras of Samos (c. 560–c. 480 BC), to recognize that the earth was round. Throughout antiquity, however, it was not possible to produce a realistic terrestrial globe as only a portion of the earth's surface was then known. The earliest recorded terrestrial globe, known only from literary sources, is that of Krates of Mallos (2nd century BC). It seems to have been a stone sphere (diam. c. 3 m) showing two band-shaped oceans crossing each other and four symmetrical islands, one of which represented the Old World (oekumene). A similar terrestrial globe was the model for the imperial orb of the Byzantine emperors, as shown for example in the mosaic of Alexander (reg AD 912–13) in Hagia Sophia, Istanbul.

The oldest extant example (diam. 510 mm; Nuremberg, Ger. Nmus.) was made by Martin Behaim of Nuremberg (1459–1506) in 1492, the year of the discovery of America by Christopher Columbus (1451–1506), although it bears no trace of the New World. It is made of papier mâché covered with paper segments. The outline of its map was based on Ptolemy's Geographia, which had been circulated throughout the Western Christian world since the early 15th century. Other sources drawn upon include the Travels of Marco Polo (c. 1300) for much of Asia, the largely fictitious Travels of Sir John Mandeville (c. 1370) and, for the west coast of Africa, the logbooks of the Portuguese navigators who had been seeking a sea passage to the Indies since the early 15th century. Behaim's creation is known as the 'speaking globe' owing to its numerous inscriptions, which were added up to the 19th century.

The Laon Globe (copper-gilt; diam. 170 mm; Paris, Bib. Serv. Hydrograph. Mar.) was probably made in Portugal at about the same time and has a cartographic representation similar to that of Behaim. Two globes dating from c. 1510, the Lenox Globe (diam. 130 mm; New York, Pub. Lib.) and the Jagiellonian Globe (diam. 73 mm; Kraków, Jagiellonian U. Lib.), have a rudimentary representation of the New World taken from the hand-drawn map (1500; Madrid, Mus. Naval) by Juan de la Cosa (c. 1460–1510). The first printed globe (woodcut; diam. 110 mm; 1507; only the segments extant, Minneapolis, U. MN Lib.; Munich, Bayer. Staatsbib.), which was also the first globe to bear the name 'America', was the work of Martin Waldseemüller (c. 1470–1518), the author of Cosmographiae introductio (St-Dié, 1507). The Nuremberg astronomer and mathematician Johannes Schöner (1477–1547) made several examples, including a magnificent manuscript globe of 1520 (diam. 900 mm; Nuremberg, Ger. Nmus.), on which at least two roughly coeval globes are based, if only indirectly: the Brixen Globe (diam. 370 mm; c. 1522; Upperville, VA, Paul Mellon priv. col.) and the Rosenthal Gores (diam. 170 mm; after 1523; New York, Pub. Lib.), the map of which

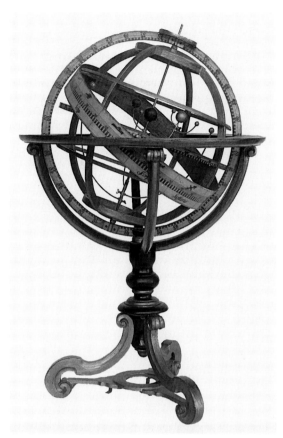

2. Armillary sphere with built-in geocentric planetary system by Andreas Spilzer, wood, diam. 300 mm, from Vienna, 1764 (Vienna, Österreichische Nationalbibliothek)

had disappeared. Using this as a model, Qian Luozhi devised another (diam. 1.85 m; AD 436; destr.), which comprised the earth at the centre, the two paths of the ecliptic (marked with the sun, moon and five planets) and the equator, celestial poles, the positions of the 28 lunar mansions, the Great Bear and the Pole Star. In Europe from the 16th century a representation of the planetary system was added to the interior, initially in a geocentric configuration (see fig. 2), and sometimes a timepiece. Costly display instruments were occasionally made, such as that (h. over 2 m; 1588–93; Florence, Mus. Stor. Sci.) designed by Antonio Santucci dalle Pomarance. An armillary clock (Seoul, Korea U. Mus.) built in 1669 is an intriguing combination of Eastern technology and Western discovery, for at the heart of its armillary sphere by Yi Min-ch'ol there is a terrestrial globe (diam. c. 90 mm) whose design was taken from a mid-17th-century European map of the world. (For further discussion of armillary spheres see SCIENTIFIC INSTRUMENTS.)

4. LUNAR GLOBES. The oldest surviving lunar globe (diam. 300 mm; 1785–96; e.g. London, BL) was made by the English portrait painter John Russell (1745–1806), following the preliminary work of Hevelius and Johann Tobias Mayer (1723–62). This is of brass and, since the

appears in the painting *The Ambassadors* (1533; London, N.G.) by Hans Holbein (ii).

Rainer Gemma Frisius (1508–55) exercised lasting influence with his globe (diam. 370 mm; *c.* 1535; Vienna, priv. col., on loan to Vienna, Österreich. Nbib.), which placed a speculatively based, narrow North Pacific Ocean between eastern Asia and North America. In this he was followed by the most important cartographer of the Renaissance, Gerard Mercator, whose globe of 1541 (diam. 410 mm), of which 12 examples are known, was the first to incorporate rhumb-lines as an essential aid to long-distance navigation. Other cartographers of this period, however, depicted a broad land link between Asia and America, as for example on the Golden Globe (diam. 230 mm; *c.* 1528; Paris, Bib. N.) and the Stuttgart Global Strips (diam. 350 mm; *c.* 1535; Stuttgart, Württemberg. Landesbib.). Philipp Apian's large terrestrial globe (1576; Munich, Bayer. Staatsbib.) partly follows the shape of Mercator's map of 1541, but with some corrections. Jacob Floris van Langren (before 1525–1610), who established himself in Amsterdam in 1586 as the first globemaker in the Netherlands, also relied on Mercator for his globes of 325 and 525 mm diameter. Hondius worked as an engraver on the globe (diam. 660 mm; 1592) produced in London by Emery Molyneux (*d* 1598–9), before collaborating with Plancius in Amsterdam on a series of globes taken from Mercator's cartography.

Under the influence of the Jesuits, terrestrial globes were brought to China from Europe in the late 16th century. The first example to be produced there (diam. 590 mm; 1623; London, BL) was designed by Nicolo Longobardi (1559–1654) and Manuel Dias (1574–1659), based on a world map of 1602 by Matteo Ricci (1552–1610). It is made of wood and covered in lacquer, and the oceans are decorated with numerous ships and sea-monsters. There are many explanatory notes in red, and a long Chinese inscription covering much of the southern hemisphere gives the five continents as Asia, Europe, America, Africa and Magellonica. The inscription also places the earth firmly at the centre of the Ptolemaic universe.

From the time of its founding in 1599 until 1708, the firm of Blaeu, continued by his son Joan (*c.* 1598–1673), produced small globes (diam. 340 mm) that still displayed Renaissance features; the only cartographic innovation to be incorporated in that time was Cape Horn in 1617. In addition Blaeu produced globes with a diameter of 680 mm that fully reflect the taste of the period, being decorated with grandiose cartouches bearing titles, dedications and detailed legends, and numerous figural depictions in the oceans and areas beyond Europe. The rapid improvements in cartographic techniques and knowledge are apparent in the outlines of the continents, Australia (although its east coast was not discovered until 1770) and the polar regions. At the same time, however, there were surprising backward steps, such as the depiction of California as an island. The interiors of the continents other than Europe had not yet been explored, and the earlier tradition continued of filling the empty spaces with fabulous beasts, utopian cities and legends. To some extent the Dutch firms of Valck and, later, Covens and Mortier perpetuated the practice with minutely detailed designs until the 19th century.

With the decline of Blaeu, Vincenzo Maria Coronelli, working in Venice and Paris, became the foremost manufacturer of globes. Attractive examples had already been produced in Italy in the 16th century by the Roselli family of cartographers in Florence, Ignazio Danti and Franciscus Bassus (*fl c.* 1570). At first Coronelli based his globes on Dutch models, correcting them with information from French state archives and from Jesuit missions in North America. The figural motifs he incorporated were often taken from contemporary travel works, and his illustrations are an important source of historical ethnography (see fig. 3). After the establishment of the Paris Observatoire in 1667 such cartographers as Jean Pigeon (1654–1739) and Bion were increasingly concerned with incorporating verified information only, omitting the unconfirmed and limiting artistic decoration to grandiose Rococo cartouches. The globes (diam. 490 mm) of Gilles Robert de Vaugondy (1686–1763) and his son Didier (1723–86) are among the leading works of this type. The first examples to leave blank regions that were unexplored included those (diam. 160 mm and 320 mm; 1700) produced by Guillaume Delisle (1675–1726). Further French globe-makers who continued this trend were Jean Fortin (1750–1831), Louis-Charles Desnos (*fl* 1761–91) and Charles-François Delamarche (1740–1817).

In Germany Doppelmayr took up French models. His globes (diam. 320 mm, 1728; diam. 200 mm, 1730; diam. 120 mm, 1736) were thought the best in German-speaking lands and were produced with corrections until the end

3. Terrestrial globe by Vincenzo Maria Coronelli, papier mâché with wooden stand, diam. 1.1 m, from Venice, 1688 (Vienna, Österreichische Nationalbibliothek)

of the 18th century. The globes (diam. 200 mm; *c.* 1710) made in Augsburg by Mattäus Seutter (1678–1757) were less accurate. John Senex (1690–1740) was the foremost English globe-maker of the first half of the 18th century, producing a number of the 'pocket globes' (diam. 70 mm) that were popular in England. These were terrestrial globes kept in a spherical container, the inner side of which showed the segments of the celestial sphere. The pocket globes (diam. 70 mm; 1750) of James Ferguson (1710–76) were the first to mark the prime meridian from Greenwich. The globes of William Cary (*c.* 1759–1825) incorporated the results of the expeditions of James Cook in the Pacific and of George Vancouver (1757–98) in north-west America.

By the beginning of the 19th century the outlines of the continents were essentially known, and cartographers could turn their attention to the exact representation of the third dimension. The earlier 'molehill' or schematic manner of showing mountains gave way to the use of equally monotonous hachures to indicate their extent. The introduction of colour lithographic printing techniques made it possible to incorporate terrain shading in combination with contour lines. By *c.* 1850 terrestrial globes had become solely mass-produced items of scientific equipment and were no longer designed as works of art.

BIBLIOGRAPHY

M. Fiorini and S. Günther: *Erd und Himmelsgloben: Ihre Geschichte und Konstruktion* (Leipzig, 1895)

E. L. Stevenson: *Terrestrial and Celestial Globes: Their History and Construction*, 2 vols (New Haven, 1921/*R* New York and London, 1971)

W. Bonacker: 'Ein Streifzug durch die Welt der Globen', *Der Globusfreund*, ix (1960), pp. 13–36

J. Needham, Wang Ling and D. J. de Solla Price: *Heavenly Clockwork: The Great Astronomical Clocks of Medieval China* (Cambridge, 1960, 2/1986)

O. Muris and G. Saarmann: *Der Globus im Wandel der Zeiten: Eine Geschichte der Globen* (Berlin and Beutelsbach bei Stuttgart, 1961)

H. Wallis: 'A Chinese Terrestrial Globe, AD 1623', *BMQ.*, xxv (1962), pp. 83–91

A. Fauser: *Ältere Erd- und Himmelsgloben in Bayern* (Stuttgart, 1964)

M. Reuther: 'Entwicklung und Probleme der Globengeschichte bis zu Gerhard Mercator im Rahmen der Kartengeschichte', *Der Globusfreund*, xv–xvi (1967), pp. 167–92

A. Fauser: *Kulturgeschichte des Globus* (Munich, 1973)

H. C. King: *Geared to the Stars: The Evolution of Planetariums, Orreries and Astronomical Clocks* (Toronto and Buffalo, 1978)

D. J. Warner: *The Sky Explored: Celestial Cartography, 1500–1800* (New York and Amsterdam, 1979)

F. Wawrik: 'Die Verwendung von Globen in der Vergangenheit', *Int. Coronelli-Ges.: Inf.*, iii (1980), pp. 3–10

P. C. J. van der Krogt: 'Aard- en hemelglobes', *De hemel is gestegen of de aarde is gedaald* (Franeker, 1981), pp. 68–92

R. Schmidt: 'Ältere Erd- und Himmelsgloben', *Alte & Mod. Kst*, clxxiv–clxxv (1981), pp. 50–51, 78

——: 'Die Konstruktion von Globen', *Der Globusfreund*, xxx (1982), pp. 41–4

F. Wawrik: 'Mond- und Marsgloben', *Mond- und Marsgloben: Eigentum: Dr.-Ing., K.-H. Meine, Sonderschau im Globenmuseum der Österreichischen Nationalbibliothek* (Vienna, 1982), pp. i–vii

A. Fauser: 'Ältere Erd- und Himmelsgloben in Bayern', *Der Globusfreund*, xxxi–xxxii (1983), pp. 107–28

P. C. J. van der Krogt: *Old Globes in the Netherlands* (Utrecht, 1984)

I. Kretschmer, J. Dörflinger and F. Wawrik, eds: *Lexikon zur Geschichte der Kartographie: Von den Anfängen bis zum ersten Weltkrieg*, 2 vols (Vienna, 1986)

J. Needham and others: *The Hall of Heavenly Records: Korean Astronomical Instruments and Clocks, 1380–1780* (Cambridge, 1986)

L. Zögner, ed.: *Die Welt in Händen, Globus und Karte als Modell von Erde und Raum* (Berlin, 1989)

J. K. W. Willers: *Focus Behaim Globus* (Nuremberg, 1992)

P. C. J. van der Krogt: *Globi Neerlandici: The Production of Globes in the Low Countries* (Utrecht, 1993)

F. Wawrik and H. Hühnel: 'Das Globenmuseum der Österreichischen Nationalbibliothek', *Der Globusfreund*, xlii (1994), pp. 189–362

H. Wohlschläger: 'Die Globensammlung Rudolf Schmidt', *Der Globusfreund*, xlii (1994), pp. 189–362

F. WAWRIK

Glockendon. German family of illuminators and print publishers. They were active in Nuremberg during the late 15th century and the earlier 16th. (1) Georg Glockendon I, son of the woodcutter Albrecht Glockendon I, had two sons, (2) Albrecht Glockendon II and (3) Nikolaus Glockendon. The 12 sons of Nikolaus (including Gabriel, Georg II, Jakob, Nikolaus, Sebastian and Wolf) were also artists.

(1) Georg Glockendon I (*fl* 1484; *d* 1514). Woodblock cutter, printer and painter. In 1492 he published Erhard Etzlaub's *Territorial Map of Nuremberg* (handcoloured version, Munich, Bayer. Staatsbib.), the oldest printed political jurisdiction map. He also issued Etzlaub's *Roadmap Through the Holy Roman Empire* in 1501, an expanded version of the famous pilgrimage map of 1500. In 1509 Georg published his *Von der Kunst Perspectiva* (2 pages of text, 37 woodcuts), a plagiarized edition of Jean Pélerin's *De arte perspectiva* (Toul, 1505 and 1509).

Johann Neudörfer, the contemporary biographer of Nuremberg's artists, praised Georg's numerous illuminated Missals and songbooks. While most of these have yet to be identified, Glockendon's talents as a painter may be observed in the '*Erdapfel*', the oldest extant terrestrial globe (Nuremberg, Ger. Nmus.). For 15 weeks in 1491 and 1492, Georg, assisted by his wife, illuminated the topographic features designed by Martin Beheim and executed by R. Kolberger. It was probably this project that subsequently led to his collaboration with Etzlaub. In 1509 Georg is documented working briefly as a painter for Frederick the Wise, Elector of Saxony.

(2) Albrecht Glockendon II (*fl* ?1506; *d* 1545). Son of (1) Georg Glockendon I. A master from at least 1515, the year after his father's death, he seems to have assumed the direction of the family's workshop. As a publisher, Albrecht reissued Etzlaub's *Roadmap* in 1533 and Georg's *Von der Kunst Perspectiva* in 1540 under his own name and also published at least 17 large woodcuts by such Nuremberg masters as Sebald Beham, Peter Flötner, Georg Pencz and Erhard Schön in the 1530s. Most of these are large broadsheets or multiple woodblock prints, such as Schön's *Twelve Clean and Twelve Unclean Birds* (*c.* 1534; Geisberg, no. 1194) or Sebald Beham's *Large Church Festival* ('The Great Country Fair') (1539; G 251–4), which consists of four large sheets showing one continuous composition.

Before the 1530s, Albrecht worked primarily as a miniaturist. His monogram and the date 1506 are on a single detached illumination of *St Christopher*, held with five other stylistically related miniatures in Berlin (Kupferstichkab., 78; also 98, 99, 102, 113 and 114). If Biermann's identification is correct, this lengthens Albrecht's known career by a decade since his next oldest signed miniatures are in a Missal of Nuremberg usage (1516; London, BL, MS. Add. 25715). Albrecht's finest illuminations are in the

Prayerbook of Hans Imhoff (1522; Nuremberg, Stadtbib., MS. Cent. V Append. 76). His compositions borrow heavily from the prints of Dürer and the manuscripts of his brother (3) Nikolaus Glockendon and of Simon Bening of Bruges. The latter's works were owned by Cardinal Albrecht von Brandenburg, Nikolaus's principal patron, and may have been available in Nuremberg for the brothers to examine in the early 1520s. Albrecht adopted Bening's whimsical page designs, with their extensive marginalia and creative framings for the principal miniatures. Sometimes the marginalia enhance the miniature's iconography; elsewhere they are unrelated and diverting—animals parading through the countryside, revellers partying in a boat.

Albrecht's *Calendar* (1526; Berlin, Staatsbib. Preuss. Kultbesitz, MS. Ger. Oct. 9) includes a series of the Twelve Labours of the Months that, again, recall Simon Bening's miniatures. Albrecht's figures, however, tend to be squat and often awkwardly proportioned. Even his *Zodiacal Man* (fol. 13*v*), a taller full-page figure, reveals a concern for strong colour and contour rather than for subtle modelling or anatomical definition. His strong colours are applied with little modulation of tone. On the basis of Neudörfer's observation that Albrecht was a poet, Degering (1977) has attributed him with the verses accompanying the calendar. Albrecht's other manuscripts include Willibald Pirckheimer's translation of Neilos' *Sententiae morales* (1517; London, Arundel Lib., MS. 503); a prayerbook (1521; Munich, Bayer. Staatsbib., Cod. Lat. 10013); a fragment of a prayerbook (before 1530; Kassel, Landesbib., MSS Math. et Art 50); a Breviary (1528–42, with Georg Glockendon II; Nuremberg, Stadtbib., MS. Hert. I, 9); the *Splendor solis* (1531–2; Berlin, Kupferstichkab., HS. 78 D 3); and the Prayerbook of Duke William IV of Bavaria (1535; Vienna, Österreich. Nbib., Cod. 1880).

(3) Nikolaus Glockendon (*fl* 1515; *d* 1534). Son of (1) Georg Glockendon I. A master by 1515, he became, following the death of Jakob Elsner in 1517, Nuremberg's leading illuminator. Since Nikolaus signed many of his illustrations, his oeuvre is fairly clearly defined. His earliest works include a Missal (Marburg, Westdt. Bib., Theol. Lat. Fol. 148), the Prayerbook of Abbot Jost Necker von Salem (Zurich, Zentbib.) and the *Pontificale Gundecarianum* (1517; Eichstätt, Ubib.), as well as several illuminations for Nuremberg's city council and for its secretary Lazarus Spengler. In 1522 Nikolaus decorated a copy of Luther's *New Testament* (Wolfenbüttel, Herzog August Bib., 25. 13. 14 Extravagantes) for John-Frederick, the future Elector of Saxony. While the stylistic influence of Simon Bening is evident, Glockendon also borrowed specific anti-papal motifs, such as the wolf dressed with the papal tiara, from Lucas Cranach I.

Nikolaus Glockendon's principal patron from 1523 was Cardinal Albrecht von Brandenburg, for whom he decorated at least six manuscripts. The most sumptuous is the *Missale Hallense* (1524; Aschaffenburg, Hofbib., MS. 10; 14 detached pages in Mainz, Landesmus., inv. no. 65.19). This manuscript shows both Nikolaus's technical mastery and his strong reliance on other artists for his compositions. Dürer's prints, specifically the *Life of the Virgin* woodcuts, were his primary source, though he also borrowed liberally from other masters: for instance, the

Nativity miniature (fol. 24*v*) copies Martin Schongauer's *Birth of Christ* engraving (B. 4), while its elaborate Renaissance-style ornamental frame derives from Hans Burgkmair's *Samson and Delilah* woodcut (B. 7). In spite of this indebtedness, Nikolaus was technically accomplished, with a sensitive use of colours, a sure handling of anatomy and proportion and a taste for lavish architecture and detailed spatial stages. Other manuscripts he illuminated for Albrecht include a fragment of a prayerbook (*c.* 1520–22/23; Kassel, Landesbib., MSS Math. et Art 50); an Hours of the Virgin (1530; Aschaffenburg, Schloss Johannisburg, Hof- & Stiftsbib., MS. 9); a confessional and Missal (1531; Aschaffenburg, Schloss Johannisburg Hof- & Stiftsbib., MS. 8); another Missal (1533; Aschaffenburg, Stiftsschatz, MS. 126); and a Prayerbook of the Passion of Christ (*c.* 1533; Modena, Bib. Estense, MS. alpha 6.7). During the early 1530s Nikolaus frequently collaborated with Georg Stierlein of Nuremberg, who painted the initials.

BIBLIOGRAPHY

NDB; Thieme–Becker

G. W. K. Lochner, ed.: *Des Johann Neudörfer Schreib- und Rechenmeisters zu Nürnberg Nachrichten von Künstlern und Werkleuten daselbst aus dem 1547 nebst der Fortsetzung des Andreas Gulden* (Vienna, 1875), pp. 140–44

Meister um Albrecht Dürer (exh. cat., Nuremberg, Ger. Nmus., 1961)

F. Schnelbögl: *Dokumente zur Nürnberger Kartographie—mit Katalog* (Nuremberg, 1966)

M. Geisberg: *The German Single-leaf Woodcut, 1500–1550*, rev. and ed. W. L. Strauss, 4 vols (New York, 1974) [G]

A. W. Biermann: 'Die Miniaturenhandschriften des Kardinals Albrecht von Brandenburg (1514–1545)', *Aachen. Ksthl.*, xlvi (1975), pp. 15–310, esp. 148–231 [superb disc. of Nikolaus and Albrecht]

H. Degering: *Albrecht Glockendon, Kalendar von 1526: MS. Ger. Oct. 9 der Staatsbibliothek Preussischer Kulturbesitz Berlin*, intro. by F. Steenbock, 2 vols (Stuttgart, 1977)

H. Schneiderler: *Die Septemberbibel Nikolaus Glockendons (1522–1524)* (diss., U. Munich, 1978)

J. C. Hutchison: *Early German Artists*, 8 [VI/i] of *The Illustrated Bartsch*, ed. W. L. Strauss (New York, 1980) [B.]

W. L. Strauss: *Sixteenth-century German Artists*, 11 [VII/ii] of *The Illustrated Bartsch*, ed. W. L. Strauss (New York, 1981) [B.]

J. M. Plotzek: *Andachtsbücher des Mittelalters aus Privatbesitz* (exh. cat., Cologne, Schnütgen-Mus., 1987), no. 79

JEFFREY CHIPPS SMITH

Glöckner, Hermann (*b* Cotta, nr Dresden, 21 Jan 1889; *d* W. Berlin, 18 June 1987). German painter, printmaker and sculptor. From 1904 to 1907 he served an apprenticeship as a technical draughtsman, attending evening classes at the Kunstgewerbeschule in Dresden, though as an artist he was largely self-taught. He made several unsuccessful applications to the Kunstakademie in Dresden, eventually studying at the city's Akademie der Bildenden Künste in 1923–4. His first show was held at the Galerie Victor Hartberg in Berlin in 1927. His early works are objective and based on shapes associated with nature, but they were already aiming towards pure, geometrically based structures that go beyond the object. Between 1930 and 1937 he worked out his constructive abstract sculptural ideas, which were to leave their mark on all his creative output, in a series of 110 works that he described as 'Tafelwerk'. Among these were *Six-point Star in Old Gold* (1932; Dresden, Kupferstichkab., see 1989 exh. cat., no. 242) and *Circle between Green and Brown* (1932; artist's estate, see 1989 exh. cat., no. 29).

Working along the same lines in isolation, due to the hounding of modern artists by the Nazis, Glöckner created many abstract works in the years up to 1945, including his first sculpture, the *Felling in Space of a Rectangle* (metal, 1935), which was destroyed in 1945 (see 1989 exh. cat., nos 430–31). In association with his wife he also worked on murals linked with architecture, especially using the sgraffito technique of incising plaster. From 1945 he produced oscillating abstractions that are lyrical in mood, as well as his structural, abstract works which continued until his death. His important experiments in printing include monotype prints, rubbings and folded works. His work began to be shown from 1955, with a major exhibition of some 150 works in Dresden in 1969.

BIBLIOGRAPHY

J. Erpenbeck, ed.: *Hermann Glöckner: Ein Patriarch der Moderne* (Berlin, 1983)

U. Schumacher and W. Schmidt: *Hermann Glöckner* (Stuttgart, 1987)

Hermann Glöckner zum 100. Geburtstag (exh. cat., ed. W. Schmidt; Dresden, Kupferstichkab.; Halle, Staatl. Gal. Moritzburg; 1989)

C. Dittrich, R. Mayer and W. Schmidt, eds: *Hermann Glöckner: Die Tafeln 1919–1985* (Dresden and Stuttgart, 1992)

EUGEN BLUME

Gloeden, Wilhelm, Baron von (*b* Wolkashagen, nr Wismar, Mecklenburg, 1856; *d* Taormina, Sicily, 1931). German photographer. After studying at the academy in Wismar, von Gloeden painted for some years, but during his first years in Taormina, which he had reached at the end of the Grand Tour in 1874, he abandoned painting for photography. He learnt the dry collodion process from a local photographer, Giovanni Crupi, who was subsequently involved in selling his photographs.

Von Gloeden's photography is characterized by classically oriented subjects, with models in antique costume placed against classical backgrounds in the natural landscape of Taormina; his models were local youths, and are almost always posed nude or semi-clothed in theatrical postures, creating erotic *tableaux vivants* (examples in Rochester, NY, Int. Mus. Phot.). Although his pictures are marked by an overt display of male nudity, there is also a tendency to use the nude symbolically, in the manner of contemporary Italian painters such as Aristide Sartorio, whom von Gloeden seems often to imitate. Von Gloeden, who was at the same time a member of the LINKED RING in London, also produced photographs of local folklore. The best documented period of his activity is 1890–1930, when he produced *c.* 2000 gelatine bromide plates and as many original prints of various sizes on platinum, albumen and, more rarely, carbon paper. Von Gloeden sold his work in a shop in Naples, often almost clandestinely. In the same period his cousin, Wilhelm von Plüschow, was working in Naples and Rome; his photographs were similar but had mostly female rather than male subjects. Some of Plüschow's photographs on sale in Rome at the atelier of the photographer Vincenzo Galdi may have been by von Gloeden operating under a false name. In 1939 von Gloeden's heirs were taken to court on charges of obscenity, and a part of the estate was destroyed by the Fascists.

BIBLIOGRAPHY

R. Peyrefitte: *Les Amours singulières* (Paris, 1949)

J.-C. Lemagny: *Taormina, début du siècle* (Paris, 1975)

M. Miraglia: 'Wilhelm von Gloeden', *Fotografia pittorica in Italia* (Milan, 1979), pp. 47–9

I. Mussa and others: *Le fotografie di von Gloeden* (Milan, 1980)

F. Faeta: 'Wilhelm von Gloeden: Per una lettura antropologica delle immagini', *Fotologia*, 9 (1988), pp. 88–104

ITALO ZANNIER

Glory. Light emanating from a sacred figure or object.

□

Gloucester [Lat. Glevum]. English city and county town in the Severn Valley.

1. INTRODUCTION. The area was settled in the pre-Roman Iron Age. From *c.* AD 40 the Romans occupied the region and established a camp a few kilometres to the north of the modern city centre. Later Glevum became a Roman *colonia* and was substantially embellished; the remains of a fine town house have been found. The town declined considerably with the collapse of Roman Britain, and in 577 was conquered by the Anglo-Saxons. In 914 Gloucester successfully defended itself against a Danish invasion, having been re-fortified and re-planned with a grid of streets that it largely retains to this day. St Oswald's Minster (*see* ANGLO-SAXON, §§II and IV, 1) was founded at this time; it housed the saint's relics and became a focus of pilgrimage. By the 10th century the town was flourishing and expanding again. The Normans embarked on an extensive building campaign in Gloucester, and rebuilt and richly endowed St Peter's Abbey when the old structure burnt down (*see* §1 below). By the 13th century Gloucester was an important centre for the manufacture of cloth and iron goods. In that century several friaries were built and a number of churches, including St Peter's Abbey and St Oswald's Priory (mostly destr.), were enlarged and embellished. With the Dissolution of the Monasteries the abbey of St Peter became the city's cathedral in 1541. The town declined from the 16th century until the 18th, when it began to prosper again, and enjoyed a boom period of building; although much of the medieval town was destroyed, many of the fine 18th-century houses erected in its place still stand, for example, around Millers Green and College Green. In the 19th century Gloucester expanded rapidly in size and population as a result of the introduction of new industries and trade promoted by the construction of canals and railways.

BIBLIOGRAPHY

D. Verey: *Gloucestershire: The Vale and the Forest of Dean*, Bldgs England (Harmondsworth, 1970, rev. 3/1980/*R* 1986)

2. CATHEDRAL.

(i) Before 1327. (ii) 1327 and later.

(i) Before 1327. Founded *c.* AD 681 as a double monastery, St Peter's was crucial to the Christianization of the recently settled Germanic Hwicce people ruled by Osric (*d* 729). Served by secular clergy from 767, St Peter's was refounded for Benedictines *c.* 1022. Some time before 1058 the church burnt down and was rebuilt on a fresh site near by. Another fire in 1088 can only have hastened the replacement of the mid-11th-century church by a much larger Romanesque structure comparable to those begun by most major English foundations between 1066 and *c.* 1090. Work started in 1089, and a dedication in 1100

probably marked the completion of the eastern parts. Fires are recorded in 1102, 1120 and 1122, but their impact on the fabric is unknown. Later medieval changes were remodellings rather than wholesale rebuildings and in consequence the greater part of the Romanesque church has survived. The eastern arm is the oldest still standing above crypt level of any major English Romanesque church. It incorporates an ambulatory and three radiating chapels at crypt, ground-floor and gallery levels, placing Gloucester among the most ambitious of 11th-century Norman and Anglo-Norman churches. Worcester Cathedral (begun 1084), western England's earliest example of this scheme, is the likeliest source. The existence of polygonally planned radiating chapels at Worcester helps to account for the Gloucester designer's enthusiasm for polygonal planning, which affected not only the radiating chapels but also the main apse and ambulatory. The first building campaign included the easternmost parts of the nave, which show that the overall scheme was always intended to differ from that of every other first-class Anglo-Norman church in combining a galleried eastern arm and a nave without a gallery. The only earlier example of such a combination is found at Mont-Saint-Michel Abbey, the home monastery of Serlo (reg 1072–1104), first post-Conquest abbot of Gloucester. The early 12th-century nave triforium, which may well conform to original intentions, is strikingly similar to that in the nave at Mont-Saint-Michel Abbey (paired units each enclosing two arches).

The detailed handling of the design can only be explained in terms of references to sources not normally drawn on by first-generation Anglo-Norman architects. Instead of the elaborately articulated compound piers in general use, all ground-floor and gallery-level supports, except the crossing piers, are massive cylinders—low and squat in the eastern arm, high yet still overpoweringly bulky in the nave (see ROMANESQUE, §II, 6(i)(b)). The nearest analogies are provided by First Romanesque architecture, especially that of St Philibert, Tournus, which has both stocky and tall drum piers. The transmission of drum piers to western England seems to have been effected by the palace chapel (destr.) at Hereford built c. 1079–95 by Bishop Robert de Losinga (reg 1079–95) from Lorraine, although Hereford was closer to Tournus in being constructed from dressed rubble rather than ashlar. Influence from Hereford would also explain the use of stone vaulting over every part of the building at Gloucester, which is uncommon in the Anglo-Norman tradition. There is no evidence to show whether the top level of the choir consisted of a tunnel vault resembling those over the chancel and nave of the Hereford chapel, or whether there was a groin vault combined with a clerestory, as in the central lantern bay at Hereford. Whatever existed at this level in 1100 was probably replaced a few years later when the choir was extensively damaged by settlement. Remedial reinforcements to the crypt include heavy unmoulded Lombard-style ribs and wide chevron-decorated arches.

The nave also makes extensive use of chevron and other abstract ornaments, but its aisle vaults incorporate narrow roll-moulded ribs of Anglo-Norman type. The 12th-century vault over the main span was replaced by the existing structure, finished in 1242. By recessing the wall plane of the triforium and clerestory behind that of the arcade storey it was possible for the original vault responds to sit on a 'shelf', an arrangement paralleled above the 'weak' piers in the eastern parts of Durham Cathedral. There is no sign in the roof spaces over the aisles of abutments comparable to Durham's. Of several works undertaken between the completion of the nave vault and c. 1330, there are only two important survivals. One is a very richly carved mid-13th-century stone screen of unknown function and provenance reset in the north transept. The other is the rebuilding of the south nave aisle c. 1318. The jambs, heads and window tracery there are smothered with ballflower ornament, the stock-in-trade of a productive south-western Decorated 'school'.

(ii) 1327 and later. In December 1327 the body of the murdered king Edward II (reg 1307–27) was buried north of the high altar. Within a few years the place was marked by a monument; its tall and unprecedentedly complex spired canopy is one of the masterpieces of this predominantly English genre. The popular cult that instantly arose was the major inspiration and source of finance for the remodelling of the eastern parts of the church from c. 1331. It marks the climax of Gloucester's architectural history and produced one of the most notable achievements of European Late Gothic architecture. The work was carried out in four separate phases: the south transept (c. 1331–6), the liturgical choir within the crossing (c. 1337–51), the presbytery (after 1351; see fig. 1) and the north transept (after 1368). The building process entailed 'skinning' and refacing the Romanesque main elevations. In the presbytery the main vessel was lengthened by demolishing the 11th-century ambulatories at ground-floor and gallery

1. Gloucester Cathedral, interior of the choir, looking east towards the presbytery, after 1351

level. The eastern corners of the new easternmost bay are farther apart than the rest of the central vessel and the east window bows outwards—peculiarities explicable in terms of the exigencies of building on top of the crypt ambulatory. The result of these improvisations is one of the most extraordinary effects in medieval architecture, a great window wall wider than the space it lights, the full width of which cannot be seen from most viewpoints.

The design of the choir and presbytery was conceived as a refinement of the frankly experimental remodelling of the south transept. Unlike the later phases, the south transept's repetitive, upright, arch-enclosing rectangles are still recognizable as a specialized form of the French Rayonnant triforium. The panelling masking the south transept gallery openings is combined with a moulding framing the opening, a combination otherwise found only on the exterior of the lower chapel of St Stephen's Chapel (partly destr.), Palace of Westminster, begun by Michael of Canterbury in 1292. The south window of the south transept, the earliest extant Perpendicular window, also includes Kentish tracery forms deriving from Michael's oeuvre. If Edward III, who made several pilgrimages to his father's tomb, had recommended an architect to the abbot, the obvious choice would have been THOMAS OF CANTERBURY, Michael's successor at St Stephen's. Thomas either died or ceased to be active after 1336, a circumstance that would help to account for the entrusting of the choir and presbytery works to a second, anonymous architect open to the influence of local Decorated architecture.

This influence is particularly apparent in the design of the high vault; its basic shape—a pointed tunnel with penetrations—derives from such vaults as that over the choir (after c. 1330) at Wells Cathedral. The extraordinarily close mesh of ribs, including diagonal ribs crossing two bays, depends on earlier experiments at Tewkesbury Abbey (Glos; c. 1340) and Exeter Cathedral. Although dense and eclectic, the design of the presbytery is the work of a disciplined and subtle mind. The use made of the basic arched panelling motif illustrates this, for whereas in the south transept the horizontals occur so intermittently as to seem somewhat arbitrary, in the presbytery they are far more regularly spaced and numerous, especially in the clerestory, which rises high above the Romanesque wall-head level, still adhered to in the earlier work. The exceptionally strong vertical emphasis of the presbytery elevation is achieved partly by the treatment of the horizontals, which are slighter than the mullions and are eliminated altogether from the immediate vicinity of the vault responds.

The presbytery vault itself resembles earlier vaults in being visually and structurally different from the sides of the vessel that it covers. In the cloisters (see fig. 2), begun c. 1351–64, tentative early 14th-century experiments with tracery-decorated vaults, mostly in south-west England, culminated in the earliest example of fully developed fan vaulting, which was almost certainly conceived as a specialized application of the all-over panelling concept of the presbytery elevation. The three-dimensional form of the cloister vaults derives from a long English tradition of conoidal rib clusters, exemplified by those over the middle piers of centralized chapter houses. The construction of

2. Gloucester Cathedral, cloisters, south walk looking west, begun c. 1351–64

the Gloucester fan vaults as ashlar shells is novel, and is paralleled at this date and on this scale only in the systematically traceried vault over the porch (completed by 1352) to the St George's Chapel precinct at Windsor Castle. Many of the most important religious houses of south-west England built imitations of the Gloucester cloister in the late 14th century and the early 15th, but virtually all later fan vaults over spaces larger than cloisters reverted to traditional rib and panel construction. Integrated into the overall scheme of the cloister are a fan-vaulted lavatorium projecting from the north walk, and, in the south walk, an unusual series of stone carrels (normally timber structures). The other outstanding building in a comparatively complete monastic precinct is the early 12th-century chapter house, covered by a tunnel vault; its pointed profile may be original, or a reconstruction made when the apse was rebuilt in the early 15th century. 'Antiquarianism' of this kind was already apparent in the extensive recycling of Romanesque elements on the outside of the eastern part of the church during its 14th-century remodelling.

In the 15th century several parts of the church were rebuilt: the west front, the west bays and south porch of the nave c. 1430, the crossing tower c. 1450–57 and the Lady chapel c. 1468–82. The tower, although owing much in its overall conception to the crossing tower (c. 1375) of Worcester Cathedral, exceeds its model and all other English cathedral towers in the extent to which structural mass is treated as seemingly weightless surface panelling. The openwork corner pinnacles are elaborations of the

pinnacles (*c.* 1360) on the east front of the presbytery. The even more extensive and literal borrowings from the presbytery that are evident in the design of the spacious Lady chapel exemplify the powerful influence that the pioneering mid-14th-century work continued to exert in the region during the late Middle Ages.

Medieval stained glass is found in the choir east window (before *c.* 1357; rest.; *see* GOTHIC, fig. 105), which depicts the *Coronation of the Virgin with Apostles, Saints and Ecclesiastics*, and in the Lady chapel east window, into which alien glass was introduced in the 19th century. CHRISTOPHER WHALL made windows (1898–1913) for the Lady chapel and chapter house.

BIBLIOGRAPHY

Archaeol. J., xvii (1860), pp. 335–42 [Summary of address by R. Willis on the hist. and dev. of Gloucester Cathedral to annu. meeting of the Archaeological Institute, Gloucester, 1860]

Historia et Cartularium Monasterii Sancti Petri Gloucestriae, ed. W. H. Hart, Rolls Series, xxxiii, 3 vols (1863–7)

F. S. Waller: 'The Crypt of Gloucester Cathedral', *Trans. Bristol & Glos Archaeol. Soc.*, i (1876), pp. 147–52

W. H. St J. Hope: 'Notes on the Benedictine Abbey of St Peter at Gloucester', *Archaeol. J.*, liv (1897), pp. 77–119

J. Bilson: 'The Beginnings of Gothic Architecture', *RIBA J.*, vi (1899), pp. 259–319

F. S. Waller: 'Gloucester Cathedral Tower', *Trans. Bristol & Glos Archaeol. Soc.*, xxxiv (1911), pp. 175–94

J. Bony: 'Tewkesbury et Pershore: Deux élévations à quatre étages de la fin du XIe siècle', *Bull. Mnmtl*, xcvi (1937), pp. 281–90

N. Pevsner: 'Bristol, Troyes and Gloucester: The Character of the Early Fourteenth Century in Architecture', *Archit. Rev.* [London], cxiii (1953), pp. 89–104

J. Bony: 'La Chapelle épiscopale de Hereford et les apparts lorrains en Angleterre après la conquête', *Actes du XVe congrès international de l'histoire de l'art: Paris, 1959*, pp. 36–43

J. H. Harvey: 'The Origin of the Perpendicular Style', *Studies in Building History*, ed. E. M. Jope (London, 1961), pp. 134–65

H. Bock: *Der Decorated Style* (Heidelberg, 1962), pp. 64–5, 94–8, 136–9

J. H. Harvey: *The Perpendicular Style, 1330–1485* (London, 1978), pp. 78–81

J. Bony: *The English Decorated Style: Gothic Architecture Transformed, 1250–1350* (Oxford, 1979)

W. C. Leedy: *Fan Vaulting: A Study of Form, Technology and Meaning* (London, 1980), pp. 166–70

C. Wilson: *The Origins of the Perpendicular Style and its Development to Circa 1360* (diss., U. London, 1980), pp. 112–70

Medieval Art and Architecture at Gloucester and Tewkesbury: British Archaeological Association Conference Transactions: Gloucester, 1981, pp. 36–83, 99–115

C. Tracy: *English Gothic Choir Stalls, 1200–1400* (Woodbridge, 1987), pp. 44–8

C. Wilson: *The Gothic Cathedral: The Architecture of the Great Church, 1130–1530* (London, 1990), pp. 204–11

D. Welander: *The History, Art and Architecture of Gloucester Cathedral* (Gloucester, 1991) [with full bibliog.]

CHRISTOPHER WILSON

Gloucester, Humfrey [Humphrey], Duke of. *See* LANCASTER, (3).

Gloucester, Thomas of Woodstock, Duke of. *See* PLANTAGENET, (5).

Glover, George (*fl* 1634–52). English engraver. During a period when engraved work in England mostly borrowed its attenuated forms from Flemish Mannerist originals, Glover was able to establish himself with portrait line-engravings that have a distinctly English quality. They are a graphic parallel to the work in oils of such portrait painters as Gilbert Jackson and Edward Bower, both of whom maintained a more traditional manner at a time when many artists were drawn to the Flemish Baroque style of van Dyck and others. Almost 100 of Glover's engravings are known (examples London, BM, and elsewhere). From their inscriptions it is clear that on occasion he was responsible for drawing as well as engraving the portraits of his sitters; works he made after others include portraits after Cornelius Johnson and Edward Bower. The best of the engravings made after his own designs is the frontispiece to Sir Thomas Urquhart's *Epigrams Divine and Moral* (1641), which shows a lively inventiveness in its design. Other types of work undertaken by Glover include title-pages, for example that for Gerard Mercator's *Atlas* (1635), and numerous (undated) series of prints, including the *Five Senses*, the *Seven Liberal Arts and Sciences*, the *Seven Deadly Sins* and the *Nine Women Worthys*, the last of which was composed of exemplary Jewish, Christian and non-religious females.

Glover worked for the painter and dealer William Peake (*c.* 1580–1639) and his son Robert Peake the younger (*c.* 1602–1667), who together ran a commercial gallery at Holborn, London, founded by William's father, the Serjeant-Painter Robert Peake. Through these connections Glover must have become acquainted with the leading engraver of the mid- to late 17th century, William Faithorne, as well as with William Dobson and other painters for whom the Peake family acted. There is nevertheless little of the fashionable Flemish-derived Baroque style emulated by such artists to be found in Glover's own work.

BIBLIOGRAPHY

DNB

A. M. Hind: *The Reign of Charles I*, ed. M. Corbett and M. Norton (1964), iii of *Engraving in England in the Sixteenth and Seventeenth Centuries* (Cambridge, 1952–64), pp. 225–50

R. T. Godfrey: *Printmaking in Britain: A General History from its Beginnings to the Present Day* (Oxford, 1979)

CHRISTOPHER FOLEY

Glover, John (*b* Houghton-on-the-Hill, Leics, 18 Feb 1767; *d* Launceston, Tasmania, 9 Dec 1849). English painter. He was employed first as a schoolteacher at Appleby (Cumbria) and after 1794 as a drawing-master at Lichfield (Staffs), from where he sent drawings to London each year; on his occasional visits to the capital he received lessons from William Payne and was clearly influenced by him. In the 1790s he also began to practise in oils, some of which were exhibited at the Royal Academy from 1795 onwards. At the first exhibition of the Society of Painters in Water-Colours (April–June 1805) Glover's pictures were priced more highly than those of any other exhibitor; he was elected President of the Society in 1807 and again in 1814–15. A typical watercolour is his *Landscape with Waterfall* (U. Manchester, Whitworth A.G.). As a painter of large landscapes in oils he appeared to many contemporaries as the chief rival to J. M. W. Turner—much to the irritation of John Constable. In palette and composition Glover remained conservative; among his characteristic mannerisms was the use of a split brush to paint sun-dappled foliage.

Glover visited Paris shortly after Napoleon's defeat in 1814, and later he travelled in Italy. In the 1820s he staged a series of one-man shows, placing his work among

pictures by Claude Lorrain and Richard Wilson (together with his own copies of 17th-century landscapes) 'as a criterion for the public to judge by'. In 1824 he became a founder-member of the Society of British Artists, and he exhibited there regularly until 1829, when he emigrated, having realized £60,000 from the sale of his house and pictures. He settled in Tasmania, where he remained until his death, farming sheep and painting local scenes. Examples of his work are in the Tasmanian Museum and Art Gallery, Hobart, and the Queen Victoria Museum and Art Gallery, Launceston.

BIBLIOGRAPHY

H. Smith: 'John Glover, O.W.C.S. 1769–1849', *Old Wtrcol. Soc. Club*, lvii (1982), pp. 7–21

PATRICK CONNER

Głowacki, Jan Nepomucen (*b* Kraków, 1802; *d* Kraków, 28 July 1847). Polish painter and writer. He studied drawing under Antoni Giziński (?1758–1847) and then trained (1819–25) at the School of Fine Arts in Kraków under Józef Brodowski (1780–1853) and Józef Peszka (1767–1831). He continued his studies under Franz Steinfeld (1787–1868) at the academy in Vienna, where he became a friend of the miniaturist Emanuel Peter (1799–1873). In 1828 Głowacki returned to Kraków, where he was based for the rest of his life, as a teacher of drawing and painting at St Anne's high school. He also taught at the Kraków School of Fine Arts, where he was Professor of Landscape Painting from about 1840.

Głowacki was a highly educated artist of wide-ranging interests. He painted portraits, some religious, mythological and genre scenes, and he was an expert miniaturist and illustrator. Above all, however, he is known as a landscape painter. His interest in landscape was sparked during his studies in Vienna, and he introduced landscape painting to Polish art. At first, he painted views of the Alps, and after his return to Kraków, he painted in particular views of the Tatra Mountains. His landscape scenes are smoothly finished, with neat, even brushwork characteristic of the idealizing style of landscape painters in mid-19th-century central Europe. Głowacki's work evinces great feeling for his motifs, in particular for their invigorating sense of space and the occasional hint of the sinister. His paintings often have a peaceful, grey, green and bronze colouring (e.g. *The Sea's Eye Lake in the Tatra Mountains*; Kraków, N. Mus.). Others use light to present a heightened mood of nostalgia or exhilaration (e.g. *The Kościeliska Valley in the Tatra Mountains* (Wrocław, N. Mus.).

Głowacki's portraits are characterized by precise delineation and suggest the influence of Viennese Biedermeier painting, for example the portrait of *Colonel Paszyca* (Warsaw, N. Mus.). In 1842, Głowacki published a small book of observations on contemporary painting in Europe.

WRITINGS

Niektóre postrzeżenia nad obecnym stanem malarstwa i wiadomości o celniejszych współczesnych artystach europejskich [Certain perceptions regarding the current state of painting and news about the more prominent modern-day European artists] (Warsaw, 1842)

BIBLIOGRAPHY

SAP; Thieme–Becker

A. Gorczyński: 'O Janie Nepomucenie Głowackim' [About Jan Nepomucen Głowacki], *Rocznik Towarzystwa Naukowego Kraków.*, vi (1862), pp. 38–45

S. Kozakiewicz: *Malarstwo Polskie: Oswiecenie, Klasycyzm, Romantycyzm* [Polish painting: the Enlightenment, Classicism, Romanticism] (Warsaw, 1976)

ZOFIA NOWAK

Glue-size. *See under* SIZE.

Gmunden. Austrian centre of ceramic production. The existence of a pottery tradition in Gmunden was discovered during excavations in 1955 when a settlement with pottery dating from the Roman period was found at nearby Engelhof. At the end of the 16th century seven potters were resident in Gmunden, but by 1747 there were only three. Local clays from Baumgarten and Vichtau were used, and the earliest pottery consisted of rather plain dishes for everyday use, which were based on Italian models.

During the 17th, 18th and 19th centuries the Gmunden potteries produced mainly marbled wares using a combination of green, blue, grey, brown and white glazes. In addition to tankards and jugs, the most popular form was the so-called 'Pfeifenschüssel', an oval plate with an undulating edge, which was mainly used as a wall decoration. Green and brown mottled ware was developed from *c.* 1600 as attempts were made to achieve a marbled effect on a white glaze by using dots and flecks of colour. Originally, in addition to light green and cobalt blue, rich green and brown were also used; from the second half of the 18th century the markings were mainly in green and the pottery was known commercially as 'Grüngeflammte' ware and became popular as typical Gmunden pottery. At the same time an 'Alt-Gmundner-Fayence' was being developed on which pictorial decoration of the human figure and views of Gmunden were used rather than ornament. For centuries Gmunden pottery presented a stylistically unified picture in the forms and patterns used by its few workshops.

The link with developments in pottery-making resulting from 19th-century industrialization was made by Franz Schleiss the elder (*d* 1887), who began potting in 1843 when he bought Ignaz Pott's pottery workshop. After Schleiss's death the company was taken over by his son Leopold Schleiss, who left the premises in 1903 and continued production at the newly built Gmundner Tonwarenfabrik in Traunleiten. Leopold's son Franz Schleiss the younger and Franz's wife Emilie Schleiss had both studied at the Kunstgewerbeschule (now the Hochschule für Angewante Kunst) in Vienna and had been pupils of Michael Powolny. They brought the factory to a peak of artistic achievement through their contacts with Viennese art potters. In 1913 a fruitful collaboration was achieved when the Künstlerische Werkstätte Franz und Emilie Schleiss merged with the Wiener Keramik to become the Vereinigte Wiener und Gmundner Keramik. A wide range of models were produced, and as a result of the contributions of Michael Powolny, Bertold Löffler, Dagobert Peche, Julius Feldmann and Ida Schwetz-Lehmann, the artistic quality was extremely high.

In 1917 Franz Schleiss founded the Keramische Schule Schleiss to provide artistic training for the next generation of potters. In 1923 he opened the Gmundner Werkstätten, where many pieces were decorated with designs based on work by Ludwig Galasek, Edith Hirschhorn and Vally

Wieselthier. In the same year the Keramik Schleiss separated from the Gmundner Keramik group and moved back to the previous premises in Theatergasse. Such eminent artists as Josef Hoffmann and Wolfgang von Wersin worked for Keramik Schleiss, which produced only studio pottery. The production of simple, everyday wares and high-quality services based on designs by artists was taken on by the company known as Gmundner Keramik AG based in Traunleiten. When the firm was taken over by the Hohenberg family it became Gmundner Keramik-Hohenberg, and a special unit called Atelier H was established where such art potters as Gudrun Baudisch, Anton Raidel and Wolfgang von Wersin were employed to produce pieces of high artistic quality.

BIBLIOGRAPHY

A. Walcher von Molthein: 'Die Gmundner Bauern-Fayencen', *Kst & Ksthandwk*, viii (1907), pp. 407–80
P. Schleiss: 'Histoire von der Schleiss Keramik, Gmunden', *Mitt. Mus. Hallstatt*, lix (1963)
Gmundner Keramik: Von der grüngeflammten Hafnerware bis zu den künstlerischen Entwicklungen der Gegenwart (Gmunden, 1978)

GABRIELE RAMSAUER

Gnadenaltar. Altar on which a miraculous image (*Gnadenbild*) is placed.

Gnauth, (Gustav) Adolf (*b* Stuttgart, 1 July 1840; *d* Nuremberg, 19 Nov 1884). German architect and teacher. He studied at the Stuttgart Polytechnikum under Christian Friedrich Leins (1814–92) and then became a railway engineer in Württemberg (1860–61). His study of Renaissance architecture on a visit to Italy (1861–2) strongly influenced his subsequent work. He spent three years (1863–6) in various architectural offices in Vienna, taught briefly at the Stuttgart Baugewerkschule (1866–7), then moved to London (1867–9) to work for the Arundel Society, preparing a book on the tombs in Venice and Verona.

In 1870 Gnauth became professor at the Stuttgart Polytechnikum as a result of the success of his Villa Siegle (*c*. 1868; destr.) in Stuttgart, based on the Early Renaissance Villa Carlotta on Lake Como. Gnauth collaborated on the villa's decoration with the painter Ludwig Lesker (1840–90), with whom he edited the *Maler-Journal* from 1875. They collaborated on several further commissions, including the Palais Engelhorn (1873–5; destr.) in Mannheim, a villa (*c*. 1876; destr.) at Ludwigshafen am Rhein and the Palais Cremer-Klett (after 1878; destr.) in Munich. From *c*. 1872 Gnauth's use of the late Italian Renaissance style was mixed with details from the German Renaissance, as in the Württembergische Vereinsbank and a house in the Uhlandstrasse, as well as from the English Renaissance Revival, evident in his villa colony in Goethestrasse (1873), all in Stuttgart and now demolished. Gnauth also adopted Baroque Revival elements at a remarkably early stage, appearing from 1874 in the designs he published in the magazine *Kunsthandwerk* and in his Gewerbemuseum (1878–9; destr.) at Nuremberg. He had moved to Nuremberg in 1877 to take up the post of Director of the Kunstgewerbeschule. Following a visit to Egypt (1875–6) with his friends Hans Makart and Franz von Lenbach, and a journey to Spain (1882), Middle Eastern or Moorish

influences appeared in his work, for example in the exhibition pavilions (1882; destr.) for the Bayerische Landesausstellung in Nuremberg. As a restorer he was conservative, his work including the restoration of the Pellerhaus of 1620 (destr. 1945) and a surveyor's report on the proposed extension of the Rathaus (*c*. 1880), both in Nuremberg.

BIBLIOGRAPHY

ADB; Thieme–Becker
H. A. Müller: *Biographisches Künstlerlexikon der Gegenwart* (Leipzig, 1882)
E. Paulus: 'Adolf Gnauth', *Über Land & Meer*, liii/11 (1885)
'La Vereinsbank à Stuttgart par M. Ad. Gnauth', *Rev. Gén. Archit.*, iv/12 (1885)
G. Wais: *Stuttgarts Kunst- und Kulturdenkmale* (Stuttgart, 1954)
B. Deneke and R. Kahsnitz, eds: *Das Germanische Nationalmuseum Nürnberg, 1851–1977* (Nuremberg, 1978), p. 1044
K. Bosl: *Bayerische Biographie* (Regensburg, 1983), p. 259
G. Blank: *Stuttgarter Villen im 19. Jahrhundert* (Stuttgart, 1987), p. 7

JULIUS FEKETE

Gniezno. City in north-west Poland, *c*. 45 km east of Poznań.

1. INTRODUCTION. From the 8th century AD it was the seat of the first Polish Piast dynasty, becoming the capital of the Polish state they created in the second half of the 10th century. Since 1000 it has also been the ecclesiastical capital of Poland. Despite losing its status as the capital to Kraków in 1038, it continued to be the main centre of Greater Poland until after the mid-13th century, when the seat of the ruling princes was transferred to Poznań and the castle passed into the hands of the Archbishop and chapter. The earliest settlement, situated on hilly terrain between the narrow River Srawa and several small lakes, consisted of a fortified princely residence on a hill above a hamlet, both surrounded by a timber and earth rampart. Further settlements developed in the 10th century, and after the adoption of Christianity in 966 a chapel was built near the castle and a cathedral in the foremost settlement.

The irregular course of some of the streets in the medieval city, which was granted a charter *c*. 1239, was influenced by the layout of the old settlements. Both inside and outside its walls are a number of brick Gothic churches mostly dating from the 14th and 15th centuries. Besides the cathedral (*see* §1 below) the most important preserved buildings are the church of St John the Baptist with its integral sculptural decoration of painted artificial stone, the twin church of the Franciscans and Clarissans and two parish churches, Holy Trinity and St Michael, of which the latter was built by a workshop attached to the cathedral in the second half of the 14th century. Under the Second Partition of Poland (1793) Gniezno passed to Prussia. The archbishop's palace on the south side of the cathedral, built 1830–36, is in the Neo-classical style, as are many of the residential districts that sprang up after the great fire of 1819. The main corridor between the market and the cathedral was developed according to plans drawn up by Prussian architects, but after Poland became independent in 1918 Polish architects made some contribution to church building in the city.

BIBLIOGRAPHY

J. Topolski, ed.: *Dzieje Gniezna* [History of Gniezno] (Warsaw, 1965)

2. CATHEDRAL. The Cathedral is dedicated to the Assumption of the Virgin and St Adalbert.

(i) Early history, to 1342. The first stone building on the site was founded after the conversion of Poland in AD 966 by Mieszko I (*d* 992); it became a cathedral in 1000, when Poland obtained the right to an archbishopric following the Gniezno Congress (AD 1000) between Boleslav I [Bołeslaw Chobry] (*reg* 992–1025; *see* PIAST) and the Holy Roman Emperor Otto III. The sanctuary's national importance is underlined by its possession of the relics of St Adalbert of Prague, who set out from here in 997 to convert the Prussians, suffered martyrdom and was proclaimed the patron saint of the young Polish kingdom.

From the end of the 10th century at least three successive structures were built on the site, each on the foundations of its predecessor. Excavations undertaken between 1954 and 1962 showed that the earliest building, dating from the last third of the 10th century, was an aisled basilica, its eastern part terminating in three apses; there was no transept. Traces of a circular pier between the nave and south aisle indicate that the nave had a columnar arcade. The western termination of this church is unknown. In 1018 the cathedral was burnt. It was then either repaired, or rebuilt to the same plan, probably by the time of Boleslav I's coronation in 1025. The vast stretches of pavement, composed of coloured ceramic tiles imitating *opus sectile*, probably date from this period. Traces in the eastern part of the nave confirm that this was the original site of St Adalbert's shrine, which was removed in 1940. The gold altar and huge gold crucifix (destr.) given by Emperor Otto III and Boleslav I placed the Gniezno Shrine among the most sumptuous of early medieval sanctuaries.

The cathedral was plundered and destroyed during the pagan insurrection and Czech invasion of 1034–8. It was replaced by a Romanesque structure, which was consecrated first in 1064 and again in 1097, perhaps on its final completion. This church was built on the foundations of its predecessor, although the choir was enlarged by shifting the apse eastwards. Remains of walls, built of finely worked granite ashlar, clearly indicate that the side apses were in echelon. There are remains of twin towers at the west end, with a double crypt built between them somewhat later. The nave had four pairs of rectangular piers with, on the main vessel, pilasters originally related to the articulation of the nave walls. The increasing importance of the cult of St Adalbert in the first half of the 12th century, as a result of Poland's expansion towards Pomerania, is manifested in the bronze doors with scenes from the Saint's life, which most scholars date to the last quarter of the 12th century. Remains of the archivolt of a sandstone portal, the dimensions of which correspond to those of the bronze door, are among preserved architectural fragments.

(ii) After 1342. In 1342 the new archbishop, Jarosław Bogoria Skotnicki, began a new cathedral, the construction of which took nearly 50 years. Except for the absence of a transept, perhaps caused by the restricted site, on top of a hill with steep slopes, the east end conforms to the classic layout of a French Gothic cathedral, the only one to do so in this part of eastern Europe. The brick and stone chevet, planned on seven sides of a dodecagon, is surrounded by an ambulatory and seven polygonal radiating chapels, which were not originally integrated into the body of the choir, being somewhat lower than the ambulatory walls. The elevation of the choir, however, differs considerably from those of western European buildings. The interior has narrowly spaced arcades, massive piers and strong horizontal emphasis in the friezes and cornices separating the arcade from the clerestory (see fig.). The cornices and delicate shafts, spaced at regular intervals, form rectangular frames enclosing the arches of the main arcade. Above, the bare tracts of wall are broken only by the short, narrow clerestory windows. Pointed niches fill the arcade spandrels of the straight bays, a design reminiscent of triforium arches. These features of *Reduktionsgotik*, equally visible in the austere exterior, with the flying buttresses concealed under the aisle roofs, are characteristic of central European Gothic. The Gniezno masons were influenced by Cistercian and mendicant architecture in southern Germany, Bohemia and Austria; the many masons' marks preserved inside the building confirm the hypothesis that the team originated from there.

The choir of Gniezno was probably near completion in 1358, when it was inspected by Kasimir III (*reg* 1333–70). Some time must have elapsed before the start of work on the nave and aisles, when there was a change of workshop, visible in both building technique and style. In the nave and aisles sandstone was replaced by artificial stone, based on lime, calcium and gypsum. The unique sculptural decoration of the nave and aisles, most of it dating from the episcopates of archbishops Suchywilk and Bodzanta (1374–82 and 1382–8 respectively), was made of this

Gniezno Cathedral, interior, from 1342

material in prefabricated components. It was used for the strongly emphasized cornice above the arcades (the piers are elongated octagonals in plan), as well as the soffits of the arcades and the vault ribs. While the architecture of the nave and aisles had certain affinities with Kraków Cathedral, the repetitive artificial stone decoration had its counterparts in Pomerania (e.g. Pelplin, Frombork Cathedral). Similar examples of ribs and cornices adorned with figure sculptures can also be found in the architecture of north-western Europe. The portals, on the other hand, as well as the capitals of the attached shafts of the north aisle walls and piers, show that these sculptors came from the same circles as the masons employed on the choir, that is, from the southern areas of central Europe, Swabia in particular. The figure sculptures of the nave and aisles follow a complex and consistent programme, with devotional and allegorical themes, as well as some political messages on the bosses of the ambulatory and aisles.

The construction of the Gothic cathedral was accompanied by another transformation of St Adalbert's shrine. Mentions in documents, descriptions and remains of emblazoned artificial stone slabs indicate that the shrine, built early in the 15th century, was in the form of a lofty chapel, the walls and roof of which were made of decorative iron grilles resting on a high socle adorned with the Pomeranian coat of arms. This 'Iron Chapel', placed traditionally in the centre of the cathedral, originally housed a tomb and altar of which nothing is known; from 1480 there was a tomb with a marble effigy of St Adalbert under an open-work canopy carved by Hans Brand, who probably came from southern Germany.

The Baroque remodellings of Gniezno Cathedral after the fires of 1613 and 1760 partly obliterated the forms of the Gothic building. After 1613 the chapels round the choir were reduced to a uniform height, their gables torn down and their external walls integrated into a whole; the stained-glass windows, the existence of which is confirmed by written sources, then disappeared. During the 17th century the Gothic portals of the aisle chapels were gradually replaced by Baroque ones with sumptuous grilles, most of which came from Gdańsk. A richly gilded canopied structure was built over the tomb and altar of St Adalbert in the centre of the nave. Work on the sumptuous sepulchral chapel of Archbishop Teodor Potocki was started in 1727 to designs by the Roman architect Pompeo Ferrari. Its decoration, the dominant feature of which is an oval dome topped by a lantern, was carried out in coloured stucco, with paintings in the dome by Mathias Johannes Mayer (*d* 1737) representing *Allegories of the Beatitudes* (1728).

The most important changes to Gniezno, however, were made after the fire of 1760, when the cathedral was rebuilt to the design of the royal architect Efraim Szreger. The Gothic nave vault was torn down, the pointed nave arcades were reduced to semicircular shapes, and classicizing pilasters were applied to the nave walls. Szreger was also responsible for the tower crowns, which were rebuilt to the same shape in the reconstruction of the cathedral after World War II. Some of the Gothic features were then restored: the walled-up choir arcades were reopened, and tracery and windows restored on the basis of preserved original remains. The most important measure, however,

was the restoration of the nave vault, the original character of which could be established from the surviving bay between the towers and the numerous segments of the original artificial stone ribs, which had been used in previous remodellings. A crypt was built under the nave to provide access to the remains of the pre-Romanesque and Romanesque structures.

BIBLIOGRAPHY
A. Świechowskiej, ed.: *Katedra Gnieznieńska*, 2 vols (Poznań, 1968–70)
A. Świechowski and Z. Świechowski: 'Der Dom zu Gnesen und seine Stellung in der gotischen Kunst', *Z. Dt. Ver. Kstwiss.*, xxvii (1973), pp. 24–54
P. Crossley: *Gothic Architecture in the Reign of Kasimir the Great: Church Architecture in Lesser Poland, 1320–1380* (Kraków, 1985)

ZYGMUNT ŚWIECHOWSKI

Gnoli, Domenico (i) (*b* Rome, 6 Nov 1838; *d* Rome, 12 April 1915). Italian writer. The author of several collections of poems, he taught Italian literature at the Università di Torino (1880–81) before becoming a librarian at the Biblioteca Vittorio Emanuele in Rome. In 1888 he founded one of the earliest and most authoritative Italian art reviews, the *Archivio storico dell'arte*, which he edited for almost a decade, and, in 1897, the *Rivista d'Italia*. His many articles on art history deal mainly with architecture and sculpture between the 15th and 17th centuries. He also showed a particular interest in the urban planning problems of late 19th-century Rome. He condemned the invasion of the space in front of the Terme di Caracalla and fought against the demolition of such ancient buildings as the Palazzo Altoviti and the Palazzo dei Bini. He was a great expert in epigraphy and epitaphs and an authority on the famous 15th-century texts on the *Hypnerotomachia Poliphili*, the subject of one of his books. His research and art-historical studies, published in various reviews, were collected and their conclusions summarized in the book *Have Roma* (1909).

WRITINGS
'Il sogno di Polifilo', *Riv. Italia*, iii (1899), pp. 44–72, 269–73
Have Roma (Rome, 1909)
Regular contributions to *Archv Stor. A.* (1888–93), *Nuova Antol.* (1867–) and *Riv. Italia* (1897–1900)

BIBLIOGRAPHY
M. De Camillis: *Domenico Gnoli* (Naples, 1924)
G. Barberi Squarotti: 'Domenico Gnoli', *Lett. It. Contemp.*, i (1979), pp. 173–6

GIULIANA TOMASELLA

Gnoli, Domenico (ii) (*b* Rome, 3 May 1933; *d* New York, 17 April 1970). Italian painter and stage designer. His interest in art was encouraged by his father, the art historian Umberto Gnoli, and his mother, the painter and ceramicist Annie de Garon, but his only training consisted of lessons in drawing and printmaking from the Italian painter and printmaker Carlo Alberto Petrucci (*b* 1881). After holding his first one-man exhibition in 1950, he studied stage design briefly in 1952 at the Accademia di Belle Arti in Rome; he enjoyed immediate success in this field, for example designing a production of William Shakespeare's *As You Like It* for the Old Vic Theatre in London in 1955. He then began to live part-time in New York, where he began to work as an illustrator for magazines such as *Sports Illustrated*. During this period he drew inspiration from earlier art, especially from master

printers such as Jacques Callot and Hogarth, from whom he derived his taste for compositions enlivened by large numbers of figures stylized to the point of caricature. In other works he emphasized the patterns of textiles or walls, boldly succumbing to the seduction of manual dexterity and fantasy in a style that was completely out of step with the prevailing trends of the 1950s.

From the early 1960s Gnoli devoted himself almost exclusively to painting, concentrating on everyday objects such as armchairs, beds, suitcases and details of ordinary items of clothing and attire, such as *Wrist Watch* (1969; Aachen, Neue Gal.). These were favourably received, since their cult of the object and plays on scale made sense in relation to Pop art and other developments of the period. Unlike most of his American counterparts, however, Gnoli retained overt links with European movements that originated earlier in the century, such as Pittura Metafisica, Magic Realism and Surrealism. This taste for historical allusions, combined with his technical virtuosity, prefigured the revivalist tendencies of Post-modernism in the 1980s.

BIBLIOGRAPHY
Domenico Gnoli (exh. cat. by G. Cortenova, Verona, Gal. Civ. A. Mod. & Contemp., 1982)
V. Sgarbi: *Gnoli* (Milan, 1983)
Domenico Gnoli (exh. cat. by B. Mantura and M. Quesada, Milan, Padiglione A. Contemp., 1985)
Domenico Gnoli (exh. cat., ed. B. Mantura; Rome, G.N.A. Mod., 1987)
Domenico Gnoli (exh. cat., ed. M. Corral and R. Barilli; Madrid, Fund. Caja Pensiones, 1990)
RENATO BARILLI

Gnome, the [Latv. Rūķis]. Latvian group of artists active in St Petersburg in the 1890s. It was founded (1892–3) by Latvian students attending the principal art institutions in St Petersburg, apparently on the suggestion of Kārlis Pētersons (1836–1908), a Latvian art teacher in the city. Established simultaneously with the growth of the Russian Revival movement and new Russification policies in the Baltic region, the group chose a name synonymous with hard work and oppression. It aimed democratically to express and promote national identity through art, and to this end it utilized both a realistic approach and a number of motifs from Latvian history, folk art and ethnography. It also sought to establish and promote a high professional standard for Latvian artists. Led by Ādams Alksnis (1864–97), who graduated from the St Petersburg Academy of Arts in 1892, the group was comprised of students from the Academy: the painters Arturs Baumanis (1865–1904), Pēteris Balodis (1867–1914), JĀNIS TEODORS VALTERS (chairman of the group after Alksnis's death), JANIS ROZENTĀLS and VILHELMS PURVĪTIS; students of the Baron Stieglitz Central Institute of Technical Drawing: the graphic artists Richard Zarriņš (1869–1939), Gotlībs Lapiņš (1859–after 1939) and Ernest Zīverts (1879–1937); the designers Jūlijs Madernieks (1870–1955), Jānis Libergs (1862–1933) and Jūlijs Janunkalniņš (1866–1919); and the sculptors TEODORS ZAĻKALNS and Gustavs Šķilters (1874–1954). Students of music at the St Petersburg Conservatoire were also members: the composers Alfrēds Kalniņš (1879–1951), Emilis Melngailis (1874–1954), Pēteris Pauls Jozuus (1873–1937) and Pāvuls Jurjāns (1866–1948).

Backed by wealthy members among the large number of Latvians in St Petersburg, the activities of the Gnome involved regular studio meetings, musical sessions and the organization of exhibitions, lectures and communal discussions on art and socio-political issues. Its first exhibition took place in Riga in 1896 and was organized to coincide with the 10th All-Russian Archaeological Congress, for which the Gnome members were also active in arranging the unprecedented Latvian Ethnographic Exhibition. Members also sought to have their work published in such local periodicals as *Austrums* (Latv.: 'The spirit of the dawn') and, in some cases (most notably that of Alksnis), attempted to live out their ideals in rural Latvia upon their return home from St Petersburg. Through these activities, as well as the members' subsequent founding of the Latvian Society for the Promotion of Art (Latviešu mākslas viecināsanas biedrība), the Gnome laid the groundwork for the development of an indigenous school of art in Latvia. Inspired by Alksnis's idealism and his sensitive tolerance of a variety of approaches, and furthered by the pragmatism of Richard Zarriņš, who was its secretary, the Gnome (as distinct from the *Kunstverein*, its German–Latvian-orientated predecessor) was the first group to promote Latvian artists *per se*.

The art of the group was highly diverse. Alksnis tended to paint as a Realist, often depicting the toil of rural life in which humans and animals blend with brown, ploughed fields and overcast skies in an expression of organic unity (e.g. *On the Way, c.* 1895; Riga, Latv. Mus. F.A.). Baumanis preferred to depict group scenes from both mythological sources and from contemporary life. His works reveal his inclination towards German Romanticism, especially in the *Kurs Cremate their Dead* (1890s; Riga, City A. Mus.) and the *Horse of Fate* (1890s; Riga, Latv. Mus. F.A.). Purvit was attracted to Impressionist landscapes, and others such as Rozentāls and Valters, who saw the assimilation of progressive, international trends as a way forward for Latvian art, experimented with more decorative approaches and with a wider variety of subject-matter. Similarly, the early portrait busts and figures by Šķilters and Zaļkalns, while often depicting Latvians, show a greater debt to Rodin and Emile-Antoine Bourdelle than to indigenous forms, as in Šķilters's *Head of a Poet* (bronze, 1903; Riga, Latv. Mus. F.A.). Madernieks's work, drawn from vernacular sources, is based on the transference of folk motifs from such traditional media as embroidery and carving to graphic art and various forms of applied art. His incorporation of image, text and pattern into a highly stylized overall design is the most comprehensive and successful expression of Latvian *Jugendstil* by an artist, as seen in his book *Ornaments* (Latv.: 'Ornaments'; Riga, 1913). In contrast, Zarriņš illustrated and published Latvian folklore but, for the most part, retained a dry, refined academic approach to composition (e.g. *Latvju dainas*: 'Latvian folk-songs', Jelgava, 1894).

BIBLIOGRAPHY
J. Siliņš: *Latvijas māksla, 1800–1914* [Latvian art, 1800–1914], ii (Stockholm, 1980), pp. 12–196
D. Blūma and others: *Latviešu tēlotāja māksla, 1860–1940* [Latvian fine art, 1860–1940] (Riga, 1986), pp. 42–63
JEREMY HOWARD

Gnosis (*fl c.* 350–300 BC). Greek mosaicist. GNOSISEPOE-SEN ('Gnosis made') is set, in one line without word division, in white pebbles on the dark ground of a pebble floor (now Pella, Archaeol. Mus.) in the *andron* (dining-room) of a large house at Pella, capital of ancient Macedon in northern Greece. It can be dated to the last quarter of the 4th century BC. Within a complex floral border the mosaic shows two over life-size young men attacking a stag with the help of a dog. The figures stand on irregular terrain against the traditional dark ground; one is almost in profile, while the other is full-face and set back beyond the stag, one foot hidden by a rock. The four standard pebble colours—black, white, yellow and red—are here used to pictorial effect, and the figures are lightly modelled with shading. It is the most painterly of pebble mosaics known from the Greek world and among the most technically accomplished. The youths are in heroic nudity, apart from cloaks and a travelling-hat, but the scene is not from legend; rather, as in a lion hunt in a neighbouring house (now Pella, Archaeol. Mus.), it depicts aristocratic Macedonian life. Gnosis is the only artist's name surviving on a pebble floor, although a fragmentary signature exists on a contemporary but inferior one from Athens (Fethiye Mosque). It is most probable that the name is that of a designer who supervised and took part in the execution. Gnosis' subtle use of graded pebbles, often tiny, looks forward to the ideals of *opus vermiculatum* in tessellated floors.

See also GREECE, ANCIENT, §VII, 1(ii) and (iii) and 2(iii)(a) and fig. 142.

BIBLIOGRAPHY
D. Salzmann: *Untersuchungen zu den antiken Kieselmosaiken* (Berlin, 1982), pp. 29, 42, 107–8, no. 103

MARTIN ROBERTSON

Goa. State on the western coast of India, with its capital at Panaji (formerly known as Panjim). While historical records from Goa date from the 3rd century BC, the earliest artistic remains, comprising various sculptural fragments and a group of rock-cut temples at Arvalem, date to the 4th or 5th century AD. Numerous remains in the region date from the post-Gupta period; these include fragments of architectural sculpture and the temples at Tambdi Surla, which were constructed in the 13th century in a style resembling the contemporary temple architecture of Karnataka. From 1312 to 1380 Goa was under Islamic rule until it was captured by the VIJAYANAGARA kings. In 1469 it fell to the BAHMANI dynasty of Gulbarga, and subsequently was ruled by the 'ADIL SHAHI sultans of Bijapur until 1510. The palace of Yusuf 'Adil Shah (*reg* 1489–1509) in Panjim currently houses the State Secretariat; apart from fragments of fortifications and gateways, little else survives from this period.

Although the Portuguese conquest of 1510 led by Afonso de Albuquerque (*see* INDIAN SUBCONTINENT, §I, 2(iv)) was motivated primarily by interest in the spice trade, colonization of the region also involved a desire to introduce Christianity. This resulted in the establishment of a number of missions, convents and monasteries, which were frequently sponsored by royal patrons from Portugal and other European countries (*see* INDIAN SUBCONTI-NENT, §III, 7(iii)). The fortified capital of Goa Velha (Old Goa) was in the 16th century one of the most splendid cities in the world. It was laid out on a grid plan with a central square surrounded by mansions and villas arranged around smaller piazzas; apart from a number of churches, few of these structures survive.

One of the best preserved monuments is the church of Our Lady of the Rosary (1543), which combines Manue-line-style and Renaissance elements with decorative forms of Hindu and Muslim derivation. Built of laterite faced with lime plaster, the church is cruciform in plan, com-prising a nave (without side aisles), transept and chancel. Its tiled roof is supported by a wooden ribbed vault. The façade comprises a two-storey portico and a central bell-tower flanked by rounded turrets surmounted by cupolas. The church of St Francis of Assisi, begun *c.* 1527, has a Tuscan-style exterior with a Manueline entrance. The three lower levels of its façade feature doors and windows with Classical pediments; the fourth and uppermost is flanked by two ornately pinnacled octagonal towers. The recon-structed interior, dating to 1661, comprises a nave with three chapels on either side, a choir, two altars in the transept and a main altar. The decoration reflects the Counter-Reformation splendour of contemporary Portu-guese architecture: the vaulted and coffered ceiling is painted and gilded, while behind the main altar is an elaborate gilded retable containing sculptures of Francis-can inspiration. The fresco paintings of religious scenes found in the apse contrast with the intricate Indian-style floral patterns in the nave. To the north of the main altar are a belfry and a sacristy; the convent of St Francis of Assisi, which adjoins the church, now houses the Archae-ological Museum.

Goa Cathedral, dedicated to St Catherine of Alexandria, was built between 1562 and 1652. Designed by the Portuguese architects Julio Simão and Ambrosio Argeiro with a Tuscan Ionic exterior and a Corinthian interior, it replaced an earlier structure built by Afonso de Albuquer-que. The three-storey façade is strongly marked by Clas-sical elements. The use of pilasters and scroll brackets recalls the contemporary church of Il Gesù in Rome. Only one square bell-tower survives, on the southern side of the façade; its northern companion collapsed in 1776. Inside, a barrel-vaulted ceiling covers a cruciform interior consisting of a central nave flanked by side aisles, each with four chapels; a transept with six altars precedes the high altar. The decoration includes a carved and gilded retable and wall paintings, some imported from Italy and Portugal. However, the most celebrated church in Old Goa is the basilica of Bom Jesus of 1594–1605. Like Goa Cathedral, it is built on a cruciform plan, and has a three-storey Classical façade with three doorways flanked in this case by Corinthian columns; the fourth and uppermost storey comprises a Classical pediment flanked by shell-volutes. The interior is relatively simple but for an ornate Baroque retable and the tomb of the Jesuit saint Francis Xavier (1506–52; *see* JESUIT ORDER, §4(i)), which is located in the southern transept. Within the gold-encrusted chapel is a marble tomb (1691–7), carved by the Florentine sculptor Giovanni Battista Foggini, a gift from Cosimo III, Grand Duke of Tuscany. The silver casket holding the saint's remains was made in Goa.

The Corinthian façade of the church of St Cajetan (1661) is often characterized as imitative of the cathedral of St Peter in Rome. Built over a well, the church has a Greek-cross plan, with an aisled nave ending in an apse. Four massive piers at the crossing support a cupola resting on a drum and crowned with a lantern. Two domed octagonal rooms on either side of the high altar served as sacristies. The church was built by Italian monks of the Theatine order; their adjoining monastery is of the late 17th century, with later additions. The church of the Immaculate Conception (1541) in Panjim was originally a small chapel, but was expanded in 1619. Standing on a plinth, it is approached by a series of ornate staircases in imitation of Spanish and Portuguese churches of the 17th century. By the beginning of the 18th century, building activity declined as Portugal's status as a colonial power diminished. This decline was also related to the severe epidemics that regularly struck the city. Churches continued to be built, but not with the scale and splendour of earlier monuments; modest structures modelled after earlier Goan churches are found in Calangute, Assagao, Macazana, Varca, Rachol and Cortalim. In 1843 Panjim replaced Old Goa as the official Portuguese capital.

Hindu temples continued to be built during the Portuguese period, albeit under strong Christian influence in terms of form and decoration. The 16th-century temple at Korgaon, for example, has an octagonal dome, and at the temple of Mhalsa in New Mardol a similar dome has an octagonal drum faced with pointed Gothic niches and engaged Corinthian columns. Both here and at the Nagesh Temple, Bandora, a spacious hall (*maṇḍapa*) seems to represent a response to the nave of the Christian church, the sanctuary being not a dark chamber but an altar at the far end of the hall, marked on the exterior by a dome rather than the traditional spire (*śikhara*). The westernized interiors of these temples can be quite lavish; for example, the Sri Mangesh Temple at Priol has stuccoed ceilings, polished blue columns and crystal chandeliers.

BIBLIOGRAPHY

S. Rajagopalan: *Old Goa* (New Delhi, 1975/*R* 1982)
Gazetteer of the Union Territory of Goa, Daman and Diu (Panaji, 1979)
M. Malgonkar: *Inside Goa* (Panaji, 1982)
Marg, xxxv/3 (1982) [special issue on Goa]
J. Musgrove, ed.: *Sir Banister Fletcher's A History of Architecture* (London, 1987)
P. Davies: *The Penguin Guide to the Monuments of India*, ii (London, 1989)

WALTER SMITH

Gobbo dei Carracci [Frutti]. *See* BONZI, PIETRO PAOLO.

Gobel, Berthold. *See* MASTERS, ANONYMOUS, AND MONOGRAMMISTS, §III: MASTER B. G.

Gobelins. French factory established in Paris in 1662 for the production of furnishings for the royal household.

1. Introduction. 2. Tapestry. 3. Hardstones. 4. Other.

1. INTRODUCTION. The assassination of Henry IV in 1610 brought to an end the development of his organized system to protect and train French artists and craftsmen. Although some of them remained in the workshops of the Galeries du Louvre in Paris, the political turmoil in ensuing years was not conducive to sustained support

from the Crown for the arts in France. After the death of Cardinal Mazarin (*see* MAZARIN, (1)) in 1661 Louis XIV decided to be his own master: following the example of his ancestor and with the assistance of Jean-Baptiste Colbert (*see* COLBERT, (1)), an exceptionally efficient administrator, the King decided to set up a special establishment—the Gobelins—in Paris for the production of paintings, tapestries and furnishings, which were destined solely for the royal palaces. Colbert was well aware of the importance attached to lavish displays of power and wealth for *la gloire de la couronne*, and the King intended the Gobelins and its products to be the envy of foreign courts. In 1662 Colbert decided to amalgamate various tapestry workshops scattered throughout Paris and purchased from a M. Leleu the Hôtel des Gobelins in the Faubourg St Marcel in Paris, on the banks of the River Bièvre. Formerly a dye works run by the Gobelin family, the hôtel had become a tapestry workshop at the beginning of the 17th century. The royal accounts show repayments to Colbert of 41,775 livres for the acquisition of the hôtel, 800 livres for an adjoining house and garden and 95,144 livres for the initial construction work to convert the buildings into workshops and lodgings. Later there were more acquisitions of neighbouring houses and further outlays on expensive repairs.

The King and Colbert invited leading foreign craftsmen to come to France, in particular from Flanders and Italy, to train the French. The King, his view of art influenced by the patronage of his mother Anne of Austria (1601–66), Cardinal Mazarin and the disgraced NICOLAS FOUQUET, wanted the products of the new Gobelins factory to surpass, in beauty and artistic merit, the best foreign imports. The new inhabitants of the Gobelins were chosen, and training and work began. The King's Premier Peintre, CHARLES LE BRUN, was officially appointed Directeur on 8 March 1663. In 1667 the official *lettres patentes*, setting out the regulations and privileges, were issued and included the following: the Manufacture Royale des Meubles de la Couronne (later more commonly known as the Manufacture Royale des Gobelins) was to be controlled and administered by Colbert, who in January 1664 had been declared Surintendant des Bâtiments et Ordonnateur Général, Arts et Manufactures, and Le Brun's appointment as administrative and artistic director was confirmed. Craftsmen and artists were then employed for painting, tapestry-weaving, sculpture, carving, metalwork, engraving, work in hardstones and dyeing. Sixty children were chosen by Colbert, taught by the director and an assistant painter, then appointed as apprentices to suitable masters. After six years' apprenticeship and four years' service they were entitled to privileges including guild entry without payment. Those who served for six uninterrupted years were entitled to become *maîtres*, but those who did not complete the service or left without permission were not admitted. Craftsmen living in the houses surrounding the Hôtel des Gobelins were exempt from providing lodging for soldiers. After ten continuous years' work foreign craftsmen were regarded as naturalized subjects. The Gobelins workers were exempt from civil guard duties and taxes. A brasserie was installed to supply them with beer. Special legal arrangements were available, and there

was a ban on the import and sale of foreign tapestries, except those already installed in the country.

Some members of this self-contained, privileged colony were drawn from the Académie Royale, the workshops of the Louvre and the tapestry factory at Maincy. In addition to being a leading painter and an industrious and talented designer, Le Brun possessed the ability both to direct the artistic skills of the people working with him and to maintain good relations. Documents show that he frequently attended employees' weddings and other ceremonies, acted as godfather and guardian to children and in due course was related by marriage to several of his collaborators. Indeed many members of the Gobelins families intermarried.

Colbert's continuing support for the director in the great schemes for the Palais du Louvre, the château at Versailles and other royal residences gave Le Brun confidence and encouragement. The outstanding success of the Gobelins under Le Brun was largely due to the fact that he was in overall charge and provided designs for all types of decorative schemes and furnishings (from vast decorative wall and ceiling paintings to detailed drawings for furniture, candlesticks and locks), producing well-thought-out harmonious schemes. The teamwork between the various craftsmen and artists in different fields was also extremely important. The craftsmen were versatile and undertook all types of work for the royal palaces: for example a sculptor, able to work in marble and metal, was employed to carve elaborate woodwork. Domenico Cucci, a talented Italian furniture-maker who was naturalized in 1664, was responsible for some of the most spectacular cabinets (see fig. 2 below) and also supplied considerable quantities of door furniture. The artists provided paintings, many cartoons for tapestries and even designs for embroidery. Contemporary newspaper accounts describe visits to the factory that were arranged for foreign ambassadors in order to spread the fame of the factory abroad. Magnificent tapestries and sometimes furnishings were given as official gifts to foreign rulers. Outstanding among the products of the factory were the superb tapestries and silver furniture. Never before had so many costly and magnificent silver furnishings been produced on such a scale; there were fire-dogs, vases, orange tubs, tables, mirror-frames, chandeliers, candlesticks, seats and perfume burners (designs in Stockholm, Nmus.). The King expended vast sums on the Gobelins factory, and many products were expressly designed to demonstrate his power, wealth and standing, in particular some of the tapestries and silver pieces, which were successful instruments of royal propaganda.

The French workers quickly learnt many new techniques, such as marquetry, but they proved less adept in learning the methods of working in pietra dura, for which special skills were needed as well as access to a stock of expensive hardstones (see §3 below). Le Brun deployed teams of craftsmen within which the Gobelins employees collaborated with craftsmen established in the Galeries du Louvre. They too had special privileges from the King, but were entitled to work for other clients. There was also a close link with the carpet factory of Savonnerie for which the painters supplied some of the designs.

The death of Colbert (1683) initiated a decline in the spectacular achievements of Le Brun at the Gobelins. Much of the originality and some of the quality of the output decreased because the new Surintendant des Bâtiments, Arts et Manufactures, François Michel Le Tellier, the Marquis de Louvois, was jealous of his predecessor's success and, instead of supporting Le Brun, undermined and thwarted him. Even the weaving of the series of tapestries known as the *Story of the King* was discontinued. Le Brun retained the King's favour, but his unsatisfactory situation under Louvois sapped his great energy and imagination; discouraged and ill, he died in 1690. Pierre Mignard, a former rival of Le Brun, took over his posts as Premier Peintre and Directeur of the Gobelins. By then expenditure on the Gobelins was greatly reduced, as the King's finances were in a disastrous state owing to the war with the United Netherlands. To raise funds the splendid silver furnishings had been melted for bullion in 1689, realizing, of course, far less than the original cost of such outstanding craftsmanship. Louvois died in 1691 and was succeeded by the Marquis de Villacerf. In 1694 the Manufacture Royale des Meubles de la Couronne was closed on account of the war, and the artists and craftsmen dispersed. In 1699 the tapestry works reopened and continued to produce in the late 20th century. The history of the Gobelins, however, as a well-organized and productive centre supplying splendid furnishings of all types for the crown had come to an end.

BIBLIOGRAPHY

H. Havard: *Dictionnaire de l'ameublement et de la décoration: Depuis le XIIIe siècle jusqu'à nos jours* (Paris, n.d.)
A. Jal: *Dictionnaire critique de biographie et d'histoire* (Paris, 1872)
J. Guiffrey: *Comptes des Bâtiments du Roi sous le règne de Louis XIV*, 5 vols (Paris, 1881–91)
H. Jouin: *Charles Le Brun et les arts sous Louis XIV* (Paris, 1889)
J. Coural: *Les Gobelins* (Paris, 1989)

FRANCES BUCKLAND

2. TAPESTRY. The name of the Gobelins has become synonymous with tapestry in many countries. In addition to such collaborators as Bandrin Yvart (1611–90), Joseph Yvart (1649–1728) and Adam Frans van der Meulen, Le Brun employed such painters as Jean-Baptiste Monnoyer, René-Antoine Houasse, Guillaume Anguier and Gilbert de Sève who specialized in different genres (flowers, animals, decorations, landscapes, history). They transferred Le Brun's designs into cartoons intended for the weavers. The heads of the workshops, who were responsible to Le Brun, were Jean Jans (*fl* 1662–8) from Flanders, Jean Lefebvre and Henri Laurent for the three high-warp workshops and Jean de La Croix and Jean-Baptiste Mozin (*fl* 1667–93; *see* MEULEN, ADAM FRANS VAN DER, fig. 2) for the low-warp workshops; they were contractors in charge of the weaving and were eventually allowed to accept private commissions. About 250 weavers lived in and around the Gobelins enclosure. Josse van der Kerchove directed the dyeing workshop. The head of each workshop was responsible for his own accounts. Tapestries were paid for on delivery according to a fixed price, from which the cost of materials (wools, silks, gold and silver threads) supplied by the Crown was deducted. The weavers were paid by the workshop heads according to a wage-scale peculiar to high or low warp, based on the

difficulty of the work; for example, such weavers entrusted with heads and flesh tones as Louis Ovis de La Tour (*d* 1735) received the highest wages. The system remained until 1790, when workers began to be paid with a fixed salary.

Under the impetus and authority of Le Brun the tapestries and other works produced until the end of the 17th century constituted an important contribution to the history of the decorative arts in France. The tapestry *Louis XIV Visiting the Gobelins* (*c.* 1667; see fig. 1), from Le Brun's celebrated series the *Story of the King*, accurately represents the precious furnishings and rich hangings made at the Gobelins for the decoration of such royal residences as Versailles. Aside from the *Story of the King*, the most famous hangings for which Le Brun provided designs include the *Elements*, the *Four Seasons*, the *Story of Alexander* and the *Months* (*see* TAPESTRY, colour pl. II, fig. 2) or the *Royal Households*; these assured the success and lasting renown of the factory. Le Brun also had tapestries made after other artists, including Raphael (*Acts of the Apostles* and the *Vatican Stanze*) and Poussin (*Story of Moses*).

In 1686 work began on the *Gallery of Saint-Cloud* after paintings by Le Brun's rival and successor, Pierre Mignard. Despite the lack of new, suitable designs, the workshops' output did not abate; 16th-century tapestries from the Garde Meuble de la Couronne were copied, including the *Story of Scipio*, *Fructus Belli*, *Mois Lucas* and the *Hunts of Maximilian*. Hangings from this period also heralded an evolution in taste: exoticism appeared in the tapestries known as the *Indies* after paintings by Gerbrand van den Eeckhout and Frans Post, which had been presented to Louis XIV by Johan Maurits, Count of Nassau-Siegen. Decorative elements were brought back into fashion by Noël Coypel in the *Triumphs of the Gods*, after a 16th-century tapestry from Brussels.

Owing to the wars and the ensuing financial problems, the factory almost closed completely in April 1694: the tapestry-workers were dismissed and many dispersed; some went back to Flanders, while others went to the tapestry factory in Beauvais. The contractors nevertheless managed to maintain one low-warp workshop, which facilitated the reopening of the tapestry works in January 1699. The architect Jules Hardouin Mansart, the new Surintendant des Bâtiments, appointed the architect and urban planner Robert de Cotte to direct proceedings. Until 1780 architects, the most famous of which was Jacques-Germain Soufflot, would succeed to this post. As the director no longer supplied designs, renowned painters were called upon to provide cartoons. The new tapestries reflect the evolution towards a lighter, more delicate style that was better suited to the more intimate decoration of smaller apartments. At the beginning of the 18th century tapestries after designs by Claude Audran III (for example the *Portières des dieux* and the *Douze mois grotesques*) were the first indications of this change.

The most important innovation, however, which was successful for a long period, was that of tapestries *à alentours* (with borders). They depicted prominent decorative motifs, reminiscent of friezes, wainscots, cords and ribbons, surrounding a central scene. This new style was initiated as early as 1714 in the cartoons for the *Story of*

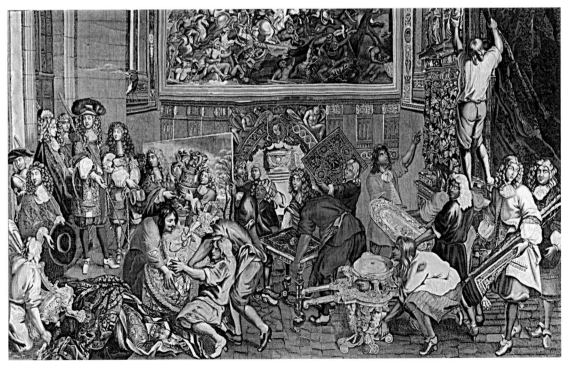

1. Gobelins tapestry, *Louis XIV Visiting the Gobelins*, designed by Charles Le Brun, *c.* 1667 (Versailles, Musée National du Château de Versailles et de Trianon)

Don Quixote by Charles-Antoine Coypel; the famous *Loves of the Gods* (1763) by François Boucher (*see* TAPESTRY, fig. 10) and others also employed this method of design. Throughout the 18th century the tradition of large hangings was maintained: tapestries depicting such historic events as the visit of the *Turkish Embassy* in 1731 after paintings by Charles Parrocel, the *Hunts of Louis XV* after Jean-Baptiste Oudry or those depicting religious or mythological subjects (e.g. the *Story of Esther* and the *Story of Jason* after François de Troy and the *Story of Theseus* after Carle Vanloo) were manufactured. As Surinspecteur, Oudry had a strong influence on the development of design at the factory; he required the weavers' complete submission to painting and obliged them to 'imitate its effects'. In order to achieve this they used a wide range of graded colours, obtained by *petits teints* (non-fast dyes), which have often failed to withstand the effects of time and light. This direction towards the imitation of painting continued for a long period in spite of some interruptions. Woven portraits, the first of which was of *Louis XV* after van Loo, were very much in favour for many years.

In the second half of the 18th century the influence of Neo-classicism appeared, for example in the *Four Seasons* (1773) after Antoine-François Callet. Returning to the tradition of the 17th century, Jean-Baptiste Pierre, the king's Premier Peintre, became Directeur in 1782; he was the last to attain this position. At the end of the *ancien régime* there was a taste for themes inspired by national history, including the *Story of Henry IV* after François-André Vincent and the *History of France* after Joseph-Benoît Suvée, Louis-Jacques Durameau and Jean-Simon Berthélemy.

After the difficulties of the revolutionary period, activity at the factory, which was linked to Napoleon's Liste Civile, was revived during the Empire Period (1804–15). Tapestries for the imperial palaces intended 'to perpetuate the great events of his reign' were produced, including *Bonaparte Crossing the St Bernard Pass* after Jacques-Louis David, the *Plague at Jaffa* after Antoine-Jean Gros and *Napoleon Receiving his Deputies after his Coronation* after Gioacchino Giuseppe Sérangeli (1768–1852). The *Tenture de la Salle du Trône* after Georges Rouget (1784–1869) is an important example made during the Restoration (1815–30). In 1826 the low-warp works were moved to Beauvais, and work at the Gobelins was focused on the high warp. In 1828 work began on the *Story of Marie de' Medici* after Rubens.

Throughout the 19th century efforts were made to restore tapestry as a creative decorative art and extricate it from its role of an art form merely imitating painting: for the July Monarchy (1830–48) *Le Grand Décor* after Jean Alaux (1786–1864) and Couderc was made; from the Second Empire (1852–70) important tapestries include the *Five Senses* after Jules Pierre Michel Diéterle (1811–89), Paul Baudry and Pierre-Adrien Chabal-Dussurgey. Woven portraits were not entirely abandoned, as the important commission (1851) for representations of sovereigns and artists for the Galerie d'Apollon in the Louvre testifies. An unsettled and difficult period began after the fall of the Second Empire, and part of the buildings was burnt in 1871. During the early years of the Third Republic (1870–1940) the Gobelins (renamed the Manufacture Nationale des Gobelins) produced tapestries for such great buildings in Paris as the Opéra, the Palais du Luxembourg and the Bibliothèque Nationale. Care was once again taken to create new designs in which the decorative element dominated; such artists as Alexis Joseph Mazerolle (1826–89), Emile François Maloisel (*fl* 1868–1912), Paul Flandrin, Alfred de Curzon, François Emile Ehrmann (1833–1910) and Jean-Paul Laurens were called upon to provide these designs. At the Exposition Universelle of 1900 in Paris tapestries after Gustave Moreau and Georges Rochegrosse were exhibited. In the following years such artists as Jules Chéret, Félix Bracquemond, Odilon Redon, Adrien Karbowski (*b* 1855) and Leonetto Capiello also provided designs.

It was, however, Jean Lurçat (*see* LURÇAT, (1)) who essentially revived the art of tapestry production in order to restore it 'to the grand art of the Middle Ages'. Lurçat advocated 'the liberation from painting, the use of a reduced range of colours, at once straightforward and vivid, the suppression of graded colours, clarity of design'. In 1937 the Gobelins was attached to the Administration Générale of the Mobilier Nationale, and Lurçat was commissioned for two cartoons, the *Illusions of Icarus* and the *Forests*, which were begun in the same year. Inspired by Lurçat the painters Marcel Gromaire and Pierre Dubreuil (1891–1970) also became enthusiastic about tapestries. In 1939 the Gobelins was moved to Aubusson, where it remained during World War II. There Gromaire, Dubreuil and Lurçat went 'to study, create and supervise, if necessary, the execution of large tapestries' and helped promote a revived interest in tapestry, which once again became an art in which great painters took an interest.

From 1945 painters, sculptors, printmakers and architects realized that the way opened by Lurçat was rich in possibilities; of different aesthetic leanings, they remained faithful to his great, rediscovered principles. The Gobelins continued to honour great contemporary artists, including Picasso (whose cartoon of 1936–7 for *Women at their Toilet* was woven in 1968), Serge Poliakoff, Alexander Calder, Zao Wou-Ki and Joan Miró. The tradition of hanging monumental tapestries in official buildings was retained particularly with such work as Pierre Courtin's designs for the Bureau International du Travail in Geneva, Guitet's for the Ecole Nationale d'Administration in Paris and those of François Rouan for the new Ministère des Finances at Bercy, Paris. The Gobelins output was always primarily reserved for the State, although such prestigious private commissions as the tapestry for the Queen of Denmark after cartoons by the sculptor Bjørn Nørgård were also made.

For illustration of the high-warp weaving technique at the Gobelins *see* TAPESTRY, fig. 2.

BIBLIOGRAPHY
M. Fenaille: *Etat général des tapisseries de la manufacture des Gobelins depuis son origine jusqu'à nos jours, 1600–1900*, 4 vols (Paris, 1903–23)
D. Meyer: *L'Histoire du roy* (Paris, 1980)

CHANTAL GASTINEL-COURAL

3. HARDSTONES. In 1668, through abbot Luigi Strozzi, Louis XIV brought three skilled artisans from Florence: Filippo Branchi (*c.* 1638–99) and the brothers Ferdinando Migliorini (*c.* 1638–83) and Orazio Migliorini (*c.* 1643–78);

Ferdinando had worked in the workshops of Ferdinando II, Grand Duke of Tuscany, in Florence. At the Gobelins they were immediately joined by Jean Arnaud (*d* 1670), probably as an assistant. In 1670 another Florentine, Gian Ambrogio Giachetti, also arrived from Florence, but his name does not appear in the payment records after 1675. After 1678 Orazio Migliorini's name no longer appears. Branchi remained active until 1699, with the apprentice Jean Le Tellier who joined him in or before 1693. In a document of 1727, when the taste for work in pietre dure and the practice of the art were already in decline, Le Tellier stated that he had been at the Gobelins for 29 years, with his son Louis Le Tellier as apprentice.

The art of cutting hardstones lasted only for a short time in Paris, both because in the early 18th century the new light Régence style made the heavy works seem rather old-fashioned, and because the greatest specialists had died. Many of the objects manufactured at the Gobelins are unfortunately lost or have been broken up. A few fine examples remain, however, including the pair of superb cabinets that belonged to Louis XIV, finished *c.* 1684 and bought in Paris in 1824 by Hugh Percy, 3rd Duke of Northumberland (see fig. 2). These two cabinets were constructed by the Italian furniture-maker DOMENICO CUCCI, who was called to France by Cardinal Jules Mazarin. They are adorned with gilt-wood carvings, bronzes, and 14 panels of pietre dure, both mosaics and reliefs. These panels depict vases and branches of fruit with birds—motifs derived from the 17th-century Florentine repertory—as well as small isolated figures of animals that reflect a more French taste.

Animals in landscapes form the main theme in two extant mosaic table-tops made of *pietre tenere* ('soft' stones): one is decorated with the royal coat of arms and initials (Paris, Louvre), and the other (Compiègne, Château) combines animal scenes with landscapes and branches bearing fruit and flowers. The 'animalistic' taste was also found at the Gobelins in those years, even in cartoons for tapestries drawn by northern European painters.

Among the drawings that belonged to the architect Robert de Cotte there were two watercolours of the tables mentioned above (probably copies rather than models), and two similar drawings of table-tops that have not been traced (Paris, Bib. N., Cab. Est.). These are also based on the combination, which was unusual in Florence, of small panels showing single subjects set into an intricate background design. A unified decorative pattern, however, appears in a third surviving table-top (Paris, Louvre) from the Gobelins, worked in intarsia with pietre dure against a background of Paragone marble and dominated by a central radiated scroll towards which converge four lyres and two vases with fruit, linked by a swirling floral festoon.

The technique of cutting and inlaying the stone sections is entirely similar to that of Florentine manufacture. The chromatic effect is quite different, however, because of the French predilection for strong contrasts and brightly coloured backgrounds, quite unlike the chiaroscuro subtleties and modulated chromatic range of the Florentine mosaics.

Throughout most of the 18th century, the art of pietre dure was unpopular; during the reign of Louis XVI,

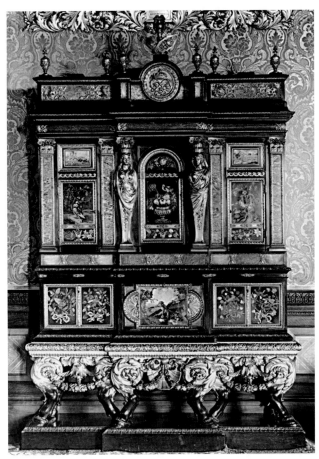

2. One of a pair of Gobelins cabinets designed by Domenico Cucci, ebony inlaid with pietre dure, 1.92×2.54×0.46 m, 1683 (Alnwick Castle, Northumberland)

however, pietre dure mosaics and reliefs were again appreciated and sought after as decorations for sumptuous furnishings of Neo-classical design, specially created by such outstanding *ébénistes* as Martin Carlin, Adam Weisweiler and Claude-François Julliot. Their furniture incorporates panels from different periods and locations, often combined in the same object. They often include 17th-century reliefs and mosaics from the Gobelins; this is the case with two fine late 18th-century cabinets (London, Buckingham Pal., Royal Col., and Stockholm, Kun. Slott), on which there are pietre dure panels, probably taken from a dismantled 17th-century piece of furniture, signed on the reverse by Gian Ambrogio Giachetti.

BIBLIOGRAPHY
J. Guiffrey: 'Ferdinand Megliorini et Philippe Branchi lapidaires', *Rev. A. Anc. & Mod.* (1887), pp. 171ff
A. Setterwall: 'Some Louis XVI Furniture Decorated with Pietre Dure Reliefs', *Burl. Mag.*, ci (1959), pp. 425–35
D. Alcouffe: *Il mobile francese dal rinascimento al Luigi XV* (Milan, 1981)
Splendori di pietre dure (exh. cat. by A. González-Palacios, Florence, Pitti, 1988), pp. 242–5

ANNAMARIA GIUSTI

4. OTHER. The royal accounts and inventories are particularly informative about the artists at the Gobelins

and some of their work. The silversmiths' workshop was on the great courtyard of the Hôtel des Gobelins. Alexis Loir I and Claude de Villiers (*fl* 1665–*c.* 1689) were lodged at the Gobelins. Some of the silversmiths working for Le Brun, such as Claude Ballin (i) and Nicolas de Launay, were based at the Galeries du Louvre. Others who worked on the silver furnishings were René Cousinet, Girard Debonnaire (*d* by 1683), Jacques Dutel, Jean de Viaucourt (*fl* 1657; *d* by 20 Nov 1675), Madeleine Turgis, the widow of Verbeck (*fl* 1665–7), and François de Villiers (*fl* 1673; *d* by 1715), brother of Claude de Villiers. The appearance of some of the massive and elaborate pieces they produced is recorded in paintings, engravings, drawings and tapestries.

Several Italian sculptors and wood-carvers who lodged at the Gobelins became naturalized: Jean Tuby, Philippe Caffiéri (i) and Joseph-François Temporiti (?1634–74). Caffiéri was the most skilled wood-carver, working on panelling and doors, as well as such furniture as tables, armchairs, pedestals, stands for cabinets, candle stands, picture frames and a bed. Paul Goujon ('la Baronnière') executed most of the gilding. Other sculptors included Antoine Coyzevox and Jean Legeret the younger.

The painter Adam Frans van der Meulen was an important artist in the early years of the Gobelins, specializing in landscape painting. In 1681 he became related by marriage to Le Brun. Other painters, many working both in the palaces and on tapestry cartoons, were René-Antoine Houasse and Guillaume Anguier, who specialized in architectural settings; Pieter Boel and François Desportes, who specialized in animals; Michel Corneille (i), known as Corneille des Gobelins; Noël Coypel; Antoine Coypel; Jean-Baptiste Martin I; and Pierre-Denis Martin the younger, also known as Martin des Gobelins (1663–1742). Jean-Baptiste Monnoyer painted flowers and fruit, and Abraham Genoels II painted landscapes. The history painter Bandrin Yvart (1611–90) and his son Joseph Yvart (1649–1728) painted numerous cartoons for tapestries, as did the brothers Gilbert de Sève and Pierre de Sève (1623–95). In the embroidery workshop Simon Fayet specialized in figures and Philibert Balland in landscapes. François Bonnemer (1622–89) executed designs for embroidery and painting on silk. Among the engravers at the Gobelins were Sébastien Leclerc (i), Girard Audran and Gilles Rousselet; their role was important in disseminating Le Brun's work.

Although he earned more from his skill as a caster, Domenico Cucci is better known as a cabinetmaker. His vast architectural cabinets on stands were decorated both with relief and mosaic pietra dura (*see* §3 above) and with gilt-bronze mounts. Freedom from guild restrictions gave him scope to exercise his various talents. Some of the tapestries made at the Gobelins depict the magnificent products made at the factory in such detail that they can be identified from the royal inventories. One of a pair of cabinets made between 1667 and 1673 can be seen on the left-hand side of the tapestry of *Louis XIV Visiting the Gobelins* (see fig. 1 above). Only two identified cabinets by Cucci are extant (see fig. 2 above) and are in the collection of the Duke of Northumberland at Alnwick Castle, Northumberland. Many of these colourful and costly pieces were dispersed in royal sales in 1741, 1751

or 1752, being considered dilapidated or old-fashioned. Some were presented to the Cabinet of Natural History in Paris and were probably dismantled for the stones. The cabinetmaker Pierre Gole, who had worked for Cardinal Mazarin, probably had links with the Gobelins, but there is little evidence for this. Philippe Poitou (*c.* 1642–1709) worked at the Gobelins but in 1674, after his marriage (1672) to Constance Boulle, went to work for André-Charles Boulle. Charles Sommer, also described as a *menuisier, marqueteur* and *ébéniste*, was probably trained at the Gobelins by Poitou, who specialized in marquetry floors and panels.

BIBLIOGRAPHY

J. Guiffrey: *Inventaire général du mobilier de la couronne sous Louis XIV, 1663–1715*, 2 vols (Paris, 1885–6)

A. Pradère: *French Furniture Makers: The Art of the Ebéniste from Louis XIV to the Revolution* (London, 1989)

FRANCES BUCKLAND

Gober, Robert (*b* Wallingford, CT, 1954). American sculptor. He studied literature and then fine art at Middlebury College, VT (1972–6) and spent a year at the Tyler School of Art, Rome (1974–5). Gober settled in New York in 1976, earning a living building stretchers for artists, renovating lofts and crafting doll's houses. His first solo exhibition (1984) was at the Paula Cooper Gallery, New York, where he exhibited *Slides of a Changing Painting* (80 slides, 1982–3; artist's col.): for this he had mounted a camera directly above a small board, over which he painted images during one year, taking hundreds of slides documenting the life of the painting, which he later edited down. In its attention to the process of painting and transformation, *Slides* is considered important for his later works. In the 1980s and early 1990s Gober presented his own hand-crafted, everyday objects, imbuing them with a strong physical, visual and theatrical presence. His series include plumbing fixtures, including sinks and urinals (1984–6), door sculptures (1986–7), and cast body fragments and wallpapers, and combinations of all these (see 1993 exh. cat.). His emphasis on the personal, the fragility of humankind and the hand-made at a time when the predominant approach in New York was 'appropriationist' has won him acclaim in the USA and Europe.

WRITINGS

'Cumulus from America', *Parkett*, xv (1989), pp. 169–71

BIBLIOGRAPHY

Robert Gober (exh. cat., essays by J. Simon and C. David; Paris, Jeu de Paume; Madrid, Cent. Reina Sofia; 1991–2)

Robert Gober (exh. cat., essay by L. Cooke, interview with the artist by R. Flood; London, Serpentine Gal.; Liverpool, Tate; 1993)

□

Gobert, Pierre (*b* Fontainebleau, 1 Jan 1662; *d* Paris, 13 Feb 1744). French painter. He was the son of the sculptor Jean Gobert (1627–81) and nephew of the sculptor André Gobert (1635–72), who made the retable for the high altar at St Jean-Baptiste, Nemours; his brother was another sculptor, Jean-Baptiste Gobert (*d* after 1723), whose best-known work was a bronzed plaster equestrian statue of *Louis XIV* (destr.) made in 1685 for the Duc de Richelieu's château at Rueil. It is not certain whether this family was related to the architect Thomas Gobert.

In 1682 Pierre Gobert painted a portrait of *Louis, Duc de Bourgogne, as a Child* (destr.; engraved 1683 by Charles Simonneau). In the next two decades he followed this with numerous portraits of members of Louis XIV's court, including the *Abbé de Fleury* (untraced; engraved 1700 by Simon Thomassin), *Louis-Alexandre de Bourbon, Comte de Toulouse* (Madrid, Prado) and one of *Louise-Elisabeth de Bourbon-Condé, Princesse de Conti*, shown both in the guise of a huntress (Versailles, Château) and as a personification of *Painting* (Barcelona, Mus. A. Catalunya). The latter painting is a fine example of the then fashionable *portrait historié*, a genre seeking to elevate the portrait by association with history painting.

Gobert's acceptance into the Académie Royale in 1701 on presentation of his portrait of the sculptor *Corneille van Cleve* (Versailles, Château) evidently brought him a large number of commissions. In the 1704 Salon alone he exhibited 17 portraits. He presumably ran a large studio and the numerous portraits attributed to him vary considerably in quality, with repetitions abounding. Gobert's somewhat academic style and the numerous copies of his work have damaged his posthumous reputation, but his contemporaries regarded him as one of the foremost portrait painters of the day. He painted *Louis XV* in his early years on several occasions (e.g. Madrid, Prado) and was commissioned in 1725 to paint a portrait of *Marie Leczinska*, the King's future wife (Versailles, Château). In 1726 he was appointed a Conseiller of the Académie Royale. The series of portraits of the *Family of the Duc de Valentinois, Prince of Monaco* (Monte Carlo, Mus. N.; Saint-Lô, Mus. B.-A.) reveal, however, that his artistic powers declined with age.

BIBLIOGRAPHY
Souchal; Thieme–Becker
E. Thoison: 'Recherche sur les artistes se rattachant au Gâtinais Pierre Gobert', *Réun. Soc. B.-A.*, xxiii (1899), pp. 160ff; xxvii (1903), pp. 98ff; xxx (1906), pp. 296ff
L. H. Labande: *Les Portraits des princes et princesses de Monaco exécutés par le peintre Pierre Gobert* (Monaco, 1908)
J. J. Luna: 'Pinturas de Pierre Gobert en España', *Archv Esp. A.*, 196 (1976), pp. 363ff
CATHRIN KLINGSÖHR-LE ROY

Gobert, Thomas (*b c.* 1630; *d* 1708). French architect and writer. He was the son of a Parisian master mason, Thomas Gobert (*d c.* 1644), who built houses on the Ile Saint-Louis (destr.), the Rue Saint-Paul (1641) and the Rue de la Bucherie. The younger Thomas Gobert was related by marriage to the Mansart family. It is not clear, however, if he was related to the painter PIERRE GOBERT. From 1660 to 1664 he was in the service of Louis II, Prince de Condé, and in 1662 qualified as Architecte des Bâtiments du Roi, building some houses near the Palais-Royal: 61, Rue de Richelieu (1668); 53, Rue Sainte-Anne; and 7, Rue du Mail. In the same district he worked on the library wing of the monastery of the Petits-Pères. In 1670 he collaborated with Antoine Le Pautre on the building of the château of Saint-Cloud (destr.), near Paris. He became Contrôleur Alternatif des Bâtiments du Roi in 1675. Gobert is mainly known for his ideas on church design, which exist in two forms: a collection of 41 drawings (Munich, Bayer. Staatsbib. MS. Cod. Icon. 118) with the title *Traité pour conduire à la perfection de l'architecture*, and

a collection of 22 engravings, of which the only example is preserved in Paris (Bib. N. Cab. Est. Ha 9). Gobert's proposed large-scale churches had two-towered façades, double aisles and an axial main chapel with cupola, whose interior elevation, with double columns carrying a lintel, looked forward to the theories of Jean-Louis de Cordemoy. The two collections also contain ideas for the chapel at the château of Versailles and an 'architectural fantasy': churches 'whose ground-plans are the twelve letters forming the name of the King Louis le Grand'. Gobert's son, Claude-Thomas Gobert (*b* 1671), who qualified in 1703 as an architect-engineer and was a citizen of Paris, is known only through some work at Nancy in 1703 for the Sieur Boursier.

WRITINGS
Traité pour la pratique des forces mouvantes (Paris, 1702)
BIBLIOGRAPHY
P. Moisy: 'Les Projets d'église de T. Gobert', *Bull. Soc. Hist. A. Fr.* (1961), pp. 65–78
W. Müller: 'Eine Grenze künstlerischer Raumgestaltung im französischen Kirchenbau des Barock', *Das Münster*, xxviii/5–6 (1975), pp. 273–9
FRANÇOISE HAMON

Gobustan [Kobystan; Kobistan; Kobustan]. Site of Mesolithic, Neolithic and Bronze Age petroglyphs *c.* 60 km south-west of Baku, Azerbaijan. The images are carved on large blocks of limestone that had broken off the edge of the nearby plateau and accumulated on the slopes and valley below. There are also petroglyphs inside the caves left by the blocks. The main animal motifs of the Mesolithic and Neolithic periods are realistic outlines of wild bulls, horses and boars; in the Bronze Age images more schematic representations of mountain goats predominate. Characteristic compositions of the Mesolithic and Neolithic periods are found on the hill known as Beyuk-dag; they include a circle of schematically depicted human figures linked in a chain and a hunting scene with archers chasing a bull. The carvings, including those on the large panel in the cave on the upper terrace of Beyuk-dag, are in various styles and appear to date to various periods: the early complex of images consists of very deeply carved, large (up to 1.5 m) silhouettes of human figures with elongated proportions, cut across by engravings of the silhouettes of bulls; the third complex, superimposed over the second layer, is composed of schematic figures of wild goats, humans and rowing boats. The latest compositions at Gobustan, on the hill Jingir-dag, are outline depictions of hunting scenes with a rider chasing a deer (turn of the 2nd–1st millennia BC).

BIBLIOGRAPHY
I. M. Dzhafarzade: *Gobustan* (Baku, 1973)
F. M. Muradova and Dzh. N. Rustamov: *Pamyatniki Gobustana* [Monuments of Gobustan] (Baku, 1986)
V. YA. PETRUKHIN

Gočár, Josef (*b* Semín, nr Pardubice, 13 March 1880; *d* Jičín, 10 Sept 1945). Czech architect, designer, urban planner and teacher. In 1906 he completed his studies at the Academy of Applied Arts, Prague, under Jan Kotěra, in whose studio he worked until 1908. His earliest work was strikingly modern and rationalist in style, revealing a purity of expression in the use of reinforced concrete; for example the Wenke Department Store (1909–10), Jaroměř,

was designed with a skeleton structure on which a lightweight, fully glazed wall was suspended to form the façade. In 1911, with Josef Chochol, Vlastislav Hofman (1884–1964), Pavel Janák and others, he became a founder-member of the Group of Plastic Artists, Prague, which sought to develop a more artistic approach to architecture; a year later he and Janák founded the Prague Art Workshops for the design of arts, crafts and furniture, and from 1914 he was a member of the Architects' Club. Influenced by Janák, Gočár adopted the prismatic surface forms of CZECH CUBISM, a move that was anticipated in his design (1909–10) for the completion of the Old Town Hall, Prague, in the form of a monumental pyramid. Two of his finest works date from this period: his sanatorium at Bohdaneč and the Black Madonna House, Prague (both 1911–12), which are characterized by an air of weightlessness despite the robust mass of the buildings. During this period he also carried out several Cubist designs in the applied arts, especially for furniture (see CZECH REPUBLIC, §V, 4). After World War I, Gočár began to work in the curved forms of Rondocubism, which was a development of Czech Cubism; he used the circle as a motif to tie together all the elements of a structure into a cohesive composition. His Legiobank (1921–3), Prague, with façade sculpture by Otto Gutfreund, demonstrated the expressive potential of the style. A later work by Gočár, the Czechoslovak pavilion at the Exposition Internationale des Arts Décoratifs et Industriels Moderne in 1925, in Paris, marked the culmination of this period.

From 1922 to 1939 Gočár was Professor of Architecture at the Academy of Fine Arts in Prague. He was President of the Association of Architects in the 1920s and of the Czech Werkbund until 1924. He worked increasingly frequently for the town of Hradec Králové from the early 1920s, and there he gradually developed a mature Functionalist style for civic architecture. He began with the design of groups of buildings there, including the Tannery School (1923–4) and another school complex, and he ultimately produced a plan (1928) for the entire city that resolved the relationship between the medieval and modern sectors with remarkable breadth of vision. He was also involved in a total of 13 competitions and studies between 1923 and 1937 for the location of the National Gallery, Prague; in various designs, none of which was executed, he sought to relate monumental Functionalist architecture to the historic environment of the city centre. Other work included collaboration on the Baťa Department Store (1928; with Ludvík Kysela), one of the first large-scale modern commercial buildings in the centre of Prague; he also designed some houses at the Werkbund exhibition (1932), Baba, Prague, which was devoted to Functionalist housing.

In the 1930s Gočár worked on urban plans for Bratislava, Prague and Humpolec. He also produced a number of studies (1937) for an ideal town for the Baťa company, in which he embodied modern ideas on the zoning of functions in compact, classically proportioned residential areas. Gočár was one of the most important avant-garde architects in Czechoslovakia in the 1920s and 1930s. His work, marked by abrupt changes of approach, reacted to new developments with skill and sensitivity; in the case of Czech Cubism in particular, he expressed the creative

principles perhaps better than any other of the movement's founders and theorists.

BIBLIOGRAPHY

Z. Wirth: *Josef Gočár* (Geneva, 1930)
M. Benešová: *Josef Gočár* (Prague, 1958)
I. Margolius: *Cubism in Architecture and the Applied Arts: Bohemia and France, 1910–1914* (London, 1979)
M. Benešová: 'K 100. Výročí narození druhé zakladatelské generace tvůrců' [Centenary of the birth of the second generation of creators], *Archit. ČSR*, xxxix (1980), pp. 411–16
Tschechische Kunst der 20er und 30er Jahre: Avantgarde und Tradition (exh. cat., Darmstadt, Inst. Mathildenhöhe, 1988–9)
Český kubismus, 1909–1925 (exh. cat., ed. T. Vlček and J. Švestka; Düsseldorf, Kstver.; Prague, N.G.; 1992)
The Art of the Avant-garde in Czechoslovakia, 1918–1938 (exh. cat., ed. J. Anděl; Valencia, IVAM, 1993)
Prague, 1891–1941: Architecture and Design (exh. cat., Edinburgh, City A. Cent., 1994)

RADOMÍRA SEDLÁKOVÁ

Godard, André (*b* Chaumont, Haute-Marne, 21 Jan 1881; *d* Paris, 31 July 1965). French archaeologist and art historian, active in Iran. Godard qualified as an architect at the Ecole des Beaux-Arts, Paris, and in 1910 became involved with the urban planning of Baghdad. At this time, he began to develop an interest in the archaeology and art of the Middle East. He visited Egypt and Syria and, in 1923, went to Afghanistan to research Buddhist remains. In 1928 he settled in Iran, where he lived until 1960, except for the years 1953–6. During his years in Iran he directed the College of Fine Arts, Tehran, and the Department of Antiquities, founded the Archaeological (Iran Bastan) Museum and drew up plans for the museums of Mashhad and Abadan. He also initiated the documentation and restoration of many ancient monuments and archaeological remains and gained access to sites previously forbidden to non-Muslims. He published many of the principal monuments of Iran in such learned journals as *Athār-é Īrān* and wrote extensively about artefacts. He also organized an exhibition on archaeological discoveries in Afghanistan and China (Paris, Mus. Guimet, 1925) and another on Persian miniature painting (1958). During World War II he served the Free French in Iran and from 1947 was a member of the Institut de France and commander of the Légion d'honneur. His wife Yedda was also involved in archaeological and art historical research in Afghanistan and Iran.

WRITINGS

with Y. Godard and J. Hackin: *Les Antiquités bouddhiques de Bâmiyân* (Paris and Brussels, 1928)
Les Bronzes du Luristan (Paris, 1931)
Le Trésor de Ziwiyè (Haarlem, 1950)
with B. Gray: *Iran: Persian Miniatures–Imperial Library*, UNESCO (Greenwich, CT, 1958)
L'Art de l'Iran (Paris, 1962); Eng. trans. as *The Art of Iran* (London, 1965)

BIBLIOGRAPHY

H. Massé: Obituary, *J. Asiat.*, cclii (1965), pp. 415–17

S. J. VERNOIT

Goddard, John (*b* Dartmouth, MA, 20 Jan 1723; *d* Newport, RI, 9 July 1785). American cabinetmaker. His father, Daniel Goddard, a housewright, shipwright and carpenter, moved his family to Newport, RI, soon after John's birth to join the Quaker community there. At age 13 John began an eight-year apprenticeship to Job Townsend (see TOWNSEND). He became a freeman about 1745

and married Hannah Townsend, the daughter of his employer. Three years later he purchased a large house in Newport and opened a cabinetmaking shop adjacent to it. The shop had five work benches, and he apparently employed his sons to help him. At least three of them—Townsend Goddard (1750–90), Stephen Goddard (1764–1804) and Thomas Goddard (1765–1858)—went on to set up their own shops.

By the 1760s Goddard was at the peak of his career and counted among his prominent customers the wealthy Brown family of merchants from Providence and Stephen Hopkins, the Governor of Rhode Island. In the early 1780s Goddard paid taxes at about half the rate of John Townsend, then the most prosperous cabinetmaker in Newport, but more than any of the other members of the Goddard and Townsend families.

Goddard made a wide range of furniture, including three signed, slant-lid desks with blocked fronts and shell carvings (e.g. of 1765–75; Providence, RI Hist. Soc.), but it is uncertain whether he made any of the great block and shell desks and bookcases once ascribed to him. Nevertheless, he and John Townsend were the leaders of the distinguished Newport school of cabinetmaking. Goddard came on hard times during the American Revolution, and his will indicates that he became bankrupt. The business was carried on by Stephen and Thomas Goddard until 1804. Stephen's son, John Goddard jr (d 1843), also worked as a cabinetmaker.

BIBLIOGRAPHY

M. Swan: 'The Goddard and Townsend Joiners', *Antiques*, xlix (1946), pp. 228–31, 292–5

M. Moses: *Master Craftsmen of Newport: The Townsends and Goddards* (Tenafly, NJ, 1984)

OSCAR P. FITZGERALD

Godde, Etienne-Hippolyte (*b* Breteuil, Oise, 26 Dec 1781; *d* Paris, 7 Dec 1869). French architect. The son of a building contractor, from 1796 he studied under Claude Mathieu Delagardette (1762–1805) at the Ecole Spéciale d'Architecture in Paris. In 1801 he was appointed Inspecteur des Travaux Publics for the Seine district. His first work was the church (1805–18) of Boves, Picardy. It was the prototype for a series of churches, all inspired by Jean-François-Thérèse Chalgrin's St-Philippe-du-Roule (1764–84), Paris, that were built by Godde and his imitators during the Empire and the Restoration: churches with tetrastyle porticos of Doric columns, basilica plans, naves with barrel-vaulting or coffered ceilings, ending in domed apses. Godde's Paris churches include St-Pierre-du-Gros-Caillou (1822), Notre-Dame-de-Bonne-Nouvelle (1823–30) and St-Denis-du-St-Sacrement (1823–35). From 1813 to 1830 Godde was chief architect of the City of Paris. His civic work included buildings for St-Sulpice Seminary (1820–38) and, in collaboration with Jean-Baptiste-Cicéron Lesueur, an extension to the Hôtel de Ville (destr. 1871). He was one of a generation of architects who, though not trained restorers, were appointed by the government to take charge of the upkeep of medieval buildings, particularly churches. He was for many years responsible for Amiens Cathedral and Notre-Dame in Paris, and his sensitive work on the abbey church of Corbie, east of Amiens, and St-Germain-des-Prés, Paris, for which he used new types of concrete and cement,

saved churches that had seriously decayed. He also built several hôtels particuliers in the Rue de Londres in Paris, and his funerary buildings include the chapel and entrance gate (1840–45) to Père Lachaise cemetery, Paris. Godde's strict adherence to Neo-classicism was severely attacked by Gothic Revival supporters. He retired in 1848, having made a considerable fortune that he then lost in property speculation.

BIBLIOGRAPHY

M. C. Ferrand de la Conté-Gélis: 'L'Architecte Etienne-Hippolyte Godde (1781–1869)', *Positions, Thèses Ecole Chartes* (1980), pp. 55–61

J. Foucart: 'L'Architecte Godde en Picardie', *Bull. Soc. Antiqua. Picardie*, lx (1983), pp. 12–33, 155–92

JEAN-MICHEL LENIAUD

Godecharle, Gilles-Lambert (*b* Brussels, 2 Dec 1750; *d* Brussels, 24 Feb 1835). Flemish sculptor. Until 1770 or 1771 he was apprenticed to Laurent Delvaux. His master's influence with Charles of Lorraine, the Austrian Governor of the Netherlands, secured for him in 1769 an allowance during his whole period of training. Having moved to Paris and been accepted (*agrée*) by the Académie Royale de Peinture et de Sculpture, Godecharle met the best French sculptors, such as Jean-Antoine Houdon, and enjoyed the protection of Jean-Baptiste Pigalle and of Jean-Pierre-Antoine Tassaert, who took him on as an apprentice. In 1775, when Tassaert was appointed court sculptor to Frederick the Great, Godecharle accompanied him to Berlin, where until 1777 he worked with his master on official commissions, mainly portraits of Prussian generals.

In 1778 Godecharle was in London; from there he travelled to Rome. In the same year he was awarded first prize for sculpture by the Accademia di S Luca; and in 1779 he completed a project for a grandiose monument dedicated to the Empress Maria Theresa by her son, the future Emperor Joseph II, and by her brother-in-law, Charles of Lorraine. This was to be an obelisk placed in an octagonal basin, to be erected in the Parc Royal at Brussels; Houdon was to collaborate on the project. It was not, however, executed, because in 1780 both the Empress and Charles of Lorraine died. Although this first commission did not come off, it showed how highly Godecharle was thought of in official circles in his native land, where he returned before the end of 1779. As a further proof of this esteem, he was commissioned in 1781 to sculpt the pediment of the façade of the palace of the Sovereign Council of Brabant at Brussels (now Palais de la Nation). The two remarkable terracotta models for this (Brussels, Mus. A. Anc.) display Godecharle's talent and virtuosity better than the pediment itself, which has suffered from erosion and the effects of a fire. For the summer residence of the Austrian governors at Laeken, Brussels (now the Royal Castle), Godecharle designed the sculptures for the pediment and the portico, consisting of 12 bas-reliefs with frolicking cupids symbolizing the months, and six reliefs on mythological subjects. The influence of French Rococo mixed with Flemish Baroque gives these reliefs much liveliness and charm. The idyllic scenes, with women draped in the antique style, recall the work of Clodion, while the animated groups of children are inspired by Edme Bouchardon.

Church authorities also gave Godecharle commissions. He produced two monumental allegorical statues in stone for the church of St Jacques-sur- Coudenberg, Brussels—the *Old Testament* and the *New Testament* (both 1787; *in situ*)—as well as three bas-reliefs, the *Nativity*, *Last Supper* and *Entombment*. His style grew more severe, tending towards Neo-classicism.

Between 1791 and 1822 Godecharle worked on an important commission for the grounds of the château of Wespelaar (between Leuven and Mechelen (Fr. Malines)); it comprised 37 busts of famous men and numerous statues, some of them copies of French or antique works. They included *Time Instructing Youth* (1791; Brussels, Mus. A. Anc.). Since 1899 most of these have been in the Musée d'Art Ancien, Brussels. Godecharle decorated the botanical gardens in Ghent and Leiden with ornamental sculptures and did the same for many other parks, such as that at Rhisnes, Namur.

Godecharle enjoyed extraordinary renown, but the quality of his output became uneven. His allegorical figures, which were produced by a team of assistants, are often weak, but his portraits, such as that of *Charles Malaise* (1805; Brussels, Mus. A. Anc.), always speak a direct and personal language. Most of his work as a teacher was done during the last 30 years of his life. In 1814 he was appointed professor at the Académie des Beaux-Arts in Brussels but produced no distinguished pupils. He received numerous distinctions and was the official sculptor for several successive governments. Godecharle was influenced by the French tradition of the 18th century, but his style remained allied to Flemish art. His terracotta models and his portraits demonstrate that he was one of the best of his country's sculptors in his time.

BIBLIOGRAPHY

M. Devigne: 'De la parenté d'inspiration des artistes flamands du XVIIe et du XVIIIe siècle: Laurent Delvaux et ses élèves', *Mém. Acad. Royale Belgique: Cl. B.-A.*, n. s. 1, ii/1 (1928), pp. 34–122

1770–1830: Autour du néo-classicisme en Belgique (exh. cat. by A. Jacobs and others, Brussels, Mus. Ixelles, 1985), pp. 105–14

Académie royale des beaux-arts de Belgique (exh. cat., ed. J. van Lennep; Brussels, Mus. Royaux B.-A., 1987), pp. 269–70, 335–41

R. Kerremans: 'Godecharle, Gilles-Lambert', *La Sculpture belge au 19ème siècle* (exh. cat., ed. J. van Lennep; Brussels, Gén. de Banque, 1990), pp. 426–8

J. van Lennep: *Catalogue de la sculpture: Artistes nés entre 1750 et 1882*, Brussels, Musées Royaux B.-A. cat. (Brussels, 1992), pp. 207–36

HELENA BUSSERS

Godefroid [Godfrey] **of Huy** [de Claire] (*b* Huy, nr Liège; *d* Neufmoustier Abbey, nr Huy, after 1173). South Netherlandish metalworker. According to a note appended *c*. 1240 to his name in the necrology of Neufmoustier Abbey, he was a monk and worker in precious metals. The note records that he was an exceptionally able goldsmith and had produced many shrines (*feretra*) and other objects in various neighbouring regions; these included two shrines, an incense burner, a chalice for the church of Huy and a reliquary for the abbey church of Neufmoustier to receive the finger of St John the Baptist that Godefroid himself had brought back from the Holy Land. None of these works can be identified with certainty, but it is probable that the two reliquary shrines preserved at Notre-Dame, Huy, containing respectively relics of St Domitian and St Mangold, are the two *feretra* mentioned in the necrology. They are in poor condition, however, and have been much altered, making it difficult to judge the quality of the work. According to a description of 1745, a reliquary shrine (destr. French Revolution) at St Vanne Abbey, Verdun, bore the inscription *Godefridus aurifex* ('Godefroid, goldsmith') and was related to the shrines at Huy (see Ronig). It may well have been another of Godefroid's works.

Since the publication of the relevant parts of the necrology of Neufmoustier by Helbig in the late 19th century, a large body of precious metalwork and enamel from the Meuse region has been attributed to Godefroid or to his followers. Thieme–Becker, for example, attributes 21 pieces to Godefroid and his workshop, divided into early, middle and late periods. The *aurifaber G.* mentioned in a letter of Abbot WIBALD OF STAVELOT of 1148 has also been identified with Godefroid, without any clear justification. The presumption that work including the Shrine of St Servatius (Maastricht, Schatkam St-Servaasbasiliek) and the four smaller reliquaries that accompanied it (Brussels, Musées Royaux A. & Hist.) were made in Maastricht by Godefroid of Huy has been rejected by Kroos, who has reassessed the romanticized image of Godefroid as an important artistic personality, asserting that his only surviving works are the two shrines at Huy and the short side of the Shrine of St Oda (London, BM).

BIBLIOGRAPHY

Thieme–Becker: 'Claire, Godefroid de'

F. Ronig: 'Godefridus von Huy in Verdun', *Aachen. Kstbl.*, xxxii (1966), pp. 7–212 (83)

J. J. M. Timmers: *De kunst van het Maasland: I* (Maastricht, 1971), pp. 317–20

Rhein und Maas: kunst und Kultur 800–1400 (exh. cat., Cologne, Josef-Haubrich-Ksthalle; Brussels, Musées Royaux A. & Hist.; 1972–3)

R. Kroos: *Der Schrein des heiligen Servatius in Maastricht und die vier zugehörigen Reliquiare in Brüssel* (Munich, 1985), pp. 94–5, 102–3

A. M. KOLDEWEIJ

Godefroy, (Jean Maur) Maximilian (*b* Paris, 1765; *d* Paris, 1848). French architect and draughtsman, active in the USA, England and France. All that is known of the first 40 years of Godefroy's life is that he served 18 months in the army, probably practised engineering briefly and spent 19 months in Napoleonic prisons before being exiled to the USA. He arrived in New York on 26 April 1805 and in December took up a post as drawing-master at the college founded by the Sulpicians of St Mary's Seminary in Baltimore. His modest competence in drawing, evident in several works in pencil and pen, bistre and coloured washes, suggests training. A few are landscapes and one, the *Battle of Pultowa* (1804–5; Baltimore, MD Hist. Soc. Mus.), is a historical composition, but most are Neo-classical designs, for example for diplomas, employing allegorical subject-matter. Godefroy's importance lies in his introduction of recent French ideas in the buildings he designed and built in Baltimore. He began to study architecture *c*. 1803, probably by self-instruction from books; Jacques-François Blondel's theory concerning expression of purpose and Jean-Nicolas-Louis Durand's methods of planning and of composing elevations had the greatest influence on him. His chapel (1806–8) for St Mary's Seminary, Baltimore, the first ecclesiastical structure in the USA to have Gothic detailing, employs pointed

and circular openings to suggest, in Blondel's manner, a character appropriate for this building dedicated to the Virgin. Along with some interior decoration, its planning is indebted to Durand in the grouping of vestibules, sacristy and collegians' chamber around the nave and sanctuary. In the Battle Monument (1815–25), Baltimore, Godefroy used Egyptian elements to commemorate the deaths of the defenders of Baltimore during the War of 1812. Battered walls and doors, cavetto cornices and sun-discs form the base for a large fasces and sculptured personification of the city. A severe Neo-classicism marks his masterpiece, the Unitarian Church (1817–18; altered) in Baltimore, where the entry, auditorium, sanctuary and service rooms fit into a compact geometrical composition. A block topped by a dome, entered through a recessed vestibule behind an Italianate column screen with arches, it resembles work of Claude-Nicolas Ledoux; Charles Percier and Pierre-François Fontaine's publication of Renaissance buildings of Rome supplied designs for doors and other details of this house for a modern religion. Both the Seminary chapel and the Unitarian Church had symbolic ornament inside, while column screens and piers, curving surfaces and the play of light and shadow enriched the interior spaces.

In August 1819 Godefroy moved to London, where he exhibited drawings at the Royal Academy (1820–24). He won third premium in the competition of 1821 for Salters' Hall (1823–7; destr. World War II), London, and some elements of his design were probably incorporated into the building by the company's surveyor, Henry Carr (c. 1772–1828). He also designed a Catholic Charities School (1825–6; destr. World War II) in Clarendon Square, London. In January 1827 Godefroy returned to Paris and was soon appointed as municipal architect in Rennes, where he was occupied with minor works and repairs (1827–8). In January 1829 he became architect of the département of Mayenne, residing in Laval. Here he renovated the Palais de Justice (a 16th-century castle) and added a wing (1829–36) consistent with the earlier style. His monumental arched entry, service buildings and enclosure walls (1831–9) at the Préfecture in Laval, and, in nearby Mayenne, the Asile de la Roche-Gandon (1829–36), show his manner after returning to France. In these late works Godefroy employed a spare classical vocabulary and, through string courses and emphatic quoining at corners and openings, achieved the expression of structural strength. The eclectic use of historic styles to express a character reminiscent of Blondel, prominent in his early works, receded before the increased impact of Durand's compositional practices.

BIBLIOGRAPHY

Colvin; *Macmillan Enc. Architects*

D. M. Quynn: 'Maximilian and Eliza Godefroy', *MD Hist. Mag.*, lii (1957), pp. 1–34 [biography]

R. L. Alexander: 'The Drawings and Allegories of Maximilian Godefroy', *MD Hist. Mag.*, liii (1958), pp. 17–33

——: *The Architecture of Maximilian Godefroy* (Baltimore, 1974)

ROBERT L. ALEXANDER

Godefroy le Batave [Batavus, Godofredus] (*fl* 1515–26). North Netherlandish illuminator, active in France. He is known solely through his activity at the court of Francis I. His name comes from a Latin inscription identifying him as *pictoris batavi* in the third volume of his best-known work, the *Commentaries on the Gallic War* (1520; Chantilly, Mus. Condé, MS. 1139). He signed himself 'Godefroy' there and in the *Triumphes* of Petrarch (*c.* 1524; Paris, Bib. Arsenal, MS. 6480). The *Commentaries on the Gallic War* (vol. i: London, BL, Harley MS. 6205; vol. ii, Paris, Bib. N., MS. fr. 13429), the *Dominus illuminatio mea* (1516; Paris, Bib. N., MS. fr. 2088) and the *Life of the Magdalene* (1517; Paris, Bib. N., MS. fr. 24955) were illuminated under the direct supervision of their Franciscan author, François Du Moulin or Demoulins (*fl* 1502–24), for presentation to the King and his mother Louise de Savoie, Comtesse d'Angoulême (1476–1531). The tiny, personalized vernacular manuscripts provide insight into court thought and taste in these early years of the French Renaissance.

Godefroy's miniatures closely complement the texts with often innovative iconography. Their sprightly calligraphic narrative style, coming directly out of the Antwerp Mannerist tradition with a keen attention to the prints of Albrecht Dürer, is distinguished by an almost exclusive use of grisaille, shot with decorative colour. The graceful figures, dressed in an inventive range of imagined Classical and contemporary costume, are set in fanciful architecture and extensive landscapes closely connected to the style of the Antwerp painter Joachim Patinir.

BIBLIOGRAPHY

M. Orth: 'The Magdalen Shrine of La Saint-Baume in 1516: A Series of Miniatures by Godefroy le Batave', *Gaz. B.-A.*, xcviii (1981), pp. 201–14

——: 'François du Moulin and Albert Pigghe, *Les Commentaires de la guerre gallique*, Renaissance Painting in Manuscripts: Treasures from the British Library (exh. cat., ed. T. Kren; Malibu, CA, Getty Mus.; New York, Pierpont Morgan Lib.; London, BL; 1983), pp. 181–6

——: 'The Triumphs of Petrarch Illustrated by Godefroy le Batave', *Gaz. B.-A.*, civ (1984), pp. 197–206

A.-M. Lecoq: *François I imaginaire: Symbolique et politique à l'aube de la renaissance française* (Paris, 1987), pp. 211–14, 229–44, 315–23, 409–10

MYRA D. ORTH

Godescalc (*fl c.* AD 781–3). Carolingian scribe. He is known from the dedicatory poem in an Evangeliary (or Gospel Lectionary; Paris, Bib. N., MS. nouv. acq. lat. 1203; *see* MANUSCRIPT, fig. 9), which has subsequently been named after him. It is clear from the poem (fols 126*v*–127*r*) that Godescalc was commissioned to write the manuscript by Charlemagne and his wife Hildegard. The verses also mention Charlemagne's march to Italy (781), on which Godescalc accompanied him, and the baptism of the King's son Pepin in Rome; the manuscript was therefore written between 781 and the death of Hildegard in 783. It consists of 127 purple leaves of parchment (310×210 mm) with two columns of script in gold and silver ink; the main text is in uncial, the headings in capitals and the dedicatory poem in the newly developed miniscule script. The codex is sumptuously ornamented: six miniatures at the beginning, initials introducing the individual lessons, and with each page surrounded by a decorative frame. The first four images show the *Evangelists* (fols 1*r*–2*v*; *see* CAROLINGIAN ART, fig. 6) with their symbols in the upper corners. The series of portraits is completed by an image of *Christ Enthroned* (fol. 3*r*). The sixth miniature shows the *Fountain of Life* (fol. 3*v*); it is the earliest example of this uncommon theme in Carolingian art. The

Godescalc Evangeliary is the first of a series of manuscripts from the Court School of Charlemagne (*see* CAROLINGIAN ART, §IV, 3). All the images are based on models from Italy and Byzantium; they show some artistic uncertainty, especially in the rendering of figures. By contrast, the initials masterfully unite Insular forms (*see* INSULAR ART, §3) with those from late antiquity.

BIBLIOGRAPHY

W. Koehler: *Die Hofschule Karls des Grossen* (1958), ii of *Karolingische Miniaturen* (Berlin, 1930–82), pp. 22–8
F. Müthevich: 'Die Buchmalerei am Hofe Karls des Grossen', *Karl der Grosse: Lebenswerk und Nachleben*, iii, ed. W. Braunfels and H. Schnitzler (Düsseldorf, 1965), pp. 9–53
H. Belting: 'Probleme der Kunstgeschichte Italiens im Frühmittelalter', *Frühmittelalt. Stud.*, i (1967), pp. 98–101, 127–9, 143

KATHARINA BIERBRAUER

Godin Tepe. Site in the Zagros mountains of central western Iran, 7 km east of Kangavar. It was occupied between *c.* 5000 and *c.* 1400 BC and between *c.* 700 and *c.* 500 BC. T. Cuyler Young's excavations (1965–73) and his 1974 survey have provided the regional archaeological sequence for *c.* 5000–*c.* 500 BC, replacing the sequence derived from Tepe Giyan. Louis Levine excavated remains from the early periods (Godin XI–VI, *c.* 5000–*c.* 3100 BC) at the nearby site of Seh Gabi. The main excavation into the summit of the Godin Tepe ruin mound (500× 300×30 m) revealed architecture and artefacts from periods VI–II. Small exposures of Period VI remains (*c.* 3400–*c.* 3100 BC) yielded bowls, beakers and jars of fine buff ware, some painted with bands of naturalistic and geometric motifs related to pottery from Tepe Sialk (Sialk III). The Godin V oval building (Late Uruk period, *c.* 3200–*c.* 3100 BC; *see* IRAN, ANCIENT, §II, 1(ii)) was an intrusive outpost of lowland Mesopotamia towards the end of Period VI, with typical lowland plain buff ceramics, cylinder seals and numerical tablets. Godin IV pottery (*c.* 2900–*c.* 2600 BC) is a highly burnished grey-black ware with white-filled excised geometric designs, related to that found in north-west Iran at YANIK TEPE. The houses and graves of the Period III town (*c.* 2600–*c.* 1400 BC) yielded buff ware with geometric, abstract and naturalistic motifs painted in bands on the upper body, as well as red-slipped and grey wares and other artefacts. The site was abandoned early in the Iron Age (*c.* 1400 BC). When it was reoccupied in the Godin II period (Median, *c.* 700–*c.* 500 BC) a large, fortified ceremonial building (50×120 m) was established on the mound's summit; it had rectangular and square columned halls and extensive storage magazines (*see* IRAN, ANCIENT, fig. 5c). The columned halls resemble those in later Achaemenid palaces at Persepolis and Susa. The buff ware assemblage has abundant shallow bowls and trefoil-mouth jugs, including some very fine ware.

BIBLIOGRAPHY

T. C. Young jr and L. D. Levine: *Excavations of the Godin Project: Second Progress Report*, Royal Ontario Museum Art and Archaeology Occasional Paper (Toronto, 1974)
E. F. Henrickson: 'An Updated Chronology of the Early and Middle Chalcolithic of the Central Zagros Highlands', *Iran*, xxiii (1985), pp. 63–108
T. C. Young jr: 'Godin Tepe Period VI/V and Central Western Iran at the End of the Fourth Millennium', *Gamdat Nasr: Period or Regional Style?*, ed. U. Finkbeiner and W. Rollig (Wiesbaden, 1986), pp. 212–24
R. C. Henrickson: 'The Godin III Chronology for Central Western Iran, 2600–1400 B.C.', *Iran. Antiq.*, xxii (1987), pp. 33–116
——: 'The Buff and the Grey: Ceramic Assemblages and Cultural Process in the Third Millennium B.C. Central Zagros, Iran', *Cross-craft and Cross-cultural Interactions in Ceramics*, ed. P. E. McGovern and M. B. Notis, Ceramics and Civilization (Westerville, OH, 1989), pp. 81–146

ROBERT C. HENRICKSON

Godl, Stefan (*b* ?Nuremberg; *fl* 1508–18). Austrian bronze-founder. He is first heard of in 1508, when he was summoned to Innsbruck from Nuremberg to make brass firearms for the Holy Roman Emperor Maximilian I. Godl was a superb technician and was soon pressed into service as one of the bronze-founders for the cenotaph of *Emperor Maximilian I* in the Hofkirche (*see* AUSTRIA, fig. 20): it was he who cast Leonhard Magt's 23 statues (bronze, 1514–18) of the Habsburg family saints. His consummate skill in translating Magt's highly individualized figures from wax to bronze earned him in 1518 the task of casting one of the over life-size figures of the members of Maximilian's family that were designed to stand as a guard of honour around the cenotaph. Godl's figure, *Duke Albert IV Habsburg*, had first been prepared by Hans Leinberger as a wooden model (1514) from Albrecht Dürer's original drawing (Liverpool, Walker A.G.). When Maximilian saw the completed figure, he dismissed Gilg Sesselschreiber, the court painter who had been directing the project, and gave the job to Godl, with orders to cast the remainder of the figures. These dark bronze statues were the first over life-size statues to be cast in German lands. They were cast in sections—arms, legs, heads and so on—by the lost-wax process, using models first carved in wood. Many of the highly complicated ornamental details of costume, jewellery and armour were also cast separately and polished by a goldsmith after being assembled.

BIBLIOGRAPHY

V. Oberhammer: *Die Bronzestandbilder des Maximiliangrabmales in der Hofkirche zu Innsbruck* (Innsbruck, 1935)
K. Oettinger: *Die Bildhauer Maximilians am Innsbrucker Kaisergrabmal* (Nuremberg, 1966)
E. Egg: *Kunst in Tirol: Malerei und Kunsthandwerk* (Innsbruck, Vienna and Munich, 1970), pp. 334–9

JANE CAMPBELL HUTCHISON

Godman, Frederick Ducane (*b* Godalming, Jan 1834; *d* London, 19 Feb 1919). English collector. Godman was among the first Western private collectors of medieval Islamic ceramics. With energy, an uncanny eye and the courage to invest considerable sums, Godman collected some of the most important and beautiful examples known as well as several important inscribed and dated works. Godman's rivals in the highly competitive and expensive market for Ottoman and Hispano-Moresque ceramics included GEORGE SALTING and John Henderson (1797–1878). Godman's interest in Islamic ceramics doubtless led him to commission WILLIAM DE MORGAN to make a fireplace in the 'Persian' style for Godman's residence, South Lodge, at Horsham, W. Sussex. After his death, Godman's daughters loaned generously to major exhibitions of Islamic art and continued their father's tradition of hospitality to scholars. Many of these, notably ARTHUR LANE, used examples from the Godman collection to forge the fundamental scholarship on Islamic ceramics. On the death in 1982 of Miss C. E. Godman, the collection

was transferred to the British Museum; comprising over 600 objects, it includes extraordinary examples of Iranian, Ottoman and Hispano-Moresque ceramics.

WRITINGS

The Godman Collection of Oriental and Spanish Pottery and Glass, 1865–1900 (London, 1901)

BIBLIOGRAPHY

Mrs F. D. Godman: 'Lustre Ware and the Godman Collection', *Connoisseur*, vii (1903), pp. 21–5

O. Hoare: 'The Godman Collection', *Christie's Review of the Season, 1983*, ed. J. Herbert (London, 1983), pp. 390–94

M. Rogers: 'The Godman Bequest of Islamic Pottery', *Apollo*, cxix (July 1984), pp. 24–31

WALTER B. DENNY

Gödöllő colony. Hungarian artists' colony. It was formed in 1901 at Gödöllő, near Budapest, when the painter Aladár Körösfői-Kriesch undertook to revive the traditional art of weaving with looms donated by the Ministry of Culture. Members included Sándor Nagy and his wife, the painter and designer Laura Kriesch (1879–1966), Ervin Raálo (1874–1959), Jenő Remsey (1885–1980), Endre Frecskai (1875–1919), Léo Belmonte (1870–1956), Árpád Juhász (1863–1914), Rezső Mihály (1889–1972), István Zichy (1879–1951), Mariska Undi (1887–1959), Carla Undi (1881–1956) and the sculptor Ferenc Sidló (1882–1953). Inspired by the ideals of John Ruskin and William Morris and by the heroic vision of peasant life celebrated by Tolstoy, the group established workshops in ceramics, sculpture, leatherwork, furniture-making, embroidery, book-binding and illustration, fabric and wallpaper design and, most importantly, in stained glass and the weaving of carpets and tapestries coloured with vegetable dyes. Their goals were social as well as artistic: to enable the rural poor to stay on the land, they taught traditional craft techniques to local young people and exhibited their work to international acclaim. They also sought to develop a modern national style by adapting the rich forms and colourful ornament of vernacular art and architecture, which they recorded and published between 1907 and 1922 in the five-volume study, *A magyar nép müvészete* (The art of the Hungarian people). In 1909 they had a collective exhibition at the National Salon in Budapest. As artists identified with a style of romantic nationalism, Gödöllő designers and craftsmen obtained such important government commissions as the decoration of the Hungarian pavilions at international exhibitions and, in 1913, the design and decoration of the Palace of Culture of Marosvásárhely (now Tîrgu Mureș, Romania), where the stained-glass windows by Sándor Nagy and Ede Thoroczkai Wigand rank as one of the greatest achievements of 20th-century Hungarian art. The colony existed until 1921. The textile workshop carried on for a few more years under the management of Sándor Nagy and the weaver Vilma Frey (1886–after 1921).

BIBLIOGRAPHY

K. Gellér and K. Keserü: *Gödöllői müvésztelep, kiállitás katalógus angolnyelvü kivonattal* [Conceptions and ideals of the artists of Gödöllő] (Kecskemét, 1977)

K. Gellér: 'Hungarian Stained Glass of the Early 20th Century', *J. Stained Glass*, xvii/2 (1986–7), pp. 200–14

K. Gellér and K. Keserü: *A Gödöllői müvésztelep* [The Godollo artists' colony] (Budapest, 1987)

E. Cumming and W. Kaplan: *The Arts and Crafts Movement* (London, 1991), pp. 191–5

FERENC BATÁRI

Godoy (y Alvárez de Faria), Manuel, Príncipe de la Paz (*b* Badajoz, 12 May 1767; *d* Paris, 4 Oct 1851). Spanish politician and collector. The scandalous rapidity of his rise from obscure member of the royal bodyguard in Madrid (1784), to General (1791), to Duque de la Alcudia and First Secretary of State (1792), to Prince (1795), to marriage with María Teresa de Borbón y Vallabriga, Condesa de Chinchón (1797), to Generalísimo (1801) and to Grand Admiral (1807), was due not to superior education, training or experience but to his role as intimate and favourite of the Spanish king and queen, Charles IV and Maria Luisa. To provide the proper courtly environment for the performance of his official duties, Godoy remodelled and redecorated the Madrid palace given to him by his royal patrons, employing such artists as Francisco de Goya and Mariano Salvador Maella. By 1792 he had begun to commission portraits of himself and to acquire paintings to embellish his residence, imitating the art patronage and collecting activities of the King. His extensive and eclectic collection of over 1000 works of varying quality was formed exclusively inside Spain from 1792 until his fall from power and forced exile in March 1808, when it was broken up and dispersed largely because of the French occupation of Madrid.

The prime document for study of the collection is the inventory drawn up in Madrid (1808) by the French connoisseur Frédéric Quilliet. Some 70% of identifiable works consisted of 16th- and 17th-century paintings of the Spanish, Italian and Flemish schools, thus reflecting earlier trends in Spanish collecting; approximately 14% were 18th- and early 19th-century Spanish paintings, and, overall, the majority of works were Spanish. The artists best represented were: Ribera (45 works), Murillo (35), Goya (26), Giordano (16), Zurbarán (12), Titian (11) and Velázquez (9). A third of the collection was composed of religious works, followed by portraits, genre, landscapes, mythological, allegorical and battle scenes, seascapes and hunting themes in descending quantities. Quilliet noted that only some 300 works were of the first order; these included Alonso Cano's *Crucifixion* (Madrid, Real Acad. S Fernando, Mus.), Correggio's *Mercury Instructing Cupid before Venus* (the '*School of Love*'; London, N.G.), Anthony van Dyck's *Martyrdom of St Stephen* (Tatton Park, Ches, NT), Giordano's *Prudence of Abigail* (Madrid, Duke of Sueca priv. col.), Goya's *Naked Maja* and *Clothed Maja* (both 1797–8; Madrid, Prado), Murillo's *St Thomas of Villanueva as a Child* (Cincinnati, OH, A. Mus.), Raphael's Alba *Madonna* (Washington, DC, N.G.A.), Ribera's *St Jerome and the Angel of Judgement* (St Petersburg, Hermitage), Titian's *Jacopo Pesaro Presented to St Peter* (Antwerp, Kon. Mus. S. Kst.) and Velázquez's *Rokeby Venus* (London, N.G.). During his exile in Rome (1808–29), Godoy amassed a second, lesser, collection (approximately 300 works), which was sold gradually in Paris (1830–52); 33 paintings were purchased in 1831 by Tsar Nicholas I for the Hermitage, St Petersburg. The largest intact portion (approximately 200 works) of the Madrid collection is located in the Real Academia de Bellas Artes de San Fernando, Madrid; and it is the Madrid collection that is significant for the history of collecting in Spain, because it simultaneously documents, reflects and serves as a compendium of Spanish collections from the 16th century to

the 18th and anticipates *nouveau riche* bourgeois collecting patterns.

Godoy and his wife were depicted by Goya in *Manuel Godoy, Príncipe de la Paz* (1801; Madrid, Real Acad. S Fernando, Mus.) and *Doña María Teresa de Borbón y Vallabriga, Condesa de Chinchón* (1800; Madrid, Duke of Sueca priv. col.), both paintings coming from his collection.

BIBLIOGRAPHY

I. Rose: *Manuel Godoy, patrón de las artes y coleccionista*, 2 vols (Madrid, 1983)

ISADORA ROSE DE VIEJO

Godwin, E(dward) W(illiam) (*b* Bristol, 26 May 1833; *d* London, 6 Oct 1886). English architect, designer and writer. He had an early interest in archaeology, which was fostered by fragments of medieval carving in his parents' garden. From the age of 15 he began sketching buildings all over the West Country. In 1851 he contributed illustrations to *The Antiquities of Bristol and Neighbourhood*, by which time he was apprenticed to William Armstrong of Bristol. Armstrong, perhaps recognizing Godwin's aptitude, entrusted him with much of his architectural work. This brought Godwin early responsibility but little formal training, a lack that he felt dogged his professional life. In 1854 he established an independent practice, and in an attempt to further his career, in 1856 he joined his brother, an engineer, in Londonderry, Ireland. During his visit he studied castles and abbeys throughout Ireland. He also designed three small Roman Catholic churches in a severe Gothic style at St Johnstown (1857–61), Newtown Cunningham (1861) and Tory Island (1857–61), all in Co. Donegal. In 1858 he returned to practise in Bristol where his earliest commissions were for two warehouses in Merchant Street (1856–8) and Stokes Croft (1860). The influence of Ruskin, seen in their solidly constructed polychromatic stonework, was also apparent in his successful competition design for a new town hall in Northampton (1861–4). The central tower, statuary, naturalistic carving and structural polychromy confirm Godwin's claim that the building was 'wholly founded upon *The Stones of Venice*'. It also allowed him to realize the ideal of 'total design', expounded in his lecture of 1863, *The Sister Arts and their Relation to Architecture*, whereby a single spirit was expressed by a building and all its decoration and fittings. He achieved this at Northampton by designing all the furniture, stained glass, woodwork and ironwork. The stout oak chairs of the council chamber were unusually simple in construction, with arms composed of semicircles of wood, which complemented the medieval character of the building. While Northampton Town Hall was being built, Godwin went into partnership in Bristol with Henry Crisp (1825–96), who allowed Godwin to devote himself to architectural competitions. He was awarded first premium by the assessors in the competitions for new municipal buildings at East Retford (1865), Plymouth (1870), Bristol (1871), Leicester (1871), Sunderland (1874) and Congleton (1864), Cheshire; of these, only the last, still Ruskinian but French rather than Italian in detail, matured into a commission.

Godwin's professional success seemed assured when he received two commissions for houses in the west of

Ireland: Dromore Castle (1866–71), Co. Limerick, for William Pery, 3rd Earl of Limerick, and Glenbeigh Towers (1867–70), Co. Kerry, for the Hon. Rowland Winn, later 1st Baron St Oswald. Godwin made use of distinctively Irish medieval features such as stepped battlements and round towers in his designs for the houses. They are both composed of several continuous blocks, some reminiscent of tower houses, ranged around a central courtyard, and for Dromore he also designed all the furniture and interior decoration. These decorations, although medieval in subject-matter, show the Japanese influence that established him as a pioneer of the Aesthetic Movement. Unfortunately the buildings were plagued with damp, which at Glenbeigh Towers caused water to run down the inside walls. Furthermore it ruined the wall paintings drawn from Spenser's *Faerie Queen* (1589), which Henry Stacy Marks had begun in the first-floor dining-room. These failures damaged Godwin's career as an architect. From this time, most of his architectural commissions came from friends in literary and artistic circles: in 1867–71 he built Beauvale Lodge, Northants, for the 7th Earl Cowper, in a vernacular style consisting of wood-framing, tile-hung gables, steeply pitched roofs and French detailing. Several artists' houses in Tite Street, Chelsea, constitute Godwin's only other architectural contribution of note. The first designs for Whistler's White House (1877–9; destr.) and Frank Miles's house (1873; see fig.) were startlingly avant-garde, being relatively low for their width, with asymmetrically disposed façades of stark, undecorated or whitewashed brick. They offended the conservative sensibilities of the Metropolitan Board of Works, lessors of the Tite Street land, and he was required to append decorative panels of terracotta and mosaic and self-consciously 'artistic' Dutch gables.

E. W. Godwin: first design for Frank Miles's house, Tite Street, Chelsea, 1873 (London, Victoria and Albert Museum)

From the 1870s most of Godwin's inadequate income came from decoration and furniture design, and architectural journalism. His earliest furniture was for his office in London (opened 1865). It was made of ebonized deal with 'no mouldings, no ornamental work and no carving' and was characteristic of most of his furniture designs. The 'Anglo-Japanese' furniture he designed for William Watt of Grafton Street, London, does have a Japanese sparseness of decoration, but it owes more to Godwin's imagination and design preoccupations than to the Orient (examples in London, V&A; Bristol, Mus. & A.G.). In his final years, Godwin's longstanding interest in the theatre was to take up most of his diminishing energies. His association with the actress Ellen Terry in the late 1860s and early 1870s brought him into contact with many leading theatrical figures. His influence on designs for a production in 1875 of *The Merchant of Venice* at the Prince of Wales Theatre in London shows his principal concern was for an archaeological—then atypical—accuracy for costumes and set. His costumes reflect his concern with 'rational dress', on which he had published a pamphlet (1884) for the International Health Exhibition in London, and exemplified by the unrestrictive folds of the Japanese kimonos that he liked Ellen Terry and their children to wear.

Godwin died in debt. Only a fraction of the buildings he designed were executed and few survive. Although he was certainly unlucky in the financial instability of some of his clients such as Whistler, he cannot be absolved from all blame for the misfortunes that befell his works, for example his Irish castles. The enduring qualities of his designs, however, are a refinement of proportion and a historicism that is inventively allusive rather than plagiarizing. Godwin, unlike most of his contemporaries, succeeded in the paradoxical Victorian quest for originality through the archaeological study of past styles.

UNPUBLISHED SOURCES

London, V&A, E. 225-1963–E.-1963 [Godwin's notebooks and sketchbooks]
London, RIBA, GOE/1–GOE/7 [Godwin's contract doc., unpubd articles etc]

WRITINGS

Many articles in the *Archaeol. J.*, *The Architect*, *Brit. Architect. & N. Engin.* and *Bldg News*, 1850s to 1880s
'On Some Buildings I Have Designed', *Brit. Architect.* (1878), pp. 210–11
Dress and its Relation to Health and Climate (London, 1884)

BIBLIOGRAPHY

Cat. Drgs Col. RIBA
W. Watt: *Art Furniture from Designs by E. W. Godwin and Others* (London, 1877)
D. Harbron: *The Conscious Stone* (London, 1949) [the only monograph]
E. Aslin: *The Aesthetic Movement* (London, 1969, 2/1981)
M. Girouard: *The Victorian Country House* (London, 1971, 2/1979)
——: 'The Victorian Artist at Home. The Holland Park Houses—I', *Country Life*, clii/3934 (16 Nov 1972), pp. 1278–81
——: 'Chelsea's Bohemian Studio Houses. The Victorian Artist at Home—II', *Country Life*, clii/3935 (23 Nov 1972), pp. 1370–74
E. Aslin: *E. W. Godwin: Furniture and Interior Decoration* (London, 1986)
A. Reid: 'Dromore Castle, Co. Limerick: Archaeology and the Sister Arts of E. W. Godwin', *Archit. Hist.*, xxx (1987), pp. 113–42
——: 'Homes Fit for Hera', *Country Life*, clxxxvi/50 (10 Dec 1992), pp. 36–9

AILEEN REID

Godwin, George (*b* London, 28 Jan 1813; *d* London, 27 Jan 1888). English architect and writer. He was the son of

an architect and surveyor, George Godwin (1789–1863), and he trained as an architect in his father's office. In 1836 he was awarded the first Silver Medal of the Institute of British Architects for an essay on concrete, and he became one of the leading advocates for its use as a building material. Throughout his career he was keenly interested in the practical aspects of architecture, but none of his designs stepped far outside the architectural conventions of the mid-Victorian period. Almost all his work was carried out in the London suburb of Kensington, where he lived and died, starting with the modest Brompton National School (1841–2; destr. 1889–90) and progressing, as the suburb expanded westwards to the vigorous terraced houses of Redcliffe Square (1869–76). Some of his later projects were designed in partnership with his brother, Henry Godwin (1831–1917).

Godwin's architectural practice gave him the necessary knowledge and professional reputation to embark on the most important aspect of his career, his editorship of the *Builder*. He took over this weekly journal in 1844 after the failure of its first two editors, and with an autocratic hand he turned it into the most important professional paper of its kind, known not just for its coverage of architecture but for its investigative reports on health and environmental issues and its interest in archaeology, history, theatre and the arts. Much of each issue was written by Godwin himself and reflected his architectural commitments and belief in social advance through a combination of voluntary action, professional knowledge and commercial energy. He was the man behind the scenes in many of the events he reported, literally so in the case of the stage sets on which he advised the actor-manager Charles Kean (1811–68). Godwin stepped down as editor of the *Builder* in 1883.

Apart from the *Builder*, his longest commitment was as secretary of the Art Union of London, an organization for the promotion of painting, engraving and sculpture through a system of lottery prize-givings; he resigned that post in 1868. In 1881, on receiving the RIBA Gold Medal, he described his life as 'one of earnest and continuous endeavour to spread information, to sustain the dignity of the profession, and to contribute to the welfare of all classes'.

WRITINGS

ed.: *Builder*, ii–xlv (1844–83)
London Shadows: A Glance at the 'Homes' of the Thousands (London, 1854)
Town Swamps and Social Bridges (London, 1859/*R* Leicester, 1972)
Another Blow for Life (London, 1864)

BIBLIOGRAPHY

A. King: 'George Godwin and the Art Union of London, 1837–1911', *Vict. Stud.*, viii (1968), pp. 101–30
——: 'Architectural Journalism and the Profession: The Early Years of George Godwin', *Archit. Hist.*, xix (1976), pp. 32–53
H. Hobhouse, ed.: *Survey of London*, xlii (London, 1986)
B. Hanson: *Mind and Hand in Architecture* (diss., U. Essex, 1986)
R. Thorne: '"Building Bridges": George Godwin and Architectural Journalism', *Hist. Today*, xxxvii (1987), pp. 11–17
R. Richardson and R. Thorne: *The Builder Illustrations Index* (London, 1994)

ROBERT THORNE

Godwin, John. *See under* HOPWOOD, GILLIAN.

Goebel, Carl (*b* Vienna, 26 Feb 1824; *d* Vienna, 10 Feb 1899). Austrian painter and lithographer. He was the son of the historical and portrait painter Carl Peter Goebel (1791–1823), and he was educated and given his first drawing tuition by his grandfather, Josef Klieber. After studying painting at the Akademie der Bildenden Künste in Vienna under the Austrian painter Carl Gsellhofer (1779–1858), he was awarded the Füger prize for composition in 1848. He recorded the events of the revolution in Vienna that year in numerous drawings, watercolours and lithographs (Vienna, Hist. Mus.). He was very influenced by the works of Josef Danhauser and Peter Fendi. Goebel temporarily worked as an assistant in the studio of the Austrian painter Mathias Ranftl (1805–54), where he met the patron and collector Graf Alexander Schönburg, who introduced him into Viennese society as a portrait painter. For over a decade he painted portraits of the most famous visitors to the Silesian spa towns of Gräfenberg and Freiwaldau. He was also employed as a portrait painter at some of the royal courts of Europe, including those of England (where he painted Queen Victoria and the Duke of Cumberland) and Romania. After 1855 he also turned to portrait lithography, influenced in this by the Austrian lithographer and painter Josef Kriehuber (1800–76). He based his lithographic portraits on drawings that he had already made. Goebel undertook numerous study tours, to Kiev in 1851, Venice, Réggio nell'Emilia and Piacenza in 1855, Paris and Belgrade in 1860–61, and Spain and Africa in 1864. He recorded his impressions of areas in Austria and from his extensive foreign travels in landscape and popular scenes, mainly in watercolours such as *Tow Men at Rest on the Danube* and *A Peasants' Room* (1888; both Vienna, Hist. Mus.). With these works and his views of Vienna (e.g. *View from the Water Glacis towards the Stephansdom*, 1875; Vienna, Hist. Mus.), animal pictures and genre scenes, he was one of the last representatives of Fendi's style of Biedermeier.

BIBLIOGRAPHY

ÖKL; Thieme–Becker

SABINE KEHL-BAIERLE

Goebel, Jenő Paizs. *See* PAIZS GOEBEL, JENŐ.

Goeldi, Oswaldo (*b* Rio de Janeiro, 31 Oct 1895; *d* Rio de Janeiro, 15 Feb 1961). Brazilian draughtsman and printmaker. In 1901 he returned to Switzerland with his father, the Swiss naturalist Emil Goeldi, founder of the ethnological Museu Paraense Emilio Goeldi in Belém do Pará. In 1917 he enrolled in the Ecole des Arts Décoratifs in Geneva and in Berne discovered the drawings of Alfred Kubin, whom he met in Germany in 1930–31 and whose essentially critical, imaginative Expressionism had a marked influence on the evolution of his work. He settled in Rio de Janeiro in 1919 and in 1921 held a much admired exhibition, which led to his participation in the 1922 Semana de Arte Moderna in São Paulo with a group of drawings. One of Latin America's most important printmakers, he took up printmaking in 1924, particularly favouring woodcuts, and he illustrated numerous books, reviews and literary supplements, especially after the success of his illustrations for Raul Bopp's poem *Cobra Norato* (Rio de Janeiro, 1937). His illustrations for the Brazilian translation of Dostoyevsky's novels, for example *The Idiot* (Rio de Janeiro, 1944), are exceptional in their technique and their poignancy. His independent work concentrated on a melancholic and dramatic treatment of humble people such as fishermen, bohemians and drunks, expressing disenchantment, solitude and silence with a grave lyric quality, as in his woodcut of an old man, *Old Age* (Rio de Janeiro, Bib. N.). In 1960 he won the engraving prize at the Bienal Interamericana in Mexico.

BIBLIOGRAPHY

A. Machado: *Goeldi* (Rio de Janeiro, 1955)
J. R. Teixeira Leite: *A gravura brasileira contemporânea* (Rio de Janeiro, 1965)
J. M. dos Reis Júnior: *Goeldi* (Rio de Janeiro, 1966)
O. da Silva: *A arte maior da gravura* (Rio de Janeiro, 1976)
C. Zílio and others: *Oswaldo Goeldi* (Rio de Janeiro, 1981)
R. Pontual: *Entre dois séculos: Arte brasileira do século XX na Coleção Gilberto Chateaubriand* (Rio de Janeiro, 1987)

ROBERTO PONTUAL

Goeneutte, Norbert (*b* Paris, 23 July 1854; *d* Auvers-sur-Oise, 9 Oct 1894). French painter and engraver. In 1871, after working briefly as a lawyer's clerk, he entered the studio of Isidore Pils at the Ecole des Beaux-Arts. When Pils died in 1875 Henri Lehmann took over the studio and Goeneutte left, moving to Montmartre. There he met Auguste Renoir, for whom he often modelled, and Marcellin Desboutin, who inspired his interest in engraving, etching and drypoint. Although Goeneutte was associated with Manet, Degas and Renoir, and his work was influenced by them, for instance in the informality of his compositions, he never exhibited with the Impressionist group, preferring instead the official Salons. Every year from 1876 he exhibited several works in the Paris Salon, such as *Boulevard de Clichy under Snow* (1876; London, Tate). He visited London in 1880, Rotterdam in 1887 and Venice in 1890.

In 1891 Goeneutte moved to Auvers-sur-Oise, where Dr Paul Gachet had a studio in his home. He had worked with Gachet on *La Renaissance littéraire et artistique* (1872–3) and on the periodical *Paris à l'eau forte*, and in 1892 he exhibited a portrait of *Dr Gachet* (Paris, Mus. d'Orsay).

Goeneutte portrayed a variety of themes: portraits, scenes depicting the everyday lives of working-class and fashionable Parisians, landscapes of Flanders, Antwerp and Venice. His subjects are depicted simply but with careful attention to detail, and his work emanates a remarkable tranquillity.

BIBLIOGRAPHY

H. Beraldi: *Les Graveurs du XIXe siècle: Guide de l'amateur d'estampes modernes* (Paris, 1885–92), vii, pp. 170–72
G. de Knyff: *Norbert Goeneutte: Sa Vie et son oeuvre ou l'art libre au XIXe siècle* (Paris, 1978)
Norbert Goeneutte (exh. cat., ed. E. Maillet; Pontoise, Mus. Pissarro, 1982)

NORBERT GEORGES GOENEUTTE

Goeree, Willem (*b* Middelburg, 11 Dec 1635; *d* 3 May 1711). Dutch art theorist. His father, Hugo Willem Goeree, was a well-known doctor and theologian in Middelburg. Willem showed early interest in the arts and science and sought contact with learned men. After his father's early death, his stepfather tried to put a stop to Willem's pursuit of academic interests. Goeree had to become a bookseller, but his enthusiasm for art and for Jewish and religious

history found expression in his subsequent writings. In 1666 he married Elisabeth van Waesbergen; he later settled in Amsterdam.

In the 1670 edition of *Inleydingh tot de practijck der algemeene schilder-konst*, Goeree explained his proposed publication plan; he wanted to put together a comprehensive work concerning the various techniques that a painter must master: drawing, knowledge of architecture, perspective, anatomy, composition, imagination, colour and shading. Goeree covered these subjects in separate books, but not so fully as he had intended. In a later edition he stated that, to his bitter regret, his relatives had treated him with scorn and abuse for 40 years and ridiculed his plan to follow his ambitious survey of painting with a great work: the *Mosaize oudheden of historie der Hebreeuwse kerk* [Mosaic antiquity or history of the Hebrew church]. His son Jan Goeree (1670–1731) was a painter, draughtsman, engraver and etcher.

UNPUBLISHED WRITINGS

Aanteekeningen over Persepolis [Notes on Persepolis]

Lexicon Vitruvianum, of verklaaring der konstwoorden die in d'Architectuur van Vitruvius voorkomen [Lexicon Vitruvianum, or explanation of the art terms that appear in Vitruvius' *On Architecture*]

Werkwoorden der bouwlieden, zijnde alle benamingen van gereedschappen, stoffen, woorden van commando enz. die bij de werkers aan de bouw dagelyx gebruikt worden [Builders' nouns, being all names of tools, materials, words of command etc that are in daily use by builders]

Woordenboek der architecture, waarin alle de konst- of werkwoorden die dagelyx in 't bouwen voorkomen, in hare gronden worden verklaard [Dictionary of architecture, comprising all the art terms or nouns in daily use in building, explained in their original words]

WRITINGS

Inleyding tot de algemeene teeken-konst [Introduction to the general art of drawing] (1668; rev. 5/Leiden, 1739)

Inleydingh tot de practijck der al-gemeene schilder-konst [Introduction to the practice of the general art of painting] (Middelburg, 1670; rev. 4/Amsterdam, 1704)

ed.: *Verligteriekunde of regt gebruik der waterwerwen, eertijds uytgegeven door Mr. Geerard ter Brugge* [Explanation of the correct use of watercolour, originally published by Mr Gerard ter Brugge] (Amsterdam, 1670)

Algemeene bouwkunde, volgens de antyke en hedendaagsche manier [General architecture according to the Antique and modern manner] (Amsterdam, 1681; rev. 1705)

Natuurlijk en schilderkonstig ontwerp der menschkunde [Natural and painterly appreciation of human physiognomy] (Amsterdam, 1682; rev. 3/1753)

A number of Goeree's writings have been reprinted (Soest, 1974)

FEMY HORSCH

Goering [Göring], **Hermann (Wilhelm)** (*b* Rosenheim, Bavaria, 11 Jan 1893; *d* Nuremberg, 16 Oct 1946). German Reichsmarschall and collector. Before World War II he acquired art chiefly through legitimate channels. His family owned a valuable collection of ecclesiastical vestments, which he augmented with *c*. 200 paintings—nudes, portraits and altarpieces being his favourite subjects. As the Nazis gained power, Goering fed his insatiable appetite for art by ruthless means. Following in the wake of looting sprees, Goering scoured the countries subdued and occupied by the German *Wehrmacht* and grabbed all the plunder he could lay his hands on. Sometimes he paid for his purchases, but in forced sales or on the pretext of offering protection to the owners and always at sharply reduced prices. He also gave examples of *entartete Kunst* to art dealers in exchange for established masterpieces. He strongly encouraged supporters to give him birthday and New Year 'gifts': in this manner he obtained four panels

of the Sterzing altar by Hans Multscher from Benito Mussolini, *Fountain Nymph* by Lucas Cranach I from the Luftwaffe and works by van Dyck and Tintoretto from the city of Berlin. Goering's rapaciousness had its critics, but he assured them that his efforts served the public good, since he planned to erect a national museum. The primary instrument for Goering's thievery was the Einsatzstab Reichsleiter Rosenberg für die Besetzten Gebiete (ERR), an organization run by Alfred Rosenberg that secured treasures belonging to Jews and Freemasons and used them in anti-Semitic propaganda. Confiscated collections, among them the Rothschilds', were transported to the ERR clearing-house in the Musée du Jeu de Paume in Paris and exhibited to the Reichsmarschall for his personal selection. By the end of the war Goering's collection totalled 1375 paintings and 868 objects and filled Carinhall, his country retreat outside Berlin, as well as six other residences. Goering was arrested by the Allies at the end of World War II, and, under their policy of cultural restitution, most of the items in his collection were recovered and returned to their original owners.

BIBLIOGRAPHY

J. Flanner: 'Annals of Crime: The Beautiful Spoils, II—Collector with the Luftwaffe', *New Yorker* (1 March 1947)

F. H. Gregory: *Goering* (London, 1974)

L. Mosley: *The Reich Marshal: A Biography* (New York and London, 1974)

D. Irving: *Göring: A Biography* (New York, 1989)

KATHRYN BONOMI

Goeritz, Mathias (*b* Danzig, Germany [now Gdańsk, Poland], 4 April 1915; *d* Mexico City, 4 Aug 1990). German painter and sculptor, active in Mexico. He studied philosophy and art history in Berlin at Friedrich-Wilhelms Universität, taking his doctorate in 1940 and also attending some courses in fine arts. In 1940 he emigrated to Spanish Morocco, where he worked as a teacher until 1944. He returned to Europe at the end of World War II in 1945, settling in Spain, first in Granada, then in Madrid and finally in Santillana, near Santander. There he devoted himself to painting, meeting avant-garde artists and in 1948 helping to found the Escuela de Altamira, which represented a call to artistic rebellion and propounded absolute creative freedom.

In 1949 Goeritz settled in Mexico in order to become professor of visual education and drawing at the Escuela de Arquitectura of the Universidad de Guadalajara, on the invitation of the school's director, Ignacio Díaz Morales (1905–92). He taught in Guadalajara until 1954, his natural restlessness finding an outlet in opening galleries and promoting a series of innovative cultural activities as well as in producing his own work. Of singular importance was his creation of a museum in Mexico City, the Museo Experimental Experimental El Eco, which operated from 1951 to 1953 and had both a national and an international impact. A sculpture made by him for the museum, *Snake* (1953; Mexico City, Mus. A. Mod.), prefigured Minimalism, and the manifesto published on the museum's inauguration, *Arquitectura emocional*, had repercussions in the work of architects such as Luis Barragán, who adopted the term to define his own work.

On moving to Mexico City in 1954, Goeritz continued to teach and entered a richly productive period, particularly

with his sculpture. He produced a series of *Heads* made from gourds or cast in bronze, and public sculptures such as *The Animal of the Pedregal* (1954) for the Jardines del Pedregal de San Angel in Mexico City. He also worked productively in collaboration with a number of architects, especially with Barragán, with whom he created a monumental sculpture, *The Towers of Satélite*, for the Ciudad Satélite in Mexico City in 1957. During the same period he produced a series of massive and roughly finished sculptures in wood, such as *Moses* (1956; Jerusalem, Israel Mus.), which were deeply expressive.

Goeritz became severely depressed by the death of his wife, the photographer Marianne Goeritz (1910–58), and his work became bitter, aggressive and hard. In 1958–9 he made the first of a series of mural-sized objects called *Messages* (e.g. 1968; Mexico City, Hotel Camino Real) from metal sheets and nails, and he turned towards spirituality by designing liturgical objects and decorations, in particular the stained-glass windows of Cuernavaca Cathedral (1961).

In 1961 Goeritz participated at the Galería Antonio Souza in a group exhibition, *Los hartos*, for which he published another manifesto. Other participants included José Luis Cuevas and Pedro Friedeberg, with whom he was instrumental in establishing abstraction and other modern trends in Mexico. His early enthusiasm returned, and he carried out a great number of works, including easel paintings, prints and sculptures. His outstanding sculptures of this period include the *Mixcoac Pyramid* (1969) at the Unidad Habitacional Lomas de Plateros in Mexico City and his collaboration with Helen Escobedo, Manuel Felguérez, Hersúa, Sebastián and Federico Silva on the Espacio Escultórico (1979; Mexico City, U. N. Autónoma), a large outdoor sculptural complex at the Ciudad Universitaria on the outskirts of Mexico City.

Through his foreign contacts Goeritz was able to help commission sculptures in Mexico by well-known foreign artists, for example a series of 18 works known as *La ruta de la amistad* (1968) in Mexico City, and also to execute works of his own abroad, notably at the Alejandro and Lilly Saltiel community centre in Jerusalem (1975–80). He was also instrumental in encouraging and promoting other artists both through his teaching (as in the case of Sebastián) and through his friendship with other artists. His rebellious nature and vigorous promotion of the avant-garde made him a leading figure in the development of modern art in Mexico. He also made regular contributions to the monthly 'Sección de arte' in the periodical *Arquitectura México* from 1959 to 1978.

WRITINGS

Arquitectura emocional (exh. cat., Mexico City, Mus. A. Mod., 1984)

BIBLIOGRAPHY

O. Zuñiga: *Mathias Goeritz* (Mexico City, 1963)
X. Moyssén: 'Los mayores: Mérida, Gerszo, Goeritz', *El geometrismo mexicano* (Mexico City, 1977), pp. 51–75
F. Morais: *Mathias Goeritz* (Mexico City, 1982)

LOUISE NOELLE

Goes, Hugo van der (*b* Ghent, *c.* 1440; *d* Rode Klooster, nr Brussels, 1482). South Netherlandish painter.

1. Life. 2. Work. 3. Stylistic development. 4. Working methods and technique. 5. Tradition and innovation.

1. LIFE. In 1467 he enrolled as master in the Ghent painters' guild, sponsored by Joos van Wassenhove, master painter in Ghent in 1464 after registering in Antwerp in 1460. In 1469 the two together acted as guarantors for the illuminator Sanders Bening when he became a master, and it was from Hugo that Joos borrowed money when he went to Rome. Sanders Bening was married to Kathelijn van der Goes, perhaps Hugo's sister. Hugo's status within the guild is further attested by the fact that he was guarantor for two other painters in 1471 and 1475, that he was one of the dean's jurors in 1468–9 and that he himself served as dean from towards the end of 1473–4 to at least 18 August 1475. He was employed regularly by the town of Ghent between 1468 and 1474 for the decorative ephemera essential to the pageants of public life.

Van der Goes's reputation extended beyond Ghent, for he was one of the many painters called to Bruges for the celebrations on the marriage of Charles the Bold with Margaret of York in 1468. His pay of 14 *sols* a day compares unfavourably with the 20 *sols* plus 3 *sols* expenses paid to Daniel de Rijke, another Ghent painter. In 1480, however, when the town of Leuven employed him to evaluate paintings left unfinished when Dieric Bouts died in 1475, he was honoured with a gift of wine and was described in the accounts as one of the most notable painters to be found.

By this date, Hugo had become a *frater conversus*, or lay brother, in the monastery of the Rode Klooster in the Forêt de Soignes near Brussels, where his half-brother Nicholas was also a monk. The precise year of Hugo's entry is not recorded. Between May 1473 and May 1477, he was the tenant of a house in the St Pieters Nieuwstraat in Ghent belonging to the van der Sickele family, and he last appears in their accounts in March 1478. He may have stopped living there somewhat earlier, for Gaspar Ofhuys, who joined the Rode Klooster in 1475, maintained that he and Hugo were novices together. Ofhuys discussed Hugo at length in his early 16th-century chronicle of the monastery, not so much for the painter's fame, which was so great that 'people used to say that he had no equal this side of the Alps', as for the moral lessons to be drawn from his lapse into insanity. According to Ofhuys, Hugo was travelling back from Cologne, some five or six years after becoming a monk, when conviction of his damnation drove him to frenzy and he had to be restrained from injuring himself. He was treated gently on his return and recovered, only to die shortly afterwards.

Ofhuys's account reveals that Hugo continued to practise as a painter after entering the monastery and to attract the attention of the great of the world, who came to see his pictures and gossiped about his madness. He was given special privileges to entertain his visitors, among them Archduke Maximilian, and Ofhuys concluded that, in trying to achieve the anonymity of the cloister, Hugo actually acquired greater personal fame. Hugo seems to have accepted that he was guilty of pride, since he renounced any special favours when he recovered from his illness and lived as the others, 'continually reading in a Flemish book'. Anxiety about his art may have contributed

to his madness, for 'he was deeply troubled by the thought of how he would ever finish the works of art he had to paint, and it was said then that nine years would scarcely suffice'. He was buried simply in the cloister under the open sky, but in his epitaph Art was told to lament, for his equal would never be found.

2. WORK. Nothing survives of the ephemera Hugo painted for the town of Ghent, and no painting can be authenticated as his from contemporary evidence. A painting of *David and Abigail*, attributed to Hugo by three 16th-century writers, is now known through some 20 later copies (e.g. Brussels, Mus. A. Anc.). A triptych of the *Virgin and Child with Prophets and Sibyls* by Hugo was owned by the humanist scholar Jerome Busleyden (*d* 1517) and is reflected in three derivative works: a panel by Ambrosius Benson (Antwerp, Kon. Mus. S. Kst), the centre of a triptych by the Master of the Holy Blood (Bruges, St Jacobskerk) and a miniature in the style of Simon Bening (Munich, Bayer. Staatsbib., MS. lat. 2367).

The two lost originals seem from these later versions to have been consistent in style with the Portinari Altarpiece (Florence, Uffizi; see fig. 1), the only surviving work attributable to Hugo from a 16th-century source. In the first edition of the *Vite* (1550) Vasari wrote that the picture at S Maria Nuova in Florence was by 'Ugo d'Anversa'. This picture is assumed to be the Portinari Altarpiece, a large triptych with the *Nativity* or *Adoration of the Shepherds* (central panel, 2.53×3.04 m) from the church of S Egidio in the hospital of S Maria Nuova, and 'Ugo d'Anversa' to be Hugo van der Goes, who is not otherwise linked with Antwerp. (By 1550 it may have been as natural to associate all Netherlanders with Antwerp as it had been in the 15th century to think of Bruges.) The patrons of S Maria Nuova were the Portinari family, and it was Tommaso Portinari, agent for the Medici bank in Bruges, who commissioned the altarpiece as his contribution to the recently rebuilt S Egidio. Tommaso is shown on the left wing with his sons Antonio and Pigello, presented by SS Thomas and Anthony, and his wife, Maria

Baroncelli, on the right wing with their daughter, Margherita, and SS Mary Magdalene and Margaret. The commission can be dated between 1473, the earliest possible birth date of Pigello, their third child, and 1478, the probable birth date of Guido, their fourth. The discovery (see Marijnissen and van de Voorde) that Tommaso's head, but not Maria's, had been painted on to a separate support and then glued to the panel suggests that Hugo was working on the wings in 1477–8, when Tommaso was in Italy but his family still in the southern Netherlands. The wings must have been insufficiently advanced before his departure for his appearance to be recorded directly on to the panel as was his wife's. Stylistic and technical differences suggest that the wings were painted later than the central panel (see Thompson and Campbell), which would have been begun *c.* 1473–4. Whether because of Hugo's working methods or the chaos in Portinari's affairs after the death of Charles the Bold in 1477, the altarpiece did not arrive in Florence until 1483. It had a great impact on Italian painters and was a major source for Domenico Ghirlandaio's *Adoration of the Shepherds* (1485; Florence, Uffizi; see GHIRLANDAIO, fig. 2).

The distance is not large between Ghent and Bruges, where Hugo is known to have worked in 1468 and where paintings by him were recorded in the 16th century. Portinari had already commissioned work from Hans Memling, resident in Bruges; whether he turned to Hugo for practical or aesthetic reasons, he obtained in the altarpiece a triptych far removed from Memling's reassuring art. In the central panel, single vanishing-point perspective, focused on the Virgin's face, establishes a steeply raked stage for the figures, who contradict the logic of the spatial construction by their discrepancies in scale. The unsteady pose of the small figure of Joseph is given an appearance of stability by the solidity of his contour and the firmness of his praying hands. His motionless pose offsets the busyness of the shepherds, who thrust forward as if against an invisible barrier around the isolated and vulnerable Child, laid on the ground as sacrificial victim, yet worshipped as God. The flowers and wheatsheaf, symbols of the Eucharistic Passion and the Sorrows of

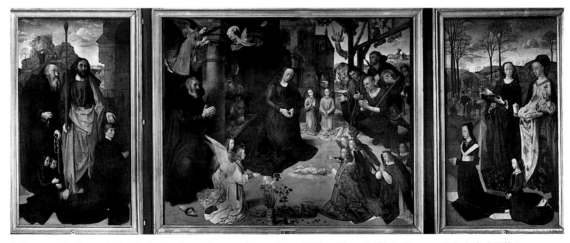

1. Hugo van der Goes: the Portinari Altarpiece, oil on panel, central panel 2.53×3.04 m, *c.* 1473–8 (Florence, Galleria degli Uffizi)

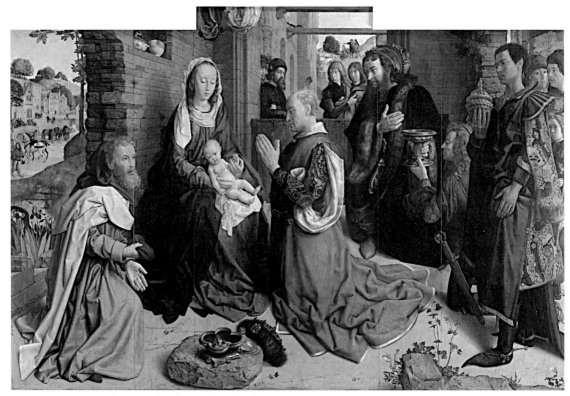

2. Hugo van der Goes: *Adoration of the Magi*, oil on panel, 1.42×2.45 m (Berlin, Gemäldegalerie)

the Virgin, complete the circle. While the setting is continuous across the three panels, the wings, where saints tower over donors in the shallow foreground, are different in conception and technique. Shut, they show a grisaille *Annunciation*, set in sculptural niches but incapable of ever being carved in stone.

The idiosyncrasies of the Portinari Altarpiece have left little disagreement about the other major works to be attributed to Hugo. Another large altarpiece for export, for Trinity College, Edinburgh, was commissioned between 1473 and 1478 (wings, both 1990×970 mm, Brit. Royal Col., on loan to Edinburgh, N.G.), judging by the appearance in the left wing of only the eldest son of James III of Scotland, kneeling behind his father and before the standing figure of St Andrew. A saint in armour, probably St George, presents the Queen, Margaret of Denmark, in the right wing. The lost central panel may have been a *Virgin and Child Enthroned*, perhaps the model for the Goesian central panel of the Évora Altarpiece in Portugal (Évora, Mus. Évora). On the reverse of the panels a *Trinity* to the left is adored on the right by *Edward Bonkil*, the Provost of Trinity College, with music-making angels. Bonkil's individualized features show that he must have commissioned the triptych and sat for his portrait when in the southern Netherlands, with which his family had substantial trading connections.

There is no external evidence for dating the other large panels attributed to Hugo. The *Death of the Virgin* (1.47×1.21 m; Bruges, Groeningemus.) comes from the Cistercian abbey of Ter Duinen in west Flanders, which

may have been its original destination, for its starkness is appropriate to a Cistercian commission. Two paintings (both Berlin, Gemäldegal.) came from Spain, which they may only have reached in the 16th century: the unusual shape of the *Nativity* or *Adoration of the Shepherds* (970×2450 mm; see fig. 5 below) suggests that it was made for a specific place or function not recorded; the *Adoration of the Magi* (1.42×2.45 m; see fig. 2) came from the monastery of Monforte, near Lemos, not founded until 1593. The Monforte *Adoration* has lost the top of the raised central section and its wings, which may have shown a *Nativity* and *Circumcision* on the pattern of the wings that accompany a reversed version of the Monforte *Adoration* by the Master of Frankfurt (Antwerp, Kon. Mus. S. Kst).

Among Hugo's smaller works, the left wing of the *St Hippolytus* triptych (Bruges, St Salvator), otherwise attributed to Dieric Bouts, can be dated *c.* 1475 from the dress of the Bruges couple portrayed on it, Hippolyte de Berthoz and Elizabeth de Keverwyck. The costume of Willem van Overbeke and Johanna de Keysere, shown on the wings of a small *Virgin and Child* by Hugo (central panel, 210×140 mm; Frankfurt am Main, Städel. Kstinst. & Städt. Gal.), indicates that they did not have the picture enshrined in a triptych until some ten years after Hugo's death. The remains of a collar, possibly of the Golden Fleece, and his patron saint, John the Baptist, are the only clues to the identity of a man on what was probably the right wing of a diptych (cut at top and bottom, 322×225 mm; Baltimore, MD, Walters A.G.). Traces of a heraldic motif on the back

of a *Lamentation*, the right wing of a diptych formed with the *Fall of Man* (each panel 338×230 mm; Vienna, Ksthist. Mus.), and the figure of *St Genevieve* on the now detached reverse of the latter show that this was another special commission.

Other compositions that appear to have originated with Hugo are now known only from copies and derivations, most completely assembled by Winkler. The popularity of his works continued into the 17th century, although their artist was largely forgotten. His name did not have the selling power of Bosch's and was not added to the numerous replicas of his most famous inventions.

3. STYLISTIC DEVELOPMENT. Conventional categories of early, middle and late works seem inappropriate to an artist who was an independent master for only 15 years. They become hard to avoid if the Portinari Altarpiece is taken as a datable and, to an extent, authenticated midpoint and other works judged earlier or later. Van Mander seems to have put a chronological interpretation on changes in Hugo's style, since he recognized a now lost *Legend of St Catherine* as a youthful work. Allowing for differences in scale and intent, it is possible to see a coherent development from the Monforte *Adoration* to the Portinari central panel followed by the wings, which are very close to the Scottish Bonkil wing panels, and finally to the *Nativity* and *Death of the Virgin*. Friedländer's

attempts to find pictures surviving in the original that antedate the Monforte *Adoration* have not gained general acceptance, for his candidates seem the works of weaker imitators rather than of the young Hugo.

The development can be summarized as a move from illusionism, based on Eyckian techniques of detailed description in rich colour and single vanishing-point perspective, perhaps learnt from Petrus Christus or Dieric Bouts and used in the Monforte *Adoration* and Portinari central panel, to an increasing emphasis on the artificiality of the picture as created image, divorced from reality by the use of limited colour and the expressive distortion of both the figures and space, as in the *Death of the Virgin*. Pächt was one of the few scholars to reject this interpretation; there has been more disagreement on relating the smaller works to it. The abstract, gold-patterned background of the *Virgin and Child*, the space-denying compression of the unidentified donor wing (Baltimore, MD, Walters A.G.) and the contrast of the continuous landscape inhabited by Adam and Eve in the *Fall of Man* with the impossible grouping of the *Lamentation* all serve to associate these works with the later phase of Hugo's style. The latter diptych, however, demonstrates his ability to compose very different types of picture at the same time, since he balances the two panels through a deliberate contrast, essential to their meaning both individually and

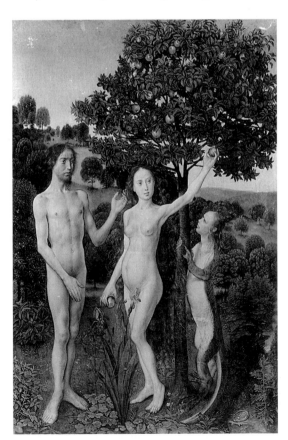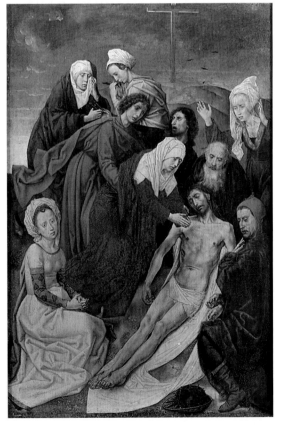

3. Hugo van der Goes: diptych with the *Fall of Man* and the *Lamentation*, oil on panel, each 338×230 mm (Vienna, Kunsthistorisches Museum)

in conjunction (see fig. 3). Such contrasts are found also in the Bonkil panels and in two diptych compositions that seem to have originated with Hugo, an *Annunciation*, as painted by the Master of 1499 (Berlin, Bodemus.), and a *St Luke Drawing the Virgin* (Lisbon, Mus. N. A. Ant.; known also through a print by Anton Wierix). Hugo had the confidence to use or discard techniques as they suited his purpose, and this makes rigid conclusions on dating difficult.

In the Bonkil panels and the latter two diptych compositions, a human is shown in a detailed interior in one panel, aware of a divine vision or visitation on the other panel, where the formalized setting has no clear spatial relationship to the interior. The division inherent in a two-panel design was stressed, not denied, in order to clarify the different levels of reality depicted. A distinction through contrasting settings was impossible in unified compositions; instead scale was used in the Portinari Altarpiece and framing devices in the interiors of the Bonkil panels with their curtained *chapelles* to divorce the living from the central image. Internal framing both divides the scene represented and distances the viewer from an image that is not to be read as a straightforward extension of reality. The barrier between viewer and image is most explicit in the *Nativity*, where two half-length figures in the foreground, assumed to be prophets, pull aside a curtain to unveil the Holy Family (see fig. 5 below). One of the prophets glares out at the viewer and, like the curtain rail physically raised in relief to enter the spectator's space, serves both to welcome and to repel. Hugo's use of figures turned to look outwards is most extreme in the *Death of the Virgin* (see fig. 4), where the central seated figure seems almost unaware of the Virgin behind him.

The contradictory spatial indications in this picture make any formal devices unnecessary to emphasize its artificiality as illusion, its reality as painted image.

Spatial impossibilities, abstract backgrounds, the use of gold, internal framing devices and distortions in figure drawing were all methods of conveying meaning while stressing the picture's existence as a picture, something that Hugo could have found in the work of Rogier van der Weyden. As Oettinger pointed out, Hugo's debt to Rogier seems to have increased with age, although he made fewer direct borrowings from Rogier than from Hubert and Jan van Eyck, if the extent to which Rogier's types had permeated south Netherlandish art is taken into account. The Ghent Altarpiece (Ghent, St Bavo; for illustration *see* EYCK, VAN, (2)), the van der Paele Altarpiece (Bruges, Groeningemus.) and the *Virgin in a Church* (Berlin, Gemäldegal.; *see* EYCK, VAN, (2), fig. 5) were all direct sources for Hugo. Hugo's development can be seen as one of an initial dependence on van Eyck that weakened through the influence of van der Weyden to attain an individuality, fed but untrammelled by the art of the past. In linking his creations so firmly to the physical world, van Eyck arrived at a solution where his technical brilliance left little room for further development. By distancing his images from the actual world, van der Weyden opened up unlimited possibilities and offered Hugo an alternative to the more literal descriptions of van Eyck. By the end of the century, it was said to have been Hugo's inability to rival the Ghent Altarpiece that drove him mad, and how far his incipient madness conditioned the stylistic changes that removed his paintings even further from reality is an inevitable, but unanswerable question.

4. WORKING METHODS AND TECHNIQUE. The Monforte *Adoration* shows that Hugo must have had a thorough training in the meticulous oil-painting techniques conventional in the Netherlands. The increasing emphasis on surface apparent in his compositions is reflected in his technique. In the Bonkil panels, the *Nativity* and the *Lamentation*, he textured hair and beards by drawing a dry brush or point through the wet paint. With the flatter colours of the *Nativity* and the *Death of the Virgin*, he used fewer glazes, relying on juxtapositions of colour instead of over-layering, producing a thinner paint layer. He was probably a significant contributor to the loosening of paint application and the simplification of technique found in many south Netherlandish painters of the later 15th century.

Where paint is thin, as in the *Lamentation*, Hugo's underdrawing is visible to the naked eye; elsewhere infrared light is needed. Most hesitant in the Monforte *Adoration*, his underdrawing tends to concentrate on outlining contours and major internal details, and on shading with broad hatching strokes. Sometimes, as in the head of the Scottish prince in the Bonkil panels, the preoccupation with wider areas of tonal definition allowed the hatching to obscure the features, whereas in the head of his mother the lines are more directional and employed to define shape. Compositions must have been planned through detailed preparatory drawings, for there are few major changes between underdrawing and painting, except in the

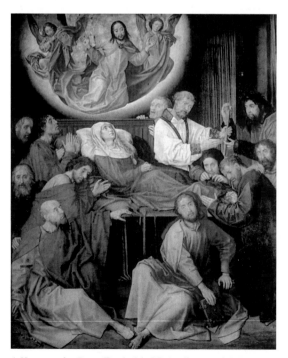

4. Hugo van der Goes: *Death of the Virgin*, oil on panel, 1.47×1.21 m (Bruges, Groeningemuseum)

wings of the Portinari Altarpiece, while in its central panel the Child was realigned after painting.

The two surviving drawings with the strongest claims to be autograph, both on coloured grounds with ink and white gouache, may be careful records made for the workshop stock of patterns rather than as preparatory studies. The *Jacob and Rachel* (Oxford, Christ Church Pict. Gal.) is a complete scene and the *Seated Female Saint* (U. London, Courtauld Inst. Gals) has been shown by Campbell (1985) to be a figure of *St Ursula* from a *Virgin and Child with Female Saints*, the lost original best reflected in a painted version (Rome, Gal. Acad. N. S Luca) and in the Grimani Breviary (Venice, Bib. N. Marciana). As a St Barbara or St Catherine, the figure was one of the most repeated patterns of the so-called Ghent–Bruges school of illuminators.

The number of compositions that seem to derive from lost originals by Hugo is large, and it is possible that some of his designs never progressed beyond drawings or were paintings left unfinished at his death, a suggestion made by Held for the *St Hippolytus* triptych (Boston, MA, Mus. F.A.). Since, according to Ofhuys, Hugo needed at least nine years to complete the works that troubled him, they must have been definite commissions or projects that had achieved some physical manifestation. He had no obvious painter heir to inherit his stock of patterns, but it seems likely that some at least survived to be used by others— some, not all—for the Portinari Altarpiece seems to have had few repercussions in the Netherlands, unlike the Bonkil panels, which did, even though they were also exported.

It is of relevance to the spread of Hugo's art that a significant number of surviving paintings on cloth can be associated with him. The fragility of both the support and the size medium makes it hard to compare them with the panels, but some, such as the *Virgin and Child with Instruments of the Passion* (Nuremberg, Ger. Nmus., on loan to Munich, Alte Pin.) and the divided diptych with the *Descent from the Cross* (New York, Wildenstein's; Berlin, Gemäldegal.), have been claimed as autograph.

Despite the use of lapis lazuli on the former, it is likely that the cheaper and easily transportable cloth paintings were a way of maximizing return on compositions worked out for more expensive panels. If Hugo did invent directly for cloth paintings with their quicker technique, it would help to explain the disproportion between the length of his working life and the number of his works. He must have employed assistants, and his *helperen* are specifically mentioned in the Ghent accounts for 1468–9.

5. TRADITION AND INNOVATION. Hugo's popularity may have resulted from his assimilation of established conventions, which made his new formulations of existing types and subjects stimulating but not shocking. His advances in landscape construction and in the exploitation of its expressive potential can be set within a developing trend to which he gave new impetus. The written evidence makes *David and Abigail*, with its landscape setting, his most famous painting. Abigail was a type for the Virgin but an unusual choice for an independent scene, perhaps selected as much for its pictorial possibilities as its meaning. The two other Old Testament subjects associated with Hugo also require landscapes: *Jacob and Rachel* and *Hagar Driven into the Desert*, partially recorded in a drawing (Boston, MA, Mus. F.A.). He also set the *Virgin and Child* in a landscape, if van Mander's description of an epitaph painting in the St Jacobskerk, Ghent, can be believed, a type increasingly adopted in the later part of the century.

While Hugo clearly learnt from the Ghent Altarpiece and other Eyckian models, his landscapes also reflect more recent north Netherlandish tradition. The apparently early *David and Abigail*, judging by surviving versions, used Bouts's device of overlapping hills to establish recession, whereas the *Fall of Man* and *Jacob and Rachel* share an ability to unite foreground, middle ground and background and to set figures in, not against, landscape. The flatter, more continuous landscapes were achieved through lowering the viewpoint and giving a new emphasis to the middle ground, bringing buildings forward from their usual place on the horizon and giving them a contemporary

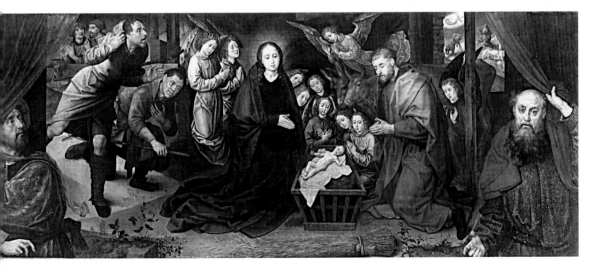

Hugo van der Goes: *Nativity*, oil on panel, 970×2450 mm (Berlin, Gemäldegalerie)

appearance to relate them to the viewer's experience of the actual world. This device can be seen in *Jacob and Rachel* and the *St Hippolytus* donor wing (Bruges, St Salvator) and the small landscapes of the Monforte *Adoration* and Portinari Altarpiece.

In the *Nativity* (see fig. 5) the Annunciation to the Shepherds appears in a background landscape, where the hovering angel is the light source irradiating the shepherds. Hugo seems to have been the originator of a nocturnal *Nativity*, where light from the Child in the manger dramatically lit the Virgin and other worshippers, with the annunciating angel as a subsidiary light source in a similar background incident, as seen in versions attributed to Gerard David and Michel Sittow (both Vienna, Ksthist. Mus.) and in the Grimani Breviary and other Ghent–Bruges manuscripts. The extreme contrasts of light and dark would have been awkwardly conveyed in a drawing, and the original must thus have been a painting accessible at least to the initiator of the chain of imitations and variants.

Hugo seems to have been most faithfully copied in his half-length compositions, which were smaller and more easily exactly repeatable. He did not invent the half-length narrative, for van der Weyden had originated a half-length *Descent from the Cross*, but he does seem to have used the form more than any of his predecessors and with an inventiveness only exceeded by Bosch. Some seem to have been reworkings of larger compositions: an *Adoration of the Magi* (versions in New York, Met.; Copenhagen, Nmus.) is closely related to the Monforte *Adoration*, and another *Nativity* (version Wilton House, Wilts) is related to the *Nativity* (Berlin, Gemäldegal.).

Hugo's most famous half-length, to judge from the 200 odd copies still extant, was a broad format *Descent from the Cross* (versions Naples, Capodimonte; Amsterdam, Rijksmus.), perhaps derived from his lost *Descent from the Cross* altarpiece that stood in the St Jacobskerk, Bruges. The gold back wall with a cornice, some of the figures and their restricted grouping are taken from van der Weyden's great *Descent from the Cross* (Madrid, Prado; *see* WEYDEN, VAN DER, (1), fig. 2). Here and in the half-length diptych with the *Descent*, which has slightly more movement, Hugo successfully abstracted iconic images from narrative, the diptych form allowing a perfect balance between the two focal-points, Christ on the left wing, the Virgin on the right. Versions of both compositions of the *Descent from the Cross*, attributable to Hugo's workshop, if not his own hand, survive on cloth (fragment of horizontal format, Oxford, Christ Church Pict. Gal.), and these smaller, close-up compositions were more widely available than the great altarpieces and also more accessible as visual and emotional experiences. That the most successful was derived in composition as well as type from van der Weyden demonstrates again how Hugo, inspired but not restricted by Rogier's dominating influence, came to rank with him as a creator of patterns central to the development of Netherlandish art.

BIBLIOGRAPHY

EARLY SOURCES

G. Vasari: *Vite* (1550, rev. 2/1568); ed. G. Milanesi (1878–85)
L. Guicciardini: *Descrittione di. . .tutti i Paesi Bassi* (1567)
M. van Vaernewijk: *Den spieghel der Nederlandscher oudtheyt* (Ghent, 1568)

K. van Mander: *Schilder-boeck* ([1603]–1604) [incl. sonnet by L. de Heere on *David and Abigail*]
W. Stechow: *Sources and Documents: Northern Renaissance Art, 1400–1600* (Englewood, NJ, 1966) [Eng. trans. of most of Ofhuys's text]

GENERAL

M. J. Friedländer: *Die altniederländische Malerei* (Berlin, 1924–37), iv (1926), pp. 9–98; Eng. trans. as *Early Netherlandish Painting* (1967–76)
E. Panofsky: *Early Netherlandish Painting*, 2 vols (Cambridge, MA, 1953)
Flanders in the 15th Century: Art and Civilization (exh. cat., Detroit, MI, Inst. A., 1960)
S. Ringbom: *Icon to Narrative: The Rise of the Dramatic Close-up in 15th-century Devotional Painting* (Abö, 1965, rev. Doornspijk, 1985)
S. N. Blum: *Early Netherlandish Triptychs: A Study in Patronage* (Berkeley and Los Angeles, 1969)
J. M. Collier: *Linear Perspective in Flemish Painting and the Art of Petrus Christus and Dirk Bouts* (diss., Ann Arbor, U. MI, 1975)
P. de Winter: 'A Book of Hours of Queen Isabella la Catolica', *Bull. Cleveland Mus. A.*, lxvii (1981), pp. 342–427
Lisbon, Museu Nacional de Arte Antiga: S Lucas retratando a Virgem pintura (Lisbon, 1981)
L. Campbell: *The Early Flemish Pictures in the Collection of Her Majesty The Queen* (Cambridge, 1985)
C. Périer-d'Ieteren: *Colyn de Coter et la technique picturale des peintres flamands du XVe siècle* (Brussels, 1985)

MONOGRAPHS

J. Destrée: *Hugo van der Goes* (Brussels and Paris, 1914)
F. Winkler: *Das Werk des Hugo van der Goes* (Berlin, 1964)
C. Thompson and L. Campbell: *Hugo van der Goes and the 'Trinity' Panels in Edinburgh* (Edinburgh, 1974)
L'Imaginaire Museum Hugo van der Goes (exh. cat. by E. Duverger and R. Hoozee, Ghent, Mus. S. Kst, 1982) [incl. documents and further bibliog.]

SPECIALIST STUDIES

H. J. Sander: 'Beiträge zur Biographie Hugos van der Goes und zur Chronologie seiner Werke', *Repert. Kstwiss.*, xxxv (1912), pp. 519–45 [incl. Ofhuys's Lat. text, with Ger. trans.]
J. Destrée: 'Un Triptyque de Hugo van der Goes', *Bull. Cl. B.-A., Acad. Royale Sci., Lett. & B.-A., Belgique*, viii (1926), pp. 26–37, 64–7
K. Oettinger: 'Das Rätsel der Kunst des Hugo van der Goes', *Jb. Ksthist. Samml. Wien*, n.s., xii (1938), pp. 43–76
H. von Einem: 'Entwicklungsfragen bei Hugo van der Goes', *Werk Kstlers*, ii (1941–2), pp. 153–99
K. G. Boon: 'Naar aanleiding van tekeningen van Hugo van der Goes en zijn school' [On drawings by Hugo van der Goes and his school], *Ned. Ksthist. Jb.*, iii (1950–51), pp. 82–101
A. de Schryver: 'Hugo van der Goes' laatste jaren te Gent', *Gent. Bijdr. Kstgesch. & Oudhdknd.*, xvi (1955–6), pp. 193–211
R. M. Walker: 'The Demon in the Portinari Altarpiece', *A. Bull.*, xlii (1960), pp. 218–19
M. B. McNamee: 'Further Symbolism in the Portinari Altarpiece', *A. Bull.*, xlv (1963), pp. 142–3
K. Arndt: 'Zum Werk des Hugo van der Goes', *Münchn. Jb. Bild. Kst*, ser. 3, xv (1964), pp. 63–98
R. Koch: 'Flower Symbolism in the Portinari Altar', *A. Bull.*, xlvi (1964), pp. 70–77
H. Kessler: 'The Solitary Bird in van der Goes's Garden of Eden', *J. Warb. & Court. Inst.*, xxviii (1965), pp. 326–9
R. Koch: 'The Salamander in van der Goes's Garden of Eden', *J. Warb. & Court. Inst.*, xxviii (1965), pp. 323–6
B. Hatfield Strens: 'L'arrivo del trittico Portinari a Firenze', *Commentari*, n.s., xix (1968), pp. 315–19
O. Pächt: 'Typenwandel im Werk des Hugo van der Goes', *Wien. Jb. Kstgesch.*, xxii (1969), pp. 43–58
R. van Schoute: 'Le Dessin de peintre chez Hugo van der Goes: La *Mort de la Vierge* du Musée Groeninge de Bruges, l'*Adoration des mages* de la Victoria Art Gallery de Bath', *Rev. Archéologues & Historiens A. Louvain*, v (1972), pp. 59–66
J. Held: 'Observations on the Boston Triptych of *St Hippolytus*', *Album amicorum J. G. van Gelder* (The Hague, 1973), pp. 177–85
B. Lane: '*Ecce panis angelorum*: The Manger as Altar in Hugo's Berlin *Nativity*', *A. Bull.*, lvii (1975), pp. 476–86
I. Alexander, F. Mairinger and R. van Schoute: 'Le Dessin sous-jacent chez van der Goes: Le Diptyque du péché originel et de la *Déploration* du Kunsthistorisches Museum de Vienne', *Rev. Archéologues & Historiens A. Louvain*, xi (1978), pp. 73–83
R. H. Marijnissen and G. van de Voorde: 'Een onverklaarde werkwijze van de Vlaamse Primitieven' [An unexplained working method of the

Flemish Primitives], *Anlct.: Acad. Kl. S. Kst.*, xliv/2 (1983), pp. 40–52 [Eng. summary in *Burl. Mag.*, cxxvi (1984), pp. 303–4]

L. Campbell: 'Edward Bonkil: A Scottish Patron of Hugo van der Goes', *Burl. Mag.*, cxxvi (1984), pp. 265–74

CATHERINE REYNOLDS

Goes, Marinus [Marin] **Robyn van der** (*b* ?Goes, ?1599; *d* Antwerp, *bur* 27 April 1639). Flemish engraver. In 1630–31 he was a pupil of Lucas Vorsterman (i), at the same time as Hans Witdoeck, and in 1632–3 he became a master in the Antwerp Guild of St Luke. He took on three pupils in 1633–4—Alexander Goubauw, Antonius Coolberger and Gaspard Leemans—and married in Antwerp in 1634. There are 18 prints known by van der Goes, four based on works by Rubens. Van der Goes also made engravings after Jacob Jordaens, Adriaen Brouwer, Cornelis Saftleven, Hendrick Martensz. Sorgh and Théodore van Thulden. He always signed his prints *Marinus*. His engravings after Rubens are the *Flight into Egypt* (Hollstein, no. 4; based on a drawing in London, BM), the *Miraculous Deeds of St Francis Xavier* (Hollstein, no. 7; based on a painting in Vienna, Ksthist. Mus.), the *Miracles of St Ignatius Loyola* (Hollstein, no. 9; based on a painting also in Vienna, Ksthist. Mus.) and the frontispiece (Hollstein, no. 20; based on a sketch in London, V&A) for *El memorable y glorioso viaje del Infante Cardenal Don Fernando de Austria* by Diego de Aedo y Gallart (Antwerp, 1635). For the same edition van der Goes engraved an equestrian portrait of the Infante after Jan van den Hoecke (who may have been a pupil of Rubens). Van der Goes successfully captured the nocturnal atmosphere of the *Flight into Egypt*, something that Rubens had, in turn, borrowed from Elsheimer. In the scenes with SS Francis Xavier and Ignatius Loyola, the artist's masterly engraving technique brings out the full character of Rubens's work.

BIBLIOGRAPHY

BNB; Hollstein: *Dut. & Flem.*; Thieme–Becker

H. Hymans: *Histoire de la gravure dans l'école de Rubens* (Brussels, 1879), pp. 204, 408–13

J. R. Judson and C. van de Velde: *Book Illustrations and Title-pages* (1977), xxi of *Corpus Rubenianum Ludwig Burchard* (Brussels, 1968–), pp. 296–9

Rubens in der Grafik (exh. cat., ed. K. Renger and G. Unverfehrt; U. Göttingen, Kstsamml., 1977), pp. 60–61

CHRISTIAN COPPENS

Goeschl, Roland (*b* Salzburg, 25 Nov 1932). Austrian sculptor and teacher. He attended Giacomo Manzu's class at the Internationale Sommerakademie für Bildende Kunst, Salzburg, and then went to Vienna, where he studied (1956–60) at the Akademie der Bildenden Künste under Fritz Wotruba. At first he was strongly influenced by his teacher, and although his sculptures were composed from separate individual elements, the overall presence of the figure was clearly visible. In 1962 a scholarship enabled him to spend nine months at the Royal College of Art, London, which brought him into contact with new tendencies and led him to start using colour.

On his return to Vienna, Goeschl became Wotruba's assistant (1963–6), and he began using blue and red to paint existing sculptures from his early period, which still used self-contained, organic forms. In the mid-1960s his already very large sculptures became increasingly detached from a figural context and took on clear geometrical and often Cubist-influenced forms. Goeschl used yellow and, later, occasionally green in order to delineate clearly the individual surfaces of his spatial structures; colour was considered to be of equal importance to material and form. Since 1962 he has taken part in numerous international exhibitions, such as Documenta III (Kassel, 1964), Documenta IV (Kassel, 1968) and the 1968 Venice Biennale. For the exhibition *Trigon 67* in Graz, he produced the monumental coloured installation *Dead End* (see Hoffmann), inside which the visitor can walk in the open air near the Kunstlerhaus. This marked a new departure, after which Goeschl's theme was the physical and psychological constriction of people. With his coloured spaces, coloured bodies, proliferations, façades and public square layouts, he created a new sense of space and made the onlooker aware of the grey monotony of the urban environment. In 1975 he was appointed professor at the Institute of Drawing and Painting at the Technische Universität, Vienna.

BIBLIOGRAPHY

W. Hoffmann: 'Fremdkörper', *Katalog Museum des 20. Jahrhunderts* (Vienna, 1969)

D. Bogner: 'Roland Goeschl: Raumfragen', *Roland Goeschl: Blau—Rot—Gelb: Farbige Raumskulpturen* (Salzburg, 1988) [cat. of Rupertinum, Salzburg]

MARTINA KANDELER-FRITSCH

Goethe, Johann Wolfgang von (*b* Frankfurt am Main, 28 Aug 1749; *d* Weimar, 22 March 1832). German writer, statesman, scientist, historian and theorist. By virtue of his prodigious literary output, his writings on art (notably in collaboration with Friedrich Schiller), his patronage as chief minister of Weimar, the extraordinary variety of his interests, and his sheer longevity, he had a profound influence on European culture.

Goethe began writing in the late 1760s, when the Romantic reaction against Neo-classicism had already started. The Rococo view of the Classical heritage, which stressed the formal elegance and rationality of the Greeks, was being dismantled by such writers as Johann Gottfried Herder, Johann Joachim Winckelmann and Gotthold Ephraim Lessing, all of whom influenced Goethe. Herder's study of folk art, Homer and the Bible concurred with Goethe's celebration of Shakespeare—in *Rede zum Shäkespears Tag* (1771)—and of Gothic art—in *Von deutscher Baukunst* (1772)—in acknowledging the role of passion and daemonic energy in art. These elements, it was claimed, were also present in Classical art; this contrasted with the Neo-classical emphasis on its rationality. This period of Goethe's life produced such characteristically Romantic poems as *Mailied* and *Wilkommen und Abschied* and the drama *Götz von Berlichingen* (1773), the first major work of that high point of the German Romantic movement known as *Sturm und Drang*; it culminated in 1774 with *Die Leiden des jungen Werthers*, a novel that took Europe by storm. Together with the earlier works, it stressed the personal and emotional aspects of creation and experience, thereby helping to foster the Romantic movement.

In 1775 Goethe went to the tiny state of WEIMAR at the invitation of its duke, Charles Augustus of Saxe-Weimar; it was to be his home for the rest of his life. He was made a member of the Duke's Privy Council and took

a full part in the detailed management of the State, from mines to road-works. After the period of *Sturm und Drang* these new responsibilities put Goethe under strain, although he continued to write prolifically while at court. In 1786 he made a sudden and secret departure to Italy, later to be recorded in his *Italienische Reise* (1816–17). He hoped in his journey to penetrate the secret of Greek art and to find the key to that spiritual wholeness that he believed the Greeks to have found and that he himself so avidly sought. Goethe came to conceive of the Greeks as a race who had realized the full potentialities of humanity in their art. Like Schiller, he saw Greek culture as uniting the rational and irrational elements of the human psyche into a harmonious whole; he strove to restore this unity in his own time. In this his exemplar was Palladio, who, he believed, had not merely imitated the ancient architects but had produced equivalent achievements in his own age.

On his return to Weimar, Goethe began a collaboration with Schiller on a series of writings, notably the two short-lived journals, *Die Horen* and *Propyläen* (1798), which articulated the notion of the Greek ideal. At the same time, in his epic poem *Hermann und Dorothea* (1797) Goethe attempted to rework the insights of the Greeks

for his own age and 'from within'. In his thought at this time, art, although handmaid neither to truth nor morality, could still help produce better human beings. His failure, however, to complete the projected epic poem *Achilleis* in 1799 seemed to indicate the impossibility of recreating Greek culture in the modern age. Subsequently he became more tolerant of other cultures, including those of the Orient; as the result of debates with Sulpiz Boisserée he also returned to an enhanced admiration for Gothic art. Rather than judge the works of all periods and nations by a Greek standard, he came to recognize that there was a multiplicity of genuine styles.

Goethe's attitudes towards art are chiefly expounded in his essays: 'On Truth and Probability in Works of Art', 'On Laokoon' (both 1789, *Propyläen*, i/1), 'The Collector and his Possessions' (1799, *Propyläen*, ii/2) and the translation and commentary to Diderot's 'Essay on Painting' (1799, *Propyläen*, i/2, ii/2). He favoured a literary art, produced by well-read artists for a well-read public; a conscious art, art being opposed to nature; an art possessing *Anmut*—a pleasing quality—even if its theme were tragic. Artists should have proper knowledge of what they were working with—anatomy, when tackling the figure;

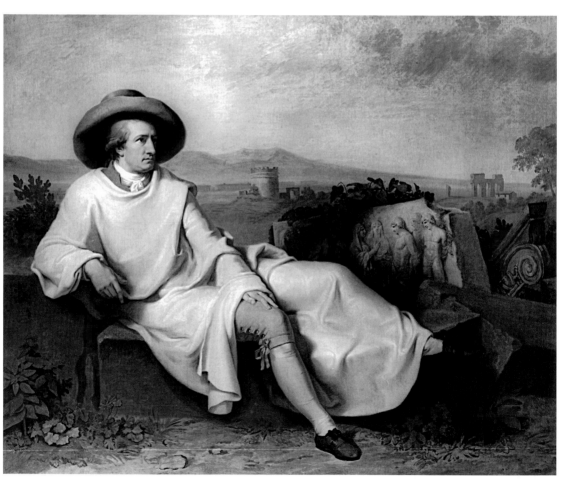

Goethe in the Roman Campagna by Wilhelm Tischbein, oil on canvas, 1.64×2.06 m, 1787 (Frankfurt am Main, Städelsches Kunstinstitut und Städtische Galerie)

the true nature of colour, when painting—and of the genres they worked in, which should be kept distinct. Certain subjects only were proper to art. Art was symbolic: it led to deeper ideas. He attempted to influence practice in accordance with these ideas. In 1791 he invited the Swiss artist Heinrich Meyer to Weimar and started a series of competitions to provide artists with the incentive to follow the advice he would later offer in *Propyläen*. These were singularly unsuccessful and were severely criticized by the Berlin sculptor Johann Gottfried Schadow. Among the many young and gifted painters entering, only Caspar David Friedrich was awarded a prize.

Although Goethe's theoretical writings on art do not seem to have greatly affected the work of practitioners, his literary works were a continual source of inspiration for painters. Daniel Chodowiecki illustrated *Werther*, while *Faust* attracted the attention of Peter Cornelius in 1816 and Delacroix in 1827. Delacroix also illustrated *Götz von Berlichingen*, as did Chodowiecki, Alfred Rethel and Eugen Neureuther. Adolph Menzel's first published work was a set of illustrations to *Künstlers Erdenwallen* (Berlin, 1834). Goethe's verbal descriptions of Swiss Alpine scenery set a precedent for later pictorial descriptions by Salomon Gessner, Joseph Anton Koch and Friedrich, and helped to set their tone. He himself was depicted by the sculptor David d'Angers and the painter Wilhelm Tischbein, who produced a much-admired informal portrait of Goethe in Rome (see fig.). In addition, his patronage encouraged many artists, including Carl Gustav Carus, Philipp Otto Runge and Heinrich Meyer; he did not refrain from attempting to influence their work.

Goethe's scientific researches also influenced various artists; his poems on the cloud studies of the meteorologist Luke Howard affected J. C. Dahl, among others. Goethe is claimed as the inventor of the science of morphology, the study of the way in which form persists through change in a way that is not capricious. It was probably for this reason that he felt an affinity with Carus, the foremost theoretician of Romantic landscape painting, who visited him in Weimar in 1821. Carus's writings, combining claims for the importance of understanding the organic structure of landscape with an artistic insight into the unity of nature and self, stimulated Goethe's belief in the organic unity of the work of art and in the need to understand it in terms of its own development. Finally, mention must be made of Goethe's controversial investigation of colour, *Zur Farbenlehre* (1810), to which he was in part stimulated by his reflections about colour in painting. Part of that work, which still meets with approbation, investigates the *physiology* of colour perception; part has to deal with the physics of light, and there, controversially, obstinately and almost certainly erroneously, Goethe disputes Isaac Newton's contention that white light is the composite of the spectrum of colours. Goethe's work on colour involves some scrupulous experimental work and includes interesting remarks on the aesthetics of colour harmony. It influenced and was influenced by Runge, who corresponded with Goethe (one such letter is appended to the second volume of *Zur Farbenlehre*). The work may well have influenced Delacroix and painters of the 19th century. Thus, the belief that overall colour harmony could best be ensured by, say, the addition of a brown glaze—what Goethe is said to have called 'the brown sauce' method of landscape painting— was undermined by his richer analyses of the basis of harmony in colour.

Goethe's influence on the visual arts did not come through his own paintings and etchings, although he was a prolific and talented draughtsman and had studied under Adam Friedrich Oeser, Johann Conrad Seekatz, Wilhelm Tischbein and Philipp Hackert, among others. He produced over a thousand paintings, etchings and sketches during his stay in Italy between 1786 and 1788. *Waterfall at Reuss* and *Parting Glimpse of Italy from the St Gothard Pass* (both 1775; Weimar, Goethe Nmus. Frauenplan) show glimpses of Romantic emotion felt in the presence of nature. Goethe accepted, however, that he lacked the kind of genius required for a practitioner of the visual arts.

WRITINGS

Essays on Art (Boston, MA, 1845) [selection of ess. trans. by S. G. Ward]
Goethes Werke, herausgegeben im Auftrage der Grossherzogin Sophie von Sachsen, 133 vols (Weimar, 1887–1919) [standard crit. edn, incl. complete lett.]
J. Gage, ed.: *Goethe on Art* (London, 1980) [anthol. with intro. and notes]

BIBLIOGRAPHY

G. H. Lewes: *The Life and Works of Goethe*, 2 vols (London, 1855/R as *The Life of Goethe*, 1965) [still recommended]
E. Ludwig: *Goethe, Geschichte eines Menschen*, 2 vols (Stuttgart and Berlin, 1920); Eng. trans. by E. C. Mayne as *Goethe: The History of a Man*, 2 vols (London and New York, 1928)
J. G. Robertson: *The Life and Work of Goethe, 1749–1832* (London, 1932)
B. Fairley: *A Study of Goethe* (Oxford, 1947)
C. Sherrington: *Goethe on Nature and Science* (Cambridge, 1947/R 1949)
H. von Einem: *Beiträge zu Goethes Kunstauffassung* (Hamburg, 1956/R as *Goethe-studien*, Munich, 1972)
Corpus der Goethezeichnungen, 7 vols (Leipzig, 1958–73) [cat. rais. with reproductions]
F. Novotny: *Painting and Sculpture in Europe*, Pelican Hist. A. (Harmondsworth, 1960) [very full bibliog.]
R. Magnus: *Goethe as a Scientist* (New York, 1961)
E. M. Wilkinson and L. A. Willoughby: *Goethe: Poet and Thinker* (London, 1962)
W. H. Bruford: *Culture and Society in Classical Weimar* (Cambridge, 1962) [excellent select bibliog. on the issues covered in the article]
H. Hatfield: *Aesthetic Paganism in German Literature* (Cambridge, MA, 1964)
H. Trevelyan: *Goethe and the Greeks* (New York, 1972) [excellent chronological app.]
Disegni di Goethe in Italia (exh. cat. by G. Femmel, Venice, Fond. Cini; Bologna, Gal. A. Mod.; Rome, Pal. Braschi; 1977)
W. D. Robson-Scott: *The Younger Goethe and the Visual Arts* (Cambridge, 1981)
H. Nisbet, ed.: *German Aesthetic and Literary Criticism: Winckelmann, Lessing, Hamann, Herder, Schiller and Goethe* (Cambridge, 1985)
D. Sepper: *Goethe contra Newton* (New York, 1988)
N. Boyle: *The Poetry of Desire, 1749–1790* (1991), i of *Goethe: The Poet and the Age* (Oxford, 1991–)

COLIN LYAS

Goetz, Hermann (*b* Karlsruhe, 17 July 1898; *d* Heidelberg, 8 July 1976). German art historian and museum director. He was educated at the Real-gymnasium in Munich and served in the military (1917–18). After World War I he took his doctorate at Munich University with a thesis, *Kostüm und Mode an den indischen Fürstenhöfen der Grossmoghul Zeit*. He then joined the State Museum of Ethnology in Berlin as assistant curator. In 1931 he went to Holland as assistant secretary of the Kern Institute of the University of Leiden and editor of the *Annual Bibliography of Indian Archaeology*. In 1936 he and his wife Annemarie moved to India, and in 1939 he was appointed director of the Baroda State Museum and Picture Gallery

by Maharaja Sayajirao Gaekwar of Baroda (now Vadodara). Goetz expended much energy on the growth and presentation of the collection of the museum, which was a pioneering institution in India. In 1942 he founded the *Bulletin of the Baroda State Museum and Picture Gallery*, which he continued to edit until 1954, and he helped the M.S. University of Baroda to establish a department of museology. He retired from the Baroda Museum in 1953, and after serving as professor of art history at the M.S. University became director of the National Gallery of Modern Art, New Delhi, which he reorganized over a period of two years. In 1961 he returned to Germany where he became professor of Oriental art in the South Asian Institute at Heidelberg University. He returned to India in 1958, 1960–61 and 1971, when he received the Jawaharlal Nehru Award for his work on Indian Art. Goetz was a prolific writer on nearly all branches of Indian art, writing more than 600 articles and 20 books in which he interpreted artistic trends in the light of the social, religious and political events that accompanied them. One of his many contributions was to demonstrate the influence of Mughal painting on Rajasthani painting, a view that amended the earlier opinions of ANANDA KENTISH COOMARASWAMY.

WRITINGS

The Art and Architecture of Bikaner State (Oxford, 1950)
India: 5000 Years of Indian Art (London, 1959)
Studies in the History, Art and Religion of Classical and Medieval India (Wiesbaden, 1974) [includes a bibliography of Goetz's writings by H. Kulke]

BIBLIOGRAPHY

Bull. Baroda State Mus. & Pict. Gal., xxviii (1978–9) [special issue dedicated to Goetz]

S. J. VERNOIT

Goetz, Karl Xaver (*b* Augsburg, 1875; *d* Munich, 1950). German medallist. After studies in several German cities and visits to Holland and Paris, he settled in Munich in 1904. His first medals date from 1905, but he is best known for his satirical and propaganda medals cast in bronze and iron during World War I, such as that portraying Crown Prince William as *Young Siegfried* (1915). Their stark expressionism is shared by the medals of other German contemporaries such as Ludgwig Gies. Copies of Goetz's *Lusitania* medal (1915) were produced in Britain as evidence of German callousness, causing the Germans to forbid its production in 1917. Some of his privately produced medals are purely propagandistic, for instance *All the World will be German* (1918); others, such as the *Laughing Heirs* (1917) and *City and Country* (1919), evince sympathy for the victims of war. Many of his post-war medals such as the *Black Shame* (1920), denouncing the French occupation of the Rhineland, are political; others, like *Goethe* (1932), are purely commemorative. During World War II he again produced propaganda medals, including several portraits of Hitler. Many of his medals were available in struck reduced versions as well as in the large cast format. His style remained largely unchanged throughout his career. He also designed postage stamps and coins.

Vollmer

BIBLIOGRAPHY

L. Forrer: *Biographical Dictionary of Medallists* (London, 1902–30), ii, p. 286; vii, pp. 379–86

G. W. Kienast: *The Medals of Karl Goetz* (Cleveland, 1967); suppl. (Lincoln, NB, 1986)
M. Jones: *The Dance of Death* (London, 1979)

PHILIP ATTWOOD

Goez, Gottfried Bernhard. *See* GÖZ, GOTTFRIED BERNHARD.

Goff, Bruce (Alonzo) (*b* Alton, KS, 8 June 1904; *d* Tyler, TX, 4 Aug 1982). American architect. In spring 1916 he was apprenticed to the local architectural firm of Rush, Endacott & Rush. His first designs for the firm were built from 1919 and show the strong influence of Frank Lloyd Wright, his mentor and later his close friend. His most famous design from his formative years, the Boston Avenue Methodist Episcopal Church in Tulsa, OK (designed in 1926 and completed in 1929), already showed his determined attempt to modify those influences. It incorporates various expressionistic motifs with elements from the PRAIRIE SCHOOL, a combination that he would continue to refine and selectively develop.

In 1929 Goff became a partner in the reorganized firm of Rush, Endacott & Goff (after 1930, Endacott & Goff). Because of the Depression the firm was dissolved in 1932. In 1934 he joined the industrial design office of Alfonso Iannelli (1888–1965) in Chicago; in 1935 he began teaching part-time at the Chicago Academy of Fine Arts as well as opening a short-lived private practice in Park Ridge, IL. In the same year he accepted a position as designer for architectural installations with Vitrolite, a division of the Libbey–Owens–Ford Glass Company, and he was later transferred to the firm's headquarters in Toledo, OH. He resigned, however, and returned to Chicago, where he succeeded in establishing an independent practice. His designs for relatively modest houses soon reflected an individual handling of abstract, angled geometries, evident in the triangular Bartman house (1941–2), near Fern Creek, KY. The office in Chicago existed until 1942, when he joined a construction battalion of the US Navy for the duration of World War II. He incorporated found materials in the residential and recreational facilities that he designed for the armed forces in the Aleutian Islands, citing wartime shortages of conventional building materials as a reason. The best-known was a chapel at Camp Parks, near Berkeley, CA, which used a standard Quonset hut as its core, with additional functional and compositional elements made from standard military stock materials. After the war the chapel was rebuilt at San Lorenzo, CA. When he left the Navy Goff stayed in Berkeley and in 1945 opened a new private practice there. Shortages of materials limited the amount of work that was completed, but this period produced unbuilt designs of extraordinary fantasy such as the Gillis house project (for Bend, OR, 1945; see De Long, 1988, pp. 80–81), one of the first of his spiral plans, or the Leidig house project (for Hayward, CA, 1946; see De Long, 1988, pp. 82–4), whose circular rooms were placed as individual islands in a pool.

Growing interest in Goff's work led in 1946 to a teaching appointment at the School of Architecture at the University of Oklahoma in Norman; after six months he became chairman of the architecture department (1947), and in the years that followed both the school and his

practice flourished. His talent found expression in such local commissions as the Ledbetter house (1947–8) and Bavinger house (1950–55; see fig.). The former expanded ideas of the earlier Leidig project, and the latter is probably Goff's best-known building. A spiral outer enclosure houses a plantlike set of separate circular platforms supported by a central steel mast. Built by its owner, Eugene Bavinger, a professor of sculpture, it was widely published, and in 1987 it received the American Institute of Architects' 25-Year Award. In other designs of this period Goff exploited more regular geometries, but still with unique results that were partly dependent on his continued exploration of unlikely materials. Examples include the Ford house (1947–50), Aurora, IL, whose intersecting partial domes are made of Quonset hut components supported on base walls of coal, and the Wilson house (1950–53), Pensacola, FL, composed of pipe-framed interlocking cubes.

Under Goff's leadership the school at Norman carried forward his ideas on the use of local materials and the design philosophy of individual response to clients. His former students, of whom Herb Greens (*b* 1929) was the best known, continued this approach, which became particularly associated with the south-western and West Coast areas of the USA. Under pressure as a result of his unconventional lifestyle, Goff resigned from the conservative university in November 1955 and moved to Bartlesville, OK, where he established his home and studio in Frank Lloyd Wright's Price Tower. Like Wright, Goff received support from the Price family, in particular Joe

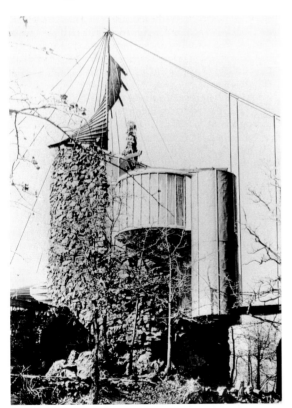

Bruce Goff: Bavinger house, near Norman, Oklahoma, 1950–55

D. Price, whose commissions sustained him through much of his later career. The first was a studio house (1956–8) for Joe D. Price, later expanded by additions that included a gallery (1966–9) and tower (1974–6). As completed it is Goff's largest and most luxurious dwelling, shaped by a triangular module that governs both section and plan. In addition to one of the earliest uses of carpet as a wall material, it features sloped walls plated with gold-coloured aluminium and a partly feathered ceiling. In other, unbuilt designs he explored such possibilities as a house composed of intersecting star shapes ('Bass' project, 1956; see De Long, 1988, pp. 150–51) and a house designed as a linear ramp ('Rodin' project, 1960; see De Long, 1988, pl. 22).

In 1964, with fewer commissions, Goff moved to Kansas City, MO, to work with a speculative developer. His designs for prefabricated houses were unbuilt and, like his other work of this period, were subdued, although there were exceptions such as the Duncan house (1965–7) near Cobden, IL, with cylinders and half-cylinders arranged to form an undulating linear axis. In 1966 he began to prepare designs for Bruce Plunkett, a former student at Norman who became another major client, and in 1970 Goff moved to Tyler, TX, to begin work on Lake Village, a recreational community. In 1970–73 several houses were built, including one for Plunkett (1970), in which Goff returned to a more decorative manner that continued in his projects and built commissions of the 1970s. Many of these reflected earlier ideas that he continued to refine. His last major work was a museum design for Price's collection of Japanese art, begun in 1978 and worked on intermittently until his death. Its spiralling composition of alcoves and cantilevered viewing platforms was realized posthumously by his former student and trusted assistant, Bart Prince (*b* 1947) and completed in 1988 as the Pavilion for Japanese Art at the County Museum of Art, Los Angeles.

BIBLIOGRAPHY
T. Mohri, ed.: *Bruce Goff in Architecture* (Tokyo, 1970)
W. Murphy and L. Muller: *Bruce Goff: A Portfolio of the Work of Bruce Goff* (New York, 1970)
Y. Futagawa: *Bruce Goff: Bavinger House and Price House* (New York, 1975)
D. De Long: *The Architecture of Bruce Goff: Buildings and Projects, 1916–1974*, 2 vols (New York and London, 1977)
J. Cook: *The Architecture of Bruce Goff* (London, 1978)
D. De Long: *Bruce Goff: Toward Absolute Architecture* (New York, Cambridge, MA, and London, 1988)

DAVID G. DE LONG

Gogel, Daniel. *See* FEHLING, HERMANN.

Gogen [von Hohen], Aleksandr [Alexander] **(Ivanovich)** (*b* 1856; *d* 1914). Russian architect based in St Petersburg. One of the first of his designs to be built was the church of the Virgin of Joy for All Sorrowing (Bogomater' vsekh skorbyashchikh radosti) attached to the glass factory on Obukhovskaya Oborona Prospect (1894–8, destr. 1932; chapel survives), with Aleksandr Ivanov. This was a fantasy on the theme of 17th-century national religious architecture: a three-part structure (bell-tower, refectory, church), with the orthodox five domes and *kokoshniki* typical of the Moscow school of architecture. The church was an example of the 'Russian style' of the

reign of Alexander III (*reg* 1881–94), leading to the Russo-Byzantine style of Konstantin Ton and Nikolay Yefimov. Gogen's use of the 'Russian style' was highly original, as in the central market building in Nizhny Novgorod (end of the 1880s; with K. Treyman, A. Trambitsky and Nikolay Ivanov), with its fairytale decoration and use of *kokoshniki*, ogee arches and other elements from Old Russian architecture.

Three independent but thematically linked buildings in St Petersburg were dedicated by Gogen to the glory of Russian weaponry. The Suvorov Museum (1901–4; with German Grimm) on Kirochnaya (later Saltykov-Shchedrin) Street 43 was conceived by the architect as a medieval fortress in a free version of the Romanesque style. The entrance, however, is accentuated by a hipped roof that recalls 17th-century Russian architecture. In the Academy of the Chiefs of Staff (1900–3; now the Communications College at Suvorovsky Prospect 32) Gogen allowed himself a certain historicism in his use of form: the building is located in a park on one side of the avenue, and its plan and the elements of the façade recall an 18th-century country house. The third thematically related building was the Officers' Club on the corner of Kirochnaya Street and Liteyny Prospect (1895–8; with Antony Tomishko, Aleksandr Donchenko and V. Gauger). The consecutive use of elements of the Romanesque, Renaissance and Baroque styles from the bottom to the top of the building was intended to reflect the continuity of the Russian army. This varied and finely decorated building was an important contribution to St Petersburg eclecticism.

Another side of Gogen's talent was revealed in his design for the Loans Office at Fontanka Embankment 74–76 (1899–1900; with Andrey Bertel's and Roman Golenishchov). The two buildings flank a small alley and employ motifs from Italian Renaissance architecture. The small ensemble clearly relates to Karl Rossi's Ministry Building on Chernyshev (later Lomonosov) Square. In 1896–7 Gogen built a house for the merchant Vargunin at Furshtadts Street 52. Although the façade is suffused with the spirit of eclecticism, the asymmetry and picturesqueness of the plan reveal the advent of Art Nouveau. The urban mansion was further developed by Gogen in his house for the ballerina Mathild Kshesinskaya on Kronverk Prospect (1904–6; with Aleksandr Dmitriyev). The combination of different-sized panes of glass, maiolica tiles, light-grey brick and grey granite creates a striking impression. The imposing interiors of the building combined Art Nouveau with eclectic and Neo-classical tendencies, but they were reworked when the building was turned into the Museum of the Revolution (now Museum of Political History of Russia).

BIBLIOGRAPHY
V. Eval'd: Obituary, *Zodchiy* (1914), no. 12, pp. 143–4

SERGEY KUZNETSOV

Gogh, Vincent (Willem) van (*b* Zundert, 30 March 1853; *d* Auvers-sur-Oise, 29 July 1890). Dutch painter. His life and work are legendary in the history of 19th- and 20th-century art. In the popular view, van Gogh has become the prototype of the misunderstood, tormented artist, who sold only one work in his lifetime—but whose *Irises* (sold New York, Sotheby's, 11 Nov 1987) achieved a record auction sale price of £49 million. Romantic clichés suggest that van Gogh paid with insanity for his genius, which was understood only by his supportive brother Theo (1857–91). Van Gogh was active as an artist for only ten years, during which time he produced some 1000 watercolours, drawings and sketches and about 1250 paintings ranging from a dark, Realist style to an intense, expressionistic one. Almost more than on his oeuvre, his fame has been based on the extensive, diary-like correspondence he maintained, in particular with his brother.

1. Life and work. 2. Correspondence and collections.

1. LIFE AND WORK.

(i) Early life and training, 1853–86. (ii) Paris, 1886–8. (iii) Arles, 1888–9. (iv) Saint-Rémy and Auvers-sur-Oise, 1889–90.

(i) Early life and training, 1853–86. In his early years there was nothing to suggest that the Rev. Theodorus van Gogh's eldest son was to become an artist. Most of the members of the van Gogh family were clergymen or art dealers by profession. Vincent left school in 1869 to become an apprentice at Goupil & Co. in The Hague, the art dealership with which his Uncle Vincent was associated. In 1873 he was posted to the firm's London branch and in 1875 he was transferred to the Paris office. During this period he learnt a great deal about both Old Master and contemporary painting and while in England he began collecting illustrations (Amsterdam, Rijksmus. van Gogh) by such artists as Frank Holl, Hubert von Herkomer and Luke Fildes from *The Graphic* and the *Illustrated London News*; these stark black-and-white images of contemporary British social problems made a lasting impression on him. He also became an avid reader of French and English poetry, novels and histories, with a preference for the historian Jules Michelet and the naturalism of the de Goncourt brothers and Emile Zola.

Van Gogh did not prove suited to the art trade. His religious fervour, which he extended to his appreciation of art, conflicted with the commercial interests of the art dealership, and in 1876 he was fired. He then went to England, where he found teaching jobs in Ramsgate and Isleworth; these, however, offered few prospects, and he returned to the Netherlands in early 1877. After a short stay in Dordrecht, where he worked in a bookshop, he decided to become a minister and went to Amsterdam in May 1877 to begin his studies. To avoid the long period of university preparation required, he enrolled in 1878 in a short course of study in Brussels to qualify for work as an evangelist among the miners in the depressed Borinage district of Belgium. In the autumn of 1878 he moved to the Borinage and worked there as a lay preacher until 1880. When he proved a failure at this job as well, the 27-year-old van Gogh underwent a serious crisis. He even interrupted his correspondence with his brother. During the winter of 1879–80 he undertook a pilgrimage to the village of Courrières in northern France, to visit Jules Breton, known for his paintings of peasants, an extremely popular genre at the time. In a letter to his brother van Gogh described this grim journey, which was apparently a turning-point in his life: he had found his new calling, to be a peasant painter after the example not only of Breton but of Jean-François Millet.

Except for some brief periods of formal instruction, van Gogh was self-taught, but he nevertheless followed a traditional programme. He collected prints and reproductions for study purposes and drew after prints, especially those of Millet (e.g. *The Sower*, 1850; Boston, MA, Mus. F.A.). He also started a collection of clothes worn by fishermen, peasants and labourers. Late in 1880 he travelled to Brussels to study life drawing at the Académie Royale des Beaux-Arts and to learn anatomy and physiognomy; he tried to follow an academic programme of instruction, insofar as his finances would allow. From this time Theo, who also worked for Goupil's, supported him financially. In order to save money van Gogh moved in the spring of 1881 to his parents' home in the village of Etten in Brabant. He adopted the custom, common among painters during the late 19th century, of spending the summer working in the country or at the seashore. From 1881 van Gogh's development as an artist can be traced through his drawings, which feature hard, graphic outlines and hatched shadowing. His early work developed slowly and laboriously and it shows little evidence of natural talent. He relied on prints for help and learnt from books.

Following conflicts with his father about his relationship with a widowed cousin and about his life as a whole, and because of his need for contact with other artists, van Gogh moved in the autumn of 1881 to The Hague, then the centre of Dutch painting and the home of such painters as Jozef Israëls, whom van Gogh greatly admired.

While there he received some instruction from his cousin Anton Mauve.

In The Hague van Gogh lived briefly with Sien (Clasina) Hoornik, an abandoned, pregnant woman who earned her living as a laundress and occasional prostitute. She and her children formed a substitute family, and they also served as his models (e.g. Sien as *Sorrow*, drawing, 1882; Amsterdam, Rijksmus. van Gogh). Van Gogh's family and acquaintances reacted with shock at his plans to marry Sien, and in the autumn of 1883 he moved alone to Hoogeveen in the northern province of Drenthe. There were also artistic reasons for his decision to leave The Hague. He longed for the countryside and the peasants, for it was still his ambition to become a painter of the working people. At this time he wrote a number of long letters in which he tried to convince Theo to abandon the art trade and to join him in Drenthe in order to draw and paint, but this plan was not realized.

In December 1883 van Gogh returned to his parents, who now lived in Nuenen, and received a cool reception. His ideas and opinions, including his preference for the works of Zola, clashed with his father's views on life. He expressed this contrast in a still-life, *Open Bible, Extinguished Candle and Novel* (Amsterdam, Rijksmus. van Gogh), that he painted in memory of his father, who died in 1885. In this work he juxtaposed an opened Bible to Zola's novel *La Joie de vivre*. (Van Gogh included books with clearly legible titles in a number of his paintings.)

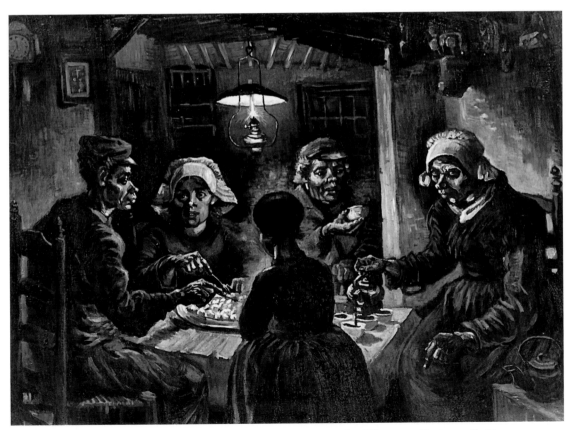

1. Vincent van Gogh: *The Potato-eaters*, oil on canvas, 815×1145 mm, 1885 (Amsterdam, Rijksmuseum Vincent van Gogh)

Van Gogh strongly identified with the work of the de Goncourt brothers, Guy de Maupassant, Zola and other contemporary French authors, whose renditions of reality with such unvarnished starkness made their writings immoral and inflammatory in the eyes of the conservative. Van Gogh remained in Nuenen until November 1885, working in its environs. It was during this period that he made the first watercolours and paintings that he did not consider mere studies or exercises, but full-fledged works of art suitable for public exhibition. These are largely interiors with weavers, and he gave several works French titles with a view to the Paris art market, in which his brother was to play the role of intermediary (e.g. *Cimetière de paysans* and *La Chaumière*; both Amsterdam, Rijksmus. van Gogh). His large and ambitious composition of *The Potato-eaters* (1885; Amsterdam, Rijksmus. van Gogh; see fig. 1), in which he gave definitive visual form to his ideas on peasant painting, was also intended for the art market. Van Gogh made a lithograph (Amsterdam, Rijksmus. van Gogh) of this composition, not an unusual practice at the time, to enable the work to reach a larger audience and also to earn some money.

These first conscious efforts to gain the acceptance of the art world failed, partly because by 1885 artists in Paris were painting in the more modern and colourful Impressionist style, which van Gogh had not yet seen. However personal and expressive an effort it was, *The Potato-eaters*, with its earthy colours and awkward composition, must have made a strange impression. The paintings of peasant subjects that received acclaim at the Salon in Paris were more idyllic in conception and painted in a more polished, academic manner. Van Gogh took seriously the criticisms of his work that reached him from Paris and from his friend Anthon van Rappard, and he defended himself by referring to Zola's dictum that a work of art is a slice of nature, viewed through a temperament. At the same time he threw himself with renewed energy into the study of colour. In 1885 he visited the newly opened Rijksmuseum in Amsterdam in order to admire and study Old Master paintings, especially Rembrandt's *Jewish Bride*. As did so many of the self-taught, he sought assistance from Charles Blanc's *Grammaire des arts du dessin, architecture, sculpture, peinture* (1867) and he read about Eugène Delacroix's technique. Delacroix delineated his forms through modelling rather than contour lines, and this influenced van Gogh to adopt a more textural handling.

In November 1885 van Gogh moved to Antwerp, the nearest city with museums and an academy where he could draw after plaster casts and live models, so as to lay a stronger foundation for his art. Paris, however, was the true centre of art, and he moved there in February 1886.

(ii) Paris, 1886–8. In Paris van Gogh proved a fast learner, who wanted to become part of the avant-garde. He shared an apartment with Theo, who was attempting, on a modest scale, to sell Impressionist paintings; Theo organized exhibitions of Claude Monet and Camille Pissarro among others, and it was thus through his brother that van Gogh became acquainted with these artists.

Van Gogh's great admiration for Georges Seurat's Pointillist works, which he saw at the alternative Salon des Indépendants, prompted him to analyse the operative laws

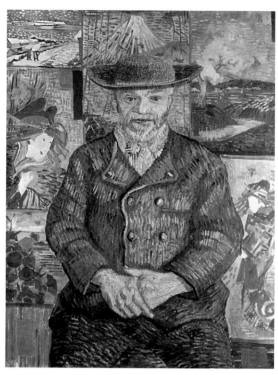

2. Vincent van Gogh: *Père Tanguy*, oil on canvas, 920×750 mm, 1887–8 (Paris, Musée Rodin)

of colour. His experiments with the Pointillist technique, primarily in a large series of flower still-lifes (e.g. *Flowers in a Copper Pot*, 1887; Paris, Mus. d'Orsay), and his use of contrasting hues of complementary colours led ultimately to his abandonment of a darker palette. The principle of complementary colours fascinated him, and among his later works are numerous examples of compositions that are based on two colours complementing one another. Although he was unable to discipline himself to the rigorous Pointillist technique, he did learn to employ the brush to create rhythmic patterns, modelling with colour. Around this time, he also discovered the mature works of the Romantic painter ADOLPHE MONTICELLI, which influenced him to paint in impasto.

Another vital source of inspiration for van Gogh was Japanese *ukiyoe* woodcuts. Like many other avant-garde artists he collected and traded these and made a number of carefully studied copies, for example after Hiroshige's *Ohashi Bridge in Rain* (*c.* 1886–8; Amsterdam, Rijksmus. van Gogh). He also used Japanese prints as background decoration in such paintings as his portrait of the colour merchant and art dealer *Père Tanguy* (1887–8; Paris, Mus. Rodin; see fig. 2). Van Gogh had admired Japanese woodcuts for their expressive character as early as his time in Antwerp; in Paris it was the effects of colour and perspective that especially attracted his attention. The striving of the younger generation of artists, to which he hoped to belong, was for the simplicity, linear forms and flat areas of colour found in these Japanese prints (*see* JAPONISME). He came into contact with this endeavour to abstraction through two artists with whom he was involved

in intensely personal relationships at various times and with whom he at other times corresponded: Emile Bernard and Paul Gauguin. While van Gogh began to assimilate these new art theories, he continued to follow a traditional programme of instruction in drawing and painting after plaster casts and live models at Fernand Cormon's studio, where he met Bernard.

Despite his flower still-lifes and townscapes (e.g. *View from Vincent's Room in Rue Lepic*, 1887; Amsterdam, Rijksmus. van Gogh), van Gogh remained loyal to his old ideals. He wanted to be a figure painter and he attempted to attain that goal through painting portraits. He concluded his period in Paris with *Self-portrait at the Easel* (1888; Amsterdam, Rijksmus. van Gogh), in which he attempted an unusual composition in a technique that was his own variant of Seurat's Pointillism.

(iii) Arles, 1888–9. In February 1888 van Gogh moved to Arles, in the south of France, in order to realize his original ambition of becoming a peasant painter. As was his custom, he explored his environment by making drawings and paintings: the flowering orchards were a favourite subject, and the canals and wooden drawbridges reminded him of the Netherlands, as did the Camargue plains, which lie between Arles and the Mediterranean. In June he travelled to Saintes-Maries-de-la-Mer, which he depicted in a number of drawings and paintings, representing its characteristic cottages with thatched roofs and the fishing boats at sea and on the beach (e.g. of 1888; Amsterdam, Rijksmus. van Gogh). These were motifs that had already occupied him in the Netherlands, but which he now rendered in a far more intense palette and with a more spontaneous touch. He also returned to the traditional subject of the sower, the biblical connotations of which he must have found appealing. He now placed the sowing figure, a borrowing from Millet, in a landscape dominated by the setting sun (e.g. of 1888; Otterlo, Rijksmus. Kröller-Müller; see fig. 3).

When he had to economize on paint for several weeks, van Gogh made numerous pen-and-ink drawings from and of the hill of Montmajour near Arles. He considered these large drawings as important as finished paintings. Such works as *La Crau Seen from Montmajour* (1888; Amsterdam, Rijksmus. van Gogh) were executed with a reed pen, the use of which was inspired by Rembrandt and by Japanese art. Rock formations, pine-trees, the abbey ruins and the sprawling fields in the plain of La Crau were translated on to paper into a wealth of shapes and forms composed of lines and dots. Aside from this

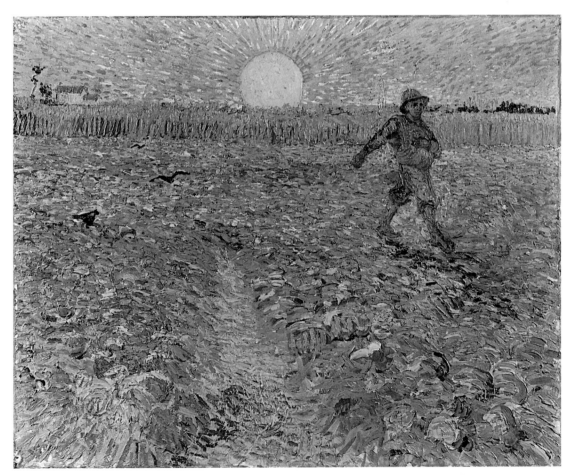

3. Vincent van Gogh: *Sower with Setting Sun*, oil on canvas, 640×805 mm, 1888 (Otterlo, Rijksmuseum Kröller-Müller)

series of landscapes van Gogh continued work on his series of portraits, using local people as his models. The postman and his family sat for him (*Postman Roulin*, 1888; Boston, MA, Mus. F.A.; *La Berceuse*, 1888–9; Otterlo, Rijksmus. Kröller-Müller), the painter Eugène Boch became *The Poet* (Paris, Mus. d'Orsay), and the portrait of gardener *Patience Escalier* (1888; priv. col., see McQuillan, p. 61) was the latest addition to the series of heads of peasants begun in Brabant. Van Gogh painted several versions of the portraits of Roulin and his wife, which exhibit minor differences. If he thought a work good, he wanted to keep it for himself, send a copy to Theo and perhaps make a present of one version to the sitter; for this reason he made a number of replicas of certain of his compositions.

Van Gogh wanted to found a community of artists in Arles, and he particularly wished that Bernard and Gauguin would join him. He had self-portraits of each artist, Bernard's including a small portrait of Gauguin, and Gauguin's, painted at the special request of van Gogh, including one of Bernard (both 1888; Amsterdam, Rijksmus. van Gogh). In this manner, van Gogh managed in Arles to be surrounded in spirit by his friends. Unlike his series of replicas, the series of sunflowers in a vase (version; London, N.G.) was intended for the decoration of the living- and working-quarters of the Yellow House that he had rented in Arles. This decorative scheme, which included other works, was particularly meant to impress Gauguin, whose enthusiastic response is reflected in his *Van Gogh Painting Sunflowers* (1888; Amsterdam, Rijksmus. van Gogh). The van Gogh brothers eventually convinced Gauguin to leave Brittany, and in October 1888 he arrived in Arles to live and work with Vincent. Van Gogh had great respect for his colleague and he tried to follow his and Bernard's theory of abstraction, for example in *Memory of the Garden at Etten* (1888; St Petersburg, Hermitage), in which he created flat areas of saturated colours circumscribed by heavy contour lines. The differences in van Gogh's and Gauguin's dispositions and temperaments, however, precluded successful collaboration. Following an argument at Christmas 1888, the frightened Gauguin left Arles, and van Gogh, in hospital after cutting off his ear, experienced his first serious attack of insanity. The two artists nevertheless remained in contact and continued to respect each other's work. Van Gogh no longer followed the path of abstraction and painting from the imagination that Gauguin espoused; he preferred to work directly from nature and clung to reality, which he rendered in an entirely personal manner. For another work of this period *see* COLOUR, colour pl. III, fig. 1.

(iv) Saint-Rémy and Auvers-sur-Oise, 1889–90. The attacks of mental illness, probably a form of epilepsy, that had manifested themselves at the end of 1888 were to recur, and from May 1889 to May 1890 van Gogh institutionalized himself in Saint-Rémy, not far from Arles. Between attacks he drew and painted in the garden and in the building, making portraits of the staff and patients and depicting the view from his window. His room looked out on to a wheat-field fenced off by a low wall, with the Alpilles mountain range in the background, as seen in

Enclosed Field at Sunrise (1890; Otterlo, Rijksmus. Kröller-Müller).

In the summer of 1889 van Gogh painted one of his most famous works, *Starry Night* (New York, MOMA). In this work he reverted to an old idea, that of painting a nocturnal sky, which he had attempted and abandoned the year before in *Starry Night over the Rhône* (1888; Paris, Mus. d'Orsay). The handling of the new version is expressionistic, and it was composed this time not directly from nature, but with the help of sketches. The painting has strong religious overtones, and the swirling stars of the sky have sometimes been interpreted as an image of the artist's equally tormented soul. He left no written explanation of this composition in his letters, but he did mention a formal source for its particular style: the old, rather brutal woodcuts that illustrate the Household edition of *The Works of Charles Dickens*, which he so loved.

Van Gogh also copied prints—translations from black-and-white into colour—again by Millet, and also by Honoré Daumier, Delacroix and Rembrandt (both the prints and the paintings are in the Rijksmuseum Vincent van Gogh in Amsterdam). Delacroix's *Pietà* (Paris, St-Denis-du-St-Sacrement) and Rembrandt's the *Raising of Lazarus* (version; Los Angeles, CA, Co. Mus. A.) supplied him with religious subjects, and his transformations of their compositions can be interpreted as a reply to the contemporary biblical subjects of Bernard and Gauguin, to which he objected because of their overt narrative symbolism. Similarly, in 1889 both Bernard and Gauguin painted versions of *Christ on the Mount of Olives* (respectively, untraced; W. Palm Beach, FL, Norton, Gal. & Sch. A.), following which van Gogh painted a series of olive groves after nature (e.g. *Olive Grove*, 1889; Amsterdam, Rijksmus. van Gogh).

Van Gogh spent the last period of his life in Auvers-sur-Oise, slightly to the north of Paris, where he interrupted his journey to visit his brother and sister-in-law and to see art, including his own paintings, which he had sent to Theo over the years. In Auvers he worked under the vigilant eye of Dr Paul Gachet, a homeopathic practitioner with an interest in art. As he had done previously, van Gogh explored the village and made paintings of the town hall (priv. col.), the Romanesque church (1890; Paris, Mus. d'Orsay; see fig. 4), the houses with their thatched roofs, the new mansions and the hilly countryside with its vast wheat-fields, including the famous *Crows in a Wheat-field* (Amsterdam, Rijksmus. van Gogh), long mistakenly thought to be his last painting. He did reap a number of small successes. Not only had the art critic Albert Aurier published an extremely favourable article about him in the prestigious *Mercure de France* in January 1890, but he was also invited to exhibit with the avant-garde Brussels artists' society Les XX. There he sold a painting of a grape harvest, the *Red Vineyard* (1888; Moscow, Pushkin Mus.), to the painter Anna Boch. This bit of recognition both pleased and perturbed him. In his letter of thanks to Aurier he credited Gauguin and Monticelli, who in his view were more important as innovators.

Van Gogh's attacks of mental illness had not ceased, and, after a new bout of depression began, he shot himself in the chest on 27 July 1890. He died calmly two days later

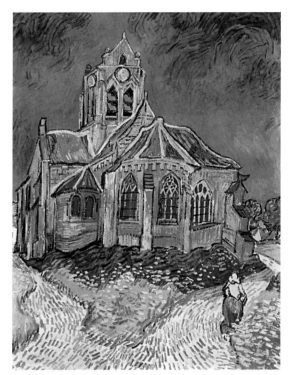

4. Vincent van Gogh: *Church at Auvers-sur-Oise*, oil on canvas, 940×740 mm, 1890 (Paris, Musée d'Orsay)

in the presence of Theo, who outlived him by only six months. In 1914 the two brothers were reinterred next to each other at the cemetery of Auvers-sur-Oise. Statues by Ossip Zadkine in commemoration of van Gogh are to be found both in Auvers and Zundert.

2. CORRESPONDENCE AND COLLECTIONS. Part of van Gogh's fame is based on his extraordinary personal letters, the most numerous of which were to Theo. From France he also wrote a series of letters to his sister Wilhelmina, in which he regularly included explanations of artistic concepts that he considered superfluous in his letters to Theo. In addition, two other sets of letters have been preserved: those to Anthon van Rappard from 1881 to 1885, and those to Emile Bernard. He also corresponded and exchanged paintings with Gauguin. All of these letters, as well as a number of others, were published first in fragmentary form in the 1890s and subsequently in their entirety.

The abundance of biographical data and the diary-like character of the letters were important contributory factors in the making of van Gogh's reputation. Due to the existence of the letters, many of the works are provided with the interpretation and commentary of van Gogh himself, to a far greater extent than with his predecessors and contemporaries. The letters have also provided the basis of a voyeuristic analysis of the sad elements of his life; the romantic version of van Gogh's life rendered in Irving Stone's novel *Lust for Life* (1934) and the film (1956) of the same name, for example, are derived from the letters.

After Theo's death in 1891 his widow, Johanna van Gogh-Bonger, moved from Paris to the Netherlands, taking with her the majority of van Gogh's production, and in 1909 Hélène Kröller-Müller started her collection of his works, which later became the nucleus of the Rijksmuseum Kröller-Müller, Otterlo; as a result the two largest collections of his works are in the Netherlands. Johanna van Gogh-Bonger's collection was eventually given a home in the Rijksmuseum Vincent van Gogh, Amsterdam, designed by Gerrit Rietveld and opened in 1972. The museum houses the archives of the Vincent van Gogh Foundation, which owns the majority of van Gogh's letters, as well as a library and documentary material on van Gogh.

WRITINGS

Verzamelde brieven van Vincent van Gogh, 4 vols (Amsterdam, 1952–4); Eng. trans., 3 vols (Greenwich, CT [1958]/*R* London, 1977)
Letters of Vincent van Gogh, 1886–1890: A Facsimile Edition (London, 1977)

BIBLIOGRAPHY

CATALOGUES

J. B. de la Faille: *L'Oeuvre de Vincent van Gogh: Catalogue raisonné*, 4 vols (Paris, 1928, 2/1939); Eng. trans. and enlargement, ed. A. M. Hammacher and others as *The Works of Vincent van Gogh: His Paintings and Drawings* (New York, 1970)
English Influences on Vincent van Gogh (exh. cat. by R. Pickvance, U. Nottingham, A.G., 1974)
Japanese Prints Collected by Vincent van Gogh (exh. cat., Amsterdam, Rijksmus. van Gogh, 1978)
J. Hulsker: *The Complete van Gogh: Paintings, Drawings, Sketches* (Oxford, 1980)
Vincent van Gogh: A Detailed Catalogue of the Paintings and Drawings by Vincent van Gogh in the Collection of the Kröller-Müller National Museum (Otterlo, 1980)
Vincent van Gogh and the Birth of Cloisonism (exh. cat. by B. Welsh-Ovcharov; Toronto, A.G. Ont.; Amsterdam, Rijksmus. van Gogh; 1981)
Van Gogh in Arles (exh. cat. by R. Pickvance, New York, Met., 1984)
Van Gogh in Saint-Rémy and Auvers (exh. cat. by R. Pickvance, New York, Met., 1986)
Vincent van Gogh from Dutch Collections: Religion—Humanity—Nature (exh. cat. by T. Kôdera, Osaka, N. Mus. A., 1986)
J. van der Wolk: *The Seven Sketchbooks of Vincent van Gogh* (New York and London, 1987)
E. van Uitert and M. Hoyle, eds: *The Rijksmuseum Vincent van Gogh*, Amsterdam, Rijksmus. van Gogh cat. (Amsterdam, 1987)
Van Gogh in Brabant: Paintings and Drawings from Etten and Nuenen (exh. cat., ed. E. van Uitert; 's-Hertogenbosch, Noordbrabants Mus., 1987)
Van Gogh & Millet (exh. cat., ed. L. Tilborgh; Amsterdam, Rijksmus. van Gogh, 1988)
Van Gogh à Paris (exh. cat. by B. Welsh-Ovcharov, Paris, Mus. d'Orsay, 1988)

MONOGRAPHS AND OTHER STUDIES

G.-A. Aurier: 'Les Isolés: Vincent van Gogh', *Mercure France* (Jan 1890); repr. in *Oeuvres posthumes* (Paris, 1893)
O. Mirbeau: 'Vincent van Gogh', *Echo Paris* (31 March 1891); repr. in *Des artistes*, i (Paris, 1922)
J. B. de la Faille: *Les Faux van Gogh* (Paris, 1930)
J. Leymarie: *Van Gogh* (Paris, 1951)
S. Lövgren: *The Genesis of Modernism: Seurat, Gauguin, van Gogh and French Symbolism in the 1880s* (Stockholm, 1959)
M. E. Tralbaut: *Vincent van Gogh* (London, 1969)
M. Roskill: *Van Gogh, Gauguin and the Impressionist Circle* (London, 1970)
B. Welsh-Ovcharov, ed.: *Van Gogh in Perspective* (Englewood Cliffs, 1974)
C. Chetham: *The Role of Vincent van Gogh's Copies in the Development of his Art* (New York, 1976)
B. Welsh-Ovcharov: *Vincent van Gogh: His Paris Period, 1886–1888* (Utrecht, 1976)
G. Pollock and F. Orton: *Vincent van Gogh: Artist of his Time* (Oxford, 1978)
J. Rewald: *Post-Impressionism: From van Gogh to Gauguin* (London, 1978)

C. M. Zemel: *The Formation of a Legend: Van Gogh Criticism, 1890–1920* (Ann Arbor, 1980)

A. M. Hammacher and R. Hammacher: *Van Gogh: A Documentary Biography* (London, 1982)

E. van Uitert: *Vincent van Gogh in Creative Competition* (Zutphen, 1983)

J. Hulsker: *Lotgenoten: Het leven van Vincent en Theo van Gogh* [Brothers in fate: The lives of Vincent and Theo van Gogh] (Weesp, 1985)

S. Alyson Stein, ed.: *Van Gogh: A Retrospective* (New York, 1986)

W. Feilchenfeldt: *Vincent van Gogh & Cassirer, Berlin: The Reception of van Gogh in Germany from 1910–1914* (Zwolle, 1988)

A. Hoenigswald: 'Vincent van Gogh: His Frames, and the Presentation of Paintings', *Burl. Mag.*, cxxx (1988), pp. 367–72

J. Hulsker: [review of 1988 Paris exh. cat.; 1984 exh. cat.; 1986 New York exh. cat.; A. Mothe: *Vincent van Gogh à Auvers-sur-Oise* (Paris, 1987)], *Simiolus*, xviii (1988), pp. 177–92 [contains appendix with chronology of van Gogh's letters, 1886–90]

R. Pabst, ed.: *Vincent van Gogh's Poetry Albums* (Zwolle, 1988)

M. McQuillan: *Van Gogh* (London, 1989)

T. Kôdera, ed.: *The Mythology of Vincent van Gogh*; Eng. trans. by Y. Rosenberg (Amsterdam)

EVERT VAN UITERT

Gogol [Gogol'], **Nikolay (Vasil'yevich)** (*b* Bol'shiye Sorochintsy, Ukraine, 1 April 1809; *d* Moscow, 4 March 1852). Russian writer and theorist of Ukrainian birth. Gogol is best known for his novel *Dead Souls* (1842) and his comedy, the *Government Inspector* (1836); his collection *Arabesques* (1835) includes essays on art, among them 'Sculpture, Painting and Music', which deals with the Romantic concept of the mutual influence of the various arts on each other and looks at different periods that contributed to the flowering of one type of art or another. In the essay 'On the Architecture of the Present Day' Gogol contrasts Neo-classicism, which had declined into eclecticism, with a concept of Romantic architecture consisting of a picturesque mixture of styles, mainly medieval. From 1836 to 1848 he lived in Italy where he became a friend of Aleksandr Ivanov, who used him as the model for Christ in *Christ Appearing to the People* (1837–57, Moscow, Tret'yakov Gal.; for illustration *see* IVANOV, ALEKSANDR). Together the artist and the writer dreamed of finding ways to the beautiful through human brotherhood, a sort of romantic Utopia. The recognition that it was impossible to translate this ideal into reality provoked a spiritual crisis in Gogol, and he turned to religion. His creative method had a considerable influence on naturalist artists, and a whole school of graphic artists (e.g. A. A. Agin, P. M. Boklevsky) grew up in connection with the illustrating of his work. He devoted a whole essay to a description of Karl Bryullov's painting the *Last Day of Pompeii* (1830–33, St Petersburg, Rus. Mus.; for illustration *see* BRYULLOV, (2)).

WRITINGS

Polnoye sobraniye sochineniy [Complete works], 14 vols (Moscow, 1937–52)

V. S. TURCHIN

Gogollari, Dhimo (*b* Përmet, 9 April 1931; *d* Tiranë, 5 March 1987). Albanian sculptor. He trained at the 'Jordan Misja' Lyceum of Arts in Tiranë (1948–52) and then at the Výsoka Škola Umělecko–Prumyslova (Academy of Applied Arts), Prague (1955–61). After returning to Albania he joined the design bureau of the Porcelain Factory, Tiranë (1961–8), before moving on to the 'Migjeni' Artistic Products Enterprise, Tiranë, where he designed articles for series production until 1971 when he became a full-time professional sculptor. He had already won acclaim for *Aksionistja* ('The girl volunteer') (1967; Tiranë, A.G.), which combined realism and psychological insight. Such works as the bronze portrait *Mentor Xhemali* (1970; Tiranë, A.G.) and *Vajza* ('The girl') (1970; Tiranë, A.G.) demonstrate his ability to capture the warmth of the sitter's personality. He produced many different types of sculpture: busts, groups of figures and vases. The latter are some of his most successful creations, and although they are painted with subjects drawn from contemporary life, they continue the decorative vase tradition (e.g. *Vezo me tre zogj e lule të verdha* ('Vase with three birds and yellow flowers'), 1980; Tiranë, A.G. and *Vezo me zambakë e lule deti* ('Vase with lilies and sea flowers'), 1984; Tiranë, A.G.). His work was distinguished by a willingness to experiment and the innovative, and sometimes controversial, techniques that he employed (e.g. *Vazo kungulli* ('Pumpkin vase'), 1984; Tiranë, A.G.).

BIBLIOGRAPHY

K. Krisiko: 'Qeramika artistike në arkitekturë' [Artistic ceramics in architecture], *Drita* (23 Nov 1980)

Ll. Blido: *Shënime për pikturën dhe skulpturën* [Notes on painting and sculpture] (Tiranë, 1987)

GJERGJ FRASHËRI

Gois, Etienne-Pierre-Adrien (*b* Paris, 31 Jan 1731; *d* Paris, 3 Feb 1823). French sculptor. A pupil of the painter Etienne Jeaurat and then of René-Michel Slodtz, he won the Prix de Rome in 1757 and, after a period at the Ecole Royale des Elèves Protégés, was at the Académie de France in Rome from 1761 to 1764. On his return to France he was accepted (*agréé*) by the Académie Royale in 1765 and received (*reçu*) as a full member in 1770 on presentation of a marble bust of *Louis XV* (Versailles, Château), a work made under the direct influence of Jean-Baptiste II Lemoyne. He had a successful official career, and was made a professor at the Académie Royale in 1781. He sculpted two marble statues for the series of 'Grands Hommes' commissioned by Charles-Claude de Flahaut de la Billarderie, Comte d'Angiviller, director of the Bâtiments du Roi: *Chancellor Michel de l'Hôpital* (exh. Salon 1777; Versailles, Château), of whom he later executed a bust for the Galerie des Consuls in the Tuileries, Paris (marble, exh. Salon 1801; Paris, Louvre), and *President Mathieu Molé* (exh. Salon 1789; Paris, Louvre). The two statues, generously draped, have the highly expressive features characteristic also of Gois's portrait busts, such as *Chevalier Guillaumeau de Fréval* (marble, 1770; Cardiff, N. Mus.), *Daniel-Charles Trudaine* (marble, 1778–9; Chaalis, Mus. Abbaye) and his masterpiece, the *Portrait of the Artist's Father* (terracotta, 1760; Dijon, Mus. B.-A.).

Gois was a prolific artist. He was responsible for, among other works, the sculptural decoration of the Hôtel des Monnaies, Paris, including the Grande Salle and the stone pedimental sculpture of the façade (model, exh. Salon 1771), and for the funerary monument (marble; Paris, Notre-Dame-des-Victoires) to Louis XV's secretary, *Jean Vassal*, who died in 1770. This is an attractive work comprising a draped portrait medallion, weeping cherubim and smoking urns. He executed for the Palais de Justice a statue of *Justice* (plaster version, exh. Salon 1785; *in situ*;

terracotta version, Paris, Louvre). He also produced small-scale commemorative monuments such as that to *Abbé Nicolas de La Pinte de Livry* (marble and bronze; Paris, Inst. France) and widely collected statuettes in a classicizing manner. He continued to work during the French Revolution, presenting at the 1793 Salon an elaborate plaster model for a monument to *Voltaire* (Paris, Carnavalet).

Gois was an artist much appreciated by his contemporaries. He was a fine portrait sculptor, working both in the grand manner developed by Jean-Baptiste II Lemoyne and Augustin Pajou and in slighter, more fashionable genres; he reflected in a small but not untalented way the great artistic currents of the second half of the 18th century. He was also known for his drawings, some of which were exhibited at the Salon. His son, Edme-Etienne-François Gois (*b* Paris, 1765; *d* St Leu-Taverny, Val-d'Oise, 1836), was a sculptor of historical subjects and portraits.

BIBLIOGRAPHY

Lami
'Le Sculpteur Gois et l'Abbé de Livry', *Mag. Pittoresque* (1885), p. 32
M. Furcy-Raynaud: *Inventaire des sculptures exécutées au XVIIIe siècle pour la direction des bâtiments du roi* (Paris, 1927), pp. 156–6

GUILHEM SCHERF

Goitia, Francisco (*b* Fresnillo, Zacatecas, 1882; *d* Xochimilco, nr Mexico City, 1960). Mexican painter. He began his studies in 1896 at the Academia de San Carlos in Mexico City. In 1904 he left for Barcelona and then for Italy, returning in 1912 to Mexico, where he resumed painting. From 1918 to 1925 he did field work with the anthropologist Manuel Gamio at Teotihuacán and Xochimilco. His early paintings included *The Witch* (1916), in the 'Tremendista' style of exaggerated Symbolist-influenced realism, *Dance of the Revolution* (1916), a very early treatment of this subject-matter, and *The Hanged Man* (1917; all Zacatecas, Mus. Goitia), all revealing his taste for sombre and even grotesque themes. In *Father Jesus* (1927; Mexico City, Mus. N. A.), generally considered his best painting, two women are shown keeping vigil over a dead man; its graphic force and dramatic quality give it particular distinction in the history of early 20th-century Mexican art. In *Santa Monica Landscape* (1945; Mexico City, Mus. N. A.) the grandeur of the landscape is heightened by the simplicity of treatment. In other landscapes and in self-portraits, however, Goitia reverted to a more traditional type of painting.

BIBLIOGRAPHY

J. Fernández: *Arte moderno y contemporáneo de México* (Mexico City, 1952)
J. A. Manrique: 'Tres astros solitarios: Atl, Goitia, Reyes Ferreira', *Historia del arte mexicano*, ed. J. A. Manrique, xiv (Mexico City, 1982), pp. 2128–32

JORGE ALBERTO MANRIQUE

Gola, Emilio (*b* Milan, 22 Feb 1851; *d* Milan, 21 Dec 1923). Italian painter. The son of a Milanese nobleman, Gola graduated in engineering at the Milan Polytecnico. He did not enrol at the Accademia di Belle Arti di Brera, but took private lessons from Sebastiano De Albertis. At the same time he became interested in the works of Tranquillo Cremona and Daniele Ranzoni. His wealthy family background enabled him to make a series of visits to France, the Netherlands and England where he encountered the work of foreign artists. Gola made his artistic début at the Brera Annual Exhibition in 1879 with a *Study from Life* and *Head: Study from Life* (both untraced). His early work was already noted for its strong colour combinations and vigorous brushwork, as in the portrait of *Contessa Gola, Mother of the Artist* (*c.* 1882; untraced, see 1953 exh. cat., p. 53). Gola's oeuvre can be divided principally by subject-matter: landscapes with figures, mostly executed in Brianza, such as *Washerwoman* (1898; Milan, Gal. A. Mod.) and *Landscape: The First Thaw* (1892; priv. col., see 1986 exh. cat., p. 131); the Milanese canals (*St Christopher's Canal*, *c.* 1890; Milan, Nuovo Banco Ambrosiano); seascapes, particularly of Alassio and the Venetian lagoon (*Beach at Alassio*, 1915–18; Milan, Gal. A. Mod.); and portraits (*Marchesa Emilia Sommi Picenardi*, *c.* 1900, Rome, G.N.A. Mod.). Gola was influenced by the work of I Scapagliati, particularly by their use of juxtaposed or superimposed brushstrokes to attain certain effects of light and colour. However, his subject-matter was different, his colours more brilliant, his brushwork freer, occasionally virtually ignoring form, and at times his figures seem carelessly positioned on the canvas. At his most successful, however, he could produce such splendidly original works as his several interpretations (in oil and watercolour) of the theme *Washerwomen at Mondonico* (e.g. ex-Chiesa priv. col., Milan).

BIBLIOGRAPHY

Emilio Gola (exh. cat., 1953)
S. Pagani: *La pittura lombarda della Scapigliatura* (Milan, 1955)
A. M. Comanducci: *Dizionario illustrato dei pittori, scultori, disegnatori e incisori italiani moderni e contemporanei*, iii (Milan, 1934, rev. 3/1962)
L. Luciani and F. Luciani: *Dizionario dei pittori italiani dell'ottocento* (Florence, 1974)
L. Caramel and C. Pirovano: *Opere dell'ottocento*, Galleria d'Arte Moderna, ii (Milan, 1975), p. 326
1886–1986. La Permanente: Un secolo d'arte a Milano (exh. cat., Milan, Pal. Permanente, 1986)
Emilio Gola (exh. cat., Milan, 1989)

CLARE HILLS-NOVA

Golconda [Golkondā]. Hill fort in western Andhra Pradesh, India. It flourished from the late 15th century until 1591, when it was superseded by the new city of HYDERABAD. Although Golconda was an important centre of power under the BAHMANI dynasty, it was not until the emergence of the QUTB SHAHI dynasty in the early 16th century that the fort became the capital of an independent line of sultans. Under Quli Qutb al-Mulk (*reg* 1512–43) the walls of the city were laid out in an approximately circular formation around the Bala Hisar, a rugged granite citadel rising 130 m above the plain, guarded by walls composed of massive granite blocks that climb up and over the natural boulders. The palace complex beneath the eastern slope of the hill was greatly expanded during the period of Ibrahim (*reg* 1550–80), and later rulers continued to add structures.

The main street of Golconda, which runs westwards from the Fateh Darvaza to the Bala Hisar Darvaza (the principal entrance to the citadel), was once lined with palaces, baths, bazaars, temples, mosques, barracks and magazines. The remains of these structures are still in evidence. In front of the Bala Hisar Darvaza stands a pair of monumental free-standing portals with quadruple arches. A short distance to the north-east is the Jami' Masjid, erected by Quli Qutb al-Mulk in 1518. The prayer

chamber, with five lateral aisles, is roofed with a single dome; another dome crowns the entrance gateway. The Bala Hisar Darvaza leads directly to a domed portico. Immediately to the north is the royal hammam, or bathhouse; gardens with axial waterways were once situated near by. Barracks, stores and granaries flank the path that leads to the summit of the citadel. Just beneath the summit is a small mosque erected by Ibrahim; its courtyard extends on to the ramparts. A Hindu shrine of Mahakali is located near by; partly excavated from a large boulder, it consists of a small, simple portico overhung by a curved cornice. The Darbar Hall occupying the highest point of the citadel is divided into vaulted bays. A stone seat on the roof-top terrace was for the personal use of the sultans.

Golconda's palace complex is laid out in a sequence of enclosures providing a transition from public to private zones. The courtly buildings are mostly ruined; their rubble walls and collapsed vaults have lost most of their fine plasterwork. The Shila Khana, or Armoury, with its triple storeys of open arcades, dominates the first enclosure. The second enclosure is overlooked from the west by the Taramati Mosque; on the south side is the Dad Mahal, or Hall of Justice, with deep vaulted chambers. The third enclosure marks the beginning of the private portion of the palace. In the middle is a paved court with a twelve-sided pond. Residential apartments open off to the east and west; the Rani Mahal on the south has a raised terrace once occupied by a lofty wooden colonnade.

The necropolis of the Qutb Shahis is located 0.5 km north-west of the city walls. It consists of a group of twenty structures, including seven royal tombs, a mosque, mortuary chamber and gateway, laid out in a series of formal gardens. In 1687 Golconda succumbed to the army of the MUGHAL dynasty and was for a while occupied by Aurangzeb (reg 1658–1707). By this time, however, nearby Hyderabad had replaced it as the capital of the Qutb Shahis.

See also INDIAN SUBCONTINENT, §§III, 7(ii)(b), and V, 4(vi)(c).

BIBLIOGRAPHY

Enc. Islam/2: 'Golkondā'
S. A. A. Bilgrami: Landmarks of the Deccan: A Comprehensive Guide to the Archaeological Remains of the City and Suburbs of Hyderabad (Hyderabad, 1927)
A. M. Siddiqui: History of Golconda (Hyderabad, 1956)
S. Toy: The Strongholds of India (London, 1957), pp. 54–60
H. K. Sherwani: History of the Qutb Shahi Dynasty (New Delhi, 1974)
G. Michell: 'Golconda and Hyderabad', Islamic Heritage of the Deccan, ed. G. Michell (Bombay, 1986), pp. 77–85

GEORGE MICHELL

Gold. Yellow metallic element, with an atomic weight of 197.2 and a specific gravity of 19.32. It is one of the so-called 'noble' metal group, which also includes silver and platinum. Gold has always been highly valued for its intrinsic beauty, its working properties and its rarity—until recent times it was used to underpin the currencies of the major trading nations, and it is still a traditional refuge in times of financial instability. It is first known to have been worked in Mesopotamia in the 6th millennium BC (see MESOPOTAMIA, §IV). Since then it has been prized as a material to fashion or to decorate a wide variety of objects, including jewellery (see JEWELLERY, colour pls II, fig. 2, III, figs 1 and 2, and IV, figs 1 and 2), coins, ritual items

(see CHINA, fig. 323, and ASANTE AND RELATED PEOPLES, fig. 3), tableware and furniture.

A scarce element, representing between 1 and 9 mg per tonne in the composition of the earth, gold is found mainly in the native state, in contrast with most other metals, which are found as ores. Deposits of gold occur either in the original formations (e.g. as veins in quartz) or as 'placer' in alluvial deposits. Traditionally, the gold was extracted by crushing the ores and then washing them over sloping troughs with lateral ribs. Because of its density, the gold was deposited against the ribs towards the top of the trough. As a final stage, the slurries were sometimes washed over sheepskins, a practice that may have given rise to the legend of the Golden Fleece. Although small amounts of gold are found in most parts of the world, the main commercial deposits are in Witwatersrand and the Orange Free State in South Africa. Famous gold-rushes occurred in the 19th century in California, Australia and the Yukon in Canada.

See also GILDING, §§I and II, and METAL, colour pl. II, fig. 1.

1. Properties. 2. Techniques.

1. PROPERTIES. Gold is one of the densest of metals, being approximately twice the density of silver and over seven times that of aluminium. The rich yellow of the pure metal is unmatched by other materials. This is enhanced by the ability of gold to take a high polish and keep its lustre almost indefinitely, owing to its extreme resistance to corrosion. Gold can normally only be chemically attacked by aqua-regia, a mixture of hydrochloric and nitric acids. These properties led to the use of gold as a protective coating for other less durable materials, from medieval reliquaries to modern aerospace components. Gold melts at 1063°C and will then flow freely, making it an ideal casting metal. In its pure state, it is one of the most easily worked of all metals because of its molecular structure, which is in the form of a lattice made up of cells of the face-centred cube type. This, combined with the type of atomic bonding that distinguishes metals from other elements (see METAL, §I), means that gold can be worked heavily and continuously without any appreciable hardening or stiffening. It is highly malleable and can be severely deformed by hammering or rolling into very thin sections, the most extreme example being gold leaf. The ductility of gold is also exceptional, enabling the production of very thin wires, slender enough to use in embroidery (see TEXTILE, §I, 2, and EMBROIDERY, colour pl. II, fig. 2).

Because of its softness, pure gold is impractical for many purposes. It is, in fact, rarely used in its pure form and from the earliest times has been mixed with other metals, particularly silver. It is not clear at what date goldsmiths began deliberately to mix their metals, but an alloy composed of approximately 80% gold and 20% silver was given the name *elektron* by the Greeks. The Snettisham Torc (1st century BC; London, BM), made in Britain during the late Iron Age, is a good example of an electrum-type alloy, being composed of approximately 60% gold and 40% silver.

Gold alloys are usually referred to in terms of carats. This represents the proportion of gold in the alloy, a carat (ct) being a 24th part. Thus 18-carat gold contains 18 parts

gold and 6 parts other metals. Current practice in the developed world has led to some standardization of gold alloys, and four are now almost universally accepted—9, 14, 18 and 22 carat. These are also referred to by the decimal equivalents (parts per thousand), respectively 375, 585, 750 and 916. The majority of gold artefacts made in the West are of 14ct or 18ct, although 9ct is used extensively in Britain. Other alloys are used in various parts of the world, largely in accordance with the prevalent system of quality marking: alloys purer than 18ct are much favoured in the Middle East and the Indian subcontinent. Systems of quality control, usually known as hallmarking, have been in existence in Europe since the 13th century. Systems vary, but usually the completed articles are tested or assayed to assess the gold content and then struck with punches to denote the metal quality, place of testing, date and the maker's name (see MARKS, §4(i)).

The particular metal or metals added to the gold will affect both the working qualities and the colour of the alloy. The larger the amount of additions, the more controllable the alloy. All 9ct gold alloys can be adapted to the widest range of uses, including such items as pins and springs where hardnesses are required that could never be attained by the purer alloys. In gold alloys, the other metals will tend to make the metal stiffen and eventually fracture when it is worked. By heating the metal to between 550°C and 700°C, the original characteristics can usually be restored, and work can continue. Colour can be affected by the choice of additional metals: copper will redden a gold alloy; silver will tend to give a colder, greener colour; silver, zinc and palladium in various combinations will give a white alloy. Such coloured alloys are mostly found from the late 19th century, in the work of Peter Carl Fabergé, for example, and in work by such contemporary German artists as Gerd Rothman (b 1941) and Claus Bury (b 1946).

2. TECHNIQUES. The long history of goldworking has led to the evolution of a large range of manipulative techniques. These can be classified under three main headings: forming, cutting and joining, and decorating. Gold can also be used to enhance the surface of other objects by the process of gilding. (Many of the processes are described in greater detail in METAL, §§IV and V.)

(i) Forming. (ii) Cutting and joining. (iii) Decorating. (iv) Gilding.

(i) Forming. The most basic method of forming metal is casting. Essentially the pouring of molten metal into a shaped mould, it is used at its simplest merely as a preliminary stage in the manufacture of an artefact, to produce an ingot that can then be further worked by hammering into sheet or wire form. There are limits to what can be done by this simple method: where gravity feeds the molten gold into the mould, the surface tension of the liquid metal is sufficiently strong to prevent the reproduction of fine detail and narrow sections, so from very early times centrifugal force has been used to drive the metal into such forms. To do this, the metal is melted on top of the mould, which is then placed in a cradle held with chains and swung vigorously by the goldsmith. It is probable that this technique was used by the Etruscans and the Hellenistic Greeks to produce some of their extremely finely detailed jewellery (see JEWELLERY, colour pl. I). A technique closely associated with centrifugal casting is that of lost-wax casting. Here, a wax model is made of the item to be cast. This is then covered in a ceramic material and fired in a kiln, which both vitrifies the mould and melts out the wax. The resulting mould is filled with molten metal. Almost all centrifugal castings are done in this way. A highly versatile process, the lost-wax method is still in extensive use, in association with either centrifugal casting or vacuum casting, where atmospheric pressure is used to force the metal into the mould. A large proportion of modern production in gold jewellery is made by this means.

Gold can be easily beaten into rod or wire, which can then be further hammered to control the form and line. Alternatively, a rod can be drawn through metal plates to produce wires of any thickness or section. Gold can also be hammered out into sheet on a flat surface. This is quite feasible even with wooden tools, but stone tools are far more effective and were used with much skill before the advent of bronze or iron ones.

There are three main techniques for producing hollow vessels from a flat sheet: blocking, raising and spinning. In blocking, the metal is hammered into a hollowed piece of wood or on to a sand-filled leather bag, thereby stretching it to produce simple forms. Another version is sinking, which involves the use of a round-faced hammer and a flat 'stake'. This again is a stretching process, which was mainly used to make vessels with thick rims by starting with a thick piece of metal and stretching the centre downwards. Blocking is most often used as a first step in the formation of a vessel, prior to raising; in this process the metal is compressed into shape by being hammered down on to stakes (shaped pieces of hard wood, bronze, iron or steel) of the appropriate form. The vast majority of hollow-ware produced before the Industrial Revolution was made using this method. It is, in skilled hands, a highly versatile technique, which can be done surprisingly rapidly. Nearly all medieval gold vessels were made this way, although the evidence is often obscured by subsequent work and decoration.

While mainly a decorative technique, repoussé was sometimes used as a forming method. Benvenuto Cellini, in his treatises on goldsmithing and sculpture and in his autobiography, described the making of a gold figural salt for Francis I of France (c. 1540–43; Vienna, Ksthist. Mus.; see CELLINI, BENVENUTO, fig. 4) by this method. The metal is initially supported on a bed of pitch, which provides a base that is both adhesive and resilient. It is then worked with hammers and punches to push it down into the pitch, so taking up the desired form. The work continues from behind until the edges begin to meet at the back, at which point it is itself filled with pitch and worked from the outside. Although this is time-consuming and requires great skill, it allows the production of very complicated hollow forms. This technique has been in use for at least 3500 years, the funeral mask of Tutankhamun (c. 1361–1352 BC; Cairo, Egyp. Mus.) being an early and outstanding example.

During the early 19th century spinning was introduced. There is some evidence for a form of the process existing as early as Roman times, but the exact nature of its use is

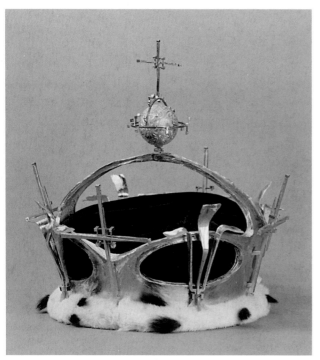

1. Gold crown by Louis Osman, h. *c.* 200 mm, 1969 (London, Tower of London)

controversial. Spinning involves the use of a fairly powerful lathe. A turned shape, in the form of the inside of the vessel, is fixed to the powered end of the lathe. A disc of gold is clamped against this, and the whole assembly set spinning. A steel tool is then worked against the rotating disc, forcing it down on to the turned shape, or chuck. This technique is most appropriate for batch and mass production and is only rarely used for gold.

Another relatively modern technique is electroforming, which was first demonstrated in 1837. Here, gold is grown on to a preformed matrix or model by means of electrolysis. The matrix need not necessarily be of metal; it is often of wax, although it is normally coated with copper before the gold deposition begins. The process has been used extensively in the production of copies of such antique metal items as coins, when it is known as electrotyping. It is less widely seen in the production of works of art, but the American jeweller Stanley Lechtzin (*b* 1936) used it extensively, and the crown designed and finished by Louis Osman (1914–96) for the investiture of Prince Charles as Prince of Wales (1969; London, Tower; see fig. 1) was produced by this technique.

(ii) Cutting and joining. These techniques are used in goldsmithing for both practical and decorative reasons. One of the most primitive methods was to cut thin sheet metal with stone knives. A later extension of this was coldchiselling, where sharp stone or metal tools are driven through the metal by hammering. Blacksmiths continue to use this technique on iron, but it has to be red-hot, whereas gold can be cut perfectly well when cold. The Pre-Columbian cultures of Mesoamerica and Central and South America achieved highly sophisticated decorative effects by this means, using stone and metal tools. There are examples surviving of quite fine-scale piercing on relatively thick metal. When iron tools became practicable, shears or snips began to be used for cutting sheet metal. Working on the same principle as scissors, these cut through the metal in a relatively crude way, leaving a sharp edge that needs to be rounded off. The advantage to the goldsmith is in speed of use. Piercing, where sheet metal is cut by a fine saw similar to a woodworker's fretsaw, has been in use for decorative purposes since the mid-18th century, when thin and reliable blades became available (there are earlier examples that are almost certainly sawpierced, but these are rare). The usual technique was to engrave the design and then cut down the engraved lines with the saw. Fine lace-like patterns were produced in hollow-ware by this means. Gold tableware is uncommon, but the technique was used for wine-coasters, fruit-baskets and the like. There was some interest in the technique in Germany and Scandinavia from the 1970s, mainly for its decorative and graphic potential. In much of this work, the saw is used simply to cut lines rather than to remove areas of metal. Sometimes the metal between the lines is slightly bent to give extra form to the piece.

There are several ways of joining gold components, perhaps the oldest of which is riveting. Here, the two pieces are drilled to take a wire or rod, which is passed through the holes, trimmed to length and then spread out at the ends by hammering. This traps the two pieces and pulls them tightly together as the ends of the rivet are spread. The rivet ends may be decorative in themselves or can be hidden. Extensive use was made of rivets in prehistoric gold work, probably due to ignorance of, or difficulties in, soldering. The handle of the Rillaton Gold Cup (1400–1000 BC; London, BM) is riveted on, and such items as the Broighter Collar (Dublin, N. Mus.; see fig. 2) make use of rivets as an essential means of construction. At later dates riveting was used because of the fact that no heat is required to make the joint. This is advantageous in such applications as enamelling, where heat would damage the decorated parts. There are numerous examples of enamelled pieces being riveted together, an interesting piece being the Royal Gold Cup of the kings of France and England (*c.* 1380; London, BM; *see* ENAMEL, colour pl. III, fig. 1). This had an additional part let into the stem in the 16th century, but because the original cup was extensively enamelled, as was the additional part, the join was made with rivets to avoid damage.

The most common method of joining gold is soldering. This is the term used by goldsmiths, although strictly speaking it is high-temperature brazing, since it is mainly carried out at temperatures in excess of 750°C. The pieces to be joined are made to fit together perfectly, then coated with a flux. The traditional flux, which is still used widely, is borax (sodium tetraborate). Its function is to exclude atmospheric oxygen from the joint as it heats, preventing oxidization and thus allowing the solder to flow freely. The use of flux is not necessary when gold of high purity is used, since it does not oxidize. The solder itself is a gold alloy, designed to melt at a lower temperature than that of the metal from which the piece is made. The parts are placed together on the hearth and heated until the required

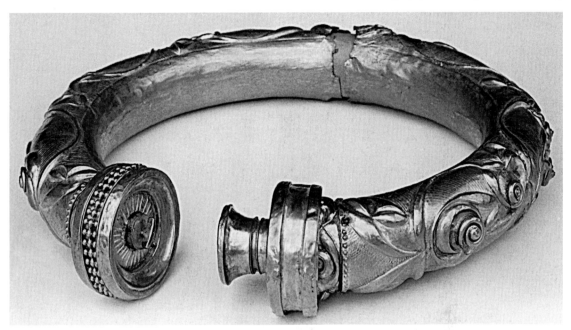

2. Gold collar, diam. 195 mm, Celtic, from Broighter, Co. Londonderry, Northern Ireland, *c.* 100 AD (Dublin, National Museum of Ireland)

temperature is reached. At this point the solder is applied, and two things happen: the solder melts and runs into the joint by virtue of capillary attraction, and, once there, it soaks into the two parts being joined. This gives an extremely strong joint, which is, in effect, one continuous piece of metal. It has been widely used since medieval times and continues to be the normal method.

Until at least the early medieval period, another method of soldering was used for gold. This is known as granulation or eutectic soldering, and it was described in the 12th century by Theophilus in his treatise *De diversis artibus.* The essential difference between this and the modern method is that the former does not require the use of separate pieces of solder; the solder is manufactured on the spot. A copper salt is mixed with an organic binder such as flour paste, and with this mixture small parts are stuck to the work, which is then heated on a hearth. The organic binder first dries, then carbonizes. This in turn reduces the copper salt to metallic copper, which with the gold forms an alloy with a lower melting-point than the parts being joined, thus creating what is effectively a solder. Because of the capillary attraction that occurs when the paste is applied, the bonding only takes place at the points of contact between the parts. It is thus a crisp and elegant way of joining gold components. The only drawback is that the temperature at which the solder is created (the eutectic) is rather close to the melting-point of the gold. It is, however, a technique that works better with gold than with any other metal, and it was used extensively in the ancient world.

(iii) Decorating. A wide range of decorative techniques is available to the goldsmith, the majority of them adaptations of constructional techniques. A good example of this is granulation, which exploits the special qualities of eutectic soldering. The most typical form of granulation is where

tiny spheres of gold, often only a fraction of a millimetre in diameter, are arranged in patterns on the surface of an object and soldered in position by the method described above. In the best examples, there is no sign of a join; the granules appear simply to sit on the surface of the piece. This kind of work is most closely associated with the Egyptians, the Hellenistic Greeks and in particular the Etruscans (see fig. 3), although many cultures throughout the world have used it. Some continue to use it, as, for example, the Nepalese, while the American jeweller John Paul Miller (*b* 1914) is an outstanding exponent of the technique. During the 19th-century vogue for archaeological jewellery, several workshops specialized in granulation, the Castellani (ii) family especially achieving technically brilliant results.

Filigree work is related to granulation, especially in that of the early periods. The term refers to fine wirework, either open or backed, and the technique has a wide geographical and historical distribution (*see* MIGRATION PERIOD, fig. 1). It was used in Mesopotamia, Egypt and Ancient Greece, and by the Etruscans, and in the late 20th century it was still employed. The wires can be of plain rectangular section, twisted or beaded, but they are always flattened laterally. This not only increases the apparent delicacy of the piece but also aids construction. The normal method is to build up the design from a series of units, often repeated ones. Frames of slightly thicker wire are made to these shapes, which are then filled with units of smaller wires, tightly packed in place, with the work resting on a flat background such as a steel plate. The points of contact between the wires are painted with a paste made from finely divided solder and borax. The piece is then transferred to the hearth, and, when heated sufficiently, the solder melts and joins all the parts in one operation. Where the filigree is attached to a backing plate,

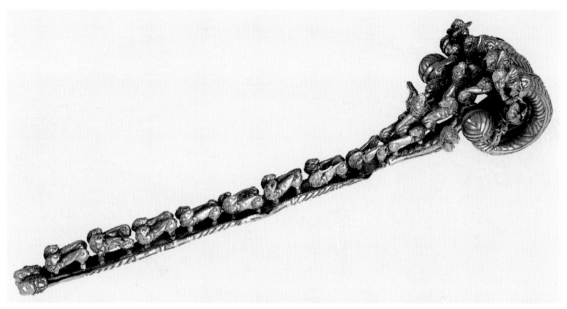

3. Gold fibula, l. 186 mm, Etruscan, from Vulci or possibly Cerveteri, 7th century BC (London, British Museum)

the process is slightly easier, since the whole assembly can be handled safely. Ancient filigree is mainly of this type, and the parts are almost certain to have been joined by eutectic soldering. Most late 20th-century production in filigree is of the openwork type. While this is mainly of silver and Italian in origin, gold filigree is also practised, especially in the Islamic world, with much work being done by traditional methods in India and the Middle East.

Repoussé and chasing (see fig. 2 above) are two closely related techniques; indeed, they are really the same technique carried out from opposite sides of the metal. They are used to enrich the surface of a form with low- or high-relief designs, either raised up from the surface (repoussé) or pushed down into it (chasing). The normal method is to draw out the design on the surface of the metal and then set the piece into a pitch bowl. This is a heavy, hemispherical, cast-iron bowl filled with pitch. The pitch is mainly bitumen, combined with an organic resin known as Swedish pitch, linseed oil, tallow and brick dust or plaster of Paris. The proportions of the constituents depend on the working qualities needed. The surface of the pitch is heated until it begins to melt, at which point the metal is set into it. Using a hammer and punches, the metal is beaten down into the pitch, which both adheres to it and supports it, while allowing the metal to move and take up its new form. The piece can be removed from the pitch and worked on from the other side, after having been annealed. Hollow vessels are often filled with pitch and worked from the outside. If they are sufficiently large, it is possible to work from the inside also, but in cases where this is not practicable a technique known as snarling is used. A snarling iron is a long slender stake, with its ends bent at right angles in opposite directions. One end is fixed in a vice, while the other, which is shaped like a small rounded hammer head, is placed inside the vessel, which is pressed down on it. The snarling iron is then struck with a hammer at a point near the vice, and the

rebound pushes up an area of metal on the surface of the vessel. Although this is a rather crude process, in skilled hands it is quick and effective. The vessel can then be filled with pitch, and the design refined from the outside. This technique is widely used in the decoration of hollow-ware in both gold and silver.

Earlier work was done without the aid of metal tools, and possibly without pitch, but even without these, the properties of gold facilitate this method of decorating. Many ancient pieces seem to have been worked by pushing or rubbing them with wooden or bone tools into carved pieces of the same materials. A fine example, almost certainly produced by this method, is the pectoral ornament from Camirus, Rhodes (7th century BC; London, BM; see fig. 4), which includes five almost identical plaques showing the goddess Artemis. There are individual differences between the plaques, but these are not inconsistent with such a method of production. The Greeks and Etruscans refined the technique further, probably making shaped bronze punches with which they hammered small, thin pieces of gold into some soft material, for example pitch or lead. This produced repeated units, which were then assembled to create a very rich appearance. An advantage of the process is that it strengthens the metal on the same principle by which corrugated iron gains its rigidity; thus, thin sections can be used with a reduced risk of damage.

Repoussé and chasing have been used wherever gold has been worked, and fine examples come from the very earliest cultures (e.g. the 'diadem' found by Heinrich Schliemann at Mycenae; 16th century BC; Athens, N. Archaeol. Mus.). There was a great vogue for this type of decoration during the later Middle Ages in northern Europe, especially in Germany, where goldsmiths produced some particularly exaggerated examples. Gold pieces in England in the early 18th century were often richly decorated by this method, and many of the Art

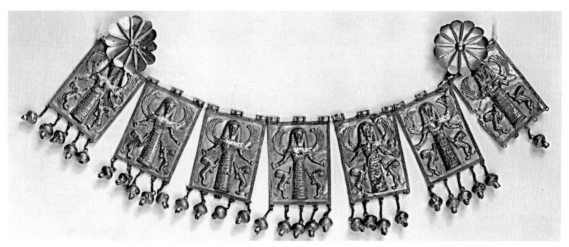

4. Gold pectoral ornament (detail), h. of each plaque 40 mm, from Rhodes, 7th century BC (London, British Museum)

Nouveau and Arts and Crafts jewellers, for example René Lalique, Georges Fouquet (1862–1957) and Henry Wilson, used chasing and repoussé extensively in their designs (*see* JEWELLERY, colour pl. II, fig. 1). Late 20th-century jewellers and goldsmiths continued to employ the techniques, but the intensive labour involved has reduced their use.

An extension of the chasing technique, which was used particularly during the 18th century, is flat chasing. The metal is fixed to a solid, flat surface, a piece of steel for example, and worked on with very fine punches. By this means it is possible to create an effect almost indistinguishable from engraving. It is only really suitable for flat surfaces and therefore was mainly used for coats of arms on trays and salvers. Another related technique, somewhat cruder and of earlier origin, is punch-work, in which shaped punches are used repeatedly over the surface of a piece of gold to produce what can be a very rich pattern. The gold is supported on either a solid backing or a resilient one. Good examples of its use are the Mold Cape from Gwynedd (*c.* 1400 BC; London, BM; *see* PREHISTORIC EUROPE, fig. 29) and the Gleninsheen Gorget (*c.* 700 BC; Dublin, N. Mus.).

Engraving involves the use of small chisels to remove metal, the technique probably deriving from the designs scratched with sharp stones on to the surface of the earliest pieces of goldwork. A good example of this, and one of the earliest, is the lunula from Ross, Co. Westmeath (1800 BC; Dublin, N. Mus.). With the advent of iron and steel tools, it became a widely used decorative technique, mainly for the enhancement of plain areas of metal. From the Middle Ages it was frequently used for the depiction of armorial bearings. A later development of engraving is engine-turning or guilloche work. Practised since the 16th century on such organic materials as wood and ivory, it was used on the precious metals from the mid-18th century. The cutting tool is connected to a geared holder on a complex lathe, which enables both the work piece and the tool to move in predetermined ways. Highly controlled designs, composed of identical but staggered lines, or of gradually changing lines or shapes, can be built up using these lathes. A very specialized technique, it can

be employed on both flat and curved surfaces. It was very popular with goldsmiths from the late 19th century until World War II for such items as powder compacts and cigarette cases. Fabergé used guilloche work behind transparent enamels to achieve iridescent and silk-like effects (*see* ENAMEL, colour pl. IV, fig. 3).

Carving is related to engraving, but larger amounts of metal are removed. Some early methods probably evolved in parallel with those for carving organic materials, as well as for stone. One such is chip-carving, where a small chisel is hammered towards a central point from three or four directions, thereby removing a chip of metal. This leaves a deep triangular or rectangular recess made up of flat facets. Sometimes carving is used to create recesses that are to be filled with such other materials as enamel or niello. The latter is a black or dark silvery-grey material used as an inlay to contrast with gold. It is usually a mixture of silver, lead and sulphur, the exact proportions of which vary. The resulting compound is applied to the hot metal in granular form and worked down into the recesses with a spatula. Once cool, the surface is smoothed out and polished to give a crisp contrast between the gold and the niello. The technique has been used extensively throughout Europe and Asia and continues to be used in such places as Morocco, Thailand and Russia.

(iv) Gilding. Gold is frequently used to decorate works made of other metals, and this is known as GILDING. Various methods have been used in the past, the commonest being mercury amalgam or fire-gilding. As the terms imply, both mercury and heat are used in the process. A paste made up of gold dust mixed with mercury is painted on to the surface of the object to be gilded. (Mercury amalgamates freely with both gold and silver at room temperature and slightly less well with copper and its alloys.) The object is then placed on the hearth and heated until the mercury has been driven off as vapour. Once the mercury has been removed, the gold is left amalgamated to the surface of the silver and can be burnished. With this technique, it is possible to leave areas of the object ungilded, a practice that is known by the

medieval term 'parcel gilding'. The disadvantage of fire-gilding is that the mercury fumes are highly toxic, for which reason it is no longer widely used. Since the late 19th century ELECTROPLATING has been the main gilding process. This has the commercial advantage of depositing a thinner layer of gold on the surface of the object, but the results do not have the richness and depth of colour achieved by fire-gilding.

When gold is applied to non-metallic materials, it is also called gilding, but this is done using gold leaf: extremely thin gold sheets hammered out to thicknesses of 0.0001 mm or less. The process of making gold leaf is datable to 1600 BC in Egypt and has hardly changed at all. Thin squares of gold are interleaved with vellum or other fine membranes and hammered until they have spread to approximately four times their original area, at which point they are quartered, and the process repeated, until the required thickness is reached. The completed leaf is normally made up into 'books' of 24 leaves. Pure gold is the easiest metal from which to make leaf, but many of its alloys are suitable. The leaf is applied to the object to be decorated by means of a glue, or size, specifically designed for the purpose. Among other things, this will fill up any porosities on the base material. The leaf is applied, while the size is tacky, with a very soft brush, and then burnished once the size has dried. With pure gold leaf, further layers can be applied directly and will stick to the original one. Panel paintings and many interior artefacts such as furniture, frames, plasterwork and decorative carvings have been enhanced by gilding with gold leaf, as have such external features as wrought-iron gates, copper roofs and the inscriptions on monuments. The Egyptians, Greeks and some other ancient peoples also applied rather thicker foil to carved wooden panels, by first burnishing it down to take up the shape and then either pinning or riveting it to the base material (usually wood), or folding the edges over on to the backing. This enabled a wide spread of thin gold to be achieved with a great increase in intrinsic rigidity.

See also INDIAN SUBCONTINENT, §VII, 15(i).

BIBLIOGRAPHY

Theophilus: *De diversis artibus* (MS.; *c*.1123); ed. and trans. by J. G. Hawthorne and C. S. Smith (Chicago and London, 1963/*R* 1979)
B. Cellini: *I trattati dell'oreficeria e della scultura di Benvenuto Cellini* (1568); Eng. trans. by C. R. Ashbee as *The Treatises of Benvenuto Cellini on Goldsmithing and Sculpture* (London, 1888/*R* New York, 1967)
R. Turner: *Contemporary Jewelry* (London, 1975)
A. K. Snowman: *Fabergé, 1846–1920* (London, 1977)
W. Bray: *The Gold of El Dorado* (London, 1978)
O. Untracht: *Jewelry Concepts and Technology* (New York, 1982)
G. C. Munn: *Castellani and Giuliano* (London, 1984)
M. Grimwade: *Introduction to Precious Metals* (London, 1985)
R. F. Tylecote: *The Pre-History of Metallurgy* (London, 1985)
V. Becker: *The Jewellery of René Lalique* (London, 1987)

MICHAEL PINDER

Gold Coast. *See* GHANA.

Golden, Daan [Daniel] **van** (*b* Rotterdam, 4 Feb 1936). Dutch painter and photographer. From 1948 until 1950 he trained to be a lathe operator, working in this capacity until 1952. Between 1952 and 1960 he was a shop window-dresser. He attended evening classes in painting at the Akademie voor Beeldende Kunsten in Rotterdam from 1954 until 1959, and in 1960 he made a mural for the Floriade flower show, Rotterdam. Also in 1960 he had his first group exhibition at Galerij Orez in The Hague and at the Rotterdamse Kunstkring. His work at this time was Abstract Expressionist. He travelled through the USA and Mexico (1961) and stayed in Paris (summer 1962); from there he made a journey through Asia, which ended in Tokyo, where he remained until the end of 1964.

Van Golden painted canvases with abstract patterns that originated from machine manufactured industrial products, particularly textile and packaging materials. In 1967 he lived in London where he worked as fashion photographer for magazines such as *Elle*, *Queen* and *Vogue*. Thereafter he made regular trips to Asia, Europe and the USA. He saw his exhibitions as works of art in themselves. His work is characterized by its diversity of techniques: oil on canvas and panel, ink and pencil drawing, screen printing, assemblage, collage, photography and film. In its use of mainly existing images, which are reproduced in a skilful way, his work is connected to Pop art.

BIBLIOGRAPHY

Daan van Golden, 1936–1982 (exh. cat., Rotterdam, Boymans–van Beuningen, 1982)
Daan van Golden (exh. cat., Amsterdam, Stedel. Mus., 1991)

JOHN STEEN

Goldenberg, Emanuel, *See* ROBINSON, EDWARD G.

Golden Fleece [Rus. *Zolotoye Runo*]. Russian artistic and literary magazine published monthly in Moscow during 1906–9. It was financed and edited by the millionaire Nikolay Ryabushinsky, and it sponsored the first exhibitions in Russia of modern and of contemporary French art. In its first two years, this beautifully produced, well-illustrated and lively magazine was principally dedicated to Russian Symbolism. The poets Aleksandr Blok, Konstantin Bal'mont (1867–1943) and Andrey Bely were regular contributors and co-editors, as were many painters of the World of Art (Mir Iskusstva) generation such as Alexandre Benois, Mikhail Vrubel', Igor' Grabar', Mstislav Dobuzhinsky, Konstantin Korovin, Nicholas Roerich, Konstantin Somov and Valentin Serov. The Blue Rose group were also represented.

By 1908, however, Ryabushinsky had become friendly with younger artists such as Mikhail Larionov, Natal'ya Goncharova and Georgy Yakulov. Under their influence, and sensitive to the changing artistic climate, Ryabushinsky altered the bias of the magazine from its distinctly Symbolist position to one that embraced contemporary French and Russian art.

In its last two years *Golden Fleece* became preoccupied with publicizing the French art shown in its exhibitions. Special issues were devoted to Gauguin and Matisse, and particular attention was paid to publishing translations of artists' writings, such as selections from van Gogh's letters and Matisse's *Notes of a Painter*. Maurice Denis and Rodin were both, for a short time, co-editors of the magazine.

The three exhibitions organized by *Golden Fleece* during 1908–10 were particularly important. The first *Salon of the Golden Fleece* (1908) presented over two hundred works by van Gogh, Gauguin, Cézanne, the Neo-Impressionists, the Nabis and the Fauves as well as the work of younger

Russian artists. The impact of this exhibition upon the latter was immense, and it substantially influenced the artistic development of Larionov and Goncharova among others. Painters who had exhibited Impressionist and mildly Symbolist canvases in the exhibition were forced to reconsider their views in the light of the French contribution. The impact on the Russians was consolidated in 1909 when the Fauves were again invited to show works at the second *Golden Fleece* exhibition. By this time, however, the Russians were already assimilating the influence of the French. Larionov's and Goncharova's latest exhibits showed a rapid development from the Impressionist paintings of the previous year to works that were Post-Impressionist and Fauvist in style. These two historic exhibitions brought into focus the latest achievements of French painting and played a fundamental role in the development of modern Russian art. But before the demise of *Golden Fleece* in 1910 due to financial problems, a third and final 'all Russian' exhibition brought together Larionov, Goncharova, Martiros Saryan, Pyotr Konchalovsky, Il'ya Mashkov and Robert Fal'k. This exhibition led to the founding of the Jack of Diamonds group later in the year.

BIBLIOGRAPHY

Zolotoye Runo: Zhurnal khudozhestvennyy literaturnyy i kriticheskiy [Golden Fleece: artistic, literary and critical magazine] (Moscow, 1906–9)
Salon 'Zolotogo Runa' [Salon of 'Golden Fleece'] (exh. cat., Moscow, 1908)
Zolotoye Runo [Golden Fleece] (exh. cats, Moscow, 1909 and 1910)
J. E. Bowlt: 'Nikolai Ryabushinsky: Playboy of the Eastern World', *Apollo*, xcviii (1973), pp. 486–93

ANTHONY PARTON

Golden Legend. *See under* JACOPO DA VORAGINE.

Golden section [golden cut, golden mean; Fr. *section d'or*]. Expression denoting a harmonic proportional ratio thought to have originated in the circle of Pythagoras (6th century BC). Expressed as a geometric ratio, the golden section holds that a:b = b:a+b, or the shorter is to the longer as the longer is to the sum of the shorter and longer. Among early mathematicians the division of a line or a rectangle according to this system (*see* SCIENCE AND ART, fig. 1) was known as 'extreme' and 'mean' ratio. With the invention of algebra it became possible to express the ratio as ϕ (Phi, the initial letter of Phidias's name, a term that gained wide acceptance only at the beginning of the 20th century), where ϕ = 1+square root of 5, divided by 2 $(1+\sqrt{[5]}/2)$. The numerical value of ϕ is 1.61803 in a positive solution, and its negative reciprocal is 0.61803.

See also ARCHITECTURAL PROPORTION.

BIBLIOGRAPHY

H. E. Huntley: *The Divine Proportion: A Study in Mathematical Beauty* (New York, 1970)

DANIEL ROBBINS

Goldfinger, Ernö (*b* Budapest, 11 Sept 1902; *d* London, 15 Nov 1987). British architect and writer of Hungarian birth. He studied architecture in Paris, first with Léon Jaussely (1920), and then at the Ecole des Beaux-Arts in the studio of Auguste Perret, whose sense of structural logic, particularly in the use of concrete, and classical propriety were to remain an inspiration. He rapidly became acquainted with the leading artistic figures of the Parisian avant-garde and, while still a student at the Ecole des Beaux-Arts, practised in partnership with his fellow Hungarian André Sive. Goldfinger's clients for shop interiors, furniture and apartments, included Lee Miller and the couturier Helena Rubinstein, for whom he designed the first Modernist shop in London at 24 Grafton Street (1927). He wrote regularly for the magazine *Organisation ménagère* and was especially interested in the application of the principles of scientific management to domestic planning (as practised by Alexander Klein and others), a common concern among contemporary Modernist architects. Russian Constructivism reached Paris in 1925 in the shape of Konstantin Mel'nikov's USSR pavilion at the Exposition Internationale des Arts Décoratifs et Industriels Modernes, which Goldfinger visited with Adolf Loos; both architects exerted a continuing influence on him.

Goldfinger was active in CIAM and was secretary of the French delegation to the conference in Athens (1933). That year he married Ursula Blackwell, an English painter, and at the end of 1934 he moved to London. There he was able to promote the construction in 1938 of 1, 2 and 3 Willow Road, Hampstead (NT), a terrace of houses, one being for his own occupation—his first significant building. In deference to its surroundings, it reflected the influence of the English Georgian tradition as well as that of European Modernism. In the same year he also designed the children's section of the MARS Group exhibition, *New Architecture*, at the Burlington Gallery, London. During World War II he designed exhibitions on social themes for the Army Bureau of Current Affairs. Early post-war commissions included two junior schools in London and offices for the *Daily Worker* newspaper and the Communist Party (1947), both in London. In the mid-1950s, under the influence of Constructivism and the heavyweight concrete architecture of Le Corbusier, he developed an expressive architectural language for office buildings. He first applied this to a small project at 45–46 Albemarle Street, London (1956), but then on a massive scale for Alexander Fleming House at the Elephant and Castle in south London (1962–6), a commission won in competition in 1959. In these designs the structural frame was powerfully expressed on the face of the building, the surface of which was articulated with cantilevered bay windows and recessed storeys.

During the 1960s Goldfinger received two major commissions for public housing schemes in London: Rowlett Street, Poplar (1966–78), and Edenham Street, North Kensington (1968–9); the most prominent feature in both is a 'slab block' of about 30 storeys, with a detached access tower at one end linked by enclosed gallery bridges at every third floor. The slenderness of these blocks and their spatial 'transparency' made them exciting at the time. Goldfinger's work is characterized by the exceptional strength of overall conception, combined with a refined elegance of detail, which reflected his scientific approach. He carried forward the French tradition of structural Rationalism, with a Modernist accent.

WRITINGS

'The Art of Enclosing Space', *Archit. Rev.*, xc (1941), pp. 129–31, 163–6; xci (1942), pp. 5–8
with E. J. Carter: *The County of London Plan Explained* (London, 1945)
British Furniture Today (London, 1951)

BIBLIOGRAPHY

R. Ginsburger: *Junge französische Architektur* (Zurich, 1930)

J. Lowrie: 'Ernö Goldfinger', *Archit. Des.*, xxxiii (1963) [special issue]

K. Frampton: 'The Elephant and Castle, London', *Archit. Des.*, xxxvii (1967), pp. 446–52

H. T. Cadbury-Brown: 'Goldfinger', *Architects' J.*, clvii (1973), pp. 240–42

J. Dunnett: 'The Architect as Constructor', *Archit. Rev.*, clxxiii/4 (1983), pp. 42–6

J. Dunnett and G. Stamp: *Ernö Goldfinger: Works 1* (London, 1983)

JAMES DUNNETT

Goldie, C(harles) F(rederick) (*b* Auckland, 20 Oct 1870; *d* Auckland, 11 July 1947). New Zealand painter. He trained in Paris between 1893 and 1898, and from 1900 he specialized in portraits of the Maori. These portraits, mainly half-length, are painted in a naturalistic manner with careful attention to minute details of dress and facial tattoos. Such titles as *A Noble Relic of a Noble Race* (1910; Auckland, C.A.G.) indicate their anecdotal and sentimental nature, sustained by an erroneous belief that the Maori was a dying race.

BIBLIOGRAPHY

A. Taylor and J. Glen: *C. F. Goldie (1870–1947): His Life and Painting* (Martinborough, 1978)

Goldie (exh. cat., Auckland, C.A.G., in preparation)

LEONARD BELL

Goldmann, Nikolaus (*bapt* Breslau [now Wrocław, Poland], 29 Sept 1611; *d* Leiden, before 6 June 1665). German theorist. He came from a wealthy Silesian family who enabled him to pursue his interests without financial constraints. He first studied law (from 1628) at Leipzig University and then (from 1632) mathematics at Leiden University. From 1637 he was a private scholar at Leiden, without academic teaching duties. Goldmann investigated the scientific and philosophical foundations of architectural theory, to which he contributed the basic concept of the module. He paid particular attention to working out proportional relationships that he perceived in the Classical orders and which he tried to formulate mathematically. He made particular use of the work of Vitruvius and wrote a highly regarded contribution on the geometrical construction of the volute of the Ionic capital for an edition of Vitruvius edited by Johann de Laet (*d* 1649) and published in Antwerp in 1649. He also took contemporary Italian, French and Dutch architecture as his exemplars, on the basis of which he wove an eclectic architectural theory. Goldmann believed in the normative power and function of ancient architecture, which he derived ultimately from divine revelation. Consequently, eliciting architectural proportions led him—in conjunction with the contemporary notion of a correspondence between macrocosm and microcosm, and between this world and the beyond—to a study of divine harmony itself, so that his methods and calculations almost suggest transcendental interpretations, as in his attempt at a detailed reconstruction of the Temple of Solomon in Jerusalem. Although Goldmann did not base any practical proposals on his ideas, and his most important work (the *Vollständige Anweisung zur Civil-Bau-Kunst*) was published long after his death when it was already stylistically obsolete, he enjoyed a widely held literary reputation even outside Germany in the 17th and 18th centuries. His scholarly approach was a major influence on Leonhard Christoph Sturm, who wrote numerous explanatory treatises on his work.

WRITINGS

Elementa architecturae militaris (Leiden, 1643)

De uso proportionarii circuli (Leiden, 1656)

Tractatus de stylometris (Leiden, 1662)

Vollständige Anweisung zur Civil-Bau-Kunst (Brunswick, 1696) [subsequent editions enlarged and rev. L. C. Sturm]

BIBLIOGRAPHY

Thieme–Becker; *NDB*

J. H. Zedler, ed.: *Grosses vollständiges Universal Lexikon aller Wissenschaften und Künste*, xi (Halle and Leipzig, 1735)

C. G. Jöcher: *Allgemeines Gelehrten-Lexikon*, ii (Leipzig, 1750)

M. Semrau: 'Zu Nikolaus Goldmanns Leben und Schriften', *Mhft. Kstwiss.*, ix (1916), pp. 349–61, 463–73

V. C. Habicht: 'Die deutschen Architekturtheoretiker des 17. und 18. Jahrhunderts', *Z. Archit. & Ingenwiss.*, n.s., lxiii/22 (1917), pp. 209–43

M. Semrau: 'Nikolaus Goldmann', *Schlesier des 17. bis 19. Jahrhunderts*, ed. F. Andreae (Breslau, 1928), pp. 54–60

WERNER WILHELM SCHNABEL

Goldscheider, Friedrich (*b* Plzeň, 6 Nov 1845; *d* Nice, 19 Jan 1897). Czech ceramics manufacturer. After completing his apprenticeship as a salesman at the haberdashery business of his father Moritz Goldscheider (*d* 1865) in Pilsen, he constructed a brickworks for the production of fireproof wares. From 1877 he became involved in the porcelain industry. After his marriage in 1873, he settled in Vienna and in 1885 established the Goldscheider'sche Porzellan-Manufaktur und Majolica-Fabrik, the success of which led to the establishment of numerous branches, including a porcelain and earthenware factory in Pilsen and a factory for painting porcelain in Karlsbad (now Karlovy Vary). In 1887 the firm participated in the International Exhibition in Leipzig, where 'maiolica' figures with thick, lead glazes were presented. Arthur Strasser, professor at the Wiener Kunstgewerbeschule, worked closely with Goldscheider, and designed numerous figures for the firm primarily in the East Asian style. At the 1888 Jubiläumsgewerbeausstellung in Vienna it was thought that Goldscheider's polychrome works would decline in popularity, but in the same year he won a silver medal at the Exposició Universal in Barcelona. The scale of production, however, made it necessary to divide the firm's output between the two main centres. In Vienna terracotta and maiolica figures, busts and murals were produced, while in Carlsbad porcelain dinner-services, coffee-, tea- and demi-tasse services were manufactured. In 1891 the firm was granted the patent for decorating wares with a bronze colour. The new wares achieved great popularity especially in Paris, and in 1892 Goldscheider opened a branch there for manufacturing 'bronzed' articles. In 1893 these were presented at the International Exhibition in Leipzig and at the World's Colombian Exposition in Chicago. After Goldscheider's death the firm was managed by his widow Regina Goldscheider and his brother Alois Goldscheider, and in 1953, owing to financial difficulties, it finally closed.

BIBLIOGRAPHY

W. Neuwirth: *Österreichische Keramik des Jugendstils* (Munich, 1974)

——: *Wiener Keramik: Historismus—Jugendstil—Art Deco* (Brunswick, 1974)

GABRIELE RAMSAUER

Goldscheider, Ludwig (*b* Vienna, 3 June 1896; *d* London, 27 June 1973). British writer and publisher of Austrian birth. He studied literature, Classics and art history at the University of Vienna. He began his career as a poet, and in 1923 he joined his schoolfriend BELA HOROVITZ in founding in Vienna the publishing house Phaidon Verlag, where he played a major role not only in publishing but also in editing and translating the literary texts that were the firm's original specialization. Goldscheider was also responsible for the distinctive design of text pages, the selection of typefaces and of black-and-white photographs and the choice of colour plates, whose reproduction he supervised personally. His association with Phaidon lasted 50 years, and he played a leading role in the development of the illustrated art book.

In the early 1930s Phaidon produced large editions of the works of the great European scholars and historiographers, with illustrations chosen by Goldscheider; among these were new editions of Theodor Mommsen's *Romische Geschichte* (1932) and Jacob Burckhardt's *Die Zeit Konstantins des Grosses* (1936). The successful formula of these books was extended to 19th-century biographies, including Carl Justi's *Velázquez und sein Jahrhundert* (1933), Hermann Grimm's *Leben Michaelangelos* (1933) and W. Suida's *Raphael* (1941), and by 1937 art history dominated Phaidon's list. When Hitler annexed Austria in 1938, Phaidon moved to London. Besides writing the introductions to colour-plate books such as *El Greco* in 1938, Goldscheider also wrote more substantial texts, including *The Paintings of Michelangelo* (1939), *Rembrandt* (1960) and *Kokoschka* (1963). His most original contribution to art history was *Zeit lose Kunst* (1934), in which he drew numerous parallels between ancient and modern art forms. Goldscheider was also an accomplished amateur painter.

WRITINGS
Zeit lose Kunst (Vienna, 1934, 2/1937; Eng. trans., London, 1937)
The Paintings of Michelangelo (London, 1939, 2/1948)
Rembrandt (London, 1960, R/1964, R/1967)
Kokoschka (London, 1963, 2/1966, 3/1967)

BIBLIOGRAPHY
Phaidon Jubilee Catalogue, 1923–1973 (London, 1973) [intro. by T. Grafe]
VALERIE HOLMAN

Goldschmidt, Adolph (*b* Hamburg, 15 Jan 1863; *d* Basle, 5 Jan 1944). German art historian. He came from a Hamburg banking family. His wide-ranging publications covered medieval illuminated manuscripts, ivories, bronze and stone sculpture, and, to a lesser extent, northern painting of the 15th to 17th centuries. He taught at the universities of Berlin (1892–1903) and Halle (1904–12) and then succeeded Heinrich Wölfflin as professor at Berlin in 1912. He retired in 1932 and finally had to leave Germany for Switzerland in 1939. Goldschmidt's career spanned the great years of German art history when, particularly in medieval studies, German scholarship and methodology dominated the field. He was among the leading figures of his generation, and through his published work and his teaching, one of the most influential. His analytical, precise approach to the study of style and iconography with an emphasis on medieval art differed from the Formalist criticism of Wölfflin. As an exceptional teacher, Goldschmidt established a following of distinguished pupils, notably Kurt Weitzmann, who extended this following through his own teaching in the USA. Goldschmidt's early monograph on the St Albans Psalter (Hildesheim, St Godehardkirche), his books on Carolingian and Ottonian manuscript illumination, Romanesque bronze doors, the 12th- and 13th-century sculpture of Saxony and the posthumous work on the illustration of Aesop's *Fables* show different aspects of his study of the style and iconography of manuscript painting and sculpture. His volumes discussing the corpus of Carolingian, Ottonian, Romanesque and Byzantine ivories, still fundamental works, are assuredly his greatest achievement.

WRITINGS
Die Elfenbeinskulpturen aus der Zeit karolingenischen und sächsischen Kaiser, 4 vols (Berlin, 1918)
Die frühmittelalterlichen Bronzetüren (1926), i of *Die deutschen Bronzetüren des Mittelalters* (Augsburg, 1926–7)
Die karolingischen Buchmalerei (1928), i of *Die deutsche Buchmalerei* (Munich and Florence, 1928; Eng. trans., Florence and Paris, 1928)
with K. Weitzmann: *Die byzantinischen Elfenbeinskulpturen*, 2 vols (Berlin, 1930–34)

BIBLIOGRAPHY
NDB
C. G. Heise: *Adolph Goldschmidt zum Gedächtnis* (Hamburg, 1963) [with full bibliog.]
K. Weitzmann: *Adolph Goldschmidt und die Berliner Kunstgeschichte* (Berlin, 1985)
NIGEL J. MORGAN

Goldschmidt, Gertrudis. *See* GEGO.

Goldsmith, Myron (*b* Chicago, IL, 15 Sept 1918). American architect. He studied architecture at the Armour Institute of Technology (BSc, 1939) and with Mies van der Rohe at the Illinois Institute of Technology (MSc, 1953), both in Chicago. His earliest architectural work was done in Mies's architectural office. In Rome (Fulbright Fellowship, 1953–5) he studied with Pier Luigi Nervi. From 1955 he was Chief Structural Engineer at the office of Skidmore, Owings & Merrill in San Francisco, transferring to their architecture department in the office in Chicago in 1958 and becoming partner in 1967. In 1961 he joined the faculty of the Illinois Institute of Technology (IIT) as Professor of Architecture.

Goldsmith's concern for the relation between structures and their environment is manifest in his best compositions, and the principles of 'structural humanism' have informed his career from its beginning. Aware of the building tradition of the industrial metropolis, his study with Mies and Nervi provided insights about the Modern Movement in architecture in the USA and abroad. His major designs, including the Alameda Coliseum (1968), Oakland, the Brunswick Building (1965), Chicago, the Arthur Keating Hall (1968), IIT, and the project for the Ruck-a-Chucky Bridge (1978), Auburn, CA, demonstrate a search for permanent architectural truth, immune to architectural fashion, High-Tech formalism and minimalism, but based on rational building and optimal scale. Some critics have claimed that the solar telescope (1972) at the national observatory at Kitt Peak, AZ, turned the mountain into a modern icon that celebrates the culture of scientific inquiry and technological enterprise, and that the structure belongs to the same realm of philosophical inquiry as Le Corbusier's Notre-Dame-du-Haut at Ronchamp.

Goldsmith's closest professional association was with Fazlur Khan (1929–82), engineer of the John Hancock Building in Chicago. Their joint pedagogy of 22 years at IIT was founded in a structural approach and teamwork; the tall buildings and long-span buildings they investigated with their students through studio and thesis projects became prototypes for subsequent design commissions of the Skidmore, Owings & Merrill office, including the John Hancock Building. Goldsmith's other teaching positions were at Harvard University, Cambridge, MA (Eliot Noyes Visiting Professor of Architecture, 1982–3), and Wuhan, China (1985); he also participated in countless juries in architectural schools and professional competitions. His work was distinguished by numerous awards from architectural and building institutions, and he exhibited in Chicago, New York, San Antonio, Cambridge, MA, and Paris.

WRITINGS

ed. W. Blaser: *Myron Goldsmith: Buildings and Concepts* (New York, 1987)

BIBLIOGRAPHY

B. Zevi: *Cronache di Architettura* (Rome, 1978), pp. 142–7

Chicago: 150 Years of Architecture, 1833–1983 (exh. cat., ed. F. Edelman and A. Glibota; Paris, A. Cent. and Paris, Mus.–Gal. Sieta, 1985–6)

R. Banham: 'Mountain of Modern Icons: The Exhilarating Experience of Kitt Peak', *Architecture* [USA], lxxiii/4 (1984), pp. 143–9

MARTHA POLLAK

Goldstein, Zvi (*b* Cluj, Romania, 21 Jan 1947). Israeli conceptual sculptor. After studying at the Bezalel Academy of Arts and Design in Jerusalem (1966–9) he completed his studies (1969–72) at the Accademia di Belle Arti, Milan. He returned to Israel in 1978, intent on cutting his connections with the Western mainstream to develop an artistic language based on a strong conceptual attitude and opposed to the then dominant trend towards figurative painting. This language was conceived as parallel to textual expressions being formulated at that time in Italy. The relationship between object and text subsequently became more intricate, with the object becoming a syntactical language transforming the text as an interpreter. Although having deliberate echoes of Russian Constructivist structures, Goldstein's works are not characterized by a stylistic approach, but build on the exchange of conflicting and parallel ideas. In 1978 he began teaching at the Bezalel Academy of Arts and Design. From this time he used metaphor in its most abstract sense, in order to propose that artists on the periphery, outside Europe and the USA, could give new forms to geographical, social and artistic works. Goldstein defined the three main categories of his work in the *Serial Constructions* series (e.g. the installation *Element F16–Second Version*, metal and formica structures, 1987; Kassel, Documenta 8), the *Anomalies* series, *Third World and World 3: Anomalous Models* (painted aluminium, wood and plexiglass, 1.50×0.60 m–3.00×1.50 m, 1987; Paris, Pompidou) and the *Perfect Worlds/Possible Worlds* series (e.g. *Future, Utopia, Eschatology* (painted aluminium, wood and plexiglass, l. 12 m, 1989; Düsseldorf, Städt. Ksthalle). He had one-man exhibitions at the Israel Museum in Jerusalem (1982), the Tel Aviv Museum (1983), and the Musée National d'Art Moderne in Paris (1987).

BIBLIOGRAPHY

Zvi Goldstein: Die Sprache der Bauens (exh. cat. by J. Heynen, Krefeld, Mus. Haus Esters, 1986)

Zvi Goldstein: The Glory of Abstraction (exh. cat. by M. Tacke and S. Schmidt-Wolffen, Munich, Kstraum, 1989)

MICHAEL TURNER

Gole [Golle], **Pierre** (*b* Bergen, nr Alkmaar, *c.* 1620; *d* Paris, 27 Nov 1684). French cabinetmaker of Dutch birth. By 1643 he was in Paris where he was apprenticed to Adrien Garbrant; he later married Garbrant's daughter and took over his workshop. A connection by marriage with the architect and engraver Jean Marot I, who was working for King Louis XIV, may have led to Gole's first known royal commission in 1661. Further commissions at Vincennes followed in the same year, and during the 1670s Gole worked almost exclusively at Versailles. He maintained his workshop in the Rue Arbre-Sec, near the Louvre, though he certainly collaborated with other craftsmen at the royal workshops in the Gobelins, possibly using them for his royal commissions. The tapestry (*c.* 1667; Versailles, Château) illustrating Louis XIV's visit to the Gobelins in 1667 almost certainly shows Gole presenting a Boulle table to the King (*see* GOBELINS, fig. 1). Gole's style developed quickly: his earliest cabinets, in ebony, followed the mid-century style of rich sobriety, but for his first royal commission he decorated a cabinet (untraced) with floral marquetry and during the 1660s and 1670s he used such exotic materials as tortoiseshell, japanning and brass and pewter marquetry with amaranth wood. Among his most exotic pieces were tables with an ivory ground in imitation of porcelain, supplied in the 1670s to the Trianon de Porcelaine at Versailles. A table of this type (Malibu, CA, Getty Mus.) was in Versailles in 1718. A cabinet (London, V&A) made for the King's brother, Philippe I, Duke of Orléans, in 1662 is decorated with floral marquetry on an ivory ground.

BIBLIOGRAPHY

T. Lunsingh Scheurleer: 'Pierre Gole, ébéniste du roi Louis XIV', *Burl. Mag.*, cxxii (1980), pp. 380–94

A. Pradère: *French Furniture Makers from Louis XIV to the Revolution* (London, 1990)

SARAH MEDLAM

Golgotha. *See* CALVARY.

Goller, Bruno (*b* Gummersbach, 5 Jan 1901). German painter. He was largely self-taught, completing his studies in Düsseldorf. In the mid-1920s he was associated with the circle around the café- and gallery-owner Joanna Ey ('Mother Ey'), which included artists such as Max Ernst, Gert Wollheim and Otto Dix. He was a member of the artists' group Das Junge Rheinland and in 1928 he became a founder-member of the Rheinische Sezession. At this time his work was consistent with the outlook of the Neue Sachlichkeit. His later style owes a debt to the Surrealist work of Ernst and Magritte, as well as to the experimental films of Hans Richter. After 1945 Goller worked independently towards an artistic solution that did not depend on officially sanctioned abstract trends but relied instead on a stylized figuration that prefigured much Pop art in the 1960s. In paintings such as *Large Shop Window* (1953; Düsseldorf, Kstsamml. Nordrhein–Westfalen) and *Various Pictures* (1955; Cologne, Wallraf-Richartz-Mus.) he

invented magic worlds in which he juxtaposed different painterly styles by means of representations of ordinary objects: hats, umbrellas, mirrors, milliners' dummies. Yet these are elevated above the commonplace by their symbolic function and the seriousness of the artist's intent. In later works he often focused on a single object, as in *The Armchair* (1965; Düsseldorf, Kstsamml. Nordrhein–Westfalen), or on one part of the human body, which was enormously magnified. He taught between 1949 and 1964 at the Staatliche Kunstakademie in Düsseldorf, where he exerted a powerful influence on his pupils, most notably Konrad Klapheck.

BIBLIOGRAPHY
A. Klapheck: *Bruno Goller* (Recklinghausen, 1958)
H. Garnerus: 'Bruno Goller', *Kst & S. Heim*, xcv/2 (1983), pp. 97–104, 145
Bruno Goller: Werke aus sechs Jahrzehnten (exh. cat., Düsseldorf, Kstsamml. Nordrhein–Westfalen, 1986)

COLIN RHODES

Gollerbakh, Erikh (Fyodorovich) [Bakh] (*b* Tsarskoye Selo [now Pushkin], 23 March 1895; *d* Moscow, 1945). Russian art historian, collector and philosopher. Originally attracted to philosophy, he was particularly influenced by the ideas of his friend VASILY ROZANOV; his debt to both Rozanov and Nietzsche is evident in his aphoristic, psychological study *V zareve Logosa, Sporady i fragmenty* ('In the glow of Logos, Sporades and Fragments'; Petrograd, 1920), as well as several unpublished works on mystical perception, madness and genius. Gollerbakh's numerous published books dedicated to art history include a generalized survey (1930) of modernist developments in western European and Russian painting and sculpture during the previous 50 years, as well as a series of studies concerned with Russian graphic art in which, through the establishment of significant chronological data, he invariably attempted to reveal the underlying patterns governing the artistic process, as in his history of engraving and lithography in Russia (1923) and his study of the work of Viktor Zamiraylo (1925). After the 1917 revolution Gollerbakh worked for the art-historical commission of Detskoye Selo, chaired by Georgy Lukomsky, with responsibility for the upkeep and description of the palaces' property. One result of this was his unique cataloguing of hundreds of works of art and buildings in his book on the palace and park complexes of Detskoye Selo (1922). Furthermore, one of his finest works, on the 'city of the muses' (1927), combines essays, factual information and reminiscences on the former imperial residences of Tsarkoye Selo together with an anthology of poetry dedicated to the place. In addition, in 1921–4 Gollerbakh worked in the history and social department of the Russian Museum, Petrograd (now St Petersburg), and from 1923 was head of the art section of the Petrograd state publishers, Gosizdat. In the 1930s, according to the political climate of the times, he restricted the themes of his published work, and his output included a series of books on portraits of Russian writers. He was a collector of modern art (porcelain, paintings and graphics), the porcelain of Dar'ko, watercolours of Maksimilian Voloshin, drawings of Dobuzhinsky, Narbut and Zamiraylo, and book plates in general.

WRITINGS
Yelizavetinskiy farfor [Porcelain of the age of Empress Elizabeth] (Petrograd, 1919)
Apologiya muzeya [A vindication of museums] (Petrograd, 1922)
Detskosel'skiye dvortsy-muzei i parki [Detskoye Selo palace-museums and parks] (Petrograd, 1922)
Farfor gosudarstvennogo zavoda [Porcelain of the state factory] (Moscow, 1922)
Istoriya gravyury i litografii vi Rossii [The history of engraving and lithography in Russia] (Moscow, 1923)
Risunki M. Dobuzhinskogo [Drawings of Dobuzhinsky] (Moscow and Petrograd, 1923)
V. Serov: Zhizn' i tvorchestvo [V. Serov: life and work] (Petrograd, 1924)
Risunki i gravyury V. D. Zamiraylo [The drawings and engravings of V. D. Zamiraylo] (Kazan', 1925)
Siluety G. I. Narbuta [Narbut's silhouettes] (Leningrad, 1926)
Akvareli M. A. Voloshina [Voloshin watercolours] (exh. cat., Moscow and Leningrad, 1927)
Gorod muz [City of the muses] (Leningrad, 1927, 2/1930)
A. Ya. Golovin: Zhizn' i tvorchestvo [A. Ya. Golovin: life and work] (Leningrad, 1928)
Khudozhestvennyy ekslibris [Artistic ex-libris] (Leningrad, 1928)
Skul'ptura N. Ya. Dan'ko (exh. cat., Leningrad, 1929)
Puti noveyshego iskusstva na zapade i u nas [Paths of modern art in the West and here] (Leningrad, 1930)

BIBLIOGRAPHY
O. Ostroy and L. Yuniberg: *Erikh Fyodorovich Gollerbakh kak kollektsioner i izdatel'* [Erikh Fyodorovich Gollerbakh as a collector and publisher] (Leningrad, 1990)

JEREMY HOWARD

Gollins, Melvin, Ward. English architectural partnership formed in London in 1947 by Frank Gollins (*b* 25 May 1910), James Melvin (*b* 22 Aug 1912) and Edmund Fisher Ward (*b* 29 Sept 1912). After early work involved with the reconstruction of bomb-damaged housing in London, the partnership made its reputation by winning the competition (1953) for a master-plan for the central development of the University of Sheffield, where it subsequently designed several buildings including a library (1959) and arts building (1965). In its commercial architecture, Gollins, Melvin, Ward introduced the first American-style fully-glazed curtain wall into England in its design for Castrol House (1960), Marylebone Road, London; its two multi-storey office buildings for P & O (1968) and Commercial Union (1969), facing the same paved square off Leadenhall Street, London, were considered the most sophisticated and successful examples of glass-walled office buildings in England at that time. Throughout the 1960s and 1970s the partnership designed many large buildings in England in variations of a mainstream modernist style, including several hospitals and schools; the Royal Military College of Science (1968), Shrivenham; the British Airways freight terminal (1969), Heathrow Airport, London; buildings for the Royal Military Academy (1970), Sandhurst, Camberley; the new Covent Garden market (1975) at Nine Elms, London; and the American Express headquarters (1978), Brighton. Overseas, Gollins, Melvin, Ward designed the British Airways terminal (1970) at John F. Kennedy Airport, New York, and buildings in Saudi Arabia, Kenya, Hong Kong and Belgium (some jointly with local architects) for which the partnership established temporary local offices. After the retirement of Gollins, Melvin and Ward in the 1970s, the practice continued as the GMW Partnership, developing into a large, multi-disciplinary organization.

WRITINGS

The Architecture of the Gollins, Melvin, Ward Partnership (London, 1974)

J. M. RICHARDS

Goll van Franckenstein. Dutch family of bankers and collectors. Johann Goll I (*b* Frankfurt am Main, 11 Aug 1722; *d* Velserbeek, 12 July 1785) was a banker in Amsterdam from *c.* 1747. He was ennobled by Empress Maria Theresa in 1766 thereafter assuming the title 'van Franckenstein'. He collected paintings and drawings. Apart from auction purchases (e.g. at the Tonneman, Feitama and Muilman sales; see Beck, 1984), his most important acquisition was the collection of drawings belonging to Valerius Röver, sold 22 January 1761. Goll van Franckenstein's unique collection of drawings by important Netherlandish and Italian artists was open to view. Goll himself drew landscapes, showing motifs from his native country and his travels abroad. He was a friend of Jacob Cats (ii) and artistic adviser to Caroline Louise, Margravine of Baden-Durlach. He went blind in the last years of his life.

His son Johan Goll van Franckenstein II (*b* Amsterdam, 24 Sept 1756; *d* Velserbeek, 25 Oct 1821) enlarged the collection of drawings and paintings considerably, but also sold some drawings. Johan II spent many years on the town council of Amsterdam and was ennobled, becoming a jonkheer in 1818. He marked his drawings in the bottom left corner with a large capital 'N' in script and an inventory number in brown or black ink (see Lugt, 1921), only the Röver drawings being marked in red ink. The inventory has been lost (see Beck, 1981).

His son Pieter Hendrik Goll van Franckenstein (*b* Amsterdam, 8 April 1787; *d* Amsterdam, 1 Dec 1832) acquired relatively few drawings (e.g. at the Molkenboer auction on 17 Oct 1825). In 1827 he sold the grisaille *Ecce homo* (1634; London, N.G.) by Rembrandt, which had belonged to Röver. The collections were auctioned in Amsterdam from 1 July 1833, there being 89 paintings (which fetched 105,955 fl.), among them Vermeer's *Geographer* (1669; Frankfurt am Main, Städel, Kstinst. & Städt. Gal.) and works by Aelbert Cuyp, Adriaen van Ostade, Paulus Potter, Rembrandt, Jacob van Ruisdael and Philips Wouwerman. Of an original group of some 5000 drawings, 2200 were sold in 47 albums (for 69,638,50 fl.).

BIBLIOGRAPHY

NNBW

F. Lugt: *Marques* (1921), no. 2987

——: *Ventes*, i (1938), ii (1953), nos 9522, 10978, 13358 and 13362

J. Knoef: 'De Verzamelaars Goll van Franckenstein' [The collectors Goll van Franckenstein], *Ned. Ksthist. Jb.* (1948–9), pp. 268–86

C. Bille: 'Johan Goll van Franckenstein: Een gelukkig verzamelaar' [Johan Goll van Franckenstein: a happy collector], *Miscellanea Prof. Dr. J. Q. van Regteren Altena* (Amsterdam, 1969), pp. 195–7

H. U. Beck: 'Anmerkungen zu den Zeichnungssammlungen von Valerius Röver und Goll van Franckenstein', *Ned. Ksthist. Jb.* (1981), pp. 111–26

——: 'Goll van Franckenstein als Käufer von Zeichnungen auf der Auktion von Abraham van Broyel in Amsterdam (1759)', *Oud-Holland*, xcviii (1984), pp. 111–16

H. U. BECK

Golosov. Russian family of architects.

(1) Pantaleymon (Aleksandrovich) Golosov (*b* Moscow, 25 July 1882; *d* Moscow, 8 June 1945). He studied in Moscow at the Stroganov School (1898–1906) and at the School of Painting, Sculpture and Architecture (1906–11). His first works, such as the Varginaya House on Ulansky Lane in Moscow, were a rationalist interpretation of Art Nouveau. After service during World War I, he worked as part of the collective Novaya Moskva (New Moscow) on the first overall plan for the reconstruction of Moscow, under the leadership of Ivan Zholtovsky and Aleksey Shchusev. He participated in the design and construction of pavilions for the All Russian Agricultural Exhibition in Moscow (1923). He was allied with the Constructivists, and from 1925 he was a member of OSA, although he was in the Functionalist wing of the group.

Pantaleymon created a series of designs (*c.* 1927) for club buildings for the Union of Railwaymen and Metalworkers, which were distinguished by their practical organization of asymmetrical elements. In 1929–30 he built a model state farm, Zernograd, in the Rostov region, and a building for the Scientific Research Institute of Raw Minerals on Tchaikovsky Street (now Novinsky Boulevard), Moscow. His best-known work is the *Pravda* publishing complex (1929–35) in Moscow (Pravda Street). Compared with his early Constructivist works, the building is vast and monumental but clearly Functionalist in intention. Its appearance is defined by a free composition of various elements hung on its structural frame: blank planes, horizontal strips separating the bands of windows, and even a vast stained-glass window. The building became a symbol of the power of contemporary means of mass communication, in which the Constructivist method was treated with mannerist complexity. Eventually Pantaleymon adopted Stalin's official style, producing classical works such as residential blocks (1937–8) on Bol'shaya Bronnaya Street and an artists' hostel (1940) on Dorogomilovskaya Embankment, both in Moscow. He also participated (from 1935) in a major building programme for Moscow.

(2) Il'ya (Aleksandrovich) Golosov (*b* Moscow, 31 July 1883; *d* Moscow, 29 Jan 1945). Brother of (1) Pantaleymon Golosov. He studied at the Stroganov School (1898–1907) and at the School of Painting, Sculpture and Architecture (1907–12), both in Moscow. Between 1914 and 1917 he served in the army as an engineer. From 1918 to 1921 he worked with Ivan Zholtovsky, from whom he absorbed a feeling for architecture as a part of artistic culture. He sought to reflect the new within the bounds of neo-classicism, simplifying it and making it more monumental, and creating a symbolic language based on the interaction of geometric masses and form symbols. He elaborated his ideas in experimental and competition designs, such as the school in memory of Lev Tolstoy at Yasnaya Polyana (1919) and a crematorium in Moscow (1919). In such projects, neo-classical and Russian Cubo-Futurist devices were paradoxically combined, demonstrating his theory of objective norms in the construction of form, which connected the dynamics and statics of architectural masses with their harmonious interaction.

From 1921 Il'ya taught in the architectural faculty of the Moscow Polytechnical Institute and at VKHUTEMAS, where he headed a workshop with Konstantin Mel'nikov. A school of 'symbolic romanticism' formed around him,

which included G. M. Ludwig (1893–1973), Aleksandr Vlasov, G. G. Vegman (1899–1973), Z. M. Rozenfel'd (*b* 1904) and R. Ya. Khiger (1901–85). The principles of symbolic romanticism were reflected in Il'ya's unexecuted designs, such as that for a radio station (1921) and the Ostankino stud farm (1922) in Moscow (see Khan-Magomedov, pp. 78, 87), and the executed design for the Far East Pavilion at the All Russian Agricultural Exhibition in Moscow (1923). His interest in the expressiveness of openwork constructions combined with blank expanses is already apparent in his unexecuted competition design for the Palace of Labour in Moscow (1923; see Khan-Magomedov, pp. 96–7), which completed his symbolic romanticist phase, and in which a complex composition was based on a notation of the plan's axes in relation to the borders of the site, emphasizing its 'sovereignness' with regard to the surroundings.

Il'ya's next series of competition designs were experiments with a bare frame, huge glass surfaces and a severe geometry of masses, and they included buildings for *Leningradskaya Pravda*, the joint stock company Arkos (1924), Rusgertorg (1925) and Elektrobank (1926), all in Moscow (see Khan-Magomedov, pp. 113, 124, 125). His growing enthusiasm for technical symbolism and the rational construction of form brought him closer to the Constructivists: he became a member of OSA, and in the second half of the 1920s he became an influential champion of the artistic possibilities of Constructivism. His first major (and executed) Constructivist building, and his best-known work, was the Zuyev Club (1927–9; see fig.) in

Moscow. It is dominated by the glass cylinder of the staircase, which seems to pierce a horizontal orthogonal volume. He repeated the cylindrical form as the central theme of his design (1928; see Khan-Magomedov, p. 169) for the Palace of Culture in Stalingrad (now Volgograd). The government building of Kalmykiya in Elista (1928–32; with B. Ya. Mittel'man), the House of Soviets (1929; with B. Yu. Ulinich) in Lenin Street, Khabarovsk, and that in Rostov-on-Don (1929–34) belong to this Constructivist period of his work.

Il'ya was one of the architects who took part in the development of a new type of residential complex, the *zhilkombinat*, uniting living quarters with a developed service system. He built such a complex between 1929 and 1932 in Ivanovo-Voznesensk (now Ivanovo), where a series of six-storey residential blocks—their ends turned towards a main road—were united by a band of glass façades behind which were service areas. In the design (1930; see Khan-Magomedov, pp. 152–3) for another *zhilkombinat* in Stalingrad, three extensive functional blocks (residential, community and the children's sector) were placed parallel to each other and united by transverse links. In the 1930s, under increasing pressure from Stalin's government in favour of conservative artistic tastes, Il'ya reverted to historicism, submitting a design with traditional motifs for the competition for the Palace of the Soviets (1932; see Khan-Magomedov, pp. 187–8). He was rewarded by several large government commissions in the late 1930s. On Yauzsky Boulevard in Moscow he built a housing complex with the appearance of a titanic monolith (1934–6), whose romanticized monumentality was quite influential. Between 1936 and 1938 he built a block in the Avtozavodsky district of the city of Gor'ky (now Nizhny Novgorod), in which enclosed yards were united by vistas through huge arches, and in which units were used as abstract compositional elements, arranged for artistic ends. He openly used Neo-classical compositional devices in the building for the higher Trade Union School (1938) in Moscow. He spent the years during World War II designing military monuments.

WRITINGS

I. Golosov: 'Moy tvorcheskiy put" [My creative path], *Arkhit. SSSR* (1933), no. 1, pp. 22–4
——: 'O bol'shoy arkhitekturnoy forme' [On large architectural form], *Arkhit. SSSR* (1933), no. 5, p. 34
——: 'Novyye puti v arkhitekture' [New trends in architecture], *Iz istorii sovetskoy arkhitektury, 1917–1925: Dokumenty i materialy* [From the history of Soviet architecture, 1917–1925: documents and materials], ed. K. N. Afanas'yev (Moscow, 1963), pp. 26–31 [paper given at Moscow Architectural Society, 13 Dec 1922]

BIBLIOGRAPHY

A. Levina: 'Arkhitektor Pantaleymon Golosov', *Arkhit. SSSR* (1968), no. 11, pp. 52–7
L. Lopovok: 'Pantaleymon Aleksandrovich Golosov', *Stroitel'stvo & Arkhit. Moskvy* (1983), no. 6, pp. 14–15
S. O. Khan-Magomedov: *Arkhitektor Il'ya Golosov* (Moscow, 1986)

A. V. IKONNIKOV

Il'ya Golosov: Zuyev Club, Moscow, 1927–9

Golovin, Aleksandr (Yakovlevich) (*b* Moscow, 1 March 1863; *d* Detskoye Selo [now Pushkin], nr St Petersburg, 17 April 1930). Russian stage designer and painter. He studied architecture, then painting under Vladimir Makovsky, Vasily Polenov and Illarion Pryanishnikov at the Moscow College of Painting, Sculpture and Architecture

(1881–90). In 1889 he attended Jacques-Emile Blanche's studio in Paris and in 1895 travelled in Italy, France and Spain. In 1897 he studied under Raphaël Collin (b 1850) and Luc-Olivier Merson in Paris. A member of the Moscow Society of Painters from 1894, he lived in Moscow until 1901. Golovin expressed a great interest in Art Nouveau and in the search for a new national style of Russian art. Together with Yelena Polenova he devised a project in 1898 for the decoration of a Russian dining-room at the house of the painter Maria Yakunchikova, and he collaborated with Konstantin Korovin on the décor of the artisan section in the Russian pavilion at the Exposition Universelle in Paris in 1900. He produced sketches with Mikhail Vrubel' for maiolica panels for the Hotel Metropol' in Moscow (*Floating Swans*, 1900).

Golovin began designing for the theatre in 1898. His designs for Koreshchenko's *Ledyanoy dom* ('Ice house', 1900; Moscow, Bakhrushin Cent. Theat. Mus., and Tret'yakov Gal.) and Rimsky-Korsakov's *Pskovityanka* ('The maiden of Pskov', 1901; Moscow, Bakhrushin Cent. Theat. Mus., and Tret'yakov Gal.; both at the Bol'shoy Theatre, Moscow) introduced new possibilities in stage design. In 1902 the directors of the imperial theatres invited him to St Petersburg and his works determined the style of many court productions. From 1908 he often worked in close collaboration with Vsevolod Meyerkhold on operas at the Mariinsky (later Kirov) Theatre (e.g. Musorgsky's *Boris Godunov*, 1911; St Petersburg, Rus. Mus.) and on plays for the Aleksandrinsky (now Pushkin) Theatre, notably Lermontov's *Maskarad* ('Masquerade'; Moscow, Bakhrushin Cent. Theat. Mus.) which constituted the confluence of all the theatrical experiments in St Petersburg in the early 20th century. Golovin attempted to harmonize architectural and painterly elements, using a series of meticulously executed large panels. The architectural monumentality of his sets distinguishes him from other stage designers of the period. For Golovin stage design and the architecture of the theatre were inseparable. He was well known as a designer of theatre curtains, and he had an intuitive sense for historical costume. He regarded theatre as a festive and solemn spectacle. He also worked with Serge Diaghilev on his first Paris productions: *Boris Godunov* (1908; Moscow, Bakhrushin Cent. Theat. Mus.) and Stravinsky's ballet *L'Oiseau de feu* (1910; Moscow, Tret'yakov Gal., and St Petersburg, Theat. Mus.). During the 1920s Golovin's style in stage design remained the same. The most important projects of this period were for Konstantin Stanislavsky at the Moscow Arts Theatre (Mkhat): Beaumarchais's *Le Mariage de Figaro* (1927) and Shakespeare's *Othello* (1927–30; not realized; designs for both in Moscow, Mkhat Mus.). In 1926 Ida Rubinstein produced for the Paris Opéra a mime drama, *Orphée*, with décor by Golovin.

At the same time Golovin continued his easel painting: he created a special genre of landscape interpreted as a decorative panel combining scrupulously worked-out details with accentuated ornament, his landscapes overall constituting an ornamental suite of harmonious colours; for example *Birch Trees* (gouache, 1908–10) and *Marsh Thicket* (tempera, 1917; both Moscow, Tret'yakov Gal.). In many works on Spanish themes he tried to solve purely pictorial problems by combining monumentality of composition with the representation of a figure as a spot of colour. In his still-lifes an object is always presented colourfully, and at the same time clearly and ingenuously transformed. Golovin also painted numerous psychologically subtle portraits in which he reinterpreted classical form in a modern way without academic coldness and alienation (e.g. the portrait of *Vsevolod Meyerkhold*, 1917; St Petersburg, Theat. Mus.). He painted numerous portraits of the singer Feodor Shalyapin on stage (e.g. *Shalyapin in the Role of Boris Godunov*, 1912; St Petersburg, Rus. Mus.).

WRITINGS

Vstrechi i vpechatleniya: Pis'ma, vospominaniya o Golovine [Meetings and impressions: letters, reminiscences of Golovin] (Leningrad and Moscow, 1960)

BIBLIOGRAPHY

D. Kogan: *A. Golovin* (Moscow, 1960)
A. Bassekhes: *Teatr i zhivopis' A. Ya. Golovina* [Theatre and paintings of A. Ya. Golovin] (Moscow, 1970)
S. Onufriyeva: *A. Golovin* (Leningrad, 1977)
E. Fedosova, ed.: *Alexander Golovin: Album* (Leningrad, 1989) [in Eng.]
M. N. Pozharskaya: *Aleksandr Golovin: Put' Khudozhnika* [A. Golovin: the artist's path] (Moscow, 1990)

V. RAKITIN

Gol'ts, Georgy (Pavlovich) (b Bolsheve, Moscow region, 6 March 1893; d Moscow, 27 May 1946). Russian architect. Before World War I, he enrolled at the prestigious Moscow Ninth Gymnasium, a school renowned for its teaching of the Classics, ancient literature, history and art. After briefly serving in the army, he entered the painting faculty of Vkhutemas (Rus.: Higher Artistic and Technical Workshops), Moscow, transferring after a year to architecture and joining the unit led by Nikolay Ladovsky, later one of the founding members of the Asnova group (Rus.: Association of New Architects). Gol'ts's Diploma project for a garden city in 1922 gave him the opportunity to travel to Italy, where he studied the work of Brunelleschi. On his return to Moscow he became interested in the attempt of Ivan Zholtovsky to develop an architecture based on a revival of Italian Renaissance ideas, and subsequently worked with him in 1927–9 and 1934–5. He was also briefly associated with OSA (Rus.: Union of Contemporary Architects).

Gol'ts's reputation as a designer was secured by three industrial buildings of the late 1920s: a paper factory (1926) in Balakhna, with Aleksandr Shvidkovsky, and a power-station (1928–31), Kiev, and a factory (1928–31), Ivanteyevka, both with Mikhail Parusnikov. Heavily glazed with steel ribbon windows and constructed of standardized components, the latter two buildings in particular exemplify modernist functional design, while achieving both a severity and an elegance. During the early 1930s he participated in the heated debates as Soviet architects became polarized between the advocates of a monumentalist architecture based on Neo-classicism, and those that sought to continue the work of the early pioneers of the avant-garde. Although believing architecture was dependent on the study and understanding of the Classical heritage, he struggled to maintain an independent position.

Gol'ts produced thirty designs for Moscow alone, including numerous ones for theatres and residential blocks, of which only nine were realized. Of these the

most outstanding is the housing project (1939–41; with Arkady Mordvinov and Dmitry Chechulin) on Bol'shaya Kaluzhskaya Street (later Leninsky Prospect), Moscow. While the building is of a rather simple, heavy masonry construction, it is historically important for the repetitive use of similar sections, and of brickwork, ceramic and concrete details. Termed 'high-speed production line' construction, the technique was one of the early attempts to introduce a form of mass production into building. As an urban planner Gol'ts was involved in the formulation of the development plan (1935) for Moscow, and in producing landscape and housing proposals for sites by the River Moskva. He subsequently led a team of designers investigating the planning of Smolensk, and participated in the plans for Stalingrad and Kiev.

BIBLIOGRAPHY
N. Tret'yakov: *Georgy Gol'ts* (Moscow, 1969)
S. O. Khan-Magomedov: *Pioneers of Soviet Architecture* (London, 1983)
A. V. Ryabushin and I. V. Shishkina: *Sovetskaya arkhitektura* [Soviet architecture] (Moscow, 1984), pp. 50, 69, 73
A. M. Shuravlev, A. V. Ikonnikov and A. G. Rochegov: *Arkhitektura Sovetskoy Rossii* [The architecture of Soviet Russia] (Moscow, 1987)
A. V. Ikonnikov: *Russian Architecture of the Soviet Period* (Moscow, 1988)
Zodchiye Moskvy [The architects of Moscow] (Moscow, 1988)

JONATHAN CHARNLEY

Goltzius [Gols; Goltius; Goltz; Golzius], **Hendrick** [Hendrik] (*b* Mülbracht [now Bracht-am-Niederrhein], Jan or Feb 1558; *d* Haarlem, 1 Jan 1617). Dutch draughtsman, printmaker, print publisher and painter. He was an important artist of the transitional period between the late 16th century and the early 17th, when the conception of art in the northern Netherlands was gradually changing. Goltzius was initially an exponent of Mannerism, with its strong idealization of subject and form. Together with the other two well-known Dutch Mannerists, Karel van Mander I and Cornelis Cornelisz. van Haarlem, he introduced the complex compositional schemes and exaggeratedly contorted figures of Bartholomäus Spranger to the northern Netherlands. These three artists are also supposed to have established an academy in Haarlem in the mid-1580s, but virtually nothing is known about this project. In 1590 Goltzius travelled to Italy, thereafter abandoning Spranger as a model and developing a late Renaissance style based on a broadly academic and classicizing approach. Later still, his art reflected the growing interest in naturalism that emerged in the northern Netherlands from *c.* 1600. In fact, Goltzius's ability to emulate the style and technique of different artists and to adapt to current trends earned him distinction as a 'Proteus of changing shapes'.

The intellectual milieu in which Goltzius worked was formed by the humanist printmaker Dirck Volkertsz. Coornhert, with whom he studied, and the learned Latin schoolmasters Franco Estius (*b c.* 1545) and Cornelis Schonaeus (1540–1611), who provided inscriptions for his engravings. Besides the art theories of van Mander (e.g. the latter's firm conviction of the affinity of painting and poetry; *see* UT PICTURA POESIS), Goltzius was influenced by the *Idea de' pittori, scultori ed architetti* (1607) of Federico Zuccaro, whom he had met in Rome. In his lifetime Goltzius's fame, in the Netherlands and elsewhere, was based largely on the technical skill and virtuosity of his engravings, which influenced many artists, including the

young Rubens. By 1596–7 examples of his prints had found their way to places as remote as the Arctic island of Novaya Zemlya, and in 1612 the English writer Henry Peachum recommended in *The Gentleman's Exercise*: 'For a bold touch, variety of posture, curious and true shadow, imitate Goltzius, his prints are commonly to be had in Pope-head-alley'.

1. Life. 2. Work. 3. Cultural context and subject-matter.

1. LIFE. Goltzius's great-grandfather, Hubrecht Goltz von Hinsbeck (*fl* 1494), was a painter at Venlo, as was his grandfather, Jan Goltz I (*fl* 1532–50). When Hendrick was three years old, his father, Jan Goltz II (1534–after 1609), moved from Mülbracht to Duisburg, where he worked as a glass painter. According to van Mander, as a child Hendrick apparently burnt his hand and thereafter was unable to extend his fingers fully. About 1574 Goltzius became a pupil of Coornhert's in Xanten. In 1577, after Haarlem had declared for William the Silent, Prince of Orange, Goltzius followed Coornhert to that city, where he worked until his death. In 1577–8 he executed large commissions as an engraver for the Antwerp publisher Philip Galle. In 1579 Goltzius married Margaretha Jansdr (*d* after 1628), a shipbuilder's daughter and a widow, who brought with her an eight-year-old son by her previous marriage, Jacob Matham; the Goltzius marriage was childless. In 1582 Goltzius opened his own graphic printing house. He became a patron and a close friend of van Mander after the latter settled at Haarlem in 1583, and in those years he negotiated with the Jesuits of Rome over an engraving commission. Jacob Matham, Jacques de Gheyn II and Jan Muller were among his pupils in the late 1580s.

Van Mander, Goltzius's chief biographer, recorded that he fell ill (probably of consumption) and that, apparently for health reasons, he went to Italy at the end of October 1590; the progress of this illness can be seen in his self-portraits. In Italy Goltzius visited Rome and Naples and, on both the outward and return journeys, Venice and Florence. There he drew a number of artists' portraits and also recorded the wonders of Rome, from famous antique statues to the façade paintings of Polidoro da Caravaggio, as well as works by other important Italian artists. By the end of 1591 Goltzius was back in Haarlem. During this period Jan Saenredam, among others, worked as an engraver in his studio (for illustration of an engraving by Saenredam after Goltzius *see* PRINTS, fig. 9). Although his health again worsened, Goltzius continued to work vigorously; his prints were on sale everywhere, including foreign countries. Then, in or about 1600, he turned to painting and more or less gave up engraving. In 1605 he was duped by an alchemist whom he had taken into his house on the strength of his claims to be able to make gold. In June 1612 Goltzius and his fellow guild artists entertained Rubens when the latter visited Haarlem. In 1614 a scandal was caused by Goltzius's alleged 'carnal' relationship with a maid. In October 1616 Sir Dudley Carleton wrote of his visit to Haarlem: 'Goltzius is yet living, but not like to last owt an other winter; and his art decays with his body'. The day after Goltzius's death, the

Haarlem funeral bell tolled half an hour for him, at a cost of 7 guilders.

2. WORK.

(i) Drawings. (ii) Prints. (iii) Paintings.

(i) Drawings.

(a) Technique and media. Goltzius was a versatile and masterly draughtsman, skilled in the use of several different instruments and media: metalpoint, quill pen and ink, brush and wash, and red and black chalk. He does not seem to have had any preference but became famous chiefly as a 'master of the pen'.

Goltzius's metalpoint technique was inherited from the traditional practice of Dürer, in which pieces of paper or parchment were first primed with a pulp of bone-ash and glue and then prepared with a light brown or yellow ground, on which the artist could work in metalpoint with great accuracy. It is often hard to know which metal is used since the lines oxidize over time, but in Goltzius's case it was mainly silverpoint. However, he used leadpoint, which is softer, leaves traces more easily and can be recognized by its shiny effect, in the portrait of *Jean Niquet* (*c.* 1595; Amsterdam, Rijksmus.). By incising the upper layer of coloured preparation, the white ground was sometimes used to create highlights, as in Goltzius's portraits of his parents-in-law, *Jan Baertsen* and *Elizabeth Waterland* (both 1580; Rotterdam, Mus. Boymans–van Beuningen). Sometimes the hard primed sheets were bound together to form a drawing-book. No actual books are known to have survived, but there are individual leaves, such as the portrait of his father, *Jan Goltz II* (1579; Copenhagen, Stat. Mus. Kst.), which are drawn on both sides. Goltzius's early realistic portrait drawings in metalpoint are the continuation of an older Netherlandish tradition: they are executed with great precision, sober

1. Hendrick Goltzius: *Gillis van Breen*, pen and brown ink, 199×214 mm, 1590 (Haarlem, Teylers Museum)

and unadorned. After 1590 their handling is looser and less detailed, as was made possible especially with the softer leadpoint. After 1600 Goltzius seems, with a few exceptions, to have practically abandoned metalpoint: an example of his later style, freer and more sketchlike, is the *Portrait of a Man with a Long Grey Beard* (*c.* 1610; Haarlem, Teylers Mus.). Goltzius used metalpoint not only for small finished portraits intended as independent works of art but also for head studies, such as that of the Polish envoy *Stanislas Sobocki* (1583; Amsterdam, Rijksmus.). This carefully executed study was then placed on a full-length body, intentionally schematic and not based on visual observation, for Goltzius's portrait engraving of the envoy (Strauss, no. 174). That metalpoint drawings also served as records of observed reality is evident from the spontaneous drawings of the artist's dog, a Drent spaniel, in various attitudes (e.g. *c.* 1596; Paris, Fond. Custodia, Inst. Néer.) and by sketches of more exotic animals, such as the *Study of a Camel* (*c.* 1589; London, BM).

Goltzius was also skilled at drawing in chalk. Even before his visit to Italy in 1590, he executed several sheets in this medium, then very little used in the northern Netherlands. His complete command of this technique is apparent in the *Four Studies of a Hand*, perhaps showing his own crippled right hand (*c.* 1588; Frankfurt am Main, Städel. Kstinst. & Städt. Gal.), a drawing in red and black chalk. Even more elaborate in technique is the drawing of a *Lumpfish (Cyclopterus lumpus)* (1589; Brussels, Bib. Royale Albert 1er), with green chalk as well as red and black, and watercolour wash and stumping. In early chalk portraits, such as that of *Gillis van Breen* (1588; Frankfurt am Main, Städel. Ksthist. & Städt. Gal.), the technique is closer to the French *à trois crayons* method than to any Italian model. Goltzius's chalk technique was enriched by his visit to Italy and his exposure to chalk drawings by Federico Zuccaro and Federico Barocci. Goltzius's portrait of *Giambologna* (1591; Haarlem, Teylers Mus.) is a true masterpiece, the equal of any chalk study by Zuccaro; it is remarkable for its expressive painterly quality, achieved by the use of black and red chalk and a light application of chestnut-brown wash to the eyes and beard. Some drawings, such as the two of the *Holy Family* (late 1590s, Otterlo, Rijksmus. Kröller-Müller; and *c.* 1600, Weimar, Schlossmus.), were clearly made in imitation of Barocci. After 1600 Goltzius's chalk technique became softer and more refined. Red and black chalk are used for lightly hatched strokes, but much of this is then dissolved through extensive stumping, as in a series of realistic, yet idealized portraits of women (e.g. *c.* 1605–10; Oxford, Ashmolean), which reveal a tenderness and feeling for female charms not previously found in Goltzius's work.

Although the technique of many of Goltzius's pen-and-ink drawings is closely related to the practice of engraving with the burin, he also made rapid, summary pen sketches, such as that of the pose of *William of Orange* (1581; Darmstadt, Hess. Landesmus.), a study for the portrait engraving (B. 178). This figure sketch was, in fact, of incidental importance: Goltzius was mainly concerned with the allegorical figures in the border and with the cartouche for the inscription, which are carefully elaborated with pen and brush. Both during and after his lifetime, Goltzius was famous for his *Federkunststücke* (or

'pen works'), a term introduced by Joseph Meder in *Die Handzeichnung* (Vienna, 1923). These are large and impressive imitations of engravings, drawn in pen and ink. One such example is a portrait, drawn two years after the chalk study, of *Gillis van Breen* (1590; Haarlem, Teylers Mus.; see fig. 1); another was recorded in Rudolf II's collection in Prague—a *Head of Mercury*, probably the drawing now in Oxford (Ashmolean). In 1604 Goltzius produced a unique, astonishing specimen of this technique: on a prepared canvas measuring 2.28×1.78 m he drew *Venus, Bacchus and Ceres with Cupid* ('*Sine Cerere et Libero friget Venus*'; St Petersburg, Hermitage), which once had pride of place in the collection of Pierre Crozat. Drawings in brush and wash alone are rare in Goltzius's work, but he used the brush and white highlights for his working drawings for engravings, such as those (e.g. three sheets of *c.* 1590; all Hamburg, Ksthalle) for an anonymous series of prints of Ovid's *Metamorphoses*. Among the known artists who made engravings after his drawings are his pupils de Gheyn, Matham and Saenredam.

(b) Style. Goltzius's draughtsmanship before 1590 is relatively straightforward: first he drew in the manner of Maarten van Heemskerck, later in that of Anthonie Blocklandt and, from 1585 onwards, that of Spranger. He had no clear style of his own but followed current fashion for commercial reasons. The only group that could be described as original is the fine series of small metalpoint portraits (*see* §(a) above). His journey to Italy in 1590–91 led to a new, broader approach. Besides the work of Zuccaro and Barocci, his models were the prints of Titian and Domenico Campagnola, as well as Dürer, Lucas van Leyden and those after Pieter Bruegel I. What is remarkable is that he was now able to imitate several styles simultaneously. From *c.* 1600 his draughtsmanship became so heterogeneous that it defies classification. Some studies of female nudes (e.g. 1594; USA, priv. col., see Reznicek, 1993, fig. 69) and two landscapes of views around Haarlem (both 1603; Paris, Fond. Custodia, Inst. Néer.; Rotterdam, Mus. Boymans–van Beuningen) seem to have been drawn from life, anticipating later examples of naturalistic Dutch art. In exploring different artistic sources, Goltzius seems to have ignored the work of Rubens as a draughtsman, although his magnificent red and black chalk drawing of a *Man with a Long Grey Beard and Bowed Head* (1610; Amsterdam, Rijksmus.) has an expressive force not inferior to anything Rubens could achieve.

(ii) Prints.

(a) Engravings and etchings. In his pioneering study of 1921 Hirschmann catalogued 361 prints by Goltzius, mostly engravings and only a few etchings. Those designed by Goltzius himself numbered 291, while the remainder were made by him after the work of other artists. Before his journey to Italy, he engraved designs by Blocklandt, Joannes Stradanus, Dirck Barendsz., Marten de Vos, Spranger and Cornelisz. van Haarlem; after his return, he made reproductive prints of ancient sculpture and Italian paintings, such as those by Raphael, Palma Giovane and Annibale Carracci. Goltzius used drawings or copies of drawings by all these artists, which stimulated the development of his engraving style.

In his early years as an apprentice in Xanten with Coornhert, who was a mediocre engraver working mostly after drawings by van Heemskerck, Goltzius does not seem to have designed engravings of his own. Afterwards he worked for Philip Galle and probably executed, anonymously, less important parts of copperplates.

Goltzius's earliest signed engravings (e.g. the *Annunciation*, 1578; S 23), dating from after he had settled in Haarlem, are in the Flemish style that then prevailed in Galle's circle. The large engraving of the *Venetian Ball* (1584; S 182), printed from two plates after Dirck Barendsz., marks the beginning of a new technique with a more balanced distribution of light and dark and a more dynamic use of the burin. This development can also be seen in the early portrait engravings. Goltzius's resourcefulness as a businessman is apparent from the series of prints illustrating the *Funeral of William of Orange* (S 192–203), who died on 3 August 1584; before the end of the year Goltzius, who calculated that an etching needle was faster than the burin, etched the funeral procession on 12 sheets, measuring nearly 5 m in length.

From 1585 Goltzius engraved for Spranger. To convey the dynamism of the latter's nudes, he developed a new burin technique in which the grooves cut in the copper gradually swelled or became thinner according to the pressure of the burin. The varying thickness of the parallel hatchings and crosshatchings determined the distribution of light and dark, the 'colour' or tone and the volumetric effect of the print. Sometimes the areas of shade were strengthened by stippled dots between the crosshatchings. This technique reached its height in 1587–8, in engravings such as the very large *Wedding of Cupid and Psyche* after Spranger (1587; S 255; *see* ENGRAVING, fig. 6), a kind of pattern-card of the influential Mannerist style, and the five prints after Cornelisz. van Haarlem, a series of the *Four Disgracers of Heaven* (S 257–60) and *Two Followers of Cadmus Devoured by a Dragon* (S 310; for the original painting *see* CORNELISZ. VAN HAARLEM, CORNELIS, fig. 1). A year later the *Great Hercules* (1589; S 283) appeared, with its strange-looking bruiser with swollen muscles, who came to be known in Holland as the *Knolleman* ('*Bulb Man*').

After Goltzius returned from Italy, he never again engraved after Spranger, Cornelisz. van Haarlem or any other compatriot. After a period of dynamism, technically and stylistically, he now sought a greater sense of harmony and restfulness. He toned down the unnatural proportions of his earlier figures, and the engravings of what have become known as the master years (1590–98) generally appear smoother. The back of the *Farnese Hercules* (*c.* 1592; S 312), with its strong contrasts of light and dark, however, still recalls the 'bulbous' style of *c.* 1588. The engraving was made after two drawings Goltzius made and brought back from Rome (both 1591; Haarlem, Teylers Mus.). The *Triumph of Galatea* (1592; S 288) after Raphael is, in its perfect sensibility, one of the finest engravings after fresco. The *Meisterstiche* or *Master Engravings* is the name given to six large engraved scenes from the *Life of the Virgin* (1593–4; S 317–22). From the outset, they were regarded as models of several different

2. Hendrick Goltzius: *Venus, Ceres and Bacchus*, engraving, 227×198 mm, 1595 (Amsterdam, Rijksmuseum)

styles: those of Raphael, Parmigianino, Jacopo Bassano, Barocci, Lucas van Leyden and Dürer. They are not direct imitations of these masters but deliberate compositions in their character and style. The *Circumcision* (s 322) comes so close to Dürer that, according to van Mander, it was mistaken for his work. Other engravings followed in the style of Dürer and Lucas van Leyden. Goltzius's ability to enter into the style of other masters is also seen in the *St Jerome* (1596; s 335) after Palma Giovane, a masterpiece dedicated to his friend the sculptor Alessandro Vittoria. The latter made a portrait bust of *Palma Giovane* (Vienna, Ksthist. Mus.), of which Goltzius made a drawing (Berlin, Kupferstichkab.)—thus shedding light on Goltzius's circle of friends in Venice.

After 1590 Goltzius made relatively few portrait engravings, although the portrait of *Dirck Volkertsz. Coornhert* (c. 1591–2; s 287), printed from an unusually large copperplate and commemorating the humanist's death in 1590, shows Goltzius at the height of his powers. He also engraved a number of small portrait medallions on silver, none of which is now traceable, although there are prints from them, which bear the inscription in reverse. The original silver plate of *Venus, Ceres and Bacchus* (1595; Vienna, Ksthist. Mus.), which was also intended as an independent work of art, was formerly in the collection of Rudolf II (for prints taken from it, see s 325 and fig. 2). After 1600 Goltzius made few engravings. Most late examples are questionable and were in some cases probably engraved by his stepson, Jacob Matham.

See also ENGRAVING, §II, 3(i)(d).

(b) *Chiaroscuro woodcuts.* There are also 25 chiaroscuro woodcuts in Goltzius's oeuvre (s 401–25), some in several states. He introduced this technique in the northern Netherlands (*see* WOODCUT, CHIAROSCURO, §2), following the example of Hans Baldung and such Italians as Ugo da Carpi and Andrea Andreani. The earliest and only dated woodcut is the *Hercules and Cacus* (1588; s 403). *The Magicians* (or '*Cave of Eternity*'; see fig. 3) is not only the most imaginative but also the most brilliant in technique and colour. There is only one state, known in *c.* twenty impressions, printed from a line block in black and two colour blocks, the darker of which is olive green or sepia, the other different shades of green and beige.

Sometimes Goltzius obtained special effects by printing the line block by itself on to blue paper, as in the impressions of the single-state *Arcadian Landscapes* (s 407), unnatural especially in their colouring. The same technique stressed the fantasy quality of his seascapes (s 413–14; for illustration of his woodcut *Seascape with Sailing Vessels* after Cornelis Claesz. van Wieringen *see* WIERINGEN, CORNELIS CLAESZ. VAN). They were important models for the landscape drawings of the young Esaias van de Velde and the brothers Jan and Jacob Pynas and, above all, for the experimental prints of Hercules Segers, but the technique had no subsequent exponents among Dutch artists.

(iii) *Paintings.* In 1916 Hirschmann catalogued 18 paintings attributed to Goltzius; the number has since risen to 39. In 1600 Goltzius, already famous as an engraver, suddenly decided, like Jacques de Gheyn II, to take up oil painting. His reasons are not known but were probably a combination of his deteriorating eyesight, his belief, shared with van Mander, that painting was the noblest of the arts and, finally, the competition from Flemish artists migrating northwards. The earliest known example is the small painting on copper of the *Dead Christ on a Stone Slab* (1602; Providence, RI Sch. Des., Mus. A.); this was followed the next year by the impressive portrait of the flabby-looking shell-collector *Jan Govertsen* (1603; Rotterdam, Mus. Boymans–van Beuningen), Goltzius's only known painted portrait.

Most of Goltzius's paintings are large; the quiet, somewhat wooden composition is usually dominated by one or two monumental religious or mythological figures, as in the *Ecce homo* (1607; Utrecht, Cent. Mus.) or *Venus and Adonis* (1614; Munich, Alte Pin.). The conception of the painted nude is quite different from that in drawings and engravings of the Spranger period: the new, academic style is rooted, first of all, in Goltzius's knowledge and admiration of the Classical statuary he drew in Rome and, second, in the life drawings he made from 1594 onwards. The poses and movements are rather stiff; the colouring, a fiery reddish-brown, is pseudo-Venetian. He does not seem to have painted landscapes or still-lifes. Few, if any, drawings can be connected with paintings.

Goltzius's painting was much admired by his contemporaries, such as van Mander, but later sharply criticized: Constantijn Huygens the elder, for instance, thought it a failure. The poet Joost van den Vondel said nothing about him as a painter. Goltzius's pictorial work was long overshadowed by his world-famous engravings and the

3. Hendrick Goltzius: *The Magicians* (or '*Cave of Eternity*'), chiaroscuro woodcut, 349×265 mm, *c*. 1588 (Coburg, Kupferstichkabinett der Kunstsammlungen der Veste Coburg)

subsequent popularity of his drawings. In 1935 Willem Martin, in his pioneering account of 17th-century Dutch painting, devoted only one line to Goltzius. In 1981 three of Goltzius's paintings were shown in the *Gods, Saints and Heroes* exhibition (see 1980–81 exh. cat.). It was only then that he was rightly recognized as the earliest representative of the Dutch classicizing school and his reputation began to be restored. His chief pupil, as a painter, was Pieter de Grebber.

3. CULTURAL CONTEXT AND SUBJECT-MATTER. It is not certain whether Goltzius belonged to the Catholic Church. However, his wife and stepson were loyal Catholics, and his personal and commercial relations with the Church were good. Two of his most important series of prints, the *Life of the Virgin* and the *Passion* (1596–9; Hirschmann, nos 21–32), were dedicated to prominent Catholics, the first to William V of Bavaria and the second to Cardinal Federico Borromeo. Works by Goltzius were also owned by the Catholic rulers Philip II and Rudolf II, the latter having bought drawings and also an engraved copperplate direct from the artist. From the days when Goltzius was a pupil of Coornhert's he was also influenced by the latter's liberal philosophy, according to which anyone who holds Christ in his heart does not need a church. Goltzius's non-political stance and pragmatic commercial outlook as a print publisher is seen from his engraved portrait of Philip II's opponent, the Protestant sovereign *William of Orange* and that of his third wife *Charlotte of Bourbon* (1581; s 143) and from the 12-plate etching of William's funeral procession. The degree of Goltzius's interest in religious subjects reflects the changing political situation in the nascent Dutch Republic, particularly in Haarlem. Around 1578 or somewhat earlier he engraved large series of elaborate Christian allegories, which could be regarded as supporting the Counter-Reformation cause. In the 1580s, after Haarlem had declared itself on the side of the Calvinists, there were fewer commissions from Catholics for works such as altarpieces; only after 1590 did Goltzius's interest in religious themes revive.

Mythological subjects are richly represented in Goltzius's work, for which van Mander must have played a considerable part as adviser. Goltzius made many drawings of scenes from Ovid's *Metamorphoses*, which were engraved as Christian moral exempla. Van Mander, for instance, explained the scene of the *Two Followers of Cadmus Devoured by a Dragon*, depicted in Goltzius's engraving after Cornelisz. van Haarlem, as symbolizing the contrast between Cadmus, the model of the God-fearing man, who is seen killing the dragon in the background, and his two unfortunate companions, who represent the idle pursuits of youth. Goltzius's work is permeated with such allegorical and symbolic meanings, giving visual form to abstract ideas and edifying thoughts (for an illustration of his engraving from 1594 of *Quis evadet?* or an *Allegory of Transience*, see ICONOGRAPHY AND ICONOLOGY, fig. 10). Another representative example is the remarkable triptych painted on canvas (Haarlem, Frans Halsmus.), with nearly life-size figures of a Haarlem citizen attired as the half-naked *Hercules Overcoming Cacus* (1613) in the centre, flanked by *Mercury* (1611; see fig. 4) and *Minerva* with their symbolic attributes. Allusions are also present in secular works: a music-making couple accompanied by a heart usually signifies Hearing, a right hand represents Work, bagpipes Gluttony and so forth.

In a different category are those works that record Goltzius's surroundings—although even some of these are not devoid of allegorical significance. The academic copies of ancient statues that Goltzius made in Rome, the first of their kind in Dutch art, are of considerable interest archaeologically and from the point of view of cultural history. They are carefully executed and give a reliable indication of the condition of the statues in 1591. They also provide documentary evidence for the reconstruction of the papal sculpture garden of the Belvedere. However, sometimes they constitute more than a simple record of what the artist had seen; for instance, the *Farnese Hercules* was probably represented from the back because Pliny the younger (*Natural History*, XXXV.xciv) praised a '*Hercules aversus*' painted by Apelles.

With the exception of the three realistic drawings made in the neighbourhood of Haarlem, most of Goltzius's landscapes are imaginary, in the style associated with Bruegel and the Venetians. It is difficult to be certain of the symbolic significance of those pure landscapes that contain no accessory elements, but in other cases the landscape forms the setting for a narrative, although, as in the landscapes engraved after Bruegel, the figures are sometimes so small as almost to escape attention. The tiny figure of Mercury with his caduceus is seen hovering, upper left, in the wide, fantastic landscape drawing at Besançon (?1596; Mus. B.-A.). Landscapes could also

4. Hendrick Goltzius: *Mercury*, oil on canvas, 2.12×1.18 m, 1611 (The Hague, Koninklijke Kabinet van Schilderijen 'Mauritshuis', on loan to Haarlem, Frans Halsmuseum)

chained devil. The informal metalpoint studies of the artist's dog served as the basis for an elaborate chalk *Portrait of Goltzius's Dog* (*c.* 1597; Haarlem, Teylers Mus.), which was conceived more like a human portrait, and for the engraving of Goltzius's young pupil *Frederik de Vries with a Dog and a Pigeon*, generally known as '*Goltzius's Dog*' (1597; s 344). According to van Mander, the dove in the engraving stands for childlike innocence, while the dog is the kindly teacher who keeps watch over human souls.

Van Mander took a lowly view of realistic portraits, the making of which, he thought, cramped the imagination. This may explain why, despite numerous sober portraits from life, Goltzius also made engravings in which the central personage is surrounded by allegorical figures and motifs expressing his or her virtues, as is true of the engravings of *William of Orange* and *Dirck Volkertsz. Coornhert.*

BIBLIOGRAPHY
K. van Mander: *Schilder-boeck* ([1603]–1604)
A. von Bartsch: *Le Peintre-graveur* (1803–21) [B.]
O. Hirschmann: *Hendrick Goltzius als Maler, 1600–1610* (The Hague, 1916)
——: *Hendrick Goltzius*, Meister der Graphik (Leipzig, 1919)
——: *Verzeichnis des graphischen Werks von Hendrick Goltzius* (Leipzig, 1921)
E. K. J. Reznicek: 'Het begin van Goltzius' loopbaan als schilder' [The beginning of Goltzius's career as a painter], *Oud-Holland*, lxxv (1960), pp. 30–49
——: *Die Zeichnungen von Hendrick Goltzius*, 2 vols (Utrecht, 1961); review by A. E. Popham in *Burl. Mag.*, civ (1962), pp. 395–6
W. L. Strauss: *Hendrik Goltzius: The Complete Engravings and Woodcuts*, 2 vols (New York, 1977) [cat. rais.] [s]
Gods, Saints and Heroes (exh. cat., ed. A. Blankert; Washington, DC, N.G.A.; Detroit, MI, Inst. A.; Amsterdam, Rijksmus.; 1980–81), pp. 94–9
L. W. Nichols: '*Job in Distress*: A Newly Discovered Painting by Hendrick Goltzius', *Simiolus*, xiii/13–14 (1983), pp. 182–8
——: *The Paintings of Hendrick Goltzius* (PhD diss., New York, Columbia U., 1990)
——: 'The "Pen Works" of Hendrick Goltzius', *Bull. Philadelphia Mus. A.* (Winter 1992) [whole issue devoted to exh. held at Philadelphia, 1991–2]
'Goltzius: Studies', *Ned. Ksthist. Jb.*, xlii–xliii (1991–2) (Zwolle, 1993) [18 articles by specialists, and bibliography]
E. K. J. Reznicek: 'Drawings by Hendrick Goltzius, Thirty Years Later: Supplement to the 1961 *Catalogue raisonné*', *Master Drgs*, xxxi/3 (1993), pp. 215–78
Dawn of the Golden Age: Northern Netherlandish Art, 1580–1620 (exh. cat., ed. G. Luijten and others; Amsterdam, Rijksmus., 1993–4), p. 305, *passim*

E. K. J. REZNICEK

have a historical or patriotic significance, as in the *Ruins of Bredero Castle* (1600; Amsterdam, Rijksmus.), which formerly belonged to Count Arnolphus of Holland.

The drawing of the *Lumpfish* would certainly not be out of place as an illustration in a book on zoology, and Goltzius's scientific interest in botany is apparent in his drawings of plants, such as the metalpoint *Study of a Tobacco Plant* (*c.* 1585; Rotterdam, Mus. Boymans–van Beuningen). Although it records an actual event that took place between Scheveningen and Katwijk on 3 February 1598, the drawing of a *Beached Whale* (1598; Haarlem, Teylers Mus.), engraved by Matham the same year (B. 61), was interpreted as an omen portending war with Spain. The *Study of a Camel* symbolized, according to van Mander, a patient, virtuous man and was probably intended to represent the artist struggling with his illness. The delightful coloured drawing of a *Little Monkey* (*c.* 1605; Amsterdam, Rijksmus.; formerly attributed to Roelandt Savery; see Reznicek, 1993, fig. 60) stands for wickedness or the

Goltzius, Hubertus (*b* Venlo, 30 Oct 1526; *d* Bruges, 2 March 1583). Flemish humanist, printmaker, publisher, painter and numismatist. He was the son of Rutger den Meeler (Rutger van Weertsburg) and Catherina Goltzius, whose family name was taken by her husband. After studying in Venlo, Hubertus was sent to Luik (Liège) to the academy of Lambert Lombard, to whom he was apprenticed until 1546. He then moved to Antwerp, where he became a member of the Guild of St Luke and took on Willem Smout as his pupil. Before 1550 Goltzius married Elisabeth Verhulst Bessemers, a painter from Mechelen, with whom he had four sons and three daughters. Her sister Mayken Verhulst was the second wife of Pieter Coecke van Aelst, which brought Goltzius into artistic circles. Goltzius was active in Antwerp as a painter and

antiques dealer, but the only painting that can be attributed to him with certainty is the *Last Judgement* (1557) for the town hall at Venlo. In Antwerp he was introduced by his friends to prominent numismatists, for whom he made drawings of coins and began a system of their classification. For the same purpose Goltzius undertook a study trip in 1556 through the Netherlands and the Rhine Valley. The results of his investigations appeared in *Vivae omnium fere imperatorum imagines* (Antwerp, 1557), published by Gillis Coppens van Diest (*fl* 1543–73). The work was subsequently published in four other languages, the frontispiece in each edition, including the original, being printed in four different stages: one for the engraved text, two woodcut tone-blocks, and one woodcut key-block for the finer lines. Goltzius was apparently one of the first printers to combine woodcut and engraving in a single frontispiece (*see* WOODCUT, CHIAROSCURO, §2). The copies of the imperial portraits published in the books are executed in a cameo technique.

Abraham Ortelius introduced Goltzius to Marcus Laurinus (1530–81), a numismatist and an important figure in the humanist movement in Bruges in the second half of the 16th century, who became Goltzius's patron. Laurinus and Goltzius agreed to publish the sequel to the *Vivae* together; it was also their intention to publish five works on Greek history and five on Roman history. In 1588 Goltzius moved to Bruges, where he began to study the coin collection of Laurinus, who also financed a study trip for Goltzius through Germany, Switzerland, Italy and France. The itinerary and the 799 coin collections that he visited are given at the end of his book *C. Julius Caesar* (1563). In order to exercise the closest possible control over the quality of the work, Laurinus financed a printing house, in De Groene Wyncle (the Green Shop) on the Biscayersplaats in Bruges, that Goltzius supervised. Between 1563 and 1576 the Officina Goltziana printed 18 complete books, among them 4 folio works illustrated with pictures of coins, including *Sicilia et Magna Graecia* (1576; see fig.). The frontispieces of the four folios published in Bruges are certainly the finest of Goltzius's plates. The iconographic themes of each frontispiece are associated with the contents of the book that it introduces and are drawn mostly from scenes on coins that Goltzius had copied. The frontispieces are executed with both etching and engraving techniques; the typography is spare and severe and bears comparison with the best of the works printed by Christoph Plantin. Goltzius used four variants of the same printer's mark, representing the personification of Abundance, accompanied by the motto *Hubertus Aurea Seculi*. The printing house closed in 1576, and Goltzius had his *Thesaurus rei antiquariae* (1579) printed in Antwerp by Plantin. Although the Officina Goltzius was a private press, it was at the disposal of the Bruges humanists, who used it to publish a total of 15 works.

After Goltzius's death, his numismatic works were republished several times, including one edition under the title *Historia Augusta* (Antwerp, 1602), by P. van Tongeren. In 1617–20 Jacobus de Bie published five volumes by Goltzius, with additional material. In 1627–30 the unsold copies and copperplates came into the possession of Rubens, who then sold them to Balthasar Moretus, who

Hubertus Goltzius: engraved frontispiece to his *Sicilia et Magna Graecia*, 292×203 mm (Bruges, 1576) (Brussels, Bibliothèque Royale Albert 1er)

produced an *Opera omnia* of Goltzius in 1644–5. Sales of these publications, however, were disappointing, so that the remaining copies, in the possession of H. Verdussen of Antwerp by 1678, were given a new title-page in 1708. They remained on sale until 1834. Goltzius, an indispensable part of the humanist movement in 16th-century Bruges, was important for the dissemination of thousands of illustrations of coins, which were a reliable source for both historians and artists of the 16th century, and it was not until the 18th century that any doubt was cast on his reliability. His son Julius Goltzius (*fl* 1575–95) was an engraver who worked for Plantin; and the well-known printmaker, draughtsman and painter HENDRICK GOLTZIUS, with whom Hubertus is sometimes confused, was a great-nephew.

For an illustration of the portrait of Hubertus Goltzius by Anthonis Mor *see* PORTRAITURE, fig. 10.

WRITINGS
Vivae omnium fere imperatorum imagines (Antwerp, 1557; Ger. and It. trans., 1557; Fr. trans., 1559; Sp. trans., 1560)
C. Julius Caesar (Bruges, 1563)
Fastos magistratum et triumphorum romanorum (Bruges, 1566)
Caesar Augustus (Bruges, 1574)
Sicilia et Magna Graecia (Bruges, 1576)
Thesaurus rei antiquariae (Antwerp, 1579)

BIBLIOGRAPHY
H. de La Fontaine Verwey: *Humanisten, dwepers en rebellen in de zestiende eeuw* [Humanists, fanatics and rebels in the 16th century] (Amsterdam,

1965), i of *Uit de wereld van het boek* [From the world of the book], pp. 69–83

W. Le Loup: 'Hubertus Goltzius drukker-graveur' [Hubertus Goltzius printer–engraver], *Archf- & Bibwzn Belgïe*, xlvi/1–2 (1975), pp. 33–49; xlvi/3–4 (1975), pp. 567–91

A. Rouzet: *Dictionnaire des imprimeurs, libraires et éditeurs des XVe et XVIe siècles dans les limites géographiques de la Belgique actuelle* (Nieuwkoop, 1975), pp. 76–8 [incl. complete bibliog. to 1972]

Hubertus Goltzius en Brugge: 1583–1983 (exh. cat. by W. Le Loup, Bruges, Gruuthusemus., 1983–4)

W. LE LOUP

Goltzsche, Dieter (*b* Dresden, 28 Dec 1934). German painter, draughtsman and printmaker. He studied from 1952 to 1957 at the Hochschule für Bildende Künste in Dresden under Hans Theo Richter and Max Schwimmer (*d* 1960), and he then spent a year as a graduate student under Schwimmer at the Deutsche Akademie der Künste in Berlin. In 1960 he settled in East Berlin, where he played a significant role in the formation of the 'Berliner Schule', a term applied primarily to modernist painters concerned with formalist principles of pictorial construction.

Goltzsche established his reputation in the 1960s primarily through his work as a printmaker, which in its use of banal elements and terse or ironic tone entailed a reaction against the heroic concepts of official art. Basing his work on direct experience, he sought to condense physical appearances, whether dealing with landscapes, portraits, still-lifes, interiors or genre scenes, as seen in his *Self-portrait* (pen and ink, 1978; Berlin, Staatl. Museen, Neue N.G.). From 1978 he taught printmaking at the Kunsthochschule in Berlin.

BIBLIOGRAPHY

G. Schmidt: *Dieter Goltzsche: Werkverzeichnis der Radierungen, Holzschnitte, Linolschnitte, 1953–1978* (Berlin, 1978)

Dieter Goltzsche: Arbeiten des Zeichners (exh. cat., E. Berlin, Staatl. Museen, 1982)

G. Schmidt: *Dieter Goltzsche* (Dresden, 1988)

GUDRUN SCHMIDT

Golub, Leon (Albert) (*b* Chicago, 23 Jan 1922). American painter. In 1942 he received a BA in art history from the University of Chicago and enlisted in the US Army. After World War II he studied at the Art Institute of Chicago (BFA 1949; MFA 1950). The Holocaust and atomic bombings of Hiroshima and Nagasaki were early themes in his work, for instance the lithograph *Charnel House* (1946), which was based on newspaper photographs of Holocaust victims. He and other Chicago artists, including Cosmo Campoli (*b* 1922), George Cohen (*b* 1919) and Nancy Spero, were named the 'Monster Roster' by the art critic Franz Schulze (*b* 1927). In 1951 Golub and Spero were married.

During the 1950s Golub received considerable attention through exhibiting in New York, Chicago, London and in Paris, where he lived from 1959 to 1964. In his paintings of this period he depicted man as the victim of his own civilization, incorporating imagery from Assyrian, Hittite and Aztec art. His series entitled *Birth, In-self, Sphinx* (e.g. *Siamese Sphinx I*, 1954; Chicago, priv. col., see 1984 exh. cat., p. 17) and *Burnt Man* (e.g. *Burnt Man IV*, 1961; priv. col., see 1984 exh. cat., p. 26) were mythic metaphors for survival. Their message is intensified by tortured paint surfaces, a characteristic technique of scraping down,

eroding and reworking that Golub had developed by 1956. Impressed by Etruscan and Roman sculpture while in Italy (1956–7), Golub took examples from late Classical art to express the tragic reduction of man's godlike qualities to anguish and vulnerability as he attempts to control the irrational by means of the rational (e.g. *Orestes*, 1956; Chicago, priv. col., see 1984 exh. cat., p. 20). The battling gods and giants of the Hellenistic Altar of Zeus from Pergamon (Berlin, Pergamonmus.) served as a source for the classical nudes of Golub's large-scale *Gigantomachies* series of 1965–8 (e.g. *Gigantomachy I*, 1965; Chicago, Gene R. Summers priv. col., see Kuspit, pp. 132–3).

In his *Vietnam* series (1972–4) Golub confronted the immoral destructiveness of contemporary violence (e.g. *Vietnam II*, 1973; artist's col., see Kuspit, pp. 148–9). This shift from an ideal concept to a precise exposition required him to specify weapons, uniform and napalm through references to news photography, which give a mordant, contemporary edge to the pathology of power. From 1970 Golub no longer used stretchers for his canvases but hung them directly from nails in the wall, sometimes cutting away portions of the paintings. This heightened immediacy continued in a series of some hundred portraits (1976–9) of world leaders such as Brezhnev, Franco, Pinochet and Kissinger.

The series *Mercenaries* (begun 1975) and *Interrogations* (begun 1981) define even more precisely and rationally, within a contemporary context, the flagrant abuse of political power that preserves itself through violence (e.g. *Mercenaries V*, 1984; London, Saatchi priv. col.). Golub's aggressive images are charged with immediacy and brutality. The monsters are real; not metaphors but mercenaries, thugs and henchmen from the underbelly of power. A Pompeian red field pushes the twice life-size figures forward to the painting's surface and into the viewer's space. In *Interrogation II* (1981; Chicago, IL, A. Inst.) four torturers prepare to work over a naked male lashed to a chair, head in a black sack, and exposed to their sadistic skills. Based on sado-masochistic pornography, these images attract voyeuristic curiosity. The evil-doers look out from the painting with shocking intimacy, making the observer privy to their dirty secrets. Viewer participation is increased in such works as *Prisoners* (1985; London, Saatchi priv. col.), where we are placed within the victim's horrifying space. Golub's work stresses political conscience and has an unswerving commitment to the expression of man's existential relationship to the world.

BIBLIOGRAPHY

Leon Golub (exh. cat. by R. Melville, London, ICA, 1957)

Leon Golub (exh. cat. by J. A. Speyer, Philadelphia, Temple U. Gal., 1964)

Leon Golub: The Development of his Art (exh. cat. by L. Alloway, Chicago, IL, Mus. Contemp. A., 1974)

Leon Golub: Portraits of Power (exh. cat. by E. Bryant, Hamilton, NY, Colgate U., 1978)

M. Baigell: 'The *Mercenaries*: An Interview with Leon Golub', *A. Mag.* [New York], lv/9 (1981), pp. 167–9

Leon Golub, Mercenaries and Interrogations (exh. cat., ed. J. Bird and M. Newman; London, ICA, 1982)

Golub (exh. cat., ed. L. Gumpert and N. Rifkin; New York, New Mus. Contemp. A., 1984)

D. Kuspit: *Golub: Existential Activist Painter* (New Brunswick, 1985)

Golub (exh. cat by P. Schjeldahl, New York, Barbara Gladstone Gal., 1986)

EDWARD BRYANT

Golubaya Roza. *See* BLUE ROSE.

Golubkina, Anna (Semyonovna) (*b* Zaraysk [now in Moscow region], 28 Jan 1864; *d* Zaraysk, 7 Sept 1927). Russian sculptor. She studied in Moscow from 1889 to 1890 with the sculptor Sergey Volnukhin (1859–1921) and from 1891 to 1894 at the School of Painting, Sculpture and Architecture. In 1894 she studied at the Higher Artistic School of the Academy of Arts in St Petersburg and from 1895 to 1896 in Paris, at the Académie Colarossi. Between 1897 and 1898 she profited from the advice of Auguste Rodin.

Golubkina had a forceful personality, and she became one of the most outstanding Russian sculptors of the early 20th century, developing a tendency in her work towards Impressionism and Symbolism. She had keen sensibilities, and in her works she expressed the romance and novelty of the onset of the Revolutionary period. She was an active participant in the first Russian Revolution of 1905–6, and she created the first sculptural portrait of *Karl Marx* in Russia (plaster, 1905; Moscow, Tret'yakov Gal.). Golubkina conveyed in generalized, symbolic forms the awakening of self-awareness in the masses (e.g. *Walking*, plaster, 1903; St Petersburg, Rus. Mus. and *Worker*, plaster, 1909; Moscow, Tret'yakov Gal.). In the spirit of Art Nouveau she often turned to motifs of the figure dissolving into or interacting with the surrounding environment, as in *Wave* (plaster, 1902), the haut-relief on the façade of the Moscow Arts Theatre and *Birch Tree* (plaster, 1927; St Petersburg, Rus. Mus.). She was also a brilliant portraitist, with an ability to convey the mobility of the model's spiritual life and the dynamics of their creative thought, as in the sculptures of the philosopher *V. F. Ern* (wood, 1913; Moscow, Tret'yakov Gal.) and the writer *Lev Tolstoy* (plaster, 1927; Tula, A. Mus.). Her studio in Moscow was made into a museum.

BIBLIOGRAPHY
A. Kamensky: *Rytsarskiy podvig: Kniga o skul'ptore Anne Golubkinoy* [Chivalrous exploit: a book about the sculptor Anna Golubkina] (Moscow, 1978, rev. Moscow, 1990)
A. S. Golubkina: Pis'ma; neskol'ko slov o remesle skul'ptora; vospominaniya sovremennikov [A. S. Golubkina: letters; a few words about the sculptor's profession; recollections of her contemporaries], ed. E. Mourina and N. Korovich (Moscow, 1984)

V. P. TOLSTOY

Gombad-e Qabus. *See* GUNBAD-I QABUS.

Gomboš, Stjepan (*b* Sombor, 10 March 1895; *d* Zagreb, 29 April 1975). Croatian architect. He studied at the Technical Faculty of the University of Budapest and worked in Hugo Ehrlich's studio in Zagreb between 1924 and 1931. From 1931 to 1941 Gomboš was in partnership with MLADEN KAUZLARIĆ, and together they won several architectural competitions, including those for the headquarters of the Pensions Fund in Svačić Square, the Jewish Hospital, Farmers' Union building and the refurbishment of the Grand Café Corso, all in Zagreb. They also designed residential buildings and villas in Zagreb and on the Dalmatian coast, as well as the celebrated City Grand Café (1933) in Dubrovnik. In 1951 Gomboš became the chief architect of the Plan group in Zagreb. From 1950 to 1954 he was a lecturer at the architectural faculty, Zagreb University. During this time he designed and built the Rade Končar and Prvomajska factories in Zagreb.

WRITINGS
Regular contributions to *Arhitektúra* [Zagreb] and *Nase Gradjevinarstvo*

BIBLIOGRAPHY
'Vila Pučar 1935–36: Gomboš a Kavzlavić', *Arhitektúra* [Zagreb], xxxix/196–199 (1986), pp. 134–5, 284
Arhitektúra [Zagreb], xl/1–4 (200–203) (1987), p. 98

PAUL TVRTKOVIĆ

Gombrich, Sir Ernst (Hans Josef) (*b* Vienna, 30 March 1909). Austrian art historian, active in England. He read art history at the University of Vienna under Julius von Schlosser. On graduating in 1933 he was invited to help Ernst Kris, then keeper of decorative arts at the Kunsthistorisches Museum, in his study of caricature. With the rise of National Socialism, he emigrated to England in 1936, with a recommendation from Kris to Fritz Saxl, Director of the Warburg Institute. During World War II Gombrich served with British Intelligence, monitoring German broadcasts. After the war he returned to the staff of the Warburg, by then part of London University, and served as director of the Institute from 1959 to 1976. He has lectured widely and received many university appointments; for instance, he was elected Slade Professor of Fine Arts at Oxford (1950–53) and, later, at Cambridge (1961–3) and was also invited to Harvard University, Cambridge, MA (1959). His Mellon lectures in Washington, DC, on the psychology of representation became the basis for his book *Art and Illusion*. Many of his writings deal with aspects of perception and the role that seeing and learning play in interpreting visual images. He has also made an influential contribution to a linguistic approach to visual images.

Gombrich's most famous publication is his classic survey *The Story of Art*, which has been reprinted many times and in numerous languages since its first appearance in 1950. Several million copies have been sold, making it the bestselling art book ever. Conceived as an introductory survey of art, it is written in an erudite but accessible style. He claimed that it was compiled almost entirely from memory and that it was never intended as a textbook but meant to be read as a 'story'. One of the century's most eminent art historians, Gombrich is renowned for the breadth of his writings, ranging from essays on theory, STYLE, decorative art, design and art education to studies of the artists Giulio Romano, Oskar Kokoschka and Saul Steinberg.

WRITINGS
Giulio Romano als Architekt (Ph.D. diss., U. Vienna, 1933)
'Zum Werke Giulio Romano', *Jb. Ksthist. Samml. Wien*, n. s., viii (1934), pp. 79–104; ix (1935), pp. 121–50
with E. Kris: 'The Principles of Caricature', *Brit. J. Medic. Psychol.*, xvii (1938), pp. 319–42; repr. in E. Kris: *Psychoanalytic Explorations in Art* (New York, 1952)
——: *Caricature* (Harmondsworth, 1940)
The Story of Art (London, 1950, 2/1950, 3/1951, 4/1952, 5/1953, 6/1954, 7/1955, 8/1956, 9/1958, 10/1960/*R* every year 1961–4; rev. and enlarged, 11/1966/*R* every year 1966–8; enlarged and redesigned, 12/1972/*R* every year 1972–6; rev. and enlarged, 13/1978/*R* 1979 and 1981–3; enlarged and reset, 14/1984/*R* every year 1985–8; rev. and enlarged, 15/1989/*R* 1990–91; rev. 16/1995)
Art and Illusion: A Study in the Psychology of Pictorial Representation (London, 1960, 2/1962, 3/1968, 4/1972, 5/1977)

Meditations on a Hobby Horse and other Essays on the Theory of Art (London, 1963, 2/1971, 3/1978, 4/1985)

Norm and Form (London, 1966, 2/1971, 3/1978, 4/1985), i of *Studies in the Art of the Renaissance*

Aby Warburg: An Intellectual Biography (London, 1970, Oxford, 2/1986) [incl. memoir on the history of Warburg Library by F. Saxl]

with J. Hochberg and M. Black: *Art, Perception and Reality* (Baltimore, 1972, 2/London, 1973)

Symbolic Images (London, 1972, 2/1978, 3/1993), ii of *Studies in the Art of the Renaissance*

with R. Gregroy: *Illusion in Nature and Art* (London, 1973)

The Heritage of Apelles (Oxford, 1976), iii of *Studies in the Art of the Renaissance*

Means and Ends: Reflections on the History of Fresco Painting (London, 1976)

Ideals and Idols: Essays on Values in History and in Art (Oxford, 1979)

The Sense of Order: A Study in the Psychology of Decorative Art (Oxford, 1979)

The Image and the Eye: Further Studies in the Psychology of Pictorial Representation (Oxford, 1982, 2/1986)

Tributes: Interpreters of our Cultural Tradition (Oxford, 1984)

New Light on Old Masters (Oxford, 1986), iv of *Studies in the Art of the Renaissance*

R. Woodfield, ed.: *Reflections on the History of Art, Views and Reviews* (Oxford, 1987)

'"Anticamente moderni e modernamente antichi": Note sulla fortuna critica di Giulio Romano pittore', *Giulio Romano* (exh. cat., ed. M. Tafuri; Mantua, Pal. Te and Pal. Ducale, 1989)

Topics of our Time: Twentieth-century Issues in Learning and in Art (London, 1991)

Ce que l'image nous dit (Paris, 1991); Eng trans. as *A Lifelong Interest: Conversations on Art and Science with Didier Eribon* (London, 1993)

BIBLIOGRAPHY

N. Goodman: *Languages of Art: An Approach to a Theory of Symbols* (New York, 1968)

W. J. T. Mitchell: 'Nature and Convention: Gombrich's Illusions', *Iconology: Image, Text, Ideology* (Chicago and London, 1986)

C. Montes Serrano: *Creatividad y estilo: El concepto de estilo en E. H. Gombrich* (diss., U. Navarra, 1989)

M. Sitt, ed.: *Kunsthistoriker in eigener Sache* (Berlin, 1990), pp. 63–100

K. Lepsky: *Ernst H. Gombrich: Theorie und Methode* (Vienna and Cologne, 1991)

J. Lorda Iñarra: *Gombrich: Una teoria del arte* (Barcelona, 1991)

J. Onians, ed.: *Sight and Insight: Essays on Art and Culture in Honour of E. H. Gombrich at 85* (London, 1994)

☐

Gomes, António (*b* Santo Tirso, *c.* 1660–70). Portuguese wood-carver and sculptor. Active in Oporto, he worked first for Domingos Lopes and then partly alone and partly in collaboration with Filipe da Silva (*fl* 1677–1725). This partnership produced carvings (1718) for the chapel of Nossa Senhora da Conceição in the church of the convent of S Francisco and the altarpiece and credence-table (1719–22) for the chapel of the Espírito Santo de Miragaia Hospital. Their finest work, however, is at the Cistercian nunnery of Arouca, where they carved frames for the choir-stalls between 1722 and 1725. These Baroque compositions contain devotional paintings, enclosing them within gilded acanthus foliage.

BIBLIOGRAPHY

R. C. Smith: *A talha em Portugal* (Lisbon, 1963), p. 165

——: *Cadeirais de Portugal* (Lisbon, 1968), p. 53

NATALIA MARINHO FERREIRA ALVES

Gomes (de Oliveira), Augusto (*b* Matosinhos, Oporto, 1910; *d* Matosinhos, 1976). Portuguese painter and designer. He attended the Escola Superior de Belas Artes in Oporto, where he later taught. Throughout his life Gomes remained attached to the human and landscape themes of his native seaside town. Drawing upon the lessons of

Florentine Quattrocento composition and colour and Neo-Realist themes of sorrow, poverty and work, he maintained an interest in compact solid form and muted tertiary colours. Despite the drama of the compositions, a lyrical tone often prevails.

The clear, crisp outlines, the matt, muted colours he used and the thinly painted, dry surface of his works made Gomes's style particularly suited to the fresco technique, and he received numerous commissions, including that of the chancel of the church of Our Lady of the Immaculate Conception in Oporto.

BIBLIOGRAPHY

Augusto Gomes (exh. cat., Matosinhos, Câmara Mun., 1980)

RUTH ROSENGARTEN

Gomes, Dórdio (Simão César). *See* DÓRDIO GOMES.

Gomes, Fernão (*b* Albuquerque, Castile, ?1548; *d* Lisbon, 25 Sept 1612). Spanish painter, active in Portugal. He became a leading exponent of Mannerist art in Portugal, where he is recorded in 1570 when he made a portrait (untraced; known from a copy, Lisbon, Comissão N. Comemorações Descobrimentos Port.) of the poet *Luís de Camões* (1524–80). Between 1570 and 1572 Gomes was in Delft as a pupil of Anthonie Blocklandt, and subsequently his style became characterized by a synthesis of those of Luis Morales and of the Italianate Netherlandish painters. In 1573 he painted an *Ascension* for Funchal Cathedral, Madeira (*in situ*). For the Convento da Anunciada, Lisbon, he painted a mural of the *Triumph of Obedience* (1588; destr. 1755), influenced by the decrees of the Counter-Reformation, which is known from a preliminary drawing (Lisbon, Mus. N. A. Ant.).

A preparatory drawing of the *Ascension* by Gomes (signed and dated 1599; Lisbon, Mus. N. A. Ant.) was possibly intended for a commission (untraced) for the Convento de Cristo at Tomar and is one of his most remarkable works, inspired by an engraving after Raphael's *Transfiguration* (1517–20; Rome, Pin. Vaticana). After 1580 Gomes painted the ceiling of the chancel in the Hospital Real de Todos-os-Santos, Lisbon (ceiling destr. 1601), known from the preparatory drawing (Lisbon, Bib. N.). In 1594 he painted five panels with scenes from the *Life of the Virgin* for the Jerónimos Monastery, Belém, Lisbon, of which there exists a *Birth of the Virgin*, after an engraving of the same subject by Albrecht Dürer, and an *Annunciation* (both *in situ*, upper choir), which shows a degree of freedom from rigid Tridentine conventions.

BIBLIOGRAPHY

D. L. Markl: *Fernão Gomes: Um pintor de tempo de Camões* (Lisbon, 1973)

——: *Duas obras inéditas de Fernão Gomes no Museu Nacional de Arte Antiga* (Lisbon, 1980)

D. L. Markl and V. Serrão: *Os tectos maneiristas da Igreja do Hospital Real de Todos-os-Santos, 1580–1613* (Lisbon, 1980)

DAGOBERTO L. MARKL

Gomes do Avelar, Francisco (*b* 1739; *d* 1816). Portuguese bishop and patron. He was representative of the Catholic Enlightenment in Portugal during the Pombaline era. In accordance with his training as an Oratorian and his concern for the welfare of his flock, his interests were more pastoral and less doctrinal than those of his friend, Frei Manuel do Cenáculo Villas Boas. His concerns led to

the building of seminaries and hospitals, and his spiritual and humanist tendencies led him to write and translate works on both religious and secular subjects, of which his essays on agriculture are an example. He believed that art was a means of human improvement and architecture a manifestation of human and Christian dignity, and his patronage of the arts, to which his visit to Rome must have contributed, was an aspect of his pastoral service. Following Gomes do Avelar's appointment as Bishop of the Algarve in 1789, he commissioned the Italian architect Francesco Saverio Fabri to build an episcopal palace in Faro and many churches (including S Maria, Tavira) as well as to work on other projects in Faro including the Arco da Vila (c. 1792) and the hospital and seminary (1790–94). After Fabri left for Lisbon in 1794, Gomes do Avelar continued the building work and acquired a reputation as an amateur architect. He was one of the instigators of Neo-classicism in Portugal, as is evident from his choice of architect. Despite the impoverished state of his diocese and his own restricted means Gomes do Avelar ensured that there were examples of contemporary painting in the Algarve. In 1790 he gave to Faro Cathedral the painting of *St Thomas Aquinas* (*in situ*) by Liborio Guerini (1750–1825) and two large canvases after cartoons by Raphael, *St Paul Preaching* and the *Death of Ananias*. In 1791 he gave *Christ Among the Doctors* by Marcello Leopardi (*d* ?1795) to the chapel of the new seminary in Faro and in 1792 he presented to the Franciscan convent, Faro, four paintings, two of which are signed, with scenes from the *Life of St Francis*. He also commissioned a *St Vincent* for Faro Cathedral from an unknown artist and the *Fathers of the Church* from Francisco Vieira Portuense (1792; Faro, Nossa Senhora de Assunção). He also acquired engravings by Piranesi.

BIBLIOGRAPHY
F. X. Athaíde de Oliveira: *Biografia de Dom Francisco Gomes do Avelar* (Oporto, 1902)
J. Cabrita: 'As cartas de Careno', *Fol. Domingo*, 1317 (1940)
JOSÉ EDUARDO HORTA CORREIA

Gómez, Juan de Alfaro y. *See* ALFARO Y GÓMEZ, JUAN DE.

Gómez, Pedro Nel. *See* NEL GÓMEZ, PEDRO.

Gómez de Silva de Mendoza y de la Cerda, Ruy. *See under* MENDOZA.

Gómez de Valencia, Felipe (*b* Granada, *c.* 1634; *d* Granada, 1679 or 1694). Spanish painter. He was a pupil in Granada of Miguel Jerónimo Cieza (*d* 1677), who worked in a style derived from Alonso Cano. Almost all of Gómez de Valencia's work has been lost or is inaccessible but various paintings said to be by him were formerly in churches in Granada, including the *Surrender of Seville to St Ferdinand III* (untraced) for the Convent of the Discalced Carmelites, and 'various pictures' in the church of S Antón. A *Pietà* (Granada, Pal. Carlos V) attributed to him is derived from an engraving of a work by van Dyck; this painting may be the *Dead Christ with Two Angels* (untraced) mentioned by Ceán Bermúdez as being in the parish church of S Gil in Granada.

BIBLIOGRAPHY
Ceán Bermúdez
D Angulo Iñiguez: *Pintura del siglo XVII*, A. Hisp. (Madrid, 1971), p. 391
A. E. Pérez Sánchez: *Pintura barroca española* (Madrid, 1992), p. 378
ENRIQUE VALDIVIESO

Gómez Moreno, Manuel (*b* Granada, 21 Feb 1870; *d* Madrid, 7 June 1970). Spanish art historian. He was the son of a professor of art history and attended the Accademia delle Belle Arti in Rome at an early age. On his return he published articles on Arab and Christian art and prepared catalogues of the monuments of Ávila, Zamora, León and Salamanca, placing them in their historical context. At the same time, he studied Visigothic, Mozarabic, Romanesque and Hispano-Arabic art. He was appointed professor of Arab art at Madrid University in 1913 and collaborated with Elías Tormo y Monzó in the Centro de Estudios Históricos, founding the review *Archivo Español de Arte y Arqueología* in 1925. Leopoldo Torres Balbás, Elie Lambert and Diego Angulo Iñiguez trained with him. In 1951 he published *Arte árabe hasta los Almohades* in the series Ars Hispaniae. Outstanding among his publications are *Escultura greco-romana* (1912), *Arquitectura Tartesiana* and *Las águilas del renacimiento español* (1941). Gómez Moreno was interested in ancient Iberian inscriptions and established the alphabet, giving an inaugural lecture on this subject at his election to the Real Academia de Bellas Artes de San Fernando in Madrid. He was also an academician and received honorary doctorates from institutions throughout the world.

WRITINGS
Escultura greco-romana (Madrid, 1912)
Arte mudéjar toledano (Madrid, 1916)
Iglesias Mozárabes: Arte español de los siglos IX a XI, 2 vols (Madrid, 1919/R Granada, 1975)
Introducción a la Historia Silense (Madrid, 1921)
Catálogo Monumental de España: Provincia de León, 2 vols (Madrid, 1925–6)
Catálogo Monumental de España: Provincia de Zamora, 2 vols (Madrid, 1927)
La escultura española del renacimiento (Munich, Paris and Barcelona, 1930)
Arte románico español (Madrid, 1934)
Las águilas del renacimiento español: Bartolomé Ordóñez, Diego Silóe, Pedro Machuca, Alonso Berruguete (Madrid, 1941)
El Greco: El entierro del Conde de Orgaz (Barcelona, 1943)
Misceláneas, i (Madrid, 1950)
Arte árabe español hasta el siglo XII: Arte mozárabe, A. Hisp., iii (Madrid, 1951)
D. Manuel Gómez Moreno y Martínez de las reales academias española, de la historia y de bellas artes (Madrid, 1964) [contains biog. of Gómez Moreno and bibliog.]
La gran época de la escultura española (Barcelona and Lausanne, 1964; Eng. trans. London, 1964)
En torno al Crucifijo de los reyes Fernando y Sancha (Madrid, 1965)
Catálogo Monumental de España: Provincia de Salamanca, 2 vols (Madrid, 1967)
Retazos: Ideas sobre historia, cultura y arte (Madrid, 1970)
Contributions to *Archv. Esp. A. & Arqueol.*, *Bol. Soc. Castell. Excurs.*, *Príncipe Viana* and *Bol. Real Acad. Hist.*

BIBLIOGRAPHY
D. Angulo Iñiguez: Obituary, *Archv Esp. A.* (1970), pp. 351–5
ISABEL MORÁN SUAREZ, J. R. L. HIGHFIELD

Gomis, Joaquim (*b* Barcelona, 19 Sept 1902). Spanish photographer. Although his professional activity was centred on commercial and industrial work, he also had a role in the art world. He was co-founder of the Amics del Art Nou (ADLAN) group, a collective that instigated and

promoted avant-garde artistic activities in Spain. An enthusiastic photographer from the age of 12, he was an intimate friend of Josep Lluís Sert, Miró and the gallery owner Joan Prats, all of whom persuaded him to show his work in public. Gomis published a number of books in which he analysed Gaudí's architecture and interpreted it photographically.

PHOTOGRAPHIC PUBLICATIONS

with Le Corbusier: *Gaudí* (Barcelona, 1958)
with J. L. Sert: *Cripta Colonia Güell* (Barcelona, 1968)

BIBLIOGRAPHY

Idas y Caos: Trends in Spanish Photography, 1920–45 (exh. cat., ed. J. Fontcuberta; Madrid, Salas Picasso; New York, Int. Cent. Phot.; 1984–6)
Joaquim Gomis: La poética de la modernitat (exh. cat., Paris, Cent. Etud. Cat., 1986)

MARTA GILI

Gonçalves, André (*b* Lisbon, Nov 1685; *d* Lisbon, 15 June 1762). Portuguese painter. A pupil of the Genoese artist Giulio Cesare de Femine (*fl* Lisbon, 1710–*c*. 1733), he joined the Irmandade de S Lucas in 1712, remaining a member until 1754. He was the most active Portuguese painter during the reign (1706–50) of John V, working mainly in Lisbon and Coimbra, but part of his large output was destroyed in the earthquake of 1755.

Gonçalves's painting is in the style of the Roman Late Baroque but varies considerably in quality. He is reputed to have owned a large collection of engravings after works by Carlo Maratti, which he copied when designing figures and drapery. His soft colouring, avoiding strongly marked outlines, owes more, however, to Sebastiano Conca and Agostino Masucci; such features can be seen in the *Adoration of the Magi* and the *Nativity* (both Coimbra, Mus. N. Machado de Castro). Some of Gonçalves's later works show the influence of a more intellectual approach to painting, either through study of the work of late Mannerist painters, such as Pier Francesco Mola (ii), or late Baroque artists, such as Maratti or Masucci. This combined influence is evident in the series of canvases of the *Life of Joseph in Egypt* (*c*. 1746–50) for the church of the convent of Madre de Deus in Lisbon, some of which have architectural backgrounds with figures ranged along the foreground plane; one of these canvases combines Mola's figures with an architectural background reminiscent of Poussin. This and two other cycles by Gonçalves in the same convent, the *Life of Christ* and the *Life of St Anthony of Padua*, are representative of his later style. In the latter, the *Woman Charged with Adultery* depicts frieze-like figures isolated in front of a sober background in an almost Neo-classical style. Other paintings by Gonçalves can be seen in the churches of S Domingos de Benfica, Meninos Deus and Lumiar in Lisbon, at the palace-convent of Mafra and at the convent of Arouca.

Machado

BIBLIOGRAPHY

J. da Cunha Taborda: 'Memória dos mais famosos pintores portugueses', *Regras da arte da pintura de M. A. Prunetti* (Lisbon, 1815)
F. de Pamplona: *Dicionário de pintores e escultores portugueses ou que trabalharam em Portugal* (Lisbon, 1956)
N. Saldanha: 'André Gonçalves: Pintor ingénuo ulissiponense (1685–1762)', *Vértice*, viii (1988), pp. 61–71

PAULO VARELA GOMES

Gonçalves, Nuno (*fl* 1450–91). Portuguese painter. His work may be said to have initiated the Renaissance in Portuguese painting. He is first named in a document of 1450, when Afonso V (*reg* 1438–81) appointed him court painter. In 1470 a payment to him is recorded for an altarpiece painted for the chapel of the Palácio Real, Sintra, which, given the dedication of the chapel, probably represented the *Pentecost* (untraced). A document of 1471 states that Gonçalves replaced the painter João Eanes (*fl* from 1454) as Pintor das Obras da Cidade de Lisboa (Painter of works for the city of Lisbon).

Gonçalves's importance in the history of Portuguese painting and the quality of his work have always been recognized. In 1548 Francisco de Holanda praised him as an artist worthy of comparison with other leading figures of his age and also recorded the one work on which Gonçalves's fame is primarily based: 'I wish to mention a Portuguese painter who I feel deserves to be remembered, since in a very barbarous age he sought to emulate in some degree the care and manner of depiction of painters of antiquity and of Italian artists. This was Nuno Gonçalves, painter to Dom Afonso, who painted the altar of St Vincent in the Cathedral of Lisbon, and I think that also by his hand is a Lord tied to a column whom two

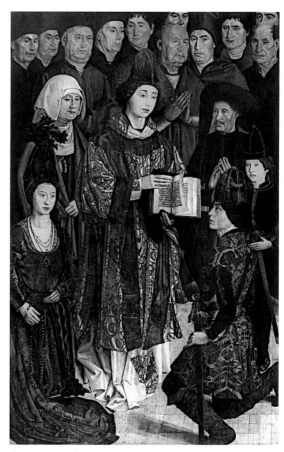

1. Nuno Gonçalves (attrib.): *St Vincent* retable (detail), oil on panel, 2.07×1.28 m, completed *c*. 1472 (Lisbon, Museu Nacional de Arte Antiga)

men are scourging, in a chapel of the Monastery of Trindade [Lisbon].' This latter painting, the *Flagellation of Christ*, of unknown date, remains untraced. Holanda confirms, therefore, that Nuno Gonçalves painted the *St Vincent* retable, then in Lisbon Cathedral (now Lisbon, Mus. N. A. Ant.; see fig. 1; *see also* PORTUGAL, fig. 6), which was rediscovered in 1882 in the monastery of S Vicente de Fora, Lisbon. Painted in oil on six wood panels of varying size, this great polyptych appears to represent St Vincent, patron of Lisbon, receiving the homage of the king, court and various communities, such as a group of fishermen, Cistercian monks and a number of kneeling warriors. The distribution of the figures, one above the other and without a precise setting, focuses attention on each individual, recording their powerful and heroic faces in a series of vivid portraits. The panels also show Gonçalves's great skill as a colourist, seen in his use of scarlet and green tones and the highly effective placing of areas of white for the habits of the monks.

A further account of the *St Vincent* retable is given by an unknown author at the end of the 16th century; he made an inventory of royal portraits then existing in Lisbon and described the panels in the cathedral of Lisbon: 'the Prince Dom Afonso [son of John II, *reg* 1481–95]. . . who fell from his horse, is portrayed in the chancel of the cathedral, on the left of the altar; high above it there used to be a gilded tomb, said to contain the body of St Vincent, and below it were two panels on which St Vincent was painted as a young man of 17 years on each panel. . .and in this figure of the saint is portrayed the Prince Dom Afonso, the face of a handsome youth, and many other figures of men who were in the said panels were lords and gentlemen of that time. . .' (see Markl, 1988). This document raises questions of dating, since Prince Dom Afonso died in a fall from a horse in 1491, by which time Nuno Gonçalves had probably also died. An X-ray examination of the heads of St Vincent in the two central panels has revealed that a portrait has been overpainted on the original of each. In this connection the 16th-century account concludes by saying: 'those of the cathedral were portrayed by Mota, who painted Dom João [John II], the father of this prince'). It is possible that John II ordered the portrait of his son to be painted over the face of St Vincent in the existing retable, and that this was carried out by an artist named Mota, who is now unknown. Some confirmation of this is given by a panel, *St Vincent Tied to a Column* (Lisbon, Mus. N. A. Ant.), that was probably originally part of the retable of *St Vincent*. It seems probable, therefore, that on his appointment as painter for the city of Lisbon in 1471, Gonçalves received the royal commission for the retable, whose execution had been initiated in 1433 by John I (*reg* 1385–1433) shortly before his death.

It has also been suggested (dos Santos) that the *St Vincent* retable was a votive picture following the conquest in 1471 of the Moroccan fortress of Arzila (Fez) and Tangier by the Portuguese, under the protection of St Vincent, which not only confirmed the domination of Portugal in north Africa but also made possible the recovery of the body of the Infante Dom Fernando, uncle of Afonso V, who had died in Fez in 1443. The capture of the two African strongholds was also depicted in two

2. Nuno Gonçalves (attrib.): *St Vincent Fastened to a Cross*, half-panel, h. 2.09 m, before 1472 (Lisbon, Museu Nacional de Arte Antiga)

Flemish tapestries of the 15th century (Spain, Pastrana, Colegiada). This means that the completion of the retable can be dated to around 1472, by which time the other panels depicting the life and martyrdom of St Vincent had

already been completed, including a half-panel of *St Vincent Fastened to a Cross* (Lisbon, Mus. N. A. Ant.; see fig. 2).

The only other work that can be attributed on stylistic grounds to Nuno Gonçalves is a panel with an upper scene of an *Adoration of the Magi* and a lower one representing *Two Franciscan Saints* (St Francis and ?St Anthony; Évora, Mus. Sé). It is an early work with a landscape background that is not treated in the Netherlandish manner but is closer to the work of Piero della Francesca.

Nuno Gonçalves's work does not show the direct influence of Netherlandish painting, and Francisco de Holanda's comments above affirmed that the Portuguese painter sought to emulate the manner of Italian artists. The panels that depict the *Martyrdom of St Vincent* show a distinctly Italianate tendency in the fine anatomical rendering of the saint's body. This link with Italian art is less evident in the rest of the polyptych, but even so the work as a whole cannot be directly associated with the contemporary aesthetic of Netherlandish art. Gonçalves avoids excessive realism in his portraits, approaching Antonello da Messina in this regard rather than Jan van Eyck (who was in Portugal in 1428) and Rogier van der Weyden. Gonçalves's art can also be linked to Burgundy and the work of Pierre Spicre, whose period of activity coincides with that of Gonçalves. Netherlandish influence on the Portuguese painter may also have been received indirectly, in particular through Provence, where a marked affinity with the work of Gonçalves can be seen in such paintings as the *Pietà* of Villeneuve-lès-Avignon (*c.* 1455; Paris, Louvre), attributed to Enguerrand Quarton. On the other hand the setting, as well as the compact and stepped arrangement of the composition in the *St Vincent* retable, is reminiscent of 15th-century Tournai tapestries, and it is possible that Gonçalves may have designed the cartoons for the Pastrana tapestries mentioned above, in which the portraits of Afonso V and of Prince Dom João (the future King John II) have similar qualities to those painted in the polyptych.

BIBLIOGRAPHY

F. de Holanda: *Da pintura antigua* (1548); ed. J. de Vasconcellos (Oporto, 1930), p. 91
J. de Figueiredo: *O pintor Nuno Gonçalves* (Lisbon, 1910)
J. Saraiva: *Os painéis do Infante Santo* (Leiria, 1925)
R. dos Santos: *Nuno Gonçalves* (London, 1955)
A. Gusmão: *Nuno Gonçalves* (Lisbon, 1957)
C. Sterling: 'Les Panneaux de Saint Vincent et leurs "Enigmes"', *L'Oeil*, 159 (March 1968), pp. 12–24
D. Markl: *O retábulo de S Vicente da Sé de Lisboa e os documentos* (Lisbon, 1988)

DAGOBERTO L. MARKL

Gonçalves Neto, Estevão (*fl* from 1606; *d* Viseu, 1627). Portuguese painter and illuminator. He was chaplain to the Bishop of Viseu, Dom João Manuel, and from 1613 he was Abbot of S Madalena do Serejo, Pinhel. In 1618 he returned to Viseu to work on the altarpieces for the Capela de S Marta, one of which survives, which was painted on both sides in a rather stylized late Mannerist style. In 1622 he was appointed a canon of Viseu Cathedral. Gonçalves Neto specialized in manuscript illumination, and his work includes the *Compromisso da Irmandade do Espírito Santo* (1606) of the hermitage chapel (Ermida) of Nossa Senhora dos Remedios, Alfama (*in situ*); the *Livro das Missas de Prima* of Viseu Cathedral (*in situ*); and the remarkable Pontifical (1610–22; Lisbon, Acad. Ciênc.), one of the finest examples of Portuguese Mannerist illumination. The codex of 44 folios on parchment has ornamented borders and 11 excellently composed biblical scenes depicted with precise draughtsmanship and rich colours; it is clearly influenced by the Roman Mannerism of Pellegrino Tibaldi and Federico Zuccaro. This work was dedicated to Bishop João de Melo, who appears to have been a patron of Gonçalves Neto.

BIBLIOGRAPHY

J. F. de Castilho: *Estudo sobre o missal de Estevão Gonçalves* (Rio de Janeiro, 1874)
J. C. Gonçalves: *Uma jóia da iluminura portuguesa: O missal de Estevão Gonçalves Neto* (Gaia, 1931)

JOAQUIM OLIVEIRA CAETANO

Goncharova, Natal'ya (Sergeyevna) (*b* Negayevo, Tula Province, 16 June 1881: *d* Paris, 17 Oct 1962). Russian painter, stage designer, printmaker and illustrator. She was a leading artist of the Russian avant-garde in the early 20th century but became a celebrity in the West through her work for SERGE DIAGHILEV and the BALLETS RUSSES. During the 1920s she played a significant role within the Ecole de Paris and continued to live and work in France until her death.

1. Life and work. 2. Working methods and technique.

1. LIFE AND WORK.

(i) 1898–1913. She was the daughter of Sergey Mikhaylovich Goncharov, an architect, and Yekaterina Il'icha Belyayeva but grew up in her grandmother's home at Ladyzhino, near Kaluga, in Tula Province. She attended the Fourth Gymnasium for Girls in Moscow and in 1898 entered the Moscow School of Painting, Sculpture and Architecture as a sculpture student where she was taught by Paolo Troubetskoy. At the school Goncharova became friendly with MIKHAIL LARIONOV. He became her lifelong companion and colleague, and he encouraged her to relinquish sculpture for painting. Goncharova's early work comprised mainly pastels, which were exhibited in 1906 at Diaghilev's Russian art exhibition at the Salon d'Automne in Paris. Her first paintings were shown a year later by the Moscow Association of Artists (Moskovskoye Tovarishchestvo Khudozhnikov), of which she was a member.

Goncharova was attracted briefly to Impressionism and Symbolism, but her participation in the GOLDEN FLEECE exhibition of 1908 introduced her to French painting; here she saw modern and contemporary paintings by Gauguin, Cézanne, Matisse, Bonnard and Toulouse-Lautrec, which decisively altered her style. A series depicting her favourite theme of Russian peasants working the land, such as *Gardening* (1909; London, Tate), reveals this influence in her flair for colour and in the simplified and stylized approach to form. Her statuesque peasants, with their thick-set bodies and massive limbs, are imbued with a heroic grandeur. During 1910 her style took on the exaggerated palette of the Fauves, although her brushwork, never as coarse as theirs, retained a lightness and delicacy. The exotically coloured *Still-life on a Tiger Skin* (1910; Cologne, Mus. Ludwig), with its surprising compositional

devices (two large rectangles of a Greek frieze and Japanese print float weightlessly across the picture plane) and spatial ambiguities, is close to developments in Larionov's work at that time, but also reveals Goncharova's interest in Eastern art forms.

In 1910 Goncharova was a founder-member of the JACK OF DIAMONDS group but later seceded with Larionov to found the rival DONKEY'S TAIL group, which held its first exhibition in March 1912. Here Goncharova exhibited over 50 works, including a remarkable series of *Peacock* paintings, such as *Peacock (Egyptian Style)* (1911; Moscow, Tret'yakov Gal.), executed in Cubist, Futurist, Chinese, Byzantine and Russian folk-art styles. Many works of this period were gaily coloured genre paintings depicting the life of the peasants and were executed in the simple and traditional popular styles. Goncharova was a connoisseur of *lubki* (old Russian popular prints; *see* LUBOK), painted trays, embroideries and icon paintings, and in the titles of her paintings freely admitted their influence. Her use of the conventions of icon painting is particularly evident in four magnificent canvases depicting the *Evangelists* (1911; St Petersburg, Rus. Mus.).

During 1913 Goncharova entered her most productive period, painting dozens of canvases. In her Neo-primitive works she continued to explore the styles of Eastern and traditional Russian art forms (see NEO-PRIMITIVISM), but she also experimented with Cubo-Futurism and adopted Larionov's new abstract style of RAYISM, which she claimed to have elaborated. In a magnificent series of Rayist *Forest* paintings Goncharova examined the possibilities of abstraction and non-objectivity. *Rayist Forest* (1913; Lugano, Col. Thyssen-Bornemisza) has a strikingly splintered style, while *Blue and Green Forest* (1913; Basle, Gal. Beyeler) is a completely non-objective experiment in colour, form and dynamism. In August 1913 Goncharova attracted international attention with a one-woman exhibition of over 700 works. As a preface to the catalogue she published a manifesto, which is important as a statement of her attitudes, aims and objectives at this point in her career. In a provocative Neo-primitive vein she dismissed Western art in scathing terms, claiming that the indigenous art forms of her own country were more profound and important than anything in the West, and she declared her intention to turn towards the East and its art forms in order to broaden her outlook.

During this period Goncharova, like Larionov, was closely associated with the literary avant-garde. She illustrated several Russian Futurist books by Aleksey Kruchonykh and Velimir Khlebnikov, while the young poet Il'ya Zdanevich (1894–1975) wrote the first monograph on the artist. Both Goncharova and Larionov gained public notoriety through their Futurist activities. Goncharova appeared in shocking cabaret reviews and starred in a Russian Futurist film. Her work seldom lacked controversy. In 1909 the police had confiscated several paintings depicting male models from her first one-woman exhibition on charges of indecency. At the same time her participation in international exhibitions increased her reputation abroad. *Woman with Hat* (1913; Paris, Pompidou; see fig. 1) is a Cubo-Futurist *tour de force*, in which the painting is spangled with multi-coloured ostrich plumes, dismembered facial features, numbers, letters and

1. Natal'ya Goncharova: *Woman with Hat*, oil on canvas, 990×660 mm, 1913 (Paris, Centre Georges Pompidou, Musée National d'Art Moderne)

bars of music. In the Sturm Autumn Salon in Berlin the painting rivalled the finest achievements of her Western colleagues.

(ii) 1914–18. In the spring of 1914 Goncharova visited Paris to execute designs for Diaghilev's production of *Le Coq d'or* at the Opéra (for illustration *see* BALLETS RUSSES). Based upon Eastern and Russian folk art, the simple yet expressive forms, rich colour harmonies and decorative approach of her décors and costumes took Paris by storm. Together with Larionov she also held an exhibition of her paintings at the Galerie Paul Guillaume and gained the friendship and support of Guillaume Apollinaire. On the declaration of war in 1914 Goncharova returned to Moscow where she published an important folio of 14 lithographs entitled *Voyna: Misticheski obrazy voyny, 14 litografy* ('War: mystical images of war, 14 lithographs'). In 1915 she designed the costumes and décors for Aleksandr Tairov's production of Goldoni's *Fan*. At the request of Diaghilev, Goncharova and Larionov left Russia for Switzerland in June 1915. Here Goncharova undertook the designs for a religious ballet, *Liturgie*. Although the ballet was never staged, she later published a folio entitled *Liturgie: 1915 Lausanne* (Paris, c. 1917), containing 16 costume designs executed in the spirit of icon paintings. In 1916 Goncharova and Larionov accompanied Diaghilev to Spain and thence to Italy. For Goncharova Spain

was a revelation. She was moved by its rich visual traditions and especially by the bearing of the Spanish women in their magnificent mantillas. Thereafter *Espagnoles* became her favourite subject in all media. Her designs for two Spanish ballets were never staged, although her costume designs for the beautiful ballet *Sadko* were successfully completed. In Rome during the winter Goncharova assisted Larionov in his designs for *Contes russes*, before returning with him to Paris in the spring of 1917.

(iii) 1919–29. In 1919 Goncharova and Larionov settled permanently in Paris: they were granted French citizenship in 1938. Here, among her colleagues in the Ecole de Paris, she was known principally as one of the most vivacious theatrical designers of her day. She never worked exclusively for Diaghilev, but her finest creations were for the Ballets Russes. Her first designs for *Les Noces* (1923) were executed in the exuberant style of *Le Coq d'or* but underwent a metamorphosis. Executed in sombre colours, restrained costumes and simple décors, her final designs for *Les Noces* admirably captured the power and drama of Igor Stravinsky's score. Equally striking were her designs for a second version of *L'Oiseau de feu*, commissioned by Diaghilev in 1926. The final backcloth for the ballet (London, V&A) depicts dozens of red and white Orthodox churches piled one on top of the other reaching up to the blue of the firmament, their onion domes cascading across the surface of the design. Created for the transformation scene of the ballet, in which a Christian church miraculously replaces the castle of Koshchey the wizard, this design is one of Goncharova's most memorable and most Russian of images.

In her paintings of the 1920s Goncharova developed her own idiom for her series of *Espagnoles* (see fig. 2 and §2 below) as well as for her many paintings of bathers such as *Autumn* (*c.* 1923; London, Tate), more abstract and experimental. She frequently participated in international exhibitions and in the Parisian Salons, and she held exhibitions in New York (1922) and Tokyo (1923). Goncharova was also active as a graphic artist. She designed tickets and posters for the Union des Artistes Russes, illustrated the work of composers, poets and writers of her day and contributed to the Bauhaus print folios (1923). Goncharova's two greatest achievements in this field were her splendid colour illustrations for an edition of Aleksandr Pushkin's classic poem *Tsar Saltan* (Paris, 1922) and a German edition, *Die Mar von der Heerfahrt Igors* (Munich, 1923), of the Russian epic *Slovo o polku Igoreve*; both are masterpieces in the history of book illustration.

(iv) 1929–62. Following Diaghilev's death in 1929 Goncharova's creative vitality declined. Her many theatrical commissions throughout the 1930s included *Tsar Saltan* (1932) for the Lithuanian State Opera, *Boléro* (1932) and *Mephisto valse* (1935) for the Opéra Comique in Paris. *La Vie parisienne* and *Voyage d'une danseuse* (1933) for the 'Chauve-souris' in New York, *Amour sorcier* (1935) for the London Coliseum, *Bogatyri* (1938) for the Metropolitan Opera, New York, and *Cinderella* (1938) for the Royal Opera, Covent Garden. Although each was beautiful in its own way, none attained the remarkable standards that Goncharova had achieved under Diaghilev. She spent the

war years making designs for a suite of ten ballets commissioned by Boris Kniaseff (1900–75), which were shown with great success in South America.

Following World War II, the writer on abstraction Michel Seuphor (*b* 1901) 'rediscovered' Rayism and, in an important exhibition entitled *Le Rayonnisme, 1909–14*, held at the Galerie des Deux Iles in Paris in 1948, re-established Goncharova and Larionov as the first masters of Russian abstraction. Following Larionov's stroke in 1950, Goncharova's own health seriously declined. She married Larionov in 1955, but the last seven years of her life were spent in pain and poverty. By 1958 she was crippled with arthritis, yet inspired by the launch of the first 'Sputnik' into space, she tied brushes to her hands with rags, and in a triumph over ill health painted a score of non-objective works. Major exhibitions at the Arts Council Gallery in London (1961) and at the Musée d'Art Moderne de la Ville de Paris (1963) established her reputation as one of the foremost Russian artists of the century.

2. WORKING METHODS AND TECHNIQUE. Goncharova was a careful and diligent artist for whom research and preparation, whether for painting, graphic work or theatre design, always played an important role. When commissioned to design *Le Coq d'or*, she visited the museums and with archaeological exactness studied the costumes, designs and architecture of the period and even held discussions with the peasants, whom she relied upon for their innate sense of beauty.

Goncharova was an artist of the people and, although she worked at times in abstraction and non-objectivity, she returned repeatedly to popular forms for inspiration. Her study of ancient, naive and folk art forms informed her Neo-primitive work as well as her stage designs. Stone idols are depicted in several early works of 1909, the influence of Niko Pirosmanashvili is evident in others of 1912, and the stylistic devices of *lubki* and icons had a pervasive influence. Later in 1913 Goncharova turned her attention more towards Eastern art forms. She wrote an article on Indian and Persian miniatures, and in the preface to the catalogue of her one-woman exhibition she declared that her path was 'toward the source of all arts, the East'.

Above all her study of Eastern art forms taught Goncharova formal beauty, delicacy of ornament and the power of unusual and striking colour harmonies. In *Espagnole* (*c.* 1920; Paris, Pompidou; see fig. 2) the elegant elongation of the figure, the interesting play of different shapes, the evocative autumn colours, gay floral ornamentation and scumbles of paint, which intrude and disappear only to counterpoint the restrained and hieratic quality of the figure, are handled with great beauty and characteristic finesse. Her refined brushwork is also a hallmark of her technique. Never coarse and ungainly like that of Larionov, Goncharova's application of paint is quite distinctive. Here her brushstrokes are light and delicate, but even when they are bold, as in some of her Neo-primitive works, they are always controlled and brought into harmony with the expressive purposes of the overall design.

Goncharova always entertained a monumental approach to figure painting. She imbued her peasants with

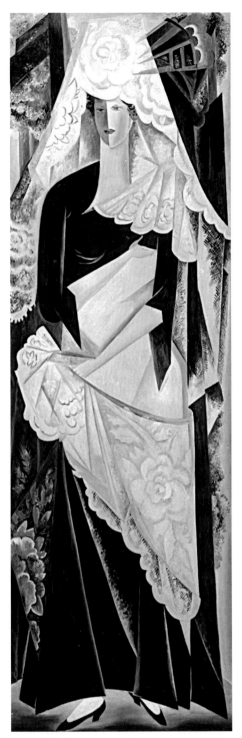

2. Natal'ya Goncharova: *Espagnole*, oil on canvas, 2.34×0.75 m, *c*. 1920 (Paris, Centre Georges Pompidou, Musée National d'Art Moderne)

southern Russian steppe. She discovered a similar treatment of the human figure in the simplified and bold forms of evangelists and archangels in huge icon panels hanging in the churches. The same monumental approach was later adopted in her *Espagnoles* (*c*. 1920; Paris, Pompidou, see fig. 2 above; and Rome, Sophia Loren priv. col.). The enormous image of the Spanish woman filling the canvas and dwarfing the viewer provoked the poet Marina Tsvetayeva's famous observation: 'these are not women, they are cathedrals'. Goncharova's work is indeed impregnated with a mystical almost religious atmosphere. Her abstract and non-objective Rayist works sprang from an animistic philosophy derived from her study of Eastern religions and the contemporary mysticism of Russian philosophers such as PYOTR USPENSKY, and Marina Tsvetayeva shrewdly noted that 'her very brushstrokes embody the idea of resurrection'.

WRITINGS

'Indusskiy i Persidskiy lubok: Predisloviye' [The Hindu and Persian lubok: foreword], *Vystavka ikonopisnykh podlinnikov i lubkov* [Exhibition of original icon paintings and *lubki*] (exh. cat., Moscow, Khudozhestvennyy Salon, 1913), pp. 11–12

with M. Larionov: *Radiantismo* (Rome, 1917)

with W. George and M. Georges-Michel: *Les Ballets Russes de Serge de Diaghilew: Décors et costumes* (Paris, 1930)

'Dekoratsiye i kostyumy u Svad'bï [The décors and costumes of *Les Noces*], *Rus. Arkhv*, xx–xxi (1932), pp. 19–31; Eng. trans. by M. Chamot as 'The Metamorphosis of the Ballet, *Les Noces*', *Leonardo*, xii/2 (1979), pp. 137–43

with M. Larionov and P. Vorms: *Les Ballets Russes: Serge de Diaghilew et la décoration théâtrale* (Belvès, 1955)

BIBLIOGRAPHY

E. Eganbyuri [I. Zdanevich]: *Natal'ya Goncharova, Mikhail Larionov* (Moscow, 1913) [first monograph, well illus.]

Oslinyy Khvost i Mishen' [Donkey's Tail and Target] (Moscow, 1913)

V. Songaylo: *O vystavke kartin Natalii Goncharovoy* [On the exhibition of paintings by Natal'ya Goncharova] (Moscow, 1913)

Vystavka kartin Natalii Sergeyevny Goncharovoy, 1900–1913 [Exhibition of paintings by Natal'ya Sergeyevna Goncharova, 1900–1913] (exh. cat., Moscow, Khudozhestvennyy Salon, 1913)

G. Apollinaire: 'L'Exposition Nathalie de Gontcharowa et Michel Larionow', *Les Soirées de Paris* (June 1914), p. 371

V. Parnack: *Gontcharova, Larionow: L'Art décoratif théâtral moderne* (Paris, 1919) [fol. of pochoirs and prints with illus. essay]

W. Propert: 'Gontcharova and Larionov', *The Russian Ballet in Western Europe, 1909–1920* (London, 1921), pp. 36–45

N. Khardzhiyev: 'Pamyati Natalii Goncharovoy i Mikhaila Larionova' [To the memory of Natal'ya Goncharova and Mikhail Larionov], *Iskusstvo Knigi*, v (1968), pp. 306–18

M. Tsvetayeva: 'Natal'ya Goncharova', *Prometey*, vii (1969), pp. 144–201

T. Loguine: *Gontcharova et Larionov: Cinquante ans à Saint Germain-des-Prés* (Paris, 1971) [40 mem. on the two artists]

M. Chamot: *Gontcharova* (Paris, 1972) [excellent pls]

L. Salmina-Haskell: *Russian Drawings in the Victoria & Albert Museum*, cat. (London, 1972) [graphics, theatre designs, sketchbooks and many items from Goncharova's personal lib.]

M. Chamot: 'Russian Avant-garde Graphics', *Apollo*, cxlii (1973), pp. 494–501

M. Slonim: 'Goncharova i Larionov' [Goncharova and Larionov], *Novoye Russkoye slovo* (15 April 1973)

Rétrospective Gontcharova (exh. cat., Bourges, Maison Cult., 1973)

J. Bowlt: 'Neo-Primitivism and Russian Painting', *Burl. Mag.*, cxvi (1974), pp. 132–40

M. Dabrowski: 'The Formation and Development of Rayonism', *A. J.* [New York], 3 (1975), pp. 200–07

Larionov Gontcharova rétrospective (exh. cat., Brussels, Mus. Ixelles, 1976) [well illus.]

S. Compton, ed.: *Russian Futurism, 1910–1916: Poetry and Manifestos* (Cambridge, 1978) [54 Russian Futurist bks on colour and monochrome microfiche]

S. Compton: *The World Backwards: Russian Futurist Books, 1912–1916* (London, 1978)

the mythological qualities of the Bogatyrs (Russian epic heroes), their gigantic scale and sculptural form recalling the medieval statues (*kamenye baby*) that littered the

M. Chamot: *Goncharova: Stage Designs and Painting* (London, 1979) [very well illus.]

M. Tsvetayeva: *Izbrannaya proza* [Selected prose] (New York, 1979), i, pp. 283–340

A. Parton: 'Russian Rayism: The Work and Theory of Mikhail Larionov and Natalya Goncharova, 1912–1914', *Leonardo*, xvi/4 (1983), pp. 298–305

J. Bowlt: 'Natalia Goncharova and Futurist Theater', *A. J.* [New York], 1 (1990), pp. 44–51

M. N. Yablonskaya: 'Natal'ya Goncharova', *Women Artists of Russia's New Age, 1900–1935* (London, 1990), pp. 52–77

A. Parton: *Mikhail Larionov and the Russian Avant-garde* (Princeton and London, 1993)

ANTHONY PARTON

Goncourt, de. French family of writers, critics, printmakers, painters and collectors. Edmond de Goncourt (*b* Nancy, 26 May 1822; *d* Champrosay, 16 July 1896) and his brother Jules de Goncourt (*b* Paris, 17 Dec 1830; *d* Paris, 20 June 1870) were born into a minor aristocratic family. Their father, Marc-Pierre Huot de Goncourt, died in 1834, and after the death of their mother, Annette-Cécile Guérin, in 1848 they were sufficiently well-off to set up as painters. Jules was notably talented, his etchings being published in 1876. However, the Goncourts soon turned to literature, in which, in a remarkable collaboration that lasted until the death of Jules in 1870, they made their name, first as journalists and historians, and a little later as novelists and art critics. Their finest and best-known works, such as *L'Art du XVIIIe siècle* (published in 12 fascicles between 1859 and 1875) and *Manette Salomon* (1867), a novel about artists and the female model, combine the various strands of their creative abilities. In *L'Art du XVIIIe siècle*, art historian, critic and artist unite (the book was illustrated with etchings by Jules) to give an unforgettable account of the working methods and achievements of 18th-century French artists, both major (e.g. Watteau, Boucher) and minor (e.g. Charles-Nicolas Cochin (ii), the Saint-Aubin brothers). In *Manette Salomon* the brothers' insight into both the studio life and practice of contemporary artists, and the psychology of the art student and the female model, finds expression in a style of startling originality and modernity. Their *Journal*, started in 1851 and continued by Edmond after Jules's death until his own in 1896, is a fascinating record of Parisian literary and artistic life in the second half of the 19th century.

More than any other 19th-century writers, the Goncourts made the vocation of writer synonymous with that of artist. This new desire for identity or synthesis was reflected in their concern with developments in precisely those areas that were fundamental to both literature and painting: style, technique and taste. For the Goncourts, the function of the writer, like that of the visual artist, was to reproduce the materiality of experience through the medium of its communication, as well as through content. Their concern, like that of the painter, was to capture the vividness or the transience of sensation, the surprise of elements juxtaposed, fragmented, rearranged or partly concealed by the accidents of experience. This necessitated the creation of an *écriture artiste*, which modified or inverted the conventional logic or order of syntax and grammar. The Goncourts' systematic use of nominalization (well analysed by Ullmann) and their creation of a new vocabulary of aesthetic neologisms (explored in detail by Fuchs) was taken up and developed by later 19th-century prose writers and poets. (Verlaine's *Fêtes galantes*, 1869, owes much to *L'Art du XVIIIe siècle*.)

As art critics and writers, the Goncourts constantly stressed the importance—and the fascination—of technique (or *cuisine* as they often called it). Two concepts were central to them: colour and the fragment. In their account of the Exposition Universelle of 1855 they argued that painting was a daughter of the earth, a materialist art in which colour, not drawing, best enlivened form; its natural field was not the history painting that had dominated European art since the Renaissance, but landscape and contemporary genre. The Goncourts were great admirers of the Barbizon school and Edmond, later, of Constable and Turner (though, surprisingly, they had little time for their contemporaries, the Impressionists). They considered Paul Gavarni the modern genre painter *par excellence* (see fig.), publishing a study of him in 1873, although later Edmond recognized the originality of Degas in this field. Their boredom with literary or academic painting led them to promote the concept of the suggestive fragment, which, whether a sketch or a drawing, they often valued more highly than a complete masterpiece. Thus the legless marble torso in the Vatican was preferred to a work

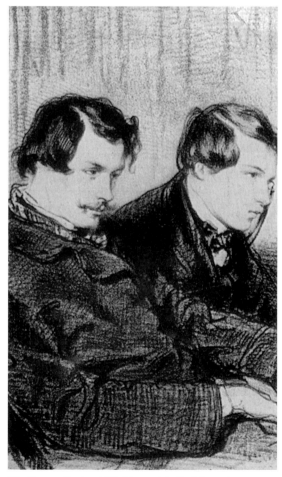

The Goncourt Brothers, 1853, lithograph by Paul Gavarni

by Raphael, the latter being dismissed as 'purely academic'. Though men of letters themselves, the Goncourt brothers constantly recommended the banishment of literature from painting so that its sensual and physical qualities could be brought to the fore.

The Goncourts' ability to combine the skills and knowledge of the artist with the flair of the journalist and publicist enabled them to exert considerable influence on the development of taste in the second half of the 19th century. In the 1850s and 1860s their eloquent celebration of 18th-century French painting not only confirmed its rehabilitation but also indicated its relevance to contemporary aesthetic concerns—both literary and artistic. Similarly, their enthusiastic and informed reception of Oriental and, above all, Japanese art encouraged the fashion for Japonisme that was later taken up by many other writers, artists and collectors. In *La Maison d'un artiste* (1881), in which the term 'artist' was again used interchangeably with that of 'writer', Edmund wrote that he and Jules had acquired their first album of Japanese prints as early as 1852, and this interest was to remain with him for the rest of his life, his works on Kitagawa Utamaro and Katsushika Hokusai being published in 1891 and 1896.

The originality and importance of the Goncourt brothers was much disputed during and after their lifetime and has only in the second half of the 20th century been more widely recognized. Living in a period when the relationship between literature and art became increasingly complex and profound, they had a vital impact as writers and connoisseurs on developments in French literature (both in the novel and in literary style in general) and on the evolution of later 19th-century taste.

WRITINGS

E. de Goncourt and J. de Goncourt: *L'Art du XVIIIe siècle*, 12 vols (Paris, 1859–75); ed. J.-P. Bouillon in *L'Art du XVIIIe siècle et autres textes sur l'art* (1967)

——: *Manette Salomon* (Paris, 1867); ed. H. Juin (1979)

——: *Gavarni: L'Homme et l'oeuvre* (Paris, 1873)

E. de Goncourt: *Les Frères Zemganno* (Paris, 1879); ed. E. Caramaschi (Naples, 1981)

——: *La Maison d'un artiste* (Paris, 1881)

——: *Outamaro: Le Peintre des maisons vertes* (Paris, 1891); ed. H. Juin as *Outamaro, Hokousaï: L'Art japonais au XVIIIe siècle* (Paris, 1986)

——: *Hokousaï* (Paris, 1896); ed. H. Juin as *Outamaro, Hokousaï: L'Art japonais au XVIIIe siècle* (Paris, 1986)

E. de Goncourt and J. de Goncourt: *Journal*, ed. R. Ricatte, 4 vols (Paris, 1956–9)

BIBLIOGRAPHY

P. Burty: *Eaux-fortes de Jules de Goncourt: Notice et catalogue* (Paris, 1876)

M. Fuchs: *Lexique du 'Journal' des Goncourt: Contribution à l'histoire de la langue française pendant la seconde moitié du XIXe siècle* (Paris, 1912)

P. Sabatier: *L'Esthétique des Goncourt* (Paris, 1920)

F. Fosca: *Edmond et Jules de Goncourt* (Paris, 1941)

R. Ricatte: *La Création romanesque des frères Goncourt, 1851–1870* (Paris, 1953)

A. Billy: *Vie des frères Goncourt*, 3 vols (Monaco, 1956)

S. Ullmann: 'New Patterns of Sentence Structure in the Goncourts', *Style in the French Novel* (Oxford, 1964), pp. 121–45

DAVID SCOTT

Gondelach [Gundelach], **Franz** (*bapt* Grossalmerode, 17 Dec 1663; *d* Altmünden, 13 May 1726). German glass engraver. His father was the glassmaker Franz Gundelach (*fl* 1660), and from *c.* 1669 the family lived in Oranienbaum. By 1682 Gondelach must have been in Kassel, where he married Anna Dorothea Trümper in 1689 and acquired citizenship in 1694. From his arrival in Kassel he seems to have worked for Landgrave Charles of Hesse-Kassel. On 18 January 1688 he obtained an official appointment and is documented as 'court master glassworker', 'court glass engraver' or 'princely glass engraver'. Gondelach has been accepted as the most important glass engraver of the Baroque period, as he skilfully mastered the techniques of *tiefschnitt* (deep-relief) and *hochschnitt* (high-relief) decoration. His most famous works are three jugs: the first (Pommersfelden, Schloss Weissenstein) was a present from the Landgrave to Lothar Franz von Schönborn in 1715, the second (made before 1714) is in Rosenborg Castle in Copenhagen, and the third (also made before 1714; Moscow, Kremlin) was given by Frederick IV of Denmark to Tsar Peter I. Other important works include a covered goblet (1717; The Hague, Gemeentemus.) decorated with St George and cherubs executed in *hochschnitt* and commissioned by Prince William of Hesse for the confraternity of St George in The Hague; a goblet with cover decorated with a faun and nymph (New York, Met.) and a goblet with a resting Venus (Berlin, Schloss Köpenick). Sometimes Gondelach signed his work with diamond-point engraving, and a particular mark was a cut eight-pointed star on the underside of the foot. From 1723 until his death Gondelach directed the Landgrave's glass factory at Altmünden.

BIBLIOGRAPHY

G. E. Pazaurek: *Franz Gondelach*, Keramik- und Glasstudien, i (Berlin, 1927)

F. A. Dreier: 'Franz Gondelach: Anmerkungen zum Leben und Werk', *Z. Dt. Ver. Kstwiss.*, xxiv (1970), pp. 101–40

'Franz Gondelach: Baroque Glass Engraving in Hesse', *J. Glass Stud.*, xxxviii (in preparation)

FRANZ ADRIAN DREIER

Gondelach [Gondolach], **Matthäus**. *See* GUNDELACH, MATTHÄUS.

Gondi. Italian family of patrons and collectors. Exiled (as Ghibellines) after the battle of Benevento (1266), they were recalled to Florence in 1278 but were excluded thereafter from public life. Bartolomeo Gondi (1492–1577) is mentioned by Vasari as the owner (before 1568) of works by Giotto, Donatello, Fra Angelico, Perugino and Giovanni Antonio Sogliani. His son, Benedetto Gondi (1539–1616), was the friend of Giambologna and executor of his will; his collection included 18 works by Giambologna, and he also purchased works by painters who worked with Giambologna on the chapel of S Antonio in S Marco, Florence: Domenico Passignano, Alessandro Allori and Giovan Battista Naldini.

The major part of Benedetto Gondi's collection, however, comprised works purchased by his father. The inventory that Benedetto had drawn up in 1609 includes paintings by Andrea del Minga (*fl* 1564; *d* 1596), Pontormo, Maso Finiguerra, Fra Bartolommeo, Daniele da Volterra, Parmigianino, Herri met de Bles, Friedrich Sustris and other anonymous Flemish artists, sculptures by Donatello, Antonio del Pollaiuolo and Lucas van Leyden, architectural plans by Giuliano da Sangallo, studies by Giulio Romano and watercolours by Alessandro Allori. Giovanni Battista Gondi (1589–1664), Florentine ambassador to the French court, was from 1623 to 1628 the

intermediary of Marie de' Medici, Queen of France, in her correspondence with the court of Ferdinando II de' Medici, Grand Duke of Tuscany, regarding the interior decoration of the Palais du Luxembourg in Paris.

BIBLIOGRAPHY
G. Corti: 'Two Early Seventeenth-century Inventories Involving Giambologna', *Burl. Mag.*, cxviii (1976), pp. 629–34
D. Marcow: 'Maria de' Medici and the Decoration of the Luxembourg Palace', *Burl. Mag.*, cxxi (1979), pp. 783–91
G. Corti: 'Two Picture Collections in Eighteenth-century Florence', *Burl. Mag.*, ccxxiv (1982), pp. 502–5

CHIARA STEFANI

Gondoin [Gondouin], **Jacques** (*b* St Ouen, nr Paris, 7 June 1737; *d* Paris, 29 Dec 1818). French architect. He was the son of the gardener at the royal château of Choisy-le-Roi and attended Jacques-François Blondel's school of architecture, the Ecole des Arts, winning third place in the Prix de Rome competition of 1759. He spent five years in Rome (1761–6) on a bursary granted by Louis XV, and he made friends there with Giovanni Battista Piranesi. He returned to France via Holland and England. In 1769, at the suggestion of the King's surgeon Germain Pichault de la Martinière, he was commissioned to design the new Ecole de Chirurgie (1771–86; now the Faculté de Médecine, Paris; *see* NEO-CLASSICISM, fig. 4). The layout is in the manner of an *hôtel particulier*, with a court surrounded by an Ionic colonnade and closed off from the present Rue de l'Ecole de Médecine by a columnar screen. It was this feature that made a great impression on Gondoin's contemporaries, lacking as it does the usual inflections by projecting end pavilions and central *avant-corps*. A line of Ionic columns on pedestals runs right across the elevation at ground-floor level, supporting a perfectly straight entablature that lacks the canonic architrave. In the centre the columns, doubled in depth, form a walk-through colonnade giving access to the courtyard. This open feature is contrasted with three arched bays at each end, which the columns punctuate. The upper storey has a rectangular window in each bay, save for three that are replaced by an oblong panel with relief sculpture. In the courtyard, which is lined by low, columned galleries, stands the anatomy lecture theatre with a hexastyle temple front. The lecture hall, seating 1500, takes the form of an amphitheatre roofed by a coffered half dome and lit by an oculus. To each side of this hall are other lecture rooms, hospital wards, a laboratory and a chapel, with a library at first-floor level over the entrance. Although the design of the school appeared to diverge from all the academic rules, it was admired by the public, both professional and lay, for what was perceived as its Greek simplicity, the disposition of its massing with its contrasting features and its subtle proportions. It was hailed by Antoine Quatremère de Quincy as 'the most classical building of the 18th century'. Gondoin's original scheme placed the school within the context of an urban plan that involved converting the Franciscan friary opposite into a debtors' prison, with a massive ashlar wall punctuated by bare windows, and adding a massive Doric portico to the church of St Côme on one of the adjacent sides. The plan remained unexecuted, however, because of the unwillingness of the Franciscans to comply.

Gondoin was elected a member of the Académie d'Architecture in 1774. At the end of 1775 he went on a year's sabbatical to Italy, where he tried unsuccessfully to purchase and develop the site of Hadrian's Villa at Tivoli. He presented the details of his scheme to Piranesi. On his return to France he began building his own Palladian villa, Les Vives Eaux, on the Seine near Melun. In 1779 he was appointed furniture designer to Louis XVI and produced designs that were executed by Jean-Henri Riesener. He received few commissions during the Revolution and withdrew to his villa, where he worked on the garden. In 1795 he was appointed a member of the new Institut de France and of the Conseil des Bâtiments Civils. The possibility of laying out a new square opposite the Ecole de Chirurgie ultimately came about (1805–6) with the demolition of the Franciscan church. Gondoin erected the monumental Fountain of Asklepios (destr.) in the square, opposite the school. In his final years he produced a scheme for renovating the château of Versailles (1807) and, together with Jean-Baptiste Lepère (1761–1844), built the Vendôme Column (1806–11), Paris, with its spiral reliefs on bronze plaques after cartoons by Pierre Nolasque Bergeret.

WRITINGS
Description des écoles de chirurgie (Paris, 1780)

BIBLIOGRAPHY
Thieme–Becker
J.-G. Legrand and C. P. Landon: *Description de Paris et de ses édifices*, 2 vols (Paris, 1806)
A. Quatremère de Quincy: *Notice de M. Gondoin* (Paris, 1821)
A. Braham: *The Architecture of the French Enlightenment* (London, 1980, 2/1989)

GÉRARD ROUSSET CHARNY

Gondola, Andrea di Pietro della. *See* PALLADIO, ANDREA.

Gondrin, Antoine-Louis de Pardaillan de. *See* ANTIN, DUC D'.

Gonfanon. *See under* FLAGS AND STANDARDS.

Gong Banqian. *See* GONG XIAN.

Gong Kai [Kung K'ai; *zi* Shengyu; *hao* Cuiyan] (*b* Huaiyin, Jiangsu Province, 1221; *d* 1307). Chinese painter, calligrapher, essayist and poet. When the Mongols became rulers of China as the Yuan dynasty (1279–1368), Gong Kai became known chiefly as one of the loyalists of the preceding Southern Song dynasty (1127–1279). Like many intellectuals of the Song period, he received a standard classical education. However, having apparently failed to distinguish himself in the official civil service examinations, he had to serve on the staff of commanders guarding the area of Lianghuai (now Jiangsu Province, north of the River Yangzi) against the constant threat from the north by the Ruzhen (Jürchen) and the Mongols. After the Yuan dynasty became established, Gong lived a secluded life with his family, mainly in the cultural centre of Suzhou and in Hangzhou, the old Southern Song dynastic capital, although he remained active in literary circles. His final years seem to have been spent in poverty. It was said that, lacking furniture in his house, he wrote or drew by resting the paper on his son's back. Nevertheless, his artistic and

literary accomplishments earned him the respect of many of his friends.

Only two of his paintings are extant. *An Emaciated Horse* (handscroll, Osaka, Mun. Mus. A.) is, according to his own poem inscribed on the painting, a depiction of the misery that afflicted intellectuals who had been Song adherents with the advent of the Yuan period. *Night Excursion of Zhong Kui* (handscroll, Washington, DC, Freer) portrays Zhong Kui, the demon-queller of the underworld, as a conqueror of ghosts (who symbolized the Mongols). Gong's calligraphic inscription was written in characters variously described as *lishu* (clerical script), *bafen* ('eight-tenths' style), an elegant version of *lishu*, and *zhuanshu* (archaic or seal script). Gong's major work was apparently a set of 36 portraits (destr.) of the followers of Song Jiang, the rebel leader portrayed in the famous novel *Shuihu zhuan* ('The water margin') by Shi Naian. According to literary records, Gong also wrote poems in praise of the heroes.

Although Gong's horse and figure paintings were supposedly based on those of Han Gan and Cao Ba (*fl* AD 713–42) of the Tang period (AD 618–907), surviving works display an individual style. The brushwork is strong and firm, and the lines are thick and expressive, lacking the realistic minutiae of Tang models. Although Gong was certainly part of the contemporary movement that returned to Tang and earlier models, the content of his work seems consistently to have been chosen for the single purpose of expressing loyalty to the vanished Song dynasty.

BIBLIOGRAPHY

Franke: 'Kung K'ai'

J. Cahill: *Hills beyond a River: Chinese Painting of the Yuan Dynasty, 1279–1368* (New York and Tokyo, 1976), pp. 17–18

Chen Gaohua: *Yuandai huajia shiliao* [Historical material on Yuan-period painters] (Shanghai, 1980), pp. 287–99

CHU-TSING LI

Gong Xian [*zi* Banqian; *hao* Yeyi, Chaizhang] (*b* Kunshan, Jiangsu Province, 1617–20; *d* Nanjing, Jiangsu Province, 1689). Chinese painter. He was regarded by traditional Chinese art historians as the leading painter of the 17th-century NANJING SCHOOL, a regional style of landscape painting distinguished by solidity of form and expansiveness of spatial rendering. Other Nanjing painters whose work shared these characteristics, in contrast to the more skeletal, two-dimensional and calligraphic styles prominent elsewhere in China, included Wu Bin (*fl* 1568–1621) and Fan Qi (1615/16–*c*. 1694), both of whom influenced his art, as well as the lesser artists Ye Xin (*fl* 1650–70s), Zou Che (1636–*c*. 1708), Gao Cen (*fl* 1670s; *d* 1689), Hu Cao (*fl* 1681), Wu Hong (*fl* 1670s–80s) and Xie Sun (*fl* 1679). Gong, Fan and the latter artists are usually referred to in traditional painting histories as the Eight Masters of Jinling [Nanjing].

Gong spent his early years in Nanjing. He began painting and writing poetry in his early teens. By his mid-20s he had established friendships within the city's literary élite and was better known as a poet than as a painter. He seems also to have had important political patronage and a promising official career, but the factionalism at the court of the last Ming emperor and the subsequent Manchu conquest of Beijing in 1644 shattered his political future.

Associated with both partisans and opponents of the Fu she ('Restoration Society') movement for conservative reform, the cause of his political demise is unclear, but *c*. 1647 he was forced into flight and spent most of the following decade in seclusion, first in his rural retreat at Haian zhen near Taizhou, Jiangsu Province, where he supported himself as a family tutor, and then, from 1651 to *c*. 1655, in Yangzhou, which was becoming a thriving cultural centre. The turmoil of this decade, which included the death of his young first wife, was a bitter experience from which he never recovered.

The rest of Gong Xian's life was shaped by his refusal to serve the Manchu government. On returning to Nanjing, he purchased his well-known 'Half-acre Garden', where he spent most of his final decades as a semi-recluse and which is still maintained as a public memorial to this patriotic artist. He was described by his neighbour, the literati patron Zhou Lianggong, as 'difficult to get along with'. Lacking any other means of income, Gong Xian was compelled to support himself as a professional painter, a demeaning experience for a Chinese scholar. Patronage came from two sources: scholar-friends of similar social background who sympathized with his political loyalty and his social predicament, including such prominent literary figures and collectors as Zhou Lianggong, Wang Shizhen and Kong Shangren (1648–1718); and newly wealthy merchants, particularly from Yangzhou. Sometimes Gong Xian openly expressed in inscriptions for his merchant clientele the disdain he felt for them, setting a precedent for 18th-century Yangzhou painters.

Gong's earliest known paintings, rather than reflecting the typical Nanjing style, were done in the pale, minimal, linear style of artists of the ANHUI SCHOOL, for example his undated six-leaf album, *Gong Chaizhang shanshui ce* ('An album of landscapes by Gong Chaizhang [Gong Xian]'; untraced; see Cahill, 1970, pls 3, 5–9). Only in the mid-1650s did he begin to evolve a style in which his forms were more substantial, moulded through the use of rich ink and strong tonal contrasts. Solids and voids described monumental landscape settings that recalled the works of Northern Song (960–1127) painters such as Li Cheng, Dong Yuan and Mi Fu. Particularly reminiscent of these is his untitled landscape of 1655 (Taipei, priv. col.; see Cahill, 1970, pl. 14). Gong's strength lay not so much in his brushwork technique as in compositions unusual for their dramatic force, for example a *Thousand Peaks and Myriad Ravines* (see fig.). Here, the tonal contrasts and powerfully rhythmic structures of his paintings owed much to DONG QICHANG, the most influential Chinese artist of the 17th century. Gong's forms, however, exceeded those of Dong in their degree of unsettling emotional expression. As in other works of the Nanjing school, the possibility of Western influence has been suggested. Evidence lies in the modelling of substantial forms, in the apparent palpability of the clouds and mist and in the accentuation of light sources, which heightens the tonal contrast. A combination of Song- and Ming-period (1368–1644) precedents may be sufficient to explain these qualities, but European topographic renderings brought to China by Jesuits show striking similarities, for

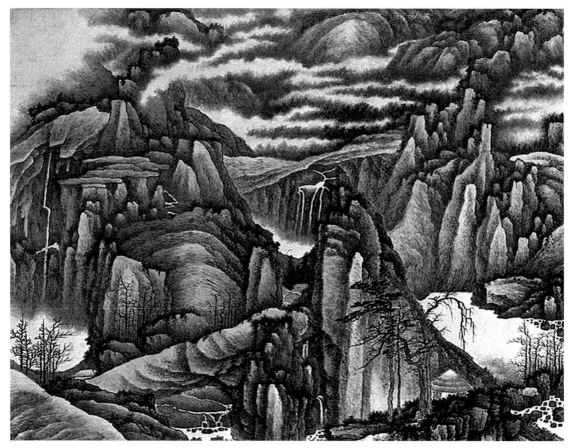

Gong Xian: *A Thousand Peaks and Myriad Ravines*, hanging scroll, ink on paper, 620×1020 mm, *c.* 1670 (Zurich, Museum Rietberg)

example Anton Wierix I's engravings for Abraham Ortelius's *Teatrum orbis terrarum* (1579; see Cahill, 1982, pls 5.38 and 5.41).

It has been suggested that the bitterness of his personal life and his political disappointments are reflected in his work; certainly, both his landscape poetry and his inscriptions on willow paintings, such as *Uncultivated Willows in Early Winter* (1650s; untraced; see Silbergeld, 1980, fig. 10), confirm the somewhat unusual intrusion of political sentiments into his artistic expression. Gong's indulgence in such Daoist activities as herbalism and breath control has also been held to account for the other-worldly vision of his landscapes. The force of such expression reached a peak between 1660 and 1670, after which some of his personal bitterness had become tempered by the passage of time and by the satisfaction of attaining a lofty artistic reputation. Subsequently, a more gentle and consciously aesthetic expression began to suffuse his landscapes, and the works of his last decade reflect not only a decline in the dynamic tension of earlier years but also lapses in quality, brought about by the demands of commercial production. Until his final months, however, he continued to produce outstanding works, such as his untitled hanging scroll (1689; Honolulu, HI, Acad. A.), in which the brushwork is more spontaneous and broadly calligraphic. The tonal contrasts of earlier works are more subdued, and the contortions and spatial disjunctures of earlier works are supplanted by forms more gracefully knitted together.

Despite Gong's large output as a professional artist, he did not attain any great financial success, which may account for his serving as a painting master. He taught his students with the use of sketchbooks, a number of which are among the oldest such works now extant. Among these are the *Banqian ketu hua shuo* ('Banqian's [Gong Xian's] painting discussions for students'), once erroneously attributed to Xi Kang (1746–*c.* 1816); *Gong Banqian shoutu hua gao* ('Gong Banqian's instructional sketchbook'; ex-Zhang Changbo Col.; for both see Wu, 1970, pls 1–9, 13, 18); and his well-known *Hua jue* ('Secrets of painting'), only the text of which survives. When Gong Xian died in 1689, he was so poor that his patron–friend Kong Shangren, a descendant of Confucius and a famous playwright, paid his funerary expenses and took over the care of his children. The personally expressive and individualistic qualities of Gong's art explain in part why he never achieved a significant following. As he claimed, 'There has been no one before me and there will be no one after me.' His pupil Wang Gai (*fl* 1677–1705), however, became noted as the compiler of the landscape volume (1679) of the *Jiezi yuan huazhuan* ('Mustard seed garden painting manual'), which provided models for painting elements

and motifs in the styles of old masters and codified the Nanjing school style into learnable type-forms, thus propagating the style, not only in China but also in Edo-period (1600–1868) Japan. Gong's work was never collected at the Qing court (1644–1911), whom he had opposed, and much of his finest work is found in Western collections.

BIBLIOGRAPHY

A. Lippe: 'Kung Hsien and the Nanking School', *Orient. A.*, n. s., ii/1 (1956), pp. 3–11

Liu Gangji: *Gong Xian* (Shanghai, 1962)

M. Wilson: *Kung Hsien: Theorist and Technician in Painting* (Kansas City, MO, 1969)

J. Cahill: 'The Early Styles of Kung Hsien', *Orient. A.*, n. s., xvi/1 (1970), pp. 51–71

W. Wu: 'Kung Hsien's Style and his Sketchbooks', *Orient. A.*, n. s., xvi/1 (1970), pp. 72–80

Wang Shiqing: 'Gong Xian de Caoxiang tang ji' [Gong Xian's collected poetry from the Hall of Fragrant Grass], *Wenwu* (1978), no. 5, pp. 45–9

W. Wu: *Kung Hsien* (diss., Princeton U., NJ, 1979)

J. Silbergeld: 'Kung Hsien's Self-portrait in Willows', *Artibus Asiae*, xlii (1980), pp. 5–38

——: 'Kung Hsien: A Professional Chinese Artist and his Patronage', *Burl. Mag.*, cxxiii (1981), pp. 400–10

J. Cahill: *The Compelling Image: Nature and Style in Seventeenth-century Chinese Painting* (Cambridge, MA, 1982), pp. 168–83

Hua Derong, ed.: *Gong Xian yanjiu* [Studies on Gong Xian] (Shanghai, 1988)

Wang Daoyun and Liu Haisu, eds: *Gong Xian yanjiu ji* [Collected studies on Gong Xian] (Nanjing, 1988)

JEROME SILBERGELD

Gong xian [Kung hsien]. Site in Henan Province, China, east of the city of Luoyang. A complex of five Buddhist caves, dating from the Northern Wei period (AD 386–534), is located on the south side of Mt Mang on the northern bank of the Yiluo River. The ground level along the river is higher than the ground level inside the caves by over a metre because of dirt accumulated from flooding. The construction of the caves, sponsored by the Northern Wei imperial family, took place between *c.* AD 505 and 526, starting with Cave 1. In addition, many small niches and inscriptions sponsored by other devotees were carved later on the outside of the caves and bear dates ranging from AD 531 to 1735.

Cave 1, on the far west, measures 6×6 m; caves 3, 4 and 5 are successively smaller in size, and Cave 2 is unfinished. All are square in layout and, except for Cave 5, have internal central pillars. The once coherent sculpted façade between caves 1 and 2 is now in a fragmentary state. Inside the caves, all surfaces are fully sculpted. The main Buddhist images occur in configurations of three or five, in niches occupying the centre portions of the west, north and east walls and the central pillars. The ceilings of caves 1, 3 and 4 are divided into squares by crossbeams, and each square is decorated with an *apsarās* (celestial nymph) or a floral motif; the ceiling of Cave 5 has a large lotus medallion. The floors of the caves are also carved. Emperors, empresses, members of the imperial family and high officials of the court are represented in panels on the south walls of caves 1, 3 and 4; in Cave 5, the south wall is occupied by two standing Buddhas. Figures of deities, monsters and musicians occupy the bottom section of the four walls and central pillars of all caves except Cave 5.

The significance of the caves lies in their imagery and meticulous arrangement of figures. Among Chinese sculptures, those in Cave 1 are the earliest to combine clearly images from both Indian Buddhist and indigenous Chinese traditions. The cave is a configuration of scenes making up a single vision from the Buddhist tradition: the preaching from the Lotus Sutra by Shakyamuni, the historical Buddha. A scene of the discourse between Vimalakirti and Manjushri from the Vimalakirti Sutra is integrated into scenes from the Lotus Sutra. Non-Buddhist images derived from the Chinese tradition include monsters intended to avert evil spirits, deities for the protection of the welfare of the country, and imperial processions, which in costume and arrangement demonstrate the rules of etiquette corresponding to the hierarchy of the Chinese court. Caves 3 and 4 are simplified versions of Cave 1. From a religious standpoint, fervour in spreading the faith has been reduced to a more pragmatic level of meeting with the Thousand Buddhas. Images from the Chinese tradition are similar to those of Cave 1, but there are some additional deities. Cave 5, even more economical in represention, has only images of the Buddhas of the Three Ages and accompanying figures.

The sculptures at the site were once painted, but only faint traces remain. They have a uniform style: seated figures sit erect with head slightly bent, arms held close to the torso and legs crossed. The torso makes a vertical axis and the crossed legs a horizontal one. A robe is draped over the body in regulated folds with strict adherence to these two axes; the cascade of pleats over the pedestal also indicates a preference for orderliness over naturalism. The clean shape of the figures is emphasized by a plain nimbus. Standing figures are also clearly defined, although the lower half of the body has an A-line contour with serrated edges and a scalloped hemline. The simple style of the sculpture, which distinguishes it from contemporary sculpture such as that at the central Binyang cave at LONGMEN, set a major stylistic trend for Chinese sculpture in the 6th century AD.

Gong xian was also home to the Northern Song (906–1127) imperial graveyard (*see* CHINA, §II, 6(ii)(d)).

BIBLIOGRAPHY

Kitano Masao: *Chinese Stone Buddha Images* (Osaka, 1953)

Chen Mingda: *Gong xian shiku shi* [Cave temples of Gong xian] (Beijing, 1963)

Zhongguo shiku: Gong xian shiku shi [Chinese cave temples: Cave temples of Gong xian] (Tokyo, 1963)

Rikuchō no bijutsu [The art of Rikuchō] (exh. cat., Osaka Mus. A., 1975)

M. Siuping Ho: *Gong xian and its Pivotal Importance to the Chinese Buddhist Sculptural Tradition of the Sixth Century* (diss., U. Chicago, IL, 1989)

MOLLY SIUPING HO

Gonin, Francesco (*b* Turin, 16 Dec 1808; *d* Giaveno, nr Susa, Piedmont, 14 Sept 1889). Italian painter, printmaker, illustrator and stage designer. He studied at the Accademia Albertina di Belle Arti in Turin under the painters Giovan Batista Biscarra (1790–1851) and Luigi Vacca (1778–1854), whose daughter he married. He was one of the first Italian artists to specialize in lithography and wood-engraving, and he became famous as the major illustrator of *I promessi sposi* and the *Storia della colonna infame* by Alessandro Manzoni (published together, Milan, 1840). He also illustrated a selection of the poetry of Carlo Porta and

Tommaso Grossi written in Milanese dialect, *Poesie scelte in dialetto milanese di C. Porta e T. Grossi* (Milan, 1842), and in these illustrations he revealed a taste for the humble and the picturesque. He was a versatile artist and, after collaborating with Vacca in the 1830s, received royal commissions for frescoes: with Carlo Bellosio (1801–49) he decorated the ballroom of the Palazzo Reale in Turin and the Sala delle Verne in the Castello di Racconigi (both 1840–41); he also decorated the Palazzo Carignano in Turin (1845). In 1854 Gonin succeeded Vacca as stage designer at the Teatro Regio in Turin. His most famous piece was the large curtain depicting the *Triumph of Venus*, of which the sketch still exists (1854; Turin, Gal. Civ. A. Mod.). He was also a painter of historical, genre and religious subjects as well as landscapes and portraits. Some of his works are held in the Galleria di Palazzo Bianco in Genoa and in the Galleria Nazionale d'Arte Moderna–Arte Contemporanea in Rome.

BIBLIOGRAPHY

Bolaffi

La cultura figurativa e architettonica negli Stati del Re di Sardegna, 1773–1861, 3 vols (exh. cat., ed. E. Castelnuovo and M. Rosci; Turin, Pal. Reale; Turin, Pal. Madama; 1980), pp. 406–7, 411–12, 424–8, 469–70, 870–74, 1448–9

SILVIA LUCCHESI

Gonnelli, Giovanni Francesco [il Cieco da Gambassi] (*b* Gambassi, 1603; *d* Rome *c.* 1664). Italian sculptor. The son of a glassmaker, he studied under the sculptor Pietro Tacca in Florence. While in the service of Carlo I Gonzaga, Duke of Mantua, he was trapped in Mantua during the Austrian siege of 1630 and somehow he was blinded. According to Filippo Baldinucci, a contemporary and acquaintance of Gonnelli's, his blindness was due to the hardships endured during the siege, not to any accident. Deprived of his livelihood, Gonnelli returned home and spent several unproductive years there. According to Baldinucci, his first completed work was a clay bust of *Carlo Gonzaga, Duke of Mantua*, begun from life ten years earlier. In time he regained his confidence and began to accept commissions.

Gonnelli's surviving works include reliefs of the *Nativity* (Casole, S Maria Assunta) and the *Pietà* (Borgo di Colle, Santa Croce and S Bernardino all'Osservanza) and a statue of *St Stephen* (Florence, S Stefano), which was mentioned by Baldinucci. Because of his blindness, Gonnelli's works were made of malleable materials such as wax and clay and were often covered with a monochrome varnish rather than painted, as was more typical of the 17th century. He is considered to be one of the last of the school of Giovanni della Robbia and to represent the provincial Italian Baroque.

Gonnelli became particularly well known for his portrait busts, which were often finished with a verdigris that gave the look of antique metal. Among his commissions were busts of *Ferdinand II, Grand Duke of Tuscany* and *Pope Urban VIII*. According to Baldinucci, subjects were posed at Gonnelli's side, and his hands would move back and forth moulding a portrait. His contemporaries had some difficulty believing he was blind: one subject, described only as 'a cardinal', tried to trick him by sending another man to pose in his place; on another occasion Gonnelli

was made to work in a darkened room. Because contemporary biographers were fascinated by his predicament and emphasized that to the detriment of scholarship, Gonnelli's works can be difficult to verify. It is probable that his loss of sight restricted him to the style of della Robbia that he was taught as a young man and prevented his full artistic growth.

BIBLIOGRAPHY

Thieme–Becker

F. Baldinucci: *Notizie* (1681–1728); ed. F. Ranalli (1846), iv

C. Ajraghi: 'Giovanni Gonnelli detto Il Cieco da Gambassi', *Emporium*, xxii (1905), pp. 122–6

D. F. Darby: 'Ribera and the Blind Man', *A. Bull.*, xxxix (1957), pp. 195–217

R. J. PYLE

Gontard, Karl [Carl] **Philipp Christian von** (*b* Mannheim, 13 Jan 1731; *d* Breslau [now Wrocław, Poland], 23 Sept 1791). German architect. He entered the court building office in Bayreuth as a clerk of works in 1749 and from 1750 to 1752 studied with Jacques-François Blondel in Paris. From 1754 he was a building inspector and head of the court building office, and in 1754–5 he accompanied Markgraf Friedrich of Bayreuth (*reg* 1735–63) on a trip to southern France and Italy. After the Markgraf's death, Gontard was summoned by Frederick II, King of Prussia, to Potsdam. As head of the building office from 1764—first in Potsdam, then, after 1779, in Berlin—he was in charge of all royal building projects, and he was ennobled in 1767. Gontard's modest early works in Bayreuth show the influence of Blondel. After his trip to Italy he built the south wing (1757–64) of the Neues Schloss and the Palais Reitzenstein (1761), both in Bayreuth, which already show Neo-classical tendencies in forms still bound to the Rococo. This trend is continued in the extension (1763–9; with Johann Gottfried Büring) of the Neues Palais in Potsdam, although Gontard was obliged to use 'Frederician Rococo' motifs. Opposite this palace he erected the Communs (buildings to accommodate the royal retinue) and a colonnaded exedra linking them (1768–9). Here, as in the Königskolonnaden (1777–80) in Berlin, Gontard continued to employ Baroque theatrical effects. By contrast, the sentimental element in this classicism is expressed with simplicity in the temples of Friendship and Antiquity (1768–70) in the park of the Neues Palais, Potsdam. In Gontard's many private houses in Potsdam and Berlin an early classical style with English influences is increasingly noticeable. In 1786 Frederick William II promoted Gontard to engineer–major, and he subsequently received further royal commissions, including the Marble Palace (1786–9) in Potsdam, which marks his definitive adoption of English Neo-classicism. Gontard's work prepared the ground for the flowering of classicism in Berlin. His most important pupils in this respect were Friedrich Wilhelm Titel (1754–1840) and Heinrich Gentz.

BIBLIOGRAPHY

NDB

P. Wallé: *Leben und Wirken Karl von Gontards* (Berlin, 1891)

K. Sitzmann: 'Die Frühzeit des Architekten Carl von Gontard in Bayreuth', *Archv Gesch. Oberfranken*, xxxvi (1952), pp. 140–85

H. Drescher: *Zum Spätstil der friderizianischen Architektur: Die Tätigkeit Carl von Gontards für König Friedrich II. von Preussen am Neuen Palais in Potsdam* (Berlin, 1968)

F. Mielke: *Das Bürgerhaus in Potsdam*, 2 vols (Tübingen, 1972)

H. Drescher: 'Das Neue Palais in Potsdam und der Spätstil der friderizianischen Architektur', *Charlottenburg, Berlin, Preussen: Festschrift für Margarete Kühn* (Munich, 1975), pp. 217–36

F.-E. Keller: 'Die Königskammern Friedrich Wilhelms II.', *Das Berliner Schloss*, ed. G. Peschken and W. Klünner (Berlin, 1982), pp. 74–94, 507–17

H. J. Giersberg: *Friedrich als Bauherr: Studien zur Architektur des 18. Jahrhunderts in Berlin und Potsdam* (Berlin, 1986)

FRITZ-EUGEN KELLER

Gontier [Gonthier], **Linard** (*b* ?Troyes, 1565; *d* ?Troyes, *c*. 1642). French glass painter. He was probably a pupil of Nicolas Macadré. Gontier headed a busy workshop in Troyes in which his three sons, Linard Gontier the younger, Nicolas Gontier and Jean Gontier were active. His creations are celebrated for their versatility: the rich, deep hues of religious compositions attained through a mastery of the enamelling technique, and the minutely detailed but ambitious secular scenes. He is recorded as having produced a treatise (lost by the 18th century), which demonstrates his commitment to technique. His better known sacred works were executed for Troyes Cathedral—*Credo*, 1606; *Mystical Wine Press*, 1625; *Life of St Peter*, 1639 (the *Immaculate Conception* and the *Martyrdom of St Stephen*, 1624, were transferred there from St Etienne, Troyes)—and for St Martin-ès-Vignes (*Life of the Virgin*, 1620–25). His civic commissions are exemplified by some 45 extant panels (1620–25; Troyes, Bib. Mun., Mus. Hist. Troyes & Champagne) from the Hôtel de l'Arquebuse, Troyes. Crisply depicted, the last eulogize the French monarchy and the allegiance of the gunsmiths to Louis XIII. Some of the preparatory drawings survive, including two in Troyes (Mus. Hist. Troyes & Champagne and priv. col.), and two for the *Battle of Ivry* and *Henry IV Handing his Crown to his Son* in Pau (Château), which correspond in size to the respective windows. The Gontiers, who often based their compositions on engravings by Albrecht Dürer, Domenico del Barbiere, Gerard de Jode (i), Nicolas Bollery and others, were the last glass painters of stature in Troyes.

BIBLIOGRAPHY
A. Babeau: 'Linard Gontier et ses fils peintres-verriers', *Annu. Admin. Statistique & Commerc. Aube* (1888), pp. 113–39
N. Hamy: 'Linard Gontier et ses fils, peintres-verriers: L'Oeuvre de l'atelier, les vitraux civils', *Mem. Soc. Acad. Agric., Sci., A. & B.-Lett. Dépt Aube*, cviii (1974–7), pp. 173–91
J. Rigal: 'Deux dessins de Linard Gontier pour des vitraux de l'Hôtel de l'Arquebuse à Troyes', *Rev. Louvre*, xxvii (1977), pp. 70–77
J. Rigal: 'L'Entrée de Henri IV à Paris: Trois vitraux de l'Hôtel de l'Arquebuse à Troyes d'après Nicolas Bollery', *Nouv. Est.*, xxxix (1978), pp. 10–13
N. Hamy: 'Linard Gontier et ses fils, peintres-verriers: La Peinture sur verre à Troyes dans la seconde moitié du 17e siècle', *Mem. Soc. Acad. Agric., Sci., A. & B.-Lett. Dépt Aube*, cx (1979–81), pp. 33–58

PATRICK M. DE WINTER

Gonzaga. Italian dynasty of rulers, patrons and collectors (see fig.). In 1328 Ludovico Gonzaga (*d* 1360) seized power from the Bonacolsi family, becoming Capitano of MANTUA. For the next four centuries the Gonzaga ruled the city, acquiring the title of Marchese, and later Duke, of Mantua. The urban development and art life of Mantua was strongly influenced by the patronage of the family: in the mid-15th century (3) Ludovico II Gonzaga, 2nd Marchese of Mantua, employed many artists and architects, among them Leon Battista Alberti and Andrea Mantegna,

from other areas in Italy, resulting in a flourishing Renaissance court. Similarly, Ludovico's great-grandson (9) Federico II Gonzaga, 5th Marchese and 1st Duke of Mantua, persuaded Giulio Romano to come to Mantua, where Giulio became the leading painter, architect and town planner. (15) Vincenzo I Gonzaga, who employed such Northern artists as Frans Pourbus the younger and Peter Paul Rubens, was one of the last notable Gonzaga patrons and collectors; his son, (17) Vincenzo II Gonzaga, 7th Duke of Mantua, the last ruler of the main line of the family, in 1626–7 sold most of the family's art collection to Charles I, King of England and Scotland, due to lack of funds. Thereafter the fortunes of the Gonzaga declined: in 1630 the city was sacked by imperial troops, and in 1707 (20) Ferdinando-Carlo, 10th Duke of Mantua, was forced to accept the rule of the Austrian Habsburgs, which lasted until 1866.

BIBLIOGRAPHY
The Splendours of the Gonzaga (exh. cat., ed. D. S. Chambers and J. Martineau; London, V&A, 1981–2)

(1) Francesco I Gonzaga, 4th Capitano of Mantua (*b* Mantua, 1366; *reg* 1382–1407; *d* Cavriana, 17 March 1407). He was the son of Ludovico Gonzaga, 3rd Capitano of Mantua (1334–82), and Alda d'Este (1333–81). In 1380 he married Agnese Visconti (*d* 1391) and in 1393 Margherita Malatesta da Rimini (*d* 1399). Francesco was a great patron of architecture and initiated a number of ambitious projects in Mantua. He ordered the building (*c*. 1388) of a small palazzo next to his official residence, known as the Casa Giocosa, and in 1395 began the construction of the Castello S Giorgio and the Ponte di S Giorgio. The castle was designed by BARTOLINO DA NOVARA, who had previously been employed by the Este of Ferrara. In 1395 Francesco commissioned the Venetian sculptor JACOBELLO DALLE MASEGNE to design the façade (destr.) of the cathedral of S Pietro, for which a detailed contract (Mantua, Archv Capitolare Cattedrale), dated 26 October, exists. After a plague epidemic of 1399 building of the pilgrimage church of S Maria delle Grazie was begun (completed *c*. 1400; consecrated 1406). There, Francesco again employed Jacobello dalle Masegne, together with his brother Pietropaolo. The sepulchral monument (mostly destr.; effigy in Mantua, Pal. Ducale) of Francesco's second wife, Margherita Malatesta, was commissioned on 5 April 1400 from Pietropaolo dalle Masegne for the church of S Francesco. Pietropaolo also carried out work on the façade of S Pietro in 1401. In 1405 the church of S Andrea was begun. Francesco also acquired books and manuscripts for the Gonzaga library; an inventory made in 1407 shows it to have been one of the most remarkable of this period, comprising 392 volumes, mostly in Latin and Italian, although a substantial number, 67, were in French or by French authors. Some of these may have been obtained in 1389, when Francesco visited Paris, where he also purchased jewels, clothes and works of art. He is buried in the chapel of St Louis of Toulouse (the Cappella dei Principi) in S Francesco, Mantua.

BIBLIOGRAPHY
P. Girolla: 'La biblioteca di Francesco Gonzaga secondo l'inventario del 1407', *Atti & Mem. Accad. N. Virgil. Mantova*, xiv–xvi (1923), pp. 30–72

Family tree of the Gonzaga dynasty

G. Paccagnini: *Mantova: Le arti*, i (Mantua, 1960), pp. 81–3, 109–13, 157–61, 241–2

E. Marani: 'Nuovi documenti mantovani su Jacobello e Pietropaolo dalle Masegne', *Atti & Mem. Accad. N. Virgil. Mantova*, xxxii–xxxiii (1960–62), pp. 71–103

E. Marani and C. Penna: *Mantova: Le arti*, ii (Mantua, 1961), pp. 91–5

☐

(2) Gianfrancesco Gonzaga, 5th Capitano and 1st Marchese of Mantua (*b* Mantua, 1 June 1395; *reg* 1407–44; *d* Mantua, 24 Sept 1444). Son of (1) Francesco I Gonzaga. He succeeded his father as 5th Capitano of Mantua in 1407, while still a minor. In 1409 he married Paola Malatesta, daughter of Malatesta Malatesta. He played a decisive role in steering Mantua towards the humanistic culture of the Renaissance. He was, however, a *condottiere* by profession and fought first (1421) for Filippo Maria Visconti, 3rd Duke of Milan, although in 1425 he changed his allegiance to the Venetian Republic, for whom he worked for much of his career, reverting to the Milanese camp only in 1437. In 1432 he bought the hereditary title of Marchese of Mantua from Emperor Sigismund of Luxemburg, thereby legitimizing the Gonzaga rule of Mantua and its territories.

Gianfrancesco did much to improve the city and the Gonzaga residences. In 1408 he built a Carthusian monastery (destr.) outside the city walls, and, on his orders, the Ponte dei Mulini (*c.* 1417; destr.), the principal bridge linking Mantua to the mainland, was covered over and the city walls repaired. At this time Paola Gonzaga enclaved the convent of the Poor Clares of S Paola and founded the adjacent church of Corpus Domini. Brunelleschi obtained permission from the Opera del Duomo, Florence, to visit Mantua in 1431 and in 1433, where he was apparently consulted about draining systems for the city and may have also advised on urban planning. In 1435 work began on the country villa of Marmirolo (destr.), later one of the most highly decorated of Gonzaga residences, and in 1436 the cloister of the Convent of S Agnese was completed. In 1441 work was done on the Palazzo della Ragione, and in 1443 Santa Croce in Corte Vecchia was completed.

In 1422 PISANELLO was recorded living in Mantua; Gianfrancesco gave him the courtesy title of *familiare* in 1439. Much of his Mantuan work has been lost; in 1424–6 he was paid for unspecified work and in 1439 was working for Paola Gonzaga in an unnamed church. He was in Mantua again in 1440–41, and in 1443 Gianfrancesco wrote to the artist in Ferrara asking him to send a canvas of *God the Father* (untraced). In March 1444 Gianfrancesco wrote again to Pisanello saying that he was keeping his rooms in the castle in case he could return to finish an undertaking. It has been suggested (Toesca) that this unfinished project can be identified as Pisanello's incomplete frescoes depicting scenes of *War and Chivalry* in the Corte Vecchia of the Palazzo Ducale and that they were commissioned by Gianfrancesco (Ventura). Other scholars (Paccagnini, Fossi Todorow, Woods-Marsden) believe that they were commissioned by (3) Ludovico II Gonzaga after Gianfrancesco's death.

In 1423 Gianfrancesco persuaded the eminent mathematician and humanist Vittorino da Feltre to enter his service as tutor to his children. Vittorino set up a school in the Casa Giocosa in Mantua, where he educated not only the Gonzaga children but, among others, Federigo da Montefeltro, later Duke of Urbino. Vittorino's wide-ranging humanist education prepared both Federigo da Montefeltro and Ludovico II Gonzaga to be among the most discerning and well-educated patrons of the next generation. Pisanello's medal of *Vittorino da Feltre* was probably commissioned by Ludovico after his tutor's death. Similarly, Pisanello's medal of *Gianfrancesco Gonzaga*, commemorating his martial exploits, is believed to have been struck after the latter's death.

Some time between 1438 and 1444 Leon Battista Alberti dedicated the revised version of his treatise *De pictura* to Gianfrancesco, writing that 'knowing your delight in the liberal arts I hope that you will read it in a moment of leisure . . . ; in the understanding of the arts you completely surpass other princes'. While it is unlikely that the Marchese could read the treatise in the original (Baxandall), his children were educated to do so. In his will Gianfrancesco bequeathed 200 ducats for the building of a tribune in SS Annunziata, Florence. He was buried in the chapel of St Louis of Toulouse (the Cappella dei Principi) in S Francesco, Mantua.

BIBLIOGRAPHY

L. B. Alberti: *De pictura* (MS. 1435, rev. 1438); It. trans. as *Della pittura* (MS. 1436); ed. H. Janitschek (Vienna, 1877); L. Mallè (Florence, 1950); Eng. trans. by J. R. Spencer (London, 1956) [Janitschek edn incl. ded. to Gianfrancesco]

F. Amadei: *Cronaca universale della città di Mantova* (Mantua, 1955), i, pp. 712–69; ii, pp. 7–48

G. Coniglio: *Mantova: La storia*, i (Mantua, 1958), pp. 443–59

——: *I Gonzaga* (Milan, 1967), pp. 41–51

M. Baxandall: *Giotto and the Orators* (Oxford, 1971), pp. 126n., 127, 130

M. Fossi Todorow: 'Pisanello at the Court of the Gonzaga at Mantua', *Burl. Mag.*, cxiv (1972), pp. 888–91

G. Paccagnini: *Pisanello alla corte dei Gonzaga* (Milan, 1972)

——: *Pisanello e il ciclo cavalleresco di Mantova* (Milan, 1972)

I. Toesca: 'Lancaster e Gonzaga: Il fregio della sala del Pisanello nel Palazzo Ducale di Mantova', *Civil. Mant.*, vii/42 (1973), pp. 361–77

U. Nicolini: 'Principe e cittadini: Una consultazione popolare del 1430 nella Mantova dei Gonzaga', *Mantova e i Gonzaga nella civiltà del rinascimento: Atti del convegno organizzato dall'Accademia Nazionale dei Lincei e dall'Accademia Virgiliana: Mantova, 1974*, pp. 35–45

I. Toesca: 'A Frieze by Pisanello', *Burl. Mag.*, cxvi (1974), pp. 210–14

——: 'More about the Pisanello Murals at Mantua', *Burl. Mag.*, cxviii (1976), pp. 622–9

——: 'Altre osservazioni in margine alle pitture del Pisanello nel Palazzo Ducale di Mantova', *Civil. Mant.*, xi/65–6 (1977), pp. 349–76

G. Amadei and E. Marani: *I ritratti gonzagheschi della collezione di Ambras* (Mantua, 1978), pp. 33–6

Vittorino e la sua scuola: Umanesimo, pedagogia, arti: Atti del convegno, Fondazione Giorgio Cini: Venezia, 1979, ed. N. Giannetto (Florence, 1981)

G. Müller: *Mensch und Bildung im italienischen Renaissance-Humanismus: Vittorino da Feltre und die humanistischen Erziehungsdenker* (Baden-Baden, 1984)

J. Woods-Marsden: 'French Chivalric Myth and Mantuan Political Reality in the Sala del Pisanello', *A. Hist.*, viii/4 (1985), pp. 397–412

——: 'The Sinopia as Preparatory Drawing: The Evolution of Pisanello's Tournament Scene', *Master Drgs*, lxxxiii–lxxxv (1985–6), pp. 175–92

G. Suitner and D. Nicolini: *Mantova: L'architettura della città* (Milan, 1987)

M. A. Grignani, ed.: *Mantova 1430: Pareri a Gian Francesco Gonzaga per il governo* (Mantua, 1990)

L. Ventura: 'Notorelle pisanelliane: Precisazioni sulla data del ciclo cavalleresco de Mantova', *Civil. Mant.*, 3rd ser., xxvii/2 (1992), pp. 19–53

(3) Ludovico II Gonzaga, 2nd Marchese of Mantua (*b* Mantua, 5 June 1412; *reg* 1444–78; *d* Goito, 12 June 1478). Son of (2) Gianfrancesco Gonzaga. He was educated at the school run by Vittorino da Feltre at the Casa

Giocosa, Mantua. Da Feltre esteemed his intellectual and political abilities highly, an opinion later shared by Bartolomeo Sacchi (il Platina) who tutored Ludovico's children and afterwards became the overseer of the Vatican Library. Ludovico was certainly one of the most intellectually gifted of the Gonzaga rulers; he associated with scholars, employed scribes and illuminators—for example Andrea da Lodi (*fl* 1458–64), who illuminated Boccaccio's *Filocolo* for Ludovico (Alexander)—and purchased items for the Gonzaga library. In 1433 he married Barbara of Hohenzollern (1422–81), niece of Emperor Sigismund of Luxemburg, with whom he had five sons and five daughters. From 1445 until the Peace of Lodi (1454), Ludovico, an accomplished soldier, was involved in the power struggle between Milan, Venice and Florence. Pisanello made a medal (*c.* 1447; London, V&A) portraying him as a military leader: the obverse carries a portrait bust of Ludovico, bareheaded, under the legend CAPITANEUS ARMIGERORUM MARCHIO MANTUE, and the reverse shows him on horseback, in full armour and crested helmet. This medal could have been made to commemorate Ludovico's appointment as Captain in the service of Florence (he had previously fought on the side of Milan). It was probably Ludovico who commissioned Pisanello's medal of *Gianfrancesco Gonzaga* (*c.* 1447; London, BM), to honour his father. Around 1447 Pisanello also decorated the Palazzo Ducale in Mantua with frescoed scenes of *War and Chivalry* (*in situ*); although unfinished, these are the most impressive examples of the artist's painting to survive. The dating of the work is uncertain; it may have been commissioned by Gianfrancesco.

Ludovico's links with Florence led to cultural exchange. In 1449 he was requested by Cosimo de' Medici to help finance the building of SS Annunziata (*see* FLORENCE, §IV, 3); ten years later Ludovico again became involved in furthering the building work, this time insisting on executive control and appointing Alberti to take charge of the project. Many Florentine artists and architects were employed in Mantua by Ludovico, among them the architects ANTONIO DI CIACCHERI MANETTI and LUCA FANCELLI. The latter, who arrived in Mantua *c.* 1450, provided designs for the windows and the main entrance to the palace that Ludovico built at Revere. Another Tuscan, the engineer Giovanni Antonio d'Arezzo (*fl* 1456–63), took part in the building works on the Palazzo del Podestà and the Ponte dei Mulini. In 1459 Alberti came to Mantua in the retinue of Pope Pius II and provided Ludovico with designs for the church of S Sebastiano and subsequently for the rebuilding of S Andrea, the foundation stone of which was laid in 1472, the year of Alberti's death (*see* ALBERTI, LEON BATTISTA, §III, 2(iii) and figs 4 and 8). A letter from Alberti to Ludovico concerning his ideas for the design of this church has survived (Mantua, Archv Stato; Chambers). Luca Fancelli supervised the construction of both churches. There also survives a bronze bust of *Ludovico Gonzaga* (1450–70; versions Berlin, Skulpgal.; Paris, Mus. Jacquemart-André), which has been ascribed to Alberti. Probably at the end of 1459 ANDREA MANTEGNA arrived in Mantua, after persistent persuasion, to decorate the chapel of the Castello di S Giorgio, part of the Palazzo Ducale. This was the start of Mantegna's long association

with the Gonzaga family, which included his renowned decoration of a room in the Castello di S Giorgio, known as the Camera Picta, later called Camera degli Sposi (1465–74; *see* ILLUSIONISM, fig. 1). This historiated portrait gallery of the Gonzaga dynasty includes a reference to Pius II's war against Giacomo Savelli, Lord of Palombara Sabina and leader of Roman barons hostile to the Pope. There is documentary evidence that another Florentine, LUCIANO LAURANA, worked for Ludovico, but his contribution to the architecture of Mantua is hard to establish with certainty.

Other notable cultural events of Ludovico's reign include the introduction of a printing press to Mantua by Pietro Adamo de' Micheli (*c.* 1441–81), who employed two German printers, Georg Butzbach (*fl*?1471–2) and Paul Butzbach (*fl*?1471–81), to run it, and the construction of a tower bearing an astrological clock (1473; rest. 1989) that Ludovico commissioned from the astrologer Bartolomeo Manfredi, one of Vittorino's pupils. This clock was described by Pietrodamo de' Micheli in one of the earliest documents to be printed in Mantua.

Ludovico died of pleurisy and was buried in the Cappella dei Principi in the church of S Francesco. His wife died in 1481 and was buried in the Capella di S Anselmo in the cathedral. A tomb was designed for her by Mantegna but it was never erected. Her name is associated with a Missal (Mantua, Mus. Dioc.), known as the Missal of Barbara of Brandenburg, that was illustrated first by BELBELLO DA PAVIA and then, after the intervention of Mantegna, by Girolamo da Cremona. The marked change in style between the earlier and later paintings gives an insight into the extent of Mantegna's influence in Mantua.

BIBLIOGRAPHY

B. Hofmann: *Barbara von Hohenzollern, Markgräfin von Mantua* (Ansbach, 1881)
F. Amadei: *Cronaca universale della città di Mantova*, ii (Mantua, 1955), pp. 49–234
E. Marani and C. Perina: *Mantova: Le arti*, ii (Mantua, 1961)
L. Mazzoldi: *Mantova: La storia*, ii (Mantua, 1961), pp. 3–35
U. Meroni: *Mostra dei codici gonzagheschi, 1328–1540* (Mantua, 1966)
G. Coniglio: *I Gonzaga* (Milan, 1967)
G. Paccagnini: *Pisanello e il ciclo cavalleresco di Mantova* (Milan, 1972)
L. Pescasio: *Pietro Adamo de' Micheli protoeditore mantovano* (Mantua, 1972)
Libri stampati a Mantova nel quattrocento (exh. cat., ed. G. Schizzerotto; Mantua, Bib. Com., 1972)
J. Alexander: 'The Scribe of the Boccaccio *Filocolo* Identified', *Bodleian Lib. Rec.*, ix (1977), pp. 303–4
D. S. Chambers: 'Sant'Andrea at Mantua and Gonzaga Patronage, 1460–1472', *J. Warb. & Court. Inst.*, xl (1977), pp. 99–127
A. Calzona: *Mantova città dell'Alberti: Il San Sebastiano: Tomba, tempio, cosmo* (Parma, 1979)
C. Vasić Vatovec: *Luca Fancelli architetto: Epistolario gonzaghesco* (Florence, 1979)
R. Signorini: 'Acquisitions for Ludovico II Gonzaga's Library', *J. Warb. & Court. Inst.*, xliv (1981), pp. 180–83
Vittorino e la sua scuola: Umanesimo, pedagogia, arti: Atti del convegno, Fondazione Giorgio Cini: Venezia, 1979, ed. N. Giannetto (Florence, 1981)
R. Signorini: 'Ludovico muore', *Atti & Mem. Accad. N. Virgil. Mantova*, n.s., i (1982), pp. 91–129
——: 'Inediti su Pietroadamo de' Micheli: Il protostampatore, l'uomo di legge e la sua morte violenta', *Civil. Mant.*, n.s., i (1983), pp. 43–62
——: *Opus hoc tenue: La Camera Dipinta di Andrea Mantegna, lettura storica iconografica iconologica* (Mantua, 1985)
J. Woods-Marsden: 'French Chivalric Myth and Mantuan Political Reality in the Sala del Pisanello', *A. Hist.*, viii/4 (1985), pp. 397–412
P. Carpeggiani and C. Tellini: *Sant' Andrea in Mantova: Un tempio per la città del principe* (Mantua, 1987)

G. Suitner and D. Nicolini: *Mantova: L'architettura della città* (Milan, 1987)

G. Rodella: *Giovanni da Padova: Un ingegnere gonzaghesco nell'età dell'Umanesimo* (Milan, 1988)

A. Calzona and L. Volpi Ghirardini: *Il San Sebastiano di Leon Battista Alberti* (Florence, 1994)

L. B. Alberti (exh. cat., ed. J. Rykwert and A. Engel; Mantua, 1994)

(4) Federico I Gonzaga, 3rd Marchese of Mantua (*b* Mantua, 2 July 1441; *reg* 1478–84; *d* Mantua, 14 July 1484). Son of (3) Ludovico II Gonzaga. On 7 June 1463 he married Margherita of Bavaria, daughter of Albert II the Pius, Duke of Bavaria (*reg* 1438–60). He was educated by Ognibene of Lonigo, a pupil of Vittorino da Feltre, but was most probably more interested in war and government than books. Bartolomeo Sacchi (il Platina) dedicated his *De principe* to Federico. He was a faithful ally of the Sforzas and energetically defended Ferrara against attacks by the Venetians. Like his father, he was interested in architecture. In 1480 he commissioned Luca Fancelli to build the Domus Nova, a wing of the Palazzo Ducale in Mantua. He is portrayed in a medal, possibly by Bartolo Talpa (*fl c.* 1495), and together with his wife in a fine fireplace frieze, originally in the palazzo at Révere and now in the Palazzo Ducale, Mantua. There is another portrait of Federico in Mantegna's Camera Picta, later called Camera degli Sposi (1465–74; *see* ILLUSIONISM, fig. 1), in the Castello di S Giorgio, part of the Palazzo Ducale. Posthumous portraits of him can be found in the Sala dei Marchesi (Mantua, Pal. Ducale) and in one of the triumphs painted by Tintoretto in 1579 for the Palazzo Ducale: the *Battle of Legnano* (Munich, Alte Pin.), which records an imaginary, rather than an actual, event. Further portraits of him and his wife are in the collection at Schloss Ambras, Innsbruck.

BIBLIOGRAPHY

F. Amadei: *Cronaca universale della città di Mantova*, ii (Mantua, 1955), pp. 235–66

L. Mazzoldi: *Mantova: La storia*, ii (Mantua, 1961), pp. 35–45

E. Marani and C. Perina: *Mantova: Le arti*, ii (Mantua, 1961), pp. 91–5

P. Eikemeier: 'Der Gonzaga-Zyklus des Tintoretto in der Alten Pinakothek', *Munchn. J. Bild. Kst*, xx (1969), pp. 75–142

G. Amadei and E. Marani: *I ritratti gonzagheschi della collezione di Ambras* (Mantua, 1978), pp. 41–4

R. Signorini: 'Per la storia di S Anselmo e delle sue traslazioni', *Sant' Anselmo, Mantova e la lotta per le investiture: Atti del convegno: Bologna, 23–25 May 1986*, pp. 102–3

M. G. Vaccari: 'I Fasti Gonzagheschi', *De gli Dei la memoria, e de gli Heroi*. (exh. cat., Mantua, Pal. Ducale, 1986), pp. 21–4

R. Signorini: 'La malattia mortale di Barbara di Brandeburgo Gonzaga, seconda marchesa di Mantova', *Civil. Mant.*, n.s. 15 (1987), pp. 1–30

RODOLFO SIGNORINI

(5) Cardinal **Francesco Gonzaga** (*b* Mantua, 15 March 1444; *d* Bologna, 21 Oct 1483). Son of (3) Ludovico Gonzaga II. He became a cardinal in 1461 and thereafter lived mainly in Rome; from 1463 he had a summer residence at Santa Agata dei Goti, and from 1467 he occupied the palace at San Lorenzo in Damaso, where he commissioned murals with mythological subjects (1479; destr.) for the ornamental garden. He revisited Mantua only for short periods and in the 1470s was resident intermittently at Bologna as papal legate. Andrea Mantegna portrayed him as a boy (*c.* 1460; Naples, Capodimonte) and in the *Meeting Scene* (*c.* 1474) of the Camera Picta in the Palazzo Ducale, Mantua, and probably helped to excite his interest in antique objects. Mantegna's and Francesco's

celebrated discussion at the spa of Porretta (1472) about his collections cannot in fact have happened, because the Cardinal's doctors had advised against his taking the waters then. He also knew Leon Battista Alberti and was involved in the rebuilding of S Andrea at Mantua, but commented disparagingly on Alberti's design for another Mantuan church, S Sebastiano. There is little evidence that Francesco was learned or exceptionally active as a patron, but he was a liberal spender, whose collecting and connoisseurship were stimulated by such figures as Cardinal Ludovico Trevisan and Cardinal Pietro Barbo (later Pope Paul II) and humanists in his entourage. Correspondence, his will and an inventory made after his death detail his collections of silverware, tapestries, bronze sculpture, jewellery, antique gems, coins, medals and *c.* 200 books. Among those not mentioned, however, was his uncompleted masterpiece, the illuminated *Iliad* or 'Vatican Homer' (Rome, Vatican, Bib. Apostolica, MS. Vat. gr. 1626), the Master of which has been tentatively identified as Gasparo Padovano, an associate of the scribe Bartolomeo Sanvito who was Francesco's steward. The goldsmith Sperandio designed a medal (*c.* 1479–83) bearing Francesco's portrait, and the brothers Antonio and Piero del Pollaiuolo a purse, but Francesco does not seem to have owned any portable paintings apart from a *Madonna* (untraced) by Botticelli. After his death his moveables were dispersed by bequests and sales to pay off debts. The cameos, among which was the Felix Gem (Oxford, Ashmolean), were sought by many collectors, including Lorenzo de' Medici (il Magnifico), but it has been disproved that they passed into the Medici collection. Some were, however, undoubtedly held by the Medici bank as loan pledges.

BIBLIOGRAPHY

G. Frasso: 'Oggetti d'arte e libri nell'inventario del Cardinale Francesco Gonzaga', *Mantova e i Gonzaga nella civiltà del Rinascimento: Atti del convegno organizzatio dall'Accademia Nazionale dei Lincei e dall'Accademia Virgiliana: Mantua, 1974*, pp. 141–4

D. S. Chambers: 'The Housing Problems of Cardinal Francesco Gonzaga', *J. Warb. & Court. Inst.*, xxxix (1976), pp. 21–58

——: 'Sant'Andrea at Mantua and Gonzaga Patronage, 1460–1472', *J. Warb. & Court. Inst.*, xl (1977), pp. 99–127

C. M. Brown: 'Cardinal Francesco Gonzaga's Collection of Antique Intaglios and Cameos: Questions of Provenance, Identification and Dispersal', *Gaz. B.-A.*, cxxv (1983), pp. 102–4

C. M. Brown, with L. Fusco: 'Lorenzo de' Medici and the Dispersal of the Antiquarian Collections of Cardinal Francesco Gonzaga', *A. Lombarda*, xc/xci (1989), pp. 86–103

D. S. Chambers: *A Renaissance Cardinal and his Worldly Goods: The Will and Inventory of Francesco Gonzaga (1444–1483)* (London, 1992)

D. S. CHAMBERS

(6) Gianfrancesco Gonzaga, Conte di Ródigo [Lord of Bozzolo, Sabbioneta, Rivarolo, Viadana and Gazzuolo] (*b* Mantua, 1445; *d* Bozzolo, 28 Aug 1496). Son of (3) Ludovico II Gonzaga. He founded the Bozzolo and Sabbioneta line of the family. As a boy, he was portrayed by Mantegna in the Camera degli Sposi (1465–74; *see* ILLUSIONISM, fig. 1) in the Palazzo Ducale, Mantua. He spent much of his early life in the service of Ferdinand I, King of Naples, and had a distinguished military career. On 17 July 1479 he married the renowned beauty Antonia del Balzo, Princess of Altamura (*d* Gazzuolo, 13 June 1538), and they held a glittering court at the fortress of Bozzolo. The sculptor known as Antico was employed

there for some years, probably from 1484. His *all'antica* style reflected Gianfrancesco's pronounced preference for the Antique. From this period date Antico's series of portrait medals of Gianfrancesco and his wife (examples, London, BM and V&A; Bologna, Mus. Civ.; Milan, Castello Sforzesco) and the bronze Gonzaga Vase (Modena, Gal. Estense), decorated with their personal imprese and a frieze of a triumphal procession, with Neptune in a boat drawn by horses and accompanied by marine deities. Gianfrancesco's collection, an inventory of which was made in 1496, comprised both antique and modern copies of Classical works. Among the latter were itemized statuettes of the groups in the Piazza del Quirinale, Rome, known as *Alexander and Bucephalus* or the *Horse Tamers*, an equestrian statuette of *Marcus Aurelius*, bronze busts of *Caesar* and *Pompey*, a *Minerva* and a *Woman with a Cornucopia* (all untraced). Although Antico is named in the inventory only as the maker of two small silver-gilt vases, his bronze statuettes of *Cupid* (Florence, Bargello), *Hercules* (Madrid, Mus. Arqueol. N.) and *Meleager* (London, V&A) undoubtedly originate from this collection. A black-chalk portrait drawing (Florence, Uffizi), probably of Gianfrancesco, has been attributed to FRANCESCO BONSIGNORI, who is known to have made several portraits of Gianfrancesco in the course of his work (from 1492) for the Gonzaga family. Gianfrancesco was buried in the church of S Francesco, Mantua. His wife Antonia lived to the age of 97, becoming known to the family as 'the mother of all'. She held court at Gazzuolo and corresponded with Isabella d'Este (who married Gianfrancesco and Antonia's nephew, (8) Francesco Gonzaga II), whose literary and musical interests she shared.

BIBLIOGRAPHY

Mostra iconografica gonzaghesca (exh. cat., ed. N. Giannantoni; Mantua, Pal. Ducale, 1937), pp. 54–5; nos 243–50

☐

(7) Ludovico Gonzaga (*b* Mantua, 1460; *d* Reggiolo, nr Mantua, 1511). Son of (3) Ludovico II Gonzaga. In 1484 he was nominated Bishop of Mantua but was never confirmed in the title. Much of his life was spent at Gazzuolo, where he established a small Renaissance court. He had a special interest in Classical art, but his lack of wealth and power limited his ambitions; consequently his collection consisted mainly of copies of antique marbles. He was unsuccessful in his bid in 1501–2 for several of the antique vases belonging to the Medici family, yet he did own some originals, for example the sculpted antique heads that he received from Cardinal Federigo Sanseverino (*d* 1516) in 1502 and which he displayed in his study. The sculptor Antico worked at Gazzuolo and made small bronze versions of Classical statues for Ludovico, including one of the *Apollo Belvedere* (1498; version, Venice, Ca d'Oro) and one of *Hercules and Antaeus* (*c.* 1500; version, London, V&A). The moulds for these and other statues were made available to Isabella d'Este. Few objects in Ludovico's collection have been identified, except for a group of heads by Antico: a pair of *Julius Caesar* and *Augustus* (*c.* 1500) and a pair of *Julius Caesar* and *Antonius Pius* (*c.* 1510; all Mantua, Pal. Vescovile).

BIBLIOGRAPHY

U. Rossi: 'I medaglisti del Rinascimento alla corte di Mantova, II. Pier Jacopo Alari-Bonacolsi detto l'Antico', *Riv. It. Numi.*, i (1888), pp. 161–94, 433–54

C. M. Brown: 'I vasi di pietra dura dei Medici e Ludovico Gonzaga vescova eletto di Mantua', *Civil. Mant.*, n. s., i (1983), pp. 63–8

A. H. Allison: 'The Bronzes of Pier Jacopo Alari-Bonacolsi Called Antico', *Jb. Ksthist. Samml. Wien*, n.s., liii/liv (1993/4), pp. 37–311

C. M. BROWN

(8) Francesco II Gonzaga, 4th Marchese of Mantua (*b* Mantua, 1466; *reg* 1484–1519; *d* Mantua, 29 March 1519). Son of (4) Federico I Gonzaga. He made his career and reputation as a *condottiere* and was involved in turbulent political and military events. When Charles VIII, King of France, invaded Italy in 1494, Francesco assisted in the formation of a league to defeat him, and, as commander of the league's forces, joined battle with Charles at Fornovo on 6 July 1495. He gained the victory but only with heavy loss of life. Despite skilful diplomatic manoeuvring, the security of Mantua was under threat from the French until Francesco's death.

Francesco's patronage of the arts, which was surpassed by that of his wife, Isabella d'Este (*see* ESTE (i), (6)), was supported by state revenues and military stipends. It was essentially strategic and pragmatic in nature, a characteristic most strongly expressed in the sculpture, music and the applied arts that Francesco patronized. His terracotta portrait bust (*c.* 1498; Mantua, Pal. Ducale) was modelled by Gian Cristoforo Romano. The medallists Bartolommeo Melioli (1448–1514), Gianfrancesco Ruberti della Grana (*fl* 1483–1526) and Gian Marco Cavalli all executed portrait medals of Francesco in armour in a strong classicizing style. In 1510 Francesco founded the first Gonzaga *cappella*, taking advantage of the availability of good musicians caused by Alfonso d'Este's temporary disbandment of the Este *cappella*. In the applied arts coinage was designed and minted to a high standard from 1497 to 1510, the design being similar to that of the medals. Francesco also had poems and books dedicated to him. Battista Spagnoli commemorated the Battle of Fornovo in his *Trophaeum Gonzagae pro Gallis expulsis* (1498). The books dealt with horses, falconry and agricultural science and were either derivatives or copies of earlier works. They reveal the stagnation of some scientific learning in the Renaissance. Francesco admired Andrea Mantegna and made him a grant of land in 1492; he may have commissioned Mantegna's series of the *Triumphs of Caesar* (London, Hampton Court, Royal Col.), the military theme of which would have appealed to him. The *Madonna of Victory* (1495–6; Paris, Louvre; *see* MANTEGNA, ANDREA, fig. 5), commissioned from Mantegna to celebrate the victory at Fornovo, shows Francesco in full armour. A portrait drawing of Francesco, attributed to Francesco Bonsignori, also survives (1492–1500; Dublin, N.G.). Domenico Morone painted the *Expulsion of the Bonacolsi from Mantua* (1494; Mantua, Pal. Ducale; *see* MANTUA, fig. 1) for Francesco.

BIBLIOGRAPHY

G. Coniglio: *I Gonzaga* (Milan, 1967/*R* Varese, 1987), pp. 101–249, 501–8

M. Cattafesta: *Mantovastoria* (Mantua, 1974/*R* 1984), pp. 169–84, 543

C. Mozzarelli: *Mantova e i Gonzaga dal 1382 al 1707* (Turin, 1987), pp. 37–49, 133–9

GORDON MARSHALL BEAMISH

(9) Federico II Gonzaga, 5th Marchese and 1st Duke of Mantua (*b* Mantua, 1500; *reg* 1519–40; *d* Mantua, 1540). Son of (8) Francesco II Gonzaga. He succeeded his father at the age of 19, having spent three years of his childhood (1510–13) in Rome as a hostage at the court of Pope Julius II. This experience, together with the influence of his mother, Isabella d'Este, disposed him to appreciate Roman art, both ancient and modern. His early familiarity with Michelangelo's decoration of the Sistine Chapel and Raphael's work in the Stanza della Segnatura nourished a taste for large-scale fresco decoration featuring writhing, muscular forms and impressive illusionist effects. Soon after becoming Marchese, Federico lent military support to the Holy Roman Emperor Charles V against the French king, Francis I, who was attempting to capture Pavia; Federico was thus awarded the device of Mount Olympus in 1522. This device, which can be seen on the obverse of Federico's medals, consists of a mountain with an ascending, spiral road and an altar inscribed FIDES, together with a female figure holding a sword and a cornucopia. As a further favour the Emperor created him a duke in 1530.

Federico was an active patron of contemporary artists. He failed, however, to acquire works by Sebastiano del Piombo or Michelangelo, despite strenuous attempts to do so, though he did acquire a series of Correggio of the *Loves of Jupiter: Io* and *Ganymede* (*c.* 1530–32; both Vienna, Ksthist. Mus.), *Danae* (Rome, Gal. Borghese) and *Leda* (Berlin, Gemäldegal.). In 1529 he commissioned Titian to paint his portrait (Madrid, Prado) and subsequently became the artist's most important patron during the 1530s—acquiring *c.* 1530 his *Madonna and Child with St Catherine and a Rabbit* (*c.* 1528–30; Paris, Louvre) and commissioning from him a series of portraits of 11 Roman emperors (destr. 1734) for the Gabinetto dei Cesari in the Palazzo Ducale, Mantua. These are known through Ippolito Andreasi's drawings (*c.* 1568; Düsseldorf, Kstmus.) and engravings (1593/4) by Aegidius Sadeler II. Federico also had a portrait of himself in armour painted by Raphael (untraced).

Federico's most significant achievement as a patron, however, was his employment of GIULIO ROMANO, who was persuaded—probably through the intercession of Pietro Aretino and Federico's ambassador Baldassare Castiglione—to come to Mantua in 1524. For 16 years he played a leading role as architect, painter, designer and town planner. His most important works in Mantua were the design of the Palazzo del Te (1527–34) and an extension to the Palazzo Ducale: the Appartamento de Troia (1536–8). The Palazzo del Te, of which Federico was immensely proud, is an idiosyncratic version of a Roman villa, with a variety of orders on its exterior surfaces (*see* ORDERS, ARCHITECTURAL, fig. 6) and lavishly painted interior decorations. The Duke laid great emphasis on the Roman nature of the enterprise, even obtaining a Roman gardener to tend the grounds. The interior paintings, especially the mythological scenes in the Sala di Psiche and the Sala dei Giganti, were characterized by daring illusionism and forceful forms and acted as powerful propaganda for both the artist and his patron. In the Sala dei Venti, in which the frescoes celebrate the reign of the Gonzaga dynasty, the Mount Olympus device is featured in the centre of the ceiling. The Sala dei Cavalli reflects Federico's passion for animals, with portraits of his favourite steeds on the walls. (In 1526 Federico had commissioned from Giulio a marble tomb for one of his dogs.) Although the building was originally intended as a retreat for the Duke and his friends, it quickly became one of the main sights of the town and set an influential pattern for villa and palace design.

BIBLIOGRAPHY
F. Hartt: *Giulio Romano*, 2 vols (New Haven, 1958)
G. Amadei and E. Marani: *I Gonzaga a Mantova* (Milan, 1975)
E. Verheyen: *The Palazzo del Te in Mantua: Images of Love and Politics* (Baltimore and London, 1977)
E. Gombrich: *The Sala dei Venti in the Palazzo del Te: Symbolic Images*, Studies in the Art of the Renaissance (London, 1985)

ANABEL THOMAS

(10) Cardinal **Ercole Gonzaga** (*b* Mantua, 1505; *d* Trento, 2 March 1563). Son of (8) Francesco II Gonzaga. He was destined for an ecclesiastical career and in May 1521 succeeded his uncle Sigismondo Gonzaga as Bishop of Mantua. At the insistence of his mother, Isabella d'Este, he went to Bologna in December 1522 to complete his education and in 1525 went to Rome, where he was made a cardinal in 1526 through Isabella's influence. In 1540 he became Regent of the Mantuan state after the death of his brother (9) Federico II Gonzaga, 5th Marchese and 1st Duke of Mantua, whose heir, Francesco Gonzaga (1533–50), was only seven years of age. After Francesco's death Ercole again became regent, this time for the future 3rd Duke, (14) Guglielmo Gonzaga. In both cases Ercole's administration was astute. After the death of Pope Paul IV (1559), he was a favourite candidate for the papacy, but the opposition of the Farnese prevented his election. In 1561 he presided over the Council of Trent and guided the proceedings with great sagacity.

His patronage, both official and personal, was motivated by his passionate belief that the arts could serve the Counter-Reformation. He appointed Giulio Romano Prefetto delle Fabbriche Ducali. Giulio was as great an asset to Gonzaga prestige as Alberti and Mantegna had been. His great skill at modernizing existing buildings was shown in the modifications (begun 1545) to the cathedral of S Pietro, Mantua. The relatively cramped Romanesque interior was transformed so that, in accordance with Counter-Reformation thought, the liturgy could be observed by the whole congregation. At the same time his plans satisfied the Cardinal's wish to spend as modestly as possible and to leave the aspect of the Piazza Sordello unchanged. The completion of the project was the climax of a programme of church improvements initiated by Ercole in the diocese of Mantua, although Vasari emphasized that this project attracted Ercole's particular interest (*see* GIULIO ROMANO). Giulio was involved in producing designs not only for the modification of buildings but also for smaller objects for Ercole (e.g. design for a salt cellar; Oxford, Christ Church). A few days after Giulio's death in 1546 Ercole wrote to his brother (11) Ferrante Gonzaga: 'The most grievous loss of our Giulio Romano hurts me so much that I seem to have lost my right hand I tell myself that the death of that rare man will at least have helped me by ridding me of the appetite for building, for silverware, for paintings etc.' In 1549 GIOVANNI BATTISTA BERTANI assumed responsibility for overseeing the ducal

buildings. He also published (1558) a translation of Vitruvius's commentary on the Ionic order, which he dedicated to Ercole.

It is known that Ercole commissioned paintings from Titian, Veronese, Battista dell'Angolo del Moro, Domenico Brususorci and Paolo Farinati; most of these commissions were related to the decoration of the newly refurbished cathedral. Other well-known artists who worked for the Cardinal included BENVENUTO CELLINI, who made a seal—known only from the sealing wax impression of it on six manuscripts in the Curia Vescovile, Mantua.

BIBLIOGRAPHY
G. Coniglio: *I Gonzaga* (Milan, 1967/*R* Varese, 1987), pp. 294–318, 501–8
M. Cattafesta: *Mantovastoria* (Mantua, 1974/*R* 1984), pp. 211–13, 544
C. Mozzarelli: *Mantova e i Gonzaga dal 1382 al 1707* (Turin, 1987), pp. 51–84, 133–9
C. M. Brown: 'Painting in the Collection of Cardinal Ercole Gonzaga after Michelangelo's Vittoria Colonna drawings and by Bronzino, Giulio Romano, Fermo Ghisoni, Parmigianino, Sofonisba Anguissola, Titian and Tintoretto', *Atti del convegno internazionale di studi su Giulio Romano e l'espansione europea del Rinascimento: Mantova, 1989*

GORDON MARSHALL BEAMISH

(11) Ferrante [Ferdinando] **Gonzaga** [Principe di Ariano; Duca di Traetto; Duca di Molfetta; Lord of Guastalla] (*b* Mantua, 28 Jan 1507; *d* Brussels, 16 Nov 1557). Son of (8) Francesco II Gonzaga. He had a distinguished military career in the service of the Holy Roman Emperor Charles V, to whose court in Spain he was sent to be a page in 1523. Returning to Italy in 1526, he fought alongside the imperial troops in the Sack of Rome in May 1527 and was, as Commander-in-Chief of the forces of Charles V, present at the siege of Florence in August 1530. In 1530 he married Isabella da Capua, Princess of Molfetta (*d* 1559). When Charles V made Ferrante a Knight of the Golden Fleece in 1531, the latter's ceremonial collar was designed by Giulio Romano. In 1533 Ferrante commissioned Sebastiano del Piombo to produce a painting as a diplomatic gift for Francisco de los Cobos, secretary to Charles V. It was a *Pietà* (Seville, Casa Pilatos) for de los Cobos's funerary chapel in S Salvador, Ubeda, Andalucia, and was completed by 4 October 1539. Sebastiano also produced a copy of the painting for Ferrante.

Ferrante was Viceroy of Sicily (1535–46) and then Governor of Milan (1546–55). He initiated a number of military building projects, including the fortifications of Guastalla, and in 1549 he employed the architect Domenico Guinti ('da Lodi') to supervise the urban development of Guastalla. Ferrante was involved, *c.* 1545, with his brother (10) Cardinal Ercole's plans for Giulio Romano to remodel the interior of Mantua Cathedral and contributed a considerable sum to the project. Ferrante also had a taste for the intricate and bizarre; this is reflected in his commissions for applied arts from Giulio Romano and Leone Leoni. During the 1540s the former produced for Ferrante a number of designs for silverwork; correspondence between Ferrante and the artist for the years 1542–6 make reference to these. Designs for a covered dish (Chatsworth, Derbys) and a salt-cellar (London, V&A, E. 5131–1910) possibly date from this period. Leoni produced a double-sided lead medal (diam. 71 mm, *c.* 1555;

London, BM) of Ferrante wearing the collar of the Order of the Golden Fleece, the reverse depicting *Hercules Destroying the Hydra*. Ferrante died from injuries received at the battle against the French at St Quentin (Aug 1557). His body was transported back to Mantua, and he was buried in the wall of the sacristy of Mantua Cathedral.

BIBLIOGRAPHY
A. de Ulloa: *Vita del valorosissimo e Gran Capitano Don F. Gonzaga, Principe di Molfetta* (Venice, 1563)
G. Campori: 'Sebastiano del Piombo e Ferrante Gonzaga', *Atti e memorie delle R. R. Deputazioni di storia patria per le provincie modenesi e parmensi*, ii (Modena, 1864), pp. 193–8
T. Cagnolati: *Il crepuscolo di Ferrante Gonzaga* (Reggio Emilia, 1928)
M. Hirst: 'Sebastiano's Pietà for the Commendador Mayor', *Burl. Mag.*, cxiv (1972), pp. 585–6

(12) Vespasiano Gonzaga, Duca di Sabbioneta (*b* Fondi, 6 Dec 1531; *d* Sabbioneta, 26 Feb 1591). He was the only son of Luigi Gonzaga (1500–32), called Rodomonte, Lord of Sabbioneta, and Isabella Colonna (*d* 1570). Vespasiano married firstly, in 1549, Diana de Cardona; secondly, in 1567, Anna of Aragon (*d* 1567); and lastly, in 1582, Margherita Gonzaga (*d* 1628). He was educated at Naples by his aunt Giulia Gonzaga. He had a distinguished military career in imperial and Spanish service and between 1568 and 1577 was employed by Philip II, King of Spain. Through his campaigns he acquired a practical knowledge of military architecture and urban planning and in the 1550s he began developing SABBIONETA (19 km southwest of Mantua), both as a fortress and as a civic and administrative centre. He wished to create an ideal city and an artistic centre to rival Mantua. He established a Hebrew printing press and opened a renowned mint (1558–91). He was given a dukedom by Emperor Rudolf II in 1577 and, after his return from Spain in the same year, he embarked on an extensive urban planning programme in Sabbioneta, which he personally supervised. During this period the Villa or Casino (begun 1577), the Corridor Grande, the Porta Imperiale (1579) and the churches of the Assunta (begun 1580) and Incoronata (begun 1586), as well as a hospital, a school and private housing, were built. He built a private residence, the Palazzo del Giardino (1584), decorated with frescoes depicting antique mythological subjects by Bernardino Campi and followers of Giulio Romano. In 1588 Vespasiano commissioned a theatre to be built for the Gonzaga court; it was designed by the architect Vincenzo Scamozzi (*see* SCAMOZZI, (2)), and work began in 1590.

In 1556 Vespasiano had begun collecting Gonzaga portraits, and the Sala degli Antenati in the Palazzo Ducale (begun 1554) was decorated by Alberto Cavalli *c.* 1575 with stucco representations of his ancestors. Around 1587 Vespasiano commissioned 12 wooden figures on horseback (four extant; Sabbioneta, Pal. Ducale) of himself and his forebears from a Venetian wood-carver, as yet unidentified. In the polychrome equestrian statue of *Vespasiano Gonzaga* (2.52×2.18×1.10 m), he wears the insignia of the Order of the Golden Fleece bestowed on him in 1585 by Philip II. According to Vasari, Vespasiano possessed a *St Jerome* and a *Nativity* by Giulio Romano. The Galleria degli Antichi (begun 1583), adjacent to the Palazzo del Giardino, was also built to house his collection of antique sculptures. Vespasiano was buried in the church of the Incoronata, Sabbioneta, in a monumental tomb designed

and executed by Giovanni Battista della Porta. The seated bronze statue of him dressed in Roman armour by Leone Leoni (probably executed 1574–7), formerly in the Piazza Grande in front of the Palazzo Ducale, was incorporated into the sepulchral monument in 1592.

BIBLIOGRAPHY
I. Affo': *Vita di Vespasiano Gonzaga* (Parma, 1780/R Mantua, 1975)
A. Carli: *Vespasiano Gonzaga, duca di Sabbioneta* (Florence, 1878)
G. Guidetti: *La zecca di Sabbioneta* (Mantua, 1966)
K. W. Forster: 'From "Rocca" to "Civitas": Urban Planning at Sabbioneta', *L'Arte*, ii/1 (1969), pp. 5–40
G. Guidetti: *Vespasiano Gonzaga nei suoi stemmi, motti, sigilli* (Reggio Emilia, 1970)
G. Faroldi: 'Vita di Vespasiano Gonzaga Colonna, duca di Sabbioneta', *Sabbioneta e Vespasiano Gonzaga*, ed. E. Marani (Sabbioneta, 1977)

(13) Cesare Gonzaga (*b* Mantua, 1536; *d* Guastalla, 1575). Son of (11) Ferrante Gonzaga. He inherited the titles Principe di Ariano, Duca di Molfetta and Lord of Guastalla from his father. Cesare served Philip II as Captain General of the imperial troops in Lombardy and in 1560 married Camilla (*d* 1582), eldest daughter of Carlo Borromeo, Archbishop of Milan and Saint. His activity as a patron included employing Francesco da Volterra to complete work on Guastalla and commissioning from Leone Leoni a life-size cast-bronze statue of *Ferrante Gonzaga*, which dominates the Piazza Mazzini, the main square of the town. Giorgio Vasari described at length the 'ravishing antiquarium and studio made by il signor Cesare Gonzaga' in the family palace at Mantua, which was on the site of the present Accademia Nazionale Virgiliana and which also contained two celebrated pictures attributed to Raphael but actually by Giulio Romano: the *Virgin with the Cat* (Naples, Capodimonte) and the *Virgin with the Basin* (Dresden, Gemäldegal. Alte Meister). The Classical marbles of the collection were described by Ulisse Aldrovandi (MS., Bologna U., Fond. Aldrovandi). The centrepiece of the antiquarium was an elaborate coin cabinet inset with semi-precious stones and embellished with marble colonnettes and antique statuettes, the acquisition of which was the subject of several letters to Cesare Gonzaga from his archaeological adviser in Rome, Bishop Girolamo Garimberto. These letters, which mention other acquisitions and discuss the restoration of a group of antique heads acquired by Cesare when he was in Rome (1560–62), provide remarkable insights into the contemporary Roman art market. On Cesare's death a comprehensive inventory of the contents of his gallery was compiled, thus making his short-lived collection (which was moved to Guastalla by his son and heir Ferrante II Gonzaga in 1587) better documented than many others of the period. With the dispersal of the collection, first in 1671, when half the antiquities were shipped to Mantua, then in 1746, after the extinction of the Gonzaga of Guastalla line, it is virtually impossible to identify any of the objects Cesare owned, though it is possible to identify types. For example the 'satyr with a youth … teaching the youth to play the pan-pipes' was clearly a Roman copy of the late Hellenistic *Pan with Apollo* by Heliodorus (Rome, Mus. N. Romano).

BIBLIOGRAPHY
D. A. Franchini and others: *La scienza a corte: Collezionismo eclettico nature e immagine a Mantova fra Rinascimento e Manierismo* (Rome, 1979), pp. 188–91 [transcription of Aldrovandi's MS.]
C. M. Brown with A. M. Lorenzoni: *Cesare Gonzaga and Gerolamo Garimberto: Two Renaissance Collectors of Greco-Roman Art* (London and New York, 1993)
C. M. BROWN

(14) Guglielmo Gonzaga, 3rd Duke of Mantua (*b* Mantua, 1538; *reg* 1550–87; *d* Goito, 14 Aug 1587). Son of (9) Federico II Gonzaga. The early death of Francesco Gonzaga, 2nd Duke of Mantua (1533–50), meant that, for the second time, (10) Cardinal Ercole Gonzaga was Regent. His influence was considerable: the young Guglielmo fervently supported the Counter-Reformation. He married Eleonora of Austria (1534–95) in 1561, thus reaffirming the Habsburg link. His patronage was chiefly concerned with ecclesiastical building and liturgical music. Like his uncle Ercole, Guglielmo believed the arts were a potent force in the aims of the Counter-Reformation; this was most strongly manifest in the construction, decoration and liturgical operations of the palatine basilica of S Barbara (1561–72) in Mantua. Giovanni Battista Bertani supervised the project. Pope Pius IV conferred special status on the basilica, which thus had its own liturgy, missal and breviary; the furnishings, including a fine organ by Graziadio Antegnati of Brescia, and relics were of high quality and importance. Mantua thus gained considerable prestige. The dominance of the S Barbara project created a conservative environment at court, which changed dramatically after Guglielmo's death.

BIBLIOGRAPHY
G. Coniglio: *I Gonzaga* (Milan, 1967/R Varese, 1987), pp. 319–55, 501–8
M. Cattafesta: *Mantovastoria* (Mantua, 1974 /R 1984), pp. 215–23, 545
C. Mozzarelli: *Mantova e i Gonzaga dal 1382 al 1707* (Turin, 1987), pp. 61–89, 133–9
GORDON MARSHALL BEAMISH

(15) Vincenzo I Gonzaga, 4th Duke of Mantua (*b* 21 Sept 1562; *reg* 1587–1612; *d* 8 Feb 1612). Son of (14) Guglielmo Gonzaga. He spent prodigious amounts on collecting earlier Italian and Flemish works, as well as contemporary paintings; he employed artists and architects from north of the Alps who gave the Mantuan court a distinctly cosmopolitan character. He also patronized the composer Claudio Monteverdi and protected the poet Torquato Tasso.

In 1592 Vincenzo met the architect ANTONIO MARIA VIANI at the Bavarian court in Munich and invited him to Mantua; he was made court painter (1592–5) and Prefetto delle Fabbriche Ducali. He held the latter post until his death *c.* 1632 and introduced a type of Bavarian Mannerism to the ducal décor. In the Palazzo Ducale, Mantua, Viani furnished the Galleria della Mostra, begun by Giuseppe Dattari (*d* 1619), with ornate coffered ceilings; it was there that the ducal collection of antique sculpture and paintings was shown (Luzio, 1922). He also decorated new apartments for the Duke, including the Stanza del Labirinto, and in 1608 built a new theatre (destr.).

In September 1599 Vincenzo met Frans Pourbus (ii) in Brussels and persuaded him to come to Mantua as court painter, a post he held from 1600 to 1609, during which time he painted a series of full-length official portraits of Vincenzo and his family (examples, Mantua, Pal. d'Arco;

Tatton Park, Ches, NT), as well as miniature portraits (see Marani and Perina, p. 446). Pourbus travelled to Naples on Vincenzo's behalf (Luzio, 1913, p. 277) and advised the Duke to buy two paintings by Caravaggio, a *Virgin of the Rosary* and a *Judith and Holofernes*, from the collection of Prince Conca.

Vincenzo intended to make a collection of portraits of beautiful women and to this end he recruited Peter Paul Rubens, whom he met in Venice in July 1600. In 1601 Rubens went to Rome to make copies of works in the collection of Cardinal Alessandro Montalto, and in 1603 he was sent to Spain, in part on a diplomatic errand but also to paint court beauties (Rooses and Ruelens, p. 81). The painter also produced works with more elevated subjects: a cycle of scenes from the *Aeneid*, of which *Aeneas Prepares to Lead the Trojans into Exile* (1602; Fontainebleau, Château) survives, was presumably painted to decorate one of the Gonzaga palaces. Rubens's most important work in Mantua, planned *c.* 1601 and executed 1604–5, was the large painting of the *Adoration of the Trinity* made for Santa Trinità, the Jesuit church, showing Guglielmo and Vincenzo Gonzaga with their wives and children kneeling in adoration (fragments Mantua, Pal. Ducale; Vienna, Ksthist. Mus.; priv. col., see *Splendours of the Gonzaga* exh. cat., p. 218). At the sides were the *Baptism* (Antwerp, Kon. Mus. S. Kst) and the *Transfiguration* (Nancy, Mus. B.-A.). In 1608 Rubens complained that none of his works was in the Duke's picture gallery and left Mantua soon afterwards.

Vincenzo employed agents to negotiate the purchase of works in Florence, Naples and Rome. In 1604 he bought Raphael's *Madonna della Perla* (Madrid, Prado) from Conte Galeazzo Canossa (Luzio, pp. 90–91); in 1607 Rubens acquired Caravaggio's *Death of the Virgin* (Paris, Louvre) for the Duke in Rome after it had been rejected for its realism by the authorities at S Maria della Scala. Vincenzo also appreciated Netherlandish and Flemish painting: in 1597 he bought a triptych of Jan van Eyck and by 1627 owned 17 paintings attributed (probably optimistically) to Pieter Bruegel I, some works by Quinten Metsys and a version of Lucas van Leyden's *Chess Players*.

BIBLIOGRAPHY

A. Baschet: 'Pierre Paul Rubens: Peintre de Vincent Ier de Gonzague, Duc de Mantoue (1600–1608)', *Gaz. B.-A.*, xx (1866), pp. 401–52

M. Rooses and C. Ruelens: *Codex Diplomaticus Rubinianus*, i (Antwerp, 1887)

A. Luzio: *La Galleria dei Gonzaga venduta all'Inghilterra nel 1627–8* (Milan, 1913/R Rome, 1974), pp. 36–44, 90–91, 275–84

——: *La corrispondenza familiare, amministrativa e diplomatica dei Gonzaga*, ii of *L'archivio Gonzaga di Mantova* (Verona, 1922), pp. 111–12

L. Mazzoldi: *Mantova: La storia*, iii (Mantua, 1963), pp. 37–82

E. Marani and C. Perina: *Mantova: Le arti*, iii (Mantua, 1965), pp. 88–90, 162–7, 179–81, 299–301, 437–41, 451–3

D. Mattioli: 'Nuove ipotesi sui quadri di "Bruol Vecchio" appartenuti ai Gonzaga', *Civil. Mant.*, x (1976), pp. 32–43

M. Jaffé: *Rubens and Italy* (Oxford, 1977), pp. 42–78

Rubens e Mantova (exh. cat., ed. G. Mulazzani and others; Mantua, Pal. Ducale, 1977), pp. 74–5

The Splendours of the Gonzaga (exh. cat., ed. D. S. Chambers and J. Martineau; London V&A, 1981–2), pp. 224–6

JANE MARTINEAU

(16) Cardinal **Ferdinando Gonzaga**, 6th Duke of Mantua (*b* Mantua, 26 April 1587; *reg* 1612–26; *d* Mantua, 29 Oct 1626). Son of (15) Vincenzo I Gonzaga. He was the best-informed and most extravagant patron and collector of the Gonzaga family. Much exposed to Jesuit influences in his youth, he was educated for an ecclesiastical career, first at the University of Ingolstadt (1601–2), then at the University of Pisa (1604–7), where he was compelled to read law, although his inclination was towards natural philosophy and literature. He was admired as a linguist and took an active interest in music, composing madrigals and, with the encouragement of his Medici relatives, devising musical spectacles at Pisa. His appreciation of the arts was enriched by travel: in Germany (where he began to form his own *Kunstkammer*), Tuscany (1604–5) and France (1606), where he was impressed by the portraits of his aunt Marie de' Medici and the Dauphin by Frans Pourbus (ii). He was made a cardinal in December 1607 and moved to Rome in February 1610, where he lived grandly in rented palaces, failing to persuade his family to buy one. He acquired, however, a *vigna* near the Porta del Popolo and, in 1612, a villa at Frascati. After the death in 1612 of his brother Francesco IV Gonzaga, 5th Duke of Mantua, he became Duke and in 1617 made a political marriage to Caterina de' Medici, though, as they produced no children, he failed to provide for the succession.

In Rome he bought works from many painters, including Paul Bril, Giovanni Baglione, Antiveduto Grammatica, Domenico Fetti, Guido Reni, Carlo Saraceni and Cristoforo Roncalli. His household included a resident painter, Bernardino Parasole (*d* 1650), and an English engraver, Benjamin Wright (*b* 1575/6). His tastes may have been fostered through his friendships with cardinals Alessandro Peretti-Montalto and Scipione Borghese and the Crescenzi brothers, especially Cardinal Pietro Paolo Crescenzi. It may have been due to the Crescenzi that he became interested in Roncalli and Caravaggio and sought a papal pardon for the latter when he was in exile.

In Mantua he commissioned a small-scale replica of the Scala Santa for the Palazzo Ducale; the Scala Santa was a staircase, supposedly from Pilate's palace, that Sixtus V had remodelled at S Giovanni Laterano in 1590 (*in situ*). In the Palazzo Ducale Ferdinando also housed his *Wunderkammer*, a fantastic collection of curiosities, in a hall aptly decorated with scenes from Ovid's *Metamorphosis* by a team of minor Roman artists. The main focus of his lavish patronage, however, was his magnificent new Villa La Favorita (1613–34; ruined), outside Mantua, built to emulate the grandeur of Roman palaces and for which he brought from Rome the architect Nicolo Sebregondi and the painter Fetti, who was required to provide frescoes and paintings on a huge scale and who remained in Mantua as court painter until 1623. Ferdinando failed to persuade Guido Reni to fresco ceilings, but Guido sent pupils in 1617 and 1618 and then four enormous canvases by himself, the *Feats of Hercules* (1617–21; Paris, Louvre), an allusion to the power of the Gonzaga dynasty. The size (2.60×1.94 m) of each of these paintings suggests the scale of the state rooms in the villa. Francesco Albani worked at La Favorita in 1621–2, only briefly because the Duke deplored his pretensions and slowness.

Ferdinando appreciated paintings depicting allegories and religious parables and commissioned them from several artists: from Fetti a series of small-scale works on

parable themes, such as the *Lost Silver* (before 1621; Florence, Pitti) and the *Rich Man and Lazarus* (Washington, DC, N.G.A.); from Fra Semplice da Verona, who was in Mantua in 1621–2, a painting depicting the parable of the *Guest without a Wedding Garment* (1622; Edinburgh, Pal. Holyroodhouse, Royal Col.); and from Baglione (also in Mantua in 1621–2) a series of paintings of *Apollo and the Nine Muses* (1621; Arras, Mus. B.-A.). Highly emotional, he was allegedly moved to tears by a painting by Alessandro Tiarini of the *Mater Dolorosa* (untraced). He also liked to possess works that alluded to his other intellectual interests, ordering (1621/2) from Albani a version of his metaphorical paintings of the *Four Elements* (Paris, Louvre) and gladly accepting (1619) Guercino's dedication of a printed book of drawings of human anatomy. He requested a painting from Guercino, who deferred to the Duke's known like of devising subjects himself; Ferdinando chose an episode from Torquato Tasso's *Gerusalemme liberata*: *Erminia and the Shepherds* (1620; Birmingham, C.A.G.). A list of the many paintings Ferdinando acquired, in addition to those he commissioned, can only be partly formed from an inventory made in 1627, as he also gave away paintings, for example Baglione's series *Apollo and the Nine Muses*, given to Marie de' Medici in 1624. His generous spending outran his financial means, a fact that had been noted by 1625, when the dealer Daniel Nys, agent for Charles I, King of England, sent Nicholas Lanier to Mantua to find out if it might be possible to purchase items from the Duke's collection. Charles did indeed buy a large part of it in 1627 from Ferdinando's brother, (17) Vincenzo II Gonzaga, 7th Duke of Mantua.

BIBLIOGRAPHY

I. Donesmondi: *Dell'istoria ecclesiastica di Mantova*, ii (Mantua, 1616/*R* Bologna, 1977) [sometimes inaccurate]

W. Braghirolli: 'Guido Reni e Ferdinando Gonzaga', *Riv. Stor. Mant.*, i (1885), pp. 88–104

A. Luzio: *La Galleria dei Gonzaga venduta all'Inghilterra nel 1627–8* (Milan, 1913/*R* Rome, 1974)

F. Sorbelli-Bonfà: *Camilla Gonzaga Faà* (Bologna, 1918)

P. Askew: 'The Parable Paintings of Domenico Fetti', *A. Bull.*, xliii (1961), pp. 21–45

D. Niccolini: 'Una piccola Versailles gonzaghesca: La Favorita', *Corte e dimore del contado mantovano* (Florence, 1969), pp. 65–80

P. Askew: 'Ferdinando Gonzaga's Patronage of the Pictorial Arts: The Villa Favorita', *A. Bull.*, lx (1978), pp. 274–95

D. A. Franchini and others, eds: *La scienza a corte: Collezionismo eclettico natura e immagine a Mantova fra Rinascimento e Manierismo* (Rome, 1979), pp. 127–51

D. S. Chambers: 'The "Bellissimo Ingegno" of Ferdinando Gonzaga (1587–1626)', *J. Warb. & Court. Inst.*, l (1987), pp. 113–47

D. S. CHAMBERS

(17) Vincenzo II Gonzaga, 7th Duke of Mantua (*b* 1594; *reg* 1626–7; *d* 25 Dec 1627). Son of (15) Vincenzo I Gonzaga. He was the last ruler of the original line of the family. He married Isabella Gonzaga da Novellara, who was beyond childbearing age. His character and career were unedifying; dwarfs and parrots appear to have been his abiding interests. The most notable act of his brief reign was the sale of most of the Gonzaga art collection to Charles I, King of England. Vincenzo's half-length portrait (1602–3; Saltram House, Devon, NT) was painted by Rubens, employed at the court of Vincenzo I. Lack of money did not prevent Vincenzo II from patronizing the arts. Giusto Suttermans visited Mantua *c.* 1621 to paint

the portrait of Vincenzo's sister, *Eleonora Gonzaga* (Vienna, Ksthist. Mus.), who married the Habsburg Emperor Ferdinand II. It was at this time that he would have painted the portrait of *Vincenzo II Gonzaga* (Mantua, Pal. Ducale) that is attributed to him, in which Vincenzo is shown in the costume of the Order of the Redeemer. Vincenzo's support of the applied arts is represented by a gold ducatone, minted in 1627 (London, BM). Ducatoni were normally minted in silver; to commission one in gold may have been a move to disguise relative poverty by flaunting wealth.

BIBLIOGRAPHY

G. Coniglio: *I Gonzaga* (Milan, 1967/*R* Varese, 1987), pp. 423–30, 501–8

M. Cattafesta: *Mantovastoria* (Mantua, 1974/*R* 1984), pp. 246–7, 546

C. Mozzarelli: *Mantova e i Gonzaga dal 1382 al 1707* (Turin, 1987), pp. 103, 114, 133–9

(18) Carlo I Gonzaga, 8th Duke of Mantua (*b* 1580; *reg* 1627–37; *d* 21 Sept 1637). Grandson of (9) Federico II Gonzaga. In 1599 he married Caterina of Lorraine and in 1625 was adopted as a 'son' by (16) Cardinal Ferdinando Gonzaga, 6th Duke of Mantua. His ill-judged diplomacy, once he had come to power, resulted in the invasion of Mantua by imperial troops in 1630. At the time Carlo was residing in France. He returned to Mantua in 1631 to find the State ruined by war and plague; his efforts to resuscitate Mantua were futile, and he was dependent on the generosity of Venice, the Grand Duke of Tuscany and the Duke of Modena. All dreams of power and splendour evaporated with the death of his three sons. In France Carlo created the city of Charleville (1606), engaging the architect Clément Metezeau. He designed a square in front of the ducal palace that was modelled on the Place des Vosges in Paris. In Mantua Carlo's patronage was limited by lack of revenue. However, in 1636 he built a monastery (destr.) for the Camaldolensian Order, to a design by Nicolo Sebregondi, in the central open space of the Bosco della Fontana, a traditional hunting forest of the Gonzaga near Marmirolo. Carlo's full-length portrait was painted by Geffels (Mantua, Pal. Ducale).

BIBLIOGRAPHY

G. Coniglio: *I Gonzaga* (Milan, 1967/*R* Varese, 1987), pp. 433–9, 501–8

M. Cattafesta: *Mantovastoria* (Mantua, 1974/*R* 1984), pp. 249–77, 547

C. Mozzarelli: *Mantova e i Gonzaga dal 1382 al 1707* (Turin, 1987), pp. 114–19, 133–9

GORDON MARSHALL BEAMISH

(19) Carlo II Gonzaga, 9th Duke of Mantua (*b* 1629; *reg* 1637–65; *d* Mantua, 1665). Grandson of (18) Carlo I Gonzaga. He was only eight years old on his accession, so did not assume real power until 1645. His reign was distinguished by the determined effort he made to restore the Palazzo Ducale in Mantua to the magnificence it had possessed before the sale of many of its treasures to Charles I, King of England, in 1626–7 and the later sack of the city by imperial troops (1630). Giovanni Benedetto Castiglione served the Duke from *c.* 1651 until 1663/5, painting many works for his collection (e.g. *Allegory in Honour of the Duke of Mantua*, 1652–4; untraced; drawing, Windsor Castle, Berks, Royal Col.), and, with his brother Salvatore Castiglione, acquiring others. Among their other acquisitions on the Duke's behalf were 29 items from the collection of antique statuary of the Venetian Domenico Ruzzini (1584–1675), known to have consisted mainly of sculpted heads, among them *Julius Caesar* and *Vespasian*

(Copenhagen, Ny Carlsberg Glyp.), and some life-size statues, for example those of *Agrippina* and *Minerva* (untraced). The Castiglione brothers also made prolonged negotiations for, but failed to acquire, the collection of Gian Francesco Imperiale in Genoa. From *c.* 1657 they were joined by Daniel van den Dyck, who acted as director of the Duke's collection, as well as court painter. Most of the works of art produced or collected for Carlo II were dispersed by Carlo's son and heir, (20) Ferdinando-Carlo Gonzaga, who despoiled the reconstituted gallery when he moved to Venice in 1707.

BIBLIOGRAPHY

E. Marani and C. Perina: *Mantova: Le arti*, iii (Mantua, 1965), pp. 513–40
Collezioni di antichità a Venezia nei secoli della repubblica (exh. cat., ed. M. Zorzi; Venice, Bib. N. Marciana, 1988), pp. 117–20
C. M. Brown: 'La Galleria della Mostra e le trattative veneziane e romane del duca Vincenzo Gonzaga per l'acquisto di antichità: Epilogue: The Contarini Marbles Acquired by Duke Carlo II Gonzaga de Nevers', *Atti del Congresso Internazionale: Venezia e l'archeologia: Venezia: 1988*
M. Eidelberg and E. W. Rowland: 'The Dispersal of the Last Duke of Mantua's Paintings', *Gaz. B.-A.*, n.s., cxxiii (1994)

C. M. BROWN

(20) Ferdinando-Carlo Gonzaga, 10th Duke of Mantua (*b* 1650; *reg* 1669–1707; *d* Padua, 5 July 1708). Son of (19) Carlo II Gonzaga. He married (1671) Anna Isabella Gonzaga (*d* 1703), heiress of the Gonzagas of Guastalla, and, after Anna Isabella's death, Henrietta Susanna of Lorraine-Elbeuf. He was an ineffectual ruler and was eventually forced in 1707 to accept Austrian rule in Mantua, which lasted until 1866. Ferdinando-Carlo's patronage of the arts included the completion of the second major building stage (1697–9) of S Andrea (begun 1472 under Luca Fancelli). The Palazzo Sordi (1680), Mantua, was built to the designs of the Flemish architect Franz Geffels (*fl* 1635–80), with statues and plasterwork by Giovanni Battista Barberini.

BIBLIOGRAPHY

G. Coniglio: *I Gonzaga* (Milan, 1967/*R* Varese, 1987), pp. 461–70, 501–8
M. Cattafesta: *Mantovastoria* (Mantua, 1974/*R* 1984), pp. 282–7, 547
C. Mozzarelli: *Mantova e i Gonzaga dal 1382 al 1707* (Turin, 1987), pp. 121–8, 133–9

GORDON MARSHALL BEAMISH

(21) Cardinal Silvio Valenti Gonzaga (*b* Mantua, 1690; *d* Viterbo, 1756). After serving as papal nuncio in Brussels and Madrid under Clement XII he was elected a cardinal on 19 December 1738 and Secretary of State in 1740, a few months after the accession of Pope Benedict XIV. From the years of his first European assignments the Cardinal showed a strong interest in the arts and bought numerous objects. About 1749 these were installed in a villa in the area of Vigna Cicciaporci near Porta Pia in Rome that had been built for the purpose by Giovanni Paolo Panini, Paolo Posi and Jacques-Philippe Maréchal (*d* 1765). His treasures included a library of more than 40,000 volumes, scientific instruments, East Asian art objects, drawings, sculptures and, above all, paintings. The gallery contained 827 paintings by Italian and northern artists, including Mantegna, Rubens, Bernardino Luini and Francesco Trevisani. The collection is exhaustively documented in an *Inventario dei quadri, suppellettili, beni stabili e non* (1756; Rome, Archv Cent. Stato) and in a catalogue (1760; Mantua, Bib. Com.). Its arrangement and contents are further documented in the painting by Panini of the *Gallery of Cardinal Silvio Valenti Gonzaga* (1749; Hartford, CT, Wadsworth Atheneum; *see* ROME, fig. 16) that represents part of the gallery. A number of paintings that can be identified in this picture were not in the collection in 1762.

On the Cardinal's death, his nephew Luigi Valenti Gonzaga (1725–1808) sold the villa to Prospero Colonna; the art collection was broken up and the paintings auctioned off in two sales held in Amsterdam on 18 May and 28 September 1763. Small groups of paintings from the Cardinal's collection are in the collection of Count Arrivabene Valenti Gonzaga in Venice, the Statens Museum for Kunst in Copenhagen, the Pinacoteca Capitolina, Rome, and the Galleria Nazionale d'Arte Antica in Rome, which acquired them in 1892 through the Giovanni Torlonia donation.

BIBLIOGRAPHY

F. Cancellieri: *Descrizione delle carte cinesi che adornano il palazzo della Villa Valenti poi Sciarra presso Porta Pia* (Rome, 1813)
G. Moroni: *Dizionario di erudizione storico-ecclesiastica* (Venice, 1840–79), lxxxvii, pp. 246–9
L. von Pastor: *Geschichte der Päpste seit dem Ausgang des Mittelalters* (Freiburg, 1891–1933), xv/1, pp. 31–4
H. Olsen: 'Et malet galleri af Pannini: Kardinal Silvio Valenti Gonzaga samling', *Kstmus. Årsskr.* 1951 (1952), pp. 90–103
C. Pietrangeli: *Villa Paolina* (Rome, 1961)
F. Arisi: *Gian Paolo Panini* (Rome, 1986), pp. 158–61
S. Cormio: 'Il Cardinale Silvio Valenti Gonzaga: Promotore e protettore delle scienze e delle belle arti', *Boll. A.*, 3rd ser., lxxi/35–6 (1986), pp. 49–76

WALTER ANGELELLI

Gonzago [Gonzaga], **Pietro di Gottardo** [P'yetro di Gottardo] (*b* Longarone, nr Venice, 25 March 1751; *d* St Petersburg, 6 Aug 1831). Italian painter, stage designer and landscape designer, also active in Russia. He studied in Venice (1769–72) under Giuseppe Moretti and Antonio Visentini (1688–1782) and finished his education in Milan (1772–8), studying with the stage designers Bernardino, Fabrizio and Giovanni Antonio Galliari. He was considerably influenced by the works of Canaletto and Piranesi. He made his début as a stage designer in Milan at the Teatro alla Scala in 1779 and designed over 60 productions in Milan, Rome, Genoa and other Italian cities. From 1792 he worked in Russia, where he went on the recommendation of Prince Nikolay Yusupov, who was at that time the chief director of music and pageantry at the court of Catherine II.

In his stage designs Gonzago put into effect his theoretical principles, which he explained in the handbook *Information à mon chef ou éclaircissement convenable du décorateur théâtral* (St Petersburg, 1807). He demanded that productions create a unified impression, and he called for the closest connections between the design and the action. The perspectival architectural designs he executed are characterized by harmony, clarity and classical grandeur, as in the designs for the theatre opened in 1818 at Arkhangel'skoye, among others. He also exploited the principles of illusionistic architectural effect in his monumental decorative paintings (e.g. the wall paintings of the 'Gonzago galleries', 1822–3, in the palace at Pavlovsk, which are partially preserved). Gonzago was also a master landscape designer; he made a great contribution in particular to the creation of the park at Pavlovsk.

BIBLIOGRAPHY
U. Sofia-Moretti: *Pietro Gonzaga: Scenografo e architetto veneto* (Milan, 1960)
Scenografie di Pietro Gonzaga (exh. cat., Venice, 1967)
F. Ya. Syrkina: *P'yetro di Gottardo Gonzaga, 1751–1831: Zhizn' i tvorchestvo; Sochineniya* [P'yetro di Gottardo Gonzaga, 1751–1831: life and work; writings] (Moscow, 1974)

F. YA. SYRKINA

Gonzalès, Eva (*b* Paris, 19 April 1849; *d* Paris, 5 May 1883). French painter. Her first introduction to art was through her parents. Her father, Emmanuel Gonzalès (of Spanish origin but naturalized French), was a well-known writer; her mother, a Belgian, was an accomplished musician. The family salon was a meeting place for critics and writers including Théodore de Banville and Philippe Jourde, the director of the newspaper *Siècle*. At 16 she had art lessons with the society portraitist Charles Chaplin, who ran a studio for women. Gonzalès rented a studio in the Rue Bréda and under Chaplin's guidance executed figure compositions and landscapes, exhibiting at the Salon of 1870 as his pupil.

Gonzalès was introduced to Edouard Manet by the Belgian painter Alfred Stevens in 1869 and became first his model and then his pupil. Manet's *Portrait of Eva Gonzalès* (exh. Salon 1870; London, N.G.) represents the young artist elaborately costumed and seated before an easel, daubing on a still-life. This work invokes the 19th-century stereotype of the 'lady amateur' and belies the seriousness of Gonzalès's attitude to art. She was Manet's only formal pupil, receiving regular instruction and advice from him. Records of their lessons in still-life reveal his method of seeking out the overall tonal relationships of a composition rather than attempting to reproduce in detail what the eye perceives.

Gonzalès exhibited at the Salon, declining invitations to join the independent exhibitions organized by her Impressionist contemporaries. The *Little Soldier* (exh. Salon 1870; Villeneuve-sur-Lot, Hôtel de Ville) was criticized for its suppression of half-tones and the use of harsh contrasts, reminiscent of Manet. Her association with Manet, realist sympathies and direct painterly handling provoked negative comments. *A Loge at the Théâtre des Italiens* (1874; Paris, Mus. d'Orsay) was rejected at the Salon of 1874, and when it was admitted in 1879, Gonzalès's association with Manet was perceived; the bouquet in the bottom left-hand corner was linked with that in Manet's *Olympia* (1863; Paris, Mus. d'Orsay). Many critics preferred her work when it recalled the delicate and more traditional handling associated with Chaplin, but Gonzalès was defended by such realist critics as Edmond Duranty, Philippe Burty, Zacharie Astruc and Emile Zola.

Gonzalès executed both pastels and oil paintings, concentrating on modern-life subjects, portraits and still-lifes. She frequently used members of her family, particularly her sister Jeanne, as models. In 1879 Gonzalès married the engraver Henri Guérard (1846–97), who, after her death following childbirth, married her sister. *Donkey Ride* (unfinished; Bristol, Mus. & A.G.), a work that features her husband and sister, reveals her adherence to Manet's method of proceeding from a sketchy underpainting to the finished work.

Gonzalès's work was exhibited in the offices of the magazine *L'Art* in 1882. In the same year, *The Milliner* (Chicago, IL, A. Inst.) was shown at the women's exhibition at the Cercle de la Rue Volney, and in 1883 she showed at the Galerie Georges Petit. In January and February 1885 a retrospective of 88 works was held at the Salons de *La Vie Moderne*. Although her work was acclaimed by several critics, the exhibition did not draw crowds, and few works were sold at the auction held soon afterwards at the Hôtel Drouot, Paris.

BIBLIOGRAPHY
Eva Gonzalès (exh. cat., preface P. Burty; Paris, Salons *Vie Mod.*, 1885)
P. Bayle: 'Eva Gonzalès', *La Renaissance*, xv/6 (1932), pp. 110–15
Rétrospective Eva Gonzalès (exh. cat., Paris, Gal. Marcel Bernheim, 1932)
C. Roger-Marx: *Eva Gonzalès* (Saint-Germain-en-Laye, 1950)
Eva Gonzalès (exh. cat., Paris, Gal. Daber, 1959)
T. Garb: *Women Impressionists* (London, 1986)

TAMAR GARB

Gonzales, [née Cata] **Rose** (*b* San Juan, c. 1905–10; *d* 1989). Native American Pueblo potter of San Ildefonso, NM. She attended the Institute of American Indian Art in Santa Fe. She married Robert Gonzales (1920) and moved to his home in San Ildefonso, where they had two children: Marie and Tsé-Pe, the latter also a potter. Gonzales was not a potter in her youth, but learnt the art from her mother-in-law, Ramona Sánchez Gonzales, a noted potter of the time. Rose tried many techniques; when her husband brought home a prehistoric Pueblo sherd with incised designs on the surface, she did some experimenting, and in 1929 began to carve the surface of her vessels. This was the first medium-incised pottery from San Ildefonso and the forerunner of a ware now commonplace in the Río Grande pueblos. Her vessels are relatively thick-walled and while still green are carved intaglio with a knife. The surface is burnished, leaving a matt background in a monochrome black or red, depending on oxidization when fired, which provides a pleasing contrast. Some potters who followed her style in the 1980s and 1990s also painted the incut sections. The designs are normally on a wide band around the neck and include geometric, floral and symbolic motifs. Gonzales is a prolific artisan, and her work is well known throughout the USA. She has exhibited in many shows and has travelled throughout the world demonstrating her ceramic skills

For general discussion of 20th-century developments in Native American art *see* NATIVE NORTH AMERICAN ART, §XV.

BIBLIOGRAPHY
Seven Families in Pueblo Pottery (exh. cat., Albuquerque, Maxwell Mus. Anthropol., U. NM, 1974), pp. 79–84
N. Fox: 'Rose Gonzales', *Amer. Ind. A.*, ii (Autumn, 1977), pp. 51–7

FREDERICK J. DOCKSTADER

González. Mexican family of painters. During the second half of the 17th century and the first half of the 18th a pictorial technique was developed in Mexico, known generically as *enconchado* (shellwork), in which parts of the ground of the picture were painted with paints made up with fragments of mother-of-pearl, giving a shine to the transparencies and glazes. Although several painters used this technique, its main exponents were Juan González and Miguel González (*b* 1664), who signed the majority of the known works, though their exact family relationship

is not known. The earliest extant work by Juan González is the *Adoration of the Shepherds* (1662; Washington, DC, Smithsonian Inst.). Other paintings include a series dedicated to the *Life of St Ignatius Loyola* (1697; Mexico, priv. col.) and a series of 24 panels of the *Conquest of Mexico* (1698; Madrid, Mus. América), signed by both Miguel and Juan. The subject of this latter group was one of the most often repeated by the exponents of *enconchado*. In 1699 Juan received a commission for two groups of 13 or 14 pictures (untraced). His last known signed work is a painting of *St Michael* (1717). Miguel González was a son of Tomás González and painted the *Virgin of Guadalupe* (Madrid, Mus. América) in 1697. His signature also appears on another series of the *Conquest of Mexico* (Buenos Aires, Mus. N. B.A.), as well as on 12 panels devoted to the *Allegories of the Creed* (Tepotzotlán, Mus. N. Virreinato; Mexico City, Banco N. de México).

BIBLIOGRAPHY
J. de Santiago Silva: *Algunas consideraciones sobre las pinturas enconchadas* (Mexico City, 1976)
M. Dujovne: *La conquista de México y Miguel González* (Buenos Aires, 1977)
M. C. García Sáiz: *Los enconchados*, ii of *La Pintura colonial en el Museo de América* (Madrid, 1980)
M. Dujovne: *Las pinturas con incrustaciones de nácar* (Mexico City, 1984)
G. Tovar de Teresa: 'Documentos sobre enconchados y la familia mexicana de los González', *Cuad. A. Colon.*, 1 (1986), pp. 97–103
MARIA CONCEPCIÓN GARCÍA SÁIZ

González (y Alvarez Osorio), Aníbal (*b* Seville, 10 June 1876; *d* Seville, 31 May 1929). Spanish architect. He graduated in 1902 from the Escuela Técnica Superior de Arquitectura and after experiments in designing houses in the prevalent modernist style began to develop an idiom based on Andalusian vernacular forms. The earliest example is his own house (1907–9), Calle Santa María de Gracia, Seville, with elements of the Arabic Revival. From this he evolved a distinctive vocabulary, notable for the predominance of brick in carefully prepared facings and enlivened with coloured tiling. From 1911 Gonzalez worked mainly in Seville, notably on works for the Exposición Iberoamericana (1929). In the Arte Antiguo pavilion (1910–14) he emphasized his 'Sevillian' style with touches of brick over a white lime background, a technique that he also used in the Conde de Ibarra's house (1912–13), Seville. His other works for the exhibition showed a variety of historic styles, such as the Isabelline of the Royal Pavilion (1914–16) and the Plateresque of the Palacio de Bellas Artes (1916–19). His other notable works in Seville include the Real Maestranza de Caballería Building (1928), the chapel of the Puente de Triana (1928) and the Plaza de España complex (1914–28), which was prepared for the Exposición. It has a semicircular plan, with characteristic vernacular elements superimposed on a classical-Renaissance frame.

BIBLIOGRAPHY
V. Pérez-Escolano: *Aníbal González* (Seville, 1973)
A. Villar: *Arquitectura del modernismo en Sevilla, 1900–1935* (Seville, 1979)
JORDI OLIVERAS

González, Bartolomé (*b* Valladolid, *c.* 1564; *d* Madrid, *c.* 1627–8). Spanish painter. He spent his early years in Valladolid and Madrid. According to Palomino, he was trained with Patricio Cajés, but also important was the influence of Italian Mannerism at the court (1600–06) of Philip III in Valladolid. Knowledge of naturalistic works by such Italians as Orazio Borgianni, with their monumental forms and chiaroscuro, also determined González's style, especially as a religious painter. González is first documented in 1606, after which he worked for the court in Burgos, Lerma, El Pardo and El Escorial. In 1608 he witnessed the will of the court portraitist, Pantoja de la Cruz, who died that year. González succeeded Pantoja de la Cruz in the completion of the royal portaits for the gallery of the palace of El Pardo, which replaced those destroyed by fire in 1604. One of his earliest known portraits is that of *Margaret of Austria* (1609; Madrid, Prado), which shows the influence of Pantoja de la Cruz.

From 1608 González produced more than a hundred portraits of members of the royal family and members of the court, many of them known—although not always identified—by the detailed descriptions in documents from 1617 and 1621. In 1617 he was nominated Pintor del Rey, in preference to Juan de Roelas. As a portrait painter, González continued the court tradition of Antonis Mor, Alonso Sánchez Coello and Pantoja de la Cruz and in turn passed it on to younger painters, such as Rodrigo de Villandrando and Felipe Diricksen. His treatment of such accessories as fabrics, embroidery and jewellery is often dull and mechanical as a result of the demand made for numerous versions of works to meet diplomatic needs; faces are generally stereotyped and sometimes copied from miniatures or previous models. His best portraits of *Philip III* and *Margaret of Austria*, dated 1621 (Madrid, Prado), were in fact painted after the sitters' deaths. González was also a faithful copyist of other styles, as is seen when he followed earlier works by Pantoja de la Cruz or van Dyck (e.g. *Infanta Isabella Clara Eugenia Dressed as a Nun*, 1626; Madrid, Convento de la Encarnación).

González's religious works show the transition from late Mannerism, evident in the *Virgin with Musician Angels* (*c.* 1613; El Pardo, Convento de Padres Capuchinos del Cristo), to the naturalism of Italian origin seen in *St John the Baptist* (1621; Budapest, Mus. F.A.). In the *Rest on the Flight into Egypt* (1627; Valladolid, Mus. Pint.) he encountered problems of scale and expression in the large monumental figures. The painting is dramatically lit in the same way as in early works by Velázquez, who was by this date established as court portrait painter to Philip IV.

BIBLIOGRAPHY
A. A. Palomino de Castro y Velasco: *Museo pictórico* (1715–24)
J. Moreno Villa and F. J. Sánchez Cantón: 'Noventa y siete retratos de la familia de Felipe III, por Bartolomé González', *Archv Esp. A. & Arqueol.*, xiii (1937), pp. 127–57
ISMAEL GUTIÉRREZ PASTOR

González, Carlos (*b* Melo, Cerro Largo, 1 Dec 1905; *d* Montevideo, 30 April 1993). Uruguayan printmaker and painter. He studied with Andrés Etchebarne Bidart (1889–1931) and produced only 32 prints—24 woodcuts, 1 etching and 7 monotypes—which nevertheless exerted an immense influence on printmaking in Uruguay. He made very small editions of his woodcuts, altering the block after each impression so that each print was unique. Admired by his fellow artists for his technical innovations, he also developed a great popular following for his

treatment of local stories and images, as in *Death of Martín Aquino* (1943), *Horse Breaking* (1938), *Branding* (1938), *Shed* (1938) and *Races* (1938), and of familiar legends, as in *Werewolf* (1944), and *Popular Story* (1942; all Montevideo, Mus. N.A. Plást.). With Luis Mazzey he worked on murals such as *Work at ANCAP* (1947) in the ANCAP Building in Montevideo, and the *History of Commerce in Uruguay* (1950), at the Centro de Vendedores de Plaza y Viajantes, Montevideo. He exhibited frequently in Uruguay at the Salón Municipal and the Salón Nacional, winning Gold Medals in 1943 and 1944, and was recognized as a major Latin American printmaker in exhibitions held in New York in 1945 and in Paris in 1949.

BIBLIOGRAPHY

J. P. Argul: *Las artes plásticas del Uruguay* (Montevideo, 1966); rev. as *Proceso de las artes plásticas del Uruguay* (Montevideo, 1975)

A. Kalenberg: 'Carlos González o la invención del grabado uruguayo', *Imágenes*, iii (1980)

Carlos González (exh. cat., ed. A. Haber; Montevideo, Centro de Exposiciones, Palacio Municipal, 1988)

ANGEL KALENBERG

Gonzalez, Christopher (*b* Kingston, Jamaica, 1943). Jamaican sculptor. He graduated from the Jamaica School of Art in 1963, subsequently studying at the California College of Arts and Crafts, Oakland, CA. From his earliest days as a sculptor he was influenced by the symbolism of Edna Manley. His *Man Arisen* (1966; Kingston, Inst. Jamaica, N.G.) is a direct descendant of Manley's *Negro Aroused* (1935; Kingston, Inst. Jamaica, N.G.). The early symbolist works of Picasso seem to have been a major influence as well, resulting in the typical emaciated Gonzalez figure of the 1960s and 1970s. His first major commission, a standing Christ for the Holy Cross Catholic Church in Kingston (1968), was rejected, possibly as much for its haunting expressionism as for its suggestion of nudity. This intense expressionism continues in two bronze reliefs representing the *Birth and Unity of the Nation*, commissioned for the tomb of the former Prime Minister Norman Manley (1975). Considered the most vivid image-maker of his generation of sculptors, Gonzalez was the logical choice for the important commission of a monument to Jamaica's cultural hero, the Rastafarian reggae star, Bob Marley. Completed in 1983, it draws heavily on popular and Rastafarian imagery and shows the hero like a massive tree with roots reaching into the ground, his locks like sinuous branches and his face agonized with mouth open in prophetic song. Controversial from the first viewing, the monument was rejected. Deposited in the National Gallery of Jamaica in Kingston, it is now a major attraction there.

BIBLIOGRAPHY

P. Archer-Straw and K. Robinson: *Jamaican Art* (Kingston, 1990), pp. 60–61, 83–4, 162

DAVID BOXER

González, Juan (*b* Camaguey, 12 Jan 1945; *d* Miami, FL, 24 Dec 1993). Cuban painter and draughtsman, active in the USA. He studied at the University of Miami, FL, from 1965 to 1972. He painted haunting dreamscapes and works full of oneiric imagery. In *Nativity* (watercolour, 1979; Eisenstein priv. col., see 1992 exh. cat., p. 9) he drew upon the motif of the theatre to highlight and delight in the ironies of representation. His drawings are subtle and enigmatic. Works by González are in a number of collections, including the Hirshhorn Museum and Sculpture Garden, Washington, DC; The Carnegie, Pittsburgh; and the Indianapolis Museum of Art. As well as in one-man shows, his work has been exhibited in group exhibitions, including *Outside Cuba/Fuera de Cuba*, a show of Cuban emigré art produced since 1960, organized by Rutgers University in 1987.

BIBLIOGRAPHY

Juan González (exh. cat., Miami, Dade Community Coll., Wolfson Campus Gal., 1981)

R. H. Cohen: 'The Art of Juan González', *A. Mag.*, 57 (1983), pp. 118–21

Juan González: A Twentieth-century Baroque Painter (exh. cat., Dallas, TX, S. Methodist U., Meadows Mus. & Gal., 1992)

RICARDO PAU-LLOSA

González, Juan Francisco (*b* Valparaíso, 1854; *d* Santiago, 1933). Chilean painter. On the recommendation of Pedro Lira he studied at the Academia de Bellas Artes in Santiago under the painters Ernesto Kirchbach (1832–80) and Juan Mochi (1831–92), also following a humanities course at the Instituto Nacional, where his fellow students included the painters Onofre Jarpa (1849–1940) and Alfredo Valenzuela Puelma (1856–1909). He made several trips to Europe, first in 1887, again in 1895–6 and finally in 1905, during which he befriended Joaquín Sorolla y Bastida. In 1897, together with Valenzuela Puelma and Alfredo Helsby, he founded the Exposiciones Municipales at Valparaíso, which rivalled in importance the annual Salón Oficial in Santiago. At the Salón Oficial in Santiago of 1898 he was awarded the Premio de Honor.

González was an extremely prolific artist, producing thousands of paintings during his long career, and his works express the restlessness, nervous energy and spontaneous joy of life that characterized his temperament. A sensual painter of great vitality, he based his pictorial theory on the first and most immediate impressions suggested to him by his subject-matter. Moving steadily towards an ever greater freedom of expression, he was greatly affected by the different cities and towns in which he lived: the port of Valparaíso, then Limache and various hamlets in the interior region of Aconcagua, later Melipilla and finally the capital, Santiago. The particularity of his views of different cities is evident in works such as *Seascape (Valparaíso)* (oil on wood, 345×745 mm), *View of La Serena* (oil on canvas, 365×500 mm), *Races in Viña del Mar* (1890s) and *Panorama of Santiago* (all Santiago, Mus. N. B.A.). Although he usually observed the whole of his subject when painting such landscapes, in his still-lifes of fruits and especially of flowers (e.g. *Roses*, oil on canvas, 436×500 mm, Santiago, Mus. N. B.A.) he tended to treat the images with a spectacular intensity in bright colours, outlining their forms in a vivid light against a mysteriously shadowed background.

There were three distinct periods in González's painting. At first he worked in a technique still bound to academic principles; his preferred subject-matter at this time included landscapes of Valparaíso Bay, of the rocky coastline and of farms. In his second phase his colours became rich and radiant, while his vision was simplified and his treatment of forms became more unified. Finally, in works such as *De la Vega Stage-coach* (oil on canvas, 320×

420 mm; Santiago, Mus. N. B.A.) he achieved a freedom and synthesis of form and colour, a skilful handling of tone and an orchestration of the brushwork for dramatic effect. He revealed himself as a master of sensitivity and lyrical feeling but also made use of chance and improvisation; rather than planning his paintings in drawings or oil sketches, he preferred to confront his subject directly and to respond to his own accumulated experiences. This way of working helped make González one of the strongest and most original of Chilean painters.

From 1908 to 1920 González was an influential teacher at the Escuela de Bellas Artes in Santiago. In 1918 he was co-founder with the painters Pedro Reszka (1872–1960) and Judith Alpi of the Sociedad Nacional de Bellas Artes.

WRITINGS
La enseñanza del dibujo (Santiago, 1906)

BIBLIOGRAPHY
A. Bulmes: *Juan Francisco González* (Santiago, 1933)
R. Zegers de la Fuente: *Juan Francisco González, el hombre y el artista* (Santiago, 1953)
Exposición retrospectiva del pintor Juan Francisco González (exh. cat., Santiago, Mus. N. B.A., 1953)
Juan Francisco González, 1853–1933 (exh. cat., intro. R. Abarca Valenzuela; Santiago, Mus. N. B.A., 1976)

CARLOS LASTARRIA HERMOSILLA

González(-Pellicer), Julio [Juli] (*b* Barcelona, 21 Sept 1876; *d* Arceuil, 27 March 1942). Spanish sculptor, metalworker, draughtsman and jeweller. As a sculptor he pioneered a technique of working directly with metal in the 1930s and is particularly known for his abstract forged and welded open-form constructions in iron, bronze and silver. Although he incorporated both Surrealist and Constructivist elements in his work, González was independent of any movement. He made a significant contribution to the 'truth to materials' discourse of his time and was an important example for David Smith as well as Anthony Caro, Eduardo Chillida and other sculptors working with welded metal after World War II.

González and his brother Joan (1868–1908) received their initial sculptural training from their father Concordio González (1832–96), a sculptor and metalworker. In 1892 the brothers attended evening classes in drawing at the School of Fine Arts in Barcelona but it was in 1897, after frequenting Els Quatre Gats (the meeting-place for the most progressive artists in Barcelona), that Julio considered becoming a painter. In 1900 the family moved to Paris. Julio always supported himself with his hand-crafted jewellery and decorative metalwork, a comprehensive selection of which is in Barcelona (Mus. A. Mod.); notable examples include a necklace of 1916–25 and an enamel image entitled *The Dream* of 1937–9.

González is best known for his sculptures of the 1930s. He did not begin his career as a sculptor until he collaborated with Picasso on a series of six wrought-metal sculptures in 1928–31 (e.g. *Wire Construction*, 605× 330×150 mm; Paris, Mus. Picasso). He developed quickly as a Cubist sculptor and his work can be characterized by *Polished Iron Head* (1930; priv. col., see 1970 exh. cat., no. 28). This bas-relief mask shows extreme simplicity and economy of means, in a general way informed by the aesthetics of African sculpture. With the exception of a thin vertical line indicating the nose, the whole piece

was cut, bent and raised from a single flat piece of iron, a technique that he also used on a number of other masks of this period. González's first fully three-dimensional abstract construction was *Harlequin* (e.g. bronze, h. 420 mm, 1930; Zurich, Ksthaus), in which he conjured up a puckish spirit through non-representational shapes and symbols. The sculpture is composed of solids and voids and despite its firm base appears to be precariously constructed with its forms connecting at seemingly fortuitous angles. González's intention here, and in such filiform sculptures as *Woman Combing her Hair* (iron, h. 1.22 m, 1934; Stockholm, Mod. Mus.), *Maternity* (h. 320 mm, 1934; London, Tate) and *Standing Figure* (bronze, h. 1.28 m, 1935; Saint-Paul-de-Vence, Fond. Maeght), was to create harmonious constructions between the material and the space it encloses. These works have conceptual and stylistic affinities with the open-form constructions of Lipchitz, Picasso, Calder, Giacometti and Gargallo, all of whom strove to create sculpture that would appear to free itself of gravity and would incorporate actual or implied motion.

The salient feature of González's sculpture of the early 1930s was his use of line to 'draw in space'. After 1934 surface as a description of form gradually became a defining characteristic, as can be seen in *Woman Combing her Hair* (wrought iron, h. 1.30 m, 1936; New York, MOMA; see fig.) and the paired *Monsieur Cactus* and *Madame Cactus* of 1939, also known as *Cactus Man I* (bronze, h. 650 mm; Barcelona, Mus. A. Mod.) and *Cactus Man II* (h. 780 mm, Karlsruhe, Staatl. Ksthalle). The crisp, uninflected line of the earlier 'drawings in space' yielded to a more cubic conception of form marked by a greater variation of thickness and tonal value and to a more textured surface. The hollow construction of the *Woman Combing her Hair* of 1936 gives the piece a more muscular, earth-bound feeling than his earlier work; González angled the planes to create an illusion of depth while keeping the actual depth quite shallow. The result is a rigorously planar sculpture intended to be seen in three-quarters rear view, thereby emphasizing the tension of the contracted back and neck muscles pulling against the tangled fall of hair.

The *Cactus* pair characterizes the more metamorphic and expressive qualities of González's drawings and sculptures of 1937 and after. These screaming figures with upraised arms are dehumanized by their transformation into pulpy and spiny cactus plants. Like Picasso's grotesque mutations in his series of etchings *Dream and Lie of Franco* (1937), they give an almost physical sense of revulsion and pain. The demonic expressions and terror of the figures reflect González's emotional reaction to the events of the Spanish Civil War. *Monserrat* (h. 1.62 m, 1937; Amsterdam, Stedel. Mus.) was commissioned by the Spanish Government to promote the Republican cause at their pavilion in the Paris Exposition Internationale of 1937. It stood near Picasso's *Guernica* (1937; Madrid, Prado) and the commissioned works of other well-known Spanish artists. Although the realism of this forged and hammered-iron sculpture seems to be a radical departure for González, the peasant mother with her sickle in one hand and bundled child on her arm recapitulates a theme that occurs frequently in his drawings as early as 1906. With its suggestive title—after the black Madonna of

Julio González: *Woman Combing her Hair*, wrought-iron, h. 1.30 m, 1936 (New York, Museum of Modern Art)

Montserrat—and serenely heroic stance, reminiscent of Socialist Realism, the life-size sculpture was enthusiastically received by the pavilion's organizers and was used in government literature.

After the *Cactus* figures, González did not produce much more sculpture. Only through the hundreds of drawings of this period can one understand González's increasing fear and demoralization engendered by his pessimistic reaction to the events and consequences of the Spanish Civil War. Because of his personal modesty and low public profile, he had little recognition during his lifetime. However his sculpture has become widely known through the retrospective exhibition at the Musée National

d'Art Moderne, Paris (1952), and exhibitions in Amsterdam (1955), New York (1956), four cities in Germany (1957–8) and Madrid and Barcelona (1960).

BIBLIOGRAPHY
D. Smith: 'Julio González: First Master of the Torch', *ARTnews*, liv/9 (1956), pp. 34–7, 64–5
Julio González (exh. cat., ed. A. Ritchie; New York, MOMA, 1956)
Julio González (exh. cat., ed. H. Kramer; New York, Gal. Chalette, 1961)
Julio González (exh. cat., London, Tate, 1970)
J. Gibert: *Catalogue raisonné des dessins de Julio González*, 9 vols (Paris, 1975)
J. Withers: *Julio González: Sculpture in Iron* (New York, 1978)
Julio González (exh. cat., ed. M. Rowell; New York, Guggenheim, 1983)

JOSEPHINE WITHERS

González, Manuel de la Cruz (*b* San José, 16 April 1909; *d* San José, 1986). Costa Rican painter, draughtsman and writer. A self-taught artist, in 1934 he joined the Círculo de Amigos del Arte founded in 1928 by Teodorico Quirós and Max Jiménez, collaborating with Quirós on a mural in encaustic for the group's meeting-place, Las Arcadas in San José. In 1946–7 he founded the Teatro Experimental. He started teaching in the fine arts faculty of the Universidad de Costa Rica in San José, but in 1949 he left the country for political reasons and went to Havana. During this period he started a series of nudes and pictures of Cuban peasant girls (*goajiras*) (e.g. *Goajira*, 1954; artist's col., see Ulloa Barrenechea, p. 106) in Indian ink with a scraping or *sgraffito* technique, in which the forms were simplified and stylized. The influence of Wifredo Lam is evident in these works.

In 1952 González went to Venezuela, where his painting was influenced by the geometric abstraction followed by the group Los Disidentes (e.g. *Space-Colour*; artist's col., see Ulloa Barrenechea, p. 108). His work lost all figurative reference, becoming purely abstract. He executed the *Spatial-mural* between 1959 and 1960 (San José, Banco Anglo Costarricense). González was a member of Grupo Ocho (1961–4), which aimed to stimulate artistic creativity through the organization of exhibitions and contacts with the international art world. The group also rejected notions of 'classical' beauty. There followed for González a period of obsessive experimentation with composition and drawing that lasted until 1971, and which can be followed in his notebooks (San José, Mus. Banco Cent.). Only a few of these ideas were transferred to canvas, using a lacquer technique. These works were not understood by Costa Ricans, still unaccustomed to avant-garde ideas, and González abandoned abstract art and returned to painting local scenes.

UNPUBLISHED SOURCES
San José, Mus. Banco Cent. [notebooks]

WRITINGS
Poemas gráficos (San José, 1976)

BIBLIOGRAPHY
E. Prieto: 'Manuel de la Cruz González: Pintor Costarricense', *Repert. Amer.*, xxii (Oct 1940)
R. Ulloa Barrenechea: *Pintores de Costa Rica* (San José, 1975), pp. 104–11

JOSÉ MIGUEL ROJAS

González, Pedro Angel (*b* Santa Ana del Norte, Nueva Esparta, 9 Sept 1901; *d* Caracas, 11 March 1981). Venezuelan painter and engraver. He studied at the Academia de Bellas Artes, Caracas (1916–22). In 1921 he became

associated with members of the Círculo de Bellas Artes whose non-academic attitude towards painting he supported. He went on to become a pioneer of engraving in Venezuela, organizing the Taller de Artes Gráficas in 1936 at the behest of the directorate of the Escuela de Artes Plásticas y Aplicadas de Caracas. His paintings depicted the valley of Caracas in the style of Manuel Cabré, recording changes in the city and its surroundings (e.g. *El Avila Seen from Sabana Grande*, 1946; Caracas, Gal. A. N.). In 1942 he was awarded the national painting prize.

WRITINGS

Pedro Angel González habla de sí mismo (Caracas, 1981)

BIBLIOGRAPHY

P. Erminy and J. Calzadilla: *El paisaje como tema en la pintura venezolana* (Caracas, 1975)

YASMINY PÉREZ SILVA

González Bogen, Carlos (*b* Upata, 6 June 1920; *d* Caracas, 1992). Venezuelan sculptor and painter. He studied at the Escuela de Artes Plásticas y Aplicadas in Caracas (1943–8), and was initially a painter. After winning the Premio Nacional de Artes Plásticas in the Salón Oficial Anual de Arte Venezolano in 1948, he spent four years in Paris, where he was a leading member (1950–57) of Los Disidentes, a group of Venezuelans who criticized the cultural institutions in their country and supported the development of geometric abstraction there. González Bogen's work moved progressively from abstraction to figurative forms until he began to sculpt, a discipline he considered a true integration of the arts. On returning to Caracas, he joined the Cuatro Muros movement, by which artists from different disciplines brought new artistic solutions to the Venezuelan cultural panorama, including the integration of mural painting and architecture.

BIBLIOGRAPHY

F. Paz Castillo and P. Rojas Guardia: *Diccionario de las artes plásticas en Venezuela* (Caracas, 1973); rev. as *Diccionario de las artes visuales en Venezuela* (Caracas, 1985), p. 158

ELIDA SALAZAR

González de Lara, Hernán (*b c.* 1512; *d* Toledo, 31 Aug 1575). Spanish architect. He was trained as a stonecutter and is first recorded in Toledo in 1541 as master mason at the monastery of S Pedro Mártir, a work planned by ALONSO DE COVARRUBIAS, with whom he probably continued his apprenticeship. He was assistant to Covarrubias in the construction of the Hospital Tavera (or de S Juan Bautista; 1541–50), Toledo, and replaced him as Maestro Mayor in 1550, later being responsible for a new design for the chapel (1560; partly executed) and a series of windows for the upper storey of the courtyard (1569). He was fundamentally most competent in the technical and functional aspects of utilitarian structures, such as bridges and municipal works. Recognizing this ability, Philip II employed him only in this capacity when he commissioned a report (1551–2) from González de Lara and the engineer Jerónimo de Bustamante de Herrera (*d* 1557) on the urban situation in Andalusian towns. Another report (1564) for Philip II, made in collaboration with Rodrigo Gil de Hontañón, concerning Juan Bautista de Toledo's design for the church of the Escorial, revealed González de Lara's prejudices regarding centralized church plans.

González de Lara often combined work as a designer—for example, of the façade of the Salón de Mesa (1562), Toledo, and the bridge at La Puebla de Montalbán (1562) or the parish churches of Menasalbas (1563) and Cuerva (*c.* 1566)—with the position of master mason at buildings designed by other architects. Among these was the house (1568; destr.) in Toledo designed by Luis de Vega and Francisco de Villalpando for Philip II's secretary, Diego de Vargas (*d* 1576), for whom González de Lara also designed the palace of the Torre de Esteban Hambrán (1569) and a country house, Soto de Villarrubia (Toledo province; 1571; destr.). From 1570 he served as Maestro Mayor of both the cathedral fabric and the city of Toledo, the latter position requiring numerous utilitarian works (all destr.). The mansion of Fernando de la Cerda (now the monastery of S José; 1572–9), which he designed, is one of the finest examples of civil architecture in Toledo. Until the 1570s González de Lara remained faithful to the Gothic religious building tradition in which he had been trained. From Covarrubias he learnt a severe, unornamented style (*see* ESTILO DESORNAMENTADO), which he combined during the 1570s with the more severe architectural line of the Escorial.

BIBLIOGRAPHY

A. Rodríguez y Rodríguez: *El hospital de San Juan Bautista, extramuros de Toledo* (Toledo, 1921)

V. García Rey: 'El arquitecto Hernán González de Lara: Datos inéditos para la historia de la arquitectura española', *Arquitectura* [Madrid], vi (1924), pp. 157–62; vii (1925), pp. 25–8

F. Chueca Goitia: *Arquitectura del siglo XVI*, A. Hisp., xi (Madrid, 1953)

A. Rodríguez and G. de Ceballos: *Bartolomé de Bustamante (1501–1570) y los orígenes de la arquitectura jesuítica en España* (Rome, 1967)

C. Wilkinson: *The Hospital of Cardinal Tavera in Toledo: A Documentary and Stylistic Study of Spanish Architecture in the Mid-sixteenth Century* (New York and London, 1976)

F. Marías: *La arquitectura del renacimiento en Toledo, 1541–1631*, 4 vols (Toledo and Madrid, 1983–6)

FERNANDO MARÍAS

González de Léon, Teodoro (*b* Mexico City, 29 May 1926). Mexican architect. He studied at the Escuela de Arquitectura at the Universidad Nacional Autónoma de México, where he won a scholarship that enabled him to live in Paris (1948–9) and work in the studio of Le Corbusier, whose influence was crucial for his future development. Another important early influence was his work with such outstanding Mexican architects as Carlos Obregón Santacilia and Mario Pani. He then established himself in professional practice in partnership with Armando Franco (*b* 1925), concentrating mainly on construction techniques that made use of prefabricated elements (e.g. Casa Catán, Mexico City, 1951). He also demonstrated his interest in urban planning with several studies for cities and rural areas in Mexico. Later, such works as the Escuela de Derecho (1966) at the Universidad de Tamaulipas, Tampico, marked González de Léon's belief that the possibilities of the International Style had been exhausted, but, still influenced by Le Corbusier, he adopted a new formal and functional position. Such elements as the Mediterranean patio began to appear in his work, along with a tendency towards massive linearity and the judicious use of concrete. His approach to the 20th century's most characteristic material was original: he used an aggregate made from stones hammered to

reveal the grain, which showed their natural colour against the drab grey of the concrete. This became an unmistakable trademark of his work.

In 1968 González de León began a period of collaboration with ABRAHAM ZABLUDOVSKY, although the two architects managed to retain a substantial degree of autonomy. Their first collaborative projects focused on solutions to Mexico's chronic housing shortage and included the Mixcoac-Lomas de Plateros housing complex (1971), the La Patera housing development (1973) and the Ex-hacienda de Enmedio (1976), all in Mexico City. It was in their designs for public buildings, however, that the two architects were able to develop their individual plastic language, creating a sense of permanence by their use of such traditional elements as the cloister, the limited use of sheltered windows and, especially, by their handling of large asymmetrical volumes in exposed, impeccably finished concrete and in their sensitivity to context. The first work of this kind produced by the partnership was the Delegación Cuauhtémoc (1972–3; in collaboration with Luis Antonio Zapiain) in Mexico City. This was followed in 1975 by the completion of three important projects: the headquarters of INFONAVIT (Instituto del Fondo de la Vivienda para los Trabajadores) and the new building of the Colegio de México, both in Mexico City, and the Mexican Embassy in Brasília, Brazil, in collaboration with Francisco J. Serrano. The partnership was also responsible for the Museo Rufino Tamayo (1981) in the Parque Chapultepec, sensitively integrated with the surrounding trees, and the Universidad Pedagógica (1983) in the rocky area of El Ajusco.

González de León continued to demonstrate a distinctive personal style, however, producing works that were responsive to particular requirements and were carried out to a high standard, with a consistent stylistic approach. His unfailing creativity was also evident in buildings where he had greater freedom of expression. Among his mature works were such civic projects as the Parque Tomás Garrido Canabal (1985), the Centro Administrativo (1986–7) and the Biblioteca del Estado (1987–8), all in Villahermosa, Tabasco, and all designed in collaboration with Francisco Serrano. The partnership with Zabludovsky continued to develop, meanwhile, in such projects as the building of several banks in Mexico City and the restoration of the National Auditorium (1989–91). In collaboration with Francisco J. Serrano and Carlos Tegeda (b 1948), he designed the Palacio de Justicia Federal (1987–92), an impressive building aligned beside a pedestrian walkway more than 200 m long. He also began to produce independent work, such as museum buildings for an archaeological site at Tajín, Veracruz (1991–2), the Rufino Tamayo Plaza (1990–91) and the office building for the Fondo de Cultura Económica (1990–92; both in Mexico City); the latter is unusual in rising to 10 floors but incorporating curved façades. The Conservatorio Nacional de Música (Mexico City), notable for its bold volumes and curvilinear façades, and the Mexican showroom of the British Museum (London) were inaugurated in 1994.

BIBLIOGRAPHY
Contemp. Architects
Teodoro González de Léon y Abraham Zabludovsky: Ocho conjuntos de habitación (Mexico City, 1976)

P. Heyer: Mexican Architecture: The Work of Abraham Zabludovsky and Teodoro González de León (New York, 1978)
J. Glusberg: 'Teodoro González de León', Seis arquitectos mexicanos (Buenos Aires, 1984)
L. Noelle: 'Teodoro González de Léon', Arquitectos contemporáneos de México (Mexico City, 1988)
Teodora González de Léon: La voluntad del creador (Bogota, 1994)

LOUISE NOELLE

González de Medina Barba, Diego (b Burgos; fl 1565–1600). Spanish soldier and writer. He was a member of an illustrious family, and his military career apparently began c. 1565, since a document of 1583 (Simancas, Archv Gen.) states that he had been serving with Philip II in Flanders, the Levant and Portugal for 16 years. The poet Lupercio Leonardo de Argensola wrote of him that he possessed 'valour, wit and a skilful hand'. González de Medina Barba's career exemplifies the combination of science and experience required by experts in fortification. In 1599 he wrote a treatise Examen de fortificación, but there is no certain evidence that he contributed to the design of any fortifications. His treatise takes the form of a dialogue between a ruler and a master of the profession. González de Medina Barba was aware of Italian methods of fortification, and the structural form he considered best for a fortress was the pentagon, the type most favoured in 16th-century citadels. He used illustrations to explain the construction of fortresses and the various elements involved. The work also discusses the number of men and artillery pieces needed and gives the dimensions required by some of the buildings, the parade ground and the streets of a fortified city. The treatise also covers urban planning, with such details as construction of suburbs, the radial plan of streets, the modernization of old city walls and the theory of the citadel. These all give the work added interest in the context of Spanish 16th-century treatises.

WRITINGS
Examen de fortificación (Madrid, 1599)

BIBLIOGRAPHY
A. Cámara: 'Tratados de arquitectura militar en España: Siglos XVI y XVII', Goya, 156 (1980), pp. 338–45
A. I. M. Carvajal: 'La ciudad militar en dos tratados de fortificación del siglo XVI', La ciudad hispánica durante los siglos XIII al XVI, ed. E. Saez, C. Segura Graino and M. Cantera Montinegro (Madrid, 1985), pp. 51–63

ALICIA CÁMARA-MUÑOZ

González de Mendoza, Pedro. See MENDOZA, (1).

González Gortázar, Fernando (b Mexico City, 19 Oct 1942). Mexican architect and sculptor. He studied architecture from 1959 to 1966 at the Universidad de Guadalajara, where he also attended Olivier Seguin's sculpture studio. He worked at first in Guadalajara, where his Large Gate (1969) in the Jardines Alcalde, which gives symbolic access to a new urban development, is made up of concrete prisms. The Fountain of Sister Water (1970), Colonia Chapalita, is an experiment in Brutalism, with rough surfaces of exposed concrete, while the structure (1972) at the entrance to the Parque González Gallo deploys bold projecting forms contrasting with the neighbouring trees. In 1972–3 he designed the Tower of Cubes, Plaza Vallarta, Guadalajara, and the Large Spike, Calzada de Tlalpan, Mexico City, both vertical monuments constructed from

prefabricated concrete prisms. He next exploited the expanses of urban squares, breaking up the flatness of their surfaces, for example with inserted bodies of water and irregularly placed cube-shaped 'islands' in the Plaza de la Unidad Administrativa (1973), Guadalajara, or with diagonal terraces and concrete prisms in the Plaza del Federalismo (1975), Guadalajara. In 1986 he went to Spain, where among other works he built the Fountain of Stairs (1987), Fuenlabrada, Madrid. With Mathias Goeritz and Enrique Carbajal Sebastián, he is one of the most prominent exponents of geometricism in Mexican urban art.

BIBLIOGRAPHY

J. A. Manrique: 'Los geometristas mexicanos en su circunstancia', *El geometrismo mexicano* (Mexico City, 1977), pp. 77–115
R. Tibol: *Fernando González Gortázar* (Mexico City, 1977)

ALBERTO GONZÁLEZ POZO

González Goyri, Roberto (*b* Guatemala City, 20 Nov 1924). Guatemalan sculptor and painter. He studied at the Escuela de Bellas Artes in Guatemala City (1938–45) and from 1942 to 1945 worked on the stained-glass windows at the Palacio Nacional. In 1948 he won a grant that enabled him to study in New York, at the Art Students League and at the Sculpture Center, until 1951. On his return from the USA he concentrated on sculpture until 1973, working particularly closely with Guatemalan architects in the 1950s on large reliefs in exposed cast concrete, mainly for government buildings in Guatemala City. The outstanding examples of these reliefs in Guatemala City, characterized by simple lines and an epic scale, are *Guatemalan Nationality* (3×40 m, 1959) for the Seguro Social building, *Culture and Economy* (14×7.5 m, 1963–4) for the Crédito Hipotecario building, *Economy and Culture* (40×21 m, 1964; Banco de Guatemala) and *The Quetzal and the Golden Eagle* (8×4 m, 1973; Inst. Guat. Amer.). He also produced a free-standing monument to the national hero, *Tecún Umán* (hammered concrete, h. 7.5 m, 1963; Guatemala City), and small sculptures such as *Wolf's Head* (bronze), which was awarded a prize in Guatemala and acquired in 1957 by the Museum of Modern Art in New York. He served briefly as director of the Escuela de Artes Plásticas in Guatemala City (1957–8).

From 1974 González Goyri devoted himself more to painting, partly because of the limitations imposed on him as a sculptor in working to commission. His technical mastery and superb use of colour, demonstrating an original application of elements from the work of Rufino Tamayo and Carlos Mérida, earned him a serious reputation in Guatemala and several national and international prizes.

BIBLIOGRAPHY

M. Aragón de Martínez: *La pintura de Roberto González Goyri* (Guatemala City, 1985)
Pinturas recientes de Roberto González Goyri (exh. cat., Guatemala City, Patrn. B.A., 1987)
J. Gómez-Sicre: 'La creación artística de Roberto González-Goyri', *Rev. Pensam. Centroamer.*, 206 (1990), pp. 25–6

JORGE LUJÁN MUÑOZ

González Pérez, José Victoriano Carmelo Carlos. *See* GRIS, JUAN.

González Ruiz, Antonio (*b* Corella, Navarre, 1711; *d* Madrid, 1788). Spanish painter and teacher. He was the son of the painter Manuel González and probably began working in his father's studio before arriving in Madrid in 1726. There he studied with Michel-Ange Houasse and later went on a bursary to Paris, Rome and Naples. In 1737 he was back in Madrid continuing his apprenticeship. Shortly after, possibly in 1738, he painted two canvases showing the *Finding of the True Cross* for the church of S Sebastián in Madrid (destr. 1936) and *St James at the Battle of Clavijo* for the monastery at Uclés (*in situ*). He also painted frescoes, miniatures and portraits for Philip V, including a portrait of the *Infanta Cardinal Luis* (1742; Dallas, TX, S. Methodist U., Meadows Mus. & Gal.), which reveals his knowledge of the paintings of Louis-Michel van Loo, who was then working for the Spanish monarch. In 1744 he began working for the preparatory board of the Real Academia de Bellas Artes de S Fernando, and when the Academia was founded in 1752 he was appointed director of painting. In 1756 he became Pintor de Cámara. Work from this period includes several portraits painted in an international style, conventional and somewhat dry in execution, and some large allegorical canvases, such as the *Allegory of the Preparatory Board of the Academia* and *Ferdinand VI, Protector of the Arts and Sciences* (both 1746; Madrid, Real Acad. S Fernando). Ruiz prepared several tracts for the teaching of drawing and executed cartoons for the Real Fábrica de Tapicés, such as *Children Skipping* (1758; Toledo Cathedral, Sacristy). In 1768 he was named Director General of the Academia and later also became a member of the Academia de S Carlos in Valencia and of the Imperial Academy of St Petersburg.

BIBLIOGRAPHY

J. Held: *Die Genrebilder der Madrider Teppichmanufaktur und die Anfänge Goyas* (Berlin, 1971)
J. L. Arrese: *Antonio González Ruis* (Madrid, 1973)
J. Camón Aznar, J. L. Morales y Marín and E. Valdivieso: *Arte español del siglo XVIII*, Summa A., xxvii (Madrid, 1984)

JUAN J. LUNA

González Rul, Manuel (*b* Querétaro, 1 Aug 1923; *d* Mexico City, 8 Nov 1985). Mexican architect and teacher. He studied at the Escuela Nacional de Arquitectura in the Universidad Nacional Autónoma de México, Mexico City, graduating in 1949. In the early period of his career he built private residences with impressive formal qualities, combining a concern for technical innovation with a search for original forms, including the Casa Dubernard in Coyoacàn and the Casa D'Avila in Mexico City (both 1949). Nevertheless, his best-known achievements are public buildings of very diverse types. The Díaz Ordaz Gymnasium (1968), Magdalena Mixhuca, Mexico City, exemplifies symbolic architecture: its exterior elevation forms the initial 'M' of Mexico. Its three-dimensional rooftops act as roofs and walls simultaneously, achieving overall an arresting formal unity. In 1975–6 González Rul designed (with Agustín Hernández) the Heroico Colegio Militar, Mexico City. This is a vast and ambitious work, its main theme being a reference to Mexican cultural roots. It contains huge squares reminiscent of the open spaces of Pre-Columbian architecture. In contrast, González Rul's pursuit of abstract architectural form is exemplified

by the Sociedad de Escritores building (1978–9) and the headquarters of the Colegio de Arquitectos (1981–3), both in Mexico City. The great visual impact of these buildings made them both landmarks. From 1957 González Rul taught at the Universidad Nacional Autónoma de México, Mexico City.

BIBLIOGRAPHY
I. Maya Gómez and J. Torres Palacios, eds: *Manuel González Rul* (Mexico City, 1984)
LOURDES CRUZ

González Velázquez. Spanish family of artists. Pablo González Velázquez (1664–1727) was an Andalusian sculptor who worked in the Baroque style and in 1702 settled in Madrid, where his three sons were born. There were numerous collaborations between the sons. (1) Luis González Velázquez and (2) Alejandro González Velázquez worked together in Madrid on the chapel of S Teresa (1737–9) in the church of S José, the church of the convent of El Sacramento, the church of El Salvador and the church of the Carmelitas Descalzas; in La Puebla de Montalbán, near Toledo, they worked together on the Ermita de la Virgen de la Soledad (1741–2), for which they executed the main altarpiece and pendentive paintings of *Esther*, *Judith*, *Rachel* and *Abigail*. The two also often undertook stage designs for the theatre in the Palacio del Buen Retiro in Madrid. They collaborated with their younger brother (3) Antonio González Velázquez on the decoration of the church of the convent of La Visitación (now S Bárbara) in Madrid in 1757–8, the church of La Encarnación, the church of the Descalzas Reales, the church of the Salesas Reales (where they completed projects begun by Corrado Giaquinto, painting scenes from the *Life of the Virgin* and *Allegories of the Virtues* in fresco on the dome), the churches of S Isabel and S Ana and the church of SS Justo y Pastor, Madrid. Antonio was the father of (4) Zacarías González Velázquez, the architect Isidro González Velázquez (1765–1829), and (5) Castor González Velázquez.

(1) Luis González Velázquez (*b* 25 Aug 1715; *d* Madrid, 24 May 1764). Painter and stage designer. He trained initially in Madrid, both in his father's studio, where he worked with his relatives, and later with the Italian decorator Giacomo Bonavia. Subsequently he joined the classes of the preparatory committee of the Real Academia de Bellas Artes de S Fernando, where he was an outstanding pupil. Family difficulties prevented a journey to Italy to obtain a further apprenticeship, and Luis remained in Madrid. His main activity was as a painter of frescoes in a late Baroque style, using brilliant colours, as in the frescoes he painted for the chapel of S Teresa in the church of S José, where he worked with his brother Alejandro and where he also executed a series of paintings of the *Life of St Teresa* (1737; in situ). In 1746, on the accession of Ferdinand VI, to whom he later became court painter, Luis was involved in the decoration of the streets of Madrid. That year he also painted the *Vision of St Ildefonsus* and several saints for the main altarpiece of the Jesuit church in Toledo. In 1752 he painted in fresco four scenes from the *Life of St Mark* on the dome of the church of S Marcos in Madrid and was appointed honorary academician at the recently founded Real Academia de Bellas Artes

de S Fernando, for which he painted the canvas *Mercury and Argus* (1752; Madrid, Real Acad. S Fernando, Mus.). In 1754 he became deputy director of painting at the Academia. For the church of the convent of La Visitación (now S Bárbara) in Madrid, he painted the *Four Evangelists* on the pendentives, and the *Coronation of the Virgin*, the *Apparition to St Francis de Sales*, *St Francis de Sales Preaching*, *St Barbara* and other religious motifs on the dome, all after religious sketches by Corrado Giaquinto.

(2) Alejandro González Velázquez (*b* 1719; *d* Madrid, 1772). Painter and architect, brother of (1) Luis González Velázquez. He probably studied in the family studio, and by around 1738 he was painting scenery for the theatre at the Palacio del Buen Retiro, Madrid. He painted illusionistic perspectives on the ceilings of the palaces of La Granja de San Ildefonso (*c.* 1744) and Aranjuez (*c.* 1747–50). He studied at the drawing school of the preparatory committee of the Real Academia de Bellas Artes de San Fernando, and when the Academia was founded in 1752 he was appointed deputy director of architecture and in 1762 deputy director of painting. He became director and teacher of perspective painting in 1766. In addition to his collaborations with his brothers, in which he painted the decorative motifs for vault paintings in various religious institutions in Madrid and was responsible for the *trompe l'oeil* decoration in the parish church of SS Justo y Pastor, Madrid, Alejandro also painted frescoes in the Palacio Real, Madrid, in collaboration with Guillermo Anglois (*fl* second half of the 18th century) and under the direction of Anton Raphael Mengs. He also prepared architectural plans for the renovation of the interiors of churches and their retables in Madrid and the provinces, and he was acclaimed for his designs, which he also executed, for the Teatro del Príncipe, Madrid (destr.).

(3) Antonio González Velázquez (*b* July 1723; *d* Madrid, 1794). Painter, brother of (1) Luis González Velázquez and (2) Alejandro González Velázquez. After training in Madrid at the drawing school of the preparatory committee of the Real Academia de Bellas Artes de San Fernando, in 1746 he obtained a grant from the committee to study in Rome, where he stayed until 1752, in the workshop of Corrado Giaquinto. In 1748 he executed decorative works for Santa Trinità degli Spagnoli, Rome, painting canvases of the *Good Shepherd*, *Pope Innocent III Giving Habits to the First Trinitarians* and *St John of Matha Visiting St Felix of Valois* for the church walls, and frescoing scenes from the *Life of Abraham* on the dome and *Moses* and three other prophets on the pendentives. Attribution of this work has been questioned, but both the documentation and the technique confirm that it was the work of Antonio and not of Goya, as has been suggested. The magnificent decoration of the vault shows the influence of Giaquinto, which was decisive in Antonio's development.

On his return to Spain in 1752, Antonio painted frescoes on the dome of the Santa Capilla in the basilica of Nuestra Señora del Pilar, Saragossa, depicting the *Apparition of the Virgin to St James* and the *Construction of the Santa Capilla*. The frescoes were again strongly influenced by Giaquinto, who praised the completed works. The *Apparition* and the

Antonio González Velázquez: *Columbus Offering America to the Catholic Kings* (*c.* 1760), fresco, Cuarto de la Reina (now state dining-room), Palacio Real, Madrid

Santa Capilla made a great impact, and their influence is particularly noticeable in the works painted later by Francisco Bayeu and Goya in Nuestra Señora del Pilar. Through his friendship with Giaquinto, Antonio sought work at the court in Madrid in 1754, and in 1757 he was appointed court painter. His main work in Madrid was as a painter of such frescoes as the *Life of St Augustine* on the dome and the *Archangel Gabriel*, *St Raphael*, *St Michael* and the *Guardian Angel* on the pendentives of the church of the convent of La Encarnación, where he collaborated with his brothers Luis and Alejandro. Antonio also undertook decorative work for the Palacio Real, including the painting of *Columbus Offering America to the Catholic Kings* (see fig.) on the ceiling of the Cuarto de la Reina (now state dining-room). From 1761 he made cartoons for the Real Fábrica de Tapices, producing such works as *Army Procession* (Madrid, Prado). He was honoured many times by the Real Academia de Bellas Artes de San Fernando, culminating in his appointment in 1785 as director of painting, for which he had first been proposed 20 years earlier.

Antonio was an excellent draughtsman with a firm, sure hand, exemplified in his drawings of *St Rita* and the *Garland of Cupids* (both Madrid, Prado). His style, initially very close to that of Giaquinto, shows a freedom of execution, interpretative skill and a marked decorative quality that was later enriched by his contact with Mengs. Antonio's work is among the liveliest and most vigorous Spanish painting of his period, and, despite the greater Neo-classicism of his later work, he never lost the brilliance of execution that stemmed from his Italian training. The portrait of *Antonio González Velázquez* (Madrid, Prado) painted by his son (4) Zacharías González Velázquez reveals the former's self-confidence and strength of character.

(4) Zacarías González Velázquez (*b* Madrid, 1763; *d* Madrid, 31 Jan 1834). Painter, son of (3) Antonio González Velázquez. He studied in Mariano Salvador Maella's studio and at the Real Academia de Bellas Artes de San Fernando in Madrid, of which his father was then director. He received several prizes there and was elected to membership of the Academia in 1790, later becoming court painter. In 1819 he became director of painting at the Academia and in 1828 its director-general.

Zacarías's output was wide-ranging. He collaborated with the Real Fábrica de Tapices in Madrid, painting such cartoons for tapestries as *Fisherman Drawing in his Net* (1785; Madrid, Prado), and was the last artist to produce cartoons for the factory. He was a skilled fresco painter, trained in the Baroque style of the 18th century but combining this with Neo-classical traits. He executed several mural paintings for the Palacio de El Pardo, near

Madrid, including *Spain Triumphant*, as well as murals on agricultural and mythological themes with allegorical figures for the Casa del Labrador at the Palacio de Aránjuez and others for the Casino de la Reina in Madrid. He also painted religious works, including a cycle of ten paintings on Franciscan themes for the church of S Francisco el Grande in Madrid (*in situ*), and a *Crucifixion* and *Martyrdom of St Peter Pascual* for Jaén Cathedral (both 1793; *in situ*). The compositions of these and other religious works by Zacarías reveal both Baroque and Neo-classical elements, especially in the choice of subject-matter. His portraits are excellent, rendering graceful interpretations of his sitters that are high in technical quality, sometimes with an underlying Romantic spirit: his most celebrated is that of his daughter *Ana María González* (Madrid, Mus. Lázaro Galdiano). He also painted popular scenes that show great skill but lack any depth of realism. His long life and the period in which he worked enabled him to witness changing aesthetic doctrines, which he drew on pragmatically to develop his own work.

JUAN J. LUNA

(5) Castor González Velázquez (*b* Madrid, 1768; *d* Madrid, 1822). Painter, brother of (4) Zacarías González Velázquez. He studied in the family workshop and at the Real Academia de Bellas Artes de S Fernando, where in 1787 he won the first prize, second class, for painting. He was a court painter and in 1807 was appointed painter–decorator in the Real Fábrica de Porcelana, of which he was also briefly director. In 1818 he was elected *académico de mérito*.

Castor González Velázquez was particularly skilled in miniature painting, having studied the technique with Anna Maria Mengs (1751–93), the daughter of Anton Raphael Mengs. Some of his miniatures were listed in catalogues to the royal collections and to that of the great 19th-century Spanish collector Sebastián Gabriel Bórbón y Braganza. For Charles IV, Castor painted two religious panels, both in Neo-classical style, for the Casita del Príncipe at the Escorial, a *Holy Family* and a *Flight into Egypt*. Other significant paintings include *St Cecilia* (Madrid, Real Acad. S Fernando, Mus.), a copy in miniature of a work by Guido Reni, and three canvases signed and dated 1800: *Cupid and the Nymphs*, the *Nine Muses* and an *Allegory of Olympus* (all Madrid, Gil Villadares priv. col.).

JOSÉ LUIS MORALES Y MARÍN

BIBLIOGRAPHY

M. Ossorio y Bernard: *Galería biográfica de artistas españoles del siglo XIX* (Madrid, 1883–4)

S. Ríus Oliva: *Los hermanos González Velázquez: Pintores del siglo XVIII* (diss. U. Madrid, 1964)

——: 'Antonio González Velázquez y los frescos de la iglesia de los Trinitarios Calzados de Roma', *Archv Esp. A.*, xli (1968), pp. 67–70

J. Held: *Die Genrebilder der Madrider Teppichmanufaktur und die Anfänge Goyas* (Berlin, 1971)

C. Bedat: *L'Académie de beaux-arts de Madrid, 1744–1808* (Toulouse, 1974)

J. Camon, J. L. Morales y Marín and E. Valdivieso: *Arte español del siglo XVIII*, Summa A., xxvii (Madrid, 1984)

Y. Bottineau: *L'Art de cour dans l'Espagne des lumières, 1746–1808* (Paris, 1986)

JUAN J. LUNA, JOSÉ LUIS MORALES Y MARÍN

Go Oc Eo. *See* OC EO.

Goodall. English family of artists. The engraver (1) Edward Goodall had four children who were painters: Edward Alfred Goodall (1819–1908), (2) Frederick Goodall, Walter Goodall (1830–89) and Eliza Goodall (*fl* 1846–54).

(1) Edward Goodall (*b* nr Leeds, 17 Sept 1795; *d* London, 11 April 1870). Engraver. Initially he worked primarily as a painter, but *c.* 1826 he settled in London and took up engraving. He worked mainly on steel and seems to have been self-taught. His reputation rests largely on his engravings after J. M. W. Turner, with whom he worked in close collaboration, producing plates of great delicacy and beauty. His earliest prints were for such popular annuals as the *Literary Souvenir*, engraved after designs by such contemporary artists as William Purser (*fl* 1805–34) and David Roberts. He began concentrating on book illustrations in the 1830s, most of which were vignettes after Turner, such as those for Samuel Rogers's *Italy* (London, 1830) and Thomas Campbell's *Poetical Works* (London, 1837). He was also a prolific engraver of landscape subjects for topographical series or travel guide-books, producing such plates as those after Turner for *Picturesque Views in England and Wales* (London, 1827–38). In the 1840s he worked on several large plates, including *Caligula's Palace and Bridge* (1842; e.g. London, BM; Tate) after Turner and *The Irish Piper* (1848; e.g. London, BM) after his son, (2) Frederick Goodall, many of which were published for the Art Unions. Between 1854 and 1869 he produced 16 plates for the *Art Journal*. He was a member of the Associated Engravers, formed to publish *Engravings from the Pictures of the National Gallery* (London, 1830–40), and supported the campaign to win recognition for engravers at the Royal Academy.

BIBLIOGRAPHY

DNB

B. Hunnisett: *Steel-Engraved Book Illustration in England* (London, 1980), pp. 101–2

DIANE PERKINS

(2) Frederick Goodall (*b* London, 17 Sept 1822; *d* London, 28 July 1904). Painter, son of (1) Edward Goodall. He was taught by his father and first exhibited at the Royal Academy in 1838. His earliest subjects were rural genre scenes and landscapes, many derived from sketching trips made between 1838 and 1857 in Normandy, Brittany, Wales, Ireland, Scotland and Venice. In the 1850s he also painted subjects from British history. More significant for his subsequent career was his visit to Egypt from September 1858 to April 1859. In Cairo he lived in a house in the Coptic quarter with Carl Haag. Together the two artists went on expeditions to Giza to draw the Nile, the Sphinx and Pyramids, and to Suez and across the Red Sea to the Wells of Moses at 'Uyûn Mûsa. Goodall also made rapid sketches in the crowded streets of Cairo. 'My sole object in paying my first visit to Egypt', he wrote, 'was to paint Scriptural subjects' (*Reminiscences*, p. 97). The first of these, *Early Morning in the Wilderness of Shur* (London, Guildhall A.G.), was exhibited at the Royal Academy in 1860 and won him critical and popular acclaim. In 1864 he was elected RA. Much of the rest of Goodall's long career was devoted to painting similar scenes of Egyptian life with biblical associations, for which he made reference to his sketches and to Egyptian artefacts

and clothing. Their success prompted a second visit to Egypt in 1870–71. Towards the end of the century, however, Goodall's popularity and his prosperity greatly declined, and in 1902 he was declared bankrupt.

WRITINGS

The Reminiscences of Frederick Goodall, RA (London, 1902)

BIBLIOGRAPHY

N. G. Slarke: *Frederick Goodall, RA* (Oundle, 1981)

BRIONY LLEWELLYN

Goodhart-Rendel, H(arry) S(tuart) (*b* Cambridge, 29 May 1887; *d* London, 21 June 1959). English architect and writer. The son of the Classical scholar H. C. Goodhart and grandson of Stuart, 1st Baron Rendel, he showed an early aptitude for music and architecture. He read music at Cambridge University but during that time also designed the façade of Gillanders House (1908–9), Clive Street, Calcutta. He entered the London office of Sir Charles Nicholson (1867–1949), who specialized in building churches, and established his own practice in 1909. He initially devoted himself to domestic work in a Regency Revival style, although in The Pantiles (1911), Englefield Green, Surrey, he combined this with requirements dictated by the client's German taste. Goodhart-Rendel's early work shows his eclecticism as well as his debt to French architectural theory, which he opposed to English Picturesque practice. After World War I he continued to work in his Regency style at Tetton House (1924–7), Kingston St Mary, Somerset, but revealed his interest in the unfashionable 19th-century Gothic Revival in additions to St Mary's (1922–36), Graham Terrace, London. At Hay's Wharf (1929–31), Tooley Street, London, he developed a personal version of Modernism, delighting in the display and ornamentation of the steel-framed structure and the designing of all the furniture, carpets and fittings. This was followed by Prince's House (1934–5), North Street, Brighton, a steel-framed structure clad in polychromatic brick, tile and mosaic. His other steel-framed buildings are the extension to the Queen Elizabeth Hospital (1936–46), Banstead Wood, Surrey, which borrows stylistically from the house by Richard Norman Shaw to which it is an extension, and Westminster Technical College (1950–55), Vincent Square, London. He accepted some of the disciplines of Modernism but never believed in its non-referential aesthetic and denial of ornament.

Goodhart-Rendel's later career was largely taken up with church work. St Wilfred's (1932–4), Elm Grove, Brighton, was his first complete church, an austere exercise in reworking the Gothic Revival. He was influenced by French Romanesque planning and vaulting at Holy Spirit (1936–8), Ewloe, Clwyd, and in his vast, unexecuted design for Prinknash Abbey (1938–59; see Powers, 1987, p. 41), Glos, which also reveal his admiration for Arthur Beresford Pite. His churches of the 1940s and 1950s developed the neo-Victorian theme with great resourcefulness and skill, the finest being the rebuilding (1951) of Arthur Blomfield's St John, Maze Hill, St Leonard's, E. Sussex; Holy Trinity (1958–60), Dockhead, London; and Our Lady of the Rosary (1960–62), Old Marylebone Road, London. In these designs, Goodhart-Rendel's interest in proportional systems and patterned polychrome brickwork are apparent, also his careful attention to lighting

and circulation. His skill in the restoration of war-damaged churches was shown at John Nash's All Souls, Langham Place, London, and George Edmund Street's St John the Divine, Vassall Road, London.

Goodhart-Rendel was also known for his writings and lectures on architecture and its history. His conservative views on architectural education brought him into conflict with supporters of the modern movement and led to his resignation as Director of Education at the Architectural Association, London, in 1938, an important event in the early history of British Modernism. He became the acknowledged expert on 19th-century Gothic Revival architecture and played a large part in reviving interest in the subject after a long period of neglect. He was Slade Professor at Oxford University from 1933 to 1936 and President of the RIBA between 1937 and 1939.

WRITINGS

Nicholas Hawksmoor (London, 1924)

Vitruvian Nights (London, 1932)

Fine Art (London, 1934)

How Architecture Is Made (London, 1947)

English Architecture since the Regency (London, 1953)

BIBLIOGRAPHY

DNB

A. Powers: 'H. S. Goodhart-Rendel: The Appropriateness of Style', *Archit. Des.*, xlix (1979), pp. 44–51

——: *H. S. Goodhart-Rendel, 1887–1959* (London, 1987)

G. Stamp: 'Victorian Survival or Revival? The Case of H. S. Goodhart-Rendel', *AA Files*, xv (1987), pp. 60–66

ALAN POWERS

Goodhue, Bertram (Grosvenor) (*b* Pomfret, CT, 28 April 1869; *d* New York, 23 April 1924). American architect and illustrator. In 1892–1913 he worked in partnership with RALPH ADAMS CRAM, designing a remarkable series of Gothic Revival churches. His later work, in a variety of styles, culminated in the Nebraska State Capitol, a strikingly original design.

In 1884 Goodhue moved to New York, where he entered the office of Renwick, Aspinwall & Russell as an office boy. In 1891 he won a competition to design a proposed cathedral in Dallas but joined the office of Cram & Wentworth in Boston as chief draughtsman and informal partner. The following year Goodhue became a full partner in Cram, Wentworth & Goodhue which, after the death of Charles Wentworth (1861–97) and his replacement by Frank Ferguson (1861–1926), became in 1898 Cram, Goodhue & Ferguson.

Before Goodhue's arrival, Cram & Wentworth had already begun work on All Saints at Ashmont, Boston, their first major work. The final design clearly derives from their earlier proposal of 1890, but Cram's strong masses were enlivened by Goodhue's eloquent details and their talents clearly complemented each other. In their crusade for good church design, they collaborated on *Church Building* (1901), for which Cram wrote the text and Goodhue prepared the sketches. Cram's books and Goodhue's sketches stimulated an interest in church design and during the 1890s they worked on a series of churches, notably All Saints (1894), Brookline, MA, Our Saviour's (1897), Middleborough, MA, and St Stephen's (1899), Cohasset, MA.

Between 1896 and 1899 Goodhue executed a series of drawings of three imaginary locations. These three drawings, *Traumburg* (1896), *The Villa Fosca and its Garden* (1897) and the town of *Monteventoso* (1899), are highly romantic and embody many of the themes of Goodhue's executed work, such as the integration of buildings and landscape.

In 1902 Goodhue designed El Foreidis, Montecito, CA, a house and estate conceived as a Mediterranean villa with Persian gardens. The commission was for James Gillespie, with whom, in preparing for the work, Goodhue travelled on horseback from the Caspian Sea to the Persian Gulf, visiting Samarkand. The trip provided inspiration for much of Goodhue's later work, particularly his garden designs for Sweet Briar College (1902), VA, Rice University (1910), Houston, and the Panama–California Exposition (1911–15).

In 1903 the firm achieved national fame with their winning entry for the competition for extensive work at the US Military Academy at West Point, NY. The buildings were acclaimed, particularly the chapel, designed primarily by Goodhue and picturesquely sited along the Hudson River, and the riding hall, designed primarily by Cram. An office was set up in New York under Goodhue's direction, but the partners' separation, their strong personalities and contentious office staff led to the partnership being dissolved in 1913.

During the decade 1903–13 Goodhue developed his independent ability as a church architect, as the New York office took the lead in the design of a number of church buildings following his West Point Chapel. These include St John's (1907), West Hartford, CT, Christ Church (1908), West Haven, CT, and the First Baptist Church (1909), Pittsburgh, PA. The chapel of the Intercession (1910), Broadway and 155th Street, New York, is an imaginative Gothic Revival design, with dramatic massing, that exploits its semi-rural location within a cemetery. The interior illustrates Goodhue's command of Gothic detail and decoration (see fig.), still very much in the style of Cram. For his own grand design for the high altar reredos at St Thomas, Fifth Avenue, New York, Goodhue won the American Institute of Architects Gold Medal in 1925.

After 1913 Goodhue executed a series of church commissions, including St Bartholomew's (1914), Park Avenue and 50th Street, New York, built in a Byzantine style with much polychromy, the church of St Vincent Ferrer (1914), 66th Street and Lexington Avenue, New York, and the Rockefeller Chapel (1918), University of Chicago; increasingly, however, his best work was secular. The Aldred House (1913), Locust Valley, NY, and the Taft School (1908), Watertown, CT, are both Gothic Revival. In 1911–15 Goodhue was consulting architect for the Panama–California Exposition in San Diego. He designed the overall plan and many individual buildings in a picturesque early Mexican style. Much other work followed from this, including Tyrone (1914), a 'company

Bertram Goodhue: interior of the chapel of the Intercession, New York, 1910

town' in New Mexico, the campus at the California Institute of Technology (1917), Pasadena, and the Academy of Fine Arts (1922), Honolulu, HI. His designs of the 1920s include the massive Sterling Library (1921, completed by James Gamble Rogers, 1924–30) at Yale University, a notable version of Perpendicular architecture. The National Academy of Sciences building (1919), Washington, DC, and the Los Angeles Library are a free interpretation of classicism, which was a distinct departure in his work. This reached a climax with his State Capitol of Nebraska (1920–32) at Lincoln, an original, forceful design, fusing Gothic drama and classical balance, with its Greek-cross plan and skyscraper tower. The building expresses both its time, the beginning of the Modern Movement, and its place, the Midwest, and is one of Goodhue's most striking designs.

BIBLIOGRAPHY

M. Schuyler: 'The Words of Cram, Goodhue and Ferguson', *Archit. Rec.*, xxix (1911), pp. 1–112

A Book of Architectural and Decorative Drawings by Bertram Grosvenor Goodhue (New York, 1914)

C. H. Whitaker, ed.: *Bertram Grosvenor Goodhue: Architect and Master of Many Arts* (New York, 1925/R 1976)

Book Decorations by Bertram Grosvenor Goodhue (New York, 1931)

R. Oliver: *Bertram Grosvenor Goodhue* (New York and Cambridge, MA, 1983)

DOUGLASS SHAND-TUCCI

Illustration Acknowledgements

We are grateful to those listed below for permission to reproduce copyright illustrative material and to those contributors who supplied photographs or helped us to obtain them. The word 'Photo:' precedes the names of large commercial or archival sources who have provided us with photographs, as well as the names of individual photographers (where known). It has generally not been used before the names of owners of works of art, such as museums and civic bodies. Every effort has been made to contact copyright holders and to credit them appropriately; we apologize to anyone who may have been omitted from the acknowledgements or cited incorrectly. Any error brought to our attention will be corrected in subsequent editions. Where illustrations have been taken from books, publication details are provided in the acknowledgements below.

Line drawings, maps, plans, chronological tables and family trees commissioned by the *Dictionary of Art* are not included in the list below. All of the maps in the dictionary were produced by Oxford Illustrators Ltd, who were also responsible for some of the line drawings. Most of the line drawings and plans, however, were drawn by the following artists: Diane Fortenberry, Lorraine Hodghton, Chris Miners, Amanda Patton, Mike Pringle, Jo Richards, Miranda Schofield, John Tiernan, John Wilson and Philip Winton. The chronological tables and family trees were prepared initially by Kate Boatfield and finalized by John Johnson.

Galilee Photo: Anthony Kersting, London

Galilei, Alessandro *1* Photo: Conway Library, Courtauld Institute of Art, London; *2* Photo: Archivi Alinari, Florence

Galizia, Fede Pinacoteca Ambrosiana, Milan

Galle: (1) Philip Galle Trustees of the British Museum, London

Galle: (3) Cornelis Galle (iii) Trustees of the British Museum, London

Gallé, Emile © DACS, 1996

Gallen-Kallela, Akseli Ateneum, Helsinki/Photo: Central Art Archives, Helsinki

Galliari: (1) Bernardino Galliari Museo Civico d'Arte Antica, Turin

Galli-Bibiena: (1) Ferdinando Galli-Bibiena Institut für Theaterwissenschaft, Universität zu Köln, Cologne

Galli-Bibiena: (3) Giuseppe Galli-Bibiena Cleveland Museum of Art, Cleveland, OH

Gameren, Tylman van Institute of Art PAN, Warsaw

Gandolfi: (1) Ubaldo Gandolfi Palazzo Comunale, Bologna

Gandolfi: (2) Gaetano Gandolfi *1* Gabinetto Fotografico, Soprintendenza ai Beni Artistici e Storici, Bologna; *2* Photo: Dr Mimi Cazort

Gandolfi: (3) Mauro Gandolfi Gabinetto Fotografico, Soprintendenza ai Beni Artistici e Storici, Bologna

Gandon, James Photo: Anthony Kersting, London

Gandy, Joseph Michael Trustees of Sir John Soane's Museum, London

Gao Fenghan Osaka Municipal Museum

Gao Qipei Rijksmuseum, Amsterdam

García Hidalgo, José Photo: Ampliaciones y Reproducciones MAS, Barcelona

Garden *1* Rome, Pucci/Photo: Overseas Agenzia Fotografica, Milan; *2* Photo: Giraudon, Paris; *3* Photo: Scala, Florence; *4, 60,* Photo: Country Life Picture Library, London; *5* Bodleian Library, Oxford; *6* Trustees of the British Museum, London; *7* Photo: Ancient Art and Architecture Collection, London; *8–9* Photo: Stanley A. Jashemski; *10* Trustees of the Chester Beatty Library, Dublin; *11* British Library, London (India Office no. 805); *12* Country Life Picture Library, London/Photo: Gill; *13* Glasgow Museums (Burrell Collection); *14, 39, 43* Photo: Archivi Alinari, Florence; *15* Photo: James Dickie; *16* Photo: Jonathan M. Bloom; *17* Photo: Bernard O'Kane; *18* Topkapı Palace Museum, Istanbul; *19* National Palace Museum, Taipei; *20–21* Photo: Chung Wah Nan and Partners, Hong Kong; *22* Photo: Ann Paludan; *23* Metropolitan Museum of Art, New York (Gift of Constance Tang Fong, in honour of Mrs P.Y. Tang, 1982; no. 1982.461); *25, 29* Photo: Werner Forman Archive, London; *27, 32* Photo: Suzanne Perrin; *30* University of Kyoto; *33* Photo: Photobank, Singapore; *34* Photo: © Tettoni, Cassio and Associates Pte Ltd, Singapore; *35* Koninklijke Bibliotheek, The Hague; *36* British Library, London (Egerton MS. 1069, fol. 1; *37* Städelsches Kunstinstitut und Städtische Galerie, Frankfurt am Main (on loan from the Historisches Museum, Frankfurt am Main)/Photo: Ursula Edelmann; *38* Bildarchiv, Österreichische Nationalbibliothek, Vienna; *40* Photo: Conway Library, Courtauld Institute of Art, London/Photo: John Shearman; *41, 45, 47* Bibliothèque Nationale de France, Paris; *42* British Library, London (no. 1299.m.9, pl. 16); *44* Board of Trustees of the Victoria and Albert Museum, London; *46* Photo: © RMN, Paris; *48* Garden Picture Library, London/Photo: Vaughan Fleming; *49* British Library, London (no. 800.cc.26); *50* Devonshire Collection, Chatsworth, Derbys. By permission of the Duke of Devonshire and the Trustees of the Chatsworth Settlement; *51* Photo: Sir John Clerk of Penicuik; *52* Photo: Anthony Kersting, London; *53* Photo: Teugh Airport, the Netherlands; *54* Photo: Bildarchiv Foto Marburg; *55* Photo: NOVOSTI Photo Library, London; *56* Photo: Prof. Magne Bruun, Agricultural University of Norway, Ås; *57* South Carolina Historical Society, Charleston, SC; *58* Lindley Library, Royal Horticultural Society, London; *59* British Library, London (no. Tab.442.a.2); *61* Dumbarton Oaks, Washington, DC/Photo: Byzantine Visual Resources/© 1996; *62* Photo: PepsiCo, Inc./© 1989

Garden city Aerofilms of Borehamwood

Gargallo, Pablo Photo: Sougez/P. Gargallo/© DACS, 1996

Gargoyle Photo: James Austin, Cambridge

Garni Institute of Art, Academy of Sciences of Armenia, Erevan/Photo: VAAP, Moscow

Garnier, Charles *1* Photo: Anthony Kersting, London; *2* Bibliothèque Nationale de France, Paris

Garnier, Etienne-Barthélemy Photo: © RMN, Paris

Garnier, Tony Photo: British Architectural Library, RIBA, London

Garofalo Photo: Archivi Alinari, Florence

Gärtner: (2) Friedrich von Gärtner Photo: Bildarchiv Foto Marburg

Gassel, Lucas Photo: © ACL Brussels

Gate-house *1* Photo: Bildarchiv Foto Marburg; *2* Photo: Dr Francis Woodman

Gate lodge Photo: Tim Mowl

Gaudí, Antoni *1–2* Photo: F. Catala Roca, Barcelona

Gaudier-Brzeska, Henri Tate Gallery, London

Gauguin, Paul *1, 3, 5* Photo: © RMN, Paris; *2* National Gallery of Scotland, Edinburgh; *4* Museum Folkwang, Essen; *6* Art Institute of Chicago, Chicago, IL/© 1996. All rights reserved

Gaul, August Photo: Hilda Deecke, Berlin

Gaulli, Giovanni Battista *1* Photo: Archivi Alinari, Florence; *2* Photo: Scala, Florence; *3* Photo: Gabinetto Fotografico Nazionale, Istituto Centrale per il Catalogo e la Documentazione, Rome; *4* Royal Collection, Windsor Castle/© Her Majesty Queen Elizabeth II

Gavarni, Paul Trustees of the British Museum, London

Gavrinis Photo: Editions Jos le Doare, Chatreaulin

Gay and lesbian art *1* Harvard University Art Museums, Cambridge, MA; *2* © Reinhard Friedrich, Berlin, and DACS, London, 1996; *3* Hirshhorn Museum and Sculpture Garden, Smithsonian Institution, Washington, DC (Museum Purchase, 1989)/Photo: Lee Stalsworth; *4*

Gifford, Sanford Robinson Metropolitan Museum of Art, New York

Gigante, Giacinto Soprintendenza per i Beni Artistici e Storici, Naples

Gilbert, Alfred *1* Photo: Conway Library, Courtauld Institute of Art, London; *2* Royal Collection, Windsor Castle/© Her Majesty Queen Elizabeth II

Gilbert, Cass Library of Congress, Washington, DC

Gilbert, Emile Bibliothèque Nationale de France, Paris

Gil de Hontañón: (3) Rodrigo Gil de Hontañón Photo: Ampliaciones y Reproducciones MAS, Barcelona

Gilding *1* British Library, London (no. C.57.b.17); *2* Trustees of the National Gallery, London; *3–4* Board of Trustees of the Victoria and Albert Museum, London

Gill, Irving Photo: © Julius Shulman, Hon. AIA, Los Angeles, CA

Gillot, Claude Photo: © RMN, Paris

Gillray, James Board of Trustees of the Victoria and Albert Museum, London

Gilly: (2) Friedrich Gilly Staatliche Museen zu Berlin, Preussischer Kulturbesitz

Gilman, Harold City Art Galleries, Sheffield

Gilpin: (2) Sawrey Gilpin Yale Center for British Art, New Haven, CT

Ginzburg, Moisey Photo: Catherine Cooke

Giocondo, Giovanni British Library, London (no. G.9009)

Giordano, Luca *1* Photo: Gabinetto Fotografico Nazionale, Istituto Centrale per il Catalogo e la Documentazione, Rome; *2* Photo: Archivi Alinari, Florence; *3* Philadelphia Museum of Art, Philadelphia, PA (Purchased: W.P. Wilstach Collection); *4* Soprintendenza per i Beni Artistici e Storici, Naples

Giorgio d'Alemagna Soprintendenza per i Beni Artistici e Storici di Modena e Reggio Emilia

Giorgio da Sebenico Photo: Tim Benton, Cambridge

Giorgione *1, 4* Kunsthistorisches Museum, Vienna; *2* San Diego Museum of Art, San Diego, CA; *3* Gabinetto Fotografico, Soprintendenza ai Beni Artistici e Storici, Venice; *5* Staatliche Kunstsammlungen Dresden; *6* Photo: Scala, Florence

Giotto *1–2, 4–10* Photo: Archivi Alinari, Florence; *3* Photo: Overseas Agenzia Fotografica, Milan

Giovanetti, Matteo Musée du Petit Palais, Avignon

Giovanni Antonio da Brescia Trustees of the British Museum, London

Giovanni da Milano *1* Photo: Archivi Alinari, Florence; *2* Trustees of the National Gallery, London

Giovanni da Modena Photo: Scala, Florence

Giovanni da San Giovanni Photo: Gabinetto Fotografico Nazionale, Istituto Centrale per il Catalogo e la Documentazione, Rome

Giovanni del Biondo Photo: Archivi Alinari, Florence

Giovanni di Consalvo Photo: Archivi Alinari, Florence

Giovanni di Paolo *1* Photo: Archivi Alinari, Florence; *2* Metropolitan Museum of Art, New York (Rogers Fund, 1906; no. 06.1046)

Giraldi, Guglielmo Biblioteca–Pinacoteca Ambrosiana, Milan

Girardon, François *1–2* Photo: Giraudon, Paris

Girodet, Anne-Louis *1–2* Photo: © RMN, Paris

Girolamo da Cremona Cleveland Museum of Art, Cleveland, OH (Gift of the Rt Rev. William A. Leonard through Florence Sullivan; no. 30.661)

Girolamo da Treviso (ii) Photo: Gabinetto Fotografico Nazionale, Istituto Centrale per il Catalogo e la Documentazione, Rome

Girona Institut d'Estudis Catalans, Barcelona/Photo: Ramon Roca i Junyent

Girtin, Thomas *1* Tate Gallery, London; *2* Board of Trustees of the Victoria and Albert Museum, London

Giulio Romano *1, 4, 6* Photo: Archivi Alinari, Florence; *2, 5* Photo: © RMN, Paris; *3* Kunstmuseum, Düsseldorf

Giunta Pisano Museo Nazionale di San Matteo, Pisa/Photo: L. Artini

Giunti, Domenico Museo d'Arte Antica, Castello Sforzesco, Milan

Giusti, Alessandro Photo: Conway Library, Courtauld Institute of Art, London

Giustiniani (i): (2) Vincenzo Giustiniani Staatliche Museen zu Berlin, Preussischer Kulturbesitz

Giza Museum of Fine Arts, Boston, MA

Glanum Photo: Ancient Art and Architecture Collection, London

Glasgow *1* Photo: Lawrence and Wrightson, London; *2, 4* Mitchell Library, Glasgow City Libraries; *3* City of Glasgow; *5* Photo: © Historic Scotland

Glass *1* Broadfield House Glass Museum, Kingswinford, West Midlands; *2* Topkapı Palace Museum, Istanbul; *3* Board of Trustees of the Victoria and Albert Museum, London; *4* Ashmolean Museum, Oxford; *5* Trustees of the British Museum, London; *6* Devonshire Collection, Chatsworth, Derbys. By permission of the Duke of Devonshire and the Trustees of the Chatsworth Settlement; *7* Photo: Tim Benton, Cambridge; *8* Photo: © Julius Shulman, Hon. AIA, Los Angeles, CA; *9* Hyatt Regency at Reunion Tower, Dallas, TX; *10* Metropolitan Museum of Art, New York (Gift of William D. and Rose D. Barker, 1978; no. 1978.438); *11* Trustees of the Wallace Collection, London

Glass painting Schweizerisches Landesmuseum, Zurich (no. LM23694)

Glastonbury Abbey *1–2* Photo: Conway Library, Courtauld Institute of Art, London

Glauber, Johannes Museum of Fine Arts, Boston, MA (Juliana Cheney Edwards Collection)

Gleizes, Albert Solomon R. Guggenheim Foundation, New York (no. FN 44.942)/Photo: Robert E. Mates/© ADAGP, Paris, and DACS, London, 1996

Glendalough Commissioners of Public Works in Ireland, Dublin

Gleyre, Charles Photo: © RMN, Paris

Globe *1–3* Bildarchiv, Österreichische Nationalbibliothek, Vienna

Gloucester *1* © Maurice H. Ridgway/Photo: Fred H. Crossley; *2* Photo: Anthony Kersting, London

Gniezno Photo: Zygmunt Świechowski

Gobelins *1* Photo: © RMN, Paris; *2* Collection of the Duke of Northumberland

Godwin, E. W. Board of Trustees of the Victoria and Albert Museum, London

Goes, Hugo van der *1* Gabinetto Fotografico, Soprintendenza ai Beni Artistici e Storici, Florence; *2, 5* Staatliche Museen zu Berlin, Preussischer Kulturbesitz; *3* Kunsthistorisches Museum, Vienna; *4* Groeningemuseum, Bruges/Photo: Bridgeman Art Library, London

Goethe, Johann Wolfgang von Städelsches Kunstinstitut und Städtische Galerie, Frankfurt am Main

Goff, Bruce Art Institute of Chicago, Chicago, IL/© 1996. All rights reserved

Gogh, Vincent van *1* Stedelijk Museum, Amsterdam; *2, 4* Photo: Bridgeman Art Library, London; *3* Kröller-Müller Museum, Otterlo

Gold *1* © Louis Osman/Royal Collection, Crown Jewels, Tower of London/© Her Majesty Queen Elizabeth II; *2* National Museum of Ireland, Dublin; *3–4* Trustees of the British Museum, London

Golosov: (2) Il'ya Golosov Photo: VAAP, Moscow

Goltzius, Hendrick *1* Teylers Museum, Haarlem; *2* Rijksmuseum, Amsterdam; *3* Kunstsammlungen der Veste Coburg; *4* Rijkdienst Beeldende Kunsten, Amsterdam (original belonging to the Mauritshuis, on loan to the Frans Halsmuseum, Haarlem)/Photo: Tom Haartsen

Goltzius, Hubertus Stedelijke Musea, Bruges

Gonçalves, Nuno *1* Museu Nacional de Arte Antiga, Lisbon; *2* Arquivo Nacional de Fotografia, Lisbon

Goncharova, Natal'ya *1* Musée National d'Art Moderne, Paris/© ADAGP, Paris, and DACS, London, 1996; *2* Musée National d'Art Moderne, Paris

Goncourt, de Photo: David Scott

Gong Xian Museum Rietberg, Zurich

González, Julio Museum of Modern Art, New York (Mrs Simon Guggenheim Fund)/© ADAGP, Paris, and DACS, London, 1996

González Velázquez: (3) Antonio González Velázquez Photo: Patrimonio Nacional Archivo Fotografico, Madrid

Goodhue, Bertram Photo: British Architectural Library, RIBA, London